PRICE GUIDE TO ANTIQUE AND CLASSIC CAMERAS

Ninth Edition 1995-1996

Edited by James M. McKeown and Joan C. McKeown

ON THE COVERS:

Dallmeyer Stereo Camera Hegelein Watch Camera Nikon M, 1949 type

Dallmeyer Half-plate transitional Wet/Dry-plate outfit Includes: single and stereo lenses, wooden flap shutters, wet and dry plate holders, and original fitted trunk.

DISTRIBUTORS

WORLDWIDE:

Centennial Photo 11595 State Road 70 Grantsburg, WI 54840 USA tel 715 689-2153 fax 715 689-2277

USA & CANADA:

Amphoto/Watson-Guptill 1515 Broadway New York, NY 10036 tel 800-451-1741 fax 908-363-0338

UNITED KINGDOM:

Newpro UK Limited Old Sawmills Road Faringdon, Oxon SN7 7DS England tel (0367) 242411 fax (0367) 241124

GERMANY PHOTO TRADE:

Stubing, Kellner & Schick Postfach 8209/10 D-33649 Bielefeld tel (0521) 4 55 55 / 56 fax (0521) 45 07 78

GERMANY BOOK TRADE:

H. Lindemanns Buchhandlung Nadlerstrasse 10 Postfach 10 31 51 D-70173 Stuttgart tel (0711) 23 34 99 fax (0711) 236 96 72

SPAIN:

Omnicon S.A. Hierro, 9 - 3° - 7 28045 Madrid tel (91) 527 82 49 fax (91) 528 13 48

NETHERLANDS:

Sonja Kalkman Bookimport Postbus 3 3830 AA Leusden tel 033 94 72 00 fax 033 95 22 51

AUSTRIA, HUNGARY, CZECHOSLOVAKIA:

Peter Jonas Ges m.b.H. Gumpendorfer Strasse 94 1060 Wien tel (0222) 596 1209 fax (0222) 596 1209 72

Ninth Edition on press. Published August 1, 1994

Copyright 1994 by James M. McKeown and Joan C. McKeown.
All rights reserved. No part of this book may be
reproduced or transmitted in any form or by any means,
electronic or mechanical, including photocopying,
recording, or by any information storage and retrieval
system, without permission in writing from the Publisher.
For information address: Centennial Photo Service
Grantsburg, Wisconsin 54840 U.S.A.

EDITORS

James M. McKeown Joan C. McKeown

PRODUCTION ASSISTANTS

Barbara Lind Terry Fisk Jim Martin

CONSULTANTS & CONTRIBUTORS

Roger Adams Dennis Allaman Ron Anger John Baird **Bob Barlow** Greg Bedore Guy Borgé Sig Bloom **British Journal**

Photographic Almanac Benn Bunyar Jeremy Byers LeeAnne Byers Robert Byers Bob Campbell William P. Carroll Danilo Cecchi Don Chatterton Christie's John Courtis Bob Coyle John S. Craig Lyle Curr Rav D'Addario Manuel De Coimbra Wim De Groot Dr. Peter Dechert Dr. Arthur Evans Ramon Farrando Stein Falchenberg Fieldgrass & Gale Jean-Paul Francesch Adam Geschwind Bill Heimanson Takashi Hibi

Leo Hilkhuiisen

Matthew Isenberg

Frederic Hoch

Ruud Hoff

Ken Hough

Taneo Imai

Leon Jacobson David L. Jentz, M.D. Robert Johnson Marti Jones Alan Kattelle KEH Camera Brokers Kirk Kekatos Mike Kessler Alan Kattelle

Mead Kibbey Dr. Rudolf Kingslake Ray Kirlin George Kirkman Jaap Korten

Mike Kramer Helmut Kummer Bajtai Lajos Wes Lambert Cliff Latford

Eaton S. Lothrop, Jr. Peter Lownds John Luebs Steve Lyons Jim Martin Bill McBride Mike McCabe Tom McKeown Tim McNally John Moorhouse Agusti Moral

W. S. Morley Thurman F. Naylor Richard Paine Parker Pen Co.

Pilecki's Camera Exchange

Bob Plotkin Patrice-Hervé Pont Harry Poster Jean-Loup Princelle

Michael Pritchard Jack & Debbie Quigley Roger Reinke Cynthia A. Repinski **IJsbrand Rogge** Gerd Rosskamp Robert Rotoloni Dr. Burton Rubin Douglas St. Denny

Marie-Christine St. Denny Richard Sanford

Bill Savage Dieter Scheiba Manfred Schmidt Basil Skinner Harry Smith Jerry Smith Bob Sperling Harold Stacy Frank Storey Jim Stewart Koichi Sugiyama Thomas A. Surovek Len Sweetman Keith Taylor Jay Tepper Helge Thelander

Peter Toch Gerardo Valdes Paul-Henry van Hasbroeck Vintage Cameras Ltd.

Gene Vogel Gerry Vogel Marge Vogel Peter Walnes

Edmond & Gaby Waltuch

Jan Weijers Allen Weiner Gene Whitman Darrel Womack Brian Woodward Max Zimmermann Marie & Bob Zimmers

ACKNOWLEDGEMENTS

This book has grown continually since we first began researching camera prices in 1969. Obviously, this could not be the work of a single individual. We are proud that our guide has become the world's standard camera reference, and much of the credit belongs to the many serious collectors who have voluntarily submitted information and photographs to share with their fellow collectors. The depth of information in these specialized areas would only be possible through their cooperation, for while the job of editing this guide requires a broad general interest in the field, this wide interest is necessarily shallow overall. As the years pass, the number of contibutors grows, and it becomes more difficult to isolate the contributions of one or another consultant. Don't let that bother you. Just read the list of consultants on the editorial page from time to time. Then, when you meet one of these people at a collectors fair, just say, "Thanks for sharing your knowledge with all of us."

McKeown's Law:

The price of an antique camera is entirely dependent upon the moods of the buyer and seller at the time of the transaction.

SAVE 20% ON EVERY NEW BOOK WE PUBLISH

We can't control the cost of paper and printing, but we can hold down your cost for the next edition of this book. Each time we go to press, we need cash to buy over 10 tons of paper, not to mention all the associated supplies an services. By ordering your book a month or two in advance, you help us tremendously. Not only does it help us with our printing costs, but it gives us time to get your mailing label and package ready so we can ship your book within hours of the time it leaves the bindery. In return for your early order, we give you a 20% discount. Where else can you get a 20% per **month** return on your investment? But we can't offer you this special price if we don't know who you are. We promise to offer you a discount, plus **first day shipping** if you will just send your name and address on a postcard or letter to:

Centennial Photo Pre-Pub Club 11595 State Road 70 Grantsburg, WI 54840

CONTENTS

On the Covers	2
Acknowledgements	4
Table of Contents	5
Introduction English German Dutch French Spanish Italian	6 12 19 25 31 37
Collectors' Organizations	44
Museums	46
Auction Records	49
Stolen Cameras	49
Still Cameras by Manufacturer	50
Movie Cameras by Manufacturer	453
Non-Cameras	472
Accessories	500
Leica Serial Numbers	512
Schneider and Zeiss Lens Numbers	517
Dating by Patent Numbers	518
Index	519
Advertisements	577

INTRODUCTION to NINTH EDITION

The first edition of Price Guide to Antique & Classic Still Cameras was published in 1974. Since that time, this guide has been the single most complete and accurate reference guide to cameras in the world. The first edition included 1000 cameras. This Ninth Edition now includes over nine times that number. Not only has it been expanded to include more camera models, but we have made every effort to expand the information given for the individual cameras, providing dates and historical information wherever possible. We have also added over 500 new photographs for this edition to make a total of 3500 illustrations. Each new edition of this guide has made significant improvements over the last, and with your support we hope to continue this tradition. For example, this edition witnesses the addition of hundreds of lenses and accessories for the camera systems of the 1960's and 1970's. Although many of these are still usable. they are also firmly established as collectibles. In addition to reporting on the cameras which are routine merchandise for dealers, we try to ferret out the cameras that are not listed in any of the standard reference works. In this edition, you will find over 2000 cameras that do not appear in any other reference book. We hope you enjoy them.

WHERE ARE PRICES GOING?

In order to understand the current and future prices of collectible cameras, it helps to know some of the history. The general trends of prices ascended through 1981 and leveled off about 1982-83 with some items beginning to drop. In 1983 and 1984, camera prices dropped considerably, especially in reference to the American Dollar, which is our basis. Partially this was due to the general softening of the market; much of the loss was due to the rapid rise in the value of the dollar compared to other currencies. The rate of decline slowed in 1985, and by 1986 had stabilized and some items had begun to recover. By late 1986 and early 1987, the relative strength of British, German, and Japanese currencies against the Dollar had strengthened the market, since shopping for classic cameras in the U.S. was a little like shopping in a discount store. Prices in the U.S. began to firm up for many of the better collectibles. From 1987 through 1989, we saw sharply rising prices in specific areas. The Japanese had been influencing prices upward for several years with the strength of the Yen. We now have an increasingly competitive environment among the collectors in Tokyo, Europe, Hong Kong, USA, & elsewhere. Some prices have escalated at rates that even dealers have trouble believing. prices have become more stable, but only to be replaced by an infatuation with Canon and Nikon rangefinder cameras. Leica copies, once a poor man's substitute, have become in many cases more valuable than the real Leicas they imitated.

The general trend in collecting is toward the high quality, sophisticated cameras of postwar period (1945-1970's). Japan played an increasingly dominant role in camera production during this period. In the last decade, the Japanese have bought these cameras back by the thousands. It became an active and lucrative market segment. More recently, serious

collectors and dealers in Hong Kong and Europe have paid prices which rival the prices of Japanese buyers. The lure of profit has created a new breed of dealers and middlemen for the inflationary mar-Quite apart from the mainstream market of chrome and leather machines, there are isolated individuals and groups who continue to discover beautiful wood, brass, and leather antique cameras. The value of many older cameras is relatively stable. There are not enough of these "antiques" to support a new generation of weekend camera dealers. One might even suspect that collectors of the older cameras have a fondness for cameras that is not directly related to cash. Early, rare, historically important cameras are seen less often, but so too are collectors and dealers who recognize them.

Rare, early cameras have set new record prices in the last two years at auction, but that market is very thin. Low reserve prices have led to spiraled competition and high prices achieved. On the other hand, high reserve prices have had the opposite effect, often causing all prospective bidders to shun some very important pieces.

Collectors have become increasingly aware of condition. A camera which is not clean and attractive becomes difficult to sell. A few cameras escape this scrutiny if they are extremely rare, but ordinary "merchandise" had better be clean, and preferably functioning as well.

When camera collecting was experiencing a boom in the late 1970's, speculators began buying heavily and indiscriminately. This fanned the flames of inflation and drove prices to the breaking point. A major slump followed in 1982-83. The inflationary market in Japan has followed a similar pattern, but is now more stable. Prices throughout the world have become more equalized, and top prices will be paid by collectors in various countries.

Some camera types have done well in the last few years. Any color other than black demands a premium. Box cameras (except ordinary black ones) are finally getting off the ground. Colored box cameras, those with art-deco styling, unusually shaped plastic ones, etc. have been picked up by the demand/supply ratio. Europe is a bit ahead of the USA in this regard. Also worth noting: some art-deco cameras have brought considerably better prices in the art market than in the traditional camera collectors circles.

RUSSIAN & SOVIET CAMERAS

For many years, Soviet cameras were not too common in Western Europe, and rarely if ever seen in the United States. phenomenon of the "Cold War" has suddenly been reversed. The Soviet Union and the Eastern Bloc countries have suddenly opened their walls. Many Soviet cameras once considered extremely rare are appearing in record numbers at collector fairs and in camera shops throughout Europe and in the United States. Prices on many Soviet cameras have dropped rapidly with the new supply. Some dealers and collectors, who bought at the old prices, are reluctant to lower their asking prices. For these reasons, the market in Russian cameras is unstable. It will take a few years before supply and demand equalize the prices. Some Russian cameras may still be rare, but not necessarily the same ones which were formerly regarded as such.

To further damage the long-term market for Russian/Soviet cameras, there are great quantities of "fakes". Any camera with special finish or special engraving is more likely to be a fake than a genuine artifact. There is an organized cartel of Russian and Polish dealers creating a steady stream of "collectible" cameras. In the process, they have ruined some cameras which had historical value, and transformed them into gold-plated or specially engraved junk. This practice will continue as long as collectors and dealers encourage it. The value of any remaining real items will be undermined, because buyers will always be skeptical. Provenance will be all-important, because lies and made-up stories come free with every camera.

At a recent collector fair, a Russian offered a "Luxus" Leica with a 4-digit serial number and WWII military markings. Not all fakes are so obvious (4-digit Leicas were out of production before Hitler came to power; military cameras were not "Luxus", etc. etc.)

"HOT" AND "COLD" MARKETS IN THE 1990'S

In the last few years, Nikon has taken the lead as the wild speculative rising star. There was a "feeding frenzy" encouraged by a small but determined number of collectors and dealers. This price spiral appears to have leveled off.

Subminiature cameras have shown continued strength, with most items still in affordable range for middle class people. But at Christie's landmark "Subminiature" auction in December 1991, a determined phone bidder caused frustration among prospective buyers in the auction room, and many lots set new price records. The ripple effect of this auction is still being felt. Subminiature prices have increased overall. However, some dreamers are still expecting "record" prices on a daily basis.

ADVICE TO NEW COLLECTORS

Our advice to collectors would depend entirely on your motives for collecting. If you are concerned with collecting as an investment, you should concentrate on the more rare and unusual camera models, which will naturally require more capital and expertise. If you are collecting primarily for the enjoyment of it, you should follow the dictates of your interest and budget. Many of the lower-priced cameras offer an inexpensive hobby, and often this is a good place to start. Depending on where you live, assembling a collection of Kodak, Coronet, or Agfa cameras could be relaxing and enjoyable, because many of the cameras can be found easily at modest prices. Most collectors start out with a general interest which often becomes more defined and specialized as they continue in collecting. If you are dealing in cameras to make a profit, you must maintain close contact with the market. Find your own niche and remain within your area of expertise. By following the market closely, you can make a profit from its ordinary fluctuations, and by knowing your customers' interests.

All prices in this edition have been updated. They are as current as possible, and data has been weighted toward the most recent figures. However, we have also retained the stabilizing influence of the last 10 year price record of each camera to prevent the "overshooting" which can occur in a less researched effort. Our prices tend to follow the long-term trends more accurately in the same way that a viscous-damped compass maintains a smooth heading.

The information and data in this edition is based on hundreds of thousands of verifiable sales, trades, offers, and auction bids. It is a reference work -- a research report. The prices do not tell you what I think the camera is worth, but they tell you what a lot of former owners and present owners thought it was worth at the moment of truth. That is the essence of "McKeown's Law" which states: "The price of an antique camera is entirely dependent upon the moods of the buyer and seller at the time of the transaction."

Several corollaries have been added to this general philosophy of collecting.

1. "If you pass up the chance to buy a camera you really want, you will never have that chance again."

2. "If you buy a camera because you know you will never have the chance again, a better example of the same camera will be offered to you a week later for a much lower price."

 "The intrinsic value of an antique or classic camera is directly proportional to the owner's certainty that someone else wants it."

These observations should always be taken into account when applying McKeown's Law.

INSTRUCTIONS FOR USE OF THIS GUIDE:

All cameras are listed by manufacturers in alphabetical order. A few cameras are listed by model name if we were not sure of the manufacturer. Generally, the cameras of each manufacturer are in alphabetical order, but occasionally we have grouped them by type, size, date of introduction, or other sequence appropriate to the situation.

Photos usually appear immediately above the boldface heading which describes that camera. For layout reasons, this is not always possible. At times, when the text continues to another column, the photograph appears in the middle of the paragraph which describes it. When the photo does not fit with the text, it is captioned in italic typeface, and a note at the end of the text gives the location of the photo. When a photo of one camera is placed at the end of a column where it splits the text of another camera, we have tried to set it apart visually with a simple bold line. Following these standards allows the normal boldface heading to double as a caption for most photos, thus saving a great deal of space. Captioning all 3500 photos would have required an additional 40 pages!

We have used different type faces to make the guide easier to follow. The pattern is as follows: MANUFACTURER (BOLDFACE UPPER CASE LETTERS) Historical notes or

comments on the manufacturer (italic).

Camera Name (Boldface) - Description of camera and current value data (medium face). *Special notes regarding camera or price (italic).*

CAMERA NAME - If the camera model name is in all caps, it is a separate listing, not related to the previous manufacturer. We use this style usually when the manufacturer is unknown to us.

At first glance, this style of layout may not be visually appealing from an "artistic" sense, but it has been carefully planned to conserve space, yet be easy to follow. Our computer could automatically add a box outline around each photo, but that would add 50 pages to this book. Similarly, if we drew little boxes around the columns of type, we could improve the appearance, but at a cost of an additional 90 pages. Our readers are serious collectors and dealers who want the maximum information in the smallest possible space. We hope you like our "little" book. If we took the easy and pretty approach to layout, this monster would be over 800 pages. That would be 30% thicker, heavier, and more expensive. We hope you will enjoy our simple style of more information in less space.

CONDITION OF CAMERAS

A camera in mint cosmetic condition, but not functioning may be perfectly acceptable to a collector who will put it on the shelf. On the other hand, a user may not care much about the appearance as long as it works. We strongly support the use of a uniform two-part grading system for appearance and operation of cameras. It should be implemented on a world-wide scale with the cooperation of price guides, collector publications and societies, auction houses and dealers.

In an effort to establish an international standard for describing condition, we proposed the following scale. We have purposely used a combination of a number and a letter to avoid any confusion with other grading systems already in use. Condition of a camera should be given as a single digit followed by a letter. The number represents cosmetic condition and the letter gives functional condition. This system has been adopted by the Photographic Collectors Club of Great Britain.

GRADE---COSMETIC CONDITION

0 - New merchandise, never sold. In original box, with warranties.

1 - AS NEW. Never used. Same as new, but no manufacturer's warranty. With box or original packaging.

2 - No signs of wear. If it had a box, you wouldn't be able to tell it from new.

3 - Very minimal signs of wear.

4 - Signs of light use, but not misuse. No other cosmetic damage.

5 - Complete, but showing signs of normal use or age.

6 - Complete, but showing signs of heavy use. Well used.

7 - Restorable. Some refinishing necessary. Minor parts may be broken or missing.

8 - Restorable. Refinishing required. May be missing some parts.

9 - For parts only, or major restoration if a

GRADE---FUNCTIONAL CONDITION

A - AS NEW. Everything functioning perfectly, with factory and/or dealer warranty.

B - AS NEW. Everything functioning perfectly, but not warranted by factory. Seller fully guaranties functioning.

C - Everything functioning. Recently professionally cleaned, lubricated, overhauled and fully guaranteed.

D - Everything functioning. Recently professionally cleaned, or overhauled, but no longer under warranty.

E - Everything functioning. Major functions have recently been professionally tested.

F - Not recently cleaned, lubed, or overhauled. Fully functioning, but accuracy of shutter or meter not guaranteed.

G - Fully functioning. Shutter speeds and/or meter probably not accurate. Needs adjusting or cleaning only.

H - Usable but not fully. Shutter may stick on slow speeds. Meter may not work.

J - NOT USABLE without repair or cleaning. Shutter, meter, film advance may be stuck, jammed, or broken.

K - Probably not repairable.

In this system, an average camera would be rated as 5F. A camera rated as 3G would mean cosmetically showing minimal signs of wear, but with questionable accuracy of meter or shutter. Thus a very specific description of condition fits in a small amount of space, and eliminates the problems which have been associated with word or letter descriptions which do not allow distinctions between cosmetic and functional condition. To be even more specific, users may wish to expand the cosmetic grade by using a second digit. Thus "56B" would mean cosmetic condition somewhere between grade 5 and 6, guaranteed to be functioning properly.

Since we proposed this system, Camera Shopper magazine and some dealers have adopted a similar system, but with the numerical values reversed so that 10 is the top grade. If buying any camera without inspecting it, be sure you know what grading system is in use.

Generally speaking, condition will affect prices as follows. However, these are only approximations. Condition affects price differently on various types and ages of cameras. Suggested allowances below are given as percentages of the listed price.

COMPARISON WITH OTHER GRADING SYSTEMS:

The following chart compares the Cosmetic portion of the condition grading system with some of the common word or letter descriptions currently in use. These comparisons are approximate and are provided only to help users move to the new system more easily. The last column in the table shows in general terms how condition will affect prices. However, these are only approximations. Condition affects price differently on various types and ages of cameras. The suggested allowances below are given as percentages of the listed price. We have not made any comparisons with the other "10-based" systems, because there are too many

variations in use by individual dealers.

McKeown			
PCCGB		German	% of
Christie's	SA	Auctions	book price
0	Ν	-	150-200%
1	LN	-	130-150%
2	M	Α	120-140%
3	M	AB	115-130%
4	E+	В	110-120%
5	E	С	95-115%
6	VG	CD	80-110%
7	G	D	55-85%
8	F	E	30-60%
9	P	-	10-30%

Any missing or loose parts should be specifically noted. Use of (-) after a condition number or letter means that it meets the standard except for minor condition AS DESCRIBED in adjoining comment. Use of (+) means it exceeds this condition standard, but doesn't qualify for next higher rating.

If your camera has missing or broken parts, it will take another similar parts camera to make it whole. Value formula: Parts camera 1 + Parts camera 2 + Labor = price of complete camera.

Sometimes collectors are more lenient in applying these standards to older and more rare cameras, and more strict in applying them to newer or more common models. This is somewhat self-defeating. If you describe a camera as "very good condition considering its age", you are adding a personal judgment that old cameras should be judged by a different set of standards. Even though most cameras of that age may show some signs of age, the fact that it is old does nothing to improve its condition.

INTERPRETATION OF PRICE FIGURES:

All price figures are in United States Dollars. Prices apply to cameras in condition range 5 according to the standards previously set forth. This is the most common condition in which cameras are found and collected, thus it makes the most useful standard. To determine the value of a particular camera, the user of this guide should consider any variation from this condition when assessing it and vary his value estimate accordingly.

Unless specifically stated "body only", the prices relate to a camera with normal lens, back, and whatever else might be part of its normal operating state.

The lower priced items in this guide and on the market tend to be slightly over-priced, simply because the cost and bother of advertising, selling, and shipping an \$5.00 item is not much different from the same costs and efforts to sell an item valued for hundreds or thousands of dollars. The middle priced items show the most accurate prices. They are the most commonly traded; they are in large supply, and thus the market is very stable. The higher priced cameras of any particular style, brand, or age tend to be the most volatile, because there is both limited supply and limited demand.

DON'T EXPECT TO GET "BOOK PRICE" FROM A DEALER

If you have one or two cameras for sale and expect to get top book price for them

from a dealer, you would do well to consider the situation from the dealer's viewpoint. In order to resell your camera, he has to repair and guarantee it. He must rent a table at camera shows, print and mail a list, and defend his price to buyers who want to pay no more than the low book price. After your camera goes unsold for a few months and shows a bit more wear from prospective buyers handling it, he wholesales it to another dealer for half price in trade for something else to sell. Often a camera passes through the hands of 4 or 5 dealers, before it finds that one elusive buyer who pays the "top price". The less valuable and more common your camera is, the more you have to learn from this example. If you indeed have an extremely rare or valuable camera, do not worry. The dealers will literally fight over it. This is a very competitive field.

PRICES OF CAMERAS IN JAPAN AND EUROPE

In some cases we have made price distinctions for the same camera in different markets such as USA, Europe, England, Germany, Japan, etc. Obviously there will be differences on other cameras where we have not made such notations. First of all, it should be made clear that the base price of most cameras is that at which it can generally be purchased in the country where it is most often available. For many simple cameras, this is the country of origin. However, since most cameras were imported into the USA, they can generally be found there for as low a price as anywhere in the world. The price difference between countries for inexpensive cameras is normally negligible and has not been noted in this guide except for particular models where a difference of more than shipping cost seems to be consistently Prices for many quality encountered. Japanese cameras are higher in Europe than in the USA. This is due to the fact that more of these cameras were originally imported into the USA. With a smaller supply in Europe, competition among collectors is greater.

The Dufa Pionyr is only one good example of a camera whose price varies considerably around the world. In Germany, near the source, these sell at auction for about \$25. Dealers in London have sold them for \$45 in original box. Those two figures define a reasonable and normal range. We have ignored the one we saw in a Ginza shop for \$125. Even though it may have sold for that price, we could not represent that as the norm.

PRICES PAST PEAK IN JAPAN

When the Japanese economy was at its peak, it was difficult for western buyers to pay competitive prices. Now we see a much more stable market worldwide.

HOW OUR PRICES ARE DETERMINED

We monitor and analyze prices from many varied sources worldwide, including traders publications, dealers lists, public auctions, and trade shows. Our database includes hundreds of thousands of transactions for each new edition, plus the accumulated base from previous editions. Although our formulas are proprietary, a few words may indicate why our statistics do not always reflect your own observations. You read a trader publication regularly and Camera X generally seems to be

advertised at \$275 to \$325. Your keen mind stores this for recall. Our computer does also. There is a good chance that the SAME ITEM has appeared for sale several times. Thus a price at which an item does not sell appears in print more often than a realistic price. In the case of the real Camera X, one dealer started offering it at \$450. After over a year of advertising, the same camera was still being offered for \$250 when we went to press. Many other confirmed sales worldwide tell us that Camera X regularly sells for \$125-175. Eventually, the dealer whose ads you have been reading may sell his overpriced camera to a buyer who has become accustomed to seeing it advertised at \$300 and thinks it a bargain when it appears for \$250. Our computer has a long memory which tracks individual cameras offered by dealers until they sell. "Unsold" prices are not data except as evidence of a price ceiling.

Our prices represent the normal range for the largest share of the cameras sold. Our prices are based on extensive research, not guesswork. We are not dealers in cameras, because we view that to be a conflict of interest.

EXCHANGE RATES

The prices in this guide represent average prices in the worldwide market. There are definite variations from these figures in particular markets. Some cameras are more common in one country than anoth-Collectors' interests are different in various parts of the world, and "trends" or "fads" affect different markets at different However, none of the world's markets are closed to outside influence, and the fluctuations have a tendency to level off on a world wide scale. A higher price in one country will tend to draw more cameras to that area and the world price rises until that demand eventually All values are exbecomes satisfied. pressed in U.S. Dollars. Because exchange rates vary continually, we will not confuse our readers with computer-generated conversions based on an arbitrary

As a general frame of reference, we are providing a chart listing the exchange rates for the U.S. Dollar values of the indicated currencies as of June 7, 1994. Multiplying these factors* times the U.S. Dollar price gives the value in the foreign currencies.

CURRENCY	= US\$	US\$1 = *
Australia \$.7345	0.3615
Austria Schill	.08602	11.625
Belgium Franc	.02917	34.282
Brazil Cruz.	.0004975	2010.05
Britain £	1.5095	0.6624
Canada \$.7287	1.3727
France Franc	.17598	5.6825
Germany DM	.6002	1.666
Hong Kong \$.12940	7.7280
Italy Lira	.0006188	1616.03
Japan Yen	.009602	104.15
Netherlands FI	.5354	1.8679
N.Zealand \$.5914	1.6909
Spain Peseta	.007331	136.41
Sweden Krona	.1262	7.9260
Switzerland Fr	.7078	1.4128

NOTE: Auction prices given in this guide are "hammer" prices, not including commissions and taxes paid by the buyer. Because the expenses paid by the buyer

and the vendor are approximately equal, the hammer price represents a logical average between the net realized by the seller and the gross paid by the buyer.

SELLING YOUR CLASSIC CAMERAS:

Whether you have a single camera for sale, or a large collection, whether you are an individual, a dealer, or a collector, there are several established means to sell collectible cameras. Each of these has advantages and disadvantages. One method may be best for one of your cameras and another method better for another camera.

AUCTIONS

Advantages - It will sell. It will be gone. You will get paid. Very rare cameras often fetch prices higher than expected. A low estimate or reserve usually brings more bidders and a higher sale price.

Disadvantages - Waiting period, usually several months, required to catalog items and prepare the sale. Commission (often more than offset by higher price realized). A high estimate sometimes discourages any bidding. When the item reappears in a subsequent auction at a lower price, the potential buyers often rememberit and abstain from bidding.

DEALERS

Advantages - Immediate sale and payment. No waiting for an ultimate buyer. Dealers pay good prices for unusual items. Sometimes dealers pay more than you could otherwise get, because they have a specialized client base in areas you could not easily reach. (Dealers often buy & sell to each other to benefit from this specialization.) No commissions deducted from sale price.

Disadvantages - Dealers must buy at a discount from what they consider retail. (This is not always a disadvantage, because they often have clients in a higher retail market than you might reach alone.) Some dealers will not make offers; you must have a price in mind. If you request offers from more than one dealer, you are effectively conducting your own auction. This is a game that gets very tiresome to dealers, and they may not wish to make offers at all. Because you are initiating the "auction game", some dealers will not begin with their best price, and you may have to "shop around" to several dealers, even returning for second bids.

CAMERA FAIRS, FLEA MARKETS - Advantages - No middleman. You keep the full price paid. (This may be more of a psychological than actual advantage after considering time & expenses.) Opportunity to mix with other collectors, share enthusiasm. Possible trades, upgrades, or purchases for your own collection or stock.

Disadvantages - Many hidden expenses, often more than a dealer's discount or auction commission.

Table or stall rental fees.

No guarantee of sales. You may carry an item for months or years, as some dealers also do.

Wear & tear on cameras can be devastating.

DISTRIBUTING LISTS

Advantages - Reach a wide market by mail, without time & expense of fairs. No handling of cameras before you sell.

Disadvantages - Potential buyers limited by size of mailing list. Cost of printing & mailing lists. Customers can not see merchandise before buying. Generally requires you to guarantee satisfaction or refund.

CLASSIFIED ADS

Advantages - Choose your publication to reach specific target audience. Club newsletters, commercial camera trading magazines, etc. Generally low cost, especially for just a few items.

Disadvantages - Time lag for publication and sale. Sale not assured, especially if you are holding out for top price. (However, sale is relatively certain if the item is really priced to sell.)

REPRODUCTIONS OF CAMERAS

As camera prices increase, so do the numbers of fakes, reproductions, and misrepresentations. For years, many collectors and dealers have known about the existence of these fakes, but instead of sharing their knowledge, they have kept their information "secret". We would like to make this information public to protect our readers and fellow collectors. We understand and accept that reproductions of rare cameras are important for museum and collection displays. We do not accept that any of these should be misrepresented and sold as originals. We have several choices. If there is room in collecting for both the collectors and the criminals, then no problem exists. Criminals are driving collectors away from their hobby. We feel that it should be the collectors who drive the criminals away. All we need do is share our information to keep fellow collectors from being misled.

The best known makers of reproductions, restorations, fakes and frauds are:

Luc Bertrand - Belgium. A craftsman who restores and reproduces cameras. Reproduces metal cameras well, and also makes wooden cameras which are quite difficult to distinguish from originals. He reproduces rare cameras in very small quantities, for his own collection and for private collectors and museums. In his favor, it must be said that he marks his reproductions with his initials and date. Unfortunately they have sometimes been misrepresented by others as originals. Pre-1989 reproductions were all done in very small series, usually 1 to 4 examples, of which Bertrand normally kept one in his own collection. Sometimes the others have a serial number 1 to 4 in addition to the "LB" or "BL" and date code. After 1989, Bertrand identifies his reproductions with a small "LFB" monogram stamped into the wood or metal. As of 1990, Bertrand had reproduced only about six cameras in series. Another fifteen or so were made in single examples for his personal collection. As of mid-1990, Bertrand stated that he had made a total of 35 replicas, half of which were still in his possession. Restorations by Bertrand are stamped also with his initials and date, on the part of the camera which has been restored.

Mr. Bertrand has been kind enough to give us samples of his monogram stampings so that we may make them public. This is an honest effort to keep any of his reproductions from being misrepresented.

INTRODUCTION: ENGLISH

Greenborough - We have not met nor spoken with Mr. Greenborough, and so our report is based on information from other collectors. Reportedly, he and his wife are both Polish, but living in Germany. Apparently he does not make cameras himself, but has had copies made of historical cameras, and has also marketed imaginative designs of recent inspiration. According to our sources, he has the copies made in Poland. It is our understanding that these copies are not identified as such, and that many are subsequently offered for sale as original cameras, either through ingnorance or deceit. One source indicates that he may no longer be operating in this business. Cameras attributed to Greenborough include: Leica 250, Minox Cigarette Lighter, Ticka Watch Camera (Taschenuhr Camera), Leica Luxus, John Player Cigarette package cameras.

Oberlaender - Has made replicas of some famous cameras, including the Doppel Sport (pigeon-borne aerial camera), and the "Photo Carnet" version of Dr. Kruegener's Taschenbuch Kamera. Some of these replicas are nearly indistinguishable from originals. We are not aware of any special markings on the pigeon cameras, and know of several cases where they have been represented and sold as originals. At least one of the Photo Carnet cameras was identified as a replica with the letter "R" after the serial number on the It was resold at Christie's in spine. December 1991. At the same sale, an example of the Doppel-Sport replica was Both of these were properly described by Christie's as replicas.

Both Greenborough and Oberlaender creations have been sold directly or indirectly to some of the most knowledgeable and respected collectors in the world. These and other reproductions have been integrated into major collections without notice being made as to their origin. They have been resold as originals, either by intent or through ignorance. A number of otherwise respected dealers have actively supported the counterfeiters by selling the forgeries as a part of their normal business, generally without admitting any knowledge of the origin of the goods, and often with a story which implies authenticity of the counterfeit goods.

Counterfeit cameras are often aged artificially.

THE FOLLOWING CAMERAS ARE KNOWN OR ALLEGED TO EXIST IN REPRODUCTION OR OUTRIGHT FORGERY:

BEN AKIBA - Cane-handle camera. Copies have been made by Oberlaender.

BERTSCH (small model). While we know of no examples of the large model being reproduced, there are definitely copies of the smaller one. Bertrand produced four examples, including two different magazine designs.

BRINS MONOCULAR CAMERA - At least four reproductions have been made by Luc Bertrand. Some have his initials and date (e.g. "BL82") stamped inside, but not all have been properly identified as reproductions by resellers. Reproductions likely outnumber originals on the market.

BUTCHER'S ROYAL MAIL POSTAGE STAMP CAMERA - Reproductions have been made in India in the mid-1980's, and offered to photographica dealers for resale. At least one reputable London dealer refused to buy any unless the maker promised to mark all of his creations distinctly as reproductions. The maker refused, and unmarked replicas have appeared on the market.

CONTAX (sand-colored) - There exists a genuine sand-colored Contax, sometimes called the "Rommel-Contax" because of its desert sand color. However, there are counterfeits made by Greenborough. At least 5 or 6 counterfeits have appeared. Generally the sand coloring comes off easily, revealing the ordinary chrome underneath.

DE NECK PHOTO CHAPEAU - Four reproductions made by Bertrand, of which at least two were sold.

ENJALBERT PHOTO REVOLER - Three known reproductions by Bertrand.

ENJALBERT TOURISTE - Copies exist from Bertrand.

FOTAL - Some copies have been offered on the market at about DM 2000. Source of manufacture unconfirmed.

JOHN PLAYER CIGARETTE PACKAGE -Reportedly made in Warsaw, Poland by a Mr. Kaminski. Although sometimes reputed to have been used by the KGB as spy cameras, we have seen no credible substantiating evidence. Most likely, these were designed and executed for the collector market.

KRUGENER TASCHENBUCH (Photo-Livre Mackenstein) - Copies have been made and sold which are somewhat crude reproductions. However, if the buyer is not familiar with the original, he could be misled by an unscrupulous seller. Other replicas are of good quality and could easily be mistaken for originals. At least one example made by Oberlaender is identified with the letter "R" (for Replica) stamped after the serial number on the spine.

LANCASTER WATCH CAMERA - Reproductions exist. Source unconfirmed.

LEICA (Anastigmat) - The Leica A Anastigmat camera is one of the rarest of Leicas. Fakes have been made, and even the lens has been sold separately. One American dealer advertised a genuine one for sale and listed its serial number in the ad. Shortly thereafter, the same serial number began to appear on fake ones.

LEICA I Elmax - Nine of ten on the market today are fakes. Lens probably started as an Elmar, then the name ground down, refilled and reengraved. These are nearly impossible to detect without removing the lens and inspecting it under a microscope

to count the lens elements. Elmar is a 4element lens and Elmax is a 5-element lens. Bodies are normally genuine.

LEICA LUXUS (gold models) - Counterfeits have allegedly been made by Greenborough, using "correct" serial numbers. Several different cameras bearing identical serial numbers have been sold to unwitting collectors. One example was offered by a well-known dealer to a shop in Brussels. The shop owner checked with the factory to verify if the number was correct. It was, so he bought the camera. Subsequently Leitz had several other inquiries regarding the same serial number, and it was determined that multiple copies existed using that same number.) Knowledgeable collectors are well aware of the existence of numerous gold Leicas originating in Poland and finding their way to the West and Japan, earlier through East Berlin. Several years ago, a genuine luxus camera, verified by the factory, was sold at Auktionshaus Cornwall in Cologne. Within six months, a fake with the same serial number had also appeared on the market. Russian "Fed" cameras have also been engraved with Leica markings and gold plated for sale to the collector market. Most "Luxus" Leica cameras on the market are fakes.

LEICA 250 REPORTER - Once thought to be a safe investment among Leica classics because of the difficulty of duplicating the body casting. This is no longer true. Fake Leica Reporters are now a staple in the Polish economy.

MARION METAL MINIATURE - maker unknown.

MINOX A LUXUS - Genuine examples have a patterned finish to the metal. Some normal models have been plated and have a smooth surface. These are easily spotted. Reportedly, there also exist some reproductions with patterned metal cases, presumably with genuine Minox working parts.

MINOX IN CIGARETTE LIGHTER - First appeared about early 1990. It consists of a normal Minox camera in a chunky gold-plated housing which also contains a butane lighter. There are several minor variations. It has been represented as a KGB camera, but is a totally modern curiosity without historical significance.

NEUBRONNER PIGEON CAMERA - Several appeared on the market about 1989. Source not verified.

RING CAMERAS - A number of cameras disguised as finger rings have appeared on the market in the last few years, sometimes attributed to the KGB. actual source is a talented artisan named Marek Mazur, of Gdansk, Poland. None are identical, although they employ a similar cylindrical film cartridge which forms the ring. The head of the ring varies. Several have a rectangular head with a small stone on each side of the central lens opening. These stones serve to regulate shutter and diaphragm. One of these rectangular head types had the trade name "Ernemann" engraved inside. similar ring camera, with a single stone in a crown-like setting, sold at auction for well

over \$20,000 in 1991. Although it was claimed to have been in a collection for over 10 years, its similarity to the assumed frauds gives cause for concern. Some of these rings are well-made and workable, while others are "all show and no go", with ill-fitting parts. It is possible that there are fake copies of the orignal Mazur rings.

SCENOGRAPHE - Reproductions exist, including the name on the bellows. Bertrand has made one for his own collection, but allegedly no others. We have heard reports of reproduced Scenographe cameras, but have not seen them and have no documentation.

SUTTON PANORAMIC CAMERA - One was made and sold by Bertrand as a reproduction. After switching hands several times it resides now in a major collection, being represented as original.

TICKA WATCH CAMERA - One example is identified inside as "TASCHENUHR CAMERA, D.R.P. 173567 H. Meyer-Frey. Frankfurt A/M." on the interior label. Authenticity is questionable. It may have been part of a scheme to replicate some of the more unusual variants of the Ticka, such as silver-plated versions. A "Watch-Face Ticka" was withdrawn from a Christie's auction after it was determined to be a forgery. It will no doubt surface again without warning.

VOIGTLÄNDER DAGUERREOTYPE CANNON - One known fake resides in a private collection. Not only is the size wrong, but the Voigtländer name is spelled wrong. Others probably exist.

READERS ARE ASKED TO REPORT FURTHER INFORMATION ABOUT ANY OF THESE OR OTHER REPLICAS & FORGERIES - We will be happy to publish further details about the cameras and/or any dealers or persons known to be intentionally defrauding camera collectors.

STOLEN CAMERAS - REWARDS OFFERED

There was a time when you could have left a half dozen of the world's most valuable cameras on an unguarded table at a collector fair, and they would have remained unharmed. Today there are an increasing number of thefts of valuable cameras. In an attempt to minimize this despicable practice, McKeown's *Price Guide to Antique and Classic Cameras* will maintain a list of stolen collector cameras in this and future editions of this guide.

Obviously, we can not list every stolen camera in the world, nor could you check every camera you purchase against such a list. So we will limit our list to cameras over \$1000 in value, and only those with serial numbers. Exceptions will be made for cameras which do not have serial numbers, but which are rare or unusual enough to be easily identifiable. We welcome other camera collector publications and clubs, to reproduce this list and add to it. Dealers, auction houses, and clubs are cooperating with this project and we all welcome your participation.

If something is stolen from you, report it to your local authorities. Give full description, serial numbers, etc. To get your lost item on this list, give us the same information,

plus your local police contact name, telephone number, and crime reference number. This will allow our readers or other police agencies to immediately contact your local authority if the items are sighted. We will not include items on our list which have not been reported to police as stolen. We act only as an information exchange, and will not become involved in any disputes.

If you are offered a camera or lens listed as stolen, you should get the identity of the person offering the camera to aid in tracing the thief. Report such stolen property to local authorities or show managers, preferably while you still have the goods in your hands or the seller is still on the premises. If you report sightings of stolen goods to Centennial Photo, we will add "last seen at..." comments. Eventually, if we all cooperate, we will see some fine cameras returned to their rightful owners. This problem will not go away by itself. We must all do our part. As the world's most widely used guide, we gladly accept the responsibility to keep this list available. Our guide is revised every two years. At any time between, we will send you a current list if you send a self-addressed, stamped envelope. We welcome your suggestions to help keep crime out of camera collecting.

FOR FURTHER INFORMATION:

We receive many inquiries and requests for further information, far more than we can possibly answer. We do not give opinions or appraisals on items not included in this book. We realize that many cameras are not included in this book, and caution you that omission does not indicate rarity. We have excluded at least 30,000 cameras for various reasons to keep this book to a reasonable size and price. Some of the excluded cameras are: most cameras produced since the 1970's, which are generally more usable than collectible; most 126 and 110 cameras which were produced in such large numbers that they are common and inexpensive; and many early cameras which rarely are seen for sale. We have selected about 9,000 cameras which are representative of the field of camera collecting, and for which we can determine typical selling prices.

We regret that we are unable to answer individual questions by mail or by phone. For further information we recommend joining one or more of the collector organizations listed in the appendix. You may also wish to write to a "help" column of a club newsletter or commercial publication.

EINFÜHRUNG

Die erste Ausgabe von Price Guide to Antique and Classic Cameras wurde 1974 veröffentlicht. Seitdem ist dieser Führer vollständigste und genauste Referenzbuch zu Kameras weltweit. Die erste Ausgabe beinhaltete 1'000 Kameras. Diese neunte Ausgabe umfasst nun mehr als neun mal soviel. Sie wurde nicht nur erweitert, um mehr Kamera-Modelle einzuschliessen, sondern wir haben jede Anstrengung unternommen, um Information über die einzelnen Kameras zu erweitern und mit verschiedenen Daten und historischen Angaben, in wie weit sie uns zur Verfügung standen, zu ergänzen. Wir haben mehr Photographien für als 500 diese Ausgabe ebenfalls hinzugefügt, und bringen somit die Zahl der Illustrationen auf 3'500. Jede neue Ausgabe dieses Führers konnte stark verbessert werden im Vergleich zur vorigen, und mit Ihrer Unterstützung, hoffen wir diese Tradition fortzusetzen. Zum Beispiel, wurden zu dieser Ausgabe hunderte Objektive und Zubehörteile für die Kamerasysteme der 1960' und 1970' Jahre hinzugefügt. Obwohl viele von diesen noch brauchbar sind, werden sie als Sammlerstücke zweifellos angesehen. Wir haben nicht nur über die im Handel üblichen Kameras berichtet, sondern bemühten uns auch solche einzubeziehen. die in keinem gängigen Kameraführer erwähnt werden. In dieser Ausgabe können Sie mehr als 2'000 Kameras finden, die Sie vergebens irgendwoanders suchen werden. Wir hoffen, dass Sie dabei Freude haben werden.

WOHIN BEWEGEN SICH DIE PREISE?

Um die Tendenz und zukünftige Preise Sammlerstücke zu verstehen, sind Rückblicke in der Preisentwicklung unumgänglich. Die allgemeinen Trends von Preisen, die während 1981 gestiegen waren, wurden um 1982-83 stabilisiert, wobei die Preise von einigen Artikeln, zu fallen begannen. 1983 und 1984, fielen die Kamerapreise beträchtlich, besonders bezogen auf den amerikanischen Dollar, der unsere Basis ist. Teilweise war dies Folge vom allgemeinen Nachgeben des Marktes und natürlich ein grosser Teil des Verlustes war die Konsequenz des schnellen Aufstieges des Dollars, im Vergleich zu anderen Währungen. Dieser Rückgang verlangsamte sich 1985, und stabilisierte sich 1986 wobei die Preise einiger Artikel sich langsam erholten. Ende 1986 und anfangs 1987, hatte die relative Stärke britischer, deutscher, und japanischer Währungen gegenüber dem Dollar, den Markt gestärkt, da das Einkaufen klassischer Kameras in den U.S.A. ein wenig wie ein Kauf in einem Rabattladen war. In den U.S.A. begannen die Preise der besseren Sammlerstücke zu steigen. Von 1987 bis und mit 1989, sahen wir steilsteigende Preise spezifischen Gebieten. Durch die Stärke des Yens beeinflussten die Japaner mehrere Jahre hindurch das Steigen der Preise. Wir haben jetzt eine zunehmend wettbewerbsfähige Umgebung unter den Sammlern in Tokio, Europa, Hong Kong, U.S.A., & anderswo. Einige Preise sind so stark gestiegen, dass sogar die Händler Mühe hatten es zu glauben. Leica-Preise sind stabiler geworden, dafür stiegen die Preise der Canon und Entfernungsmesser-Kameras umsomehr. Einige Leica-Kopien, früher als billiger

Ersatz betrachtet, wurden wertvoller als die entsprechendenwirklichen Leicas.

Der allgemeine Trend in Sammeln geht in gezüchtete Richtung hochqualitative Kameras der Nachkriegsperiode (1945-1970). Japan spielte zunehmend vorherrschende Rolle in der Kamera-Produktion dieser Periode. letzten Jahrzehnt, kauften die Japaner tausende dieser Kameras zurück. aktives und lukratives wurde ein Neulich haben ernste Marktanteil. Sammler und Händler in Hong Kong und Europa Preise bezahlt, die denjenigen der japanischen Käufer gleichkommen. Die Verlockung mit Gewinn hat eine neue Art Händler und Zwischenhändler für die inflationären Märkte geschaffen. Abseits Hauptstrom der Chrom-Leder-Maschinen, gibt es Einzelne und Gruppen, die die Schönheit von Holz, Messing, und Leder antiker Kameras wiederentdecken. Der Wert vieler älterer Kameras ist verhältnismässig stabil. Es gibt nicht genug dieser "Antiken" um eine Generation Wochenende-Kamerahändlern zu unterstützen. Man könnte sogar die Sammler der älteren Kameras verdächtigen, eine Vorliebe für Kameras zu haben, die in keiner direkten Beziehung zum Geld steht. Ältere, seltene, und historisch wichtige Kameras werden knapper aber das gleiche trifft mit Sammlern und Händlern zu, die in der Lage sind sie zu erkennen. Seltene, ältere Kameras haben neue Preisrekorde geschaffen

Seltene, ältere Kameras haben neue Preisrekorde geschaffen bei Versteigerungen, aber es handelt sich um einen sehr kleinen Markt. Niedrig gesetzte Angebotslimiten haben oft zu spiralwachsender Konkurrenz und hohen Ersteigerungspreisen geführt. Umgekehrt haben hochgesetzte Anfangspreise auf potentielle Anbieter wichtiger Posten eine erschreckende Wirkung gehabt.

Seltene, ältere Kameras haben neue Preisrekorde geschaffen bei Versteigerungen, aber es handelt sich um einen sehr kleinen Markt. Niedrig gesetzte Angebotslimiten haben oft zu spiralwachsender Konkurrenz und hohen Ersteigerungspreisen geführt. Umgekehrt haben hochgesetzte Anfangspreise auf potentielle Anbieter wichtiger Posten eine erschreckende Wirkung gehabt.

Sammler achten zunehmend auf den Zustand. Eine Kamera, die nicht tadellos und attraktiv ist, wird schwierig zu verkaufen. Einige Kameras werden nicht so peinlich genau untersucht, wenn sie äusserst rar sind, aber gewöhnliche "Ware" sollte lieber tadellos und funktionsfähigsein.

Als Kamerasammelneinen Boom während der späten 1970' erlebte, begannen Spekulanten viel und achtlos zu kaufen. Dies verursachte eine Preisinflation bis zum Zusammenbruch. 1982-83 folgte ein Preiszerfall. Der inflationäre Markt in Japan entwickelte sich auf ähnlicher Weise, ist aber jetzt stabiler geworden. Die Preise weltweit haben sich angenähert und Spitzenpreise werden in verschiedenen Ländern von Sammlern bezahlt.

Einige Kameratypen waren in den letzten Jahren besonders erfolgreich.

Europäische Plattenkameras mit brauner Belederung werden höher bewertet als solche mit der üblichen schwarzen Belederung. Wer eine andere Farbe als schwarz wünscht, muss dafür zuzahlen. Boxkameras (mit Ausnahme der gewöhnlichen schwarzen) beginnen endlich geschätzt zu werden. Farbige Boxkameras, jene mit Art-Deco-Design oder solche aus Kunststoff mit seltsamen Formen, werden besonders gesucht, im Verhältnis zu Angebot und Nachfrage. Europa ist in dieser Entwicklung ein wenig den USA voran. Einige Art-Deco-Kameras haben beträchtlich bessere Preise auf dem Kunstmarkt als in den traditionellen Kreisen der Kamerasammler, erzielt.

RUSSISCHE UND SOWJETISCHE KAMERAS

Jahrelang waren sowjetische Kameras in Westeuropa nicht sehr verbreitet, und in den Vereinigten Staaten selten wenn überhaupt zu sehen. Diese Erscheinung des "Kalten Krieges" kehrte plötzlich um. Als die Sowjetunion und Ostblockländer ihre Mauer öffneten, gesehene tauchten viele selten sowjetische Kameras in Rekordzahlen bei vielen Sammlerbörsen und Fotogeschäften über ganz Europa und in den Vereinigten Dieser neue Zufuhr Staaten auf. verursachte einen Preiszerfall vieler Modelle. Einige Händler und Sammler, nachdem sie zu den alten Preisen gekauft haben, sind dagegen ihre Verkaufspreise zu senken und so ist der Markt von russischen Kameras im besten Fall als unbeständig zu bezeichnen. Es wird einige Jahre dauern, bevor Angebot und Nachfrage die Preise ausgleichen werden. Einige russische Kameras mögen noch selten sein, aber nicht unbedingt die gleichen, die als solche früher betrachtet wurden.

Zusätzlich haben Mengen grosse Fälschungen dem Russisch/Sovietischen Kameramarkt langfristige Schäden zugefügt. Jede Kamera mit besonderem oder Sondergravur wahrscheinlich eher eine Fälschung als eine Echte. Ein organisiertes Kartell russischer und polnischer Händler schafft Dauerstrom einen solcher 'Sammelkameras". Dabei wurden sogar wertvolle historische Kameras ruiniert, sie in vergoldetem oder sondergraviertem Ramsch umgewandelt wurden. Solange Händler und Sammler dieses Vorgehen unterstützen, wird es so weiter gehen. Die übriggebliebenen echtwertvollen Artikel werden dadurch an Wert verlieren, einfach weil die Käufer bleiben werden. skeptisch Das allerwichtigste wird der Ursprung sein, weil Lügen und erfundene Geschichten jeder Kamera umsonst beigelegt werden.

Bei einer kürzlich stattgefundener Sammlerbörse, offerierte ein Russe eine "Luxus" Leica mit einer 4-zähliger Seriennummer und versehen mit einem Militärkennzeichen vom zweiten Weltkrieg. Nicht alle Fälschungen sind so klar und deutlich erkennbar (4-zählige Leicas liefen vor dem Aufstieg von Hitler aus, Armeekameras waren nicht "Luxus" Ausführungen, usw.)

"HEISSE" UND "KALTE" MÄRKTE IN DEN 90' JAHREN

In den letzten Jahren, hat Nikon eine

Führungsstelle als wild spekulativer aufgehender Stern, angenommen. Eine kleine aber entschlossene Anzahl Sammler und Händler haben dazu beigetragen. Diese Preisspirale scheint jetzt abgeflacht.

Kleinstbildkameras haben fortgesetzte Stärke gezeigt, mit den meisten Artikeln noch zugänglich für Kaüfer Mittelklasse. Aber bei der bedeutenden Kleinstbildversteigerung von Christie's im Dezember 1991, im vollbesetzen Saal, verursachte ein entschlossener Telefonanbieter Frustration unter den potentiellen Käufern, und viele Posten wurden versteigert für Preise, die bedeutend höher waren als realistischerweise dafür erwartet hatte. Wellenartige Wirkung Versteigerungist immer noch spürbar. Die Preise von Subminiaturen sind allgemein gestiegen. Einige "Träumer" erwarten tagtäglich "Rekordpreise".

RAT AN NEUE SAMMLER

Unser Rat an Sammler hängt ganz davon ab, von Ihrer Motivation zum Sammeln. Falls Sie Sammeln als eine Anlage betrachten, sollen Sie sich auf seltene und ungewöhnliche Kamera-Modelle konzentrieren, die natürlich mehr Kapital und Expertise erfordern werden. Falls Sie hauptsächlich zum Vergnügen sammeln, sollten Sie unbedingt auf Ihre Vorliebe und Ihre finanziellen Möglichkeiten achten. Viele günstigere Kameras bieten ein billiges Hobby und ein guter Anfang an. Je nachdem wo Sie leben, bringt das Sammeln von Kodak, Coronet, Agfa, oder Fex Kameras Freude und Entspannung, weil viele dieser Kameras leicht und zu bescheidenen Preisen gefunden werden können. Die meisten Sammler fangen mit einem allgemeinen Interesse an und mit der Zeit spezialisieren sie sich auf ein bestimmtes Sammelgebiet. Falls Sie mit Kameras handeln, um einen Gewinn zu erzielen, müssen Sie nahen kontakt mit dem Markt behalten. Finden Sie Ihre eigene Nische und bleiben Sie dabei. Wenn Sie den Markt genau verfolgen, und das Interesse Ihrer Kunden gut kennen, können Sie einen Gewinn aus seinen normalen Schwankungenerzielen.

Alle Preise dieser Ausgabe sind auf den gegenwärtigen Stand gebracht worden. Sie sind so aktuell wie nur möglich, und alle Angaben entsprechen den jeweiligen aktuellen Zahlen. Jedoch, haben wir für jede Kamera den stabilisierenden Einfluss der Preisen, die registriert wurden während den letzten 10 Jahren beibehalten, um das Risiko von kurzfristig erhobenen Zufallspreisen zu vermindern. Unsere Preise verfolgen die langfristigen Trends analog zu einem ölgedämpften Kompass, der sein Ziel unabhängig von momentanen Schwankungen geradeaus verfolgt.

Die Information und Daten in dieser Ausgabe basieren auf hunderttausende nachprüfbare Verkäufe, Tauschgeschäfte. Angebote, und Versteigerungen. Es ist ein Referenzbuch, ein Forschungsbericht. Die Preise spiegeln nicht meine Meinung über den Wert einer Kamera, sondern was unzählige frühere und gegenwärtige Besitzer glaubten sie sei wert beim entscheidenden Augenblick des Besitzwechsels. Dass ist der Grundsatz

von was Sie McKeown's Gesetz nennen können, nämlich: "Der Preis einer **Antikkamera** ist vollständig davon abhängig Gemütszustand von Käufer und Verkäufer im Augenblick des Besitzwechsels."

Einige Schlussfolgen davon haben wir zu diesem Prinzip der Sammelphilosophie hinzugefügt.

1. "Wenn Sie die Gelegenheit verpassen eine hochbegehrte Kamera zu kaufen. werden Sie eine solche Gelegenheit nie wieder begegnen."

2. "Wenn Sie eine Kamera kaufen, weil Sie nie wieder eine solche Gelegenheit finden werden, wird ein besseres Exemplar der gleichen Kamera Ihnen eine Woche später für einen viel tieferen Preis angeboten

3. "Der eigentliche Wert einer antiken oder klassichen Kamera hängt viel davon ab von der Überzeugung ihres Eigentümers, dass sie von anderen begehrt wird.' Diese Beobachtungen sollen immer berücksichtigt werden beim anwenden

vom McKeown's Gesetz.

GEBRAUCHSANWEISUNGEN FÜR DIESEN FÜHRER

Kameras sind geordnet nach Hersteller in alphabetischer Reihenfolge. Einige wenige Kameras sind Modellname geordnet, da wir nicht sicher waren wer der Hersteller war. Prinzipiell sind die Kameras jedes Herstellers alphabetisch aufgeführt aber gelegentlich haben wir sie nach Typ, Grösse, Datum ihrer Einführung oder nach einem anderen passenden Grundsatz, geordnet.

Photos erscheinen gewöhnlich unmittelbar über der fettgedruckten Überschrift, die die beschreibt, insofern Gestaltung der Seite es erlaubt. Gelegentlich, wenn der Text auf einer anderen Spalte fortgesetzt wird, erscheint die Photographie mitten im Paragraphen der sie beschreibt. Wenn das Photo nicht zum Text gehört, ist die Legende kursiv und eine Note am Ende des Textes zeigt wo das Photo hingehört. Wenn ein Photo einer Kamera sich am Ende einer Spalte befindet, wo sie den Text einer anderen Kamera unterbricht, haben wir es mit einer dicken Linie visuell davon getrennt. Nach diesen Kriterien, dient der in Fettdruck gesetzten Titel gleichzeitig als Legende der meisten Photos, was sehr viel Platz Getrennte Legenden für alle erspart. 3'500 Photos hätten zusätzlich 40 Seiten erfordert!

Wir haben unterschiedliche Schriftarten benutzt, und damit dieses Buch leichtleserlicher gemacht. Der Aufbau ist wie folat:

HERSTELLER (FETTE SCHRIFT. GROSSBUCHSTABEN) Historische Noten oder Kommentare über den Hersteller. (Kursivschrift)

Name der Kamera (fette Schrift) -

Beschreibung der Kamera und aktueller Wert (halbfette Schrift). Spezielle Hinweise betreffend Kamera oder Preis (Kursivschrift).

NAME DER KAMERA - Falls der Name Kameramodelles Grossbuchstaben ist, gehört er einer getrennten Gruppe und ist nicht auf den vorigen Hersteller bezogen. Wir benutzen diesen Stil gewöhnlich, wenn Hersteller uns unbekanntist.

Auf den ersten Blick, mag diese Anordnung nicht "künstlerisch" attraktiv zu wirken, aber sie wurde sorgfältig ausgewählt um Platz zu sparen und trotzdem das Buch leichtleserlich zu Unser Computer könnte einen Rechteckumriss um iedes automatisch hinzufügen, aber dass hätte 50 zusätzliche Seiten bewirkt. Auch die Spalten mit Rechtecken zu umschlingen hätte dieses Buch 90 Seiten dicker gemacht. Unsere Leser sind ernste Sammler und Händler, die die höchste Informationsrate im kleinstmöglichen Raum wünschen. Wir hoffen, dass Sie kleinstmöglichen unser "Büchlein" gerne lesen werden. Wir hätten es ohne weiteres "hübscher" machen können, aber das Ergebnis wäre ein Monsterbuch von über 800 Seiten, im Vergleich 30% dicker, schwerer und teurer. Wir hoffen, dass Sie unser einfacher Stil von mehr Information in weniger Platz schätzen werden.

ZUSTAND VON KAMERAS

Eine Kamera in neuwertigem äusserlichem Zustand aber nicht funktionsfähig, mag vollkommen annehmbar für Sammler sein, der sie auf das Regal setzen wird. Anderseits, mag ein Benutzer sich nicht viel um die Erscheinung kümmern solange sie arbeitet. Wir befürworten die Kameras nach einer zweiteiligen Skala einzustufen: äussere Erscheinung und Betriebsfähigkeit. Sie weltweit eingeführt sollte werden, unterstützt von Kameraführern. Sammlerveröffentlichungen,

Sammlerverbänden, Versteigerern und Händlern.

Mit dem Ziel eine internationale Norm für

die Zustandsbeschreibung zu schaffen, schlugen wir die folgende Skala vor. Wir haben eine Kombination einer Zahl und einer Buchstabe absichtlich benutzt, um jedes Durcheinander mit einstufenden Systemen bereits Gebrauch, zu meiden. Der Zustand einer Kamera soll mit einer Einzelziffer gefolgt von einer Buchstabe angegeben werden. Die Zahl beschreibt den äusserlichen Zustand und die Buchstabe den Betriebszustand. Dieses System wurde vom "Photographic Collectors Club" in Grossbritannien angenommen.

GRAD --- ÄUSSERLICHER ZUSTAND

- Neue Ware, nie verkauft. Originalschachtel, mit Garantie.

1 - WIE NEU. Nie benutzt. Wie neu aber ohne Garantie. Mit Schachtel oder Originalverpackung.

- 2 Keine Gebrauchsspuren. Wäre die Schachtel dabei, hätten Sie sie von einer neuen Kamera nicht unterscheiden
- 3 Sehr minimale Gebrauchsspuren.
- 4 Leichte Gebrauchsspuren aber nicht misshandelt. Kein anderer äusserlicher Schaden.
- Vollständig, aber zeigt normale Gebrauchs-oder Altersspuren.
- **6 -** Vollständig, aber zeigt Gebrauchsspuren. Sehr abgenutzt. starke
- **7** Kann restauriert werden. Muss teilweise restauriert werden. Kleine Teile fehlen, oder sind gebrochen.

8 - Kann restauriert werden.

restauriert werden. Eventuell fehlen einige Teile

9 - Nur als Teilspender brauchbar oder benötigt eine umfassende Restauration, falls die Kamera selten sei.

FUNKTIONSFÄHIGER ZUSTAND

A - WIE NEU. Alles funktioniert einwandfrei, mit Werksgarantie.

B - WIE NEU. Alles funktioniert einwandfrei, aber keine Werksgarantie. Der Verkäufer gibt vollständige Garantie auf Funktionsfähigkeit.

C - Alles funktioniert. Wurde vor kurzem fachmännisch gereinigt, geölt, revidiert und ist vollständig unter Garantie.

D - Alles funktioniert. Wurde vor kurzem fachmännisch gereinigt oder revidiert aber befindet sich nicht mehr unter Garantie.

E - Alles funktioniert. Hauptfunktionen wurden kürzlich fachmännisch überprüft.

F - Weder gereinigt und geölt noch revidiert in den letzten Zeiten. Vollfunktionsfähig, aber Genauigkeit von Verschluss oder Belichtungsmesser nicht garantiert.

garantiert.

G - Vollfunktionsfähig. Verschlusszeiten und/oder Belichtungsmesser wahrscheinlich ungenau. Benötigt nur

Justierung oder Reinigung.

H - Brauchbar aber mit Einschränkungen.
Der Verschluss könnte bei den langsamen
Geschwindigkeiten stecken bleiben. Der
Belichtungsmesser könnte nicht
funktionieren.

J - Nicht brauchbar ohne Reparatur oder Reinigung. Der Verschluss, das Belichtungsmesser, der Filmtransport könnten blockiert oder defekt sein.

K - Wahrscheinlich nicht reparierbar.

System, würde deisem durchschnittliche Kamera die Einstufung 5F erhalten. Eine 3G - Kamera zeigt minimale äusserliche Gebrauchsspuren wahrscheinlich ungenaue Belichtungsmesser oder Verschluss. Auf dieser Weise wird der spezifische Zustand Kamera knapp aber unmissverständlich beschrieben. Die Auslegungsschwierigkeiten von den Einstufungen mit Buchstaben oder Worten, zwischen optischem und funktionsmässigem Zustand zu unterscheiden, werden bei unserem vorgeschlagenen System vermieden. Wer der äussere Zustand einer Kamera noch feiner beschreiben möchte, könnte es mit einer zweiten Ziffer tun.

Seit wir dieses System vorgeschlagen haben, haben Camera Shopper-Magazin und einige Händler ein ähnliches System adoptiert, aber mit umgekehrten numerischen Werten so dass 10 der obere Grad ist. Sollten Sie eine Kamera kaufen ohne sie vorher kontrolliert zu haben, vergewissern Sie sich nach welchem System sie eingestuftwurde.

VERGLEICH MIT ANDEREN EINSTUFENDEN SYSTEMEN

Die folgende Tabelle vergleicht die optische Komponente des Zustandes nach unserem System mit den entsprechenden Stufen mit Buchstaben oder Worten anderer gebräuchlichen Systeme. Diese Vergleiche sind approximativ und sollen dem Leser lediglich helfen, sich mit dem neuen System leichter anvertrauen. Die letzte Kolonne der Tabelle zeigt ganz allgemein, wie Zustand Preise beeinflusst, jedoch, sind diese nur Annäherungen. Der

Zustand beeinflusst den Preis auf unterschiedlicher Weise je nach Typ und Alter der Kamera. Die unten vorgeschlagenen Vergütungen werden als Prozentsätze des aufgeführten Preises angegeben. Wir haben keine Vergleiche mit den anderen 10 Systemen gemacht, weil es zu viele Variationen im Gebrauch durch individuelle Händler gibt.

McKeown PCCGB		Deutsche	
Christie's	SA	Auktionen	Preises
0	Ν	-	150-200%
1	LN	-	130-150%
2	M	Α	120-140%
3	M	AB	115-130%
4	E+	В	110-120%
5	E	С	95-115%
6	VG	CD	80-110%
7	G	D	55-85%
8	F	E	30-60%
9	P	-	10-30%

Jeder fehlende oder lose Teile soll ausdrücklich erwähnt werden. Gebrauch von (-) nach einer Zustandszahl oder Buchstabe bedeutet, dass die Masstäbe dieser Stufe (mit leichten Abweichungen WIE BESCHRIEBEN im darauffolgenden Hinweis) erfüllt werden. Gebrauch von (+) bedeutet, dass diese Stufe übertrifft wird ohne die nächsthöhere Stufe zu erreichen.

Sollten irgendwelche Teile bei Ihrer Kamera fehlen, muss man sie aus einer anderen gleicher Sorte entnehmen.

Der Wert Ihres Gerätes berechnen Sie also mit der Formel:

Teile der ersten Kamera + Teile der zweiten Kamera = Preis der vollständigen Kamera.

Manchmal sind Sammler nachsichtiger beim Anwenden dieser Masstäbe zu älteren und seltenen Kameras, und strenger bei neueren oder üblichen Modellen. Dies sei aber Selbstbetrug. Wenn Sie eine Kamera in etwa so beschreiben: "in sehr gutem Zustand angesichts ihres Alters," bedeutet dies Sie sind der Meinung, dass alte Kameras nach anderen Masstäben beurteilt werden sollen. Obwohl die meisten Kameras gleichen Alters gewisse altersbedingte Abnützung zeigen werden, die Tatsache diese Kamera alt sei, macht sie nicht deswegenbesser.

INTERPRETATION DER PREISE

Alle Preise sind in U.S. Dollars. Die Preise für Kameras der Stufe 5 sind anzuwenden nach den bereits erklärten Kriterien. In diesem Zustand werden die meisten Kameras gefunden und gesammelt und er liefert deswegen die nützlichsten Einstufungskriterien. Wir empfehlen den Zustand einer Kamera, die man erwerben möchte, mit dieser Stufe zu vergleichen und dementsprechend ihren Wert zu berechnen.

Wenn nicht ausdrücklich erwähnt "Body only" (Gehäuse allein), beziehen sich die Preise auf eine Kamera mit Normalobjektiv, Rückteil und allen anderen Teilen, benötigt um das Gerät in Betrieb zu setzen.

Billige Artikel neigen dazu in diesem Buch relativ höher bewertet zu werden, aus dem einfachen Grund, dass die Grundkosten für Werbung, Verkauf und Versand oft

gleich hoch sind für einen \$5 Artikel wie für einen anderen, der hunderte oder sogar tausende Dollar kostet. Artikel der mittleren Preisklasse zeigen die genauesten Preise. Diese werden am häufichsten gehandelt. Ihr Vorrat ist gross und daher ist der Markt dafür sehr stabil. Kameras der oberen Preisklasse einer bestimmten Marke, Stil oder Alter haben meistens unstabile Preise, da sowohl Angebotwie Nachfrage knapp sind.

ERWARTEN SIE NICHT, DASS EIN HÄNDLER IHNEN DEN "BUCHPREIS" BEZAHLT.

Wenn Sie eine oder zwei Kameras verkaufen möchten und von einem Händler den höchsten im Buch genannten Preis erwarten, sollen Sie die erwarten, Angelegenheitmal von seinem Standpunkt betrachten. Um Ihre Kamera weiterzuverkaufen. muss er instandsetzen, garantieren, Tischmiete in Fotoaustellungen bezahlen, Preislisten drucken und versenden lassen, und verteidigen seinen Preis gegenüber Kunden, die nur den niedrigsten Preis, der im Buch für diese Kamera erwähnt wird, bezahlen wollen . Nachdem Ihre Kamera unverkauft während einigen Monaten bei ihm bleibt und etwas weniger attraktiv wirkt, weil sie inzwischen von mehreren Leuten in die Hände genommen wurde, verkauft er sie einem anderen Händler zum halben Preis, im Tausch gegen etwas anderes, das er zum Verkauf anbieten wird. Oft muss Ihre Kamera zwischen den Händen mehreren Händlern von durchgehen bevor sie den langersehnten Käufer findet, der dafür den "Spitzenpreis"

Je weniger wertvoll und selten Ihre Kamera ist, desto mehr müssen Sie aus dieser Mustergeschichte lernen. Sollten Sie aber tatsächlich eine äusserst seltene oder wertvolle Kamera besitzen, dann müssen Sie sich natürlich keine Sorgen machen. Die Händler werden sie Ihnen von den Händen reissen. In der Fotobranche wird echt gute Ware sehr hart umkämpft.

PREISE VON KAMERAS IN JAPAN UND IN EUROPA In bestimmten Fällen

haben Preisunterschiede für die gleiche Kamera auf verschiedenen Märkten (z.B. USA, Europa, England, Deutschland, Japan Selbstverständlich usw.) angegeben. werden sich auch bei anderen Kameras Preisunterschiede ergeben, die wir nicht berücksicht haben. Vor allem sollte klar sein, dass der Grundpreis einer Kamera ist der Preis, der dafür bezahlt wird im Land in welchem sie am leichtesten gefunden werden kann. Bei vielen einfachen dieses Land Kameras ist Ursprungsland. Da aber die meisten Modelle in die USA importiert wurden, können sie dort in der Regel zu einem gleichniedrigen Preis wie in Ursprungsland, erworben werden.

Bei billigen Kameras sind die Preisunterschiede zwischen verschiedenen Ländern minimal. Wir haben sie nur erwähnt bei solchen Modellen, die nennenswerte und dauerhafte Preisunterschiede, unabhängig von den Versandkosten, zeigen. Die Preise vieler hochqualitativen japanischen Kameras sind höher in Europa als in den USA, weil

ursprünglich mehr dieser Kameras in die USA importiert wurden. Mit einem kleineren Vorrat in Europa, ist der Wettbewerb unter Sammlern grösser.

Die Dufa Pionyr (Tschechoslowakei) ist nur ein gutes Beispiel einer Kamera, deren Preise weltweit ziemlich grosse Unterschiede aufweisen. In Deutschland, neben der Quelle, verkauften sich solche Kameras, bei einer Versteigerung, für umgerechnet ca. \$25. Händler in London haben sie in der ursprünglichen Schachtel für umgerechnet \$45 verkauft. Diese 2 Zahlen begrenzen einen vernünftigen und normalen Bereich. Wir haben eine solche Kamera, die in einem Geschäft in Ginza (Japan) zu einem Preis von umgerechnet \$125 offeriert war, nicht berücksicht. Obwohl diese Kamera zu einem solchen Preis einen Abnehmer hätte finden können, können wir ihn nicht als repräsentativ

IST DER HÖHEPUNKT DER PREISE IN JAPAN VORBEI?

Solange die japanische Wirtschaft Hochkonjunktur erlebte, hatten westliche Käufer kaum eine Chance konkurrenzfähige Preise zu zahlen. Jetzt aber ist der Weltmarkt viel ausgeglichenergeworden.

WIE UNSERE PREISE BESTIMMT WERDEN.

Wir verfolgen und analysieren Preise vieler verschiedenen Quellen weltweit, einschliesslich Makler-Veröffentlichungen. Händler-Preislisten, öffentliche Versteigerungen, und Handelsaustellungen. Unsere Datenbasis schliesst hunderttausende Geschäfte zu jeder neuen Ausgabe ein, zusätzlich zu den gesammelten Daten früherer Ausgaben. Obwohl unsere Formeln unser Eigentum sind, einige Worte können Ihnen erklären warum unsere Statistik sich nicht immer mit Ihren eigenen Beobachtungen deckt. Sie lesen eine Händlerveröffentlichung regelmässig und die Kamera "X" wird in der Regel zwischen \$275 und \$325 angeboten. Ihr scharfer Verstand behält diese Angaben in Erinnerung. Unser Computer tut es auch. Es ist gut möglich, dass der GLEICHE ARTIKEL mehrmals angeboten wurde. Daher ein Preis, zu welchem ein Artikel nicht verkauft wird, erscheint öfters als ein realistischer Preis. Im Falle der wirklichen Kamera "X", fing ein Händler sie zu einem Preis von \$450 anzubieten. Nach über einem Jahr Werbung, die gleiche Kamera war noch immer zu haben, diesmal für \$250, als unser Buch gedruckt wurde. Viele andere bestätigte Verkäufe weltweit teilen uns mit, dass diese Kamera "X" für \$125-175 in der Regel verkauft wird. Schliesslich der Händler, dessen Anzeigen Sie gelesen haben, mag seine überpreiste Kamera einem Käufer verkaufen, der sie so oft für \$300 angeboten sah, dass er jetzt überzeugt ist ein gutes Geschäft zu machen, wenn er dafür \$250 bezahlt. Unser Computer hat ein langes Gedächtnis, das einzelne Kameras von Händlern angeboten so lange verfolgt, bis sie endlich verkauft werden. Preise von unverkauften Kameras sind keine echte Daten, es sei man verwendet sie nur zur Bestimmung der oberen Grenze.

Unsere Preise zeigen den normalen Bereich für den grössten Teil der Kameras, die tatsächlich verkauft werden. Sie basieren auf umfangreiche Forschung, nicht bloss Vermutungen. Wir sind keine Kamerahändler, da dies uns in einem Interessenkonfliktverwickeln würde.

WECHSELKURSE

Die Preise in diesem Führer darstellen durchschnittliche Preise auf dem Weltmarkt. Es gibt eindeutige Abweichungen von diesen Zahlen in besonderen Märkten. Einige Kameras sind häufiger in einem Land als in einem anderen. Sammlerinteressen sind unterschiedlich in verschiedenen Teilen der Welt, und "Trends" oder "Moden" beeinflussen unterschiedliche Märkte zu unterschiedlichen Zeiten. Aber keiner der Weltmärkte kann sich äusserlichen Einflüssen entziehen und die Fluktuationen neigen weltweit sich auszugleichen. Ein höherer Preis in einem Land wird dazu führen, dass mehr Kameras dorthin kommen und die internationalen Preise werden so lange steigen bis die Nachfrage schliesslich befriedigt wird. Alle Preise werden in U.S. Dollars angegeben. Da Wechselkurse dauernd schwanken. werden wir unsere Leser nicht mit computer-erzeugten, künstlich umgerechneten Preisen für jede Kamera verwirren, da diese sowieso auf einen Kurs eines willkürlich gewählten Tages basieren.

Als ein allgemeiner Bezugsrahmen haben wir eine Karte zusammengestellt, die die Wechselkurse für die U.S.-Dollar-Werte angezeigten Währungen 07.VI.1994

WÄHRUNG	= US\$	US\$1 = *
Australia \$.7345	0.3615
Austria Schill	.08602	11.625
Belgium Franc	.02917	34.282
Brazil Cruz.	.0004975	2010.05
Britain £	1.5095	0.6624
Canada \$.7287	1.3727
France Franc	.17598	5.6825
Germany DM	.6002	1.666
Hong Kong \$.12940	7.7280
Italy Lira	.0006188	1616.03
Japan Yen	.009602	104.15
Netherlands FI	.5354	1.8679
N.Zealand \$.5914	1.6909
Spain Peseta	.007331	136.41
Sweden Krona	.1262	7.9260
Switzerland Fr	.7078	1.4128

*Wenn sie diese Faktoren durch die Dollarpreise multiplizieren, bekommen Sie die entsprechenden Werte in anderen Währungen.

HINWEIS:

Die angegebenen Versteigerungspreise sind die erzielten Preise als der Hammer herunterging und schliessen Kommissione noch Taxen ein. Da alle diese Umkosten normalerweise etwa gleich, zwischen Käufer und Verkäufer verteilt werden, ist der "Hammerpreis" ein logischer Mittelwert zwischen dem Nettobetrag der Verkäufer erhält und dem Bruttobetrag, der vom Käufer bezahlt werden muss. Alle Versteigerungspreise sind in Dollar umgerechnet mit dem Wechselkurs. der in diesem Tag gültig war.

VERKAUF IHRER SAMMLERKAMERAS

Es gibt verschiedene erprobt Wege um Sammlerkameras zu verkaufen, gültig sowohl für eine einzelne Kamera wie auch für eine grosse Sammlung, sei sie von einem Privaten, einem Händler, oder einem Sammler. Jede dieser Methoden hat Vor- und Nachteile. Die eine mag für

eine Ihrer Kameras geeigneter sein, die andere Könnte sich für ein anderes Gerät als besser etweisen.

VERSTEIGERUNGEN

Vorteile - Das Gerät wird verkauft werden. Sie werden es loskriegen. Sie werden Ihr Geld bekommen. Äusserst seltene Stücke erreichen oft höhere Preise, als erwartet. Eine niedrigere Grundschätzung als Angebotbasis zieht mehr Anbieter an und führt zu einem

höheren Versteigerungspreis.

Nachteile - Lange Wartezeit, in der Regel mehrere Monate, bedingt durch die Vorbereitung vom Katalog und von der Versteigerung selbst. Kommission (oft Versteigerung selbst. Kommission (oft durch den erzielten Versteigerungspreis mehr als wettgemacht). Eine hohe An-fangsbewertung entmutigt manchmal alle Anbieter. Wenn der gleiche Gegenstand darauffolgenden Versteigerung erneut auftaucht, wird er von den früheren potentiellen Käufern erkannt und sie en thalten sich.

HÄNDLER

Vorteile Sofortiger Verkauf und Barzahlung. Kein warten auf einen Endkäufer. Für seltene Stücke bekommt man von Händlern gute Preise, manchmal mehr als Sie sonst irgendwo bekommen könnten, weil sie eine spezialisierte Kundschaft in Gebieten haben, die Sie nicht leicht erreichen könnten. (Händler kaufen und verkaufen oft voneinander um von der Spezialisierung von jedem profitieren zu können). Vom Verkaufspreis wird keine Kommission abgezogen.

Nachteile - Händler sind gezwungen unter ihren geschätzten Wiederverkaufspreisen zu kaufen. (Da sie aber oft Kunden haben, die ihnen dafür mehr bezahlen als was sie Ihnen zahlen würden, ist diese Tatsache für Sie nicht in jedem Fall nachteilig). Einige Händler werden Ihnen keine Angebote unterbreiten. Sie müssen also eine eigene Preisvorstellung haben. Wenn Sie Angebote von mehreren Händlern verlangen, inszenieren Sie Ihre eigene "Versteigerung". Händler machen bei einem solchen Spiel ungern mit. Sie können sich davon ganz zurückziehen oder aber Ihnen weniger am Anfang der Verhandlungen offerieren und Sie dazu zwingen mehrere "Runden" und Zweitversuche beim gleichen Händler zu führen.

PHOTOMÄRKTE, FLOHMÄRKTE

Vorteile - Keine Vermittlungsgebühren, sie behalten also den vollen Verkaufspreis. (Wenn sie die Zeit und Geldinvestition berücksichtigen, könnte es sich aber um einen eher psychologischen als um einen effektiven Vorteil handeln). Gelegenheit mit anderen Sammlern zu verkehren und ihre Begeisterung zu teilen. Tauschmöglichkeiten zum ergänzen oder bereichern Ihrer eigenen Sammlung bzw. Ihres Warenlagers.

Nachteile - Viele versteckte Ausgaben, die oft mehr ausmachen als die Kauf-Verkauf Gewinnspanne vom Händler oder die Kommission vom Versteigerer. Tischoder Standmiete. Keine Verkaufsgarantie. Sie können einen Gegenstand über Monate oder sogar Jahre herumtragen, übrigens auch einem Händler geschehen kann. Abnützung und Schaden können verheerende Wirkungen er-

reichen.

POSTVERSAND VON LAGERLISTEN

Vorteile - Sie erreichen einen breiten Markt ohne soviel Zeit und Geld zu investieren, wie in einem Photomarkt. Die Kameras bleiben unangetastet bis zum Verkauf.

Nachteile - Die Anzahl der potentielle Käufer ist von der Grösse des Empfängerkreises begrenzt. Druck- und Versandkosten. Die Kunden können die Ware vor dem Kauf nicht sehen. In der Regel müssen Sie bei Unzufriedenheit den Kaufpreis zurückerstatten.

KLEINANZEIGEN

Vorteile - Wahl des geeigneten Veröffentlichungsmittel um bestimmte Kreise zu erreichen. Photoblätter für Vereinmitgliede, Photohändlerzeitschriften, usw. In der Regel preisgünstig, i.B. für einige wenige Artikel.

Nachteile - Zeitverlust bis zur Veröffentlichung und Verkauf. Der Verkauf ist nicht garantiert, i.B. wenn Sie auf einen Höchstpreis zielen. (Anderseits ist der Verkauf praktisch sicher, wenn sie Ihren Preis danach gestalten.)

NACHGEBAUTE KAMERAS

Je höher die Preise der Kameras, desto grösser die Anzahl von Fälschungen, Kopien und mehr oder weniger misslungenen Nachahmungen. Jahrelang wussten Sammler und Händler dass es solche Fäschungen gab, aber anstatt es bekanntzugeben, hielten sie es "geheim". Wir möchten diese Information verbreiten um unsere Leser und Kollegen die Kameras sammeln, zu beschützen. Wir verstehen und akzeptieren Reproduktionen seltener Kameras zum Zweck von Austellungen und Museen. Wir sind dagegen nicht bereit plumpe Darstellungen, die als Originale verkauft werden, anzunehmen. Wir stehen vor mehreren Alternativen. Wenn es bei unserer Sammeltätigkeit sowohl für die Sammler wie auch für Verbrecher Platz gibt, dann ist kein Problem vorhanden. Die Verbrecher vertreiben die Sammler von ihrem Hobby. Nach unserer Auffassung, müssten es umgekehrt die Sammler sein, die die Verbrecher vertreiben. Und alles was wir dazu benötigen, ist unsere Information darüber Kollegen mitzuteilen, um zu vermeiden dass sie irregeführt werden.

Die bekanntesten Hersteller von Reproduktionen, Restaurierungen, Fälschungen und Betrug sind die Folgenden:

Luc Bertrand, Belgien. Ein Handwerker, der Kameras restauriert und reproduziert. Er kann gute Kopien von Metallkameras herstellen, und produziert auch Holzkameras, die sich kaum von den Originalen unterscheiden lassen. Aus seltenen Kameras macht er nur wenige Kopien für seine eigene Sammlung sowie für private Sammler und Museen. Um ihm gerecht zu sein, muss man erwähnen, dass er seine Reproduktionen mit seinen Inizialen und mit dem Datum kennzeichnet. wurden seine Arbeiten manchmal durch andere Leute als Originale angegeben. Alle Reproduktionen vor 1989 wurden in sehr kleinen Serien hergestellt, üblicherweise 1 bis 4 Stück aus welchen, in der Regel, jeweils ein Stück in seiner eigenen Sammlung blieb. Manchmal tragen die anderen, neben den Initialen "LB" oder "BL" und dem Datum, die Seriennummer 1 bis 4. Nach 1989 stempelt Bertrand in

seinen Werken "LFB" als kleines Monogramm auf das Metall oder das Holz. Bis 1990 hatte Bertrand nur 6 Kameras in Serie reproduziert. Weitere 15 (ca.) wurden als Einzelkopien für seine eigene Sammlung gemacht. Mitte der '90 erklärte Bertrand, dass er insgesamt 35 Kopien hergestellt hatte, von welchen die Hälfte nich in seinem Besitz waren. Wenn Bertrand eine Kamera restauriert, stempelt er ebenfalls seine Initialen und das Datum auf den Teil, der von ihm restauriert wurde.

Herr Bertrand hatte die Freundlichkeit, uns Muster seines Stempelmonogrammes zu geben, damit wir sie veröffentlichen können, eine ehrliche Bemühung seinerseits um zu vermeiden, dass seine Reproduktionen betrügerischen Zwecken dienen sollen.

Greenborough - Weder haben wir ihn kennengelernt noch mit ihm gesprochen. Unser Bericht stützt sich deswegen auf die Auskünfte von anderen Sammlern. Er und seine Frau sollen Polen sein, aber mit Wohnsitz in Deutschland. Er selbst sollte keine Kameras herstellen, sondern Kopien historischer Kameras -sowie einige fantasievolle Designmuster von zeitgemässer Inspiration- vermarkt haben. Nach unseren Quellen, hatte er sie in Polen herstellen In wie weit uns bekannt ist, werden diese Kopien nicht als solche gekennzeichnet, und viele davon, sei es aus Unwissenheit oder aus Betrug, werden danach als Originale offieriert. einem unserer Informanten, sollte er sich aus dieser Tätigkeit bereits zurückgezogen haben. Folgende Kameras sollte er gefälscht haben: Leica 250, Minox Zigarettenzünder, Ticka Taschenuhr-Kamera, Leica Luxus, John Player Zigarettenschachtel-Kamera.

Oberlaender. Er hat Kopien von einigen berühmten Kameras hergestellt, darunter die Doppel Sport (Taubengetragene Luftbildkamera) und die "Photo Carnet", Version von der Taschenbuch-Kameravon Dr. Kruegener. Einige dieser Kopien können kaum von den Originalen unterschieden werden. Uns ist nichts von irgendeinem Kennzeichen auf den Taubenkameras bekannt, und wissen, dass einige als echt offeriert und verkauft wurden. Mindestens eine der Photo Carnet Kameras wurde als Kopie mit einer "R" nach der Seriennummer auf den Rücken, gekennzeichnet. Sie wurde in Dezember 1991 bei Christie's weiterverkauft. Zur gleichen Zeit wurde eine der Doppel-Sport-Kopien ebenfalls verkauft. Beide wurden von Christie's deutlich als Kopien beschrieben.

Sowohl die Kopien von Greenborough wie die von Oberlaender wurden direkt oder indirekt an einige der erfahrensten und respektiersten Sammler der Welt verkauft. Diese und andere reproduzierte Kameras wurden ohne Ursprungsangaben in bedeutenden Sammlungen integriert und als Originale, absichtlich oder aus Unkenntnis, weiterverkauft. Eine bestimmte Anzahl Händler, die ansonst einen guten Ruf besitzen, haben diese Fälschungen aktiv unterstüzt, indem sie solche, als Bestandteil ihres üblichen Handels, verkauft haben, in der Regel ohne zuzugeben, dass sie irgendwelche Kenntnisse über den

Ursprung dieser Ware hatten und manchmal sogar mit einer Geschichte, die zu verstehen geben sollte, dass es sich um echte Erzeugnisse handele.

Gefälschte Kameras werden oft künstlich gealtert.

Von den folgenden Kameras sind Reproduktionen bzw. klare Fälschungen bekannt oder vermutet:

BEN AKIBA Stockgetarnte Kamera. Davon hat Oberlaender Kopien gemacht.

BERTSCH (kleine Ausführung). Obwohl uns vom grösseren Modell keine Kopien bekannt sind, gibt es zweifellos Kopien der kleineren Version. Bertrand hat 4 Stück mit zwei verschieden gestalteten Magazinen, davon produziert.

BUTCHER'S ROYAL - BRIEFMARKEN-KAMERA

Kopien davon wurden in Indien mitte der '80 Jahre hergestellt und Händlern offeriert zum Wiederverkauf.

Mindestens ein Londoner Fotohändler mit einem guten Ruf, weigerte sich solche zu kaufen, es sei denn alle Kopien würden deutlich als solche gekennzeichnet. Der Hersteller hat diese Forderung abgelehnt und Kopien ohne jegliche Angabe sind auf dem Markt erschienen.

BRINS MONOKULARE KAMERA. Mindestens vier Reproduktionen wurden von Luc Bertrand hergestellt. Obwohl einige seine Initialen und Datum im innern gestempelt (z.B. "BL82") haben, wurden nicht alle von Wiederverkäufer als Kopien angegeben. Höchstwahrscheinlich gibt es auf dem Markt mehr Kopien als Originale.

CONTAX (in Sandfarbe). Echte sandfarbige Contax existierten und werden oft als "Rommel-Contax" benannt wegen ihrer Färbung. Aber anderseits hat Greenborough Fälschungen davon gemacht. Mindestens 5 oder 6 solche sind aufgetaucht. In der Regel ist diese Farbe leicht zu entfernen und das Chrom wird sofort darunter sichtbar.

DE NECK PHOTO CHAPEAU. Vier Reproduktionen hat Bertrand davon gemacht von welchen mindestens zwei verkauft wurden.

ENJALBERT PHOTO REVOLVER. Drei Reproduktionen von Bertrand sind bekannt.

ENJALBERT TOURISTE. Es gibt davon Kopien von Bertrand.

FOTAL. Einige Kopien wurden zu ca. DM 2'000.-offeriert. Hersteller unbekannt.

JOHN PLAYER Zigarettenschachtel-Kamera. Nach Berichten, in Polen durch ein Herr Kaminski, hergestellt. Auch wenn manchmal behauptet wird, sie wurde von der KGB für Spionage benutzt, haben wir keine glaubhafte Beweise gefunden, die diese Behauptungen bestätigen könnten. Wahrscheinlich wurden sie für den Sammlermarktgebaut.

KRÜGENER TASCHENBUCH (Photo-livre Mackenstein). Kopien, oft sehr grob nachgebaut, wurden gemacht und

verkauft. Wenn der Käufer die echte Kamera nicht gut kennt, könnte er Opfer von skrupellosen Händlern werden. Gewisse Kopien sind dagegen so gut gemacht, dass man sie für echte halten könnte. Mindestens eine Kopie von Oberlaenderkann anhand des Buchstaben "R" (wie bei "Reproduktion") nach der Seriennummer auf dem Rücken, identifiziert werden.

LANCASTER UHRENKAMERA - Ursprung unbekannt.

LEICA (Anastigmat). Diese ist eine der seltensten Leicas. Es wurden davon Fälschungen hergestellt, und sogar die Objektive wurden separat verkauft.

LEICA I Elmax. Neun von zehn der heutzutage auf dem Markt vorhandenen, sind Fälschungen. Es begann wahrscheinlich mit einem Elmar, dann wurde der Name wegpoliert, eben ausgeglichen und mit "Elmax" neu graviert. Diese können praktisch nicht mehr erkannt werden. Man muss das Objektiv entfernen und die Linsenanzahl unter dem Mikroskop prüfen. Das Elmar ist 4-linsig und das Elmax dagegen 5-linsig. Die Gehäuse sind in der Regel echt.

LEICA "Luxus" (Goldausführungen). Es wird vermutet, dass Greenborough Fälschungen mit den entsprechenden "richtigen" Seriennummern produziert hat. Verschiedene Kameras mit der gleichen Seriennummer wurden an gutgläubige Sammler verkauft. Ein bekannter Eigentümer eines Fotoladens in Brüssel dient als Beispiel. Als er eine solche von einem anderen Händler offeriert bekam, setzte er sich mit dem Werk in Verbindung, um zu erfahren, ob die Seriennummer stimmte. Da sie richtig war, kaufte er die Kamera. Als später mehrere Anfragen zu Leitz kamen, wegen Kameras, die alle die gleiche Nummer trugen, stellte sich heraus, dass mehrere Kopien mit der gleichen Nummer produziert worden waren. Gutinformierte Sammler wissen, dass zahlreiche vergoldete Leicas in Polen hergestellt, oft durch Ostberlin transitiert haben, um schlussendlich nach westlichen Ländern oder nach Japan zu gelangen. Vor einigen Jahren wurde eine echte, werksüberprüfte Luxus Leica vom Cornwall in Köln versteigert. Inerhalb sechs Monaten erschien auf dem Markt eine Fälschung, die die gleiche Nummer trug. Russische "Fed" Kameras wurden ebenfalls mit Leica-Zeichen graviert und vergoldet und danach Sammlern offeriert. Die meisten "Luxus" Leicas auf dem Markt sind Fälschungen.

LEICA 250 REPORTER. Früher war sie von Sammlern als sichere Investition zwischen den klassischen Leicas gesehen, weil der Gehäuseguss sehr schwer zu kopieren war. Das hat sich radikal verändert. Gefälschte Reporter Leicas sind heute ein Hauptprodukt der polnischen Wirtschaft.

MARION METAL MINIATURE - Ursprung unbekannt.

MINOX A LUXUS. Die echten haben eine gemusterte Metalloberfläche. Einige gewöhnliche Kameras wurden versilbert und haben eine gleichmässige Oberfläche. Damit lassen sie sich leicht als Fälschungen entpuppen. Es sollten aber auch

gemusterte Reproduktionen geben, vermutlich mit echten Minox-Bestandteilen.

MINOX in Zigarettenzünder. Sie sind zuerst anfang 1990 erschienen. Es handelt sich um eine normale Minox Kamera in einem plumpen vergoldeten Gehäuse, das auch einen Butanzünder beinhaltet. Es gibt etliche Varianten. Sie wurde als KGB-Kamera vorgestellt, aber es handelt sich um eine moderne Kuriosität ohne historische Bedeutung.

NEUBRONNER TAUBENKAMERA. Einige sind um 1989 aufgetaucht. Unbestätigter Ursprung.

RINGKAMERAS. Eine Anzahl von Kameras, getarnt als Fingerringe, sind in den letzten Jahren erschienen, manchmal dem KGB unterstellt. In Wirklichkeit sind sie das Werk eines begabten Handwerkers namens Marek Mazur, aus Gdansk, Polen. Jede sieht etwas anders aus, obwohl alle gleiche zylindrische Filmpatrone verwenden, die den Ring darstellt. Der Kopf des Ringes sieht unterschiedlich aus. Einige haben einen rechteckigen Kopf mit einem kleinen Stein auf jeder Seite der mittleren Objektivöffnung. Diese Steine regeln Blende und Verschluss. dieser rechteckigen Köpfe trug drinnen als Warenzeichen "Ernemann" graviert. Eine ähnliche Ringkamera mit einem einzigen Stein kronförmig gestaltet wurde 1991 für US\$ 20'000.- versteigert. Obwohl behauptet wurde, dass sie in einer Sammlung länger als 10 Jahre verbrachte, ist die Ähnlichkeit mit den vermuteten Fälschungen beunruhigend. Einige dieser Ringe sind gut verarbeitet und funktionsfähig, andere dagegen sind nur "für das Auge" bestimmt, mit Teilen die kaum zueinander passen. Es ist denkbar, dass diese letzten, schlechte Kopien der originalen Mazur-Ringensein könnten.

SCENOGRAPHE. Es bestehen Reproduktionen davon, inklusiv Name auf dem Balgen. Bertrand hat eine für seine eigene Sammlung hergestellt, aber anscheinend keine weiteren. Gerüchte über Nachahmungen der Scenographe-Kameras sind uns auch bekannt, aber wir konnten sie weder sehen noch darüber Auskunft erhalten.

SUTTON Panoramische Kamera. Eine wurde von Bertrand produziert und verkauft. Nach mehrfachigem Besitzerwechsel, befindet sie sich nun in einer grossen Sammlung und wird als echt vorgestellt.

TICKA Uhrenkamera - Ein Exemplar trägt drinnen die folgende Inschrift: "TASCHENUHR CAMERA, D.R.P. 173567 H. Meyer-Frey. Frankfurt A/M.". Ihre Echtheit ist zweifelhaft. Es könnte sich um Teil einer Machenschaft handeln mit dem Zweck, einige der seltensten Ausführungen der Ticka zu kopieren, z.B. die versilberten Modelle. Eine "Uhrengesicht-Ticka" wurde von einer Versteigerung bei Christie's entfernt, nachdem sie als Fälschung entlarvt wurde. Zweifellos wird sie einmal ohne Warnung wieder auftauchen.

VOIGTLÄNDER DAGUERREOTYPE CANNON - Eine bekannte Fälschung befindet sich in einer privaten Sammlung. Nicht nur die Grösse davon ist falsch, sogar der Name Voigtländer ist falsch geschrieben.

WIR LADEN UNSERE LESER EIN, JEDE AUSKUNFT ÜBER DIE HIER ERWÄHN-TEN ODER ÜBER ANDERE FÄLSCHUN-GEN, ZU MELDEN.

Gerne werden wir jede Angabe über die Geräte und/oder über Händler und Privatleute, die Sammler absichtlich betrogen haben, veröffentlichen.

GESTOHLENE KAMERAS -FINDERLOHN

Einst konnte man ein halbes Dutzend der wertvollsten Kameras der Welt auf einem unbewachten Tisch einer Photomesse lassen und sie nachher unberührt zurückfinden. Heutzutage wächst die Anzahl Diebstähle Artikeln. von wertvollen McKeowns Preisführer von antiquen und klassischen Kameras wird ab dieser Ausgabe eine Liste von gestohlenen Sammlerkameras veröffentlichen, in einem Versuch dieser abscheulichen Taten zu bekämpfen. Selbstverständlich ist es uns nicht möglich jegliche Diebstähle der Welt aufzulisten, genau wie Ihnen unmöglich wäre jede gekaufte Kamera anhand einer solchen Mammutliste zu überprüfen Deswegen werden wir nur Kameras mit einem Mindestwert von US\$ 1'000.-bzw. Gegenwert in anderen Währungen, und versehen mit einer Seriennummer, in unsere Liste aufnehmen. Als Ausnahme werden Kameras ohne Seriennummer, aber selten genug um sie leicht identifizieren zu können, in unserer Liste ebenfalls figurieren. Wir laden andere Sammlerveröffentlichungen und Vereine ein, diese Liste zu verbreiten und zu ergänzen. Händler, Versteigerer, und Vereine sind in diesem Versuch beteiligt und wir alle fordern Sie auf, uns Ihre Hilfe zu gewäh-

Sollte Ihnen etwas gestohlen werden, melden Sie es bei Ihrer zuständigen Polizeistelle mit möglichst genauer Beschreibung, Angabe der Seriennummer, usw. Teilen Sie uns ebenfalls diese Auskunft mit und fügen Sie Kontaktperson, Telefonnummer und Referenznummer Ihrer lokalen Polizei hinzu. Somit sind andere Leser und Polizeistellen in der Lage mit ihnen Kontakt aufzunehmen, sollte der gestohlene Gegenstand auftauchen. Nur was polizeilich gemeldet wurde, werden wir veröffentlichen. Wir fungieren als reine Informationsaustauschstelle und werden uns in keinerlei Streitigkeiten verwickeln lassen.

Wenn sie etwas angeboten bekommen. das als gestohlen aufgeführt ist, versuchen Sie die Personalien des Anbieters zu ermitteln. Melden Sie es den Messeorganisatoren oder der Polizei, falls möglich solange Sie den Gegenstand noch haben der und Verkäufer noch verschwunden ist. Wenn Sie es uns melden, wird diese Auskunft als "zuletzt gesehen" aufgenommen. Schlussendlich, wenn wir alle mitmachen, werden einige wertvolle Kameras ihre legitime legitime Eigentümer zurückfinden. Von sich selbst wird diese Plage nicht verschwinden. Jeder von uns muss dazu beitragen. Wir. als meistgelesener Kameraführer der Welt, übernehmendie Verantwortung diese Liste zu führen und zu aktualisieren. Da unser Werk jede 2 Jahren revidiert wird, genügt es inzwischen, wenn sie uns einen selbstadressierten und genügend

frankierten Umschlag (bzw. internationalen Antwortschein im Wert einer Brieffrankatur) zustellen, um den aktuellen Stand dieser Liste zu erhalten. Ihre Ratschläge zur Bekämpfung der Kriminalität im Bereich der Kamerasammlung sind herzlich willkommen.

FÜR NÄHERE ANGABEN:

Wir werden oft um Auskunft gebeten, und bekommen viele Anfragen, viel mehr als uns möglich wäre sie alle zu beantworten. Über Artikel die in diesem Buch nicht erwähnt werden, erteilen wir weder Meinung noch Bewertung. Wir sind uns darüber bewusst, dass viele Kameras in diesem Buch nicht behandelt werden, und Sie darüber warnen, zum falschen Urteil zu gelangen, dass ihre Abwesenheit ein Zeichen von Seltenheit sei. Wir haben mindestens 30,000 Kameras verschiedenen Gründen ausgeschlossen, um dieses Buch in vernünftigen Grösse und Preis zu bewahren. Folgende Kameras -unter anderen- wurden ausgeschlossen: die meisten Kameras, die nach den 70' hergestellt wurden, da diese, in der Regel, eher zum gebrauchen als zum sammeln geeignet sind; die meisten 126 und 110 Kameras, die in solchen grossen Zahlen produziert wurden, dass sie häufig und billig sind, viele frühere Kameras, die sehr selten zum Verkauf gelangen. Wir haben ungefähr 8'000 Kameras ausgewählt, als repräsentative Sammelkameras, für welche wir typische Verkaufspreise bestimmen können.

Es ist uns leider nicht möglich Einzelanfragen brieflich oder telephonisch zu beantworten. Wir empfehlen Ihnen, Mitglied von einem oder mehreren der im Anhang erwähnten Fotovereine, zu werden. Sie Können dann Ihre Anfragen an die Redaktoren der Veröffentlichungen solcher Fotoclubs oder an die zuständigen Redaktoren der Foto-Zeitschriften, die Leserfragen beanworten, richten.

VOORWOORD

De eerste editie van de "Price Guide to Antique & Classic Still Cameras" werd gepubliceerd in 1974. Vanaf die tijd is deze gids het meest accurate en volledigste naslagwerk dat er te koop is. Bevatte de eerste uitgave 1000 camera's, deze negende editie omvat méér dan 9 x dat aantal. Hij behandelt niet alleen meer camera's, maar ook de informatie per camera is uitgebreid en waar mogelijk zijn historische gegevens toegevoegd. hebben we 500 foto's meer afgebeeld. waarmee het aantal illustraties op 3500 is gekomen. Met iedere nieuwe editie hebben we belangrijke verbeteringen aangebracht en met Uw steun zullen we deze lijn voortzetten. Om een voorbeeld te geven: in deze uitgave zijn honderden lenzen en accessoires opgenomen van camera's uit de zestiger en zeventiger jaren, en hoewel velen daarvan nog zeer bruikbaar zijn, heeft een aantal zich ontwikkeld tot verzamelobject. aanvulling op de beschrijving van de camera's, die gemeengoed zijn geworden voor handelaren, trachten we juist nog die exemplaren op te sporen die in geen enkel standaardwerk te vinden zijn. In deze nieuwe editie treft U 2000 camera's aan die nergens anders beschreven zijn. Wij hopen dat U er veel plezier van zult hebben.

HOE ZULLEN DE PRIJZEN ZICH ONTWIKKELEN?

Teneinde de huidige en toekomstige prijzen van verzamelcamera's te kennen. is het nuttig iets te weten over de prijsontwikkelingen. In het algemeen stegen de prijzen door tot in 1981, waarna in de jaren 1982-83 een stabiele situatie bereikt was. Eind 1983 en 1984 daalden de prijzen aanzienlijk, zeker ten opzichte van de Amerikaanse dollar, die onze referentiebasis is. Gedeeltelijk was dit te wijten aan een verslapping van de interesse, maar vooral ten gevolge van een forse waarde stijging van de dollar ten opzichte van Europese- en andere muntéénheden. waardestijging Die stagneerde in 1985, om in 1986 te stabiliseren, waarna de waarde van bepaalde stukken zich begon te herstellen. Eind 1986, begin 1987 zorgden de relatief sterke Europese munten ervoor dat de markt weer aantrok, waardoor op de Amerikaanse markt regelrechte koopies te halen waren. Tengevolge daarvan trokken de prijzen van de betere verzamel objecten stevig aan. Gedurende 1987 tot in 1989 zagen we een scherpe prijsstijging in bepaalde gebieden. Vooral de Japanners beinvloedden de prijzen in opwaartse richting met hun sterke Yen. Nu, in 1992, zien we dat zich een sterke concurrentiestrijd ontwikkelt tussen belangrijke verzamelaars in Europa, Hong Kong, de Verenigde Staten en elders. Sommige van de prijzen hebben een niveau bereikt waarvan de realiteit zoek is. De prijzen van Leica zijn vrij stabiel geworden, maar daar staat tegenover dat Nikon en Canon meetzoeker camera's sterk in de lift zitten. Leica copieën, eens een goedkoop alternatief voor de gewone man, zijn in menig geval duurder geworden dan het nagemaakte origineel.

De belangrijkste trend in de verzamelwereld ontwikkeld zich naar de camera's van hoge kwaliteit, zoals die in

de naoorlogse periode tussen 1945 en 1980 zijn gebouwd. Gedurende deze veroverde Japan dominerende rol in de camera produktie. Gedurende de afgelopen 10 jaar hebben de Japanners deze camera's weer in grote aantallen terug gekocht, waardoor er in Amerika en Europa een actieve en vooral lucratieve markt ontstond. Sinds kort echter, betalen de serieuze verzamelaars en handelaren uit Hong Kong en Europa, prijzen, die die van de Japanners evenaren. De verlokking van gewin heeft een nieuwe generatie van handelaren en scharrelaars doen opstaan, op een toch al volle marktsector. Geheel buiten deze stroming van "chroom en techniek" stroming van apparaten, vindt men nog de enkeling, en ook groepjes, die stug doorgaan met het zoeken naar de schoonheid van hout. messing en leder van de antieke en klassieke camera's. De waarde van deze oude camera's is relatief stablel. Bovendien is het aanbod van deze antiquiteiten te gering om een nieuwe generatie van "weekend dealers" te laten ontstaan, Men mag zelfs stellen dat verzamelaars van vroege camera's een affiniteit hebben met hun verzameling, die in de laatste plaats op winst is gebaseerd. Vroege, zeldzame, historisch belangrijke apparatuur is steeds moeilijker te vinden. dat zelfde geldt voor de collectioneurs en handelaren, die er zich mee bezig houden.

Zeldzaam vroege camera's hebben nieuwe recordprijzen opgebracht op veilingen de afgelopen twee jaar, maar die markt is erg klein. Lage inzetprijzen leidden tot een cummulatieve competitie en er werden hoge prijzen gerealiseerd. Aan de andere kant hadden hoge inzetprijzen het tegengestelde effect, waardoor verwachte kopers afhaakten bij enkele zeer belangrijke stukken.

Verzamelaars leggen zich meer en meer toe op kwaliteit. Een camera in slechte conditie wordt moeilijk verkoopbaar. Een enkele camera ontsnapt aan deze ontwikkeling vanwege zijn zeldzaamheid maar het gewone "spul" moet er perfect uitzien en bij voorkeur nog goed werken ook.

Aan het eind van de jaren '70, toen de verzamelwoede explosief toenam, kochten speculanten zich in, ongehinderd door kennis van zaken. Aldus de "inflatie" aanwakkerend, schoten de prijzen omhoog. In 1982-83 volgde een recessie. De oververhitte markt in Japan heeft eenzelfde patroon laten zien, maar is nu enigszins tot rust gekomen. Over de gehele wereld zijn de prijzen meer met elkaar in evenwicht gekommen, wat ook inhoudt dat topprijzen in meerdere landen worden betaald.

Bepaalde typen camera's hebben zich de de laatste jaren gunstig ontwikkeld. Europese platen camera's met bruine beledering en dito balg stijgen sneller in prijs dan de gewone zwarte. Trouwens, iedere gekleurde camera is aanzienlijk duurder dan een zwarte. Boxcamera's (uitgezonderd de gewone zwarte) zitten behoorlijk in de lift. Gekleurde Boxcamera's, diegene met een Art-Deco patroon, de bakelieten en plastic boxen met een aparte vorm, krijgen de laatste tijd een behoorlijke aandacht. Op dit gebied loopt Europa voor op de Verenigde Staten.

Een andere ontwikkeling is dat sommige Art-Deco camera's op gespecialiseerde kunstveilingen een veelvoud opbrachten van de gangbare prijs in de camera verzamelwereld.

CAMERA'S UIT DE VOORMALIGE SOVJET UNIE

Vele jaren waren camera's uit de U.S.S.R. vrij ongewoon in Europa en zelfs zeldzaam in de Verenigde Staten. In deze exponent van de "Koude Oorlog" is plotseling verandering gekomen. De muren van de Oostbloklanden zijn geslecht en de Sovjet heeft haar ijzeren opengeschoven. Vele Sovjet camera's die eens als zeldzaam te boek stonden, duiken in grote hoeveelheden op bij veilingen en beurzen, alsmede camerawinkels in Europa en de U.S. Tegelijkertijd zijn de prijzen drastisch gedaald. Sommige handelaren en verzamelaars, die nog voor de oude prijs kochten, aarzelen hun vraagprijs te verlagen. Mede hierdoor is de markt voor Russische camera's vrij onstabiel. Het zal enkele jaren duren voordat mechanisme van vraag en aanbod de prijzen gestabiliseerd heeft. Sommige Russische camera's zullen zeldzaam zijn maar niet noodzakelijkerwijs dezelfde als voorheen.

De markt voor Russische camera's zal verder in diskrediet raken door de grote hoeveelheid vervalsingen. Bijna iedere camera met een speciale bekleding, gouden metaal delen of speciale graveringen, moet op zijn minst met argwaan worden bekeken. Er is een georganiseerde groep van Russische en Poolse handelaren die een voortdurende stroom van 'zeldzame' produceert. Tijdens dit proces hebben zij menigmaal camera's met een historische waarde omgevormd tot 'Goldplated'. Of camera's voorzien van een speciale praktijken zullen Deze aanhouden zolang verzamelaars en handelaren dit aanmoedigen door te blijven kopen. De waarde van de echte camera's zal ondergraven worden aangezien kopers op hun hoede zullen worden zijn. Bewijs van echtheid zal van vitaal belang worden, aangezien 'interessante verhalen' gratis bij iedere camera kunnen worden geleverd.

Kort geleden werd op een verzamelbeurs een Leica 'Luxus' sangeboden met een 4-cijferig nummer en militaire merktekens uit de Tweede Wereldoorlog. Niet alle versalsingen zijn zo doorzichtig. (4-cijfer registraties op een Leica dateren van lang voor Hitler's tijd, militaire camera's waren nimmer in een 'Luxus' uitvoering, enz, enz.)

WAT "IN" EN "UIT" ZAL ZIJN IN DE JAREN 90.

De laatste paar jaar heeft de speculatieve markt zich voornamelijk op Nikon geworpen, gevoed door een klein maar invloedrijk groepje verzamelaars en handelaren. Het ziet er naar uit dat aan deze prijsopdrijving een eind is gekomen.

Miniatuur camera's komen steeds meer in de belangstelling, waarbij de meesten nog zeer betaalbaar zijn voor de eenvoudige verzamelaar. Echter tijdens de spraakmakende veiling bij Christie's Londen in december 1991, heeft een

anonieme telefonische bieder voor flinke frustraties gezorgd bij de aanwezige kopers in spé. De meeste stukken gingen voor een vele malen hoger bedrag weg dan de verwachtte opbrengstprijs. Het schokeffect van deze veiling is nog steeds merkbaar, Miniatuurcamera's zijn in het algemeen in prijs gestegen. Echter, sommige verkopers gaan er vanuit deze topprijzen op elk moment te kunnen realiseren.

EEN ADVIES AAN NIEUWE VERZAMELAARS

Ons advies aan beginnende verzamelaars is afhankelijk van de motieven om te gaan verzamelen. Als U gaat verzamelen uit het oogpunt van belegging, dient U zich te concentreren op zeldzame en ongewone modellen, wat echter meer geld en expertise eist. Gaat het U echter expertise eist. voornamelijk om het plezier van het verzamelen, dan volgt U gewoon Uw gevoel en portemonnee. De vele beschikbare goedkope camera's stellen U in staat een betaalbare hobby te hebben en voor velen is dit een goed begin gebleken. Afhankelijk van het land waar U woont, kunt U eenvoudig, goedkoop en met veel plezier een collectie starten van Kodak, Ensign, Agfa of uitsluitend Nederlandse camera's De meeste Nederlandse camera's verzamelaars zijn in de breedte begonnen, terwijl ze zich pas later zijn gaan specialiseren. Indien U geld probeert te verdienen met de handel in camera's dan dient U op de hoogte te blijven van wat op dat moment gewild is. Ontwikkel Uw eigen interesse en blijf binnen dat gebied waarin U een specialisatie heeft opgebouwd. Door de ontwikkelingen goed te volgen, is het mogelijk om winst te maken op het mechanisme van vraag en aanbod in samenhang met de interesse van Uw klanten.

Alle prijzen in deze editie zijn herzien. Ze zijn zo actueel mogelijk en de omschrijvingen zijn bijgewerkt volgens de laatste gegevens. Wij hebben echter, om prijs opdrijving te voorkomen, een algeheel gemiddelde van geregistreerde prijzen van een object genomen over de afgelopen 10 jaar. Wij kijken liever naar de lange termijn voor het vaststellen van onze prijzen dan ons te laten leiden door wilde uitschieters.

De gegevens in deze uitgave zijn gebaseerd op vele honderdduizenden prijzen, afkomstig van veilingen, beurzen en onderlinge verkopen. Het is een naslagwerk, een rapportage. De genoemde prijzen geven niet weer wat ik denk dat de waarde is, maar wat de waarde was op het moment dat een nieuwe eigenaar even met de billen bloot En hiermee komen wij aan de moest. essentie van "de Wet van McKeown" die luidt: "De priis van een verzamelcamera wordt uitsluitend bepaald door de gevoelens van de koper en verkoper op het moment van de transactie".

Op deze filosofie zijn nog een aantal aanvullingenmogelijk:

1. "Als U de kans voorbij laat gaan de camera te kopen, die U al heel lang zocht, zult U deze kans nooit meer krijgen."

2. "Indien U een camera koopt, die U al

2. "Indien U een camera koopt, die U al heel lang zocht, zult U binnen een week een tweede vinden die er veel beter uitziet en slechts de helft kost."

3. "De gevoelswaarde van een antieke of klassieke camera is evenredig aan de overtuiging van de eigenaar, dat iemand anders hem wil hebben."

Met deze beschouwingen dient U altijd rekening te houden als de Wet van McKeownwordt toegepast.

GEBRUIKSSAANWIJZING VOOR DEZE GIDS

Alle camera's zijn alfabetisch gerangschikt op naam van de maker. Enkele camera's zijn op naam van het model geplaatst omdat we de naam van de maker niet konden achterhalen. Over het algemeen zijn de typen camera's van een maker of fabriek ook weer op alfabetische volgorde gezet, maar in enkele gevallen hebben we type, formaat, jaartal of andere overeenkomstenbij elkaar gezet.

De foto's zijn meestal direct boven de vetgedrukte kop de camera-aanduiding geplaatst. Om opmaaktechnische redenen is dit echter niet altijd mogelijk. Soms, wanneer de tekst doorloopt in een volgende kolom, staat de foto in het midden van de beschrijving. Indien de foto niet bii de tekst hoort is het onderschrift cursief gedrukt en geeft een voetnoot aan waar de foto staat. Indien een foto tussen twee beschrijvingen in is geplaatst heben we geprobeerd dit met een dikke lijn onder de foto aan te geven. Op deze manier kan de vetgedrukte camera-aankondiging tevens als fotobijschrift dienen, hetgeen een hoop ruimte scheelt. Wij besparen 40 pagina's door niet alle 3500 foto's van een apart onderschrift te voorzien.

We hebben verschillende lettertypen gebruikt om deze gids duidelijker te maken. De methode is alsvolgt:

MAKER (VETGEDRUKTE HOOFD-LETTERS) Historische gegevens of

opmerkingen (cursief).

Naam van de camera (vetgedrukt)
- Beschrijving van de camera en

waardegegévens (onderkast). Speciale opmerkingen betreffende camera of prijs (cursief).

CAMERA NAAM - Indien de naam van het model of de camera in hoofdletters is gedrukt, is er sprake van een aparte beschrijving die geen verband houdt met de vorige camerabouwer. Deze methode gebruiken we onder meer als de maker of fabrikant onbekend is.

Op het eerste gezicht zal deze lay-out niet de schoonheidsprijs verdienen, maar er is zorgvuldig over nagedacht om zoveel mogelijk ruimte te besparen en het toch overzichtelijk te houden. Onze computer had op eenvoudige wijze een kader om elke foto kunnen trekken, maar dat had 50 pagina's méér betekend. Het zou nog eens 90 pagina's extra gevergd hebben als de camera-kopjes omkaderd waren. Aangezien lezers serieuze onze verzamelaars zijn, wensen zii het maximum aan informatie op een minimale ruimte. Wij hopen dat u van ons "kleine" boek zult genieten. Indien we voor de fraaiste weg hadden gekozen, zou dit een monster van 800 bladzijden zijn geworden en daardoor 30% dikker, zwaarder en

duurder. Wij hopen dut u het met de door ons gevolgde methode eens bent.

CONDITIE WAARIN DE CAMERA ZICH BEVINDT

Een camera die er perfect uitziet, maar niet werkt, kan volledig geaccepteerd worden door een verzamelaar die hem alleen maar in de vitrine zet. Evenzo kan iemand zich niet druk maken om het uiterlijk, zolang de camera maar goed functioneert. Daarom zijn wij sterk voorstander van een tweevoudige beoordeling van camera's betreffende uiterlijk en werking. Dit zou een wereldstandaard moeten ziin prijsgidsen, veilingen, publicaties van verzamelaarsverenigingen verkooplijsten van handelaren.

dergeliike een poging een wereldstandaardop te zetten stellen we de volgende referentieschaal voor. Met opzet hebben we gekozen voor een cijfer en een letter om te voorkomen dat er een misverstand ontstaat met reeds bestaande systemen. De conditie van een camera zou door een cijfer weergegeven moeten worden, gevolgt door een letter. Het cijfer is een waarde-aanduidingvoor de uiterlijke staat en de letter zegt iets over hoe de camera functioneert. Dit systeem is in gebruik bij de Britse Fotograficavereniging.

WAARDERINGSCHAAL---HET UITERLIJK

- **0 -** Nieuw, nooit gebruikt. In originele verpakking met garantie en gebruiksaanwijzing.
- 1 Als nieuw. Nooit gebruikt. Zelfde als hierboven, maar zonder garantie. Origineel verpakt.
- **2** Geen gebruikssporen. Als er een doos omheen zat was het niet van nieuw te onderscheiden.
- **3** Zeer minimale gebruikssporen.
- **4 -** Lichte gebruikssporen, geen beschadigingen.
- **5** Compleet, maar met sporen van normaal gebruik of ouderdom.
- **6** Compleet, maar met duidelijke sporen van gebruik. Intensief mee gewerkt.
- 7 Te restaureren. Mogelijk wat bijverven. Minder belangrijke (onder)delen kunnen ontbreken of kapot zijn.
- 8 Te restaureren. Moet opgeknapt worden. Sommige (onder)delen ontbreken of zijn kapot.
- **9** Uitsluitend nog geschikt voor het slopen van onderdelen, tenzij de camera zeer zeldzaam is.

WAARDERINGSCHAAL---DE WERKING

- A Nieuw. Alles uitstekend werkend. Met fabrieksgarantie.
- B Nieuw. Als boven, echter zonder fabrieksgarantie. Verkoper geeft garantie.
- C Werkt uitstekend. Professionele servicebeurt gehad en gegarandeerd door de verkoper.
- **D** Goed werkend. Professioneel nagegekeken, maar niet langer onder garantie.
- **E** Goed werkend. De belangrijkete functies zijn recentelijk nagezien.
- F Goed werkend, maar niet onderhouden. Werking van de sluiter en/of meter niet gegarandeerd.
- **G** Werkend, maar sluitersnelheden en/of meter wijken vermoedelijk af. Moet bijgesteld worden.
- H Bruikbaar, sluiter hangt en meter hapert.

J - Onbruikbaar, maar kan gerepareerd worden. Sluiter, meter, filmtransport geblokkeerd of kapot.

K - Waarschijnlijk niet te repareren.

In dit systeem komt de bescrhrijving van de gemiddelde camera uit op 5F. camera met waardering 3C heeft lichte gebruikssporen, maar meter of sluiter kunnen afwijken. Zo kan een accurate en beknopte beschrijving worden gegeven en worden problemen, ontstaan door het gebruik van cijfers en letters zonder onderscheid tussen uiterlijk en werking. vermeden. Als gebruikers het uiterlijk van een camera nog nauwkeuriger willen omschrijven kan zelfs een tweede cijfer toegepast worden. Een camera met beoordeling 56B zou dan aangeven dat de uiterlijke toestand tussen de 5 en 6 ligt, terwijl de B aanduidt dat de camera goed werkt.

Sinds we dit systeem hebben voorgesteid is een aantal tijdschriften en handelaren een dergelijk systeem gaan gebruiken, echter met het cijfer 10 ais topwaarde en dus in omgekeerde volgorde. Zorg er dus voor dat u weet welk systeem gebruikt wordt als u een camera koopt.

EEN VERGELIJKING MET ANDERE WAARDERINGSYSTEMEN:

Het voigende staatje vergelijkt het uiterlijk gedeelte van het waarderingstysteem zoals dat elders in gebruik is, met letter en cijferaanduidingen. Deze vergelijkingen zijn gemiddelden en worden gegeven om het gebruikers gemakkelijk te maken op het nieuwe systeem over te gaan. De laatste kolom in de tabel toont in algemene zin hoe de conditie de prijs kan beönvloeden. Deze mogen echter alleen als gemiddelden worden gebruikt. conditie beönvloedt de prijsverschillen bij de diverse typen en jaartallen van camera's. De voorgestelde marges zijn percentages van prijzen in de gids. Wij hebben geen enkele vergelijking gemaakt met andere systemen, omdat er teveel in omloop zijn.

McKeown PCCGB		German	% of
Christie's	SA	Auctions	book price
0	Ν	-	150-200%
1	LN	-	130-150%
2 3	M	Α	120-140%
	M	AB	115-130%
4	E +	В	110-120%
5	Ε	С	95-115%
6	VG	CD	80-110%
7	G	D	55-85%
8	F	E	30-60%
9	P	-	10-30%

Alle losse of zoekgeraakte onderdelen dienen vermeld te worden. Het gebruik van (-) voor of na het waarderingscijferof - letter betekent alleen dat het net niet de waardering aangeeft. Het omgekeerde geldt voor (+).

Als uw camera delen mist of delen kapot zijn, zal er een tweede camera nodig zijn om hem compleet te maken. Waarde oordeel: Camera 1 + camera 2 + arbeidsloon = waarde van de goede camera die ontstaan is.

Soms zijn verzamelaars wat "soepeler" in het hanteren van deze waarden bij oude en zeldzame camera's, terwijl ze bij algemene of gebruikscamera's accurater zijn in hun beschrijving. Indien men een camera beschrijft als "in zeer goede conditie gezien de ouderdom" dan men er een persoonlijke omschrijving aan toe als zouden oude camera's andere camera's een andere beschrijving behoeven. Zelfs het feit dat bijna iedere een beschrijving oude camera leeftijdsporen vertoont, houdt nog niet in dat de ouderdom de conditie ervan verbetert.

DE TOEPASSING VAN DE PRIJZEN.

Alle prijzen zijn vermeld in Amerikaanse dollars. De prijzen zijn voor camera's in conditie 5 zoals hierboven beschreven. Dit is de meest voorkomende situatie en daarom ons standaard-gemiddelde. Teneinde de waarde van een specifieke camera vast te stellen, dient de gebruiker van deze gids alle kleine variaties van deze beschrijvingen mee te laten tellen en zo de waarde aan te passen.

Tenzij "Body only" wordt vermeld is de genoemde prijs van toepassing op de camera inclusief de lens, achterwand en alle andere delen die er normaal bijhoren.

De laag geprijsde artikelen zijn altijd enigszins te hoog geprijst vanwege het simpele feit dat overheadkosten bijna net zo hoog zijn ais op een camera die een paar honderd of duizend gulden waard is. De wat duurdere camera's zijn her nauwkeurigst geprijst. Vanwege het grote aanbod blijven de prijzen hiervan stabiel. De prijzen van kostbare camera's zijn veel onzekerder, aangezien vraag en aanbod beperkt zijn.

VERWACHT NOOIT DE HOOGST VERMELDE PRIJS VAN EEN HANDELAAR TE KUNNEN KRIJGEN.

Als u één of twee camera's te koop heeft verwacht een topprijs van een handelaar te krijgen, dient u de zaak even van zijn kant te bekijken. Teneinde de camera weer te kunnen verkopen moet hij hem opknappen en aan de nieuwe koper garanderen. Bovendien heeft hij een hoop kosten ais tafelhuur, verzekering en reiskosten e.d. Bovendien heeft hij vaak te maken met een koper die naar de laagste prijs in de gids wijst. Als een camera een paar maanden onverkocht blijft daalt de waarde ervan, omdat iedereen er met zijn handen aanzit op beurzen en dergelijke. Uiteindelijk ruilt hij hem misschien in voor de helft van de prijs bij een transactie met een andere handelaar. Zo kan de camera wel op 4 of 5 verschillende tafels komen. voordat er een "goede" prijs voor betaald wordt. Dit voorbeeld gaat vooral op bij algemene camera's. Voor zeldzame camera's geldt natuurlijk een ander verhaal. De kopers zullen er om vechten en elkaar beconcurreren.

CAMERAPRIJZEN IN EUROPA EN JAPAN

In sommige gevalien moeten we een onderscheid maken tussen prijzen voor een bepaalde camera in Amerika, Europa en Japan. Ook per land in Europa bestaan er verschillen. Dit onderscheid is echter niet altijd gemaakt. Het moet duidelijk zijn dat onze basisprijs geldt voor de prijs van het land van herkomst. Aangezien de meeste camera's ook naar de Verenigde Staten werden geëxporteerd, zal de prijs over het algemeen hetzelfde zijn als in de rest van de wereld.

Het prijsverschil van goedkope camera's in verschillende landen is over het algemeen te verwaarlozen en is dan ook niet vermeld in deze gids, behalve voor specifieke modellen waarbij de prijs niet alleen hoger is tengevolge van verzendkosten. Vele japanse kwaliteitscamera's zijn in Europa duurder dan in Amerika. Dit ten gevolge van het feit dat er destijds meer in Amerika werden geimporteerd. Vanwege een geringer aanbod in Europa is de competitie in het verzamelcircuit groter.

Om een voorbeeld te geven: in Duitsland, dicht bij de bron, kost een DUFA Pionyr \$25,-, in Londen wordt hij verkocht voor \$45-. Deze twee waarden drukken een acceptabel verschil uit. Wij gaan echter voorbij aan de waarneming in Tokyo waar er \$125,- voor gevraagd werd. Zelfs indien verkocht, kunnen we de prijs niet als standaard accepteren.

ZIJN DE PRIJZEN IN JAPAN OVER HUN HOOGTEPUNT?

Toen de Japanse economie op zijn hoogtepunt was, was het zeer moeilijk voor westerse kopers om dezelfde prijzen te betalen. Inmiddels heeft de markt zich wereldwijd gestabiliseerd.

HOE WORDEN ONZE PRIJZEN VASTGESTELD?

We verzamelen en analyseren de prijzen van vele bronnen uit de hele wereld, veilingopbrengsten, waaronder dealerlijsten beursprijzen, fotohandelaren. Ons elektronisch archief bevat honderdduizenden opbrengsten voor iedere nieuwe editie alsmede onze aangepaste oude gegevens. Enige uitleg is vereist bij het feit dat onze opgaven niet altijd overeen komen met Uw eigen U leest bijvoorbeeld waarneming. regelmatig dat camera X wordt aangeboden voor een prijs tussen de \$275,- en \$325,-. Dit zet zich vast in Uw herinnering. Dat doet onze computer ook. De kans bestaat dat DEZELFDE camera een aantal malen wordt aangeboden. Op die manier leest U een aantal malen een prijs die niet reël is. In het geval van camera X begon de verkoper met een prijs van \$450,- Na een jaar was de camera nog niet verkocht en kostte inmiddels \$250,- op het moment dat onze gids gedrukt werd. In onze gegevens bleek dat camera X normaal op meerdere plaatsen in de wereld voor tussen de \$125,- en \$175,- verkoopt. Uiteindelijk kon de te duur geprijsde camera verkocht zijn aan iemand die zo gewend was geraakt aan het hoge bedrag dat hij uiteindelijk denkt dat \$250 - een koopje is. Onze computer heeft echter een ver geheugen dat de uiteindelijke verkoopprijs registreerd. hoge prijzen zijn alleen bruikbaar als prijsplafond.

Onze prijzen reflecteren het grootste gedeelte van de gerealiseerde prijzen, gebaseerd op feiten en geen natte vingerwerk. Wij zijn geen handelaren in camera's omdat we geen vermenging van zaken willen.

VALUTA'S

De prijzen in deze gids vertegenwoordigen een gemiddelde van de wereldmarkt prijzen. Sommige camera's zijn in het ene land zeldzamer dan in het andere. De interesse van verzamelaars verschilt per land of werelddeel en

"grillen" "modeverschijnselen" en beinvloeden het beeld. Echter, geen van de verzamelgebieden is ongevoelig voor invloeden van buitenaf en de fluctuaties lijken wereldwijd minder heftig te worden. Hoge opbrengsten in een bepaald land brengen een stroom op gang totdat aan de vraag voldaan is waarna de opbrengst Alle waarden zijn in weer daalt. Amerikaanse dollars gegeven omdat we nu eenmaal van een basis moeten Teneinde een bruikbare uitgaan. vergelyking te maken, geven wy een staatje met de wisselkoersen 07.VI.1994. U dient deze waarden met de amerikaansedollars te vermenigvuldigen.

VALUTA	= US\$	US\$1 = *
Australia \$.7345	0.3615
Austria Schill	.08602	11.625
Belgium Franc	.02917	34.282
Brazil Cruz.	.0004975	2010.05
Britain £	1.5095	0.6624
Canada \$.7287	1.3727
France Franc	.17598	5.6825
Germany DM	.6002	1.666
Hong Kong \$.12940	7.7280
Italy Lira	.0006188	1616.03
Japan Yen	.009602	104.15
Netherlands Dfl	.5354	1.8679
N.Zealand \$.5914	1.6909
Spain Peseta	.007331	136.41
Sweden Krona	.1262	7.9260
Switzerland Fr	.7078	1.4128

VEILINGPRIJZEN:

veilingprijzen Genoemde hamerprijzen, dus zonder opgeld en B.T.W. Aangezien de kosten van de koper en de verkoper nagenoeg gelijk zijn, vertegenwoordigt de hamerprijs logisch evenwicht tussen de netto prijs van de verkoper en de brutoprijs van de koper.

VERKOOP VAN VERZAMELCAMERA'S

Of u nu een enkele camera of een grote wilt verkopen, verzameling prive-verzamelaar of als handelaar kunt u van diverse mogelijkheden gebruik maken. Allen hebben zowel voor- als nadelen. Die verschillen van camera tot camera

VEILING

Voordelen - Uw ingebrachte artikelen worden vrijwel zeker verkocht. U krijgt uw geld. Zeer zeldzame stukken brengen niet zelden meer op dan verwacht. Eeen lage inzatprijs trekt meer kopers aan en levert vaak meer op.

Nadelen - Lange wachttijd, vaak enkele maanden in verband met catalogus en uitbetaling. u betaalt een commissie (meer naarmate de opbrengst hoger is). hoge inzetprijs ontmoedigt kopers. Dit feit volgende bij een verkoop onthouden, waardoor er weer niet wordt geboden.

VERKOOP AAN DE HANDEL

Voordelen - U hoeft niet lang op een koper te wachten en 'boter bij de vis. Handelaren betalen een goede prijs voor een goed stuk. Niet zelden betalen ze meer dan u op een andere manier zou krijgen, omdat zij hun afzetgebied goed kennen. (Vaak verkopen handelaren om die reden aan elkaar en maken beiden winst). U krijgt de volle prijs die u wilt en hoeft geen commissie af te dragen.

Nadelen - Handelaren kopen in tegen een lagere prijs dan de werkelijke verkoopwaarde. (Dit hoeft voor u geen echt nadeel te zijn aangezien u de top van

de markt toch niet kunt bereiken). Menige handelaar biedt geen bedrag, ze willen graag horen wat u ervoor wilt hebben. Als u langs gaat bij verschillende handelaren om de hoogste prijs te horen, bent u feitelijk met een soort prive veiling bezig. Vele handelaren houden niet van deze methode, het kost u (en hen) veel tijd en het levert niet altijd meer op. Je bent vaak beter af het aan een handelaar te verkopen die u kent en vertrouwt.

BEURZEN EN VLOOIENMARKT

Voordelen - Geen tussenpersoon. De gehele opbrengst is voor u. (Vaak is dit voornamelijk een psychologisch effect. Wanneer je tijd en onkosten zoals autokosten, tafelhuur e.d. in aanmerking De mogelijkheid om andere verzamelaars te ontmoeten, te ruilen, je eigen verzameling op te waardenenenz. Nadelen - Vele verborgen onkosten, vaak meer dan de veiling-commissie of de lagere prijs van de handel. De tafelhuur is op de meeste beurzen zeer hoog. Vaak duurt het lang voordat je een stuk kunt verkopen (dit geldt tevens voor de handel).

RONDSTUREN VAN VERKOOPLIJSTEN Voordelen - U kunt zoveel mensen bereiken als u wilt, zonder kosten te hebben voor reizen en tafelhuur. U hoeft niet met de camera's te zeulen.

Door het vele vervoer gaat de camera er

Nadelen - Potentiele kopers gelimiteerd door omvang adressenbestand. Kosten voor drukken en verzenden. De koper kan de camera niet bekijken dus moet u een terugkoop garantie geven, of een korting of extra porto-kosten.

ADVERTEREN

niet beter uitzien.

Voordelen - U kunt zeer gericht op uw doelgroep werken door in het juiste blad te Dit kunnen clubbladen, adverteren. fotografica- of fotobladen zijn. Zeer bruikbaar voor kleine aantallen tegen aantrekkelijke kosten.

Nadelen - Er zit vaak geruime tijd tussen aanbieden en verkopen. U bent niet zeker van verkoop, speciaal niet indien u een topprijs verlangt. Hoe redelijker de prijs des te groter is de kans op verkoop.

CAMERA REPRODUKTIES

Met het stijgen van de prijzen stijgt ook het aantal vervalsingen, reprodukties en andere misleidingen. Al vele jaren zijn verzamelaars en handelaren hiervan op de hoogte. Maar in plaats van hieraan iets te doen, heeft men deze informatie voor zichzelf gehouden. Het is tijd om deze kennis publiek te maken om onze lezers en mede-verzamelaars te beschermen. Reprodukties van zeldzame camera's voor museale collecties en topverzamelingen zijn noodzakelijk. Wij accepteren echter niet dat deze ooit als origineel worden aangemerkt.

We hebben verschillende mogelijkheden. Als er ruimte is voor zowel de verzamelaars als de vervalsers, dan hebben deze geen probleem. Volgens ons moeten verzamelaars de criminelen van hun 'hobby' verdrijven en niet andersom. Wij zullen elkaar op de hoogte moeten houden van iedere misleiding.

volat een opsomming van replica-makers restaurateurs. en vervalsers:

Luc Bertrand - Belgie. Een kundig vakman die zowel restaureert als replica's maakt. Maakt zowel vroege metalen als houten replica's die moeilijk van echt te onderscheiden zijn. Maakt zeldzame onderscheiden zijn. camera's in een kleine oplage voor zowel zijn eigen verzameling als voor musea en prive verzamelaars. Hierbij moet worden opgemerkt dat Bertrand zijn reprodukties voorziet van zijn initialen en datum. Ongelukkigerwijs zijn sommige in de handel gekomen als originelen. replica's van voor 1989 zijn in kleine oplage gemaakt, meestal niet meer dan 4 stuks, waarvan er zich 1 bevindt in de collectie van de maker. De anderen hebben vaak een serienummer van 1 tot 4. volgend op de initialen 'LB' of 'BL' en een datum-aanduiding. Na 1989 voorziet Luc Bertrand zijn replica's van een klein monogram 'LFB' in het hout of metaal gestanst. Na 1990 heeft Bertrand volgens zeggen slechts 6 camera's in serie gebouwd. 15 anderen zijn vanaf die datum voor zijn eigen collectie vervaardigd als unica's. Bertrand verklaarde vanaf midden 1990 zo'n 35 replica's te hebben gemaakt, waarvan de helft nog steeds in zijn bezit is. Ook gerestaureerde delen van zeldzame camera's voorziet hij van zijn monogram gevolgd door de datum.

90

Luc Bertrand is zo vriendelijk geweest ons een voorbeeld te sturen van zijn monogram zodat we dit publiek kunnen Dit is een eerlijke poging om maken misverstandente voorkomen.

Greenborough - We hebben de heer Greenborough nimmer ontmoet, noch gesproken. Onze informatie is louter gebaseerd op wat we van andere verzamelaars hebben gehoord. Volgens zeggen zijn Greenborough en zijn vrouw die in Duitsland wonen. Vermoedelijk maakt hij de camera's niet zelf, maar laat hij nieuwe ontwerpen die tot de verbeelding spreken. Volgens onze bronnen worden zijn camera's in zijn opdracht in Polen gemaakt. Wij hebben begrepen dat ze niet als replica herkenbaar zijn en veelal als origineel ter verkoop worden aangeboden, hetzij door onwetendheid of bewuste misleiding. Volgens een onzer bronnen zou hij nu gestopt zijn. Aan zijn praktijken toegeschreven camera's zijn onder meer: Leica 250, Minox Aansteker camera, Ticka Watch Camera (Duitse Versie), Leica Luxus, John Player Special (Sigaretten pak camera).

Oberlaender heeft replica's gemaakt van meerdere zeldzame camera's, waaronder de 'DOPPEL SPORT' (de camera die aan de borst van een postduif werd bevestigd) en de 'Photo Carnet' versie van Krugener's Taschenbuch Kamera. Sommige van deze kopieen zijn nauwelijks van de originelen te onderscheiden. Voor zover we weten zijn er geen speciale kentekens in de Postduif Camera aangebracht en we weten van een aantal gevallen waarin ze voor echt verkocht zijn. Er is ons een geval bekend waarbij een Photo Carnet Camera was gemerkt met een R achter het serienummer op derug van het boek. De camera werd opnieuw verkocht bij Christie's in Londen. Bij dezelfde veiling, in december 1991, werd een Doppel Sport

replica geveild. Beide camera's werden door Christie's correct beschreven als replica's.

Zowel de Greenborough als Oberlaender produckten zijn direct of via-via verkocht aan enkele van de belangrijkste verzamelaars in de wereld. Deze en andere reprodukties zijn opgenomen in belangrijke collecties zonder als zodanig te zijn gemerkt. Zij zijn opnieuw verhandeld als originelen, hetzij uit onwetendheid hetzij uit bewuste misleiding. Een aantal gerespecteerde handelaren heeft op deze wijze de vervalsers in de kaart gespeeld door hun vervalsingen als onderdeel van hun normale verkopen op te nemen, zonder zich bewust te zijn van de ware herkomst en vaak vergezeld van een aannemelijk verhaal over de herkomst.

Vervalsingen worden vaak bewust 'verouderd' om ze echt te laten lijken.

VAN DE VOLGENDE CAMERA'S IS BEKEND DAT ZE ZIJN VERVALST:

BEN AKIBA - Wandelstok camera, kopieen vervaardigd door Oberlaender.

BERTSCH - (klein model) Voor zover we weten is er geen kopie van het grote model in omloop. Bertrand heeft echter 4 kleine modellen gemaakt.

BRINS VERREKIJKER CAMERA - Tenminste 4 exemplaren zijn door Luc Bertrand gemaakt. Enkele zijn voorzien van zijn initialen + datum (bijv. 'BL 82'), maar niet ieder exemplaar is als zodanig kenbaar gemaakt bij doorverkoop. Er zijn meer replica's dan originelen in omloop.

BUTCHER'S ROYAL MAIL POSTAGE STAMP CAMERA. In het midden van de jaren tachtig werden reprodukties in India gemaakt en aan de verzamelhandel te koop aangeboden. Er is een geval bekend van een fotografica-dealer uit Londen die ze alleen wilde verkopen als ze ook als kopie werden kenbaar gemaakt. Dit werd door de maker geweigerd en zo verschenen er falsificaties op de markt.

CONTAX (zandkleurig) - Er bestaat een originele zandkleurige Contax, vaak de 'ROMMEL-CONTAX' genoemd naar de Duitse generaal van het Afrika Korps. Er zijn echter zeker 6 vervalsingen gemaakt door Greenborough. De zandkleur houdt echter niet echt goed op de chroom onderlaag.

NECK PHOTO CHAPEAU - Vier reprodukties van de hand van Bertrand waarvan er twee verkocht zijn.

ENJALBERT PHOTO REVOLVER - Drie reprodukties bekend van Bertrand.

ENJALBERT TOURISTE - Replica's bekend van de hand van Bertrand.

FOTAL - Enkele kopieen werden recentelijk aangeboden voor rond DM 2000,-. Maker niet achterhaald.

JOHN PLAYER SPECIAL - Volgens zeggen gemaakt in Warschau, Polen, door ene KAMINSKI. Hoewel vaak wordt gemeld dat deze zouden zijn gebruikt door de KGB is daar nimmer een bewijs voor geleverd. Het lijkt er meer op dat deze

speciaal voor verzamelaars zijn gecreeerd.

KRUGER TASCHENBUCH (Photo - Livre Machenstein) - Enkele slecht gemaakte replica's zijn de laatste tijd verkocht. Wanneer de koper het origineel niet kent, is hij snel misleid door een onscrupuleuze verkoper. Er zijn echter ook zeer kundig vervalste exemplaren in omloop. Een kopie, vervaardigd door Oberlaender, is gemerkt met de letter 'R' (voor replica) achter het serienummer op de rug van het boek.

LANCASTER WATCH CAMERA - maker onbekend.

LEICA (Anastigmat) - De Leica A Anastigmat is een van de zeldzaamste Leica's. Er zijn falsificaties in omloop en zelfs de lens is apart vervalst. Nadat een Amerikaanse dealer een echte in zijn lijst to koop aanbood met vermelding van het serie-nummer, verschenen er kort daarop kopieen op de markt met allen hetzelfde registratie-nummer.

LEICA I ELMAX - Negen van de tien zijn vervalsingen. De lens is waarschijnlijk een vermomde Elmar die opnieuw gegraveerd is. Om achter de ware toedracht te komen zou men de lens moeten demonteren teneinde vast te stellen of er 4 (Elmar) of 5 (Elmax) lens elementen zijn. De body's zijn meestal wel echt.

LEICA "Luxus" (Gouden uitvoering) -Meerdere vervalsingen gemaakt door Greenborough, waarbij er 'correcte' serienummers zijn aangebracht. Verschillende verzamelaars hebben een camera met hetzelfde serienummer. Een exemplaar werd in Brussel aangeboden door een bekende dealer. Toen de koper het registratie-nummer liet controleren door Leitz in Wetzlar werd het nummer correct beyonden. Kort daarop kreeg Leitz nummer ter verificatie aangeboden vanuit andere landen, zodat werd vastgesteld dat meerdere kopieen met hetzelfde nummer in omloop waren. Vele verzamelaars zijn inmiddels op de hoogte van de vele gouden Leica's die plotseling uit Polen komen via Oost-Berlijn.

Enkele jaren geleden werd een echte LUXUS geveild bij Cornwall in Keulen. Een half jaar later verscheen er een falsificatie met hetzelfde serienummer op de markt. Er zijn zelfs Russische FED camera's van Leica tekens voorzien en met een goud coating op de de markt gebracht. Het is droevig vast te stellen dat de meeste 'LUXUS' Leica's die nu te koop zijn, vals zijn.

LEICA 250 REPORTER - Eens beschouwd als een veilige investering in verband met de gecompliceerde techniek. Nu echter helpen ze de Poolse economie te steunen.

MARION METAL MINIATUUR - maker onbekend.

MINOX A LUXUS - Echte exemplaren zijn voorzien van een patroon in het metaal. Sommige kopieen zijn alleen gematteerd en vallen snel door de mand, er zijn echter ook normale Minox camera's valselijk voorzien van een patroon.

MINOX IN SIGARETTEN AANSTEKER - Dook in 1990 op. Het betreft een normale MINOX in een nogal ruwe goudkleurige behuizing die tevens een gasaansteker bevat. Hij wordt gepresenteerd als zijnde een KGB camera, maar is gewoon een modern fantasie ding en als zodanig zonder waarde.

NEUBRONNER POSTDUIF CAMERA - Enkele exemplaren verschenen in 1989 op de markt. Maker onbekend.

RING CAMERA'S - Een aantal camera's vermomd als vinger-ring zijn de laatste jaren op de markt verschenen, soms aangeduid als KGB camera's. werkelijke bron is een getalenteerde kunstenaar uit Gdansk in Polen, genaamd Marel Mazur. Hoewel zijn camera's allen verschillen, is het hart gelijk en bestaat uit een cilinder-vormige filmcassette die de ring vormt. Zij zijn aan weerszijden van de lens met half-edelsteentjes versierd. In stond de naam 'Ernemann' gegraveerd. Een van deze ring camera's is voor bijna f 40.000,- geveild in 1991. Hoewel er gezegd is dat deze ring zich al tien jaar in een en dezelfde collectie bevond, is er reden om hieraan te twijfelen. Enkele van de ringen werken perfect, terwijl anderen alleen maar show modellen zijn. Mogelijk zijn de laatsten kopieen van de Mazur ring camera.

SCENOGRAPHE - Er zijn reprodukties in omloop compleet voorzien van de naam op de balg. Bertrand heeft er een voor eigen collectie gemaakt. Wij hebben gehoord van het bestaan van andere reprodukties, maar weten geen bijzonderheden.

SUTTON PANORAMA CAMERA - Bertrand heeft er een gemaakt en verkocht als replica. Na een aantal malen in andere handen te zijn overgegaan is de camera in een belangrijke collectie opgenomen als zijnde een origineel.

TICKA WATCH CAMERA - Een exemplaar is van binnen voorzien van het opschrift 'TASCHENUHR CAMERA, D.R.P. 173567 H. MEYER - FREY. FRANKFURT A/M'. De echtheid moet worden betwijfeld. Waarschijnlijk maakt het deel uit van de trend om de ongewone TICKA's zoals de 'WATCH FACE TICKA' te vervalsen. Van de laatste is een vervalsing vorig jaar op een Christie's veiling teruggetrokken na ontmaskerd te zijn. Zonder twijfel zal dit exemplaar wel weer een keer als echt opduiken.

VOIGTLÄNDER DAGUERREOTYPIE CAMERA - Minstens een kopie bevindt zich in een belangrijke prive-collectie. Buiten het feit dat het formaat niet klopt, is ook de naam Voigtländer verkeerd gespeld. Het is mogelijk dat er meerdere vervalsingen in omloop zijn.

De lezers worden opgeroepen om verdere informatie te geven over genoemde en of andere falcificaties of replica's. Met groot genoegen zullen we publiceren over camera's of verkopers die de opzet hebben verzamelaars te bedonderen.

GESTOLEN CAMERA'S - beloning uitgeloofd-

Er is een tijd geweest dat je op een beurs je tafel met de meest waardevolle camera's onbewaakt kon laten en bij terugkomst stond alles er nog net zo. Vandaag de dag wordt er echter steeds vaker gestolen. In een poging deze praktijken een halt toe te roepen zal Mc Keown's Price Guide to Antique and Classic Camera's een lijst opnemen van gestolen verzamel-camera's in deze en toekomstige edities.

Het mag duidelijk zijn dat we niet iedere gestolen camera kunnen opnemen, noch kunt u alle camera's controleren die u koopt. We zullen ons beperken tot camera's van \$1000 of meer, mits we het serienummer weten. Een uitzondering wordt gemaakt voor kostbare camera's zonder serienummer of camera's die zo ongewoon zijn dat ze gemakkelijk herkenbaar worden. We nodigen iedereen uit om aan deze lijst bij te dragen. Handelaren, veilingen en fotografica-verenigingen hebben hun medewerkingtoegezegd.

Als u bent bestolen, licht dan de plaatselijke politie in. Voorzie hen van een goede omschrijving, serienummers en dergelijken. Stuur ons dezelfde informatie te samen met het nummer van het proces-verbaal, telefoonnummer en de naam van de verbalisant. Als de camera gevonden wordt, kan op deze manier onmiddellijk actie worden ondernomen. Wij nemen geen camera's op in onze lijst die niet officieel als gestolen zijn aangegeven en alleen als zij genoemde waarde te boven gaan. Wij wisselen uitsluitend informatie uit en zullen ons niet inlaten met verdere discussies.

Als u een gestolen camera of ander waardevol artikel wordt aangeboden, dient u de identiteit van de verkoper te weten te komen. Rapporteer het feit aan de clubleiding of de politie, bij voorkeur wanneer de verkoper nog op de beurs of in de winkel is. Wanneer wij allen samenwerken moet het mogelijk zijn om menig gestolen camera bij de rechtmatige eigenaar terug te bezorgen. Dit probleem zal zich niet vanzelf oplossen. Als 's werelds belangrijkste cameragids acht Centennial Photo het zijn plicht om hierin een rol te spelen. Elke twee jaar wordt onze gids bijgewerkt. In de tussentijd kunnen we wijzigingen sturen, als u ons de onkosten vergoed. We staan open voor verdere suggesties om dit kwaad uit te bannen.

VERDERE INFORMATIE

Wij ontvangen vele verzoeken om aanvullende informatie, meer dan we ooit kunnen beantwoorden. Wij geven geen opinie of taxatie over zaken die niet in dit boek staan. Wij zijn ons er van bewust dat er nog vele camera's in dit boek ontbreken. Wij waarschuwen er echter voor dat dit niet betekent dat ze ook zeldzaam zijn. Wij hebben minstens 30.000 camera's uitgesloten teneinde dit boek hanteerbaar en betaalbaar te houden. Onder die uitgesloten camera's zijn ondermeer camera's uit de jaren '70, als ze meer gebruikscamera's dan verzamelcamera's zijn, de meeste 126 en 110 formaat camera's die in gigantische hoeveelheden zijn gemaakt en daardoor

zonder waarde en vele vroege camera's die zelden aangeboden worden. Wij hebben ruim 8000 camera's geselecteerd die wij representief achten voor de verzamelwereld waarvoor we specifieke verkoopprijzenkunnen vaststellen.

Tot onze spijt kunnen we geen individuele vragen behandelen. Wij raden u aan om lid te worden van een vereniging van verzamelaars die uw vragen kan beantwoorden. U kunt zich ook wenden tot een van de commerciele bladen.

Translation: Ruud C. Hoff, Amsterdam

La première édition du Price Guide to Antique and Classic Cameras a été publiée en 1974. Depuis lors, ce guide a été le livre de référence des appareils photo le plus complet et le plus précis au monde. La première édition comptait mille appareils. La neuvième, présentée ici, en comporte maintenant neuf fois plus. Non seulement nous avons ajouté des modèles, mais nous avons fait d'énormes efforts pour élargir l'information donnée pour chaque appareil, fournissant les dates et l'histoire autant que possible. Nous avons également ajouté plus de cinq cents nouvelles photographies dans cette édition, pour parvenir à un total de 3.500 illustrations. Chaque nouvelle édition de ce guide a connu des améliorations et avec votre appui, nous espérons continuer cette tradition. Par exemple, cette édition voit l'addition de centaines d'objectifs et d'accessoires pour les systèmes photographiques des années 60 et 70. Quoique beaucoup de ces appareils soient toujours utilisables, ils sont déjà bien établis dans le domaine des collections. Au-delà de nos recherches sur les appareils de collection habituels, nous essayons de dénicher les appareils peu connus qui ne figurent dans aucun autre livre de référence. Dans cette édition, vous en trouverez plus de deux mille, de ces orphelins. Nous vous souhaitons de prendre un grand plaisir à les découvrir.

OU VONT LES PRIX?

Pour mieux comprendre les prix actuels et futurs des appareils de collection, il faut connaître un peu d'histoire. En général, les prix ont augmenté jusqu'en 1980, et sont restés sans grand changement pendant les années 1982-1983, à part quelques-uns qui commençaient à baisser. 1983-1984, ils fondirent considérablement, surtout par rapport au dollar américain, qui est notre référence. Cela était dû, en partie, à une baisse de vitalité du marché, mais surtout à l'appréciation du dollar vis à vis des autres devises de l'époque. Cette petite chute ralentit en 1985, et en 1986, le marché était de nouveau stable et commençait à récupérer. Vers la fin de 1986, et début 1987, la vigueur des devises anglaises, allemandes et japonaises fortifiait les prix et, aux Etats-Unis, le commerce des appareils classiques ressemblait un peu à une braderie. Les prix pour les appareils les plus recherchés commencèrent à se consolider, dans ce pays. De 1987 à consolider, dans ce pays. 1989, nous les virent même flamber dans des domaines spécifiques. Les acheteurs Japonais avaient influencé l'augmentation des prix pendant plusieurs années, avec la puissance du yen. Aujourd'hui, en 1992, nous sommes dans un milieu de plus en plus compétitif parmi les collectionneurs de Tokyo, d'Europe, de Hong Kong, des Etats-Unis et d'ailleurs. Certains prix ont connu des hausses telles que même les marchands ont du mal à y croire. marché des Leica est devenu plus stable, mais seulement pour être remplacé par un engouement pour les appareils Canon et Nikon à télémètre. Les copies de Leica, à une époque le palliatif pour amateur sans moyens, sont devenues assez souvent plus cheres que les véritables Leica qu'elles imitaient.

La tendance générale parmi les collectionneurs va vers les appareils de haute qualité et de grande précision des

années d'après-guerre Durant cette période, le Japon joua un rôle de plus en plus important dans la production des appareils. Au cours des dix dernières années, les Japonais rachetèrent ces appareils par milliers. Ce secteur du marché est devenu vigoureux Plus récemment, lucratif. collectionneurs d'Europe et de Hong-Kong ont payé des prix identiques à ceux des acheteurs pour le marché japonais. Ces nouveaux profits ont créé une nouvelle race de marchands pour les marchés régionaux où les prix montent rapidement. Mais. en dehors du marché quotidien des "machines" en chrome et faux cuir, il y a des collectionneurs et des petits groupes qui continuent à découvrir les jolis appareils anciens en bois, laiton et cuir. La valeur de beaucoup d'appareils anciens est relativement stable. Il y a trop peu de ces antiquités pour supporter une nouvelle génération de commerçants du week-end. peut même penser que collectionneurs d'anciens ont un goût pour ces appareils qui n'est pas directement lié à l'argent. Les appareils anciens, rares et d'une importance historique, apparaissent de moins en moins, de même que les collectionneurs et marchands qui savent les reconnaître.

Des appareils photographiques rares et anciens ont atteint de nouveaux records de prix à l'occasion de récentes ventes aux enchères, mais il ne s'agit là, que d'un marché très restreint. Une mise à prix modeste conduit souvent à une surenchère qui grandit en spirale pour aboutir à un prix de vente parfois élevé. Par contre, une mise à prix plus haute, peut dissuader les acheteurs potentiels de lots importants.

Les collectionneurs sont devenus plus exigeants en ce qui concerne l'état des appareils. Le matériel qui n'est pas beau et impeccable, est plus difficile à vendre. Peu d'appareils sont assez rares pour échapper à cette exigence de qualité. La marchandise courante doit être non seulement de bel aspect, mais également en bon état de marche.

A l'époque de l'expansion rapide du marché de la collection des appareils photo vers la fin des années 1970, les spéculateurs commencèrent à acheter en gros, sans discrimination. Ce fut une poussée inflationniste et les prix montèrent jusqu'à casser le marché. Un grand plongeon s'en suivit en 1982-1983. Le marché inflationniste au Japon s'est développé de façon similaire, mais actuellement, il demeure plus stable. De par le monde, les prix se sont davantage uniformisés et les collectionneurs dans tous les pays, sont prêts à payer parfois très cher, la "pièce" convoitée.

Certains types d'appareils ont, dernièrement, suscité plus d'intérêt. Les appareils européeens à plaque, recouverts de cuir marron sont plus appréciés que les modèles noirs. Un appareil en couleur se vend plus cher qu'un noir. Les appareils "box" (sauf les noirs, ordinaires) ont commerncé leur ascension. Les "box" en couleur, ceux décorés de dessins art déco et ceux en plastique moulé aux formes particulières ont été sélectionnés par la loi de l'offre et de la demande. L'Europe est un peu en avance par rapport aux Etats-Unis à cet égard. Il faut aussi noter

que quelques appareils de genre art-déco ont atteint des prix considérablement plus élevés dans le marché de l'art que dans les cercles traditionnels des collectionneurs d'appareils photo.

APPAREILS RUSSES ET SOVIÉTIQUES

Pendant des années, les appareils soviétiques ont été assez rares en Europe occidentale: aux Etats-Unis, on ne les avait jamais (ou presque jamais) vus auparavant. Ce phénomène lié à la "guerre froide" a disparu tout d'un coup. L'Union soviétique et les pays de l'Est ont soudainement ouvert leurs portes. Plusieurs appareils soviétiques. considérés antérieurement comme assez rares, se voient maintenant en quantité dans les foires à la photo et dans les magasins photographiques, partout en Europe et aux Etats-Unis. Les prix de plusieurs appareils soviétiques ont baissé rapidement avec cette nouvelle abondance. Parmi les collectionneurs et vendeurs, ceux qui ont acheté aux anciens prix hésitent à baisser les leurs. C'est la raison pour laquelle, le marché des appareils russes n'est pas stable. Il faudra quelques années pour que la loi de l'offre et de la demande stabilise ce marché. Il y aura des appareils russes qui seront toujours rares, mais pas toujours ceux qui avaient cette réputation.

A tout cela s'ajoute les quantités considérables d'appareils dénaturés par des modifications parfois grossières qui ont causé des dommages certains au marché photographique russe/soviétique. Tous les appreils ayant un "finish" clinquant ou des gravures hors du commun, ont de fortes chances d'être des appareils modifiés. De ce fait, il serait souhaitable que les commerçants et les collectionneurs n'encouragent plus cette pratique afin de conserver aux modèles authentiques leur valeur intrinsèque et de rendre aux acheteurs potentiels plus de confiance dans leur quête.

Lors d'une récente foire à la Photographie, un Russe proposait un Leica "Luxus" avec un numéro de série à quatre chiffres avec une gravure militaire de la deuxième guerre mondiale. Toutes les imitations ne sont pas aussi simples à déceler (Les Leica à quatre chiffres ont été fabriqués bien avant l'accession d'Hitler au pouvoir; les appareils photographiques militaires n'étaient pas présentés dans une version "de luxe" etc...).

MARCHÉ "CHAUD" ET "FROID" DES ANNÉES 90

Au cours de ces dernières années, NIKON a pris une telle position de leader, qu'il est devenu l'objet d'une spéculation des plus effrénée. Ce processus est entretenu par un petit nombre de collectionneurs et de commerçants mais cette spéculation semble peu à peu s'amoindrir.

L'intérêt pour les appareils miniatures continuent à se vérifier, avec des articles à des prix encore abordables pour la plupart. Mais, à la vente aux enchères de Christie's de décembre 1991, un acheteur déterminé, au téléphone, a causé pas mal de frustrations parmi les acheteurs prospectifs présents dans la salle des ventes. Plusieurs lots ont atteint des prix que personne n'aurait osé imaginer avant la vente. L'onde de choc généré par cette vente aux enchères se fait encore sentir.

Notamment les prix des appareils miniature ont augmenté un peu partout. Quelques rêveurs attendent quotidiennement de "nouveaux records de prix".

CONSEILS AUX DÉBUTANTS

Notre conseil aux collectionneurs dépend entièrement de leur motivation pour la Si vous collectionnez pour collection. investir, vous devez vous concentrer sur les modèles rares ou uniques. aurez, évidemment, besoin d'argent et d'expertise. Si votre but est le plaisir de collectionner, vous devez suivre ce que vous dictent vos intérêts et votre budget. Parmi les appareils de moindre prix, vous trouverez un hobby pas cher et c'est un bon commencement. Selon votre lieu d'habitation, la collection de Kodak, Coronet, Agfa ou Fex, peut vous offrir un agréable passe-temps car beaucoup de ces appareils se trouvent facilement à des La plupart des modérés. collectionneurs commencent avec intérêt général, qui se précise et se spécialise par la suite. Si vous voulez spécialise par la suite. acheter et vendre les appareils pour faire du profit, vous devez vous tenir au courant. Trouvez votre centre d'intérêt et restez dans votre domaine d'expertise. En vous tenant au courant, vous pourrez réaliser des bénéfices à partir des fluctuations ordinaires du marché et par votre connaissance des intérêts de vos

Tous les prix figurant dans cette édition ont été mis à jour. Ils sont aussi actuels que possible et les données ont été révisées en accord avec les chiffres les plus récents. Cependant, nous avons également retenu l'influence stabilisante du dossier comportant les prix de chaque appareil pour les dix dernières années afin d'éviter les erreurs d'appréciation qui pourraient survenir lors de recherches moins rigoureuses. Nos prix cherchent à suivre les tendances à long terme, exactement comme une boussole avec amortissement hydraulique garde le cap de façon imperturbable.

L'information et les données présentées dans cette édition sont fondées sur des centaines de milliers de vrais prix de ventes, d'échanges, d'offres et d'enchères. C'est un ouvrage de référence, un rapport de recherche. Les prix ne vous indiquent pas la valeur que j'attribue à un appareil, mais ce qu'était l'opinion de beaucoup de possesseurs anciens et actuels au moment de l'épreuve de vérité. C'est l'essence de "la loi de McKeown" qui dit: "Le prix d'un appareil ancien dépend entièrement de l'humeur de l'acheteur et du vendeur au moment de la vente."

Plusieurs corollaires s'ajoutent à cette philosophie générale de la collection.

1. "Si vous laissez passer l'occasion d'acheter un appareil photo que vous voulez vraiment, celle-ci ne se présentera plus jamais."

2. "Śi vous achetez un appareil sachant que l'occasion ne se présentera plus jamais, un meilleur exemplaire du même modèle vous sera proposé la semaine suivante à un prix plus intéressant."

3. "La valeur intrinsèque d'un appareil ancien ou classique est directement proportionnelle à la certitude qu'a le possesseur de la volonté d'achat d'un autre."

Il convient de toujours prendre en considération ces observations au moment de l'application de la "loi McKeown".

RECOMMANDATIONS POUR L'UTILISATION DE CE GUIDE:

Tous les appareils sont classés par noms de fabricants dans l'ordre alphabétique. Quelques-uns sont classés par noms de modèles en cas de doute sur le nom du fabricant. En général, les appareils de chaque fabricant sont dans l'ordre alphabétique, sauf pour ceux que nous avons parfois regroupés par taille, type, date d'apparition, ou autre caractéristique de classement appropriée à la situation.

La photographie apparaît en générale immédiatement au-dessus du titre en gras qui décrit cet appareil. Pour des raisons de mise en page, cela n'a pas toujours été possible. Parfois, quand le texte continue dans une autre colonne, la photographie apparaît au milieu du paragraphe qui le décrit. Quand celle-ci a dû être déplacée, elle est accompagnée d'une légende en italique et une note explicative se trouve à la fin du texte presentant l'appareil pour indiquer l'emplacement de la photo. Quand la photo d'un appareil se trouve en fin de colonne, et que cette dite photo divise le texte décrivant un autre appareil, nous avons essayé de la distinguer visuellement par un simple trait en gras. Le fait de suivre ces règles permet, pour la plupart des photographies, d'utiliser le titre en gras comme légende, de là un appréciable gain de place. Légender toutes les 3500 photos aurait coûté 40 pages supplémentaires!

Nous avons utilisé des caractères différents pour faciliter l'utilisation du guide. En voici l'explication:

FABRICANT (CARACTERES MAJUSCULES EN GRAS) Notes

historiques ou commentaire concernant le fabricant (italique).

Nom de l'appareil (en gras) -

Descriptif de l'appareil et informations sur la valeur actuelle (en moyen). Remarques particulières concernant l'appareil ou le prix (italique).

NOM DE L'APPAREIL (EN MAJUSCULES) indique que nous ignorons le nom du fabricant et sert à séparer cet appareil du texte précédent.

A première vue et sur un plan artistique, ce style de mise en page n'est peut-être pas visuellement attirant, mais cela a été soigneusement calculé pour économiser de l'espace, tout en conservant la facilité Notre ordinateur pourrait d'utilisation. ajouter automatiquement un cadre autour de chaque photo, mais cela aurait ajouté 50 pages à ce livre. De même, si nous l'avions fait autour de chaque texte, nous aurions amélioré l'apparence, mais au prix de 90 pages supplémentaires. lecteurs sont des collectionneurs et des marchands sérieux qui souhaitent le maximum d'informations dans le plus petit volume possible. Nous espérons que vous aimerez notre "petit" livre. Si nous avions choisi une mise en page facile et belle, ce monstre contiendrait plus de 800 pages. Cela représenterait 30% supplémentaire en épaisseur, poids et prix. espérons que vous apprécierez notre simplicité de style pour plus d'informations en moins de volume.

L'ÉTAT DES APPAREILS PHOTO

Un appareil dans un état esthétique "parfait" ("mint"), mais qui ne fonctionne peut être accepté par collectionneur qui va le mettre dans une vitrine. Par contre, un utilisateur considère moins l'apparence si l'appareil fonctionne Nous soutenons vigoureusement l'utilisation d'un système unique de classement fondé sur deux critères, l'apparence d'une part et la fonctionnalité de l'autre. Il devrait être appliqué à l'échelle mondiale avec la coopération des guides des prix, des publications pour collectionneurs, des clubs, des salles des ventes et des marchands.

perspective d'établir classement international, nous proposons Nous avons utilisé, la grille suivante. intentionnellement, une combinaison d'un chiffre et d'une lettre pour éviter toute confusion avec d'autres systèmes de classement déjà en place. L'état d'un appareil devrait être représenté par un seul chiffre suivi d'une lettre. Le chiffre représente l'état esthétique et la lettre fournit l'indice de fonctionnalité. Ce système de classement a été adopté par le "Photographic Collectors Club" Grande-Bretagne(PCCGB).

ÉCHELLE---ÉTAT ESTHÉTIQUE

Marchandise neuve, jamais vendue.
 Dans sa boîte d'origine, avec toutes les garanties.

1 - Comme neuf. Jamais utilisé. Comme marchandise neuve, mais sans les garanties, avec sa boîte d'origine, contenu complet.

2 - Pas de trace d'utilisation. Seule l'absence de la boîte d'origine indique que ce n'est pas du neuf.

3 - Très peu de traces d'utilisation.

4 - Traces d'utilisation, mais sans abus.

5 - Complet, mais avec traces d'utilisation normale ou d'âge.

6 - Complet, avec traces importantes

d'utilisation. Beaucoup servi.
7 - Possible à restaurer. Peut-être pièces mineures cassées ou manquantes.

8 - Possible à restaurer, avec effort. Peut-être pièces manquantes.

9 - Epave. Seulement pour pièces, ou restauration d'importance pour appareil très rare.

ÉCHELLE---FONCTIONNALITÉ

A - Comme neuf. Fonctionnement parfait. Etat de sortie d'usine avec garantie.

B - Comme neuf. Fonctionnementparfait, mais sans la garantie d'usine. Etat de marche totalementgaranti par le vendeur.

C - Tout fonctionne. Récemment ajusté, réglé, nettoyé et lubrifié par un réparateur professionnel et complètementgaranti.

D - Tout fonctionne. Récemment ajusté, réglé, nettoyé et lubrifié par un réparateur professionnel mais sans garantie.

E - Tout fonctionne. Les éléments essentiels du fonctionnement ont été vérifiés professionnellement.

F - Pas récemment ajusté, nettoyé ou lubrifié. Tout fonctionne, mais la précision de l'obturateur et de la cellule n'est pas garantie

G - Tout fonctionne. Obturateur et/ou cellule probablement pas précis. Besoin seulement de réglage, ajustement, nettoyage et/ou lubrification.

H - Utilisable mais pas complètement. L'obturateur coince peut-être. La cellule ne marche peut-être pas.

J - Pas utilisable sans réparation ou

nettoyage. Obturateur, cellule ou avance de film cassé, coincé ou collé.

K - Probablementpas réparable.

Avec ce système, un appareil moyen serait jugé "5F". Un appareil noté "3G" comporte esthétiquement des traces d'usage minimes, mais la précision de l'obturateur et/ou de la cellule est en question. Ainsi, un descriptif très spécifique de l'état est possible en peu d'espace et élimine les problèmes de systèmes d'échelon à mots ou lettres qui ne distinguent pas l'apparence de la fonctionnalité. Pour être encore plus précis, les utilisateurs pourraient souhaiter élargir l'échelle "état esthétique" avec un deuxième chiffre. Par exemple, "56B" décrit l'état esthétique d'un appareil entre les échelons 5 et 6, dont le fonctionnementcorrect est garanti.

Depuis que nous avons proposé ce système, la revue "Camera Shopper" et quelques marchands ont adopté un système similaire, mais avec des valeurs numériques inverses pour que 10 représente la meilleure qualité. Lors d'un achat sans examen possible, assurezvous du système de classement utilisé.

COMPARAISON AVEC D'AUTRES SYSTEMES DE CLASSEMENT:

Le tableau suivant compare la partie "esthétique" du système de classement avec quelques-uns des systèmes de description par mots ou couramment utilisés. Nous n'avons pas fait comparaisons avec les systèmes de "10" mais basés sur d'autres critères, car il existe trop de variations dans leur application par les différents marchands. Ces comparaisons sont approximatives et sont seulement fournies pour aider les utilisateurs à passer plus facilement au nouveau système. dernière colonne du tableau indique en termes généraux comment l'état affecte Généralement parlant, l'état les prix. affectera prix les comme indiqué Ces éléments n'étant, ci-dessous. cependant, que des approximations car l'état affecte différemment le prix selon les types d'appareils et leur âge. suggestions dans la grille sont exprimées comme pourcentages des prix écrits dans ce quide.

McKeown PCCGB Christie's	SA	Ventes aux Enchères Allemandes	% du prix du guide
0	N	-	150-200%
1	LN	-	130-150%
2	M	Α	120-140%
3	M	AB	115-130%
4	E+	В	110-120%
5	E	С	95-115%
6	VG	CD	80-110%
7	G	D	55-85%
8	F	E	30-60%
9	P	-	10-30%

Toute pièce manquante ou mal accrochée doit être signalée. L'utilisation d'un signe moins (-) après le chiffre ou la lettre concernant l'état indique que l'appareil atteint le niveau décrit, à l'exception des défauts mineurs déclarés. L'utilisation d'un signe plus (+) indique que l'appareil dépasse le niveau, mais n'atteint pas celui situé au-dessus.

S'il manque à votre appareil certaines pièces ou que certaines de ces pièces soient cassées, il vous faudra un autre appareil du même type pour récupérer ces pièces. La formule permettant de calculer la valeur de l'appareil réparé est: Les parties du premier appareil + les parties du deuxième + la main d'oeuvre = le prix de l'appareil réparé.

Les collectionneurs sont quelquefois plus souples quand ils appliquent ce système à des appareils plus anciens ou plus rares et plus rigoureux quand ils l'appliquent à des appareils plus récents ou plus ordinaires. Ceci est quelque peu auto-destructeur. Si vous décrivez un appareil comme "en très bon état pour son âge", vous introduisez un jugement personnel selon lequel les appareils anciens devraient être jugés selon des règles différentes. Le fait qu'ils soient d'un certain âge et que cela se voit ne peut pas être porté à leur avantage.

INTERPRÉTATION DES CHIFFRES DES PRIX

Tous les prix sont exprimés en dollar américain. Ils s'appliquent aux appareils en l'état "5", selon le système déjà présenté. Cela est l'état le plus commun des appareils qui sont trouvés et collectionnés, ce qui en fait la norme la plus utile. Pour déterminer la valeur d'un appareil en particulier, l'utilisateur de ce guide doit prendre en considération toute variation par rapport à cette dite norme quand il procède à l'expertise et faire varier en proportion sa propre estimation de la valeur.

Sauf indication explicite "boîtier nu", les prix se référent à un appareil avec son objectif standard, son dos et toutes les autres parties nécessaires à son fonctionnementhabituel.

Les articles de moindre valeur présentés dans ce guide et sur le marché ont tendance à être légèrement surévalués. simplement parce que le coût et la peine investis pour faire la publicité, vendre et expédier un article à \$5 sont les mêmes que pour des appareils qui valent des centaines, voire des milliers de dollars. Les appareils de valeur moyenne reflètent les prix les plus précis. Ce sont eux que l'on trouve le plus souvent dans le commerce; ils existent en grand nombre et par conséquent, le marché les concernant est très stable. Les appareils d'une valeur plus importante, quel que soit leur style, leur marque ou leur âge, ont tendance à être les plus volatils, parce qu'à la fois l'offre et la demande sont, pour ces articles, limitées.

NE VOUS ATTENDEZ PAS A OBTENIR LE "BOOK PRICE" D'UN MARCHAND.

Si vous avez un ou deux appareils à vendre et que vous vous attendez à obtenir d'un marchand le prix le plus élevé décrit dans ce livre, mettez-vous à sa place. Pour revendre votre appareil, il doit le réparer et le garantir. Il doit louer une table pour les foires, faire imprimer et poster sa liste de ventes, et défendre ses prix face aux acheteurs qui réclament le prix le plus bas. Après plusieurs mois, n'ayant toujours pas vendu votre appareil, qui présente, suite à son passage dans les mains des acheteurs potentiels, un peu plus de traces d'utilisation, il le cède à moitié prix à un autre marchand en échange d'un autre article qu'il espère vendre. Un appareil passe, souvent, dans les mains de quatre ou cinq marchands avant de rencontrer cet acheteur

insaisissable qui paiera le "prix fort". Moins la valeur de votre appareil est importante, plus il est commun, et plus vous avez à apprendre de cet exemple. Si vous possédez un appareil vraiment très rare ou de très grande valeur, vous n'avez aucun souci à vous faire. Les marchands vont se l'arracher. Le marché est très compétitif.

PRIX DES APPAREILS AU JAPON ET EN EUROPE

Dan certains cas, nous avons introduit des distinctions de prix pour le même appareil dans des marchés différents comme les l'Europe, Etats-Unis, l'Angleterre. l'Allemagne, le Japon etc. Evidemment, il y a des différences concernant d'autres appareils pour lesquels nous n'avons pas fait de semblables commentaires. conviendrait de noter, en premier lieu, que le prix de base de la plupart des appareils photo est celui qu'on paie dans le pays où l'appareil est le plus disponible. Pour beaucoup d'appareils très simples, c'est le pays d'origine. Cependant, comme la plupart des appareils ont été importés aux Etats-Unis, on les y trouve à des prix aussi bas qu'ailleurs dans le monde. différence de prix entre pays pour les appareils photo les moins chers est normalement négligeable, et cela n'est pas noté dans ce guide, sauf dans certains cas où, d'une manière constante, la différence est plus importante que le coût de l'expédition. Les prix pour beaucoup d'appareils japonais de qualité sont plus élevés en Europe qu'aux États-Unis. Ceci est dû au fait qu'ils ont été importés en plus grand nombre aux Etats-Unis. Avec une offre plus limitée en Europe, la concurrence entre les collectionneurs est plus importante.

Le "Dufa Pionyr" (de la Tchécoslovaquie) est un bon exemple d'un appareil dont le prix varie considérablement dans le monde. En Allemagne, près de la source, cet appareil se vend aux enchères pour, à peu près, \$25. A Londres, les marchands l'ont vendu pour \$45, avec la boîte d'origine. Les deux prix cités ici décrivent un écart raisonnable et normal. Nous avons omis celui que nous avons vu en vitrine sur la "Ginza" (Tokyo) pour \$125. Bien qu'il soit possible qu'il ait été vendu à ce prix, nous ne pouvions pas présenter cela comme la norme.

LA FIN DE L'ESCALADE DES PRIX AU JAPON?

Alors que l'économie japonaise jouissait d'une totale notoriété il était quasiment impossible aux acquéreurs occidentaux de pouvoir prétendre à des prix concurrentiels. De nos jours, le marché mondial est plus équilibré.

COMMENT AVONS-NOUS DÉTERMINÉ NOS PRIX

Nous surveillons et analysons les prix provenant de sources diverses dans le monde entier, y compris les publications spécialisées, les listes de ventes des marchands, les ventes aux enchères, les bourses et les foires. Notre base de données comprend des centaines de milliers de transactions pour chaque nouvelle édition, en plus des bases de données accumulées pour les éditions précédentes. Bien que nos formules soient notre propriété, quelques mots peuvent vous indiquer pourquoi nos statistiques ne reflètent pas toujours vos

propres observations. régulièrement une publication spécialisée et l'appareil "X" est proposé, en général, Votre esprit à l'affût pour \$275-325. enregistre, pour utilisation ultérieure. Notre ordinateur aussi. Il y a de bonnes chances que ce même article ait été offert à la vente à plusieurs reprises. Ainsi, le prix auquel l'appareil ne se vend pas apparaît plus souvent que le véritable prix. Dans le cas d'un vrai appareil "X", un marchand l'a proposé a \$450. Après plus d'un an d'annonces, le même appareil était offert pour \$250 au moment où nous mettions sous presse. Beaucoup d'autres ventes mondialement confirmées nous indiquent que l'appareil "X" se habituellement pour \$125-175. Finalement, le marchand dont vous avez lu les annonces vendra peut-être son article surévalué à un acheteur qui s'est habitué à le voir offert à \$300 et pense faire une affaire quand il est proposé à \$250. Notre ordinateur conserve, dans sa mémoire, des appareils particuliers proposés par les marchands jusq'uà leur vente. Les prix "non vendus" ne sont pas considérés comme des informations mais seulement comme manifestations d'un prix plafond.

Nos prix représentent la gamme normale pour la plus grande partie des appareils vendus. Ils sont fondés sur la recherche extensive, non la divination. Nous ne sommes pas des marchands d'appareils photographiques, parce que nous considérons que ce serait un conflit d'intérêts.

TAUX DE CHANGE

Les prix dans ce guide représentent les prix moyens dans le marché mondial. Il y a des variations définitives dans certains marchés. Quelques appareils sont plus communs dans un pays que dans un Les intérêts des collectionneurs sont différents dans d'autres coins du monde et des tendances ou engouements affectent des marchés différents à des moments différents. Quoi qu'il en soit, aucun marché au monde n'est fermé aux influences extérieures et les fluctuations ont tendance à se niveler à l'échelle mondiale. Un prix plus élevé dans un pays a tendance à attirer plus d'appareils photo vers cet endroit et le prix mondial grimpe jusqu'au moment où la demande est satisfaite. Toutes les valeurs sont exprimées en dollar américain. Parce que les taux de change continuellement, nous ne voulons pas troubler nos lecteurs avec des conversions formulées par ordinateur basées sur un taux de change à partir du cours d'un jour choisi arbitrairement.

Comme cadre de référence général, nous vous proposons un tableau comportant les taux de change pour les devises indiquées selon le cours pour le 5 juin 1994.

scion ie cours p		
DEVISE	= US\$ US	\$\$1 ≕ *
Australia \$.7345	0.3615
Austria Schill	.08602	11.625
Belgium Franc	.02917	34.282
Brazil Cruz.	.0004975	2010.05
Britain £	1.5095	0.6624
Canada \$.7287	1.3727
France Franc	.17598	5.6825
Germany DM	.6002	1.666
Hong Kong \$.12940	7.7280
Italy Lira	.0006188	1616.03
Japan Yen	.009602	104.15
Netherlands FI	.5354	1.8679

 N.Zealand \$
 .5914
 1.6909

 Spain Peseta
 .007331
 136.41

 Sweden Krona
 .1262
 7.9260

 Switzerland Fr
 .7078
 1.4128

 *En multipliant
 ces coefficients
 par le

prix en dollar américain, on arrive au prix en devises étrangères.

NOTE: Les prix des ventes aux enchères présentés dans ce livre sonte les prix d'adjudication qui ne tiennent pas compte des frais et des taxes payés par l'acheteur. Parce que les frais payés par l'acheteur et le vendeur sont presque équivalents, le prix adjugé représente la moyenne logique entre le net réalisé par le vendeur et le brut payé par l'acheteur.

LA VENTE DE VOS APPAREILS DE COLLECTION

Il existe des moyens bien connus pour vendre, aussi bien un appareil tout seul qu'une collection complète, que vous soyez un particulier, un commerçant ou un collectionneur.

Chacun de ces moyens possède ses avantages et ses inconvénients mais chacun aussi peut être plus adapté à un appareil qu'à un autre.

VENTE AUX ENCHERES

Avantages: L'article en question sera vendu. Vous en serez débarrassé. Vous recevrez votre argent. Des appareils extrèmement rares peuvent parfois atteindre des prix bien plus hauts que vous ne l'espéreriez. Une mise à prix modeste suscite davantage d'offres ce qui conduit souvent à un prix définitif assez élévé.

Inconvénients: Une longue période d'attente; souvent plusieurs mois sont nécessaires pour référencer les articles et préparer la vente. La commission à payer. Une mise à prix initiale élévée peut décourager toutes offres. Lorsque cet article réapparaîtra lors d'une prochaine vente, les acheteurs potentiels s'en souviendrontet pourront s'abstenir.

COMMERCANT SPECIALISÉ

Avantages: La vente et le paiement sont immédiats. Pas besoin d'attendre qu'un acquéreur se présente. Les commerçants paient parfois des prix élevés pour des articles peu courants, plus que vous ne pourriez en obtenir ailleurs; ils ont une clientèle spécialisée dans des régions que vous ne fréquentez pas habituellement (les commerçants font souvent entre eux, un commerce en rapport avec la spécialisation de chacun). Aucune commission n'est à déduire du prix de vente.

Inconvénients: Le commerçant est obligé d'acheter à des prix bien en dessous des prix de vente estimés. (Ceci n'est pas toujours un inconvénient car il a souvent une clientèle plus fournie que celle que vous pourriez joindre par vos propres moyens). Certains commerçants ne vous feront pas d'offre; il vous faudra avoir une estimation assez précise de ce que vous avez l'intention de vendre. Si vous proposez des offres à plusieurs commerçants vous organisez alors votre propre vente aux enchères. Les commerçants ne se prêteront volontiers à ce style de commerce et finiront par vous proposer un prix plus bas que celui qu'il vous aurait proposé initialement.

FOIRES PHOTO ET MARCHÉS AUX PUCES

Avantages: Pas d'intermédiaire. Vous empochez l'intégralité du prix de vente (ceci peut être souvent un avantage psychologique plutôt qu'un avantage réel, si vous comptez le temps et les frais investis). L'occasion vous est donnée de rencontrer d'autres collectionneurs et de partager leur enthousiasme. Des possibilités de faire du troc et de compléter ou d'enrichir votre propre collection ou votre stock.

Inconvénients: Des frais imprévus considérables dépassant souvent la commission du commissaire priseur ou la marge bénéficiaire du commerçant. Le prix à payer pour la table ou le stand. Aucune garantie de vente. Vous pouvez être forcé à transporter vos appareils pendant des mois, voire des années. L'usure et la casse de vos appareils photographiques peuvent les rendre à la longue, improposables à la vente.

ENVOI DES LISTES PAR POSTE

Avantages: Vous atteignez un large marché sans pour autant devoir à payer de frais et à fréquenter les foires. Les marchandises sont à l'abri de toutes manipulationsparfois dangereuses.

Inconvénients:

Les acheteurs potentiels sont limités par l'importance de votre liste d'adresses. Les frais d'impression de votre liste. Les clients ne peuvent pas voir les marchandises avant l'achat. Vous serez souvent dans l'obligation de proposer soit la garantie de l'article vendu, soit son remboursement et sa reprise.

PETITES ANNONCES

Avantages: Le choix de la publication la plus indiquée pour atteindre le public qui vous intéresse (bulletins de club, journaux du commerce spécialisé etc...) Les frais sont en général modestes, surtout si vous annoncez un nombre restreint d'articles.

Inconvénients: L'inévitable attente jusqu'à la parution, puis jusqu'à la vente. La vente n'est pas assurée surtout si vous cherchez un prix élevé (par contre la vente est certaine si vous choisissez un prix raisonnable).

RÉPLIQUES ET CONTREFACONS D'APPAREILS

Le nombre de contrefaçons, copies ou répliques plus ou moins réussies, grandit proportionnellement à la valeur des appareils contrefaits. Pendant de appareils contrefaits. nombreuses années, l'existence de ces contrefaçons étaient bien connues des collectionneurs et des commercants qui, au lieu de répandre cette information, ont préféré la conserver "secrète". Notre but ici, est d'informer nos lecteurs afin de leur permettre d'éviter ces pièges. Si nous n'avons rien contre le principe de contrefaire des appareils rares pour des expositions ou pour des musées, nous nous insurgeons par contre, sur le fait que ces contrefaçons puissent être proposées en tant qu'appareils authentiques. Nous nous trouvons alors confrontés à plusieurs alternatives. Ou bien nous admettons que collectionneurs et les faussaires puissent cohabiter sans que cela nous gêne et dans ce cas, se collectionneurs qui peu à sont les peu détacheront de leur hobby, ou bien il appartient aux collectionneurs de faire eux même la "chasse" aux faussaires et dans

ce cas, nous devons nous entraider.

Les plus célèbres créateurs de reproductions et contrefaçons sont les suivants:

Luc Bertrand, Belgique. C'est un artisan qui restaure et reproduit des appareils photographiques. Il est capable de reproduire de très bonnes copies aussi d'appareils métalliques d'appareils de bois dont il est difficile de pouvoir les distinguer du modèle original. Il ne réalise qu'un nombre restreint de copies de modèles rares, pour sa collection personnelle ou pour des musées. Nous nous devons de préciser à sa décharge, que Luc Bertrand date toutes ses oeuvres et les signe de ses initiales. Malheureusement il est tout de même arrivé que par ignorance ou malhonnêteté, ces copies aient présentées comme des originaux. Toutes reproductions de Luc Bertrand effectuées avant 1989 ont été faites en très petites séries de 1 à 4 pièces par modèle, dont une pour sa collection privée. Parfois, en plus de la date et des initiales "LB" ou "BL", les modèles reproduits portaient un numéro de série de 1 à 4. A partir de 1989, il a gravé sur ses oeuvres, un petit monogramme "LFB", sur le métal ou sur le bois. Jusqu'en 1990, il n'a effectué que des séries de 1 à 6 appareils par modèle. Par ailleurs, il reconnaît avoir fabriqué une quinzaine de modèles en un seul exemplaire pour sa collection privée. Vers le milieu de 1990, il déclarait avoir fabriqué en tout et pour tout, 35 copies de modèles différents et n'en posséder qu'environ la moitié. Il précise encore que lorsqu'il restaure une chambre, il grave également ses initiales et la date sur la partie restaurée.

Monsieur Bertrand a eu la gentillesse de nous fournir un échantillon de son monogramme afin que nous puissions le publier. Un geste spontané pour éviter que ses reproductions servent à des fins malhonnêtes.

Greenborough. Nous n'avons pas eu l'occasion de lui parler et de faire sa Nos renseignements connaissance. reposent donc sur des informations fournies par d'autres collectionneurs. Sa femme et lui seraient des citoyens polonais vivant en Allemagne. fabriquerait pas d'appareils, mais commercialiserait des copies d'appareils de valeur historique ainsi que quelques créations modernes et fantaisistes. fabrication proprement dite, selon nos informations, se ferait en Pologne. A notre connaissance. ces appareils posséderaient aucun signe distinctif pour les différencier des modèles originaux, et plusieurs d'entre eux, par ignorance ou malhonnêteté auraient déjà été proposés comme modèles authentiques. Toujours selon nos informations. Greenborough se serait déjà retiré de ses activités et aurait copié les appareils suivants: Le Leica 250, Le Minox en briquet, l'appareil-montre Ticka, le Leica "de Luxe" et l'appareil en forme de paquet de cigarettes John Player.

Oberlaender. Oberlaender a fabriqué des copies d'appareils célèbres comme de

Doppel-sport (appareils photographie aérienne transporté par des pigeons) et le photo Carnet, version de l'appareil "Taschenbuch" du Docteur Krügener. Quelques unes de ces copies difficilement différenciables modèle original. Nous ne possédons renseignement prouvant que Oberlaender ait apporté sur les copies de Doppel-Sport, un signe distinctif et nous savons que quelques uns d'entre eux ont été proposés comme des modèles originaux. Nous savons également qu'au moins un Photo-Carnet portait sur le dos, un "R" (pour réplique) après le numéro de Cet appareil a été vendu en Décembre 1991 par Christie's et, à la même occasion, il a également été vendu un Doppel-Sport. Ces deux appareils ont correctement été présentés comme des copies.

Qu'il s'agisse des copies de Greenborough ou de celles de Oberlaender, les unes comme les autres ont été proposés directement indirectement ou quelques-uns des collectionneurs réputés pour être parmi les plus respectés et les plus connaisseurs su monde. appareils ont été intégrés dans des collections très importantes sans aucune mention de leur origine frauduleuse, puis revendus par la suite comme des originaux, sans, ou en toute connaissance de cause. Un certain nombre de commerçants jouissant d'une très bonne réputation ont favorisé la vente de ces contrefaçons. Ils les ont intégrées dans leur stock de matériel à vendre sans mentionner, dans la plupart des cas, ce qu'ils savaient de leur origine, allant parfois jusqu'à inventer une fable pour faire croire à l'authenticité de l'article en

Les répliques sont parfois vieillies artificiellement.

Nous connaissons ou croyons connaître l'existence de confrefaçons des appareils suivants:

BEN AKIBA - Appareil déguisé en canne. Oberlaender en a fait des copies de très bonne qualité.

BERTSCH (Petit Modèle) - Tandis que nous ne connaissons pas de copie du grand modèle, nous savons qu'il en existe, sans aucun doute, du petit modèle. Luc Bertrand en a fait quatre avec des variantes au niveau des magasins.

BRINS - (Chambre Monoculaire) Au moins quatre copies ont été réalisées par Luc Bertrand. Bien que quelques unes portent ses initiales et la date de la réalisation à l'intérieur (par exemple "BL82"), les vendeurs n'ont pas toujours précisé qu'il s'agissait de copies. Il existe fort probablement plus de copies sur le marché que de modèles originaux.

BUTCHER'S ROYAL POSTAGE STAMP CAMERA - Appareil Timbre Poste. Des reproductions en ont été faites en Inde au milieu des années 1980, elles ont été offertes à des commerçants pour être revendues. Au moins un marchand photo londonien jouissant d'une bonne réputation a refusé l'achat, si le fabricant ne promettait pas de marquer clairement

toutes ses oeuvres comme étant des reproductions. Celui-ci ne se plia pas à cette exigence et des copies sans aucune indication sont apparues sur le marché.

CONTAX (couleur sable) - Les Contax couleur sable ont bel et bien existé. Souvent sont-ils appelés les "Rommel Contax". Greenborough de son coté a fait des contrefaçons. Au moins 5 ou 6 ont été fabriqués. Généralement, la couleur s'enlève facilement et le chrome apparait en dessous.

DE NECK PHOTO CHAPEAU - Quatre reproductions ont été réalisées par Bertrand. Au moins deux d'entre elles ont été vendues.

ENJALBERT PHOTO REVOLVER - On en connaît trois reproductions de Bertrand.

ENJALBERT TOURISTE - Bertrand en a fait des copies.

FOTAL - Quelques copies ont été proposées par un fabricant inconnu pour environ DM 2000

JOHN PLAYER - Paquet de cigarettes. Cet appareil a été fabriqué apparemment en Pologne et, bien que l'on prétende qu'il ait été utilisé par le KGB, nous n'avons trouvé aucune preuve de cette affirmation. Il semblerait qu'il ait été fabriqué à la seule intention des collectionneurs.

KRÜGENER - Livre de poche (Photo-livre de Mackenstein), des copies souvent grossières ont été faites et vendues. Si l'acheteur ne connaît pas bien l'appareil, il peut être victime de commerçants malhonnêtes. Il existe pourtant de si bonnes copies qu'elles peuvent être confondues avec des originaux. Une copie au moins, celle de Oberlaender, peut être identifiée grâce à un "R" (Réplique) qu'elle porte après le numéro de série au dos.

LANCASTER - Appareil montre. Il existe des copies dont l'origine est inconnue.

LEICA Anastigmat - Ce Leica est l'un des plus rares. On en a fait des contrefaçons, et même les objectifs ont été vendus séparément.

LEICA Elmax - 9 de ces modèles sur 10 sont contrefaits. A l'origine il s'agissait probablement d'un Elmar. Le nom a été effacé, la surface polie et le nom de Elmax gravé à nouveau sur cet emplacement. Un tel objectif ne peut pratiquement pas être identifié sans l'aide d'un microscope. L'Elmar est en effet un objectif à 4 lentilles tandis que l'Elmax en a 5. Les boitiers sont généralementauthentiques.

LEICA "Luxus" (Modèle en or) - On prétend que Greenborough a produit des copies avec les vrais numéros de série qui correspondent à ces versions. Plusieurs contrefaçons portant toutes le même numéro de série ont été vendues à des collectionneurs naïfs. Un de ces modèles a été proposé par un commerçant connu au propriétaire d'un magasin de photo. Ce dernier s'est renseigné auprès du fabricant pour savoir si le numéro de série était correct, comme il l'était, il s'en est rendu acquéreur, par la suite, Leitz a reçu plusieurs demandes concernant le même

numéro de série. L'on a pu ainsi découvrir que plusieurs appareils portaient le même numéro de série. Les connaisseurs savaient bien que de nombreux Leica dorés et fabriqué en Pologne arrivaient à l'Ouest et au Japon après avoir transité par Berlin-Est. Il y a quelques années, un Leica authentique en or, vérifié par le fabricant fut vendu par le Commissaire Priseur Cornwall à Cologne. Dans les six mois qui suivirent sont apparus sur le marché, des contrefaçons portant le même numéro de série. Les appareils russes "Fed" ont été dorés et gravés pour être transformés en Leica vendus aux collectionneurs. La plupart des Leica "de luxe" que l'on peut trouver sont des contrefaçons.

LEICA 250 REPORTER - Dans le passé ces appareils étaient considérés par les collectionneurs de Leica classiques, comme des investissements sûrs car le boîtier était très difficile à copier. Cette situation a bien changé, actuellement les faux Leica Reporter constituent des articles d'exportation de l'economie Polonaise.

MARION METAL MINIATURE - Copies existent. Fabricant inconnu.

MINOX "A" LUXUS - Les modèles authentiques ont une surface ouvragée. Quelques appareils courants ont été dorés sur leur surface polie. Ceci permet de les distinguer. Apparemment on trouve des contrefaçons dont la surface est ouvragée, probablement fabriquées avec des pièces d'origine au moins à l'intérieur.

MINOX en briquet - Ces appareils sont apparus au début des années 1990. Il s'agit de Minox normaux dans de gros boîtiers dorés contenant un allume cigarettes à gaz. Il existe quelques variantes. Il a été attribué au KGB, mais il s'agit d'une curiosité moderne sans valeur historique.

NEWBRONNER "DOPPEL-SPORT" - Appareil photographique se fixant sur le cou d'un pigeon, plusieurs copies sont apparues en 1990.

APPAREILS EN BAGUE - Un certain nombre d'appareils en forme de bague ont été fabriqués ces derniers temps. auraient été fabriqués pour le KGB, mais en réalité, ils sont l'oeuvre d'un artisan polonais de Gdansk, le talentueux Marek Aucun de ces appareils ne se ressemblent, par contre, tous utilisent la même cartouche cylindrique qui forme la bague. Il en existe avec têtes de formes différentes, certaines sont rectangulaires avec une petite pierre de chaque côté de l'objectif, ce sont elles qui permettent de régler les diaphragmes et les ouvertures d'obturation. Une de cette forme "tête rectangulaire" est maquée "Ernemann" à l'intérieur. D'autres ont la tête en forme de couronne dont l'une s'est vendue dans une vente aux enchères pour plus de \$ 20.000 en 1991. Bien que le vendeur ait affirmé que cette bague ait été conservée dans une collection pendant près de dix ans, sa similitude avec les modèles contemporains Certains de ces donne à réfléchir. appareils bague fonctionnent bien tandis que les autres donnent davantage l'impression d'avoir été créés pour la parade. Il est possible que ces dernières

soient de mauvaises copies des oeuvres de Mazur.

SCENOGRAPHE- Il existe des copies qui portent même le nom sur le soufflet. Leur origine est inconnue. Luc Bertrand en a fait une pour sa propre collection mais affirme n'en avoir pas fait d'autres. Nous avons entendu dire qu'il existait des répliques mais nous n'en avons vu aucune et n'avons recueilli aucun renseignement à ce sujet.

SUTTON: Chambre Panoramique - Luc Bertrand en a fabriqué une et l'a revendue en tant que copie. Après avoir changé plusieurs fois de propriétaire, elle se trouve actuellement dans une très importante collection où elle est exposée comme une pièce authentique.

TICKA: Montre Photographique - Un exemplaire est identifié à l'intérieur par l'inscription: "TASCHENUHR CAMERA, D.R.P. 173567 H. Meyer-Frey. Frankfurt A/M." Son authenticité est douteuse. Il se peut que ce modèle soit un des éléments constitutifs d'un projet de répliques de variantes des Ticka les moins courantes, comme celles argentées par exemple. Une "Watch-face Ticka" fut retirée d'une vente aux enchères chez Christie's lorsqu'il s'est avéré qu'elle n'était qu'une contrefaçon. Il est sûr qu'elle réapparaîtra un jour!

VOIGTLÄNDER DAGUERREOTYPE CANNON - Une contrefaçon présumée se trouve actuellement dans une collection privée. Non seulement ses dimensions sont erronées, mais en plus, le nom de Voigltänderest mal écrit.

NOUS INVITONS NOS LECTEURS A NOUS INFORMER DE TOUTES LES CONTREFAÇONS OU COPIES DES MODELES MENTIONNÉS AINSI QUE D'AUTRES. Nous publierons volontiers tous les renseignements sur les appareils et/ ou sur tous marchands ou toutes autres personnes ayant, en connaissance de cause trompé des collectionneurs.

APPAREILS VOLÉS; RÉCOMPENSES OFFERTES

Autrefois, à l'occasion des foires, on pouvait se permettre de laiser sur une table, une demi-douzaine d'appreils sans surveillance et sans risquer de les voir disparaître. Aujourd'hui, le problème est tout autre, le nombre de vols ne cesse de croître. Aussi, ce Guide McKEOWN est-il destiné, et ce pour la première fois, à publier une liste d'appareils volés afin d'essayer de remédier à ce fléau. Il va de soi qu'il n'est pas possible d'enregistrer tous les appareils volés au monde. plus, une aussi longue liste serait peu pratique pour le contrôle de vos achats. Pour ces raisons, nous nous limiterons à ne lister que les articles d'une valeur minimale de US\$ 1000 et munis d'un numéro de série. Toutefois, nous ferons une exception pour des appareils dépourvus de numéro de série mais dont rareté peut on. Nous permettre seule invitons l'identification. publications réservées aux collectionneurs ainsi que les clubs d'amateurs photo à nous aider à alimenter cette liste. commerçants, des Commissaires-Priseurs et des Clubs participent déjà à cette tâche.

S'il vous arrive de vous faire voler votre appareil photographique, faites en la déclaration à votre Commissariat de Police en n'omettant point de donner de cet appareil, un descriptif détaillé ainsi que son numéro de série. Faites nous parvenir ces informations avec les coordonées du Commissariat de Police, le numéro de Procès Verbal, le nom du Fonctionnaire, son numéro de téléphone etc... De cette façon, vous multiplierez les chances de retrouver votre matériel.

Nous ne nous publierons que du matériel dont le vol a été déclaré aux services de Police. Notre fonction est celle d'un centre d'échange d'information et nous ne nous nullement dans engagerons quelconque litige. S'il vous est proposé un appareil répertorié dans notre liste, essayez de vous renseigner plus avant sur le vendeur et signalez le aux organisateurs de la Foire ou aux services de Police. nous communiquerez Vous information que nous publierons avec la mention "vu récemment". Ce fléau ne disparaîtra pas de lui même, nous devons nous entraider. En tant que guide le plus lu dans le monde, nous nous engageons à tenir cette liste à jour. Notre ouvrage étant actualisé tous les deux ans, il vous suffit de nous faire parvenir une enveloppe timbrée avec votre adresse ou un coupon de réponse international pour recevoir la mise à jour de cette liste.

Faites nous parvenir vos suggestions pour combattre la criminalité dans ce domaine précis nous vous en saurons gré.

POUR PLUS D'INFORMATIONS

Nous recevons beaucoup de demandes pour un complément d'informations, beaucoup trop pour notre capacité de réponse. Nous ne donnons pas d'opinions ou d'estimations sur les articles qui ne sont pas contenus dans ce livre. Nous nous rendons compte que beaucoup d'appareils photo ne se trouvent pas dans ce livre et devons vous prévenir que l'omission d'un appareil photo n'indique pas sa rareté. Nous avons exclu au moins trente mille appareils pour diverses raisons pour que ce livre reste d'une taille et d'un prix Certains des appareils raisonnables. exclus sont: la plupart des appareils photo fabriqué depuis les années 70 qui sont en général des appareils plutôt pour utilisation que pour collection, la plupart des appareils 126, 110 qui ont été fabriqués en si grand nombre qu'ils en sont devenus communs et bon marché, et de nombreux anciens appareils que l'on voit rarement Nous avons proposés à la vente. sélectionné à peu prés 8000 appareils photo qui sont représentatifs dans le domaine de la collection et pour lesquels nous pouvons déterminer des prix de vente typiques.

Nous sommes désolés de n'avoir pas la possibilité de répondre aux questions individuelles de nos lecteurs par lettres ou par téléphone. Nous vous conseillons vivement de joindre un ou plusieurs Clubs de collectionneurs mentionnés dans l'appendice. Vous avez également la possibilité de vous adresser aux rubriques spécialisées d'aide aux lecteurs dans les bulletins des Clubs ou dans les revues photographiques.

INTRODUCCION

La primera edición de la Guía de Precios de Cámaras Fotográficas Antiguas y Clásicas se publicó en 1974. Desde entonces esta guía ha sido la referencia más completa y precisa de cámaras del mundo. La primera edición incluía mil cámaras. Esta noventa edición incluye más de nueve veces esa cifra. No solamente ha sido ampliada para incluir más modelos de cámaras, sino que hemos hecho todos los esfuerzos posibles para ampliar la información sobre cada aparato. con fechas e información histórica cuando nos ha sido posible. También, hemos aumentado en más de quinientas el número de fotografías en esta edición, a tres mil quinientos llegar ilustraciones. Cada edición de esta guía incorporado mejoras significativas respecto a la versión previa, y con la ayuda de los lectores esperamos poder continuar con esta tradición. Por ejemplo, esta octava edición añade cientos de objetivos y accesorios para los equipos fotográficos de los años 60 y 70. Aunque muchos de estos todavía son perfectamente utilizables, también están firmemente consolidados como material de coleccionista. Además de informar sobre las cámaras que se compran y venden cada día, buscamos los equipos y aparatos que no figuran en ninguna de las referencias tradicionales. En esta edición encontrará más de dos mil cámaras que no aparecen en ningún otro libro de consulta. Esperamos que disfrute con ello.

TENDENCIAS DE LOS PRECIOS

Para poder entender los precios actuales y futuros de las cámaras coleccionables, es importante conocer un poco la historia. La tendencia general de precios subió durante 1981, y se niveló en 1982 y 1983, incluso con algunos precios empezando a bajar. En 1983 y 1984, los precios de las cámaras cayeron considerablemente, sobre todo en su cotización en dólares norteamericanos en las que se basa nuestro trabajo.

parcialmente se debe debilitamiento general del mercado, y por supuesto, gran parte de esta pérdida se debe a la rápida revalorización del dólar en comparación con otras monedas. La velocidad de la caída se ralentizó en 1985. y se estabilizó en 1986, con algunos artículos comenzando a apreciarse. A finales de 1986 y principios de 1987 la fuerza relativa de las monedas inglesa, alemana y japonesa frente al dólar había reforzado el mercado, ya que por esas épocas comprar una cámara clásica en Estados Unidos era como comprar en unas rebajas de liquidación. Los precios en EE. UU. para las cámaras más atractivas empezaron a adquirir firmeza. Desde 1987 hasta 1989 vimos una fuerte subida en ciertas áreas. El mercado japonés había estado dirigiendo los precios al alza durante varios años debido a la fuerza del yen. Hoy en día tenemos un ambiente cada vez más competitivo entre los coleccionistas en Tokio, Europa, Hong Kong, EE. UU y otros lugares. Algunos precios han subido tanto que incluso a los que se dedican a comprar y vender les cuesta creerlo. Los precios de Leica se han estabilizado, pero solamente para ser adelantados por la pasión por las cámaras de telémetro de Canon y Nikon. Las copias de Leica, que en su día fueron el

substituto para los que no tenían suficiente dinero se han convertido, en muchos casos, en más valiosas que las Leicas que imitaban.

La tendencia general en el coleccionismo es hacia las avanzadas cámaras de alta de la posquerra mundial (1945-1970). Durante esta época Japón iudó un papel cada vez más dominante en la fabricación de cámaras. En la última década, los japoneses han recomprado miles de estas cámaras, ya que se convirtieron en un sector de mercado muy lucrativo. Recientemente, coleccionistas serios y comerciantes en Hong Kong v Europa han pagado precios rivalizando con los de los compradores japoneses. La atracción de los beneficios ha creado una raza de comerciantes intermediarios que se ceban en el mercado inflacionista. Aparte del mercado general de cámaras en acabados cromados y de cuero, hay algunos individuos y grupos que todavía consiguen descubrir preciosas cámaras antiguas de madera, latón y partes de cuero. El valor de muchas de estas cámaras antiguas es relativamente estable, porque no hay suficientes como para soportar una nueva de comerciantes domingueros". Incluso, se entiende que los coleccionistas de las cámaras más antiguas tengan un cariño especial hacia estos aparatos que va más allá del valor monetario. Las cámaras históricamente importantes se ven menos, pero al mismo tiempo cada vez hay menos comerciantes que las reconozcan.

Cámaras muy poco comunes, de los primeros tiempos, han alcanzado nuevos precios récord en subastas celebradas durante los dos últimos años, pero se trata de un mercado muy poco sólido. Unos precios de salida muy bajos produjeron una competencia en espiral que hizo que se alcanzasen precios altos. Por otra parte, los precios de salida altos produjeron justamente el efecto contrario, haciendo a menudo que todos los posibles postores descartasen de entrada algunas piezas importantes.

Los coleccionistas son cada día más exigentes en cuanto al estado de la cámara. Una cámara que no esté limpia y resulte atractiva será difícil de vender. Unas cuantas se escapan de este escrutinio si son muy poco comunes, pero la "mercancía" normal debe estar limpia y, preferiblemente, funcionando.

Cuando el coleccionismo vivió la expansión de finales de los 70, los especuladores compraron en cantidad e indiscriminadamente. Esto avivó las llamas de la inflación y llevó los precios al límite. El mercado sufrió un bajón en 1982 y 1983. El mercado inflacionista japonés ha seguido una pauta similar, pero está ahora más estable. Los precios se han igualado a nivel mundial y en diversos países los coleccionistas están pagando precios altos

Algunos tipos de cámaras han ido muy bien durante los últimos años. Las cámaras de placas europeas con cuero marrón son más apreciadas que las negras, que son más comunes. Cualquier color que no sea el negro implica un sobreprecio. Las cámaras de cajón

(excepto las negras comunes) están por fin despegando. Las cámaras de cajón con diseños "art decó", con colores, con formas curiosas hechas en plástico, etc. están subiendo en la curva de la demanda. En este área, Europa va un poco por delante de los Estados Unidos. También cabe mencionar que algunas cámaras "art decó" han conseguido mejores precios en el mercado de arte que en los círculos tradicionales de fotografía.

CAMARAS RUSAS Y SOVIETICAS

Durante muchos años, las cámaras soviéticas no eran muy comunes en Europa Occidental, y, raramente, como mucho, se veía una en Estados Unidos. Este fenómeno de la "guerra fría" se ha invertido de repente. La Unión Soviética y los países de Europa Oriental han abierto sus puertas. Muchas cámaras soviéticas consideradas hasta hace muy poco tiempo como muy escasas están apareciendo en cantidad en ferias de coleccionistas y en tiendas por toda Europa y EE.UU. Con tal incremento de oferta, los precios de muchos modelos han caído rápidamente. Algunos comerciantes y coleccionistas que compraron a precios antiguos se sienten poco dispuestos a bajar sus precios de venta. Por estas razones, el mercado de cámaras rusas está es una fase inestable, y se tardará unos años hasta que la oferta la demanda asienten los precios. Algunas de estas cámaras todavía pueden ser escasas, pero no son necesariamente las mismas que antes se consideraban

Para mayor deterioro a largo plazo del mercado de cámaras rusas/soviéticas. existe una gran cantidad de falsificaciones. Cualquier cámara con un acabado o inscripción especial es, con probabilidad, una falsificación antes que un artefacto genuino. Existe un cártel organizado de comerciantes rusos y polacos que está creando un flujo continuo de cámaras "de colección". En el proceso. han destrozado algunas cámaras que tenían valor histórico, para transformarlas en chatarra chapada en oro o con inscripciones inútiles. Esta práctica continuará mientras los comerciantes y los coleccionistas alienten esta actividad. Las posibles unidades auténticas que puedan quedar resultarán devaluadas, pues los compradores se han vuelto escépticos y seguiran así durante un tiempo indeterminado. La procedencia y la viabilidad de quien vende serán de importancia capital, porque las mentiras y las historietas inventadas vienen sin cargo con cada cámara.

En una reciente feria de coleccionismo, un ruso ofreció una Leica "Luxus" (de lujo) con un número de serie de 4 dígitos y marcas de identificación militares de la segunda guerra mundial. No todas las falsificaciones son tan obvias (las Leicas de 4 dígitos estaban fuera de producción antes de que Hitler accediera al poder; las cámaras militares no se fabricaban en versión "Luxus", etc. etc.).

MERCADOS "CALIENTES" Y "FRIOS" EN LOS NOVENTA

Durante los últimos años, Nikon se ha convertido en el líder indiscutible de la carrera especulativa. Existía una presión sobre los precios promovida por un grupo pequeño pero muy activo de

coleccionistas y comerciantes. En la actualidad, este fenómeno parece haberse estabilizado.

Las cámaras subminiatura han mostrado un alza continuada, pero con la mayoría de los aparatos dentro del presupuesto de la clase media. Pero en la subasta histórica de cámaras subminiaturas de Christie's en diciembre de 1991, un postor telefónico causó frustración entre los potenciales compradores presentes en la sala, ya que muchos lotes se vendieron encima de las estimaciones razonables. La influencia de esta subasta todavía se deja sentir. Los precios de las cámaras subminiatura han subido en todas partes. Sin embargo, algunos soñadores todavía esperan, a diario, conseguir precios récord.

CONSEJOS A COLECCIONISTAS QUE **EMPIEZAN**

Nuestro consejo a los coleccionistas dependerá enteramente de sus motivos para coleccionar. Si usted está interesado en coleccionar como inversión, debería centrarse en los modelos más escasos e insólitos, aunque éstos naturalmente requieren más capital y conocimiento. Si colecciona primordialmente por placer, entonces no hay más que seguir lo que le dicte su interés y presupuesto. Muchas de económicas le cámaras más proporcionarán una afición no muy cara, y suele resultar un buen nivel para comenzar. Dependiendo de donde resida. puede hacerse con una colección de Kodaks, Coronets, o Agfas de manera relajante y entretenida, ya que muchas de estas cámaras se pueden encontrar fácilmente a precios modestos. Muchos coleccionistas empiezan con un interés general que suele definirse continúan especializarse según coleccionando. Si lo que busca es ganar dinero, ha de estar en continuo contacto mercado. Encuentre el especialidad, y manténgase en su área de conocimiento. Siguiendo el mercado de cerca podrá sacar beneficios de sus cotidianas; fluctuaciones у conocimiento de sus clientes.

Todos los precios que se incluyen en esta edición han sido actualizados. Están lo más al día posible, y se ha dado una mayor importancia a los precios alcanzados más recientemente. De todos modos, hemos tenido en cuenta la influencia estabilizadora del precio máximo de los últimos diez años para prevenir cualquier "disparo" en los precios que se pudiera dar en los casos menos estudiados. Nuestros precios tienden a seguir una tendencia a largo plazo, que resulta más indicativa a través del tiempo. La información en esta edición está basada en cientos de miles de ventas reales, cambios, ofertas y pujas en subastas. Este es un libro de referencia -un trabajo de investigación. Los precios no dicen lo que yo creo que valgan, si no lo que muchos propietarios y compradores han pensado que valía en el momento de la verdad. Eso es la esencia de la "Ley de McKeown", que dice así: "El precio de cámara antigua depende únicamente del estado de ánimo del comprador y del vendedor en el momento de la transacción".

A esta filosofía general del coleccionismo

se le han añadido varios anexos:

"Si deja pasar la oportunidad de comprar una cámara que realmente quiere, nunca volverá a tener esa oportunidad".

2. "Si compra una cámara porque sabe que nunca va a tener la misma oportunidad, un ejemplar mejor de la misma cámara se le ofrecerá la semana siguiente-y a mejor precio".

"El valor intrínseco de una cámara antigua o clásica es directamente proporcional al convencimiento propietario de que alguien más la quiere. Dan Adams

Estas observaciones siempre deberían tomarse en cuenta cuando se aplique la "Lev de McKeown".

INSTRUCCIONES PARA EL USO DE **ESTA GUIA**

Todas las cámaras están agrupadas por el nombre de su fabricante, en orden alfabético. Cuando no estamos seguros del fabricante las cámaras están listadas por el nombre del modelo. Generalmente, las cámaras de cada fabricante vienen por orden alfabético, pero de vez en cuando está agrupadas por tipo, tamaño, fecha de introducción, y otra secuencia apropiada a la situación.

Las fotos suelen aparecer justo encima de la cabecera en negrilla que describe la cámara. Por razones de diseño del libro esto no es siempre posible. A veces, cuando el texto continúa en otra columna, la foto aparece en medio del párrafo que la describe. Cuando la foto no entra en el texto, el pie de foto viene en cursiva y una nota al final del texto indica dónde se encuentra. Cuando la foto está al final de una columna, donde rompe el texto de otra hemos intentado separarla visualmente por medio de una simple línea oscura. Siguiendo esta práctica. la cabecera de una cámara sirve como pie de foto para la mayoría de las fotos, ahorrando de esta manera ¡cuarenta páginas!, que es lo que hubiese costado poner pie de foto a cada una de las tres mil quinientos fotos.

Hemos usado diferentes tipos de letra para facilitar el uso de la guía. El diseño es el siguiente:

FABRICANTE (MAYUSCULAS NEGRILLA) - Notas históricas o comentarios sobre el fabricante (cursiva)

Nombre de la cámara (negrilla) -Descripción de la cámara y cotización actual (tipo normal). Notas especiales sobre la cámara o el precio (cursiva)

NOMBRE DE LA CAMARA - Si el modelo de la cámara está en mayúsculas, entonces es un listado separado, sin relación con el fabricante anterior. Usamos esta presentación normalmente cuando desconocemosel fabricante.

A primera vista, puede que este sistema de diseño no sea el más estético desde un punto de vista "artístico", pero ha sido cuidadosamente planeado para ahorrar espacio, y al mismo tiempo, ser fácil de seguir. Nuestro ordenador fácilmente Nuestro ordenador fácilmente seguir. podría enmarcar cada una de las fotos. pero eso hubiese añadido cincuenta páginas al libro. Igualmente podíamos haber hecho cajas alrededor de cada columna, lo cual hubiese mejorado la apariencia, pero también añadiría noventa

páginas. Nuestros lectores coleccionistas serios y comerciantes que necesitan la máxima información en el mínimo espacio posible. Esperemos que les guste nuestro "pequeño" libro. Si en el diseño de este libro prevaleciese lo fácil y lo bonito, este sería un "monstruo" de más de ochocientas páginas, sería un treinta por ciento más grueso, más pesado y más caro. Esperemos les guste nuestro estilo simple de más información en menos espacio.

ESTADO DE LAS CAMARAS

Una cámara en perfecto estado externo, que no funciona puede perfectamente aceptable para coleccionista que la vaya a poner en una vitrina. Sin embargo, hay gente a la que no le importa el aspecto externo, siempre y cuando el aparato funcione. Nosotros estamos decididamente a favor de un sistema uniforme para valorar apariencia y la operabilidad de la cámara. Esta escala debería de ser puesta en práctica a nivel mundial con cooperación de guías de pupublicaciones y sociedades precios, coleccionistas, casas de subastas y comerciantes.

En el esfuerzo por establecer un baremo internacional para describir el estado de las cámaras, hemos propuesto la siguiente escala. El sistema utiliza letras y números intencionadamentepara no ser confundido con otros métodos de valoración ya existentes. El estado de una cámara debería de representarse por un solo dígito seguido por una letra. El número indica el estado externo mientras que la letra indica el funcionamiento. Este sistema ha sido adoptado ya por el "Photographic Collectors Club of Great Britain' (Club de Coleccionistas Fotográficos de Gran Bretaña).

VALORACION - ESTADO EXTERNO

O - Nueva, nunca vendida. En su caja original, con las garantías del fabricante.

1 - COMO NUEVA - Nunca usada. Igual

que nueva, pero sin la garantía del fabricante. En su caja, o envoltura original.

2 - Ninguna señal de uso. Si tuviese caja, no podríamos diferenciarla de una nueva.

3 - Mínimas señales de uso.

4 - Pequeñas señales de uso, pero no de maltrato. Ningún otro daño externo.

5 - Completa, pero con señales de un uso normal o de su antigüedad.

6 - Completa, pero muestra un uso continuo, bien usada.

 Restaurable. Necesita algunos retoques. Pequeñas piezas de importancia pueden estar rotas o faltar.

8 - Restaurable. Necesita ser retocada. Pueden faltar algunas piezas.

 Sólo para piezas, requeriría restauración muy importante si se trata de una cámara especial.

VALORACION -ESTADO DE FUNCIONAMIENTO

A - COMO NUEVA. Todo funciona a la perfección, con la garantía de fabrica, de la tienda o de ambos.

B - COMO NUEVA. Todo funciona a la perfección, pero sin la garantía de fábrica. El vendedor garantiza integramente su funcionamiento.

C - Todo funciona. Ha sido limpiada, totalmente lubricada, repasada recientemente totalmente está У garantizada.

D - Todo funciona. Ha sido limpiada, o totalmente repasada recientemente, pero ya no está bajo la garantía.

E - Todo funciona. Las funciones principales han sido probadas por profesionales recientemente.

F - No ha sido limpiada, lubricada o repasada recientemente. Funciona todo, pero la precisión del obturador o del exposímetro no están garantizadas.

G - Funciona plenamente. Probablemente la velocidad de obturación y/o el exposímetro no estén ajustados. Necesita solamente ser ajustada y limpiada.

H - Utilizable, pero no totalmente. Es posible que el obturador se atasque a baja velocidad y/o que el exposímetro no funcione.

J - NO UTILIZABLE sin reparaciones o limpieza previa. El obturador, el exposímetro, o el avance de la película pueden estar atascados o rotos.

K - Probablementeno tenga arreglo.

Con este sistema, una cámara media sería clasificada como 5F. Una cámara clasificada como 3G mostraría mínimas señales de uso, pero la precisión del exposímetro del obturador sería dudosa. De esta manera una descripción precisa cabe en muy poco espacio, y elimina los problemas relativos a la valoración del estado de conservación externo y su funcionamiento normalmente asociados con sistemas de valoración solamente numéricos o escritos. Para ser todavía más precisos, se puede describir una cámara con dos dígitos, de esta manera un "56B" indicaría un estado externo entre el 5 y el 6, con el funcionamiento garantizado.

Desde que iniciamos este sistema, la revista "Camera Shopper", y algunos comerciantes han adoptado sistemas similares, pero con el valor numérico invertido, para que el 10 sea la máxima puntuación. Al comprar una cámara sin antes inspeccionarla, asegúrese de saber qué sistema de evaluación se está aplicando.

Generalmente, el estado en que se encuentra la cámara afectará a los precios como exponemos a continuación. Aún así, esto son tan sólo aproximaciones. El estado afecta al precio de forma diferente, según los tipos y la antigüedad de las cámaras. Más abajo, se indican en forma de porcentajes las variaciones sobre el precio, en función del estado en que se encuentra la cámara.

COMPARACION CON OTROS SISTEMAS DE VALORACION

La siguiente tabla compara la parte correspondiente a la valoración al estado externo con algunas de las descripciones más comunes. Estas comparaciones son aproximadas y las exponemos para que los usuarios de esta guía realicen el cambio al nuevo sistema más fácilmente. La última columna de la tabla muestra en términos generales cómo los precios se ven afectados por el estado la cámara. Esto son solamente aproximaciones, ya que el estado afecta al precio de manera distinta según el modelo antigüedad de la cámara. Los porcentajes indicados se aplican sobre los precios de venta marcados. No hemos comparado el sistema con ninguna otro numérico, sistema porque

demasiadas variaciones entre los distintos comerciantes.

McKeown PCCGB		Cubactas	0/ 4-1
		Subastas	% del
Christie's	SA	alemanas	precio
0	Ν	-	150-200%
1	LN	-	130-150%
2 3	M	Α	120-140%
	M	AB	115-130%
4	E+	В	110-120%
5	E	С	95-115%
6	VG	CD	80-110%
7	G	D	55-85%
8	F	E	30-60%
9	P	_	10-30%

Cualquier pieza suelta o que falte debería estar indicada claramente. El signo "-" después del número o letra de condición indica que la cámara cumple el nivel requerido, excepto por detalles mínimo EXPLICADOS en un comentario adjunto. El uso del signo "+", indica que sobrepasa el nivel de estado, pero no llega a cumplir con la especificaciones del nivel de estado superior.

Si a su cámara le faltan piezas o las tiene rotas, le hará falta una segunda cámara similar destinada al despiece, con el fin de completar y reparar la principal. La fórmula para la valoración es: Cámara principal + cámara para despiece + mano de obra = precio de la cámara completa.

Algunos coleccionistas son más indulgentes al aplicar estos baremos cuanto más vieja y más escasa sea la cámara, y más estrictos cuanto más común o nueva sea la cámara. Esta práctica resulta derrotista, ya que si se describe una cámara como en muy buen estado, considerando su antigüedad. estamos valorando personalmente que las cámaras más antiguas deberían de ser juzgadas por otro baremo. Aunque la mayoría de las cámaras de esa edad muestren señales de vejez, el hecho de que sea más antigua no mejora su estado.

INTERPRETACION DE PRECIOS

Todos los precios están en dólares norteamericanos. El precio es para cámaras en condición 5, según la valoración expuesta previamente. Esta es la condición más común en la que se encuentran y coleccionan cámaras, por lo tanto establece el listón. Para determinar el valor de cada cámara, el usuario de esta guía debe considerar cualquier variación sobre esta norma, y estimar el precio a partir de esa variación.

Salvo que se especifique "cuerpo sólo", los precios se refieren a la cámara con el objetivo normal, el respaldo y todo aquello que pueda ser parte de su configuración normal para que funcione.

Los aparatos de menor valor suelen estar sobrevalorados en esta guía y en el mercado, simplemente porque los gastos de anunciar, vender y transportar una cámara de cinco dólares no son muy distintos que los de una cámara de cientos de miles de dólares. Los productos de gama media tienen los precios más precisos; son con los que más se comercian, y los que más oferta tienen, por lo tanto representan el mercado más estable. Las cámaras más caras de cada

estilo, marca o antigüedad son las más volátiles, ya que la oferta y la demanda son muy limitadas.

NO ESPERE QUE EL ESPECIALISTA SE AJUSTE AL "PRECIO DEL LIBRO"

Si tiene una o dos cámaras para vender y espera conseguir el mejor precio por ellas, haría bien en considerar la situación desde el punto de vista del especialista. Para poder vender su cámara, el comerciante ha de limpiarla, arreglarla y garantizarla. Ha de alquilar una mesa en las ferias. imprimir y mandar una lista de precios, y defender su precio ante compradores que no quieren pagar por ella. Después de no vender su cámara durante unos meses, y cuando empieza a mostrar más uso y desgaste por todos los compradores potenciales que la han estado mirando, el negociante la vende a mitad de precio en un cambio por otro material. Una cámara, a menudo pasa por las manos de cuatro o cinco comerciantes antes de encontrar el iluso comprador que pagará el alto precio de la cámara. Cuanto menos valiosa sea su cámara, más ha de aprender de este ejemplo. Si su cámara es efectivamente de las que quedan pocas y, por lo tanto. muy valiosa, no se preocupe, lo comerciantes se pelearan literalmente por ella. Este es un mercado muy competitivo.

PRECIOS DE CAMARAS EN JAPON Y EUROPA

En algunos casos hemos diferenciado el precio de la misma cámara en distintos mercados como EE.UU., Europa, Inglaterra, Alemania, Japón, etc. Por supuesto, habrá diferencias de precios en cámaras en las que no hemos hecho esta distinción. Primero, ha de quedar claro que el precio base de la mayoría de las cámaras es en el país donde más disponible está. Para muchas cámaras sencillas, este es el país de origen. Pero como muchas cámaras fueron exportadas a Estados Unidos, el precio allí será tan bajo como lo pueda ser en cualquier otro sitio. La diferencia de precios entre países. para cámaras baratas es insignificante, y no lo hemos apuntado en esta guía salvo para algunos modelos en que la diferencia es superior al del precio de transporte. constantemente. El precio para cámaras japonesas de calidad es más alto en Europa que en Estados Unidos. Esto se debe a que se exportaron a Estados Unidos más cantidad de estas cámaras que a Europa. Con una menor oferta en Europa, el precio tasado por coleccionistas es mayor.

La Dufa Pionyr es un buen ejemplo de una cámara que varía de precio alrededor del mundo. En Alemania, cerca de su lugar de nacimiento, se vende en subastas por unos veinticinco dólares. Comerciantes en Londres la han vendido por cuarenta y cinco dólares en su caja original. Estos dos precios definen los límites de un precio normal y razonable. No hemos tenido en cuenta, la que vimos en Tokio por ciento veinticinco dólares. Aunque es posible que se vendiese más caro que eso, no podíamos indicar ese precio como normal.

¿HAN ALCANZADO LOS PRECIOS EN JAPON SU PUNTO MAS ALTO?

En el momento en que la economía japonesa estaba en su máximo auge, a muchos compradores occidentales les

resultó difícil pagar precios competitivos. Ahora se puede apreciar, a nivel mundial, un mercado mucho más estable.

COMO DETERMINAMOS LOS PRECIOS

Seguimos y analizamos precios de fuentes muy distintas en todo el mundo, incluyendo publicaciones de comerciantes. listas de precios, subastas, y ferias. Nuestra base de datos incluye cientos de miles de precios para cada nueva edición, más la base acumulada de ediciones previas. Aunque las fórmulas son de propiedad nuestra exclusiva, unas palabras pueden indicar por qué nuestras estadísticas no reflejan sus propias observaciones: Usted lee una publicación de un comerciante regularmente, y la cámara X suele venir anunciada en doscientos setenta y cinco a trescientos veinticinco dólares. Usted se acuerda de estas cifras, nuestro ordenador también. Hay buena probabilidad que la MISMA cámara haya salido a la venta varias veces. Por lo tanto un precio al que una cámara no se vende, aparece publicado más a menudo que un precio auténtico. En el caso de la cámara X, un comerciante empezó ofreciéndola a cuatrocientos cincuenta dólares. Después de un año anunciándola, la misma cámara, se ofrecía a doscientos cincuenta dólares cuando nuestra guía iba ya a la imprenta. Muchas otras ventas confirmadas alrededor del mundo nos indican que la cámara X se vende entre ciento veinticinco y ciento setenta y cinco dólares. Finalmente el comerciante que le ha estado mandando su lista de precios, vende la cámara a un comprador que se ha acostumbrado a verla ofrecida por trescientos dólares, y le por parece barata cuando aparece doscientos cincuenta. Nuestro ordenador tiene una larga memoria que sigue la pista a cámaras ofrecidas por comerciantes hasta que se venden. Los precios a los que la cámara no fue vendida no son utilizados para calcular el precio, si no sólo como referencia sobre "techo" de un precio.

Nuestro precio representa el valor normal para la mayor parte de las cámaras vendidas. Nuestros precios están basados en estudios exhaustivos y no en precio imaginarios. Nosotros no vendemos cámaras, porque consideramos que estaríamos ante un caso de conflicto de intereses.

CAMBIO DE DIVISAS

Los precios en esta guía representan el precio medio en el mercado mundial. Hay diferencias definitivas entre estas cifras. según los distintos mercados. Algunas cámaras son más comunes en un país que en otro. Los intereses de coleccionistas también varían, y las "modas" afectan a distintos países en distintos momentos. Pero ningún mercado está cerrado a influencias externas, y las fluctuaciones tienden a nivelarse mundialmente. Un precio más alto en un país atraerá más cámaras a ese mercado, v subirá el precio mundial hasta que esa demanda se calme. Todos los precios vienen en dólares ya que el valor de las divisas cambia constantemente. No vamos a confundir a nuestros lectores con conversiones de monedas generadas por un ordenador, basado aleatoriamente en el cambio de un día de nuestra elección.

Para su comodidad, incluimos esta tabla

con el cambio de divisas a dólares el día siete de junio de 1994. Multiplicando estos factores "*" por el precio en dólares le dará el valor en su monedalocal.

MONEDA	= US\$	US\$1 = *
\$ australiano	.7345	0.3615
Chelín austríaco	.08602	11.625
Franco belga	.02917	34.282
Cruzeiro brasileño	.0004975	2010.05
Libra esterlina	1.5095	0.6624
\$ canadiense	.7287	1.3727
Franco francés	.17598	5.6825
Marco alemán	.6002	1.666
\$ Hong Kong	.12940	7.7280
Lira italiana	.0006188	1616.03
Yen japonés	.009602	104.15
Florín Holandés	.5354	1.8679
\$ neozelandés	.5914	1.6909
Peseta española	.007331	136.41
Corona sueca	.1262	7.9260
Franco suizo	.7078	1.4128

COMO VENDER CAMARAS CLASICAS

Tanto si queremos vender una sóla cámara o una colección completa, sea a nivel personal o como comerciante o coleccionista, existen varios métodos establecidos para vender cámaras de colección. Cada uno de ellos tiene ventajas e inconvenientes. Un método puede resultar más indicado para una cámara en particular y otro puede ser mejor para otra cámara distinta.

SUBASTAS:

Ventajas - Se venderá. Cambiará de manos. Cobraremos.

Las cámaras menos comunes suelen alcanzar precios más altos de lo esperado. Un precio de salida bajo suele atraer a más postores y generalmente produce un precio de venta más alto.

Desventajas - Requiere un periodo de espera largo, habitualmente de varios meses, necesario para catalogar las piezas y preparar la venta. Pago de comisión (a menudo desproporcionada, más alta de lo calculado). Un precio de salida alto echa para atrás a los postores y puede no llegarse a pujar. Si la pieza reaparece con posterioridad en otra subasta, con un precio más bajo, los compradores potenciales suelen acordarse y se abstienen de pujar.

COMERCIANTES:

Ventajas - Venta y pago inmediatos. No hay que esperar para que aparezca el comprador definitivo. Los comerciantes pagan buenos precios para piezas poco usuales. En ocasiones, los comerciantes pagan más de lo que se podría obtener de otra forma, pues disponen de una clientela a la que dificilmente podríamos acceder. (Los comerciantes compran y venden a menudo entre sí, para beneficiarse de esta especialización.) No se deducen comisiones del precio de venta.

Desventajas - Los comerciantes se ven obligados a comprar a un precio inferior al que han de vender. (Esto no siempre es una desventaja, pues a menudo tienen clientes con alto poder adquisitivo a los que uno por su cuenta no podría acceder). Algunos comerciantes se niegan a ofertar un precio, ya que esperan a que nosotros indiquemos cuanto queremos por la cámara. Si nos dirigimos de esta forma a comerciantes, es como estuviésemos realizando nosotros mismos una subasta, un juego que puede llegar a ser muy cansado, pues los comerciantes podrían no querer ofertar en absoluto. Puesto que somos nosotros los que iniciamos el juego de "subasta", es posible que el comerciante no empiece con su mejor precio y podríamos tener que recorrer varios establecimientos o incluso hacer un segundo recorrido, ofreciendo la pieza a un precio inferior.

FERIAS, RASTROS:

Ventajas - Sin intermediarios. Sin comisiones. (Esto puede tener más valor psicológico que comercial, teniendo en cuenta el tiempo empleadoy los gastos)
Oportunidad de contactar con otros coleccionistas y compartir el entusiasmo. Posibilidad de trueques, cambio a una unidad mejor o de compras para la propia colección.

Desventajas - Muchos gastos imprevistos, a menudo superiores al pago de una comisión por subasta o al descuento de un comerciante. Gastos de alquiler del tenderete o de la mesa. Sin garantía de realizar ventas. Podemos cargar con piezas sin vender durante años, tal como les ocurre a los comerciantes. El desgaste y deterioro sufrido por las cámaras puede ser devastador.

LISTAS DE DISTRIBUCION:

Ventajas - Puede alcanzarse -por correo- un mercado muy amplio, sin los gastos ni el tiempo empleado, asociados a una feria. Las camaras no sufren manipulación alguna antes de su venta.

Desventajas - Los compradores potenciales están limitados a los incluidos en la lista. Costos de impresión y de envío de la lista. Los compradores no pueden ver la mercancía antes de comprarla.

Generalmente, se exige que si el comprador no queda satisfecho se le devolverá el importe.

ANUNCIOS CLASIFICADOS:

Ventajas - Puede escogerse la publicación más adecuada según la clientela que deseemos. Puede hacerse en boletines de asociaciones, revistas fotográficas especializadas, técnicas, etc. En general, el coste es muy bajo, sobre todo para unas pocas piezas.

Desventajas - Desfase entre la contratación del anuncio y su publicación y posible venta. La venta no está asegurada, sobre todo si nos hemos pasado en la estimación del precio. (Sin embargo, la venta está casi asegurada si el precio pedido es realista.)

REPRODUCCIONES DE CAMARAS

Conforme suben los precios de las cámaras, también lo hace el número de reproducciones falsificaciones, presentaciones de objetos falsos como auténticos. Durante muchos años. coleccionistas y comerciantes han estado al corriente de la existencia de estas falsificaciones, pero en lugar de divulgar lo que sabían, han mantenido "el secreto". Ahora, queremos hacer público este hecho para proteger a nuestros lectores y a otros compañeros del mundo del coleccionismo. Entendemos y aceptamos que reproducciones de cámaras poco corrientes resulten interesantes para los museos y para muestras de colecciones, pero no podemos aceptar que ninguna de estas reproducciones se presente como auténtica ni mucho menos que se venda como original. Tenemos varias opciones.

Si aceptamos que en el mundo del coleccionismo hay sitio tanto para coleccionistas como para delincuentes, no hay ningún problema. Pero, los delincuentes están alejando de su afición a los coleccionistas. Personalmente pensamos que son los coleccionistas los que deben alejar a los delincuentes. Lo único que debemos hacer es compartir nuestra información para evitar que los compañeros coleccionistas puedan ser llamados a engaño.

A continuación, relacionamos los personajes más conocidos de entre quienes realizan reproducciones, restauraciones, falsificaciones o fraudes:

Luc Bertrand (Bélgica). Se trata de un artesano que restaura y reproduce cámaras. Hace buenas reproducciones de cámaras de metal y también hace cámaras de madera que resultan muy difíciles de distinguir de las originales. Hace reproducciones de cámaras muy poco usuales, en muy pequeñas cantidades, para su propia colección y para coleccionistas privados y museos. Hay que decir, en su favor, que identifica sus reproducciones tanto con sus iniciales como con la fecha. Desafortunadamente, en ocasiones, sus reproducciones han sido presentadas, por otras personas, como originales. Las reproducciones anteriores a 1989 se hicieron en series muy cortas, de 1 a 4 unidades, de las que normalmente Bertrand conserva una para su propia colección. En ocasiones, el resto tiene un número de serie -del 1 al 4además de "LB" o "BL" y el código de la fecha. Con posterioridad a 1989, Bertrand identifica sus reproducciones con un pequeño monograma "LFB" estampado en la madera o el metal. Desde 1990. Bertrand ha reproducido sólo unas seis cámaras en serie. Hizo otras quince aproximadamente, una unidad de cada, para su colección personal. Desde mediados de 1990, Bertrand ha manifestado haber realizado un total de 35 réplicas, la mitad de las cuales todavía permanecen en su poder. Las restauraciones realizadas por Bertrand también reciben su sello estampado, con sus iniciales y la fecha, en aquella parte de la cámara que ha sido restaurada.

)B 90

Luc Bertrand ha tenido la amabilidad de darnos muestras de sus monogramas estampados, con el fin de hacerlos públicos. Se trata de un honesto esfuerzo para evitar que cualquiera de sus reproducciones pueda ser presentada malintencionadamentecomo original.

Greenborough. No conocemos personalmente ni hemos hablado con el señor Greenborough, por lo que nuestro informe está basado en informaciones recibidas por parte de otros coleccionistas. Según se dice, tanto él como su esposa son polacos, pero viven en Alemania. Aparentemente él no fabrica las cámaras, sino que encarga la fabricación de copias de cámaras históricas y también ha come rcializado algunos diseños imaginativos de reciente inspiración. De acuerdo con ouestras fuentes, las copias están realizadas en Polonia. Entendemos que estas copias no están identificadas como

tales y que por tanto, muchas son ofrecidas posteriormente como cámaras originales para su venta, bien por ignorancia, bien con intención de engañar. Una fuente de información indica que Greenborough podría no estar operando actualmente en este negocio. Entre las cámaras atribuidas a Greenborough se incluyen las siguientes: Leica 250, Encendedor Minox de cigarrillos, Ticka Watch Camera (Taschenuhr Camera) (Cámara reloj Ticka), ¿Leica Luxus?, ¿Cámaras paquete de cigarrillos John Player?

Un señor Oberlaender ha realizado réplicas de algunas cámaras famosas, in cluyendo la Doppel Sport (una cámara aérea portada por paloma mensajera), y la Carnet", versión Taschenbuch Kamera del Dr. Kruegener. Algunas de estas réplicas resultan prácticamente imposibles de distinguir de los originales. No somos conscientes de que las cámaras de paloma mensajera lleven algún tipo de identificación de que se trata de réplicas y sí sabemos de varios casos en los que han sido presentadas y vendidas como auténticas. Al menos una cámara de tipo "Photo Carnet" fue identificada como réplica con una "R" tras el número de serie en el lomo. Fue revendida en Christie's en diciembre de 1991. En la misma subasta, se vendió una muestra de la réplica Doppel Sport, Ambas fueron descritas adecuadamente por Christie's como tales réplicas.

creaciones de Greenborough y Oberlaender han sido vendidas, directa o indirectamente a algunos de los más entendidos y respetados coleccionistas del mundo. Esas y otras reproducciones se han integrado en grandes colecciones sin tomar nota de su auténtico origen. Han sido revendidas como originales, bien intencionadamente, bien por desconocimiento. Unos cuantos -por otra parte respetables- comerciantes han apoyado activamente a los fabricantes de imitaciones vendiendo sus falsificaciones como parte de una actividad normal de su negocio, generalmente sin admitir estar al tanto del origen de sus mercancías, y a menudo, con una historia que daba a entender una autenticidad de mercancías que eran falsas

Las cámaras falsificadas suelen envejecerse de forma artificial.

CAMARAS QUE EXISTEN O SE DICE QUE EXISTEN BAJO FORMA DE REPRODUCCION O DE DESCARADA FALSIFICACION

BEN AKIBA - Cámara camuflada en pomo de bastón. Existen copias realizadas por Oberlaender.

BERTSCH (modelo pequeño). Aunque no tenemos constancia de que se hayan realizado reproducciones del modelo grande, es seguro que existen copias del modelo pequeño. Bertrand hizo cuatro copias, incluyendo dos diseños distintos del chasis.

BUTCHER'S ROYAL MAIL POSTAGE STAMP CAMERA: A mediados de los años 80 alguien en la India realizó reproducciones de esta cámara, que ofreció para su venta a los comerciantes en material fotográfico de colección. Al menos un respetado comerciante londinense rehusó hacerlo. Luego han aparecido en el mercado réplicas sin ningúntipo de marca.

CAMARA MONOCULAR BRINS: Luc Bertrand hizo al menos cuatro reproducciones. Algunas tienen sus iniciales y la fecha (por ejemplo, "BL82") grabadas en el interior, pero no todas las que han sido revendidas han sido identificadas adecuadamente como copias por los revendedores. Es muy probable que el número de reproducciones presentes en el mercado supere al de originales.

CONTAX (color arena): Existe una Contax genuina de color arena, denominada a veces "Contax de Rommel" debido a su color arena del desierto. Sin embargo, existen imitaciones realizadas por Greenborough. Han aparecido al menos 5 6 6 imitaciones. Por lo general, el color arena se quita fácilmente, apareciendo el cromado ordinario bajo el acabado falso.

EL PHOTO CHAPEAU DE NECK (Cámara camuflada en sombrero): Cuatro reproducciones hechas por Bertrand, de las que al menos dos fueron vendidas.

PHOTO REVOLVER ENJALBERT Se tiene conocimiento de tres reproducciones hechas por Bertrand.

ENJALBERT TOURISTE: Existen copias hechas por Bertrand.

FOTAL: Se han ofrecido copias en el mercado, a aproximadamente 2.000 marcos alemanes. No existe confirmación sobre la fuente de fabricación.

JOHN PLAYER (PAQUETE DE CIGARRILLOS): Según referencias, fabricada en Varsovia (Polonia), por un tal Kaminski. Aunque se dice que fueron utilizadas como cámaras espía por la KGB, no hemos tenido acceso a ninguna información que dé credibilidad a esa afirmación. Lo más probable es que fuesen realizadas ex profeso para el mercado de coleccionismo.

KRUGENER TASCHENBUCH (Libro de Krugener) (Photo-Livre Mackenstein): Se han fabricado y vendido copias, o más bien reproducciones bastante toscas. Si embargo, si el comprador no está familiarizado con el original, podría ser llevado a engaño con facilidad por un vendedor escrupuloso. Otras réplicas son de buena calidad y podrían confundirse fácilmente por originales. Al menos un ejemplar, Oberlaender, fabricado por identificado por una letra "R" (Replica) grabada tras el número de serie situado en el lomo

LANCASTER WATCH CAMERA (Cámara reloj Lancaster): Fabricante desconocido.

LEICA (Anastigmat): La Leica A Anastigmat es una de las Leicas menos comunes. Se han realizado falsificaciones, e incluso se ha vendido el objetivo por separado.

LEICA I Elmax: Nueve de cada diez cámaras que se encuentran en la

actualidad en el mercado son falsas. Lo más probable es que se partiera de un objetivo Elmar, para a continuación eliminar parcialmente el nombre, recubriéndolo con metal y volviéndolo a grabar. Son prácticamente imposibles de detectar, salvo desmontando el objetivo y observando con el microscopio para contar el número de elementos. Los Elmar son de 4 elementos y los Elmax de cinco. Los cuerpos suelen ser auténticos.

LEICA LUXUS (modelos en oro): Se dice que Greenborough fabricó imitaciones utilizando números de serie "correctos". Existen varios coleccionistas que, sin saberlo, compraron cámaras que tenían -todas ellas- exactamente el mismo número de serie. Se pasó al patrón de una tienda en Bruselas: Cuando un señor conocido le ofreció un modelo para su venta, consultó con la fábrica, para verificar si el número era correcto. Lo era, cámara. compró la que Posteriormente, recibió Leitz otras consultas respecto al mismo número de serie y se pudo determinar que existían múltiples copias con el mismo número de serie

coleccionistas expertos Los conscientes de la existencia de numerosas Leicas de oro falsos originarias de Polonia, que luego se han visto y vendido en Japón y en varios países de Europa occidental, a menudo a través de Berlín Este. Hace varios años, se vendió una cámara "Luxus" genuina, verificada por la factoría, a través de la Auktionshaus Cornwall, en Colonia. Dentro de los seis meses siguientes, apareció en el mercado una falsificación con el mismo número de serie. Las cámaras rusas "Fed" también han sido tomadas como base para falsificaciones de Leica, grabándoles las inscripciones Leica y chapándolas en oro, para venderlas en el mercado de coleccionismo. La mayor parte de las cámaras Leica "Luxus" presentes en el mercado son falsificaciones.

LEICA 250 REPORTER: Este modelo, considerado en tiempos un valor seguro de coleccionismo debido a la dificultad de duplicar el cuerpo de fundición de metal, no lo es ahora, hasta el punto de que las Leica Reporter falsas son casi parte de la dieta básica de la economía polaca.

MARION METAL MINIATURE - Existen copías. Fabricante desconocido.

MINOX A LUXUS: El metal de los ejemplares genuinos es texturado y las unidades normales que se han chapado se detectan fácilmente por sus superficies lisas. Según se dice, existen también algunas reproducciones con cuerpo metálico texturado y probablemente con mecánica funcional, original Minox.

MINOX EN ENCENDEDOR DE CIGARRILLOS: Aparecieron por primera vez hacia 1990. Consiste en una cámara Minox normal en una carcasa tosca chapada en oro, que contiene, además, un encendedor de gas. Existen pequeñas variaciones de una unidad a otra. Se han presentado como cámaras del KGB, pero se trata de una curiosidad moderna, sin ningún valor histórico.

NEUBRONNER PIGEON CAMERA (Cámara Neubronner de paloma mensajera): Aparecieron varias en el mercado hacia 1989. Origen sin confirmar.

CAMARAS ANILLO: En los últimos años, atribuidas generalmente a la KGB, han aparecido en el mercado una serie de cámaras camufladas como anillos. La fuente real es un artesano con talento, que se llama Marek Mazur, de la conocida ciudad de Gdansk (Polonia). Ninguna de ellas es idéntica, a pesar de emplear un cartucho de película similar, cilíndrico, que configura el anillo. La parte superior del anillo varía y, así, algunos son de forma rectangular, con una piedra de pequeño tamaño a cada lado de la abertura central para el objetivo. Una de estas unidades tiene grabado en el interior de su parte superior la marca registrada "Ernemann". Otra cámara-anillo similar, con una sola piedra montada en un engarce en forma de corona, se vendió en subasta, en 1991, bastante por encima de los 20.000 dólares. Aunque se aseguró que había permanecido en una colección durante más de 10 años, su similitud con la supuesta pieza fraudulenta, es causa de preocupación. Algunas de estas cámaras-anillo están bien fabricadas y son funcionales, mientras que otras son de "mírame y no me toques", con partes que ajustan malamente. Es posible que sean copias falsas de los anillos originales Mazur.

SCENOGRAPHE: Existen reproducciones, incluyendo el nombre sobre el fuelle. Bertrand construyó una para su propia colección, pero según afirma, ninguna más. Hemos recibido informes acerca de reproducciones de la cámara Scenographe, pero no hemos visto ninguna ni tenemos documentación al respecto.

CAMARA PANORAMICA SUTTON: Bertrand fabricó y vendió una, como reproducción. Después de cambiar de manos varias veces, se encuentra actualmente en una colección importante, presentada como original.

TICKA WATCH CAMERA (Cámara-reloj Ticka): Existe un ejemplar, identificado en su interior "TASCHENUHR CAMERA, D.R.P. 173567 H. Meyer-Frey. Frankfurt A/M." Su autenticidad es dudosa. Podría formar parte de un plan destinado a hacer réplicas de algunas de las variantes más comunes de la Ticka, tales como las versiones plateadas. En una ocasión, tras comprobar que se trataba de una falsificación, se retiró de una subasta en Christie's una "Watch-Face Ticka". No hay duda de que reaparecerá de nuevo, sin previo aviso.

CAÑON DE DAGUERROTIPOS VOIGTLÄNDER: Un coleccionista privado tiene una supuesta falsificación. No sólo no coincide el tamaño, sino que la inscripción Voigtländer está escrita erróneamente.

SE RUEGA A LOS LECTORES EL ENVIO DE CUALQUIER INFORMACION SOBRE CUALQUIERA DE ESTAS U OTRAS REPLICAS Y FALSIFICACIONES.

Estaríamos dispuestos a publicar -gustosamente- detalles complementarios sobre las cámaras así como sobre cualquier comerciante o personas que se sepa estén tratando de defraudar

intencionadamente a los coleccionistas de cámaras.

RECOMPENSAS POR CAMARAS ROBADAS

Hubo una época en la que se podrían haber dejado media docena de las cámaras más valiosas del mundo sin vigilancia, sobre una mesa, en una feria de coleccionismo, y no hubiesen corrido riesgo, de ningún tipo. Hoy en día, se observa un incremento en el número de robos de cámaras valiosas. En un intento de minimizar esta execrable práctica, esta guía "McKeown's" publicará una lista actualizada de cámaras robadas a colec cionistas, tanto en ésta como en futuras ediciones.

Obviamente, no podemos poner en la lista todas y cada una de las cámaras robadas en el mundo y tampoco sería posible para el lector comprobar cada una de las cámaras que pensase comprar. Debido a ello, limitaremos nuestra lista a cámaras con un valor superior a 1000 dólares y con números de serie. Se realizarán excepciones para aquellas cámaras que, careciendo de números de serie, sean poco comunes o fácilmente identificables. Animamos a otras publicaciones de coleccionismo y asociaciones a reproducir esta lista y a añadir su propia información. Comerciantes, empresas de subastas y asociaciones están cooperando en este proyecto y aceptaremos encantados la participación de todos los interesados.

Quien sufra el robo de una pieza de su colección, deberá denunciarlo en la comisaría de policía más próxima. Deben aportarse todos los detalles posibles, números de serie, etc. Para incorporar dicho objeto robado a nuestra lista debemos recibir la misma información más la copia de la denuncia, con el teléfono de contacto de la policía. Esto permitirá a los lectores y a otras comisarías de policía contactar automáticamente con la policía del lugar donde se presentó la denuncia, en el caso de que la pieza robada sea detectada. No incorporaremos a nuestra lista piezas cuyo robo no haya sido previamente denunciado a la policía. Actuamos sólo como un medio de intercambio de información y no nos involucraremosen disputa alguna.

En el caso de que alguien nos ofrezca una pieza que figure en la lista como robada, deberíamos tratar de obtener la identidad de la persona que ofrece la cámara, con el fin de ayudar a seguir la pista del ladrón. Debemos denunciar el descubrimiento a las autoridades locales o a la dirección de la feria, preferiblemente mientras tenemos la mercancía en la mano o el posible vendedor se encuentra en el interior de las instalaciones. Si se comunica a Centennial Photo que se ha localizado un objeto robado, añadiremos a la lista "visto por última vez en...". Con el tiempo, si todos cooperamos, conseguiremos que unas pocas cámaras de calidad vuelvan a las manos de sus legítimos propietarios. Se trata de un problema que no desaparecerá por sí sólo. Todos tenemos que poner algo de nuestra parte. Nosotros, responsables de la guía más difundida del mundo, aceptamos gustosos responsabilidad de mantener al día esta lista. Dado que nuestra guía se publica cada dos años. En el intervalo entre una
INTRODUCCION: ESPAÑOL

edición y la siguiente, podemos enviarla por correo, adecuadamente actualizada, siempre que se nos envíe un sobre franqueado o un cupón de respuesta internacional indicando la dirección de la persona interesada. Agradeceríamos cualquier sugerencia que ayude a mantener el coleccionismo fotográfico a salvo de la criminalidad.

PARA MAS INFORMACION

Recibimos muchas peticiones y solicitudes para más información, muchas más de las que podemos contestar. No damos opiniones ni estimaciones sobre material que no viene incluido en este libro. Somos conscientes de que hay muchas cámaras que no están aquí incluidas, y avisamos que omisión no indica que una cámara sea más o menos poco común. Para poder mantener este libro en tamaño y precio razonables, hemos tenido que excluir por diferentes razones unas treinta mil cámaras. Algunas de ellas pueden incluirse en alguno de los siguientes grupos: a) la mayoría de las cámaras producidas desde 1970, que generalmente son más bien cámaras en uso que coleccionables; b) la mayoría de las cámaras de formato 126 y 110, que se produjeron en tales cantidades que son comunes y baratas; y c) muchas de las primeras cámaras que rara vez salen a la venta. Hemos seleccionado unas nueve mil cámaras que son representativas del mundo del coleccionismo, y para las cuales podemos determinar precios promedio.

Sentimos no poder contestar consultas individuales por correo o teléfono. Para más información, recomendamos asociarse a una o más agrupaciones de coleccionistas de las que figuran en el apéndice. También existe la posibilidad de dirigirse por escrito a la sección de correo de lectores de las revistas técnicas de fotografía que incorporen alguna sección sobre coleccionismo o a los boletines de las propias agrupaciones.

INTRODUZIONE ALLA NONA EDIZIONE DELLA "MCKEOWN'S PRICE GUIDE"

La prima edizione della Price Guide to Antique & Classic Still Cameras è stata pubblicata nel 1974. Da allora si è affermata come la più completa e accurata Guida di riferimento al mondo. Nella prima menzionate edizione erano fotocamere. Questa nona edizione ne include un numero nove volte superiore. Non abbiamo aumentato solo il numero degli apparecchi, ma ci siamo adoperati per ampliare le informazioni relative ai singoli apparecchi fotografici, fornendo date e informazioni storiche, laddove reperibili. Abbiamo aggiunto anche 500 nuove fotografie in questa edizione, per un totale di 3.500 illustrazioni. Ogni nuova ha apportato miglioramenti edizione rispetto alla precedente e, con il vostro contributo, speriamo di continuare in questa tradizione. Ad esempio, questa edizione aggiunge centinaia di obiettivi e accessori per sistemi fotografici degli anni sessanta e settanta. Sebbene molti di questi siano ancora utilizzati, rientrano comunque a pieno titolo tra gli oggetti da gli presentare collezione. Oltre а fotografici trattati apparecchi correntemente dagli operatori del settore, abbiamo cercato di scoprirne alcuni mai citati in precedenza in alcuna pubblicazione di riferimento. In questa nona edizione potrete trovare oltre 2000 fotocamere che non compaiono in altri testi di riferimento. Speriamo di aver fatto cosa gradita.

LA TENDENZA DEI PREZZI

Per comprendere i prezzi correnti e futuri delle fotocamere da collezione, è utile l'evoluzione brevemente riassumere storica dei prezzi. La tendenza generale è stata in netta ascesa fino al 1981 e si stabilizzò tra il 1982 e il 1983, con alcuni trend che iniziarono un discendente. Negli anni 1983 e 1984 i prezzi diminuirono sensibilmente, specie se si prende come riferimento il dollaro americano, che è la valuta che noi utilizziamo come base. Ciò fu determinato in parte da un rallentamento del mercato, e molto invece dalla forte rivalutazione del dollaro rispetto alle altre valute. L'intensità della flessione rallentò nel 1985 e nel 1986 i prezzi si stabilizzarono, con alcuni articoli che ripresero a crescere. Tra la fine del 1986 e l'inizio del 1987, la forza delle monete inglese, tedesca e giapponese nei confronti del dollaro rafforzò il mercato, dal momento che acquistare fotocamere classiche negli Stati Uniti era paragonabile a fare acquisti in un negozio discount. I prezzi negli U.S.A. iniziarono a stabilizzarsi per molti dei migliori oggetti da collezione. Dal 1987 al 1989, abbiamo osservato repentine crescite dei prezzi in aree specifiche. I Giapponesi, data la forza dello yen, hanno influenzato l'aumento dei prezzi per molti anni. Attualmente rileviamo una situazione di sempre maggiore competitività tra i collezionisti di Tokyo, dell'Europa, di Hong Kong, degli USA e delle altre parti del mondo. Alcuni prezzi sono saliti a livelli a cui anche gli operatori specializzati fanno fatica a credere. I prezzi di Leica sono diventati più stabili, ma solo per essere sostituiti da un'infatuazione per le Canon e le Nikon a telemetro. Le copie delle Leica, un tempo considerate un surrogato povero per chi non poteva permettersi l'originale, sono diventate in molti casi più preziose delle vere l'eica che imitavano.

La tendenza generale nel collezionismo è verso l'alta qualità, le sofisticate fotocamere del periodo post-bellico (1945-anni '70). In questo periodo il Giappone ha giocato un ruolo sempre più produzione degli nella dominante apparecchi fotografici. Nell'ultimo decennio giapponesi hanno riacquistato questi apparecchi fotografici a migliaia. E questo è diventato un attivo e redditizio segmento di mercato. Più recentemente importanti collezionisti e commercianti di Hong Kong ed europei hanno pagato prezzi che rivaleggiano con quelli pagati degli acquirenti giapponesi. Il richiamo del profitto ha creato una nuova specie di commercianti e di intermediari che hanno spinto i prezzi al rialzo.

Se il mercato si interessa principalmente delle macchine cromate e in cuoio, ci sono persone che continuano scoprire splendide fotocamere d'antiquariato in legno, ottone e cuoio. Il valore di molti degli apparecchi più vecchi è piuttosto stabile. Non esiste infatti un numero sufficiente di queste "antichità" che consenta la nascita di una nuova generazione di commercianti del week-end. Si potrebbe anche pensare che i collezionisti delle fotocamere più antiche nutrano una passione per questi oggetti che non è direttamente collegata con il denaro. Le prime, rare fotocamere storicamente importanti si vedono con minore frequenza, ma altrettanto rari sono i collezionisti e gli operatori in grado di riconoscerle.

Queste fotocamere rare e antiche hanno stabilito nuovi record nei prezzi delle aste degli ultimi due anni, ma questo mercato è molto limitato. Bassi prezzi base hanno portato a una spirale competitiva e al raggiungimento di alti prezzi. Di contro alti prezzi base hanno avuto l'effetto opposto, inducendo spesso i potenziali offerenti ad evitare alcuni pezzi molto importanti.

I collezionisti sono diventati sempre più attenti alle condizioni degli apparecchi. Una fotocamera che non sia pulita e attraente diventa difficile da vendere. Solo pochi apparecchi fotografici, quelli estremamente rari, sfuggono a questo esame; ma quelli più comuni è meglio siano puliti e preferibilmente funzionanti nel modo migliore.

Quando il collezionismo fotografico sperimentò il suo boom nei tardi anni settanta, gli speculatori iniziarono ad acquistare massicciamente indiscriminatamente. Questo soffiò sul fuoco dell'inflazione e portò i prezzi a un punto di rottura. Questo portò alla sensibile discesa dei prezzi negli anni 82-83. La crescita dei prezzi in Giappone ha seguito un andamento simile, ma ora è più stabile. Le quotazioni nelle diverse parti del mondo sono diventate più omogenee e i prezzi più alti sono pagati da collezionisti di paesi diversi.

Alcuni tipi di fotocamere hanno avuto buoni apprezzamenti negli ultimi anni. Apparecchi in colore diverso dal nero spuntano un prezzo maggiore.

Gli apparecchi "Box" (ad eccezione di quelli neri, comuni) stanno finalmente

prendendo quota. Gli apparecchi "Box" a colori, quelli con decorazioni art-deco, quelli in plastica dalle forme insolite sono la della cresciuti per legge domanda/offerta. L'Europa in auesto settore è un po' più avanti rispetto agli Stati Uniti. Vale anche la pena di notare come alcune fotocamere art-deco abbiano raggiunto quotazioni considerevolmente più alte nel mercato dell'arte che in quello tradizionale del collezionismo fotografico.

FOTOCAMERE RUSSE & SOVIETICHE

Per molti anni, le fotocamere sovietiche non sono state molto diffuse nell'Europa occidentale, e venivano viste assai di rado negli Stati Uniti. Questo effetto della "Guerra Fredda" si è improvvisamente invertito. L'Unione Sovietica e il Blocco Orientale hanno improvvisamente aperto le loro porte. Molti apparecchi fotografici volta considerati sovietici una estremamente rari stanno facendo la loro comparsa in numeri da record alle fiere antiquarie e nei negozi di tutta Europa e degli USA. A seguito di queste nuove immissioni sul mercato i prezzi di molte sovietiche fotocamere sono conseguenza scesi rapidamente. Di contro alcuni commercianti e collezionisti, che avevano comprato alle vecchie quotazioni, sono riluttanti ad abbassare i propri prezzi di vendita. Per queste ragioni, il mercato delle fotocamere russe è instabile. Ci vorranno alcuni anni prima che offerta e domanda trovino un equilibrio sui prezzi. Alcune fotocamere russe possono ancora risultare rare, ma non necessariamente si delle stesse che erano in precedenza considerate tali.

danneggiare ulteriormente nel lungo periodo il mercato delle fotocamere russe/sovietiche ci sono grandi quantità di falsi. Ogni fotocamera che presenti una speciale finitura o una particolare incisione è più probabile sia un falso piuttosto che un prodotto originale. C'è un "cartello" organizzato di operatori russi e polacchi che creano un continuo flusso di fotocamere da collezione. Così facendo hanno rovinato apparecchi fotografici che loro valore storico. avevano un trasformandoli in cianfrusaglie placcate Questa d'oro o con speciali incisioni. pratica continuerà finchè collezionisti e operatori continueranno ad incoraggiarla. Ed il valore anche degli altri prodotti rimasti inalterati risulterà incerto poiché gli acquirenti saranno sempre nel dubbio. La provenienza della fotocamera sarà quindi di estrema importanza.

A una recente fiera di collezionismo, un russo offriva una Leica "Luxus" con un numero di serie di quattro cifre e marcature militari WWII. Non tutti i falsi sono così evidenti (le Leica con numero di serie costituito da quattro cifre erano fuori produzione prima della salita al potere di Hitler, le fotocamere militari non erano le "Luxus", etc.)

MERCATI "CALDI" e "FREDDI" NEGLI ANNI NOVANTA

Negli ultimi anni su Nikon si è concentrata la maggiore e più selvaggia speculazione. C'era una frenesia incoraggiata da un piccolo, ma determinato, numero di collezionisti e di commercianti. Questa spirale dei prezzi sembra essersi livellata.

Il mercato delle microcamere è in continuo rafforzamento, con molti modelli ancora

abbordabili per il collezionista medio. Ma alla fondamentale asta di Christie's del dicembre 1991, un acquirente determinato, telefono, causò frustrazione tra i potenziali acquirenti presenti nella sala d'asta e molti lotti si attestarono su prezzi record. Gli effetti di quest'asta si avvertono ancora. I prezzi delle microcamere sono complessivamente aumentati. Nonostante ciò alcuni sognatori attendono ancora quotazioni "record".

CONSIGLI PER I NUOVI COLLEZIONISTI

I nostri consigli al collezionista dipendono interamente dalle motivazioni spingono al collezionismo. Se intendete il collezionismo come forma di investimento, dovreste concentrarvi sui modelli più rari e insoliti, che naturalmente richiedono maggior impegno di capitali e maggior competenza. Se collezionate soprattutto per il piacere di farlo, dovreste seguire i vostri interessi e le vostre possibilità economiche. Molte delle fotocamere di basso prezzo consentono un hobby non costoso e spesso sono un buon punto di partenza. Farsi una collezione di fotocamere Kodak, Coronet o Agfa, a seconda di dove vivete, può essere rilassante e divertente, poiché molte di queste macchine possono essere reperite con facilità a prezzi contenuti. La maggior parte dei collezionisti inizia con un approccio di tipo generico che diventa poi più definito e specializzato man mano che si procede nella collezione.

Se trattate fotocamere per ricavarne un profitto, dovete mantenervi in stretto contatto con il mercato. Individuate la vostra nicchia e rimanete nella vostra area di specializzazione. Seguendo da vicino il mercato potete trarre profitto dalle sue ordinarie fluttuazioni, come pure dalla conoscenza degli interessi dei vostri

Tutti i prezzi di questa edizione sono stati aggiornati. Essi sono il più attuale possibile e i dati sono stati valutati secondo le quotazioni più recenti. Abbiamo tenuto conto anche dell'influenza stabilizzatrice dei prezzi degli ultimi 10 anni di ciascuna fotocamera per evitare errori di valutazione come può avvenire nel caso di una ricerca meno accurata. Le nostre quotazioni tendono a seguire soprattutto l'andamento di lungo periodo.

Le informazioni e i dati in questa edizione sono basati su centinaia di migliaia di verificabili vendite, offerte e aste. E' una guida di riferimento, un'opera di ricerca. Le quotazioni non indicano il valore che io penso che abbia la fotocamera, ma dicono che cosa molti dei precedenti e degli attuali possessori pensino che valga. Questo è lo spirito della Legge di McKeown" che dice:

"Il prezzo di una fotocamera d'antiquariato dipende interamente dagli orientamenti dell'acquirente e del venditore al momento della transazione".

Molti corollari si aggiungono a questa filosofia generale del collezionismo.

1. "Se perdete l'occasione di acquistare la fotocamera a cui tenete realmente, questa non vi si presenterà mai più."

2. "Se acquistate una fotocamera perché sapete che l'occasione non vi si presenterà più, la settimana successiva vi sarà offerto un esemplare migliore della stessa fotocamera a un prezzo molto inferiore."

"Il valore intrinseco di una fotocamera antica o comunque da collezione è direttamente proporzionale convinzione del possessore che qualcun altro la desidera".

Queste considerazioni dovrebbero sempre essere tenute presenti quando si applica la

legge di McKeown.

ISTRUZIONI PER L'USO DI QUESTA GUIDA

Tutte le fotocamere sono elencate per fabbricante, in ordine alfabetico. Alcuni apparecchi fotografici sono presentati con il nome del modello quando non c'è sicurezza sul produttore. Di solito le fotocamere di ciascun fabbricante sono in ordine alfabetico, ma occasionalmente le abbiamo raggruppate per tipo, dimensioni, data di immissione sul mercato o secondo altri criteri appropriati al caso specifico.

Le fotografie sono generalmente sopra il titolo indica la fotocamera. Per ragioni di impaginazione non sempre però questo è possibile. A volte, quando il testo continua su un'altra colonna, la fotografia compare al centro del paragrafo che dà la descrizione della fotocamera. Quando la foto non può essere impaginata con il testo, è accompagnata da una didascalia in corsivo e una nota al termine del testo indica la posizione della foto. Quando la foto di una fotocamera è posta al fondo di una colonna, e la foto divide il testo descrittivo di un altro apparecchio, abbiamo cercato di separarla visivamente mediante un filetto nero. Questa impostazione fa sì che i normali titoli in neretto siano anche didascalie per la maggior parte delle foto, con un notevole risparmio di spazio. Per didascalizzare tutte le 3500 fotografie ci sarebbero volute 40 pagine in più.

Abbiamo utilizzato differenti caratteri per rendere la guida più facile da consultare.

Lo schema è il seguente:
PRODUTTORE (NERETTO, LETTERE MAIUSCOLE)

Note storiche o commenti sul produttore in corsivo.

Nome della fotocamera (Neretto) Descrizione della fotocamera e dati relativi alla sua quotazioni (Valori medi). Note speciali riguardanti la fotocamera o il prezzo

NOME DELLA FOTOCAMERA

Se il nome del modello della fotocamera è tutto in maiuscolo, questo indica che il produttore non è noto e serve a separare l'apparecchio dal testo precedente.

A prima vista questo schema di impaginazione può non essere visivamente accattivante in senso "artistico" ma è stato studiato attentamente al fine di risparmiare spazio e per una facile consultazione. Il nostro computer potrebbe automaticamente disegnare un box intorno a ciascuna foto. questo ci costringerebbe aggiungere 50 pagine al volume. Analogamente, se disegnassimo piccoli box intorno alle colonne di testo, miglioreremmo l'aspetto estetico, ma la contropartita sarebbe 90 pagine in più. I nostri lettori sono collezionisti e operatori che desiderano il massimo dell'informazione nello spazio più ridotto possibile. Speriamo che apprezziate il nostro "piccolo" volume. Se avessimo

optato per un'impaginazione più gradevole e più ariosa, questo "mostro" avrebbe avuto oltre 800 pagine, avrebbe avuto uno spessore maggiore del 30%, sarebbe stato più pesante e più costoso. Speriamo apprezziate il nostro stile che offre più informazioni in minor spazio.

LE CONDIZIONI DELLE FOTOCAMERE

Una fotocamera in condizioni estetiche perfette, ma non funzionante, può essere perfettamente accettabile per collezionista che la ponga nella sua vetrina. D'altro canto chi invece le fotocamere le utilizza non terrà in particolare conto l'aspetto esteriore, quanto piuttosto il funzionamento dell'apparecchio. Noi sosteniamo vivamente l'uso di un sistema di classificazione in due parti, uno relativo all'aspetto, l'altro all'operatività della fotocamera. Dovrebbe essere seguito su scala mondiale, con la cooperazione delle guide-prezzi, delle pubblicazioni collezionistiche, delle case d'asta e dei commercianti.

Nel tentativo di creare uno standard internazionale per la descrizione delle condizioni, abbiamo proposto la seguente codifica. Abbiamo intenzionalmente usato una combinazione di un numero e di una lettera per evitare ogni confusione con altri sistemi di classificazione già in uso. Lo stato di una fotocamera dovrebbe essere espresso con un numero a cifra singola seguito da una lettera. Il numero rappresenta le condizioni estetiche e la lettera indica quelle di funzionamento. Questo sistema è stato adottato dal Photographic Collectors Club of Great

LIVELLI DI CODIFICA: **CONDIZIONI ESTETICHE**

0 - Nuova, mai venduta. In imballo originale, con garanzia.

1 - Come nuova. Mai usata. Stesse caratteristiche del nuovo, ma senza garanzia del produttore. Con scatola o imballo originale.

2 - Nessun segno di usura. Se avesse la sua confezione originaria non sarebbe possibile distinguerla dal nuovo.

3 - Segni di usura veramente minimi

- 4 Segni di usura leggeri, ma nessun segno di cattivo uso. Nessun altro danno estetico.
- 5 Integra, ma con segni di uso normale.
- 6 Integra, ma con segni di grande uso. Usata in modo corretto.
- 7 Restaurabile. Sono necessari alcuni ritocchi. Alcune parti secondarie possono essere rotte o mancanti.
- 8 Restaurabile. E' necessario un lavoro di ritocco. Alcune parti possono essere
- 9 Utile solo per alcune parti; necessari restauri rilevanti, nel caso di fotocamere

LIVELLI DI CODIFICA: **CONDIZIONI DI FUNZIONAMENTO**

A - Come nuova. Tutte le parti funzionano perfettamente, con garanzia fabbricante e/o del negoziante.

B - Come nuova. Tutte le parti funzionano perfettamente, ma non c'è la garanzia del fabbricante. Il venditore ne garantisce completamenteil funzionamento.

Tutte le parti funzionano. Recentemente pulita in professionale, lubrificata, accuratamente

revisionata e completamentegarantita.

D - Tutte le parti funzionano. Recentemente pulita in modo professionale o revisionata, ma non più in

E - Tutte le parti funzionano. Le principali funzioni sono state recentemente controllate in modo professionale.

F - Non è stata recentemente sottoposta a pulizia, lubrificazione o revisione. Pienamente funzionante, ma non è garantita la precisione dell'otturatore o dell'esposimetro.

G - Completamente funzionante. L'otturatore e/o l'esposimetro probabilmente non sono precisi. Sono necessari interventi di taratura o di pulizia.

H - Utilizzabile, ma non completamente. L'otturatore può incepparsi sui tempi lenti. L'esposimetropuò non funzionare.

J - Non utilizzabile senza riparazione o pulitura. L'otturatore, l'esposimetro o il sistema di trascinamento della pellicola possono essere bloccati, inceppati o rotti.

K - Probabilmentenon riparabile.

Secondo questa codifica, una fotocamera in condizioni medie sarebbe classificata 5F. Un apparecchio fotografico indicato come 3G avrebbe segni di usura minimi dal punto di vista estetico, ma con un'incerta precisione dell'esposimetro o dell'otturatore. Così una descrizione molto dettagliata delle condizioni può essere espressa in poco spazio ed elimina i problemi connessi con descrizioni basate su parole o lettere che non consentono distinzioni tra le condizioni estetiche e quelle funzionali. Per essere ancora più specifici, gli utilizzatori potrebbero desiderare di espandere la codifica estetica aggiungendo una seconda cifra. Così "56B" verrebbe a significare che le condizioni estetiche sono intermedie tra i livelli 5 e 6, e che l'apparecchio è perfettamente funzionante.

Da quando abbiamo proposto il nostro sistema, la rivista Camera Shopper e alcuni commercianti hanno adottato un sistema analogo, ma con i valori numerici invertiti, cosicchè 10 indica il livello massimo. Se quindi state acquistando una fotocamera senza ispezionarla, verificate qual'è il sistema di classificazione che è stato utilizzato.

In generale, le condizioni influenzano i prezzi come indicato più avanti. Tuttavia quelle pubblicate sono solo approssimazioni. Le condizioni influenzano i prezzi in modo differente a seconda dei modelli e della datazione delle fotocamere. Le variazioni suggerite sono espresse in percentuale sul prezzo pubblicato.

CONFRONTO CON ALTRI SISTEMI DI CLASSIFICAZIONE

Il seguente schema mette a confronto la componente Estetica del sistema di classificazione con alcune delle più comunemente utilizzate descrizioni che fanno uso di parole o lettere. Questi confronti sono approssimativi e vengono riportati unicamente per aiutare gli utilizzatori a comprendere più facilmente il nuovo sistema. L'ultima colonna della tabella indica a grandi linee come le condizioni influenzano i prezzi. In ogni caso si tratta solo di approssimazioni.

Le condizioni influenzano i prezzi in modo differente a seconda dei modelli e della datazione delle fotocamere. Le variazioni suggerite sono espresse in percentuale sul prezzo pubblicato. Non abbiamo fatto confronti con gli altri sistemi "su base 10" poiché sono troppe le varianti utilizzate dai singoli commercianti.

McKeown PCCGB		Aste	% del
Christie's	SA	tedesche	prezzo
0	Ν	-	150-200%
1	LN	-	130-150%
2	M	Α	120-140%
2 3	M	AB	115-130%
4	E+	В	110-120%
5	E	С	95-115%
6	VG	CD	80-110%
7	G	D	55-85%
8	F	E	30-60%
9	Р	-	10-30%

Ogni parte mancante o staccata dovrebbe essere specificatamente annotata. L'uso del segno (-) dopo una codifica significa l'apparecchio soddisfa caratteristiche della codifica con l'eccezione di alcuni dettagli, come descritto nel commento allegato. L'uso del segno (+) significa che l'apparecchio ha delle caratteristiche superiori rispetto a quelle standard della sua codifica, ma che non può rientrare nel livello più elevato di classificazione.

A volte i collezionisti sono più indulgenti nell'applicare queste codifiche alle fotocamere più antiche o più rare, e più rigorosi sui modelli più recenti o comuni. Questo è in qualche misura autolesionismo. Se si definisce una fotocamera come "in condizioni molto buone considerando la sua età", si aggiunge un giudizio personale secondo il quale le fotocamere antiche dovrebbero essere giudicate secondo parametri differenti. Anche se gran parte degli apparecchi fotografici di quell'età possono mostrare alcuni segni del tempo, il fatto che siano antichi non influisce sul miglioramento delle loro condizioni.

NOTE INTERPRETATIVE DEI PREZZI

Tutti i prezzi sono espressi in dollari americani. I prezzi si riferiscono alle fotocamere di livello 5 secondo la nostra codifica. Questa è la condizione più comune in cui si trovano e si collezionano le fotocamere; il che rende questa l'indicazione più utile. Per determinare il valore di una particolare fotocamera, l'utilizzatore di questa guida dovrebbe valutare qualsiasi variazione rispetto alle caratteristiche standard e variare di consequenzala stima.

Gli articoli di prezzo inferiore in questa guida e sul mercato tendono ad essere leggermente sopravvalutati, semplicemente perché il costo e l'onere della comunicazione pubblicitaria, della vendita e del trasporto di un modello da 5 dollari non sono molto differenti dai costi e dal lavoro necessari per vendere un esemplare da centinaia di migliaia di dollari. Gli articoli di prezzo medio sono quelli che hanno i valori più precisi. Sono quelli più comunemente trattati; sono quelli disponibili in maggiori quantità e quelli per cui il mercato è più stabile. Le fotocamere di prezzo più elevato di qualsiasi tipo. marca o epoca tendono ad essere quelle dal mercato più volubile a causa sia della loro limitata disponibilità, che della limitata domanda.

NON ASPETTATEVI DI OTTENERE DA UN NEGOZIANTE IL "PREZZO PUBBLICATO"

Se avete una o due fotocamere da vendere e vi aspettate di ottenere da un commerciante il prezzo massimo indicato da questa guida, fareste meglio a considerare la situazione dal punto di vista del negoziante. Per rivendere la vostra fotocamera, egli deve ripararla e garantirla. Deve affittare uno spazio espositivo alle fiere specializzate, stampare e spedire un suo catalogo e sostenere i propri prezzi nei confronti degli acquirenti che non vogliono pagare di più delle quotazioni minime pubblicate dalla guida. Dopo che la vostra fotocamera è rimasta invenduta per alcuni mesi e mostra un po' più di usura a causa della manipolazione degli eventuali acquirenti, egli la vende a un altro commerciante a metà prezzo in cambio di un altro oggetto che spera di vendere. Spesso una fotocamera passa attraverso le mani di 4 o 5 commercianti prima di trovare un raro acquirente che paghi il prezzo massimo. Quanto più comune e di minor valore è la vostra fotocamera, più imparerete da questo esempio. Se invece possedete una fotocamera estremamente rara o di valore, non preoccupatevi. I commercianti si batteranno letteralmente per averla. Questo è un settore molto concorrenziale.

I PREZZI DELLE FOTOCAMERE IN GIAPPONE E IN EUROPA

In alcuni casi abbiamo fatto distinzione di prezzo per la stessa fotocamera in mercati differenti quali USA, Inghilterra, Germania, Giappone etc. Ovviamente ci saranno differenze anche su altre fotocamere per le quali non abbiamo fatto notazioni. Innanzitutto dovrebbe essere chiaro che il prezzo base per la maggior parte delle fotocamere è quello al quale esse possono essere acquistate nel paese dove sono più frequentemente disponibili. Per molte fotocamere questo è il paese d'origine. Tuttavia, dal momento che la maggior parte delle fotocamere è stata importata negli Stati Uniti, esse possono essere trovate in questo paese a prezzi inferiori rispetto a qualsiasi altro paese nel mondo. La differenza di prezzo tra vari paesi per apparecchi fotografici di basso costo è normalmente irrilevante e non è stata riportata in questa guida tranne che per particolari modelli per i quali si rileva una differenza che va al di là dei semplici costi trasporto. Per molte fotocamere giapponesi di qualità i prezzi sono più alti in Europa che negli USA. Ciò è dovuto al fatto che la maggior parte di queste fotocamere era stata originariamente importata negli USA. Con una minore disponibilità, in Europa la competizione tra i collezionisti è più forte.

La Dufa Pionyr è solo un buon esempio di fotocamera il cui prezzo varia considerevolmente nel mondo. In Germania, vicino al luogo di produzione, è venduta alle aste a circa 25 dollari. Negozianti a Londra l'anno venduta a 45 dollari nell'imballo originale. Queste due cifre indicano un range ragionevole e normale. Abbiamo volutamente ignorato l'esemplare che abbiamo visto in un egozio di Ginza a 125 dollari. Anche se esso fosse stato venduto a quel prezzo, non potremmo considerarlo come norma.

I PREZZI ALTISSIMI IN GIAPPONE SONO FINITI

Quando l'economia giapponese era al suo massimo era difficile per gli acquirenti occidentali pagare prezzi competitivi. Adesso vediamo che il mercato mondiale è molto più stabile.

COME SONO DETERMINATI I NOSTRI PREZZI

Noi monitoriamo e analizziamo i prezzi provenienti da varie fonti in tutto il mondo, incluse le pubblicazioni commerciali, i listini dei negozianti, le aste pubbliche e le fiere. Ad ogni nuova edizione il nostro database aggiunge centinaia di migliaia di transazioni a quelle delle edizioni precedenti. Sebbene le formule che usiamo siano di nostra proprietà, un esempio pratico basta a spiegare perché le nostre statistiche non sempre riflettano osservazioni. Leggendo regolarmente una pubblicazione per commercianti rilevate che la fotocamera X sembra essere reclamizzata tra i 275 e i 325 dollari. La vostra mente attenta immagazzina la notizia in modo da poterla richiamare. Il nostro computer opera nello stesso modo. Ci sono buone probabilità che proprio lo stesso modello sia offerto in vendita diverse volte. Così un prezzo al quale un modello non viene venduto compare sulla stampa più spesso di un prezzo realistico. Nel caso reale della fotocamera X, un negoziante iniziò a offrirla a 450 dollari. Dopo oltre un anno di inserzioni pubblicitarie, mentre andiamo in stampa, la stessa fotocamera viene ancora proposta a 250 dollari. Molte altre vendite a livello internazionale ci dicono che la fotocamera X viene normalmente venduta per 125-175 dollari.

Forse il negoziante i cui annunci avete letto riesce a vendere la sua supervalutata fotocamera a un acquirente che si è "abituato" a vederla pubblicizzata a 300 dollari e che pensa sia un affare quando appare per 250 dollari. Il nostro computer ha una memoria lunga che segue le singole fotocamere offerte dai commercianti fino alla loro vendita. I prezzi dell'invenduto non sono considerati informazioni, ma soltanto manifestazioni di un prezzo estremo.

I nostri prezzi rappresentano il normale "range" per la maggior parte delle fotocamere vendute. Le nostre quotazioni sono basate su un'ampia ricerca e non su congetture. Non siamo commercianti di fotocamere perchè vediamo in questo un conflitto di interesse.

I CAMBI DELLE MONETE

I prezzi pubblicati in questa guida sono prezzi medi del mercato mondiale. Esistono variazioni rispetto a queste cifre in particolari mercati. Alcune fotocamere sono più comuni in un paese che in un altro. Gli interessi dei collezionisti sono differenti nelle varie parti del mondo, e le tendenze o le mode influenzano i diversi mercati in tempi differenti. Comunque nessuno dei mercati del mondo è chiuso alle influenze esterne e le fluttuazioni hanno una tendenza a livellarsi su scala mondiale. Un prezzo più alto in un paese tenderà ad attirare più fotocamere in quell'area e il prezzo mondiale si alzerà fino a che la domanda alla fine sarà soddisfatta. Tutti i valori sono espressi in dollari americani. Poiché il tasso di cambio

varia continuamente, noi non confonderemo i lettori con conversioni generate al computer e basate su un arbitrario tasso di cambio giornaliero.

Come riferimento generale, forniamo uno schema che riporta i tassi di cambio del U.S. dollaro alla data del 07.VI.1994. Moltiplicando i relativi coefficienti per il prezzo in dollari americani si ha il valore nelle diverse valute.

VALUTA	= US\$	US\$1 = *
\$ Australia	.7345	0.3615
Scellino - Austria	.08602	11.625
Franco - Belgio	.02917	34.282
Cruz Brasile	.0004975	2010.0
Sterlina-Inghilterr	a 1.5095	0.6624
\$ - Canada	.7287	1.3727
Franco - Francia	.17598	5.6825
Marco - Germania	a .6002	1.666
\$ - Hong Kong	.12940	7.7280
Lira - Italia	.0006188	1616.03
Yen - Japan	.009602	104.15
Fiorino - Olanda	.5354	1.8679
\$- Nuova Zelanda	.5914	1.6909
Peseta - Spagna	.007331	136.41
Corona - Svezia	.1262	7.9260
Franco - Svizzera	.7078	1.4128

NOTA: Le quotazioni delle aste che vengono fornite in questa guida sono prezzi che non includono le commissioni e le tasse pagate dall'acquirente. Poiché le spese pagate dall'acquirente e dal venditore sono circa uguali, il prezzo battuto rappresenta una logica media tra il netto realizzato dal venditore e il lordo pagato dall'acquirente.

VENDERE LA VOSTRA FOTOCAMERA DA COLLEZIONE

Che dobbiate vendere una singola fotocamera o una grande collezione, che siate un collezionista, un commerciante o un semplice appassionato, ci sono molti canali per vendere fotocamere da collezione. Ciascuno di questi ha vantaggi e svantaggi. Un canale può risultare il mi gliore per una delle vostre fotocamere e uno differente può essere più adatto per un'altra.

ASTE:

Vantaggi - Sarà venduta. Sarete pagati. Le fotocamere molto rare spesso raggiungono quotazioni più alte di quanto ci si attenda. Una bassa stima di solito porta più offerenti e un più alto prezzo di vendita.

Svantaggi - Il periodo d'attesa, di solito di diversi mesi, necessario per catalogare i modelli e preparare la vendita. La commissione (spesso più che compensata dal maggior prezzo realizzato). Una stima alta qualche volta scoraggia gli offerenti. Quando il modello riappare in un'asta suc cessiva a un prezzo inferiore, i potenziali acquirenti spesso lo ricordano e si astengonodalle offerte.

COMMERCIANTI

Vantaggi - Vendita e pagamento immediati. Nessuna attesa del compratore. I negozianti pagano buoni prezzi per articoli insoliti. Qualche volta i negozianti pagano più di quanto potreste ottenere in altro modo, perché hanno una base di clienti specializzati in aree che voi non potete raggiungere facilmente. (I negozianti spesso comprano e vendono tra di loro per trarre vantaggio dalla propria specializzazione). Nessuna commissione

INTRODUZIONE: ITALIANO

viene detratta dal prezzo di vendita. **Svantaggi -** I negozianti devono comprare a un prezzo inferiore rispetto a quello a cui pensano di rivendere. (Questo non sempre è uno svantaggio, perché spesso hanno un mercato con prezzi più alti rispetto a quelli alla vostra portata). Alcuni negozianti non vi faranno un'offerta; dovete avere voi in mente un prezzo.

Se richiedete offerte a più di un negoziante, in effetti conducete una vostra asta personale. Questo è un gioco che è molto fastidioso per i negozianti ed essi potrebbero non farvi alcuna offerta. Nella fase iniziale della vostra "asta personale", alcuni negozianti potrebbero non offrirvi il loro migliore prezzo e voi potreste dover girare diversi negozianti, e anche ritornare per un seconda tornata di offerte.

FIERE SPECIALIZZATE, MERCATI DELLE PULCI

Vantaggi - Nessun intermediario. Voi incassate l'intero prezzo pagato. (Questo può essere un vantaggio più psicologico che reale, dopo aver considerato il tempo impiegato e le spese).

L'opportunità di incontrarsi con altri collezionisti con cui condividere la passione del collezionismo. Possibili scambi, arricchimenti della vostra collezione.

Svantaggi - Molte spese non rilevabili immediatamente, spesso superiori allo sconto dei negozianti o alla commissione d'asta. Spese per il noleggio dello spazio o della bancarella.

Nessuna garanzia di riuscire a vendere. E' possibile dover attendere per mesi o anni prima di riuscire a vendere, come accade ad alcuni commercianti. L'usura delle fotocamere può risultare devastante.

VENDITA SU MAILING LIST

Vantaggi - Raggiungono un vasto mercato via posta, senza l'impegno di tempo e le spese delle fiere. Le fotocamere non vengono maneggiate prima della vendita.

Svantaggi - Il numero dei potenziali acquirenti dipende dalle dimensioni della mailing list. Il costo della stampa e della spedizione. I clienti non possono vedere la merce prima di comprarla. Di solito si richiede che il venditore garantisca la soddisfazione del cliente, con l'impegno all'eventuale restituzione dell'importo.

PUBBLICITA' SULLA STAMPA SPECIALIZZATA

Vantaggi - Scegliete la pubblicazione adatta per raggiungere il pubblico a cui intendete rivolgervi. Newsletter dei club, riviste specializzate nel settore, etc. I costi sono generalmente bassi, specialmente per vendere pochi articoli.

Svantaggi - Può passare del tempo prima della pubblicazione e della vendita. La vendita non è assicurata, specialmente se cercate di ottenere il prezzo più alto. (Comunque la vendita è relativamente certa se chiedete un prezzo ragionevole.)

LE COPIE DELLE FOTOCAMERE

Crescendo i prezzi delle macchine, cresce il numero dei falsi, delle copie. Per anni molti collezionisti e commercianti sapevano dell'esistenza di questi falsi ma, invece di rendere nota questa informazione, l'hanno tenuta segreta. Noi vogliamo renderla pubblica per proteggere i nostri lettori e i compagni collezionisti. Noi comprendiamo e accettiamo che le copie

di rare fotocamere sono importanti per musei e esposizioni. Non possiamo invece accettare che alcuna di queste copie sia presentata in modo ingannevole e venduta Ci sono diverse originale. desideriamo che alternative. Se collezionisti e criminali convivano nel collezionismo, il problema non esiste. I criminali allontanano i collezionisti dal loro Noi pensiamo invece che dovrebbero essere i collezionisti ad i criminali. Quello allontanare fare è condividere dobbiamo informazioni in modo da evitare che i compagni collezionisti siano ingannati.

I più conosciuti fabbricanti di copie, falsi e frodi sono:

Luc Bertrand - Belgio. Un artigiano che riproduce fotocamere. restaura e Riproduce bene fotocamere in metallo e fabbrica anche fotocamere in legno che sono difficili da distinguere dagli originali. Egli riproduce rare fotocamere in quantità molto piccole, per la propria collezione, per collezionisti privati e per musei. A suo favore si deve dire che egli contrassegna le sue riproduzioni con le sue iniziali e la data. Sfortunatamente talvolta sono state falsamente presentate da altri come originali.

Le riproduzioni precedenti al 1989 sono state prodotte in serie molto piccole, generalmente da 1 a 4 esemplari, e di questi Bertrand normalmente ne ha tenuto uno per la sua collezione. Talvolta gli altri esemplari hanno un numero di serie da 1 a 4, oltre alla sigla "LB" o "BL" e la data: dopo il 1989 Bertrand identifica le sue riproduzioni con una piccola sigla "LFB" incisa sul legno o sul metallo. Dal 1990 Bertrand ha riprodotto in serie solo circa 6 macchine. Altre 15 macchine circa sono state fabbricate in esemplari singoli per la sua collezione personale. A metà del 1990 Bertrand ha dichiarato di aver fatto un totale di 35 copie, metà delle quali erano ancora in suo possesso. Anche i restauri fatti da Bertrand riportano incise le sue iniziali e la data, sulla parte della macchina che è stata restaurata. 90

Bertrand è stato cortese da darci copia della sua sigla, cosicchè noi possiamo renderla di pubblico dominio. Questo è uno sforzo onesto per evitare che le sue riproduzioni siano presentate in modo ingannevole.

Greenborough - Non abbiamo incontrato nè parlato con Mr. Greenboroughe quindi riportiamo le informazioni ricevute da altri collezionisti. Si dice che lui e sua moglie polacchi, ma che vivano in Germania. Sembra che egli non produca fotocamere direttamente, ma che abbia avuto copie di fotocamere storiche e che abbia anche venduto fantasiose creazioni di recente ispirazione. Secondo le nostre fonti le copie che possiede sono fabbricate in Polonia. Secondo quello che ci risulta queste copie non sono identificate come tali, e che di conseguenza molte sono offerte in vendita come originali, con approfittando dell'ignoranza l'inganno, dell'acquirente. Una fonte indica che egli ha cessato di operare in questo campo. Le fotocamere attribuite a Greenborough comprendono: Leica 250, Minox Cigarette Lighter, Ticka Watch Camera (Taschenuhr Camera), Leica Luxus, John Player Cigarette package cameras.

OBERLAENDER ha prodotto copie di alcune famose fotocamere, compresa la Doppel Sport (fotocamera aerea adatta ad essere applicata al corpo dei piccioni per il trasporto) e la "Fotocamera libro" del Dr. Kruegener's (Taschenbuch Kamera). Alcune di queste copie sono quasi indistinguibili dagli originali: Non siamo a conoscenza di alcuna speciale sigla su queste fotocamere, e sappiamo di parecchi casi in cui sono state falsamente presentate come originali e vendute come tali. Almeno una delle "fotocamere libro" è stata identificata ed ha la lettera "R" dopo il numero di serie. E' stata rivenduta da Christie's nel dicembre 1991. Alla stessa asta fu venduta una copia di Doppel-Sport: modelli furono entrambi questi correttamente presentati da Christie's come copie.

Sia le creazioni di Greenborough che di Oberlaender sono state direttamente o indirettamente ad alcuni dei più conosciuti e rispettati collezionisti nel mondo. Queste ed altre riproduzioni sono state inserite in importanti collezioni senza riferimento alla loro origine. Esse sono originali rivendute come intenzionalmente o per ignoranza. Un certo numero di per altro rispettati attivamente commercianti hanno supportato i contraffattori vendendo i falsi nell'ambito del loro abituale lavoro, generalmente ammettere senza conoscenza dell'origine delle macchine e spesso fornendo una storia che suggerisse l'autenticità della merce contraffatta.

Le fotocamere contraffatte sono spesso invecchiate artificialmente.

SI SA O SI SOSTIENE CHE LE SEGUENTI FOTOCAMERE ESISTONO IN RIPRODUZIONE O IN COMPLETA CONTRAFFAZIONE:

BEN AKIBA - Microcamera incorporata in un bastone da passeggio. Le copie sono state fabbricate da Oberlaender .

BERTSCH (modello piccolo formato). - Mentre sappiamo che nessun esemplare dei modelli di grande formato è stato riprodotto, ci sono copie del modello piccolo. Bertrand ha prodotto quattro esemplari.

BRINS MONOCULAR CAMERA - Almeno quattro riproduzioni sono state fatte da Luc Bertrand. Alcune riportano incise le sue iniziali e la data (e.g. "BL82"), ma non tutte sono state correttamente identificate come riproduzioni da coloro che le hanno rivendute. Le riproduzioni probabilmente superano il numero degli originali sul mercato.

BUTCHER'S ROYAL MAIL POSTAGE STAMP CAMERA - Le riproduzioni sono state fatte in India alla metà degli anni '80 e offerte a commercianti fotografici per la vendita. Alcuni rispettabili commercianti di Londra si rifiutarono di acquistare qualsiasi esemplare a meno che il produttore non si impegnasse a siglare tutte le sue creazioni come riproduzioni. Il fabbricante si rifiutò e copie non siglate apparvero. sul mercato.

CONTAX (color sabbia) - Esiste una Contax originale color sabbia, talvolta chiamata "Rommel-Contax" per il suo colore di sabbia del deserto. Tuttavia esistono delle contraffazioni realizzate da Greenborough. Esistono almeno 5 o 6 falsi. Generalmente il color sabbia viene via facilmente rivelando la normale cromatura sottostante.

DE NECK PHOTO CHAPEAU - Esistono quattro riproduzioni fatte da Bertrand delle quali almeno due sono state vendute.

ENJALBERT PHOTO REVOLVER - Sono conosciute tre riproduzioni fatte da Bertrand.

ENJALBERT TOURISTE - Esistono delle copie realizzate da Bertrand.

FOTAL - Alcune copie sono state offerte sul mercato a circa 2000 marchi. E' incerta l'origine.

JOHN PLAYER CIGARETTE PACKAGE-Si dice che siano state realizzate a Varsavia in Polonia da un certo Mr. Kaminski. Sebbene talvolta si dica siano state usate dal KGB per spionaggio non vi sono prove evidenti e credibili. Più probabilmente furono disegnate e realizzate per il mercato collezionistico.

KRUGENER TASCHENBUCH (Photo - Livre Mackenstein) - Sono state fatte e vendute copie alquanto approssimative. Tuttavia se l'acquirente non conosce bene l'originale potrebbe essere tratto in inganno da un venditore con pochi scrupoli. Altre copie sono di buona qualità e potrebbero essere prese per originali. Almeno un esemplare fatto da Oberlaender è identificato dalla lettera "R" (che sta per Replica) incisa dopo il numero di serie.

LANCASTER WATCH CAMERA - Esistono delle riproduzioni . L'origine è incerta.

LEICA (Anastigmat) - La Leica A Anastigmat è una delle fotocamere Leica più rare. Ne sono stati fatti dei falsi ed venduto anche l'obiettivo è stato Un separatamente. commerciante americano pubblicizzò un modello originale pubblicando il numero di serie. Poco dopo lo stesso numero di serie cominciò ad apparire su alcuni falsi.

LEICA I ELMAX - Attualmente ci sono sul mercato nove o dieci falsi. L'obiettivo originale probabilmente era un Elmar, poi il nome fu cancellato e reinciso. Sono dei falsi quasi impossibili da scoprire se non si rimuove l'obiettivo andando ad ispezionarlo sotto il microscopio per contare gli elementi dell'obiettivo. Elmar è a 4 elementi ed Elmax a 5 elementi. I corpi sono generalmente originali.

LEICA "Luxus" (modelli d'oro) - Si dice che esistano dei falsi realizzati da Greenborough usando "corretti" numeri di serie. Parecchie fotocamere con l'identico numero di serie sono state vendute a inconsapevoli collezionisti. Un esemplare fu offerto da un noto commerciante a un negozio a Bruxelles. Il proprietario del negozio controllò con la fabbrica per verificare se il numero fosse corretto. Lo era, quindi egli acquistò la fotocamera.

Successivamente Leitz ricevette parecchie altre richieste di informazioni sullo stesso numero di serie e così si comprese che esistevano diverse copie con lo stesso numero. Collezionisti ben informati ben conoscono l'esistenza di numerose Leica d'oro provenienti dalla Polonia e che prendono la strada dell'Occidente e del Giappone passando prima per Berlino Est. Parecchi anni fa un originale Luxus Camera, controllato dalla fabbrica, fu venduto alla casa d'aste Cornwall a Colonia. Sei mesi dopo apparve sul mercato un falso con lo stesso numero di serie. Anche le fotocamere russe "Fed" sono state usate per inciderci sopra il marchio Leica e per placcarle d'oro allo di venderle sul mercato collezionistico. Molte "Luxus" Leica sul mercato sono false.

LEICA 250 REPORTER - Una volta si pensava che fosse un investimento sicuro tra le fotocamere Leica a causa della difficoltà di duplicare il corpo. Questo non è più vero. Oggi false Leica Reporter sono un elemento di punta dell'economia polacca.

MARION METAL MINIATURE - Esistono delle riproduzioni. L'origine è incerta.

MINOX A LUXUS - I modelli veri hanno una superficie metallica finemente lavorata. Alcuni modelli normali sono stati placcati ed hanno una superficie liscia. Questi falsi sono stati facilmente riconosciuti. Si dice che esistano anche riproduzioni con custodia in metallo, presumibilmentecon parti originali Minox.

MINOX in un accendino - Apparve per la prima volta agli inizi del 1990. Consiste di una normale fotocamera Minox inserita in un contenitore placcato d'oro che contiene anche un accendino a gas. Ci sono parecchie varianti minori. E' stata presentata come una fotocamera del KGB ma è una curiosità assolutamente moderna, priva di significati storici.

NEUBRONNER PIGEON CAMERA - Ne sono apparse diverse sul mercato intorno al 1989. L'origine è incerta.

RING CAMERAS - Un certo numero di fotocamere camuffate da anelli sono apparse sul mercato negli ultimi anni, talvolta attribuite al KGB. La fonte attuale è un abile artigiano di nome Marek Mazur, di Gdansk, in Polonia. Non sono identiche sebbene usino tutte una simile cartuccia della pellicola, che forma l'anello. La parte superiore dell'anello varia. In alcune è rettangolare con piccole pietre su entrambi i lati ed al centro l'obiettivo. Queste pietre servono a regolare otturatore e diaframma. Una di queste fotocamere riportava inciso il marchio "Ernemann". Una fotocamera simile con una pietra singola fu venduta ad un'asta per ben oltre 20.000 dollari nel 1991. Sebbene si dichiarasse che questa macchina era stata in una collezione per oltre 10 anni, la sua somiglianza ai falsi è fonte di preoccupazione. Alcune di queste Cameras sono ben fatte e Rina funzionano, mentre altre, realizzate con difettose, componenti non sono funzionanti. E' possibile che ci siano copie delle originali Mazur Rings.

SCENOGRAPHE - Esistono riproduzioni, compreso il nome sul soffietto. Bertrand ne

ha fatta una per la propria collezione e asserisce di non averne fatte altre. Noi abbiamo sentito voci di copie della Scenographe, ma non le abbiamo viste e non ne abbiamo documentazione.

SUTTON PANORAMIC CAMERA - Una è stata fatta e venduta da Bertrand come riproduzione. Dopo aver cambiato proprietario per parecchie volte è ora in una importante collezione, presentata come originale.

TICKA WATCH CAMERA - Un esemplare è identificato dalla seguente sigla sull'etichetta interna: "Taschenuhr Camera, D.R.P. 173567 H.Meyer-Frey. Frankfurt A/M." L'autenticità è discutibile. Potrebbe far parte di un programma di duplicazione delle più insolite varianti della Ticka, come le versioni argentate. Una "Watch-Face Ticka" fu ritirata da un'asta di Christie's dopo che ci si accorse che era un falso. Senza dubbio tornerà di nuovo a galla.

VOIGTLÄNDERDAGUERREOTYPE CANNON - Un falso conosciuto è in una collezione privata. Non solo sono sbagliate le dimensioni, ma anche il nome Voigtlaender. Probabilmente esistono altri falsi.

CHIEDIAMO AI LETTORI DI COMUNICARCI ULTERIORI INFORMAZIONI SU QUESTE O ALTRE COPIE E FALSI.

Saremo lieti di pubblicare ulteriori dettagli sulle fotocamere e/o su qualsiasi commerciante o persona che inganni intenzionalmentei collezionisti.

FOTOCAMERE RUBATE; RICOMPENSE OFFERTE.

C'era un tempo in cui tu potevi lasciare una mezza dozzina delle più preziose fotocamere al mondo su un tavolo incustodito a una fiera del collezionismo, senza che nessuno le toccasse. Oggi c'è un crescente numero di furti di fotocamere di valore. Allo scopo di contenere questa deprecabile pratica, la McKeown's Price Guide to Antique and Classic Cameras pubblicherà costantemente in questa e nelle prossime edizioni una lista delle fotocamere rubate.

Ovviamente noi non possiamo pubblicare tutte le fotocamere rubate al mondo, nè voi potete controllare con questa lista tutte le fotocamere che acquistate. Perciò noi ci limiteremo a pubblicare le fotocamere del valore di oltre 1000 dollari e solo quelle con il numero di serie. Faremo eccezione per quelle fotocamere che non hanno il numero di serie, ma che sono così rare o insolite da essere facilmente identificabili. Saremo lieti se altre pubblicazioni per collezionisti e club riprodurranno questa lista, aggiungendovi ulteriori informazioni. Commercianti, aste e club stanno collaborando a questo progetto e noi siamo lieti se vorrete partecipare.

Se vi rubano qualcosa denunciatelo alle autorità locali fornendo una completa descrizione, numero di serie etc. Per inserire l'oggetto rubato in questa lista forniteci le stesse informazioni aggiungendo l'indicazione dell'ufficio di Polizia, il numero di telefono e i riferimenti della denuncia. Questo consentirà ai nostri lettori o ad altre Polizie di contattare

immediatamente le autorità del vostro paese nel caso l'oggetto rubato venga individuato. Noi non inseriremo nella nostra lista oggetti il cui furto non sia stato denunciato alla Polizia. Noi siamo solo uno strumento informativo e non saremo parte attiva in nessuna disputa.

Se vi offrono una fotocamera o un obiettivo inseriti nella lista degli oggetti rubati dovreste prendere nota dell'identità della persona che vi fa l'offerta per aiutare a scoprire il ladro. Dovreste segnalare l'oggetto rubato alle autorità locali, preferibilmente mentre avete l'oggetto o siete in contatto con il venditore. Se segnalate di aver individuato oggetti rubati a Centennial Photo, noi aggiungeremo le seguenti informazioni "individuato per l'ultima volta a.....". Se collaboreremo tutti riusciremo a far tornare alcune fotocamere ai legittimi proprietari. Il problema non si risolve da solo. Ciascuno deve fare la sua parte. Dal momento che questa è la più diffusa Guida a livello internazionale, accettiamo di buon grado la responsabilità di pubblicare questa lista. La nostra Guida viene pubblicata ogni due anni. Nel frattempo se ci inviate una busta affrancata con il vostro indirizzo noi vi manderemo la lista aggiornata. Saremo lieti di ricevere i vostri suggerimenti per aiutarci ad allontanare il crimine dal collezionismo.

PER ULTERIORI INFORMAZIONI:

Riceviamo molte domande e richieste di ulteriori informazioni al di là delle nostre possibilità di risposta. Noi non forniamo opinioni o valutazioni su prodotti non inclusi in questo volume. Sappiamo che molte fotocamere non sono incluse in questo volume e avvertiamo che questa omissione non significa rarità. Abbiamo escluso almeno 30.000 fotocamere per far sì che questo volume rimanga di dimensioni e prezzo ragionevoli. Alcune delle fotocamere escluse sono: la maggior parte delle fotocamere prodotte dagli anni 70 che generalmente sono più rivolte al settore dell'usato che al collezionismo: la maggior parte delle fotocamere formato 126 e 110, che furono prodotte in così grande numero da essere estremamente comuni e di basso valore; molte delle prime fotocamere che raramente si sono viste in vendita. Abbiamo selezionato circa 9000 fotocamere che sono rappresentative degli interessi del collezionismo e per le quali possiamo determinare i prezzi di vendita.

Ci spiace di non poter rispondere nè per posta nè per telefono alle domande personali. Per ulteriori informazioni suggeriamo di iscriversi ad un o più club di collezionisti che pubblichiamo dell'appendice. Potete anche rivolgervi alle newsletter dei club o alle riviste specializzate.

COLLECTORS' ORGANIZATIONS

ALL JAPAN CLASSIC CAMERA CLUB

c/o Monarch Mansion Kohrakuen Room 802 No. 24-11, 2-chome Kasuga, Bunkyo-ku Tokyo 112 JAPAN 03-815-6677 Dues: 3000 yen. Membership: 417. Meet-

AMERICAN PHOTOGRAPHIC HISTORICAL SOCIETY

ings: bi-monthly. Quarterly journal.

1150 Avenue of the Americas New York, NY 10036 (212) 575-0483 Dues: \$25.00 non-profit. Shows: May, Nov. Membership: 500. Meetings: monthly. Monthly newsletter, journal.

AMERICAN SOCIETY OF CAMERA COLLECTORS, Inc.

4918 Alcove Ave North Hollywood, CA 91607 (818) 769-6160 Dues: \$20.00 non-profit. Shows: March, Sept. Membership: 283. Meetings: monthly. Newsletter.

ARIZONA PHOTOGRAPHIC COLLECTORS, Inc.

PO Box 14616
Tucson, AZ 85732-4616
Dues: \$25.00. Membership: 24. Meetings: monthly. Monthly newsletter.

BAY AREA PHOTOGRAPHICA ASSN. (BAPA)

2538 34th Ave San Francisco, CA 94116 Phone: 415 664-6498 Dues: \$0.00. Membership: 28. Meetings: bi-monthly. Newsletter.

CALGARY PHOTOGRAPHIC HISTORICAL SOCIETY PO/CP 24018 Tower Postal Outlet

PO/CP 24018 Tower Postal Outlet Calgary, Alberta T2P 4K6 CANADA Dues: C\$20.00, \$20US international. Membership: 50. Meetings: quarterly. Quarterly journal.

C.A.M.E.R.A. (Camera and Memorabilia Enthusiasts Regional Association)

c/o William J. Tangredi, Sec'y PO Box 11172 Loudonville, NY 12211 Dues: \$12.00 non-profit. Shows: March, Nov. Membership: 18. Meetings: monthly.

CASCADE PHOTOGRAPHIC HISTORICAL SOCIETY

PO Box 22374 Milwaukie, OR 97269-2374 Phone: 503 654-7424 or 503 292-9714 Dues: \$10.00 non-profit. Membership: 35. Meetings: monthly. Newsletter.

CHESAPEAKE ANTIQUARIAN PHOTOGRAPHIC SOCIETY

PO Box 1227 Severna Park, MD 21146-8227 Phone: (410) 744-7581 or 987-5318 Dues: \$10.00. Shows: May, Oct. Membership: 25. Meetings: bi-monthly.

CHICAGO PHOTOGRAPHIC COLLECTORS SOCIETY

PO Box 303 Grayslake, IL 60030-0303 Dues: \$25.00 non-profit. Shows: March, Oct. Membership: 205. Meetings: monthly. Monthly newsletter, bi-annual journal.

CLASSIC CAMERAS COLLECTORS PHOTOCIRCLE

a/o arch. Roberto Antonini

Strada Respoglio 8 I-01100 Viterbo ITALY Tel/Fax: 0761 / 306655 Dues: Lire 35.000, Lire 45.000 international. Membership: 30. Quarterly newsletter.

CLUB DAGUERRE

c/o Klaus Storsberg
Mohlenstr. 5
D-5090 Leverkusen GERMANY
(2173) 40080
Dues: DM100, DM20 joining fee, non-profit. Shows: Oct. Membership: 495. Meetings: monthly. Newsletter, semi-annual journal.

CLUB DAGUERRE-DARRAH

2562 Victoria Wichita, KS 67216 (316) 265-0393 Dues: \$12.00. Shows: Feb. Membership:

18. Meetings: monthly. Newsletter.

CLUB NIEPCE LUMIERE c/o Jean-Paul Francesch

Residence Bonnevay

1-B rue Pr Marcel DARGENT F-69008 Lyon FRANCE Phone: 78 74 84 22 Dues: 325 FF non-profit. Shows: Oct. Membership: 200. Meetings: monthly. Quarterly journal.

CLUB ROLLEI

Jersey PhotographicMuseum Hotel de France St. Saviour's Rd Jersey, C.I. JE2 7LA ENGLAND Phone: 0534 73102 Dues: £20. Annual Exhibition. Membership: 450. Meetings: London and Jersey. Quarterly journal.

DANISH PHOTOGRAPHY SOCIETY

Teglgårdsvej 308 3050 Humlebek, D.K. DENMARK Phone: 42 19 22 99 Dues: D.KR.300,- non-profit. Meetings: monthly. Quarterly journal.

DELAWARE VALLEY PHOTOGRAPHIC COLLECTORS ASSN.

PO Box 74 Delanco, NJ 08075 Dues: \$15.00 non-profit. Shows: Feb, June, Aug, Nov. Membership: 90. Meetings: monthly. Newsletter.

DUTCH SOCIETY OF FOTOGRAFICA COLLECTORS PO Box 4262

NL-2003 EG Haarlem NETHERLANDS Phone: 31 15 610 234 Dues: \$30.00 international. Shows: March, Nov. Membership: 1500. Quarterly journal (Dutch), newsletter.

EDMONTON PHOTOGRAPHIC HISTORICAL GROUP

6307 34 B Avenue Edmonton, Alberta T6L 1E3 CANADA Phone: (403) 463-8127 Membership: 25. Meetings: monthly. Newsletter.

THE EXAKTA CIRCLE

6 Maxwell Road Sholing, Southampton, S02 8EU ENG-LAND Phone: 0703 329 794 Dues: £12, £15 international. Show: May. Membership: 100. Meetings: 3/yr. Quarterly newsletter.

FRIENDS OF THE FLEETWOOD MUSEUM

North Plainfield NJ 07063 (908) 756-7810 Dues: \$0.00. Membership: 25. Meetings: bi-monthly.

GRAFLEX HISTORICAL SOCIETY

PO Box 710692 Houston TX 77271-0692 Dues: \$24.00.

614 Greenbrook Road

HISTORICAL SOCIETY FOR RETINA CAMERAS

51312 Mayflower Rd South Bend, IN 46628 Phone: 219 272-0599 Fax: 219 232-2162 Dues: \$0.00. Membership: 70.

IHAGEE HISTORIKER GESELLSCHAFT

(IHG) c/o H. D. Ruys Tesselschadelaan20 NL-1217 LH Hilversum NETHERLANDS

INTERNATIONAL KODAK HISTORICAL SOCIETY

PO Box 21 Flourtown PA 19031 Phone: (215) 233-2032

Dues: \$20.00. Membership: 120. Journal.

INTERNATIONAL PHOTOGRAPHIC HISTORICAL ORGANIZATION PO Box 16074

San Francisco, CA 94116 Phone: (415) 681-4356 Dues: \$0.00. Membership: 280. Meetings: bi-monthly. Newsletter.

LEICA HISTORICA e.V.

p.a. Klaus Grothe Bahnhofstr. 55 D-W-3252 Bad Münder GERMANY (050) 42-4444 Dues: DM50 non-profit. Shows: Spring, Fall. Membership: 500. Quarterly journal.

LEICA HISTORICAL SOCIETY

c/o G. F. Jones 23 Salisbury Grove Wylde Green, Sutton, Coldfield West Midlands B72 1XT ENGLAND 021 384-7100 Dues: L12, L14 international. Shows: March, July, Oct. Membership: 300. Meetings: monthly. Quarterly journal.

LEICA HISTORICAL SOCIETY OF AMERICA

7611 Dornoch Lane
Dallas, TX 75248-2327
Dues: \$35.00, \$50.00 international, nonprofit. Shows: Oct. Membership: 1250.
Meetings: annually. Quarterly journal.

MAGIC LANTERN SOCIETY

ings: quarterly. Journal.

'Prospect', High Street Nutley, Uckfield E. Sussex, ENGLAND Dues: £20.00. Membership: 350. Meet-

MICHIGAN PHOTOGRAPHIC HISTORICAL SOCIETY

Box 2278 Birmingham, MI 48012-2278

COLLECTORS' ORGANIZATIONS

(313) 540-7052 Dues: \$10.00 non-profit. Shows: Nov. Membership: 150. Meetings: bi-monthly. Newsletter.

MIDWEST PHOTOGRAPHIC COLLECTORS SOCIETY

1540 Bluefield Drive Florissant, MO 63033 Dues: \$5.00. Membership: 25. Meetings: monthly.

MIRANDA HISTORICAL SOCIETY

Box 2001 Hammond, IN 46323 Phone: (219) 844-2462

Dues: \$18.00, \$27.00 international. Membership: 92. Quarterly newsletter.

THE MOVIE MACHINE SOCIETY

50 Old County Rd Hudson, MA 01749 Phone: (508) 562-9184 Dues: \$17.00, \$20.00 international, nonprofit. Membership: 175. Meetings: annually. Quarterly journal.

NATIONAL STEREOSCOPIC ASSOCIATION

Box 14801 Columbus, OH 43214 (614) 263-4296 Dues: \$22.00; \$32, 1st class; \$34 international. Shows: June, Aug. Membership: 3000. Meetings: annually Quarterly jour-

NIKON HISTORICAL SOCIETY

c/o Robert Rotoloni PO Box 3213 Munster, IN 46321 Phone: 708 895-5319 Dues: \$25.00, \$35.00 international. Shows: spring, fall. Membership: 250. \$35.00 international. Quarterly newsletter.

THE OHIO CAMERA COLLECTORS

PO Box 282 Columbus, OH 43216 (614) 885-3224 Dues: \$10.00. Shows: May. Membership: 100. Meetings: monthly. Newsletter.

PENNSYLVANIA PHOTOGRAPHIC HISTORICAL SOC., Inc.

PO Box 862 Beaver Falls, PA 15010-0862 (412) 843-5688 Dues: \$15.00 single, \$20.00 family, non-profit. Shows: Aug. Membership: 55. Meetings: bi-monthly. Newsletter.

PHOTO RETRO CAMERA CLUB DE BELGIQUE

Rue Ferdinand Nicolay, 180 B-4420 St. Nicolas BELGIUM Phone: 041-53.06.65 or 041-58.66.17 Dues: 1.000 FB. Shows: Oct. Membership: 15. Meetings: monthly. Newsletter.

PHOTOGRAPHIC COLLECTORS CLUB **of GREAT BRITAIN**

5 Station Industrial Estate Low Prudhoe, Northumberland NE42 6NP **ENGLAND** Dues: L17, L20 Eur, L27 USA, L3 joining fee. Shows: May. Membership: 950. Meetings: monthly. Quarterly journal, postal auctions.

PHOTOGRAPHIC COLLECTORS of **HOUSTON**

PO Box 70226

Houston, TX 77270-0226 (713) 868-9606 Dues: \$20.00.

Shows: March, Sept. Membership: 150. Meetings: monthly. Newsletter.

PHOTOGRAPHIC COLLECTORS of **TUCSON**

PO Box 18646 Tucson, AZ 85731 (602) 721-0478

Dues: \$0.00. Shows: March, Nov.

PHOTOGRAPHIC COLLECTORS SOCIETY (Australia) 14 Warne St

Eaglemont3084, MelbourneAUSTRALIA Phone: (03) 457-1050 Dues: A\$15.00. Shows: March, Oct. Membership: 256. Meetings: bi-monthly. Newsletter.

THE PHOTOGRAPHIC HISTORICAL SOCIETY

PO Box 39563 Rochester, NY 14604 Dues: \$15.00 non-profit. Shows: Oct (triennial). Membership: 100. Meetings: monthly. Newsletter.

PHOTOGRAPHIC HISTORICAL **SOCIETY OF CANADA**

1712 Avenue Rd-Box 54620 Toronto, Ontario, M5M 4N5 CANADA Phone: (416) 243-1576 Dues: \$32.00, 24.00, non-profit. Shows: March, Oct. Membership: 260. Meetings: monthly. Quarterly journal.

PHOTOGRAPHIC HISTORICAL SOCIETY OF NEW ENGLAND, Inc.

PO Box 189 West Newton Sta.

Boston, MA 02165

Phone: (617) 731-6603 Fax: (617) 277-7878 Dues: \$25.00, \$35.00 international, nonprofit. Shows: April, Oct. Membership: 700. Meetings: monthly. Quarterly journal.

THE PHOTOGRAPHIC HISTORICAL **SOCIETY of the WESTERN RESERVE**

PO Box 25663 Garfield Htg, OH 44125 (216) 382-6727 or 232-1827 Dues: \$12.00 non-profit. Shows: July-Aug. Membership: 65. Meetings: monthly. Newsletter.

PHOTOGRAPHICA - A.S.B.L.

Chaussee de la Hulpe 382 B-1170 Brussels BELGIUM 02-673.84.90 Dues: 1200 (BFRS) non-profit. Shows: May. Journal.

PUGET SOUND PHOTOGRAPHIC COLLECTORS SOCIETY

10421 Delwood Dr. S.W. Tacoma, WA 98498 (206) 582-4878 Dues: \$10.00 non-profit. Shows: April. Membership: 115. Meetings: monthly. Newsletter.

ROYAL PHOTOGRAPHIC SOCIETY HISTORICAL GROUP

The Octagon, Milsom St. Bath BA1 1DN ENGLAND (0225)462841Dues: L10 non-profit. Membership: 300. Meetings: monthly. Quarterly journal.

STEREO-CLUB FRANCAIS

45, rue Jouffroy F-75017 Paris FRANCE 47-63-31-82

Dues: 280 FF non-profit. Shows: March, June, Oct. Membership: 700. Meetings: monthly.

THE STEREOSCOPIC SOCIETY

195 Gilders Road Chessington, Surrey KT9 2EB ENGLAND 081-397-8712 Dues: L10. Membership: 400. Meetings: monthly. Quarterly journal.

SYDNEY STEREO CAMERA CLUB

PO Box 465 Pymble, N.S.W. 2073 AUSTRALIA (621) 488-8798

Dues: A\$23.00. Membership: 95. Meet-

ings: monthly. Newsletter.

TRI-STATE PHOTOGRAPHIC **COLLECTORS SOCIETY**

8910 Cherry Blue Ash, OH 45242 Phone: (513) 891-5266 Dues: \$5.00. Membership: 13. Meetings: monthly.

WESTERN CANADA PHOTOGRAPHIC HISTORICAL ASSN.

2606 Commercial Dr. PO Box 78082 Vancouver, B.C. CANADA V5N 5W1 Phone/Fax: (604) 254-6778 Dues: \$20.00. Shows: Membership: 70. Meeti March, Nov. Meetings: monthly. Monthly newsletter.

WESTERN PHOTOGRAPHIC COLLECTOR ASSN. Inc. (WPCA) PO Box 4294

Whittier, CA 90607 (310) 693-8421 Dues: \$25.00 single, \$20.00 corresponding, \$30.00 international, non-profit. Shows: May, Nov. Membership: 400. Meetings: bi-monthly. Quarterly journal.

ZEISS HISTORICA SOCIETY

PO Box 631 Clifton, NJ 07012 (201) 472-1318 Dues: \$25.00, \$35.00 international. Membership: 300. Meetings: annual. Semiannual journal.

This list was prepared by the Western Photographic Collectors' Assn. and updated by Centennial Photo Service. If your organization is not included in this listing, please contact the WPCA or Centennial Photo.

MUSEUMS

AUSTRIA

BAD ISCHL Photomuseum des Landes Oberösterreich - Marmorschlössl, A-4820 Bad Ischl, tel (0043) 6132-4422 - Founded in 1976 to display the Frank Collection, closed from November 1 - March 31.

Höhere Graphische Lehr- und Versuchsanstalt - Leverstrasse 6. A-1140 Wien.

Technisches Museum Wien - Mariahilfer Strasse 212, A-1140 Wien - Founded in 1918, 58 cameras displayed, owns 459, library, closed Saturdays.

BELGIUM

ANTWERP/ANVERS Museum voor Fotografie - Waalse Kaie 47, B-2000 Antwerpen, tel (03) 216.22.11 - Founded 1986, 500 cameras displayed, owns 7000, library, closed Mondays.

BERTRIX

Musée Photo - Rue de la Gare 29a, B-6880 Bertrix - Private museum, owns 800 cameras, visits on Saturday PM or by appointment.

CHARLEROI Musëe de la Photographie - 11 Avenue Paul Pastur, B-6032 Mont sur Marchienne, tel (32) 71 43.58.10, fax (32) 71.36.46.45 - Founded 1987, 300 cameras displayed, owns 2000, library, closed Mondays.

CZECHOSLOVAKIA

KOSICE Slovenske Technicke Muzeum -Leninova 88, Kosice CZ-043 82 - Founded 1947, owns 10000 cameras, library, closed Saturdays & Sundays.

PRAGUE Narodni Technicke Muzeum (National Technical Museum) Kostelni 42, Praha 7, CZ-170 78 - Founded 1910, 800 cameras displayed, owns 2000, library, closed Mondays.

Petzval Museum - Spisska Bela -Founded 1964, 183 cameras displayed, library, closed Sundays & Mondays.

DENMARK

Danmarks Fotomuseum - Museumgade 3, DK-7400 Herning, tel (07) 225322 - Founded 1984, library, closed mondays.

ESTONIA

TALLINN Photomuseum - Raekoja Str. 4/6,

FINLAND

HELSINKI Suomen Valokuvataiteen Museo/ Photographic Museum of Finland - Keskuskatu 6, 7th floor, Box 596, SF-00100 Helsinki, tel (0) 658-544 - 66 cameras displayed, owns 2000, library, open daily.

FRANCE

BIEVRES (78) Musée français de la Photographie - 78 ru de Paris, 91570 Bièvres, tel 69.41.10.60 / fax 60.19.21.11 - Founded 1960, 3000 cameras displayed, owns 15000, open daily.

CHALON SUR SAONE (71) Musée Nicéphore Niepce - 28 Quai des Messageries, 71100 Chalon sur Saône, tel 85.48.41.98 - Founded 1972, 200 cameras displayed, among which is the original camera of Nicéphore Niepce. owns 1420 cameras, library (by appointment), closed Tuesdays.

LABRUGUIERE (81) Musée Arthur Batut - 9ter Bld. Gambetta, 81290 Labruguière, tel 63.50.22.18 - Founded 1988, 12 kite cameras displayed, owns 20 such cameras, library, closed Tuesdays & Sunday mornings, and from April 15 - October 15. Visits also possible by appointment.

LIMOGES (87) Musée Municipal de l'Evéché -Place de la Cathédrale, 87000 Limoges, tel 55.45.61.75 - Founded 1912, owns 40 cameras, none presently displayed, closed Tuesdays except July, August, & Septem-

LYON (69) Institut Lumière - 25 rue du Premier 69008 Lyon Monplaisir, 78.00.86.68- owns 700 cameras.

MOUGINS (06) Musée de la Photo - Porte Sarrazine, 06250 Mougins - Founded in 1986, 18 cameras displayed, open daily except Monday and Tuesdsy afternoons (also open evenings in July & August), closed November.

PARIS (75) Cité des Sciences et de l'Industrie - 30 Ave Corentin Cariou, 75019 Paris, tel 40.05.70.00- several cameras displayed.

Conservatoire National des Arts et Métiers - 292 rue Saint Martin, 75003 Paris, tel 40.27.22.84, fax 40.27.26.62 - Founded 1794, 200 cameras displayed, owns 2000, library, closed Mondays.

SAUXILLANGES (63) Musée de la Photographie - chez L. & G. Boquet, Usson, 63490 Sauxillanges, tel 73.71.01.05 - Private museum, open daily.

GREAT BRITAIN

National Centre of Photography/ Royal Photographic Society - The Octagon, 46 Milsom Street, Bath/Avon BA1 1DN, tel (0225) 462841, fax (0225) 448688 - Founded 1979, 400 cameras displayed, owns 6000, library (by appointment only), open daily.

BIRMINGHAM

Museum and Art Gallery/ Dept. of Science and Industry - New Hall Street, Birmingham B3 1RZ, tel 021-236 1022 - Founded 1951, 11 cameras displayed, owns 92, library (by appointment only), open daily, Sundays afternoon only.

BRADFORD National Museum of Photogra-phy, Film & Television - Princes View, Bradford, West Yorkshire BD5 0T, tel (0274) 727488 - Founded 1989, 2000 cameras displayed, owns 10000 cameras (formerly in the Science Museum of London and in the Kodak Museum).

CHIPPENHAM Fox Talbot Museum - Chippenham, Wilts. BA12 6QD.

CHIPPING CAMPDEN Woolstaplers Hall Museum - High Street, Chipping Campden, Gloustershire one showroom.

EDINBURGH National Museums of Scotland/ Dept. of Science, Technology and Working Life - Chambers Street, Edinburgh EH1 1JF, tel 031-225-7534, fax 031-220-4819 - Founded 1985, owns 1000 cameras (among which are some of Henry Fox Talbot's cameras), library (by ap-

FRESHWATER Medina Camera Museum - Golden Hill Fort, Freshwater, Isle of Man.

pointment only), open daily, Sundays PM

Jersey Photographic Museum -Hotel de France, St. Saviour's Road, Jersey/Channel Islands, JE2 7LA tel (0534) 73102, fax (0534) 887342 - Founded 1972, 500 cameras displayed, owns 2000; 200 photographs displayed, 40,000 image library, closed Saturday afternoons and Sundays. Free admission.

Fox Talbot Museum - Lacock Abbey,

Lacock, Wiltshire, tel (024) 973-459 - Fox Talbot's cameras. LONDON

Museum of the Moving Image -Waterloo Bridge, South Bank, London SE1 8XT - movie cameras.

MANCHESTER Museum of Science & Industry -Liverpool Road Station, Liverpool Road, Castlefield, Manchester M3 4JP, tel (061) 832 2244, fax (061) 833 2184 - Founded 1983, 54 cameras displayed, owns 300, library (by appointment), open daily.

NEWBURY Newbury District Museum - The Wharf, Newbury/Berkshire RG14 5AS, tel (0635) 30511 - Founded 1904, camera display since 1975, owns 70 cameras, open daily from October through March except Wednesdays, Sundays, and bank holidays, from April to September, open daily except closed Wednesdays, Sunday mornings, and mornings of bank holidays. OXFORD

Museum of the History of Science - Broad Street, Oxford.

TOTNES

The British Photographic Museum
- Bowden House, Totnes, Devon TQ9
7PW, tel (0803) 86 36 64 - Founded 1987,
owns 4500 cameras. Private museum,
open only Tuesday, Wednesday & Thursday from Easter to 27th September.

WEDNESBURY
Wednesbury Art Gallery &
Museum - Hollyhead Road, Wednesbury, West Midlands WS10 7DF, tel (021)
556 0683 - George Parker Collection.

WESTON SUPER MARE Woodspring Museum - Burlington Street, Weston-Super-Mare.

GERMANY

BERLIN

Museum für Verhehr und Technik
- Trebbiner Strasse 9, DW-1000 Berlin 61,
Tel (030) 254-840. Currently displaying
stereo cameras. Closed Mondays.

BURCHAUSEN Foto-Museum der Stadt Burghausen - In der Rentmeisterei burg Nr.1, DW-8263 Burghausen, tel (08677) 47 34. Founded 1983, 500 cameras displayed, owns 1000, library, closed November 1 - March 31, and on Mondays & Tuesdays.

COLOGNE/KÖLN
Agfa Foto Historama - In
Wallraf/Richartz Museum Ludwig,
Bischofsgarten Strasse 1, DW-5000 Köln
1, tel (0221) 221 23 82. Founded 1974 in
Leverkusen, since 1985 in Cologne, 200
cameras displayed, owns 20,000, library,
closed on Mondays.

DRESDEN Technisches Museum Dresden -Reinhold Becker Strasse 5, DO-8060
Dresden.

ESSEN

Abring Foto Museum - Burg Horst, Haus Horst 1, DW-4300 Essen 14, tel (0201) 53 85 90 - 1500 cameras displayed, owns 4000, private museum, visit by appointment.

FRANKFURT am MAIN Archiv für Filmkunde Paul Sauerländer - Klarastrasse 5, DW-6000 Frankfurt am Main 50. Ciné/movie apparatus.

Museum für Technik und Musik Heinz Panke - Deuil-la-Barre Strasse 36, DW-6000 Frankfurt 56.

FREIBURG
Freiburger
Sammlung - c/o Michael H. Guttenberg, beim oberen Bäumle 6, DW-7801 Mengen bei Freiburg, tel (07664) 23 24 - Established 1975, owns 1200, library.

HAMBURG
Museum für Kunst und Gewerbe c/o Dr. Claudia Babriele Philip, Steintorplatz 1, DW-2000 Hamburg 1.

MARXZELL Fahrzeugmuseum Marxzell - DW-7501 Marxzell.

MÖLKAU/LEIPZIG Fotomuseum Peter Langner - 9 Gottschalk Strasse, tel 69 46 81 - Only Sunday afternoons or by appointment.

MÜHLTAL

Photomuseum Fotografica - Reinstrasse 42, DW 6109 Mühltal 1.

MÜNCHEN

Deutsches Museum - Museuminsel 1, DW-8000 München 22 - 130 cameras displayed.

Fotomuseum im münchner Stadtmuseum - Sankt Jakobs Platz 1, DW-8000 München 2, tel (089) 201-4976/22398 - Founded 1963, library, closed mondays.

OBERKOCHEN

Optisches Museum - am Ohlweiler 15, DW-7082 Oberkochen, tel (07364) 20 28 78 / 20 41 80, fax 20 33 70 - Founded 1971, 53 cameras displayed, library not open to public, closed Saturdays and Sunday afternoons.

RATZENBURG Kreismuseum - closed Mondays.

SOLMS

cases

Leica Museum - Oskar Barnack Strasse 11, DW 6336 Solms, tel (06442) 2080, fax (06442) 208-333 - Founded 1954, 107 cameras displayed, owns 212, library (open only on request), closed Saturdays & Sundays, exclusively Leica cameras.

WETZLAR Leitz Museum - Leitzwerke, Postfach 2020, DW-6330 Wetzlar 1 - Several glass

ZEIL am MAIN Zeiler Photomuseum - Schulring 2, 97475 Zeil am Main, tel (09524) 9490 or 7460 - Founded 1993, 700 cameras, 1500 other pieces displayed, including a 1.5 ton Gossen Repro-camera. Open Sundays, or to groups on weekdays by appointment.

GREECE

ATHENS

Athens Photographic Museum - 3 Kranaou Street, Koumoundourou Square, PO Box 4198, 102.10 Athens. Founded 1994, displays will show pre-photographic/ photographic development from Aristole to present.

ITALY

BRESCIA Museo Nazionale della Fotografia Cinefotoclub - Corso Zanardelli, 20, I-25121 Brescia - Founded 1983.

Museo Nazionale del Cinema -Palazzo Chiablese, Piazza San Giovanni 2, I-10122 Torino - several showrooms, closed at this time.

JAPAN

TOKYO

JCII Camera Museum - Ichiban-cho Bldg. 25, Ichiban-cho, Chiyoda-ku, Tokyo 102, tel (033) 263-7111, fax (033) 234-4264 - 500 cameras displayed, owns 2800,

MUSEUMS

library, closed Mondays.

Pentax Gallery Camera Museum - 3-21-20 Nishi-Azabu, Minato-ku, Tokyo 106, tel (03) 3401-2186 - Founded 1967, 600 cameras displayed, owns 4000, library, closed Sundays.

LITHUANIA

SIAULIAI

Fotografijos Muziejus - Vilniaus G 140, 5400 Siauliai, Lietuva, tel 27203 - 92 cameras displayed, owns 380, library, open afternoons from Wednesday to Saturday.

MAURITIUS (ILE MAURICE)
Musée de la Photographie - Route
St. Jean, Quatre Bornes, Ile Maurice, tel
454-5242 - Founded 1966, 102 cameras
displayed, owns 210, library, visit by
appointment.

NETHERLANDS

AXEL

Foto Radio Museum - Bastionstraat 45, Axel, tel 01155-4291 - Founded 1986.

NEW ZEALAND

Graham Howard Museum - 35 Domett Street, Westport, tel (0289) 64.11 - 600 cameras displayed, owns 1000. Private museum; visit on request.

New Zealand Centre for Photography - 3 Inverlochy Place, Wellington, tel (04) 385-8188 - Founded 1990, 350 cameras, library, closed Sundays & Mondays.

NORWAY

HORTEN

Preus Fotomuseum - Longgt 82, Postboks 124, N-3191 Horten, tel (033) 42 737/42 557, fax (033) 44 614 - Founded 1976, 500 cameras displayed, owns 3000, library, closed Saturday and Sunday mornings.

POLAND

KRAKOW

Muzeum Historii Fotografii - ul. Jozefitow 16, 30-045 Krakow.

SWEDEN

GOTHENBURG

Foto Museum - c/o Stina Malmborg, Gothenburg Chamber of Commerce, Gothenburg - Owns 1250 cameras, private museum.

OSBY

Fotomuseet - Esplanadgatan 5, Osby S-28300, tel 0479/101 18 - Founded 1985, 500 cameras displayed, visit by appointment (only in summer).

MUSEUMS

SWITZERLAND

DÜBENDORF
Museum der Schweizerischen
Fliegertruppe - Case Postale, CH8600 Dübendorf, tel 01/823 22 83, fax
01/820 01 12 - Founded 1978, 17 aerial
cameras displayed, closed Mondays and
Sunday mornings.

VEVEY Musée Suisse de l'Appareil Photographique - Ruelle des Anciens Fossés 6, CH-1800 Vevey, tel (021) 921-9460, fax (021) 921-6458 - Founded 1979, owns 3500 cameras (some formerly in the Polytechnic School of Zürich and in the Swiss Kodak museum), library, closed Mondays, open only PM between November and February.

RUSSIA

Polytechnic Museum - Place Novaya 3/4, Moscow 101000, tel 925-06-14 - about 300 Russian & German cameras displayed.

SOUTH AFRICA

DURBAN Whysall Camera & Photographic Museum - Jeremy Whysall, 33 Brickhill Road, PO Box 676, Durban 4001. Tel (031) 371431. Private museum, founded 1948, 4000 cameras displayed, owns 5000, closed Saturdays & Sundays.

JOHANNESBURG Bensusan Museum - Marquer Square, Hillbrow, Johannesburg 2001.

THAILAND

Museum of Imaging Technology - Chulalongkorn University, 10500 Bangkok.

UNITED STATES

AUSTIN Gernsheim Collection - University of Texas, Austin, TX.

BOSTON Naylor Museum of Cameras & Images - P.O. Box 23, Waltham Station, Boston MA 02254, tel (617) 731-6603 - Private museum, founded 1976, 3200 cameras displayed, owns 6000, library, visit by appointmentonly.

CASSVILLE, WISCONSIN Stonefield Village - Nelson Dewey State Park, Cassville, WI.

CHICAGO
Chicago Historical Society - Clark
Street at North Avenue, Chicago IL 60614,
tel (312) 642-4600 - Founded 1856, owns
35 cameras made in Chicago, library,
closed Sunday mornings.

International Cinema Museum - 319 W. Erie St., Chicago IL 60610, tel (312) 654-1426 - Founded 1993, large collection, expansion of display areas in progress.

DEARBORN, MI Henry Ford Museum & Greenfield Village - 20900 Oakwood Blvd., PO Box 1970, Dearborn MI 48121 - Founded 1929, 45 cameras displayed, owns 250, library, open daily.

FOND DU LAC, WI Galloway House Museum - Pioneer Road, Fond du Lac, WI.

GAINESVILLE, FL Florida State Museum - Gainesville, FL.

KEYSTONE, SD Horseless Carriage Museum -Keystone SD, tel (605) 342-2279 - 30 cameras displayed.

LITTLE ROCK
The Gallery of Photographic
History - 310 Lanehart Road, Little Rock
AR 72204, tel (501) 455 0179 - Founded
1973, 100 cameras displayed (mainly
professional), library, visit by appointment.

LOS ANGELES Los Angeles County Museum - 900 Exposition Blvd., Los Angeles CA.

MEDFORD, OR Jacksonville Museum of Southern Oregon History - History Center, 106 N. Central Ave., Medford OR 97501-5926, tel (503) 773-6536 - Founded 1950, 6 cameras displayed, owns 50, closed Mondays.

MINDEN, NB Pioneer Village - Minden NB, tel (308) 832-1181, 40 cameras displayed.

NORTH PLAINFIELD, NJ Fleetwood Museum - (see advertisement on page 498) - 614 Greenbrook Road, North Plainfield NJ 07063 - Exhibits a collection of cameras and images. Open Saturdays 10AM to 4PM & Sundays 1PM to 4PM.

RIVERSIDE, CA
California Museum of Photography - University of California, 3124 Main
St., Riverside CA 92521, tel (714) 7874787 - Founded 1973, closed Sunday mornings and Mondays.

Riverside Camera Museum - Mission Inn, Riverside CA - 200 cameras displayed, owns 6000.

ROCHESTER, NY International Museum of Photography - George Eastman House, 900 East Ave., Rochester NY 14607, tel (716) 271-3361 - Founded 1947, permanent and changing displays of cameras and images, owns 3000 cameras.

SAN FRANCISCO
California Academy of Sciences Golden Gate Park, San Francisco CA
94118-4599, tel (415) 221-5100 - Founded
1853, owns 125 cameras, none displayed,
new location planned), library.

WASHINGTON, DC National Museum of American History/Smithsonian Institution -Room 5715, 1000 Jefferson Drive SW, Washington DC 20560, tel (202) 628-4422/(202) 357-2059 - Owns 1200 cameras, library, closed Saturdays & Sundays, by appointmentonly.

WATERBURY, CT
Mattatuck Museum (Scovill) - 144
W. Main St., Waterbury CT 06702, tel
(203) 753-0381 - 3 cameras displayed,
library, closed Sundays & Mondays.

This list of museums is reprinted from "LE FOTO SAGA, THE CAMERA COLLECTOR'S NEW HANDBOOK" with the kind permission of the editor, Patrice-Hervé Pont. It is only a sample of some of the useful information included in that bilingual (French/English) guide for collectors. Other topics listed include: second hand shops, fairs, auctions, bibliography, booksellers, clubs, magazines, repair shops, and other practical information. This guide is available from booksellers, or directly from Fotosaga, Flassy, 58420 Neuilly, France.

The museums in this list are those which have exhibits of cameras and related objects. In some cases, it is a small photographic exhibit as part of a much larger museum, and in other cases, photography is the central theme of the museum. It would always be best to make advance arrangements before traveling a great distance to visit any of these museums. Not only might the visiting hours be changed, but the exhibits may be on tour or in storage.

RECORD PRICES / STOLEN CAMERAS

RECORD PRICES AT AUCTION FOR PHOTOGRAPHIC CAMERAS

One of the best indicators of the strength of the camera collecting field is the prices achieved at public auctions. There are and have been auctions in the field for over 20 years. During this time, certain types of cameras have demonstrated enduring value when compared with the field in general and also when compared with other forms of investment.

The most prominent auction houses specializing in Photographica are Christie's South Kensington (London), Auktionshaus Cornwall (Cologne) and Auktion Team Köln (Cologne). Cornwall is a photographic specialist whose main business is photographic auctions. Auktion Team Köln specializes in auctions of technical antiques. Christie's is a large international auction house dealing in all sorts of antiques, but with a specialty department for cameras and optical toys.

Some types of cameras seem to achieve better results at one or another of these auctions, but generally the final price is

more directly related to the item offered than to the podium from which it is sold.

As can be expected, the highest prices overall have been paid in the most recent years, as values continue to increase on most items. What is surprising is that all of the top record prices have been achieved by the same house, Christie's. Lacking any direct comparison of similar items sold by the others, we caution readers that we are not comparing auction houses. It is possible that these cameras might have achieved similar or even higher prices in another environment. The purpose of this list is to demonstrate what types of cameras bring the best prices. As can be expected, the top prices are centered around three general categories: Leica, subminiature, and very early (wet-plate/daguerreian).

These records are listed in order by price. In this edition, since the top prices were all in Sterling, we are listing them in order by the Sterling price rather than the Dollar equivalent at the time of the sale. Prices listed here include buyer's commission.

PRICE	DATE	CAMERA
£39,600		Leica Luxus, brown lizard skin.
£39,600		Adams De Luxe Sultan's Camera (gold fittings).
£33,000	93 07 08	Leica I Luxus Gold with f3.5/50mm lens.
£29,700	92 03 12	Lancaster Pocket Watch Camera (Ladies).
£28,600	93 01 14	Nikon S3M (Half-frame) with motor.
£28,600	92 11 05	Sutton Panoramic Camera for curved wet collodion plates.
£26,400	89 11 09	Leicaflex R6 Platinum. Special edition sold for charity.
£23,100	91 12 09	Brin's Patent monocular camera.
£22,000	91 12 09	Lancaster Pocket Watch Camera (Men's).
£21,000	77 10 12	Dancer Stereo Camera for wet collodion plates.
£20,900	94 06 09	Leica KE-7A, U.S. military, Elcan f1.0/90mm lens.
£18,700	93 05 06	Hegelein Pocket Watch Camera.
£18,700	91 12 09	Mast Dev. Corp. Lucky Strike Cigarette Package Camera.
£18,700	91 12 09	Houghton's Ticka, Presentation model, special engravings.
£18,700	89 11 09	Briois Thompson Revolver Camera.
£17,600	94 06 09	Nikon I, original bill of sale.
£17,600	93 07 08	Brin's Patent Spy Glass Camera.
£17,600	92 05 14	Marion Soho Reflex Stereo Tropical.
£17,600	92 05 14	Gaudin Daguerreotype Camera.
£16,500	93 07 08	Leitz Leica 72.
£16,500	93 07 08	Doryu 2-16 Pistol Camera.
£16,500	89 11 09	Robert's Pattern Daguerreotype Sliding-box Camera.
£15,400	93 07 08	Leitz Leica 72.
£14,300	94 06 09	Leica X-Ray camera.
£14,300	92 09 10	Kodak George Washington Camera.
£13,200	94 06 09	Nikon SP chrome camera with motor unit.
£13,200	93 07 08	Leitz Leica I Anastigmat.
£13,200	92 11 05	Lancaster Watch Pocket Camera, Improved, 1.5x2".
£13,200	92 11 05	Damoizeau Cyclographe.
£12,650	94 06 09	Leica IIIg black, three-crowns, 4-lens outfit.
£12,650	92 07 30	Lumiere Le Cinematographe 35.
£12,100	94 01 13	Scovill Book Camera.
£12,100	93 07 08	Ottewill Folding Sliding-box Camera, 10x12".
£12,100	93 07 08	Mamiya Pistol Camera.

STOLEN CAMERAS -----

Leitz Canada Leica 72, Black dial - Body: 357430 Elmar 5cm/3.5 No. 806594. Missing from London premises 8 Jul.93. Reward. Contact:

D.C.Trevor, Chelsea Police, London Tel:081-741-6212. Crime Ref:C1548.

Leica I (A) Elmar, No. 27701. Taken from a museum in France. Contact: J.P. Francesch, Police Inspector, Lyon, France Tel: 33-7860-1198.

The following cameras were all taken from the same location in Salt Lake City, Utah. Finding any of them may lead to others. For this reason, we are also including some lenses which may lead to recovery of other associated items. Contact Salt Lake City Police Department, 315 East 200 South, Salt Lake City UT 84111 USA. Tel: 1-801-799-3740.

Leica I (A), No. 3067

Leica I (A), No. 32572, gold plated. Leica I (A), No. 44497. Leica I (A), No. 58324.

No. 2607. Leica IIIc, grey, No. 387994. Luftwaffe model. Leica 250 (FF), No. 150068. Leica 250 (GG), No. 300025. f2.2 Thambar (Black), No. 90mm 226085. 90mm f4 Elmar, No. 556702. 105mm f6.3 Elmar (Black), No. 136497. Other Leica bodies taken from the same location: 70601 (I) (C) 111763 (III) F 122254 (III) F 133821 (IIIa) 149413 (E) 170085 (IIIa) 232955 (IIIa) 280642 (IIIb) 442107 (IIc) 466147 (IIIc) 486489 (IIIc) 523235 (lc)

Leica IIIa (G), No. 133821. Rare

Leica IIIb (G), No. 280642. Had motor

24x32mm format.

574779 (IIf) 575797 (If) 613035 (IIf) 559795 (IIIf) 711828 (IIf) 772350 (IIIf) 780257 (M3) 892466 (IIIg) 944951 (M2-X) 1005169 (M2, black) 1078708 (M3) 1222391 (Leicaflex SL)

To report stolen cameras, first report to your local authorities. Then send the following information to Centennial Photo Serivce: (address on page 2)

1. Camera name and serial number.

2. Value of camera.

3. Name, address, & telephone of local police to whom the theft has been reported.

4. Police report or file number.

5. We also suggest sending the same information to your local collector club and collector magazines.

ACCURAFLEX

ACCURAFLEX - c1950's. Twin lens reflex for 21/₄x21/₄" on 120 rollfilm. Accurar Anastigmat f3.5/80mm lens. Accurapid 1-300, B,ST sync shutter. Semi-automatic film transport. Original price was \$60 in 1957. Current value: \$75-100.

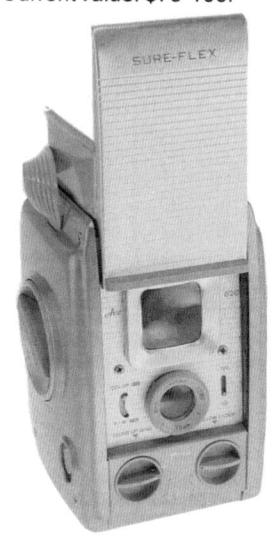

ACE CAMERA EQUIPS. PVT. LTD. (Bombay, India)

Sure-Flex - Twin-lens box camera based on the design of the Anscoflex II, but with the addition of two stops and two shutter speeds. We suspect that the dies were purchased from Ansco after they discontinued the Anscoflex II. \$35-50.

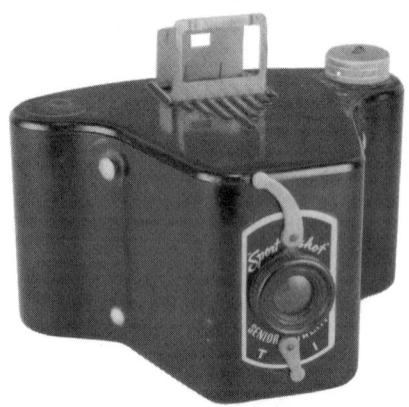

ACMA (Australasian Camera Manufacturers, Australia)
Sportshot Senior Twenty - c1938-39. Bakelite box camera, trapezoidal shape, for either 620 or 120 film. Lentar f13.3; sector shutter B&I(1/35). Made in green, brown, maroon, blue-grey, and black. Folding frame finder on top. Green: \$50-75. Other colors: \$30-45.

ACRO SCIENTIFIC PRODUCTS CO. (Chicago)

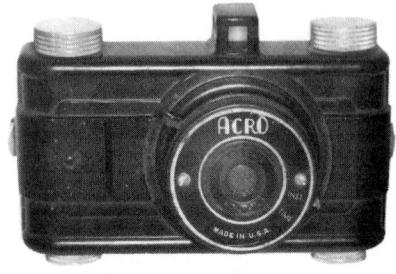

Acro - c1940. Brown bakelite minicam for 16 exposures on 127 rollfilm. Identical to Photo Master. \$12-20.

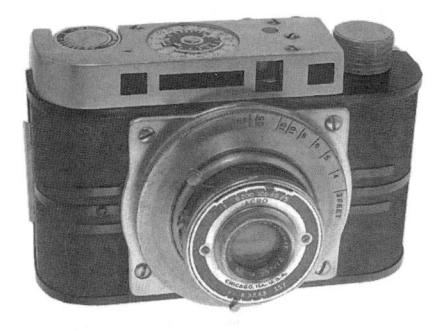

Acro Model R - Black plastic and metal camera for 16 exp. on 127 rollfilm. Built-in rangefinder & extinction meter. Styled similar to the Detrola. Wollensak f3.5 or Acro f4.5/2" lens in Alphax shutter. \$35-50.

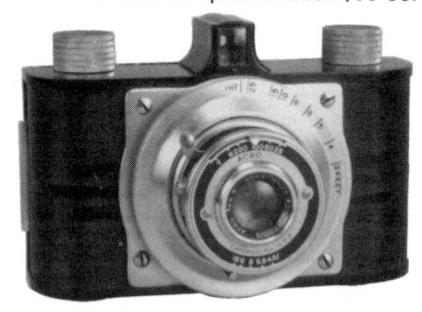

Acro Model V - Heavy black bakelite body for 16 exp. on 127 film. Metal back & telescoping front. Simple model without RF. Rigid optical finder. Similar to Detrola cameras. Helical focus; knob advance. Acro Anastigmat f4.5/2" in Acro 25-200,B,T shutter. \$25-35.

ADAMS & CO. (London) Adams made many important cameras not listed in this guide. In most cases, they were the most expensive of their kind, only sold direct, and all relatively uncommon. The only examples listed are items for which we have recent sales data.

Aidex - c1928. Folding single-lens reflex camera, in sizes for 21/2x31/2" or 31/4x41/4" plates. Self-capping FP shutter T,B, 3-1000. Ross Xpres f3.5 lens. \$400-600.

Challenge - c1892. Mahogany tailboard camera in all the common sizes. \$500-750.

Club - c1890's-1930's. Folding mahogany field camera for $61/_2$ x8 $1/_2$ ". Ross Symmetrical with wheel stops or Rapid Rectilinear lens with iris diaphragm are typical lenses. \$300-450.

De Luxe - c1898. A deluxe variation of the earlier Adams Hand Camera for $3^{1}/_{4}x^{4}$ plates. Spanish mahogany with sealskin covering. Double extension bellows; rack and pinion focusing. \$500-750.

Hand Camera - c1891-96. Leather covered hand camera with detachable 12-plate magazine. Rising, shifting front, double swing back. Ross Rapid Symmetrical f8 lens, Iris T,I shutter. Rare. 4x5": 400-550. 31/₄x41/₄": \$400-600.

Hat Detective Camera - c1892-96. Camera fits into a bowler-style hat. Bayonet mount Rapid Rectilinear f11 lens and T,I between-the-lens shutter are in the crown of the hat. 1/4-plate is secured in a strut folding mechanism inside the hat. Advertised as a "secret Camera that defies detection". Made from Jekeli & Horner's patent of the Chapeau Photographique; Adams had sole rights in Great Britain. Extremely rare. No known sales. Genuine: \$15.000-23.000.Fakes exist.

Ideal - c1892-95. Magazine box camera for 12 plates, $31/_4$ x $41/_4$ ". Falling-plate mechanism. Rapid Rectilinear f8/51/₂". Shutter 1-100. \$100-150.

Idento - c1905. Folding camera with side panels supporting the lensboard, similar to the Shew Xit. Ross Homocentric or Zeiss Protar f6.3/5" lens. Between-the-lens 1/2-100, T shutter. Leather covered. Made in 5 sizes 21/2x31/2" to 1/2-plate. \$300-450.

Minex - c1910-1950's. DeLuxe single lens reflex cameras similar to the Graflex. 21/2×31/2": \$250-375.31/4×41/4": \$200-300.

Minex Tropical - 21/2x31/2, 31/4x41/4, 4x5, 43/4x61/2" sizes. Beautifully construct ed and finished teakwood SLR with brass binding. One unusually fine and complete

matching outfit, with 9 dark slides, FPA, RFH, tropical Adams lenshood, etc. in exceptional condition brought \$10,000 at auction in January 1988. More typical price for camera and plateholders would be \$3500-5500.

Minex Tropical Stereoscopic Reflex - A stereo version of the Tropical Minex, with brown leather bellows & focusing hood. Ross Xpres f4.5 lenses. Estimate: \$7500-12,000.

Royal - c1890's. Compact folding field camera made in half-plate and 1/1-plate sizes. Very similar to the Club, but a less expensive and somewhat heavier model. \$120-180.

Vaido - c1930. Leather covered hand and stand camera. $1/_4$ - and $1/_2$ -plates sizes. Focal plane shutter 3-1000. \$500-750.

Vaido Tropical - c1930. Similar to the Vaido, but made of brass-bound polished teak. \$1700-2400.

Verto - c1930. Double extension folding plate camera. Ross Combinable lens, shutter 1-200,TB. Focusing scale is engraved for single or combined lenses. $31/_4$ x $41/_4$ ": \$250-375.2 $1/_4$ x $31/_4$ ": \$120-180.

Vesta - Folding bed and strut cameras. Ross Xpres f4.5 lens. Several versions:

Focal Plane Vesta - c1912. For 9x12cm plates. \$250-375. Vesta Model A - For 9x12cm plates. Basic model without FP shutter. \$90-130. Rollfilm Vesta - c1930's. Compound 1-200,T,B shutter. Takes 6.5x9cm plates and

Videx - 1903-1910. SLR. 31/₄x41/₄", 4x5", and less common 41/₄x61/₂". \$150-225.

6x9cm on 120 rollfilm. \$120-180.

Yale No. 1, No. 2 - c1895. Detective magazine camera for 12 plates 31/4x41/4".

Adams Patent Shutter 1/2-100. Focus by internal bellows. No. 1 has Rapid Rectilinear f8 lens, No. 2 has Cooke f6.5/5" lens. \$200-300.

Yale Stereo Detective No. 5 - c1902. Leather covered body. Zeiss 71/2" lenses. Internal bellows with rack focusing. Leather plate changing bag. \$600-900.

ADAMS & WESTLAKE CO. (Chicago)

Adlake Regular - c1897. Manual plate changing box camera. Looks like a magazine camera but is not. Holds 12 steel plateholders inside the top door compartment behind the plane of focus. Holders are manually inserted into a slot at the focal plane and the top door closed. A lever on the side (under handle) opens the front of the plateholder to prepare it for exposure. Made in 31/₄x41/₄" & 4x5" sizes. \$60-90.

Adlake Repeater - Falling-plate box camera, made in 31/₄x41/₄" and 4x5" sizes. Side crank advances 12 plates in succession. Fixed focus lens. \$50-75.

Adlake Special - c1897. Same as Adlake Regular, but with aluminum plate-holders rather than steel. Made only in 4x5" size. \$75-100.

ADINA - Folding 6x9cm rollfilm camera. f6.3/105mm Rodenstock Trinar lens in Adina or Compurshutter. \$15-25.

ADOX KAMERAWERK (Wiesbaden) Adox, Adox II, Adox III - c1936-50. 35mm cameras with extensible front. Made by Wirgin, styled like the Wirgin Edinex. \$35-50.

Adox 35 - c1955. 35mm viewfinder camera. Body style is similar to the DeJur D-1, but top housing is dissimilar. Film advance knob, not lever. Kataplast f2.8/45mmin Prontor-S. \$90-130.

Adox 66 - c1950. Bakelite box camera for 6x6cm on 120, \$20-30.

Adox 300 - c1958. The first German 35mm camera with interchangeable magazine backs. Large film advance & shutter cocking lever concentric with lens. Built-in meter. Synchro-Compur to 500. Steinheil Cassar or Schneider Xenar f2.8/45mm lens. Originally supplied with 3 magazines in 1957. \$175-250.

Film Magazine for Adox 300 - All Adox 300 magazines were made by Leitz. A few are marked "Ernst Leitz Wetzlar Germany". Those with Leitz marking bring at least double the normal price: \$35-50.

Adrette - c1939. 35mm camera with extensible front. Identical to the Wirgin Edinex. Front focus Steinheil Cassar f3.5/50mm, Schneider Radionar f2.9/50mm, or Xenon f2/50mm lens in Prontor, Prontor II, or Compur shutter. \$75-100.

Adrette II - c1939. Same as the Adrette, but with helical focus. Prontor II, Compur, or Compur Rapid shutter. \$75-100.

Blitz - c1950. Bakelite box camera for 6x6cm on 120 film. Styled like the Adox 66. f6.3/75mmlens. \$20-30.

Golf - c1950's. 6x6cm folding camera. Adoxar or Cassar f6.3 lens. Vario or Pronto shutter. Rangefinder model: \$50-75. Simple model without rangefinder: \$20-30.

Golf IA Rapid - c1963-65. Simple, boxy 35mm camera for rapid cassettes. Adoxon f2.8/45mmin Prontor to 125. \$1-10.

Golf IIA - c1964. Similar, but with built-in selenium meter above lens. Prontor-Matic shutter to 125. \$12-20.

Golf IIIA - c1960's. Radionar L f2.8/45mm in Prontor 500LK. Coupled light meter. \$12-20.

Juka - c1950. A postwar version of the

ADOX...

Junka-Werke "Junka" camera for 3x4cm on special rollfilm. Achromat f8/45mm lens. Single speed shutter. \$75-100.

Polomat - c1962. Rigid body 35mm camera with BIM. f2.8 lens. Pronto LK shutter 15-250. \$20-30.

Rollfilm camera - 1930s. 6x9cm folding rollfilm camera. Adoxar f4.5 or f6.3/105mmlens. \$20-30.

Sport - c1950. Folding dual-format roll-film cameras for 6x9 or 4.5x6cm on 120 film. Steinheil Cassar f6.3 or Radionar f4.5. Vario shutter. Optical or folding viewfinder models. Common. \$25-35.

Start - c1950. Folding rollfilm camera, similar to the Sport. Cassar f6.3/105mm lens in Vario shutter. \$20-30.

A.D.Y.C. (Argentina) Koinor 4x4 - Simple fixed-focus stamped metal camera for 120 film. Body release. Sync. \$30-45.

AERIAL CAMERA KE-28B - c1966. Gray, hand held aerial camera for 50 exp. 56x72mm on 70mm film. FP shutter ¹/₁₂₅-1000. Elcan f2.8/6" lens. Large, spring loaded sportsfinder. \$600-900.

AEROGARD CAN CAMERA - c1987. Camera is the standard 250ml can shape originated by the Coke can camera for 110

cartridge film. This one advertises Aerogard Personal Insect Repellent, which we assume must come in a spray can. Blue can with white label. Made in Taiwan. The few examples of this camera that we have seen came from Australia. \$45-60.

AFIOM (Italy) Kristall - c1955. Leica copy. Elionar f3.5/5cm lens. \$250-375.

Wega II, IIa - c1950. Leica copies which accept Leica screw mount lenses. CRF. Synchronized FP shutter to 1000. Trixar f3.5/50mm.\$300-450.

AGFA (Munich) Originally established in 1867. "Actien Gesellschaft für Anilin Fabrikation" was formed in 1873. AGFA is an abbreviation from the original name. Agfa purchased Rietzschel's factory (Munich) in 1925, from which time the Rietzschel name was no longer used on cameras and the first "Agfa" cameras were produced. Agfa's USA operations joined forces with Ansco in 1928 to form Agfa-Ansco, which eventually became GAF. Agfa also continued operations in Germany both in the production of in Germany both in the production of cameras and films, with the Munich, Leverkusen, and Wolfen factories in operation before WWII and resuming production in the summer of 1945. (The Wolfen factory continued operations under the name ORWO for ORiginal WOlfen. It still exists for the summer of th after the reunification of Germany.) In 1952, Agfa founded "Agfa AG für Photofabrikation" in Leverkusen and "Agfa Camera-Werk AG" in Munich. These merged in 1957 to become Arfa AC which to become Agfa AG, which soon acquired Perutz Photowerke, Leonar-Werke, Mimosa, and others before merging with Gevaert of Belgium in 1964. Some cameras made by Agfa are to be found under the "AGFA-ANSCO" or "ANSCO" headings, as they were marketed by these firms.

Agfaflex - c1959-63. 35mm SLR cameras with built-in meter. Prontor Reflex 1-300 shutter.

Agfaflex I - Non-interchangeable Color Apotar f2.8/50mm lens. Interchangeable waist-level finder. \$75-100.

waist-level finder. \$75-100. **Agfaflex II -** Similar, but with interchangeablepentaprism. \$75-100.

Agfaflex III - Interchangeable Color Solinar f2.8/50mm lens. Interchangeable waist-level finder. Coupled meter. \$75-100.

Agfaflex IV - Similar to the Agfaflex III,

but with interchangeable pentaprism. \$100-150.

Agfaflex V - Interchangeable Color Solagon f2/55mm lens. Interchangeable pentaprism. \$90-130.

Agfaflex lenses - Color-Ambion f3.4/35mm, Color-Telinear f3.4/90mm, or f4/135mm: \$35-50.

Finders for Agfaflex:

Waist-level: \$12-20. Prism finder: \$35-50.

Agfamatic 200 sensor - c1972. 126 cartridge camera with lever wind, flash-cube socket on top. \$1-10.

Agfamatic 901 motor - 1979-81. Motorized 110 cartridge camera. In olive green with "Wehrbereichsverwaltung VI" markings: \$120-180. Version with "CDU" markings: \$120-180. Normal model: \$20-30.

Agfamatic 2000 pocket - c1974. Simple 110 cartridge camera. \$1-10B.

Agfamatic 2008 tele pocket -c1976. 110 cartridge camera with Color-Agnar f11/26mm lens switchable to 43mm telephoto. \$12-20.

Agfamatic 3008 pocket - c1976. 110 cartridge camera with 4 weather symbols for setting the lens/shutter. \$1-10.

Ambi-Silette - c1957-61. 35mm range-finder camera. Synchro-Compur to 500. With normal Color-Solinar f2.8/50mm: \$75-100.

Ambi-Silette lenses: 35mm f4 Color-Ambion - \$45-60. 50mm f2.8 Color-Solinar - \$20-30. 90mm f4 Color-Telinear - \$50-75. 130mm f4 Color-Telinear - \$50-75. Proximeter II - \$25-35.

Ambiflex - c1959-63. Models I-III. SLR cameras with coupled meters. Prontor Reflex 1-300 shutter. Identical to the following Agfaflex models: Ambiflex I = Agfaflex III; Ambiflex II = Agfaflex IV; Ambiflex III = Agfaflex V. Models II and III: \$100-150. Model I: \$75-100.

Ambiflex / Agfaflex lenses: 35mm f3.4 Color-Ambion - \$90-130. 90mm f3.4 Color-Telinear - \$75-100. 135mm f4 Color-Telinear - \$75-100. Prism finder - \$35-50.

Automatic 66 - c1956. Horizontally styled folding camera for 6x6cm on 120. CRF. Fully automatic metering with manual override. Color Solinar f3.5/75mm in Prontor-SL shutter. Helical focusing. We have heard of sales and offers at all imaginable prices from \$15,000 to \$1,500. \$500-750.

Autostar X-126 - 1976-80. Simple 126 cartridge camera. \$1-10.

AGFA

Billette - c1931-33. Folding rollfilm camera, like the Billy II, but with f4.5 lens and rim-Compurshutter. \$35-50.

Billy - A series of folding rollfilm cameras produced from 1928-1960.

Billy - c1928-30. Renamed Billy I in 1931. Folding rollfilm camera with square ends. Igetar f8.8 lens in Automat shutter 1/25-100. Lens name changed to Igestar in 1930. Exported to the USA and England under the name Speedex. \$25-35.

Billy 0 - c1932-37. Vertical folding rollfilm camera for 4x6.5cm on A-8 (127) film. Igestar f5.6/75mm in Pronto or Solinar f3.9/75mmin rim-Compur. \$100-150.

Billy I, prewar - c1931-33. Same basic camera as the original Billy, but the lens in now called Igestar. Exported to the USA and England as the No. 1 Speedex. Black or colored imitation leather. \$25-35.

Billy I, postwar - c1950-57. Re-styled folding rollfilm camera. Agnar f6.3 lens in synched shutter. Two versions: c1950 has eye-level frame finder on right side of body (probably using pre-war bodies). Vario 1/25-

200,B. c1952 has optical eye-level finder on right side of body. Pronto $^{1}/_{25}$ -200,B. \$20-30

Billy I Luxus - c1931. Igestar f8.8/100 in Billy Automat 25-100 shutter. Aluminum rims. Black, blue, or grey covering. \$120-80.

Billy II - c1931-33. Folding rollfilm camera with rounded body ends and other minor differences from the Billy I. Igestar f7.7 lens. Sold in the USA and England as the No. 2 Speedex. \$25-35.

Billy III - c1932-34. Similar to the Billy II, but improved strut design, etc. Igestar f5.6 in Pronto, or Oppar or Solinar f4.5 in rim-Compur. \$30-45.

Billy-Clack - c1934-42. Strut-type folding 120 rollfilm cameras similar in appearance to the Jiffy Kodak cameras. Two sizes: one takes 16 exp. 4.5x6cm; the other takes 6x9cm. Exported to the USA and England as the Speedex Clack. 4.5x6cm: \$30-45.6x9cm: \$20-30.

Billy Compur - c1934-42 and 1948-49. With Compur shutter and f4.5 or f3.9 Solinar or f4.5 Apotar. Body style like the Billy Record f4.5, recognizable by relatively flat, low struts which unlock by pinching small disks under the shutter. Sold in England and the USA under the names Speedex 21/4x31/4" or Speedex Compur. \$35-50.

Billy Optima - c1932-40. 7.5x10.5cm. Solinar f4.5/120mm in Compur 1-250 or Igestar f6.3/130 in Pronto. \$75-100.

Billy Record Cameras - Billy Record cameras were listed in catalogs by lens

openings as models 8.8, 7.7, 6.3, and 4.5. The names are based on the maximum lens opening. The basic body is the same for the 8.8, 7.7, and 6.3 models. The f4.5 model uses the body style of the Billy Compur.

Billy Record 8.8, 7.7, 6.3 - c1933-42+. Folding rollfilm cameras with ribbed leatherette covering. Available with Igestar f8.8, f7.7, f6.3 lens in Automat shutter 1/25-100. The 6.3 model was also available in 1948 and the 7.7 model in 1949, probably using prewar inventory or parts. Sold in England and the USA as the Speedex Record. \$20-30.

Billy Record 4.5 - c1938-50. Folding rollfilm camera, like the Billy Compur but without Compur shutter. Body style like Billy Compur, recognizable by low, relatively straight struts with strut-release disks near front of bed below shutter. Apotar f4.5 in Prontor II 1-150 (prewar) or Prontor-S 1-300 X shutter (postwar). Eye-level frame finder on right side of body. \$20-30.

Billy Record 1 - c1950-52. Self-erecting folding rollfilm camera. New postwar design with hinged struts. Optical eye-level finder and accessory shoe on right side of body. No waist-level finder. Radionar or Agnar f4.5/105mm lens in Pronto 1/25-200,B shutter. Exported to the USA and England as the Ventura 69. \$20-30.

Billy Record II - c1950-52. Similar to the Billy Record I, but better lens and shutter, and reflex brilliant finder in addition to the optical eye-level finder. Apotar f4.5 in Prontor-S 1-250,B or Solinar f4.5 in Compur-Rapid 1-400,B. The latter type was the replacement for the Billy Compur. Exported as the Ventura 69 Deluxe. \$20-30.

Box cameras - c1930's-1950's. Misc. sizes, styles including 45, 50, and 94. Basically, these are leatherette covered metal or cardboard box cameras with simple lens and shutter. See also Box 24, Box 44, and Box-Spezial all under the Agfa heading. \$8-15. *Earlier models in prime condition bring a bit more.*

Box 24 - c1933-35. Box camera similar to the Schul-Prämie but in black. No metal viewer rim. \$25-35.

Box 44 - c1932-36. Box camera for 6x9cm on 120 film. Leatherette covering on cardboard body and metal front plate. \$25-35.

AGFA...

Box 54 - c1930-33. Box camera for 6x9cm on 120 film. Red Agfa diamond on front. \$25-35.

Box B-2 - c1937. Cardboard box camera with art-deco metal front plate. \$15-25.

Box-Spezial (Nr 64) - c1930-35. Aluminum 6X9cm box camera. Simple lens and shutter with a 3-point distance scale for "portrait", "group" or "distance" settings. Agfa diamond trademark on front. \$12-20.

Clack - c1954-65. Metal eye-level box

camera with reptile-grained covering. Takes 6x9cm on 120 film. Common. \$8-15

Click (rapid cassette) - Boxy camera resembling 126 instant-load type, but for the Agfa rapid cassette system. Imitation meter cell on front. Made in Spain by Certex S.A. \$1-10.

Click I - c1958-70. Simple plastic eyelevel box camera for 6x6cm on 120 film. Meniscus lens, single speed shutter. Common. \$1-10.

Click II - c1959-70. Similar to Click I, but with zone-focusing f8.8 Achromat. Common. \$1-10.

Colorflex I, II - c1959-63. 35mm SLR cameras. (Sold as Agfaflex I and II in the U.S.A.) \$75-100.

Flexilette - c1960-61. 35mm TLR. Color Apotar f2.8/45mm in Prontor 1-500. Unusual design has viewing lens above taking lens in a round front panel. \$100-150.

Folding Plate cameras - 6x9cm with f4.5/105 and 9x12cm with f4.5/135mm Double Anastigmat or Solinar lenses. Compur shutters. 9x12cm: \$35-50. 6x9cm: \$30-45.

Folding Rollfilm cameras - Common models for 116 and 120 films. \$12-20.

Isobox - 1934. Simple metal box camera taking 6x9cm on 120 rollfilm. \$30-45.

Iso Rapid I, IF, IC - c1965-70's. Compact cameras resembling the 126 cartridge type, but for Rapid 35mm cassettes. I has hot shoe. IF has AG-1 flash. IC has flash-cube socket. \$1-10.

Isoflash Rapid - c1965. Similar to the Iso Rapid IF. \$1-10.

Isoflash Rapid C - Similar to the Isoflash Rapid, but uses flashcubes. \$1-10.

Isola - c1956. Renamed Isola II in 1957. Simple eye-level camera for 6x6cm on 120

film. Telescoping front. Agnar f6.3 lens in Singlo shutter. \$1-10.

Isola I - c1957-63. Similar, but with Meniscus lens in single speed shutter. "Agfa Isola I" on shutter face. \$1-10.

Isola II - c1956-63. 2¹/₄x2¹/₄". Agnar f6.3/75mm in Singlo 2 shutter B,30,100. \$1-10.

Isolar - c1927-35. 9x12cm double extension folding plate camera. Solinear f4.5/135mm in Dial Compur to 200 (1927-31). Solinar in Rim Compur (1931-35). Metal body. \$45-60.

Isolar Luxus - c1927-30. Deluxe version of above with brown bellows and brown leather covering. Unusual. \$175-250.

Isolette - A series of horizontal folding rollfilm cameras for dual format 6x6cm & 4.5x6cm on 120 film. After 1946, for 6x6cm format only.

Isolette, original model - 1938-42. Originally introduced as the Isorette, the name was changed to Isolette during 1938. Top housing is black plastic, instead of chrome like on all the models after 1949. Igestar f6.3 in Vario or Pronto, Apotar f4.5 in Prontor II or Compur, or Solinar f4.5 in Compur Rapid. \$20-30.

Isolette 4.5 - c1946-50. Top housing made of aluminum. Apotar f4.5 in Prontor II or compur Rapid; Solinar in Compur Rapid. \$20-30.

Isolette I - c1952-60. f4.5 Agnar in Vario or Pronto. \$15-25.

Isolette II - c1950-60. f4.5 Agnar, Apotar or f3.5 Solinar in Vario, Pronto, Prontor-S, Prontor-SV, Compur Rapid, Synchro-Compur. With f3.5: \$35-50. With f4.5: \$20-30.

isolette III - c1952-58. Non-coupled rangefinder. f4.5 Apotar in Prontor SV or f3.5 or f4.5 Solinar in Prontor SV or Synchro-Compur. With f3.5: \$60-90. With f4.5: \$25-35.

Isolette V - c1950-52. Similar to Isolette I; no body release. Agnar f4.5/85mm in Vario or Pronto. \$20-30.

Isolette L - 1957-60. Last model in the Isolette series. Specially designed for color slides or photos. Takes 12 exp. 6x6cm or 24 exp. 24x36mm. Uncoupled BIM. Color Apotar f4.5/85mm in Pronto. \$75-100.

- **Super Isolette** - c1954-57. Folding camera for 6x6cm on 120 film. Coupled rangefinder. Solinar f3.5/75mm. Synchro-Compur MXV shutter to 500. Not often seen. \$175-250.

Isoly - c1960-67. Inexpensive plastic eyelevel cameras for 16 exposures 4x4cm on 120 film. Models include:

Isoly Junior - Single speed shutter; 2 stops. \$1-10.

Isoly (I) - Achromat f8 in B.30-100 shutter. \$1-10.

Isoly II - Agnar f6.3/55mm in Singlo 30-100,B. \$1-10.

Isoly IIa - Color-Agnarf5.6. \$8-15. Isoly III - Color Apotar f3.9/60mm in Prontor 30-250, B. \$8-15.

isoly IIIa - Color Agnar f3.5/60mm in Prontor 250. \$12-20.

isoly-Mat - c1961. Like Isoly, but with built-in automatic meter with selenium cell below lens. Color Agnar f5.6/55mm. \$1-10.

Isomat-Rapid - c1965-69. 35mm electric eye camera. 24x24mm exposures on Agfa Rapid film. \$20-30.

Isorette - c1938. Horizontally styled folding-bed camera for 6x6cm on 120 film. Models include: Igestar f6.3/85mm in Vario or Pronto; Apotar f4.5 in Prontor II or Compur; Solinar f4.5 in Compur Rapid. This camera continued as the Isolette. \$30-45.

Karat - A long-lived series of cameras for 24x36mm exp. on 35mm film in Karatcassettes, the original design which eventually led to the international standard "Rapid Cassette" system. The pre-WWII models, officially named by their lens aperture, all have the same body style with tapered ends and with the viewfinder protruding from the slightly rounded top. **Karat 6.3 -** 1937-38: Art-deco front.

Igestar f6.3/5cm in Automat shutter, 1939-40: White front; Igestar f6.3/5.5cm in automat. \$35-50.

Karat 3.5 - 1938-41. Solinar f3.5/5.5cm in Compur or Compur Rapid shutter. \$35-50

Karat 4.5 - 1939-50. Oppar f4.5 in Pronto shutter. \$25-35.

Karat 2.8 - 1941. This model with CRF has the body style of the postwar models, being almost identical to the Karat 12 except for the lack of an accessory shoe. Xenar f2.8 in Compur or Compur Rapid shutter. Probably not many were made because of the war. \$60-90.

Karat - Postwar models with CRF have a new body style with beveled ends; viewfinder incorporated with rangefinder in the top housing. **Karat 12 -** 1948-50. Solinar f3.5 or

Xenar f2.8 lens in Compur-Rapid shutter (1948). Apotar f3.5 in Prontor-S or Prontor ÌI (1948-1950).\$50-75.

Karat 36 - (also called Karomat 36) 1949-52. Xenar f2.8 in Compur Rapid or Xenon f2 in Synchro-Compur (1949). Xenon or Heligon f2 in Synchro-Compur (1950). Solinar or Solagon f2.8 in Synchro-Compur (1952). With f2: \$60-90. With f2.8: \$35-50.

Karat IV - 1950-56. Identifiable by the equally sized and spaced finder windows on the front. Solinar f2.8 (1950). Solagon f2 (1955-1956). Also available with Xenon f2. Prontor SV or SVS. With f2 lens: \$75-100. f2.8: \$60-90.

Proximeter or Proximeter II for Karat - \$15-25.

Karomat - c1951. Also called Karat 36. f2.8 Xenar or f2 Xenon in Compur Rapid. \$75-100.

Moto-Rapid C - 1965-69. Spring-motor driven camera for 24x24mm on Agfa-Rapid 35mm cassette film. Color Isomar f8 in Parator shutter. \$25-35.

Motor-Kamera - c1962. Unusual 35mm camera for remote control use. Agfa Color Telinear f3.4/90mm. Large electric motor built on to front of camera and externally coupled to the advance knob. (A rather clumsy arrangement when compared with modern mass-marketed autowinders.) \$350-500.

Nitor - 1927-30. 6x9cm on plates, pack. or rollfilm. Helostar f6.3/Pronto or Linear f4.5/Compurto 250. \$35-50.

Opal Luxus - c1925-26. Folding bed camera for 6.5x9cm plates. Brief continuation of the former Rietzschel model, but with Agfa rhombus on base of front standard. Double extension brown bellows. Brown leather covering, Rietzschel Solinear f4.5/105mm in Compur. Rare. \$200-300

Optima - A series of 35mm cameras. Original model - 1959-63. Left-hand exposure setting lever which must be held down while pressing the top-mounted shutter release. Color Apotar f3.9 in Compur. Claimed to be the first fully automatic 35mm camera in the world. \$35-

Optima I - 1960-64. Color Agnar f2.8/45mm in Prontorlux. Right-hand release. \$20-30.

Optima IA - c1962. Advance lever on top; removable back. \$20-30.

Optima II - 1960-64. \$25-35.

Optima IIS - 1961-66. Like the II, but with CRF. \$25-35.

Optima III - 1960. Built-in meter. \$25-35. Optima IIIS - 1960. Built-in meter & CRF. \$35-50.

Optima 500 Sensor - c1967-74. Compact 35mm camera with CdS meter. Color-Apotar f2.8/42mm lens in Paratic 1/30-500, B. Available in all black and black/chrome. \$15-25.

Optima Parat - c1964-72. Metered halfframe 35mm camera. Color Solinar f2.8/30mm in Compurto 500. \$50-75.

Color Telepar f2.8/55mm lens attachment: \$20-30.

Optima Rapid 125C - c1962. Simple camera for 16 exposures 24x24mm with Agfa-Rapid cassettes. Fully automatic exposures controlled by selenium meter. Color-Apotar f2.8/35mm in Paratic shutter. \$1-10.

Optima Reflex - c1962-66.35mm TLR with eye-level pentaprism, automatic exposure metering, matched Color Apotar f2.8/45mm lenses. An unusual design, and not commonly found. \$150-225.

Paramat - c1963. Like the Parat but with meter. \$30-45.

Parat, Parat I - c1963. Half-frame

AGFA...

(18x24mm). Color Apotar f2.8/30mm. \$35-50

Preis-Box - c1932. Box camera which originally sold for 4 marks. Meniscus lens, simple shutter. Renamed as Box Nr 44 from 1933-36. Blue: \$100-150. Black: \$12-20. (A timed shutter release was made by Cenei for the Preis-Box. One recorded sale at \$88.)

Record I - c1952-54. Folding-bed rollfilm camera with self-erecting front. This is a continuation of the Billy Record I camera. Accesory shoe mounted on top of the chrome housing that integrates the view-finder and knobs. Agnar f6.3 or f4.5 in Pronto. \$20-30.

Record II - c1952-57. Similar to the Record I. Agnar or Apotar f4.5 in Pronto; Apotar f4.5 in Prontor S or SV; Solinar in Synchro-Compur.\$25-35.

Record III - c1952-55. Similar to the Record II, but with uncoupled RF. Apotar f4.5 in Prontor SV or Solinar f4.5 in Synchro-Compur.\$100-150.

Registrier-Kamera - c1950's. 35mm camera with 24v electric motor drive and remote release. Fitted with Color Ambinon f4/35, Color-Solagon f2/55mm, or Color Solinar f2.8/50mm. One with "Bundeswehr" engraving sold at auction for just over \$1000. Normal price range \$300-450.

Schul-Prämie Box - c1932. Originally given out in Germany as a school premium to the best in the class, which accounts for

the inscribed title. A blue box for 6x9cm rollfilm, made from cardboard with metal front and back. \$60-90.

Selecta - c1962-66. 35mm rangefinder camera. Automatic metering. Color Apotar f2.8/45. Prontor-Matic P shutter. \$35-50.

Selecta-Flex - c1963-67. Pentaprism 35mm SLR. Auto or manual exposure. Prontor Reflex P shutter, 30-300. Interchangeable f2.8 Solinar or f2 Solagon. Often seen with slow speeds hung up. \$90-130

Selecta-Flex Lenses:

35mm f3.4 Color Ambion: \$45-60. 90mm f3.4 Color Telinear: \$45-60. 135mm f4.0 Color Telinear: \$35-50. 180mm f4.5 Color Telinear: \$50-75.

Selecta-M - c1962-65. Fully automatic motor camera for 24x36mm. Shutter regulated by BIM. Solinar f2.8/45mm in Compur30-500. \$120-180.

Selectronic S Sensor - c1971-74. 35mm with CRF, electronic shutter, Color Solinar f2.8/45mm lens. \$20-30.

Silette - A series of 35mm cameras introduced in 1953 and ranging from the simple viewfinder model to the metered rangefinder models. Common.

Silette (I) - \$12-20. Silette II - \$12-20. Silette F - 12-18. Silette L - \$20-30. Silette LK - \$25-35. Silette SL - \$30-45. Silette SLE - \$25-35. Super Silette - \$30-45.

Super Silette L - \$35-50. **Super Silette LK -** \$45-60. Proximeter for Super Silette - \$1-10.

Silette Automatic - c1958-60. 35mm with built-in meter, rapid film advance lever, Prontor SLK 1-300 shutter, Color-Solinar f2.8/50mm. \$15-25.

Silette Rapid - c1965. Similar to the normal Silette but for 12 exp 24x36mm on rapid cassettes. All have Color Agnar f2.8/45mmlens.

Silette Rapid I - Prontor 30-125 shutter. \$8-15.

Silette Rapid F - Parator 30-250 shutter. \$1-10.

Silette Rapid L - Prontor 30-250 shutter. Uncoupled exposure meter. \$12-20.

Solina - c1960-62. Simple 35mm camera with large viewfinder window centered above the lens. Color-Apotar f3.5/45mm in Pronto 1/25-200, B. Lever advance. \$30-45.

- **Super Solina** - c1960-62. 35mm CRF. Color-Apotar f2.8/45mm in Prontor SVS 1-500,B. \$20-30.

Solinette, Solinette II - c1952-55. Folding 35mm cameras. Solinar or Apotar f3.5/50 in Prontor-SVS or Synchro-Compur. \$35-50.

- **Super Solinette** - c1953-57. Similar but with CRF. \$50-75.

Solinette (non-folding) - c1958. An inexpensive basic viewfinder 35. Same body style as the 1958 Silette. Advance lever incorporated into top housing. Color Apotar f3.5/45mm in Prontor SVS shutter. \$20-30

Speedex 21/_ax31/_a" - c1933-36. Selferecting folding rollfilm camera, sometimes referred to as the Speedex Compur. f4.5 Anastigmat in Compur. This was the export version of the Billy Compur. \$30-45.

Speedex 0 - c1935-38. Vertical style vest pocket folding bed camera taking 4x6.5cm on 127 film. Solinar f3.9 lens in Compur. Leather covered with chrome and enamel side panels. This is the export version of the Billy 0. \$75-100.

Speedex No. 1 - c1928-33. See also ANSCO Speedex No. 1, an entirely different folding rollfilm camera made in USA. Export version of the Billy I for England. Square cornered body. \$30-45.

Speedex No. 2 - c1930-33. Export version of the Billy II. Rounded ends on body. \$25-35.

Standard, plate models - c1926-33. Various f4.5 or f6.3 lenses in Automat or Compur shutter. 6.5x9cm: \$50-75. 9x12cm: \$35-50.

Standard, deluxe plate models -Brown leather covering and brown bellows. Original price was only about 10% higher than standard plate model. Currently: \$150-225.

Standard, rollfilm models - c1926-33. Various lenses and shutters. 6.5x11cm: \$35-50. 6x9cm: \$30-45.

Standard, deluxe rollfilm model - 6.5x11cm. Brown leather covering and brown bellows. Uncommon. \$120-180.

Superior (black) - 1930-32. Vertically styled folding rollfilm camera for 8x14cm. Trilinear f6.3 or Solinar f4.5 in Compur. \$35-50.

Superior (brown) - 1930-32. A deluxe folding camera for 8x14cm "postcard size" photos. Reddish-brown leather, brown bellows. Trilinear f6.3 or Solinear f4.8 in Compur. \$175-250.

Synchro-Box - c1951-58. Metal box camera for 6x9cm on 120 film. Plastic covering and art-deco front. \$1-10.

Synchro-Box (Made in India) - c1950. Unusual variant of Synchro Box; made by New India Industries Ltd, Baroda, India. Rare. One sale in 1985 for about \$150, and an auction sale in 9/90 for about \$200. These prices brought a few more "out of the woodwork". \$175-250.

Trolita - c1938-40. Folding bed, self-erecting rollfilm camera for 6x9cm or 6x6cm on 120 film. Made of "Trolit" plastic (similar to bakelite). Leather bellows. Apotar f4.5/105mm. Prontor II shutter. \$150-225.

Trolix - c1936-40. Nicely styled box camera made of "Trolit" plastic, similar to bakelite. Takes 6x9cm photos on Agfa B2 (120) film. Half price when cracked or chipped. Perfect condition: \$50-75.

Ventura 66 - c1950. Among the first postwar products of Agfa Camerawerk. Horizontal style folding camera for 6x6cm

AGFA ANSCO

on 120. Export version of the Isolette V. Agnar f4.5 in synchronized Vario to 200. \$20-30.

Ventura 66 Deluxe - c1950. Similar to the regular 66, but with Apotar f4.5 in Prontor-S or Solinar f4.5 in Compur-Rapid. Double exposure prevention. Export version of the Isolette II. \$20-30.

Ventura 69 - c1950. Vertically styled folding rollfilm camera for 6x9cm on 120 film. Export version of the Billy Record I. Agnar f4.5 or f6.3 in Vario or Prontor-S. \$20-30.

Ventura 69 Deluxe - c1950. Vertical folding rollfilm camera, similar to the Ventura 69, but with double exposure prevention. Solinar f4.5 in Compur. Export version of the Billy Record II. \$25-35.

AGFA ANSCO CORPORATION (Binghamton, NY) Formed in 1928 by

the USA operations of Agfa and the well established Ansco company. This venture combined not only the prestige of the two names, but also resulted in some cameras which incorporated ideas and patents of the two companies. Some export models of cameras made by Agfa in Germany, and all USA-made Ansco cameras were marketed under the Agfa Ansco label. In 1939, the company name was changed to General Aniline & Film Corporation. The Agfa Ansco label continued to be used until 1943 when the Agfa name was dropped and "Ansco" continued alone. To oversimplify, Ansco became "Agfa Ansco" from about 1928-1943. We are listing here the cameras which were produced or marketed solely or primarily under the Agfa Ansco name. Some of these cameras may also exist under the Ansco name alone.

Agfa-Ansco Box - Simple cardboard box cameras with colored exterior covering and metal front and back. Made in No. 2 and 2A sizes in various colors. \$30-45.

Cadet A-8 - c1937. Made by Agfa-Ansco in the USA. Simple box camera for 4x6.5cm on A-8 (127) rollfilm. Uncommon. \$35-50.

Cadet B-2 - c1939. Made by Agfa-Ansco in Binghamton, New York. After 1943, sold under the Ansco Cadet name. Metal and cardboard box camera. \$1-10.

AGFA-ANSCO...

Cadet B-2 Texas Centennial - c1936. Special comemmorative version of the B-2 Cadet box camera made for the hundredth anniversary of the state of Texas. Single star above the lens for the "Lone Star" state. Very uncommon. \$300-450.

Cadet D-6 - c1935-41. Like the Cadet B-2, but 21/2x41/4" on D-6 (116) rollfilm. \$1-10.

Captain - Made by Agfa-Ansco in USA. 6x9cm folding camera. Captain lens in Agfa T,I shutter. \$20-30.

Chief - c1940. Metal eye-level box camera. Similar to the Pioneer, but with zone focus and built-in finder. \$1-10.

Clipper PD-16 - c1938. Metal bodied camera with extensible rectangular front section. Takes 16 exp. on 616 film. Single speed shutter & meniscus lens. Made by Agfa-Anscoin U.S.A. \$1-10.

Clipper Special - c1939. Like the Clipper, but with f6.3 Anastigmat and 25-100 shutter. Optical finder. \$1-10.

Major - Folding bed camera for 6x9cm exp. on 120 film. Made in the U.S.A. by Agfa-Ansco.\$12-20.

Memo (full frame) - c1939. Horizontally styled folding bed camera for 24x36mm exposures on 35mm Agfa Karat cassettes. Rapid advance lever on back. Made by Agfa-Ansco in the U.S.A. Agfa Memar f3.5, 4.5, or 5.6 lens. \$50-75.

Memo (half-frame) - Similar to the above, this single-frame (18x24mm) model was added in 1940. \$60-90.

PD-16 - This was Agfa-Ansco's number for the same size film as Kodak 116. Several cameras use this number in their name, but they are listed by their key word (Clipper, Plenax, etc.)

Pioneer - c1940. Metal & plastic eyelevel box camera with tapered ends in both PD-16 and PB-20 sizes. Made in the USA by Agfa-Ansco. After 1943, sold as "Ansco" Pioneer. Very common. \$12-20.

Plenax - c1935. Folding rollfilm cameras made by Agfa-Ansco in the U.S.A. Models PD-16 & PB-20. Antar, Tripar, or Hypar lens. \$1-10.

Readyset Traveler - c1931. Folding cameras in #1 & 1A sizes (for 120 & 116 film). These are covered in canvas with colored stripes. Four different colored stripings were available. A matching canvas case was an optional accessory. \$50-75.

Shur-Flash - Basic box camera with flash. \$1-10.

Shur-Shot Regular - c1935-41. Made in USA by Agfa-Ansco. Common box cameras, made in B2 (120) and D6 (116) sizes. Hinged masks at focal plane allow full or half-frame images. Earlier type, c1935, has black faceplate with rectangular art-deco design. Intermediate type, c1938, has dark face, light vertical band and concentric circle around lens. Later type, c1940, has light faceplate with Agfa rhombus below lens. \$1-10.

Shur-Shot Special - c1935-41. Same as Shur-Shot Regular, but with built-in closeup lens. Early type, c1935 has black art-deco faceplate has vertical band of 30 narrow stripes, flanked by three stars on each side of lens. Later, c1939, has light face with U-shaped band of 6 thin black stripes. \$1-10.

Speedex B2 6x6cm - c1940. Horizontally styled rollfilm camera made in USA. f4.5 Anastigmat in 1/2-250 shutter. \$12-20.

Speedex Jr. - c1940. Similar to the Speedex B2, but with fixed-focus lens in T&I shutter. \$1-10.

Tripar PB-20 - c1935. Self-erecting camera for 8 or 16 exposures on PB-20 (620) film. A lens variant of the Plenax camera, but also with a more intricate art-deco pattern on the sides. Focusing Tripar f11 lens in T,B,25-100 shutter. Marked "Agfa", but made by Agfa-Ansco in U.S.A. \$20-30.

View cameras - Various models in $31/4 \times 41/4$ " to 5×7 " sizes. As collectible cameras, these do not create as much interest as they do for studio use. Collector value \$90-130 with shutter and lens. If the camera has full movements, it is a usable item for commercial photographers and will fetch \$100-250 without lens or shutter.

AIRES

Viking - c1940. Folding cameras for 120 or 116 rollfilms. f6.3 or 7.7 lens. The body design and fabrication are Ansco; the Trolitan covering is an Agfa invention. \$12-20.

AGILUX LTD. (Croydon, England) A subsidiary of Aeronautical & General Instruments, Ltd., from which the AGI names originate. Founded in 1936 to make military cameras. Added amateur cameras from about 1954-65, but subsequently withdrew from the amateur market to concentrate on military & industrial aerial cameras.

Agiflash - c1954-58. Streamlined, leatherette covered black bakelite camera for 8 exp, 4x6.5cm on 127 film. Socket on top next to VF for #5 flashbulb. Removable bakelite plug marked "Flash" covers socket when not in use. \$12-20.

Agiflash 35 - Simple boxy grey plastic 35mm camera, same as the Ilford Sprite 35. Fix-focus f8 lens. Single speed shutter. Double exposure prevention. \$12-20.

Agiflash 44 - c1959-64. Plastic camera for 127 film. Aluminum top housing with eye-level finder and recessed socket for flashbulbs. Body originally was black, two-tone grey version after 1960. \$12-20.

Agiflex - c1947. Agilux originally made a handheld aerial camera called the ARL for the Royal Navy during WWII. It had no reflex viewing, but was based on the body design of the Reflex Korelle. The postwar civilian models included reflex viewing, and were named Agiflex. All have focal plane shutter.

I - 1946. f3.5 lens. Speeds 25-500, no slow speeds, no sync. Smaller bayonet will not accept most tele lenses. \$75-100.

II - 1949. Speeds 2 sec - 500, sync. Standard lens f3.5. Larger bayonet accepts all lenses. \$120-180.

III - 1954. Restyled version. Standard lens is f2.8 preset. Speeds 2 sec-500. Coax 3mm sync socket. \$175-250.

Agifold (rangefinder model) - c1955. 6x6cm folding camera with built-in uncoupled rangefinder and extinction meter. Agilux anastigmat f4.5/75mm. \$45-60.

Agima - c1960. Interchangeable lens 35mm CRF camera. Finder has 35mm, 45mm, and 90mm frames. Normal lens is four-element Anastigmat f2.8/45mm. Unusual single stroke combined shutter release and advance lever around right

side of lens. Uncommon in U.S., but not difficult to find in England. \$75-100.

Agimatic - c1956. Rigid body 35mm with uncoupled RF and BIM. Agilux f2.8/45mm in Agimatic 1-300, B. \$45-60.

Auto Flash Super 44 - c1959-64. Twotone grey plastic camera for 4x4cm on 127 film. Automatic exposure. Single speed shutter. Fixed focus. \$12-20.

Colt 44 - c1961-65. Inexpensive grey plastic camera for 127 film. Also made for llford and sold as the Sprite. \$1-10.

AHI - Japanese novelty subminiature of the Hit type. \$25-35.

AIGLON - c1934. French subminiature. All metal, nickel-plated body with removable single-speed shutter attached to the lens cone. Special rollfilm records 8 exposures with meniscus lens. Top auction price \$300. Normal range: \$175-250.

AIR KING PRODUCTS CO. INC. (Brooklyn, NY)
Air King Camera Radio - The perfect marriage of a brown, green, or red pseudoreptile-skin covered tube radio and concealed novelty camera for 828 film. Europe: \$300-450. USA: \$200-300.

AIRES CAMERA IND. CO. LTD. (Tokyo)

Aires 35-III - c1957-58. 35mm RF

camera. f1.9/45mm in Seikosha MX. Single stroke lever advance. Bright frame finder. \$35-50.

- 9cm tele lens attachment - \$35-50.

Aires 35-IIIC - c1958-59. Improved version of III & IIIL, incorporating coupled LVS system, self-timer, and automatic parallax correction. Strongly resembles the Leica M3 from a distance. It was designed to accept Aires or Leica M3 cassettes. \$45-60.

Aires 35-IIIL - c1957-59. Similar to III, but with LVS shutter 1-500. Rewind knob has crank. \$45-60.

Aires 35-V - c1959-62. BIM, bayonet mount interchangeable lenses, fast f1.5 normal lens. Also available were f3.5/100mm and f3.2/35mm. With normal lens: \$75-100. *Extra lenses \$45-60 each*.

Aires Automat - c1954. TLR for 6x6cm on 120 rollfilm. f3.5/75mm lens in Seikosha-Rapid 1-500. With Nikkor lenses: \$300-450. With Zuiko or Coral lenses: \$100-150.

Airesflex - c1953-55. 6x6cm TLR. Coral f3.5/75mm in Copal 1-300 or Seikosha-Rapid 1-500. \$75-100.

Airesflex Z - 1952. 6x6cm TLR. f3.5/75mm lenses; Seikosha-Rapid B, 1-500. With Nikkor lenses: \$300-450. With Coral lenses: \$75-100.

Penta 35 - c1960. Low-priced 35mm SLR. Non-interchangeable Q Coral f2.8/50mm lens accepts supplementary wide angle & telephoto lenses. Seikosha SLV 1-500. \$60-90.

AIRES...

Penta 35 LM - c1961. Similar to Penta 35, but with f2 lens and BIM. \$60-90.

Radar-Eye - c1960. 35mm with built-in selenium meter, CRF, Seikosha-SLS B,1-1000, Coral f1.9/45mm. \$45-60.

Viceroy - Copy of Super Ikonta for 6x6cm or 4.5x6cm on 120. CRF. Coral f3.5/75mm in Seikosha shutter. Scarce. \$350-500.

Viscount - c1962. Low-price 35mm RF camera. Even with its fast f1.9 lens, it sold for less than \$40 new. \$30-45.

AIVAS (A. Aivas, Paris) Beginner's Camera - c1910. 1/₄-plate tailboard camera. Mahogany body, blue or grey cloth bellows. Brass barrel lens, gravity guillotine shutter. \$175-250.

AKIRA TC-002 - Novelty 35mm from Taiwan, \$1-10.

AKTIEBOLAGET SVENSKA KAMERA-FABRIKEN

Svenska Magazine Camera - Black leathered wood body for 8x10.5cm plates. Lens with 4 stops. \$35-50.

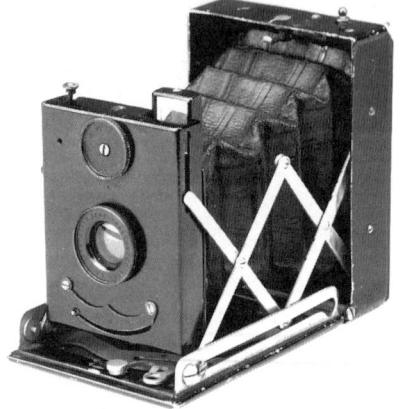

ALBINI CO. (Milan, Italy) Alba 63 - c1914. Small 4.5x6cm plate camera. Strut-folding with bed. Anastigmat f7.5 lens, shutter 1/₂₅-100. \$150-225.

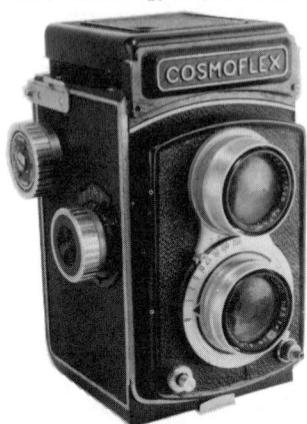

ALFA OPTICAL CO. (Japan) Cosmoflex - c1952. TLR cameras with knob advance. Model I has Toyo shutter & no sportsfinder; Model II has S.Luna shutter and sportsfinder. \$35-50.

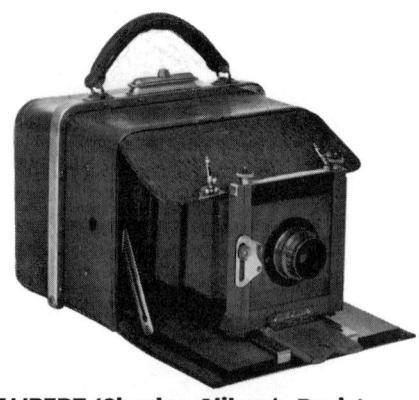

ALIBERT (Charles Alibert, Paris) Kauffer Photo-Sac à Main - c1895. Folding plate camera disguised as a handbag. Several models were made. One is styled like a square-cornered case which hinges from the middle and a strut-supported front extends. A similar model uses the strut-supported front but in a smartly styled handbag with a split front door hinged at the top and bottom. The other variation has the handbag shape but uses the bottom door as a bed to support the lens standard. Designed by Bernard Kauffer of Paris. Estimated: \$3500-5500.

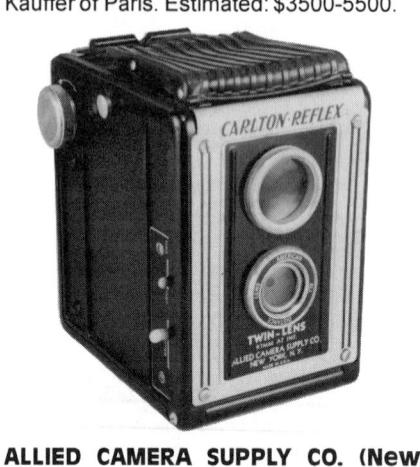

York, NY)
Carlton Reflex - c1950. Black bakelite
TLR-style box camera, identical to the
Spartus Ful-Vue. Faceplate sports Allied
name, but "Utility Mfg. Co." is molded
inside the back. \$8-15.

ALSAPHOT (France)

Ajax - Metal-bodied camera with leatherette covering and telescoping tube front. Takes 12 exp. on 120 film. Front element focusing Alsar f3.5 in Alsaphot 1-300 shutter. \$30-45.

Cady - Stamped metal telescoping-front camera similar to the Ajax & d'Assas. 6x6cm on 120. Alsaphot Anastigmat f6.3 focusing lens in B,25,75 shutter. \$20-30.

Cyclope - Unusually styled camera for 6x9cm on 120 film. Depth of camera is minimized by using two mirrors to fold the light path. Film travels across front of camera. Small sliding door on front covers red exposure-counting window. The f3.5 version is quite rare and brings somewhat more than the also rare f4.5 model. \$800-1200.

D'Assas - Stamped metal camera with telescoping front. Grey crinkle-painted body. 6x6cm on 120. Alsar or Boyer Topaz f3.5/75 in B,25-200 shutter. \$30-45.

D'Assas-Lux - The deluxe model of the D'Assas camera, with body release, rubberized black leatherette covering. The grey plastic top and bottom plates may improve the form of the camera, but certainly do nothing for its durability. Boyer Topaz f3.5/75 in 1-300 shutter. \$30-45.

AMERICAN CAMERA MFG. CO.

Dauphin, Dauphin II - Pseudo-TLR, 21/₄x21/₄". One version is marked "Made in Holland". \$30-45.

Maine - c1960's. Metal-bodied 35mm cameras with leatherette covering, all with Berthiot f2.8/45mm lens. Model I: Basic knob-advance model. Model IIc: Collimated viewfinder; lever advance. IIIa: Built-in meter for automatic exposures. \$20-30.

ALTHEIMER & BAER INC.

Photo-Craft - Black bakelite minicam, 3x4cm on 127 rollfilm. \$12-20.

ALTISSA KAMERAWERK (B.Altmann, Dresden) Same firm as E. Hofert of Dresden, eventually becoming Eho-Altissa. See Eho-Altissa.

ALVIX - Prewar folding 6x9cm rollfilm camera from Germany. Trino Anastigmat f4.5/105mmin Pronto. \$30-45.

AMCO - Japanese paper "Yen" box camera for single exposures on sheetfilm in paper holders. The Amco is larger than most cameras of this type, taking 4.5x6.5cm exposures. It is covered in brown & tan rather than the normal black. An unusual item for a collection of novelty cameras. \$50-75.

AMEREX - Early Japanese 16mm subminiature of the Hit type. One of very few marked "Made in Occupied Japan". \$120-180.

AMERICAN ADVERTISING & RESEARCH CORP. (Chicago)

Cub - c1940. Small plastic camera for 28x40mm exposures on 828 film. All plastic construction, similar to the Scenex. Simple lens & shutter. Toothpaste premium. (Original cost was 15 cents and a Pepsodent box.) Common but cute. \$12-20

AMERICAN CAMERA CO. (London) Demon Detective Camera - Small

metal camera for single round exposures on dry plates. Originally introduced in 1889 for 21/₄" diameter photos on 21/₄x21/₄" plates (later called No. 1 size). A larger model (No. 2 size) for 33/₄" plates was introduced in 1890. Funnel-shaped front with flat, rectangular back. The striking design of the back stamping (by W. Phillips of Birmingham) makes the back view more interesting than the front view of these cameras. \$1500-2000.

AMERICAN CAMERA MFG. CO.

(Northboro, Mass. USA) This company was founded in 1895 by Thomas Blair, who had previously founded the Blair Touro-graph & Dry Plate Co. in 1881 (later changed to Blair Camera Co.). He still held partial interest in the Blair Camera Co. until 1898, but internal difficulties had prompted him to leave the Blair organization about 1892. The American Camera Mfg. Co. was in business for only a short time, since Thomas Blair sold out to George Eastman about 1897. The company was moved to Rochester about 1899 and continued to operate under the American Camera Mfg. Ĉo. name at least through 1904, even though owned by Kodak. By 1908, the catalogs showed it as the American Camera Division of Eastman Kodak Co. If all of this seems confusing, remember also not to confuse this with the American Optical Co., which is a completely different company.

Book Cameras

Buckeye Cameras:

No. 2 Buckeye - c1899-1908? Box camera for 4x5" exposures. Similar to the Blair Hawk-eye box cameras. \$60-90.

No. 3 Buckeye - c1895. Folding rollfilm camera. Maroon leather bellows. f8 lens. \$60-90.

No. 8 Folding Buckeye - c1904. 4x5" rollfilm camera. Rollholder lifts up to focus on ground glass. \$350-500.

Buckeye Special - c1897. Like the No. 2 Buckeye, but for rollfilm or glass plates. \$100-150.

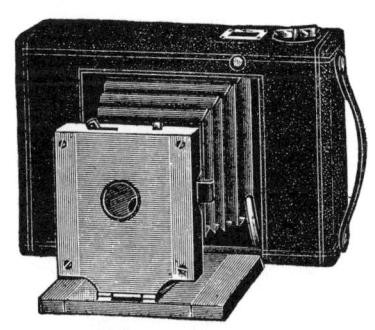

No. 1 Tourist Buckeye - c1895. Folding rollfilm cameras in sizes for $31/_2x31/_2$ " or $31/_4x41/_2$ " exposures. Maroon bellows, wooden lens standard. \$150-225.

Folding Poco, No. 15 - c1904. Folding bed plate camera, 4x5". Rapid Rectilinear lens, Unicum shutter. Red bellows. \$90-130.

Folding Poco, No. 16 - c1904. Folding bed plate camera, 4x5". Rapid Rectilinear lens, Unicum shutter. Red double extension bellows. \$100-150.

Triple Bed Poco, No. 19 - c1904. Folding plate camera, 4x5". Triple extension maroon leather bellows. \$100-150.

AMERICAN FAR EAST

AMERICAN FAR EAST TRADING CO. Santa Claus Camera - c1980. Novelty camera for 126 film. Santa Claus face forms the front of the camera. \$12-20.

AMERICAN MINUTE PHOTO CO. (Chicago)

American Sleeve Machine - A street camera for tintypes, similar to the more common models by the Chicago Ferrotype Co. \$120-180.

AMERICAN OPTICAL CO. (New York) Acquired the John Stock Co. (including the C.C. Harrison Co.) in 1866 and was then bought out by Scovill Mfg. Co. in 1867. Flammang's Patent Revolving Back Camera - c1886. Tallboard style view camera. Patent revolving and tilting back. Tapered bellows, rise front. Mahogany body with brass fittings. Usually found in 5x7" and 61/2x81/2" sizes. \$200-300.

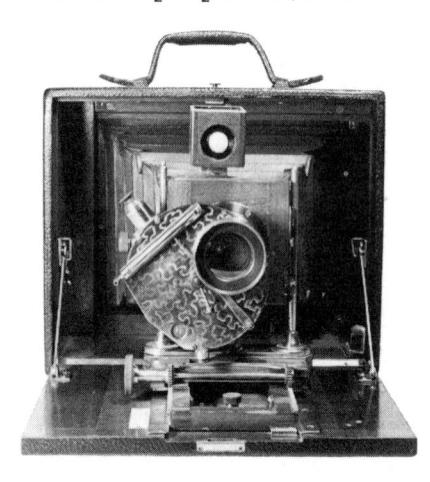

Henry Clay Camera - c1892. 5x7 inch folding plate camera. A well-made hand camera with many desirable features, such as double shift and swing front, fine focusing, etc. Uncommon and quite distinctive. With original Wale shutter: \$600-900.

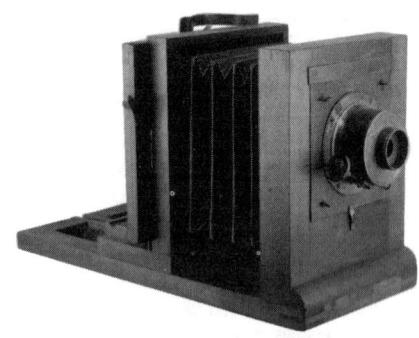

John Stock Wet Plate Camera - c1866. Tailboard style studio camera for wet collodion plates. Examples we have seen ranged from 4x5" to 8x10" sizes. Square back allows vertical or horizontal format. Side-hinged ground glass viewing screen swings out of the way to insert plateholder. Drip trough protects bed from chemicals. Brass plateholder retaining springs stamped "John Stock Patented May 31, 1864" and "Assigned to Am. Optical Co." 'Am. Optical Co. Manufacturer, NY" stamped at rear corners of bed. \$750-1000.

Plate camera, 5x8" - horizontal format. With lens, back, holder: \$175-250.

Revolving Back Camera - 1890's. Wood body, tapered bellows. Made in 12 sizes from 4x5" to 20x24". \$200-300.

View camera - 1890's. Mahogany and brass body, tapered maroon bellows, brass lens. Made in a variety of names and sizes. For 5x7": \$200-300.

Wet Plate Camera, 4-tube - c1866. Tailboard-style studio camera of heavy construction. Takes 4 exposures 2x2" each. \$1200-1800.

AMERICAN RAND CORP.
Photo Binocular 110 - c1980. A pair of 4x30mm binoculars with a built-in camera with 80mm telephoto lens for 110 cartridge film. Made by Sedic Ltd. Also sold as Tele-Spot 110 by J. Gerber Co. Ltd., Japan. \$50-75.

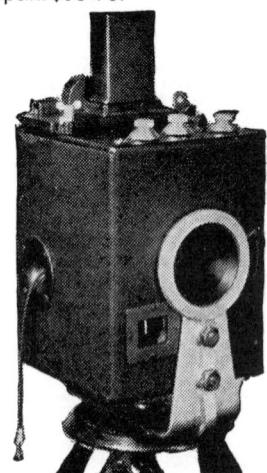

AMERICAN RAYLO CORP. (New York) Raylo Color Camera - c1925. Magazine-loading color separation camera for 4.5x8cm plates. Automatic clockwork mechanism apportions the time through each color filter in the correct ratio to produce three negatives of even scale. Rare. \$1700-2400.

AMERICAN SAFETY RAZOR CORP. (New York)

ASR Fotodisc - c1950. A small cast metal camera with eye-level finder. A film disc in a special holder fastens by bayonet mount to the back of the camera. Takes 8 exposures 22x24mm on a film disc. With disc: \$600-900.

AMICA INTERNATIONAL (Japan) Amimatic - c1967. 126 cartridge camera. All-metal body, electric eye exposure control. Amicor f2.8/35mm, Citizen shutter. \$12-20.

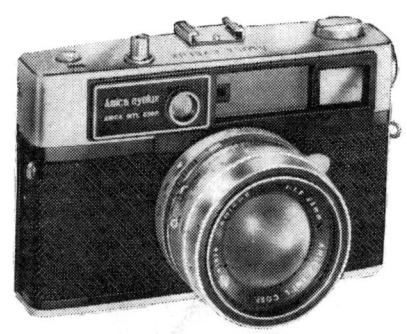

Eyelux - c1966. 35mm RF. f1.8/45mm lens in Citizen MVE shutter. \$35-50.

ANDERSON (J.A.) (Chicago, Illinois) studio camera, multiplying back - c1890. Non-folding studio camera with integral shifting back. Interchangeable masks allow several mulltiple formats on 5x7" plate. \$300-450.

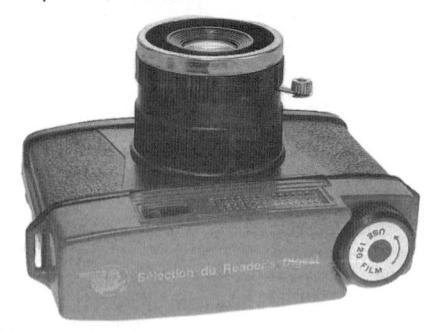

ANNY - Plastic 120 rollfilm camera of the "Diana" type. One version was used as a promotion for the French-language "Selection du Readers Digest". This one would be worth double the normal price. \$1-10.

ANSCHÜTZ (Ottomar Anschütz, Berlin) Anschütz never made any cameras, but was involved with a Berlin retail firm cashing in on his name. See GOERZ for the majority of cameras bearing the Anschütz name.

Rollda - c1900-05. Double extension folding rollfilm camera for 8x10.5cm. Anschütz Aplanat f7.2/135mm in B&L Unicum shutter 1-100. \$75-100.

ANSCO (Binghamton NY USA)
Formed by the merger of the E.& H.T.
Anthony Co. and Scovill & Adams in 1902.
The name was shortened to Ansco in 1907. A
merger with the American interests in the
German firm of Agfa in 1928 formed AgfaAnsco. In 1939, Agfa-Ansco changed its
name to General Aniline & Film Corporation, but still used the Agfa-Ansco name in
advertising until 1943 when the Agfa name
was dropped. The Ansco Division of General
Aniline kept its name as the main banner of
the company until the company name was
officially shortened to GAF in 1967. More
recently, GAF withdrew from the consumer
photographic market but the Ansco name
continues as part of Haking International.
See also Agfa, Anthony, Scovill.

Admiral - Black plastic twin lens box camera, 21/4x21/4". \$1-10.

Ansco Special - c1924-28. Simple, red leather covered box camera, brass trim. No. 2 size for 120 rollfilm; No. 2A for 116 rollfilm. \$35-50.

ANSCO

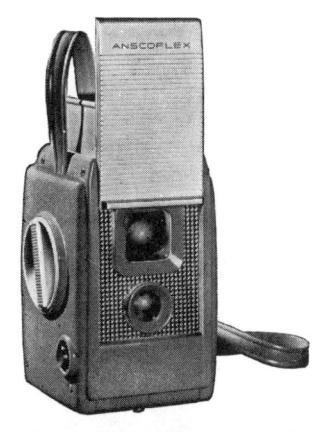

Anscoflex, Anscoflex II - c1954. All metal 6x6cm reflex-style camera. Gray & silver color. Front door slides up and opens finder hood. Model II has closeup lens and vellow filter built in and controlled by knobs on the front. Less common in Europe: \$25-35. USA: \$12-20.

Anscomark M - c1960-63, 35mm RF camera. Interchangeable bayonet mount Xyton f1.9/50mm or f2.8/50 Xytar lens. Viewfinder has frames for 100mm & 35mm lenses. Coupled meter. With 3 lenses: \$90-130. With normal lens only: \$35-50.

Anscomatic Cadet - c1966-67. Plastic 126 cartridge camera. \$1-10.

Anscoset - c1960. 35mm RF. BIM with match-needle f2.8/45mm operation, Rokkor. Made by Minolta for Ansco. \$30-

Anscoset III - 1964. Made by Minolta for export to the USA. Identical to the Uniomat III, but says "Anscoset III". New price: \$89.95. Current value: \$35-50. Higher in Japan where they are less common.

Arrow - c1925. Cardboard box camera with leatherette exterior. Removable metal back; wooden interior section. "The Arrow" on strap, no other identification. Styled like an oversized Ansco Dollar Camera, but with two finders. Uncommon. \$20-30. Illustrated at top of next column.

Ansco Arrow

Automatic No. 1A - c1925. Folding rollfilm camera for 6 exp. 21/2x41/4" in six seconds. Required a new film "No. 6A Automatic" since the regular 6A film only allowed 5 exposures. Spring-wound automatic film advance. Designed and patented in 1915 by Carl Bornmann, who had also designed the 1888 Antique Oak Detective Camera for Scovill & Adams and was still designing for the company, now 38 years later. Anastigmat f6.3 lens. Original price about \$75. \$150-225

Automatic Reflex - High quality TLR introduced in 1947 at the healthy list price of \$262.50. This original model did not cock the shutter with the film advance, and was lacking flash sync. The improved model (sometimes called Model II, although not marked as such) has a sync post in the lower corner of the front plate. and features automatic shutter cocking. By 1950, the list price had dropped to \$165. Anastigmat f3.5/83mm lens. f3.2/83mm viewing lens. Shutter to 400. Ground glass focusing screen and optical eye-level finder. \$150-225.

Autoset - c1961, 35mm RF camera. Similar to the Anscoset, but fully automatic shutter speed control rather than matchneedle. \$30-45.

Autoset CdS - 1964. Made by Minolta for GAF, 35mm rangefinder, Built-in CdS meter. Ansco Rokkor f2.8/45mm, shutter 1/30-500 auto, B. \$45-60.

Bingo No. 2 - c1925. Black box camera for 120 film. Metal back. Two finders. Uncommon name. Made by Ansco for the Goodwin Film & Camera Co. \$20-30.

Box cameras - Colors other than black: \$25-35. Black models: \$1-10.

Buster Brown Box Cameras: No. 0 Buster Brown - c1923. 4x6.5cm on 127 (2C) rollfilm. \$8-15.

No. 2 Buster Brown - 6x9cm on 120 (4A) film. \$8-15. c1906-23

No. 2A Buster Brown - c1910-24.

2¹/₂x4¹/₄" on 118 film. \$12-20. **No. 2C Buster Brown -** c1917-23.

27/₈x47/₈". \$12-20. **No. 3 Buster Brown -** c1906. 31/₄x41/₄". \$12-20. **No. 3A Buster Brown -** c1914-16. 31/₄x51/₂". \$20-30.

Buster Brown Special, Nos. O, 2, 2A - c1923. Box cameras with red covering and lacquered brass trim. \$30-45.

Buster Brown Folding Cameras: 1 Folding Buster Brown. Model B - c1910. \$12-20. No. 2 Folding Buster Model B - c1914-17.\$15-25. Brown, No. 2A Folding Buster 1910's. \$12-20 No. 3 Folding Buster Brown c1914. \$15-25 No. 3A Folding Buster Brown -1910's. The postcard size. Deltax or Actus shutter, \$15-25.

ANSCO...

Buster Brown Junior - Folding camera for 116 roll. \$12-20.

Cadet cameras: Cadet B2 and D-6 box cameras c1947. Basic rectangular box cameras. \$1-

Cadet (I) - c1959. Black plastic camera with metal faceplate, \$1-10.

Cadet Flash - c1960. Similar to the Cadet 4x4cm, but with large built-in flash on top. \$1-10.

Cadet II, Cadet III - c1965. Horizontally styled gray plastic cameras with aluminum faceplate for 127 film. Originally came in hard plastic carrying case. \$1-10. **Cadet Reflex -** c1960. Reflex brillant

Cadet Reflex - c1960. Reflex brillant finder version of the Cadet. 4x4cm on 127 film. \$1-10.

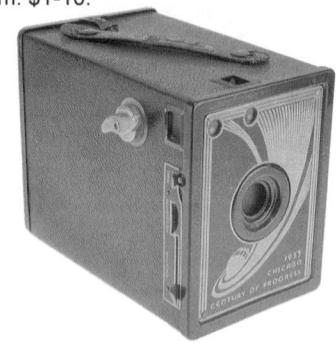

Century of Progress - Cardboard box camera with art-deco style World's Fair design on metal front. Made for the 1933 World's Fair at Chicago. \$75-100.

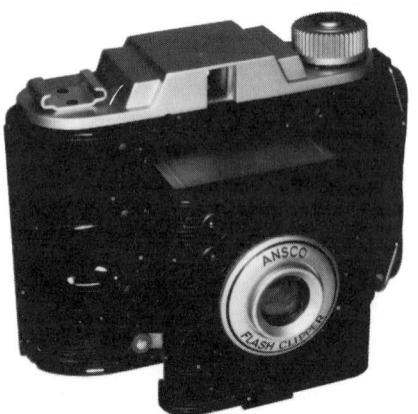

Clipper, Color Clipper, Flash Clipper, Clipper Special - 1940's-1950's. A series of metal cameras with rectangular extensible front. Flash Clipper: \$1-10. Others: \$1-10.

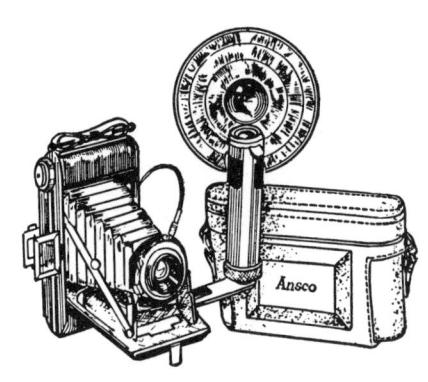

Commander - Mid-1950's folding rollfilm camera. Agnar f6.3 zone focusing lens in Vario sync shutter. \$20-30.

Commercial View - 1930's. 8x10" view camera with typical movements. Double extension black leather bellows. \$200-300.

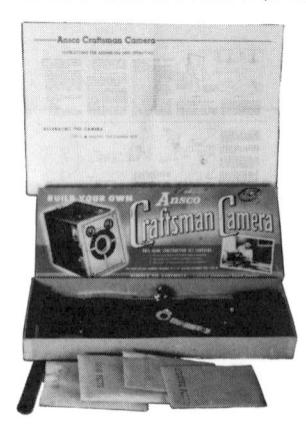

Craftsman Kit - c1950. A construction kit to build your own 6x9cm box camera. The camera kit was pre-tested by Ansco for several months before the decision was made to market it. Over 100 grammar school children participated in the tests. Current value of an original unused kit with assembly instructions \$50-75. Assembled Craftsman \$1-10. There was an earlier Ansco box camera named Craftsman. It was advertised in Ansco catalog No. 45 (ca.1926). This was a high-quality, wooden bodied, box camera. Since the Craftsman name did not appear on the camera, it is not likely to cause confusion with the kit model of 1950.

DeLuxe No. 1 - c1925-1928. Folding camera with rich blue leather covering and brass-plated metal parts, otherwise the same as Ansco Junior No. 1. Catalogs call it Ansco Junior Deluxe, but it has "No. 1 Ansco Deluxe" nameplate on bed. \$35-50.

Dollar Box Camera - c1910-28. A small $4x31/_2x21/_2$ " box camera for 127 film. Available in black, burgundy or green. No strap. Some are identified "Ansco Dollar Camera" on the front. The same camera in red and with a strap was sold as the Kiddie Camera c1926-29. \$20-30.

Flash Champion - Metal-bodied camera with rectangular extensible front. Similar to the Clipper cameras. \$1-10.

Folding Ansco cameras: (There is a certain amount of confusion over the correct name for some of these cameras, since Ansco catalogs called them by different names even within the same catalog. For example, the No. 4 Folding Pocket Ansco is the same as the No. 4 Ansco Model B, or the No. 4 Folding Ansco.) The "Folding Pocket Ansco" name originated during the "Anthony & Scovill" period.

No. 1 Folding Ansco - c1924-28. Folding bed camera for 6x9cm. Anastigmat f7.5 in llex General shutter 1/₅-100. \$12-20. **No. 1 Special Folding Ansco** - c1924-28. \$12-20.

No. 1A Folding Ansco - c1915-26. For 116 film. Anastigmat f7.5 in Ilex. \$12-20. No. 3 Folding Ansco - c1914-28. For 118 film. \$15-25.

No. 3A Folding Ansco - c1914-32. Common postcard size. Lenses: Wollensak, RR, Ansco Anast. ShuttXQs: Ilex, Deltax, Bionic, Speedex. \$15-25.

No. 4 Folding Ansco - c1905. Models C & D. Horizontal format, 31/4x41/4" on 118 film. Mahogany drop bed, nickel trim. Wollensak lens, Cyko Auto shutter. \$25-

No. 5 Folding Ansco - c1907. Wollensak lens. Cyko Automatic shutter. Black bellows. \$25-35.

ANSCO

No. 6 Folding Ansco - c1907. Models C & D. 31/4x41/4". Wollensak f4 lens. Red leather bellows. For roll or cut film. \$30-45. No. 7 Folding Ansco - (Anthony & Scovill Co.) Postcard sized rollfilm camera. Last patent date 1894. Red bellows, brass barrel Wollensak lens. \$30-45.

No. 9 Ansco, Model B - c1906. Horizontal style folding camera for $31/_4$ x51/ $_2$ " on rollfilm. Cherry wood body, leather covered. Red bellows. Cyko shutter in brass housing. \$35-50. Later models with black bellows & nickeled shutter: \$25-35.

No. 10 Ansco - pat. Jan. 1907. Folding camera for 31/₂x5" on 122 film. (Model A has removable ground glass back. Ansco Automatic shutter.) \$30-45.

Goodwin cameras Named in honor of the Rev. Hannibal Goodwin, the Newark NJ clergyman who invented the flexible transparent film base which has become the standard of the photographic industry. Goodwin's 1887 patent application took over 11 years to process, during which time rollilm gained widespread use. His Goodwin Film & Camera Co. was acquired by Anthony & Scovill (later Ansco) after his death in 1900. Goodwin cameras, made by Ansco, served to promote Ansco products and keep the Goodwin name alive. The Goodwin Film & Camera Co. Inc. name was used by Ansco in the late 1920's as the Premium and Special Sales Division of Ansco Photoproducts Inc.

No. 1 Goodwin Jr. - c1925. Folding camera. Strut-supported front pulls straight out. \$25-35.

No. 1A Folding Goodwin - c1930. Folding bed rollfilm camera for 116 film. Says "Goodwin Film & Camera Co." on the shutter face \$20-30

shutter face. \$20-30.

No. 2, 2A, 3 Goodwin - c1930. Box cameras. \$8-15.

No. 3A Folding Goodwin - Similar to the No. 3A Folding Ansco, but black crinkle finished bed; less chrome. Leatherette rather than leather for body and bellows. Ilex Rapid Rectilinear US8 lens in Ilex Automatic shutter. \$12-20.

Junior A series of folding rollfilm cameras, beginning with the Model A about 1910. At first horizontally styled, the later models switched to the vertical styling.

Ansco Junior (Model A & Model B)

Ansco Junior (Model A & Model B) - c1906-13. Horizontal style folding camera. 21/2x41/4" exposures. RR lens. \$25-35.

No. 1 Ansco Junior - c1924-32. 21/4x31/4" on 120 rollfilm. Vertical style. Originally available with Achromatic, Rectilinear, or Modico Anastigmat lens in Actus or Bionic shutter. Later versions had other options. \$15-25.

No. 1A Ansco Junior - c1916-32. Like No. 1, but 21/₂x41/₄" on 116 film. \$15-25. No. 2C Ansco Junior - c1917-23. $2^{7}/_{8}x4^{7}/_{8}$ " on 130 film, otherwise like the No. 1 above. \$25-35.

No. 3 Ansco Junior - c1923. 3¹/₄x4¹/₄" on 118 film. Introduced somewhat later than the other sizes, in the early 1920's. \$15-25.

No. 3A Ansco Junior - c1916-31. $31/_4$ x5 $1/_2$ " on 122 film, otherwise like the No. 1 above. \$25-35.

Junior Press Photographer - c1949-50. Specially packaged version of the Pioneer camera, promoted during the Christmas seasons of 1949-50. The camera sports a special "Jr. Press Photographer" faceplate, and comes in a kit with flash, bulbs, instructions, assignment book, and ID card. In 1949, it came in a cardboard presentation box. In 1950, it was cased in a brown compartment bag styled by Raymond Loewy. Complete outfit \$35-50. Camera only: \$8-15.

Juniorette No. 1 - c1923. Folding roll-film camera for 6x9cm. Like the No. 1 Ansco Junior and No. 1 Folding Ansco, but with lower-priced Single Achromatic f8 lens in Deltax shutter. \$12-20.

Karomat - c1951-56. 35mm strut-folding rangefinder camera made by Agfa München, and identical to the Agfa (& Ansco) Karat 36. Early models have hinged knob on advance lever, and a depth of field calculator on top. Beginning about 1953, the advance lever has a fixed knob, and there is no longer a depth calculator. Originally with Heligon or Xenon in Compur-Rapid. Later with Schneider Xenar f2.8 or Xenon f2.0 in Synchro-Compur. With f2 Xenon: \$45-60. Others: \$35-50.

Kiddie Camera - c1926-29. Listed in

the catalogs along with the Dollar Camera, with shared description and photo. It is the same cardboard box camera, but with red covering and a strap. \$15-25.

Lancer - c1959. Streamlined cast metal camera made for Ansco by Bilora. Identical in style to the Bilora Bella 44. Simple f8 lens in 2-speed shutter. Takes 12 exposures 4x4cm on 127 film. \$12-20.

Lancer LG - c1962. Identical, but with uncoupled meter attached to the front. \$25-35.

Memar - c1954-58. Basic 35mm camera made by Agfa München. Same as the Agfa Silette. Apotar f3.5/45mm in Pronto. \$15-25.

Super Memar - c1956-59. Similar to the Memar, but with CRF and f3.5 Apotar in Prontor SVS. Made by Agfa München; also sold as the Agfa Super Silette. \$25-35.

Super Memar LVS - c1957-59. CRF, Synchro-Compur LVS shutter, and f2 Solagon lens. Made by Agfa München; same as the Agfa Super Silette. \$30-45.

Memo cameras - The Memo cameras have presented a problem to some collectors who advertise one for sale and do not indicate which model they are selling. Ansco sold several different cameras which were simply called "Memo" with no

ANSCO...

further designation. In recent years, serious collectors and dealers have tried to identify them further by using the year of introduction along with the name.

Memo (1927 type) - intro. 1927. Half-frame 35mm camera. Wooden vertical box body with leather covering. Tubular optical finder on top. Makes 50 exposures 18x23mm on 35mm film in special cassettes which were originally made of wood. 40mm f6.3 Wollensak Cine-Velostigmat or Ilex Cinemat lens. Sliding button on back for film advance, automatic exposure counter. Some models focus, others are fixed focus. A shutter release guard was added to later models. Although these can sell for about 50% more in Europe, they are fairly common in the U.S.A. \$75-100.

Memo (Boy Scout model) - The "Official Boy Scout Memo Camera" has a wooden body painted olive-drab color and has a special nameplate with the official insignia, and comes in a matching olive-drab case. Much less common than the normal models. With case: \$200-300. Official Boy Scout Memoscope (matching projector) \$150-225. Camera only: \$175-250.

Memo (Wood finished) - The earliest variation of the 1927 type Memo, this had varnished wood and brass trim rather than leather covering. Less common than the others of the series. (Original ads in December 1926 and January 1927 illustrate this wood model.) \$250-375.

Memo (1940 type) - see AGFA Memo.

Memo Automatic - c1963. Single frame (18x24mm) camera for standard 35mm cartridges. Features spring-motor film advance. Made by Ricoh for Ansco, and identical to the Ricoh Auto Half. Also continued as the Memo II under the Ansco and GAF labels. \$35-50.

Memo II Automatic (GAF) - c1967. Relabeled version of the Memo Automatic, above. Made for GAF by Ricoh. Memar f2.8/25mmlens. \$35-50.

Memory Kit - c1923. A specially packaged outfit including a folding camera in a fitted polished wood box with 4 rolls of film. A metal plate on the box is suitable for engraving. Came with No. 1 Ansco Junior, No. 1 Folding Ansco, or No. 1 Readyset Royal. Complete with camera and original boxes of film: \$150-225. Camera and presentation box only: \$100-150.

Panda - c1939-50. Small black plastic TLR box camera with white trim for 6x6cm exposures. Ansco's answer to Kodak's Baby Brownie cameras. \$1-10.

Photo Vanity - A small Ansco box camera concealed in one end of a case. May be operated from the exterior with the case closed. The case also contains artdeco designed lipstick, powder, rouge & comb, and a mirror in the lid. Apparently the vanity case was made by Q.L.G. Co. and fitted with an Ansco camera, so only the camera itself is actually on Ansco product. One reached \$4200 at auction in 1989. More typical price is: \$1200-1800.

Pioneer - c1947-1953. Plastic & metal eye-level cameras in the PB-20 and PD-16 sizes. Earlier examples are called Agfa Pioneer. Common. \$1-10.

Readyflash - A low-priced plastic eyelevel camera for 6x9cm on 620 film. Sold new in 1953 for \$14 with a flash, 6 bulbs, gadget bag & film. \$1-10.

Readyset (No.1, 1A, Eagle, etc.) - 1920's. Folding cameras. \$12-20.

Readyset Royal, Nos. 1, 1A (Ostrich grain) - c1925-32. Folding cameras with golden brown leather covering, pimpled to resemble ostrich skin. Russet colored bellows. These are attractive but not rare. \$30-45 in the USA. Somewhat higher in Europe.

Readyset Royal, Nos. 1, 1A (Silver Fox) - c1931-32. Folding camera with genuine leather covering in specially embossed and colored finish. The somewhat random radial striations and the brown & black mottled colors give the appearance of the fur of a silver fox. The exposed metal parts are grey enameled. Black bellows; chrome trim. Originally packaged in silver-colored cardboard box. With box: \$60-90. Camera only: \$35-50.

Readyset Special, Nos. 1, 1A - 1940's. Folding rollfilm cameras. Brown: \$30-45. Black: \$12-20.

Rediflex - c1950. Plastic twin lens box camera, 6x6cm on 620 film. \$12-20.

Regent - c1953. Made by Agfa München; identical to the Agfa Solinette II. Horizontally styled folding bed 35mm camera. Apotar f3.5 in Prontor-SV to 300. \$25-35.

- **Super Regent** - 1954-60. Made by Agfa München; the Ansco equivalent of the Agfa Super Solinette. CRF. Solinar f3.5 lens in Synchro-Compurshutter. \$50-75.

- **Super Regent LVS** - 1955-60. Same as the Super Regent, but with the improved Synchro-Compur LVS shutter. \$50-75.

Royal, No. 1A - c1925-30. Folding roll-film camera, brown bellows, brown imitation ostrich skin covering. \$30-45.

Semi-Automatic Ansco - c1924. Folding rollfilm camera. A lever on the rear of the drop bed actuates a spring-wound advance system. There are two distinct variations. One has the advance lever on the operator's right while the other has the advance lever on the left. It differs from the Automatic model which further couples the winding mechanism to the shutter release. Ansco Anastigmat f7.5/130mm in llex shutter. \$120-180.

ANSCO

Shur-Flash - c1953. Basic box camera with flash attachment. \$1-10.

Shur-Shot - c1948. A basic box camera with vertically striped aluminum front. Perhaps the most common of the Ansco box cameras. \$1-10.

Shur-Shot Jr. - c1948. Basic box camera with metal faceplate. $2^{1}/_{4}x3^{1}/_{4}$ " on 120 film. \$1-10.

Speedex - (See also the listing of Speedex cameras under Agfa. Similar cameras were marketed under both the Agfa and Ansco names.)

Speedex 1A - c1916. Folding camera for 116 film. Anastigmat f6.3 in Ilex Universal shutter, \$20-30.

Speedex 45 - c1946-50. Horizontal folding rollfilm camera, similar to the Isolette V from the same years. Combines German and American engineering. Basic body, front door, and struts are like Isolette; other details differ and are based on American patents. Normal Speedex has Agnar f4.5 lens in Vario. \$20-30.

Speedex 6.3 - c1950. Original Ansco USA product. Styled like the Titan, but with lower specification. Anastigmat f6.3 lens in everset $^{1}/_{100}$ shutter. Also called the Standard Speedex. \$12-20.

Speedex Jr. - c1945-48. Similar to the Speedex 45, but simple lens and shutter. \$8-15.

Speedex Special - The Speedex 45 with Agfa Apotar f4.5 in Prontor shutter. \$35-50.

Speedex Special R - c1953-. Horizontally styled folding camera for 6x6cm on 120 film. Made in Germany; similar to Agfa Isolette III. Uncoupled rangefinder. Apotar f4.5/85 in Prontor-S or SVS. Original price \$55. \$35-50.

Standard Speedex - c1950. Original Ansco USA product. Styled like the Titan, but with lower specification. Anastigmat 6.3 lens in everset $1/_{100}$ shutter. Also called the Speedex 6.3. \$12-20.

Studio, 8x10" - c1947. Large, heavy studio camera with fixed tailboard. Double extension bellows. Sliding back. With normal lens: \$150-225.

Sundial Camera - c1925? Black leatherette-covered box camera for premium use. "Sundial Camera" on the strap; "Time will tell- wear Sundial Shoes" gold-embossed on side. \$25-35.

Super Speedex - c1953-58. (Same as Super Isolette). Folding camera for 6x6 on 120. Similar to the Speedex Special R, but rangefinder is coupled. Solinar f3.5/75mm in Synchro-Compur1-500. Sold for \$120 in 1953. \$120-180.

Titan - c1949. Horizontal folding rollfilm camera for 21/₄x21/₄" on 120. Similar in style to the "Standard" f6.3 Speedex, but with better specification. Ansco Anastigmat f4.5/90mm, 1/₂-400,TB shutter. Advertised as "Ansco's finest folding camera." \$30-45.

Vest Pocket Ansco: While we tend to think that all vest pocket cameras are for 4x6.5cm exposures on 127 film, Ansco called its No. 1 and No. 2 models "Vest Pocket" even though they were larger cameras.

Vest Pocket No. 0 - c1916-23. For 4x6.5cm exposures on 127 film. Ansco

Anastigmat f6.3 or Modico Anastigmat f7.5. Strut-supported front pulls straight out \$30-45.

Vest Pocket No. 1 - c1915-19. Folding camera for 6x9cm. Strut-supported front. Patents to 1912. Actus shutter. \$25-35.

Vest Pocket No. 2 - c1915-24. Similar to the No. 1 and also for 6x9cm on 120 film. Renamed "No.1 Expert Ansco" in 1923. The unusual feature of this camera is the hinged lens cover. Ansco Anastigmat or f7.5 Modico Anast. Bionic or Gammax shutter. \$30-45.

Vest Pocket Model A - Designed with a folding bed, unlike the other vest pocket models above. B&L Zeiss Tessar lens. Ansco shutter. \$30-45.

Vest Pocket Junior - c1919. Folding bed camera for 6x9cm on 4A (120) film. \$20-30.

Vest Pocket Readyset - Folding bed style camera for 4x6.5cm exposures on 127 film. Pastel enameled in various colors including blue, red, and green (1925-29): \$75-100. Black leather covered models (1925-31): \$30-45.

ANSCO...

Vest Pocket Speedex No. 3 - c1916-20. Folding bed rollfilm camera for 6x9cm on 4A (120) film. Tessar f4.5, Goerz-Celor f4.8, Ansco Anastigmat f5 or f6.3, or Modico Anastigmat f7.5 in Acme Speedex shutter. \$35-50.

Ansco View - View cameras are difficult to price as collectibles because their main value lies in their usability. Any usable view camera with tilts and swings generally exceeds the price collectors would pay. Shutter & lens are even more important in estimating the value, since a good lens has more value than the camera itself. Collectible value, with older type lens & shutter \$120-180. Usable value with full movements, not including lens \$175-250.

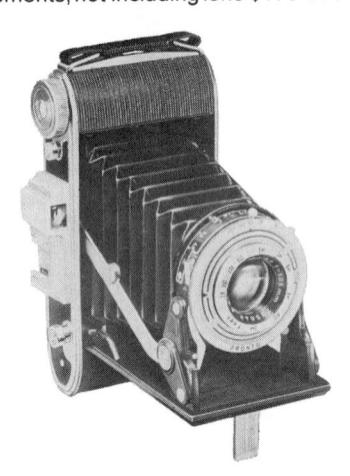

Viking - c1946-56. Self-erecting folding bed cameras for 6x9cm. Early model made by Ansco c1946 has small brilliant finder on lens standard and folding optical finder on body; uses 620 (PB20) film; Viking f6.3 in Ansco 25-100 shutter. Later model (made by Agfa München, same as the Agfa Billy Record I) has rigid eye-level optical finder in a small housing with an accessory shoe; uses 120 film; Agnar f6.3 in Vario or f4.5 in Pronto shutter to 200. \$15-25.

Viking Readyset - c1952-59. Self-erecting folding camera for $2^{1}/_{4}$ X31/₄" on 120. Made by Agfa München, same as Agfa Billy Meniscus. Fixed focus Isomat lens. Folding frame finder. \$12-20.

ANTHONY The oldest American manufacturer of cameras and photographic supplies. Begun by Edward Anthony in 1842 as E.Anthony. Edward's brother Henry joined

him in 1852, and in 1862 the firm's name was changed to E. & H.T. Anthony & Co. In 1902, they merged with the Scovill & Adams Co. to form Anthony & Scovill, and five years later the name was shortened to Ansco, a contracted form of the two names. At the same time, they moved from their original location on Broadway to Binghamton, N.Y. (See also Agfa, Ansco, Scovill.)

Ascot - c1899. Folding plate cameras. Note: The plate & hand camera division of E.& H.T. Anthony Camera Co., which made the Ascot Cameras, merged with several other companies in 1899 to become the Rochester Optical & Camera Co. Ascot cameras are quite uncommon, since they were made for such a short time.

Ascot Cycle No. 1 - 4x5" size. Orig. price \$8 in 1899. \$90-130. **Ascot Folding No. 25 -** 4x5" size. \$90-

Ascot Folding No. 29 - 4x5" size. Original price \$15 in 1899. \$90-130.

130

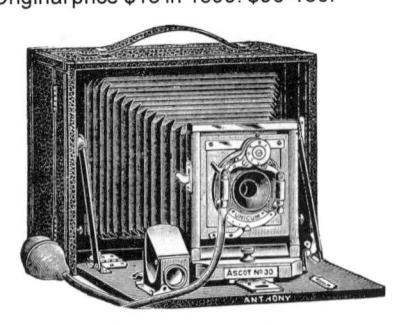

Ascot Folding No. 30 - The big brother of the above cameras, this one takes 5x7" plates. Like the others, it has a side door for loading and storage of plate holders. \$100-150.

Bijou - c1887-93. 3¹/₄x4¹/₄" plate camera that folds to a compact 5x5x3¹/₂". Mahogany body, brass or nickel trim. \$250-375.

Box cameras - c1903-1906. Leather covered box for $31/_4$ x $41/_4$ " on rollfilm. \$45-60. Focusing model for 4x5" exposures on

plates or with rollholder. \$50-75.

Buckeye - c1896. Box cameras for 12 exp. on daylight-loading rollfilm sold by

Anthony. (Some models equipped for either plates or rollfilm.) Made in $3^{1}/_{4}$ x41/ $_{4}$ " & 4x5" sizes. These were probably by American Camera Mfg. Co. with Anthony acting as a sales agent. These cameras were the competition for the Boston Bullseye and the Eastman Bullet cameras of the day. \$60-90.

Champion - c1890. A series of mahogany field cameras, in sizes from 4x5" to 8x10". Folding bed with hook-shaped "patent clamps" to hold it rigid. Rising front, swing back. Originally supplied with coneshaped brass barrel single achromatic lens, case, holder, and tripod. \$200-300.

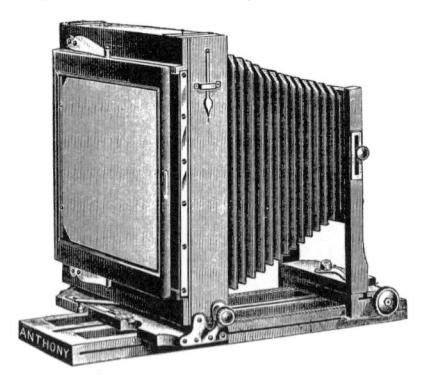

Clifton - c1901. A series of view cameras with a great variety of movements including double-swing back and front, rising & shifting front, reversible back, front & rear rack focus. Made in 6 sizes from 5x7" to 14x17". \$200-300.

Climax Detective - A rather large wooden box "detective" camera from the late 1880's for 4x5" plates. It was called a detective camera because it didn't look like the large tripod-mounted bellows style view cameras which were the order of the day. It could be operated hand-held, and all the shutter controls could be operated without opening the box. A removable rear storage compartment holds five double plateholders. Available in polished wood or leather covered models. \$1000-1500.

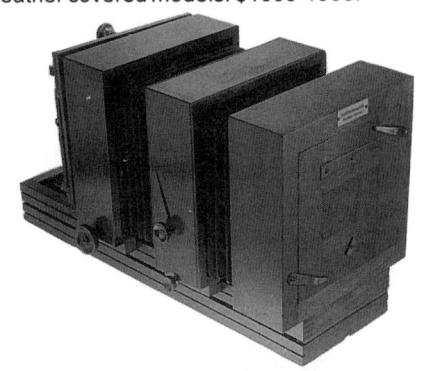

Climax Enlarging, Reducing, Copying Cameras - c1880's-1890's. Essentially a long extension view camera with a lensboard mounted in a center standard for enlarging or reducing. To use as a copy camera, the lens was moved to the front standard. Various configurations were made, some with multiple frames to support the long bellows. Made in sizes from 31/4x41/4" to 20x24". \$200-300.

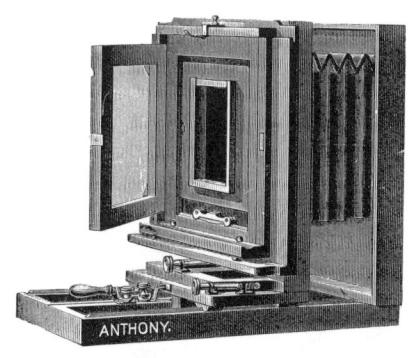

Climax Imperial - c1885-1900's. Heavily-built studio camera, 8x10". Single extension bellows. \$200-300.

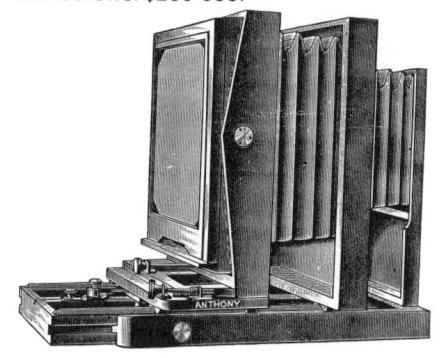

Climax Portrait Camera - c1888. A large studio view camera, usually found in the 11x14" size, but made up to 25x30". Two sets of bellows allow long extension with telescoping bed. With brass barrel lens \$300-450

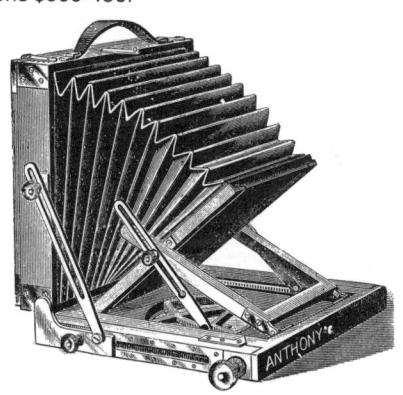

Compact Camera - c1890's. A compact folding field camera based on English designs of the time. The lensboard folds flat against the bed using its center tilt axis. A rotating tripod top is built into the bed. The lens must be removed to fold the camera, and unfortunately many cameras of this style have become separated from their original lenses. Made in sizes from 5x7" to 8x10". \$250-375.

Daylight Enlarging Camera - c1888. A view camera & enlarger for plates to 111/₂x111/₂". Rotating back & bellows. Masking back for enlarging. Without lens \$200-300.

Fairy Camera - c1888. A lightweight folding view camera. Similar in design to the more common Novelette camera, it featured a revolving back & bellows combination for horizontal or vertical orientation. It also offered rack & pinion focusing while the Novelette employed a sliding back with a fine-focus screw. The Fairy

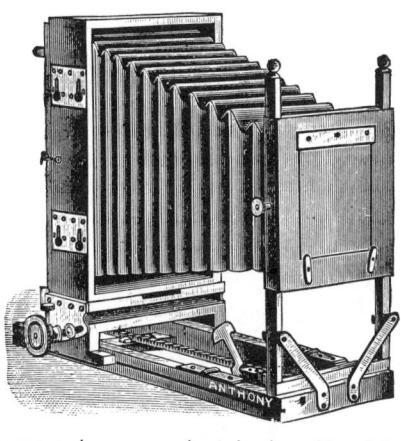

camera has a walnut body with nickel plated fittings. Made in 6 sizes from 4x5" to 8x10". \$250-375.

Gem Box - c1877. A series of cameras for making multiple "gem" tintypes by using from 4 to 12 lenses on Anthony's Universal Portrait & Ferrotype Camera. Camera sizes from 31/₄x41/₄" to 61/₂x81/₂". Quite rare. We would recommend consultation with several reputable dealers or advanced collectors, since these would interest only a small group of collectors in the estimated price range of \$2400-3200.

Klondike - c1898. Fixed focus box camera for 31/4x41/4" plates. Adjustable shutter speeds & diaphragm.\$75-100.

Lilliput Detective Camera - c1889. A detective camera in the shape of a miniature satchel. Takes 21/₂x21/₂" plates in double plateholders. A rare item. Two examples with restored or replaced leather covering have sold in excess of \$2000 at auction. In original condition: \$5500-7500.

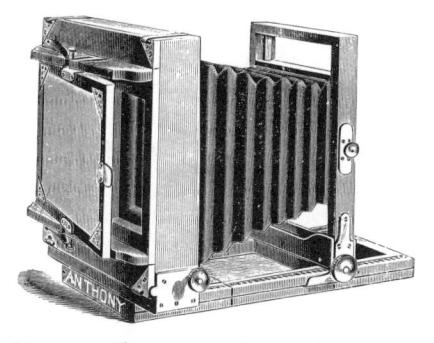

Normandie - According to the Anthony 1891 catalog, this was the "lightest, most compact, and easily adjustable, reversible back camera in the market." The springloaded ground glass back was a relatively new feature at that time. Made in sizes from 4x5" to 14x17". Current value with original lens \$250-375.

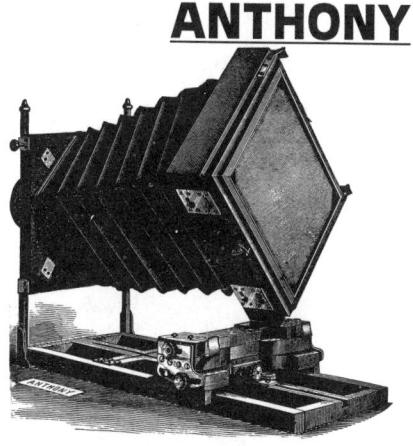

Novel - A family of view cameras from the 1880's with a rotating back & bellows combination. Although 4x5" & 5x7" sizes were made, by 1888 the Novel cameras were made only in sizes 8x10" and larger. The smaller sizes were replaced by the Novelette. With brass barrel lens \$200-300

Novelette, Duplex Novelette - c1885. View cameras. Similar in design to the Novel, with the rotating back & bellows unit. The Duplex Novelette carried this idea one step further by allowing the bellows to be easily released from the lensboard. This permitted the user to convert from a 5x8" to an 8x10" back in seconds. Made in all standard sizes from 4x5" to 11x14" in basic, single swing, and double swing models ranging from \$12 to \$54. Current value with lens \$300-450.

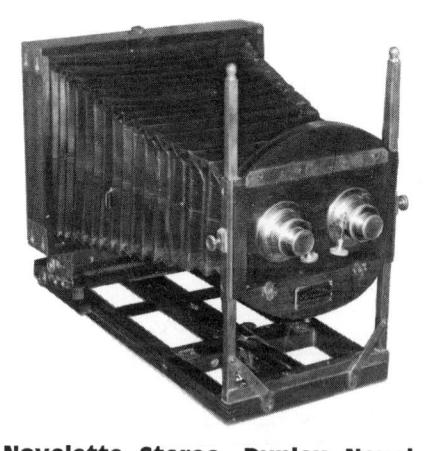

Novelette Stereo, Duplex Novelette Stereo - Essentially the same camera as above, but fitted with twin lenses to make stereo views. \$400-600.

PDQ - c1890. A detective box camera for 4x5" plates or films. Made in polished walnut and leather covered models. Original price \$15-25. Currently \$600-900.

ANTHONY...

Portrait Camera - c1870's-1890's. Several models were made, from No.2 to No.17, and in sizes from $4^{1}/_{4}x6^{1}/_{2}$ to 18x22". With stand: \$400-600.

Satchel Detective Camera - Consists of a Climax Detective camera in a special covering designed to look like a satchel with a shoulder strap. The bottom of the satchel is completely open to allow access to the camera's controls. This outfit was called the "Climax Detective Satchel Camera" in the 1893 catalog, although earlier catalogs used the "Satchel Detective Camera" name. This is an extremely rare camera, and obviously the price would be negotiable. One sold at auction a few years ago in the range of \$15,000-\$20,000.

Schmid's **Patent Detective** Camera - The first hand-held instantaneous camera produced in America. Although two years earlier the Englishman, Thomas Bolas, produced and patented two hand-made prototype cameras which were hand-held with viewfinders, these were never commercially produced. Therefore the Schmid was the world's first "commercially produced" hand-held camera. Patented January 2, 1883 by Wm. Schmid of Brooklyn, NY. The earliest model for $3^{1}/_{4}$ x4 $^{1}/_{4}$ " plates featured a rigid one-piece carrying handle formed from a brass rod. The second model featured a folding handle. Later models had the focusing scale on the right side, and leather covering was optional. The 1891 catalog offers 6 sizes from 31/4x41/4" to 8x10", sizes above

4x5" on special order only. \$4500-6500.

Solograph - c1901. Nicely finished folding-bed camera made in 4x5" & 5x7" sizes. Mahogany body with morocco leather covering, red russia leather bellows. Catalog numbers 1-7 were used for various shutter/lens combinations. \$120-180.

Stereo Solograph - c1901. Well-crafted lightweight folding-bed stereo camera for 41/₂x61/₂" plates. Mahogany body with morocco leather covering. Polished wood interior. Red Russian leather bellows. Rack & pinion focus. \$500-750.

Victor - c1891-93. Mahogany folding view cameras, made in at least 6 sizes from 4x5" to 8x10". Typically with brassmounted lens in B&L shutter. \$175-250.

Victoria Four-Tube - c1870's-1900. Fixed tailboard studio camera for 5x7" plates. Rear insert allows taking four photos on one plate. With four Gem lenses: \$1500-2000.

Vincent - c1890-93. A new style of camera in which the bed is made of two solid wood sections. The front standard is fixed to the front of the inner section telescopes inside the solid front door. In the collapsed position, the inner bed section extends rearward from the camera back, then hinges up to form a protective cover for the ground glass. Made in 5x7, 5x8, 61/2x81/2, and 8x10" sizes. Reversible back; rising front. \$350-500.

View cameras - Anthony made a variety of view cameras, most of which can be identified with a certain amount of research. However, it is relatively safe to say that most do not fall into the category of useful equipment today, and therefore can be classified strictly as collectible cameras. They were made in all popular sizes from $31/4 \times 41/4$ " to 18×22 ". While some of the earlier models stir more interest, the later, more common folding-tailboard types can generally be found in very good condition, with an original vintage lens, for \$250-375.

ANTHONY & SCOVILL (New York)
This name was used for several years after
the merger of these two companies. During
this time, they manufactured a full line of

cameras including a series of box cameras named "Ansco". In 1907, the company name was shortened to Ansco. Many of the camera models continued through the various company names. For sake of continuity we may have listed them together under ANTHONY, SCOVILL, or ANSCO. The earliest "Ansco" cameras are listed here because they predate the use of that same name as a company name. This distinction is significant to historians.

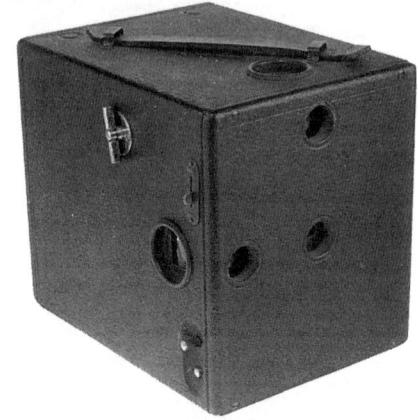

Ansco No. 2 - c1903-1906; continued and modified after the company name change to Ansco. Introduced "Ansco" as a camera name just after the merger. Eventually this name was adopted as the official company name. A leather covered wooden box camera for 31/4x41/4" exposures on rollfilm. "The Anthony & Scovill Co." on top strap. No other model identification on the camera. Flip-flop shutter is operated by alternate use of two buttons in the lower front corner of the right side. Early versions ca. 1903-1904 have the film advance knob near the upper rear corner of the right hand side. Later, ca. 1906, the knob is just forward of the upper center. \$30-45.

Ansco No. 3 - c1903-1906. The larger version of the original "Ansco" box camera, for 4x5" exposures on rollfilm. Anthony & Scovill version: \$35-50.

APM (Amalgamated Photographic Manufacturers Ltd., London) APM was formed in 1921 and brought together seven British photogrpahic companies: A. Kershaw and Son Ltd, Kershaw Optical Co., Marion and Co. Ltd, Marion and Foulgar Ltd, Paget Prize Plate Co. Ltd, Rajar Ltd, and Rotary Photographic Co. Ltd. APM aimed to bring together the resources of these companies which included both equipment manufacturers and producers of sensitised materials. The "APeM" tradename was adopted for many of its products.

The amalgamation was never a commercial success despite the wide range of its products and on February 1, 1929 APM divided. The sensitised materials manufacturers of Marion and Co., Paget, and Rajar formed Apem Ltd. and based themselves in the Watford factory of Paget. Apem was taken over and absorbed into Ilford Ltd c1932. The remaining companies all concerned with equipment production (except Rotary which undertook printing) remained as APM until c1930 when they regrouped as Soho Ltd.

APM produced a wide range of cameras which tended towards the lower end of the market, although by 1928 studio cameras featured heavily alongside a vast number of accessories. Their cameras included the

Apem press camera, Soho Reflex made by Kershaws and the Rajar No. 6 camera (1929). The Rajar is noteworthy because it was one of the first all plastic-bodied cameras and was distributed through premium schemes.

Box cameras - c1920's. Leather covered wooden box cameras in $2^{1}/_4 \times 3^{1}/_4$ " and $2^{1}/_4 \times 4^{1}/_4$ " sizes. Three stops; single speed shutter. \$25-35.

Focal Plane Camera, plate model -Strut folding 9x12cm plate camera with focal plane shutter. Kershaw Anastigmat f4.5/51/2" lens. \$50-75.

Rajar No. 6 - Folding camera with 4 cross-swing struts. Body and front plate made of bakelite. Its 1929 introduction makes it one of the earliest bakelite rollfilm cameras. \$25-35.

Reflex - Inexpensive single lens reflex cameras in 21/4x31/4" and 31/4x41/4" sizes, made by Thornton-Pickard, also associated with Apem. Cooke Apem Anastigmat f4.5. \$75-100.

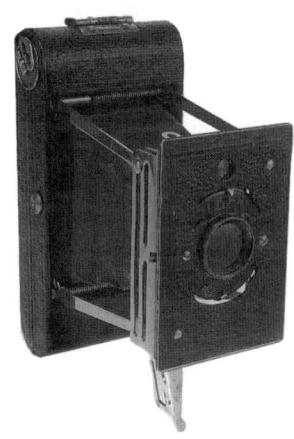

Vest Pocket - c1922. Strut-type camera for 127 rollfilm. Identical to Ansco Vest Pocket; made by Ansco for APeM. Unidentified lens in Ilex "APEM" shutter. \$30-45.

APPARATE & KAMERABAU GmbH. (Friedrichshafen, Germany) Akarelle - c1954. Unusually designed

35mm camera with two side-by-side finders for 50mm and 75mm lenses. Lever wind. Various interchangeable lenses f2 to f3.5. Prontor shutter. \$50-75.

Akarelle Lenses: Lenses mount with a 35mm female threaded locking ring at the rear of the lens.

Schneider Radionarf 4.5/75mm - \$35-50. Tele-Xenarf3.5/90mm - \$60-90.

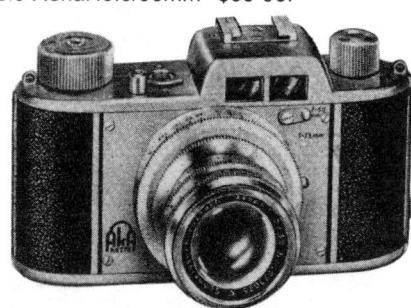

Akarette Cameras - c1949. Similar to

Akarette 0 - Basic black enameled model with Radionarf3.5 lens. \$60-90. Akarette I - Has chrome faceplate, selftimer, and film reminder in advance knob. \$45-60.

Akarette II - Metal parts chromed. leather covered, has strap lugs, and one of the following lenses: Radionar f3.5, Xenar f3.5, 2.8, or f2, \$45-60.

Akarex I - c1953. 35mm camera with fixed lens and uncoupled rangefinder. Westar f3.5/45mm in Pronto or Prontor SVS. \$45-60.

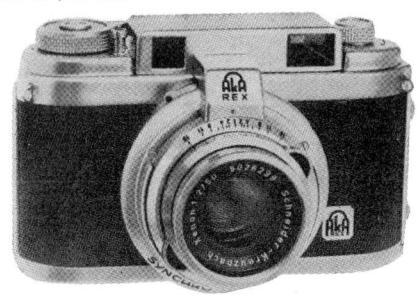

Akarex III - c1953. 35mm rangefinder camera. Rangefinder and lens are interchangeable as a unit. Normal lens: Isco Westar f3.5/45mm. Also available: Schneider Xenon f2/50mm, Tele-Xenar f3.5/90, and Xenagon f3.5/35mm. Camera with 3 lenses: \$150-225. Camera with f2 lens only: \$60-90. With f3.5 lens: \$50-75.

Arette - 35mm cameras of the late 1950's. Purely by observation, we are beginning to sort out some of the codes for the model letters. "B" models have meter (Belichtungsmesser). "C" has coupled rangefinder. "D" has rangefinder and meter. "n" indicates non-changeable lens, while "W" is interchangeable(wechselbar).

Arette la - Early models c1956 are basic. Later variation c1957 has bright frame. Front cell focusing Color Arettar or Color Isconar f2.8 lens in Pronto or Prontor SVS. No RF; no meter.

Arette Ib - has meter, otherwise like la.

Arette Ic - c1957. CRF. Arette Id - c1957. Meter & rangefinder. Arette A - Basic model. Arettar f2.8/45mm in Vario 1/25-1/200. Similar basic models also called Ia, and P.

Arette Bn - c1958. Fixed lens with front cell focusing, meter. **Arette Bw** - c1958. Interchangeable

lenses in helical focusing mount, meter, no rangefinder.

Arette C - c1958. CRF, helical focusing fixed lens, no meter.

Arette Dn - c1958. CRF, helical focusing fixed lens, meter.

Arette P - Simple version of the model A. Fixed lens in Vario shutter.

Arette W - Interchangeable Wilon f2.8/50 in Prontor SVS to 1/300. Bright frame finder, no rangefinder or meter.

Despite the differences of equipment, these cameras all sell in a narrow range. The better equipped models usually in the \$35-50 range and the more basic models from \$25-35.

Arette Automatic S - c1959. Color-Westanar f2.8/45mm in Prontormat. Builtin automatic meter. \$30-45.

Arette Automatic SE - c1959. Prontor SLK shutter, plus CRF. \$35-50. Arette Automatic SLK Prontor SLK shutter, no RF. \$30-45.

Optina IA - c1957. Name variant of the late Arette IA with bright-frame finder. Uncommon with this name. \$50-75.

APPLETON & CO. (Bradford, England)

Criterion - c1900. Half-plate mahogany field camera. Thornton-Pickard shutter. Voigtländer lens with wheel stops. \$120-

ARCOFLEX - Japanese novelty camera of the "Hit" type. Not a reflex camera as the name would imply. A rather uncommon name. \$20-30.

ARCON (Taiwan)

Micro-110 (in can) - c1986. This is a standard Micro 110 camera, but it's packed in a cylindrical cardboard can with pull-tab top. \$12-20.

ARGUS, INC. (Ann Arbor, Michigan & Chicago, Illinois.) Originally founded as International Research Corp., Ann Arbor, Michigan. The name was changed to "Argus, Inc." in 1944, the new name coming from their popular Argus cameras. We are listing the Argus cameras basically in alphabetical order, but with the "A" and "C" series chronological. Therefore the "B" and "FA" fall as variations within the "A" series, where they belong in reality despite their model letter.

Argus A - 1936-41. 35mm cartridge camera with bakelite body. Argus Anastigmat f4.5/50mm in collapsible mount.

ARGUS...

Early models have fixed pressure plate, sprockets on one side of film. Later models have floating pressure plate and sprockets on both sides. Of the early types, it should also be noted that the first 30-35 thousand were made before a tripod socket was added to the bottom and the rewind knob thickened to match. Originally advertised in the following color combinations: Black/chrome, gray/gunmetal, ivory/gold, and brown/gold. In actual practice, the "gunmetal" may be chrome and the "gold" is definitely brass. Gold: \$120-180. Gray or Olive drab: \$50-75. Black: \$20-30.

Argus A (126 cartridge) - To avoid confusion with the original Argus A above: This is a recent 2-tone gray plastic camera for 126 "Instamatic" film. \$1-10.

Argus AF - 1937-38. Same as A, but lens mount focuses to 15". \$12-20.

Argus B - 1937. Body same as A, but with fast Argus Anastigmat f2.9 lens in Prontor II shutter with self-timer. Reportedly only 1,000 made. \$50-75.

Argus A2 (A2B) - 1939-50. Similar to the A, but with extinction meter. Two position focus. Coated lens after July 1946. \$15-25.

Argus A2F - 1939-41. Like A2 with extinction meter but also close focusing to 15". \$25-35.

Argus AA (Argoflash) - 1940-42. Synchronized for flash, otherwise similar to the "A". However, it has a simpler f6.3 lens and T&I shutter. \$25-35.

Argus A3 - 1940-42. A streamlined version of the A series, with fully rounded body ends and a chrome top housing incorporating an extinction meter. Exposure counter on front. Body shutter release. \$25-35.

Argus 21 (Markfinder) - 1947-52. A reincarnation of the A3 body style, with interchangeable lenses and a bright-frame finder. Cintar f3.5/50mm coated lens. \$25-35.

Argus FA - 1950-51. The last of the "A" series with the original body style. Large flash socket added to the left end of the body. Argus Anastigmat f4.5/50mm. Two position focus. 25-150,B,T. \$30-45.

Argus A4 - 1953-56. Body style completely different from the earlier "A" cameras. Boxy plastic body with aluminum faceplate. Cintar f3.5/44mm, sync. \$12-20.

Argoflex - There are a number of Argoflex twin-lens reflex style box cameras, none of which cause excitement among collectors. All take 6x6cm on 620 film.

Argoflex E - 1940-48. Focusing 3-element f4.5/75mm Varex Anastigmat; shutter b-200. \$25-35.

Argoflex EM - 1948. Also called Argoflex II. Metal body. \$25-35.

Argoflex EF - 1948-51. Flash model. \$25-35.

Argoflex 40 - 1950-54. Beginning with this model, the lenses are no longer externally coupled, and the viewing lens does not focus. \$8-15.

Argoflex Seventy-five - 1949-58. Black plastic body. Fixed focus. \$1-10. Slightly higher in Europe.

Argus Seventy-five - Same as Argo-flex Seventy-five except for shortened name. \$1-10.

Argus Seventy-five (Australia) - c1959. Like the USA model, but marked "Made in Australia" on lens rim. Black plastic body with red or black shutter button. Lumar 75mm lens. First assembled with imported components; later made in Australia by Hanimex. \$12-20.

Argus 75 - 1958-64. Brown plastic body.

Argus 75 - 1958-64. Brown plastic body. Continuation of the Argoflex/Argus Seventy-five with minor cosmetic changes, name written with numerals. \$1-10. Slightly higher in Europe.

Argus Super Seventy-five - 1954-58. Focusing Lumar f8/65mm coated lens, otherwise like the Argoflex Seventy-five. \$12-20.

Autronic I, Autronic 35, Autronic C3 - 1960-62. Although the camera bore several designations during its short life, it was really just one model. Similar in appearance to the C33, but incorporating a meter for automatic exposure with manual override. Cintar f3.5/50mm. Synch shutter 30-500, B. \$20-30. (Often found with inoperative meter for about half as much.)

Argus C - 1938-39. The original brick-shaped camera with a non-coupled range-
finder. With olive drab body: \$75-100. With speed range select switch: \$100-150. Without speed range select switch, as in

C2: 40-60.

Argus CC (Colorcamera) - 1941-42. Streamlined camera based on the A3 body, but with uncoupled selenium meter instead of extinction type. \$45-60.

Argus C2 - 1938-42. Like the "C", but the rangefinder is coupled. Introduced just after the model C in 1938. An early "brick". \$25-35. Slightly higher in Europe.

Argus C3 - 1939-66. The most common "brick". A solid, durable, and well-liked camera, like the C2, but with internal synch. Common. Somewhat higher in Europe. \$12-20.

Argus C3 Matchmatic - 1958-66. Basically a face-lifted C3 in two-tone finish. Designed for use with a non-coupled clipon selenium meter. Must be complete with meter to be valued as a collectible. Somewhathigher in Europe. \$20-30.

Argus C3 Accessories: Sandmar 35mm f4.5 lens - with 35-100 finder: \$50-75.

Tele-Sandmar 100mm f4.5 - with hood & caps: \$25-35.

Soligor 135mm f4.5 - with viewfinder

mask: \$35-50. **Argus C-3 Meter -** \$8-15.

Golden Shield (Matchmatic C-3) - Special exterior trim enhances an otherwise normal Matchmatic C-3. Bright embossed metal front and small "Golden Shield by Argus" nameplate. With meter: \$50-75.

Argus C4 - 1951-57. Similar to the Model 21 Markfinder of 1947, but with coupled rangefinder rather than bright frame view-finder. Cintar f2.8/50mm. \$20-30. Some C4 cameras were adapted to take interchangeable lenses, and these use a different mounting flange from the C44. Available lenses included Enna Lithagon 35mm, 45mm, and 100mm. This modification was done by dealers representing Geiss America and Enna-Werk. Wide angle or tele lens: \$35-50.

Argus C4R - 1958. Like the C4, but with rapid film advance lever. \$45-60.

Argus C44 - 1956-57. Similar to the C4 series, but with interchangeable lens mount. Three-lens outfit: \$75-100. With Cintagon f2.8/50mm normal lens: \$45-60.

Argus C44R - 1958-62. Flat top deck with recessed rewind crank. Features like the C44 but with rapid advance lever. Three-lens outfit (Cintagons): \$100-150. With normal lens: \$45-60.

C44 Accessories:

35mm f4.5 Coated Cintagon - \$25-

35mm f4.5 Enna-Lithagon - \$20-30. 100mm f3.5 Coated Cintagon - \$30-45.

100mm f4.5 Enna Tele-Lithagon - \$20-30

ARGUS...

135mm f3.5 Coated Cintar - \$30-45. **Variable Power Viewfinder -** \$20-30

Argus C20 - 1956-58. Replaced the A4, using the same basic body style but incorporating a rangefinder. Brown plastic body. \$15-25.

Argus C33 - 1959-61. A new design incorporating features of the C3 and C4 series in a boxy body even less appealing than the famous brick. It did have a combined view/rangefinder and interchangeable lenses, and accepted an accessory coupled meter. Shutter cocking is coupled to the film advance lever. With normal lens: \$30-45.

Argus C33 Accessories:
Accura Telephoto - Front of lens attachment, 46mm thread. \$8-15.
Schneider Cintar 100mm f4.5 - \$30-45

Camro 28 - Same camera as the Minca 28, but with a different name. \$30-45.

Delco 828 - Same camera as the Minca 28, but with a different name. \$30-45.

Argus K - 1939-40. One of the more desirable Argus cameras, the Model K is assumed to be a simplified version of the legendary Model D (a spring-motor autowind camera announced in 1939 but apparently never marketed). The Model K retained the same body style, but without the autowind feature. It did include a COUPLED extinction meter for its \$19.50 original price. \$300-450.

Lady Carefree - Cheap 126 cartridge camera made for Argus by Balda-Werke in

ARGUS...

Germany. Tan with brown covering or white with cream brocade covering. \$1-10.

Argus Model M - 1939-40. Streamlined bakelite camera for 828 film. Argus anastigmat f6.3 lens in a collapsible mount. For 8 exp. 24x36mm or 16 exp. 19x24mm. \$50-75.

Minca 28 - (also called Model 19) 1947-48. A post-war version of the streamlined bakelite Model M camera. Lunar f9.7 lens. (Also sold under the names "Camro 28" and "Delco 828".) \$30-45.

Argus SLR - c1962-66.35mm SLR made by Mamiya for Argus. Mamiya-Sekor f1.7/58mm, bayonet mount. FP shutter 1-1000,B.\$60-90.

Argus Solid State Electronic (transparent) - c1969. Automatic electronic 126 cartridge camera, made by Balda-Werke in Germany Design is same as the Argus Electric Eye Instant Load model 374, but clear plastic front reveals workings of Prontor Electronic shutter. \$45-60.

Argus V-100 - 1958-59. Rangefinder camera made in Germany for Argus. BIM. f2/45mm Cintagon II or f2.8/50mm Cintar II in Synchro-Compur.\$30-45.

ARGUS/COSINA Argus STL 1000 - 35mm SLR. With f1.8/50mm:\$50-75.

ARNOLD, KARL (Marienberg) Founded in 1888 by Karl Arnold, the firm was a manufacturer and dealer in photographic goods including wooden field cameras, tripods, etc. In the mid-1930's, under the ownership of Arthur Hötzeldt, in addition to accessories the company produced several models of KARMA cameras, an abbreviation of KArl ARnold, MArienberg.

Karma-Flex - There is some confusion in identification of Karma-Flex 4x4cm models. Original factory literature is not consistent in the use of Model 1 and Model 2 designations, possibly due to printer error. The bulk of the evidence we have seen suggests that the single-lens reflex model was called model 1, and the twin-lens style was called model 2.

Some factory illustrations show the twin-lens model with "Karma-Flex 2" on the viewing hood.

Karma-Flex 4x4 Model 1 - c1932-37. SLR for 4x4cm on 127 film. Ludwig Vidar or Laack Regulyt f4.5/60mm. Guillotine shutter 25-100. Black leather covered metal body. \$300-450.

Karma-Flex 4x4 Model 2 - c1932-36. Typical Karma body style, but twin-lens-reflex, with two small closely spaced lenses on front. Takes 4x4cm on 127 film. Fixed focus f11 lens in M,Z shutter. Rare. \$600-900.

Karma-Flex 6x6cm - Rare model resembling the trapezoidal Karma camera with a reflex finder perched on top almost as if an afterthought. Focal plane shutter to 500. Victar f3.5/75mm in helical focusing mount. This is much less common than the 4x4cm models. \$750-1000.

Karma-Lux - c1937. Box-form camera with unusual finder perched on top. Finder has hooded reflex viewing from above, and also eye-level viewing from the rear. Simple Z,15,50 shutter. Three-element f7.7

lens. Original price: RM24. in 1937. Estimate \$800-1200.

Karma-Sport - c1935. 6x6cm rollfilm camera for 120 film. Trapezoid-shaped body with black leather. Eye-level telescopic finder and optional top-mounted uncoupled rangefinder. Ludwig Victar, Laack Dialytar, or Meyer Trioplan f3.5/75mm lens, helix focus. Focal plane shutter 25-500, T. \$500-750.

ARROW - Novelty camera of "Hit" type for 14x14mm on 16mm paper-backed rollfilm. Japanese made: \$25-35. Later Hong Kong version: \$12-20.

ARROW - Plastic 120 rollfilm camera of the Diana type. \$1-10.

ARS OPTICAL CO. LTD.

Acon 35 - c1956-58. Japanese 35mm RF cameras. f3.5/45mm Vita lens. Models I, II, & IIL. \$30-45.

Sky 35 Model II - Same as the Acon 35

ASAHI

except for the unusual name. Vita Anastigmat f3.5/45mm. Signa B,10-200 shutter. \$45-60.

ARTI-SIX - c1950's. England. Black bakelite eye-level camera for 6x9cm on 120 film. Helical telescoping front. Similar to the Wembley Sports camera. \$20-30.

AS DE TREFLE (France) As de Trèfle (Ace of Clubs) is a French retailer which had some cameras made with their own name.

As Phot - Black bakelite camera with helical telescoping front. Similar to the common Photax cameras from MIOM. An identical camera was sold by Gevaert as the Gevaphot. In addition to the As Phot faceplate, the "As de trèfle" name is molded into the back. \$20-30.

ASAHI KOGAKU (Tokyo) Founded in 1919, the Asahi Optical Co. began making projector lenses in the 1920's and camera lenses in 1931. During the war, Asahi production was strictly military. Their claim to fame is the introduction of the first Japanese 35mm SLR, the Asahiflex I of 1951. The Asabiflex line became the Pentax line which remains among the major cameras of today. From 1937 to 1943, there existed another "Asahi" company, Asahi Optical Works, which took the Riken name in 1943. This manufacturer is listed separately. To better follow the evolution of the series, we are listing all 35mm cameras in chronological order by year of introduction, followed by the 6x7 cameras, then the Auto 110 models. All 35mm Pentax cameras were available on black or chrome finish.

Asahiflex Cameras - The early Asahiflex cameras made from 1951-1957 are considerably different from the later Pentax models. Aside from the fact that they are boldly marked "Asahiflex" on the front, there are several other features which distinguish them. The reflex viewing is waist-level only, and there is a separate eye-level finder. The lens mount is a 37mm screw-thread, not the standard 42mm size.

Asahiflex I - 1952. FP shutter 20-500. Single synch post on front for FP bulbs. Takumar f3.5/50mm with manual diaphragm. The first Japanese 35mm SLR. Uncommon. \$400-600. *Illustrated at top of next column.*

Asabiflex I

Asahiflex Ia - 1953. FP shutter 25-500. Slow speed change to 1/25. Added synch for electronic flash and maintained synch for FP bulbs, so has F and X synch posts on front. Simpler shutter design. Takumar f3.5/50mm with preset aperture. \$250-375.

Asahiflex IIB - 1954. Instant-return mirror. Takumar f3.5/50mm preset or f2.4/58mm. No slow shutter speeds. Sold by Sears as Tower 23 with Takumar f3.5/50mm or Tower 24 with Takumar f2.4/58mm.\$250-375.

Asahiflex IIA - 1955. Like IIB, but with slow speed dial added to front. Slow speed dial has T,2,5,10. High speed dial 25-500,B. Takumar f3.5/50 or f2.4/58mm preset lenses. Also sold in USA by Sears as Tower 22. \$250-375.

Asahi Pentax (original) - 1957.

Also called the Pentax AP. In a completely new design from the earlier Asahiflex cameras, the Pentax incorporated an eyelevel pentaprism, interchangeable lenses with standard 42mm threaded lens mount, rapid advance lever, folding rewind crank. Normal lenses: Takumar f2.2/58mm, f2.2/55mm, or f2.4/58mm, all with preset diaphragm. Sold by Sears as Tower 26. \$150-225.

Asahi Pentax S - 1957-65. Identical to the original Pentax, but with arithmetic progression of shutter speeds, 1, 2, 4, 8, 15, 30, 60, 125, 250, 500. Takumar f1.8/55mm preset lens. Black rewind knob. \$75-100.

Asahi Pentax K - 1958. Internally coupled semi-automatic diaphragm. Closes to preselected aperture when shutter is released; opens by manual cocking lever on lens. Central microprism grid added to finder. FP shutter 1-1000. Auto-Takumar f1.8/55mm screwmount lens. Sold as Tower 29 by Sears. With lens: \$120-180. Body: \$90-130. Pentax bayonet-mount lenses are often called K-mount, but this mount originated in 1975 with the K-2. Pentax K has the standard 42mm screwmount.

Asahi Pentax S2 Asahi Pentax H2 Honeywell Heiland Pentax H2 -1959. FP shutter 1-500. All shutter speeds on one non-rotating dial. Shutter cock indicator. Lens Auto-Takumar f2/55mm. with normallens: \$90-130.

Asahi Pentax S3 Honeywell Heiland Pentax H3 Honeywell Pentax H3 - 1961. FP shutter 1-1000. Single, non-rotating speed dial. The interchangeable lens has fully automatic diaphragm operation by shutter release. A diaphragm lever at base of mirror housing pushes pin on the back of the lens, closing down the diaphragm to setting. The aperture of the fully automatic lens opens up immediately after shutter reaches its end. A lever on the rear of this lens can be set at A for Auto or M for manual diaphragm. Standard lens with this model is marked Auto-Takumar, but it has a fully automatic diaphragm like the Super Takumar series. Early versions of the H3 and H1 before April 1961 would not accept the clip-on Pentax Exposure Meter. With lens: \$90-130.

Asahi Pentax S1 Honeywell Heiland Pentax H1 Honeywell Pentax H1 - c1961-66. Like the Pentax S3, but top shutter speed 1/500. Standard lens is semi-automatic Auto Takumar f2.2/55mm. \$75-100.

Asahi Pentax Super S2 - 1961. Same as S1, but top shutter speed 1/₁₀₀₀. Standard lens Super Takumar f2/55mm. Japan home market only. \$90-130.

Asahi Pentax SV Honeywell Pentax H3v - 1962. Similar to the S3, with $1/_{1000}$ top speed, but with self-timer & self-zeroing exposure counter. Standard lens Super Takumar f1.8/55mm. This is a new lens with totally automatic diaphragm as on S3, but now marked Super Takumar. \$75-100. Illustrated at top of next column.

Asahi Pentax SV

Asahi Pentax S1a Honeywell Pentax H1a - 1962. Like the Pentax SV, but shutter marked 1-500. Will fire at 1/1000 if set to next (unmarked) click-stop beyond 500. For marketing reasons a pricing difference. Originally with Auto Takumar f2/50mm. With normal lens: \$75-100. Body: \$50-75.

Early Pentax Spotmatic SP

Late Honeywell Spotmatic

Asahi Pentax Spotmatic (SP)
Honeywell Spotmatic - c1964. A
totally new Pentax, the first with throughthe-lens exposure metering. Named
"Spotmatic" because prototype had spot
meter, but production versions have
averaging meter. Two CdS cells read light
from ground glass focusing screen. Directly coupled to shutter & film speed setting.
Photo-electrically coupled to lens diaphragm (stop-down metering). New selftimer. Early versions of both Asahi and
Honeywell models have a narrow meter

switch; later ones have a wider switch. Standard lens is the new Super Takumar f1.4/50mm. Also sold with f1.8/55mm lens. FP shutter B,1-1000. With normal lens in clean collectible condition: \$100-150. Worn but working bodies for use: \$45-60.

Asahi Pentax SL Honeywell Pentax SL - 1965. As Spotmatic but without metering system. With normal lens \$90-130.

Pentax Spotmatic Motor Drive - c1967. Presented at 1966 Photokina for professional use. Same as regular Spotmatic, but with special bottom plate to accept motor drive. (Normal Spotmatic can not be adapted for motor.) Identifiable by "MOTOR DRIVE" engraved on the front of the bottom plate. With motor drive unit, battery grip and normal lens: \$300-450. Camera only: \$120-180.

Asahi Pentax SP500 Honeywell SP500 - 1971. As Spotmatic, but top shutter speed 1/500, no self-timer. With Super Takumar f1.8/50mm: \$75-100.

Asahi Pentax Spotmatic II (SPII) Honeywell Pentax SPII - 1971. Improved version of the popular Spotmatic with wider film speed range. Hot flash shoe. Top speed 1/1000. With standard 50mm f1.4 or 55mm f1.8 SMC Takumar: \$120-180.

Asahi Pentax Spotmatic II (motor drive) - 1971. A special order item with battery handle. Accessories include radio controls, intervalometers, 250 exposure back. \$250-375.

Honeywell Pentax Spotmatic IIa - 1972. As Pentax II, but body incorporates sensor for automatic flash exposures with Honeywell Strobonar electronic flash. Honeywell/USAonly. \$100-150.

Asahi Pentax ES Honeywell Pentax ES - 1972. Fully automatic exposure. Electronically controlled shutter 1-1000, manual control 1/₆₀-1/₁₀₀₀ without batteries. Hot shoe flash; no self-timer. Open aperture or stop-down metering with memory circuit. Standard lens SMC Takumar f1.4/50mm.\$90-130.

Asahi Pentax ESII Honeywell Pentax ESII - 1973. Like ES, but controlled shutter speed down to 8. Evolutionary changes from ES include finder window blind to prevent light from influencing meter, shutter release lock, and increased film speed range. \$120-180.

Asahi Pentax Spotmatic F (SPF)

Honeywell Spotmatic F - 1973. As Spotmatic II, but with shutter release lock & open aperture TTL metering. Cloth FP shutter 1-1000, B. With standard SMC Takumar f1.4/50mm: \$100-150.

Asahi Pentax Spotmatic 1000 Asahi Pentax Spotmatic SP 1000 Honeywell Spotmatic SP 1000 -1974. Like Spotmatic II but no self-timer. Standard lens SMC Takumar f2/55mm. The last screw-mount Pentax made. Traditional prism shape without accessory shoe. With standard 55mm lens: \$100-150.

Pentax K2 - 1975. Introduced a new bayonet lens mount, abandoning the "standard" Praktica thread mount used on earlier Pentax cameras. Vertical run automatic electronic focal plane shutter 8-1000. Silicon photo diode TTL metering. ASA scale 8-6400. Shutter speed, aperture, meter needle, improper exposure warning, and film speed settings visible in finder. Split-image focusing plus custom screens. Standard lens SMC Pentax f1.2/50mm, f1.4/50mm, or f1.8/55mm. \$100-150.

Pentax K2DMD - 1976. Same as the Pentax K2, but with Data back and Motor Drive. With motor drive and grip: \$400-600

Pentax KX - 1975. K-mount SMC Pentax lens system. Rubberized cloth

focal plane shutter, all mechanical B,1-1000. Sync $^{1}/_{60}$ only. Fast action silicon cell match-needle metering. Speeds, aperture, and meter needle visible in finder. Standard lenses are SMC Pentax f1.2, f1.4, and f1.8/55mm.\$100-150.

Pentax KM - 1975. A slightly simpler version of the KX. CdS meter cell. Meter needle visible in finder, but not shutter or aperture settings. Same mechanical shutter and same standard lenses as KX. \$100-150.

Pentax K1000 - 1975. Similar to the Pentax KM, but without self-timer. No mirror lock-up. With f2/50mm SMC Pentax M: \$60-90.

Pentax K1000 SE - 1979. Special edition. As the Pentax K1000, but with splitimage focusing and covered in brown leather. With f2/50mm SMC Pentax M: \$75-100.

Pentax ME - c1976-81. Compact 35mm SLR with fully automatic aperture priority exposure. No shutter speed dial. Electronically timed Seiko MFC vertical run metal shutter is totally controlled by the meter. LED in finder indicates 8-1/₁₀₀₀ shutter speed or exposure warning. Accessory motor drive. New compact lens system in Pentax K bayonet mount. Standard SMC Pentax M f1.7/50mm lens. With 50mm lens: \$75-100.

Pentax ME-SE - As ME, but with split-image screen. \$75-100.

Pentax MX - 1976. Compact SLR, slightly more traditional than the ME; horizontal rubberized silk focal plane shutter, 1-1000,B. Full manual exposure control. Gallium photo diode. Standard lens SMC Pentax M f1.4/50mm or f2.8/40mm in Kmount. \$150-200.

Pentax LX - 1980. Fully featured SLR developed for professional and advanced photographers. Electronically controlled titanium shutter, $1/_{125}$ - $1/_{2000}$ stepless. Mechanical speeds $1/_{75}$ - $1/_{2000}$. Full information in finder. Exposure modes include aperture preferred fully automatic, match-LED, or manual. IDM (Integrated Direct Metering) system measures flash and ambient light off the film plane, integrates both. With sufficient ambient light, the flash does not fire. Accepts motor drive, 250 exposure back. With FA-1 finder: \$400-600

Pentax LX Winder - \$140-180.

Pentax MV - 1979. Economized version of the ME, not allowing accessory winder. Shutter and metering system remained the same. With SMC Pentax M f2/50mm lens: \$65-100.

Pentax MV-1 - 1980. As Pentax MV, but with winder capability. With normal lens: \$65-100.

Pentax ME Super - c1980-86. Upgraded version of ME with speeds 4- 1/2000; full selection of speeds also in manual mode. Accepts motor drive. Standard lens SMG Pentax M f1.4/50mm. Black model, add

10%. Chrome model with 50mm lens: \$100-150.

Pentax MG - c1982. Updated version of ME, with dedicated flash capability, flash-ready LED in the finder. Three colored LEDs for shutter speed indication. Silicon cell metering, not gallium. No manual speeds. Accepts Pentax ME & MEII winders. With normal lens: \$75-100.

Pentax ME-F - 1982. The first 35mm autofocus SLR, featuring through the lens electronic focusing control. Electronically controlled stepless speeds 4 sec to ½2000, or the same range manually selected. Body same as ME Super, but with new control switch on top for TTL electronic focusing control. Original price was high, but the first generation of autofocus SLR cameras was not popular, and the ME-F was closed out at lower prices within three years. With 35-70mm f2.8 autofocus zoom (built-in focusing motor): \$150-200. Body only: \$75-100.

Pentax 35mm Lenses: The Pentax lenses fall into several name categories which help to date the lenses. Takumar lenses originated with the Asahiflex cameras, but these were not in the standard 42mm mount. **Takumar** 42mm screwmount lenses were introduced in 1957 for the Pentax cameras. They have manual or preset diaphragms. Auto Takumar lenses were introduced in 1958, and had semi-automatic diaphragm which closed automatically, but required manual reopening. Super Takumar lenses had fully automatic diaphragms and were introduced about 1965 with the Spot-matic cameras. SMC Takumar (Super Multi Coated) lenses were introduced in 1971 with the Spotmatic II. For the most part, they are identical to the Super Takumar equivalent, but with the improved coating. SMC Pentax lenses are essentially the Kmount bayonet version of the screwmount SMC Takumars. They arrived in 1975. SMC Pentax-M lenses are compact, lightweight designs which replaced many of the earlier designs. SMC Pentax-A lenses, introduced in 1983 for the Pentax Super A, have electrical contacts for programmed automatic exposure. SMC Pentax F lenses are autofocus lenses designed for the Pentax SFX. Presently, we are not including these recent autofocus lenses in this guide.

SINGLE FOCAL LENGTH LENSES:

15mm f3.5 SMC Takumar - c1972. Ultra-wide angle without barrel distortion. 13 elements; focus to 0.3m; 111° diagonal view, 100.5° horizontal field; built-in filters. \$250-375.

15mm f3.5 SMC Pentax - 13 elements, 12 groups; focus to 0.3m (1'); built-in filters. \$200-375.

15mm f3.5 SMC Pentax-A - 13 elements, 12 groups; focus to 0.3m; built-in filters. \$350-500.

16mm f2.8 SMC Pentax-A Fish-Eye - (c1986, replaced 17mm/f4); 9 elements, 7 groups; focus to 0.2m. \$250-375.

17mm f4 Super Takumar Fish-Eye - (replaced 18mm/f11) \$150-225.
17mm f4 SMC Takumar Fish-Eye - (same as Super Takumar Fish-Eye, but with SMC coating). 11 elements; 160° angle. UV, Y2, O2 filters built in. \$175-250.
17mm f4 SMC Pentax Fish-Eye - 11 elements, 7 groups; focus to 0.2m. \$200-

18mm f3.5 SMC Pentax - 12 elements, 11 groups; focus to 0.25m; 100° \$250-375.

18mm f11 Takumar Fish-Eye - With caps & box, one reached \$337 at auction in 9/91, and we have seen asking prices at double that amount. Normal range of known sales: \$250-375.

20mm f2.8 SMC Pentax-A - 10 elements, 9 groups; focus to 0.25m. \$300-450.

20mm f4 SMC Pentax - no price data. **20mm f4 SMC Pentax-M** - 8 elements; focus to 0.25m; 94°. \$250-375.

20mm f4.5 Super Takumar - Ultrawide, without barrel distortion. \$175-250.
20mm f4.5 SMC Takumar - (same as Super Takumar, but with SMC coating). 11 elements; focus to 7.8"; 94° angle. \$200-300.

24mm f2.8 SMC Pentax - 9 elements, 8 groups; focus to 0.25m; 84°. \$150-225. **24mm f2.8 SMC Pentax-M** - \$150-225.

24mm f2.8 SMC Pentax-A - 9 elements, 8 groups; focus to 0.25m. \$175-250

24mm f3.5 Super Takumar - (retrofocus) \$120-180.

24mm f3.5 SMC Takumar - 9 elements; focus to 10"; 84°. \$120-180. 24mm f3.5 SMC Pentax - no sales

24mm f3.5 SMC Pentax - no sales data.

28mm f2.0 SMC Pentax - 9 elements; focus to 0.30m; 75°. No sales data.

28mm f2.0 SMC Pentax-M - 8 elements, 7 groups; focus to 0.30m; 75°. \$120-180.

28mm f2.0 SMC Pentax-A - 8 elements, 7 groups; focus to 0.3m. \$120-180.

28mm f2.8 SMC Pentax-M - 7 elements; focus to 0.3m. \$50-75. **28mm f2.8 SMC Pentax-A -** 7 elements; focus to 0.3m. \$75-100.

28mm f3.5 Super Takumar - 7-element retrofocus design, minimum focus 15.75"; 75° angle. \$60-90.

28mm f3.5 SMC Takumar - same specs as Super Takumar but SMC coating. \$90-130.

28mm f3.5 SMC Pentax - \$50-75. 28mm f3.5 SMC Pentax-M - 6 elements; focus to 0.30m; 75°. \$50-75.

28mm f3.5 SMC Pentax Shift - 12 elements, 11 groups; focus to 0.3m (1'); built-in filters; manual diaphragm. \$400-600

30mm f2.8 SMC Pentax - 7 elements; focus to 0.3m; 72°. \$90-130.

35mm f2.0 Super Takumar - \$100-150. **35mm f2.0 SMC Takumar** - 8 elements; focus to 15"; 63°. \$150-225. **35mm f2.0 SMC Pentax** - \$150-225. **35mm f2.0 SMC Pentax-M** - 7 elements; focus to 0.3m; 62°. \$150-225. **35mm f2.0 SMC Pentax-A** - 7 elements; focus to 0.3m. \$150-225.

35mm f2.3 Auto Takumar - mid-1960's only. 6-element; 63° angle. \$100-150.

35mm f2.8 SMC Pentax-M - 6 elements; focus to 0.3m; 62°. \$50-75. **35mm f2.8 SMC Pentax-A -** 6 elements; focus to 0.3m. \$75-100.

35mm f3.5 Super Takumar - 5 elements; focus to 1.5'; 63° angle. \$50-75. 35mm f3.5 SMC Takumar - same but SMC coating. \$60-90. 35mm f3.5 SMC Pentax - \$35-50.

35mm f4 Takumar - (Asahi's first W.A. lens) \$50-75.

40mm f2.8 SMC Pentax-M - 5 elements, 4 groups; focus to 0.6m; 56°. \$90-130.

50mm f1.2 SMC Pentax - 7 elements, 6 groups; focus to 0.45m; 46°. \$120-180. **50mm f1.2 SMC Pentax-A** - 7 elements, 6 groups; focus to 0.45m. \$150-225.

50mm f1.4 Super Takumar - (Spotmatic standard lens c1965) \$50-75.
50mm f1.4 SMC Takumar - 7 elements; focus to 18"; 46°. Standard lens for Spotmatic II & IIa. \$50-75.

50mm f1.4 SMC Pentax-M - 7 elements, 6 groups; focus to 0.45m; 46°. \$50-75

50mm f1.4 SMC Pentax-A - 7 elements, 6 groups; focus to 0.45m. \$60-90.

50mm f1.7 SMC Pentax-M - 6 elements, 5 groups; focus to 0.45m. \$45-60. **50mm f1.7 SMC Pentax-A** - 6 elements, 5 groups; focus to 0.45m. \$30-45.

50mm f2.0 SMC Pentax - (Standard lens for Pentax K-1000)

50mm f2.0 SMC Pentax-M - 5 elements; focus to 0.45m. \$30-45. 50mm f2.0 SMC Pentax-A - 5 ele-

ments; focus to 0.45m. \$30-45.

50mm f2.8 SMC Pentax-A Macro - 6 elements, 4 groups; focus to 0.24m. \$150-225.

50mm f4 Macro Takumar - (manual diaphragm) \$75-100.

50mm f4 SMC Macro Takumar - auto diaphragm; 4 elements; focus to 9.5"; 46°. \$120-180.

50mm f4 SMC Pentax-M Macro - 4 elements, 3 groups; focus to 0.234m (0.77'); 46°. \$100-150.

55mm f1.8 Auto Takumar - (Standard lens on Pentax K) \$30-45.

55mm f1.8 Supér Takumar - 6 elements; focus to 18"; 43°. Standard lens for Spotmatic & SL. \$30-45.

55mm f1.8 sMC Takumar - 6 elements; focus to 18"; 43°. Standard lens for Spotmatic II & IIa. \$35-50.

55mm f2.0 Auto Takumar - (Intro-

duced with Pentax S2) \$25-35. **55mm f2.0 Super Takumar -** 6 elements; focus to 18"; 43°. Standard lens for SL & SP500. \$20-30. \$25-35.

55mm f2.2 Takumar - (Pentax AP & Pentax S) \$35-50.

58mm f2.2 Takumar - (preceded 55mm f2.2) \$35-50.

85mm f1.4 SMC Pentax A* - 7 elements, 6 groups; focus to 0.85m. \$350-500.

85mm f1.8 Auto Takumar - semiautomatic diaphragm. 5-element; 29° angle. \$120-180.

85mm f1.8 SMC Takumar - \$120-180.

85mm f1.8 SMC Pentax - \$120-180.

85mm f1.9 Super Takumar - \$100- 150.

85mm f1.9 SMC Takumar - 5 elements; focus to 2.75'; 29°. \$120-180.

85mm f2.0 SMC Pentax-M - 5 elements, 4 groups; focus to 0.85m; 29°. \$120-180.

85mm f2.2 SMC Pentax Soft - simple soft-focus portrait lens, adjustable softness filter. 2 elements, 1 group; focus to 0.57m; manual diaphragm. \$150-225.

85mm f4.5 Ultra-Achromatic Takumar - (ultra-achromatic = corrected for chromatic aberration in the infrared and ultraviolet portions of the spectrum as well as visible light.) 5 elements; focus to 2'; 29°. No sales data.

100mm f2.8 SMC Pentax-M - 5 elements; focus to 1.0m; 24.5°. \$75-100. **100mm f2.8 SMC Pentax-A** - 5 elements; focus to 1.0m. \$120-180. **100mm f2.8 SMC Pentax-A Macro** - 7 elements; focus to 0.31m. \$300-450.

100mm f4 Bellows Takumar - \$75-100.

100mm f4 SMC Bellows-Takumar - preset; 5 elements; focus to 6" with Bellows II; 24.5° view. \$100-150.

lows II; 24.5° view. \$100-150.

100mm f4 SMC Pentax Bellows - auto/manual diaphragm; 5 elements, 3 groups \$100-150

groups. \$100-150. **100mm f4 SMC Pentax-M Macro** - (not for bellows); 5 elements, 3 groups; focus to 0.45m (1.48'). \$175-250.

100mm f4 SMC Pentax-A Macro - (not for bellows); 5 elements, 3 groups; focus to 0.45m. \$200-300.

105mm f2.8 Takumar - preset. 5-element; 23° angle. No sales data.

105mm f2.8 Auto Takumar - No sales data.

105mm f2.8 Super Takumar - auto diaphragm.5-element.\$75-100.

105mm f2.8 SMC Takumar - 5 elements; focus to 4'; 23°. \$90-130. 105mm f2.8 SMC Pentax - \$90-130.

120mm f2.8 SMC Takumar - 5 elements, 4 groups; focus to 3.9'; 20°. \$100-150

120mm f2.8 SMC Pentax - 5 elements, 4 groups; focus to 1.2m; 21°. \$100-150

120mm f2.8 SMC Pentax-M - 5 elements; focus to 1.2m. \$90-130.

135mm f1.8 SMC Pentax A* - 7 elements, 6 groups; focus to 1.2m. \$350-500

135mm f2.5 Super Takumar - \$75-

135mm f2.5 SMC Takumar - 5 elements; focus to 5'; 18°. \$100-150. **135mm f2.5 SMC Pentax** - 6 elements; focus to 1.5m. \$75-100.

135mm f2.8 SMC Pentax-A - 4 elements; focus to 1.2m. \$75-100. **135mm f3.5 Takumar** - preset. 5-

element; 18°. angle. \$35-50.

135mm f3.5 Auto Takumar - semiauto diaphragm. \$35-50.

135mm f3.5 Super Takumar - auto
diaphragm. \$35-50.

135mm f3.5 SMC Takumar - 5
elements; focus to 1.5m (5'); 18°. \$50-75.

135mm f3.5 SMC Pentax-M - 5

150mm f3.5 SMC Pentax-M - 5 elements; focus to 1.8m; 17°. \$60-90.

elements; focus to 1.5m. \$45-60.

150mm f4 Super Takumar - \$60-90. **150mm f4 SMC Takumar** - 5 elements; focus to 6'; 16.5°. \$90-130. **150mm f4 SMC Pentax** - \$90-130.

200mm f2.5 SMC Pentax - 6 elements; focus to 2m; 12°. No sales data.

200mm f2.8 SMC Pentax A* - 6 elements; focus to 1.8m. No sales data. 200mm f2.8 SMC Pentax A*ED - low dispersion glass; 6 elements; focus to 1.8m. \$600-900.

200mm f3.5 Takumar - preset. 4-element; 12° angle. \$75-100.

200mm f4 Super Takumar - \$75-100. 200mm f4 SMC Takumar - 5 elements; focus to 1.8m (8'); 12.5°. \$90-130. 200mm f4 SMC Pentax-M - 6 elements, 5 groups; focus to 2m. \$75-100.

200mm f4 SMC Pentax-A - 6 elements; focus to 1.9m. \$120-180.
200mm f4 ED SMC Pentax A*
Macro - \$600-900.

200mm f5.6 Takumar - Preset diaphragm. 5-element; 12° angle. Focus to 9'. \$90-130.

300mm f2.8 SMC Pentax-A*ED(IF) low dispersion glass, internal focusing, white barrel; 8 elements; focus to 3.0m. \$1200-1800.

300mm f4 Takumar - manual clickstop diaphragm. 3-element; 8° angle. Focus to 25'. \$100-150.

300mm f4 Super Takumar - No sales data.

300mm f4 SMC Takumar - 5 elements; focus to 18'; 8°. No sales data.
300mm f4 SMC Pentax - 7 elements,

5 groups; focus to 4m. \$250-375. **300mm f4 SMC Pentax-M** - 8 elements, 7 groups; focus to 4.0m. \$300-450. **300mm f4 SMC Pentax-A*** - 8 elements, 7 groups; focus to 4.0m. \$400-

600.

8°. \$750-1000.

300mm f5.6 Ultra-Achromatic Takumar - (ultra-achromatic = corrected for chromatic aberration in the infrared and ultraviolet portions of the spectrum as well as visible light.) 5 elements; focus to 16':

300mm f6.3 Tele Takumar - Preset. Black barrel. \$100-150.

400mm f2.8 SMC Pentax-A*ED(IF) - low dispersion glass, internal focus, white

barrel; 8 elements; focus to 4.0m. \$3200-4600.

400mm f5.6 Tele Takumar - No sales data.

400mm f5.6 SMC Tele-Takumar - manual click-stop diaphragm; 5 elements; focus to 8m (27'); 6°. No sales data.
400mm f5.6 SMC Pentax - 5 ele-

400mm f5.6 SMC Pentax - 5 elements; focus to 8m (27'); manual diaphragm. No sales data.

400mm f5.6 SMC Pentax-M - 5 elements; focus to 5m.; auto diaphragm. \$300-450

400mm f5.6 SMC Pentax-A - 7 elements, 6 groups; focus to 2.8m. \$350-500.

500mm f4.5 Tele Takumar - (replaced the f5 model) \$300-450.

500mm f4.5 SMC Takumar - manual click-stop diaphragm; 4 elements; focus to 33': 5°. \$350-500.

500mm f4.5 SMC Pentax - 4 elements; focus to 10m (35'); manual diaphragm. \$600-900.

500mm f5.0 Takumar - Manual clickstop diaphragm. 2-element; rack & pinion focus to 35'; 5° angle. \$300-450.

600mm f5.6 SMC Pentax-A*ED(IF) Internal focusing by shifting of lens groups. Low dispersion glass. White barrel to deflect heat. 8 elements, 6 groups; focus to 5.5m. \$1700-2400.

1000mm f8 Takumar - Click-stop diaphragm. 3-element; rack & pinion focus to 98'. 2.5° angle. \$600-900.

1000mm f8 SMC Tele-Takumar - same as above but with SMC coating. \$1000-1500.

1000mm f8 SMC Pentax - 5 elements; focus to 30m (100'); manual diaphragm. \$1200-1800.

1000mm f11 SMC Pentax Reflex - mirror lens; 6 elements, 4 groups; focus to 8m (26.2'); ND filter built in. \$600-900.

1200mm f8 SMC Pentax-A*ED(IF) low dispersion glass, internal focus; 9 elements, 8 groups; focus to 8m. \$5500-7500.

2000mm f13.5 SMC Pentax-M Reflex - mirror lens; 6 elements, 4 groups; focus to 20m; ND filter built in. \$4500-6500.

PENTAX ZOOM LENSES FOR 35mm CAMERAS:

24-35mm f3.5 SMC Pentax-M Zoom - 9 elements; focus to 0.5m. \$90-130.

24-50mm f4 SMC Pentax-M Zoom -12 elements, 10 groups; focus to 0.4m. \$100-150.

24-50mm f4 SMC Pentax-A Zoom - 11 elements, 10 groups; focus to 0.4m. \$120-180.

28-50mm f3.5-f4.5 SMC Pentax-M Zoom - 10 elements; focus to 0.6m (2'); 75-45° view. \$75-100.

28-80mm f3.5-f4.5 SMC Pentax-A Zoom - 12 elements, 9 groups; normal focus to 0.8m, macro focus to 0.4m. \$100-150

28-135mm f4 SMC Pentax-A Zoom - 17 elements, 15 groups; normal focus to 1.7m, macro focus to 0.4m. \$250-375.

35-70mm f2.8-f3.5 SMC Pentax-M Zoom - 7 elements; focus to 1.0m. \$100-150

35-70mm f2.8 SMC Pentax AF

Zoom - autofocus motor built in; 7 elements; focus to 1.2m. \$90-130.

35-70mm f3.5-f4.5 SMC Pentax-A Zoom - 8 elements; normal focus to 0.7m, macro focus to 0.32m. \$100-150. 35-70mm f4 SMC Pentax-A Zoom -

7 elements; focus to 0.25m. \$90-130.

35-105mm f3.5 SMC Pentax-A Zoom - 15 elements, 13 groups; normal focus to 1.5m, macro focus to 0.3m. \$120-180.

35-135mm f3.5-f4.5 SMC Pentax-A 200m - 16 elements, 12 groups; Normal focus to 1.6m, macro focus to 0.75m. \$150-225.

35-210mm f3.5-4.5 SMC Pentax-A Zoom - \$250-375.

40-80mm f2.8-f4 SMC Pentax-M 200m - 7 elements; normal focus to 1.2m, macro focus to 0.37m. \$90-130.

45-125mm SMC Zoom Takumar - \$100-150.

45-125mm f4 SMC Pentax Zoom - 14 elements, 11 groups; focus to 1.5m (5'); 50.5-20° view. \$100-150.

70-150mm f4.5 Zoom Takumar (Super Takumar series) - \$90-130.

70-210mm f4 SMC Pentax-A Zoom - 13 elements, 10 groups; normal focus to 1.2m, macro focus to 0.45m. \$120-180.

75-150mm f4 SMC Pentax-M Zoom - 12 elements, 9 groups; focus to 1.2m. \$100-150.

80-200mm f4.5 SMC Pentax Zoom - 15 elements, 12 groups; focus to 1.6m (5.5'); 30-12° \$90-130.

85-210mm f4.5 SMC Zoom Takumar - (replaced the 70-150mm). 11 elements; 28.5 to 11.5° angle of view. Focus to 11.5', or to 6.2' with closeup lens originally supplied. \$150-225.

135-600mm f6.7 SMC Pentax Zoom - manual diaphragm; 15 elements, 12 groups; focus to 6m (20'); 18-4° view. \$800-1200.

400-600mm f8-12 SMC Pentax Reflex Zoom - catadioptric mirror zoom lens; 12 elements, 7 groups; focus to 3.0m; ND filter built in. \$400-600.

Pentax 6x7 - c1969-. Medium-format SLR, designed like an oversized 35mm SLR. Takes 6x7cm images on 120 or 220 rollfilm. Interchangeable lenses and finders, including metered prism. A full range of lenses made the system an instant success among professional users. Horizontal FP shutter, 1-1000,B. Despite its age, this is still primarily a usable camera. However, the earliest models lack a mirror lock-up, and are not as popular among users. Non-metered prisms are also less popular. Collectors have a chance to acquire one of these older models, in clean condition, with prism and normal lens for \$750-1000. Professional users do not always pamper their equipment, so you may have to pass up a number of "worn" examples before you find a nice clean one for your collection. Well-used ones will sell for less.

Pentax 6x7 Lenses - Most of these lenses still belong in the "user" domain, but collectors should be aware that most of the basic lenses in the 75mm to 200mm range sell for \$200-300.

Pentax Auto 110 - 1979-83. Interchangeable lens SLR for 110 cartridge film, 13x17mm. Automatic TTL shutter, f2.8 lens. With 18mm wide angle, 24mm normal, 50mm tele lenses, flash, winder and cases, quite common at \$175-250. Camera with 24mm lens: \$60-90.

Pentax Auto 110 (brown) - A deluxe model, with dark brown top and bottom, and tan middle. Otherwise like the normal model. Uncommon. \$300-450.

Pentax Auto 110 (transparent) - c1979. Working demo model with clear plastic body, 24mm f2.8 lens. \$150-225.

Pentax Auto 110 Super - c1982. Improved version of the Auto 110, with brighter viewing screen, electronic self-timer, single stroke advance, slow speed warning in finder. With normal 24mm f2.8 lens: \$90-130.

Auto 110 Lenses and accessories:

18mm f2.8 - \$35-50. 24mm f2.8 - \$25-35. 50mm f2.8 - \$50-75. 70mm f2.8 - \$120-180. 20-40mm f2.8 - \$175-250.

ASAHI OPTICAL WORKS Founded by Riken about 1936, this company made cameras. At that time, the other, long established "Asahi Kogaku" was producing optical products including telescopes, eyeglasses, and camera lenses, but not cameras. Nevertheless, the names were too confusing, and this company took on the Riken name in 1943. The other company, Asahi Kogaku, began producing its own Asahiflex cameras in the 1950's, and obviously is much better known today after its long and successful line

AURORA

of Pentax cameras. See "Asahi Kogaku" above for the Asahiflex and Pentax lines.

Super Olympic Model D - 1936. Japan's first 35mm camera, with a body style similar to the Korelle model K. The major difference is that the Korelle was a half-frame and the Super Olympic is full-frame 24x36mm. Uses Contax spools. Ukas f4.5/50mmlens. \$75-100.

Letix - c1940. Eye-level camera for 127 film. Bakelite body, telescoping front. Automatic exposure counter. "Letix" on shutter face, but "Retix" molded on front of body. Ukas Anastigmat f4.5/50mm in AKK shutter, 25-150, T,B. \$60-90.

ASAHIGO - Japanese paper "Yen" camera for single exposures on sheetfilm in paper holders. \$25-35.

ASANUMA TRADING CO. Kansha-go Field Camera - c1925. Teak and brass field camera for 8x10.5cm plates. With lens: \$200-300.

Robo-Cam - c1990. Name variation of the Torel 110 Talking Camera. See description below. \$25-35.

Torel 110 Talking Camera - c1987.

The top section is a micro-110 type camera, and the bottom is a miniature battery-operated phonograph, which says: "Say Cheese! HA HA Ha Ha ha ha..." when rear button is pressed. Camera operates independently presumably after the recorded voice has put a smile on the subject's face. \$25-35.

Torel 110 "National" - c1985. Small cameras which snap onto 110 film cartridge. Faceplate designs imitate the national flags of various countries. \$20-30.

ASIA AMERICAN INDUSTRIES LTD. (Tokyo)
Orinox Binocular Camera, Model AAI-720 - c1978. Camera for 110 film built into binoculars. \$90-130.

ASIANA - Plastic 120 novelty camera of the Diana type. \$1-10.

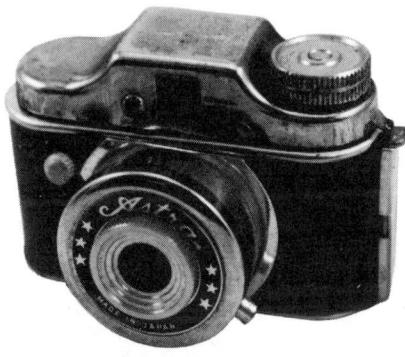

ASTRA - Japanese novelty subminiature of the Hit type. \$15-25.

ASTROPIC - Japanese novelty subminiature of the Hit type. \$12-20.

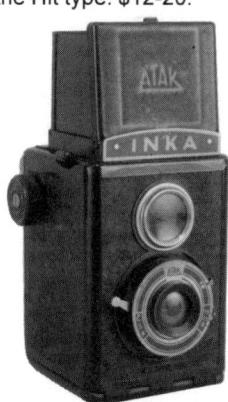

ATAK (Czechoslovakia)

Inka - Bakelite TLR-style box camera, similar to the Voigtländer Brillant. Fixed focus. B,25,75 shutter. \$35-50.

ATKINSON, J.J. (Liverpool, England) Stereo camera - c1900. For 9x18cm. Mahogany body, brass trim, lilac leather bellows. Beck Rectilinear 5" lenses in T-P Stereo shutter $^{1}/_{30}$ - $^{1}/_{90}$ sec. One sale in late 1988. \$750-1000.

Tailboard camera - 1/₄-plate size. Mahogany construction with brass land-scape lens. \$175-250.

Wet plate field camera - c1870? For 12x16.5cm wet plates. Fine wood with brass trim. Square black bellows. Brass barrel lens with revolving stops. \$300-450.

ATLAS-RAND

Mark IV - 126 cartridge camera with electronic flash. Made by Keystone. \$1-10.

ATOM OPTICAL WORKS (Japan) Atom-Six-1 - c1951. Folding camera for 6x6cm on 120 rollfilm. Eye-level and waistlevel finders. Seriter Anastigmat f3.5/75mm, Atom shutter B,1-200. \$60-90.

Atom-Six-II - c1952. Similar, but dual-format 6x6cm or 4.5x6cm. Separate finder for each size. Atom Anastigmat f3.5/75mm. N.K.S. shutter B,1-200. \$60-90.

ATOMS (St. Étienne, France) The ATOMS name is an acronym for "Association de Techniciens en Optique et Mécanique Scientifique", a company founded in 1946 to build twin-lens reflex cameras.

Aiglon - A series of TLR style cameras in which the finder lens is fixed focus, and the objective focuses by turning the front element. Various lenses in Atos I or II shutters. \$45-60.

Aiglon Reflex - c1950. A better quality model with coupled Angenieux, Berthiot or Roussel f4.5 lenses. \$50-75.

Atoflex - The best of ATOMS' TLR cameras with externally gear-coupled lenses. Angenieux f4.5 or f3.5 objective. Shutter 10-300. \$50-75.

ATTACHE CASE CAMERA 007 - c1960's. Sophisticated toy from Japan. A James Bond style attache case with a spy camera, radio, telescope, and decoder. \$120-180.

AURORA PRODUCTS CORP. Ready Ranger Tele-photo Camera

AUTOMAT

Gun - c1974. A novelty collectible with some interesting features. The actual camera is a "Snapshooter" slip-on camera for 126 cartridges, which is little more than a lens and winding knob. The most interesting part is the outlandish telephoto attachment, shaped like a giant blue bazooka with a folding stock. In new condition with the original box: \$30-45. Camera & tele lens only: \$12-20.

AUTOMAT 120 - Japanese TLR. Tri-Lausar lens in Rectus shutter. Crank film advance, \$50-75.

AUTOMATIC RADIO MFG. CO. (Boston)

Tom Thumb Camera Radio - c1948. A great combination of a 4-tube portable radio and a plastic reflex novelty camera, all in a wooden body with gray and red exterior. Identical in appearance to the "Cameradio" of Universal Radio Mfg. Co. Sells in Europe for double the USA price of \$100-150

AVANT INC. (Concord, MA) Manufacturer of special purpose cameras, particularly identification cameras for Polaroid instant inentification cameras for Polaroid instant film. Some earlier Quad cameras including models for Polaroid rollfilms were sold by Itek Corporation of Lexington, MA.

Quad Model 32-100 As - c1966.

Special purpose amounted in clarge about the leaves mounted in clarge about the leaves mounted in the solution.

lenses mounted in a large shutter. Used to

take four identical exposures on Polaroid Type 100 pack film for identification and passport purposes. The single shutter exposes all four segments at the same time, but a special rotary lens mask allows photos to be taken in pairs. \$120-180.

B & R MANUFACTURING CO. (NY) Photoette #115 - Small metal box camera with cardboard back. Covered with leather-pattern black fabric. 4.5x6cm on 127 film. Not common. \$30-45.

B & W MANUFACTURING CO.

(Toronto, Canada)
Press King - c1948-50. 4x5" press camera, similar to the Crown Graphic. Lightweight metal body, double extenion bellows, drop-bed, revolving spring back. \$175-250.

BABETTE - Hong Kong novelty camera for 127 film. Also sold with the "Bazooka" name as a chewing gum premium. Various colors. \$1-10

Baby Camera, folding type

BABY CAMERA - Small novelty "Yen" camera, available in both folding style and box type. Paper covered wood with ground glass back. Takes single sheets of film in

Baby Camera, box types

paper holders for 3x4.5cm negatives. Folding style: \$30-45. Box style: \$25-35.

BABY FINAZZI - c1950. Made in Baden, Switzerland. Box camera for 6x9cm on 120 rollfilm. Red leatherette, red lacquered metal parts. \$45-60.

BABY FLEX - c1950. Japanese subminiature TLR for 13x14mm exp. on 17.5mm paper-backed rollfilm. Sanko f3.5/20mm lens in Peace Model II shutter 1/25, 1/150. A rare subminiature. \$600-900.

BACO ACCESSORIES CO. (Hollywood, CA)
Baco Press Club, Model B - c1950. Heavy, rigid-bodied cast metal press camera for 21/4x31/4" film holders. \$75-100.

BAIRD (A.H. Baird, Edinburgh, Scotland) Single lens stereo camera - Tailboard style camera with sliding lensboard to allow either single or stereo exposures.

Mahogany with brass fittings. Roller-blind shutter. \$600-900.

Tropical Field Camera 5x7" - Brass bound field camera of light wood. Squarecornered bellows. \$350-500.

BAKER (W.G.) Crescent Improved **Camera** c1900. Box camera for 21/4x31/4" glass plates. Top door hinges forward to load plateholders. Uncommon. \$50-75.

BAKER & ROUSE (Armadale Vic, Australia) Baker & Rouse was a photo chemical manufacturing company taken over by Eastman Kodak to become Kodak Australasia Pty Ltd before WWI. Many different British made cameras, mostly from Houghtons, were imported and rebadged Austral.

Austral No. 1A - c1900. Drop plate box camera for 6.5x9cm plates. \$50-75.

Baldeweg, BALDA-WERK (Max Dresden) Founded 1908 by Max Baldeweg, the firm was most noted for producing photographic accessories, especially film holders and rollbacks. In the mid-1920's, folding plate & rollfilm cameras became an important part of the business. After WWII, the Dresden factory remained, eventually becoming a part of the VEB Pentacon. The post-war cameras listed here are from Balda Kamera-Werk in Bünde, West Germany.

AMC 67 Instant Load - c1967. A very basic camera for 126 cartridges. Made for Associated Merchandising Corp., a buying office for major department stores in the USA \$8-15.

Balda Box - c1930. Leather covered 6x9cm box camera. Meniscus lens, simple shutter. \$8-15.

Balda-Kamera - c1925. Folding bed cameras for plates.

-Nr.1 - 9x12cm, single extension.

-Nr.2 - 10x15cm, single extension.

-Nr.3 - 9x12cm & 10x15cm sizes, single rack & pinion.

-Nr.4 - 9x12cm, double extension with rack & pinion.

\$35-50.

Baldafix - Folding camera for 6x9cm on rollfilm. Enar f4.5/105mm in Prontor. \$30-45

Baldak-Box - c1938. \$12-20.

Baldalette - c1950. Folding 35mm. Schneider Radionar f2.9/50 or Carl Zeiss Tessar f2.8. Compur Rapid or Pronto shutter. \$75-100.

Baldalux - c1952. Folding camera for 6x9cm or 4.5x6cm on 120 film. Radionar f4.5 lens in Prontor SV shutter with body release and DEP. Eye level and reflex finders, \$30-45.

Baldamatic I - c1959. 35mm range-finder camera with non-changeable f2.8/45mm Xenar in Synchro-Compur. Bright frame finder with auto parallax correction. Match-needle metering. \$50-75.

Baldamatic II - c1960. \$50-75.

Baldamatic III - c1960. Similar, but interchangeable lenses. \$100-150. (extra lenses additional).

Baldax 6x6 - c1935. Folding camera for 6x6cm on 120 film. Trioplan f2.9/75mm in Compur or Compur-Rapid. Newton finder with manual parallax adjustment. \$35-50.

Baldax V.P. - c1930's. Compact folding camera for 16 exp. 4.5x6cm on 120 film. Available in a large variety of lens/shutter combinations, f2.8-f4.5, \$35-50.

Baldaxette Model I - c1936. For 16 exp. 4.5x6 cm on 120 film. f2.9/75 Hugo Meyer Trioplan or f2.8/80 Zeiss Tessar. Rimset Compur or Compur Rapid shutter with self-timer. \$90-130.

Model II - For 12 exp. 6x6cm on 120. CRF. \$120-180.

Baldessa - c1957. Basic 35mm with bright frame finder. No meter or range-finder. Baldanar, Westanar, or Color Isconar f2.8/45mm, non-interchangeable. Vario or Prontor SVS, \$15-25.

Baldessa la - Baldanar f2.8/45mm in Prontor SVS shutter, \$35-50.

Baldessa F - c1964. Basic 35mm without meter or RF. Similar to standard Baldessa. but with built-in flash for AG-1 bulbs. \$20-

Baldessa Ib - c1958. 35mm, BIM, CRF, bright frame finder. f2.8 Isco lens. \$35-50.

Baldessa LF - c1965. One step up from Baldessa F, with addition of BIM. Color Isconar f2.8/45mm in Prontor. \$35-50.

Baldessamat - c1960. Color Baldanar f2.8/45mm in Prontormat. \$25-35.

Baldessamat F, RF - c1963-66. 35mm with Baldanar f2.8/45mm lens in Prontor-Lux-B 1 /₃₀-500 sync shutter. "F" has built-in flash for AG-1 bulbs. "RF" also has built-in rangefinder, \$30-45.

Baldi - c1930's. For 16 exp. 3x4cm on 127. f2.9 or 3.5/50mm Trioplan. \$45-60.

Baldina - c1930's. Folding 35 (similar to the early folding Retina Cameras). Common combinations include: f3.5/50 Baldanar, f2/45 Xenon, f2.9/50 Xenar. Prontor-S or Compur Rapid shutter. \$45-

BALDA

Balda Erkania

Baldinette - c1951. Retina-style 35mm. Various shutter/lens combinations, \$35-50.

Baldini - c1950. Retina-style folding 35mm camera, similar to the Baldinette. \$35-50.

Baldix - c1952. Self-erecting folding camera, 6x6cm on 120. Baltar f2.9/75mm or Ennagonf3.5 in Prontor SV. \$35-50.

Baldixette - c1950's. 6x6cm rollfilm camera with telescoping front. Baldar f9/72mm in B,M shutter. \$12-20.

Beewee-Kamera - c1925. Simple folding-bed camera for 9x12cm plates. Wood body with leatherette covering. Spezial Aplanat f8 or Extra-Rapid-Aplanat f7.7 in Vario, \$30-45.

Doppel-Box - c1933. Metal box camera with leather covering. Dual format, 6x9cm or 4.5x6cm on 120 film. Two brilliant finders and folding frame finder. Universal Doppel f11 lens. Z,M shutter. Built-in portrait lens. This is a variation of the Rollbox, apparently named for the "doppel" lens, rather than the standard meniscus. \$1-10.

BALDA...

Electronic 544 - c1973. Non-stylish 126 cartridge camera, 28x28mm. Isconar f5.6/35mm lens, electronic shutter 18-1/250 sec. \$8-15.

Erkania - c1938. Simple metal box camera for 6x9cm on 120. Juwella Anastigmat f6.3/105mm. \$25-35. *Illustrated at top of previous page.*

Fixfocus - c1938. Self-erecting dual-format folding bed camera for 6x9cm or 4.5x6cm on 120 rollfilm. Normally with Trioplan f4.5/105mm lens in Pronto shutter. \$20-30.

Front-Box (early type) - c1930. Metal box camera, leatherette covering. Early version has very square corners, not rounded as later types. Uncommon. Germany: \$20-30.

Front-Box - c1936. Metal box with leatherette covering. Nicely styled front with chrome edges. Shield under lens. Germany: \$12-20. USA: \$20-30.

Gloria - c1934. Folding camera for 6x9cm or 4.5x6cm on 120 film. Folding eye-level finder and small reflex finder. Lenses include f4.5 Radionar, Xenar, & Tessar or f3.8 Trioplan in Pronto or Compur. \$30-45.

Clorina - c1936. Folding 6x9cm rollfilm camera. Various shutter/lens combinations including Trioplan f3.8/105mm in Compur S, 1-250. Waist-level and folding optical finders. \$35-50.

Hansa 35 - c1948-50. Folding 35mm camera styled like Retina. Also sold under other names such as Central 35, etc. Westar f3.5/50mm in Prontor-S 1-300, B. \$45-60.

Jubilette - c1938 (the 30th anniversary of Balda-Werk, thus the name). Folding 35mm similar to the Baldina. f2.9/50mm Baltar, Trioplan, or Corygon. Compur shutter. \$35-50.

Juventa - c1934. Called "Die Volks-Roll-film-Kamera" in catalog advertising, this low-cost basic 6x9cm folding rollfilm camera featured a front-element focusing f7.7 anastigmat lens in Singlo T,B,25,75 shutter. Metal body has "Durabella" ribbed covering. \$25-35.

Juwella - c1939. 6x9cm folding rollfilm camera. f6.3 or f4.5 Juwella Anast. Prontor T,B, 25-125, self-timer. \$30-45.

Lady Debutante - Inexpensive basic camera for 126 cartridges, but in attractive colored finish. \$12-20.

Lisette - c1936. Folding camera for 4.5x6cm on 120 rollfilm. Uncommon name variant of the Baldax, sold by Photo Porst. Xenar f2.8/7.5cm in Compur. \$35-50.

Micky Rollbox - Small box cameras for 4x6.5cm exposures on 127 film. Original advertising featured the Disney characters, but the cameras are rather simple. Several variations: Model I: Meniscus lens. Model

II: Double lens. Two-zone focusing. Built-in close-up lens. Cable release socket. Two tripod bushes. \$45-60.

Piccochic - c1932. Vest-pocket camera for 16 exp. 3x4cm on 127 film. Normal lens: Ludwig Vidar f4.5/50mm. Also available: f3.5 Trioplan, f2.9 Vidonar, f2.9 Schneider Xenar, f3.5 Elmar. Compur, Prontor, or Ibsor shutters. New prices ranged from \$12.50 to \$37.50. With Elmar: \$175-250. With other lenses: \$75-100.

Pierrette - c1934. Unusual folding 4x6.5cm rollfilm camera with leather covered "barn-door" front doors and strutsupported front. Trioplan f3.5/75 in Compur 1-300 or Pronto 25-100. Folding optical finder. Uncommon, \$175-250.

Pinette - c1930. 3x4cm. Trioplan f2.9/50mmin Compur. \$90-130.

Poka - c1929-38. Metal box camera for 6x9cm exp. on 120 rollfilm. Meniscus lens, simple shutter. Poka I has meniscus f7.7 lens; reflex finders only. Poka II also has retractable frame finder; f11 double lens. \$20-30.

Poka II - c1929. Similar to the Poka (I), but with extensible wire frame finder and rear peep hole. Early versions have advance knob at bottom, while later ones have knob at top of right hand side. \$20-30.

Pontina - c1938. Self-erecting rollfilm camera for 6x9cm on 120. Trioplan f3.8/105; Trioplan, Trinar, or Radionar f4.5; Tessar f4.5 or f3.8. Prontor or Compur shutter. \$35-50.

Primula - 1930's. Box camera for 6x9cm. Similar to Rollbox. \$12-20.

Rigona - c1936-42. Folding camera for 16 exp. 3x4cm on 127 film. Similar to the

Baldi. Normal lenses: f4.5 Vidanar, f2.9 Schneider Radionar, f2.9 Meyer Trioplan. Prontor shutter. \$50-75.

Rollbox 4x6.5cm - Small box camera for 127 film. Some versions also made for dual-format (3x4cm half-frames possible). \$12-20.

Rollbox 120 - c1934. All metal 6x9cm box. Unusual variation with brown covering: \$50-75. Normal models, common in Germany: \$12-20.

Rollfilm-Kamera - c1925. Folding-bed camera for 6x9cm. Rise & cross front. Spezial Aplanat f8, Extra-Rapid Aplanat f7.2, or Doppel-Anastigmat Polynar in Vario or Ibso shutter. \$25-35.

Springbox - c1934. Uncommon strutfolding vest-pocket camera for two formats on 127 film. Takes 4x6.5cm or 3x4cm on 127 film. Doppel-Objectiv f11. \$50-75.

Super Baldamatic - Automatic exposure 35mm. \$30-45.

Super Baldamatic I - Automatic exposure 35mm similar like Super Baldamatic, but also with CRF. \$35-50.

Servo-Baldamat - Accessory winder for Super Baldamatic. Attaches to bottom of camera. Also fits earlier Baldessa and Baldamatic cameras. Operates on six batteries. An interesting accessory, more rare and valuable than the cameras it fits. \$100-150.

Super Baldax - c1954-57. Folding rollfilm camera with CRF. 6x6cm on 120 film. Schneider Radionar f2.9/80 in Prontor SV 1-300,B; Balda Baltar f2.9 in Prontor SVS 1-300, B; or Enna Ennit f2.8/80 in Synchro Compur 1-500, B. \$90-130.

Super Baldina (bellows style) c1937-40. Folding "Retina-style" 35mm. CRF. Trioplan f2.9, Tessar f2.8, Xenon f2. Compur or Compur Rapid. \$50-75.

Super Baldina (telescoping front) c1955. 35mm cameras, with or without RF. Schneider Xenon f2/50mm. \$50-75.

Super Baldinette - c1951. f2 lens, CRF. Sold as Hapo 35 by Porst. \$60-90.

Super Pontura - c1938. Folding 120 camera for 6x9cm, adaptable for 16 exp. 4x6cm. CRF, automatic parallax compensation. f3.8 or 4.5 Meyer Trioplan. Compur Rapid to 400. Uncommon. \$300-450.

BALLIN RABE (Germany) Folding plate camera, 9x12cm - DEB. RB. Meyer Aristostigmat f6.8/135mm in Compound. \$50-75.

BAN - c1953. Small Japanese camera for

BAUCHET

28x28mm on Bolta-size film. Sunny Anastigmat f2.8/40mm. Uncommon. \$120-180.

BANIER - Plastic Diana-type novelty camera. \$1-10.

BANNER - Novelty camera of Diana type. \$1-10.

BAOCA BC-9 - c1985. Novelty 35mm camera from Taiwan. Small pseudo-prism. Retractable lens shade. \$1-10.

BARCO - c1954. Japanese novelty subminiature of the Hit type. Simple fixedfocus lens, single-speed shutter. Unique construction- front half is cast aluminum. Shutter housing appears to be copper, not brass. In colors. \$50-75.

BARON CAMERA WORKS (Japan) Baron Six - c1953. Horizontally styled self-erecting camera for 6x6cm and 4.5x6cm images on 120 film. Ciskol Anastigmat f3.5/80mm in N.K.S. shutter B,1-200. \$60-90.

BARRY PRODUCTS CO. (U.S.A.) Barry - c1940's. Black plastic "minicam"

for 16 exposures on 127 film. Uncommon name. \$12-20.

BARTHELEMY Stereo Magazine Camera - c1905. Leather-covered wooden box camera for stereo exposures on 45x107mm plates. Changing mechanism for 12 plates. Guillotine shutter. \$300-450.

BAUCHET (France)

Mosquito I - c1962. Plastic camera with rectangular telescoping front. Made by Fex for the Bauchet firm. Similar to the Ultra Fex. No sync or accessory shoe. \$20-30.

Mosquito II - c1962. Like the Mosquito I, but with accessory shoe and flash sync. \$20-30.

BAUDINET

BAUDINET INTERNATIONAL

Pixie Slip-On - Lens & shutter assembly which snaps onto a 126 film cartridge to form a camera. \$1-10.

BAUER - Folding camera for 8 exposures 6x9cm or 16 exposures 4x6cm on 620 roll-film. Schneider Radionar f4.5/105. Vario sync. shutter. \$25-35.

BAUER RX1 - c1978. Relatively small and lightweight 35mm SLR, made by Cosina and introduced at Photokina in 1978. CdS aperture-priority auto metering. Neovaron f1.4/50mm, f1.7/50mm, or f2.5/40mm normal lens. Uncommon. Never officially sold. Normally marked on back "Unverkäufliches Muster" (Sample-not for sale). \$200-300. Bauer RX accessories included 8 lenses from 28mm to 210mm, including two macro zooms, autowinder and extension rings.

Bauer RX2 - c1978. Similar to the RX1, but also with electromagnetic release, electronic self-timer. With normal lens: \$200-300.

BAZIN & LEROY (Paris)

Le Stereocycle - c1898. Jumelle-styled stereo camera for 12 plates 6x13cm. Ross Rapid Rectilinear lenses. Guillotine shutter. \$350-500.

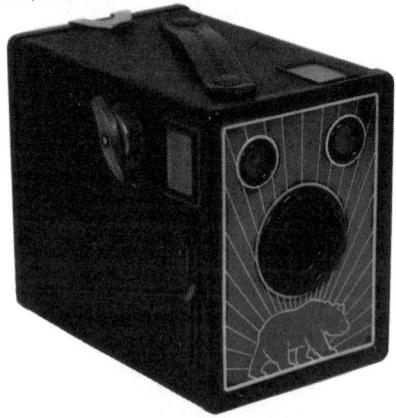

BEAR PHOTO CO. (California) Bear Photo Special - Simple metal box camera for 6x9cm. Made by Ansco for the Bear Photo Co. Decorative front plate with outline of bear. \$75-100.

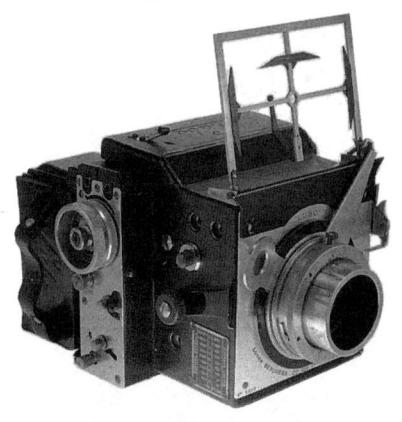

BEAUGERS (Lucien Beaugers, Paris)
After 15 years as a photographer, Lucien
Beaugers designed a press camera which
would allow ground glass focusing without
the bulk of a single-lens-reflex. His patented

design may have survived in another era, but 1941 was not an easy time to introduce a new concept.

Lubo 41 - 1941. Innovative press camera which incorporated single-lens ground glass focusing, but used a parallax-corrected frame finder to follow action. An ingenious mechanism tilts the lens down, raises the viewing hood, and positions the mirror & ground glass for focusing. A split-second maneuver realigns the lens for exposure. Magazine back for 9x12cm plates. Flor f3.5/135mm normal lens in bayonet mount. Focusing helix incorporated in body. Cloth focal plane shutter 1/6-1/2000. Rare. Total production estimated 20-25 units, with some variations in design. \$1000-1500.

BEAURLINE INDUSTRIES INC. (St. Paul, Minnesota)

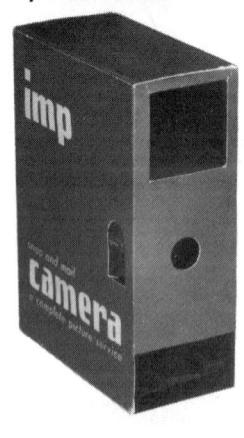

Imp - A disposable mail-in camera, factory loaded. Plastic body covered with bright red or yellow paper. Camera is self-addressed to the processing lab. \$12-20.

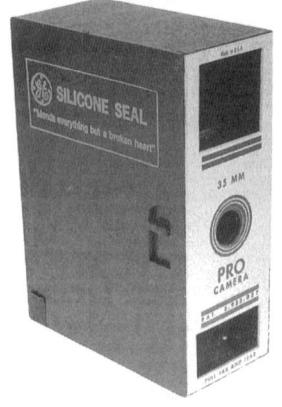

Pro - c1954. Disposable mail-in 35mm plastic camera, factory loaded with 12 exposure Ansco film. Premium models with advertising: \$20-30. Normal model: \$12-20.

BEAUTY CAMERA CO.

Beaumat - c1960. 35mm RF camera. Selenium meter surrounds lens. Biokor f2.8/45mm.\$30-45.

Beauty Super-L - c1958. Rangefinder 35mm with uncoupled selenium meter. Sockets on camera front for booster cell. Meter gives LV readings, which are manually transferred to the cross-coupled shutter and diaphragm. Canter-S f1.9/45mm lens in Copal SVL 1-500. \$120-180.

Lightomatic - c1959. 35mm RF camera. Coupled selenium meter on front below release button. Beauty-S f1.9/45mm in Copal SV B,1-500. \$45-60.

Varicon SL - c1958. Name variant of the Super-L. With booster cell: \$175-250.

BECK (R & J Beck, Ltd., London) Beck used the trade name "Cornex" which was derived from their address on Corn Hill, London.

Beck's New Pocket Camera - c1905. Folding rollfilm camera for 31/4x41/4". Red bellows. Cornex shutter with round brass face is built into square nickeled lensboard. Beck Symmetrical lens. Patented transparent depth of field scale rides over focus scale. \$100-150.

British Ensign - Made for G. Houghton by Beck. See listing under Houghton.

Cornex Model A - c1903. Drop-plate magazine box camera. Wood body with leatherette covering. 1/₄-plate size. Single Achromatic f11 lens. Shutter: T, 10, 20, 40, 80. Automatic exposure counter. \$50-75.

Dai Cornex - c1905. Falling-plate box camera with mahogany interior. Beck Symmetrical lens in Unicum shutter. What sets this camera apart from other falling plate cameras and gives it its name is the special system for loading a stack of 12 plateholders in daylight. When the holders are in a stack, they are lightproof, the front one being a dummy. Successive stacks of plates can be loaded and unloaded in the field. Uncommon. \$175-250.

BEIER

Folding Frena - c1905. Folding camera with integral magazine for special notched Frena sheetfilms. Unusual appearance because front bed folds out from one side of the front while the other half is the magazine. When changing films, the camera must be pointing vertically down, or an interior pendulum locks the magazine mechanism. Small tubular finder with ground glass front can be pushed into the plane of focus for critical focusing as long as the magazine is pulled out. This tube and the reflex finder are stored inside the magazine for portability. With the magazine detached, the camera can be used by itself with special plateholders. Camera with magazine back: \$1000-1500. Camera only with plateholder: \$500-750.

F.O.P. Frena - c1900. Similar to the other Frena cameras, but in addition to the standard notched filmholders, it also accepts similar holders for plates. The initials in the name stand for "Film Or Plates". Rarest of the box Frenas. \$100-150.

Frena (original) - c1893. From 1894 with the introduction of other sizes, it was called No.1. The original Frena was the only one made in the 31/4x31/4", the standard British lantern slide size. Slightly different mechanically from the later models. Uses special notched sheetfilms. Alternate sheets have the square notches in opposite positions. A set of moving fingers allow one sheet to drop when slid to one side and the next sheet to drop when slid back. These fingers are controlled by rotating an external knob. \$120-180.

Frena No.0 - From c1901. 25/8x31/2", "Memorandum size".

Frena No.2 - From c1894. 31/₄x41/₄". Frena No.3 - From March 1896. 4x5". Frena No.22 - c1909 31/₄x41/₄".

Detective box magazine cameras for special sheetfilms. "Swan-neck" changing handle until about 1900 when it was replaced with a straight handle. Either type of handle has a spirit level built in. The camera could thus be tilted slightly and the film plumbed with the handle to create the same effect as a tilt back. All have Rapid Rectilinear lenses except the No.22, which has a single achromatic lens. \$150-225.

Frena Presentation Model - c1897. Deluxe version of the Frena, in the same sizes. Covered with brown calves leather. Polished brass fittings. \$1200-1800.

Hill's Cloud Camera - c1923. Extreme wide angle camera designed by Robin Hill to photographthe entire sky on a 31/4x41/4" plate. An entire hemisphere was reduced to a 21/2" circular image. Flat, square mahogany body with extreme wide angle lens. One failed to reach its estimate of \$3700 in July of 1988. Confirmed auction sale at \$3100 in November 1989. Current estimate: \$4500-6500.

Telephoto Cornex - c1905. Basically a

falling plate camera, but with a long extension body and a built-in negative lens element. When the negative lens element is raised by pulling up a rod on the camera top, the camera can be used for telephoto shots. A second focusing scale is on the side for telephoto use. Beck Symmetrical lens in Unicum shutter. \$250-375.

Zambex - c1911. Polished mahogany folding camera for 31/₄x41/₄" cut film in Zambex Skeleton. Does not accept plates. Nickel trim. Red bellows. Various shutters and lenses, the Beck Symmetrical being one of the more popular at the time. Patented depth of field scale on transparent plastic rides over standard focusing scale. Rare. \$500-750.

BEDFORDFLEX - Twin lens novelty camera for 4x4cm on 127 film. \$8-15.

BEICA - Japanese "Hit" type novelty camera. \$25-35.

BEIER (Kamera-Fabrik Woldemar Beier, Freital, Germany) Several major reference books have misspelled the name of this company. In an effort to keep the incorrect spellings from proliferating, we would like to affirm that the first name is spelled with an "o" and that the last name is NOT "Bayer".

Beier-Flex w/ Rodenstock Imagon 12cm lens.

Beier-Flex - c1938. 21/4x21/4" SLR, similar to the Beflex Korolla First model.

similar to the Reflex-Korelle. First model has FP shutter 1/25 to 500. Second model has 2 sec to 500. Xenar f3.5/75mm lens. Fine examples of the first model sell for \$800-1200. Other data, for the second model, indicates a range of \$300-450.

Beiermatic - c1961. Trioplan f3.5/45mm in Juniormatic Auto shutter. BIM. \$25-35.

Beira (bed-type) - c1936? Horizontally-

styled 35mm camera with self-erecting front. Top housing looks as though it were designed to include a rangefinder, but there is none. Trioplan f2.9/50mm lens in Compur (with Balda faceplate). Helical focusing, \$175-250.

Beira (**strut-type**) - c1930. 35mm camera with pop-out front supported by scissor-struts. Dialytar f2.7/50mm. Originally for unperforated 35mm rollfilm and without rangefinder. Later modified for standard 35mm film and unusual prismatic telescopic rangefinder added. This was called Model II in German advertising, but not in U.S.A. ads. Compur or Compur Rapid. Rangefinder model: \$350-500. Without RF: \$150-225.

Beirax - c1930's. Folding 6x9cm rollfilm camera. E. Ludwig Victar f4.5/105. Prontor or Vario shutter. \$25-35.

Beirette (folding type) - ca. late 1930's compact, horizontal style folding 35mm camera. Cast metal body with leather bellows. Rodenstock Trinar lens: f2.9, 3.5, or 3.9 in Compur or Compur Rapid shutter. \$150-225.

Beirette (rigid) - c1966-on. Low cost East German 35mm camera. Meritar f2.9/45mm lens, shutter 1/₃₀-125,B. Rapid wind lever. Sold new as late as 1981 for \$24. Used value: \$20-30.

Beirette II - Similar to the 1960's Beirette. \$20-30.

Beirette Junior II - Like the Beirette II, but Trioplan f3.5/45mm lens. \$20-30.

Beirette K - c1960's. From VEB Beier, a version of the Beirette for Rapid cassettes. Meritar f2.9/45 in Model II shutter. \$12-20.

Beirette VSN - c1960's. Inexpensive 35mm. Meritar f2.8/45mm in Priomat 3-speed with weather symbols. \$12-20.

Box - Box camera for 120 rollfilm, 6x9cm. Models I,II also made in dual format (6x9cm, 4.5x6cm) versions. Imitation leather covering, nickeled trim. Later variations, c1937, have a diamond-shaped nickel trim on front.

-Box 0 - c1928-38. Meniscus lens. Waistlevel viewfinders.

-Box I - c1930-35. Doublet lens. Wireframe eye-level viewfinder and waist-level viewfinders.

BEIER...

-Box II - c1933-38. Similar to Model I, but built-in close-up lens. Uncommon. \$25-35.

Edith II - c1925-33. Folding plate camera with leather covered aluminum body. Made in sizes for 6.5x9cm or 9x12cm plates. Various lens/shutter combinations, with Fotar f6.3/105mmin Vario. \$35-50.

Folding sheet film cameras - 31/₄x41/₄" or 9x12cm sizes. Rodenstock Trinar Anast. f4.5 or Betar f4.5 in Compur shutter. \$35-50.

Lotte II - c1925-37. Leather covered aluminum folding plate camera in 6.5x9cm and 9x12cm sizes. DEB. Rack and pinion focus. Various shutters/lenses. \$35-50.

Precisa - c1937. Folding camera for 6x6cm on 120. 75mm lenses range from f2.9 to f4.5. AGC, Compur, or Compur Rapid shutter. \$35-50.

Rifax - 6x9cm rollfilm. Rodenstock Trinar f3.8/105. Prontor II, 1-150. \$45-60.

Rifax (Rangefinder model) - c1937.

Vertical style folding-bed camera for 6x6cm or 4.5x6cm on 120 film. CRF. \$90-130.

Voran - c1937-41. Self-erecting camera for 6x9cm and 4.5x6cm on 120 rollfilm. Various shutters and lenses. \$35-50.

BEIJING CAMERA FACTORY (China) Great Wall DF-2 - c1981. Waist-level SLR for 6x6cm exposures on 120 rollfilm. Similar in design to the 1930s Pilot Super. f3.5/90mmlens. \$50-75.

Great Wall SZ-1 - c1975. 35mm springmotor camera. CRF. f2.8/45mm coated lens, rotating $^{1}/_{30^{-}}$ $^{1}/_{300}$ shutter. Leather covered aluminumbody. \$75-100.

BELCA-WERK (Dresden)

Belfoca (I) - c1952. Folding cameras for 8 exp. 6x9cm on 120. Some models are dual format, taking 6x9cm and with 6x6cm or 4.5x6cm masks. Folding frame finder. Variations include: Bonar f6.3/105 in Binor 8,25-100, or Ludwig Meritar f4.5 in Prontor shutter. Some examples are marked "Welta", some are marked "Belfoca I", others simply "Belfoca". \$25-35.

Belfoca II - c1954. Similar to Belfoca, but with finder incorporated in top housing. Bonotar f4.5/105mm in Junior or Tempor shutter. \$25-35.

Belmira - c1950s. Rangefinder 35mm. VF window at end of top housing. Rapid wind lever on back. Trioplan f2.9 or Tessar f2.8 in Cludor or Vebur shutter. Also exists under the Welta name. \$25-35.

Belplasca - c1955. Stereo 24x30mm on 35mm film. Tessar f3.5/37.5 lenses. Shutter 1-200, sync. Very common in Germany, less common in USA. Popular among stereo enthusiasts. In excellent working condition: \$400-600.

Accessories for Belplasca: Close-up attachment - \$90-130.

Belcaskop viewer - \$45-60. Belplascus V Stereo projector - \$150-225.

Beltica - c1951. Folding 35mm with folding viewfinder. Lenses: Ludwig Meritar f2.9/50, Zeiss Tessar f3.5/50, or Trioplan f2.9/50. Ovus or Cludor 1/200 shutter. \$25-35.

Beltica II - c1952. Similar to the first model, but non-folding viewfinder incorporated in top housing. Tessar f2.8/50mm lens. Vebur 1-250 shutter. \$25-35.

BELCO - Small black-enameled cast metal camera for 36x36mm exposures on 127 film. Extinction meter, \$35-50.

BELL-14 - c1960. Novelty 16mm subminiature camera styled like a 35mm. Simple fixed-focus lens, single-speed shutter. Various colored and patterned coverings. \$30-45.

BELL & HOWELL (Chicago) Auto 35/Reflex - 1969-73. 35mm SLR made by Canon, also sold as the Canon EX-EE. FP shutter 1/₈-500. With interchangeable Canon EX f1.8/50mm: \$60-90.

Autoload 340 - 1967-72. 126 cartridge camera. f3.5/40mm lens, programmed shutter 1/₃₀-250. \$1-10.

Autoload 341 - 1970-72. Similar to the Autoload 340, but with uncoupled range-finder. \$1-10.

Autoload 342 - 1970-72. 126 cartridge camera with coupled rangefinder. f2.8/40mmlens. \$1-10.

Dial 35 - Half-frame 35mm. Auto wind. Same as Canon Dial 35, but sold under B&H label. With unique molded plastic case: \$50-75.

Electric Eye 127 - (originally announced in late 1958 under the name "Infallible".) A heavy all-metal box camera with an automatic diaphragm and a large

eye-level optical finder. Normally with silver enamel and black leatherette, but also with black enamel and grey covering. 4x4cm on 127 film. \$12-20.

Foton - c1948. 35mm spring-motor driven, 6 frames per sec. CRF. Original price of \$700 (subsequently reduced to \$500) made it a marketing failure and it was discontinued in 1950. With Amotal f2.2/50mm normal lens: \$600-900.

Accessory lenses for Foton: Cooke 4" - \$200-300. Cooke 12" - \$350-500. Accessory viewfinder - \$60-90.

Stereo Colorist I - c1954-60. Stereo camera for 35mm film. f3.5 Rodenstock Trinar lenses. Made in Germany for Bell & Howell. \$175-250.

Stereo Colorist II - c1957-61. Similar, but with rangefinder. \$200-300.

Stereo Vivid - c1954-60. f3.5/35mm Steinheil Trinar Anastigmats, focus to 21/2'. Shutter $1/_{10}$ - $1/_{100}$, MFX sync. Front squeeze shutter release. Combined rangefinder-viewfinder with spirit level. Leather covered cast aluminum body. Common. \$150-225. Model 116 projector for Stereo Vivid: \$150-225.

BELL CAMERA CO. (Grinnell, Iowa) Bell's Straight-Working Panorama Camera - c1908. Panoramic camera in

which neither the film nor lens swings, pivots, or moves, which justified the cumbersome name. This camera is basically an extra-wide folding camera for 5 exp. $31/4 \times 111/2$ on rollfilm. On some models, knobs on top of camera allow user to change format in mid-roll to 31/4x51/2' postcard size, 10 exposures per roll. Scarce. \$500-750.

BELL INTERNATIONAL CORP.
Bell Kamra Model KTC-62 - c1959. Combination 16mm cassette camera & shirt-pocket sized transistor radio. Identical to the Kowa Ramera, but not often found under this name. \$150-225.

BELLCRAFT CREATIONS

Can-Tex - Plastic novelty camera, "Cardinal" type, for 16 exp on 127 film, \$1-

BELLIENI (H. Bellieni & Fils, Nancy, France)

Jumelle - Trapezoidal, leather covered wood camera with magazine back for 9x12cm plates. Zeiss Protar f8/136mm or Goerz Doppel Anast. \$300-450.

Stereo Jumelle - c1894. 6x13cm or 9x18cm stereo plate cameras, magazines backs. Some versions could also take panoramic exposures. Goerz or Zeiss lenses in aluminum barrel, brass dia-phragmring. 6 speed shutter. \$250-375.

BELOMO (Minsk, Byelorussia)

Formerly MMZ (Minsk Mekanicheski Zavod c1957)

Agat 18 - c1984-89. Vertically styled plastic camera, 35mm half-frames. Industar-104 f2.8/28. Shutter 16-250. \$30-45. Chaika - c1965. (Cyrillic letters look like

YANKA.) Half-frame 35mm for 18x24mm exposures. Industar-69 f2.8/28mm lens. Shutter 1/30 to 1/250. \$30-45.

Chaika II - c1967. Nearly identical to the Chaika, but the 39mm Leica-thread lens may be removed for use on enlarger (despite warnings against removal in the instruction book). \$30-45.

Chaika III - c1970. Later model of Chaika with lightmeter. \$35-50.

Chaika 2M - c1972. Like Chaika III, but without meter. Last of the Chaika series, replaced by the Vilia. \$30-45.

Estafeta - c1960. Metal-bodied eve-level camera for 6x6 on 120 rollfilm. \$30-45.

Vilia - c1974. Nameplate uses Cyrillic and Roman lettering so it resembles BNANR-VILIA. Simple black plastic 35mm. Replaced the Chaika series. Shutter B,30-250. Triplet 69-3 f4/40mm lens. \$12-20.

Vilia-Auto (BNANR-ABTO) - c1974-85. Inexpensive plastic 35mm camera from Russia. Like regular Vilia, but automatic exposure controlled by selenium cell around Triplet 69-3 f4/40mm lens. \$15-25.

BENCINI (Milan, Italy) Originally founded in 1937 as I.C.A.F., then C.M.F. About 1946 became C.M.F.-Bencini, and about 1953, Bencini. See prewar cameras under C.M.F.

Akrom I - c1953. Vertically styled cast

BENCINI...

aluminum camera for 3x4cm on 127. Focusing lens; B,50 shutter. Name variant of the Comet III, made for the distributor M. Hoffer S.A. in South America. Uncommon. \$90-130.

Animatic 600 - c1955. Cassette camera for 126 film. \$1-10.

Comet - c1948. Cast aluminum body, telescoping front. 4x4cm on 127 film. Achromatic f11 lens, shutter 1/₃₀,B. \$12-20.

Comet II - c1951. Like the Comet II, but focusing 75mm lens. \$12-20.

Bencini Comet III

Comet 3, III - c1953. Unusual 3x4cm rollfilm camera styled vertically like a movie camera. Shutter B, 50. Model 3 is fixed focus, Model III has helical focus. \$35-50.

Comet NK 135 - Simple cast metal and plastic 35mm camera. Color Bluestar 50mm f2.8 in 3-blade shutter with release button on front of body. \$45-60.

Comet S - c1950. Aluminum body with rigid front. For 16 exposures 3x4cm on 127 rollfilm. Focusing f11 lens. Synchronized shutter 1/50,B. \$12-20.

Cometa - c1959. Cast aluminum camera for 4x4cm on 127 film. Integral accessory shoe cast into bottom. Aplanatic f8/55mm. Shutter B,50,100. \$12-20.

Koroll - c1951. Cast aluminum body, telescoping front. 6x6cm on 120. Achromatic f11/150mm. Shutter B,50. \$12-20.

Koroll II - c1961. Cast aluminum eyelevel camera for 16 exposures 3x4.5cm on 120 film. Focusing f8 lens in B,30,60,125 shutter. \$12-20.

Koroll 24 - c1953. For 16 exposures, 3x4cm, on 120 film. Achromatic lens, shutter B.50. \$20-30.

Koroll 24 S - c1953. Similar to the Koroll 24, but takes 4x4cm on 120 film. \$12-20.

Koroll S - c1953. Cast aluminum camera for 12 exposures on 120 film, or 16 exposures with insertable masks. Extensible front. Focusing f11 lens. Sector shutter, B, 50. \$12-20.

Minicomet - c1963. Simple, vertically styled rectangular plastic box camera for 2x3cm exposures on 127 film. \$15-25.

Rolet - c1946. Compact 3x4cm rollfilm

camera with telescoping front. Shutter will not release unless front is extended and locked. Planetar f11/75mm lens. \$20-30.

BENETFINK (London)
Lightning Detective Camera c1895. 1/4-plate. Ilex string-cock shutter.
\$100-150.

Lightning Hand Camera - c1903. Falling-plate magazine camera for 12 plates 31/4x41/4". \$100-150.

Speedy Detective Camera - Falling plate box camera with unusual 10-plate changing mechanism & counter. Guillotine shutter attached to inner side of hinged front. \$100-150.

BENSON DRY PLATE & CAMERA CO. Street camera - 1920's. Leather covered, box-shaped, tintype camera with developing tank, cloth sleeve, and different sized film masks. Wollensak Rapid Rectilinear lens. \$500-750.

Victor - Street Camera with cloth sleeve, tank, and tripod. Three-way internal film carrier holds tintypes or direct positive paper in 21/2x31/2", 13/4x21/2" sizes or photo buttons. Below the film plane is a two-compartment storage drawer. Wollensak RR lens, two-speed shutter, helical focusing mount. \$150-225.

BENTLEY BX-3 - c1986. Novelty 35mm from Taiwan, styled to strongly resemble a 35mm SLR camera, and with metal weight added inside the plastic body to enhance the illusion of quality. \$1-10.

BENTZIN (Curt Bentzin, Görlitz, Germany) (Succeeded by VEB Primar, Görlitz)

Folding Focal Plane Camera c1902-1930's in different improved versions. Strut-type folding camera with focal plane shutter to 1000. Made in various sizes from 6x9cm to 1/2-plate. A typical example in the 9x12cm size would have Tessar f6.3/150mm.\$100-150.

Planovista - c1930's. Name variation of the Primarette, named for Planol Vertrieb, a German export company. Marketed by the Planovista Seeing Camera Co. Ltd. of London. See Primarette below.

Primar (Plan Primar) - c1938. Double extension 6.5x9cm folding plate/sheetfilm camera. Meyer Trioplan f3.8 or Zeiss Tessar f4.5. Rimset Compur. \$100-150.

Primar Reflex - Early 1900's through 1950's. Many variations of size and equipment. Typical prices for 6.5x9 or 9x12cm with Tessar f4.5 lens: \$200-300.

Primar Klapp Reflex - c1911-1920's. 9x12 cm folding reflex. Meyer Trioplan or Tessar f3.5/210mm. Focal plane shutter 1-1000, T, B. \$150-225.

Primarette - c1933-37. Twin-lens folding camera (NOT a reflex). A "taking" camera topped by a second "viewing" or "finder" camera. Separate lens and bellows for each half. For 8 exp. 4x6.5cm on 127 film. Tessar f3.5 or Meyer Trioplan f3.5/75mm in Pronto shutter, 25-100, T, B. Top lens tilts down for automatic parallax correction. Variations: with or without body release. \$750-1000.

Primarflex (Primar Reflex) - c1936.

An early 6x6cm SLR which pre-dates the Hasselblad by over 10 years. f3.5/105 Tessar. FP shutter. Uses rollfilm or single glass plates. (Primar Reflex name appears to have been used after WWII for the same camera which was formerly called Primarflex.) Working: \$200-300. With inoperative shutter: \$150-225.

Primarflex II - c1951. Similar to the Primarflex, but with interchangeable finder hood and optional pentaprism. Also sold under the name "Astraflex II". Both this and the earlier model tend to have shutter problems. Working: \$175-250. Defective: \$120-180.

"Rechteck" Primar (stereo model) - c1912-1920's. Called "Primar Folding Hand Camera" in English language catalogues. Folding-bed camera with double extension bellows. Leather covered wooden body. Made in 9x12cm and 10x15cm sizes. Tessar f4.5 lenses in Stereo Compurshutter. \$400-600.

Stereo-Fokal Primar - c1923-29. Strut-type focal plane camera for stereo exposures on 6x13cm plates. Tessar f4.5/120mmlenses. \$300-450.

Stereo Reflex Primar - c1918-30. Reflex-style stereo camera for 6x13cm plates. Focal plane shutter to 1000. Tessar f4.5/120mmlenses. \$500-750.

BENTZIN (Richard Bentzin, Germany)

Landschaftskamera - c1890. Huge 30x40cm folding tailboard wooden camera with brass trim. Double extension blue/grey square bellows with red corners. With Goerz Doppel Anast. Ser. III No. 5 270mm lens, one sold at auction in 9/87 for \$210.

BERA - There is no such camera name, but the word "Vega" in Cyrillic letters somewhat resembles "Bera" in Roman script. See Kiev Vega.

BERMPOHL & CO. K.G. (Berlin, Germany) Two distinctive designs in color-separation cameras were produced by Bermpohl. Miethe's Three-color camera took successive exposures on a shifting plate. Bermpohl's Naturfarbenkamera (natural color camera) used beam-splitting mirrors to expose three plates at the same time.

Bermpohl's Naturfarbenkamera -

A beautifully constructed teakwood beamsplitting tri-color camera made in 9x12cm, 13x18cm (5x7"), and 18x24cm sizes.

BERNING

These rarely appear on the market, and are of interest to a limited number of collectors. Sales in the early 1980's were \$1800-2200, then prices dropped as low as \$1100. Current auction prices have now returned to former levels. \$1700-2400.

Bildmeister Studio Camera - c1950. Wooden 9x12cm monorail view. Brown square bellows. Since it is a very usable camera, its price without lens: \$300-450.

Miethe/Bermpohl Camera - c1903. Folding bed camera of polished mahogany with brass trim. Wine red bellows. Tall sliding back allows for three successive exposures through blue, green, and red filters. Goerz Doppel-Anastigmat f4.6/180mm or Goerz Dogmar f4.5/190mm lens. \$2400-3200. Companion viewer, a 3-tiered wooden box with tilting base sells for about \$1500-2000.

BERNARD PRODUCTS CO. Faultless Miniature - c1947. Boxy bakelite minicam for 3x4cm on 127 film. Metal art-deco faceplate. \$1-10.

BERNER (W.Heinz Berner, Erfurt, Germany)

Field camera, 13x18cm - c1895-1900. Wooden view camera with brass trim. Tapered green bellows with wine red corners. Double extension tailboard. Brass barrel lens with rollerblind shutter. \$200-300.

BERNING (Otto Berning & Co., Düsseldorf, Germany) Currently known as Robot Foto & Electronic GmbH & Co. K.G., the company was founded in 1933 and its first camera presented at the 1934 Leipzig Spring Fair.

Robot I - c1934. For 1"x1" exp. on 35mm film. Spring motor automatic film advance. First supplied with Meyer Primotar f3.5, then with Zeiss Tessar f3.5 or f2.8/32.5mm. Rotating shutter 2-500. Robot I cameras require special supply and take-up cassettes which open automatically inside the camera, and close when the camera is opened. Includes builtin lever-actuated green filter. Serial numbers below 30,000 with no letter prefix. \$200-300.

BERNING...

Robot II - c1939-50. Improved model of Robot I. Built-in flash synchronizer, but no filter. Enlarged finder housing includes right-angle finder. Various lenses f1.9, f2.8, f3.8, in 37.5 or 40mm focal lengths. Also available with tall double spring. Serial number has "B" prefix. \$120-180.

Robot IIa - c1951-53. Similar to II, but takes standard 35mm or special Robot cartridges. Accessory shoe. Double flash contacts on front. Available with tall double spring, "C" serial numbers, \$120-180.

Robot Junior - c1954-60. Similar to Ila, but without right-angle viewing. Schneider Radionar f3.5/38mm. "J" serial prefix. \$120-180

Robot Luftwaffe Model - 1940-45. Most commonly found with 75mm lens. Note the tall winding grip. "F" serial prefix. Not uncommon, but some counterfeits have been made from civilian models. Tele-Xenar f3.8/75mm or Biotar f2/4cm lens. \$300-450.

Robot Recorder 24 - c1955-. Special purpose model without viewfinder and rangefinder, and with removable back. With normal lens: \$175-250. Body: \$120-

Robot Recorder 24e - c1959. Body: \$400-600.

Robot Recorder 24F - c1963-65. Body: \$350-500.

Robot Recorder 36 - c1955-. Techni-

cal/scientific model without finders. Similar to Recorder 24, but for 24x36mm image size. \$120-180.

Robot Royal III - c1953-57. Newer style, but still for 24x24mm exposures. CRF. Continuous firing mode. "G" serial prefix. \$350-500.

Robot Royal 18 - Similar to the Royal 24, but with finder masked for 18x24mm format, and exposure counter to 70 frames. One very nice example sold at auction in 1990 for nearly \$2000.

Robot Royal 24 - c1957-69. Renamed continuation of the Robot Royal III. "G" serial prefix. \$300-450.

Robot Roval 36 - c1955-59, 24x36mm full-frame size, rather than the 24x24mm format of the other models. Available with or without continuous firing mode. Schneider or Zeiss 45 or 50mm lenses. "Z" serial prefix. With Xenar f2.8/45mm: \$350-500.

Robot Star - c1952-59. "D" serial prefix. f1.9 Xenon. MX sync. \$175-250.

Robot Star II (Vollautomat) - c1958-69. New body style. "L" serial prefix. \$250-375

Robot Star 25 - c1969-. Similar to Star II, but black top housing. Spring motor capable of 25 exposures. \$300-450

Robot Star 50 - c1969-. Like Star 25, but with tall winding spring extending up from middle of top housing. Capable of 50 exposures per winding. \$200-300. Robot Lenses: Robot lenses were originally supplied in a screw mount. With the introduction of the Robot Royal in late 1953, a new threaded bayonet mount was introduced. We are using abbreviations SM=screwmount, BM=threaded bayonet

30mm f2.8 Tessar (SM) - Standard lens, introduced shortly after the original Primotar, \$50-75

30mm f2.8 Tessar (dummy) (SM) -Rare. \$75-100.

30mm f3.5 Primotar (SM) - c.1938. 4 elements, 3 groups. The first standard lens for the Robot I. \$50-75.

30mm f3.5 Tessar (SM) - \$35-50. **30mm f3.5 Xenagon (SM) -** \$35-50. 30mm f3.5 Xenagon (BM) - \$100-150

35mm f2.8 Xenagon (BM) - \$175-250

37.5mm f2.8 Tessar - \$35-50 37.5mm f3.5 Radionar (SM) - \$35-

38mm f2.8 Xenar (SM) - \$35-50. **38mm f2.8 Xenar (BM) -** from c1953.

38mm f3.5 Radionar (SM) - \$35-50. **40mm f1.9 Heligon (SM) -** \$50-75. 40mm f1.9 Xenon (SM) - \$50-75.

40mm f1.9 Xenon (BM) - \$60-90. 40mm f2 Biotar (SM) - 6 elements, 4 groups. \$45-60. 40mm f2 Biotar (SM)(Luftwaffen-

Eigentum) - \$75-100.

50mm f2 Sonnar (BM) - \$175-250. 50mm f5.5 Tele-Xenar (SM) - no sales data.

75mm f3.8 Tele-Xenar (SM) - \$90-

75mm f3.8 Tele-Xenar (BM) - \$120-

75mm f3.8 Tele-Xenar (SM)(Luftwaffe) - \$120-180.

75mm f4 Sonnar (SM) - 4 elements, 3 groups. \$50-75

75mm f4 Tele-Xenar (SM) - \$90-130. 75mm f4 Tele-Xenar (BM) - \$120-

135mm f4 Tele-Xenar (SM) - \$120-180

135mm f4 Tele-Xenar (black)(BM) -\$175-250

150mm f4 Tele-Xenar (SM) - \$100-150

150mm f4.5 Tele-Xenar (SM) - \$120-180. Add \$50 for finder & case.
200mm f5.5 Tele-Xenar (SM)(black)

- \$175-250

400mm f4 Zoomatar (BM) - c1970's. \$150-225.

Bright frame finder (I) - \$50-75. Finder mask 75mm - \$60-90. Reflex finder (I) - \$100-150. Reflex finder 150mm - \$90-130. Robot II Storz reflex housing -Rare! \$300-450. finder Universal 30-150mm c1950's. Made by Tewe. \$120-180. **Wide-Angle finder 30mm -** \$60-90.

BERTRAM (Ernst & Wilhelm Bertram, Munich, Germany)

Bertram-Kamera - c1954-56. Presstype camera for 21/4x31/4" exposures. Unusual design for a press camera, with no bed. CRF. Parallax compensation. Tilt and swing back. Rack & pinion focus. Lenses are bayonet-mounted, rather than using interchangeable lensboards as did most contemporary press cameras, and the viewfinder automatically matches the

lens in use. Lenses included Schneider Angulon f6.8/65mm wide angle, Xenar f3.5/75mm, Xenar f3.5/105mm normal, and Tele-Xenar f5.5/180mm. Synchro-Compur 1-400 shutter. With normal, WA, and tele lenses: \$800-1200. With normal lens only: \$600-900.

BERTSCH (Adolphe Bertsch, Paris) Chambre Automatique - c1860. A small brass box camera with fixed-focus brass barrel lens, and a permanently attached wooden plateholder designed for 21/2x21/2" wet plates. The camera case also housed the equipment and chemicals to prepare and develop plates in the field, while an outer case served as a darkroom. A museum-quality collectible. Estimated value \$7500-12,000. Stereo version (c1864) would likely bring \$10,000-15,000.

BESELER (CHARLES) CO. (East Orange, New Jersey) **Press camera -** 1959. 4x5" press camera, all black die-cast aluminum body.

FP shutter 1/25-1000. Raptar f4.7/135mm lens in Rapax shutter. Combined range/viewfinder with parallax compensation for 90-240mmlenses. \$500-750.

BESTA - Bakelite minicam for 3x4cm on 127 rollfilm. \$8-15.

BIAL & FREUND (Breslau, Germany) Field Camera, 13x18cm - c1900. Walnut body with brass trim. Tapered green double extension bellows, leather corners. Brass lens with waterhouse stops. \$250-375.

Plate Camera, 9x12cm - c1890. f8 Anastoskop Meniscus lens. \$100-150.

Magazine Camera - c1900-05. Fallingplate box camera for 12 plates, 9x12cm. Guillotine shutter. Two stops. \$100-150.

BIANCHI (Alfred Bianchi, Florence Italy)

Tropical Stereo Camera - Folding-bed style camera with polished walnut body, brass trim. \$750-1000.

BIFLEX 35 - An unusual Swiss subminia-

ture for 11x11mm exposures in staggered vertical pairs on 35mm wide rollfilm. Meyer Görlitz Trioplan f2.8/20mm or Biflex Trivar f2.8/2cm. Shutter 10-250. Quite rare. \$1200-1800.

BILLCLIFF (Joshua Billcliff, Manchester, England)

Field Camera - c1890's. Folding mahogany field camera with solid front door. Dark maroon square-cornered bellows with slight taper. Front standard slides in grooves near outer edges of baseboard. This same camera was also sold under J. T. Chapman label. With TT&H Cooke f4.5 Anastigmat. \$500-750.

Royalty - Mahogany 1/2-plate field camera, aluminum trim. The Royalty camera does not have any manufacturer name on the camera, and has been attributed to Houghton and Thornton Pickard. However the best evidence indicates that it was made by Billcliff and possibly sold by Houghton.\$250-375.

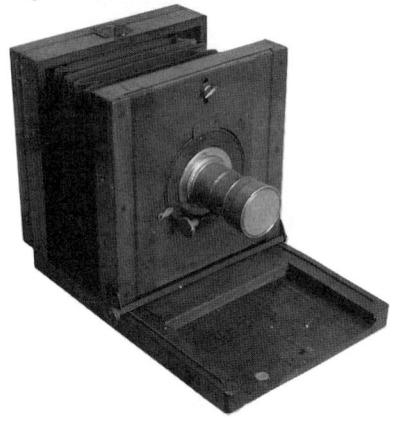

Studio Camera - c1880-1910. Mahogany body with fixed bed; double extension track. Red square bellows. Brass-bound lens. Whole or ¹/₂-plate size. Well made, but basic and not as nicely finished as the field cameras. \$250-375.

BILORA (Kürbi & Niggeloh)

Bella (4x6.5 cm) - Cast aluminum eyelevel camera for 8 exposures, 4x6.5cm on 127 film. All black enamel or blue-grey combination.\$12-20.

Bella 35 - c1959. Simple cast aluminum camera for standard 35mm film. Trinar f2.8/45mmin Pronto. \$12-20.

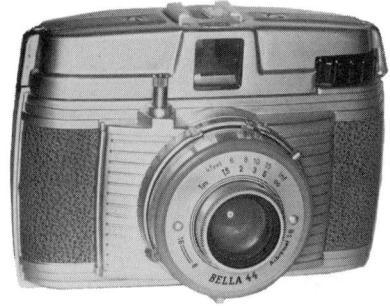

Bella 44 - c1958. Cast metal camera for 4x4cm exp. on 127 film. Styled like a 35mm camera. \$12-20.

Bella 46 - c1959. Similar to the previous Bella cameras, but for 4x6cm on 127 film. Grey covering. \$20-30.

BILORA

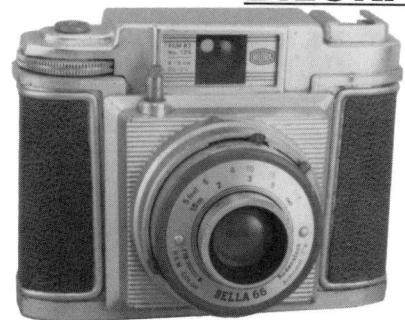

Bella 66 - c1956. Aluminum body. 6x6cm exposures on 120 film. Grey leatherette covering. \$12-20.

Bella D - c1957. For 4x6cm on 127 film. Achromat f8. Shutter 50,100. \$12-20.

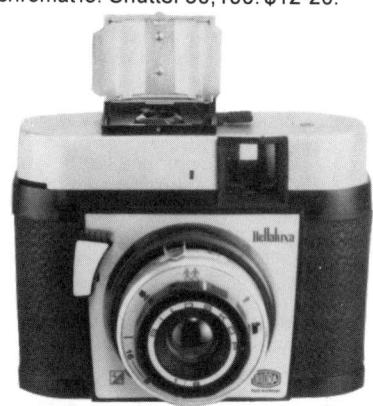

Bellaluxa 4/4 - Rigid bodied camera for 4x4cm on 127. Hinged flash reflector on top. Lever advance w/ double exposure prevention. Zone focusing Biloskop f8 lens. \$15-25.

Bellina 127 - Compact camera for 4x4cm on 127. Rectangular collapsible front. Introduced ca. 1964, but still being sold as late as 1980 for \$18 new. \$12-20.

Blitz Box - c1948-58. Basic metal box camera with flash sync. Two speed shutter. Front lens focus. \$15-25.

Blitz Boy - c1950's. Red-brown plastic eye-level camera with flash shoe. Gold trim. \$30-45.

Bonita 66 - c1953. Twin-lens box camera covered with imitation reptile skin. Meniscus f9 lens. \$25-35.

Box Cameras - c1950's. Simple lenses and shutters, some with sync. \$8-15.

BILORA...

Boy - c1950. Small round-cornered bakelite box camera. Brown with gold trim: \$35-50. Black: \$15-25.

Cariphot - Name variation of Bilora box. Uncommon. \$20-30.

Mikro-Box outfit - c1952. A pair of basic metal box cameras for use with microscope. One camera with ground glass back and no shutter works for viewing. The other has shutter and uses 120 film. The set comes in a wooden box with 4 glass filters. Uncommon. One complete outfit sold at auction in 10/90 for \$333.

Quelle Box - c1950's. Synchronized. \$15-25.

Radix - c1947-51. Small 35mm camera for 24x24mm on rapid cassettes. Biloxar f5.6/38mm lens. Simple model has rotary B&I shutter. Better model has f3.5 lens, 5 shutter speeds, plus accessory shoe. Cameras with case in unique original decorative metal box have sold for \$75-\$100 on the strength of the box. The camera itself is common. \$30-45.

Stahl Box - c1950. Name variation of Bilora box. \$12-20.

Standard Box - c1950's. Exactly as its name implies. It looks like all the rest of Bilora's many metal box cameras. With or without sync for those who object to too much standardization.\$12-20.

BING (Germany)

Fita - c1931-36. Simple folding-bed roll-film camera for 5x8cm. Meniscus f11/105mm. M,Z shutter. \$30-45.

BINOCA PICTURE BINOCULAR - c1950, Japan. 16mm subminiature built into 2.5x opera glasses. Bicon f4.5/40mm fixed focus. Shutter B,25-100. Red, blue, green, or grey: \$1000-1500. White: \$600-900. Illustrated at top of next column.

BIOFLEX - c1965. Hong Kong. 6x6cm TLR-style plastic novelty camera. Two-speed shutter. Not to be confused with the all-metal Bioflex made by Tokiwa Seiki in Japan. \$12-20.

Binoca Picture Binocular

BIRDSEYE CAMERA CORP. (New York City)
Birdseye Flash Camera - c1954.
Plastic eye-level box camera similar to the

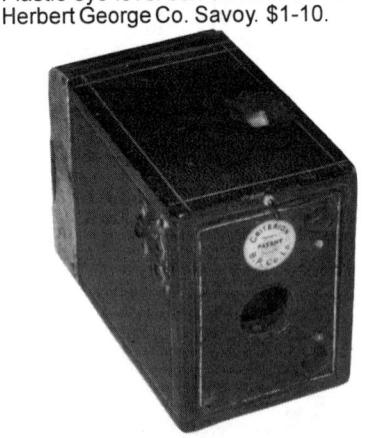

BIRMINGHAM PHOTOGRAPHIC CO. LTD. (London)

Criterion - c1897. Simple little box camera for 1/₁₆-plates (4x5cm). Uncommon. \$120-180.

BIRNBAUM (Böhmen, Germany and Rumburk, Czechoslovakia) Emil Birnbaum, owner.

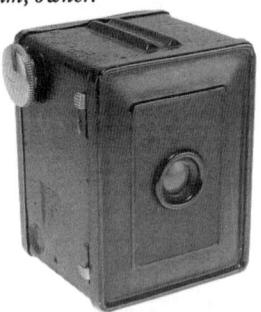

Box - c1934. Tiny all-black enameled metal box camera which resembles in size the baby box cameras of Zeiss and Eho. Very simple construction, and no identification on the camera. After WWII, a nearly identical box camera was produced by Georges Paris in France. This earlier, unidentified Birnbaum camera could easily be mistaken for the postwar models. Identifiable by the "V" sighting groove formed by two ridges pressed out from the top. \$30-45.

Filmoskop - c1930. Cardboard camera for 32x32mm exposures on unperforated 35mm film. Similar to the Ernemann Bob. Simple Z&M shutter. Very rare. \$300-450.

Perforeta (**Perforette**) - c1935. Simple, low quality 35mm camera with

German lenses: Trinar, Trioplan, Cassar, Doxanar, Xenar, Tessar. Variations: Small optical finder between two top knobs; optical finder built into stylish top housing. Relatively common in Czechoslovakia. \$25-35.

Super Perforeta (Super Perforette) - c1940. Similar to the Perforeta, but with uncoupled rangefinder and Comput or Prontor II shutter. \$30-45.

BIRNIE (A.) (Scotland)

Field camera - c1890s. Wooden field camera, 4x5". Wray brassbound lens. \$400-600.

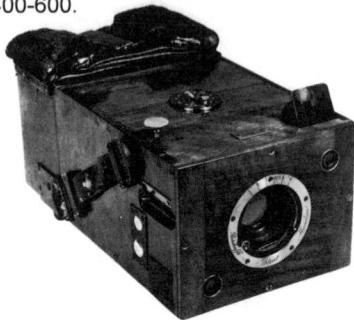

BISCHOFF (V. Bischoff, Munich)
Detective camera - c1890. Box
camera for 9x12cm plates. Polished wood
body. Aplanat lens, iris diaphragm. Twospeed shutter. \$800-1200.

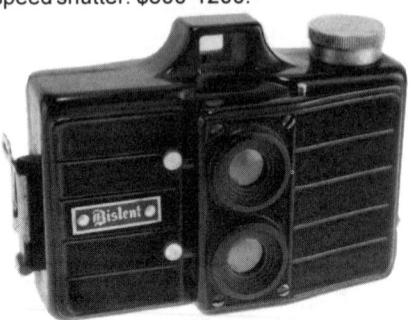

BISLENT - Unusual and rare twin-lens camera for 25x36mm images on 120 roll-film. Made in Argentina. Separately operated shutters are not coupled for stereo use, but provide two stacked "35mm size" images per frame on a horizontally traveling film. Bakelite body; meniscus lenses; single speed shutters. Unusual and rare. \$120-180.

BITTNER (L.O. Bittner, Munich) Roka Luxus - c1923. Folding rollfilm camera with brown bellows and brown lizard-skin covering. Trinar f6.3/105mm in Pronto. Radial focus. Rare. \$150-225.

BLAIR CAMERA CO. Thomas H. Blair applied for a patent in 1878 for a unique camera which included its own miniature dark-tent for in-camera processing of wet collodion plates. This camera, called the Tourograph, was built for him by the American Optical Division of Scovill Mfg. Co. In 1879, Blair incorporated as "Blair Tourograph Co." in Connecticut. In 1881, he moved to Boston and reincorporated as the Blair Tourograph & Dry Plate Co. (shortened to Blair Camera Co. in 1886). In 1890, Blair absorbed the Boston Camera Co., manufacturer of the Hawkeye cameras. In 1899, Eastman Kodak Co. bought Blair Camera Co., moving it to Rochester, N.Y. Beginning in 1908, it was no longer operated

independently, but as the Blair Camera Division of Eastman Kodak Co.

Baby Hawk-Eye - 1896-98. A small 7 ounce box camera similar to Kodak's Pocket Kodak cameras. Takes 12 exposures 2x21/2" on daylight-loading rollfilm. Much less common than the comparable Kodak cameras. \$200-300.

Boston Detective Camera - c1884. Rack & pinion focusing bellows camera fitted into a detective case, which also houses extra plateholders. Camera can be removed from the case for "ordinary work" according to Blair's catalog. \$250-375.

Century Hawk-Eye - 1895-96. A leather covered wooden folding camera for $61/_2 \times 81/_2$ " plates. Nearly identical to Folding Hawk-Eye cameras of the same vintage, but the opening for plate holders is at the side instead of at the top. \$350-500.

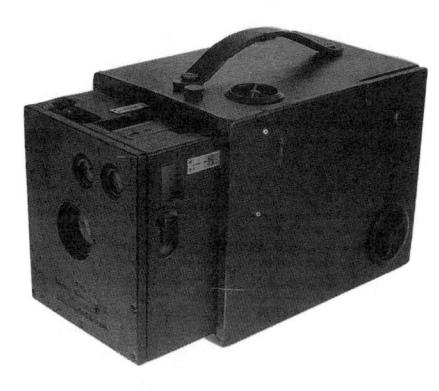

Columbus - Box camera similar to the '95 Hawk-Eye Box, but with integrated roll-film system and not for plates. \$400-600.

Combination Camera - c1882. A 4x5" view camera with an accessory back in the shape of a truncated pyramid which allows it to use 5x7" plates. \$350-500.

No. 3 Combination Hawk-Eye Model 1 - 1904-05. Replaced the No. 3 Focusing Weno Hawk-Eye. This camera is nearly identical to the better known Screen Focus Kodak Camera of the same year. The rollfilm back hinges up for focusing on the ground glass. \$350-500.

English Compact Reversible Back Camera - c1888-98. Very compact view camera, made in 7 sizes from 31/4x41/4" to 10x12". Sunken tripod head in bed of camera. Mahogany body, brass trim. Double extension. \$300-450.

Focusing Weno Hawk-Eye No. 3 - 1902-03. Horizontally styled folding bed rollfilm camera. A clever design allows the rollfilm section to be raised, automatically

advancing the ground glass to focusing position. Uses 118 film for $31/_4$ x $41/_4$ " exposures. Double extension maroon bellows; rack & pinion focus. \$400-600.

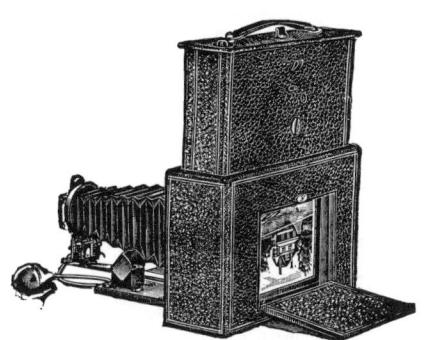

Focusing Weno Hawk-Eye No. 4 - 1902-03. (Advertised as the "Focussing Weno Film Camera" in England). Allowed use of No. 103 rollfilm or 4x5" plates, and groundglass could be used with either. Rollfilm holder pulls out from the top like a drawer. This design was probably the inspiration for the Screen Focus Kodak and Combination Hawk-Eye cameras which appeared in 1904. Double extension red bellows. Wood interior. B&L RR lens. Blair/B&L pneumaticshutter. \$400-600.

Folding '95 Hawk-Eye - c1895-98. A 4x5 folding plate camera, basically a cube when closed. Similar to the No. 4 Folding Kodak Camera of the same period. Top back door for loading plate holders. Could also use roll holder. \$300-450.

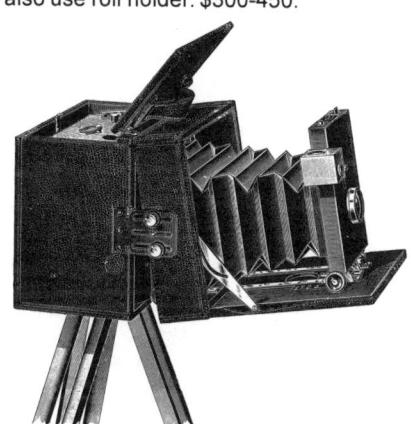

Folding Hawk-Eye 5x7 - c1892. Again, a cube-shaped camera when closed. Black lacquered wood with brass trim. Top back door accepts plate holders or Eastman Roll Holder. Model No.1 has built-in shutter. Model No.2 has exterior shutter and more movements. \$350-500.

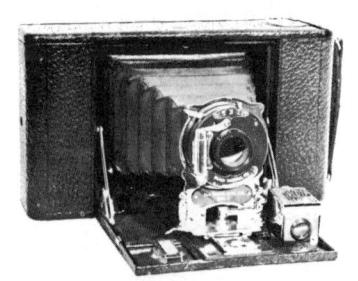

No. 3 Folding Hawk-Eye, Model 3 - 1905-07. Horizontal format folding rollfilm camera for 31/₄x41/₄" exp. Wood interior. Maroon bellows. B&L RR lens. \$50-75.

No. 3 Folding Hawkeye, Model 6 - 1902. \$30-45.

BLAIR

No. 3B Folding Hawk-Eye, Model 1 - c1906-1907. Horizontal format folding rollfilm camera; red bellows. \$50-75.

No. 4 Folding Hawk-Eye, Models 3 & 4 - 1905-13. Horizontal format folding rollfilm camera for 4x5" exp. Red double-extension bellows. Rapid Symmetrical lens. Hawk-Eye pneumatic shutter. Nickel trim. Wood focus rails. \$50-75.

No. 4 Folding Weno Hawk-Eye - 1902. Horizontal style folding camera. Polished mahogany interior, leather exterior. Meniscus, R.R., or Plastigmat lens in B&L automatic shutter. \$50-75.

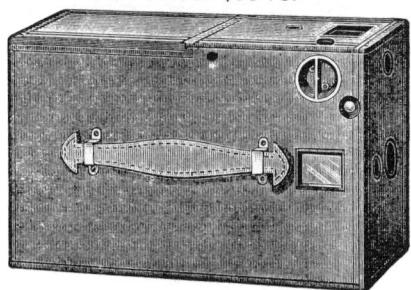

Hawk-Eye Camera (Also called Hawk-Eye Detective Camera or Detective & Combination Camera)

1893-98. Originally made by Boston Camera Co., then continued by Blair. A large polished light wood box camera with brass fittings. Internal bellows focus. No leather covering. Takes 4x5" plates.
 First Blair version - Self-capping

- First Blair version - Self-capping shutter cocked by a knob. Just below the knob on the side is a hole through which tension strengths of 1, 2, and 3 are read. The distance scale window has become a small slit. Time release button on the front, instant release on top. \$250-375.

- **Improved model** - Separate releases on top for time and instant. Distance scale is on the focusing knob on top. \$250-375.

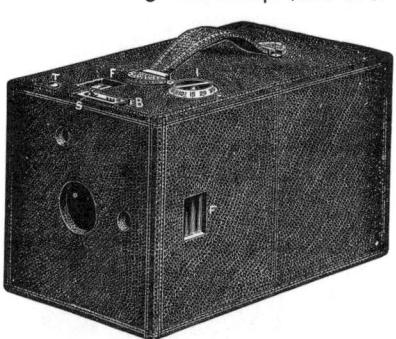

Hawk-Eye Camera (Leather Covered) - 1893-98. Box camera for 4x5" plates in plate holders. Top back door hinges forward to change holders. Leather covered wood construction. Essentially the

BLAIR...

same as the Hawk-Eye camera above except for the leather covering. \$150-225.

'95 Hawk-Eye Box - c1895. Box camera for plates, or will accept Blair roll-holder. \$400-600.

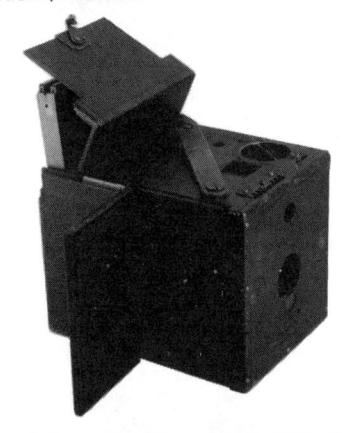

Hawk-Eye Junior - 1895-1900. Box for $31/2 \times 31/2$ " on rollfilm or plates. \$60-90.

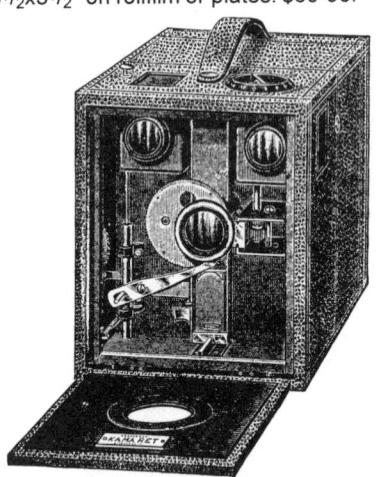

L Lens. R R Film Rolls. F F Focal Plane.

Kamaret, 4x5" - intro. 1891. This large box camera (5.5x6.5x8.75") was advertised as being "one-third smaller than any other camera of equal capacity" because it was the first American box camera to move the film spools to the front of the camera. Made to take 100 exposures 4x5" on rollfilm. Other features included double exposure prevention, automatic film counter, and an attachment for using plates or cut film. \$500-750.

- **5x7 size** - Relatively rare. \$800-1200.

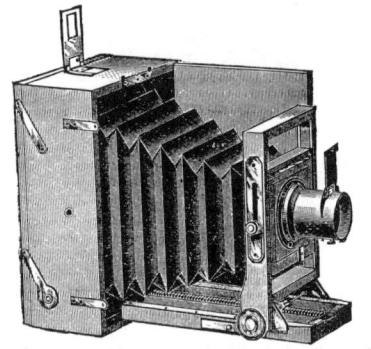

Lucidograph - c1885-86. A folding plate

camera with all wood body. Front door hinges to side, bed drops, and standard pulls out on geared track. Tapered black bellows. Brass-barrel single achromatic lens with rotating disc stops. Several sizes: No. 1 for 31/₄x41/₄", No. 2 for 41/₄x51/₂, No. 3 for 5x8". 5x8" model also has sliding front. Not often seen. \$800-1200.

Petite Kamarette - c1892. Small box camera, like the Kamaret but in a "petite" size for 31/₂" round exposures. \$600-900.

Reversible Back Camera - c1895. Six sizes from 4x5 to 8x10". With Darlot lens: \$250-375

- Improved Reversible Back Camera - c1890's. Six sizes from 4x5 to 8x10". \$250-375.

Special Folding Weno Hawk-Eye No. 3 - Nearly identical to the regular No. 3 Folding Weno Hawk-Eye, but with slightly larger overall dimensions "to provide ample space for fitting all popular highgrade lenses and shutters". One nice example in original box sold in 1990 for \$175.

Stereo Hawk-Eye, Models 1,2,3,4 - 1904-07. RR and other lenses in B&L Stereo Automatic shutter. Single extension wine-red bellows. Leather covered wood body. \$350-500.

Stereo Weno - 1902-03. Leather covered, wood bodied stereo rollfilm cameras for 31/₂x31/₂" exp. Blair Hawk-Eye models 1 & 2 are from 1904-06. Later models by EKC/Blair 1907-16. Maroon bellows, simple B&L stereo shutter in brass housing. \$200-300.

Stereo Weno Hawk-Eye - 1901-1903. Leather covered, wood bodied stereo roll-film cameras for 31/₂x31/₂" exposures. \$200-300.

Tourist Hawk-Eye - 1898-1904. Folding rollfilm camera. 31/₂x31/₂ or 4x5" size. Plain-looking wooden standard conceals lens and shutter. \$120-180. (With optional accessory plate attachment add \$50-75.)

Tourist Hawk-Eye Special - 1898-1901. Horizontally styled folding camera for 4x5" exposures on rollfilm (or plates with accessory back.) Unicum shutter. \$175-250.

View cameras: 4x5", 5x7" or 5x8" field type - with lens. \$200-300. 61/2x81/2" - with lens. \$250-375. 11x14" - \$300-450.

No. 2 Weno Hawk-Eye - 1904-15. Box camera for $3^{1}/_{2}x3^{1}/_{2}$ " on 101 rollfilm. Similar to the "Bulls-Eye" series of the Boston Camera Co. \$30-45.

No. 3 Weno Hawk-Eye - c1904. $31/_4$ x $41/_4$ " box. \$30-45.

No. 4 Weno Hawk-Eye - 1904-15. Large 4x5" box camera. Single speed shutter. Two finders. \$30-45. *Illustrated at top of next column.*

No. 6 Weno Hawk-Eye - 1906-07. Box for $31/_4$ x5 $1/_2$ " on 125 film. \$30-45.

No. 7 Weno Hawk-Eye - 1908-15. Box camera for $31/_4x51/_2$ " on 122 rollfilm. Most

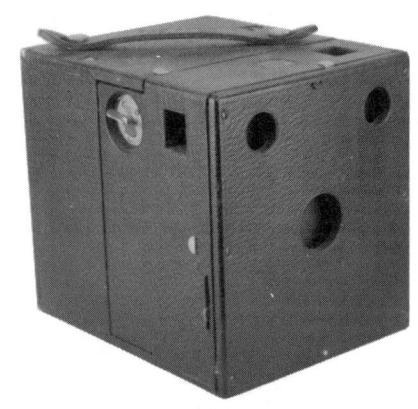

Blair No. 4 Weno Hawk-Eve

commonly found model of the Weno Hawk-Eyes. \$30-45.

BLAND & CO. (England) Manufacturers of a variety of cameras for wet collodion plates. Bland & Co. cameras should be individually evaluated. We have seen examples sold at prices ranging from \$395 to \$3000. The large stereo, sliding-box, and collapsible types are obviously of much greater value than the more common view cameras.

BLOCH (Edmund & Leon Bloch, Paris, France) Leon was the manufacturer, while Edmund was the designer.

Photo-Bouquin Stereoscopique c1904. Stereo camera disguised as a book with the two objectives and the finder lens in the spine. For 45x107mm stereo plates. The camera is operated with the book cover open, and operating instructions in French are on the "first page". No recent sales data. Estimate \$5500-7500.

Photo-Cravate - c1890. An unusual camera designed to be concealed in a necktie, with the lens masquerading as a tie-pin. The body of the camera is a flat metal box with rounded ends. Six 23x23mm glass plates are advanced on a roller-chain controlled by an exterior knob, and the shutter is released by a concealed bulb release. One confirmed sale in 1993, with original silk cravate, lens trim ring, and plates for \$15,000. Estimated value for camera only: \$7500-12,000.

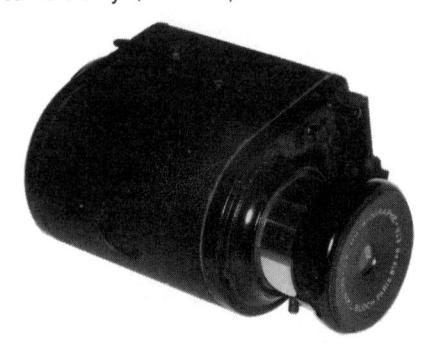

Physio-Pocket - c1904-07. Camera disguised as a monocular, with deceptive right-angle viewer in eyepiece. Krauss Tessar f6.3 lens is concealed behind a small round hole in the side. This monocular camera was later sold with the Physiographe name. This basic design was later used in the Nettel Argus, Zeiss Ergo, etc. \$1200-1800.

Physiographe (monocular) - see description and price under Physio-Pocket above.

Physiographe (binocular) - A "binocular" version of the Physio-Pocket. The second side is actually a plate changing magazine for 12 plates, 4.5x6cm. \$1200-1800.

Physiographe Stereo - (Also sold in England as "Watson's Stereo Binocular".) Patented in 1896 and sold until the 1920's. the Physiographe Stereo camera resembles a pair of binoculars (slightly larger than the regular Physiographe). Incorporating the deceptive angle viewfinder in one eyepiece, the other is used as a handle to slide out the plate magazine which is hidden in the second half. Takes 45x107mm plates. Current value: \$1500-2000. Note: the first two models of the Stereo Physiographe used 5x12cm plates, with the earliest model using a leather bag for plate changing rather than the magazine. These early models would naturally be more valuable.

BOBBY - Cast metal subminiature, similar to the Aiglon, but with black enamel finish. Made in Germany, "Bobby" molded on front. One variation, marketed in Spain, has "Riba" stamped in the rear finder. \$175-250.

BOCHOD - see GOMZ Voskhod.

BOLLES & SMITH (L.M. Bolles & W.G. Smith, Cooperstown, NY)
Patent Camera Box - c1857. An unusual sliding-box style camera for incamera processing of single 41/4x61/2" wet collodion plates. With this camera, the photographer could sensitize, expose, and develop wet plates entirely within the camera. Patented in 1857, this pre-dates the famous (and less complicated) Dubroni camera. It is also more rare. Estimate: \$7,500-12,000.

BOLSEY CORP. OF AMERICA (New York) See also Pignons for Alpa cameras which were designed by Jacques Bolsey before his move to the United States. Cameras designed in the U.S.A. by Bolsey were manufactured by the Obex Corporation of America, Long Island, NY. and distributed by Bolsey. After June 1, 1956, all distribution was also taken over by Obex.

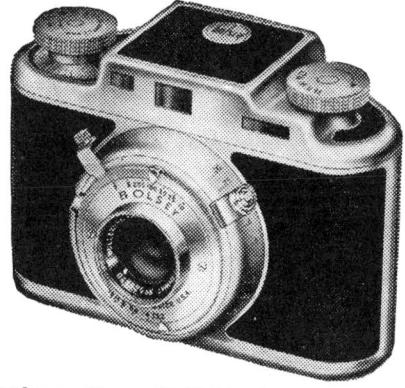

Bolsey B - c1947-56. Compact 35mm camera with CRF. f3.2/44mm Anastigmat in helical mount. Shutter to 200, T, B. \$20-30. Often found with inoperative shutter for \$12-20.

Bolsey B (red) - Both the B and B2 have been offered for sale with red leather covering for \$125-150 each. In each case these were represented as being original.

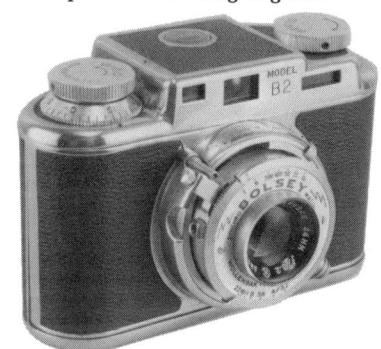

Bolsey B2 - c1949-56. Similar to the B, but with double exposure prevention and sync shutter. \$20-30.

- **Air Force model** - Identical to the B2, except for the top plate which, in typical government language says "Camera, Ground, 35mm" and "Property USAF". \$120-180.

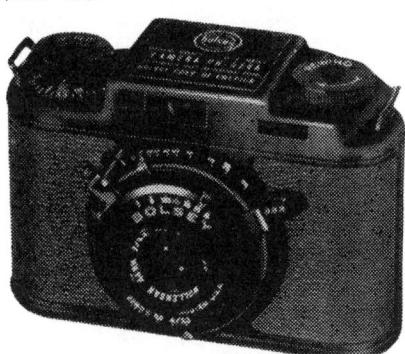

- **Army model, PH324A** - An olivedrab and black version made for the U.S. Army Signal Corps. \$120-180.

Bolsey B22 - c1953. Set-O-Matic fea-

ture. Wollensak Anastigmat f3.2 lens. If working \$20-30.

Bolsey B3 - 1956. Similar to the 1955 Jubilee, but without the Set-O-Matic system. Less common than the other "B" models. \$35-50.

Bolsey BB Special - c1954. 35mm camera with bayonet mount Wollensak Anastigmat f3.2/44mm lens. All-white body. Was originally sold in an outfit as a close-up camera for medical research. Camera only: \$25-35.

Bolsey C - c1950-56. 35mm TLR with CRF. f3.2/44mm Wollensak Anastigmat lens, Wollensak 10-200, B,T, synch. \$75-100

Bolsey C22 - c1953. Similar to C, but with Set-O-Matic. \$75-100.

Bolseyflex - c1954.6x6cm TLR, 120 rollfilm. f7.7/80mm lens. Grey-green covering. Made in Germany by Ising for Bolsey. The earlier model has a smaller finder hood and "Bolsey-Flex" is hyphenated. The later model has a larger finder hood which covers the shutter release, and "Bolseyflex" is not hyphenated. The same camera models were also sold by Sears under the Tower name. \$25-35.

BOLSEY...

Explorer - c1955. Same as Braun Gloriette. f2.8 lens. Rapid wind. \$30-45.

Explorer "Treasure Chest" outfit - In special display box with flash, case, instructions, guarantee, etc. \$50-75.

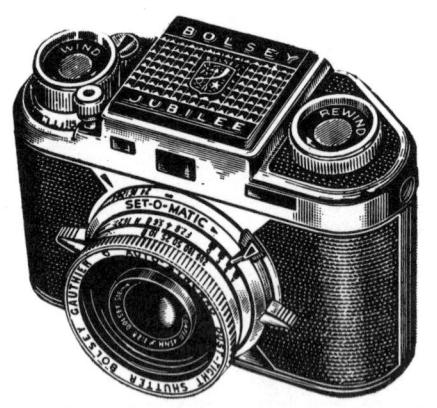

Jubilee - c1955-56. 35mm camera with coupled rangefinder. Steinheil f2.8/45mm. Gauthier leaf shutter 10-200, B. \$35-50.

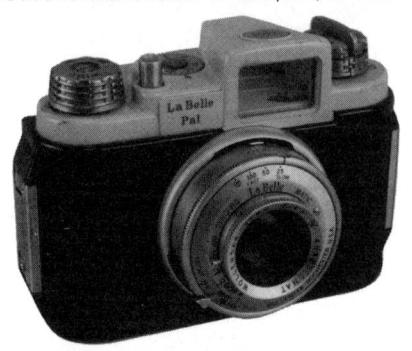

La Belle Pal - c1952. A simplified and restyled 35mm camera without a range-finder. Manual front-element focusing. Wollensak f4.5/44mm anastigmat in Wollensak Synchro-Matic shutter. Originally was to be called Bolsey Model A, but apparently it was only marketed by La Belle as the Pal. Scarce. Formerly sold in excess of \$200. Currently: \$60-90.

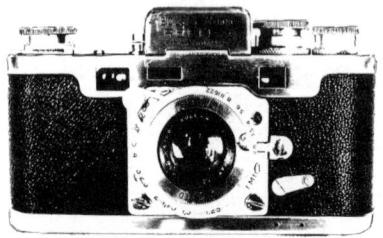

Bolsey Reflex - Original model. Made by Pignons SA, Balaigues, Switzerland, probably in the early 1940's. This camera is identical to the Alpa I developed by Jacques Bolsey shortly before he moved to the United States. 35mm SLR, 24x36mm. Interchangeable lens. Focal plane shutter 25-1000. Focus with ground glass or split-image RF.

- **Model A** c1942?. Bolca Anastigmat f2.8/50mm.\$1000-1500.
- **Model G** c1946. Angenieux f2.9/50mm. \$250-375.
- **Model H** c1946. Angenieux f1.8/50mm. \$300-450.

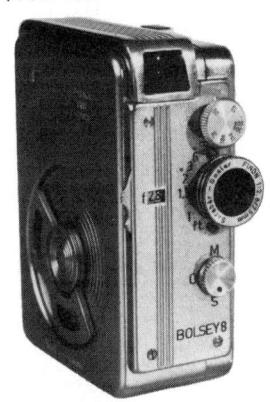

Bolsey 8 - 1956. Still or motion picture camera. Shutter speed variable from 1/₅₀-1/₆₀₀. Stainless steel body, size of cigarette pack. \$150-225.

Bolsey Uniset 8 - 1961. Similar to Bolsey 8 but without variable shutter speeds. Rare. \$250-375.

BOLTA-WERK (later called Photavit-Werk GmbH. Nürnberg, Germany)

Boltavit - c1936. A small cast metal camera for 25x25mm exp. on rollfilm. Black enameled body or bright chrome plated. Both versions have black leather front panel. Variations exist in shutter face style. Doppel Objectiv f7.7 or Corygon Anastigmatf4.5/40mmlens. \$100-150.

Photavit (**Bolta-size**) - c1937. Body design like the Boltavit, and uses Boltasize rollfilm. All black body or chrome with black leather front panel. One variation has "Photavit" decals applied over the Boltavit name on the shutter face and the back plate. \$100-150.

Photavit (35mm) - c1938. Models I, II, III, IV, V. Compact 35mm cameras for 24x24mm exposures on standard 35mm film, but in special cartridges. Film advances from one cartridge to the other. No rewinding needed, and the old supply cartridge becomes the new take-up cartridge. Wide variety of shutter & lens combinations. Standard model I of 1938 is black enameled with leather covering. Deluxe model I and all later models are chrome plated with leather covering. \$100-150.

Photavit (828) - Post-war version, styled like the chrome and leather 35mm model, but for 828 rollfilm. \$100-150.

BOOTS (Nottingham, England) Boots is a large drugstore chain with branches all over Britain. Cameras were made with their name by Houghton among others. In later years, German, Japanese, & other cameras were also imported and sold under the Boots name. Obviously, Boots cameras are more plentiful in Britain than elsewhere.

Boots Comet 404-X - Basic 126 cartridge camera made in Italy by Bencini for Boots. \$1-10.

Boots Field Camera - $31/_4$ x $41/_4$ ", brass and mahogany Planomat lens in roller-blind shutter. \$350-500.

Boots Special - c1911. Lightweight compact folding field camera. Mahogany with brass fittings. Beck Rapid Symmetrical f8 lens. Thornton-Pickard rollerblind shutter. \$300-450.

BOREUX (Armand Boreux, Basel, Switzerland)

Nanna 1 - intro. 1909. Folding stereo camera for 45x107mm plates. Streamlined body with rounded edges and corners. Clamshell-opening front with struts to support lensboard. Suter Anastigmat 6.8/62mm lenses. 3-speed guillotine shutter. Folding frame finder. Unusual design. \$350-500.

BORSUM CAMERA CO. (Newark, N.J.) The Reflex cameras sold by Borsum were apparently the same as those manufactured and sold by the Reflex Camera Co. of Yonkers and later Newark. The two companies share a complex history. Lenses on the cameras vary. Borsum listed no specific lenses in their catalog, stating that any make of lens would be fitted at no charge.

5x7 Reflex - patents 1896-1897.c1906. A very early American SLR. Measures 15x11x81/2" when closed. Focal plane shutter. \$350-500.

5x7 New Model Reflex - c1906. Large box with internal bellows focus. Small front door hinges down to uncover lens. Identical to the 5x7 Reflex of the Reflex Camera Co. \$350-500.

BOSTON CAMERA CO. (Boston. Mass.) Founded in 1884 by Samuel Turner, who later invented numbered paper-backed rollfilm. Boston Camera Co. began marketing the Hawk-Eye detective camera in 1888. In 1890, it was purchased by the Blair Camera Co., which continued to market improved versions of the Hawk-Eye cameras. About 1892, Turner left the Blair Co. and started a new company named "Boston Camera Manufacturing Co." which made "Bulls-Eye" cameras. Thus there are two separate "Boston" companies, both founded by Samuel Turner. The first made "Hawk-Eye" cameras and the second made "Bulls-Eye" cameras. It was this second company which held the rights to Turner's numbered rollfilm, and George Eastman purchased the company in 1895 to secure those rights.

Hawk-Eye "Detective" box cameras - c1888-1890 as a "Boston" camera, but continued by Blair after 1890. Large wooden box camera for 4x5" plates. Rotating brass knob at rear focuses camera by means of internal bellows. Certain features distinguish it from the later Blair models: Wire tensioning device on the side; small shutter cocking lever in a curved front depression; top front shutter release; distance scale window on side near center. All wood box model: \$250-375. Leather covered model: \$175-250.

BOSTON CAMERA MFG. CO. (see historical note above under Boston Camera Co.) Bull's-Eye box cameras - intro c1892. Simple, wooden, leather-covered box

cameras for rollfilm. Very similar to the later Blair and Kodak Bull's-Eye cameras, but easily identified by the "D"-shaped red window. Historically important as the first cameras to use numbered paper-backed rollfilm and red windows. With D-shaped window: \$250-375. With round window: \$120-180.

Bull's-Eye "Ebonite" model - c1893-94. An early thermoplastic camera, essentially the same in overall design as the wooden model introduced in 1892. Dshaped red window. This ebonite model is quite rare, so sales are infrequent. One sale 11/90 at \$350 and one 8/91 at \$600, possibly the same camera.

BOUMSELL (Paris)

Azur - c1950. A series of folding rollfilm cameras for 6x9cm on 120 film. \$30-45.

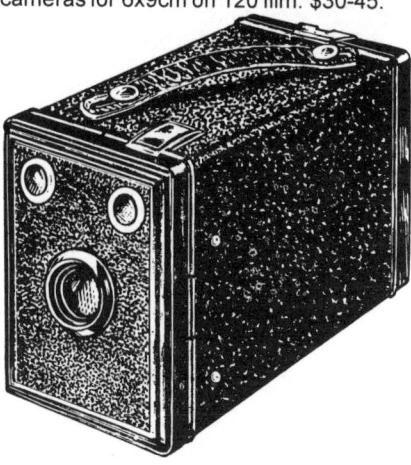

Box Metal - c1950. Basic metal box camera for 6x9cm on 120 film. Imitation leather covered. \$15-25.

BOWER

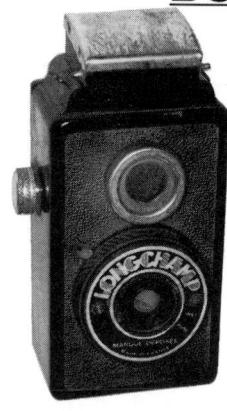

Longchamp - c1950. Simple bakelite reflex-style camera for 3x4cm on 127 film. Similar to Clix-O-Flex. \$20-30.

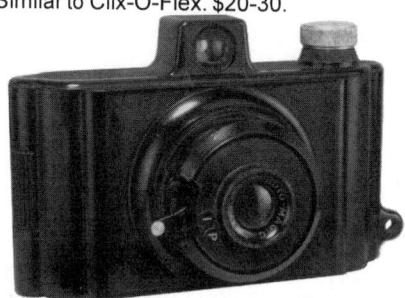

Photo-Magic - c1950. Small bakelite eye-level camera similar to the MIOM. Black or wine-colored. Takes 4x6.5cm photos on 127 film. (An identical camera was also made in England, and is marked "British Made" inside the back.) \$25-35.

BOWER (Saul Bower Inc., New York City)

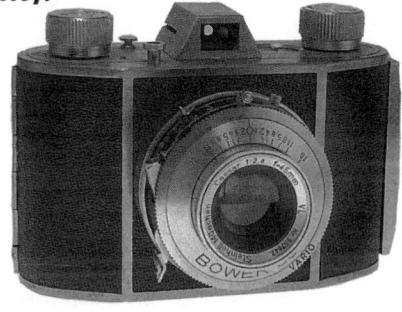

Bower 35 - c1952-58. Basic 35mm VF camera, imported from Germany. Made by Neidig; same as Perlux 24x36mm. Steinheil Cassar f2.8 or Meritar 45mm lens. Vario, Prontor-S or SV shutter. \$25-35.

Bower-X Model II in burgundy

Bower-X - c1951-58. German-made folding camera for 620 rollfilm. Models I, II,

BOX

and 63: \$20-30. Colored models: \$60-90.

BOX CAMERAS - The simplest, most common type of camera. Box cameras have been made by most camera manufacturers, and of most common materials from paper to plastic to metal. Many models are listed in this guide under the manufacturer, but to save you the trouble of looking, common boxes usually sell for ten dollars or less, including sales tax, postage, and green stamps. They can make a fascinating collection without straining the average budget.

BOYER - Boyer is a lens commonly used on bakelite cameras such as the "Photax" which often have no model name on the camera, but only the lens name. If you have a black bakelite camera with a Boyer lens, look under "MIOM" for photos & descriptions which may match.

BRACK & CO. (Munich)

Field camera, 13x18cm - c1895. Wood and brass camera with tapered green bellows, brass Bistigmat lens with waterhousestops. \$175-250.

Field camera, 18x24cm - square cloth bellows (black with red corners) extend backwards. A fine wood and brass camera. With appropriate lens: \$250-375.

BRADAC (Bratri Bradácové IBradac Brothers), Hovorcovice, Czechoslovakia) Bradac Brothers began production in the 1930's with the Kamarad I ca. 1936 and the Kamarad II about 1937. At the beginning of 1936, they closed their factory and part of their production was taken over by Optikotechna in Prague. The cameras were renamed Flexette (formerly Kamarad II) and Autoflex (would have been Kamarad IIa). The Autoflex does exist with Bradac Prague markings, however. See Optikotechna for the continuation of these cameras.

Kamarad (I) - c1936. TLR for 6x6cm on 120 film. Ludwig Dresden Bellar f3.9/75mm lenses. Prontor II shutter. This was the first camera in the line which became Flexette, Autoflex, Optiflex, etc. from Optikotechna.\$100-150.

Kamarad MII - c1937. Same as (I), but with Trioplan f2.9/75mm in Compur 1-250. \$100-150.

BRAND CAMERA CO. (Los Angeles, CA)

Brand Press View (Brand 17) c1947. All-metal view camera, designed for use on a tripod or hand-held as a press camera. Cast metal rear section has integral handle. Full movements. Dual telescoping base rods allow for bellows extension to 17". \$200-300.

BRAUN (Carl Braun, Nürnberg, Germany)

AMC M235 - c1960. Name variant of the

Super Paxette II BL, made for Associated Merchandising Corp., a buying office for major USA department stores. CRF and uncoupled Bewi meter. Cassarit f2.8/50 in Prontor-SVS. Uncommon. \$50-75.

Gloria - c1954. Eye-level camera for 6x6cm on 120 film. Styled like an oversized 35mm RF camera. Uncoupled range-finder. Telescoping front. Praxar or Praxanar f2.9/75mm in Pronto 25-200 or Prontor SVS 1-300. \$35-50.

Cloriette - c1954. Non-RF 35mm camera 24x36mm. f2.8/45mm Steinheil Cassar. Vero, Pronto, or Prontor SVS shutter. \$25-35.

Imperial 6x6 (eye-level) - c1953. Eye-level camera for 6x6cm on 120 film. Bellows with internal struts. Branar f8/75mm. Shutter B,25,75. Built-in extinction meter. \$20-30.

Imperial Box 6x6 (twin lens) - c1951. Twin-lens reflex style box cameras. Model S has single speed shutter, fixed focus lens. Model V has synchronized M,Z shutter, 2 stops. \$20-30.

Imperial Box 6x9 S

Imperial Box 6x9 - c1951. Standard metal rectangular box cameras. Model S has simple lens with 2 stops, Z,M shutter. Model V slightly restyled, synchronized. \$20-30.

Luxa six - c1953. Eye-level 6x6cm camera with pop-out front. Bellows supported by interior struts. Extinction meters beside finder. Also sold as "Imperial" and "Reporter".\$20-30.

Nimco - c1960. Export and department store version of the Imperial 6x6 Box. Nicely designed art-deco front. Uncommon with this name. \$25-35.

Norca - c1953. 6x9cm folding rollfilm camera with cast aluminum body. Praxar f8, Gotar or Cassar f6.3 or f4.5 lenses. Shutter 25,75. \$30-45.

Norica I - c1952. Folding 6x9cm rollfilm camera. Praxar achromatic f8/10.5cm in B,25,75. Folding frame finder. \$20-30.

Norica II - Gotar f6.3 lens. Optical finder and shoe in small housing. \$20-30.

Norica II Super - Cassar f6.3 in Vario. Double exposure prevention with warning signal. \$25-35.

Norica III - Like II, but Gotar f4.5 in Pronto 1-250. \$30-45.

Norica IV - Like II Super, but Cassar f4.5 in Prontor-S. \$30-45.

Pax - c1950. Compact metal camera with square extensible front. For 6x6cm on 120 film. Identical to the Paxina I. \$12-20.

BRIOIS

Paxette Cameras - A series of 35mm compact cameras. Most use the same basic chassis, but some features may be determined from model numbers & names:

"B" = belichtungsmesser (light meter).

- "L" = Lever rewind, bright frame finder.

- "M" = uncoupled rangefinder. - "Super" = coupled rangefinder.

- "I" models are basic.

- "II" models have interchangeable screwmount lens.

- "III" model (Super Paxette) has bayonet mount.

Paxette I - c1952. Compact 35mm camera. Looks like a rangefinder camera, but actually houses an extinction meter in the second window. \$30-45.

Ib c1950's. Cassar f2.8/45mm, Pronto, optical meter, rapid wind lever. \$30-45.

Paxette IIM - c1953, 35mm camera with uncoupled rangefinder and interchangeable prime lenses. Knob advance. Normal lenses include Cassarit. Staeble-Kata, or Ultralit f2.8/45mm. Interchangeable front elements include: Staeble-Choro f3.5/38mm and Staeble-Telon f5.6/85mm. Body covering in various colors including brown, red, green, grey. \$35-50.

Paxette Automatic Super III c1958. Interchangeable f2.8/50 Color Ennit or Color Ultralit lens. Prontor SLK shutter. BIM, CRF. \$35-50.

Paxette Electromatic - c1960-62 35mm with built-in meter.

Model I - fixed focus f5.6, single speed shutter: \$12-20.

Model II - focusing f2.8, shutter 1/30-300:

Model la - interchangeable f2.8/40mm lens mounted in front of shutter: \$30-45.

Paxette Reflex - c1959. Leaf-shuttered SLR with small selenium meter on front below rewind knob. Match-needle readout on top. Enna-Reflex-Ultrilit f2.8/50mm or Steinheil Reflex-Quinon f1.9/50mm in fixed mount. \$50-75.

Paxette Reflex Ib - Like the Paxette Reflex, but with built-in meter. Fixed lenses as above. \$50-75.

Paxette Reflex Automatic - c1963. SLR with built-in selenium meter above Interchangeable bayonet-mounted Braun-Reflex-Ultralit f2.8/50mm in front of shutter. Synchro-Compur 1-500 crosscoupled to diaphragm. \$60-90. Illustrated at top of next column.

Paxette Reflex lenses: 35mm f3.5 Lithagon - \$20-30 135mm f3.5 Tele-Ultralit SLK - \$15-25

Braun Paxette Reflex

Paxiflash - c1961. Plastic eye-level box camera for 4x4cm on 127 film. Grey body: \$25-35. Black body: \$12-20.

Paxina I - c1952. Metal camera with telescoping square front. f7.7/75mm lens. Shutter built into front has 30, 100, T. \$12-20.

Paxina II - c1952. 6x6cm rollfilm camera. Round telescoping front. Staeble Kataplast f3.5/75mm lens in Vario sync shutter. Later variations, c1953, include:

II - Steinar f2.9 in leaf B.25-200 shutter.

IIb - Optik f8 in M&B sync shutter.

IIC - Pranar lens in M&B shutter. Current value: \$12-20.

Reporter - c1953. Unusually styled eyelevel 6x6cm camera. Extinction meter; extensible front with bellows supported by spring-loaded internal struts. Body is rather sophisticated for the simple 2-speed shutter and Luxar f8 lens. \$20-30.

Super Colorette - c1957. 35mm RF cameras.

I - CRF, f2.8, rapid advance. \$25-35.

Ib - Meter, 4-element lens. \$30-45.

II - Interchangeablelenses, \$35-50. IIb - Like II, but with meter. \$45-60.

Super Paxette - "Super" Paxettes have

coupled rangefinder.

Super Paxette I - Non-changeable Staeble-Kataf2.8/45mmlens. \$30-45. Super Paxette IB - \$30-45.

Super Paxette IL - \$30-45.

Super Paxette II Series - "II" models have interchangeable lenses.

Super Paxette II - c1956. Cassarit f2.8/50mm or Xenar f2.8/50mm in Prontor-SVS. CRF. \$35-50.

Super Paxette IIL - Screw-mount interchangeable lens; coupled rangefinder. \$45-60

Super Paxette IIB - \$45-60. Super Paxette IIBL - \$45-60

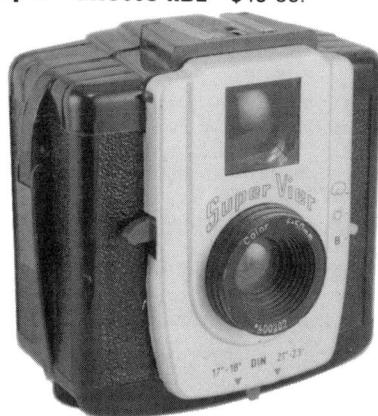

Super Vier - c1965. Inexpensive black plastic camera with hot shoe for flash. As the name implies, it takes 4x4cm negatives on 127 film. Also sold as Paxiflash. Color 50mm lens. Unusual. \$15-25.

BRIN'S PATENT CAMERA - London. c1891. A miniature detective camera hidden in an opera glass. Takes 25mm circular plates. f3.5/30 lens, simple front shutter. Very rare. Until recently, \$3000-4500 has been considered the normal price. In 12/91, two stubborn bidders reached \$40,000 for an authentic example. In 1/94, one failed to reach its reserve of £10 000 This is a highly speculative market, tainted with replicas. We would estimate a stable value for a genuine example at \$6500-9500. Replicas exist and have been misrepresented as originals. Replica: \$800-1200.

BRINKERT (Franz Brinkert, Germany) Manufacturer of novelty subminiature cameras, sold primarily in the collector market.

Efbe - "FB" for F. Brinkert. Novelty subminiature taking 6 exposures on a 47mm film disc. Enna f2.8/20mm lens, 25-100,B shutter from Goldeck 16 surplus stock. The bodies are handmade, machined from aluminum. As one would expect from handmade cameras, there are variations of color, finish, and model number. These sell regularly for about \$65-\$125 in Germany, sometimes higher in the USA and England.

BRIOIS (A. Briois, Paris) Thompson's Revolver Camera intro. 1862. Designed by Thompson. Brass pistol-shaped camera with scope, wooden

BRITISH FERROTYPE CO.

pistol grip, but no barrel. Takes four 23mm dia. exposures in rapid succession on a 7.5cm circular wet plate. Ground glass focusing through the scope which is above the cylindrical plate chamber. Petzval f2/40mm lens, single speed rotary behind-the-lens shutter. The lens is raised and sighted through to focus, then dropped into place in front of the plate, automatically releasing the shutter. The circular plate was then rotated a 1/4 turn and was ready for the next exposure. Rare. One sold at auction 11/89 for \$30,000.

BRITISH FERROTYPE CO. (Blackpool, England)

Telephot Button Camera - c1911. Like the Talbot Errtee Button Tintype Camera. For 1" dia. ferrotype dry plates. Rapid Rectilinear lens, between-the-lens shutter. \$750-1000.

BROOKLYN CAMERA CO. (Brooklyn, NY)

Brooklyn Camera - c1885. ¹/₄-plate (3¹/₄x4¹/₄") collapsible-bellows view camera with non-foldingbed. \$175-250.

BROWNELL (Frank Brownell, Rochester, NY)

Stereo Camera - c1885. A square bellows dry-plate camera for stereo exposures. Historically significant, because Frank Brownell made very few cameras which sold under his own name. He made the first Kodak cameras for the Eastman Dry Plate & Film Co., and was later a Plant Manager for EKC. Rare. No recent sales.

BRÜCKNER (Rabenau, Germany) Field camera - c1900-10. Tailboard style cameras in various sizes including 9x12cm, 13x18cm, and 18x24cm. Fine wood body, brass trim, square black bellows. \$175-250.

schüler-Apparat (Student camera) - c1905-10. Tailboard camera for 9x12cm plates. Mahogany body with brass trim. String-set shutter built into wooden front. Voigtländer Collinear III f7.7 lens. \$175-250

Union Model III - c1920-30. Highly polished mahogany body with much brass trim. Square grey double extension bellows with black corners. Brass-bound Busch Rapid Aplanat f7.5/260 in rollerblind shutter. \$400-600.

BRUMBERGER 35 - c1960. 35mm RF camera designed to look like a Nikon S2. Non-changeable f2.8 or f3.5/45mm coated lens in leaf shutter to 300. Made by Neoca for Brumberger.\$50-75.

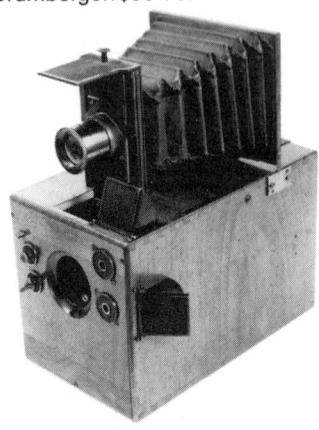

BRUNS (Christian Bruns, Munich)
Bruns was the designer of the Compound

shutter, and for a short time was a partner of Deckel as "Bruns & Deckel". His camera designs are few but very interesting

designs are few, but very interesting.

Defective camera - c1893. An unusual wooden box detective camera for plates. Unique design incorporates an auxiliary bellows with ground glass which mounts piggy-back on top of the camera. Camera lens slides up to double as a lens for the full-size ground glass viewer. Two sizes: 12x16.5cm sold at auction 10/88 for \$4500.9x12cm size: \$3200-4600.

BUESS (Lausanne) Multiprint - A special camera for 24 small exp. on a 13x18cm plate which shifts from lower right to upper left by means of a crank on the back. Corygon f3.5/105mm lens, rotating shutter 1-100. Reflex finder. (Only 25 of these cameras were made. We know of only 2 examples. One sold at a German auction in 1976 for \$820, the other in late 1984 for \$450.)

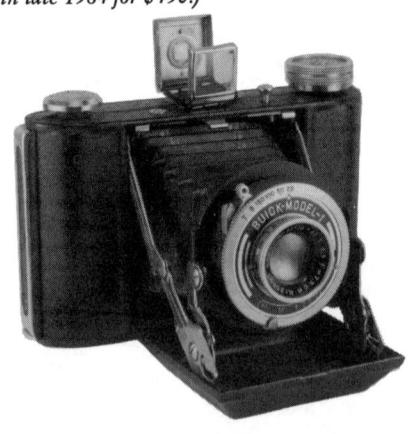

BUICK MODEL 1 - Pre-war Japanese folding Ikonta-style camera for 6x6cm on 120 film. "Buick Model 1" on shutter face. This may only be the shutter name, but there is no other name on the camera. Shutter speeds T, B, 25-150. Tritar Anastigmat f3.5 or Kokko Anastigmat f4.5/7.5cm lens. \$100-150.

BULL (D.M. Bull, Bullville, N.Y.) Detective - c1892. 4x5" falling-plate magazine camera for 12 plates. Key locks back. Rare. \$200-300.

BULLARD CAMERA CO. (Springfield, MA) Founded about 1895 by Edgar R. Bullard, and absorbed into the Seneca Camera Co. about 1902.

Folding Magazine Camera - c1898. For 18 plates in 4x5" format. First models (rare) were made in Wheeling, West Virginia and were heavier and better made than

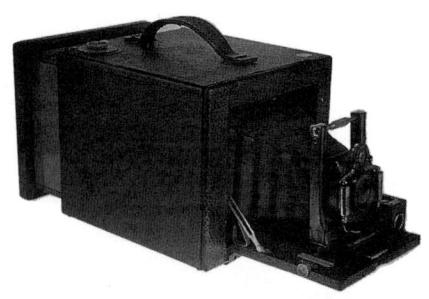

the later ones made in Springfield, MA. Push-pull action of back advances plates. Front bed hinges down and bellows extend. Unusual, because the majority of the magazine cameras were box cameras, and did not employ folding bed or bellows. \$300-450.

Folding plate camera - c1900. Leather covered folding camera. Polished mahogany interior, red bellows. Reversible back. Made in 31/4x41/4" and 4x5" sizes. Various lenses, including B&L, Rauber, Wollensak, and Periscop-Aplanat. Victor or Wollensak double pneumatic shutter. \$100-150.

BÜLTER & STAMMER (Hannover, Germany)

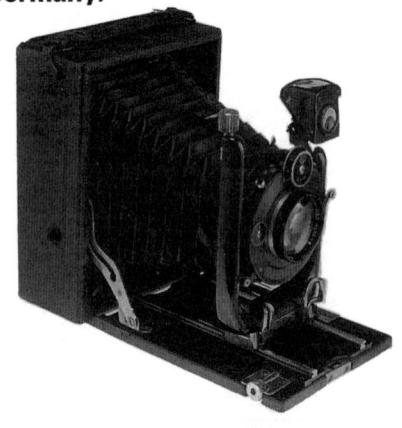

Folding camera Model 55 - Folding camera for 9x12 plates. Wooden body and bed. Rack & pinion focus, micrometer-screw rising front. \$60-90.

Folding camera Model 86 - c1915. Double extension folding plate camera, 10x15cm. Square body. Euryplan lens in Compoundshutter. \$90-130.

BURKE & JAMES, INC. (Chicago)

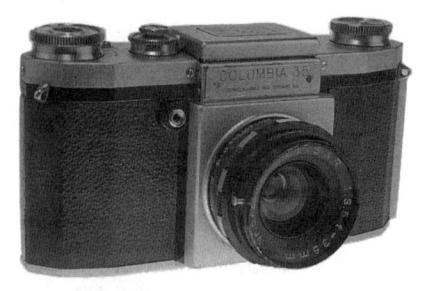

Columbia 35 - c1957-59. Import version of the Praktica FX, but with the original name obliterated, and "Columbia 35" nameplate screwed to the front of the camera. \$50-75.

cub - c1914. Box cameras. They stand out in a collection of box cameras because they load from the side. Made in 2A, 3, & 3A sizes. \$12-20.

Grover - 1940's-1960's. Monorail view cameras in 4x5", 5x7", and 8x10" sizes. Valued as usable equipment rather than collectible, the most important consideration is the shutter and lens, which can vary greatly in value. Without lens or shutter. 4x5 or 5x7: \$100-150; 8x10: \$150-225.

Ingento: c1915. 1A Ingento Jr. - f6.3 lens. \$15-25. 3A Ingento Jr. - Vertical format. Ilex lens. Ingento shutter. \$20-30. 3A Folding Ingento, Model 3 -

Horizontal format. Ilex lens. Ingento shutter. \$20-30.

Korelle - Marketed by Burke & James, but manufactured by Kochmann. See Kochmann.

Panoram 120 - c1956-71. Wide angle camera for 4 exposures 6x18cm (21/4x7") on 120 film. A civilian camera modified from surplus stock of U.S. Navy Aircraft
Torpedo Camera made by Solar Aircraft
Co. Originally available from B&J with Ross f4/5" lens in focusing or fixed focus mount, single speed (1/100 sec) shutter. The current surge of interest in panoramic photography has increased the popularity of these cameras with their wide-format rollfilm backs. With detachable ground glass back and magazines, we've seen them from \$100-550.

PH-6-A - U.S. Signal Corps special wide angle camera for 5x7" filmholders. Wollensak f12.5 Extra Wide Angle lens in Betax No. 2 shutter, \$120-180.

Rembrandt Portrait Camera c1950-55. Wooden fixed-tailboard studio cameras for portrait work. (Model II with folding tailboard c1956-1960's.) Lack of front movements and limited rear movements (rise & tilt) make it unsuitable for most commercial work, however it made a sturdy portrait camera. Designed for easy mounting of Packard shutter behind lensboard, so often found with Packard shutter installed. A good quality lens, especially in a synchronized leaf shutter, is often worth more than the camera.

- 4x5 - without lens. \$175-250 - 5x7 - without lens: \$150-225.

Rexo cameras:

Rexo Box - for 6x9cm rollfilm, \$1-10.

1A Folding Rexo - c1916-31. For 21/₂x41/₄" on 116 film. Anastigmat lens. \$15-25. *Illustrated at top of next column.*

1A Rexo Jr. - c1916-24. Folding camera for 21/2x41/4" on 116 film. Single Achromatic or RR lens. llex shutter. \$12-

2C Rexo Jr. - c1917-24. Folding camera.

No. 1A Folding Rexo

3 Folding Rexo - c1916-31. 31/4×41/4" rollfilm. RR or Anastigmat lens. Ilex shutter. \$20-30.

3 Rexo Jr. - c1916-24. 31/4x41/4", single achromatic lens. Ilex shutter, \$12-20.

3A Folding Rexo - c1916-24. Postcardsize camera, \$15-25.

Vest Pocket Rexo - Wollensak Anastigmat lens in Ultex shutter. \$25-35.

Rexoette No. 2 - c1910. Box camera for 6x9cm. Wooden body with leatherette covering. \$12-20.

Press/View cameras: Value determined primarily by USABILITY.
21/4x31/4" & 31/4x41/4" - with lens:

4x5" Watson Press - c1940. With f4.7/127mm Kodak Ektar lens: \$120-180. **4x5" view -** with lens: \$250-375. **5x7" view -** without lens: \$120-180. **8x10" view -** Full movements, without

lens: \$350-500.

Watson-Holmes Fingerprint

Camera - 1950's-60's. A special purpose camera for 1:1 reproductions of fingerprints or small objects. Front of camera rests on object being photographed and interior bulbs provide illumination. (Military version is called PH-503A/PF), \$90-130.

BURLEIGH BROOKS INC. (Englewood, NJ)

Bee Bee - c1938-41. German folding plate cameras sold in the USA under the Bee Bee" name (for Burleigh Brooks) Model A for 6.5x9cm, Model B for 9x12cm.

Bayonet mount for easy changing of lens and shutter. Identical to the Certo Certotrop cameras, \$60-90.

Brooks Veriwide - 1970's. Wide angle camera using the Schneider Super Angulon 47mm lens (f8 or f5.6 versions) on a thin camera body compatible with the Graflex XL system. Price includes any one of the normal backs. f5.6: \$600-900. f8: \$500-750.

Stereo camera - Mahogany tailboard camera with square leather bellows, twin brass-barreled Burr lenses and Thornton-Pickard roller blind shutter. \$600-900.

Wet plate camera - c1860. Slidingbox style. Polished mahogany with brass barrel lens and brass fittings. Sliding back allows three exposures on a single 31/4x41/4" plate. \$3200-4600.

BURTON MFG. CO.

Clinicamera - Special purpose camera for medical/dental closeup photography Black bakelite camera is suspended in the center of a large octagonal art-deco reflector. A single flashbulb provides "ringlight" illumination. Uses 31/₂x41/₄" plates in standard double holders. \$120-180.

BUSCH, Emil (London, England) see also Emil Busch Rathenow, below. This was the London office of the Rathenow firm, selling mainly Krügener cameras with Busch lenses in competition with Houghton selling

similar cameras with any lenses.

Folding plate camera, 9x12cm - c1907. Leather covered body, ground glass back. Lukar f6.8/150mm lens in Compoundshutter. \$60-90.

Freewheel, Model B - c1902. Horizontally styled folding rollfilm camera which also allows the use of a ground glass or plateholders without removing the rollfilm. The name derived from the "freewheeling" advance knob which allowed the film to be rewound onto the supply spool to accommodate the viewing screen or plateholder. Busch f6 lens in Wollensak Regular shut-

BUSCH...

ter. One sold at auction in England for \$100 in 7/87.

Heda - c1902. Strut-folding focal plane camera to 1000 sec. Leather and metal parts are black. Folding viewfinder. Busch Anastigmatf7.7/130mmlens. \$75-100.

Stereo Beecam - Stereo camera for 31/₂x61/₂" plates. Busch Periplanet No. 1 lenses in pneumaticshutter. \$250-375.

BUSCH, Emil (Rathenow, Germany) see also Emil Busch London, above.

Ageb - c1909. Single extension folding camera for 9x12cm plates. Busch Bi-Periskop f12/150mm in B&L Auto Junior shutter. Uncommon. \$100-150.

Folding plate camera, 10x15cm - c1914. Double extension bellows. Rapid Aplanat Ser. D f7/170mm or Tessar f4.5/165mmin Cronos-C.\$60-90.

Folding rollfilm camera, 5x7.5cm - c1928. Folding bed camera, with radial lever focusing. Glaukar f6.3 or Corygon f4.5/90mm lens. Pronto or Ibsor shutter. Waist level and eye-level frame finders. \$35-50.

Folding rollfilm camera, 6x9cm - c1928. Folding bed camera. Glaukar f4.5/105mmin Compurshutter. \$25-35.

Folding rollfilm camera, 7x10cm - Red bellows. Simple lens/shutter. \$30-45.

Stereo Reflex - c1920's. 6x13cm stereo, made for Busch by Bentzin (same as Stereo Reflex Primar). GGB. Roja Detective Aplanat f6. FP 20-1000. \$400-600.

Vier-Sechs - c1920. Strut-folding camera for 4.5x6cm plates. Leather covered wood body. Detectiv-Aplanat f6.8/75mm in Compound 25-100, B,T. Uncommon. \$200-300.

BUSCH CAMERA CORP. (Chicago)

Pressman 4x5 - f4.7 Ektar, Optar, or Raptar lens. Press camera styled like Graphic. \$175-250.

Pressman 21/4x31/4" - Miniature press camera. Although sometimes offered at higher prices, there is usually no shortage of good working cameras in the normal range of \$100-150.

Verascope F-40 - c1950's. Stereo camera for 24x30mm pairs. f3.5/40mm Berthiot lens. Guillotine shutter to 250. RF. Made by Richard in France; sold under the Busch name in the USA. Considered to be one of the best stereo cameras, and not often found for sale. \$500-750.

BUTCHER (W.Butcher & Sons, London) William Butcher set up in business as a chemist in Blackheath, South London in 1860. However, it was not until c1894 that Butchers began manufacturing photographic goods under the "Primus" trademark. The photographic business was run by Mr. W.F. Butcher and Mr. F.E. Butcher, sons of founder William Butcher.

The business grew very rapidly. By February 1902 it moved to Camera House, Farringdon Avenue, London EC. Some cameras and accessories continued to be made at Blackheath and much was bought from other manufacturers, notably German firms. In fact, before WWI, the firm was primarily an importer. Before 1909, most of its cameras were made by Hüttig, thereafter by Ica.

The outbreak of war in 1914 caused the cessation of its German supplies and resulted in Butchers pooling manufacturing resources with Houghtons to form the Houghton-Butcher Manufacturing Co. Ltd in 1915. This company made products for both firms which remained separate until their selling operations were finally merged in January 1, 1926 to form Houghton-Butcher (Great Britain) Ltd.

Although the Butcher firm had joined forces with George Houghton, and eventually became a part of Ensign Ltd., it remained a family tradition. Two of Butcher's grandsons were still associated with the Ensign firm in the 1930's. Check Houghton-Butcher for cameras not listed here.

Cameo - A series of folding plate cameras imported from Germany, introduced around the turn of the century and continuing for many years in all sorts of variations. In the common sizes with normal lens and shutter: \$35-50.

Cameo Stereo - c1906-15. Folding bed

style stereo camera for 9x18cm plates. Black covered wood body. Made for Butcher by Hüttig, then Ica. The No. 0 and No. 1 models are simpler, with T,B,I shutter. The No. 2 features rack focusing, DEB, rising front, and shutter speeds to $1/1_{100}$. Aldis, Beck, or Cooke lens. \$250-375.

Carbine cameras - A series of German-made folding cameras primarily for rollfilm, but most models have a removable panel in the back which allows the use of plates as well. Quite a variety of models with various lenses and shutters. The models with better lenses and shutters obviously bring the better prices. \$35-50.

Clincher - c1913-19. Falling-plate box cameras in several sizes. Wood body with Morocco leatherette covering. T&I shutter. No. 1 takes 6 plates, $2^{1/4}x^{31/4}$ ". No. 2 takes 6 plates, $3^{1/4}x^{41/4}$ ". No. 3 takes 12 plates, $3^{1/4}x^{41/4}$ ". No. 4 takes 6 plates 9x12cm. \$30-45.

Coronet No. 1, No. 2 - c1913-19. Folding field camera, made in 1 /₄-, 1 /₂-, and 1 /₁-plate sizes. Mahogany with brass trim. Turntable fitted in baseboard. No. 2 originally fitted with Primus RR, Beck Symmetrical, or Aldis Uno in front of roller blind shutter. No. 1 fitted with single achromatic lens and revolving shutter. \$250-375.

Dandycam Automatic Camera - c1913-15. Box camera for ferrotype buttons. Daylight-loading magazine holds 12 plates of 1" (25mm) diameter. Wooden body with Morocco leatherette covering. \$500-750.

Klimax - 1910's. Folding camera for plates, made by Ica. Aluminum body covered with Morocco leather. In various sizes from $^{1}/_{4^{-}}$ to $^{1}/_{2^{-}}$ plate. Model I is single extension, while Model II is double extension. A great variety of shutter and lens combinations were available. \$30-45.

Butcher Pom-Pom No. 3

Little Nipper - c1900. Butcher's name for the Hüttig Gnom. Simple magazine box cameras for glass plates. One model for 4.5x6cm plates, and the larger model for 6.5x9cm plates. Add-on finder is similar to that of the original Brownie camera of the same era. \$60-90.

Maxim No. 1 - c1903-1920. A leather covered wooden box camera for 6x6cm exposures on rollfilm. A rather scarce box camera from the days of the first "Brownie" cameras. \$45-60.

Maxim No. 2 - Similar, but for 6x9cm images. \$30-45.

Maxim No. 3 - Similar, but for 6.5x11cm images. \$30-45.

Maxim No. 4 - for 8x11cm. \$35-50.

Midg - c1902-20. A series of imported drop-plate magazine box cameras in $3^{1}/_{4}x4^{1}/_{4}$ " or postcard $(3^{1}/_{4}x5^{1}/_{2}$ ") sizes. The No. 0 is the simplest, with built-in shutter and lens. Shutter speed dial is low

on the front. The models 1, 2, 3, & 4 have a hinged front which conceals the better lens and shutter. \$60-90.

National - c1900-05. 1/2-plate folding field camera. Fine mahogany finish. Reversible back, tapered black bellows, Ross f6.3/7" homocentric lens. Thornton-Pickard roller-blind shutter. \$350-500.

Pilot No. 2 - c1904-06. Falling-plate magazine camera, 21/2x31/2". \$35-50.

Pom-Pom No. 3 - c1903. Uncommon folding rollfilm camera. Wine-red bellows. Shutter built into leather-covered lensboard. Limited sales data in range of \$120-180. *Illustrated top of previous column.*

Popular Carbine - c1920's. Made in Nos. 1, 1A, and 2 sizes. Wide variety of lens/shutter combinations. \$35-50.

Popular Pressman - c1909-26. Butcher's entry into the field of reflex cameras. Made by Ica in sizes 31/₄x41/₄" & 31/₄x51/₂". Focal plane shutter. Generally found with f4.5 lens by Beck, Aldis, Cooke, Dallmeyer, or Ross. \$175-250.

Primus No. 1 - c1899. Box cameras in $1/_4$ -plate, 4x5", and $1/_2$ -plate sizes. RR lens in roller-blind shutter. With 3 slides and case: \$75-100.

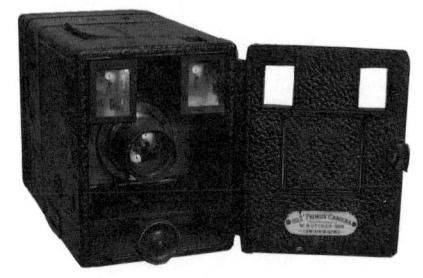

Primus No. 2 - Similar but with Euryscope f6 lens. \$75-100.

BUSCH...

Primus No. 3 - Folding hand and stand camera. 1/₄-pl, 4x5", 1/₂-pl sizes. TP rollerblind shutter, brass-boundlens. \$150-225.

Primus So-Li-To - c1897-1899. Unusual collapsible morocco leather covered box in shape of a truncated pyramid. Designed to appeal to cyclists and tourists. Only one recorded sale, at auction 11/89 for \$650.

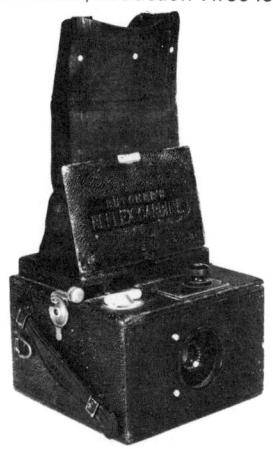

Reflex Carbine - c1925. 6x9cm 120 film SLR. Aldis Uno Anastigmat f7.7/41/₄". Two separate releases for T & I. Body of wood covered with black leather. The same basic camera was sold by Houghton as "Ensign Roll Film Reflex". \$100-150.

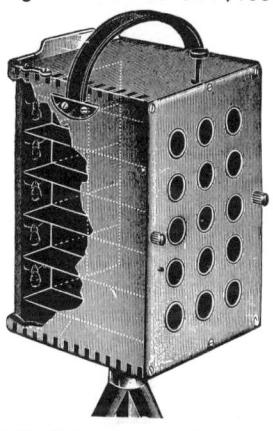

Royal Mail Postage Stamp Camera - c1907-15. Wooden box camera, multiple exposures on a single 31/4x41/4" plate. Two major variations exist. The 3-lens model takes 3 or 6 exposures on a plate by shifting the lensboard. Current value of 3-lens model: \$1000-1500. The 15-lens model simultaneously exposes 15 stamp-sized images on the plate. Recent auction prices have been as high as \$4000; more commonly \$1500-2000. Reproductions have been made in India, and offered to photographica dealers for resale. At least one reputable dealer refused to buy any unless the maker promised to mark his creations distinctly as reproductions. The maker refused and unmarked replicas have appeared.

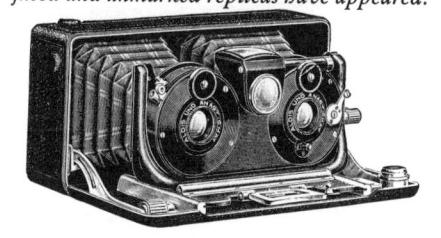

Stereolette - c1910-15. Miniature fold-

BUSCH...

ing-bed stereo camera from Ica for 45x107mm plates. Zeiss Tessar f6.3 or f4.5 or Aldus Uno Anastigmat in Compound Shutter. \$300-450.

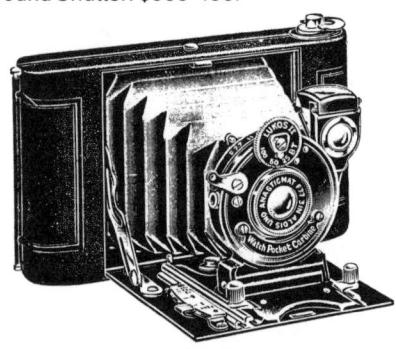

Watch Pocket Carbine - c1910's-1920's. Compact folding rollfilm cameras, in 6x6cm, 6x9cm, and 6.5x11cm exposure sizes. The 6x6cm models are horizontal, while the larger models are vertically oriented. Leather covered metal body. Some imported from Ica. Often with f7.7 Aldis Uno Anast. in Lukos II shutter. \$50-75.

Tropical Watch Pocket Carbine - c1923. Like the regular models, but with black unleathered body and Russian leather bellows. \$150-225.

Watch Pocket Klimax - c1913-20. Folding bed camera for 13/4x21/4" plates. Same as Ica Victrix. Model I has Aldis Uno Anastigmat f7.7/3" or Triotar f6.3 in Lukos II shutter. Model II has Compound shutter with Aldis Uno, Beck Mutar f4.9, Zeiss Triotar f6.3, or Tessar f4.7. \$75-100.

BUTLER (E.T. Butler, England)
Patent Three-Colour Separation
Camera - A mahogany camera for three
exposures on separate plates through the
use of semi-silvered mirrors. Rack-out
front similar to large format SLR's of the
day. Made in sizes for 21/4x31/4", 31/4x41/4",
and 41/4x61/2" plates. \$2800-4000.

BUTLER BROS. (Chicago)

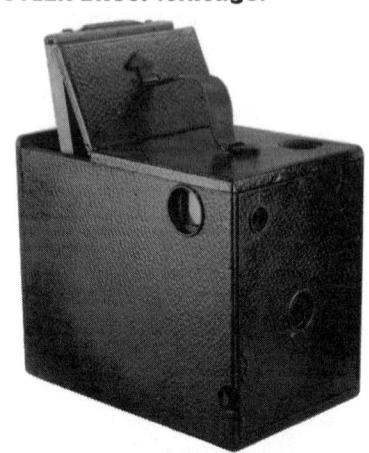

Pennant Camera No. 20 - Box camera for 4x5" plates in standard plateholders which load through a door at the top rear. \$35-50.

Universal - Wooden box camera with leatherette covering. For 2¹/₄x3¹/₄" on roll-film. Manufactured for Butler Bros. by

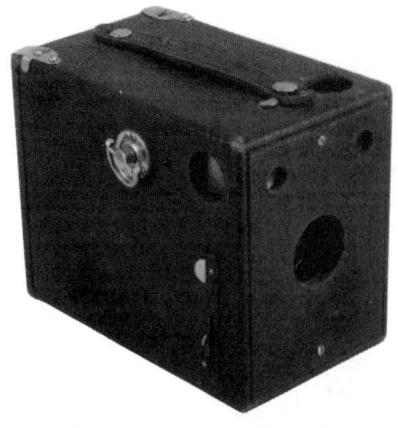

Burke & James. Identical to the B&J Rexoette except for the top strap which reads "UNIVERSAL". Uncommon. \$12-20.

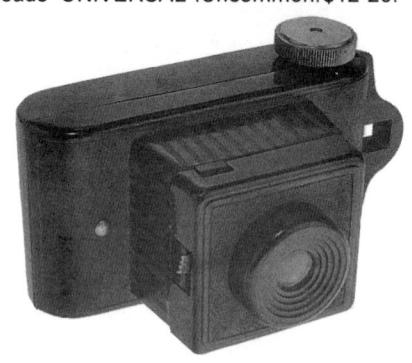

CADET - c1930's. French bakelite camera for 30x35mm on rollfilm. Simple lens & shutter. Uncommon. \$90-130.

CADOT (A. Cadot, Paris) Scenographe Panoramique - Jumelle style 9x18cm plate camera. One lens rotates to center position to change from stereo to panoramic mode. \$350-500.

CAILLON (Paris)

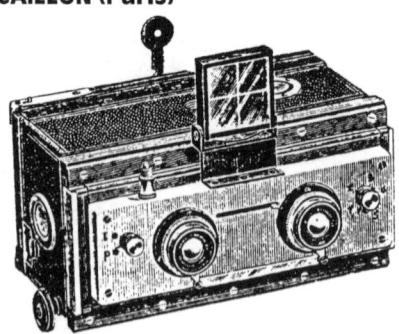

Bioscope - c1915-25. Rigid-bodied jumelle style stereo cameras in 45x107mm, 6x13cm, and 8x16cm sizes. Convertible for use as a panoramic camera. \$250-375.

Kaloscope - c1916. Folding bed stereo camera. Leather covered teak body. Lacour-Berthiot f6.8, Hermagis f6.8, or Zeiss Tessar f6.3/112mm lenses. Lensboard can be shifted to use left lens for panoramic pictures. \$350-500.

Megascope - c1915. Jumelle style stereo with changing magazine for 12 plates, 6x13cm. Rising/falling front. Folding frame viewfinder. Leather covered metal body. Hermagis f6.3/85mm lenses, guillotine shutter 1/2-200. \$175-250.

Scopea - c1920-25. Jumelle-style stereo camera. Made in 45x107mm and 6x13cm sizes. Various lenses include: Berthiot Olor f6.8/85, or Roussel Stylor f6.3. Three speed shutter, 20-100. \$150-225.

CALUMET MFG. CO. (Chicago, Illinois)

Calumet 4x5 View - Monorail view camera for studio use. A continuation of the 4x5" "Kodak Master View" whose design was sold to Calumet in the mid-1950's. A practical design, still in widespread use today. Early models have silver enameled body; later ones black. Without lens: \$200-300.

CAM-O CORP. (Kansas City, MO) Ident - 35mm TLR "school camera" for bulk rolls of 46mm film. Wood body. f9.5/114mm. \$75-100.

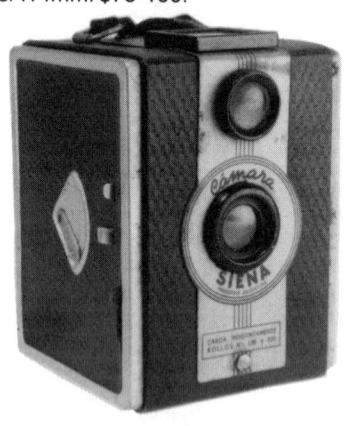

CAMARA SIENA - Twin lens reflex style box camera from Argentina. Possibly named for the color of its reddish brown basket-weave paper covering. Cardboard, metal and plastic construction. Uncommon. \$30-45.

CAMERA - c1930's. Yes, that's the full name of this small Japanese paper "Yen" box camera for single 3x5cm exposures on sheetfilm in paper holders. (See YEN-KAME for description of process.) Ground glass back. Black: \$20-30. Colored: \$35-50.

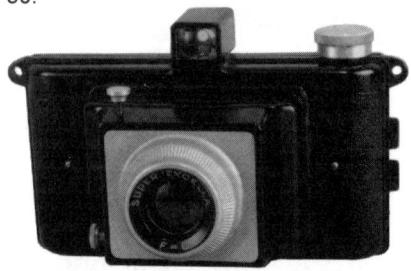

CAMERA (Super Excella) - c1950. Small black bakelite eye-level camera. "Camera" and "Made in Czechoslovakia" molded on front in small type near rivets; easily overlooked. That is the only name on the camera except for the lens which is marked "Super Excella f=6". We're hoping one of our Czech readers will tell us more about this one. \$20-30.

CAMERA CORP. OF AMERICA (Chicago) Original name "Candid Camera Corp. of America" 1938-1945 was shortened to "Camera Corp. of America" in 1945. Ceased operations about 1949 and sold its tools and dies to Ciro Cameras Inc. This is not the same company as the Camera Corp of America (Detroit) which sold the Camcor camera c1956-59, and also not the same as the Camera Corp. of America (Hicksville, NY) also known as Chrislin Photo Industry, which sold the Chrislin Insta Camera c1966-

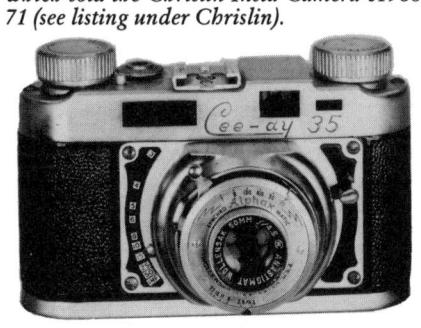

Cee-Ay 35 - 1949-50. Wollensak Anastigmat f4.5 in Synchro Alphax 25-150, T,B or Wollensak Anastigmat f3.5 in Synchro Alphax 10-200, T,B. Rarely seen with the Cee-Ay 35 markings. This was the dying effort of the company and it reappeared under the Ciro 35 name. Rare. One reported sale at about \$400.

Perfex Cameras (listed chronologically): Note: Perfex cameras are often found with inoperative or sticky shutters, usually at about half the normal prices listed below.

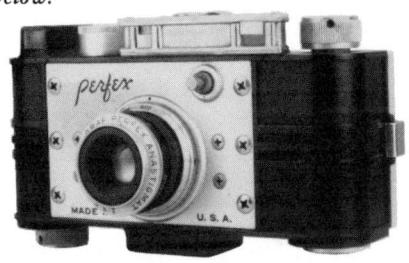

Perfex Speed Candid - 1938-39. Bakelite-bodied 35mm camera with uncoupled RF. Extinction meter at bottom. Interchangeable f3.5/50mm or f2.8 Graf Perfex Anastigmat. Cloth focal plane shutter 25-500, B. The first American 35mm to use a focal plane shutter. Not seen often. \$50-75.

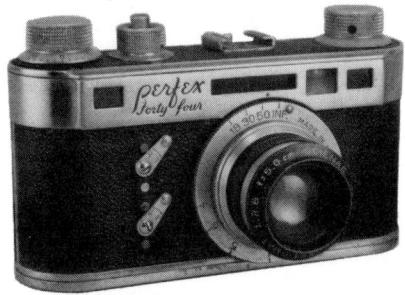

Perfex Forty-Four - 1939-40. Aluminum-bodied 35mm CRF camera. Interchangeable f3.5 or 2.8/50mm Graf Perfex Anastigmat. Cloth FP shutter 1-1250, B, sync. Extinction meter. \$35-50.

Perfex Thirty-Three - 1940-41. f3.5 or f2.8/50mm Scienar Anastigmat. FP

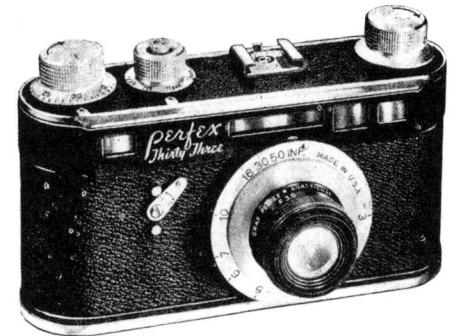

shutter 25-500, B, sync. CRF. Extinction meter. \$35-50.

Perfex Fifty-Five - 1940-47.f3.5 or 2.8 Scienar or Wollensak Velostigmat lens. FP shutter, 1-1250, B, sync. CRF. Extinction meter, exposure calculator to 1945; postwar models lack meter. \$35-50.

Perfex Twenty-Two - 1942-45. f3.5 Scienar Anastigmat. FP shutter 1-1250, B, sync. CRF. Extinction meter. Black or aluminumbody. \$45-60.

Perfex DeLuxe - 1947-50. The first of the post-war Perfex models, it introduced the stamped metal body to replace the original die-cast design. Wollensak f2.8 or f2.0 lens. \$50-75.

Perfex One-0-One - 1947-50. With Ektar f3.5 or f2.8 lens in Compur Rapid shutter: \$50-75. With Wollensak Anast. f4.5/50mm lens in Alphax leaf shutter 25-150, T. B: \$35-50.

CAMERON

Perfex One-O-Two - 1948-50. With Ektar f3.5 or f2.8 lens in Compur Rapid shutter: \$50-75. With Wollensak f3.5/50mmlens in Alphax shutter: \$35-50.

CAMERA MAN INC. (Chicago)

Champion - Black plastic "minicam" for 16 exp. on 127 film. \$8-15.

President - A lofty name for a nicely styled but rather simple black plastic minicam for 3x4cm on 127 film. \$12-20.

Silver King - An art-deco styled plastic minicam with a metal back. \$25-35.

CAMERA OBSCURA - Pre-photographic viewing devices used to view or to trace reflected images. While technically these are not cameras, they did indeed lead to the development of photography in an attempt to fix their image. Original examples which pre-date photography are highly prized, but to a small group of collectors, and they vary widely in price depending on age, style, and condition. \$750-3000.

CAMERETTE - Japanese novelty "yen" box camera for single exposures on sheet film in paper holders. \$20-30.

CAMERON SURGICAL SPECIALTY CO.
Cavicamera - Small special-purpose

CAMOJECT

camera for medical/dental use. One auction sale 10/90 at \$860.

CAMOJECT LTD. (England) Camoject - Unusual bakelite subminiature for 14x14mm exposures. \$100-150.

CANADIAN CAMERA & OPTICAL CO. (Toronto, Canada)
Gem Glencoe No. 7 - 5x7" folding plate camera. Glencoe 5x7 convertible lens. \$100-150.

Clencoe No. 4 - 4x5" folding plate camera. Leather covered, red bellows, reversible back. Brass-barrel lens and brass trim. Wollensak shutter. \$90-130.

CANDID CAMERA SUPPLY CO.
Minifoto Junior - Black plastic minicam for 127 film. Identical to the Falcon Miniature, and actually made by Utility Mfg. Co. for Candid Camera Supply Co. \$8-15.

CANON INC. (Tokyo) Originally established in 1933 as Seiki-Kogaku (Precision Optical Research Laboratory), this firm concentrated on 35mm cameras. (There is a rare Seiki subminiature for 16mm film which was made by a different company also named Seiki-Kogaku.) The Seiki-Kogaku name was used through the end of WWII. In 1947, the company name was changed to Canon Camera Co., and the Seiki-Kogaku name was dropped. The Canon name was derived from the first 35mm cameras designed by the company in 1933, which were called Kwanon.

Most of the historical and technical information, photographs, and structuring of this section are the work of Dr. Peter Dechert, who is widely regarded as one of the world's leading collectors and historians in the field of Canon rangefinder cameras. Information on the sales of these rare cameras is obviously quite limited. Former price estimates for the early Canon cameras were from Dr. Dechert when he was actively assembling his collection. More recently, other collectors and dealers have given us information on sales of these rare cameras. Since these sales often take place behind closed doors, this information is much appreciated. Dr. Dechert has graciously volunteered to help other collectors with questions if they will enclose a self-addressed stamped envelope with their queries, or call 5:00-9:00 PM Mountain Time or on weekends. You may contact him at P.O. Box 636; Santa Fe, NM 87504 USA. Telephone: 505-983-2148. Dr. Dechert is the author of a 1985 book, Canon Rangefinder Cameras: 1933-1968, and a new 1992 book, Canon SLR Cameras 1959-1991, available from Historical Camera Publications (see advertising section).

PRODUCTION QUANTITIES of CANON RANGEFINDER CAMERAS: Altogether approximately 600,000 Canon Leica-derived RF cameras were made between 1935 and 1968. About half this total was composed of the four most common models: IID, IVSB, P, and 7. The following table groups RF Canons according to the number produced.

1-99 - Kwanon, JS, S-I, 1950, IIA, IIAF, IIIA Signal Corps.

100-999 - Hansas, Original, J, NS, J-II, Seiki S-II, IIC.

1000-2999 - S, IV, IID1, IIS, IIF2. 3000-9999 - Canon S-II, IIIA, IVF/IVS, VT-Deluxe, VT-Deluxe-Z, VT-Deluxe-M,

VI., VI-2, VI-19610X6-2, VI-19610X6-1M, VI., VI-2, VI-1 10000-19999 - IIB, III, IIF, IVSB2, IID2, IIS2, L-1, L-2, L-3, VI-L, 7s.

20000-35000 - IID, IVSB. 90000-95000 - P. 135000-140000 - 7

SERIAL NUMBER RANGES of CANON RANGEFINDER CAMERAS: Rangefinder Canons after the Hansa/Original and J series were numbered more or less consecutively as they were produced (with many large gaps) and, until #700,001, without regard for model identification. The next table shows the models produced within the several serial number ranges.

Kwanon, Hansa, Original - No top serial number; use the number on the lens mount.

1000-3000 - J, JS (1938-42) **8000-9000 -** J-II (1945-46)

10001-15000 - S, NS, S-I (1938-46) **15001-25000 -** Seiki S-II, Canon S-II

(1946-49) **25001-50000 -** IIB, IV trial models

(1949-51) **50001-60000 -** IIC, III (1950), IV (1950-

51) 60001-100000 - IIA, IIAF, IID, IID1, IIF,

III, IIIA, IIIA Signal Corps, IV, IVF, IVS, IVSB (1951-53)

100001-169000 - IID, IID1, IIF, IIS, IVSB, IVSB2 (1953-55). REUSED for 7s and 7sZ (1964-68)

170001-235000 - IID2, IIF2, IIS2, IVSB2 (1955-56)

500001-600000 - VT, VT-Deluxe, VT-Deluxe-Z, VT-Deluxe-M, L-1, L-2, L-3, VL, VL-2 (1956-58)

600001-700000 - VI-L, VI-T (1958-60)

700001-800000 - P (1958-61) **800001-999000 -** 7 (1961-64)

Various prototypes and trial models were numbered outside the above ranges.

SEIKI-KOGAKU CANONS - Canon cameras from 1933-1947 were manufactured by Seiki-Kogaku. Their early lenses, lensmounts, and finder optics were designed and in most cases manufactured by Nippon Kogaku. Serenar lenses made by Seiki-Kogaku were slowly phased in during WWII on Model J and X-Ray Canons, and on other Canons from 1946. Prices on all Canons marked "Seiki-Kogaku" are quite variable, depending on demand, supply, and location worldwide, and are best considered negotiable.

KWANON SERIES (1934-1935) - These were largely mock-ups and a few working prototypes. The only working Kwanon known today is a very roughly-made Leica II copy repurchased by Canon Japan from a private owner in the 1960's. Canon has made one or more inexact copies of this Kwanon for promotional purposes.

ORIGINAL SERIES (1935-1940) - The only Canons with the exposure counter on the front face of the body. Speeds 25-500. Nikkor f3.5 lens (early ones have black face without serial number). Pop-up finder. Serial numbers on lens mount and inside of baseplate. Wide variation in details, especially in early production.

Canon / NK Hansa - 1935-37. Original series features, but occasionally with random parts originally made for Kwanon cameras. Earliest Hansa cameras were assembled at Seiki Kogaku Kenkyujo under the supervision of Nippon Kogaku managers between 10/1935 and 8/1937; these were marked "Nippon Kogaku Tokyo" next to the serial number on the focusing mount. Design elements came from both companies. These cameras can be considered forerunners of both "Nikon" and "Canon" descendents. Prices in same range as Canon Hansa below.

Canon Hansa - 1937-40. In August 1937 Seiki Kogaku Kenkyujo was reorganized and refinanced as Seiki Kogaku K.K.K. Shortly thereafter the "Nippon Kogaku Kokyo" name was dropped from the camera body. Although the camera remained essentially the same, it was hereafter primarily a "Canon" product and not directly a "Nikon" predecessor; nor did these later cameras incorporate Kwanon parts. Estimating a "top" price is pure speculation, which is not what our research is about. Authentic examples will surely bring \$4000+ depending on cosme-
tic values. Mint examples will bring \$7500-12,000. One dealer reportedly refused an offer of \$6000 in 1990. Top estimates range from \$9000-12,000.

Original Canon - Most Canon Hansas were sold through Omiya Trading Co. and marked with Omiya's "Hansa" trademark. A smaller number were sold directly and not so marked; for some years collectors used to call the latter the "Original Canon." Both Canon/NK Hansas and Canon Hansas are found without "Hansa" logos. Since they are less common than "Hansa" marked versions they may bring somewhat increased prices. Hansas and non-Hansas of equal vintage are, however, essentially identical cameras. All varieties were known at the time simply as "the Canon Camera." The term "Original Canon" is outmoded and should not be used except to describe the non-Hansa variation.

J SERIES (1939-1946) - None has rangefinder. Viewfinder is built into top housing. "Canon", "Seiki-Kogaku", and serial number on top.

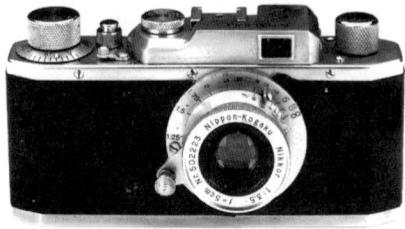

Canon J - 1939-44. Speeds 20-500. No cover patch on slow dial area. Finder housing cut straight from front to back beside a large rewind knob. Nikkor f4.5 or f3.5 in screw mount similar to but not interchangeable with Leica mount. \$7500-12,000.

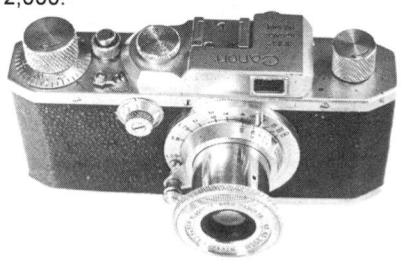

Canon JS - 1941-45. Identical to J except for slow dial on front face, speeds 1-500. Limited production, most for armed forces. Some were modified after manufacture from model J cameras, either by the factory or elsewhere. \$7500-12,000.

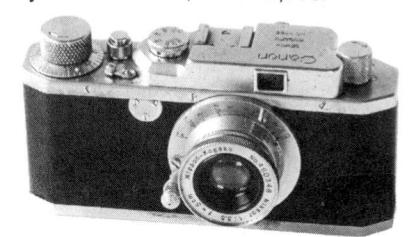

Canon J-II - 1945-46. Like the J. but

finder housing nests around smaller rewind knob similar to Leica. No slow speeds. Slow dial area usually covered by metal patch, sometimes by body covering material. Nikkor or Seiki-Kogaku Serenar f3.5 in same mount as J and JS. Generally considered less desirable than the prewar J & JS, so slightly lower average prices. \$6500-9500.

S SERIES: Retained the Hansa pop-up finder until 1946, but moved the frame counter to the top beneath the advance knob, like Leica. Retained the Original Series' bayonet lens mount until 1946.

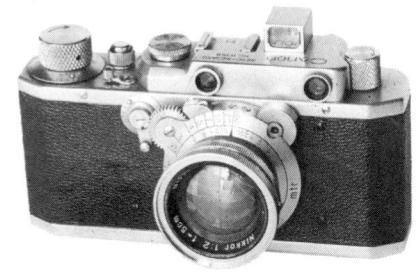

Canon S - 1938-46. Slow dial on front, lever-operated to avoid fouling focusing mount. Considerable detail variation in cameras and lenses, particularly during wartime. Canon records use the designation "S-I" for a small number made after the war, but these were assembled from left-over parts and are hard to distinguish from wartime production. A Japanese Navy version, marked entirely in Japanese, was made c.1942. Nikkor f4.5, f3.5, f2.8, and f2 lenses. \$7500-12,000.

Canon NS - 1940-42. Like the S, but without slow speeds. Considerable variation in construction, but none with patch over slow dial area. Nikkor f4.5 and f3.5 lenses. \$7500-12.000.

Seiki S-II - 1946-47. Marked "Seiki-Kogaku" on the top plate. Combined single-stage rangefinder-viewfinder. Speeds 1-500. Formed metal body (a few late ones were die-cast). Earliest production retained the J-type lensmount. Slightly later production had a lensmount with sufficient "slop" to accomodate J-lenses or Leica-derived lenses. Final version has Leica thread mount. Nikkor f3.5, Seiki-Kogaku f3.5 and f2 lenses in versions to fit all three mounts. With "Seiki-Kogaku" markings, with lens: \$600-900. (If not marked "Seiki", see Canon S-II below.)

CANON

Canon IIC

X-RAY CANONS: Dr. Mitarai, one of the early Canon founders, was especially interested in making cameras to record the images on X-ray screens, and these formed a considerable part of Canon's early production. Three versions of the earliest model were produced, marked as "Seiki" with bird logo, "X-Ray Canon 35", and "Canon CX-35", from about 1939 until 1956, when more elaborate units in 35mm, 60mm, and 70mm were substituted. The three early versions are interesting because they used Nikkor and Seiki-Kogaku Serenar (later Canon Serenar) 2 and \$1.5\$ lenses. Most X-ray cameras were scrapped when replaced, and are hard to find. On the other hand, most collectors are not particularly interested in finding them. Prices negotiable. We have heard of asking prices to \$25,000. One reached \$900 at auction (2/89). You be the judge.

CANON CAMERA CO. CANONS: In September of 1947, the company name was changed from Seiki-Kogaku to Canon Camera Co. At the same time, the lens names were changed from Seiki-Kogaku Serenar to Canon Serenar. In 1952, the Serenar lens name was dropped and they were called simply "Canon" lenses.

CANON II SERIES (1947-1956): All Canon II cameras have a top speed of 500 and film loading through the baseplate. Nikkor lenses were discontinued in 1948.

Canon S-II - 1947-49. Like the Seiki S-II, but almost all have die-cast bodies, later production with thicker wall than early production. No finder magnification adjustment. Nikkor f3.5, Canon Serenar f3.5 and f2 lenses. \$300-450.

Canon IIB - 1949-52. First 3-way mag-

nification control of combined rangefinderviewfinder operated by 2-piece lever under rewind knob. Speed dials split at 20. No flash synch rail or original factory synch. Serenar f3.5 & f1.9 collapsible lenses. \$200-300.

Canon IIC - 1950-51. Like IIB, but speed dials split at 25. Same lenses. Rare. \$600-900. *Illustrated at top of previous page.*

Canon IIA - 1952-53. No slow speeds. Slow dial area covered by metal patch with body covering insert. No synch. Price negotiable, very rare. \$2000-3000.

Canon IIAF - 1953. Like IIA, but with flashbulb synch by side rail. Canon f3.5 or f2.8 lenses. Price negotiable, extremely rare. Estimate \$3500-5500.

Canon IID - 1952-55. Like IIC, but onepiece VF selector lever. No flash synch or film reminder dial. Speed dials split at 25. With one of the Canon f3.5, f2.8, or f1.8 lenses. \$250-375.

Canon IID1 - 1952-54. Like IID, but with film speed reminder built into wind knob. Uncommon; less than 2400 made. \$300-450.

Canon IID2 - 1955-56. Like IID1, but speed dials split at 30. Canon f2.8 or f1.8 lenses. \$250-375.

Canon IIF - 1953-55. Fast and slow speed dials split at 25. Side synch rail. No X-synch position on speed dials. Top speed 500. Some examples model-identified on loading diagram. Canon f3.5, f2.8, f1.8 lenses. \$200-300.

Canon IIS - 1954-55. Like IIF, but includes X-synch setting on slow dial at $^{1}/_{15}$ area. Lock on slow speed dial. Some examples model-identified on loading diagram. \$250-375.

Canon IIF2 - 1955-56. Like IIF, but speed dials split at 30. About 2600 made.

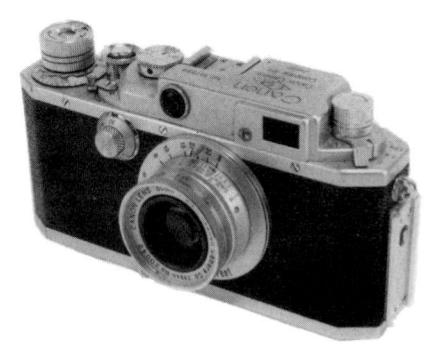

One exceptional example sold at \$450. Normal range: \$250-375.

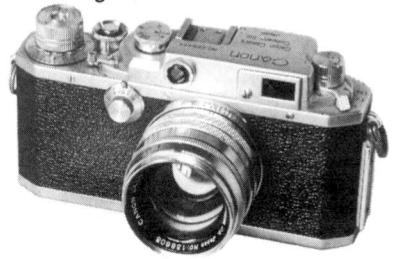

Canon IIS2 - 1955-56. Like IIS, but speed dials split at 30 and X-synch also marked on top dial at 1/45 area. \$250-375.

CANON III SERIES: All Canon III cameras have speeds 1-1000 on two dials, film loading through baseplate, and NO flash synch.

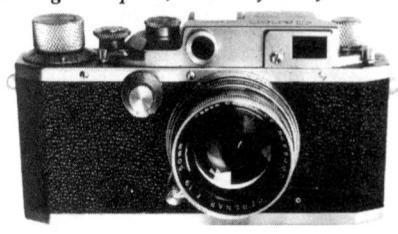

Canon III - 1951-52. Two-piece finder selector lever. No film speed reminder. Canon Serenar f1.9 lens. \$175-250.

Canon IIIA - 1951-53. Like III but onepiece finder selector lever, and film speed reminder in wind knob. There are many varieties of III/IIIA hybrids. These are not uncommon and not greatly more valuable than true examples of either type. \$150-225.

Canon IIIA Signal Corps - 1953. A small run of very late IIIA cameras marked on the baseplate "U.S. ARMY. SIGNAL CORPS". 50mm, 28mm, 135mm, and 800mm Canon Serenar lenses for these cameras were also so marked. Cameras and lenses were otherwise identical to the standard model, and their current prices depend on demand and supply. \$600-900.

CANON IV SERIES: All Canon IV cameras have two-dial speeds 1-1000, film loading through baseplate, and side-mounted flash synch rails. (Note: Hybrid variations of models IV through IVSB exist, partly because of running changes during manufacture and partly because of authorized updating. These are not uncommon and are not greatly more valuable than true examples of each type.)

Canon 1950 - 1950. An early version of the Canon IV, marked "Canon Camera Co. Ltd." and with other cosmetic and mechanical differences. Serenar f1.9 lens, serial numbers between 50000 and 50199. Only 50 were made; most were sold by C. R.

Skinner, San Francisco, as model "IIC" (Canon's original short-lived designation) or "IVM" (Skinner's own later designation). Few remain. \$2000-3000.

Canon IV - 1951-52. Two-piece finder magnification lever. No film speed reminder. No X-synch. Serenar f1.9 lens. "Canon Camera Co. Inc." maker's logo. \$300-450.

Canon IVF - 1951-52. One-piece finder selector lever. Film speed reminder in wind knob. No X-synch. No lock on slow dial. Built-up interior wall next to film supply chamber. Serenar f1.8 lens. \$250-375.

Canon IVS - 1952-53. Like IIF but flat die-cast wall next to film supply chamber. \$250-375.

Canon IVSB (IVS2) - 1952-55. X-synch marked on slow dial at 1/₁₅ area. Slow dial locks at 25, at which speed dials are split. Canon f1.8 lens. Model IVSB was known as IVS2 in many countries including USA, but IVSB is proper factory manufacturing designation. Auction high over \$700 (Cornwall 9/92). Normal range: \$350-500.

Canon IVSB2 - 1954-56. Like IVSB but speed dials split at 30 and X-synch also marked on top dial at 1/45 area. \$250-375.

CANON V SERIES: All Canon V cameras load through a hinged back, have two speed dials split at 30, and wind with a trigger that folds into the baseplate. Normal lenses were 35mm and 50mm in speeds between f2.8 & f1.2.

Canon VT - 1956-57. Identified on front

of baseplate (a few prototypes marked simply "Model V"). Numerous small manufacturing variations during production. \$250-375.

Canon VT-Deluxe - 1957. Identified on front of baseplate. Cloth shutter curtains. No baseplate opening key. Black: \$2000-3000. Chrome with 50mm f1.8: \$250-375.

Canon VT-Deluxe-Z - 1957-58. Like VT-Deluxe but with baseplate opening key. Prices as VT-Deluxe.

Canon VT-Deluxe-M - 1957-58. Marked simply "VT-Deluxe", but with factory-in-stalled metal shutter curtains and silvercoated finder optics. Prices as VT-Deluxe.

CANON L SERIES: All Canon L cameras have back loading, thumb lever wind on top, two speed dials split at 30. Lenses as on V cameras.

Canon L-1 - 1956-57. Identified on bottom. Cloth shutter curtains. No selftimer. Some VL prototypes with metal curtains may also be marked "L-1". Black: \$2000-3000. Chrome: \$300-450.

Canon L-2 - 1956-57. **Canon L-3 -** 1957-58. Identified on bottom. Common in Japan but scarcer in USA. \$300-450.

Canon VL - 1958. No model identification on body. Like L-1 but has metal shutter curtains and self-timer. Speeds to 1000. X & FP synch. \$300-450.

Canon VL-2 - 1958. No model identification on body. Like VL but has speeds to 500 only. Common in Japan but rare in USA. \$250-375.

LATE CANON RF SERIES: These cameras all have back loading, single speed dial on top with 1-1000 range. Lenses varied, the 50mm f1.4 and f0.95 (on 7 & 7s only) are most desirable.

Canon VI-L - 1958-60. No model identification on body. Top lever wind. Single

speed dial. Black: \$2000-3000. Chrome: \$300-450.

Canon VI-T - 1958-60. Name on baseplate. Last baseplate trigger wind model. Black: \$600-900. Chrome: \$250-375.

- **VI-T Meter** - Early style has fixed foot; later style pivots. \$75-100.

Canon P - 1958-61. Identified on top, this model also exists with special 25th anniversary and Japanese army markings. Numerous running changes during manufacture. With normal lens: Black: \$3200-4600. Chrome: \$250-375. Add \$100-150 for rare 50mm f2.2 lens.

Canon 7 - 1961-64. Name on top. Dual mounting flange accepts screwmount lenses, bayonet-mounted f0.95 and reflex accessories. Most common Canon RF; often optimistically priced. With normal f1.4 or f2: black \$2000-3000; chr. \$250-375.

Canon 7s - 1964-67. Identified on top,

CANON.

with RF adjustment port in front of shutter speed dial: \$350-500.

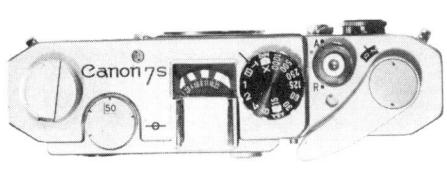

Canon 7s, top; Canon 7sZ, bottom.

Canon 7sZ - 1967-68. Also marked "7s" but with RF adjustment port above second "n" in "Canon" logo on top of camera. With f1.4 or f2: \$350-500. See list of Canon screwmount lenses below for price of the 50mm f0.95 lens.

BLACK RF CANONS: The following models are known to exist with black enameled bodies: IVSB (never commercially available), L-1, VT-Deluxe, VT-Deluxe-M, VI-L, VI-T, P, and 7. Produced in relatively small quantities, these black Canons usually command higher prices than the equivalent chrome versions, on the order of two-times with considerable paint wear to 3-times in excellent condition. A black 7s has been reported but not confirmed.

CANON SCREWMOUNT LENSES: Earliest versions are Seiki Kogaku Serenar lenses, later Canon Serenar beginning about 1947, and finally Canon Lens from about 1953. These dates are approximate; when old stock ran out it was replaced by new.

19mm f3.5 Canon Lens - w/finder

\$600-900

19mm f3.5 FL with type B adapter - Breechlock lens with adapter to fit screwmount cameras. \$300-450.

25mm f3.5 Canon Lens - w/finder \$500-750

28mm f2.8 Canon Lens - \$500-750. 28mm f3.5 Serenar - w/finder \$400-600

28mm f3.5 Canon Lens - \$400-600. 35mm f1.5 Canon Lens - \$300-450.

35mm f1.8 Canon Lens - \$175-250. **35mm f2.0 Canon Lens -** \$200-300.

35mm f2.8 Canon Lens - \$100-150.

35mm f3.2 Serenar - \$90-130. **35mm f3.5 Serenar -** c1950-. \$60-90.

50mm f0.95 Canon Lens - w/finder:

\$500-750.Lens only: \$500-750. **50mm f1.2 Canon Lens -** \$120-180.

50mm f1.4 Canon Lens - \$120-180.

50mm f1.5 Serenar - \$120-180 50mm f1.5 Canon (rigid mount) -\$120-180

50mm f1.8 Serenar - \$35-50 50mm f1.8 Canon (rigid mount) -

50mm f1.9 Serenar - Collapsible

mount. Normal lens for IIB, etc. \$50-75. 50mm f2.0 Serenar - Collapsible mount. Normal lens for S-II; replaced by f1.9 about 1949. \$250-375.

50mm f2.8 Canon - Collapsible mount.

50mm f3.5 Serenar - \$150-225. 85mm f1.5 Serenar - \$300-450.

85mm f1.5 Canon Lens - \$300-450. 85mm f1.8 Canon Lens - \$120-180.

85mm f1.9 Serenar - c1950-. \$120-180.

85mm f1.9 Canon Lens - \$120-180. 85mm f2.0 Serenar - Introduced c1949. \$120-180.

100mm f2.0 Canon Lens - \$120-180. 100mm f3.5 Canon Lens - \$50-75. 100mm f4.0 Serenar - \$75-100. 135mm f3.5 Serenar - common. \$50-

135mm f4.0 Serenar - Introduced c1949. \$50-75.

-The 135mm f4 also exists in the earlier Hansa/Seiki bayonet mount. Very rare. No sales data.

200mm f3.5 M (for Mirror Box) -20cm f4.0 Seiki Kogaku Serenar -Very rare. Limited sales data. About \$4500-6500

400mm f4.5 Canon Lens (for Mirror Box) - with Mirror Box: \$400-600. 600mm f5.6 (for Mirror Box) - with Mirror Box: \$500-750.

800mm f8.0 (for Mirror Box) - with Mirror Box: \$750-1000. 1000mm f11.0 (for Mirror Box) -

with Mirror Box: \$750-1000.

FINDERS:

28mm - \$75-100. **35mm -** \$45-60.

50mm for f0.95 lens - \$90-130.

85mm - \$25-35. 100mm - \$50-75 13.5cm - \$20-30

Multi-field 85,90,100,110,135mm tubular - \$100-150.

Folding sportsfinder 50, 85, 100, 135mm - \$250-375.

ACCESSORIES FOR CANON RF MODELS

Mirror Box 1 - for early screwmount models: \$200-300.

Mirror Box 2 - for models 7, 7s: \$175-250

Rapid winder - \$120-180. Auto-up for 50mm f1.8 - \$35-50. Canon Self-Timer - \$25-35.

CANON SLR CAMERAS: Each basic model is identified on its body. Some improved versions have a suffix "n" or "new" which does not appear on the body, so they have to be identified by features. Some were issued in black as well as chrome. Typically a really clean black model is valued about 30% more than its chrome counterpart, but "used" condition black models do not command a premium. Four different but relatively compatible series of lens mounts were used. These are described just before the listing of lenses, after the SLR camera models. In the camera listings, where lens mounts are given we have abbreviated the types as R, FL, FD, and NFD.

Canonflex - 1959-60. Canon's first SLR. Cloth FP shutter, 1-1000. Interchangeable prism or reflex finder. Breech-lock "R" series f1.8/50mm lens. \$120-180.

Canonflex RP - 1960-62. Fixed prism version of the Canonflex. "R" series breechlock lenses. \$100-150.

Canonflex R2000 - 1960-62. The first 35mm SLR with shutter to 2000. Otherwise similar to the Canonflex. R series lenses. \$150-225.

Canonflex RM - 1961-64. Like Canonflex, but with built-in selenium meter. Match-needle on top. R series lenses. \$90-130

Canonex - 1963-64. The first auto-exposure Canon SLR. Trapped needle, shutter preferred automatic or manual exposure. Canon Lens S 48mm f2.8 in fixed mount. \$120-180.

Canon FP - 1964-66. SLR with cloth 1-1000,B shutter. Detachable CdS matchneedle meter couples to shutter dial. FL mount breechlock lenses. \$90-130

Canon FX - 1964-66. Like the FP, but with built-in coupled CdS meter. Stoppeddown metering with match-needle readout on top. FL lenses. \$90-130.

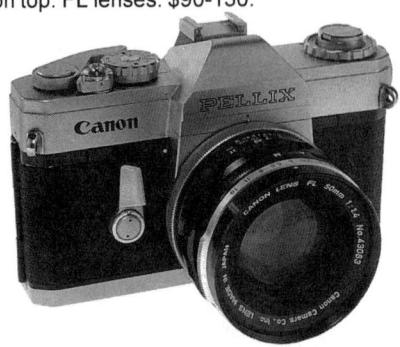

Canon Pellix - 1965-66. Unique in design, with its "pellicle", a semi-silvered mirror which split the light between the finder (30%) and the film (70%). The advantages of eliminating the moving mirror are obvious. However, the brightness of both the image and the finder had to suffer. Use of a fast f1.4 normal lens overcame this shortcoming. FL mount. Excellent or better: \$200-300. Very Good: \$120-180.

Canon Pellix QL - 1966-70. The "quickload" version of the Pellix. Black or chrome. With normal lens: \$150-225.

Canon FT QL - 1966-72. Cloth FP, 1-1000,B. CdS TTL stopped down spot metering. (The first Canon with TTL metering). FL lenses. Black or chrome body: \$90-130.

Canon TL QL - 1968-72. Simplified version of FT-QL. Top speed $^{1}/_{500}$, no selftimer. FL lenses. Body: \$75-100.

Canon EX Auto QL - c1969. Name variant of EX-EE.

Canon EX-EE - 1969-73. Fixed lens with interchangeable front elements. Automatic shutter priority TTL CdS metering. \$75-

Canon EX-EE Front lens elements: 95mm f3.5 - \$50-75 125mm f3.5 - \$50-75

canon EF - c1973-78. (Not to be confused with the more recent EF-M). The first Canon camera to use the new Silicon Photocell, giving five stops more sensitivity than previous models. Electro-mechanical shutter timed electronically at 1 second or longer; mechanically at 1/2 to 1/1000, B. Mechanical speeds do not require battery. Black body. With f1.8/50mm FD SC lens: \$200-300.

F-1 CAMERAS: After the success of the original F-1, Canon retained the name "F-1" for two subsequent models. The 1976 version, usually called F-1n (small n), is a slightly improved version of the original camera. The 1981 "New F-1", often designated F-1N (large N), is a totally redesigned system. Unfortunately, the F1-n and F-1N cameras are labeled the same as the original F-1, leaving the customer to identify what the factory should have done.

Canon F-1 - 1971-76. Top of line professional SLR capable of taking motor drive, bulk film back, interchangeable finders & screens. Black only. With FD 50mm f1.4 normal lens: \$250-375.

Canon FTb QL - c1971. Improved version of the FT-QL, with speed, aperture, exposure warning, & battery check visible in finder along with meter needle. Introduced new mount for FD lenses. Chrome body with 50mm f1.4 or f1.8 lens: \$150-225. Add 30-50% for clean black body. See FTbn QL below for the later model of this camera, which is also identified as FTb QL on the body, and must be properly identified by comparing features.

Canon TLb QL - c1972. Budget priced version of the FTb. Top speed 1/500. Full aperture metering FD mount. With normal lens: \$75-100.

Canon EF - c1973. SLR with metal FP shutter 30 sec- ¹/₁₀₀₀. Speeds mechanically timed from ¹/₂-¹/₁₀₀₀, electronically timed below ¹/₂. CdS TTL shutter priority, full-aperture metering. Dedicated hot shoe. Intended as an advanced camera, but lacking provision for autowinder, it was overshadowed by the popular AE-1 in 1976. Black only. FD mount. \$175-250.

Canon FTbn QL - c1974. Slightly modified FTb, with speeds visible in finder. The camera body is still identified as FTb, without the "n", but it can be identified by several external changes. The film advance lever has a black plastic tip, while that of the earlier FTb had an all metal lever. The self-timer lever is all black with a white stripe, while the earlier model had a wedge-shaped lever. FD mount. With 50mm f1.4 lens: \$150-225.

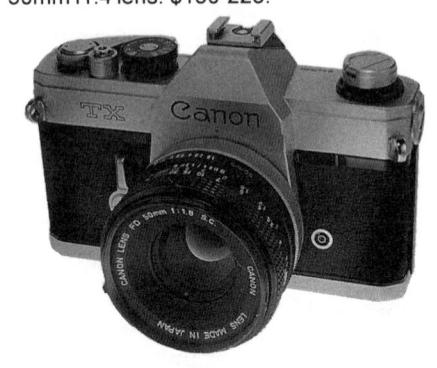

Canon TX - 1975-79. Like FTb, but top speed only 1/500. FD mount. \$60-90.

Canon F-1n - 1976-81. (Note small "n"). Relatively minor changes distinguish this from the original F-1. Most noticeable for quick identification are the black plastic tipped advance lever and the film identification holder on the back. Film speed range increased to ASA/ISO 3200. Not to be confused with the F-1N (large "N"), as the totally new "New F-1" is often called. \$250-375.

Canon F-1n 1980 Olympics - 9/79. Special limited edition version of the F-1n. "Lake Placid 1980" and interlocking rings Olympic logo on the body front. Lenscap has Olympic logo and "The Official 35mm

Camera of The 1980 Olympic Winter Games", \$300-450.

Canon F-1(N) (or New F-1) - 1981-. A newly designed F-1, generally incompatible with the older F-1 cameras. A truly modular camera, with light metering capabilities determined by selection of prism finders. FN finder provides semi-automatic mode. With the AE FN finder, it adds aperture-preferred auto exposure with readout below the focus screen. Shutterpreferred mode takes over when one of the accessory motor drives is attached. User-interchangeable focusing screens. Black body with f1.8/50mm FD: \$300-450.

Canon F-1(N) 1984 Olympics - 12/1983-. Special limited edition of the F-1(N) made for the 1984 summer Olympics. "Los Angeles 1984" and Olympic logo on body front, \$300-450.

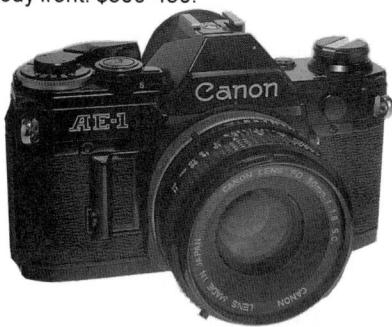

Canon AE-1 - c1976. A very popular SLR with electronically controlled cloth shutter 2- 1/₁₀₀₀, B. Shutter priority, full aperture auto TTL exposure, or manual mode. Accepts autowinder, flash. With FD 50mm f1.8: dedicated \$150-225. Body: \$120-180. Black body add 30%.

Canon AT-1 - c1977. Simpler version of the AE-1. Match-needle, full-aperture metering; needle visible in finder. FD f1.8/50mm. \$100-150.

Canon A-1 - c1978. Updated AE-1 with more sophisticated metering system. Five automatic modes: aperture or shutter priority, programmed, stopped-down, electronic flash AE, or manual mode. With 50mm f1.4 FD: \$300-450. Black body only: \$250-375.

Canon AV-1 - c1979. Similar to AE-1 but aperture priority metering. FD mount. With 50mm f1.8: \$100-150.

Canon AE-1 Program - c1981, Program mode, shutter-priority auto mode, and metered manual exposures possible. Chrome body \$120-180. Black, add \$60-

CANON SLR LENSES: Ignoring the few fixed-mount and front-element changing SLR's, Canon has used four series of interchangeable lens mounts, most of which are relatively compatible. We are not including the modern "AC" and "EOS" series of autofocus lenses. To oversimplify, the R series should not be used interchangeably with the later FL, FD, and New FD series. Most of the FL lenses may be used on newer (FD) bodies, but will only work within the limitations of the FL lens. This rules out full-aperture metering, but the lenses work perfectly well in the stopped-down metering mode if the body has this option. FD lenses work well on older (FL type) bodies, but only with stop-down metering. Following are basic descriptions of the four systems:

R Series - For "Canonflex" cameras. Breechlock mount. Two rear pins, one to arm the stop-down spring in the lens and the other to activate it upon exposure.

FL Series - Breechlock with single rear coupling pin for diaphragm. Allows stopped-down metering only. The FL series of lenses are for the Pellix, FP, FTQL. FX.

FD Series - c1971-. Breechlock with two rear coupling levers. Allows full aperture metering. Rotating chrome mounting ring at rear. Usually marked SC (Spectra Coating), a single layer coating, or SSC Spectra Coating) a multi-layer (Super coating

New FD - Abbreviated FD(BM) below. Bayonet mount rather than breechlock. Lens mounts by twisting the entire lens into the mount, rather than by turning a mounting ring. Similar to the earlier FD series, with two rear coupling levers, but without the rotating mounting ring. Some are listed as FD/L, indicating the use of low-dispersion fluorite elements.

Not all lenses below have current prices listed. In the limited time since we began tracking prices of the more recent lenses, we have not gathered enough data to provide reliable averages for all models. The list itself will be of value, and in future editions it will include more data.

7.5mm f5.6 FD (BM) Fisheye - \$300-

14mm f2.8 FD/L (BM) - \$700-1000. 15mm f2.8 FD SSC - \$300-450. 15mm f2.8 FD (BM) Fisheye - \$300-

17mm f4.0 FD SSC - \$200-300. 17mm f4.0 FD (BM) - \$200-300.

19mm f3.5 FL (retrofocus) - (for FP. FX). \$250-375

19mm f3.5 FLP (retrofocus) - (for Pellix only). \$175-250. 20mm f2.8 FD SSC - \$200-300.

20mm f2.8 FD (BM) - \$200-300. 20mm f3.5 Canon Macrophoto -

(manualdiaphragm)\$100-150. 24mm f1.4 FD SSC Aspherical -\$500-750

24mm f1.4 FD/L (BM) - \$500-750. 24mm f2.0 FD (BM) - \$200-300. 24mm f2.8 FD SC - \$120-180. 24mm f2.8 FD SSC - \$120-180.

24mm f2.8 FD (BM) - \$120-180.

28mm f2.0 FD SSC - \$150-225

28mm f2.0 FD (BM) - \$175-250. 28mm f2.8 FD SC - \$50-75

28mm f2.8 FD (BM) - \$50-75.

28mm f3.5 FD SC - \$35-50. 28mm f3.5 FL - \$35-50

35mm f2.0 FD SSC - \$120-180.

35mm f2.0 FD (BM) - \$120-180.

35mm f2.5 FL - \$40-60.

35mm f2.8 Canon Macrophoto -

(manual diaphragm) \$50-75. **35mm f2.8 FD (BM)** - \$60-90. **35mm f2.8 TS SSC** - (TS = Tilt & Shift) \$400-600.

35mm f3.5 FD SC - \$50-75.

35mm f3.5 FL - \$30-45. 38mm f2.8 FLP (for Pellix) - \$50-75.

50mm f1.2 FD (BM) - \$120-180. 50mm f1.2 FD/L (BM) - \$250-375.

50mm f1.4 FD SC - \$50-75 50mm f1.4 FD SSC - \$50-75

50mm f1.4 FL (for Pellix, FP, FX) -\$30-45

50mm f1.4 FD (BM) - \$50-75. 50mm f1.8 FD - \$25-35.

50mm f1.8 FD SC - \$25-35.

```
50mm f1.8 FL (for Pellix, FP, FX) -
$20-30.
```

50mm f1.8 FD (BM) - \$30-45.

50mm f3.5 FD Macro SSC - \$150-225. 50mm f3.5 FL Macro - (for Pellix, FX, FP) \$100-150

50mm f3.5 FD Macro (BM) - \$120-

55mm f1.2 FD SSC - 7 elements, 5

groups. \$150-225. 55mm f1.2 FD SSC Aspherical - 8

elements, 6 groups. \$300-450. **55mm f1.2 FL -** \$90-130. **58mm f1.2 FL -** \$90-130.

85mm f1.2 FD SSC Aspherical -\$400-600

85mm f1.2 FD/L (BM) - \$450-700. 85mm f1.8 FD SSC - \$150-225.

85mm f1.8 FL - \$100-150.

85mm f1.8 FD (BM) - \$150-225.

85mm f2.8 FD (BM) Soft Focus -\$350-500

100mm f2.0 FD (BM) - \$200-300. 100mm f2.8 FD SSC - \$100-150.

100mm f2.8 FD (BM) - \$100-150.

100mm f3.5 FL - \$90-130. **100mm f4.0 FD SC Macro -** \$200-300. 100mm f4.0 FLM -

100mm f4.0 FD (BM) Macro - \$200-

135mm f2.0 FD (BM) - \$250-375.

135mm f2.5 FD - \$100-150. 135mm f2.5 FD SC - \$100-150.

135mm f2.5 FL - \$35-50.

135mm f2.5 M - for Mirror Box.

135mm f2.8 FD (BM) - \$100-150.

135mm f3.5 FD SC - \$35-50. 135mm f3.5 FL - \$30-45.

135mm f3.5 FD (BM) - \$45-60.

200mm f2.8 FD SSC - \$200-300. 200mm f2.8 FD (BM) - \$250-375.

200mm f3.5 FL - \$50-75

200mm f4.0 FD SSC - \$100-150.

200mm f4.0 FD (BM) - 7 elements, 6

groups; focus to 1.5m. \$100-150. 200mm f4.0 FD (BM) Macro - 9 elt., 6

groups; focus to 0.58m. \$350-500. **200mm f4.5 FL -** \$50-75.

300mm f2.8 FD SSC Fluorite - \$1000-1500.

300mm f2.8 FD/L (BM) - \$2000-3000.

300mm f4.0 FD (BM) - \$300-450. **300mm f4.0 FD/L -** \$500-750.

300mm f4.0 R (for Pellix, FP, FX) -\$200-300

300mm f5.6 FD SC - No sales data. **300mm f5.6 FD SSC -** \$120-180.

300mm f5.6 FL Fluorite - \$250-375

300mm f5.6 FL SC Fluorite - \$250-

300mm f5.6 FD (BM) - \$175-250. 400mm f2.8 FD/L (BM) - \$2400-3200.

400mm f4.5 FD SSC - \$500-750. 400mm f4.5 FD (BM) - \$500-750.

400mm f4.5 R (for Pellix, FP, FX) -

400mm f5.6 FL SC - Front Component.

With Focusing Unit. \$450-700. **500mm f4.5 FD/L (BM) -** \$2000-3000. 500mm f5.6 FL-Fluorite - \$700-1000.

500mm f8.0 Reflex SSC - \$200-300. 500mm f8.0 Reflex (BM mirror lens) - \$200-300.

600mm f4.5 FD SSC - \$1200-1800.

600mm f4.5 FD (BM) - \$1200-1800.

600mm f5.6 FL SC - Front Component. With Focusing Unit: \$600-900. 600mm f5.6 R (for Pellix, FP, FX) -

No sales data

800mm f5.6 FD SSC - \$1500-2500. 800mm f5.6 FD/L (BM) - \$2000-3000. 800mm f8.0 FL SC - Front Component.

With Focusing Unit. \$1000-1500.

800mm f8.0 R (for Pellix, FP, FX) -No sales data

1000mm f11.0 R (for Pellix, FP, FX) No sales data.

1200mm f11.0 FL SC - Front Component. With Focusing Unit: \$1500-2000. 1200mm f11.0 FL SSC - No sales data.

Zoom lenses:

20-35mm f3.5 FD/L (BM) - \$450-700. 24-35mm f3.5 FD SSC (aspherical) -\$400-600.

24-35mm f3.5 FD/L (BM) w/hood -

\$400-600

28-50mm f3.5 FD SSC - \$175-250 28-50mm f3.5 FD (BM) Macro w/hood - \$200-300.

28-55mm f3.5 FD - \$200-300.

28-55mm f3.5-f4.5 FD (BM) Macro -

28-85mm f4.0 FD (BM) Macro -\$200-300.

35-70mm f2.8-f3.5 FD SSC - \$250-350

35-70mm f2.8-f3.5 FD (BM) Macro -\$250-350

35-70mm f3.5-f4.5 FD (BM) Macro -\$75-100

35-70mm f4.0 FD (BM) - \$75-100. 35-70mm f4.0 FD (BM) AF - \$120-

35-105mm f3.5 FD (BM) Macro -\$150-225.

50-135mm f3.5 FD (BM) Macro w/hood - \$120-180

50-300mm f4.5 FD/L (BM) - \$700-950. 55-135mm f3.5 FL - \$60-90.

70-150mm f4.5 FD (BM) - \$75-100. 70-210mm f4.0 FD (BM) Macro -

\$120-180. 75-200mm f4.5 FD (BM) Macro -

80-200mm f4.0 FD SSC - \$175-250 80-200mm f4.0 FD (BM) - \$175-250. 80-200mm f4.0 FD/L Macro (BM) -

\$300-450.

85-300mm f4.5 FD SSC - \$450-700 85-300mm f4.5 FD (BM) - \$450-700. 85-300mm f5.0 FL - fits Pellix, FX, FP.

100-200mm f5.6 FL - \$75-100.

100-200mm f5.6 FD SC - \$75-100.

100-200mm f5.6 FD (BM) - \$75-100. 100-300mm f5.6 FD (BM) - \$150-225.

150-600mm f5.6 FD (BM) - \$150-225.

CANON SLR ACCESSORIES

Bellows FL - \$45-60.

Databack A - Replaces back cover of AE-1. Prints day, month, year in lower right corner of photo. \$50-75.

Life Size Adapter - extension tube for 50mm macro lens. FD: \$35-50. FL: \$30-

MA motor - with nicad battery pack & charger: \$175-225.

Power Winder A - Mounts below AE-1 to provide 2 frames per second. \$40-60.

Power Winder A2 - \$90-130.

Waist Level Viewer 2 - eyepiece adapter. \$40-60.

Canomatic C-30 - c1966. Auto-exposure, zone focusing camera for 126 cartridges. Built-in socket for standard flashcubes. Lever film advance. 40mm f3.5 lens. \$20-30.

Canomatic M70 - c1972. 126-cartridge camera with automatic electric film advance. Selenium meter cell surrounds 40mm f2.8 lens. Programmed EE shutter to 1/800 sec. \$30-45.

CANONET CAMERAS - A long-lived and very popular series of rangefinder cameras with non-changeable lenses. The first Canonet was introduced in 1960 and the series continues through the G-III models into the 1980's. Sometimes with f2.8 lens, but more commonly found with f1.7 or f1.9 lenses. Models with the QL designation use Canon's "quick-load" system for easy film loading. \$35-50.

DEMI CAMERAS - A series of half-frame cameras initiated in 1963-64 with the Demi and continued as the **Demi II** (1964-65), **Demi S** (1964-66), **Demi C** (1965-66), **Demi EE17** (1966-71), **Demi EE28** (1967-70), **Demi Rapid** (1965-66). All have built-in meter. \$50-75.

Dial 35 - 1963-67 (Model 2: 1968-71). Half-frame 35mm camera with spring actuated motor drive. Unusual styling with meter grid surrounding the lens and round spring housing extending below the body to serve as a handle, \$60-90.

Snappy '84 - 1984. Special edition of the Snappy 20. The 1984 Summer Olympics logo and "Los Angeles '84" on the front of the body in red, white, and blue. Original price about \$90; closed out at \$40 in early 1985. Current value \$60-90.

CAPITAL MX-II - c1986. Novelty 35mm from Taiwan, styled with small pseudoprism. \$1-10.

CAPITOL 120 - 21/₄x31/₄" metal box camera. Body identical to Metropolitan Industries Clix 120, but no B,I. U.S. Capitol dome pictured on front plate. Two versions: Silver faceplate with black letters & design, or the opposite. \$20-30.

CARDINAL CORP. (U.S.A.) Cardinal, Buckeye, Cinex, & Photo **Champ** - All are nearly identical small plastic novelty cameras for 16 exp. on 127 film. Similar cameras by other manufacturers include "Can-Tex" (USA), "Halina Baby" & "Empire Baby" from Haking of Hong Kong. \$1-10.

CARL ZEISS JENA Founded in 1846, still in operation today as a respected manufac-turer of optics. After WWII, some of its personnel moved to nearby Oberkochen in West Germany and started yet another "Zeiss" company, known as Carl Zeiss Oberkochen.

Werra - c1955. Smartly styled 35mm cameras, with streamlined knobless top. Film advanced and shutter cocked by turning ring around lens barrel. Lens shade reverses to encase shutter and lens. Olive green covering to 1960, or black ebonite from 1961. Flat top to 1960, rounded from 1961. Werra V always round. Cheapest model I & III with Vebur shutter. More expensive early models had Compur Rapid, Synchro-Compur from 1955. Prestor RVS with rotating blades to 1/500 from 1959, and 1/750 from 1961.

Werra, Werra I, Ic - No meter or rangefinder.

Werra II - Bright-frame finder; built-in meter.

Werra III - Coupled rangefinder; interchangeablelens; no meter.

Werra IV, Werramatic - CRF; coupled meter; interchangeable lens. At least two significant variations. Early version has separate finder windows; pebble grain. Later has long clear plastic window over VF, RF, and BIM; chevron-grainedbody.

Werra V - c1960. CRF; coupled meter; interchangeablelens.

Prices: Little difference among the various \$35-50 in Germany where models. common. \$60-90 in U.S.A.

Werra Microscope Camera - c1960. Special version with microscope adapter. Prontor-Press front shutter. \$120-180.

CARMEN (**France**) - c1930's. Small black enameled stamped metal camera for 24x24mm exp. on 35mm wide paper backed rollfilm on special spools. Meniscus lens, simple shutter. Also sold under the name "Pygmee". \$120-180.

CARPENTIER (Jules) (Paris)
Photo Jumelle - c1890's. Rigid-bodied, binocular styled camera. One lens is for viewing, the other for taking single exposures. This is not a stereo camera, as many jumelle-styled cameras are. Magazine holds 12 plates. To change plates, a rod extending through the side of the camera is pulled out and pushed back in. Various models in 6x9cm and 4.5x6cm sizes. \$120-180. (There is also a very rare Stereo version of this camera. No recorded sales. Price would be negotiable.)

CASH BUYERS UNION (Chicago) Maxim Camera - c1907. Box camera for 4x5" glass plates in double holders. Identical to the Conley Senior box camera, except for the special labeling inside the top rear plate door. Obviously made by Conley, but uncommon with this marking. \$30-45.

CBC - Novelty TLR from Hong Kong. Takes 4x4cm on 127 film. Similar to Bedfordflex, Splendidflex, etc. \$12-20.

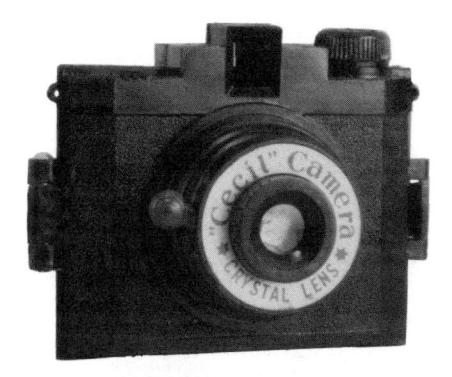

CECIL CAMERA - Small black plastic camera from Hong Kong for 16 on 127. Similar to the Wales Baby, Empire Baby, and Cardinal cameras. \$1-10.

century camera co. Century began operations in 1900, which probably explains the company name well enough. In 1903, George Eastman bought controlling interest in the company. In 1905, Century took control of the Rochester Panoramic Camera Company, which had recently introduced the Cirkut camera. In 1907 it belowing "Century Camera Div., EKC". Following that, it was in the Folmer-Century Division of EKC which became Folmer Graflex Corp. in 1926.

Copying/Enlarging/Reducing Camera - c1900-10. Professional studio camera for copying photographs. Front & rear bellows. \$120-180.

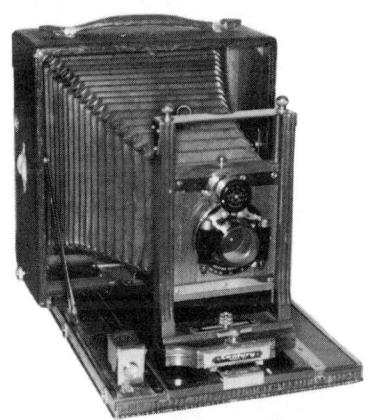

Field cameras - c1900's. Since many of the Century cameras are not fully identified, this listing is provided as a general reference. (Classified by size, with normal older lens & shutter. A good usable lens in a synchronized shutter will add to the values given here):

4x5 - including models such as #40, 41, 42, 43, 46. \$120-180.

41/₄x61/₂ - including No. 2, etc. \$150-225.

5x7 - including models 15, 47, etc. \$100-150.

61/₂x81/₂ - including No. 69, etc. \$150-225.

8x10 - Leather-covered self-casing types: \$150-225. All-wood field cameras with reasonable movements for use: \$300-450. **11x14** - \$300-450.

Grand - c1901-08. Folding cameras for plates. Leather covered wood body. Red bellows. 4x5", 5x7" or 61/₂x81/₂" size with triple convertible lens: \$175-250. With normal lens and shutter: \$150-225. *Illustrated at top of next column*.

CENTURY

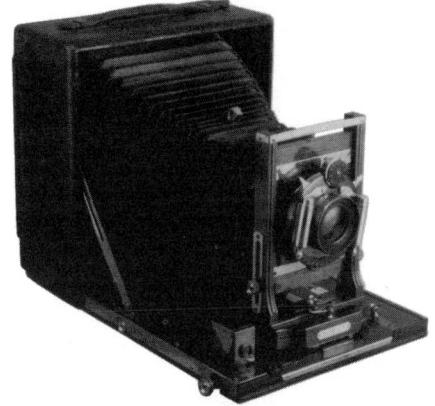

Century Grand

Grand Sr. - c1903-08. Deluxe plate camera, 5x7" or $61/_2x81/_2$ " size. \$150-225.

Long Focus Grand - c1902-05. Similar, but with additional rear track for extra bellows extension. \$200-300.

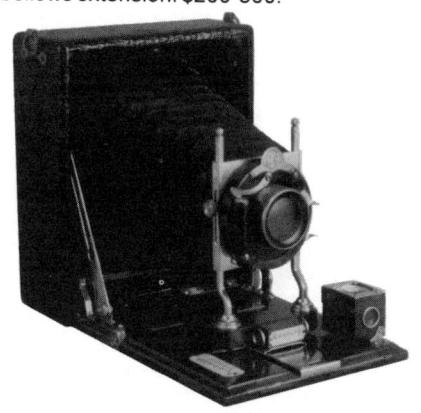

Petite - Compact folding-bed camera without reversible back. The No.2 (illustrated) is the original design of Petite Century. No.1 is similar but lacks rack & pinion focus. No.3 has swing bed and back. Shutter for the No.1 & 2 is the B&L "No.3 Automatic" with TBI speeds and a lever to open for focusing. \$120-180.

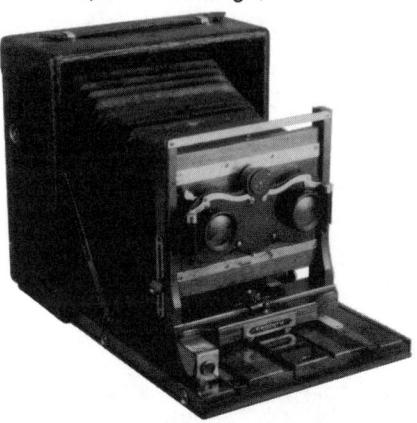

Stereo Model 46 - c1900's. 5x7 folding-bed style. "Century Model 46" at base of lens standard. Identifiable as a stereo model by the wide lensboard, even if missing its original stereo shutter. Symmetrical 4x5 lenses in B&L stereo shutter. \$400-600.

Studio camera - The large Century studio cameras are often found with stand, lens, vignetter, and other accessories. They haunt the basements and attics of

CERTEX

old studios, too large to haul away easily, too cumbersome for most of today's studio work. But some collectors with unlimited display space, and some users requiring a large format but only limited movements will pay \$250-300 for such an outfit.

CERTEX S.A. (Barcelona) The predominant Spanish manufacturer of cameras, mostly inexpensive mass-market types.

Digna - c1956. Essentially the same as Dacora Digna, but made in Spain. "Certex" & "Made in Spain" markings on shutter face and body. Many lens variations. Less common than the German models. \$20-30.

Indiana Jones Camara Safari c1987. Simple tan plastic camera for 35mm film. Decals on front feature the film character. Tan lanyard and leopard-spotted box complete the package. \$20-30.

Werlisa - There are numerous models of Werlisa cameras (named for Pablo Wehrli, the founder of Wehrli S.A., later Certex). 35mm cameras with grey plastic body. Achromatic f7.5/50mm lens. \$20-30.

CERTO KAMERAWERK (Dresden, Germany)

Certi - Simple 35mm with Triplon f3.5/45mm lens. \$12-20.

Certix - c1930's. 6x9cm folding rollfilm camera. Various shutter and lens combinations cause prices to vary widely. \$15-50.

Certo Six - c1950's. 6x6cm folding 120 rollfilm camera. Tessar f2.8/80mm lens, Synchro Compur or Prontor SVS shutter. CRF. Common in Germany at \$75-100.

Certolob XI - c1927. Folding camera for

6.5x9cm plates & filmpacks. Model XI/0 is simple model. Model XI has rising front and radial focus. \$30-45.

Certonet - c1926. 6x9cm folding 120 film camera. f4.5 Schneider Radionar or Certo Certar. Compur, Vario or Pronto shutter. \$30-45.

Certonet XIV - c1928. 6.5x11cm on rollfilm. Periskop f11, Trilan f6.3, Trioplan f6.3 or f4.5 in Vario. \$35-50.

Certonet XV Luxus - c1931. Folding rollfilm camera, 6x9cm. Brass body covered with brown leather, brown bellows. Radial lever focusing. Various lenses including Xenar f4.5/105mm. Compur shutter. \$150-225.

Certo-phot - Rigid bodied simple 120 rollfilm camera for 6x6cm exposures. \$20-30.

Certoplat - c1929-31. Folding bed camera for 9x12cm plates. Rack and pinion focus. Rising front. Meyer Plasmat f4 or Schneider Xenar f3.5/150mm. Compur 1-200. \$50-75.

Certoruf - c1929. Folding bed camera for 9x12cm plates. Double extension bellows. Ennator or Unofokal f4.5 in Compur. \$45-60.

Certoruhm - c1925-30. Folding plate camera, similar in construction to the Certoruf, but with square back that holds plates horizontally or vertically. 9x12cm and 10x15cm sizes. Double extension. \$50-75.

Certosport - c1930's. Folding plate cameras. 6.5x9 & 9x12cm sizes. Double extension bellows. Normally with f4.5 lens (Meyer or Schneider) in Compur or Ibsor shutter. \$35-50.

Certotix - c1931. Folding camera for 6x9cm on 120 rollfilm. \$20-30.

Certotrop - c1929-41. Folding plate cameras, 6.5x9cm, 9x12cm, & 10x15cm sizes. \$50-75.

Certotrop (brown) - As above but brown leather covering and brown bellows. \$175-250.

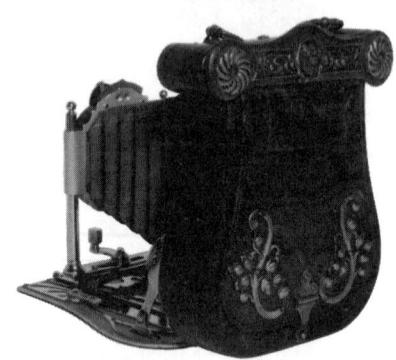

Damen-Kamera - c1900. Lyre-shaped body covered in alligator skin. Looks like a stylish woman's handbag when closed. 1/4-plate size. Same camera was sold by Lancaster as the Ladies Gem Camera and by Dr. Adolf Hesekiel & Co. as the Pompadour. Rare, price negotiable. Estimate: \$10,000-15,000.

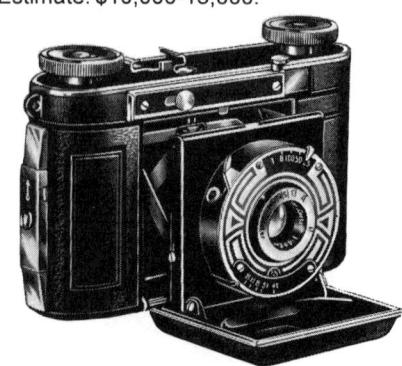

Certo Dollina "0"

Dollina - Folding 35mm cameras made from the 1930's to the 1950's. Since the

CERTO

various models are not well identified on the camera body, there has been a certain amount of confusion among buyers and sellers. Hopefully the distinguishing features and illustrations here will help sellers to correctly identify their cameras.

Dollina "0" - c1937. No rangefinder. Certar f4.5 in Vario or f2.9 in Compur. \$50-75. *Illustrated bottom of previous page.*

Dollina I - 1936-39. No rangefinder. All black or with chrome metal parts. Focusing knob on top. Compur 1-300 or Compur Rapid 1-500 shutter. Radionar f2.9, Xenar f2.9 or f3.5, or Tessar f2.8 lens. \$50-75.

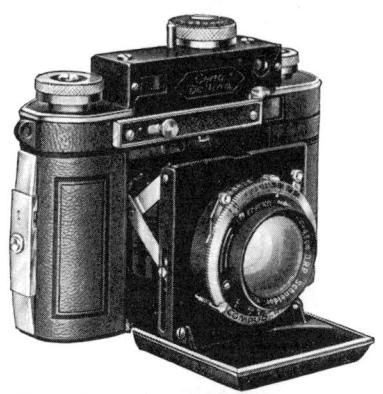

Dollina II - c1936. Rangefinder above body and focus knob above rangefinder. Compur or Compur Rapid shutter. Various lenses including f2 Xenon, f2.8 Tessar and f2.9 Radionar. Made in black enameled or chrome finish. Originally, chrome was more expensive. Because chrome is also more durable, the more common black version has a slightly higher value than chrome if exceptional condition. \$50-75.

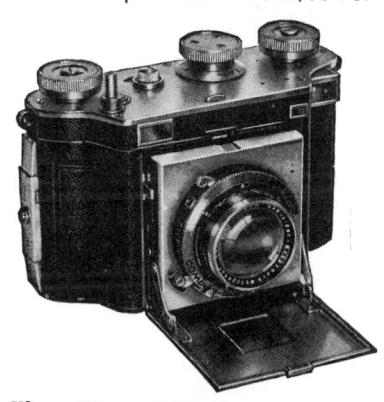

Dollina III - c1938. Separate eyepiece rangefinder incorporated in body. Focus knob on same plane as advance and rewind knobs. \$150-225.

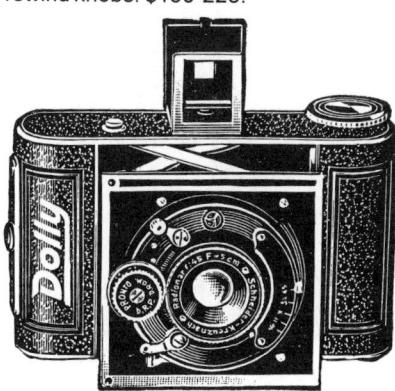

Certo Dolly 3x4 (miniature)

Dolly Vest Pocket cameras - c1934-40. There are two major styles produced concurrently. The "miniature" or 3x4cm model has a straight pop-out front with scissor-struts. The V.P. or 4x6.5cm model is a self-erecting bed type capable of taking either 4x6.5cm or 3x4cm size on 127 film.

Dolly 3x4 (miniature) - c1932-37. Compact strut camera for 16 exp. 3x4cm on 127 film. f2.9, 3.5, or 4.5 lens. Vario, Pronto, or Compur shutter. Deluxe models have radial focusing lever and optical finder. Original prices ranged from \$11 to \$70. Currently: \$60-90. *Illustrated bottom of previous column*.

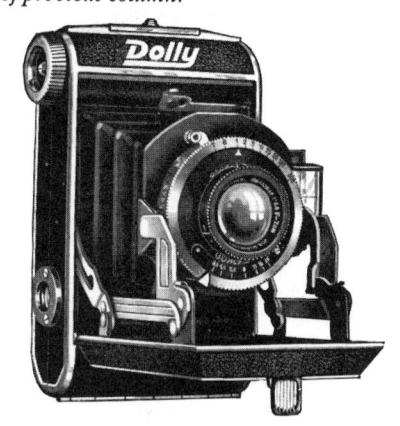

Dolly Vest Pocket - c1936. Also called Dolly Model A. Self-erecting bed style. 8 or 16 exp. on 127 film. A variation of this camera, marketed as the "Dolly Model B" had interchangeable backs for plates or rollfilm. The same camera, in both rollfilm & combination models was sold under the name "Sonny". \$75-100.

Doppel Box - c1935. Box camera for 8 exp. 6x9cm or 16 exp. 4.5x6cm on 120 film. Format changeable by turning a dial. Certomat lens, single speed shutter. \$35-50.

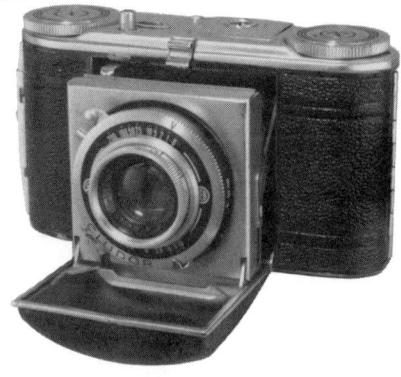

Durata - c1950's. Horizontally styled folding 35. Early model has slim top housing with folding optical finder, no accessory shoe. Later model has rigid optical finder incorporated in taller top housing with recessed accessory shoe. Trioplan lens in Cludor shutter. \$30-45.

Kafota - c1939. Uncommon name variation of the Dollina 0. Cassar f2.9/50mm in rim-Compur.\$75-100.

KN35 - c1973. Inexpensive 35mm VF camera. Non-changeable Kosmar f2.8 lens. \$20-30.

Plate camera, 9x12cm - DEB. \$45-

Super 35 - c1956. Like the Super Dollina II below, but with Light Value Scale (LVS) and MXV shutter. \$45-60.

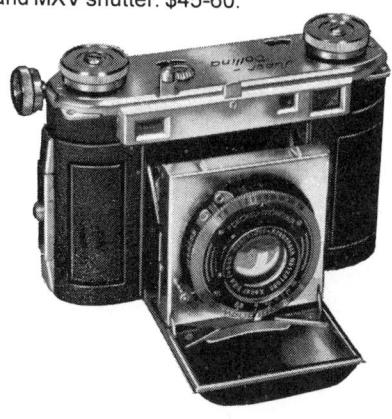

Super Dollina - c1939. Rangefinder incorporated in body. Focus knob on right side. Separate eyepiece for rangefinder. Tall knobs sit above flat top plate. Not synchronized. Compur Rapid shutter with f2 Xenon or f2.8 Xenar or Tessar. \$75-100.

Super Dollina II - c1951. (Also called Super Certo II, Certo Super 35, and Certo 35.) Like pre-war Super Dollina, but with single eyepiece for viewfinder & range-finder. Flat knobs recessed into chrome top housing. Compur Rapid MX sync shutter with f2.8 or f3.5 coated Tessar or f2 Heligon. Common at German auctions for \$50-75.

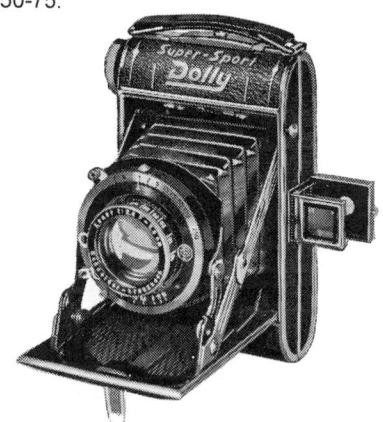

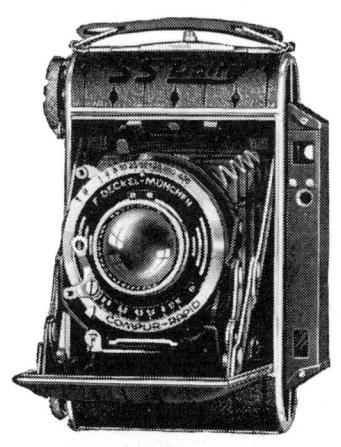

Supersport Dolly - c1935-41. Folding camera for 12 exp. 6x6cm or 16 exp. 4.5x6cm on 120 film. Available with or without CRF. After November 1938, an extinction meter was built into the range-finder housing. "Super-Sport Dolly" or "SS Dolly" embossed in leather. Various lenses

CHADWICK

f2, f2.8, f2.9. Rimset Compur. With Range-finder: \$150-225. Without RF: \$90-130.

CHADWICK (W.I. Chadwick, Manchester, England)

Hand Camera - c1891. Black-painted mahogany box camera for single plates. External controls. Rack & pinion focusing. Kershaw shutter. Rotating waterhouse stops. \$250-375.

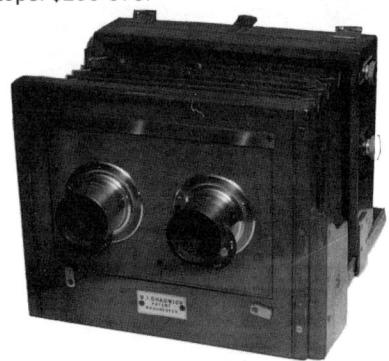

Stereo Camera - c1890. 1/2-plate tailboard stereo. Mahogany body, brass trim, rectangular black bellows. Accepts single or stereo lensboard. Brass barrel Chadwick 5" lenses with rotating waterhouse stops. Thornton-Pickard roller-blind shutter. Other lens variations exist. \$600-900.

Tailboard camera - c1890. 1/2-plate tailboard camera. Mahogany body, brass trim, brass barrel Beck Rectilinear 7" lens. \$300-450.

CHADWICK-MILLER

Fun-Face Camera - c1979. Novelty cameras for 126 cassettes. Little boy's or girl's face on front of camera with lens in nose. \$12-20.

CHAMBRE DE VOYAGE - French for "field camera". This is a generic listing for a very common type of camera sold in France from approximately the 1890's through 1930's. Typical construction includes such features as a hinged tailboard which locks in place by sliding an inner panel partially into the front base section. Back and bellows normally revolve, the back attaching in either direction via four keyhole slots in the base and extended screwheads on two sides of the back section. With appropriate lens in brass barrel, these sell in France for \$300-450.

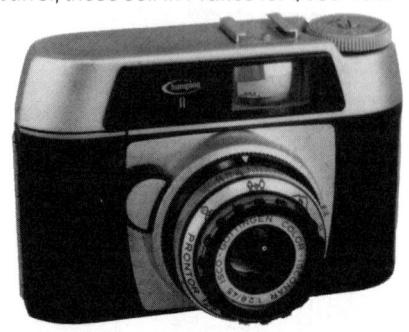

CHAMPION II - Basic 35mm camera with lever advance and bright-frame finder. Color-Isconar f2.8/45mm in Prontor 125. Made in West Germany. \$20-30.

CHAPMAN (J.T. Chapman, Manchester, England)

The British - c1900. 1/₄-plate magazine camera. Wray Rapid Rectilinear f8 lens, rollerblind shutter. \$150-225.

The British - c1903. Folding camera in $1/_{4^-}$ and $1/_{2^-}$ plate sizes. Brass lens, waterhouse stops. Red double extension bellows, brass trim. English auction sales range \$200-300.

The British - c1903. Full-plate size folding camera. Mahogany body with brass trim. Black tapered double extension bellows. Wray brass f8 lens, iris diaphragm. \$300-450.

Forward Siderigger Camera - c1880. Full-plate camera with hinged wooden wing on side. The unusual style uses the outrigger to support the front bed, rather than a rear bed as most cameras. Lensboard has L-shaped slots for choice of rise or shift, but not both at once. Lens panel reverses to store the lens inside the camera. Plateholder stores behind ground glass screen to protect it. \$300-450.

Millers Patent Detective Camera "The British" - c1900. Black ebonized wood detective box camera for 1/4-plates. Falling-plate mechanism. String-cocked rollerblind shutter behind hinged front. Rack focusing. \$150-225. Also available with brown reptile skin covering; no sales data on this finish.

Stereoscopic Field Camera - 1/2-plate folding stereo view camera. Dovetailed mahogany construction with brass trim. Twin Wray 5x4 lenses with iris diaphragm. \$500-750.

CHARMY - Novelty camera of "Hit" type. With colored covering: \$50-75. Black covering: \$20-30.

CHASE - Novelty camera of "Cardinal" type for 16 exp. on 127 film. Identical to the Wales-Baby and Halina-Baby Made in Hong Kong. \$1-10.

CHASE MAGAZINE CAMERA CO., (Newburyport, Mass. USA)
Chase Magazine Camera - c1899. 12
plate magazine camera, 4x5". Plates are

plate magazine camera, 4x5". Plates are advanced (dropped) by turning large key at side. Variable apertures. Shutter speeds I & T. \$120-180.

CHEVALIER (Charles Chevalier,

Paris) One of the earliest makers of cameras, beginning shortly after Daguerre's process was made public. Chevalier produced the first folding camera, a wooden box with hinged sides, and other Daguerreian cameras. As far as we know, there have been no recent discoveries or sales of Chevalier's folding cameras, and estimates of value would be pointless and misleading. One Chevalier sliding-box camera sold at auction for about \$15,000 a few years back, and would easily bring more today. If you have a genuine Chevalier camera for sale, we would be happy to provide free consultation to help you achieve maximum price.

CHICAGO CAMERA CO. (Chicago, III.) Photake - c1896. A seamless cylindrical camera, taking 5 exposures on 2x2" glass plates. f14/120mm achromat, Guillotine shutter. Very unusual camera, originally sold for a mere \$2.50. It was packed in a wooden box with a small piece of ruby paper. Instructions describe how to use a candle in the box with the red paper over

the top as a safelight. With finder, box, instructions: \$1500-2000. Camera only: \$1000-1500

CHICAGO FERROTYPE CO. (Chicago, III.) Founded by Louis & Mandel Mandel, the Chicago Ferrotype Co. was the United States' leading producer of direct positive "street" cameras for tintypes, button tintypes, paper prints, and post cards. See also "PDQ Camera Co."

Mandel No. 2 Post Card Machine c1913-30. Direct positive street camera, 5 styles of photos from postcards to buttons. \$120-180.

Mandelette - Direct positive street camera. $2^{1}/_{2}x3^{1}/_{2}$ " format. Camera measures $4x4^{1}/_{2}x6$ ". Sleeve at rear, tank below. Simple shutter and lens. A widely publicized camera which sold for about \$10.00 in 1929. With tank: \$75-100.

Wonder Automatic Cannon Photo Button Machine - c1910. An unusual all-metal street camera for taking and developing 1" dia. button photographs. With tank: \$750-1000. Without tank, deduct \$90-130.

CHILD GUIDANCE PRODUCTS INC.

Mick-A-Matic - c1971. Camera shaped like Mickey Mouse's head. Lens in nose. Original model uses the right ear for a shutter release. Later models have a shutter release lever between the eye and ear. Although these cameras took a speculative jump a few years ago, they have settled back to a more normal price range. Actually, they are not hard to find at these prices in the USA, but they command a bit more in Europe where they are not as common. Original (ear shutter) model: \$50-75. Later models: \$35-50. Add 50% if new in box.

CHIYODA KOGAKU SEIKO CO. LTD. Konan-16 Automat - c1950. 16mm subminiature. The precursor of the Minolta-16. Very similar in style, but much heavier. "Made in Occupied Japan". Rokkor f3.5/25mm fixed focus, shutter T,B, 25-200, sync. Auction high (12/91): \$250. Normal range: \$120-180.

Minolta - Although the Minolta cameras were made by Chiyoda, we have listed them under the more widely recognized name-Minolta.

CHIYODA SHOKAI (Japan) CHIYODA CAMERA CO. LTD. REISE CAMERA CO. LTD. CHIYOTAX CAMERA CO. LTD.

Chiyoca 35 (I) - c1951. Rare Japanese copy of the Leica Standard camera, but without rangefinder. Hexar 50mm f3.5 lens in collapsible mount. FP 1/20-500,B. The "Chiyoca" name was soon dropped because of its similarity to "Chiyoka", a registered trademark of Chiyoda Kogaku Seiko (Minolta), and the new version was called Chiyotax. \$1000-1500.

Chiyoca 35-IF - c1952. Similar to earlier model, but with twin pinhead sync posts. Hexar f3.5/50mm. \$800-1200.

Chiyoca Model IIF - c1953. Improved version of the IF, with CRF. Lena Kogaku or Reise Kogaku f3.5/50 in collapsible mount. Early version has two pinhead sync posts. Later version has single PC post. \$800-1200.

Chiyotax Model IIIF - c1954. In addition to the features of the Chiyoca IIF which it replaced, the camera now has slow speeds. Model number engraved on the top plate. Normal lens is Konishiroku Hexar f3.5/50 in collapsible mount. Later version has "Chiyotax Camera Co. Ltd." on top plate. \$1000-1500.

Chiyoko - 6x6cm TLR. Seikosha MX shutter. f3.5 Rokkor lens. \$50-75.

CHRISLIN PHOTO INDUSTRY (Hicksville, NY) Also DBA Camera Corporation of America, but not related to the other companies which also used that name.

Chrislin Insta Camera - c1965-69. Blue plastic box camera for 8 self-developing 60 sec. prints per roll. Eye level view-finder in handle. This was in direct competition with the Polaroid Swinger camera, and never got off the ground. Unusual and uncommon. \$100-150.

CHUO PHOTO SUPPLY

Harmony - c1955. Inexpensive eye-level metal box camera from Japan for 6x6 on 120. Focusing lens, 3 speed shutter, PC sync. \$20-30.

CHURCHIE'S OFFICIAL SPY CAMERA - Hong Kong novelty 127 rollfilm camera with tiny adhesive label advertising Churchie's. \$1-10.

CIA STEREO - c1910. Manufacturer unknown. Stereo box camera for two 6x9cm exposures on 9x12cm plates. Meniscus lens with 3 stops. Individual lenses may be closed off for single exposures. Folding frame finder. Rare. \$150-225.

CIMA KG. (Fürth, Germany)
Cima 44, Cima 44 S, Luxette,
Luxette S - c1954. Eye-level cameras
for 4x4cm on 127 film. Metal body with

black crinkle finish. Röschlein Cymat f7.7 in Cylux 25-100 shutter. (Luxette S has Synchro-Cylux shutter.) \$35-50.

CINESCOPIE (La Cinescopie, Brussels, Belgium) Inventor/designer was André Edouard Louis Van Remoortel.

Cinescopic - c1929-1939. Early 35mm camera for 24mm square exposures on 35mm film in special spools. Successor to the "Photoscopic". Manual film advance without automatic stop or exposure counter. A wire feeler inside is perhaps used to audibly count sprocket holes when advancing film. O.I.P. Labor f3.5/50mm lens in lbsor shutter, T, B, 1-150. Removable front section allows shutter and lens to be used with an enlarger. Uncommon. Only known recent sale was at auction 12/91 for \$1500.

Photoscopic - c1924. Unusually designed early 35mm camera for 50 exposures 24x24mm on 35mm film in special cassettes. O.I.P. Gand Labor f3.5/45mm lens. Pronto or Ibsor shutter. Metal body with black hammertone enamel. Tubular Galilean finder. Only 100 examples were made according to the maker, and several variations are known, including: 1. Pull-tab film advance like earlier Amourette camera. Full focusing. 2. Full focusing but with knob advance. 3. Fixed focus with knob advance. \$600-900.

CINEX DELUXE - Unusually styled grey and black plastic "minicam" for 16 exposures on 127 film. Streamlined design. Available with either chrome or black faceplate, for those who may want one of each. \$1-10.

CIRO

CIRO CAMERAS, INC. (Delaware, Ohio)

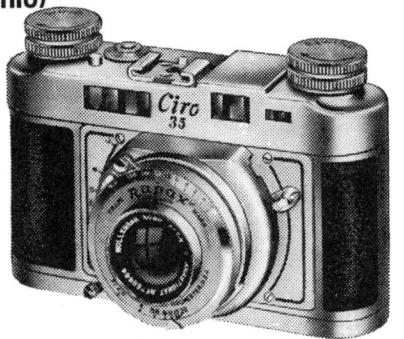

Ciro 35 - c1949-54. Basically the same camera as the Cee-Ay 35 camera from the Camera Corp. of America. Ciro bought the design and dies and made only minor cosmetic changes. It still did not fare well, and soon was in the hands of Graflex. Graflex sold the Ciro 35, then modified it to make the Graphic 35. The Ciro 35 is a 35mm RF camera. Three models: R- f4.5, S- 3.5, T- f2.8. Black body less common: \$45-60. Chrome: \$25-35.

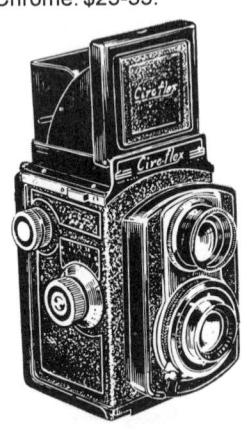

Ciroflex - c1940's. Common 6x6cm TLR, models A through F, all similar, with each new model offering a slight improvement. Models A-D: \$25-35. Models E,F (better, less common): \$35-50.

CITY SALE & EXCHANGE (London)
Used the trade name "Salex" from an abbreviated form of their name. Never actually
made cameras, but sold other makers'
cameras under their own name.

Ancam - c1903-05. Falling plate magazine camera for 12 ¹/₄-plates or 24 cut films. Simple version has RR f8 lens. Better versions have Ross f5.6/6" lens or Beck Isostigmar f5.8 lens. Leather-covered mahogany body. Shutter ¹/₁₅-100. Two waist-level viewfinders for viewing horizontal or vertical photos. \$35-50.

Field cameras - Lightweight folding cameras, similar to the Thornton-Pickard models. With normal lens and shutter such as Unicum or Thornton-Pickard. \$250-375.

Planex - Reflex cameras in 31/2x21/2", 1/4-plate, 5x4", postcard, & 1/2-plate sizes. At least two different styles, the later one prominently advertised as "British-made" c1912. Tall folding viewing hood. Rack & pinion focusing. Originally fitted with Ross, Zeiss, Dallmeyer, Cooke, or Voigtländer lens. At London auctions: \$300-450.

Salex Reflex - c1912. SLR for 6.5x9cm plates. Cube-shaped body. Folding leather hood for waist-level reflex viewing. Front door covers a Taylor-Hobson Cooke f3.9/5" lens. FP shutter 1/5-1000. \$100-150.

Salex Tropical Reflex - Polished teak body, tan leather bellows, brass trim. 31/4x41/4" plates. With Taylor-Hobson Cooke f3.9 or Ross Anastigmat f4.5/6" lens. \$1200-1800.

Triple Diamond - Mahogany field camera with brass trim. \$250-375.

CITEX - c1920. Basic box camera, made in U.S.A. Cardboard construction with leatherette covering. Uncommon. \$12-20.

CIVICA INDUSTRIES CORP. (Taipei, Taiwan)
Civica PG-1 - c1985. Cute 110 camera with sliding lens cover. Two bird-like cartoon characters dancing on round lens cover. Black back with blue or white front. Made in Taiwan. \$15-25.

CLARUS CAMERA MFG. CO. (Minneapolis, Minn) Note: The Clarus Camera company never did well, because they could not escape their reputation, although they finally managed to make their camera work.

MS-35 - 1946-52. Rangefinder 35mm camera. Interchangeable f2.8/50mm Wollensak Velostigmat lens. Focal plane shutter to 1000. At least two versions made. (Shutters tend to be erratic and sluggish, which would decrease the value from the listed price.) Common in the USA at \$35-50. These bring a bit more outside the USA, where fortunately they didn't sell when new.

classic 35 - This name has been applied to several entirely different cameras, the earliest of which is a tiny die-cast aluminum camera with black horizontal stripes, made by Craftsmen's Guild. The others were imported to the USA and sold by Peerless Camera Co. of New York. To avoid further confusion, we are listing these full-frame models here.

Classic 35 - c1956. Made by Altissa-Werk in "USSR occupied" Germany. Same as the Altix camera. Trioplan f2.9 coated lens. \$35-50.

Classic II - c1957-58. Made in Japan. Original price \$18. \$35-50.

Classic III - c1959. Made in Japan. Original price \$18. \$35-50.

Classic IV - c1960. Fujita Opt. Ind., Japan. Orig. price of \$20 reduced to \$14. \$35-50.

CLOSE & CONE (Chicago, Boston, & NY)

Quad - c1896. Box-plate camera. The only camera using the new "Quadruple plateholder", an unusual mechanism which turned the four plates into the focal plane. The camera which measured $45/_8x45/_8x6$ " for $31/_2x31/_2$ " plates was advertised in 1896 as "the largest picture and smallest camera combined ever made", and it cost \$5.00 new. \$120-180.

CLOSTER (Italy)

Closter IIa - c1950. Bottom loading 35mm VF camera. Mizar f4.5/50mm lens. Closter shutter to 300. \$25-35.

C60 - c1960. Simple plastic and aluminum 35mm. Lambron f7/50mm, single-speed shutter. \$25-35.

Olympic - c1959. Inexpensive plastic and metal 127 rollfilm camera, 3x4cm. f8/56mm lens. \$12-20.

Princess - c1951. 35mm RF. Aires f3.5/50mm lens, Rimset 1-300 shutter. \$35-50

Sport - c1956. Viewfinder 35mm. Closter Anastigmat f8/50mm. Two-speed shutter. \$20-30.

Sprint - Inexpensive 35mm. f7/50mm lens, Sincro-Closter shutter to 150. \$20-30.

C.M.C. - Japanese novelty camera of "Hit" type. With gold colored metal parts: \$60-90. With colored leatherette: \$50-75. Chrome with black leatherette: \$20-30.

C.M.F. (Milano, Italy) Founded in 1937 as I.C.A.F., the company changed name to C.M.F. shortly thereafter. After WWII, the company was called C.M.F.-Bencini or simply Bencini. We have listed postwar models under BENCINI.

Argo - c1939. Simple folding rollfilm camera for 120 film. Fixed-focus Aplanatic lens in I&P shutter. \$25-35.

Delta - c1940. 120 folding rollfilm camera. Aplanatic f10.4 lens, simple I&P shutter. Identical to the Argo camera; the Delta name was used by Wilson's of Brooklyn, NY. \$25-35.

Eno - Inexpensive 6x9cm rollfilm camera. \$25-35.

Gabri - c1938. Metal box camera for 4x6cm on rollfilm. f11/75mm lens in B,30 shutter. \$25-35.

Robi - c1937. Metal box camera for 6x9cm on 120 film. Achromatic f11/105mm lens in simple shutter. Pivoting reflex finder. \$20-30.

COLUMBIA

COLIBRI, COLIBRI II - c1952-53. Tiny subminiature plastic cameras for 13x13mm on special rollfilm. Original model has lens marked "1:4.5". "Colibri II Aplanat 1:5.6" is marked on the lens rim of the second model. Only apparent difference is a smaller stop behind the lens. Post-war Germany, U.S. Zone. Uncommon. \$120-180.

COLLEGIATE CAMERA NO. 3 - Small Japanese novelty "Yen" box camera for single paper film holders. Uncommon name. \$35-50.

COLLINS (C.G. Collins, London) "The Society" - c1886. ¹/₁-plate compact mahogany field camera made under license as improved version of McKellin's 1884 Treble Patent Camera. \$300-450.

COLORFLASH DELUXE CAMERA - Identical to the Diana DeLuxe. Accessory flash uses AG-1 bulbs. \$1-10.

COLUMBIA OPTICAL & CAMERA CO. (London)

Pecto No. 1A - c1902. 4x5" polished mahogany plate camera. Red bellows. Shutter built into lensboard. \$120-180.

Pecto No. 5 - c1897. Folding bed camera for 9x12cm plates. B&L RR lens. Unicum shutter Double extension bellows. Rising front. Leather covered wood body. \$100-150.

COLUMBIA...

Pecto No. 7 - c1900. 5x7" leather covered hand and stand camera. Double extension red bellows. RR lens, shutter 1-100. \$150-225.

C.O.M.I. Luxia, Luxia II - c1949. Small 35mm half-frame cameras. Delmak f2.9/27mm lens, between-the-lens shutter. Gold w/colored leather: \$1000-1500. Chrome with black leather: \$800-1200. Chrome with black leather: \$600-900.

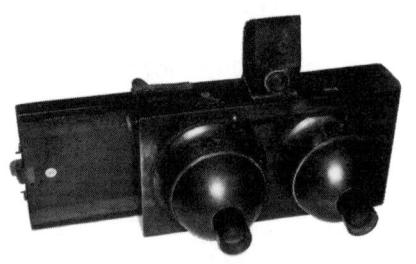

COMPAGNIE FRANCAISE DE PHOTO-GRAPHIE

Photosphere - c1888. One of the first all-metal cameras. For 9x12cm plates, or could take special roll back for Eastman film. Shutter in the form of a hemisphere. Smaller size for 8x9cm plates: \$1500-2000. Unusual 13x18cm (5x7") size: \$2000-3000. Stereo model: \$6500-9500. Size for 9x12cm plates: \$1700-2400.

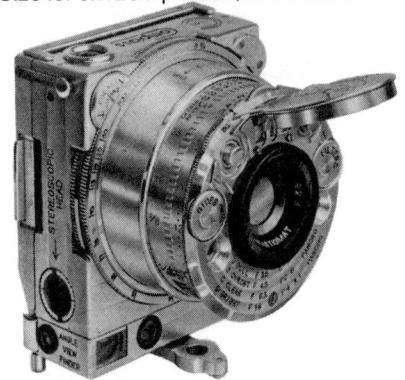

COMPASS CAMERAS LTD. (London) Mfd. by Jaeger LeCoultre & Cie., Sentier,

Switzerland for Compass Cameras Ltd. Compass Camera - c1938. The ultimate compact 35mm rangefinder camera system. A finely machined aluminum-bodied camera of unusual design and incorporating many built-in features which include: f3.5/35mm lens, shutter from 4.5 sec to $^{1}/_{500}$, RF, right-angle finder, panoramic & stereo heads, level, extinction meter, filters, ground glass focusing, etc. For 24x36mm exposures on glass plates, or on film with optional roll back. There are two distinct variations of the Compass, the later version having a folding focusing magnifier on the ground glass back. The high prices in the current market are due primarily to collector enthusiasm, not rarity, since they are regularly offered for sale. Outfits with camera, plate back, rollback, case, and instructions have sold in the \$2400-3200 range and regularly sell at auction for at least \$1200-1800. Camera only: \$1000-1500.

Compass Tripod - Rare accessory for the Compass camera. \$500-750.

COMPCO Miraflex & Reflex cameras - c1950. Low-cost twin lens box cameras of the 1950's. \$12-20.

CONCAVA S.A. (Lugano, Switzerland)

Tessina - c1960 to present. For 14x21mm exp. on 35mm film in special cartridges. The camera, about the size of a package of regular-sized cigarettes, is a side-by-side twin-lens reflex. One lens reflects upward to the ground glass for viewing. The other lens, a Tessinon f2.8/25mm, reflects the image down to the film which travels across the bottom of the camera. Shutter speeds 2-500. Springmotor advance for 5-8 frames per winding. Available in chrome, gold, red, black. Gold, red, or black camera: \$500-750. Chrome camera: \$350-500.

Tessina Accessories:
Daylight film loader - \$35-50.
Wrist strap - \$30-45.
Meter - \$100-150.
Neck chain - \$25-35.
Prism finder - \$100-150.

Watch - Rectangular watch with Tessina logo on face. Made to fit on top of Tessina camera. Rare. \$250-375.

CONLEY CAMERA CO. (Rochester, Minn.) In addition to the cameras marketed under their own label, Conley also made many cameras for Sears, Roebuck & Co. which were sold under the Seroco label, or with no identifying names on the camera.

Conley Junior - c1917-22. Folding roll-film cameras, similar in style to the better known Kodak folding rollfilm cameras. Made in several sizes. \$20-30. *Illustrated at top of next column.*

Conley Junior No. 2

Folding plate cameras: 31/4x51/2 Folding Plate Camera - c1900-10. Vertical folding camera. Fine polished wood interior. Nickel trim. Double extension red bellows. f8/61/2" lens in Wollensak Conley Safety Shutter. \$75-100

4x5 Folding Plate Camera - c1900-10. Black leathered wood body. Polished cherry interior. Red bellows. Usually with Conley Safety Shutter and one of the following lenses: Wollensak Rapid Symmetrical, Rapid Orthographic, Rapid Rectilinear, or occasionally with the Wollensak 6"-10"-14" Triple Convertible (worth more). Normally found in case side by side with holders "cycle" style. The 4x5 is the most commonly found size of the Conley folding models. \$100-150.

5x7 Folding Plate Camera - c1908-17. Except for size, similar to the two previous listings. \$150-225.

61/₂x81/₂ View Camera - c1908-17. The least common size among Conley cameras. \$150-225.

8x10 View Camera - c1908-17. Prices vary depending on accessories, particularly lens and shutter, since large format shutters and lenses still have some value as useful equipment. \$175-250.

Folding Kewpie Camera - c1916-17. (Formerly called "Conley Junior Film Cameras" from 1912-15). Inexpensive folding cameras with vertically styled, square-cornered, wooden body. Red leather bellows. Made in 21/4x31/4, 21/2x41/4, 31/4x41/4, & 31/4x51/2" sizes. Generally with simple shutter and lens. \$20-30.

Folding Rollfilm Camera, Model C, Model E, etc. - c1917. $3^{1}/_{4}$ x $4^{1}/_{4}$ or $3^{1}/_{4}$ x $5^{1}/_{2}$ "postcard" size, on 122 film. Various models and equipment, including Vitar Anastigmat f6.3 in B&L Compound shutter. Body with rounded ends & leatherette covering. Red or black leather

bellows. These and other Conley models are noted for their heavy chrome plating of metal parts. \$20-30.

Kewpie box cameras: c1917-22. No. 2 - For 120 film. Loads from side. Rotating disc stops on front of camera.

No. 2A - for $21/_2x41/_4$ exp. on #116 rollfilm. \$12-20.

No. 2C - for $27/_8x47/_8$ " exposures. \$12-20. **No. 3** - $31/_4x41/_4$ " exp. \$12-20. **No. 3A** - $31/_4x51/_2$ postcard size. \$15-25.

Long Focus Revolving Back Conley Model XV - 1909-18. Introduced in 1909, the "Model XV" designation was added in 1910. Self-casing folding view camera with double-extension bellows and rack & pinion focus. Mahogany body covered with bear grain leather. Rapid Orthographic lens in Conley Safety shutter. Made in 5 sizes to $6^{1}/_{2}x8^{1}/_{2}$ ". \$100-150.

Magazine Camera - c1908-12. Leather covered wooden box camera for 4x5" 12 plates. Plates advanced by crank on right side of camera. \$50-75.

Panoramic Camera - c1911-17. Pivoting-lens panoramic camera for 140° views, $31/_2$ x12". Design based on patents acquired in 1908 from the Multiscope & Film Co. of Burlington, Wisconsin, Four speeds were possible. Without a fan, the equivalent shutter speed was 1/50th of a second. Attaching the smallest of the three fans gave 1/25th; the medium and large fans giving $1/_{12}$ and $1/_{6}$. Rapid Rectilinear f8 lens with iris diaphragm. Original price of \$17.50 in 1911. Current value \$400-600.

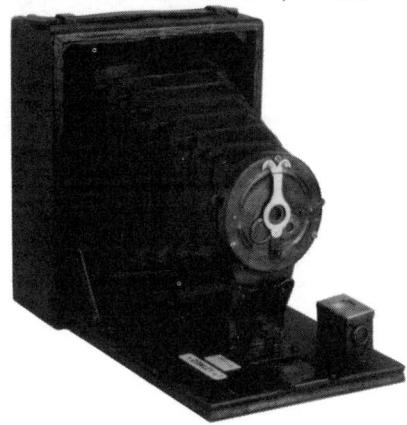

Shamrock Folding - c1908. Vertical folding 4x5 plate camera with simple metal lens standard. Oxidized and burnished copper shutter with exterior diaphragm. The name is obviously derived from the three diaphragms which form a shamrock shape. Sears, Roebuck used the "Sham-rock" name for this camera, which was called "Queen City Folding Camera No. 5" in Conley's catalog. The predecessor of this camera, called "Conley Folding Camera" through 1907, has a diaphragm which even more resembles a shamrock, since it does not have the bright chrome pivot support for the diaphragm in front. Since none of them are identified on the body, just remember that the one which really looks like a shamrock wasn't called by that name. This one was. \$50-75.

Snap No. 2 - Strut-type folding camera for 6x9cm on 120 film. Design with crossswing struts is more typical of Ansco than Conley cameras. \$25-35.

Stereo box camera - c1908. For $41/_4$ x6 $1/_2$ " plates in plateholders. Simple shutter, I & T. Meniscus lenses. \$300-450.

Stereo Magazine camera - c1903. Drop-plate magazine box camera for stereo images on glass plates. \$350-500.

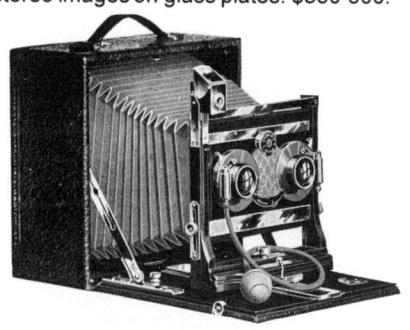

Stereoscopic Professional - c1908. Folding plate camera for stereo images on 5x7" plates. Wollensak Regular double valve stereo shutter. Rise and shift front. (Note: similar models without full movements are of nearly equal value.) \$400-

CONTESSA

Truphoto No. 2 - Folding camera for 120 rollfilm. One of the most interesting features is the pivoting brilliant viewfinder. Both lenses of the finder are rectangular, each oriented a different direction. Pivoting the finder automatically presents the properly oriented rectangle for composition while the other serves as the finder's objective. Fixed focus Meniscus lens. T & I shutter. Very uncommon. Not listed in any Conley or Sears catalogs. \$35-50.

CONTESSA, CONTESSA-NETTEL (Stuttgart) Contessa merged with Nettel in 1919. In 1926, a large merger joined Contessa-Nettel with Ernemann, Goerz, and Ica, to form Zeiss-Ikon. The general assumption from the listed dates is that pre-1919 cameras listed here are "Contessa" models. Pre-1919 "Nettel" cameras are listed under Nettel. From 1919-1926, the line includes many models which existed earlier as "Nettell" or "Contessa" cameras, and some of these continued after 1926 as Zeiss-Ikon models. See also Nettel, Zeiss.

Adoro - c1921. 6.5x9cm and 9x12cm folding plate cameras. f4.5 Tessar in Compur. Double extension bellows. \$50-

Tropical Adoro - c1921. Like the regular model, but teak wood, brown leather bellows, nickeled trim. \$400-600.

Alino - c1913-25. Single extension folding plate camera, 6.5x9cm. Tessar f6.3/120mm lens in Compur 1-250 shutter. \$45-60.

Altura - c1921. 31/4x51/2". Citonar 165mm lens in dialset Compur shutter. \$60-90

CONTESSA...

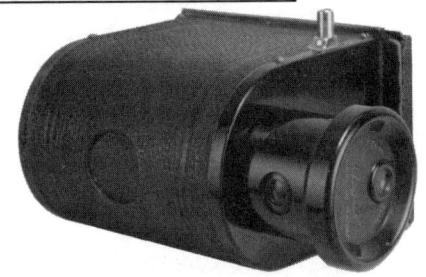

Argus - Monocular styled camera with deceptive angle finder. A continuation of the Nettel Argus, Contessa-Nettel later changed the camera name to Ergo, and the camera continued in production by Zeiss-lkon under that name. \$1000-1500.

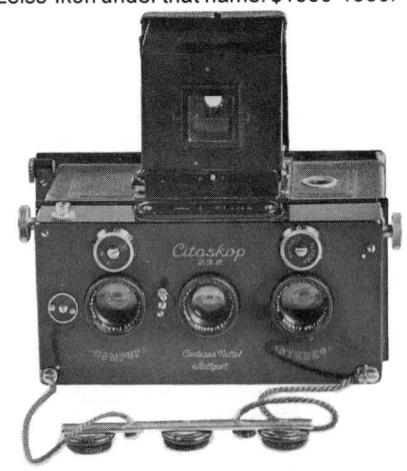

Citoskop Stereo - c1924. 45x107mm. f4.5/65mm Tessar lenses. Stereo Compur. \$250-375.

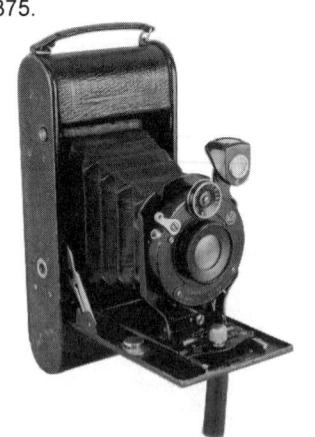

Cocarette - c1920's. Folding bed rollfilm cameras made in 2 sizes, 6x9cm on 120 film & 2¹/₂x4¹/₄" on 116 film. Many combinations of shutters & lenses. \$25-35.

Cocarette Luxus - Brown leather and bellows. \$200-300.

Deckrullo-Nettel - c1919-26. (Continuation of the 1908-1919 Nettel model; continued after 1926 by Zeiss-Ikon.) Folding plate camera with focal plane shutter. Top shutter speed dependent on size: $1/_{2800}$ on 9x12 and 10x15, $1/_{2300}$ on 13x18, and $1/_{1200}$ on 6.5x9. Typical combinations include 6.5x9cm with Tessar f4.5/120mm, 9x12cm size with Zeiss Tessar f4.5/150mm, or 10x15cm size with Tessar f4.5/180mm. Black leather covered body. Ground glass back. \$150-225.

Deckrullo (Tropical model) - c1919-26. Folding 9x12cm plate camera. Teak-

wood body partly covered with brown leather. Light brown bellows. f4.5/120mm Tessar. FP shutter to $^{1/2800}$ sec. Wide range depending on condition. \$350-900.

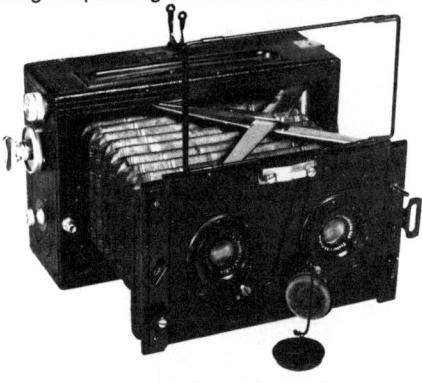

Deckrulio-Nettel Stereo - Focal plane shutter. 6x13cm size with Tessar f4.5/90mm lenses or more commonly in 10x15cm size with f4.5 or f6.3/12cm Tessar. \$250-375.

Deckrullo Stereo (Tropical) - c1921-25. Folding teakwood-bodied stereo plate cameras. GG back, brown bellows, nickel trim. FP shutter to 2800. 9x12cm size with f2.7/65mm Tessars. 10x15cm size with Double Amatars f6.8 or Tessars f6.3 or 4.5. 10x15cm size takes panoramic exposures with a small eccentric lensboard for one lens (9x12cm could be special ordered with this feature). \$1200-1800.

Donata - c1920's. Folding plate or pack camera, 6.5x9cm and 9x12cm sizes. f6.3 Tessar or f6.8 Dagor. Compur shutter. GG back. \$60-90.

Duchessa - c1913-25. 4.5x6cm folding plate camera. f6.3/75mm Citonar Anastigmat, Compur1-100. \$250-375.

Duchessa Stereo (Focal Plane Type) - c1913-14. Compact strut-folding stereo camera for 45x107mm plates. Focal plane shutter. Various lenses, including Dagor f6.8, Tessar f6.3, f4.5. \$350-500.

Duchessa Stereo (Front Shutter Type) - c1913-22. Compact 45x107mm folding stereo camera with lazy-tong struts. Crackle-finish on lensboard. Compound, Compur, or Derval shutter. Lenses include Teronar, Tessar, Citoplast, Tessaplast, Hellaplast, Dagor. Most common with Tessar f4.5 and Compur 1-250. \$350-500.

Duroll - c1913-25. Folding cameras with interchangeable plate or roll backs. 6x9, 9x12, & 9x14cm sizes. \$50-75.

Ergo - c1913-26. Monocular-shaped camera for 4.5x6cm plates. Tessar f4.5, Compur 25-100,B. Right angle finder. \$800-1200. (Earlier model was the Nettel Argus, later model was the Zeiss-Ikon Ergo.)

Miroflex - 1926. Originally designed by a Dutch inventor, Brandsma, who sold the rights to Nettel. Nettel brought the camera out just before WWI, but had to cease production. In 1919, Nettel merged with Contessa, and the camera was brought out by CN just a year before the merger which formed Zeiss-Ikon. The later Zeiss-Ikon Miroflex is more often found than the Contessa-Nettel model. SLR for 9x12cm plates. Tessar f4.5/150mm lens. FP shutter to 2000. \$300-450.

Nettix - c1919-25. (Formerly Nettel). 4.5x6cm strut-folding plate camera. Leather covered metal body. Citonar f6.3/75mm lens in Derval ¹/₂₅-100 or Pronto shutter. \$200-300.

Onito - c1919-26. 9x12cm. Lenses include: Double Anastigmat Citonar f6.3, Nostar f6.8, or Nettar Anastigmat f4.5/135mm. Derval 25-100; Gauthier or Ibsor 1-100. The 6.5x9cm and 10x15cm sizes sell in the same range. \$35-50.

Piccolette (201) - c1919-26. Folding vest-pocket camera for 4x6.5cm exp. on 127 film. Among the various lenses and shutters seen are the Tessar f4.5/75mm, Triotar f6.3, or meniscus f11 lens; Dial Compur, Derval, Piccar, or Acro shutter. Often \$45-60 in Germany. Elsewhere up to: \$90-130.

Piccolette Luxus (205) - c1924. Brown leather covering and tan bellows. \$300-450.

Pixie - c1913. Compact strut camera for 4x6cm on rollfilm. Lazy-tong struts support front with built-in 3-speed shutter. Rare. \$250-375.

Recto - c1921. Small lazy-tong strut camera for 4.5x6cm plates. (A low-priced version of the Duchessa.) Acro shutter 25, 50, 75. \$175-250.

CORNU

Sonnar - Folding 9x12cm plate camera, double extension bellows. Contessa-Nettel Sonnar f4.5/135. Compur 1-200. \$60-90.

Sonnet - c1920's. (Formerly Nettel). Double-extension folding camera for 9x12cm plates. Sonnar f4.5/135mm in Compur. \$60-90.

Sonnet Tropical - c1920's. (Formerly Nettel). Tropical folding plate cameras, 4.5x6cm and 6.5x9cm sizes with teakwood bodies. f4.5 Zeiss lens. Dial Compur 1-300. Light brown bellows. 4.5x6cm size: \$800-1200.6.5x9cm size: \$350-500.

Stereax, 45x107mm - c1912-19. Stereo camera with folding bed and struts. Colorplaste 60mm lens. Focal plane shutter 1/₅-1/₁₂₀₀. \$250-375.

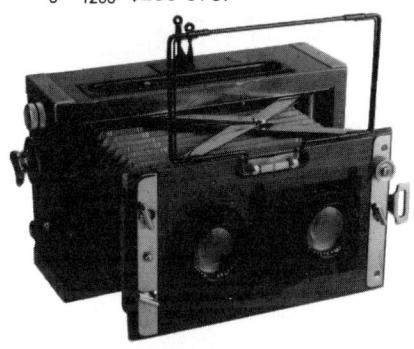

Stereax, 6x13cm - c1919-27. Continuation of Nettel Deckrullo Stereo. Strutfolding stereo in leather covered and tropical versions. Tessar f4.5/90mm lens. Focal plane shutter 1-1200. Wire sports finder with side pieces that expand the view for panoramic exposures. Tropical: \$750-1000. Leathered: \$250-375.

Steroco - c1921. A cheaply made stereo camera for 45x107mm. f6.3 Tessars, Compur. \$250-375.

Suevia - c1919-25. Single extension folding plate camera, 6.5x9cm. Leather covered wood body. Nettar f6.3/105mm lens in Derval 1/₂₅-100 shutter. \$45-60.

Taxo - c1921. 9x12cm folding plate camera. f8/135 Extra Rapid Aplanat. Duvall shutter to 100. \$45-60.

Tessco - c1913-26. Folding plate cameras in 6.5x9, 9x12, & 10x15cm sizes. Double extension bellows. GG back. Contessa-Nettel Sonnar f4.5 or Citonar f6.3. Dial Compur 1-200. \$50-75.

Tropical model plate cameras - c1920's. 6x9cm size. Zeiss Tessar f4.5/120. Compur shutter 1-250. Finely

finished wood, reddish-brown bellows, brass trim or combination of brass and nickel trim. General guidelines: Strut-type with focal plane shutter: \$600-900. Bedtype with front shutter: \$400-600.

CONTINENTAL CAMERA CO. (Chicago)

Insta-Load I, II - Simple black plastic bullet-shaped camera. Clever design allows use of 127 rollfilm or 126 cartridges. This is the only camera in the world to accept both film sizes. An adapter plate slips over the focal box for 127 film. Apart from minor differences in markings, the I and II are identical, however, only model II was supplied with the 127 adapter plate and takeup spool. Uncommon. \$35-50.

CONY INDUSTRIES CORP. (Tokyo) Triplon BCR-111 - Combination 2.5x binoculars, radio, and 110 cartridge camera. Fixed focus f11/70mm telephoto lens; 1/₁₂₅ shutter. As new with case and box \$50-75.

CORD (France)
Cord Box 6x9 - c1946. Simple, poorly
constructed cardboard box camera. Boyer
Meniscus lens. \$20-30.

CORFIELD (K.G. Corfield, England) Formed in 1948, this company is important because it represents a British post-war quality camera manufacturer. The company was taken over by Guinness and ceased camera production in late 1961, and finally closed in 1971.

Corfield 66 - 1961. SLR for 6x6cm on 120 film or cut film backs. FP sh. 1-500. Lumax f3.5/95mm interchangeable lens. Reportedly only 300 made. \$300-450.

Periflex - 35mm cameras for 36 exp. 24x36mm. Interchangeable f2.8/50mm Lumax or f1.9 or f2.8/45mm. Focal plane shutter to 1000. Unusual through-the-lens periscope reflex rangefinder which, despite its cumbersome appearance, worked quite well. Most often found in England at indicated prices. Occasionally found at slightly higher prices outside of England.

Periflex (original model) - 1953. Brown pigskin covering, black anodized top and bottom plates. \$600-900.

Periflex (1) (black) - c1954. Like the original, but black leatherette covering. Early production has shutter speeds and

name engraved on top plate. Later models have speeds on chrome ring and name on periscope. \$175-250.

Periflex (1) (silver) - c1955. Top and bottom plates finished in anodized silver color to resemble satin chrome. Lumar-X lens in restyled mount with leatherette grip rings. \$150-225.

Periflex 2 - 1958. Simplified version of the Periflex 3. Top speed 1/₅₀₀. Lacks film speed reminder and EV scale. Non-interchangeable finder. \$120-180.

Periflex 3 - 1957. Newly designed taller body incorporates finder and eye-level automatic periscope FP shutter 1-1000. \$175-250.

Periflex 3a - 1959. Improved version of the 3. \$175-250.

Periflex 3b - 1961. Recent asking prices \$300-450. No confirmed sales in that range. Estimate: \$175-250.

Periflex Interplan - 1961. No periscope mechanism. Sold as low-priced body with one of three lens mounts: Interplan A = Leica mount; B = Praktica/Pentax; C = Exacta. \$175-250.

Periflex Gold Star - c1961. (There is a gold star on the front.) Periscope view-finder. Interchangeable Lumax f1.9 or f2.8/50mm lens. Focal plane shutter 1-300. \$120-180.

Periflex Lenses & Accessories: 28mm f3.5 Retro-Lumax - \$75-100. 135mm f3.5 Tele-Lumax - Black barrel. Leica thread. \$35-50. Extension Tubes - \$12-20. Telemeter - Cream/black finished rangefinder. \$35-50.

CORNU CO. (Paris)

Fama - Small cast-metal 35mm camera with interchangeable shutter and lens mount. Normally found with Flor f2.8/50mmlens. \$50-75.

Ontobloc - c1946. 35mm compact camera. Dark grey hammertone painted cast metal body. Based on the Reyna, but

CORNU...

with rigid, non-collapsible front. Som Berthiot Flor f3.5/50mm lens in Coronto Paris 1/2-300 3-blade shutter. Model I has rigid rectangular tube finder cast as part of the body. Models II & III are identified on top of their slightly modernized top housing. \$60-90.

Ontoflex - c1934. TLR for 6x9cm on 120 film. Rotating back for horizontal or vertical format. Model A is for rollfilm only. Model B has interchangeable rollfilm and plate backs. Berthiot f3.5, Tessar f3.5, f3.8, or f4.5 in Compur. \$350-500.

Ontoscope - c1934. Rigid-body stereo cameras, made in the popular 45x107mm and 6x13cm sizes in a number of variations: Focusing/non-focusing, Magazine back/plate back, Panoramic/non-panoramic. Inclusion of beautifully constructed Cornu rollfilm back for 127 or 120 film will add to the value. \$200-300.

Ontoscope 3D - Stereo camera for 24x30mm frames on 35mm film. Cast metal body, Flor Berthiot f3.5/40mm lenses. Shutter speeds 1-100 set by knob between the lenses. Additional speeds of 200 and 400 by employing a supplementary spring controlled by another knob. Very rustic in comparison with the contemporary Richard Verascope F40, and much more rare. Probably only a few hundred made. \$400-600.

Reyna II - c1942. Cast metal 35mm camera. Variations include body finish in black hammertone or brown; Berthiot Flor f3.5/50mm, Boyer Saphir f3.5; Compur

Rapid, Vario, Reyna, and Reyna Cross II shutters. Front lens focus. \$50-75.

Reyna Cross III - c1944. Made now by P. Royet at St. Étienne in the "free zone" during the German Occupation. Black painted cast aluminum bodied 35mm. f3.5 Berthiot or f2.9/45mm Cross. Two blade shutter 25-200, B. \$50-75.

Week-End Bob - Cast metal 35mm camera of obvious relation to the Reyna etc., but with attractive grey enameled aluminum body & gold colored knobs. Interchangeable shutter/lens units with Leica thread. Close focusing is allowed by pulling out front tube. Uncommon even in France, where it sells for \$90-130.

CORONET CAMERA CO. (Birmingham, GB)

Coronet Camera Co. 1926-1946 Coronet Ltd. 1946-1967 Standard Cameras Ltd. c1931-1955

This company was formed c1926 by F.W. Pettifer and manufactured a large number of cheap box and folding cameras until c1967. Many of its cameras were distributed via premium schemes or mail order catalogues. Most of its pre-war box cameras and post-1945 plastic molded cameras appear with different nameplates and lens panel styings. The company linked up with Tiranty of Paris after WWII to produce cameras and avoid French import restrictions. These cameras usually have "Made in France" and French instructions on controls and include the Rapide, Le Polo, Weekend and Fildia. Throughout its life the firm produced various

Coronet accessories, flash units, closeup filters and viewers and its own Coronet film in 120 and 127 sizes. Close links between Coronet, Standard Cameras Ltd. and Conway cameras exist with molds and body parts being interchanged. Over 50 different Coronets exist.

Ajax (black) - c1930's. Simple 6x9cm box camera with black leatherette covering. Built-in closeup lens. \$15-25.

Ajax (blue) - c1935. Box camera for 6x9cm. Anastigmat f7.7. Shutter 25-100. Blue leather covering. \$45-60.

Ambassador - c1955. Metal & bakelite box camera for 6x9cm. Quite attractive with chromed hinged covers over brilliant finders. Two small levers above shutter release engage time exposure and green filter. Fixed focus lens. \$12-20.

Coronet 020 Box

Box cameras - c1935. Coronet made a great variety of box cameras, most of which are common and not in great demand by collectors. Some were made in France after WWII because of French import restrictions. \$8-15.

Cadet - Bakelite eye-level camera with flat metal back. 6x6cm exposures on 120 rollfilm. \$12-20.

Cameo - Bakelite subminiature for 13x18mm on rollfilm. Meniscus lens, simple shutter. \$75-100.

Captain - Box camera for 21/₄x31/₄" on 120 rollfilm. Bakelite front, metal back. Decorative green/red/silver faceplate. Built-in filter & closeup lens. \$12-20.

Clipper - Simple, folding camera for $2^{1}/_{4}x3^{1}/_{4}$ " exposures on 120 rollfilm. Fixed

CORONET

Conne

focus f16 lens in 2-speed sync shutter. \$15-25.

Commander 2 - Inexpensive plastic camera of the size, shape, color, quality of a "Diana" type from Hong Kong. This one, from England, takes 24x36mm vertical exposures on 120 rollfilm. \$1-10.

Consul - Bakelite and metal box camera for 6x9cm on 120 film. Red & green enameled metal faceplate. \$20-30.

Conway Camera, Popular Model - c1930's. 6x9cm box camera. Meniscus

lens, single speed shutter. Available in black or olive. \$12-20.

Conway Super Flash - Metal & bakelite box camera for 120 film. Similar to Consul and Ambassador. \$20-30.

Coronet Camera - c1929. Simple cardboard box camera for single glass plates 21/2x31/2". Wine-red and black marbelized paper covering. The back of the camera slips off like a shoe-box cover, and the single plate must be loaded in a darkroom. The camera carries no identification unless you find it in the original box, which is labeled "Coronet Camera". Uncommon. \$35-50.

Coronet 66 - Black bakelite eye-level camera with metal back. Takes 12 exp. on 120 film. Two synch sockets. \$12-20.

Cub - Plastic bodied camera for 28x40mm on 828 film. Spring-loaded telescoping

front. Folding optical finder. Fixed focus; single shutter speed; no flash sync. \$15-

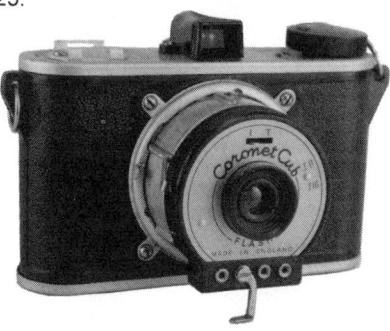

Cub Flash - Similar to the Cub, but with flash sync. Also has T & I shutter, f11 or f16, non-folding optical finder, and hinged front leg. \$15-25.

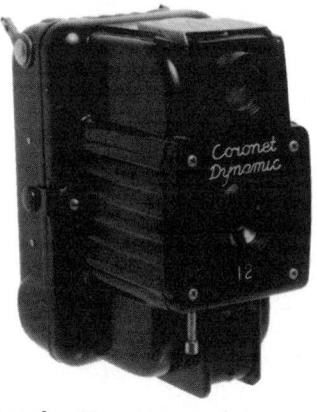

Dynamic 12 - Unusually shaped black bakelite TLR-style box camera for 127 film. \$30-45.

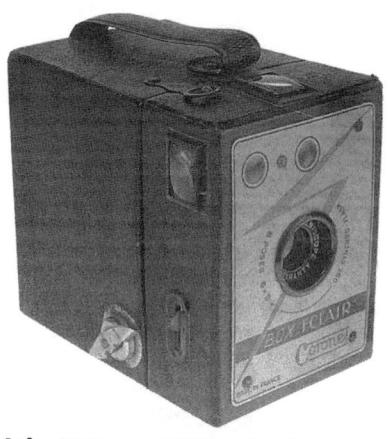

Eclair Box - c1950's. Cardboard box camera for 6x9cm on 120. Made in France. Meniscope Tiranty lens. \$12-20.

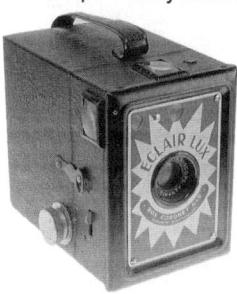

Eclair Lux - c1950's. Metal box camera for 6x9cm on 120 film. Made in France by Tiranty under license from Coronet. Several faceplate variations. \$30-45.

CORONET...

F-20 Coro-Flash - Reflex style box camera for 6x6cm on either 620 or 120 film. Fixed focus; Time or Instant shutter. Built-in green filter. \$12-20.

Fildia - c1950. Cardboard 6x9cm box camera with hexagonal metal faceplate. Made in France by Tiranty under license from Coronet. \$12-20.

Flashmaster - Black bakelite eye-level finder, metal back. Takes 12 exp. on 120 film. Two synch sockets. \$12-20.

Folding Rollfilm Camera - Folding $2^{1/4}$ x3 $^{1/4}$ " cameras. Several variations in body style and lens equipment were sold under this general name in Coronet's catalogs. Normally they have no model identification on the camera itself. Meniscus models are typically not self-erecting. The table stand serves as a front door latch on some. Colored: \$30-45. Black: \$12-20.

Midget - c1935. A small colored bakelite 16mm novelty camera. Taylor Hobson Meniscus lens f10. Single speed ¹/₃₀ shutter. Six exposures per special roll. Original price \$2.50. Current values in England and USA: Black: \$75-100. Brown or red: \$100-150. Green: \$120-180. Blue: \$175-250.

Plate box camera - c1929. Simple cardboard box camera for $2^{1/2} \times 3^{1/2}$ " exposures on dry plates. Meniscus lens, rotary shutter. Single waist-level ground glass finder. Original advertisements called this a "toy camera" for "every school boy and school girl". Originally sold complete with dry plates, chemicals, printing frame, and instruction book, all stored in the camera body. Complete outfit: \$75-100. Camera only: \$30-45.

Polo - Leatherette-covered metal box camera for 6x9cm on 120 film. Made in France. Boyer Menisque lens, single speed shutter. \$12-20.

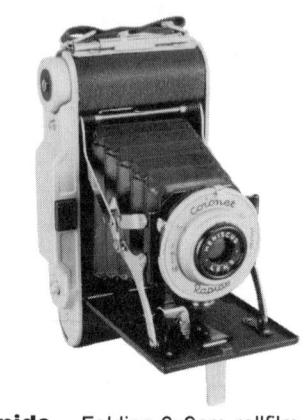

Rapide - Folding 6x9cm rollfilm camera. Body release. Eye-level optical finder. Made in France by Tiranty under license from Coronet. \$12-20.

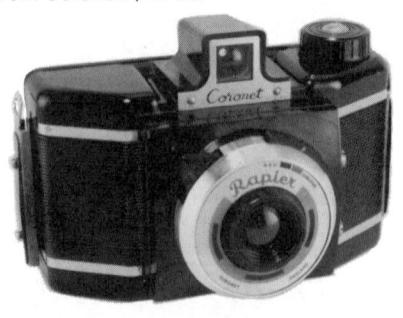

Rapier - Bakelite eye-level camera with flat metal back. Basic design is for 6x6cm image, but a 4x4cm reducing mask is glued inside the original opening. Synchronized. \$25-35.

Rex - c1950. Cardboard 6x9cm box camera with round metal faceplate. Made in France by Tiranty. Menisque Boyer lens. \$8-15.

Rex Flash (box) - Basic box-style camera. Bakelite front section with metal

body. Sync sockets on left hand side. Built-in filter and closeup lens. \$8-15.

Rex Flash (eye-level) - Bakelite eye-level camera with flat metal back. Synchronized. \$25-35.

"3-D" Stereo Camera - c1953. Inexpensive plastic stereo camera for 4 stereo pairs or 8 single exp. 4.5x5cm on 127 film. Single speed shutter, 1/50. Twin f11 meniscus fixed focus lenses. At least four variations exist. Common. \$50-75.

Twelve-20 - c1950. Pseudo-TLR metal box camera for $2^{1}/_{4}$ X2 $^{1}/_{4}$ " on 120 or 620 film. Meniscus lens, single-speed shutter. Built-in color filter. Slight model variations. Colored: \$35-50. Black: \$12-20.

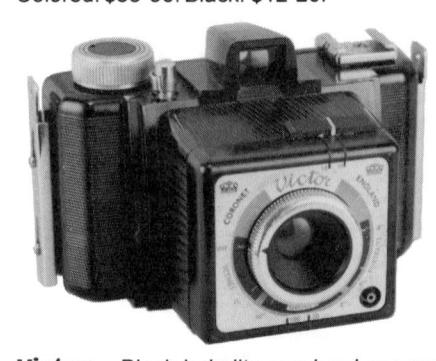

Victor - Black bakelite eye level camera for 4x4cm on 127 film. Focusing f11 lens in synch shutter. \$12-20.

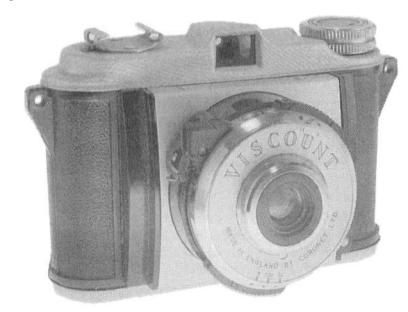

Viscount - Inexpensive plastic and metal

eye-level camera for 828 rollfilm. Synchronized 3-speed shutter. \$12-20.

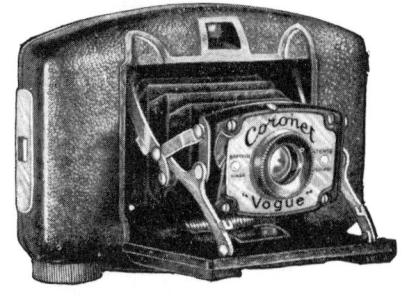

Vogue - c1937. A brown bakelite-bodied folding camera which uses "Vogue 35" film, a spool film similar to Eastman Kodak 828. Fixed focus lens. Simple B&I shutter. \$100-150.

COSMIC - c1950's-present. Russian 35mm. f4/40mm lens. Shutter 1/5-1/250. \$12-20.

COSMO CAMERA CO. (Japan) Cosmo 35 - c1955. Inexpensive 35mm camera with large shutter lever on front. Identical to Micronta 35 below. S.Cosmo f3.5/45mmlens. \$50-75.

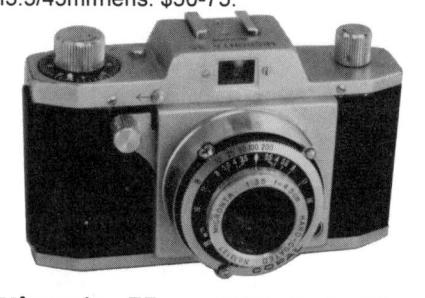

Micronta 35 - c1955. Basic 35mm scale-focus camera. Identical to the Cosmo 35. Micronta f3.5/45mm lens in Copal B,10-200. \$50-75.

COUFFIN (Pierre Couffin, Paris) Malik Reflex - c1960. The first French 35mm reflex with zoom lens. Cast metal SLR with interchangeable mount, but with an exceptional standard lens, a small 35-75mm f2.8 zoom with preset diaphragm. FP shutter 1/30-1/500. Very rare, having been produced only in a pilot series and abandoned before mass production began. No recorded sales.

CRAFTEX PRODUCTS Hollywood Reflex - c1947. (Including models A-E, Sportsman, Sightseer, etc.) Cast metal twin-lens reflex style cameras. Generally simple construction, although at least one model had externally coupled lenses for true reflex focusing. \$20-30.

CRAFTSMAN SALES CO. Cinex Candid Camera - Black plastic "minicam" for 16 exp. on 127. \$1-10.

CRAFTSMEN'S GUILD
Classic 35 - c1948. Small, streamlined
35mm half-frame camera. Die-cast aluminum body. Satin finished with black horizontal stripes or leather covered. Some examples have recessed knobs and buttons. Fixed focus Craftar f4.5/32mm lens.

CREST-FLEX - c1950's. Inexpensive black plastic TLR box camera. Fixed-focus 81mm Crestar lens. Uncommon name variant of Compco Reflex. \$12-20.

CRESTLINE Empire-Baby - Black plastic novelty camera for 16 exp. on 127. Made in Macao. \$1-10.

CROMA COLOR 16 - Japanese subminiature nearly identical to the Mykro Fine Color 16, but in green, red, brown, or black bakelite. (Styled like the Whittaker Pixie cameras.) Often chipped where the front section attaches to the back, and sometimes at the latch cogs. Mint: \$150-225. Chipped: \$60-90.

CROWN CAMERA - Japanese novelty subminiature of the Hit type. Gold metal: \$60-90. Chrome: \$25-35.

CROWN CAMERA CO. (NY) Dandy Photo Camera - intro. 1910.
Simple paper-coveredbox camera for 11/2" circular plates in paper holders. Meniscus lens, simple shutter. Originally sold in an

CRYSTAR

outfit with developing tank, chemicals, lifting spoon, and illustrated instructions, all in a cardboard carton. Full outfit: \$350-500. Camera only: \$120-180.

CRUISER CAMERA CO.

Cruiser - Folding camera for 6x9cm exposures on 120 rollfilm. Probably made by Wirgin. Cast metal body with leatherette covering. Wirgin Edinar f6.3/105mm. Vario shutter B, 25, 50, 100. PC sync. \$15-25.

CRUVER-PETERS CO. INC. Later called Palko, Inc.

Palko camera - c1918-1930's. One of the few folding rollfilm cameras with provision for ground glass focusing without film removal. Based on a 1912 patent of W.A. Peters. Production was apparently started during WWI with the U.S. Government as the primary customer. Adjustable image size of $^{1}/_{3}$, $^{2}/_{3}$, or full postcard size. B&L Tessar f4.5 lens in Acme to 300. Original price from \$70 in 1918 to \$122 in the early 1930's, but closed out at \$65 with case. Rare. Current value: \$800-1200.

CRYSTAR - "Hit" type novelty camera for 14x14mm exposures on 17.5mm paper-backed rollfilm. With colored leatherette: \$50-75. With black covering: \$20-30.

CRYSTAR...

CRYSTAR OPTICAL CO. (Japan)

Crystar 15 - c1954. Horizontally styled dual-format folding camera for 6x6cm or 4.5x6cm exposures on 120 film. Hinged exposure masks at the film plane. C.Master Anastigmat f3.5/ 75mm lens in Crystar Optical Co. B,1-200 shutter. \$75-100.

Crystar 25 - c1954. Twin-lens reflex for 21/4x21/4" exposures. Similar to the Crystarflex, but has sync on front. C-Master Anastigmat f3.5/80mm lens in Luzifer or Fujiko shutter, 1-200,B. \$60-90.

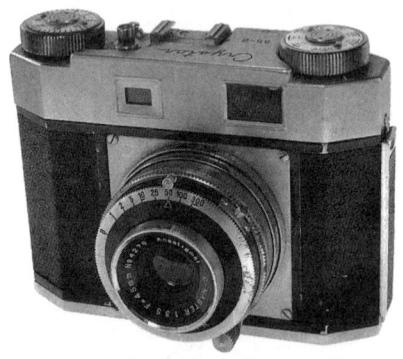

Crystar 35-S - c1955. 35mm with coupled rangefinder. Knob advance. C-Master f3.5/45mm in B,1-300 Crystar shutter. Uncommon. \$50-75.

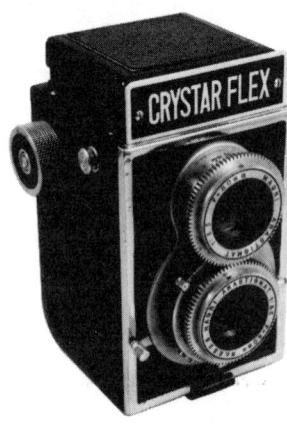

Crystarflex - c1953. Medium-priced TLR with externally coupled lenses. Variations include: Magni Anastigmat f3.5/80mm in Magni synch shutter and C-Master Anastigmat in Crystar shutter. \$50-75.

Sister - c1954. Horizontally styled folding camera for 6x6 or 4.5x6cm on 120. Similar

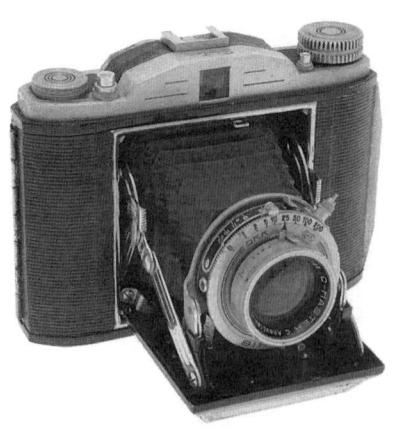

to Crystar 15. C-Master Anastigmat f3.5/75mm in Sister B,1-200 shutter. Uncommon.\$100-150.

CURTIS (Thomas S. Curtis Laboratories, Huntington Park, CA) Curtis Color Master - c1948. 4x5" tricolor camera. Ilex Patagon f4.5/51/2" lens, Acme shutter. CRF. \$400-600.

Curtis Color Scout - c1941. Tri-color camera, 21/₂x3". Ektar f4.5/80mm, Compur 1-200 shutter. CRF. \$400-600.

CUSSONS & CO. (D.H. CUSSONS & CO., Manufacturers. Southport, England)
Tailboard camera - Brass and mahogany tailboard camera, 41/2x71/2".
\$250-375.

CYCLONE - Western Camera Co. manufactured Cyclone cameras until about 1899, when it was taken over by the Rochester Optical Co., which continued to produce Cyclone models. We have listed Cyclone models under each of these makers.

DACORA KAMERAWERK (Reutlingen & Munich) Originally located in Reutlingen, the company name went through several changes including: Dangelmaier (1952), Daco Dangelmaier (1954), Dacora Kamerawerk (1970), and then Dacora Kamerawerk at Munich (1972-1976). For the sake of unity, we are listing all cameras here regardless of the company name at the time of manufacture.

Daci, Daci Royal - Metal box camera for 12 exp. 6x6cm on 120 film. Red: \$45-60. Grey, or green: \$30-45. Black: \$12-20.

Daco, Daco II - c1950. Black bakelite box cameras with slightly curved sides and rounded corners. Similar in style to the common metal Daci camera. Daco has f11 lens; Daco II has f8. Uncommon. \$50-75.

Dacora I - Folding camera for 12 exp. 6x6cm on 120. Eunar f3.5/75mm. Prontor 1-100. \$15-25.

Dacora II - Horizontally styled folding camera for 6x6cm on 120. Ennar f3.5/75 in Pronto, B,25-200. \$20-30.

Dacora-Matic 4D - c1961-66. 35mm with coupled meter. Four shutter release buttons for focus zones. Lens rotates to proper focus as release button is pushed. \$20-30.

Digna - c1958. Simple camera with tubular telescoping front for 6x6cm on 120. Very common. \$1-10. See Certex for "Made in Spain" version.

Dignette - c1957-59. Basic 35mm VF camera with f2.8 lens, $1/_{300}$ shutter. (Orig. price \$18.) \$12-20.

- A stereo Daguerreotype camera sold at Breker 10/91 for about \$10,000.

- In 4/91, Breker sold a Chevalier studio type for about \$15,000.
- A 9x12cm sliding-box type with pillbox and platebolder brought \$4500 et a

 A 9x12cm sliding-box type with pillbox lens and plateholder brought \$4500 at a 1993 auction.

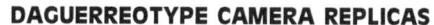

- There have been several known replicas made of various Daguerreotype cameras. Jerry Smith of Missouri, USA has made small-scale models of the original Giroux camera. Another man in Mexico has also made reproductions of the Giroux. These were done for display purposes, with no intentions to represent them as original cameras and no known cases of these replicas being misrepresented. Currently, Doug Jordan of Florida is making working models of American chamfered-box style Daguerreotype cameras. These are made to take modern 4x5" film holders, and are usually fitted with the customer's own original period lens. Modern Daguerreotypists are among his customers, as well as museums and collectors for display purposes. Approximately 20 of these were produced before he began marking them as replicas, but they can be easily distinguished from authentic cameras by the acceptance of standard film holders.

DAIDO SEIKI CO. (Japan) Daido Six Model I - c1953. Horizontally styled folding camera for 6x6cm or 4.5x6cm on 120 film. Side-by-side viewfinder for the two image sizes almost gave the appearance of a rangefinder camera. C.Daido Anastigmat f3.5/75mm in N.K.S. B,1-200. \$60-90.

DAIICHI KOGAKU (Japan)
DAI-ICHI MANUFACTURING CO.
DAI-ICHI OPTICAL WORKS (Japan)
(See Okada Kogaku for the earlier Waltax I camera)

Ichicon 35 - c1954. Leica copy. Hexanon f3.5/50mm in collapsible mount. Forerunner of the Honor S1 camera. Rare. No recent sales records. Estimate \$1700-2400.

Semi Primo - c1941. Horizontally styled folding cameras for 4.5x6cm on 120 film. Oscar Anastigmat f3.5/75mm in Rapid-Presto T,B, 1-500. Model I has black enameled metal parts; Model II has chromed metal parts. \$60-90.

Waltax I - c1947. Folding camera for 4.5x6cm on 120 film. Copy of Ikonta A. Kolex Anastigmat f3.5/7cm in Dabit Super T,B, 1-500 shutter. \$50-75.

Waltax Acme - c1951. Rangefinder camera, similar to the Super Ikonta A. Bio-Kolex f3.5/75mm lens in Dabit-Super shutter, B, 1-500. Rare. \$300-450.

Waltax Jr. - c1951. Copy of Ikonta A, for 16 exposures 4.5x6cm on 120 or 620 film. Bio-Kolex f4.5/75mm lens. Okako shutter B, 25-150. \$50-75. Waist-level f Anastigmatic Dale - Japan Dale

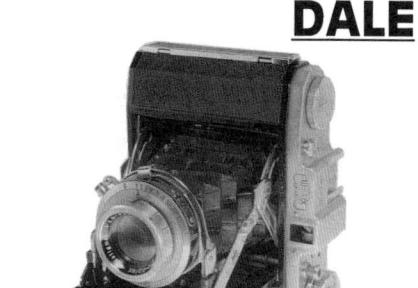

Waltax Senior - c1951. Copy of Ikonta A. For 16 exposure, 4.5x6cm, on 120 roll-film. Bio-Kolex Anastigmat f3.5/75mm lens in Dabit-Super or D.O.C. Rapid shutter, B, 1-500. \$50-75.

Zenobia - c1949. Folding camera for 16 exp. 4.5x6 cm on 120 film. Styled like the early Zeiss Ikonta cameras. f3.5/75mm Hesper Anastigmat. D.O.C. Rapid shutter 1-500, B. (Similar to the Compur Rapid.) \$50-75.

Zenobiaflex - c1953. Rollei-style TLR with Neo-Hesper f3.5/75mm in Daiichi Rapid sh. \$75-100.

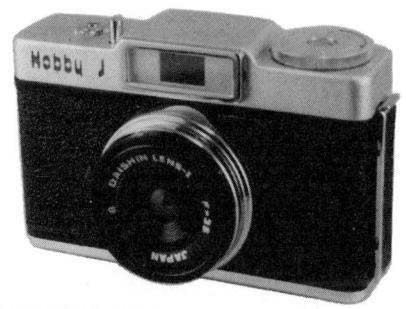

DAISHIN SEIKI K.K. Hobby Junior - c1965. 24x36mm on paper-backed "Bolta" size film. Daishin f8/35mm lens, single speed shutter. A number have been offered and sold new in box for \$15-25.

DAITOH OPTICAL CO. (Tokyo) Grace - Simple eye-level camera for 120 film. Bakelite & metal body. Folding frame finder. Synchronized. \$12-20.

Grace Six - c1950. 6x6cm folding rollfilm camera. Chrome top plate. Eye-level and waist-level finders. Helical focusing Erinar Anastigmatf3.5/75mm. \$120-180.

DALE - Japanese novelty subminiature of "Hit" type. \$25-35.

Instacora E - c1966. A high-quality camera for 126 cartridges. Electric eye, $1/_{30}$ - $1/_{125}$ speeds, zone focusing f3.5/45mm Color Dignar lens. \$15-25.

Royal - c1955. Folding camera for 6x6cm on 120. Uncoupled RF. Ennagon f3.5 or 4.5 lens in Pronto. (Orig. \$31-34.)\$45-60.

Subita - c1953. Horizontally styled selferecting folding camera for 6x6cm on 120 film. Subita f6.3/75mm Anastigmat in Singlo 25,75,B shutter. Advertised originally as a low-priced camera at 45 marks. Uncommon. \$20-30.

Dacora Super Dignette 500 LK

Super Dignette - c1960's. Non-RF 35mm with built-in meter. Cassar, Dignar, or Isconar f2.8/45mm. Pronto LK, Prontor LK, or Vario LK shutter. \$15-25.

DAGUERREOTYPE CAMERAS - The earliest type of camera in existence, many of which were one-up or limited production cameras. Since so few of even the commercially made models have survived time, most Daguerreotype cameras are unique pieces, and price averaging is senseless. Therefore we are listing specific examples of known sales:

- Several half-plate American sliding-boxin-box style cameras have been offered for sale at \$5000-6000.

DALKA

DALKA INDUSTRIES PTY. LTD. (Victoria, Australia)

Dalka Candid - c1949-53. Black plastic eye-level camera for 6x6cm on 620 film. Teco 66mm lens; B&I sector shutter. Styled like the popular "minicams" from Chicago, but slightly taller. Curved back and film plane. Molded inside the back is "use 620 or 120 film". The 120 film spool, however, is too long to load on the winding knob side; it loads on the supply side, but will not turn freely. The instructions for the camera also suggest 620 or 120 film, but are overprinted with a rubber stamp which reads "FOR 620 FILM ONLY". Very rare, even in Australia. Only a few known to survive. \$75-100.

DALLMEYER (J.H. Dallmeyer,

London) Founded c1860 by J.H. Dallmeyer. Not actually a camera maker. Most "Dallmeyer" cameras are just cameras retailed by Dallmeyer with their lenses and label applied. This holds true for most of the 19th century wooden cameras and 20th century reflexes. Some cameras were made by other makers for Dallmeyer to sell with their lenses, and we have attemped to identify these where possible.

Correspondent - c1904-14. Leather covered hand camera, 4x5". Double or triple extension bed made it ideal for telephoto work. \$300-450.

"Naturalists Hand Camera" - c1894-1904. A long eyepiece tube extends to the rear. It used a combination of a portrait lens and a negative lens of about half its focus. Probably made by George Hare. No known sales. Estimate: \$600-900.

New Naturalists' Hand Camera - c1904-10. Probably made by Hare. Long extension bellows on front of cubical body allowed use of ordinary lenses in the compact position, or long focus lenses when extended. Short vertical-tube eyepiece views greater portion of the image than previous model. Goerz Anschutz FP sh to 1000. Uncommon. One sold at auction in 1991 for \$765.

Naturalist's Reflex Camera - c1911-13. Made by Kershaw. Folding hood rather than tube for focusing. Specially designed to carry the Grandac lenses, which "give focal lengths from 10 ins. to 45 ins. at apertures from f/4 upwards." No known sales. Estimate: \$400-600.

Snapshot Camera - c1929. Folding camera for 6x9cm filmpacks. Cross-swinging strut design. Two-speed shutter built into front. Made by Houghton-Butcher for Dallmeyer. \$50-75.

Special Press Reflex - c1930's. Ensign 31/₄x41/₄" Reflex with Dallmeyer lens and name. Focal plane shutter 15-1000. \$250-375

Speed Camera - mid-1920's. Press-type camera made for Dallmeyer by N&G, and equipped with the Dallmeyer "Pentac" f2.9 lens. This fast lens, as well as the $^{1}/_{8}$ to $^{1}/_{1000}$ sec. FP shutter, account for the camera's name. Small 4.5x6cm size: \$250-375. 6.5x9cm: \$200-300. $^{31}/_{4}$ x41/₄": \$200-300.

Stereo Wet Plate camera - c1860. Sliding box style. Brass bound corners on finely crafted wood body. Actual maker's name not specified on camera, which carries a Dallmeyer labe. Fitted with consecutively numbered brass barrel Dallmeyer lenses and wooden flap shutter. \$2800-4000. Full outfits in fine condition with three sets of lenses, flap shutters, and other accessories have sold for \$6000 to \$15,000. Other "Dallmeyer" equipped wet plate stereo cameras of similar type have sold from \$1500-3500. *Illustrated on front cover.*

Studio camera, 4x5" - Transitional wet/dry plate variation. Mahogany body, brass fittings. Rising, falling front. Removable repeating back with masks. Brassbound Dallmeyer Triple Achromatic lens. \$1200-1800.

Studio camera - c1900. Mahogany bellows camera with rack focusing, swing/tilt back. Petzval-type Portrait lens, waterhousestops. \$400-600.

Wet Plate camera, 8x10" - c1870. Wood body, red bellows. Dallmeyer lens. \$750-1000.

Wet Plate Sliding Box Camera - Mid-1860's. \$2000-3000.

DAME, STODDARD & KENDALL (Boston)

Hub (Box camera) - Top loading box camera for 4x5 plates. \$30-45.

Hub (Folding) - Late 1890's leather covered folding camera for 4x5" plates. Side door at rear for inserting and storage of plateholders. Rotary shutter built into wooden lensboard. Simple lens. \$100-150.

DAMOIZEAU (J. Damoizeau, Paris) Cyclographe à foyer fixe - c1894.
An early panoramic camera which revolves on its tripod while the film is transported in the opposite direction past the focal plane slit. Capable of exposures up to 360° (9x80cm). \$18,000-27,000.

DAN CAMERA WORKS (Tokyo) Later became Yamato Camera Industry (Yamato Koki Kogyo Co. Ltd.) maker of Pax cameras. Dan 35 Model I - c1946-48. Japanese compact camera for 15 exposures 24x24mm on paper backed 35mm wide Bolta-sized rollfilm. Removable top. Dan Anastigmat f4.5/40mm. Silver-B shutter B, 25-100. \$200-300.

Dan 35 Model II - c1948-50. Similar, but with body serial number, automatic frame counter, removable bottom. \$200-300.

Dan 35 Model III - c1949. 24x32mm exposures on Bolta-size rollfilm. Dan Anastigmat f3.5/40mm, Silver-B shutter B.25-100. \$200-300.

Dan 35 IV - Photavit copy. Rare. \$250-375.

Super Dan 35 - A predecessor of the Pax cameras, with exterior styling similar to Leica. Eria Anastigmat f3.5/45mm. Silver-C leaf shutter. \$500-750.

DANCER (J.B. Dancer, Manchester, England)

Stereo Camera - c1856. For stereo pairs on 12 plates 31/₂x7". A nicely finished wooden stereo camera which set a new record for the highest price paid for an antique camera, \$37,500.00 in 1977. This record has since been broken.

Tailboard view camera - Mahogany 1/2-plate camera. Ross Rapid Symmetrical lens with wheel stops. Gravity shutter. \$250-375.

DANGELMAIER: see Dacora

DARIER (Albert Darier, Geneva, Switzerland)

Escopette - c1888. Invented by Darier, manufactured by E.V. Boissonas (Geneva). Wooden box camera with wooden pistol grip, giving it the general appearance of a pistol. The grip and two small brass front legs serve as a tripod. Brass metal parts. This was one of the first cameras to use the same rollfilm as the #1 Kodak Camera, taking 110 exposures, 68x72mm. Steinheil Periscopic f6/90mm lens. Spherical shutter with trigger release. Speeds variable by adjusting spring tension. Rare. Estimated: \$8000+.

DARLOT (Paris)

Rapide - c1887. Rigid wooden camera in shape of truncated pyramid. The unusual feature is the external magazine which

holds 12 plates, 8x9cm, and which attaches below the camera. Plates slide into the inverted camera by gravity from a slit at the end of one side of the magazine. After exposure, the magazine is inverted and reattached to the camera so the exposed plate is returned to the other side of the magazine. \$5500-7500.

DATA CORPORATION (Rockville, Maryland USA)

Aquascan Camera KG-20A - Underwater slit-scan panoramic camera for 35mm film on 100' spools. 50° x 120° field of view. Leitz Elcan lens. Pistol grip with trigger-operated magnetic release. Motorized film advance. The ultimate special-purpose camera and a great weekend toy if you outgrow your Calypso and Nikonos. \$2400-3200.

DAVE - Simple box camera for 6x9cm on 120 film. Meniscus f11/105mm lens. \$8-15.

DAVY CROCKETT - Not the Herbert-George box camera, but a black plastic minicam style for half-frame 127. Uncommon. \$45-60.

DAYDARK SPECIALTY CO. (St. Louis, MO)

Photo Postcard Cameras - "Street" cameras for photo postcards or tintypes, complete with developing tank, dark sleeve, RR lens, and Blitzen Daydark shutter. \$150-225.

Tintype Camera - small amateur model. Measures 41/₂x5x71/₄. \$90-130.

DBGM, DBP, DBPa: DBGM stands for "Deutsches Bundes-Gebrauchsmuster" (Registered design in the Federal Republic of Germany). DBP stands for "Deutsches Bundespatent" (German Federal Patent). DBPa stands for "Deutsches Bundespatent angemeldet" (German Federal Patent pending). Since the Federal Republic of Germany was founded in 1948, these markings indicate West German construction after 1948.

DEARDORFF (L.F.) & SONS (Chicago.

IL) Established as camera builders in 1923, the company name goes back to 1893 when Laben F. Deardorff started a camera repair company. In 1923 Laben was commissioned by a group of Chicago architects to build 10 cameras to photograph that new Chicago wonder, the skyscraper. Amazingly enough, five of the first 10 cameras built still exist, four of them in daily studio use! In 1989, the company name and logo (a camera in a circle) were sold to a Japanese-owned firm located in Tennessee. Production of an 8x10 field camera resumed in 1991.

Deardorff cameras are primarily "user" cameras though there are a few who collect them avidly. There were no serial numbers until 1951, so earlier models must be identified by features. The condition of the older cameras can vary greatly because those sold to studios generally have seen very hard use, while those sold to individual users may have been "babied" and may remain in mint condition even though they are 20-40 years old. L.F. Deardorff is a manufacturing concern that has made MANY one-of-a-kind cameras and accessories through the years. All were well made, but in checking used equipment make sure that all parts are present or it may be useless. On cameras, make sure all racks, gears, wood panels, and especially bellows are in good working order. The bellows are one of the most expensive parts to replace. Be wary of a camera with taped bellows. Tape causes great stress on the camera when closed and this in turn can cause damage to the wood parts.

The "refinished" price reflects a camera that has been PROFESSIONALLY restored by Ken Hough Photographic Repair Service, who has a complete inventory of original parts, wood and metal, to repair any age camera. Fully restored cameras include new bellows, wood work and parts where needed, and a duplicate of the factory finish. All prices were compiled by Ken Hough, of Valparaiso, Indiana. Ken remains dedicated to keeping the pre-1989 cameras working. Phone 219-464-7526 for information about his repair/restoration services. We are also indebted to Merle Deardorff for the history of

the Baby Deardorff.

8x10" Cameras The early (pre-1926) cameras are of a light colored, finished mahogany. This wood was taken from the bar tops of Chicago taverns that were closed down during prohibition. Beginning in 1926, the wood was a deep red color.

the wood was a deep red color.

First series - 1923. Ten cameras.

Parquet style bed. Lensboard opening measures 51/2x6". Only the first series had this size lensboard. No recent reported sales.

Second series - 1924. 25 cameras. Parquet style bed. Standardized 6x6" wooden lensboard. Aluminum front standard. Current value: Refinished: \$1500-2000. Good condition: \$400.

Third series - 1924. 25 cameras. Same as the Second series, but all aluminum front standard. Refinished: \$1500-2000. Good: \$400.

Fourth series - 1925. 75 cameras. Same as the Third Series, above.

Standardized V8 8x10"

1926-37. Wood is deep red in color. Standardized construction with familiar four piece bed, narrow knobs with fine knurling,

DEARDORFF

1936 8x10 with front swing conversion

all brass parts painted with a special gold lacquer. Lensboards are 6x6" with square corners and 1/8" lip. Refinished with front swings added: up to \$2600. Refinished as original: \$1800-2000. EX: \$900. Good: \$350-500.

1938-48. Same as above but brass parts are nickel plated and knobs are wider. Refinished with front swings: up to \$2600. Refinished: \$1200-1400. EX: \$950. Good: \$350-500.

1949-89. Serial #100-6503). Front swings are standard as is the round bed plate. Early cameras may not have the bed plate. Nickel plated parts. It is now called the "8x10 View". Refinished with front swing: up to \$3200. EXC: to \$2500. Good: \$900. Serial numbers began in 1951 with #100; it was then called the 8x10 View.

AN Series - A large group of 8x10" cameras made for the Army and Navy. There are two differences in these cameras from the standard models. 1. A small rectangular plate on the bottom of the bed that gives a government Number and model number. 2. A 1/8" thick rabbet on the front sliding panel. This requires 6x6" Kodak-style lensboards. Prices fall into the same ranges as other 8x10" Deardorff cameras.

5x7" Old Style (OS) V5

1937 5x7 Old Style

1929-37. Basically the same construction as the 8×10 " cameras of this time. Red finish on wood. Original square cornered $41/2\times41/2$ " lensboard, or factory modified

DEARDORFF...

4x4" lensboard. Refinished: up to \$1200. VG: \$750. Fair: \$350.

1938-48. Same construction as the 8x10" cameras of this time. Original round or square cornered 41/2x41/2" lensboard, or factory modified 4x4" lensboard. Refinished: \$1200. EX: \$900. VG: \$500. Good: \$200. Fair: \$100. Note: This camera may also be seen in a "yellow" colored wood. These were made of Spanish cedar wood because of the wartime shortage of mahogany that was being used in PT boats. Prices may be slightly lower.

1949-89. Serial #100-2231. Redesigned camera body. Front swings, round bed plate, and nickel plated parts are standard. Square cornered 4x4" lensboard. Serial numbers began in 1951 with #100; it was then called the 5x7 View. EXC + or Refinished: \$2300. EX: \$1800. VG: \$1000. Good: \$500. Many 5x7 cameras are seen with 4x5 back only.

4x5" Old Style (OS) V5 with 4x5 back

1929-37. Same as the 5x7" camera, but with a 4x5" reducing back.

1938-48. Same as the 5x7" camera, but with a 4x5" reducing back.

1949-89. 4x5 SPECIAL. Serial #100-2695. Redesigned camera body. Front swings, round bed plate, and nickel plated parts are standard. Square cornered 4x4" lensboard only. Prices same as equivalent 5x7 models.

1936 Baby Deardorff Prototype

Baby Deardorff V4 - Designed by Merle Deardorff, this camera looks like a miniature 4x5" or 5x7" camera. It takes up to a 4x5" back. 31/2x31/2" lensboard only.

First style - 1936 only. Wood separator strips on bed between front and rear extension. Twelve prototype cameras were made to test the market. These were recalled for evaluation by Merle Deardorff after about one year. Only eight were returned and these were destroyed when their beds were found inferior. The remaining four examples are all known to exist, one in everyday use. One sold in 1988 in EXC condition for \$1900.

Second style - 1940-45. Extruded extension guides, L-shaped guides on front sliding panel. Refinished: \$1400-1600. EX: \$1200. VG: \$450. Good: \$400.

Third style - 1945-49. Same as the Second style, but with U-shaped guides on front sliding panel. Refinished: \$1200-1450. EX: \$1100. VG: \$500. Good: \$450.

Backs available for the Baby Deardorff:

Standard 4x5" still manufactured. 31/₄x41/₄" Graflex style: \$60-80. 21/₄x31/₄" standard CFH type: \$80-100. 35mm back. This was a Kodak 35 body that was mounted on a sliding panel with a ground glass focusing screen, similar to a Leica Focoslide, but vertical in normal operation. Only reported sale: \$120.

Triamapro - An ultra precise 4x5" Press Style camera, featuring a rotating back, front and rear swings, front rise, and lateral sliding front. May be seen with Hugo Meyer or Kalart rangefinder. Backs seen are standard cutfilm back, either Graflex or Grafloc style. The word Triamapro means TRIple extension, AMAteur, and PROfessional. Usually seen in good to VG condition. EX: \$1000-1200. G-VG: \$400-600. Note: there were also two 5x7" Triamapro cameras built. No reported sales.

11x14" Cameras:

Early style - Looks like a giant 8x10" view camera. Has no front swings. Many were built for the US Marines for "on the beach" photo reconnaissance. Came with tripods whose legs could be used as bayonets! Refinished: \$2500-3000. EX: \$2100. VG+: \$1200.

Second style - Serial #100-500. Similar to the Early style, but with front swings. Made in small numbers since 1951. New in 1989 for \$6500. Mint: \$6500. Refinished: up to \$5000. EX+: \$3500-5500.

Folding Field Cameras: 10x12" - Slightly bigger than an 8x10. Thirty-five were built in 1936. No recorded

8x20" - 1949-87. Uses bed and front from VII. New in 1987 \$7200. Used, EXC+: \$5500. EXC-: \$4500.

12x20" - Construction same as 8x20. Not seen often. Prices same as 8x20".

16x20" - 1940's. Only two were built. No sales records. If you have seen one, we would be pleased to hear of it.

Commercial Cameras - 8x10" or 11x14" cameras that must be used on 700 lb. Bi-post stands, 8', 10', or 12'. Also known as the "Dog house type". It is almost always found in large studios.

8x10" - Until recently, these were seldom found for sale. However, at a large studio auction early in 1989, many were sold in VG condition, with bipost stand for \$3501000. Refinished: \$2100. EXC: \$1000. 11x14" - Refinished: \$2600. EX: \$2000. VG: \$1600. Good: \$1000. Fair: \$400. Bi-post stands - \$400-1600.

5x7" Home Portrait - 1940-89. Tailboard style camera with split 5x7 back. Horizontally sliding lensboard for two exposures 31/2x5" on one sheet of film. New in 1985 (built from old stocked parts): \$200-300. EX: \$75-100. Good: \$50-75.

DEBONAIR - Hong Kong 120 rollfilm novelty camera of the Diana type. \$1-10.

DEBRIE (Ets. Andre Debrie, Paris) Sept - c1923-27. Spring motor drive camera for still, rapid sequence, or cine. 18x24mm on 5m cartridge of 35mm film. Roussel Stylor f3.5/50mm. First model has square motor housing with single spring. A double-spring model with round housing was later added. (Burke & James Inc. of Chicago was selling both models as late as 1940!) Not hard to find. \$175-250.

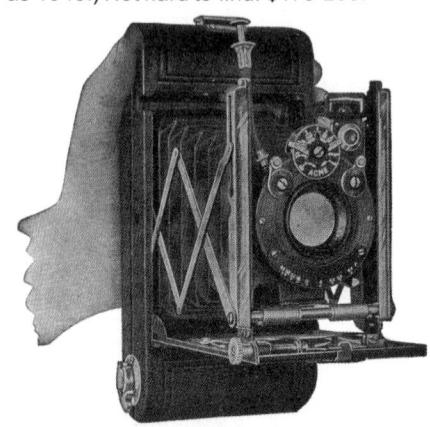

DEFIANCE MFG. CO. Auto Fixt Focus - c1916-20. Wellmade folding camera with bed and lazytong strut construction. Focusing can be done with the camera in the open or closed position. Self-erecting front assumes correct focus when opened. Goerz f4.8 or f6.8 lens in Acme shutter. Uncommon. \$50-75.

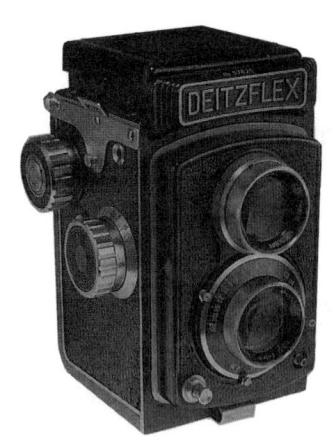

DEITZFLEX - c1950's. Japanese TLR. Rack focusing, knob advance, frame finder, magnifier. Tri-Lausar f3.5/80mm in CHY-FB shutter. Uncommon. One recorded sale 3/90 at \$175.

DEJUR-AMSCO CORP. (New York)

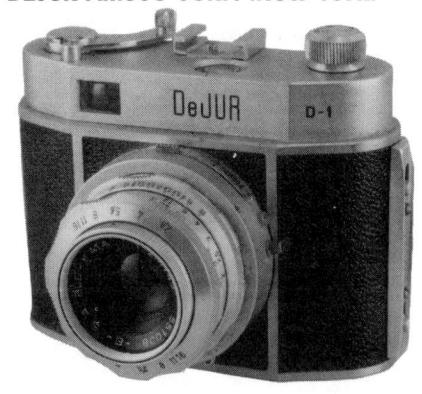

DeJur D-1 - c1955-57. 35mm VF camera with interchangeablelenses, imported from Germany. Similar to Neidig Perlux I, but without rangefinder. Lever film advance cocks shutter. DEP. Staeble-Kata f2.8/45mm normal, f5.6 tele, or f3.5 W.A. lenses. (Orig. price for the 3-lens outfit was under \$100.) With normal lens: \$30-45. Tele & W.A. lenses each: \$15-25.

DeJur D-3 - Similar in appearance to the D-1, but with the addition of a separate eyepiece coupled rangefinder in the top housing. Same as Neidig Perlux II. Prontor-S 1-300 shutter. Staeble-Kata 45mm f2.8, 38mm f3.5, and 85mm f5.6 lenses were available. Original price was \$60 with normal lens. Currently \$35-50. Add \$15-25 each for tele and W.A. lenses.

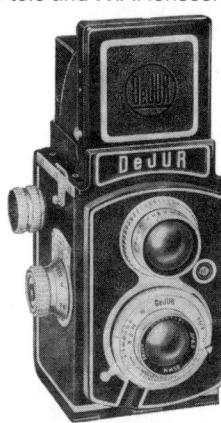

Dejur Reflex Model DR-10 - c1952. 6x6cm TLR. DeJur Chromtar f3.5. Wollensak Synchromatic 10-200 shutter. \$50-75.

Dejur Reflex Model DR-20 - c1952. Same as DR-10, but Rapax $1-1/_{400}$ sec. shutter. \$60-90.

Dekon SR - c1960. 35mm SLR made by Tokyo Kogaku. Simlar f2.8/50mm lens, Seikosha SLV 1-500 shutter. \$100-150.

DELTAH CORPORATION Deltah Unifocus - Unusual folding vest-pocket camera for 127 film. All black model, or brown enameled with brown leatherette and black bellows. \$25-35.

DELUXE PRODUCTS CO. (Chicago) Delco 828 - Streamlined bakelite camera for 828 film. Identical to the Argus Minca 28, this camera merely sports the name of its distributor. \$25-35.

Remington - Plastic "minicam" for 3x4cm on 127. \$8-15.

DELUXE READING CORP. (Topper Toy Div.) DELUXE TOY CO. LTD. (London)

Secret Sam Attache Case - c1960's. Plastic attache case containing a takeapart pistol and a 127 film camera which can be used with the case closed. Supersleuths could try to locate both the USA and UK models distinguished by the markings inside the case and on the left handgrip of the pistol. \$100-150.

Secret Sam's Spy Dictionary c1966. Novelty which incorporates a camera in a plastic "book" which also

DEMARIA

shoots plastic bullets. The camera takes 16 exp. on 127 film. \$150-225.

DEMARIA (Demaria Freres, Demaria-LaPierre, Paris)

Caleb - c1920's. Folding 9x12cm plate camera. Rectilinaire Hector Extra-Rapide lens. Rack focus. \$50-75.

Dehel - Folding 120 rollfilm cameras. f4.5 or f3.5/75mm lens. AGC shutter. \$30-45.

Field camera - c1900. 24x30cm. Fine wood body, brass trim, red square double extension bellows. Aluminum and brass Rietzschel Extra Rapid Aplanat f8/480mm lens in Thornton-Pickard shutter. \$300-450.

Jumelle Capsa (Demaria Freres) - Stereo camera in 4.5x10.7cm or 6x13cm. All metal body. Guillotine. \$250-375.

Plate Camera - Strut-type folding camera for 6x9cm plates in single metal holders. Black enamel finish. Demaria Anast. Sigmar f6.3 in Vario 25, 50, 100, T, B. Basic construction is similar to Zion Pocket Z. Unusual and complicated focusing system with radial lever operated cam

DEMARIA.

sliding a large plate whose two diagonal slots engage pins at either side of the shutter housing, \$50-75.

Telka II - Self-erecting camera for 4.5x6cm on 120 film. Anastigmat Manar f3.5 or f4.5 in B-300 Prontor S. Four small windows on the shutter face indicate proper f-stops for various lighting conditions depending on shutter speeds. \$75-

Telka III - c1948-. Self-erecting 6x9cm rollfilm camera. The first of the Telka series, easily identified not only by the name on the shutter face but also by its coupled rangefinder. Sagittar f3.5 in Prontor II (simply marked AGC). Later variations include IIIA with Prontor SV and IIIB with Prontor SVS shutter. \$100-150.

Telka X - c1950's. Simple folding camera with meniscus lens in P&I shutter. \$20-30.

Telka XX - c1950's-'60's. Good quality folding rollfilm camera with body release. Takes 6x9cm on 120. Manar Anastigmat f4.5/110 in Gitzo shutter to $^{1}/_{175}$ or $^{1}/_{200}$. Variations include folding finder or top housing with integral finder. \$35-50.

DEMILLY (France)

Midelly - Cast aluminum box cameras for 6x9cm on 620 film. Hinged masks at film plane convert it to take 4.5x6cm negatives. Simple model has simple 3-speed shutter built into the front, and meniscus lens. Deluxe model has Boyer Topaz f4.5 lens in Gitzo 25-200 shutter. Deluxe model, very rare: \$120-180. Simple model: \$30-45.

DEROGY (Paris) Field camera - c1900. Wood body, brass trim, double extension brown leather bellows, 13x18cm, Brass Derogy Aplanat f8 lens. \$300-450.

Single lens stereo camera - Light walnut view camera with sliding front panel and slotted back for single or stereo exposures. Entire bellows rotates to change from horizontal to vertical exposures. Brass trim and brass barrel Derogy lens. \$500-750.

Wooden plate camera - c1880. 9x12cm. Derogy Aplanat No. 2 brass barrel lens. Black tapered bellows, polished wood body, brass trim. \$250-375.

DESTECH INC. (Toronto, Canada) Clickit Sports - c1988. Among the hundreds of novelty "Micro-110" types which snap onto a film cartridge, this one stands out by virtue of its sliding lens cover and especially its detachable wrist-strap. New price was about \$10.

DETECTIVE CAMERAS: The earliest "Detective" cameras were simply designed as a box or case. Before long, they were disguised in all shapes and sizes. The original box, case, and satchel cameras are commonly referred to by the name "detective" cameras, while the later disguised/concealed varieties normally are not. Disguised cameras seem to have a special appeal and therefore the prices have remained strong despite the ups and downs of our economy. The magic of the mere name "detective" for an otherwise ordinary-looking box camera has worn thin in the current market and those prices have softened. In any case, they are listed by name of manufacturer.

Dette Spezial-Camera

DETROLA CORP. (Detroit, Mich. c1939-1940) All letter models listed below are similar "minicam" type cameras for 3x4cm on 127 film. Except for Detrola A, all have rectangular aluminum plate in center of front. The "W" in models GW, HW, and KW indicates the Wollensak lens. The plastic used for some of the viewfinders is unstable and shrinks as though melted.

Detrola A - Basic minicam. Meniscus fixed focus. \$20-30.

Detrola B - Duomicroflex f7.9 lens. Extinction meter. \$20-30

Detrola D - similar, f4.5 lens, \$20-30. Detrola E - similar, f3.5 lens. \$20-30.

Detrola G - Ilex or Detrola Anastigmat f4.5. No meter. Viewfinder is made of an unstable plastic which is often shrunken and appears to have been melted. \$15-25. Detrola GW - Basic model with Wollen-

sak Velostigmat f4.5. \$20-30. **Detrola H -** extinction meter. \$20-30.

Detrola HW - similar to GW, but with meter. \$25-35. Detrola K - Detrola Anastigmat f3.5,

extinction meter. \$15-25. Detrola KW - Wollensak f3.5. \$15-25.

Detrola 400 - A Leica-inspired CRF

35mm camera with interchangeable Wollensak Velostigmat f3.5 lens. Focal plane shutter to 1500. Sync. (Original cost about \$70.) \$400-600.

DETTE SPEZIAL-CAMERA - c1930's. Basic folding camera for 9x12cm plates. Leatherette covered wooden body, metal bed. Special Aplanat lens in Vario shutter. \$25-35. Illustrated at top of previous page.

DEVAUX (A. Devaux, Paris)
le Prismac - c1905. Designed by Deloye; built by Devaux. Early rollfilm stereo camera. Two 90° prisms reflect the image at right angles from the lenses onto the film, allowing for a more compact body than usual. Used Pocket Kodak Camera size #102 rollfilm. Kenngott Anastigmat f8/54mm lenses, 5-speed guillotine shutter. Rare. Estimate: \$2400-3200.

DEVIN COLORGRAPH CO. (New York) (After 1940, Devin-McGraw Colorgraph Co., Burbank California. All rights sold c1950 to

Bob Frazer of Altadena, CA.)
Tri-Color Camera, 5x7" - c1939. For making color separation negatives. Original professional size for 5x7". Apo-Tessar f9/12". Dial Compur shutter. \$500-750.

6.5x9cm size - intro. c1938. Goerz Dogmar f4.5/5¹/₂" lens. Compound shutter. \$600-900.

DEVRY: see ORS DeVry Corp.

DEVUS - c1950's on. USSR, 6x6cm TLR. Lomo f4.5/75mm, 1/15-250. Copy of the Voigtländer Brillant, similar to the Lubitel. \$45-60.

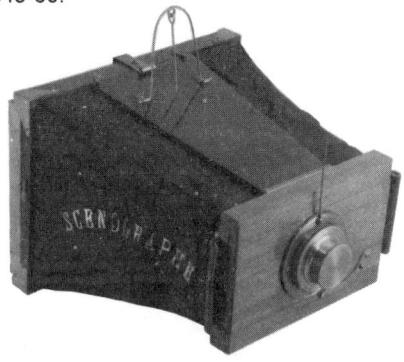

DEYROLLE (France) Scenographe (Original model) c1876. A very early collapsible bellows camera. Wooden body with green silk bellows; later model with black cloth bellows. Gate-type wooden struts support wooden front with sliding lensboard. Takes single or stereo exposures on 10x15cm plates. Very unusual. \$4500-6500. Beware; very good reproductions exist, and the once rare Scenographe cameras are appearing with increasing regularity.

DIAMANT - c1903. French folding bed camera for 9x12cm plates. Leather covered body. 5-speed guillotine shutter is leather-covered lensboard. Mensicus lens. \$120-180.

DIAMOND JR. - c1898. Top loading box camera for 31/4x41/4" plates. \$60-90.

DIANA TYPES - Camera manufacturing and "badge engineering" have gotten a bit carried away at times. One camera which is in strong competition for the title of "Same Camera with the Most Names" is the Diana type, an inexpensive eye-level camera for 120 film. Most take only a 4x4cm image although

some of the "Deluxe" models use more of the available film with a 5.5x5.5cm image. Generally with focusing lens; single speed shutter and sometimes B. Some have body release. Some are synchronized and they even exist with built-in flash. These cameras have continued to be popular among some photographers who enjoy the distorted effects of the cheap lenses. Others use them for training

classes in photography.

Name Variations - Anny, Arrow, Arrow Flash, Asiana, Banier, Banner, Colorflash Deluxe, Debonair, Diana, Diana Deluxe, Diana F, Dionne F2, Dories, Flocon RF, Hi-Flash, Justen, Lina, Lina S, Mark L, MegoMatic, Merit, Mirage, Panax, Photon 120, Pioneer, Raleigh, Reliance, Rosko, Rover, See, Shakeys, Stellar, Stellar Flash, Tina, Traceflex, Tru-View, Valiant, Windsor, Zip, Zodiac.

There are surely other names that we have not included on this list, so we would appreciate any additions that readers can supply. Please send name of camera and include a photograph of it if possible to: Jim McKeown; Centennial Photo; 11595 State Road 70; Grantsburg, WI 54840 USA.

DIANA - Novelty camera for 4x4cm on 120 film. The same camera exists under many other names with only minor variations in style. (Diana-F is synchronized for flash.) \$1-10.

DIANA DELUXE CAMERA - Novelty camera for 120 film. Body release, helical zone focus, hot shoe, imitation meter cell. \$1-10

DIONNE F2 - Hong Kong "Diana" type novelty camera. \$1-10.

DIPLOMAT - "Hit" type novelty camera. \$20-30

DORIES - "Diana" type novelty camera. \$1-10.

DORYU CAMERA CO. LTD.

Doryu 2-16 - c1955. Unusually designed subminiature camera disguised as a pistol. Flash cartridges are shaped like bullets. For 10x10mm on 16mm film. Until 1991,

DREXLER

known sales had been \$4000-7500. 12/91, one sold at Christie's auction for a shocking \$20,000. In 7/93, they sold one for \$22,500 and in 11/93, another for about \$15,000.

DOSSERT DETECTIVE CAMERA CO. (NYC)

Detective Camera - c1890. 4x5" boxplate detective camera. Leather covered to look like a satchel. Sliding panel hides lens. Ground glass covered by diamondshaped panel. Entire top hinges forward to reveal the plate holders for loading or storage. \$800-1200.

DOVER FILM CORP.

Dover 620 A - c1950. A plastic & chrome camera for 16 exp. 4.5x6cm on 620 film. Body design based on the failed "Speed-O-Matic" camera. Somco meniscus lens. 5 rotary disc stops. Single speed shutter. Built-on flash. \$12-20.

DREXEL CAMERA CO. (Le Center, Minnesota) While we have not yet researched this company, we suspect that its only camera was produced in Chicago, using the same dies as the cameras from the "Camera Man" company.

Drexel Jr. Miniature - Black plastic minicam for 127 film. Body style identical to the "Champion" and "President" by Camera Man Inc. of Chicago. \$20-30.

DREXLER & NAGEL (Stuttgart) Carl Drexler and August Nagel formed this firm in 1908. It was renamed Contessa Camerawerke in 1909, so it existed under this name

for a very short period of time. **Contessa** - 1908. Folding plate camera 4.5x6cm. Staeble Isoplast f6.8/3" lens.

\$800-1200.

DRGM

DRGM, DRP: "Deutsches Reichs-Gebrauchsmuster", "Deutsches Reichspatent", design registration and patent notices indicating German construction before WWII. However, some products designed and patented before the war continued to use these notices in the postwar period. Leica cameras were marked "DRP" until at least 1954.

DRUCKER (Albert Drucker & Co., Chicago)

Ranger - c1939. A stark-looking focal plane camera for 16 exposures on 127 film. Six speeds, 25-200 plus B. Polaris Anastigmat f2.0 or f2.8/50mm lens in collapsible mount with Leica thread. Sold originally by Burke & James for \$30 with f2 lens, on a par with the lower-priced 35mm, rollfilm, and plate cameras of the day. Working and with original lens: \$200-300. Normally without lens and with inoperative shutter, these are offered for \$150-225.

DRUOPTA (Prague, Czechoslovakia)

Corina - Simple bakelite eye-level camera for 120 film. Helical telescoping front, 3 click-stops for zone focus. \$20-30.

Druex - c1960's? 6x6cm bakelite box camera. Druoptar f6.3/75mm in Druo B,25-100 shutter. Folding optical finder. \$35-50.

Druoflex I - c1950's. 6x6cm bakelite TLR. Druoptar f6.3/75mm, Chrontax ¹/₁₀-200. Copy of Voigtländer Brillant. \$45-60.

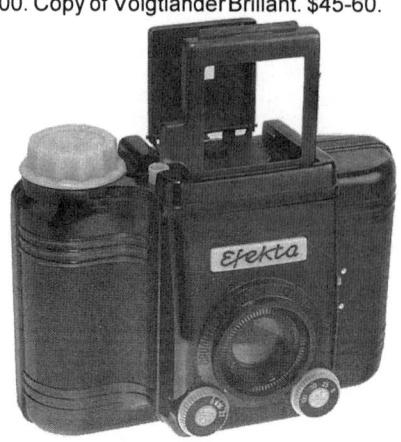

Efekta - c1950's?. 6x6cm bakelite eyelevel box camera. Fix-focus f8 Druoptar. B,25-100.\$25-35.

Stereo camera, 45x107mm - c1910. RR lenses. \$250-375.

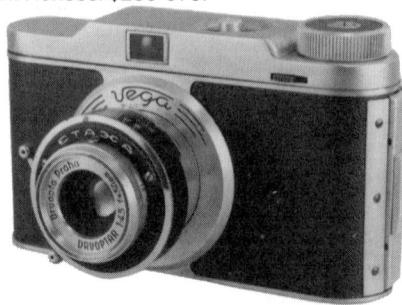

Vega II - c1949-51. Basic 35mm camera without rangefinder. Non-interchangeable Druoptar f4.5/50mm in Etaxa 10-200,B,T Collapsible front. \$50-75.

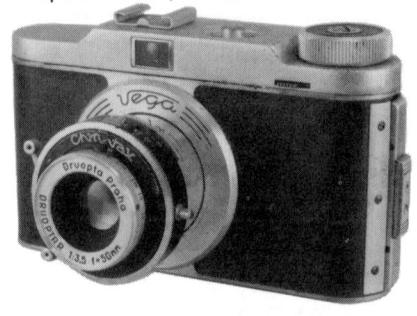

Vega III - c1957. Like Vega II, but Druoptar f3.5 lens in synchronized Chrontax shutter. Accessory shoe on top. \$50-75.

DUBRONI (Maison Dubroni, Paris) The name Dubroni is an anagram formed with the letters of the name of the inventor, Jules Bourdin. It seems that young Jules, who was about twenty-two years old when he invented his camera, was strongly influenced by his father. The father, protective of the good reputation of his name, didn't want it mixed up with this new-fangled invention. Dubroni camera - c1860's-1870's. Wooden box camera with porcelain interior (earliest models had amber glass bottle interiors and no wooden sides on the body) for in-camera processing. Various models were made, each of which originally came in a wooden box with accessories. At first, only the small box models were made, but their success led to the larger models with a folding bellows front and a

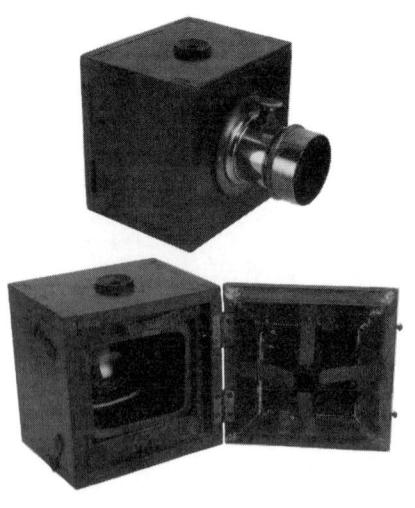

"laboratory"back.

- No. 1 - Box style, for round images 4cm diameter.

No. 2 - Box style, for rectangular images, 5.5cm long.

No. 3 - Box style, 7cm long oval images.
 No. 3 Carré - Box style; rectangular images, 10cm long.

 No. 4 - Bellows camera with detachable laboratory back. Takes rectangular photos, 10cm long.

- No. 5 - Bellows camera with detachable laboratory back. Rectangular photos 15cm long.

 No. 6 - Bellows camera with detachable laboratory back. Rectangular photos 18x24cm.

The most common model is the No.2. A complete outfit with case, pipettes, bottles, tripod, and instructions, sells for \$4500-6500. The "exposed bottle" model has sold at auction for \$4600. Sales for the wooden-sided No. 2 camera alone have been as low as \$1500-2000. Typically \$3500-5500.

Wet plate tailboard camera, 9x12cm - c1870. Wood body with brass trim. Rectangular brown bellows. Dubroni brass lens with rack focusing and waterhouse stops. \$800-1200.

DUCATI (Societa Scientifica Radio Brevetti Ducati, Milan, Italy) This company still exists, making high-class motorbikes.

Ducati - c1950. Several sources erroneous-

EASTERN

ly date this to 1938, but we find no evidence that the company existed before WWII. For 15 exp. 18x24mm on 35mm film in special cassettes. FP shutter to 500. **Simplex** model has non-changeable Etar f3.5/35mm lens; no rangefinder. **Sogno** models have rangefinder and interchangeable lenses, normally f3.5 or 2.8 Vitor. Little if any price distinction between Simplex and Sogno models. \$400-600.

Ducati Sogno "Per Collaboratore" - c1950. Limited production of a few hundred cameras for employees, marked "non cedibile" and "per collaboratore". Same price as standard models.

DUERDEN, T. (Leeds, England) Field camera - Brass-bound mahogany field camera, $61/_2x81/_2$ ". Aldis Anastigmat brass-bound f7.7/11" lens. \$250-375.

DUFA (Czechoslovakia)

Fit, Fit II - Black bakelite cameras with helical telescoping front. Styling similar to the Photax cameras from France. Take 6x6 or 4.5x6cm on 120 film. \$25-35.

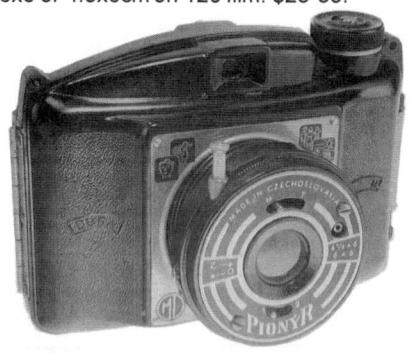

Pionyr - Black or red-brown bakelite eyelevel camera, 6x6 or 4.5x6cm on 120 film. Helical telescoping front. Later versions have click-stops for zone focusing. Design is basically that of the Fit II. Even the more recent synchronized models sold by Druopta retain the "DUFA" and "F--II" markings. Meniscus, T&M shutter. \$35-50.

Durst Automatica

DUO FLASH - Inexpensive American plastic pseudo-TLR, \$1-10.

DURST S.A. Most photographers know Durst for their enlargers. However, at one time they made some solid, well-constructed, innovative cameras

innovative cameras. **Automatica** - 1956-63. For 36 exp. 24x36mm on standard 35mm cartridge film. Schneider Durst Radionar f2.8/45mm. Prontor 1-300, B, and Auto. (Meter coupled to shutter by pneumatic cylinder.) \$120-180. Illustrated bottom of previous column.

Duca - 1946-50. Vertically styled 35mm camera for 12 exp. 24x36mm on Agfa Karat Rapid cassettes. Ducan f11/50mm. T & I shutter. Zone focus. Rapid wind. Aluminum body. Made in black, brown, blue, red, & white with matching colored pouch. \$90-130.

Durst 66 - 1950-54. Eye-level camera for 12 exp. 6x6cm on 120 film. Light grey hammertone painted aluminum body with partial leather covering in black, brown, red, blue, or white. Durst Color Duplor 62.2/80mm lens. Shutter 1/2-200, B, sync. Built-in extinction meter. Colors: \$50-75. Black covering: \$25-35.

Durst Gil with Swedish markings

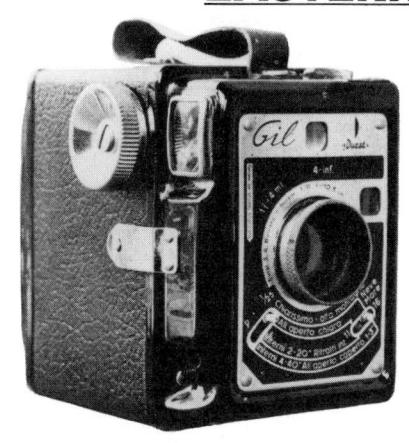

Gil - c1938-42. Box camera for 6x9cm on rollfilm. Black metal body with imitation leather covering. Functions labeled in language of country of destination, either German, Italian, Swedish or English. Approximately 50,000 made. This was the first camera made by Durst Uncommon. \$60-90. English version illustrated above; Swedish version illustrated at bottom of previous column.

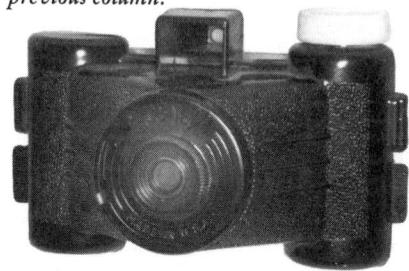

EARL PRODUCTS CO.

Scenex - c1940. Small plastic novelty camera for 3x4cm exposures. Similar to the Cub. \$12-20.

EARTH K.K. (Japan)

Guzzi - c1938. Cast metal subminiature with eye-level frame finder. Fixed-focus lens; B,I shutter. \$300-450.

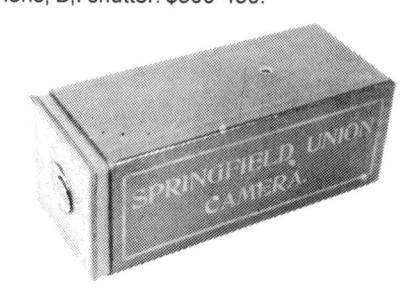

EASTERN SPECIALTY MFG. CO. (Boston, MA)

Springfield Union Camera - c1899. Premium box camera taking 31/2" square plates. Four plates could be mounted on the sides of a cube. Each plate was exposed, in turn, by rotating the cube inside the camera. An unusual internal design from a technical standpoint, and visually appealing with the boldly lettered exterior. \$500-750.

EASTMAN KODAK

EASTMAN DRY PLATE & FILM CO. EASTMAN KODAK CO.

After designing the Eastman-Cossitt detective camera which was not marketed, the first camera produced by the Eastman Dry Plate & Film Co. was called "The Kodak", and successive models were numbered in sequence. These numbers each introduced a specific new image size and continued to represent that size on many cameras made by Kodak and other manufacturers. The first seven cameras listed here are the earliest Kodak cameras, and the remainder of the listings under Eastman Kodak Co. are in alphabetical order by series name and number. Some of the Eastman models listed are continuations of lines of cameras from other companies which were taken over by Eastman. Earlier models of many of these cameras may be found under the name of the original manufacturer.

For more detailed information on Kodak cameras including production dates, original prices, identification features, and photographs of each model, see "Collectors Guide to Kodak Cameras" by Jim and Joan McKeown available at bookstores, camera stores, or by mail for \$18.95 postpaid from Centennial Photo, 11595 State Rd 70, Grantsburg, WI 54840, USA.

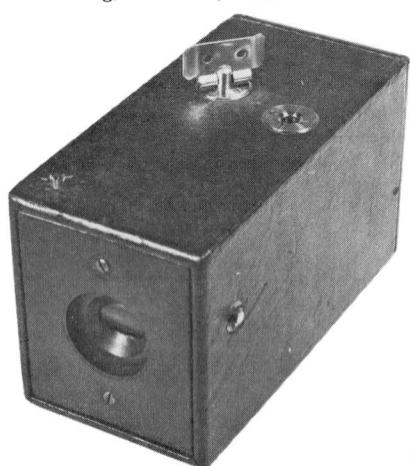

Kodak Camera (original **model)** - ca. June 1888 through 1889. Made by Frank Brownell for the Eastman Dry Plate & Film Co. Factory loaded with 100 exposures $2^{1}/_{2}$ " diameter. Cylindrical shutter, string set. Rapid Rectilinear lens f9/57mm. This was the first camera to use rollfilm, and is a highly prized collectors' item. Having slumped in price for several years, these have regained ground and now sell for \$2500-3500 in the USA and at European auctions.

The Kodak Camera (replica) - c1988. Made by Kodak Ltd., England to com-memorate the 100th anniversary of the original Kodak camera. A non-working model suitable for display. With original packaging, these are selling on the collector market for \$300-450.

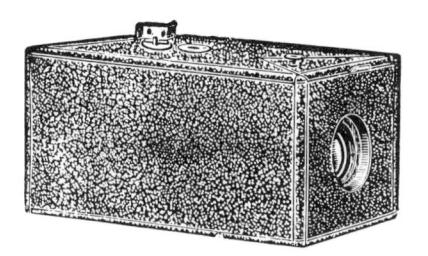

No. 1 Kodak Camera - 1889-95. Similar to original model, but with sector shutter. Factory loaded for 100 exp. 21/2" dia. RR lens f9/57mm. \$800-1200.

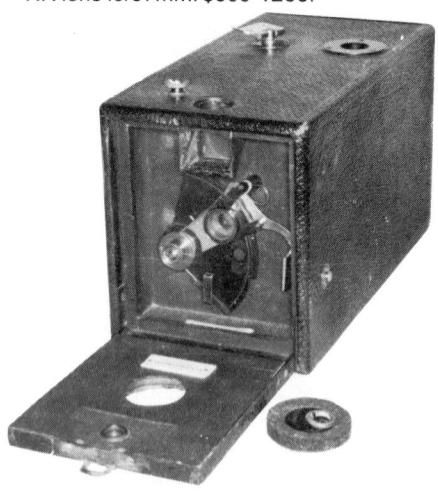

No. 2 Kodak Camera - Oct. 1889-97. Also similar and still quite rare, but more common than the previous models. Factory loaded for 60 exp. 31/2" dia. One fine example reached a healthy \$945 at a German auction (10/90). Normal range: \$500-750.

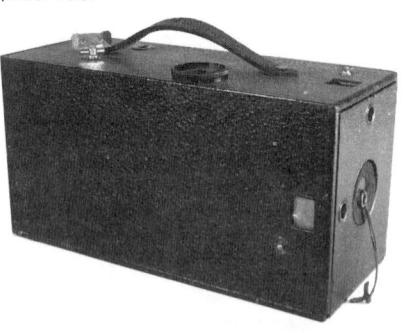

No. 3 Kodak Camera - Jan. 1890-97. A string-set box camera, factory loaded for either 60 or 100 exp. 31/4x41/4". Bausch & Lomb Universal lens, sector shutter. One fine example with rare original carton sold for nearly \$800 in England. Normally: \$400-600

No. 3 Kodak Jr. Camera - Jan. 1890-

1897. A relatively scarce member of the early Kodak family. Factory loaded with 60 exposures 31/4x41/4" on rollfilm. Could also be used with accessory plate back. B&L Universal lens and sector shutter. Overall size: 41/4x51/2x9". \$400-600.

No. 4 Kodak Camera - Jan. 1890-97. String-set box camera, factory loaded for 48 exposures 4x5", but with capacity for 100 exposures for prolific photographers. B&L Universal lens and sector shutter. \$350-500.

No. 4 Kodak Jr. Camera - Jan 1890-97. Similar to the No. 3 Kodak Jr. Camera, but for 4x5". Factory loaded for 48 exposures on rollfilm. B&L Universal lens, sector shutter. Can also be fitted for glass plates, \$400-600.

ANNIVERSARY KODAK CAMERA - A special edition of the No. 2 Hawk-Eye Camera Model C, issued to commemorate the 50th anniversary of Eastman Kodak Co. Approximately 550,000 were given away to children 12 years old in 1930. Covered with a tan colored reptile-grained paper covering with a gold-colored foil seal on the upper rear corner of the right side. (On a worn example, the gold coloring of the foil seal may have worn off and left it looking silver.) Like New w/Box: \$60-90. Mint, but without box: \$45-60. VG to Excellent: \$25-35.

EASTMAN: AUTOMATIC 35

AUTO COLORSNAP 35 - 1962-64. Kodak Ltd. Black & grey plastic 35mm with BIM for automatic exposure. \$12-20.

AUTOGRAPHIC KODAK CAMERAS The Autographic feature was introduced by Kodak in late 1914, and was available on several lines of cameras. Listed here are those cameras without any key word in their name except Autographic or Kodak.

No. 1A Autographic Kodak Camera - 1914-24. For $2^{1}/_{2}$ x $4^{1}/_{4}$ " exp. on No. A116 film. Black leather and bellows. \$12-20.

No. 3 Autographic Kodak Camera - 1914-26. 31/₄x41/₄" on A118 film. \$20-30.

No. 3A Autographic Kodak Camera - 1914-34. 31/4x51/2" (postcard size) on A122 film. This is the most common size of the Autographic Kodak Cameras. \$20-30.

No. 4 Autographic Kodak Camera - This is actually a No. 4 Folding Pocket Kodak Camera with a retrofit back, available in 1915. A No. 4 Autographic Kodak Camera was never made. See No. 4 Folding Pocket Kodak Camera.

No. 4A Autographic Kodak Camera - This too is not an Autographic Kodak Camera, but simply a 1915 retrofit back on a No. 4A Folding Kodak Camera. See No. 4A Folding Kodak Camera.

AUTOGRAPHIC KODAK JUNIOR CAMERAS

No. 1 Autographic Kodak Junior Camera - 1914-27. 21/₄x31/₄" on 120 film. EUR: \$25-<u>35.</u> USA: \$15-25.

No. 1A Autographic Kodak Junior Camera - 1914-27. $2^{1}/_2$ x $4^{1}/_4$ " exp. on A116 film. Very common. EUR: \$20-30. USA: \$15-25.

No. 2C Autographic Kodak Junior Camera - 1916-27. 27/8×47/8". A very common size in this line. EUR: \$20-30. USA: \$15-25.

No. 3A Autographic Kodak Junior Camera - 1918-27. 31/4x51/2" on A122. \$12-20.

AUTOGRAPHIC KODAK SPECIAL CAMERA The "Special" designation indicates superior finish or equipment, and in some cases a coupled rangefinder. None of the No. 1 or No. 3 size have rangefinder. The other sizes have coupled rangefinder (CRF) after 1917.

No. 1 Autographic Kodak Special Camera - 1915-26. No CRF. \$35-50.

No. 1A Autographic Kodak Special Camera - 21/₂x41/₄". 1914-16 without CRF: \$35-50. 1917-26 with CRF: \$50-75.

No. 2C Autographic Kodak Special Camera - 1923-28. CRF. \$35-50.

No. 3 Autographic Kodak Special Camera - 1914-24. No CRF. 31/4x41/4"

exposures on A118. Uncommon size, fairly rare. \$45-60.

No. 3A Autographic Kodak Special Camera - 31/4x51/2" on 122. 1914-16 without CRF: \$35-50. 1917-33 with CRF, including the common Model B: \$50-75.

No. 3A Signal Corps Model K-3 - A specially finished version of the 3A Autographic Kodak Special Camera with coupled rangefinder. Body covered with smooth brown leather with tan bellows. Gunmetal grey fittings. B&L Tessar f6.3 in Optimo shutter. Name plate on bed says "Signal Corps, U.S. Army K-3" and serial number. One hundred of these cameras were made in 1916. Rare. \$1000-1500.

AUTOMATIC 35 CAMERAS Improved version of the Signet 35 Camera design. Built-in meter automatically sets the diaphragm when the shutter release is pressed.

Automatic 35 Camera - 1959-64. Flash sync. posts on side of body. \$20-30.

EASTMAN: AUTOMATIC 35B

Automatic 35B Camera - 1961-62. Kodak Automatic Flash shutter. \$20-30.

Automatic 35F Camera - 1962-66. Built-in flash on top for AG-1 bulbs. \$20-30.

Automatic 35R4 Camera - 1965-69. Built-in flashcube socket on top. \$20-30.

AUTOSNAP - 1962-64. Kodak Ltd. Grey plastic eye-level camera for 4x4cm on 127 film. Automatic exposure. \$1-10.

BANTAM CAMERAS - For 28x40mm exp. on 828 rollfilm.

Bantam, original f6.3 - 1935-38. Rigid finder. f6.3 lens. \$30-45.

Bantam, original f12.5 - 1935-38. Original body style, but with a folding frame finder. Doublet f12.5 lens. \$12-20.

Bantam f8 - 1938-42. Kodalinear f8/40mm. Rectangular telescoping front rather than bellows. Often with original box for \$30-45. Camera only: \$15-25.

Bantam f6.3 - 1938-47. Kodak Anastigmat f6.3/53mm. Collapsible bellows. Like original model, but has folding optical finder. \$20-30.

Bantam f5.6 - 1938-41. Kodak Anastigmat f5.6/50mm. Collapsible bellows. \$20-30.

Bantam f4.5 - 1938-48. Kodak Anastigmat Special f4.5/47mm. Bantam shutter 20-200. Bellows. The most commonly found Bantam. With box: \$25-35. Camera only: \$15-25.

- Military model - Signal Corps, U.S. Army PH502/PF, Ord. No. 19851. \$175-250

- **Military model** - British Air Force. Air Ministry contract number (14A/3663) is

engraved on base. One reported sale at

Bantam Colorsnap - Made in London by Kodak Ltd. Kodak Anaston lens, single speed shutter. \$12-20.

Bantam RF Camera - 1953-57. Non-interchangeable f3.9/50mm Kodak Ektanon Anastigmat. Shutter 25-300. Coupled rangefinder3' to infinity. \$25-35.

Bantam Special Camera - A masterpiece of art-deco styling. Quality construction. Kodak Anastigmat Ektar f2 lens. Compur Rapid shutter (1936-40) is more common than the Supermatic shutter (1941-48). CRF 3' to infinity. With Supermatic: \$250-375. With Compur Rapid: \$175-250. About 50% higher with original box or at European auctions.

Flash Bantam Camera - 1947-53. Early model (1947-48) has Kodak Anas-

EASTMAN: BROWNIE

tigmat Special f4.5/48mm lens and shutter 25-200. Later model (1948-53) has Kodak Anastar f4.5/48mm lens. \$25-35.

Six-20 Boy Scout Brownie Camera

BOY SCOUT BROWNIE CAMERA SIX-20 BOY SCOUT BROWNIE

CAMERA - Simple box cameras. Special metal faceplate with Boy Scout emblem. First version made in 1932 for 120 film; second version made in 1933-34 for 620 film. Rare 120 model: \$200-300. More common in 620 size: \$120-180.

BOY SCOUT KODAK CAMERA (U.S.A.) - 1929-33. Folding camera for 4.5x6cm on 127 rollfilm. This is a vest-pocket camera in olive drab color with official Boy Scout emblem engraved on the bed. With original green bellows and matching case: \$200-300. Often seen with replacement black bellows: \$100-150.

BOY SCOUT KODAK CAMERA (ENGLAND) - Similar in concept to the USA model. Dark green crinkle-enameled body. Door has U.K. Boy Scout insignia; black shutter face has "Boy Scout Kodak" and small logo. Originally supplied with black bellows, unlike the American model. With matching case: \$200-300.

BROWNIE CAMERAS

Brownie Camera, original - Introduced in February, 1900, this box camera was made to take a new size film, No. 117 for 2¹/₄x2¹/₄" exposures. The back of the camera fit like the cover of a shoe-box. Constructed of cardboard, and measuring 3x3x5" overall, this camera lasted only four months in production before the back was re-designed. A rare box camera. With accessory waist-level finder. \$600-900.

The Brownie Camera (1900 type) - This is a hybrid that falls between the original Brownie and the No.1 Brownie. It has the improved back of the No.1, but the name printed inside the camera's back is still. "The Brownie Camera". One fine example, complete with original box, finder, case, and film sold at auction for \$240 (11/89). Normal range: \$90-130.

Brownie Camera (1980 type) - We include this only because it has the same name as the original Brownie which is much more valuable. This is a small plastic eye-level camera for 110 cartridges. Made by Kodak Limited, and really just a renamed version of the Pocket A1 camera. \$1-10.

No. 0 Brownie Camera - A small (4x31/₄x6cm) box camera of the mid-teens for 127 film. Slightly larger than the earlier "Pocket Kodak" of 1895. Cute, but not scarce. \$15-25. *Illustrated at top of next column*.

No. 0 Brownie Camera

No. 1 Brownie Camera - In May or June of 1900, this improved version of the original Brownie Camera was introduced, and became the first commercially successful Brownie camera. Although not rare, it is historically interesting. \$45-60. With accessory finder, winding key and orig. box. \$90-130. The earliest examples of this camera were marked "The Brownie Camera". When additional sizes were introduced, the designation was changed to "No. 1". The early type is listed above as "The Brownie Camera (1900 Type)".

No. 2 Brownie Camera - 1901-33. Cardboard box camera for 6 exposures 21/4x31/4" on 120 film, which was introduced for this camera. Meniscus lens, rotary shutter. An early variation had smooth finish and the same rear clamp as the No. 1. This variation has an estimated value of \$20-30. Most have grained pattern cloth covering. Later models made of aluminum and came in colors, some of which were also made in London. Black: \$1-10. Colored: \$35-50.

No. 2 Brownie Camera, silver - 1935. Special edition of the No. 2 Brownie box camera in silver finish with black trim. Made for the British Silver Jubilee. Asking

EASTMAN: BROWNIE...

prices up to \$85 in England. Confirmed sales: \$45-60.

No. 2A Brownie Camera - 1907-33. Box camera for $2^{1}/_{2}$ X4 $^{1}/_{4}$ " on 116 film. Early models have cardboard bodies. Later ones have aluminum bodies, some colored, made in USA or UK. Common. Black: \$1-10. Colored models: \$30-45.

No. 2C Brownie Camera - 1917-34. Box camera, 27/₈x4⁷/₈" on 130 film. \$1-10.

No. 3 Brownie Camera - 1908-34. Box camera, 31/₄x41/₄" on 124 film. \$1-10.

Brownie 44A - 1959-66. Made by Kodak Ltd. Plastic eye-level box camera

for 4x4cm on 127 film. Dakon lens, single speed shutter. Soft plastic front cover hinged to bottom. \$8-15.

Brownie 44B - 1961-63. Similar to the 44A, but without the hinged plastic cover. \$8-15.

Brownie 127 Camera - 1953-59. Bakelite body with rounded ends, as if slightly inflated. Made in England. Several variations of faceplate: plain, horizontally striped, diagonally checkered. \$8-15.

Brownie 127 (1965 type) - 1965-67. Only the name is directly related to the earlier model. Body style completely changed. Shutter release is white square on front next to viewfinder. \$20-30.

Brownie 620 - c1934. Kodak AG, Dr. Nagel Werk, Stuttgart. Box camera with art-deco front. Kodak Doublet f11, T&M shutter. \$60-90.

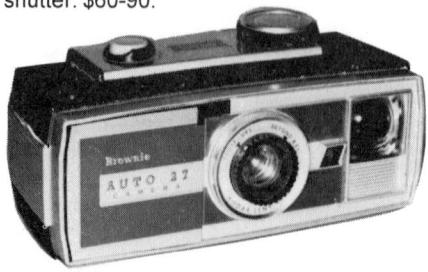

Brownie Auto 27 Camera - 1963-64. Electric-eye version of Brownie Super 27. \$12-20.

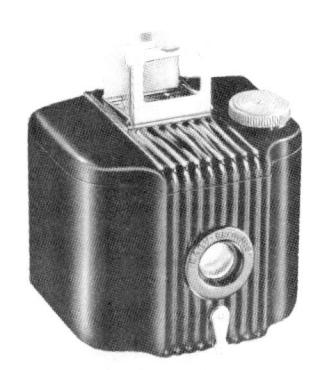

Baby Brownie Camera - 1934-41. Bakelite box camera for 4x6.5cm exp. on 127 film. Folding frame finder. \$12-20.

Baby Brownie Camera (Kodak Ltd.)- The British-made version of the Baby Brownie. Like the USA model, but with a "brief time plunger" above the lens. Uncommonin the U.S. \$25-35.

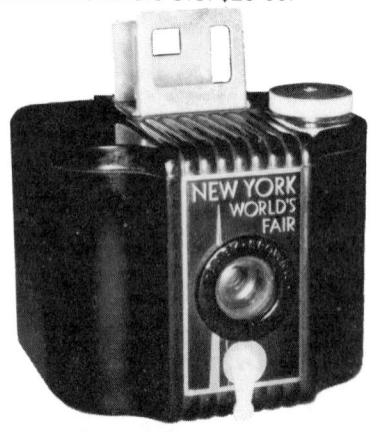

Baby Brownie, New York World's Fair Model - 1939. A special version of the Baby Brownie was made in 1939-1940 for the World's Fair, with a special New York World's Fair faceplate. Reportedly 50,000 were produced. They were sold at the fair and through dealers, but were not listed in regular Kodak catalogs. \$175-250.

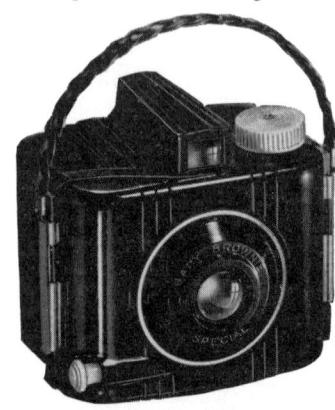

Baby Brownie Special - 1939-54. Bakelite box camera for 4x6.5cm exp. on 127 film. Rigid optical finder. \$8-15.

BEAU BROWNIE CAMERAS, NO. 2, 2A - 1930-33. A simple No. 2 or No. 2A Brownie (box) camera, but in classy two-tone color combinations of blue, green, black, tan, or rose. Either size in rose: \$100-150. Color other than rose: \$60-90.

Generally the same price range applies in Europe, although a few examples at auction have reached nearly \$200 with case. One
EASTMAN: BROWNIE FLASH

general antiques guide in the USA reportedly has listed the value of Beau Brownies at \$1300. If you want to sell one at this price, try selling it to the people who wrote that book. If you want to buy at that price, or even at one half or one quarter of that price, call some of the dealers who advertise in this guide; you will soon have all you can afford.

Brownie Bull's-Eye Camera - 1954-60. Vertically styled bakelite camera with metal faceplate and focusing Twindar lens. For 21/4x31/4" on 620 film. Black: \$12-20. Gold: \$15-25. See also "Six-20 Bull's-Eye Brownie Camera" below.

Brownie Bullet Camera - 1957-64. A premium version of the Brownie Holiday Camera. 4.5x6cm on 127 film. \$1-10.

Brownie Bullet II Camera - 1961-68. Similar to the Brownie Starlet camera (USA type). Not like the Brownie Bullet Camera! 4.5x6cm exp. on 127 film. \$1-10.

Brownie Chiquita Camera - Same as the Brownie Bullet Camera, except for the faceplate and original box which are in Spanish. With original box: \$20-30. Camera only: \$12-20.

Brownie Cresta - c1955-58. Black plastic eye-level box camera for 21/₄x21/₄" on 120 film. Made by Kodak Ltd. London.

Kodet lens. Styled after the popular Brownie 127, but larger and not quite as streamlined. \$8-15.

Brownie Cresta II - c1956-59. Slightly revised Cresta, flash synchronized through mount rather than PC post. \$12-20.

Brownie Cresta III - c1960-65. Restyled with black plastic body, sculpted grey plastic top housing. Synchronized through flash mounting screw. \$12-20.

Brownie Fiesta Camera - 1962-66; **Fiesta R4 -** 1966-69. \$1-10.

Brownie Flash Camera - Black bakelite box camera identical to the Brownie Hawkeye Flash Model. Made in France for the French market. "Brownie Flash

Camera Made in France" on front plate. \$15-25.

Brownie Flash II - 1956-59. Kodak Ltd, London. Metal box camera. Fixed focus f14 lens with built-in close-up lens, no filter. \$12-20.

Brownie Flash II (Australia) - 1958-63. Made by Kodak Australasia Pty Ltd., Melbourne, Australia. Identical to the UK model. Initially assembled from imported parts and finally some 500,000 made in Australia. \$12-20.

Brownie Flash III - 1957-60. Kodak Ltd, London. Metal box with black leatherette covering. Built-in close-up lens and yellow filter. \$12-20.

Brownie Flash IV - 1957-59. Same as Brownie Flash III, but with tan covering, brass metal parts. With matching canvas case: \$25-35. Camera only: \$20-30.

Brownie Flash 20 Camera - 1959-62.

EASTMAN: BROWNIE FLASH...

Styled like the Brownie Starflash Camera, but larger size for 620 film. \$8-15.

Brownie Flash Six-20 Camera - Post-war name for Six-20 Flash Brownie Camera. Trapezoidal metal body. With flash: \$1-10.

Brownie Flash B - Metal box camera from Kodak Ltd. in London. Shutter B, 40, 80. Brown and beige color. \$15-25. Add \$5 for original canvas case.

Brownie Flashmite 20 Camera - 1960-65. 2¹/₄x2¹/₄" on 620 film. Less common than the Brownie Starmite, a smaller, 127 film version of this camera. \$8-15.

FOLDING BROWNIE CAMERAS Identifiable by their square-cornered bodies and horizontal format. The No. 3 and No. 3A are at least ten times more commonly found for sale than the No. 2, although prices are much the same. Red (maroon) bellows models sell more easily and for higher prices than models with black bellows, especially outside of the USA.

No. 2 Folding Brownie Camera - 1904-07. Maroon bellows, wooden lens standard. 21/₄x31/₄" on 120 film. \$45-60.

No. 3 Folding Brownie Camera - 1905-15. 31/₄x41/₄" on 124 film. Maroon bellows: \$45-60. Black bellows \$20-30.

No. 3A Folding Brownie Camera - 1909-15. 31/₄x51/₂" "postcard" size. Maroon bellows: The most common size. Maroon bellows: \$45-60. Black bellows: \$20-30.

FOLDING AUTOGRAPHIC BROWNIE CAMERAS These are a continuation of the Folding Brownie Camera series, but with the addition of the "Autographic" feature. Some of the earlier examples still have the square corners of the earlier style. About 1916, when the 3A size was introduced, they were all given the new rounded corners. To the prices below add 25% for square corners or for RR lens. Add 50% for both features.

No. 2 Folding Autographic Brownie Camera - 1915-26. 21/4x31/4" on 120 film. Very common. \$12-20.

No. 2A Folding Autographic Brownie Camera - 1915-26. 21/2x41/4". By far the most common size of this line. \$12-20

No. 2C Folding Autographic

Brownie Camera - 1916-26. 27/₈x47/₈" exp. \$15-25.

No. 3A Folding Autographic Brownie Camera - 1916-26. 31/4x51/2". \$12-20.

FOLDING POCKET BROWNIE CAMERAS Horizontal style folding rollfilm cameras. Square-cornered bodies. Early models with red bellows bring higher prices. All are worth 50-100% more in Europe.

No. 2 Folding Pocket Brownie Camera - 1907-15. 21/₄x31/₄". A continuation of the No. 2 Folding Brownie, but with metal not wooden lensboard. Red bellows: \$30-45. Black bellows: \$15-25.

No. 2A Folding Pocket Brownie Camera - 1910-15. 21/₂x41/₄" on 116 film. Red bellows: \$35-50. Black bellows: \$20-30.

FOLDING BROWNIE SIX-20 (model I) 1937-40. (Kodak Ltd., London). Vertically styled folding camera for 21/₄x31/₄" photos on 620. Meniscus lens, B&I shutter. Folding open frame finder. \$12-20.

- **(Model 2)** - Production resumed in 1948 with a folding optical finder, and also a more sophisticated model which bore the name "Six-20 Folding Brownie". \$15-25.

EASTMAN: BROWNIE SIX-20

Brownie Hawkeye Camera - 1949-51. Molded plastic box camera for $2^{1}/_{4} \times 2^{1}/_{4}$ " exp. on 620 film. No flash sync. Not rare, but much less common than the flash model below. \$8-15.

Brownie Hawkeye Camera Flash Model - 1950-61. Similar to the above listing, but with flash sync. Common. \$1-10. See "Brownie Flash Camera" above for the French version of this camera.

Brownie Holiday Camera - 1953-57; Flash model, 1954-62. 4x6.5cm exp. on 127 film. EUR: \$12-20. USA: \$1-10.

Brownie Junior 620 Camera - 1934-36. Metal box camera. Made by Kodak A.G. Dr. Nagel-Werk and not imported to the U.S.A. \$12-20.

Brownie Model I - 1957-59. Kodak Ltd., London. Metal box camera for 6x9cm. A simple model in the series with the Brownie Flash II, III, IV. No close-up lens nor filter. \$12-20.

Brownie Pliant Six-20 - c1939. Folding rollfilm camera for 620 film. Very similar to the Kodak Junior Six-20 Series II. Simple lens, Kodo I+T shutter. \$30-45.

Popular Brownie Camera - 1937-40. Made by Kodak Ltd., London. Box camera for 6x9cm on 620 film. \$12-20.

Portrait Brownie Camera, No. 2 - 1929-35. Kodak Ltd. 6x9cm on 120 film. Colored: \$35-50. Black: \$12-20.

Brownie Reflex Camera - 1940-41. Pseudo-TLR for 15/8x15/8" exp. on 127 film. No flash sync. EUR: \$20-30. USA: \$8-15.

Brownie Reflex Camera Synchro Model - 1941-52. Like the above listing, but with flash sync. Occasional sales in Europe at: \$20-30. Common in the USA: \$1-10.

Brownie Reflex 20 Camera - 1959-66. Reflex style like the Brownie Starflex Camera, but larger for 620 film. Europe: \$8-15. USA: \$1-10.

Six-16 or Six-20 Brownie Cameras (USA type) - 1933-41. Cardboard_box cameras with metal art-deco front. EUR: \$12-20. USA: \$1-10.

Six-16 or Six-20 Brownie Junior Cameras - 1934-42. Box cameras with art-deco front. \$1-10.

Six-16 or Six-20 Brownie Special Cameras - 1938-42. Trapezoid-shaped metal box. \$8-15.

Six-20 Brownie (UK type) - 1934-37. Cardboard bodied box camera with bold black & nickel vertical-stripe art-deco faceplate. Two built-in closeup lenses, 3 apertures. \$20-30.

Six-20 Brownie B - 1937-41. Made by Kodak Ltd, London. Simple box camera with art-deco faceplate. 21/4x31/4" on 620 film. \$20-30.

Brownie Six-20 Camera Models C,D,E - 1946-57. Kodak Ltd., London. Metal box cameras for $2^{1}/_{4}$ X3 $^{1}/_{4}$ " exp. on 620 film. Each was available with two different faceplate styles, with the change

EASTMAN: BROWNIE SIX-20...

occuring in 1953. Both basic types of Model C had no flash contacts, but a later version the second type also came with flash contacts. Model D had flash contacts on the second version. Model E had flash contacts on both versions. \$12-20. Illustrated in next column.

Brownie Six-20 Camera Model F - 1955-57. Sporty version of the Model E. Tan covering & brass trim. \$20-30. *Illustrated in next column*.

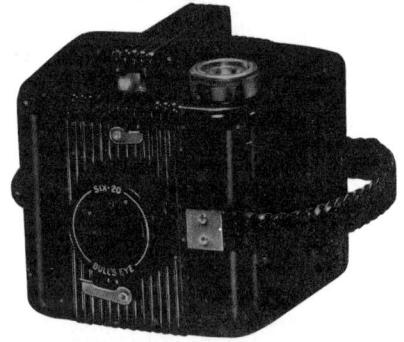

Six-20 Bull's-Eye Brownie Camera 1938-41. Black bakelite trapezoidal body with eye-level finder above top. Braided strap on side. For 21/4x31/4" exp. on 620 film. Uncommon. \$12-20.

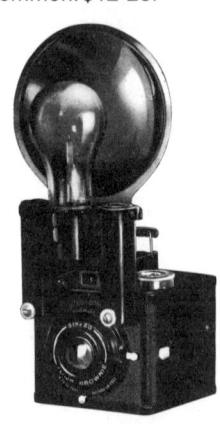

Six-20 Flash Brownie Camera, Brownie Flash Six-20 Camera -1940-54. Metal trapezoidal box camera, sold under both names. 21/4x31/4" exp. on 620 film. \$1-10.

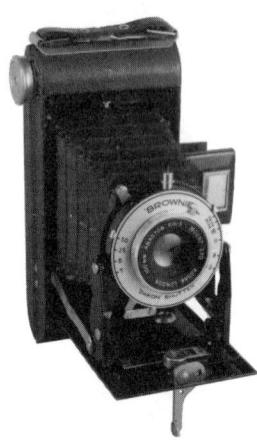

Six-20 Folding Brownie (model 2) - 1948-54. Kodak Ltd, London. A post-war improved version of the "Folding Brownie Six-20". Vertically styled folding camera for 21/4x31/4" on 620. Anaston f6.3/100mm in Dakon T,B,25,50 synched shutter. \$15-25.

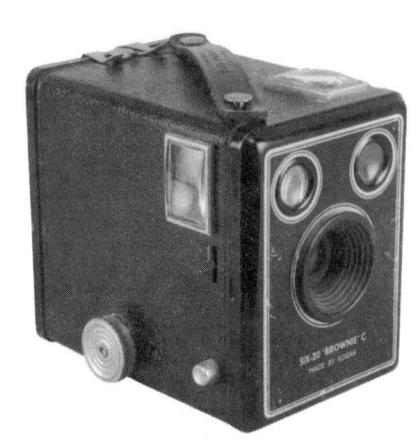

Brownie Six-20 Camera Models C,D,E,F

Six-20 Portrait Brownie - Kodak Ltd. Metal body, hinged back door. Art-deco front bezel meets a matching side bezel for the shutter lever. \$12-20.

Brownie Starflash, USA and French versions
Brownie Starflash Camera - 195765. Blue, red, or white: \$12-20. Black: \$110. Diehard collectors can try to include the models made in France and Australia. In addition to these colors, models "Made in Australia" include a two-tone black and grey which has reached a budget-breaking \$20.

Brownie Starflash Coca-Cola - 1959. Special version with red and white body (Coca-Cola trade colors). Small Coca-Cola

EASTMAN: BROWNIE TARGET

decal on top. Rare. Known sales in the \$75-100 range.

Brownie Starflex Camera - 1957-64. 4x4cm on 127 film. Also available with "Australasia" markings. \$1-10.

Brownie Starlet Camera (USA) - 1957-62. 4x4cm on 127. Also made in France with French markings. \$1-10.

Brownie Starlet Camera (Kodak Ltd.) - 1956. 4x6.5cm on 127. The identical camera is also made in Australia and so marked. \$1-10.

Brownie Starluxe, II - French-made versions of the Brownie Starmites. \$8-15.

Brownie Starluxe 4 - ca. late 1960's. French-made version of the Brownie Fiesta R4. \$8-15.

Brownie Starmatic Camera - 1959-1961

Brownie Starmatic II Camera - 1961-63. 4x4cm on 127 film. Built-in automatic meter. One of the better and less common of the "Star" series. \$12-20.

Brownie Starmeter Camera - 1960-65. Uncoupled selenium meter. \$15-25.

No. 2 Stereo Brownie Camera

Brownie Twin 20 Camera

Brownie Starmite Camera - 1960-63; Starmite II, 1962-67. \$1-10.

No. 2 Stereo Brownie Camera - 1905-10. Similar to the Blair Stereo Weno Camera. $31/_4$ x $21/_2$ " exposure pairs on roll-film. Red bellows. Stereo Brownie models are much less common than comparable Stereo Hawk-Eye Cameras. \$400-600. *Illustrated bottom of previous column.*

Brownie Super 27 - 1961-65. \$1-10.

Target Brownie Six-16 and Six-20 Brownie Target Six-16 and Six-20 Cameras - Metal and leatherette box cameras. Introduced in 1941. Name

EASTMAN: BROWNIE TWIN 20

changed from Target Brownie to Brownie Target in 1946. Six-16 discontinued in 1951; Six-20 in 1952. EUR: \$12-20. USA: \$1-10.

Brownie Twin 20 Camera - 1959-64. Waist level and eye-level finders. Unusual. \$1-10. *Illustrated at top of previous page.*

Brownie Vecta - 1963-66. Kodak Ltd. London. Vertically styled grey plastic 127 camera of unusual design. Long shutter release bar at bottom front. \$20-30.

BUCKEYE CAMERA - c1899. Eastman Kodak Co. purchased the American Camera Mfg. Co., which originated this model. The Eastman camera is nearly identical to the earlier version. A folding bed camera of all wooden construction, covered with leather. Lens standard of polished wood conceals the shutter behind a plain front. An uncommon rollfilm model. \$120-180.

BULL'S-EYE CAMERAS After Kodak took over the Boston Camera Manufacturing Co., it continued Boston's line of cameras under the Kodak name. (See also Boston Bull's-Eye.) Bull's-Eye cameras are often stamped with their year model as were other early Kodak cameras. Leather exterior conceals a beautifully polished wooden interior.

No. 2 Bull's-Eye Camera - 1896-1913. Leather covered wood box which loads from the top. $31/_2$ X $31/_2$ " exposures on 101 rollfilm or double plateholders. Rotary disc shutter. Rotating disc stops. EUR: \$60-90. USA: \$35-50.

No. 3 Bull's-Eye Camera - 1908-13. This model loads from the side. $31/_4$ x $41/_4$ " on No. 124 film. Less common than the No. 2 and No. 4. \$50-75.

No. 4 Bull's-Eye Camera - 1896-1904. Nine models. Side-loading 4x5" box for

103 rollfilm. Internal bellows focus by means of an outside lever. \$45-60.

No. 2 Folding Bull's-Eye Camera - 1899-1901.31/₂x31/₂". Scarce. \$120-180.

BULL'S-EYE SPECIAL CAMERAS Similar to the Bull's-Eye box cameras above, but with higher quality RR lens in Eastman Triple Action Shutter. 1898-1904.

No. 2 Bull's-Eye Special Camera - 31/2×31/2" on 101 film. EUR: \$90-130. USA: \$60-90

No. 4 Bull's-Eye Special Camera - 4x5" exposures on 103 rollfilm. \$75-100.

BULLET CAMERAS

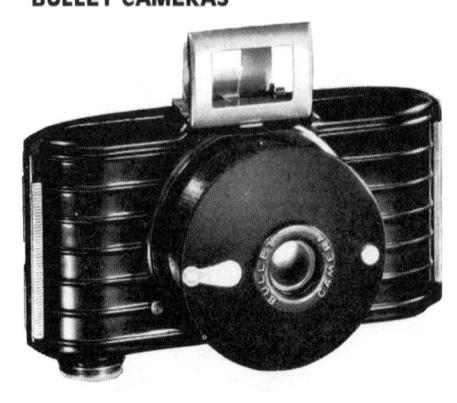

Bullet Camera (plastic) - 1936-42. A

cheap & simple torpedo-shaped camera with fixed focus lens mounted in a spiral-threaded telescoping mount. Common, inexpensive, yet novel. \$12-20.

Bullet Camera, New York World's Fair Model - 1939-40. A special World's Fair version of the plastic Bullet camera, marked "New York World's Fair" on a metal faceplate. Reportedly 10,000 were made and sold through dealers or at the fair, but not listed in regular catalogs. In colorful original box: \$250-375. Camera only: \$120-180.

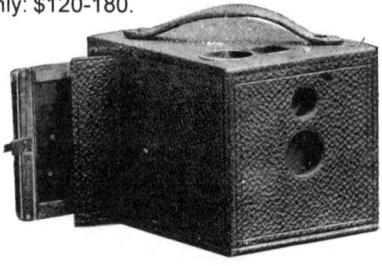

No. 2 Bullet Camera - 1895-96; Improved model 1896-1900; Double plateholder option 1900-1902.

- Box camera for $31/_2$ X $31/_2$ " exposures on glass plates or on rollfilm which was first introduced in 1895 for this camera and later numbered 101. Measures $41/_2$ X $41/_2$ X6". Some models were named by year and marked on the camera. \$50-75.

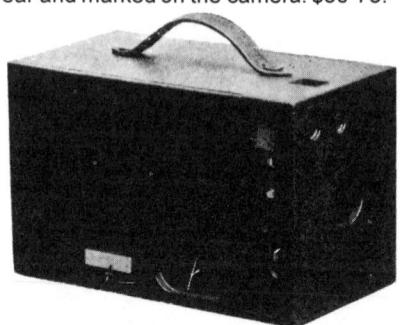

No. 4 Bullet Camera - 1896-1900. For 4x5" exposures on No. 103 rollfilm (introduced for this camera) or could be used with a single plateholder which stores in the rear of the camera. A large leather covered box. \$75-100.

BULLET SPECIAL CAMERAS Similar to the No. 2 and No. 4 Bullet Cameras above, but with a higher quality RR lens in Eastman Triple Action Shutter.

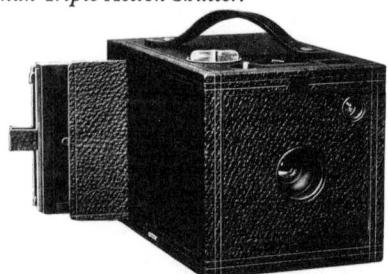

No. 2 Bullet Special Camera - 1898-1904. \$120-180.

No. 4 Bullet Special Camera - 1898-1904, \$250-375.

EASTMAN: COLORBURST

CAMP FIRE GIRLS KODAK - 1931-34. A brown folding vest-pocket camera. Camp Fire Girls emblem on the front door and "Camp Fire Girls Kodak" on shutter face. This is a very rare camera, unlike the less rare Girl Scout or the common Boy Scout models. With matching case: \$600-900.

CARTRIDGE KODAK CAMERAS Made to take "cartridge" film, as rollfilm was called in the early years.

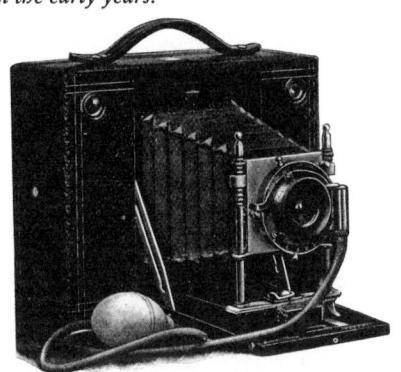

No. 3 Cartridge Kodak Camera - 1900-07. 41/₄x31/₄" on No. 119 rollfilm, which was introduced for this camera. This is the smallest of the series. Various shutters/lenses. Rare in this size. \$200-300.

No. 4 Cartridge Kodak Camera - 1897-1907. For 5x4" exp. on 104 rollfilm (introduced for this camera). This is the first of the series. Leather covered wood body, polished wood interior. Red bellows. Various shutters/lens combinations. (Orig. price was \$25.) \$150-225.

No. 5 Cartridge Kodak Camera - 1898-1900 with wooden lensboard and bed; 1900-1907 with metal lensboard. For 7x5" exp. on No. 115 rollfilm or on plates. (No. 115 rollfilm, introduced for this camera, was 7" wide to provide the 7x5" vertical format.) Red bellows. Various shutters/lens combinations. \$175-250.

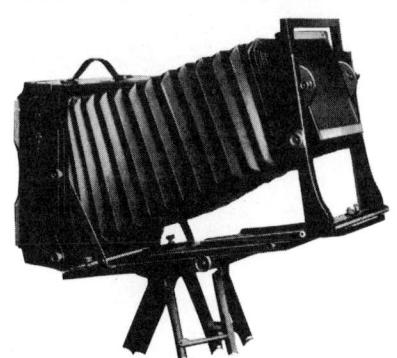

CENTURY UNIVERSAL CAMERA - A

well-made cherry wood self-casing view camera. Designed for commercial and industrial use, it provides ample movements for most work. The 30" bellows fold compactly enough to use wide angle lenses of 5" focus. Collectors must compete with users for this camera. \$350-500.

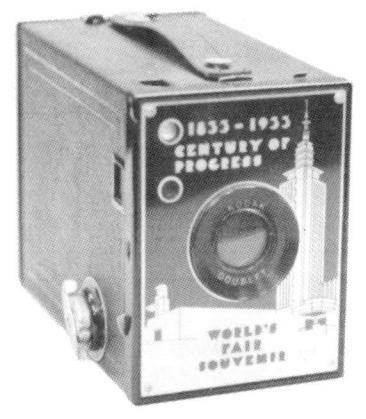

CENTURY OF PROGRESS, WORLD'S FAIR SOUVENIR - Made for the 1933 World's Fair. Box camera for $2^{1}/_{4}x3^{1}/_{4}$ " exp. on 120 film. \$175-250.

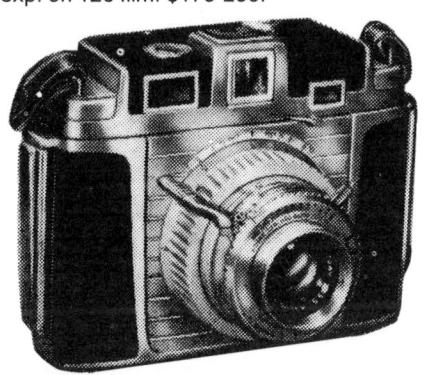

CHEVRON CAMERA - 1953-56. For 21/₄x21/₄" on 620 film. Kodak Ektar f3.5/78mm lens. Synchro-Rapid 800 shutter. \$200-300.

CIRKUT CAMERAS, CIRKUT OUTFITS
Manufactured by the Rochester Panoramic
Camera Co. 1904-05; Century Camera Co.
1905-07, Century Camera Division of
Eastman Kodak Co. 1907-1915; Folmer &
Schwing Div. of EKC 1915-17; F&S Dept. of
EKC 1917-26; Folmer Graflex 1925-45;
Graflex, Inc. (sales only) 1945-49. For obvious reasons of continuity, we are listing all
Cirkut equipment under the Eastman Kodak
beading rather than split it among all these
various companies.

Basically, a Cirkut OUTFIT is a revolving-back cycle view camera with an accessory Cirkut back, tripod, and gears. A Cirkut CAMERA is designed exclusively for Cirkut photos and cannot be used as a view camera. Both types take panoramic pictures by revolving the entire camera on a geared tripod head while the film moves past a narrow slit at the focal plane and is taken up on a drum. They are capable of making a full 360° photo. These cameras are numbered according to film width, the common sizes being 5, 6, 8, and 10 inches. Early models used external air fans to regulate speed, but the majority were made with governors.

NOTE - All prices listed here are for

NOTE - All prices listed here are for complete original outfits with tripod and gears. Reconditioned models, with electric drive motors bring higher prices as usable

cameras. Prices depend on type and amount of restoration.

No. 5 Cirkut Camera - 1915-23. With Turner Reich 61/₄, 11, 14" Triple Convertible lens. \$750-1000.

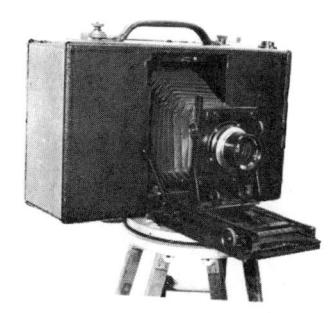

No. 6 Cirkut Camera - 1932-49. With 7, 10, 151/₂" Triple Convertible lens. \$1200-1800.

No. 6 Cirkut Outfit - 1907-25. (5x7 RB Cycle Graphic). With Series II Centar lens: \$600-900. With Graphic Rapid Rectilinear convertible 5x7 lens: \$750-1000. With 71/2",12",18" triple convertible lens: \$750-1000.

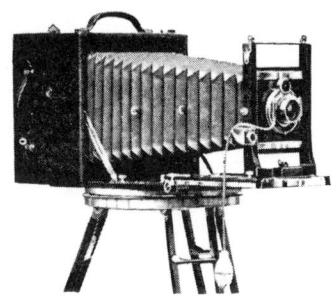

No. 8 Cirkut Outfit - 1907-26. Based on $61/_2x81/_2$ RB Cycle Graphic. Uses 6" or 8" film. With $101/_2$, 18, 24" Triple Convertible lens: \$1000-1500.

No. 10 Cirkut Camera - 1904-40. Uses 10", 8", or 6" film. This is the most desirable as a usable camera. Before 1932, used 10½, 18, 24" Triple Convertible. From 1932-41, used 10, 15½, 20" lens. With either Triple Convertible lens: \$3500-5500. A revived interest in using Cirkut cameras has made demand exceed supply in this size, which is most popular for use.

No. 16 Cirkut Camera - 1905-24. Takes 16", 12", 10", or 8" film. Quite rare. Limited production. With 15",24",36" triple convertible lens: \$9000-14,000.

COLORBURST - A series of cameras for

EASTMAN: COLORSNAP

instant pictures. Models include: 50, 100, 150, 200, 250, 300, 350. Little collector interest except for a few diehard Kodak nuts, and there are more than enough Colorbursts to go around. More advanced models (250, 300, 350): \$1-10. Simple models: \$1-10. Note: Kodak's settlement with owners of instant cameras resulted in many instant cameras with nameplates removed. These have virtually no collector value, and are easily found.

COLORSNAP 35 - 1959-64. Basic 35mm camera based on the earlier Bantam Colorsnap body. Plastic and metal construction. Scale-focus Kodak Anaston f3.9 less. Single speed shutter. Double exposure prevention. Asking prices in England: \$15-25.

COLORSNAP 35 MODEL 2 - 1964-67. Restyled version of the Colorsnap 35. Cleaner looking top housing with recessed knobs. \$15-25.

COMPAÑERA - c1983. Brown plastic camera for 126 cartridges. Made in Brazil. \$1-10.

NO. 1 CONE POCKET KODAK - c1898. A very unusual early Kodak camera which is essentially a non-folding box camera version of the Folding Pocket Kodak

camera. Early records indicate that 1000 were shipped to London, from where they were apparently shipped to France. Since 1981 at least two examples have surfaced. Price negotiable. Rare.

COQUETTE CAMERA - 1930-31. A boxed Kodak Petite Camera in blue with matching lipstick holder and compact. Art-deco "lightning" design. \$800-1200.

DAYLIGHT KODAK CAMERAS The Daylight Kodak Cameras are the first of the Kodak string-set cameras not requiring darkroom loading. All are rollfilm box cameras with Achromatic lens and sector shutter. Made from 1891 to 1895, each took 24 exposures on daylight-loading rollfilm.

A Daylight Kodak Camera 23/₄x31/₄". (Orig. cost-\$8.50) \$1200-1800.

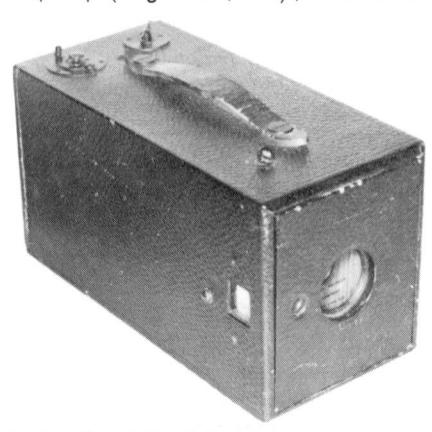

B Daylight Kodak Camera - 31/₂x4". (Orig. cost- \$15.00) \$600-900.

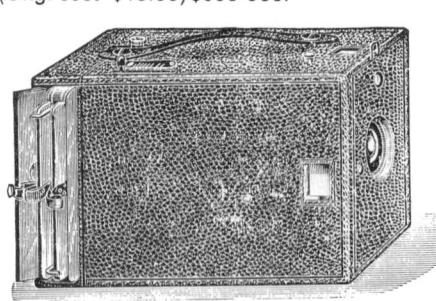

"C" Special Glass Plate Kodak Camera

C Daylight Kodak Camera - 4x5". (Orig. cost- \$25.00) \$500-750. (Also available in a plate version called C Special Glass Plate Kodak Camera.)

DISC CAMERAS - The disc cameras made

a big splash when introduced, but have lost their popularity among users. There is no shortage of used disc cameras for collectors, and prices are low. Most models can be picked up for under \$5 each, but dealers understandably ask up to \$20 for a really clean example of one of the better models, in original box.

Models include Disc 2000, 3000, 3100, 3600, 4000, 4100, 6000, 6100, 8000. Special promotional models such as the illustrated "abc" example may be of more

interest to collectors.

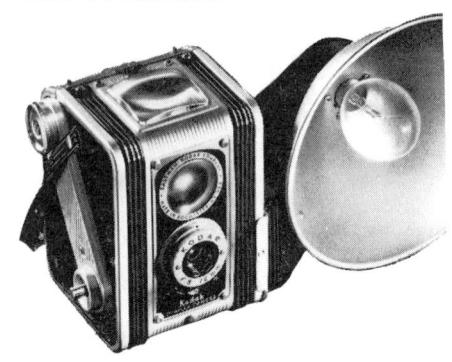

DUAFLEX CAMERAS - Models I-IV, 1947-60. Cheap TLR's for 21/₄x21/₄" on 620 film. Focusing: \$8-15. Fixed focus: \$1-10

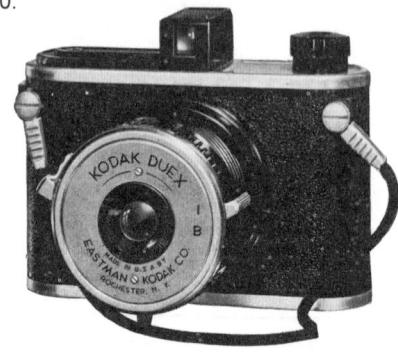

DUEX CAMERA - 1940-42, 4.5x6cm on 620 film. Helical telescoping front. Doublet lens. \$12-20.

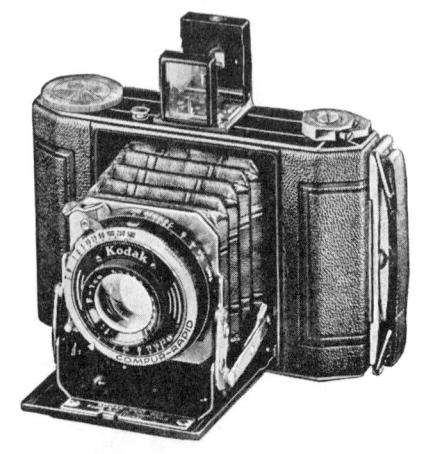

DUO SIX-20 CAMERA - 1934-37. Folding camera for 16 exposures 4.5x6cm on 620 film. Made in Germany. f3.5/70mm Kodak Anast. or Zeiss Tessar lens. Compur or Compur Rapid shutter. \$50-75.

DUO SIX-20 SERIES II CAMERA (without RF) - 1937-39. Folding optical finder on top. No rangefinder. \$50-75. *Illustrated at top of next page.*

Duo Six-20 Series II Camera without RF

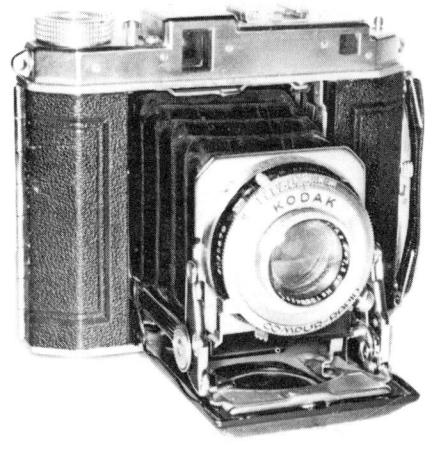

DUO SIX-20 SERIES II CAMERA W/RANGEFINDER - 1939-40. Rangefinder incorporated in top housing. Kodak
Anastigmat f3.5/75mm lens. Compur
Rapid shutter. Uncommon. \$500-750.

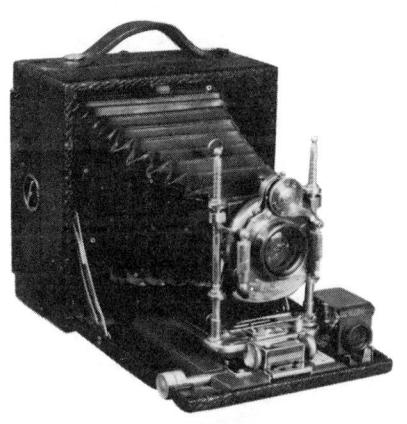

EASTMAN PLATE CAMERA, Nos. 3, 4, and 5 - c1903. No. 3 in 31/₄x41/₄", No. 4 in 4x5", and No. 5 in 5x7". Folding bed cycle style plate cameras with swing back more typical of some of the Rochester Optical Co. earlier models. Double extension bellows. RR lens. Kodak shutter. \$175-250.

KODAK EKTRA - 1941-48. 35mm RF camera. Interchangeable lenses & magazine backs. Focal plane shutter to 1000. A precision camera which originally sold for \$300 with the f1.9/50mm lens. Current value with f1.9/50mm:\$500-750.

Ektra accessories:

35mm f3.3: \$100-150. 50mm f1.9: \$75-100. 50mm f3.5 (scarce): \$120-180. 90mm f3.5: \$100-150.

EASTMAN: FIFTIETH ANNIVERSARY

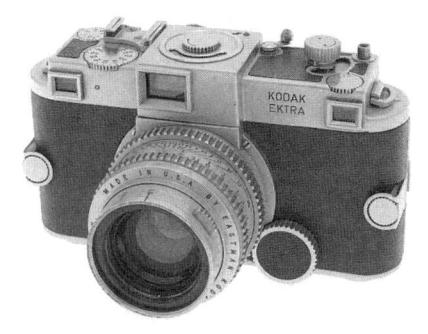

135mm f3.8: \$120-180. 153mm f4.5: \$800-1200. Magazine back: \$120-180. Ground glass back: \$150-225.

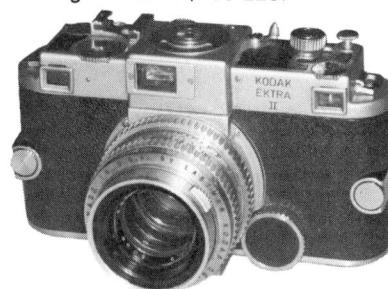

KODAK EKTRA II - Yes, there is an Ektra II, c1944. Apparently made as an experimental model. We know of one extant example (Ser. #7021), which also had a spring-motor auto advance back. Price information not available.

KODAK EKTRA 1, 2, 100, 200, 250 CAMERAS - 1978-. Simple 110 pocket cameras for 13x17mm exposures. \$1-10.

EMPIRE STATE CAMERA - c1893-1914. View camera, usually found in 5x7", 61/₂x81/₂", and 8x10" sizes. With original lens and shutter: \$150-225.

KODAK ENSEMBLE - 1929-33. A Kodak Petite Camera with lipstick, compact, and mirror in a suede case. Available in beige, green, and old rose. \$600-900.

EUREKA CAMERAS 1898-99. Box cameras for glass plates in standard double holders which insert through side door. Storage space for additional holders. Achromatic lens, rotary shutter.

No. 2 Eureka Camera - 31/₂x31/₂" exp. on plates or on No. 106 Cartridge film in rollholder. \$90-130.

No. 2 Eureka Jr. Camera - same size, but cheaper model for plates only. \$75-100

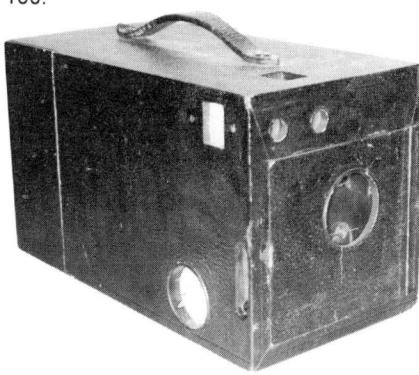

No. 4 Eureka Camera - Made in 1899 only. For 4x5" exposures on No. 109 Cartridge film in rollholder. \$100-150.

THE FALCON CAMERA - 1897-98. Style similar to the Pocket Kodak Camera, but larger. 2x21/2" exposures on special roll-film. \$100-150.

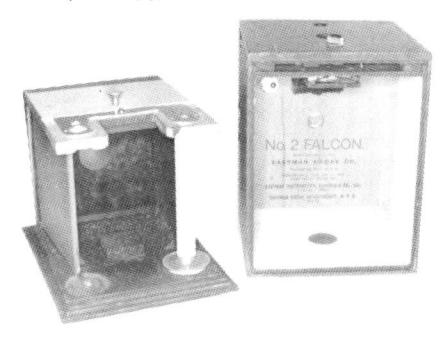

NO. 2 FALCON CAMERA - 1897-99. Box camera for 31/₂x31/₂" exposures on No. 101 rollfilm. Knob on front of camera to cock shutter. Leather covered wood. \$90-130

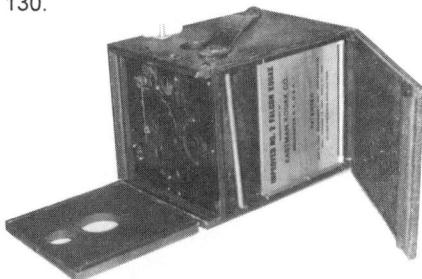

NO. 2 FALCON IMPROVED MODEL - 1899. The improved model can be recognized by its removable sides and back, like the more common Flexo which replaced it late in 1899. Identified inside as "Improved No. 2 Falcon Kodak". \$75-100.

FIESTA INSTANT CAMERA - \$1-10. No value without nameplate. See notes under "Instant Cameras".

FIFTIETH ANNIVERSARY CAMERA (see Anniversary Kodak Camera)

EASTMAN: FISHER-PRICE

Fling 35

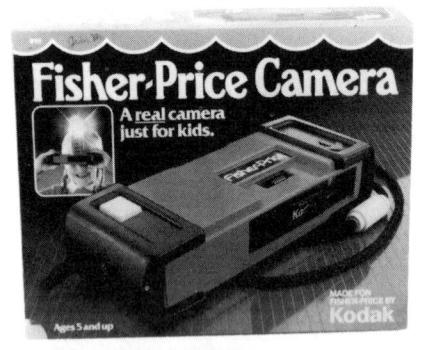

FISHER-PRICE CAMERA - c1984. Pocket 110 cartridge camera with cushioned ends. Made by Kodak for Fisher-Price. New, in box: \$25-35.

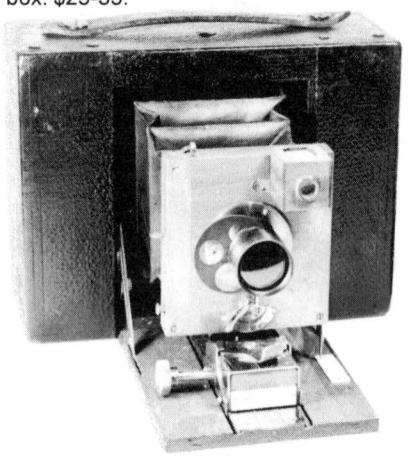

FLAT FOLDING KODAK CAMERA - 1894-95. Kodak's first folding camera with integral rollfilm back. Marketed only in England. RARE. \$1200-1800.

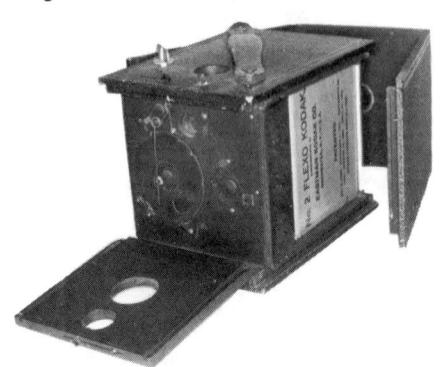

FLEXO KODAK CAMERA, No. 2 - 1899-1913. Box camera for 12 exp. 31/2x31/2" on No. 101 rollfilm. The most unusual feature is that the sides and back come completely off for loading, and are held together only by the leather covering. It is very similar in outward appearance to the Bull's-Eye

series, but was slighty cheaper when new. The same camera was marketed in Europe under the name "Plico". Achromatic lens, rotary shutter. (Orig. cost-\$5.00). Not often found with original leather corner hinges intact and supple. In this condition it will bring double the normal price for one with some cracking of hinges: \$35-50.

FLING 35 - Disposable 35mm camera. Bright yellow box with multi-colored K logo on front. We only include a current camera in the guide because disposable cameras tend to disappear quickly and become collectible. New price about \$9.

FLUSH BACK KODAK CAMERA, No. 3 - 1908-15. A special version of the No. 3 Folding Pocket Kodak Camera for 31/4x41/4" exposures on 118 film, or for glass plates. B&L RR lens in B&L Auto shutter. Made for the European market and not sold in the U.S.A. \$60-90.

FOLDING KODAK CAMERAS There are two distinct styles of "Folding Kodak" cameras which share little more than a common name. The earlier models, numbered 4, 5, and 6 by size, resemble a carrying case when closed, and are easily identifiable by the hinged top door which hangs over the sides like a box cover. The later model can be distinguished by its vertical format and rounded body ends in the more common style. We are listing the early models first followed by the later one.

FOLDING KODAK CAMERAS (early "satchel style") There are three variations of the No. 4 and No. 5: Sector shutter in 1890-91; Barker shutter, 1892; and the Improved version with B&L Iris Diaphragm shutter and hinged drop bed, 1893-97.

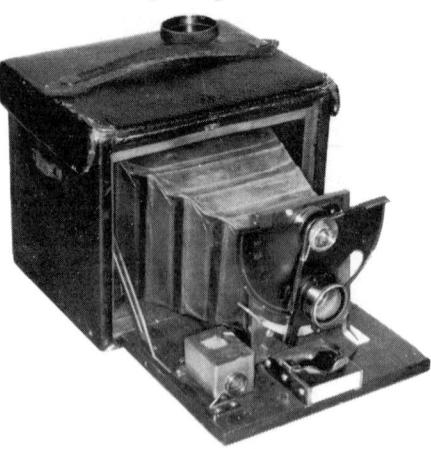

No. 4 with early sector shutter

No. 4 Folding Kodak Camera and Improved Model - 1890-97. For 48 exp. 4x5" on glass plates or rollfilm in rollholder. \$500-750.

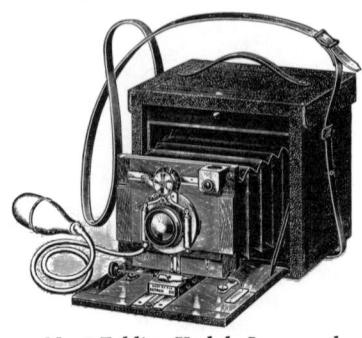

No. 5 Folding Kodak, Improved

No. 5 Folding Kodak Camera and Improved Model - 1890-97. Similar specifications, but for 5x7" film or plates. \$500-750. Illustrated bottom of previous column.

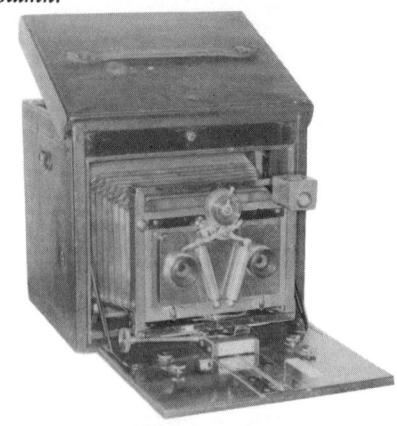

No. 5 Folding Kodak Camera Improved Model with stereo lensboard - The same camera as the No. 5 Folding Kodak Improved Camera, but with a stereo lensboard and partition for stereo work. RARE. No recent sales.

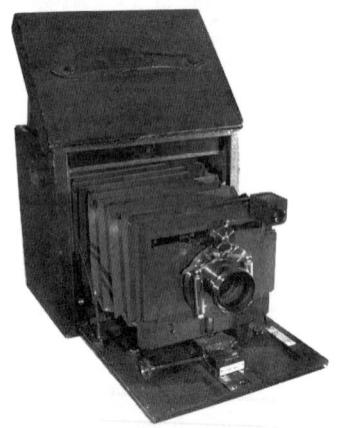

No. 6 with B&L Iris Diaphragm shutter

No. 6 Folding Kodak Camera Improved - 1893-95. Similar, but for $61/_2$ x8 $1/_2$ ". Since the No. 6 was not introduced until 1893, it was only made in the "Improved" version with B&L Iris Diaphragm shutter. This size is even less common than the others. \$800-1200.

NO. 4A FOLDING KODAK CAMERA 1906-15. Vertical folding-bed camera similar to the "Folding Pocket" series. For 6 exp., 41/4x61/2" on No. 126 rollfilm. (126 rollfilm, made from 1906-1949, is not to be confused with the more recent 126 cartridges.) Red bellows. \$150-225.

FOLDING POCKET KODAK CAMERAS

Original model (left) has 4 round openings on front, lens cone, and no backlatch slide. Second model (right) has only two finder openings, no lens cone and has metal back-

The Folding Pocket Kodak Camera - Renamed No. 1 after 1899. For 21/4x31/4 exp. on No. 105 rollfilm. Leather covered

front pulls straight out. Double finders concealed behind leather covered front. Red bellows. The earliest production models (c1897-1898) included a sequence of changes which led to the more standard "No. 1". The true "Original" had ALL of these features, and later models had some.

1. Recessed lens opening, a wooden "cone" shape (the shutter is quite different from later versions because of this odd opening.)

2. All brass metal parts are unplated. 3. There are four small openings on the face, two of which are used for finders.

4. No locking clasp for the back.

5. Patent pending.
6. Flat bar provided for horizontal standing, but no vertical stand.

--Original model - all features above:

-- Transitional models - Brass struts. but not all of the above features: \$175-250. --Nickeled struts - c1898-99:\$75-100.

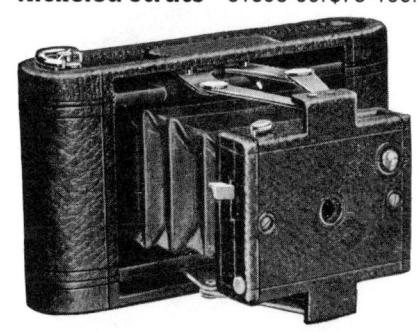

No. 0 Folding Pocket Kodak - 1902-1906. Similar in style to the original. For 4.5x6cm exposures on No. 121 film which was introduced for this camera. It is the smallest of the series, but by no means the first as some collectors have been misled to believe. \$100-150.

No. 1 Folding Pocket Kodak, (pullout front) - 1899-1905. Nickeled struts. Similar to the original model. \$60-90. Illustrated at top of next column.

EASTMAN: FOLDING POCKET KODAK

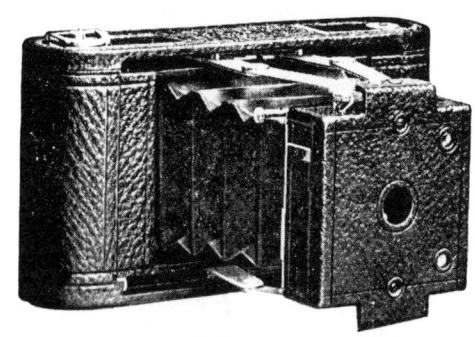

No. 1 Folding Pocket Kodak, pull-out front

Twin-finders variation

No. 1 Folding Pocket Kodak, (bed-type) - 1905-15. 21/4x31/4" exposures. Recognizable by the domed front door, red bellows, twin sprung struts for the lens-board. Self-erecting bed. Various models. With twin-finders (made briefly): \$50-75. With single, reversible finder: \$25-35.

No. 1A Folding Pocket Kodak, (pull-out front) - 1899-1905. Similar to the original FPK, but for 21/2x41/4" exposures. \$45-60.

1A Folding Pocket Kodak,

(bed-type) - 1905-15. For 21/2x41/4" exposures on 116 rollfilm. Domed front door, twin sprung struts, red bellows. Selferecting bed. Various models. With twin-finders (made briefly): \$50-75. With single, reversible finder: \$35-50.

1A Folding Pocket Kodak Camera R.R. Type - 1912-15 and
No. 1A Folding Pocket Kodak
Special Camera - 1908-12. Similar to the regular "1A" but with better lenses and shutters. \$35-50.

No. 2 Folding Pocket Kodak - Horizontal style camera for square exposures 31/2x31/2" on No. 101 rollfilm. Front is not self-erecting. Bed folds down, and front standard pulls out on track. Flat rectangular front door. First model (1899-1905) has leather covered lensboard with recessed lens and shutter: \$75-100. Later models (1905-1915) have wooden standard with exposed shutter and lens: \$60-90.

No. 3 Folding Pocket Kodak - Vertical style folding-bed camera for 31/4x41/4" exposures on 118 rollfilm. Flat rectangular front door. Early models (1900-1903) with leather covered lensboard concealing the rotary shutter: \$90-130 in EUR, \$50-75 in USA. Later models (1904-15) with exposed lens and shutter: \$30-45. Illustrated at top of next page.

No. 3 Folding Pocket Kodak, Deluxe - 1901-03. A No. 3 Folding Pocket Kodak in Persian Morocco covering and brown silk bellows. Rare. Price negotiable. Estimate: \$800-1200.

EASTMAN: FOLDING POCKET KODAK...

No. 3 Folding Pocket Kodak, early version

No. 3A Folding Pocket Kodak - 1903-15. Vertical folding-bed camera for 31/4x51/2" exposures on 122 rollfilm (introduced for this camera). Flat, rectangular front door. Red bellows. Polished wood insets on bed. By far the most common model of the FPK series. \$35-50.

No. 4 Folding Pocket Kodak - 1907-15. Vertical folding-bed camera for 4x5" exposures on 123 rollfilm. Red bellows, polished wood insets on bed. \$90-130.

GENESEE OUTFIT - c1886. An early and relatively unknown 5x7" view camera made by Frank Brownell for the Eastman Dry Plate & Film Co. Complete with plateholders, brass-barrel R.R. lens with waterhousestops, etc. \$400-600.

GEORGE WASHINGTON BICENTENNI-AL CAMERA - c1932. One of the rarest of Kodak box cameras. This one, like the 50th Anniversary of Kodak camera is based on the No. 2 Rainbow Hawk-Eye Model C, but with special colored covering and a seal on the side. This camera is a very attractive blue, with an art-deco front plate with an enameled red, white, and blue star. Unfortunately, due to the depressed economy in 1932, Kodak decided not to market the camera, and only two examples are known to exist. Both were

donated by Kodak to the International Museum of Photography at George Eastman House. One of these was subsequently sold at Christie's for 13,000 Pounds Sterling.

GIFT KODAK CAMERA, No. 1A - 1930-31. A special rendition of the No. 1A Pocket Kodak Junior Camera. The camera is covered with brown genuine leather, and decorated with an enameled metal inlay on the front door, as well as a matching metal faceplate on the shutter. The case is a cedar box, the top plate of which repeats the art-deco design of the camera. To go one step further, the gift box is packed in a cardboard box with a matching design.

Original price in the 1930 Christmas season was just \$15.00. A few years ago these brought a bit more, but enough have appeared to fill the demand and reduce the price. Camera with original brown bellows, cedar gift box, instructions and original cardboard box: \$600-900. Camera with gift box: \$400-600. Camera only: \$120-180.

GIRL GUIDE KODAK CAMERA - British version of the Girl Scout Kodak Camera. Blue enameled body with Girl Guide emblem. Black bellows. Blue case. \$250-375 in England. Slightly higher in the U.S.A.

GIRL SCOUT KODAK CAMERA - 1929-1934. Vest pocket camera for 4.5x6cm

exposures on 127 rollfilm. Bright green color with official Girl Scout of America emblem engraved on the bed. With matching case: \$250-375.

HANDLE, HANDLE 2 INSTANT CAMERAS - With nameplate: \$1-10. See notes under "Instant Cameras".

HAPPY TIMES INSTANT CAMERA - 1978. A special two-tone brown premium version of "The Handle" camera with Coca-Cola trademarks. Originally sold for \$17.95 with purchase of Coca-Cola products. Not often found for sale. Sought by Coca-Cola collectors and camera collectors. \$120-180.

HAWKETTE CAMERA, No. 2 - c1930's. British made folding Kodak camera for $2^{1}/_{4}$ X31/₄" exposures on 120 rollfilm. Folding style like the Houghton Ensignette with cross-swinging struts. Body of brown marbled bakelite plastic. These cameras were used as premiums for such diverse products as Cadbury Chocolates and Australian cigarettes. A very attractive camera. Common in England. \$60-90.

EASTMAN: HAWK-EYE

HAWK-EYE CAMERAS The Hawk-Eye line originated with the Blair Camera Co. and was continued by Kodak after they absorbed the Blair Co. See also Blair Hawk-Eye Cameras.

Hawk-Eye No. 2 - c1913-. Inexpensive cardboard box camera. Meniscus lens: rotary shutter. 21/4x31/4" exposures on 120 rollfilm. \$1-10.

Hawk-Eye No. 2A - c1913-. Black box camera of cardboard 21/2x41/4" on 116 film. \$1-10. construction.

Hawkeye Ace, Hawkeye Ace Deluxe - c1938. Small box camera for 4x6.5cm on 127 film. Made in London. Similar to Baby Hawkeye, but with leather-ette covering on front. Fixed focus lens, T & I shutter. \$25-35.

Baby Hawkeye - (An earlier camera called Baby Hawkeye, was made c1896 by the Blair Camera Co. It is a leather-covered wooden box.) - c1936. Small box camera for 4x6.5cm on 127 film. Made by Kodak Ltd., London. Fixed focus lens, flip-flop shutter, \$35-50.

CARTRIDGE HAWK-EYE CAMERAS (Box cameras)

No. 2 Cartridge Hawk-Eve Camera - 1924-34. $2^{1}/_{4}x3^{1}/_{4}$ " on 120. Some versions also made in London and Canada. Originally all metal, but leatherette covered after 1926. Model A (metal): \$8-15. Model B (covered): \$1-10. Model C (single finder): \$1-10.

No. 2A Cartridge Hawk-Eye Camera - 1924-34. Originally all metal body. Beginning 1926 with Model B. there is a leatherette covering. 21/2x41/4" on 116. Model A (metal): \$8-15. Model B: \$1-10.

FILM PACK HAWK-EYE CAMERAS Box

cameras taking film packs.

No. 2 Film Pack Hawk-Eye Camera - 1922-25. 21/4x31/4". All metal construction. \$12-20.

No. 2A Film Pack Hawk-Eye Camera - 1923-25. 21/₂x41/₄". \$12-20. 2A Film

Film Pack Hawk-Eye "DRINK FIRST AID" - Like the normal No. 2 Film Pack Hawk-Eye, but with gold lettering on the back "Drink First Aid". This camera and other premium items were offered by the First Aid soft drink company. Several years back, five of these cameras were found, in their original boxes, with instructions, and with a poster illustrating the various premi-um items. These few "outfits" in new condition have occasionally appeared on the market. Current estimate: \$400-600.

HAWKEYE FLASHFUN. FLASHFUN II **CAMERAS - \$1-10.**

FOLDING HAWK-EYE CAMERAS

No. 1A Folding Hawk-Eye Camera - 1908-15. 21/2x41/4". Red bellows. Various lens and shutter combinations. With Meniscus or RR lens in Kodak Ball Bearing or pneumatic shutter: \$20-30. With Zeiss-Kodak Anastigmat or Tessar IIB lens in Compoundshutter: \$30-45.

No. 3 Folding Hawk-Eye Camera -1904-15. Models 1-9. 31/4x41/4" exposures on 118 film. Horizontal format. \$35-50 No. 3A Folding Hawk-Eye Camera -1908-15. Models 1-4. 31/₄x51/₂" exposures on 122 film. Horizontal format. \$35-50. No. 4 Folding Hawk-Eye Camera - 1904-13. Models 1-4. 4x5" exposures on 103 rollfilm, \$45-60.

Six-16 or Six-20 Folding Hawk-Eye camera -1933-34. Brown: \$25-35. Black: \$20-30.

FOLDING **HAWK-EYE SPECIAL** CAMERAS - In four sizes, with Kodak Anastigmat f6.3 lens. No. 2 Folding Hawk-Eye Special Camera - 1928-33. \$15-25. No. 2A Folding Hawk-Eye Special Camera - 1928-30. \$15-2 No. 3 Folding Hawk-Eye Special Camera - 1929-34, \$15-25 No. 3A Folding Hawk-Eye Special Camera - c1929. \$20-30.

FOLDING **CARTRIDGE** HAWK-EYE CAMERAS No. 2 Folding Cartridge Hawk-Eye Camera - 1926-33.21/4x31/4" on 120 film. Kodex shutter. Colored models: \$25-35. Black: \$12-20.

No. 2A Folding Cartridge Hawk-Eye Camera - 1926-34. 21/2x41/4" on 116 film. Single Achromatic or RR lens. \$12-20

No. 3A Folding Cartridge Hawk-Eye Camera - 1926-35. 31/4x51/2" on 122 film. Kodak shutter. RR or Achromatic lens. \$20-30.

FOLDING FILM PACK HAWK-EYE CAMERA, No. 2 - 1923. Hawk-Eye shutter. Meniscus Achromatic lens. $2^{1/4}$ x $3^{1/4}$ " exposures on film packs. \$15-25.

HAWKEYE Model BB - Made by Kodak Ltd. in London. 21/4x31/4" on 120 rollfilm. Black with bright metal trim. I+T shutter. \$8-15

EASTMAN: HAWK-EYE...

HAWKEYE INSTAMATIC CAMERAS - 1963-78. A series of 126 cartridge cameras made as premiums. \$1-10. Includes:

Hawkeye Instamatic A-1 Hawkeye Instamatic F Hawkeye Instamatic II Hawkeye Instamatic R4 Hawkeye Instamatic X

PORTRAIT HAWKEYE, No. 2 - 1930. Kodak Ltd. Box camera for 2¹/₄x3¹/₄" on 120 rollfilm. Built-in close-up lens; I+T shutter. \$8-15.

PORTRAIT HAWKEYE A-STAR-A 1933. Kodak Ltd. Cardboard box camera with blue or green leatherette exterior. Takes 21/4x31/4" on 620 film. Originally sold for premium use. \$20-30.

RAINBOW HAWK-EYE CAMERAS Box cameras, similar to Cartridge Hawk-Eye, but in blue, brown, green, maroon, vermillion.

No. 2 Rainbow Hawk-Eye Camera - 1929-33. 21/₄x31/₄" exposures. Colors: EUR: \$35-50. USA: \$25-35. Black: \$1-10. No. 2A Rainbow Hawk-Eye Camera - 1931-32. Same, but in 21/₂x41/₄" size. Colors: EUR: \$35-50. USA: \$25-35. Black:

--"The Fox Co." - A premium version of the No. 2A Rainbow Hawk-Eye Model B. Round foil label on the side is embossed with "Your Kodak Finishers -The Fox Co. -San Antonio Texas". \$75-100.

--"Tim's Official Camera" - A special version of a red No. 2A Rainbow Hawk-Eye camera, with a decal on the side with the comic character's head and the words "Tim's Official Camera". Tim was an advertising character, apparently created during the 1930's to promote clothing and other merchandise of the May Company and others. He was also tied in with Superman in radio and print advertising. \$75-100.

FOLDING RAINBOW HAWK-EYE CAMERAS Similar to the Folding Hawk-Eye Cameras, but available in black and colors: blue, brown, green, old rose. Black "Rainbow" models bring the same prices as the ordinary Folding Hawk-eye cameras. Prices below are for colored models. (Subtract 35% for black replacement bellows.)

NO. 2 Folding Rainbow Hawk-Eye Camera - 1930-34. 21/4×31/4". \$60-90.

NO. 2A Folding Rainbow Hawk-Eye Camera - 1930-33. 21/2×41/4". \$60-90.

FOLDING RAINBOW HAWK-EYE SPECIAL CAMERAS, Nos. 2, 2A - 1930-33. Available in black and colors: blue, brown, green, maroon. \$60-90.

HAWK-EYE SPECIAL CAMERAS - No. 2, 1928-33; No. 2A, 1928-30. Deluxe model box cameras with embossed moroccograin imitation leather. \$15-25.

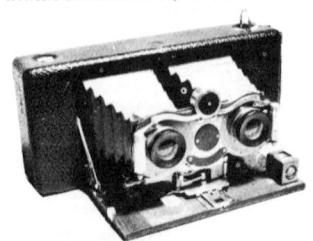

STEREO HAWK-EYE CAMERA - A continuation of the Blair Stereo Hawk-Eye series produced through 1916, and labeled "Blair Division of Eastman Kodak Co." A folding stereo camera taking twin 31/₂x31/₂"

exposures. Various models, numbered in sequence, offered various lens/shutter combinations. Mahogany interior, brass trim, red bellows. \$400-600.

TARGET HAWK-EYE CAMERAS, No. 2, No. 2 Junior, No. 2A, Six-16, and Six-20 - 1932-33. Simple box cameras. No. 2 available in black only, others available in black, blue, and brown. Black: \$1-10. Colors: \$20-30.

VEST POCKET HAWK-EYE CAMERA VEST POCKET RAINBOW HAWK-EYE

CAMERA Very similar cameras exist with and without the "Rainbow" designation in the name, but they are all available in the same colors. The Vest Pocket Hawk-Eye cameras have "VEST POCKET HAWK-EYE" nameplate on the shutter face, and a circle on the inside of the door with the words "Use No.127 Film". They also have 6 rivet heads on the back of the body with a wide, double-edged raised area. The Vest Pocket Rainbow Hawk-Eye cameras have "RAINBOW HAWK-EYE VEST POCKET" on the shutter face, and no "127 film" circle. The back may be the type just described, or it may have no rivet heads, and a raised area that is narrow and single edged.

VEST POCKET HAWK-EYE CAMERA 1927-34. 4.5x6cm exposures. Single or Periscopic lens. See descriptions above. Available in black, blue, green, orchid, & rose. Colors, with original colored bellows: \$90-130. Black: \$25-35. *See note above.*

VEST POCKET RAINBOW HAWK-EYE CAMERA - 1930-33. See the description under the double heading above. Orchid or rose with original colored bellows: \$120-180. Blue or green with original colored bellows: \$100-150. Black: \$25-35.

WENO HAWK-EYE CAMERAS Box cameras originally made by Blair Camera Co., continued by Kodak until 1915. See also Blair Weno Hawk-Eye Camera.

No. 2 Weno Hawk-Eye Camera -

31/₂x31/₂". \$30-45. No. 4 Weno Hawk-Eye Camera -

No. 5 Weno Hawk-Eye Camera -31/₄x41/₄' \$30-45

No. 7 Weno Hawk-Eye Camera - 31/₄x51/₂". Introduced in 1908 after Blair became a part of EKC. \$35-50.

INSTAMATIC CAMERAS - Introduced in 1963 for the new 126 cartridge. Numerous models, most of which are easily found. To give a fairly complete list in a small space. we have grouped them by features.

Basic models - 100, 104, 124, 44, X-15, X-15F, 25: \$1-10.

With meter - 300, 304, 134, 314, 333X, X-30, X-35, X-35F: \$1-10.

Spring motor models - 150, 154, 174, X-25: \$12-20.

Spring Motor & meter - 400, 404, 414, X-45: \$20-30.

f2.8 metered models - 324, 700, 704, 714: \$30-45.

f2.8, meter, motor, RF - 800, 804, 814, X-90: \$30-45.

Instamatic 250 - 1965-67. Made in Germany. Streamlined continental styling. Focusing f2.8 lens, shutter to 1/250, B. AG-1 flash. Lever advance. \$30-45.

Instamatic 500 - 1963-66. Germany. Continental-styled metered model with Schneider Xenar f2.8/38mm in Compur 1/30-1/500 shutter. Hot shoe and PC sync. Common, \$45-60.

Instamatic Reflex (Type 062) 1968-74. 126 cartridge SLR. Interchangeable Retina lenses. CdS meter. Fully electronic shutter (one of the first in the world). Last models with hot shoe on top. Black, with lens: \$175-250. Chrome, with Xenar f2.8/45mm or Xenon f1.9/50: \$100-150.

Instamatic S-10 & S-20 - 1967-71/72 Compact models with rectangular pop-out front. Advance knob on end. S-20 has meter \$1-10

Instamatic X-30 Olympic - A normal X-30 with a special transparent decal with 5-ring Olympic logo, marked "Selected for use by the U.S. Olympic Team". \$20-30.

INSTANT CAMERAS - In October 1985, after nine years of patent litigation with Polaroid, Kodak was banned from making and selling instant cameras and film. The ban took effect January 1986, at which time Kodak announced a trade-in program. The owners of 16.5 million cameras were given the chance to trade in their cameras for a share of Kodak common stock, a new camera, or \$50 worth of Kodak merchandise. The obvious immediate effect on the value of used Kodak instant cameras was that Kodak would pay more for them than most collectors. By June of 1986, several class action lawsuits had been filed against Kodak by instant camera owners. The courts brought Kodak's rebate plan to a halt pending the outcome of these suits, which asked, among other things, for a cash rebate option. The final settlement called for owners to return the camera's nameplate for a refund of cash and credits. This turn-in has been completed, and it appears that of the over 16.5 million Kodak instant cameras once in circulation, certainly there are more than enough examples, complete with their original nameplate, for all of the world's collectors at less than \$5 each. A few of the top-of-line models, specialpurpose types, or commemorative models will attract more collector interest, as they would have done without the legal hoopla. Kodak Instant cameras without nameplates are flooding the market, and have virtually no collector or commercial value.

JIFFY KODAK CAMERAS Common rollfilm cameras with pop-out front, twin spring struts. Vest pocket model has a Doublet lens. other models have Twindar lens, zone focus. Note: Back latch is often broken which reduces the value by 40-50%. See "Kodak Enlarger 16mm" for a specialized version.

Jiffy Kodak Six-16 - 1933-37. Art-deco enameled front. 21/2x41/4" on 616. \$12-20.

EASTMAN: JIFFY KODAK...

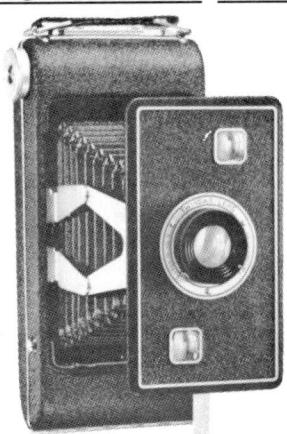

Jiffy Kodak Six-16, Series II - 1937-42. Similar to the Six-16, but with imitation leather front instead of art-deco. Less common. \$12-20.

Jiffy Kodak Six-20 - 1933-37. Art-deco front. 2¹/₄x3¹/₄" on 620 rollfilm. \$12-20.

Jiffy Kodak Six-20, Series II - 1937-48. Similar to the Six-20, but with imitation leather front. \$12-20.

Jiffy Kodak Vest Pocket - 1935-42. 4.5x6cm on 127 rollfilm. Black plastic construction. \$25-35.

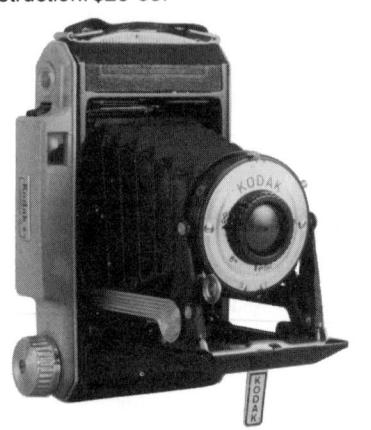

KODAK A MODELE 11 - Self-erecting folding camera for 6x9cm. Grey plastic top housing with incorporated optical finder. Made in France. \$25-35.

KODAK BOX 620 CAMERA - 1936-37. All black metal box, leatherette covering. Made by Kodak A.G., Stuttgart. \$12-20.

KODAK BOX 620C CAMERA - c1939-40. Made by Kodak A.G., Stuttgart. Unlike the Box 620, this camera looks more like the Six-20 Brownie Special. Folding frame finder. Meniscus lens, Kodak Spezial shutter. \$35-50.

KODAK ENLARGER 16mm - c1939. Folding camera for enlarging frames of 16mm movie film onto 616 film. The body is basically a Jiffy Kodak Six-16 Model II, with modifications for enlarging. \$25-35.

KODAK JUNIOR CAMERAS Two of Eastman's first cameras bore the name Junior along with their number. They are the No. 3 Kodak Jr., and the No. 4 Kodak Jr. Both are box cameras with string-set shutters, and are listed at the beginning of the Eastman Kodak section.

The models listed here are folding-bed cameras. Nos. 1 and 1A were introduced in 1914 shortly before the Autographic feature

became available. These cameras had a short life-span, with the Autographic Kodak Junior Cameras taking their place. (See Autographic Kodak Junior Cameras.) Kodak funior I and II are from Kodak Ltd., London, c1950's. They have grey plastic top housing with incorporated optical finder and are identified inside the front of the bed.

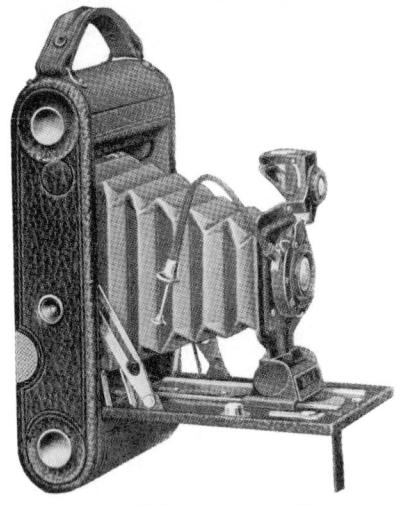

No. 1 Kodak Junior Camera - 21/4×31/4" on 120 rollfilm. \$12-20.

No. 1A Kodak Junior Camera - 21/2×41/4" on 116 film. \$12-20.

Kodak Junior 0 - c1938. Made by Kodak A.G., Stuttgart. Simple 6x9cm folding rollfilm camera. Triskop f11/105mm in Kodak Spezial shutter 1/25, B. \$35-50.

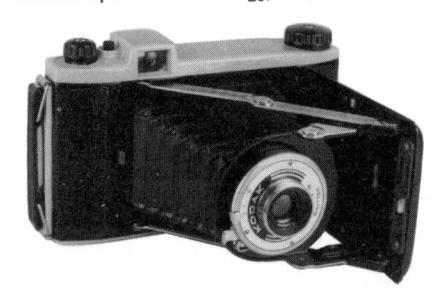

Kodak Junior I - 1954-59. Kodak Ltd, London. Self-erecting folding camera for $2^{1}/_{4}$ X31/₄" on 620. Grey plastic top housing incorporates optical finder. Fixed focus lens in Kodette III shutter. Not synchronized, no body release. \$12-20.

Kodak Junior II - 1954-59. Similar to above, but with Anaston f6.3/105 focusing lens in sync'd Dakon II shutter, 50,25,B,T. Body release. \$12-20.

Kodak Jr. Six-16, Series II

Kodak Jr. Six-16 - 1935-37. 21/₂x41/₄" in 616 film. Octagonal shutter face. Self-erecting bed. \$20-30.

Kodak Jr. Six-16, Series II - 1937-40. \$12-20. Illus. bottom of previous column.

Kodak Jr. Six-16, Series III - 1938-39. Self-erecting. Streamlined bed supports. \$12-20.

Kodak Jr. Six-20 - 1935-37. Octagonal shutter face. Self-erecting bed. \$15-25. Kodak Jr. Six-20, Series II - 1937-40. Similar. \$12-20.

Kodak Jr. Six-20, Series III - 1938-39. Self-erecting. Streamlined bed supports. \$12-20.

Kodak Junior 620 - c1936-38. Kodak A.G. \$15-25.

KODAK REFLEX CAMERAS - Twin lens reflex cameras with Kodak f3.5 lens in Flash Kodamatic shutter.

Kodak Reflex - 1946-49. \$35-50.

Kodak Reflex IA - Introduced December 1950. Kodak Reflex IA cameras are Kodak Reflex cameras with the original ground glass replaced by an Ektalite field lens. The conversion kit included the lens and bezel, nameplate, and screws. The original cost of the conversion kit was \$10.00. Conversions were made by Kodak and other repair organizations. The number of converted cameras is unknown. Much less common than the Kodak Reflex and Reflex II models. \$75-100.

Kodak Reflex II - 1948-54. \$35-50. KODAK SERIES II, SERIES III CAMERAS - Folding rollfilm cameras from the same era as and similar in appearance to the Pocket Kodak folding cameras.

No. 1 Kodak Series III Camera - 1926-31.21/₄x31/₄" on 120 film. \$20-30.

No. 1A Kodak Series III Camera - 1924-31. 2¹/₂x4¹/₄" exp. on 116 film. \$20-30.

No. 2C Kodak Series III Camera - $1924-32.27/_8$ x $47/_8$ " on 130 film. \$20-30.

No. 3 Kodak Series III Camera - 1926-33.31/₄x41/₄" on 118 film. \$35-50.

No. 3A Kodak Series II Camera - 1936-41. 31/₄x51/₂" exposures on 122 film. \$45-60.

No. 3A Kodak Series III Camera - $1941-43.\ 31/_4x51/_2$ " exposures on 122 film. \$45-60.

KODAK 35 CAMERA - 1938-48. For 24x36mm exposures on 35mm cartridge film. Various lens/shutter combinations. No rangefinder. Very common. \$20-30.

KODAK 35 CAMERA (Military Model PH-324) - Olive drab body with black trim. PH-324 printed on back. \$120-180.

KODAK 35 CAMERA, with Rangefinder - 1940-51. f3.5 Kodak Anast.

EASTMAN: KODET

Special or Kodak Anastar lens. Kodamatic or Flash Kodamatic shutter. Very common in USA, \$20-30.

KODAK 66 MODEL III - 1958-60. Kodak Ltd, London. Horizontally styled folding bed camera for 6x6cm on 120. Anaston f6.3/75mmin Vario. \$25-35.

KODAMATIC INSTANT CAMERAS -

See notes and prices under "INSTANT CAMERAS".

KODET CAMERAS No. 3 Folding Kodet Camera - Vertically styled folding bed camera, similar to the No. 4 but slightly smaller. Probably sold only in England. Rare. Estimated

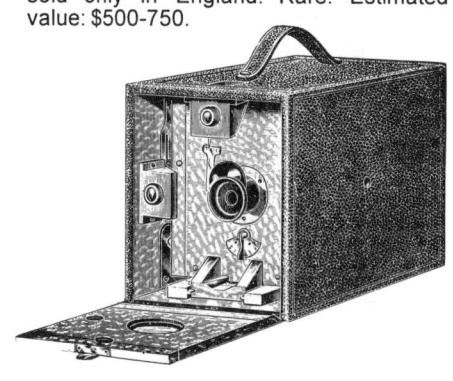

No. 4 Kodet Camera - 1894-97. For 4x5" plates or rollfilm holder. Leather covered wooden box. Front face hinges down to reveal brass-barrel lens and shutter. Focusing lever at side of camera. Uncommon.\$500-750.

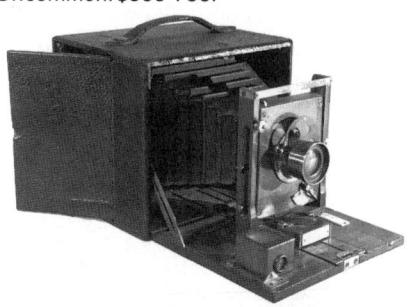

No. 4 Folding Kodet Camera - 1894-1897. Folding-bed camera for 4x5" plates or special rollholder. Basically cube-shaped when closed. Early model with variable speed shutter built into wooden lens standard. Brass barrel lens with rotating disc stops: \$500-750. Later models with Gundlach or B&L external shutters: \$350-500.

EASTMAN: KODET...

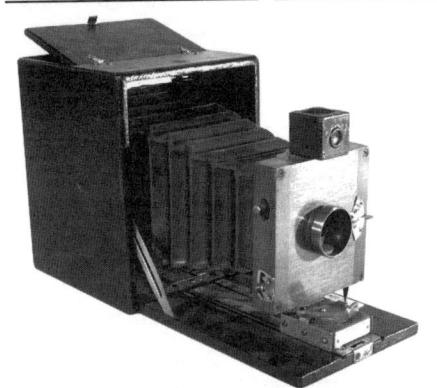

No. 4 Folding Kodet Junior Camera - 1894-97. Rare. Negotiable. Estimate: \$500-750.

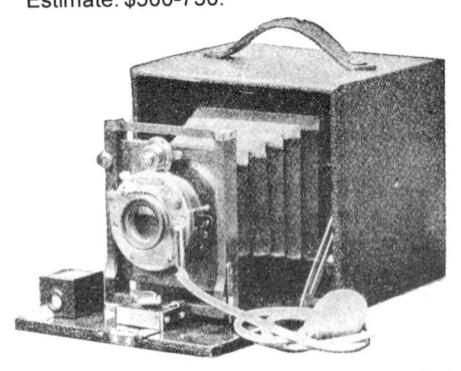

Special Kodet 4 Folding Camera - 1895-97. \$350-500.

No. 5 Folding Kodet Camera No. 5 Folding Kodet Special Camera - 1895-97. \$350-500.

MATCHBOX CAMERA - 1944-45. Simple metal and plastic camera shaped like a matchbox. Made for the Office of Secret Services. 1/2x1/2" exposures on 16mm film. Rare. \$2800-4000.

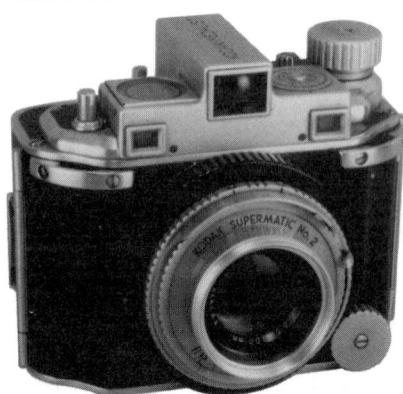

Medalist I

MEDALIST CAMERAS - 21/4x31/4" on 620 film. Kodak Ektar f3.5/100mm. Split image RF. Because the Medalist cameras are less common in Europe than in the USA, they bring about 10-15% more at European auctions. In less than excellent condition, they

are often advertised in the USA for less than

Medalist I - 1941-48. Supermatic shutter to 400, B. No sync. \$175-250. Illustrated bottom of previous column.

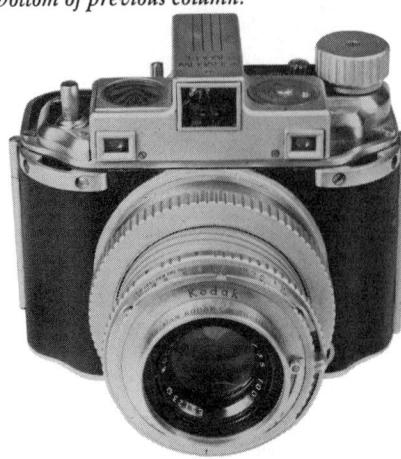

Medalist II - 1946-53. Flash Supermatic shutter. \$175-250.

Medalist Accessories: Ground Glass Back - \$30-45.

MICKEY-MATIC - c1988. Pocket 110 cameras in blue or magenta color, with Mickey Mouse label. Although of recent vintage, these appeal to both Kodak and Mickey collectors. \$25-35.

MONITOR CAMERAS - 1939-48. Folding rollfilm cameras:

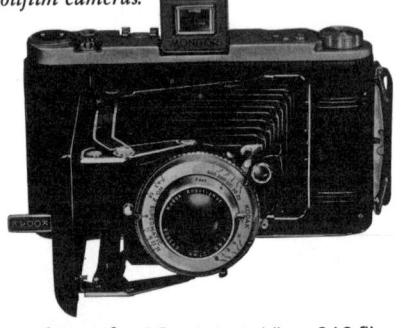

Monitor Six-16 - 21/2x41/4" on 616 film

f4.5/127mm lens in Kodamatic or Supermatic shutter, 10-400. (This is the less common of the two models.) \$35-50.

Monitor Six-20 - 21/4x31/4" on 620 film. f4.5 lens. Common. More sellers than buyers at \$30-45.

MOTORMATIC 35 CAMERAS - Similar to the Automatic 35 series, but with motorized film advance. Made in 3 variations:

Motormatic 35 Camera - 1960-62. Flash sync. posts on end of body. \$35-50.

Motormatic 35F Camera - 1962-67. Similar, but built-in flash for on top AG-1 bulbs. \$30-45.

Motormatic 35R4 Camera - 1965-69. Built-in flashcube socket on top. \$30-45.

NAGEL Some cameras made by Kodak A.G. in Stuttgart (formerly Dr. August Nagel Werk) are continuations of cameras which were formerly sold under the Nagel brand. These cameras may be found under their model name in both the Eastman and Nagel sections of this guide. (e.g. Pupille, Ranca, Regent, Vollenda.)

ORDINARY KODAK CAMERAS A series of low-priced wooden Kodak box cameras without leather covering made from 1891-1895. They were called "Ordinary" to distinguish them from the Daylight, Folding, Junior and Regular Kodaks, as they were called at that time. All are made for 24 exposures on rollfilm. All have Achromatic lens, sector shutter. They differ only in size and price.

Illustrated bottom of previous page.

A Ordinary Kodak Camera -

 $2^{3}/_{4}x3^{1}/_{4}$ ". (Original cost \$6.00.) \$1700-2400.

B Ordinary Kodak Camera - 31/₂x4". (Original cost \$10.00.) \$1200-1800.

C Ordinary Kodak Camera - 4x5". (Original cost \$15.00.) \$1000-1500. (Also available in the plate version called the C Ordinary Glass Plate Kodak Camera.)

PANORAM KODAK CAMERAS Rollfilm panoramic cameras in which the lens pivots and projects the image to the curved focal plane. Although designed basically for wide views, it could also be used vertically.

No. 1 Panoram Kodak Camera - April 1900-26. For $2^{1}/_{4}$ X7" exposures on No. 105 rollfilm for an angle of 112°. (Original cost \$10.) Model A: \$350-500. Models B, C, D: \$250-375.

No. 3A Panoram Kodak Camera - 1926-28. Takes $3^{1}/_{4}$ x $10^{3}/_{8}$ " exposures on 122 rollfilm for an angle of 120°. This is the least common of the series, having been made for only two years. \$350-500.

No. 4 Panoram Kodak Camera, Original - 1899-1900. Has no door to cover the swinging lens. For $31/_2$ x12" on No. 103 rollfilm. 142° angle. Rapid Rectilinear lens. (Original cost \$20.) \$250-375.

No. 4 Panoram Kodak Camera, Models B, C, D - 1900-24. Same as the original model, but with a door over the lens. \$250-375.

PEER 100 - c1974. An Instamatic 92 camera whose exterior is designed to look like a package of Peer cigarettes. Used as a sales promotion premium. \$350-500.

PETITE CAMERA - 1929-33. A Vest Pocket Kodak Model B in colors: blue, green, grey, lavender, and old rose. For 4.5x6cm on 127 film. Meniscus lens, rotary

EASTMAN: POCKET KODAK

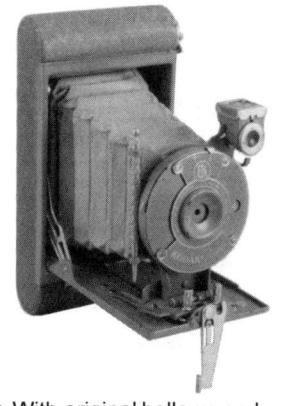

shutter. With original bellows and matching case: \$120-180. With black replacement bellows: \$75-100. (See also Kodak Ensemble, Coquette.)

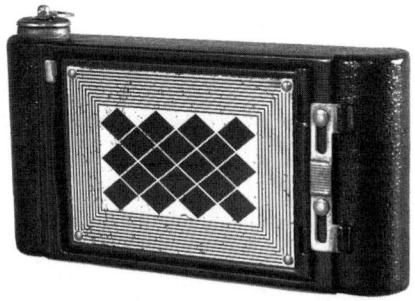

Petite "Diamond Door" - Unlike the fabric covered models, this version has brown leatherette covering and an enameled front door with a pattern of 18 diamonds. Brown enameled metal parts. Uncommon. With original brown bellows, instructions, and art-deco cardboard box: \$350-500. Camera only: \$300-450.

Petite "Lightning Bolt": See Coquette.

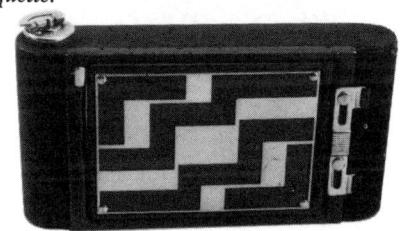

Petite "Step Pattern" - Rather than the normal fabric covering on the front door, some of the Petite cameras had an enameled metal front in an art-deco "step" pattern. With original colored bellows: \$350-500. With replacement black bellows: \$250-375.

PIN-HOLE CAMERA - ca. late 1920's and early 1930's. This is a small kit which consists of 5 cardboard pieces, gummed

tape, a pin to make the hole, and instruction booklet. These were given to school children for use as science projects. We have seen a number of unused kits offered for sale at prices from \$195 to \$350. Obviously these are no longer for kids to play with. Assembled: \$90-130.

PLEASER, PLEASER II - See notes under "Instant Cameras".

KODAK PLIANT Modele B11 - c1950-55. Made by Kodak Pathe, France. Self-erecting folding camera, 6x9cm on 620 film. Achromatiens. \$20-30.

PLICO - European name variation of the Flexo. \$50-75.

POCKET A-1 CAMERA - c1978-80. Boxy camera for 110 cartridges. Made by Kodak Ltd., London. \$1-10.

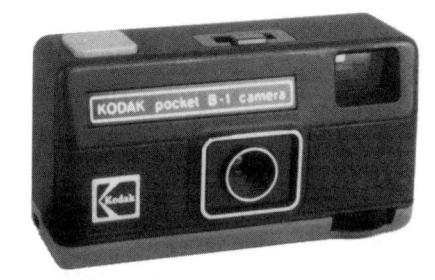

POCKET B-1 CAMERA - c1979-80. Same as Pocket A-1, but sold for premium use. \$1-10.

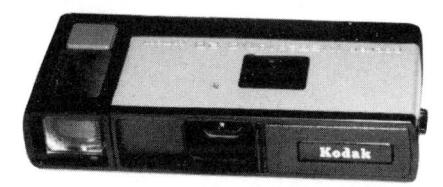

POCKET INSTAMATIC CAMERAS - Introduced in 1972 for the new 110 cartridge. 13x17mm exposures. Most models are too new to have much collector value, but the better ones still have value as usable cameras. Model 60: \$25-35. Model 50: \$25-35. Model 40: \$12-20. Simpler models: \$1-10.

POCKET KODAK CAMERAS Except for the first camera listed here, the Pocket Kodak cameras are of the common folding rollfilm variety.

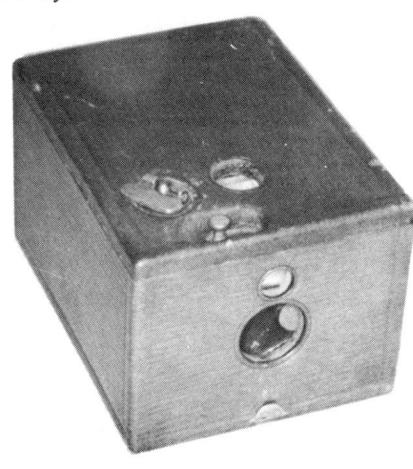

The Pocket Kodak (box types) - 1895-1900. A tiny box camera for 11/2x2" exposures on No. 102 rollfilm which was introduced for this camera. An auxiliary

EASTMAN: POCKET KODAK...

plateholder could also be used. Single pebble-grained leather. Several production changes in 1895 with regard to shutter placement, film guides, and spool compartments resulted in at least four distinct variants. Evidence suggests that the first type had felt film guides, plain metal flaps on the spool compartments, shutter first attached to the film carrier, then separate. The second type had felt film guides, printed flaps. The third type had roller guides, printed or plain flaps. The fourth type has roller guides, shutter attached to film carrier. All 1895 types have round viewfinder window on top, sector shutter. Shutter type changed from sector to rotary in 1896. Identified by model year inside bottom. Some of the early ones were covered in a red leather. These will bring about 25% more than the normal brown ones. Original 1895 type: \$150-225. Later models: \$120-180.

Pocket Kodak Cameras (folding types) - All of these incorporate the Autographic feature, but the word Autographic does not form part of the name.

No. 1 Pocket Kodak Camera - 1926-31, black; 1929-32, colors. 21/₄x31/₄" on 120 film. Colors (blue, brown, green or grey): \$25-35. Black: \$8-15.

No. 1A Pocket Kodak Camera - 1926-31, black; 1929-32, colors. 21/₂x41/₄" on 116 film. Colors (blue, brown, green, grey): \$25-35. Black: \$8-15.

No. 2C Pocket Kodak Camera - $1925-32.2^{7/8}x4^{7/8}$ " on 130 film. Black only. \$12-20.

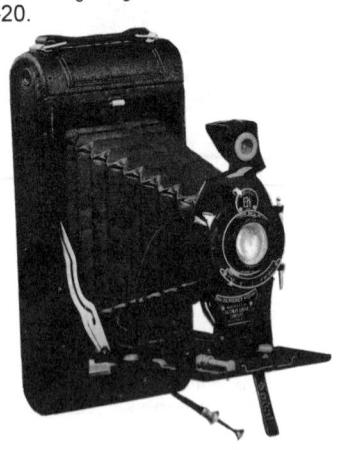

No. 3A Pocket Kodak Camera - 1927-34. 31/₄x51/₂" on 122 film. Black only. \$15-25.

POCKET KODAK JUNIOR CAMERAS 1929-32. Folding bed camera available in black, blue, brown, and green. Meniscus lens in Kodo shutter.

No. 1 Pocket Kodak Junior Camera - 21/₄x31/₄" on 120 film. Black: \$8-15. Colors: \$35-50.

No. 1A Pocket Kodak Junior Camera - 21/₂x41/₄" on 116 film. Black: \$8-15. Colors: \$35-50.

POCKET KODAK SERIES II CAMERAS

No. 1 Pocket Kodak Series II Camera - 1922-31. Focusing and fixed-focus models. Black only. \$12-20.

No. 1A Pocket Kodak Series II Camera, black - 1923-31. Focusing and fixed-focus models. \$12-20.

No. 1A Pocket Kodak Series II Camera, colors - 1928-32. Available in beige, blue, brown, green, and grey. Meniscus Achromatic lens in Kodex shutter. Originally came with matching carrying case. Complete with case and box in EUR: \$90-130; in USA: \$60-90. Camera only: \$20-30.

POCKET KODAK SPECIAL CAMERAS Folding bed cameras in black. Kodak Anastigmat f6.3, f5.6, f4.5 lenses in Kodamatic shutter. (No. 2C not available with f6.3 lens.) Models with f4.5 lens are hard to find; would be worth about 30-40% more. All models less common in Europe where they sometimes bring more than the USA prices below:

Pocket Kodak Special No. Camera - 1926-34.21/4x31/4" on 120 film. Kodak Special 1A Pocket No. 1926-34. 21/₂x41/₄" on 116 film. **Pocket Kodak Special** Camera -No. 2C Camera - 1928-33.27/8x47/8" on 130 film. Kodak Special No. 3 Pocket **Camera** - 1926-33. 31/4x41/4" on 118 film. \$20-30

Pony IV

PONY CAMERAS

Pony II - 1957-62. For 24x36mm exposures on 35mm film. Non-interchangeable Kodak Anastar f3.9/44mm lens. Bakelite body. \$12-20.

Pony IV - 1957-61. 35mm. Non-interchangeable Kodak Anastar f3.5/44mm. \$12-20. *Illus. bottom of previous column*.

Pony 135 - 1950-54; Model B, 1953-55; Model C, 1955-58. The first Pony Camera for 35mm film. Non-interchangeableKodak Anaston f4.5 or f3.5 lens in focusing mount. \$8-15.

Pony 135 (Made in France) - 1956. 24x36mm on 35mm film. Angenieux Pony f3.5/45mm lens. Shutter 1/₂₅-1/₁₅₀, B. \$20-30.

Pony 828 - 1949-59. The first in this series, it took No. 828 film. Easily distinguished from the later 35mm models by the lack of a rewind knob on the top right side of the camera next to the shutter release. Common. \$8-15.

PREMO CAMERAS The Premo line was taken over by Kodak from the Rochester Opt. Co. and was a very popular line of cameras. See Rochester for earlier models.

PREMO BOX FILM CAMERA - 1903-08.

Box camera for filmpacks. $3^{1}/_{4}x4^{1}/_{4}$ " or 4x5" sizes. Achromatic lens, Automatic shutter. \$12-20.

CARTRIDGE PREMO CAMERAS - Simple rollfilm box cameras.

No. 00 Cartridge Premo Camera - 1916-22. 11/₄x13/₄". Meniscus lens. The smallest Kodak box camera. \$100-150.

No. 2 Cartridge Premo Camera - 1916-23.21/₄x31/₄". \$12-20.

No. 2A Cartridge Premo Camera - 1916-23. 21/₂x41/₄". \$12-20.

No. 2C Cartridge Premo Camera - 1917-23. 27/₈x47/₈". \$12-20.

FILM PREMO CAMERAS - Wooden-bodied folding bed cameras for filmpacks. Four sizes, 31/x41/4" through 5x7", usually found in the 31/x41/4" & 31/x51/2" sizes.

No. 1 Film Premo Camera - 1906-16. Simple lens and shutter. \$30-45.

No. 3 Film Premo Camera - 1906-10. Various lens/shutter combinations. \$35-50.

FILMPLATE PREMO CAMERA - 1906-16. Folding camera for plates or filmpacks. $31/_4$ x41/₄", $31/_4$ x51/₂", 4x5" sizes: \$50-75. 5x7" size: \$60-90.

FILMPLATE PREMO SPECIAL - 1912-16. This is the same camera as the one above. The Filmplate Premo Camera with the better lens/shutter combinations was called the Filmplate Premo Special after 1912. (Only the version with the Planatograph lens was still called the Filmplate Premo.) \$60-90.

PREMO FOLDING CAMERAS - Folding cameras for plates or filmpacks.

Premo No. 8 - 1913-22. Planatograph lens (or Anastigmat on the $31/_4$ x5 $1/_2$ ") in Kodak Ball Bearing shutter. Made in 3 sizes: $31/_4$ x5 $1/_2$ ": \$50-75. 4x5": \$60-90. 5x7": \$75-100.

Premo No. 9 - 1913-23. Various lens/shutter combinations. 3 sizes: 31/₄x51/₂": \$50-75. 4x5": \$60-90. 5x7": \$75-100

Premo No. 12 - 1916-26. 21/₄x31/₄" on plates, packs or rollfilm. Various lens/shutter combinations. \$50-75.

FOLDING CARTRIDGE PREMO CAMERAS - Folding-bed rollfilm cameras.

Meniscus Achromatic or Rapid Rectilinear lens.

No. 2 Folding Cartridge Premo Camera - 1916-26. 21/4x31/4" on 120 film. The most common size. \$12-20.

EASTMAN: PREMO

No. 2A Folding Cartridge Premo Camera - 1916-26. 21/₂x41/₄" on 116 film. \$12-20.

No. 2C Folding Cartridge Premo Camera - 1917-23. 27/₈x47/₈" on 130 film. Uncommon size. \$25-35.

No. 3A Folding Cartridge Premo Camera - 1917-23. 31/₄x51/₂" on 122 film. \$12-20.

PREMO JUNIOR CAMERAS - Filmpack box cameras with simple lens and shutter. Uncommon in Europe, where they sometimes sell for more than these USA prices:

No. 0 Premo Junior Camera - 1911-1916. 13/₄x21/₄". \$25-35.

No. 1 Premo Junior Camera - 1908-1922. 21/4x31/4". The first model in the series. When it was introduced in 1908 it was called simply Premo Jr Camera. \$25-35

No. 1A Premo Junior Camera - 1909-21.21/₂x41/₄". \$25-35.

No. 3 Premo Junior Camera - 1909-19. 31/₄x41/₄". \$25-35.

No. 4 Premo Junior Camera - 1909-1914. 4x5". \$30-45.

EASTMAN: PREMO...

POCKET PREMO CAMERAS

Pocket Premo, 21/₄x31/₄" - 1918-23. Self-erecting, folding bed camera for film-packs only. Mensicus Achromatic lens, Kodak Ball Bearing shutter. \$35-50.

Pocket Premo C - 1904-16. $31/_4$ x $41/_4$ " and $31/_4$ x $51/_2$ " sizes. Uses plates or filmpacks. Black or red bellows. \$35-50.

PONY PREMO CAMERAS - Folding plate cameras. The 4x5" and 5x7" sizes could also use filmpacks or rollfilm.

Pony Premo No. 1 - 1904-12. 4x5". Inexpensive lens and shutter. \$75-100. Pony Premo No. 2 - 1898-1912. Inexpensive lens/shutters. Made in 3 sizes: 31/4x41/4", 4x5", 5x7". \$75-100.

Pony Premo No. 3 - 1898-1912. With inexpensive lens/shutter combinations. 31/4x41/4": \$60-90. 4x5", 5x7": \$90-130.

Pony Premo No. 4 - 1898-1912.

Various lens/shutter combinations. 4x5": \$75-100.5x7": \$100-150.

Pony Premo No. 6 - 1899-1912. Various lens/shutter combinations. For plates. 4x5": \$50-75. 5x7": \$100-150. 61/₂x81/₂": much less common, \$150-225. 8x10": \$150-225.

Pony Premo No. 7 - 1902-12. Various lens/shutter combinations. For plates. 4x5": \$50-75. 5x7": \$100-150. 6¹/₂x8¹/₂": much less common, \$150-225.

STAR PREMO - 1903-08. Folding bed camera for 31/₄x41/₄" exposures on plates or filmpacks. Various lens/shutter combinations. \$60-90.

PREMOETTE CAMERAS - Leather-covered wood-bodied "cycle" style cameras in vertical format. For filmpacks.

Premoette (no number) - 1906-08. $2^{1}/_{4}$ X3 $^{1}/_{4}$ ". Became the No. 1 in 1909 when the No. 1A was introduced. \$45-60.

Premoette No. 1 - 1906-12. 2¹/₄x3¹/₄". (Models with better lens/shutter combinations were referred to as Premoette Special No. 1 for a few years.) \$35-50.

Premoette No. 1A - 1909-12. $2^{1}/_{2}$ x4 $^{1}/_{4}$ ". (Models with better lens/shutter combinations were referred to as Premoette Special No. 1A for a few years.) \$35-50.

PREMOETTE JUNIOR CAMERAS - Leather-covered aluminum-bodied folding bed cameras for filmpacks. The bed folds down, but not a full 90°. There is no track on the bed, but the front standard fits into one of several slots at the front of the bed for different focusing positions. These cameras are becoming less common in the USA, and are infrequently seen in Europe at higher than these USA prices:

Premoette Junior (no number) - 1911-12. 21/₄x31/₄". Became the No. 1 in 1913 when the No. 1A was introduced. \$25-35.

Premograph, original

Premoette Junior No. 1 - 1913-23. 21/4×31/4". \$35-50. Premoette Junior No. 1 Special - 1913-18. Kodak Anastigmat f6.3. \$35-50. Premoette Junior No. 1A - 1913-18. 21/2×41/4". \$35-50. Premoette Junior No. 1A Special - Premoette Junior No. 1A Special - 1913-18.

Premoette Junior No. 1A Special - 1913-18. Kodak Anastigmat f6.3. \$50-75.

PREMOETTE SENIOR CAMERAS -1915-23. Folding bed camera for filmpacks. $21/_2 \times 41/_4$ ", $31/_4 \times 41/_4$ ", and $31/_4 \times 51/_2$ " sizes. (The only Premoette made in the $31/_4 \times 51/_2$ " size.) Similar in design to the Premoette Jr. models. Kodak Anastigmat f7.7 or Rapid Rectilinear lens. Kodak Ball Bearing shutter. \$35-50.

PREMOETTE SPECIAL CAMERAS, NO. 1, 1A - 1909-11. Versions of the Pre-

moette No. 1 and No. 1A with better lenses and shutters. In 1912, the name "Special" was dropped and these lens/shutter combinations were options on the Premoette No. 1 & No. 1A. \$35-50.

PREMOGRAPH CAMERAS - Simple boxy single lens reflex cameras for $31/\sqrt{x^4}/\sqrt{x^4}$ filmpacks. Not to be confused with the earlier Premo Reflecting Camera, found under the Rochester heading in this book.

Premograph (original) - 1907-08. Single Achromatic lens. Premograph Reflecting shutter. \$250-375. Illustrated at top of previous page.

Premograph No. 2 - 1908-09. Better lens. Premograph Reflecting or Compound shutter. \$175-250.

PUPILLE - 1932-35. Made in Stuttgart, Germany by the Nagel Works. 3x4cm exp. on 127 film. Schneider Xenon f2/45mm. Compurshutter 1-300. \$250-375.

PUPILLE (Gold) - One sale at auction (11/89) of a gold model with red leather at \$720. We have no information to confirm or deny its authenticity.

QUICK FOCUS KODAK CAMERA, No.

3B - 1906-11. Box camera for 3¹/₄x5¹/₂" exposures on No. 125 film. Achromatic lens, rotary shutter. Original cost: \$12.00. An unusual focusing box camera. Focus knob (lever on early models) on side of camera is set to proper focal distance. Upon pressing a button, the camera opens (front pops straight out) to proper distance, focused and ready. \$150-225.

RADIOGRAPH COPYING CAMERA - Body is identical to the Pony 135, but this apparently was sold in an outfit for specialized use. \$25-35.

RANCA CAMERA - 1932-34. Made by Kodak A.G. Similar to the Pupille Camera, but with dial-set Pronto shutter. Nagel Anast. f4.5 lens. 3x4cm exposures on 127 film. \$250-375.

RECOMAR CAMERAS - 1932-40. Kodak's entry into the crowd of popular compact folding long-extension precision view cameras. Made in Germany by Kodak A.G.

Recomar Model 18 - 21/₄x31/₄". Kodak Anastigmat f4.5/105mm in Compur shutter. \$60-90.

Recomar Model 33 - $31/_4$ X $41/_4$ ". Similar, but 135mm lens. More common than the smaller model. \$60-90.

REGENT CAMERA - 1935-39. Made by Kodak A.G. in Stuttgart, Germany. Dual format, 6x9cm or 4.5x6cm on 620 film.

EASTMAN: RETINA

Schneider Xenar f3.8 or f4.5, or Zeiss Tessar f4.5 lens. Compur-S or Compur Rapid shutter. Coupled rangefinder incorporated into streamlined leather covered body. Asking prices to \$250. Most sales \$120-180.

REGENT II CAMERA - 1939. Made by Kodak A.G. in Germany. For 8 exposures 6x9cm on 120 film. Schneider Xenar f3.5 lens. Compur Rapid shutter. Coupled rangefinder in chrome housing on side of camera. Quite rare. Despite asking prices to \$2000, confirmed sales including major auctions in England and Germany have been in the \$800-1200 range.

REGULAR KODAK CAMERAS "Regular" is the term used in early Kodak advertising to distinguish the No. 2, 3, and 4 "string-set" Kodak cameras from the "Junior", "Folding", "Daylight", and "Ordinary" models. The "Regular Kodak" cameras are listed at the beginning of the Eastman section, where we have called them by their simple original names: No. 2, 3, and 4 Kodak cameras.

RETINA CAMERAS A series of 35mm cameras made in Germany by Kodak A.G. from 1934 to 1969.

The history of the Kodak Retina camera begins with the purchase of Dr. August Nagel Camerawerk in Stuttgart by Kodak A.G. in 1932. Dr. August Nagel remained in control of the plant and personally worked on the development of the Retina camera. The first Retina (Type 117) was introduced 1934 and was the first camera to use the then new 35mm film Daylight Loading Cartridge (DLC). This first Retina camera and the DLC are historically important because they made possible the explosive growth of 35mm photography in the late 1930's due to the relatively low price of this quality 35mm camera and the ease of use of the 35mm Daylight Loading Cartridge

Daylight Loading Cartridge.
The Retina camera and its lower priced cousin, the Retinette, were in production until 1940-41 when the German government requisitioned the plant for production of mechanical time fuses for 88mm anti-aircraft ammunition. Dr. August Nagel died during World War II in October, 1943 and the Allies bombed the Stuttgart plant in March, 1944. Following cessation of hostilities in May, 1945, the plant was under the supervision of the US Army Military Government; Helmut Nagel, the son of Dr. Nagel, was then manager of the plant. A purchase order for Retina I cameras was placed on August 9, 1945 by the Army Exchange Service for distribution in PX's. The first Retina I Type 010 cameras came off the production line on November 17, 1945 to fill this first order. Production of Retina cameras continued until 1969.

RETINA I CAMERAS: PRE-WAR FOLDING MODELS, NO RANGEFINDER.

Retina (Type 117) - 1934-35. The first

Retina camera. Black lacquer finish with nickel plated control surfaces. Large diameter wind and rewind knobs with film release clutch on wind knob. Film advance release knob next to wind knob. Exposure counter next to rewind knob. Shutter release on shutter housing. \$150-225.

Lens/Shutter combinations:

Schn. Xenar f3,5 5cm \ COMPUR Schn. Xenar f3,5 5cm \ COMPUR-RAPID

Retina (Type 118) - 1935-36. Very similar to Type 117 except film advance release lever moved to rear of top housing next to viewfinder. Common on German auctions in average used condition for \$50-75. Nice condition: \$100-150.

Lens/Shuttercombinations: Schn. Xenar f3,5 5cm \ COMPUR Schn. Xenar f3,5 5cm \ COMPUR-RAPID

Retina "I" (Type 119) - 1936-38. Black lacquer finish with nickel plated control surfaces, Leather trim adjacent to and under rewind knob. Smaller diameter wind and rewind knobs. Five milled rows on rewind knob, Film release lever behind wind knob on top housing. Exposure counter now adjacent to wind knob. Not marketed by Kodak in USA. \$60-90.

Lens/Shuttercombinations:
Retina-Xenar f3,5 5cm \ COMPUR
Retina-Xenar f3.5 5cm \ COMPUR-RAPID

Retina "I" (Type 126) - 1936-37. Identical to Type 119 but with satin chrome finish and chrome plated control surfaces. Occasional models with black lacquered trim on body edges. Two screws or accessory shoe next to rewind knob. \$50-75.

Lens/Shuttercombinations: Anastigmat Ektar f3,5 5cm

\ COMPUR-RAPID
Zeiss Tessar f3,5 5cm \ COMPUR-RAPID
Kodak-Pupillar f3,5 5cm
\ COMPUR-RAPID

Retina I (Type 141) - 1937-39. Satin chrome finish with chrome plated control surfaces. Seven milled rows on rewind knob. Shutter release on top housing on inside edge of larger exposure counter. Two screws or accessory shoe next to rewind knob. Nice examples sell for \$60-90. Many worn but working ones at \$35-50.

Lens/Shuttercombinations:
Anastigmat Ektar f3,5 5cm \ COMPUR
AnastigmatEktar f3,5 5cm
\ COMPUR-RAPID
Retina-Xenar f3,5 5cm \ COMPUR
Zeiss Tessar f3,5 5cm \ COMPUR-RAPID

Retina I (Type 143) - 1938-39. Identical to Type 141 but with black lacquer finish with nickel plated control surfaces. Black leather trim adjacent to and under rewind knob. Not marketed by Kodak in USA. \$75-100. Like most black enameled prewar cameras, exceptionally clean examples are hard to find and command better prices.

Lens/Shuttercombinations:
Retina-Xenar f3,5 5cm \ COMPUR
Retina-Xenar f3,5 5cm \ COMPUR-RAPID

Retina I (Type 148) - 1939-40. Satin chrome finish with chrome plated control surfaces. Smaller exposure counter moved closer to viewfinder housing. Shutter release on top housing with separate threaded cable release socket. Double

exposure prevention mechanism present. Two screws or accessory shoe next to rewind knob. Body serial number always ends with a capital "K". \$60-90. Lens/Shuttercombinations:

Lens/Shuttercombinations: Anastigmat Ektar f3,5 5cm \ COMPUR Anastigmat Ektar f3,5 5cm \ COMPUR-RAPID

Retina-Xenar f3,5 5cm \ COMPUR Zeiss Tessar f3,5 5cm \ COMPUR Only the Ektar/Compur Rapid version was sold in the USA.

Retina I (Type 149) - 1939-40. Identical to Type 148 with chrome top housing and chrome plated control surfaces but with black lacquer body edges and black leather trim adjacent to and under rewind knob. Not marketed by Kodak in USA. \$75-100.

Lens/Shutter combinations: Retina-Xenar f3,5 5cm \ COMPUR Anastigmat Ektar f3,5 5cm \ COMPUR

Retina I (Type 160/I) - 1939. Very similar to Type 149 with chrome or black lacquer on top housing and chrome plated control surfaces. Black lacquer body edges and black leather or chrome plate adjacent to and under rewind knob. Front element lens focusing. Not marketed by Kodak in USA. \$75-100.

Lens/Shuttercombinations:
Kodak-Anastigmat f3,5 5cm \ COMPUR
Kodak-Anastigmat f4,5 5cm
\ AGC 4 speed

RETINA I CAMERAS: POST-WAR FOLDING MODELS. NO RANGEFINDER.

Retina I (Type 010) - 1945-48. Quite similar to pre-war Type 148 with following changes: Serial number never ends with capital "K". USA imports have "ek" or "EK" prefix present on serial numbers. Focusing ring lacks milled edge that is present on pre-war Type 148 models. Exposure counter indicator arrow is located at front of top housing rather than at mid-housing position of Type 148. Fairly common. \$50-75.

Lens/Shutter combinations: Retina-Xenar f3,5 5cm (uncoated) \COMPUR Retina-Xenar f3,5 5cm (uncoated) \ COMPUR-RAPID
Retina-Xenar f3,5 5cm (coated)
\ COMPUR-RAPID
Retina-Xenar 3,5/5cm (coated)
\ COMPUR-RAPID
Anastigmat Ektar f3,5 5cm \ COMPUR
Anastigmat Ektar f3,5 5cm
\ COMPUR-RAPID
Kodak-Anastigmat f3,5 5cm \ COMPUR
Kodak Ektar f3.5 50mm \ COMPUR
Kodak Ektar f3.5 50mm \ COMPUR
Kodak Ektar f3.5 50mm
\ COMPUR-RAPID
Rodenstock Ysar 1:3,5 5cm
\ COMPUR-RAPID

Only the version with Retina Xenar coated

lens was sold in the USA.

Retina I (Type 013) - 1949-51. Full top housing extended to rewind knob with integrated viewfinder. Accessory shoe. Film type indicator dial at base of rewind knob. Depth of field indicators move to shutter housing and flash synchronization with PC socket added to Compur-Rapid shutter Semi-circular focusing knob on focusing ring. Not marketed by Kodak in USA. \$50-75.

Lens/Shutter combinations:
Retina-Xenar 3,5/5cm (coated)
\ COMPUR-RAPID
Retina-Xenar 1:3,5/50mm
\ COMPUR-RAPID
Retina-Xenar f2,8/50mm
\ COMPUR-RAPID
Kodak Ektar f3.5 50mm
\ COMPUR-RAPID

Retina la (Type 015) - 1951-54. Single stroke film advance lever on top housing with built-in exposure counter. Film release button behind shutter release. Rewind button on camera base adjacent to tripod mount. Film type indicator dial integrated into top of rewind knob on later models. Body serial number on or behind accessory shoe. Strap lug eyelets present at front body corners. Synchro-Compur shutter has M and X flash synchronization. Not marketed by Kodak in USA, but still a very common model. \$45-60.

Lens/Shutter combinations:
Retina-Xenar f3,5/50mm
\ COMPUR-RAPID
Retina-Xenar f2,8/50mm

\ COMPUR-RAPID Kodak Ektar f3.5 50mm \ COMPUR-RAPID Retina-Xenar f3,5/50mm \ SYNCHRO-COMPUR Retina-Xenar f2,8/50mm \ SYNCHRO-COMPUR Kodak Ektar f3.5 50mm

\SYNCHRO-COMPUR

Retina Ib (Type 018) - 1954-57. Folding camera body modestly enlarged with rounded body corners. Single stroke film advance lever moved to bottom of camera. Rectangular strap lugs at body ends. Chrome metal shroud covers bellows. 10 second self timer and Exposure Value system with linkage of f/stops to shutter speeds added to Synchro-Compur shutter. Not marketed by Kodak in USA. \$75-100. Lens/Shuttercombinations:

Lens/Shuttercombinations
Retina-Xenar f2,8/50mm
\SYNCHRO-COMPUR

Retina IB (Type 019/0) - 1957. Similar to Type 018 but taller integral top housing and uncoupled selenium exposure meter with Exposure Value system read-out added. Viewfinder frame size identical to Type 018. Not marketed by Kodak in USA. \$90-130.

Lens/Shutter combinations:
Retina-Xenar f2,8/50mm
\SYNCHRO-COMPUR
Retina-Xenon C f2,8/50mm
\SYNCHRO-COMPUR

Retina IB (Type 019) - 1958-60. Larger

EASTMAN: RETINA...

viewfinder with bright line illuminated field frame making a second window on front of top housing necessary. ASA range of exposure meter changed from 5-1300 to 10-3200 on later models. Not marketed by Kodak in USA. \$90-130.

Lens/Shuttercombinations:

Lens/Shuttercombination
Retina-Xenar f2,8/50mm
\SYNCHRO-COMPUR
Retina-Xenon C f2,8/50mm
\SYNCHRO-COMPUR

RETINA II CAMERAS: PRE-WAR FOLDING MODELS WITH RANGE-FINDER

Retina II (Type 122) - 1936-37. Coupled rangefinder with separate eyepiece and two round rangefinder windows. Short stroke lever type film advance. Large rewind knob with lock to prevent occlusion of rangefinder view. Body shutter release on top housing. Threaded cable release socket behind film counter on top housing. "Retina" engraved on top housing. Not marketed by Kodak in USA. Scarce. \$120-180.

Lens/Shuttercombinations:
Kodak Ektar f3,5 5cm \ COMPUR-RAPID
Schn. Xenon f2,8 5cm \ COMPUR-RAPID
Schn. Xenon f2 5cm \ COMPUR-RAPID

Retina II (Type 142) - 1937-39. Similar to Type 122 except film advance lever replaced by wind knob and body shutter release and cable release are located together on lower level of top housing adjacent to wind knob. "Retina II" engraved on top housing. \$60-90.

Lens/Shuttercombinations:

Lens/Shuttercombinations:
Kodak Ektar f3,5 5cm \ COMPUR-RAPID
Retina-Xenon 2,8 5cm \ COMPUR-RAPID
Retina-Xenon f2 5cm \ COMPUR-RAPID
The version with Ektar lens was not sold in
the USA.

Retina IIa (Type 150) - 1939-40. Coupled rangefinder/viewfinder with single eyepiece. Smaller rewind knob. Exposure counter adjacent to wind knob. Accessory shoe present on top housing. Carrying strap eyelets on both ends of top housing. Infrared focus point indicator. "Retina IIa" engraved on top housing. Not marketed by

Kodak in USA. \$100-150. Lens/Shutter combinations: Kodak Ektar f3,5 5cm \ COMPUR-RAPID Retina-Xenon 2,8 5cm \ COMPUR-RAPID Retina-Xenon f2 5cm \ COMPUR-RAPID

RETINA II AND RETINA III CAMERAS: POST-WAR FOLDING MODELS WITH RANGEFINDER

Retina II (Type 011) - 1946-48. Similar to Type 150 with slightly narrower single piece top housing. No strap lugs. Exposure counter moved away from wind knob but still on lower deck of top housing. Threaded cable release socket moved forward, adjacent to body shutter release. \$90-130.

Lens/Shuttercombinations: Kodak Ektar f2 47mm \ COMPUR-RAPID Retina-Xenon f2 5cm (uncoated)

\COMPUR-RAPID

Retina-Xenon f2 5cm (coated) \COMPUR-RAPID

Retina-Xenon 2/50mm \ COMPUR-RAPID

Rodenstock-Heligon f2 5cm \COMPUR-RAPID

Only the Xenon version was imported into the USA.

Retina II (Type 014) - 1949-51. Similar to Type 011 but with film type indicator dial present under rewind knob. Depth of field indicator moved to shutter housing opposite the focus scale on the focusing ring. Semi-circular focus knob on focus ring. PC socket with flash synchronization. New style conical chrome front to shutter housing. Occasional early models lack flash

sync (COMPUR-RAPID nfs) and have a flat surface to shutter housing. \$90-130.
Lens/Shuttercombinations:
Retina-Xenon f2 5cm (coated)
\ COMPUR-RAPID
Retina-Xenon 2/50mm\ COMPUR-RAPID
Retina-Xenon f2/50mm

\ COMPUR-RAPIDnfs Rodenstock-Heligon f2 5cm \ COMPUR-RAPID Retina-Heligon f2/50mm \ COMPUR-RAPID

Retina IIa (Type 016) - 1951-54. Single stroke film advance lever on top housing with built-in exposure counter. Film release button behind shutter release. Rewind button on camera base adjacent to tripod mount. Film type indicator dial integrated into top of rewind knob on later models. Body serial number on or behind accessory shoe. Strap lug eyelets present at front body corners. Synchro-Compur has M, X flash synchronization. \$75-100.

Lens/Shuttercombinations: Retina-Xenon 2/50mm\ COMPUR-RAPID Retina-Heligon f2/50mm

\ COMPUR-RAPID Retina-Xenon f2/50mm \ SYNCHRO-COMPUR Retina-Heligon f2/50mm \ SYNCHRO-COMPUR

Only the Xenon/Synchro-Compur version was sold in the USA.

Retina IIc (Type 020) - 1954-58. Folding camera body modestly enlarged with rounded body corners. Single stroke film advance lever moved to bottom. Rectangular strap lugs at body ends. Viewfinder/Rangefinder windows of unequal size. No exposure meter. Chrome metal shroud covers bellows. 10 second self timer and Exposure Value system with linkage of f/stops to shutter speeds added to Synchro-Compur shutter. Interchangeable front lens elements can change 50mm normal lens to 35mm wide- angle or 80mm telephoto lens. Wide-angle and telephoto lenses require separate 35-80 Optical Viewfinder for proper framing. \$100-150.

Lens/Shuttercombinations: Retina-Xenon C f2.8/50mm

\SYNCHRO-COMPUR Retina-Heligon C f2.8/50mm \SYNCHRO-COMPUR

Only the Xenon-C version was sold in the USA.

Retina IIC (Type 029) - 1958-59. Very similar to Type 020 (IIc) but Viewfinder/Rangefinder windows are larger and of equal size. Bright line frames present for three lenses in viewfinder. Not marketed by Kodak in USA. \$200-300.

Lens/Shutter combinations:
Retina-Xenon C f2.8/50mm
\SYNCHRO-COMPUR
Retina-Heligon C f2.8/50mm
\SYNCHRO-COMPUR

Retina IIIc (Type 021) - 1954-57. Similar to Type 020 (IIc) but built-in uncoupled dual range exposure meter. Bright viewfinder frame for normal lens only. Interchangeable front lens elements can change 50mm normal lens to 35mm wideangle or 80mm telephoto lens. Wide-angle and telephoto lenses required separate 35-80 optical viewfinder. Very common. Mint in box: \$175-250. Normally: \$120-180.

Lens/Shuttercombinations: Retina-Xenon C f2/50mm

\SYNCHRO-COMPUR Retina-Heligon C f2/50mm \SYNCHRO-COMPUR

Only the Xenon-C version was sold in the USA

Retina IIIc (Type 021/I) - 1957. Later production model of Type 021 (IIIc) with

newer extended single range exposure meter identical to meter present on Type 028 (Retina IIIC). \$150-225.

Lens/Shuttercombinations:
Retina-Xenon C f2,0/50mm
\SYNCHRO-COMPUR
Retina-Heligon C f2,0/50mm
\SYNCHRO-COMPUR

Retina IIIC (Type 028) - 1958-61. Very similar to Type 021 (IIIc) but viewfinder/rangefinder windows are larger and of equal size. Bright line frames present for three lenses in viewfinder. Uncoupled exposure meter identical to Type 021/L with an ASA range of 5-1300. Later production models have exposure meters with ASA range of 10-3200 and rewind knobs with film indicator dials with 3 sections for "Color Outdoors", "Color Indoors", and "Black & White". A common camera but popular among collectors and users. Widely ranging prices. Mint condition in original box can exceed \$1000. Many worn, damaged, or dead meter examples \$65-175. Normal range: \$250-375.

Lens/Shutter combinations:
Retina-Xenon C f2,0/50mm
\SYNCHRO-COMPUR
Retina-Heligon C f2,0/50mm
\SYNCHRO-COMPUR

Retina IIIC (Type 028/N) - 1977. "New Type" Retina IIIC cameras were hand assembled in 1977 from left-over spare parts. Exactly 120 cameras made. These cameras were made to celebrate the 50th anniversary of Kodak A.G. in Germany. They were never marketed but were gifts to Kodak VIPs. The cameras possess exposure meters with an ASA range of 10-3200 and have rewind knobs with film indicator dials with 3 sections for "Color Outdoors", "Color Indoors", and "Black & White". The cameras closely resemble late production Retina IIIC (028) cameras from 1960. The only distinguishing feature is the presence of the body serial number embossed into the leatherette of the camera back. The serial number is six digits long and begins with "99". There is no serial number present on the top hous-

ing. Verification of camera authenticity with the Historical Society for Retina Cameras or other established experts is strongly suggested prior to purchase. New condition has exceeded \$2000 (Cornwall 9/92 auction). Normal range: \$500-750.

Lens/Shuttercombinations: Retina-Xenon C f2,0/50mm \SYNCHRO-COMPUR

RETINA CAMERAS: RIGID BODY (NON-FOLDING) MODELS

Retina IIS (Type 024) - 1959-60. A rigid (non-folding) body Retina camera which appears to have evolved from the Retina IIIC (028) but has a Retina-Xenar f2,8 45mm non-interchangeable lens. The exposure meter is coupled to the shutter speed and f/stop selection mechanism. There are automatic red depth of field indicators which change with the f/stop selection. Not marketed by Kodak in USA. Uncommon. \$100-150.

Lens/Shuttercombinations: Retina-Xenar f2.8/45mm \SYNCHRO-COMPUR

Retina IIIS (Type 027) - 1958-61. The first rigid body Retina camera, it possesses a slightly longer body than the IIS (024) or IIIC (028). Coupled exposure meter present identical to IIS (024). Fully interchangeable "S" type lenses which range from an f/4 28mm lens to an f/4 135mm lens. Bright line frame fields for 35mm, 50mm, 85mm, and 135mm lenses which automatically display in viewfinder when lens is mounted. The 28mm lens requires an accessory viewfinder (see section on Retina Interchangeable lenses). \$100-150.

Lens/Shuttercombinations:

Retina-Xenar f2,8/50mm \SYNCHRO-COMPUR Retina-Xenon f1,9/50mm \SYNCHRO-COMPUR Retina-Ysarex f2,8/50mm \SYNCHRO-COMPUR Retina-Heligon f1,9/50mm \SYNCHRO-COMPUR

Only the Xenar and Xenon versions were sold in the USA.

Retina Automatic I (Type 038) - 1960-63. Rigid body camera with shutter release located on body front adjacent to "V" shaped lens/shutter mounting plate. Selenium meter with automatic exposure control and "STOP" warning in viewfinder when insufficient light. Manual control of f/stops for "B" setting and X-synch flash. No rangefinder. Three click stops for zone focusing with dot indicators also visible in viewfinder. Later production models (after serial number 150000) have larger selenium meter cell. ASA setting dial on top housing above the meter window. Not marketed by Kodak in USA. At European auctions: \$35-50.

Lens/Shuttercombinations: Retina-Reomar 1:2,8/45mm \PRONTORMAT-S

Retina Automatic II (Type 032) - 1960-63. Body similar to Type 038 except ASA setting dial moved to shutter housing and a meter read-out window replaces it. Compur Automats shutter allows automatic selection of f/stop or manual control. "STOP" warning in viewfinder when insufficient light. No rangefinder. Three click stops for zone focusing with dot indicators. Later production models (after serial number 150000) have larger selenium meter cell. Not marketed by Kodak in USA. In Europe: \$35-50.

Lens/Shuttercombinations: Retina-Xenar f2,8/45mm \COMPURAUTOMAT

Retina automatic III (Type 039) - 1961-63. Nearly identical to Type 032 but with coupled rangefinder. Later production models (after serial number 150000) have

larger selenium meter cell. \$50-75. Lens/Shutter combinations: Retina-Xenar f2,8/45mm \COMPURAUTOMAT

Retina I BS (Type 040) - 1962-63. Body basically resembles late production Automatic II (032) but lacks automatic exposure control. Top housing is slightly taller with recessed rewind knob and recessed accessory shoe. Exposure meter needle is visible in viewfinder. No rangefinder. Three click stops for zone focusing with dot indicators also visible in viewfinder. Not marketed by Kodak in USA. \$90-130.

Lens/Shuttercombinations:
Retina-Xenar f2,8/45mm
\COMPURSPEZIAL

Retina IF (Type 046) - 1963. Similar to Retina I BS (040) but exposure counter moved to camera bottom. Pop-up reflector for AG-1 flash bulbs. No rangefinder. Clicks stops with symbols for zone focusing. Exposure meter needle visible on viewfinder. Not marketed by Kodak in USA. \$75-100.

Lens/Shuttercombinations: Retina-Xenar f2,8/45mm \PRONTOR500 LK

Retina IIF (Type 047) - 1963-64. Body very similar to Retina IF (046) but with coupled rangefinder, lacks zone focusing and has pop-up reflector for AG-1 flashbulbs on top housing. Shutter, lens, and metering are identical to Retina I BS (040). Not common. \$100-150.

Lens/Shuttercombinations: Retina-Xenar f2.8/45mm \COMPURSPEZIAL

Retina \$1 (Type 060) - 1966-69. Black plastic body. No rangefinder. No meter. Flashcube socket and hot shoe. Manual exposure with weather symbol guide. Flash setting which couples focusing ring to f/stop ring when using flash cubes. Zone focusing symbols on focusing ring. Unusual rewind system that uses camera film advance lever. Note: Camera does not operate without film. \$35-50.

Lens/Shuttercombinations: Schneider Reomar f2,8/45mm\KODAK

Retina \$2 (Type 061) - 1966-69. Quite similar to Retina \$1 but coupled selenium meter. Meter needle visible on right side of viewfinder. Lacks weather symbol guide for exposure. Focusing, flash, and rewind systems identical to Retina \$1 (060). Not marketed by Kodak in USA. \$35-50.

Lens/Shuttercombinations: Schneider Reomar f2,8/45mm\KODAK

RETINA REFLEX CAMERAS: A series of 35mm single lens reflex cameras made in Germany by Kodak A.G. from 1956 to 1967. Retina Reflex (Type 025/0) - 1956. Prototype of first Retina Reflex camera. Identifiable by lack of an accessory shoe and presence of uncoupled dual range exposure meter identical to that used on early and mid-production Retina IIIc (021) cameras. PC flash socket located on the shutter housing. Only 100 cameras made for 1956 Photokina. No recent price data.

Lens/Shuttercombinations:
Retina-Xenon C f2/50mm
\SYNCHRO-COMPUR
Retina-Heligon C f2/50mm
\SYNCHRO-COMPUR

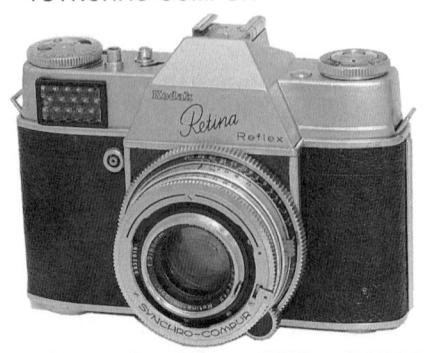

Retina Reflex (Type 025) - 1957-59.

First production Retina Reflex. Single lens reflex camera with interchangeable "C" type front lens elements identical the those used on Retina IIc (020), IIC (029), IIIc (021) and IIIC (028). Accessory shoe present on pentaprism housing and uncoupled single range exposure meter was of the same type used on the Retina IB (019) or IIIC (028). The PC flash socket was located on the body front below the top housing and meter. \$90-130.

Lens/Shutter combinations:
Retina-Xenon C f2,0/50mm
\SYNCHRO-COMPUR
Retina-Heligon C f2,0/50mm
\SYNCHRO-COMPUR

Only the Xenon-C version was sold in the USA.

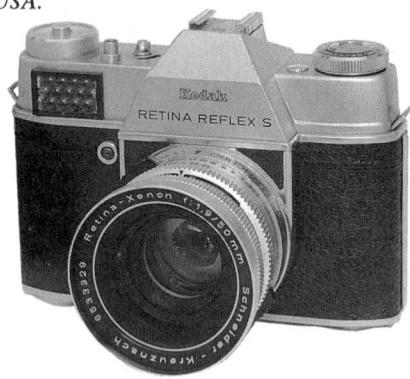

Retina Reflex S (Type 034) - 1959-60. Single lens reflex camera with "S" type interchangeable lenses identical to those used on the Retina IIIS (027). Like the IIIS (027), the exposure meter is coupled to the f/stops and shutter speeds. Interchangeable lenses ranged from an f/4 28mm wide angle to an f/4 135mm telephoto. \$100-150

Lens/Shuttercombinations: Retina-Xenar f2,8/50mm

Netina-Xenar 12,8/50mm
\ SYNCHRO-COMPUR
Retina-Xenon f1,9/50mm
\ SYNCHRO-COMPUR
Retina-Ysarex f2,8/50mm
\ SYNCHRO-COMPUR

Retina-Heligon f1,9/50mm \SYNCHRO-COMPUR

Only the Xenar and Xenon versions were sold in the USA.

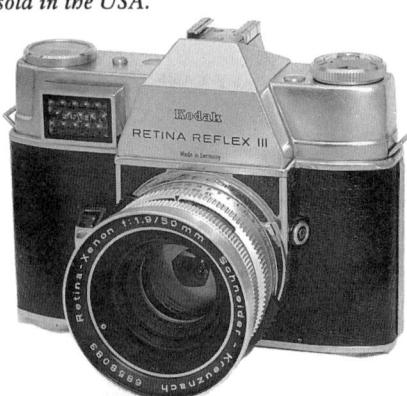

Retina Reflex III (Type 041) - 1961-64. Shutter release moved to body front. Meter needle now visible in viewfinder. Taller top housing with larger rectangular viewfinder eyepiece. Exposure counter was moved to camera bottom. After spring of 1962, Type 041 models had a larger exposure meter selenium cell and a f/4.8 200mm telephoto lens was introduced. \$100-150.

Lens/Shuttercombinations:

EASTMAN: RETINETTE

Retina-Xenar f2,8/50mm \SYNCHRO-COMPUR Retina-Xenon f1,9/50mm \SYNCHRO-COMPUR Retina-Ysarex f2,8/50mm \SYNCHRO-COMPUR Retina-Heligon f1,9/50mm \SYNCHRO-COMPUR

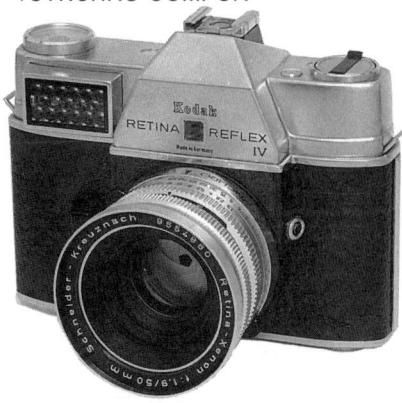

Retina Reflex IV (Type 051) - 1964-67. Small window added to front of pentaprism housing to display selected f/stop and shutter speed in viewfinder. Hot shoe flash contact present in accessory shoe. Recessed rewind knob with folding crank. Exposure counter automatically reset when camera back is opened. Early production models lacked rectangular strap lugs. With f1.9: \$150-225. With f2.8: \$120-180.

Lens/Shutter combinations:
Retina-Xenar f2,8/50mm
\SYNCHRO-COMPUR-X
Retina-Xenon f1,9/50mm
\SYNCHRO-COMPUR-X

Retina Reflex IV (Type 051/N) - In 1979, approximately 300 Retina Reflex IV cameras were hand assembled from spare parts at Kodak A.G. in Germany. The only distinguishing feature is the lack of a serial number on top of the pentaprism housing and the body serial number is embossed into the leatherette of the camera back. The serial number is five digits long and starts with "6". All have rectangular strap lugs like the original later production cameras. Sold exclusively to relatives of Kodak AG managers. No price data.

Lens/Shuttercombinations: Retina-Xenar f2,8/50mm \SYNCHRO-COMPUR-X

RETINA LENSES: Retina interchangeable lenses exist in two basic types.

Component type - Retina IIc & IIIc use lenses with interchangeable front elements. The basic rear element remains with the camera. Schneider and Rodenstock jointly developed the lens system, so both brands of lenses were available. The system debuted in Europe with the Heligon C lenses from Rodenstock, and later became available in the USA with the Xenon C lenses. The 50mm lens front component could be f2.8 or f2.0. Other front components convert the lens to wide angle or telephoto. This series of lenses is identified by the suffix "C" for "converter".

"S" type - Retina IIIS, Retina Reflex, and Instamatic Reflex use completely interchangeable lenses which mount into the stationary leaf shutter on the camera. These lenses are similar in appearance to the component types, but are not interchangeable with them. In the list below, lenses

without "C" suffix are "S-type" lenses.

28mm f4 Retina-Curtagon - \$45-60.

35mm f2.8 Retina-Curtagon - \$45-60.

35mm f4 Retina-Heligon C - \$75-100.

35mm f4 Rodenstock Retina-Eurygon - \$60-90. 35mm f4 Retina-Curtar-Xenon C -\$75-100.

55mm f5.6 Retina-Heligon C - \$60-

35mm f5.6 Retina-Curtar-Xenon C - \$50-75.

50mm f1.9 Retina-Xenon - \$15-25. **50mm f2 Retina-Heligon C -** \$15-25. **50mm f2.8 Retina-Xenar -** \$15-25.

50mm f2.8 Retina-Xenar - \$15-25. 50mm f3.5 Retina-Xenar - \$15-25. 80mm f4 Retina-Heligon C - \$60-90. 80mm f4 Retina-Longar-Xenon C -

85mm f4 Retina-Tele-Arton - \$50-

85mm f4 Rodenstock Rotelar - \$90-130.

90mm f4 Schneider Tele-Arton - \$90-130.

135mm f4 Rodenstock Retina-Rotelar - \$75-100.

135mm f4 Schneider Tele-Xenar (chrome) - \$30-45.

135mm f4 Schneider Tele-Xenar (black) - \$50-75. 200mm f4.8 Retina-Tele-Xenar -\$175-250.

RETINA ACCESSORIES:

\$45-60

Closeup set - Combination rangefinder and parallax-corrected viewfinder fits accessory shoe. Comes with 3 closeup lenses (prewar version has 4 closeup lenses). Most common in Germany, where they regularly sell at auction for \$20-30.

Finder 28mm - \$50-75.

Microscope adapter kit Model B - for Retina IIIc, IIC, Ib. \$60-90.

Optical finder 35-80mm - Shows

Optical finder 35-80mm - Shows field of view for 35mm and 80mm components of C-type lenses. Slips into accessory shoe. \$35-50.

Sportsfinder 50-80mm - Open frame finder. \$20-30.

Stereo attachment - Optical splitter attaches to lens of Retina IIc, IIIc, or Retina Reflex. \$175-250.

Stereo viewer - \$100-150.

RETINETTE CAMERAS: A series of low priced 35mm cameras made in Germany by Kodak A.G. from 1939 to 1967.

RETINETTE CAMERAS: PRE-WAR FOLDING MODELS.

Retinette (Type 147) - 1939. First Retinette. Slightly larger, different body style than other folding cameras of the Retina and Retinette series. Folding door hinged

at bottom and opens downward. Black lacquer finish with ribbed top housing. Ribbed aluminum lens/shutter mounting board. Front element focusing of lens. Not marketed by Kodak in USA. \$150-225.

Lens/Shuttercombinations: Kodak-Anastigmat f6,3 5cm \AGC 3 speed

Retinette II (Type 160) - 1939. Quite similar to Type 149 Retina I body style but with black lacquer finish on top housing and body edges. Ribbed aluminum lens/shutter mounting board. Front element focusing of lens. Not marketed by Kodak in USA. \$60-90.

Lens/Shuttercombinations: Kodak-Anastigmat f3,5 5cm \ COMPUR Kodak-Anastigmat f4,5 5cm \ AGC 4 speed

RETINETTE CAMERAS: POST-WAR FOLDING MODELS

Retinette (Type 012) - 1949-51. Body style similar to Type 010 Retina I with chrome top housing, however body trim and edges are black lacquer. Black leather is adjacent to and under the rewind knob. Depth of field indicator on front of shutter housing. Front element focusing of lens. Prontor-S shutter has PC flash socket and 10 second self timer. Not marketed by Kodak in USA. Uncommon. \$120-180.

Lens/Shutter combinations:
Schneider Reomar 1:4,5/50mm
\PRONTOR-S
Ennatar f4,5/50mm \PRONTOR-S
Kodak Anstigmat Angenieux f4,5 50mm

Retinette (Type 017) - 1951-54. First

EASTMAN: RETINETTE...

Retinette marketed in the USA. Full top housing extended to rewind knob with integrated viewfinder. Accessory shoe. Body serial number is located on the accessory shoe. Shutter release button threaded for cable release. Prontor-SV shutter has M and X flash synchronization. \$50-75.

Lens/Shuttercombinations: Schneider Reomar 1:4,5/50mm \PRONTOR-S

Schneider Reomar 1:4,5/50mm

Kodak Anastigmat Angenieux f4,5 50mm

Kodak Anastigmat Angenieux f3,5 50mm

Only the Reomar version was marketed in the USA.

RETINETTE CAMERAS: RIGID BODY (NON-FOLDING) MODELS

Retinette (Type 022) - 1954-58. First rigid body Retinette camera. Camera body modestly enlarged with rounded body corners. Single stroke film advance lever on bottom of camera. Rectangular strap lugs at body ends. No exposure meter. Rectangular shaped grey metal rigid lens/shutter mount. 10 second self timer and Exposure Value system with linkage of f/stops to shutter speeds was added to Compur-Rapid shutter on mid- and late production models. Not marketed by Kodak in USA. \$30-45.

Lens/Shuttercombinations: Schneider Reomar 1:3,5/45mm \COMPUR-RAPID

Retinette f (Type 022/7) - 1958. A special production model of the Type 022 body made solely for export to Kodak Pathe in France. The Angenieux lens and shutter were installed in France. \$75-100. Lens/Shuttercombinations:

Kodak Anastigmat f3,5 Angenieux 45mm \ KODAK

Retinette I (Type 030) - 1958-60. Continuation of Type 022 style but with taller top housing with a larger brighter viewfinder with bright line frame window. Rectangular front plate with "V" design about lens/shutter mount. Same lens and shutter as the late production Type 022. Not marketed by Kodak in USA. \$35-50.

Lens/Shuttercombinations:

Schneider Reomar 1:3,5/45mm \ COMPUR-RAPID

Retinette f (Type 030/7) - 1958-59. Special production model of Type 030 body made solely for export to Kodak Pathe in France. Angenieux lens and shutter were installed in France. \$45-60.

Lens/Shuttercombinations:
Kodak Anastigmat f2,8 Angenieux45mm
\ KODAK

Retinette IA (Type 035) - 1959-61. Continuation of Retinette I line with longer focal length lens (50mm) and lens/shutter mount changed to single "V" shaped metal plate. Exposure value system was discontinued. The tripod mount, film advance lever and rewind knob shaft were made from black plastic rather than aluminum metal. Vero shutter was replaced by Pronto shutter with self timer in later production. Not marketed by Kodak in USA. \$30-45.

Lens/Shuttercombinations: Schneider Reomar f3,5/50mm\VERO Schneider Reomar f3,5/50mm\PRONTO

Retinette IA (Type 035/7) - 1959-60.

Special production model of Type 035 body made solely for export to Kodak Pathe in France. Angenieux lens and shutter were installed in France. \$45-60.

Lens/Shutter combinations:
Kodak Anastigmat F:2,8 Angenieux50mm
\ KODAK

Retinette IA (Type 042) - 1961-63. Continuation of Retinette IA line with a change to a faster, shorter focal length f2.8 45mm lens. Three click stops marked by dots on focusing ring for zone focusing. \$30-45.

Lens/Shuttercombinations:
SchneiderReomar f2,8/45mm\PRONTO

Retinette IA (Type 044) - 1963-67. Last of Retinette IA line with hot shoe flash contact present in the accessory shoe. Zone focusing symbols on focus ring but click stops were deleted. Both feet and metric scales on focusing ring. Prontor 250 S shutter was replaced by Prontor 300 S shutter in later production. \$35-50.

Lens/Shutter combinations: Schneider Reomar f2,8/45mm \PRONTOR250 S Schneider Reomar f2,8/45mm \PRONTOR300 S

Retinette IB (Type 037) - 1960-63. Very similar to Type 042 body style but with coupled exposure meter with match needle read-out in viewfinder. Click stop zone focusing. Pronto-LK shutter speeds ranged up to $1/_{500}$ sec. Reomar lens manufactured by Rodenstock. No marketed by Kodak in USA. \$35-50.

Lens/Shuttercombinations: Rodenstock Reomar 1:2,8/45mm \PRONTO-LK

Retinette IB (Type 045) - 1963-66. Continuation of Retinette IB line with hot shoe flash contact in accessory shoe. Larger selenium cell used on exposure meter. Three zone focusing symbols on focus ring, click stops were deleted. Both feet and metric scales on focusing ring. Not marketed by Kodak in USA. \$35-50.

Lens/Shuttercombinations: Rodenstock Reomar 1:2,8/45mm \PRONTOR 500 LK

Retinette II (Type 026) - 1958. Body style very similar to Type (030) Retinette I except exposure counter is identical to that used on Retina cameras such as the IIC or IIIC. Exposure value system with coupling of shutter speeds to f/stops; red depth of field indicators changed automatically with the f/stop selection. Self-timer present. Not marketed by Kodak in USA. \$45-60.

Lens/Shuttercombinations: Schneider Reomar 1:2,8/45mm \COMPURRAPID

Retinette IIA (Type 036) - 1959-60. Body style very similar to Type 035 and Type 042 Retinette IA but built-in exposure meter with automatic selection of shutter speed and f/stop. Automatic depth of field indicators coupled to selected exposure or f/stop. Not marketed by Kodak in USA. \$45-60.

Lens/Shuttercombinations: Schneider Reomar f2,8/45mm \PRONTORMAT

Retinette IIB (Type 031) - 1958-59. Body style, lens and shutter identical to Type 026 Retinette II but has the addition of an uncoupled selenium exposure meter with exposure value read-out. Exposure

meter is identical to that found on Retina IIIC (028) Not marketed by Kodak in USA. \$45-60.

Lens/Shuttercombinations: Schneider Reomar 1:2,8/45mm \COMPUR RAPID

Information and Photographs in this section were compiled by David L Jentz and Peter L Toch of the Historical Society for Retina Cameras (HRSC).

If you feel you have an unusual Retina or

If you feel you have an unusual Retina or Retinette camera or if you are interested in joining the Historical Society for Retina Cameras please contact:

David L Jentz; The Historical Society for Retina Cameras; 51312 Mayflower Road; South Bend, Indiana 46628 U.S.A. Phone: (219) 272-0599.

Kodsic Onternal Change of the Change of the

RIO-400 - c1965. A reincarnation of the Brownie Starlet (U.S.A. type), made in Brazil. Reportedly the first Kodak camera made in Brazil, in the D.F.V. (Vasconcellos) factory. The camera name commemorates the 400th anniversary of Rio de Janeiro in 1965. Uncommon. \$35-50.

SCREEN FOCUS KODAK CAMERA, NO. 4 - 1904-10. For 4x5" exposures on No. 123 film, which was introduced for this camera. Various lens/shutter combinations. This was one of the first cameras to provide for the use of ground glass focus on a rollfilm camera. The rollfilm holder hinges up to allow focusing. Similar to Blair's No. 3 Combination Hawk-Eye and the earlier Focusing Weno Hawk-Eye No. 4. \$300-450.

EASTMAN: SIGNET

KODAK SENIOR CAMERAS - 1937-39. Folding bed cameras in Six-16 (2¹/₂x4¹/₄") and Six-20 (2¹/₄x3¹/₄") sizes. \$20-30.

SIGNET CAMERAS - A series of cameras with coupled rangefinders for 24x36mm exposures on 35mm film.

Signet 30 - 1957-59. Kodak Ektanar f2.8/44mm lens. Kodak Synchro 250 shutter 4-250. \$25-35.

Signet 35 - 1951-58. Kodak Ektar f3.5/44mm lens. Kodak Synchro 300 shutter. EUR: \$25-35. USA: \$20-30.

Signet 40 - 1956-59. Kodak Ektanon f3.5/46mm lens. Kodak Synchro 400 shutter. EUR: \$30-45. USA: \$15-25.

EASTMAN: SIGNET...

Signet 50 - 1957-60. Styled like the Signet 30, but with built-in exposure meter. Kodak Ektanar f2.8. Kodak Synchro 250 shutter. \$30-45.

Signet 80 - 1958-62. Interchangeable lenses. Behind-the-lens shutter. Built-in meter. \$45-60.

Signet 80 Lenses: 35mm f3.5 - \$30-45. 50mm f2.8 - \$8-15. 90mm f4 - \$30-45.

Signal Corps Model KE-7(1) - Version of Signet 35, made for U.S. Army Signal Corps. Olive drab color or U.S.A.F. black anodized model. No normal serial number on the body. Serial number on military contract number plate on base. \$150-225.

No. 3A Six-Three Kodak Camera

SIX-THREE KODAK CAMERAS - 1913-15. A variation of the Folding Pocket Kodak Cameras with f6.3 Cooke Kodak Anastigmat lens in B&L Compound shutter. The camera itself is identified as Folding Pocket Kodak Camera, but the official name is the Six-Three Kodak Camera.

No. 1A Six-Three Kodak Camera - 2½x4½" exp. on 116 film. \$25-35.

No. 3 Six-Three Kodak Camera - 3½x4½" exp. on 118 film. \$20-30.

No. 3A Six-Three Kodak Camera - 3½x5½" exp. on 122 film. \$20-30.

Illustrated bottom of previous column.

KODAK SIX-16 and SIX-20 CAMERAS - 1932-34. Folding bed cameras. Enameled art-deco body sides. Available in black or brown. 616 and 620 films were introduced for these cameras.

Kodak Six-16 Camera - 21/₂x41/₄". \$20-30.

Kodak Six-20 Camera - 21/₄x31/₄". \$20-30.

KODAK SIX-16 and SIX-20 CAMERAS (IMPROVED MODELS) - Folding bed cameras. Similar to the earlier models, but improved design on the bed-support struts, recognizable by art-deco black enameling.

Kodak Six-16, Improved - 1934-36. 21/₂x41/₄". \$35-50.

Kodak Six-20, Improved - 1934-37. 21/₄x31/₄". \$35-50. *Either size with Compur shutter.* \$50-75.

SIX-20 KODAK A - 1951-55. (Kodak Ltd.) Self-erecting 2¹/₄x3¹/₄" rollfilm camera with low chromed struts. Folding optical finder. Kodak Anastar f4.5 or f6.3 in Epsilon shutter. \$25-35.

SIX-20 KODAK B - 1937-40. (Kodak Ltd.) Self-erecting 21/₄x31/₄" folding camera with streamlined art-moderne struts. Folding optical finder. Body release for AGC (Gauthier) T,B,25,50,100 shutter. K.S. Anastigmat f4.5 or f6.3/105mm.\$30-45.

SIX-20 KODAK JUNIOR - 1933-40. (Kodak Ltd.) Various models with Doublet, Twindar, or Kodak Anastigmat lens. \$12-20

SPECIAL KODAK CAMERAS - Earlier than the Kodak Special Six-16 and Six-20 Cameras listed below. These cameras are similar to the Folding Pocket Kodak cameras but with better lenses in B&L Compound shutters. They were discontinued in 1914 when the Autographic feature was introduced, and this line became Autographic Kodak Special Cameras.

No. 1A Special Kodak Camera - 1912-14. 21/₂x41/₄". \$60-90.

No. 3 Special Kodak Camera - 1911-14. 31/₄x41/₄". \$60-90.

No. 3A Special Kodak Camera - 1910-14.31/₄x51/₂", postcard size. \$50-75.

KODAK SPECIAL SIX-16 and SIX-20 CAMERAS - 1937-39. Folding bed cameras, similar to the Kodak Junior Series III Cameras, but with better lens and shutter.

Kodak Special Six-16 Camera - 21/2×41/4". \$25-35. Kodak Special Six-20 Camera - 21/4×31/4". \$25-35.

SPEED KODAK CAMERAS Folding bed cameras, not at all similar to each other in body style. Focal plane shutter to 1000.

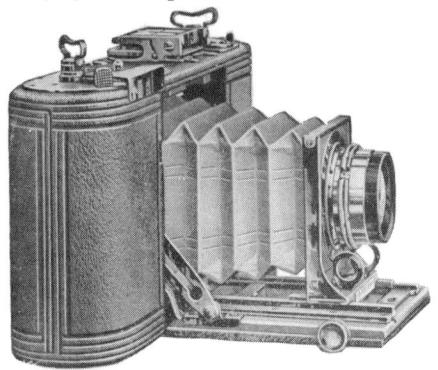

No. 1A Speed Kodak Camera - April 1909-13. 21/₂x41/₄" on 116 rollfilm. Kodak Anast. f6.3, Tessar f6.3 or f4.5, and Cooke f5.6 lens available. \$300-450.

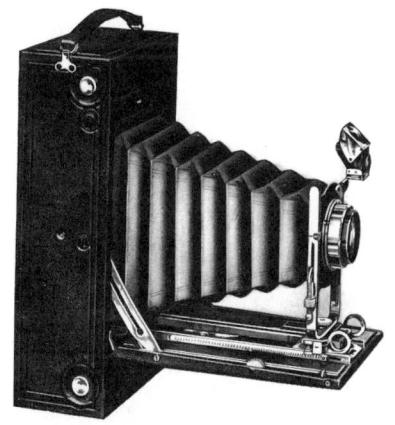

No. 4A Speed Kodak Camera - 1908-13. $4^{1}/_{4}x6^{1}/_{2}$ " exp. on 126 rollfilm. (No. 126 rollfilm was made from 1906-1949.) f6.3 Dagor, Tessar, or Kodak Anastigmat or f6.5 Cooke lens. \$400-600.

KODAK SPORT SPECIAL CAMERA OUTFIT - c1987. Specially packaged outfit for the America's Cup races at Freemantle, Australia. Includes Kodak Sport Camera with built-in flash (made in Brazil), wall chart of courses at Freemantle, mini photo

EASTMAN: SUPREMA

album, and a Gold 200 film made in France. Boxing kangaroo adorns the outer box. Original price about \$55.

KODAK STARTECH CAMERA - c1959. Special purpose camera for close-up medical and dental photography Body style similar to the Brownie Starflash. 15/8x15/8" exp. on 127 film. Full kit with flash shield, 2 close-up lenses, original box: \$35-50. Camera only: \$12-20.

STEREO KODAK CAMERAS See also Brownie Stereo and Hawk-Eye Stereo in this Eastman section.

Stereo Kodak Model 1 Camera -1917-25. Folding camera for $3^{1}/_{8}x3^{3}/_{16}$ " pairs on No. 101 rollfilm. Kodak Anast. f7.7/51/₄" lens. Earliest version has Stereo Automatic shutter, later with Stereo Ball Bearing shutter. \$350-500.

No. 2 Stereo Kodak Camera - 1901-05. Kodak's only stereo box camera. $31/_2$ x6" stereo exposures on No. 101 film. Rapid Rectilinear f14/125mm. \$600-900.

Kodak Stereo Camera (35mm) - 1954-59. For pairs of 24x24mm exposures on standard 35mm cartridge film. Kodak Anaston f3.5/35mm lenses. Kodak Flash 200 shutter 25-200. Common and easy to find for \$100-150 in USA, or about 30% higher in Europe.

Kodak Stereo Viewers: Model I - Single lenses. \$50-75. Model II - Doublet lenses. AC/DC model: \$90-130. DC only: \$75-100.

STERLING II - c1955-60. Folding camera made by Kodak Ltd. in London. Anaston f4.5/105mmin Pronto 25-200. \$20-30.

SUPER KODAK SIX-20 - 1938-44. The first camera with coupled electric-eye for automatic exposure setting. Takes 21/4x31/4" exposures on 620 film. Kodak Anastigmat Special f3.5 lens. Built-in 8 speed shutter. \$1700-2400.

KODAK SUPREMA CAMERA - 1938-39. Made by Kodak AG, Stuttgart. "Gulliver's Retina" for 21/₄x21/₄" exp. on 620 rollfilm.

EASTMAN: TELE-EKTRA

Schneider Xenar f3.5/80mm lens in Compur Rapid 1-400 shutter. Once considered rare, but quite a few have surfaced since the price jumped to \$350-500.

KODAK TELE-EKTRA 1 & 2 CAMERAS KODAK TELE-INSTAMATIC CAMERAS KODAK TRIMLITE INSTAMATIC

CAMERAS - Late 1970's cameras for 13x17mm exposures on 110 cartridge film. Similar to the Pocket Instamatic Cameras. Too new to establish a "collectible" value. Very common. \$1-10.

TOURIST CAMERAS

Kodak Tourist Camera - 1948-51. Folding camera for $2^{1}/_{4}$ X 3 I/₄" on 620 film. With Kodak Anastar f4.5 in Synchro-Rapid 800 shutter: \$50-75. With Kodak Anaston f4.5, f6.3, f8.8 or Kodet f12.5 lens: \$15-25.

Kodak Tourist II Camera - 1951-58. With Kodak Anastar f4.5 in Synchro-Rapid 800 shutter: \$50-75. Low priced models: \$12-20.

VANITY KODAK CAMERA - 1928-33. A Vest Pocket Kodak Series III Camera in color: blue, brown, green, grey, and red, with matching colored bellows. 4.5x6cm exposures on 127 rollfilm. The original colored bellows were fragile and many were replaced with more durable black bellows, which reduce the collector value of the camera. Camera only, usually with black replacement bellows: \$75-100. With matching satin-lined case: \$150-225. With original colored bellows and matching

case: \$250-375. Add \$90-130 for original cardboard box.

VANITY KODAK ENSEMBLE - 1928-29. A Vest Pocket Kodak Model B Camera in color: beige, green and grey. With lipstick, compact, mirror, and change pocket. "Vanity Kodak Model B" on shutter face. \$600-900. For original cardboard box, add \$175-250.

VEST POCKET KODAK CAMERAS -Folding cameras for 4.5x6cm exposures on 127 rollfilm. Early versions have trellis struts, later models with folding bed.

Vest Pocket Kodak Camera - 1912-1914. Trellis struts. No bed. Meniscus Achromatic lens is most common. f6.9 is uncommon, but the least common is the Kodak Anastigmat f8 lens introduced in the Fall of 1913 with the Gift Case. Kodak Ball Bearing shutter. Earliest model with square-cornered bellows: \$120-180. Later models \$35-50.

Vest Pocket Autographic Kodak Camera - 1915-26. Trellis struts. No bed. Similar to the Vest Pocket Kodak Camera, but with the Autographic feature. Meniscus Achromatic, Rapid Rectilinear or Kodak Anastigmat f7.7 fixed focus lens. Kodak Ball Bearing shutter. Common. \$35-50.

Vest Pocket Autographic Kodak Special Camera - 1915-26. Like the regular model, but with Persian morocco covering and various focusing and fixed focus lenses. \$35-50.

Vest Pocket Kodak Model B Camera - 1925-34. Folding bed camera (with autographic feature until about 1930). Rotary V.P. shutter. \$35-50.

Vest Pocket Kodak Series III Camera - 1926-33. Folding bed camera with autographic feature. Diomatic or Kodex shutter. f6.3 or f5.6 Kodak Anastigmat lens, or f7.9 Kodar. \$30-45. Colored models: see Vanity Kodak Camera, above.

Vest Pocket Kodak Special Camera (early type) - 1912-14. Trellis struts. No bed. Like the V.P.K., but with Zeiss Kodak Anastigmat f6.9 lens. \$60-90.

EASTMAN: WORLD'S FAIR

Vest Pocket Kodak Special Camera (later type) - 1926-35. Folding bed camera with autographic feature. Same as the Series III, but better lens: f5.6 or f4.5 Kodak Anastigmat. \$60-90.

Vest Pocket Kodak Special (Lizard skin) - Unusual variation with brown lizard skin covering and matching clamshell case. Reportedly 500 made. \$750-1000.

VIEW CAMERAS - Because of the many uses of view cameras, there are really no standard lens/shutter combinations, and because they are as much a part of the general used camera market as they are "collectible", they are listed here as good second-hand cameras. A modern usable lens and shutter has more value than the camera body itself. Prices given here are for cameras in Very Good condition, no lens. **5x7" -** \$150-225. **61/₂x81/₂" -** \$100-150.

8x10" - Have increased in value in recent years. The very common model 2D is inexpensive when compared with current model 8x10 cameras, and for many purposes will perform as well. \$300-450.

VIGILANT CAMERAS - Folding rollfilm cameras with folding optical finders and body release. Lenses available were Kodak Anastigmat f8.8, f6.3, f4.5, and Kodak Anastigmat Special f4.5 lens.

Vigilant Six-16 - 1939-48. 21/2x41/4" on 616 film. \$20-30.

Vigilant Six-20 - 1939-49. 21/4x31/4" on 620 film. \$20-30.

VIGILANT JUNIOR CAMERAS - Folding bed rollfilm cameras with non-optical folding frame finder. No body release. Kodet or

Vigilant Junior Six-16 - 1940-48. 21/2x41/4" on 616 film. \$12-20.

Vigilant Junior Six-20 - 1940-49 21/4x31/4" on 620 film. \$12-20.

VOLLENDA CAMERAS - Mfd. by Kodak A.G., formerly Nagel-Werk, in Stuttgart, Germany. See also NAGEL-WERK for earlier models.

Vollenda No. 48 (3x4cm) - 1932-37 as Kodak model; formerly Nagel. Folding bed camera with self-erecting strut-sup-ported lensboard. 3x4cm on 127 film. ported lensboard. 3x4cm on Uncommon with Leitz Elmar f3.5: \$300-450. With Tessar f2.8 or f3.5, Radionar

f3.5 or f4.5, Xenar f2.9 or f3.5: \$60-90 Vollenda No. 52 (4x6.5cm) - 1932-37 as Kodak model; formerly Nagel. Vertically oriented self-erecting camera. Low struts in L-pattern. Tessar, Xenar, or Radionar f4.5 lens. \$50-75.

Vollenda 620 (6x6cm) - 1940-41. Horizontal style for 6x6cm. \$30-45.

Vollenda 620 (Types 107 & 110) (6x9cm) - 1934-39. Vertically oriented folding camera. \$30-45.

Vollenda Junior 616 - 1934-37. Vertical style. 6.5x11cm. \$25-35. **Vollenda Junior 620 -** 1933-37. Vertical style. 6x9cm. \$25-35.

WINNER CAMERA, 1988 OLYMPICS c1988. Red plastic pocket 110 camera with special emblem above finder: "Kodak, Official Sponsor of the 1988 Olympic Games". \$1-10.

KODAK WINNER POCKET CAMERA -1979-. Premium version of the Trimlite Instamatic 18 Camera. 13x17mm exp. on 110 cartridge film. \$1-10.

WORLD'S FAIR FLASH CAMERA 1964-65. Sold through dealers, listed in

EASTMAN: ZENITH KODAK

catalogs and sold at the New York World's Fair. 15/8x15/8" on 127. (Original box, shaped like the pentagonal Kodak pavillion, doubles the value.) Camera only: \$8-15.

ZENITH KODAK CAMERAS - 1898-99. Rare box cameras: No. 3 for 31/4x41/4" and No. 4 for 4x5". Identical to Eureka cameras of the same period. They accept standard plateholders through a side-opening door and allow room for storage of extra holders. Made in England. Not found often. \$150-225.

EBNER, Albert & Co. (Stuttgart)

Ebner, 4.5x6cm - c1934-35. Smaller, horizontally styled version of the streamlined brown bakelite camera. Various lens/shutter combinations including: Meyer Görlitz Trioplan f4.5/7.5cm, Compur T,B, 1-300. Front-element focus. Unusual parallelogram folding frame finder. \$150-225.

Ebner, 6x9cm - c1934-35. Folding camera for 8 exp. on 120 film. Streamlined brown marbelized bakelite body. Black was also available, but not as popular. Among the available lenses: Tessar f4.5/105mm, Radionar f4.5, or Xenar f4.5. Rim-set Compur 1-250 or Pronto shutter. The classic Ebner design inspired imitation from the Pontiac, Gallus, and Nagel Regent cameras of the same vintage. Most often found in Germany at \$150-225.

ECHOFLEX - c1952-56. Japanese TLR.

The earlier Echoflex c1952 has a nameplate with concave bottom and letters of varying height to fit. No bayonets. Echo f3.5 in Echo B,1-200. The later Echoflex c1955 has name in italic block letters of equal height in an oval. Double bayonets on the Echor Viewer & Echor Anastigmat f3.5 lenses. Synchro-Super B,1-300 shutter. \$75-100.

ECLAIR - c1900. 13x18cm wooden field camera with brass trim. Tapered green bellows with black corners. Euryscop Extra Rapide Series III brass barrel lens. \$175-

ECLIPSE 120 - Metal box camera for 21/4x21/4" on 120 rollfilm. Sync. \$1-10.

EDBAR INTERNATIONAL CORP. (U.K.

and Peekskill, NY) V.P. Twin - c1938. Small plastic novelty camera for 3x4cm on 127 film. Made in England. Reportedly sold by Woolworths in the U.K. in two halves in order to fit below their upper price limit. Most common in black, also available in green, red, walnut. Some have metal faceplate, others are all plastic. Colors: \$12-20. Black: \$1-10.

EDER PATENT CAMERA - c1933. Unusual German horizontal twin-lens (nonreflex) camera for plates or rollfilm in sizes 4.5x6cm, 6x6cm, and 6x9cm. Resembles a folding-bed stereo camera, but one lens makes the exposure while the other is a viewing lens. Rack & pinion focusing with automatic parallax correction. Tessar or Xenar f4.5 taking lens, Edar Anastigmat f4.5 viewing lens. Compur shutter to 300. Rare. One mint example with case sold at a German auction in 10/88 for \$2700. Another sold in England in 5/90 at \$1800. Current estimate: \$2800-4000

E.F.I.C.A. Suprema in black

E.F.I.C.A. S.R.L. (Argentina)

Alas - Black crinkle-finished metal box camera with grey enameled front. Unusually shaped lens bezel with wings. (Spanish 'alas" = "wings"). \$25-35.

Splendor 120 - Metal 6x9cm box camera with black crinkle finish. \$20-30.

Suprema - Horizontally styled eye-level camera with telescoping front. Takes 4.5x5.5cm or 5.5x8cm images on 120 or 620 film. Hinged masks at focal plane. All black or chrome top versions. \$30-45. Illustrated bottom of previous column.

EHIRA K.S.K. (Ehira Camera Works. Japan)

Astoria Super-6 IIIB - c1950. 6x6cm on 120 rollfilm. Super Ikonta B copy. Lausar f3.5/85mm. Shutter 1-400,B. CRF. \$200-300.

Ehira-Six - c1948-55. Copy of the Zeiss Super Ikonta B, complete with rotating wedge rangefinder. Tomioka f3.5/85mm lens in Ehira Rapid shutter B,1-400. \$175-250.

Weha Chrome Six (also Ehira Chrome Six) - c1937. Collapsible 120 rollfilm camera using a telescoping tube front rather than the bed and bellows design. Ikonta-type rotating prism coupled rangefinder. \$200-300.

Weha Light - Double extension folding plate camera for 6x9cm. f4.5/105mm lens. \$50-75.

EHO-ALTISSA (Dresden) Founded by Emil Hofert as Eho Kamerafabrik c1928. The first Altiflex cameras were introduced company name changed to Amca-Camera-Werk Berthold Altman in 1940, and after WWII became VEB Altissa-Camera-Werk.

Altiflex - c1937-49. 6x6cm TLR for 120 films. f4.5/75mm Ludwig Victar, f4.5 or 3.5 Rodenstock Trinar, or f2.8 Laack Pololyt lenses. Prontor or Compurshutter. \$60-90.

Altiscop - c1937-42. Stereo camera for six pairs of 6x6cm exposures on 120 roll-film. Ludwig Victar f4.5/75mm lenses. Vario-type shutter 25,50,100,B,T Original price in 1942: \$60. Current value: \$120-180

Altissa (eye-level finder) - c1930's. Box camera with rectangular tube eye-level finder. Altissar f8 lens. Less common than the postwar models. \$30-45.

Altissa (prism-shaped top) - c1950's. Made by VEB Altissa-Camera-Werk. Basic metal box camera with leatherette covering. Shroud for eye-level optical finder is shaped like a pentaprism housing, which lends a bit of class to an otherwise ordinary camera. Although not seen often in the U.S.A., these are quite common in Germany. \$12-20.

Altissa (pseudo-TLR) - c1938. Box camera for 12 exposures on 120 .ixfilm. The finder on this model is like many of the cheap TLR cameras: just an oversized brilliant finder (not coupled to focusing

mechanism). Hinged viewing hood. Rodenstock Periscop f6 lens. Simple shutter. Black hammertonefinish. \$25-35.

Altissa II - c1938. Similar to the Altissa described above, but with unusual view-finder which can be changed from eye-level to waist-level viewing. Trinar Anastigmat f3.5/75mm in Compur 1-30. Originally sold for \$25 but closed out in 1939 by Central Camera Co. for \$14.75. Uncommon. \$45-60.

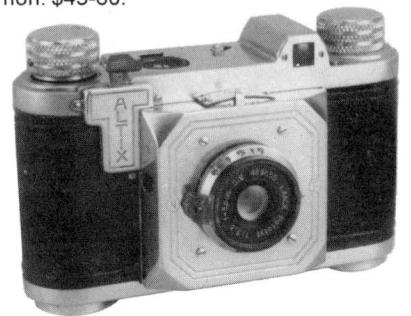

Altix (I)(pre-war) - c1938. Scale-focus 35mm. Shutter is enclosed behind square chromed front housing with beveled corners. "ALTIX" on T-shaped cover for shutter linkage. Takes 24x24mm frames. \$35-50.

Altix III - c1947. 24x24mm frame size. Body release mechanism is now internal, with button on top behind counter window. "ALTIX" in outline block letters on front above shutter. Laack Tegonar f3.5/35. Not synchronized. \$25-35.

Altix IV - c1955. 24x36mm image. Body release, viewfinder, advance & rewind knobs all above the top plate. Sync post on front below finder. Non-interchangeable Trioplan f2.9/50 in Cludor 1-200 or Vebur 1-250 shutter. \$25-35.

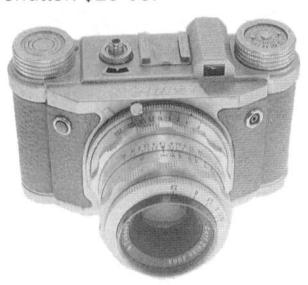

Altix V - c1957. Similar to the IV, but with lens interchangeability Some have lens lock button on front opposite sync post. Interchangeable Meritar or Trioplan f2.9 or Tessar f2.8/50mm lens. Tempor 1-250,B or Prontor SVS B,1-300 shutter. Black, brown, or green leather. (Original price \$20). \$25-35.

EHO-ALTISSA

Altix-N - c1959. Restyled version of the Altix. Streamlined top housing incorporates the viewfinder below the top plate. Lever film advance. Accessory shoe. Interchangeable Trioplan f2.9/50mm lens. \$30-45

Altix NB - c1960. Similar to N, but with built-in meter. \$30-45.

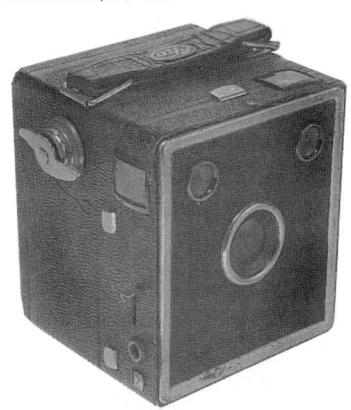

Eho box, 3x4cm - c1932. For 16 exposures on 127 film. (Nicknamed "Baby Box" in this small size, although we have no evidence that it was ever called by that name except by collectors.) f11/50mm Duplar lens. Simple shutter, B & I. Metal body. Rarest of the Eho boxes. \$75-100.

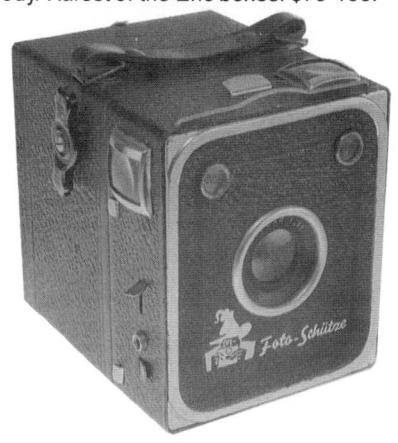

Eho box, 4.5x6cm - For 16 exposures on 120 film. Unusual variation with "Foto Schutze" advertising has sold for \$90-130 in Europe. Normal range: \$30-45.

Eho box, 6x9cm - c1930's. Rodenstock Periscop or Duplar f11 lens. Simple box shutter. With green leather covering: \$50-75. Black: \$20-30.

Eho Stereo Box camera - c1930's. For 5 stereo pairs 6x13cm or 10 single 6x6cm exp. on 120. B,I shutter. Duplar f11/80mm lenses. \$200-300.

Gehaflex - c1937. Uncommon TLR with Trinar f2.9/75mm in Rim Compur. \$90-130.

EHO-ALTISSA...

Juwel - Box camera for 6x6cm on 120. Eye-level finder in roof-shaped housing on top of body. Appears to be simply a name variation of the eye-level Altissa "Brillant" camera. \$30-45.

Mantel-Box 2 - c1930's. Small metal box camera with leatherette covering. Takes 4.5x6cm exposures. Duplar f11 lens. "Mantel-Box 2" on front under lens. Rare. \$100-150.

Super Altissa - c1938. Leather-covered box camera for 6x6cm on rollfilm. Victar f4.5/75mm; ¹/₂₅-100 shutter on telescoping front. Decorative sunburst pattern front plate. Rare. \$60-90.

EICHAPFEL (B. Eichapfel, Dresden) Noviflex - c1934. German SLR for 6x6cm on 120 film, the first of this style, beating the better known Reflex Korelle to the market. Originally offered with Schneider Xenar f2.8, Meyer Trioplan f3.5, or Ludwig Victar f3.5/75mm lens. FP shutter $1/20^{-1}/1000$. First model (illustrated) has fixed lens. Second model, c1937, has interchangeable lens mount, frame finder, and pan film cover. Interchangeablelenses included the original types listed above, plus Meyer Trioplan f2.9/75mm and Tele-Megor f5.5/150mm. Either version of this camera is uncommon.\$300-450.

EIKO CO. LTD (Taiwan)

Can Cameras - c1977-83. Modeled after the original 250ml Coke Can Camera from Japan, these cameras are all shaped like a 250ml beverage can, but with different product labels. While we can't document the origin of each label, we assume that most of them are from Eiko: Budweiser, Coca-Cola, Mickey Mouse, Orangina, Pepsi-Cola, 7-up, Snoopy, Panda, Formell, Aerogard, Gent Coffee, MillerLite, Dunlop Reaction. Often reach \$40-60 at European auctions.

Popular - c1987. Round camera styled like a car tire and wheel. Taiwanese copy of the Potenza camera from Japan. Some versions say "EIKO POPULAR", others only "POPULAR". \$25-35.

EIKO-DO CO. (Japan) Ugein Model III - c1940. Horizontally styled folding camera for 6x6cm on 120 film. Wester Anastigmat f3.5/75mm in NKK Wester T,B,1-200 shutter. \$60-90.

Ugein Model III A - c1940. Similar to model III, but dual-format 4.5x6cm / 6x6cm on 120 film. Ugein Anastigmat f3.5/80mm in Wester Model II shutter. \$60-90.

ELBOW CAMERA FIRM

Elbow flex - c1954. TLR for 120 film. Rack focus; knob wind; automatic film stop. Minor body variations in latch & shutter release for those who must have every possible variant. Correct Anastigmat f3.5/8cm in Rectus 1-300 or T.S.K. 1-200 shutter. \$60-90.

E.L.C. (Paris)

l'As - c1912. Folding 4.5x6cm plate camera with cross-swinging struts. Rotary disk stops in front of simple shutter. The name means "Ace". \$200-300.

ELDON - Simple black plastic camera. Looks almost like a toy, but has surprising features. Iris diaphragm and shutter release lock seem inconsistent with a cheap camera. Eye-level finder is rectangular, but image is square, 35x35mm on 127 film. Fixed-focus f8/66mm lens, single speed shutter \$12-20

ELECTRONIC - Japanese subminiature of the Hit type. \$25-35.

ELFLEX DELUXE CAMERA - Hong Kong. Inexpensive 6x6 on 120 camera. \$12-20.

ELGIN LABORATORIES

Elgin - Unusual eye-level camera for 828 film. Stainless steel body with leatherette covering. \$50-75.

Elgin Miniature - Plastic minicam for 3x4cm on 127 film. \$1-10.

ELITE - Japanese novelty subminiature of Hit type. \$25-35.

ELLISON KAMRA COMPANY (Los Angeles, CA) Michael Ellison and Edward S. McAuliffe filed for a patent in 1926 for a novel two-blade shutter, which was used in the Ellison Kamra and later in the similar, but smaller and more common QRS Kamra.

Ellison Kamra - c1928. A long brick-shaped black bakelite camera for bulk loads of 35mm film in special cassettes. Similar in styling to the later QRS Kamra, but with a hinged bakelite door which covers the simple fixed-focus lens. The film crank, which also serves as a shutter release, is usually not broken on the Ellison model although rarely found intact on the later QRS model. \$150-225.

ELMO CO. LTD. Originally founded by Mr. H. Sakaki in 1921 as Sakaki Shokai Co. Although more widely recognized for their movie equipment, there were several still cameras as well.

Elmoflex - Twin lens reflex cameras, made in several variations from the first model of 1938 through the last one intro-

duced in 1955. f3.5/75mm lens. 6x6cm on 120 rollfilm. \$60-90.

ELOP KAMERAWERK (Glücksburg & Flensburg, Germany) *Brief history*

taken from names used in advertising. 1948: ELOP = Elektro-Optik GmbH, Glücksburg. 1950: ELOP = Vereinigte Electro-Optische Werke, Flensburg-Mürwik. 1952: UCA = Uca Werkstätten für Feinmechanik und Optik GmbH, Flensburg. ELOP made Elca, Elca II, & Uniflex cameras. UCA made the Ucaflex (=Uniflex) and Ucanett (=Elca with some changes).

Elca, Elca II - c1948-51. 35mm camera with Elocar f4.5/35mm lens. Elca has single speed shutter; Elca II has Prontor S or Vario. Takes 50 exp. 24x24mm on standard 35mm cassette. Black painted and nickeled metal body. Model I: \$75-100. Model II, less common: \$90-130.

EMERALD - Box camera. \$12-20.

EMMERLING & RICHTER (Berlin) Field Camera - for 13x18cm plates.
Wooden body. Nickel trim. Without lens: \$120-180.

EMPIRE - Japanese "yen" box camera for "No Need Darkroom" film in paper holders. See complete explanation under "YEN-KAME". \$20-30.

EMPIRE 120 - All metal box camera for 6x9cm. \$1-10.

EMPIRE SCOUT - Inexpensive eye-level camera from Hong Kong for 6x6cm on 120 film. Simple focusing lens; three stops. B & I shutter. \$1-10.

EMSON - Japanese novelty camera of Hit type. 14x14mm exposures on 16mm paper backed rollfilm. \$25-35.

ENCORE CAMERA CO. (Hollywood, CA)

Encore! Camera
Encore De Luxe Camera - c1940's-1950's. Inexpensive cardboard novelty cameras. Factory loaded. User returns complete camera & film to factory with \$1.00 for processing. (Vaguely reminiscent of the "You push the button..." idea which made Eastman rich and famous, but the audience didn't want an Encore.) \$30-45.

Hollywood Camera - Another novelty mail-in camera, sometimes used as an advertising premium. \$30-45.

ENJALBERT (E. Enjalbert, Paris) Colis Postal - c1886. An unusual detective camera consisting of the Alpinist folding camera tied with a cord. The package even included a mailing label to complete the disguise. Extremely rare. No known sales. Estimated value: \$9000-14,000.

Photo Revolver de Poche - c1883. Highly unusual camera which very closely resembles a pistol. The cylinder contained a magazine mechanism for 10 plates, each 16x16mm. This camera is extremely rare and highly desirable. It is certainly a "world class" collectible, and price would be negotiable. Estimate: \$18,000-27,000. Replicas exist. Three known reproductions by Bertrand should be identified with initials LB, but unmarked replicas may also exist.

Touriste - c1882. Bed & bellows style camera with unusual magazine back. Eight plates are contained in a light-proof magazine, each supported in a wooden frame. Eight corresponding slots in the rear of the camera accept the ground glass accessory to focus for the chosen plate position. With the focusing glass removed, the magazine is inserted fully into the back, and the selected plate frame is secured to the opposite side of the back with a small screw. When the magazine is again withdrawn from the center position, the chosen plate remains in the pre-focused position. An ingenious, but cumbersome system. Fine wood body, brass trim and handle, tapered red bellows. Steinheil Gruppen-Antiplanet 48, spring shutter. Rare. We have no confirmed sales

ENTERPRISE

records. One example with 6 of 8 plates failed to reach its reserve of \$3850 at a German auction in 10/88. *Replicas exist.*

ENSIGN LTD. The successor company to Houghton-Butcher. For sake of continuity, we have listed all Ensign cameras under the Houghton heading.

ENTERPRISE CAMERA & OPTICAL CO. Little Wonder - c1900. Not related to the 1930's metal Little Wonder camera. Miniature box camera for 2x2" plates. Made of two cardboard boxes sliding into one another. Almost identical to the Yale and Zar cameras, \$90-130.

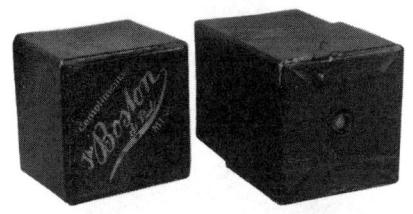

Little Wonder (Compliments the Boston) - ca. late 1890's. A rare variation of the Little Wonder camera, this special promotional edition was gold-stamped on the back: "Compliments The Boston, St. Paul Minn." Takes 5x5cm plates, and came originally with chemistry and paper for making prints. \$150-225.

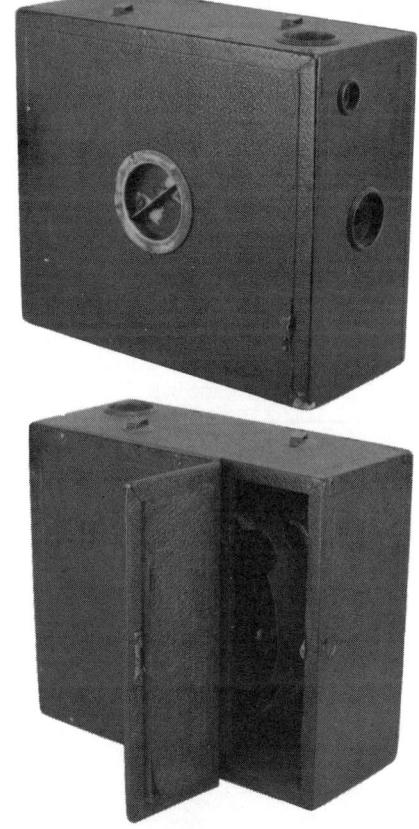

enterprise repeating camera which employs a rotating drum to hold and position five glass plates, 6.5cm square. There were several other cameras which used the same system, but apparently none ever gained much support, since any camera using this method for changing plates is quite rare. Similar in function, though not in appearance are the Mephisto, the Photo-Quint and a rare Ernemann Bob, all from about 1899-1900.\$250-375.

EPATANT

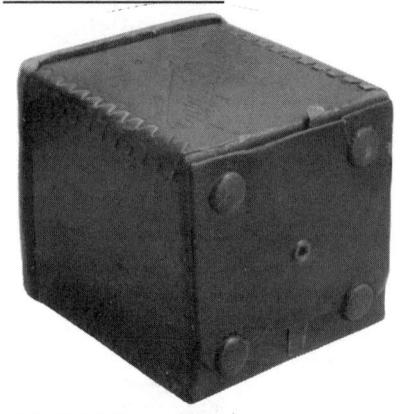

L'EPATANT - c1905. Small cardboard box camera for 4.5cm square plates, individually loaded in darkroom. Made in France. \$90-130

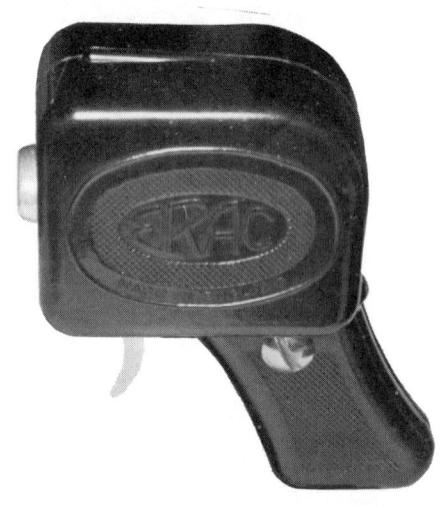

E.R.A.C. SELLING CO. LTD. (London) Erac Mercury I Pistol Camera -c1938. An unusual disguised subminiature. The outer bakelite shell is shaped like a pistol, complete with trigger. Inside is a small cast metal "Merlin" camera that is coupled to the trigger, which takes the picture and winds the film. Meniscus f16 lens in single speed shutter. While the camera only bears the ERAC name, the original box calls it the "ERAC MERCURY I SUPERCAMERA".\$300-450.

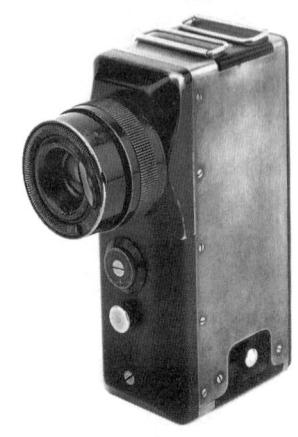

ERIKSEN (Stockholm) Pistol Camera - c1924. Wood & metal body. Takes 24 plates 28x28mm in interchangeable magazines. Shutter to 1/500 sec. Helically focusing f3 or f3.5 lens. Uncommon. One sold at Christie's 7/93 for £2000+

ERKO FOTOWERKE

(Freital, Germany)
Erko - 9x12cm folding plate camera. Wood body covered with black leather. Erko Spezial Anastigmat f8 or Erko Fixar f6.8/135mm lens. Ibso shutter, T. B. 1-150.

ERNEMANN (Heinrich Ernemann Werke Aktien Gesellschaft. Dresden, Germany) Founded 1889 by Heinrich Ernemann. Became Heinrich Ernemann AG in 1898. Purchased the Herbst & Firl Co. of Görlitz in 1900. Merged with Contessa-Nettel, Goerz, and Ica to form Zeiss-Ikon in 1926. Some Ernemann cameras continued under the Zeiss-Ikon name.

Berry - c1900-06. Field camera. Tapered green bellows with red corners. Busch Rapid Aplanat #2 lens, \$200-300.

Bob Cameras (c1910-1920's) *Early* English-language advertisments called these cameras "Ernemann's Roll Film Cameras" before the name "Bob" was used as the camera name. Originally, "Bob" was the name of a shutter. All are folding bed style rollfilm cameras with rounded body ends. Frequently the model name is on the bed or near the handle. The model number indicates the level of specification, not size. Most were available in various sizes. Not all sizes are necessarily listed here for each model.

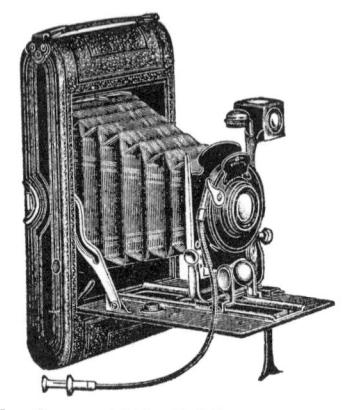

Bob 0 - c1913. Folding cameras for plates or rollfilm. Ernemann Rapid Detective or Detective Aplanat lens in Auto shutter. Small 4.5x6cm size: \$120-180. 9x12cm size: \$45-60. 9x14cm: \$45-60.

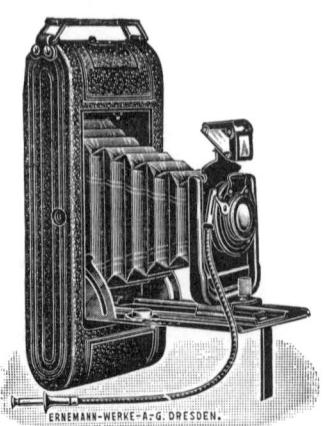

Bob 00 - c1924-25. For 6x9cm on 120 film, or single metal plateholders. Aplanat or Anastigmat f6.8 lens. \$35-50.

Bob I - c1913. Folding rollfilm or plate camera. 4.5x6cm, 9x12cm (-1/4-plate) or postcard sizes. Single extension, rack & pinion focus. Aplanat f6.8 or Double Anas-

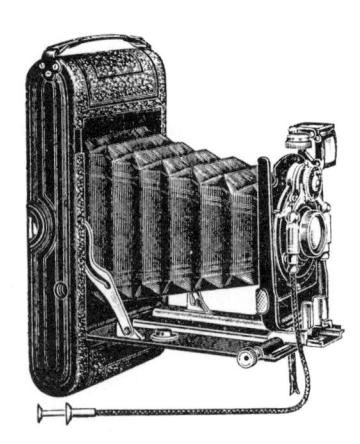

tigmat f6 lens. Bob, Automatic, or Auto Sector shutters. One with brown leather covering and red bellows sold for \$200. Small 4.5x6cm size: \$120-180. 6x9cm: \$35-50.9x12cm: \$45-60.

Bob II - c1913. 10x15cm, 8x10.5cm or postcard size. Very similar to the Bob I, but with double extension bellows, focus scales for complete lens or rear element only. 10x15cm: \$75-100. Others: \$50-75.

Bob III (horizontal style) - c1906. Early, horizontal folding bed camera for 10x15cm on rollfilm, or 9x12cm plates. Leather covered wood body. Wine red double extension bellows. Aplanat f6.8 or Roja Busch Aplanat f8 in Bob shutter. \$250-375.

Bob III (vertical style) - c1926. 6x9cm folding bed rollfilm camera. Aluminum body. Rigid U-shaped front. Chronos shutter. \$30-45.

Bob IV, 6x9cm - c1926. Similar to Bob III, but with radial focusing and rising front. \$35-50.

Bob IV, 9x14cm - c1906. Panoramic and stereo camera. Aluminum bed. Double extension wine-red bellows. Detective Aplanat f6.8 lenses in double pneumatic Bob shutter. Rare. \$300-450.

Bob V - c1924-26. Folding rollfilm camera in 4x6.5cm, 6x6cm, 6x9cm, 6.5x11cm, 7.25x12.5cm, and 8x10.5cm sizes. Radial lever focusing. 4x6.5cm: \$75-100. Larger sizes: \$45-60.

Bob V (stereo) - c1911. Folding bed stereo camera for 45x107mm on No. 0 rollfilm. \$250-375.

Bob X - 45x107mm stereo version. \$250-375.

Bob XV - c1911-14. Folding rollfilm cameras in 4x6.5cm, 6x9cm, and 8x10.5cm sizes. The larger model also takes 9x12cm plates. Earlier models had twin reflex finders on bed, later with single folding reflex finder attached to lensboard and bed. \$50-75.

Bob XV Stereo - c1913-14. Stereo model for 45x107mm on rollfilm. Folding bed style with self-erecting front. \$250-375.

Bobette I - c1925. Folding camera for 22x33mm format on 35mm paper-backed

rollfilm. This is a strut folding type without bed. Ernoplast f4.5 lens. \$250-375.

Bobette II - Similar to Bobette I, but with folding bed construction and radial lever focusing. Ernoplast f4.5, Ernon f3.5, or Ernostar f2 lens in Chronos shutter. With Ernostar (The first miniature camera with f2 lens): \$400-600. With Ernoplast or Ernon: \$150-225.

Combined 1/4-plate, Postcard, Stereo, Plate & Rollfilm Camera -

c1907. That is actually the name it was called in the British Journal Almanac advertisment for 1907. Horizontally styled folding bed camera for 31/₂x51/₂" plates. Probably a predecessor of the Stereo Bob. Shifting front allows use of both lenses for stereo or one lens for single photos. Triple extension with rack focusing. \$300-450.

Double Shutter Camera - see Heag VI Zwei-Verschluss-Camera.

Ermanox - 4.5x6cm rigid-bodied model, c1924-25. (After the 1926 merger, the Ermanox continued as a Zeiss-Ikon model with Zeiss-Ikon identification on the finder hood.) Originally introduced as the "Ernox". Metal body covered with black leather. Focal plane shutter, 20-1000.

ERNEMANN

Ernostar f2/100mm (rarer and earlier) or f1.8/85mmlens. \$1500-2000.

Ermanox (collapsible bellows model) - c1925-26. Strut-folding "klapp" type camera.

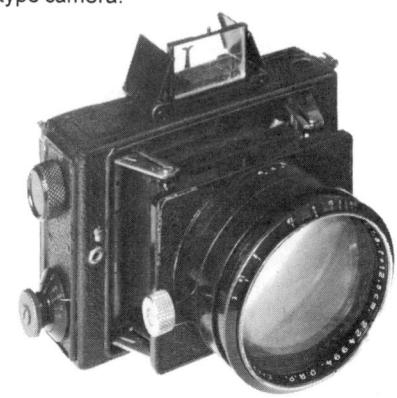

- **6.5x9cm size** - Ernostar f1.8 lens. Rare. \$1500-2000.

- **9x12cm size** - Ernostar f1.8/165mm lens, FP shutter $^{1}/_{15^{-1}}/_{1500}$. Rare. Only one confirmed sale in October 1984 for about \$3000.

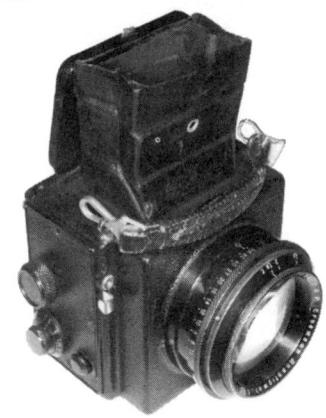

Ermanox Reflex - c1926. SLR for 4.5x6cm plates. Ernostar f1.8/105mm lens in helical focusing mount. \$1000-1500.

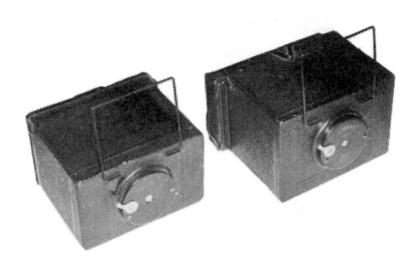

Ernette, Erni - c1924. Simple filmpack box cameras. Ernette also uses plates. Folding frame finder. T&I shutter. Achromatic lens. Rare in any size. 4.5x6cm, 6.5x9cm, or 9x12cm: \$200-300. Stereo 45x107mm:\$250-375.

Ernoflex Folding Reflex: Originally called "Folding Reflex" and later "Ernoflex Folding Reflex" in English-language catalogs and advertisements. Called Klapp-Reflex in German. Five basic types: Original type, Model I (single extension), Model II (triple extension), Miniature Ernoflex, and Stereo Ernoflex. (The latter two are listed under "Miniature" and "Stereo".)

ERNEMANN...

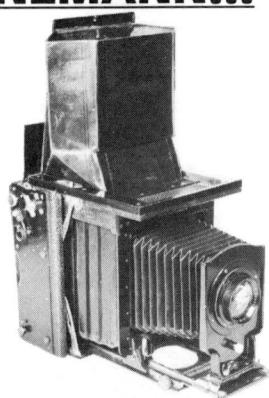

(Ernoflex) Folding Reflex (original type) - Klapp Reflex - c1914. Folding SLR with drop bed and rack focus. Made in 9x12cm/ ¹/₄-plate size only. Single or double extension models. Ernemann f6.8 or Zeiss Tessar f4.5 lens. \$600-900.

Ernoflex Folding Reflex (Klapp Reflex) Model I - c1924-26. Unlike the original version, this model has no bed, but scissor-struts to support the front, and helical focus mount for the lens. Single extension only. 4.5x6cm, 6.5x9cm, 31/4x41/4", or 9x12cm sizes. Ernotar f4.5, Ernon f3.5, or Zeiss Tessar f4.5. \$300-450.

Ernoflex Folding Reflex (Klapp Reflex) Model II - c1924-26. Triple extension. An intermediate front is supported by trellis struts and moves to infinity position upon opening the camera. For additional extension, a front bed with a double extension rack extends beyond the intermediate front. This allows for extreme close-ups with the normal lens, or long focal length lenses may be used for telephoto work. 1/4-plate or 9x12cm. \$400-600.

Film K - c1917-24. Leather covered wood box camera made in 4 sizes. Meniscus f12.5 lens in T&I shutter.

Film K, 6x6cm - \$90-130. Film K, 6x9cm - The most common size. \$60-90.

Film K, 6.5x11cm and 7.25x12.5cm - \$45-60.

Film U - c1925. Box camera for 6x9cm on rollfilm. More compact than the 6x9cm Film K, because it has a collapsing front. Folding frame finder. Doublet lens in automatic shutter. Rare. \$175-250.

Folding Reflex: see Ernoflex Folding Reflex.

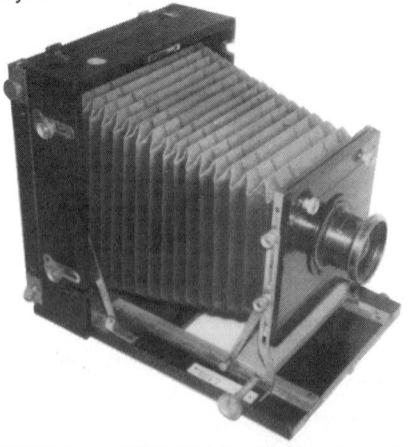

Globus - c1900. Folding field camera in 13x18cm or 18x24cm sizes. Double extension square-cornered colored bellows. Focal plane shutter. Polished wood body with brass trim. With contemporary lens: \$400-600.

Globus Stereo - c1910. Double extension field camera for stereo exposures on 13x18cm plates. Leather covered mahogany body, nickel trim, tapered wine-red bellows. Tessar f6.3/135mm lenses. Stereo Compound shutter. Also takes single lensboard. \$600-900.

Heag An acronym for Heinrich Ernemann Aktien Gesellschaft. Used mainly to identify a series of folding bed plate cameras. Englishlanguage advertising did not always use the name "Heag", but usually the model number was used.

Heag 0 - c1918. 6.5x9cm and 9x12cm plate cameras. Single extension. \$35-50.

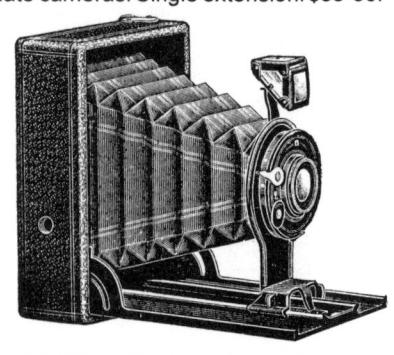

Heag 00 - c1914. A cheap single-extension model in 6.5x9cm and 1/₄-plate sizes. T.B.I shutter, \$35-50.

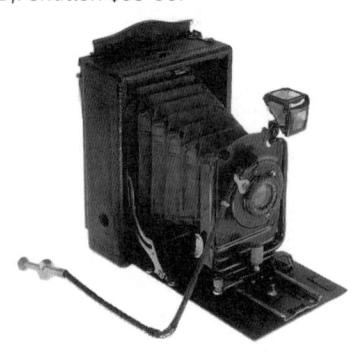

Heag I - c1914. Folding-bed camera in 6.5x9cm, 1/₄-plate, postcard, or 1/₂-plate sizes. Single extension. Black imitation leathered body. Detective Aplanat f6.8. ErnemannAutomat shutter. \$35-50.

Heag I Stereo - c1904. Folding bed stereo camera for 9x12cm plates. Leather covered wood body. Red tapered double-extension bellows. Detective Aplanat f6.8 lenses. Ernemann Automat shutter 1/2-100. \$300-450

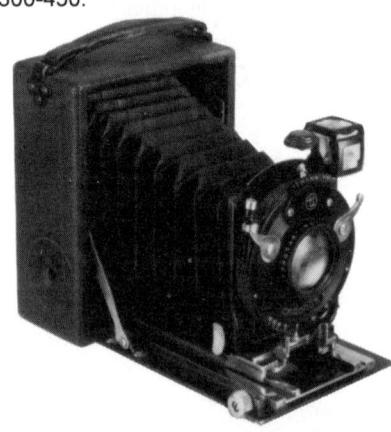

Heag II - c1911-26. Similar to Heag I, but with rack focusing, genuine rather than imitation leather. 6.5x9cm, ¹/₄-plate, post-card, and ¹/₂-plate sizes. Model I (single extension) and Model II (double extension). Aplanat f6.8 lens. \$50-75.

Heag III - c1926. All metal body. Ushaped front standard. Single extension. 6.5x9cm or 9x12cm sizes. \$50-75.

Heag III (stereo) - c1910. Two-shuttered stereo for unusual 7x15cm format. Nickel trim, wine-red bellows. Detectiv-Aplanat f6.8 lenses. \$400-600.

Heag IV (stereo) - c1907-1920. Folding bed camera for stereo photos on plates. Double extension, rack focusing. Ernemann Aplanat, Anastigmat, or Vilar f6.8 lenses. \$300-450.

Heag V - intro. 1924. A single extension camera like the Heag III, but with radial lever focus, micrometer rising front. Small 4.5x6cm size: \$175-250. Larger sizes: \$50-75.

Heag VI (Zwei-Verschluss-Camera) - c1907. Leather covered folding bed plate camera in 31/₄x41/₄" or 31/₂x51/₂" size. Focal plane shutter to 1/₂₀₀₀. Inter-lens shutter T,B,1-100. Double extension, rack focusing. English ads often call it "Double Shutter Camera" and German ads call it "Zwei-Verschluss-Camera" with neither mentioning the "Heag" name, but Ernemann catalogs use the Heag VI name and "Zwei-Verschluss-Camera" as a subheading. \$300-450. (See "Tropical" for teak version of this camera).

Heag VI Stereo (Zwei-Verschluss-Camera) - c1907. This is a stereo version of the "Double Shutter Camera Model VI", available in postcard or 1/2-plate sizes. Focal plane and front shutters. English-language advertising called it the "Combined Postcard and Stereo, Model VI". \$400-600. *Illustrated at top of next column.*

Heag VI Stereo

Heag VII - intro. 1924. Similar to the Heag V, but also includes double extension with rack focusing. 6.5x9cm, or 9x12cm sizes. Vilar f6.8, Ernotar f4.5, or Tessar f4.5. Chronos shutter. \$50-75.

Heag IX Universal Camera with single and stereo lensboards

Heag IX Universal Camera - c1904-1907. An interesting design for a dual-

ERNEMANN...

purpose strut camera. The basic design is for a stereo lensboard. To use for single photos, a separate lensboard with its own bellows & struts allows the extra extension needed for the longer focus of the single lens. In English-language ads, this was called "Combined Stereo and Half-Plate Focal-Plane Camera". With stereo or extensible lensboard: \$200-300. With both lensboards: \$350-500. Note: Ernemann made similar extension fronts for use on other standard cameras for telephoto or closeup photographic work.

Heag XI - c1913-26. Leathered wood body and aluminum bed. Double extension bellows. R&P focus. Rise, fall, cross front. Swing back. Focusing scales for complete lens or rear element only. Anastigmat f6.8 or f6, Aplanat f6.8 lens. 1/2-plate or post-card sizes. \$50-75. (See "Tropical Heag XI" for teakwood model).

Heag XII - c1906-13. Made in 1/4-plate or 1/2-plate sizes. Compact folding type, vertical style. Earlier versions have red bellows. Ser.I is single extension, Ser.II is double extension. Bob shutter with aluminum housing. \$45-60.

Heag XII (stereo) - c1910. Double extension folding bed stereo camera for 6x13cm plates. Wine-red bellows. Detectiv-Aplanat f6.8 lenses in 1/2-1/100 shutter. \$350-500.

Heag XII Ser. III - c1919. Horizontal folding bed camera for 9x12cm plates. Double extension. Tessar f6.3/125mm in Automat shutter. \$75-100. *Illustrated at top of next page.*

Heag XII Ser. III (stereo) - c1919. Folding bed stereo/panorama camera for 9x18cm plates. Double extension with rack focusing. Micrometer rise, fall, cross front. \$250-375.

ERNEMANN...

Heag XII Ser. III

Heag XIV - c1910. Folding two-shutter cameras. Front shutter plus FP 50-2500.

- **4.5x6cm** - Ernemann Doppel Anastigmat f6/80mm. Front shutter 1-100. \$150-

- **9x12cm** - Ernon f6.8/120mm. \$100-150.

Heag XV, 4.5x6cm - c1911-14. Vertical format self-erecting folding plate camera, 4.5x6cm "vest pocket" size. Early variations have two rigid reflex finders on the front of the bed. Later models have a single folding finder. Both of these types exist in focusing and fixed focus versions. Ernemann Double Anastigmat f6.8/80mm in Automat shutter 1-100. \$100-150.

Heag XV, 6.5x9cm - c1912. Rarer in this size than 4.5x6cm, but also in less demand. Like the 4.5x6cm model with reversible folding finder. Radial lever focusing. Ernemann Detective Aplanat #00 f6.8 lens. Automat shutter 1-100. \$60-90.

Heag XV, 9x12cm - c1912. Vertical format self-erecting camera. Uncommon

mechanism which erects front lies flat against the baseboard. Eye-level and reflex finders also extend and retract automatically \$60-90.

Heag XV, 4.5x10.7cm - c1912. Small stereo camera with self-erecting front, automatic opening brilliant and Newton finders. \$250-375.

Heag XV, 6x13cm - c1912-14. Stereo version of the 6.5x9cm Heag XV. Similar to the 4.5x10.7cm size, but also has iconometer and rising front. \$250-375.

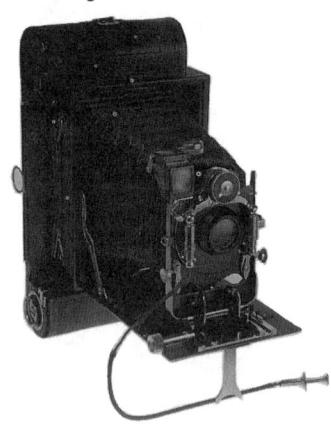

Heag XVI - c1913. Combination folding camera for plates or rollfilm. Detachable rollfilm back allows for use with 9x12cm plates. The 1913-14 Ernemann catalog claims this camera combines the advantages of the Heag XII and the Bob II. The rollback has its own darkslide; it can be removed at any time to use plates. Both plates and rollfilm lie in the same focus position, which is not always the case with combination cameras. Ernemann Detectiv Aplanat f6.8 in Ernemann Patent shutter. Uncommon.\$150-225.

Heag (tropical model), listed with "Tropical" cameras, later in this heading.

"Klapp" cameras - The word "klapp" indicates a folding camera, and came to be used primarily for folding cameras of the strut type. In the case of Ernemann, it was used for their strut-folding plate cameras with focal plane shutters. In English language advertising, these were usually called "Focal Plane Cameras". These were also available in tropical models.

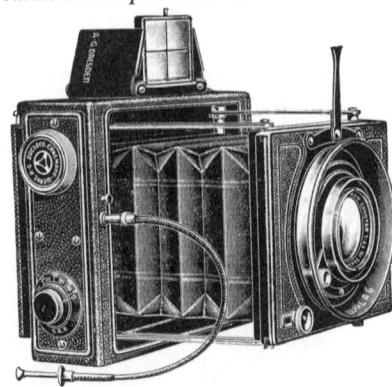

Klapp - c1904-26. Strut-folding focal plane cameras in 6.5x9cm, $31/_4$ x4 $1/_4$ " or 9x12cm, $31/_2$ x5 $1/_2$ " or 10x15cm, 4x5", and 12x16.5cm sizes. Early models had single-pleat bellows, unprotected Newton finder, and more complex shutter controls on two metal plates on side. Later models had

normal pleated bellows, Newton finder with protective clamshell cover, and two round shutter knobs on side. Ernostar f2.7, Ernotar f4.5, Tessar f4.5, or Ernon f3.5 lenses. Wide range of prices, mostly between \$200-300.

Klapp Stereo - c1904. Strut-folding focal plane stereo cameras, made in 6x13cm and 9x18cm sizes. \$250-375.

Liliput - c1914-26. Economy model 4.5x6cm or 6.5x9cm folding bellows vest pocket camera. Single-pleat bellows with manually positioned internal gate struts. Fixed-focus achromatic lens and T, I shutter. Folding frame finder. Both sizes sell for about the same prices, although the larger size is less common. In top condition, the 6.5x9 has reached \$135 at auction. 4.5x6cm size has reached \$160 (Cornwall 2/93) in top condition with original box. In average condition it sells regularly at German auctions for \$60-90.

Liliput Stereo - c1919-25. Stereo version of the compact folding Liliput camera for 45x107mm. Meniscus lens. Guillotine shutter. \$250-375.

Magazine Box - Drop-plate box camera for twelve $31/4 \times 41/4$ " plates. \$200-300.

Mignon-Kamera - c1912-19. 4.5x6cm compact folding camera with cross-swing struts. Usually with Detectiv Aplanat f6.8. Z,M shutter. \$100-150.

Miniature Ernoflex 4.5x6cm (formerly "Folding Reflex") or Miniature Klapp-Reflex - c1925. Strut-type folding reflex for 4.5x6cm plates. Ernon f3.5/75 or Tessar f4.5/80mm lens. Focal plane shutter to 1000. One of the smallest folding SLR cameras ever made. \$1000-1500.

Miniature Klapp (4.5x6cm) - c1925. Body style like the later "Klapp" style above, but also with front bed/door. Ernostar f2.7/75mm, Tessar f3.5, Ernotar f4.5, or Ernon f3.5. Focal plane shutter to 1000. Good clean working examples: \$350-500.

Reflex - c1909. Non-folding SLR with tall focus hood and flap over lens. Reversing back. FP shutter to ½500, T. Removable lensboard with rise and fall. Double extension, rack & pinion focus. 6.5x9cm, 31/4x41/4", 41/4x61/2" sizes. Ernemann f6.8 Double Anastigmat or Zeiss Tessar f4.5. \$250-375.

Rolf I - c1924-25. Folding vest pocket camera for 127 film. Leatherette covered body. Rapid Rectilinear f12/75mm lens. T,B,I shutter. \$50-75. *Illustrated at top of next column.*

Rolf II - c1926. Similar to Rolf I, but with genuine leather covering, Chronos precision shutter, Ernemann Double Anastigmat f6.8 or Ernoplast f4.5 lens. \$50-75.

Simplex 9x12cm (early type) - c1919. Inexpensive folding-bed plate camera. Black metal body, black single-extension bellows. Simple f12/135mm lens in M,Z shutter built into front standard. Uncommon.\$100-150.

Simplex (later type) - c1924-25. Leatherette covered body. Lens mounted in Automat shutter with two stops, f11 & f24, and speeds Z&M. Made in 6.5x9cm and 9x12cm sizes. \$50-75.

Simplex Ernoflex - c1926. Simple boxform SLR. No bellows. Helical focusing lens mount. FP shutter with 16 speeds $1/_{20}$ - $1/_{1000}$ sec. Cover for folding hood has front hinge on some models and rear hinge on others. 4.5x6cm size: \$600-900. 6.5x9cm or 9x12cm size: \$250-375.

Stereo Bob - see Bob above.

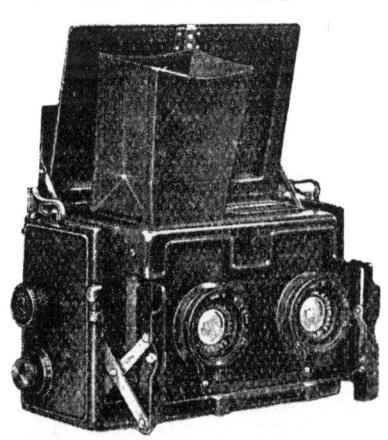

Stereo Ernoflex - c1926. A stereo version of the Miniature Ernoflex camera for 45x107mm. Scissor-struts support lensboard. Full width top door, but focus hood on one side only. FP shutter ¹/₁₀-1000. Ernotar f4.5, Ernon f3.5, or Tessar f4.5 lenses. \$1200-1800.

Stereo Reflex - c1913. Rigid body jumelle form stereo camera with reflex viewing. Full width viewing hood. FP to 2500, T. Ernemann Anastigmat f6 or f6.8, Zeiss Tessar f6.3 or f4.5, or Goerz Dagor f6.8 lenses. \$500-750.

Stereo Simplex - c1920. Non-collapsing, "jumelle" style stereo camera for

ERNEMANN...

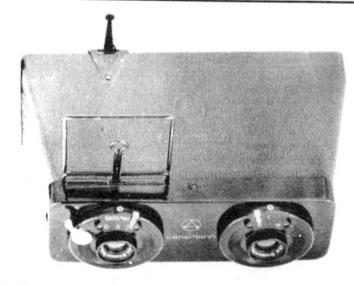

45x107mm plates. This is not a reflex model, but has only a wire frame finder. Ernemann Doppel lens f11/60. Guillotine shutter, T, B, I. \$150-225.

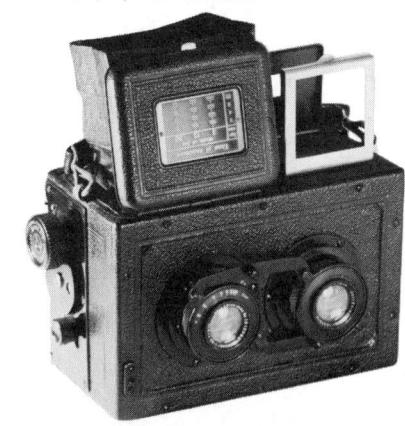

Stereo Simplex Ernoflex - c1926. Simple reflex stereo box camera. No bellows. Ground glass focus on both sides, but reflex focus on one side only. Ernon f3.5/75mm lenses in externally coupled helical mounts. FP 25-1000. \$800-1200.

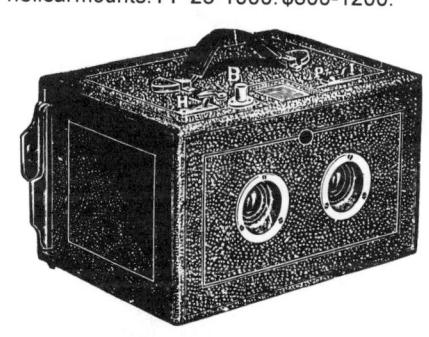

Stereoscop-Camera - c1901. Stereo box camera, 9x18cm pairs. Fixed focus meniscus lenses. B&I shutter. \$300-450.

Tropical cameras - All tropical cameras, including Ernemann, are relatively uncommon. Prices increased rapidly a few years ago, and are now holding steady. Prices differ widely between the focal plane shutter models and inter-lens shutter types.

Tropical Heag VI (Zwei-Verschluss-Camera) - c1914. Horizontally styled 1/4-

ERNEMANN...

plate folding bed camera of teak with brass fittings. Double extension, removable lensboard. FP shutter to 1/2500. Front shutter T,B,-1/2-100. Ernemann Anastigmat f6 or Zeiss Tessar. \$1200-1800.

Tropical Heag XI - c1920-30. (Zeiss-Ikon after 1926.) Vertically styled 9x12cm folding-bed camera. (NOT focal plane type.) Teak body, brown double extension bellows, brass fittings. Ernemann Vilar f6.8/135mm, Ernar f6.8, Ernoplast f4.5, or Ernotar f4.5 in Chronos B shutter to 100 or Chronos C shutter 1-300. \$750-1000.

Tropical Klapp - Strut-folding focal plane camera. Same features as normal "Klapp" camera, but polished teak body with lacquered brass trim. Brown bellows, brown leather hood on GG back. \$1200-1800.

Unette - c1924-29. Miniature box camera for 22x33mm exposures on roll-film. Overall size: 3x31/₂x21/₄". Two speed (T&I) shutter. f12.5 meniscus lens. Revolving stops. \$150-225.

Universal - c1900. 13x18cm double extension folding plate camera. Polished wood body, brass trim. Goerz Double Anastigmat f4.6 brass-barreled lens. Focal plane shutter. \$500-750.

Velo Klapp - c1901-14. A focal plane

camera originally introduced c1901 with top speed of $^{1}/_{1000}$; by 1904 speeds expanded to $^{1}/_{2000}$; and by 1914 to $^{1}/_{2500}$. Aplanat f6.8 lens. The Velo Klapp continued for a time as a lower-priced alternative after the introduction of the more expensive Ernemann Klapp cameras. \$150-225.

Zwei-Verschluss-Camera - see Heag

ESPINO BARROS E HIJOS S.A. (Monterrey, Mexico) Manufactured cameras for Doyle Riley Company, Dallas, Texas

Noba - c1955-59. Mahogany studio cameras, in sizes from 4x5" to 8x10" with various sliding backs, etc. Focusing drive mechanism uses v-belts. Matching stands also use v-belts and heavy counterweights for ease of raising and lowering the camera. Exterior finish of cameras is enamel, often black, but also exists in an enameled "white oak" finish. Camera with stand: \$400-600.

ESPIONAGE CAMERA (FRENCH) - WWII vintage subminiature for 45 exp. 8x11mm. Metal FP shutter to 250. An uncommon camera, usually found without the lens. Top auction price 12/91: \$1400. Normal range: \$750-1000. No recorded sales with lens.

ESSEM - 5x7" folding camera. RR lens in B&L shutter. Mahogany interior, red bellows. \$100-150.

ESSEX - Plastic minicam, styled like Falcon Minicam Jr., Metro-Cam, Regal Miniature, etc. \$1-10.

ESTES INDUSTRIES
(Penrose, Colorado)
Astrocam 10 - c1979. Small 110 car-

Astrocam 110 - c1979. Small 110 cartridge camera designed to be launched via a rocket to take aerial photos. Shoots one photo per flight. The 1/500 second shutter is activated at ejection just prior to parachute deployment. With companion Delta II rocket in original box: \$30-45.

ETA (Prague, Czechoslovakia) Etareta - c1950-55. Non-rangefinder 35mm camera. Etar II f3.5/50mm lens in Etaxa 10-200,B,T shutter. Collapsible front. \$35-50.

ETAH - British mahogany field camera taking 41/₄x61/₂" plates. Brass trim. \$250-375

ETTELSON CORP. (Chicago)
Mickey Mouse Camera - c1956. Black
bakelite box camera with red trim. Has
Mickey Mouse nameplates on the front,
rear, and on the advance knob. This is an
uncommon camera, especially if found in
its original box. Complete with original box:
\$175-250. Camera only: \$90-130.

EULITZ (Dr. Eulitz, Harzburg) Grisette - c1948. Bakelite camera for 35mm film. 45mm achromat lens. Simple

EUMIC (Austria) Eumigetta (I) - Cast aluminum eye-level camera for 6x6cm on 120 rollfilm. Model 1 is not identified as Eumigetta or Model 1 on the body. Diamond-shaped Eumig nameplate on top. Square viewfinder above top plate (not in streamlined housing as model 2). Eumar f5.6/80mm lens. \$30-45.

Eumigetta 2 - Totally restyled camera. Viewfinder is now incorporated in top housing. Eumar f4/80mm lens in $\frac{1}{25}$ -200 shutter marked "Eumigetta 2". \$35-50.

EVES (Edward Eves Ltd., Leamington Spa, England) Blockmaster One-Shot - c1954. Color separation camera utilizing beam-splitting mirrors to make 3 filtered exposures on 4x5" plates. Schneider Xenar f4.5/210mm lens in Compoundshutter. \$1000-1500.

EXCELLA - Simple bakelite eye-level camera for 127 film. Excella Idar Optik lens. We have been unable to discover the manufacturer of this camera, but suspect it was made in Czechoslovakia. Readers comments are welcomed. \$30-45.

EXCO - simple box-type stereo camera, also useable for single exposures. Double anastigmat lenses. \$150-225.

EXPO CAMERA CO. (New York)

Easy-Load - c1926. Small box camera for 15/8x21/2" exposures on rollfilm in special cartridges, called Expo "Easy-Load" film. Meniscus lens, rotary sector shutter. Red, brown, or green: \$60-90. Black: \$30-45.

Focal Plane Police Camera - An unusual variation of the Police camera. Only minor differences of construction, the most noticeable being a rotating view-finder. Uncommon. One example in original box sold for \$300, and then resold at auction 12/91 for \$1500.

Police Camera - c1911-24. A tiny allmetal box camera for 12 exposures on special cassettes. Fixed focus achromatic lens, 2 apertures. Cloth focal plane shutter, T & I. \$500-750.

Watch Camera - Introduced c1905, produced for about 30 years. Disguised as a railroad pocket watch. Takes picture through the "winding stem", while the "winding knob" serves as a lens cap. Special cartridges. This is an interesting camera, but actually quite common since it

was marketed for so long. Several variations exist. Black, blue, or red enameled versions, produced about 1935, rare. Top price 12/91 \$1700. Normal ranges: Colored: \$1000-1500. Nickeled camera with reflex finder and original box: \$250-375. Nickeled camera only, complete with lens cap: \$175-250. Add \$45-60 for cartridge or finder.

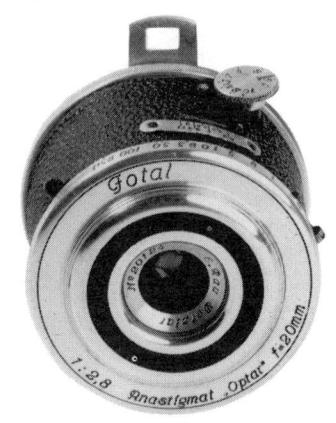

FABRIK FOTOGRAFISCHE APPARATE (Lübeck, Germany)

Fotal - c1950. Round subminiature for 8x12mm exposures on Special-Rollfilm. Optar Anastigmat f2.8/20mm lens. Prontor II 1/250 shutter. Brown, green, or blue leather covering. Top auction price 12/91 \$3000. One sold at auction for only \$425 a few years back. \$1500-2000.

FAISSAT (J. Faissat, Limoges)
Field camera, 9x12cm - c1895-1900.
Tailboard-style camera with single-extension by rack and pinion. Fine wood body with brass trim. Brass barrel lens for waterhousestops. \$150-225.

FALCON CAMERA CO. (Chicago) The history of the Falcon Camera Company is somewhat unclear. The Falcon line was begun by the Utility Manufacturing Co. of New York about 1934. One source indicates that Utility, which also made Spartus cameras, was sold to the Spartus Corp. in 1940, the new firm taking its name from the Spartus cameras. (The Utility name continued to be used at least as late as 1942, however, on price lists for Falcon cameras.) While the ownership may have belonged to Spartus, the Falcon Camera Co. name was used in advertising in 1946, as was the Spencer Co. name. In fact, we have a camera with the Falcon Camera Co. name, but its instruction book bears the Spencer Co. name. Both of these companies operated out of a building at 711-715 W. Lake St. in Chicago, which is also the address of the Spartus

FALLOWFIELD

Camera Co., Herold Mfg. Co., and Galter Products. If this is not confusing enough, we should add that the founder of the original Utility Manufacturing Co., Mr. Charles Fischberg, was later prominent in the Herbert-George, Birdseye, and Imperial companies. See also Utility Mfg. Co. for Falcon cameras.

Falcon Miniature - c1947. Bakelite minicam for 3x4cm on 127 rollfilm. \$8-15.

Falcon Miniature Deluxe - c1947. Marbelized brown bakelite minicam for 3x4cm on 127 film. Folding eye-level finder. \$20-30.

Falcon Minicam Senior - Another 35mm-style camera for 3x4cm on 127 film. Cast aluminum: \$25-35. Bakelite: \$8-15.

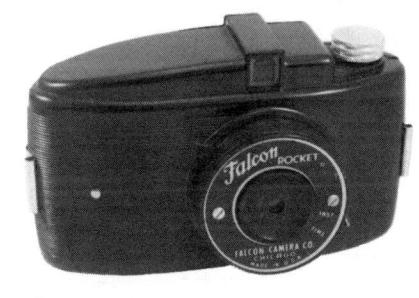

Falcon Rocket - Minicam for 3x4cm on 127 rollfilm. \$8-15.

FALLER (Eugene Faller, Paris) Field Camera - c1900. Tailboard camera for 13x18cm plates. Double extension, tapered, green bellows. Brass barrel lens with waterhouse stops. \$175-250.

Wet-plate camera - c1870. Mahogany body with square red bellows, Brass lens with wheel stops. 1/₄-plate size. \$1000-1500.

FALLOWFIELD (Jonathan Fallowfield Ltd., London) Fallowfield was a dealer, not a manufacturer. Most if not all Fallowfield cameras & lenses were made for him by other makers.

Facile - c1890. Mahogany box detective magazine camera, made for Fallowfield by Miall. A grooved box carries the fresh plates over a slot where they drop into a

FALLOWFIELD...

second grooved box behind the lens. A milled knob simultaneously moves the top box forward and the lower box backward so that each successive plate drops into the plane of focus in front of the previous one. An uncommon camera, which was designed to be concealed as a package wrapped in paper. Several of the early mahogany models have sold at Christie's in the late 1980's for \$500-750. One upgraded version brought \$2000 in 4/89. Later black painted model: \$350-500.

Miall Hand Camera - c1893. A very unusual and rare detective camera disguised as a gladstone bag. In addition to its unusual shape, it boasted the ability to be reloaded, 12 plates at a time, in broad daylight. Original advertising states that this camera was made only to order, which helps account for its rarity. Price negotiable. Estimate: \$9000-14,000.

Peritus No. 1 - Mahogany field camera for 10x12" plates. Ross-Goerz Patent Double Anastigmat f7.7/14" lens. \$350-500.

Popular Ferrotype Camera - c1911. Vertically styled wooden tintype camera. Lens is high and offset to the right. Sliding back at top of camera includes ground glass at far right. Curved nickeled pull at

bottom of sliding back allows plates to drop into tank. Design is based on the earlier "Quta" camera whose top section was hinged. Probably made by Quta and distributed by Fallowfield in England. Gennert sold the Quta in U.S.A. \$1000-1500.

Prismotype - c1923. Direct positive street camera for 21/₂x31/₂" cards. Unusual design with reflecting turret eliminates the lateral reversal common to most direct positive cameras. \$1000-1500.

Studio Camera 21x27cm - c1860. With Ross brass lens, square black bellows. One sold at auction in Germany 9/89 for \$1160.

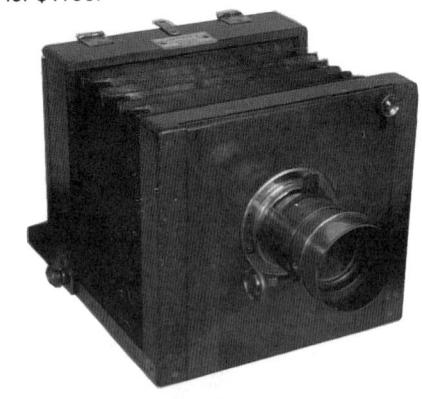

Tailboard cameras - Various sizes, 1/2-plate to 10x12". Dovetailed mahogany construction with square bellows. Rising and sliding front. Rack focus. With brass barrel lens: \$250-375.

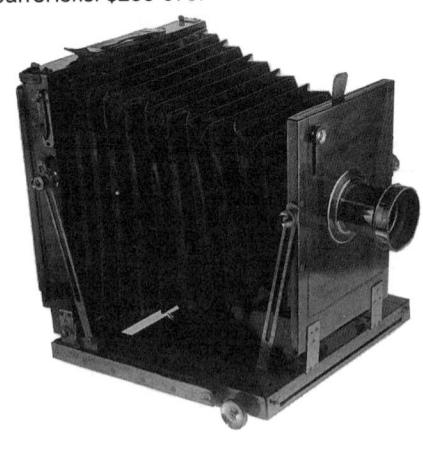

Victoria - c1892. Compact folding field camera, probably made by Henry Park for Fallowfield. Ivory label on top identifies it as "The Victoria -- Fallowfield Charing Cross Rd.". See Park for more complete description. \$300-450.

Wet plate 9-lens camera - c1870. Mahogany sliding-box camera with carte de visite sliding back. Lens panel contains 9 lenses. Front flap shutter. Rack and pinion focus. \$3500-5500.

FALZ & WERNER (Leipzig, Germany) Field camera, 9x12cm - c1900. Small field camera with brass trim and green bellows. \$120-180.

Field camera, 13x18cm - c1900. Double extension tapered green bellows with red corners. Brass Tetrar f4.5/180mm lens. \$175-250.

Universal Salon - c1895. Studio camera taking 18x24cm plates with reducing back to 9x12cm. Fine wood, brass trim. Large wooden studio tripod. Brass Voigtänder lens for waterhouse stops. One sold at auction in 1990: \$1575.

FAMA - German single extension folding plate camera, 9x12 size. Verax f8/135 or Sytar f6.3/135 in Vario shutter. \$35-50.

FAP (Société FAP, Suresnes, France) FAP = Fabrique d'Appareils

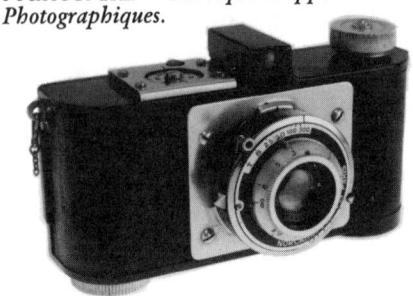

Norca A - c1938. France's first competitor in the popular 35mm market. Although its leather covered black plastic body and spring-loaded telescoping front closely resemble the Argus A, its current value in the collector market would shock Oscar Barnack. Boyer Saphir f3.5/50 in Norca T,B,25-300 shutter. Not generally available except in France where they easily bring \$150-225.

Norca B - c1945. Modified front tube is no longer spring loaded. Berthiot, Boyer, or FAP f3.5 lens in Atos, Compur, or Norca shutter. \$75-100.

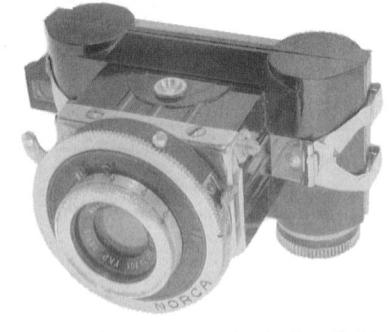

Norca Pin-Up - c1945. Small black bakelite camera for 24x36mm exposures on special perforated rollfilm. The body is modified from the Rower by the addition of an automatic film counter, a better shutter & lens mounted on a chrome front plate, an optical finder, and a few other improvements: FAP Paris Anastigmat f3.5/50mm in Norca 1/10-1/300 shutter. Rare. \$400-600.

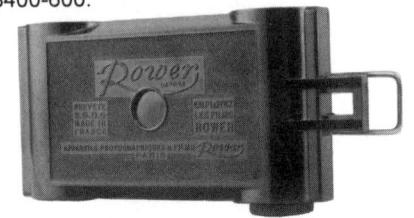

Rower - c1936. Small black plastic camera for 32x40mm on special rollfilm. Appearance is nearly identical to the Universal Univex A of 1933. Common in France where they sell for \$35-50.

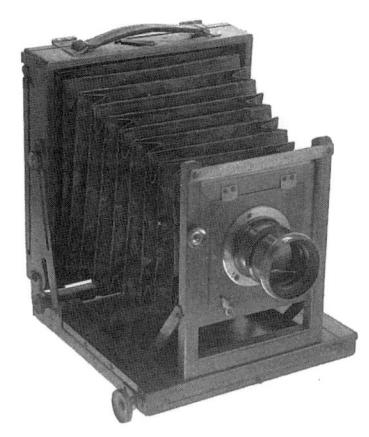

FARROW (E.H. Farrow & Co., Hornsey Rise, London) Field Camera, 1/2-plate - c1880's.

Field Camera, 1/2-plate - c1880's. Compact folding camera, square cornered tapered bellows. Front standard attaches to base with keyhole slots. \$300-450.

FED (Dzerzhinsky Commune, Kharkov, Ukraine) The name "FED" comes from the initials of Felix Edmundovich Dzerzhinsky. The youth rehabilitation commune which bears his name was created as a memorial to Dzerzhinsky, the founder of the Soviet secret police. For a detailed history of the Dzerzhinsky commune, see the excellent article presented by Oscar Fricke in the quarterly "History of Photography" April 1979.

Engraving Styles of Fed-1:

Type 1: 1934-35. Ser.#31-6000.

ФЗД Трудкоммуна им. Ф.З.Дзержинского

Ф.З. Дзержинского Харъков

Туре 2: 1935-39. Ser.#6000-95000 ФЗД

Трудкоммуна НКВД-УССР

им.

Ф.З.Дзержинского Харъков

Туре 3: 1939-41. #95000-175000 ФЗД НКВД-СССР

Харъковский КОМБИНАТ

им. Ф.З.Дзержинского

Type 4: c1946-48. #175000-200000

ФЗД завод

им.

Ф.З.Дзержинского г. Харъков

Type 5: c1948-53. #200000-400000

завод

Ф.З.Дзержинского

Type 6: c1953-55. #400000-700000.

Fed - The Fed was the earliest successful Leica copy, and the only one achieving any measure of success before WWII. Early models are more difficult to identify because they are not numbered until the Fed-2 of 1955. However, the engraving on the top and the serial numbers are helpful in identifying and dating the early models.

Fed-1 - c1934-55. Copy of Leica II(D) camera. Usually with FED f3.5/50mm lens (coated after 1952). Production increased annually except during WWII, so naturally the earlier models are less common and more valuable to a serious collector. Earliest models, without accessory shoe (including "BOOMU" marked model): \$800-1200. Other prewar models: \$175-250. Postwar models: \$60-90.

Fed-C - 1938-41. Like the Fed-1, but shutter to $1/_{1000}$ and with f2 lens as standard. \$120-180.

Fed 2 - c1955-1970s. Removable back, combined VF/RF. From 1956 with self-timer, sync. Originally with Fed f3.5/50mm. From 1957 with Industar-26M. From 1964 with Industar-61. Body covering sometimes in dark red, dark green or very dark blue, much less often than black, which is common. Black: \$60-90.*

Fed 3 - c1962-80. Slow speeds, shorter RF base than Fed-2. From 1964 with lever film advance. Industar-26M superseded in 1964 by Industar-61. \$60-90.*

Fed 4 - c1964-70s. Built-in meter. Industar-61 lens. \$45-60.*

* Note: The Fed 2, 3, and 4 are common in Europe, but not in the U.S.A., so they sell for 50% above these figures in the U.S. Fed-3 and 4 were also sold as "Revue"-3 & 4 by Foto-Quelle.

Fed Micron - c1968. Half-frame (18x24mm) 35mm camera with automatic diaphragm. Selenium meter cell around lens, like many popular cameras of the early 1960's. \$50-75.

Fed Micron-2 - c1978. Full-frame 24x36mm version of the Fed Micron. Shutter 1/₃₀ to 1/₆₅₀, B. Industar-81 f2.8/38mm. Automatic diaphragm with CdS meter cell. \$25-35.

Fed 10 - c1964. Full-frame 35mm with selenium meter cell on front of top housing. \$25-35.

Fed 11 (Atlas) - c1967. Similar to Fed 10, but lever film advance. Control knobs recessed in top housing. \$25-35.

Zarya (Zapa) - c1958-59. (Zarya = Dawn). 35mm, similar to the Fed 2, but restyled and simplified top housing without rangefinder. Uncommon. Occasionally sells for over \$200, but more stable at \$120-180.

FEINWERK

FEDERAL MFG. & ENGINEERING CO. (Brooklyn, NY)

Fed-Flash - c1948. Low priced camera for 8 exp. 4x6.5cm on 127 film. Original prices: Camera \$9.95, Case \$3.95, Flash \$4.51. Finally closed out in 1956 at \$4.95 for the complete outfit. Currently: \$8-15.

FEINAK-WERKE (Munich)
Folding plate camera - 10x15cm.
Horizontal format. Double extension bellows. Schneider Xenar f4.5/165mm. Dial Compur to 150. Leather covered metal body. \$100-150.

FEININGER FARB FOTOLEHRE - Motorized disc camera disguised as a book. Unusual. One sold at auction in 1990: \$190.

FEINOPTISCHES WERK (Görlitz,

Germany) The names of camera manufacturers and sales co-operatives in post-war East Germany went through many changes as the companies organized into VEB's (Volkseigener Betrieb = People-owned factory). The VEB's in turn were organized in common interest associations called Interest Verband (IV) or Verband Volkseigener Betriebe (VVB). In this atmosphere of change, we see the names "Optisch-Feinmechanischen Werke & Görlitzer Kamerawerke", "Optik Feinoptisches Werk Meyer, Görlitz VEB", "Optik Primar Kamera Werke Görlitz VEB", and "Optik VVB Feinoptisches Werk Görlitz". These names are all essentially the same company, formerly Meyer-Görlitz which also incorporated Bentzin.

Astraflex-II - c1952. 6x6cm SLR. Astraflex was the U.S.A. name given to the camera by Sterling-Howard Corp., while the Primar Reflex II camera was distributed exclusively in the U.S.A. by Ercona Camera Corp. The two cameras are nearly identical, and prone to shutter problems. Tessar f3.5/105mm coated lens. Focal plane shutter, T, B, to 1000. Excellent working condition: \$200-300. With shutter problems: \$90-130.

FEINWERK TECHNIK GmbH (Lahr, Germany)

Mec-16 - ca. late 1950's. Subminiature for 10x14mm exposures on 16mm film in

FEINWERK...

cassettes. f2.8 lens. Shutter to 1000. Gold-colored body is most common, but also seen with silver-color, black with white or grey leather or all black. Like new, in original presentation case: black with colored leather: \$175-250; silver: \$100-150; gold: \$75-100, Gold camera only: \$50-75.

Mec 16 (new style) - An unusual variation of the Mec 16 camera, this model has body styling similar to the Mec 16SB, with aluminum-colored metal and black leatherette. With case & chain: \$100-150. Camera only: \$75-100.

Mec-16 SB - c1960. Similar but with builtin coupled Gossen meter and f2 Rodenstock Heligon lens. The first camera with through-the-lens metering. Mint condition with presentation case: \$150-225. Camera only: \$75-100.

FERRANIA (Milan, Italy) Manufacturer of cameras and film. Currently owned by the 3M company.

Alfa - c1945. Simple metal eye-level camera for 4x5cm on 127 film. Black crinkle enameled finish. Meniscus lens focuses crudely by turning front. \$20-30.

Box camera - c1935. 6x9cm bakelite box. Simple lens and shutter. \$35-50.

Condor I, Ic - c1950. 35mm rangefinder cameras with front leaf shutter. Some models have "Ferrania" on the top, while others do not. The shutter face bears the name of "Officine Galileo" in either case, and the camera is variously attributed to both companies. This camera is often described as a Leica copy by vendors with imagination.\$90-130.

condor Junior - c1950. Similar to normal Condor, but without rangefinder.

Galileo Eliog focusing f3.5/50mm lens. Iscus Rapid shutter 1-500. \$75-100.

condoretta - c1951. Non-RF 35mm camera. Knob wind; exposure counter on bottom. Terog f4/4cm lens in Aplon B,1-300 shutter. \$75-100.

Elioflex - c1950-53. Inexpensive TLR. Focusing Galileo Monog f8 in B,25-200 shutter. Non-focusing reflex finder. \$35-50.

Elioflex 2 - Similar to the Elioflex, but with focusing Anastigmat f6.3/75mm lens. \$35-50.

Eura - c1959. Plastic and aluminum eyelevel box camera for 6x6cm. Focusing lens; T,I shutter. \$8-15.

Euralux 44 - c1961. Smaller version of the Eura, made for 4x4cm on 127 rollfilm. Built-in flash with fan reflector on bottom of camera. Interesting as a collectible, but the low flash angle was obviously not designed for the most flattering portraits. \$20-30

Ibis - c1950. Small cast aluminum camera for 4x6cm on rollfilm. \$20-30.

Ibis 34 - Cast aluminum eye-level camera for vertical half-frames on 127 film.

Fixed front. Focusing f7.7/58mm acromatico in B,50,100 shutter. \$20-30.

Ibis 6/6 - c1955. Cast aluminum body. Gray or black imitation leather. \$20-30.

Lince 2 - c1962. Inexpensive metal 35mm camera. Cassar f2.8/45mm. Vero shutter. \$25-35.

Lince Rapid - c1965. Inexpensive 35mm camera for rapid cassettes. Dignar Anastigmat in 3-speed shutter. \$20-30._

Lince Supermatic - c1962. Autoexposure 35mm camera made for Ferrania by Dacora. Same as the Dacora CC. Selenium meter automatically adjusts diaphragm to match chosen shutter speed and shows readout in finder. Rodenstock Ysarex f2.8/45mm in Prontor-Matic shutter. \$35-50.

Rondine - c1948. Small all metal box camera for 4x6.5cm exposures on 127 film. Measures 31/₂x31/₂x21/₂". Meniscus f8.8/75mm Linear (focusing) lens. Simple shutter with flash sync. Available in black, brown, tan, green, blue, & red. Fairly common. \$35-50.

Tanit - c1955. Small eye-level camera for 3x4cm on 127 film. \$30-45.

Zeta Duplex - c1940-45. **Zeta Duplex 2 -** c1946. Metal box camera for 6x9cm or 4.5x6cm on 120 film. Achromat f11 lens. P,I shutter. Olive or grey: \$25-35. Black: \$12-20.

FERRO (Buttrio-Udine, Italy)

G.F. 81 Ring Camera - 1981. Subminature camera built into a large gold finger ring. Takes special discs of film, 25mm diameter. Variable speed guillotine shutter. Removable reflex finder doubles as screwdriver to set the controls. Originally packed in a cylindrical wooden case. Limited production. Top auction price 12/91 \$5500. Normal range \$1500-2000.

G.F. 82 - c1982-83. Similar to the G.F. 81, but with fixed viewfinder. \$1200-1800.

FERTSCH (W.u.P. Fertsch, Jena)

Feca (35mm) - c1955. Simple but attractive black bakelite 35mm. Meritar f3.5/50mm. Junior 25,50,100,Bsh. \$75-100.

Feca (plate camera) - Folding plate camera, made in 6x9cm and 9x12cm sizes. Tessar or Xenar f4.5 lenses. Double extension bellows, GG back. \$35-50.

FETTER (France)

Folding Camera - c1910. Folding camera of unusual design, where front shutter & lens pivots out on one wing strut and a second wing secures the front in open position. Soft leather bag bellows. Simple guillotine shutter. 6.5x9cm and 9x12cm sizes. \$350-500.

Photo-Eclair - c1886. A French version of the concealed vest camera, designed by J.F. Fetter and manufactured by Dubroni in Paris. Similar to the Gray and Stirn Vest camera in outward appearance. Several variations exist, the major difference being that early models had the lens toward the top; later models c1892 were inverted so a waist-level finder could be used above the lens. Takes five photos 38x38mm, changed by rotating the back. \$2000-3000.

FETZINGER (Vienna, Austria)

Field camera - c1900. Mahogany body, brass trim, 18x24cm. Double extension tapered green bellows with brown corners. Busch Portrait Aplanat f6/280mm lens. \$175-250.

FEX (Made in Czechoslovakia) - Small black bakelite camera for 4x6.5cm on 127 film. Nearly identical to the French version listed below, but plainly printed "MADE IN CZECHOSLOVAKIA" on the faceplate. \$45-60.

FEX/INDO (France) Originally the company name was FEX, then both names were used concurrently before the Fex name was dropped from use. A prolific manufacturer of inexpensive plastic cameras, many of rather interesting design. Some were used for promotional and premium use, so they have other company names, logos, and/or advertising messages.

Delta - Black bakelite eye-level camera, similar to the Ultra-Fex. Rectangular telescoping front. Meniscus lens. \$20-30.

Elite-Fex - c1965. Dual format plastic eye-level camera for 6x9 or 6x6cm on 620 film. This was the top of the 6x9cm line from Fex. Rectangular extensible front. Extinction meter. Three-speed shutter, 2-stop lens. Silver & black plastic body. \$12-20.

Fex - c1944. Simple black bakelite camera for 4x6.5cm on 127 film. Lens is identified as Fexar Spec.-Optik. "Optik" is a curious spelling for a French camera, so I was not surprised to find a nearly identical Fex camera whose nameplate states "Made in Czechoslovakia". The Czech version has an M,T shutter and a simple plastic frame finder while the French model has an I,P shutter and an optical finder. By 1945, the name was changed to Superfex and the lens was no longer identified on the camera. Uncommon. \$50-75.

FEX/INDO

Fex 4.5 - Horizontal black bakelite camera with silver enameled top housing. Built-in extinction meter. Rectangular telescoping front. Image convertible from 6x9cm to 6x6cm with hinged masks at focal plane. Color-Fexar f4.5 lens in B,25-250 shutter. \$30-45.

Fex 5.6 Cap Nord - Horizontally styled black plastic eye-level camera for 6x9cm on 620 film. Vertically ribbed body with rectangular telescoping front. Fexar f5.6 lens in Syncro-Rapid shutter B,25-250. \$25-35.

Graf - Simple rectangular bakelite box camera. Same as the Super-Boy and Champion, but made for promotional use by Graf, a French cheesemaker. \$20-30.

Juni-Boy 6x6 - Simple black plastic eyelevel camera. \$12-20.

FEX/INDO...

Pari-Fex - c1960's. Inexpensive black plastic eye-level camera for 4x4cm on 127 film. Light blue plastic covering. \$12-20.

Rubi-Fex 4x4 - c1965. Inexpensive plastic camera for 127 film. \$12-20.

Sport-Fex - c1966. Similar to Elite and Ultra, but the least featured of the series. Simple snapshot model without shutter or lens adjustments. 6x9cm on 620. \$12-20.

Super-Boy (cardboard) - Small cardboard box covered with red diamond-

Super-Boy, plastic body

patterned paper. Bakelite front section houses shutter & lens. Rare. \$60-90.

Super-Boy (plastic) - Simple, rectangular black plastic camera for 3x4cm on 127 film. Also sold under the name "Champion". \$12-20. Illustrated bottom of previous column.

Superfex - c1945-55. Bakelite camera, 4x6.5cm on 127 rollfilm. Unidentified lens, I & P shutter. Based on the "Fex" camera, but with optical finder, metal advance knob, metal latches for back. Much more common than the earlier Fex. \$25-35.

Superior - c1940's. Black bakelite camera for 4.5x6cm, similar to the Superfex. Fexar Super lens. T,M shutter. \$20-30.

Ultra-Fex - c1946-66. Black plastic eyelevel camera for 6x9cm on 120 rollfilm. Features rank it below the Elite-Fex and above the Sport-Fex. Lacks extinction meter and dual format of Elite, but has 3-speed shutter, 25-100. Extensible front, Fexar lens. Variations: originally with front shutter release; later with body release which involved major modification of dies. Other variations involve accessory shoe existence and location; metal or plastic extension tube; etc. \$25-35.

Ultra-Reflex (meniscus) - c1952. Twin-lens box camera for 6x6cm. Heavy black bakelite body with metal back. Fexar meniscus lens. \$12-20.

Ultra-Reflex (f4.5) - The "Ultra Reflex" model name does not appear on this camera as it does on the meniscus model.

The basic body is similar, but the large Atos B,25-300 shutter and f4.5 Fexar lens give it a much more serious appearance. \$30-45.

Uni-Fex - c1949. Black plastic eye-level box camera, 6x9cm on 120 film. Rectangular telescoping front. T,I shutter. \$12-20.

Weber Fex - c1960's. A series of 35mm scale-focus cameras, all with Ugo Lantz Ikar f2.8/50mm lens in 5-speed shutter. In addition to the standard model, there are several other models including the Junior which sometimes has an f3.5 lens. Most if not all were available in black or colors. \$30-45.

FIAMMA (Florence, Italy)

Fiamma Box - c1925. Small metal box camera for 3x4cm on 127 film. Black crack-le-finish paint. Mensicus lens, T&I shutter. \$30-45.

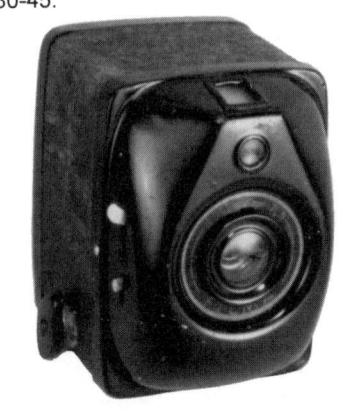

FILMA (Milano, Italy) Box cameras - c1936. 4.5x6cm and

FOITZIK

6x9cm sizes. Front corners are rounded. Achromatlens, guillotine shutter. \$30-45.

FINETTA-WERK (Peter Saraber, Goslar) Began as Kamerafabrik Peter Saraber, then Finetta-Werk about 1950.

Ditto 99 - c1950. Same as the Finetta 99 below.

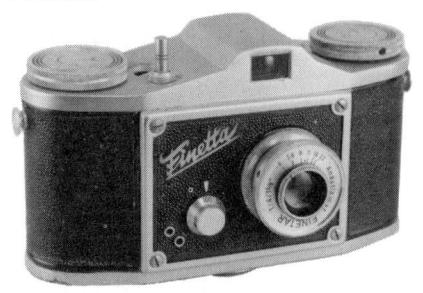

Finetta - c1950. Basic 35mm camera without rangefinder or motor drive. Finetar f2.8/45mm interchangeable lens. Originally \$30. Currently: \$35-50.

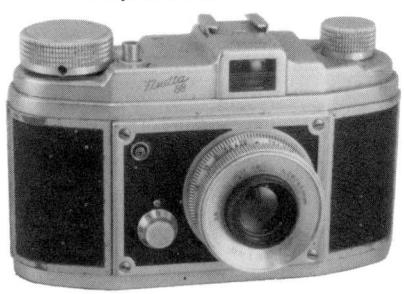

Finetta 88 - c1954. Basic knob-wind 35mm viewfinder camera. Interchangeable bayonet-mount lenses. Finetar f2.8/45mm normal lens. Behind-lens two-blade leaf shutter, B,1/25-1/250. \$60-90.

Finetta 99 - c1950. Spring motor camera. 36 exposures 24x36mm on 35mm film. Interchangeable Finetar f2.8/45mm or Finon f2.8/45mm macro-focusing lens. An early use of a macro lens fitted as standard lens. Focal-plane shutter 25-1000. Light grey. Excellent working condition: \$150-225. Common with defective shutter or advance: \$75-100.

Finetta 99L - c1954. Similar to the Finetta 99, but Finon-S f2.8/45mm (macro focusing) lens and FP shutter 1-1/₁₀₀₀. \$150-225.

Finetta Lenses: Finetar 90mm f6.3 - \$30-45. Finetar 105mm f6.3 - \$30-45.

Finetta Super - Finetar f2.8/45mm, Central shutter 25-100, \$45-60.

Finette - f5.6/43mm Achromat Finar. Simple shutter, T, B, I. Aluminum body. \$25-35.

FIPS POCKET CAMERA - Inexpensive paper folding bellows camera built into a postcard. Postcard flaps open to reveal paper bellows, which extend and are supported by two thin metal struts. Single plates or films must be darkroom loaded into a folded paper packet behind the bellows. Probably made in Germany, and marketed in England. Rare. \$120-180.

FIPS MICROPHOT - Tiny black plastic subminiature for 12 exposures, 13x13mm on special 16mm rollfilm. 25mm/f6.5 lens. Made in Western Germany. \$100-150.

FIRST CAMERA WORKS (Japan) First Camera Works was a tradename used by Kuribayashi. See Kuribayashi for listings of "First" brand cameras.

FISCHER (C.F.G. Fischer, Berlin)

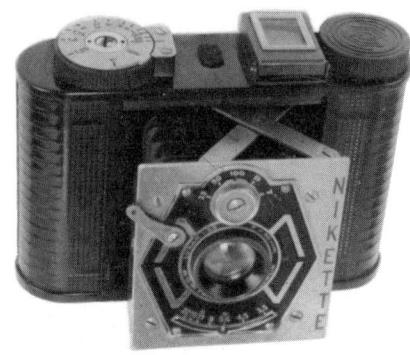

Nikette - c1932. Black bakelite-bodied folding camera, pop-out strut-supported front. Focusing knob on top controls strut movement. Luxar f3.5/50mm, \$120-180.

Nikette II - c1932. Similar, but Maxar f3.5/50mm lens; black or colored body. \$120-180.

FIVE STAR CAMERA CO. Five Star Candid Camera - Plastic novelty minicam for 3x4cm on 127. \$8-15.

FLASH CAMERA CO. Candid Flash Camera - 3x4cm. \$8-15.

FLASHLINE - Plastic & metal eye-level box camera from Japan, 6x6cm on 120 film. Fixed focus. Two speeds marked with weather symbols, plus B. PC sync post on front. \$8-15.

FLEKTAR - c1955. 6x6cm TLR made in East Germany. Row Pololyt f3.5/75mm lens in Blitz I shutter. \$35-50.

FLOCON RF - c1964. Novelty camera of the Diana type for 4x4cm images on 120 rollfilm. Imitation honeycomb meter cell around lens. \$1-10.

FODORFLEX - c1955. Japanese TLR, probably made by Sanwa Photographic Supply, as it is similar to their "Mananflex".

Horinon Anastigmat f3.5/7.5cm in NKS-FB shutter B,1-300.\$60-90.

FOITZIK (Feinmechanische Werkstätten Ing. Karl Foitzik, Trier, Germany) Name changed in 1956 to "Karl Foitzik Kamerawerk. For a history of Foitzik, see Photo-Antiquaria 2/1982 & 3/1982. Photo-Antiquaria is the journal of the Club Daguerre (see appendix for club listings).

Foinix - c1951-55. 6x6cm horizontal style folder like Ikonta B. Steinar f3.5/75mm coated lens. Singlo, Vario, Pronto, Prontor, or Synchro-Compur. Also sold as Life-O-Rama and Reporter. Rangefinder model: \$60-90. Regular models: \$35-50.

Foinix 35mm - c1955. 35mm viewfinder camera. Foinar f2.8 or f3.5/45mm. Vario or Pronto shutter. Rapid wind lever. \$35-50.

Reporter - c1953. Horizontally oriented folding bed camera for 6x6cm on 120. Name variant of the Foinix Orito. Optical finder incorporated in top housing. Reporter Anastigmat f4.5 lens in Pronto shutter. \$50-75.

Unca - c1953. Similar to the 6x6cm Foinix. f3.5 lens. Prontor-S shutter. \$35-50.

Visobella - c1950's. Name variant of the 6x6cm Foinix without rangefinder. All markings are standard Foinix, but "Visobella" nameplate glued on front. \$35-50.

FOKAFLEX

FOKAFLEX - c1950's. Black bakelite TLR-style box camera with brilliant finder. Made in Czechoslovakia, probably for Foka, a photographic distributor in Rotterdam. "Special" f8/75mm lens in Fokar 2 shutter B,25-100. Back and bottom open separately for access to film compartment. Uncommon. \$60-90.

FOLMER & SCHWING

Folmer & Schwing (NYC), 1887. Folmer & Schwing Mfg. Co. (NYC), 1890. Folmer & Schwing Mfg. Co. of New York, 1903.

Folmer & Schwing Co., Rochester (EKC), 1905.

Folmer & Schwing Div. of EKC, 1907. Folmer & Schwing Dept. of EKC, 1917.

Folmer-Graflex Corp., 1926.

Graflex, Inc., 1945.
Because of the many organizational changes in this company which are outlined above, and in order to keep the continuous lines of cameras together, we have chosen to list their cameras as follows regardless of age of camera or official company name at time of manufacture:

Cirkut Cameras- see Eastman Kodak Co. Graflex, Graphic Cameras- see Graflex

Banquet cameras - c1915-29. Banquet cameras are essentially view cameras with wide proportions for panoramic photographs. They were originally used to photograph entire rooms of people at banquets, and required a wide angle lens with extreme coverage. Surprisingly, these cameras are still used for the same purposes today, and maintain their value as usable equipment based on the prices of current cameras. In any case, the lens with the camera is an important consideration in determining the value. At least one filmholder should be included in the prices listed here. The film holders would be expensive if purchased separately (new prices of \$200 and up). Common sizes are 7x17" and 12x20". With an appropriate wide angle lens: \$500-750. Without a lens, they bring \$350-500. "User" prices: \$650+. There is a serious conflict between the collectible and usable market for Banquet cameras. Working professionals seek out these cameras, then begin to modify them with shifts, swings, tilts, extension rails, etc. While this destroys the original camera and its antique value, it definitely adds to its commercial value. If you are a preservation-ist, buy and hide one before the users get them all!

Finger Print Camera - c1917-29. Portable fingerprint camera. Contains four battery operated lights. Leather covered. Kodak f6.3 lens. \$75-100.

Multiple Camera - c1930's. Masks make it possible to take 1, 2, 4, 9, 16, or

20 portraits on one 5x7" plate or film. Complete with original lens, bipost stand or 3-leg studio tripod: \$400-600.

Sky Scraper Camera - c1904-15. A special purpose view camera incorporating an extra high rising lensboard and a back with extreme tilt to correct for architectural distortion. It was the perfect solution to the problem of taking photographs of the skyscrapers of the early 1900's. With lens & shutter: \$500-750. Without lens: \$300-450.

FORTE FOTOKÉMIAI IPAR (Hungary)

Forte Photochemical Industry.

Optifort - c1948. Simple black enameled cast aluminum camera with helical front extension. Fixed focus 98mm lens in T&M shutter. Folding frame finder. Uncommon. One sold at Cornwall 9/92 for

FOSTER INSTRUMENTS PTY. LTD. (Australia)

Swiftshot "Made in Australia" - c1950. This is the same basic camera as the Model A below, but without a model number. Instead, the faceplate is marked "Made in Australia" below the Swiftshot name. It appears that the "Made in Australia" version was originally made by Swains Industries, and then by Foster. \$30-45.

Swiftshot Model A - c1950. Metal box camera for 6x9cm exposures on either 620

or 120 rollfilm. Color and texture variations of the covering include: snakeskin pattern in green & brown or tan & brown; lightly pebbled surface in olive green, maroon flocked covering, etc. Vertically striped faceplate in green, brown, or red to complement the covering. \$30-45.

FOTAX FLEXO - Sweden. Reflex-style camera for 3x4cm on 127 film. Similar to Clix-O-Flex, Falcon Reflex, etc., but less common. \$35-50.

FOTAX MINI, FOTAX MINI IIa - c1948. Sweden. Bakelite camera for 25x25mm on special 35mm rollfilm. f8/35mm lens. \$60-90

FOTET CAMERA CO. (London)

Fotet - c1932. Vest-pocket camera with strut-supported front. Takes 16 exposures 3x4cm on 127 film. Meyer Trioplan f3.5 or f4.5 lens. Vario, Pronto, Ibsor, or Compur shutter. Name variant of the Korelle 3x4cm strut-folding type. \$75-100.

FOTEX - Small stamped metal camera for 127 rollfilm. Made in Switzerland. Black crinkle finished body with chromed top, bottom, and front. 47.5mm lens in simple shutter. Uncommon. \$90-130.

FOTH (C.F. Foth & Co., Berlin)

Derby (original) - 1930-31. The only

Derby for 24x36mm on 127 rollfilm. Identified by its small image size. Originally with folding Newton finder, later with an optical telescopic viewfinder. Foth Anastigmat f3.5/50, FP 1/25-1/500. Very rare. \$100-150.

Derby (I) - c1931-36. 3x4cm on 127 roll-film. Optical telescopic viewfinder. Foth Anastigmat f3.5 or f2.5/50mm, FP shutter $^{1}/_{25}$ - $^{1}/_{500}$. No self-timer. Black or brown leather covering. This model was referred to as Derby until the improved version with a self-timer was introduced. It then was called the Derby I and the self-timer version was called the Derby II. Not often seen. \$45-60. (With Elmar lens add \$150-225.)

Derby I or II? - Period advertising is not consistent in its use of the "II" designation. In the U.K., Model II was the same as Model I, except that it was fitted with Zeiss Tessar lenses in an interchangeable mount. Foth lenses could not be fitted to that model, although a Dallon telephoto lens in focussing mount could be used interchangeably with the Tessar lenses. This model II was fitted with folding direct vision finder instead of the tubular type. These designations are confirmed in advertising from the agents, Peeling & Van Neck, and in the BJ Almanac 1938. For other uses of the "II" designation in the USA and France with regard to rangefinders, see below.

Derby II - c1934-42. 3x4cm on 127 roll-film. Optical telescopic viewfinder. Foth Anastigmat f3.5 or f2.5/50mm, FP 1/25-1/500, ST. Black or brown leather covering. There were also two rangefinder additions to this camera that were not made by Foth. The first, made in France c1937-40, had a black and chrome rangefinder that was added on to the top of the camera body. The rangefinder remains stationary on the body when the struts extend the front. A focusing knob coupled to the RF was added to the front plate. The second, c1940-42 US-made chrome RF mounted above the front plate, not to the top of the body. When the struts are extended, the RF also moves forward. A vertical bar connects the helical lens mount to the RF. This CRF could be added to any Derby II, by returning it to the US distributor. Advertisements in the U.S. referred to the Derby II without the added CRF as the "Standard" model or "Model I", and called the Derby II with the US added CRF simply Derby II or Derby Model II. With French CRF: \$150-225. With US CRF: \$150-225. Without CRF, \$60-90.

Folding rollfilm cameras - c1933. Versions for 116 or 120 rollfilm. Foth Anastigmat lens. Waist level & eye level finders. \$20-30.

Folding rollfilm camera, Deluxe version - Brown or green alligator skin covering; black or matching colored bellows. These seem to be as common as the plain leather ones, or perhaps more common. Nevertheless, they usually bring \$75-100

Foth-Flex - c1934. TLR for 6x6cm on 120. Foth Anastigmat f3.5/75mm. Cloth focal plane shutter 25-500, B. \$90-130.

Foth-Flex II - c1935. Similar, but shutter has slow speeds to 2 second. Focusing lever replaces knob focusing c1938. Available with f3.5 or f2.5 lenses. \$120-180.

FOTIMA REFLEX - Black bakelite reflexstyle "minicam" for 3x4cm images on 127 film. Like the Clix-O-Flex and similar cameras, but made in Sweden. Uncommon. \$45-60.

FOTOBRAS

FOTO-FLEX CORP. (Chicago)

Foto-Flex - Twin-lens box camera of unusual design. The small viewing and taking lenses are both within the round front disc which resembles a normal lens. (Design is similar to the 35mm Agfa Flexilette.) Takes 4x4cm on 127 film. One model has a cast metal body. Another has a plastic body with a cast metal faceplate. Interior of body is marked "Hadds Mfg. Co." Apparently Hadds manufactured the body or the entire camera for the Foto-Flex Corp. \$12-20.

FOTO-QUELLE (Nürnberg, Germany) Founded in 1957, Foto Quelle steadily grew to become the world's largest photographic retailer. Their "Revue" brand is known worldwide, made up of cameras produced by major manufacturers for sale under the "Revue" name.

Revue 3 - c1970. Same as Fed 3, but made for Foto-Quelle. "Revue 3" printed on front of top housing. \$35-50. Common in Germany for under \$35.

Revue-4 - Same as Fed 4K, which is a lever-advance Fed 4. Interchangeable Fed N-61 f2.8/52mm lens in Leica-size screw mount. Common in Europe. \$35-50.

Revue 16 KB - c1960's. Name variation of the Minolta 16 MG subminature. Rokkor f2.8/20mm lens. Programmed shutter 30-250. With case, chain, flash, & filters: \$35-50.

Revue Mini-Star - c1965-70. Name variant of the Yashica Atoron, a subminiature for 8x11mm on Minox film. Both the smooth and waffle-patterned variants were available with this name, \$45-60.

FOTOBRAS

Magica-flex - Inexpensive TLR-style box camera. Stamped metal body with leatherette covering. Focusing lens, but fixed brilliant finder with folding hood. \$35-50. Illustrated at top of next page.

FOTOCHROME

Fotobras Magica-flex

FOTOCHROME, INC. (U.S.A.)
Fotochrome Camera - c1965.
"Unusual" is a kind description for this machine, designed by the film company to use a special direct-positive film loaded in special cartridges. The camel-humped body houses a mirror which reflects the 5.5x8cm image down to the bottom where the "color picture roll" passed by on its way from one cartridge to another. Single speed shutter coupled to the selenium meter. Made by Petri Camera in Japan. Often seen new in box for \$60-90. Camera only: \$30-45.

FOTOFEX-KAMERAS (Fritz Kaftanski, Berlin)

Minifex - c1932. Unusual looking subminiature for 36 exposures 13x18mm on 16mm film. Large Compur, Pronto, or Vario shutter dwarfs the tiny body. Has sold for \$1200 with rare Astar f2.7 lens. Normal range: \$750-1000.

Visor-Fex - c1933. Unusual folding camera for 6x9cm or 4.5x6cm on 120 roll-

film. Also accepts single plateholders while the rollfilm is still loaded in the camera. The rollfilm back has a darkslide, and the back hinges down to allow use of ground glass or plateholder. Catalog advertising claimed erroneously that this was the first and only camera in the world to allow ground glass focusing between rollfilm exposures while film was loaded. There were several such cameras early in the century, and the Palko camera existed in the years immediately before the Visor-Fex. However it is the smallest such camera, and quite rare. Last recorded sale was at auction 6/90 in C/D condition for \$790. A nice example would probably sell for \$1000-1500.

FOTOTECNICA (Turin, Italy) Bakina Rakina - c1946. Inexpensive camera for 3x4cm on 127 film. Clippertar f9 lens; B&I shutter. \$20-30.

Bandi - c1946. Box camera covered in brown leather, with blue front. 6x6cm on 120 rollfilm. Aplanat 75mm lens, shutter 25-100. \$45-60.

Eaglet - c1952. Side-loading metal box camera for 6x9cm on 120. Pivoting reflex finder. Marketed by Hanimex. \$12-20.

Filmor - c1950. Metal box cameras for 6x6cm or 6x9cm exposures. Achromat lenses, quillotine shutter. \$20-30.

Herman - c1950. Simple but heavy cast metal 35mm non-RF camera. Tecnar Koristka lens in T,B,25-250 leaf shutter. Spring-loaded telescoping front pops out when focusing ring is turned from stop position. Uncommon.\$100-150.

Rayelle - c1954. Side-loading metal box camera, 6x9cm on 120. Like the Eaglet, but with tubular eye-level finder. \$12-20.

Rayflex - c1946. Simple 6x9cm box camera. Duotar Optik f9 lens, guillotine shutter. \$15-25.

Tennar, Tennar Junior - c1954. Folding cameras for 6x9cm, 620 film. \$12-20.

FOWELL CINEFILM - A Spanish-language version of the Spartus Miniature, a simple black bakelite 35mm camera. Made in Spain. Uncommon. \$30-45.

FR CORP. (Fink-Roselieve Corp., New York)

FR Auto-Eye II - c1961. German-made 35mm, built-in meter. Schneider Radionar f2.8/45mm; Prontormat shutter. \$25-35.

FRANÇAIS (E. Français, Paris)
Cosmopolite - c1892. Early twin-lens
reflex camera, box-shaped when closed.
Side hinged front door conceals brass
barrel lenses. \$750-1000.

Kinegraphe - c1886. Very early twinlens reflex. Polished wood body, exterior brass barrel lens with waterhouse stops. Sold in England by London Stereoscopic Co. as "Artist's Hand Camera". \$1200-1800.

Photo-Magazin - c1895. Magazine camera for 6.5x9cm plates. Leather changing bag. String-set shutter. \$600-900.

FRANCEVILLE - c1910. Magazine camera for 6 plates, 4.5x6cm. \$120-180.

FRANCKH (Editions Franckh)
Opticus Photographe - c1950's.
Optical experiment kit for children to build a rollfilm box camera. With original box and instructions, one sold at auction (6/90) for \$55.

FRANCYA - 14x14mm Japanese subminature of the "Hit" type. \$20-30.

FRANKA-WERK (Beyreuth, Germany) Franka cameras were sold in the U.S.A. by Montgomery Ward Co. Bonafix - c1950. 6x9cm folding rollfilm

camera. Similar to the Rolfix. Radionar f4.5/105mm; Vario 1/25-100. \$25-35.

Franka - c1950. Basic 35mm camera without rangefinder. The top housing allows room for rangefinder, but none is installed. This was one of the first German post-war cameras. "FRANKA" above shutter on front housing which encloses cocking and release mechanisms. Radio-

nar f2.9/50mm in Compur-Rapid. Uncommon, \$250-375.

Frankarette - c1958. 35mm CRF. Isconar f2.8/45mm in Prontor SVS 1-300 shutter. \$60-90.

Rolfix - ca. WWII, pre- and post. A dual-format folding camera for 120 film. Some take 8 or 12 exposures per roll, others take 8 or 16 exposures. Post-war models made in U.S. occupied zone from pre- and post-war parts. \$30-45.

Rolfix II - c1951-57. Folding rollfilm camera, similar to the Rolfix, but better lens and shutter. Trinar f3.5/105mm lens. Early ones have Compur-Rapid shutter 1-400, folding viewfinder. Later ones with Synchro-Compur 1-500 shutter, non-folding viewfinder built into chrome housing. \$50-75.

Rolfix Jr. - c1951-55. Folding camera for 8 exposures 6x9cm or 12 exposures

6x6cm on 120 rollfilm. Frankar f4.5/105 in Vario 25,50,200,B. Standard model has folding direct eye-level finder. Deluxe model has non-folding optical finder in small add-on top housing, \$20-30.

Solid Record - c1950. Similar to the Solida. \$25-35.

Solida - Pre- and post-war folding cameras for 12 exposures, 6x6cm on 120 film. **Solida 1 -** f6.3/75mm, \$25-35.

Solida II - Anastigmat f3.5 in Vario shutter. \$35-50.

Solida III - Radionar f2.9/80mm in Prontor SVS. \$35-50.

Solida IIIL - as III, but with light meter. \$45-60.

Solida Jr. - c1954. Horizontal folding 120 rollfilm camera, 6x6cm. f6.3/75mm lens. Shutter B,25,75. \$12-20.

FRANKA PHOTOGRAPHIC CORP.

(Taipel, Taiwan) Not related to Franka-Werk of Germany. Named for founder Frank Lin, this is a marketing company for the Civica Industries Corp. factory. They produce a full line of inexpensive cameras for premium use. In addition to their standard brand names of Civica, Franka, and Konex, which include traditional 35mm and 110 types, they have produced countless cameras with special logos for advertising campaigns. These, of course, are of the greatest interest to collectors, so we are listing only the custom models. We are interested in learning of other "promotional" cameras that come to the attention of our readers. Since they do not generally appear in catalogs, it is hard for us to keep track of the many variations.

Kentucky Fried Chicken - Body style like Civica PG-1. White front with red vertical stripes. Col.Sanders face logo on sliding lens cover. \$12-20.

NBA 76ers - Civica PG-1 style. White front with NBA logo. Basketball and 76ers logo on sliding lens cover. \$12-20.

St. Louis Steamers - Civica PG-1 style. Yellow front with Steamers logo. Soccer ball on sliding lens cover. \$12-20.

FRANKE & HEIDECKE (Braunschweig)

Heidoscop - Three-lens stereo camera for stereo pairs on plates or cut film, in two sizes: 45x107mm and 6x13cm. Named for the designer, Reinhold Heidecke, these were the first cameras made by Franke & Heidecke. Both models have Stereo Compoundshutters.

45x107mm size - 1921-41. Carl Zeiss Jena Tessar f4.5/55mm lenses. \$350-500. **6x13cm size -** 1925-41. Carl Zeiss Jena Tessar f4.5/75mm lenses. \$500-750. (Add \$100-150 for 120 rollback.)

Ifbaflex M102 - 1974. A rare name variant of the Zeiss-Ikon SL706. Made for a French photographic and hi-fi chain store

FRANKE & HEIDECKE

named Flash. (All of their SLRs were called Ifbaflex, but most were made by Cosina). Stamped/engraved on the bottom "Made in Germany by Rollei". Ifbagon (Planar) 11.8/50mm. FP shutter. One sold at Cornwall auction 10/90 for \$300.

Rollei-16 - 1963-67. (#2,700,000-2,727,999). Subminiature for 12x17mm exposures on 16mm film. Tessar f2.8/25mm. Outfit with case, flash, filter: \$100-150. Camera only: \$60-90.

Rollei-16S - 1966-72. (#2,728,000-2,747,882). Similar to the earlier model, but with the back latch relocated inside the finder, universal focus mark at 10 feet. Less obvious changes are the softer shutter release action and double-claw film advance. Cream snake: \$175-250. Black snake: \$120-180. Green: \$150-225. Red: \$150-225. Black: \$60-90.

Rollei-16 Accessories: Copy Stand - \$25-35. Mutar 0.6x - \$50-75. Mutar 1.7x - \$50-75. Tripod head - \$1-10.

Rollei 35 - 1967-75. (#3,000,000-on). Tessar f3.5/40mm. Singapore model also available with Schneider Xenar. Model from Germany: \$175-250. From Singapore with Schneider Xenar: \$175-250. From Singapore with Tessar: \$120-180. In gold: \$600-900.

Rollei 35B - 1969-78. (#3,600,000-on). Zeiss Triotar f3.5/40mm. \$120-180.

Rollei 35C - intro. 1969. (#3,600,000-on). \$120-180.

Rollei 35LED - 1978-80. \$90-130.

Rollei 35S - intro. 1974. In gold, as new in box: \$800-1200. In silver, as new in box: \$500-750. Black, as new: \$300-450. Chrome, like new: \$250-375.

Rollei 35SE - Sonnarf2.8/40. \$150-225.

Rollei 35T - 1976-80. Black or chrome. \$175-250.

Rollei 35TE - Black or chrome. \$200-300.

Rollei A26 - c1973-78. Self-casing pocket-sized camera for 126 cartridges. Sonnar f3.5/40mm. Programmed shutter 30-250. With case, flash, & charger: \$60-90.

Rollei A110 - c1974-1980. Well-made camera for 13x17mm exposures on 110 film cartridges. Automatic exposure; zone focusing. Made in Germany & Made in Singapore. Black, brushed chrome, or gold finish. Gold: \$200-300. Black or chrome: \$90-130.

Rollei E110 - c1976-78. Well-made pocket camera for 110 film cartridges.

FRANKE & HEIDECKE...

Similar to the A110, but brushed chrome finish. Automatic exposure controlled by CdS cell. On the market for less time than the A110, it is less common. \$120-180.

Rolleicord - A series of 6x6cm TLR cameras.

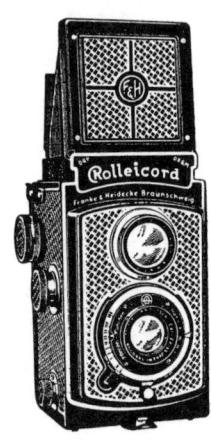

Rolleicord I, nickel-plated - 1933-36. Art-deco, nickel-plated exterior. Zeiss Triotar f4.5/75mm lens. Compur shutter 1-300, B, T. \$175-250.

Rolleicord I, leather covered - 1934-36. Black leather-covered exterior. Zeiss Triotar f3.8 lens. Compur shutter 1-300, B, T. No sync. \$90-130.

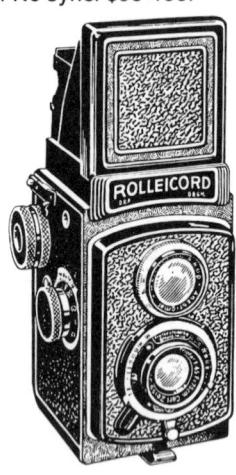

Rolleicord la - 1936-47. Zeiss Triotar f4.5/75mm lens. No bayonet mounts on viewing or taking lenses. Rim-set compur shutter 1-300, B, T. No sync. Most have a frame finder in the focusing hood. We have seen early versions (type 2) selling at auction for \$175-250. Much more common at \$90-130.

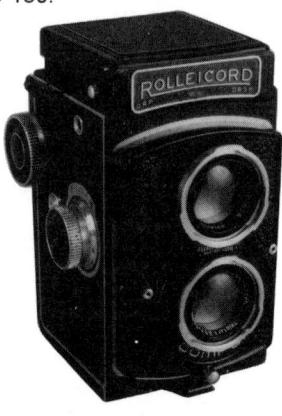

Rolleicord II - 1936-50. f3.5/75mm

Zeiss Triotar or Schneider Xenar lens. Compur shutter 1-300, B, T or Compur Rapid 1-500, B. No. sync. Originally with no bayonet mounts, but bayonet added to the taking lens and then the viewing lens during the course of production (#612,000-1,135,999). Version with bayonets on both the taking and viewing lenses sometimes referred to as the IIa. \$75-100.

Rolleicord III - 1950-53. (#1,137,000-1,344,050). f3.5/75mm Zeiss Triotar or Schneider Xenar lens. Compur-Rapid shutter 1-500, B. X sync. \$100-150.

Rolleicord IV - 1953-54. (#1,344,051-1,390,999). Schneider Xenar or Zeiss Triotar f3.5/75mm lens. Synchro-Compur 1-500, B. MX sync. Double exposure prevention. \$120-180.

Rolleicord V - 1954-57. (#1,500,000-1,583,999). Schneider Xenar f3.5/75mm lens. Synchro-Compurshutter, 1-500. Self-timer. MXV sync. LVS scale. Double exposure prevention. Large focusing knob with film speed indicator on right side. \$120-180.

Rolleicord Va - 1957-61. (#1,584,000-1,943,999). Schneider Xenar f3.5 lens. Synchro-Compur shutter 1-500, B. Large focusing knob on left side. Non-removable focusing hood. \$120-180.

Rolleicord Vb - 1962-70. (#2,600,000-on). Schneider Xenar f3.5 lens. Synchro-Compur 1-500 shutter. Large focusing knob on left side. Removable focusing hood. \$175-250.

Rolleidoscop - 1926-41. The rollfilm version of the Heidoscop stereo camera. Actually, some of the very earliest production models of the Rolleidoscop still bore the name Heidoscop. Like the Heidoscop, this is a three-lens reflex. The center lens, for reflex viewing, is a triplet f4.2. Stereo Compoundshutter 1-300.

45x107mm - Tessar f4.5/55mm lenses.

Much less common than the 6x13cm size. \$1500-2000.

6x13cm - Tessar f4.5/75mm lenses. Stereo Compound 1-300. For B11 or 117 rollfilm. Many converted for 120 rollfilm by users. \$1500-2000.

Rolleiflex - 6x6 TLR cameras. For 6x6cm exposures on 120 film.

Rolleiflex I, original - 1929-32. (#?-199,999). The "little sister" of the already well-known Heidoscop and Rolleidoscop. Readily identified by the Rim-set Compur shutter, 1-300, B & T, and the film advance system, which, on this early model was not automatic; hence, no exposure counter. With Zeiss Tessar f4.5/75mm, or more often, f3.8/75mm lens. This first model was made to take 6 exposures on No. 117 film, but some were converted to the standard 12 exposures on 120 film. Film winding knob, not lever. The earliest version of this model had no distance scale on the focus knob, and the back is not hinged, but fits into a groove. The second version has focus scale and hinge. \$200-300.

Rolleiflex Automat models:

Automat (1937) - 1937-39. (#563,516-805,000). Zeiss Tessar f3.5/75mm lens. Bayonet mount for accessories on taking lens only. Compur-Rapid shutter 1-500, B, T, and self-timer. Automatic film feed. No ruby window. Knurled wheels for setting lens stops and shutter speeds. No sportsfinder. \$120-180.

Automat (1939) - 1939-49. (#805,000-1,099,999). Tessar or Xenar f3.5 lens. Like the 1937 model, but bayonet mounts on both the taking and the viewing lenses. \$120-180.

Automat (X-sync.) - 1949-51. (Called the Automat II in Germany.) (#1,100,000-1,168,000). Tessar or Xenar f3.5/75mm

lens. Synchro-Compur shutter, 1-500, B. Self-timer. X-sync. Sportsfinder. \$150-225.

Automat (MX-sync.) - 1951-54. (#1,200,000-1,427,999). Tessar or Xenar f3.5/75mm lens. Synchro-Compur 1-500, B. Self-timer. Lever for selecting M or X type sync. Very common. \$150-225.

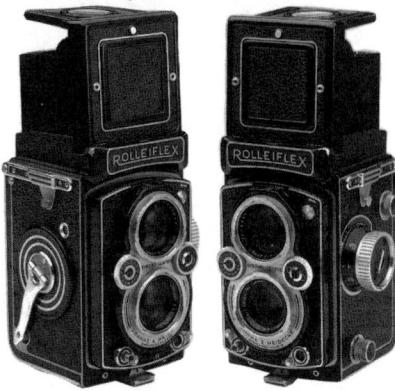

Automat (MX-EVS) - 1954-56. (#1,428,000-1,739,91). Tessar or Xenar f3.5/75mm lens. Synchro-Compur shutter, 1-500, B. Self-timer. MX sync and LVS scale on shutter, \$150-225.

Rolleiflex 2.8A - 1950-51. (Also known as Automat 2.8A.) (#1,101,000-1,204,000). Zeiss Tessar f2.8/80mm lens. Synchro-Compur shutter, with X or MX sync. Self-timer. Sportsfinder. \$250-375.

Rolleiflex 2.8B - 1952-53. (Also known as Automat 2.8B.) (#1,204,000-1,260,000). Zeiss Biometar f2.8/80mm lens. MX sync. \$200-300.

Rolleiflex 2.8C - 1953-55. (Also called Automat 2.8C.) (#1,260,350-1,475,405). f2.8/80mm Schneider Xenotar or Zeiss Planar lens. Synchro-Compur shutter with MX sync. No LVS scale. \$250-375.

Rolleiflex 2.8D - 1955-56. (#1,600,000-1,620,999). f2.8/80mm Schneider Xenotar or Zeiss Planar lens. Synchro-Compur shutter with MX sync and LVS scale. Top prices at German auctions: \$300-450. Normal range \$200-300 in USA.

Rolleiflex E - 1956-59. Dual-range, non-coupled exposure meter. (Original distributor's advertising referred to this camera as the model "G" when sold without the meter.) MX sync. Two variations:

Rolleiflex 2.8E - (#1,621,000-

Rolleiflex 2.8E - (#1,621,000-1,665,999). f2.8/80mm Schneider Xenotar or Zeiss Planar. Normal range \$300-450. Rolleiflex 3.5E - (#1,740,000-1,787,999 and 1,850,000-1,869,999). f3.5/75mm Zeiss Planar or Schneider Xenotar. \$300-450

Rolleiflex E2 - No exposure meter. Flat, removable focusing hood. Two variations:
Rolleiflex 2.8E2 - 1959-60.
(#2,350,000-2,357,xxx). f2.8/80mm Xenotar or Planar. \$500-750.

Rolleiflex 3.5E2 - 1959-62. (#1,870,000-1,872,010 and 2,480,000-2,482,999). f3.5/75mm Xenotar or Planar. \$350-500.

Rolleiflex E3 - 1962-65. No exposure meter. Removable focusing hood. Planar or Xenotar lens. Two variations:

Rolleiflex 2.8E3 - (#2,360,000-2,362,024). f2.8/80mm lens. \$300-450.

(#2,380,000-

3.5E3

2,385,034). f3.5/75mm lens. \$300-450.

Rolleiflex

FRANKE & HEIDECKE...

Rolleiflex F - 1960-1981. The last series of traditional Rolleiflex cameras, and therefore the most in demand for use. The F series has a coupled meter, and was available with f3.5 or f2.8 lens. Early types accept only 120 film; later versions accept 120 or 220. Since the user market sets the prices, the best combination of features yields the higher price. Lens types, in order of user preference, are Planar, Xenotar, and Tessar. Obviously, f2.8 is preferred over f3.5. Bodies which accept 120/220 are preferred over the early types.

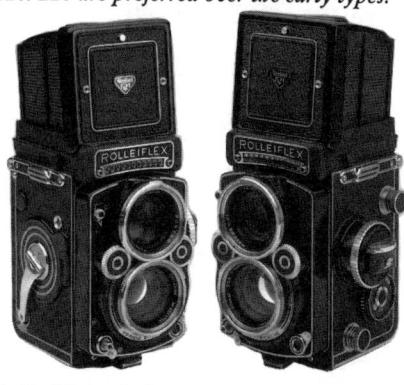

Rolleiflex 2.8F - With Planar, the preferred and most common lens, has sold for \$1500-2000 in original box. Asking prices in USA up to \$1000 for 120/220 model. Typical price at auctions in U.K. and Germany: \$500-750. Many confirmed sales worldwide at \$500-750.

Rolleiflex 2.8F Aurum - 1983. Goldplated commemorative model with alligator leather covering. Approximately 450 made. Schneider Xenotar f2.8/80mm. As new with original teak box, strap, etc.: \$1700-2400.

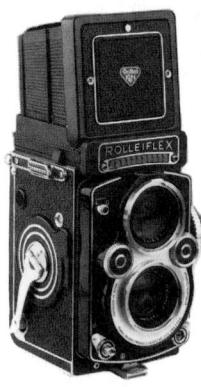

Rolleiflex 3.5F - Most often with Planar lens (illustrated here with Xenotar). Top auction prices about \$1000. Normal range \$400-600.

Rolleiflex 3.5F Police - c1960-69. Police markings engraved on body. Xenotar f3.5/75mm lens in Synchro Compur shuter. One sold at auction (1990) for \$650.

Rolleiflex SL26 - 1968-73. Sophisticated SLR for 126 cartridge film. Interchangeable Tessar f2.8/40mm lens. TTL metering. \$120-180.

Rolleiflex SL26 Accessories: Pro-Tessar 28mm f3.2 - \$45-60. Pro-Tessar 80mm f4 - \$60-90.

Rolleiflex SL35 - 1970-76. 35mm SLR with TTL CdS match-needle metering. Cloth shutter, 1-1000,B. Interchangeable Zeiss Planar or (rarer) Xenon f1.8/50mm normal lenses in Rollei bayonet mount.

Black or chrome body. Originally made in Germany, later in Singapore. \$120-180.

Rolleiflex SL35M - 1976-80. Improved version of Zeiss-Ikon SL706 (ex Icarex), Voigtländer VSL-1. Full aperture metering. Black body only. Planar f1.4 or f1.8 normal lens. \$120-180

Rolleiflex SL35ME - 1976-80. Automatic exposure version of SL35M. Aperture priority TTL CdS metering. With f1.4 or f1.8 Planar: \$120-180.

Rolleiflex SL35E - 1978-82. Similar to Voigtländer VSL-3. Meter uses SPD cells instead of CdS. Black or Chrome body. \$150-225.

Rolleiflex SL35 Accessories:
16mm f2.8 Distagon HFT - \$250-375.
21mm f4 Rolleinar-MC - \$175-250.
28mm f2.8 Rolleinar-MC - \$60-90.
35mm f2.8 Angulon - \$75-100.
35mm f2.8 Rolleinar-MC - \$50-75.
50mm f1.4 Planar HFT - \$75-100.
50mm f1.8 Planar HFT - \$35-50.
85mm f2.8 Sonnar - \$100-150.
135mm f2.8 Planar HFT - \$120-180.
135mm f2.8 Rolleinar - \$75-100.
135mm f2.8 Rolleinar - \$75-100.
135mm f3.5 Tele-Xenar - \$50-75.
135mm f4.0 Tele-Tessar HFT - \$75-100.
200mm f3.5 Rolleinar-MC - \$90-130.
Autowinder E - \$100-150.

Rolleiflex Standard models:

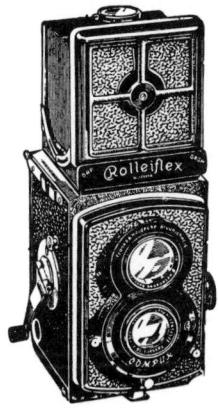

Old Standard - 1932-38. (#200,000-567,550). Zeiss Tessar f4.5, f3.8, or f3.5/75mm lens. Compur 1-300, B, T or Compur-Rapid 1-500, B shutter. Lens mount accepts push-on accessories; no bayonet. Single lever below lens for tensioning and releasing the shutter. Levercrank film advance. Exposure counter. \$90-130.

New Standard - 1939-41. (#805,000-927,999). Zeiss Tessar f3.5/75mm lens. Compur-Rapid, 1-500, B (no T or self-timer). Bayonet mount on viewing and taking lenses. Lens stops and shutter speeds set by levers. \$120-180.

Studio - 1932-34. 9x9cm or 6x9cm. The only Rolleiflex in the 9x9cm size, this is the rarest of the Rolleiflexes. Prototypes only or possibly very limited quantities. Zeiss Tessar f4.5/105mm lens in Compur S shutter 1-1/250, T, B. Price negotiable. No known sales.

Rolleiflex T - 1958-75. (#2,100,000-on). Zeiss Tessar f3.5/75mm lens. Shutter with X or MX sync. Provision for built-in dual-

FRANKE & HEIDECKE...

range exposure meter. Available in black or grey. Grey: \$300-450. Black, with meter: \$300-450. Without meter: \$175-250. (Higher in Germany.)

Tele Rolleiflex - intro. 1959. Zeiss Sonnar f4/135mm lens. Removable focusing hood. Later models allow use of 120 or 220 film. \$1200-1800.

Wide-Angle Rolleiflex (Rolleiwide) - 1961-67. Distagon f4/55mm lens. Less than 4000 produced. \$1700-2400.

Rolleiflex 4x4 Cameras: For 4x4cm exposures on 127 film. Some variations called "Baby Rolleiflex", or "Rolleiflex Sport".

Rolleiflex 4x4, original - 1931-38. (#135,000-523,000). The first "baby" Rolleiflex. Zeiss Tessar f3.5 or f2.8/60mm. Compur shutter 1-300, B,T or Compur-Rapid 1-500, B,T. Earliest models (1931-33) have rim-set shutter. Later versions (1933-38) have levers for setting the lens stops and shutter speeds. Lens mount accepts push-on accessories (no bayonets). Widely ranging prices. \$200-300.

Sports Rolleiflex - 1938-41. (#622,000-733,000). Zeiss Tessar f2.8/60mm lens. Compur-Rapid shutter, 1-500, B,T. Bayonet mount on taking lens; some also have a bayonet mount on the finder lens. \$350-500.

Rolleiflex Grey Baby - 1957-59. (#2,000,000- on). Grey body. Xenar f3.5. MXV shutter with LVS scale and self-timer. Double bayonet. Common. \$175-250.

Rolleiflex Post-War Black Baby - 1963-68. (#2,060,000-?). Black body. f3.5/60mm Zeiss Tessar or Schneider Xenar lens. Synchro-Compur MXV 1-1/₅₀₀, B shutter. Rare. \$500-750.

Rolleimagic (I) - 1960-63. (#2,500,000-2,534,999). 6x6cm TLR. Automatic exposure control. Xenar f3.5/75mm. \$120-180.

Rolleimagic II - 1962-67. (#2,535,000-2,547,597). Manual override on the exposure control. Super nice examples have reached \$350 at auction in Germany. Normally: \$175-250.

Rollei Accessories: Extension tubes - 40mm & 80mm. \$120-180.

Panorama head - \$50-75.

Pistol grip - \$35-50.

Plate back kit - Allows use of 6x9 glass plates. Includes plate back attachment, three plate holders, film inserts. \$50-75.

Prism finder - \$200-300.

Rolleifix - Quick-release tripod adapter. \$20-30.

Rolleikin - 35mm film adapter. \$35-50.

Rolleikin II - \$35-50.

Rolleikin RSp - adapter for 35mm film for Auto, Standard Rolleiflex, Ia, II, and Rolleicord. \$50-75.

Rolleilux - \$90-130.

Rolleimeter 2.8 - For Rolleiflex 2.8E. \$45-60.

Rolleimeter 3.5 - for Rolleiflex 3.5F. \$45-60.

Rolleimot - c1963. Battery-operated unit for remote operation of Rolleiflex with cable. Fires shutter and advances film. \$750-1000.

Rolleimutar 0.7x - For Rollei 6x6, bayonet size III for f2.8 Planar. Highly sought. \$750-1000.

Rolleimutar 1.5x - Bayonet size II; with case and box: \$500-750.

Rolleinar 1 - Closeup lens set. \$45-60.

Rolleinar 2 - \$30-45. Rolleinar 3 - \$35-50.

Stereo slide bar - \$75-100. **Sun shade for 4x4 -** \$12-20.

FRANKS (A.)

Presto - Box camera for 31/₄x41/₄" plates. Rubberbandshutter. \$35-50.

FRAPHOT - c1932. Cast metal subminiature for 2x2cm on rollfilm. Made in France. Identical to the Photolet except for the name. Also similar to the German "STM" Ulca. \$100-150.

FRATI 120 - Basic box camera for 6x9cm on 120 film. Made in Argentina. Cardboard body with metal front and back. The name

FRATI is embossed on the front. This camera may also exist with the name

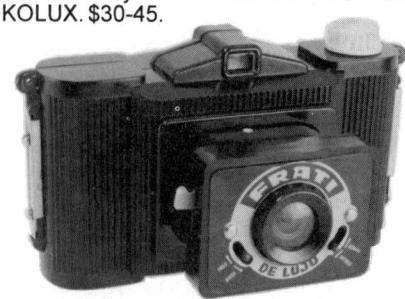

FRATI DE LUJO - c1959. Brown bakelite eye-level camera with rectangular telescoping front. Early models have shutter plunger on top of rectangular shutter housing; two red windows on back door to allow 4.5x6cm images; uses 620 or 120 film. Later model has shutter lever on right hand side of shutter; single window on back door; uses only 620 film. \$30-45.

FRECCIA - German folding camera for 6x9cm on 120 rollfilm with mask for 4.5x6cm. Ludwig Victar f4.5 lens in Prontor II 1-150,B shutter. Reflex finder and folding direct finder with half-frame mask. \$35-50.

FRELECA MAGIC F - Inexpensive plastic 127 camera, made in Hong Kong. \$1-10.

FRENNET (J. Frennet, Brussels) Stereoscopic Reflex - c1910. Graflex-style cameras for stereo exposures on 6x13cm or 7x15cm glass plates. \$500-750.

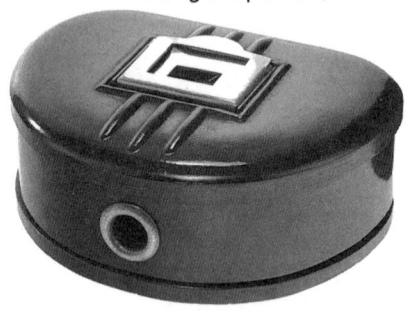

FRICA - Small kidney-shaped bakelite camera for 10x14mm exposures on special cassette film. Made in black and colors. Uncommon, \$400-600.

FROST & SHIPHAM LTD. (Sydney, Australia) Optical lens makers, photographic chemical supplier, and a major importer and maker of magic lantern equipment from the earliest years of photography in Australia. Some equipment was imported, other made locally because of the ease of working with Australian Red Cedar. Field - c1890. Tailboard dry plate field camera for 6.5x4.74" (165x120mm) glass plates with unmarked standard and telephoto lenses. Fabric focal plane shutter fits on front of lens. \$500-750.

FT-2 - see Krasnogorsk.

FUJI - Japanese novelty subminiature of the "Hit" type. Gold colored metal parts. Black leatherette. Top has stamped outline depicting Mount Fuji. Quite uncommon. \$60-90.

FUJI KOGAKU SEIKI Made cameras primarily before WWII, but the subminiature Comex was a post-war model.

Baby Balnet - 1940's. Japanese copy of

Baby Bainet - 1940's. Japanese copy of Zeiss Baby Ikonta, 3x4cm on 127 rollfilm.

Balnet shutter. Nomular Anastigmat f2.9/50mm lens. Two styles: Early version has folding viewfinder and black trim. Later version, c1947, has rigid optical viewfinder, chrome trim, and accessory shoe. \$120-180.

Baby Lyra - c1941. Folding camera for 3x4cm on 127 film. Terionar f3.5/50mm in Picco 25-100 shutter. Rare. \$150-225.

Comex - Novelty subminiature for 14x14mm on rollfilm. Marked "Made in Occupied Japan". Uncommon. \$250-375.

Lyra 4.5x6cm (Semi-Lyra) - c1936-40. Compact folding camera for 16 exposures 4.5x6cm on 120 rollfilm. Similar to Zeiss Ikonta A. Terionar 13.5/75mm anastigmat. Fujiko or Noblo shutter. Folding viewfinder. (Later c1952 version has optical rigid viewfinder.) \$50-75.

Lyra Six, Lyra Six III - c1939. Horizontally styled folding cameras for 6x6cm on 120. Similar to Zeiss Ikonta B. Less common than the "semi" model. Terionar f3.5/75mmlens, Fujiko shutter. \$50-75.

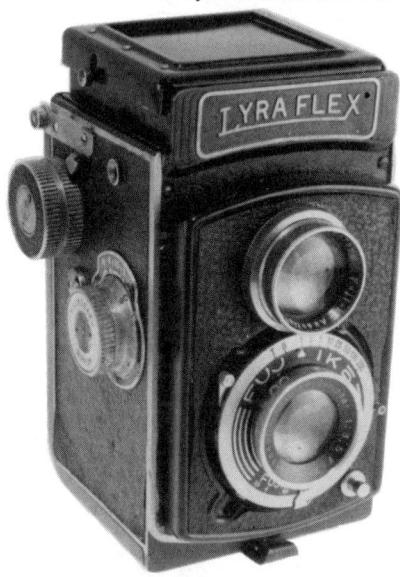

Lyraflex, Lyraflex F, Lyraflex J - c1941. 6x6cm TLR. Terionar or Goldar f3.5/75mm lens, Fujiko shutter. Uncommon Rolleicord copies. \$100-150.

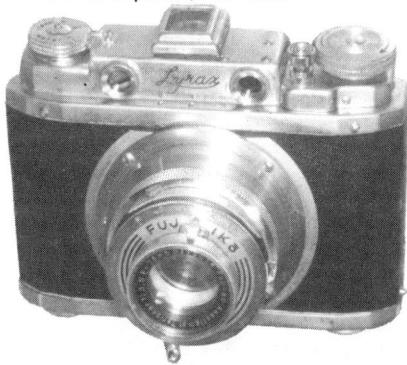

Lyrax - c1939. Telescoping front camera for 4.5x6cm on 120. Uncoupled range-finder. Terionar f3.5/75mm in Fujiko shutter. \$150-225.

FUJI PHOTO FILM CO. Founded about 1934, the Fuji Photo Film Co. made film before WWII, but didn't begin camera production until after the war. The Fuji Photo Film Company is the manufacturer of

Fujica cameras, many of which are still in use today. We are only listing a few of the more collectible models in this collectors guide. Some of the recent "disposable" or single-use Quicksnap cameras for special promotions are also listed here.

Fotojack - Disposable camera. Earlier and less common than the bright green "Quicksnap" which is currently sold throughout the world. \$20-30.

Fujica Drive - Half-frame 35mm, spring motor drive. Fujinon f2.8/28mm in Sei-kosha-L shutter. Auto exposure. \$35-50.

Fujica Half - c1963. Compact half-frame 35mm camera with selenium metering. Fully automatic or manual exposure. Fujinon f2.8/28mmlens. \$50-75.

Fujica Half 1.9 - c1965. Upgraded version of the original Fujica Cross-coupled stops & shutter speeds $^{1}/_{8}$ - $^{1}/_{500}$ visible in finder. Six-element f1.9 Fujinon lens. \$60-90.

Fujica Mini - c1964. Very small half-frame camera for 35mm film in special cartridges. Fujinar-K Anastigmat f2.8/25mm fixed-focus lens. Shutter coupled to meter. \$120-180.

Fujica Rapid S - c1965. Streamlined camera for 16 exposures 24x24mm on 35mm rapid cassettes. Fixed focus 40mm lens. \$25-35.

Fujica Rapid S2 - c1965. Similar to the Rapid S, but with selenium cell around lens for automatic exposure; focusing Fujinar-K f2.8 lens. As with other rapid cameras, these are not commonly found in the USA. \$25-35.

Fujica V2 - c1964. Rangefinder 35 with CdS metering. Fujinon f1.8/45mm. \$30-45.

Fujicaflex - c1954. Twin lens reflex for 6x6cm on 120. Fujinar f2.8/83mm. Seikosha-Rapid B,1-400. \$200-300.

Fujicarex - c1962. SLR with 1-500,B leaf-shutter. Innovative placement of controls. Two thumb-wheels are located on the back of the top housing, just below the advance lever. The top one controls the diaphragm, and the lower one focuses the lens. Interchangeable 35mm, 50mm, & 80mm front lens components. Matchneedle metering; selenium cell in front of prism. \$60-90.

Fujicarex II - c1963. Only minor changes from Fujicarex. \$60-90.

Fujipet, Fujipet EE - c1959. Simple eye-level cameras for 6x6cm on 120 film. The EE model has a built-in meter and is somewhat similar in styling to the Revere Eyematic EE127. Meniscus lens, I,B shutter. Black, green or maroon colored body. \$20-30.

Pet 35 - Inexpensive lightweight 35mm. Fujinar f3.5/4.5cm focusing lens. Copal shutter, B, 25, 50, 100, 200. \$25-35.

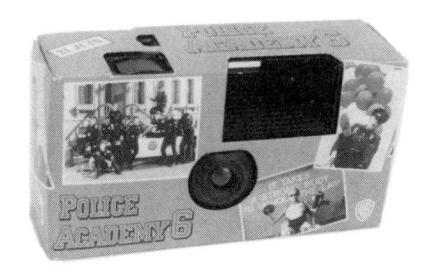

Police Academy 6 - c1989. Special promotional model of the Fujicolor Quicksnap 24 exposure disposable camera, made for the debut of the movie in France. \$15-25.

ST 701 - c1971. SLR for Praktica-thread lenses. TTL silicon blue metering at working aperture. Cloth 1-1000,B shutter. Fujinon f1.8/55mm. \$75-100.

ST 801 - c1973. Updated version of 701. The first SLR to use match LED's in the finder instead of a meter needle. Silicon metering at full or working aperture. Shutters speed increased to $1/_{2000}$. Fujinon EBC (Electron Beam Coated) lenses use Praktica-thread mount with additional safety lock. \$75-100.

ST 901 - c1974. Praktica-thread SLR. Aperture priority auto TTL exposure. Cloth 20-1/₁₀₀₀ shutter. \$75-100.

ST 605 - c1977. Similar to ST-701, but speeds $\frac{1}{2}$ - $\frac{1}{700}$, B. \$60-90.

ST 705 - c1977. Similar to ST-701 but full aperture match-needle metering; top speed increased to 1/₁₅₀₀. \$75-100.

ST 705W - c1978. Same as ST 705, but accepts accessory winder. \$75-100.

AZ-1 - c1978. Electronically controlled cloth shutter, 1-1000,B. Accepts dedicated flash & autowinder. Standard lens was Fujinon Z 43-75mm zoom. With standard zoom lens: \$120-180.

Winchester - c1991. Promotional model of the Fujicolor Quicksnap single-use camera. "WINCHESTER, Because Every Round Counts" slogan promotes the firearms company. Outer cardboard covering has brown & tan camouflage pattern. \$12-20.

FUJIMOTO

FUJIMOTO MFG. CO. (Japan) Prince Peerless - c1934. Bentzin Plan Primar copy. Thin folding body, 6.5x9cm on plates or cutfilm. Radionar f4.5/100, Compur 1-1/₂₅₀. Uncommon. \$300-450.

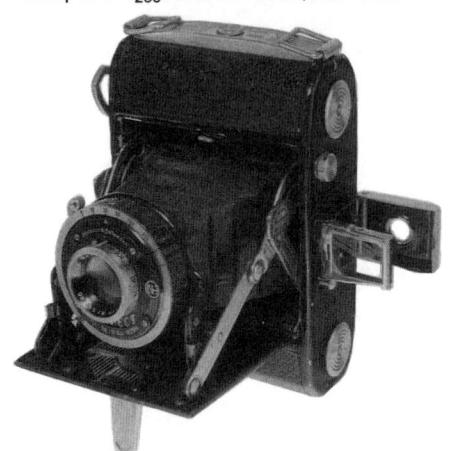

Semi Prince, Semi Prince II - c1935-36. Copies of the Zeiss Ikonta A, 4.5x6cm. Schneider or N&H 4.5/75mm lenses; various shutters. \$75-100.

FUJITA OPT. IND. LTD. (Japan) Classic 35 IV - c1960. Inexpensive 35mm camera imported to the USA by Peerless Camera Co., NY as one of a series of "Classic" cameras. f3.5/45mm. Fujita shutter B,25-300. \$50-75.

Fujita 66SL - c1958. Similar to the 66ST, but slow speeds to $^{1}/_{5}$ sec. Block lettering on nameplate. \$100-150.

Fujita 66SQ - c1960. Improved model of the 66SL with quick-return mirror. Fujita f2.8/80mmlens. \$100-150.

Fujita 66ST - c1956. SLR for 6x6cm on 120 film. Interchangeable F.C. Fujita f3.5/80mm. Focal plane shutter B,25-500. Script lettering on nameplate. \$100-150.

FUTURIT - Made in Slovakia. Bakelite camera for 4.5x6cm on rollfilm. M&T shutter. \$25-35.

FUTURA KAMERA WERK A.G., Fritz Kuhnert (Freiburg) The quickest way to identify Futura models is by shutter type. Both the Standard and the P have a black "Futura" nameplate without model designation. The Futura-S has a chrome nameplate with its model letter clearly stated.

Futura (Futura Standard) - c1951-55. Compact 35mm CRF. Compur Rapid 1-400,B,T. Interchangeable Elor f2.8, Evar f2.0 or Frilon f1.5/50mm lens. With f1.5 lens: \$175-250. With f2: \$120-180. With f2.8: \$75-100.

Futura-P - c1953-55. Similar to the Futura Standard, but with Prontor SV 1-300 shutter. This was the budget model, normally supplied with Futar f3.5/45mm or Xenar f2.8/45mm lens. \$60-90.

Futura-S - c1950's. The top of the early Futura line with a Synchro-Compur 1-500, B shutter. A very well constructed 35mm with CRF. Interchangeable Kuhnert Frilon f1.5/50mm normal lens. With normal, wide angle, tele lenses and auxiliary finder: \$250-375. With normal lens: \$100-150.

Futura-SIII - c1956-59. Improved version of Futura-S, with rapid advance lever. \$150-225.

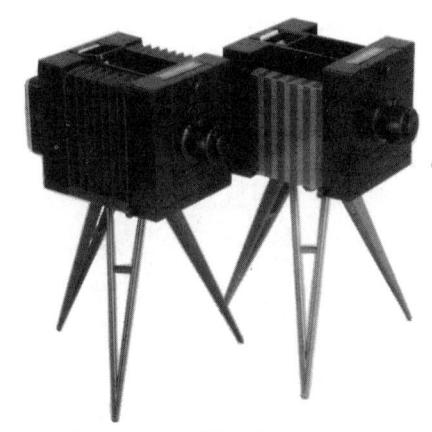

Gakken Antique Tripod Cameras

Futura Lenses: These lenses are not often sold separately from the cameras, so our pricing data is limited.

35mm f1.4 Ampligon - With finder: \$90-130.

45mm f3.5 Futar - \$30-45.

45mm f2.8 Schn.-Xenar - \$30-45.

50mm f2.8 Elor - \$60-90.

50mm f2.0 Evar - \$60-90.

50mm f1.5 Frilon - \$60-90. **70mm f1.5 Frilon -** \$175-250.

75mm f3.8 Tele-Futar - w/finder: \$100-150.

90mm f5.6 Tele-Elor - w/finder: \$100-150

Futura 35-100mm finder - \$90-130.

GABRIEL TOY CO. (Jersey City, NJ) U-2 Spy Plane - Kit containing a 127 film camera and parts to assemble a model airplane which carries it. A wind-up timer fires the camera, which takes 16 exposures per roll. No sales data.

GAERTIG & THIEMANN (GÖrlitz)
Ideal Model VI - c1906-09. Triple
extension field camera. Brass trim, brass
Steinheil lens with Waterhouse stops.
Brown tapered bellows. \$200-300.

GAICA SEMI - c1940. 120 folding rollfilm camera, 4.5x6cm. Gaica K.O.L. f4.5/75mm lens, RKK 1/₁₇₅ shutter. \$75-100.

GAKKEN CO. (Tokyo) - The Gakken Co. publishes magazines for science students in Japan. In 1974, they began to give simple cameras to students to teach the principles of photography. The kits include a simple plastic camera which usually requires some assembly. At the back of the camera is a removable plastic focusing screen and filmholder, which are standard in size from year to year, though the outer bodies of the cameras show many interesting variations. Along with the camera comes sensitized paper, developer, and fixer.

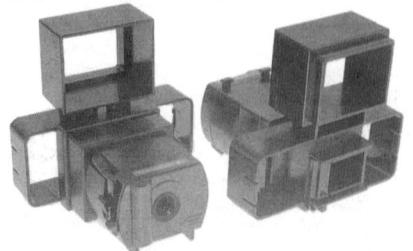

110 Camera - 1988, 1989. Simple camera front with some of the shutter mechanism exposed on the side. The function of the parts is obvious as the

shutter is tensioned. This simple front attaches to a dual adapter back which allows use of standard Gakken materials or 110 cartridges. The 1989 model has an accessory front finder, otherwise the two years are identical. \$20-30.

Antique Tripod Cameras - 1986, 1987. There are two versions of the antique view camera, the 1986 model being the more realistic with its pleated plastic bellows. The 1987 version has striped paper decals to represent the bellows. The cameras are otherwise similar. \$50-75. Illustrated at top of previous column.

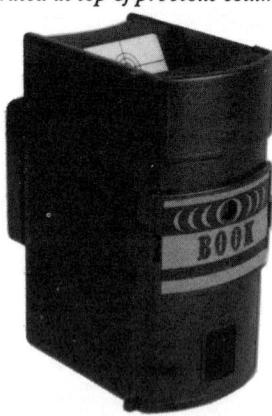

Book Camera - 1984. Black plastic body shaped like book. Red decal for spine and front clearly identify it as a book. The spirit of Krügener's Taschenbuch is alive and well. \$50-75.

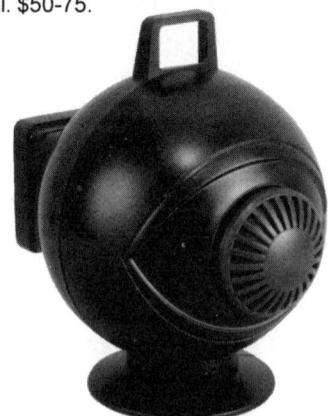

Eye Camera - 1985. The similarities between the eye and camera become obvious in this novel camera, whose lenscap is a stylized iris. \$50-75.

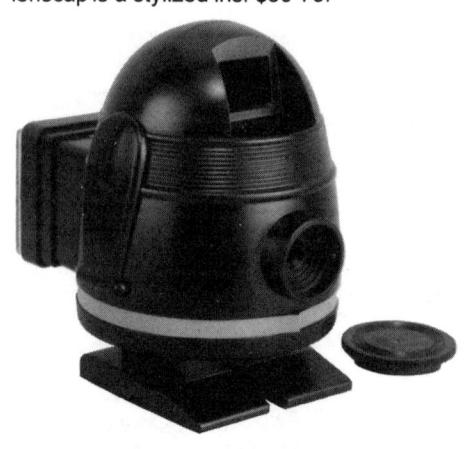

Robot Camera - 1984. Miniature cousin of R2-D2. \$50-75.

GALTER

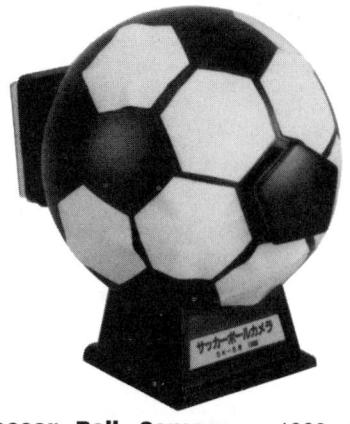

Soccer Ball Camera - 1983, 1986. Although similar in size, the two versions of the soccer ball are quite different. In 1983, the shape is a polyhedron, while the 1986 model is a sphere. The earlier model with its flat hexagonal sides is a much better candidate for the self-sticking white decals. The illustrated model is the 1986 version, which proves that a flat decal will wrinkle on a curved surface. Some Gakken cameras apparently teach more than photography \$50-75.

GALILEO OPTICAL (Milan, Italy) Associated with Ferrania, also of Milan.

Condor I - c1947. 35mm rangefinder camera, similar in style to Leica, but with front shutter. Eliog f3.5/50mm in Iscus Rapid shutter B,1-500. CRF with separate eyepiece. Collapsible front. \$100-150.

Gami 16 - c1955's. Subminiature for exposures 12x17mm on 16mm film in cassettes. f1.9/25mm lens. Shutter 2-1000. Coupled meter, parallax correction, springmotor wind for up to 3 rapid-fire shots. Original cost \$350. These are not rare, yet are occasionally advertised at higher prices. Normal range: \$400-600. An outfit with the rare 8x lens, 4x lens, enlarger, and other accessories sold for £1500 at Christie's 3/93. Outfit without 8x lens, but with f4/4x telephoto, flash, filter, 45° viewer, wrist strap, etc. typically sells for 2 to 3 times the cost of the camera & case only.

Gami Accessories:
Developing tank - \$100-150.
Film cutter - \$12-20.
Spool winder - rare. \$150-225.
Telephoto 4x - Top auction pri

Telephoto 4x - Top auction price 12/91 \$1200. Normal range: \$300-450. **Telephoto 8x** - Very rare. Top auction

Telephoto 8x - Very rare. Top auction price 12/91 \$1400. Normal range: \$750-1000.

GALLUS (Usines Gallus, Courbevoie, France)

Bakelite - A streamlined folding camera made of bakelite plastic. Design is based on the Ebner camera from Germany. Takes 6x9cm exposures on 120 rollfilm. Achromat f11 lens and P & I shutter. \$60-90.

Derby - c1939-41. Folding strut camera for 3x4cm on 127 film. Som Berthiot Flor or Saphir f3.5 lens. Focal plane shutter. A French-made version of the Foth Derby. \$60-90.

Derby-Lux - c1945? All polished aluminum camera for 3x4cm exposures on 127 rollfilm. This was the first postwar reincarnation of the Foth Derby, and it was renamed "Derlux" before very long. It can be identified by the camera name on the back plate. Strut-supported front. Boyer Saphir 13.5 lens and FP shutter B,25-500. \$150-225.

Derlux - c1947-52. Folding camera for 3x4cm exposures on 127 rollfilm. Polished aluminum body. Very similar to the Foth Derby. Early examples are identified as "Derby Lux" on the back, see above. Gallus Gallix f3.5/50mm lens. FP shutter 25-500.\$120-180.

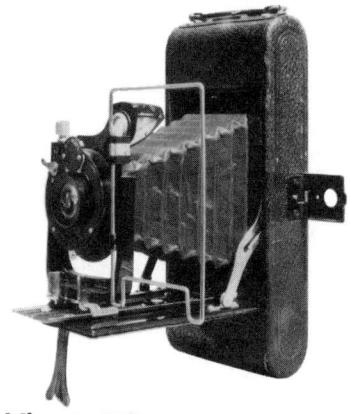

Folding Rollfilm Camera - c1920. For 6.5x11cm. Gallus Anastigmat f6.3/120mm in lbsor shutter. Rising front with micrometer screw. \$30-45.

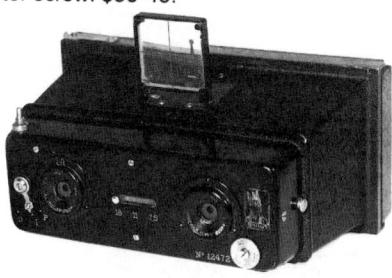

Stereo camera - c1920's. Rigid "jumelle" style all metal camera for stereo exposures in the two popular formats: 6x13cm or the smaller 45x107mm. Simple lenses, I&B shutter or more expensive versions with nickel-plated aluminum bodies, 1/₃₀₀ jewelled shutters, and Goerz, Krauss, or Zeiss lenses. \$120-180.

GALTER PRODUCTS (Chicago) Founded in 1950 by Jack Galter, former president of Spartus Camera. Co., and apparently in business for only a few years. Spartus Camera Co., meanwhile, became Herold Mfg. Co. at about the same time, having been bought by Harold Rubin, former Sales Manager for Spartus.

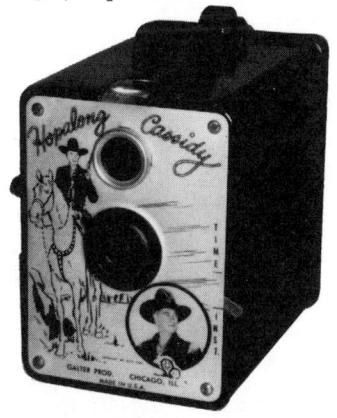

Hopalong Cassidy Camera - c1950. Plastic box camera for 8 exposures 6x9cm on 120 rollfilm. Simple shutter and meniscus lens. The front plate depicts the famous cowboy and his horse. These are synchronized and non-sync models. The original flash unit, with Hoppy and his horse pictured on the reflector, is quite rare. Camera and flash have sold for \$120-180. Camera only, with or without synch: \$30-45.

GALTER...

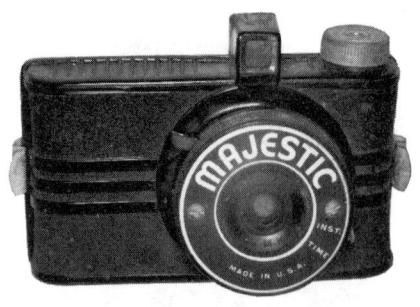

Majestic, Pickwik, Regal, Regal Miniature - Plastic "minicam" type cameras for 3x4cm on 127 film. \$8-15.

Sunbeam 120 - Black bakelite box camera without flash sync. Body style identical to the Hopalong Cassidy camera. \$8-15

GAMMA (subminiature) - Novelty subminiature from "Occupied Japan". Shutter release on top of body. Angel f4.5 lens with rotating disc stops. Top auction price (12/91) \$275. Normally: \$150-225.

GAMMA (Societa Gamma, Rome) Alba - c1956. Non-RF 35mm. Heavy cast metal body. Ennagon f2.8/45mm in Pronto B.25-200. \$45-60.

Gamma (35mm) - c1947-50. Leicainspired 35mm cameras. Model I c1947 has bayonet-mount lens, FP shutter with speeds B,20-1000 on one dial. Model III c1949 has screw-mount lens, and shutter speeds 1-1000. Gamma, Angenieux, or Koristka Victor f3.5 lens. Rare. Estimate: \$600-900.

Perla A I - c1951. 35mm camera with coupled rangefinder and built-in selenium meter. Ennagon or Radionar f2.8/50mm lens in Prontor SVS shutter. \$150-225.

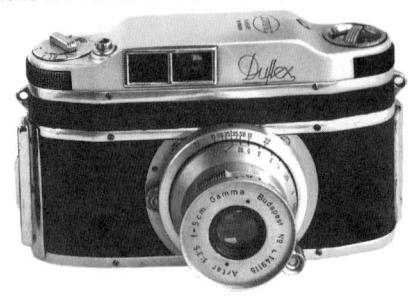

GAMMA WORKS (Budapest Hungary)

Duflex - c1947. 24x32mm. First 35mm SLR to have a metal focal plane shutter, instant return mirror and internally actuated automatic diaphragm. An advanced camera for its time. Reflex focusing finder uses porroprism; a separate finder includes framing lines for 35mm, 50mm, & 90mm lenses. Only the 50mm lens was produced. Extremely rare. One source indicates a total production of about 800 cameras, while another source quotes 360. One source indicates that the serial number on lens can be decoded as follows: Ignore first digit; second and third digits are year of production; final three digits are serial number of lens. A second source indicates that the first three digits give month and year of production, while the last three digits give camera or lens number (K=body, L=lens). A third source says that known serial numbers do not confirm this theory. We would appreciate more serial numbers from Duflex owners to help clarify this issue. \$2000-3000.

Pajta's - c1960. Heavy black bakelite eye-level camera for 6x6 on 120. Achromat f8; T&M shutter. \$50-75.

GANDOLFI (London) The history of the Gandolfi family in the camera business is already a legend, and 1985 marked the hundredth anniversary of the founding of the

business by Louis Gandolfi. It has remained a family business since that time, with sons Thomas, Frederic and Arthur working with their father and eventually taking the reins after his death in 1932. The company has always specialized in hand-made wooden cameras, some of which were custom-built to the specifications of clients. It would be difficult to give specific prices to such a wide range of individually crafted cameras. In the 1950's and 1960's, Gandolfi offered the cheapest large format cameras on the English market; thus there are many common Gandolfi cameras which sell in England at about \$100. Currently the user market places a higher value on 4x5 and 8x10 format cameras than does the collector market. This is especially true for cameras fitted with Graflok (international) backs, which were never offered by Gandolfi. We have a number of recorded sales in the range of \$175-450 and some up to \$1000. This is understandable in view of the recent prices for new Gandolfi cameras of \$1600 for 4x5 and \$2250 for 8x10. Obviously, since the cameras were made for 100 years in a traditional style, they are still as much in demand for use as for collections. The majority of Gandolfi cameras found today are post-1945. Some specific examples of recent sales are: Field camera - c1890's. Mahogany

tailboard camera with brass trim and appropriate lens. 8x10": \$750-1000. 61/2x81/2": \$300-450. 41/4x61/2" and 4x5": \$400-600. **Tropical camera** - Teak tailboard camera for 1/2-plates. Brass fittings. Almost identical to the Universal Stereo below

camera for 1/2-plates. Brass fittings. Almost identical to the Universal Stereo, below, but nameplate bears only the manufacturer's name and no camera name. Brass lens in Thornton-Pickard roller-blind shutter. \$800-1200.

Universal - 4x5" hand and stand camera. Leather covered body, brass trim. Meyer Trioplan f4.5/135mm. \$500-750.

Universal - 61/2x81/2" tailboard camera. Mahoganyand brass. \$350-500.

Universal Stereo - c1900. Folding tailboard stereo camera for 12x16.5cm plates. Black square bellows. Brass trim. Brass f8 Thornton-Pickard Crown lenses in Thornton-Pickard roller-blind shutter. \$600-900.

GARLAND (London, England)
Wet Plate camera - c1865. 8x10".
Ross lens. \$1700-2400.

GATLING 72 - c1963. Half-frame 35mm, house-brand name for the Ricoh Auto Half. Ricoh f2.8/25mm lens. BIM. \$75-100.

GATTO (Antonio Gatto, Pordenone, Italy)

Sonne IV - c1948. Leica-inspired CRF camera. Adlenar f3.5/50mm lens in interchangeable 39mm Leica thread resembles Elmar. Elionar 3.5/50mm resembles

Summar. FP shutter 20-1000, not synchronized. First model has name in script. Later changed to block letters. \$600-900.

GAUMONT (L. Gaumont & Cie.. Paris)

Block-Notes - Compact folding plate

4.5x6cm - c1904-24, f6.8 Tessar, Hermagis Anastigmat, or Darlot. \$150-225. **6.5x9cm** - c1909-24. f6.3 Tessar lens. Less common than the smaller model. \$120-180.

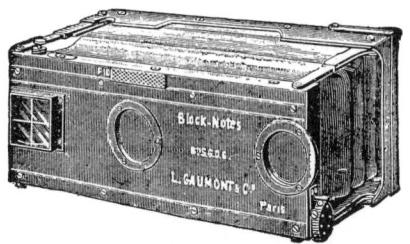

Block-Notes Stereo - Compact folding cameras like the other Block-Notes models, but for stereo formats: 6x13cm and 45x107mm. f6.3 lenses. Variable speed guillotine shutter. For single plateholders or magazines. \$250-375.

Bramham - 35mm stereo camera. Finetar f4/43mm lenses. \$300-450.

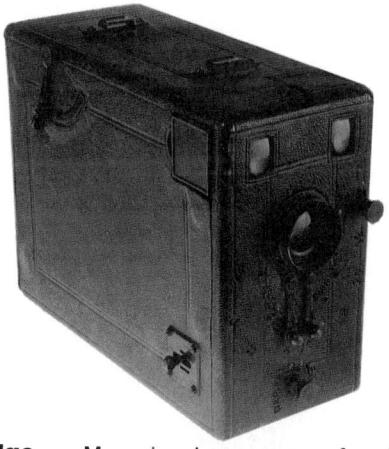

Elge - Magazine box camera for 12 plates, 6.5x9cm in metal sheaths. Dropplate mechanism operated by side lever. Automatic exposure counter on back door. Dual reflex finders with hinged hoods. Two-speed P&I shutter; focusing lens. \$60-90.

Folding Spido - c1925. Strut-folding press camera, nickel body. 12-plate magazine for 9x12cm plates. Zeiss Tessar lens, FP shutter to 2000. \$175-250.

Miniature - Rectangular metal camera with leather covering for 16mm film. Shutter release beneath a flexible rubber covering. Film advance and shutter ten-

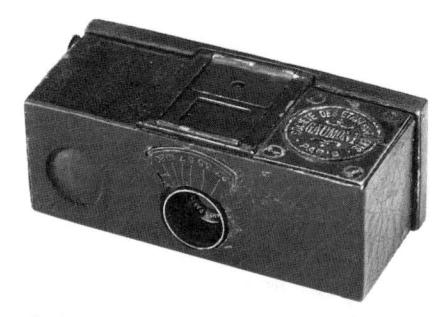

sioning controlled by extensible rod Folding frame finder. Krauss Zeiss Tessar 2cm lens. One sold at Christie's 11/93 for

Polain No. 1 - Stereo jumelle camera, 6x13cm. Polished metal body with magazine back. Krauss/Zeiss Tessar f6.3/84mm lenses, \$300-450.

Reporter - c1924. Heavy metal strutfolding camera for 9x12cm single plates or magazine. Flor f3.5/135mm lens. FP 1/25-1000 shutter. \$300-450.

Reporter, Tropical model - 9x12 or 9x14cm size. \$600-900.

Spido - c1898. 6x9cm or 9x12cm magazine camera. Leather covered. Tapered front "jumelle" shape. Berthiot, Protar, or Dagorlens, pneumaticshutter. \$200-300.

Stereo Spido Ordinaire - c1906-31. Black leather covered jumelle style stereo cameras for 6x13cm or 8.5x17cm stereo plates. Krauss Zeiss Protar f12.5/183mm or Tessar f6.3. Six speed Decaux Stereo Pneumatic shutter. \$250-375.

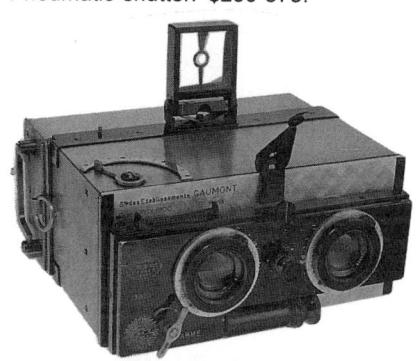

Stereo Spido Metallique - c1920's. Model A (panoramic version) with 120 rollback: \$400-600. Non-panoramic models C & D, 6x13cm size without rollback: \$250-375.

Stereo cameras - Misc. or unnamed models, 6x13cm. f6.3/85mm lenses; guillotine shutter. \$250-375.

Transistomatic Radio Camera c1964. Combination of a G.E. Transistor radio and Kodak Instamatic 100 camera. \$120-180.

GENNERT

GENERAL PRODUCTS CO. (Chicago) Candex Jr. - Black plastic minicam for 127 half-frames, \$8-15

Candex Miniature Camera - Black plastic minicam for 16 exposures on 127 film. \$8-15.

Clix Miniature Camera marbelized plastic minicam for 3x4cm on 127 film. \$8-15.

GENIE CAMERA CO.

(Philadelphia, PA)
Genie - c1892. Focusing magazine-box camera for 31/₄x4" plates. Push-pull action changes plates and actuates exposure counter on brass magazine. String-set shutter. \$600-900.

GENNERT (G. Gennert, NYC)

Compact D.E. Cycle Montauk c1900-1915. Folding-bed cameras with leather covered body. Double-extension red bellows. Made in 4x5, 5x7, and 61/₂x81/₂" sizes. Usually fitted with Extra Rapid Collinear or Rapid Symmetrical lens in iris or Triplex shutter. \$100-150.

Montauk - c1890. Detective style camera for plateholders which load from the side. Shutter-tensioning knob on the front next to the lens opening. Internal

GENNERT...

bellows focusing via radial focus lever on top of camera. \$150-225.

Folding Montauk, Golf Montauk, Montauk III - c1898. Folding plate cameras, 4x5" or 5x7". Leather covered wood bodies. "Cycle" style. Wollensak Rapid Symmetrical, Ross Patent, or Rapid Rectilinear lens. \$100-150.

Long Focus Montauk - c1898. Like the Folding Montauk, but also has rear bellows extension. \$120-180.

Montauk rollfilm camera - c1914. \$30-45.

"Penny Picture" camera - c1890. A 5x7" studio camera with sliding back and masks to produce multiple small images on a single plate. \$350-500.

Stereoscopic Montauk - c1898. Like the 5x7" Folding Montauk, but with Stereo lensboard. \$350-500.

Wet Plate Camera, 4-lens - Fixed tailboard bellows-style camera with 4-tube lensboard. Side-hinged ground glass

screen. Drip trough below ground glass. Wooden septum fastens inside 7x7" opening to allow 4 photos on 5x7" plate. \$1000-1500.

GENOS K.G. (Nurnberg, Germany) Flash Box - Bakelite pseudo-TLR. \$20-30.

Genos - c1949. Small black bakelite eyelevel camera for 25x25mm on 35mm wide rollfilm. Postwar version of the Nori & Hacon. f8 lens, Z&M shutter. \$45-60.

Genos Fix - c1951-56. Two-tone 4.5x6cm bakelite rollfilm box camera, similar in style to the better known Bilora Boy. \$35-50.

Genos Rapid - c1950. Plastic reflex camera for 12 exp. 6x6cm on 120 film. \$20-30.

Genos Special - c1953. Black bakelite box camera for 6x6cm, similar to the Genos Rapid. Achromat f8 lens, simple shutter. \$25-35.

Special Fix - c1950. Black bakelite eyelevel box camera for 4.5x6cm on 127. "Special" on metal nameplate above lens. "Fix" molded into body below lens. \$25-35.

GERLACH (Camera-Werk Adolf Gerlach, Wuppertal, Germany) This same small manufacturer apparently was later called Camera Werk Nixon, Wuppertal

Ideal Color 35 - c1956. Basic 35mm camera with lever advance, double exposure prevention, focusing Nixon or Nixonar Anastigmat f3.5/45mm in B,25-100 shutter. Appears to be an improved version of the Steinette camera. \$25-35.

Trixette - c1955. Folding rollfilm camera for 6x6cm on 120. Supra Anastigmat 65.6/75mm in Vario $^{1}/_{25}$ - $^{1}/_{200}$. Unusual folding mechanism. Also sold by Nixon Camera Werk as the Nixette. Uncommon. 60-90

GERSCHEL (Paris)

le Mosaic - c1906. An unusual camera designed to take 12 exposures, 4x4cm each, on a single 13x18cm plate. The camera is approximately the size and shape of a cigar box standing on end. A removable partition divides the camera interior into twelve chambers. The lens and shutter move horizontally and vertically on two tambours (like a roll-top desk) to allow for twelve separate exposures. The sliding front has index marks to indicate the proper lens position for each exposure. There is also a second set of index marks for making nine exposures per plate with a different interior partition. Oddly, it comes with a Rapid Rectilinear lens fitted in either a Wollensak or Bausch & Lomb shutter. \$2800-4000.

GEVAERT Founded in 1890 by Lieven Gevaert to manufacture calcium paper. Merged with Agfa in 1964. Although a leader in photographic materials, the company was never a major producer of cameras. The cameras listed here were made for Gevaert by other manufacturers.

Gevabox: c1950. Box cameras in several variations for 120 film:

Gevabox 6x6 - c1950-51. Black bakelite camera with white trim. Looks like an overgrown "Ansco Panda", and nearly identical to the Adox 66. Made by Herman Wolf GmbH of Wuppertal, Germany. \$25-35.

Gevabox 6x9 (eye level) - c1955-59. Metal box camera with eye-level finder above body. Shutter $^{1}/_{50}$ and $^{1}/_{100}$. Made by Kürbi & Niggeloh (Bilora) in Germany. \$12-20.

Gevabox 6x9 (waist level) - c1951-54. Waist level brilliant finders. B,M shutter. Made by Herman Wolf GmbH, Wuppertal, Germany. \$20-30. *Illustrated at top of next page*.

Gevabox Special - c1951. Streamlined box camera 6x9cm on for 120 rollfilm. f11 lens, shutter 50,100,B.\$20-30.

Gevabox 6x9 (waist level)

Gevalux 144 - Grey & brown plastic camera for 127 film. Same design as Ansco Cadet II & III. Made in USA; marketed in Europe. \$12-20.

Gevaphot - c1960? Bakelite eye-level camera, 6x9cm on 620 film. Similar to the Photax from which it was derived, but with the viewfinder moved from top center to one end. Helical telescoping front. \$20-30.

Ofo - Not a camera name, but an indication of large diaphragm, filter, and small diaphragm on the "Lujo" & "Rex-Lujo" cameras made by S.I.A.F. for Gevaert and Gradosol.

Rex-Lujo - 1944-59. Bakelite camera with helical telescoping front. Similar to the Photax camera from France. Both cameras are based on designs by Kaftanski, whose creations were manufactured in

Germany, France, and Italy This one, however, is made by "SIAF Industria Argentina". Black or brown. \$50-75.

GEYMET & ALKER (Paris) Jumelle de Nicour - c1867. An early binocular-styled camera for 50 exposures on 11/₄x11/₄" plates. A large cylindrical magazine contained the 50 plates, which were loaded and unloaded from the camera for each exposure by gravity. (Rather like a modern slide tray.) Rare. Estimate: \$13,000-19,000.

GEZI - c1950's. Black bakelite camera for 4x4cm on 127. Metal top housing incorporates eye-level and reflex finders. Simple 3-speed shutter and focusing Achromat 6cm lens. Double-exposure prevention. Made in Germany, although not marked. Dual finders; no sync. Back latch button is on top of camera, precluding an accessory shoe. One reader has this model in a case marked "Erko". We are still hoping to discover the manufacturer and some history of this camera. \$45-60.

GEZI II - c1950's. Very similar to Gezi (I), but back latch button moved to camera front above lens; accessory shoe on top. Synchronized. Also sold under Lieberman & Gortz name. Same camera with a single finder was sold by Rothlar-Optik. None of these cameras are common. We would appreciate hearing from anyone who has information on the manufacturer. \$45-60.

G.G.S. (Milan, Italy)

Lucky - c1948. Small, inexpensive 35mm camera. Solar Anastigmat f3.2/50mm lens in leaf shutter. Rare. Last known sale at Christie's 12/91 auction: \$550. Most prices at that sale were abnormally high, so use your own judgement.

Luckyflex - c1948. Small TLR for 24x36mm exposures on 35mm film. Solar Anastigmat f3.2/50mm in leaf shutter. Viewing lens externally gear-coupled to taking lens. Top auction price 12/91 \$1900. Normal range \$600-900.

GIBBS (Oakland, California) Gibbs was a manufacturer of photographic supplies. For a short time in the 1890's, he also made some cameras.

Gibbs View Camera - c1890's. Self-casing view camera of uncommon design. Rear door pivots 270° and attaches to the camera bottom to form a rigid base. A pivoting tripod head is built into this back door/baseboard. Front door hinges down and attaches to the new baseboard. The front standard screws into one of several positions on the base for coarse focusing, and a short rack allows fine focusing. Square-cornered, tapered light tan bellows. Rare. \$1000-1500.

GIBSON (C.P. Gibson, Hull, England) Stereo camera - Mahogany tailboard camera with brass trim, brass bound Clement and Gilmer lenses. $41/_4$ x6 $1/_2$ " plates. Square red bellows. \$750-1000.

GILLES-FALLER (Paris)

Studio camera - c1900. 18x24cm. Hermagis Delor f4.5/270mm lens with iris diaphragm. Finely finished light colored wood. \$350-500.

GINREI KOKI (Japan)

Vesta - c1949. Novelty subminiature from "Occupied Japan". Two models: one has eye-level finder, the other has both eye and waist level finders. \$75-100.

Vester-Six - c1940. Horizontally styled camera for 6x6cm on 120 film. Nearly identical to the Clover Six B. Venner Anas-

GIRARD

tigmat f3.5/75 in Vester 3 shutter T,B,1-200, \$90-130.

GIRARD (J. Girard & Cie., Paris)
Le Reve - c1908. Folding 9x12cm camera. Special detachable rollfilm back has darkslide so that it can be removed and replaced by a ground glass screen or a plateholder. Beckers f6.3 or Roussel Anastigmat f6.8/135mm lens in Unicum shutter. Red bellows. \$175-250.

GIROUX (Alphonse Giroux) Brother-inlaw of J.L.M. Daguerre, and maker of the

very first Daguerreotype cameras.

Daguerreotype Camera - c1839. The original Giroux cameras were easily identifiable, because they are prominently marked with an oval label. If you are in possession of a genuine Giroux camera and wish to sell it for top price, undoubtedly it should be done at public auction. Opening bids are likely to be over \$50,000. Selling price will likely exceed \$100,000. You should also be aware that replica Giroux cameras have been made for museum display, and if you are offered a "Giroux" camera for a high price, it could very well be a replica.

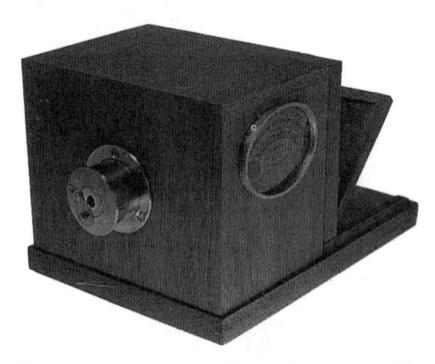

Giroux Daguerreotype Replica, 1/3 scale - c1970-1980s. Approximately 50 small scale replicas of the original Giroux camera were made by Jerry Smith of Missouri. Most were made of mahogany or walnut, some in two-tone, and a few in exotic woods. They are working cameras except they do not have plateholders. Only two working replicas of the Giroux plateholder were made for these cameras. \$120-180.

GIRVAN (T.F. Girvan, Dunedin, New Zealand)

Kapai Camera - c1900. The Kapai (Maori word for "good") was advertised as available in 1/₄-, 1/₂-, 1/₁-plate, 10x8, 12x10, and 15x12" sizes. Conventional view camera with built-in turntable. Made from

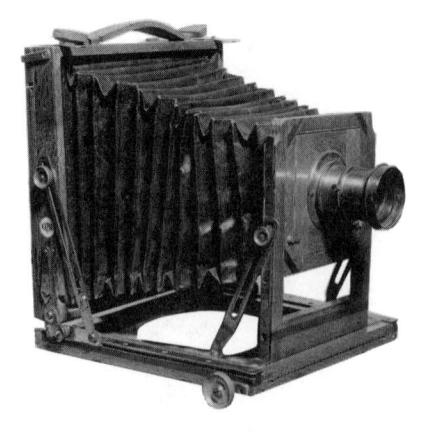

native "Rewarewa" wood (honeysuckle), with diagonal corner reinforcements of mahogany Supplied with French-made "Zealandia" lens, or with other lens of purchaser's choice. Few actually have Zealandia lens, although the lens is known to exist. The Zealandia lens carries the mark of "KP&Co". An advertisement from 1900 listed Kempthorne, Prosser & Co.'s New Zealand Drug Co. as the sole agents for the Kapai camera. Although the cameras bear a nameplate attributing manufacture to Girvan, a second source has attributed the camera to Henry John Gill, who was in business from 1890 to 1925. We will be happy to receive further documentation on this camera from our readers. One recorded sale about 1989 for \$70 without lens. Current estimate: \$175-250.

GLOBAL - Japanese 16mm "Hit" type novelty camera. \$25-35.

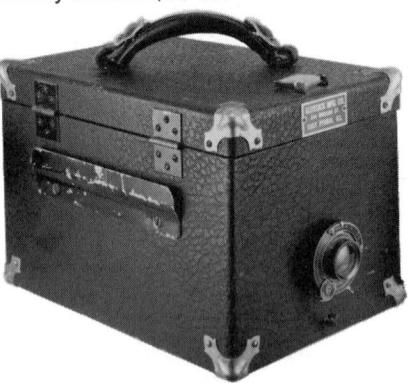

GLOSSICK MFG. CO. (East Peoria, Illinois)

Direct Positive Street Camera - A leather-covered wooden camera with a rear sleeve for manipulating the 6x9cm sheets of direct positive paper. Suitcase styling is typical of street cameras, but tapered in toward the top. \$120-180.

GLUNZ (G. Glunz & Sohn Kamerawerk, Hannover) The company was originally founded in 1889, according to their catalog claims. The name Glunz & Bülter was used from about 1894-1904, at which time G. Glunz & Sohn split away, leaving Bülter & Stammer. G. Glunz & Sohn remained in business until sometime in the 1930's. (The latest catalog we have on file is 1932.)

Folding plate camera, 6.5x9cm - c1920's. Double extension bellows. Tessar f4.5/120mm. Compur 1-250. \$50-75.

Folding plate camera, 9x12cm c1920's. Wood body, leather covered. Double extension bellows. Dial Compur

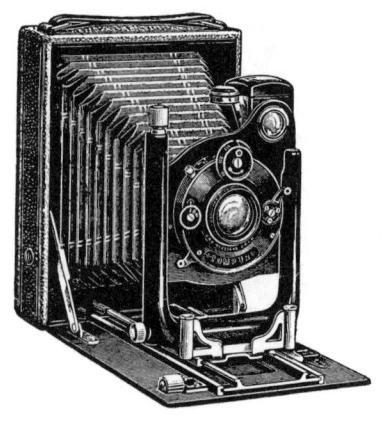

shutter. Goerz Tenastigmat f6.8, or Zeiss Tessar f4.5 lens. \$50-75.

Folding plate camera, 13x18cm - c1905. Horizontally styled folding camera. Leather covered wood body. Triple extension bellows. Hemi-Anastigmat Series B f7.2 lens. Unicum double pneumatic shutter. \$90-130.

Folding rollfilm models - f6.3 Tessar. Compurshutter. \$30-45.

Ingo - c1932. Compact horizontally styled camera for 3x4cm on 127 film. Interesting "barn-door" front which provides solid support for the extended front. (This same system proved to be much more popular on the 1950's Voigtländer Vitessas.) The Ingo was also sold by Rodenstock as the Rodinett, recognizable by its Rodenstock Ysar lens. The Ingo has the Glunz name on the advance knob. With Makro Plasmat lens in helical mount, an astute collector would pay \$60-90 extra. With normal Trinar, Trioplan, or Radionar lens in Compur: \$175-250.

GNCO - "Hit" type Japanese novelty subminiature. Gold: \$60-90. Chrome: \$25-35.

GOERZ

GNO III - c1955. Scale-focus 35mm camera with cast metal body. Emarl Anastigmat f3.5/45mm lens in Gno-35 B,1-200 shutter. Well made and very uncommon. \$75-100.

GNOFLEX - c1956. Japanese Rolleicord copy. Horinor f3.5/75mm lens. NKS shutter B,1-300. \$60-90.

GNOME PHOTOGRAPHIC PRODUCTS, LTD. (England)

Baby Pixie - c1951. Metal box camera for 16 exposures on 620 film. B&I shutter. Chrome with leatherette covring. \$25-35.

Pixie - Metal box camera, 6x6cm on 620 film. Black crinkle-finish enamel. \$12-20.

GOECKER (AD. Goecker, Copenhagen, Denmark) Founded in 1862 and was still in existence a hundred years later. A wholesaler and retailer of photographic supplies, chemicals, and other goods. Cameras bearing the Goecker name were probably sold but not manufactured by Goecker. Field camera - 18x24cm. Carl Zeiss Series Ila f8/140mmlens. \$150-225.

GOERZ (C.P. Goerz, Berlin, Germany) Started in a two-room shop in 1886 as a mail-order firm selling mathematical drawing tools to schools. In 1888 Goerz acquired a mechanical workshop and started making amateur cameras. Lensmaking began in late 1888 or early 1889 and became the main business. Became a major manufacturer with over 3,000 employees within the lifetime of the founder. In 1926, three years after the death of Carl Paul Goerz, the company merged with Contessa-Nettel, Ernemann, and Ica to form Zeiss-Ikon. Some Goerz models were continued under the Zeiss name. In 1905, Mr. Goerz organized C.P. Goerz American Optical Co. to supply the steady demand for his products in the United States. This company is still in business, at the leading edge of space-age technology.

Ango - Strut-type folding camera with focal plane shutter, introduced in 1896 as the Anschütz camera. The ANGO name, a contraction of ANschütz and GOerz, was apparently adopted in 1905 after the introduction of the new self-capping shutter. This name was phased in slowly, however, and does not appear in any catalogs we have seen until after 1908. As for the camera itself, the new self-capping shutter shows up in 1906 catalogs. The Newton finder has the rear sight changed from a peep hole to a lens in 1907. By 1911, the new model with both shutter and finder improvements is called the Ango, while the earlier style is still being sold as the Anschütz, Model I. The same evolving design was in production for at least 30 years. Goerz Dagor f6.8, Dogmar f3.5, Syntor f6.8, Double Anastigmat f4.6, or Celor f4.8 are among the lenses you could expect to find. The more common sizes include 9x12cm, 10x15cm, and 13x18cm. \$100-150.

Ango Stereo - Same as Anschütz stereo.

Anschütz (box form) - c1892. (Note: An earlier version, c1890, existed, but there are currently no known examples, nor even any illustration.) Dovetailed walnut box camera for 9x12cm plates. Cloth focal plane shutter. Goerz Extra-Rapid Lynkeioscop lens. Folding sportsfinder. Uncommon. \$1700-2400.

Anschütz (strut-type) - Introduced in 1896 and quite common with the press during the early part of the century. A bedless "strut" type folding camera, using a focal plane shutter based on the design of Ottomar Anschütz. The name was gradually changed to the contracted form "ANGO" between 1905-1910. Most often found in the 6x9cm, 9x12cm, and 4x5" sizes. \$100-150.

Anschütz Deluxe - Similar, but green leather panels and bellows. \$300-450.

Anschütz Stereo - c1896-1921. Began life as Anschütz, but was re-named "ANGO". A focal plane strut-folding bedless stereo camera for paired exposures on 8x17cm, 9x14cm or 9x18cm plates. Panoramic views are also possible by sliding one lens board to the center position. With Goerz Dagor Double Anastigmat or Goerz Wide-Angle Aplanat lenses. A relatively uncommon camera. \$250-375.

Box Tengor - c1925. Made in two sizes for 6x9cm or 6.5x11cm exposures on roll-film. Goerz Frontar f11 lens. 6.5x11cm: \$50-75.6x9cm: \$30-45.

Folding Reflex - 1910-11. A compact folding single lens reflex camera for 4x5" plates. Designed to operate as an efficient full-size SLR, but be as portable as an ordinary press camera when folded. Made for only a short period due to patent problems. \$300-450.

Folding rollfilm cameras - for 120 or 116 rollfilms. Various models with Goerz lens and Goerz or Compur shutter. \$30-45.

GOERZ...

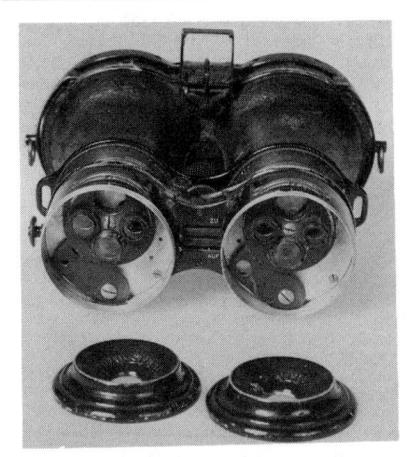

Photo-Stereo-Binocle - c1899. An unusual disguised detective binocular camera in the form of the common field glasses of the era. In addition to its use as a single-shot camera on 45x50mm plates, it could use plates in pairs for stereo shots, or it could be used without plates as a field glass. f6.8/75mm Dagor lenses. \$3200-4600

Roll Tengor - c1925. Vertical folding rollfilm cameras. Cheaper lenses than the Roll Tenax.

4x6.5 cm - Vest Pocket size, 127 film. Goerz Frontar f9/45mm lens. Shutter 25-100, T,B. \$45-60.

6x9cm - Tenaxiar f6.8/100mm in Goerz 25-100 shutter. \$25-35.

6.5x11cm - Tenaxiar f6.8/125mm in Goerz 25-100 shutter. \$25-35.

8x14cm - Tenaxiar f6.8/165mm. Pronto shutter. \$45-60.

Tenax Cameras: listed by film type; plate cameras followed by rollfilm cameras.

Vest Pocket Tenax (plate type) c1909. Strut-type folding camera for 4.5x6cm plates. A smaller version of the "Coat Pocket Tenax". Goerz Double Anastigmat Celor f4.5/75mm, or f6.8 Dagor or Syntor lens. Compound, Compur, or guillotine shutter. \$150-225.

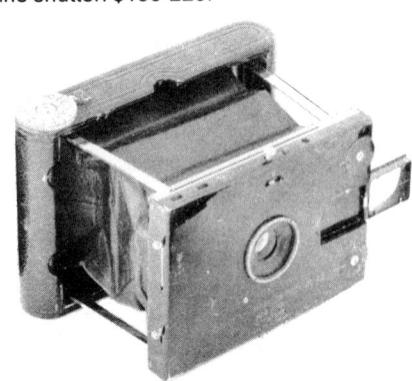

Coat Pocket Tenax - c1912-25. 6.5x9cm on plates or film packs. Strut-type camera like the Vest Pocket Tenax. Goerz Dagor f6.8/90mm or Dogmar f4.5/100mm. Compoundshutter 1-250, T, B. \$60-90.

Tenax Folding Plate cameras, bed type (Tenax, Manufoc Tenax, Taro Tenax, etc.) - c1915-1920. Folding bed cameras in common square-cornered plate camera style. Double extension bellows. Ground glass back.

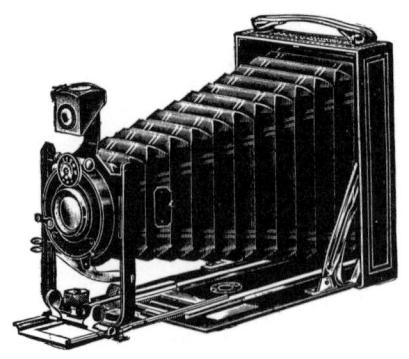

Goerz Taro Tenax

9x12cm size - Goerz Dogmar f4.5/150mm. Dial Compur1-150. \$60-90. **9x12cm, Tropical -** c1923. Teakwood

9x12cm, Tropical - c1923. Teakwood with brass fittings. Brown or red leather bellows. Dogmar f4.5 or Xenar f3.5/135mm in dial Compur. \$350-500.

9x14cm size - Goerz Dogmar f4.5/ 165mm, \$75-100.

10x15cm - Goerz Dagor f6.8/168mm, or Tenastigmat f6.3. Compound or Compur shutter. \$60-90.

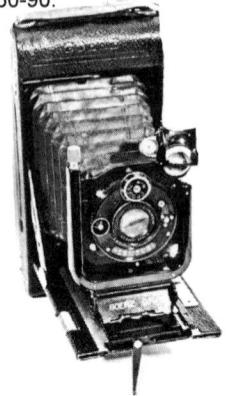

Roll Tenax - c1921. Bed-type folding rollfilm models.

4x6.5cm - Vest pocket size for 127 film. Similar to the folding vest pocket cameras of Kodak & Ansco. f6.3/75mm Dogmar in Compurshutter to 300. \$60-90.

6x9cm - Tenastigmat f6.3/100mm in Compurshutter 1-250. \$35-50.

6.5x11cm - Goerz Dogmar f5/125mm in Compur. \$30-45.

8x10.5cm - Tenastigmat f6.8/12.5cm or Dogmar f4.5/12.5cm. \$45-60.

8x14cm - Postcard (31/₄x51/₂") size. Dogmar f4.8/165mm or Dagor f6.8 in Compur. \$60-90.

Roll Tenax Luxus - c1925-26. Metal parts are gold-plated. Wine red leather covering and bellows. (Also made in blue/green version.) Dogmar f4.5/75mm. Compur 1-300. Rare. \$600-900.

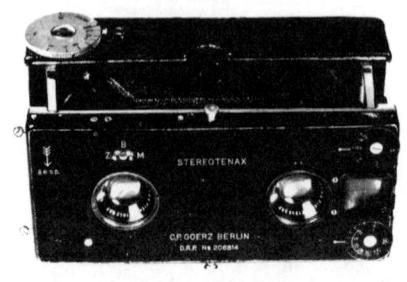

Stereo Tenax - c1912-25. Strut folding stereo camera for 45x107mm plates or packs. Goerz 60mm Dagor f6.8, Syntor f6.3, or f4.5 Dogmar or Celor. Stereo

Compuror Compoundshutter. \$250-375.

Tengor - see Box Tengor, Roll Tengor

GOERZ (Optische Anstalt C.P. Goerz, Vienna) This is a different company from C.P. Goerz, Berlin which existed from 1886-1926.

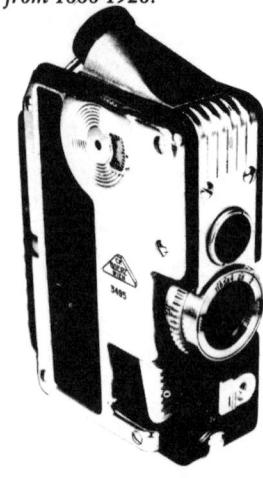

Minicord - c1951. Subminiature TLR for 10x10mm exposures on 16mm film in special cartridges. f2/25mm Goerz Helgor lens. Metal focal plane shutter 10-400, sync. Occasionally found with gold metal and red or green leather. A red/gold example topped \$1200 at Christie's 12/91 auction. Normal black/chrome models are common at \$300-450.

Minicord III - c1958. Brown leather covered. \$300-450.

Minicord Enlarger - In wooden case which also serves as base for enlarging. \$100-150.

GOLDAMMER (Gerhard Goldammer, Frankfurt)

Golda - c1949. 35mm camera with uncoupled rangefinder. Trinar f3.5/45mm, Ennaron f2.8/50mm, or Radionar f2.9/50mm in Prontor-SV, or Prontor II shutter. \$75-100.

Goldeck 6X6 - c1960. Rigid-bodied 120 rollfilm camera with telescoping lensmount. Six models per original brochure:

-Goldeck I - Steiner Bayreuth f2.9, Prontor SVS.

-Goldeck II - Steiner f2.9, Pronto B,25-200.

-Goldeck III - Steiner f3.5/75mm, Vario 25-200,B.

-Goldeck IV - Steiner f4.5, Vario. -Goldeck V - f7.7, Gauthier Acro B,25,75

-Goldeck V - f7.7, Gauthier Acro 8,25,75 shutter.

-Goldeck VI - f8, Gauthier Acro shutter. Current price range: \$30-45.

Goldeck 16 - c1959. Subminiature for 10x14mm exposures on 16mm film. Interchangeable "C" mount f2.8/20mm Enna-Color Ennit lens. Behind the lens shutter. Several models exist. Standard model has fixed focus lens in Vario shutter. Model IB is similar, but with focusing mount. The Super Model has a 9-speed Prontor shutter and front cell focusing. All have rapid wind lever, bright frame finder. While classified as a subminiature because of its small film, the camera is about the same size as a compact 35mm camera. With normal and telephoto lenses: \$120-180. With normal lens only: \$90-130.

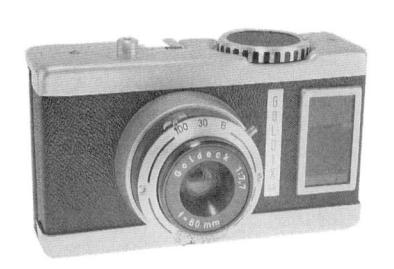

Goldix - c1950's. Unusual brick-shaped camera for 4x4cm on 127 film. Eye-level viewfinder is built into the far side of the body. Goldeck f7.7/60mm. Singlo-2 shutter 30-100. \$30-45.

GuGo - c1950. Low priced 6x6cm camera with telescoping front. Similar to the Welta Perle Jr. 120. Kessar f4.5/75mm in Vario 25-200. \$20-30.

GOLDMANN (R. A. Goldmann. Vienna)

Amateur Field Camera, 9x12cm c1895-1900. Wood body with brass trim, tapered bellows. Goerz Doppel Anastigmat f4.6/150mm. \$150-225.

Field camera, 13x18cm - c1900. Reversible back, Aplanat lens, mahogany body with brass trim. \$150-225.

Press camera - c1900. Bedless strutfolding 9x12cm plate camera. Zeiss Tessar f6.3/135. Focal plane shutter T, B, 1/2-90. Black wood body, leather bellows, nickel trim & struts. \$175-250.

Universal Detective Camera - c1896. Black wood body, nickel trim. 13x18cm plates. Rare. \$600-900.

Universal Stereo Camera, 9x18cm c1906. Strut-type focal plane stereo camera. Ebonized wood body. Tessar f6.3/136mmlens. Rare. \$800-1200.

GOLDSTEIN (France)

Camping - c1950. Cardboard box camera with leatherette covering. An

uncommon name variant of the Goldy box for 6x9cm on 120. Colors: \$75-100. Black: \$12-20

Goldy - c1947. Box camera of heavy cardboard with colored covering. Takes 6x9cm on 120 film. Built-in yellow filter. Made in black, blue, white, red, green, and maroon. Also available under such diverse names as Spring, Superas, Week-End, and Racing. Colors: \$30-45. Black: \$8-15.

Goldy Metabox - Vertically styled aluminum box camera with tapered front. Rigid Galilean finder on top under strap. Takes 120 or 620 film. Double exposure prevention. \$15-25.

Olympic - c1948. Cardboard box camera similar to the Goldy box. Special foil front includes the Olympic Games logo of five interlocking rings. Uncommon. \$30-45.

Spring - c1948. Cardboard box camera; name variant of Goldy box. \$12-20.

Starmetal Goldy - c1948. Brown anodized aluminum box camera for 6x9cm. Heavy bakelite interior. Reversing

finder is unusual for a box camera. Uncommon. \$75-100.

Week End (metal) - Stamped aluminum 6x9cm box camera with black crinkle finish. \$25-35. See Goldy above for card-board version of Week-End camera.

GOLTZ & BREUTMANN (Berlin and Dresden) Started in Berlin, later moved to Dresden. Began the manufacture of reflex cameras and strut cameras in 1898, probably made more than anyone else in the world except Graflex. Name changed from "Goltz & Breutmann Fabrik Photogr. Apparate" to "Mentor-Kamera-Fabrik". Later Mentor cameras were made by Rudolph Grosser, Pillnitz. All Mentor cameras are listed here, including those manufactured by Mentor-Kamera-Fabrik, or Rudolph Grosser. Klein-Mentor - c1913-35. A small SLR

for 6x9cm and 6.5x9cm formats. Fold-up viewing hood. Measures 31/2x4x43/4" when closed. This camera is a smaller version of the Mentor Reflex. Triotar f6.3/135mm in Compur 1-250, \$175-250.

Mentor Compur Reflex - c1928, SLR

GOLTZ...

box for 6.5x9cm plates. Also made in less common 9x9cm size. Zeiss Tessar f4.5/105 or f2.7/120mm lens. Compur shutter 1-250. Reflex viewing, ground glass at rear, and adjustable wire frame finder. Black metal body, partly leather covered. \$150-225.

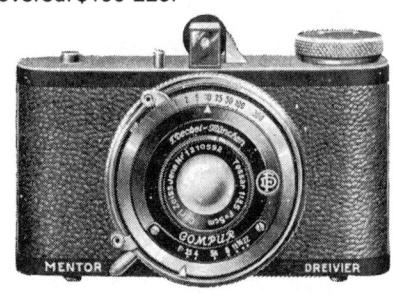

Mentor Dreivier - c1930. An eye-level camera for 16 exposures 3x4cm on 127 film. Styled much like a 35mm camera. Tessar f3.5/50mm lens in Compur shutter 1-300. Rare. \$750-1000.

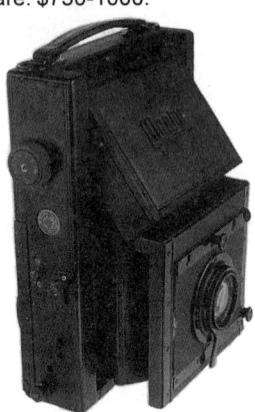

Mentor Folding Reflex (Klappreflex) - c1913-30. Compact folding SLR in four different styles. The only common style folds up tall and thin and was made in a wide range of sizes, including 6x9cm, 9x12cm and 4x5". Zeiss Tessar lenses, usually f2.7 or f4.5. Focal plane shutter to 1000. \$200-300.

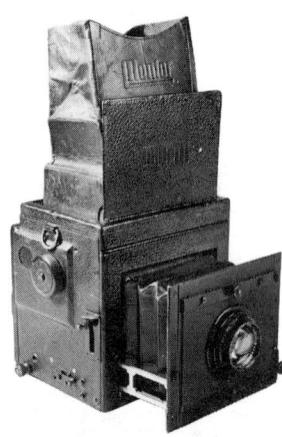

Mentor Reflex - c1898-1960's. Basically a cube when closed. Fold-up viewing hood, bellows focus, focal plane shutter. Various styles with or without bellows or R.B. in three common sizes: 6.5x9cm, x12cm, and 10x15cm. For plates or packs. Most common lenses are f4.5 Tessar, Heliar, and Xenar. \$250-375.

Mentor Sport Reflex, 9x12cm c1936. Box-form SLR without bellows. This is the only post-1905 Mentor Reflex without bellows. Tessar f4.5/135mm lens. FP $^{1}/_{8}$ -1300. Rare. \$200-300.

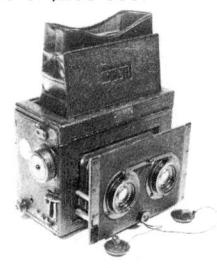

Mentor Stereo Reflex - c1913-25. Bellows focusing focal plane box reflex for stereo pairs in the two common European stereo sizes: 45x107mm, with Tessar f4.5/75mm lenses, and 6x13cm with Tessar f4.5/90mm lenses. Both sizes have focal plane shutter 15-1000. \$500-750.

Mentor Studio Camera - c1960-70s. Double extension folding plate camera. Solid wood and metal construction. Tessar f4.5/210mmlens. FP shutter. \$250-375.

Mentor Studio Reflex - c1935-60. Waist-level SLR, 13x18cm plates. Long extension bellows. Tessar f3.5/250mm lens. FP shutter, 1/5-1500. Later ones could also take a 6x9cm rollholder. \$200-300.

Mentor II - c1907. A strut-folding 9x12cm plate camera (NOT a reflex). Triplan f6/125mm or Tessar f4.5/120mm lens. Focal plane shutter. Wood body covered with black leather. Ground glass back. \$150-225.

Mentorett - c1936. TLR for 12 exposures 6x6cm on 120 film. Mentor f3.5/75mm. Variable speed focal plane shutter, $^{1}/_{15}$ - $^{1}/_{600}$ sec. Film transport, shutter setting and release are all controlled by a single lever. Automatic exposure counter. This is a relatively rare camera, which shows up about once a year at auction in Germany, where it sells in the range of \$600-900.

can be recognized by the logo of a pentaprism with an arrow indicating the reflected light path, entering at the lower right and exiting at the lower left. The Cyrillic letters for GOMZ often appear in the trademark, and they resemble the Roman letters "roM3". A similar logo was used by the Krasnogorsk factory, but it had a trapezoidal shape, with the arrow entering from the left and exiting at the right. The GOMZ factory changed its name to "Leningrad" because of modifications of the economic structure about the beginning of the 1950's, then became LOMO

about 1966. "Lomo" is an acronym for Leningrad Optical-Mechanical Union. At this time, the trademark changed to the simple word "Lomo" which appears as a tall inverted "V" over the letters "OMO".

Cosmic-35 - Name variant of Smena cameras marketed widely in UK. \$20-30.

Fotokor - c1930. Russian folding plate camera. Gomz f4.5/135mm lens in 25-100,K,D shutter. \$60-90.

Global 35 - Name variation of Smena 6, black bakelite 35mm camera of simple but attractive design. f4/40mm lens; B, 15-250 shutter. Also sold as Cosmic 35. \$20-30.

Junost (10HOCMb) - ca. late 1950's. 35mm RF camera. A small clip couples the diaphragm and shutter settings when the exposure value is set. Separate eyepieces for viewfinder and rangefinder. T-32 f3.5/45mm lens; B,1/₈-250 shutter. Shutter and diaphragm settings read correctly when the camera is inverted by the user. Focusing scale and depth of field can only be read from above. \$300-450.

Komsomoletz - c1946-49. (Komsomoletz = Communist Youth). Bakelite twin lens reflex, copy of Voigtländer Brillant. Predecessor of the Lubitel. The camera body has "Leningrad" molded on the front below the shutter in Cyrillic letters (leHu-Hrpad). T-22 f6.3/75mm in B,25,50,100 shutter. \$75-100.

Lubitel, left; Lubitel 2, right

Lubitel - c1949-1956. (Lubitel = Amateur). TLR, 12 exposures, 6x6cm on 120 film. Successor to Komsomolesk, copy of Voigtländer Brillant. f4.5/75mm T-22 lens. Variable speed shutter, 10-200. \$25-35.
Lubitel 2 - c1955-1977. Improved version of Lubitel. Same bakelite body, but shutter has synchronization and self-timer. \$25-35. *Illustrated bottom of previous page.*

Lubitel 166 - c1977. (Factory name now Lomo). Restyled Lubitel, more modern in appearance. f4.5/75mm T-22 lens externally gear-coupled to viewing lens. Shutter B, 15-250. Hot shoe. \$20-30.

Lubitel 166B - c1980. Similar to 166, but with self-timer. \$20-30.

Maliutka - c1938. (Maliutka = little one). Small bakelite body, successor to Liliput (copy of Sidax). Uncommon. \$75-100.

Moment (MOMEHM) - c1952-54. Russian copy of Polaroid 95. Black bellows. T-26 f6.8/135mm lens in 10-200,B shutter. Folding reflex brilliant finder. Reportedly about 9000 were made but production was stopped due to difficulties producing film. Rarely found outside the former USSR until recent years. \$100-150.

Smena (1st model) - c1938. Small bakelite camera with pop-out strut-supported front. Styled after Kodak Bantam. Uncommon. Estimate \$60-90.

Smena 2

Smena - c1952-on. Cyrillic letters resemble "CMEHA". Black plastic 35mm cam-

eras, models 1 to 8. f4.5/40mm lens. Shutter 10-200, T. \$15-25.

Smena SL - Inexpensive black plastic 35mm camera with metal trim. Large weather symbol chart on top is mechanically coupled to the shutter speed ring. \$12-20.

Smena Symbol - c1970's. \$12-20.

Sport (Cnopm) - c1935? This camera is reputedly dated to 1935, which would qualify it as the first 35mm SLR. We have yet to see any proof of that date. Takes 50 exposures 24x36mm in special 35mm cassettes. Large boxy top housing serves as viewing hood for the focusing magnifier. Also features optical finder for eye-level direct viewing. Industar 10 f3.5/50mm lens. FP shutter B, 1/25-1/500. Once considered quite rare in the west, but now appearing regularly at auctions for \$300-700.

Sputnik (CNYTHNK) - c1960. (Sputnik = Traveling Companion). Black bakelite

GOMZ Turist

GRAEFE & BARDORF

three-lens reflex for 6x13cm stereo pairs on 120 rollfilm. f4.5/75mm lenses. Shutter 15-125. Ground glass focus. Originally packaged with collapsible viewer and printing frame. \$350-500.

Turist (Mypucm) - c1936. Interesting bakelite bodied strut-folding camera for 6.5x9cm plates. GOMZ Industar f3.5 105mm lens in Automat ¹/₂₅-¹/₁₀₀ shutter. Uncommon. \$120-180. *Illustrated bottom of previous column*.

Voskhod - c1970. Cyrillic letters look like "BOCHOD", while Roman-lettered models read "Voskhod", the Russian word for "sunrise". An unusual vertically styled 35mm camera featuring a built-in meter. Lomo T-48 f2.8/45mm lens. Shutter to 1/250. \$100-150.

GOODWIN FILM & CAMERA CO.

Named for the Rev. Hannibal Goodwin, the inventor of flexible film, but taken over by Ansco. See Ansco for the listing of "Goodwin" cameras.

GOYO CO. (Japan)
Rosko Brilliant 620, Model 2 c1955. Black bakelite 6x6cm reflex style
camera. 620 rollfilm. It is an export model
of the Palma Brillant Model 2 which used
120 film. \$25-35.

G.P.M. (Giuseppi Pozzoli, Milano, Italy)

Fotonesa - c1945. Black bakelite subminiature for 20x20mm exposures. Frontar Periscop f8. I,T shutter. Uncommon. \$200-300.

GRAEFE & BARDORF (Berlin)
Clarissa Nacht-Kamera - c1926. A
small focal-plane camera for 4.5x6cm
plates. Similar in style to the Ermanox. No
sales data.

GRAFLEX

GRAFLEX, INC. (Also including Folmer & Schwing and Folmer Graflex products from 1887-1973 except Cirkut cameras which are

listed under Eastman.)

Founded in 1887 as a partnership between Wm. F. Folmer & Wm. E. Schwing and incorporated in 1890 as the Folmer & Schwing Manufacturing Co., it began camera manufacturing in 1897. It incorporated in 1903 as the Folmer & Schwing Manufacturing Co. of New York. George Eastman purchased the company in 1905, moving it to Rochester NY where it was called the Folmer & Schwing Co., Rochester. The company dissolved in 1907, becoming first the Folmer & Schwing Division of Eastman Kodak and then in 1917 the Folmer & Schwing Division of Eastman Kodak and then in 1917 the Folmer & Schwing Department of Eastman Kodak Co. The new Folmer-Graflex Corporation took over the reins in 1926, changing its name to Graflex Inc. in 1945. Graflex was a division of General Precision Equipment Corp. from 1956 until 1968 when it became a division of Singer Corporation. In 1973, Graflex dissolved and Singer Educational Systems was formed, the latter being bought by Telex Communications in 1982.

BRIEF EXPLANATION OF SERIAL NUMBERS RELATING TO GRAFLEX

The numbers on the attached chart have been taken directly from the original company serial number book. The first existing page of that book starts somewhere in the year 1915. From observations of actual cameras made previous to 1915 it would be safe to assume that the serial numbers run sequentially at least back to 1905. Because of the purchase of Folmer & Schwing in 1905 by Eastman Kodak, it is not known at this time whether the serial numbering was changed because of that purchase. Furthermore, it must be kept in mind that Folmer & Schwing did not actually start manufacturing their own cameras until 1897. Before that year, the cameras that they offered under their own name were manufactured by someone else. The question is; was the serial numbering started before 1897, or only after the company began its own manufacturing? Also, whenever the serial numbering started did it begin with number 1?

The attached chart only takes the serial numbers through the end of 1947. After that year, a great deal of confusion begins, and it would take more room than the Price Guide allows to explain it all. Basically, after 1947 different camera models were assigned different serial number blocks, and the blocks do not run sequentially. In addition, several numbers were repeated within the same camera model line. The serial number list will be printed in its entirety and the confusion minimized in the forthcoming book on the history of Graflex by Roger M. Adams.

The accompanying chart should also be used only as an approximation, as it reflects only the dates that the serial numbers were entered in the book. The cameras were actually made sometime during the following 8-12 months. It should NOT be used to figure the total amount of cameras that were manufactured as some cameras were scrapped and others were never made, even though the serial numbers had already been assigned. The serial number book was never changed to show any of these variations. Actual

production figures may never have existed, and if they did, have not been located as of this date.

Folmer-Graflex Corporation 147,607-159,488-----1926-1927 159,489-175,520-----1928-1930 175,521-183,297-----1934-1937 229,311-249,179-----1938-1939 249,180-351,511-----1940-6/15/45

Graflex, Inc. 351,512-457,139-----7/30/45-1947

A great deal of information in this section was used with the kind permission of Mr. Richard Paine, from his 1981 book "A Review of Graflex" published by Alpha Publishing Co., Houston, Texas. Collectors wishing more detailed information on Graflex cameras should consult this book.

We would also like to thank Roger Adams for reviewing this section and adding notes and corrections where necessary. Mr. Adams is currently working on a book on Graflex cameras.

NOTE: To keep major lines together, we have divided this section into three parts, each in alphabetic order:

1. Graflex Single Lens Reflex Cameras.

Craphic cameras, including press and small format types.
 Other cameras made by Graflex

GRAFLEX SLR CAMERAS: All models have focal plane shutters to 1000, unless otherwise noted.

Graflex (original) - c1902-05. (Earliest patent granted 11/5/01.) Boxy SLR with fold-up viewing hood. Stationary back. Top-hinged door covers the interchangeable lens. Focal plane shutter to 1200. Shutter controls on one piece plate. Normal lenses f4.5 to f6.8. Rare, negotiable. Estimates: 4x5" and 5x7": \$400-600. 8x10": Find one first, then ask the price!

Graflex 1A - 1909-25. 21/₂x41/₄" on 116 film. B&L Tessar f4.5 or f6.3, Zeiss Kodak Anastigmat f6.3, or Cooke f5.6 lens. Early cameras have an "accordian" style hood with struts for support. Later ones have the

more typical folding hood. Autographic feature available 1915-on. \$120-180.

Graflex 3A - 1907-26. 31/₄x51/₂" "post-card" size on 122 film. Minor body changes, including the addition of the autographic feature, in 1915. Various lenses, f4.5 to f6.8. \$120-180.

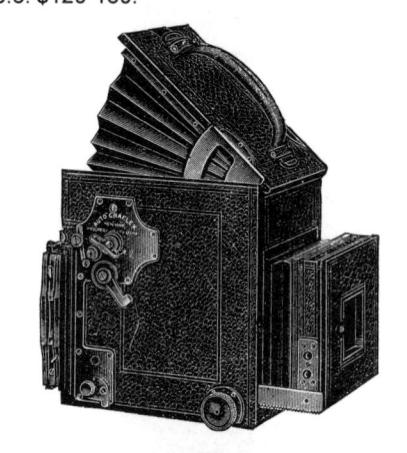

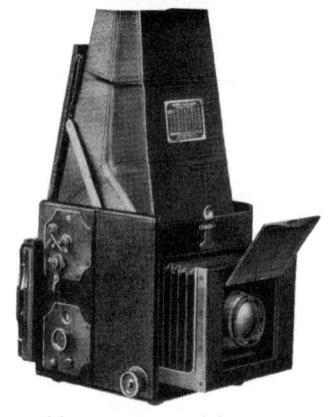

Early and later versions of the Auto Graflex

Auto Graflex - 1906/1907-1923. (Patented 2/5/07.) Stationary Graflex back. Extensible front with lens door hinged at top. Normal lenses f4.5 to f6.8. Design changes include: Pleated hood with front hinge, 1907-c.1910. Folding hood with front hinge c.1911-15. Folding hood with rear hinge 1916-23. 31/4x41/4": \$100-150. 4x5": \$120-180. 5x7": \$175-250. Add \$50-75 for early model with pleated bood.

Auto Graflex Junior 21/4x31/4" - 1914-24. Stationary Graflex back. Top door hinges at back. Bulge at rear for reverse-wind curtain. Extensible front. Same body later used in the 21/4x31/4" series B. \$120-180.

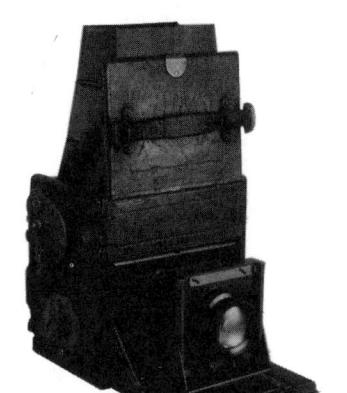

Compact Graflex - Stationary Graflex back. Top door hinged at front. Front bed. Double curtain to cap shutter. 31/4x51/2" - 1915-24.\$175-250. 5x7" - 1916-25.\$250-375.

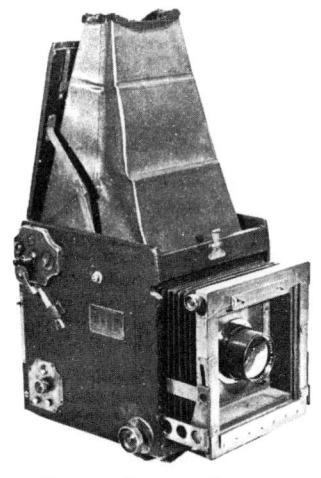

Home Portrait Graflex - 1912-42. 5x7". Revolving back. FP 1/2-500. Also available as "Special Press Model" with shutter to 1000. The focal plane shutter could be set to pass one, two, or more of the aperture slits for a single exposure, allowing a broad range of "slow" speeds. Normal lenses f4.5 to f6.3. This camera was the basis for "Big Bertha". \$350-500.

National Graflex - SLR for 21/₄x21/₂" on 120 rollfilm. Focal plane shutter to 500, B. B&L Tessar f3.5/75mm. Two models: **Series I** - 1933-35. Non-interchangeable lens. Mirror set lever at operator's right of hood. \$150-225.

Series II - 1934-41. Cable release. Mirror set lever at operator's left of hood. Ruby window cover. With normal f3.5/75: \$120-180. (B&L f6.3/140 telephoto: \$90-130.)

Naturalists' Graflex - 1907-21. One of the rarest of the Graflex cameras, it has a long body and bellows to accomodate lenses up to 26" focal length. The 1907 model has a stationary viewing hood, set to the rear. After that, viewing hood could be positioned to view from top or back. \$2800-4000.

Press Graflex - 1907-23. 5x7" SLR with stationary detachable spring back, extensible front and no bed. Focal plane shutter $1/_5$ -1500. Normal lenses f4.5 to f6.8. \$300-450.

Reversible Back Graflex - c1902-05. Very similar to the original Graflex camera, but featuring a reversible back. Made in 4x5" and 5x7" sizes. Focal plane shutter to 1200. A knob on the front standard to raises and lowers the lensboard. \$400-600.

Revolving Back Auto Graflex - Normal lenses f4.5 to f6.8. 31/4x41/4" - 1909-41. Style of 1909-16 has front door which forms bed, unlike earlier 4x5" model; front hinged top lid,

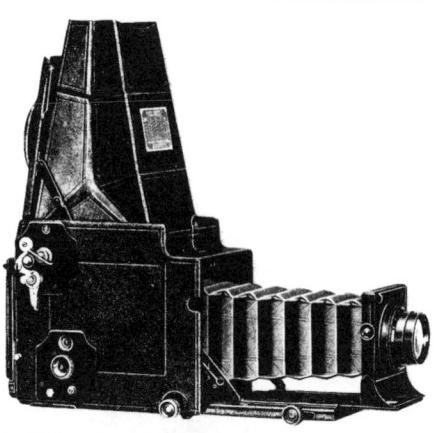

3x3" lensboard. Version from c1917-41 has a unique top-front curve, rear hinged top lid, and a $3^{1}/_{4}x3^{1}/_{4}$ " lensboard. \$120-180.

4x5" - 1906-41. Early models from 1906-1908 are styled like the original Graflex. Extensible front racks out on two rails; front flap covers lens. Later styles like the 31/4x41/4" size described above, but with 3.75x3.75"lensboard. \$150-225.

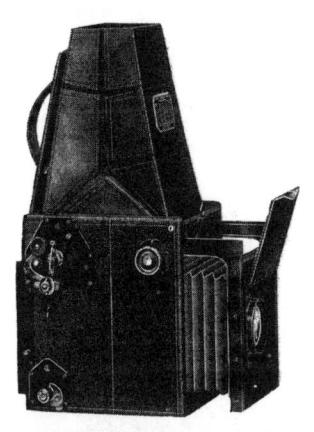

R.B. Graflex Junior - 1915-23. Smaller $2^{1}/_{4}$ x31/₄" size featuring the revolving back. Fixed lenses, normally f4.5 to f6.3. Lensboard suspended from focusing rails. Similar body style later used for the R.B. Series B. Rare. \$175-250.

Graflex Series B - Stationary back. Kodak Anastigmat f4.5 lens. Small, unhooded front door opens upward allowing lens and small bellows to extend for focusing.

Illustrated at top of next page. 21/4×31/4" - 1925-26 only. Rare. \$200-300

GRAFLEX...

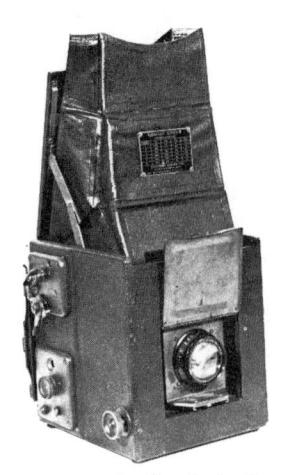

Graflex Series B

31/_{**a**}**x41**/_{**a**}" - 1923-37.\$75-100. **4x5**" - 1923-37.\$120-180. **5x7**" - 1925-42.\$175-250.

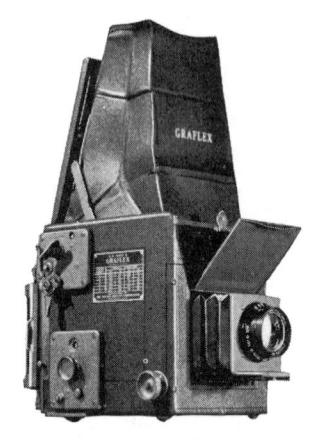

R.B. Graflex Series B - Revolving

back. Kodak Anastigmat f4.5 lens. 21/4x31/4" - 1923-51. Same body style as earlier RB Graflex Junior. Small front door opens allowing lens and small bellows to extend. \$150-225.

31/4x41/4" - 1923-42. Same body style

as RB Tele Graflex. \$100-150.

4x5" - 1923-42. Same body style as RB Tele Graflex. \$120-180.

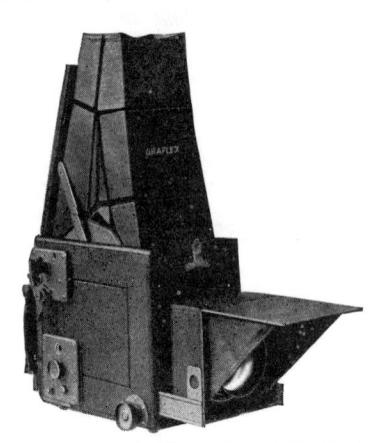

R.B. Graflex Series C - 1926-35. Only available in 31/₄x41/₄" size. Revolving back. Fixed Cooke Anastigmat f2.5/61/₂" lens. Extensible front with hood over the lens. Rare. \$150-225.

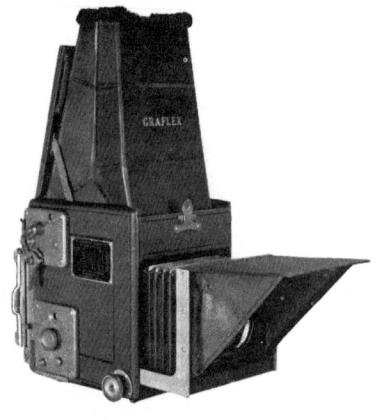

R.B. Graflex Series D - Same body as the earlier RB Tele Graflex and RB Series B. Interchangeable lensboards. Extensible front with hood over the lens. Grey-painted hardware. Later 4x5" models have black hardware and chrome trim.

31/₄x41/₄" - 1928-41.\$100-150. **4x5" -** 1928-47.\$150-225.

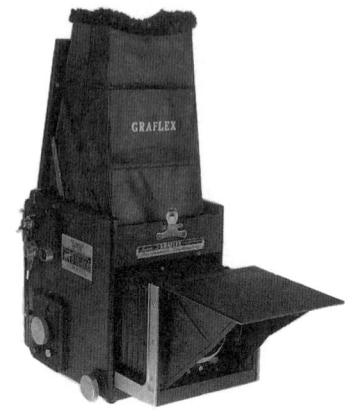

R.B. Super D Graflex - Revolving back SLR. Flash synch on focal plane shutter. Automatic stop-down diaphragm. Minor variations made during its life.

31/4x41/4" - 1941-63. Normal lenses: Kodak Anastigmat f4.5, Kodak Ektar f4.5 and f5.6. \$175-250.

4x5" - 1948-58. f5.6/190mm Kodak Ektar or Graflex Optar. \$300-450.

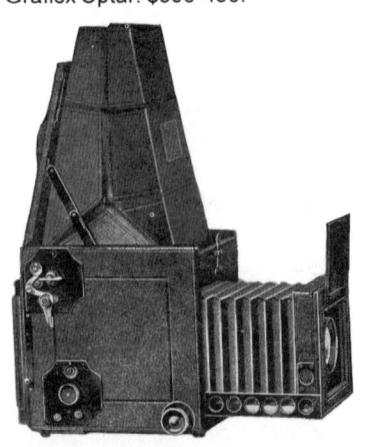

R.B. Tele Graflex - 1915-23. Revolving back. Designed with a long bellows to allow the use of lenses of various focal lengths. Same body used for RB Graflex Series B beginning in 1923. 31/₄x41/₄": \$100-150.4x5": 110-140.

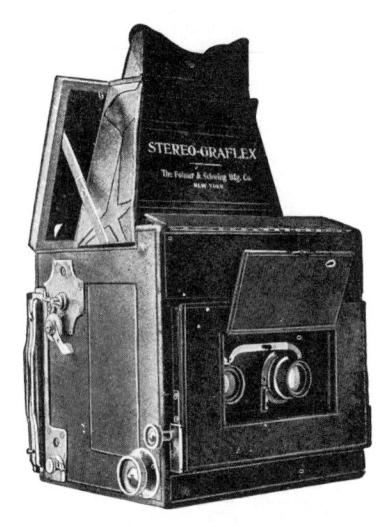

Stereo Graflex - 1904-05. 5x7" stereo SLR. Stationary back. Similar to style to the original Graflex, but wider to allow for stereo exposures. Two magnifiers in the hood. Quite rare. \$2400-3200.

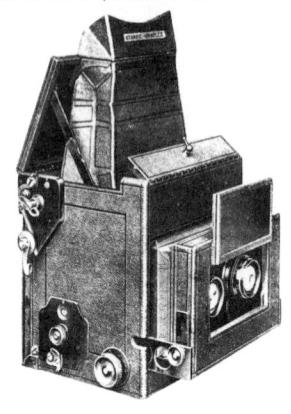

Stereo Auto Graflex - 1906-23. 5x7" stereo SLR with only minor improvements having been made on the Stereo Graflex. Stereo prisms in the viewing hood resulted in one STEREO image on the ground glass. That has to be the ultimate composing aid for stereo photographers. Rising front. Very rare. \$1700-2400.

Tourist Graflex - c1902-05. Stationary back. Extensible front. Sliding-door covers interchangeable lens. Shutter controls on one piece plate. 4x5" and 5x7" sizes. Very rare. Estimate: \$500-750.

GRAPHIC CAMERAS:

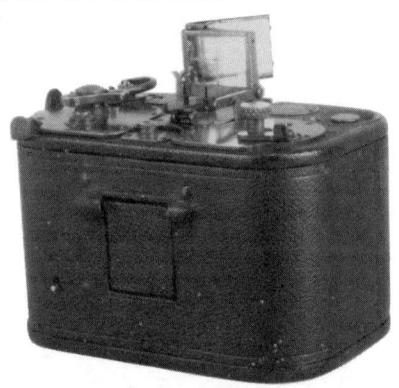

No. 0 Graphic - 1909-23. 15/8x21/2" on rollfilm. Focal plane shutter to 500. Fixedfocus Zeiss Kodak Anastigmat f6.3 lens. \$200-300.

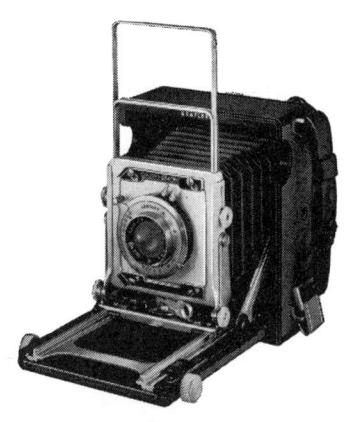

Century Graphic - 1949-70. 21/4x31/4" press camera. Basic features of the Pacemaker Crown Graphic, but no body release, Graflok back only, and has a plastic body. Black or grey body with black or red bellows. With Ektar f4.5: \$175-250. With Xenotar f2.8: \$250-375.

Combat Graphic - c1942. 4x5" military camera made for the armed forces in WWII. Rigid all wood body, without bellows. Olive drab color. No tension knob on shutter. Sold as a civilian model "Graphic 45" in 1945. \$300-450. Note: the name "Combat Graphic" has been applied by collectors to other military models of conventional cameras, but we have listed those by their proper designation after the correspond-ing civilian models. See Anniversary Speed Graphic for PH-47-E, Pacemaker Speed Graphic for KE-12(1), and Super Speed Graphic for KE-12(2). The 70mm model KE-4(1) is with the miscellaneous models at the end of the Graflex Inc. section.

Crown Graphic Special - c1958-73. Same as the 4x5" Pacemaker Crown Graphic, but sold with Schneider Xenar f4.5/135mm lens. Rangefinder/viewfinder mounted on top. Synchro-Compur 1-500,B. \$250-375.

Deceptive Angle Graphic - c1904. Leather covered box camera for 31/4x41/4'

exposures using double plate holders, magazine plate holder or cartridge rollholder. The 1904 Graflex catalog calls it "in every sense of the word a detective camera, being thoroughly disguised to resemble a stereo camera and so arranged as to photograph subjects at right angles to its apparent line of vision." Quite rare. Estimate: \$3200-4600.

Graphic camera - c1904. Simple plate cameras with single extension red bellows. No back movements. Made in 4x5", 5x7", 8x10" sizes. \$175-250.

Graphic 35 - c1955-58. 35mm camera. Body was designed and built in the U.S.A. by Graflex. Lens and shutter for this camera were made in Germany and imported by Graflex for use on this camera. Graflar f3.5 or 2.8/50mm lens in helical mount with a unique push-button focus. Prontor 1-300 shutter. Coupled split-image rangefinder. \$30-45.

Graphic 35 Electric - c1959. 35mm camera with electric motor built into the takeup spool. Made by Iloca in Germany for Graflex. Coupled meter. Ysarex f2.8 or Quinon f1.9 lens in Synchro Compur shutter. Interchangeable front lens element. In excellent working condition: \$100-150. Often found with inoperative motor: \$35-50.

Graphic 35 Jet - c1961. An unusual design, incorporating an auto advance mechanism powered by CO2 cartridges. Made by Kowa for Graffex. Quite prone to problems with both the shutter and the CO2 advance system.

Completely operational, with original case, box, and a few spare CO2 cartridges: \$250-375.

- As normally found with the CO2 system inoperative: \$120-180.

With shutter also bad: \$60-90. Note: Because of the problems with the CO2 advance mechanism, a completely manual model was also made.

Graphic Sr. - c1904. Very similar to the Graphic camera of the same era, but with

GRAFLEX...

swing back. Red bellows. Polished brass trim. 4x5" or 5x7". \$150-225.

Pacemaker Crown Graphic - Front shutter only. No focal plane shutter. Built-in body release with cable running along bellows. Metal lensboard. Hinged-type adjustable infinity stops on bed. Wide range of current prices

21/₄x31/₄" - 1947-58.\$150-225. 31/₄x41/₄" - 1947-62. Not a popular size for use. \$100-150.

4x5" - 1947-73. (The top mounted Graphic rangefinder with interchangeable cams was added in 1955.) With Graflok back: \$250-375

Reversible Back Cycle Graphic -c1900-06. "Cycle" style cameras with reversible back. Interchangeable lensboards. Black leather, triple-extension red bellows, rising front

31/₄x41/₄" & 4x5" sizes - \$150-225. 5x7" & 61/₂x81/₂" sizes - \$175-250.

Reversible Back Cycle Graphic Special - 1904-06. Similar to the original R.B. Cycle Graphic, but sturdier design. Double-swing back. Rising/falling, shifting front. Drop-bed. Front and back focusing. Black leather, triple extension black bellows. Grey-oxidized brass trim. An accessory focal plane shutter was available. 5x7" and 61/2x81/2" sizes. Quite rare. \$200-300.

GRAFLEX...

Revolving Back Cycle Graphic -1907-22. Very similar to the Reversible Back Cycle Graphic (above), but has revolving back, no back focus or rear movements. An accessory focal plane shutter was available. 4x5": \$120-180. 5x7", 61/2x81/2", 8x10": \$250-375.

SPEED GRAPHIC CAMERAS Many modifications and improvements were made in these cameras during their exceptionally long life-span (1912-68), so they are usually sub-divided for identification purposes into the following periods: Early (or top handle), Pre-anniversary, Anniversary, and Pace-maker. All models have focal plane shutters. The Speed Graphics are listed here in essentially chronological order.

Early Speed Graphics - Top handle. Barrel lenses. Tapered bellows, almost double extension. Rising front. Folding optical finder with cross-hairs. Single focus knob on wooden bed.

31/₄x41/₄" - 1915-25. \$90-130. 31/₄x51/₂" - 1912-25. \$150-225. 4x5" - 1912-27. (More compact style introduced in 1924, and called Special Speed Graphic.) \$100-150.

5x7" - 1912-24. \$175-250.

Pre-anniversary Speed Graphic -Side handle. Larger, straight bellows accomodate larger lens standard and board. Early versions with folding optical finder, later changed to tubular finder. Hinged (not telescoping) sportsfinder. Wooden bed with single focus knob. Grey trim.

31/₄x41/₄" - 1935-39.\$100-150. **4x5"** - 1928-39.\$150-225. **5x7"** - c1932-41.\$200-300.

Miniature Speed Graphic - 1938-47. 21/4x31/4". Could almost be classified as an Anniversary model with its two focus knobs on the metal bed and chrome trim, but other features from the pre-anniversary years remain. The bed does not drop; the front does not shift. The sportsfinder is

hinged, not telescoping. Earliest models with folding optical, later with tubular finder. \$150-225.

Anniversary Speed Graphic - 1940-47. Metal drop-bed with two focus knobs. Rising/shifting lens standard. Wooden lensboard. Telescoping sportsfinder. No body release for front shutter. All black (wartime models) or chrome 31/4x41/4": \$90-130.4x5": \$150-225. Military Model PH-47-E - Black version, came as part of the PH-104 outfit

with a wood tripod in a fibre carrying case. Outfit: \$250-375. Camera only: \$175-250. Military Model PH-47-H - Black version which came as part of a later PH-104 outfit with a metal tripod in an olive drab

"LE-9(1)" Halliburton case. Outfit: \$250-375. Camera only: \$175-250.

Pacemaker Speed Graphic - Metal lensboard. Two focus knobs on the metal drop-bed. Built-in body release with cable running along the bellows. Single control on focal plane shutter. Hinged adjustable infinity stops on bed. Telescoping sportsfinder. Tubular viewfinder. Chrome trim. Prices vary widely. Most fall into the

ranges listed, and there is no shortage of these cameras, but some vendors consistently advertise at higher prices.

21/₄x31/₄" - 1947-58, \$200-300, 31/₄x41/₄" - 1947-63, \$120-180, 4x5" - 1947-68, (Top mounted Graphic

rangefinder with interchangeable cams added in 1955.) \$250-375

Military model KE-12(1) - 4x5". Optar f4.5/127mm. Olive drab leather & enamel: \$250-375. Full set KS-4A(1), with flash unit, film holders, tripod, etc. in Halliburton case, \$350-500.

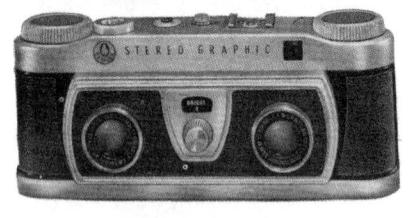

Stereo Graphic (35mm) - ca. mid-1950's for stereo pairs on 35mm film. Graflar f4/35mm lenses in simple shutter. 1/50, B. \$90-130.

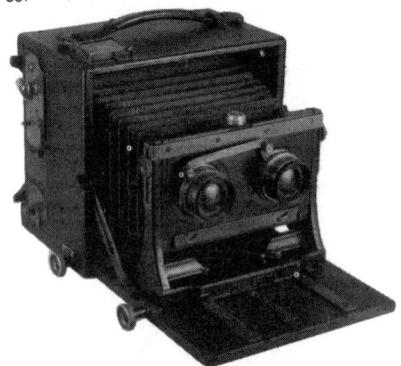

Stereoscopic Graphic - c1902-21. Solidly built 5x7" stereo camera. Focal plane shutter. Rising front. Drop bed. Black bellows. Grey metal parts. Very rare. \$1700-2400.

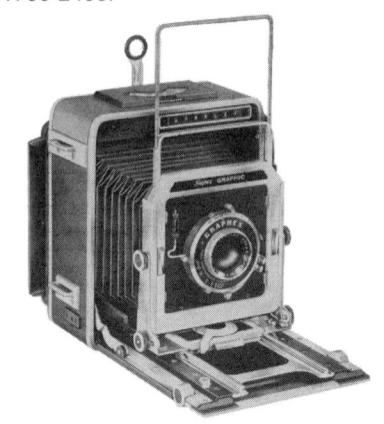

Super Graphic - 1958-73, 4x5", Allmetal press style camera. Built-in coupled rangefinder. Focusing scale for lenses from 90 to 380mm. Normal lenses include: Kodak Ektar f4.7/127, Schneider Xenar or Graflex Optar f4.7/135mm. Rise, swing, shift, tilt front movements. Revolving back. Electric shutter release. \$300-450.

Super Speed Graphic - 1959-70. 4x5". Same as the Super Graphic (above), but with Graflex-1000 front shutter. No focal plane shutter. \$300-450

Military model KE-12(2) - with tripod. flash, etc. in olive drab Halliburton case: \$300-450.

Graphic View - 1941-48. 4x5" monorail view camera. Front and rear standards have base tilt, not axis tilt. Without lens: \$175-250

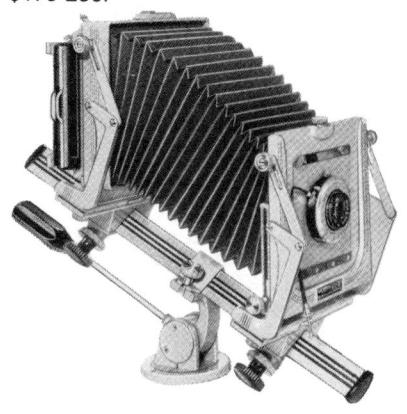

Graphic View II - 1949-67. Improved version of the 4x5" monorail view camera. Has center axis tilts, not available on Graphic View I, and longer bellows. Without lens: \$250-375.

MISCELLANEOUS CAMERAS FROM GRAFLEX INC.:

Century 35 - c1961. 35mm camera made by Kowa in Japan. Several models including A, N, NE. Prominar f3.5, 2.8, or 2.0 lens. Similar to the Kallo 35. \$30-45.

Century Universal - c1929-36. Triple extension 8x10" view camera with reversible back, full front swings & tilts. Edward Weston reportedly retired his former camera in 1932 to get a Century Universal. He is quoted as saying he had earned the privilege of working with the best camera made. A good working example readily brings \$400-600 or more from a commercial user, while most collectors would pay \$200-300.

Ciro 35 - c1950. 35mm RF camera, formerly sold by Ciro Cameras Inc. f4.5, 3.5, or 2.8 lens. Alphax or Rapax shutter. \$30-45.

Crown View - 1939-42. Wooden 4x5" view camera. 4x4" lensboards interchangeable with 4x4" Speed Graphic. Rare. \$250-375.

Finger-Print Camera - 21/4x31/4". A

special-purpose camera for photographing fingerprints or making 1:1 copies of other photos or documents. The pre-focused lens is recessed to the proper focal distance inside a flat-black rigid shroud. To make an exposure, the camera front opening is placed directly on the surface to be photographed. Four battery-operated flashlight bulbs provide the illumination. (Two similar cameras called the Inspectograph (see listing below) and the Factograph were also made. The Factograph used special positive paper film on a roll. Later versions of the Factograph became very specialized using bulk loads of film, motorized advance, and special lighting: these versions bore no resemblance to the earlier models.) \$100-150.

Graflex 22 - TLR for 6x6cm on 120 roll-film. Optar or Graftar f3.5/85mm lens. Century Synchromatic or Graphex shutter. Black or grey covering. Fairly common. \$35-50.

Inspectograph Camera - Identical to the Fingerprint camera (see listing above), but wired for 110V AC current instead of built-in batteries. Only about 500 made. \$90-130.

KE-4(1) 70mm Combat Camera - c1953. Two versions: Civilian black or Signal Corps Model in olive drab. For 5.5x7cm exposures on 70mm rollfilm. Designed by the late Hubert Nerwin, formerly of Zeiss Ikon, the camera resembles an overgrown Contax and is nicknamed "Gulliver's Contax". A few years ago, these were scarce and highly sought. Then Uncle Sam started disposing of them, and now they are easy to find. The f4.5/21/2" Ektar wide angle is the least common lens. Camera set KS6.(1) with normal tale.

- Camera set KS6-(1) with normal, tele, and W.A. lenses and case: \$800-1200 in USA.

- Often found with f2.8/4" and f4/8" Ektar lenses, flash, and Halliburton case: \$600-900 asking prices.

Camera with normal lens only: \$350-500.
Mint examples have sold in Europe for 2-3 times the USA prices.

GRAFLEX...

Norita - c1969-73. Eye-level SLR for 6x6cm on 120 or 220 film. Three models: Deluxe, Professional (with front shutter), and Super Wide. Made by Norita Kogaku K.K. in Tokyo, imported by Graflex. Originally imported as the Warner. Noritar f2/80mm lens in interchangeable breechlock mount. Focal plane shutter 1-500. \$300-450.

Photorecord - Developed around 1934, introduced to the open market in 1936. Made through the 1950's in many different forms and models, including civilian and military versions. Special purpose camera for microfilming, personnel identification, and copy work. All versions were designed around the same basic heavy cast metal camera and film magazine unit, and were offered as complete outfits including lights, stands, copy or I.D. apparatus. Designed for use with 100 ft. rolls of 35mm film, they were capable of 800 "double frame" or 1600 "single frame" exposures. Also capable of single exposures using Graflex plate or film holders. Camera with film magazine: \$75-100.

XL - 1965-1973. A versatile, modular, medium-format camera system. The three bodies are Standard, Rangefinder, and Superwide. These are usually abbreviated XLS, XLRF, and XLSW. By far the most common is the XLRF. There are minor variations in the XLRF bodies as well. Some bodies require manual resetting of the rangefinder each time a new lens is mounted, by means of a small button on the top. The XL system was also used by the Brooks Veriwide camera, which is for practical purposes the same as the XLSW. Since the entire system is modular, there is no such thing as a standard camera. The basic body attaches to a back with four corner pins. The most common back attachment is a Graflok back adapter, which then allows use of rollfilm holders of various formats, or a focusing spring back which accepts sheetfilm holders. Polaroid backs and 70mm film backs attach directly with pins, eliminating the need for the Graflok adapter. Lens/shutter units are mounted on interchangeable barrels. Pricing a modular system gets a bit complicated, because of the number of component parts. Prices are determined by the user market. Collectors must be prepared to compete for the cleanest examples.

XLS Body - \$60-90. XLRF Body - \$75-100.

XLRF KS-98B - Standard rangefinder body in special version for U.S. military. Mostly black, with little or no chrome visible. Usually are fitted with Tessar 100mm

GRAFLEX...

f3.5. Shutter and lens rims are blackened over original chrome. A complete system, with grip, rollback, lens, straps, sportsfinder, flash, etc. in original case will bring more from a collector than a comparable civilian model. Outfit: \$600-900.

XLSW - Special body to accomodate the short focus of the Schneider Super Angulon 47mm lens. This body and lens are normally found together for \$500-750.

XL LENSES IN SHUTTER & BARREL: 47mm f8 Super Angulon - \$400-600. 58mm f5.6 Grandagon - \$300-450. 80mm f2.8 Planar - \$250-375. 95mm f2.8 Heligon - 175-225. 100mm f2.8 Planar - \$250-375. 100mm f3.5 Tessar - \$90-130. 180mm f4.8 Sonnar - \$250-375.

XL BACKS:

Graflok back adapter - Adapts 4-pin XL system to standard Graflok system for use with RH-10, RH-20, and focusing back. \$30-45.

Focusing back with hood - \$35-50 RH-10 - For 10 exposures, 6x7cm on 120 film. \$60-90.

RH-20 - For 20 exposures, 6x7cm on 220 film. \$60-90.

RH-50 - For 50 exposures, 6x7cm on 70mm film cartridges. \$60-90.

Polaroid back - \$90-130.

XL ACCESSSORIES: Multi-grip - \$35-50. Quick-focus lever - \$12-20.

GRAY (Robert D. Gray, NYC) Vest Camera - c1885. All metal discshaped camera designed to be worn under a vest. Forerunner of the more common Stirn Vest Camera. Manufactured for Gray by the Western Electric Co. Takes 6 round exposures on an octagonal glass plate.

\$1500-2000.

View camera - c1880. 8x10". Periscope No. 4 lens, rotary disc stops. \$250-375.

GREEN CAMERA WORKS (Japan) Green 6x6 - c1950. Horizontally styled folding camera for 6x6cm on 120. Waistlevel and eye-level finders. Green Anastigmat f3.5/75mm in Pisco 1-250,B,T shutter. \$150-225.

GREENPOINT OPTICAL CO. (Long

Island, N.Y.) Greenpoint Optical was founded by key employees of Anthony, and worked as an arm of the Anthony firm. From 1881, Anthony held controlling interest. Blair entered into the ownership in an 1891 merger. In 1901, it became part of the new Anthony & Scovill Company.

View Camera - c1880's. Relatively

simple 31/4x41/4" view camera. Achromatic lens with rotating stops. "G.O.Co." stamped on wood track. \$200-300.

GRIFFIN (John J. Griffin & Sons, Ltd., London)
Pocket Cyko Cameras - c1902. Folding cameras of unusual book form, designed by Magnus Niell, the Swedish designer who is also responsible for the popular Expo and Ticka designs. Also sold on the continent under the name "Lopa". Several sizes and styles exist, including the No. 1 for 6.5x9cm plates, and the No. 2 with magazine back for 8x10.5cm plates. \$600-900.

GRIFFITHS (Walter M. Griffiths & Co., Birmingham, England) Guinea Detective Camera - c1895. Leather covered cardboard camera in the shape of a carrying case. The top hinges to one side to change plateholders, and the front conceals a quillotine shutter. \$250-375.

CROSSER (Rudolph Grosser, Pillnitz) Manufacturer of Mentor cameras during the 1950's. However, all Mentor Cameras are listed in this edition under Goltz & Breutmann.

GRUNDMANN Leipzig Detective Camera - All wood box detective camera for 9x12cm plates. String-set shutter. \$800-1200.

Stereo camera - Mahogany with brass trim, brass bound Rapid Symmetrical lenses. 41/4x61/2" plates. \$300-450.

GUANGZHOU CAMERA FACTORY

Five Goats - c1970. TLR for 6x6cm on 120 film, predecessor of the more common Pearl River. The name alone is worth the price. \$75-100.

GUÉRIN (E. Guérin & Cie., Paris)

Guérin also worked with Lucien Leroy. We have a 1916-1917 catalog from Lucien Leroy which is overstamped with the name "L. Leroy & E. Guérin'

Le Furet - c1923. Small, early 35mm camera for 25 exposures 24x36mm using special cassettes. This camera is the smallest of the pre-Leica 35mm cameras. \$1200-1800.

Minimus Leroy: see Leroy. Although Guérin joined forces with Lucien Leroy and the "Minimum Leroy" was sold under the Guérin name, we have grouped all Leroy cameras under LEROY.

GUILFORD - Polished walnut 5x7" English view camera with brass fittings. Brassbarreled Ross Extra Rapid lens. \$200-300.

GUILLEMINOT (Guilleminot Roux & Cie., Paris) Guilleminot Detective Camera . c1900. Polished walnut detective camera for 9x12cm plates. Brass knobs rack front panel forward and concealed viewfinders are exposed. Brass carrying handle and fittings. Aplanat f9/150mm lens. Eight speed rotary sector shutter. \$1000-1500.

GUNDLACH OPTICAL CO. GUNDLACH MANHATTAN OPTICAL CO. (Rochester, N.Y.) Originally

founded by Ernst Gundlach for the production of optical goods, but for most of the company's history it was operated by H.H.Turner, J.C.Reich, & J.Zellweger. Gundlach Optical Co. acquired the Milburn Korona Company in 1896, which added a line of cameras to their line of lenses. Shortly thereafter, they joined with Manhattan Optical to become one of the leading sellers of dry-plate cameras well into the 1900's. The company was taken over by John E. Seebold in 1928 and the name changed to the "Seebold Invisible Camera Company."

Criterion View - c1909-1930's. Traditionally styled wooden view camera, virtually unchanged in appearance from its 1909 Gundlach catalog listing to the mid-1930s catalogs of Burke & James. Made in 5x7", 61/2x81/2", and 8x10" sizes. Current value is still as a good used view camera, depending on size and condition. \$150-

Korona, 31/4x41/4" or 31/4x51/2" -Folding plate cameras, including "Petit" models. Cherry wood body, leather covered. Red bellows. \$60-90.

Korona, 4x5" - Self-casing "cycle" style view camera. Leather covered wood body; red bellows. \$100-150.

HAKING

Korona, 4x5" View - Basic studio & field camera made from the turn of the century to the 1950's. Folding front bed; detachable rear extension beds. Bellows extend to about 20". Value still influenced greatly by usability. With early lens & shutter \$120-180. A good coated lens in synchronized shutter will double the value.

Korona, 5x7" - Similar to the 4x5 size, in both self-casing and open field types, but for 5x7" format. With uncoated lens in non-sync shutter: \$120-180. Usable modern lens/shutter adds to value.

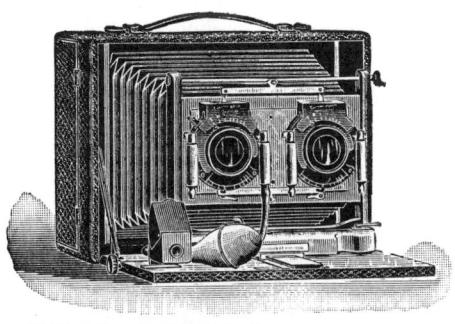

Korona, 5x7" Stereo - Folding plate camera for stereo exposures on standard 5x7" plates. Leather covered wood body with polished wood interior. Simple stereo shutter. \$400-600.

Korona, 61/₂x81/₂" View - \$120-180. Korona, 8x10" View - \$250-375.

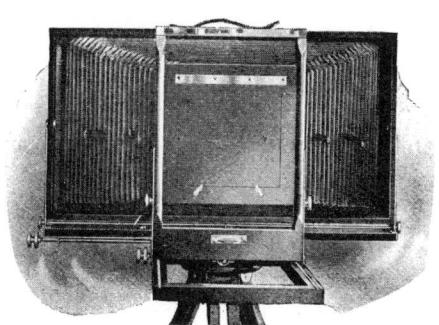

Korona, 7x17, 8x20, and 12x20" Panoramic View - usually called "Banquet" cameras.

- With holder, without lens: \$500-750. Add for lens, depending on type.

- A good working outfit with several holders and a good lens & shutter will bring \$800-1200. Collectors must compete with users for any "Banquet" cameras on the current market. Panoramic photography is increasing in popularity, and large format wide field cameras are very expensive.

Long Focus Korona - \$175-250.

Milburn Korona - c1895. Beautiful mahogany folding plate camera made for the Milburn Korona Co. Single extension red bellows. Brass trim, brass f8 lens. Pneumatic shutter. One fine example sold for \$500 at a German auction in 9/87.

HACHIYO KOGAKU KOGYO (Suwa, Japan)

Alpenflex - c1952-54. A series of TLR cameras. Alpo f3.5/75mm lens in Orient II or III shutter. \$75-100.

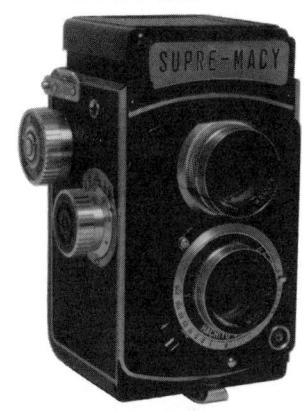

Supre-Macy - c1952. TLR made for Macy's of New York. Similar to Alpenflex IS. Alpo f3.5/75 in Orient II shutter B,1-200. \$75-100.

HACO JUNIOR - Simple plastic camera for 5x5cm on rollfilm. Design is similar to Ensign Cupid. No further details available. Who knows the manufacturer or history? \$12-20.

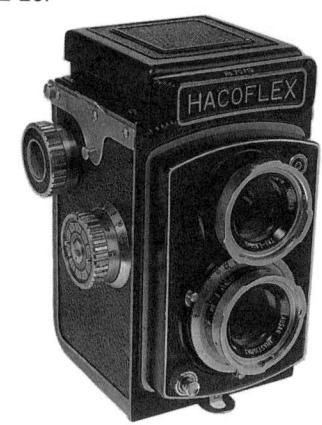

HACOFLEX - 1950s. Japanese Rolleiflex copy with Tri-Lausar f3.5/8cm lens, shutter 1-300. \$75-100.

HADDS MFG. CO. - see Foto-Flex Corp.

HADSON - Japanese novelty subminiature of Hit type. \$25-35.

HAGI MFG. (Japan)

Clover - c1939. Folding camera for 4.5x6cm on 120 film. Venner f4.5/75mm Anastigmat in Vester shutter, T,B,1-200. \$100-150.

Clover Six, Clover Six B - c1940. Folding camera for 6x6cm on 120 film. G.R.C. Venner f4.5/80mm in Oriental shutter T,B,1-200. \$120-180.

HAKING (W. Haking, Hong Kong)

While Haking produces many cameras, most are not yet of collectible age. We are listing a few of the "novelty" types.

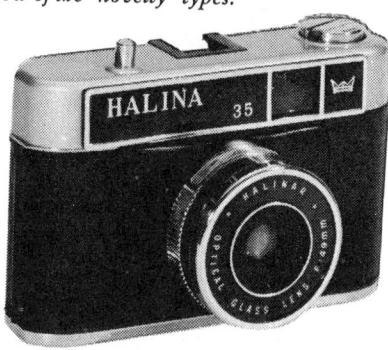

Halina 35 - c1982. Inexpensive plastic 35mm camera. Although a recent model, this is definitely a novelty camera. The same camera, of very inexpensive construction, appears under various names, often as a low-cost premium. \$12-20.

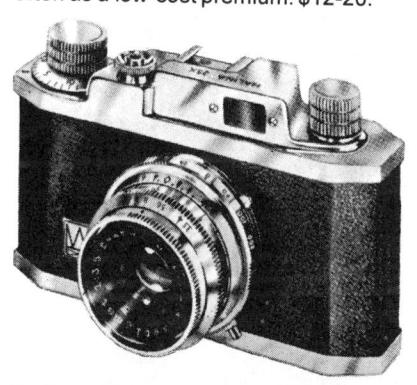

Halina 35X - c1959. Inexpensive but heavy 35mm camera with cast metal body. \$20-30.

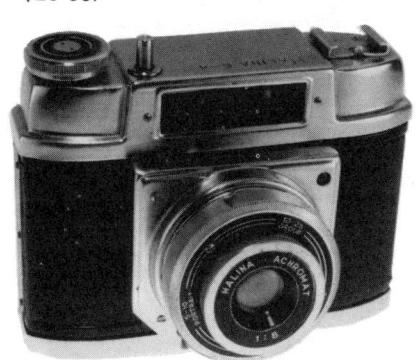

Halina 6-4 - Simple stamped-metal eyelevel camera for 120 film. Its interesting feature is the dual format capability. Two finders, one for 4x4 and the other for 6x6cm. The camera takes 120 film, with no apparent way to take a smaller spool. Two red windows on the back are marked for the two formats, apparently allowing either 12 or 16 exposures on 120 film. \$15-25.

HAKING...

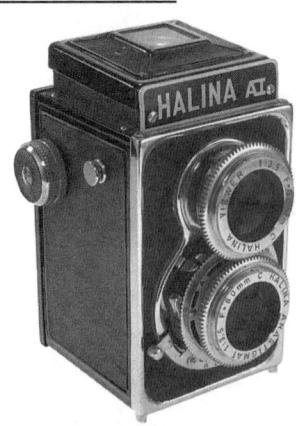

Halina A1 - c1952. TLR, 6x6cm. Very closely resembles the Ricohflex IIIb, but with shiny chrome finish and optical finder in hood. Halina f3.5/80mm taking lens externally coupled to viewing lens. Shutter 25-100.\$50-75.

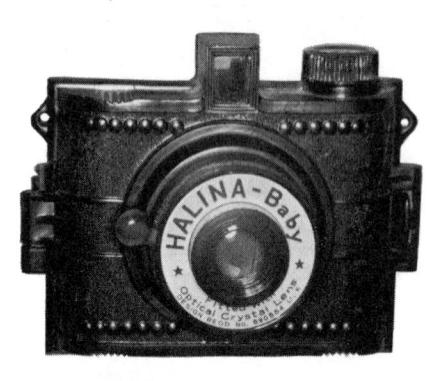

Halina-Baby - Plastic novelty camera from Macau. \$1-10.

Halina-Prefect Senior - Fixed focus TLR-style camera, 6x6cm. Stamped metal body with leatherette covering. Double meniscus f8 lens, B&I shutter. \$12-20.

Halina Micronta 35X

Halina Viceroy - Twin-lens box camera similar to Halina-Prefect Senior. \$12-20.

Kinoflex Deluxe - c1960. TLR style box camera, similar to the Halina-Prefect Senior, \$12-20.

Kinoflex Super Reflex - c1960. TLR style box camera. B&I shutter, f8 Double Meniscus lens. \$12-20.

Micronta 35X - c1959. Inexpensive cast-metal scale-focus 35mm. Halina Anastigmat 45mm f3.5 in 25-200 shutter. Name variation of the Halina 35X. Not to be confused with the Micronta 35 from Cosmo Camera Co. of Japan. \$25-35. *Illustrated bottom of previous column.*

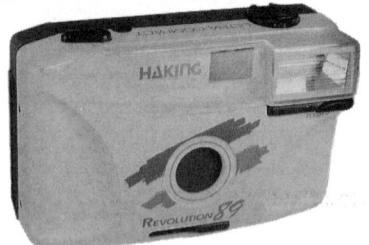

Revolution 89: 13x17mm and 24x36mm models

Revolution 89 - 1989. To celebrate the 150th anniversary of photography and the 200th anniversary of the French Revolution, Haking made two special commemorative models sporting the French national colors, and accompanied by a booklet highlighting the histories of France and photography Very limited production from one of today's most prolific camera manufacturers. Compact 35mm & pocket 110 cameras, both with built-in electronic flash. \$75-100.

Roy Box - c1960's. For 4x4cm. Halimar 47mm lens. Single speed shutter. Built-in flash. \$1-10.

Star-Lite Super Reflex - TLR-style box camera. \$20-30.

Sunscope - Twin-lens reflex-style box camera, similar to the other Halina TLR cameras. \$12-20.

Votar Flex - c1958. TLR style box camera, also similar to the Halina-Prefect Senior. \$12-20.

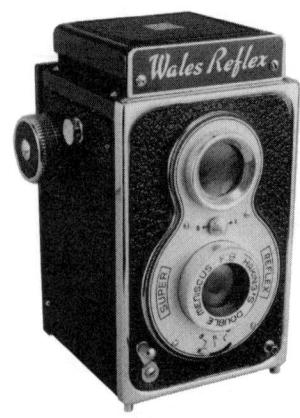

Wales Reflex - TLR style camera similar to Halina-Prefect Senior (above). \$12-20.

HALL CAMERA CO. (Brooklyn, NY)

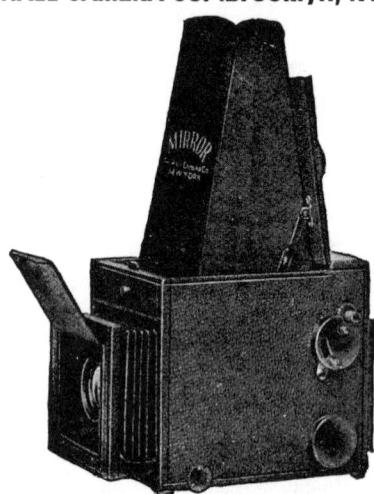

Mirror Reflex Camera - c1910. 4x5" Graflex-style SLR. f4.5/180mm lens. \$150-225.

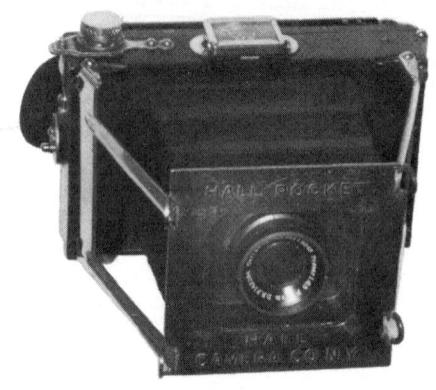

Pocket Camera - c1913. Small focal plane strut camera. Goerz Celor f3.5 lens. \$800-1200.

HALMA (Japan) We are unsure of the manufacturer of the Halma cameras, although they appear physically very close to cameras of the Osiro Optical Co.

Halma-44 - c1950's. TLR for 127 film.

Halma-44 - c1950's. TLR for 127 film. Left hand focus knob. Right hand film advance knob; rear window exposure counter. Anastigmat f3.5/60mm in CHY-FB (prontor type) shutter, B,25-300.\$90-130.

Halma-Auto - c1950's. The advanced model of the "Halma Flex" series, with crank advance, auto film stop & exposure counter, double exposure prevention, bayonet lens mount. \$100-150.

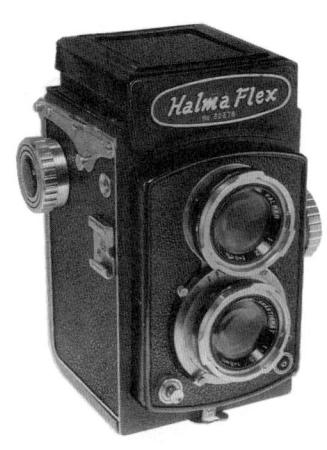

Halma Flex - c1950's. 6x6cm TLRs.

 Model I - red window exposure counter; no bayonets.

 Model IB - Same as Model I, but with bayonet lens mount.

- **Model II** - Automatic film stop, auto resetting exposure counter, no bayonets.

 Model IIB - As Model II, plus bayonet lens mount.

All models have Halmar Anastigmat f3.5/80mm. Rack focusing knob on left hand side. Knob advance. \$90-130.

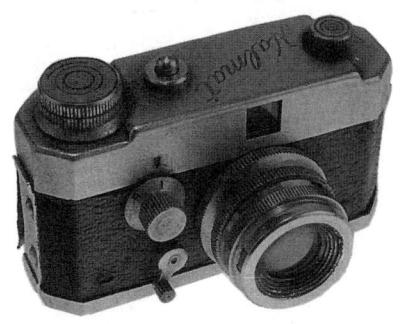

HALMAT - Japanese subminiature, very similar to the Gem 16 and Kiku 16 from Morita Trading Co. Top cover is different shape, but body and mechanism appears similar. Uncommon.\$250-375.

HAMAPHOT KG (Martin Hanke & Co. Monheim, Germany) $Most\ of\ the$

Hamaphot cameras are relatively common in Germany, where the basic black models sometimes sell for half of the prices listed here. However, with the increased interest in bakelite and colored cameras, the German prices are rising to meet the international market prices listed.

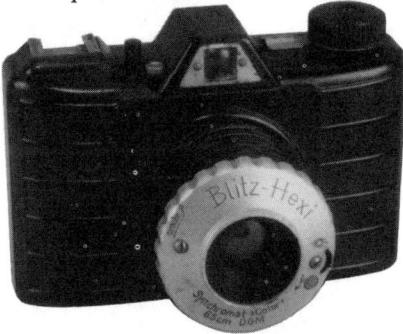

Blitz-Hexi - c1955-57. Black bakelite. Helical telescoping front. Synchromat f8/6.5cm lens. Same as Hexi-I, but originally supplied with flash unit. \$12-20.

Hexi-0 - c1955. Bakelite camera with telescoping front. Hexi-0 has Hexar f11/7.5cm in synchronized shutter. \$12-20.

Hexi-I - c1955-57. Like Hexi-0, but color corrected Synchromat f8/6.5cm. \$12-20.

Hexi-Lux - Bakelite camera with telescoping front; Tricomat f8/6.5cm. \$12-20.

Modell P56L - c1952. Bakelite camera with telescoping front. 6x6cm on 120. Available in black or dark green. \$12-20.

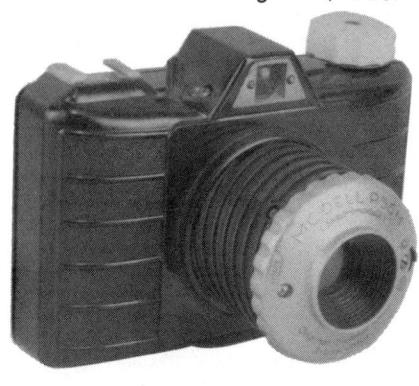

Modell P56M Exportmodell - Dark green bakelite camera, helical telescoping front. Gold-colored metal trim. \$12-20.

Modell P66 - c1950. Bakelite eye-level camera for 6x6cm on 120 rollfilm. Achromat f7.7/80mm. B,25,50,100.\$12-20.

Moni - c1954. A name variation of the Hexi-Lux camera. This one has T&M shutter in addition to the two diaphragm settings. Trichromat f8/6.5cm lens. \$12-20.

HAMCO - Japanese 14x14mm novelty camera of Hit type. \$25-35.

HAMILTON SUPER-FLEX - c1947. Bakelite novelty TLR for 16 exposures on 127 film. Similar to Metro-Flex, etc. \$12-20.

HANAU (Eugene Hanau, Paris) le Marsouin - c1900. Rigid aluminum body stereo camera for 18 plates in magazine back. No. 1 size for 45x107mm plates; No. 2 size for 6x13cm plates.

Tessar or Balbreck lenses. Guillotine shutter. \$300-450.

Passe-Partout - c1890. Unusual wooden detective camera, conical brass front. Several size and style variations. One version uses a double 6x13cm plateholder for two exposures per side, making a 6cm round exposure at each position. Another makes 6x13cm exposures on 13x18cm plates. Yet another makes single 8x8cm photos on 8x8cm plates. Quite rare. Its sales history shows cameras offered for sale in early 1982 at \$6500, in October of 1984 for \$2775, and in late 1986 for \$2800. Confirmed 1988 sale at \$2250.

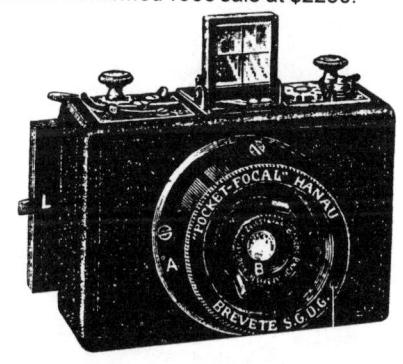

Pocket-Focal - c1905-10. Small focalplane plate camera. Telescoping front. Helical focus. Krauss-Zeiss Tessar IIb 40mm or 56mm lens. \$1000-1500.

Stereo-Pocket-Focal - c1905-10. Stereo version for 45x107mm plates. Tessar IIb lenses. \$2400-3200.

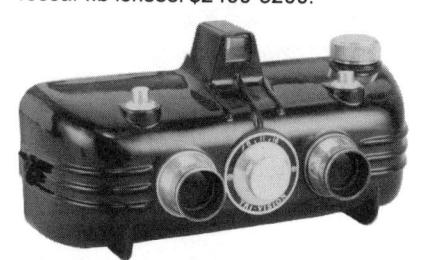

HANEEL TRI-VISION CO.
(Alhambra, CA)
Tri-Vision Stereo - c1953. Plastic and aluminum stereo camera for 28x30mm

HANIMEX

pairs on 828 rollfilm. f8 meniscus lenses with 3 stops. At auction in Germany, these have sold for up to \$150 in red and \$95 in black. However, they are not uncommon in the USA. Often found in the USA in excellent condition with original box, stereo viewer, etc. for \$50-75. Camera only \$30-45 in USA.

HANIMEX (HANnes IMport Export, Sydney Australia) Jack Hannes began importing European cameras to Australia at the end of World War II. His company held the agencies for many well known companies, including Hasselblad. It spread its influence to film, darkroom equipment, and projectors both still & cine. In the early 1950's, Hannes began unfluencing the design of many cameras, rebadging them Hanimex. These often bore a close resemblance to the original, but were uniquely Hanimex. by the 1960's, the company was designing cameras and projectors in Australia, manufacturing in several countries and exporting to dozens of world markets. The chief designer at Hanimex from the 1960's, Jerry Arnott, was responsible for the trombone 110 miniature camera and the compact 35mm SLR & flash cameras.

C35, D35 - c1959 on. 35mm cameras with CRF. Hanimar f2.8/45. B-300. Maker unknown. \$30-45.

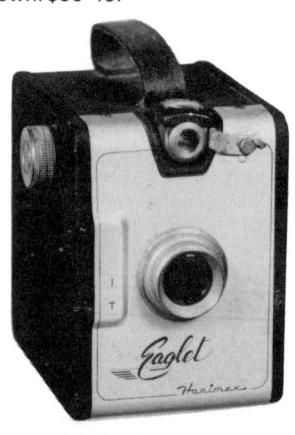

Eaglet - c1952. Box camera made by Fototecnica, Turin, Italy. Metal box for 6x6cm exposures on 120. Sector I&T shutter; achromatic 65mm lens. \$15-25.

Electra II - c1962. Hanimex version of the Dacora-Matic 4D. Hanimar f2.8/45 in automatic shutter coupled to Bertram meter. Four shutter release buttons engraved with zone focus symbols. Lens rotates to proper focus for each release button. Made by Dacora Kamerawerk, Germany. Rarely working. \$25-35.

Hanimar - c1951. Basic knob-wind 35mm viewfinder camera with bayonet mount f2.8/45mm Finetar lens. Two-blade

leaf shutter behind the lens, B 25-250. Made by Finetta Werke, Germany. \$30-45.

Holiday, Holiday 35, Holiday II c1958 on. 35mm cameras with CRF. S-Kominar f2.8 or f3.5/45 in Copal B-300. Made by Walz Trading Co., Japan. \$30-45.

Mini - 1972. First "trombone" 110 camera (slides like trombone to advance film) designed by Hanimex's Jerry Arnott and made by W.Haking, Hong Kong. Single speed shutter. \$1. Boxed \$5.

RF-35 - c1962. 35mm camera with CRF. Hanimar f2.8/45. B-300. Possibly made by Taron, Japan. \$30-45.

Standard 120 Box - c1954. Made for Hanimex by Vredeborch. Metal box camera, 6x9cm on 120. \$12-20.

HANNA-BARBERA
Fred Flintstone, Huckelberry
Hound, Yogi Bear (127 types) Novelty cameras for 127 film, each featuring the image of a cartoon character printed on the side. Imitation light meter surrounds the lens. \$12-20.

Fred Flintstone, Yogi Bear (126 types) - Similar small cameras, but for 126 cartridge film. On these, the front of the camera is in the shape of the character's head, with the lens in the mouth. \$20-30 in USA

HANSEN (J.P. Hansen, Copenhagen) Norka - c1920's. Studio view camera for 2,3,4, or 6 portraits on one 12x16cm plate. Cooke Aviar Anastigmat f4.5/152mm or Corygon Anastigmat f3.5/105mm lens. With large Norca studio stand: \$1200-1800.

HAPPY - Japanese Hit-type novelty camera. \$30-45.

HARBERS (Leipzig, Germany)
Courier Model V - c1894. Woodenbodied hand-and-stand camera, 13x18cm.
Brass trim. Square double extension
bellows. Large brass spring shutter. One
recorded auction sale, 1989: \$670.

Paris - c1900. Folding tailboard camera for 13x18cm plates. Fine wood body. Double extension tapered wine-red bellows. Voigtländer Euryscop lens with iris stops. \$175-250.

HARBOE, A. O. (Altona, Germany) Wood box camera - c1870. For glass plates. Simple cameras of this type were made in various sizes by various makers in Germany and Denmark during the 1870-1890 period. Although it pre-dated the "Kodak", it was made for the ordinary person to use. Brass barrel lens, simple shutter, ground glass back. Only one sale on record, in late 1976 at \$600.

HARE (George Hare, London) Stereo Wet plate camera, 31/4x63/4" - c1860. For 31/4x63/4" wet collodion plates. Mahogany body with twin red bellows. Matching brass lenses with waterhouse stops. With ground glass back and wet plate holder: \$2400-3200.

Stereo Wet plate camera, 5x8" - c1865. For stereo views on 5x8" wet plates. Polished mahogany body with brass fittings. Petzval lenses with waterhouse stops and flap shutter. \$3200-4600.

Tailboard Camera - Half-plate, ¹/₁-plate, and 10x12" sizes. Mahogany construction. Rack focus. Dallmeyer Rapid Landscape lens. \$350-500. Add \$120-180 for changing box.

Tourist camera - c1865. Half-plate. Fallowfield Rapid Doublet lens with iris diaphragm. Changingbox. \$600-900.

HARRINGTONS (Harringtons Ltd., Sydney, Melbourne, Brisbane,

Australia) Harringtons Ltd was one of Australia's largest camera importers and manufacturers. Most cameras were imported, almost exclusively from Britain, and many were rebadged "Ton". The trade name may appear inside or near a 'One Ton' symbol. Harringtons Ltd also imported Ensign film & chemicals, so the 'British Made' sticker usually remains inside the camera together with the recommended film.

Ton 2-1/4 A Box - c1920. Box camera for 6x6 on 120 rollfilm. Sector shutter I,B. Only one reflex finder on side. \$12-20.

HARTEX - Japanese subminiature of the Hit type. \$25-35.

HARUKAWA (Japan)

Septon Pen Camera - c1953. A rare subminiature of unusual design. Camera is combined with an oversized mechanical pencil. There are two major variations.

Deluxe Model - Has serial number on metal lens rim. Guillotine shutter. Variable f-stops controlled by knob under view-finder. Back fastens with sliding latch.

Simple Model - Even more rare than

the deluxe model. No serial number. No metal lens rims. Sector shutter. No f-stops. Back fastens with two thumb-screws.

Several years ago, a few new "Deluxe" models were discovered, complete with original box and instructions. These quickly sold for approximately \$1250 each. Recent transactions exceed that price. Auction sales usually \$2800-4000, new in box. Used models, without the box and instructions sell for about half as much.

Septon Penletto - c1953. A name variant of the Septon. Features are like the simpler version. One variation has conical lens mount with narrow front. \$2000-3000.

HASSELBLAD (Victor Hasselblad Aktiebolag, Goteborg, Sweden)

The Hasselblad family was in the marketing business for 100 years before Victor Hasselblad established a new company to manufacture cameras. The original Hasselblad company was founded by Fritz Victor Has-selblad in 1841 as F.W. Hasselblad & Co. The company opened a photo department in 1887. Due to expansion in that department, a separate company, "Hasselblads Fotografiska Aktiebolag", was founded in 1908 and became the Kodak general agent in Sweden. The early companies sold mostly cameras made by other manufacturers. The real beginning of the Hasselblad we all know was when "Victor Hasselblad Aktiebolag" was established in 1941 to manufacture aerial cameras for the Royal Swedish Air Force, as well as ground reconnaissance cameras. Victor Hasselblad retained his staff after the war and began the final designing of the Hasselblad 1600F, which was introduced in 1948. To ascertain the year of production, the two letters before the serial number indicate the year, with the code "VH PICTURES" representing the digits "12 34567890". Dr. Victor Hasselblad retired in 1977 at age 70, and sold the company to Safveaan Investment Co. of Goteborg. Although Victor Hasselblad died in 1978, he lived to see and use the 2000FC camera. With its return to a focal-plane shutter, not much faster than the original 1600F, the mechanical design had come full-circle and the exterior design was essentially un-

Hasselblad's Pocket Kamera - (F.W. Hasselblad & Co.) c1905. Folding bed camera for sheetfilms or plates in 8.2x10.7cm and 9x12cm sizes. In their 1905 catalog, Hasselblad claims this to be of their own manufacture, although the lenses and shutters are imported. Rapid Aplanat, Busch Anastigmat, or Goerz Double Anastigmat in B&L Simplex or Unicum shutter. No recorded sales.

Svenska Express - (F.W. Hasselblad & Co.) c1900. Falling plate magazine camera made by Murer and marketed by Hasselblad. Leather covered. Two waist-level brilliant finders. Achromatic lens with revolving diaphragm, set by turning knob below lens. Back stamped in gold "Hasselblad" or "Hasselblad Svenska Express". Recent sales in Sweden and Germany: \$120-180. *Illustrated at top of next column.*

HASSELBLAD

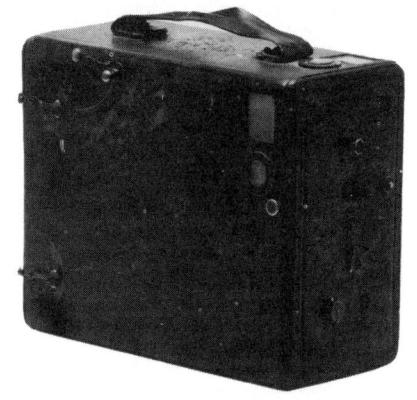

Hasselblad Svenska Express

Aerial Camera HK7 - c1941-45. Handheld aerial camera for 50 exposures on 70mm film. Tele-Megor f5.5/250mm. Shutter 1/₁₅₀-400. \$1000-1500.

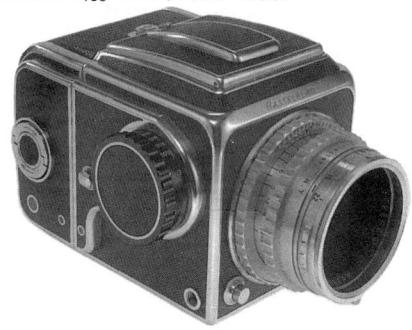

Hasselblad 1600F - 1948-52. The world's first 6x6cm SLR with interchangeable film magazines. It is most easily distinguished by its focal plane shutter to 1/1600. Originally supplied with Kodak Ektar 1/1600. Somm lens and magazine back for \$548. Accessory lenses included 135mm f3.5 Ektar and 250mm f4 Zeiss Opton Sonnar. The shutter on the 1600F was not of the quality we have since grown to expect from Hasselblad, and often this model is seen for sale with an inoperative shutter for less. The prices given here are for cameras in VG-E condition, operational, with back and original lens: \$600-900.

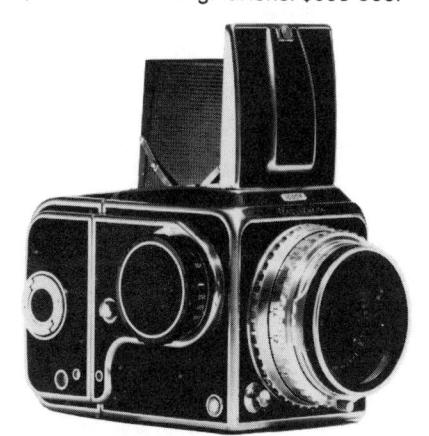

Hasselblad 1000F - 1952-57. The second Hasselblad model, and still with a focal plane shutter, but with the top speed reduced to $1/_{1000}$ sec. This attempted to eliminate the accuracy and operational problems of the older shutter. Sold for \$400 when new. Replaced the 1600F, but while supplies lasted, the 1600F continued to sell at \$500. Despite the improvements, these still are often found with inoperative

HASSELBLAD...

shutters for less than the prices listed here. With back and normal lens: \$500-750.

Super Wide Angle - 1954-59. Serials 1001-2999. Also called SW and SWA. Can be easily distinguished from the normal models, since it has a short, non-reflex body. "Super Wide Angle" is inscribed on the top edge of the front. The early SWA can be distinguished from the later SWC in several ways. The most obvious is that it has a knob for film advance rather than a crank, and shutter cocking is a separate function. The shutter release is on the lower right corner of the front, while the SWC has a top release button. Zeiss Biogon f4.5/38mm lens in MX Compur to 500. Despite its advanced age, the primary value of this camera is not as a collectible, but as a usable camera. With finder and magazine back: \$800-1200.

Hasselblad 500C - 1957-71. Serials 30,000-106,700. Historically, the 500C broke with tradition for medium format SLR's by adopting the innovative Compur front shutter with full aperture viewing and automatic diaphragm, a system first seen on the Contaflex. From a practical standpoint, however, the value of the 500C is primarily as a very usable piece of equipment, despite the advanced age of some of the earlier ones. Collectors want cosmetically clean cameras, but users will bid against collectors for a clean 500C. A nice 500C with back, finder, and f2.8/80mm Planar sells for \$800-1200.

Hasselblad SWC - 1959-80. Serials 3000-15,471 & 141,001-142,11. Modified version of SWA. Film advance and shutter tensioning accomplished by single crank. Shutter release button moved from lower right front to top. Biogno 38mm f4.5 in Synchro-Compur B,1-1/₅₀₀. Beginning 1969 the lens barrel is black anodized. Black or chrome body trim. Although some examples are over 30 years old, their usability maintains their value. \$1200-1800.

Hasselblad 500EL - c1965-71. Serials 8000-15074. An electric motor-drive version of the 500C. Film advance and shutter cocking is accomplished automatically after each exposure. The motor is part of the camera, and is powered by one or two rechargeable NiCad batteries, each of which will power the camera for about 1000 exposures. Other features and accessories same as 500C. Replaced about 1971 by the 500EL/M which had interchangeable finder screens. Body with finder, batteries, charger: \$350-500.

Hasselblad 500C/M - c1970-. Serials 106701+. Evolutionary replacement for the 500C. Still a basic mechanical camera. Little change from the 500C except that finder screens are easily interchangeable with two side clips instead of four corner screws. Advancing film reopens diaphragm and returns mirror. The basic mechanical Hasselblad for over 20 years, still sold since 1989 as the "500 Classic" with 80mm Planar and A12 back. Body and waist-level finder: \$400-600.

Hasselblad 500C/M 25th Anniversary - 1974. To celebrate the 25th anniversary of the 1600F camera, Hasselblad released a commemorative series of 1500 500C/M cameras with a silver plate bearing Victor Hasselblad's signature. No recent sales data.

Hasselblad 500EL/M - c1972-84. Serials 15075+. Motorized version of the 500C/M, or updated version of the 500EL. The only significant change is the capability of using interchangeable focusing screens. A modular camera still very much in professional use today despite some examples being older than many camera collectors. Body with waist-level finder, battery & charger: \$600-900.

Hasselblad 500EL/M "10 Years on the Moon" - 1979. Commemorative version of the 500EL/M to celebrate the use of special 500EL cameras on the first lunar landing. On the front of the lower section is a metallic plaque depicting the moon's surface. 1000 examples were made in chrome trim and 500 with black trim. It was supplied with 80mm Planar lens and standard 12-exposure magazine. Upon registration, the owner also received a commemorative bronze medallion. New in box, these have sold at auction for \$1500-2000.

Hasselblad 2000FC - 1977-81. Twenty years after switching to leaf shutters, Hasselblad brought back focal-plane shutters with this model. Obviously there were many technological developments which made this possible. This camera has an electronically controlled titanium foil shutter with a top speed of 1/2000 second. The camera's name reflects this top speed and the F indicates Focal plane shutter. The 2000FC uses a new "F" series lens which does not have built-in leaf shutter. Of course, it will also accept the Compur shuttered C and CF series lenses using either the leaf or focal plane shutter. With waist-level finder, 80mm F lens, A12 back: \$1200-1500mint.

Hasselblad SWC/M - 1980-88. Serials 142112+. Updated version of the SWC. Will accept Polaroid backs. Biogon 38mm f4.5 lens. With finder and magazine: \$1800-2500.

Hasselblad 2000FC/M - c1981-84. Replaced the 2000FC. With waist-level finder, 80mm F lens, A12 back: \$1200-1800.

Hasselblad 500EL/M "20 Years in Space" - 1982. Limited edition of 1500 cameras with light grey leather covering and oversized square shutter button. Silver nameplate inscribed "Hasselblad 20 Years in Space". Commemorates the 1962 Mercury mission, the first to use a Hasselblad camera. Originally supplied with a black 80mm Planar, and packed in a gold colored box. New price was about \$3700.

Hasselblad 500ELX - 1984-88. Replaced the 500ELM. Features off-the-film flash metering (TTL-OTF). Non-vignetting mirror. Replaced in 1988 by the 553ELX. Body with waist-level finder, charger, battery: \$800-1200.

Hasselblad 2000FCW - 1984-88. Replaced the 2000FCM. Body with waist-level finder: \$1000-1500.

HAVENHAND (L.) (England)

Havenhand was a retailer of optical and scientific equipment.

Field camera - Brass and mahogany field camera for 41/₄x61/₂" plates. Brass lens with wheel stops. \$175-250.

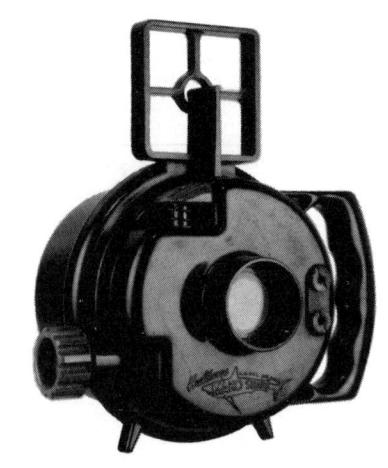

HEALTHWAYS

Mako Shark - c1957. Cylindrical plastic underwater camera. The entire working mechanism including shutter, lens, and film transport are identical to the Brownie Hawkeye Flash Model. Synchronized and non-sync models. \$50-75.

HEGELEIN (John C. Hegelein, N.Y.) Watch Camera - c1895. Subminiature camera built into a pocket watch case. Seven section metal tube extends forward. Plateholders fit on back. Design is similar to the Lancaster watch camera from England. The Hegelein camera was marketed by E. & H.T. Anthony as "Anthony's Watch Camera". For many years only a single example was known in a private collection. It had no plateholder. This camera was offered at auction in 11/92 but failed to reach the reserve of £20,000. A second example with plateholder sold at Christie's in 3/93 for £17,000 plus commissions, a world record price for any American camera. A third example, in its original pouch and maker's box was offered at Christie's in 1/94. It included two film holders, two boxes of original plates, and original instructions. It failed to reach the £20,000 reserve but later was sold privately. The Hegelein ranks among the rarest of cameras with only three examples known. \$20,000-30,000. Illustrated on front cover.

HEILAND PHOTO PRODUCTS (Div. of Minneapolis-Honeywell, Denver, Colorado)

Premiere - c1957-59. 35mm non-RF camera made in Germany. Steinheil Cassar f2.8/45mm, Pronto to 200. \$25-35.

HELIN-NOBLE INC. (Union Lake, Michigan)

Noble 126 - Miniature gold & black "snap-on" camera for 126 cartridges, with matching flash. Winding knob pivots for compactness. Advertised as the world's smallest 126 cartridge camera. With tele and W.A. lenses in original plastic box: \$60-90.

HELM TOY CORP. (New York City) Bugs Bunny - c1978. Plastic camera with figure of Bugs Bunny. "Eh-Doc, Smile!". \$45-60.

Mickey Mouse - c1979. Blue plastic camera with white molded front. Mickey Mouse riding astraddle a toy train. \$30-45.

Mickey Mouse Head (110 film) c1985. Cheaply constructed camera in shape of Mickey Mouse head with red bow tie. Round camera mechanism for 110 film is based on the Potenza design. \$20-30.

Punky Brewster - c1984. Red plastic 110 pocket camera. Added-on front with hinged top cover. Decals applied to the front, top, and carrying case. \$12-20.

Snoopy-Matic - Shaped like a dog house with Snoopy on roof. The chimney accepts magicubes. This camera is less common than the others from Helm, and is a more interesting design. \$100-150.

HEMERASCOPE - c1897. Folding camera with ebonized wooden gate-struts and leather bag bellows. Plastic rear section has a series of slots and ridges designed to allow development of the plate in the camera by placing the camera, back side down, into successive trays of chemicals. Very uncommon. \$1700-2400.

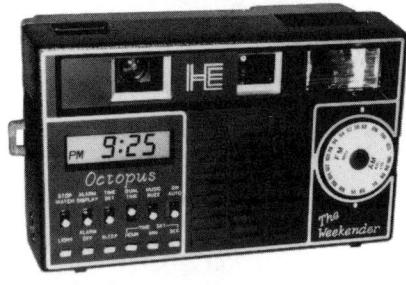

HENDREN ENTERPRISE Octopus "The Weekender" - c1983. Named for its multiple functions; it houses an alarm clock with stopwatch functions, AM-FM transistor radio, storage compartment, flashlight and 110 camera with electronic flash. It sold new for \$70-80. This high price, coupled with quality problems, kept it from making great waves in the marketplace. Less than 5000 made. The manufacturer was still attempting to liquidate in 1989 for \$80 each in a "collector's packet" with the product history signed by the inventor. The few used examples which appear for sale are priced \$20-30.

HENNING (Richard Henning, Frankfurt/M, Germany) The trade name Rhaco presumably stands for Richard Henning And Co.

Rhaco Folding Plate Camera - c1930. 6.5x9cm. Ennatar Anastigmat f4.5/105mm. Ibsor 1-125 shutter. Radial lever focusing. \$30-45.

Rhaco Monopol - c1933. 9x12cm folding plate camera. Radionar f6.3/135mm in lbso 1-100. Radial lever focusing. \$30-45.

HENSOLDT (Dr. Hans Hensoldt, Wetzlar) Henso cameras were actually made by I.S.O. in Milan, but sold with the Hensoldt, Wetzlar label for the Italian market.

Henso Reporter - c1953. 35mm RF camera produced by ISO in Italy. Dr. Hans Hensoldt Iriar f2.8/5cm or Arion f1.9/50mm lens. FP shutter 1-1000. Folding rapid advance lever in base. \$1200-1800.

Henso Standard - Similar, but knob wind rather than lever. \$1000-1500.

HERBERT GEORGE CO. (Chicago)

Founded by Herbert Weil and George Israel c1945. Bought out in 1961 and name changed to "Imperial Camera Corp."

Davy Crockett - Black plastic box camera for 6x6cm. Metal faceplate illustrates Davy Crockett and rifles. \$35-50.

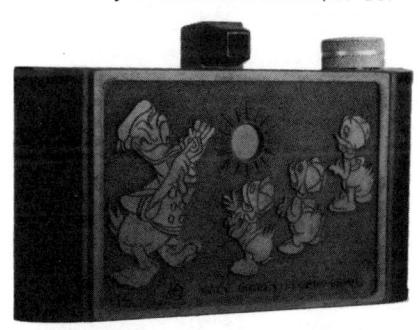

Donald Duck Camera - c1946. Plastic 127 rollfilm camera for 15/₈x15/₈" exposures. Figures of the Disney ducks (Donald, Huey, Louie, and Dewey) in relief on the back. Meniscus lens, simple shutter. This was the first camera design patented by George L. Israel. The earliest models, ca. Sept 1946 were olive-drab color and without external metal back latches. This version brings about \$15 more than the later ones. The body was soon changed to black plastic, and by November 1946, external back latches had been added. This is the most common version. With original cardboard carton: \$50-75. Camera only: \$30-45.

Flick-N-Flash - Twin lens box camera. \$1-10.

Happi-Time - Plastic camera for 127. Essentially the same design as the Donald

HERBERT GEORGE

Duck camera, but without the bas-relief back. \$12-20.

Herco 12 - uncommon name variation of the Donald Duck style camera. \$12-20.

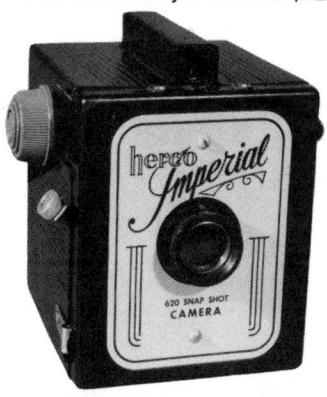

Herco Imperial 620 Snap Shot - Cheap plastic box camera, \$1-10.

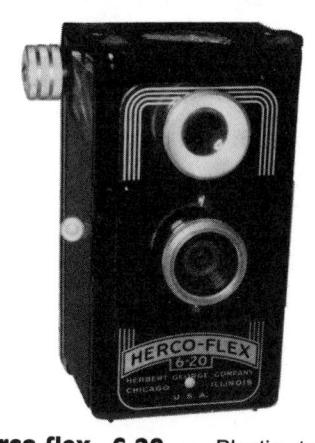

Herco-flex 6-20 - Plastic twin-lens style. 21/₄x21/₄" on 620 rollfilm. \$1-10.

Imperial Debonair - Bakelite box camera with interesting styling. Brown, olive, maroon colors: \$20-30. Normally found in black: \$1-10.

Imperial Mark XII Flash - Plastic box camera, in grey, black, blue, or red color. \$1-10.

Imperial Reflex - ca. mid-1950's plastic 6x6cm TLR for 620 film. Simple lens and shutter. \$1-10.

Imperial Satellite 127, Imperial Satellite Flash - Red or tan colors: \$1-10.

Insta-Flash - Twin lens box camera. \$1-10.

HERBERT GEORGE...

Roy Rogers & Trigger - Black plastic box camera, 620 film. Aluminum faceplate pictures Roy Rogers on Trigger. \$20-30.

Roy Rogers Jr. - Uncommon variant of the Donald Duck camera style. One of the earliest Herbert George cameras. \$30-45.

Royal - Basic black plastic box camera for 620 film. Eye-level finder. Style same as Savoy Mark II. \$1-10.

Savoy, Savoy Mark II, etc. Common plastic box cameras. \$1-10.

Official "Scout" cameras - Boy Scout, Brownie Scout, Cub Scout, Girl Scout. In black or in official scout colors. These cameras were based on many different "civilian" models, so quite a number of variations exist. Camera only: \$8-15. In original box with flash unit: \$20-30.

Stylex - An unusual design for the Herbert-George company. Plastic body with rectangular telescoping front. 6x9cm on 620 film. \$8-15.

HERBST & FIRL (Görlitz, Germany) Field camera - c1900. 13x18cm tailboard camera. Mahogany body, nickel trim, green tapered bellows with brown

corners. Universal Aplanat Extra Rapid f8. \$350-500.

Studio camera - c1920. Large wooden studio camera, 13x18cm. Square black bellows. Nickel trim. Used on a large wooden studio tripod. Heliar f4.5/210mm lens, Compoundshutter. \$500-750.

HERLANGO AG (Vienna) Amalgamation of Hrdliczka, Langer & Co., and Goldman. An importer, mainly of German cameras.

Folding camera - For 7x8.5cm plates or rollfilm back. Tessar f4.5/105mm. Compurshutter 1-250. \$45-60.

Folding Plate Camera, 10x15cm - Folding bed camera for 10x15cm plates. Double extension bellows. \$35-50.

HERMAGIS (J. Fleury Hermagis, Paris)

Field Camera, 13x18cm - Polished walnut camera with brass handle and inlaid brass fittings. Thornton-Pickard roll-er-blind shutter. Hermagis, naturellement, Aplanastigmat f6.8/210mm lens. Rotating maroon bellows for vertical or horizontal use. \$250-375.

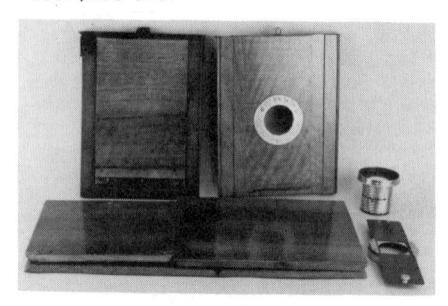

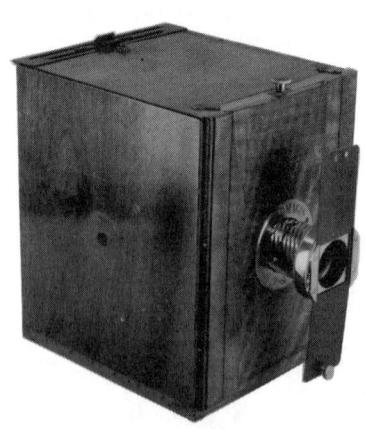

Micromegas - c1875. An unusual wooden box camera with hinged edges, designed to fold flat when the lensboard and viewing screen are removed. Nickelplated lens with small slot for waterhouse stop in the focusing helix. \$4500-6500.

Velocigraphe - c1892. Detective style drop-plate magazine camera for 12 plates 9x12cm in metal sheaths. Polished wooden body built into a heavy leather covering which appears to be a case. Front and back flaps expose working parts. \$1200-1800.

Velocigraphe Stereo - c1895-97. Polished walnut magazine box camera for six 8x17cm plates. Matching, individually focusing Hermagis lenses in bright nickel-plated barrels. Shutter tensioning and plate changing mechanisms are coupled. And you thought the first idiot-proof cameras were made of plastic! \$1700-2400.

HEROLD MFG. CO. (Chicago) The Herold name was first used in 1951 when Harold Rubin, former Sales Manager for Spartus Camera Co., purchased the Spartus company and renamed it. This was about the same time that Jack Galter, former President of Spartus, had formed Galter Products. Herold Mfg. continued to produce Spartus cameras, changing its name to Herold Products Co. Inc. in 1956, and to "Spartus Corporation" about 1960. Check under the "Spartus" heading for related cameras.

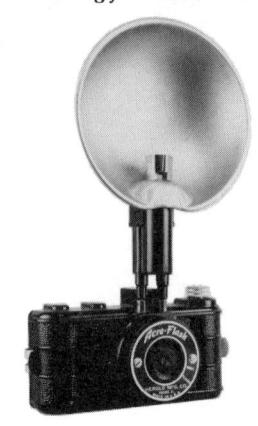

Acro-Flash - Black bakelite minicam for 127 film. Twin sync posts above the lens barrel. One of the few synchronized "minicams". \$8-15. Add \$5 for flash unit.

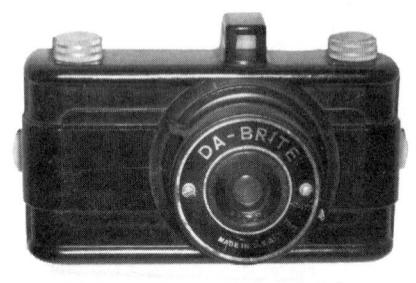

Da-Brite - Brown bakelite minicam for 3x4cm on 127 film. \$12-20.

Flash-Master - Synchronized minicam like the Acro-Flash. 3x4cm on 127. \$8-15.

Herold 40 - Black bakelite minicam for 3x4cm on 127 film. \$8-15.

Photo-Master - Economy model plastic minicam. "Photo Master" molded into the plastic shutter face rather than using a metal faceplate. \$1-10.

Spartacord - c1958. Inexpensive 6x6cm TLR, but with focusing lenses. Nicely finished with brown covering and accessories. \$20-30.

Sparta-Fold V - c1958. Self-erecting folding camera for 120 film. Diecast metal

body with grey plastic top housing (inspired by Kodak Tourist series). Simple I&T shutter with body release. Inexpensive, but rather uncommon, \$20-30.

Spartus 35 - Low cost brown bakelite 35mm with grey plastic top. \$12-20.

Spartus 35F, Spartus 35F Model 400 - Variations of Spartus 35. \$12-20.

Spartus 120 Flash Camera - c1953. Brown bakelite box camera with eye level finder on side. \$8-15.

Spartus Co-Flash - c1960. Small bakelite box camera with built-in flash reflector beside the lens. 4x4cm on 127. Some cameras have double exposure prevention. Some are labeled "Herold Mfg. Co." and some "Spartus Corporation".\$12-20.

Sunbeam 120 - Bakelite box camera, either brown or black. Synchronized. Several variations. \$8-15.

Sunbeam 127 - Two types:

- Plastic box camera for 12 square pictures 4x4cm on 127 film. Styled like the more common Spartus Vanguard. \$1-10.

- Streamlined brown bakelite minicam for 16 exposures 3x4cm on 127 film. \$8-15.

Sunbeam Six-Twenty - Plastic TLR style box camera. Many variations. \$1-10.

HERZOG (August Herzog, New York City)

Herzog Amateur Camera - c1877. Very simple $2x2^{1}/2$ " plate camera made of wood and cardboard. Dry plate slides into the back which is mounted on a baseboard. Pyramidal front holds brass lens that slides in and out for focusing. Rare. We have seen only one offered for sale in mid-1983 for \$3500 in the original box with accessories.

HESEKIEL (Dr. Adolf Hesekiel & Co., Berlin) Hesekiel did not actually manufacture cameras, but marketed them.

Original Spiegel Reflex - c1897. Beautiful tropical box-form SLR for 9x12cm

plates. Front extends for focusing. Square brown bellows, nickel trim. Brass barrel lens, FP shutter. Probably made by Reinhold Zoller. \$2800-4000.

Pompadour - Same as Certo Damen-Kamera and also sold as the Ladies' Gem Camera by Lancaster. See Certo Damen-Kamera for full description, photo, & price.

HESS & SATTLER (Wiesbaden, Germany)

Field Camera, 9x12cm - c1895-1900. Tailboard style field camera. Fine wood body with brass trim. Tapered wine-red bellows. Hess & Sattler Universal Aplanat Extra Rapid lens with waterhouse stops. \$175-250.

Universal Camera Duplex 1 - c1905. Horizontal folding plate camera. Leather covered wood body with wine-red bellows. Busch Detective Aplanat f8 lens, Unicum double pneumatic shutter. \$90-130.

HESS-IVES CORP. (Philadelphia, PA) Hicro Color Camera - c1915. Box-shaped camera for color photos 31/4x41/4" by the color separation process via multiple exposures with filters. Meniscus lens. Wollensak Ultro shutter. (Made for Hess-Ives under contract by the Hawk-Eye Division of E.K.C.) \$120-180.

HETHERINGTON & HIBBEN (Indianapolis)

Hetherington Magazine Camera c1892. Magazine camera for 4x5" plates. More than one model of made from similar camera. The No.1 measures 11³/8x6x7³/8" and holds 12 plates; another model measures 6x6¹/2x9" and holds 6 plates. Dark brown or black leather covered body. Plate advancing, aperture setting, & shutter tensioning are all controlled by the same key placed in different keyholes. There is an unusual method of opening the camera - pushing down on the finder glass allows top to slide forward. This camera was once marketed by Montgomery Ward & Co. It also exists with a label from "The United States Camera Co., Indianapolis". \$600-900.

HIRONDELLE

HG TOYS INC. (Long Island, NY) HG TOYS LTD. (Hong Kong)

Masters of the Universe He-Man 110 Camera - c1985. Green plastic body shaped like "Castle Grayskull". Made in China under Mattel's license. \$8-15.

Princess of Power She-Ra 110 Camera - c1985. Pink plastic camera shaped like "Crystal Castle". Made in China under license from Mattel. \$8-15.

HI-FLASH - Novelty camera of Diana type. Synchronized. \$1-10.

HILCO EXPORT CO. (Chicago)
Hilco Camera - Black plastic "minicam"
for 3x4cm on 127 film. \$1-10.

HILCON - Inexpensive metal eye-level camera for 4x5cm exposures on 120 film. Similar to the General, Rocket, and Palmer cameras from the Rocket Camera Co., but with a slightly longer body. Uncommon. \$12-20.

HILGER (Adam Hilger, Ltd., London)
Three-Colour Camera - Color separation camera with 2 small semi-silvered mirrors behind the lens, \$1000-1500.

HILL (G. Hill & Son, Brimingham, England)

Field camera - c1888. Mahogany body, brass trim and brass lens. 41/₄x61/₂" plates. \$200-300.

HIRONDELLE La Parisienne - c1885. Simple folding plate camera, 9x12cm. Name means "The Swallow". Fine wood body, brass trim, tapered bellows. Brassbound lens with built-in spring shutter. Woodenlensboard. \$400-600.

HIT

HIT TYPE CAMERAS - There are many small cameras which were made in post-WWII Japan. One class of these subminiatures is commonly called "Hit-types" because the Hit name (from Tougodo) was one of the first and most popular names found on this type of camera. Despite their overall similarity, there are many subtle differences in construction from one camera to the next, and there is a seemingly endless number of names which graced the fronts, tops, and cases. There may never be a complete list, but this is probably the most complete one to date. If you know of others not on this list, please write to the authors. This list is intended to include only the inexpensive, lightweight "Hit" type cameras. Heavier models, such as the Corona, Mighty, Mycro, Rocket, Tacker, Tone, Vesta, Vestkam, etc. are not included on this list.

Prices for most of the Hit types are usually about \$20-30 in the USA where they are fairly common. The more recent and common ones (Arrow, CMC, Colly, etc.) are the lowest priced, often \$12-20. Uncommon names will sell for \$30-45 each, because most Hit collectors will pay a bit more to add a new name to their collection. Gold metal and colored leatherette each add another \$12-20 to the price. Prices in Europe are about 50% higher than the USA prices.

Name variations - AHI, Amerex (Occupied Japan), Arcoflex, Arrow, Astra, Astropic, Atomy, Babymax, Barco, Beica, Bell 14, Betsons, Blue Star (heavy), Charmy, Click, CMA, CMC (in chrome or gold with a variety of colored coverings), Colly, Crown, Crystar, Dale, Diplomat, Electronic, Elite, Emson, Enn-Ess TC, Francya, Fuji, Global, Globe, GNCO, Hadson, Hamco, Happy, Hartex, Hit (Occupied Japan, chrome, and gold models), Homer, Homer 16 (rectangular body), Homer No. 1 (gray rectangular body), I.G.B., Jay Dee, Kassin, Kent, Lenz, Lloyd's, Lucky, Madison, Marvel, Midge, Midget, Mighty Midget, Minetta, Mini Camera (Hong Kong), Miracle, Mity, Mykro Fine, Old Mexico, P.A.C, Pacific, Pamex, Peace, Pen, PFCA, Prince, Q.P, Real, Regent, Rocket (heavier Rocket also exists, but labeled "Rocket Camera Co."), Satellite, Shalco, Shayo, Sil-Bear, Sing 88, Siraton, Speedex, Spesco, Sputnik, Star-Lite, Stellar, Sterling, Swallow, Tee Mee, Tiny, Toyoca (note: heavier "Toyoca 16" also exists), Traveler, Vesta (this is a heavier type, but not by much!), Walklenz.

PLEASE SEND ANY ADDITIONS AND CORRECTIONS TO:

Jim McKeown; Centennial Photo; 11595 State Rd 70; Grantsburg, WI 54840 USA. Please send your name and address if you wish to be on our "Hit list" and to cooperate in the research and enjoyment of these little

HOBBIES LTD. (England)

Field camera - $4^{1}/_{4}$ x $6^{1}/_{2}$ " plate camera. Mahogany body, brass trim. Busch 5" brass bound lens in roller-blind shutter. \$250-375.

HOEI INDUSTRIAL CO. (Japan)
Anny-44 - c1960. Inexpensive metal
eye-level box camera for 4x4cm on 127
rollfilm. Designed to look like a 35mm

camera. f8 fixed focus lens, single speed shutter. \$12-20.

Ebony 35 - c1957. Bakelite camera for 25x37mm exposures on 828 rollfilm. f11 meniscus lens. Simple B & I shutter. \$30-45.

Ebony 35 De-Luxe - c1955. Like the Ebony 35, but metal trim on front and finder. f8 lens. \$45-60.

Ebony Deluxe IIS - c1957. Metal front and top housing. PC sync accessory shoe. f8/50mm lens. \$45-60.

HOFERT (Emil Hofert, EHO Kamera Fabrik, Dresden, Germany): see EHO-ALTISSA.

HOH & HAHNE (Leipzig, Germany) Field camera, 13x18cm - c1900. Tapered red bellows. Brass-barrel Rodenstock Bistigmat lens with revolving stops. \$250-375. Folding plate camera - c1930. 10x15cm. Double extension. Unofokal f4.5/165mm lens in Compur shutter. \$75-100.

HOLLYCAM SPECIAL - Unusual small wooden camera for 127 film. Some parts have a definite appearance of factory production, but the wooden body and acrylic viewfinder give the appearance of something assembled from a kit. We have been unable to find any documentation on this camera, and solicit help from our readers. Few known examples. \$120-180.

HOMER - Hit-type novelty subminature. \$25-35.

HOMER 16 - c1960. Japanese novelty camera for 14x14mm exposures on 16mm film. Meniscus lens, simple shutter. Hittype camera, but with rectangular top housing and thumb-wheel advance. (Similar to Bell 14 and Homer No. 1.) Chrome top body with black covering. "Homer 16" on viewfinder glass and shutter face. \$35-50.

HOMER NO. 1: see Kambayashi & Co.,

HONEYWELL Electric Eye 35, 35R - c1962. 35mm
RF camera made by Mamiya with Honeywell name. Meter for auto diaphragm surrounds lens. \$25-35.

HORIZONT - See Krasnogorsk

HORNE & THORNTHWAITE (Newgate, C.B.)

Collapsible camera - 1850s. Unusual folding camera: sides collapse when front and back are removed, making it a relatively small item to carry. Mahogany with brass fittings, brass bound lens in rising/shifting lens panel. Two sold in England in 1988 for \$4000 and \$12,000.

Powell's Stereoscopic Camera - Patented in 1858 by T.H. Powell, the camera had a sliding back for two successive exposures on the same plate. The single lens camera could be positioned for the second exposure by sliding it along the tracks on the carrying case and its hinged lid. We have no recent sales recorded, but at least 2 examples sold in 1974 in the \$3500-4000 range.

Wet plate camera - c1860. Sliding box style for 12x16.5cm plates. \$1700-2400.

Wet plate triple-lens stereo - c1865. Unusual stereo with 3 brass bound lenses mounted on a single lens panel. Center lens takes waterhouse stops. Position of sliding shutter determines if single or stereo exposure will be made. Mahogany body, brass trim. \$3500-5500.

HORSMAN (E. I. Horsman Co., N.Y.C.) In addition to cameras, the Horsman company sold lawn tennis equipment and bicycles.

No. 2 Eclipse - c1888-1900. 31/₄x41/₄" plates. Polished cherry, leatherette bellows. Originally advertised in 1888 "with tripod and complete chemical outfit" for \$5. In 1897, Sears Roebuck still sold the outfit for just \$4.50. Current value \$250-375.

No. 3 Eclipse - c1890's. Folding bed, collapsible bellows, polished cherry-wood view camera for 41/₂x61/₂" plates. Styled like the more common Scovill Waterbury camera. Brass barreled meniscus lens. Rubber-bandpowered shutter. \$250-375.

Eclipse - c1895. An unusual box-plate camera for single exposures 4x5". Black papered wood body. Primitive meniscus lens. Wooden lens cap. \$250-375.

HOUAY Anny-35 - c1964. Inexpensive 35mm novelty camera. Looks convincing from a distance, but is only a box camera. \$12-20. Perhaps Houay and Hoei are variations in the English translation of the same manufacturer. The Anny-35 has "Houay" stamped into the top. The Anny-44 has "Hoei Industrial Co." on the lens rim. The two cameras are quite similar in construction.

HOUGHTON (London, England)

Houghtons dates back to 1834 when George Houghton joined Antoine Claudet as a glass seller. After the announcement of the Daguerreotype process in 1839, Richard Beard secured the patent rights to operate the process in England, from a patent agent appointed by Daguerre. Claudet secured a license directly from Daguerre and spent

most of his time operating his own studio, while Houghton began selling Daguerreotype requisites. On Claudet's death in 1867 the firm became George Houghton and Son, George Houghton and Sons in 1892, and Houghtons Ltd. in 1904. The firm produced a vast range of cameras and accessories, notably after 1904 when it absorbed a number of smaller camera makers. From 1895 Houghtons was also responsible for producing the Sanderson camera. From 1900 until around 1909, a large number of Houghton's cameras were German imports, primarily Krügener.

The firm came together for manufacturing purposes with W. Butcher in 1915 and the two finally merged on January 1, 1926 as Houghton-Butcher (Great Britain) Ltd. Houghton-Butcher manufactured products and a selling arm, Ensign Ltd, was set-up in 1930. On the night of September 24-25, 1940 enemy action completely destroyed Ensign's premises at 88/89 High Holborn. Johnson and Sons, manufacturing chemists, took over Ensign forming Houghtons (Holborn) Ltd and sold apparatus including that manufactured by Johnsons. The "Ensign" name was retained by H-B which in 1945 joined forces with the long established Elliott and Sons to form Barnet-Ensign. Barnet Ensign Ross followed in 1948 and Ross-Ensign in 1954. George Houghton's sons and grandsons had continued in the business throughout all the mergers until the firm finally disappeared about 1961.

Throughout its history the firm produced cameras and accessories notably after 1926 for the mass-amateur market. During the inter-war period it was the largest producer of photographic equipment and was the most important in Britain.

All Distance Ensign Cameras - c1930. This name was applied to box and folding rollfilm model cameras for 21/4x31/4" (6x9cm). Colored models bring about twice the prices listed here for black ones. Box models: \$12-20. Folding models: \$20-30. (Including Ensign Pocket Models I & II.)

"Automatic" Magazine Camera - c1891. An unusual wooden magazine

HOUGHTON

camera for 12 quarter plates. An internal scoop, operated by a large external handle, shovels the plate into taking position with the help of gravity. (The camera must be rotated to drop the plate). Brass barreled f8 lens with external focusing lever. Behind the lens roller-blind shutter with external string setting. \$1200-1800.

Autorange 16-20 Ensign - c1953. Copy of the Super Ikonta A, taking 16 4.5x6cm exposures on 120 or 620 rollfilm. CRF. Ross Xpres f3.5/75mm lens in Epsilon 1-400,B,T. \$120-180.

Autorange 220 Ensign - 1938-40. Folding camera offering a choice of 12 or 16 exposures on 120 film. f4.5 Ensar or Tessar in Prontor or Compur. Focus by radial lever on bed. \$90-130.

Autorange 820 Ensign - c1957. Folding-bed camera for 6x9cm on 120 film. Coupled rangefinder. Ross Xpres f3.8 lens. \$350-500.

Box Ensign 2-1/4B - Box camera of leatherette covered cardboard. Dual reflex finders and folding wire frame finder. Lens cover attached to body with braided cord. Colored models: \$25-35. Black: \$8-15.

British Ensign (nicknamed Flat Back Ensign) - c1905. Folding rollfilm camera with flat back. Red bellows. Beck Symmetrical lens in Unicum shutter. This camera inspired competition from Kodak, who marketed their own "Flush Back Kodak" a few years later. \$120-180.

Coronet - Brass and mahogany field camera, 41/₄x61/₂". Brass-bound lens, roller-blind shutter. \$250-375.

Empress - c1912-23. Mahogany field camera with extensive tilting movements. Made in 1/₄-, 1/₂-, and 1/₁-plate sizes. Brass barrel lens in roller-blind shutter. \$350-500.

Ensign Autospeed - c1933. 6x6cm format 120 rollfilm camera with FP 15-500.

HOUGHTON...

Film advance cocks the shutter. Aldis f4.5/4" lens. \$250-375.

Ensign box cameras - Including E20, E29, 2-1/₄A, 2-1/₄B, Duo, etc. Black: \$12-20. Colored: \$25-35.

Ensign Cadet - c1927-31. Simple box camera with leather-grained covering. Folding frame finder on side. Everset I+T shutter, achromaticlens. \$20-30.

Ensign Cameo - c1927-38. Folding plate camera in 21/₂x31/₂", 31/₄x41/₄", and postcard sizes. Leather-covered wood body with metal front. Aldis Uno Anastigmat f7.7 or Zeiss Tessar lens. \$60-90.

Ensign Carbine - 1920's-1930's. A series of folding cameras originated by Butcher and continued after the merger. Primarily for rollfilm, but most models have a removable panel in the back which allows use with plates as well. Many models in a wide range of prices. \$35-50.

Ensign Carbine (Tropical models) - c1927-36. Nos. 4, 6, 7, 12. Bronzed brass body, tan bellows. Tessar f4.5 lens in Compurshutter. \$150-225.

Ensign Commando - c1945. Folding

rollfilm camera for 6x6cm or 4.5x6 cm. Built-in masks at the film plane and in the viewfinder. Rangefinder coupled to the moving film plane. Ensar f3.5/75mm lens in Epsilon 1-300 shutter. \$120-180.

Ensign Cupid - Introduced 1922. Simple metal-bodied camera for 4x6cm exposures on 120 film. The design is based on a 1921 prototype for a stereo camera which was never produced. Mensicus achromatic f11 lens. Available in black, blue, grey, and perhaps other colors. \$60-90.

Ensign Double-8 - c1930-40. Strutfolding camera for 3x4cm on 127. Ensar Anastigmat f4.5 lens in 25-100 shutter. \$60-90.

Folding Ensign 2-1/4B - 1910's-20's. Folding-bed rollfilm camera. Wooden body with leatherette covering. Rear door slides out to load film. Several body and equipment variations over the years. \$20-30.

Ensign Ful-Vue - c1939 & 1945. Box camera with large brilliant finder. Two major styles. Black rectangular box-

shaped model c1939 is less common than the postwar models with the oddly rounded top. Postwar model available in colors. Prewar model: \$25-35. Postwar: Blue: \$50-75. Red: \$45-60. Grey: \$30-45. Black: \$20-30.

Ensign Ful-Vue Super - Black cast metal body. Similar to Ful-Vue, but with hinged finder hood. Achromat f11 lens. Two-speed shutter. One unusual example marked "Made in India" brought \$45 at a 1986 auction, but normal models sell for \$25-35.

Ensign Greyhound - Folding bed 6x9cm rollfilm camera. Metal body with grey crackle finish. \$25-35.

Junior Box Ensign - c1932. Simple box camera, identified as "J B Ensign" on the front. 6x9cm. Two-speed shutter. \$20-30

Ensign Mascot A3, D3 - c1910. Dropplate magazine box cameras for 31/₄x41/₄" plates. \$50-75.

Ensign Mickey Mouse - c1935. Box camera for six exposures 15/₈x11/₄" on roll-film. Mickey Mouse decal on front. Originally available alone or in the "Mickey Mouse Photo Outfit" complete with darkroom equipment and chemicals. Camera only: \$90-130.

Ensign Midget - 1934-40. Compact folding cameras for 3.5x4.5cm exposures on E-10 film.

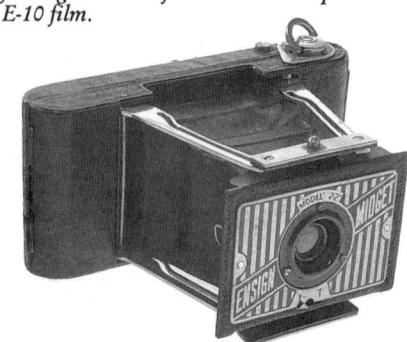

Ensign Midget Model 22 - Meniscus lens, T,I shutter. Uncommon. \$60-90.

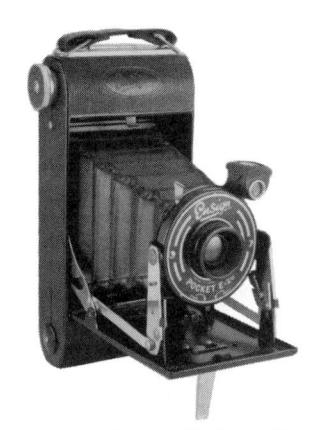

Ensign Pocket E-20

Ensign Midget Model 33 - Meniscus lens. Shutter 25-100. Most common model. \$50-75.

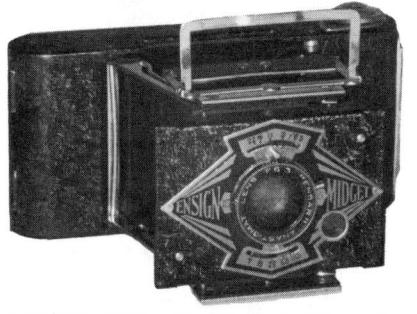

Ensign Midget Model 55 - Ensar Anastigmat f6.3 focusing lens. Shutter 25-100. The most complex model. \$60-90.

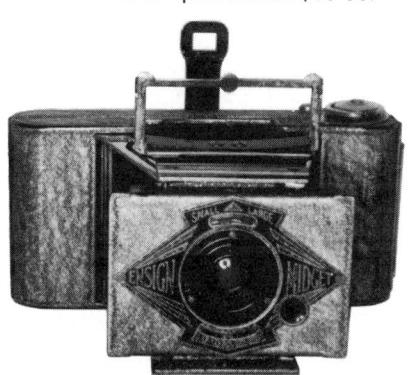

Ensign Midget Silver Jubilee nodels - 1935. Specially finished in silver ripple enamel to commemorate the silver jubilee of the King and Queen. Model S/33 has fixed focus lens; Model S/55 has Ensar f6.3 Anastigmat. These are the rarest of the Ensign Midgets. \$100-150.

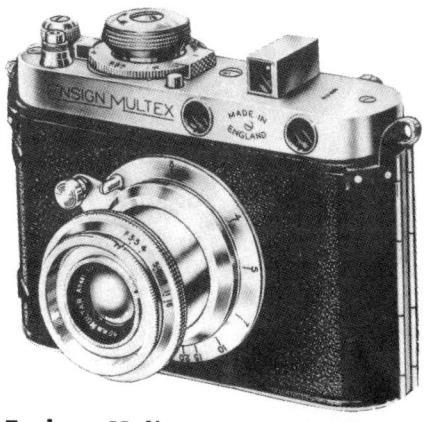

Ensign Multex - c1936-47. Small

rangefinder camera for 14 exposures on 127 rollfilm. Coupled rangefinder in top housing with viewfinder above. FP shutter T, 1-1000. Ross Xpres f3.5 or f2.9 lens. \$250-375.

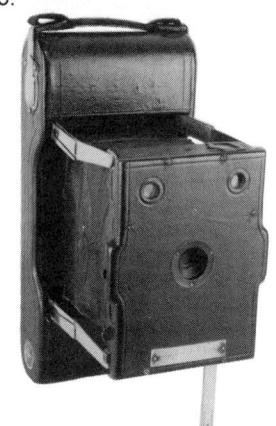

Pocket Ensign 2-1/4 B - Strut-type folding camera for 120 rollfilm. T & I shutter, 3 stops. \$20-30.

Ensign Pocket E-20 - Self-erecting camera for 6x9cm on 120 rollfilm. Fixed focus lens, T & I shutter. \$12-20. *Illustrated at top of next column.*

Ensign Pressman Reflex - A continuation of the imported Ica Reflex, previously imported by Butcher. \$200-300.

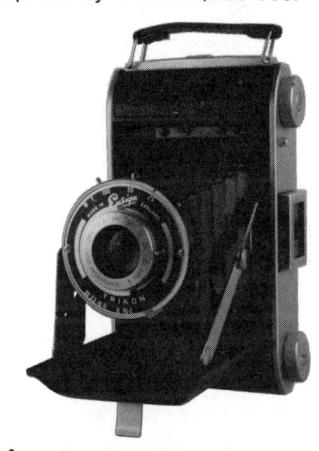

Ensign Ranger, Ranger II, Ranger Special - c1953. Folding cameras for 6x9cm on 120 or 620 film. \$35-50.

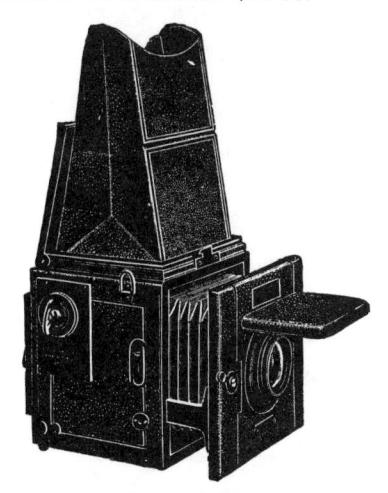

Ensign Reflex, Deluxe Reflex, Popular Reflex - c1910-30. Unlike the imported "Pressman" reflex, these are

HOUGHTON...

English-made SLR cameras. $21/2 \times 31/2$ " and $31/4 \times 41/4$ " sizes. Focal plane shutter to 1000. Various lenses. \$200-300.

Ensign Roll Film Reflex - c1920's. For 6x9cm exposures on 120 rollfilm. Several models. The same basic camera was also sold by Butcher as the Reflex Carbine. \$150-225.

Ensign Roll Film Reflex, Tropical -c1925. Teak with brass trim. Aldis Uno or Dallmeyer Anastigmat lens. Focal plane shutter 25-500. \$500-750.

Ensign Selfix 12-20, 20, 220, 320, 820 - c1950's. Folding rollfilm cameras for 6x6cm or 6x9cm. Various inexpensive lenses and shutters. \$45-60.

Ensign Selfix 12-20 Special - Wellbuilt camera with built-in rangefinder. Ross Xpres f3.5 lens. \$90-130.

Ensign Selfix 16-20 - c1950's. For 16 exposures 4.5x6cm on 120 film. (This style of camera was often called a "semi" at that time, because it took half-size frames on 120.) f4.5/75mm Ensar or f3.8 Ross Xpress. \$75-100.

Ensign Selfix 420 - Self-erecting camera for 8 exposures 6x9cm or 12 exposures 6x6cm on 120 film. Folding direct frame finder and small pivoting brilliart finder. Ensar Anastigmat f4.5/105mm lens in Epsilon 1-150,B,T or Prontor II shutter. \$35-50.

Ensign Selfix 820 Special - Better quality folding camera with uncoupled rangefinder; Xpres f3.8 lens. \$90-130.

Ensign Special Reflex - c1930's. British-made SLR in 2.25x3.25 or 3.25x4.25" sizes. Black leather covered body. Focal plane shutter 1/₁₅-1/₁₀₀₀. \$200-300.

Ensign Special Reflex, Tropical - c1930's. As regular model, but teak body, brassbound. Brown Russian leather bel-

HOUGHTON...

lows & viewing hood. FP shutter 15-1000. \$600-900

Ensign Speed Film Reflex - Called "Focal Plane Rollfilm Reflex" for a time. Box-form SLR with tall folding hood. Similar to the "Roll Film Reflex" but with focal plane shutter, 25-500,T. For 6x9cm on 120 film. Ensar f4.5 Anastigmat is standard lens, but others were available. \$150-225.

Ensign Speed Film Reflex, Tropical - c1925. 6x9cm SLR. Teak body, brassbound. Aldis Anastigmat f7.7/108mm. FP shutter 25-500. \$500-750.

Ensign Super Speed Cameo - A special model of the Cameo. Cast metal body, leather-lined panels at sides and top. Two variations: Brown crystalline enamel with bronze fittings and brown bellows. Black model has chrome plated fittings. Dallmeyer Dalmac f3.5 lens in Compur shutter. Brown: \$100-150. Black: \$45-60.

Vest Pocket Ensign - c1926-30. Body design is the same as the Ensignette, but takes $15l_8x2^1l_2$ " exposures on 127 rollfilm. Enameled aluminum body. Achromatic f11 lens, 3 speed shutter. \$60-90.

Ensignette - c1909-30. Folding rollfilm camera of the bedless strut type. Similar to the Vest Pocket Kodak camera but has extensions on both ends of the front panel which serve as table stands. Made in three sizes: No. 1 for 11/₂x21/₄", No. 2 for 2x3", and Junior No. 2 for 21/₄x31/₄". Early No. 1 & No. 2 have brass body, later are all-aluminum. Junior No. 2 is wood with metal back. Simple lens and shutter. \$60-90.

Ensignette No. 2 (silver) - Rare variation of No. 2 Ensignette, with silver plated finish. One example in original box sold at Christie's (11/89) for \$1400.

Anastigmat Ensignette, Ensignette Deluxe - Versions of the No. 1 and No. 2 with focusing Anastigmat lenses such as Aldis Plano or Tessar f6.8, or Cooke f5.8 and better shutters. \$120-180.

Holborn Magazine Camera - c1900-05. Magazine box cameras, most common in 1/₄-plate size. Leather covered exterior, polished wood interior. \$175-250.

Holborn Postage Stamp Camera - c1901. 9-lens copy camera. Makes 9 simultaneous stamp-sized copies of a photographon a quarter plate. \$400-600.

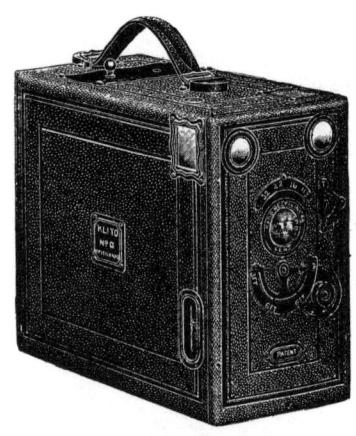

Klito, No. 0 - c1905. Magazine box camera, $3^{1}/_{4}$ X4 $^{1}/_{4}$ " falling plate type. Rapid Rectilinear lens. Rotating shutter. \$45-60.

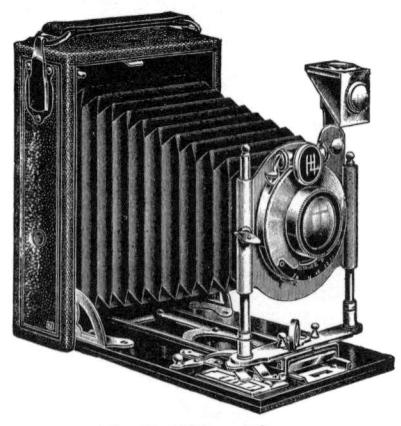

No. 00 Folding Klito, pre-1909 version made by Krügener

Folding Klito - 1900's-1920's. For 31/4x41/4" sheet films. Several variations include pre-1910 versions made by Krügener and later ones (beginning c1912?) made in London. \$50-75.

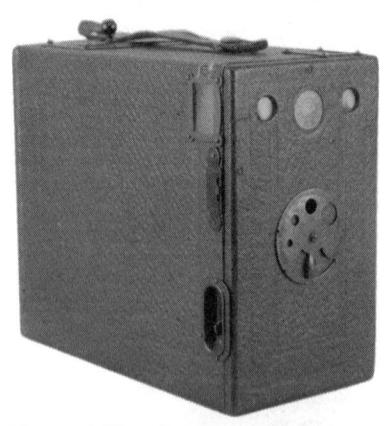

Mascot No. 1 - Drop-plate box camera for 6.5x9cm plates. Fixed focus f11 lens with 4 stops on external rotating disc. T&I shutter. Identified on strap. \$35-50.

Royal Mail Stereolette - Polished wood stereo box camera for 45x107mm plates. Guillotine shutter. Small reflex finder. \$800-1200.

Sanderson cameras Even though later manufactured by Houghton, all Sanderson cameras are listed under Sanderson.

Shuttle - c1892. A wonderfully engineered magazine camera for 31/₄x41/₄" plates or sheetfilms in metal septa. To

change plates, a rod is drawn out from the camera front. It pulls the rearmost septum down and slides it forward under the other septa, then returns it to a vertical position in front of the other plates. As if this total control of the plate were not enough, the same motion also tensions the internal shutter. Uncommon. \$600-900.

Studio camera - c1914. Mahogany and brass tailboard camera, 12x15". Brass Dallmeyer 5" lens. \$500-750.

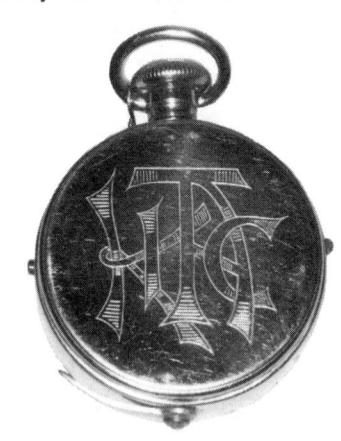

Ticka - c1905-14. Pocket-watch style camera manufactured under license from the Expo Camera Co. of New York, and identical to the Expo Watch Camera. For 25 exposures 16x22mm on special cassette film. Fixed focus f16/30mm meniscus lens. I & T shutter. Solid silver (identifiable by hallmark): \$2000-3000. Standard chrome: \$300-450.

Ticka Replica - Several counterfeit Tickas have surfaced. One has an interior marked "TICKA TASCHENUHR CAMERA". More importantly, the camera does not take the standard film spool. The ready availability and relatively low value of a normal Ticka would hardly warrant making a replica or counterfeit, so the possibility exists that some counterfeits were planned with special markings or silver plating, which could be sold to collectors at higher prices. Recently a Watchface Ticka was withdrawn from a Christie's auction after it was determined to be a forgery. It will no doubt reappear. Beware of any Watchface Ticka with a photographically reproduced watchface.

Ticka, solid silver - Some examples of the Ticka were made in solid silver, and properly hallmarked. One sold at Christie's auction (12/91) for \$3400. At the same auction, an authenticated silver Ticka with the monogram of Queen Alexandra, and with provenance, sold for \$30,000.

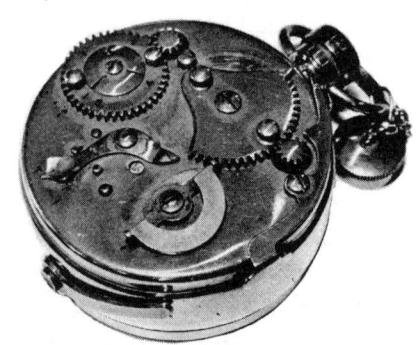

Ticka, Focal plane model - With focusing lens. Rare. (Exposed works make it easy to identify.) \$1700-2400.

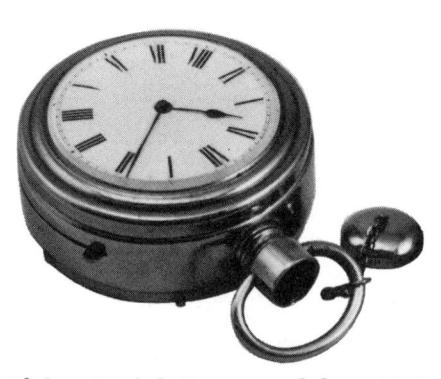

Ticka, Watch-Face model - c1912. Hands on the face show the viewing angle. An uncommon model. \$2000-3000. Caution: Good quality replicas exist, difficult to distinguish from original models. More fakes than genuine ones appearing recently. Watchface should be enameled, not photographically reproduced.

Ticka Enlarger - to enlarge the 16x22mm Ticka negative to 6x9cm. Meniscus lens. \$100-150.

Triple Victo - c1900's. Triple extension field camera. Sizes 4.75x6.5" to 12x15". Mahogany body, brass trim. Taylor Hobson Cooke brass-bound lens. Thornton-Pickard roller-blind shutter. Front movements. \$300-450.

Triple Victo, Tropical Model - c1908. Teakwood instead of mahogany Brass pins in corner joints of body. Bellows held on with brass plates. TP rollerblind shutter ebonized, not mahogany With brass-bound period lens. \$400-600.

Tudor - c1906. Folding bed camera, ¹/₄-plates. Combined rising/ swing front. Rack focus. Aldis Anastigmat or other lenses in Unicum or Automat shutter. \$100-150.

Victo - c1900. Triple extension field camera in sizes from $31/_4$ x $41/_4$ " to 10x12". Polished wood, black bellows, brass trim. Variety of lenses available. Thornton Pickard roller-blind shutter is typical. Also seen with Automat pneumatic shutter. \$300-450.

Victo-Superbe - c1912-14. Like the Triple Victo, but with extra rack and pinion to move the back forward when using short focal-length lenses. \$400-600.

HOWARD (C.B. Howard Co., Philadelphia)

Reo Miniature - Black thermoplastic "minicam" for 3x4cm exposures on 127 film. Uncommon. \$30-45.

HOWE (J.M. Howe, San Francisco) Pinhole camera - Compact folded disposable paper camera, self-contained single dry plate, developing instructions. Few have survived. Estimate: \$200-300.

HUNTER (R. F. Hunter, Ltd. London)See also Hunter & Sands, Sands & Hunter. **Gilbert** - Steel box camera with brown lizard skin covering. \$50-75.

Hunter 35 - Viewfinder 35. Made in Germany. Same as the Steinette. \$20-30.

Purma Plus - c1951. A re-styled version of the Purma Special. Metal body. 32x32mm on 127 rollfilm. Purma Anastigmat f6.3/55mm. Metal FP shutter to 500, speeds are gravity controlled. \$45-60.

Purma Special - c1930's. Bakelite & metal camera for 16 exposures 32x32mm (11/4" sq.) on 127 film. Three speed metal focal plane shutter. Speeds controlled by gravity. Plastic viewfinder lens, (one of the first uses of a plastic lens). Fixed focus f6.3/21/4" Beck Anastigmatlens. \$45-60.

HUNTER & SANDS (London) In December of 1883, the names were reversed to Sands & Hunter. See Sands & Hunter for post-1883 models.

HÜTTIG

Tourist Camera - c1880's. Folding tailboard camera with side wing strut. Takes 5x4" glass plates. Illustrated one is fitted with a Dallmeyer No. 2C. \$300-450.

HURLBUT MFG. CO. (Belvidere, III.) Velox Magazine Camera - c1890. An unusual magazine-plate detective camera. Plates are dropped into the plane of focus and returned to storage by turning the camera over. Focusing lever and plate changing lever are hidden in a recessed bottom. \$750-1000.

HUSBANDS (Bristol) Field camera - Mahogany and brass folding plate camera, 41/₄x61/₂". Brass Dallmeyerlens. \$300-450.

HUTH BROS. (Dresden, Germany) Field camera - c1895-1905. Wooden tailboard camera, for 13x18cm plates. Has nickel trim and green tapered bellows with black corners. Huth Universal Rapid Aplanat f8 in roller-blind shutter. \$250-375.

HÜTTIG (R. Hüttig, A.G., Dresden, R. Hüttig & Son, Dresden) Founded 1862. Claimed to be the oldest and largest camera works in Europe, just prior to its 1909 merger with Krügener, Wünsche, & Carl Zeiss Palmosbau to form Ica AG, which later merged to form Zeiss-Ikon in 1926.

Atom - c1908. Continued as an Ica model after 1909 merger. 4.5x6cm plate

model after 1909 merger. 4.5x6cm plate camera. f8/90mm lens. Compound shutter 1-250. Two versions, vertical and horizontal, as with the later and more common lca models. \$200-300.

Cupido, 9x12cm - Self-erecting plate camera with radial focusing. Rising front controlled by micrometer screw. Extra Rapid Aplanat Baldour f8/125mm lens in Hüttig shutter, B, T, 1-100. \$45-60.

Cupido, 10x15cm - c1908. Folding plate camera with radial lever focusing. f6.8/165mm lens in Compound shutter. 2 waist-level Brilliant finders. \$45-60.

HÜTTIG...

Fichtner's Excelsior Detective - c1892. Polished wood, built-in 9x12cm 12-plate magazine. 125mm Goerz Lynkeioskop. 3-speed rotating shutter. 2 reflex viewfinders. \$1000-1500.

Folding plate camera - c1906. 9x12cm plates. Black leathered wood body, aluminum bed. Red double extension bellows. Pneumaticshutter. \$60-90.

Gnom (metal) - c1900-07. Falling-plate magazine box camera of leather covered metal. Holds up to 6 plates 4.5x6cm. Other sizes include 6x9cm, 6.5x9cm, and 9x12cm. Meniscus lens. Rotary shutter. External reflex finder. \$250-375.

Gnom (wood) - c1905. Leather covered wooden magazine box camera for six plates 4.5x6cm. \$90-130.

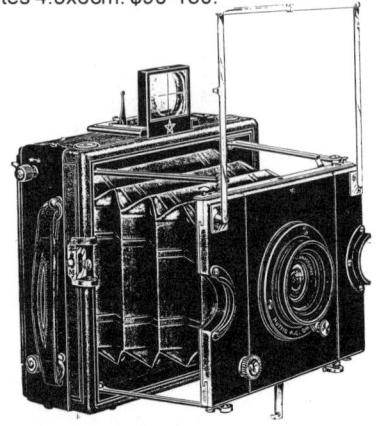

Helios - c1907. Strut-type folding plate

camera, 9x12cm. 185mm Anastigmat lens. Focal plane shutter 6-1000. \$120-180.

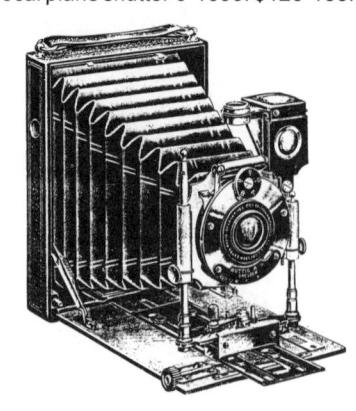

Ideal, 9x12cm - c1908. Folding-bed plate camera. Hüttig Extra Rapid Aplanat Helios f8 lens. Automat shutter, 25-100, B, T. Aluminum standard and bed. Red bellows. \$75-100.

Ideal, 9x18cm - c1907. Helios f8/125mm. Sector shutter 1-250. \$120-180.

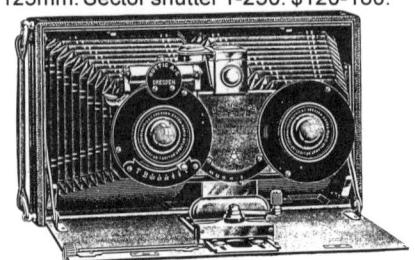

Ideal Stereo - c1908. 6x13cm plates. Extra Rapid Aplanat Helios f8/105mm. Hüttig Stereo Automat shutter 1-100, T, B. \$200-300.

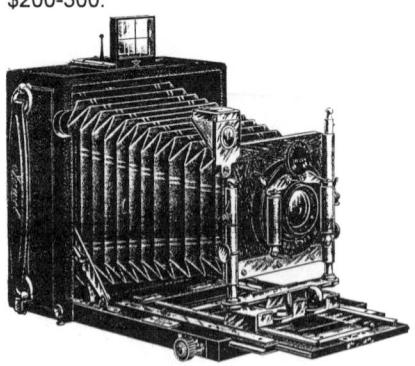

Juwel - c1905. Folding plate, 13x18cm. Leather covered wood body, nickel trim, double extension red bellows. Extra Rapid Anastigmat f8/130mm; Lloyd double pneumatic1-100,B,Tshutter. \$250-375.

Lloyd, 9x12cm - c1905. Folding camera for 31/₄x41/₄" rollfilm or 9x12cm plates. Goerz Dagor f6.8/135mm lens. Compound shutter 1-250. Double extension red bellows. \$90-130.

Lloyd, 13x18cm - c1905. Unusual in this large size. Double extension red bellows. Extra Rapid Aplanat f8 lens in Double pneumatic shutter. With focal plane and front shutters: \$250-375. With front shutter only: \$175-250.

Magazine cameras - c1900. 6.5x9cm and 9x12cm drop-plate style box cameras, leather covered. Focusing Aplanat lens and simple shutter. \$60-90. (Polished wood models without leather covering \$500-750.)

Merkur - c1906. 9x12cm magazine box camera, holding 12 plates. Black leather covered wood body. Achromat f11 lens, Z+M shutter. \$75-100.

Monopol - c1905. Magazine box camera for 12 plates. 6x9, 6.5x9, and 9x12cm sizes. \$60-90.

Nelson - c1907. Double extension folding plate camera, 9x12cm. Hüttig Aplanat f8/125mm lens; Hüttig pneumatic shutter 1-100,B,T. \$45-60.

Record Stereo Camera - for 9x12cm plates. Hugo Meyer Aristostigmat f6.8/120mm lenses. Focal plane shutter. \$350-500.

Stereo Detective - c1900. Polished wood box camera for 9x18cm plates. Nickel trim. M&Z shutter. \$600-900.

Stereolette - c1909. Small folding stereo camera for 45x107mm plates. Helios f8/65mm lens and I,B,T, shutter. \$250-375.

Toska - c1907. Folding bed camera for 9x12cm plates. Leather covered mahogany body. Double extension aluminum bed. Rack focus. Universal Rapid Aplanat f7/130mm.\$35-50.

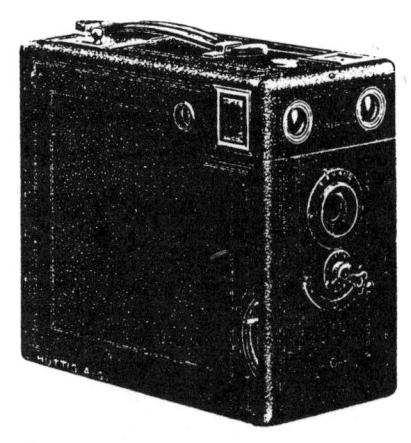

Trilby - c1905. Magazine box camera for 12 plates 9x12cm. Several variations. Some have simple shutter built on back side of hinged front. Others have automat shutter mounted inside. This was a more expensive alternative to the Merkur and Monopol. \$100-150.

Tropical plate camera - 6x9cm. Fine wood body with brass trim and bed. Double extension brown bellows. Steinheil Triplan f4.5/135mm lens in Compound shutter 1-150. \$600-900.

HYATT (H.A. Hyatt, St. Louis, MO) Patent Stamp Camera - c1887. 16lens copy camera for making 16 stampsize photos on a 4x5" plate. \$750-1000.

ICA A.G. (Dresden) Formed in 1909 as a merger of Hüttig, Krügener, Wünsche, and Carl Zeiss Palmos factory. Zulauf of Switzerland, maker of Polyscop and Bébé, joined Ica in 1911. Ica became a part of Zeiss-Ikon in 1926, along with Contessa-Nettel, Ernemann and Goerz. Some models were continued under the Zeiss name. See also Zeiss-Ikon.

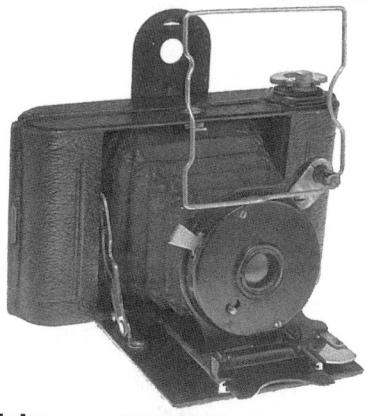

Alpha - c1919-1924. Compact vestpocket sized camera, 6x6cm on 120 film. A simple, lower-priced version of the Icarette I. Simple lens in single speed shutter. Folding frame finder only. Model 490 has Periskop f12.5; model 492 has Novar f6.8 Anastigmat. Uncommon. \$75-100.

Atom - c1909-25. Small folding cameras for 4.5x6cm plates, formerly made by Hüttig. In two distinctly different models, both in appearance and current value:

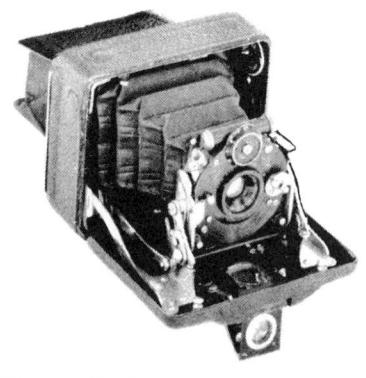

Atom, horizontal-format - (Model B). Folding bed, self-erecting front. Generally with f4.5/65mm Tessar or f6.8 Hekla. Compound shutter, 1-300. Unusual location of reflex brilliant finder: Viewing lens on center of bed, but mirror and objective lens extend below the bed. \$250-375.

Atom, vertical-format - (Includes Models A, 50, 51.) More traditional folding style. Reflex finder is still on the bed front, but remains above the bed. \$175-250.

Aviso - c1914-25. 4.5x6cm magazine box camera. Simple lens and shutter. \$75-100.

Bébé - c1911-25. Bedless strut-type folding plate camera, formerly made by Zulauf. Bébé 40 for 4.5x6cm, Bébé 41 for 6.5x9cm. Earlier models with Compound shutter. Typically with Tessar f4.5 lens in dial-set Compur shutter which is built into the flat front of the camera. \$175-250.

Briefmarken Camera - c1910. Polished mahogany camera with brass trim. Takes 15 stamp-sized photos on a 9x12cm plate. Rare. Only one recorded sale, at an auction in October 1986 for \$3800.

Corrida - c1910. 9x12cm folding plate. Helios f8/130mm in Automat sh. \$35-50.

Cupido 75 - Self-erecting camera for 6.5x9cm plates. Tessar f4.5/12cm in Dial

Compur. Radial focus. Rising front with micrometer screw. Pivoting collapsible brilliant finder. "Cupido 75" on strap. \$60-90.

Cupido 77, 80 - c1914. 9x12cm folding bed camera, plates or rollfilm back. Tessar f4.5/12cm. Compur dial-set sh. \$45-60.

Delta - c1912. Folding 9x12cm plate camera. Double extension bellows. Hekla f6.8/135mmin Compoundshutter. \$45-60.

Elegant - c1910-25. Tailboard field camera, 13x18cm. Highly polished mahogany, nickel trim, double extension square black bellows. \$150-225.

Favorit - c1925. Folding-bed plate cameras. Square black double extension leather bellows.

Favorit 265 - 9x12cm. \$35-50. **Favorit 266 -** 9x12cm. Tropical version of model 265. Teakwood body without leather covering. Tessar f4.5/150mm lens in Compurshutter. \$350-500.

Favorit 335 - 10x15cm. \$60-90. Favorit 425 - 13x18cm (5x7") plates. 60.3/210mm Tessar. Compur dial-set 1-150. An uncommon size. \$175-250.

Favorit Tropical - see Favorit 266.
Folding plate camera - misc. models in 6x9 & 9x12cm sizes. \$35-50.

Halloh 505, 506, 510, 511 - c1914-26. Folding rollfilm cameras (also for plate

backs) in the 8x10.5cm (31/4x41/4") size. Tessar f4.5/12cm or Litonar f6.8/135mm. Dial Compurshutter 1-250, B.T. \$50-75.

Hekla - c1912-14. Double extension 9x12cm folding plate camera. Hekla Anastigmat f6.8/135mm; Automat sh. \$35-50.

Icar 180 - c1913-26. Folding bed plate camera, 9x12cm. Ica Dominar f4.5/135. Compurdial-set 1-200, T,B. \$45-60.

Icarette I, above; Icarette C, below Icarette - 1920's. Folding bed 120 rollfilm cameras. Two basic styles: the horizontally styled body for 6x6cm exposures such as the Icarette I or A, and the vertical body style for 6x9cm such as the Icarette C, Ď, and L. Prices average the same for either style. \$45-60. Asking prices with Tessar lens are about \$60-90 higher.

Icarette 501, 502, 503 - c1919. 6.5x11cm on rollfilm. Hekla f6.8/12cm or Tessar f4.5/12cm in Compur. or Novar f6.8/135mmin Derval shutter. \$50-75.

Ideal - c1920's. Folding-bed vertical style plate cameras. Double extension bellows,

dial Compur shutter. (See also Zeiss for the continuation of this line of cameras.)

Ideal, 6.5x9cm - (Model 111) Hekla f6.8/90mm, Tessar f6.3/90mm, or Litonar f4.5/105. \$50-75.

ideal, 9x12cm - (Including models 245, 246.) f4.5/150mmTessar. \$50-75. **Ideal, 10x15cm -** (Model 325) Tessar

f4.5/165mm. \$100-150.

Ideal, 13x18cm (5x7") - (Model 385) Hekla f6.8/180mm or Tessar f4.5/210mm lens. This size is much less common than the others. One example of an unusual variant having dark blue leather covering and blue bellows sold for \$145 on auction. Black: \$100-150.

ingo 395 - c1914-25. Folding camera for 13x18cm plates. Horizontal style. Novar Anastigmat f6.8/180mm. Ica Automat shutter. \$90-130.

Juwel (Universal Juwel) - c1909-25. (Also continued as a Zeiss model after 1926.) A drop-bed folding plate camera of standard style, but with square format bellows and rotating back. It also incorporates triple extension bellows, wide angle position, all normal movements. 9x12cm, 10x15cm, 13x18cm sizes. \$300-450.

Klapp-Stereo-Palmos - c1911-26 as an Ica camera. (Originally from Zeiss Palmos Werk c1905.) Folding-bed stereo camera for 9x12cm plates. Aluminum body and bed, covered with leather. Focal plane shutter. Zeiss Tessar f6.3 or f4.5/9cm lenses. Some Zeiss and Ica models have the Dr. W.Scheffer inter-lens adjusting system. The two lenses are drawn closer together by stylus-type rods running in converging tracks on the camera bed. This allows for close-up work with automatic adjustment. This rare accessory dates from c1908-14. With close focus system: \$500-750. Normal models: \$350-500.

Lloyd - c1910. Folding cameras for exposures 8x10.5cm on rollfilm or 9x12cm on plates. Dominar f4.5/135mm. Compur 1-200, \$50-75.

Lloyd-Cupido 560 - c1922-25. Horizontally styled self-erecting rollfilm camera for 8.3x10.8cm. Hekla f6.8/100mm in Compound. Helical focus. Rare. \$120-180.

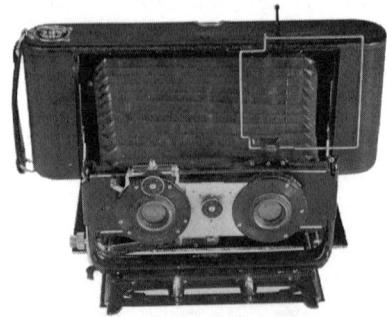

Lloyd Stereo - c1910. Folding stereo or panoramic camera for plates or rollfilm. 8x14cm or 9x18cm sizes. A lever on the top moves the cloth roller septum in back for panoramic exposures. f6.3 Tessars or Double Anastigmat Maximar f6.8 lenses in Stereo Compound 1-100 or Compur 1-150 shutter. \$250-375.

Lola 135, 136 - c1912-14. Folding bed, single extension camera for 9x12cm plates. Similar to the Sirene. Wood body with leatherette covering. Periskop Alpha f11, Ica Automatic shutter. \$35-50.

Maximar - c1914-26. Precision folding bed double extension plate camera. Although the Zeiss-Ikon Maximar is much more common, it originated as an Ica model. 9x12cm size with f4.5/135 Novar, f6.8/135 Hekla, f4.5/135 Litonar, in Compoundor Compur shutter. \$60-90.

Minimal 235 - c1912. 9x12cm folding bed double extension sheetfilm camera. f6.8/135 Hekla, or f6.8/120 Goerz Dagor lens. Ica Automat or Compound shutter. Leather covered wood body. \$50-75.

Minimum Palmos 1909-1920's. Previously made by Carl Zeiss Palmos Camerabau. Compact vertical format folding bed plate camera with focal plane shutter, T,B, 50-1000. The 4.5x6cm size (not introduced until 1925) is Ica's smallest focal plane camera. Zeiss Tessar f2.7 or f4.5 lens. 4.5x6cm: \$400-600. 6.5x9cm: (456): \$120-180. \$200-300. 9x12cm 10x15cm: \$200-300.

Nelson 225 - c1915. Folding bed double extension 9x12cm plates. Tessar f4.5/ 150mm. Dial CompurT, B, 1-150. \$45-60.

Nero - c1905. 9x12cm magazine box camera. Guillotine shutter, T & I. \$60-90.

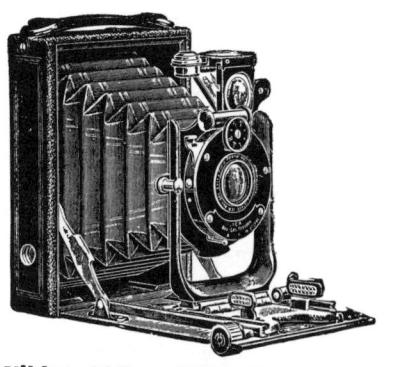

Niklas 109 - c1920's. Folding bed plate cameras, 6.5x9 and 9x12cm sizes. f4.5 Litonar or Tessar in Compur. \$45-60.

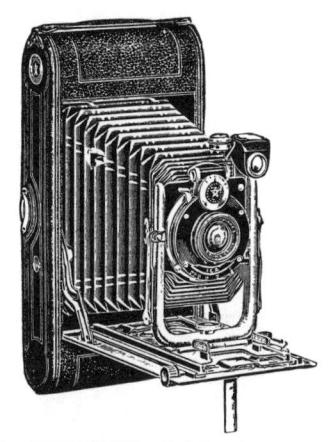

Nixe - 1909-1920's. Folding bed cameras, formerly made by Wünsche. Model numbers include 555, 595. 9x12cm: \$120-180. 9x14cm plates or 122 rollfilm. \$60-90.

Orix 209 - c1924-25. Double extension 9x12cm folding plate. Double Anastigmat Litonar f4.5/135. Compur 1-200. \$35-50.

Periscop - 9x12cm plate camera. Alpha lens. \$45-60.

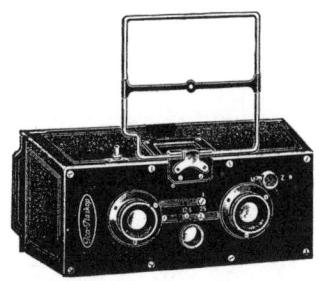

Plaskop - c1925. Rigid-bodied stereo camera for plates or packfilm. Ica Novar Anastigmat lens in guillotine shutter, T & I. Black leather covered wood body with black painted metal parts. Reflex & wire frame finders. 6x13cm: \$150-225.45x107mm:\$120-180.

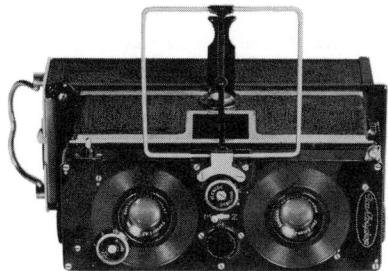

Polyscop (rigid body) - c1911-25.

Formerly made by Zulauf. Rigid-bodied stereo camera. Some models had plate backs; some had magazine backs. Could also be used as a panoramic camera by using one lens in the center position and removing the septum. Tessar f4.5 or 6.3 lenses. 6x13cm: \$175-250. 45x107mm: \$175-250.

Polyscop (strut-folding model) - For 45x107mm plates. Less common than the rigid models. \$200-300.

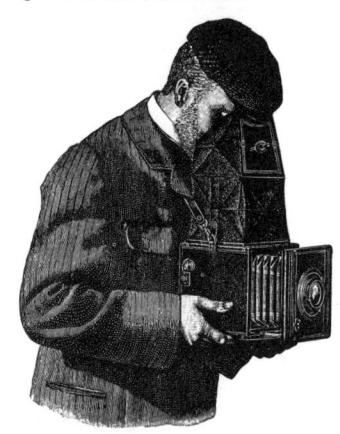

Reflex 748, 750, 756, 756/1 - c1910-25. Large-format SLR's, such as the Artists Reflex for 6x9cm, 8.5x11cm, or 9x12cm plates. The name Tudor Reflex was sometimes used for models of slightly lower specification. Tessar f4.5 or Maximar f6.8 lens. Focal plane shutter to 1000. \$175-250.

Folding Reflex - c1924. Very compact SLR which folds to about one-third the size of the box model. f4.5 Tessar or Dominar. \$250-375.

Reporter (Record) - c1912. Strut-folding 9x12cm plate. Tessar f4.5/150mm. FP shutter to 1000. \$120-180.

Sirene - c1914-26. Folding plate cameras, 6x9 or 9x12cm sizes. Economy models with f11 Periskop or f6.8 Eurynar lens. Ibso shutter. (Most common is Model 135 for 9x12cm.) \$35-50.

Stereo Ideal (650) - c1914-26. Folding stereo camera for 9x18cm plates. Twin f6.3 Tessar lenses. Compound shutter to 150. Twin black bellows. \$300-450.

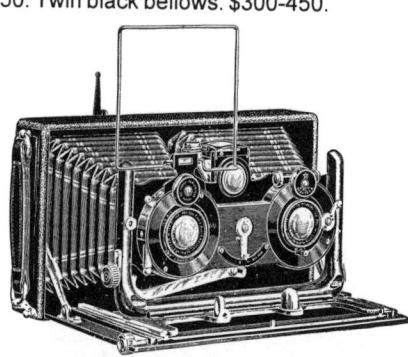

Stereo Ideal (651) - c1910. Folding bed stereo camera for 6x13cm plates. 90mm lenses (f4.5 or 6.3 Tessar or f6.8 Double Anastigmat) in Stereo Compound shutter. Magazine back. \$300-450.

Stereo Minimum Palmos (693) - c1924-26. Strut-folding stereo camera for 6x13cm plates or filmpack. Aluminum body with leather covering and leather bellows.

Folding frame finder. Externally coupled focusing Tessar f4.5 or Triotar f3.5 lenses. Focal plane shutter 1/30 to 1000. \$500-750.

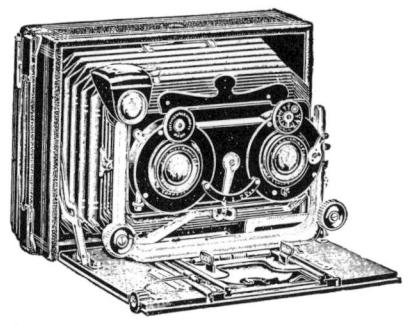

Stereo Reicka - c1910-14. Folding bed stereo camera for 10x15cm plates. Various lenses in Stereo Compound shutter. \$300-450.

Stereo Toska (680) - c1912-1920's. Folding-bed stereo for 10x15cm plates. Hekla f6.8/135mm. Compound shutter to 100.\$250-375.

Stereofix - c1919. Simple rigid-body jumelle-style stereo camera for 45x107mm plates. Novar Anastigmat f6.8 in Ica Automatic shutter, T,B, 25-100. \$200-300.

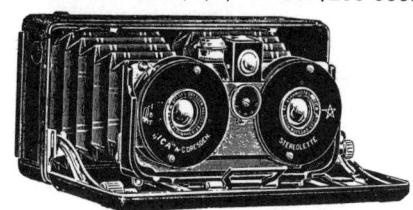

Stereolette 610, 611 - c1912-26. Compact folding-bed stereo camera for 45x107mm plates. Variety of available lens/shutter combinations. Model 610 has rack focus. Model 611 has radial lever. Wide range of sales from \$200-300.

Stereolette Cupido (620) - c1912. Folding 45x107mm stereo. Hekla f6.8 or Tessar f4.5 lenses. Stereo Compound or Compurshutter. \$250-375.

Teddy - c1914-22. 9x12cm folding plate camera. f8/130mm Extra Rapid Aplanat Helios or f6.8/135 Double Anastigmat Heklar. Automat shutter, \$50-75.

Toska, 9x12cm - c1914-26. Folding plate camera. Zeiss Double Amatar f6.8/135 or f8/130 Rapid Aplanat Helios. Ica Automat or Compound sh. \$50-75.

Toska 330, 10x15cm - Horizontally-styled double extension plate camera. Extra wide lens standard allows use as a stereo camera with optional stereo lensboard. Zeiss Doppel-Protar Series VII f7/145mmin Compur 1-200. \$300-450.

Trilby 18 - c1912. Magazine box camera for 6 plates 9x12cm or 12 exposures on sheet film. Ica Achromat lens. Guillotine shutter, T & I. Automatic exposure counter. \$120-180.

Triplex - c1912-14. Leather-covered folding plate camera, 13x18cm. Triple extension, black, bellows. Nickel trim. Dagor f6.8/180mm lens in Compound shutter. \$300-450.

Trix - c1915. Cut film cameras. Model 185, 9x12cm: \$50-75. Model 311, 10x15cm: \$60-90.

Trona - c1912-26. Double extension plate/rollfilm cameras. f4.5 Tessar. Compurshutter.

4.5x6cm - \$75-100. 6x9cm, 9x12cm - \$60-90.

Tropica 285 - c1912-26. Tropical model folding-bed 9x12cm plate camera. Square back style. Double extension bellows, finely finished wood body with nickel plated brass trim. \$500-750.

Tropica 345 - 10x15cm size. \$600-900.

Tudor Reflex - c1919-26. 9x12 SLRs, basically the same as the Ica Reflex, but the Tudor name was used in advertising those of slightly lower specification.

Dominar f4.5/105mm or Tessar 150mm lens. FP shutter. \$150-225.

Victrix - c1912-25. Folding bed_camera Dominar 4.5x6cm plates. Ica f4.5/75mm or Hekla f6.8/75mm. Automat or Compur shutter. Focus by radial lever on bed. \$100-150.

Volta 105, 106 - c1910-15. Folding-bed plate camera in 6.5x9cm size. Periskop f11 lens in Automat, or Novar f6.8/10.5cm. \$45-60.

Volta 125, 146 - c1914. Folding-bed 9x12cm plate camera. Novar Anastigmat f6.8/105mm. Shutter 25-100, T,B. \$45-60.

ICO S.C. (Belgium) Liberty-620 - c1950. Metal box camera for 6x9cm on 620 rollfilm. Simple f11 lens, 2-speed shutter. Folding frame finder on top. Rare. One recorded auction sale at

IDAM (Société d'Appareils Mécaniques IDAM, Colombes, France)

Belco - Cast metal camera for 36x36mm exposures on 127 rollfilm. Similar to the Clic camera, but with extinction meter incorporated in finder housing. Since the camera is not adjustable, the meter serves only to let the user know if it is practical to take a picture. The same camera was also sold with the name Roc. \$60-90.

Clic - c1953. Cast metal camera for 3x3cm on special film similar to Kodak 828. Single speed shutter. Bilux f8 lens.

Roc - Specifications and prices as Belco,

IDEAL TOY CORP. (Hollis, NY) Kookie Kamera - c1968. Certainly in the running for the most unusual camera design of all time, from the plumbing pipes to the soup can. It looks like a modern junk sculpture, but takes 13/4x13/4" photos on direct positive paper for in-camera processing. With colorful original box, instructions, disguises etc.: \$150-225. Camera only: \$100-150.

I.G.B. Camera - Japanese novelty subminiature of the Hit type. \$25-35.

IHAGEE KAMERAWERK, Steenbergen & Co., Dresden, Germany (The name derives from the German pronunciation of the initials "IHG" from the full company name "Industrie und Handels Gesellschaft" which means Industry and Trading Company. Ihagee was the largest independent camera maker in Germany. The larger firms, Voigtländer, Zeiss Ikon, and Agfa were owned by other firms (Scheering, Carl Zeiss Jena, & IG Farben.) After 1973, cameras bearing the Exakta name were made in Japan by various manufacturers.

Derby - c1924-34. Single extension folding bed camera for 9x12cm plates. Luxar f7.7/135mm in Vario 25-100. \$30-45.

Duplex cameras - Ihagee used the name "Duplex" for double-extension cameras. One of the Duplex models also had two shutters, and is listed under "Zweiverschluss".

Duplex (Vertical format) - c1920's-1940's. Folding bed plate camera with double extension bellows. 6.5x9cm or 9x12cm. Steinheil f3.5 or 4.5 lens, Compur shutter. \$60-90.

Elbaflex VX1000 - 35mm SLR. Same as Exakta VX1000. FP shutter 12-1000. Body with waist-level finder: \$90-130.

Exa - c1950's. 35mm SLR. A lower priced companion to the Exakta with simple metal shutter. Normal lenses: Meritar f2.8 or Domiplan f2.9 in Exakta bayonet mount with external diaphragm coupling. \$50-75.

Exa la - c1960. Redesigned Exa, modernized styling. Rapid advance lever. \$35-50.

Exa Ib - c1963. Similar to Ia, but for 42mm screwmountlenses. \$35-50.

Exa II - c1960. Fixed pentaprism version of Exa. Focal plane shutter B,-1/2-250. Lever advance. Interchangeable Exaktabayonet lenses. \$35-50.

Exa IIa - c1963. Like II, but with splitimage focusing screen. \$60-90.

Exa IIb - c1965. Instant return mirror. \$60-90.

Exa 500 - c1967. Top speed increased to $1/_{500}$, otherwise similar to IIb. \$50-75.

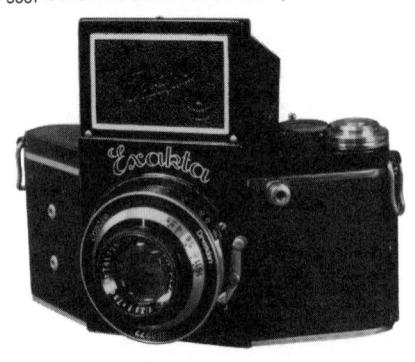

Exakta (original), Exakta A - 1933. First small focal plane SLR. 8 exposures 4x6.5cm on 127 rollflm. f3.5 Exaktar or Tessar. Focal plane shutter 25-1000. Black finish. No slow speeds or synch. (Called model A only after the introduction of model B in 1934. Synch was added to all models in 1935.) \$200-300.

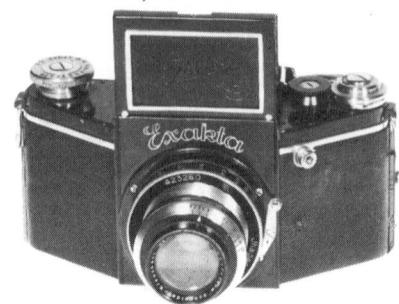

Exakta B - c1935. Similar to the original model (A) above, but with slow speeds. Main body still black leather covered, but some models have chrome finish on metal parts. Focal plane shutter 25-1000, and slow speeds to 12 sec. Self-timer. f2.8 or f3.5 Tessar or Xenar normal lens. Early models have knob wind, later ones have lever. \$175-250.

Exakta C - c1935. Much less common than the A & B. Accepts plate back adapter with ground glass for using plates or cut film. \$200-300.

Exakta Jr. - c1936. Similar to the model A, but speeds only 25-500. "Exakta Jr" on

IHAGEE

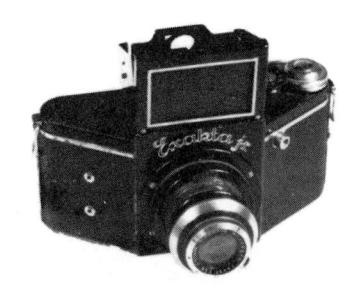

the front. Non-interchangeable lens. No self-timer. \$300-450.

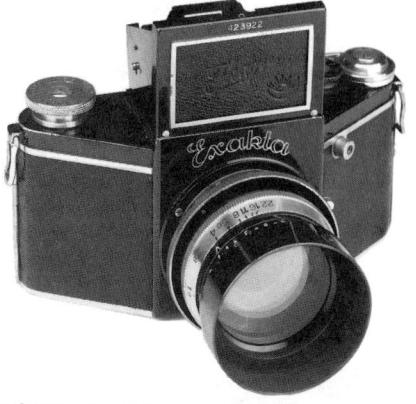

Night Exakta - c1936. Similar to the model B, but with special fast lenses. It was available in all-black until 1937, when chrome became an option. Biotar f2.0/80mm, Xenon, or f1.9 Primoplan lens. \$400-600. The easiest way to make a quick identification is that the serial number is on the viewing hood and not on the lens flange.

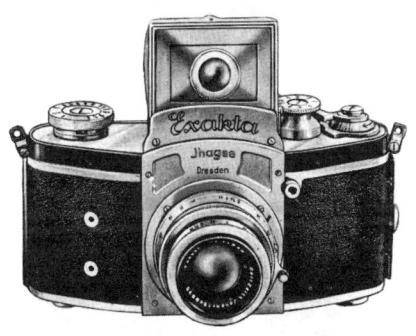

Kine Exakta I (original type) - 1936. Identifiable by the round magnifier in the non-removable hood. Similar in appearance to the larger "VP" model from which it was derived. Focal Plane shutter 12 sec. -1/1000. Bayonet mount interchangeable lenses include Exaktar f3.5/50, Primotar f3.5/50, Tessar f3.5/50, Primotar f3.5/50, Tessar f2.8/50, Primoplan f1.9/50, and Biotar f2/58mm. One of the first 35mm SLR's; the Russian "Sport" camera having possibly taken that honor in 1935. Historically important and rare. \$800-1200.

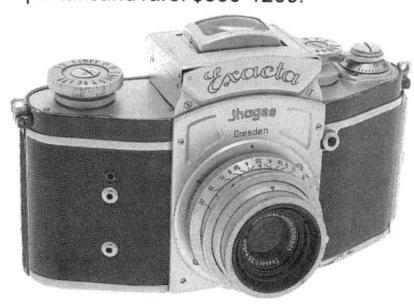

Version engraved "Exacta"

Kine Exakta I (rectangular magnifier) - c1937-48. Like the original type, but with a rectangular focusing magnifier. No cover on the magnifier. Non-removable finder. One model with name engraved "ExaCta". Prewar production identifiable by: central groove on milled rim of slow speed dial; "lhagee" on back leather; flocked mirror chamber. Postwar models have ribbed mirror chamber. \$150-225. Illustrated at bottom of previous column.

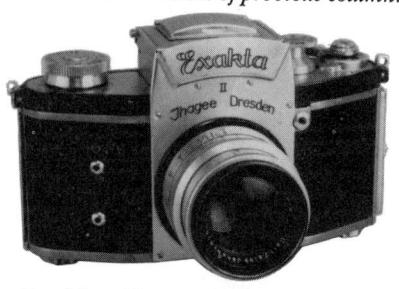

Exakta II - c1949-50. 35mm SLR. Rectangular focus magnifier with hinged protective door. Interchangeable bayonet-mount lenses: f2.8 or 3.5/50mm Tessar, f2.8/50 Westar, f2/50 Schneider Xenon. \$120-180.

Exakta V (Varex) - c1950. First 35mm with interchangeable pentaprism finder. Normal lenses as listed above with Exakta II. Nice working examples: \$100-150. Often seen for less when not working.

Exakta VX (Varex VX) - 1951, model changes in 1953 & 1956. Same normal lenses as Exakta II. Very common. With normal lens: \$75-100. Body only: \$45-60.

Exakta VX IIA (Varex IIA) - 1957, model changes in 1958 & 1961. Also very common. With normal lens and prism finder in Excellent condition: \$90-130. Body only: \$50-75.

Exakta VX IIB (Varex IIB) - c1960's. Similar to the VX IIA with minor cosmetic changes. With normal lens: \$100-150.

Exakta VX 1000 - c1967. Newly designed camera with instant return mirror. Bayonet-mount lenses with external coupling for automatic diaphragm. With normal lens: \$120-180.

Exakta VX 500 - c1969. Like VX 1000, but top speed of 1/₅₀₀. \$75-100.

Exakta Real - c1967. Technically, this camera is from a different company, Exakta West, but because of the similar name and historical roots, we are including it with the other Exakta models. Made by "lhagee West", a new firm created by one of the designers of the pre-war Exaktas. The Exakta style bayonet is a new, larger size (46mm) with internal diaphragmlinkage. An adapter ring allowed use of the older Exakta 38mm bayonet-mount lenses on the Real, but not vice-versa. Cloth shutter 2-1/1000 sec. Instant-return mirror. According to our files, it was only made for about a year, and only a few thousand actually

Exakta RTL 1000 - c1970. Totally redesigned camera, with modernized "rectangular" body, top-mounted, right-hand shutter release and internal coupling for diaphragm. Also retains the traditional

made it to market. No sales data.

left-hand front release to couple with the older lenses. Interchangeable finders include WL, prism, & TTL metering prism. Exakta bayonet mount lenses. \$75-100.

Exakta Twin TL - c1973. Made in Japan by Cosina, but sold under the Exakta label. All black finish. Copal Square 1-1000,B shutter. CdS TTL stopped-down, match-needle metering. Exaktar f1.8/50mm or f1.4/55mm in the large "Exakta Real" type (46mm) bayonet mount. Adapters available for standard 38mm Exakta bayonet or Praktica screw mount lenses. One version of the camera, called Twin TL 42, came with standard 42mm thread mount. The same camera was also advertised as "Carena MSTL". \$75-100.

Exakta TL 500 - c1976. Made in Japan; like Petri FTX or Exakta FTL 1000, but top speed only 1/500. Standard M42 lens mount. Chrome only. \$75-100.

Exakta TL 1000 - c1976. Made in Japan; appears nearly identical to the Petri FTX. Standard 42mm threaded lenses. Shutter B, 1-1/₁₀₀₀. Stopped-down TTL CdS metering. Black or chrome. \$75-100.

Exakta FE 2000 - c1977. Made in Japan by Petri. Cloth-shuttered SLR with Praktika thread mount. CdS TTL shutter-priority metering. \$100-150.

Exakta EDX 3 - c1978. Made in Japan by Tokyo Kogaku. Topcon/Exakta bayonet lens mount. Copal Square metal shutter, 1-1000,B. CdS TTL metering with match-LED display in finder. \$100-150.

Exakta 66 - Single lens reflex for 12 exposures 6x6cm on 120 rollfilm. f2.8 Tessar or Xenar. Two distinct body styles:

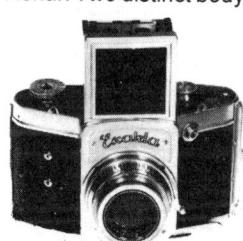

-Pre-war model - c1938. Horizontal body style and film transport (like an overgrown Exakta A, B or C). Focal plane shutter, 12 sec to 1/1000. \$750-1000.

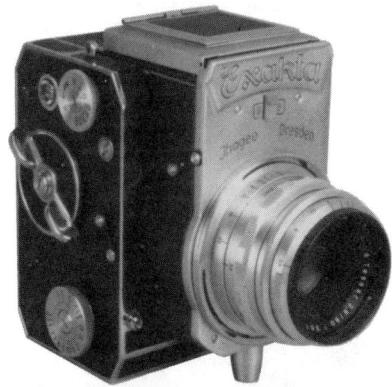

-Post-war style - c1954. Vertical style. Features interchangeable lenses from 56mm to 400mm, interchangeable backs for rapid film change. M-X sync. shutter 12 sec.- 1/₁₀₀₀ sec. With f2.8/80mm preset Zeiss Tessar normal lens: \$800-1200.

IHAGEE...

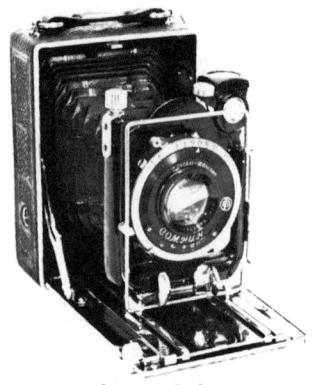

Ihagee folding plate cameras -Large range of sizes from before WWI until WWII. Most commonly found: 6x9cm with f4.5/105mm Tessar in Compur shutter or 9x12cm with similar equipment: \$60-90.

Ihagee folding rollfilm cameras - 1920's-'30's. Large range of sizes. Typical example with f4.5 anastigmat lens in Compur or Prontor shutter: \$35-50.

Newgold - c1927. Tropical folding plate camera. 6.5x9cm or 9x12cm sizes. Polished teak, brass fittings. Brown leather bellows. U-shaped gilt brass front standard with rise/fall/shift. Tessar f5.6 lens in gilt Compurshutter. \$750-1000.

Parvola - c1930's. Also called Klein-Ultrix. For 127 rollfilm, plates or packs. Helical telescoping front. Three models: 3x4cm, 4x6.5cm, and the twin or "two-format" model taking either size. 3x4cm: \$100-150.4x6.5cm: \$75-100.

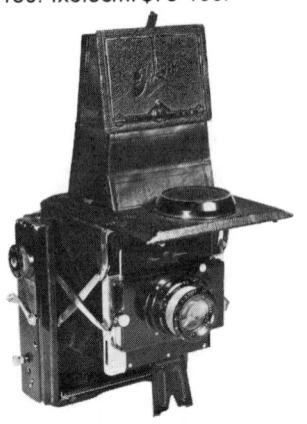

Patent Klapp Reflex - c1920's. Compactfolding SLR for 6.5x9 or 9x12cm.

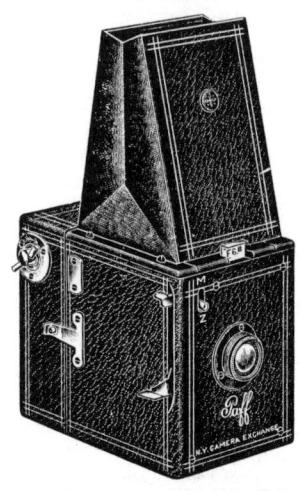

Early version of Roll-Paff-Reflex.

Focal plane shutter to 1000. f4.5 Dogmar, Tessar or Xenar. \$300-450.

Photoknips - pre-1924. Compact 4.5x6cm plate cameras. Front supported by cross-swinging struts. Wire frame finder. Achromatic lens. Front wheel with 3 stops. Shutter 1/4-100,Z. Uncommon. \$250-375.

Plan-Paff - 1921-c1930. Box style SLR for 6.5x9cm plates. Trioplan f6.3/105mm lens. Z,M shutter. Also available in 4.5x6cm size which brings a bit more. \$150-225.

Roll-Paff-Reflex - intro. 1921. SLR box camera for 6x6cm on 120 film. Simple meniscus Achromatic or Meyer Trioplan f6.8/90mm lens. Z,M shutter. \$90-130. *Illustrated bottom of previous column*.

Stereo camera - Folding bed style for 6x13cm plates. Meyer Trioplan f6.3/80mm lens. Stereo Prontor shutter. \$250-375.

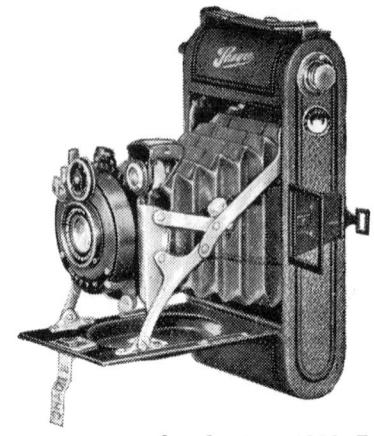

Ultrix (Auto, Simplex) - c1930. Folding bed camera. Small size for 4x6.5cm on 127 rollfilm: \$90-130. Larger size for 6x9cm on 120 film: \$60-90. These prices are based on numerous sales, mostly in Germany where the cameras are relatively common. Dealers in the USA have been known to ask higher prices.

Ultrix (Cameo, Weeny) - c1931. Models with telescoping screw-out lens mount like the Parvola, above. \$75-100.

Ultrix Stereo - c1925-37. Folding bed rollfilm camera for 7x13cm stereo exposures. Doppel-Anastigmat f4.5/80mm. Compur shutter 1-300. Leather covered. Black enamelled baseboard. Brass and nickeled parts. \$250-375.

Victor - c1924-34. Double extension folding plate camera. Compurshutter. **9x12cm** - Xenar f4.5/105mm. \$45-60. **10x15cm** - Veraplan f6.8/165. \$50-75.

Zweiverschluss Duplex - c1920's. Folding bed plate camera. Square body with DEB. Focal plane shutter in addition to the front inter-lens shutter. 6.5x9cm and 9x12cm sizes. \$175-250.

IKKO SHA CO. LTD. (Japan) The first of the Start cameras was made by Nomura Optical Co. about 1948. Beginning during the production of the Start II, the Ikko-sha

name was used. The first "Start" camera was a bakelite box camera which did not use rollfilm, but single film sheaths, each containing one piece of 35mm film, similar to the film used in the low-cost "Yen-kame".

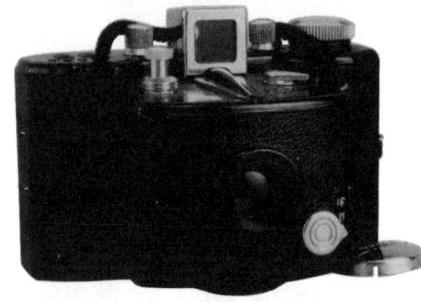

Start 35 - c1950. A simple bakelite eyelevel camera for 24x24mm on 35mm wide Bolta-size rollfilm. "Start 35" is molded into the top. Top removes to load film. Fixed focus f8, B,I shutter. Original box says "Start Junior Pen Camera" and instructions call it "Start Junior Camera". This model is much less common than the later ones. \$100-150.

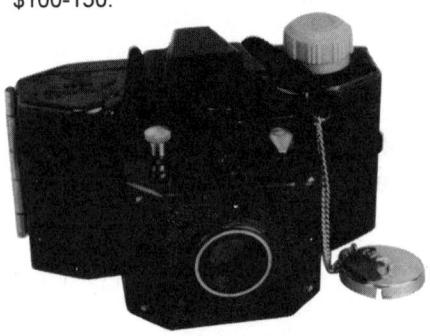

Start 35 K - Similar, but with hinged back. \$35-50.

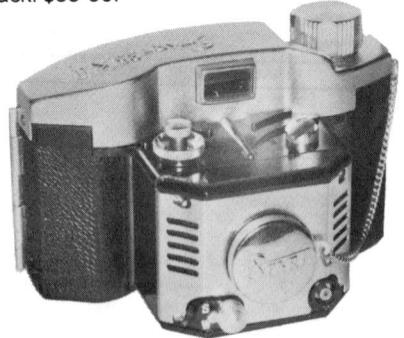

Start 35 K-II - c1958. A deluxe version with metal top housing and front trim plate. PC sync post on front. "Start 35 K-II" on top. An attractive camera. \$50-75.

ILFORD LTD. (England) Ilford commenced business in 1879, but concentrated on photographic supplies in the early years. Its plates and papers were widely used and acclaimed.

Advocate - c1953. Cast metal 35mm. Ivory enameled finish. Early model (I) had Dallmeyer Anastigmat f4.5 and later model (II) had Dallmeyer f3.5/35mm. A few had Wray Lustrar f3.5. The rarest variety has the Ross f3.5. Shutter 25-200. \$90-130. Dealers ask \$150-200 with Lustrar, but they remain unsold for many months.

Advocate X-ray - c1956. Black enamel version of the Advocate with sheath-shutter for X-ray photography \$200-300.

Craftsman - Bakelite reflex box camera with focusing lens. Large brilliant finder. \$30-45.

Envoy - c1953. Bakelite 120 rollfilm camera, 6x9cm. Optimax lens, single speed shutter. Optical eye-level viewfinder molded into top. \$12-20.

Sporti 4 - An inexpensive plastic eyelevel camera for 127 film. Styled like a 35mm camera. Black & tan body with brass-colored trim. Made by Dacora for llford. \$20-30.

Sportsman - c1959. A line of mostly viewfinder 35mm cameras made for Ilford by Dacora. Like the Super Dignette. Dignar

f2.8/45mm. Variations include Vario, Pronto LK 15-500, or Prontor SVS 1-500 shutter. First introduced without a bright frame finder. About 1960, the bright frame finder was added to the same basic design. Later the design changed with the addition of a rangefinder window; sometimes a rangefinder was installed, but sometimes the rangefinder window was only decorative. \$15-25.

Sportsmaster - c1960. Made by Dacora for Ilford, similar to the Dacora-Matic 4D. Simple rigid 35mm with BIM. Dacora Dignar f2.8, Prontor-Lux shutter, $1/_{30}$ -500. Four shutter release buttons on front used to select four different focusing ranges. \$35-50.

Sprite - 4x4cm gray plastic eye-level box camera. Made by Agilux (Colt 44). \$8-15.

Sprite 35 - Inexpensive grey plastic 35mm. Fixed focus f8 lens, with f11 and f16 stops. Single speed shutter. Lever advance. DEP. Identical to Agilux Agiflash 35. \$12-20.

Witness - c1951. 35mm, coupled range-finder. Originally with 2.9/50mm Daron, later with Dallmeyer Super-Six f1.9/2" lens in interrupted screw-thread mount. FP shutter 1-1000. Less than 350 were made. Uncommon. Several incomplete or broken examples have sold at auction in England for low prices. Good, working examples sell for \$2400-3200.

IMPERIAL CAMERA CORP. (Chicago)

Deluxe Reflex - Inexpensive plastic TLR box camera. \$1-10.

IMPULSE

Plastic 4x4cm cameras - c1964. Such as: Cinex, Cubex IV, Delta, Deltex, Lark, Mark 27, Matey 127 Flash, Mercury Satellite 127, Nor-Flash 127, Roy, Satellite II. Colored: \$12-20. Black: \$1-10.

Plastic 6x6cm cameras - c1956. Such as: Adventurer, Mark XII Flash, Reflex, Savoy, Six-twenty, Six-Twenty Reflex. Colored: \$12-20. Black: \$1-10.

Special models - Scout cameras, Rambler Flash Camera (AMC preminum), etc. \$20-30.

IMPERIAL CAMERA & MFG. CO. (LaCrosse, WI)
Magazine camera - c1902. Falling-plate magazine box camera for twelve 4x5" plates. \$50-75.

IMPULSE LTD. (Maryland Heights, MO. USA)
Voltron Starshooter 110 - c1985. A working 110 camera forms part of the body of the Voltron robot. The robot converts to the shape of a 35mm camera, with the real 110 camera taking lens appearing to be

INDO

the viewfinder of the dummy 35mm camera. Made in Macau. \$30-45.

INDO (Lyon & Paris, France) The name is an abbreviation of Industrie Optique. The camera line is a continuation of cameras from Fex. Most are low-priced models, often used as premiums and found with promotional messages printed on them.

Comodor 127 - Simple, boxy, 127 camera. Built-in flash for AG-1 "peanut" bulbs, below and to left of the lens. \$20-30.

Compact 126 XR - One of the few 126 cameras to break away from the boxy design of the orignial Kodak "Instamatic" cameras. For those who collect 126, this is worth looking for. Rarely found outside of France. \$15-25.

Impera - c1969. Simple black plastic

eye-level camera for 4x4cm on 127 film.

Safari - Simple rectangular plastic camera for 127 film. Similar to the Comodor, but without flash. \$12-20.

Safari X - c1978. Basic camera for 126 cartridges and X cubes. \$1-10.

INDRA CAMERA Ces.mbH.
(Frankfurt, Germany) Founded by Walter Draghissevis & Werner Klatten.
Indra-Lux - c1949. Streamlined black plastic camera for 4x4cm on 127 film. Fixed focus f7.7/60mm lens from Wetzlar. Z&M shutter. Direct eye-level finder has tinted plastic front to simulate result on B&W film. Very Rare. Indra Camera was in business only a few months. First advertising appeared about December 1949. Until our seventh edition, no major reference book even had a photograph of this camera, but only the line drawings used in early advertising. \$150-225.

INDUMAG (Argentina)
Leduc X-127 - Two-tone grey plastic camera for 4x4cm on 127 film. Styling inspired by Ansco Cadet II & III. \$15-25.

Irwin Kandor Candid

INETTE - Folding 6x9cm rollfilm camera, made in Germany. Inetta f6.3/85mm lens in Embezit shutter. \$15-25.

INFLEX - c1950. Unusual German castmetal camera for 4x4cm on 127 rollfilm. Waist-level reflex styling, but viewer is a simple brilliant finder. Zeyer Anastigmat f3.8/50mm lens in Vario shutter. Rare. \$175-250.

INGERSOLL (Robert Ingersoll Brothers New York City)

Brothers, New York City)
Shure-Shot - Tiny all-wood box plate camera for single exposures on glass plates. Simple rotary shutter. 21/2×21/2" size: \$250-375. 33/4×33/4" size, less common: \$250-375. Note: This is not to be confused with the later model "Shur-Shot" box cameras by Agfa and Ansco for rollfilms.

INTERNATIONAL METAL & FERRO-TYPE CO. (Chicago, III) Diamond Gun Ferrotype - Large nickel cannon-shaped street camera. \$1200-1800.

IRWIN (U.S.A.)
Inexpensive 3x4cm cameras c1940's. Such as: Dual Reflex, Irwin Reflex, Irwin Kandor, Kandor Komet, SuperTri-Reflex. Metal sardine-can shaped
novelty cameras in horizontal and vertical
styles. \$30-45. Illustrated bottom of previous column.

ISE (Germany) Edelweiss Deluxe - Folding camera for 6.5x9cm plates. Brown leather, tan double extension bellows. Tessar f4.5/120mm lens in Compur. \$100-150.

ISGOTOWLENO: Translates as "Made in the U.S.S.R."

ISING (Eugen Ising, Bergneustadt, Germany)

Isis - c1954. Metal eve-level camera with telescoping front for 6x6cm on 120 film. Steiner f4.5/75mm lens in Pronto 25-200 sync shutter with self-timer. Uncommon. \$45-60.

Isoflex I - c1952. Heavy cast metal reflex box, 6x6cm. Focusing lens. Large brilliant finder. Same as Pucky I. \$20-30.

Puck - c1948. Compact 3x4cm rollfilm camera with telescoping front. Small optical finder through body. Cassar f2.8/50mm in Prontor II. \$75-100.

Pucky - c1949-50. Twin-lens box camera. Bakelite body. Large brilliant finder. M&Z shutter. \$30-45.

Pucky I, Ia, II - c1950-54. Like Pucky but with cast aluminum body. Model I is found with or without hinged finder hood. Models Ia & II have hood, \$35-50.

ISO (Industria Scientifica Ottica S.R.L., Milan, Italy)

Bilux - c1950. 35mm with coupled rangefinder. Essentially the same camera as the Iso and Henso Reporter cameras. Lever advance in baseplate. Interchangeable Iriar f3.5/50mm lens. Focal plane shutter 1-1000. \$1200-1800.

Duplex 120 - c1950. Stereo camera for 24 pairs of 24x24mm exposures on 120 film. The 24x24 format was the common format for 35mm stereo, but putting the images side-by-side on 120 film advanced vertically was a novel idea. Fixed-focus Iperang f6.3 lenses. Three-speed shutter. \$150-225.

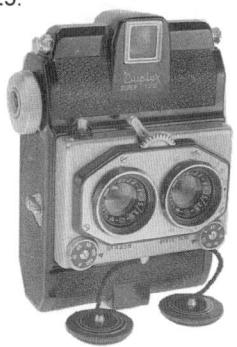

Duplex Super 120 - c1950. Stereo camera, fuller-featured version of the Duplex 120. Focusing f3.5 Iriar lenses. Six shutter speeds P,10-200. Single or stereo exposures are selectable by side lever. \$300-450.

Reporter - c1954. Rangefinder 35mm. Similar to the Standard, but with folding Leicavit-type trigger wind mechanism on bottom. Arion f1.9 in rigid mount, or Iriar f2.8 in collapsible mount. Also sold by Hensoldt of Wetzlar as the Henso Reporter. \$1000-1500.

Standard - c1953. Rangefinder 35mm. ladar f3.5/50mm. FP shutter 20-1000. A knob-advance version of the ISO/Henso Reporter, also sold under the "Henso Standard"name. \$750-1000.

ISOKAWA KOKI (Japan)

Isocaflex - c1950s. TLR for 6x6cm on 120 rollfilm. Isunar f3.5/75mm lens, 1-200, B shutter. Knob wind. \$90-130.

ISOPLAST GmbH (Germany)

Filius-Kamera - c1954. Black plastic novelty camera for 32x40mm exposures on Juka film. Meniscus f11 lens in 1/50 sec shutter. \$60-90.

ITEK CORP. (Lexington, MA)

Quad 32-40 - c1962. Four-lens camera with Polaroid rollfilm back for 8-exposure Type 40 instant rollfilms. (See the manufacturer Avant for a later model using type 100 pack film.) Each of the 8 exposures is split into four simultaneous frames. An accessory rotary mask for the front of the lenses allows single or paired exposures. Original price in 1962 was \$495. Collector value \$60-90.

IVES (F.E. Ives, Philadelphia, Penn.) Kromskop Triple Camera - c1899. First American camera making tri-color separation negatives in a single exposure. Three plates exposed simultaneously through 3 colored filters, by the use of prisms. Plates were arranged vertically in the camera body. Rare. One sold at Breker 10/91 for \$2500. Similar asking prices noted in London shops.

JAK-PAK

Kiddie Camera - Novelty camera for 126 cartridges. A boy's or girl's face covers the camera front, \$12-20.

JEANNERET

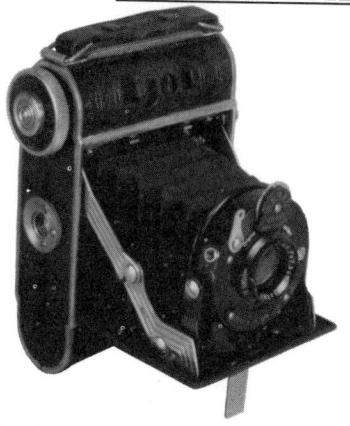

JANSEN (Photohaus Emil Jansen, Barmen, Germany)

After several years of looking for a clue on Ejot cameras, one of our readers supplied photos of Ejot labels found on a camera and case. These labels gave the first positive link to Emil Jansen in Barmen, a suburb of Wuppertal. Jansen apparently was a dealer, not a manufacturer. However, at least one camera was "badge engineered" with the Ejot name. Any readers having information on other models of Ejot cameras are requested to contact the editors. Thank you.

Ejot - c1933. Folding camera for 4.5x6cm on 120. Name variation of the Baldax 4.5x6, made by Balda for Emil Jansen. "Ejot" embossed on front leather. Ejotar Anastigmat f4.5/75mm lens in Vario shut-

ter. \$50-75.

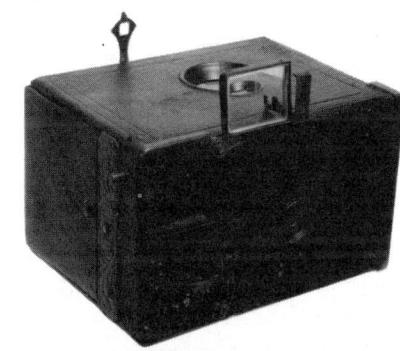

JAPY & CIE. (France)

le Pascal - c1898. Box camera with spring-motor transport. 12 exposures, 40x55mm on rollfilm. Meniscus lens, 3 stops. 2-speed shutter, B. Leather covered wood and metal body with brass trim. The first motorized rollfilm camera. \$400-600.

JAY DEE - "Hit" type Japanese novelty subminiature, \$25-35

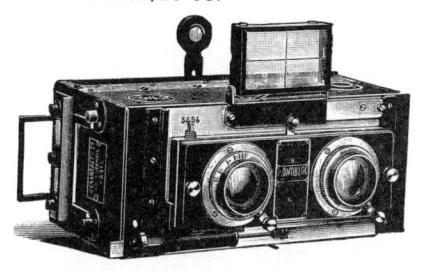

JEANNERET & CIE. (Paris)

Monobloc - c1915-25. Stereo camera for 6x13cm plates. Metal body, partly leather covered, with built-in magazine. f4.5 Boyer Sapphir or f6.3 Roussel Stylor 85mm lenses. Pneumatic shutter. \$250**JEM**

JEM (J. E. Mergott Co., Newark, N.J.)

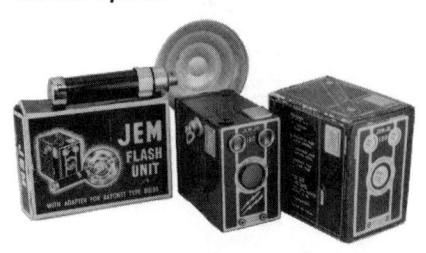

Jem Jr. 120 - c1940's. All metal box camera. Simple lens and shutter. \$8-15.

Jem Jr. 120, Girl Scout - All metal, green-enameled box camera. The Girl Scout emblem is on the front below the lens. \$20-30.

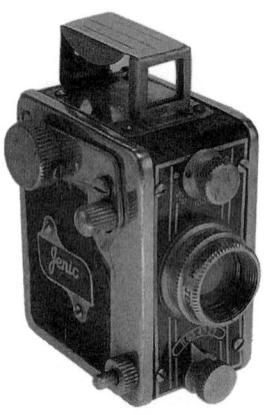

JENIC - c1949. Japanese subminiature for 15x15mm exposures on "Mycro-size" roll-film. Fixed focus Jenic Anastigmat f2.8/3.5cm lens. Top mounted optical finder. Uncommon. \$1200-1800.

JEWELL 16 - Plastic camera for half-frame exposures on 127 rollfilm. \$8-15.

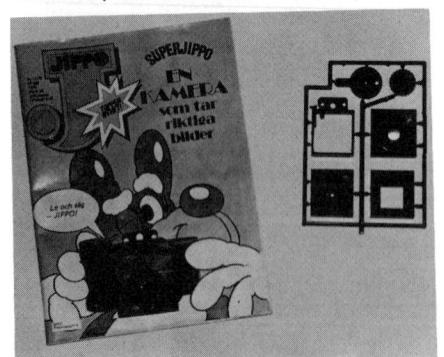

JIPPO - 1978. Simple kit for building a camera which attaches to 126 cartridge. Sold with the Finnish children's newspaper "Jippo" in May, 1978. Unassembled, with original magazine: \$20-30.

J.M.V. (Spain)

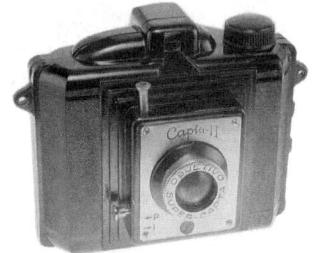

capta, capta II, Super-capta - c1940's. Black bakelite cameras for

4x5.5cm on 120 rollfilm. Top styling similar to Kaftax. Super-Capta lens. Two speed shutter. \$25-35.

Capta-Baby - Black bakelite camera for 4x6.5cm on 127 film. Fix-focus lens, P&I shutter. \$30-45.

JONTE (F. Jonte, Paris, France)
Field camera - c1895-1900. 5x7"
mahogany camera with brass binding.
Rotating bellows for vertical or horizontal
use. \$250-375.

JOS-PE GmbH (Hamburg & Munich)
The company name comes from one of the owners, JOSef PEter Welker, a banker. The other owners were photographer Koppmann and engineer Gauderer.

Tri-Color Camera - c1925. All-metal camera for single-shot 3-color separation negatives. Coupled focusing via bellows to each plate magazine. Scarce.

4.5x6cm size - Quinar f2.5/105mm lens. Compound shutter: \$2000-3000.

9x12cm size - Cassar f3/180mm in Compound 1-50 shutter. \$1500-2000.

JOTA BOX - c1949. German metal box camera, 6x9cm. Simple lens and shutter. \$45-60.

JOUGLA (J. Jougla, Paris, France) sinnox - c1901-06. Magazine-box camera with tapered body. Magazine holds 6 plates, 9x12cm. Rapid Rectilinear lens in Wollensak pneumaticshutter. \$200-300.

JOUX (L. Joux & Cie. Paris, France) Alethoscope - 1905. All-metal stereo plate camera. Rectilinear Balbreck lenses. 5-speed guillotine shutter. Newton finder. 45x107mmor 6x13cm sizes. \$200-300.

Ortho Jumelle Duplex - c1895. Rigid-bodied "jumelle" style camera. Magazine holds 6.5x9cm plates. f8/110 Zeiss Krauss Anastigmat. Five speed guillotine shutter. An uncommon camera. \$200-300.

Steno-Jumelle - c1895. Rigid, tapered body, magazine camera for 18- 6.5x9cm or 12- 9x12cm plates. The magazine is built to the camera body, and is loaded through a panel on top. Raising the hinged top when the lens is pointed upward

moves the push-pull plate-changing mechanism. \$250-375.

Steno-Jumelle Stereo - c1898. Similar design to the Steno-Jumelle, but with 2 lenses for 8x16cm stereo exposures. 12-plate magazine. \$400-600.

JUHASZ INC. (Los Angeles)
Clink - Unusually designed snap-on camera for 110 cartridge, made in Taiwan for Juhasz. Red, white, & blue front label in American flag motif. \$1-10.

JULIA - c1900-05. Horizontally styled folding bed rollfilm camera for 9x9cm. Leather covered wood body. Shutter built into wooden lensboard. \$250-375.

JUMEAU & JANNIN (France)

Le Cristallos - c1890. 6x9cm or 9x12cm folding bed cameras, for darkroom-loaded rollfilm. Black leather with gold outlines. Lens has external wheel stops. \$250-375.

JUMELLE The French word for "twins", also meaning binoculars. Commonly used to describe stereo cameras of the European rigid-body style, as well as "binocular-styled" cameras where one of the lenses is a viewing lens and the other takes single exposures. See French manufacturers such as: Bellieni, Carpentier, Gaumont, Joux, Richard.

JUNIOR CAMERA - Box style Yencamera. \$20-30.

JUNKA-WERKE (Zirndorf b/Nürnberg, Germany)

Exhibit - An uncommon export version of the Junka, with English language markings. \$90-130.

KAFTANSKI (Fritz Kaftanski)

Banco Perfect - Plastic bodied rollfilm camera with telescoping front. 21/₄x31/₄" exposures. Focusing lens, built-in yellow filter. \$12-20.

Kali-flex - c1966. Simple, plastic, TLRstyle camera. Kalimar f8 to f22 lens.

KALIMAR (Japan)

Between-the-lens shutter.

KALIMAR

6x6cm

Kalimar A - c1955. 35mm non-range-finder camera. f3.5/45mm Terionon lens. Between-the-lens synchro shutter to 200. \$25-35.

Kalimar 44 (Colt 44) - c1960. Made for Kalimar by Hoei Industrial Co. Both names, "Colt 44" and "Kalimar 44" appear on the camera. 4x4cm on 127 rollfilm. Kaligar f8/60mm lens. Single speed shutter. \$20-30.

Kalimar Reflex - c1956-62. Made for Kalimar by Fujita Optical Ind. SLR. Interchangeable Kaligar f3.5/80mm lens, focuses to 31/2". FP shutter 1-500, B, X sync. Instant return mirror. Export version of Fujita 66. With normal lens: \$90-130.

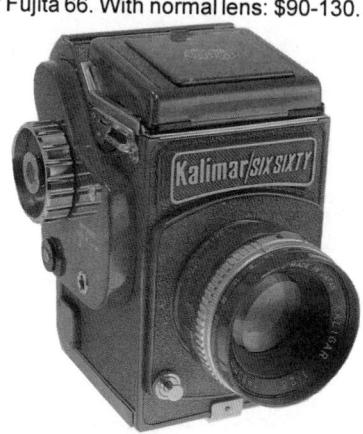

Kalimar Six Sixty - c1963-69. Nicely styled two-tone grey SLR for 6x6cm on 120 film. Successor to the Kalimar Reflex. Made by Fujita as a moderately priced alternative to the Hasselblad, Rollei, and Bronica models, with a list price of \$190 and street price as low as \$109 in 1967. Interchangeable f2.8 preset Kaligar; 1/5 to 1/500 cloth focal plane shutter. \$120-180.

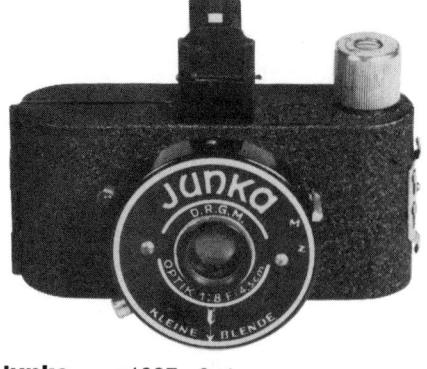

Junka - c1937. 3x4cm exposures on special paper-backed rollfilm. Achromat f8/45mm lens in single speed shutter. \$50-75. The same basic camera was sold by Adox after WWII and was named Juka.

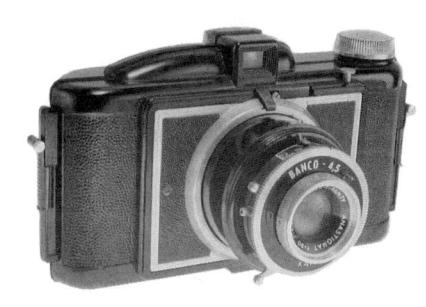

Banco 4.5 - The best of the Banco cameras, it retains the same basic body, but with major modifications to the back. While the meniscus models had a curved film plane and back, the f4.5 anastigmat model required a flat film plane and pressure plate. The modified back becomes obvious only if you look for it. Transpar-Tiranty f4.5/80 in B,25-150 shutter on telescoping front. \$30-45.

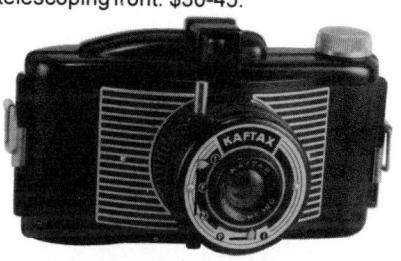

Kaftax - Similar in design to the Banco Perfect, but simpler. Rigid body with noncollapsing front. Fixed focus lens. \$12-20.

JURNICK (Max Jurnick, Jersey City, New Jersey)
Ford's Tom Thumb Camera - c1889.
Similar body style to the Photosphere camera. All metal. Camera is concealed in a wooden carrying case for "detective" exposures. Later models are called the Tom Thumb camera, dropping Ford's name from the camera name. With original wooden case: \$3500-5500.

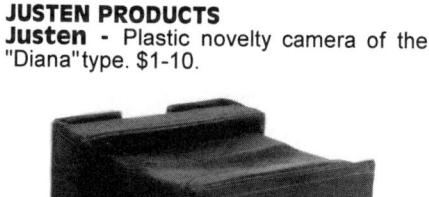

KALART CO. (New York City) Kalart Press camera - 1948-53. 31/4x41/4". Dual rangefinder windows to allow for use with either eye. f4.5/127mm Wollensak Raptar in Rapax 1-400 shutter. Dual shutter release triggers controlled by Electric Brain. \$200-300.

J.V. (Paris)
Le Gousset - c1910. Inexpensive folding camera for 4.5x6cm plates. Single-pleat bellows held erect by manually operated interior struts. Periscopique or "Stereoscopique" lens (you figure out how a single meniscus lens merits the stereo name). Astra No. 1 or No. 2 shutter. \$175-250.

KALIMAR...

TLR 100 - Black plastic TLR made by the Gomz factory in Russia. Copy of Voigtländer Brillant body, but viewing lens is externally coupled to the taking lens. Lomo T-22 f4.5/75mm. Shutter B, 15-250. Also sold as Lubitel 2. \$12-20.

KALOS CAMERABAU GMBH

(Karlsruhe, Germany) Kalos - c1950. Subminiature for 30 9x12mm on unperforated exposures, 16mm film. Eye-level optical finder. Mikro-Anastigmat f4.5/20mm lens. Shutter B,30,50,100. Uncommon. Top recorded auction price 12/91: \$645. Normal range: \$400-600.

Kalos Spezial - An improved version of the Kalos, with more streamlined ap-pearance. Staeble-Werk Kata f2.8/25mm lens. Similar camera later sold as Kunik Petitux IV. \$350-500

KAMBAYASHI & CO. LTD. (Japan) **Homer No. 1** - c1960. Novelty subminiature. Construction similar to "Hit" type cameras, but style is different. Gray metal exterior. Black plastic interior. 14x14mm exposures on 16mm rollfilm. Meniscus lens. Single speed shutter. \$60-90.

KAMERA & APPARATEBAU (Vienna, Austria) **Sport-Box 2, Sport-Box 3** - c1950. Black bakelite eye-level box cameras. Folding frame finder. f8/50mm lens. M,T shutter. \$35-50.

KAMERAWERKE THARANDT (Germany) Vitaflex - c1949. TLR-style, 6x6cm on 120 film. Some with f3.5/75mm Brillantar or Pololyt, others with f4.5 lens. \$50-75.

Versions of the Kamerette and Kamerette Junior cameras

KAMERETTE No. 1, No. 2 - Small Japanese "Yen" box camera with ground glass back. Uses sheet film in paper holders. \$20-30

KAMERETTE JUNIOR No. 1, No. 2, No. 4 - c1930. Japanese "Yen" box camera for 11/4x2" cut film. \$20-30.

KAMERETTE SPECIAL - Japanese folding "Yen" camera for single sheet films in paper holders. Wood body, ground glass back. \$50-75.

KAMETAMA (Egg Camera) - c1988. Camera shaped like large white egg. Front door has jagged edges as though cracked open. Interior mechanism is "micro-110" type. Country of origin not marked, but possibly Japan or Taiwan. Apparently very little distribution. Estimate \$100-150.

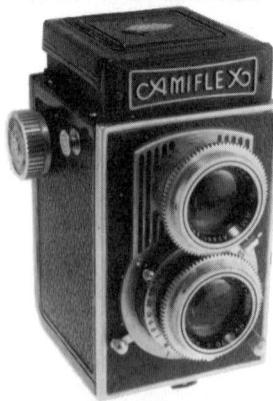

KANTO OPTICAL WORKS (Japan) Amiflex, Amiflex II - c1953. TLR for 120 film. Externally gear-coupled C.Ami Anastigmat f3.5/80mm lenses. Shutters include NKS, NKS-TB, and RKS. With or without sportsfinder in hood. \$75-100.

KASHIWA (Japan) Motoca - c1949. 35mm Leica copy. Lunar Anastigmat f3/45mm in interchangeable mount, but Kashiwa made no other lenses to fit this camera. Shutter 25-

300,B. \$500-750.

KASSIN - Japanese novelty subminiature of the Hit type. \$30-45.

KEITH CAMERA CO. Keith Portrait Camera - c1947. 5x7" wooden studio camera. Silver hammertone finish. 17" bellows extension. Swing back. \$200-300.

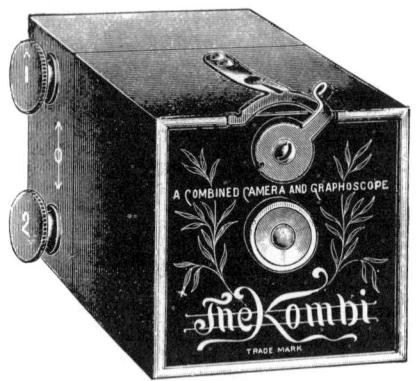

KEMPER (Alfred C. Kemper, Chicago)

Kombi - intro. 1892. The mini-marvel of the decade. A 4 oz. seamless metal miniature box camera with oxidized silver finish. Made to take 25 exposures 11/8" square (or round) on rollfilm, then double as a transparency viewer. (From whence the name "Kombi".) Sold for \$3.00 new, and Kemper's ads proclaimed "50,000 sold in one year". Although not rare, they are a prized collector's item. \$200-300. (Add \$25-35 for original box, often found with the camera.)

KENFLEX - Japanese 6x6cm TLR. First Anastigmat f3.5/80mm lens. \$50-75.

KENILWORTH CAMERA - c1930s? Simple, vertically styled box camera with small reflex brilliant finder. Takes either 620 or 120 spools for 6x6cm images. Made in England. Perhaps one of our British readers knows the manufacturer. Uncommon. \$20-30.

KENNEDY INSTRUMENTS LTD. (London, England)

K.I. Monobar - c1950. 35mm monorail camera, with full movements. 24x36mm exposures. \$1200-1800.

KENNGOTT (W. Kengott, Stuttgart) 6x9cm plate camera - c1920's. Folding-bed style. Double extension bellows. f4.8/105mm Leitmeyr Sytar lens in Ibsor 1-125 shutter, \$45-60

9x12cm plate camera - c1930. Double extension folding bed camera. f4.5/150mm Dialytar in Compur. \$35-50.

10x15cm plate camera - Revolving back. Triple extension, leather covered wood. Kengott (Paris) Double Anastigmat f6.8/180mmin Koilos 1-300. \$75-100.

10x15cm plate camera, Tropical model - Lemonwood body. Gold-plated brass trim. Light brown leather bellows. Steinheil Unifocal f4.5/150 lens in Kengott Koilos 1-100, T, B shutter. \$750-1000.

Matador - c1930. 6.5x9cm folding plate camera. Self-erecting front. Spezial Aplanat f8/105mm in Vario. Rare. \$60-90.

Phoenix - c1924. Tropical camera with gold-plated metal parts. Brown bellows. Sizes: 6x9cm, 9x12cm, or 9x14cm. Most common in 9x12cm size with Tessar f4.5/135mm in dial Compur. \$750-1000.

Supra No. 2 - c1930. Double extension folding camera for 6.5x9cm plates. Xenar f4.5/105mmin Compur 1-250. \$35-50.

KENT - "Hit" type Japanese camera. Several faceplate variations. \$25-35.

KERN (Aarau, Switzerland) Bijou - c1925. Aluminum-bodied hand and stand camera. Inlaid leather panels on sides. Rounded corners. Kern Anastigmat f4.5 lens in Compur 1-200 shutter. 6.5x9 or 9x12cm size. \$400-600.

Rollfilm camera - c1920's? Cast aluminum folding camera, which obviously

was modeled after the No. 4 Cartridge Kodak, and using the same No. 104 film for 4x5" vertical exposures. We have no catalog references to this camera, but suspect it would have been fitted with a 150mm Kern lens. Our only recorded sale was in 1991 with a Weitwinkel 13.5cm lens for \$700. Further historical information or documentation from readers would be most welcome.

Stereo Kern SS - 1930-35. Early 35mm stereo camera, 20x20mm exposures. Kern Anastigmat f3.5/35mm lenses, with 64mm inter-lens separation (larger than the Homeos). All controls are located on the top of the camera. Leica-style viewfinder. \$1200-1800. (A complete outfit with camera, case, transposing table viewer, etc. could nearly double this price.)

KERSHAW (A. Kershaw and Sons

Ltd.) Abram Kershaw established his firm in 1888 and by 1898 was making camera parts for trade manufacturers. During the early 1900's the photographic side of the business expanded. Field cameras, studio cameras and tripods were being made. From 1905 the Kershaw Company started in earnest to produce the Soho Reflex, based on Abram Kershaw's patent of 1904. These were being made for Marion and Co., London Stereoscopic Co., Ross, Beck, & Fallowfield who sold them under their own names. Kershaw also produced cameras for other manufacturers.

Kershaw joined APM in 1921 and became the dominant partner of Soho Ltd. in 1929. In both companies Kershaw produced most of the cameras and equipment marketed under APeM and Soho names. Concurrently, Kershaw pursued its own projects, notably the production of cine equipment through its associated company of Kalee Ltd. The firm continued to produce a range of cameras until the 1950's when production ceased because Rank Organisation, which had acquired Kershaw in 1947, wished to direct production to other products.

Most of the Kershaw cameras were named after birds because company directors were

avid bird-watchers.

Kershaw Eight-20 King Penguin

KERSHAW

Curlew I, II, III - c1948. Self-erecting folding camera for 6x9cm exposures on 120 rollfilm. Camera had sturdy construction but poor sales. Production is estimated at less than 300 for all three models combined, \$120-180

Eight-20 King Penguin - c1953. Self-erecting rollfilm camera for 21/₄x31/₄". Synchronized B&I shutter. \$20-30. Illustrated at bottom of previous column.

Eight-20 Penguin - c1953. Self-erecting folding rollfilm camera, 6x9cm exposures. \$15-25.

Kershaw 110 - Simple self-erecting folding 120 rollfilm camera for 6x6cm exposures. Unidentified f11 lens in B&I shutter. Synchronized. \$15-25.

Kershaw 450 - Self-erecting folding rollfilm camera, using the same body as the Kershaw 110 above, but better equipped. British Etar Anastigmat f4.5 scale-focusing lens in German Velio shutter. \$25-35.

KERSHAW...

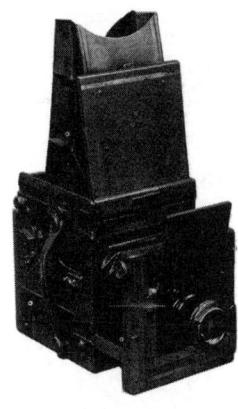

Kershaw Patent Reflex - c1905-39. Large-format single lens reflex. Revolving back. \$200-300.

Peregrine I, II, III - 6x6cm folding 120 rollfilm cameras. Taylor-Hobson Adotal f2.8/80mm or f3.5/80mm lens in Talykron 1-400,B sync shutter. Model III with coupled rangefinder: \$350-500. Models I and II: \$120-180.

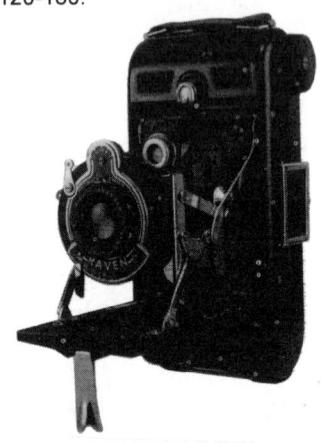

Raven - Folding rollfilm camera with nearly black bakelite body. Leather design molded into the front and back. Kershaw Anastigmat f4.5/4" lens. Waist-level reflex and folding frame finders. \$30-45.

KEYS STEREO PRODUCTS (U.S.A.)
Trivision Camera - c1950's. For 6
stereo pairs or 12 single shots on 828 rollfilm. Fixed focus f8 lenses. Single speed
shutter. Similar to Haneel Tri-Vision, but
large black decal covers aluminum back.
\$30-45.

KEYSTONE (Berkey Keystone, Division of Berkey Photo, Inc.)

There are many Keystone cameras, most of which were low-priced amateur models, including cartridge-loading and instant types. Even the models with built-in electronic flash have not reached a point where they have significant collector value, so we will wait a bit longer before including them in this guide.

Wizard XF1000 - c1978. Rigid-bodied instant camera for Polaroid SX-70 film. f8.8/115mm lens. Electronic shutter. Production of this camera resulted in a legal confrontation between Keystone and Polaroid. \$12-20.

KEYSTONE FERROTYPE CAMERA CO. (Philadelphia, PA)

Street camera - Suitcase style direct-positive street camera with ceramic tank inside. Various masks allow for taking different sized pictures. \$175-250.

kidde in Taiwan) A series of cameras, all employing a basically round body similar to that originated by the Potenza tire camera from Japan. Although the basic structure is copied, there is plenty of imagination on the exterior design, and some even include electronic music boxes which play when the shutter is released. The lens is hidden under the nose which doubles as a lenscap. Practicality is not the main concern. Most children would either lose the lenscap or forget to remove it. Nevertheless, it is a cute series of novelty cameras. "Kiddie Camera" is the brand name used on the packaging of most that we have seen.

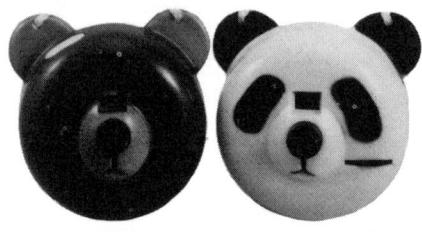

Bear Camera - Camera shaped like a bear's head. Made in Taiwan. Uses 110 film. Removable nose is lens cap. Several variations of color and equipment. Colors include "Brown Bear" with brown face and yellow nose and ears; "Panda" in black and white; Tan with panda markings; Orange with white nose and red eyes, etc. Some have hot shoe; others have plugged top. \$35-50.

Clown Camera - The same round camera with the facade of a clown's head. The lens is still under the removable nose, but the clown's hat is the shutter release. Some have plugged top, others have electronic music box which plays "Home Sweet Home". \$45-60.

Clown Girl - c1990. More recent than the others, and with a simplified mechan-

ism. The lens has its own ribbed shade and no "nose" to cover it, so perhaps it will ruin less film. It may also be from a different distributor, but we have yet to see one in a box. \$25-35.

Dog Camera - Basically round camera with facade of Dog's head. Head is brown with orange around mouth; nose and tongue are red. \$35-50.

Santa Claus - The same round camera, but this time with the visage of the famous man from the North Pole. Molded in white plastic, with red hat and lips. \$35-50.

KIEV ARSENAL (Kiev, Ukraine)
"KIEV" resembles "KNEB" in Roman letters.

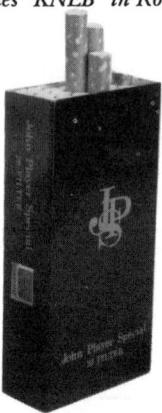

John Player Special - Spy camera disguised as package of John Player cigarettes. Camera mechanism is Kiev-Vega (copy of Minolta 16). Disguise is a metal duplicate of a cigarette package; the "cigarettes" protruding from the top are actually the controls to operate the camera. There is space for two real cigarettes to complete the illusion of reality. Once touted as "KGB" spy cameras, current information indicates that most or all of these cameras have been manufactured expressly for collectors by modern entrepreneurs in Poland. Though sales once reached \$2500+, these have become generally available for \$600-900.

Kiev - 1947-49. Made with Zeiss parts. Generally with lens from 1947-1948. \$60-90.

Kiev-2 - c1950. 35mm CRF camera, copy of Contax II. Jupiter-8 f2/50mm lens. FP shutter 1/2-1250,B. \$60-90.

Kiev-2A - c1950. Same as the Kiev-2 with flash sync added to front. \$60-90.

Kiev-3 - c1956. 35mm CRF with meter. Copy of Contax III. Jupiter-8 f2/50mm lens. FP shutter $^{1}/_{2}$ -1250,B. Not synchronized. \$125-175.

Kiev-3A - c1956. Same as the Kiev-3 with flash sync added to front. \$75-100.

KIGAWA

Kiev-4 - c1957. Minor body modifications in Kiev-3A resulted in the Kiev-4. \$75-100.

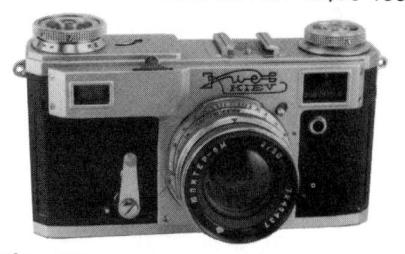

Kiev-4A - c1958. Minor body modifications in the Kiev-2A resulted in the Kiev-4A. \$90-130.

Kiev-5 - Modernized version of Kiev-4A with the light meter incorporated into the camera body. Rare. Estimate: \$250-375.

Kiev-6C - c1970's. Medium format eyelevel SLR. Styled like Pentacon Six. With \$150-250.

Kiev-10 Automat (aBmomam) - c1967. First Soviet 35mm SLR to feature automatic exposure control. Unique fanbladed focal plane shutter, 1/2-1/1000, B. Artdeco design. Helios-81 f2/50mm. Estimate \$150-225.

Kiev-15 TEE - c1974. Modernized version of Kiev-10. TTL metering. Unfortunately no more art-deco design, but still with the unique fan-bladed shutter. Helios-81 f2/50mm. FP shutter $^{1}/_{2}$ - $^{1}/_{1000}$, B. Rare. Estimate \$200-300.

"No-Name" Kiev - c1963. Rangefinder camera made for the USA market. Does not have the "Kiev" name on the front. Because they closely resemble the Zeiss Contax IIa or IIIa cameras, they are sometimes referred to as "No-Name Contax". \$300-450.

Kiev Lenses, bayonet mount: 28mm f6 Orion-15 - Rare. With matching finder: \$120-180.

35mm f2.8 Jupiter-12 - \$50-75. **50mm f2 Jupiter-8M -** Normal lens. \$15-25.

85mm f2 Jupiter-9 - \$50-75. 135mm f4 Jupiter-11 - \$35-50.

Kiev 30 - c1960. Subminiature for 13x17mm exposures on 16mm film. Third in the series, following Kiev-Vega, Kiev-Vega 2. All black body. Exposure calculator dial on back. Synchronized. \$50-75.

Kiev 30 and Kiev 30M

Kiev 30M - A simplified version of the

Kiev 30. Similar but lacking exposure calculator dial and without sync. Quality of finish is noticeably poorer. \$50-75.

Kiev 1989 - Commemorative version of the Kiev subminiature. Back is engraved "KNEB 1949-1989". Front has hammer & sickle in star, and 1989 date. \$120-180.

Kiev-Vega, Kiev-Vega 2 ("Vega" in Cyrillic script resembles "Bera" in Roman script.) - Subminiature for 20 exposures on 16mm. Copies of Minolta-16, but with focusing lenses. Industar f3.5/23mm. Shutter 30-200. \$75-100.

Kiev 35A (KNEB 35A) - Compact 35mm camera, copy of the Minox 35GT. KOPCAP f2.8 35mm lens. Automatic exposure. \$60-90.

Kiev-80 - c1972. Name variant of Salyut-S (Hasselblad copy). Vega 12B f2.8/90mm lens with automatic diaphragm. Typical cased outfit with 80mm lens and two backs: \$250-375.

Kiev-88 - c1983-. Hot-shoe version of Salyut-S. Split-image focusing screen. Typical outfit with two backs and normal 80mm lens: \$300-450.

Kiev-88 TTL - c1983-. Same as Kiev-88, but with metering prism. Cased outfit with Volna-3 80mm lens, metered prism, 2 backs: \$300-450.

Kneb - see Kiev.

Salyut - c1958-. Russian copy of Hassel-

blad. Focal plane shutter 1/2-1/1500. Industar-24 f2.8/80mm. \$300-450.

Salyut-S - c1972. Modified version of Salyut. Vega 12B f2.8/90mm interchangeable lens with automatic diaphragm. FP shutter $1/2-1/_{1000}$, B. \$250-375.

Zenit 80 (Zenith 80) - c1971. Copy of Hasselblad. Export version of Salyut-S. Industar 80mm/f2.8 lens. FP 1/₂-1000 shutter. With magazine: \$250-375.

KIGAWA OPTICAL (Japan) Before about 1940, the firm was called Optochrome Co. Carl-6 Model II - c1953. Folding rollfilm camera, 6x6cm or 4.5x6cm on 120. Carl Anastigmtat f3.5/80mm lens in K.O.C. 1-200,B shutter. \$120-180.

Kiko Semi - c1940. 4.5x6cm folding rollfilm camera. Kiko Anastigmat Erinar f3.5/75mm lens, 1-200 shutter. Two versions: folding frame finder or waist-level and eye-level viewfinders mounted in chrome housing on top of body. \$75-100.

Tsubasa 6x6 - 120 rollfilm. Kiko Erinar f3.5/75mm lens. waist-level and eye-level finders mounted in polished chrome top housing. \$90-130.

Tsubasa Baby Chrome - c1937. Bakelite bodied eye-level camera for 16 exposures, 3x4cm on 127. Optical eye-level finder. New Gold f6.3/50mm in New Gold shutter B,25-100. \$75-100.

Tsubasa Chrome - c1937. Dual format eye-level camera for 4x6.5cm or 3x4cm on 127 film. Lucomar f6.3/75mm in Wing Anchor shutter T,B,25-150. Spring-loaded telescoping front. \$60-90.

KIGAWA...

Tsubasa Semi - c1952. Vertical folding bed camera, 4.5x6cm on 120. Bessel f3.5/75mm lens. KKK shutter 10-200,B. \$60-90.

Tsubasa Super Semi - c1938. Horizontal folding bed camera, 4.5x6cm on 120. Lucomar Anastigmat f4.5/75mm. New Gold shutter 25-150, T,B. \$60-90.

Tsubasaflex Junior - c1951. Inexpensive 6x6cm TLR. Lenses externally gear-coupled. Lause Anastigmat f3.5/80mm. Shutter 10-200, B. \$75-100.

KIKO 6 - Japanese 120 rollfilm camera. Helical focus. Rapid Kiko 1-1/₅₀₀ shutter. \$75-100.

KIKO-DO CO. (Japan)

Superflex Baby - c1938. Single lens reflex for 4x4cm on 127 film. This was the first 4x4cm SLR from Japan. Design similar to Karmaflex. Super Anastigmat f4.5/70mm. Behind the lens shutter B,25-100. \$250-375.

KILFITT (Heinz Kilfitt, Munich, Germany; Heinz Kilfitt Kamerabau, Vaduz, Liechtenstein; Metz Apparatefabrik, Fürth/Bayern, Germany). Heinz Kilfitt was a watchmaker by trade. He designed the first Robot camera in 1933 while he was a still student. Lacking money, he sold the design to Berning. Later, he designed the Mecaflex and sold that design to Metz, who were to produce the bodies while Kilfitt supplied the lenses. When Metz backed out of the project, Kilfitt had already contracted for 20,000 lenses so he had the bodies made for him by a firm from Monaco. Kilfitt also designed a 6x6cm SLR about 1963.

Mecaflex - c1953. A well-made 35mm SLR with 24x24mm format for 50 exposures on regular 35mm cartridge film. Interchangeable bayonet mount lenses, f3.5 or 2.8/40mm Kilar. Prontor-Reflex behind-the-lens shutter. Entire top cover of camera hinges forward to reveal the waist-level reflex finder, rapid-wind lever, exposure counter, etc. When closed, the mattechromed cast metal body with its grey or black leatherette covering looks somewhat like a small, sleek, knobless Exakta. Not many were made, and it was never officially imported into the United States. \$1000-1500.

KIMURA OPTICAL WORKS

Alfax Model I - c1940. Japanese camera for 4x6.5cm on 127 film. Recta Anastigmat f3.5/60mm in New Alfa shutter. Waist-level and eye-level finders. \$75-100.

KINDER CO. (So. Milwaukee, Wisconsin)

Kin-Dar Stereo camera - c1954. Stereo camera for 5-perforation format on 35mm film in standard cartridges. Steinheil Cassar f3.5/35mm lenses. Five speed shutter, 1/₁₀-1/₂₀₀, B. Advancing the film cocks the shutter, but the shutter can also be cocked manually. Viewfinder and rangefinder combined in single eyepiece, located near the bottom of the camera. Designed by Seton Rochwite, whose first major success had been the Stereo Realist Camera. Original price in 1954 was \$99.50.\$75-100.

KING CAMERA (American) - c1895. Small cardboard box camera which takes 2x2" glass plates. One example in original box, with an unopened package of glass plates reportedly sold in 1990 for about \$200

KING CAMERA (Japanese) - c1930's. Miniature cardboard "Yen" box camera for single sheet film in paper holder. Single speed shutter with separate cocking lever. Ground glass back. This is one of the better quality "Yen" cameras. \$30-45.

KING KG (Bad Liebenzell, Germany)
Founded in 1951 by Mr. King, a watchmaker, in the Black Forest region of Germany
where skilled craftsmanship was a long
tradition. The family business continued
under the leadership of King's son-in-law Mr.
Bauser. About 1984, they became insolvent
and stopped manufacture of cameras, appar-

ently due to losses in the disc camera field. **Azore V** - c1955. Relatively low priced 35mm camera in its day, due to uncoupled rangefinder and extinction meter. Originally \$43 with f3.5 lens in ¹/₃₀₀ shutter, or \$55 with Cassarit f2.8 in Prontor SVS. \$30-45.

Dominant - Postwar German 35mm. Cassar f2.8/45mm in Prontor 500LK shutter, \$20-30.

Mastra V35 - c1958. A very simple variant of the Regula, made for Photopia Ltd. of Newcastle, UK. Lacks meter, range-finder, strap lugs, and other refinements of the more expensive models. Cassar f2.8/45mmin Vero shutter. \$20-30. Illustrated at top of next column.

King Mastra V35

Regula - 35mm cameras, introduced in 1951. Various models: IA through IF, IP, IPa; IIIa, b, bk, c, d; Cita III, IIId; Gypsy; KG, PD, RM, etc. f2.8 Cassar, Gotar, Ennit, or Tessar lens. Interchangeable lens models: \$100-150. Others: \$45-60.

Regula Citalux 300 - c1956. Luxus version of the Regula Cita with red leather and gold trim. The first model of this camera was reportedly presented to Ossi Reichert, her country's only gold medalist (Women's Giant Slalom) in the 1956 Olympic winter games. CRF. Cassar S f2.8/45mm.\$300-450.

Regula Reflex CTL - c1967. Fixed prism 35mm SLR. Cloth shutter 1-2000,B. TTL CdS match-needle metering. Normal lens: Isco Westomat f1.9/50mm, Prakticathread. \$75-100.

Regula Reflex SL - c1967. 35mm SLR, similar to Regula Reflex CTL, but without metering. \$60-90.

Regula Reflex 2000 CTL - c1969-75. Well-made 35mm SLR. FP shutter 1-2000. Like Reflex CTL, but with shutter speeds, film speeds, and battery check visible in finder. Behind-the-lens CdS meter. All black and black/chrome versions. Also sold under Kalimar/Regula name. Body: \$175-250.

Regula Reflex K650, Kalimar/ Regula Reflex K650 - c1972. Improved version of 2000 CTL. Spot and averaging TTL CdS metering. Shutter priority auto exposure. Westomat f1.9/50mm in Nikon bayonet mount. \$250-375.

KING SALES CO. (Chicago, Illinois)
Cinex Candid Camera - Bakelite half-

frame 127 minicam. Identical to the Rolls Camera Mfg. Co.'s Rolls camera. \$8-15.

KING'S CAMERA - Plastic novelty camera for half-127. Made in Hong Kong. \$1-10.

KINGSTON - c1960. Small novelty TLR from Hong Kong. Takes 4x4cm on 127 film. Plasicon f8/65mm lens. \$8-15.

KINN (France)

Kinaflex - c1951. Twin lens reflex made by ATOMS. Berhtiot Flor f3.5/75mm taking lens is externally coupled to the viewing lens. Atos-2 shutter. \$60-90.

Kinax (I) - c1949. Folding camera, 8 exposures on 120 film. Berthiot f4.5/105mm lens. This model does not have parallax corrected finder. Colored: \$50-75. Black: \$25-35.

Kinax II - c1950. Folding camera for 120 rollfilm, 6x9cm. Parallax correction in view-finder. Variations include: black or gray leather with black or gray bellows, red metal with red leather bellows. f4.5/105 Som Berthiot or Major Kinn in Kinax shutter. Red or grey: \$50-75. Black: \$25-35.

Kinax Alsace - c1952. Folding rollfilm camera for 6x9cm on 620 film. Berthiot f6.3/100mm lens. Kinax shutter 25-100. Burgundy: \$50-75. Black: \$25-35.

Kinax Baby - c1950. Low-priced version of the Kinax with Meniscus lens. 6x9cm on 120 film. \$25-35.

Kinax Junior - c1950. One of the betterequipped of the Kinax series. Kior Anastigmat f6.3/100mm in 25-150 shutter. \$30-45.

Super Kinax - c1950. Folding rollfilm camera taking 3 image sizes: 6x9cm, 6x6cm, and 4.5x6cm on 620 with masks. Bellor f3.5/100mm lens. \$35-50.

KINOBOX - c1953. Made in Budapest, Hungary. Bakelite & aluminum camera for 24x32mm on 35mm film. Fixed focus lens; M,B shutter. Rare. No price data.

KINON Kinon SC-1 - c1986. Novelty 35mm camera from Taiwan, styled like range-finder type. \$1-10.

KINUSA K-77 - c1986. Novelty 35mm camera from Taiwan, styled with small pseudo prism. \$1-10.

KIRK Stereo camera, Model 33 - Brown bakelite body. Same body style as Haneel Tri-Vision. Takes six stereo pairs, 26x28mm on 828 film. At least three variations: 1. Has aperture numbers 1,2,3 on front but no name on back. 2. Has "Kirk Stereo" on back, but no aperture numbers on front. 3. Has neither name nor numbers. \$75-100.

KITKAT - c1990. Micro-110 type camera used to promote the KitKat chocolate bar. Red faceplate, top decal, and original box all have oval KitKat logo. \$1-10.

KITTY - Hit-type subminiature. Uncommon name. \$30-45.

KIYABASHI KOGAKU (Japan) Autoflex - c1957. 6x6cm TLR for 120 film. f3.5 Tri-Lausarlens. \$75-100.

KOCHMANN

K.K. - Found after the name of many Japanese camera companies, the initials K.K. stand for "Kabushiki Kaisha" meaning "Joint Stock Co."

KLAPP - Included in the name of many German cameras, it simply means "folding". Look for another key reference word in the name of the camera.

KLEER-VU FEATHER-WEIGHT - Plastic novelty camera made in Hong Kong. Half-frame on 127. \$1-10.

KLEFFEL (L. G. Kleffel & Sohn, Berlin)

Field camera - c1890. 13x18cm horizontal format. Brown square-cornered bellows. Wood body with brass trim. Brass barrel lens. \$200-300.

KLOPCIC (Louis Klopcic, Paris) Klopcic "Reporter" - Introduced c1903, though all known illustrations and cameras are later models. Strut-folding camera for 9x12cm plates or magazine back. Flor Berthiot f4.5 or Tessar f3.5/135mm lens. FP 1/2-1200 or later 1/2-2000. \$200-300.

Klopcic - Strut-folding focal plane camera, 10x15cm size. Similar to Deckrullo-Nettel. Berthiot Series I f4.5/165mm lens. Focal plane shutter 1-2000. \$200-300.

KNIGHT & SONS (London)
Knights No. 3 Sliding-box camera c1853. From the transition period between
Daguerreotypes and wet plates, which first
were used about 1851. Sliding box-in-box
style camera of dovetailed mahogany
Rising front. Two positions for plateholder.
Brass landscape lens with waterhouse
stops. Full-plate size: \$1700-2400.

KNOEDLER KAMERABAU Brinox - Tiny black plastic camera for 14x14mm negatives on rollfilm. Like Colibri, Colibri II cameras. \$100-150.

KNOLL (Leipzig) Field camera - c1905. Wooden folding camera, 13x18cm. Square green bellows with wine-red corners. Brass Doppel-Rigonar f6.3/240mmlens. \$250-375.

KOCH (Paris, France) Stereo wet plate camera - c1860.
Wooden stereo box camera, 9x21cm wet plates. Jamin f11/125mm lenses mounted on a tamboured panel for adjustment of lens separation. Rare. \$4500-6500.

KOCHMANN (Franz Kochmann, Dresden) Became Korellewerke KG in 1939 and Korelle-Werk G.H.Brandtmann & Co. in 1940.

Enolde - c1931. Folding 6x9cm selferecting rollfilm camera with an unusual detachable telescope-viewer which mounts on the side. The front of the telescopic

KOCHMANN...

finder attaches to the lens standard while the rear portion is fixed to the camera body. It serves for focusing and as a view-finder, especially for close-ups. Rack & pinion focusing to 3 feet. Enolde Anastigmat f4.5 in 3-speed shutter or Zeiss Tessar f4.5 in Compur. With unusual telescopic finder: \$250-375.

Enoide I,II,III - c1930. Folding bed cameras for 6.5x9cm plates. Models I and II are single extension; Model III has double extension. Model I has a small reflex brilliant finder; Model II has reflex and wire frame finders. \$35-50.

Korelle cameras - There are several basic types of Korelle cameras which appear regularly on today's market. The most common of these by far is the reflex. All types, even if not identified by model name or number on the camera, are easily distinguished by size and style. For this reason, we have listed the Korelle cameras bere in order of increasing size.

18x24mm (Korelle K) - c1933. Compact 35mm half-frame, in vertical format. Thermoplastic body is neither folding nor collapsing type. Shutter/lens assembly is a fixed part of the body. Front lens focusing. Tessar f3.5 or Trioplan f2.8/35mm in Compur 1-300. Reddish brown: \$600-900. Black: \$300-450. Double the price for Elmar f3.5/35mm lens.

3x4cm, strut-folding type - For 16 exposures on 127 film. E. Ludwig Vidar f4.5/50mm lens in Vario or Compur shutter. Relatively common in Germany for \$50-75

4x6.5cm, strut-folding convertible type - c1930. For 8 exposures on 127 film. However, the film guide roller and mask slide out to allow insertion of a plateholder, film pack adapter, or cutfilm holder. This model was called the "3-in-1" by Burke & James, the U.S. distributor. Schneider Radionar f3.5/75mm or Xenar f2.8/75mm. Compur or Compur Rapid shutter. Appears basically the same as the

Korelle "P" below, but with rounded ends added to the length of the body to house the film rolls. In fact these two cameras were contemporary and sold for the same price when new. A good quality camera and clever design which has gone unnoticed by many collectors. Despite the fact that the less sophisticated model P has been selling for much more, this unsung convertible model has been bringing only \$50-75 in Germany and in USA.

4.5x6cm (Korelle P) - c1933. Strutfolding type for plates, similar to the above convertible model, but shorter and with square ends, since it does not allow use of rollfilm. A fine quality vest-pocket plate camera. Tessar f2.8/75mm or f2.9 Xenar. Compur shutter 1-250. Leather covered metal body. Uncommon.\$300-450.

6x6cm, strut-folding rollfilm type - c1937. Strut-folding type with hinged lens shade/cover. Various lenses f4.5 to f2.8; Prontor I,II; Compur, Compur Rapid; Ibsor shutters. \$60-90.

Reflex-Korelle - Introduced 1935, after the Noviflex, neither of which is the first

6x6cm SLR. Single lens reflex for 12 exposures on 120 film. The first model is identifiable by the focal plane shutter $^{1}/_{10}$ to $^{1}/_{1000}$. Later models had $^{1}/_{25}$ - $^{1}/_{500}$. A more expensive model added slow speeds to 2 seconds. The $^{1}/_{1000}$ top speed returned again on the chrome III camera. A camera of similar appearance was made by WEFO of Dresden after WWII and called "Meister Korelle" (Master Reflex in the USA). \$100-150.

KOGAKU - Japanese for "Optical". This term is found in the name of many Japanese firms, usually preceded by the key name of the manufacturer. (However, if you are reading the name from a lens, it may only be the maker of the lens and not the camera.)

KÖHNLEIN (Konrad Köhnlein, Nürnberg, Germany)
Wiko Standard - c1936. Bakelite subminiature for 13x17mm on special 16mm rollfilm. Laack Poloyt f4.5/3cm or f3.5/3.5cm. Focal plane shutter 20-200. Available with fixed lens or interchangeable lens. Rare. Top auction prices (12/91): \$1250 with fixed lens; \$1500 with interchangeable lens. No recent known sales in the real world.

KOJIMA OPTICAL SEIKI CO. (Japan)

Flex-O-Cord - c1954-55. Heavy bakelite TLR with externally gear-coupled lenses. Film transport section pulls out like a drawer from the right side of the camera. Appears identical to the Mikono Flex P except for the nameplate. It was also advertised as "Flex-O-Cord II", but we can find no evidence of more than one model. Mikono Anastigmat f3.5/80mm in MRS shutter. \$120-180.

Mikono-Flex P - c1952. Heavy bakelite TLR, identical to Flex-O-Cord above. \$120-180.

KOLAR (Václav Kolár, Modrany & Prague, Czechoslovakia) The Kolar company was financially ruined in 1935, and all Kolar cameras are scarce.

Box Kolex - c1932. Brown leathered metal box camera for 4.5x6cm plates. Front cell focusing Rekolar f6.3/75mm lens in Pronto or Vario. Rare. \$175-250.

Kola - c1932. An unusual box-shaped camera for various formats on either of two film types. Using different masks, it takes 4x4cm or 3x4cm exposures on 127 film, or 24x36mm exposures on unperforated 35mm film in special Kola cartridge. Lenses include Primotar f3.5 or f4.5, Trioplan f3.5, Kolyt T f3.5 or f4.5, Dialytar T f4.5, Rekolar f3.5, Zeiss f2.8/60mm Tessar, f2.9/50mm Xenar, f3.5/50mm Novar in Compur shutter. Early model has folding optical finder; later model has tubular finder. An accessory "Leica FODIS" type Kola rangefinder was available. Estimated production 700-1000. Once considered rare, now appearing regularly on German auctions. \$175-250.

Kola (folding rollfilm) - c1934. Folding camera for 16 exposures 4.5x6cm on 120 rollfilm. Rekolat f6.3/75mm in Vario 25-100. \$45-60.

Kola Diar - c1933. Small bakelite "diary" camera for children and beginners. Twelve 32x32mm exposures on special rollfilm. Folding direct frame finder. Simple construction. Fixed focus f11/50mm Achromat. Two stops. Siko shutter for instant or time. Price dropping with more frequent appearancein Germany. \$100-150.

Kolar - c1930s. Bakelite camera, similar to the Photax but in brown and chrome. 6.5x7.5cm. Rekolar f6.3/75mm lens in Vario. \$60-90

Kolarex - c1932. Self-erecting folding camera, 4x6.5cm on 127 film. Essentially a rollfilm version of the Kolex plate camera. Rekolar, Trioplan, Primotar T, Kolyt T, or Dialytar T lenses in Vario, Prontor S, or Compur shutter. Brown leather covering Uncommon. Have reached \$250 at auction, but typically: \$90-130.

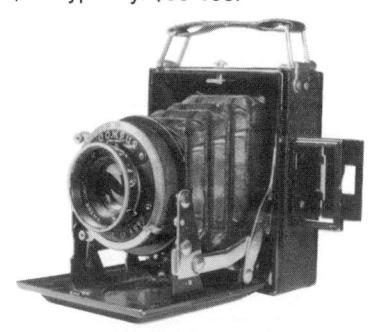

Kolex - c1932. Small vertically styled selferecting camera, 4.5x6cm plates. Rekolar f6.3, f4.5, or f3.5/75mm in Vario or Pronto. Also Trioplan, Primotar T, Kolyt T f4.5 or f3.5/75mm in Compur. Rare. \$150-225

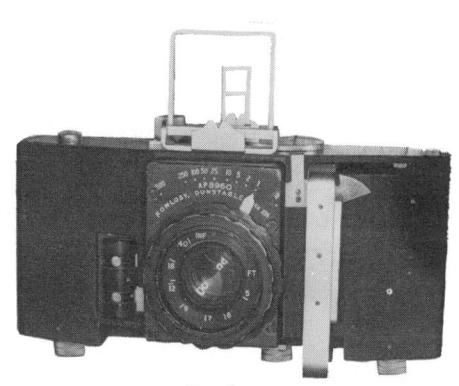

Komlosy

KOLBE & SCHULZE (Freital b.Dresden, Germany)

Autix - c1932. Self-erecting camera for 6x9cm, also adaptable for 4.5x6cm. Akor or Vidar f6.3 or f4.5, or Regulyt f4.5/105mm lens in Vario, Pronto, Ibsor or Compurshutter, \$20-30

KOMLOSY - Metal-bodied 70mm camera. Rapid advance. \$100-150. Illustrated bottom of previous column.

KONISHIROKU KOGAKU (Japan)

Konishiroku and its predecessors have been involved in the photographic business since 1873 when Konishi-ya sold photographic and lithographic materials.

1873-Konishi-ya 1876- Konishi Honten

1902- Rokuoh-sha factory founded. 1921- Reorganized as corporation "Konishiroku Honten".

1936- Incorporated as a limited company "Kabushiki Kaisha Konishiroku" (Konishiroku Co. Ltd.).

1943- Name changed to "Konishiroku Shashin Kogyo Kabushiki Kaisha" nishiroku Photo Industry Co. Ltd.).

1944- Merger with Showa Photo Industries

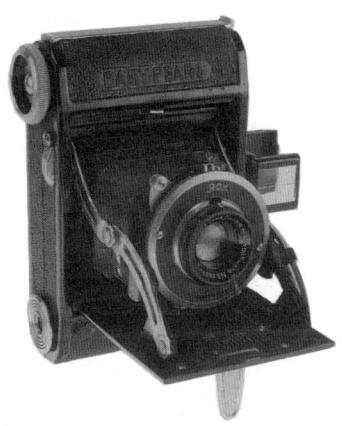

Baby Pearl - c1934-46. Self-erecting folding cameras, 16 exp. on 127 film. f4.5/ 50mm Hexar or Optar lens. Rox shutter B.25-100. Prewar models without body release. Earliest types have all black shutter face and black lens bezel. \$120-180

GSK-99 - c1939. Military aerial camera for 6x6cm on 120 rollfilm in interchangeable magazines. Fixed-focus Simlar f3.5/7.5cm lens. 1/100-1/400 shutter. \$750-1000.

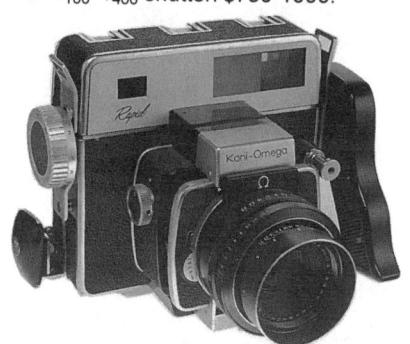

Koni-Omega Rapid - c1965. Second generation of Omega camera, evolved from the original Simmon Brothers Omega design of the 1950's. Not to be confused with the later "Rapid Omega" series. Interchangeable film backs, interchangeable lenses. Push-pull lever advances film and cocks shutter. With Hexanon 90mm f3.5 normal lens: \$150-225.

KONISHIROKU

Koni-Omega Rapid M - c1967. Similar to the Koni-Omega Rapid, but introduced a new magazine back, which could be changed mid-roll without losing a frame. With lens and magazine back: \$200-300.

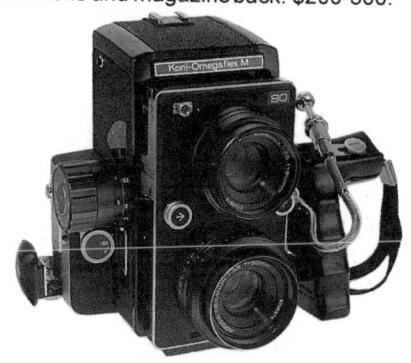

Koni-Omegaflex M - c1969. Twin-lens version of Rapid M with same film magazine. Despite the implication of the name, it is not a reflex. An optional reflex viewing attachment was available. Sold new for \$200-250 with lens and back. Asking prices for clean used ones are \$300-450.

Koni-Omegaflex Lenses: 180mm f4.5 Hexanon - \$175-250. 135mm f3.5 Hexanon - \$150-225.

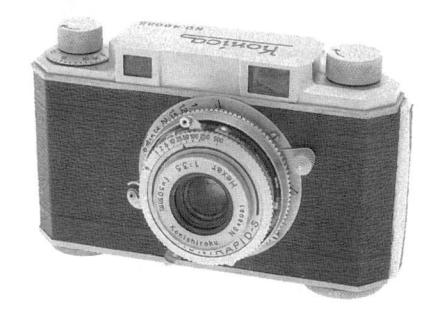

Konica - c1948-54. 35mm RF. Hexar or Hexanon f2.8 or 3.5 in Konirapid or Konirapid-S 1-500. Earliest models were made in Occupied Japan, and were not synched. No double exposure prevention. \$90-130.

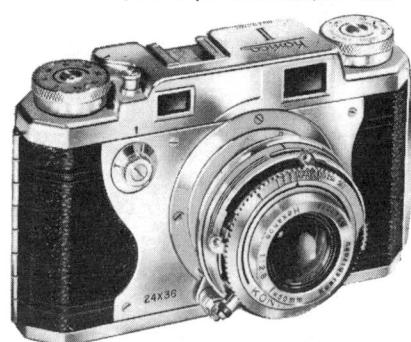

Konica II - 1951-58. 35mm RF. Hexanon f2.8/50mm in Konirapid-MFX 1-500 shutter. Double exposure prevention. \$75-100.

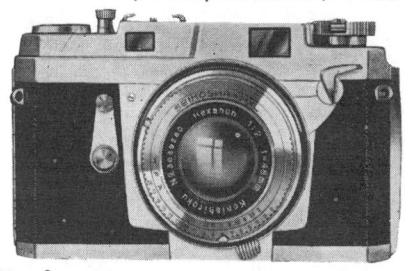

Konica III - 1956-59. 35mm RF. Hexa-

KONISHIROKU...

non f2/48mm lens in Konirapid-MFX 1-500 shutter, \$50-75.

Konica IIIA - 1958-61. Similar to the Konica III, but large center viewfinder window and larger rangefinder windows. Hexanon f2/48mm lens. \$60-90.

Konica IIIM - 1959-60. 35mm RF with meter (usually not working). Hexanon f1.8/50mm lens in Seikosha SLV 1-500 shutter. Takes full or half frame exposures. \$120-180.

Konica Auto S - 1963-65. 35mm RF with dual-range CdS meter on front of top housing. Automatic or manual exposure control; needle visible in finder. Hexanon f1.9/47mm in Copal SVA shutter B,1-500. Also sold as Wards am 550. \$50-75.

Konica Autoreflex - c1967. First Japanese 35mm SLR with focal plane shutter to feature automatic exposure

control. Full or half-frame. Interchangeable bayonet-mount lenses. (Also marketed as the Autorex.) \$150-225. Subsequent Autoreflex models follow in chronological order.

Rew models follow in chronological order.

Konica Autoreflex T - c1968. Automatic TTL shutter priority metering.

Copal Square metal 1-1000 shutter. Black or chrome. With 50mm f1.7, 52mm f1.8, or 57mm f1.4 normal lens, working: \$75-100.

Konica Autoreflex A - c1969. Simplified version of T, without self-timer and depth preview. \$75-100.

Konica Autoreflex T2 - c1971. With Hexanon 52mm f1.8: \$60-90.

Konica Autoreflex T3 - c1973. With normal lens: \$100-150.

Konica Autoreflex A3 - c1974. \$75-

Konica Autoreflex T3N - c1976. Hot shoe, \$120-180.

Konica Autoreflex TC - c1977. \$90-

Konica Autoreflex T4 - c1978. \$120-

Konica F - c1960. Konishiroku's first 35mm SLR. Coupled selenium meter. Vertical metal shutter to 1/₂₀₀₀. Scarce in the U.S.A. \$600-900.

Konica FS - c1961-64. Fixed-prism 35mm SLR without meter. Interchangeable Hexanon f1.4/50mm in early style Konica bayonet mount. FP 1-1000,B.\$75-100.

Konica FP - c1963. Variation of the FS; minor changes include new focusing screen. \$50-75.

Konica FM - c1965. Improved version of the FS/FP with front-mounted CdS cell and match needle on top. \$60-90.

Konilette - c1950. Dark brown bakelite folding-bed camera for 28x36mm exposures on unperforated 35mm film in special cassettes. Konitor f4.5/50mm in Konix $1/_{25}$ - $1/_{200}$,B shutter. Identifiable by blue-greentop housing \$90-130.

Konilette II - c1953. Dark brown bakelite camera similar to the Konilette (I), but with matte-chrome top housing, and Copal $\frac{1}{25}$ - $\frac{1}{200}$, B shutter. \$90-130.

Konilette 35 - c1959. 35mm viewfinder camera. Body based on Taisei Koki Welmy cameras of c1956. Konitor f3.5/45mm lens. Shutter to 1/200, B, sync. \$50-75.

Pearl (Showa 8), Pearl No. 2 c1923-31. Folding-bed rollfilm cameras for 6x9cm. The first Japanese camera to use 120 rollfilm. Early models made of wood, c1927 changed to all metal. Shutter 25-100, T,B. \$75-100.

Pearl I - c1949-50. Folding camera 4.5x6cm "semi" or half-frames on 120 film. Hexar f4.5/75mm in Durax shutter T,B,1-100. Uncoupled rangefinder. \$120-180.

Pearl II - c1952-55. Similar to Pearl I, but with coupled rangefinder and Konirapid-S shutter to 500. "Pearl II" on top housing. \$120-180.

Pearl IV - c1958. Folding 120 rollfilm camera, 4.5x6cm exposures. CRF. Elaborate system of projected frames in view-finder. Hexar f3.5/75mm. Seikosha-MXL, B,1-500. \$200-300.

Pearlette - c1925-46. Trellis-strut folding camera for 4x6.5cm exposures. First Japanese camera to use 127 rollfilm. Various models. Most commonly found with Rokuohsha Optar f6.3/75mm in Echo shutter 25-100. Deluxe models have f4.5 lens, folding optical finder. \$90-130.

Rapid Omega 100 - c1975. Range-finder camera with interchangeable backs and shutter/lens units. The third generation of Omega cameras. Uses interchangeable pre-loadable rollfilm holders for 120 or 220 film. Still usable and versatile, but reaching the age of retirement. With 90mm f3.5 lens and back in clean collectible condition: \$120-180.

Rapid Omega 200 - c1975. Upscale model of the Rapid Omega. Allows film magazines to be changed in mid-roll without a lost frame. With 90mm f3.5 lens & back: \$175-250.

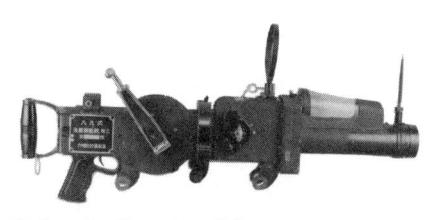

Rokuoh-Sha Machine-gun Camera Type 89 - World War II vintage training camera for machine gunners. Size, shape, and weight comparable to a machine gun, but holds 35mm film to make moving picture of targeted subject. Camera runs while trigger is squeezed, making 18x24mm images. Hexar f4.5/75mm lens. \$600-900

Sakura (Vest Pocket Camera) - c1931. Not related to the Sakura Seiki Co. which made the Petal camera. Small brown or maroon bakelite camera for ten exposures 4x5cm on 127 film. One of very few cameras to use the 4x5cm format on 127 film. Pull-out front. Rokuoh-Sha fixed focus lens. B.I shutter, \$120-180.

Semi-Pearl - c1938-48. Self-erecting folding bed camera for 16 exposures, 4.5x6cm, on 120 film. Hexar f4.5/75mm lens. Shutter to 100, \$60-90.

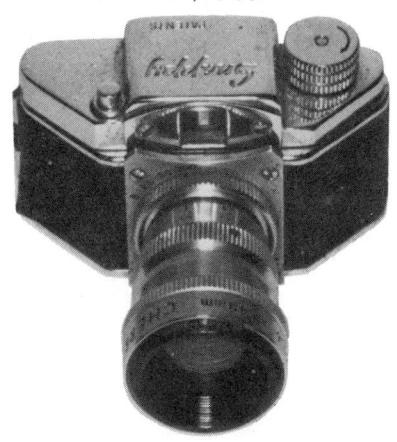

Snappy - c1949. Subminiature camera for 14x14mm exposures. Interchangeable Optar f3.5/25mm lens. Guillotine shutter behind the lens: B, 25, 50, 100. Made in Occupied Japan. With normal lens: \$150-225. With f5.6/40mm Cherry Tele lens add: \$75-100.

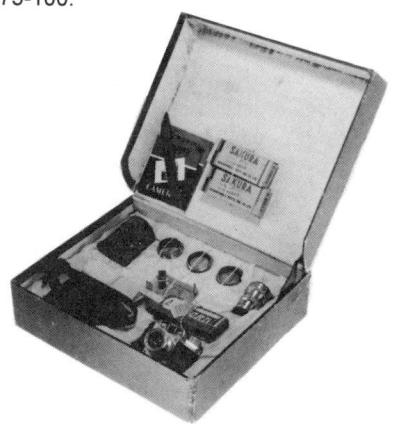

Snappy Camera Set - Boxed set including Snappy camera, Cherry Tele lens, leather case for each, tripod adapter, sunshade, closeup lens, yellow filter, and two boxes of film. Attractive red & black cardboard presentation box with hinged lid. \$300-450

KORSTEN (Paris) Litote - 1902-04. Rigid-bodied jumellestyle stereo for plates. 4.5x10.7cm or 6x13cm sizes. Aplanat or Krauss lenses. 3-speed guillotine shutter. Newton finder. \$120-180

KOSSATZ (Konstantin Kossatz. Berlin, Germany)

Spiegel-Reflex - ca. late 1890's to WWI. Large format SLR. Leather covered body with nickel-plated metal 13x18cm exposures on plates. Goerz Dogmar f4.5/240mm lens. Focal plane shutter. Rare. One nice example with working shutter sold at auction in 1983 for \$368. No further sales data.

KOWA OPTICAL (JAPAN)

Kallo - c1955. Rangefinder 35, some models with uncoupled meter. Prominar f2.8 or f2 lens. Seikosha shutter, B,1-500.

Kalloflex - c1954. 6x6cm TLR, 120 film. Prominar f3.5/75mm lens in Seikosha 1-500 shutter. \$90-130.

Komaflex-S - c1960. One of the very few 4x4cm SLR's ever made. 127 film. Die-cast body. Gray enameled finish. Gray covering. Kowa Prominar f2.8/65mm. Seikosha SLV between the lens shutter, 1-500, B. \$120-180.

KOWA SLR CAMERAS - Prices for Kowa SLR cameras are generally lower than for similar cameras from many other manufacturers for several reasons. Kowa cameras were among the lowest priced cameras initially. Many have fixed lenses which limits usability. They are not noted for reliability, and repairs are reportedly difficult and expensive. Therefore users are not competing much with collectors for these cameras.

Kowa E - 1962-66. 35mm SLR. Coupled selenium meter. Prominar f2/50mm noninterchangeable lens (with telephoto and wide-angle attachments available). Seikosha SLV leaf shutter, 1-500, B. Also sold under name of "Kowaflex E", \$45-60.

Kowa H - 1963-67. 35mm SLR. Coupled selenium, automatic, shutter preferred. Fixed Kowa f2.8/48mm lens in Seikosha 30-300 inter-lens leaf shutter. \$45-60.

Kowa SE - c1964-69. Like the Kowa H. but has round CdS meter above lens instead of selenium meter, \$45-60.

Kowa SER - c1965-70. Similar to the SE. but leaf shutter now behind the lens to interchangeable bayonet-mount lenses. Match-needle & aperture scales in finder for cross-coupled CdS metering system. \$50-75.

Kowa SET - c1967-. Fixed-lens SLR with TTL metering. Seikosha SLV 1-500 leaf shutter. Kowa f1.8/50mm lens. \$35-50.

Kowa SETR - c1968-71. Combined TTL full-aperture metering and interchangeable

KOWA...

lenses at a low price (list \$155 but street price of \$90 in 1969). Kowa f1.9/50mm normal lens; Seikosha behind-lens 1-500 leaf shutter. \$35-50.

Kowa SETR2 - c1970. Externally like the SETR, but with f1.8 normal lens. Reportedly has about 30 internal changes. \$45-60.

Kowa Six - c1968. SLR for 6x6cm on 120 or 220 rollfilm. Interchangeable lenses, prisms, screens. From its introduction, it was called the "poor man's Hasselblad", and there are some external design features, such as the viewing hood, which cause a second glance to be sure. However, its compact design houses the film within the camera body rather than using a magazine back. With Kowa f2.8/85mm standard lens and waist-level finder: \$300-450.

Kowa Six MM - c1971. All-black version of Kowa Six, with multiple exposure provision and mirror lock. \$300-450.

Kowa Super 66 - c1974. Major overhaul of the Kowa Six, resulting in an interchangeable L-shaped magazine back. With f2.8/85mm lens, WL finder, and 12/24 back: \$400-600.

Kowa SW - c1964. 35mm wide angle camera with fixed Kowa f3.2/28mm lens. Seikosha SLV 1-500,B shutter. Unusual appearance with peep-hole style viewer. Uncommon. \$300-450.

Kowa UW190 - c1972. Special 35mm SLR for wide angle use. Non-changeable f4/19mm lens. Uncommon. No sales records.

Kowaflex E - c1960-63.35mm SLR with coupled selenium meter. Same as the Kowa E, but has "Kowaflex" name on it. \$35-50.

Ramera - intro. 1959. Plastic six-transistor radio with 16mm sub-miniature camera. Also sold under the name Bell Kamra. 10x14mm exposures. Prominar f3.5/23mm. 3-speed shutter, 50-200, B. Available in: black, blue, red, white. Generally found new in box for \$120-180.

Super Lark Zen-99 - c1960. Gray 127 camera with imitation light meter and rangefinder windows. 4x6cm or 4x4cm on

127 rollfilm. Prominar f11/70mm fixed focus. I,T shutter. \$12-20.

Zen-99 - Inexpensive eye-level camera for 8 or 12 exposures on 127 film. Dark grey enamel, light grey covering. \$12-20.

KOZY CAMERA CO.

Pocket Kozy - c1895. Flat-folding bellows camera. Bellows open like the pages of a book. Early model has a flat front; later model (illustrated) has rounded front. 31/2x31/2" exposures on rollfilm. Meniscus f2.0/5" lens. Single speed shutter, T. Waist-level viewfinder. \$1200-1800.

Pocket Kozy, Improved - c1898. Similar to the first model, but front end with lens is rounded, not flat. \$800-1200.

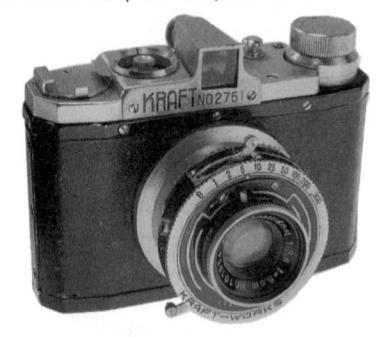

KRAFT WORKS (Japan)

Kraft - c1938. Compact camera for 4x4cm on 127 film. Automatic film counter. Kraft Anastigmat f3.5/5cm in Kraft-Works 1-300 shutter. Telescoping front. Top housing is very similar to the Letix camera by Asahi Optical Works (Riken), but body is metal, not bakelite. Rare. \$300-450.

KRANZ (L.W. Kranz) Sliding-box Daguerreotype Camera - c1856. Wood body. 9x12cm. \$7500-12,000.

KRASNOGORSK MECHANICAL FACTORY "KMZ" (Krasnogorsk,

USSR) Krasnogorsk is a suburb of Moscow, and the camera factory is named for its location. Locally, it is called KMZ, which stands for "Krasnogorsk Mekanicheski Zavod" (Krasnogorsk Mechanical Factory). Its trademark is a trapezoidal prism with an arrow entering horizontally from the left, reflecting from the bottom, then exiting horizontally to the right. This trademark is used on both camera bodies and lenses. They began by making Zorki cameras and continue today. They have made Zenit 35mm, Zenit 80 etc., Horizont, FT-2, and cine cameras.

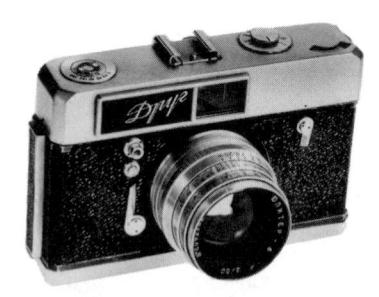

Drug (Dpyr) - c1960. ("Drug" = Friend). 35mm RF camera. Rapid film advance lever hinges down from bottom. It pulls in a straight line across the bottom to advance the film and tension the shutter, similar to earlier Leica & Canon cameras. Collimated viewfinder (projected frame lines). Interchangeable 39mm Leica-thread lenses. Standard lens is Jupiter-8 (1OANTEP-8) f2/50mm. FP shutter B,1/2-1000 with self-timer. Very few made. \$100-150.

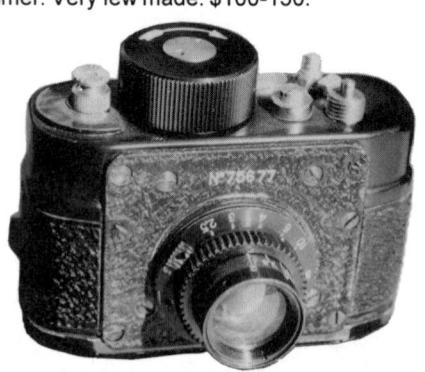

F-21 - c1951-1980's. Small camera with spring-motor film advance. Winding knob on top makes it look like a miniature Robot camera. These cameras first started trickling into the western collector market about 1989, and have showed up in increasing numbers since the reunification of Germany. Originally made for the KGB in a separate area of KMZ. Lack of viewfinder indicates special purpose use. Small ears on each end of the camera body allow it to be latched into position. Usually found complete with two special cartridges in protective case, reinforcing the theory that a large quantity of these cameras was sold as surplus in recent years. We would welcome further documentation from readers. Originally, these surplus cameras sold for very high prices to subminiature collectors (up to \$3000), but prices have dropped as they appear more regularly. Current sales range at press time \$500-750, and likely to drop further as they continue to flood the market.

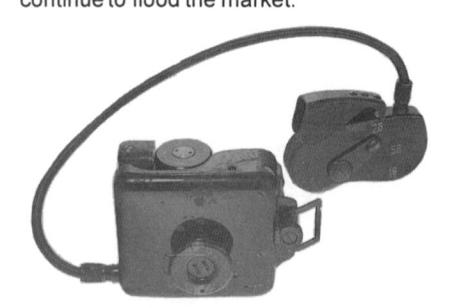

F-21 Button Camera - An ingeniously concealed version of the CdS-metered model of the F-21. Special housing with remote release attaches to the front of the camera. The camera remains concealed, while the front projects through a buttonhole. A coat button conceals the lens. In

the center of the coat button are four holes with thread, as though the button is sewed on normally. In reality, the center of the button splits and opens momentarily as the photo is taken. The CdS meter of the F-21 camera reads the scene through a tiny hole near one edge of the button. The remote release simultaneously opens the button and fires the shutter of the camera. Diaphragm settings can also be made from the remote handle. A remarkably clever spy camera. Our only recorded sale: Cornwall 9/92 for 1000DM (\$650).

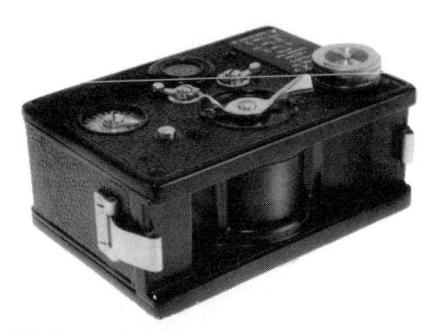

FT-2 - c1958-65. Panoramic camera for 12 exposures 24x110mm on 35mm film. Industar f5/50mm lens. Shutter 100-400. Early models have separate shutter adjustment on bottom in addition to the normal two top levers. These early models had many problems. They can also be identified from the top by the single-ended tensioning lever. \$300-450.

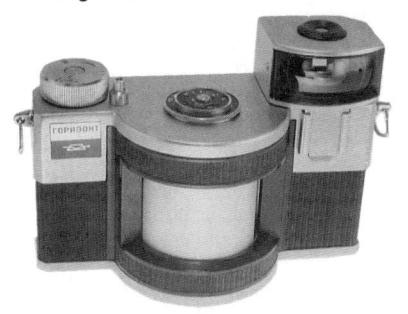

Horizont - c1967-. Year of manufacture approximated by first two digits of body serial number. 35mm panoramic camera with f2.8/48mm pivoting lens for 120° view. Speeds 30,60,125. With standard detachable finder and grip: \$400-600.

Iskra - c1961. (Iskra = "spark"). Horizontally styled folding bed camera for 6x6cm on 120 rollfilm. Copy of Agfa Super-Isolette. Coupled rangefinder. Industar-58 f3.5/75mm lens in T,1-1/₅₀₀ shutter. \$120-180.

Iskra-2 - c1961. As Iskra, but with selenium meter cell between rangefinder windows. Less common than Iskra. \$150-225.

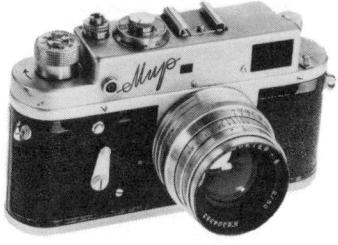

Mir - c1959-60.35mm CRF. Similar to the Zorki 4, but no slow speeds. Uncommon. \$75-100.

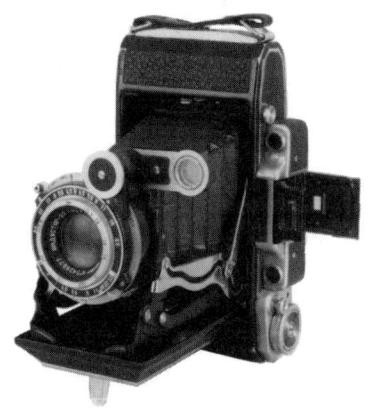

Moscow (Moskwa) - c1945-60. Russian cameras based on the designs of Zeiss Ikon Ikonta and Super Ikonta C. Moment shutter 1-250. Industar f3.5/105 or f4.5/110mm. Major model distinctions: 1) Copy of Zeiss Ikon Ikonta. Basic model without rangefinder. 2) Rangefinder model. Copy of Super Ikonta C. 3) An Ikonta-style self-erecting camera with a 6.5x9cm plate back. 4) Synchronized version of model 2. 5) A new camera with die-cast body, not pressed metal as Super Ikonta C. Heavily influenced by the Bessa II. Streamlined top housing with integral optical finder. \$100-150.

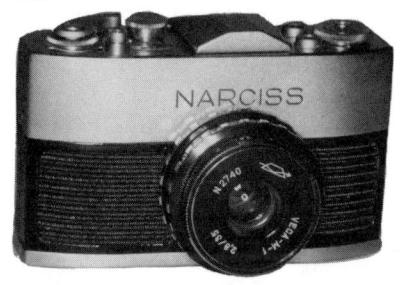

Narciss - c1960. Cyrillic-lettered versions look like "Hapyucc". Subminiature SLR for 14x21mm on 16mm unperforated film. White or black leather covering. Industar-60 or Vega-M-1 f2.8/35mm normal lens in 23mm screw mount. Original outfit included lenscap, 4 cassettes, case, adapter to use "Zenit" lenses (39mm thread), adapter ring and frame for enlarger, spool flange for developing tank, and instructions, all neatly packed in a presentation box with hinged lid. In recent years, many have come out of the former Soviet Union, and they no longer command the high prices they once did. A complete outfit will bring \$400-600. Camera with normal lens sells regularly at European auctions for \$250-350, and sometimes less.

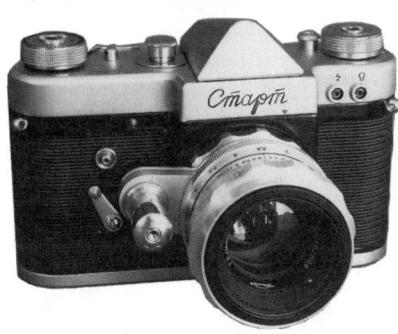

Start (Cmapm) - c1958-1960's. 35mm SLR, apparently inspired by Exakta. Cloth focal plane shutter. Bayonet-mount lenses have Exakta-style shutter release arm. Helios f2/58mm normal lens. Once consid-

KRASNOGORSK

ered uncommon, now appearing regularly on the market. \$120-180.

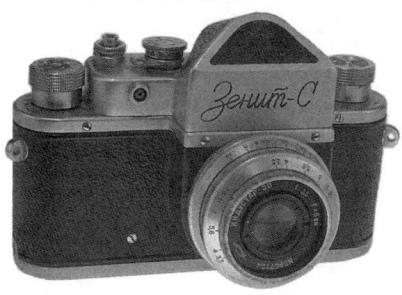

Zenit, Zenit-C - c1950's. Leica/Zorkiderived SLR with 39mm lens thread. Base loading. Mirror set by string. \$60-90.

Zenit 3, Zenit 3M, Zenum 3M - 1960's-1970's. 35mm SLR cameras. Fixed pentaprism. FP shutter 30-500, B. Including one of the various 39mm screwmount standard lenses. \$30-45.

Zenit 4 - c1964. SLR with bayonet-mount lenses; coupled selenium matchneedle meter; automatic resetting exposure counter. Introduced the central diaphragm shutter to replace the earlier focalplane type. A new series of lenses was introduced to fit the Zenit 4 & 5, including 37mm f1.8 Mir-1, 89mm f2.8 Jupiter-25-tc, 135mm f4 Tair=38-tc, & 200mm f5.6 Teletair-200-ts. With normal 50mm f2.8 Vega-3 lens: \$150-225.

Zenit 5 - c1964. Same as Zenit 4, but with built-in electric motor which automatically winds film after each exposure. Fully charged battery said to last 400-500 exposures. Manual film advance possible if battery is discharged. Bayonet-mount lenses with diaphragm shutters (see list above with Zenit 4). With 50mm f2.8: \$100-150.

Zenit 6 - c1966. SLR with interchangeable WL & prism finders. Diaphragm shutter to 1/₅₀₀; coupled selenium meter; single knob adjustment for diaphragm/shutter. Like Zenit 4, but supplied with bayonetmount Rubin-1 37-80mm f2.8 zoom lens. \$250-375.

KRASNOGORSK...

Zenit-B - c1969. Basic SLR with fixed pentaprism, instant-return mirror. Standard 42mm lensmount, no provision for automatic diaphragm. Originally supplied with Industar 50-2 (manual diaphragm) or Helios 44-2 preset lens. Cloth FP shutter B,30-500.\$30-45.

Zenit E - Early 1970s. Metered version of Zenit. Uncoupled selenium meter in front of prism, match-needle on top housing. Helios-44 f2/58mm. Common in Europe, where they sell with difficulty at \$45-60.

Black Zenit EM, 1980 Olympics **Zenit EM -** Mid-late 1970s. Metered version with automatic diaphragm, using Helios 44M lens. Chrome or black body, and Moscow Olympic versions. \$45-60.

Zenit TTL

Zenit ET - Black body. A bit less common than some other Zenits, but still sells at European auctions for \$35-50.

Zenit TTL - ca. mid-1970s-1980s. Black body. TTL stopped-down match-needle metering. Automatic diaphragm control with Helios 44M f2/58mm lens. \$45-60. *Illustrated bottom of previous column.*

Zenit 19 - c1980. Black body. TTL full-aperture metering, match needle visible in finder. Automatic diaphragm control with Zenitar-Mor Helios-44M lenses. \$50-75.

Zenit Photo Sniper - c1968-1990's. Zenit E or other Zenit camera with fast-focusing Tair-3 300mm/f4.5 lens attached to a gunstock with pistol grip. In fitted metal case. On both the camera and lens, the first two digits of the serial number indicate the year of production. The latest models (1990's) are Fotosniper FS-5 (with Zenit-Automat), Fotosniper FS-12 (with Zenit-12XP), and Fotosniper FS-122 (with Zenit-122C). Some dealers ask up to \$325 (with ads repeated for months!) but these are increasingly common in Europe and regularly sell for \$150-225.

Zorki Cameras - These are 35mm copies of Leica and other well-known cameras. Zorki cameras, as well as many other Russian cameras, are seen with the name written in Roman letters or in Cyrillic letters. "Zorkii" in Cyrillic resembles the Roman characters "ZopKuu" or "3OPKNN". Early Zorki cameras have consecutive serial numbers (less than 8 digits) without an indication of year of manufacture. After about 1955, the first two digits of the 8-digit body number will indicate the year of manufacture. Industar-22 lens serial numbers began using the dating code a few years earlier.

Fed-Zorki - 1948-49. Styled like the Fed I, but with larger collar around shutter release. Both Fed and Zorki names engraved on top. Few examples known.

Zorki - c1950-56. Leica II copy with separate RF/VF windows. 38mm RF base. Removable base. Industar-22 f3.5/50mm. Consecutive serial numbers at least through 1954, without year of manufacture indication. Some pre-1955 Industar-22 lenses are date coded, which may help to date an early body if the lens is original. Fairly common in Germany, where they sell for: \$60-90.

Zorki 2 - c1952-55. Similar to the Zorki, but with self-timer. \$75-100.

Zorki C (S) - c1955-58. Similar to the Leica II, but rangefinder cover is slightly taller and extended, incorporating flash

sync. Industar-22 or Industar-50 f3.5/50mm lens. Common in Germany. Clean & working: \$50-75. Often with defective shutter for \$25-35.

Zorki 2C - c1956-58. Similar to the Zorki C, but with self-timer. Industar-50 f3.5/50mm or Jupiter-8 f2/52mm. \$60-90.

Zorki 3 - c1952-55. 35mm with CRF, removable back, like the Kiev cameras. 39mm RF base. Slow speed dial on front. Jupiter-8 f2.0/52mm. \$60-90.

Zorki 3C - c1955-56. Similar to the Zorki 3M, but has flash sync. Top cover has been redesigned. \$60-90.

Zorki 3M - c1955. Similar to the Zorki 3, but slow speeds appear on the shutter speed dial on top. \$60-90.

Zorki 4 cameras with Cyrillic lettering (top) and Roman lettering (bottom)

Zorki 4 - c1956-73. Coupled rangefinder. Jupiter-8 f2/50mm or Industar-50 f3.5/50mm. Focal plane shutter 1-1000. Similar to the Zorki 3C, but with self-timer. The most common Zorki. Later models have 42mm screwmount (not interchangeable with Zenit lenses.) Normal range: \$45-60.

Zorki 4K - c1973-77. Similar to the Zorki 4, but has lever wind and fixed take-up spool. Jupiter-8 f2/50mm. Very common. \$45-60.

Zorki 5 - c1958-59. 35mm CRF. Industar-50 f3.5/50mm or Jupiter-8 f2/50mm. FP shutter 25-500, sync. Rapid advance lever. Removable base. \$60-90.

Zorki 6 - c1960-66. Like the Zorki 5, but with hinged back and self-timer. FP 30-500. \$50-75.

Zorki 10 - c1965. Boxy design with

KRÜGENER

bottom advance lever and with selenium cell around lens. Similar to the Ricoh Auto 35; not at all like the earlier Leica derivatives. Fixed Industar-63 f2.8/45mm lens, leaf shutter 1/30-500. Automatic exposure. \$35-50.

Zorki 11 - Similar to the Zorki 10, but no rangefinder. \$35-50.

Zorki 12 - Half-frame version of the Zorki 11. Helios-98 f2.8/28mmlens, \$50-75.

KRAUSS (E. Krauss, Paris) See the next listed manufacturer, G.A. Krauss of Berlin, for other Krauss cameras.

Eka - c1924. For 100 exposures, 30x44mm on 35mm unperforated film. Krauss Zeiss Tessar f3.5/50mm lens in Compur 1-300 shutter. Helical focusing mount. \$750-1000.

le Mondain - c1906. Unusual strut camera made in 4.5x6cm, 6.5x9cm and 9x12cm sizes, plus stereo versions in 45x107mm & 6x13cm. Polished metal body; red leather bellows; lever focusing. Stereo or 4.5x6cm: \$400-600. 6.5x9cm or 9x12cm: \$200-300.

Photo-Revolver - c1920's. For 18x35mm exposures on 48 plates in magazine or special rollfilm back. Krauss Tessar f4/40mm lens. 3-speed shutter, 25-100, T. Normal ranges: with rare rollfilm back, \$3200-4600; with magazine back, \$2000-3000.

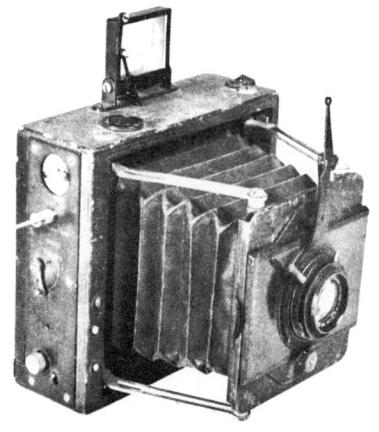

Takyr - c1906. Strut-folding camera for 9x12cm plates. Krauss Zeiss Tessar 6.3/136mm lens. Focal plane shutter. \$200-300.

KRAUSS (G.A. Krauss, Stuttgart)

For other Krauss cameras, see the previous listings under E. Krauss, Paris.

Nanos - c1923. Strut-folding plate camera, 4.5x6cm. Tessar f4.5/75mm lens. \$120-180.

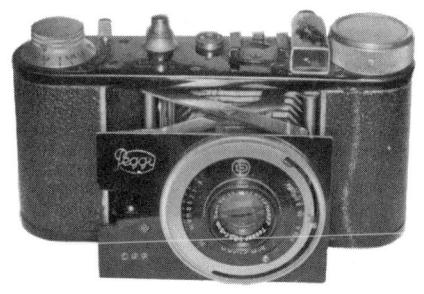

Peggy I - 1931. 35mm strut-folding camera. Tessar f3.5/50mm lens. Compur shutter 1-300. \$500-750.

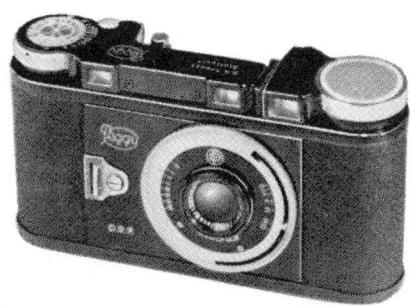

Peggy II - c1934. Basically the same as Peggy I, but with coupled rangefinder. Early model automatically cocked the shutter by pushing in the front and releasing it, but this meant that the camera was stored with the shutter tensioned. Later model (scarcer) had manual cocking lever. Often seen with Xenon f2 or Tessar f2.8. \$400-600.

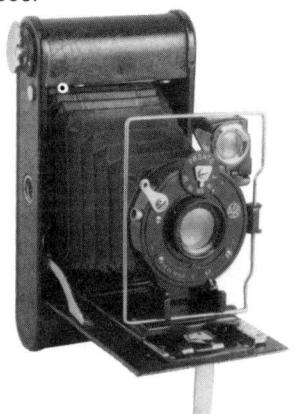

Rollette - c1920's. Folding rollfilm cameras, with Krauss Rollar f6.3/90mm lens in Pronto 25-100 shutter. Late models focus by radial lever on bed. \$45-60.

Rollette Luxus - c1928. Similar, but with light brown reptile covering and brown bellows. \$120-180.

Stereoplast - c1921. All-metal rigid body stereo, similar to the Polyscop. 45x107mm exposures. f4.5/55mm, or Meyer f4/5.3cm lenses. Stereo-Spezial shutter to 250 or 300. Magazine back for glass plates. \$300-450.

KREMP (Wetzlar, Germany)

Kreca - c1930. Unusual 35mm with prismatic telescope for rangefinder. Identical to the Beira II camera from Woldemar

Beier, but rarer still. Cornwall indicates that only about 10 were made. "Kreca" embossed on front leather. "Kremp, Wetzlar" logo embossed on back. Kreca f2.9 lens in rim Compur to 300. \$500-750.

KROHNKE (Emil Krohnke, Dresden) Photo-Oda - c1902. Unusual rectangular metal subminiature for 18x18mm on special rollfilm. Meniscus lens, single speed shutter. Nickel finish with decorative engraving. Produced at the same time as the cane handle camera, the Photo-Oda appears to have been a ladies detective camera. The only known example sold at auction in May 1989 for \$9100 with original box and a roll of film.

KRÜGENER (Dr. Rudolf Krügener, Bockheim/Frankfurt, Germany)

Merged in 1909 with Hüttig, Wünsche, and the Carl Zeiss Palmos factory to form Ica AG. Many of Krügener's camera lines continued under the Ica label, and indeed these later "Ica" models are more commonly found. Such names include: Halloh, Plascop, Teddy, Trix, & Trona.

Delta (plate camera) - c1905. Vertically styled 9x12cm folding plate camera. Black leather covered wood body. Aluminum standard, nickel trim. f6.8/120mm Dagor or Euryscop Anastigmat lens. Delta shutter 25-100. \$90-130.

Delta (plate & rollfilm) - Horizontally styled rectangular body. Folding bed. Early models c1900 have wooden lensboard with built-in shutter or external brass "Delta" shutter. Later types c1905 have Unicum shutter and large metal frame

KRÜGENER...

finder. Wine red or light brown bellows. 9x9cm and 9x12cm sizes. Early types with built-in shutter or Delta shutter: \$300-450. Later types with Unicum shutter: \$175-250.

Delta (rollfilm) - c1900-03. Horizontally styled folding bed 6x9cm camera Rounded ends. Leather covered wooden body and aluminum bed. Leather-covered wooden lensboard with built-in M,Z shutter and reflex finder. Wine-red bellows. \$100-150.

Delta Detective - c1890. Small polished mahogany box camera. Leather changing bag for 12 plates, 6x8cm. Shutter cocked and released by pulling on 2 strings on top of the camera. \$600-900.

Delta Magazine Camera - c1892. For 12 exposures 9x12cm on plates which are changed by pulling out a rod at the front of the camera. Achromat lens in simple spring shutter. \$600-900.

Delta Patronen-Flach-Kamera, 8x10.5cm - c1903. Aluminumbed, winered bellows, nickel trim, plate back. Delta Anastigmat f6 lens in ¹/₂₅-¹/₁₀₀ shutter. \$120-180

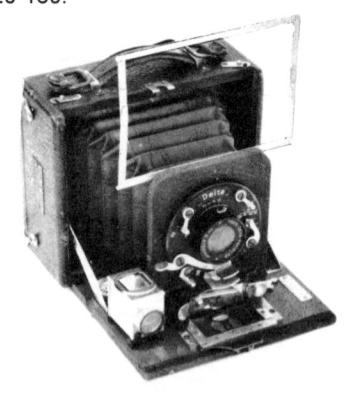

Delta Periskop - c1900. Folding bed camera for 9x12cm plates. Leather covered wood body. Red bellows. Krügener Rapid Delta Periscop f12 lens in delta shutter 25-100. \$100-150.

Delta Stereo - c1898. Folding bed stereo camera, 9x18cm on plates or roll-film. Earliest models with wooden lensboard, later made of metal. Periplanat or Extra-Rapid Aplanat lenses. Red bellows. Polished wood interior. \$215-325.

Delta-Teddy - c1898. Folding camera for 9x12cm plates. Delta Achromat lens, 3-speed shutter with revolving diaphragm mounted in front of the lens. \$120-180.

Electus - c1889. Non-focusing TLR-style magazine box camera. Similar to the Simplex Magazine camera, but only holds 18 plates. Steinheil lens. Single speed shutter. \$1200-1800.

Halloh, 9x14cm - c1909. Leather covered wood body, aluminum bed, nickel trim, plate back. Goerz Syntor f6.8/150mm in Compound.Rare. \$250-375.

Jumelle-style magazine camera -For 18 plates 6x10.7cm. Brass-barrel Periscop lens, leather covered wood body. Built-in changing magazine. \$200-300.

Million - c1903. Leather covered stereo. Looks like a box camera, but has a short red bellows extension. 9x18cm on rollfilm, single or stereo exposures. Periskop lenses. Guillotine shutter. \$250-375.

Minimum Delta - c1909. Double extension folding plate camera with very thin body. 9x12cm. Pneumatic shutter, 1/25-100. \$90-130.

Normal Simplex - c1892. Polished mahogany magazine camera for 12 plates, 9x12cm. Small box with waist-level view-finder retracts into the top of the camera body when not in use. Antiplanat lens, 3 diaphragmstops. \$1700-2400.

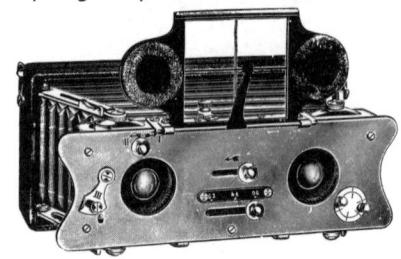

Plaskop 45x107mm - c1907. Compact strut-folding camera for 45x107mm stereo plates. Unusual hinged frame finder incorporates lenscaps. Metal body available with or without leather covering. Various lenses. Four speeds plus time. Rare. \$250-375.

Plaskop 6x13cm - c1925. Stereo with Novar f6.8/75mm lenses, guillotine shutter. \$120-180.

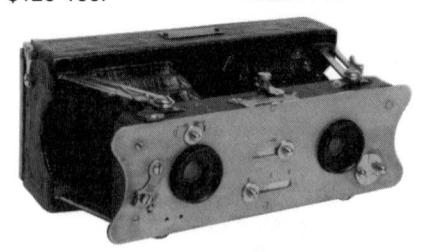

Plastoscop - c1907. Strut-folding stereo camera for 45x107mmplates. \$175-250.

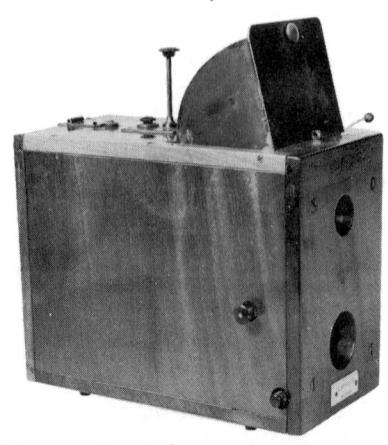

Simplex Magazine - c1889. Non-focusing TLR-style with changing mechanism

for 24 plates, 6x8cm. Polished mahogany Steinheil or Periscop f10/100mm lens. Single speed sector shutter. \$1500-2000.

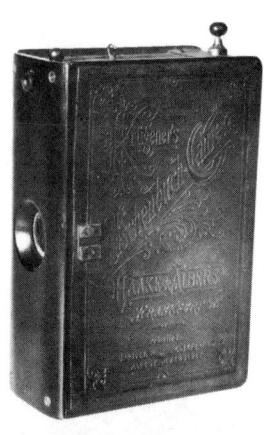

Taschenbuch-Camera - c1889-92. Leather covered camera, disguised as a book. Achromatic f12/65mm lens is in the "spine" of the book. Guillotine shutter, T, I. Shutter is cocked and released by pulling on 2 strings. Internal magazine holds 24 plates for 40x40mm exposures. \$3500-5500. *Replicas exist; see next entry.*

Taschenbuch Replica - Various replicas of the Taschenbuch Camera have been made, and have sometimes been misrepresented as genuine. Some copies are poorly crafted. Even when properly represented as a replica, a well-made copy has a legitimate value for museum display. At Christies auction 12/91, a replica with the title "Photo Carnet", and with serial number 939R (R=replica) reached a \$1450 hammer price.

K.S.K.

Corona - Subminiature made in Occupied Japan. 14x14mm exposures. Rim-set leaf shutter, iris diaphragm. Red leather covering, gold-colored metal parts. Also in chrome finish. Uncommon. \$300-450.

KUEHN (Berlin, Germany) Lomara - c1921. Large SLR for plates. Focal plane shutter. \$200-300.

Lomaraskop - Stereoscopic camera for 127 film. Lomara Anastigmat f4.5/5cm lenses. Uncommon. \$300-450.

KUGLER (Earl Kugler, U.S.A.) Close Focus Camera - Unusual vertically styled polished wood folding bed camera for $2^{1/2}x4^{1/4}$ " exposures on rollfilm. Rack and pinion focusing to 12". Symmetrical 4x5 lens in Unicum shutter. Rigid wood handle on top. \$200-300.

KUH (Czechoslovakia) Companion Reflex - c1939. TLR.
Trioplan f2.8/75mm, Compur 1-250 shutter. \$60-90.

KULLENBERG, O. (Essen, Germany) Field camera - 5x7" vertical format field camera with red tapered bellows, brassbarreled Universal Aplanat f8 lens with iris diaphragm. Rouleau shutter. \$250-375.

KUNIK, Walter KG. (Frankfurt) Foto-Füller - c1956. The plain German version of the French Stylophot. It lacks

the imitation snake covering of the "Luxus" version, but still has the chrome-plated back typical of the German versions. Considerably less common than the Stylophot. \$300-450.

Foto-Füller (Luxus) - c1956. The German version of the French Stylophot, designed by Fritz Kaftanski. This luxus version has a crudely applied covering of imitation snakeskin. Hardly in competition with the Luxus Leica, but still not often found. One reached a high of \$680 at 12/91 auction, but the normal auction range is \$300-450.

Mickey Mouse Camera - c1958. Subminiature, like the Ompex 16, but with the Mickey Mouse name on the faceplate. 14x14mm exposures on 16mm Tuxi film. Red hammertone body. Meniscus lens in single speed shutter. Relatively uncommon. However, in 1990, about six cameras were found with the original tagboard figure of Mickey Mouse which holds the camera for display. These sold quickly to collectors at about \$140 each. Current range with paper Mickey display figure: \$300-450.

Ompex 16 - c1960. Subminiature similar to the Tuxi. Black or red body. Meniscus lens, single speed shutter. Red: \$75-100. Black: \$60-90.

Petie with gold trim

Petie - c1958. Subminiature for 16 exposures 14x14mm on 16mm film. Meniscus f11/25mm lens in simple shutter. Gray crinkle finish enamel with gold-colored trim: \$90-130. Black with silver parts: \$50-75.

Petie Lighter - c1956. Petie camera in a special housing which also incorporates a cigarette lighter. Art-deco enamel finish or leather covered. At the 12/91 Christies

auction, prices went over \$2000, about double the normal price range. Currently: \$1200-1800.

Petie Vanity - c1956. Petie camera housed in a make-up compact. Front door opens to reveal mirror and powder. One top knob contains a lipstick, another provides storage for an extra roll of film. Beautiful art deco marbelized finish in red. green, or blue. Chrome or gold-colored metal. Also made with colored leatherette covering. Said to be made by Kreher & Bayer, Öffenbach, West Germany. Kigu, a British maker of powder compacts, reportedly made some pre-production samples for the ensemble. A few of Kigu's original sample cameras first went on auction in 1989, in original boxes. Record price of \$3000 was set for blue/chrome version at the famous 12/91 "Spy Camera" auction. New condition cameras have continued to appear regularly at auction. Normal range: \$800-1200

Petietux - c1957. Similar to the other Petie cameras, but with built-in meter, flash synchronization, and helical focusing Kratz Optic f2.8/25mm lens. 14x14mm. \$400-600.

Petitax - c1962. Novelty camera for 14x14mm exposures. Similar to the Petie

series. f11/25mm lens in simple shutter. \$60-90.

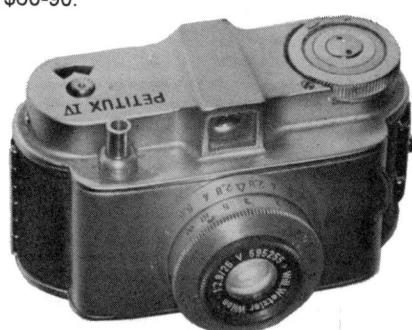

Petitux IV - Heavy cast metal body, identical to Kalos Spezial. Wilon f2.8/28mm or Roeschlein Supronar f2.8/25mm lens in helical focusing mount. 7-speed shutter built into body. Synch socket on bottom. \$600-900.

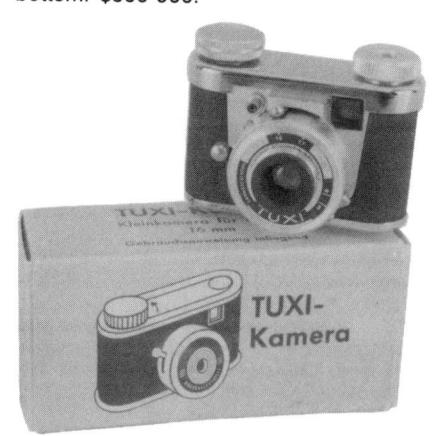

Tuxi - c1960. For 14x14mm on 16mm film. Achromat Röschlein f7.7/25mm lens in synched shutter, B, M. \$75-100.

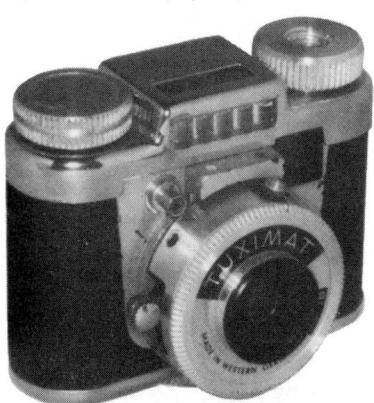

Tuximat - c1959. 14x14mm on 16mm film. Meniscus lens f7.7/25mm. Synched shutter. Simple built-in meter. \$175-250.

KURBI & NIGGELOH - see Bilora

KURIBAYASHI

KURIBAYASHI CAMERA WORKS, PETRI CAMERA CO. (Tokyo)

Kuribayashi Camera Works was established in 1907 as a small workshop producing photographic accessories such as plate holders and wooden tripods. Its first production camera was the Speed Reflex of 1919. Most pre-WWII models were sold under the "First" brand name by Minagawa Shoten, a trading firm. During the Occupation, the name "Petri" was chosen, contracted from "Peter the First". This was hoped to improve acceptance in non-Japanese markets. The company name was changed to Petri Camera Company in 1962. After seventy years, the company went bankrupt in 1977. None of the pre-WWII models were marketed outside of Japan. Though Kuribayashi was a leading domestic manufacturer, most models were still made in small lots and are now quite rare and highly sought in Japan. During the Occupation, nearly all Japanese cameras, including Petri models, were sold to Allied forces and western markets.

Most of the historical and technical information on Kuribayashi/Petri as well as the photos in this section were provided by Mr. John Baird. His book, Collectors Guide to Kuribayashi-Petri Cameras, was published in 1991 by Centennial Photo, and should be available from the dealer where you bought this guide. John also publishes a newsletter and a series of monographs on collectible Japanese cameras. For further information, write to: Historical Camera Publications; P.O. Box 90, Gleed Station; Yakima, Washington 98904.

Cameras in this section are listed in chronological order.

1919 Speed Reflex - Similar to the English Ensign large format SLR's. Two models with either quarter-plate or 6x9cm formats. German Tessar lens, cloth focal plane shutter with speeds to $^{1}/_{1000}$. Very rare. No recorded sales.

HAND PLATE CAMERAS

Folding hand plate cameras with interchangeable ground glass focusing backs and plate holders for 2!/x3!/4" formats. Initially fitted with imported European shutters and optics, by the early 1930's Kuribayashi's plate models mounted some of the very first all-Japanese made shutters and lenses (Seikosha and Tokyo Kogaku).

Mikuni - c1926. One of the leading Japanese-made cameras during the late 1920's. Tessar f4.5-6.3/105mm lens, Vario shutter. No known example in any Japanese collection. Value unknown.

First Hand

First Hand, new model

Kokka Hand, new model

Tokiwa Hand

Romax Hand

First Hand - 1929, new model 1932. **Kokka Hand -** 1930, new model 1932. **Tokiwa Hand -** 1930.

Romax Hand - 1934.

All of the above models are similar, fitted with Tessar or Trinar 105mm lenses and Vario or Compur shutters. The 1929 First Hand was the original model bearing the name "First". In 1934 the majority of the factory's models mounted Toko and State (Tokyo Kogaku) 105mm Anastigmat lenses and the Vario-inspired Seikosha Magna shutter. All models are rare and available only in Japan. Collectors' price \$75-300.

First Etui Camera - 1934. Patterned after the KW Patent Etui, this is a very compact folding camera fitted with Toko Anastigmat 105mm lens and Magna shutter. \$200-300.

PRE-WAR ROLLFILM MODELS

Starting in the early 1930's with the increasing supply of rollfilm in Japan, the hand plate camera gave way to the compact and easy to use rollfilm cameras. These models have self-erecting folding bellows and are fitted with a variety of Japanese made lenses and shutters, dominated for the most part by Toko Anastigmats and Seikosha's copy of either the Vario or rim-set Compur shutter. In fact, the 1936 model of Semi First was the first to sport the Compur-inspired Seikosha shutter.

First Roll - 1933. Folding metal bodied camera fitted with either Radionar, Trinar or Toko (State) 105mm and a variety of shutters of Japanese and German make. Made full frame exposures on 120 rollfilm. \$200-300.

Semi First - 1935. 4.5x6cm on 120 roll-film. \$150-225.

Baby Semi First - 1936. 4.5x6cm on 120 rollfilm. \$150-225. *Illustrated at top of next page*.

First Six - 1936. First Japanese-made camera for 12-on-a-roll format. f3.5/75mm Toko Anastigmat. Seikosha T, B, 1-250 shutter. Vertical body. (See Tokiwa Seiki for a later First Six, c1950's.) \$90-130.

First Center - 1936, 6x9cm, \$90-130.

First Speed Pocket - 1936. The first Japanese camera to take both Vest and Baby formats. 127 film. \$100-150.

BB Semi First - 1940. 4.5x6cm on 120

rollfilm. The first camera to be made in Japan with a built-in exposure meter (extinction type), \$200-300.

BB Baby Semi First - 1940. 4.5x6cm on 120 rollfilm. No sales.

Auto Semi First - 1940. 4.5x6cm on 120 rollfilm. \$175-250.

First Reflex - 1937. One of the first Japanese-made 120 twin lens reflex cameras, fitted with First Anastigmat 75mm and First shutter, 1-200. Very rare, with less than five examples known. Few sales. \$300+.

First Reflex (model 2) - c1940. Similar to the original model, but with various shutter/lens combinations, most notably the Hit Anastigmat f3.2/7.5cm in Hit Rapid shutter to 1/500. Uncommon.\$150-225.

POST-WAR ROLLFILM MODELS

After the war, Kuribayashi introduced its own line of shutters and lenses; Carperu leaf shutters in a variety of speeds with Orikon and Orikkor lenses.

KURIBAYASHI...

Kuri Camera - 1946. No sales. **Lo Ruby Camera -** 1947. Both models are improved versions of the pre-war Semi First. Made in small quantities mounting First or Kokka 75mm Anastigmats, and First or Wester Compur-type shutters. No sales.

Petri Semi, II, III - 1948. First use of the name "Petri". Fitted with Petri and Orikon 75mm lenses and Petri 1-200 shutter. Built-in uncoupled rangefinder. Majority are marked MIOJ on the back cover latch. \$100-150.

Petri RF - 1952. Compact version of the larger Petri Semi type. Orikon f3.5/75mm lens and Carperu 1-200 shutter. Uncoupled rangefinder.\$120-180.

Petri RF 120 - 1955. Very similar to the Petri RF, but rangefinder is now coupled. Uncommon. Price unknown. No sales.

Petri Super - 1955.
Petri Super V - 1956. Last of the Kuribayashi self-erecting rollfilm models. Very similar to the pre-war Auto Semi First with coupled rangefinder. Fitted with Tessarinspired Orikkor 75mm lens and Carperu or Seiko Rapid shutter. Uncommon, high quality folding cameras. \$350-500.

KURIBAYASHI...

Karoron S

Karoron - 1949.

Karoron S - 1951. Popular models of the more expensive and feature-laden Petri Semi. Neither fitted with rangefinders. Orikon 75mm lens and Carperu shutter to 200, \$90-130.

Karoron S-II, Karoron RF - 1951-52. Both exactly alike and different from the Petri RF in nameplate alone. Orikon f3.5/75mm, Carperu shutter. Uncommon. \$100-150.

Petriflex - 1953. The only post-war TLR camera to be manufactured by Kuribayashi Camera. Rolleicord-inspired with matched Orikkor f3.5/75mm taking and viewing lenses and Carperu shutter to 200. Rare. \$150-225.

PETRI 35mm MODELS

Petri 35 - 1954. First 35mm rangefinder camera from Kuribayashi. Orikkor f3.5 or f2.8/45mm lens, Petri-Carperu shutter, 1/₁₀-200. Original model: \$45-60.

Petri 35X, MX - 1955. Petri Automate - 1956. Petri 35 2.0 - 1957. Petri (35) 2.8 - 1958. Petri 35 1.9 - 1958.

These models were based on the original

Petri Automate

Petri (35) 2.8

1954 Petri 35. Fitted with Orikkor 45mm f2.8, 2.0, 1.9 lenses. Copal and Carperu shutters with speeds of either 1/300 or 1/500. All have coupled rangefinders. Common, with prices starting at \$15.

PETRI COLOR SUPER SERIES

The Petri Color Super series were improved models with a projected bright line view-finder with automatic parallax correction. High quality taking lenses.

Petri 2.8 Color Super

Petri 1.9 Color Super

Petri 2.8 Color Super - 1958. Petri 1.8 Color Super - 1959. Petri 1.9 Color Super - 1960. Vast numbers sold. Common. \$10 and up.

Petri EBn - 1960. Built-in selenium cell

exposure meter fitted in Petri Color Super body. Orikkor 45mm f1.9 or 2.8 lens. Copal or Carperu shutter in geometrical progression to 500. \$30-45.

PETRI SEVEN SERIES

Coupled rangefinder models with selenium cell (CdS on Racer) mounted inside of lens ring, called "Circle Eye" by the factory. All have f1.8 or 2.8 Petri lenses (f1.8 only on Petri Pro Seven) and shutters to 500. Exposure readout in viewfinder and on the top cover with the exception of the Petri Seven fitted only with finder meter scale.

Petri Seven

Petri Pro Seven

Petri Racer

Petri Seven - 1961. Petri Seven S - 1962. Petri Pro Seven - 1963. Petri Racer - 1966. Petri Seven S-II - 1977.

Very popular camera models with user prices at \$10-30.

OTHER PETRI CRF MODELS

With the exception of the selenium-celled Petri Prest and Hi-Lite, these models contain fully automatic CdS photometers. All have coupled rangefinders with projected bright line frames. Petri lenses in 40 and 45mm focal lengths and in a range of apertures to f1.7 using the Petri and some Seiko-made shutters.

antiniani.

Petri Prest

Petri Hi-Lite

Petri ES Auto 1.7

Petri Prest - 1961. Petri Hi-Lite - 1964 Petri Computor 35 - 1971.

Petri M 35 - 1973. Petri ES Auto 1.7 - 1974. Petri ES Auto 2.8 - 1976.

Petri 35 RE - 1977.

Prices start at \$10.

PETRI HALF FRAME MODELS

Kuribayashi was the second Japanese camera maker to market a line of half-frame models. All are equipped with projected bright line viewfinders and Petri-Orikkor f2.8/28mm lenses.

Petri Half

Petri Half, Junior, Compact - 1960. Petri Compact E - 1960. Petri Compact 17, Petri Half -

The 1960 Petri Half was fitted with a rapid

Petri Compact E

advance lever and Carperu shutter to 250. Compact E was the same as the Petri Half. but with a built-in uncoupled selenium exposure meter. The 1962 half-frame models sported electric eye photometer for fully automatic exposure and revised body design. All still available both for the user and collector. Compact and high quality. Prices start at \$35.

PETRI FULL FRAME COMPACT 35mm

Full frame, compact 35mm cameras with a retractable Petri f2.8/40mm lens patterned after the Rollei 35.

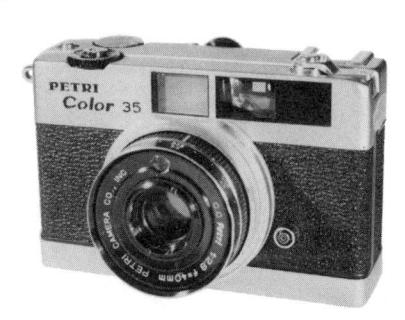

Petri Color 35

Petri Color 35 - 1968. Petri Color 35E - 1970. Petri Micro Compact - 1976.

One of Petri's most successful models, the original 1968 Petri Color 35 had a coupled CdS photometer with shutter speeds to 250. The Color 35E and Micro Compact were very similar to the Color 35 but fea-

tured a fully automatic exposure mechanism. \$35-50.

PETRI SINGLE-LENS-REFLEX MODELS

Most of these models were supplied with 55mm f2 or f1.4 normal lens in Petri breech mount. All share the same basic body design and front-mounted shutter release. Most models are common and still available on the used market.

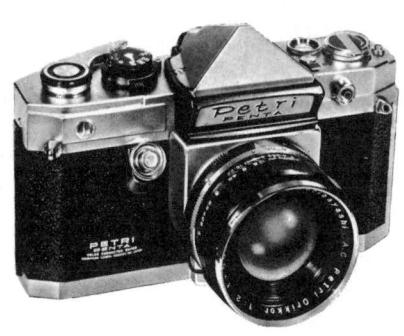

Petri Penta

KURIBAYASHI...

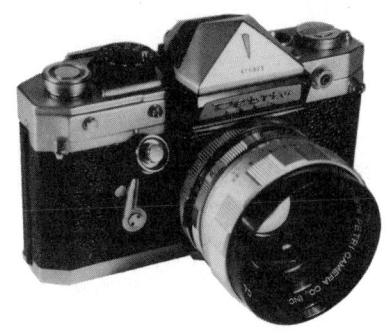

Petri Penta V3

Petri Penta - 1959.

Petri Penta V2, Petri Flex V - 1961

Petri Penta (Flex) V3 - 1964. Petri Penta (Flex) V6 - 1965.

Petri Penta (Flex) V6-II - 1970

The Petri Penta was Kuribayashi's first modern SLR camera with focal plane shutter of 1/2-500 and pre-set screwmount Petri Orikkor f2.0/50mm lens. Later improvements include automatic lens aperture and introduction of Petri breech lens mount system with the Petri Penta V2 (called Petri Flex series in non-Japanese markets). Clip-on CdS photometer on the Petri Penta V3 and later Petri V6. Japan: \$200-300. USA: \$75-100.

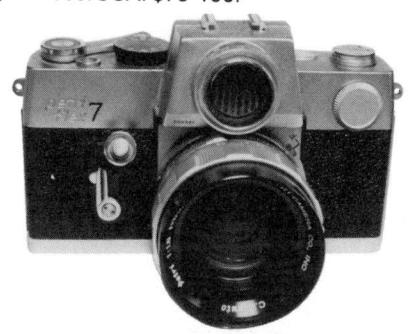

Petri Flex Seven - 1964. External CdS cell. Cloth focal plane shutter $1-1/_{1000}$. Breech lensmount. Rare and highly sought after by Japanese collectors. \$250-375.

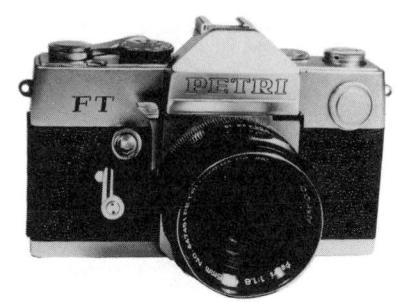

Petri FT

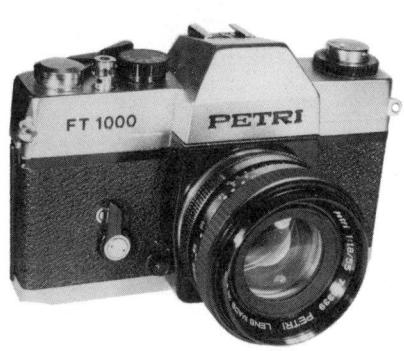

Petri FT 1000

KURIBAYASHI...

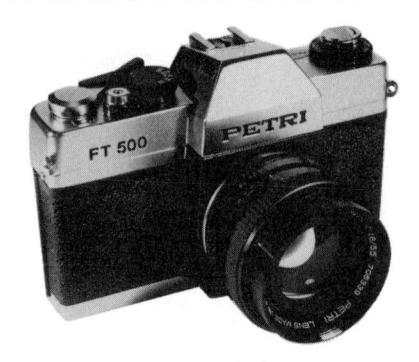

Petri FT 500

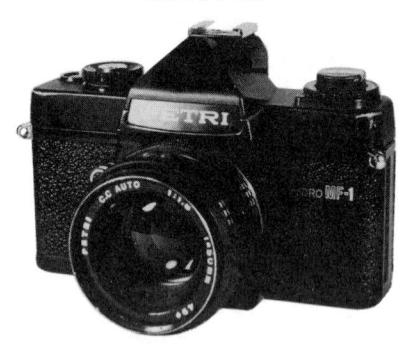

Petri Micro MF-1

Petri FT - 1967. Petri FT-II - 1970. Petri FTX - 1974.

Petri FT 1000, FT 500 - 1976. Petri MFT 1000 - 1976. Petri Micro MF-1 - 1977.

These Petri models featured TTL photometers with stop-down aperture and matchneedle meters. Cloth focal plane shutter 1-1/₁₀₀₀ (only to 1/₅₀₀ on the FT 500). Breech lens mount used on models FT and FT-II; universal 42mm screw-type lens mount on all the other models. Petri MFT 1000 and Micro MF-1 are compact models. Petri FT 1000 and FT 500 were also sold under various other brand names. User prices range from \$60-150.

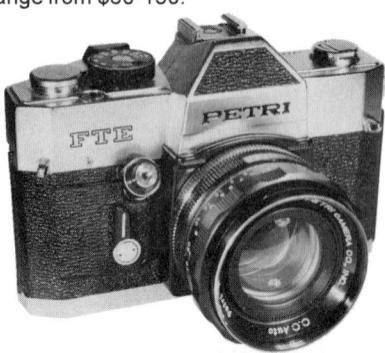

Petri FTE

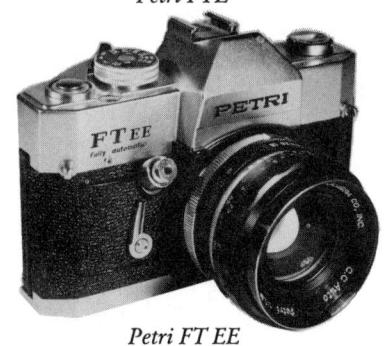

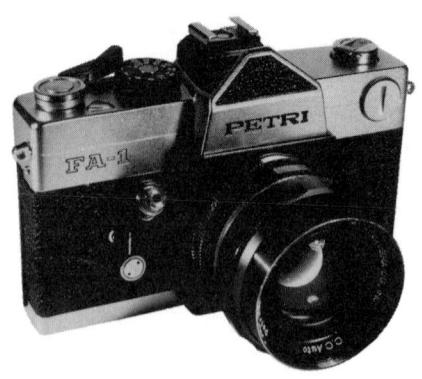

Petri FA-1

Petri FT EE - 1969. Petri FTE - 1973. Petri FA-1 - 1975.

All shutter speed priority, fully automatic reflexes. TTL meter sets f stop with full aperture metering. Cloth focal plane shutter in FT EE and FTE similar to Petri Flex V (-1/₂-500), and 1-1000 with FA-1. FT EE and FTE nearly alike, except for designation. FA-1 most deluxe and advanced model of its type from Petri Camera. All use standard Petri breech lens mount. \$60-150.

RAPID FILM SYSTEM MODELS

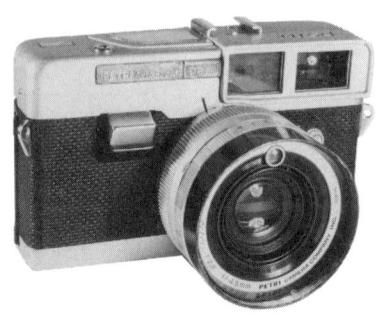

Petri Auto Rapid

G.A.F. Anscomatic 726

Petri Auto Rapid - 1965. Petri Auto Rapid - 1965.
Petri Instant Back (AKA Anscomatic 726) - 1966.
Petri Pocket 2 - 1975.
Petri Grip-Pack 110 - 1977.
Petri Push-Pull 110 - 1977.

All these feature quick loading film systems; Petri Auto Rapid (Agfa Rapid), Petri Instant Back (Eastman Kodak 126), and Petri Pocket 2, Grip Pak, and Push-Pull (Eastman Kodak 110 cartridge load). Leaf shutter and fixed Petri lenses. All common with prices at \$25-35.

Fotochrome Camera - 1965. Made by Petri Camera for USA firm of Fotochrome Inc. Using mirror-type image reversing system, special drop-in film packs allowed for direct color prints without negative with

factory processing. Unusual plastic body with flip-up reflector for built-in bulb flash. Petri f4.5/105mm lens and Vario-type shutter. Still found new in boxes usually for \$25-35 in USA; \$50-75 in Europe.

KAMERA WERKSTÄTTEN (München) Jolly - c1950. Subminiature for 10x15mm exposures. T & I shutter. One of the first post-war subminiatures from Germany. Early advertising indicates that it was manufactured by "Kamera-Werkstätten" with no further details. One modern reference attributes it to a Kamera Werkstätten in Munich which is very likely unrelated to the well-known KW below. We would welcome further documentation. Auction record 12/91 \$1000. Very rare. \$600-900.

K.W. (Kamera Werkstätten Guthe & Thorsch, Dresden, Germany)

When Guthe & Thorsch had to leave Germany, the business was taken over by Charles A. Noble and moved to Niederse-dlitz. The name was changed to Kamera-werkstätten Niedersedlitz. After WWII, the Noble family lost the business during the Soviet occupation, and it became "VEB Kamerawerkstätten Niedersedlitz", then part of the "V.E.B. Pentacon" group which formed in 1964. In one of the bright notes in camera history, the Noble family was able to reclaim their factory and home after the reopening of East Germany. The Noblex panoramic cameras were produced shortly thereafter, making their debut at Photokina

Astra 35F-X - c1953-57. Same as the KW Praktica FX. Three versions: c1953 has 3 front sync contacts; c1955 has 1 sync contact; c1957 has large sync contact. \$50-75.

Astraflex 35 - c1955-62. Same as the Contax D. \$90-130.

Cavalier II - House-brand version of the Praktica Nova, sold by Peerless Camera Stores in New York. \$30-45.

Happy - c1931. Folding 6.5x9cm plate camera. A name variant of the Patent Etui. Black leather covered metal body. Schneider Radionar f6.3/105mm lens in Vario shutter. \$75-100.

Kawee - Apparently this was the American marketing name for the "Patent Etui". See the following entries.

Patent Etui, 6.5x9cm - Tessar f4.5/105mm or Radionar f6.3/105mm lens. Focus knob on bed. Vario, lbsor or Compur shutter. Grey, brown, red, blue, or black leather covering and matching colored bellows. Colored models are uncommon. Red or blue: \$300-450. Grey or brown: \$200-300. Black: \$75-100. Relatively common, so often seen in lesser condition for lower prices.

Patent Etui, 9x12cm - The most common size. f4.5 or f6.3 Rodenstock Eurynar, Schneider Radionar, Isconar, Erkos Fotar, or Zeiss Tessar or Trioplan lens. Shutter: Ibsor, Vario, or Compur. Made with grey, red, blue, brown or black leather covering and matching colored bellows. Red or blue: \$300-450. Grey or brown: \$200-300. Black: \$60-90.

Pentaflex, Pentaflex SL - Same as the Praktica Nova, below.

Pilot 6 - 1936-39. SLR for 12 exposures 6x6cm on 120 film. Laack Pololyt f3.5/75mm or 80mm, or KW Anastigmat f6.3/75mm. Metal guillotine shutter 25-100, later 20-150. Last models c1938-39 have interchangeable lenses, and 20-200 shutter. Replaced in 1939 by the Pilot Super. \$100-150.

Pilot Reflex - 1931-37. TLR for 16 exposures 3x4cm on 127 film. With f2.0 Biotar: \$500-750. With Xenar f2.9, f3.5; or Tessar f2.8, f3.5: \$300-450.

Pilot Super - 1939-41. SLR for 12 exposures 6x6cm on 120 film. Could also take 16 exposures 4.5x6cm with mask. Built on the same chassis as the Pilot 6, but easily distinguished by the addition of a small extinction meter attached to the viewing hood. Interchangeable lens, such as: Ennastar, Pilotar, or Laack, f2.9, 3.5, or 4.5. Shutter 20-200, T,B. \$120-180.

Pocket Dalco - A name variation of the Patent Etui 6x9cm. Tessar f4.5/105mm in Compur. Available in black, and probably the other colors as well. We have sales records of at least one in blue leather covering with blue bellows at \$250-375. Black: \$75-100.

Praktica Cameras: For sake of continuity, we are listing all Praktica cameras under the KW heading. In reality, KW was eventually absorbed into the VEB Pentacon family and the Praktica cameras thus became "Pentacon" Prakticas. Many were marketed in the U.S.A. by Hanimex under the "Hanimex-Praktica" label, but with the same or similar model designations and characteristics. Other house brand versions also exist; some are noted here.

Praktica - c1949. 35mm SLR. Interchangeable lens: f2.8 or 3.5. Waist-level viewing. Focal plane shutter $^{1}/_{2}$ - $^{1}/_{500}$, B. \$50-75

Praktica FX - 1952-57. 35mm SLR with

waist-level finder. Westanar or Tessar f2.8 or 3.5 lens. Focal plane shutter 1/2-1/500. \$45-60

Praktica FX2 - 1956-58. Redesigned finder system, accomodating the new prism in the "normal" position, rather than the high up prisms which could be used with the first model. With normal lens and prism finder: \$50-75.

Praktica FX3 - c1957. Like FX2, but with internal automatic diaphragm stop-down. \$50-75.

Praktica IV - 1959-64. Fixed prism VF, rapid advance lever on bottom. \$50-75.

Praktica IVB - 1961-64. As IV, but with meter on front of prism housing. \$60-90.

Praktica IVBM - 1961-64. Metered version as IVB, but also with rangefinder built into focusing screen. \$60-90.

Praktica IVFB - 1961-64. Metered prism, fresnel viewing screen. \$60-90.

K.W. ...

Praktica IVF - 1962-64. Improved version of Praktica IV with fresnel viewing screen. \$45-60.

Praktica VF - 1964-65. Instant-return mirror, \$50-75.

Praktica Nova - c1965. 35mm eye-level SLR. Domiplan f2.8 lens. Focal plane shutter 2-500. \$45-60.

Praktica Nova B - 1965-68. Domiplan f2.8/50mm. \$35-50.

Praktica PL Nova I - 1967-72. Pancolar f1.8/50mm. \$35-50.

Praktica PL Nova IB - 1967-74. Selenium meter. FP shutter 1-1/₅₀₀, B. F&X sync. Domiplan f2.8/50mm. Name variants include Porst FX4. \$35-50.

Praktica Super TL - 1968-74. CdS TTL averaging meter. Cloth FP shutter 1-1/500,B. F&X sync. Meyer Oreston f1.8/50mm. Name variants include Revueflex SL, Pentor Super TL, Porst Reflex FX6. \$35-50.

Praktica "L" Series - Includes L, LB, LTL, and LLC. Standard features for the series include steel vertical FP shutter 1-1000,B. Instant return mirror. Depth of field preview. Fresnel lens with microprism scrren and ground glass circle. Hot shoe with 1/105 sync for electronic flash. Single stroke film advance. To these basic features, the LB adds an external selenium meter. The LTL has TTL CdS center weighted stopped-down metering. The LLC pioneered the use of electrical coupling between lens and body. Full-aperture metering; self-timer.

Praktica L - 1969-75. Basic unmetered SLR with hot shoe. Pentacon auto f1.8/50mm.\$45-60.

Praktica LB - 1972-75. Like Praktica L, but with selenium meter cell on front of top housing, and match-needle on top. Hot shoe. Oreston f1.8/50mm. \$50-75.

Praktica LLC - 1971-. The top model of the L series. Full-aperture TTL metering

via electrical contacts on the lens and its mount. This was a technological first, and it was advertised at the time as "the only 35mm SLR with automatic electric diaphragm control." Unfortunately, there are not too many screw-mount lenses currently available with the requisite electrical contacts. Historically interesting. With normal lens: \$90-130.

Praktica LTL - c1972-. L series standard features, plus CdS TTL stopped-down metering. With f1.8/50mm or f1.4/55mm normal lens: \$60-90.

Praktica Prisma - c1962. 35mm eyelevel SLR. Appears to be a variant of the Praktica IV, marketed in the USA. Tessar f2.8. Focal plane shutter 2-500. \$50-75.

Prakticamat - 1965-69. 35mm SLR. Interchangeable lens with 42mm thread. Cloth FP 1-1000,B. TTL CdS metering. First European SLR with coupled TTL metering. \$45-60.

Praktiflex - c1938. Early 35mm SLR, probably the 2nd or 3rd produced. Victor f2.9/50mm, Tessar f3.5 , or Biotar f2.0 lens. Waist-level finder. Focal plane shutter 20-500. Red or Blue: no sales data. Grey lacuered with brown leather: \$200-300. Black finish: \$175-250. Normal: \$75-100.

Praktiflex II - c1948. Victor f2.9/50mm lens. *There was an earlier Praktiflex II*

shown during the war, but it was different and never sold. \$60-90.

Praktiflex FX - c1955. Same as Praktica FX, possibly given this name by U.S. importers. Tessar f2.8 or Primoplan f1.9 lens. \$35-50

Praktina FX - c1956-59. (Old stock sold in USA through mid-1960's.) 35mm SLR. Interchangeable Biotar f2/58mm lens. FP shutter 1-1000, B. Interchangeable pentaprism. Without motor: \$75-100.

Praktina IIa - c1959-74. 35mm SLR. Usually with Jena Flexon f2/50mm. Focal plane shutter to 1000. \$75-100 in Germany, \$100-150 in USA without motor.

Praktina Accessories: Spring motor drive - \$90-130. Bulk film back - \$50-75.

Praktisix, Praktisix II - c1957-62. (Later models from VEB Pentacon were Pentacon Six and -Six TL; also modified to Exakta 66.) 6x6cm SLR. Interchangeable bayonet mount Meyer Primotar f3.5/80mm or Tessar. Later models have Biometar. Focal plane shutter 1-1000. Changeable waist-level or prism finders. \$175-250.

Praktisix Accessories: Metered prism finder - \$60-90. 50mm f4 Flektogon MC - \$100-150. 80mm f2.8 Biometar (normal lens)

120mm f2.8 Biometar - \$150-225 180mm f2.8 Auto Sonnar - \$150-225.

Reflex-Box - c1933. Boxy SLR for 8 exposures 6x9cm on 120 rollfilm in horizontal format. KW Anastigmat f6.3/105mm, or Steinheil f4.5/105mm lens. Three speed shutter 25-100, B. Folding top viewing hood, \$150-225.

Rival Reflex - c1955. Praktica 35mm SLR body with crude name change for export to the USA. Wetzlar Vastar f2.8/50mm lens. Focal plane shutter, sync. \$50-75.

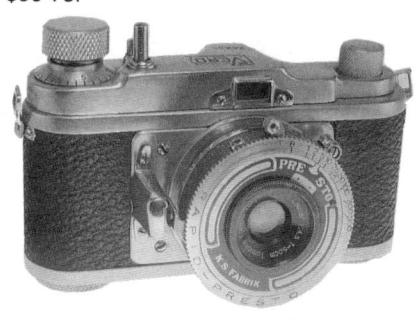

KYOTO PRECISION MFG. (Japan) Cine Vero - c1947. Compact 35mm camera with telescoping front and helical **Bottom** loading. Uncommon 24x35mm image size. Tomioka Kogaku Lausar f4.5/50mm lens in K.S. Fabrik Presto T,B,1-500 shutter. Uncommon. \$120-180.

KYOTO SEIKI CO. (Japan)

Lovely - c1948. Rare Japanese subminiature taking 14x14mm exposures on paper-backed rollfilm. Simple fixed-focus lens, shutter 25-100,B. Few known examples, and not all are complete with the front door. The best example known, complete with its original box, sold at auction 12/91 for \$2550.

LA CROSSE CAMERA CO.

(LaCrosse, Wisc.)
Snapshot - c1898. Miniature cardboard and brass box camera. Makes four 26x30mm exposures on a strip of film wrapped around a rectangular drum.

LABORATORIOS

(Identical to the Comet Camera made by Aiken-Gleason Co. of LaCrosse.) Uncommon. \$350-500.

LA ROSE (Raymond R. La Rose &

Sons, Culver City, USA)
Rapitake - c1948. Unusually designed 35mm for 18x24mm exposures. Metal body. Tubular viewfinder. Fixed focus f7.5/35 lens. Single speed shutter. Plunger at back is the shutter release and also advances the film. \$250-375.

LAACK (Julius Laack & Sons, Rathenow)

Ferrotype camera - c1895. Metal cannon camera for 25mm dia. ferrotypes. f3.5/60mmlens. \$1000-1500.

Merkur - 10x15cm folding plate camera. Polyxentar f6.8/150mm lens in Koilos shutter, \$50-75.

Padie - 9x12cm folding plate camera. Laack Pololyt f6.8/135mm. Rulex 1-300 shutter. \$35-50.

Tropical camera - Folding plate camera, 9x12cm. Wood exterior, brown bellows. Laack Pololyt f4.5/135 lens in Ibsor shutter or Laack Dialytar f4.5 in Compur. With gold plated metal parts: \$750-1000.With brass trim: \$400-600

Wanderer - 6.5x9cm plate camera. \$35-

LABARRE (J.B.R. LaBarre) Tailboard camera - Wood body with brass trim, brass barrel Rectilineaire Extra Rapid f8 lens. Revolving red bellows. Lenscap acts as shutter. \$300-450.

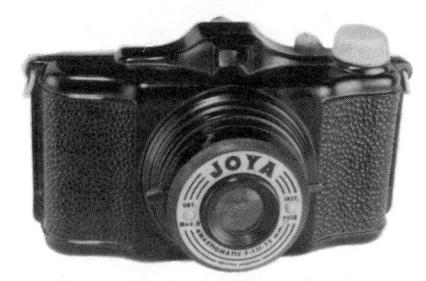

LABORATORIOS **MECANICOS** (Argentina)

Joya - Black bakelite eye-level camera for 6x9cm on 620 film. Anastigmatic f11/75mm lens; I&P shutter. Body is apparently made from molds modified from the Nebro Flash camera, \$25-35.

LACHAIZE

LACHAIZE (Paul Lachaize, Lyon France)

Mecilux - c1955. Unusually styled 35mm amateur camera. Single weather setting adjusts shutter and diaphragm; blocks shutter if flash is needed. Pop-up flash with folding reflector. Star-shaped film advance knob on bottom. Back locks closed until film is rewound. Boyer 45mm/f2.8. Scarce. \$300-450.

LACON CAMERA CO., INC. (Shinano Camera Works, Japan) Lacon C - c1954. 35mm viewfinder camera. S-Lacor f3.5/45mm lens, shutter 25-300,B.\$60-90.

LAMPERTI & GARBAGNATI (Milan) Detective camera - c1890. 9x12cm.
Polished wood body. Leather changing sack. \$350-500.

Spiegamento rapido - c1900. Horizontally styled folding camera for 9x14cm plates. Self-erecting front with unusual strut configuration. Various body styles and strut configurations exist. Two reflex finders built into body. \$200-300.

Wet plate camera - c1870. Polished walnut body, square blue bellows. 18x18cm. Tilting back. Brass barrel Darlot Petzval lens, waterhouse stops. \$2000-3000.

LANCART (Etablissements Lancart, Paris)

Xyz - c1935. Nickel-plated subminiature. Roussel Xyzor f7/22mm lens. Shutter: 25,

B, I. 12x15mm exposures. Top auction price in 12/91 \$2700. Usual price \$1500-2000.

LANCASTER (J. Lancaster, Birmingham, England) Aluminium Bound Instantograph -

Less common than the brass bound models. Mahogany body with aluminium reinforcements. Lens is also aluminium bound. \$300-450.

Brass Bound Instantograph - c1908. Mahogany view, with brass binding. Lancaster lens and shutter. \$300-450.

Gem Apparatus - c1880. 12-lens camera, taking 12 exposures on a 9x12cm ferrotype plate. Polished mahogany body. Front panel is slid sideways to uncover the lenses and back again to end the exposure. \$1700-2400.

Instantograph 1/a-plate view -c1886-1908. Brass barrel Lancaster f8 or f10 lens in Lancaster rotary shutter. Iris diaphragm. Tapered red bellows. Wood body. Widely ranging auction prices in England. \$350-500.

Instantograph 1/2-plate or 1/1-plate view - c1880-1910. Wood body. Major change in design c1887, so two distinct types, the earlier ones less common. Nameplate sometimes specifies year model. Brass-barrel Lancaster lens. \$250-375.

International Patent - c1885-1905. Tailboard style mahogany camera with reversible back. Most commonly found in $1/_{4}$ - and $1/_{2}$ -plate sizes. Wine-red square bellows. Lancaster brass barrel lens with iris diaphragm. \$250-375.

Kamrex - c1900. $^{1}/_{4}$ - or $^{1}/_{2}$ -plate camera, more common in the $^{1}/_{2}$ -plate size. Red

leather bellows. Mahogany with brass trim. R.R. lens. \$175-250.

Ladies Cameras: Note there are several cameras with similar names.

Ladies Camera - c1880's. Folding tailboard view camera of polished mahogany. Not to be confused with the handbag style "Ladies" cameras. \$350-500.

c1894-1900. Ladies **Camera** reversible-back Self-casing, camera. Achromatic lens with iris diaphragm. Single speed pneumatic shutter. When closed, the case resembles a ladies' purse with tapered sides. NOTE: This camera should not be confused with a contemporary camera which has been erroneously advertised in recent years as a "Ladies Camera". This similar camera was first called "Portable Instantograph", then "Folding Instantograph". They are easily distinguished when opened. On the true Ladies Camera, the front door hinges 270° to lay flat under the body; the rear door forms a tailboard for rearward extension of the back. The Folding Instantograph uses the front door for a bed on which to extend the front with tapered bellows. From the outside, the Ladies Camera can also be recognized by its more delicate braided handle. Made in sizes of a quarter, half, and full plate. \$1700-2400.

Ladies Gem Camera - c1900. Lyreshaped body covered in alligator skin. (Same camera as the Certo "Damen-Kamera".) Looks like a stylish woman's handbag when closed. 1/4-plate size. Rare. Negotiable. Estimate: \$10,000-15,000.

Le Meritoire - c1880-1905. Wooden view. Brass trim. Brown or blue double extension bellows. Lancaster lens. Sizes 1/4-plate to 10x12". Pre-1886 bodies body style is uncommondesign. \$250-375.

Le Meritoire Stereo - Collapsible inner septum and wide lensboard. Square cut black bellows. Takes 31/₄x61/₂" plates. With brass bound lenses: \$600-900.

Special Brass Bound Instantograph

Le Merveilleux - c1880-1905. 1/₄-plate field camera. Aplanat lens. The later style, after 1886 is quite common on auctions in England. \$200-300.

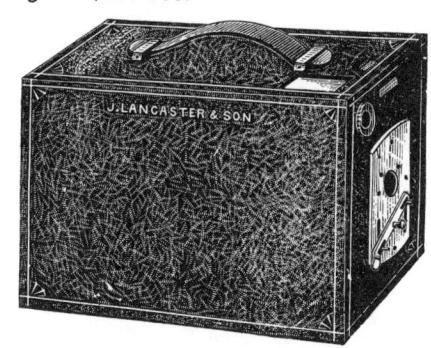

Omnigraph - c1890's. 1/₄-plate detective box. At least 3 different versions. Achromatic lens. See-Sawshutter. \$120-180.

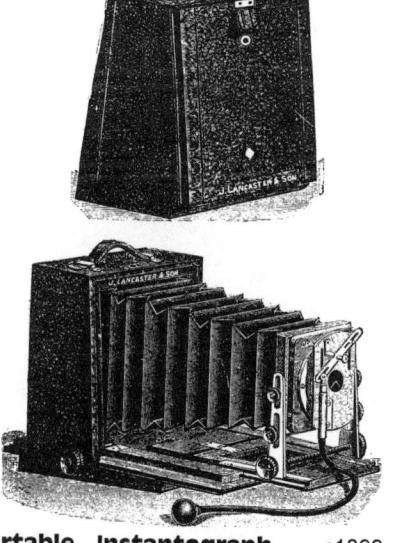

Portable Instantograph - c1893. Self-casing folding view camera made in quarter, half, and full plate sizes. Closed, it is similar in outward appearance to the Ladies Camera, but the Portable Instantograph, later called Folding Instantograph, has a front door which serves as a bed for the lens standard. This camera can be mistaken for the Ladies Camera, and has been erroneously advertised as such in recent years. \$500-750.

Postage Stamp Cameras - c1896. Wood box cameras of various designs,

LANCASTER

having 4 or 6 lenses, for "gem" exposures. \$2400-3200.

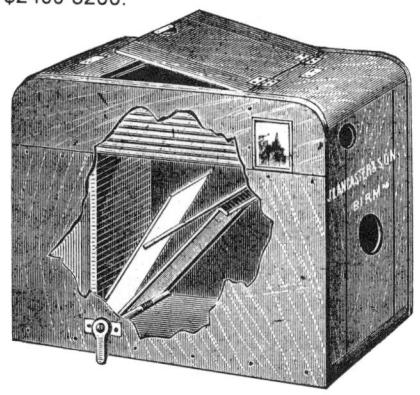

Rover - c1891. Detective box camera, holding 12 plates. Rectilinear lens, See-Saw shutter. \$600-900

Special Brass Bound Instanto-graph - c1891. Folding tailboard camera, double swing. Brass bound. Red or black square leather bellows. Rectigraph or Lancaster lens. Patent See-Saw shutter. 1/4- and 1/2-plate sizes. \$300-450. *Illustrated bottom of first column*.

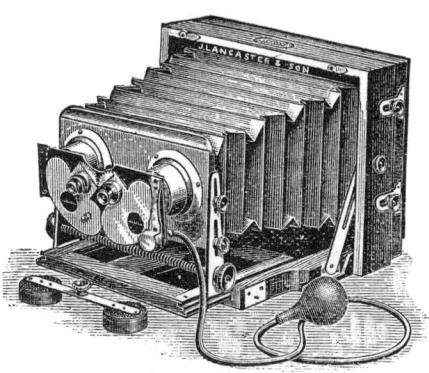

Stereo Instantograph - c1891. Folding 8x17cm stereo. Red bellows. Rectograph lenses. \$600-900.

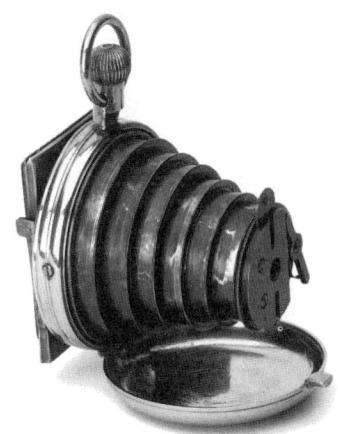

Watch Camera, Men's version

Watch Camera - c1886-90's. Designed like a pocket watch. Self-erecting design consists of six spring-loaded telescoping tubes. Men's size: 11/2x2" plates; Ladies' size: 1x11/2" plates. Rare. Price negotiable. Top auction prices, Christie's 3/92, when a ladies' model (one of three known to still exist) sold for \$47,500 to a telephone bidder. This set a new world record auction price for a camera. At Christie's 12/91, a men's model sold for \$34,000 against an estimate of \$20,000-\$25,000. Any other

LANE

price estimates would be pure speculation. Beginning about 1982, reproductions of this rare camera have been offered for sale for \$1100-1200.

LANE (J.L.) (England) Woodbury Universal Tourist c1880's. Field camera. Folds into a box shape, becoming it's own carry-case. Main body can be removed and replaced to change from vertical to horizontal format. Worm gear focusing. \$500-750.

LAURIE IMPORT LTD. (Hong Kong)

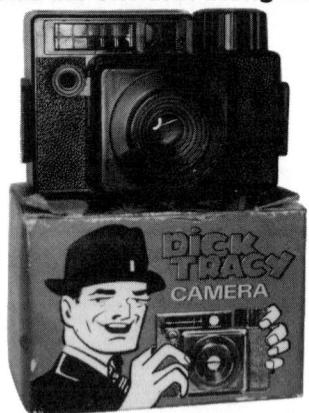

Dick Tracy - c1974. Miniature plastic novelty camera as described below. The camera has no special markings, but the box has the name and picture of Dick Tracy. With box: \$12-20.

Miniature Novelty Camera - c1974. Small plastic novelty for 14x14mm exposures on Mycro-size rollfilm. Originally could be obtained for 10 Bazooka gum wrappers. \$12-20.

LAVA-SIMPLEX INTERNATIONALE Simplex Snapper - c1970. Novelty camera for 126 cartridge. The film cartridge becomes the back of the camera. 28x28mm exposures. \$1-10

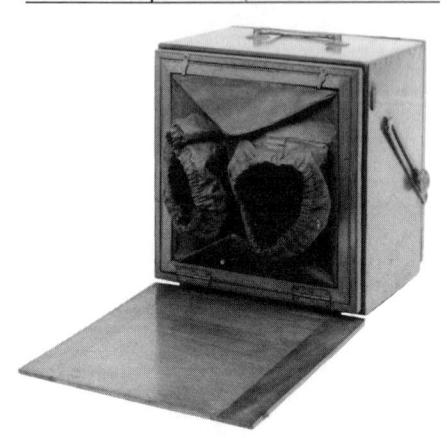

Lawley Folding Plate Camera

LAVEC INDUSTRIAL CORP.

(Taipei, Taiwan) Lavec LT-002 - Inexpensive 35mm novelty camera styled like a pentaprism SLR. \$1-10.

LAWLEY, Walter (London)

Wet plate camera - c1860. Bellowstype, plates up to 13x13cm. Petzval brass lens, waterhouse stops. \$1500-2000.

Folding Plate Camera with changing box - Unusual mahogany folding plate camera with integral changing box for 61/2x81/2" plates. Twin light-tight sleeves at rear. Internal folding light-tight flap. Brass bound lens. \$750-1000. Illustrated bottom of previous column.

LE DOCTE (Armand Le Docte, Brussels, Belgium) Excell - 1890. Twin-lens reflex style box camera. Teak body, brass fittings. Rapid Rectilinear f8 lenses are on a recessed board, behind the front door. Bag-type plate changer. Magazine holds 20 plates, 8x10.5cm. Mirror system allows for either horizontal or vertical viewing. \$1200-1800.

LEADER CAMERA - Beige and black plastic camera of the "Diana" type. Made in Hong Kong. \$1-10.

LECHNER

Hand Camera, 9x12cm - c1905-07. Folding camera with single-pleat bellows and gate struts. Ebonized wood body with trim. Focal plane shutter. Goerz Doppel Anastigmat Series III f6/120mm. Accessory reflex finder fits in shoe. \$200-300.

LEE INDUSTRIES (Chicago, IL) Leecrest - Bakelite minicam, 3x4cm on 127 rollfilm. \$8-15.

LEECH & SCHMIDT

Tailboard camera - 13x18cm. Walnut body. Bellows and focusing screen revolve as a unit to change orientation. \$250-375.

LEHMAN (Gebr. Lehman, Berlin) Pelar-Camera - c1947. One of Germany's first post-war cameras. Body style resembles Leica A (actually more like Leica B, since it has no FP shutter). Ludwig Pelar f2.9/50mm in 25-100 front shutter which resembles Vario or Stelo. Only about 83 were made. Extremely rare. One known auction sale in 1986 for \$350.

LEHMANN (A. Lehmann, Berlin) Ben Akiba - c1903. Cane handle camera. Obviously, a rare camera like this cannot be shackled with an "average" price. Two known sales were for \$5,000 and \$8,000 in the 1980's. An authenticated example would likely bring double that amount or more today. Readers are advised to be aware that increasing numbers of replicas are showing up, sometimes presented as genuine. Informed collectors are very cautious of any Ben Akiba. See next entry.

Ben Akiba Replica - There have been some very good quality replicas made of the Ben Akiba, by a master craftsman. Since the man reportedly is no longer making replicas, some of his earlier ones are in demand by museums for display purposes. At Christie's 12/91 auction, a good replica sold for \$2550.

LEIDOLF (Wetzlar)

Auto Malik - Automatic exposure 35mm. Quite rare with this name, as it was an export version for the French distributor, Malik. Lordonar f2.8/5cm in Prontor-Matic B,30-500. \$50-75.

Leidox, Leidox II - c1951. 4x4cm. Triplet f3.8/50mm lens in Prontor-S shutter to 300. \$35-50.

Lordomat, Lordomat II, Lordomat C-35, Lordomat SE, Lordomat SLE, Lordomatic, Lordomatic II - c1954-1960's. 35mm cameras with interchangeable Lordonar f2.8/50mm. Prontor-SVS shutter. CRF. Some models have built-in meter. Two-stroke film advance. Early

models: \$60-90. With meter and multi-lens viewfinder: \$100-150.

Lordox - c1953. Compact 35mm viewfinder cameras. Various models. Lordon f2.8 or 3.8/50mm lens. Pronto shutter, sync. Body release. \$35-50.

Lordox Blitz - Interesting 35mm with built-in AG-1 flash on front of top housing opposite finder. Well styled and finished. Triplon 2.8/5cm in Pronto. \$30-45.

LEITZ (Ernst Leitz GmbH, Wetzlar)
The history of Ernst Leitz in the optical industry began in 1849, only a decade after Daguerre's public announcement of his process. It was not until 75 years later that the first Leica camera was put on the market. If that seems like a long time for research and development it must be pointed out that the Leica was not the raison d'etre of the company. In 1849, Ernst Leitz began working in the small optical shop of C. Kellner at Wetzlar, whose primary business was the manufacturing of microscopes and telescopes. After Kellner's death, Ernst Leitz took over the company in 1869, and the operation continued to grow, becoming one of the world's major manufacturers of microscopes. Oskar Barnack, who worked for Zeiss from 1902-1910, joined the Leitz firm in 1911 and built the first Leica model in 1913. This first prototype had a fixed speed of 1/40 second, the same as movie cameras. Several 35mm still cameras were marketed at about this time by other companies, but without great success. At any rate, the "Leica" was moth-balled for 10 years before finally being placed on the market in 1925. The immediate popularity of the camera coupled with continued quality of production and service catapulted the Leitz company into a strong position in the camera industry.

LEICA COLLECTING - Leica collecting is a fascinating field which has attracted collectors of all ages, from those who used the Leica cameras when they were youngsters to those who have just acquired their first camera within the last few years. Hence, there is an international demand worldwide for cameras of all ages, from the first Leica I with fixed lens to the latest limited editions

During the late 1970's, the prices of rare or unusual Leica cameras had increased to such an extent that speculators joined the bandwagon and the ensuing unselective buying sent the prices sky high for even the most mundane items. Fortunately, the

price structure is now a more adequate reflection of demand.

TWO GOLDEN RULES that apply to Leica Collecting are:

That all items in excellent or like-new condition should be acquired.

2. That items of extreme rarity be acquired regardless of condition.

Thus, common items in less than excellent condition should be acquired only for use or for parts. For some of the more specialist items such as the Leica M Anniversary cameras, it is now essential for them to have their certificates, as of late some forgeries have been circulating. On the whole, the price structure has not changed, although rarer items have seen their values increase disproportionately to common ones. The five most desirable Leica cameras are the following: The Leica I with Elmax, the Leica Compur, the Leica 250, the Leica 72, and the Leica MP. These items will always demand very high prices, and the condition is important but not essential. More important is the authenticity and the originality of these cameras. It is better to have a camera in lesser but all original condition than a likenew specimen that has been renovated at great cost.

Leica cameras - All models listed are for full-frame (24x36mm) exposures. The listing is in chronological order by date of introduction. Although we have included a few basic identification features for each camera, these are meant only for quick reference. For more complete descriptions, or history of each model, we would suggest that you refer to a specialty book on Leica cameras. There are a number of good references, among which are: "Leica, The First Fifty Years" by G. Rogliatti, published by Hove Foto Books in England; "Leica Illustrated Guide" by James L. Lager, published by Morgan & Morgan in New York; or "Leica, A History Illustrating Every Model and Accessory" by Paul-Henry van Hasbroeck, published by Sotheby Publications in London.

SERIAL NUMBERS: In most cases, concurrent camera models shared the same group of serial numbers. Therefore, where a serial number range is listed for a particular model, it does not belong exclusively to that model. A chart of Leica serial numbers, model types, and years of production may be found in the appendices at the end of this guide. While this may help identify a particular camera, it will only tell what model the camera was when it first left the factory. It must be remembered that Leitz encouraged owners to send their cameras back for updating as new models were introduced. Many early Leicas were factory converted to later specifications with the addition of standardized lens mount, synchronization, or other useful features. We do not list any of the myriad possible conversions, nor the value of converted models. See page 49 for a list of stolen cameras.

This guide presents the basic information to help a novice collector to determine the probable value range of most common Leica cameras. It is not intended to be a complete or extensive guide to Leicas. That would require much more space than our format will allow. Our intention with this guide is not to give Leica specialists a price list, but rather to report to our more general audience the current price ranges which are being established by those

specialists. There are many specialists in Leica cameras, and several of them have shared their expertise with us over the years. For this edition, we were fortunate to have the assistance of Bob Coyle, a professional photographer and ardent Leica collector. A "blind" survey comparing his separate price estimates with our data proved to be surprisingly close on most items. We should caution, however, that the Leica market fluctuates greatly around the world. Some cameras have highest values in Japan, others have highest values in the USA or Europe. Condition is always a critical factor in determing price, more so for Leica than for many of the other areas of collecting. You should consult with several respected authorities before making any major decisions about which you are unsure. Another of our Leica consultants is a well-known dealer in the field, Don Chatterton. Either of these consultants who would be happy to help you with questions on important cameras. Of course, they would also be interested in hearing about Leica cameras you have for sale. Contact: Don Chatterton, P.O. Box 15150, Seattle, WA 98115 (206-525-1100) or Bob Coyle, 1006 Lincoln Ave., Dubuque, IA 52001 (319-588-9694).

condition of Leica cameras: Leica collectors are generally extremely conscious of condition. The spread of values is quite great as condition changes from VG to EXC to MINT. With the exception of some of the very early and rare Leicas which are collectible regardless of condition, it would be wise to assume that EXCELLENT CONDITION should be considered the MINIMUM condition which collectors seek. Therefore we are using figures in this section of the book only which represent cameras in at least EXCELLENT but not quite MINT condition. Cameras which are truly MINT or NEW would bring higher prices and be easier to sell. Cameras in less than excellent condition are difficult to sell and often must be discounted considerably below these figures. Even the rare models, where less than perfect condition is tolerated, must be complete and in the ORIGINAL state.

For further information, or if in doubt about authenticity of rare models, contact: Leica Historical Society of America, 7611 Dornoch Lane, Dallas, TX 75248. Phone: 214-387-5708. Memberships \$28.00/yr.

Except where noted, Leica prices are given for body only. A separate list of add-on prices for normal lenses is at the end of the Leica section.

Ur-Leica (Original) - Oscar Barnack's original prototype. Based on this design, a number of replicas have been made for historical or display purposes. See next listing.

Ur-Leica (Replica) - Non-functional display model of Oscar Barnack's original

One Piece Top Plate No Rangefinder to Cover

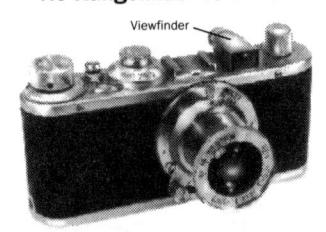

One Piece Top Plate which Covers the Rangefinder

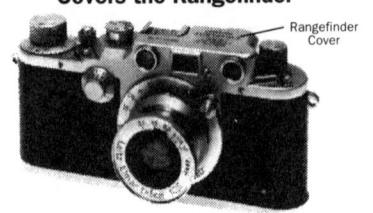

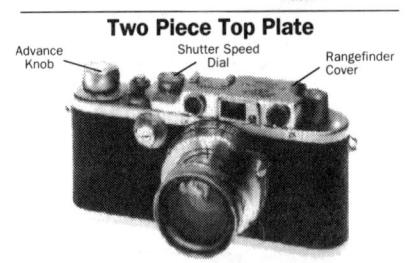

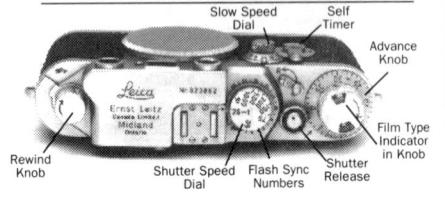

A Basic Guide to Leica Identification

Leica Rangefinder Screw Mount Models												
DATES OF PRODUCTION	NAME OF MODEL	VIEW- FINDER	RANGE- FINDER	TOP?	SYNC?	IDENTIFICATION POINTS						
1925 - 36	A (I)	NO VIEWFINDER. 2 ACC SHOES.	THESE CAMERAS HAVE NO RANGEFINDER.	THESE HAVE A ONE PIECE TOP WITH NO RANGEFINDER TO COVER.	NO	Comes with a fixed Anastigmat, Elmax, Hektor or Elmar lens. Non-interchangeable.						
1929 - 31	LUXUS				NO	Gold plated model "A" with non-interchangeable lens.						
1926 - 41	B (Compur)				NO	Has a Compur shutter on the front of the lens.						
1930 - 33	C (I)				NO	First model with interchangeable lenses. 1st type, non-standardized mount –needed matched lenses. 2nd type, standardized mount –accepted any lenses. SR# under 72,000. Many conversions.						
1932 - 50	E Standard				NO	Same as standardized mount model C with an extendable rewind knob.						
1949 - 52	IC				NO	Has two accessory shoes on top. Shutter speed dial on large circular dias. No slow speeds.						
1952 - 57	IF BD or RD				YES	Has two accessory shoes on top with black or red sync numbe under the shutter speed dial. No slow speeds. Flash sync on fr						
1957 - 63	IG	NO VIE			YES	No numbers under the shutter speed dial. Top has a step –it is not flat like the IF. Has slow speeds.						
1932 - 48	II (D)	0	IHESE CAMERAS ALL HAVE A BUILT IN RANGEFINDER.	THESE HAVE A TWO PIECE TOP AND RANGEFINDER COVER.	NO	First model with a built in rangefinder. No strap lugs. No slow speeds. 1/500 top shutter speed.						
1933 - 43	Reporter (250)				NO	Big 250 exposure spools fit in the circular ends.						
1933 - 39	III				NO	First model with strap lugs and slow speeds. Top shutter speed 1/500. Separate eyepiece.						
1935 - 48	IIIA				NO	Same as III but with top speed 1/1000.						
1938 - 41	IIIB	IDER AN			NO	Same as III but eyesight correction lever is under the rewind knob. Rangefinder and viewfinder eyepices are immediately adjacent to each other.						
1940 -	IIIC pre- 1945	ALL WITH VIEWFINDER, BUT VIEWFINDER AND RANGEFINDER NOT COMBINED.		THESE HAVE A ONE PIECE TOP AND RANGEFINDER COVER.	NO	First Leica model with rangefinder and top plate all one piece. 1/8" longer body. Many variations.						
1951	IIIC post- 1945				NO	Same as above but with the SR# over 400,000.						
1939 - 47	IIID				NO	Same as the old III C but with self timer on the front. Many fakes. Rare.						
1948 - 51	IIC				NO	Just like III C but with no slow speeds.						
1950 - 63	"72"				YES	"18 x 24" III A body with III F sync. The only half frame Leica. Made in Wetzlar and in Canada.						
1950 - 54	BD or RD		THESE		YES	First Leica with Flash sync. Film type indicator built into wind knob. Red or black flash sync numbers.						
1951 - 56	IIF				YES	Just like III F but with no slow speeds.						
1954 - 57	IIIF RD w/self timer			-	YES	Same as above but red dial only. Self timer on front of body.						
1957 - 60	IIIG				YES	Bigger 3/4" x 1/2" finder window on front, with automatic flash sync and self timer. SR#s above 825,015. Bright line frames.						

There are several rare cameras that don't quite fit in this chart. The easiest and surest way to identify Leica screw mount bodies is to look up the serial number. Watch for conversions, where a model has updated features but an "old" serial number!

The main features that differentiate the screw mount series from the bayonet series are 1) bayonet lens mount system, 2) hinged back door to facilitate film loading and 3) a lever for the film advance. There are many other differences between the models, only a simple overview is listed in this chart. The bayonet mount series are known as "M" cameras, and all have the model designation before the serial number on top or on the front.

Leica Rangefinder Bayonet Mount Series												
DATES OF PRODUCTION	1954 - 66	1956 - 57	1958 - 67	1959 - 64	1965 - 66	1966 - 77	1967 - 75 1978 - 80 1981 - 87	1971 - 75	1973 - 76	1984 -		
LEICA MODEL	M3	MP	M2	M1	MD	MDa	M4 M4 - 2 M4 - P	M5	CL	M6		
RANGE- FINDER	RANGEFINDER			With Viewfinder	No Vie	wfinder	RANGEFINDER					
				N	lo Rangefinde	er						
METER	No Exposure Meter Built in								n Exposure Meter			
FILM COUNTER	Internal Film Counter				Internal Film Counter							
FRAME LINES	50/90/135 mm. ³		35/50/90 mm.	35/50 mm.			35/50/90/ 135 mm. M4-P + 28/75 mm.	35/50/90 135 mm.	40/50/90 mm.	28/35/50 75/90/135 mm.		

Reprinted with permission of: Lesley Bell

Fujii Cameras, Inc., Buyers of Collectibles, Boulder, CO 1-800-782-7314

1913 prototype, reproduced by Leitz for museums, etc. Cosmetic condition is the important consideration, since these are inoperative cameras. \$750-1000.

Leica O-Series - Preproduction series of 31 cameras, Serial #100-130, hand-made in 1923 & 1924. Since the focal plane shutter was not self-capping on the first seven examples, they required the use of a lens cap which was attached with a cord to a small bracket on the camera body. This feature was retained on the second batch even though they had a self-capping shutter. The viewfinder (either folding or telescope type) is located directly above the lens. Leitz Anastigmat f3.5/50mm lens in collapsing mount. Extremely rare and highly desirable. Price negotiable. Christie's 6/94 catalog offered no. 112, listed in original factory records as issued to Oskar Barnack. Estimated at £100,000-150,000, it drew much attention, but failed to sell. Some of its perceived value is attributable to the camera's first owner being the inventor. However, any null-series camera will attract serious buyers at \$50,000+.

Leica I (A) - 1925-30. The first commercially produced Leica model, and the first mass produced 35mm camera of high quality. These facts make the Leica I a highly sought camera among not only Leica collectors, but general camera collectors also. Black enameled body. Non-interchangeable lenses, all 50mm in collapsible mount with helical focus. "Hockey stick" lens lock on the front of the body is the most obvious identification feature. Body serial numbers listed are approximate and may overlap between the variations. Value depends on lens and serial number.

Leica I (A) Anastigmat f3.5/50mm (1925) - The earliest and rarest. Perhaps 100-150 made. (#130-260?) Shutter speed 1/₂₅-1/₅₀₀. A mint example would sell for over \$20,000. Confirmed sales \$15,000-23,000.

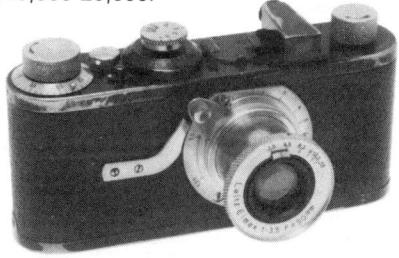

Leica I (A) Elmax f3.5/50mm (1925-26) - (#260?-1300?) Originality and completeness of original fittings is an important consideration with this camera. There are lots of fakes, perhaps as many as the real ones. Recent recorded sales from \$7500-12,000.

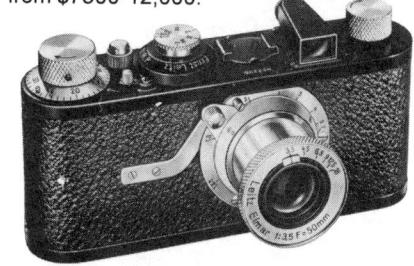

Leica I (A) Elmar f3.5/50mm (1926-30) - (#1300?-60000) Priced by Serial #. 4-digit: truly mint \$2000; super

clean \$1200, average \$600. 5-digit: near mint \$650. Most examples found are in less than excellent condition and would bring \$250-375, while a truly mint example could top \$1000. The close focusing model (to 20" rather than 1m.) may add \$35-50 to above prices, but that price distinction generally has disappeared.

Leica I (A) Hektor f2.5/50mm (1930) - (#40000-60000) Relatively rare, but not as appealing to some collectors as the other early Leicas. In Exc + condition: \$1500-2000.Super clean: \$3200-4600.

Leica I Luxus - Gold-plated A-Elmar camera with lizard skin covering. Only about 95 were made by the factory, but many imitations abound. Authentic serial 28692-28700, 34803-34818, numbers: 37134-37138, 37251, 37253-37262. 37265-37268, 37270-37272, 37274-37279, 38632, 37282, 38641-38642, 48401-48404(Hektor), 48406-48415. 48403, 48417-48419, 48426-48440. 48441, 55696(Hektor), 68601, 68834. Even with a "correct" number, you need to find out if it is real or a forgery. The forgeries out-number the authentic models by a wide margin. Only a handful of original authentic specimens have been recorded. Authentic, with verified serial number, not modified: about \$25,000. With original crocodile case, add \$1500-2000.

Leica Luxus Replica - A gold-plated model which is not factory original. A number of replicas or "counterfeit" Luxus models have been made from other Leica I cameras, and while these resemble the real thing for purposes of display, they are not historically authentic. High quality conversions (some of the best conversions are being imported from Korea), if beautifully Mint condition have sold for \$1,000-\$1,800. Many replicas are offered in lesser condition for \$1000, most of which are only worth half that amount. While they serve a good purpose for decoration, they are not necessarily considered to be a good investment item.

Leica Mifilmca - c1927. Microscope camera with permanently attached microscope adapter tube with a Mikas beam splitter and an Ibsor shutter. Body design is like the Compur Leica (B) but without a viewfinder or accessory shoe. The design was modified about 1932 to accomodate the standard lens flange fittings. Early Mifilmca camera with fixed tube is quite rare, but not as highly sought as nontechnical models, so despite rarity, when encountered they sell for: \$3500-5500. The later models with detachable tube might bring \$3200-4600.

Leica I (B) - 1926-30. The "Compur" Leica. Approximately 1500 were made in two variations, both with Elmar f3.5/50mm lenses:

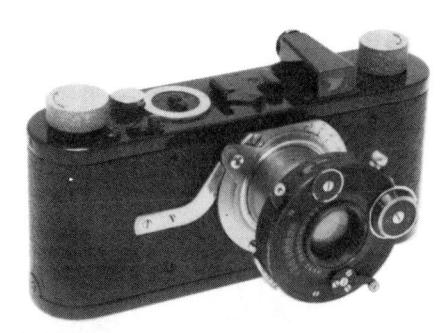

Leica I (B) Dial-set Compur - 1926-29. Extraordinarily rare, especially if in excellent condition. About \$6500-9500.

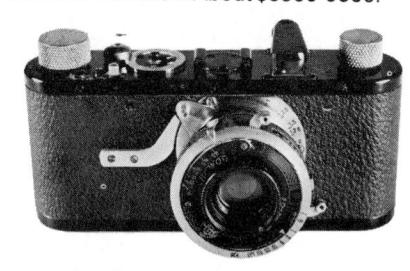

Leica I (B) Rim-set Compur - 1929-30. Although not as rare as the dial-set version, this is still a highly sought camera. Near mint original \$6500-9500. Average: \$3500-5500.

Leica I (C) - 1930-31. The first Leica with interchangeablelenses. Two variations: **Non-Standardized lens mount** -

Lenses were custom fitted to each camera because the distance from the lens flange to the film plane was not standard. The lens flange is not engraved, but each lens is numbered with the last three digits of the body serial number. With matching engraved Elmar lens: \$1500 if very clean. A very few (first couple hundred made) had the full serial number on the lens. These bring an extra \$100-150. Most which do not have a swing-down viewfinder mask were fitted with Hektor lenses: \$2400-3200. It is difficult to locate an outfit with two lenses, let alone three lenses. With swing-down mask and 35mm, 50mm, and 135mm lenses, all with matching number; full set: \$5500-7500 estimated, but no recent sales records. 2-lens matched set sold at Christie's 8/93 for £3200+ commissions. STOLEN: #70601. See page 49.

Standardized lens mount - The lens mount on the body has a small "o" engraved at the top of the body flange. Lenses now standardized and interchangeable from one body to another. With f3.5/50mm. Mint: \$500-750. Excellent: \$300-450.

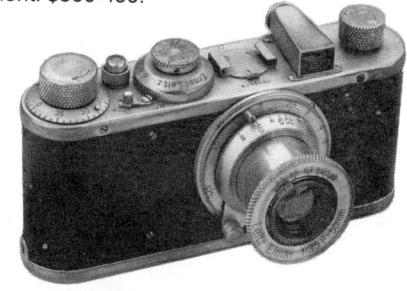

Leica I (C) Luxus - 1931. Records indicate that three examples of the Luxus camera were produced in 1931, with serial numbers 48417, 48418, and 48419. The

latter, including matching numbered lens, sold for £30,000 (\$45,000) + commissions at Christie's 7/93. This set a new world record price for a camera sold at auction, topping the £27,000+ record set in 1992 for a Lancaster Ladies Watch Camera.

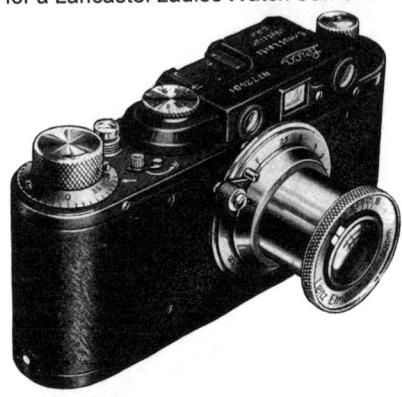

Leica II (D) - 1932-48. First Leica with built-in coupled rangefinder. A desirable camera, but if in exceptional condition.

Black body - Quantity-wise, there are more black ones, but condition is harder to maintain on black. A mint black body of this age is highly unlikely, but one very nice one with original box sold for \$1200 at auction in Sweden. In exceptionally fine condition: \$500-750. Normally: \$200-300.

Chrome body - Less common than black, but retails for less. Top prices about \$350-500. Normal range: 150-220.

Body & lens - Body with matching lens in the correct serial number range, the set will bring a slight premium. Serial numbers for lenses up through the early post-war models should be approximately 50% above the serial number of the body. This is because about three lenses were made for every two bodies. So a nice clean outfit with a black body and a nickel Elmar lens would bring \$350-500. A chrome body and lens in similar condition: \$300-450.

Leica Standard (E) - 1932-48. Similar to standardized "C", but smaller (12mm dia.) rewind knob, which pulls out for easier rewinding. A rare camera especially if seen in black and nickel finish with rotating rangefinder, nickel lens. Mint bodies: chrome \$350-500; black: \$400-600.

Leica III (F) - 1933-39. The first model

with a slow-speed dial, carrying strap eyelets, and a diopter adjustment on the rangefinder eyepiece. Shutter to 500. Black body: \$400-600. Chrome body: \$200-300.

Leica 250 Reporter - 1934-43. The early model (FF) is like Model F, but the body ends were extended and enlarged to hold 10 meters of 35mm film for 250 exposures. Only about 950 were made. Later model (GG) is built on a model G body and has shutter speed to 1000. These were designed for heavy use, and most were used accordingly, so there are not many which are still very clean, but they are difficult to sell if restored. Very clean, original examples would sell in these ranges -- FF: \$8000-12,000; GG: \$6500-9500. Most auction sales in the last two years have been in the \$6000-9000 range. Probably the rarest but not the most expensive is the chrome version of the 250. Motorized version worth at least double. One reported sale of a motorized version for \$50,000. STOLEN: #150068, #300025. See page 49.

Leica IIIa (G) - 1935-50. Basically like the "F", but with the addition of $^{1/}_{1000}$ sec. shutter speed. Chrome only. (There are rumors of a small number of black finished IIIa's, but to date none with any sort of pedigree have appeared.) The IIIa was the most produced of all pre-war Leicas, and therefore is not highly rated as a collectible. However, an early example in near mint condition might prove to be a wise purchase, since they can be bought with Elmar lens for \$175-250.

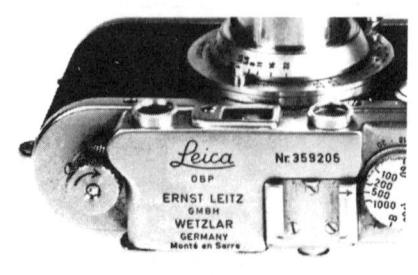

Leica IIIa "Monté en Sarre"Assembled after WWII (between 1950 and 1955) in the French occupied German state of Saarland, from pre-war and postwar parts. Very few were made, probably about 300. The top of the body is engraved "Monté en Sarre" below the normal "Ernst Leitz, Wetzlar" engraving. Genuine: \$3500. Beware of fakes.

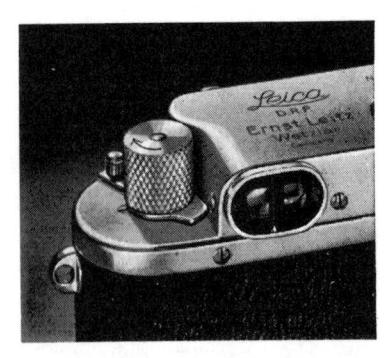

Leica IIIb (G) - 1938-46. Similar to the IIIa, but rangefinder and viewfinder eyepieces are next to each other. Diopter adjustment lever below rewind knob. Hard to find in excellent condition, but worth: \$300-450. This was the last pre-war camera produced by Leitz, and the first to have batches allocated to the military.

Leica IIIb Luftwaffen Eigentum - \$3200-4600.

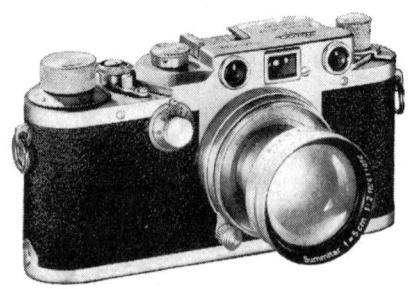

Leica IIIC - 1940-46. Die-cast body is ¹/₈" longer than earlier models. One-piece top cover. The first production, beginning with #360,101, had a small "platform" under the advance-rewind lever; postwar production (#400,000+) lacks this platform. This is a difficult camera to locate in fine condition, due to the poor quality of the chrome during wartime Germany. An exceptionally clean example under #400,000 would be worth \$300-450. Over #400,000: \$150-225 (50% more for sharkskin covered). Early model with red curtain (one curtain has red side facing forward): \$500-750.

Leica IIIc "K-Model" - The letter K at the end of the serial number and on front of the shutter curtain stands for "kugellager" (ball-bearing), or perhaps "kaltefest" (cold weather prepared). The ball-bearing shutter was produced during the war years, primarily for the military. Chrome model: \$1600. Often blue-grey painted. \$1000-2000, depending on condition.

Leica IIIc, grey - Without K shutter, and without military engravings. Up to \$2000; with most selling near \$1200-1800.

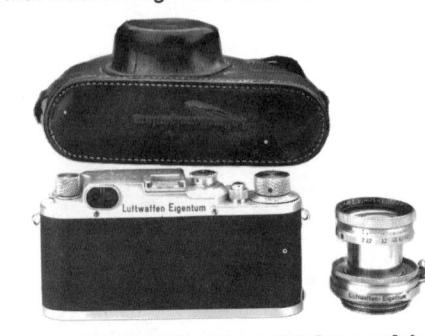

Leica IIIc Luftwaffe & Wehrmacht models - Engraved with "Luftwaffen Eigentum", "W.H.", eagle, or other military

designations. Most have "K" shutter. The most interesting military markings are worth more. Top auction prices \$3000-4000 for grey model with lens. Normal prices: Grey \$2800-4000; Chrome \$2400-3200 for truly MINT condition with lens. Some lenses also have military markings. Some military markings have been engraved by modern entrepreneurs. Caution advised. STOLEN:#387994. See page 49.

Leica IIId - 1940-42. Similar to the IIIc, with the addition of an internal self-timer. This was the first Leica to include the self-timer. Original production of 427 cameras. Factory and other conversions exist, and considering the elevated price of this camera, it would be wise to verify authenticity. Several known sales at \$9,000-10,000. More stable at \$5500-7500.

Leica 72 - 1954-57. Similar to the IIIa but for 18x24mm format. Identifiable by exposure counter for 75 exposures, half-frame masks on viewfinder and at film plane. About 150 were made in Midland, Ontario. About 33 were made in Wetzlar, but verify serial number as there have been many fakes of the Wetzlar model. Either type sells for \$13,000-19,000. STOLEN 7/93: #357430 Midland Type. Reward offered. See page 49 for details.

Leica IIc - 1948-51. Like IIIc, but no slow speeds. Top speed 500. Not a hot selling camera. Body only, MINT: \$300-450.

Leica Ic - 1949-51. No slow speeds. No built-in finders. Two accessory shoes for mounting separate view and range finders. Difficult to find in Mint rating, when they will reach \$500-750. Normal range: \$350-500.

Leica IIIf - 1950-56. Three variations, all common. MX sync. Prices are for MINT. "**Black-dial**" - synchronization dial is lettered in black; shutter speeds 30, 40, 60. \$250-375. Factory retrofitted self-timer adds \$50 to value.

"Red-dial" - synchronization dial is lettered in red; speeds 25, 50, 75. \$275. "Red-dial" with self-timer - An exceptionally clean example with f3.5/50

Elmar sold at Cornwall 10/90 for \$1350. A fine example engraved *Leitz Limited*, *Midland Ontario* sold at Christie's 7/93 for £1500+. More typically, in mint: \$500-750.

Leica IIIf (Swedish Army) - All black body, made for Swedish Army. Complete with matching black lens: \$5500-7500.

Leica IIf - 1951-56. Like the IIIf, but no slow speeds. Black dial: \$300-450. Red dial: has hit \$800 at auction in like new condition. Normally \$350-500 MINT.

Leica If - 1952-56. No slow speed dial nor finders. Separate finders fit accessory shoes. Flash contact in slow speed dial location. Black dial body is rare, but often faked. Difficult to find in really clean condition, they sell currently for \$1200-1800. Red dial body: \$500-750 MINT; \$275-375 normal range.

Leica If Swedish 3 crown - Chrome body. Actually engraved by Swedish military, not Leitz. Not a legitimate Leica model.

Leica IIIg - 1956-60. The last of the screw-mount Leicas. Bright-line finder and small window next to viewfinder window which provides light for finder illumination. Chrome, MINT condition sells for \$800-1200. EXC to EXC+: \$500-750.

Leica IIIg, black - Very rare. We have few recent sales records. \$4500-6500.

Leica IIIg Swedish Crown Model

Leica IIIg Swedish Crown Model - 1960. A batch of 125 black-finished cameras for the Swedish Armed Forces were among the very last IIIg cameras produced. On the back side of the camera and on the lens are engraved three crowns which is the Swedish coat-of-arms. With lens: \$7500-12,000. Illustrated bottom of

previous column.

De la companya del companya de la companya del companya de la comp

Leica Ig - 1957-60. Similar to the Leica IIIg, but no finders or self-timer. Two accessory shoes accept separate range & view finders. The top plate surrounds the rewind knob, covering the lower part when not extended. Only 6,300 were made. A superb example of the body only in original box sold at auction 7/89 for \$1500. Body only, mint: \$1000-1500. Excellent: \$750-1000.

Leica Single-Shot - c1936. Ground glass focus. Single metal film holder. Ibsor shutter. Complete with lens, shutter, film holder, and ground glass for \$750-1000. *Add \$250-375 for rare viewfinder.*

Leica M3 - 1954-66. This is a classic Leica, in itself, and much sought after, being one of the leading cameras of the 1950's. Some users claim it is the bestbuilt 35mm camera ever made, especially the final version. Fine specimens will reach good prices especially if boxed and in Mint condition. There is a definite price differential based on serial number ranges. Prices listed here are for body only in MINT condition. Excellent or less may bring only half as much.

Two variations in film advance:

Double-stroke advance - #700000-700200, glass pressure plate: \$800-1200. #70200 up: auction peak 10/93 \$1800; normally \$600-900.

A notable exception was no. 800000, originally presented by Leitz to Konrad Adenauer in 1956. This camera sold at Christie's 7/93

for £6600 + commissions.

Single-stroke advance - with serials below 1,000,000: \$850 MINT. Serials 1,000,000 to 1,100,000: \$900 MINT. Serials above 1,100,000: \$1000 MINT. Normal range for excellent: \$500-750.

Leica M3, black paint - Genuine, original: \$2400-3200.Lots of fakes.

Leica M3, olive - With "Bundeseigentum" engraved lens: \$2400-3200.

Leica MP, black (above) and chrome (below)

Leica MP - 1956-57. A variation of the M3. Normally identifiable by the MP serial number, but authenticity should be verified as counterfeit examples have reached the market. Chrome: \$6000, complete with Leicavit MP winder. Black: \$8000 complete with winder. The Leica MP must not be confused with the Leica MP2 which is a motorized Leica M3. This motorized Leica MP2 is extremely rare.

Leica MP2 - \$7000.

Leica M2, chrome - 1957-67. Like the single-stroke M3, but with external exposure counter. Finder has frame lines for 35, 50, & 90mm lenses. All early models and some later ones were made without self-timer. (Existence of self-timer does not affect price). Most sell at \$400-600 excellent condition. Prices listed below are for body only, MINT. Button rewind: \$750-1000. Lever rewind, serials under 1,100,000: \$800-1200. Serials over 1,100,000:\$800-1200.

Leica M2, black paint - Mint body: \$2800-3300.Exc+ \$1200-1800.

Leica M2, Grey finish - Much rarer than green M3 or M1. \$4500-6500.

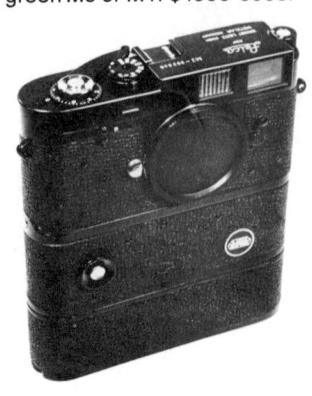

Leica M2 MOT, M2M - Motorized versions. \$3200-4600.

Leica M2, motorized - Modified by Leitz New York from original M2. Leitz New York logo on front of motor. Camera & motor: \$2200-3000.

Leica M2S - c1966. Made for the USA Army. Rapid-load system of M4. \$1200-1800.

Leica M2R - As chrome M2, but with rapid load system of M4. Reportedly, one black sample (#1207000) was made by Leitz, and another (#1248646) was rebuilt in black by Leitz in Northvale. The latter sold at Christie's 7/90 for \$7500. Normal chrome model: \$1200-1800.

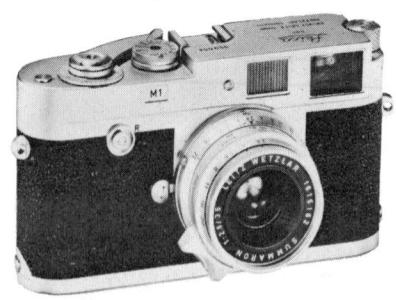

Leica M1 - 1959-64. Simplified camera for scientific use, based on the M2. Lacks rangefinder, but has automatic parallax correcting viewfinder. \$900 MINT. Normal range: \$600-900.

Leica M1 Military Green - \$4500.

Leica MD - 1965-66. Replaced the M1, and further simplified. Based on the M3 body, but has no rangefinder or viewfinder. Allows insertion of identification strips to be printed on film during exposure. Auction record: Cornwall 10/90 \$1500 with Summaron f3.5/35mm. Normal body price \$850 MINT.

Leica MDa - 1966-75. Similar to the MD in features, but based on the M4 body (slanted rewind knob). Auction record (Christie's 7/89) \$1780 with 28mm f5.6 Summaron. Normal range: \$800-950 MINT.

Leica MD-2 - \$850 MINT.

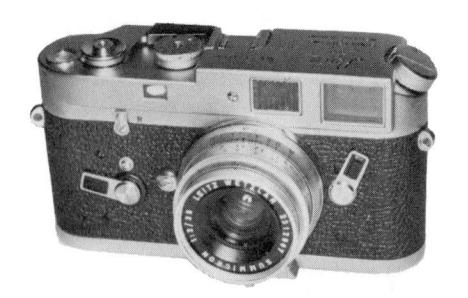

Leica M4 - 1967-73 (plus a later batch in 1974-75 in black chrome). Similar to M2 and M3, but slanted rewind knob with folding crank. Frames for 35, 50, 90, and 135mm lenses.

Leica M4, silver chrome - Excellent: \$600-900.Mint: \$1200-1800.

Leica M4, black chrome - Mint: Canadian or Wetzlar model: \$1500-2000. These can be identified by the wax seal in a small hole at 12 o'clock on the lens mounting flange. New cameras have excised letters: "C" for Canada or "L" for Wetzlar. Factory serviced cameras have incised letters: "Y" for Rockleigh, "51" for Vancouver, "T" for Toronto, "L" for Wetzlar.

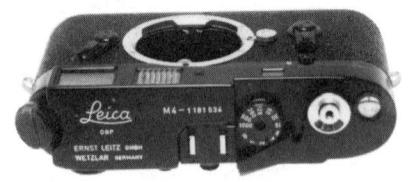

Leica M4, black enamel - \$2000-

Leica M4, olive - \$3500-5500.

Leica M4 50 Jahre Anniversary Model - Must be NEW in box with warranty cards for top price. Wetzlar model: \$2000-3000.Midland: \$2400-3200.

Leica M4M, M4 Mot - Should be complete with electric motors, and MINT condition. \$4000-\$4500. (At Christie's 7/93, one with *E. Leitz New York* motor sold for £5500 + commissions.) In Exc+condition: \$2000-3000.

Leica KE-7A - A special rendition of the M4, made for the U.S. Military and using their designation "KE-7A Camera, Still Picture". With Elcan f2/50mm lens. Military version with federal stock number, or "Civilian" model without back engraving. In the late 1980's, a small quantity of these cameras were removed from military service and sold to the public. These used models sold for \$2500-3500. In 1990, about 55 examples were sold at auction, all new and still hermetically sealed in brown kraft bags with military stock numbers and serial numbers recorded on the outside of each bag. Most of these were bought by dealers in an attempt to

corner the market. The asking price of the largest buyer was \$7000 each. A smaller quantity reportedly sold at about \$5000 each by other dealers. Obviously, the existence of so many new examples on the market will not help the value of the used examples. New condition, still sealed: \$6500-9500.

Leica M4-2, black - 1978-80. As M4, but lacks self-timer, accepts motor winder. With M4-2 Winder: \$1000-1500. Body only: \$750-1000.

Leica M4-2, gold - 1979-80. With gold 50mm f1.4 lens. Asking prices \$4500-5500 for new old stock. Confirmed sales at: \$3300 UNUSED.

Leica M4-P - 1981-87. As M4, but finder frames include 28mm and 75mm. \$800-1200.

Leica M4-P, 70th Anniversary -

c1983. Commemorates the 70th anniversary of the first Leica Prototype. \$1100-\$1600 MINT with box.

Leica M5, chrome (above) and black (below)

Leica M5 - 1971-85. Rangefinder camera with TTL metering. Earlier production, with 2 strap lugs is valued at \$100-150 less. Following prices are for 3-lug model. Black: \$1000-1500 MINT. Chrome: \$1200-1800 MINT. If absolutely like new, in box with cards, the silver chrome model will bring more than the anniversary model, because most were used and fewer remain in truly mint condition. On any M-camera, the condition of the strap lugs is often an indicator of the amount a camera has been used. Any scratch can knock the price down 50%.

Leica M5 Fiftieth Anniversary

model - Must be NEW for top price. Black chrome: \$2200. Silver chrome: \$2800-4000.

Leica CL - 1973-75. Designed by Leitz Wetzlar, but made in Japan by Minolta. With Summicron f2/40mm: \$600-900. Body: \$350-500.

Leica CL 50 Jahre Anniversary model - New in box with cards: \$1200-1800. Mint: \$750-1000.

Leica M6 - 1984-. Rangefinder camera with TTL metering, but otherwise retaining the classic features of a quality rangefinder camera. Bright frames in viewfinder automatically shift to match the attached lens. Quiet, fully mechanical cloth focal plane shutter 1-1/1000. Mint in box: \$2000-3000.

Leica M6, Commemorative Models

- It takes a few years for collector values to stabilize. Typically the collector value drops below the issue price for several years, but then regains lost ground. After about five years, the demand begins to exceed supply and prices find their level. We will add prices to these listings as prices stabilize.

prices to these listings as prices stabilize. **Leica M6, Columbo '92 -** 1992.

Commemorating the 500th anniversary of Christopher Columbus' discovery of America. Made for Polyphoto S.P.A., the Italian agency for Leica. 200 made. Secondary serial numbers on accessory shoe prefixed by the letters I, T, A, L, Y.

Leica M6, Rooster - 1993. A special collector edition made for the Schmidt Group, the Leica agency for Southeast Asia. Celebrating the Year of the Rooster, it has a golden rooster engraved on top, along with an inscription in Chinese characters which reads "Leica-Good Luck". 268 were made, furnished with matching numbered 50mm f1.2 Summicron.

Leica M6, LHSA 25th Anniversary -

1994. To commemorate the 25th anniversary of the Leica Historical Society of America, a limited edition of 151 examples were produced, of which 149 were offered to LHSA members only. The set includes an M6 body with silver chrome finish, dark grey leather with embossed emu pattern, LHSA logo in red, special engraving and serial edition number. Three Summicron lenses (35, 50, 90mm) with special engraving and caps. Cherry wood collector case with black silk lining. Issue price \$7,995.

Leicaflex, chrome

LEICA PLEY

Leicaflex - Original model introduced 1964. A landmark in the development of reflex cameras, due to its very bright prism system. Chrome: \$750-1000 if MINT; EXC+: \$400-600. Black: \$750-950 excellent; over \$1000 MINT. Chrome version illustrated bottom of previous column.

Leicaflex SL: chrome (above), black (below)

Leicaflex SL - Chrome: \$250-375, up to \$600 Mint. Black Enamel: \$250-375 if used, up to \$850 MINT. Black Chrome: \$300-450.

Leicaflex SL Olympic - NEW in box with cards: \$1000-1500.

Leicaflex SL Mot - With motor, nice condition: \$750-1000.

Leicaflex SL2 - Important in that it is the last mechanical Leitz reflex camera and sought after by both collectors and users. This accounts for the high prices. Black or Chrome: \$750-1000. MINT: \$1200-1800.

Leicaflex SL2 50 Jahre Anniversary Model - Top price only if NEW. Black: \$1500-2000. Chrome: \$1700-2400.

Leicaflex SL2 Mot - With motor: \$2000-3000.

Leica R3 - Black: \$400-500 MINT; usually \$350-500. Chrome: new in box \$1000-1500. \$500-750 MINT. This camera was produced in Portugal. A small number have German baseplates as though made in Germany and not Portugal. One source indicates that this may have been done to avoid problems with customs for Photokina. At any rate, the "German" models in either black or chrome bring about the same price as the normal chrome model or perhaps just slightly more.

Leica R3 Gold - Must be complete with gold Summilux-R f1.4/50mm lens, in original wood case, with box, strap, etc. AS NEW: \$2300-3300.

Leica R3 Safari - c1972. About 2500 made. Olive green body. With original box, as new: \$1000-1500. With 50mm f1.4 Summilux-R or 50mm f2 Summicron-R, as new, to \$1600.

Leica R3 Mot - With winder, box, cap: \$500-750.

Leica R4 - Although people collect them, these are primarily usable cameras, and an important word of warning comes from one of our consultants. Due to the high cost of repairs, Leitz only repairs the R4 under its "Signature Service" which costs \$235. There are four generations of R4 cameras, the first three of which were subject to electronic problems. Try to avoid a used R4 which is out of warranty or with serial number below 1,600,000. Black or Chrome: \$500-750.

Leica R4, Gold - 24 carat gold plated with matching gold plated Summilux-R 1.4/50mm lens. Black lizard skin body. Walnut presentation case. One thousand examples were made. Original price about \$3500. Christie's 8/93: £1600 (\$2400) plus commissions. As new: \$2500-3000.

Leica R4 Mot - The name "Mot" was abandoned due to consumer pressure in Germany. The body was not motorized as the name might imply, but simply capable of being motorized. Over 1000 were made, but they are uncommon in Europe where they were replaced by Leitz with newer R4's upon return for repairs. Since they all have serial numbers under 1,600,000 they are in the "risky" group. As collector pieces, they may bring slightly more than the normal R4. Asking prices: \$625-850 Mint.

Leica R6 Platinum

Leica R4S - A limited version of the R4. Same warnings apply, and not much different in price. \$550-750 Mint.

Leica R6 Platinum - 1989. Although the R6 is a new camera, and not subject to listing in this guide, one example can not be overlooked. A specially numbered, unique example of the platinum edition honoring the 150th anniversary of photography, and 75 years of Leica photography was sold at Christie's for 26,400 Pounds Sterling in November, 1989. This set a new world record price for a camera at auction, beating the previous record of 21,000 Pounds Sterling set in 1977 for a Dancer Stereo camera. The R6 record price has since been broken. See separate list of world record prices. Illustrated bottom of previous column.

Leica 110 Prototype - c1974. Pocket camera designed to take the Kodak 110 cassettes. A small quantity of working prototype cameras had been made prior to the anticipated introduction at Photokina 1974. The camera was never introduced, however several of the prototypes have reached the collector market. At Christie's 7/93, one sold for £5500+.

LEICA RANGEFINDER LENSES - ("R" series lenses for reflex cameras are listed separately at end.) The following lens prices are "add-on" values to the body prices listed above. Condition is extremely important in buying a used Leica lens. Because of the age of many screwmount lenses, and the type of balsam glue used to cement the elements together, a large number of these lenses are showing signs of separation, crazing, or cloudiness. They should be carefully checked by shining a flashlight through from the rear of the lens and examining closely. If the lens shows signs of deterioration, forget it. Not only would it be costly to repair, but it would be virtually impossible to match the original optical quality.

We have listed screw-mount and bayonet-mount lenses together, in order by focal length. The abbreviations "SM" and "BM" to distinguish between them. Prices given are for MINT condition unless otherwise specified. This is the preferred condition for easy saleability. If we quote only a MINT price, deduct AT LEAST 25% to arrive at an estimate for Excellent condition. Some lenses exist in both SM and BM versions. Often the SM is more rare and valuable, so some "conversions" have been made by those who value money more than integrity. Beware of conversions at original prices.

Military lenses exist with engraved markings from various military branches of Germany and other countries. These special markings are in high demand, and usually increase the value of the lens over the normal models. However, not all special markings originated at the factory; lenses subsequently marked by the military may have no special value. Counterfeit military markings also exist.

In some cases, we have distinguished between lenses based on their filter type/size. These are given as a letter and number. The letter indicates slip-on (A) or screw-in (E); the number indicates the diameter in mm. Several lenses were available with A36 or E39 variations.

15mm f8 Zeiss Hologon (BM only) -\$4500, MINT with filter and finder.

21mm f4 Super Angulon (SM) -\$1200 original; \$900 converted. 21mm f4 Super Angulon (BM) -\$750-1000MINT. 21mm f3.4 Super Angulon (BM) -Black \$1000-1500, Chrome \$850 MINT. 21mm f2.8 Elmarit-M (BM) -\$800-1200.

28mm f6.3 Hektor (SM) -Nickel \$500-750, Chrome \$350-500 MINT. 28mm f5.6 Summaron (SM) -\$600-900 MINT 28mm f2.8 Elmarit (BM) Blk,

Canada - Early, pre-M5, with longer rear element \$600; later type for M5, \$750-1000 MINT.

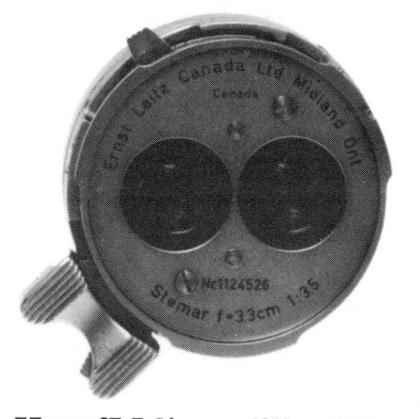

33mm f3.5 Stemar (SM or BM) - \$3700 MINT & complete with viewfinder, beamsplitter, hood, caps, & case. Missing parts will detract from price.

35mm f3.5 Stereo Elmar (SM) -

35mm f3.5 Elmar (SM) - early nickel \$350-500, later nickel \$200, chrome \$150

35mm f3.5 Summaron (SM) E-39 -Latest version; 39mm filter screws into the lens flange: \$275. Earlier versions used E-36 filters which clamp over the lens with a screw: \$175-250.

35mm f3.5 Summaron (BM) - All are E-39. \$250-375

35mm f3.5 Summaron (BM for M3 **only) -** with finder attachment for RF & VF. \$250-375.

35mm f2.8 Summaron (SM) -

\$500-750 MINT. Examine to be sure not taken from M3 "bug eye" model. It will fit on body but will not focus.

35mm f2.8 Summaron (BM) No eyes - \$350-500 MINT. 35mm f2.8 Summaron (BM) w/eyes - \$300-450MINT.

35mm f2 Summicron (SM, chrome) - \$1200 MINT. Note: Many fakes converted

from lower-valued bayonet-mount lenses.
35mm f2 Summicron (BM, chrome) - \$750-1000.MINT

35mm f2 Summicron (BM, black paint) - \$1200 MINT.

35mm f2 Summicron (BM, chrome, M3 eyes) - \$525. 35mm f2 Summicron (BM, black

paint, M3 eyes) - \$1000-1500. 35mm f1.4 Summilux (BM, chrome) - \$750-1000. 35mm f1.4 Summilux (BM, black) -

\$800-1200 35mm f1.4 Summilux (BM.

chrome, w/M3 eyes) - \$800-1200. 35mm f1.4 Summilux (BM, black, w/M3 eyes) - \$1050.

40mm f2.8 Elmarit-C (BM) - \$1200. 40mm f2 Summicron-C - \$250-375 MINT w/hood.

50mm f3.5 Elmar (SM, early nickel w/low serial) - \$200-300. 50mm f3.5 Elmar (SM, chrome pre-war uncoated) - \$100-150MINT. 50mm f3.5 Elmar (SM, chrome, postwar, black scale, coated) -\$125 MINT

50mm f3.5 Elmar (SM, postwar, red scale, coated) - \$295 MINT.
50mm f3.5 Elmar (BM) - \$275.
50mm f3.5 Wollensak Velostigmat (SM) - \$125

50mm f2.8 Elmar (SM) -\$250-375 MINT

50mm f2.8 Elmar (BM) -\$250-375 MINT w/hood.

50mm f2.5 Hektor (SM) nickel or chrome - \$250-375. 50mm f2 Summar (collapsible SM)

nickel or chrome - \$50-75

50mm f2 Summar (rigid SM) - nickel \$1100, chrome \$1250.

50mm f2 Summicron (collapsible SM) - Inspect carefully. About 90% have scratches on front element, and they are also subject to haze and crystallization. Unscratched and crystal clear - \$150 EXC to \$275 MINT.

50mm f2 Summicron (rigid SM) -\$1100 MINT

50mm f2 Summicron (collapsible BM) - \$250-375.

50mm f2 Summicron (rigid BM chrome) serial below #2,300,000 -

50mm f2 "Dual Range" Summicron (rigid BM, chrome) - dual focus scale mtr/ft to 18", #2,300,000+:\$350-500 MINT. 50mm f2 Summicron (rigid BM, black paint) - \$1000-1500 50mm f2 Summicron (rigid BM,

black anodized) - \$400-600.

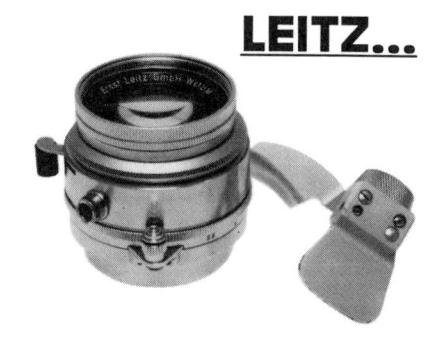

50mm f2 Summicron (in Compur Shutter, BM only) - \$4000 with arm. 50mm f2 Summitar (SM) - \$85-90 to \$110 for late model MINT. 50mm f2 Summitar* (SM) -Prototype Summicron formula, marked as Summitar*. \$2200. **50mm f1.5 Summarit (SM) -** \$125. 50mm f1.5 Summarit (BM) -\$150-225 50mm f1.5 Summarit, Canada -50mm f1.5 Xenon (SM, early) -2 knurled rows on focus ring, indicators at f1.9 & f2.9: \$250-375. 50mm f1.5 Xenon (SM, later) -3 knurled rows on focus ring: \$200-300. 50mm f1.4 Summilux (SM, chrome only) - \$2750 MINT. 50mm f1.4 Summilux (BM, black paint) - \$1100 MINT. 50mm f1.4 Summilux (BM, black anodized) - \$850 MINT. 50mm f1.4 Summilux (BM chrome) - Over Ser. #1,840,000:\$600-900 MINT. Under Ser. #1,840,000: \$400-**600 MINT.** 50mm f1.2 Noctilux (BM) -\$1600 MINT. 50mm f1 Noctilux (BM) -

65mm f3.5 Elmar (Visoflex) - With 16464 focusing adapter and special rear cap. \$300-450 chrome MINT, \$350-500 black MINT. Black lens is recomputed design.

\$1200 MINT.

73mm f1.9 Hektor (SM) black & nickel \$500-750; black & chrome \$425 MINT.

75mm f1.4 Summilux (BM) - first model w/ removable shade \$1100; current model with sliding shade \$1200 MINT.

85mm f1.5 Summarex (SM, black) with caps and hood to \$2000 MINT.

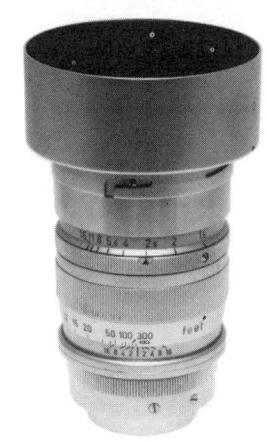

85mm f1.5 Summarex (SM, **chrome) -** with hood & caps \$800-1200

90mm f4.5 Wollensak Velostigmat (SM) - \$150-225 90mm f4 Elmar (SM, early, "fat Elmar") - \$350-500 90mm f4 Elmar (SM, black or chrome, A36 front) - \$75-100 90mm f4 Elmar (SM, chrome, E39 front) - \$100-150. 90mm f4 Elmar (SM, 3 elt. design W/ click stops) - \$750-1000.
90mm f4 Elmar (BM, E39 front) -90mm f4 Elmar (BM, 3 elt. design w/ click stops) - \$500-750 90mm f4 Elmar (Collaps. BM) -\$350-500 MINT. 90mm f4 Elmar-C (BM) - \$300-450. 90mm f2.8 Elmarit (SM) - Rare. \$1000 MINT. 90mm f2.8 Elmarit (BM) -Black: \$775 MINT. Chrome: \$725 MINT. 90mm f2.8 Tele-Elmarit (BM, chrome) - \$500-750 90mm f2.8 Tele-Elmarit (BM, black, early 5 elt.) - \$400-600. 90mm f2.8 Tele-Elmarit (BM, black, later 4 elt.) - \$600. 90mm f2.2 Thambar (SM) - \$2700 MINT, COMPLETE with shade, caps, and most importantly, with diffusion disc. 90mm f2 Summicron (SM, chrome, removable shade) - \$1300 MINT. 90mm f2 Summicron (SM, chrome, sliding shade) - \$1000 MINT. 90mm f2 Summicron (BM, chrome, removable shade) - \$1300 MINT. 90mm f2 Summicron (BM, chrome, old style) - \$600-900 90mm f2 Summicron (BM, black, old style) - \$500-750. 90mm f2 Summicron (BM, black, new style) - \$750-1000

105mm f6.3 Elmar ("Mountain" Elmar) (SM) - \$900 complete w/ caps & shade.

125mm f2.5 Hektor (for Visoflex or bellows) - \$600 w/hood & caps.

127mm f4.5 Wollensak Velostigmat (SM) - \$150-225.

135mm f4.5 Elmar (SM, early black & nickel) - \$150-225 135mm f4.5 Elmar (SM, later black & chrome) - \$90 135mm f4.5 Hektor (SM, black) -135mm f4.5 Hektor (SM, black & chrome, E36) - \$90. 135mm f4.5 Hektor (BM, E39) - \$90. 135mm f4 Elmar (SM, chrome only) - \$500-750 MINT 135mm f4 Elmar (BM, chrome only) - \$275 MINT 135mm f4 Tele-Elmar (BM, parallel focus) - \$450-700 135mm f2.8 Elmarit-M (BM) - \$400-600

180mm f2.8 Elmarit (for Visoflex) - \$1000-1200MINT.

200mm f4.5 Telyt (for Visoflex) -\$250-375. 200mm f4 Telyt (for Visoflex) -\$250-375.

280mm f4.8 Telyt (for Visoflex) -\$350-500

400mm f5 Telyt (for Visoflex, attached shade) - \$750-1000. 400mm f5 Telyt (for Visoflex removable shade) - \$1200-1800. **LEICA R-SERIES LENSES FOR SLR**

CAMERAS - Since the Leicaflex was introduced over 30 years ago, it becomes increasingly important to list its lenses in our collector's guide. However, these lenses are by no means relegated to gather cobwebs. Their optical quality keeps them in use. Some of the earlier lenses are less convenient to use. Their single cam bayonet mount does not permit full-aperture metering. Beginning with the SL, a second cam on the lens mount allowed full-aperture metering. The current 3-cam lenses, introduced with the R3, are more valuable from a user's viewpoint, but a collector interested in original equipment may prefer the one of the older types whose mount has not been upgraded by Leitz. Code numbers in parentheses are the catalog numbers assigned by Leitz.

15mm f3.5 Super-Elmar-R - (11213):

\$2000-3000.

16mm f2.8 Fisheye-Elmarit-R - (11222) For R and SL2 only. \$600-900. 19mm f2.8 Elmarit-R -(11225): \$700-1100

21mm f3.4 Super-Angulon-R -Early type. \$600-900 21mm f4 Super-Angulon-R -(11813) \$700-1000. 24mm f2.8 Elmarit-R -(11221): \$700-1000

28mm f2.8 Elmarit-R -(11204)(11247) \$450-700 28mm f2.8 PC Super-Angulon -(11812): \$1500-2000.

35mm f1.4 Summilux-R -(11143): \$1000-1500 35mm f2 Summicron-R -(11115) 2-cam. \$350-500. - 3-cam: \$600-900 35mm f2.8 Elmarit-R -(11201) c1964-74.\$200-300. (11251) c1974-77.\$300-450. 35mm f4 PA Curtagon-R - (11202) Perspective control lens. \$600-900.

50mm f1.4 Summilux-R -(11875)(11776) 2-cam. \$300-450. (11777) 3-cam, \$600-900. 50mm f2 Summicron-R -(11215)(11216) \$200-300

60mm f2.8 Macro-Elmarit-R -(11203)(11253) With 1:1 adapter: \$600-900. 80mm f1.4 Summilux-R -

90mm f2 Summicron-R -(11219) 2-cam. \$300-450. (11254) 3-cam. \$600-900. 90mm f2.8 Elmarit-R -(11239) 2-cam. \$300-450. (11154) 3-cam. \$400-600.

(11881) \$1000-1500.

100mm f2.8 Apo-Macro-Elmarit-R -(11210) \$1200-1800 100mm f4 Macro-Elmar (for bellows) - (11230) \$200-300 100mm f4 Macro-Elmar-R -(11234)(11232) \$600-900 135mm f2.8 Elmarit-R -(11211) \$200-300.

180mm f2.8 Elmarit-R -(11919) \$400-600. (11923) Late type, E67, \$700-1000. **180mm f3.4 Apo-Telyt-R** -(11240)(11242) \$700-1000. 180mm f4 Elmar-R -(11922) \$500-750

250mm f4 Telyt-R -

(11920) 2-cam. \$450-650. (11925) 3-cam. \$1000-1500. **280mm f2.8 Apo-Telyt-R -**(11245)\$2800-4000

350mm f4.8 Telyt-R -(11915) \$1500-2000 400mm f6.8 Telyt-R -(11960)(11953) \$600-900.

500mm f8 MR-Telyt-R -(11243) \$800-1200 560mm f5.6 Televit-R - \$1000-1500. 560mm f6.8 Telyt-R -(11865)(11853) \$1000-1500.

800mm f6.3 Telvt-S - (11921) \$5000+. **ZOOM LENSES FOR LEICA R-MOUNT:**

28-70mm f3.5-4.5 Vario-Elmar-R -\$500-750 35-70mm f3.5 Vario-Elmar-R -(11248) \$500-750 45-90mm f2.8 Angenieux Zoom - (on request) \$500-750. 70-210mm f4 Vario-Elmar-R -(11246) \$800-1200 75-200 f4.5 Vario-Elmar-R -(11226) \$600-900. 80-200mm f4.5 Vario-Elmar-R -(11224) \$400-600.

LEICA VIEWFINDERS - Some of the more commonly traded Leica viewfinders: 35mm bright line (SBLOO) -Mint \$250-375, Exc+ \$200-300. 50mm bright line (SBOOI) -Mint \$85. Exc+ \$60. 85mm bright line (SGOOD) -Mint \$450, Exc+ \$350-500 90mm bright line (SGV00) -Mint \$150, Exc+ \$110. 135mm bright line (SHOOC) -Mint \$135, Exc+ 110 35-50-85-90-135 Universal Imarect (VIOOH) - Mint \$100-150, Exc+ \$60. 28mm attachment for Imarect (TUVOO) - Mint \$250-375, Exc+ \$190. 21mm bright line (12008) Current. Mint: \$295. 28mm bright line (12009) Current. Mint: \$275.

LEICA ACCESSORIES - It would take a specialty book to list all the Leica accessories, so this sample list is only to advise you not to "throw in" the accessories when you sell off the old family Leica.

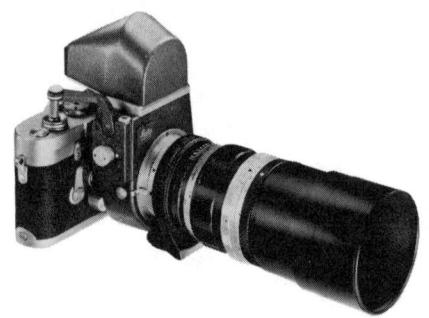

Visoflex III - with #16499 90° magnifier. Mint \$395 Slow speed attachment (HEBOO) for Leica II & Standard. Mint \$125. Lens Turret (OROLF) -Mint \$1000-1500 Waterproof Case (MBROO) - Everready case for Leica to IIIf. Mint \$350-500. Rapid winder (SCNOO) - Chrome finish, mint - \$500-750.

Motor (MOOLY) - for short baseplate Leicas; external arm. Exc+ \$1200-1800.

LENINGRAD (Leningrad Optical-

Mechanical Union, Leningrad, USSR) Formerly GOMZ, later LOMO. See GOMZ for historical outline; see LOMO for other cameras made in a Leningrad factory. **Leningrad** - late 1950's-mid 1960's. 35mm RF camera with spring-motor drive. Jupiter-8 f2/50mm lens in Leica mount. FP shutter, 1-1000. \$250-375.

LENNOR ENGINEERING CO. (Illinois) Delta Stereo - c1955. 35mm stereo camera, 23x25mm pairs. Usually blue enamel and leatherette covered, but also found in black plastic with brushed aluminum trim and leatherette covering. La Croix f6.3 lens in guillotine shutter 25-100, B. Scale focus 5,8,10,12' to infinity. Camera and case only: \$90-130. With matching viewer: \$150-225.

LENZ - "Hit" type novelty camera for 16mm film. \$25-35

LEONAR KAMERAWERK (Hamburg)

Filmos - c1910. Folding camera for

8x10.5cm on rollfilm or 9x12cm on plates. Leonar Aplanat f8 or Periscop Aplanat f11/130mm lens. \$50-75.

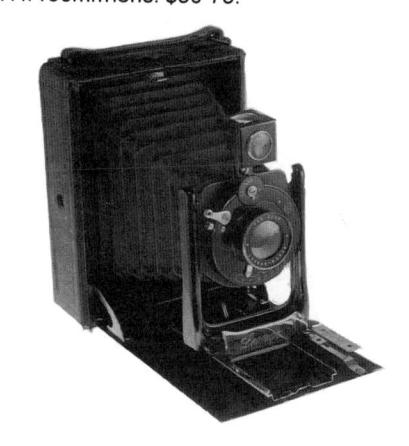

Leonar, 9x12cm - c1910. Low-cost folding plate camera. Wooden body with metal front door. Periscop lens in single speed shutter. Simple, but attractive nickeled pull at the bottom of the lens standard. Uncommon, \$30-45.

Leonar, 10x15cm - c1910. Similar to the Filmos, but Leonar Anastigmat f8/140 or f6.8/170 lens. Dial Compur 1-200 shutter. Triple extension. Uncommon size. \$100-150.

Perkeo Model IV - c1910. Simple folding camera for 9x12 plates or 8x10.5cm filmpacks. Achromat f16, Aplanat f11, or Extra-Rapid Aplanat f8 lens. B&L Auto shutter, \$35-50.

LEPAGE (Enrique LePage and Co.. Buenos Aires, Argentina.) Field camera - Well-made wooden field

camera for 18x24cm plates. Bellows detach from lens standard when folded. Without lens: \$250-375.

LEREBOURS (Paris) Gaudin Daguerreotype camera c1841. Cylindrical all-metal daguerreotype camera. Fixed-focus lens. Rotating diaphragm. One recorded sale in Oct. 1982: \$8350

LEROY (Lucien LeRoy, Paris)

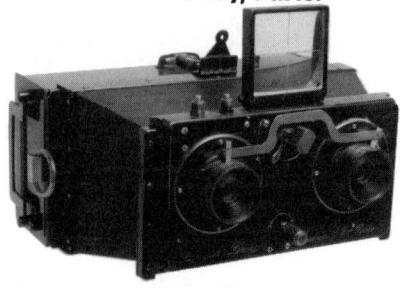

Minimus - c1924. Rigid body 6x13cm stereo jumelle. \$250-375.

Stereo Panoramique - 1905-11. Black, all-metal camera for 6x13cm plates in stereo or, by rotating one lens to center position, panoramic views. Krauss Protar f9/82mm or Goerz Doppel Anastigmat f8.5/80mm lens. Five speed shutter. \$300-450. Illustrated at top of next column.

Leroy Stereo Panoramique

LESUEUR & DUCOS du HAURON Melanochromoscope - c1900. Color separation camera taking three exposures on one plate. Could also be used as a chromsoscope, for viewing the pictures. Despite considerably higher estimates, one failed to attract bids over \$1800 at a November 1982 auction, and remained unsold. No recent sales records. We would welcome further information from our readers

LEULLIER (Louis Leullier, Paris)

Summum - c1925. Roussel Stylor f4.5/75mm lenses. Made in focusing and fixed-focus models. Stereo shutter 25-100. Rising front. Changing magazine holds six 6x13cm stereo plates. \$175-250.

Summum Sterechrome - c1940. 24x30mm stereo exposures on 35mm film. Berthiot Flor f3.5/40mm lens. Shutter to 300. \$400-600

LEVI (S.J. Levi, London, England) Leviathan Surprise Detective c1892. Polished walnut box camera holding six 31/4x41/4" plates on the three vertical sides of a revolving drum. \$1000-1500.

Minia Camera - 1/4-plate. Black leather covered body with maroon leather bellows. Rack focus. Ross/Goerz Patent Doppel-Anastigmat f7.7/5" lens. Thornton-Pickard rollerblind shutter. \$150-225.

Pullman Detective - c1896. Satchel style-detective cameras, made in sizes for 31/4x41/4", 4x5", and 5x7" plates. When the leather case is placed on its back, the bottom opens to become the bed of the camera. The lid of the leather case and one side open to access the ground glass and plateholders. Single or stereo lens-boards were available. With Archer & Sons lens and roller blind shutter. Two recorded sales in 1990 at about \$3000 each. Current estimate: \$4500-6500.

LEVY-ROTH

LEVY-ROTH (Berlin)

Minnigraph - c1915. 18x24mm exposures on 35mm film in special cassettes. The first European still camera to use cine film. Lenses include Minnigraph Anastigmat f3.5/54mm and Pentagraph Berlin f3.0 among others. Single speed flap shutter. \$800-1200.

LEWIS (W. & W.H. Lewis, New York) Daguerreotype camera - c1852.
Initiated the so-called "Lewis-style" daguerreotype cameras later made by Palmer & Longking. Collapsible bellows daguerreotype camera for 1/2-plates. Ground glass focusing. \$7500-12,000.

Wet Plate camera - c1862. Large size, for plates up to 12x12". Folding leather bellows. Plates and ground glass load from side. A rare camera. \$1200-1800.

LEXA MANUFACTURING CO.

(Melbourne, Australia)
Lexa 20 - c1948. Metal box camera for 6x9cm on 120 film. Advertised for sale in October 1948 for \$1.95. Several dozen examples are known in collections without the interior film carrier, and it was suggest-

ed that perhaps the camera was never actually sold. But examples are known with the film carrier, so the mystery remains. \$25-35.

L.F.G. & CO. (Paris, France)

Français - c1910. Small metal box camera. Takes two 4x5cm plates which pivot into position for exposure. Meniscus f11/55mm lens in simple shutter. \$120-180.

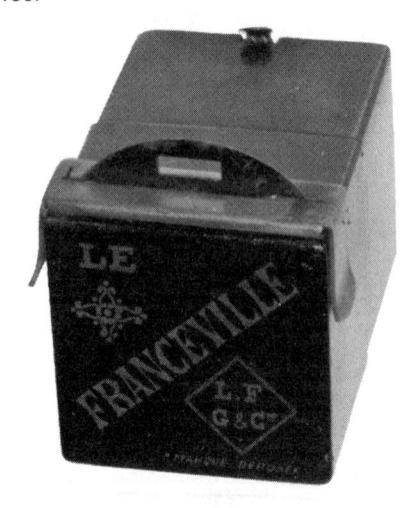

Franceville: back view of cardboard version (above), plastic version (below)

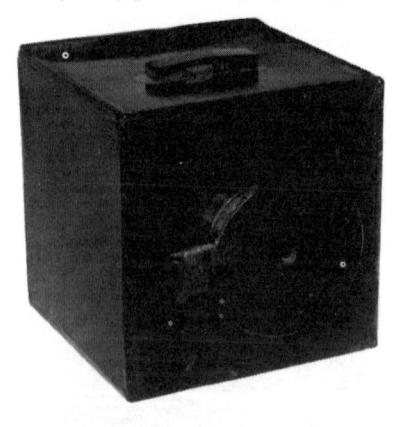

Franceville - c1908. Simple black box camera made of plastic or cardboard. Takes 4x4cm exposures on plates. Meniscus lens, guillotine shutter. Plastic version is unidentified. Cardboard type has gold lettering on back. \$150-225.

LIEBE (V. Liebe, Paris)

Monobloc - c1920. For stereo or panoramic views on 6x13cm plates. Tessar f6.3 or Boyer Saphir f4.5/85mm lenses in pneumatic spring shutter. Metal body is partly leather covered. \$250-375. See also Jeanneret Monobloc.

LIEBERMAN & GORTZ (Germany)
Dual-finder rollfilm camera

c1950's. Simple bakelite camera for 4x4cm exposures on 127 rollfilm. Eye-level and waist-level finders in aluminum top housing. Unusual location of back latch on top of front section. Also sold as "Gezi II", and a similar camera with only a single finder was sold as the "Rothlar 4x4". Uncommon. \$45-60.

LIESEGANG (Düsseldorf, Germany) Field camera - c1900-05. 10x15cm plate camera. Wooden body with brass handle and brass lens in Unicum shutter. Bright red tapered bellows with wine-red corners. \$175-250.

LIFE TIME
Life Time 120 Synchro Flash - All
metal box camera identical to the Vagabond 120, \$1-10.

LIFE-O-RAMA CORP.

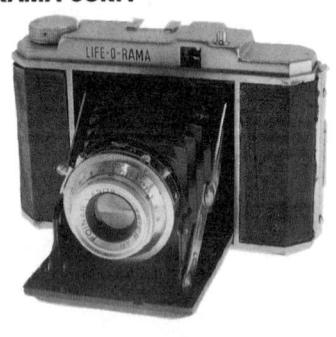

Life-O-Rama - Horizontally styled folding camera for 6x6 exposures on 120 rollfilm. Actually, it is a Foinix, including the embossed Foitzik and Foinix names on the body, but the front of the top housing is engraved Life-O-Rama for the distributor. Foinar f4.5/75mm lens in Vario shutter. \$20-30.

Life-O-Rama III - c1953. German made camera taking 6x6cm exposures on 120 rollfilm. f5.6/75 or f3.5 Ennar lens. Vario shutter, sync. \$20-30.

LIGHT - c1934. Japanese Maximar copy. 6.5x9cm. Heliostar f4.5/105mm lens in Neuheil rim-set 25-150 shutter. \$75-100.

LIGHT INDUSTRIAL PRODUCTS (China)

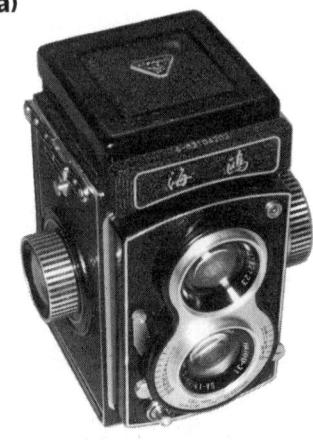

Seagull 4 - c1970's. TLR for 6x6cm on 120 rollfilm. f3.5/75mm lens. 1-300 shutter, x-synch. \$50-75.

LIONEL

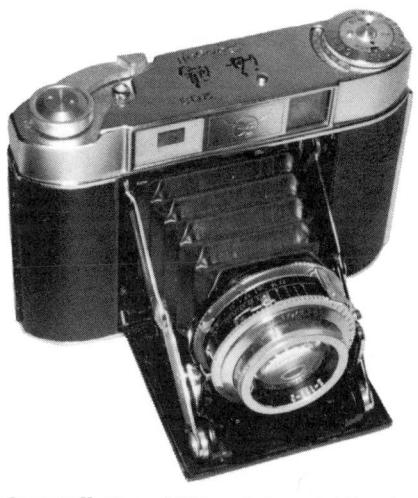

Seagull No. 203 - 6x6cm folding bed camera. Copy of Zeiss Ikonta IV. 12 or 16 exposures on 120 film, f3.5/75mm lens. \$45-60.

LIGHT SUPER - Inexpensive Japanese 127 camera. Uera lens. \$60-90.

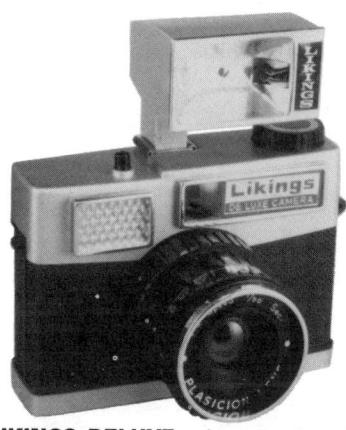

LIKINGS DELUXE - Inexpensive silver & black plastic camera of the "Diana" type for 55x55mm on 120. \$1-10.

LILIPUT - c1900-05. Wooden tailboard camera, 13x18cm. Square black bellows. \$150-225.

LINA, LINA-S - 4x4cm plastic novelty cameras of the "Diana" type. \$1-10.

LINCA MODELO L-50 - Stamped metal camera with telescoping front. Made in Argentina. 6x6cm on 620 or 120 film. Zone-focusing f8.8 lens in I&P shutter which will not fire unless front is extended. \$30-45.

LINDEN (Friedrich Linden,

Lüdenscheid, Germany) Lindar - c1950. Metal box camera, leather covering. 6x6cm on 120. Meniscus f9.5/80 lens. T, I shutter. Large waist-level brilliant finder. Built-in yellow filter. \$35-50.

Lindi - c1950. Metal 6x6cm box camera with large reflex brilliant finder. Black or grey hammertone finish. Meniscus f10.5/ 80mm lens. A lower priced version of the Lindar. Grey: \$50-75. Black: \$30-45.

Reporter 66 - c1952. Metal box camera with leather covering. 6x6cm exposures. Similar to the Lindar and Lindi. Meniscus f9.5/80mm lens. \$30-45.

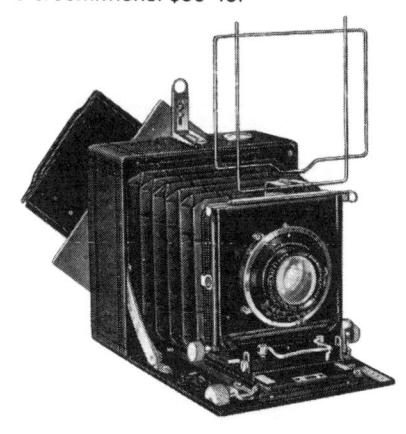

LINHOF PRÄZISIONS KAMERAWERK (V. Linhof, Munich) While we are presenting a selection here of cameras which could be considered "collectible", generally the Linhof line tends to be a family of cameras which fall more into the category of usable equipment.

(early folding cameras) - c1910-30. (pre-"Technika" models.) Folding plate cameras in standard sizes from 6.5x9cm to 13x18cm. Ground glass focus. \$120-180.

Kardan - A series of well-built monorail view cameras. Despite the age of the earlier types, they are still more in demand as usable cameras than as collectibles. With various fronts, backs, and middle sections, the camera could take many forms and sizes from 9x12cm (4x5") to 18x24cm (8x10"). Designs evolved from the early Kardan cameras of the 1950's, the Kardan Color of the 1960's, the Kardan Super Color of the 1970's, and the Kardan Master models of the 1980's. Pricing would be very dependent on age, accessories, lens, etc. and is more appropriate for a book on usable equipment.

Standard Präzisionskamera (Precision View) - c1930. Triple extension hand plate camera. Rise/cross front. Tessar f4.5/135mm lens in Compur shutter. \$250-375.

Stereo Panorama - c1920. 6x13cm exposures (stereo or panoramic). Two Rietzschel Sextar f6.8/120mm lenses and one Rietzschel Linar f5.5/150mm lens. Compound shutter. Metal body, leather covered. \$350-500.

Technika I - c1930. The "Technika" series of precision cameras was distinguished from the "Standard" series by the back which extended rearward with independent adjustment at each corner for perspective control, and by the ground glass focusing screen which hinged to the side for easy insertion of the plateholder.
With Tessar f4.5 in Compound or Compur shutter. 6.5x9cm: \$600-900. 9x12cm: \$500-750.5x7": \$600-900.

Technika III - 1946-58. These are old enough to be considered collectible, but their primary value lies in their usability. Price dependent on lens/shutter, accessories. Common with f4.5 Xenar. 21/4x31/4" or 4x5": \$400-600.5x7": \$500-750.

Technika Press 23 - 1958-63. 6x9cm press camera. Accepts cut film, film packs rollfilm. Interchangeable lenses. Compur shutter to 400. The high prices are due to usability, not rarity. \$500-750.

LIONEL MFG. CO. (The train people) Linex - c1954. Cast metal subminiature for stereo pairs of 16x20mm exposures on rollfilm. f8/30mm lenses. Guillotine shutter, synched. Camera only: \$75-100. Viewer only: \$25-35. Outfit with case, flash, viewer: \$90-130.

LIPPISCHE

LIPPISCHE CAMERAFABRIK (Barntrup)

Flexo - c1950. Twin lens reflex for 6x6cm on 120 film. Helical focus operated by lever below lens. Identical taking and viewing lenses include Ennar f3.5 or f4.5 and Ennagon f3.5. Prontor-S, Prontor-II, or Vario shutter. \$50-75.

Flexo Richard - c1953. Unusual name variation of the Flexo. "Flexo Richard" on nameplate at front of finder hood. \$75-100.

Flexora - c1953. 6x6cm TLR, Models I, II, IIA, III, IIIA. Ennar f3.5 or 4.5/75mm or Ennagon f3.5/75mm lens. Vario, Pronto-S, or Prontor-SV shutter. \$60-90.

Optimet (I) - c1958. 6x6cm TLR, similar to Rollop. Rack and pinion focus with left-hand knob. Ennagon f3.5/75mm lens in Prontor-SVS shutter. \$75-100.

Rollop - c1954. TLR for 6x6cm on 120 film. Ennagon f3.5/75mm lens. Prontor-SVS shutter 1-300. \$75-100.

Rollop Automatic - c1956. TLR for 6x6cm on 120. Called Automatic because shutter is tensioned by film advance. Ennit f2.8/80mm lens in. Prontor SVS 1-300 shutter. \$100-150.

LIRBA - c1950. Small box camera for 35x35mm on special rollfilm. Meniscus fixed-focus lens; rotary sector shutter; brilliant finder. Black, green, or red covering. Made in Spain. \$35-50.

LIZARS (J. Lizars, Glasgow) Challenge - c1905. 31/₄x41/₄" or 41/₄x61/₂" plates. Leather covered mahogany construction. f6 or f8 Aldis or Beck lens, or f6.8 Goerz. \$300-450.

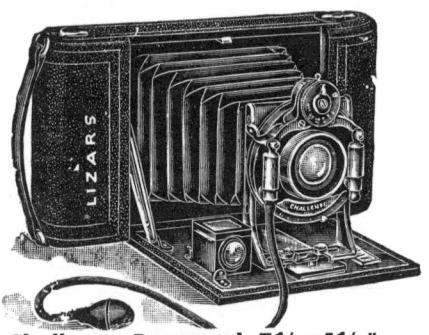

Challenge Dayspool, 31/₄x41/₄" - c1905. For rollfilm. Leather covered mahogany construction. f6 or f8 Aldis or Beck lens, or f6.8 Goerz. \$200-300.

Challenge Dayspool Tropical - Similar to the above model, but with polished Spanish mahogany body, rather than leather covered. Red leather bellows. \$600-900.

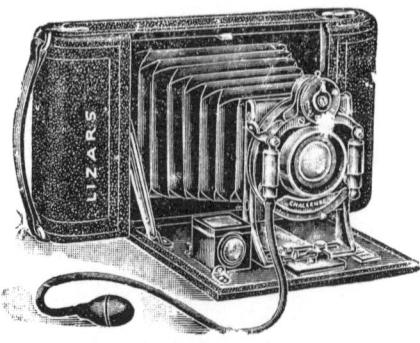

Challenge Dayspool No. 1, 41/4x61/2" - c1900. For rollfilm. Leather covered. Red bellows. Beck Symmetrical lens. \$200-300.

Challenge Dayspool Stereoscopic Tropical - c1905. Mahogany camera for 21/4x63/4" plates or rollfilm. \$1000-1500.

Challenge Junior Dayspool - c1903-11. Horizontally styled folding-bed rollfilm camera. Identical to the No. 1 Dayspool but with B&L single valve shutter, 25-100. Three sizes: A: 2¹/₄x2¹/₄". B: 2¹/₄x3¹/₄". C: 2¹/₂x4¹/₄". "A" size, rare: \$300-450. "B" or "C": \$250-375.

Challenge Magazine Camera - c1903-07. Box camera for 12 plates or 24 films, 31/₄x41/₄". Beck Symmetrical lens. Unicum shutter. \$60-90.

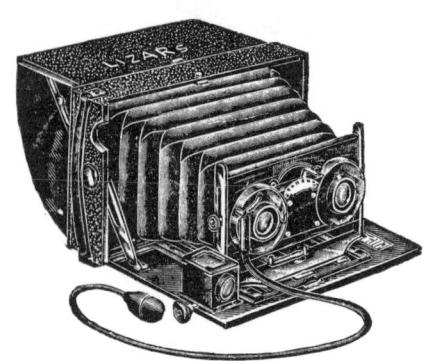

Challenge Stereo Camera, Model B - c1905. 31/₄x63/₄" plates. Leather covered wood body. B&L RR or Aldis Anastigmat lenses in B&L Stereo shutter. Wooden "Tropical" model, teak with brass trim: \$1000-1500. Leather covered model: \$600-900.

Challenge Stereoscopic Camera, Model 1B - c1905. Folding bed stereo camera with Goerz-Anschutz FP shutter, or with T-P shutter built into the front standard. Beck, TT&H, Dallmeyer, or Goerz lenses. \$600-900.

Rambler - c1898. Field camera for 8x10.5cm plates. Mahogany body, brass trim, brass barrel lens. Tapered black bellows. Thornton-Pickard shutter. \$300-450.

LLOYD (Andrew J. Lloyd & Co., Boston) Box camera - 4x5" glass plates. \$60-90.

LLOYD (Fred V.A. Lloyd, Liverpool, England)

Field camera - c1910. 1/2-plate folding camera. \$200-300.

LLOYD'S - Japanese subminiature of the "Hit" type. \$25-35.

LOEBER (Eugene Loeber, Dresden) Field Camera, 13x18cm - c1895-1900. Tailboard style field camera with fine wood and brass trim. Tapered green bellows with wine red corners. Rodenstock Bistigmat 13x18 brass lens with revolving stops and built-in manually operated shutter blade. \$200-300.

Klapp camera - c1915. Strut-folding 9x12cm plate camera. Anastigmat f6.8/135mmlens. \$120-180.

LONDON STEREOSCOPIC

Magazine Camera - c1905. Leather covered box camera for 12 9x12cm plates. f8 lens, 3-speed shutter. Rapid wind lever. Two large brilliant finders. \$120-180.

LOEBER BROTHERS (New York) The Loeber Brothers manufactured and imported cameras c1880's-1890's.

Folding bed plate camera - British 1/1-plate camera. Fine polished wood, black bellows, brass trim. Brass-barreled lens with waterhousestops. \$250-375.

LOGIX ENTERPRISES (Montreal, Canada & Plattsburgh, NY)
Kosmos Optics Kit - 35mm SLR with interchangeable lenses in an optical experiment kit. \$20-30.

Logikit - Kit of plastic parts to build your own 35mm SLR. \$20-30.

LOLLIER (X. Lollier, Paris)
Stereo-Marine-Lollier - c1903. An unusual instrument which combines the features of a stereo camera and binoculars. Unidentified lenses. Two-speed guillotine shutter. Its general appearance and operation are somewhat similar to the more common Goerz Photo-Stereo-Binocle, but it uses standard 45x107mm stereo plates. Very rare. \$5500-7500.

LOMAN & CO. (Amsterdam)

Loman's Reflex - 1890-c1910. Box-

style SLR. Polished wood, brass fittings. Loman Aplanat f8/140mm lens. FP shutter 3-200. (The first focal plane shuttered camera to achieve commercial success.) Sizes $1/_4$ - to $1/_2$ - plate. \$1500-2000.

Loman Reflex - c1906. Leather covered SLR with tall folding viewing hood. Rack focusing front with bellows. Focal plane shutter 1/8-1300. Eurynar Anastigmat f4/135mm. \$175-250.

LOMO (Leningrad, USSR) This factory was formerly called "Leningrad", and earlier "GOMZ". The letters "LOMO" are an acronym for Leningrad Optical-Mechanical Union. The trademark is the word "LOMO" which appears as an inverted "V" above the letters "OMO".

Almaz-103 - c1982-87. Copy of Nikon F2, but with Pentax K bayonet mount. Interchangeable finder. Metal focal plane shutter 1-1/₁₀₀₀. Volna (Bovha) f1.8/50mm normal lens. \$300-450.

Lomo 135 BC (VS)

Lomo 135 M - late 1970's - current. Spring-wound 35mm. f2.8 lens, shutter to 250. Common except in USA where Russian cameras have not enjoyed good marketing. \$45-60.

LONDON & PARIS OPTIC AND CLOCK

CO. Manufacturers to the trade only, this company advertised a line of "Royalty" cameras which included the Baron, Baroness, Duke, Duchess, Empress, King, Queen, & Princess. They also sold "Royalty" lenses & stands. Cameras labeled by other dealers with these royal names could well be manufactured by the London & Paris Co.

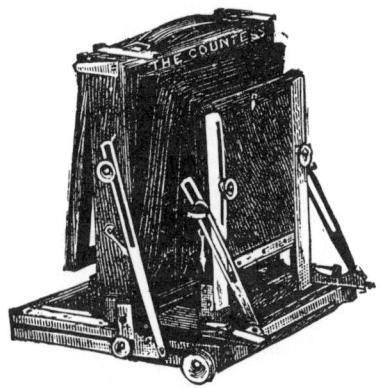

Countess - c1890's. Mahogany field camera. Brass fittings. With appropriate period lens: \$300-450.

Duchess - c1887. Mahogany 1/2-plate field camera, brass trim, maroon bellows. RR brass barrel lens. \$400-600.

Princess May - c1895. Half-plate mahogany and brass field camera. Ross Anastigmat f8/71/2" lens. \$350-500.

LONDON STEREOSCOPIC & PHOTO CO. (THE STEREOSCOPIC CO.) This company imported and sold under their own name many cameras manufactured by leading companies at home and abroad.

Artist Hand Camera - c1889. Twin lens reflex style box camera. Mahogany body, brass lens. Identical to the Français Kinegraphe.9x12cm plates. \$1500-2000.

Artist Reflex - c1898. Leather covered wooden body; flat wooden door hinged on left side. Rack & pinion focusing with sliding panel. Tall bellows-type viewing hood supported by single strut on each side. Basically like the the Carlton but no magazine. Uncommon. Estimate: \$750-1000.

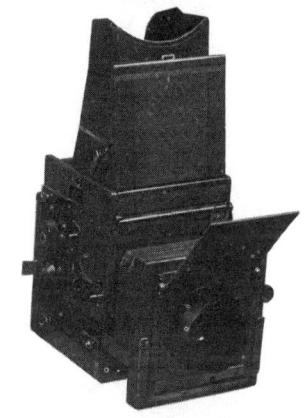

Artist Reflex, Tropical - c1910. SLR for 1/4-plates. Same as Marion Soho Tropical. Mahogany or teak body, usually green or occasionally red leather hood and bellows. Brass trim. Heliar f4.5/150 lens. FP shutter to 1000. \$2400-3200.

Binocular camera - c1898. Jumelle

LONDON STEREOSCOPIC..

style rigid-bodied magazine stereo. No. 1 for 12 11/2x21/2" plates; No. 2 for 18 21/2x31/2". Krauss-Zeiss Anastigmat f6.3 or f8/110mm. Guillotine shutter. \$200-300.

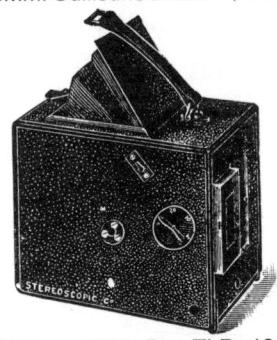

Carlton - c1895. Box TLR, 12 plates or films. 1/4-plate, 4x5", 1/2-plate. Euryscope f5.6, RR or Ross Goerz Double Anastigmat f7.7. Shutter 1-100, T.I. \$500-750.

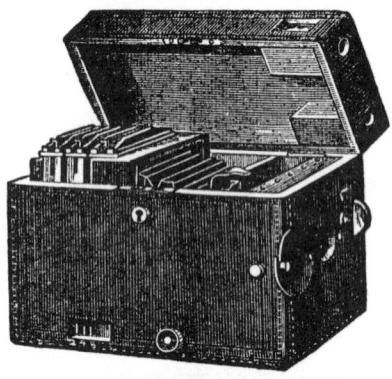

Dispatch Detective - c1888. Woodenbox style detective camera covered in dark green leather. Camera is in the front half of the box, the 9x12cm plates store in the back half. Side-hingedlid. \$800-1200.

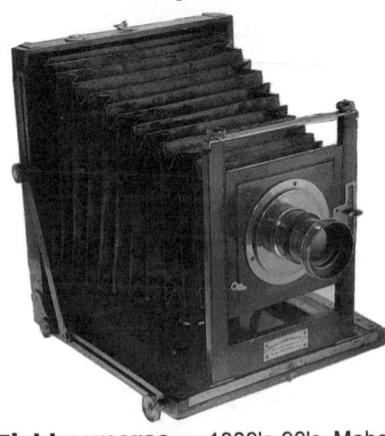

Field cameras - c1880's-90's. Mahogany body, brass trim, dark maroon double extension bellows. London Stereoscopic "Black Band" Registered lenses include Rapid Rectilinear f8 or Portrait lenses. Full and half plate sizes. \$300-450.

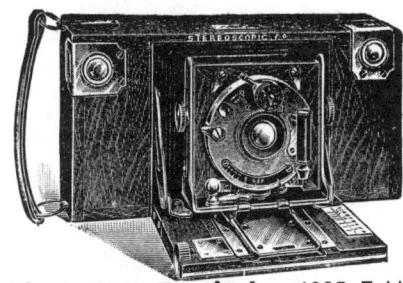

King's Own Tropical - c1905. Folding

bed camera for 21/2x41/4" plates or rollfilm. Teak with brass fittings. Goerz Dagor f6.8/120mm lens in Koilos pneumatic shutter, 1-300. \$1700-2400.
- 41/4x61/2" - Goerz Doppel Anastigmat

f9/180mm in B&L shutter. \$1700-2400.

Parvex - c1911. Thin, strut-folding camera for 21/4x31/4" on rollfilm. TTH Cooke lens, dialset shutter. \$175-250.

Tailboard stereo camera, 31/2x 61/4" - c1885. Swift & Son 4" lenses. Side board panel. Thornton rollerblind shutter. Dark maroon bellows. \$750-1000.

Tailboard stereo camera, 5x7" -Mahogany and brass body with brass Clement & Gilmer lenses and Thornton-Pickard roller-blind shutter. \$800-1200.

Twin Lens Artist Hand Camera c1889. Large TLR. Front door covers the Leather lenses. recessed 9x12cm, 4x5", 1/2-plate sizes. Magazine holds 24 sheets or 12 plates. \$400-600.

Vesca - Name variation of V.P. Tenax folding camera, 4.5x6cm, made by Goerz. Goerz Dagor f6.8/75mm lens. Green leather covering, green leather bellows: \$350-500. Black: \$300-450.

Vesca Stereo - Name variation of Tenax stereo folding camera, 45x107mm, made by Goerz. Green leather covering, green leather bellows. Goerz Celor f4.5/60mm lenses. \$500-750. Black: \$300-450.

Wet plate camera - c1855. 4x5" sliding box style. Light colored wood body (7x71/2x61/4" overall) which extends to 10' London Stereoscopic Petzval-type lens in brass barrel, \$2400-3200.

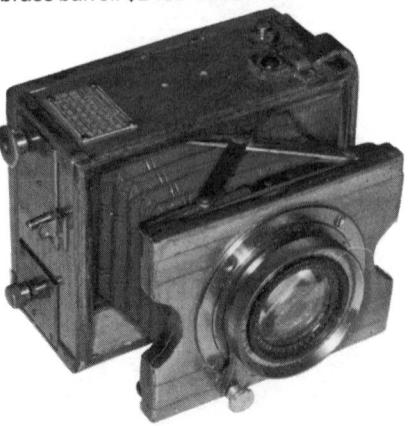

LORENZ (Ernst Lorenz, Berlin) Clarissa - c1929. Tropical 4.5x6cm plate camera. Light colored wood body, red or

brown bellows. Brass struts and lens barrel. Either wooden or brass front standard. Focal plane 1/20-1000. Meyer Görlitz Trioplan f3/75mm or Helioplan f4.5. Few sales: widely ranging prices: \$1500-3000.

LORILLON (E. Lorillon, Paris) Field camera - c1905. 13x18cm, tail-board style. Wood with brass trim, square red bellows. Taylor, Taylor & Hobson lens in roller-blind shutter. \$200-300.

LUCINE - Metal-bodied box camera for plates, 4.5x6cm. \$150-225.

LUCKY - Japanese novelty subminiature of the Hit type. \$25-35.

LUDIX - c1949. Rollfilm camera, 4.5x6cm. Emylar f4.5/70; Pronto 1/25-125. \$75-100.

LUMIERE & CIE. (Lyon, France)

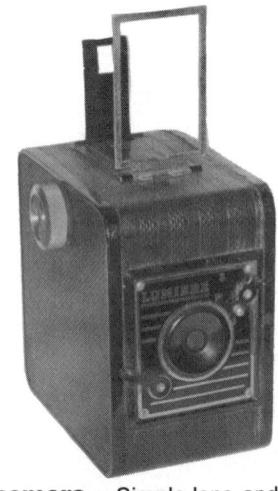

Box camera - Simple lens and shutter, 127 rollfilm. \$12-20.

Box camera, No. 49 - for 122 film.

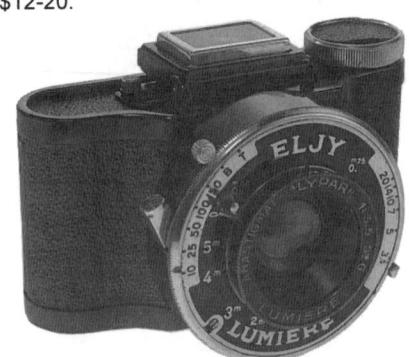

Eljy, Super Eljy - c1937-48. 24x36mm exposures on special 30mm wide paperbacked rollfilm. Lypar f3.5/50mm lens in Eljy shutter. Fairly common. \$75-100.

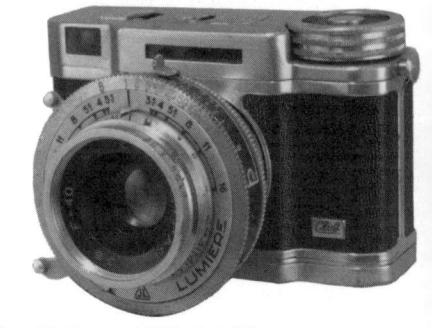

Eljy Club - c1951. 24x36mm exposures on special 35mm film. Lypar f3.5/40mm.

LÜTTKE

Synchro shutter 1-300. Chrome top housing incorporates optical finder and extinction meter. (Last model is without extinction meter.) \$150-225.

Lumibox - c1934-38. Metal box camera for 6x9cm on 120. Focusing lens. \$12-20.

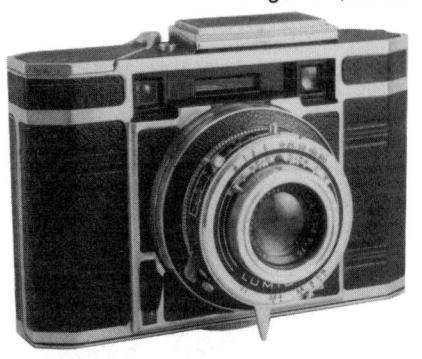

Lumiclub - c1951. Heavy, well-made cast aluminum camera for 120 or 620 film. Originally designed and advertised by Pontiac as the "Versailles" but never produced. Lumière bought the molds from the failing Pontiac company and modified them to make the Lumiclub. Takes 6x6cm or 4.5x6cm with internal mask. Eye-level and waist-level finders, extinction meter, telescoping front, lever advance neatly fitted into body top, DEP, body release. Rare, even in France. \$250-375.

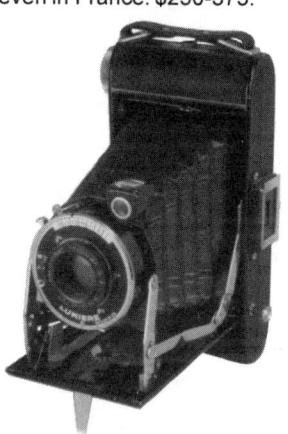

Lumirex - c1946. Self-erecting camera for 6x9 on 620 film. Fidor f6.3 or Spector f4.5/105mm lens. Reflex and frame finders, body release. \$20-30.

Lumix F - c1946. Folding 6x9cm rollfilm camera. Same body as Ludax and Lumirex, but with a simple shutter and meniscus lens. \$20-30.

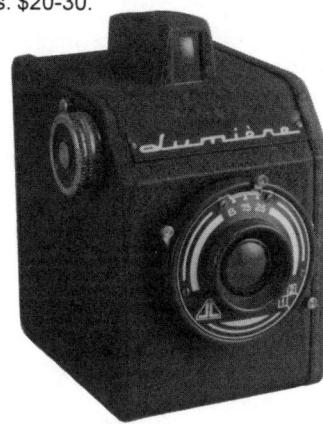

Lux-Box - Metal box camera with brown crinkled paint. For Lumière #49 film (same

as Kodak 620). Eye-level optical finder. Synchronized shutter, 25,75,B. \$20-30.

Optax - c1948. Bakelite 35mm. First model has folding finder like Eljy and collapsible tube front. Second model (1949) has rigid optical finder and noncollapsing front. \$100-150.

Periphote - c1901. Cylindrical metal panoramic camera. The lens and a prism are mounted on the side of the cylinder. The image is projected onto an inner drum. Roll film is fixed around the inner drum with emulsion facing out. Rare. \$15,000-23,000.

Scout-Box - c1935. Painted metal box camera. 6x9cm on 120 rollfilm. \$12-20.

Sinox - 6x9cm folding rollfilm. Nacor Anastigmat f6.3/105mm lens. Central shutter 25-100. \$25-35.

Starter - c1955. Simple black plastic 35mm with grey plastic top housing. Lypar f3.5/45mm.\$35-50.

Sterelux - c1920-37. Folding stereo camera for 116 rollfilm, 6x13cm. Spector Anastigmat f4.5/80mm lens. Shutter 1/25-1/100, later models have 1-100. \$250-375.

LUMIKA 35 - Japanese 35mm viewfinder camera. Tri-Lausar Anastigmat f3.5/45mm lens in Rektor 1-300 shutter, ST. \$50-75.

LUNDELIUS MFG. CO. (Port Jervis, N.Y.)

Magazine camera - c1895. For 12 vertical plates. Leather covered wood body measures 10x8x41/2, \$150-225.

LURE CAMERA LTD. (Los Angeles, CA)

Lure - c1973. Plastic 110 cartridge camera. Camera was sent in for processing of film; pictures and new camera were mailed back. Same camera also appears as "Lure X2" in Hawaii, "Blick" in Italy, "Rank" in England and Europe, and "Love" which is made in Brazil. New: \$1-10.

LÜTTKE (Dr. Lüttke & Arndt, Wandsbek, Hamburg, & Berlin, Germany)

Field camera - c1900. Tailboard 9x12cm camera. Fine wood, brass trim. Single extension green square bellows, black corners. Periscop f16 lens, Junior shutter. \$175-250.

Filmos - c1902. Folding plate camera, 8x10.5cm. Leather covered wood body, nickel trim, red bellows. Periscop f10 lens in pneumaticshutter. \$175-250.

Folding plate camera - 9x12cm, horizontal format. Black leathered wood body. Red-brown bellows. Lüttke Periscop lens with rotary stops. Brass shutter. \$75-100.

Folding plate camera, 13x18cm - c1900. Wine-red bellows. Iris diaphragm. \$175-250.

Folding plate/rollfilm camera - c1900-02. Unusual folding camera for either rollfilm or 9x12cm plates. Wooden body with nickel trim. Rare. \$250-375.

Folding rollfilm camera - 8x10.5cm. Black leathered body with red cloth bellows. Nickel trim. Lüttke Periplanat lens. \$60-90.

Linos - c1898. 9x12cm folding plate camera. Walnut body, brass trim. Aplanat f8/165mm lens. Pneumatic shutter. \$400-600

Transvaal - 9x9cm horizontal folding rollfilm camera also accepts plates. Leather covered wood body, with wooden lensboard, nickel trim. f8 lens, M/Z shutter. \$300-450.

Vidol - Folding rollfilm camera, similar in size to the No. 3A Folding Pocket Kodak. Light-tight pocket on back for Vidol film, a special film that had a ground-glass-style area between the image areas to allow for focusing. \$200-300.

MACKENSTEIN

MACKENSTEIN (H. Mackenstein.

Field Camera - c1900. 13x18cm tailboard style folding view camera. Polished wood with brass trim and brass handle. Tapered wine-red bellows. Carl Zeiss Anastigmat lens in Mattioli roller-blind shutter. \$250-375.

Folding camera - c1890. Hinged mahogany panels with round cutout support front standard, like the Shew Eclipse, Maroon bellows, Brass Aplanat f9/150mmlens. \$300-450.

Francia, 9x12cm - c1910. Strut-folding plate camera. Wine red single pleat bellows. Leather covered wood body. Focal plane shutter 15-2000. With Dagor f6.8/ 120mm and magazine back: \$250-375.

Francia Stereo (folding) - c1906. Strut-folding stereo cameras 45x107mm or 6x13cm plates. Max Balbreck or Sumo Aplanat lenses, guillotine shutter with variable speeds. Red leather bellows. \$250-375.

Francia Stereo (rigid) - c1900-10 Jumelle-style stereo cameras in 6x13cm and 9x18cm sizes. Goerz Doppel Anastigmat or Dagor f6.8 lenses. Guillotine shutter. Large Newton finder. With magazine back: \$300-450.

Jumelle Photographique - c1895. Rigid jumelle-style camera for single (nonstereo) exposures. Leather covered wood body. 6.5x9cm and 9x12cm sizes. Goerz Doppel Anastigmat f8. Six-speed guillotine shutter. With magazine back: \$200-300.

Photo Livre - c1890. The French edition of the popular Krügener Taschenbuch-Camera. A leather-covered camera disguised as a book. Achromatic f12/65mm lens is in the "spine" of the book. Guillotine shutter. Internal magazine holds 24 plates for 4x4cm exposures. \$3500-5500.

Pinhole camera - c1900. Polished walnut 1/4-plate tailboard camera. Maroon bellows. 6 "pinhole" openings on lens-board, take 6 exposures per plate. One offered Nov. 1982 at \$750. No further data.

Stereo Jumelle - c1893. For 18 plates 9x18cm in magazine. Goerz Double Anastigmat 110mm lens, variable speed guillotine shutter. \$200-300.

MACRIS-BOUCHER (Paris) Nil Melior Stereo - c1920. A wide-

angle stereo camera, based on the theory that short focus wide angle lenses gave more natural stereo vision and allowed 6x13cm exposures in a camera just slightly larger than most 45x107mm stereos. Boyer Sapphir or E. Krauss Tessar f4.5/65mm lens in seven-speed spring shutter. Large newton finder. 12-plate magazine for 6x13cm plates. \$175-250.

MACVAN MFG. CO. Macvan Reflex 5-7 Studio camera c1948. Large studio-style TLR. Revolving, shifting back. Parallax correction. 5x7" plates or cut film. Ilex Paragon f4.5/81/2" lens in Ilex #4 Universal shutter. Reflex or ground glass viewing. \$300-450.

MACY ASSOCIATES

Flash 120 - Metal box camera, 6x9cm. Black crinkle enamel finish. Art-deco faceplate. \$12-20

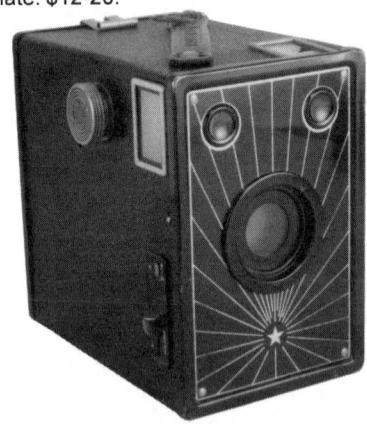

Macy M-16 - c1930s. Basic black box camera, probably made by Ansco for Macy's. Interesting faceplate with star and radiating lines. \$12-20.

Supre-Macy - c1952. Japanese 6x6cm TLR made by Hachiyo Optical Co. for Macy's. Similar to Alpenflex I. Alpo f3.5/ 75mm in Orient II 1-200 shutter. \$75-100.

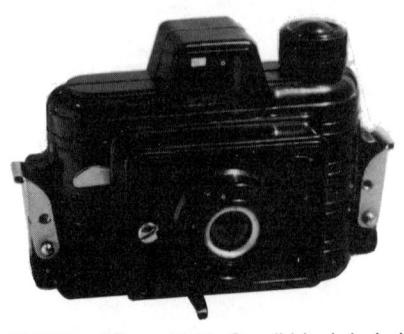

MADEL 35 - c1950. Small black bakelite

camera for 26x30mm on 35mm film in special 12 exposure cassettes. Meniscus fixed focus f7.7/35mm lens; rotary sector shutter. Made in Spain. \$50-75.

MADER (H. Mader,

Isny, Württemberg)
Invincibel - c1889. All-metal folding camera for 5x7" plates. The bed folds down; sides fold out. Aplanat f6/180mm lens. Iris diaphragm. \$1200-1800.

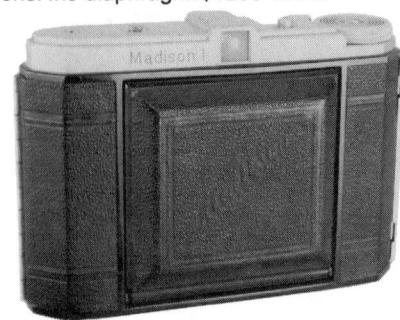

MADISON I - Folding camera for 6x6cm exposures on 620 film. f4.5 lens. Shutter to 200. \$35-50.

MAGIC INTRODUCTION CO. (N.Y.)

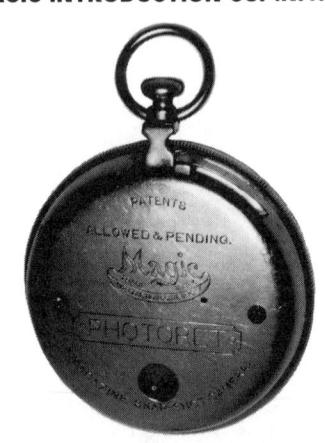

Photoret Watch Camera - c1894. For 6 exposures 1/2x1/2" (12x12mm) on round sheet film. Meniscus lens. Rotating shutter. Auction record 12/91: \$1900 with box and film tin. Normal range, complete: \$800-1200. Deduct \$75-100 each if missing box or film tin.

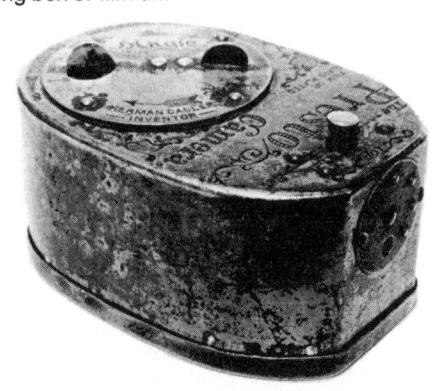

Presto - c1896. All-metal, oval-shaped camera, invented by Herman Casler. 28x28mm exposures on rollfilm or glass plates. Meniscus lens with rotating front stops. Single speed shutter. Auction high, 12/90: \$800. Normally \$600-900. (Original box and plates will add \$175-250.)

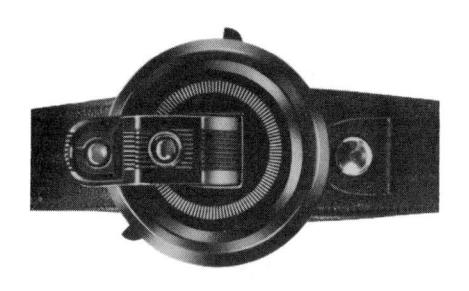

MAGNACAM CORP. (New Jersey)
Wristamatic Model 30 - c1981.
Short-lived plastic wrist camera. 6 circular exposures on 9mm dia. film. Fixed focus. Like new in box: \$45-60.

MAL-IT CAMERA MFG. CO. INC. (Dallas, TX)
Mal-It Camera - Factory-loaded disposable cardboard camera, pre-addressed to the processing lab. The original price of the camera included processing and printing of 8 Jumbo pictures. \$45-60.

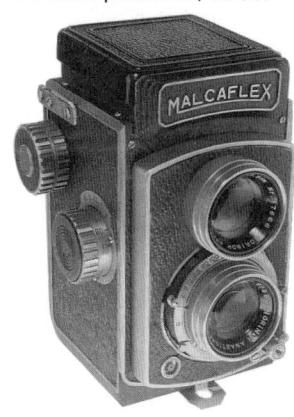

MALCAFLEX - Japanese TLR with rack focusing; knob advance with ruby window. Horinor Anastigmat f3.5/75 in NKS-SC shutter. Pivoting guard for shutter release button doubles as socket for cable release. \$75-100.

MAMIYA CAMERA CO. (Tokyo) Auto-Lux 35 - c1964-67. Seleniummetered auto exposure SLR with fixed Mamiya/Sekor f2.8/48mm lens, Copal-X 1-500 shutter. \$100-150.

Camex Six - c1950. Horizontally styled folding bed rangefinder camera for 6x6cm on 120. Similar to the Mamiya 6, with movable film plane for focusing. Reportedly an export model of Mamiya 6 IV for India. Takatiho Zuiko f3.5/75mm in Seikosha-Rapid1-500. Unusual. \$250-375.

Family - c1962. 35mm SLR. Behind-thelens Copal shutter B,15-250. Sekor f2.8/48mm interchangeable lens. Uncoupled exposure meter with cell on front of prism. \$75-100.

Junior - c1962. 35mm SLR with matchneedle metering. Selenium cell on front of fixed prism. Sekor f2.8/48mm in fixed mount. Leaf shutter 1/₁₅-250. \$50-75.

Korvette - c1963. Name variant of the Mamiya Family, marketed in England by B.Bennett & Sons Ltd. \$75-100.

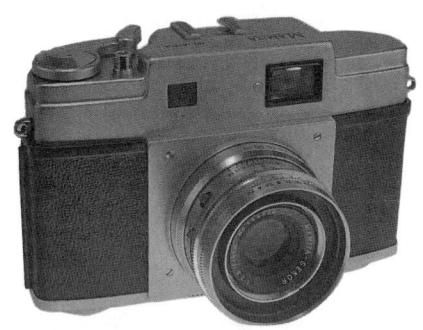

Magazine 35 - c1957. 35mm rangefinder camera. Non-interchangeable Mamyia/Sekor f2.8/50mm lens. Seikosha-MXL, 1-500,B. Interchangeable film magazines. \$120-180.

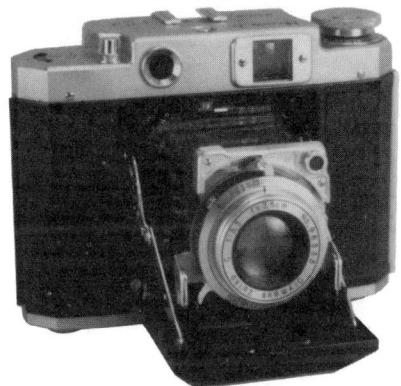

Mamiya 6 - c1940-1950's. Basically a horizontal folding-bed camera for 12 square exposures, 6x6cm, on 120. Some featured the option of 16 vertical exposures, 4.5x6cm, as well. About a dozen models were made. Coupled rangefinder. Unusual feature: Knurled focusing wheel just above the back door of the camera moves the film plane to focus while the lens remains stationary. Prewar models with K.O.L. Special f3.5/75mm lens and NKS 1-200 shutter bring a premium price of \$250-375. Later models with Zuiko f3.5/75mm lens in Copal or Seikosha shutter: \$90-130.

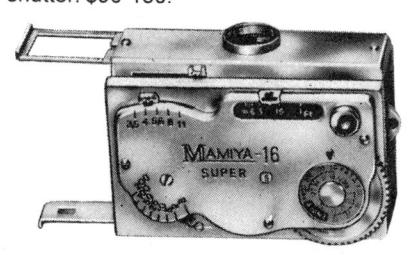

Mamiya-16 - c1950's. Subminiature for 20 exposures 10x14mm on 16mm film. Various models including: Original model, Deluxe (with plain, smooth body), Super (like original but with sliding filter), Au-

tomatic (built-in meter). No significant price difference among these models. All are relatively common. \$45-60. *Up to 25% higher in Europe.*

Mamiya-16 Police Model - c1949. This was the first Mamiya 16 camera, made in black finish. Has no serial number. Fixed focus lens. Shutter B,25,50,100 only. No built-in filter. Detachable waist-level brilliant finder. \$500-750.

Mamiya 23 Cameras - The original Mamiya 23 Press was designed as fast-acting press camera with 15° swings and tilts, standard Graflok back, and interchangeable lenses. In 1964, the new model line included a scaled-down model without the back movements. At that time, the old 23 Press became the Mamiya 23 Deluxe, and the less expensive new model became the Mamiya 23 Standard.

Mamiya 23 Press or Deluxe - with Sekor 90mm f3.5 normal lens, \$175-250. Body only: \$75-100.

Mamiya 23 Standard - body: \$60-90.

Mamiyaflex Identification Guide

To quickly narrow the choices in identifying a camera with only "Mamiyaflex" on the nameplate, look first at the shutter.

Merit = Mamiyaflex I or II
Seikosha Rapid (dial set) = Automat A
Seikosha Rapid (lever set) = Automat B
Seikosha MX = C or PF
Seikosha S = C2

The earlier Mamiyaflex Junior and the later models of the C series are identified on the nameplate.

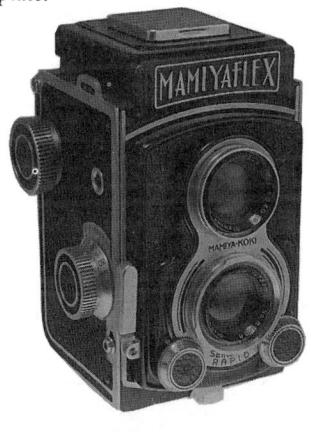

Mamiyaflex Automatic-A - c1949. This was the first Japanese TLR with automatic film stop (not requiring use of red window). Zuiko f3.5/75mm in Seikosha-Rapid dial set shutter (two dials in lower corners of front). The earliest version has no sportsfinder. Second type has a small optical sportsfinder in the top of the viewing hood. Third type has full size sportsfinder. \$150-225.

Mamiyaflex Automatic A-II - c1954. Similar to the Automatic A, but bayonet mount on viewing and taking lenses. Zuiko f3.5/75mm; dial-set Seikosha-Rapid 1-500,B shutter. \$100-150.

Mamiyaflex I - c1951. TLR for 6x6cm on 120 film. Models I & II were the only Mamiyaflexes with Merit shutter. Model I lacks self-timer and sportsfinder. Name-plate does not have an underline connecting M to X in "Mamiyaflex". Front element focusing Setagaya Koki Sekor f3.5/7.5cm

MAMIYA...

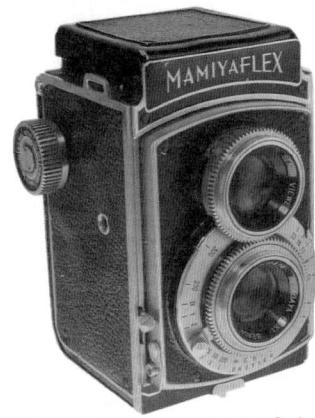

is externally gear-coupled to Sekor Viewer lens. ASA sync post on left hand side. \$100-150.

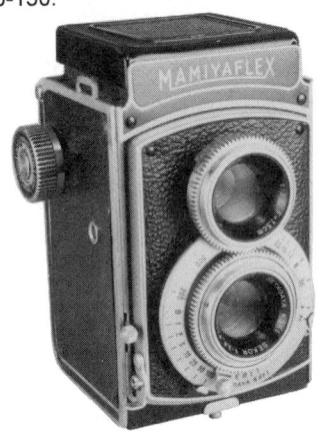

Mamiyaflex II - c1952. Similar to model I, but with sportsfinder and self-timer. Setagaya Koki Sekor f3.5/7.5cm. Merit B,1-300. Front element focus; viewing lens externally gear-coupled. ASA synch post. Film advance cocks shutter. \$100-150.

Mamiyaflex C - c1956. Professional TLR. Sekor f2.8/80mm. \$120-180.

Mamiyaflex C2 - with f2.8/80mm Sekor: \$100-150.

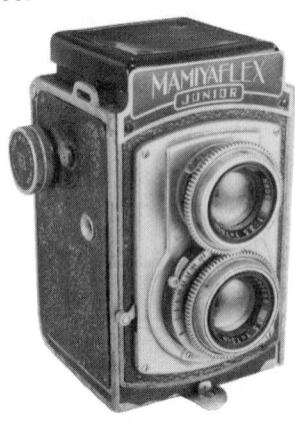

Mamiyaflex Junior - c1948. Mamiya's first TLR, of relatively simple design especially when compared with sophisticated models of the next two decades. At least three variations, all with Towa Koki Neocon f3.5/75mm in Stamina shutter. The first model has the winding knob low on the right side, while the others place it near the top. First two have speeds to 200, third goes to 300. All have front-element focusing with externally gear-coupled taking and viewing lenses. Uses 120 film for 6x6cm

images. First model: \$150-225. Later "high-knob" variations: \$75-100.

Mammy - c1953. Small bakelite camera for 24x28mm exposures on 828 film. Cute Anastigmat f3.5/45mm lens. Shutter 25-100,B. Unusual design. \$90-130.

Myrapid - c1967. Automatic half-frame 35mm with meter cell surrounding lens. Tominon f1.7/32mm in Auto Copal 30-800. \$25-35.

Pistol camera - c1954. Half-frame 35mm camera, shaped like a pistol. Sekor fixed focus f5.6/45mm lens. Single speed shutter. Only 250 believed to have been made for police training. At Christie's 7/93: £11,000 (\$16,500) plus commissions.

Prismat NP - 1961. The first 35mm SLR marketed by Mamiya. Fixed prism, no meter. Horizontal cloth focal plane shutter T,B,1-1000. Mamiya-Sekor F.C. f1.7/58mm standard lens in bayonet mount. External arm on lens for semi-automatic diaphragm stop-down. Also sold by Sears as Tower 32B. \$60-90.

Prismat PH - c1961. Leaf-shutter SLR with selenium cell on front of fixed prism. Seikosha-SLV behind-lens leaf shutter B,1-500. Shutter speed dial on front of body, left hand side. Interchangeable bayonet-mountf1.9/48mm.\$60-90.

Saturn - c1963. Name variant of Mamiya Family camera. Marketed in England by Dixons Photographic Ltd. \$75-100.

Super Deluxe - c1964. 35mm CRF camera with built-in CdS meter. Mamiya-Sekor f1.7/48mm lens, Copal-SVE 1-500,B shutter. \$45-60.

Mamiya/Sekor (CWP) - c1964-67. 35mm SLR. Body has Mamiya/Sekor nameplate; USA advertising referred to it as the "CWP". Through-the-lens metering; CdS meter window on right side of metal front plate. Mamiya-Sekor f1.7/58mm lens. FP shutter 1-1000,B.\$60-90.

Mamiya/Sekor 500 DTL - c1969. 35 SLR with CdS meter. Like the 500 TL but with dual metering system; meter can be set for spot or area metering. Mamiya/Sekor f2/55mm lens. FP shutter 1-500,B. \$50-75.

Mamiya/Sekor 500 TL - c1966. 35 SLR with CdS meter, the first Mamiya with TTL metering. Interchangeable Mamiya/Sekor f2.8/55mm. FP shutter 1-1000,B. \$50-75.

Mamiya/Sekor 528 TL - c1967. SLR with fixed f2.8/48mm lens in Copal leaf shutter. TTL shutter-priority auto metering. \$35-50.

Mamiya/Sekor 528 AL - c1975. Similar to 528 TL, but with exposure warnings in finder. \$35-50.

Mamiya/Sekor 1000 DTL - c1968. 35 SLR with CdS meter, switchable between spot and averaging. Similar to the 500 DTL, but FP shutter 1-1000,B. Mamiya/Sekorf1.8/55mm.\$60-90.

Mamiya/Sekor 1000 TL - c1966. 35 SLR with CdS meter. Similar to the 500 TL, except FP shutter 1-1000,B. Mamiya/Sekorf1.8/55mm.\$60-90.

Mamiya/Sekor Auto XTL - c1971. 35mm SLR. Advanced design but limited production due to poor sales. TTL automatic exposure. Auto Mamiya-Sekor f1.8/ 55mm interchangeablelens. \$100-150.

Mamiya/Sekor Auto X1000 - c1975. Improved version of Auto XTL with exposure warnings in finder. \$60-90.

Mamiya/Sekor DSX 500 - c1974. Fixed prism SLR with TTL spot/average metering. Auto SX f1.8/55mm normal lens in Praktica screw mount. \$60-90.

Mamiya/Sekor DSX 1000 - c1974. Upscale version of DSX 500. Top speed 1/₁₀₀₀; self-timer. With f1.8/55mm:\$60-90.

Mamiya/Sekor MSX 500 - c1975. Spot metering only, otherwise like DSX 500. With normal lens: \$60-90.

Mamiya/Sekor MSX 1000 - c1975. Simplified version of DSX 1000. Spot metering only; no self-timer; no shoe. With Auto Mamiya Sekor SX 55mm f1.8 standard lens: \$50-75.

MANHATTAN OPTICAL CO. (New York) (See also Gundlach-Manhattan)

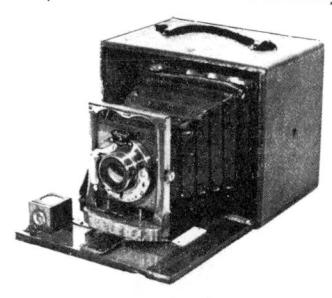

Bo-Peep, Model B, 4x5" - c1898. Folding plate camera. Red bellows, brass shutter. \$90-130.

Bo-Peep, Model B, 5x7" - c1898. Double extension bellows. Brass lens with rotating stops. \$100-150.

Night Hawk Detective - c1895. For 4x5" plates. Polished oak body, or leather covered. String-set shutter, T & I. Ground glass or scale focus. Rapid Achromatic lens. All wood: \$400-600. Leather covered: \$300-450.

Wizard Duplex No. 1, No. 2 - c1902. Folding bed rollfilm camera for 31/₄x41/₄" exposures. Focusing similar to the Screen Focus Kodak: ground glass focusing where back is removed. Dark slide on back prevents exposures of film. \$350-500.

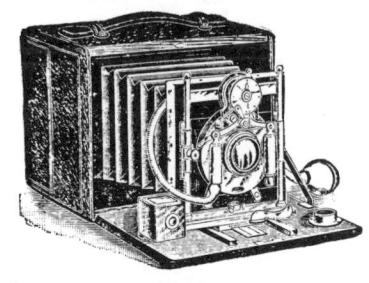

Wizard folding plate cameras: 4x5" size - Including Baby, Cycle, Wide Angle, Senior, Junior, A, and B models. \$100-150.

5x7" size - Including Cycle, B, and Senior models. \$100-150.

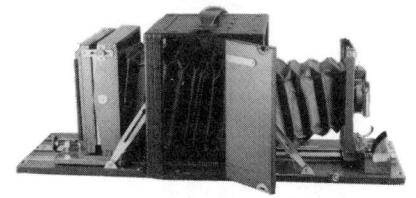

Long-Focus Wizard - 4x5" or 5x7" sizes. Including Cycle and Senior models. Triple extension maroon bellows, RR lens, Unicum shutter. \$150-225.

Wizard Special - c1896. Leather covered folding plate camera. $31/_4$ x $41/_4$ " or 4x5" size. Nickel trim. Double extension red bellows. Wizard Sr. double pneumatic shutter. \$150-225.

MANIGA - Small die-cast metal subminiature, similar to the Aiglon and Bobby. Takes 13x14mm exposures on rollfilm. Oversized round or oval shutter. Uncommon. \$250-375.

MANIGA 3X4cm - c1930. Sardine-can shaped metal camera for 3x4cm on 127 rollfilm. Simple lens and Maniga shutter as on the subminiature model. \$200-300.

MANIGA MANETTA - c1930. Small metal camera for 3x4cm on rollfilm. Body shaped like sardine can with tubular finder on top. Laack Poloyt f4.5/50mm on lens in Manetta (Pronto-style) shutter 25-100,B,T. Uncommon.\$250-375.

MANSFIELD (A division of Argus, Inc.)

Mansfield Automatic 127 - Horizontal black plastic box camera for 4x4cm on 127 film. Styling like Tower Camflash 127, Tower Automatic 127, and USC Tri-matic. Automatic exposure. Single speed shutter. Selenium meter controls diaphragm. Builtin AG-1 flash beside lens. \$8-15.

MANSFIELD HOLIDAY

Skylark - c1962. 35mm camera, coupled meter. Luminor Anastigmat fixed focus lens. Shutter 10-200, X-sync. \$15-25.

Skylark V - Postwar 35mm rangefinder camera. Cinenar f1.9/45mm lens. \$45-60.

MANUFACTURE FRANCAISE D'ARMES ET CYCLES DE ST. ETIENNE (St. Étienne, France) This manufacturer of firearms and cycles, as its name translates to

MARCHAND

English, was also active in distribution of photographic cameras & supplies under the trade name "Luminor". Many of these cameras were made by other manufacturers and had no name on the camera itself.

Luminor - Box camera for 6x9cm on 120 film. Wooden body with blue-green imitation reptile covering. \$50-75.

Nécessaire de Photographie "Luminor" - c1930. Photographicoutfit for the beginner. Simple drop-plate magazine box camera for 6 plates, 6.5x9cm. Packed in a display-type box are the camera, three celluloid developing trays, wooden plate-drying rack, candle safelight, box of plates, packet of paper, developer & fixer, book on basic photography A similar outfit was available with a rollfilm camera. The complete outfit is quite uncommon. A relatively complete outfit of the plate type sold at auction 10/90 for \$200.

MAR-CREST MFG. CORP.
Mar-Crest - Bakelite novelty camera for half-frame 127. \$1-10.

MARCHAND (Charbonnieres,

France) A small manufacturer who attempted to enter the camera business after the war with a simple, lightweight camera, sold by toy distributors.

Fischer Baby - c1948. Same as Flash 6x9, possibly renamed to avoid the confusion caused by a "flash" camera without flash capability. Equally rare. \$50-75.

Flash 6x9 - c1948. Black thermoplastic eye-level camera for 6x9cm on 120 rollfilm. Rounded bulbous shape. Meniscus lens in simple I&P shutter. Not synchronized.

MARION

despite the misleading name. Uncommon. \$50-75.

MARION & CO., LTD. (London)

Marion was established in 1850 as an offshoot of the Parisian firm of A. Marion and Cie. and was set up to exploit the carte-devisite craze. It expanded to deal in photographic materials and as photographic dealers it sold cameras. In 1887 it set up its own plate manufacturing plant at Southgate, North London.

The Soho range of cameras (named after Marion's Soho Square address) was sold by Marion but most were made by Kershaw of Leeds. This arrangement was formalized in 1921 when the two firms joined with five others to form APM. Marion was also a part of the 1930's regrouping that resulted in the formation of Soho Ltd.

Academy - c1885. TLR-style camera. Eye-level viewfinder. Made in 4 sizes: 11/4x11/4" to 31/4x41/4". Magazine holds 12 plates. Petzval-type lens. Rotary shutter, T,I. Nicely finished wood with brass fittings. Rack and pinion positioning of plates for exposure. In 1887, a mirror was added to the finder of the larger models to make it usable as a waist-level camera. This improved version was called the "New Academy". Estimate: \$3200-4600. A nice example of the smallest size, with magazine and viewfinder magnifier all in a fitted plush lined box sold at auction in 11/88 for \$6300.

Cambridge - c1901-04. Compact folding field camera. Mahogany body with brass trim. Made in 1/₄-, 1/₂-, and 1/₁-plate sizes. RR lens and rollerblind shutter. \$300-450.

Field camera - c1887. Mahogany tailboard camera for 1/1-plates. Square bellows. Marion Rapid Rectilinear lens, metal drop shutter. \$350-500.

Krügener's Patent Book Camera -English edition of the better known Krügener's Taschenbuch Camera. Its cover gives the story; embossed in the leather it says: "Manufactured in Germany for Marion & Co. The Sole Agents." One auction sale, late 1986: \$2500. Current estimate: \$3500-5500.

Metal Miniature - c1884. Tiny, allmetal plate camera. Back moved into focus by a rack-and-pinion. Petzval-type f5.6/55mm lens. Guillotine shutter. Later versions were more streamlined and had a sliding lens tube for focusing. Made in 5 sizes from 3x3cm to half-plate. \$3200-4600.

Modern - c1898-1905. Simple folding plate camera. Single extension black bellows. Mahogany body, brass trim. Achromatic or Rapid Rectilinear lens. T+I shutter. \$150-225.

Parcel Detective - 1885. Box detective camera, neatly covered with brown linenlined paper and tied with string to look like an ordinary parcel of the time-period. Fixed focus lens. It used standard 31/4x41/4" plates which could be loaded into the camera in daylight from flexible India-Rubber plateholders. No known sales. Estimated value: \$6500-9500. Illustrated at top of next column.

Marion Parcel Detective

Perfection - c1890. Folding field cameras in full plate, 10x12", or 12x15" sizes. Fine polished wood. Dallmeyer f8 RR lens in brass barrel with iris diaphragm. \$500-750.

Radial Hand camera - c1890. Mahogany magazine camera for 12 1/₄-plates. Plates were held in radial groves to be moved into position for exposure and then moved back again. Guillotine shutter. \$800-1200.

Soho Reflex - Large-format SLR cameras. Focal plane shutter. **4.5x6cm** - Uncommon in this small size. Ross Xpres f4.5/3¹/₂" lens. \$600-900. **21/2x3¹/₂"** - Tessar f4.5/4" lens. \$250-375. **31/4x4¹/₄"** - Ross Xpres f3.5/5¹/₂" lens.

\$250-375. **31/₂x51/₂" -** Ross Xpres f4.5 lens. \$250-375.

43/₄x61/₂" - Dagor f6.8/210mm lens. \$250-375.

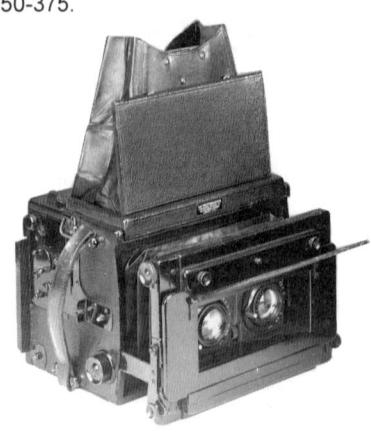

Soho Stereo Reflex - c1909. Similar to the Soho Reflex, but for stereo exposures. Goerz lenses. FP shutter. 31/₄x63/₄" plates. \$800-1200.

Soho Stereo Tropical Reflex - c1909. Similar to the Soho Tropical Reflex, but takes 31/₂x51/₂" stereo exposures. Ross Compound Homocentric f6.8/5" lenses. A rare and beautiful camera. One nice example with tropical magazine back sold at Christie's in 11/88 for £4950 (\$8800). The same camera resold at Christie's in 5/92 for £16,000.

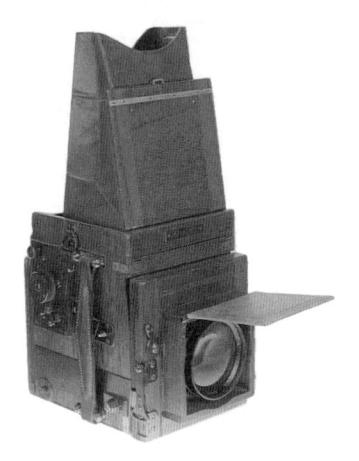

Soho Tropical Reflex - 21/2x31/2" or 31/4x41/4" size. Dallmeyer f3.5 Dalmac or other popular lenses. (Ross sold the same camera with Ross Xpres f3.5 lens.) Revolving back. Fine polished teak wood. Red leather bellows and viewing hood. Brass trim. A beautiful tropical camera. \$2400-3200.

MARK \$-2 - c1958-65.35mm RF, copy of Nikon S-2. Made in Japan. Fixed Tominor f2/50mm, Copal 1-300 shutter. \$120-180.

MARKS (Bernard Marks & Co., Ltd., Canada)
Marksman Six-20 - Metal box camera, 6x9cm. \$1-10.

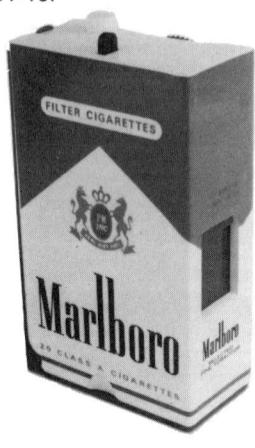

MARLBORO - c1989. Plastic camera for 110 film in the shape and size of a cigarette package. Red & white body and decal imitate Marlboro trade dress. Eager buyers at auctions and trade fairs have paid very high prices for this simple camera. Auction record (Cornwall 10/90): \$575. Normal price from photographica dealers. \$45-60.

MARLOW BROS. (Birmingham, England)

MB, No. 2 and No. 4 - c1900. Mahogany field camera, with brass fittings. Various sizes $3^{1}/_{4}x^{4}/_{4}$ " to 10x12". \$350-500 with appropriate lens.

MARSHAL OPTICAL WORKS (Japan) Marshal Press - c1966. Press camera for 6x9cm on 120/220 rollfilm. Designed by Mr. Seichi Mamiya, the founder of the Mamiya Optical Co. Nikkor-Q f3.5/105mm lens. Converters which screw into the front of the normal lens make it f4.7/135 or f5.6/150. Seiko shutter B, 1-500. While not uncommon in Japan, they are not seen often in Europe or the U.S.A. Therefore, this is one quality camera which will bring as much in the U.S. as it does in Japan. With normal lens only: \$500-800. The auxiliary lenses are less common and will bring an additonal \$100-150 each.

MARTAIN (H. Martain, Paris) View Camera - Bellows and back swivel for vertical or horizontal 13x18cm format. Sliding lensboard. With Darlot lens: \$250-375.

MARUSO TRADING CO. (Japan)
Spy-14 - c1965. Actually, the Spy-14 is not a camera, but rather an outfit which includes a Top II camera with case, film, and developer in an attention-getting display box. Sometimes found like new, in original box, for about \$75-100.

Top Camera - c1965. Bakelite Japanese subminiature camera with metal front and back. The entire camera is finished in grey hammertone enamel so it looks like an allmetal camera. Rectangular shape is similar to the Minolta-16, but construction quality is more like the Hit-types. Takes 14x14mm exposures on standard "Midget" size rollfilm. Meniscus lens, single speed or I&B shutter. One version has a combination eye-level or reflex finder. \$60-90.

Top II Camera - c1965. Nearly identical to the Top Camera, above. Some exam-

ples have black front and back; others are all grey. \$60-90.

MARVEL - Half-127 camera similar to the Detrola. Extinction meter and uncoupled rangefinderin top housing. \$20-30.

MARVEL PRODUCTS INC. (Brooklyn, NY)

MarVette - Bakelite minicam for 127 half-frames. Shorter body length than most cameras of this type, because it does not allow for a spare film roll to be stored inside. \$20-30.

MARYNEN (Brussels) Studio camera - c1910-20. Large wooden studio camera, 18x24cm plates. Brass trim, Brass Eurynar f4.5/360mm lens. Square green bellows. One sold at auction in 9/87, with large wooden studio stand, for \$950.

MASHPRIBORINTORG (Moscow,

USSR) Not a manufacturer, but an exporting organization. For lack of accurate information on the actual factories, we formerly listed a number of Russian cameras together here. We have now grouped them under specific manufacturer names, which can be found in the index.

MASON (Bradford, England) Field camera - Double extension mahogany camera which folds very compactly. Brass trim, brass Busch Bistelar lens. Roller-blind 1/₁₅-1/₉₀ shutter. \$200-300.

MASON (Perry Mason & Co., Boston)

Argus Repeating Camera - c1890. Metal-bodied camera in leather case giving the appearance of a handbag. Vertical style. 12-plate magazine. 3" dia. image on 31/₄x41/₄" plates which drop into plane of focus when lenstube assembly is turned. \$2400-3200.

Companion - c1886. 4x5" polished mahogany tailboard view. Brass Achromatic lens, rotating disc stops. \$150-225.

Maw of London Nustyle

Harvard camera - c1890. For $2^{1}/_{2}x3^{1}/_{2}$ " plates. Meniscus lens. All metal. Black with gold pin-striping. \$120-180.

Phoenix Dollar Camera - c1890. Inexpensive black tin camera for 4.5x6cm plates. \$120-180.

MAST DEVELOPMENT CO. (Davenport, Iowa, USA)

Lucky Strike - c1950. Actually, the camera was called "Concealable Still Camera". Designed for U.S. Army Signal Corps. We use the "Lucky Strike" name to avoid confusion with a similar, undisguised camera called "Mast Concealable Camera". Lucky Strike camera is masterpiece of camouflage, designed in the shape of a package of cigarettes. Even the top of the metal camera was machined to look like a folded foil package. The extended "cigarettes" are the controls, and the lens is hidden behind a blind on one side of the packet. Only two were made, one of which remains in the Signal Corps museum. The other, originally the property of the project engineer, Ed Kaprelian, has sold several

MAW

times. Included with the camera were an original manual and an exposure meter disguised as a box of matches. This rare outfit sold most recently at Christie's 12/91 for approximately \$30,000.

MAW OF LONDON

Nustyle - Simple folding camera for 6x9cm on 120 film. T&I shutter. \$15-25. *Illustrated at top of previous page.*

Nustyle DeLuxe Fashion Model - Metal box camera, not quite as deluxe as the name might imply. \$12-20.

MAWSON (John Mawson, Newcastle, England) Wet plate camera - c1860. Slidingbox style. Petzyal type lens. \$1500-2000.

Wet plate stereo camera - c1865. Bellows style for 31/₄x61/₂" stereo exposures on wet plates. Ross Achromatic lenses. \$1500-2000.

MAXIM MF-IX - c1986. Novelty 35mm from Taiwan, styled with a small pseudoprism. \$1-10.

MAY FAIR - c1930. Metal box camera. T & I shutter. \$15-25.

MAY, ROBERTS & CO. (London, England)

Sandringham - c1900. 8x10.5cm field camera. Wood body, brass fittings, black bellows. Wray 5" lens. \$250-375.

MAYFIELD COBB & CO. (London, England)

Companion - Mahogany 1/2-plate field camera. Brass trim, brass Lancaster Portrait lens. Roller-blind shutter. \$250-375.

MAZO (E. Mazo, Paris)
Field & Studio camera - c1900.
9x12cm or 13x18cm on plates. Fine wood
body, GG back, double extension bellows.
Horizontal format. Mazo & Magenta Orthoscope Rapid f8 lens in Thornton-Picard
shutter. Wide price range: \$300-450.

Stereo camera - Polished mahogany tailboard stereo. Brass-barrel Mazo lenses in Thornton-Pickard shutter. Red leather bellows. \$600-900.

MAZUR (Marek Mazur, Gdansk, Poland) An artisan who specializes in making small, disguised, and novelty cameras. Most of his cameras have been sold to collectors by way of the international camera auctions in Germany and England. Some of his cameras have been disguised as: cane, bat, brooch, cigarette lighter, ring, and pipe.

Brooch camera - Recently made collectors item in the form of a flower, brooch, etc. Prices have ranged from \$100-900 at auction.

Ring Cameras - Beginning in the mid-1980's, several Mazur ring cameras of similar design have appeared on the collector market. They are very well crafted, each differing from the others in appearance, though operationally similar. The film strip mounts in an inner ring which surrounds the finger. This fits into the outer ring which forms the body of the camera. Normally a sliding button on one side advances the film, and a small adjacent button fires the shutter when the fingers are squeezed together. The lens is the center jewel. Design & construction are excellent, but they have been marketed in a very deceptive manner. Several variations in approximate order of appearance on the market are:

"Ernemann" Ring Camera - Large rectangular head with a blue stone on each side of the lens. Silvered metal finish. Interior of the ring is engraved with Ernemann name, even though Ernemann did not exist after the 1926 Zeiss-Ikon merger. May have been the first of the series to appear on the market. No price data.

"Warsavie" Ring Camera - c1987. Chromed metal finish. Engraved 'Trioplan 2.8/10' and 'Warsavie'. Sold at auction in July, 1987 for \$1925.

"Russian" "KGB" Ring Camera - c1988. Rectangular head with round center section. Reportedly offered for sale in Russia for \$4,500 and represented as a "KGB" camera by its Russian owner.

Christies "KGB" Ring Camera - c1991. Gold plated version with crownshaped lens bezel. Allegedly in the posession of the vendor since the early 1970s. Sold at Christies 3/91 reportedly to a jewelry collector for about \$25,000.00.

McBEAN (Edinburgh) Stereo Tourist - 9x18cm. Steinheil Antiplanat lens. Thornton-Picard shutter 1-225. \$600-900. McCROSSAN (Glasgow, Scotland) Wet plate camera - Sliding-box style. Petzval-type lens. \$800-1200.

McGHIE and Co. (Glasgow, Scotland)

Detective camera - c1885. Leather covered wooden box which contains a bellows camera and enough room to store 6 double plate holders. Brass bound lens. One failed to reach the reserve of \$925 at a late 1988 auction in Germany. Estimate: \$800-1200.

Field camera - Folding camera for 1/2-plates. Mahogany body with brass trim, brass bound lens. Tapered black bellows. \$300-450.

Studio View - c1890. Polished mahogany, folding bed camera. Square bellows. Brass barrel lens, focused by rack and pinion. Swing/tilt back. GG back. Pneumatic shutter. \$250-375.

McKellen (S.D. McKellen, England) Treble Patent Camera - c1884. Mahogany field camera, named for its three patents: 1. Solid inset tripod head, which never became common but was soon modified by him and others to an open metal turntable. 2. Front folding and support arrangement, still used world wide on some field cameras. 3. Double-pinion focusing arrangement, by which a long or short focus lens can be used without detaching the front or back. By 1887, McKellen listed eight patents for this camera including: 4. Back horizontal swing, with slots on sides at rear. 5. Safety screws to prevent loss. 6. Movable rails to allow use of wider darkslides or rollholders. 7. New method of attaching the reversible back without use of hooks or springs. 8. Threefold tripod legs with cam lever grip. Made in half or full plate sizes. Dallmeyer R.R. lens with waterhouse. \$400-600.

MEACHER (London, England) Stereo camera - c1870. Polished mahogany tailboard stereo, 9x18cm exposures. Brass-barrel Dallmeyer lenses. \$600-900.

Tailboard camera - ca late 1870's onwards. Dovetailed mahogany Brass trim. Typical construction features include rounded brass-bound corners on the rear of the tailboard, removable brass strut on top of camera for added rigidity, and lead-screw focusing with crank at rear. Side wing supports tailboard, a style which was very likely introduced by Meagher. Brass barrel lens with waterhouse or wheel stops. Full range of sizes. \$750-1000.

MEOPTA

Wet plate bellows camera - c1860. Made in front bed and tailboard styles. Half plate, full plate, or 10x12" size. Polished mahogany tapered maroon bellows. Dallmeyer or Ross lens. Waterhouse stops. Normal range: \$750-1000.

Wet plate sliding-box camera - c1860. Polished mahogany Sliding box moves by rack and pinion. Made in sizes 1/4-plate to 51/2x71/2" sizes. Petzval-type brass barrel lens. \$2000-3000.

MECABOX - c1949. Nicely styled stamped aluminum box camera with leatherette covering. Made in Argentina. Built-in closeup lens. Rare. \$60-90.

MECUM - c1910. Stereo box camera for 9x12cm plates. Leather covered. Ground glass or waist-level viewing. Meniscus lenses. T,B,I shutter. Either lens can be capped for single exposures. \$150-225.

MEFAG (Sweden)
Handy Box - Compact metal box camera for 6x6cm on 120 rollfilm. Rare. \$35-50.

MEGO MATIC - Blue and black plastic camera of the "Diana" type. \$1-10.

MEGURO KOGAKU KOGYO CO. LTD. (Japan)

Melcon - c1955. 35mm Leica-copy. Collapsible Hexar f3.5/50mm lens. Focal plane shutter 1-500, T,B. \$1000-1500.

MENDEL (Georges Mendel, Paris) Detective camera - Box camera for 12 plates 31/₄x41/₄". RR lens, rotating shutter, iris diaphragm. \$150-225.

Triomphant - c1900-05. Magazine box camera for 9x12cm plates. Brown leather covered wood body. Ortho-Symmetrical lens. Extra Rapid shutter. \$150-225.

MENDOZA (Marco Mendoza, Paris, France)

View camera - Mahogany tailboard camera, sizes from ¹/₄-plate to 12x18cm. \$175-250.

MENTOR-KAMERA-FABRIK See Goltz & Breutmann.

MEOPTA (Prerov, Czechoslovakia)Formerly called Optikotechna, but renamed in 1945 after the war.

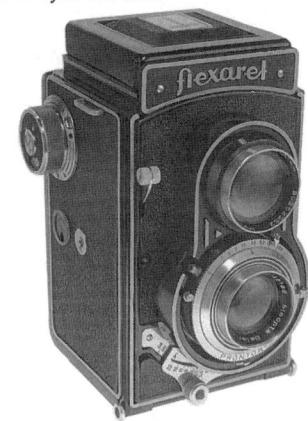

Flexaret IVa

Flexaret - c1948-62. 6x6cm TLR. Models (I), II, III, IV, IVa, V, VI. Mirar or Belar f3.5/80mm lens in Prontor II or Prontor SVS shutter. Crank advance on early models was changed to knob advance in model IV. Model VI with grey leather: \$90-130. Earlier models: \$60-90.

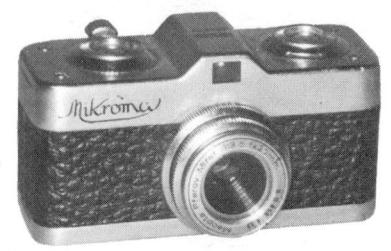

Mikroma - c1949. 16mm subminiature. Mirar f3.5/20mm lens. Three-speed shutter 25-200. Rapid-wind slide. \$100-150.

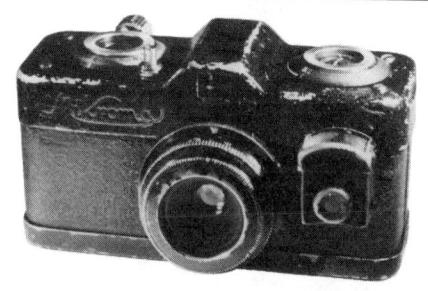

Mikroma, black - c1960. Made for the Czechoslovakian police. Black finish on all metal parts. Besides the normal eye-level finder on top there is a waist-level brilliant finder mounted on the front. \$600-900.

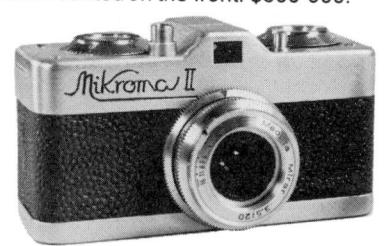

Mikroma II - c1964. Similar to Mikroma, but with 7-speed shutter, 1/5-400. Normally with green leather covering, sometimes black, occasionally beige. Beige: \$120-180. Black or green: \$75-100.

Milona - c1952. Horizontally styled folding-bed camera for 6x6cm on rollfilm. Scissor-struts support front standard which slides out in front door tracks. Mirar f4.5/80mm, Compur Rapid 1-500. \$35-50.

Opema - c1950. Copy of Leica Standard, but for 24x32mm image. Opemar f2 or Belar f2.8 lens. FP shutter $1/_{25}$ -500. \$120-180.

Opema II - c1951. Same as Opema (I) but with coupled rangefinder. \$100-150.

Stereo 35 - c1960's. 12x13mm stereo exposures on 35mm film. Mirar f3.5/25mm fixed focus in Special shutter 1 /₆₀, B. Stereo slides fit into View-Master type reels. Diagonal film path allows 80 stereo pairs to be exposed in two diagonal rows on a single pass of the film. MX sync. Plastic and metal. Camera only: \$120-180. Add \$60-90 for cutter and viewer.

Stereo Mikroma (I) - c1961. For stereo exposures on 16mm film. Mirar f3.5/25mm lenses. Shutter $1/_5$ -100. Sliding bar cocks shutter. Full outfit: \$300-450. Camera only: \$175-250.

Stereo Mikroma II - Similar to the Stereo Mikroma, but advancing film automatically cocks shutter. Grey or black leather. \$175-250.

Stereo Mikroma Accessories - Cutter: \$35-50. Viewer: \$25-35.

MERIDIAN

MERIDIAN INSTRUMENT CORP.

Meridian - c1947. 4x5" press/view. Designed by Vic Yager who also designed and marketed the Vidax camera. Manufactured by Paul Klingenstein and distributed through his company, Kling Photo Supply. Four-way swing back with revolving feature. Rise, slide, tilt, swing front. Model A has drop bed, round lensboard. Model B has drop bed and inner track for wideangle work; square lensboard. Both have long 16" bellows. A wide variety of lenses was originally available, including Kodak Ektar in Supermatic or Flash Supermatic, Wollensak Raptar in Rapax, Rapax X, or Synchromatic Rapax; or Ilex Paragon in Acme. \$200-300.

MERIT - Plastic Hong Kong novelty camera of the "Diana" type. 4x4cm on 120 film. \$1-10.

MERKEL (Ferdinand Merkel; Tharandt, Germany) Originally founded by Merkel in Tharandt; succeeded by Richter in Tharandt. Dissolved in 1948, when Reflekta production moved to Welta. Elite - c1924. Double extension camera for 6.5x9cm plates. Anastigmat 6.8/120mm.1-100 shutter. \$50-75.

Metharette - c1931. Folding rollfilm camera for 3x4cm exposures. Trinar f2.9/50mm. Ring Compur. Rare. \$120-180.

Minerva - c1925. Tropical style folding bed camera. Mahogany body with brass trim. Brown double extension bellows. Rack focus. 9x12cm size has Meyer Trioplan, Methan's Anastigmat, or Steinheil Unofokal f4.5/135mm lens in Compur or Ibsor shutter. 6.5x9cm size has Selar f4.5/105mmlens. \$600-900.

MERTEN (Gebr. Merten, Gummersbach, Germany) Merit Box - c1935. Brown marbelized or

Metascoflex

red and black bakelite box for 4x6.5cm on 127 film. f11/75mm Rodenstock lens. T & I shutter. Also exists in 6x9cm size. Colors: \$150-225.Black: \$60-90.

METASCOFLEX - 6x6cm Rolleicord copy from Japan. Metar f3.5/80mm lens. Uncommon. \$120-180. *Illustrated bottom of previous column*.

METRO MFG. CO. (New Jersey) Metro Flash - Folding rollfilm camera, 6x9cm. \$15-25.

Metro Flash No. 1 Deluxe - Selferecting, 6x9cm rollfilm camera with artdeco covering. \$25-35.

METROPOLITAN INDUSTRIES (Chicago, III.)

Cardinal 120 - Metal box camera with art-deco faceplate. \$12-20.

Clix 120 - All metal box camera, 6x9cm on 120. \$1-10.

Clix 120 Elite - Basic metal box camera with simple art-deco faceplate. \$12-20.

Clix Deluxe - Black plastic minicam for half-127, \$1-10.

Clix Miniature - Black plastic minicam for 828 film. \$1-10.

Clix-Master - Black plastic minicam for 127 film. \$1-10.

Clix-O-Flex - c1947. Reflex style plastic novelty camera. Half-frame 127. \$12-20.

Clix-Supreme - c1946. Unusual "minicam" in several respects. Takes 12 rather than 16 photos per roll of 127 film. Longer focal length requires extended front. Originally supplied with a metal lens shade. Despite its simple appearance, the advertising claimed that it was "Awarded the Certificate of Merit by the New York Museum of Science & Industry for Outstanding Performance." With sunshade and original box: \$12-20.

Metro-Cam - Black plastic minicam for 3x4cm on 127 film. \$1-10.

Metro-Flex - Plastic, TLR-style novelty camera. Half-frame 127. Several variations in body styling. \$12-20.

Rival 120 Elite - Basic metal box camera. Metal faceplate has four rectangles in checkerboard pattern. \$12-20.

METROPOLITAN SUPPLY CO. (Chicago, III.)

King Camera - Small 2x2x31/2" cardboard camera for glass plates. Back fits on like a shoe-box cover, similar to Yale and Zar. Not to be confused with the Japanese King Camera of the WWII era. \$100-150.

MEYER (Ferd. Franz Meyer, Blasewitz-Dresden, Germany) Field Camera (English style) -

c1900. Self-casing field camera of the compact "English" folding type. Solid wood front door becomes bed. Front standard hinges forward, lensboard pivots on horizontal axis. Tapered red or green bellows with accented corner reinforcements. Brass barrel Rapid Rectilinear. \$200-300.

Field Camera (revolving bellows) - c1900-05. Tailboard style folding camera for 13x18cm plates. Fine wood with brass trim, brass handle. Tapered green bellows with black or red corners. Back and bellows rotate as a unit to change orientation. Rise and cross front. Meyer Lysioskop #2 lens. \$175-250.

Field Camera (square bellows) - c1900-05. Tailboard style 13x18cm view camera with square black bellows. Fine wood with brass trim. Meyer Universal Aplanat f7.8 brass barrel lens. \$150-225.

MEYER (Hugo Meyer & Co., Görlitz)

Megor - c1931. 3x4cm strut-folding roll-film camera, a Korelle as marketed by Meyer with its lens equipment. Leather covered aluminum body. Trioplan f3.5/50mm lens. Compur 1-300, T,B shutter. \$100-150.

Silar - c1930. Folding-bed view camera with generous movements. Triple extension bellows. Made in 4.5x6, 6.5x9, 9x12, 10x15, and 13x18cm sizes. These cameras were probably made by Perka, but Meyer fitted them with Plasmat or Aristostigmat lenses in Compur. \$250-375.

MEYER & KASTE

Field camera - c1900. Fine wood vertical tailboard camera. Green rectangular bellows, black corners. Nickel barrel f8 Universal Aplanat Extra Rapid. \$200-300.

MF Stereo Camera - Takes 45x107mm plates. f6.8 Luminor lenses. \$175-250.

MICRO 110 - c1986. Miniature novelty camera which snaps onto a 110 film cartridge. Same camera also sold as "Mini 110" and "Baby 110". Retail \$1-10.

MICRO 110 (Cat & Fish) - c1988. Novelty camera for 110 cartridge. Oversized hinged lens cover shaped like a cat holding a fish. Some have small digital clock in middle of the fish's back. \$12-20.

MICRO 110 (Cheeseburger) - c1988. Lens cover depicts cheeseburger. With or without digital clock. \$12-20.

MICRO 110 (Panda) - c1988. Lens cover is Panda eating bamboo shoots. With or without digital clock. \$12-20.

MICRO PRECISION PRODUCTS (U.K.)

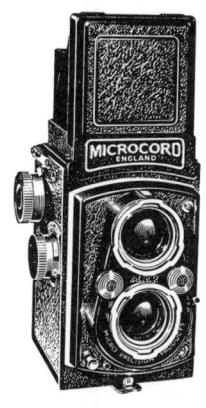

Microcord - c1952-59. Rolleicord copy. Ross Xpres f3.5/75mm, Prontor SVS 1-300. Mk1 has mirror in finder hood for eyelevel viewing. Mk2 has frame finder in hood. However, many Mk1 have the Mk2 hoods. The Mk1 was fitted with an Epsilon shutter; the Mk2 with a Prontor. \$100-150.

Microflex - c1959. Rolleiflex copy, 6x6cm. Micronar f3.5/77mm lens in Prontor SVS 1-300 shutter. \$120-180.

MICRONTAFLEX - Postwar TLR, 6x6cm. Made in Japan. Horinor f3.5/75mm in NKS SC shutter. \$120-180.

MIDDL OPTICAL WORKS LTD. (OTOWA OPTICAL WORKS)

Middl 120-A - c1952. Horizontal selferecting folding camera, "semi" (4.5x6cm) on 120. Seriter Anastigmat f3.5/80, NKS B,1-200 shutter, ASA sync post. Camera and case bear OKS logo for Otowa Kogaku; "Middl Optical Works" embossed in leather strip over latch. \$75-100.

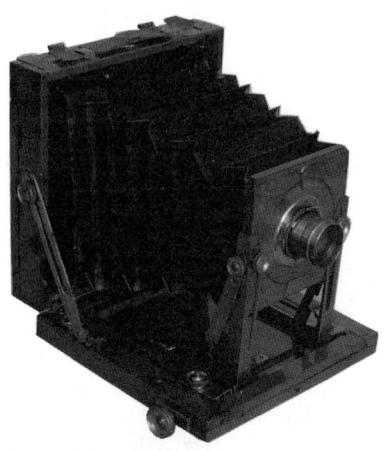

MIDDLEMISS (W. Middlemiss, Bradford, England)
Middlemiss Patent Camera - c1887.

MIMOSA

Very compact folding field camera, various sizes. Mahogany body, brass trim. The back is hinged, not to the baseboard but to a slotted brass plate at which the side strut pivots. This brass plate, whose curved slots permit horizontal swings, is normally attached near the back of the baseboard, but may be repositioned toward the front for use with wide angle lenses. With brass bound lens: \$300-450.

MIDGET - Japanese Hit-type novelty camera. \$25-35.

MIGHTY MIDGET - Japanese Hit-type novelty camera. Red leather covering. \$50-75.

MIGNON - Cast metal miniature camera for 20x25mm on rollfilm. Made in Czechoslovakia. Black enameled body with nickeled fittings. f8.8/31mm lens. One sold at Christie's 11/93 for £1000+.

MIKUT (Oskar Mikut, Dresden)
Mikut Color Camera - c1937. For 3
color-separation negatives 4x4cm on a
single plate 4.5x13cm. Mikutar f3.5/130mm
lens. Compurshutter 1-200. \$3200-4600.

MILBRO - c1938. Simple Japanese folding bed "Yen" camera, 3x5cm sheet film. Meniscus lens, simple shutter. \$50-75.

MILOFLEX - Japanese postwar TLR, 6x6cm. Tri Lausar f3.5/80mm. \$100-150.

MIMOSA AG (Dresden)

Mimosa I - c1948. Compact 35mm.

MIMOSA...

Meyer Trioplan f2.9/50mm lens. Compur Rapid shutter. Unusual boxy style for 35mm camera. \$60-90. There were isolated earlier sales for higher prices, but recent confirmed sales have all been in the \$50-80 range.

Mimosa II - c1950. Meritar or Trioplan f2.9 lens. Usually with Velax shutter 10-200, but also available with Prontor-S. \$60-90. see note above.

MINETTA - "Hit" type Japanese 16mm rollfilm novelty camera. A relatively late and common model. \$20-30.

MINI-CAMERA - Common "Hit" type novelty camera from Hong Kong. Much poorer quality than the earlier Japanese types. \$12-20.

MINOLTA (Osaka, Japan) The Minolta Camera Company was established by Mr. Kazuo Tashima in 1928 under the name of "Nichi-Doku Shashinki Shokai" (Japan-Germany Camera Company). The company's history is more easily followed by breaking it into five distinct periods. The brand names of the cameras made during each period follow in parentheses.

1928-31 Japan-Germany Camera Company (Nifca cameras)

1931-37 Molta Company (Minolta cameras) 1937-62 Chiyoda Kogaku Seiko (Minolta, Konan, and Sonocon cameras)

1962-82 Minolta Camera Co. Ltd. (Minolta cameras)

1982- Minolta Camera Co. Ltd. (Minolta cameras)

The Nifca period - 1928-31. The newly formed company produced cameras which were of the latest designs of their day, using Japanese made bodies and German made lenses and shutters. NIFCA=(NI)ppon (F)oto (CA)meras.

The Molta Period - 1931-37. As the company grew it was reorganized as a joint stock firm under the name of the Molta Company. It was during the early years of this period that the name Minolta was adopted as a trade name on the cameras. MOLTA= (M)echanismus (O)ptik und (L)insen von (TA)shima.

The Chiyoda Period - 1937-62. As expansion and progress continued the company went through another reorganization emerging as Chiyoda Kogaku Seiko, K.K. and becoming the first Japanese camera company to manufacture every part of their own cameras.

The Minolta Period - 1962-82. Began with change of the company name to The Minolta Camera Company, Ltd. Marketing areas were expanded; so were the products that were manufactured. It was during this period that Minolta entered the fields of office copy machines, planeteria,

and manufacturing for other companies.

The Modern Minolta Period - 1982-. Signified by the new Minolta logo. To date, Minolta has produced in excess of 40 million cameras.

Many arguments exist regarding which of Minolta's many "firsts" was most significant to photography. My nomination is Minolta's founder, the late Mr. Kazuo Tashima, who remained at the bead of his company from 1928-82. "The first founder of any camera company to remain its president for 54 years." (His son, Hideo Tashima, became Minolta's president at that time, and Kazuo Tashima stepped into the role of "Chairman of the Board" of the Minolta Camera Co.)

Most of the information and photographs in this section were provided by Debbie Quigley and the late Jack Quigley of Quigley Photographic Services.

The cameras in the Minolta section have been arranged in a somewhat unusual manner. Generally we have followed a chronological order, but with second and third generation models immediately after their predecessor to aid collectors in identification and comparing of features. For the same reason, we have separately grouped 35mm SLR cameras, twin-lens reflex models, and subminiatures. These three groups are toward the end of the Minolta section.

Nifcalette - 1929. Folding camera for 4x6.5cm on 127 film. Hellostar Anastigmat f6.3/75mm. Koilos 25-100,T,B shutter. There were 5 models of Nifcalette A, 4 models of Nifcalette B and 2 models of Nifcalette D. Some have Compur 1-300,T,B shutters with Zeiss Anastigmat lenses. Others had Vario shutters with Wekar lenses. The camera itself was marked Nifca Photo. \$400-600.

Nifca-Klapp - 1930. 6.5x9cm folding plate. f6.3/105mm Zeiss Anastigmat or

Wekar Anastigmat. Vario 25,50,100,TB or Compur 25-200 shutter. \$300-450.

Nifca-Sport - 1930. 6.5x9cm folding plate camera. Wekar Anastigmat f4.5/105, Compur 1-200,T,B. There were three models of this camera. Some had Vario and Koilos shutters with Zeiss Anastigmat lenses. \$300-450.

Nifca-Dox - 1930. 6.5x9cm strut folding camera. First Japanese camera with front cell focusing. Two models were made. One had Nifca Anastigmat f6.8/105mm in Koilos 25-100,T,B. The other had a f6.3/105 lens, details uncertain. \$600-900. *Illustrated at top of next page.*

Arcadia (Molta Co.) - 1931. Folding hand camera for 6.5x9cm plates. Metal body. Helostar f4.5/105mm lens. Lidex rimset shutter 1-200, the first Japanese complex leaf shutter. \$300+

Happy (Molta Co.) - 1931. 6.5x9cm folding plate camera, similar to the Arcadia. Earliest models were equipped with Zeiss and Wekar Anastigmat f4.5 lenses in a Compur shutter 1-200. Later models had Coronar Anastigmat f4.5/105mm, Crown 5-200,T,B, some with self-timer. \$300+.

NIFCA-DX

Nifca-Dox

Semi-Minolta I - 1934. Folding camera, 4.5x6cm on 120. Coronar Anastigmat f4.5/75mm in Crown 5-200, T,B sh. \$150-225.

Semi Minolta II - 1937. Folding camera for 16 exposures, 4.5x6cm on 120 rollfilm. Coronar Anastigmat f3.5/75mm in Crown 5-200,T,B. Quickest way to distinguish from model I is lack of a handle.\$60-90.

Auto Semi Minolta - 1937. Folding

camera for 6x4.5cm exposures on 120 rollfilm. Promar Anastigmat f3.5/75mm lens in Crown II-Tiyoko 1-400,T,B. CRF. Self-stop film counter and advance. The body is almost identical to the Welta Weltur. \$150-225.

Semi-Minolta IIIA

Semi Minolta III - First postwar Minolta camera. Three versions: IIIA in 1946; IIIB in 1947; IIIC in 1948. Self-erecting folding rollfilm camera, 4.5x6cm. Most often with Rokkor f3.5/75mm in Konan-Rapid 1-500,B. Very slight differences between models. A= no sync. B= sync; black shutter face. C= sync; chrome shutter face. \$120-180.

Semi-Minolta P - 1951. The last of the semi series, and the last of the folding cameras from Minolta. Eye-level optical finder with parallax correction marks. Chiyoko Promar SII f3.5/75mm lens in Konan Flicker shutter B, 2-200 with ASA sync post. Fairly common. \$75-100.

Minolta - 1933. (Note: This was the first use of this brand and model name.) 6.5x9cm strut folding camera. Coronar Anastigmat f4.5/105mm, Crown 1-200,TB. Featured a built-in footage scale. \$250-375

MINOLTA

Minolta Best (Also called Vest and Marble; Best is the official name.) - 1934. Collapsing dual format 127 rollfilm camera. Formats 4x6.5cm and 4x3cm obtained by inserting a plate at the film plane. The Minolta name was embossed in the leather. There were three different models. Model I: f8/75mm fixed focus. Model II: f5.6/75mm front element focus. Model III: f4.5/80mm front element focus. All were Coronar Anastigmat lenses in Marble 25-100 shutters. The body and back door were made of a plastic which was not widely known at that time. It was only in the experimental stage in Germany. The telescoping plastic sections were reinforced with bright stainless steel. \$90-130.

Baby Minolta - 1935. Bakelite 127 roll-film camera; 4x6.5cm or 4x3cm formats were changed by a removable plate at the film plane. Coronar Anastigmat f8/80mm fixed focus, fixed f-stop, pull-out lens in bakelite housing. Japanese-made Variotype 25-100, TB shutter. \$100-150.

Minolta Six - 1935. Collapsible folding camera for 6x6cm on 120 follfilm. Horizon-

MINOLTA...

tally styled bakelite body without bed or struts. Front standard pulls out with telescoping stainless steel snap-lock frames around bellows. Coronar Anastigmat f5.6/80mm. Crown 25-150, T,B. \$90-130.

Auto Minolta - 1934. 6.5x9cm strut folding plate camera. Actiplan Anastigmat f4.5/105mm, Crown 1-200, T,B. Top mounted CRF, the first Japanese camera with rangefinder coupled to lens. Footage scale on the face of the camera. \$250-375.

Minolta Autopress - 1937. 6.5x9cm strut folding plate camera, styled after the Plaubel Makina. Promar Anastigmat f3.5/105. Crown Rapid 1-400,T,B, synched at all speeds. CRF on the top aligns with a folding optical finder on the camera face. Coupled automatic parallax correction. Footage scale on the face. This camera is recognized as a Plaubel Makina copy; however, it had added features not found in Plaubel Makina until many years later. Complete outfit includes ground glass focusing panel, three single metal plate holders, flashgun, and FPA. Complete outfit with flashgun: \$350-500. Camera only: \$250-375.

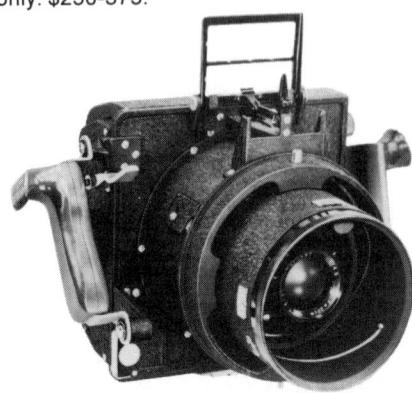

Aerial camera - 1939. Designed for military use. Never commercially sold. 11.5x16cm format. Unmarked Minolta f4.5/200mm lens with f4.5, f5.6 settings. Shutter speeds 200, 300, 400. Current value: \$500-750.

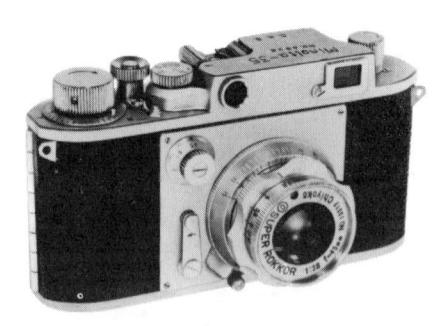

Minolta 35 (first model) - intro. 3/1947. 35mm rangefinder camera, styled like Leica, first for 24x32mm and later 24x36mm on standard 35mm cassettes. Interchangeable (Leica thread) Super Rokkor f2.8/45mm lens. Horizontal cloth focal plane shutter 1-500,T,B, ST. This was Minolta's first 35mm camera. It went through six minor model changes:

(Type A) - 2/48. Serial #0001-4000. Image size of 24x32mm. Originally marked "Chiyoda Kogaku Osaka" on top. First marketed 2/48. Top marking simplified to "C.K.S." within about three months (confirmed before #2822). Slow speeds read correctly from front not top.

correctly from front, not top.

(Type B) - 8/48. Serials to about 4800. Image size 24x33.5mm, "C.K.S." on top,

otherwise like the Type A.

(Type C) - 2/49. Serial range uncertain.

Image size 24x34mm. Slow speed knob
reads correctly from above, not from front.

(Type D) - 8/49. Begins with serial #9001. Exact physical changes not yet determined, but this is probably the first with front grooved for focusing tab, and with repositioned rewind lever.

Model E - 2/51. Begins with Serial #10,001. "Model-E" engraved on front. Has strap lugs.

Model F - 2/52. Begins with serial #20,000."Model-F"on front.

None of these cameras were exported, although some were brought back by soldiers. Early type A: \$500-750. Later types: \$250-375.

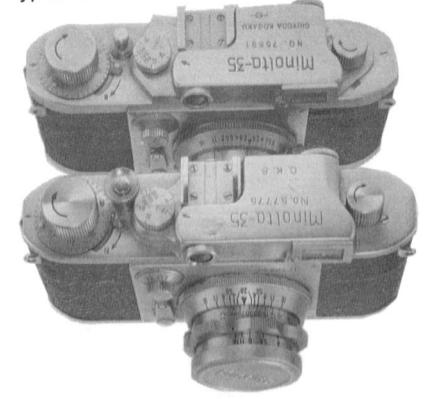

Minolta 35 Model II - 1953. 35mm rangefinder camera for 24x34mm images. Interchangeable Super Rokkor f2.8/45mm or optional f2.0/50mm lens. Horizontal cloth focal plane shutter, 1-500,T,B, ST. Early version has "C.K.S." top housing with rounded corners under speed dial and no shelf under rewind knob. Later version has "Chiyoda Kogaku" top housing with angled corners under speed dial and a small shelf under the rewind knob. Current value: with f2.0, \$175-250; with f2.8, \$150-225.

Minolta 35 Model IIB - 1958. The first Minolta camera to use the standard 24x36mm image size. Otherwise similar to

the 35 Model II. Super Rokkor f1.8/50mm. \$300-450.

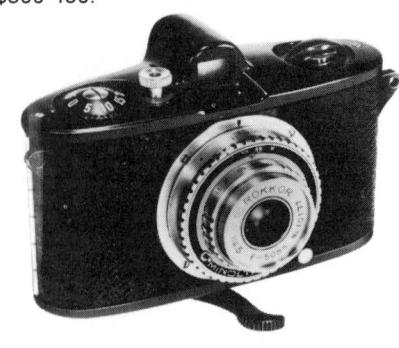

Minolta Memo - 1949. 35mm view-finder camera. Rokkor f4.5/50mm lens. Between-the-lens 25-100, B shutter. Helical lever focusing. Rapid advance lever. This was Minolta's low priced 35mm camera of the day. Steel body and basic mechanism, bakelite top and bottom plates. \$100-150.

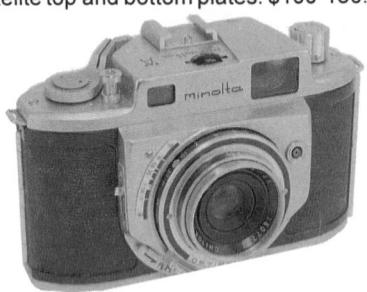

Minolta A - 1955-57. 24x36mm range-finder. Early models had Optiper MX, Chiyoda Kogaku, and Citizen MV between-the-lens shutters set by wheel on camera top. Non-interchangeable Chiyoko Rokkor f3.5/45mmlens. \$50-75.

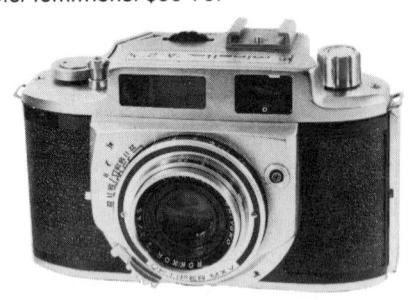

Minolta A2 - 1955-58. 35mm range-finder. Non-interchangeable Chiyoko Rokkor f3.5 or f2.8/45mm lens. Between-the-lens shutter set by wheel on camera top. Citizen in 1955-56, Citizen MV and MVL in 1957, and Optiper MXV in 1958. \$35-50.

Minolta A3 - 1959. 35mm rangefinder. Non-interchangeable Minolta Rokkor f2.8/45mmlens. Shutter 1-500, B. \$45-60.

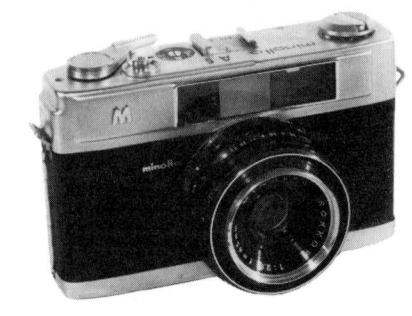

Minolta A5 - 1960. 35mm rangefinder camera. Rokkor fixed mount lens in Citizen

MVL shutter.

Two Japanese models: f2.8/45mm or f2.0/ 45mm lens. Shutter 1-1000, B. \$50-75 U.S.A. model: f2.8/45mm lens, shutter 1-500, B. \$20-30.

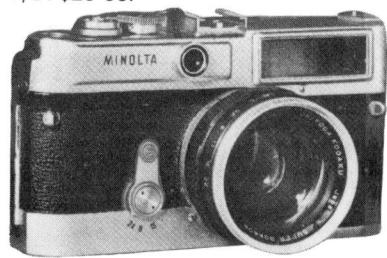

Sky Minolta 35mm rangefinder camera designed by Minolta for release in 1957, but was never introduced into the public marketplace. About 100 made. Builtin bright-line viewfinder, auto parallax correction. Designed for interchangeable Minolta M-mount lenses. It could also use screw mount lenses from the Minolta 35 and 35 Model II by use of an M-mount/SM adapter. Estimate: \$9000-14,000.

Minolta Super A - 1957. 35mm range-finder. Seikosha-MX 1-400,B between-thelens shutter. Single stroke lever advance. Most commonly found with Super Rokkor f1.8/50mm lens. Other normal lenses are f2.0/50mm and f2.8/50mm. Body with normal lens: \$150-225

Other Super Rokkor lenses:

35mm/f3.5:\$50-75.

Lenses with auxiliary finders and case:

85mm/f2.8: \$75-100. 100mm/f3.8:\$75-100. 135mm/f4.5:\$75-100.

Coupled selenium meter: \$20-30. (The meter clipped into the accessory shoe and coupled to the shutter speed control.)

Minolta Autowide - 1958. 35mm rangefinder camera, similar to Super A, but with Rokkor fixed mount f2.8/35mm lens. between-the-lens Optiper MVL 1-500,B,ST shutter. Film advance and rewind located on the bottom of the camera. Also featured CdS match needle metering. \$60-90

Minolta V2 - 1958. 35mm rangefinder camera. Rokkor f2.0/45mm lens with between-the-lensOptiper HS (High Speed)

1-2000, B shutter. \$90-130. Note: Usually found with loose lens and shutter assembly due to the loosening of screws. They should be replaced, not just tightened, to be worth the value shown.

Minolta V3 - 1960. Like Minolta V2, but with selenium metering. Rokkor f1.8/45mm lens, Optiper HS 1-3000,B shutter. \$120-180. Note: These also are usually found with a loose lens and shutter assembly. The screws should be replaced, not just tightened, to be worth the value shown. It costs about \$45-60 to have this done professionally.

Uniomat - 1960. 35mm RF, coupled built-in selenium meter. Minolta Rokkor f2.8 lens. Shutter speeds automatically determined by the light readings. \$50-75.

Uniomat III - 1964. 35mm rangefinder. Built-in meter on the lens front. Camera only says "Uniomat" not "Uniomat III". Noninterchangeable Rokkor f2.8/45mm. Shutter automatically controlled by the meter and ASA settings. \$50-75.

Minolta AL - 1961-65. 35mm rangefinder. Built-in selenium meter. Non-interchangeable f2.0/45mm Rokkor PF lens.

MINOLTA

Citizen shutter 1-1000, B, MX sync, ST. \$35-50

Minolta AL-2 - 1963. 35mm rangefinder. Built-in CdS meter. Non-interchangeable Rokkor f1.8/45mm lens. Shutter 1-500, B. \$45-60

Minolta AL-S - 1965. 35mm rangefinder with meter. Non-interchangeable Rokkor QF f1.8/40mm. Shutter 1-500, B. Made for the USA market. \$75-100.

Minolta AL-F - c1968. 35mm rangefinder camera. Automatic, CdS controlled, shutter-priority metering. Shutter 30-500. Rokkor f2.7/38mm lens. \$50-75.

Minolta Repo - 1962. Half-frame 35mm rangefinder. Built-in meter automatically sets shutter speeds on Citizen L shutter. MX sync. Non-interchangeable Rokkor f2.8/30mmlens. \$35-50.

Minolta Repo-S - 1964. Half-frame 35mm rangefinder. Black or chrome finish. Built-in match needle metering. Rokkor PF f1.8/32mm. Shutter 1/8-500, B. \$60-90.

Hi-Matic 1962. 35mm rangefinder camera with built-in selenium meter.

MINOLTA...

Rokkor PF f2.0/45mm lens in Citizen shutter to 500, ST, sync. \$50-75.

Variation: Ansco Autoset - 1962. Made by Minolta for Ansco in the USA. Identical to the Hi-Matic but with Rokkor f2.8/45mm lens. Also, the automatic metering is slightly different. \$35-50. Higher in Japan where less common.

Hi-Matic 7 - 1963. 35mm rangefinder; built-in meter. Non-interchangeableRokkor PF f1.8/45mm lens . Shutter has manual speeds 1/₄-500, B. It could also be used on automatic. \$35-50.

Hi-Matic 9 - 1966. Similar to the Hi-Matic 7, but incorporating "CLC" (Contrast Light Compensator) metering system. Rokkor PF f1.7/45mm lens. \$35-50.

Minoltina-P - 1964. 35mm rangefinder camera. Match needle metering. Non-interchangeable Rokkor PF f2.8/38mm lens. Citizen shutter 1/₃₀-250, B, ST, MX sync. \$35-50.

Minoltina-S - 1964. 35mm rangefinder. Built-in meter. Rokkor QF f1.8/40mm lens. Shutter 1-500, B. \$35-50.

Minolta 24 Rapid - 24x24mm on 35mm. RF; built-in CdS meter. Rokkor f2.8/32mm. Manual shutter 1/₃₀-250,B. Could also be used on automatic. \$60-90.

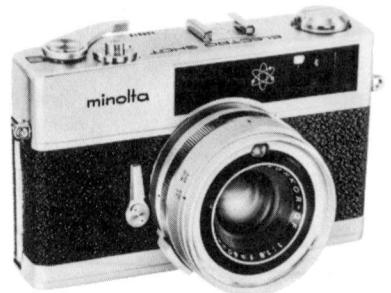

Electro Shot - 1965. Auto 35mm range-finder. Non-interchangeable Rokkor QF f1.8/40mm. Auto shutter 1/₁₆-1/₅₀₀. This was the first electronically controlled 35mm lens/shutter camera. \$35-50.

MINOLTA 35MM SLR CAMERAS Listed in chronological order.

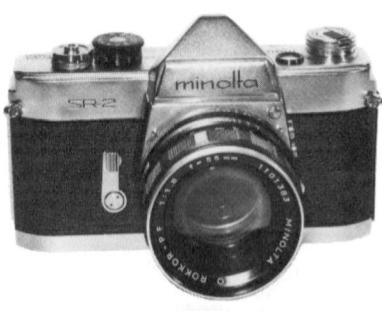

Minolta SR-2 - 1958. 35mm SLR. Quick return mirror, auto diaphragm. Horizontal cloth FP shutter 1-1000,B. Minolta bayonet lens mount. Most common lens is Minolta Rokkor PF f1.8/55. With lens: \$100-150.

Minolta SR-1, early style - 1959. 35mm SLR. Minolta bayonet lens mount. Most common lens is the Minolta Rokkor PF f2.0/55mm. Horizontal cloth focal plane shutter, 1-500, B. There were five different models of the first style SR-1. The first 3

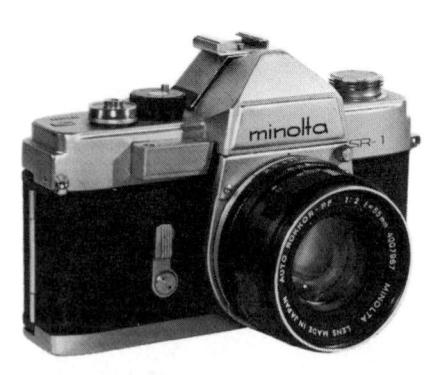

models, 1959-61, did not have the bracket for the coupled meter. The bracket was added in 1962. Other changes include the addition of depth of field preview button. On very early models the name "SR-1" was placed to the left of the word Minolta. Any of the five models, with lens: \$60-90.

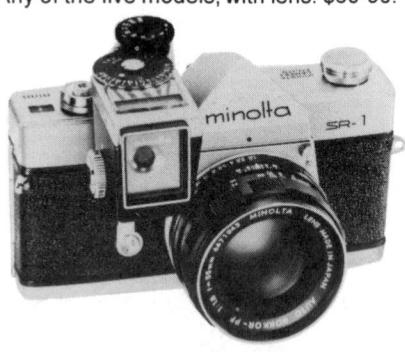

Minolta SR-1, new style - 1964. Same features as early SR-1 of 1962, but body styling more squared in appearance around the top cover edges. Viewfinder eyepiece squared rather than rounded as on the early model. New set of accessories introduced with this model such as a slip on CdS meter. With normal lens: \$60-90.

MinoIta SR-15 - 1964. Same features as the SR-1 of 1964, but top shutter speed now 1000, not 500. With clip-on meter: \$90-130. Body and lens: \$60-90.

Minolta SR-3 - 1960. 35mm SLR. Minolta bayonet lens mount. Most common lens

is the Minolta Auto Rokkor PF f1.8/55mm. Horizontal cloth focal plane shutter, 1-1000, B. Detachable coupled CdS exposure meter. \$100-150.

Minolta XK - c1973. Top quality camera system with interchangeable finders & screens. TTL metering with interchangeable metering finder. Minolta bayonet-mount lenses. Electronically controlled titanium foil shutter, 16 sec.- 1/2000. Motorized body with AE-S auto finder: \$800-1200. Standard body with AE-S finder: \$300-450.

Minolta XE-5 (XE-1) - c1975. Fixed prism SLR, slightly less featured than the XE-7. Aperture-preferred automatic metering; needle in finder shows automatically set shutter speed. Aperture not visible in finder. Match-needle or manual mode. Electronically controlled metal "CLS" shutter, stepless speed range 4 sec to 1/1000. Lacks multiple exposure capability. Minolta cousin of the Leica R5. \$120-180.

Minolta XE-7 (XE) - c1975. Fully automatic SLR with manual override. Aperture & shutter speed visible in finder. Stepless, electronically timed, vertically running metal "CLS" shutter, a new development of Copal & Leitz. The new shutter is smaller, simpler, quieter and more jamproof than earlier Copal square shutters. \$150-225.

Minolta SR-7, early style - 1962. First 35mm SLR with built-in CdS meter and scale. Minolta bayonet lens mount. Most common lens is the Rokkor PF f1.4/58mm. Horizontal cloth focal plane shutter, 1-1000, B. ASA dial settings from 6 to 3200. \$90-130. The dies for this camera were later used in China for the Seagull DF-1 camera.

Minolta SR-7, new style - 1964. Same features as the early SR-7, but with squared off body styling. \$90-130.

Minolta ER - 1963. 35mm SLR. Fixed mount Rokkor f2.8/45mm lens; inter-lens 1/₃₀-1/₅₀₀, B shutter. Wide angle and tele auxiliary lens sets available. \$120-180.

Minolta SRT-101 - c1966. 35mm SLR available in black or chrome versions. Cloth FP shutter 1-1000, B. X-synch at 1/₆₀. and FP bulb synch. Features TTL metering, self-timer, accessory shoe. Most have mirror lock-up. Viewfinder displays shutter speeds with pointer showing selected speed. Match-needle exposure selection. Body: \$100-150. Add \$35-50 for normal lens.

Minolta SRT-100 - c1971. Same as the SRT-101, except top shutter speed is 500, no self-timer, and viewfinder doesn't display the shutter speeds. Body: \$75-100.

Minolta SRT Super - Japanese market. Minolta SRT-102 - USA market. Minolta SRT-303 - European market. c1973. Same as the SRT-101, but also features split-image screen, multiple exposure provision, and hot shoe. Body: \$120-180.

Minolta SRT-101B - Japanese market. Minolta SRT-201 - USA market. c1975. Similar to the SRT-101, but FP bulb sync, and most do not have mirror lock-up. Most have split-image screen and hot shoe. Black body: \$150-225. Chrome body: \$100-150.

Minolta SRT-200 - c1975. Similar to the SRT-100, but shutter to 1000. Some have hot shoe and split image screen. \$90-130.

Minolta SR-505 - Japanese market. Minolta SRT-202 - USA market. Minolta SRT-303B - Europeanmarket. c1975. The last of the SRT series of cloth-shuttered, fixed-prism cameras. Speed, aperture, & needle visible in finder. Similar to SRT-102, but safe-load signal added and most do not have mirror lock-up. Body: \$150-225.

Minolta SRT-MC, SRT-MCII, SRT-SC, SRT-SCII - c1975-80. Camera models made under special contract for Department stores (Sears, K-Mart, etc.), Oil companies, and Credit card companies, etc. Only slight variations from the standard SRT models. Most don't have self-timer. \$90-130.

Minolta SR-M - 1970. First 35mm SLR with integrated motor built in the body. Power supply was a grip on the side of the body. Minolta SR/SRT bayonet mount. Most common lens is the Minolta Rokkor MC RF f1.7/55mm. Horizontal cloth focal plane shutter, 1-1000, T,B. Sync at 1/₆₀. There was no meter built into the body or provision for adding one. Body and grip: \$200-300.

Minolta XD-7, XD-11, XD - 1977. Made in black and chrome, this camera was marketed in Europe as the XD-7, in

MINOLTA...

North America as the XD-11, and in Japan as the XD. This is the world's first multimode exposure 35mm camera. Shutter or aperture priority and metered manual modes. X-sync at $^{1/}_{100}$. Mechanical speeds "O", $^{1/}_{100}$, B. Minolta bayonet mount for the shutter priority mode MD lens. Vertical traverse metal focal plane shutter with electomagnetic release. Electronic stepped or stepless speeds 1-1000, B. Black: \$250-375. Chrome: \$175-250.

Maxxum - 1985. We're including a camera this recent only because of its name. This is a story of the world business atmosphere of the mid-1980's: International trade agreements, grey-market dealing, import and export restrictions, warranty contracts... all symbols of the times.

Separate brand names for different countries led to the name Maxxum for the North American version of the camera called "7000 AF" in Europe and "Alpha 7000" in Japan. In spelling the name Maxxum, the decision was made to use an interlocking double X. That all sounds like a great idea, until giant Exxon sees the advertising. Exxon, of course, has used the interlocking double X in their trademark for some time. Although nobody at either Minolta or Exxon is worried that people will put cameras in their gas tank or tigers in their cameras, but from a legal viewpoint, if any infringements on a trademark are allowed, the protected design could soon become generic, unprotectable, and useless as an identifiable symbol for the original product.

So, now the innocent new baby, Maxxum, with cameras, lenses, and advertising materials already in distribution, faces a change. Minolta agreed to change the design of the Maxxum logo. Exxon agreed to allow a gradual phasing in of the changes to avoid disrupting Minolta's production schedules. Now that's a reasonable way to conduct business. After all "we all make misteaks."

Will the double-crossed Maxxum be collectible? Of course, if you can afford to buy one and let it sit around. Will it be rare? Probably not. There were many produced and shipped.

MINOLTA...

MINOLTA 6X6cm TWIN LENS REFLEX CAMERAS

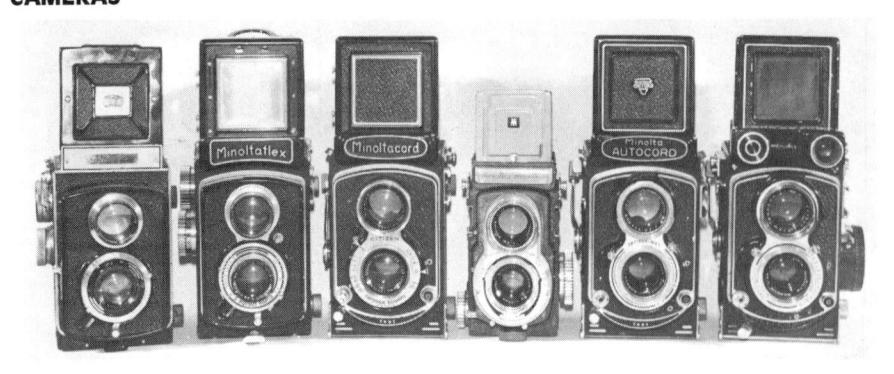

Minoltaflex (1937), Minoltaflex (1950's), Minoltacord, Minolta Miniflex, Minolta Autocord (non-metered), Minolta Autocord CdS

1937 Minoltaflex (I) (two models) 1939 Minolta Automat (two models)

1950-54 Minoltaflex II, IIB, III (three models)

1953-54 Minoltacord (three models)
1955 Minoltacord Automat (one model)

1955 Minolta Autocord L (one model) (selenium metered)

1955 Minolta Autocord LMX (one model) (selenium metered)

1955-65 Minolta Autocord (seven models) (non-metered)

1957 Minolta Autocord RA (one model) (non-metered)

1965 Minolta Autocord CdS (three models) (CdS metered)

There are 24 different models of Minolta 6x6cm TLRs. Any internal or external change is considered to be a new model of that camera. All use either 120 or 220 roll-film and have f3.5/75mm lenses. The shutters are Konan, Citizen, Seikosha, and Optiper.

Minoltaflex (I) - 1936. The first Japanese TLR. 6x6cm exposures on 120 rollfilm. Says "Minolta" on front, not "Minoltaflex". Promar Anastigmat f3.5/75mm viewing lens, Minolta Anastigmat f3.2/75mm viewing lens. Crown II-Tiyoko 1-300,B shutter. The main camera body is identical to Rolleicord, the top of the hood is identical to Ikoflex. Had a unique side lock and shutter release for double exposure prevention. Also available with Zeiss lenses and Compur shutters. \$175-250. (illustrated above)

Minolta Automat - 1939. TLR for 6x6cm exposures on 120 rollfilm. Crank advance like the early Rolleiflex. Hood like

Ikoflex. Promar f3.5/75mm taking and viewing lenses. Crown 1-300,B. \$250-375.

Minoltaflex II, IIB, III - 1950-54.6x6cm TLR. Rokkor f3.5/75mm lens in S-Konan Rapid 1-500 shutter, B. \$75-100. (illustrated above)

Minoltacord, Minoltacord Automat - c1955. TLR predecessors of the Minolta Autocord. Chiyoko Promar SIII f3.5/75mm lens in Optiper MXS, or Rokkor f3.5/75 in Citizen 1-1/400 shutter. \$75-100. *(illustrated above)*

MinoIta Autocord, Autocord RA - 1955-65. Non-metered models. Rokkor f3.5/75mm lens. Optiper MX 1-500 shutter. \$90-130. (illustrated above)

Minolta Autocord L, LMX - Selenium meter. \$100-150.

Minolta Autocord CdS I, II, III - CdS meter. \$150-225. (illustrated left)

Miniflex - 1959. TLR, for 4x4cm on 127 film. Minolta Rokkor f3.5/60mm lens. Optiper or Citizen MVL shutter 1-500, B. Less than 5000 made. There were unconfirmed reports that the Miniflex had sold for thousands of dollars in Japan a few years ago. Recent confirmed sales in the USA/Canada and Europe have been at \$500-750. (illustrated above left)

MINOLTA SUBMINIATURE CAMERAS: Konan 16 - 1950 (Chiyoda Kogaku). 16mm subminiature, 10x14mm exposures. Chiyoko Rokkor f3.5/25mm lens. 25-200,T,B shutter. Push-pull advance and shutter cocking. \$90-130.

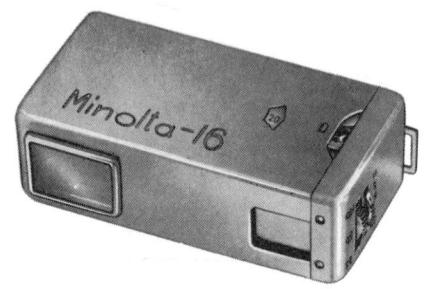

Minolta 16 Model I - 1957-60. Subminiature taking 10x14mm exposures on 16mm film in special cassettes. Rokkor f3.5/25mm lens. Shutter has only three speeds, 25,50,200. No bulb. Push-pull advance. At Christie's 12/91, a set of 6 different colors sold for \$820. Normal prices: Blue: \$150-225. Green: \$100-150. Red: \$90-130. Gold: \$120-180. Black: \$45-60. Chrome finish is very common. \$25-35.

Minolta 16 Model II - 1960-66. Identical in appearance to the Model I, but with f2.8 lens and shutter has five speeds 30-500, plus B. To be completely serviceable, it should include the original supplementary lenses: one negative lens allows focusing to infinity at full aperture; two positive lenses for close focusing. Prices for colored models same as the Model I, above. Very common. \$25-35.

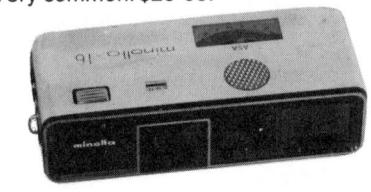

Minolta 16 Model P - 1960-65. Rokkor f3.5/25, shutter ¹/₁₀₀ only, sync. \$25-35.

Sonocon 16mm MB-ZA - 1962. 16mm subminiature, 10x14mm exposures. Black body. Rokkor f2.8/22mm lens, shutter 30-500, B. This is actually a Minolta 16-II combined with a 7 transistor radio. \$600-900.

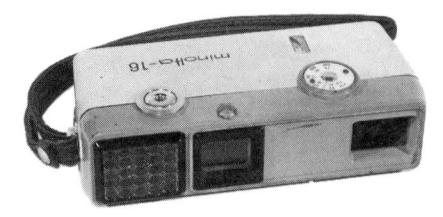

Minolta 16 EE - 1962-64. Rokkor f2.8/25mm; shutter 30-500. Auto exposure using selenium cell. \$30-45.

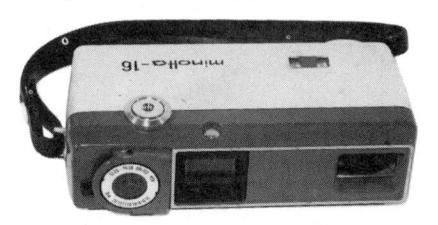

Minolta 16 EE II - 1963-65. Rokkor f2.8/25mm, shutter speeds H (High) and L (Low) (200 and 50). Auto exposure CdS metering \$30-45.

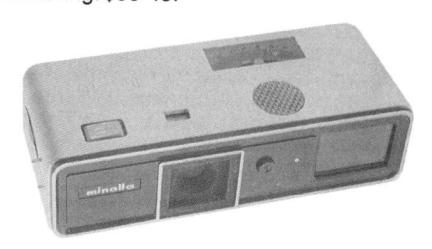

Minolta 16PS - 1964-74. Identical in appearance to the Model P, but with shutter speed selection lever on the front next to the lens. Sets shutter to $^{1}/_{30}$ for flash and $^{1}/_{100}$ for normal photos. Note that even the markings on the camera do not include the "S" designation. Originally made only for export to the U.S.A. Very common. Usually found like new, with case, box, and instructions for \$35-50. Camera with case only: \$25-35.

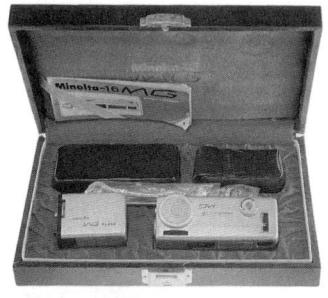

Minolta-16 MG - 1966-71. Rokkor f2.8/20mm, shutter 30-250. Match needle metering. Very common. Kit with case, chain, and MG flash: \$45-60. Camera with case and chain only: \$30-45.

Minolta-16 MG-S - 1969-74. 12x17mm size. Made in black or silver. Rokkor f2.8/23mm, shutter 30-500. Auto match needle metering. With case, flash, strap, instructions in presentation box: \$50-75. Camera and case only: \$30-45.

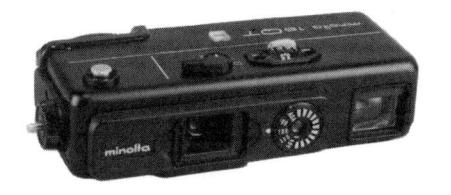

Minolta 16 QT - 1972-74. 12x17mm size. Rokkor f3.5/23mm, shutter 30-250. Auto metering. Black or chrome. Very common. Often found with case, electronic flash, etc. in presentation box. Like new: \$50-75. Camera and case only: \$30-45.

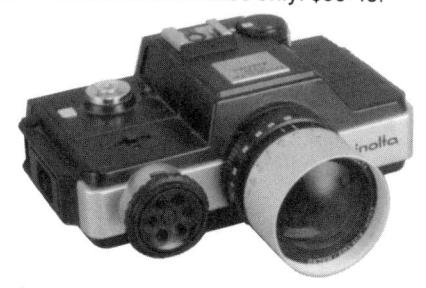

Minolta 110 Zoom SLR - c1976. The first SLR for 110 film. Fully automatic aperture-priority exposure. \$75-100.

Minolta 110 Zoom SLR Mark II - c1979-. Restyled totally from the earlier model, Mark II resembles a small 35mm SLR. Automatic TTL metering. Zoom Rokkor Macro 25-67mmf3.5. \$150-225.

MINOLTA AUTOPAK CAMERAS (126 Cartridge) In a sea of inexpensive, basic cameras for 126 cartridges, Minolta stands out for its quality. Although operation was kept simple, it was through complex engineering, not simple design. One outstanding feature of most Minolta Autopak cameras was the ability to keep a flashcube mounted on the camera at all times. The camera would automatically fire the flash only if needed. This later became common with electronic flashes, but was unusual during the age of flashcubes and x-cubes.

Autopak 400-X - c1972. Cartridge loading, automatic selenium metering, fixed focus. Automatically fires magicube when needed. No batteries required for meter or flash. Rokkor f2.8/38mm glass lens. \$15-25.

Autopak 500 - c1966. Selenium cell surrounds lens, sets exposure and fires flashcube if needed. Automatically rotates cube after flash. Rokkor f2.8/38mm zone-focus lens. Programmed EE shutter, 1/40, 1/90. \$15-25.

Autopak 550 - c1969. Auto exposure, spring-motor drive for 11 shots. Manual focus knob on left hand side selects one of three focus zones. Rokkor f2.8/38mm. \$15-25.

Autopak 600-X - c1971. Similar to the 550, but uses magicubes (x-cubes). Flash fires automatically only when needed; requires no battery. Meter requires battery. Four focus zones. \$15-25.

Autopak 700 - c1965. Styled like a traditional 35mm rangefinder camera, but loads with 126 cartridge film. CRF, automatic parallax compensation. Auto, semi-auto, or manual metering with CdS cell. Speeds 30-250. Rokkor f2.8/38mm. \$12-20.

MINOX

Autopak 800 - c1969. CRF, bright frame finder. CdS meter selects 1/₉₀ or 1/₄₅ speed. Automatically fires flashcube if needed. Rokkor f2.8/38mm. Spring-motor advance. \$35-50.

MINOX Subminature cameras for 8x11mm exposures on 9.5mm film in special cassettes. The original model, designed by Walter Zapp, was made in 1937 in Riga, Latvia.

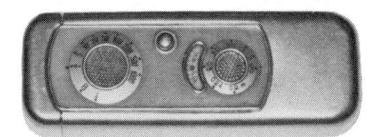

Original model (stainless steel body) - Made in Riga, Latvia by Valsts Electro-Techniska Fabrika. Guillotine shutter 1/2-1/1000. Minostigmat f3.5/15mm lens. Historically significant and esthetically pleasing, but not rare. \$750-1000. The original zippered blue, brown, or black case with "Riga" markings will fetch an additional \$50-75.

Minox "Made in USSR" - Stainless steel model made during the short time the Russians held Latvia before the German occupation. (Approximately Spring to Fall, 1940.) \$1200-1800.

Minox II - 1949-51. Made in Wetzlar, Germany. Export model of the Minox A for the USA. Aluminum body, built-in filters. \$75-100.

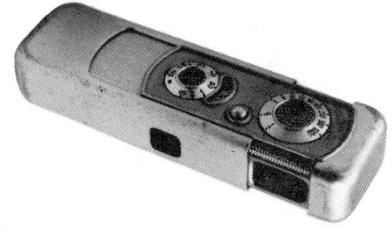

Minox III - 1951-56. Export model of the Minox A for the USA. Like Model II, but filters automatically retract when camera is closed. Not synchronized. \$150-225.

Minox III, Gold-plated - With design pattern in metal, gold-plated, in crocodile case with gold chain. \$1700-2400.

MINOX...

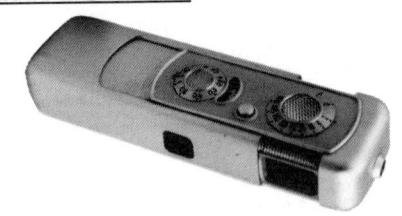

Minox III-S - c1954-63. Synchronized for flash. Gold: Full outfit with gold meter, alligator case, etc.: \$2400-3200. Camera only: \$1200-1800. Black: \$350-500. Chrome model, with case and chain: \$90-130.

Minox A - c1948. Wetzlar. Complan f3.5 lens. (U.S.A. versions of Mixox A were called II, III, and IIIs). Gold: outfit with gold meter: \$3200-4600. Gold camera only: \$2000-3000.Chrome: \$175-250.

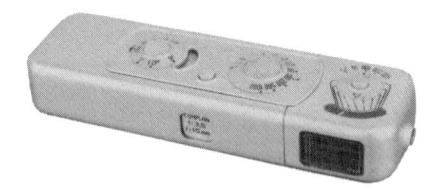

Minox B - c1958-71. Built-in meter. Gold: \$1500-2000. Black: \$300-450. Chrome: \$120-180.

Minox BL - c1971-76. CdS meter. Gold: \$800-1200. Black: \$300-450. Chrome: \$200-300.

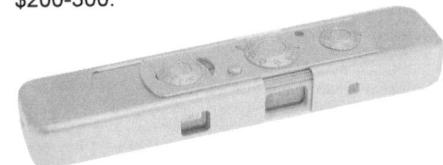

Minox C - c1969-79. Black: \$250-375. Chrome (extremely common): \$150-225.

Minox EC - Black plastic body. Fixed focus, fully automatic exposure. The "point & shoot" Minox. \$100-150.

Minox LX - \$300-450.

Minox LX Gold (Minox Selection) - Special commemorative edition celebrating the 50th anniversary of Minox, 1938-1988. Total production 999, of which 200 for USA. Gold plated Minox LX camera, gold plated flash unit, each with case, packaged in mahogany box with commemorative papers. In new condition: \$1200-1800.

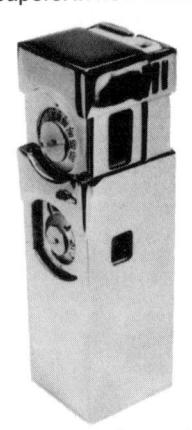

Minox with Cigarette Lighter c1988. Minox A camera and cigarette lighter built into gold plated housing, sometimes covered with exotic leather.

The camera is an older model Minox, but the housing and lighter are modern. The assembly is not made by Minox, but by a private individual. It is a modern designer item marketed for collectors. Limited sales through camera auctions have established and maintained prices of about \$600-900.

Minox Accessories:
Binocular attachment - \$20-30.
Copy stand - \$30-45.
Daylight Developing Tank - with thermometer. \$30-45.

Enlarger - \$150-225. Flashgun for Model B - with case. \$8-

Minosix meter - \$50-75.
Pocket tripod - \$35-50.
Reflex finder for Model B - \$8-15.
Right angle finder for Model B -

Tripod adapter - \$15-25. Viewer/Cutter - \$25-35.

Minox Salesman's Kit - Presentation kit with Minox B camera, flash, cases, tripod, copy stand, binocular clamp, tripod adapter, right angle and reflex finders, viewer, cutter, slide mount, and films. Uncommon. We have recorded two auction sales. Most recently at Cornwall 4/94 for \$3350+.

MINSK MECHANICAL ZAVOD - see BELOMO

M.I.O.M. (Manufacture d'Isolants et d'Objets Moulés, Vitry-sur-Seine, France)

Astra - c1937-38. Black bakelite eyelevel camera, identical to the Jacky, etc. However, the original name has been milled from the front and the "Astra" name engraved in the milled-out area by the factory. An unusual variant of an uncommon camera. \$45-60.

Jacky - c1937-38. Black bakelite eyelevel camera based on the design of the Lec Junior, but because if its larger size, it used a helical telescoping front. Uses 120 film for 6x9cm or 4.5x6cm with mask. The same body style was sold under the names Photax, Loisir, MIOM, & Camera 777. \$45-60.

Lec Junior - c1937-38. Rigid, light brown or black bakelite body. 4x6.5cm on rollfilm. "Lec Junior" molded into back. \$25-35.

Loisirs - c1938. Plastic rollfilm camera for 8 or 16 exposures on 120 film. Radior lens, simple shutter, T & I. \$20-30.

Miom - Rigid black bakelite body, like Lec Junior but with octagonal shutter housing. 4x6.5cm on rollfilm. \$25-35.

Photax (original) - c1937. Black bakelite body, with rectangular finder tube projecting above body. 6x9cm or 4.5x6cm with mask. Same as Jacky etc. This earliest Photax uses a metal ring with helical thread to extend the front section, while later Photax Blindé is all plastic. \$45-60.

Photax "Blindé" - c1938-1950's. Streamlined black bakelite body. Helical telescoping front. 6x9cm on rollfilm. The unique part of this camera is the molded bakelite front cap which covers the shutter and lens, and is the only place to find the camera's identity. This unique "capot blindé" is responsible for the camera's nickname. Several model improvements over the years, but all retaining the same body style. With front cap: \$30-45.

Photax V - Retains the same overall

size as the classic Photax cameras, but the exterior design is a free-form work of art. Synchronized. Very rare, and hard to find even in France. \$60-90.

Rex - c1937. Small black bakelite camera for 4x6.5cm on 127 film. Same basic body as the original MIOM introduced in 1937 and continued during wartime. "Rex" molded in back. Reginor Serie IIa lens in P&I shutter. \$30-45.

MIRACLE - Japanese novelty subminiature of the Hit type. \$25-35.

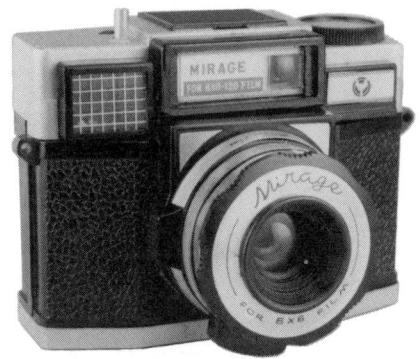

MIRAGE - Deluxe "Diana" type camera for 6x6cm on 120. Built-in AG-1 flash, hinged reflector. Imitation meter cell. \$1-10.

MIRANDA CAMERA CO. LTD. (Tokyo, Japan) The Miranda Camera Company is a descendant of the Orion Seiki Company, a photographic services and photographic equipment firm that was formed in Tokyo by Mr. Akira Ogihara in 1946 during the American Occupation of Japan. Initially the company manufactured a limited line of products; most of its business was as a service center for professional photographic equipment. Early products included an adapter for Contax and Nikon rangefinder lenses for use on screw-mount Leicas, the Mirax reflex mirror box for use with Leica-thread rangefinder and other cameras, the Focabell bellows, and the Supreme 105mm f2.8 for use with the Focabell.

Following the success of these products, investigation and development began for the Phoenix, a revolutionary eye-level SLR with a removable prism. It existed only in the form of a single prototype produced about 1954. Since the Phoenix name was already in use on a German camera, the name was changed to Miranda before production began. Only photographs remain of the first Japanese eye-level SLR. It had a Zeiss-Tessar in the unique 44mm screw mount used by Miranda.

Introduction of the first production model camera, the Miranda T, began in Japan in 1954. The early bodies were marked "Orion Camera Company" on the front. The pentaprism was engraved "Miranda" and the rear of the body near the serial number was engraved "Miranda T". In 1956, the firm

changed names from Orion Camera Company to Miranda Camera Company and "Miranda" replaced "Orion" on the front of the camera.

In the years following the introduction of the T, a revolutionary camera in Japan, 33 additional SLR models for general use, 4 microscope SLR models and 1 rangefinder model were manufactured. The last model, the Dx3, was a small, lightweight SLR with an electronic shutter and was the only SLR produced by the Miranda Camera Company with a fixed pentaprism. Production ended in 1978 with the bankruptcy of Allied Impex Corporation, an American importing and distribution company that bought the Miranda Camera Company and Soligor Optical Company.

The Miranda name is currently being used by a firm not associated with the original Japanese company.

Note: All early Miranda SLRs have removable backs. This includes all lettered models, Automex, II, III, Sensorex 1.9, early Sensorex 1.8 to Ser. #799,999. Most of the later models have beinged backs.

Most of the historical and technical information in this section was supplied by the Miranda Historical Society; Box 2001; Hammond, Indiana 46323 USA. The club historian, Thomas Surovek, welcomes your comments and questions at: (219) 844-2462.

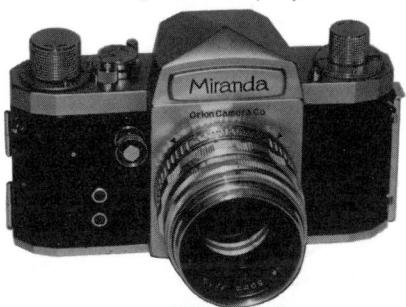

Miranda T (Orion Camera Co.) -

c1953-56. Also referred to as the Miranda Standard. First Miranda-made 35mm SLR, and the first Japanese SLR with a pentaprism (and a removable one at that)! Knob wind. Marked "Orion Camera Company" above lens mount. Removable prism engraved "Miranda". The prism was made without the provision to be leathered. Serial number on rear of body below film advance knob and prefixed with "Miranda T". Focal plane shutter, 1-500,B, in two ranges. Non-return mirror. Originally sold with Zunow 5cm f1.9 or Ofunar 5cm f1.9 lens, later with Soligor-Miranda 5cm f1.9 lens. All lenses are preset in 44mm screw mount. FP, X synch. Worldwide prices vary considerably Several known sales at \$1300 in Japan, though \$800-1200 is more common there. Europe & USA: \$600-1200 to a collector. A very few were made in black. These are extremely rare. The Pentax Gallery has one.

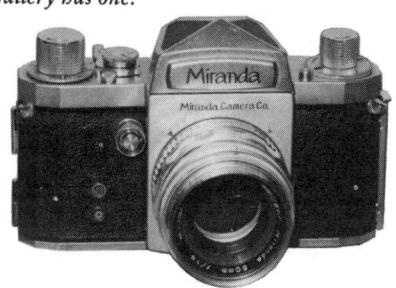

Miranda T (Miranda Camera Co.) -

MIRANDA

1956. Same as the above except engraved "Miranda Camera Company" above lens mount. Early ones have a prism with or without the indented area for leather. Sold in USA with Soligor Miranda 5cm f1.9 or 5cm f2.8. (Correct optional lens is all bright metal with "MT" serial number prefix.) Also sold in Australia and Japan with Arco 5cm f2.4, Miranda 5cm f1.9, or Zunow 5cm f1.9. All lenses in 44mm screw mount. Asking price of \$2500 noted at Tokyo trade fair. Nice ones sell for \$600-900.

Miranda TII - Similar to T but top speed of 1/1000 sec. Black trim on film advance knob, film rewind knob, & high speed shutter select dial; folding rewind crank in rewind knob. Advertised and usually sold with Arco f2.4/5cm lens until Arco went bankrupt. Estimated TII production is 600 units, making it one of the rarest Miranda models. About \$600-900 with lens.

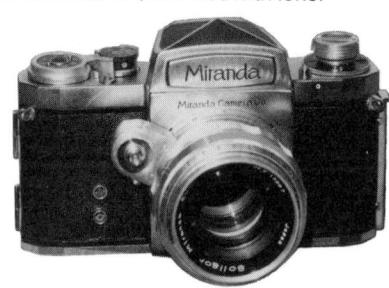

Miranda A - 1957. The first lever wind Miranda. Rapid-rewind crank. Focal plane shutter 1-1000,B. Film counter engraved in black with red arrows at 20 and 36. This counter dial is larger than the all black dial of the All. Camera serial number as on the T. Split-image rangefinder in focusing screen. Correct original lens is a Soligor Miranda 5cm f1.9 with "Y" serial number prefix. The lens is in a polished metal lens barrel. Some lenses are of the preset type; others have an outboard automatic diaphragm button that fits over the shutter button, stopping down as the shutter is tripped. Lenses now in 4-claw breech mount. With lens: \$100-150.

Detail showing differences in film advance dials on Miranda A & AII

Miranda All - 1957. Same as A except smaller film counter dial without red arrows at 20 & 36. Ground glass focusing screen with central microprism spot. \$100-150.

Miranda B - 1957. Like A II but first instant-return mirror model. Body serial with "B" prefix. Same correct lens as the A. Not imported to USA. At the time, Miranda was so popular that they couldn't keep up

MIRANDA...

with production, so the Miranda B and S were assembled by Ricoh for Miranda. Clean & working: \$120-180.

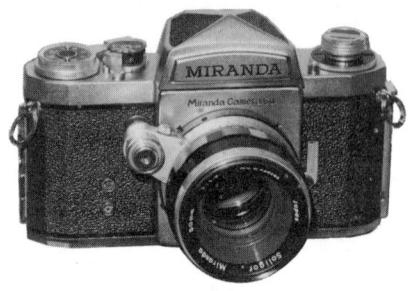

Miranda C - 1959. Like Miranda B but self-timer added on front of body below rewind knob. Proper lens is Soligor Miranda 5cm f1.9 in black barrel with bright aperture ring. "K" serial prefix. \$120-180.

Miranda ST - 1959. Like T but no model designation, folding rewind crank in rewind knob. Not engraved "ST" on rear. Twelvespeed FP shutter 1-500,B,X. Top & front release buttons. Non-return mirror. Not imported to USA. Mint & working: \$600-900. Blemished: \$300-450.

Miranda S - 1959. Last of the knob wind bodies. Similar to T except speeds 30-500,B. Serial number is on top of body in front of the advance knob. Engraved "Miranda S Japan" on top of body at knob. Originally advertised with removable waist level finder and Soligor Miranda 5cm f2.8 lens. Correct lens has a six-digit number without letter prefix but with the abbreviation "No." before the serial number as "No.xxxxxxx." Sold with Arco 5cm f2.4 lens in markets other than the U.S. Normal lenses are preset in screw mount. Pentaprism finder available only as an accessory. Assembled by Ricoh for Miranda. \$150-225.

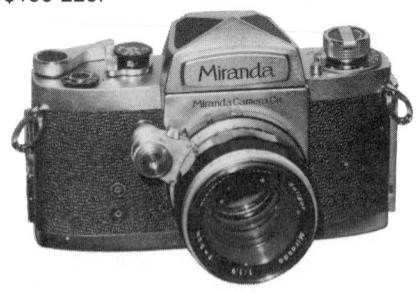

Miranda D - 1960-62. During production of the D, a new body style with rounded corners instead of sharp angles was introduced. Early D's have the sharp-angled body like the C and earlier cameras. Later D's have the rounded body style like DR and later models. Some marked "Miranda D" on back near rewind; others unmarked. Speeds 1-500.B in two ranges. Speed selector is similar to the model T and ST with a small handle replacing the split shield as on the Miranda A, B & C. Shutter release only on front. Film counter is now on a small dial in front of the film advance lever. Top of advance lever and speed dial covered with black leather (some with black paint). Standard focusing screen is plain ground glass. Optional replacement was a true split-image screen, not a microprism type as in the DR. Screens not userinterchangeable. Correct original lens is screw-mount Soligor Miranda 5cm f2.8 preset with "T" prefix. Soligor Miranda 5cm f1.9 automatic also available in 4-claw

breech mount. In markets other than USA, the standard lens was Prominar Miranda 5cm f1.9 with side arm for automatic stopdown. \$75-100.

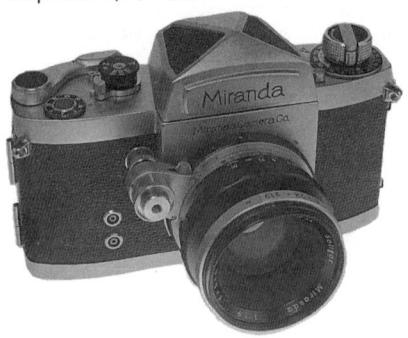

Miranda DR - 1962. Similar to the D except red leather covering the film counter, no letter prefix on body serial number. Factory-interchangeable focusing screens; microprism spot with matte collar is standard. Standard lens is a Soligor Miranda 5cm f1.9 automatic with sidearm. Miranda 5cm f2.8 preset lens was an option. Correct lens has "K" prefix. \$60-90.

During the course of production of the DR, Miranda changed its style of engraving the "Miranda" name on the prism front and on the back of the top housing. All previous models and early DR's have "Miranda" in upper and lower case letters. Late DR's and subsequent models have "MIRANDA" in all caps

Early Miranda F with optional meter prism Preview button opposite front shutter release.

Miranda F - 1963. Speeds 1-1000,B. No model designation on camera. Lens diaphragm coupled internally to body. Early type has stop down lever on side of mirror box. Later ones lack this button and use preview button on lens. Film counter is below top plate and covered by a window. New design of shutter speed dial: all speeds on one dial, no shifting necessary. Early versions have 13-speed FPS 1-1000, B, X on single dial. Later version has top speed of $1/_{500}$. The speed dial of the later models ($1/_{500}$ sec) could be removed to fit a snap-on meter, thus producing an the equivalent of an Fv. Front & top shutter releases. First Miranda also available in black. Also sold as FM and FT when fitted with optional meter prisms. A really nice black one: \$100-150. Chrome: \$60-90.

Miranda Fv - 1966. Like F with "Fv" engraved on the front below the rewind knob. Serial number moved to a bezel at the rewind crank. Top speed 1/1000 (some to 1/500). Removable speed dial for fitting of snap-on CdS meter which is coupled to shutter speed. Also available in black and with a black meter. Black: \$90-130. Chrome: \$75-100.

Miranda G - 1965/66. Marked "G" on front. Self-timer, 8 user-interchangeable screens, mirror lockup. 13-speed FPS 1-1000,B,X. ASA indicator under rewind knob. Top & front shutter release. Three varieties: 1. Unmetered prism. 2. Prism with snap-on CdS meter coupled to shutter. 3. Prism with uncoupled meter; made primarily for F, but seen on G. Also sold as GT when fitted with a TTL meter prism. Available also in black. Black GT: \$120-180. Chrome without meter: \$60-90.

Miranda Automex - 1959. First Miranda with inbuilt coupled meter. ASA range only to 400. Selenium cells in front of the removable prism; coupled with shutter speeds and the aperture by means of an external arm. "Automex" engraved on body front. Correct lens has a button at 1 o'clock that switches the diaphragm from manual to auto. Serial number of the normal f1.9 lens has "K" prefix. Many cameras are found missing the cover/adapter for the flash/pc socket. Some have motor wind facility. \$75-100.

Miranda Automex II - 1963. "Automex II" on body front. Improved meter to ASA 1600. Same lens as Automex. Baseplate may have motor drive provision. \$75-100.

Miranda Automex III - 1965. "Automex CdS" on body front. Selenium cells replaced with a CdS cell where flash connection was on earlier models. Meter fully cross-coupled. Lens has a rectangular stop-down button replacing the round button. Letter prefix on the lens serial number has disappeared.\$75-100.

Most later models are also available in black.

Sensomat - c1969-73. With 50mm f1.8 Auto Miranda: \$75-100.

Sensomat RE - c1971-76. With 50mm f1.8 Auto Miranda: \$50-75.

Sensomat RE-II - c1975-78. With 50mm f1.8: \$50-75.

Sensorex - c1968-72. With 50mm f1.8 Auto Miranda. Black: \$100-150. Chrome: \$60-90.

Auto Sensorex EE - c1971-77. With 50mm f1.8 Auto Miranda E: \$60-90.

Sensorex II - c1971-77. Sensorex with hot shoe. With 50mm f1.8 Auto Miranda: \$50-75.

Miranda DX-3 - c1976-80. With Auto Miranda EC f1.8/50mm: \$75-100.

Sensoret - c1972-75. 35mm CRF camera with built-in CdS meter. Miranda Soligor f2.8/38mm lens. Electronic Seiko ESF shutter, 4-1/800 sec. Hot shoe. Normally found with original accessory soft shutter button release and pouch. The only non-SLR Miranda. \$25-35.

Miranda microscope models:

Laborec, Laborec II, Laborec III, and Mirax Laborec Electro-D with motor drive. Insufficient sales data.

MIRANDA ACCESSORIES:

Focabell (Orion Camera Company) - No bayonet mount on Focabell. In original red box with instruction book & accessory literature: \$60-90.

Focabell (Miranda Camera Co.) - in

original red box: \$90-130.

Laborec I, II - Prices vary widely. Astrophotographers are happy to buy them at \$300 each for use. Collectors must be prepared to pay at least that much.

MIRROFLEX - c1960s, Japan. TLR, Rolleiflex copy. Tri-Lausar f3.5/80mm lens, Rectus shutter. \$75-100.

MISUZU KOGAKU KOGYO CO. LTD. MISUZU OPTICAL INDUSTRY

Alta - c1957. Leica III copy, but with twin PC sync posts on front. FP shutter T,B,1-500. Interchangeable Altanon f2/50mm in rigid mount. Rare. \$1200-1800.

Bower - All black laboratory camera. Features similar to the Alta, but without lens and finder. Knob wind. \$750-1000.

MISUZU TRADING CO. (Japan) Midget Jilona cameras - A series of subminiature cameras. Similar in style to the cheap "Hit" cameras, but heavy cast metal construction. The earliest models were from the late 1930's, but the most commonly found ones in the U.S.A. are the post-war models.

Midget Jilona (I) - c1937. This earliest of the Midgets is easily identifiable by the folding finder. It initiated a style which led the way for the Mycro and Hit types. Takes 14x14mm exposures on 17.5mm paperbacked rollfilm that eventually became known as "Mycro-size" rollfilm. Uncommon. \$250-375.

Midget Jilona Model No. 2 - c1949. Name on top. Shutter B,I (1/50). \$90-130.

Midget Model III - c1950. "Model III Midget" on top. Body release. Shutter B,25-100, \$90-130.

Vest Alex - c1936. Telescoping-front camera for 4x6cm on 127 film. Efith Anastigmat f6.3/75mm in Complete B,25-100 shutter. \$50-75.

MITHRA 47 - c1950. Brown enameled aluminum box camera for 6x9cm on 120 film. Meniscus lens. I&B shutter. Made in Switzerland, \$35-50.

MITY - Japanese novelty subminiature of "Hit" type, \$25-35.

MIYAGAWA SEISAKUSHO (Tokyo)

Boltax I, II, III - c1938. Small viewfinder 35mm, 24x24mm on Bolta film. Picner Anastigmat f4.5/40mm. Model I had Picny-D 25-100, B shutter. Models II & III have accessory shoe, and shutters. \$120-180.

Picny - c1935. Compact camera for 3x4cm exposures on 127 film. Very similar in size and shape to Gelto-D by Toakoki Seisakusho but rounded ends and better finish almost make it look like a stubby

Miyagawa Silver

MOLLIER

Leica. Even the collapsing lens mount is a direct copy of Leica styling. Picny Anastigmat f4.5/40mm lens. Picny 1/25-1/100, T,B. Black: \$300-450. Chrome: \$120-180.

Silver - c1947. Compact camera for Bolta-size film. Similar to the Boltax cameras and nearly identical to Yamato Dan 35 II. Sold at Christies 12/91 for \$300. Illustrated bottom of previous column.

MIZUHO KOKI (Japan)

Mizuho-Six - c1952. Folding two-format camera for 120 film, 6x6cm and 4.5x6cm. Militar Speciial f3.5/80mm lens. NKS shutter 1-200, B. \$60-90.

Mizuho-Six Model V - c1952. Similar to the Mizuho-Six, but built-in uncoupled rangefinder. \$75-100.

MOCKBA - See Krasnogorsk Moscow

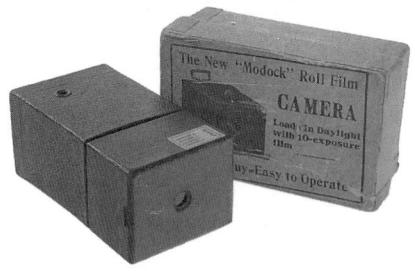

MODOCK - Small cardboard box camera for 10 exposures on daylight loading rollfilm. Uncommon. \$120-180.

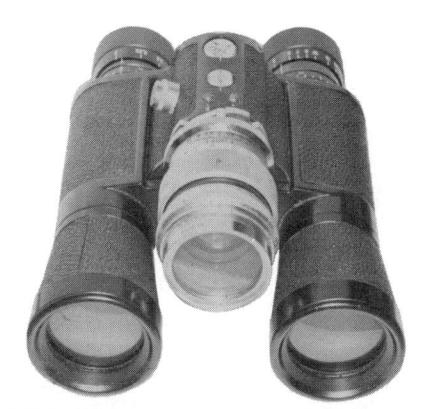

MÖLLER (J. D. Möller, Hamburg, Germany)

Cambinox - c1956. A combination of high quality 7x35 binoculars and a precision camera for 10x14mm exposures on 16mm film. Interchangeable f3.5/90mm lenses. Rotary focal plane shutter 30-800. Auction record 12/91 \$1600. Normal range \$800-1200.

Cambinox accessories: 35mm f3.5 Idemar - \$300-450. 180mm f3.5 Idemar - \$400-600.

MOLLIER (Etablissements Mollier. Paris)

Le Cent Vues - c1925-30. An early camera for 100 exposures 18x24mm on 35mm film. Several variations. Early ones have a square cornered, vertically oriented metal body. The metal front has rounded corners. 'Le "Cent Vues" (100 views) written above the lens. Second model c1926 has leather covered body with rounded ends. 'Le "Cent Vues" engraved on engine-turned bottom plate. Hermagis Anastigmat f3.5/40mm in Compur shutter 1-300. Helical focus mount. \$1700-2400.

MOLTENI

MOLTENI (Paris, France)
Detective camera - c1885. Wooden body, 9x12cm plate camera of an unusual design. The front portion of body hinges up 180° to rest on the top of the camera body, becoming the front of the viewfinder. The back of the body lifts up to form the back of the viewfinder. Brass fittings. Brass barrel Molteni Aplanat lens. Brass lens cap acts as the shutter. \$1500-2000.

MOM (Magyar Optikai Müvek (Hungarian Optical Works), Budapest)

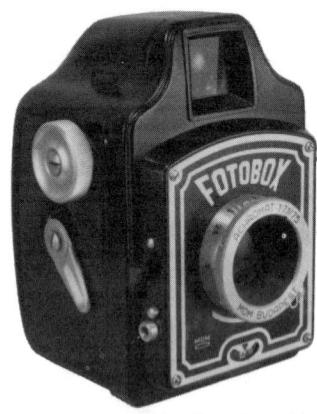

Fotobox - c1950. Good quality 6x6cm metal box camera. Large built in eye-level finder on top. Achromat f7.7/75mm focusing lens, shutter 1/₂₅-100. \$35-50.

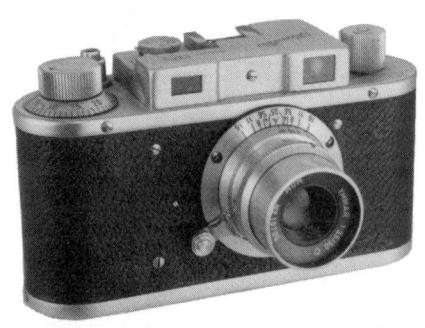

Mometta - 35mm. Coupled rangefinder with single eyepiece. Bottom loading. Non-interchangeable Ymmar f3.5/50mm lens. Focal plane shutter, Z, 25-500.\$120-180.

Mometta II - c1953. Rangefinder 35. Ymmar f3.5/50mm lens. FP shutter ¹/₂₅-500. \$120-180.

Mometta III - c1957. Rangefinder 35mm for 24x32mm format. Interchangeable Ynmar f3.5/50mm lens. FP shutter 1/₂₅-500, sync. \$120-180.

Mometta Junior - c1957. Similar to the Mometta III, with interchangeable Ynmar lens, but without rangefinder. Takes

24x32mm exposures on 35mm film. Very rare. No sales data.

Momikon - c1950. Rangefinder 35. Ymmar f3.5/50mm lens. FP shutter 25-500. \$150-225.

MONARCH MFG. CO. (Chicago) Also spelled Monarck.

spelled Monarck.

Plastic novelty cameras - c1939.
Half-frame on 127 rollfilm. Minicam-style with horizontal or reflex-type bodies.
Numerous names: Churchill, Dasco, Fleetwood, Flash Master, Flex-Master, Kando Reflex, Majestic, Pickwik, Pickwik Reflex, Remington, Royal Reflex. Reflex style: \$12-20. Horizontal: \$1-10.

Monarch 620 - c1939. Simple, cast aluminum body, 4.5x6cm on 620 film. Also sold as Photo-MasterTwin 620. \$15-25.

MONARCK MFG. CO. (Chicago)
Also spelled Monarch.
Monarck - Plastic novelty cameras for full or half frames on 828 film. TLR styles: \$12-20. Minicam-styles: \$1-10.

MONO-WERK (Rudolph Chaste, Magdeburg, Germany)

Mono 00 - c1913. Folding bed camera for 6.5x9cm plates. \$35-50.

Mono Spiegel-Reflex - c1915. Waist-level SLR for 6.5x9cm plates. Lever operated mirror, rack and pinion focusing. Monar Anastigmat f6.8/120mm lens in dialset Vario shutter. \$250-375.

Monoscop - c1905. 9x12cm folding plate camera. Leather covering, wine-red bellows, aluminum bed. Simple f8 lens in 1/₂₅ to 1/₁₀₀ shutter. \$75-100.

Mono-Trumpf - c1914. 9x12cm folding bed plate camera. Mono Doppel Anastigmat f6.3/136mm. lbsor shutter. \$35-50.

MONROE CAMERA CO. (Rochester, N.Y.) (Incorporated in 1897, merged in 1899 with several companies to form Rochester Optical & Camera Co.)

Folding plate cameras (bed types) - "cycle" style folding cameras. 4x5": \$75-100. 5x7": \$100-150.

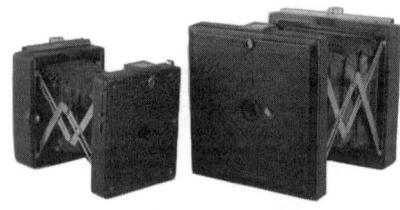

Vest Pocket Monroe (left), Pocket Monroe No. 2 (right)

Folding plate cameras (strut types) - c1898. These cameras fold to a very compact size, only about 11/2" thick including brass double plateholder.

- Vest Pocket Monroe 2x21/2" exposure size. \$300-450.
- **Pocket Monroe No. 2** The middlesized version of the compact strut-folding Monroe cameras, made for 31/₂x31/₂" plates. \$250-375.

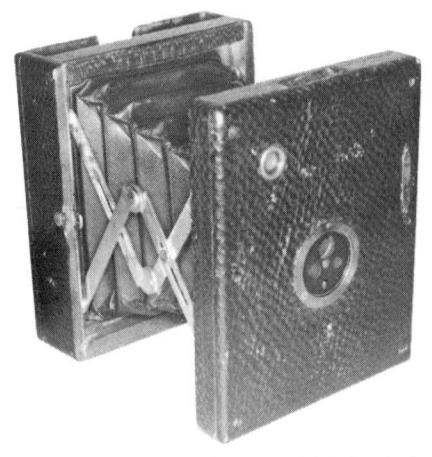

- **Pocket Monroe A** - 31/₄x41/₄". Last of the series before the merger. \$250-375.

Monroe No. 5 - Folding plate camera. Leather covered wood body, red bellows, polished wood interior. Reversible back. Rapid Rectilinear lens, Unicum shutter. \$100-150.

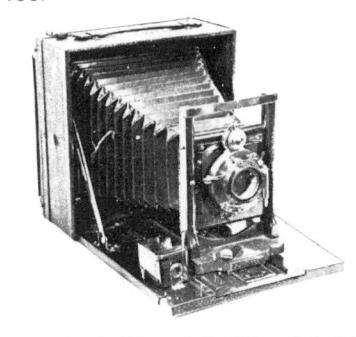

Monroe Model 7 - A 5x7" "cycle" style

plate camera. Double extension maroon bellows. RR lens, Gundlach shutter. This camera looks like the Rochester it is about to become. \$120-180.

MONROE SALES CO.

Color-flex - c1947. Pseudo-TLR aluminum camera. Cream colored enamel and burgundy leatherette covering. With matching burgundy leatherette case, in mint condition: \$120-180. As usually found, with minor abrasions to enamel: \$50-75.

MONTANUS CAMERABAU (Solingen, Germany) About 1953, Potthoff & Co. began using the name "Montanus Camerabau Potthoff & Co.", then simply "Montanus Camerabau" in their advertising. See also "Potthoff & Co." for other cameras by this manufacturer.

Delmonta - c1954-59. 6x6cm TLR. f3.5/75mm Pluscanar lenses; Vario or Prontor SVS shutter. Relatively common. \$60-90.

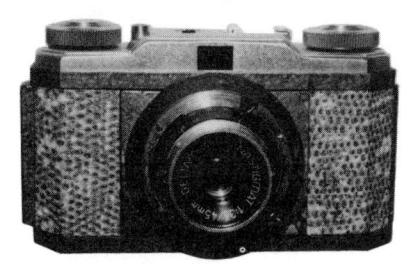

Montana - c1956. Basic 35mm scalefocus camera. Deltamon Anastigmat f3.5/ 45mm, 50-200 shutter. With imitation reptile cover: \$90-130. Normal black: \$30-45.

Montiflex - 6x6cm TLR. Pluscanar f3.5/75mm or Steinheil Cassar f2.8/80mm. Prontor-SVS shutter. \$75-100.

Rocca Automatic - c1954-58. 6x6cm TLR. Cassar f2.8/80mm in Prontor-SVS. \$90-130.

Rocca Familia - c1959. Rangefinder 35mm with coupled selenium meter. Ennagon f2.8/45mm in Prontormat shutter. \$50-75.

Rocca LK - c1959. Scale-focus 35mm with coupled match-needle metering. Ennagon f2.8 in Pronto-LK B,1/₁₅-1/₂₅₀. \$25-35.

Rocca Super Reflex - c1955. 6x6cm TLR. Steinheil Cassar f2.8/80mm lens. Prontor 1-300 shutter, MX sync. \$90-130.

MONTGOMERY WARD & CO. Long Focus Thornward - 4x5" hand and stand camera. \$75-100.

Model B - 4x5" folding plate camera. Leather covered wood body. Rapid conv. lens. Wollensak shutter. \$60-90. Note: Most of the cameras sold through Montgomery Ward were not marked with the company name. Sears was one step ahead of Wards in that respect.

MW - Horizontally styled bakelite folding camera; similar to Vokar A,B and Voigt Jr. Probably sold by Montgomery Ward, but we can find no catalog references. \$30-45.

Wardette

MONTGOMERY WARD

Thornward Dandy - Detective-type box-plate camera, 4x5". Same camera as

the Gem Poco box camera made by Rochester Camera Mfg. Co. \$60-90.

Wardette - Metal box camera made for

Wards by Kürbi & Niggeloh (Bilora). \$1-10. Illustrated bottom of previous column. Wardflex (metal) - c1955-59. Metal-

Wardflex (metal) - c1955-59. Metalbodied 6x6cm TLR. Made by Taiyodo. Telmer f3.5/80mm lens. TKK shutter B,1-200. Rack and pinion focus. \$60-90.

Wardflex (plastic) - c1941. Black plastic TLR, 6x6cm on 120. An Argoflex E with the Wardflex name. Argus Varex f6.3/75mm lens, extrenally gear-coupled to finder lens. Shutter 25-150, T,B. \$20-30.

Wardflex II - c1957. Best of Wardflex models. Fresnel field lens for bright focusing. Biokor f3.5 lens in Synchro MX 1-300. Rolleiflex-style double bayonets on both lenses. "Wardflex II" on top. \$90-130.

Wards 25 - Grey plastic eye-level 127 camera, 4x4cm. Made by Imperial; body identical to Mercury Satellite 127. \$1-10.

Wards 35 - c1956. An Adox Polo 1S with the Wards 35 name. Adoxar f3.5/45mm lens. Shutter 1-300. \$20-30.

Wards 35-EE - c1963. A Rondo 35 with

MONTGOMERY WARD...

the Wards 35-EE nameplate. Made in Japan by Rondo Camera Co. Automatic metering by selenium cell around lens. Four-element f4.0 lens in single speed 1/60 shutter. \$25-35.

Wards am 550 - c1965. Badge-engineered version of the Konica Auto S. Automatic or manual metering with dualrange CdS cell on front of top housing. Needle visible in finder. Hexar f1.9/47mm in Copal SVA B,1-500. Built-in sliding lens hood. \$50-75.

Wards x100 - c1964. Simple, boxy 35mm camera with film advance lever & exposure counter on bottom. Made by Adox Fotowerke, Frankfurt. Adoxon f2.8/45mm.\$8-15.

Wards xp400 - Simple 35mm camera with automatic diaphragm. Made in Japan. Meter cell surrounds the lens. \$20-30.

MONTI (Charles Monti, France) Monte Carlo, Monte Carlo Special c1948. Folding rollfilm cameras for 6x9cm on 120 film. f3.5 or 4.5/90mm lens. \$30-45.

MOONFLEX - c1957. Japanese TLR, similar to Toyocaflex IB. Rack focusing. Tri-Lausar f3.5/80 in unmarked shutter 1-300,B. \$75-100.

MOORE & CO. (Liverpool, England)
Aptus Ferrotype Camera - 18951930's. Black leather covered wood body,
for 4.5x6.3cm exposures on plates. Menis-

cus lens. Suction bulb takes unexposed plate and swings it into position for exposures. \$250-375.

MOORSE (H. Moorse, London) Single-lens Stereo - c1865. Unusual stereo camera for 9x18cm exposures on wet plates. Camera sits in a track on the top of its case. Between the two exposures, the camera is moved along the track to give the proper separation for the stereo exposures. Meniscus lens. \$3500-5500.

MORITA TRADING CO. (Japan)

Gem 16, Model II - c1956. Novelty subminiature for 14x14mm on paper-backed rollfilm. Mensicus lens. B,I shutter. There apparently was not a model I, but if you feel deprived, you could look for the variations with and without "JAPAN" marked on the bottom. Top auction price \$170. Normally \$100-150.

Kiku 16, Model II - c1956. Same as Gem 16, Model II, above. Same prices also apply.

Saica - c1954. Similar to Kiku 16 and Gem 16, but rarely seen with this name. Our only recorded price was Christie's 12/91 at \$250.

MORLEY (W. Morley, Ltd., London, England) Wet plate camera, 1/4-plate c1860. Bellows camera. Jamin-Darlot lens, waterhousestops. \$800-1200.

Wet plate camera, full plate -c1860-70. Bellows type camera for 16x18cm wet plates. Fine wood body with brass trim. Square red bellows. With original Jamin brass lens: \$1500-2000.

Wet plate stereo camera - c1860. Negretti & Zambra brass-barrel lenses, waterhousestops. \$2400-3200.

MOTOSHIMA OPTICAL WORKS (Japan)

Zeitax - c1939. Self-erecting "semi" camera for 4.5x6cm on 120 film. Early version has rigid tube finder and shutter to 1/₂₀₀. Later version c1941 has folding optical finder and Shinko shutter to 1/₃₀₀. Both have body release and Zeitax Anastigmat f3.5/75mm lens. \$75-100.

MOUNTFORD (W.S. Mountford Mfg., NY)

Button tintype camera - Leather-covered cannon-style button tintype taking 100 1" dia. tintypes. \$1200-1800.

MOURFIELD
Direct Positive Camera - Large
brown-leathered camera. Prism mounted
in front of lens. \$150-225.

MOZAR (Dr. Paul Mozar, Düsseldorf, Germany)

Diana - c1950. Bakelite box camera for 6x9cm on 120 film. f11 lens. M&Z shutter. Uncommon \$75-100.

MÜLLER (Conrad A. Müller, Strengenberg, Germany)
Noris - c1930's. Folding camera for 4.5x6cm on 120 film. Cassar f2.9/75mm lens in Compurshutter. \$60-90.

MULTI-SPEED SHUTTER CO. (New York, NY)

Simplex - c1914. Early 35mm camera. Film cassettes held 50' of perforated film. Format could be changed from 24x36mm to 18x24mm between exposures by moving a lever. Also made without the 18x24mm capability. B&L Tessar f3.5/50mm lens. Shutter 1-300,T. One reportedly attracted offers of \$6000+, while another found no buyer at \$3000.

Multi-Speed Precision Camera - c1920. Folding bed camera for 31/4×41/4" plates. Spring-loaded back accepts single metal holders in front of ground glass. Emil Busch Multi-Speed Leukar f6.8/61/2" in Multi-Speed shutter. Body is obviously imported from Germany and fitted with Multi-Speedbrand shutter/lens. \$90-130.

MULTIPLE TOYMAKERS (N.Y.C.) Camera Kit, Wonderful Camera - c1973. Small plastic half-frame 127 camera in kit form. Simple assembly of 5 large pieces and a few small ones yields a camera named "Wonderful Camera" with f8 lens in 1/50 sec. shutter. The kit comes bubble packed on a card. Made in Hong Kong. Unassembled: \$20-30. Assembled: \$1-10.

MULTIPOSE PORTABLE CAMERAS LTD. (France)

Maton - c1930. Brown bakelite box taking 24 exposures, 24x30mm, on positive paper-backed film. Crank advance. Rousell Trylor f4.5/85mm, Gitzo shutter. \$350-500.

MULTISCOPE & FILM CO.

(Burlington, Wisc.) The Multiscope & Film Co. manufactured the Al-Vista cameras from 1897 through 1908. In their 1908 catalog, they listed a line of 116 different "Badger" plate cameras. We have yet to see any example of a camera bearing that name. At the end of 1908, the company sold all the rights, patents, and equipment for the panoramic cameras to the Conley Camera Co. of Rochester, Minnesota.

Prices quoted are for complete camera, normally with 3 diaphragms, set of 5 fans,

and viewer.

Al-Vista Panoramic Cameras - patents 1896, 1901, and 1904. Takes panoramic pictures (model no. gives film height in inches) The standard five-format models take pictures in lengths of 4, 6, 8, 10, or 12 inches on rollfilm. The dual-format models take a standard proportion picture or double-width panoramic view. The late Al-Vistas manufactured had the carrying strap mounted on the side, and a rubber slide was used to set the length of picture desired.

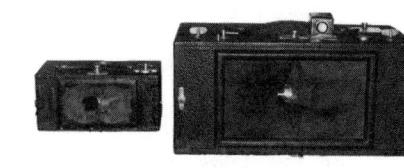

Baby Al-Vista - c1906-08. For 2¹/₄x6³/₄" pictures on 120 film. Actually, there are two models. No. 1 was a simple model with 4-position spring tensioning for speed adjustment. It sold originally for \$3.50. Baby Al-Vista No. 2, which originally cost \$5.00, had an external fan to slow down the swinging shutter. \$400-600.

Al-Vista 3B - c1900-08. Dual-format model. Picture 31/2" high by either 41/2 or 9" long. \$300-450.

Al-Vista 4B - c1900-08. Standard five-format model. Pictures 4" high by 4,6,8,10, or 12" long. \$250-375.

Al-Vista 4G - c1904. Dual format, 4" high by 5 or 10" long. Takes snapshots only. \$300-450.

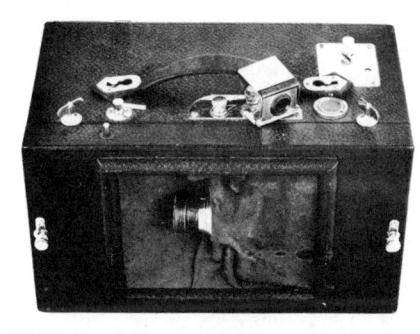

Al-Vista 5B - c1900-08. Standard five-format model. Pictures 5" high by 4,6,8,10, or 12" long. \$350-500.

Al-Vista 5C - c1900-03. Five panoramic formats on rollfilm. 4x5" photos on glass plates with lens tube locked in center position and rear lens hood detached. A "semiconvertible" model. \$350-500.

Al-Vista 5D - c1900-08. Like the 5B, but lengths of 6,8,10,12, and 16". \$300-450.

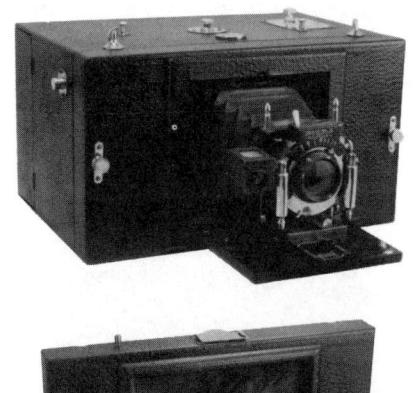

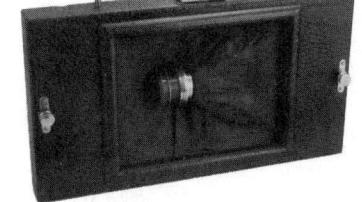

Model 5F with folding-bed front (above), and panoramic front (below)

MURER & DURONI

Al-Vista 5F - c1900-08. The convertible model. This camera has two fronts which use the same back. One front is the swinging lens panoramic, and the other is a folding-bed front which looks like the typical folding plate cameras of the day. An unusual and rare set. \$600-900. Illustrated bottom of previous column.

Al-Vista 7D - c1901. Dual format, 7" high by 71/₂ or 15" long. Uncommon.\$400-600.

Al-Vista 7E - c1901-08. Dual format, 7" high by $101/_2$ or 21" long. Uncommon. \$400-600.

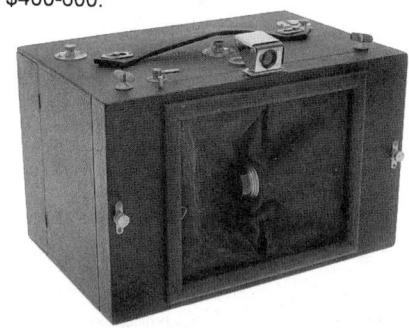

Al-Vista 7F - c1901-07. Large size convertible model, similar to 5F above. The standard front has extra long bellows for use with convertible lenses, such as the 81/2" rectilinear lens originally supplied. Complete: \$1500-2000.

Al-Vista Senior - 1899. Professional model for $81/2 \times 26$ " on 500 inch long roll-film. Very few made. No known recent sales. Estimate: \$1700-2400.

Note: Other models and variations of Al-Vista cameras generally sell in the \$250-375 range. Some of these include: 4, 4A, 4C, 5, and 5A.

MUNDUS (France)

Mundus Color - c1958. Beige vertical camera for 8x14mm exposures on double 8 movie film. Resembles a movie camera. Interchangeable Berthiot f2.8/20mm lens. Shutter 1-300. \$250-375.

Mundus Color 60 - c1960-73. Body is more stylized than the original rectangular-shaped Mundus Color. Som-Berthiot f2.8/20mm.\$200-300.

Mundus Color 65 - c1974-76. Almost identical to the Mundus Color 60, but lens is f2.8/25mm. \$200-300.

MÜNSTER KAMERABAU (Germany)

Phips - 1949. Simple metal box camera for 120 film, 6x9cm. Parts of the camera came unassembled in a kit. Achromat f9, I+T shutter. Unassembled, in original box: \$300-450. Assembled: \$90-130.

MURER & DURONI (Milan, Italy)
Muro - c1914. Vertical 4.5x6cm strutfolding camera. Suter Anastigmat
f5/70mm. FP shutter to 1000. \$200-300.

Newness Express - c1900. Magazine box cameras for various sized plates: 4.5x6cm, 6x9cm, 7x8cm, 8.5x11cm (31/₄x41/₄") and 9x12cm. Murer Anastigmat f4.5 or 6.3, focal length depending on size of camera. Focal plane shutter. \$50-75.

MURER & DURONI...

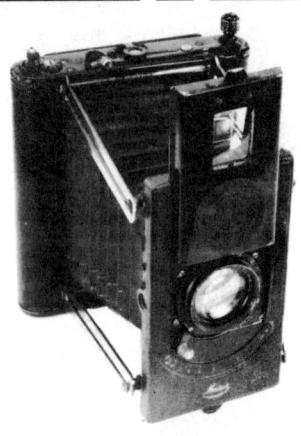

Folding plate, focal plane cameras - c1905-30. Strut folding style in all the sizes listed above. \$150-225.

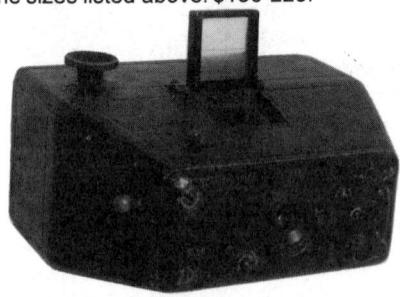

Piccolo - c1900. Rigid bodied rollfilm camera in the truncated pyramid "jumelle" style. Made to take 4x5cm exposures on the same rollfilm as the Pocket Kodak box cameras of 1895-1900 (including the elusive "Cone Pocket Kodak" of nearly identical design). \$150-225.

Reflex - Mid to late 1920's. SLR for 6.5x9cm plates. Murer Anastigmat f4.5/120mm. Focal plane shutter 15-1000. \$150-225.

\$L - c1900. Small leather covered wooden 4x5.5cm box camera. Three stops: 10,20,40. P&L shutter. Two brilliant finders. \$100-150.

SL Special - c1910. Strut-folding camera for 45x107mm stereo plates. Murer Rapid Aplanat f8/56mm lenses. Newton finder has lenscaps attached. In retracted position, the lenses are protected. \$175-250.

Sprite - c1915. Vertical 4.5x6cm strutfolding cameras. Made in 127 rollfilm and plate versions. Rapide Aplanat f8/70mm lens. Shutter 25-100. \$100-150.

Stereo - c1920. Folding camera for 45x107mm exposures. Focal plane shutter, 15-1000. Murer Anastigmat f8 or f4.5/60mm.\$200-300.

Stereo Box - c1905. Magazine box camera for stereo exposures. 6x13cm or 8x17cm sizes. Rapide Rectilinear f10 lenses. \$250-375.

Stereo Reflex - Mid to late 1920's. SLR 45x107mmplates. F4.5 lenses. \$500-750.

UF - c1910. Strut-folding camera for 4.5x6cm filmpacks in special back. Aplanat lens. Between-the-lens shutter 25-100. \$120-180.

UP-M - c1924. Strut-folding camera for 4.5x6cm plates. Rapid Aplanat f8/70mm. Between-the-lensshutter. \$100-150.

MUSASHI MANUFACTURING CO. (Japan)

Malcaflex - c1952. TLR, 120 film. Rack focusing. Some have sportsfinder in hood, some not. Horinor Anastigmat f3.5/7.5cm. B,1-200 NKS-sc or T.K.S. sh. \$100-150.

MUSASHINO KOKI Today known as Wista, and from ca. 1970 specializing in large format metal folding cameras such as the 45SP, then monorails and eventually also wooden field cameras. Also one of the leading producers of rollfilm holders for 4x5 international (Graflok) backs.

Optika IIa - c1956-60. Essentially a name variant of the Rittreck IIa, but shutter to 400, not 500. With f3.5/105mm Luminor and rollback: \$250-375. Add \$60-90 each for extra lenses or rollbacks.

Rittreck IIa - c1956-60. SLR for 6x9cm on sheetfilm or 120 rollfilm. Historically, this was the first 6x9cm SLR from Japan. Professionally, it was a very competent studio camera. Close focusing bellows. Interchangeable lensboards and backs. FP shutter, T,B,1/20-500. With normal lens and back: \$250-375. *Add \$60-90 each for extra lenses or rollbacks*.

Rittreck 6x6 - Medium format SLR for

6x6cm on 120/220. Interchangeable Rittron f2/80mm lens. FP sh. B,1-500. Reflex finder or optional pentaprism. Also sold as Warner, Norita, Graphic 6x6. \$350-500.

Warner 6x6 - c1968. Medium format SLR for 6x6cm on 120/220 films. Interchangeable f2/80mm Rittron lens. FP sh. B,1-500. Also sold as Rittreck 6x6, Norita 6x6, Graphic 6x6. \$350-500.

MUSE OPTICAL CO. (Tokyo, Japan)
The Muse Optical Co. name was used by
Tougodo for various cameras.

Museflex, Model M - c1949. TLR for 3x3cm on paper-backed 35mm rollfilm. f5.6/55mm. Automatic shutter. \$120-180.

MUTSCHLER, ROBERTSON, & CO. Manufacturer of the "Ray" cameras, which were later sold & labeled under the "Ray Camera Co." name. See Ray.

MYCRO CAMERA CO. (NYC) Several small cameras were sold by Mycro Camera Co., which also furnished processing services for Mycro-size films. These cameras are listed under their proper manufacturers, although some have the Mycro Camera Co. name on the camera or on the original box. "Mycro" cameras may be found under Sanwa.

MYKEY-4 - c1960's? Eye-level camera for 4x4cm on 127 film. Tokinon f3.5/60mm lens in B,25-300 shutter. We assume Japanese manufacture and it has a TSK

NATIONAL INSTRUMENT

logo on the accessory shoe. A free cup of coffee for anyone who can give us more details about the manufacturer or date. Recorded sales of \$25 & \$125 in 1987. Current estimate: \$60-90.

MYKRO FINE COLOR 16 - Japanese subminiature for 13mm wide exposures on 16mm film in special cassettes. Body style similar to the Whittaker Pixie. \$75-100.

MYSTIC PLATE CAMERA CO. (New York)

Mystic Button Camera - Button tintype camera. Spring loaded tube advances buttons for exposure. \$300-450.

NAGEL (Dr. August Nagel Camerawerk, Stuttgart, Germany) Formed by Dr. Nagel in 1928, when he left Zeiss Ikon. Sold to Kodak A.G. in 1932. Earlier in his career, Nagel was supposedly embarassed in the Zeiss Ikon board room by his lack of academic qualifications. He was given an honorary degree by the University of Freiburg in 1918.

Anca (10,14,25,28) - 1928-34. Folding plate cameras in 6.5x9cm and 9x12cm sizes. Most commonly found with Nagel Anastigmat f4.5, 6.3, 6.8 lenses in Pronto 25-100 shutter. \$120-180.

Fornidar 30 - 1930-31. 9x12cm folding plate camera. Nagel Anastigmat f6.3/135, f4.5, or Laudar f4.5/135mm lens. Compur shutter 1-200. \$100-150.

Librette (65,74,75,79) - 1933. 6x9cm folding rollfilm cameras. Most commonly found with Nagel Anastigmat f4.5, f6.3, or f6.8 lens in Pronto 25-100 shutter. Most sales in the \$60-90 range.

Pupille - 1931-35. (Also called "Rolloroy" in England). 16 exposures 3x4cm on 127 film. With Leitz Elmar f3.5/50mm lens: \$600-900. Normally equipped with Schneider Xenon f2, Xenar 2.9, or 3.5/50mm in Compur 1-300 shutter. \$200-300.

Ranca - 1930-31. 3x4cm on 127 film. Similar to Pupille, but cheaper. Front-lens focusing. Nagel Anastigmat f4.5/ 50mm in Pronto or Ibsor 1-150 shutter. \$175-250.

Recomar 18 - 1928-32. Folding-bed plate camera, 6x9cm. Compur shutter 1-250. With Leitz Elmar f4.5: \$200-300. With normal lens; Nagel Anastigmat, Xenar, Tessar f3.8, 4.5, 6.3/105mm: \$75-100.

Recomar 33 - 1928-32. Folding 9x12cm plate, double extension. Compur 1-250, T, B. With Leitz Elmar f4.5/135mm: \$250-375. With normal f4.5/135mm: \$75-100.

Vollenda, 3x4cm - 1931-32. Horizontal style folding bed rollfilm camera. Pronto or Compur shutter. With Elmar f3.5/50mm:

\$200-300. With Tessar f2.8/50mm: \$100-150. With Radionar or Xenar f3.5 or 4.5/50mm: \$75-100.

Vollenda, 4x6.5cm, 5x7.5cm, or 6x9cm - c1930-32. Folding bed rollfilm cameras for 127, 129, or 120 film. With normal f4.5 lens: \$50-75.

Vollenda 70/2 - c1930. Deluxe version of Vollenda, 6.5x9cm. Has brown leather covering, brown bellows, nickel trim. Xenar f4.5/105mm; Compur shutter. \$100-150.

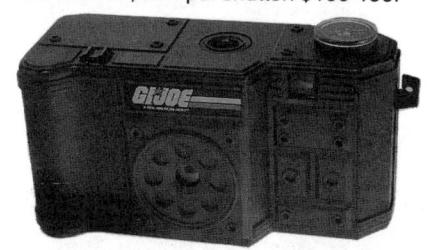

NASTA INDUSTRIES INC. (New York) G.I. Joe - 1984. Olive drab plastic camera for 126 cartridges and x-cubes. Military styling, compass on top. \$12-20.

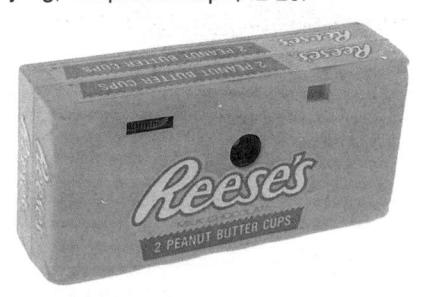

Reese's Peanut Butter Cups - c1991. Plastic camera disguised as two packets of Reese's famous candy. Uses 110 cartridge film. A training camera for the children of secret agents. Retail price about \$10 when new, and likely to increase in value as a collectible.

NATIONAL (Osaka, Japan)

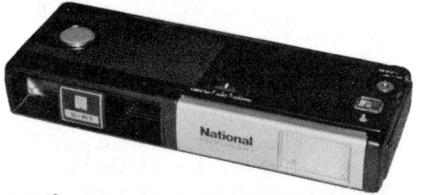

Radicame CR-1, Radio/Flash CR-1 - c1978. 110 cartridge camera with built-in flash and radio. \$100-150.

Radio/Flash CR-2 - Black. Similar to CR-1, with Fujinon lens. \$100-150.

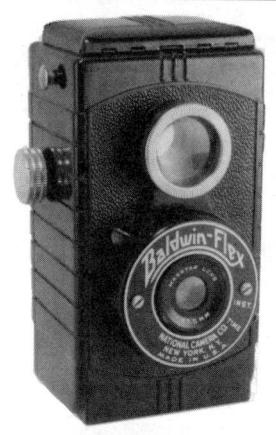

NATIONAL CAMERA CO. (N.Y.C.)
Baldwin-Flex - TLR-style minicam for 3x4cm on 127 film. \$12-20.

NATIONAL CAMERA CO. (St. Louis, Missouri)
Naco - Horizontal folding rollfilm, 8x14cm. Similar to the #3A Folding Hawk-Eye. Rapid Rectilinear f4 lens. Ilex 25-100 shutter, B,T. Uncommon.\$45-60.

NATIONAL INSTRUMENT CORP. (Houston, Texas)

Camflex - 6x6cm aluminum box. \$20-30.

Colonel - c1947. Aluminum 6x6cm box camera. \$25-35.

NATIONAL INSTRUMENT...

Major - c1947. Stamped aluminum box. 6x6cm on 620 film. Uncommon \$25-35.

Box-Nebro - Simple metal box camera with black crinkle finish. \$20-30.

Nebro Flash - Horizontally styled bakelite eye-level camera for 6x9cm on 620 or 120 film. Body moldings bear the markings of "Laboratorios Mecanicos M.C." which also made the Joya camera. \$25-35.

NATIONAL PHOTOCOLOR CORP.

5x7" size - c1939. Similar to above, except for size. \$500-750.

NATIONAL SILVER CO. National Miniature - Black plastic minicam for half-frame 127. \$1-10.

NAYLOR (T. Naylor, England)
Field camera - Full-plate brass and mahogany field camera. Brass bound lens. \$200-300.

NEBRO (Argentina)

Baby Nebro - Black bakelite camera for 6x6cm on 620 film. Unusual vertical orientation of the camera body is awkward and unnecessary for a square format. The Nebro name on the front shows obvious signs of an altered mold. The original name "Baby Joya" is molded inside the back, along with the markings of "Laboratorios Mecanicos M.C.". \$25-35.

Super Nebro - Black bakelite, similar to the Nebro Flash, but without sync. \$25-35.

NECKA JR. - Box camera. \$1-10.

NEFOTAF (Holland)

Neofox II - Box camera, 6x9cm. \$25-35.

NEGRA INDUSTRIAL, S.A. (Barcelona, Spain)

Nera 35 - Low cost 35mm. Two speed Speed Acrinar lens. Hot shoe. shutter, \$15-25

NEGRETTI & ZAMBRA (London, England)

Cosmos - c1903. Falling plate stereo camera, 45x107mm. Holds 12 plates. Extra Rapid lenses. \$600-900.

Field Camera - Mahogany 1/2-plate camera. Brass-barrel lens with Rollerblind shutter. \$350-500.

One-Lens Stereo Camera - c1865-70. Wet plate sliding-box camera, 8x8cm. For stereo exposures, camera is mounted on top of its stoarge case and moved in its mount between exposures. Negretti & Zambra lens. Rare and desirable. Price negotiable. Estimate: \$15,000-23,000.

Stereo Camera - c1862. Mahogany sliding-box wet plate camera. Brass-barrel Negretti & Zambra lenses. \$3500-5500.

NEIDIG (Richard Neidig Kamera-Werk, Plankstadt, Germany) Perlux (24x24mm) - c1950. 35mm camera, 24x24mm exposures, Many lens and shutter combinations, including Kataplast f2.8/45mm in Vario 25-200. \$50-75.

Periux (24x36mm) - c1952. Similar to the original Periux, but with 24x36mm image size. Recognizable by the trapezoidal finder tube. Kataplast f2.8 in Prontor-S shutter. Name variants include Bower 35. DeJur D-1, and Adox 35, \$50-75.

Perlux II - c1953. Same basic body as Perlux 24x36mm, but full-length top housing has uncoupled rangefinder. Interchangeablelenses. \$60-90.

Perlux IIa - c1953. As Perlux II, but rangefinderis coupled. \$60-90.

Neithold (Carl NEITHOLD

Frankfurt/M Germany)
Ce-Nei-Fix - c1930. Simple folding camera for 6x9cm on 120 rollfilm. f11 lens in AGC shutter to $^{1}/_{50}$. Unusual strut mechanism extends from the end of the camera below the bed, rather than the more common internal struts. \$30-45.

NEMROD METZELER, S.A. (Barcelona, Spain) Named for Nemrod the hunter, King of Babylonia.

Siluro - c1960-66. Underwater camera molded from "Novodur" plastic. Takes 12 exposures, 6x6cm, on 120 rollfilm. Styled like the Healthways Mako-Shark camera, but built for use at depths to 40 meters. Lead weights inside back. Valve on front to pressurize interior. Fixed focus f16 lens, 1-2.5 meters. Single speed shutter 1/55 sec. Battery and capacitor for external flash are contained within the camera body. \$90-

NEO FOT A - c1950's. Black bakelite camera for 4.5x6cm on 120 rollfilm. Made in Denmark. Unusual body design. \$30-45.

NEOCA CO. (Japan)
Neoca 15 - c1955. 35mm with coupled rangefinder. Neokor f3.5/45mm lens. Ceres shutter 5-300, B. \$50-75.

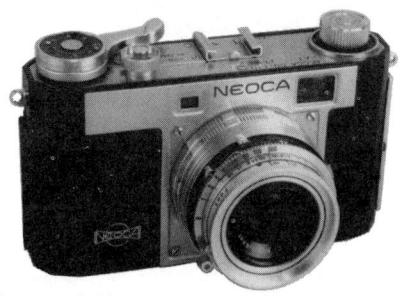

Neoca 2S - c1955. 35mm with coupled rangefinder; lever advance. Neokor f3.5/45mm lens. Rectus shutter 1-300,B. \$50-75.

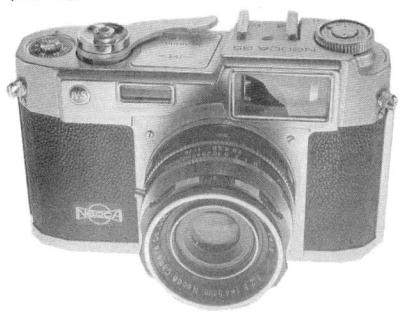

Neoca IVS - Coupled rangefinder 35mm. Neokor f2.8/45mm in Citizen MV B,1-400 shutter. \$50-75.

Robin - Rangefinder 35. Neokar f2.8/45mm lens. Citizen MV shutter to 500. A number of different models, but all in the same price range. \$45-60.

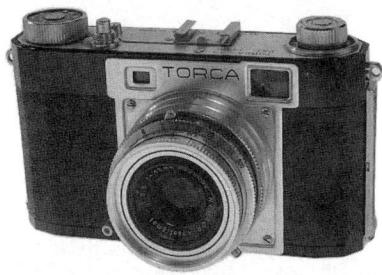

Torca-35 - c1956. Rangefinder 35mm, styled similar to Nikon S2. An early name variant of the Neoca 35A. Neokor Anastigmat f3.5/45mm in Rectus B,1-300 shutter. Uncommon. One recorded sale in 1992 at \$200.

NETTEL KAMERAWERK (Sontheim-Heilbronn, Germany) Formed in 1902 as Süddeutsches Camerawerk Körner & Mayer GmbH. Became Nettel Kamerawerk ca 1909; merged with Contessa in 1919 to form Contessa-Nettel; further merged to form Zeiss-Ikon in 1926.

Argus - c1911. Monocular-styled camera. Right angle finder in monocular eyepiece. An unusual disguised camera, less common than the later Contessa-Nettel and Zeiss-Ikon "Ergo" models. British catalogs called it the "Intimo". \$1200-1800.

Deckrullo - c1908-19. Successor to the original Nettel camera of 1904, but with a self-capping ("deck"=cover) shutter. From 1919, continued as a "Contessa-Nettel" model. A series of strut-folding focal plane "klapp" cameras for glass plates. Focal plane shutter 1/2-2800. Typical lenses include Nettel Rapid Aplanat, Nettel Anastigmat, Goerz Dagor & Celor, Zeiss Tessar.

9x12cm size - Zeiss Tessar f6.3/135mm or Dogmar f4.5/150mm, \$120-180

10x15cm size - Tessar f4.5/165mm or 180mm. \$175-250.

13x18cm size - Nettel Anastigmat f6.5/18cm. \$175-250.

18x24cm size - Xenar f4.5/210mm. FP shutter. \$250-375.

Folding plate camera, 9x12cm - Double extension bellows. Tessar f6.3/135mm lens. Dial Compur 1-250. \$60-90.

Folding plate camera, 5x7" - Zeiss Anastigmatf8/210mm. \$120-180.

Sonnet - c1913. 10x15cm folding plate camera. Single extension. Tessar f6.3/165mm, Compur1-200. \$90-130.

Sonnet (Tropical model), 4.5x6cm- Tessar f4.5/75mm. Compound shutter 1-300. Teakwood with light brown bellows. \$500-750.

- **6x9cm size** - Tessar f4.5/120mm in Compoundshutter. \$300-450.

Stereax 6x13cm - c1915. Stereo focalplane strut-camera. Tessar f4.5/120mm lenses. \$350-500.

Stereo Deckrullo Nettel, Tropical - c1912. Teakwood with brass trim. Tessar f4.5 lenses. Focal plane shutter. Made in 9x14, 10x15, 9x18cm sizes. \$1000-1500.

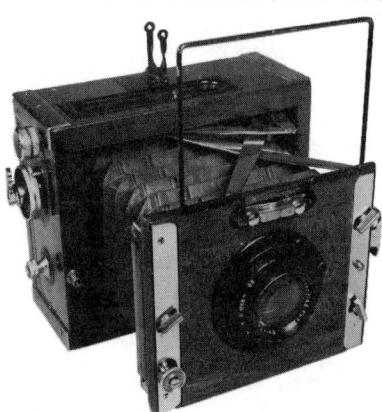

Tropical Deckrullo Nettel, 10x15cm - c1910-19. Teakwood camera with nickel struts and trim. Brown bellows. Nettel Anastigmat f4.5/165mm. Focal plane 1/2-2800. \$750-1000.

NEUMANN (Felix Neumann, Vienna, Austria)

Field camera - c1900. Wood tailboard camera, brass trim, black tapered double extension bellows. \$200-300.

NEW TAIWAN

Helios - c1890's. Leather covered wooden box camera for plates or rollfilm. Made in 6x9cm & 9x12cm sizes. Simple fixed focus lens in Z,M shutter. One reported auction sale (Breker) at \$5000.

Magazine camera - c1895. Wood box for 12 plates 9x12cm. Leather changing bag, meniscus lens. \$250-375.

NEUMANN & HEILEMANN (Japan) Condor - Folding 120 rollfilm camera, half-frame. \$75-100.

NEW HIT - 16mm subminiature made in Occupied Japan. \$50-75.

NEW IDEAS MFG. CO. (New York)Manufacturing branch of Herbert & Huesgen.

Magazine camera - c1898. Polished wood box detective camera. String-set shutter. \$350-500.

Tourist Multiple - c1913. One of the earliest cameras to use 35mm motion picture film for still pictures, and the first to be commercially produced. Vertically styled body, leather covered. Tessar f3.5, Goerz Hypar f3.5, or Steinheil Triplar f2.5 lens, guillotine shutter. Film capacity of about 50 feet for 750 exposures 18x24mm. The outbreak of WWI slowed the tourist market for which this camera was intended, and probably only about 1000 were ever made. \$2400-3200.

NEW TAIWAN PHOTOGRAPHIC CORP. Yumeka 35-R5 - c1983. A poor quality transistor radio built into a poor quality 35mm camera. New in box: \$30-45.

NEW YORK FERROTYPE

NEW YORK FERROTYPE CO.

Tintype camera - c1906. Professional model with three-section plateholder for postcards, 11/2x21/2" tintypes, and "button" tintypes. Two-speed Wollensak shutter. With tank and black sleeve. \$200-300.

NEWMAN & GUARDIA, LTD. (London)

Deluxe - c1896. Box-style camera with bellows extension. Zeiss Protar f9/220mm lens. \$350-500.

Folding Reflex - 1921-1930's. (Available until 1957). SLR for 6.5x9cm plates. Ross Xpress f2.9 or f4.5 lens. Folds to compact size. \$200-300.

High Speed Pattern - Variation of the Universal Pattern B with faster Zeiss Tessar f4.5 lens. N&G pneumatic shutter 1/2-100 and FP shutter 1/10-800. \$400-600.

Nydia - c1900. Tapered bellows, folding plate camera. Unusual design for folding. Bellows detach from lensboard, which then swings to the end of the body. 9x12cm and 10x13cm sizes. Wray Rapid Rectilinear or Ross f8 or f6.3 lens. Guillotine shutter 2-100. \$750-1000.

Sibyl Cameras - Early models with just the "Sibyl" name seem to be pre-1912, when the company began assigning more specific names. Some cameras were made only in certain sizes.

Baby Sibyl (4.5x6cm) - c1912-35. 4.5x6cm on plates or filmpacks. Rollfilm model for 15/8x25/8". Ross Xpress or Tessar f4.5/75. N&G shutter 2-200. \$500-750.

New Special Sibyl (6.5x9cm) - c1914-35. For $2^{1}/_{2}x3^{1}/_{2}$ " plates or $2^{1}/_{4}x3^{1}/_{4}$ " filmpacks. Rollfilm model gives $2^{5}/_{16}x3^{5}/_{8}$ " image. Ross Xpress f4.5/12mm. N&G Special shutter. \$250-375.

New Ideal Sibyl (31/4x41/4") - c1913. For 31/4x41/4" plates or filmpacks. Rollfilm model gives 3x45/8" image. Tessar f4.5/135mm. N&G shutter. \$250-375.

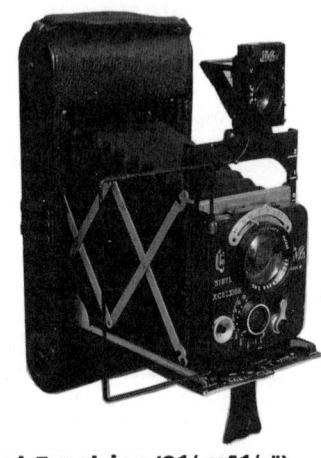

Sibyl Excelsior (21/₂x41/₄") - c1933. Rollfilm size. Ross Xpres f4.5/136mm lens. N&G patent shutter. Possibly the first camera to use the winding knob as a back opening knob. The back consists of two halves which open from the center, automatically lifting out the film spool holders for easy loading. Not common even in England. \$300-450.

Postcard Sibyl - c1912-14. Folding plate camera with bed and trellis struts.

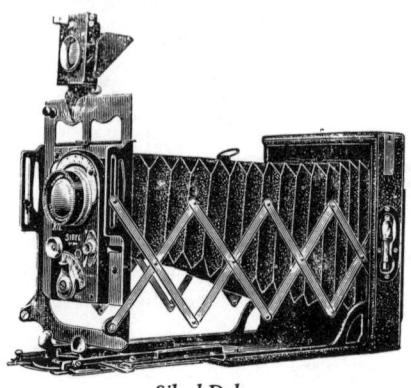

Sibyl Deluxe

Zeiss Tessar f4.5/150mm lens. N&G pneumaticshutter 1/2-100. \$300-450.

Sibyl - c1907-12. Folding-bed rollfilm or plate cameras. Tessar f6.3/120mm, Ross f3.5 or 4.5 lens. N&G Special shutter. 6.5x9cm: \$120-180.3¹/₄x4¹/₄": \$150-225.

Sibyl Deluxe - c1911. 9x12cm. Double extension bellows. Zeiss Protar f6.3/122mm. N&G shutter 2-100. \$400-600. *Illustrated bottom of previous column.*

Sibyl Stereo - c1912. 6x13cm plate camera. Trellis struts like other Sibyl cameras. Zeiss Tessar f4.5/120mm lenses. Shutter 2-100. \$1500-2000.

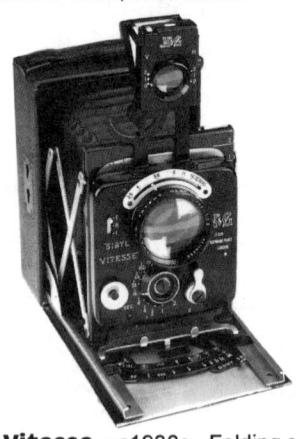

Sibyl Vitesse - c1930s. Folding camera with trellis struts. Ross Xpres 112mm f3.5 lens. \$250-375.

Special Stereoscope Rollfilm Sibyl - c1920. Probably the rarest Sibyl. Folding bed camera with rounded body ends. 13/₄x41/₄" exposures on A116 rollfilm. Ross Xpres f4.5/75mm lenses. N&G shutter ¹/₂-100. \$2400-3200.

Stereoscopic Pattern - c1896-1911. Variation of the Universal Pattern B for stereo exposures on 1/2-plates. f6.3 lenses. N&G pneumaticshutter. \$1200-1800.

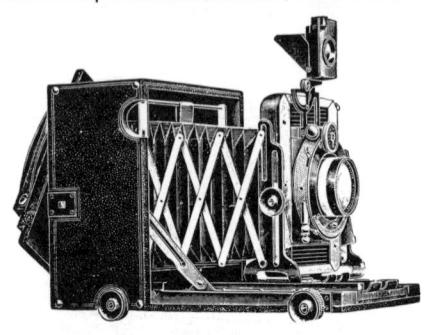

Trellis - c1910's-1930. Folding-bed plate camera in $^{1}/_{4}$ - and $^{1}/_{2}$ -plate sizes, with typical N&G struts. Protar lens, N&G shutter. \$400-600.

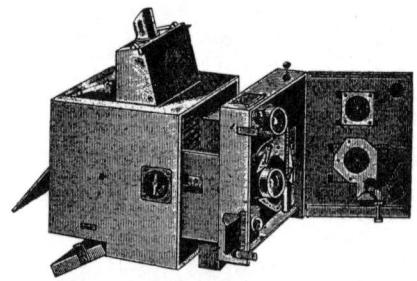

Twin Lens Pattern - c1895. 9x12cm, box-TLR. Viewed through a chimney-like

<u>NICCA</u>

extension in the viewing hood. Also has 2 small waist-level viewfinders, typical of box cameras. Leather-coverd wood body. Rack and pinion focusing. Newman Patent Pneumaticshutter, 1/2-100. \$750-1000.

Universal Pattern B, Universal Special Pattern B - c1905-13. Box magazine camera for 31/4x41/4" or 4x5" plates. Internal bellows allow front of box to slide out for copy work or close-ups. Zeiss Anastigmat f12.5 or f6.3 lens. N&G pneumatic shutter 2-100. Available special order with tan leather: \$500-750. With normal black leather: \$250-375.

NEWTON & CO. (London) Tailboard camera - c1887. Mahogany and brass field camera with brass bound lens. Sizes 1/2-plate to 10x12". \$250-375.

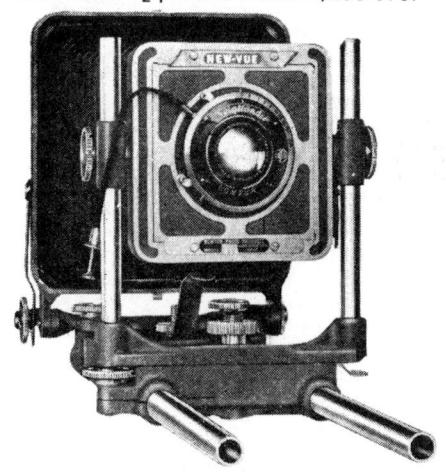

NEWTON PHOTO PRODUCTS (Los Angeles, CA)
Newton New Vue - c1947. All-metal bi-rail view. Gray enamel, nickel trim. Rotating back. Rapid front focus, micro focus at rear. With appropriate lens/shutter. \$200-300.

NIAGARA CAMERA CO. (Buffalo, NY) Niagara #2 - Box camera for $3^{1}/_{2}x3^{1}/_{2}$ " plates in double plateholders which load through hinged door on top. Uncommon camera, named for the famous waterfalls. \$45-60.

NIC (Barcelona, Spain) Founded in late 1931 by two brothers, Tomás & José Maria Nicolau y Griñó, inventors of a toy projector for animated drawings. For 40 years, they produced a variety of silent and sound projectors and films. Our primary interest here is their unusual still camera.

Foto Nic - c1935. A relatively complicated, though cheaply constructed camera for positive photos in 5 minutes. Basically a

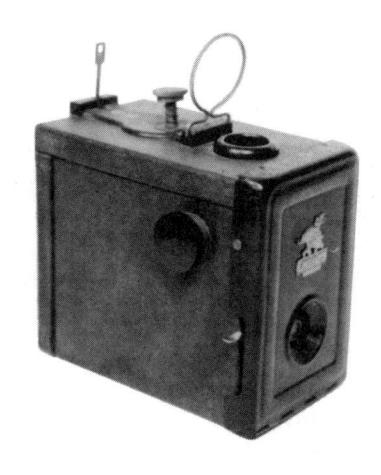

box camera, but with built-in pads for developer and fixer. A brief summary of operation: 1. Load camera with its special photographic paper. 2. Saturate developer and fixer pads. 3. Expose photo. 4. Turn advance knob until exposed emulsion faces the developer pad. 5. With exterior knob, push developer pad into contact with paper and turn for 1 minute. 6. Advance to fixer position; turn fixer pad against paper for 1 minute. 7. Open top door and remove negative from backing strip. 8. This paper negative is then re-photographed by the same camera, using built-in frame and close-up lens, and developed in the same manner to produce the final print. This camera is rather rare. \$250-375.

NICCA CAMERA WORKS (Japan) Kogaku Seiki Co. 1940-1947 Nippon Camera Works 1948-1948 Nicca Camera Works 1949-1958 see Yashica for post-1958

The Kogaku Seiki Co. produced its first camera, the Nippon, in 1942. In 1948 the first Nicca was produced by Nippon Camera Works. Subsequent Nicca models were manufactured under the Nicca Camera Works name, with such features as flash sync, lever wind, hinged backs and projected frame lines added over the course of the production. Nicca also made cameras for Sears under the "Tower" name. The company was absorbed by Yashica in 1958 and the final two "Nicca" models were the Yashica YE (a Leica IIIc copy) and YF (similar in appearance to Leica M2).

Nippon - 1942–47. Two versions: 1. With rangefinder and slow speed dial. 2. Without rangefinder or slow speed dial. Lenses include K.O.L. Xebec f2/5cm, Nikkor f4/5cm, and Sun Xebec f2/5cm. FP shutter 1-500 or 1/20-500. \$2400-3200.

NICCA Quick Identification:

Common features: To ease identification, we are not repeating common features, but only those which serve to distinguish one model from another. All of the Nicca models, unless otherwise specified, have cloth focal plane shutter 1-500 with slow speeds 1-20 on front dial. All accept screw-mount lenses in Leica thread which couple to rangefinder. Separate eyepieces are used for RF and VF. Except for the original Nicca (Nippon Camera Works, 1948), all have diopter adjustment on viewfinder eyepiece.

adjustment on viewfinder eyepiece.

KNOB WIND models, 1949-57. Basically similar to the original Nicca, but minor variations on each model.

Nicca Type 3, Nicca IIIA: No sync. Nicca IIIB, IIIS, 3S, 3F (early): Sync added. Nicca 4, Nicca 5: Focal plane shutter to 1000, sync. LEVER WIND models, 1957-58.

Nicca 3F (later type), Nicca 33: Retained the early Leica-style appearance, but a lever advance was added.

Nicca IIII: A re-styled top housing incorporating a large combined range/viewfinder. Somewhat similar in appearance to Leica M3. The lever advance was built into the top housing, not on the top.

Nicca (Original) - 1948. First two digits of serial number indicate year of manufacture. 23XXX = Showa 23 = 1948. Essentially identical to the prewar and postwar rangefinder Nippon except for the top plate engraving and Nikkor-QC f3.5/5cm rather than K.O.L. Xebec lens. Body style similar to the Leica III. Separate RF/VF eyepieces; no diopter adjustment. \$1200-1800.

Nicca III (Type-3) - 1949. Features like previous model, but with diopter adjustment. "Nicca Type-3" on top. Original lens is Nikkor-HC f2/5cm. No sync. \$200-300.

Nicca IIIA - 1951. The last of the nonsync models. Nikkor-HC 5cm/f2 lens. Also sold as Tower Type-3 (See Sears). \$200-300.

Nicca IIIB - 1951. Twin sync posts on front for FP bulbs. Otherwise similar to IIIA. Nikkor-SC f1.5/5cm lens. (Also sold as Sears Tower Type-3). \$300-450.

Nicca IIIS - 1952. Sync changed to two PC posts for FP or X sync. Nikkor-QC f3.5/5cm. (Sears sold this camera as Tower Type 3S through 1956 with f2 and f1.4 Nikkor lenses.) \$250-375.

Nicca 4 - 1953. Nikkor-SC f1.5/5cm lens. Speeds to 1/₁₀₀₀ sec. \$350-500.

Nicca 3-S - 1954. Shutter speeds changed to geometric progression with synch at $^{1}/_{25}$ and top speed of $^{1}/_{500}$. Nik-kor-QC f3.5/5cm lens. \$250-375.

Nicca 3-F - c1956-57. Top housing restyled for cleaner look. Front center portion of extends downward to act as lens escutcheon. Sync post moved to back of top housing below shoe. Nikkor-H f2/5cm lens. Early version has knob wind. Later version has lever wind. \$250-375.

Nicca 5 - 1955. Single piece top housing like 3F, but top speed to $^{1}/_{1000}$. Sync post on rear of top housing below shoe. Knob advance. Back door opens sideways like a gate rather than swinging upward like the Nicca 5L. Nikkor-H f2/5cm. \$500-750.

Nicca 5L - 1957. Similar to the Nicca 5, but with lever advance. Rear door hinges up to aid loading. Also sold by Sears as the Tower 45/46. \$300-450.

Snider 35 - 1956. A rare variation of the Nicca 5 named "Snider" was imported and sold in Australia by Gardner & Salmon Pty Ltd of Sydney. Sold with Schneider Xenon f2/50mm lens. FP 1-1000 with M & X synch. Film loaded through the base, but aided by opening back. Original order was for 90 cameras, but only two known to survive. No sales data. Estimate \$2400-3200.

Nicca 33 - 1957 (continued as Yashica YE after 1958). Single piece top housing no longer extends down toward lens. Hinged back. Nicca f2.8/5cm lens. \$350-500.

NICCA...

Nicca IIIL - 1958. Modernized top housing style is somewhat similar to Leica M3. (In 1959, after the Yashica takeover, IIIL became the Yashica YF, with a top housing even more closely resembling Leica M3.) Nikkor-H f2/5cm lens. \$350-500.

NICCA L-3 - c1986. Novelty 35mm camera from Taiwan. Not related to the Japanese Nicca cameras. Simple styling without phony prism found on many such cameras. Retail price \$8. Now: \$1-10.

NICHIRYO TRADING CO. (Japan)
Nicnon Binocular Camera - c196878. Binocular camera for half-frame on 35mm. Nicnon f3.5/165mm. 3-speed shutter, 60-250. Viewing is done as with regular binoculars. A beam-splitting device in the right side enables the viewed object to be photographed. The camera body is the Ricoh Auto Half. Motorized film transport. Later distributed by Ricoh under the name "Teleca 35". \$500-750.

NICHOLLS (H. Nicholls, Liverpool, England)

Detective camera - Black leather covered wood box taking 31/₄x41/₄" plates. Rack focusing. Eureka RR lens, iris diaphragm, T-P roller blind shutter. \$100-150.

NIELL & SIMONS (Cologne)

Lopa - c1902. Unusual book-form camera, also sold by Griffin as the Pocket Cyko. Versions for single plates or with magazine back. \$600-900.

NIHON KOKI CO. (Japan)
Well Standard Model I - c1939. Rollfilm camera with telescoping front. Styled
like a 35mm camera. Takes unusual image
size of 4x5cm for 10 exposures on 127
film. Eye-level and waist-level finders. Well
Anastigmat f4.5/65mm in NKK shutter, T,
B, 25-150, or Well Anastigmat f3.5/65mm
in Well-Rapid 1-500 shutter. Recorded
sales from \$80-350.

NIHON SEIMITSU KOGYO NIHON PRECISION INDUSTRY (Japan) Zany - c1950. Subminiature for 10x14mm on 16mm film in special cassettes. Fixedfocus Gemmy Anastigmat f4.5/25mm. Internal shutter. Some examples marked "N.S.K." on top and others are labeled "N.D.K.". A rare subminiature. Auction record 12/91 \$1100. Normally: \$350-500. NIHON SEIKI (Japan)

Nescon 35 - c1956. 35mm viewfinder. Similar to Ranger 35 & Soligor 45. Nescor 13.5/40mm. Shutter 25-200.B. \$60-90.

Ranger 35 - c1956. Basic scale-focus 35mm. Nescor f3.5/40mm lens. \$60-90.

Soligor 45 - c1956. Same as Nescon 35, but with Soligor name and Soligor f4.5/40mmlens. \$60-90.

NIKO - Plastic body. 16 exposures, 3x4cm on 127 film. \$1-10.

NIKOH CO. LTD. (Japan)

Enica-SX - c1983. Subminiature for 8x11mm on Minox cassette film. Built-in butane lighter. Similar to the Minimax-Lite, but has built-in electronic flash. Tortoiseshell covering; gold edges. Suzunon f3.8/14.3mm fixed focus. Single speed shutter. \$90-130.

Minimax-lite - c1981. Subminiature 8x11mm camera with built-in butane lighter. Fixed focus, single speed. \$75-100.

Nova Micron - Identical to Minimax-lite. Made for Nova Cameras Ltd., England. \$90-130.

Supra Photolite - Identical to Minimax-lite, but with a different name. \$75-100.

NINOKA NK-700 - c1986. Novelty 35mm camera styled like an SLR. Originally offered as a free premium by a travel club, which then offered the companion flash for the inflated price of \$21. (Similar camera and flash outfits retail at less than \$15.) Collectible value with flash: \$1-10.

NIPPON AR-4392 - A smartly styled but inexpensive novelty 35mm camera from Taiwan. Ergonomically styled grip. This is a cheap camera, not to be confused with the pre-WWII Nippon camera from Nicca camera works. \$1-10.

NIPPON KOGAKU K.K. (Tokyo)

Nippon Kogaku K.K. was formed in 1917 by the merger of some smaller optical firms. During the pre-war years, they made a large variety of optical goods for both the military and scientific communities. These included microscopes, telescopes, transits, surveying equipment, binoculars, periscopes, aerial lenses, sextants, microtesters and other related equipment. Because of the types of items produced, they were virtually unknown to the general public and to the world outside of Japan. With the advent of WWII, they were chosen to be the primary supplier of optical ordnance for the Japanese military establishment and grew to over twenty factories and 23,000 employees. Most of the optical equipment used by the Japanese Army, Air Force and Navy was produced by Nippon Kogaku.

After the end of the war they were reorganized for civilian production only and were reduced to just one factory and 1400 employees. They immediately began to produce some of the fine optical equipment they made before the war for the scientific and industrial fields, but had yet to produce any cameras for general use. Before the war they had begun to make photographic lenses, includ-ing those for the famous Hansa Canon, and actually made all of Canon's lenses up to 1947. They also produced their lenses in a Leica-type screw mount as well as the early Canon bayonet. Sometime in 1945 or 1946, they decided that they should get into the camera field in an attempt to expand their product line. Since they were making lenses for 35mm cameras, it was a logical step to make a camera to use these same lenses. By September of 1946, they had completed the design of what was to become their first camera and decided on the name NIKON, from NIppon KOgaku. They studied the strong points of the two leading 35mm cameras of the day, the Contax and Leica, and combined many of the best features of both in the new Nikon design.

The majority of the information and photographs in the Nikon section are the work of Mr. Robert Rotoloni, a prominent collector and avid user of Nikon cameras. His interest in the field led him to write and publish a book entitled "The Nikon - An Illustrated History of the Nikon Rangefinder Series", in 1981. Although his first book is out of print, Mr. Rotoloni has written a new edition entitled "Nikon Rangefinder Camera" published in 1983 by Hove Foto Books in England. In the U.S.A., autographed copies are still available directly from the author at the address below. Since Mr. Rotoloni is also a respected dealer in collectible Nikon cameras, readers are invited to contact him with regard to buying or selling Nikons as well as exchanging information on the subject. Serious Nikon enthusiasts should write to him for full information on The Nikon Historical Society and its newsletter. As a courtesy, please include a stamped self-addressed envelope with queries. He may be reached at: P.O. Box 3213; Munster, IN 46321 USA. Tel. 708-895-5319.

Other Nikon consultants are Dr. Burton Rubin of New York City and Peter Lownds of Rotterdam. They are both interested in any Nikon items. You may write to: Dr. Burton Rubin, 4580 Broadway, New York, NY 10040. Tel. 212-567-2908. Peter Lownds, P.O. Box 10132, 3004 AC Rotterdam, Netherlands. Tel. 31-10-415-9136.

It is impossible to give any price which will be meaningful throughout the world, so we are continuing with our policy of reporting achievable, realistic prices. Our figures represent a median price, taking into account three important markets: Japan, Europe, and the USA. Some Japanese prices can be very unrealistic by western standards. Nikon Rangefinder cameras generally sell for more in Europe than in the USA primarily because Europe imported far fewer of these cameras before 1959. Most cameras bring 10-20% more in Europe; prices in Japan are 25-40% higher than the USA for common items. Formerly, the rarest items brought much higher prices in Japan than elsewhere, but recently, the competition for the rarer models has equalized worldwide. Prices are given for cameras in Excellent condition. They reflect the influence of the strong prices in Japan for mint cameras. We have noted some specific prices from the Japanese market to give some perspective to the listed prices. Where separate prices are given for Mint, these are generally the prices paid by buyers for the Japanese market. Asking prices on the Ginza sometimes, but not always, achievable in the rest of the world, (and not always on the Ginza either!) Nikon in particular has been subject to wild inflation in the last few years. It can not possibly last much longer; indeed there are some indications that it is already turning. Any currency fluctuation or other stimulus could drastically change this frenzied and inflated market.

NIKKOREX SLR CAMERAS:

Nikkorex 35, 35-2 - c1960-62. 35mm SLR with coupled selenium meter on prism front. Non-changeable f2.5/50mm Nikkor. Leaf shutter 1-500,B. \$75-100.

Nikkorex F with accessory meter

Nikkorex F - c1962-66. 35mm SLR. Body style more closely resembles a Nikonthan the other Nikkorex models. Nikonmount interchangeable f2/50mm Nikkorlens. FP shutter 1-1000, B, \$60-90.

Nikkorex F (black) - Only found in Denmark, Sweden, Norway. Working, and with no dings: \$500-800.

Nikkorex Auto 35 - c1964-67. 35mm SLR with coupled selenium meter. Non-changeable f2/48mm Nikkor lens. Leaf shutter 1-500,B. \$60-90.

Nikkorex Zoom 35 - c1963. The first still camera with a non-interchangeable

zoom lens. Zoom Nikkor Auto f3.5/43-86mm. Selenium meter. \$150-225.

NIKKORMAT SLR CAMERAS: The Nikkormat (Nikomat in Japan) series of cameras originated as a lower-priced alternative to the Nikon F cameras. While the lens mount was the same and it took all standard Nikon F lenses, the Nikkormat series lacked some of the "professional" NIkon F features, such as interchangeable prisms, motors, etc. Many professionals, particularly photojournalists, preferred the Nikkormats because of their smaller size and lighter weight. For those who used a Nikon F as their main camera, often the backups were Nikkormats. The Nikkormat name never had the snob appeal of Nikon F, and was considered by many to be the "poor cousin". Those of us who used them knew otherwise. (My Nikon F was the backup, while I shot daily with the Nikkormat!). Rugged, workhorse cameras!

Nikkormat FS - c1965. "Standard" version of the Nikkormat series. No meter. Fixed prism. Accepts Nikon bayonet lenses. \$100-150.

Nikkormat FT - c1965. TTL metering SLR for Nikon bayonet lenses, but less features than the Nikon F. Fixed prism; does not accept motor drive. CdS metering with needle visible in finder. 85-125.

Nikkormat FTN - c1967. Improved version of the Nikkormat FT. Centerweighted metering; speeds and over/under exposure indicator visible in finder. Black body: \$120-180. Chrome Body: \$100-150.

Nikkormat FT2 - c1975. Improved version of the Nikkormat FTN. Black or chrome. Black body: \$150-225. Chrome body: \$120-180.

Nikkormat EL - 1972. Fully automatic exposure control. Aperture priority TTL CdS metering. Black body: \$150-225. Chrome body: \$120-180.

Nikkormat EL Dummy - Black dummy camera, with dummy 50mm f1.4. Mint or better: \$600-750.

Nikkormat FT3 - c1977. Black body: \$175-250. Chrome body: \$150-225.

Nikkormat ELW - c1976. Black or chrome. Successor to this model was named "Nikon EL2", not "Nikkormat". \$175-250.

NIKON RANGEFINDER CAMERAS:

Nikon I - 1948. Focal plane shutter to 500. Bayonet lens mount which continued to be used for later models. Unusual image size of 24x32mm. Despite printed information to the contrary, the exposure counter is NOT numbered past 40 in any case. Made for a little over one year, with a total

NIPPON KOGAKU

production of about 750 cameras. Originally supplied with Nikkor 50mm f3.5 or f2.0 lens. Serial numbers 609-1 to 609-758, of which the first 20 or 21 were pre-production prototypes. Rare. Price negotiable. Auction results: Christie's 1/94 £12,000+ with f3.5 lens. Speculators' dreams: \$15,000-30,000+. Stable price, in original condition with no flash synch added, with original leather, working condition, with correct lens: \$13,000-19,000. Excellent or better: \$8000-16,000. Modified in some way, or only VG condition: \$4500-6500. Parts cameras \$2000-3000.

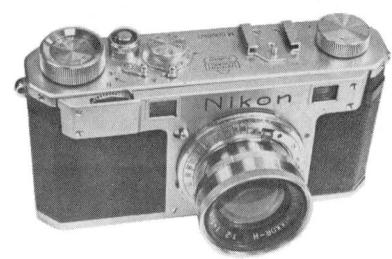

Nikon M - August 1949 to December 1951. Total production of about 3,200. The 24x34mm format is a compromise between the 24x32 of the Nikon I and the standard 24x36. It is the only Nikon range-finder camera to be identified on the camera. The letter "M" precedes the serial number on the top plate. Current value with normal f2.0 or f1.4 lens: 1949 type (no synch) \$3,000-5,000 MINT. 1950 type (with synch) \$1200-1800. Note: Late M's with flash sync are considered by the factory to be S's, even though they have the M serial number. Illustrated on front cover.

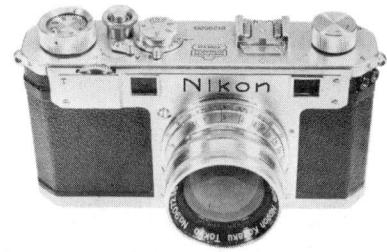

Nikon S - 1951-54. First Nikon to be officially imported into the USA. Identical to later Nikon M with flash sync (which the factory already called "S"). The only difference is the serial number no longer has the "M" prefix. (#6094100- on.) 24x34mm format. Replaced in December 1954 by the S2. "MIOJ" model \$1500-2000. With 8-digit serial number: \$800-1200. Otherwise, quite common. With f2 or f1.4 lens: MINT: \$400-600. EXC: \$250-375.

Nikon S2 - Dec.1954-early 1958. New features include rapid wind lever, shutter to 1000, crank rewind, and larger viewfinder window permitting 1:1 viewing. The top plate steps up over the new larger viewfinder, but the accessory shoe remains on the lower level, unlike the later S3. Over 56,000 produced, which is more than any other Nikon rangefinder camera. It was the first to have the 24x36mm format, be avail-

NIPPON KOGAKU...

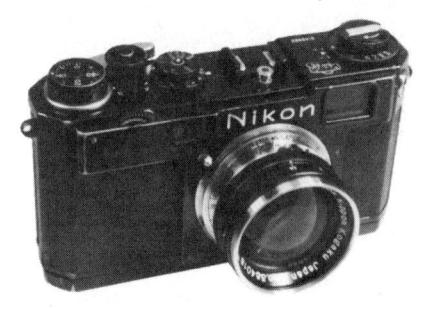

Nikon S2: black (above), chrome (below)

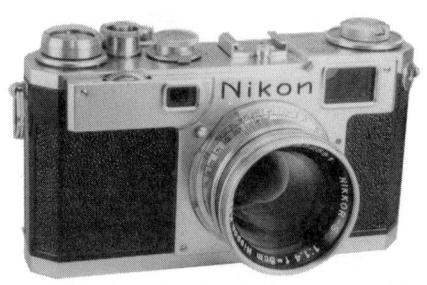

able in black, and take a motor drive accessory. Current prices include f2.0 or f1.4 lens. Chrome: \$300-450. Chrome with black dials: \$500-750. Black: \$2400-3200. Note: Chrome model is very common and often seen advertised above and below the normal range.

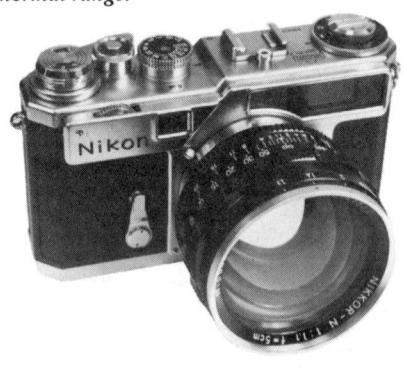

Nikon SP: chrome (above) and black with motor drive (below)

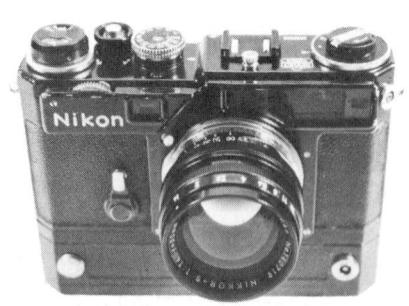

Nikon SP - Sept. 1957-at least 1964. The most famous and significant Nikon rangefinder camera, again showing innovation in camera design. Approximately 23,000 made. It offered a removable back which could be replaced with a motor-drive back. Universal finder for six focal length lenses 28-135mm. The popular motor-drive back led the way for Nikon's dominance of motor-driven photography in the following two decades. Easily recognized by the wide viewfinder window which extends over the lens. The "Nikon" logo, no longer fitting above the lens, was placed off center below the shutter release. Prices include f2 or f1.4 lens. Chrome, EXC:

\$800-1200 (double for MINT). Black, EXC: \$2400-3200 (double for MINT). \$1000-1500 for motor drive. Note: Chrome model is very common and often seen advertised above and below the normal range.

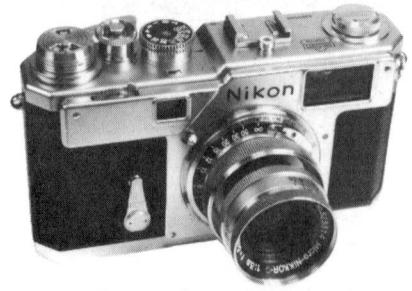

Nikon S3: chrome (above) and black Olympic (below)

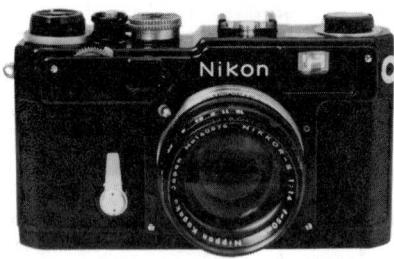

Nikon S3 - Introduced in 1958, this popular version of the SP could also be motorized. At least 14,000 were made during its production run which continued at least until 1960. Styled similar to the SP, but with a rectangular viewfinder window, and the Nikon logo again centered over the lens. Two major features distinguish it from the earlier S2: The viewfinder window is larger on the S3. The top plate steps up in the center (accessory shoe is on the high side). Prices with f2 or f1.4 lens. Chrome: \$800-1200 MINT. Black: \$1000-1500 EXC; \$3000 MINT. Black "Olympic" with "Olympic" lens: \$3500-5500.

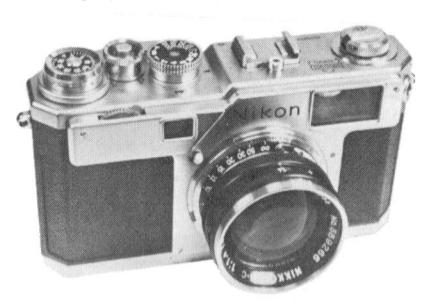

Nikon S4 - Announced in 1959, this simplified version of the S3 was never imported into the USA, so they are seen less frequently in the United States than in Japan. At least 5900 were made, all in chrome finish. With f2 or f1.4 lens: \$750-1000 EXC; \$1500 MINT.

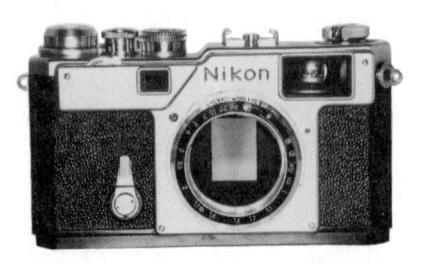

Nikon S3M - 1960. Modified S3 for halfframes, 72 exposures per load. Nikon's

first half-frame camera, in black or chrome. Only 195 were reportedly made, although more may exist. Most were motorized. Chrome or black body with f2 or f1.4 lens. Reported private offers and refusals in the \$75,000 price range. Confirmed public sales at Christie's 1/93 in the \$35,000 to \$50,000 range. Chrome or black without motor: \$30,000-40,000. Extra clean with S72 motor: \$50,000-60,000.

NIKON LENS CODES: Nikkor lenses were coded for the number of lens elements. This same coding system was also used for Nikkor lenses made for other brands of cameras, such as Bronica, which used Nikkor lenses as standard equipment. The letter codes are hy-phenated to the NIKKOR name on the front rim of the lens. The codes are the first letter of Latin or Greek numericals.

U=1 element (Uns)

B=2 elements (Bini)

T=3 elements (Tres)

Q=4 elements (Quatuor) P=5 elements (Pente) H=6 elements (Hex)

S = 7 elements (Septem)

O=8 elements (Octo) N=9 elements (Novem)

D=10 elements (Decem)

= coated; represents NIC (Nikon Integrated Coating) **Auto** = automatic diaphragm.

W = Wide Angle, used without regard to the number of elements or formula.

PC-Nikkor = Perspective control GN Nikkor = Guide number

Micro Nikkor = Microphotography Medical Nikkor = Medical & other closeup photography

Zoom Nikkor = Zoom optics Reflex Nikkor = Mirror & lens optics EL-Nikkor = enlarging use

NIKON RANGEFINDER LENSES All are

Nikkor lenses in bayonet mount. 21mm f4 black only, with finder: \$1500-2000. Add \$90-130 for shade.

25mm f4 chrome, with finder: \$600-900. 25mm f4 black, with finder: \$800-1200. 28mm f3.5 chrome Type 1 or 2: \$300-450. 28mm f3.5 black: \$350-500. 35mm f3.5 MIOJ, 612 type: \$1000-1500 35mm f3.5 MIOJ, 910 type: \$500-750.

35mm f3.5 chrome Type 1 or 2: \$120-180. 35mm f3.5 black: \$175-250.

35mm f3.5 Stereo Nikkor: Outfit with lens, prism attachment, UV filter, shade, finder in leather case. Very rare. \$13,000-19,000. 35mm f2.5 chrome: \$150-225

35mm f2.5 black Type 1: \$250-375. 35mm f2.5 black Type 2 (f2.5 lens in f1.8type barrel. Not easily found): \$600-900.

35mm f1.8: black and chrome (left) and all black (right)

35mm f1.8 all black: \$2000-3000. 35mm f1.8 black and chrome: \$350-500.

50mm f3.5 collapsible: Looks very much like the Leitz Elmar, but in Nikon mount. Sold only on Nikon I. \$1200-1800.

Micro-Nikkor lenses: screwmount (left) and bayonet mount (right)

50mm f3.5 Micro-Nikkor: \$1000-1500.

50mm f2.0 collapsible: \$600-900.

50mm f2.0 chrome: \$75-100.

50mm f2.0 black: \$90-130. 50mm f2.0 all black: \$400-600. 50mm f1.5: \$1000-1500. 50mm f1.4 chrome (MIOJ): \$150-225. 50mm f1.4 chrome: \$100-150. 50mm f1.4 aluminum: \$1200-1800 50mm f1.4 black and chrome: \$120-180. 50mm f1.4 all black (early): \$750-1000. 50mm f1.4 Olympic: \$1000-1500. 50mm f1.1 Internal bayonet: \$800-1200. External bayonet: \$1000-1500. Add \$90-130 for matching shade. 85mm f1.5: \$1000-1500. 85mm f2 chrome MIOJ: \$500-750. 85mm f2 chrome: \$150-225. 85mm f2 black: \$300-450. 105mm f4: \$800-1200. 105mm f2.5: \$250-375. 135mm f4 Short bellows mount: \$350-500. 135mm f4 chrome: Serial #523xx: \$750-1000; Serial #611xx: \$800-1200; Serial #904xx: \$600-900. 135mm f3.5 MIOJ: \$300-450. 135mm f3.5 chrome: \$120-180. 135mm f3.5 black: \$150-225. 180mm f2.5: \$750-1000. 250mm f4 manual: \$750-1000. 250mm f4 preset: \$600-900. 350mm f4.5 black: \$1000-1500. 500mm f5 black: \$3500-5500 with original wooden case. 1000mm f6.3: Black, only 2 known sales: \$20,000+. Grey: \$15,000-25,000.

NIKON RANGEFINDER ACCESSORIES **Finders**

Chrome optical; 35, 85, 105, 135mm: \$45-60.

21mm optical: \$250-375. 25mm optical: \$150-225. 28mm optical: \$90-130. 35mm mini for S2: \$600-900. Chrome 24X32 Variframe: \$2400-3200. Chrome MIOJ Variframe: \$500-750. Chrome Variframe: \$175-250. Black Variframe, with shoe: \$400-600. Black Variframe, no shoe: \$500-750. 28mm adapter for black Variframe: \$600-900

Varifocal Zoom Finder MIOJ: \$1200-1800. Varifocal: \$100-250.

28mm adapter for Varifocal: \$250-375. Black bright line finder; 35, 85, 105, 135mm: \$200-300.

Black bright line finder; 50mm: \$500-750. Black bright line VF, stereo: \$1000-1500. Folding Sports finder: \$250-375. RangefinderIlluminator: \$300-450.

Reflex Housings

Type one, copy of Leica PLOOT: \$2400-

Type two, 45°: \$1500-2000. 90° finder for type 2: \$3500-5500.

Flash Equipment

BCB: \$35-50 BCB II: \$30-45. BCB-3: \$20-30. BC 4, BC 5, BC 6: \$8-15.

Closeup Attachments

For S with f2 or f1.4: \$300-450. For S2, either lens: \$300-450. For SP, either lens: \$300-450.

Copy Stands

Model S: \$1200-1800. Model SA: \$600-900. Model P: \$750-1000. Model PA: \$600-900

Motor Drives:

Black or chrome: \$800-1200. Chrome S72 for S3M: \$9000-14,000.

Special Shades:

21mm: \$200-300. 25mm: \$100-150. 50mm/f1.1: \$200-300. 50mm Micro Collar: \$250-375. 85mm/f1.5: \$75-100. 105mm/f4.0: \$75-100.

Miscellaneous:

Bellows attachment: \$1200-1800. Exposure meter, grey top: \$300-450. Exposure meter, black: \$100-275. Microflex Microscope Unit, Type one: \$1000-1500. Microflex Microscope Unit, Type two: \$800-1200. Panorama Head, bubble level: \$200-300.

NIKON SLR CAMERAS: Nikon SLR cameras all use bayonet mount lenses, but the mount is not the same as the Contax mount used for the rangefinder cameras. The Nikon F bayonet mount is considerably larger, and there is an external "fork" on the diaphragm ring which couples to the camera's metering system. A modification in the mount, introduced in 1977, eliminated the need to index the lens to the camera's meter upon changing lenses. The new AI lenses (auto indexing) and earlier ones are totally compatible and interchangeable, but the auto indexing feature requires that both the body and lens be of the AI type. This is far from a complete listing of Nikon SLR cameras. While some of the early models are very much of collectible vintage, they are still very usable equipment. Even the oldest of the Nikon F lenses will fit some of the latest cameras. However, care should be taken with some autofocus camera models which can be damaged by the use of unmodified early lenses. The basis for most prices is usability, and to that extent, collectors must compete with users in the market.

NIKON F COLLECTING: In the last two years, Nikon "F" collecting has come of age; it now stands shoulder to shoulder with the Leicas, Contaxes, Canons, and its older brother the Nikon rangefinders. The Nikon F has found fame in the hands of many a photo journalist in Vietnam, saved lives, stopped a bullet, been carried out of some desolate place wrapped in a plastic bag, immersed in a bucket of dirty water . . . the stories go on and on, and so does the legendary camera. We now know that Nikon made about 784,000 "F" cameras, 95% the same give or take a screw or two. With vintage wines, some years are better than others. 1959 was a good year for wine and is the best year for collectors of Nikon F. Col-lectors vie for the first 5% of the Nikon F cameras, made in 1959.

NIPPON KOGAKU...

Nikon F - c1959. First Nikon SLR. Interchangeable Auto Nikkor lenses. FP shutter 1-1000,B. Typical eye-level prism finder. It is hard to believe that this professional workhorse camera is now 35 years old. The first 50 were pre-production types, not made for general release. The body had a cloth shutter. Very rare. \$3500++++. Clean 1959 models, first batch of 1000 cameras (serials 6400000-6400999): \$1000+; black worth at least double. Must have the correct prism with NIPPON KOGAKU, and not NIKON, also crossed type self-timer and hollow advance lever. Watch out for mis-matches.

Nikon F "red point" - Has a red point before the number; starts about 6574XXX. Modified for the TTL Photomic. \$200-350.

Nikon F "66XXXX" - Only about 2200 in this serial range; difficult to find. \$500+.

Nikon F (cutaway) - As useful as a chocolate teapot according to Peter Lownds, who has tried using both. Including lens: \$1000+.

Nikon F (NASA) - Specially marked for the American space program. \$2400-3200.

Nikon F "Nikkor F" - Made for the West German market to avoid confrontation with Zeiss-Ikon, who thought "Nikon" sounded too close to their own name. Made in black and chrome, \$500-750.

Nikon F High Speed (7 FPS) - Shoots 7 frames per second. Special viewfinder on top of prism. Must have large knob on motor, plus 15v power pack (not 12v as normal models). About 100 made. Working condition and looking good: \$5000+. Reported sales as high as \$12,000.

Nikon F High Speed (9 FPS) - Shoots 9 frames per second. Required total rethink of body to achieve this speed. Transparent pellicle mirror does not move. About 200 made. Hint: check all Nikon F with motors; to the untrained eye it looks like any other motorised Nikon F. cordless battery packs: \$5000+. Reported sales as high as \$12,000.

Nikon F Photomic - c1962. The Nikon F with "Photomic" CdS meter prism. Light is read directly by the meter, not through the lens. The Photomic meter is recognizable by the round CdS cell on the front of the prism finder. \$350-500.

Nikon F Photomic T - c1965. Nikon F with "Photomic T" CdS meter prism. The Photomic T has a through-the-lens meter; needle visible in finder. \$175-250.

Nikon F Photomic Tn - c1967. lmproved metering capability, with center weighting. Photomic Tn finder recognizable by the "N" engraved on top next to the power off button. \$120-180.

NIPPON KOGAKU...

Nikon F Photomic FTn - c1968. Shutter speed & needle visible in finder. From the outside, the FTn finder can be identified by the aperture-numbered indexing slot on the prism front. \$150-225.

Nikon F2 - c1971. Increased speed range, 10 sec.-1/₂₀₀₀. Clean chrome body, standard unmetered (DE-1) prism: \$175-250. Black body, add \$50-75. Early F2 starting #7100000 has become very collectible if you can find the 5% oddball bodies. The first 1000 worth about 50% more than normal range. Check that the eyepiece is not cracked, and that it has the right leather.

Nikon F2 Photomic - c1971. As F2, but interchangeable CdS TTL metered DP-1 prism: Chrome: \$200-300. Black body, add \$50-75.

Nikon F2S Photomic - c1973. Metering prism (DP-2) uses SPD cells, not CdS; readout is LED not needle. Chrome: \$250-350. Black body, add \$50-75.

Nikon F2SB Photomic - c1976. As F2S, but DP3 metering prism (same as F2AS). Only made for about 10 months. SPD metering cell. Non-AI mount. Hard to find in nice condition. \$350-500.

Nikon F2T - c1976. "Titanium" version of the F2. Baseplate, prism cover, and back made of titanium for durability. Distinctive textured finish. First version engraved "Titan" on front. Later model has simple "T" prefix to serial number. \$800-1200.

Nikon F2A Photomic - c1977. Meter prism (DP-11) identified with small "A" on front. Designed to accept a new "A!" (auto indexing) lens. Through a minor variation in the original bayonet mount, the new lenses could automatically relay to the meter their aperture range. Earlier lenses could be used without modification and indexed manually, or be modified to match the new system. \$300-450.

Nikon F2A 25 Years - 2500 cameras made for the U.S. market, packed in "25 Years of Nikon" box. Number engraved on baseplate and "25 Years" top cover plate. Mint in box: \$500-1000.

Nikon F2AS Photomic - c1977. An F2 with Photomic AS (DP-12) metering finder for automatic aperture control. Similar to F2SB but with AI lensmount. Identifiable by "AS" on front below prism. \$450-700.

Nikon F2 Data Set MF10 - Camera body F2AS Data, Data back F2 36, Motor MD2, Battery pack MB1, all in one overbox marked MF10. Mint: \$2000-3000.

Nikon F2 Data Set MF11 - Like the MF10 set, but sold as a set with MF1 250 back for F2 plus 250 data back.

Nikon FM - c1977. A newly designed fixed-prism mechanical camera. Matchdiode metering visible in finder. A solid, no-frills camera in the tradition of the Nikkormats. Accepts MD-11 or MD-12 motor. Black or Chrome. \$150-225.

Nikon EL2 - c1977. Successor to Nikkormat EL and ELW cameras; predecessor of the Nikon FE. This camera heralded the end of the Nikkormat name. \$175-250.

Nikon FE - c1978. Combines features of the mechanical FM and the electronically controlled EL-2, plus interchangeable focusing screen. Superseded by the FE2 in 1983. Black or chrome. With 50mm f1.8 Series E lens: \$200-300.

Nikon F3 - c1980. A step away from the fully mechanical cameras, the F3 features an electronically controlled shutter. Mirror and film transport are still mechanical. Use without battery limited to 1/80 sec, B. A professional camera with interchangeable finders, motors, etc. Collectors must compete with users. Body: \$350-550.

Nikon FG - c1982. Compact SLR with all of the basics for manual or programmed use. Electronically controlled shutter with manually selectable speeds 1-1000, aperture priority, or full program mode. TTL flash metering with SB-15 speedlight. Accepts moter drive MD-E or MD-14 and databack. Black or chrome. \$120-180.

Nikon F3AF - 1983. Nikon's first autofocus SLR, introduced at October 1982 Photokina. Historically, this camera fits between early "experimental" autofocus SLRs from other makers and the first "standardized" Nikon autofocus camera, the 1986 N2020. F3AF is "modern" in its use of TTL rather than external focus measurement, and phase detection rather than contrast detection. However, its use of in-lens motors groups it with the earlier types, making it incompatible with standard Nikon AF lenses. Electronic focusing system uses DX-1 autofocus finder (the world's first interchangeable autofocus finder) and dedicated lenses. DX-1 finder can be used as a focusing aid on F3 and F3HP, but not for autofocusing. Likewise, F3AF gives finder-aided focusing for manual focus lenses. Dedicated lenses such as 80mm f2.8 and 200mm f3.5 incorporate tiny motors receiving signals and electrical power from the finder. \$500-750.

Nikon N2020 AF - c1986. Nikon's second autofocus SLR; the first to use a body-mounted motor to control lens focusing. This became Nikon's standard autofocus mount, eclipsing the in-lens motor system of F3AF. A mechanical coupling added to the standard Als mount allows the body to focus the lens. Despite these

changes, F3AF lenses do mount and automatically focus on the N2020. \$175-250.

NIKON SLR LENSES & ACCESSORIES:

The original mount for Nikon SLR cameras has remained basically the same to the present. Minor changes were made to allow it to keep up with technological changes in the industry. We are using the following codes to indicate the lens mount types:

LENS MOUNT TYPES:

F or NF or NON-AI - original Nikon F mount. Before the introduction of the AI series, these were called Nikon F mount. The term "NON-AI" was subsequently applied to this mount because, even after the introduction of the AI mount, Nikon continued to make some lenses which were not auto-indexing. These lenses have an external prong on the diaphragm ring to couple to the metering system. The metal prong is semi-circular, with a single slot to engage the coupling pin of the camera. The lens can be modified to "AI", either by Nikon or private camera repairmen.

Al - The first major modification was "Al" (auto indexing) introduced about 1977. The bayonet is the same, but the back edge of the diaphragm ring is notched. To make these Al lenses backward compatible, Nikon left the external coupling prong. For easy identification, the Al coupling prong has an extra perforated hole on

each side of the prong slot.

Als - Looks like AI, but with a small semicylindrical notch machined into the back side of the lens mount. This notch relays lens specifications to the body.

Series E - A less expensive series of Al and Als lenses introduced for the EM camera. Lighter weight through use of more plastic, they are not as rugged for

hard use, but optically equal to standard Nikkor Al and Als lenses.

AF Nikkor - Autofocus lenses. With few exceptions, these are like Als lenses, but with an added shaft which allows the motor in the camera body to mechanically control the focusing movement of the lens. Two exceptions are lenses made for the transitional Nikon F3AF camera, which used an in-lens motor for focusing. These provide autofocus only on the F3AF camera, although they will mount on any Nikon and function as a manual focusing AlS lens. Two more exceptions are a 300mm and 600mm EDIF AF lens with servo motor which were made for the Nikon F4 and will not autofocus on other models.

LENS CODES:

Original type - The earliest series of lenses for Nikon F and Nikkormat FT/FTN cameras. Most easily identifiable by chrome filter ring. Lens name usually includes the word "Auto" to indicate automatic diaphragm.

IC - Non-Al lenses with Integrated Coating. Like the original series but multicoated optics. Identifiable by black filter ring. Some have a letter "c" engraved with the name on front bezel. Multiple coating is also recognizable by its golden, iridescent look compared to the older blue coating.

Al - Automatic Indexing of maximum aperture. Allows full-aperture metering on all Al Nikon and Nikkormat cameras.

Al'd - Early non-Al (IC) lenses which have been converted to automatic indexing, either by the factory or privately. As collectibles their value is diminished, but they are more usable. Prices usually fall between the values of original IC and AI lenses.

ED - Extra-Low Dispersion glass used for maximum contrast and clarity, minimum of chromatic aberration in long lenses

IF - Internal Focusing for compactness and light weight.

PC - Perspective Control to correct archi-

tectural distortion, etc.

Lens elements are listed as a fraction; the first digit is the number of elements, and the second digit is the number of groups. NEW PRICES from January 1978 are given for many lenses; both AI and NON-AI types were available on that price list for most optical designs. This affords a direct comparison of contemporary original list prices. The October 1978 price list no longer listed many of the IC (Non-AI) lenses.

6mm f2.8 Fisheye-Nikkor Auto (Non-Al) - (6.3mm) 12/9 elt; 220°. Makes 23mm diameter image. Focus to 10". Five built-in filters. Weight: 5.2kg (11.5lb). Couples to exposure meter and Photomic systems. (List 1/78: \$7169.) \$3500-5500.

6mm f2.8 Fisheye-Nikkor AI - (List 1/78: \$8387) \$4000-6000.

6mm f2.8 Fisheye-Nikkor Als -\$4000-6000.

6mm f5.6 Fisheye-Nikkor (Non-AI) -(6.2mm) 9/6 elt; 220°. Makes 21.6mm diameter image. Fixed focus. Six built-in filters. Weight: 430g (15.2oz). Cannot be used with Photomic system on Nikon F. Fits only cameras with independent mirror control. Supplied with 160° optical centering finder. (List 1/78: \$1568. 12/79: \$1761.)\$500-700.

7.5mm f5.6 Fisheye-Nikkor (Non-Al) - 10 elt; 180°. Makes 23mm diameter image. Manual diaphragm. Can not be used with Photomic system on Nikon F. Fits only cameras with independent mirror control. Supplied with optical centering finder. \$700-1000.

8mm f2.8 Fisheye-Nikkor Auto (Non-Al) - 10/8 elt; 180°. Makes 23mm diameter image. Five built-in filters. Weight: 1kg (2.2lb). Couples to exposure meter and Photomic systems. (List 1/78: \$1175.) \$700-900.

8mm f2.8 Fisheye-Nikkor AI - 180°

(List 1/78: \$1392.) \$800-1100.

8mm f8 Fisheye-Nikkor - 9 elt; 180°. Makes 24mm diameter image. Fits only cameras with independent mirror control. With finder: \$350-500.

10mm f5.6 OP Fisheye-Nikkor (Non-Al) - Orthographic Projection formula. 9/6 elt; 180°. Manual diaphragm. Six built-in filters. Weight: 400g (14.1oz). Can not be used with Photomic system on Nikon F. Fits only cameras with independent mirror control. Supplied with 160° optical centering finder. (List 1/78: \$1407. 12/79: \$1581.) Estimate: \$400-600.

13mm f5.6 Auto-Nikkor IC - Rectilinear image with 118° angle of view. (List 1/78 with case & filters: \$6250.) Very limited sales data. Estimate: \$3000-4000

13mm f5.6 Auto-Nikkor AI - Rectilinear image. (List 1/78 with case & filters: \$7325.) Very limited sales data. Estimate: \$3500-4500

15mm f3.5 Nikkor - Rectilinear image. Focuses to 12". Rear-mounting filters. \$600-900

15mm f3.5 Auto-Nikkor AI - Recti-

linear image. (List 10/78 with case: \$1646.) \$700-1000

15mm f3.5 AIS - \$800-1200

15mm f5.6 Nikkor-QD Auto (Non-Al) - 14/12 elt; 110°. Four built-in filters. \$500-750

15mm f5.6 Auto-Nikkor IC - (List 1/78: \$1249.) \$500-750

15mm f5.6 Auto-Nikkor AI - (List 1/78: \$1465.) \$600-900.

16mm f2.8 Fisheye-Nikkor AI -Introduced at 1978 Photokina. 180° image fills 24x36mm format. Rear-mounting filters. (List 12/79: \$753.) \$350-450.

16mm f2.8 Fisheye-Nikkor Als -\$400-500

16mm f3.5 Fisheye-Nikkor Auto (Non-Al) - 8/5 elt; 170°. Fills 24x36mm format. \$250-375.

16mm f3.5 Auto-Nikkor IC Fisheve - (List 1/78: \$570.) \$250-37:

16mm f3.5 Fisheye-Nikkor AI - (List 1/78: \$670.) \$300-450.

18mm f3.5 AIS - (New: \$1075.) \$450-

18mm f4 Auto-Nikkor IC - (List 1/78: \$649.) \$300-500

18mm f4 Auto-Nikkor AI - Rectilinear image. (List 1/78: \$725.) \$400-600.

20mm f2.8 AIS - \$250-375.

20mm f3.5 Nikkor-UD Auto (Non-Al) - 11/9 elt; 94°. Rectilinear image. 72mm filters. \$200-300.

20mm f3.5 Al - 52mm filter. \$250-375. **20mm f3.5 AlS -** 52mm filter. \$300-450.

20mm f4 Auto-Nikkor IC - (List 1/78: \$400.) \$120-180.

20mm f4 Auto-Nikkor AI - (List 1/78: \$468.) \$200-300.

20mm f4 AIS - \$250-375

2.1cm f4 Nikkor-O (Non-Al) - Fits only cameras with independent mirror control. With finder: \$250-375.

24mm f2 Auto-Nikkor AI - (List 1/78: \$500.) \$250-350.

24mm f2 AIS - \$300-450

24mm f2.8 Nikkor-N Auto (Non-Al) 9/7 elt; 84°. Floating element design. \$150-225

24mm f2.8 Auto-Nikkor IC - (List 1/78: \$292.) \$150-225

24mm f2.8 Auto-Nikkor AI - (List 1/78: \$348.) \$175-250.

24mm f2.8 AIS - \$200-325

24mm f2.8 AF-Nikkor - \$175-250.

28mm f2 Nikkor-N Auto (Non-Al) -

9/8 elt; 74°. Floating element. \$175-250. **28mm f2 Auto-Nikkor IC -** (List 1/78: \$460.) \$175-250.

28mm f2 Auto-Nikkor AI - (List 1/78: \$539.) \$200-300.

28mm f2 AIS - \$250-400.

28mm f2.8 Auto-Nikkor IC - (List 1/78: \$318.) \$120-180

28mm f2.8 Auto-Nikkor Al - (List 1/78: \$385.) \$150-225

28mm f2.8 AIS - \$175-250

28mm f2.8 Series E - \$90-130.

28mm f2.8 AF-Nikkor - \$100-150 28mm f3.5 Nikkor-H Auto (Non-Al)

- 6/6 elt; 74°. \$75-100.

28mm f3.5 Auto-Nikkor IC - (List 1/78: \$253.) \$75-100

28mm f3.5 Auto-Nikkor AI - (List

1/78: \$297.) \$100-150. 28mm f3.5 AIS - \$100-150.

28mm f3.5 PC-Nikkor - Introduced at 1980 Photokina. \$400-600. 28mm f4 PC-Nikkor IC - (List 1/78:

\$835.) \$400-600.

NIPPON KOGAKU...

35mm f1.4 Nikkor-N Auto (Non-Al) 9/7 elt; 62°. Floating element design. \$200-300

35mm f1.4 Auto-Nikkor IC - (List

1/78: \$495.) \$200-300. 35mm f1.4 Auto-Nikkor Al - (List 1/78: \$561.) \$300-450.

35mm f1.4 AIS - \$350-500.

35mm f2 Nikkor-O Auto (Non-Al) -8/6 elt; 62°. \$120-180

35mm f2 Auto-Nikkor IC - (List 1/78: \$283.) \$120-180.

35mm f2 Auto-Nikkor AI - (List 1/78: \$330.) \$150-225.

35mm f2 AIS - \$175-250

35mm f2 AF-Nikkor - \$175-250.

35mm f2.5 Series E - (List 12/79: \$145.)\$60-90.

3.5cm f2.8 (Non-AI) - First wide angle lens for Nikon F. Hard to find, \$50-75.

35mm f2.8 Nikkor-S Auto (Non-Al) 7/6 elt; 62°. \$50-7

35mm f2.8 Auto-Nikkor IC - (List 1/78: \$205.) \$50-75.

35mm f2.8 Auto-Nikkor AI - (List

1/78: \$242.) \$100-150

35mm f2.8 PC-Nikkor (Non-Al) - 8/7 elt; 62°. Perspective control lens with 11mm shift. \$200-300

35mm f2.8 PC-Nikkor IC - (List 1/78: \$462.) \$200-300.

35mm f2.8 PC-Nikkor AIS - \$250-375. 35mm f3.5 PC-Nikkor - \$300-450.

45mm f2.8 GN Auto Nikkor (Non-Al) - 4/3 elt; 50°. Guide Number scale can be set to match film; diaphragm couples to focusing ring. Focusing the lens automatically adjusts the aperture for proper flash exposure. USA: \$120-180. Higher in Europe.

45mm f2.8 GN Auto-Nikkor IC - (List 1/78: \$149.) USA: \$120-180. Higher in

45mm f2.8 GN Auto-Nikkor AI -USA: \$120-180. Higher in Europe.

50mm f1.2 Auto-Nikkor IC - (List 1/78: \$318.) \$100-150. **50mm f1.2 Auto-Nikkor Al -** (List

10/78: \$398.) \$175-250. **50mm f1.2 Als -** \$175-250.

50mm f1.4 Nikkor-S Auto (Non-Al) - 7/5 elt; 46°. As new, with box, doubles price! \$75-100.

50mm f1.4 Auto-Nikkor IC - (List 1/78: \$216.) As new, with box, doubles price! \$75-100.

50mm f1.4 Auto-Nikkor AI - (List 1/78: \$245.) \$90-130

50mm f1.4 AF-Nikkor - \$120-180. **50mm f1.8 Auto-Nikkor Al** - (List 10/78: \$170.) \$60-90.

50mm f1.8 AIS - \$70-100.

50mm f1.8 Series E - (List 12/79: \$114.) \$35-50.

50mm f1.8 AF-Nikkor - \$50-75.

50mm f2 Nikkor-H Auto (Non-Al) -6/4 elt; 46°. \$35-50.

50mm f2 Auto-Nikkor IC - (List 1/78: \$125.) \$35-50

50mm f2 Auto-Nikkor AI - (List 1/78:

\$141.) \$40-60.

5cm f2 Nikkor-S Auto (Non-Al) -Early 7 elt. version, \$50-75

55mm f1.2 Nikkor-S Auto (Non-Al) - 7/5 elt; 43°. \$120-180

55mm f1.2 Auto-Nikkor AI - (List 1/78: \$354.) \$150-225 55mm f2.8 Micro-Nikkor H - \$120-

55mm f2.8 Micro-Nikkor AI or AIS-\$175-250

NIPPON KOGAKU...

5.5cm Micro-Nikkor (preset) - Early version. Focus to 21cm. \$350-500

55mm f3.5 Micro-Nikkor-P (Non-Al) - 5/4 elt; 43°. High-resolution, flat-field lens with close focusing to 24.1cm (1:2 ratio). With M2 adapter, it focuses to 1:1 ratio. \$150-200.

55mm f3.5 Auto-Micro-Nikkor IC with Pk-3 Auto Ring - (List 1/78: \$293.) \$150-200

55mm f3.5 Auto-Micro-Nikkor Al -(List 1/78: \$303.) Auto extension ring PK-13 (List 1/78: \$44.) \$150-200

58mm f1.2 Auto Noct-Nikkor AI -(List 1/78: \$1095.) \$450-700.

58mm f1.2 Auto Noct-Nikkor AIS -\$500-750

5.8cm f1.4 (Non-Al) - The first Nikon F normal lens. \$120-180.

60mm f2.8 AF Micro-Nikkor - \$200-

80mm f2.8S AF-Nikkor - 6/4 elt. Autofocus lens for F3AF only, but usable as manual lens on any model. \$90-130. 85mm f1.4 AIS - \$400-600

85mm f1.8 Nikkor-H Auto (Non-Al)

- 6/4 elt; 28.5°. \$175-250. 85mm f1.8 Auto-Nikkor IC - (List 1/78: \$300.) \$175-250.

85mm f1.8 Auto-Nikkor AI - \$175-250

85mm f1.8 AF-Nikkor - \$175-250. 85mm f2 Auto-Nikkor AI - (List 1/78: \$347.) \$150-225

85mm f2 AIS - \$200-250.

100mm f2.8 Series E - (List 12/79: \$195.) \$90-130

105mm f1.8 AIS - \$300-400

10.5cm f2.5 (Non-Al) - \$120-180 105mm f2.5 Nikkor-P Auto (Non-AI) - 5/4 elt; 23.3°. \$120-180.

105mm f2.5 Auto-Nikkor IC - (List 1/78: \$307.) \$120-180.

105mm f2.5 Auto-Nikkor AI - (List

1/78: \$359.) \$150-200. **105mm f2.5 AIS -** \$150-225

105mm f2.8 Micro-Nikkor AIS -\$300-400

105mm f2.8 AF Micro-Nikkor -\$350-450

10.5cm f4 Nikkor-P (for bellows) -5/3 elt; 23.3°. Manual preset diaphragm. For use on Bellows Focusing Attachment. \$300-450.

10.5cm f4 (Non-Al) - \$300-450 105mm f4 Auto-Micro-Nikkor IC with PN-1 Ring - (List 1/78: \$530.)

105mm f4 Auto-Micro-Nikkor AI -(List 1/78: \$522 lens only.) Auto extension ring PN-11 AI (List 1/78: \$94.) \$250-375

105mm f4 Auto-Micro Nikkor Als -\$300-450

105mm f4.5 UV-Nikkor - \$500-600.

120mm f4 Medical-Nikkor IF - With LA-2 and LD-2 power units: \$600-900.

135mm f2 Auto-Nikkor IC - (List 1/78: \$650.) \$350-500 135mm f2 Auto-Nikkor AI - (List

1/78: \$759.) \$400-600.

135mm f2 AIS - \$400-600.

135mm f2 AF DC - Autofocus "Defocus Control" lens. 7/6 elt. Deliberately produces spherical and other aberrations to control the out-of-focus images. A modern version of the venerable soft-focus portrait lenses. New: \$1000. No sales data

135mm f2.8 Nikkor-Q Auto (Non-

AI) - 4/4 elt: 18°, \$90-130. 135mm f2.8 Auto-Nikkor IC - (List 1/78: \$320.) \$90-130.

135mm f2.8 Auto-Nikkor AI - (List

1/78: \$380.) \$120-180. **135mm f2.8 AIS -** \$175-250 135mm f2.8 Series E - \$75-125.

135mm f3.5 Nikkor-Q Auto (Non-Al) - 4/3 elt; 18°. \$60-90.

135mm f3.5 Auto-Nikkor IC - (List 1/78: \$230.) \$60-90

135mm f3.5 Auto-Nikkor Al - (List 1/78: \$275.) \$75-100.

135mm f3.5 AIS - \$90-130.

13.5cm f3.5 (Non-Al) - engraved in cm. Early version: \$100-150. \$120-180.

180mm f2.8 Nikkor-P Auto (Non-Al) - 5/4 elt; 13.6°. \$250-375. 180mm f2.8 Auto-Nikkor IC - (List

1/78: \$630.) \$250-375 180mm f2.8 Auto-Nikkor AI - (List

1/78: \$741.) \$300-450 180mm f2.8 ED AIS - \$400-600.

180mm f2.8 AF-Nikkor ED-IF - First version (heavy on plastic): \$300-500. Add 50% for new type.

200mm f2 ED-IF AIS - \$1600-2200. 200mm f3.5S AF-Nikkor ED(IF) - 8/6 elt. Autofocus lens for F3AF camera only; focusing motor built into lens. Will not autofocus on other cameras, but can be used manually on any model. \$300-450. **20cm f4 (Non-Al)** - Early version

marked in cm. Focus to 3m. \$120-180. 200mm f4 Nikkor-Q Auto (Non-Al)

4/4 elt; 12.3°. Fairly common. \$100-150. 200mm f4 Auto-Nikkor IC - (List 1/78: \$325.) \$100-150.

200mm f4 Auto-Nikkor Al - (List 1/78: \$382.) \$125-200.

200mm f4 Auto-Nikkor AIS - \$150-

200mm f4 Auto-Micro-Nikkor Al -Introduced at 1978 Photokina. (List 12/79: \$765.) \$300-450.

200mm f4 Auto-Micro-Nikkor AlS -\$450-700

200mm f5.6 Medical-Nikkor Auto (Non-AI) (Model I) - 4/4 elt; 12.6°. Fixed-focus lens for 1:15 ratio. Supplementary lenses allow ratios from 1:8 to 3:1. Built-in ring-light flash with modeling lamps, \$350-450.

200mm f5.6 Medical-Nikkor Model II - Non-AI. (1978 list AC outfit: \$1210, Battery outfit: \$1275.) \$350-450.

300mm f2 ED-IF AIS - No sales data. 300mm f2.8 (Manual diaphragm) (Non-Al) - No sales data.

300mm f2.8 ED Nikkor-H Auto IC -Auto diaphragm. (List 1/78: \$3299.) \$1500-2000

300mm f2.8 ED-IF Auto-Nikkor AI -(List 10/78: \$2849.) \$1700-2400.

300mm f2.8 ED-IF AIS - No data. 300mm f2.8 AF-Nikkor ED-IF sales data.

300mm f4 AF-Nikkor ED-IF sales data.

300mm f4.5 Nikkor-H Auto (Non-AI) - 6/5 elt; 8°. With Nippon Kogaku markings: \$200-300.

300mm f4.5 Auto-Nikkor IC - (List 1/78: \$485.) \$200-300.

300mm f4.5 Auto-Nikkor AI - (List 1/78: \$550.) \$250-375

300mm f4.5 AIS - \$300-400 300mm f4.5 ED Auto-Nikkor (Non-AI) - (List 1/78: \$990.)

300mm f4.5 ED Auto-Nikkor AI -

(List 1/78: \$1155.) \$400-600. 300mm f4.5 ED-IF Auto-Nikkor AI -Introduced Photokina 1978. (List 12/79: \$1090.)\$500-750. 300mm f4.5 ED-IF AIS - \$500-750.

400mm f2.8 ED-IF AIS - No sales data. 400mm f3.5 ED-IF Auto-Nikkor AI -(List 1/78: \$3250.) \$1700-2400.

400mm f3.5 ED-IF AIS - \$1800-2500. 400mm f4.5 Nikkor-Q Auto - 4/4 elt; 6°. For separate focusing unit 199 (Non-\$350-500.

400mm f4.5 Auto-Nikkor IC - Built-in lenshood. Requires #199 or AU-1 focusing adapter. (List 1/78: \$1066.) Lens head: \$400-550.

400mm f5.6 Nikkor-P Auto (Non-AI) - 5/3 elt; 6°. With Nippon Kogaku markings: \$300-400.

400mm f5.6 ED Auto-Nikkor (Non-Al) - (List 1/78: \$1500.) \$600-900. **400mm f5.6 ED Auto-Nikkor Al** - (List 1/78: \$1750.) \$700-1000.

400mm f5.6 ED-IF Auto-Nikkor AI -Introduced at Photokina 1978. (List 12/79: \$1966.) \$700-1000

400mm f5.6 ED-IF AIS - \$700-1000.

500mm f4 P ED-IF - New: \$4200. \$2500-3500

50cm f5 Mirror lens - With filters &

case, clean glass: \$400-600. 500mm f8 Reflex-Nikkor (Non-Al) -5/3 elt; 5°. 39mm screw-in filter. \$250-350. 500mm f8 Reflex-Nikkor IC - (List 1/78 with 5 filters, hood, & case: \$693.) \$250-350.

600mm f4 ED-IF Auto-Nikkor AI (List 12/79 with TC-14 teleconverter & case: \$4615.) \$2800-4000.

600mm f4 ED-IF AIS - \$3200-4600. 600mm f5.6 Nikkor-P Auto - 5/4 elt; 4°. Built-in hood. (List 1/78: \$1405.) Requires #199 or AU-1 focusing adapter. Lens head: \$500-650.

600mm f5.6 ED Auto-Nikkor IC -Requires #199 or AU-1 focusing adapter. (List 1/78: \$2265.) Lens head: \$700-1000. 600mm f5.6 ED-IF Auto-Nikkor AI -(List 1/78: \$3250.) \$1500-2000. **600mm f5.6 ED-IF AIS -** \$1700-2400.

800mm f5.6 ED-IF Auto-Nikkor AI -(List 12/79 w/case: \$4451.) \$2000-3000. 800mm f5.6 ED-IF AIS - \$3000-4000 800mm f8 Nikkor-P Auto - 5/5 elt; 3°. For separate focusing unit 199. (Non-\$800-1200. 800mm f8 Auto-Nikkor IC - Built-in

hood. Requires #199 or AU-1 focusing adapter. (List 1/78: \$1825.) \$800-1200.

800mm f8 ED Auto-Nikkor IC Requires #199 or AU-1 focusing adapter. (List 1/78: \$2783. 12/79: \$2544.)

100cm f6.3 Nikkor - Mirror lens. Very rare lens, also found in rangefinder mount. Often found with modified mount, i.e. bellows removed, holes drilled. Possibly used on 16mm or 35mm film cameras.

\$3000-5000. Less for missing parts.

1000mm f11 Reflex-Nikkor (Non-Al) - 5/5 elt; 2.5°. Four built-in filters. With

chrome ring: \$550-800.

1000mm f11 Reflex-Nikkor IC - (List 1/78 with 5 filters, hood, & case: \$1452.) \$700-1000.

1200mm f11 Nikkor-P - 5/5 elt; 2°. Manual diaphragm. Built-in hood. (List 1/78: \$2095.) Requires #199 or AU-1 focusing adapter. Lens head: \$1000-1550. 1200mm f11 Nikkor IC - Built-in hood. Requires #199 or AU-1 focusing adapter. (List 1/78: \$2095.) \$1000-1500.

1200mm f11 ED Auto-Nikkor IC -Requires #199 or AU-1 focusing adapter. (List 1/78: \$3475.) \$2000-3000.

1200mm f11 ED-IF Auto-Nikkor AI -(List 12/79 w/case: \$5665.) \$2800-4000.

2000mm f11 Reflex-Nikkor (Non-Al) - 5/5 elt; 1.16°. White barrel with integral top handle. Four built-in filters. Mounts on AY-1 mounting yoke. \$2800-4000. 2000mm f11 Reflex Nikkor IC -(1978 list, with case: \$9845.) \$2800-4000.

ZOOM NIKKOR LENSES: 24-50mm f3.3-4.5 AF Nikkor - \$200-300 25-50mm f4 Zoom Nikkor - Intro-

duced at 1978 Photokina. \$300-400. 28-45mm f4.5 Auto-Nikkor IC - (List 1/78: \$660.) \$150-2

28-45 Auto-Nikkor AI - (List 1/78: \$770.)\$175-250

28-50mm f3.5 AIS - \$200-300 28-85mm f3.5-4.5 AIS - \$250-375. 28-85mm f3.5-4.5 AF - Early type: \$175-250. New type: \$200-300.

35-70mm f2.8 AF - \$350-500. 35-70mm f3.3-4.5 AIS - \$120-180. 35-70mm f3.3-4.5 AF - \$100-150 35-70mm f3.5 Auto-Nikkor Al (72mm). focus to 1m. (List 1/78: \$700.) \$200-300.

35-70mm f3.5 AIS (62mm) - 1981-87. Close focusing to .7m. \$300-400. **35-105mm f3.5-4.5** - CLose focus to

1.4m; Macro ratio 1:4. \$250-350.

35-105mm f3.5-4.5 AF - Focus to 1.4m; macro 1:3.5. \$250-350. 35-135mm f3.5-4.5 AIS - \$225-350.

35-135mm f3.5-4.5 AF - First version: \$200-300

35-200mm f3.5-4.5 AIS - \$350-450. 36-72mm f3.5 Series E - \$100-150.

43-86mm f3.5 Zoom-Nikkor-Auto (Non-AI) - 9/7 elt; 54-28.5°. \$90-130. **43-86mm f3.5 Auto-Nikkor IC** - (List 1/78: \$300.) \$90-130.

43-86mm f3.5 Auto-Nikkor AI - (List 1/78: \$359.) \$100-150.

50-135 f3.5 AIS - Focus to 1.3m. \$200-

50-300mm f4.5 Zoom-Nikkor-Auto (Non-Al) - Various Nikon literature lists this as 20/13 element or a 14 element design. 46°-8.2°. \$300-450

50-300mm f4.5 Auto-Nikkor IC -(List 1/78: \$1450.) \$300-450.

50-300mm f4.5 Auto-Nikkor AI - (List 1/78: \$1738.) \$500-750.

50-300mm f4.5 ED Auto-Nikkor AI -(New product in 1978. List 1/78: \$2485.) \$800-1200.

50-300mm f4.5 ED AIS - No sales data.

70-210mm f4 Series E - %150-250. 70-210mm f4 AF - (1986-86) Focusing to 1.1m. \$150-22

75-150mm f3.5 Series E - \$100-150 75-300mm f4.5-5.6 AIS AF - \$300-450.

80-200mm f2.8 ED - \$600-900. 80-200mm f2.8 ED-IF AF - No sales 80-200mm f4 AIS - \$350-450.

80-200mm f4.5 Zoom-Nikkor-Auto (Non-Al) - ca. 1970. 15/10 elt; 30-12.5° Still considered very sharp despite 25 year age. Turn the lens upside down and the focusing ring should slide down under its own weight. Found for \$200+ clean.

80-200mm f4.5 Auto-Nikkor IC -(List 1/78: \$705.) \$175-250.

80-200mm f4.5 Auto-Nikkor AI -(List 1/78 with case: \$825.) \$250-350.

8.5-25cm f4-f4.5 Auto Nikkor Telephoto-Zoom (Non-Al) - 15 elt; 28.5-10°. Introduced 1959. Early type marked in cm, two-ring type. With closeup filter: \$300-500.

85-250mm f4-f4.5 Auto Nikkor -One ring zoom. Clean, with closeup filter: \$100-200. Add 20% for all black.

100-300mm f5.6 Zoom Nikkor Als -\$250-350

180-600mm f8 ED Auto-Nikkor IC -(List 1/78: \$6375. 12/79: \$7162.) \$3000-

200-400mm f4 ED AIS - \$2000-3000. 20-60 cm f9.5-f10.5 Auto Nikkor Telephoto-Zoom (Non-Al) - Angle of view: 12-4.2°. We have seen this listed as a 19/12 element, and as a 13 element lens in Nikon literature. So far, we have not found one to disassemble and verify. Automatic diaphragm, but does not couple to exposure meter. Early version marked in cm. In wooden box with closeup filter, metal cap, shade: \$\$350-500.

200-600mm f9.5 Auto-Nikkor IC -For stop-down metering. Similar to above but marked in mm. (List 1/78: \$1583.)

Rare. \$400-550.

360-1200mm f11 ED Auto-Nikkor IC - (List 1/78: \$9349. 12/79: \$10,502.) \$3000-4500.

LENS ACCESSORIES:

Focusing Mount Adapter 199 - For 400, 600, 800, or 1200mm lenses. Only one mount required for all four lenses. (List 1/78: \$583.) \$150-225

Focusing Adapter AU-1 - For 400/4.5, 600/5.6, 800/8, and 1200/11 lenses. (List 1/78: \$825.) \$150-225

Bronica Focusing Mount - \$200-300.

Nikon F with early meter

METERS FOR NIKON F:

Model 1 - Roundedcorner, \$120-180. Model 2 - Long window; no provision for the meter booster. Also found with Nikkorex marking. \$75-150.

Model 3 - Square corners; shoe for booster. The most common of the three types. \$90-130.

Booster - Works on meter for rangefinder cameras, also on type 1 and 3 meters for Nikon F. - \$50-150.

Photomic, original - Hinged blind to cover CdS cell in upper right corner. Comes with tubular adapter for telephoto

NIPPON KOGAKU...

use, and incident light diffuser. With both adapters: \$60-90.

Photomic, type 2 - With on-off switch. \$50-75. All black worth 100% more.

Photomic T - First Nikon TTL meter. Lens opening needs to be set against ASA speed dial. Found in black or chrome versions. With meter switch on, check that the meter needle does not jump from side to side; must be a smooth slow action. \$65-125

Photomic TN - Improved meter with 60/40 center weighting. Identified by "N" next to on/off switch. \$60-90.

Photomic FTN - Most common Photomic meter. Black or chrome: \$65-130. "NIKKOR F" Photomics - "NIKKOR F" markings about double the normal prices.

MOTORS FOR NIKON F:

Type 1 - # on baseplate \$300-450.
Type 2 - # on front with Nippon Kogaku

logo. \$175-250.

Type 3 - # on back of motor. \$150-225. KS80A Motor Drive - This modification was made by Ehrenreich Photo Optical Industries for the U.S. Navy. About 2000+ were made in about 5 variations. It is said that Ehrenreich lost money on every set, but he wanted the prestige of supplying the Army and Navy. Never found working or with the correct batteries. \$300-500. Complete with correct camera body engraved U.S. Navy, and long (approx. 3cm) rewind knob: \$600-900.

KS80A 250 Black Model - Same as above set but only 10 were made in black. Very rare. Only one known among collectors. Estimate \$1500-2000.

Brown battery pack - \$55-90. Black battery pack - \$45-80. Cordless battery pack, type 1 -\$60-100.

Cordless battery pack, type 2 -Large screw just under the release. It is the most common type. \$60-100.

Cordless battery pack, type 3 - Made near end of Nikon F production. Remote connection is standard 3-pin as found on all Nikon motor drives, \$75-100.

NIKON F ACCESSORIES: Waist level finder, Nikon logo -\$50-75

Waist level finder, Nikon F - \$35-50. Copy stand - In wooden box. Box must be in good condition, and have all items including table clamp & mounting arm. \$200-250

Bellows Type 2 - With slide copier, double rails: \$75-125.

Bellows Type 3 - Single rail, light weight. \$75-100.

Extension ring set K - In leather case, \$20.

N-F Adapter ring - Permits long range-finder lens on Nikon F. \$50-75. Panorama Head - With spirit level.

\$100-150

Action Finder - Black or chrome. \$100-175

Electronic flash SB-1 - working and

with charger \$150-225. Ring Flash SN1 - For the SB1. \$65-80.

Ring Flash SM1 - For the SB1. With its own power pack. Complete: \$70-130.

Flash unit BC-7 - Well made bulb flash

with leather case. \$20-30. Microscope attachment - \$45-60.

Telescope attachment - \$35-50. 250 exposure back - with cassette: \$250-375.

NIPPON KOKEN

NIPPON KOKEN CAMERA WORKS

Nikko Flex - c1950. Externally gear-coupled f3.5/8.0cm Koken Anastigmats. Lotus T,B,1-200. Uncommon. \$200-300.

NIPPON KOSOKKI SEISAKUSHO

Taroflex - c1943. TLR. 6x6cm on 120 rollfilm. Taro Anastigmat f3.5/75mm, NKS 1-200 shutter. \$250-375.

NISHIDA KOGAKU (Japan) Apollo 120 - c1951-53. Also called Apollo Semi II. Folding camera for 42x55mm exposures on 120. Earlier versions lack sync and have leather covering. Later ones have a vulcanite-type covering and synchronized shutter. C.O.W., S.O.W. or Wester Anastigmat f3.5 in N.K.K. Wester 1-200 shutter. \$60-90.

Atlasix - c1955. Horizontally styled folding camera for 6x6cm on 120. Inexpensive construction. Welcon f4.5/75mm in B,25-300 shutter. Uncommon name, possibly made for a specific distributor. \$90-130.

Mikado - c1951. Copy of Kodak Duo 620 Series II, 4.5x6cm. Westar Anastigmat f3.5/75mm lens. Northter Model II shutter to 200. \$50-75.

Wester Autorol - c1956. Folding bed camera, 6x6cm on 120 film. CRF. Wescon f3.5/75mm in NKK 1-400, B. \$50-75.

NITTO SEIKO (Japan) Elega-35 - c1952. Leica-styled 35mm. Eleger or Elega f3.5/45mm screw-mount lens (not interchangeable with the Leica lenses). Rotary shutter 1-200, B. \$600-900.

NIXON CAMERA-WERK (Germany) Nixette - Self-erecting folding camera for 6x6 on 120 film. Unusual spring-loaded front opens with the speed of a switch-blade and a loud thump. Three-pleat bellows folds unconventionally as the front standard swings down and inwards to closed position. Supra Anastigmat f5.6/ 75mm lens in Vario shutter. \$60-90.

NOMAR No. 1 - Metal box for 127 film. Film spools behind plane of focus. Black, red, or green enameled. \$35-50.

NORISAN APPARATEBAU GmbH (Nürnberg, Germany) Afex - Small bakelite

camera for 25x25mm on standard 828 film. Similar to the Hacon and Nori, but with metal top and bottom plates. \$45-60.

Hacon - c1935. Small bakelite camera for 25x25mm on rollfilm. The same design also appears under the name "Genos", probably after WWII. \$45-60.

Nori - c1935. Black bakelite camera for 25x25mm exposures on 35mm wide rollfilm. Meniscus or f6.3 lens. Early version has folding finder. Later version has rigid

optical finder. A postwar version was sold as under the name "Ernos" by Photoprint AG. \$45-60.

NORTH AMERICAN MFG. CO. (Chicago)

Namco Multi-Flex - c1939. Twin-lens novelty camera for 16 exposures on 127. Similar to "Clix-O-Flex". Cast metal: \$15-25. Plastic: \$12-20.

NORTHERN PHOTO SUPPLY CO.

Liberty View - c1913. Same camera as the New Improved Seneca View, 8x10". \$150-225.

NORTON LABORATORIES In 1933. Universal Camera Corp. had Norton Labs design a camera. After a falling out between the two companies, Norton continued with the "abandoned" joint project, while Universal set about modifying and producing their own version, the Univex A. See Universal Camera Corp. for related models, including the Norton-Univex.

Norton - c1934. Cheap black plastic camera for 6 exposures 11/8x11/2" on No. 00 rollfilm on special film spools. The end of the film spool extends outside the camera body and functions as a winding knob. Stamped metal viewfinder on back of body. \$30-45.

Norton, Century of Progress - c1934. Same as the Norton camera, but with a decal on the back for the 1934 Chicago World's Fair. \$120-180.

NOVA - c1938. Cast metal camera for 3x4cm on 35mm wide rollfilm. Front extends via telescoping boxes. Special Anastigmat f4.5, shutter 25-100. This Kaftanski design returned after WWII as the Tex. \$200-300.

NOVELTIES - c1955. Japanese TLR for 6x6cm on 120 film. Rack & pinion focus. Tri-Lausar f3.5/8cm lenses in B.1-300 shutter. Uncommon name. \$300-450.

NOVO CAMERA CO. Novo 35 Super 2.8 - c1950s. 35mm RF. Lever film advance. Non-interchangeable Novo Avigon f2.8/45; Copal. \$75-100.

NYMCO - Better than average "Yen" box camera, cut film in paper holders. Separate shutter cocking lever; plated metal frame around ground glass back. \$25-35.

NYMCO FOLDING CAMERA - c1938. Low-cost Japanese folding "Yen" camera, 3x5cm cut film in paper holders. Leatherette covered. Simple lens, single-speed shutter. \$50-75.

OBERGASSNER (Munich)

Oga - 35mm viewfinder camera. Built-in meter. f2.8/45 lens. \$20-30.

Ogamatic - c1960's. 35mm camera with coupled meter. Color Isconar f2.8/45mm in Prontormat shutter. \$20-30.

OCEAN OX-2 - c1986. Novelty 35mm from Taiwan, styled with small pseudoprism. \$1-10.

OEHLER (B.J. Oehler, Wetzlar, Germany)

Infra - c1951. Plastic 35mm with metal top and bottom. Extinction meter incorporated in top housing. Punktar f2.8/35mm lens in Prontor 25-200 shutter. 24x24mm exposures using Karat cassettes. \$50-75.

OKADA KOGAKU (abbreviated OKAKO) OKADA OPTICAL WORKS OKADA OPTICAL INDUSTRIAL CO. LTD. (Tokyo, Japan) Gemmy - c1950. Pistol-shaped subminia-

Oko Semi

ture camera for 10x14mm exposures on 16mm film in special cassettes. Trigger advances film. Fixed focus f4.5/35mm lens. Three-speed shutter, 25,50,100. Current estimate: \$1500-2000.

Kolt - c1950. 13x13mm subminiature from Occupied Japan. Kolt Anastigmat f4.5/25mm. Iris diaphragm. Shutter, B, 25, 50, 100. \$200-300.

Waltax (I) - c1940-47. Folding Ikonta-A style camera for 16 exp. on 120 rollfilm. Kolex Anastigmat f3.5/75mm lens in Dabit 1-500 shutter marked OKAKO TOKYO on top. Folding optical finder. Little difference between pre- and postwar models. \$75-100. (See Daiichi Kogaku for other postwar Waltax models.)

Walz Baby - c1936. Folding strut camera 16 exp. 3x4cm on 127 film. Similar in style to the Foth Derby, but with front shutter. Walz Anastigmat 50mm/f4.5 in Walz shutter T,B,25-100. Uncommon. \$90-130.

OKAM (Slatinany, Czechoslovakia)This small company, owned by Odon Keyzlar, was ruined in the 1929 depression.

Okam - c1926. Box cameras for 4.5x6cm plates. One very rare model has interchangeable lenses. Normal model has non-interchangeable Meyer Helioplan f6/105mm lens. Both have Patent 2 disc shutter 1/5-1/1000. Uncommon. Auction record 12/91: \$935. Normal range: \$350-500.

Okam (simple model) - c1926. Simplified version of the Okam box camera for beginners. Single speed ¹/₄₀ "door-formed" shutter. Even this simple model is uncommon. \$350-500.

OKAYA OPTICAL WORKS (Japan) Lord IVB - c1958. 35mm CRF. Highkor

OLYMPIC

f2.8/40mm "semi-wide-angle" lens; Sei-kosha-MX 1-500, B shutter. \$75-100.

Lord 5D - c1958. Rangefinder 35mm camera. Similar to the IVB, but with brighter lens. Highkor f1.9/40mm in B,1-500 shutter. \$75-100.

OKO SEMI - c1940. Folding camera for 4.5x6cm on 120 film. Dual finder for eyelevel or reflex viewing. Uncommon. \$75-100. *Illustrated at top of previous column.*

OLBIA (Paris)

Clartex 6/6 - Bakelite camera for 6x6cm on 620 film. \$35-50.

Olbia BX - Black or maroon bakelite eyelevel camera for 6x6cm on 620 film. Identical to the Clartex. Meniscus lens in two-speed shutter. \$35-50.

OLYMPIC CAMERA WORKS (Japan) New Olympic - c1938. Bakelite rollfilm camera for 4x4cm on 127. Ukas f4.5/50mm lens. Shutter 25-150, T,B. \$60-90

Olympic Junior - c1934. Bakelite half-frame 127. Front extends and focuses with bakelite helix. Simple model has folding frame finder; simple lens and shutter like Ruberg cameras. Expensive models have better lens/shutters such as f6.3/50mm helical focus lens in Olympic shutter 25,50,B. \$90-130.

Semi-Olympic - c1937.4.5x6cm on 120. Bakelite body. Ukas f4.5/75mm lens. Shutter 25-150, T,B. \$75-100.

Super-Olympic - c1935. The first Japanese 35mm, using Contax spools. Bakelite body. f4.5/50mm lens. Shutter 25-150, T,B. \$150-225.

Vest Olympic - c1938. Half-frame on 127 rollfilm. Similar to Ruberg Baby Ruby. Telescoping metal tube front. Ukas f4.5/75mm Anastigmat. Shutter 25-150,T,B. \$100-150.

OLYMPUS

OLYMPUS KOGAKU (Japan)

Olympus was founded on October 12, 1919 as Takachiho Seisakusho with the intention of building the first Japanese microscopes. Its first microscope was marketed in 1920, and since that time, the company has always kept close to medical technology, as evidenced by its introduction of the world's first gastro camera in 1951. The first camera was the 1936 "Semi-Olympus", a bellows-type folding camera. The company name changed in 1942 to "Takachiho Kogaku Kogyo Co., Ltd." and again in 1949 to "Olympus Opti-cal Co., Ltd.", adopting the name of its cameras. Although Olympus has made many cameras which are not far from the main-stream, they have also made several notable products which set them apart as an innovative company. Olympus has often managed to squeeze the full functions of a quality camera into a smaller and lighter body. In addition to their light and compact fullframe models, one can't help but think of the half-frame "Pen" cameras which were so popular in the 1960s and '70s.

We are listing these cameras basically in a chronological fashion. However, when a particular type of camera is introduced, we have tried to keep its successors with it in order to show the development of the various lines of cameras. We are indebted to Dominique & Jean-Paul Francesch for their research and photographs used in this section. For further reference on Olympus cameras we highly recommend their book "Histoire de L'Appareil Photographique Olympus de

1936 à 1983".

Semi-Olympus Model I - 1936. Using a Japanese-made Zuiko 75mm f4.5 lens in an imported Compur rimset shutter, this vertically styled folding bellows camera for 16 exposures on 120 film began the long line of Olympus cameras. The second variation (1937) used a Japanese-made Koho shutter to 1/150. Folding optical finder. Rare. \$400-600.

Olympus Standard - 1937. Unusual rangefinder camera, 4x5cm on 127. Styled like the 35mm rangefinder cameras of the day, with interchangeable lenses. Only 10 examples made. Extremely rare. If you see one for sale, be prepared for a bidding battle with a dozen Samurai warriors.

Semi-Olympus Model II - 1938. The first Olympus camera made entirely in Japan. Camera body is now horizontally oriented and has a rigid finder rather than a folding one. Accessory shoe. Body and bellows are large enough to have been made for 6x6cm, but the format remains 4.5x6cm. Zuiko 75mm f4.5 in Koho to 150. \$350-500.

Olympus Six - 1939, 1940. Horizontally styled self-erecting bellows camera for 6x6cm on 120. Although the design reverted to a folding finder and the accessory shoe disappeared, this new model went to the larger square format, and added a body release for the Koho shutter. The 1939 model has the same 4-element lens as the earlier Olympus cameras, while the 1940 model introduced new 5-element Zuiko 75mm f4.5 and f3.5 lenses. (Late wartime lenses designated "S Zuiko" are of this 5-element design). Koho shutter to 200. \$150-225.

Olympus Six (Postwar) - 1946-48.

Made from pre-war parts. Identical to the pre-war f3.5 version except that the lens has 4, not 5, elements. It can only be distinguished by removing and examining the front lens. Takachiho's Hatagaya plant which made the Koho shutters had been destroyed in April 1945, so when the existing stock of Koho shutters ran out, the Copal shutter from Copal Koki Co. was used. \$100-150.

Olympus Chrome Six There are a number of variations of the Chrome Six, none of which are adequately identified on the camera body. In fact, they say "Olympus Six" without the word "chrome". The "Chrome" Six series can be identified by the fact that they have a chrome top plate or top housing, and rigid tube finder rather than folding optical type found on the pre-war design. The bodies are diecast rather than stamped metal. All are dual-format for 6x6cm or 4.5x6cm on 120 film.

For quick identification: Chrome Six I, II, III have tubular finder above top plate. I has f3.5 lens; II has f2.8; III has flash sync post on shutter, heavy machined accessory shoe. Chrome Six IV, V, RII have finder integrated in top housing.

Chrome Six I - 1948-50. Combines the best features of the Semi-Olympus Model II (rigid tube finder and accessory shoe) and the Olympus Six (f3.5 lens and body release). Copal 1/₂₀₀ shutter. \$120-180.

Chrome Six II - 1948-50. Same as Chrome Six I, but with f2.8 lens. \$120-180.

Chrome Six III - 1950-54. Improved version of I/II above. Synchronized shutter; heavy machined accessory shoe; backtensioned supply spool for better film flatness. With f3.5 lens it is IIIA; with f2.8 it is IIIB. \$100-150. *Illustrated top of next page*.

OLYMPUS...

Olympus Chrome Six III

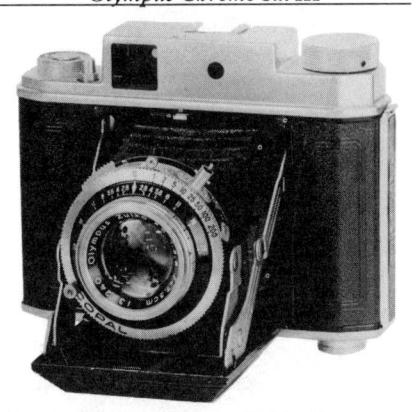

Chrome Six IV - 1954 (January - November). Built-in uncoupled rangefinder with tiny unadorned circular window in the center of the top housing. Viewfinder is at the right end of the top housing, next to shutter release. Only Olympus Six with both rangefinder and knob advance. The later model RII has lever advance. With f3.5 it is IVA; with f2.8 it is IVB. Uncommon because it was made for less than a year. \$120-180.

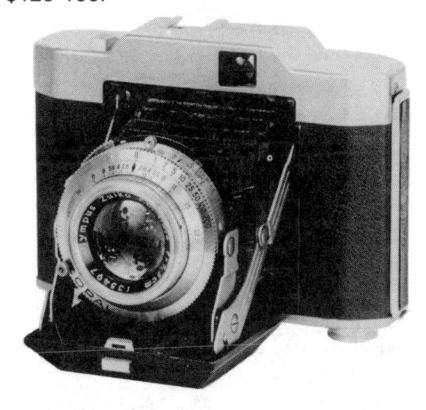

Chrome Six V - 1955 (January-October). Characteristics: Full top housing but no rangefinder; lever advance, so no knobs on top. With f3.5 = VA; with f2.8 = VB. Although made for a shorter time than the Chrome Six IV, the V was made in larger quantities and is easier to find. \$100-150.

Chrome Six RII - 1955-57. Rangefinder built into top housing. Lever advance. First issued with the same Copal $^{1}/_{200}$ shutter used on the other Chrome models. In 1956, this was increased to $^{1}/_{300}$. RIIA = $^{1}/_{300}$. RIIB = $^{1}/_{300}$. RIIB = $^{1}/_{300}$.

Olympus Twin Lens Reflex Cameras Although the Rolleiflex had been around since 1929, and Minolta had produced its first TLR in 1937, it wasn't until after WWII that the demand for 6x6 TLR cameras became epidemic. The 1950's saw Rolleicord copies flooding from the land of the rising sun. Olympus had better manufacturing facilities available, since many of the others were assembled in rather spartan little shops. Although the basic design still leans beavily toward Franke & Heidecke, Olympus made a few positive changes. Like Rolleicord, Olympus used a right-hand focus knob, but raising the shutter release to the midpoint of the front allowed focusing with the right hand while the trigger finger remained ready to shoot. Some features such as bayonet mounts were intentionally made to match the popular Rollei cameras.

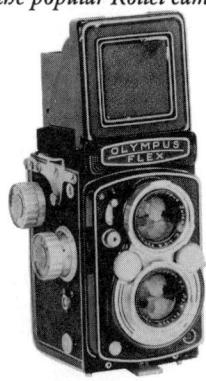

Olympus Flex B I - 1952. The first TLR from Olympus and the first Japanese TLR with f2.8 viewing and taking lenses. Zuiko 75mm f2.8 taking lens (6 elements in 4 groups) and similar viewing lens (4 elements in 3 groups). Seikosha-Rapid shutter 1-400. \$150-225.

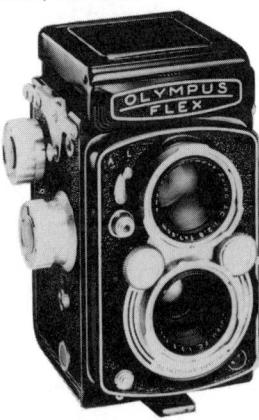

Olympus Flex Bil - 1953-55. Similar to the BI, but with Rollei-style focus magnifier; click-stops on shutter & aperture settings. \$120-180.

Olympus Flex A A lower cost version of the B series, introduced in the wake of poor sales brought about by three major factors: The improved Rolleiflex cameras took a better market share; the American occupation of Japan ended; and the Korean war ended. Since American soldiers had been heavy purchasers of TLR's, their reduced numbers had a parallel effect on sales. The economized A series eliminated the small knurled knobs for shutter and aperture setting and used levers at each side of the shutter housing.

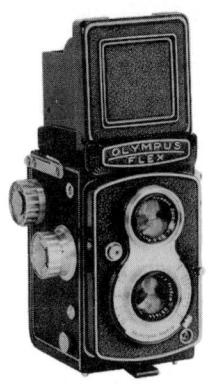

Olympus Flex A3.5 - 11/54-8/56. In addition to the simplified setting levers, this first version of the A also eliminated the double bayonets in favor of a simpler threaded mount for the lens accessories. D-Zuiko f3.5 lens in Seikosha-Rapid 1-500 shutter. \$90-130.

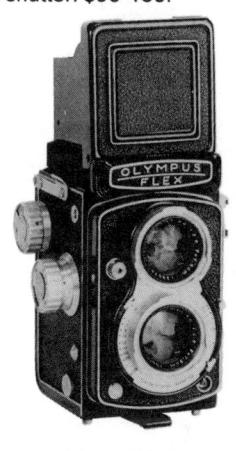

Olympus Flex A2.8 - 11/55-8/56. An upgraded model, introduced a year after the A3.5. In addition to the obvious f2.8 lens, this model also brought back the bayonets, though retaining the levers to set the shutter and aperture. On the market for less than a year, it is not a very common model. \$120-180.

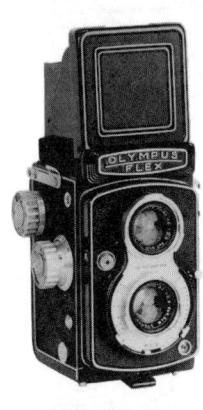

Olympus Flex A3.5II - 6/56-9/57. The last of the Olympus TLRs; also their last camera for 120 rollfilm. Like the earlier A3.5, it had levers for shutter & diaphragm. However, it used bayonets for lens accessories. It is the only Olympus TLR with MFX selection lever for flash sync. \$90-130.

OLYMPUS...

OLYMPUS PEN HALF-FRAME CAMERAS

There are 19 models of the compact half-frame Pen cameras, plus four reflex models of the "F" series. The compacts were made for over 20 years, from 1959 into the 1980's. The concept of a camera that could be carried and used as easily as a writing instrument was the inspiration for the name. The instant success of the new half-frame series caused a boom in half-frame cameras in Japan during the 1960's. Although a number of earlier 35mm cameras had used the single- or halfframe format, they had appeared at a time when medium and large formats still held a large market share, and 35mm was still considered "small format". By the late 1950's, the 24x36mm frame was considered more standard than small, and 35mm cameras had gotten larger and heavier. This, plus better available films made a compact half-frame camera more appealing.

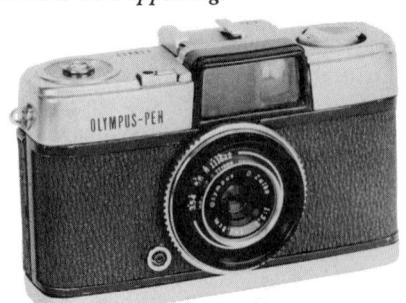

Pen - 10/59-11/64. This first model of the Pen series was not originally manufactured by Olympus. It was produced by a subcontractor, but tested and shipped by Olympus. (Olympus began production in its own Suwa plant in 1960 with the Pen S.) Zuiko 28mm f3.5 lens in Copal X shutter (25 50 100 200 B). \$60-90.

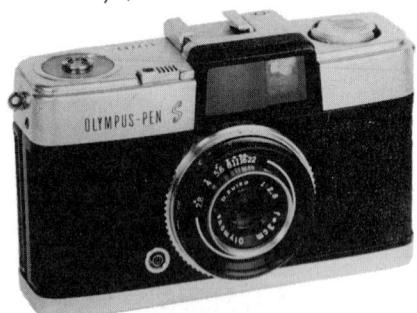

Pen S 2.8 - (1960-64) Pen S 3.5 - (1965-67)

Similar to the original Pen, but with Zuiko 30mm f2.8 lens; Copal X shutter with standardized speeds (8 15 30 60 125 250 B). The second model of the Pen S with a 30mm f3.5 lens appeared at the time the original Pen was discontinued. It is basically the same except for the shutter speeds. \$50-75.

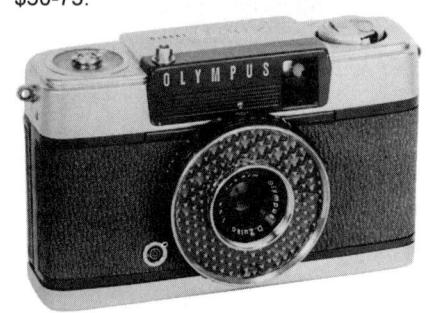

Pen EE - 8/61-5/63. The EE, of course

stands for the large Electric Eye which surrounds the fixed-focus 28mm f3.5 lens. Today we would call this a point-and-shoot camera, and for that reason coupled with its original price below \$50, it sold in record numbers. Common. \$35-50.

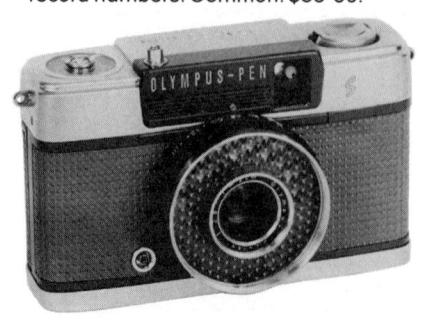

Pen EES - 1962-68. Improved version of the EE, with f2.8/30mm zone-focusing lens. Cost \$60 new. \$45-60.

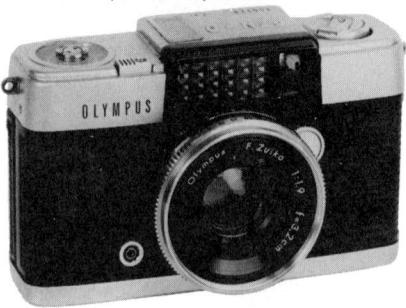

Pen D - 1962-66. Advanced model with fast Zuiko f1.9/32mm. Copal-X shutter ¹/₈-500,B. Built-in meter with readout on top of camera. Sold for \$70 at the time. \$60-90.

Pen D2 - 1964-65. Like the Pen D, but with CdS meter instead of selenium type. Was \$80 new. \$60-90.

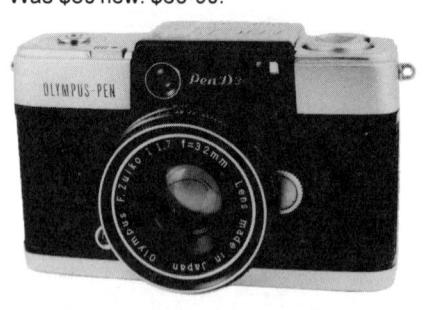

Pen D3 - 1965-69. Took over from the D2 with a slightly faster f1.7 Zuiko lens. \$75-100.

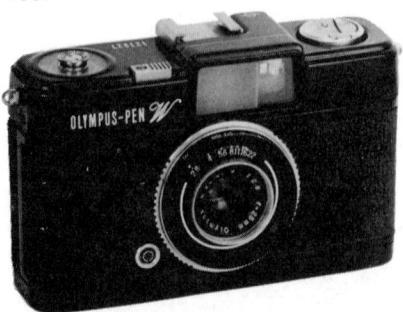

Pen W (Wide) - 1964-65. All black version of the Pen S body, but fitted with a 25mm f2.8 wide angle lens. Although it sold for under \$50 when new, it is rather hard to find one these days. We have recorded sales up to \$250, but most have been in the range of \$90-130.

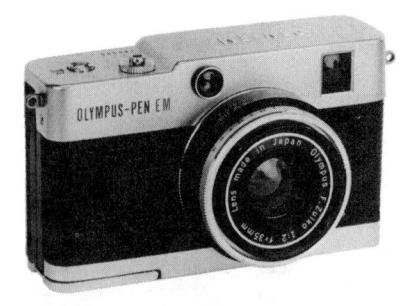

Pen EM - 1965-66. Motorized film advance and rewind. F.Zuiko 35mm f2 lens. Subject to problems with the motor drive. Variation: with flash shoe. \$50-75.

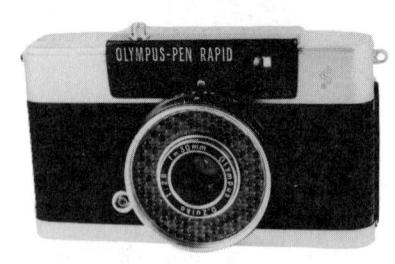

Pen Rapid EES - 1965-66. Essentially the same as the regular Pen EES, but rather than standard 35mm cartridges, it was built to accept the Agfa-Rapid cassette which required no rewinding. Unfortunately, the "Rapid" system never gained worldwide popularity, and so the cameras made to use this film didn't break sales records either. \$75-100.

Pen Rapid EED - 9/65-5/66 only. The "Rapid" cassette version which preceded the standard Pen EED. Very Rare. \$120-180.

Pen EE-EL - 1966-68. Pen EES-EL - 1966-68

Same as Pen EE, but with takeup spool slotted in four places and with a tooth at the bottom of each slot to engage the film for faster loading. This change was dubbed "Easy Loading" and there is a small "EL" sticker on the front of the camera (unless it has fallen off.) Prices same as regular models of EE and EES: \$35-50.

Pen EED - 1967-72. Automatic CdS metering with shutter speeds 1/₁₅-1/₅₀₀ and

f1.7 lens. Low light warning in viewfinder. Easy load system. \$75-100.

Pen EES2 - 1968-71. Automatic exposure controlled by meter cell around lens. Zone focus. D.Zuiko f2.8/30mm lens. \$45-60.

Pen EE-2 - 1968-77. Fully automatic regulation of shutter & diaphragm, fixed focus f3.5/28mm lens, and compact size made this a very popular camera to keep in a pocket. \$45-60.

Pen EE-3 - 1973-83. Essentially identical to the Pen EE-2. \$50-75.

Pen F - c1963-66. The first 35mm halfframe SLR. Porro-prism allows streamlined design without roof prism. New rotary focal plane shutter synched to 1/500. Lever cocks shutter on first stroke, advances film on second. Bayonet-mount normal lenses include Zuiko f1.4/40mm and Zuiko f1.8/ 38mm. An accessory meter mounts to the shutter speed dial via bayonet. Common. EUR: \$150-225. USA: \$150-225.

Pen FT - c1966-72. An improved version of the Pen F, incorporating CdS meter, single stroke lever advance, and self-timer. With f1.8/38mm normal lens. Black model: \$350-500. Chrome model is very common. USA: \$150-225.

Pen FV - 1967-70. A compromise between the F and FT. Single-stroke lever, self-timer, but no built-in meter. Accepts external accessory meter. Less common than the others. Black model is rare. Chrome: \$175-250.

PEN F ACCESSORIES 20mm/3.5 G Zuiko Auto W -\$175-250

25mm f2.8 G Zuiko Auto W -\$150-225

25mm f4 E Zuiko Auto W -\$100-150.

38mm f1.8 F Zuiko Auto S - \$60-90. 38mm f2.8 Compact - \$150-225.

38mm f3.5 Macro - \$175-250 40mm f1.4 G Zuiko Auto S -\$100-150

42mm f1.2 H Zuiko Auto S -

\$90-130

60mm f1.5 G Zuiko Auto T -\$120-180

70mm f2 F Zuiko Auto T - \$120-180. 100mm f3.5 E Zuiko Auto T -\$100-150

150mm f4 E Zuiko Auto T -\$175-250.

250mm f5 E Zuiko T - \$200-300. 400mm f6.3 E Zuiko T - \$750-1000.

800mm f8 Zuiko Mirror T - Only 36 made, \$2400-3200

50-90mm f3.5 Zuiko Auto Zoom -\$120-180

100-200mm f5 Zuiko Zoom -\$200-300

Bellows - \$25-35.

CdS Meter for F, FV - \$50-75.

OLYMPUS 35 CAMERAS The first 35mm cameras from Olympus began with a prototype designed by Mr. Eiichi Sakurai in 1947. This prototype is called the Olympus 35, and its commercial result is the Olympus 35 (1). Since most of the Olympus 35 series cameras are identified on the body simply as "Olympus 35", it is important to consider the features for proper identification.

Quick Identification Features:

I & III - External linkages from shutter to body. Right hand side has rectangular

OLYMPUS...

housing over body release linkage. Opposite side has a pin through a curved slot in the body. I=24x32mm; III=24x36mm.

IV - Front of camera has no external linkages, but top plate still has knobs & finder above it. IVa=Copal; IVb=Seikosha-Rapid.

V - Streamlined top housing incorporates finder. Va=f3.5; Vb=f2.8.

K - Rangefinder; Copal to 500.

Olympus 35 I - 1948-49. Essentially the same as the prototype of 1947 but with an improved finish. Takes 24x32mm exposures, which led to its demise in favor of the standard 24x36mm image. Zuiko f3.5/40mm lens in Seikosha-Rapid shutter. \$75-100.

Olympus 35 II - 1949. Prototypes only. Not released.

Olympus 35 III - 1949-50. The first 24x36mm from Olympus. Zuiko f3.5/40mm in Seikosha-Rapid. In addition to the format, it can be told from model I by a machined rather than stamped metal accessory shoe, and by a round knob instead of a lever to open the back. Made for only a few months, so not commonly found. \$100-150.

Olympus 35 IV - 1949-53. Copal B, 1-200 inter-lens shutter replaces the behindlens Seikosha-Rapid of earlier models. ASA flash synch post on front. "Made in Occupied Japan" branded into leather. \$50-75.

OLYMPUS...

Olympus 35 IVa - 1953-55. As model IV, but shutter to 300 and marked "Made in Japan", not "Occupied Japan". \$35-50.

Olympus 35 IVb - 1954-55. As Model IVa, but with Seikosha-Rapid 1-500. (No longer externally linked as on models I & III). Flash sync is PC type on shutter, not ASA type on body. \$60-90.

Olympus 35 Va - 1955. Restyled top housing with incorporated finder. Hinged, not removable, back. Copal 1-300 shutter with self-timer. \$35-50.

Olympus 35 Vb - 1955. Same as Va, but Seikosha-Rapid 1-500. A bit less common. \$35-50.

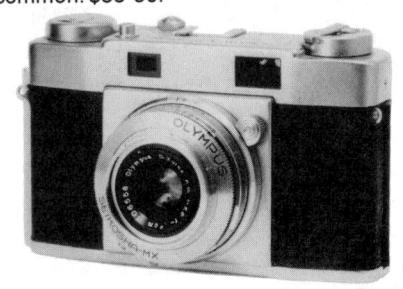

Olympus 35-S - 1955-58. Improved

body incorporates RF in top housing; film advance lever also cocks shutter. First type has V-shaped focusing knob, lacks crank on rewind knob, has Seikosha-Rapid shutter with f3.5 or f2.8 lens. Second type, available in f3.5 or f2.8 (also f1.9 from 1956-57), has round focusing knob, folding rewind crank, and Seikosha MX shutter. \$50-75.

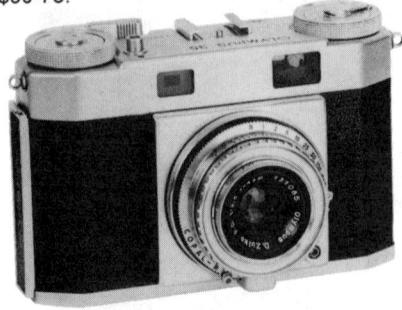

Olympus 35-K - 1957-59. RF 35, styled much like the 35-S series. "Olympus 35" on the top doesn't give much clue to its model, but it can be easily recognized by its focusing ring near the front of the lens, rather than next to the body. The coupling between the lens and the rangefinder is in a small housing below the lens. It sports a Copal 1-500 shutter, whereas earlier cameras marked simply "Olympus 35" had no RF and their Copal shutters went only to 300. \$50-75.

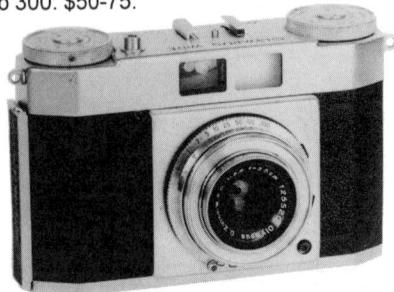

Olympus Wide - 1955-57. Basic scale-focus camera with f3.5/35mm wide-angle lens. \$45-60.

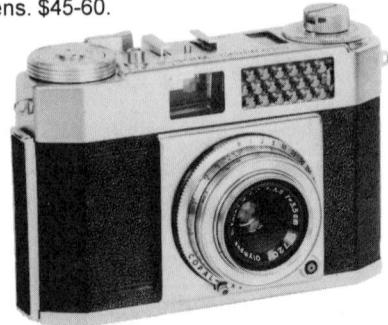

Olympus Wide E - 1957-58. Improved version of the Olympus Wide incorporating selenium meter and lever wind. \$50-75.

Olympus Wide II - 1958-61. Like the

Olympus Wide, but with lever advance, and folding crank on rewind knob. The positions of the finder and bright-frame windows are reversed from the original model. Some early ones have "W" embossed on the front of the top housing; later ones do not. Not exported to Europe, so less common there than in Japan or the USA. \$50-75.

Olympus Wide S - 1957-58. The best of the Wide series, with coupled rangefinder and fast f2/35mm lens in Seikosha-Rapid to 1/500. \$50-75.

Olympus 35-S II - 1957-59. Based on the Olympus Wide S body, this series marked "Olympus 35-S" can be distinguished from the earlier 35-S models by the 3 window front.

-f1.8 (first version) - 1957-58. Identifiable by self-timer lever on front below shutter button.

-f1.8 (second version) - 1958. Lacks self-timer; has stylized "S" on front of top housing.

-f2.8 - 1957-59. E.Zuiko f2.8/45mm lens. More common than the other models.

-f2 - 1958-59. Despite the 10 month production period, the f2 model is difficult to find.

With the exception of the first f1.8 version, none of these have self-timer, and all share the same basic body. Current values: f2: \$60-90. f1.8: \$60-90. f2.8: \$35-50.

Olympus Ace - 1958-60. The first attempt by Olympus to market an interchangeable lens RF camera. (The 1937 Standard was never marketed.) Bayonet lenses include: E.Zuiko 45mm/f2.8, 35mm/f2.8, & 80mm/f5.6. Less common with all three lenses: \$250-375. With normal lens only: \$75-100.

Olympus Ace E - 1958-61. Improved "Ace" with match-needle metering. With set of 3 lenses: \$250-375. With normal lens: \$90-130.

Olympus Auto - 1958-59. Contemporary with the original Ace, the Auto featured metering but fixed 42mm/f1.8 lens. Choice of aperture or shutter priority. \$50-75.

Olympus Auto B - 1959-60. Lower-priced version of the Auto, with f2.8 lens and lacking the cover for the meter cell. \$50-75.

Olympus Auto Eye - 1960-63. An advanced camera for its day. Automatic shutter-priority metering with diaphragm readout in viewfinder. Flash exposures determined by "Flash-matic" system. D.Zuiko 45mm/f2.8 in Copal SV to 500. \$60-90.

Olympus Auto Eye II - 1962-63. Simplified version of Auto Eye, without "Flashmatic" system. D.Zuiko 43mm/f2.5 lens. \$75-100.

Olympus-S "Electro Set" - 1962-63. Rangefinder; selenium 42mm/f1.8 lens. \$50-75.

Olympus-S (CdS) - 1963-65. Similar to the previous model, but with round CdS meter cell rather than rectangular "beehive" selenium cell. \$50-75.

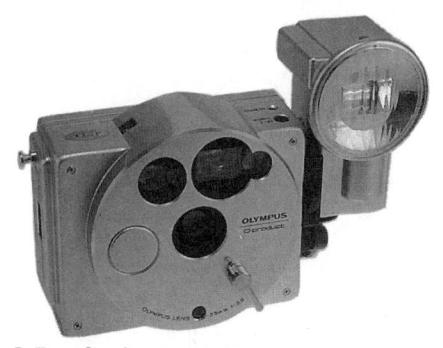

O-Product - 1988. Limited edition compact 35mm. White aluminum body. Olympus f3.5/35mm lens, programmed electronic shutter 1/45-1/400. Auto focus,

OLYMPUS...

auto film advance and rewind. As new, selling at auction for \$600-900.

With the exception of the O-Product camera, we have chosen the arbitrary date of 1965 to cut off our listings of Olympus 35mm RF cameras in order to include some of the earliest Olympus SLRs.

OLYMPUS 35MM SLR CAMERAS Despite their long history and numerous 35mm cameras, Olympus did not enter the fullframe SLR market until 1971. The Pen F had virtually created the half-frame 35mm SLR market eight years earlier. The first fullframe SLR, the TTL, was a rather ordinary screw-mount camera. The OM-1 which replaced it within two years was truly a masterpiece. In this collectors guide, we are listing only the first few Olympus SLRs. The later ones definitely are more usable than collectible.

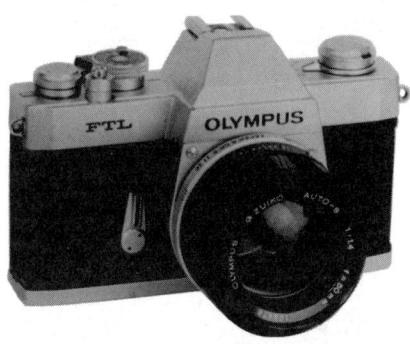

FTL - 1971-72. Interchangeable 42mm screw-mount lenses included: 50mm f1.4 & f1.8 normal lenses plus 28mm/f3.5, 35mm/f2.8, 100mm/f3.5, & 200mm/f4. Other accessories were also available for this short-lived system. With normal lens: \$75-100. Add \$30-45 each for extra lenses.

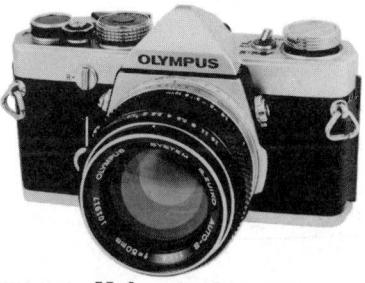

Olympus M-1 - c1972. 35mm SLR introduced at Photokina in 1972. The original model designation "M-1" (already registered by Leica since 1959) was quickly changed to "OM-1". Very few were marked "M-1". FP shutter 1-1000,B. \$250-375.

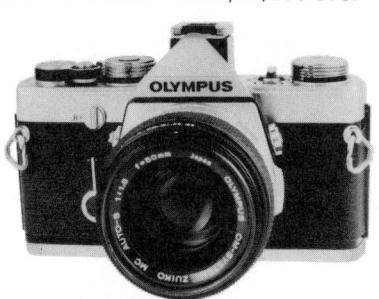

Olympus OM-1 - 1973-74. Weighing in at only 660 grams, accepting a full range of bayonet-mount lenses and interchangeable screens, and introducing a quiet

OLYMPUS...

shutter all improved the first impression of the OM-1 as it entered a world of more experienced and reputed cameras. Its lenses are still usable on more current Olympus cameras, and the OM-1 itself, though aging, is still primarily a usable camera. Match-needle CdS TTL metering. With normal 50mm/f1.8 lens: \$120-180.

Olympus OM-1 MD - c1974. Same as OM-1, but with port on bottom to accept motor drive. \$120-180.

Olympus OM-1N MD - c1979. Improved version of OM-1 MD. LED flash indicator in finder. \$150-225.

Olympus OM-2 MD - 1975. Similar to the OM-1 MD, but with fully automatic aperture priority metering. \$150-225.

Olympus OM-2N MD - c1979. Improved version of OM-2 MD. LED flash indicator in finder. \$150-225.

Olympus OM-10 - c1979. Simplified, fully automatic version of the OM-2. No manual speeds except with special adapter. Does not accept motor drive. With Zuiko 50mm f1.8: \$100-150.

OMI (Ottico Meccanica !taliana, Rome)

Sunshine - c1947. Small three-color camera/projector. A few years ago, these sold for about \$3000, since only a few were known to exist. Since that time, more have surfaced and we have seen them offered as new, in box, for as low as \$500 from 1984 to 1986. Auction sales have been in the \$240-500 range, up to \$900 with projector.

O.P.L.-FOCA (Optique et Précision de Levallois S.A., France) This company manufactured precision instruments such as machine guns and marine rangefinders for national defense. In 1938 they decided to make an entirely French precision camera to compete with the German Leica and Contax. The war brought the camera project to a halt because of military priorities. However, during the German occupation, the project was undertaken again and the first Foca cameras were ready in late 1945.

Foca (**) (1945 type) - 1945 only. This is the earliest of the Foca models, and rather rare. However, not all two star models are from 1945. (The common model PF2B of 1947 also has two stars on its nameplate.) The 1945 type has several identifying charactistics: 1. The two stars are printed, not engraved, on the nameplate. 2. Tall shutter knob; stem is as tall as knurled top part. 3. Speeds 20-500, not 25-1000. 4. Leather covering may be brown or black. 5. The lens is engraved FOCA, not OPLAR as on later models. On the first thousand examples, serial number is on the cast metal body. \$175-250.

Foca (*) (1946 type) - 1946 only. Simplified replacement for the (**) of 1945. No rangefinder. Fixed, non-interchangeable lens. That is its easiest recognition point. The lens flange and mounting screws are clearly visible. The single star on the nameplate is printed, not engraved

as on the "Standard". This is probably the rarest of the Foca cameras. Foca f3.5/3.5cm lens. Shutter 20-500, \$200-300.

Foca (**) **PF2B** - c1947-late 1950s. Similar to the (**) of 1945, but shutter speeds 25-1000. While the very earliest ones still had no sync, most had two posts for M & X at the left hand side of the top housing. It can also be distinguished from the 1945 version of the (**) by its nameplate on which the stars are engraved rather than printed. \$100-150.

Foca PF2B Marine Nationale - A short series of PF2B's were made with the "Marine Nationale" name on the small front nameplate in lieu of the two stars. Some were covered with blue leather but most often black. Relatively rare, none exceeding three digit serial number. \$250-375.

Foca (***) **PF3, PF3L** - Easily recognized by the three stars on the front plate, the PF3 is like a PF2 but with a slow speed dial added to the front. PF3L has lever advance rather than knob. \$150-225.

Foca (*) PF3L "AIR" -** Standard PF3L, but engraved "AIR" (Air Force) on back of the body. Very rare. \$300-450.

Foca Standard (*) - c1947-1962. No rangefinder. Replaced the single star model of 1946 (fixed lens). The Standard has interchangeable screw-mount lenses, and has a single engraved (not printed) star on the nameplate. Shutter 25-500. Earliest models not synchronized (adds 30% to price). Later with dual posts. The most common of the Foca cameras. \$120-180.

Foca Universel, Universel R - c1948. The earlier Foca models had removable lenses, but only the normal lens coupled with the rangefinder. The Universel allowed a full line of bayonet-mount lenses

ORION

from 28mm to 135mm to couple with the rangefinder. From the exterior, it appears much like the others, though it has no stars on its nameplate. Slow speed dial on front. Earliest models had no sync (adds 30% to collector value). Later ones had dual posts. Universel R has lever advance. With normal lens: \$120-180. Add \$50-75 for each extra lens.

Foca U.R. - 1955. U.R.=Universel-Retardateur (Universal with self-timer). Similar to the Foca Universel, with advance lever and self-timer concentric with exposure counter on the top. One speed (1/40) added. \$150-225.

Foca U.R. "Marine Nationale" - A short series (about 200) of Foca UR made with the Marine Nationale name on a small nameplate. Relatively rare. \$300-450.

Foca URC - 1962-63. The last Foca with interchangeable lenses. Similar to the UR, but with large, collimated, parallax corrected viewfinder in a restyled, taller top housing. Exposure counter dial and top knobs are black. Less than 2000 made. Last and most desirable Foca. \$200-300.

Foca URC "Marine Nationale" - 1963. Less than 100 examples of the URC were delivered to the Marine Nationale, and a few to the air force. Very rare. No price data.

Foca Marly - Simple plastic camera for 4x4cm on 127 film. Built-in flash. Fixed focus meniscus lens. Single speed shutter. \$20-30.

Focaflex - c1960. Unusually styled 35mm SLR. By using a mirror instead of a prism, the top housing does not have the

familiar SLR bulge. Styling is very much like the rangefinder cameras of the same era, but without any front windows on the top housing. Oplar Color f2.8/50mm lens; front element focusing; fixed mount. Leaf shutter B, 1-250. \$200-300.

Focaflex II - c1962. Upgraded version of the Focaflex. Interchangeable lenses in helical focusing mounts include: Néoplex f2.8/50mm, Retroplex f4/35mm, and Téléoplex f4/90mm. Prontor Reflex shutter. With normal lens: \$250-375.

Focaflex Automatic - c1962. Similar to the original Focaflex, but built-in meter automatically controls diaphragm and gives arrow in finder. Oplar-Color f2.8/5cm lens. \$120-180.

Focasport - c1955-. Compact 35mm. Many variations in three families: classic design, rectangular, and cheap. Most common with Neoplar f2.8/45mm lens, Atos-2 1-300 leaf shutter. \$50-75.

FOCA RANGEFINDER LENSES: Prices preceded by "+" add 20% for black covering.

Screw Mount lenses (*, **, and ***)
2.8cm f6.3 Oplar - \$120-180.
2.8cm f4.5 Oplar, Oplex - \$100-150.
3.5cm f3.5 Oplar - \$60.
5cm f3.5 Oplar - \$45-60.
5cm f2.8 Oplar - \$60.

5cm f1.9 Oplarex - \$90-130.

9cm f3.5 Oplar, Oplex - +\$100-150. 13.5cm f4.5 Teleoplar - +\$100.

Bayonet Mount lenses (U, UR, URC)
2.8cm f6.3 Oplar - \$120-180.
2.8cm f4.5 Oplar, Oplex - \$100-150.
3.5cm f3.5 Oplar, Oplex - \$60.
5cm f2.8 Oplar, Oplex - \$60.
5cm f1.9 Oplarex - \$90-130.
9cm f3.5 Oplar, Oplex - +\$100-130.
13.5cm f4.5 Teleoplar - +\$100.
20cm f6.3 Teleoplar - \$200-300.
500mm f6.3 Miroplar - rare. \$600-

Reflex Housing for 20cm & 500mm - Three different models. Very rare. \$600-900.

OPTIKOTECHNA (Prague and

Prerov, C.S.S.R.) In early 1936, the Bradac Brothers of Hovorcovice had to close their factory due to depression and some of their production was taken over by Optikotechna. The Bradac brothers then worked for Optikotechna as designers. In 1945, the company was renamed Meopta. See Bradac and Meopta for related cameras.

Autoflex - c1938. TLR camera for 6x6cm on 120. Trioplan f4.5 or f2.9/75mm in Compur S shutter with body release. Front element focusing coupled to finder lens. \$90-130.

Coloreta - c1939. Three-color camera for 35mm film, essentially the same as the Spektareta. Chrome body with leather covering. \$3500-5500.

Flexette - c1938. TLR for 6x6cm on 120 film. This is the renamed Kamarad II, formerly manufactured by Bradac. Trioplan f4.5 or f2.9/75mm lens in Compur 1-250 or Prontor II shutter. \$120-180.

Optiflex - c1938. TLR for 6x6cm on 120 film. Mirar T3 f2.9/75mm in Compur S. Self-timer & body release. \$90-130.

Spektareta - c1939. Three-color camera, for 3 simultaneous filtered exposures on 35mm film. Body is styled like a movie camera. Spektar f2.9/70mm. Compur 1-250 shutter. \$3500-5500.

ORIENT CAMERA CO. (Japan) Orient Camera Model-P - Inexpensive stamped metal eye-level camera for 4x5.5cm on 120 film. Uncommon.\$30-45.

ORION CAMERA, MODEL SIMPLICITE - Plastic novelty camera from Hong Kong. 3.5x4cm on 127. \$1-10.

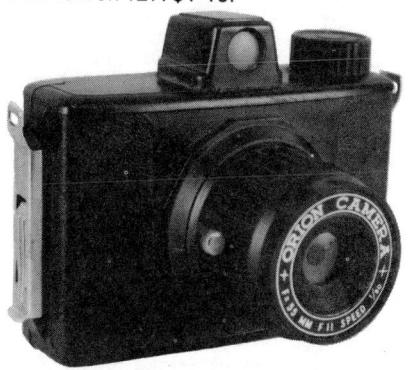

ORION CAMERA, No. 142 - Plastic novelty camera from Hong Kong. 3x4cm on 127. \$1-10.

ORION WERK (Hannover)

Daphne - Vest pocket rollfilm camera. F.Corygon Anastigmat f6.3/85mm in Pronto. \$50-75.

ORION...

Orion box camera - c1922. Meniscus f17 lens, simple shutter. For 6x9cm glass plates. \$50-75.

Rio 44C - c1921-25. Horizontally styled folding bed camera for 9x12cm plates. Typically with Corygon f6.3 in Vario or Helioplan f4.5/135mm in Compur 1-200. Uncommon.\$60-90.

Rio folding plate cameras - c1923. 6.5x9, 9x12cm, and 10x15cm sizes. Leather covered wood body with metal bed. f4.5 or f6.3 Meyer Trioplan, Helioplan, or Orion Special Aplanat. Vario or Compur shutter. \$60-90.

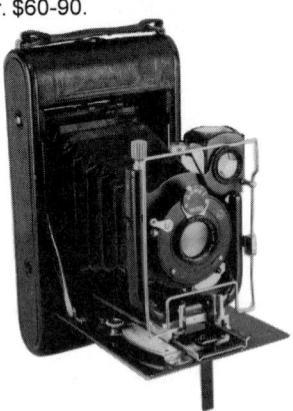

Rio folding rollfilm cameras - Individual models are difficult to identify, since many variations were produced but not generally marked with model number. Most common in the 6x9cm and 8x10.5cm sizes. \$75-100.

Tropen Rio 2C, 5C - c1920. Folding-bed 9x12cm plate cameras. Teak and brass. Brown double extension bellows. Model 5C is like 2C but with slightly wider front standard to accomodate faster lenses in larger shutter. Model 2C normally with f6.3 or f6.8 lens. Model 5C typically with Tessar or Xenar f4.5/150mm lens in Compurshutter 1-150. \$350-500.

OSHIRO OPTICAL WORKS (Japan)

Emi 35A - c1956. Scale-focus 35mm camera. Helical focusing mount. Unusually positioned shutter release is angled up from the front of the body, not a common practice at the time. Tri-Lausar f3.5/45mm in B,1-300 shutter. \$50-75.

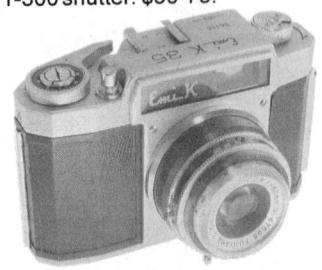

Emi K 35 - c1956. Scale-focus 35mm camera with bright frame finder. Front window and top housing look large enough to house a rangefinder, but there is none. Eminent Color f2.8/50mm in B,25-300 shutter. \$45-60.

Lumica - c1956. Name variant of the Emi 35A. \$45-60.

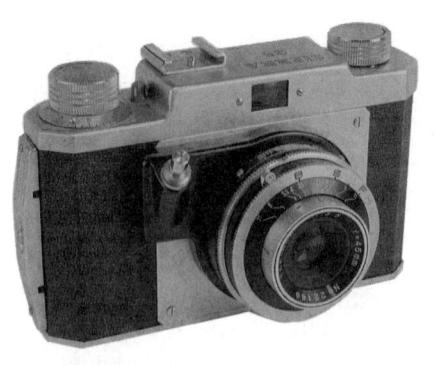

Sierra 35 - c1956. Scale-focus 35mm. Same basic body as Emi 35A & Lumica, but simpler shutter & front cell focusing Tokina f3.5/45mm lens. Shutter speed markings are in a world of their own, marked "B,S,M,F,H" for bulb, slow, medium, fast, & high. Uncommon. \$35-50.

Spinney - c1956. Name variant of the Emi K 35. Fujiyama C. Eminent Color f2.8/50mmin B,25-300 shutter. \$45-60.

Three Cs - c1956. Name variant of the Emi K 35. Fujiyama C. Eminent f2.8/50mm lens in B,25-300 shutter. \$45-60.

O.T.A.G. (Österreichische Telefon A.G. Vienna, Austria) Amourette - c1925. Early 35mm for

Amourette - c1925. Early 35mm for 24x30mm exposures using special double cassettes. Lenses include Trioplan f6.3, Double Miniscope f6.3/35mm. Early model has Compur shutter 25, 50, 100. Later, c1930, with Compur to 300. Also known with nameless T,25,100 shutter. \$300-450.

Lutin - Nearly identical to the better known Amourette. \$350-500.

OTTEWILL (Thomas Ottewill, London) Sliding-box camera - c1851. Mahogany wet plate camera in 9x11" size. Camera is completely collapsible when front and back panels are removed. Ross or Petzval-type lens. \$15,000-23,000.

OWLA KOKI (Japan)

Owla Stereo - c1958. For stereo pairs 24x23mm on 35mm film. Owla f3.5/35mm lenses. Shutter 10-200, B. \$350-500.

PACIFIC - Japanese "Hit" type novelty subminiature. \$25-35.

PACIFIC PRODUCTS LTD. (Hong Kong, Los Angeles, Taipei) Exactor, Lynx PPL-500XL - c1986. Inexpensive novelty 35mm cameras. \$1-

PALMER & LONGKING Lewis-style Daguerreotype camera - c1855. 1/2-plate. \$7500-12,000.

PANAX - Plastic novelty camera of the "Diana" type. \$1-10.

PANON CAMERA CO. LTD. (Japan)

Panon Wide Angle Camera - c1952. 140° panoramic camera. 2x4.5" exposures on 120 rollfilm. Hexar f3.5/50mm or Hexanon f2.8/50mm. Shutter 2, 50, 200. \$1000-1500.

Panophic - c1963. Panoramic camera taking 6 exposures, 5x12cm on 120 roll-film. 140° view. f2.8/50mm lens; shutter 1/8, 60, 250. \$1500-2000.

Widelux - c1959- current. Panoramic camera for 24x59mm images on standard 35mm film. Lux f2.8/26mm lens. Also sold under the Kalimar label. Various models, including FV, F6, F6B, F7. The F7 has been in production since about 1975. Main value as usable, not collectible, camera. \$750-1000.

PANORAX OPTICAL IND. CO. (Tokyo) Panorax 35-ZI - c1959. Unusual panoramic camera for 45° to 350° exposures on 35mm film. Vertically oriented lens in a mirrored periscope rotates to project the image to the inside of a drum. Panoler f3.5/40mm lens. Eleven speeds, 1-1000. \$9000-14,000.

PAPIGNY (Paris)

Jumelle Stereo - c1890. For 8x8cm plates. Magazine back. Chevalier f6.5/100 lenses. Guillotine shutter. \$250-375.

PARIS (Georges Paris) Georges Paris manufactured flashlight bodies. Just before WWII, he began to make inexpensive box cameras, apparently based on an earlier Birnbaum design. After the war, the cameras used the name GAP, from the manufacturer's initials.

GAP Box 3x4cm - ca late 1940's. Small box camera shaped somewhat like the Zeiss Baby Box. Available black painted, black leather covered, or with decorative front panels in gold, blue & gold, or red & gold. Some were used for advertising and have business name or message embossed on the front. \$35-50.

GAP Box 6x9cm - c1947. Metal box camera, normally with black leatherette covering but occasionally found with marbled colors. 6x9cm on 120 rollfilm. \$15-25.

GAP Super - c1950. Horizontally styled metal eye-level camera with rectangular telescoping front. Black crinkle-enameled. Identified simply as "GAP" on the face of the octagonal shutter, it was called "Supergap" by the factory. Very similar to the VOG camera. Meniscus lens in P&I shutter. \$35-50.

Vog - c1950. Essentially the same as the Gap Super above, though with a polished aluminum shutter face. \$35-50.

PARISIEN - c1900? Simple cardboard box camera for 4x5cm plates. Single lens behind front; simple metal blade for shutter. "Le Parisien, Perfectionné, Deposé" on side. \$150-225.

PARK (Henry Park, London)
Henry Park advertised that he had worked seven years with P. Meagher and eight with G. Hare.

Tailboard cameras - c1890's. Park sold a variety of field and studio cameras in 1/2-plate, full plate, and 10x12" sizes. Mahogany construction with brass trim. With comtemporary brass-bound lens, these have recently sold in the range of \$350-500.

Twin Lens Reflex - c1890. Large wooden TLR with separate viewing and taking bellows. Rack and pinion focus. Taylor, Taylor & Hobson 5" lenses with wheel stops. \$1200-1800.

Victoria - c1892. Folding field camera. Possibly named for the manufacturer's location near Victoria Park. The squarecornered, tapered maroon bellows detach

Parker Camera

PEARSALL

from lensboard. Front standard hinges at bottom and folds rearward to lie flat on the bed. When the baseboard folds up, the standard thus assumes an inverted position. Mahogany body with brass fittings.

PARKER PEN CO. (Janesville, Wisc.) Parker Camera - c1949. Plastic subminiature for 8 images, 13x16mm on a 147mm strip of unperforated 16mm film in a special cylindrical cassette. Parker Stellar f4.5/37mm lens in rotary shutter, 30-50. At least 100 cameras were used in a test marketing study by Parker and a Chicago advertising firm. At one time they were presumed to have been destroyed, and only a few examples were known to exist. Since then, more have surfaced. Auction high: Christie's 12/91 at \$2700. Most recent sales: \$1000-1500. *Illustrated* bottom of previous column.

PCA (Photronic Corp. of America) **Prismat V-90 -** c1960-63. 35mm SLR made by Mamiya. Bayonet mount f1.9/48mm Mamiya-Sekor lens. Coupled match-needle selenium meter on pentaprism front. Leaf shutter 1-500, B. \$75-100.

PDQ CAMERA CO. (Chicago) PDQ Photo Button Camera - c1930. All-metal button tintype camera. Echo Anastigmatlens. \$1000-1500.

Mandel Automatic PDQ, Model G c1935. Large street camera for 6x9cm exposures rolls of direct positive paper. Built-in developing tank with tubes to change solutions. RR f6/135mm lens. \$300-450.

PDQ, Model H - Street camera for $2^{1}/_{2}x3^{1}/_{2}$ " direct positive paper. Tank has light-tight baffles on bottom, allowing it to be dipped into external tanks for development. This camera was still listed in directories in the 1960's with Steinheil f3.8/ 105mm lens in X-sync shutter. \$150-225.

PEACE - c1949. Early "Hit-type" camera with cylindrical finder. Simple fixed-focus lens; B & I shutter. \$175-250.

PEACE III - c1950. Similar to the earlier version, but with Kowa f4.5 lens, R.K. shutter, different back latch. \$175-250.

PEACE, PEACE BABY FLEX - c1949. Japanese reflex style subminiatures for 12x14mm on rollfilm. Fixed focus lens, B.I. shutter. Auction highs \$1800 (10/90), \$2200 (12/91). This is starting to look more like a pattern than an aberration.

PEARSALL (G. Frank E. Pearsall,

Brooklyn, NY) Compact - c1883. First camera to use the basic folding camera design, used by most American folding plate cameras into the 1920's. Full plate size. Only one known sale, in 1981, for \$3200.

PECK

PECK (Samuel Peck & Co., New Haven, Conn.)

Ferrotype, 4-tube camera - c1865. Takes 1/9 plate tintypes. \$1200-1800.

Wet plate camera - c1859. Full plate size. \$1200-1800.

PEER 100 - Camera disguised as a package of cigarettes. The camera is a Kodak Instamatic 92 or Instamatic 100 camera within a plastic outer housing which resembles a package of Peer 100 cigarettes. Auction high \$1100 (12/91). Normal range \$400-600.

PEERLESS MFG. CO.

Box camera - Early paperboard box camera for single 21/2x21/2" glass plates. \$90-130.

PENROSE (A.W. Penrose & Co. Ltd., England) Studio camera - c1915. 19x19". \$300-

PENTACON (VEB Pentacon, Dresden, Germany) At the end of WWII, as the U.S. troops moved out of Jena & Dresden and the Russians moved in, many of the Zeiss-Ikon personnel moved out with the American troops and set up a second Zeiss-Ikon operation in the former Contessa factory in Stuttgart, where they continued making rollfilm cameras (Ikonta, etc.) which had always been made there. Some Carl Zeiss Jena staff moved west to Oberkochen. The machinery and dies for the Contax II and III cameras were moved to Russia. Despite these handicaps, production started again shortly after the war at Zeiss-Ikon in Dresden. Ercona (continuation of Ikonta), Tenax I, and soon the new Contax S were produced. After much dispute with the West German operation at Stuttgart, the Zeiss Ikon and Contax names were relinquished completely. In 1959, various Dresden and Sachsen firms reorganized as VEB Kamera und Kinowerke Dresden. In 1964, after absorbtion of VEB DEFA, the result was VEB PENTACON. In 1968, the combination of VEB Feinoptisches Werk Görlitz and VEB Pentacon resulted in KOMBINAT VEB PENTACON DRESDEN. It is unfortunate to note as we enter the 1990's that Pentacon was unable to compete in the free world after the reunification of Germany, and had to close its doors.

Astraflex Auto 35 - c1965-71. Same as the Pentacon F. \$75-100.

consul - c1955. Rare name variation of the Pentacon (Contax-D). Identical except for the factory-engraved Consul name.

Contax D - c1953. 35mm SLR. Standard PC sync on top. Zeiss Jena Biotar f2, or Hexar or Tessar f2.8. FP shutter to 1000. Four or five variations. Last version has auto diaphragm like Contax F, but is not marked F. Clean and working: \$100-150. Common on German auctions for \$60-90.

Contax E - c1955. Like the Contax D. but with uncoupled selenium meter built onto prism. \$120-180.

Contax F - c1957. Same as the Contax D, but with semi-automatic cocking diaphragm. Clean & working: USA: \$100-150. GERMANY: \$75-100.

Contax FB - Zeiss Biotar f2/58mm. Focal plane shutter 1-1000. USA: \$120-180. GERMANY: \$90-130.

Contax FM - c1957. Zeiss Biotar f2/58mm. Automatic diaphragm. Interchangeablefinder screen. \$120-180.

Contax S - 1949-51. The first 35mm prism SLR, along with the Rectaflex. Both were exhibited in 1948 and produced from 1949. The Contax patent date is first, however. Identifiable by sync connection in tripod socket. Biotar f2 lens. FP shutter 1-1000, B. Early models have no self-timer. Later models have a self-timer with lever below shutter release. Early models are

well-finished with typical Zeiss quality. Clean and working: \$250-375.

Ercona (I) - c1949-56. Folding bed camera for 6x9 or 6x6cm on 120 rollfilm. Folding optical finder. Lenses include Novar f4.5/11cm, Tessar f3.5/105mm, Novonar f4.5/110mm in Junior, Compur. Prontor S, or Tempor shutter. \$30-45.

Ercona II - c1956. Improved model of the Ercona. Restyled top housing incorporates optical finder. Novonar f4.5/110mm or Tessar f3.5/105mm in Junior, Priomat, or Tempor shutter. Several mint examples with Tessar reached \$100 at auction, but the more normal range is \$50-75.

Hexacon - c1954. Same as the Contax D. Clean & working: \$100-150.

Orix - c1958. For half-frames (18x24mm) on 35mm film. Precursor of the Penti. \$75-100.

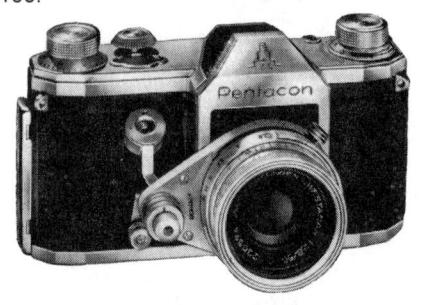

Pentacon - c1948-62. Same as Contax

What's in a name?

Trademark usage and export/import regulations led to various names being used on the East-German Contax SLR cameras. The Contax S was the earliest model (c1949-51) and does not exist with other name variations, because it was out of production before the trademark and name changes began. It is recognizable by sync. in tripod socket. There are three or four versions. Generally the earliest are finished best. The following chart compares the original "Contax" model with name variants.

CONTAX Model FEATURES (VEB Zeiss-Ikon)

Sync. in tripod socket Contax S Contax D Standard PC sync. on top

Meter built onto top of prism Contax E Auto diaphragm Contax F Contax FB Auto diaphragm plus meter

Contax FM Auto diaphragm plus interchangeable finder screen Contax FBM

Auto diaphragm, meter, RF

NAME VARIATIONS of PENTACON MODELS NONE

Pentacon, Consul, Hexacon*, Astraflex*, "No name"* None known. Pentacon F, Ritacon F Pentacon FB Pentacon FM

Pentacon FBM

The model letters are based on the camera's features. F=Automatic Diaphragm, B=Built-in meter, M=Split-image finder screen

*Note: Hexacon and Astraflex are "House brands". The original Pentacon name has been obliterated and the store name riveted or glued on. The "No name" version has the Pentacon Tower emblem, but no camera name engraved.

D. 35mm SLR. Tessar f2.8/50mm lens. Focal plane shutter 1-1000. \$100-150.

Pentacon "No-Name" - Like Pentacon, and has Pentacon tower emblem, but no name engraved. This should not be confused with the so-called "No-Name Contax" or "No-Name Kiev" which is a range-finder camera. \$250-375.

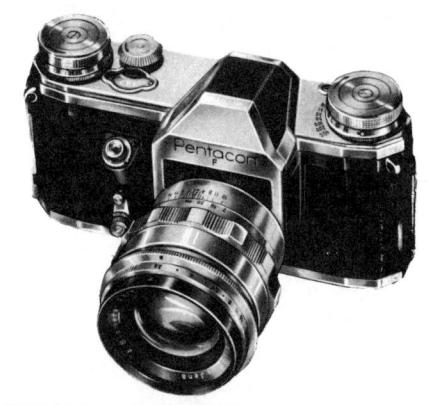

Pentacon F - c1957-60. Meyer Primotar f3.5/50mm or Tessar f2.8/50mm. USA: \$75-100. GERMANY: \$45-60.

Pentacon FB - c1959. Built-in exposure meter. Tessar f2.8/50 or Steinheil f1.9/55 lens. USA: \$75-100. GERMANY: \$45-60.

Pentacon FBM - c1957. Built-in exposure meter. F2 or f2.8. USA: \$100-150. GERMANY: \$50-75.

Pentacon FM - c1957. Built-in exposure meter. Tessar f2.8/50mm lens. USA: \$75-100. GERMANY:\$35-50.

Pentacon Super - c1966. 35mm SLR with metal FP shutter, 8 sec to 1/2000. Interchangeable finders; TTL meter with open aperture metering. Speeds & f-stop visible in finder. Accessories include motors, bulk back, etc. With Pancolar f1.8/50mm lens: \$350-500. Back for 17m cassettes: \$75-100.

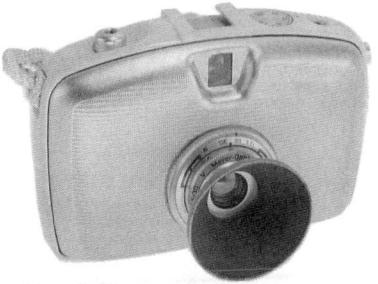

Penti - c1959. 18x24mm on 35mm film in rapid cassettes. Meyer Trioplan f3.5/30mm lens. Gold colored body with enamel in various colors: aqua, red, cream, etc. Film advances by push rod which extends from left side of body when shutter is released. \$35-50

Penti II - c1961-62. Restyled version of Penti, with bright-frame finder. With or without built-in meter. Colors include: black & gold, black & silver, or ivory & gold. One very nice example with built-in meter reached \$120 at auction 10/90. \$35-50.

Pentina, Pentina E, Pentina FM - c1960's. 35mm leaf-shutter SLR. Tessar f2.8 lens in breech-lock mount, similar to Praktina mount. Rarely in working order.

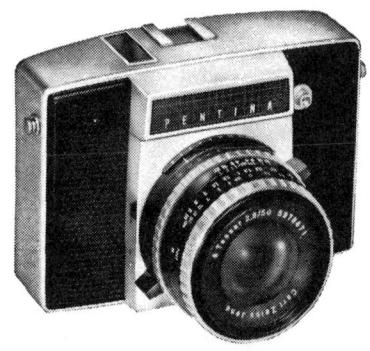

Repairmen hate them according to one source. Normally \$35-50; more if clean & working.

Pentona, Pentona II - Low-priced basic 35mm viewfinder camera. Bright frame finder. Meyer f3.5/45mm lens. \$35-50.

Pentor Super TL - c1968-. Screwmount 35mm SLR with TTL metering. Name variant of Praktica Super TL. Cloth FP 1-500. \$35-50.

Prakti - c1960. Electric motor drive 35mm camera, but motor drive rarely working. Meyer Domiton lens. \$35-50.

Praktica - Although the Praktica cameras became part of the Pentacon family, we have chosen for the sake of continuity to list all Praktica cameras under KW, where the line originated.

PERKEN

Ritacon F - c1961. Name variant of the Pentacon F. Very rare with this name. \$150-225.

Taxona - c1950. For 24x24mm exposures on 35mm film. Novonar or Tessar f3.5 lens. Tempor 1-300 shutter. (This is the DDR successor to the postwar Zeiss Tenax.) \$50-75 in Germany. Somewhat higher in U.S.A.

Verikon - c1961. Name variant of the Pentacon F. Original name scratched out and Verikon nameplate screwed to front of prism housing. Distrubuted in the USA by Camera Specialty Co. Not often seen with this name. \$120-180.

PEPITA - c1930. German telescoping-front camera for 3x4cm images. Rapid Aplanat f7.7/50mm in 25-100 shutter. Uncommon. One example with green leather covering brought \$230 at auction in 9/88. More normal price with black leather: \$75-100.

PERFECT CAMERA - c1910. Simple cardboard box camera for 6x9cm single plates. \$120-180.

PERKA PRÄZISIONS KAMERAWERK (Munich, Germany)

Perka - c1922. Folding-bed plate cameras, 9x12cm or 10x15cm. Double extension bellows. Lenses include: Symmar f5.6/135mm, Staeble Polyplast-Satz f6/135mm, and Tessar f4.5/150mm. Compound, Compur, or Compur-Rapid shutter. Construction allows tilting of back and lens standard for architectural photos. \$200-300.

PERKEN, SON, & RAYMENT (London) Established 1852, according to their advertisements, but obviously not under that name. In 1886, Lejeune & Perken were advertising in the British Journal (including Rayment's Patent camera), but by 1888, the company name was Perken, Son & Rayment. After 1900, it was Perken & Son.

PERKEN...

Optimus Camera DeLuxe - c1894. 1/4-plate folding camera. Opens like an early Folding Kodak. Black leather. Extra Rapid Euryscope lens. Rack and pinion focus. Thornton-Pickard Roller-blind shutter. Iris diaphragm. Estimate: \$500-750.

Optimus Detective - c1888. 1/₄-plate mahogany bellows camera inside of a black leather covered box. External controls. Brass RR lens, waterhouse stops, rotary shutter. Nearly identical to the Detective Camera of Watson & Sons. Estimate: \$750-1000.

Optimus Folding Camera - c1890. Mahogany with brass trim. Optimus lens. 1/2-plate size. \$300-450.

optimus Long Focus Camera c1892-99. Tailboard style field camera. Mahoganybody, brass trim. Square red-

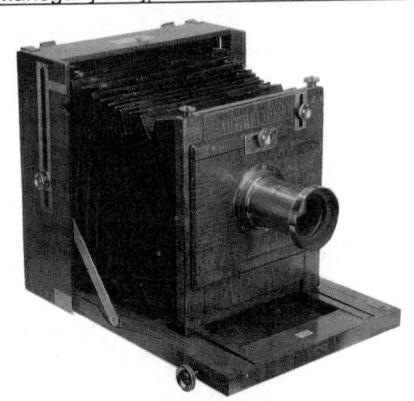

Rayment's Patent

brown double extension bellows. Rack and pinion focus. \$300-450.

Rayment's Patent - c1886. Folding view camera with solid wood front door/bed. Double extension with rack focusing. "Rayment's Patent" nameplate inset on front of bed. Double swing reversing back. Rise & shift front. Beautifully constructed, to the point that the slots are aligned on all of the brass screws. Made in 7 sizes from 41/4×31/4" to 15x12". One nice 8x10" outfit in case with lens and holders brought an easy \$650 in late 1989. Typical price in average condition: \$350-500. Illustrated bottom of previous column.

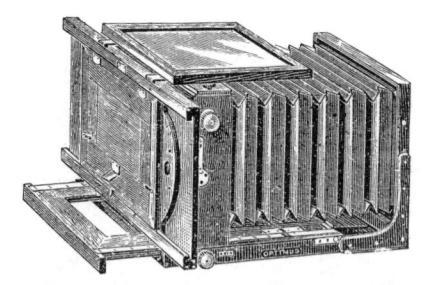

Studio camera - c1890's. Full-plate $(61/_2 \times 81/_2")$ size. \$250-375.

Tailboard camera - c1886. 1/₄-, 1/₂-, and full plate sizes. Mahogany body with brass fittings. Ross lens, waterhouse stops. Maroon leather bellows. \$250-375.

PFCA - Japanese novelty subminiature camera of the Hit type. Unusual streamlined top housing, large flat advance knob. \$50-75.

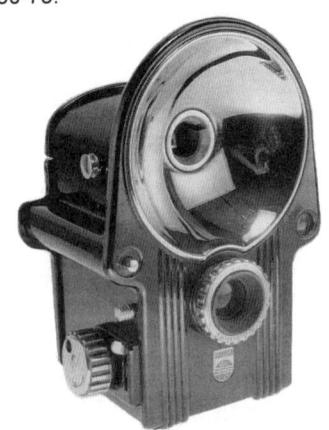

PHILIPS (Netherlands)
Philips Box Flash - Very well-finished black bakelite box camera for 6x6cm on 620 film. Built-in flash reflector above lens. The overall styling is very similar to the Spartus Press Flash, but it is much more rare, even in Holland and France where it was distributed. \$60-90.

PHOBA A.G. (Basel, Switzerland)
Diva - 6x9cm folding-bed plate camera.
Titar f4.5/105mm lens. Compur shutter.
\$45-60.

PHO-TAK CORP. (Chicago) Eagle Eye - c1950-54. Metal box camera with eye-level optical finder. Precision 110mm lens. T&I shutter. \$1-10.

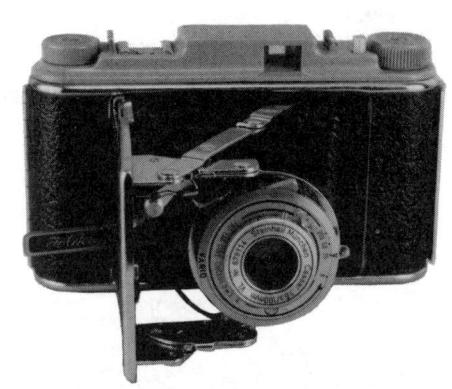

Foldex, Foldex 30 - c1950's. Folding cameras for 120/620 rollfilm. All metal. Octvar or Steinheil lens. \$12-20.

Macy 120, Marksman, Spectator Flash, Trailblazer 120, Traveler 120 - c1950's. Simple metal box cameras for 6x9cm on 120 rollfilm. EUR: \$12-20. USA: \$1-10.

Reflex I - c1953. TLR-styled box camera. \$12-20.

Scout 120 Flash - Metal box camera made for the Boy Scouts. Similar to the Macy 120. \$12-20.

PHOCIRA - Small box camera for 3x4cm on 127 rollfilm. Similar to Eho Baby Box. \$75-100.

PHOTAVIT-WERK (Nürnberg, Germany) Originally called Bolta-Werk.

Photavit - c1937. A series of compact 35mm cameras for 24x24mm exposures on standard 35mm film loaded in special cartridges. \$100-150. (Descriptions and photos of various models are under the Bolta heading).

Photina - c1953. 6x6cm TLR. Westar f3.5/75mm in Pronto, or Cassar f3.5/75mm in Prontor-SVS shutter. \$60-90.

Photina III - c1954. TLR with externally gear-coupled lenses. Westar f3.5/75mm. Prontor SVS shutter. \$75-100.

PHOTO-BOX - c1939. French paper box camera. Black paper covering. \$20-30.

PHOTO DEVELOPMENTS LTD. (Birmingham, England) Envoy Wide Angle - c1950. Wide angle camera for 6x9cm on 620 or 120 rollfilm, or cut film. f6.5/64mm Wide Angle lens. 82° angle of view. Agifold 1-150 shutter. \$175-250.

PHOTO HALL (Paris) Perfect Detective - c1910. Leather covered box camera for 9x12cm plates. Extra-Rapid Rectilinear lens. \$200-300.

Perfect, folding plate - 9x12cm. Berthiot f4.5/135mmin Gauthier. \$45-60.

Perfect Jumelle - c1900. Single lens jumelle-style 6.5x9cm plate camera. Magazine back. Zeiss Protar f8/110mm. \$200-300.

stereo camera - c1905. Rigid truncated pyramid "jumelle" style camera for 6x13cm plates in single metal holders. Guillotine shutter 10-50. Folding Newton finder. \$100-150.

PHOTO-IT MFG. CO. (LaCrosse, WI)
The Photo-It - Round subminiature pinhole camera, 65mm dia. Stamped metal body, cream enamel, brown lettering. 8 exposures on a 12mm film strip wrapped on an octagonal drum. \$2400-3200.

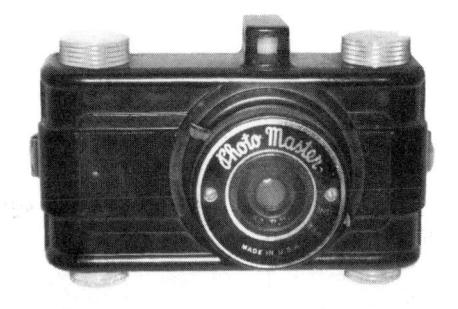

PHOTO MASTER - c1948. 16 exposures 3x4cm on 127 film. Brown or black bakelite or black thermoplastic body. Rollax 50mm lens, single speed rotary shutter. \$1-10.

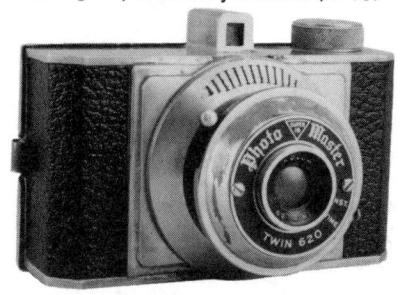

PHOTO MASTER SUPER 16 TWIN 620

- Cast aluminum eye-level camera for 16 exposures 4x5.5cm on 620 film. Styling similar to the aluminum "Rolls" cameras. Fixed focus Rollax 62mm lens. Instant & Time shutter, \$15-25.

PHOTO MASTER TWIN 620 - Simple cast-metal camera for 16 shots on 127 film. Identical to the Monarch 620, and probably made in the same factory in Chicago. \$15-25.

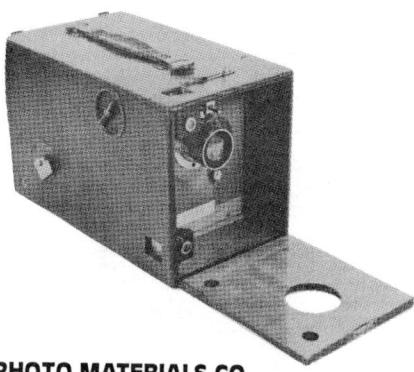

PHOTO MATERIALS CO. (Rochester, NY)

Trokonet - c1893. Leather covered wooden magazine box camera. Holds 35 cutfilms or 12 glass plates, 4x5". Gundlach rectilinear lens, variable speed shutter. Inside the box, the lens is mounted on a lensboard which is focused by rack and pinion. \$750-1000.

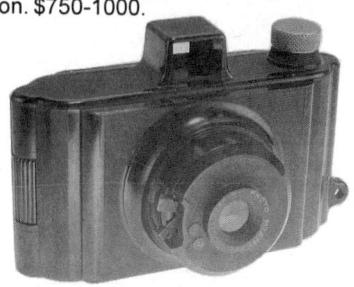

PHOTO MIAMI - c1948. Small black bakelite camera for 4x6.5cm on 127 film.

PHOTO-PORST

Made in France. Identical to the "Photo Magic" camera. The overall design of the body was inspired by the original MIOM and Lec Junior cameras of 1937, but with a 2-levered I&P shutter and a single strap lug at the bottom. "PHOTO MIAMI" molded on back. Uncommon. \$30-45.

PHOTO-OPERA (Paris)

Piccolo - Jumelle-style rollfilm camera, made for the new Folding Pocket Kodak sized rollfilm, 3x4cm. Simple lens, guillotine TI shutter. One brought \$500 at auction in 1989.

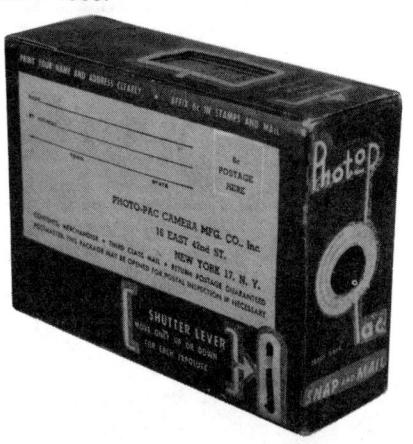

PHOTO-PAC CAMERA MFG. CO., INC. (New York City & Dallas, TX)

Photo-Pac - c1950. Disposable cardboard mail-in camera. We have seen two different body variations under the Photo-Pac name. One had a Dallas address and it had the shutter release near the TOP of the right side. The other type has a N.Y.C. address and has the shutter release on the lower front corner of the right side. The two versions also have their address labels on opposite sides. \$30-45.

PHOTO-PLAIT (Paris)
No. 2 Plait Pliant - c1920. Leather covered folding camera. Brilliant viewfinder. Anastigmat f6.3/135mm lens in Wollensak Ultex shutter. \$30-45.

PHOTO-PORST (Hanns Porst,

Nürnberg) Distributor of many brands of cameras, including some made with their own name "Hapo" = HAnns POrst.

Hapo 5, 10, 45 - c1930's 6x9cm folding rollfilm cameras, made by Balda for Porst. Schneider Radionar f4.5, Steinheil Cassar f3.8, or Trioplan f3.8 10.5cm lenses. Compur or Compur Rapid shutter. \$20-30.

Hapo 35 - c1955. Folding 35mm, made Balda for Porst. Enna Haponar f2.9/50mm lens. Prontor-SVS 1-300 shutter. Coupled rangefinder. \$25-35.

Hapo 36 - 35mm with non-coupled rangefinder. f2.8 Steinheil in Pronto shutter. \$25-35.

Hapo 66, 66E - 6x6cm. Enna Haponar f3.3 or f4.5/75mm lens in Pronto sync. shutter, 1/2-200. Model 66E has rangefinder. \$30-45.

Haponette B - c1960's. 35mm camera. Color Isconar f2.8/45mm in Prontor shutter. \$12-20.

PHOTO-PORST...

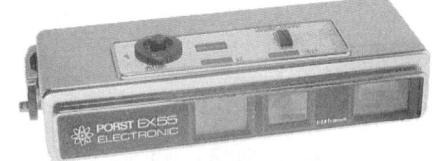

Porst EX55 Electronic - c1970. Chrome version of Yashica Atoron Electro, made by Yashica for Porst. A subminiature for 8x11mm on Minox cassettes. Complete with snap-on front cover: \$60-90.

Porst KX50 - c1965. Re-badged version of the Yashica Atoron for Porst. \$75-100.

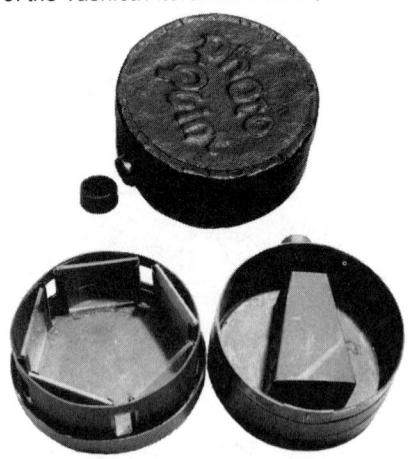

Photo Quint, exterior and interior views

PHOTO QUINT - c1911. Made by Offenstadt, Paris. Simple cardboard camera for 5 plates, 4x5cm. The lens cap serves as shutter, and the plates are moved into position by rotating the bottom. Though barely more than a toy, this camera is unusual and rare. Estimate: \$750-1000.

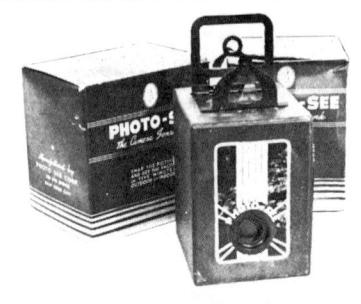

PHOTO SEE CORP. (N.Y.C.)

Photo-See - An art-deco box camera and developing tank for photos in 5 minutes. An interesting, simple camera. According to a popular but untrue rumor, the viewfinders are on backwards and instructions were never printed. Actually the finders are as designed and instructions exist, though not often found with the cameras. These are usually found new in the box, with developing tank, and always with traces of rust from storage in a damp area. USA: \$35-50.

PHOTOGRAPHIE VULGARISATRICE (Paris, France)

Field camera - c1900. Folding camera made of light wood. Mazo lens. \$250-375.

PHOTOLET - c1932. French subminature for 2x2cm on rollfilm. Meniscus f8/31mm. Single speed rotary shutter. Body marked "Fabrication francaise" is identical to the "FRAPHOT" camera. Both are similar to the German-made "STM" Ulca. \$120-180. *Illustrated at top of next column.*

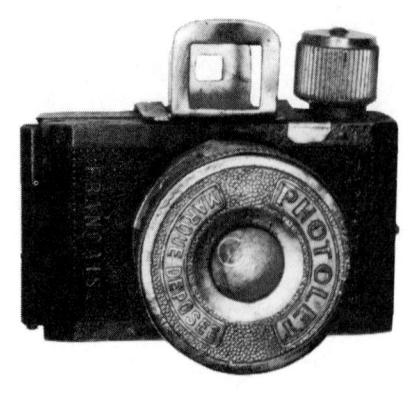

Photolet

PHOTON 120 CAMERA - Grey & black plastic camera of the "Diana" type. Matching flash for AG-1 bulbs fits in hot shoe. Made in Hong Kong. \$1-10.

PHOTOPRINT A.G. (Germany)

Ernos - c1949. Small bakelite camera for 25x25mm exposures on 35mm wide roll-film. Identical to the pre-war "Nori" from Norisan Apparatebau \$45-60.

PHOTOREX (Société Française Photorex, St. Étienne, France)

Founded in 1944 by André Grange as a distribution company; began production of cameras in 1949, but was forced to cease operations in 1952 due to financial difficulties. The molds for the Rex Reflex cameras were sold to René Royer, who continued the series with some changes under the name "Royflex". During its brief existence, the Rex Reflex introduced the feature of lens interchangeability on a 6x6 TLR. The first models used four screws, one at each corner, to retain the lens panel. In 1952, a simpler system with two levers was introduced.

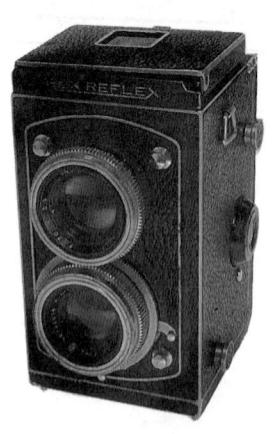

Rex Reflex B1 - c1949-52. The first production model of the Rex Reflex. Knob wind; automatic exposure counter. Interchangeable lens panel with four screws. Normal lenses: Angenieux X1 or Flor f3.5/75mm in Atos or Prontor S shutter. Viewing lens, AG6 f2.5/70mm, covers a wider angle than the taking lens. Framing lines on the viewing screen indicate the actual field. On the very earliest models, the red window on the back is not centered. Uncommon. \$150-225.

Rex Reflex B2 - c1951-52. Crank advance, otherwise similar to B1. Interchangeable lens panel with four screws. \$120-180.

Rex Reflex Standard - c1951-52. Simplified version of the TLR without the automatic exposure counter, and with fixed lens panel. Various shutter and lens combinations. Uncommon. Estimate: \$120-180.

PIC - c1950. Unusual English disk-shaped plastic camera. 3x4cm exposures on 127 rollfilm. Meniscus lens, rotary sector shutter. \$100-150.

PICTURE MASTER - Stamped metal minicam for 16 exposures on 127 film. Not to be confused with the Bell & Howell plastic pocket 110 camera called "Picture Master". Body style identical to Scott-Atwater Photopal. \$30-45.

PIERRAT (André Pierrat, France)

During the occupation of France, André Pierrat was secretly working on his copy of the Zeiss Ikonta camera, and it became one of the first quality French-made cameras after the end of WWII.

Drepy - c1946-50. The Drepy, named from a contraction of the designer's name, was essentially a copy of the Zeiss Ikonta. Takes 8 or 16 exp. on 120 film. The most common model has leatherette covered body with black enameled edges. Drestar Anastigmat f4.5/105mm in Drestop shutter B,1-250. \$25-35.

PIGGOTT (John Piggott, London, England) Sliding-box wet plate camera c1860. Mahogany body. Takes 8x8" plates. Petzval-type brass bound lens. \$1700-2400. PIGNONS AG, (Ballaigues,

Switzerland) Pignons S.A. was a family business, founded in 1918 for making watches and clocks. Because of continual fluctuations in that business, the decision was made to move into the photographic market by producing a camera which combined the advantages of reflex viewing and a rangefinder. The first of these prototypes appeared in 1939, and bore the name "Bolca", before the name "Alpa Reflex", which first was shown in 1944 at a public fair in Basel. The company closed its doors in the Spring of 1991. See also BOLSEY CORP. OF AMERICA for cameras produced by Jacques Bolsey after he moved to the U.S.A.

Editor's note: The information in this section is primarily the work of Jim Stewart. whose particular interests revolve around Alpa, 35mm, and subminiature cameras. In addition to this section, he has made other important contributions to this guide. Contact him at Box 415, Mt. Freedom, NJ

07970. Phone: (201)-361-0114.

Cameras are listed chronologically by year of introduction. Serial number ranges are approximate. Prototypes fall into the 10000, 25000, and 28000 ranges. Dates and serial number ranges indicate the regular series production. Some prototypes predede these dates and numbers, and special orders often occurred as long as parts were available. Many contemporary models were intermixed in the same serial number range. Almost any custom variation, such as format or pin registration, could be factory ordered. It is interesting to note that the 50 year total production of all Pignons cameras did not exceed three-quarters of the production of the Leica model A!

Bolca I - 1942-46. (#11000 series). Waist-level SLR, eye-level VF and splitimage CRF. Cloth FP shutter 1-1000. Berthiot f2.9/50mm in collapsible mount. Samples for Jacques Bolsky in New York marked "Bolsey Model A". All are semiprototype, especially the "Bolsey A". Bolca I: \$1500-2000.Bolsey A: \$2000-3000.

Bolca (Standard) - 1942-50. (#11000 series). Similar to the Bolca I, but without reflex viewing. VF/CRF only. From 1947-50, sold as "Alpa Standard". Very rare. \$1200-1800. Total of all "Bolcas" is much less than 500.

Alpa Reflex (I) - 1944-45. (#120,000 series used instead of 12,000 series). Reflex similar to the "Bolca" but with a modified lens bayonet. RF coupling still at top of mount. Angenieux f2.9/50mm in collapsible mount. Only a few known. \$1000-1500. The 3/94 issue of "Cyclope" announced the availability of "like new" examples of the "1942 Alpa Reflex". These are recently built from original parts purchased when the factory closed. The seven remaining examples were offered for 11000 FF (\$2000) each.

Alpa Reflex (II) - 1945-52. (#13000-16000 & 20000-25000). First real production model. Features of Alpa Reflex (I) above, but with RF coupling moved to bottom of lens mount and other improvements. Full speed range. Also sold as Reflex". With Angenieux f2.9/50mm collapsible: \$350-500. With f1.8/50mm rigid lens: \$400-600.

Alpa (Standard) - 1946-52. (#13000-16000 & 20000-25000). Non-reflex type similar to the Alpa Reflex (II). Angenieux f2.9/50mm in collapsible mount. \$1200-1800. (Several known with no slow speeds (25-1000 only): \$2000-3000.)

Alpa Prisma Reflex (III) - 1948-52. (#22000-25000). WL reflex hood and finder of the Alpa Reflex were replaced with 45° eye-level prism. (One of the earliest prism SLR's). Lenses as "Reflex" above, plus some late models have Xenon f2.0. \$350-500. Note: #28,000 series reserved for prototypes and #29,000 for display dummies. No prices established for these oddities.

Alpa 4 - 1952-60. (#30004-ca.39000). All new diecast magnesium alloy body. Introduced new bayonet lens mount used for all subsequent models. Integral magnifier hood for non-prismatic reflex viewing. Spektros f3.5/50mm collapsible lens. Rare.

Alpa 4a - 1952-60. Same as model 4, but self-timer added. No recorded sales.

Alpa 5 - 1952-60. (#30005-ca.39000). As model 4, but integral 45° prism. Old Delft f2.8/50mm, rigid or collapsible mounts. \$250-375.

PIGNONS

Alpa 5a - 1955-56. (#33824-33903). As model 5, but adds self-timer. No recorded

Alpa 7 - 1952-59. (#30034-ca.39000). As model 5, but adds self-timer, superimposed image vertical base RF & multi-focal (35, 50, 135) built-in finder (first time done). Kern Switar f1.8. \$300-450.

Alpa 6 - 1956-59. (#35650-ca.39000). As model 5, but adds split-wedge RF on ground glass, plus self-timer. \$250-375.

Alpa 7s/8 - 1957-59. (#36162-ca.39000). As model 7, plus prism RF of model 6. First auto lenses. Very short production run, most as model 8. \$400-600.

Alpa 4b - 1959-65. (#39825-41700). As model 4, but rapid return mirror and added advance lever. Old Delft f2.8/50mm, rigid mount only. Less than 100 made. \$600-900. Note: from this model on, black, and in some cases other finishes were available.

Alpa 4b Omega - 1963, 1965, 1971. Modified 4b cameras incorporated into Omega's "Photosprint" race timer. Production 74. No known sales.

Alpa 5b - 1959-65. (#39801-41600). As model 5, but rapid return mirror and added advance lever. Macro Kern Switar (redesigned and black finished) f1.8/50mm (focus to 8"). Rare. \$350-500.

Alpa 6b - 1959-63. (#39601-42600). As model 6, but rapid return mirror and added advance lever. Macro Kern Switar f1.8/50mm (focus to 8"). \$250-375.

Alpa 7b - 1959-65. (#40071-41700). As model 7, but rapid return mirror, advance lever. Macro Kern Switar f1.8/50mm. Less than 100 made. No sales records.

Alpa 8b - 1959-65. (#39585-41800). As model 8, but rapid return mirror and added advance lever. Macro Kern Switar f1.8/50mm. Scarce. \$350-500.

Alpa 6c - 1960-69. (#42601-46298). Kern 45° prism replaced with standard pentaprism. Uncoupled selenium meter added. Macro Kern Switar f1.8/50mm. Third largest production. \$250-375.

Alpa 9d - 1965-69. (#46230-52399). As

PIGNONS...

model 6c, but top deck match-needle TTL CdS meter. One of the first SLR cameras with TTL metering; the first with cells in prism housing, which became standard. Some gold or black finish with red or green covering. Macro Kern Switar f1.8/50mm. Second largest production. \$350-500.

Alpa 9f - 1965-67. (#46201-46500). As model 9d, but without meter. Macro Kern Switar f1.8/50mm. Rare. \$500-750

Alpa 10d - 1968-74. (#52501-57100) New body with cross-coupled "zero center" match needle CdS meter. Normal lens Macro Kern reformulated. f1.9/50mm. Fourth largest production. Some marked "Revue" for German distributor. Gold or black with colored leather: \$400-600. Chrome: \$300-450.

Alpa 10s - 1972-75. (#57101-57193). As 10d, but simplified. Only 2 CdS cells, no self-timer, no metering lock. Very low production, less than 100. \$600-900.

Alpa 10f - 1969. (#51002-?). As 10d, but no meter. Less than 50 made. No sales recorded.

Alpa 11e - 1971-75. (#57201-58300). As 10d, but lighted over-under exposure arrows, both off at correct exposure. Many all black, some gold or black with red or green covering. Kern Macro Switar f1.9/50mm. Black leather: \$400-600. Colored leather: \$500-750.

Alpa 11el - 1972-76. (#58301-59900). As 11e, but both arrows lighted on correct exposure. Enlarged mirror and other improvements. Colored leather: \$600-900. Black: \$400-600.

Alpa 11si - 1976-89 (#60009-64150). As 11el, but lighted arrows replaced by red, green, yellow diodes. Gold-plated: \$2000-3000. Majority of production black with black chrome top deck. \$600-900.

Alpa 11es - c1973. (ca 58800-?). Special 11el for crystalography Less than 25 made. No recorded sales.

Alpa 11a - 1973-85. (#59501-63825). According to factory records, the largest production Alpa. However, since it is a post camera, all are still in use and none have become available for open sale. No prism or viewing apparatus. 1/60 shutter. Special non-Alpa lenses & mounting collar. Formats include 24x24, 24x27, 24x36mm.

Alpa 11f - 1973-89 (#58300-?). As 11si, but no meter. Xenon f1.9/50mm. Rare; less than 25 made. \$600-900.

Alpa 11p - 1974. (#56984 & 56998). As 10d, but removable prism and revised metering. No sales recorded, as only two were made.

Alpa 11m - 1977-82. (61102-62317). "Alpa Mercure" portable microfilm outfit, based on 11si with no viewing apparatus. Shutter speeds 1/60 or B for use with builtin strobe. Comes with two (35mm & 28mm) special Alpa Mercure Takumar Formats include 10x15 or lenses. 11.75x16.5mm. Only 70 made. \$1200-1800.

Alpa 11r - c1975. (#58499-?). Special order 11.5x16.5mm format pin-registered filmstrip camera for use in "Revox-Audio-card microfiche system. No recorded sales.

Alpa 11s - c1976. (#58800-?). As 11si, but simplified like 10s. Less than 50 made. No recorded sales.

Alpa 11z - c1978-? (#58848-?). Special order single frame model. No meter; similar to 11f, but shutter 1/60 only, microprism screen only (no prism). Very rare; less than 50 made. \$800-1200.

Alpa S.81 - c1972 prototype. Special surgical model of 10d with removable prism, no meter, only 1/60 shutter, and special sync terminals. Apparently 100 made. No recorded sales.

Master - 1977-83. (#60500-64050). 11si (usually) combined with spacer, Combestan or Novoflex bellows, and light source to form a high quality slide duplicator. Rare. \$1200-1800.

ALPA LENSES: All use the same Alpa bayonet mount except the Si 2000, which uses 42mm universal thread mount.

PINHOLE CAMERA CO. (Cincinnati, Ohio) Pinhole Camera - Cardboard body. \$30-45.

PINNOCK (Pinnock Photographic Supplies, Sydney, Australia) A

large postwar supplier of imported and locally made cameras and equipment with several attempts being made to manufacture in Australia. Some succeeded, most failed

due to the small population.

35 (prototype) - 1947. Close copy of Leica I with drawn steel case and FP shutter 25-500. Announced in press, with photo, in 1947, camera did not go into production. Existence confirmed by Eric Waterworth of Tasmania who made the f3.5/50mm lens. No sales data.

Gymea Minor (prototype) - 1948. Simple box camera, steel drawn case, for 4.5x6cm on 120 rollfilm. Sector shutter

I&T. Only one known to exist. No price

Studio - 1946. Half-plate camera made from Australian cedar with chrome plated fittings. \$500-750.

PIONEER - Blue and black plastic camera of the "Diana" type. \$1-10.

PIONIER DEKO - c1955. Small bakelite camera for 16 exposures 3x4cm on 127 film. Made in the former Kodak film & chemical plant in Berlin-Köpenick. Available in blue, red, or black bakelite. Very uncommon outside of the former East Germany, rarely seen until the wall started tumbling. Still uncommon. \$120-180.

PIPON (Paris)

Magazine camera - c1900. Leather covered wood box for 9x12cm plates. Aplanoscopef9 lens. \$100-150.

Self-Worker - c1895. Jumelle camera for 9x12cm plates. Goerz Double Anastigmat 120mm lens. 6-speed guillotine shutter. \$200-300.

PLANOVISTA SEEING CAMERA LTD. (London) Imported a camera with their name on it, but it was actually a Bentzin camera. See Bentzin.

PLASMAT GmbH (Berlin-Halensee, Germany) Dr. Paul Rudolph is well known not only for his Plasmat lens designs, but also for the first Anastigmat (1891), Planar (1896), Unar (1899), Tessar (1902), Magnar (1909), and the Film Plamos camera (1900).

Roland - 1934-37. Telescoping front camera for 4.5x6cm exposures on 120 rollfilm. Coupled rangefinder. Designed by Dr. Winkler in association with Dr. Paul Rudolph, who designed the various Plasmat lenses. It was highly regarded for

its 6-element Plasmat f2.7/70mm lens and sold new for \$93-143. Two basic models. First one had built-in optical exposure meter. Second model had no meter, but had automatic exposure counter. Either model was available with normal Compur 1-250 or Compur Rapid shutter to 400. \$1000-1500.

PLASTICS DEVELOPMENT CORP. (Philadelphia, Penn.)
Snapshooter - c1970. Black plastic slipon camera for 126 cartridges. \$1-10.

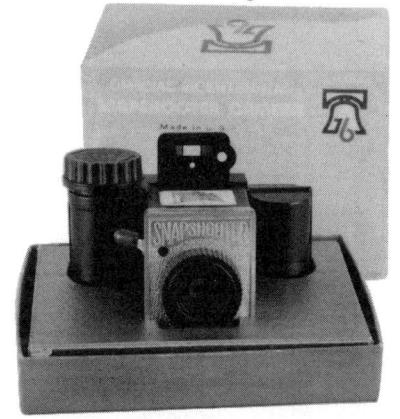

Snapshooter Bicentennial 1976 - c1976. Commemorative model for the 200th anniversary of the U.S.A. Like new in box: \$35-50.

PLAUBEL & CO. (Frankfurt, Germany)

Aerial Camera - c1955. Hand-held aerial camera for 6x9cm on 120 rollfilm in interchangeable magazine backs. Reports indicate that 60 were made for the Swedish Army. Grey hammertone body. Anticomar f3.5/100mm interchangeable lens. Focal plane shutter 20-1000. With universal 100-600mm viewfinder, 2 film magazines, case, and filters. Three were offered for sale a few months apart at German auctions during 1985, with reserve of 2500 DM (approx. \$1000-1200 at the time). The first two sold for just over the minimum bid, while the third remained unsold at that price.

Baby Makina - 1912-35. 4.5x6cm size. Anticomar f2.8/75mm. Compur shutter. \$400-600.

Folding-bed plate camera - 6x9 and 9x12cm sizes. Double extension bed and bellows. Anticomar or Heli-Orthar lens. Ibso or Compurshutter, \$45-60.

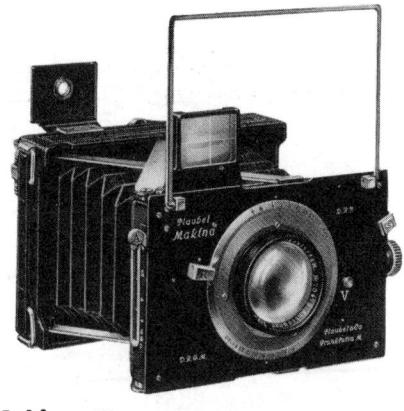

Makina (I) - 1920-33. Compact strutfolding 6.5x9cm sheet film camera. No rangefinder. Anticomar f2.9 lens. Dial or rim Compur shutter. Common on German auctions for \$120-180.

Makina I/II conversion - When the model II with rangefinder was introduced, Plaubel offered the service of fitting a coupled rangefinder to older model cameras. Thus it is possible to find even an early dialset model I with factory-installed coupled rangefinder.

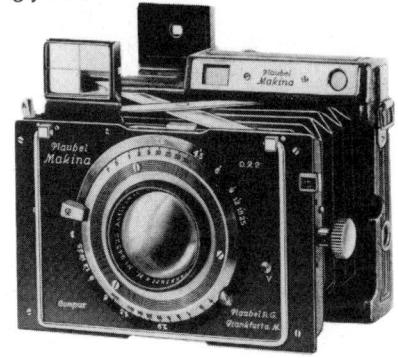

Makina II - 1933-39. Anticomar f2.9/100mm lens. Compur rim-set shutter. Coupled rangefinder. \$175-250.

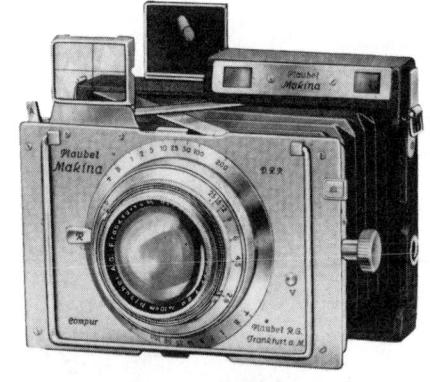

Makina IIS - 1936-49. S = Speed Change: unlike the Makina II, all lens elements in front of the shutter. Lenses are interchangeable with a half-twist. Normal lens is Anticomar f2.9/50mm. Shutter 1-200. \$200-300.

Makina IIa - 1946-48. Fixed, non-changeable Anticomar f4.2/100mm or Xenar f4.5/105mm lens. Shutter to ¹/₄₀₀. Self-timer. \$200-300.

Makina lib - Like the Makina IIa, but shutter to 200, no self-timer. \$175-250.

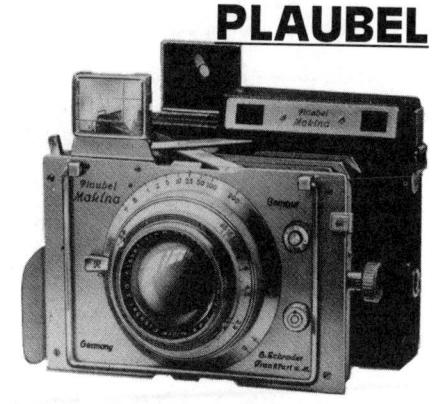

Makina III - 1949-53. 6x9cm strut-folding camera. Anticomar f2.9/100mm lens. Rimset Compur shutter 1-200. Coupled range-finder. \$250-375.

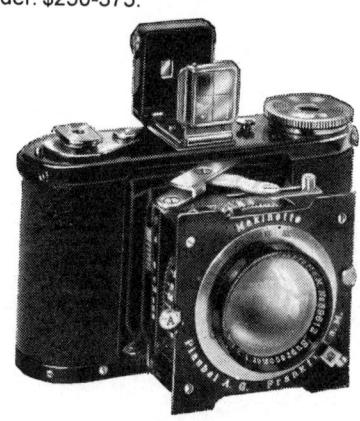

Makinette - c1931. Strut-folding camera for 3x4cm on 127 rollfilm. Anticomar f2.7 or most often with Supracomar f2/50mm. Compur 1-300. Rare. (Ginza asking price \$1800). ENGLAND/USA: \$800-1200. GERMANY:\$600-900.

Normal Peco - c1926. Folding plate camera, 9x12cm. Leather covered metal body. Double extension rack and pinion. Anticomar f4.5/150mm lens. Compur shutter. One auction sale a few years ago at \$110 with tele and WA lenses.

Prazision Peco - c1922-32. Like the Normal Peco, but more solid construction with brass and nickel parts. Anticomar f3.2/135mm. Compur shutter. \$300-450.

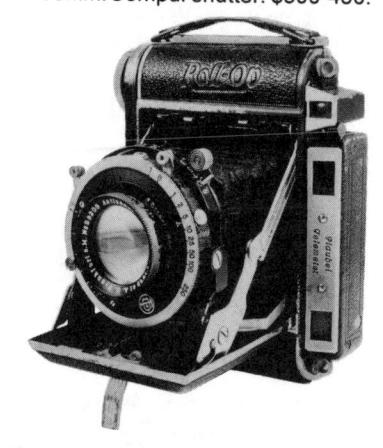

Roll-Op (II) - c1935. Although the camera itself is simply labeled Roll-Op, original brochures called it Roll-Op II. Folding bed rollfilm camera, for 16 exposures 4.5x6cm on 120 film. Anticomar f2.8/75mm lens. Compur Rapid shutter 1-250. Coupled rangefinder.\$250-375.

PLAUBEL...

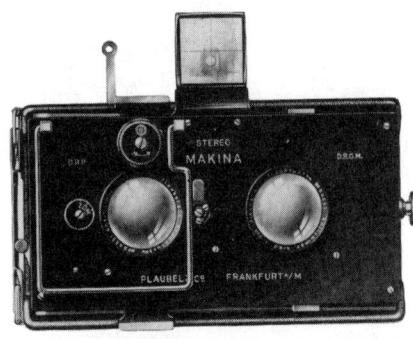

Stereo Makina, 6x13cm - 1926-41. Strut-folding stereo camera. Anticomar f2.9/90mm lenses in stereo Compur shutter 1-100. Black bellows. Black metal body, partly leather covered. \$750-1000.

Stereo Makina, 45x107mm - 1912-27. Similar, but f6/60mm Orthar or f3.9 Anticomarlens. \$750-1000.

Veriwide 100 - c1960. Wide angle camera for 6x9cm on 120 film. 100° angle of view. Super-Angulon f8/47mm in Synchro Compur 1-500 shutter, B, MXV sync. \$600-900.

PLAUL (Carl Plaul, Dresden, Germany)

Field camera, 9x12cm - c1900-10. Simple wooden tailboard style field cameras. Square bellows or tapered red bellows. Carl Plaul Prima Aplanat lens in brass barrel, waterhousestops. \$175-250.

PLAVIC - c1920. Leather covered wood body. 6x9cm on rollfilm. Meniscus lens, guillotine shutter. \$30-45.

PLAYLAB SR. - c1975. Camera kit made by Alabe Products, NY. Assembles into a plastic 120 rollfilm camera with normal, wideangle, and telephoto lenses, simple shutter. NEW: \$20-30. Assembled: \$12-20.

PLAYTIME PRODUCTS INC. (New York, NY)

Cabbage Patch Kids 110 Camera c1984. Yellow plastic 110 pocket camera with black trim. Green "Cabbage Patch Kids" decal on front. Uses flip-flash. Made in China. \$15-25.

Go Bots 110 Camera - c1984. Grey plastic 110 camera, black & red trim. Go Bots sticker on front. Same basic camera as Cabbage Patch Kids above. \$15-25.

PLIK - 127 rollfilm, plastic box camera made in Brazil. Similar in style to the Bilora Boy. \$45-60.

PLUS (Paul Plus Ltd., Newcastle, England)

Plusflex 35 - c1958. 35mm SLR with Exa/Exakta bayonet mount. Made by Tokiwa Seiki Co., labeled for Paul Plus Ltd. Similar to the pentaprism version of the Firstflex 35. Simple mirror shutter, B, 60, 125. Auto Pluscaron 45mm/f2.8 lens. \$100-150.

POCK (Hans Pock, Munich, Germany)

Detective camera - c1888. Mahogany detective camera, concealed in a leather satchel. Gravity-operated guillotine shutter, 1-100. Magazine holds 15 plates 6x9cm. Voigtländer Euryskop fixed-focus lens. \$2400-3200.

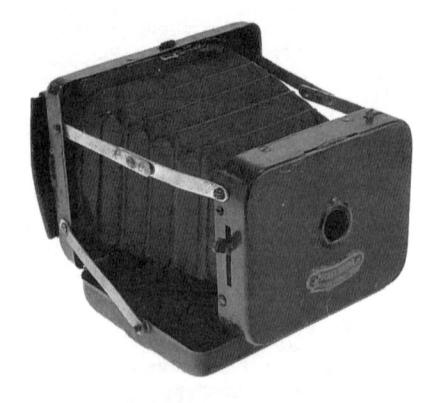

POCKET MAGDA - c1920. Compact French all-metal folding camera in 4.5x6cm and 6.5x9cm sizes. Meniscus lens, simple shutter. 4.5x6cm size: \$600-900. 6.5x9cm size: \$250-375.

POCKET PLATOS - French 6.5x9cm folding plate camera. Splendor f6.2/90mm lens in Vario shutter. \$120-180.

POLAROID (Cambridge, MA) Polaroid cameras, using the patented process of Dr. Land, were the first commercially successful instant picture cameras which were easy to use, and were not in need of bottles of chemicals, etc. The idea of in-camera development is not new; there are records of ideas for instant cameras from the first year of photography. In 1857, Bolles & Smith of Cooperstown, New York patented the first instant camera which actually went into production. Jules Bourdin of France invented a simple system which was successfully marketed as early as 1864. Many other attempts met with mediocre success, but Polaroid caught on and became a household word. Because of the success of the company, their cameras generally are quite common, and obviously none are very old. There is more supply than demand for most models in the United States, but some of the early models sell better in Europe. We are listing them in order by number, rather than chronologically. We have not listed cameras introduced after 1965, so this list is by no means a complete history of Polaroid.

Polaroid 80 (Highlander) - 1954-57. The first of the smaller sized Polaroid cameras. Grey metal body. Hot shoe. 100mm/f8.8 lens. Shutter 1/25-1/100 sec. \$8-15.

Polaroid 80A (Highlander) - 1957-59. Like the 80, but with the shutter marked in the EV system. (Orig. price: \$72.75)\$8-15.

Polaroid 80B - 1959-61. Further improvement of the 80A with new cutter bar and film release switch. \$1-10.

Polaroid 95 - 1948-53. The first of the Polaroid cameras, which took the market by storm. Heavy cast aluminum body, folding-bed style with brown leatherette covering. f11/135mm lens. Folding optical

Polaroid 110 (Pathfinder) - 1952-57. Wollensak Raptar f4.5/127mm lens and coupled rangefinder. Shutter 1-1/400 sec. \$45-60.

Polaroid 110A (Pathfinder) - c1957-60. Improved version of the 110. Rodenstock Ysarex or Enna-Werk Ennit f4.7/127mm lens in Prontor SVS 1-1/₃₀₀ shutter. Special lens cap with f/90 aperture added in 1959 for the new 3000 speed film. Charcoal covering. (Originally \$169.50) \$45-60.

Polaroid 110B (Pathfinder) - 1960-64. Like the 110A, but with single-window range/viewfinder. \$45-60. These professional models can be converted to pack film.

Polaroid 120 - 1961-65. Made in Japan by Yashica. Similar to the 110A, but with Yashica f4.7/127mm lens in Seikosha SLV shutter 1-500,B. Self-timer. CRF. Not as common in the U.S.A. as the other models, because it was made for foreign markets. \$50-75.

Polaroid 150 - 1957-60. Similar to the 95B with EV system, but also including CRF with focus knob below bed, parallax correction, and hot shoe. Charcoal grey covering. (Originally \$110.) \$8-15.

Polaroid 160 - 1962-65. Japanese-made version of the 150 for international markets. \$8-15.

Polaroid 180 - 1965-69. Professional model pack camera made in Japan. Tominon f4.5/114mm lens in Seiko shutter 1-1/500 with self-timer. Zeiss-lkon range/viewfinder. Has retained its value as a usable professional camera. \$200-300.

Polaroid 185 - Sold only in Japan. Mamiya Sekor f5.6 lens. CdS meter. Combined electronic and mechanical "trapped-needle" auto exposure with manual override. Reportedly only about 30 made. Rare. \$300-450.

Polaroid 190 - European version of the Model 195. Zeiss finder, f3.8 lens. Electronic developmenttimer. \$175-250.

Polaroid 195 - Like the Model 180, but Tominon f3.8/114mm lens instead of f4.5. Albada finder like the Model 100. Mechanical wind-up developmenttimer. \$175-250.

Polaroid 415 - Variation of the Swinger Model 20. \$1-10.

Polaroid 700 - 1955-57. Uncoupled rangefinder version of the 95A. Grey leatherette covering. \$15-25.

Polaroid 800 - 1957-62. All the features of the 150, but with carefully selected lens, electronically tested shutter, and perma-

POLAROID

nently lubricated roller bearings. (Original price: \$135 with flash, bounce bracket and 10 year guarantee.)\$12-20.

Polaroid 850 - 1961-63. Similar to the 900 below, but with dual-eyepiece range-finder & viewfinder. \$8-15.

Polaroid 900 - 1960-63. The first Polaroid with fully automatic electric-eye controlled shutter. Continuously variable shutter speeds (1/12-1/600) and apertures (f/8.8-f/82). \$8-15.

Big Shot - 1971-73. Unusually designed pack-film camera for close-up portraits at a fixed distance of one meter. Since the lens is fixed focus, the rangefinder functions only to position the operator and subject at the correct distance. Built-in socket and diffuser for X-cubes. EUR: \$30-45. USA: \$8-15

Camel - Special version of the Model 640, made in England for Camel Cigarettes. Used as a prize in a contest among vending machine suppliers in Germany. Uncommon. \$100-150.

Countdown 90 - c1971. Folding film-pack camera with grey plastic body. Double-window finder, slide-on flash shoe, electronic timer on back. \$1-10.

Polaroid J-33 - 1961-63. Newly styled electric-eye camera to replace the "80" series. Still using the 30 series double-roll films for 6x8cm pictures. \$1-10.

Polaroid J-66 - 1961-63. Newly styled electric-eye camera, with simple f/19 lens. Tiny swing-out flash for AG-1 bulbs. \$1-10.

Swinger Model 20 - 1965-70. White plastic camera for B&W photos on Type 20 roll film, the first roll film to develop outside the camera. If this is not the most common camera in the world, it certainly must be near the top of the list. Current value \$5 per truckload, delivered.

Swinger Sentinel M15 - 1965-70. Variation of the Swinger Model 20. Lacks built-in flash. \$1-10.

SX-70 (Deluxe Model) - 1972-77. The original SX-70 camera. Ingeniously designed folding SLR which ushered in a new era of instant photography The miracle was watching the colored photo slowly appear in broad daylight after being automatically ejected from the camera. The technical and esthetic marvel was the compact machine which fit easily into a coat pocket. The basic folding design was not new. Perhaps one of Polaroid's engineers had seen the circa 1905 "Excentric" camera of R. Guénault, which is sur-

finder with sighting post on the shutter housing. Diehard collectors like to distinguish between the early models with the flexible spring sighting post and the later ones with a rigid post. EUR: \$60-90. USA: \$15-25.

Polaroid 95A - 1954-57. Replaced the Model 95. Essentially the same but sighting post was replaced with a wire frame finder, X-sync added, and shutter speeds increased to 1/₁₂-1/₁₀₀. 130mm/f8 lens. EUR: \$35-50. USA: \$8-15.

Polaroid 95B (Speedliner) - 1957-61. Like the 95A, but the shutter is marked in the EV (Exposure Value) system, rather than the traditional speeds. (Orig. price: \$94.50) EUR: \$35-50. USA: \$8-15.

Polaroid 100 (rollfilm) - 1954-57. (Do not confuse with the 1963 "Automatic 100" for pack film.) Industrial version of the 95A. Better roller bearings and heavy duty shutter. Black covering. \$8-15.

Polaroid 100 ("Automatic 100") -1963-66. An innovative, fully automatic transistorized electronic shutter made the world stand up and take notice once again that the Polaroid Corporation was a leader in photographic technology. In addition to the marvelous new shutter, Polaroid introduced a new type of film in a flat, drop-in pack which simplified loading. Furthermore, the photographs developed outside the camera so that exposures could be made in more rapid succession. Threeelement f8.8/114mm lens. Continuously variable speeds from 10 seconds to 1/1200. RF/viewfinder unit hinged for compactness. \$8-15. Price in Europe can be double the USA price, but that only accounts for the cost of transportation.

Polaroid 101, 102, 103, 104, 125, 135 - c1964-67. Various low-priced pack cameras following after the Automatic 100. \$1-10.

POLYFOTO

prisingly similar. But Guénault would never have dreamed of an even more compact camera incorporating SLR focusing to 10½ inches, automatic exposure up to 14 seconds, and motorized print ejection, all powered by a disposable flat battery which came hidden in the film pack. This is a landmark camera, but quite common because it was so popular. EUR: \$50-75. USA: \$30-45.

POLYFOTO - c1933. Repeating-back camera, taking 48 ½x1½" exposures on a 5x7" plate. Plate moves and exposure is made when a handle is cranked. \$175-250.

PONTIAC (Paris) Founded in 1938 by M. Laroche, whose first product was a polarising filter. The first cameras of the firm were the streamlined "Bakelite" models based on the Ebner camera from Germany. During the war, the aluminum-bodied Bloc-Metal cameras were produced in an attempt to improve the quality and durability of both the cameras and the company image. While other materials were in short supply during wartime, aluminum was produced in abundance in France. Its availability and strength led to its choice for the bodies of the Bloc-Metal and Lynx cameras.

Baby-Lynx - c1950. Simple, non-RF 35mm camera. Well-finished, polished cast aluminum body with telescoping front. Flor f3.5/50 in Prontor II; Berthiot f2.8/50 in Prontor-S, or Flor f3.5 in Atos 2. Some were made in France and some in French Morocco, and are marked accordingly.

\$120-180.

Bakélite - c1938-41. Folding camera for 8 6x9cm exposures on 120. Bakelite body design originated by the Ebner, continued by Gallus, and then Pontiac. Berthiot f4.5/105mm. Shutter 25-150. \$75-100.

Bloc-Metal 41 - 1941-48. Cast aluminum-alloy body with grained texture and

painted finish, due to wartime shortage of leather. Original 1941 model has MFAP shutter to 100. Later versions have Pontiac or Prontor II shutter to 150. Pontiac or Berthiot f4.5 lens. \$45-60.

Bloc-Metal 45 - c1946. As the model number indicates, this was to have been a 1945 model, but it did not actually appear until late in 1946. It was more professional than the model 41 in features and appearance. Streamlined die-cast top housing incorporates an optical finder and a rotating depth of field scale. The model number was supplemented with a letter to indicate the lens: 45A= Trylor Roussel (uncoated); 45AF= Special Berthiot (coated); 45B= Flor Berthiot (coated). All f4.5/105mmin Prontor II with body release. Early examples still have cloth rather than leather bellows. \$50-75.

Lynx, Lynx II - c1948. Polished aluminum body. (Model II also exists with black enameled body.) 16 exposures 3x4cm on 127 film. Berthiot Flor f2.8/50mm coated lens in Leica-style collapsible mount. Focal plane shutter. \$75-100.

Super Lynx, I, II - c1950's. Made in Paris and Morocco. 35mm body has an aluminum finish, black enamel, or is leather covered. f2.8 or f3.5 Flor lens; Super Lynx II has interchangeable lenses. Rarely seen with the fast f2.0 Sacem Hexar lens. FP shutter. Some dealers really stetch the point by calling this a Leica copy. However, the lenses are in a collapsible mount

which resembles the Leica style even on the fixed-lens model I. \$300-450.

PONTOS OPTIKAI LENCSEGYAR (Budapest) Pontos Optikai Lencsegyár = Pontos Optical Lens Factory.

Dici - c1934. Bakelite box camera for 3x4cm on 127 film. Styling is loosely based on the Kodak Baby Brownie camera. M,B shutter. Rare. No sales data.

POPULAR PHOTOGRAPH CO. (New York)

Nodark Tintype Camera - c1899. All-wood box camera for 21/2x31/2" ferrotype plates. The camera has a capacity of 36 plate. With tank: \$800-1200. Less \$100 if missing tank.

POTENZA CAMERA - c1981. 110-cartridge camera shaped like a tire. Meniscus f11 lens, single speed shutter. New in box: \$35-50.

POTTHOFF (Kamerafabrik Potthoff & Co., Solingen, Germany) See also Montanus Camerabau, the new name of Potthoff & Co. beginning about 1953.

Amplion-Reflex - c1952. Name variation of the Plascaflex, possibly for export. See description below. Pluscanar f3.5/75mmin Prontor-SVS.\$50-75.

Plascaflex PS 35 - c1952. Bakelite TLR for 6x6cm. Unusual feature is the removable focusing magnifier which stores on the lower right-hand side and doubles as a compartment for a spare roll of film. Model PS 35 has Plascanar f3.5/75mm in Prontor-S shutter; model V 45 has f4.5 lens in Vario. \$60-90.

POUVA (Karl Pouva, Freital, Germany)

Start - c1952-56. Helical telescoping camera for 6x6cm exposures on 120 roll-film. Bakelite body and helix. Fixed focus Duplar f8 lens. Z&M shutter. \$20-30.

PRÉCIDES - Simple French stamped metal box camera with light grey cloth covering. Also sold as "Menetrel". \$15-25.

PRECISION CAMERA INC. (Minneapolis, MN)

Andante 100 - Large blue and gray plastic "school" camera using bulk rolls of 35mm film. Twin lens reflex style. \$75-100.

PREMIER INSTRUMENT CO. (New York)

Kardon - c1945. 35mm Leica IIIa copy. Made for the Signal Corps, and also for civilians. Ektar f2/47mm lens. Cloth focal plane shutter, 1 to 1000. Coupled range-finder.

Civilian Model - Uses standard Leicastyle advance knob and shutter release. No rear nameplate on body. Civilian lens mounts with knurled focusing wheel toward top between slow speed dial and RF window (11 o'clock position viewed from front). \$500-750.

Signal Corps Kardan, front and back views
Signal Corps Model - Obvious identification is rear nameplate on body. Military models were also designed to be operated more easily when wearing gloves, with an enlarged cylindrical advance knob, removable tall extension for release button, and with lens focusing wheel near bottom of camera (7 o'clock position) away from the other controls. Body: \$300-450. With lens: \$400-600.

PRESCOTT & CO. (Glasgow) Field camera - Brass and mahogany folding camera for 1/2-plates. Lens is set in a Challengepneumaticshutter. \$300-450.

PRIMO - c1950's. Basic scale-focus 35mm camera made in the Netherlands. Design is based on the German Steinette. Improvements include lever wind, two small feet on bottom to allow camera to stand on a flat surface, top shutter speed increased to 200. Nedinsco-Venlo f3.5/45mm lens in unidentified shutter 25-200. Black leatherette or grey rubberized covering, \$35-50.

PRINCE - c1960's. Rectangular green and black bakelite subminiature from Japan. Uses Mycro-size rollfilm. Fixed focus f10, B,I shutter. Scarce. \$250-375.

PRINCE RUBY - c1960. Novelty subminiature, like Bell-14. Essentially a "Hit-type" camera with a modernized top housing. Uncommon with this name. \$45-60.

PRINTEX PRODUCTS (Pasadena, CA) Printex - c1946. Rigid-bodied, all-metal press camera. Telescoping lens mount rather than the bellows found on the popular Speed Graphics of its day. Made in 21/4x31/4" and 4x5" sizes. Uncommon. \$120-180.

PRO CAMERA - Factory loaded disposable camera. 28x31mm on 35mm film. \$20-30.

PRONA TROPICAL - c1925. Single extension folding plate camera, 6.5x9cm. Brown leather, black bellows. Prona Anastigmat f6.3/105mm. Vario shutter. One auction sale, mint condition: \$100.

PRONTA (Spain) Various cameras, all bearing the Pronta name, were marketed by a distributor in Barcelona. They were not necessarily made by the same manufacturer.

Pronta Lux PL - Inexpensive plastic eye-level camera for 6x6cm on 120 film. Design based on the Agfa Click I. \$12-20.

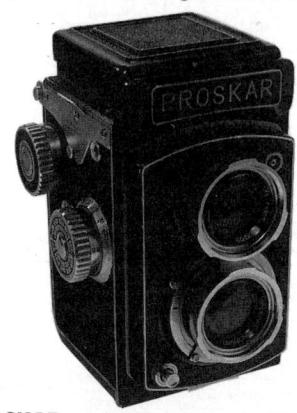

PROSKAR - c1957. Japanese TLR. Rack & pinion focus; double bayonets on both Tri-Lausar f3.5/8cm lenses. B,1-300 shutter. Uncommonname. \$200-300.

PROUD CO. (Japan)
Rosen Semi - c1937. Folding camera,
4.5x6cm on 120 rollfilm. Rosen Anastigmat
f4.5/75mmlens in Rosen shutter. \$75-100.

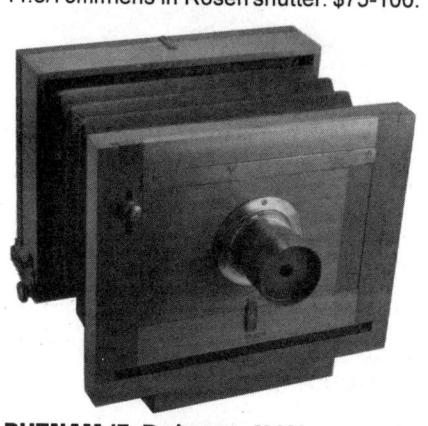

PUTNAM (F. Putnam, N.Y.)
Marvel - c1885-95. 5x8" horizontal folding view camera. Appears to be the same as the Scovill Waterbury View. Scovill Waterbury lens with rotating disc stops. Earlier examples have removable washer-

Earlier examples have removable washerstyle waterhouse stops. \$200-300.

PYNE (Manchester, England)

Stereoscopic Camera - c1860. Tailboard stereo, 8x17cm plates. Ross lenses.

One sold at auction in 1979 for \$4800. Sorry, but we know of no recent sales.

Q.P. - c1950. Japanese "Hit" type novelty camera using 16mm paper backed relies.

camera using 16mm paper-backed rolls. \$25-35.

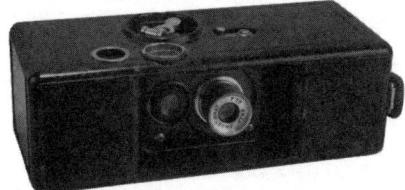

O.R.S.-DeVRY CORP. (Chicago)
O.R.S. Kamra - c1928. Brick-shaped brown bakelite body. 40 exposures, 24x32mm, on 35mm film in special cassettes. Graf Anastigmat f7.7/40mm. Single speed shutter trips by counter-clockwise motion on winding crank. With crank intact: \$120-180. As normally found with broken crank: EUR: \$120-180; USA: \$60-90.

RAACO

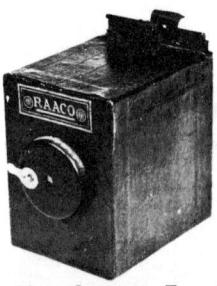

RAACO (Strasbourg, France)
Mignon - c1929. Inexpensive box
camera for 4.5x6cm plates. Cardboard
construction. Meniscus lens. Sector shutter. \$100-150.

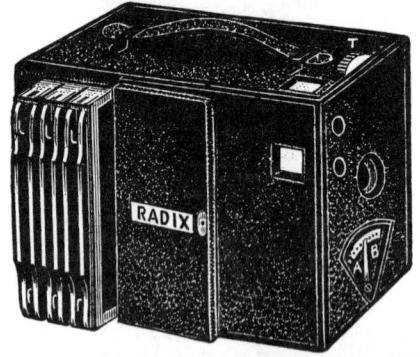

RADIX - c1897. Box camera for 31/4x41/4" glass plates in standard double holders. Hinged door on side of camera to change and store plateholders. \$60-90.

RAJAR LTD. A manufacturer of sensitised photographic materials, it merged in 1921 with several other photographic companies with several other photographic companies to form APM (Amalgamated Photographic Manufacturers, Ltd). It was one of the companies that split from APM in 1929 to form Apem Ltd. See APM for more information, including the Rajar No. 6 camera.

RAKSO - c1970's. Specialized apparatus for creative work. Peak performance at full aperture without diaphragm. Shutter is activated and film ejected immediately prior to complete system shutdown. Occasional mulitple exposures possible without full recharge. Body only: \$35-50.

RALEIGH - 4x4cm novelty of the "Diana" type. \$1-10.

RANDORFLEX - Small novelty TLR for 4x4cm on 127 film. Same as Bedfordflex, Windsorflex, Splendidflex, Stellarflex, Wonderflex, etc. \$1-10

RANKOLOR LABORATORIES (U.S.A.) Rank - c1975. Small plastic camera, factory loaded with 110-size film. This is the European name variation for the "Lure" camera. Made in U.S.A. for distribution by Rank Audio Visual of Brentford, England. Camera is returned intact for processing and a new camera is returned with processed prints. \$1-10.

RAY CAMERA CO. (Rochester, N.Y.) Originally established in 1894 as Mutschler, Robertson & Co., the company began making "Ray" cameras in 1895. In 1898 the company moved to a new building and changed its name to "Ray Camera Co." In 1899, it became part of the new "Rochester Optical & Camera Co.

Box camera - For 31/2x31/2" glass plates. Rear section of top hinges up to insert holders. \$45-60.

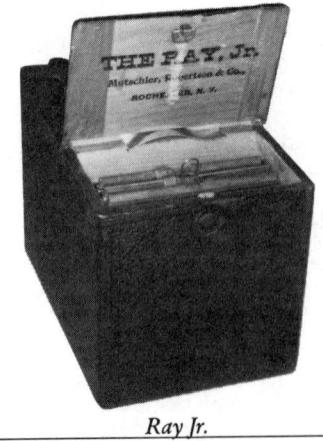

Pocket Ray - c1904. Folding plate camera, 31/₄x41/₄". Leather covered wood body, red bellows. Brass RR lens, Ray automatic shutter. \$75-100.

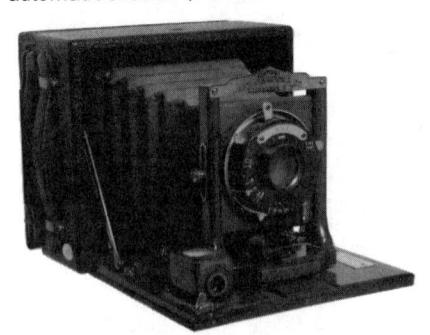

Ray No. 1, No. 4, No. 6 - c1899. 4x5" wooden folding plate cameras. Red bellows. Black leather covered. \$100-150.

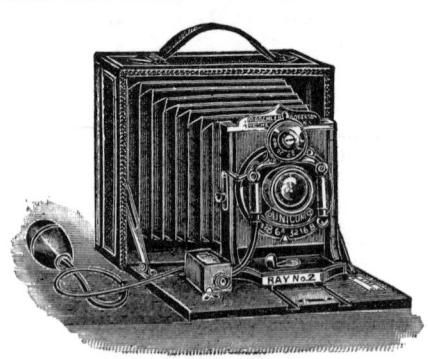

Ray No. 2, No. 7 - c1899. 5x7" folding plate camera, similar construction to the No. 1. Dark mahogany interior, red bellows. Brass barrel lens, Unicum double pneumaticshutter. \$90-130.

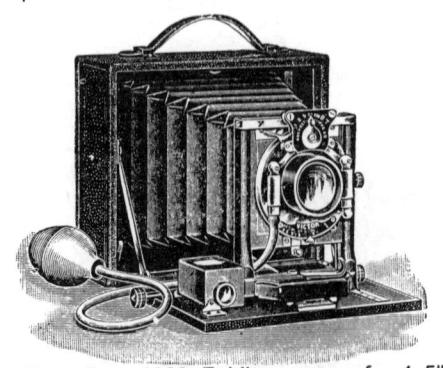

Ray A - c1898. Folding camera for 4x5" plates. Normally with Rochester symmetrical or Zeiss anastigmat Series IIa lens. \$100-150.

Ray C - c1899. Box camera for 4x5" plates in double plateholders. Wood body covered with black leather. \$60-90.

Ray Jr. - c1897. For 21/2x21/2" plates. \$60-90. Illustrated at top of previous col-

Telephoto Ray Model C - c1901. Folding bellows camera, 4x5". Wollensak Automatic shutter. \$100-150.

REAL CAMERA - Japanese novelty subminiature of the Hit type. \$25-35.

RECORD CAMERA - c1890. English mahogany twin-lens reflex style box camera. 31/4x4" plates. Fixed focus lens. T.I shutter. \$1200-1800.

RECTAFLEX (Rome, Italy)

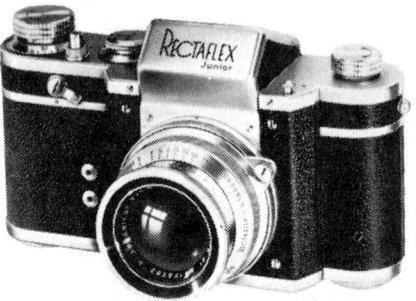

Rectaflex Junior - c1952. 35mm SLR. Angenieux f2.9/50mm. 25-500 shutter. \$150-225.

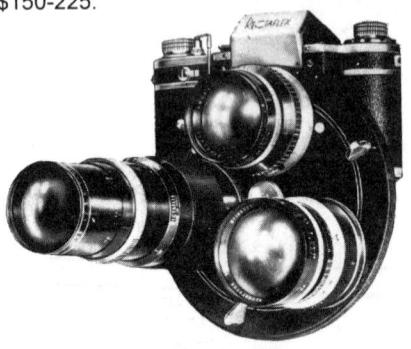

Rectaflex Rotor - c1952. 35mm SLR with 3-lens turret. One nice outfit with Xenar 50mm, Travenar 35mm, Travenar 135mm, grip, box, & instructions sold at auction (Cornwall, 3/90) for \$1850. With normal lens: \$1000-1500. Wide angle and tele lenses, each \$60-90. Add \$60-90 for grip. Add \$120-180 for gunstock.

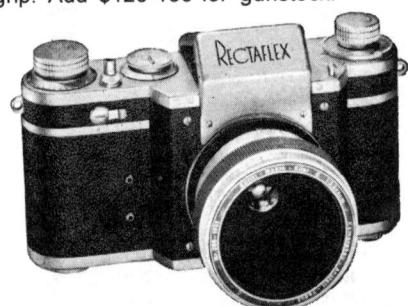

Rectaflex Standard - 1949-56. One of the first prism SLR's, along with the Contax S. Both cameras were exhibited in 1948 and produced in 1949. The Contax has an earlier patent date. Schneider Xenon f2.0 or f2.8/50mm, Biotar f2/58mm, Angenieux f1.8/50mm, or Macro-Kilar lens. Focal plane shutter 1-1000 (up to 1300 after 1952), sync. These standard (non-
rotor) Rectaflex cameras are also designated Rectaflex 1000 and 1300 after their top shutter speed. Model 1000: \$300-450. Model 1300: \$250-375.

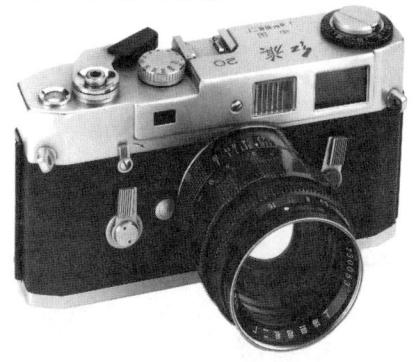

RED FLAG 20 - c1971-76. Chinese copy of Leica M4. Reportedly only 182 made. First two digits of serial number indicate year of production. With Red Flag 20 f1.4/50mm (Summilux copy) lens. Although quite rare, we have seen these offered under \$3000 in less than ideal condition. Complete with shade and case have reached \$7500 at auction.

REDDING (H.J. Redding & Gyles, London, England)
Redding's Patent Luzo - c1896-99.
(Formerly made by Robinson from 1889.)
Mahogany detective box camera. Brass fittings. Several sizes, including 21/4x31/4" and 3x4" exposures on Eastman rollfilms. The first English rollfilm camera. f8 lens, sector shutter. \$1200-1800.

REFLEX 66 - c1955-65. Japanese copy of the Reflex Korelle. Anastigmat f3.5/75mm. FP shutter to 1000. \$175-250.

Reflex Camera Co.'s Focal plane postcard camera

REFLEX CAMERA CO. (Newark, NJ & Yonkers, NY) Founded by J.L.R. Holst.
Originally located in Yonkers, NY from

Originally located in Yonkers, NY from about 1897-1909, when they moved to Newark, NJ and took over the Borsum Camera Co., with whom they shared a complex association. The Reflex Camera of c1898-99 was one of the early popular American SLR cameras, although the Monocular Duplex had reached the market about 15 years earlier.

Focal plane postcard camera - c1912. Vertical styled folding plate postcard camera. Focal plane shutter. Cooke Anastigmat or Ilex RR lens in plain mount. \$175-250. Illustrated bottom of previous column.

Junior Reflex - c1911. Simple SLR box camera for 31/₄x41/₄" plates. Simple lens, 4-speed sector shutter coupled to mirror. \$150-225.

Patent Reflex Hand camera - c1902. Early model leather covered 4x5" SLR box camera. Internal bellows focus. Focal plane shutter. Red focusing hood. Fine finished wood interior. Without lens: \$350-500.

Reflex camera, 4x5" - c1910. Later model than the above listing. Leather covered wood box with tall viewing hood.

REICHENBACH

Internal bellows focus. Euryplan Anastigmat 7" lens. \$175-250

Reflex camera, 5x7" - c1910. f16/210mm Anastigmat lens. \$350-500.

REGAL FLASH MASTER - Black bakelite box camera with integral flash. Identical to Spartus Press Flash, \$1-10.

REGAL MINIATURE - Plastic novelty camera for half-frame 828. \$1-10.

REGENT - Japanese Hit-type novelty camera. \$25-35.

REICHENBACH, MOREY & WILL CO. (Rochester, N.Y.) Started in 1896 by Henry Reichenbach, president, John E. Morey, treasurer, and Albert Will, secretary. Reichenbach left his employment as a chemist at Photo Materials Co. to start the new company, which remained in business until 1898.

Alta Automatic - c1897. Folding camera for 4x5" plates. Named for self-erecting front, which is not common among cameras of this type. Leather covered mahogany body. Light tan leather bellows. Reversible back. Unidentified lens in R.M.&W. shutter, I&T. The shutter is easily removable from the front board with a simple twist of the locking plate whose milled edge surrounds the shutter. Uncommon.\$150-225.

Alta D - c1896. 5x7" folding plate camera. \$120-180.

REID & SIGRIST (Leicester, England)

Reid I - 1958-65. Viewfinder 35mm, copy of Leica Standard. Interchangeable Taylor Hobson f2/2" lens with Leica screwmount thread, helical focus. Cloth focal plane shutter 1/20-1000, B,T. \$350-500.

Reid la - 1958-65. Similar to the Reid I, but has a second accessory shoe (like the Leica If) instead of the attached viewfinder. No reported sales.

Reid I. la Military - c1958. Identical to the Reid I and Ia, above, but back has British military markings, such "0553/8810" with broad arrow. Examples with military markings appear to be more common than without, nevertheless some have sold at higher prices. \$600-900.

Reid II - 1958-65.35mm camera, coupled rangefinder. Similar to the earlier Reid III, but no slow speeds. Focal plane shutter 1/20-1000, B,T. \$2000-3000.

Reid III - 1947-65. 35mm CRF, copy of Leica IIIb. Referred to only as "Reid" until 1958 when other models were introduced. Top plate says "Reid". Interchangeable Taylor Hobson f2/2" (50mm) lens with helical focusing. Cloth focal plane shutter 1-1000. Originally introduced without sync. B,T sync added in 1953. Prices given are for camera with lens. Body only has half the value. Early versions without sync: \$600-900. Synchronized: \$400-600.

RELIANCE - 4x4cm "Diana" type novelty camera. \$1-10.

REMCO TOYS (New York City) Hulk Hogan - 1991. World Wrestling Foundation star wrestler is depicted in a three-dimensional figure attached to the front of a bright yellow pocket 110 camera

with electronic flash. Hulk Hogan's color image also appears on each photo taken with the camera, thanks to a small transparency attached at the focal plane. Original price about \$15.

Teenage Mutant Ninja Turtles -1990. Pocket 110 camera with electronic flash. Three-dimensional figure of "Michaelangelo" attached to the front. An outline image of the cartoon character also appears on each photo taken with the camera. Three fluorescent colors: chartreuse, orange, or green. Original price about \$15.

Teenage Mutant Ninja Turtles Talking Camera - 1991. An improved version of the standard model. Now prints a COLOR image of Michaelangeloon each photo. Top-mounted unit speaks "Cowabunga, Smile" when button is pushed. Same colors as original model, with top section of a second fluorescent color. Original price about \$25.

REMINGTON MINIATURE CAMERA -Black bakelite minicam for half-frames on 127 film. \$1-10.

REPORTER MAX - c1960. Black plastic 6x6cm. Single-speedshutter. \$12-20.

Automatic-1034 - c1969. Inexpensive plastic camera for 126 cartridges. Its only claim to fame is that the plastic body, leatherette covering, and metal trim came in several color combinations. \$1-10.

Evematic EE 127 - c1958. 127 film. Wollensak f2.8/58mm lens. \$25-35.

c1953. Amaton, Enna Stereo 33 -Chromar S, or Wollensak f3.5/35mm. Shutter 2-200, MFX sync. Rangefinder. \$150-225.

REWO (Renemans Works, Utrecht, Netherlands)

Rewo Louise c1949. Metal box camera with black hammertone finish. Meniscus lens made by Oude Delft, M&T shutter. \$20-30.

Baby Powell - Small rollfilm camera. Copy of Zeiss Baby Ikonta. Hexar f4.5/50mm lens in Konishiroku rimset shutter. \$120-180.

REX MAGAZINE CAMERA CO.

Rex Magazine Camera - c1899, 4x5" and 31/4x41/4" sizes. Simple lens & shutter. Unusual plate changing mechanism. Plates are moved from rear storage slots to plane of focus by: 1) Select plate number by placing peg in hole. 2) Slide receptacle to rear until stopped by peg. 3) With receptacle in vertical position, invert camera. 4) Slide receptor to focal plane and re-invert camera to normal position. 5) After exposure, return exposed plate to storage by reversing these steps. Holds 12 plates. \$250-375.

Rex Magazine Camera - 2x2" format. The baby brother of the above model. \$250-375.

REYGONAUD (Paris)

Stand camera - c1870. Jamin Darlot lens. Brass trim. For 8x11cm plates. \$500-

REYNOLDS & BRANSON (Leeds, England)

Field camera - c1890. Full or half plate size. Mahogany body. Brass barrel RR lens. \$300-450.

RHEINMETALL (VEB Rheinmetall, Sömmerda, East Germany)

Exa System - Similar to the earlier Ihagee Exa, but marked "System Exa, VEB Rheinmetall Sömmerda" on faceplate. Tessar f2.8/50mm. \$100-150. on the

Perfekta - c1955. Black bakelite box camera, 6x6cm on 120. Rigid rectangular front. Large eye-level folding frame finder. Achromat f7.7 lens, M,Z shutter. Synchronized and non-synch models. \$15-25.

RIETZSCHEL

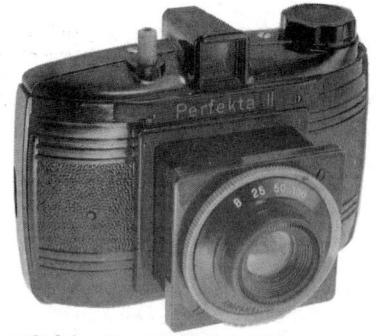

Perfekta II - Black bakelite camera with collapsible rectangular telescoping front. Optical eye-level finder built into top. Achromat f7.7/80mm. B,25,50,100 shutter. Double exposure prevention. \$15-25.

RICH-RAY TRADING CO.

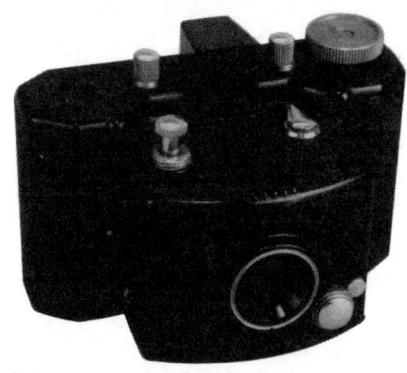

Rich-Ray - c1951. Small bakelite camera, 24x24mm on Bolta film. Nearly identical to Start-35. Marked "Made in Occupied Japan" on bottom; "Rich-Ray" on top. Simple fixed focus f5.6 lens, lever-operated f8 waterhouse stop. B,I shutter. \$45-60.

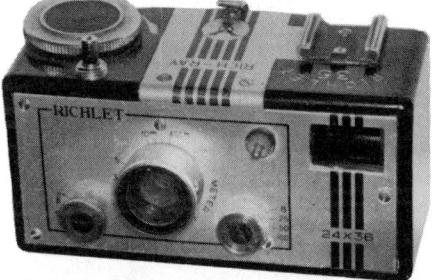

Richlet 35 - c1954. Rectangular bakelite body, metal faceplate. 24x36mm on Boltasize film. Focusing f5.6. B,25-100 shutter. Stores spare film roll inside. \$45-60.

RICHARD (F.M. Richard) Detective - c1895. Magazine box camera for 13x18cm plates. Rack and pinion focusing. \$750-1000.

RICHARD (Jules Richard, Paris, France)

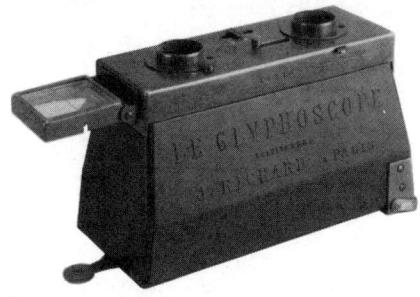

Glyphoscope - c1905. 45x107mm

stereo camera of simple construction. Black ebonite plastic or leather covered wood. Meniscus lens, guillotine shutter. Lens panel removable to use the rest as a viewer. \$90-130.

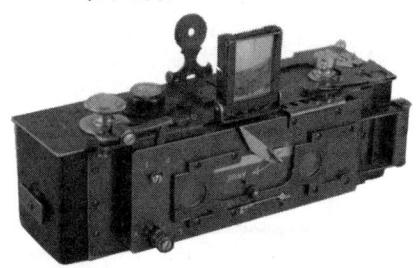

Homeos - c1914. The first stereo for 35mm film. 25 exposures on standard 35mm cine film. Optis or Zeiss Krauss Anastigmat f4.5/28mm. Guillotine shutter. \$2400-3200. (Add \$600-900 for viewer and printer.)

Homeoscope - c1900. Stereo cameras in 6x13 and 9x18cm sizes, \$250-375.

Verascope The Verascope line of stereo cameras bridged from the 1890's to the 1930's, with numerous variations. They were made in 45x107mm, 6x13cm, and 7x13cm sizes, with many shutter and lens combinations. Although definitely collectible, their value is still largely related to their usability.

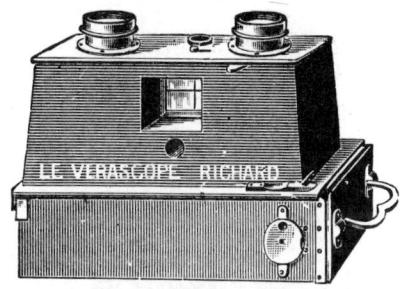

Verascope, simple models - Fixed-focus lenses, single speed shutter. All metal body, made only in 45x107mm size. Basic camera: \$90-130. Add \$45-60 for magazine back. Add \$120-180 for usable 127 or 120 film rollback, less for early 126 and 116 rollbacks.

Verascope, better models - Higher quality lenses and shutters. More common than the simple models. Basic camera: \$150-225. Add \$45-60 for magazine back. Add \$120-180 for usable 120 or 127 film back, less for early 126 or 116 rollbacks.

Verascope F40 - c1950's. Stereo camera for 24x30mm pairs of singles. Berthiot f3.5/40mm lens. Guillotine shutter to 250. RF. Made by Richard in France but sold under the Busch name in the U.S.A. Generally considered to be one of the best stereo cameras, and not often found for sale. With printer and transposing viewer: \$600-900. Camera and case: \$500-750.

RICHTER (Germany) Rica-Flex - c1937. 6x6cm TLR. Pololyt f3.5/75mmin Stelo shutter. \$100-150.

RIDDELL (A. Riddell, Glasgow) Folding plate camera - c1880's.
9x12cm. Built-in roller-blind shutter. \$250-375.

RIETZSCHEL (A. Heinrich Rietzschel GmbH Optische Fabrik, Munich, Germany) Merged with Agfa in 1925, at which time the Rietzschel name was no

used on cameras and the first Acfa

longer used on cameras and the first Agfa cameras were produced.

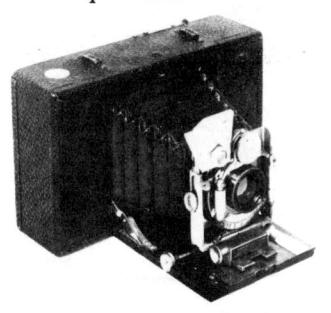

Clack I - c1910. Folding bed camera for plates. 9x12cm or 10x15cm sizes. Black leathered wood body, red bellows, nickel trim. f6.3 or f8 lens. Early version, c1900-01, has brass shutter: \$400-600. Later version with double pneumatic shutter: \$100-150.

Clack Luxus - Deluxe version of the Clack folding bed plate cameras. Brown leather, brown double extension bellows. Compur shutter. 6.5x9cm size has Solinar f4.5/120mm lens. 9x12cm has Linear f4.8/135mmlens. \$300-450.

Condor Luxus - c1925. Folding plate camera, 9x12cm. Brown leather covering, double extension brown bellows. Solinear f4.5/135mm in Compur shutter. Waist-level brilliant finder and large eye-level frame finder. \$300-450.

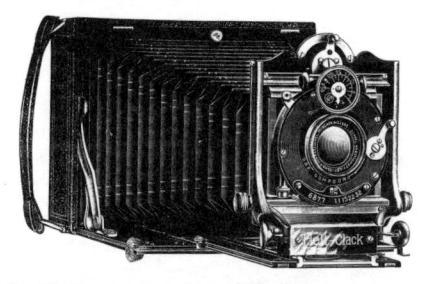

Heli-Clack, horizontal type - c1910. 9x12cm or 10x15cm horizontal format folding plate cameras. Double extension bellows. Double Anastigmat f6.8 or Tri-Linear f4.5 lens in Compound shutter. \$150-225.

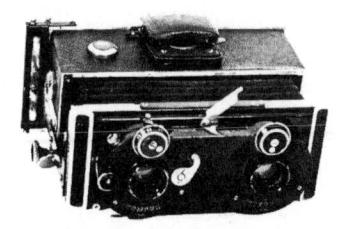

Kosmo-Clack Stereo - c1914. 45x107mm format. Double Anastigmat f6.3, Rietzschel f4.5/60mm or f6.8/65mm lenses in Compur 1-250. Panoramic photos also possible. \$350-500. A usable rollback would add \$120-180 to this price.

Ladies Hand camera - c1900. Horizontal folding camera, 9x12cm. Luxus covering of brown snakeskin, gold colored braided leather handle, polished nickel trim, beautiful wood interior, tapered winered bellows. When folded, the slightly tapered body, with its stylish exterior, looks like a ladies' handbag. Rietzschel Anastigmat f8 lens in double pneumatic 1-1/100 shutter. One sold at auction in 1990 for \$3350.

RIETZSCHEL...

Miniatur-Clack 109 - c1924. Small folding-bed camera for 4.5x6cm plates, it was the first camera produced by Rietzschel in this size. Double extension bellows. Linear Anastigmat f4.5/165mm lens in Compound or Compur shutter. \$250-375.

Platten Tip I - c1906-10. Double extension folding plate camera, 9x12cm size. Rectigraphique f8 lens in shutter ¹/₂₅-100. \$150-225.

Reform-Clack - c1910-1920's. 6.5x9cm folding plate camera. Dialyt f6.8/105mm in Compound or Dial-set Compur 1-250. Double extension bellows. \$100-150.

Taschen Clack 128 - c1920-25. Folding rollfilm camera, 4.5x6cm. Also accepts plates. (Rietzschel did not make very many rollfilm cameras.) Sextar f6.8/90mm in Compur. \$90-130.

Universal Heli-Clack - Folding bed camera. Similar to the regular Heli-Clack, but with wide lensboard.

- **Type I** - Panoramic with single lens. 13x18cm size, with Linear Anastigmat f4.8/210mm lens: \$150-225.8x14cm size: \$100-150.

- **Type II** - Stereo version with two lenses in stereo shutter. 13x18cm size with Doppel Apotar f6.3/120mm stereo lenses: \$500-750.8x14cm size: \$300-450.

- Type III - 3 lenses in Stereo-Panorama shutter. No sales data.

RIKEN OPTICAL (Japan)

Adler Semi - c1938. Folding-bed rollfilm cameras for 16 exposures 4.5x6cm on 120 film. Two different body types are most easily identified by the strut styles. One has lazy-tong struts and the other has the more common diagonal strut configuration. Adler Anastigmat f3.5 or f4.5 lens in Automat or Newmann-Heilemann shutter. \$75-100.

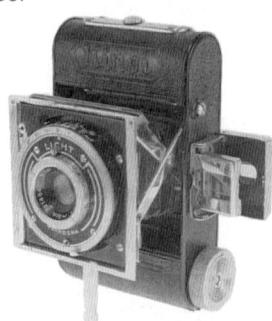

Baby Kinsi - c1941. Strut-folding 127 rollfilm camera taking 3x4cm exposures. Kinsi Anastigmat f4.5/5cm lens in Seikosha Licht shutter. \$300-450.

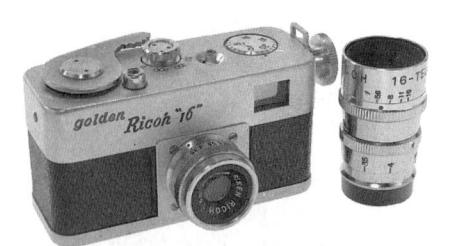

Golden Ricoh 16 with telephoto lens

Golden Ricoh 16 - c1957. Subminiature for 25 exposures 10x14mm on 16mm film. Interchangeable Ricoh f3.5/25mm fixed focus lens. Sync. shutter 50-200,B. Have sold for up to \$325 at German auction. Often found with case and presentation box for \$200-300 in USA. Camera and normal lens only: \$90-130.

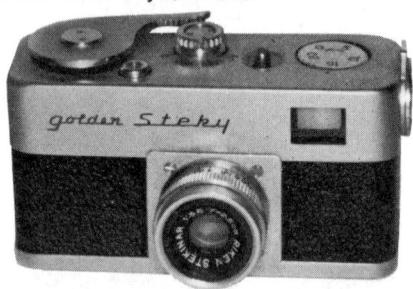

Golden Steky - c1957. Subminiature for 10x14mm on 16mm film. Same as Golden Ricoh 16 except for name. Shutter 50-200,B. Stekinar fixed focus f3.5/25mm lens. \$200-300. Add \$50 for f5.6/40mm telephoto.

Hanken - c1952. Subminiature camera nearly identical to the Steky III, but with additional waist-level viewer. Reportedly made for police use. Rare. Auction record (Christie's 12/91): \$2700. Real value is anybody's guess.

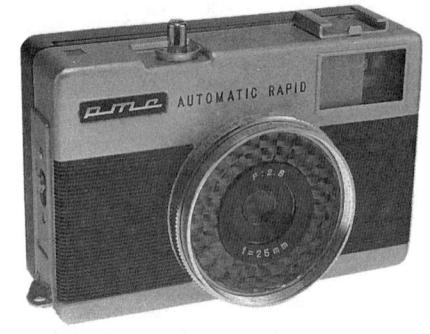

PMC Automatic Rapid - c1965. Compact 35mm camera for 17x24mm exposures on 35mm film in rapid cassettes. Selenium cell surrounds f2.8/25mm lens. \$35-50.

Ricoh 16 - c1958. Subminiature for 10x14mm exposures on 16mm film. Inter-

RIKEN

changeable Ricoh f2.8/25mm focusing lens. Shutter 50-200,B. Rapid wind. Like the Golden Ricoh 16, but in chrome. Much less common. \$200-300.

Ricoh 35 - c1955. 35mm RF. Ricomat f3.5/45mm lens in Riken shutter 10-200,B, or f2.8/45mm in Seikosha-Rapid 1-500,B. Film advance knob on top and rapid lever on bottom. \$30-45.

Ricoh 35 Deluxe - c1956. Rangefinder 35 with film advance by top knob or bottom lever. Riken Ricomat f2.8/45mm in Seikosha-MX. Early version has PC sync post on shutter, no embossed frames around finder windows, and a folding rewind crank which does not fit into the rewind knob. Next came the top housing with embossed windows and a more compact rewind crank. The sync post was later moved to the front of the top housing when the shutter setting rings were changed to read from the top. \$60-90.

Ricoh 35S - c1957. Rangefinder 35; film advance by top knob or bottom trigger lever. Ricoh f2.8/45mm in Riken B,10-300 shutter. Body style like the Ricoh 35 DeLuxe, but with quick focusing knobs added to lens mount. \$35-50.

Ricoh 35 Flex - c1963-66. 35mm SLR with coupled selenium meter on pentaprism front. Fixed Ricoh f2.8/50mm lens in 1/₂₀-300,B front shutter. \$60-90.

Ricoh 126C-Flex TLS - c1969-71. One of few sophisticated cameras for 126 cartridge film. SLR with aperture priority automatic metering. Fixed Rikenon f2.8/55 lens in B,30-300 shutter. \$75-100.

Ricoh 300 - c1959-60.35mm RF. Noninterchangeable Rikenon f2.8/45mm lens in Riken leaf shutter 1/₁₀-1/₃₀₀. \$12-20.

Ricoh 300S - c1962. Similar to the Ricoh 300. Shutter $\frac{1}{8}$ - $\frac{1}{300}$. \$20-30.

Ricoh 500 - c1957-61. 35mm CRF. Ricomat f2.8/45mm in Seikosha-MXL shutter 1-500. Lever advance on bottom with pivoting trigger. \$35-50.

Ricoh Auto 35 - c1960-65. 35mm. Top half of body is chrome, bottom blue-gray. Automatic electric eye meter cell surrounds lens. Ricoh f4/40mm fixed focus lens, shutter $\frac{1}{25}$ - $\frac{1}{170}$. Lever advance on bottom. \$30-45.

Ricoh Auto 35-L - same as Ricohmatic 35 below.

Ricoh Auto 35-V - c1961. Rectangular body. Automatic metering via selenium meter cell around lens. Bottom trigger advance. Bright frame finder. \$30-45.

Ricoh Auto 66 - c1960-64. TLR for 6x6cm on 120 rollfilm. Rolleimagic copy. Built-in coupled selenium exposure meter. Ricoh f3.5/80mm lens, Seikosha-L shutter 1-250. \$150-225.

Ricoh Auto Half - c1960-63. Springwind half-frame 35mm. Built-in selenium meter. Ricoh f2.8/25mm fixed focus lens in Seikosha shutter $1/_{30}$, $1/_{125}$. (Also sold in the USA as the Ansco Memo II.) \$35-50.

Ricoh Auto Half SE - 1967-69. Same features as the Ricoh Auto Half, but with self-timer. \$50-75.

Ricoh Auto Shot - c1960-66. Springwind 35mm. Built-in coupled selenium meter around lens. Rikenon f2.8/35mm lens in Copal shutter 1/₃₀, 1/₁₂₅. Unique lens cover becomes a flash attachment when inserted into accessory shoe. With lens cover: \$30-45.

Ricoh Auto TLS EE - c1973. 35mm SLR with TTL CdS shutter priority auto metering. Cloth shutter, 1-1000,B. Auto Rikenon

f1.7/50mm normal lens in universal Praktica thread mount. \$45-60.

Ricoh Diacord G - c1958. The simpler of the Diacords, model G has no meter. Helical focusing operated by levers at each side; focus scale at bottom. Ricoh f3.5/8cm in Citizen-MV B,1-300 shutter. \$75-100.

Ricoh Diacord L - c1958. TLR with built-in LV meter. Easily recognized by meter cell behind nameplate, and large meter knob on right hand side. Rikenon f3.5/8cm in Seikosha MXL shutter. \$60-90.

Ricoh Singlex - c1964-66. 35mm SLR. Nikon-bayonet mount Auto Rikenon f1.4/55mm lens. FP shutter 1-1000,B. Optional CdS meter on right side of front plate. \$100-150.

Ricoh Singlex TLS - c1968. Universal screwmount SLR with TTL CdS matchneedle metering. Metal shutter 1-1000. Rikenon Auto f1.4/50mm normal lens. Black or chrome body. \$60-90.

Ricoh Singlex II - c1976. Improved version of Singlex TLS, with hot shoe. \$75-100.

Ricoh Six - c1952. 6x6cm or 4.5x6cm on 120 rollfilm. Orinar f3.5/80mm. Riken shutter 25-100,B. \$60-90.

RIKEN...

Ricoh SLX 500 - c1976. Simplified version of Ricoh Singlex TLS. Lacks self-timer. Top speed 1/500. \$50-75.

Ricoh Super 44 - c1958. 127 TLR. Riken f3.5/60mm. Citizen-MV 1-400,B. \$75-100.

Ricoh Teleca 240 - c1971. Half-frame 35mm camera built into 7x50 binoculars. Rikenon f3.5/165mm lens. Copal 60-250 shutter. Motorized film transport. Same camera/binoculars sold under the Nicnon name. \$500-750.

Ricohflex - Models III (1950), IIIB (1951), IV (1952), VI (1953), VII (1954), VIIS (1955). (Note: There are no models I, II, or V.) 6x6cm TLR. Ricoh Anastigmat f3.5/80mmlens. \$35-50.

Ricohflex Dia - c1955. TLR, 6x6cm. Ricoh f3.5/80mm lens, Citizen-MXV shutter 1-400,B. \$50-75.

Ricohflex TLS-401 - c1970. 35mm SLR. Pentaprism converts from normal eye-level to reflex viewing by turning small knob on side of prism housing. CdS TTL metering. Auto Rikenon f1.7/50mm lens. \$90-130.

Ricohl Mod. 1 - c1941. Body styled like a 35mm camera, but for 3x4cm exposures on 127 rollfilm. Non-interchangeable Gokoku Anastigmat f3.5/50mm lens in Leica-style collapsible mount. FP shutter 2,20-500. Uncommon. One failed to reach a £1000 reserve at Christie's 7/93. Estimate \$600-900.

Ricohmatic 35 - c1961-64. Similar to the Ricoh Auto 35, but with coupled RF, faster f2.8/40mm focusing lens, and shutter to 200. \$35-50.

Ricohmatic 44 - c1956. Gray TLR, 4x4mm on 127. Built-in meter. Riken f3,5/60mm. Shutter 32-170, B. \$60-90.

Ricohmatic 225 - c1959-62. TLR, 6x6cm. Built-in direct reading selenium meter. Rikenon f3.5/80mm lens, Seikosha-SLV shutter 1-500,B. Crank film advance. Built-in 35mm adapter. \$100-150.

Ricolet - 1954. First Riken 35mm camera. No rangefinder. "RICOLET" on front of cast-metal finder housing. Ricoh f3.5/45mm. Riken 25-50-100, B shutter. \$30-45.

Ricolet S - 1955. Similar to original Ricolet, but shutter $1/_{10}$ - $1/_{200}$, new top housing has room for rangefinder, but none present. \$30-45.

Ricolet II - 1955. Body style is similar to Ricolet S, but with coupled rangefinder. Larger, single shroud covers linkage arms between body and lens. Ricoh f3.5/4.5cm lens in Riken B,1/10-1/200 shutter. \$35-50.

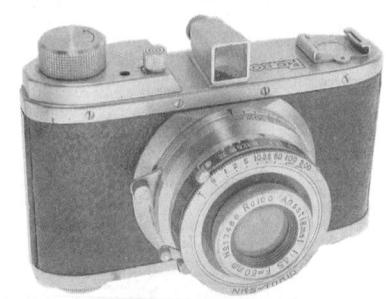

Roico - c1940-43. Eye-level camera for 4x4cm on 127 film. Telescoping front. Automatic film stop. Roico Anastigmat f3.5/60mm. Early model c1940 has T,B,1/₅-1/₂₀₀ shutter. Later, c1943, with R.K.K. or NKS T,B,1-200 shutter. \$120-180.

Semi Heil - c1941. Folding "Ikonta-style" camera for 16 on 120 film. Ukas f4.5/75 in Heil shutter or Wester f3.5/75 in Buick Model-1 shutter. Variations in body, struts, and finder. Uncommon. \$100-150.

Steky - c1947. Subminiature for 10x14mm exposures on 16mm film. Nickel plated body. Stekinar f3.5/25mm Anastigmat fixed focus lens in interchangeable mount. Shutter 25, 50, 100. \$90-130. Up to

50% higher in Europe, or with original wooden box.

Steky "Made in Tokyo" - c1947. Possibly the earliest type of Steky camera. "MADE IN TOKYO" stamped on side, but "Japan" has not been engraved below it. Rare. \$350-500.

Steky "Made in Tokyo, Japan" - c1947. Early variant of nickel-plated original Steky. "MADE IN TOKYO" stamped on the side, and "JAPAN" engraved below. Uncommon. Auction record 12/91 \$650. Few previously known sales, \$300-450.

Steky II, III, IIIa, IIIb - c1950-55. Only minor variations in the models. All have focusing, interchangeable screw-mount lenses. \$75-100. 50% higher in Europe. (Add \$25 for tele lens.)

Telephoto (left) and Wide Angle (right) lenses with accessory viewfinder

Steky Accessories:
-Steky Flash Gun - \$8-15.
-Steky Pocket Tripod - Compact pocket tripod with telescoping legs and

camera bracket. \$25-35.

-Steky Telephoto Lens f5.6 - Dou-

bles the size of the image. \$25-35.
-Stekaton Telephoto f3.2/40mm -Introduced in response to a demand for a faster telephoto lens. Helical focusing mount, leather case, viewfinder mask. Focuses to 3.5 feet. \$35-50.

-Sunshade & Filter Kit - Leather case contains four filters: haze, red, green, and

blue conversion, plus sunshade. \$15-25.

-Wide Angle Converter - Fits on front of normal lens to convert it to a 17mm wide angle lens. With finder & case. \$25-35.

-Transparency viewer viewer for unmounted strips of transparencies. \$12-20.

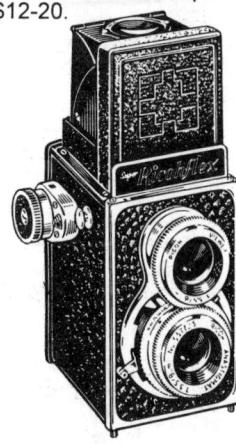

Super Ricohflex - c1955. TLR for 120 film or for 3 different film sizes with appropriate inserts: 6x6cm on 120, 4x4cm on 127, 24x36mm on 35mm. Ricoh Anastigmat f3.5/80mm. Riken shutter 10-300, B. Originally sold for just \$20 for the basic camera, \$10 for the 35mm insert, & \$5 for the accessory auto-stop advance knob. Multi-film model has two selectable red windows on back; simpler model for 120 film only has single red window. Common. \$35-50.

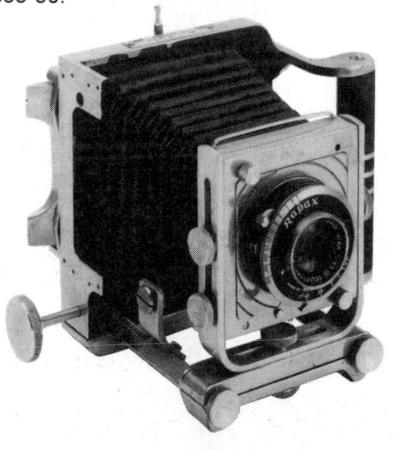

RILEY RESEARCH (Santa Monica, CA) Rilex Press - c1948. 21/4x31/4" all aluminum press & view camera with generous front movements and revolving back. Tessar f4.5 or Wollensak Velostigmat f4.5 lens. The first model had just gone into production when the company made the decision to change the body casting to allow a Kalart rangefinder to be fitted. Overnight, the dies were altered. Most examples are rangefinder compatible. Bodies are identified as models A, B, and AB. \$150-225.

RILO - 6x9cm metal box camera, leatherette covering. \$12-20.

RIMEI BOX - Box camera for 6x6cm exposures. \$35-50.

RING CAMERAS - Beginning in the mid-1980's, several ring cameras of similar design have appeared on the collector market, originating in Poland. They are very well crafted, each differing from the others in appearance, though operationally similar. The film strip mounts in an inner ring which surrounds the finger. This fits into the outer ring which forms the body of the camera. Normally a sliding button on one side advances the film, and a small adjacent button fires the shutter when the fingers are squeezed together. The lens is the center jewel. See the maker MAZUR for further details. Also see FERRO for a different ring camera made in Italy.

RIPPAFLEX - c1955. Japanese TLR for 6x6 on 120 film. Tri-Lausar lens. Knob advance. \$75-100.

RIVAL - c1953-57. Folding camera made in versions for 620 and 120 rollfilm. $21/4 \times 31/4$ " or $15/8 \times 21/4$ ". f4.5 lens, shutter to 200. \$12-20.

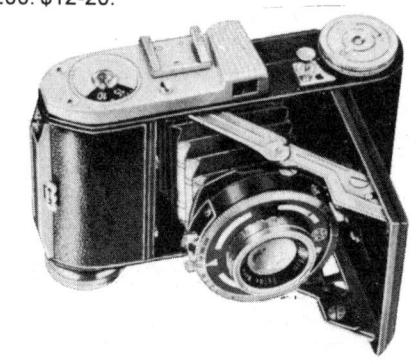

RIVAL 35 - c1950. Folding 35mm made by Balda Bünde and sold by Peerless Camera Stores in U.S.A. Radionar or Ennagon f3.5/50mm in Prontor S shutter. \$30-45.

RIVAL 120 - c1950. Box camera for 6x9cm on 120 rollfilm. Art-deco front plate. \$12-20.

RIXA KAMERABAU (Ludwigsburg, Germany) The Rixa cameras are also attributed to Emil Baumann, Stuttgart, and Münch GmbH, Ludwigsburg.

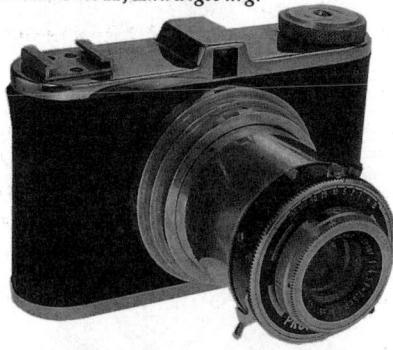

Rixa - c1951. Simple, metal camera with telescoping front. Model I: f7.7/7.5cm in Vario. Model II: Ennar f4.5 in Pronto. Model III: Ennar f3.5 in Pronto. \$35-50.

RO-TO (Turin, Italy)

Elvo - c1938. Brown bakelite strut-folding camera for 3x4cm on 127 film. Achromatic f8 lens. \$60-90.

ROCAMCO

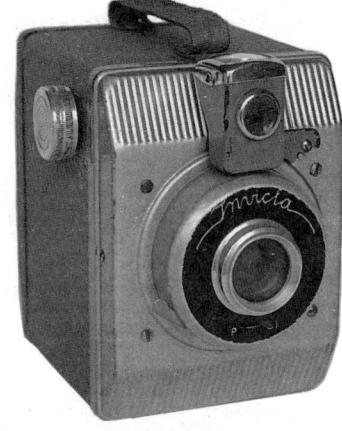

Invicta - c1950. Metal box camera with pivoting finder. Uncommon. \$25-35.

Nea Fotos - c1948. Inexpensive bakelite 35mm camera with telescoping front, curved film plane. Eye-level finder. f7.7/54mm lens. Shutter: 25-100,B. \$25-

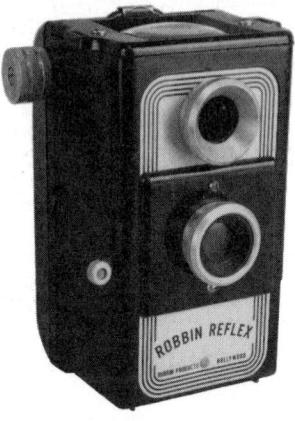

ROBBIN PRODUCTS (Hollywood, CA) Robbin Reflex - Simple TLR-style box camera similar to the Herco-Flex 620. Made by Herbert George Co. for Robbin. A common looking camera, but uncommon with this name. Originally with a cheap imitation leather ever-ready case. \$8-15.

ROBINSON (J. Robinson & Sons) Luzo - c1889. Mahogany detective box camera. 6x6cm on rollfilm. A model also exists for glass plates. Aplanat f8/75mm. Rotary sector shutter. \$1200-1800.

ROCAMCO PRODUCTS (Boonton, NJ) Also known as Rochester Camera Co., New York City. Named for its president, Richmond Rochester.

Rocamco - c1936. Small metal box for 2.5x3cm on special 35mm film. \$150-225. Illustrated at top of next page.

ROCAMCO...

Rocamco

Rocamco No. 3 Daylight Loading **Camera** c1938. Rollfilm 30x32mm on special rollfilm. Small bakelite camera. "A Rochester Product" molded on back. "No. 3 Daylight Loading Rollfilm Camera" designation is used on the original box. \$45-60

ROCHE (J. Roche, Villeurbanne, France)

 c1948. Leatherette covered stamped metal eye-level camera for 6x9cm. Cast aluminum top and front. Achromatic f11 lens in simple I&P shutter. Very uncommon, having not sold well even in France. \$60-90.

Rox - c1948. Similar to the Allox, but with Rox.A f8 Aplanat or Trylor f4.5 lens in Gitzo shutter. Uncommon even in France. \$90-130.

ROCHECHOUARD (Paris)

Le Multicolore - c1912. Magazine box camera for 9x12cm plates. Color filters could be moved into place, one at-a-time behind the lens for color separation plates. Rapid Rectilinear lens. Guillotine shutter. \$1200-1800.

ROCHESTER CAMERA MFG. CO. **ROCHESTER CAMERA & SUPPLY CO. ROCHESTER OPTICAL COMPANY ROCHESTER OPTICAL & CAMERA CO.**

THe Rochester OPTICAL Company was established in 1883 when W.F. Carlton took over the business of Wm. H. Walker & Co. Rochester CAMERA Mfg. Co. was founded in 1891 by H.B. Carlton, brother of W.F. Thus there existed in Rochester, N.Y. two contemporary companies with similar names and owned by brothers. Their major camera

lines even had similar names. The Rochester CAMERA Mfg. Co. made POCO cameras, while the Original Rochester OPTICAL Company began the PREMO camera line in 1893. To further complicate the name game, the Rochester Camera Mfg. Co. changed its name in 1895 to "Rochester Camera Co.", and in 1897 to "Rochester Camera & Supply Co.". In 1899, the two "Rochester" companies merged with Monroe Camera Co., Ray Camera Co. (formerly Mutschler & Robertson Co.), and Western Camera Mfg. Co. of Chicago (mfr. of Cyclone cameras), to form the new "Rochester Optical and Camera Company". The new company retained the original products: Cyclone, Poco, Premo, and Ray. In 1903, George Eastman purchased the company and shortened the name again to "Rochester Optical Co.". In 1907 it became "Rochester Optical Division, E.K.C." and finally "Rochester Optical Department" in 1917. While the many name changes can seem confusing at first, they do help to date particular examples of cameras: Rochester Camera Mfg. Co.: 1891-1895

Rochester Camera Co.: 1895-1897 Rochester Camera & Supply Co.: 1897-1899 Rochester Optical Co.: 1883-1899, (& 1903-

1907, owned by Eastman) Rochester Optical & Camera Co.: 1899-1903 Rochester Optical Div., EKC: 1907-1917

ROCHESTER CAMERA MFG. CO.

Favorite - c1890. 5x8" or 8x10". Brass Emile No. 5 lens with waterhouse stops. \$250-375.

Folding Rochester - c1892. The first folding plate camera that they made. 4x5" and 5x7" sizes. Made only briefly. Seldom seen. \$400-600.

Pocket Poco A - c1903. Strut-folding plate camera similar in design to the Pocket Monroe A (see Monroe). 31/4x41/4' size. B&L Achromatic lens, Automatic shutter. NOT similar to the Pocket Poco which is a folding bed camera. \$175-250.

Poco Cameras - Introduced in 1893. Listed here by size:

- 31/4x41/4", Pocket Poco - Folding plate camera. Red bellows, RR lens, single pneumaticshutter. \$75-100.

- 4x5", Folding-bed plate cameras - Models 1-7, A, B, C, including Cycle

Pocos. Leather covered wood body. Nicely finished wood interior. Often with B&L RR lens and Unicum shutter. \$90-130.

- 5x7", Folding-bed plate cameras - Models 1-5, including Cycle Pocos. Black leather covered wood body. Polished interior. Red bellows. RR lens. Unicum shutter. \$120-180.

8x10" - Similar, but larger. Double extension bellows. B&L Symmetrical lens. \$120-180.

Gem Poco - c1897. 4x5" box for plates. Focuses by sliding lever at left front. Shutter tensioned by brass knob on face. \$60-90.

Gem Poco, folding - c1895. Very compact folding camera for 4x5" plates in standard holders. Red bellows. Polished wood interior. Shutter built into polished wood lensboard. \$120-180.

King Poco - c1899. 5x7" folding view, advertised as "Compact, elegant in design, and equipped with every known appliance. Especially adapted for those desiring the most perfect camera made." This was the top of the line. Not seen often. \$200-300.

Stereo Poco - c1898-1903. Folding plate camera, 5x7". Basic body style is similar to the Cycle Poco cameras. Rapid Rectilinear lenses in pneumatic Unique Stereo shutter, \$350-500.

Telephoto Poco, Telephoto Cycle

- 4x5" - c1891. Folding plate camera. Double or triple extension red leather bellows. B&L lens in Auto or Victor shutter.

Some have storage in back of camera for extra plateholders. \$120-180.

- **5x7"**, **61/**₂**x81/**₂" - c1902. Folding plate cameras. Red leather bellows, double or triple extension. B&L RR lens, Auto shutter. \$120-180.

Tuxedo - c1892. Leather covered 4x5" folding plate camera. Black wood interior, black wood front standard. This is an all-black version of the Folding Rochester camera. Brass trim. \$250-375.

View - c1899. Tailboard view in sizes 5x7" to 8x10". Maroon bellows, nickel trim. With contemporary brass lens. \$250-375.

ROCHESTER OPTICAL CO.

Carlton - c1893-1903. The last and the finest of Rochester Optical Company's view cameras, named for the company founder. All-wood, double extension view, similar to the Universal. Double swing back can be moved forward to avoid bed interference with wide angle lenses. Swiveling tripod head built into bed. Brass trim. With lens: \$300-450.

Cyclone Cameras - (formerly made by Western Camera Mfg. Co., prior to 1899.)

Magazine Cyclone - No. 2, 4, or 5. c1898. For $3^{1}/_{4}$ X41/₄" or 4x5" plates. Black leathered wood box. Meniscus lens, sector shutter. \$60-90.

Cyclone Junior - c1902. Plate box camera for 31/₂x31/₂" glass plates in standard holders. Top door hinges forward to load plateholders. A cheaper alternative to the more expensive magazine cameras. \$45-60.

Cyclone Senior - c1902. Plate box camera, 4x5" for standard plateholders. \$35-50.

Cyko Reko - c1900. An export model of the Pony Premo D. Made for Army & Navy Auxiliary Supply, London. Folding bed camera for 4x5" plates. Meniscus Achromatic lens in Unicum shutter. \$90-130.

Empire State View - c1895. Folding field camera. Polished wood. Brass fittings. 5x7" & 6¹/₂x8¹/₂": \$90-130. 8x10": \$120-180. 11x14": \$250-375.

Folding Pocket Cyko No. 1 - For 31/4x41/4" plates. Aluminum body. Sector shutter. \$250-375.

Handy - c1892. 4x5" detective box-plate camera. Internal bellows focus. A simple, less expensive version of the Premier. \$120-180.

Ideal - c1885-95. Folding view cameras, 4x5" to 8x10" sizes. Cherry wood, brass trim. Ranging in price, depending on size and equipment, from \$175-250.

Monitor - c1886. View camera in full plate and 8x10" sizes. Wood body folds in the "English" compact style. \$175-250.

ROCHESTER

New Model View, New Model Improved View - c1895. All common sizes from 4x5" to 8x10". \$200-300

Peerless view - c1897. 5x7" plates. Dark mahogany Brass Wollensak Regular shutter. \$200-300.

Premier box camera - c1891. Internal bellows focus with external control knob. Side panel opens to insert plate holders. 4x5 and 5x7" sizes. \$175-250.

Premier folding camera - c1892. 4x5 or 5x7" plates. Originally with shutter built into wooden lensboard: \$350-500. Later with B&L pneumaticsh.: \$250-375.

Premo Cameras See also Eastman for their continuation of the Premo line. Prices here are for cameras with normal shutter/lens combinations. (Often B&L lenses, Victor shutter.)

es, Victor shutter.)
- 31/4x41/4" - Pony Premo No. 2, Star Premo, etc. Brass RR lens; Gem shutter. \$100-150.

- **4x5"** - c1900. Folding plate cameras, including: Pony Premo, Premo Senior, Star

ROCHESTER...

Premo, Premo A-E, 2, 4, 7, and 15. Red bellows. EUR: \$100-150. USA: \$75-100.

- 5x7" - c1900. Red bellows folding plate cameras, including: Pony Premo B and E, Pony Premo Sr., No. 4, and No. 6, Premo No. 6, Premo B, Premo Senior. \$120-180.

Premo Folding Film Camera No. 1-1904-05. Folding bed cameras for film-packs. Made in 31/₄x41/₄", 31/₄x51/₂", and 4x5" sizes. Double RR lens in Gem Automatic shutter. \$75-100.

Premo Folding Film Camera No. 3 - 1905. Folding bed camera for filmpacks. Same as No. 1 in three sizes, but better lens/shutter equipment including: f6.8 B&L Plastigmat, B&L Zeiss Protar, f6.8 Goerz Double Anastigmat, or Planatograph lens, Volute or B&L Automaticsh. \$100-150.

Folding Premo Camera - 1893-94. This is the original folding plate model. Rapid Rectilinear lens, Star shutter. Sizes 4x5", 5x7", and 61/₂x81/₂". \$150-225.

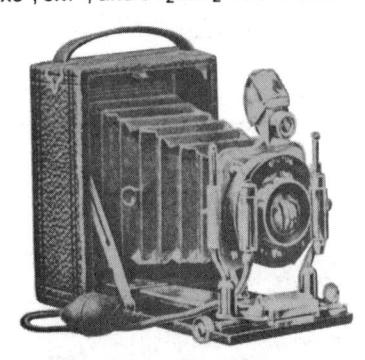

Pocket Premo - 1903-05. 31/₄x41/₄" folding bed camera for plates or filmpacks. Various lenses in B&L Automatic or Volute shutter. \$50-75.

Pony Premo No. 5 - 1898-1903. Various lens/shutter combinations. For plates. 4x5": \$75-100. 5x7": \$90-130. 61/₂x81/₂", much less common: \$150-225.

Long Focus Premo - 1895-1904. Triple extension red bellows. Sizes 4x5, 5x7, 61/₂x81/₂". Various lens/shutter combinations. \$250-375.

Premo Reflecting Camera - 1905-06. 4x5" single lens reflex camera with front bed and bellows (unlike the later Premograph). Various B&L or Goerz lenses. FP shutter. Reversible back. Tall focusing hood supported by trellis strut. This is a rare model and should not be confused with the less rare Premograph. Price negotiable. A few known sales at: \$800-1200.

Premo Sr. Stereo - 1895-1900.5x7" or full plate. Rapid Rectilinear lens. B&L Stereo pneumatic shutter. Maroon bellows. Folding plate camera, a modification on the Premo Sr. \$350-500.

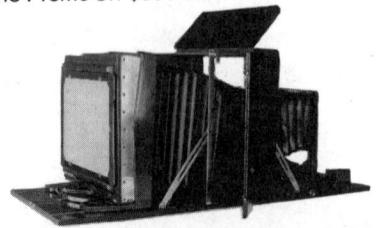

Reversible Back Premo - 1897-1900. Made in 4x5, 5x7, 61/₂x81/₂, & 8x10" sizes. Looks like a Long Focus Premo, but back also shifts from horizontal to vertical. Identified on nameplate at base of front standard. \$200-300.

Reko - c1899. Folding camera for 4x5" plates. Leather covered mahogany body with brass trim. Red leather bellows.

Special Reko Rectilinear lens in Unicum shutter, Uncommon, \$90-130.

Rochester Stereo Camera - c1891. Wooden stereo field camera with folding tailboard. 5x7 or 61/₂x81/₂" size. B&L shutter. Red bellows. \$300-450.

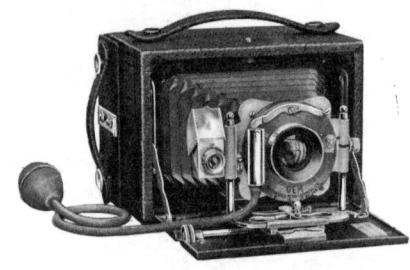

Snappa - c1902. Unusual 1/4-plate folding-bed view with integral magazine back. Holds 12 plates or 24 cut films. Red bellows, nickel & brass fittings. RR lens. Quite rare. One sold in early 1982 for \$585 in very fine condition. Several subsequent sales at \$150-200 in need of some work. At Christie's 11/93, a nice example in original box brought about \$550.

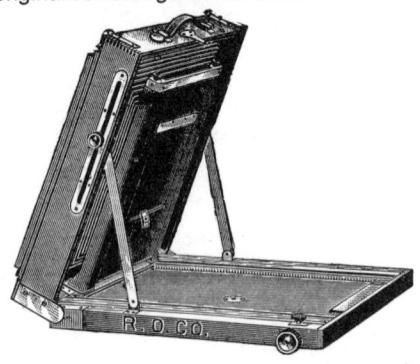

Universal - intro. 1888. Polished wood view, 5x7" or 61/₂x81/₂". Brass trim, brass barrel lens with Waterhouse stops. \$175-250

ROCKET CAMERA CO. LTD. (Japan)

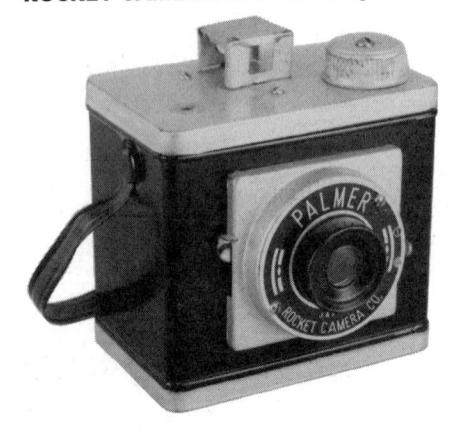

General, Palmer, Rocket Camera - c1955. Simple metal box cameras, 4x5cm exposures on 120 film. Fixed focus, B,I shutter. \$12-20.

New Rocket - Early postwar Japanese novelty subminiature, 14x14mm. Some cameras are marked "Rocket Camera Co." below lens, others have "Tokyo Seiki Co. Ltd." A third variation has "New Rocket" on the shutter face and no manufacturer name. All have "New Rocket" on top. Chrome: \$175-250. Gold: \$300-450. *Illustrated at top of next page.*

New Rocket

RODEHÜSER (Dr. Rodehüser,

Bergkamen, Westf., Germany)
Panta - c1950. Cast metal camera body
with telescoping front. Made in two sizes: 5x5.5cm exposures on 120 rollfilm, or 4x6.5cm exposures on 127 rollfilm. Ennar f4.5, or Steiner or Radionar f3.5/75mm lens with Prontor, Prontor S, or Vario shutter. \$45-60.

RODENSTOCK (Optische Werke G. Rodenstock, Munich) Never made cameras, but sold mainly Welta cameras with Rodenstock lenses under their own names.

Astra - Double extension folding plate camera 6.5x9cm. Eurynar f6.8/90mm in Compound shutter. \$45-60.

Citoklapp - c1930. Self-erecting folding rollfilm, 6x9cm. Trinar f4.9/100mm lens in Pronto shutter. \$50-75.

Citonette - c1933. Self-erecting folding bed camera for 16 exposures, 4.5x6cm, on film. Trinar f2.9 or f3.9, Ysar f3.5 or f4.5/75mm. Pronto S or Compur S shutter. \$45-60.

Clarovid, Clarovid II - c1932. Foldingbed dual-format rollfilm cameras for 6x9cm or 4.5x6cm exposures. Trinar Anastigmat f4.5 or f3.8/105mm lens. Rim-set Compur 1-250 shutter. Coupled rangefinder. The

rangefinder is Rodenstock's, but the camera body is from Welta, \$120-180.

Folding plate/sheetfilm camera -6.5x9cm or 9x12cm. f2.9, f3.8, or f4.5 Trinar, \$45-60.

Folding rollfilm camera - Models for 120 rollfilm, 4.5x6 and 6x6cm, or 116 rollfilm. Rodenstock Trinar f2.9 or Eurynar f4.5 lens. Rim-set Compur 1-250. \$35-50.

Prontoklapp - c1932. Self-erecting folding bed camera for 6x9cm on 120 film. Trinar Anastigmat f4.5 or f5.8/105mm. Vario, Pronto, or Compurshutter. \$30-45.

Robra - c1937. Folding camera, 4.5x6cm on 120. Robra Anastigmat f3.5/75mm. Compurshutter. \$50-75.

Rodella - c1932. Strut-folding rollfilm camera, 3x4cm exposures. Trinar f4.5 or f2.9/50mm lens in Prontor II or Compur shutter, \$75-100

Rodinett - c1932. Small rollfilm 3x4cm camera with front "barn-door" and strut system to support lens panel. Made by Glunz, using the body of the equally scarce Glunz Ingo, but fitted with a Roden-stock Ysar f3.5/50mm lens. Asking price in Tokyo \$600. Sales records: \$300-450.

Rofina II - c1932. Strut-folding vest pocket camera for 4x6.5cm on 127 film. Trinar f2.9/75mm in Compur-S.\$75-100.

Wedar, Wedar II - c1929. Folding bed camera. Model II has rack and pinion focus. Made in 6.5x9cm and 9x12cm plate sizes. Various lenses and shutters. \$35-

ROLLO-FREX

Ysella - c1932. Strut folding camera with bed. Half-frame 127. Trinar f2.8 or 4.5/50mmin Compurshutter. \$75-100.

ROGERS JUNIOR - Folding 6x9cm rollfilm camera. Uncommon. \$30-45.

ROKUOH-SHA - See Konishiroku

ROKUWA CO. (Japan) Stereo Rocca - c1955. Plastic stereo camera for 23x24mm stereo pairs side-byside on 120 rollfilm. Film travels vertically through camera. Fixed focus f8 lens, shutter 30, B. \$150-225.

ROLAND (Alphonse Roland, Brussels, Belgium) Folding plate camera - c1895. Leather covered mahogany body, brass trim, brass f11 lens. 9x12cm. \$250-375.

ROLLO-FREX - c1941. Forget the technical description. The name alone makes it a crassic. Possibly made by Taiko-do Co. Relatively scarce TLR from the immediate pre-war period. Rarity and the unusual name would surely attract a few buyers. No known sales. Estimate: \$200+

ROLLS

ROLLS CAMERA MFG. CO. (Chicago)

Beauta Miniature Candid - Bakelite minicam for half-127 film. Originally sold as a punchboard premium. \$1-10.

Picta Twin 620 - Cast aluminum camera for 620 film. Front appears to be collapsing type, but is rigid. Rollax 62mm lens in simple shutter. \$15-25.

Rolls - c1939. Bakelite novelty camera for half-frame 127. \$1-10.

Rolls Twin 620 - c1939. Cast aluminum box camera for 620 film. \$15-25.

Super Rolls 35mm, f3.5 - Inexpensive 35mm cast metal camera with body release. Retractable front with helical focusing. Shutter 25-200. Achromatic Rollax f3.5 lens. \$20-30.

Super Rolls 35mm, f4.5 - Similar, but

without body release. Anastigmat f4.5 lens. \$20-30

Super Rolls Seven Seven - Heavy cast metal camera for 4x5.5cm exposures on 620 film. T,B,I leaf shutter with body release. Named for its f7.7 Achromatic Rollax lens. Focuses 3' to infinity by manually extending the front to proper footage mark. \$15-25.

RONDO CAMERA CO. (Japan)

Adams Auto 35 - c1962. Simple autoexposure 35mm with fixed-focus lens. Also sold under other names, including Rondo 35, Wards 35EE, etc. \$20-30.

Rondo Colormatic - c1962. 35mm camera with meter cell surrounding lens. \$20-30.

Rondo Rondomatic - c1962. Identical to the Colormatic. \$20-30.

ROROX - 3x4cm on 127 film. Bottom loading. \$45-60.

ROSKO - Novelty camera of the "Diana" type. Imitation meter grid on top housing. \$1-10.

ROSKOFLEX - Novelty TLR-style box camera for 4x4cm on 127 film. \$12-20.

ROSS (Thomas Ross & Co.)

Field Camera - c1890. Half-plate mahogany compact folding camera with square cornered bellows. Front standard is hinged at the base to a sliding brass frame which expands via a micrometer screw to lock into position. Bellows lift out from the front standard to close. Some versions have a round brass tripod head built into the bed. Ross Rapid Symmetrical 6x5 lens. \$300-450.

Folding Twin Lens Camera - c1895. Boxy twin lens reflex style camera. Front

double doors open straight out. Goerz Double Anastigmat f7.7/5" lens. \$750-

Kinnear's Patent Wet Plate Landscape Camera - c1860's. Wet plate field camera. Mahogany construction, tapered bellows. Named for the patented bellows design of C.G.H. Kinnear, a Scottish photographer. His tapered bellows folded more compactly than the typical square type of the day. Made in 6x7" and 10x12" size. Brass barrel landscape lens. \$750-1000.

Portable Divided Camera - c1891. Called "Portable Twin Lens Camera" beginning in 1895. Boxy twin-lens reflex. Front door is hinged at left side and swings 270° to lay flat against the side of the body. Wooden body is covered with handsewn black hide. Ross Rapid Symmetrical lens. \$600-900.

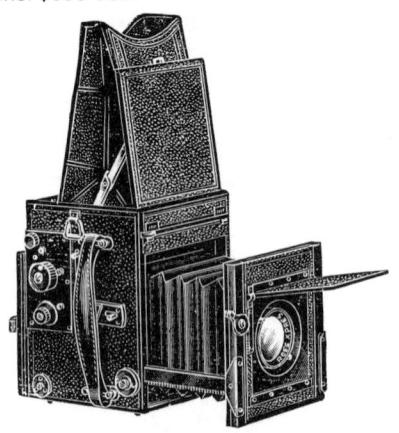

Reflex - c1912-35. Single lens reflex, similar to the Marions Soho Reflex. 1/4plate to 5x7" sizes. FP 1/14-800. \$200-300.

Stereo camera - c1900. 1/2-plate. Polished mahogany tapered leather bellows. Ross lenses. Thornton-Pickard shutter. \$750-1000.

Sutton Panoramic Camera - c1861. Designed by Thomas Sutton, who sold the rights to Ross. Takes curved glass plates

in special curved holders. And wet collodion plates at that! Only about 30 were made. The lens is water-filled and gives an angle of 120°. Three of these cameras sold at auction in 1974 for approximately \$24,000 to \$27,000. In June 1983 there were two offered for sale at \$14,000 and \$17,000. Confirmed sales known at that time in the \$12,000-14,000 range. The most recent sale we know of was Christie's 11/92 for £26,000 plus commissions. Beware of reproductions; at least one wellcrafted forgery was represented and sold as an original.

Tailboard camera (dry plate) -

c1888. Mahogany and brass folding plate camera, brass trim, brass bound Ross lens. Thornton-Pickard FP shutter. 1/2plate, to 10x12 sizes. \$300-450.

Tropical Reflex (postcard size) -Polished teakwood body, lacquered brass Red leather bellows and viewing hood. Ross Tessar f4.5/150mm lens. Cased outfit with tropical darkslides and film pack adapter: \$2800-4000.

Twin lens reflex (double door style) - Introduced later than the Portable Twin Lens Camera in a more compact design. Stitched black hide over mahogany body. The lens panel slides out in grooves in the front doors. Sometimes fitted with a Thornton Pickard shutter which pushes on to the front of the lens. Simple hinged viewing hood. Ross Symmetrical lenses. "ROSS LONDON PATENT" nameplate on front near top. \$750-1000.

Wet plate camera (sliding box style) - Each camera must be individually

evaluated. Prices generally range from \$2000-5000.

Wet plate camera (tailboard style) - c1865. Mahogany camera with folding tailboard and bellows. Brass fittings. Brassbound Ross or Euryscop lens with waterhouse stops. Various sizes. Full outfits have sold for \$4500-6500; cameras from \$2000-3000.

Wet plate Stereo (sliding-box style) - Mahoganybody. Grubb or Dallmeyer brass bound lenses. \$3500-5500.

Wet plate Stereo (tailboard style) c1865. Full plate size. Maroon square bellows. Ross Petzval 6" lenses, waterhouse stops. \$3200-4600.

ROSS ENSIGN LTD. Fulvueflex Synchroflash - c1950. Inexpensive plastic reflex-style box camera, 6x6cm on 120 film. Fixed focus Astar

Ross lens, B & I shutter. Twin sockets on left side for flash. \$20-30.

Snapper - Self-erecting camera for 6x9 on 620 film. Cast aluminum body with integral eye-level finder. Grey crinkle-finish enamel. \$25-35.

ROTH (A. O. Roth, London)

Mainly an importer of Meyer lenses and Mentor cameras.

Reflex, 4.5x6cm - c1926. SLR. Hugo Meyer Trioplan f6.3/75mm lens in FP shutter 10-1000.\$350-500.

Reflex, 8x10.5cm - c1920's. SLR. Hugo Meyer Trioplan f2.8/95mm lens in FP shutter 10-1000, \$250-375.

ROTHLAR-OPTIK

Rothlar/Gezi 4x4 - Bakelite body with stamped aluminum top and bottom. Same body as Gezi II, but with single finder. The only identification on the camera is "Made in Germany" stamped on the rear of the top. "Achromat F=6cm" on lens rim. Z & M speeds on middle lens collar. Rear collar has stops: 16, 12.5, 9. Identifying characteristic: the back latch button is oddly located front and center, above and behind lens. If you happen to find one in its original case, the case front says "Rothlar-Optik". \$35-50.

ROUCH (W.W. Rouch & Co., London, England)

Eureka - c1888. Polished mahogany detective camera. Magazine for 12 8x8cm exposures or 1/4-plate size. Brass barrel Rouch 150mm lens, rollerblind shutter. Also exists in black version. \$400-600.

Excelsior - c1890. Mahogany detective camera, similar to Eureka, but takes ordinary double slides as well as the Eureka magazine back. 1/4-plate size. \$400-600.

Patent Portable Camera - c1880's. Mahogany field camera with brass fittings. Unusual folding design. The baseboard, in the collapsed position, covers and protects the ground glass screen, and the extensible wooden track is exposed to the rear. Bed pivots 270° and front standard clips to track. Focus knob is on removable center track, not on edge of bed as most cameras of the period. Earliest versions for 71/2x71/2" wet plates. Later, c1885, for dry plates. Sizes from 43/4x61/2 to 12x15 inches. Ross Rapid Symmetrical lens with Waterhouse stops. \$600-900 in England.

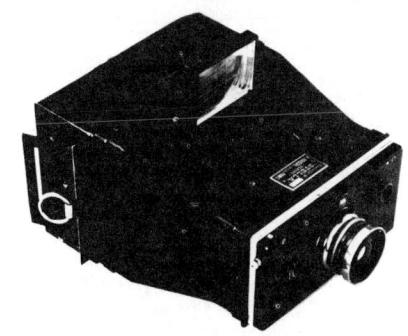

ROUSSEL (H. Roussel, Paris) Stella Jumelle - c1900. 9x12cm plates. Roussel Anti-Spectroscopique f7.7/130mm in 7-speed guillotine shutter. Leather covered wood body. \$250-375.

ROVER - Hong Kong "Diana" type novelty camera. \$1-10.

ROYAL CAMERA CO. (Japan) Royal 35 - c1960. 35mm RF. Non-changeable Tominor f2.8/50mm lens. Copal 1-300 shutter. \$100-150.

ROYAL...

Royal 35M - c1957. 35mm with coupled rangefinder, built-in selenium meter. f2.8/45mm Tominor in Copal MXV. \$60-90.

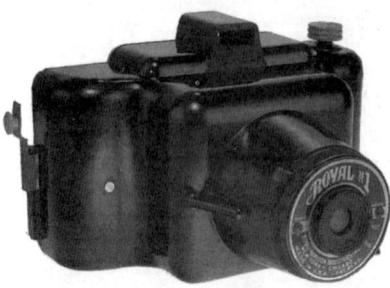

ROYAL-HAMILTON INDUSTRIES INC.

(New York & Chicago)
Royal #1 - Unusually styled bakelite camera for 21/₄x31/₄". Obviously related to the many "minicam" types for 3x4cm on 127 and 828 film, this one is overgrown and with protruding snout to hold the normal sized lens and shutter. Quite uncommon. The only example known to us sold most recently in 10/92 for \$50.

ROYALCORD - c1956-64. Semi-automatic TLR, 6x6cm. Horinor Anastigmat f3.5 /75mm, Ceres 1-300 synchro. \$100-150.

ROYCE MFG. CO.

Royce Reflex - c1946. Twin lens reflex, cast aluminum body and back. Externally gear-coupled lenses. f4.5/75mm in Alphax shutter 25-150, T,B. \$30-45.

ROYER (René Royer, Fontenay-sous-Bois, France) Officially named SITO (Société Industrielle de Technique Optique), the company is more commonly known by the name of the founder. The name Royer appears on the cameras, but not the name "VITO"

but not the name "SITO".

Altessa - c1952. Telescoping front.
Takes 6x9cm or 6x6cm on 120 film. Interchangeable Angenieux 3.5/105. \$75-100.

Royer A - c1949. Self-erecting folding bed camera for 6x9cm on 120 film. Built-in optical finder. Angenieux Type VI f4.5/105mmin Sito 10-200. \$20-30.

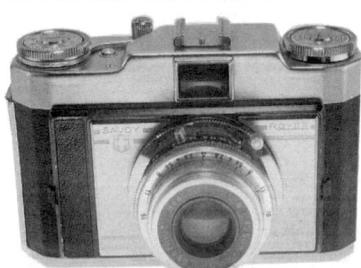

Savoy II - c1960. 35mm viewfinder camera with rapid wind lever. Removable front lens panel allows lens to be used on projector or enlarger. On the disastrous first Savoy, the back did not open; the film had to be loaded through the lens panel. Savoy II has a hinged back. Berthiot f2.8/50mmin Royer 1-300 shutter. \$60-90.

Savoyflex - c1959. 35mm SLR. Som Berthiot f2.8/50mm. Prontor Reflex interlens shutter, 1-500.\$75-100.

Savoyflex Automatique - c1959. The first 35mm SLR with automatic exposure, controlled by selenium cell above lens. Aperture or shutter priority. Fixed Som Berthiot f2.8/50mm lens in helical focusing mount accepts 35mm or 80mm

supplementary lenses. Prontor Reflex B,1-300 leaf shutter. \$100-150.

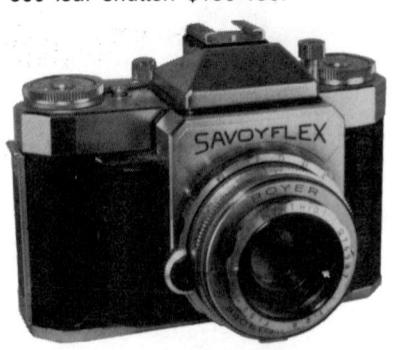

Savoyflex II - Similar to Savoyflex but with helical focusing. \$75-100.

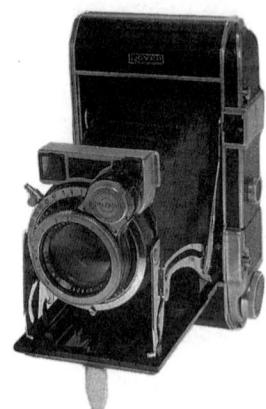

Teleroy - c1950. Folding bed rollfilm camera with coupled rangefinder. Previous rangefinder designs such as Ikonta had part of the rangefinder mechanism on the body and a rotating prism on the front standard. The Teleroy has the entire rangefinder on the front standard. While the unity of construction may have some advantages, the disadvantages of a small, off-center split-image seem more obvious. Nevertheless, the camera is very well constructed and finished. One unusual feature of this and other Royer cameras is the use of a self-timer knob and mechanism on the body. It activates the shutter through the linkage of the body release. Angeniuex X1 or Flor f3.5/105 in B,1-300 shutter. First model has "TELEROY" on the front of the rangefinder, and commands about 25% more than the later model. Second model with yellow tinted rangefinder window: \$150-225

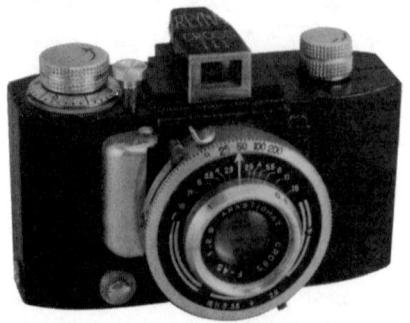

ROYET (Paul Royet, St. Étienne, France)

Reyna Cross III - Black painted cast aluminum bodied 35mm. f3.5 Berthiot or f2.9/45mm Cross. Two blade shutter 25-200, B. This camera was essentially a continuation of the Cornu Reyna line, but manufactured away from Paris which was

under German occupation. See Cornu for similar models. \$35-50.

RUBERG & RENNER

Adickes - c1933. Black bakelite body with helical lens mount. Rodenstock lens, I+T shutter. Similar to the Baby Ruby. Sold in Germany as the Rubette. \$50-75.

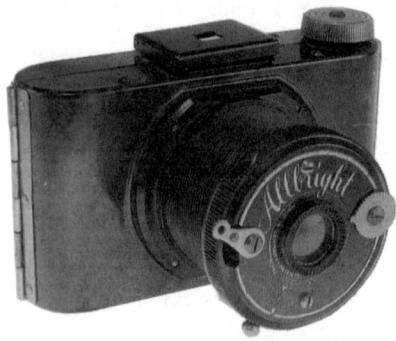

Allbright - Typical round-ended 4x6cm format Ruberg camera in red marblized enamel finish. Helical front. English language markings. Colored body: \$75-100.

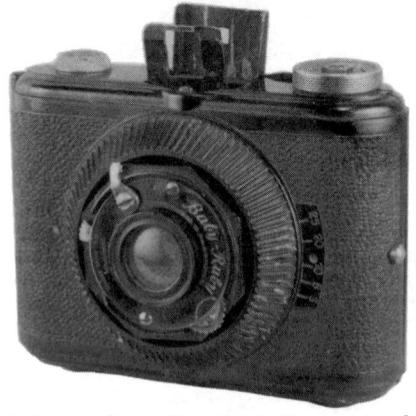

Baby Ruby - Small bakelite camera for 3x4cm exposures. Front extends to focus position via ring and helix. Fixed focus lens with 2 stops, "BIG" and "Small". T & I shutter. \$50-75.

Dixi - Rectangular metal body with chamfered edges. Black cracked laquer finish reveals blue substrate. Plastic front and helix. Uncommon. \$75-100.

Fibiru - Metal body with red & black

marbelized enamel. Black bakelite helical front. Finder pops up when front is twisted into position. Colored body: \$75-100.

Fibituro - c1934. Metal body in red marbelized enamel. Takes 4x6cm or 3x4cm on 127 film. Rodenstock Periscop f11. M&Z shutter. Colored body: \$60-90.

Hollywood - c1932. Black painted metal camera with bakelite helical telescoping front. Similar to the "Dixi", with rectangular body and molded shutter face rather than enameled metal. Takes 40x55mm photos on 127 film. One version has markings all in French, including "Fabrique en Allemagne". Another version has the normal German-language front. \$25-35.

Hollywood Duplo - Outward appearance much like the rest of the Ruberg family. However, there is a small sliding lever on the bottom which swings masks into position to allow 3x4cm or 4x6cm photos. Black crinkle enamel on metal body. \$35-50.

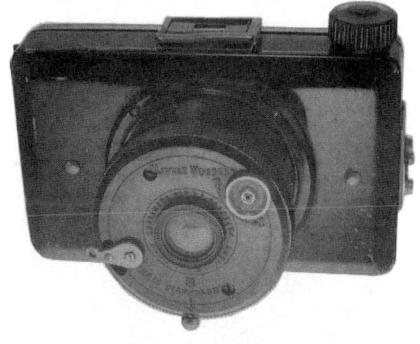

Little Wonder - c1932. (Not related to the c1900 "Little Wonder" box camera.) Metal body, similar to the Dixi and Hollywood. 40x55mm on 127 rollfilm. Simple folding frame finder does not automatically erect when front helix is extended. T&I shutter. Meniscus lens. Distributed by L. Trapp & Co., London. \$60-90.

Nenita - c1950's. Named "little baby", this camera has all of its markings in Spanish. Other than that, it is like the Ruberg Futuro or Fibituro. Red & black marbelized enamel on metal body. Helical extending front. Takes 4x6cm on 127 roll

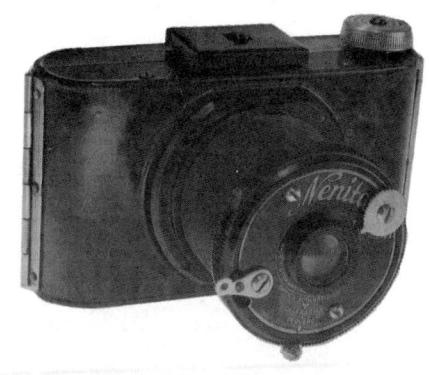

film. The rarest of the Ruberg family. If the price scares you, don't worry. You'll probably never see one. \$100-150.

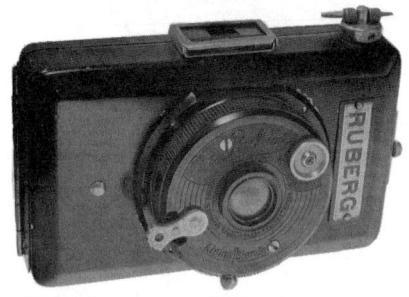

Ruberg - c1953. Metal body eye-level cameras for 127 rollfilm. Helical extending front section. Two major body styles: 1. round-ended body, 4x6cm image size, frame finder opens automatically when helical front is extended; 2. rectangular body with chamfered edges, 4x5.5cm image, narrow finder does not automatically open. \$35-50.

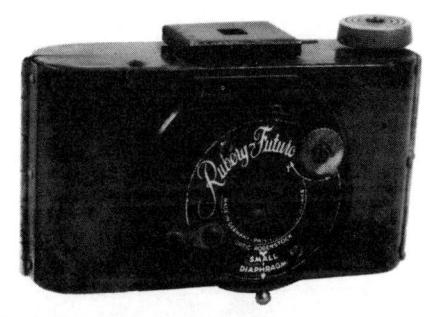

Ruberg Futuro - Metal body, 4x6cm on 127 rollfilm. Red or black enameled. Helical lens mount. \$35-50.

RUTHINE - 35mm CRF camera. Friedrich Corygon f2.8/45mm lens. Shutter 25-100, B. \$25-35.

SAINT-ETIENNE (France)

Universelle - c1908. Vertical folding plate/rollfilm camera, along the lines of the Screen Focus Kodak, but with a removable back. Beckers Anastigmat f6.8/150mm in B&L Unicum shutter. \$200-300.

SAKURA SEIKI CO. (Japan)

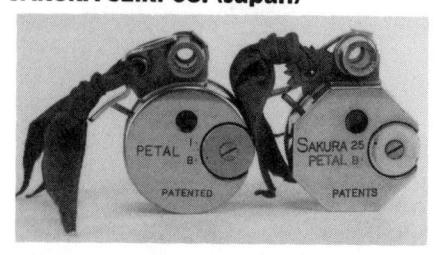

Petal - c1948. Subminiature camera about the size of a half-dollar. (Approx-

SANDERSON

imately 30mm dia.) 6 exposures on circular film. Original price about \$10. Two models: **Petal, octagonal body** - This is the

Petal, Octagonal body - This is the later version, but not as common. Made by Sakura and identified on the front as "Sakura Petal". \$300-450.

Petal, round body - The more common early model, made by Petal Kogaku Co. Pre-dates the Sakura octagonal model. \$200-300.

SAN GIORGIO (Genova, Italy)

Janua - c1949. 35mm rangefinder Leica copy. Essegi f3.5/50mm. FP shutter 50-1000. Built-in meter. \$750-1000.

Parva - c1947. Subminiature for 16mm rollfilm. Less than 10 made. Highest recorded sale was at Christie's 12/91 for \$16,000. Another sold at Christie's 11/92 for £6500 plus commissions.

SANDERS & CROWHURST (Brighton, England)

Birdland - c1904. ¹/₄-plate SLR. Extensible front. Waist-level focusing hood also allows for eye level focusing. Dagor f6.8 lens. FP shutter to 1000. \$350-500.

SANDERSON CAMERA WORKS

(England) Mr. Frederick H. Sanderson (1856-1929) was a cabinet maker and a wood and stone carver. In the 1880's, be became interested in photography, particularly in architectural work, which required special camera movements. These movements were available on the cameras of the day, but he found their manipulation awkward, so he designed his own camera. In January of 1895 he patented a new design. All Sanderson cameras incorporate his patented lens panel support system. Production cameras were built by the Holmes Brothers whose works became known as the Sanderson Works. The cameras were marketed by Houghton's with ads appearing as early as 1896. After the 1904 merger, Holmes Bros became part of Houghton, and thus Houghton became the manufacturer of Sanderson cameras.

Dating Sanderson Cameras: All Sanderson cameras are serialized consecutively, likely to have started at #100 and ending at about 27,000(?) by 1939. Roughly half of this production was before the First World War. Working from these basic figures will allow you to approximate the age of your camera. Some numbers are prefaced by a letter; some have a comma or decimal in them. The significance of these is unclear, but they do not seem to affect the sequence.

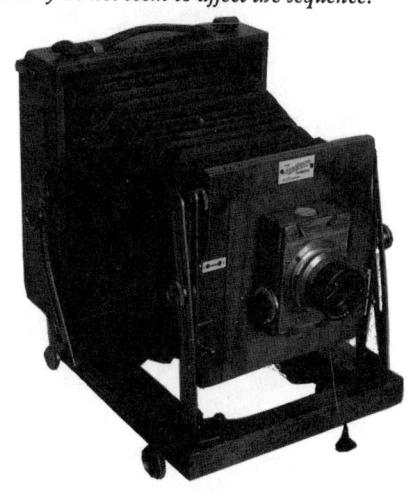

Sanderson Field camera - c1898.

SANDERSON...

Mahogany folding cameras in 1/2-plate, full plate, and 10x12" sizes. Brass fittings. Double extension, tilt/swing back. Thornton-Pickard roller-blind shutter. One fine example sold for \$800. Normal range \$400-600.

Sanderson Field Camera, aluminium bound - c1896. Full plate size. Probably made to special order. Combination of brass hardware for normal knobs & struts (wearing parts) and aluminium binding to strengthen the wood. Mahogany body. Fitted with aluminium bound Ross Zeiss Triple convertible lens, 9.25, 14, 19.25 inch. \$500-750.

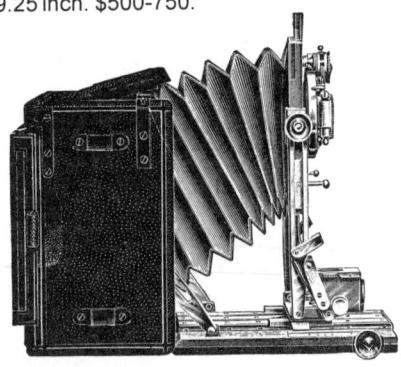

Sanderson "Regular", "Deluxe", and "Junior" Hand and Stand cameras - Folding plate cameras with finely polished wood interior, heavy leather exterior. Generally common, though some models are rare. Made in 31/4x41/4", 4x5", 41/4x61/2", and 5x7" sizes. \$300-450.

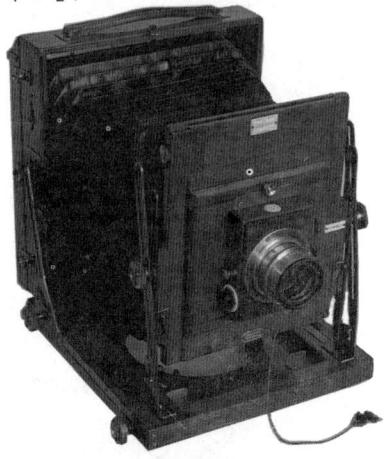

Sanderson Tropical Field Camera 6.8x8.5" - c1920's. Probably made to order in tropical finish with brass pinned corners, brass bellows attachment strips,

teakwood body and special brass reinforcing hardware to prevent splitting. Available with or without tripod head built into the front door/bed. \$800-1200.

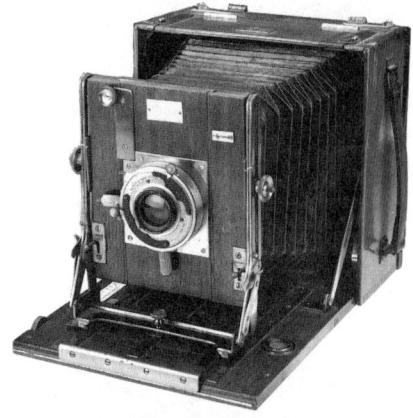

Sanderson Tropical Hand and Stand cameras - 1/₄- to 1/₂-plate sizes.
Polished teak with brass fittings. We have noted sales with the following lenses, which may not have been original equipment. Goerz Dagor f6.8, Aldis f6.3, or Beck f7.7 lens. Compurshutter. \$800-1200.

SANDS, HUNTER & CO., LTD. (The Strand, London, England) Formerly Hunter & Sands until December 1883. (This name change took place at the time that Louis Gandolfi began making cameras for the firm, according to his son, Fred Gandolfi. Although Louis Gandolfi founded his own company shortly thereafter, be continued to make cameras for Sands, Hunter.)

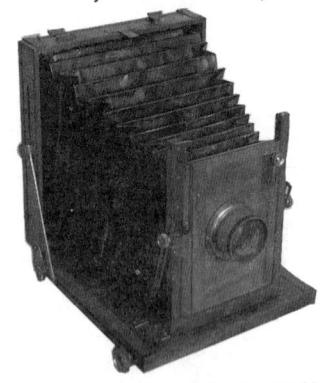

Field cameras - c1880's-1930's. Tailboard or folding bed styles. Half plate to 10x12" sizes. Turn-of-century models typically with brass-bound Anastigmat or Rectilinear lens. \$350-500.

SANEI SANGYO (Japan)

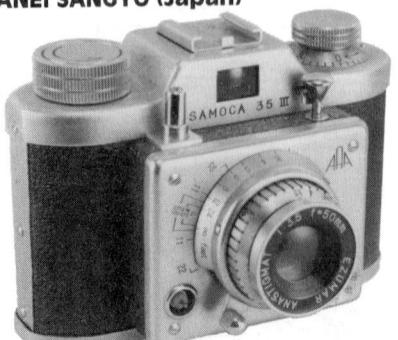

Samoca 35, 35II, 35III, 35IV - c1950's. Simpler viewfinder models. Ezumar f3.5/50mm. Shutter 25-100 or 1-200. \$35-50.

Samoca 35 V - c1955. Body style similar to the Samoca 35 Super and not the earlier Samoca 35's, but without the range-finder. Ezumar Anstigmat f3.5/50mm lens, 1/10-200 shutter. \$60-90.

Samoca LE - c1957. 35mm rangefinder camera of conventional design. Built-in selenium meter. Ezumar f2.8/50mm. Shutter 1-300,B. \$35-50.

Samoca 35 M-28 - c1960. 35mm CRF. Ezumar f3.5/50mm, Samoca Synchro shutter 1-300. \$35-50.

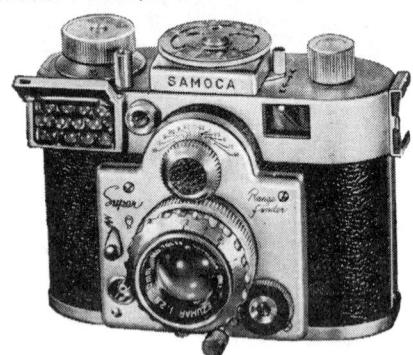

Samoca 35 Super with and without meter Samoca 35 Super - c1956. "Super Rangefinder" on front. 35mm camera for 36 exposures, 24x36mm on standard cartridges. Ezumar f3.5/50mm lens. Shutter 10-200. Coupled rangefinder. Versions with and without built-in selenium meter. \$50-75.

Samocaflex 35 - c1955. 35mm TLR. Waist-level reflex viewing with split-image focusing. Also has optical eye-level finder. Ezumar f2.8/50mm lenses. Seikosha Rapid 1-500,B. Not common. \$300-450.

Samocaflex 35 II - c1956. Same basic features as Samocaflex 35, but Seikosha MX shutter, B,1-500. \$300-450.

Samoca EM - c1956. 35mm with CRF. Ezumar f3.5/50mm, shutter to 200. BIM. \$60-90.

SANEIKOKI (Japan)

Starrich 35 - Small bakelite camera for 24x36mm exposures on "Bolta" size 35mm paper-backed rollfilm. Similar to the Ebony and Start cameras, but not as common. \$60-90.

SANGER-SHEPHERD (London, England)

Three-color camera - c1907. Takes one exposure on a single plate. Similar in design to the Ives Kromskop. Only one known example. Value estimate: \$3200-4600

SANRIO CO. LTD. (Japan)
Hello Kitty Camera - c1981. 110 film
plastic camera in bright colors. Rotating kitty acts as cover for lens and viewfinder. Built-in electric autowinder and electronic flash. A cute but expensive camera for the child who already has a silver spoon. \$60-

SANWA CO. LTD., SANWA SHOKAI

(Japan) Some of the company's Mycro IIIA Cameras were also sold under the name of

Mycro Camera Company Ltd.

Mycro (original model) - 1938. The first pre-war model of the Mycro camera. There is no streamlined top housing as on the later Sanwa Mycro cameras, but rather a square optical finder attached to the top. Next to the finder is a small disc marked "T.A.Co.", but we have not yet discovered the meaning of these initials. This early model is uncommon, and diehard subminiature collectors have been known to pay \$200-300.

Mycro - 1940-49. 14x14mm novelty camera. Mycro Una f4.5/20mm lens. 3-speed shutter. There are a number of variations of the Mycro cameras. With the exception of the original and the IIIa, most of these sell for \$50-75. With colored leatherette add 25%.

Mycro IIIA - c1950. Similar to the normal Mycro, but shorter, streamlined top housing. Some versions are marked "Mycro Camera Company Ltd."; others, "Sanwa Co. Ltd". In the 1970's, this was the scarcest of all Mycro cameras. However, they have been appearing regularly in Europe for the last several years. In late 1991, an unknown quantity of master cartons of unsold old stock appeared on the market. These will need some time to establish a stable value, but the first ones are soldfor about \$500 for a pack of 6 cameras packaged as new. This is close to the normal price for a single camera: \$60-90.

Suzuki Baby I - c1951. Folding bed camera for 3x4cm on rollfilm. Teriotar f4.5/50mmlens in STK shutter. \$150-225.

SAS GmbH (Viotho, Germany)
Sassex - c1951. Simple eye-level camera for 6x6cm on 120 film. Thermoplastic body is shaped like the Reflex Korelle, but this camera is not a reflex. Large eye level folding frame finder. Sas-Siagon f9/80mm lens. T,B,M shutter. Dark brown \$90-130. Black: \$50-75.

SATELLITE - A later "Hit" type subminiatures with cheaper construction. \$20-30.

SAWYERS INC. (Portland, Ore.) Mark IV (same as Primo Jr.) - c1958. 4x4cm on 127 film. Topcor f2.8/60mm lens. Seikosha MX shutter 1-500, B. Auto wind. \$120-180.

Nomad 127, Nomad 620 - c1957. Brown bakelite box cameras. 4x6.5cm on 127 and 6x6cm on 620, \$12-20.

View-Master Personal Stereo c1952. For making your own view-master

slides. Film was wound twice through the camera with lenses raised/lowered for each pass. 69 stereo pairs, 12x13mm. Anastigmat f3.5/25mm lenses. 1/10-1/100 shutter. Quite common. Brown & beige model: \$150-225. Black models with flash: \$120-180. Mark film punch: \$120-180.

Sawyers Europe: View-master Stereo Color - c1961. The European model, made by Regula-Kamerawerk King in Germany for Sawyers Europe, whose headquarters was in Sint Niklas, Belgium. Some models are marked "Viewmaster Mark II". For stereo exposures 12x13mm on 35mm film. Diagonal film path allows stereo pairs to be exposed on one pass of the film. Rodenstock Trinar f2.8/20mm lenses and single-speed shutter. \$150-

View-Master Projectors:

Senior - Metal non-stereo projector with automatic frame centering. Anastigmat f3/3" lens. Helical focusing. Uses 75-watt bulb to project a 36" wide image. Built-in screen pointer. \$35-50.

Junior - Plastic and metal non-stereo projector. Doublet f3 lens. Uses 30-watt bulb to project a non-stereo image, 16" wide. \$8-15.

View-Master Projector - Projects a non-stereo image, 22" wide. \$12-20.

Deluxe Projector - Projects a nonstereo image, 50" wide. Focusing f2.8/21/4" lens. \$25-35

Deluxe 300w Projector - Similar to the Deluxe Projector listed above, but is fan-cooled because of the higher wattage bulb. \$35-50.

Entertainer - 30w bulb. Projects a nonstereo image. Blue plastic body. Less boxy shape than the Deluxe Projectors. \$25-35.

Stereo-Matic 500 - Projects stereo images using a 500 watt bulb. Two models producing 40" wide and 50" wide images. (Special polarized glasses were used to view the image in stereo.) Die-cast aluminum body. Anastigmat f3 lenses, automatic focusing. Fan-cooled. With 21/4" lenses: \$400-600.With 3" lenses: \$350-500.

SCAPEC (France)

Rollex - Unusual cast aluminum box camera for 6x9cm. Interesting waist-level reflex finder folds into small housing above shutter. Not exactly cute, but very interesting and not common. \$25-35.

S.C.A.T.

S.C.A.T. (Societa Construzioni Articoli Technici, Rome)

Scat - c1950. Subminiature for 7x10mm on 16mm film in special cassettes. f3.5 lens, single speed revolving shutter. Leather covered metal body. \$175-250.

SCHAAP & CO. (Amsterdam) Van Albada Stereo - c1900. 6x13cm box stereo. FP shutter with variable tension and slit width. Two-element lenses in nickel-plated mounts with rotary stops. The English patent 11 488 accepted 19 March 1903 illustrates two meniscus elements in the same direction. \$800-1200.

SCHATZ & SONS (Germany)

Sola - c1938. Unusually-shaped subminiature, 13x18mm on unperforated film in cassettes. Spring drive, 12 exposures per wind. Interchangeable Schneider Kinoplan f3/25 or Xenon f2/25 lens. Behind-the-lens shutter, 1-500, B. Waist-level or eye-level viewing. Auction records: \$3750 at Breker and at Christie's (1991). Estimate for normal sales: \$2400-3200.

SCHAUB (Jacob Schaub, Logan Utah) Camera c1899 Multiplying Unusually designed camera for 6, 15, or

24 exposures on 4x5" plate in standard plateholder. Front and back standards are fixed to baseboard. Focusing is by rack & pinion control of interior lens. Back shifts vertically and horizontally, positioned by arm & pin system, for the multiple exposures. Bag bellows of rubberized cloth. Very rare. \$2000-3000.

SCHEECAFLEX - 1950s. 35mm SLR. Interchangeable Tessar f2.8/50mm lens. FP shutter. BIM. One sold at auction in 1990: \$650

SCHIANSKY Universal Studio Camera - c1950. All metal body, using 7x91/4" sheet film, with reducing back for 13x18cm (5x7"). Black bellows extend to 1 meter. Zeiss Apo-Tessar f9/450mm lens. Only 12 were made. One known sale in 1976 for \$500.

SCHMITZ & THIENEMANN (Dresden) Patent-Sport-Reflex - c1931. Box-form SLR for 6.5x9cm plates. Trioplan f4.5/ 105mm lens in Pronto shutter. Uncommon. \$200-300.

Uniflex Reflex Meteor - c1931. SLR box for 6.5x9cm. Meyer Trioplan f4.5/ 105mm lens in self-cocking Pronto shutter 25-100. \$150-225.

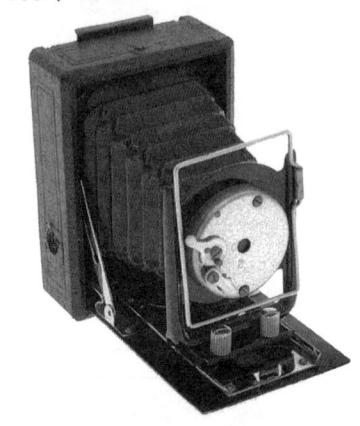

- c1920. Simple **SCHÜLERKAMERA** German folding camera for 4.5x6cm plates. Wood body, metal bed, leatherette covering. Direct frame finder. Simple shutter. Variations in finder design and metal finish. \$75-100.

SCHUNEMAN & EVANS (St. Paul, Minnesota)

Lightning - Folding 4x5" plate camera. Black leather exterior; polished mahogany interior. Red bellows. B&L Unicum shutter. \$75-100

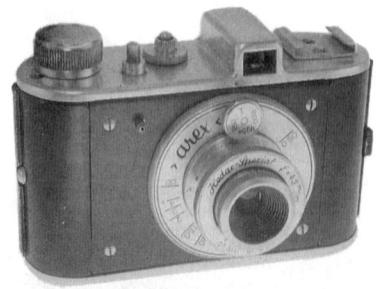

SCHWARZBAUER (Hanns Schwarzbauer, Austria) Arex - Simple 35mm camera. Cast

aluminum body with stamped aluminum top and bottom plates. Hedar Spezial f5.6/43mm lens. Behind the lens sector shutter, Uncommon, \$45-60.

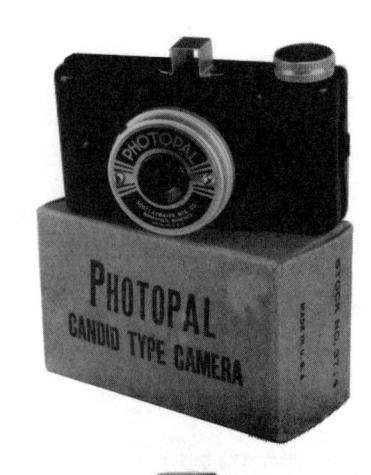

SCOTT-ATWATER MFG. CO.

(Minneapolis, Minn.)
Photopal - Simple, stamped metal novelty camera, enameled black. 3x3.5cm or 4x6cm sizes. \$35-50.

SCOVILL MANUFACTURING CO. (N.Y.) Brief summary of name changes: Scovill & Adams, 1889; Anthony & Scovill, 1902; Ansco, 1907. (See also Anthony and Ansco., Scovill produced some excellent cameras, all of which are relatively uncommon today.

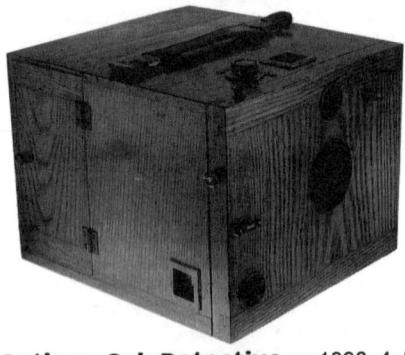

Antique Oak Detective - c1890. 4x5" box-plate camera finished in beautiful golden oak. String-set rotary shutter, variable speeds. \$750-1000.

Book Camera - c1892. Camera dis-

guised as a set of 3 books held with a leather strap. Rare. One recent sale, Christie's 1/94 at £11,000+

Field/View cameras:
- 4x5" - Square black box with folding beds on front and rear. Bellows extend both directions. Top and side doors permit loading the plateholders either way into the revolving back when only the front bellows are being used. Nickel plated Waterbury lens. \$175-250.

- 8x10" - ca. early 1880's. Light colored wood body. \$175-250.

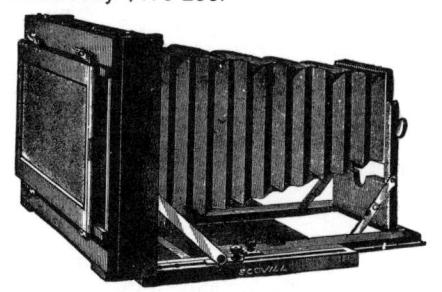

Irving - c1890. 11x14" compact folding view. RR lens, waterhouse stops. \$350-

Knack Detective - c1891. The Antique Oak Detective camera with a new name. \$750-1000.

Mascot - c1890-92. 4x5" format leather covered wood box camera. Similar to the Waterbury detective camera listed below, but with an Eastman Roll Holder, Stringset shutter. \$400-600.

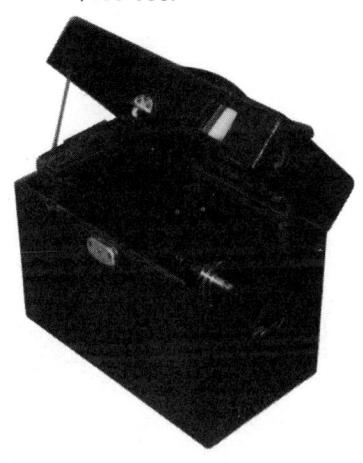

Scovill Detective - c1886. Leather covered box detective camera for 4x5" plates in standard plateholders. Entire top of camera hinges open to one side to reveal the red leather bellows (and to change plates). The bottom of the camera is recessed, and the controls are located there, out of sight. A very uncommon detective camera. This camera was never shown close-up in original advertising in order to preserve its "concealed aspects". \$750-1000.

St. Louis - c1888. 8x10" reversible back camera No. 116. With lens: \$175-250.

Stereo Solograph - c1899. A compact folding stereo camera for 4x61/2. Stereo RR lenses in Automatic Stereo shutter. \$400-600.

Triad Detective - c1892. Leather covered box detective camera using 4x5"

plates, rollfilm, or sheet film. Variable speed string-set shutter. \$350-500.

Waterbury Detective Camera. Original model - c1888. Black painted all wood box, or less common leather-covered model. Side door for loading plates. Focused by means of sliding bar extending through the base of the camera. Recessed bottom stores an extra plateholder. 4x5": \$500-750. 5x7": \$750-1000.

Waterbury Detective, Improved model - c1892. Same as the original model, except focus knob is at top front. \$350-500.

Waterbury Stereo - c1885, 5x8", All Scovill Waterbury lenses. wood body. \$400-600.

Waterbury View - This was a popular camera, made in at least 7 sizes from 4x5 to 8x10 inch. Usually supplied with Waterbury lens in brass barrel. Most often found in the 5x8" size.

Waterbury View, 4x5" - c1886-94. Folding-bed collapsible bellows view camera. Eurygraph 4x5 RR lens, Prosch Duplex shutter, \$150-225.

SEARS

Waterbury View, 5x8" or 61/2x81/2" - c1886-94. Horizontal format. Light wood finish. Brass barrel Waterbury lens. \$150-225.

Wet plate camera - c1860's. 4-tube wet plate tintype camera for 4 exposures on a 5x7" plate. \$1700-2400.

SDELANO: Identifying mark on some Russian cameras beginning in the late 1950's. It means "Manufactured in the U.S.S.R." This is not a camera model or manufacturer's name.

SEARS ROEBUCK & CO. (Seroco)

Seroco is an abbreviation for Sears, Roebuck & Co., whose cameras were made by other companies for sale under the Seroco name. The Conley company made many cameras for Sears after the turn of the century, and was purchased by Sears.

Delmar - box camera for plates. Top rear door hinges up to insert plateholders. Storage space for extra plateholders. For 31/4x41/4" or 4x5" plates. \$30-45.

Marvel S-16 - c1940. 116 rollfilm box cameras. Art-deco faceplate. \$1-10.

Marvel S-20 - c1940. 120 rollfilm box camera made by Ansco for Sears. Artdeco faceplate. \$1-10.

Marvel-flex - c1941. 6x6cm TLR. Wollensak Velostigmat f4.5/83mm. Alphax 10-200, T,B shutter. \$25-35.

Perfection - 4x5" plate camera. \$45-60.

Plate camera - "Cycle-style" camera for 4x5" plates. Styled somewhat like the Pony Premo E. Shutter concealed in wooden lensboard. "Sears Roebuck & Co. Chicago III." at base of lens standard. \$120-180.

SEARS...

Seroco 4x5" folding plate camera - c1901. Black leathered wood body with polished interior. Red bellows. Seroco 4x5 Symmetrical lens and Wollensak shutter are common. \$100-150.

Seroco 5x7" folding plate camera - similar to the above except for the size. \$120-180.

Seroco 61/2x81/2" folding plate camera - Red double extension bellows. \$150-225.

Seroco Magazine - c1902. 4x5" box camera. Leather covered, nickel trim. 12-plate magazine. \$60-90.

Seroco Stereo - 5x7" plates. Leather covered mahogany body with polished interior. Red leather bellows. Wollensak Stereo shutter & lenses. \$400-600.

Tower, Type 3 - c1949. Made by Nicca Camera Co. in Occupied Japan, and sold by Sears. Copy of a Leica III. This is the same camera as the Nicca III. Nikkor f2/50mm interchangeable lens. With normal lens: \$175-250.

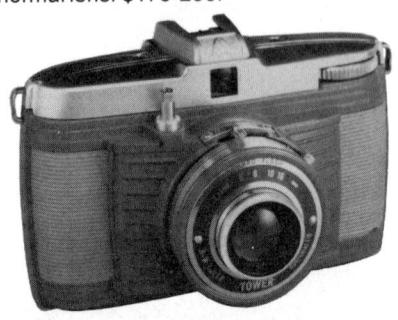

Tower No. 5 - c1958. 4x4cm on 127 rollfilm. Styled like a 35mm. Blue-gray enameled with gray plastic partial covering. Made by Bilora for Sears and similar to the Bilora Bella. \$15-25.

Tower 10A - c1960. 35mm RF camera with coupled match-needle selenium meter. Made by Mamiya for Sears. Mamiya-Sekor f2.8/48mm lens in B,1-500 shutter. Original price was \$55. Current value: \$25-35.

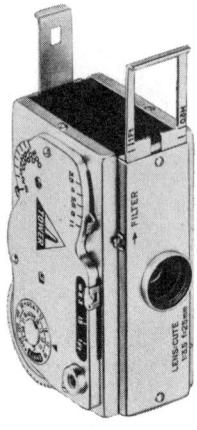

Tower 16 - c1959. A Mamiya-16 Super with the Tower name on it. An uncommon variation, \$120-180.

Tower 18A - c1960. Similar to the Tower 10A, but with faster f1.9 lens. Original price: \$75. Current value: \$30-45.

Tower 18B - c1962. 35mm camera with coupled rangefinder and built-in meter. Made by Mamiya for Sears. Mamiya-Kominar f2/48mm lens in Copal SVK B, 1-500. \$25-35.

Tower 19 - c1960. Rangefinder 35 with interchangeable bayonet-mount lenses in front of Seikosha SLV shutter. Made for Sears by Olympus; identical to the Ace E. Match-needle selenium meter. E.Zuiko f2.8/45mmnormal lens. \$90-130.

Tower 22 - c1957-59. 35mm SLR made by Asahi Optical Co. in Japan and sold by Sears. Export version of the Asahiflex IIA (1955). First listed in Sears 1957 camera catalog. Takumar f3.5/50mm or 2.4/58mm. FP shutter. Top speed dial 25-500. Slow speed dial T,2,5,10,25 on front. \$175-250.

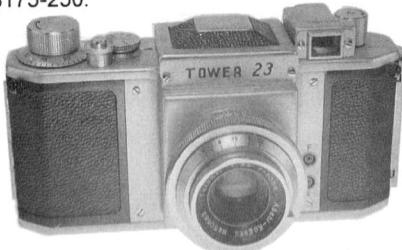

Tower 23 - c1955-59. Sears version of Asahiflex IIB. Instant return mirror; no slow speed dial. Some have speed dial patch as do later model Asahiflex IIB cameras. FP shutter 1/₂₅ to 1/₅₀₀. Standard lens Takumar f3.5/50mm.\$175-250.

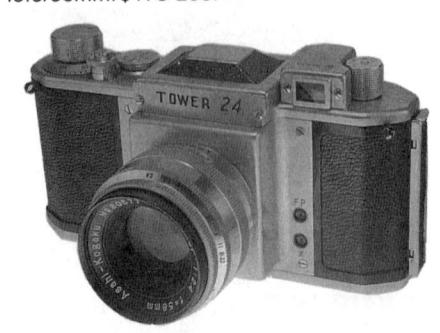

Tower 24 - Sears version of the Asahiflex IIB. Instant return mirror. According to Sears catalogs, this is the same camera as

the Tower 23, but furnished with the faster Takumar f2 4/58mm lens \$200-300.

Tower 26 - c1958-59. Name variation of the Asahi Pentax (original model). Takumar f2.4/55mmlens. \$175-250.

Tower 29 - c1959. Name variation of the Asahi Pentax K. Auto-Takumar f1.9/55mm lens. \$100-150.

Tower 32A - c1963. 35mm SLR made by Mamiya for Sears. Based on Mamiya's Prismat NP camera. Sold with an optional clip-on exposure meter which fits over the prism and couples to the shutter speed dial. Interchangeable Mamiya/Sekor f1.7/58mm lens. External linkage from body to lens arm stops down lens when shutter is released. Focal plane shutter 1-1000,B. \$100-150.

Tower 32B - c1964. 35mm SLR made by Mamiya for Sears. Same as Mamiya's Prismat NP. Fixed pentaprism. Cloth focal plane shutter T,B,1-1000. Interchangeable bayonet mount lenses. Originally supplied with Mamiya-Sekor F.C. f1.7/58mm lens with external arm for diaphragm stopdown. \$100-150.

Tower 33 - c1960. 35mm SLR made by Braun for Sears. Same as the Braun Paxette Reflex. Coupled selenium meter on left side of front plate. Braun-Reflex-Quinon f2.8/50mm lens. Synchro-Compur 1-500,B,ST. \$60-90.

Tower 34 - c1960. Like the Tower 33, but with f1.9/50mm lens. \$75-100.

Tower 37 - c1961. SLR made by Mamiya for Sears. External linkage stops lens down before exposure, but diaphragm must be manually reopened for viewing. Mirror returns when winding film. \$60-90.

SEARS...

Tower 39 Automatic 35 - c1962. Boxy 35mm with built-in flash for AG-1 bulbs. Automatic exposure controlled by selenium meter. Zone focusing f3.8 Mamiya lens. \$20-30.

Tower 41 - c1962. Boxy 35mm, similar to Tower 39, but with f2.8 lens, range-finder, accessory shoe, and sync post in addition to built-in AG-1 flash. Made by Mamiya. \$25-35.

Tower 44 - c1960-62. Small TLR, made in Japan for Sears by Tougo-do. Nearly identical to the deluxe model of the Kino-44. Automatic film stop and exposure counter. Kinokkor f3.5/6cm in Citizen-MV B,1-500. \$120-180.

Tower 45 - c1957. Leica-styled 35mm made by Nicca for Sears. Same as the Nicca 5L. Nikkor f2 lens. (With f1.4 lens, it was called Tower 46.) Back opens like the Leica M-3 to facilitate loading. FP shutter 1-1000, with slow speed dial on front. \$150-225.

Tower 46 - As Tower 45 above, but with originally sold with f1.4 lens. \$150-225.

Tower 50 (35mm) - c1954-58. Basic scale-focus 35mm made by Iloca for Sears. Originally sold for just \$29.00. Cast metal body. Cassar f2.8/45mm lens in 25-200,B shutter. \$12-20.

Tower 50 (rollfilm) - c1952. Self-erecting camera for either 620 or 120 rollfilm. Not synchronized. Same as USC Rollex. \$12-20.

Tower 51 (35mm) - c1954-58. Similar to Tower 50, but with CRF & lever advance. Cassar f2.8/50mm in Prontor-SVS B, 1-300. Made by Iloca. \$25-35.

Tower 51 (rollfilm) - c1955. Folding bed 6x9cm camera, identical to the USC Rollex, synchronized model. Same as the Tower 50 (rollfilm) above, but with hot shoe built into top housing. \$12-20.

Tower 55 - c1959-62. Basic scale-focus 35mm made for Sears by Yamato Koki Kogyo. Sold new for \$18. Lever advance. Color Luna f3.5/45mm in B,25-300 leaf shutter. \$25-35.

Tower One-Twenty, One-Twenty Flash, Flash 120 - c1950's. 6x9cm box cameras. Leatherette or enamel finish. \$1-10.

Tower 127EF - Horizontally styled cameras for 15/8×15/8" on 127 film. Electronic flash beside lens. Capacitor and electronics in detachable handle. Early example of a camera with built-in electronic flash. \$35-50.

Tower Automatic 127 - c1960. Horizontally styled white plastic body. Flash and meter built-in. 4x4cm on 127. Looks like the United States Camera Corp. Automatic 127, \$20-30.

Tower Bonita Model 14 - Metal twinlens box camera with reptile-grained covering. Made by Bilora for Sears. "Bilora" on strap, "Bonita" on viewing hood. "Tower

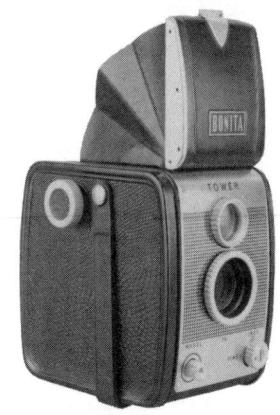

Model 14" on front plate. Time & Inst. shutter. Taking lens focuses via lever concealed under finder hood. \$30-45.

Tower Camflash 127, Camflash II 127 - Horizontal style 4x4cm, like the United States Camera Corp. Comet 127. Built-in flash. \$8-15.

Tower Companion - Plastic 6x6cm box camera, identical to the Imperial Debonair.\$1-10.

Tower Hide Away - c1960. Grey and green plastic box camera made by Imperial, same style as the Imperial Mark 27. Built-in flash with retractable cover. \$1-10.

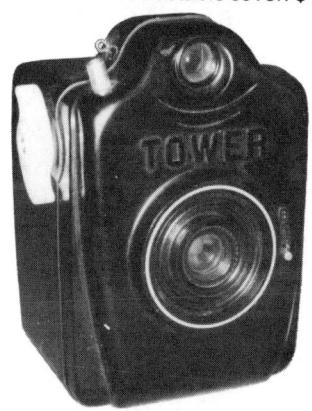

Tower Junior - c1953-56. Small bakelite box camera with eye-level finder. Made by Bilora for Sears and identical to the Bilora Boy. "Tower" on front, "Bilora" on back. \$35-50.

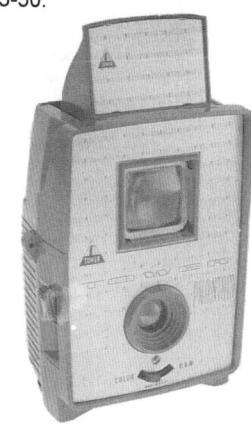

Tower Phantom - c1960-61. Grey plastic TLR-style box camera for 4x4cm on 127 film. Made by Imperial for Sears, and like the Imperial 127 Reflex Flash Camera. \$1-10

SEARS...

Tower Pixie 127, Pixie II 127 - Gray plastic 4x4cm, 127 camera. \$1-10.

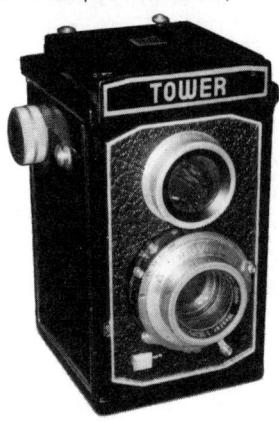

Tower Reflex - 6x6cm TLR. Various models, made by various manufacturers, but most are simply identified as "Tower" on the camera itself.

Tower Reflex, c1955 - Type II is the same as the Photina I. Front-element focusing Cassar f3.5/75mm lens. Type III is the same as the Photina II. Front-element focusing Westar Anastigmat f3.5/75mm. Pronto 25-200 shutter. \$60-90.

Tower Reflex, c1957 - Rack and pinion focusing. Same as the Tougo-do Toyocaflex IB. Tri-Lausar Anastigmat f3.5/80mm, 1/25-300, B shutter. \$60-90.

Tower Reflex, c1960 - Built-in matchneedle exposure meter. Made by Fuji. Fujitar f3.5/80mm lens in Citizen-MV 1-500,B shutter. \$100-150.

Tower Reflex Type - c1955. Various styles of 6x6cm pseudo-TLR bakelite box cameras. \$12-20.

Tower Skipper - 4x4cm plastic box. Identical to Mercury Satellite 127. \$1-10.

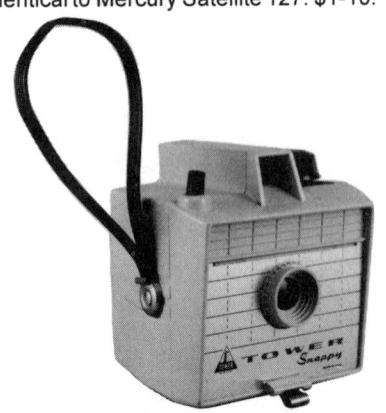

Tower Snappy - Plastic 6x6cm 620 camera, identical to the Herbert-George Savoy. In colors. \$8-15.

Tower Stereo - c1955-60. Made in Germany by Iloca for Sears. Same as Iloca Stereo II; also sold by Montgomery Ward as the Photrix Stereo. Isco-Westar 13.5/35mm lenses. Prontor-S shutter 1-300. \$150-225.

Trumpfreflex - c1940. German-made 6x6cm TLR sold in the U.S. by Sears. Looks very similar to the Balda Reflecta

and Welta Reflekta. Parallax correction accomplished by the taking lens tilting up at close focusing distances. Normally found with Trioplan f3.5/75mm lens. Shutter 1-300. \$60-90.

SEASTAL - TLR, 6x6cm. C-Master f3.5/80mmlens. \$50-75.

SECAM (Paris) Stylophot cameras - c1950's "pen" style cameras, according to the name, but even if compared to the large deluxe European fountain pens, it ends up looking a bit hefty. The pocket clip is the closest resemblance to a pen. For 18 exposures 10x10mm on 16mm film in special cartridges. Shutter cocking and film advance via pull-push sliding mechanism which pushed film from cartridge to cartridge. Automatic exposure counter. Weight: 3 oz. (85 gr.) Note: The same camera was also sold in Germany as the Foto-Füller, listed in

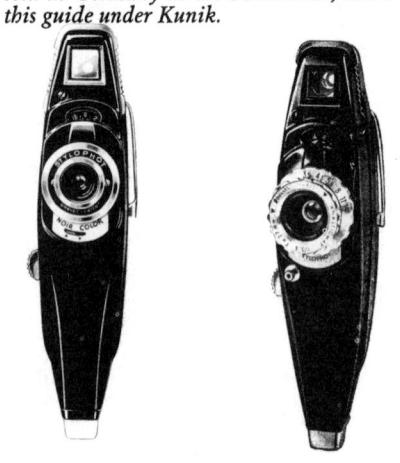

Stylophot "Standard" or "Color" model - The cheaper of the two models, with fixed focus two-element f6.3 coated lens, single speed shutter (1/50). Also sold under the name "Private Eye". Original price: \$15. Current value: \$150-225.

Stylophot "Luxe" or "Deluxe" model - with f3.5/27mm Roussel Anastigmat lens. Iris diaphragm. Focus to 21/₂ ft. (0.8m). Single speed shutter (1/₇₅) synched for flash. Original price: \$33. Uncommon.\$175-250.

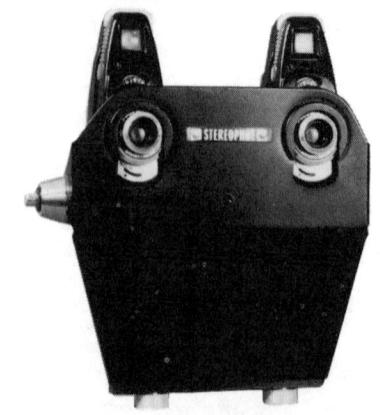

Stereophot - An unique stereo camera consisting of two Stylophot cameras mounted side-by-side on a special mounting plate. Awkward, maybe... but rare. \$750-1000.

S.E.D.E. (Rome)
Kelvin Maior - c1952-60. Inexpensive cast-metal 35mm camera. Duo-Kelvin f8

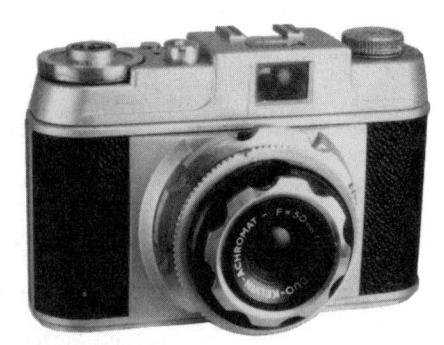

50mm Achromat; 3-speed shutter; three stops. \$12-20.

Kelvin Minor - c1952-60. Similar to the Maior, but with no stops and only 2-speed shutter. \$12-20.

Vinkel 50 - c1960. Simple cast aluminum 35mm camera. Single speed shutter ($^{1}/_{50}$) and simple lens. \$12-20.

Vinkel Deluxe - c1960. Similar in style to the Vinkel 50, but with 3-speed shutter and 3 stops. \$12-20.

sedic Ltd. (Japan) A large manufacturer of cameras, many of which are sold under the house names of other companies. Most of their cameras are too new to be collectible, except for some of the novelty shapes, such as binoculars, beverage cans, etc. which we have generally listed under the distributors names.

SEE - Another name variant of the "Diana" type for 120 film. \$1-10.

SEEBOLD INVISIBLE CAMERA CORP. (Rochester, NY) Founded in 1928 by John E. Seebold, when he took over the Gundlach Manhattan Optical Company and changed its name. The name is appropriate, because the company remained nearly invisible in the market.

Folding Rollfilm Camera - c1928. Body is a Glunz Model 333, imported from Germany, but with an Ilex Acme shutter and "Seebold Invisible Camera Corp. Radar Anastigmat f4.5" lens. Uncommon. \$35-50.

SEEMAN (H. Seeman)

Stereo camera - Black wooden strutfolding camera, nickel-plated fittings. Goerz Dagor 120mm lenses. \$400-600.

SEETORETTE - c1938. Simple German folding rollfilm camera. Radionar f4.5/105mm, Prontor II shutter. \$25-35.

SEIKI KOGAKU CO. (Seiki Kogaku means "Precision Optical" and this name was used on more than one occasion by unrelated companies. This company is not related to the Seiki Kogaku which made the early Canon cameras.)

Seiki - c1950. Oval-shaped 16mm subminiature. Seek Anastigmat f3.5/25mm. B, 25, 50, 100 shutter. \$750-1000.

SEISCHAB (Otto Seischab,

Nürnberg, Germany) Esco - c1922. 400 exposure half-frame 35mm. Similar in style to the Leica Reporter. Steinheil Cassar f3.5/35mm. Dial-set Compur 1-300. Rare. One recorded sale at \$2000. Another failed to reach a reserve of about \$5800 at a 1986 auction. One sold at auction in 7/88 for DM 5000 (\$2800) with case, and in 11/89 for \$4500. At Cornwall 9/92, one sold for DM 5000 (\$3350).

S.E.M. (Sociéte des Établissements Modernes; Aurec, France) In 1942-45, during the German occupation of Paris, the Reyna Cross 35mm cameras were made in St. Étienne under license from Cornu. Once the war was over, the St. Étienne firm broke the ties with Cornu and re-established itself in the neighboring town of Aurec under the S.E.M. name. The Reyna-Cross camera design, with some improvements, soon appeared as the Sem-Kim, and S.E.M. went on to design and build a number of small and medium-format cameras up through the early 1970's.

Babysem (first type) - c1949. Greyenameled 35mm. Same body as Sem-Kim. but no body release or double exposure prevention. Cross f2.9/45mm, or Berthiot f3.5 or f2.8. Orec shutter 25-200. \$30-45.

Babysem (new type) - While guarding the same functional characteristics of the earlier Babysem, the new model was

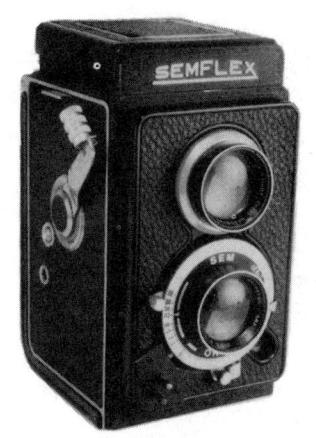

Semflex Otomatic

nicely styled in cast aluminum with the rectangular front facade concealing the knobs. Light grey painted with partial leatherette covering in blue or red. \$35-50.

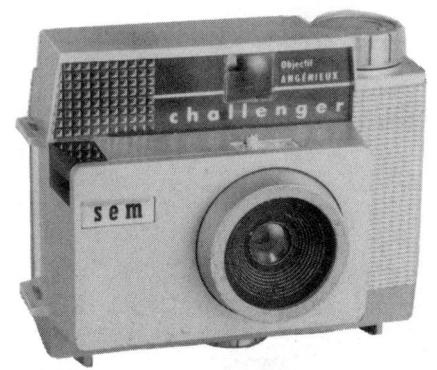

Challenger - c1959. Aluminum-colored plastic camera for 16 exposures 4x4cm on 620 film. \$25-35.

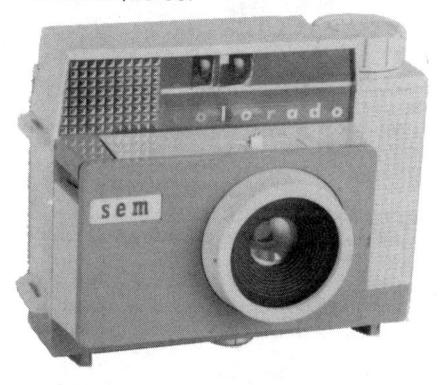

Colorado - Grey plastic dual-format camera. Takes 16 exposures 4x4cm or 20 exposures 24x35mm on 620 film. \$35-50.

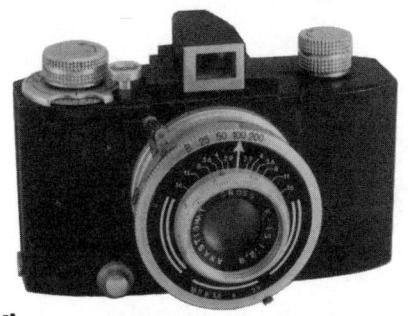

Kim - c1947. Simple cast aluminum 35mm. Successor of the Reyna-Cross. Cross Anastigmat f2.9/45mm. Shutter 25c1947. Simple cast aluminum 200, later extended to 1-200. \$35-50.

SEMI KREIS

Orenac III - c1950. Viewfinder 35. Cast aluminum body with leather covering.

Angenieux f2.9 or Berthiot f2.8 in Orec 1/400 shutter. Helical focusing. \$30-45.

Semflex Joie de Vivre 45 - Lightgray plastic covered TLR. Metal faceplate. Berthiot f4.5/80mmlens. \$60-90.

Semflex Otomatic - c1950's. TLR with lever advance and automatic film stop. Several model variations. \$60-90. Illustrated at top of previous column.

Semflex Standard - c1950. Twin-lens reflex camera for 6x6cm on 120 film. Several model variations. \$50-75.

Semflex Studio Standard - c1951-72. 6x6cm TLR with extended front for use with Tele-Berthiot f5.4/150mm lens. Viewing lens is f3.9. Long focusing rack allows close focusing to 1.5m. Two versions: Knob advance or crank advance. Single lever below lens tensions and releases shutter. Synchro Compur shutter after 1972. \$250-375.

SEMI KREIS - Probably late 1930's, Selferecting folding camera for 4x5.5cm on

SEMMENDINGER

120. K.O.L. Trio f3.5/7.5cm in Orient 21 shutter. \$100-150.

SEMMENDINGER (A. Semmendinger, Ft. Lee, NJ)

Excelsior - c1870's. Wet plate cameras in sizes 5x5" to 12x12". Fixed tailboard, square-cornered bellows. Ground glass viewing screen swings to one side. Rising front, tilt & swing back controlled by screw mechanisms. Large sizes may have sliding backs. With appropriate brass-barreled lens: \$1000-1500.

SENECA CAMERA CO. (Rochester, N.Y.)

Black Beauty - Folding "cycle style" view cameras in 31/₄x51/₂" and 4x5" sizes. \$75-100.

Busy Bee - c1903. 4x5" box-plate camera. Fold-down front reveals a beautiful interior. \$60-90.

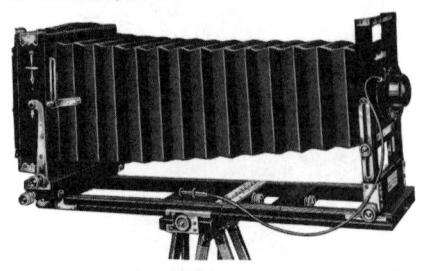

Camera City View - c1907-25. 5x7" to 8x10" view cameras. Seneca Anastigmat lens. Ilex shutter. \$175-250.

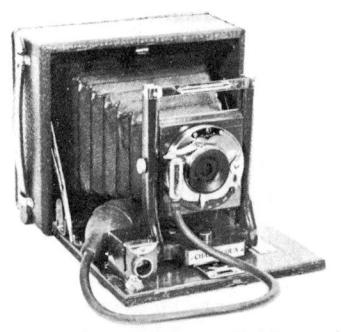

Chautauqua 4x5" - Folding plate camera with Wollensak lens, Seneca Uno shutter. A very plain all-black camera. \$75-100.

Chautauqua 5x7" - All black "ebonized" model: \$75-100. With polished wood interior: \$150-225.

Chief 1A - c1918. 21/2x41/4" on rollfilm. \$20-30.

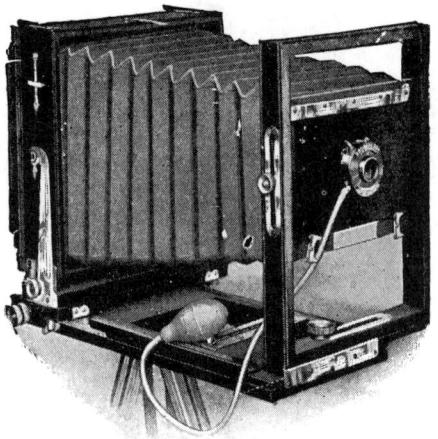

Competitor View - c1907-25. 5x7" or 8x10" folding field camera. Light colored wood or medium colored cherry wood. \$120-180.

Competitor View, Stereo - Same as normal 5x7 Competitor, but equipped for stereo. \$300-450.

Duo - Not a camera name. This is a shutter with T,B,1,2,5,25,50,100; the medium-priced shutter in the Seneca line-up.

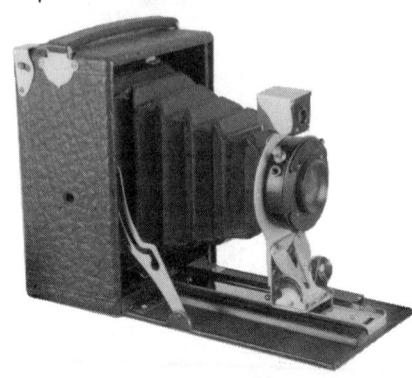

Filmett - 1910-16. Folding camera for $31/_4$ x $41/_4$ " film packs. Leather covered wood body. Black bellows. Wollensak Achromatic or Rapid Rectilinear lens. Uno or Duo shutter. \$35-50.

Folding plate cameras:

31/₄x41/₄" - Wollensak f16 lens. Uno shutter. \$45-60.

31/4X51/2" Black double-extension bellows and triple convertible lens. \$45-60. 4x5" - Black leathered body with nickel trim. Double extension bellows. Seneca

Uno or Auto shutter. \$45-60.

5x7" - Similar, black or polished wood interior, black leathered wood body. 7 Rogers or Seneca Anastigmat lens in Auto shutter. \$75-100.

No. 9 Folding Plate Camera - c1907-23. 31/₄x41/₄" and 4x5" sizes. Leather covered wood body. Black polished wood interior. Black or maroon double extension

bellows. With f4 Convertible lens or Velostigmat in Compur: \$100-150.

No. 9 Folding Plate Camera, 5x7" c1907-23. Maroon bellows. Velostigmat or Symmetrical Convertible lens in Duo shutter. \$120-180.

1 Seneca Junior 21/4x31/4" exposure folding rollfilm camera. Strut-supported lensboard and hinged front-cover. Ilex shutter. \$20-30.

Kao - Box cameras for glass plates in standard double holders. Fixed focus. All black. Kao Jr. is for 31/2x31/2" plates; Kao Sr. is 4x5". \$35-50.

Pocket Seneca No. 3A - c1908. Folding plate camera. Double extension bellows. Rapid convertible lens, Auto shutter 1-100. \$50-75.

Pocket Seneca No. 29 - c1905. Simple 4x5" folding plate camera. Seneca Uno shutter. f8 lens. \$50-75.

Roll Film Seneca No. 1, No. 1A c1914-24. Folding rollfilm camera made in two sizes, 21/₄x31/₄", 21/₂x41/₄". Simple lens and shutter. \$20-30.

Scout cameras: Made in box and folding varieties.

No. 2, 2A, 3, 3A Scout - c1913-25. Box cameras for rollfilm. \$12-20.

No. 2A Folding Scout - c1915-25. Wollensaklens, Ultro shutter. \$15-25. No. 2C Folding Scout - c1917-25. \$15-

SHALCO

No. 3 Folding Scout - c1915-25. Ultro or Trio shutter. \$15-25. No. 3A Folding Scout - c1915-25. Seneca Trio shutter. 122 film. \$15-25.

Senco No. 1 - c1912. Folding rollfilm camera with unusual design. Back is split in the middle and hinged at the front corner of each end. This design made it difficult to prevent light leaks, and provided no pressure plate. The camera must have found little success, as we have never found it in any Seneca advertising or catalogs. Uncommon. \$45-60.

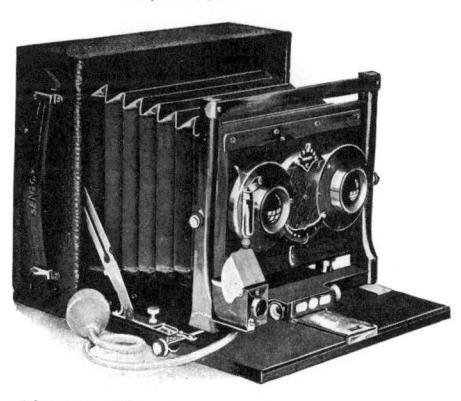

Stereo View - c1910. 5x7" folding-bed collapsible bellows view. Wide front lensboard. Leather covered wood body. Wollensak lenses. Stereo Uno or Automatic Double Valve Stereo shutter. \$350-500.

Trio - Trio is a shutter name, not a camera name.

Uno - Not the name of a Seneca camera, but rather the low-priced shutter on Seneca cameras. Provides I,T,B speeds. (There are, however, several cameras by other manufacturers where the word "Uno" figures as part of the camera name.)

Vest Pocket - c1916-25. Compact folding camera for 127 film. Side-hinged front door opens to reveal strut-supported front. Seneca Anastigmat f7.7 lens. Trio shutter 25-100. \$35-50.

View Cameras: 5x7" - c1903. Seneca Rapid convertible or Goerz Syntor f6.8 lens. Ilex shutter 1-100. Black double extension bellows. Polished wood body. \$120-180.

5x7" Improved - c1905-25. Fine wood, black leather bellows. Wollensak Planatic Series III lens. Auto shutter. \$120-180.

61/2x81/2" Improved - c1905-24. Goerz Double Anastigmat f6.8/7" lens in Volute shutter. \$120-180.

8x10", and 8x10" Improved model c1902-25. With Wollensak Velostigmat Ser. 2, f4.5/12" lens or double anastigmat lens in Optimo or Wollensak Regular shutter. \$150-225.

SEVILLE SUPER SW 500 - c1985. Novelty 35mm from Taiwan styled with small pseudo-prism. \$1-10.

SEYMORE PRODUCTS CO. (Chicago, IL) See also alternate spelling "Seymour".

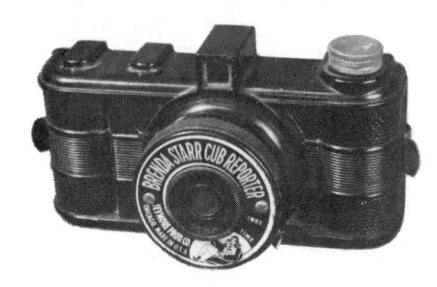

Brenda Starr Cub Reporter - Bakelite minicam for 16 exposures on 127 rollfilm. Enameled 4-color illustrated faceplate. Probably the rarest and most desirable of all the "Minicam" type cameras. \$100-150.

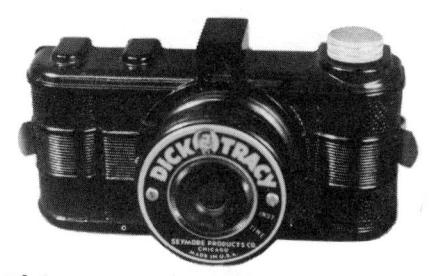

Dick Tracy - Like the Seymour Sales Dick Tracy, but black faceplate. \$35-50.

SEYMOUR SALES CO. (Chicago) See

also alternate spelling "Seymore".

Dick Tracy - Black bakelite minicam for 3x4cm on 127 film. Picture of Dick Tracy and camera name are printed in red on the metal faceplate. \$35-50. See second variation above under "Seymore Products".

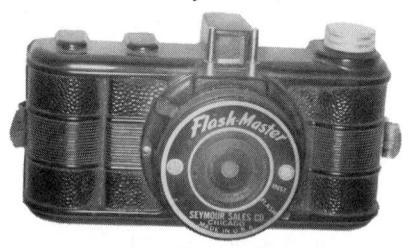

Flash-Master - Inexpensive 3x4cm 127 rollfilm minicam with sync. \$1-10.

S.F.O.M. (Société Française d'Optique Mécanique)

Sfomax - c1949. Cast aluminum subminiature with black or grey leatherette covering. Takes 20 exposures 14x23mm on unperforated 16mm film in special cartridges. S'fomar f3.5/30mm lens. Shutter 30-400 (early models 25-400). Split image rangefinder \$600-900.

SGDG: Breveté S.G.D.G. (Sans garantie du gouvernement) indicates French manufacture. According to French patent law, if an article is marked "breveté" (patented) it must also be marked "sans garantie du gouvernement" or S.G.D.G.

SHACKMAN (D. Shackman and Sons, London, England)

Auto Camera, Mark 3 - c1953. 24x24mm on 35mm film in 250 exposures cassettes. Recording camera designed for scientific work. Motorized advance. Fixed focus Dallmeyer lens. Gray painted body. \$120-180.

SHAJA - 9x12cm double extension plate camera. Tessar f4.5/135mm in Compur shutter. \$35-50.

SHAKEY'S -Plastic novelty 4x4cm camera of the "Diana" type. Made in Hong Kong. \$1-10.

SHALCO - 14x14mm Japanese Hit-type novelty camera. \$25-35.

SHANGHAI

SHANGHAI CAMERA FACTORY Shanghai 58-I, 58-II - c1950's. Chinese copy of Leica IIIf. Collapsible f3.5/50mm lens. 58-I: \$1200-1800.58-II: \$175-250.

SHANSHUI B - Chinese plastic 120 camera. \$25-35.

SHAW (H.E. Shaw & Co.)
Oxford Minicam - Black plastic half127, made by Utility Mfg. Co. for Shaw Co.
\$1-10.

SHAW-HARRISON Sabre 620 - c1956-72. Plastic 6x6cm box camera. Various colors. \$1-10.

Valiant 620 - Colored plastic 6x6cm box camera. Identical to the Sabre 620. \$1-10.

SHAYO - Japanese novelty subminiature of the Hit type. \$25-35.

SHEW (J. F. Shew & Co., London) Day-Xit - c1910 variation of the Xit. Black leathered wood body. \$200-300.

Eclipse - c1890. Mahogany with dark brown bellows. Darlot RR lens in inter-lens shutter named "Shew's Eclipse Central Shutter". 31/4x41/4", 4x5", 41/4x61/2", or 5x7" sizes: \$300-450.

Focal Plane Eclipse - Similar to the Eclipse, but focal plane shutter. \$300-450.

Guinea Xit - c1906. Mahogany gatestrut folding camera. Red bellows. 8x10.5cm on plates or cut film. Achromatic 5¹/2" lens. Central rotary shutter. \$200-300.

Stereo Field Camera - c1900. 5x7". Mahogany body with brass trim. Front bed supported by wooden wing brace at side. Tapered wine-red bellows. Double extension rack and pinion focus. Tessar f6.3/120mm lenses in double pneumatic shutter. Unusual style and rare. \$800-1200.

Tailboard camera - c1900-05. 13x18cm folding plate camera. Mahogany body with brass trim, brass Beck Symmetrical f8 lens. Iris diaphragm. Red square leather bellows. \$250-375.

Xit, Aluminum Xit - c1900. Similar to the Eclipse with aluminum and mahogany construction. ¹/₄- and ¹/₂-plate sizes: \$300-450.

Xit Stereoscopic - Folding gate-strut stereo camera. \$800-1200.

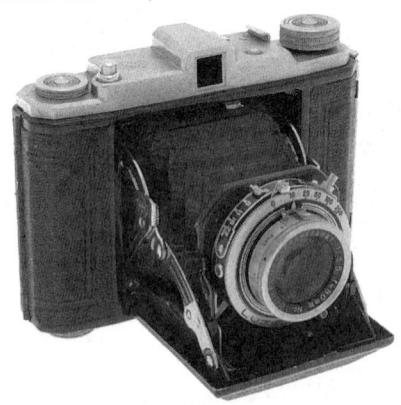

SHICHIYO OPTICAL CO. (Japan)
Pluto Six - c1954. Horizontally styled folding camera for 6x6cm or 4.5x6cm on 120 film. Built-in hinged masks at focal plane for "semi" size. "Pluto-Six" embossed in back leather, but "Pluto 7" logo embossed on front door and engraved on top plate. Pluto Anastigmat f3.5/80mm in Luzifer B,10-200 shutter. \$90-130.

SHIMURA KOKI (Japan)

Mascot - c1950. Vertical subminiature for 14x14mm on paper-backed "Midget" roll-film. Mascot f4.5/25mm. Shutter 25-100, B. \$400-600.

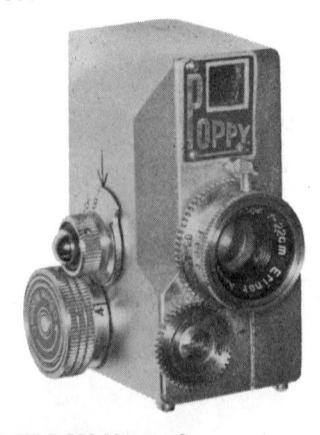

SHIN NIPPON (Japan)
Poppy - Rare Japanes

Poppy - Rare Japanese subminiature. Price negotiable. Previous estimates about \$750 until 12/91, when one sold at Christie's for \$3230.

SHINANO CAMERA CO. LTD., SHINANO OPTICAL WORKS (Japan) Pigeon - c1952. Viewfinder 35mm.

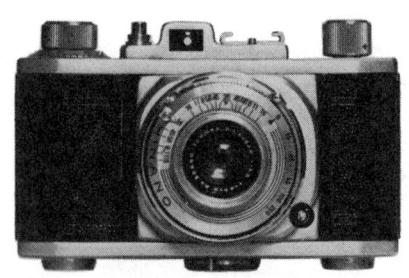

Tomioka Tri-Lausar f3.5/45mm. Synchro shutter 1-200. Advance knob. \$45-60.

Pigeon III - c1952. Viewfinder 35mm. Tomioka Tri-Lausar f3.5/45mm. NKS or TSK shutter 1-200. Lever wind. \$45-60.

SHINCHO SEIKI CO. LTD. (Japan)

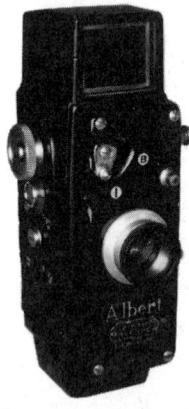

Albert - A name variation of the Darling-16. "Albert Fifth Avenue New York" on metal faceplate. \$500-750.

Darling-16 - c1957. Vertically styled subminiature accepts 16mm cassettes for 10x12mm exposures. Bakelite body with metal front and back. \$400-600.

SHINSEI OPTICAL WORKS (Japan)
Monte 35 - c1953. Inexpensive 35mm.
Monte Anastigmat f3.5/ 50mm in Heilemann, SSS or SKK shutter. \$45-60.

SHOEI MFG. CO. (Japan)
Ruvinal II, III - c1951. 6x6cm folding
cameras taking 120 or 620 rollfilm. Pentagon f3.5/80mm or Seriter f3.5/75mm lens. Shutter 1-200. \$30-45.

SHOWA KOGAKU (Japan)

Gemflex - c1949. Subminiature TLR for 14x14mm on standard "Midget" paperbacked rollfilm. Gem f3.5/25mm, shutter 25-100. Early models: Back plate has serial number and "Made in Occupied Japan"; finder hood opens for eye level viewing. Later models: No serial number: not marked Occupied Japan; no eye-level viewing provision. Auction high (12/91) \$1000. Normal range: \$400-600.

Leotax Cameras - IMPORTANT

NOTE: Prices include normal lens. Unlike Leica cameras, which are usually priced for body only, Japanese cameras must be complete with correct normal lens. Although it is not difficult to find a Leica lens to complete a camera, this is much more difficult to do with Japanese cameras of this time period. Leotax Model I - 1940 Leica copy. Uncoupled rangefinder, no accessory shoe. Only one known. Impossible to price.

Leotax Special, Special A - Wartime. Viewfinder window to left of coupled RF windows. No slow speeds. \$1200-1800.

Leotax Special B - Wartime camera. Viewfinder window to left of RF windows. Slow speeds. \$1200-1800.

Leotax Special DII - 1947. Viewfinder window between RF windows. No slow speeds. \$600-900.

Leotax DII MIOJ - \$350-500.

Leotax Special DIII - 1947. Viewfinder window between RF windows. Slow speeds. \$750-1000.

Leotax DIII MIOJ - \$300-450.

Leotax NR III - c1949. Variant of Leotax D III made for US Military during Korean war. CRF. Simlar f3.5/50mm. FP 1-500 shutter. Less than 50 made. \$2000-3000.

Leotax DIV - 1950. Rangefinder magnification 1.5X, no sync. \$350-500.

Leotax S - 1952. RF magnification 1.5X; synch posts on front; slow speed dial; no self timer. Front viewfinder bezel has round corner at upper right. \$200-300. Illustrated bottom of previous column.

Leotax F - 1954. Fast speed dial now 25-1000. Slow speed dial, self-timer. \$250-375.

Leotax T - 1955. Top speed 1/500. Slow speed dial, self-timer. \$200-300.

Leotax K - 1955. Top speed 1/500, selftimer. No slow speeds. \$200-300.

Leotax TV - 1957. Slow speeds, self timer. \$350-500.

Leotax FV - 1958. Lever wind, self timer, slow speeds to 1000. \$350-500.

Leotax T2 - 1958. Slowest speed on fast speed dial now 1/30. Slow speed dial, no self-timer. \$350-500

Leotax K3 - 1958. Slow speeds limited to 1/8 & 1/15. No self timer. \$350-500.

Leotax TV2 (Merit) - 1958. Lever wind. self timer, slow speeds to 500. \$400-600.

Leotax T2L (Elite) - 1959. Lever wind. no self timer. Slow speeds to 500. \$400-

Leotax G - 1961. Shutter 1-1000. Small dial. \$400-600.

Semi-Leotax - c1940's. Folding camera for 4.5x6cm exposures on 120 film. f3.5/75mmlens. 1-200 shutter. \$90-130.

SIAF (Argentina & Chile)

Amiga - Black plastic eye-level camera made in Chile. Streamlined design like many Kaftanski cameras. Dual format, 6x9cm or 4.5x6cm with metal insert, on 120 film. f7.5/135mm lens. Instant & Pose speeds. \$25-35.

SIDA

Gradosol - Identical to the Amiga above, but made in Argentina. \$25-35.

Gradosol Lujo - More sophisticated version of the bakelite eye-level camera, with helical telescoping front. 6x9cm, or 4.5x6cm with adapter, on 120. Nearly identical to the Gevaert Rex-Lujo, but without tripod bush. Fixed focus f10/91mmlens in I&P shutter. \$30-45.

SIDA GmbH (Berlin-Charlottenburg)

Sida - c1936. Small eye-level cameras, 24x24mm. Variations include early black or green cast metal body, later version made in France with black plastic body ("SIDA OBJ" on lens rim), also called Sidax. Italian version in red marbelized plastic ("Sida Optyka" on lens rim, "Brev. Italiano" on back). "Made in England" versions in red or green plastic. "Made in Poland" versions in black plastic. Other combinations of color and country surely exist. \$50-75.

Sida Extra - c1938. Small eye-level

SIDA...

camera making 24x24mm exposures. Dark brown/black plastic body. Similar to the Sida, but the name "Extra" is molded into the body above the lens. \$60-90.

Sida Standard - c1938. Black castmetal miniature for 25x25mm exposures. Several variations include shutter release on bottom. \$35-50.

Sidax - c1948. Small black bakelite camera similar to the Sida and Extra. Made in Paris by Kafta. Fritz Kaftanski, the designer of Sida in Berlin, had moved to Lyon France during the war and then to Paris, where he reincarnated the Sida. Uses Lumiere #1 rollfilm for 25x25mm exposures. \$60-90.

Turf - c1938-39. Bakelite folding camera with art-deco styling. Sida Anastigmat f3.5/7.5cm lens. Uncommon. \$150-225.

SIGRISTE (J.G. Sigriste, Paris) Sigriste - c1900. Jumelle-style camera 6.5x9cm or 9x12cm sizes. Zeiss Tessar f4.5. Special Focal Plane shutter 40-2500. (This shutter had speeds to $1/_{10,000}$ on some cameras.) Rare. \$5500-7500.

Sigriste Stereo - Rare stereo version of the above. \$7500-12,000.

SIL-BEAR - "Hit" type camera. \$25-35.

SILVA - Black bakelite camera for 4x6.5cm on 127 film. Telescoping front; folding frame finder. Probably made in Italy, but we can find no documentation on this uncommon camera. \$45-60.

SIMCO BOX - 6x6cm reflex style box camera made in Germany. Stamped metal with black crinkle-enamel. \$12-20.

simda (Le Perreux, France) The company name is taken from the name of the man and wife, Simone and Daniel Guébin, who founded and operated the company.

Panorascope - c1955. Wide angle stereo camera for 16mm film. Some have "Panorascope" on front, some just say "Simda". Leather covered metal body. Early version has fixed focus Roussel Microcolor 25mm f3.5 lenses, black covering, two-piece front finder without rear finder. Later version with Angenieux f3.5/25mm lenses and 2-tone grey covering. Stereo shutter 1-250, sync. Less than 2500 were made. \$750-1000.

SIMMON BROTHERS, INC. (N.Y.)

Omega 120 - c1954. A professional roll-film press camera for 9 exposures $2^{1}/_{4} \times 2^{3}/_{4}$ " on 120 film. Omicron f3.5/90mm lens. Sync shutter 1-400. Coupled range-finder. \$200-300.

Signal Corps Combat Camera - Cast magnesium camera with olive drab finish for 21/4x31/4" filmpacks only. Wollensak Velostigmat f4.5/101mm in Rapax shutter. \$200-300.

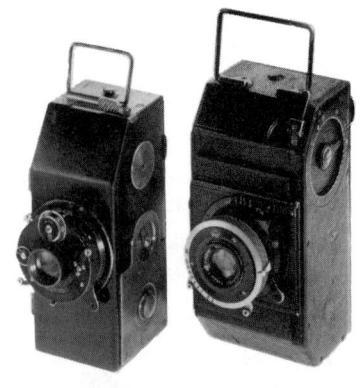

SIMONS (Wolfgang Simons & Co., Bern, Switzerland)

Sico - c1923. Two models. The better known has dark brown wooden body with brass trim. For 25 exposures 30x40mm on unperforated 35mm paper-backed rollfilm. Dagor f6.8 Double Anastigmat or Sico f3.5/60mm Rüdersdorf Anastigmat lens in focusing mount. Iris diaphragm to f22. Dial Compur shutter 1-300. An unusual variation has a leather-covered body, slightly larger in size, and different controls. \$1200-1800.

SIMPRO CORP. of AMERICA

Simpro-X - Novelty camera front for 126 cartridges. Film cartridge forms the back of the camera. \$1-10.

SIMPRO INTERNATIONAL LTD.

Slip-on - 126 film cartridge forms the back of the camera body. \$1-10.

SINCERE - Novelty 35mm camera from Taiwan, \$1-10.

SINCLAIR (James A. Sinclair & Co.,

Ltd., London)
N&S Reflex - c1910. Box-form SLR for 31/₄x41/₄" plates in standard double darks-lides. Tall viewing hood folds into top, easily removable for cleaning of the viewing screen. Most unusual design feature for the time was its front shutter. Surprisingly, this type of front shutter never really became popular until it was reintroduced by Compur on the Zeiss Contaflex about 1953. Cocking the shutter opens it for viewing. Upon pressing the release lever, a capping blade closes and the mirror raises and locks. This action in turn releases the shutter, which has speeds 1/₂-1/₁₀₀. Ross f4.5 lens. Uncommon. \$350-500.

Traveller Roll-Film Camera - c1910. Horizontally styled box camera for 31/4x41/4" on #118 rollfilm. Goerz Dagor f6.8 lens in B&L Automat shutter, concealed behind the hinged front panel with sliding lens cover. Unusual. \$300-450.

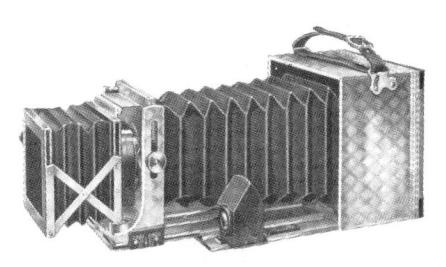

Traveller Una - c1927. Similar to the Una, but made of Duralumin, a special metal, almost as light as aluminum, but stronger. 6x9cm. Ross Combinable Lens in N.S. Perfect shutter. \$3200-4600.

Tropical Una - 1910's-1920's. Similar to Una, but teak or polished mahogany brass fittings. 6x9cm to 1/2-plate. \$1000-1500.

Tropical Una Deluxe - Same, but triple extension. \$1200-1800.

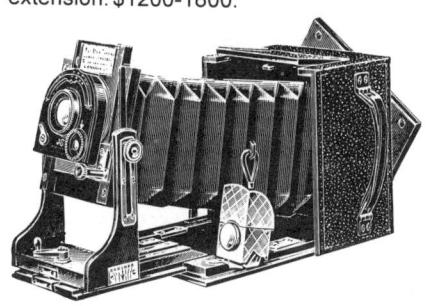

Una - c1904. Folding plate camera, 6x9cm to 5x7" sizes. Heavy wood construction. Goerz f6.8 Double Anastigmat lens. Revolving back. \$400-600.

Una Deluxe - c1908. Same as Una, but hand-stitched leather exterior. Available in brown with mahogany interior or black with black interior. No. 1 was double extension, No. 2 was triple extension. \$800-1200.

SING 88, 388, 838 - 14x14mm novelty subminiatures, later rectangular versions of "Hit" types. Made in Hong Kong. \$25-35.

SIRATON - Japanese novelty subminiature of the "Hit" type. \$25-35.

SIRCHIE FINGER PRINT LABORATORIES INC. (Raleigh, NC) Finger Print Camera - All-metal closeup camera. Built-in lights. Various models for $2^{1}/_{4}x3^{1}/_{4}$ " filmholders, filmpacks, or for $3^{1}/_{4}x4^{1}/_{4}$ " Polaroid pack film. Raptar f6.3 lens. Alphax 25-150 shutter. \$75-100.

SIRIO (Florence, Italy)
Elettra I - c1950. Viewfinder 35mm.
Fixed Semitelar f8/50mm. Shutter 25-200.
\$175-250.

Elettra II - c1950. VF 35mm. Scupltor f5.6/40mm. Shutter 25-200. \$175-250.

SITACON CO. LTD. (Taiwan) Sitacon ST-3 - c1982. Inexpensive 35mm novelty camera. Identical to the Windsor WX-3. \$1-10.

SIVA - c1930's. Folding rollfilm cameras, made in France. Sizes: 6x9cm on 120 film, or 6.5x11cm on 116 film. Body covering in brown reptile-pattern with tan bellows, or blue leather covering with blue bellows. Boyer Topaz or Hermagis Anastigmat f6.3 lens in Gitzo, "Edo" or "Siva" 25-100,T,B. Nicely finished. Uncommon. \$50-75.

S.J.C. & CO. (England) Camelot - c1900. Small mahogany field camera, 8x10.5cm. Brass trim, brass Landscape lens. Black, double extension, square leather bellows. \$200-300.

SKAIFE (Thomas Skaife, London, England)

Pistolgraph - c1858. Brass miniature camera for 28mm dia. exposures on wet plates. Dallmeyer Petzval-type f2.2/40mm, waterhouse stops. Double-flap shutter. One known sale at auction in August 1977 for \$15,000.

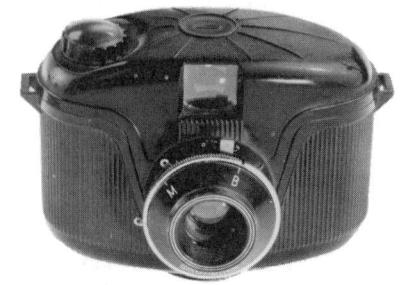

SKOLNICK (WKOAbHNK) - Black plastic

SNK CAMERA

eye-level camera for 6x6cm on 120 film. M & B shutter speeds; stops 8,11,16. The name means "student", and the low-cost camera was obviously made for a beginner. The smoothly rounded style of the body is reminiscent of the rare Indra-Lux from Germany or the Brownie 127 from England. Uncommon. No recorded sales.

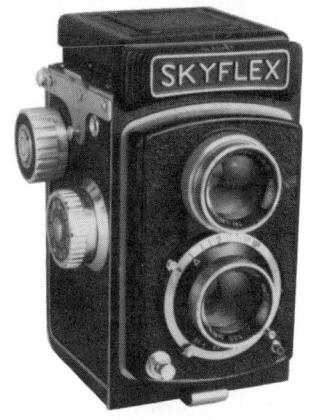

SKYFLEX - c1955. Japanese twin lens reflex for 6x6cm on 120 film. Tri Lausar f3.5/80mm in B,1-300 shutter. Manufacturer unknown, but body style is very similar to Toyocaflex IB. \$100-150.

SKYVIEW CAMERA CO. (Cleveland, OH)

Skyview Aerial Camera Model D -c1939. Cast-aluminum hand-held aerial camera with 31/₄×41/₄" spring-back. Goerz Dogmar f4.5 in Ilex Acme shutter. Despite its "aerial" name, it focuses down to 6 feet. \$100-150.

Skyview Aerial Camera Model K - c1939. Small hand-held aerial camera for 21/4x31/4" filmpacks. One-piece cast aluminum body with integral finder. Hinged aluminum back. Wollensak Aerialstigmat f4.5/5" lens. \$100-150.

SMEDLEY & CO. (Blackburn, England)
Up-to-Date - c1901. Brass and mahogany 10x12" field camera. Folds very compactly. Rising/falling front; double swing, reversing back. Rapid Rectilinear brass-boundlens. \$350-500.

SMITH (Gosport, England) Detective camera - Polished mahogany magazine box camera for 12 plates 31/4x41/4" distributed by Smith. Built-in leather changing bag. Brass trim. Two waist level viewfinders with brass covers. Guillotine shutter. \$600-900.

SMITH (James H. Smith, Chicago, IL) Known mainly for the manufacture of professional equipment.

Multiplying Camera - c1870's. 43/₄x61/₂" plate can be moved hoizontally and vertically to take 2 to 32 exposures on it. Polished mahogany body; sliding back. Brass trim. Bellows focus. Portrait lens, pneumaticflap shutter. \$750-1000.

SNAP 16 - Black and gold cardboard box camera for 3x4cm on 127 film. \$20-30.

SNAPPY - Plastic camera of the Diana type. \$1-10.

SNK CAMERA WORKS (Japan) Folding rollfilm camera - Folding bed camera. Waist level and eye level finders. Erinar Anastigmat f3.5/75mm. \$120-180.

SNK CAMERA...

Sun B - Styled in general pattern of Hit subminiatures, but heavier like Vesta. Made in Occupied Japan. \$90-130.

SÖNNECKEN & CO. (Munich) Field Camera - 5x7". Mahogany body.
Univ. Aplanat Extra Rapid lens with iris diaphragm. \$120-180.

Folding camera - Double extension, 6x9cm. Steinheil Unofocal f5.4/105mm lens. \$30-45.

SOHO LTD. (London) Soho was the result of the split of APM in 1928 and consisted of the equipment manufacturers of APM. Kershaw of Leeds took the dominant role. Eventually Soho became absorbed by Kershaw into Kershaw-Soho (Sales) Ltd. During the 1930's the firm produced a number of plastic-bodied cameras of good quality which are very collectable.

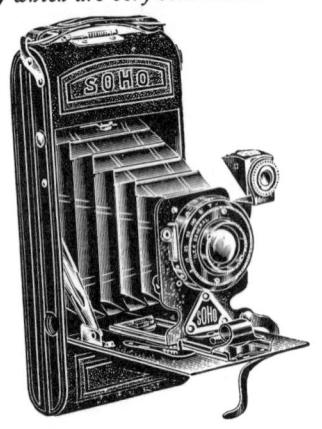

Soho Altrex - c1932. 6x9cm folding bed rollfilm. Leather covered body. Kershaw Anastigmatlens, 7-speed shutter. \$25-35.

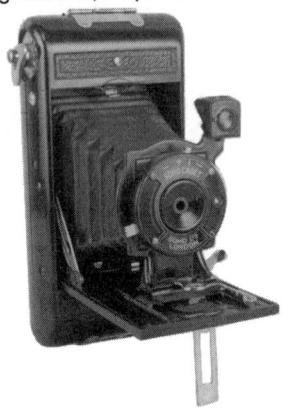

Soho Cadet - c1930. Reddish-brown bakelite 6x9cm folding bed rollfilm camera. Meniscus lens. 2-speed shutter. \$45-60.

Soho Model B - Reddish-brown folding

bakelite camera for 6x9cm on 120 film. Cross-swinging metal struts support bakelite front. Wine-red bellows. Fixed focus lens, T & I shutter. An attractive camera. \$30-45.

Soho Myna Model SK12 - Metal folding-bed rollfilm camera with self-erecting front. 6x9cm on 120. \$20-30.

Soho Pilot - c1933. Black bakelite folding rollfilm camera for 6x9cm on 120 film. Octagonal bakelite shutter face. Intricate basket-weave pattern molded into front & back. Angular art-deco body styling. Fixed focus lens, T & I shutter. \$30-45.

soho Precision - Well-made self-casing triple extension camera with full range of movements. Takes 21/₂x31/₂" plates. A copy of Linhof, and a fine professional view camera in its day, though it does not take modern film holders. Although generally selling for considerably less, a very nice complete outfit in case sold at a British auction in 1986 for \$670. Normal range: \$300-450.

Press camera - c1931-34. Leather-covered strut-folding for 21/₄x31/₄" plates. Focal plane shutter, 1/₁₆-800. Soho Anastigmat f4.5/43/₄" lens. \$120-180.

Soho Vest Pocket - c1930. Strut-folding camera for 4x6.5cm on 127 film. Leather covered. Single Achromatic lens, 3-speed shutter. \$30-45.

SOKOL AUTOMAT - c1970's. Russian 35mm with Industar 70 f2.8/50mm lens in 30-500 shutter. Rapid wind lever. \$30-45.

SOLAR MATES

In-B-Teens - c1988. Fashion coordinated sunglasses and Mini-mate 110 camera. Another version also has binoculars. About \$5. *Illustrated at top of next column*.

Sunpet 826 - c1986. Simple plastic camera for 126 cartridges. Nothing exciting about it except that it comes with a match-

Solar Mates In-B-Teens

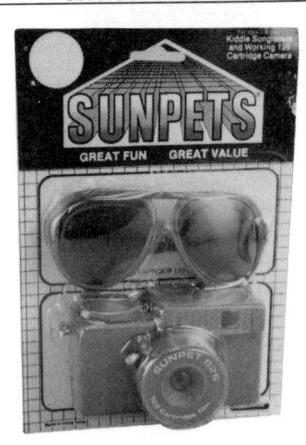

ing pair of sunglasses. Available in red, blue, or yellow. Retail about \$4.

SOLIGOR Soligor was a trade name used by Allied Impex Corp. for cameras imported from gravious manufacturers.

from various manufacturers.

Soligor 35 - c1955. 35mm SLR made by Tokiwa Seiki. Waist-level finder. Interchangeable Soligor f3.5/50 lens. Leaf shutter 1-200, B. Same camera as the earlier Firstflex 35, but sold originally with a different lens. Scarce. One reported sale at over \$400. Other sales around \$100.

Soligor 45 - c1955. Viewfinder 35mm made by Nihon Seiki Co. Nearly identical to the Nescon 35. Soligor f4.5/40mm. Shutter 25-100. \$75-100.

Soligor 66 - c1957. 6x6cm SLR. Interchangeable Soligor f3.5/80mm. FP shutter 25-500, T,B. \$100-150.

Soligor Reflex, Reflex II, Semi-Auto - c1952.6x6cm TLR for 120 film. Made in Japan. Soligor f3.5/80mm, Rektor rim-set shutter. First model has externally gear-coupled lenses. Model II has rack focusing. Semi-Auto model has auto film stop & exposure counting.\$100-150.

SOMMER (Bernard Sommer,

Dresden, Germany) Sommer was a maker of focal plane shutters, both as accessories, and built into other cameras. The early Ihagee Klapp Reflex has a Sommer shutter; later Ihagee improved it and made it themselves. Sommer did make a strut-camera, but the venture was short-lived and reportedly few cameras were produced.

Sommer Modell R.I. - c1927. Strut-

folding press camera, 6.5x9cm plates. Black lacquered metal body. FP shutter to 1/1000. Anticomar f2.9/100mm. \$150-225.

SONORA INDUSTRIAL S.A. (Manaus, Brasil)

Love - c1975-present. A disposable camera which comes pre-loaded with 16mm wide film for 20 exposures. After exposure, the entire camera is returned for processing, and a new camera is returned with the finished prints. Two-element 28mm f/11 lens. Film advanced by rotating magicube socket. Over 5 million had been sold in Brazil by 1984. Similar to "Lure" from USA. New price about \$5.00

SOUTHERN (E.J. Southern Ind., New York City)

Mykro-Fine - Japanese subminiature of the Hit type. This one actually has the U.S. distributor's name on the shutter faceplate. \$25-35.

spartus corp. (Chicago, III.) Began as Utility Mfg. Co. in New York about 1934, which sold out to the Spartus Corp. of Chicago in the 1940's. During the 1940's, several names were used including Falcon Camera Co., Spencer Co., and Spartus Corp., all of which were probably the same company. In 1951, the firm was purchased by its Sales Manager, Harold Rubin, who changed the name to Herold Mfg. Co. Meanwhile, the former President of Spartus, Jack Galter started a new company called "Galter Products" about 1950. See also "HEROLD" for later model Spartus cameras.

Cinex - Reflex-style novelty camera for 3x4cm on 127. Bakelite body. Identical to Spartus Reflex. \$12-20.

Spartacord - Brown plastic TLR. \$20-30.

Spartaflex - Plastic TLR. \$12-20.

Spartus box cameras - includes 116, 116/616, 120, 620, Rocket. \$1-10.

Spartus folding cameras - including Spartus 4, Spartus Vest Pocket. \$20-30.

Spartus Full-Vue - c1948-60. Reflex-style 120 box camera. \$1-10.

Spartus Junior Model - Bakelite folding vest-pocket camera for 4x6.5cm on 127 film. Like the earlier Utility Falcon Junior Model, but with different back latches. \$12-20.

Spartus Press Flash - 1939-50. Bakelite box camera. Advertised in April 1939 under both the Spartus Press Flash (Utility Mfg. Co.) and Falcon Press Flash names. As far as we know, it is the first camera to have a built-in flash reflector. It also exists under other names, such as Galter Press

SPARTUS

Flash and Regal Flash Master. Historically significant and interesting from a design standpoint, yet common. \$8-15.

Spartus Super R-I - TLR-style camera, non-focusing finder. \$1-10.

Spartus 35, 35F - c1947-54. Bakelite 35mm. Simple lens and shutter. \$12-20.

Spartus Vanguard - c1962. 4x4cm plastic box camera. \$1-10.

SPECIAL CAMERA

SPECIAL CAMERA - c1930's. Japanese novelty folding "Yen" camera for sheet film in paper holders. GG back. \$35-50.

SPECTRA SUPER II - c1985. Novelty 35mm from Taiwan styled with small pseudo-prism. \$1-10.

SPEED-O-MATIC CORP. (Boston, Mass.)

Speed-O-Matic - c1948. An instant-picture camera with meniscus lens, single speed shutter, extinction meter. Takes 12 photos 2x3" on direct positive paper in film pack. With developing tank: \$30-45. (Clear plastic salesman's "demo" model - \$50-75.) A modified design of the same body was later used for the Dover 620 camera.

SPEEDEX - 14x14mm "Hit" type Japanese novelty subminiature. \$25-35.

SPEICH (Cesare Speich, Genoa, Italy)

Stereo Speich - c1953. Unusual stereo reflex taking 2 side-by-side 10x12mm exposures on 35mm film. Waist level VF. Rodenstock f2.8/20mm lenses. Shutter 1-250. Only about 20 made. \$1500-2000.

spencer co. (chicago, IL) The Spencer Co. name is one of many names used by the manufacturers at 711-715 W. Lake Street in Chicago. Among the other names emanating from this building were: Falcon, Galter, Herold, Monarch, Monarck, and Spartus. The Spencer name often appears on the instruction books for cameras which bear one of the other brand names. Some cameras do carry the Spencer brand name, but usually the same camera is also available with one or more of the other brand names.

Flex-Master - Reflex style minicam for 16 exposures on 127 film. Synchronized and non-sync versions. \$12-20.

Spencer Majestic

Full-Vue - 1940s. Black bakelite pseudo-TLR. 6x6cm. \$1-10.

Majestic - This black plastic "minicam" would be hard to identify as a Spencer model without the original instructions. The camera faceplate has no company name, and the box says simply "Candid Type Camera". However, the original instructions bear the imprint of the Spencer Co. Takes 16 exposures on 127 film. \$1-10. Illustrated bottom of previous column.

SPICER BROS. (London, England) Studio camera - c1888. Studio camera, 61/₂x81/₂". Swing back. Rising/falling lens. \$250-375.

SPIEGEL Elf - 120 metal box, 6x9cm. \$15-25.

SPIROTECHNIQUE (Levallois-Perret, France)

calypso - c1960. The first commercially produced camera which was specifically designed for underwater use without any external housing. It takes standard 24x36mm frames on 35mm film, and the overall size is about the same as a normal 35mm camera. Body covering is a grey plastic imitation sealskin. Features interchangeable lenses (Angenieux f2.8/45mm, Flor f3.5/35mm, or Berthiot Angulor f3.3/28mm.) First model of 1960 has guillotine shutter marked 30-1000. Second model of 1961 has guillotine shutter marked 15-500. Nikon bought the design and the Calypso evolved into the successful line of Nikonos cameras. Uncommon. \$200-300.

SPITZER (Otto Spitzer, Berlin) Espi, 4.5x6cm - Compact lazy-tong strut camera for 4.5x6cm plates. Isconar f6.8/90mm lens in Pronto shutter. \$120-180.

Espi, 9x12cm - c1908. Folding bed camera for 9x12cm plates. Even the simple models are well-built, but lack rack & pinion focusing. Wooden body and bed with leatherette covering. Special Aplanat f11 lens in Singlo shutter. \$35-50.

Espi, 13x18cm - c1910. Folding bed camera for 13x18cm plates. Wood body with leather covering, nickel trim. Wine red

double extension bellows. Dagor f6.8/180mm in Compound 1/2-250. \$90-130.

Princess - c1918. Strut folding camera, 6.5x9cm. Tessar f6.3/120mm, Compur shutter. Also sold as Espirette. \$75-100.

SPLENDIDFLEX - 4x4cm reflex-style plastic novelty camera. \$1-10.

S.P.O. (Société de Photographie et d'Optique, Carpentras, France) Folding camera - 6x9cm self-erecting rollfilm camera. Anastigmat Sphinx Paris f6.3/105mm.\$12-20.

SPORTS ILLUSTRATED - c1985. Inexpensive plastic 35mm given as a premium with magazine subscription. \$1-10.

SPUTNIK - Japanese novelty subminiature of the "Hit" type. A rather uncommon name. The few examples we have seen have come from Germany. Normally this type of camera sells for \$25-35, but we have several confirmed sales for "Sputnik" at \$50-75.

SPY CAMERA - Plastic 127 camera, made in Hong Kong. \$1-10.

STANDARD CAMERA (Hong Kong) - Small black plastic camera for 3x4cm on rollfilm. Meniscus f11/50mm lens. Simple shutter B,1/50. \$1-10.

STANDARD CAMERAS LTD.

(Birmingham) Close links exist between Standard Cameras Ltd. & Coronet Camera Co. of Birmingham. Some models are nearly identical, others share common parts.

Conway Camera - Box camera for 6x9cm on 120 rollfilm. Several models, including Standard model, Colour Filter Model, Conway Deluxe. \$12-20.

Robin Hood Camera - c1930's. Stereo box of marbelized bakelite. Takes darkroom loaded single sheets of 45x107mm film. Originally came with film, paper, and darkroom safelight. Sometimes seen in England, but rarely elsewhere. \$90-130.

Standard Camera No. 2 - Inexpensive cardboard box camera with blue leatherette covering. "No.2 Standard Camera - Made in England" on metal faceplate. We assume that this is made by Standard Cameras, Ltd., but we have no confirming references. Takes 6x9cm on 120 film. I & T shutter. \$25-35.

STANDARD PROJECTOR & EQUIPMENT CO.
Gatling f1.7 - c1963. Half-frame 35mm

with spring motor drive for 12 rapid exposures. Color Rikenon f1.7/35mm lens. Made by Riken. \$120-180.

STARFLEX - c1955. Japanese TLR, possibly made by Tougo-do. Knob wind, rack focusing. Tri-Lausar f3.5/8cm in 1-300 shutter. \$90-130.

STAR LITE - c1962. Inexpensive reflex-style camera. \$1-10.

STAR-LITE - Japanese "Hit" type novelty camera. \$25-35.

STEGEMANN (A. Stegemann, Berlin) Field camera - 13x18cm. Mahogany body. Single extension square cloth bellows. Normally with Meyer or Goerz lens. \$300-450.

Hand-Camera, 6.5x9cm - c1905-18. Folding strut camera. Black wooden body. Metal knee-struts. Focal plane shutter. Tessar f4.5/120mm lnes. \$500-750.

Hand-Camera, 13x18cm - c1895-1905. Strut-folding camera for 13x18cm plates. Unusual design with hinged struts made of wood rather than metal. Fine wood body with nickel trim. Tapered black single pleat bellows. Folding Newton finder. Carl Zeiss Anastigmat f7.7/195mm with iris diaphragm. \$800-1200.

Stereo Hand-Camera - c1905. Struttype folding camera for 9x18cm plates. Polished black wooden body. Focal plane shutter. Sliding lens panel has provision for two separate square lensboards, allowing use as a non-stereo camera with two different lenses mounted. \$750-1000.

STEINECK KAMERAWERK (Tutzing)
Steineck ABC Wristwatch camera

- c1949. For 8 exposures on circular film in special magazine. Steinheil f2.5/12.5mm fixed focus lens. Single speed shutter. Auction record 12/91 \$3200 in original box. Normal prices: In original presentation box: \$1000-1500.Camera only: \$750-1000.

STEINHEIL

STEINER OPTIK (Bayreuth, Germany)

Hunter 35 - c1950s. 35mm viewfinder camera. Steiner f3.5/45mm lens, shutter $1/_{25}$ - $1/_{100}$. Hunter 35 was the name used for the Steinette when sold by R.F. Hunter in Britain. \$35-50.

Steinette - c1950s. Relatively simple 35mm viewfinder camera. Steiner f3.5/45mm lens in 25-100 shutter. A similar camera made in Holland was called "Primo"; a later version from Germany was the Ideal Color 35. \$30-45.

STEINHEIL (Optischen Werke C. A. Steinheil Söhne GmbH, Munich)

Casca I - c1948. Name derived from C.A. Steinheil CAmera. Viewfinder 35. Culminar f2.8/50mm lens in special bayonet mount. Gear at rear of lens couples to focusing wheel on camera front. Focal plane shutter 25-1000. \$250-375.

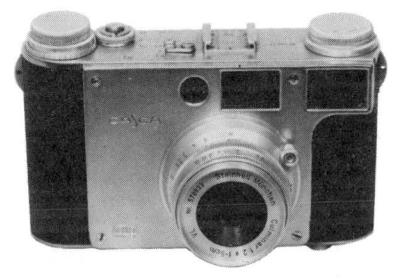

Casca II - c1948. Similar in appearance to Casca I, but with coupled rangefinder. The unusual bayonet mount uses three opposing pairs of spring-loaded bearings in detents to secure the lens. This is totally different and incompatible with Casca I. Interchangeable lenses include 35mm f4.5 Orthostigmat, 50mm f2.8, 85mm f2.8, & 135mm f4.5 Culminars. A small top lever switches projected frame lines in finder for 85/50/135mm. Sliding bar on rear selects shutter speeds B,1/2-1000. \$300-450.

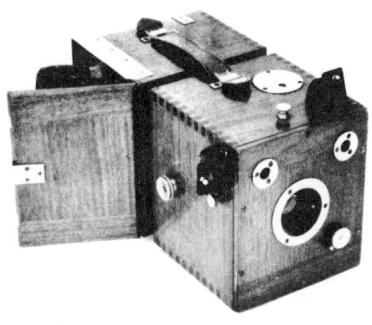

Detective camera - c1895. Magazine camera for 12 plates, 9x12cm or 10x15cm. Wood body with nickel trim. Steinheil or Periskop lens. Rotary or guillotine shutter. \$600-900.

STEINHEIL...

Folding plate camera - c1930. Double extension folding bed, 9x12cm. Triplar f4.5/135mm in Ibsor. \$45-60.

Kleinfilm Kamera - c1930. Small bedless strut-folding camera for 3x4cm on 127 film. Style similar to Welta Gucki. Cassar f2.9/50mm lens in Compur 1-300. \$90-130.

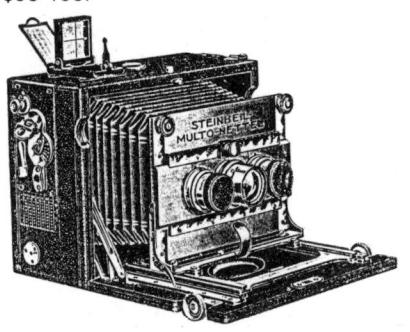

Multo Nettel - c1910-12. Folding-bed stereo camera for $3^{1/2}x5^{1/2}$ " (9x14cm) plates. Three convertible lenses on one lensboard allow for stereo or single exposures with a choice of several focal lengths. FP shutter. \$500-750.

Stereo Detective - c1893. Wooden body with changing magazine for 81/2x17cm plates. Rotating shutter. \$1200-1800.

Tropical camera - 9x12cm plates. Double extension brown tapered bellows. Fine wood with nickel trim. \$600-900.

STELLAR - Japanese novelty subminiature of the Hit type. \$25-35.

STELLAR FLASH CAMERA - 4x4cm "Diana" type novelty camera, sync. \$1-10.

STELLARFLEX - Twin lens reflex style novelty camera for 4x4cm on 127 film. Identical to the Bedfordflex and a few other names \$8-15.

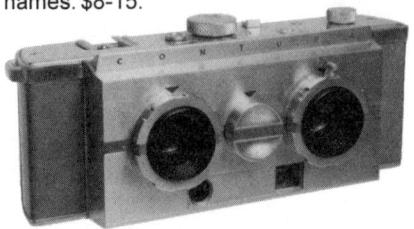

STEREO CORPORATION (Milwaukee, Wisc.)

Contura - ca. mid-1950's. Stereo camera designed by Seton Rochwite, who also designed the Stereo Realist for the David White Co. It was styled by renowned product stylist Brooks Stevens, who was also responsible for the Excalibur automobile. It was engineered to be the finest stereo camera ever made. The f2.7/35mm Volar lenses focus to 24 inches with a single-window rangefinder. Probably the first camera to incorporate "Auto Flash" which adjusted the diaphragm automatically based on the focus distance. The camera reached the production stage too late, just as stereo camera sales were plummeting, and a corporate decision was made to abandon the project. Ultimately, 130 cameras were assembled and sold to stockholders for \$100 each. The rarity and quality of this camera keep it in demand among collectors. There are usually more offers to buy than to sell. \$1200-1800.

STEREOCRAFTERS (Milwaukee, Wisc.)

Videon - c1950's. Stereo camera for standard 35mm cassettes. Black metal and plastic construction. Iles Stereon Anastigmat f3.5/35mm lenses. Sync. shutter, \$90-130.

Videon II - c1953. Similar to the Videon, but top and faceplate are bright metal. \$120-180.

STERLING - Hit type novelty camera. \$25-35

STERLING CAMERA CORP. (Sterling, Illinois)

Buddie 2A - Basic box camera for $21/2 \times 41/4$ " on 116 film. Metal, wood, and cardboard construction, with leatherette covering. One known example has an interior black paper label with white lettering which gives the manufacturer's name. On other examples, the only identification is "2A-BUDDIE" on strap. \$20-30.

2-A Sterling - Basic leatherette-covered cardboard box camera for $2^{1}/_{2}x4^{1}/_{4}$ " on 116 film. Very similar to the 2A Buddie. Relatively scarce. \$20-30.

STERLING MINIATURE - Black plastic "minicam" for 28x40mm exposures. \$1-10.

STIRN (C. P. Stirn, Stirn & Lyon, N.Y., Rudolph Stirn, Berlin)

Concealed Vest Camera, No. 1 - c1886-92. Round camera, six inches in diameter, for 6 photos 13/4" diameter on 5" diameter glass plates. Original price, \$10.00, and early ads proclaimed, "Over 15,000 sold in first 3 years." Needless to say, many are lost. Auction record \$4000 in original wooden box. Normal range: \$1200-1800. The original wooden box, which also allows the camera to be used on a tripod, doubles the value of the camera.

Concealed Vest Camera, No. 2 - c1888-90. Similar to the above, but for 4 exposures, $2^{1}/_{2}$ " (6.5cm) dia. Camera measures 7" in diameter. \$1200-1800.

Detective Magazine camera - c1891. Mahogany box camera for 12 plates 6x8cm (also made in 9x12cm size). Leather changing bag. Aplanetic lens. Early version has horizontal guillotine shutter, and only a single finder. By 1893, it has rotary shutter and two finders. \$750-1000.

S.T.M. & CO. (Birmingham, England)

Itakit - c1890. Falling plate magazine camera, 31/₄x31/₄". Removable magazine. \$500-750.

SUMIDA

STOCK (John Stock & Co., New York, NY)
Stereo Wet plate cameras, 5x8" - Very early models of heavier construction: \$3200-4600. Later models, more common, lighter construction: \$1200-1800.

STÖCKIG (Hugo Stöckig, Dresden)

Stöckig was one of Germany's largest catalog mail order houses. Most if not all cameras with their logo on them have been made by Ernemann. If you find a Stöckig camera not listed here, do not be alarmed. Just refer to the Ernemann section. Many Ernemann cameras sold between 1907 and 1926 can be found with a Stöckig label with "Union" name. Included here are some examples of cameras sold in recent years.

Union camera - c1907-26. Folding-bed plate cameras with leather covered wood body and finely polished interior. Wine-red or blue-green single or double extension bellows. 9x12 and 13x18cm sizes. With Meyer Anastigmat f7.2, Detective Aplanat f8, or Union Aplanat f6.8 lens in Union shutter. Made by Ernemann & sold by Stöckig. \$200-300.

Union Zwei-Verschluss - c1911. Folding-bed camera for 9x12cm plates, made for Stöckig by Ernemann. Leather covered wood body. Double extension wine red bellows. Focal plane shutter 1/50-1/2500. Meyer Aristostigmat f6.8/120 in Ernemann 1/2-1/100 front shutter. \$300-450.

STOP (BOX CAMERA STOP) - Cardboard box camera for 6x6cm on 120 film. Made in France. Simple construction. Rear cover pulls off after removing advance knob by turning and pulling. Telescoping wire frame finder and rear sight. Variations include: All-black with silver lettering on front; black body with aluminum faceplate. Uncommon. A few have surfaced in France, in original box, at \$35-50.

STRACO (Strahm & Co., Switzerland) Rigi-box - Plastic box camera for 6x6cm on 120 rollfilm. \$50-75.

STUDENT CAMERA CO. (New York City)

Student No. 1 - Small wooden box camera for $2^5/_8x3^3/_8$ " on single glass plates held behind two nails on each side of the camera. Interesting diaphragm on the front, but the shutter was the user's finger-tip. \$100-150.

Student No. 2 - Similar, but for $31/_4 \times 45/_8$ " plates. \$100-150.

SÜDDEUTSCHES CAMERAWERK KÖRNER & MAYER (Sontheim &

Heilbronn, Germany) Founded 1902 by Max Körner & Robert Mayer; renamed Nettel-Camera-Werk in 1909. Continued as part of Contessa-Nettel after 1919 and Zeiss Ikon after 1926.

Cewes-Film-Klapp-Camera - c1903. Advertised as the "only folding camera without focal plane shutter which can be extended and folded with one motion, and which offers close focusing". Scissor-form struts, rounded body ends, folding frame finder. Made in 9x12cm and 10x12.5cm sizes. Nettel Extra Rapid Aplanat or Aristostigmat lens in Unicum shutter. \$150-225.

Nettel-Klapp-Camera - c1903. Strut camera for 9x12cm plates. Predecessor of the line of Deckrullo-Nettel cameras, which continued under Nettel, Contessa-Nettel, and Zeiss-Ikon. Focal plane shutter 1-1500. Originally advertised with Aristostigmat f5.5, f7, or f7.2 lenses in 120mm, 135mm, and 150mm lengths. \$200-300.

SUGAYA KOKI, SUGAYA OPTICAL CO., LTD. (Japan)

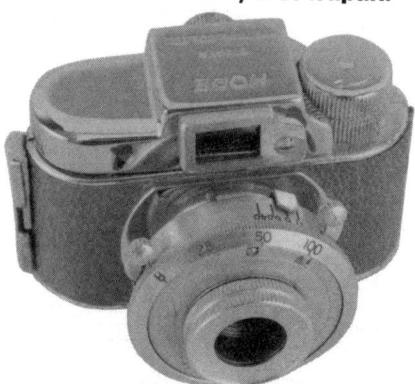

Hope (Sugaya Model II) - c1950. Subminiature for 14x14mm on 17.5mm rollfilm. Similar to the Myracle with its large "Sugaya Model II" shutter. "HOPE" embossed in top. Hinged back door. Blue leatherette covering: \$175-250. Black: \$120-180.

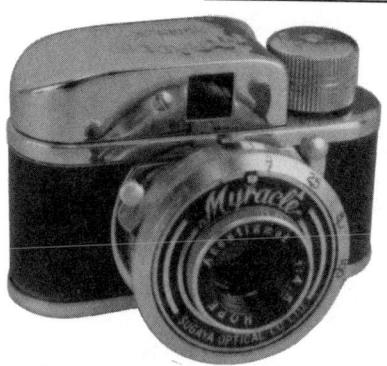

Myracle, Model II - c1950. Subminiature for 14x14mm on 17.5mm rollfilm. Similar to the Hit-type cameras, but with a better lens and shutter. Hope Anastigmat f4.5. Shutter 25-100, usually with plain faceplate, but also with "Myracle" or "Mycro II" faceplate. Red, blue, or black leather. Some examples marked "Made for Mycro Camera Co. Inc. N.Y." on bottom. Some have hinged back, others load from top. \$100-150.

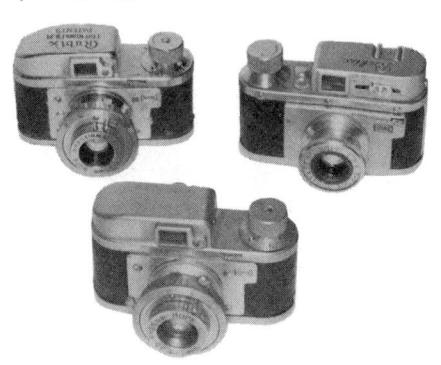

Rubix 16 - c1950's. Subminiature for 50 exposures 10x14mm on 16mm cassette film. Several variations. Hope f3.5 or 2.8/25mm lens. Shutter 25-100 or 25-150. \$200-300.

Rubix 16 Model III - c1950's. Heavy, oversized body, but taking 16mm cassettes for 50 exposures. Hope Anastigmat f3.5/25mm in Rubina shutter. Uncommon. Only recent recorded sale at Christie's 12/91 for \$480.

SUMIDA OPTICAL WORKS (Japan)
Proud Chrome Six III - c1951. Japanese Super Ikonta B copy. 6x6cm or 4.5x6 cm on 120. Coupled rangefinder. Congo f3.5/75mm in Proud Synchront 1-200 shutter, B. \$100-150.

Proud Model 50 - c1950. Folding bed camera for 4.5x6cm on 120 rollfilm. Some examples have waist-level finder on lens standard. Eye-level finder in top housing. Proud Anastigmat or Wester Anastigmat

SUMNER

f3.5/75mm in N.K.S or KSK shutter 1-200,B. \$75-100.

SUMNER (J. Chase Sumner, Foxcroft, Maine) Stereo rollfilm box camera - similar to the No. 2 Stereo Kodak box camera. \$500-750.

SUN - Japanese subminiature camera with reflex finder. Uses Mycro-size film for 14x14mm exposures. Sanko 35mm lens; B&I shutter. Probably the rarest of the reflex-type subminiatures; only a few examples known. \$600-900.

SUNART PHOTO CO. (Rochester, N.Y.)

Sunart folding view - c1898. Various Vici and Vidi models. Black leather covered wood body with polished cherry interior. Double extension bellows. B&L RR lens. Unicum shutter. 5x7": \$120-180. 4x5": \$90-130.

Sunart Junior - c1896. 31/₂x31/₂" and 4x5" plate box cameras, similar in style to the Cyclone Sr. \$50-75.

SUNBEAM CAMERA CO. We have no documentation on the Sunbeam Camera Co., but it appears that they had cameras made by Galter, Herold, Irwin, & Spartus. Historical records indicate that these companies had close ties.

Sunbeam Minicam (bakelite) - Black bakelite minicam for 16 exposures 3x4cm on 127 film. \$1-10.

Sunbeam Minicam (metal) - All metal body in "sardine-can" shape, with black crinkle finish. Body is identical to the Irwin Kandor cameras. Uncommon. \$25-35.

sunbeam Six Twenty - Gray plastic twin-lens 6x6cm box. Sunbeam label conceals the Spartus name beneath. \$15-25.

SUNNY - Small Japanese bakelite camera for 24x24mm exposures on 35mm film. Cartridge-to-cartridge film advance with standard 35mm cartridges elimates the need to rewind. Combination eye-level direct or reflex finder with semi-silvered mirror. Uncommon.\$100-150.

SUNPET - Inexpensive black plastic eyelevel camera for 6x6cm on 120. Similar to "Diana" types. Made in Hong Kong. \$1-10.

SUNPET 826 BAZOOKA - Specially marked premium version of the inexpensive Sunpet 826 camera. \$1-10.

SUPEDEX VP 35 S - Inexpensive 35mm camera from Hong Kong. Simple focusing Supedex f3.5/40mm lens. Three-speed shutter. \$1-10.

SUPER CAMERA - c1950. Japanese paper covered wooden "Yen" cameras for sheet film in paper holders. Folding style: \$50-75. Box Style: \$20-30. Folding style illustrated at top of next column.

Super Camera, folding style

SUPERIOR FLASH CAMERA 120 - Synchronized metal box camera, 6x9cm. \$1-10.

SURUGA SEIKI CO. Mihama Six IIIA - c1953. Horizontally styled folding camera for 6x6cm or 4.5x6cm on 120 film. Separate eye-level finders for each size. Mihama or Kepler Anastigmat f3.5 in NKS shutter. \$75-100.

SUTER (E. Suter, Basel, Switzerland)

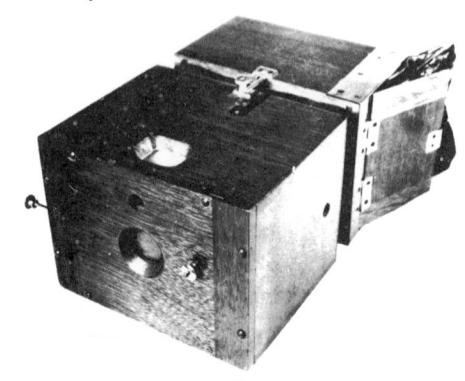

Detective magazine camera - c1890. Early model for 12 plates, 9x12cm. Periskop lens, guillotine shutter. Polished wood with nickel trim. \$750-1000.

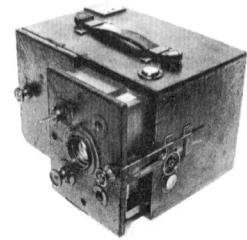

Detective magazine camera -

c1893. Later model for 20 exposures on 9x12cm plates. Suter f8 lens with iris diaphragm, rotating shutter. Leather covered mahogany box with brass trim. \$600-900.

Folding plate camera - 1913-26. Double extension folding plate camera, 9x12cm GG back. Contessa-Nettel body with Suter Anastigmat f6.8/135mm lens. Rare. \$75-100.

Stereo Detective - c1895. Polished wood stereo box camera for 9x18cm plates. Not a magazine camera. \$1200-1800.
Stereo Detective, Magazine -

c1893. Leather covered stereo magazine camera, for 6 plates 9x18cm. Built-in magazine changing-box sits below the camera body and is operated by pulling on a knob. f10/90mm Rectilinear lenses. Coupled rotary sector shutters. \$1000-1500.

Stereo Muro - c1890's. Press-type, side struts, 9x18cm plates. Suter f5/85mm lenses. FP shutter 30-1000. \$400-600.

SUZUKI OPTICAL CO. (Japan)

Camera-Lite - c1950. Cigarette-lighter spy camera which looks like a Zippo lighter. Very similar to the Echo 8. A supply of Camera-Lites was discovered at a flea market about 1966-67, but released slowly into the collector market. This helped to maintain the same market value for several years at \$200-300. Now they usually sell for about \$400-600.

Camera-Lite Seastar - Normal Camera-Lite, but with Seastar logo on narrow back edge of body. We don't know the origin or meaning, but one sold at auction in late 1985 for \$350.

Echo 8 - 1951-56. Cigarette-lighter camera. Designed to look like a Zippo lighter, it also takes 5x8mm photos with its Echor f3.5/15mm lens on film in special cassettes. At least two sizes, the larger measuring 17x47x58mm; the earlier more common smaller one is 15x42x56mm. There were also different film cassettes, either "square" or "rapid" shaped. Also sold under the name Europco-8. Auction record price (Christie's 12/91) \$2500 with presentation box & film slitter. Normal range: \$350-500. With presentation box and film slitter add \$250-375.

Press Van - c1953. Japanese 6x6cm strut-folding rangefinder camera. Two variations: One takes an alternate image size of 4.5x6cm on 120, the other 24x36mm on 35mm film. Takumar f3.5/75mm in Seikosha Rapid shutter 1-500,B. \$350-500.

SVENSSON (Hugo Svensson & Co., Göteborg)

Hasselblad Svea - c1905. Leather covered falling-plate detective camera, 9x12cm plates. Brass lens. \$175-250.

Stella - c1910. Compact folding camera of interesting design. The entire body is a

rectangular bellows with two large pleats. Extending the front and back sections causes interior knee-struts to snap into locked position, and the camera assumes a box form. Makes 8x12cm images using standard 9x12cm metal plateholders. Large meniscus lens is positioned behind the front section on a pair of rails. A rod protruding from the front knob pulls the lens forward for focusing. Six-speed guillotine shutter concealed in front. Some examples have the "Stella" name embossed in the leather on top of the back section; others are not named. \$300-450.

SWALLOW - Hit type novelty subminiature. \$25-35.

SWINDEN and EARP (England) Magazine camera - c1887. The first falling-plate magazine camera. Clement & Gilmer lens, flap and roller blind shutters. Few known sales. \$60-90.

SWISS-BOX - Small metal box camera for 3x4cm on 127 film. Very inexpensive construction. Single speed shutter with long 90° shutter stroke. Grey crinkle-finish enamel. Uncommon.\$90-130.

TACHIBANA TRADING CO. (Japan) Beby Pilot - c1940. Bakelite-bodied folding camera for 3x4cm on 127 film. Pirot (sic) Anastigmat f4.5/50mm in "Pilot,O" shutter. \$120-180.

TAHBES (Holland)

Populair - c1955. All metal camera with telescoping front. Nickel-plated body with chrome front: \$50-75. Leatherette-covered model with black faceplate: \$30-45. *Illustrated at top of next column.*

Synchrona - Similar to the Populair, but synchronized through top-mounted tripod socket. Grey or green leatherette covering. Large round Albada finder. \$35-50.

TAISEI KOKI

Tabbes Populair

TAISEI KOKI (Japan)

Super Welmy - Two models, same description & price as Super Westomat.

Super Westomat 35 (2-window) - c1956. Rangefinder 35, also sold as Super Welmy. The 2-window version has a superimposed image rangefinder. The two front windows are nearly equal in size. Variations include: Taikor f2.8/45mm with lefthand focusing lever and B,25-200 shutter. Taikor f2.8 or Terionon f3.5, with geared focus wheel for right hand, in B,5-300 shutter. \$30-45.

Super Westomat 35 (3-window) c1956. Rangefinder 35 camera, also sold as Super Welmy. The 3-window version has a split-image rangefinder with a separate eyepiece. The front finder window is flanked by two narrow rangefinder windows. Focusing by geared wheel, operated by right hand. Terionon f3.5/45mmin B,25-200 shutter. \$30-45.

Welmy Six, Welmy Six E - c1951-53. Folding cameras for 6x6cm on 120 film. Terionar f4.5/75mm or f3.5/75mm lens. Shutter 1-200 or 1-300. Eye-level and waist-level finders. \$50-75.

Welmy 35 - c1954. A non-rangefinder folding 35mm. Terionar f3.5 or f2.8/50mm lens. Welmy shutter 25-150,B. \$35-50.

TAISEI KOKI...

Beauty Super L

Welmy M-3 - c1956. Rangefinder model with Terionar f3.5/45mm in 5-300 shutter. \$50-75.

Welmy Wide - c1958. 35mm viewfinder camera with Taikor f3.5/35mm lens. Shutter 25-200,B. \$45-60.

Westomat - c1957. 35mm CRF. Terionon f3.5/45mm, $1/_{25}$ - $1/_{200}$ shutter. \$25-35.

TAIYODO KOKI (T.K.K., Japan)

Beauty - c1949. Occupied Japan subminiature. Eye-level and deceptive angle finders. f4.5/20mm fixed focus lens. B,25-100 shutter. Auction record 12/91 \$290. Normally \$150-225.

Beauty Canter - c1957. Coupled range-finder 35mm. Canter f2.8/45mm lens. Copal-MXV1-500,B.\$45-60.

Beauty 35 Super - c1956. Identifiable by the word "BEAUTY" on the front of the

top housing. "Super" is not marked on the camera. Canter f2.8/45mm in Copal Synchro MX B,1-500 shutter. \$30-45.

Beauty 35 Super II - c1958. 35mm CRF. Canter f2/45mm in Copal SV 1-500,B shutter. Lever advance. \$30-45.

Beauty Super L - c1958. Similar to Super II, but with built-in meter with booster. Canter-S f1.9/45mm. \$35-50. *Illustrated at top of previous column.*

Beautycord - c1955. 6x6cm TLR for 120 film. Beauty f3.5/80mm in 10-200 shutter. \$50-75.

Beautycord S - c1955. 6x6cm TLR. Tri-Lausar or Beauty f3.5/80mm lens. TKK 1/₁₀-200 shutter. \$75-100.

Beautyflex - c1950-55. 6x6cm TLR. Several slight variations, but usually with f3.5/80mm Doimer Anastigmat lens. 1-200 shutter. \$50-75.

Beautyflex III - c1950. 6x6cm TLR. Doimer f3.5/80mm lens, 1-200,B shutter. \$60-90.

Beautyflex S - c1954. 6x6cm TLR. Beauty f3.5/80mm in NKS-FB B,1-300 shutter. Also sold as Beauty S, same except for nameplate. \$60-90.

Epochs - c1948. Heavy cast metal subminiature for 14x14mm on "Midget" size rollfilm. Identical to the Vestkam and Meteor cameras. "Epochs" on top only, not on shutter face. This name is not common. Talent f3.5/20mm. TKK shutter 25,50,B. \$175-250.

Meteor - c1949. Same as Epochs, except for name. "Meteor" name on top and shutter face. This name is not common. Vestkam f4.5/25mm lens. TKK shutter 25,50,B. \$175-250.

Reflex Beauty - c1954-56. Japanese copy of the Kochmann Reflex Korelle for 6x6cm on 120 film. An early Japanese 6x6cm SLR (first was Shinkoflex of 1940).

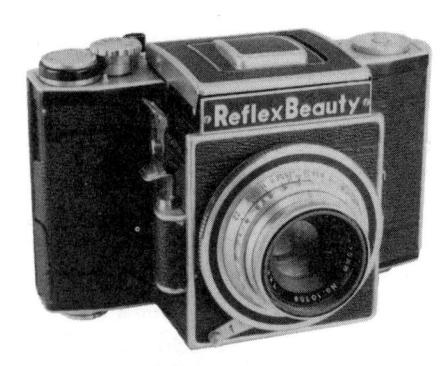

Reflex Beauty II

Canter f3.5/75mm lens. Focal plane shutter to 500. Model I has chrome nameplate with script lettering. Model II has embossed nameplate and bayonet-mounted lens. \$175-250.

Vestkam - c1949. Same as Epochs and Meteor, except for name. Marked "Made in Occupied Japan". This is the most common name. Vestkam f3.5/20mm. TKK shutter 25,50,B. \$120-180.

TAIYOKOKI CO., LTD. (Japan) Viscawide-16 - c1961. Panoramic camera for 10 exposures 10x46mm on specially loaded 16mm film. Lausar f3.5/25mm lens. Shutter 60-300. 120° angle of view. \$250-375.

TAKAHASHI OPTICAL WORKS

Arsen - c1938-42. Similar to the more common Gelto, but for 12 exp. 4x4cm on 127 film rather than 16 exp. Collapsible front. f3.5 or f4.5/50mm lens in 5-250 shutter. \$75-100.

TAKAMINE OPTICAL WORKS TAKANE OPTICAL CO. (Japan)

Mine Six IIF - c1955. Folding bed rollfilm camera, 6x6cm on 120. CRF. Deep-C Anastigmat or Takumar f3.5/7.5cm in Rectus 1-300 or Copal. \$120-180.

Mine Six Super 66 - c1957. Folding bed rollfilm camera, similar to the Super Ikonta IV. 6x6cm or 4.5x6cm on 120. CRF. Built-in selenium meter. Takumar f3.5/75mm in Copal MXV 1-500 shutter. \$120-180.

Sisley Model 1 - c1950s. Folding camera, 6x6cm or 4.5x6cm on 120 rollfilm. Copy of Super Ikonta. Deep-C f3.5/75mm, NKS-SC 1-200 shutter. \$75-100.

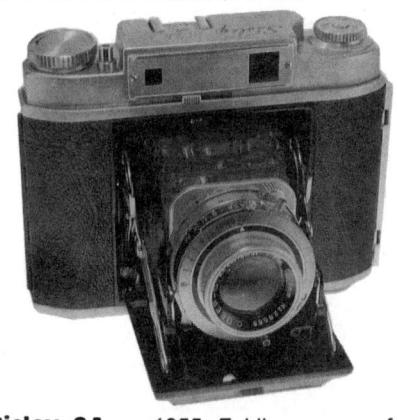

Sisley 2A - c1955. Folding camera for 6x6cm or 4.5x6cm on 120. Coupled range-finder. Deep-C Anastigmat f3.5/75 in Copal 1-300. \$100-150.

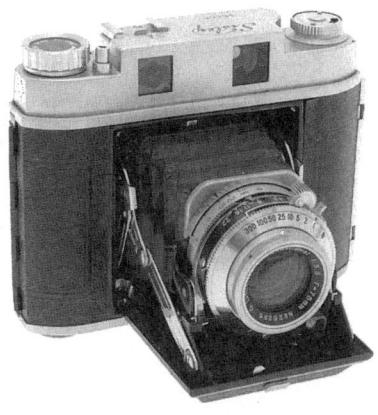

Sisley 3A - c1956. Folding camera for 6x6 on 120 film, with automatic film counter. Coupled rangefinder. Deep-C Anastigmat f3.5/75 lens in Copal-MX B,1-300. \$100-150.

TAKKA - c1950. Subminiature camera for Mycro-size rollfilm. Slightly heavier than the "Hit" types. Takka 20mm lens in TKW B,25,50 shutter. Uncommon. Brought \$250 at Christie's 12/91 sale.

TALBOT (Romain Talbot, Berlin)

Makers of the Errtee cameras. In German, the letters R.T. (for R. Talbot) are pronounced "Err-Tee".

Errtee button tintype camera - c1912. A cylindrical "cannon" for 100 button tintypes 25mm diameter. Rotating pedestal contains three processing tanks; exposed plates drop through chute into selected tank. Laack Schnellarbeiter f3.5 or f4.5/60mm lens. Single speed shutter. \$800-1200.

Errtee folding plate camera -

c1930. 9x12cm. Double extension bellows. Dialytar or Laack Pololyt f4.5/135mm lens. Compur shutter 1-200. \$35-50.

Errtee folding rollfilm camera, 6x9cm - For 120 rollfilm. Anastigmat
Talbotar f4.5/105mm in Vario shutter 25-100. Brown bellows and brown leather covering: \$50-75. Black leathered: \$30-45.
Errtee folding rollfilm camera, 5x8cm size - Poloyt Anastigmat f6.3/90mm in Vero shutter. Black leather and bellows. \$30-45.

TALBOT (Walter Talbot, Berlin) Invisible Camera - c1915-30. Unusual camera shaped like a 7cm wide belt, 34cm long, with a film chamber at each end. The camera is made to be concealed under a vest with the lens protruding from a buttonhole. The versions advertised around

1930 are made for 35mm daylight-loading cartridges, but these ads usually mention that the camera had been in use for "over 15 years", (before there were standard 35mm cartridges.) We suspect that they were not commercially available in the early years. This suspicion is based on the lack of advertising until the late 1920's, and because of their rarity in the current collector market. Rare. Price negotiable.

TALBOT & EAMER CO. (London, England)
Talmer - c1890. Magazine box with changing bag. 8x10.5cm plates. \$400-600.

TANAKA KOGAKU TANAKA OPTICAL CO., LTD. (Japan)

Tanaka Kogaku had a rather short history starting with the manufacture of Leica copies about 1953 and ending about 1960 just as its designs started to show some originality.

designs started to show some originality. **Tanack IIC** - 1953-55. Similar to the Leica IIIB, but with hinged back, sync post on front, and with no slow speeds. Location of slow speed dial is capped. Interchangeable Tanar f3.5/50mm lens. Focal plane shutter 1/20-500, B. \$350-500.

Tanack IIIF - c1954. Slow speed dial added to front, otherwise like IIC. Interchangeable Tanar f2.8/50mm lens. FP shutter 1-500, B,T. \$300-450.

Tanack IIIS - c1954. Top housing stamped as one piece (as Leica IIIc). Two posts on front for FP & X sync. Otherwise like Tanack IIIF, including slow speeds. Tanar f2.8/50mm. \$300-450.

Tanack IIISa - c1955. Like IIIS with single piece top housing, but has only one sync post. Tanar f3.5/50mm. Uncommon. \$350-500.

Tanack IV-S - c1955. Standard lens was six-element f2/50mm Tanar with helical focusing. FP shutter 1-500, B,T. The IVS was widely advertised in the USA. Original-

TARON

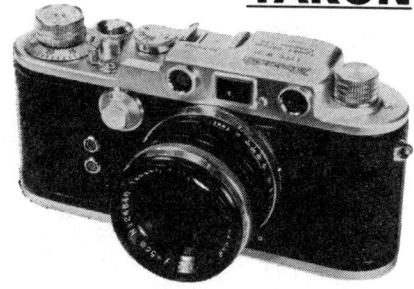

ly it sold for \$104. (List price was \$169.) By 1960 they were being sold for \$65. Current value \$300-450.

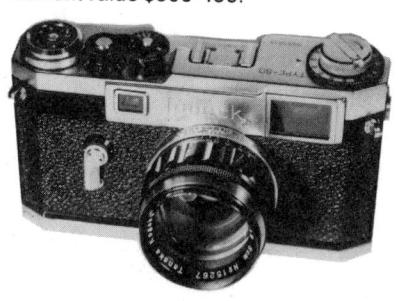

Tanack SD - 1957. 35mm RF resembling a rangefinder Nikon more than a Leica. Combined range/viewfinder window. Interchangeable screw-mount Tanar f1.5/5cm lens. FP shutter 1-1000, B,T, ST. Lever advance. A nice 3-lens outfit with finder sold quickly at \$800. With normal lens: \$500-750.

Tanack V3 - c1958. Inspired by the Leica M-series, the V3 sports a re-styled top housing with the sync post at the end below the rewind knob. The lenses use a 3-lug bayonet mount, not compatible with Leica's 4-lug system. This was the only Tanack with bayonet mount. \$350-500.

Tanack VP - c1959. The last of the Tanack line has a new top housing with a large window to illuminate the projected frame lines in the finder. Screwmount lenses, with Tanar f1.8/5cm as standard. \$300-450.

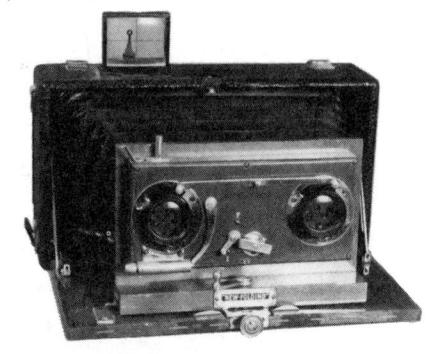

TARCET (Paris)
New Folding Stereo - Folding bed
stereo camera for 9x18cm plates. Leathered wood body with polished wood interior and nickel trim. Stereo shutter built into
wooden lensboard. Focusing knob on the
front of the bed. \$350-500.

TARON CO. LTD. (Japan) Formerly Nippon Kosokki Co. before 1960, but the company name was changed to match the name of its Taron cameras.

Cavalier EE Auto 35 - c1965. Modified and renamed version of Taron Auto EE camera of 1963. Sold by Peerless Camera

TARON...

Stores. Peerotar f1.8/45mm in Citizen MVE shutter. \$35-50.

Chic - c1961. Vertically styled camera for 18x24mm half-frames on 35mm film. Taronar f2.8/30mm. Taron-LX shutter controlled by selenium meter. \$75-100.

Fodor 35 - c1955. Rangefinder 35, same as Taron 35, but renamed for a European distributor. Tomioka Lausar f2.8/45mm in NKS-MX 1-300,B shutter. \$35-50.

Taron 35 - c1955. 35mm CRF. Lausar f2.8/45mm, NKS 1-300, B shutter. \$30-45.

Taron Super LM - 35mm CRF. BIM. Taronar f1.9/45mm. \$45-60.

TASCO Bino/Cam 7800 - c1977-81. Combination of 7x20 binoculars and 110 cartridge camera with Tele-Tasco 112mm f5.6 lens. Single speed ¹/₁₂₅ shutter, variable aperture. Original selling price about \$200. Currently \$120-180.

Bino/Cam 8000 - c1980-83. Similar to model 7800, but with interchangeable screw-mount lenses. Two speed shutter, $1/_{125}$ & $1/_{250}$. Normal lens f5.6/100mm. 70mm & 150mm lenses also available. With normal lens: \$150-225. Add \$15-25 each for 70mm or 150mm lens.

TAUBER - c1920's. German 9x12cm folding plate camera. Rapid Aplanat f8/135mmlens. \$35-50.

TAYLOR (A & G Taylor, England) View camera - Tailboard style ¹/₂-plate mahogany view. Clement & Gilmer brass barrel lens, iris diaphragm. \$250-375.

TAYLOR, J. (Sheffield, England)
Tailboard camera - Full plate brass
and mahogany camera. Rack and pinion
focus. Brassbound Vogel lens with waterhouse stops. \$250-375.

TECHNICOLOR CORP. Techni-Pak 1 - c1960. Plastic 126 factory loaded cartridge camera. Camera must be returned for processing and reloading. \$1-10.

TEDDY CAMERA CO. (Newark, NJ) Teddy Model A - c1924. Stamped metal camera in bright red and gold finish. Takes direct positive prints 2x31/2" which

develop in tank below camera. Original price just \$2.00 in 1924. Current value with tank: \$600-900.

TEEMEE - Japanese novelty subminiature of the Hit type. \$25-35.

TELLA CAMERA CO. LTD. (London, England) **No. 3 Magazine Camera -** c1899. Leather covered box, holds 50 films in a filmpack. Taylor Hobson f6.5, pneumatic sh. Detachable rise/cross front. \$300-450.

Signal Si

TEX - c1949. German miniature for 3x4cm on unperforated 35mm film in special cartridges. Rectangular telescoping front. Vidar or Helur f4.5/50mm lens, Singlo or Compur shutter. Most common with Helur in Singlo. Cast metal body identical to the Nova camera. \$100-150.

THOMAS (W. Thomas, London) Wet plate camera - c1870. Folding-bed bellows camera for $\frac{1}{2}$ -plates. Brass trim, f11 lens. \$1200-1800.

THOMPSON (W.J. Thompson Co.,

Direct positive street camera - Box-style street tintype camera. Plates, devloping tank, etc. all packed inside the camera's body. \$120-180. Deduct \$50 for missing tank.

THORNTON-PICKARD MFG. CO. (Altrincham, England) The company was formed in 1888 when Mr. Edgar Pickard joined the Thornton Manufacturing Co. Its first major product was the T-P roller blind shutter and it soon claimed "the largest sale in the world". T-P undertook a short-lived and relatively unsuccessful scheme to break into the American market in 1894. Camera production concentrated on the Ruby field camera which really took off after 1896 with the introduction of the cheaper version, the Amber. It also produced a range of folding

and pocket type cameras in an attempt to break into Kodak's market.

The firm prospered until 1914 when the war upset production and marketing. Directly post-war the firm's position seemed hopeful. To consolidate its position T-P was involved with APM in 1921 and Soho Ltd in the 1930's. This did nothing, however, to halt its decline which resulted from lack of investment. T-P ceased to exist in 1940 although the name was kept alive until at least 1963.

Aerial Camera, Type C - c1915. Brass reinforced mahogany camera for 4x5" plates in special magazines. Long body accomodates Ross Xpres f4.5/101/4" lens. Focal plane shutter. Detachable cylindrical brass finder. \$3500-5500.

Amber - c1899-1905. Compact "English style" folding view camera. Sizes from ¹/₄-to ¹/₁-plate. Front door/bed often has turntable for tripod legs. Round opening in bed allows lens and shutter to protrude when camera is folded. \$250-375.

Automan (Nimrod Automan, Oxford Automan) - c1904. Hand and stand folding plate camera in 31/₄x41/₄" and 4x5" sizes. Polished mahogany interior. Leather covered exterior. Red bellows. Aldis Anastigmat f6 lens. B&L Automat or T-P Panoptic shutter. \$250-375.

College - c1912-26. Compact mahogany/ brass double extension field camera. Five sizes, 9x12cm to 18x24cm. T-P Rectoplant in rollerblind shutter. \$350-500.

Duplex Ruby Reflex - c1920-30. SLR. Aldis Anastigmat f4.5 lens. FP shutter. \$200-300.

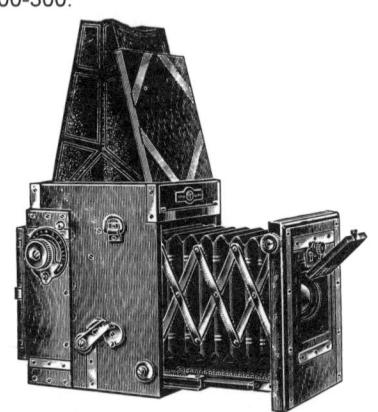

Duplex Ruby Reflex "Overseas" (**Tropical**) - SLR, 6.5x9cm and 1/₄-plate sizes. Teak and brass body. Double extension orange bellows. Focal plane shutter to 1000. Cooke Anastigmat f6.3 lens. \$2800-4000.

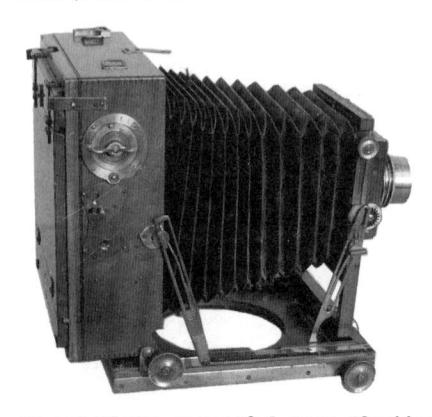

Focal Plane Imperial Two-Shutter Camera - c1909. Essentially the same as the normal Imperial, but with a built-in focal plane shutter. The earlier examples are not self-capping. About 1910, the Imperial and other cameras were fitted with the new self-capping shutter. \$600-900.

Folding plate camera, 1/2-plate or 5x7" - c1900's. Zeiss Unar f5/210mm lens. Focal plane shutter 15-80. \$200-300.

Folding Ruby - c1920's. 31/₄x41/₄" folding plate camera. Revolving back, fine wood interior, leathered exterior, various correctional movements. Cooke Anastigmat f6.5 lens. \$200-300.

Horizontal Reflex - c1923. Large SLR, 31/4x41/4". Entire front extends via rack and pinion. Leather covered wood, black metal parts. Cooke Anastigmat f4.5/5" lens, FP shutter. \$200-300.

Imperial Perfecta - c1913. Similar to the Imperial Triple Extension, but only double extension. 1/2-plate to 1/1-plate sizes. Beck Symmetrical lens. T-P roller-blind shutter. \$350-500.

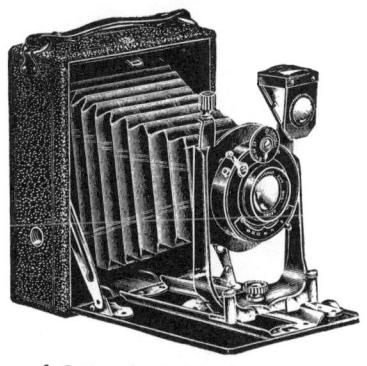

Imperial Pocket - c1916. Folding-bed plate cameras. Lower priced models have wood body, single extension metal bed. Better models have all metal body, rack focusing. \$50-75.

Imperial Stereo - c1910. Folding bed camera, 9x18cm. Accomodates single or stereo lensboards. \$350-500.

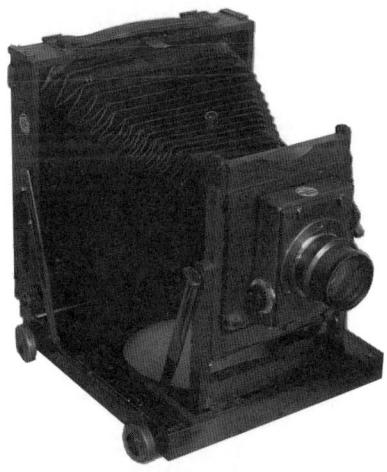

Imperial Triple Extension - c1904-26. One of the more advanced field cameras with triple extension tapered leather bellows. 1/2-plate size. Mahogany with brass trim. Beginning c1910, there were brass strips added above and below the lensboard, and on the front of the bed. This was called the "New" Imperial. Beck Symmetrical, T-P Rectoplanat lenses. Rollerblind shutter. One fine example sold in 1991 for \$560. Common in England in average used condition for \$350-500. Fine condition less common and worth an extra \$150-225.

THORNTON-PICKARD

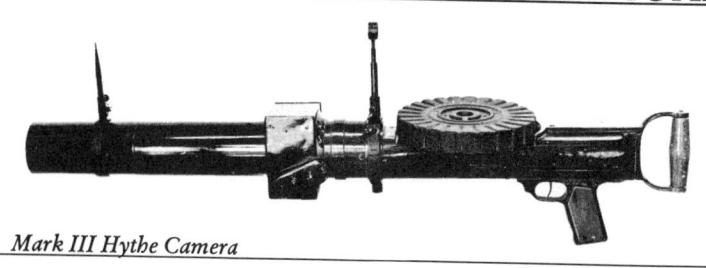

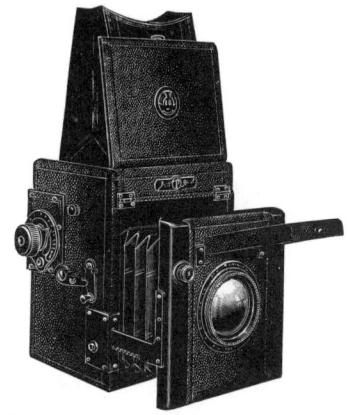

Junior Special Ruby Reflex - c1926-35. Press-type SLR, 6x9cm or 31/₄x41/₄" sizes on plates. Black leather covering. Dallmeyer Anastigmat f4.5/130mm. FP shutter 10-1000, T. \$175-250.

Mark III Hythe Camera - c1915. Rifletype camera, 4.5x6cm on 120 rollfilm. Used in WWI to train British R.A.F. machine gunners. f8/300mm lens. Central shutter. \$750-1000. Illustrated at top of this column.

Puck Special - 4x5" plate box camera. Focus and shutter adjustable. \$75-100.

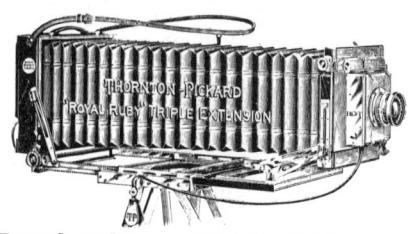

Royal Ruby - c1904-30. Folding plate camera, same as the Ruby, but all Royal Ruby are triple extension. Top of the Thornton Pickard line. Stereo outfit: \$800-1200. Nice normal outfit: \$600-900. Camera only: \$400-600.

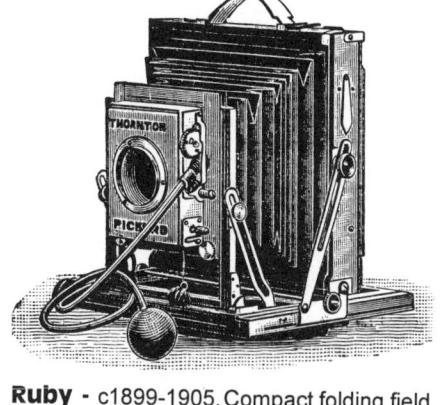

Ruby - c1899-1905. Compact folding field camera. Front door becomes baseboard, with tripod legs fastening to built-in turntable. Ruby R.R. lens. T-P rollerblind shutter. \$350-500.

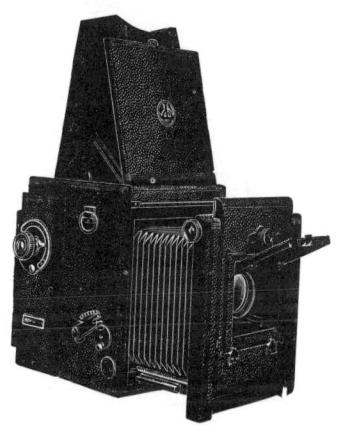

Ruby Deluxe Reflex - c1912-1930's. Leather covered mahogany SLR (also made in an "overseas" model). Specifications varied over the years, and it was made in most sizes. Various lenses. Focal plane shutter $\frac{1}{10^{-1}}\frac{1}{1000}$. \$250-375.

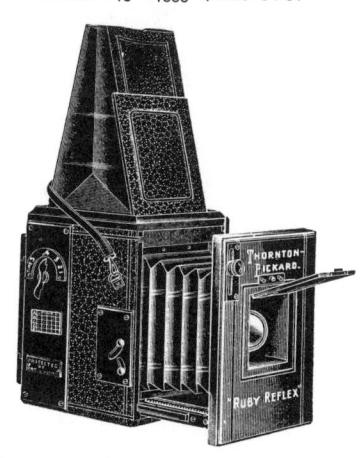

Ruby Reflex - c1928. 4x5" SLR. Ross Homocentric 6.3/6". FP shutter. \$250-375.

THORNTON-PICKARD...

Ruby Speed Camera - c1925. Small focal plane camera with f2 lens. Inspired by the 1924 Ermanox. Taylor-Hobson Cooke Anastigmat f2/3" lens in helical focusing mount. Machined cast aluminum body with leather covering. Focal plane shutter T,1/10-1000. Only one recorded sale, at auction in 1985 for about \$2700.

Rubyette No. 1, No. 2, No. 3 c1934. SLR, 6.5x9cm for plates or rollfilm. Dallmeyer Anastigmat f8, f4.5 or f2.9 lens. FP shutter 10-1000. Nice examples fetch \$300-450, average ones \$150-225.

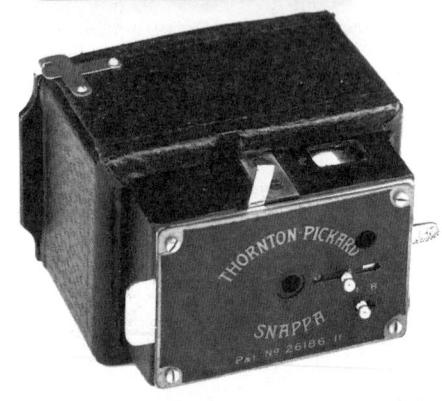

Snappa - c1913. Simple 4.5x6cm plate camera with pull-out box-shaped front, no bellows. Single Achromatic lens with sliding diaphragm. \$500-750.

Special Ruby - c1905. Wood field camera with double extension black bellows. Brass trim. Goerz Doppel-Anastigmat f2.5/210mm, T-P roller-blind shutter. \$350-500.

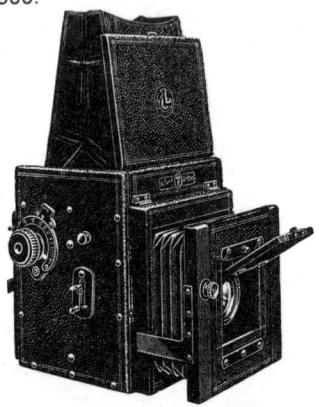

Special Ruby Reflex - c1923-38. $21/_4$ x $31/_4$ " or $31/_4$ x $41/_4$ " sizes. Cooke Anastigmat f4.5 lens. Focal plane shutter. \$150-225.

Stereo Puck - c1925. Inexpensive roll-film box for 6x8.5cm on 120 film. Meniscus

lenses, simple shutter. Black covered wood body. Camera only: \$120-180. With box and viewer, it will bring at least double that price.

Tribune - c1913. Small, lightweight compact-folding field camera for $3^{1/4}$ x41/4" plates. Built-in rotating tripod head in bed. \$175-250.

Victory Reflex - c1925. 21/4x31/4" SLR. Dallmeyer or Cooke lens. \$175-250.

Weenie - c1913. Simple folding bed plate camera, 1/2-plate. Fittings are nickel. Single Achromatic lens, T-P Everset T,B,I shutter. \$40-60.

THORPE (J. Thorpe, NY) Four-tube camera - c1862-64. Wet plate camera with 4 lenses for up to 4 exposures on a 5x7" plate. One on record in 1980 with wet plate holder and dipping tank for \$1250.

THOWE CAMERAWERK (Freital & Berlin)

Field camera, 9x12cm - Horizontal format. Has rear bellows extension. Blue square cornered bellows with black corners. \$150-225.

Folding plate camera, 9x12cm - c1910. Leather covered wood body. Doxanar f6/135mm lens. Shutter 25-100. \$45-60.

Thowette - c1932. 3x4cm rollfilm camera with telescoping front. Xenar f3.5/50mm lens in Ring Compur 1-300 shutter. \$200-300.

Tropical Plate Camera, 6.5x9cm or 9x12cm - Folding bed camera. Brown double extension bellows. Reptile leather covering. Brown lacquered metal parts. Brass trim. \$350-500.

TIEZONETTE - c1932. Strut-folding plate camera, 4.5x6cm. Xenar f3.5/45mm lens in Compurshutter. \$175-250.

TIME - Minimum-quality 35mm camera from Taiwan. All black plastic with red & white "TIME" on front of top housing. Given free with \$20 subscription to TIME magazine in mid-l985. Several variations of body style, probably from different factories. \$1-10.

TIME FC-100 - Similar to the above, but with model number and slight variation in body style. Given free during the same

promotion, this version of the camera showed up in Australia. \$1-10.

TIME-FIELD CO. (Newark, Delaware USA)

Pin-Zip 126 - c1984. Cardboard camera with drilled brass pinhole. Uses 126 cartridge film. An interesting modern pinhole camera, named for the sound made by the light as it enters the pinhole. \$1-10.

TINY - Japanese novelty subminiature of the Hit type. Uncommonname. \$35-50.

TIRANTI (Cesare Tiranti, Rome) Summa Report - c1954. Unusual press camera with two pairs of lenses mounted on a turret. The normal lens pair was a Schneider Xenar f4.5/105mm in Synchro Compur, and a Galileo Reflar f4 viewing lens. The wide-angle pair was a Schneider Angulon f6.8/65mm in Synchro Compur, and a Galileo Reflar f3.5 viewing lens. The impressive cast aluminum body took 6x9cm plates, packs, or rollfilm. Only 100 made. Unusual and rarely seen for sale. \$5500-7500.

TIRANTY (Paris)

ST 280 - c1960. 35mm rangefinder camera. Body imported from Germany, made by King. Lever advance, helical focus. Assembled in France with Angenieux f2.8/45mm in Atos 2 shutter B,1-300. \$25-35.

Stereo Pocket - Jumelle type stereo camera for 45x107mm plates. Transpar f4.5/54mm lenses in Jack shutter 25-100,B,T. With magazine back: \$175-250.

TISCHLER (Anton Tischler, Munich, Germany)

Colibri - c1893. Small leather covered box camera for 4x4cm plates. Waist-level viewfinder mounted on top of body. Simple lens and shutter. Originally sold with box of plateholders, in a large case. One auction sale in 10/88 for \$3200 in mint condition with holders, boxes, etc.

TISDELL & WHITTELSEY (pre-1893) TISDELL CAMERA & MFG. CO. (post-1893) (New York)

T & W Detective Camera - c1888. Detective box camera for 31/₄x41/₄" plates. All wood box. Truncated pyramid rather than bellows for focusing. Achromatic meniscus lens. Rare. One sold a few years ago for \$1200, and another for \$2800. No recent recorded sales.

Tisdell Hand Camera - c1893. In 1893, the name of the T & W Detective Camera was changed to "Tisdell Hand Camera". Leather covered. Internal bellows focus. \$800-1200.

TIVOLI - c1895. English 1/2-plate. Mahogany body. Rectilinearlens. \$300-450.

TIZER CO. LTD. (Japan)
Can Camera 110 TX Coca-Cola 1978. Camera the size and color of a
Japanese 250ml Coke can. 110 cartridge
film. Synched and non-synched versions.
Fixed focus. Single speed shutter. \$50-75.
See Eiko Co. Ltd. for later can cameras from
Hong Kong.

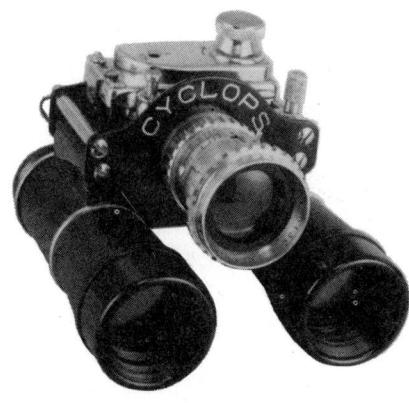

Toko Photo Cyclops

Orangina Camera - c1977. 110 camera in the shape of a can of orange soda. \$45-60.

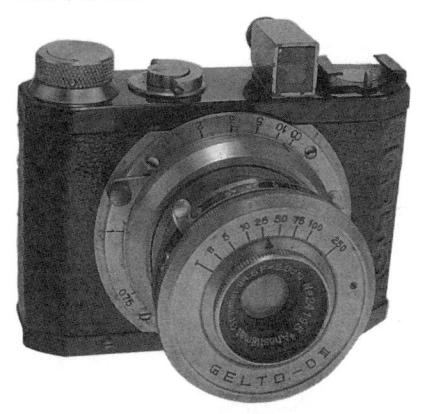

TOAKOKI SEISAKUSHO (Japan) Gelto D III - c1938 and 1950. 1/2-frame 127 film cameras. Pre-war model has black body and Grimmel f4.5/50mm lens in collapsible mount. Post-war models have chrome or gold body and f3.5 lens. Common features include: eye-level optical finder, shutter T,B,5-250. Prewar: \$150-225. Postwar: \$90-130.

TOGODO OPTICAL CO. (Japan)
"Togodo" and "Tougodo" are roman spelling variations of the same name. See Tougodo.

TOHOKOKEN CAMERA CO. Camel Model II - c1953. Inexpensive 35mm camera with styling similar to Canon, but with front shutter and no range-finder. Even the type style for the name "Camel" is similar to the style used by Canon. Camel f3.5/50mm. Nippol 1-200 shutter. \$60-90.

TOKIWA SEIKI CO. (Japan) Bioflex - c1951. TLR, 6x6cm on 120 film. First Anastigmat f3.5/8cm lens, externally gear-coupled to the viewing lens. B,10-200 shutter. Not to be confused with the cheap plastic Bioflex novelty camera. \$60-90.

First Six I, III, V - c1952-54. Horizontal folding cameras for 6x6cm or 4.5x6cm on 120 rollfilm. Separate viewfinder for each image size on Models I, III. Model V has uncoupled rangefinder. Neogonor Tri-Lauser Anastigmat f3.5/80mm. (See First Camera Works for an earlier camera with the same name.) \$60-90.

Firstflex - c1951-55. A series of 6x6cm TLR cameras. f3.5/80mm. Some models have shutters to 1/₂₀₀, others have MSK 1-400 shutter, B. Cheaply made. \$60-90.

Firstflex 35 (1955 type) - 35mm SLR with waist-level finder. Removable bayonet-mount f3.5/50mm lens. Behind-the-lens leaf shutter 25-150,B.\$150-225.

Firstflex 35 (1958 type) - 35mm SLR with built-in prism. Mirror acts as shutter. Exa/Exakta bayonet mounted Auto Tokinon f2.8/45mm. Also sold under the Plusflex name in England and GM 35 SLR in the USA. \$75-100.

Kenflex - c1951. Basic TLR with externally gear-coupled lenses. Essentially a name variant of the Firstflex I. First Anastigmat f3.5/80 in B,10-200 shutter. \$50-75.

Kwikflex - c1950s. TLR, 6x6cm. Tri-Lausar Anastigmat f3.5/80mm in Rectus shutter. \$75-100.

TOKYO KOGAKU

Lafayette 35 - c1955. Export version of Firstflex 35. Interchangeable Soligor Anastigmat f3.5/50, behind-the-lens leaf shutter B,25-100. Waist level finder. \$120-180.

Windsorflex, 35mm - c1955. Same as the 1955 type Firstflex 35 (waist-level, not eye-level prism). \$120-180.

TOKO PHOTO CO. (Japan) Cyclops - c1950's. 16mm Japanese binocular camera, identical to the Teleca. 44.5/35mm lens. Shutter 250-100. \$500-750. *Illustrated at bottom of first column.*

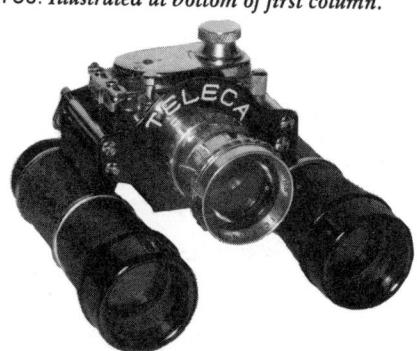

Teleca - c1950. 10x14mm subminiature 16mm telephoto camera built into binoculars. Non-prismatic field glasses have camera mounted on top center. \$600-900.

TOKYO KOGAKU (Japan) Tokyo Kogaku's TLR cameras were sold by three different distributors under different names: "Primoflex" by J.Osawa & Co., "Laurelflex" by K.Hattori & Co., the makers of Seiko shutters, and "Topconflex" for direct sales by Tokyo Kogaku.

Tokyo Kogaku.

Laurelflex - c1951. 6x6cm TLR. Toko or Simlar f3.5/75mm. Konan Rapid-S or Seikosha Rapid 1-500, B. \$60-90.

Minion - c1938. Self-erecting bellows camera for 4x5cm on 127 film. Toko f3.5/60mm. Seikosha Licht 25-100, B,T. Original 1938 model painted black; chrome model introduced in 1939. \$100-150.

Minion 35 C

Minion 35 - c1948. Viewfinder 35. Toko

TOKYO KOGAKU...

f3.5/40mm. Seikosha Rapid 1-500, B. Variations: A & B have 24x32mm "Nippon size" format; B has body release. C has standard 24x36mm size. \$120-180.

Primo Jr., Primo Jr. II - c1958. 4x4cm TLR for 127 film. Sold in the U.S.A. by Sawyers. Topcor f2.8/60mm. Seikosha 1-500,B. \$100-150.

Primoflex - c1950-56. A series of 6x6cm knob-wind TLR cameras. Most often with Toko f3.5/75mm in Rectus shutter. \$90-130.

Primoflex Automat - c1956. 6x6cm TLR, crank advance. Topcor f3.5/75mm in Seikosha MX shutter. \$90-130.

Topcoflex - c1950. Knob-wind 6x6cm TLR; name variant of Primoflex. First version lacks sportsfinder in hood. Later version, c1951-52, has sportsfinder. Toko f3.5/75, NKS or Rectus shutter. \$75-100.

Topcoflex Automat - c1957. 6x6cm TLR. Crank advance. Topcor f3.5/75 in Seikosha MXL shutter. \$75-100.

Topcon 35-L - c1957. 35mm RF. Topcor f2/44mm in Seikosha-MXL 1-550,B. Auto parallax-correcting bright-frame finder. Accessory selenium meter clips in top shoe; reads directly in EV numbers. Add \$20 for meter. Camera & normal lens only: \$60-90.

Topcon Auto 100 - c1965-73. 35mm SLR with through-the-lens CdS metering. This was the first automatic TTL camera. Interchangeable UV Topcor f2/53mm lens. Shutter 1/8-500, B. \$60-90.

Topcon B - c1959-61. 35mm SLR. Pentaprism interchangeable with waist-level finder. Interchangeable Exakta-mount Auto-Topcor f1.8/58mm, externally linked auto diaphragm. FP 1-1000, B. \$120-180.

Topcon C - c1960-3. Like Topcon B, but internal automatic diaphragm. \$100-150.

Topcon D-1 - c1965-71.35mm SLR with through-the-lens CdS metering. Interchangeable RE Auto-Topcor f1.8/58mm lens. FP 1-1000,B.\$90-130.

Topcon R - c1958-60. Same as the Topcon B. \$175-250.

Topcon RE Super - Introduced 1963. The first SLR with fully coupled through the lens metering system. (Note that the Mec-16 SB subminiature already had a coupled behind the lens metering system in 1960, but it is not an SLR.) Removable prism. FP shutter 1-1000,B. With f1.4/58mm lens: \$120-180.

Topcon Super D - c1963-74. 35mm SLR. Same as the Topcon RE Super. With interchangeable RE-Auto Topcor f1.8/58mm lens: \$175-250.

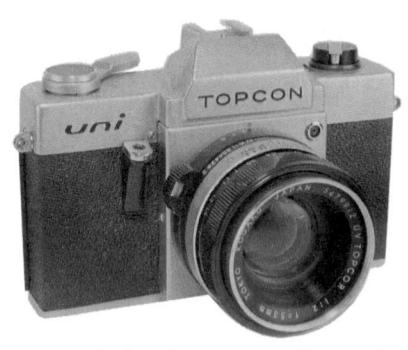

Topcon Uni - Same as the Topcon Auto 100. \$60-90.

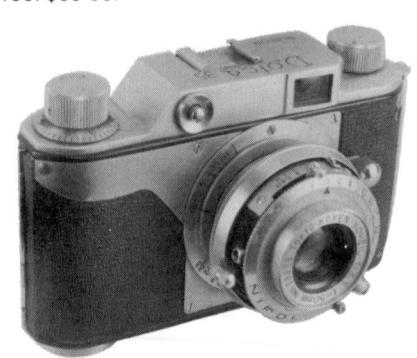

TOKYO KOKEN CO. (Tokyo) Dolca 35 (Model I) - c1953. Leaf-shutter 35mm camera without rangefinder. Extensible front with helical housing. Komeil f3.5/50mm lens in Nipol shutter B,1-200. ASA sync post. \$60-90.

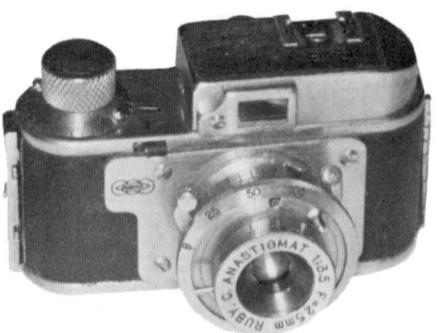

TOKYO KOKI CO. (Japan)
Rubina Sixteen Model II - c1951.
Subminiature for unperforated 16mm film in special cassettes. Made in Occupied Japan. Ruby f3.5/25mm lens. Shutter 25-100,B. Some are marked "Made for Mycro Camera Co. Inc. N.Y." on the bottom. \$175-250.

TOKYO SEIKI CO. LTD. See also Rocket Camera Co.

Doris Semi P - c1952. Folding camera

front only as "Doris"; model Semi P can be identified by front door which swings sideways when camera is in horizontal position. "Occupied Japan". Perfa Anastigmat f3.5/75mm lens, Convex or NKS shutter B,10-200.\$50-75.

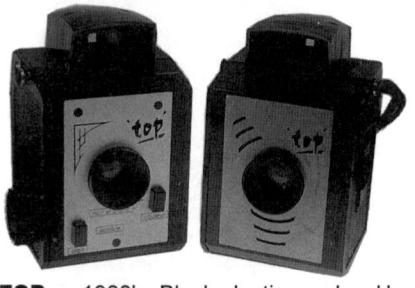

TOP - c1960's. Black plastic eye-level box cameras made in France. One version has metal faceplate, diaphragm & shutter controls. Simple version has silver-grey plastic faceplate, no controls. \$30-45.

TOP CAMERA WORKS

Top - c1948. Cast metal subminiature from Occupied Japan. Eye-level frame finder. Fixed focus lens. B,I shutter. Same as the pre-war "Guzzi". Not to be confused with boxy rectangular "Top" subminiatures from Maruso Trading Co. \$175-250.

TOPPER - Cheap plastic box camera for 127 film. Long shutter release plunger on left side. This is the same camera which is built into the Secret Sam Attache Camera and Dictionary. \$8-15.

TOSEI OPTICAL (Japan)

Frank Six - c1951. Folding camera for 6x6cm or 4.5x6 cm on 120. f3.5/75mm Anastigmat lens. T.K.S. shutter B,1-200. Optical eye-level viewfinder. \$60-90.

Frank Six Model IV - c1953. Modified version of the earlier Frank Six. Top housing incorporates eye-level and waist-level finders. Tri-Lausar or Tosei Anastigmat f3.5/80 in T.K.S. shutter. \$60-90.

TOUGODO OPTICAL TOGODO SANGYO LTD. (Toyohashi, Japan) Established in 1930 by Masanori Nagatsuka and named for Admiral Tougo of

Nagatsuka and named for Admiral Tougo of the Japanese Navy. The Togodo Sangyo name can be found on mid-1950s instructions for cameras such as Hit, Q.P, and P.A.C. It appears likely that many of the "bit-type" cameras were made by Tougodo.

Alome - c1950. Early name variant of the first Hit camera, with identical physical characteristics. Marked "Made in Occupied Japan" on shutter face. Exposure counter ring under advance knob. Rare. \$75-100.

Baby-Max - c1951. Novelty subminiature, similar in construction to "Hit" types, but different shape. f11/30mm fixed focus lens. Single-speed shutter. \$35-50.

Buena 35-S - c1957. 35mm viewfinder camera. Buena f3.5/45mm lens. Shutter B,25-300.\$45-60.

Click - c1951. Subminiature camera of "Hit" type. \$25-35.

Colly - c1951. "Hit" type subminiature for 14x14mm exposures. Meniscus f11 lens. \$25-35.

Hit - c1950's. Japanese novelty camera for 14x14mm exposures on 16mm paper backed rollfilm. Similar cameras are available under a number of other names, but usually called "Hit type" cameras by collectors. Many of these were probably made by Tougodo, but some have come from other manufacturers. Gold models: \$75-100. "Occupied Japan" model ("Made in Occupied Japan" below lens): \$50-75. Normal chrome models: \$25-35.

Hobiflex, Model III - c1952. 6x6cm TLR. Externally gear-coupled lenses. Hobi Anastigmat or Tri-Lausar f3.5/80. Shutter 1-200,B.\$50-75.

Hobix - c1951. Compact camera for 28x28mm on Bolta-size film. All-metal. Meniscus f8/40mm. Complete shutter, B,25,50,100.\$50-75.

Hobix D I - c1952. Similar to the Hobix, but with reflex and eye-level finders. (It was also called "HobiFLEX", but this causes confusion with the full-sized Hobiflex cameras.) Takes 24x32mm exposures on Bolta-spooled film in special

cartridges. Fixed-focus f4.5 lens in Complete B,25,50,100 shutter. Uncommon. Mint has reached \$450 (1992), but normally \$150-225.

Hobix Junior - c1955. Inexpensive camera for 28x28mm on Bolta-size rollfilm. Fixed focus lens; B,I shutter with PC sync. \$35-50.

Kino-44 - c1959. Baby Rollei-style TLR for 4x4cm on 127. Kinokkor f3.5/60mm in Citizen MXV 1-500 shutter. \$100-150.

Leader - c1955. Japanese 35mm stereo. Looks like the Windsor Stereo. Black bakelite with aluminum trim. Leader Anastigmat f4.5/45mm lenses, 3 speed shutter $^{1}/_{25}$ - $^{1}/_{100}$. Takes single or stereo exposures. While users might pay \$120-180, a serious collector would pay \$350-500 for this rare camera.

Meikai - c1937. Twin lens reflex for 35mm film. In addition to the normal viewfinder for eye-level framing, this uniquely Japanese design incorporates a waistlevel reflex finder with true twin-lens focusing. The lenses are located side-by-side. which allowed the overall size to be only barely larger than a standard 35mm rangefinder camera. The first two models used "No Need Darkroom" sheet film in paper holders for daylight developing. (See "Yen-Kame" for description of this process.) The first rollfilm versions c1939 used 16exposure spools of paper-backed 35mm wide rollfilm for 3x4cm exposures. Meikai f3.5 or f4.5/50mm Anastigmat. Later models had f3.8/50mm Meikai Anastigmat. \$400-600.

Meikai EL - c1963. Cheap 35mm view-finder novelty camera. Imitation exposure meter on front. Fixed focus lens, simple shutter. \$12-20.

Meiritto No. 3 - c1940. Small camera for 28x40mm exposures on special paper-backed daylight-loading film. Waist-level and eye-level finders on top. Fixed focus f6.3 lens, shutter 1/25, 1/100. \$200-300.

Meisupi, Meisupi II, Meisupi IV - c1937. Side-by-side twin lens, 3x4cm on sheet film. Uncommon. \$500-750.

TOUGODO OPTICAL

Meisupi I - c1937. The first Meisupi camera. Telescoping front, dual finder. Small side door takes single sheets of print stock in lightproof sleeves. Toumei shutter, B,100,50,25. Knob on top is a closeup lens fitted over a spirit level. Uncommon. \$120-180

Meisupii Ia - c1950s. Single-lens camera for 24x36mm on Bolta-size film. Not to be confused with the side-by-side twin lens Meisupi from the 1930s. Eyelevel finder. Simple, fixed-focus f8/50mm lens. \$20-30.

Meisupii Half - c1959. Simple inexpensive 35mm half-frame camera. \$20-30.

Metraflex II - TLR for 6x6cm on 120 film. Metar Anastigmat f3.5/80mm lens. \$75-100.

P.A.C - c1955. A "Hit-type", similar to the "Mighty Midget". Elongated octagonal front trim plate. Shutter face has concentric stripes, not stars. Diamond-shaped rear window bezel. Uncommon. One recorded sale in 1993 at \$75.

Stereo Hit - c1955. Plastic stereo camera for 127 film. S-Owla f4.5/90mm lens. B,I synch shutter. Inexpensive construction. As a usable camera it would bring \$120-180. Anxious collectors have paid more.

Sweet-16 Model-A - c1955. Oversized subminiature camera for twelve 14x18mm exposures on 17.5mm paper-backed roll-film. Fixed focus f8/30mm lens in 3-speed shutter. Simple construction, but rare. One reported sale in 1992 at \$800.

TOUGODO OPTICAL...

Tougo Camera - 1930. The Tougo Camera was the first of the popular "Yen" cameras from Japan, produced by Tougodo in the Kanda district of Tokyo. The camera itself is of simple construction: a wood body with a paper covering, ground glass back, and simple shutter. The most historically significant feature was the novel film system, which incorporated a 3x4cm sheet of film in a paper holder. The disposable film holder also carried the film through the developing process without the need of a darkroom. The process used a red-colored developer, which effectively filtered daylight into red light. Its simplicity made it very popular, and soon there were many other simple "Yen" cameras on the market. An early example (clearly identified "Tougo Camera" on the shutter face) would easily fetch \$50+ from a knowledgeable collector, while the later versions usually sell for \$20-30.

Toyoca 16 - c1955. 14x14mm subminiature, styled like a miniature 35mm. "Toyoca 16" on top. Two models; essentially identical except that the "improved" model has exposure counting numbers on the winding knob. \$120-180. Not to be confused with at least two other styles of "Toyoca" which are cheaper novelty cameras of the "Hit" type.

Toyoca 35 - c1957. Well made 35mm RF camera with a hint of Leica-inspired styling. Lausar f2.8 or Owla f3.5/45mm lens in B,1-300 leaf shutter. \$50-75.

Toyoca 35-S - c1957. Scale-focus 35mm camera. Several minor variations.

One version also uses Bolta-size rollfilm. Round or teardrop-shaped release button. Tri-Lausar f3.5/4.5cm lens in B,25-300 shutter. \$30-45.

Toyoca Ace - c1965. Subminiature, 14x14mm. Similar to the Bell-14. Toyoca Ace 2-speed shutter. EUR: \$60-90. USA: \$30-45.

Toyocaflex - c1954. 6x6cm Rolleicord copy. Triotar or Tri-Lausar f3.5/80mm. Synchro NKS 25-300 or 1-200 shutter. \$75-100.

Toyocaflex 35 - c1955. Side-by-side 35mm TLR. Direct and reflex finders. Owla Anastigmat f3.5/45mm viewing and taking lenses. NSK shutter 1-300, B. \$250-375.

TOWN - An unusual marriage of two Japanese specialties of the postwar period. This camera is styled just like the Hit types, but is considerably larger, taking 24x24mm exposures on "Bolta-size" rollfilm. "Made in Occupied Japan" on front. Unusual and uncommon. Last recorded sale at \$100 in 1984. Current estimate \$250-375.

TOY'S CLAN Donald Duck Camera - Plastic camera shaped like Donald Duck's head. The lens is in one eye and the viewfinder in the other. The tongue serves as a shutter release lever. Takes 3x4cm photos on 127 film. Made in Hong Kong. We saw one at a German auction in the 1970's, but never

again until 1984 when a small number, new in boxes, came into circulation and rapidly began selling to avid duck fans for \$100-150.

TOYO KOGAKU (TOKO, Japan)

Mighty - c1947. Made in Occupied Japan. Subminiature for 14x14mm exposures on "Mycro" size rollfilm. Meniscus lens, single speed shutter. Camera with telephoto attachment in case: \$120-180. Camera only: \$60-90.

Mighty, gift box - c1948. Gift-boxed outfit with Mighty camera, 2x telephoto attachment, sunshade, case, & instructions in red presentationbox: \$250-375.

Peacock III - c1939. 127 rollfilm camera, 3x4cm. Fixed-focus Peacock Anastigmat f6.3/50mm in Peacock shutter T,B,1/₁₀-100. Body shutter release. A variation has focusing Recta Anastigmat lens in New Alfa T,B,1-300 shutter, without body release. \$50-75.

Tone - c1948. Subminiature for 14x14mm on "Midget" size rollfilm. Made in Occupied Japan. Eye-level and waist-level finders. f3.5/25mm in 3 speed shutter. German auctions: \$200-300. USA: \$90-130.

TOYOCA - Lightweight Japanese novelty camera of the Hit type. \$25-35. Not to be confused with the heavy "Toyoca 16" made by Tougodo.

TRAID CORPORATION (Encino, CA)
Fotron & Fotron III - Grey and black
plastic cameras of the 1960's, originally
sold by door-to-door salesmen for prices
ranging from \$150 to \$300 and up. The
cameras were made to take 10 exposures
1x1" on special cartridges containing
828 film. They featured many high-class

Trambouze Tailboard View camera

ULCA

advancements such as built-in electronic flash with rechargeable batteries, electric film advance, etc. At the time these cameras were made, these were expensive features. Still, the Fotron camera campaign is considered by some to be the greatest photographic "rip-off" of the century. \$30-45.

TRAMBOUZE (Paris) Tailboard view camera - 13x18cm.
Brass barreled f8 lens. \$250-375. *Illustrated bottom of previous page.*

TRAVELER - 14x14mm "Hit" type Japanese novelty subminiature. One of the later ones of cheap construction. \$25-35.

TRAVELLER - Simple plastic Hong Kong 6x6cm TLR-style novelty camera. Shutter 25, 50. \$12-20.

TRIOFLEX - Post-war Japanese TLR. Tri-Lausar f3.5/80mm lens. \$75-100.

TROTTER (John Trotter, Glasgow) Field camera - Mahogany and brass, brass bound lens. 1/2-plate size. \$250-375.

TRU-VIEW - 4x4cm "Diana" type novelty camera. \$1-10.

TRUSITE CAMERA CO. (New York)

Girl Scout Official Camera - Like the Trusite Minicam, but with Girl Scout face-plate. Uncommon. \$35-50.

Trusite Minicam - c1947. Cast metal minicam for 3x4cm on 127 film. \$1-10.

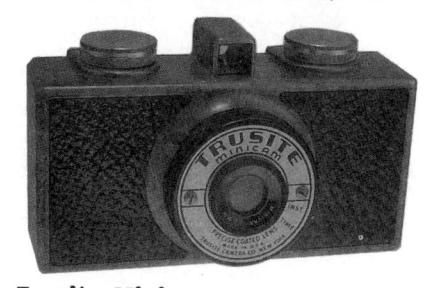

Trusite Minicam (square) - Unusual

brick-shaped cast aluminum body. 12 exposures 4x4cm on 127 film. Very uncommon. One recorded sale in 1991 at \$75

T.S.C.

Tacker - 14x14mm subminiature from Occupied Japan. f4.5 lens, rotary disc stops. Shutter 25, 50, 100, B. \$150-225.

TUCHT, Carl (Düsseldorf) Focal plane camera - c1900. Leather covered folding camera for 13x18cm plates. Polished wood interior, double extension red bellows. Busch Rapid Aplanat f7 lens. Focal plane shutter built into lensboard. \$250-375.

TURILLON (Louis Turillon, Paris) Photo-Ticket - c1905. Aluminum jumelle-style rollfilm camera; No. 2 for 4x5cm, No. 3 for 4.5x6cm. Petzval-type f4.5/95mm.FP shutter. \$1200-1800.

TURRET CAMERA CO. (Brooklyn, NY) Panoramic camera - c1905. For 4x10" panoramic views. \$1200-1800.

TYLAR (William T. Tylar, Birmingham, England) Pocket Titbit - c1890. Strut-folding 6x9cm plate camera. \$350-500.

Tit-bit - c1895. Makes 2 exposures on a 6x9cm plate. Lens is mounted on circular plate which is rotated to position it over one half of the plate to make the first exposure, then rotated again over the other side to make the second exposure. \$350-500.

TYNAR CORP. (Los Angeles, CA)
Tynar - c1950. For 14 exposures,
10x14mm on specially loaded 16mm
cassettes. f6.3/45mm lens. Single speed
guillotine shutter. Shaped like a small
movie camera (similar to Universal Minute
16), \$35-50.

UCA (Uca Werkstätten für Feinmechanik & Optik, Flensburg, Germany) Brief bistory taken from names used in advertising: 1948: ELOP = Elektro-Optik GmbH, Glücksburg. 1950: ELOP = Vereinigte Electro-Optische Werke, Flensburg-Mürwik. 1952: UCA = Uca Werkstätten für Feinmechanik und Optik GmbH, Flensburg. ELOP made Elca, Elca II, & Uniflex. UCA made the Ucaflex (=Uniflex) and Ucanett (=Elca with some changes).

Ucaflex - c1950. 35mm SLR of odd design, a copy of the Neucaflex made in Jena. Combines features of SLR and viewfinder. Small mirror and prism move out of the way to allow direct viewing as the shutter is released. Elolux f1.9/50mm lens. Focal plane shutter, 1-1000. Also sold under the name Elcaflex. \$500-750.

Ucanett - c1952. 35mm camera for 24x24mm. Ucapan f2.5/40mm in Prontor-S. Successor of Elop Elca II. \$175-250.

ULCA CAMERA CORP. (Pittsburgh, PA) Ulca - c1935. Cast zinc subminiature

UNDERWOOD

cameras for 20x20mm or 24x24mm on rollfilms. Meniscus lens, simple shutter. \$60-90. Note: Ulca cameras were also made in England and Germany with variations in body style and markings. The shutter settings are one indication of country of origin. TMS & STM are German. STI- English. TSL-American. One variation from England has no shutter speeds, but is marked "Made in England". This variation also exists with green enameled body. The camera was designed and patented by Otto Henneberger of Nürnberg, Germany.

UNDERWOOD (E. & T. Underwood; Birmingham, England)

Field cameras - Various models with slight variations in features. Names include: Club, Convention, Exhibition. Sizes: 1/4- or 1/2-plate. Rear extension, square leather bellows. Underwood f11 brassbarrel lens with iris diaphragm. Thornton-Pickard shutter. Swing-out ground glass. \$300-450.

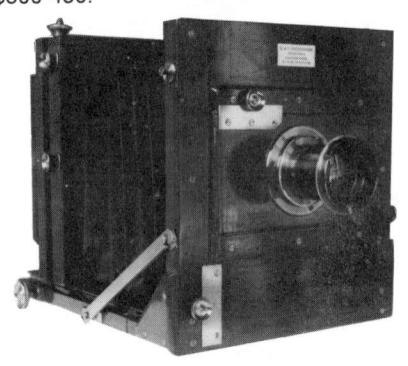

Instanto - c1896. Mahogany tailboard camera in $1/_{4-}$, $1/_{2-}$, or $1/_{1-}$ plate size. Underwoodlandscapelens. \$250-375.

Stereograph - c1896. Tailboard style stereo camera. Almost identical to the Instanto, but with stereo lenses. \$500-750.

Umbra - Mahogany & brass field camera, 41/₄x61/₂". Brass bound Underwood 1/₂-plate Rapid Rectilinear. \$200-300.

UNGER & HOFFMAN (Dresden)

Verax - Folding plate cameras, in 4.5x6 and 6.5x9cm sizes. Single extension bellows. f3.5 or 4.5 lens. Compound shutter 1-300. Ground glass back. \$75-100.

Verax Gloria - c1924. Deluxe version of 4.5x6cm Verax. Brown morocco leather covering with light brown bellows. Dogmar f4.5/75mmin Compur1-300. \$350-500.

Verax Superb - c1930. Folding rollfilm camera, 6x9cm. \$30-45.

UNIBOX - c1950. Bakelite twin-lens box camera. 6x6cm exposures on 620 rollfilm. The body was cast at the Perstorp factory in southern Sweden and assembled by

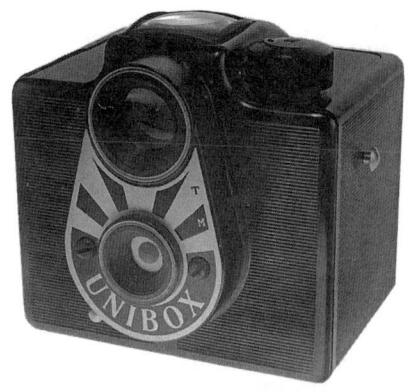

clerks in a central Stockholm office. Large waist-level brilliant finder on top. Meniscus lens, T,M shutter. \$90-130.

UNIMARK PHOTO INC.

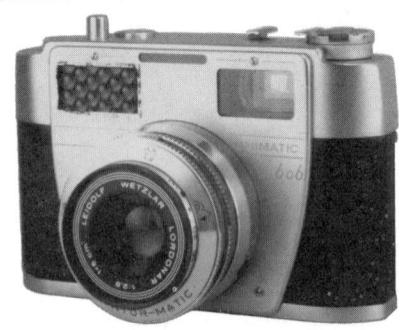

Unimatic 606 - c1961. Auto diaphragm 35mm made by Leidolf for Unimark. Lordonar f2.8/50mm in Prontor-Matic 30-500. f-stops visible in finder. \$25-35.

Unimatic 707 - c1961. Like 606, but also has CRF. \$25-35.

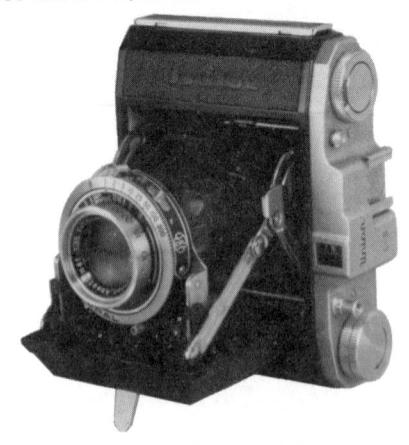

UNION OPTICAL CO. (Japan) Union C-II - c1953. Folding "semi" camera for 4.5x6cm on 120 film. Very similar to the Zenobia and Walcon semi cameras. Coonor Anastigmat f3.5/7.5cm in Copal shutter, B,1-300. \$60-90.

UNITED CAMERA CO. (Chicago) Label on one camera box is printed "UNITED CAMERA CO. NOT INC." This company obviously is related to the Sterling Camera Co. of Sterling, Illinois. None of the products from either company seem to have achieved any measure of success, because they are not often seen.

Ucet - Box camera for 6.5x11cm. The unusual camera name is derived in part from the initials of the company name. Identical to the #2A Buddie made by Sterling Camera Corp. \$12-20.

UNITED OPTICAL INSTRUMENTS (England)

Merlin - c1936. Cast-metal 20x20mm subminiature. Black, blue, or green crack-le-finish enamel. No identification on the camera except small name decal on some examples. \$100-150.

UNITED STATES CAM-O CORP.

Cam-O - Oddly shaped wooden TLR "school camera". 250 exposures 4x6.5cm on 70mm film. Wollensak Raptar f4.5/117mm. Alphax shutter. \$75-100.

UNITED STATES CAMERA CORP. (Chicago)

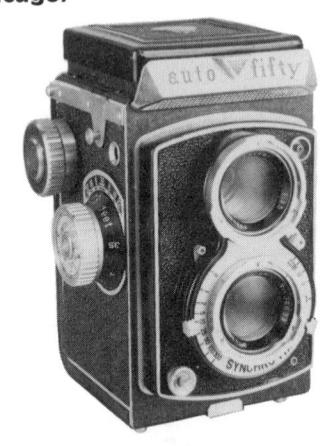

Auto Fifty - TLR for 6x6cm on 120. Biokor f3.5/80mm. Synchro MX 1-300, B. Made in Japan. \$50-75.

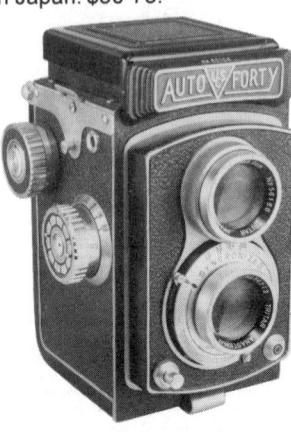

Auto Forty - Good quality TLR, made in Japan. Rack and pinion focus. Tritar Anast. f3.5/8cm. Synchronized shutter, B, 25-300. Automatic film stop and exposure counter. \$50-75.

UNIVERSAL

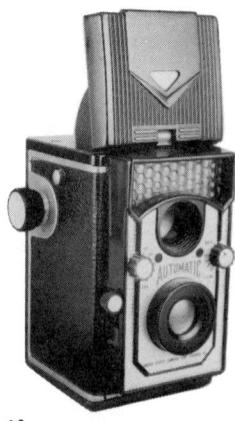

Automatic - c1960. Cast aluminum TLR with black plastic hood and front. Selenium meter cell above viewing lens for automatic exposure. 6x6cm on 620 film. Fixed focus lens. \$50-75.

Reflex, Reflex II - c1960's. Inexpensive TLR box cameras. \$1-10.

Rollex 20 - c1950. Folding 6x9cm rollfilm camera with self-erecting front. Cheap construction. \$8-15.

USC 35 - Viewfinder 35mm. Made in Germany. Built-in extinction meter. Steinheil Cassar f2.8/45mm. Vario 25-200 shutter. \$25-35.

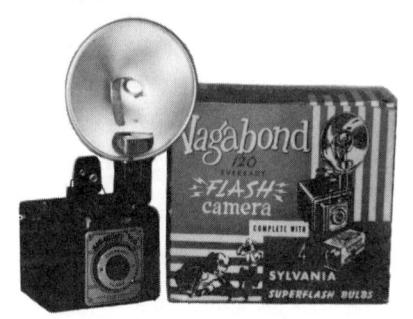

Vagabond 120 Eveready Flash -c1951. Metal box camera for 21/₄x31/₄" on rollfilm. \$1-10.

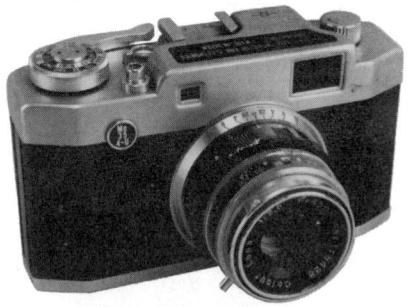

UNITED STATES PROJECTOR & ELECTRONICS CORP.

Me 35 4-U - c1958. Rangefinder 35mm made by Yamato; identical to the Pax Ruby and Pax Sunscope except for the name. Speaking of names, if prizes were to be awarded for odd names, this would rank high on the list. \$50-75.

UNIVERSAL CAMERA CORP. (NYC) The Universal Camera Corporation was incorporated on January 26, 1933 in New York. Otto Wolff Githens, a former NY loan company executive, and Jacob J. Shapiro, a taxicab insurance agent, formed the company on the assumption that what America needed most was a photographic line affordable to everyone. The company boasted of

manufacturing "more cameras per year than any other company in the world". That claim may very well have been true. Their first venture, Univex Model A, at a cost of \$.39, sold over 3 million in 3 years. The early success was not solely attributed to the sale of inexpensive cameras; but more so to the sale of the low-cost six exposure rollfilm that was necessary to utilize these cameras. The #00 rollfilm, packaged in Belgium on a special patented V-spool, sold for only \$.10 in the United States. Twenty-two million rolls were sold by 1938. Special Univex films proved to be one of the major factors responsible for the company's collapse twenty years later. Universal became involved with home

Universal became involved with home movies in 1936, when it introduced the model A-8 camera for just under \$10 and its companion P-8 projector for less than \$15. They used a special Univex Single-8 film, manufactured by Gevaert. In the next two years, 250,000 cameras and 175,000 projectors were sold.

During Universal's brief existence, it manufactured almost forty different still and movie cameras and a complete line of photographic accessories. The 1939 New York World's Fair provided Universal with an opportunity to exhibit the newly introduced non-standard 35mm Mercury and the new B-8 and C-8 movie cameras.

Universal verged on bankruptcy in 1940, when all film shipments from Belgium were temporarily suspended because of the war in Europe. Two years later there was still a film shortage, even though Universal was now packaging its film in the United States. The U.S. entry in the war brought Universal a government contract to manufacture binoculars and other optics, and by 1943 Universal had acquired \$6,000,000 in sales from the United States government.

After the war, Universal returned to its prewar line of cameras, some of which were given different names. Having gained experience in optics during the war years, Universal was now able to manufacture most of its own lenses. Universal again met with financial difficulties during the 1948-49 recession. At that time, Universal's prized post-war Mercury II was, for the most part, rejected by the public, mainly because the price had been set at more than triple that of the pre-war Mercury! Two other reasons for the eventual failure of Universal presumably were the \$2,000,000 investment into the poorly designed Minute-16 and another investment into a complicated automatic phonograph. Neither of these items proved profitable. Consequently, Universal declared bankruptcy on April 16, 1952.

Universal never gained much respect from the photographic industry, because its business practices were generally believed to be somewhat unethical. Nevertheless, the one thing that Universal will always be remembered for is the originality and ingenuity it displayed in designing some of the most unusual cameras in America.

Our thanks to Cynthia Repinski for her help with the Universal Camera Company in this section and in the movie camera section at the end of the book. Cindy spent years researching all products of the Universal Camera Co. Her new book "The Univex Story" is filled with details of the company's history and products. It is available from the author at N79W15273 Goldenrod Dr., Menomonee Falls, WI 53051, or from the publisher, Centennial Photo, and from other dealers in photographic books.

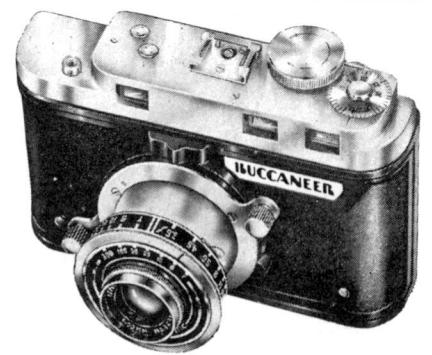

Buccaneer - c1945. Bakelite 35mm camera. CRF. f3.5/50mm Tricor lens. Chronomatic shutter 10-300. Built-in extinction meter, flash sync. \$20-30.

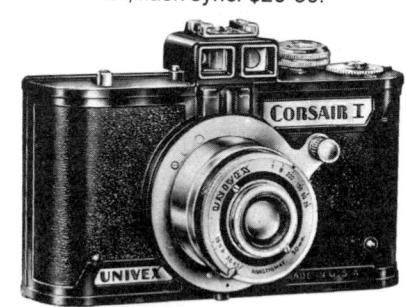

Corsair I - c1938. For 24x36mm exposures on Special Univex #200 perforated 35mm film. Univex f4.5/50mm lens in rimset shutter 25-200. \$20-30.

Corsair II - c1939. Similar to Corsair I model, but accepts standard 35mm film cartridge. \$20-30.

Duovex - c1934. Two Univex A's mounted in a special attachment for stereo work. Manufactured by Pacific Coast Merchandise Co. of Los Angeles and sold as a package with a simple metal viewer and 12 mounting cards. Scarce. With viewer and original box \$300-450. Camera only \$150-225.

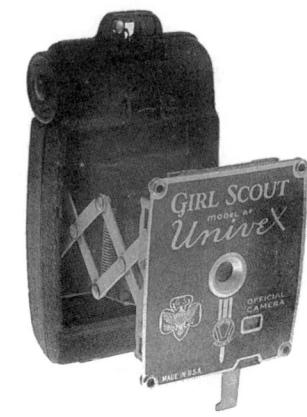

Girl Scout Model AF Univex - c1936-

UNIVERSAL...

38. Special model of the AF series cameras. Green front plate with Girl Scout name and trefoil emblem. Uncommon. \$200-300.

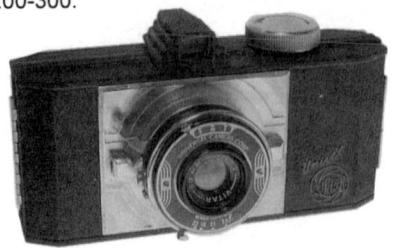

Iris - c1938. Heavy cast-metal camera for 6 exposures $11/_8x111/_2$ " on No. 00 Universal film. Vitar f7.9/50mm lens in Ilex TBI shutter; telescoping front. Common. Some have factory mounted flash shoe. Often with original box for \$15-25.

Iris Deluxe - c1938. Similar to the standard Iris, but with leatherette covering and chromium finish. Late Deluxe models had an adjustable focus lens, focusing to 4'. Flash models were factory mounted with a hot shoe. There is currently no price difference with or without the flash. Not common. \$30-45.

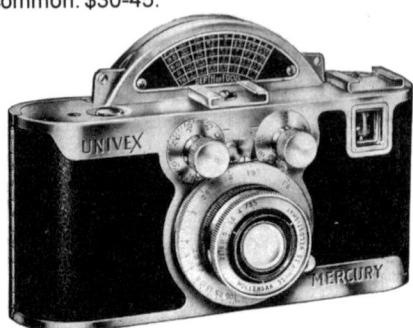

Mercury (Model CC) - 1938-42. The first Mercury model. Takes 18x24mm vertical exposures on Universal No. 200 film, a special 35mm wide film. 35mm Wollensak f3.5 Tricor, f2.7 Tricor, and f2.0 Hexar lenses. Rotating focal plane shutter, $1/_{20}$ - $1/_{1000}$. Common in U.S.A. for \$35-50. *Up to 50% higher outside the U.S.A.*

Mercury (Model CC-1500) - 1939-40. Similar to the standard model CC but with 1/1500 shutter speed. Same lenses as Model CC. Scarce. \$175-250. Note: This price is for the combination of the rare body and the rare Hexar lens. One without the other would only bring half as much.

Mercury II (Model CX) - c1945. Similar to Mercury CC, but for 65 exposures on standard 35mm film. 35mm Universal Tricor f3.5, f2.7 or Hexar f2.0 lenses.

Rotary shutter 20-1000. Common. \$35-50 in USA, 50% higher abroad.

Mercury Accessories:

- Mercury/Univex Photo Flash Unit - c1938. Two-piece flash consisting of 4" metal reflector and black bakelite lamp/battery unit. Accepts screw-base flashbulbs. Prewar version used flat 2-cell battery; postwar version used 2 standard AA batteries. Common. \$8-15.

Mercury Exposure Meter - c1938.
 Cube-shaped chrome metal extinction meter marked "Univex". Fits Mercury accessory shoe. Not common. \$15-25.

- Mercury II Exposure Meter - c1946. Similar to the original Mercury I meter, except unmarked and modified to fit Mercury II (viewing eyepiece lengthened and bottom rear corner cut off). Not common. \$20-30.

- Mercury Rapid Winder - c1939. Rapid sequence shots were possible with this device, consisting of metal winder and "pinion" shutter/film wind knob. Camera's regular shutter/film wind knob had to be replaced with pinion knob, without which the winding device was inoperable. Rare. Complete, both pieces: \$45-60.

- Mercury Rangefind Mercury Rangefinder - c1939. Superimposed image type. Partial diecast construction with black enamel finish and chrome hardware. Fits Mercury accessory shoe. Scarce. \$35-50.

- Univex Daylight Loading Film Cartridges, M-200 - c1939. Metal film cartridge for bulk 35mm film with "swinggate" lock. For use in Mercury I & Corsair I cameras. Rare. \$8-15.

- Univex Daylight Bulk Film Winder - c1939. Black & red bakelite unit for loading bulk 35mm film into Univex #200 film cartridges. Rare. \$75-100.

Meteor - c1949. For 6x6cm on 620 roll-film. Telescoping front. Extinction meter. \$1-10.

Minute 16 - c1949. 16mm subminiature which resembles a miniature movie camera. Meniscus f6.3 lens. Guillotine

shutter. Very common. With flash and original box: \$45-60. Camera only: \$15-25.

Norton-Univex - c1935. Cheap black plastic camera taking 6 exposures on Univex #00 film. Because of the overwhelming success in 1933 of the Univex Model A, the Norton camera made by Norton Labs never gained public interest when introduced in 1934. The Norton Univex appeared in 1935, after Norton Labs sold the remains of their line to Universal. Not common. \$25-35.

Roamer I - c1948. Folding camera for 8 exposures 21/₄x31/₄" on 620 film. Coated f11 lens, single speed shutter, flash sync. \$12-20.

Roamer II - c1948. Similar to the Roamer I. f4.5 lens. \$12-20.

Roamer 63 - c1948. Folding camera for 120 or 620 film. Universal Anastigmat Synchromatic f6.3/100mm lens. \$15-25.

Stere-All - c1954. For pairs of 24x24mm exposures on 35mm film. Tricor f3.5/35mm lenses, single speed shutter. \$90-130.

Twinflex - c1939. Plastic TLR for $11/8 \times 11/2$ " (29x38mm) on No. 00 rollfilm. Meniscus lens, simple shutter. \$30-45.

UTILITY

UNIFLAS O

Uniflash - c1940. Cheap plastic camera for No. 00 rollfilm. Vitar f16/60mm lens. With original flash & box: \$15-25. Camera only: \$1-10.

Uniflex, Models I & II - c1948. TLR for 120 or 620 rollfilm. Universal lens, f5.6 or 4.5/75mm. Shutter to 200. \$25-35.

Univex, Model A - c1933. The original small black plastic gem for No. 00 rollfilm. Similar to the Norton, which was originally designed for Universal Camera Corp. Wire frame sportsfinder attached to front of camera, and molded plastic rear sight. Cost \$0.39 when new. Several minor variations. \$15-25.50% higher in Europe.

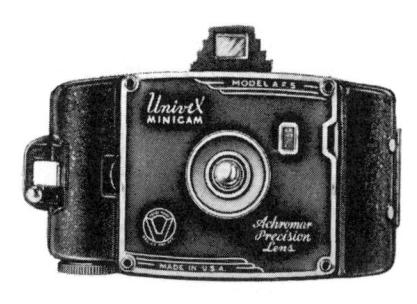

Univex Model AF-5

Univex, Model A, Century of Progress - c1933. Special commemorative model of the simple Model A camera made for the Chicago World's Fair. Like the ordinary model, but with a fragile decal at one end. \$90-130.

Univex AF, AF-2, AF-3, AF-4, AF-5 c1935-39. A series of compact collapsing cameras for No. 00 rollfilm. Cast metal body. Various color combinations. \$30-45. *Illustrated bottom of previous column.*

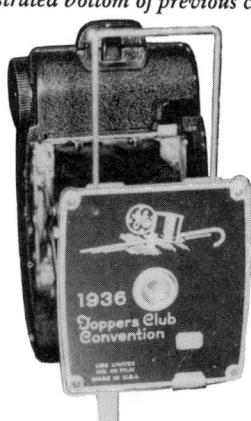

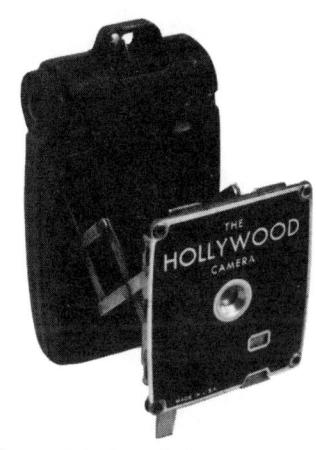

Univex AF, Special models - c1936-38. Special faceplates and colors transformed the normal Univex AF into a promotional or premium camera. These include such models as the G.E. Toppers Club Convention, Hollywood, or the Official Girl Scout model (described separately above). Rare. \$200-300.

Vitar - c1951. Viewfinder 35mm. Extinction meter. Telescoping Anastigmat f3.5/50mm. This camera was a promotional item and supposedly never advertised to the public. Not common. \$25-35.

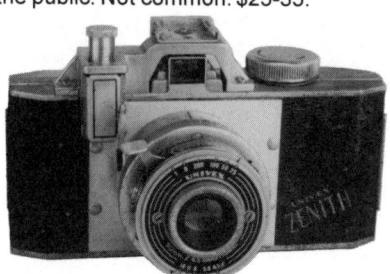

Zenith - c1939. Lightweight aluminum body, leatherette covering, chrome finish. Six exposures on Univex #00 film. Univex f4.5/50mm, shutter 25-200. Lens focuses to 31/2'. Flash models were factory mounted with a hot shoe. Rare. \$120-180.

UNIVERSAL RADIO MFG. CO. Cameradio - ca. late 1940's. 3x4cm TLR box camera built into a portable tube radio. Like the Tom Thumb listed under Automatic Radio Mfg. Co. \$150-225.

UNIVEX (Casa Univex, Empresa Enrique Wiese, Barcelona, Spain)

Primarily a maker of simple bakelite cameras, but also including folding rollfilm cameras. Of bistorical interest is the use of the Univex trademark in exactly the same style as that of the American company, Universal Camera Corporation. There is no evidence of any authorization for the use of this trademark. None of the Casa Univex cameras resemble products of the Universal Camera Corporation; only the trademark was borrowed. The camera designs, however, resemble some late 1930's French cameras. Univex Supra - c1948. Rigid bodied black bakelite camera for 6x8cm on 120 film. Meniscus lens; P&I shutter. "UniveX Supra" is molded on the front of the shutter face and on the back, using the same lettering style as the "UniveX" trademark from Universal Camera Corp., possibly without permission. Uncommon. \$30-45.

URANIA - Wooden rollfilm camera. Roll-holder section detaches to allow the use of plates. Metal fittings are white. B&L lens. \$120-180.

US NEWS & WORLD REPORT Disc Camera - Inexpensive; given to subscribers as a premium. \$20-30.

UTILITY MFG. CO. (New York & Chicago)
Carlton Reflex - TLR style box camera for 6x6cm. \$8-15.

Deluxe Century of Progress - 1933. Simple cardboard box camera, similar in design to the Falcon Midget 16, but with "slip-off" cardboard back. Body is covered with a pastel green foil paper; a silver foil "1933 Century of Progress" label adorns the front; the top finder screen has a gold foil border. Very scarce; we know of only one example. Latest sale, 1992: \$300.

UTILITY...

Falcon - c1930's. 4x6.5cm folding 127 camera. Cast metal body with black or colored enamel. This was called the "Standard" Falcon, Model No. 1 in brochures. The front is not self-erecting as on the larger "Automatic" models 2 and 4. Cost \$3.50 in 1934. 12-18.

Falcon Junior Model - Bakelite folding vest-pocket camera for 4x6.5cm on 127 film. At least two different faceplate styles with different art-deco patterns. Colored models: \$20-30. Black: \$12-20.

Falcon Junior 16 - c1934. Small cardboard box camera for 16 shots on 127 film. Maroon leatherette covering. Red, black, & silver art-deco foil faceplate. Also comes in blue, green, tan, & black versions. Cost 50 cents in 1934. Uncommon. \$30-45.

Falcon Midget 16 - c1933. Vertically styled cardboard box camera for 16 shots on 127. Enameled metal back. The unusual design keeps the film spools at the back near the film plane, which wastes space and gives a small 3x4cm half-frame

image from a box large enough to make full size negatives. Colored models: \$30-45. Black: \$12-20.

Falcon Minette - Black minicam for 3x4cm on 127 rollfilm. \$1-10.

Falcon Miniature - c1938. Minicam for 3x4cm on 127 film. Several different body styles. \$1-10.

Falcon Minicam Junior - Black minicam for 3x4cm on 127 rollfilm. Various body styles. \$1-10.

Falcon Minicam Senior - c1939. Half-frame (3x4cm) camera for 16 exposures on 127 film. Cast aluminum body with leatherette covering. Minivar 50mm lens. Optical finder is in an elongated top housing, as though styled to look like a range-finder. Has a body release, which is unusual for this type of camera. The same camera was also sold under the Falcon Camera Co. name in Chicago. \$12-20.

Falcon Model Four - c1939-42. Folding camera for 8 exposures 6x9cm on 120 film. Falcon brochures call it the "Automatic" model because if its self-erecting front. Pre-1940 model has black art-deco shutter face. \$15-25.

Falcon Model F - c1938. One of the better models from Utility in 1938, selling for \$17.50 with its Wollensak Velostigmat f4.5 lens in Deltax shutter. Eye-level optical finder. Body made of black "Neilite" plastic. Metal helical focusing mount. Takes 16 exposures on 127 film. \$20-30.

Falcon Model FE - c1938. Same as Model F, but with extinction meter in top housing next to viewfinder. \$25-35.

Falcon Model G - c1938. Half-frame 127. Wollensak f3.5/50mm. Alphax 25-200

shutter. Telescoping lens mount, helical focusing. \$20-30.

Falcon Model GE - c1938. Same as Model G, but with extinction meter. \$25-35.

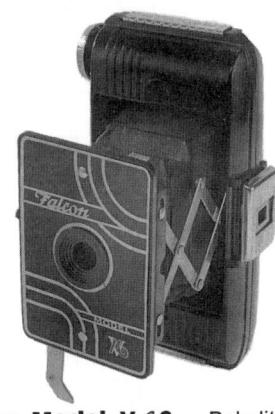

Falcon Model V-16 - Bakelite folding vest-pocket camera identical to the Falcon Junior, but for 16 exposures 3x4cm (-1/2-frame) on 127 film. Colored models: \$20-30. Black: \$12-20.

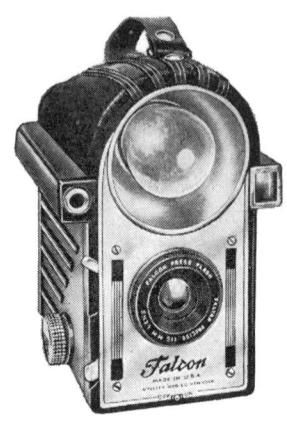

Falcon Press Flash - c1939-41. Bakelite 6x9cm box camera, with built-in flash for Edison-base bulbs. Forerunner of Spartus Press Flash. The first camera with built-in flash, introduced in April 1939 under the Falcon Press Flash and Spartus Press Flash name. \$8-15.

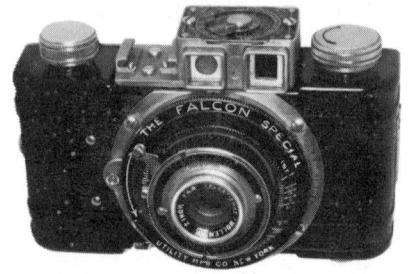

Falcon Special - c1939. Black bakelite camera for 16 exposures on 127 film. Cast metal back. Extinction meter on top next to viewfinder. Wollensak Velostigmat f4.5 in Alphax Jr. T,B,25-200 shutter. Helical focusing mount. "The Falcon Special" on focusing ring. \$25-35.

Falcon-Abbey Electricamera -

c1940. Black bakelite box camera, nearly identical to the original Falcon Press Flash, but with additional shutter button on front. Normal shutter lever at side for manual shutter release. Front button is electric release for solenoid which trips shutter and fires flash in synchronization. \$20-30.

VICAM

Falcon-Flex, 3x4cm - TLR-style novel-ty camera, 127 film. Cast aluminum body. Similar in style to the Clix-O-Flex. \$20-30.

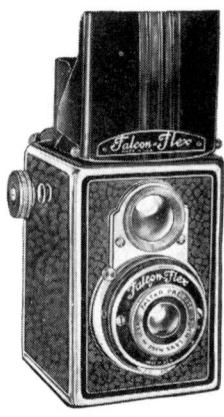

Falcon-Flex, 6x6cm - c1939. Pseudo-TLR box camera. Cast aluminum body. \$12-20.

Girl Scout Falcon - Basic black bakelite "minicam" but with a special green-enameled faceplate with Girl Scout logo. \$35-50.

"Minicam" types, 3x4cm - c1939, including Carlton, Falcon Midget, Falcon Minette, Falcon Miniature, Falcon Minicam Junior, Falcon Special, Rex Miniature, Spartus Miniature, etc. Plastic-bodied cameras for 3x4cm on 127 film. Various body styles and names, but no practical difference. Usually with Graf or Minivar 50mm lens. \$8-15.

UTITARS - c1950's? Black bakelite camera made in Budapest, Hungary. The name means "traveling companion". Based on the design of the Hamaphot cameras from Germany, but with a rigid front rather than the helical telescoping type. Very uncommon. \$35-50.

UYEDA CAMERA (Japan)

Vero Four - c1938. Eye-level camera for 4x4cm on 127 film. Verona Anastigmat f3.5/60mm. Rapid Vero shutter T,B,1-500. \$150-225.

VAN DYKE BITTERS CAMERA - Box camera, 9x9cm dry plates in double holders. An early example of a camera used as a premium. Uncommon. \$150-225.

VAN NECK (London, England)

Press camera - Strut-folding camera in 9x12cm and 4x5" sizes. Ross Xpres f4.5 lens. \$100-150.

VANGUARD - Cast metal camera styled like a 35mm, but for 4x4cm on 127. Telescoping front. \$12-20.

VANITY FAIR

Character 126 cartridge cameras - "Recent" collectibles. Prices are for NEW condition

Holly Hobbie, Sunny-Bunch, Super Star, Barbie Cameramatic - \$15-25.

Incredible Hulk, Spider-Man - \$25-

VARSITY CAMERA CORP. Varsity Model V - Streamlined oval bakelite camera for 13/8x13/8" exposures on rollfilm. Also called the "Streamline Model V". \$25-35.

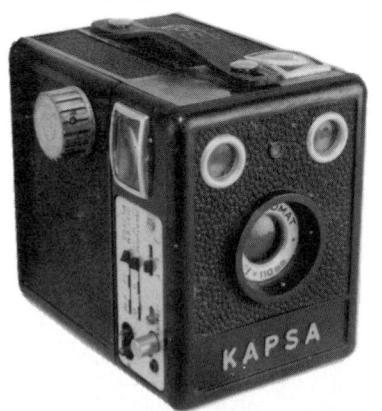

VASCONCELLOS (D.F. Vasconcellos, Sao Paulo, Brasil)

Kapsa - c1950's. Black plastic box camera for choice of 6x9cm or 4x6cm with hinged masks. Uses 620 or 120 film. Two auxiliary lenses operated by a lever allow three focusing positions. \\110mm lens; T&I shutter. \\$25-35. Vascromat

Tuka - Black plastic eye-level camera for 127 film. Body style is identical to Ansco Cadet II, Cadet III, and 127 Readyflash. Probably made from old Ansco molds, but eliminating shutter adjustment and synchronization. Uncommon. \$25-35.

VAUXHALL - Folding camera for 12 or 16 exposures on 120 film. English importer's name for mainly Beier cameras. Usually with f2.9 lens. Some with CRF: \$50-75. Without RF: \$35-50.

VEGA S.A. (Geneva, Switzerland) Telephot Vega - c1902. A compact camera for long focus lenses. The top section of the camera has the lens in front and an internal mirror at the rear. The light path is reflected to the front of the lower section, where it is again reflected to the plate at the rear of the lower section. For compactness, the top section drops into the bottom half, effectively reducing the size of the camera to just over 1/3 of the focal length of the lens. Several variations in size and folding method. \$3200-4600.

Vega - c1900. Folding book-style plate camera. Camera opens like a book, the lens being in the "binding" position, and the bellows fanning out like pages. Plate changing mechanism operated by opening and closing the camera. \$750-1000.

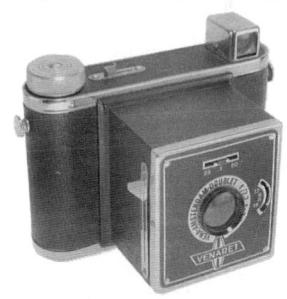

VENA (Amsterdam, Netherlands) Venaret - c1949. Eye-level box camera for 6x6cm exposures on 120 film. f7.7/75mm doublet lens. Simple shutter 25, 50. Metal body covered with black or colored leatherette. Nickel trim. \$30-45.

VICAM PHOTO APPLIANCE CORP. (Philadelphia, PA) Vicamphoto - Compact 35mm "school

VICTORY

Vive No. 1

camera" for bulk rolls of unperforated film. Fixed focus lens. Small compartment on front conceals the string used to measure subject-to-lens distance. \$75-100.

VICTORY MFG. CO. Lone Ranger - Photo-ette novelty camera for 28x40mm on 828 with drawing of Lone Ranger on his horse. Uncommon. \$100-150.

VIDMAR CAMERA CO. (New York) - c1948. Rollfilm press-type camera for 3 formats on 620 or 120 film: 6x9cm, 6x6cm, 4.5x6cm. Also accepts cuXQfilm or filmpacks. Ektar f4.5. Built-in RF. Designed and manufactured by the late Vic Yager, who also designed the Meridian. Only 100 body castings were made. About 50 units were assembled before the announcement of the first PolBroid camera rocked the industry and dried up investment funds. Total production was 75-85 units. \$500-750.

VIENNAPLEX (Austria) Pack 126 - c1980. Disposable camera for 126 cassette. \$1-10.

VIFLEX - c1905. Unusual SLR box camera for 4x5" plates, or sheetfilm. When folded, viewing hood becomes carry case. \$250-375.

VINTEN (W. Vinten, Ltd., London) Aerial reconnaissance camera For 500 exposures 55mm square on 70mm film. Black laquered body. Anastigmat f2/4" lens. \$175-250.

VISTA COLOUR - Black plastic box camera styled like oversized "Bilora Boy" for 6x6cm on 120 film. Made in England. Fixed focus lens; single speed sector shutter. \$20-30.

VIVE CAMERA CO. (Chicago) Folding B.B. - Folding "cycle" style camera for 4x5" plates. \$60-90.

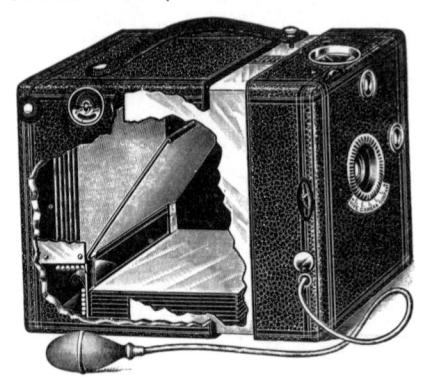

M.P.C. (Mechanical Plate Changing) - c1900. Magazine plate box cameras. Side crank advances plates. Two sizes: for 41/₄x41/₄" or 4x5" plates. Focusing model was called "Vive Focusing Portrait and View Camera". \$75-100.

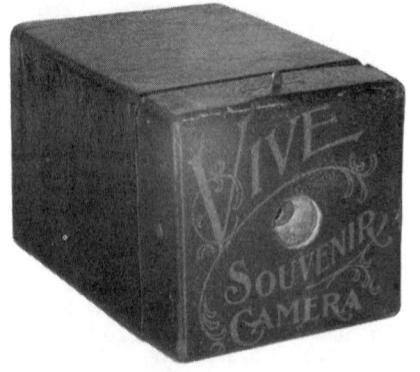

Souvenir Camera - c1895. Small cardboard box camera for single plates, 6x6.5cm. "Vive Souvenir Camera" in gold letters on front. \$100-150.

Tourist Magazine No. 3 - Magazine box camera for $31/_4$ x $41/_4$ " plates. Removable internal changing bag. \$60-90.

Twin Lens Vive - c1899. For stereo pairs on 31/₂x6" plates. Similar to the No. 1, but stereo. \$600-900.

Vive No. 1 - c1897. The first commercially successful U.S. camera to use the darksleeve to change plates in a camera. Actually, the Blair Tourograph had a sleeve (mitt) in 1879, but there was very limited production. For 12 plates 41/4×41/4." Simple lens and shutter. \$90-130. Illustrated top of first column.

Vive No. 2 - c1897. An improved model of the Vive No. 1, with a self-capping shutter, and with the viewfinder at the center front. \$90-130.

Vive No. 4 - c1897. Like Vive No.1, but for 4x5" plates. Focusing model. \$90-130.

VOIGT - c1947. Horizontal folding camera for 21/4x21/4" on 120 rollfilm. Not made by Voigtländer, but "Voigt" is written on the camera in script deceptively similar to Voigtländer's. Wirgin Anastigmat f4.5/75mm in Gitzo shutter T,B,25-125. \$35-50.

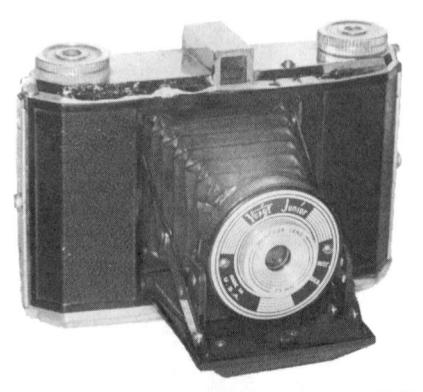

VOIGT JUNIOR MODEL 1 - c1947. Horizontally styled bakelite folding camera for 6x6cm on 120 film. Inexpensively equipped version of the Voigt camera, above. Identical to the Vokar, Model B. Similar cameras also sold under the Wirgin Deluxe and Vokar names. \$30-45.

VOIGTLÄNDER & SOHN

(Braunschweig) Please note that the Voigtländer name has never had the letter "h" in it until collectors started spelling it incorrectly. Founded in 1756 by Johann Christoph Voigtländer in Vienna, who made scientific instruments such as compasses and quadrants. His son, Johann Friedrich continued the business, adding optical glasses, spectacle lenses, and opera glasses. Peter Wilhelm Friedrich Voigtländer, grandson of the founder, worked with mathemetician Petzval to design the first mathematically computed lens in 1840. The lens had an incredible speed of f3.7! Voigtländer designed an equally incredible camera to use the lens. It was the first all-metal camera and

Avus folding plate, 9x12cm

the first camera with rack & pinion focusing. The company was moved to Braunschweig in 1849. At the turn of the century, the Heliar f4.5 lens was produced. This was the first anastigmat of such large aperture. Camera production was a major part of the company's business from the turn of the century through the 1960's. Zeiss-Ikon had begun buying into Voigtländer in the early 1950's, and by the mid-1960's, they owned it completely. Reportedly, Zeiss-Ikon was most interested in the excellent optical design section. Some cameras bear the Zeiss-Voigtländer name, and there are obvious Voigtländer influences on some of the subsequent "Tais: Ihon" cameras

"Zeiss-Ikon" cameras.

About 1972, Zeiss-Ikon sold the Voigtländer concern to Rollei. During this time of transition, there were nearly identical cameras called Zeiss Icarex and Voigtländer VSL-1, followed by VSL-2 which was similat to the Rollei SL35. Other models continued to appear which had roots in earlier Voigtländer studies and designs, including the popular and successful Rollei SL2000. The Voigtländer name was finally sold to a German camera store chain, and has appeared as a "house brand" on various photographic related products imported from around the world.

Alpin, 9x12cm - 1907-28. Folding plate camera for horizontal format 9x12cm plates. Light metal body, painted black. Black tapered triple extension bellows. Voigtländer Collinear f6.8/120mm or Heliar f4.5/135mm lens. Koilos, Compound, or Compur shutter. \$250-375.

Alpin, 10x15cm - \$300-450.

Alpin Stereo-Panoram - c1914-26. Three-lens stereo version of the Alpin camera. Made in the larger 10x15cm size. Triple Compound or Compur shutter. \$500-750.

Avus, folding plate 6.5x9cm - c1927-36. Skopar f4.5/105mm. Compur 1-250. \$60-90.

Avus, folding plate 9x12cm - c1919-34. Skopar f4.5/135mm. Compur or lbsor shutter. \$60-90. Illustrated at top of previous column.

Avus, rollfilm models - Although the plate models are much more common, rollfilm versions also exist.

- **6x9cm** - c1927. Folding bed style camera. Metal body with leather covering. Voigtar f6.3/105mm in Embezet or Skopar f4.5 in Compur. \$35-50.

- **6.5x11cm** - c1927. Folding bed camera in 1A size, 21/₂x41/₄". Voigtar f6.3/105mm in Embezet or Skopar f4.5 in Compur. \$35-50.

Bergheil - c1914-1930's. Top quality folding plate cameras. These cameras were also called "Tourist" in English language advertising. Features of the later models include bayonet system to mount shutter/lens assembly, focusing knobs on both sides of bed, spirit levels in rise and focus knobs. Struts remain locked while front is extended. Covering is generally green Russian leather. Note: Models in colors other than black are listed below under Bergheil Deluxe, as they are often called by collectors. Actually, based on our sales data, the 4.5x6cm and 6.5x9cm sizes are no more common in black than in color, but lack the appeal of the colored leather models. Bergheil, 4.5x6cm - Double extension. Heliar f4.5/80mm lens, Compur 1-300 shutter. Rare in this size. \$200-300.

Bergheil, 6.5x9cm - c1930. Heliar f4.5/105 lens. Compur 1-250. Bayonet system for interchanging of lens/shutter units. \$120-180.

Bergheil, 9x12cm - c1925. Double extension. Heliar f3.5 or f4.5/135mm lens. Compoundor Compurshutter. \$120-180.

Bergheil, 10x15cm - c1924. 165mm Skopar f4.5 or Collinear f6.3 lens. Compur shutter. \$150-225.

Bergheil Deluxe - There are two distinct styles of the Bergheil Deluxe. The most deluxe and desirable is the small 4.5x6cm model with BROWN leather and bellows and GOLD metal parts. The larger versions with green Russian leather covering and green bellows are a step up from the black models, but are not truly "Luxus" models.

VOIGTLÄNDER

Bergheil Deluxe, 4.5x6cm - c1923-27. Brown leather, brown bellows, gold colored metal parts. Heliar f4.5/75mm lens; Compur 1-300 shutter. Auction high (Cornwall 10/90) \$1350. Normal range: \$750-1000.

Bergheil Deluxe, 6.5x9cm - c1933. Green leathered body and green bellows. f3.5 or 4.5/105 Heliar lens. Compur 1-200 shutter. Nickel trim. \$300-450.

Bergheil Deluxe, 9x12cm - c1933. Green leather covered body and green bellows. \$200-300.

Bessa (early models) - c1931-49. Folding rollfilm cameras usually seen in 6x9cm size. Most have waist-level and eye-level viewfinders. Various shutter/lens combinations, including Voigtar, Vaskar, and Skopar lenses f3.5 to f7.7. Single, Prontor, or Compur shutters. Better models with f3.5 or f4.5 lens tend to fall in the range of \$50-75. Models with f6.3 or f7.7 lens usually sell for \$35-50.

VOIGTLÄNDER...

Bessa RF - c1936. CRF. Compur Rapid 1-400 shutter. With Heliar f3.5/105mm add \$12-20. With Helomar or Skopar f3.5/105mm:\$120-180.

Bessa I - With Skopar or Helomar f3.5/105mm: \$75-100. With Vaskar f4.5: \$60-90

Bessa II - c1950. Updated version of the Bessa RF, with housing for coupled range-finder in chrome instead of black. Compur Rapid or Synchro-Compur 1-400 shutter. With Apo-Lanthar f4.5 (rare): \$1700-2400. With Heliar f3.5: \$350-500. With Skopar f3.5/105mm:\$300-450.

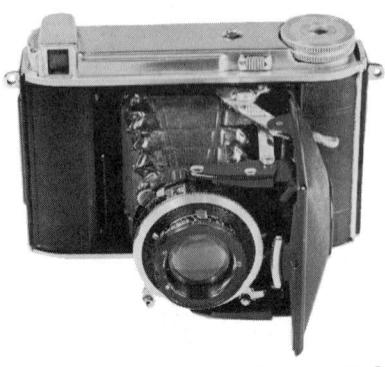

Bessa 46 "Baby Bessa" - c1939. Selferecting folding camera for 16 exposures 4.5x6cm on 120 film. Optical finder incorporated in top housing. Trigger release for shutter protrudes from side of front door. Voigtar or Skopar f3.5/75mm lens in Compur 1-300 shutter, or Heliar f3.5/75mm in Compur Rapid 1-300. \$150-225.

Bessa 66 "Baby Bessa" - c1930. Several viewfinder variations: optical finder incorporated in top housing; folding optical finder; folding frame finder. Very common, with widely ranging prices. In top condition (like new), these will bring \$200-300. Often

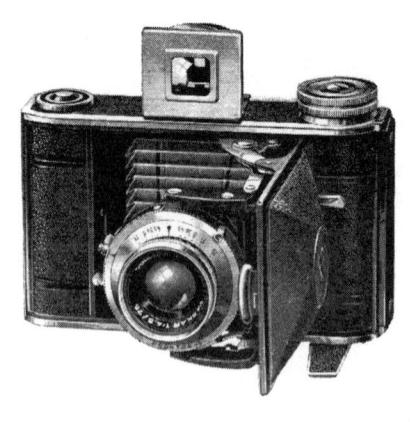

found in Germany, in "B" condition, for \$120-180. Common in "C" or Excellent condition. With Skopar f3.5: \$35-50. With Voigtar f3.5/75mmor Vaskar f4.5: \$30-45.

Super Bessa - c1936. 6x9cm folding rollfilm camera. CRF. f4.5 Skopar or f3.5 Skopar, Helomar or Heliar 105mm lens in Compur Rapid 1-400BT shutter. Hinged yellow filter. \$200-300.

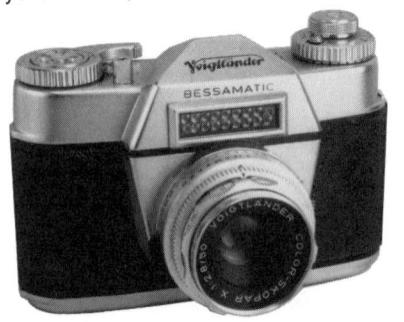

Bessamatic - c1959. 35mm SLR, built-in meter. Synchro-Compur shutter. Interchangeable lenses. With Zoomar f2.8/36-82mm (world's first SLR Zoom lens): \$400-600. With Skopar f2.8/50mm: \$100-150.

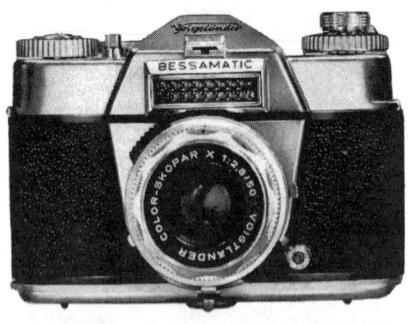

Bessamatic Deluxe - c1963. Similar, but diaphragm and shutter speed visible in finder. Externally recognizable by the small T-shaped window above the meter cell. With Septon f2 lens: \$120-180. With Skopar f2.8: \$90-130.

Bessamatic M - c1964. Low-priced version of the Bessamatic without meter. Interchangeable Color Lanthar f2.l8/50 in Synchro-Compur1-500. \$100-150.

Bessamatic CS - 1967-69. SLR with coupled CdS metering. Battery compartment in front of prism, with front door where meter cell was located on previous models. Color-Lanthar f2.8, Color-Skopar f2.8, or Septon f2 in Synchro Compur X. \$150-225.

Bessamatic Lenses: 35mm f3.4 Skoparex - \$60-90. **40mm f2 Skopagon -** Rare. \$300-450.

50mm f2.8 Color Lanthar - \$90-130. 50mm f2.8 Color Skopar-X - \$50-75. 50mm f2 Septon - \$75-100. 90mm f3.4 Dynarex - \$200-300. 100mm f4.8 Dynarex - \$500-750. 100mm f4.8 Tele-Dynarex - \$120-180. 135mm f4 Super Dynarex - \$75-100.

200mm f4 Super Dynarex - \$300-450. 350mm f5.6 Super Dynarex - Top

condition has sold for \$750-1000. Normal range: \$400-600.

36-82mm f2.8 Zoomar - \$250-375.

Bijou - c1908. The first miniature SLR, 4.5x6cm plates. All-metal box body, tapers toward the front. Originally sold only with 100mm Heliar lens. \$600-900.

Box - c1950. Metal box camera for 6x9cm on 120. Meniscus f11 lens, 3-speed shutter. \$35-50.

Brillant - c1933. Inexpensive TLR cameras. Among the variations: 1933-metal body with non-focusing finder lens. 1937- Plastic body with compartment for extinction meter. 1938- Focusing model. Lenses include 75mm f6.3 or 7.7 Voigtar, f4.5 Skopar, or f3.5 Heliar. Early model, complete with accessory meter, sells for \$120-180. Otherwise quite common. \$35-50.

Daguerreotype "cannon" - 1840. Brass "cannon"-shaped daguerreotype camera: 31cm long, 35cm high. Makes 80mm diameter image. This original Voigtländer daguerreotype camera is historically important for its introduction of the fast f3.7 lens. This 4-element lens, mathematically computed by Dr. Joseph Petzval, was 15 times faster than the lenses used by Daguerre. Reportedly 600 of these cameras were sold by 1842, but finding an original today is highly unlikely. About a dozen are known to exist.

Daguerreotype "cannon" replica -Reproduction of the original 1840 Voigtländer brass Daguerreotype camera. The first replicas were made in 1939 by the Voigtländer factory and they continued to supply replicas through the years. There are thought to be very few of the first 1939 replicas. The later authentic Voigtländer replicas are often from the 1950's or later. In 1978, a limited series of 100 replicas was made of the Voigtländer metal camera No. 84. These cameras are serial numbered. Post-1939 authentic replicas generally sell with stand and facsimile instructions for \$2400-3200. In recent years some non-authentic replicas have been turned from solid brass by a private vendor. These have little value except for display purposes.

Dynamatic, Dynamatic II - c1961. 35mm with automatic electronic meter. Lanthar or Color-Skopar f2.8/50mm in Prontormat-SV or Prontor-Matic-V shutter. \$45-60.

Folding plate cameras (misc. models) - \$45-60.

Folding rollfilm cameras (misc. models) - 5x8cm, 6x9cm, and 6.5x11cm sizes. \$45-60.

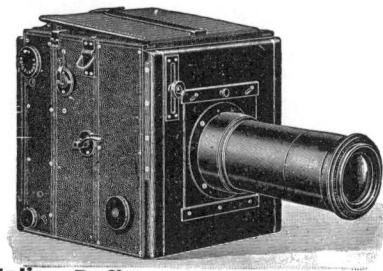

Heliar Reflex - c1909. Boxy SLR for 9x12cm plates (and many other sizes), made by Bentzin for Voigtländer. Heliar f4.5/180. FP shutter 20-1000. \$250-375.

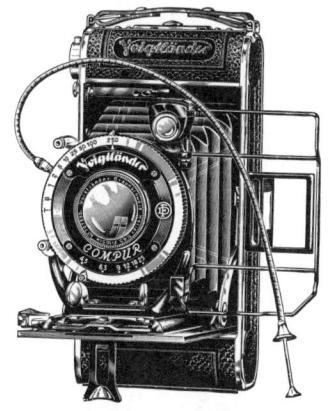

Inos (I) - c1931-32. Dual-format folding bed camera, 6x9cm and 4.5x6cm on 120 film. Wire frame finder indicates both formats. Compur to 250, or Embezet shutter to 100. With Heliar f4.5: \$120-180. With Skopar f4.5/105mm:\$100-150.

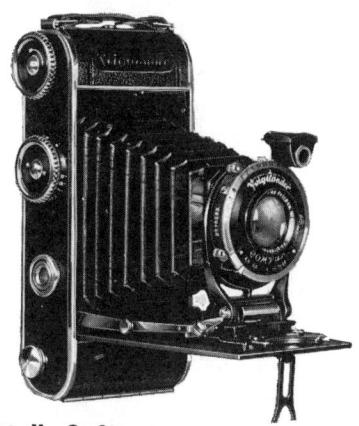

Inos II, 6x9cm - c1933-34. Like Inos, but front standard automatically slides forward when bed is dropped. Focusing knob on body can be preset before opening camera. For 6x9cm or 4.5x6cm with reducing masks. Small folding frame finder with hinged mask for half-frames. Skopar f4.5/105mm lens. Compur 1-250 shutter. Common in Germany. \$75-100.

Inos II, 6.5x11cm - c1933-34. Like the more common 6x9cm size but for 6.5x11cm and 5.5x6.5cm images on 116 film. Uncommon in this size. Heliar f4.5/118mm or Skopar f4.8/118mm lens. \$100-150.

Jubilar - c1931. Folding camera, 6x9cm on 120 rollfilm. Voigtar f9 lens. \$30-45.

Perkeo, 3x4cm - c1938. Folding camera with self-erecting front. For 16 exposures 3x4cm on 127 film. Camera can be focused before opening, via external knob. With Heliar f3.5, Skopar f3.5, or 4.5/55mmlens: \$350-500.

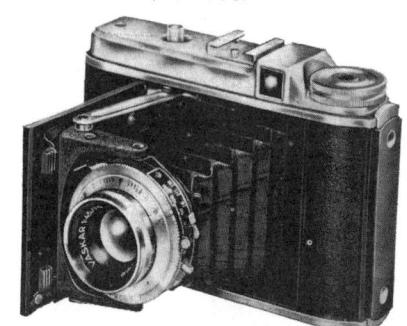

Perkeo I - 1952. Folding camera for

VOIGTLÄNDER...

6x6cm exposures on 120 film. Prontor shutter. f4.5 Vaskar lens. \$50-75.

Perkeo II - c1952. Similar, but automatic film counting, and f3.5 Color Skopar in Synchro-Compurshutter. \$75-100.

Perkeo E - c1954. Like the Perkeo II, but with rangefinder. Color-Skopar lens in Prontor SVS shutter. \$175-250.

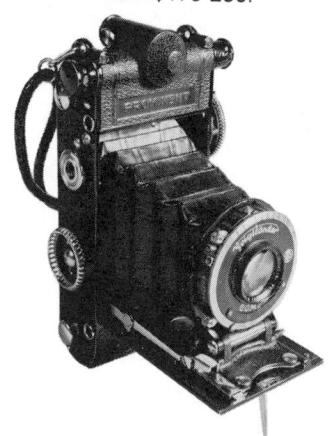

Prominent - c1932. Folding camera for 6x9cm on 120 film, or 4.5x6cm with reducing masks. Self-erecting front. Coupled split-image rangefinder. Extinction meter. Heliar f4.5/105mm lens in Compur 1-250 shutter. \$800-1200.

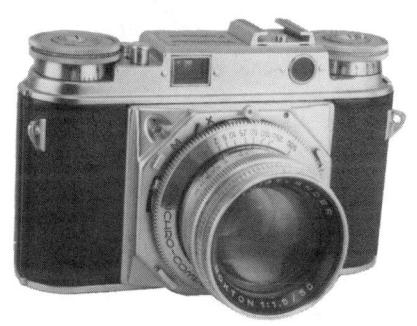

Prominent - c1952-58. 35mm range-finder camera for interchangeable lenses. Compur-Rapid or Syncho-Compur shutter. Earliest ones have no accessory shoe. Rapid wind lever added in 1956. With f2 Ultron or f1.5 Nokton: \$175-250. With f3.5 Color Skopar: \$150-225.

Prominent II - c1958-60. Similar but larger bright frame viewfinder for 35, 50, 100, and 150mm lenses. At German auctions: \$400-600.

Prominent Lenses & Accessories: 35mm f3.5 skoparon - \$90-130. 50mm f2 Ultron - \$45-60. 50mm f1.5 Nokton - \$45-60. 100mm f4.8 Dynaret - \$60-90. 100mm f4.5 Dynaron - \$120-180. 100mm f4 Dynaron - \$75-100. 150mm f4.5 Super Dynaron - \$200-300. Prism loupe - \$90-130. Proximeter I, II - \$30-45. Turnit finder 339/35 - \$35-50.

Stereflektoskop - c1913-1930's. Stereo cameras with plate changing magazine. 45x107mm and 6x13cm sizes. Three Heliar f4.5 lenses in Stereo Compur shutter. (Early version had only two Heliar lenses with a small triplet finder lens above and between the taking lenses.) This is a three-lens reflex, the center lens used for

VOIGTLÄNDER...

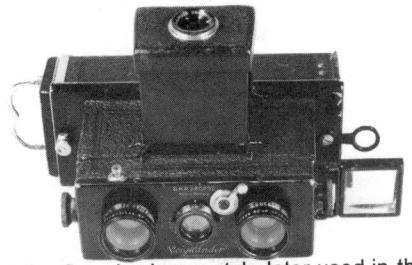

1:1 reflex viewing, a style later used in the Heidoscop and Rolleidoscop cameras: **45x107mm size -** \$350-500. **6x13cm size -** \$400-600.

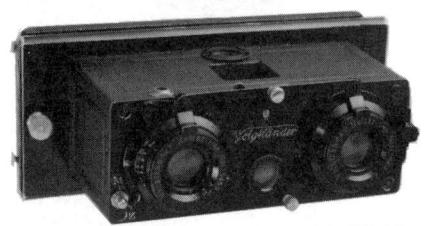

Stereophotoskop - c1907-24. Rigidbody 45x107mm stereo camera. Magazine back for 12 plates. Simple reflex bright finder and side Newton finder. Heliars f4.5; sector shutter. \$300-450.

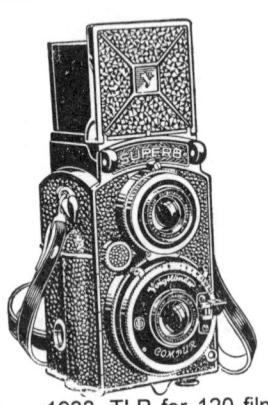

Superb - c1933. TLR for 120 film, later version has sportsfinder hood. Prism reflects settings for easy visibility. Uncommon with Heliar: \$400-600. Common with f3.5/75mmSkopar: \$250-375.

Ultramatic - c1963. SLR. Auto/manual metering. Selenium meter on front of prism. Aperture and speed visible in finder. Color Skopar f2.8/50 in Compur 1-500. \$150-225.

Ultramatic CS - 1965. Similar to Ultramatic, but CdS meter cells. One of the

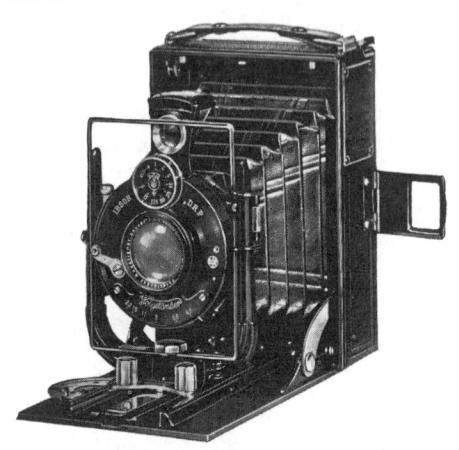

Vag

earliest TTL metered SLR's with full information in the finder. Fully automatic aperture control. Color Skopar f2.8 or Septon f2. Behind-thelens Compur. \$150-225.

Vag - c1920's. Folding plate cameras, 6x9cm and 9x12cm sizes. Voigtar f6.3 or Skopar f4.5 lens in Ibsor or Embezet shutter. \$45-60. *Illustrated at bottom of previous column*.

Vida - c1911-14. SLR for 9x12cm plates. Revolving back. Rack and pinion front extension. FP shutter 1/12 to 1000. Heliar f4.5/180mm. Uncommon. \$425-550.

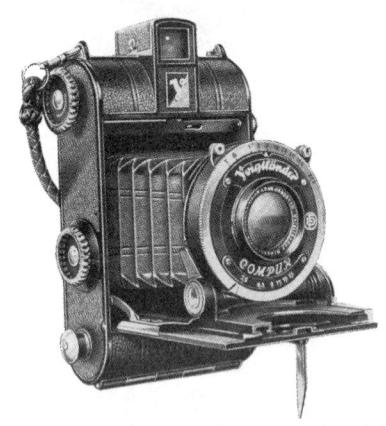

Virtus - c1935. Similar to Prominent, but smaller, and more common. For 16 exposures on 120 film. Automatically focuses to infinity upon opening. Compur shutter 1-250. With Heliar f3.5/75mm: \$300-450. With Skopar f4.5/75mm: \$250-375.

Vitessa Cameras: A series of smartlystyled 35mm cameras introduced in 1950. Most are of the folding style with "Barndoors" on front. Named for the rapid winding system operated by a long plunger extending from the top of the camera.

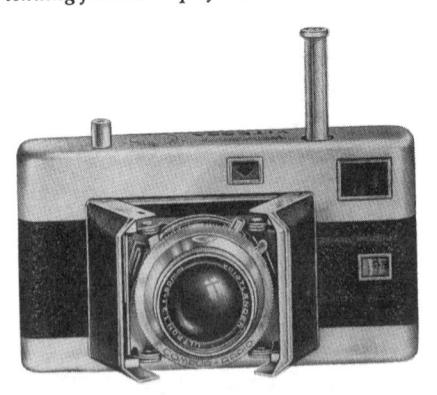

Vitessa - c1950-1957. All have coupled rangefinder Several variations:

Type 1 (1950): Smooth top without shoe. Manual parallax correction. Diamond-shaped rangefinder patch. Pressure plate hinged to body. Non detachable back. No strap lugs. Compur Rapid shutter. "Voigtländer" & "Vitessa" engraved on top plate. Illtron f2 lens only.

Ultron f2 lens only.

Type 2 (1950): Automatic parallax correction (rear finder moves). Pressure plate attached to back door. Fully removable back with strap lugs. "Germany" embossed in back leather. Synchro-Compur shutter.

Type 3 (1951): Accessory shoe on top. Synch contact on front door. 50mm f2.8 Color Skopar or f2 Ultron lens. Synchro Comput 1-500 shutter.

All types in same price ranges. Germany: \$120-180 USA: \$100-150.

Vitessa N - c1951. Same as Vitessa, 1951 type, except: f3.5 Color Skopar only. Square rangefinder patch. Rear finder immobile during focusing. "VITESSA" embossed on polished chrome top plate. "Voigtländer"engraved on front. \$100-150.

Vitessa L - c1954. Like Vitessa (1951 type) but with selenium meter. Ultron f2/50mm lens only. \$150-225.

Vitessa T - c1957. Rigid front without barn doors. Interchangeable Color Skopar f2.8/50mm normal lens. Synchro-Compur 1-500 behind-the-lens shutter. Common. EUR: \$150-225. USA: \$100-150.

Vitessa T Lenses (bayonetmount): 35mm f3.4 Skoparet - \$50-75. 100mm f4.8 - \$75-100. 135mm f4 Super-Dynaret - \$75-100.

Vito - c1939-50. Folding 35mm. Compur 1-300 shutter. Skopar f3.5/50mm lens, yellow hinged filter until 1948: \$100-150. 1949-50, Color-Skopar lens, no attached filter: \$45-60.

Vito II - c1950, 35mm, Color Skopar f3.5 lens. Prontor or Compur shutter, \$50-75.

Vito IIa - c1955. Less common that the Vito and Vito II. \$50-75.

Vito III - c1950. Folding style with coupled rangefinder. f2 Ultron. Synchro Compur 1-500 shutter. \$200-300.

Vito B - c1954. Normally with f3.5 Color Skopar in Pronto or Prontor SVS shutter. Less common with f2.8 Color Skopar in Prontor SVS. Two styles of top housing: short with small finder window; tall with larger bright-frame finder. \$45-60.

Vito BL - c1957-59. Color-Skopar f2.8/50. Built-in exposure meter. \$50-75.

Vito Automatic

Vito C - c1961. f2.8/50 Lanthar. Prontor shutter. \$30-45.

Vito CD - c1961. Like the C, but with exposure meter. \$30-45.

Vito CL - c1962. Like the CD, but meter is coupled. Common. \$30-45.

Vito CLR - c1962. Like the CL, but also has CRF. Common. \$30-45.

Vito Automatic - c1962. f2.8/50mm Lanthar. Prontor Lux shutter. \$30-45. Illustrated bottom of previous column.

Vitomatic I - intro 1958. 35mm view-finder camera with coupled selenium meter. Match needle readout on top plate only. Color-Skopar f2.8/50mm lens in Prontor SLK-V 1-300, B. \$50-75.

Vitomatic la - c1960. Same basic camera as the Vitomatic I, but Prontor SLK-V shutter speed to 500, meter matchneedle visible also in finder. \$45-60.

Vitomatic Ib - c1965. 35mm viewfinder camera with built-in selenium meter, a restyled version of the Vitomatic Ia. Meter readout in finder only. Shutter release on front. Color-Skopar f2.8/50mm lens in Prontor 500 SLK-V 1-500, B. \$75-100.

Vitomatic II - intro 1958. Similar to the Vitomatic I, but with coupled rangefinder. BIM. Color-Skopar f2.8/50mm lens in Prontor SLK-V 1-300, B. \$60-90.

Vitomatic IIa - intro 1959. Similar to the II, but Prontor 500 SLK-V shutter 1-500, B. Semi-automatic exposure. Match-needle in finder. Originally sold with Color-Skopar f2.8/50mm, but later was also available with Ultron f2/50mm lens. With Ultron: \$100-150. Common with Skopar: \$60-90.

Vitomatic IIb - c1965. Similar to the Ib, but also has coupled rangefinder. \$75-100.

Vitomatic IIIb - c1965. Same as IIb, but with fast Ultron f2.0/50mm lens. \$175-250.

Vitoret - c1963. Inexpensive, basic 35mm camera. Vaskar f2.8/50mm in Prontor $^{1}/_{30}$ - $^{1}/_{125}$. \$20-30.

Vitoret D - c1963. Vitoret with built-in exposure meter. \$20-30.

Vitoret D Rapid - As Vitoret D, but for Rapid cassette system. Color-Lanthar f2.8/40mm.\$20-30.

Vitoret DR - As D, with meter, but also with coupled rangefinder. Color-Lanthar f2.8/50mm; Prontor 300. \$35-50.

Vitoret F - c1964. Basic Vitoret camera, but with built-in flash socket for AG-1 bulbs. \$20-30.

VOIGTLÄNDER...

Vitoret R - Basic Vitoret, but with coupled rangefinder. No meter. Lanthar f2.8 lens. \$25-35.

Vitrona - c1964. 35mm, built-in electronic flash. f2.8/50mm Lanthar lens. Prontor shutter 1-250. Novel, and originally expensive. Reportedly not made in large quantity, but they are common and easily found today. Complete with battery grip: \$60-90.

VOJTA (Josef Vojta, Prague) Field camera - c1905. Folding 18x24cm plate camera, tapered red bellows, nickel trim. Brass Rodenstock Bistigmat lens with revolving stops. \$300-450.

Magazine Camera - Wooden box camera for 6.5x9cm plates, manually changed through leather sleeve at top rear of camera. Two reflex finders. M&Z shutter. \$200-300.

VOKAR CORPORATION (Dexter, Michigan) Formerly "Electronic Products Mfg. Corp." of Ann Arbor, Michigan.

Vokar, Models A, B - c1940. Bakelite folding camera for 6x6cm on 120. Also sold under the Voigt Junior and Wirgin Deluxe names. \$30-45.

Vokar I, II - c1946. 35mm RF cameras. f2.8/50mm Vokar Anastigmat lens in helical mount. Leaf shutter 1-300. \$60-90.

VOOMP

VOOMP (Voomp Opytny Zavod, Leningrad)

Voomp - 1934-35. Copy of the Leica II. Approximately 300-400 produced. Christie's 8/93 auction reported only seven examples known worldwide, but the example offered failed to reach the reserve of £5000. It sold 3/94 at £1000.

VORMBRUCK CAMERABAU (Germany)

Feca (reflex) - c1947. Single lens reflex for 35mm film. One of the first cameras from post-war Germany. Rau Optik Wetzlar Astro-Astan f2.9/4.7cm interchangeable lens. No recent sales data.

VOSS (W. Voss, Ulm, Germany)
Diax (I), Ia, Ib - c1948-1950's. Short series of 35mm RF cameras. Xenon f2/45mm lens in Synchro-Compur 1-500 shutter. Models Ia and Ib, have interchangeable lenses. Unusual mounting system with fixed male-thread ring fixed to front of shutter and rotating female-thread ring on rear of lenses. With normal lens: \$60-90.

Diax II, IIa, IIb - Similar to the Diax I series, but with coupled rangefinder. Diax IIa and IIb have interchangeable lenses. \$150-225.

Diax Lenses: 35mm f3.5 Westron - \$25-35. 35mm f3.5 Xenagon - \$35-50. 85mm f4.5 Isconar - \$25-35. 90mm f3.5 Tele-Xenar - \$50-75. 135mm f4 Tele-Xenar - \$50-75. Accessory finder - 35/85-90/135mm. \$20-30.

Diaxette - c1953. Low-priced viewfinder 35mm based on the early Diax I body. Non-interchangeable Steinheil Cassar f2.8/45mm lens. Prontor 25-200 shutter. \$60-90.

VREDEBORCH (Germany) Adina - c1950. For 6x9cm on rollfilm. \$12-20.

Alka Box - c1953. Metal box camera, 6x9cm on 120. \$12-20.

Bunny - c1950's. Metal eye-level box for 6x6 on 120. Zone focus. \$12-20.

Ecla Box - c1950. Box camera for 6x9cm on rollfilm. \$25-35.

Evans Box - c1950's. Metal box camera, 6x9cm on 120. \$15-25.

Felica, Felita - c1954. Metal eye-level box cameras, 6x6cm on 120 film. Meniscus lens, zone focus, simple shutter 25, 50, B. Light gray or black colored. \$8-15.

Felicetta - c1965. 35mm with BIM. Nordinar f3.5/45mm in Spezial shutter $1/_{30}$ - $1/_{125}$. \$12-20.

Fodor Box Syncrona - c1950. Box camera for rollfilm. \$25-35.

Haaga Syncrona Box - c1955. Basic rectangular box camera, similar to normal Sychrona Box. Meniscus lens, M,B,T shutter. Uncommonname. \$20-30.

Ideal - c1950. 6x9cm on rollfilm. \$15-25.

Junior - c1954. Same as the Felica, but with the "Junior" name. \$8-15.

Kera Jr. - Simple plastic & metal eyelevel box camera for 6x6cm on 120. Lux Spezial focusing lens. \$1-10.

Klimax - c1950's. Metal eye-level box camera. Grey enameled with grey leatherette. Zone focusing. \$12-20.

Kruxo Favorit - c1950's. Box camera. \$20-30.

Manex - c1950. 6x9cm on rollfilm. \$15-25

N-Box - 1950's. Box camera. \$12-20.

Nordetta 3-D - c1951. Strut-folding stereo, taking two 42x55mm exposures on 127 rollfilm. f4.5/75mm lenses. Guillotine shutter. Cheap construction, but not very common. \$150-225.

Nordina - c1953. Telescoping front. 6x6cm on rollfilm. Steinar 75mm coated lens. Model I has f4.5, Vario shutter. Model II has f3.5, Vario shutter. Model III has f2.9, Pronto 1/25-200 shutter. \$25-35.

optomax Syncrona - c1952. Basic metal box camera for 6x9cm, but covered in light grey leather. Meniscus lens. Synchronized M,T shutter. \$15-25.

WALZ

Reporter Junior II - c1950's. Eye-level 6x6 camera like Felica and Felita. Grey or black leather covering. \$8-15.

Slomexa - c1950's. Basic metal box camera like Vrede Box. Meniscus f11 lens. \$20-30.

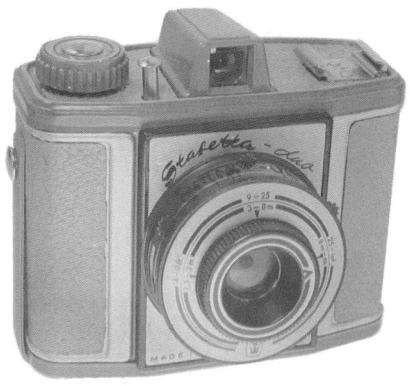

Stafetta-duo - c1950's. Grey metal eye-level box camera for 6x6cm or 4x4cm on 120 film. Metal mask slides into position at film plane for the smaller negative size, automatically changing an indicator mark on the top of the camera from black to white. A matching triangular mark on the back changes from black to white as the correct red window is opened. \$20-30.

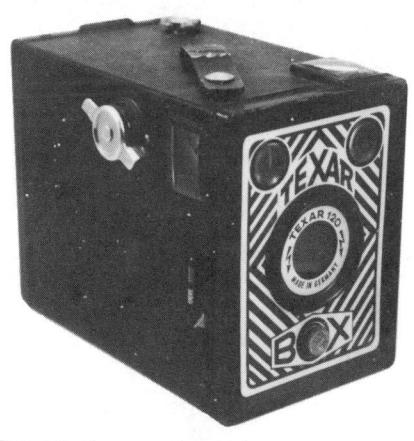

Texar Box - Metal box camera for 6x9cm on 120 film. \$12-20.

Union-Box - c1950's. Box camera for 6x6cm. M & Z shutter. Union-Box name-plate below lens. \$20-30.

Vrede Box - c1953. Metal box camera with paper covering in various colors. Models include Paloma, Paloma S, Synchrona, etc. With and without PC flash sync. With green or red covering: \$35-50. Black: \$12-20.

VRSOFOT (Prague, Czechoslovakia) Epifoka - 1947-48. Hand-held aerial camera for 120 rollfilm, designed by the well-known Czech photographer, Mr. Premsyl Koblic. During its two years of production, Mr. Jindrich Svec and his staff of 2 to 4 employees at Vrsofot made less than 1500 cameras total. One model for 6x9cm, another for 6x6cm or 4.5x6cm. Tessar or Dagor lens. Compur or Prontor II shutter. Folding frame finder. Very rare, even in Czechoslovakia. \$175-250.

WABASH PHOTO SUPPLY (Terre Haute, IN)
Direct positive camera - c1935. Wood body. Ilex Universal f3.5/3" portrait lens. Dimensions 5x8x20". With enlarger and dryer: \$200-300.

WAITE (J. Waite, Cheltenham, England) Not a camera maker, but a chemist (= drug store in USA).
Wet plate Stereo - c1855. Mahogany

Wet plate Stereo - c1855. Mahogany sliding-box camera for 4x71/2" wet plates. Brass trim, brass bound Derogy lenses. Made in London, sold by Waite. One nice outfit in box with chemicals and plates brought \$4711 at auction in England several years ago. No recent sales records.

WALDES & CO. (Dresden)

Foto-Fips - c1925. Unusual, low cost folding camera made of light cardboard and paper. Uses single 4x4cm plates. Actually, the camera is built into the bottom half of a small box which also stores the plates, bromo paper, developer and fixer. Boxtop and supplies are all labeled in Czech. Very rare. We have records of only two complete outfits, both of which sold at auction in Germany. One brought \$350 in 3/85 and the other sold in 10/88 for \$845. In 12/91, one of these resold at Christie's for \$550.

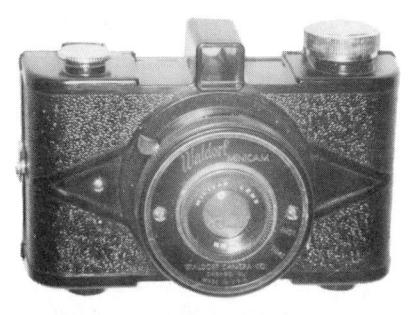

WALDORF CAMERA CO.
Waldorf Minicam - Black bakelite half127 camera. Made by Utility Mfg. Co. for Waldorf. \$1-10.

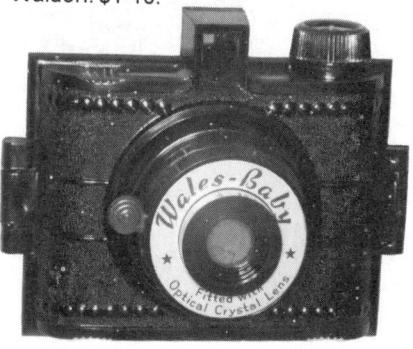

WALES-BABY - Plastic half-127 novelty camera. \$1-10.

WALKER CO. (Wm H. Walker & Co., Rochester, NY)

Walker's American Challenge - c1882. Early monorail camera, perhaps the first American one. When body is in collapsed position, the rail pivots to allow compact storage. Pivoting base for monorail also doubles as tripod head. Red fabric bellows; polished cherrywood body. Unidentified meniscus lens in nickeled barrel which threads into matching nickled rise/fall lensboard. Made in 31/4x41/4", 4x5" sizes. Very rare. No recorded sales. Estimate: \$2000-3000.

Walker's Pocket Camera - c1881. Wooden box camera for 23/₄x31/₄" dry plates. Achromatic lens, guillotine shutter. Rare. \$3200-4600.

WALKER MANUFACTURING CO. (Palmyra, N.Y.)

TaklV - c1892. Cardboard and leatherette construction. Multiple exposures for 4 pictures, each 21/2x21/2" on dry plates. Rotating shutter and lens assembly. Septums for 4 exp. at rear. \$1200-1800.

WALKLENZ - Japanese novelty subminiature of the Hit type. \$25-35.

WALLACE HEATON LTD. (London)

Zodel was the house name used by Wallace Heaton for cameras that it sold. The majority of these cameras were imported from Germany.

Zodel - c1926. Folding plate cameras made by Contessa Nettel. Variations include 6.5x9cm size with Zodellar f4.5/120mm lens in Compur shutter, or 9x12cm size with f4.8/135mm Zodellar in Gammax.\$60-90.

WALZ CO. (Japan) Walz Automat - c1959. 4x4cm TLR. Zunow f2.8/60mm. Copal shutter 1-500, B. \$150-225.

Walz Envoy 35 - c1959. Rangefinder 35. Kominar f1.9/48mm. Copal SLV shutter, 1-500,B, MFX sync. ST. Single stroke advance. \$35-50.

Walz-wide - c1958. 35mm. Walzer f2.8/35mm, Copal shutter 1-300,B.\$50-75.

WALZ...

Walzflex, Walzflex IIIA - c1955. 6x6cm TLR cameras for 120 film. f3.5/75mm Kominar lens in Copal shutter. \$75-100.

WANAUS (Josef Wanaus & Co., Vienna)

View Camera - c1900. Field-type camera for 13x18cm plates. Light colored polished wood, nickel trim. Gustav-Rapp Universal Aplanat lens, waterhouse stops. Geared focus, front and rear. \$250-375.

WARWICK (Birmingham, England) Warwick No. 2 Camera - Basic box camera for 6x9cm on 120 film. Dark brown leatherette covering. \$12-20.

WATSON (W. Watson & Sons, London)

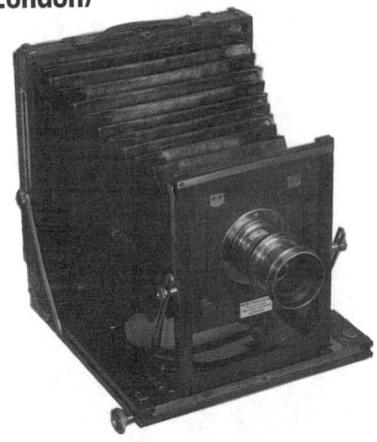

Acme - c1890-1927. Light-weight double extension field camera. Half-plate, ¹/₁-plate, or 8x10". \$350-500.

Alpha - c1892. Mahogany hand camera commonly found in 31/4x41/4" and 4x5"

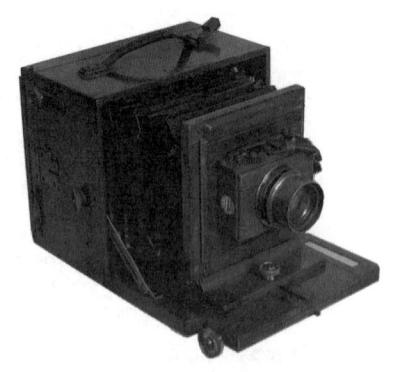

sizes. Rising front combined with drop bed permitted the use of wide angle lenses. Rapid Rectilinear lens, T+I front shutter. \$500-750.

- **Tropical Alpha** - c1892. Like the above, but tropical version. Mahogany body has brass reinforcements, maroon bellows. 4x5" size. B&L lens, Unicum shutter. \$600-900.

Argus Reflex - c1907. Earlier models were imported from Germany, before Watson began making their own Argus Reflex. SLR for ¹/₄-plates. Extensible front, short focusing hood. FP shutter ¹/₅-¹/₁₀₀₀. Holostigmat 6" lens. \$175-250.

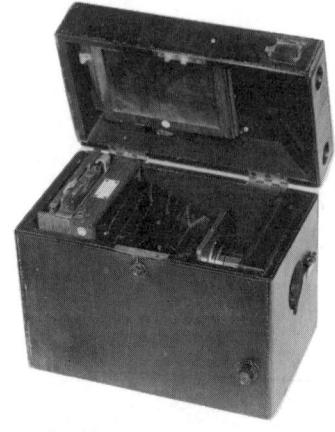

Detective Camera - intro. 1886. Black leather covered box contains a 1/4-plate bellows camera. Box also holds three double plateholders behind the camera, or Eastman's roll-holder also could be used. External controls in bottom of box. Two waistlevel viewfinders in the lid. Rapid Rectilinear lens, adjustable guillotine shutter. Focus by means of a lever in the bottom of the box, from 15' to infinity. \$750-1000.

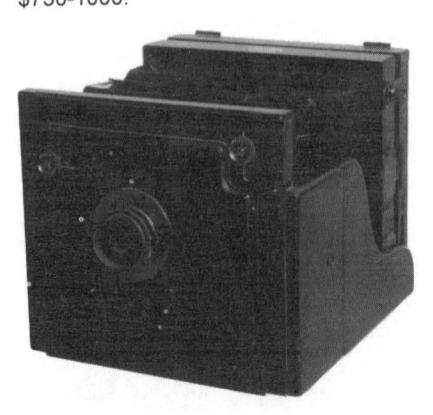

Field camera - c1885-90. Tailboard style in sizes from 1/2-plate to 8x10". Fine

wood body, brass trim. Thornton-Pickard roller blind shutter. Watson f8 brass barrel lens. \$350-500.

Gear - c1901. Leather covered box camera with internal bellows for focusing. $1/_4$ -plate size. Rapid Rectilinar, shutter $1/_{15}$ - $1/_{75}$. \$50-75.

Magazine box camera - c1900. Falling-plate magazine box cameras, including, "Tornado", "Repeater", etc. For 12 plates, 31/₄x41/₄". \$90-130.

Stereoscopic Binocular Camera - c1901. English imported version of the Bloch Stereo Physiographe. Krauss Tessar lenses. 45x107mm. \$1500-2000.

Twin Lens Camera - c1899. An early twin lens style camera for quarter plates. Black leather covered mahogany body. Rapid Rectilinear lens, iris diaphragm. Thornton-Pickard T,I shutter. Reflex viewing. \$500-750.

Vanneck - intro. 1890. Plate-changing compartment holds 12 31/₄x41/₄" plates. Rapid Rectilinear lens. First SLR with instant return spring mirror. Leather covered body. \$600-900.

Vril - c1910-13. Strut-folding camera, $3^{1}/_{4}$ x4 $^{1}/_{4}$ " (Import version of Ernemann Klapp). Black lacquered wood body, nickel and brass trim. Focal plane to 1500. Holostigmat f6.5/4 $^{1}/_{2}$ " lens. \$300-450.

WATSON SUPPLY HOUSE (Chicago) Star Camera - c1898. Small cardboard box camera for 2x2" glass plates, individually loaded in a darkroom. Packaged in a kit with plates, chemicals, trays, etc., and used as a premium for promoting magazine sales. One example with original box sold for \$190 at Christie's 12-91.

WAUCKOSIN (Frankfurt, Germany)

Not a manufacturer, but a wholesale firm dealing in Plaubel and other makes, including some with their own name.

Waranette - c1930. Folding rollfilm cameras in 3 sizes.

- **3x4cm** - Strut-folding similar to the Balda Piccochic. Vidar f4.5/50mm in Vario or f2.9/50 in Ring Compur. \$90-130.

or f2.9/50 in Ring Compur. \$90-130.

- **5x8cm** - Folding bed. Polluxar f6.3/85mm lens in Vero shutter 25-100. \$35-50.

- **6x9cm** - Folding bed. Primo Anastigmat f7.7/105mmin Vario. \$35-50.

WEBSTER INDUSTRIES INC.

(Webster, NY) Founded c1947. In 1953 the company name was changed to "Monroe Research", then within a few months to "Zenith Film Corp." Cameras and printed materials are also found using the name "Winpro Camera Co." and sometimes the city is listed as Rochester, of which Webster is a suburb.

Winpro 35 - 1947-55. Gray or black "Tenite" plastic body 35mm. Non-interchangeable Crystar f8/40mm. Rotary shutter, 50, B. Regular or "Synchro Flash"

models. \$15-25.

WEDEMEYER (Eric Wedemeyer, NY) Viking Camera - Folding vest-pocket camera made for Wedemeyer by Utility Mfg. Co. Stamped metal body with brown crinkle-enamel finish. Similar to the Falcon vest camera, but uncommon with this name. \$25-35.

WEFO (Dresden)
Meister Korelle (Master Reflex in USA) - A post-war camera of different construction, but similar in appearance to the pre-war Kochman Reflex-Korelle. Primotar 85mm f3.5 lens. \$60-90.

WEIMET PHOTO PRODUCTS CO. Rocket - c1947. Inexpensive plastic 3x4cm camera. \$1-10.

WELTA KAMERA-WERKE (Waurich & Weber, Freital,

Germany) Founded by Waurich & Weber in 1914 as Waurich & Weber, Welta Kamera Werke. Simplified to just Waurich & Weber by 1935, but later became VEB Welta-Werk, Freital.)

Belmira - c1960. Unusually styled range-finder 35mm camera, originally from Belca-Werk. A later version has "Welta" embossed in front leather. VF window is at the end of the top housing. Keyhole-shaped RF window. Rapid wind lever on back. \$25-35.

Diana - c1926. 9x12cm folding bed plate camera. Pololyt f4.5/135mm lens in lbsor shutter. \$35-50.

Dubla - c1930. Two-shuttered folding plate cameras. Compur front shutter to 200; rear FP shutter 1/10-1000.

Dubla, 9x12cm - Triple extension bellows. Eurynar, Tessar, or Xenar f4.5 lens. \$150-225.

Dubla, 10x15cm - Xenar f4.5/165mm. \$150-225.

Garant - c1937. Two-format folding bed rollfilm camera taking 6x9cm or 4.5x6cm exposures. Also a single format version for 6x9cm only. Dual-format type has removable mask at focal plane & hinged internal finder mask. Trinar f3.5 or f3.8, or Trioplan f4.5/105mm lens. Compur f_{250} or Compur-Rapid f_{400} shutter. \$45-60.

Gucki - c1932. Strut-folding 127 rollfilm camera. 3x4cm and 4x6.5cm sizes. Some models have a folding bed in addition to the struts. Schneider Xenar f2.9 or Radionar f3.5. Compurshutter. \$75-100.

Peerflekta (I), II, V - c1956. 6x6cm TLR for 120 film. Pololyt f3.5/75mm lens in Prontor shutter 1-300. \$35-50.

Perfekta - c1934. Folding TLR of unusual design for 6x6cm exposures on

120 film. Meyer f3.5, or Xenar or Tessar f3.8/75mm lens. Compur shutter 1-300. \$200-300.

Perle, 4.5x6cm - c1934-39. Self-erecting camera with front lens or helical focusing. Folding Newton finder. Trioplan, Xenar, or Tessar 75mm lens. Compur shutter. \$50-75.

Perie, 5x8cm - c1932. Self-erecting camera with radial focusing lever at front of bed. Lever automatically resets to infinity when camera is closed. Brown leather bellows and exterior. Reversible brilliant finder on lens standard, plus folding frame finder on body. Weltar f6.3, or Trinar or Xenar f4.5/90mm. Pronto, Prontor, Ibsor or Compurshutter. \$75-100.

Perie, 6x6cm - c1934-38. Similar to the 4.5x6cm except for image size. \$60-90.

Perle, 6x9cm - c1932-36. Similar to 5x8cm size, but black leather and bellows. Same lens choices but 10.5cm focal length. \$45-60.

WELTA...

Perle, 6.5x11cm - c1932-36. Also similar to the 5x8cm size, but black leather. 12cm lens. \$50-75.

Radial - c1930. Folding bed camera, 6x9cm on 120 rollfilm. Xenar f4.5/105mm in Compur 1-300. \$45-60.

Reflecta, Reflekta - c1930's-1950's. 6x6cm TLR for 120 film. Pre-war models c1930-38 seem to spell the name with "c" and postwar models with "k". After the war until about 1952, the manufacturer was Kamerawerk Tharandt in Freital. We also have references to C. Richter, Tharandt as manufacturer. We would appreciate hearing from any reader who can help us with a brief history of the Reflecta and Reflekta cameras. Various lenses and shutters. Common in USA & Germany at \$25-35.

Reflekta II - c1950's. Various f3.5/75mm lenses including: Meritar, Trioplan, Triotar. Junior or Vebur shutter. \$30-45.

Reflekta III - c1955. Similar to II. Row Poloyt f3.5/70mm lens Prontor SV 1-300. \$30-45.

Sica - c1950. Black bakelite box camera of unusual design. Reflex finder with

ground glass screen. Achromat f7.7/105mm lens. Uncommon. One sold at auction (Cornwall 6/90) for \$300 in its original box.

Solida - c1933. Folding 6x9cm rollfilm camera. Coupled rangefinder. Schneider Radionar or Xenar f4.5/105mm. Compur 1-250, T,B. \$75-100.

Superfekta - c1932. Folding 6x9cm TLR for 120 film. An unusual design, similar to the Perfekta, above. Pivoting back for taking horizontal pictures. Tessar or Trioplan f3.8/105mmlens. Compur shutter. \$400-600.

Symbol - c1937-39. Self-erecting folding rollfilm camera for 6x9cm exposures on 120 rollfilm. Beginning in about 1938, a mask was provided to allow half-frame (4.5x6cm) negatives also. This was the budget priced model with Weltar f6.3/105mm lens in Vario, Prontor, or Prontor II shutter. \$25-35.

Trio - c1936. 6x9cm on 120 film. Also allowed 4.5x6cm beginning about 1938. f4.5/105mm lens in rimset Compur shutter. \$25-35.

Walta - c1932. Folding bed rollfilm camera, 6x9cm. Weltar f9, Singlo shutter. \$25-35

Watson 35 - c1940. Folding 35mm, same as the Weltix. Cassar f2.9/5cm in Compur. \$50-75.

Welta, 6x6cm - 120 film. f4.5 Weltar, or f2.8/75mm Tessar lens. Compur shutter. \$30-45

Welta, 6x9cm - Folding plate camera. Orion Rionar, Meyer Trioplan, Tessar, or Xenar f4.5/105mm lens. Ibsor shutter 1-125. \$45-60.

Welta, 9x12cm - c1933. Folding plate camera. f3.5 Rodenstock Eurynar or f4.5 Doppel Anastigmat 135mm lens. Compur shutter. \$50-75.

Welta 35 - c1936. Folding 35mm with optical viewfinder. Similar to the Retina cameras of the same time period. Trioplan f2.9/50mm. Ring Compur or Vebur shutter. \$30-45.

Weltaflex - c1955. TLR for 6x6cm on 120 film. Ludwig Meritar f3.5/75mm lens in Prontor 1-300 shutter or Trioplan f3.5 in Vebur 1-250. \$60-90.

Weltax - c1939. Dual format folding bed camera for 4.5x6cm or 6x6cm images on 120 film. Xenar or Tessar f2.8; Meritar, Tessar, or Trioplan f3.5/75mm lens in Tempor, Junior, Compur, or Prontor shutter. GERMANY: \$45-60. 50% higher outside Germany.

Welti (I), Ic, II - c1935-1950's. Folding 35mm. Vebur, Cludor, or Compur shutter. With Tessar f2.8, or f3.5, Xenar f3.5, or Trioplan f2.9/50mm: \$35-50.

Weltini, Weltini II - c1937-41. Folding 35mm with coupled rangefinder. The early version (c1937-38) has a smaller, angular rangefinder housing. On the later version (c1939-41) the rangefinder housing has tapered ends and it covers the full end of the camera body. With Elmar f3.5/50mm in Compur Rapid: \$200-300. Common with Xenon f2 or Tessar f2.8 lens in Compur shutter; usually sell for \$60-90.

Weltix - c1939. Folding 35mm. Steinheil Cassar f2.9/50 in Compur shutter. \$60-90.

Weltur - c1936-40. Folding 120 rollfilm, with coupled rangefinder. Compur 1-250 or Compur Rapid 1-400 shutter. Four sizes:

Weltur, 4.5x6cm - 16 exposures. Trioplan f2.9, Xenar f2.8, or Tessar f2.8, f3.5, or f3.8. Black: \$175-250. Chrome: \$100-150.

Weltur, 6x6cm - 12 exposures. Tessar or Xenar f2.8/75mm. \$90-130.

Weltur, 6x6cm/4.5x6cm - with view-finder slider and body insert for 16 exp. \$100-150

Weltur, 6x9cm - 8 exp. 6x9cm or 16 exposures 4.5x6cm. (Compur is 1-300.) Tessar f4.5 or f2.8/75mm, Xenar f3.8 or f2.8, Cassar or Trioplan f2.9. \$120-180.

WEMBLEY SPORTS - c1950-56. Black

bakelite camera for 6x9cm on 120 film. Helical front with four click-stops for focusing positions. Sportar f11/85mm lens in Rondex Rapid shutter 25,50,100. Made in England, but reminiscent of Kaftanski body designs such as Photax and Fex models. \$12-20.

WENK (Gebr. Wenk, Nürnberg, Germany)

Wenka - Post-war 35mm camera with interchangeable 40mm thread Xenar f2.8/50mm lens. Behind the lens shutter.

WESTERN CAMERA MFG. CO.

(Chicago) The Cyclone cameras listed here were made in 1898, before Western became a part of Rochester Optical & Camera Co. in 1899. See Rochester for later models.

Cyclone Jr. - 31/2x31/2" plate box cam-

era. \$30-45.

Cyclone Sr. - 4x5" plate box camera. Not a magazine camera. Top rear door to insert plateholders, \$45-60.

Magazine Cyclone No. 2 - \$45-60. Magazine Cyclone No. 3 - 4x5", \$45-

Magazine Cyclone No. 4 - $31/_4 \times 41/_4$ ". Magazine Cyclone No. 5 - 4x5". \$45-

WET PLATE

Pocket Zar - c1897. Cardboard box camera for 2x2" glass plates. In original box, with plates: \$200-300. Camera only: \$75-100

WESTFÄLISCHE KAMERA & APPARA-TEBAU GmbH This small company existed only a few years.

Navax c1950's. Viewfinder 35mm. Röschlein Pointar interchangeable f2.8/45mm. Metal focal plane shutter 5-1000, sync. Very low production. \$250-

WESTON WX-7 - c1985. Novelty 35mm from Taiwan. Cheap camera well disguised to resemble a 35mm SLR. Carefully designed and placed weights which make the plastic body feel as solid as your favorite \$300 SLR! As a photographic instrument, it rates poorly. As a deceptive work of art, it is fantastic. \$1-10.

WET PLATE CAMERAS - What is a wetplate camera worth? Probably between \$500 and \$5000. A lot depends on the style and age of the camera. Unlike most mass-produced cameras of more recent vintage, wet-plate cameras do not lend themselves to easy averaging of prices because of the wide differences among the few examples sold.

Many wet collodion cameras are listed specifically by manufacturer, and you may wish to look under one of the following: American Optical Co., Atkinson, Bolles & Smith, Burr, Dallmeyer, Dubroni, Fallowfield, Garland, Gennert, Hare, Horne & Thornthwaite, Knight & Sons, Koch, Lamperti & Garbagnati, Lawley, Lewis, London Sterescopic, Mawson, McCrossan, Meagher, Moorse, Morley, Negretti & Zambra, Ottewill, Peck, Piggott, Ross, Rouch, Scovill, Semmending-er, Stock, Thomas, Thorpe, Waite, Wing, Wood. These 35 makers produced a variety

WET PLATE...

of styles including sliding-box, bellows, stereo, and multiple-lens types. For your convenience, we have analyzed the general price patterns which are summarized below.

Since many cameras from the wet collodion era do not bear a manufacturer's label, they are often sold today under the generic name "Wet plate camera", subdivided by body style and country of origin if known. Prices for unidentified cameras seem to fall into line with similar identified cameras, and with appropriate lens could be generally summarized by type as follows:

- Sliding box style - c1850-60. \$1500-2000. Obvious exceptions to this price range would be the rare Bolles & Smith Patent Camera Box which featured incamera processing, or the Ottewill design

which folds flat for portability.

- Tailboard style - c1860-70. Most identified cameras fall into the \$500-1000 range, except stereo and multiple lens types. Unidentified ones have sold at auction for as little as \$200-350 without lens

- Stereo - c1850-70. Earlier sliding-box types normally range from \$5500-7500. A fine complete boxed outfit with chemicals and accessories occasionally brings an extra \$1000-1500. "Tailboard style" bellows types generally sell in the \$1500-2500 range. Notable exceptions: singlelens stereo wet-plate cameras by Moorse or Negretti & Zambra, in which the camera makes its second exposure after being shifted laterally along the top of its carrying case

- Four lens (sliding box style) - c1860. Not often seen for sale. Range

\$3500-5500.

- Four lens (bellows style) - c1860-70. For 4 simultaneous exposures on a 5x7" plate. These generally bring just slightly less than a stereo camera of the

same vintage, averaging \$1200-1800.
- Specialized wet-plate cameras -Refer to manufacturers for BERTSCH Chambre Automatique, BOLLES & SMITH Patent Camera Box, BRIOIS Thompson's Revolver, DUBRONI, ROSS Sutton Panoramic, SKAIFE Pistolgraph.

WHITE (David White Co., Milwaukee, Wisc.)

Realist 35 - c1955. (not stereo) 35mm camera made for David White by Iloca. Identical to Iloca Rapid A. Cassar f3.5 or 2.8 lens. \$30-45.

Realist 45 (Model 1045) - 1953-57. Stereo 35 made for White by Iloca. Same as Iloca Stereo Rapid. Cassar f3.5 lenses. \$120-180.

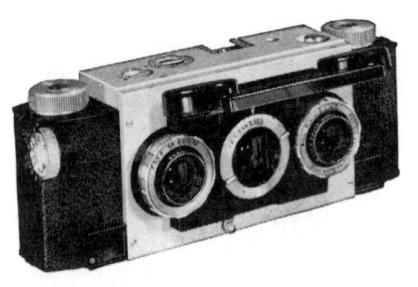

Stereo Realist - c1950's. 35mm stereo camera. Movable film plane controlled by focus knob.

Model 1042 - with f2.8 lenses, case. flash: \$250-375.

Model 1041 - with f3.5 lenses, case, flash: \$120-180.

Stereo Realist Custom (Model **1050)** - c1960. With matched color corrected, coated "rare earth" f2.8 lenses. Shutter 1-200,T,B. Black coarse-grained kangaroo leather covering. There are two varieties. Some were assembled and sold by a large camera dealer after the supply of genuine ones had sold out. These later ones sell more in the price range of the standard f2.8 model. Genuine factory-made Custom models are identifiable in four ways. 1. Wind and rewind knobs are different sizes. The rewind knob is 40-50% larger and actually cuts into the top plate. 2. The rangefinder knob has a light ratchet feel to it. 3. Serial numbers are 021xxx to 024xxx. 4. Looking directly into the lens, you will not see any lettering around it. Genuine: \$500-750.

Stereo Realist Macro (Model 1060) - c1971. Probably less than 1000 were produced. Matched f3.5 lenses, focused at 4-5". Sync shutter to 125. Mint outfits will bring more than the normal range for camera only: \$1500-2000.

Stereo Realist Viewers: Model 2061 - Black with red buttons and

knobs. Doublet lenses. \$60-90.

Model 2062 - Black with green buttons and knobs. AC/DC fittings. Doublet lenses. \$100-150

Model 2063 - Pale green with black front. \$35-50.

Model 2064 - Dark brown with white buttons and knobs. Single lens. Uncommon. \$50-75

Model 2065 - Black with green buttons

and knobs. DC only. \$90-130.

Model 2066 - Black with gold buttons and knobs. For use with views from Macro camera Model 1060. Pairs of doublet lenses. Rare. \$175-250.

Stereo Realist Accessories: Slide mounting jig - \$35-50. Steinheil 25 Redufocus lens set -\$250-375.

WHITEHOUSE PRODUCTS (Brooklyn,

Beacon, Beacon II - c1947-55. Plastic rollfilm camera for 3x4cm on 127 film. Plastic lens, simple spring shutter. Colored models: \$25-35. Black: \$1-10.

Beacon 225 - c1950-58. Similar to the other Beacons, but 6x6cm on 620. Colored: \$25-35. Black: \$1-10.

Beacon Reflex - Pseudo-TLR.\$12-20.

Charlie Tuna - 126 cartridge camera, shaped and colored like Starkist's Charlie Tuna. Truly a novelty camera in "good taste". Sorry, Charlie. \$100-150. There is a companion radio, somewhat smaller, but also shaped like Charlie Tuna. Beware if your collecting takes such a turn, because you'll also need a Coke can radio to match your Coke can camera... then a Rolls Royce automobile to go with your "Rolls" camera...

WHITTAKER (Wm. R. Whittaker Co., Ltd., Los Angeles, Calif.)

Micro 16 - c1947-1950's. Subminiature for 16mm film in special cassettes. Cartridge to cartridge feed. Achromatic doublet lens, single speed shutter. Black, blue, or green: \$50-75. Chrome: \$35-50. 50% higher outside USA. Add \$12-20 for viewer.

Pixie - c1950. Black plastic 16mm subminiature wriststrap camera. \$35-50. With flash, wrist strap, etc.: \$60-90.

Pixie Custom - Marbelized brown plastic body. Gold-plated metal parts. Uncommon variation; few known. \$250-375.

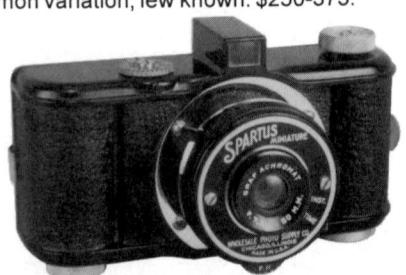

WHOLESALE PHOTO SUPPLY CO. (Chicago)

Spartus Miniature - Simple bakelite 35mm camera. The same camera and a synchronized version were also sold as the "Spartus 35" by the Spartus Corp. \$12-20.

WIRGIN

WIDMAYER, Rudolph (Leipzig) Paris - Folding field camera 18x24cm.
Light colored wood, green bellows. Dallmeyer brass lens. \$250-375.

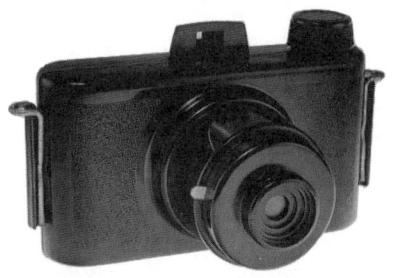

WIDMER (Robert Widmer, Germany)

Cowi - Plastic camera for 32x40mm on #828 rollfilm. Also accepts special spool with triangular keyway. \$35-50.

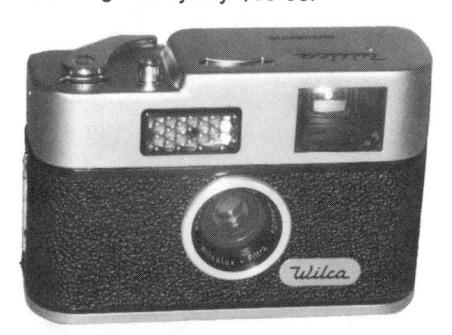

WILCA KAMERABAU (West Germany)

Wilca Automatic - c1963. Subminiature for 24 exposures 10x19mm on 16mm film in special cassettes. Coupled selenium meter. The special notched film cassettes automatically set the light meter for the correct film speed. Wilcalux Filtra f2/16mm lens. Sync. Prontor shutter. Rare, reportedly less than 100 made. Auction record \$1000 (12/91). \$600-900.

WILKIN WELSH CO. (Syracuse, NY) Folding plate camera - c1900. Folding bed camera for 4x5" plateholders. Leather covered body with polished wood interior, red bellows. Rauber & Wollensak brass shutter. Rare. \$120-180.

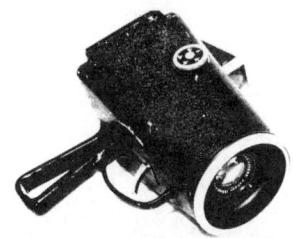

WILLIAMSON MANUFACTURING CO. LTD. (London, England)

Pistol Aircraft camera - c1930. 6x9cm plate or filmpack camera, with a pistol grip. Dallmeyer Ross Xpress f4.5/5" lens. Behind the lens louvre shutter 50-200. \$250-375.

WINDSOR - 4x4cm "Diana" type novelty camera. \$1-10.

WINDSOR WX-3 - Inexpensive plastic 35mm from Taiwan. \$1-10.

WINDSOR CAMERA CO. (Japan)

Cameras were probably made by Tougodo or Toyo Kogaku for marketing under the Windsor name.

Windsor 35 - c1953. 35mm RF, made in Japan. Color Sygmar f3.5/50mm lens. Shutter 1-200 or 1-300,B. \$30-45.

Windsor Stereo - c1954-60. Black bakelite 35mm stereo camera. Windsor 4.5/35 lenses. Windsor 1/25-1/50. \$120-180.

WINDSORFLEX - Plastic 4x4cm novelty TLR. Made in Hong Kong. Same as the Bedfordflex, Wonderflex, etc. \$1-10.

WING (Simon Wing, Charlestown, Mass.)

Multiplying View Camera - c1862. Multiple images on single 5x7" wet plate. Mahogany body, shadow box front, vertical & lateral back movements. \$6500-9500.

Multiple-lens camera - c1870. Wet plate studio camera with 4-tube lens set and Wing patented shutter. \$2000-3000.

New Gem - c1901. Takes 15 exposures

on 5x7" plates. Sliding front lens panel. \$1000-1500.

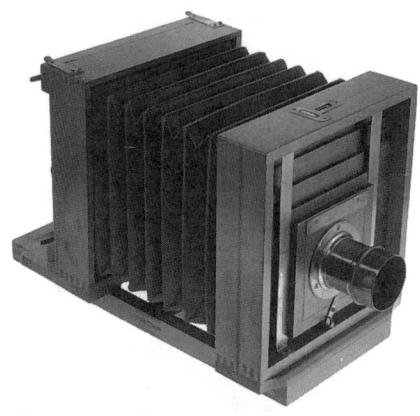

View Camera - Catalog advertising calls it "View Camera with Adjustable Lensholder Front". For indexing purposes, we will call it simply "View Camera". A tailboard camera with square-cornered black fabric bellows. Front lens panel has rise/fall motion using Wing's typical sliding wooden panels. Original patent also covered shifting motion, but it was not employed in the actual production models. Brass strips on each side of the lensboard prevent side movement. About six of these cameras in nearly new condition came from the Wing estate. Most did not have lens or lensboard. Some take 4x5" plates in double wooden plateholders, others use thin metal holders. A seventh example was in the 5x7" size. No other examples are known. Uncommon. \$1000-1500.

WINTER (Chr. Fr.) & SOHN (Leipzig, Germany)

Field camera - c1900. Wooden camera with double extension square bellows. Made in sizes 10x15cm and 13x18cm. Brassbound lens with iris diaphragm or for waterhousestops. \$175-250.

WIRECRAFT CO.

Jewel Sixteen - Small plastic novelty camera, for 3x4cm exposures. Similar to the Cardinal. \$1-10.

WIRGIN (Gebr. Wirgin, Wiesbaden, Germany)

Alka 16 - c1960. Subminiature camera for 12x17mm on 16mm rollfilm. Similar to the Edixa 16. Travegar f2.8/25mm lens. \$60-90.

Astraflex 1000 - c1958-71. 35mm waist-level SLR. Similar to the Edixa Reflex, but originally sold with interchangeable f2.8/50mm Tessar or f1.9 Primoplan lens and FP shutter 1-1000. \$45-60.

Astraflex 1000 LM - c1959-71. Like the Astraflex 1000, but uncoupled selenium meter on left side. \$50-75.

Auta - c1936. Self-erecting folding bed rollfilm camera, 6x9cm. Metal edges are black enameled. Radionar f4.5/105mm, Prontor shutter 1/25-150. \$25-35.

Baky - c1935. Bakelite folding bed camera for 16 exposures 4.5x6cm on 120 film. Same as Wirginex. See below.

WIRGIN...

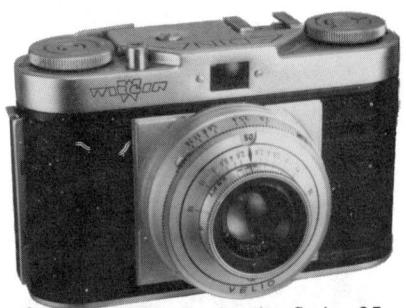

Edina - c1954. Basic viewfinder 35mm camera. Edinar f2.8 or f3.5/45mm in Vario 25-200 or Velio 10-200 shutter. \$30-45.

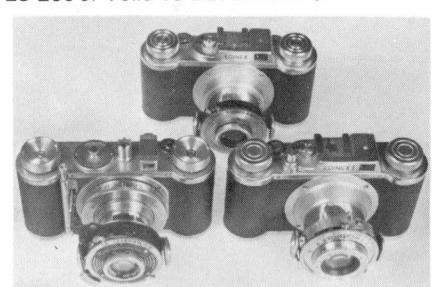

Edinex - c1930's-1950's. Compact 35mm camera, almost identical to the Adox Adrette. Also sold in the USA under the name "Midget Marvel" although not marked as such. Telescoping front. Film loads from bottom. Late models such as III, IIIS with coupled rangefinder: \$60-90. Early models, without rangefinder, with f4.5, 3.5, 2.8, or f2 lens. \$35-50.

Edinex 120 - c1953. Folding rollfilm camera for 2 formats: 6x9cm, 4.5x6cm. \$25-35.

Klein-Edinex (127 film) - c1938. Same camera as the Gewirette. We can find no original advertising with the "Klein Edinex" name, but it has appeared in some collector publications. See Gewirette below.

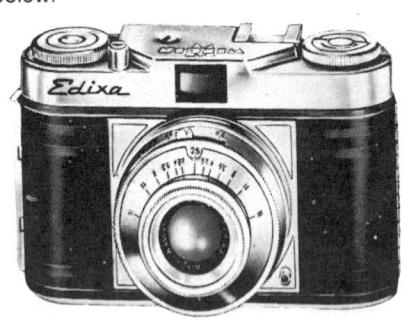

Edixa - c1955. Viewfinder 35mm. Commonly found with Isconar f2.8/43mm in Prontor SVS shutter. \$30-45.

Edixa II - c1956. Similar to the Edixa, but with CRF. \$30-45.

Edixa 16, 16M, 16S - c1960's. Subminiature cameras for 12x17mm exposures on 16mm film. Schneider Xenar f2.8/25mm lens. \$50-75.

Edixa 16MB - Metered version of the 16M. Black enameled finish. \$175-250.

Edixa Electronica - c1962. 35mm SLR. Fully automatic with selenium meter.

Culminar or Xenar f2.8/50mm lens Compur sync shutter 1-500. \$200-300.

Edixa Flex B - c1959-60. Like the Edixaflex, but with internally coupled diaphragm control for auto lenses. \$75-100.

Edixa-Mat B, BL - c1961-67. 35mm SLR with interchangeable waist-level finder and pentaprism. Steinheil f1.9/50mm lens, 42mm thread. Diaphragm coupled internally. FP 1-1000,B. \$75-100.

Edixa-Mat C, CL - c1961-67. Like the Edixa-Mat B, but uncoupled selenium meter. \$75-100.

Edixa-Mat D, DL - c1961-67. Like the Edixa-Mat B, but Xenar f2.8/50mm lens; shutter 9-1/₁₀₀₀, B. \$75-100.

Edixa Prismaflex - c1965-68. 35mm SLR with fixed pentaprism. Steinheil f2.8/50mm lens, 42mm thread. FP shutter 1/₃₀-500,B. \$60-90.

Edixa Reflex - c1955-60. 35mm waist-level SLR. 42mm screw-mount f2.8 Isconar or Westanar lens. Focal plane shutter 1 to 1000,B. \$50-75.

Edixa Reflex B - c1958-60. Like the Edixa Reflex, but interchangeable pentaprism. FP B,1-1000. \$50-75.

Edixa Reflex C - c1958-60. Like the Edixa Reflex, but uncoupled selenium meter. \$60-90.

Edixa Reflex D - c1959-60. Like the Edixa Reflex B, but FP shutter $9-1/_{1000}$. \$50-75.

Edixa Stereo - c1955. 35mm stereo. Steinheil Cassar f3.5/35mm lenses. Vario shutter. \$75-100.

Edixa Stereo II, IIa - c1957. Range-finder 35mm stereo camera. No meter. Steinheil f3.5. Pronto or Prontor SVS shutter to 200, ST. \$75-100.

Edixa Stereo III, IIIa - c1957. Range-finder 35mm stereo camera. Built-in light meter. Prontor SVS shutter. \$120-180.

Edixaflex - c1958-60. 35mm SLR. Like the Edixa Reflex, but without slow speeds below $^{1}/_{25}$. \$50-75.

Franka 16 - Variant of the Edixa 16. Uncommon. \$120-180.

Gewir - c1936. 6.5x9cm folding bed plate camera. Double extension with rack and pinion focusing. Rise and cross front with micrometer movement. Gewironar f2.9, f3.5; Wirgin Zeranar f3.8; Meyer Trioplan f2.9/105mmlens. Compurshutter. \$50-75.

Gewirette - c1937. Eye-level camera for 3x4cm exposures on 127 film. Telescoping front. Film loads from the top. Similar in appearance to the 35mm Edinex, but for 3x4cm exposures on 127 film. Gewironar 44.5, Steinheil Cassar, or Schneider Xenar f2.9/50mm lens. \$120-180.

Midget Marvel - see Edinex.

Reporter - Similar to Gewirette. Fixanar f2.9/50mmin Compur 1-300. \$150-225.

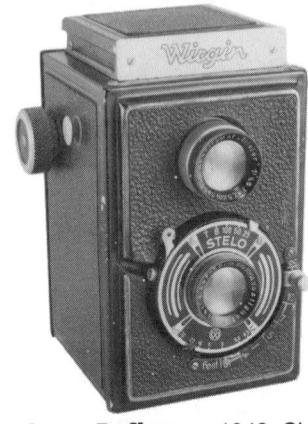

Twin Lens Reflex - c1940. Similar to Welta Reflekta, but with Wirgin nameplate. Probably imported to the USA from the DDR and sold under the Wirgin name. The same camera was also sold as the "Peerflekta" by Peerless Camera Stores, and nearly identical cameras sport the names "Trumpfreflex" and "Vitaflex". Anastigmat Triolar f4.5/75mm in Stelo T,B,100,50,25 shutter. \$50-75.

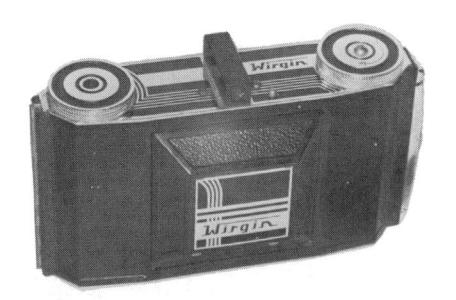

Wirgin Deluxe - Bakelite bodied folding cameras for 6x6cm on 120 film. Made in U.S.A. Similar to Vokar Model B and Voigt Jr. Art-deco metal plates on top, bottom, and front door. Model 11: meniscus lens. Model 45: Wirgin Anastigmat. Model 51: Wollensak Velostigmat. \$25-35.

Wirgin folding rollfilm camera -6x9cm on 120 film. Schneider Radionar or Xenar f4.5, or Gewironar f8.8 or f6.3 lens. Compurshutter. \$25-35.

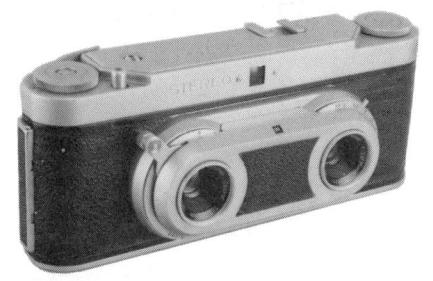

Wirgin Stereo - Stereo camera for 22x24mm stereo pairs on 35mm film. Steinheil Cassar f3.5/35mm lenses with coupled focusing. Vario B,25,75,200 stereo shutter. Ratcheted lever film advance. \$100-150.

Wirgin 6x6cm TLR - c1950. Rodenstock Trinar f2.9/75mm. Built-in extinction meter. \$50-75.

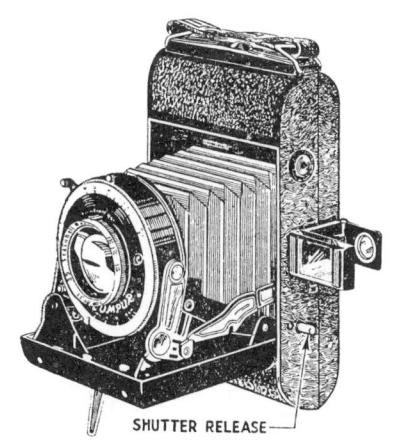

Wirginex (Baky) - c1935. Bakelite self-erecting camera for 16 exposures 4.5x6cm on 120 rollfilm. Black or brown bakelite body. There is no identification on the camera itself, and it was also advertised under the name "Baky" by Wirgin. British importers also advertised it as the Westminster Victoria and Norfolk Miniature. Lenses include: Schneider Radionar, Xenar, or Cassar f2.9 in Compur, Compur Rapid, or Prontor II shutter. Some versions have body release. Lower-priced models have f3.5, f4.5, or f6.3 Anastigmat lens. \$120-180.

WITT (lloca Werk, Wilhelm Witt, Hamburg, Germany)

Iloca IA

Iloca IIA

Iloca I, Ia, II, IIa - c1950's. Basic 35mm cameras. f2.9 or f3.5/45mm Ilitar lens in Prontor shutter. Models II and IIa with coupled rangefinder. \$30-45.

Iloca Quick A - c1954. Viewfinder 35. Ilitar f3.5/45mm. Vario 25-200,B. \$25-35.

Iloca Quick B - c1954. Coupled range-finder. Ilitar f2.9/45mm in Prontor SV 1-300. \$25-35.

Iloca Rapid, Rapid A1, Rapid B, Rapid IIL - c1950. Coupled RF, 35mm. Rapid wind. Cassar f2.8/50mm. \$30-45.

Iloca Reporter - c1951. Basic 35mm viewfinder camera. Black covering with horizontal white stripes. Reporter Anastigmat f3.5/45mm. Prontor-S shutter. \$30-45.

Iloca Stereo, Original Model c1950. Individually focusing lenses. Apertures and shutters coupled through tube at bottom. Unusual, \$250-375.

Iloca Stereo, Models I, II, IIa c1950's. 35mm stereo camera for 23x24mm pairs. Ilitar f3.5 lenses, 35mm or 45mm. Prontor-S shutter to 300. Iloca Stereo Model II was also sold by Sears as Tower Stereo and by Montgomery Ward as Photrix Stereo. \$200-300.

WITTNAUER

Iloca Stereo Rapid - c1955. 35mm stereo, 23x24mm pairs. Coupled range-finder. Rapid wind. Prontor SVS 1-300 or Vero 25-200. Rangefinder version of the Realist 45. With Cassarit f2.8: \$300-450. With Cassar f3.5: \$100-150.

Photrix Quick B - 35mm. Cassar f2.8/50mm, Prontor-SVS to 300. \$20-30.

Photrix Stereo - c1950's. 35mm stereo sold by Montgomery Ward in the U.S.A. Basically the same as the Iloca Stereo Model II and Tower Stereo (Sears). \$100-150.

WITTIE MFG. & SALES CO. Wit-eez - Black bakelite minicam, styled like the Rolls. \$1-10.

WITTMAN (R. Wittman, Dresden, Germany)
Tailboard camera - c1880. Folding camera for 13x18cm plates. Square bellows. Wittman Universal Aplanat lens, waterhousestops. \$300-450.

WITTNAUER

35mm cameras - c1959. Misc. models including Adventurer, Automaton, Captain, Challenger, Continental, Festival, Legionaire, Scout. RF. Chronex f2.8/45mm lens. \$25-35.

Wittnette Automatic Electric Eye - Wittnette Deluxe - c1959. Inexpensive TLR box cameras with automatic metering. "Wittnette Deluxe" or "Wittnette Automatic Electric Eye" on shutter face.

WITTNAUER...

Large selenium meter cell nestled above viewing lens. Similar to the USC Automatic Reflex. \$30-45.

Wittnette Reflex - c1959. Inexpensive non-adjustable TLR style box camera. Similar to the USC Reflex III. In presentation box with flash and accessories: \$30-45. Camera only: \$1-10.

WÖHLER (Dr. Wöhler, St Ingbert, Saarland)

Favor - c1949. Basic 35mm camera. Docar f2.8 or Citar f3.5/45mm lens. Prontor-S or Prontor-SVS shutter. \$120-180.

WOLLENSAK OPTICAL CO. Wollensak Stereo, Model 10 - c1955. 35mm stereo camera. f2.7 lenses; shutter to 300. Similar to the Revere Stereo 33, but faster lenses and shutter, and in black leather, not brown. \$250-375.

WONDER CAMERA - Falling-plate box magazine camera, $2^{1}/_{2}x3^{1}/_{2}$ " glass plates. \$50-75.

WONDERFLEX - c1965. Hong Kong plastic novelty TLR-style camera, 4x4cm. Same camera sold as Bedfordflex, Splendidflex, etc. \$1-10.

WOOD (E.G. Wood, London)
Wet plate camera, sliding box Half-plate mahogany sliding-box camera.
Petzval lens with rack focusing and waterhouse stops. \$1200-1800.

WOOD BROS. (England) Pansondontropic camera - Wooden field camera, 5x7". Brass trim, brass lens. \$250-375.

WRATTEN & WAINWRIGHT (London, England)
Tailboard camera - c1890. Mahogany view camera in 5x8" to 8x10" sizes.

Maroon square bellows. Ross Rapid Symmetrical lens. \$350-500.

WRAY OPTICAL WORKS (London)
Peckham Wray - 1955-62. 4x5" SLR
press camera. Unusual rigid body. Mirror
drops down behind the lens, reflecting the
mage to an eye-level viewfinder on top. A
frame finder is also mounted on top. Interchangeable Wray Lustrar f4.8/135mm. FP
1/15-800 and Compur 1-500. \$200-300.

Stereo Graphic - Made under license from Graflex. Same as the Graflex version, but with Wray f4/35mm lenses. Outfit with viewer: \$250-375. Camera only: \$120-180.

Wrayflex - c1950. The only Englishmade 35mm SLR. Originally designed with a mirror rather than pentaprism. FP shutter 1/2-1000. Standard lens was Wray f2 or f2.8/50mm. Other interchangeable lenses included 35mm, 90mm, & 135mm Lustrars, and an 8"/f4.5 lens which was produced but not advertised and which is quite rare. Model variations:

Detail view of Wrayflex I, Ia. Model I film counter reads past 40. This is the quickest way to distinguish between the two. Serial numbers will not distinguish for they were produced with shared serial number range.

Wrayflex I - approximately 850 made. 24x32mm format. Mirror, not prism. \$350-500.

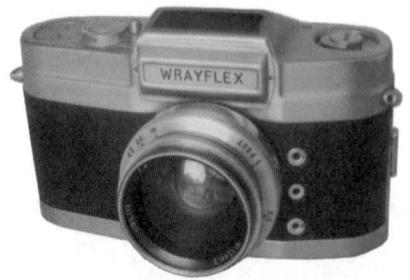

Wrayflex la - approx. 1600 made. 24x36mm standard format. Mirror, not prism. \$250-375.

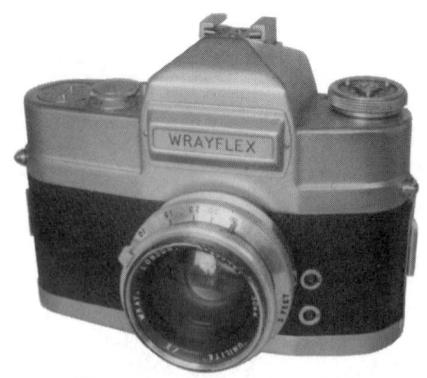

Wrayflex II - maximum 300 made. Pentaprism model, standard 24x36mm format. \$500-750.

wrist watch camera - Very well made camera/watch combination. Camera is built into a standard digital quartz watch, with the lens at the top center of the watch face. Built for covert use by law enforcement agencies, and sold in a kit with developing tank, film, chemicals, thermometer, and changing bag. The few that have leaked into the collector market have sold at auctions in the \$1500-2500 range.

WÜNSCHE (Emil Wünsche, Reick

b/Dresden) Founded in 1887; camera manufacture from 1896. Merged in 1909 with Hüttig, Krügener, and the Carl Zeiss Palmos factory to form Ica.

Afpi - c1904-09. Folding bed plate cameras for 9x12cm or 10x13cm plates. Many variations were made, and we are listing only a few.

Afpi, vertical - Leather covered body; wine red double extension bellows. \$100-150.

Afpi, square - Called "Quadratisch" in original catalogs. Allows horizontal or vertical format. Double extension. Fine wood bed. Black bellows and leather covering. \$100-150.

Afpi (with "metal shutter, Model III") - Polished wood lensboard with interesting shutter. Brown leather bellows. \$150-225.

Elite - c1900. Stereo magazine camera for 9x18cm. Leather covered wood body. Magazine holds 12 plates. Periscope lenses; M,Z shutter. \$500-750.

Excelsior, 13x18cm - c1900. Fine wood body, square green bellows with red corners, roller-blind shutter. One very nice outfit with Rodenstock lens sold at auction 9/89 for \$725.

XIBEI

Favorit - c1900-06. Double extension folding bed plate camera for 9x18cm stereo exposures. Busch Rapid Aplanat f8 lenses in stereo roller-blind shutter. \$300-450.

Field cameras - c1900. Wood body. For 31/₄x41/₄", 5x7", or 10x15" plates. Wünsche Rectilinear Extra Rapid f8 brass barrel lens. \$250-375.

Julia - c1899. Leather covered folding camera for 8x8cm on rollfilm. Maroon bellows. Achromat lens, M&Z shutter. \$120-180.

Juwel - c1895-1900. 9x12cm falling-plate magazine box camera. f12 lens. Single speed shutter. \$75-100.

Knox - c1906. Polished wood folding bed camera for 9x12cm plates. Rotary shutter built on front of wooden lens standard. Tapered single extension blue-green bellows with red corners. \$350-500.

Lola - c1905. Strut-folding camera for 9x12cm plates. Design of knee-struts is nearly identical to the earliest Folding Pocket Kodak Camera. Leather covered body. Shutter built into leather covered front. \$350-500.

Lola Stereo - c1905. Strut-folding stereo for 9x18cm plates. Leather-covered wood body, nickel trim. Anastigmat f7.7/90mm lenses. \$400-600.

Mars 99 - c1895. Leather covered boxplate camera for 9x12cm plates. Aplanat f12/150mm lens. Rotating shutter. \$250-375.

Mars Detective - c1893. Polished mahogany 12-plate magazine camera. $1/_4$ -or $1/_2$ -plate sizes. Aplanat f8/130mm. Rotary shutter. Plates are moved to and from the plane of focus by sliding a moving sheath above the desired plate, then inverting the camera to drop the plate into the sheath. The sheath is then moved to the plane of focus and when the camera is righted, the plate slides into position for use. \$500-750.

Mars Detectiv-Stereoskop - c1897. Wooden magazine plate camera for 8.5x17cm plates. Takes single or stereo exposures. Aplanat lenses. See Mars, above, for description of the plate changing mechanism. The stereo model has the film sheath at the side rather than at the top. Holds 12 plates. Rare. \$1000-1500.

Postage stamp camera - c1907. 12 lens camera makes twelve 24x30mm exposures on a 1/2-plate. Wood body with wooden door (flap shutter) covering the lenses. \$2000-3000.

Reicka - c1906. Double extension folding plate camera. Leather covered wood body. **Reicka, 9x12cm** - With Rodenstock Heligonal f5.4/120mm lens in Koilos 1-300 shutter. \$60-90.

Reicka, 13x18cm - With Goerz Dagor f6.8/180mm.\$150-225.

Sport - c1895. Stereo box camera for 8.5x17cm plates. Polished wood body. Two brass barrel lenses. Stereo sector shutter. Unusual hinged lenscaps. \$1200-1800.

WZFO (Warszawskie Zaklady Foto-Optyczne, Warsaw, Poland) The WZFO name was used 1952-1968. From 1968 it was called Polskie Zaklady Optyczne (PZO).

Alfa - Vertical format 35mm. Cast metal body enameled dark blue, light blue, or dark red. Cream colored trim; aluminum faceplate. Euktar f4.5/45 in B,30,60,125 sync shutter. \$120-180.

Alfa 2 - c1963. Vertical format 35mm. Dark blue, light blue, cream, pale green, or red body; cream colored trim. Emitar f4.5/45mm. Shutter 30-125. Unusual style. \$120-180.

Druh - Black bakelite eye-level camera with helical front. Bilar f8/65mm lens; B,M shutter. Similar to cameras from Hamaphot. \$12-20.

Noco-Flex - TLR. Rack & pinion focus. Easily recognized by the bold cast metal nameplate on the front of the finder hood. \$60-90. *Illustrated top of next column.*

WZFO Noco-Flex

Start - TLR for 6x6cm on 120. Euktar f4.5 taking and f3.5 viewing lenses. B,10-200 shutter. \$30-45.

Start-B - TLR. Euktar f3.5 taking & viewing lenses. Synch post on upper front. Rack focusing. B,15-250 shutter. \$30-45.

XIBEI OPTICAL INSTRUMENT FACTORY (China)

Huashan DF-S - c1980's. Low-priced SLR from mainland China. The greatest interest from a technological standpoint is the clever simplicity of the design for a prism SLR, with automatic metering and flash, at a retail price below \$40. If you

YALE

collect cameras for their mechanical features, this is one worth investigating.

YALE CAMERA CO.

Yale Camera - c1910. Small paper box camera for 5x5cm glass plates. Single plates must be darkroom loaded. Similar to the Zar, but with exposed brass shutter pivot. \$90-130.

YAMAMOTO CAMERA CO. (Japan) Semi Kinka - c1938. Self-erecting folding bed camera, 4.5x6cm on 120 rollfilm. Ceronar Anastigmat f4.5/75mm lens in Felix 1/25-150 shutter. \$90-130.

YAMATO KOKI KOGYO CO. LTD. YAMATO KOKI CAMERA INDUSTRY CO. LTD. (TOKYO)

Alpina M35 - c1957. Same as the Pax M3. \$35-50.

Atlas 35 - c1959-61. Basic scale-focus 35mm camera. Similar to the Pax Ruby but without RF. The identical camera was sold by Sears as the Tower 55. Color Luna f3.5/45mm lens. B,25-300 shutter. \$35-50.

Atlas Deluxe - Rangefinder version. Luna f2.8/45mm. \$35-50.

Atlas II - Revised styling of top housing. Single front window includes finder and bright frame windows. Although there is room for a rangefinder mechanism inside, none is mounted. \$35-50.

Barclay - Basic scale-focus 35mm. Similar to the Pax Jr. but with direct (plain glass) viewfinder. Luminor Anastigmat f3.5/45mm. Also sold as Starlite. \$30-45.

Bonny Six - Zeiss Ikonta B copy. Bonny Anast. f4.5/75mm. \$50-75.

Hilka - Scale-focus 35mm, large bright-frame optical VF. Same as Pax Jr. \$30-45.

Konair Ruby - c1955. Rangefinder 35, same as Pax Ruby. Konair f3.5/45mm lens in synchro B,10-300 shutter. \$30-45.

Lycon M3 - c1957. Rangefinder 35, same as Pax M3, but name sounds close to Leica. The name is also written in a script which mimics the Leica logo. Lycon Anastigmat f2.8/45mm in B,10-300 leaf shutter. Brings more than other Yamato models because of the name. \$75-100.

Mini Electro 35 Automatic - c1961. Metered version of the classic Yamato 35 cameras. Luminor 40mm lens; hot shoe. Same as Palmat Automatic. \$35-50.

Minon 35 - c1949. 24x24mm on Boltasize film. Round eye-level finder. Eira Anastigmat f3.5/40mm, 1/₂₅-100,B shutter. \$500-750.

Minon Six II - c1950. Folding bed camera for 6x6cm or 4.5x6cm on 120 film. Uncoupled rangefinder. Minon Anastigmat f3.5/75mm; TSK shutter 1-200, B. \$75-100.

Pal Jr. - c1960's. Scale-focus 35 with large bright frame finder. Same as Pax Jr. At least two body variations: knob rewind and crank rewind styles each require a different top housing design. Luminor Anastigmat or Yamanon f3.5/45. \$35-50.

Pal M4 - Name variant of the Pax M4. \$50-75.

Palmat Automatic - One of the more sophisticated Yamato cameras with automatic exposure controlled by selenium meter. Luminor 40mm lens. \$35-50.

Pax (I) - c1952-55. Original box & instructions call it "Pax-35", but the camera top is simply engraved "Pax". 35mm with coupled rangefinder; styled after the Leica, but smaller and has front shutter. Knob advance. Original version has Magino f4.5/40mm lens in Silver-C 1/25-200,B shutter. More commonly seen with Luminor f3.5/45mm in YKK 1/25-150,B shutter. \$60-90.

Pax Golden View - Deluxe version of the Pax. All metal parts are gold-colored. Green or red leather covering. \$250-375.

Pax Jr. - c1960's. Basic scale-focus 35mm. Large optical finder with bright frame. Also sold as Hilka, Pal Jr., Tower 55B, etc. Luminor Anastigmat f3.5/45mm lens. Shutter 1/25-300. \$35-50.

Pax M2 - c1956. Similar to the Pax (I),
but combined range/viewfinder. Front of top housing now has only one small round window and one rectangular window. Knob advance. Luminor f3.5/45mm, synchro shutter 1/10-300. \$50-75.

Pax M3 - c1957. Small 35mm with CRF. Like M2, but restyled full-length top housing. Rectangular rangefinder window, lever wind. Luminor or Lycon f2.8/45mm, synchro shutter 1/10-300. \$35-50.

Pax M4 - c1958. Features similar to M3, but restyled top housing has three rectangular windows on front. Luminor f2.8/45mm, synchro shutter 1/10-300. \$50-75.

Pax Ruby - c1958. Color Luna f2.8 or f3.5/45mm, Synchro shutter ¹/₁₀-300. Styling similar to Pax M3, but rangefinder window on front is much smaller. The same camera was also sold as Pax Sunscope, Ricsor, Me35 4-U, Konair Ruby, etc. \$45-60.

Pax Sunscope - c1958. Export version of the Pax Ruby. Top housing has shallow recess on top with applied nameplate. Colour Luna f3.5/45mm. \$35-50.

Rex Kaysons - Rangefinder 35 like Konair Ruby & Pax Ruby. Colour Luna f3.5/45mm lens. B,10-300 leaf shutter. \$45-60

Ricsor - Rangefinder 35, similar to the Pax Ruby. Colour Luna f2.8/45mm lens. \$35-50

Rippa - c1950. 35mm with direct optical viewfinder. Color-Luna f3.5 lens, 1/25-300,B shutter. \$30-45.

Rippaflex - c1950s. Rolleiflex copy. Tri-Lausar f3.5/80mm lens, Rectus shutter. \$75-100.

Simflex 35 - c1962. Basic 35mm with bright frame finder. Luminor Anastigmat f3.5/45mm in B,25-300 leaf shutter. \$35-50.

Skymaster - Rangefinder 35. Another name for the Pax M3. Luminor Anastigmat f2.8/45mm.\$35-50.

Starlite - 1960's. Inexpensive 35mm sold by Mansfield Industries and Starlite Mdse. Co. in the U.S.A. Luminar f3.5/45mm. Shutter 25-300, B. \$25-35.

Tac Deluxe - A typical Yamato 35mm camera, "badge-engineered"for the Trans-American Import Export Co. Originally packaged in a presentation case with camera, case, and accessories. Full outfit: \$100-150. Camera: \$45-60.

YASHICA (Japan)

Yashica 44 - c1958. TLR for 4x4cm on

YASHICA

127 film. Yashikor f3.5/60mm lens. Copal-SV 1-500,B shutter. Crank advance with automatic stop. Bayonets on both lenses. Available in black, grey, lavender & grey, or brown. Note: Model 44A nameplate reads "44" on front but has "A" engraved on top. See below. \$75-100.

Yashica 44A - c1959. 4x4cm TLR for 127. Simplified version of 44. Knob advance using rear window, not crank with auto stop. Yashikor f3.5/60mm. No bayonets on lenses. Copal shutter 25-300,B. Available in various colors, including blue, grey, rose, or black enamel with grey leatherette. Most nameplates have "44" on front with "A" engraved on top. Some late ones have "44A" on front. \$75-100.

Yashica 44LM - c1959. Built-in uncoupled meter. Yashinon f3.5/60mm. Copal-SV shutter 1-500,B. Available in black, grey, and brown. \$75-100.

Yashica 635 - c1958. Dual format TLR for 6x6cm on 120 rollfilm or 24x36mm on 35mm film. Yashikor f3.5/80mm; Copal-MXV 1-500,B shutter. Rewind knob for

Yashica A

YASHICA...

35mm on upper left hand side of camera. Conversion kit for 35mm film includes mask assembly, pressure plate, takeup spool adapter, & cartridge end adapters. Complete with 35mm kit: \$120-180. Camera only: \$75-100.

Yashica 72E - c1962. Half-frame 35mm. Selenium meter surrounds Yashinon f2.8/28mmlens. \$25-35.

Yashica A - c1959. Inexpensive TLR for 6x6cm on 120. Yashikor f3.5/80mm. Copal 25-300 shutter. Black or grey. \$35-50. Illustrated bottom of previous page.

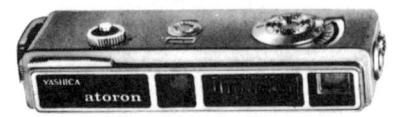

Yashica Atoron - c1965. Subminiature for 8x11mm on 9.5mm film (Minox cassettes). Selenium meter. Yashinon f2.8/18mm fixed focus lens. Shutter 45-250,B. Made in smooth finish or waffle-patterned. With case, flash, filters in presentation box: \$50-75. Camera only: \$25-35.

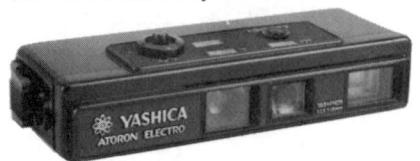

Yashica Atoron Electro - c1970. 8x11mm subminiature. Black finish. CdS meter. Yashinon DX f2.8/18mm focusing lens. Automatic shutter 8-350. (The same camera was available in chrome finish under the "Porst EX55 Electronic" name.) Outfit with case, flash, filters, presentation box: \$50-75. Camera only: \$30-45.

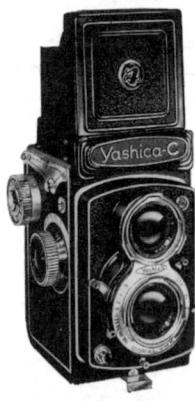

Yashica C - c1958. 6x6cm TLR. Yashikor f3.5/80mm. Copal MX 1-300. \$60-90.

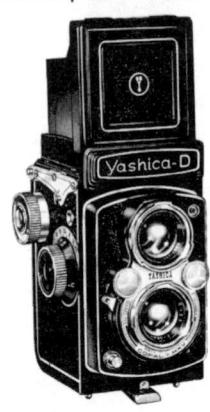

Yashica D - c1958-74. TLR, 6x6cm on

120 film. Yashikor f3.5/80mm lens in Copal MXV 500 shutter. \$60-90.

Yashica E - c1964. 6x6cm TLR. Electric eye meter cell surrounds lens. AG-1 flash socket under hinged nameplate. \$75-100.

Yashica EE - c1962. Viewfinder 35mm. Yashinon f1.9/45mm. Copal SVA 1-500, MX sync. Meter cell around lens. \$35-50.

Electro 35 (original) - c1966. Range-finder 35mm with CdS exposure meter. Yashinon-GXf1.7/45mm.\$35-50.

Yashica Electro 35 GSN

Electro 35 (later models) - Following the successful Electro 35, the name continued to be applied to a full line of range-finder cameras. Some are marked "Hong Kong". Models include: Electro 35 CC, FC, GL, GS, GSN, GT, GTN, MC, and Professional. Generally these sell for \$35-50.

Electro AX - c1973. Aperture-priority automatic exposure SLR. With Auto Yashinon f1.4/50mm normal lens: \$60-90.

Flash-O-Set - c1961. Rangefinder 35mm camera with built-in meter and AG-1 flash unit in top housing. Auto or manual diaphragm. Yashinon f4/4cm lens in single speed leaf shutter. \$25-35.

Flash-O-Set II - c1962. Similar to Flash-O-Set, but with meter cell around lens. "FII" serial number prefix. \$25-35.

FX-1 - c1975. Aperture preferred fully automatic or manual metered SLR. Speeds, apertures, warning lights visible in finder. Electronically controlled cloth FP shutter. Manual speeds 1-1000. Yashica 50mm f1.2, f1.4, or f1.7 normal lens. First Yashica model to use Contax bayonet mount. \$40-60.

FX-2 - c1976. A no-frills 35mm SLR with center-weighted CdS TTL metering. Cloth FP shutter 1-1000. Normal lens: Yashica DSB f1.9/50mm in Contax/Yashica bayonet lens mount. X-sync hot shoe, self timer. \$40-60.

Yashica J - c1961. 35mm rangefinder camera. Not to be confused with the Penta J SLR. Yashinon f2.8/45mm in Copal 25-300, B shutter. \$25-35.

Yashica J-3 - c1963. Upgraded version of Penta J, with two stage built-in CdS meter coupled to shutter and film speed. Exposure reading from top scale is manually transferred to diaphragm. Shutter release on top; self-timer added. \$30-45.

Yashica J-5 - c1964. Advanced version of the J-3 with fully automatic diaphragm controlled by CdS meter. Auto Yashinon f1.8/55mm lens in standard 42mm thread mount. \$35-50.

Yashica J-P - c1964. The economy model of the J-series, without built-in meter. Slightly modified from the Penta-J. Self-timer added, but still retains the front shutter release. External finder couples to shutter speed dial; reads directly in f-stops. \$35-50.

Yashica LM - c1957-61. TLR, similar to the Yashica C but with built-in uncoupled selenium meter. Calculator wheels on focus knob compute shutter speed & diaphragm settings from "0-10" meter readings. Yashinon f3.5/80mm in Copal-MXV. \$60-90.

Lynx 1000 - c1960. Coupled range-finder; selenium meter. Yashinon f1.8/45mm.\$35-50.

Lynx 14 - c1965. Improved version of Lynx with CdS meter, f1.4 lens. \$50-75.

Mimy - c1964. Half-frame 35mm. Automatic exposure controlled by selenium meter around lens. \$45-60.

Minister (1960) Minister II (1962)

Minister D (1963) - A series of rangefinder 35mm cameras with built-in meter. Minister I & II have selenium meter, D has CdS cell. \$20-30.

ZEH

Penta J - c1962-64. 35mm SLR. Interchangeable Auto Yashinon f2/50mm lens. FP shutter 1/2-500,B. Accepts accessory clip-on meter which couples to the shutter speed dial. \$50-75.

Pentamatic - c1960-64. Yashica's first 35mm SLR. Interchangeable Auto Yashinon f1.8/55mm lens. FP shutter 1-1000,B. \$50-75.

Yashica Rapide - c1961. Half-frame 35mm. Unusual style: stands vertically like a pocket-sized transistor radio. Interchangeable Yashinon f2.8/28mm lens in Copal 1-500 shutter. Built-in meter. \$50-75.

Yashica Rookie - c1956. TLR for 6x6 on 120. Yashimar f3.5/80 in Copal 25-300. \$60-90.

Yashica Sequelle - c1962. 35mm half-frame for 18x24mm. Styled like a movie camera. Yashinon f2.8/28mm lens in Seikosha-L shutter 30-250,B. Built-in meter. Battery-powered motor drive. \$90-130.

Yashica Y16 - c1959. Subminiature for 10x14mm on 16mm cassette film. f2.8 or 3.5/25mm Yashinon lens. Various color combinations include: aqua & grey, royal blue & grey, maroon & grey, two-tone grey, tangerine & cream. \$35-50.

Yashica YE - c1959. Rangefinder 35mm, made by the newly acquired Nicca factory. A continuation of the Nicca 33 or 3-F, with similarities to the Leica IIIg and M3 cameras. Interchangeable Yashikor f2.8/50mm. FP shutter 1/2-500, B,T. Slow speed dial on front. Rapid wind lever. Uncommon. \$300-450.

Yashica YF - c1959. A continuation of the Nicca camera line, specifically, a modification of the Nicca IIIL. (Yashica purchased Nicca in 1958.) It includes the back door which opens upward to assist loading. Styled like Leica M3. Interchangeable Yashinor f1.8/50mm lens. FP shutter 1-1000,B.\$350-500.

Yashica YK - c1959. Rangefinder 35mm. Yashinon f2.8/45mm lens. Between-the-lens 25-300 shutter. Single-stroke advance lever. \$35-50.

Yashica-Mat - c1957. TLR, 6x6cm on 120. Yashinon f3.5/80mm lens, Copal-MXV 1-500,B shutter. \$50-75.

Yashica-Mat LM - c1958. Like the standard Yashica-Mat, but with built-in uncoupled exposure meter. \$60-90.

Yashimaflex - c1953. 6x6cm TLR. Forerunner of the Yashica TLR cameras. Tri-Lausar f3.5/80mm lens in NKS-TB B,1-200 shutter. \$200-300.

YASHINA SEIKI CO. LTD. (Japan)
Pigeonflex - c1953. 6x6cm TLR. Tri-Lausar f3.5/80mm. NKS shutter 1-200, B. \$60-90.

YEN-KAME (Yen cameras): A unique and inexpensive camera type which flourished during the 1930's in Japan, and continued to be popular after WWII. They are occasionally found with "Made in Occupied Japan" markings. The cameras are simple ground-glass backed box or folding cameras which take single sheets of film in paper holders. The negative could be processed in daylight by dipping the entire paper holder into a red-colored developer and then a green-colored fixer. The red coloring in the developer eliminated the need for a darkroom, and the slogan "No Need DarkRoom" is often printed on the camera faces. This slogan is also used to identify the film type.

There are many names on the low-priced cameras, and several are listed alphabetically in this guide. We do not have space to give each "brand" a separate listing, but some of the names you might encounter are: Amco, Asahi, Asahigo, Baby, Baby Reflex, Baby Special, Baby Sports, Camera, Camerette, Collegiate, Empire, Highking, Hitgo, Junior Camera, Kamerette Senior No. 1, Katei, King, King Super, Koseido, Light, Lion, Maruso, Milbro, Million, Nichibei, Nitto Camera, Nymco, Nymco Folding Camera, Pocket, Special Camera, Special King, Super Camera, Tokyo, Tougo Camera, Victory Camera, and Yuuhigo. There are even generic versions with no name at all. To the street vendors and the public, the name was not as important as the low-cost magic of the camera. Generally, these box versions sell for \$20-30. Folding models: \$50-75.

YUNON YN 500 - c1984. One of the many inexpensive "Taiwan-35" types. Single speed shutter, hot shoe, 4 stops with weather symbols. The "Yunon" name was used in a promotion by Prestige Travel Club, which had about 5000 surplus cameras in late 1985. \$1-10.

ZEH (Zeh-Camera-Fabrik, Paul Zeh, Dresden)

Bettax - c1936. Folding 6x6cm rollfilm camera. Radionar f4.5/100mm. Compur shutter. \$35-50.

Coloprint - c1930. Folding-bed camera for 3x4cm on 127 film. Name variant of the Goldi camera. Coloprint Anastigmat f4.5/50 in Vario. Uncommon. \$90-130.

ZEH...

Goldi 3x4 - c1930. Folding-bed camera for 16 exposures 3x4cm on 127 film. f2.9 or 4.5 Zecanar lens. Vario, Prontor, or Compur shutter. Also sold under the name "Coloprint". Richard Henning & Co. sold it as the "Rhacofix"; Friedrich Laetsch as the "Ralikona"; Burke & James as the "Weston". \$75-100.

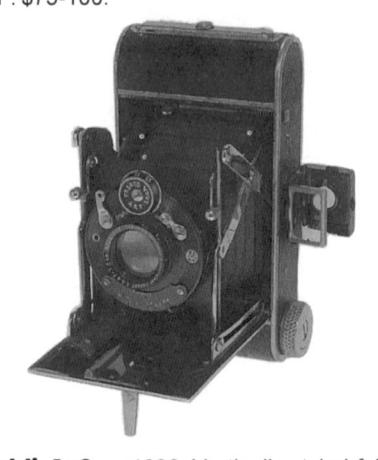

Goldi 4x6 - c1930. Vertically styled folding bed camera. Strut style is like the smaller model, with scissor struts on each side toward the top of the lens standard and guide rails at the bottom. Cassar f3.8/7cm in Pronto. \$75-100.

Sport - c1933. Folding bed camera for $6.5 \times 9 \text{cm}$ plates. Leather covered metal body. Zecanar Anastigmat 6.3/105 mm; Pronto 1/25-100. \$35-50.

Zeca, 6x9cm - c1940. Folding sheet-film camera. Lenses include f4.5 Sytar or Zecanar, Steinheil f6.8 or Periskop f11. Vario shutter, 25-100. \$35-50.

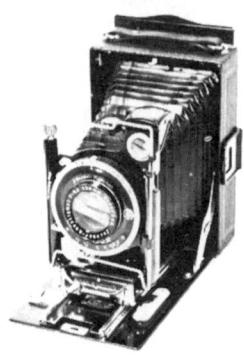

Zeca, 9x12cm - c1937. Folding sheet-film camera. 135mm lenses: f6.3 Schneider Radionar or Rodenstock Trinar, f4.5 Zecanar or Xenar. Leather covered wood body. \$45-60.

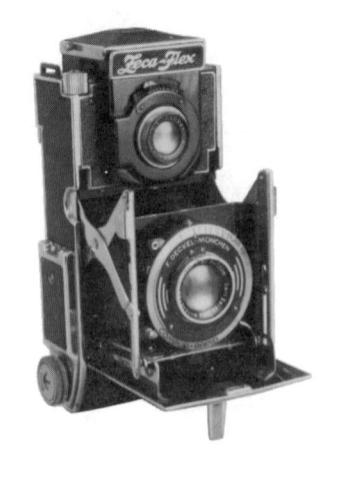

Zeca-Flex - c1937. Interesting, strutfolding TLR for 6x6cm exposures on 120 rollfilm. Taking lens is a Schneider Xenar or Zeiss Tessar f3.5/75mm. Finder lens is "Sucher Anastigmat" f2.9. Compur or Compur Rapid shutter. The folding style 6x6cm twin-lens reflex never became popular, so this model, along with the Perfekta and Superfekta from the neighboring suburb of Freital, was not made in large quantities. \$1000-1500.

ZEISS (CARL ZEISS JENA; Jena, Germany) See next manufacturer, ZEISS-IKON for other "Zeiss" cameras.

Founded in 1846 in Jena, and still there today, Carl Zeiss Jena has had a prominent place in the world of optics throughout its history. Its early history included microscopes and scientific instruments. The special glass requirements for microscopes led to the foundation of Schott glass works in Jena. When several new glass types were available from Schott, Dr. Paul Rudolph was hired by Carl Zeiss Jena to design photographic lenses with them. His well-known designs include the Zeiss Anastigmat of 1890, Planar of 1896, Carl Zeiss took over the Palmos A.G. company which had been founded just two years earlier, and thus entered the camera manufacturing business. Carl Zeiss Palmos A.G. was divested to became part of Ica in 1909, while Carl Zeiss Jena continued in its tradition of lensmaker.

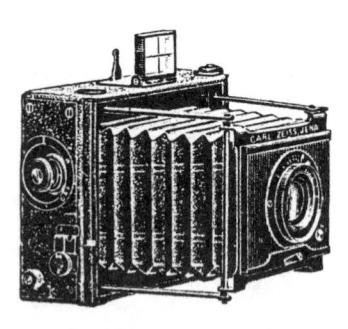

Minimum Palmos - c1905. Strut-type focal plane camera in 6.5x9cm and 9x12cm plate sizes. Tessar f6.3 or f4.5 lens. FP shutter 1/₁₅-1000. \$175-250.

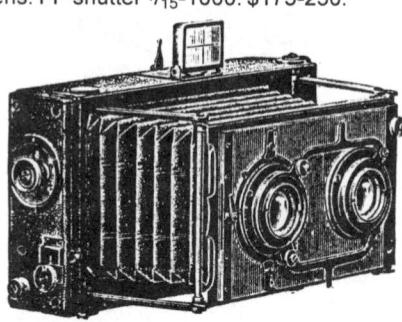

Minimum Palmos Stereo - c1907. Strut-camera for stereo or panoramic exposures on 9x18cm plates. Focal plane shutter 10-1000. With single f6.3/112mm lens for panoramicuse: \$500-750.

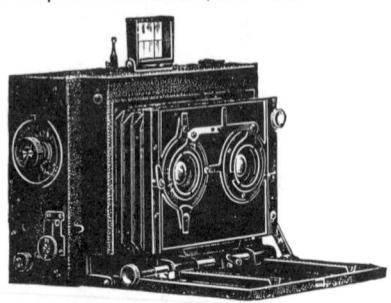

Stereo Palmos - c1905-11. Folding-bed stereo camera for 9x12cm plates. FP shutter 25-1000. Zeiss Tessar f6.3/84mm lenses. Rack focusing. \$500-750.

Universal Palmos - c1904-. Folding-bed camera with front shutter only. (A focal plane shutter accessory was available, however.) Rack & pinion focus. Normally with Tessar f6.3/150mm or Double-Protar f7/143mm in Compound. Uncommon. \$300-450.

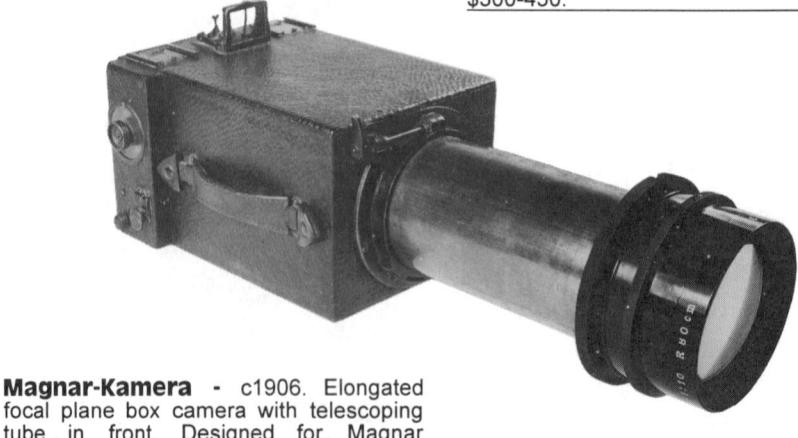

focal plane box camera with telescoping tube in front. Designed for Magnar f10/800mm telephoto lens. Newton finder or monocular finder. A very rare camera.

\$1700-2400.

Magnar-Kamera

ZEISS IKON A.G. For pre-1926 "Zeiss" cameras, see the manufacturer "CARL ZEISS JENA" immediately preceding this listing. ZEISS IKON began in late 1926, when some of the major camera manufacturers in Germany, Contessa-Nettel, Ernemann, Goerz, and Ica merged to form Zeiss-Ikon, setting up their headquarters in Dresden. The new firm combined the strengths of the merging companies and continued many of their previous models under the new Zeiss-Ikon logo. In 1946, after WWII, a new Zeiss-Ikon started up in the old Contessa Nettel factory in Stuttgart, West Germany. Camera models were also still being made in the Jena (Carl Zeiss) and Dresden factories. The trademark became the subject of much dispute and litigation. As a result, the stateowned eastern Zeiss group had the rights to market their products with the Zeiss name in certain eastern bloc countries, including the former Soviet Union. (We have listed these models under the manufacturer Pentacon.) Zeiss-Ikon Stuttgart had the marketing rights in most NATO countries. The trademark "Zeiss-Ikon" relates to photographic products, only a small part of Zeiss operations. Camera production ceased in 1971 with assembly continuing into 1972. However, the Zeiss companies are still very active in producing other optical products. Since the reunification of Germany, western Zeiss and Jenaoptik have joined hands and have begun

to revitalize the Jena operations.
In a single year Zeiss Ikon offered in their catalog 104 different model names with an average of 3 separate formats and more than 3 lens/shutter combinations per format-936 choices or "stock" models in that one catalog. The most variations that year were in the Deckrullo (later called "Nettel") press camera. One could order it in 4.5x6, 6.5x9, 9x12, 10x15, and 13x18cm formats plus all except the smallest in tropical style with varnished teak and brown leather bellows. With an actual count of 30 different lenses for the 9 types, one had 39 possible choices for this single model! This was in the 1927 catalog before the introduction of the really famous Zeiss Ikon cameras like the Contax, Contarex, Contaflex, Kolibri, and Super Ikontas.

From the above you can get some idea of the complexity of identifying and pricing all Zeiss Ikon cameras so please regard this list as covering only the more usual types and/or those of exceptional value. Where the Zeiss Ikon model number is available this number is included in the description to help in identification. Often, these numbers appear on the camera body, either engraved in the metal, or often embossed in the leather covering near one end of the back. Sometimes, especially on U.S.A. models, they are not on the camera itself, but only in the catalog. The the camera itself, but only in the catalog. The number is usually expressed as a fraction-that for a 9x12 Ideal being 250/7 and a 6.5x9cm Ideal being 250/3. Basically, the first balf of the number designates the camera model. The second balf of the number indicates negative size and is standard from one model to another. The chart below (listed in "Zeiss Historica" Journal Vol. 3 No. 1) sixes the size numbers used on Vol. 3 No. 1) gives the size numbers used on Zeiss Ikon still cameras from 1927 to 1960, after which decimal numbers for models were used. (The focal length of the most usual lens for the format is also shown.) A new or improved model usually changes only the last digit of the first number, generally increasing it by one. Hopefully this information will help the user of this guide to locate his Zeiss camera by name, number, illustration, or a combination of the three.

Number 1 2 3 4 5 6 7 8 9 10 11 12 13 14 15 16 17 18 20	Metric size 4.5x6cm 22x31mm 45x107mm 6x9cm 6.5x9cm 6.5x9cm 8.5x11.5cm 8x14cm 9x12cm 9x14cm (Ica) 10x15cm 9x18cm (Ica) 13x18cm 4x6.5cm 13x18cm (Ica) 5x7.5cm 6.5x11cm 6x6cm 8x10.5cm 3x4cm 18x24cm	F.L. 75mm 45, 50mm twin 65mm 105mm twin 75mm 135mm 135mm 165mm 210mm 75mm 90mm 120mm 80mm 120mm 50mm
	8x10.5cm 3x4cm 18x24cm 24x30cm	
24 27	24x36mm 24x24mm	50mm 40mm

Zeiss Ikon cameras have attracted a following whose buying habits resemble those of Leica collectors in some respects. This has led to a wider range of prices based on condition. Since most items are not rare, their condition is a very important consideration in establishing prices. The prices here are from our database, showing cameras in condition range 4 to 5. Items in condition range 2-3 would bring a bit more. Range 6 to 9 would not only bring less money, but also be harder to sell.

Editor's note: The basic structure of this chapter is the work of Mr. Mead Kibbey, widely respected as one of the world's foremost authorities on Zeiss-Ikon. In addition to his Zeiss collecting, Mead also serves as an officer of the Zeiss Historica Society. See the list of clubs in the back of the book for details of this organization. Additional information has been provided by Greg Bedore. "TIME MACHINES", a traveling Zeiss-Ikon camera collection exhibit is available to museums, universities, libraries, science centers, and camera clubs on a short term basis. Interested groups should contact Greg Bedore; St. Petersburgh, FL U.S.A. 1-813-527-4317.

Adoro - see Tropen Adoro

Aerial Camera, 13x18cm - c1930. Cast metal aerial camera for hand use. Two hand grips. Folding frame finder. Tessar 250mm/f3.5 lens. Focal plane shutter. \$400-600.

Baby-Box 54/18, 1931

Baby-Box Tengor - Baseball sized box camera with name on front or back. 3x4cm on 127 film. Note: On all models except

the earliest, the shutter won't work unless wire front sight is lifted.

Baby-Box 54/18 - 1931. Frontar f11 lens. Plain leather front. GERMANY: \$50-75. Add \$8-15 in USA. Illustrated at bottom of previous column.

Baby-Box 54/18 - 1934-38. Metal front plate with "Baby-Box" under lens. \$50-75.

Baby-Box 54/18(E) - 1931-34. Focusing Novar f6.3 lens. Black metal front plate. \$75-100.

Baldur Box (51) - 1934-36. Inexpensive black box camera for 16 exposures 4.5x6cm on 120. Frontar f11/90mm. Shutter 1/₃₀, T. Rare. \$50-75.

Baldur Box 51/2 - 1934-36. For 8 exposures 6x9cm on 120 film. Goerz Frontar 115mm/f11 lens. Shutter $^{1}/_{30}$, T. Germany: \$25-35.

Balilla - c1936. Export version of the Baldur box for Italy. Balilla was the name of the facist youth organization under Mussolini. This simple box camera is very

rare. Auction record Cornwall 4/94 for \$1150+.

Bebe (342) - 4.5x6cm strut camera with unpleated bellows. Front cell focus. 75mm Tessar f4.5 or Triotar f3.5 in dial set Compur (1928): \$250-375. Tessar f3.5 in rimset Compur (1930): \$400-600.

Bebe (342/3) - 6.5x9cm folding camera. Tessar 105mm/f4.5 or rimset Compur with Tessar f3.5. \$250-375.

Bob (510, 510/2) - 1934-41. Inexpensive black folding cameras, 4.5x6 and 6x9cm sizes. Nettar lens. Gauthier shutter 25-75, B, T. \$35-50.

Bob IV, V - 1927. (Cameras left over from Ernemann.) Sizes: 4x6.5, 6x6, 6x9, 6.5x11, 7.25x12.5cm. 33 different lens/shutter combinations. 7.25x12.5cm size: \$90-130. Other sizes: \$45-60.

Bobette I (549) - 1929. Strut folding camera for 22x31mm on rollfilm. With Ernoplast 50mm/f4.5 or Erid 40mm/f8: \$250-375. With Frontar f9/50mm: \$100-150

Bobette II (548) - 1929. Folding camera for 22x31mm on rollfilm. Leather covered body. Black bellows. Ernostar 42mm/f2 or Ernon 50mm/f3.5 lens. Shutter 1/2-100. The first miniature rollfilm camera with f2 lens. \$500-750.

Box Tengor 54 - 1934-39. 4.5x6cm (-1/2-frame) on 120 film. Goerz Frontar f11 lens, rotating waterhouse stops, 1 close up lens controlled from the front of the camera. Single speed shutter. Flash synch. Diamond shaped winding knob. 2 ruby windows. \$35-50.

Box Tengor 54/14 - 5x7.5cm on 127 film. Frontar f11. Plain leather front. Winding knob on bottom right side, as viewed by operator. First model (1926-28) has two finder lenses vertical at upper front corner. Quite rare. \$150-225. Second model (1928-34) has two finder lenses horizontal across the top of the front. \$100-150.

Box Tengor 54/2 - 6x9cm on 120 film. Frontar f11 lens.

-1926-28. Plain leatherette front. View-finder objectives vertical in upper front corner. Winding knob at bottom. \$30-45.

-1928-34. Plain leatherette front. Winding knob at top. Viewfinder objectives horizontal on front. Stops and closeups. \$30-45.

-1934-38. Extended hexagon front plate around lens with stops and closeup settings around it. Black enamel trim around front edge of camera. Diamond shaped winding knob at top of operator's right side.

Box Tengor 54/2, 1934-38

Relatively common in Germany for \$25-35 in excellent condition.

-1938. Same as the previous listing, but release button moved to the top of camera on operator's right. \$25-35.

Box Tengor 55/2 - 1939. Same as the 54/2 of 1938, but serrated round winding knob with leatherette center, black front trim, and double exposure interlock on winding knob. \$35-50.

Box Tengor 56/2 - 1948-56. Chrome trim. Lever shutter release on lower right side, flash contact on lower left (from operator's viewpoint). Frontar f9 lens, internal sync. \$35-50.

Box Tengor 54/15, 760 - 6.5x11cm ($2^{1}/_2x4^{1}/_4$ ") on 116 rollfilm. Fairly rare in this size. Goerz Frontar lens.

-1926-28. Ground glass viewfinder windows. Viewfinder objective lenses vertical in upper corner. Winding knob at bottom. \$60-90

-1928-33. Viewfinder objectives horizontal across top of front. Winding knob at top. Shutter has mirror on front. Close up lenses and diaphragm control on metal strips pulled up on top of camera. \$60-90. -1933-38. Similar to the 1928-33 model,

but metal plate like elongated hexagon on front around lens. Brilliant viewfinders with square lenses. Close up and diaphragm settings on front metal plate around lens. \$60-90.

Citoskop (671/1) - A top quality stereo camera for 45x107mm cut film or plates. Sucher Triplett 65mm/f4.5 viewing/focusing lens located between the Tessar 65mm/f4.5 taking lenses. All metal pop-up viewing hood with newton finder lens at front. "Citoskop" on front of camera. Fairly rare. \$300-450.

Cocarette - 1926-29. Rollfilm is loaded by removing the winder and film track from the side of the camera, somewhat like a Leica (the back does not open). (Also made in a plate back model.) Single extension. Derval, Klio, and Compur dial set shutters. Frontar, Periskop, Novar, Dominar, and Tessar lenses. 64 different lens/shutter combinations. Made in black include: #207 models. Variations #209 (5x7.5cm) an uncommon size; (6x9cm); #514 in 5 sizes. #517, #518: lever focus, vertical lens adjustment, each in 2 sizes. #519: lever focus, no vertical lens adjustment, in 3 sizes. With Tessar lens in dialset Compur: \$75-100. With less expensive lens/shutter such as Dominar, Novar or Nettar in Derval or Klio shutter: \$50-75. (In 1930, #517, #518, #519 were made with rimset Compur. Add \$8-15 for these rimset models.)

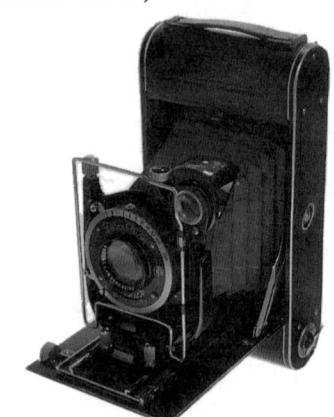

Cocarette Luxus (521/2, 521/15, 522/17) - 1928. 6x9cm, 6.5x11cm and 8x10.5cm sizes. Brown leather covering, polished metal parts. Double extension. Dial set Compur. Dominar f4.5: \$120-180. Tessar f4.5: \$250-375.

Colora (10.0641) - 1963-65. An inexpensive 35mm camera. "Colora" on top. Novica 50mm/f2.8 (a fairly unusual lens). Prontor 125 shutter, X sync. \$35-50.

Colora F (10.0641) - 1964-65. Similar to the Colora, but AG-1 flash bulb socket under the accessory shoe. Shoe tips back to become the flash reflector and to uncover the socket. Rewind knob has flash calculator in top. \$25-35.

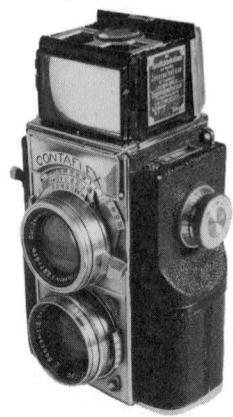

Contaflex (860/24) - TLR 35mm. 80mm viewing lens. 8 interchangeable taking lenses, 35mm to 135mm. First camera with built-in photoelectric exposure meter. \$1500-2000 if excellent to mint. In average condition, \$600-900.

Contaflex TLR lenses:

35mm f4.5 Orthometar or f2.8 Biogon: \$1200-1800.
50mm Sonnar f2 or f1.5: \$300-450.
50mm Tessar f2.8: \$300-450.
85mm Sonnar f2: \$1200-1800.
85mm Triotar f4: \$600-900.
135mm Sonnar f4: \$800-1200.
35mm viewfinder: \$300-450.

Contaflex I (861/24) - 1953-58. 35mm SLR which broke with tradition by using the newly developed reflex Compur interlens shutter. Although this "innovative" shutter design had been proven effective by Alfred Newman's N&S Reflex design about 1910, most SLR's had retained the trouble-prone cloth focal plane shutters. The new Compur design was later adopted by Hasselblad. Tessar 45mm/f2.8. Synchro-Compur. No exposure meter. Readily available. \$75-100.

Contaflex II (862/24) - 1954-58. Like the I, but with built-in exposure meter. Readily available. \$75-100.

Contaflex III (863/24) - 1957-59. 35mm SLR. Tessar 50mm/f2.8, interchangeable front element. Knob for film advance and shutter tensioning. No meter. Not as common as Contaflex II. \$90-130.

Contaflex IV (864/24) - 1957-59. Like the III, but with built-in exposure meter. Door covers the meter. LVS settings. Readily available. \$90-130.

Contaflex Alpha (10.1241) - 1958-59. Same as the Contaflex III, but with the less expensive Pantar 45mm/f2.8 lens. Interchangeable front element for Pantar series lenses. \$75-100.

Contaflex Beta (10.1251) - Like the Alpha, but with exposure meter. \$75-100.

The Contaflex Rapid, Prima, Supers, and S Automatic all have rapid film advance, accessory shoe on prism housing, and interchangeable magazine backs.

Contaflex Rapid (10.1261) - 1959-61. Tessar 50mm/f2.8, interchangeable front element. This model is rarely offered. \$90-130.

Contaflex Prima (10.1291) - 1959-65. Like the Rapid, but with Pantar 45mm/f2.8. Uncovered match needle exposure meter on operator's left side. Uncommon. \$90-130.

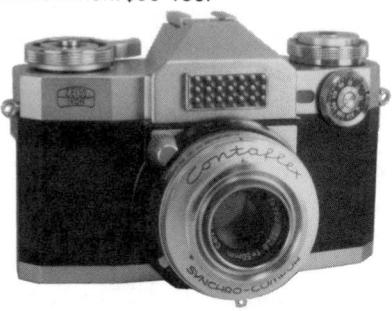

Contaflex Super (10.1262) - 1959-62. Similar to the Rapid, but with coupled exposure meter. Uncovered meter window in front of prism housing. Meter adjustment wheel on front of camera, operator's left. No other Contaflex has this external wheel. Common. Mint examples sometimes bring \$120-180, but normal range is \$75-100.

Contaflex Super (New Style-10.1271) - 1962-67. "Zeiss-Ikon" printed on front of larger exposure meter window. No external setting wheel as above. Tessar 50mm/f2.8. Shutter says "Synchro-Compur X" under lens. Exposure meter window on top has two red arrows and no numbers. Inside viewfinder tiny "2x" visible at top of exposure meter slot. No automatic exposure control. Common. \$120-180.

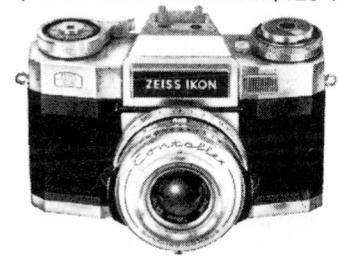

Contaflex Super B (10.1272) - 1963-68. Looks like the new style Super, except has numbers in exposure meter indicator on top and in viewfinder. Shutter says "Synchro-Compur" under lens. Automatic exposure control. \$120-180.

Contaflex Super BC (10.1273) - 1967-70. Similar to above except no external exposure meter window. Has internal through-the-lens CdS meter. Black rectangle over the lens, with "Zeiss-Ikon". Battery compartment with square door at 9 o'clock from lens. Black: \$250-375. Chrome: \$150-225.

Contaflex Super BC "BW" - Engraved for or by the Bundeswehr (German Army). Several have sold at auction for \$200-300.

Contaflex S Automatic (10.1273-BL) - 1970-72. "Contaflex S" on front of prism housing. "Automatic" above lens on shutter. Rare in black: \$250-375. Chrome: \$175-250.

Contaflex 126 (10.1102) - 1970-73. For 28x28mm on 126 cartridge film. "Contaflex 126" on front. Fully automatic exposure control. Interchangeable f2.8/45mm Tessar or Color Pantar. Not unusual to find an outfit with camera and four lenses; 45mm/f2.8, 32mm/f2.8, 85mm/f2.8, and 135mm/f4 for \$250-375. With 45mm/f2.8 lens only, very common: \$100-150.

Contaflex SLR lenses, for full frame models

35mm f4 Pro-Tessar (11.1201, and 1003). 49mm external filters. \$35-50.

35mm f3.2 Pro-Tessar (11.1201). 60mm external filters. \$75-100.

85mm f4 Pro-Tessar (11.1202, and 1004).

60mm external filters. \$100-150. 85mm f3.2 Pro-Tessar (11.1202). 60mm external filters. \$100-150.

external filters. \$100-150. 115mm_f4_Pro-Tessar_(11.1205). 67mm

external filters. \$90-130. Pro-Tessar M-1:1 (11.1204). High resolu-

tion close copy lens. \$120-180.

Monocular 8x30B - see Contarex lenses below.

Steritar A (Stereo prism for above) (20.2004, and 812). \$150-225. Teleskop 1.7x (fits models I and II only) (11.1203) With bracket: \$75-100.

For Alpha, Beta, Prima, and Contina III

30mm f4 Pantar (11.0601), \$35-50, 75mm f4 Pantar (11.0601 or 1002), \$75-100.

Steritar B (20.2005 or 813) (for Contaflex III through S). \$150-225. Steritar D (20.2006 or 814). \$120-180.

Contaflex 126 lenses

25mm f4 Distagon (11.1113). Very rare. No sales records. Estimate: \$150-225. 32mm f2.8 Distagon (11.1101). Mint: \$30-45.

45mm f2.8 Color Pantar (11.1102). \$12-20.

45mm f2.8 Tessar (11.1103). \$12-20. 85mm f2.8 Sonnar (11.1104). \$60-90. 135mm f4 Tele Tessar (11.1105). \$30-45. 200mm f4 Tele Tessar (11.1112). \$150-225.

Contarex Cameras - All models of this superbly made 35mm camera, except the microscope version, have the word "Contarex" on front.

We are grateful to Peter Walnes of Fieldgrass & Gale Ltd., London, for his valuable assistance in updating the Contarex prices.

Contarex "Bullseye" (10.2401) - 1959-66. Large round coupled exposure meter windowover lens. Interchangeable

Planar 50mm/f2. Later models (c1964-66) with data strip slot, Exc-Mint: \$600-900. Early models without data strip slot at rear, Exc-Mint: \$450-675.

Contarex Special (10.2500 body) - 1960-66. No meter. Interchangeable reflex or prism view hood. "Contarex" in script-like letters. Exc-Mint: \$800-1200.

Contarex Professional (10.2700 body) - 1967-68. No meter. Only prism viewer. "Professional" on front. Very rare. Only 1500 made, and few mint examples remaining. Exc-Mint: \$1200-1800.

Contarex Super (10.2600 body) - 1968-72. "Super" on front. First model has through-the-lens meter switch on front at 2 o'clock from the lens (opposite from focus wheel): Exc-Mint: \$900-1350. Second model has switch on top under the winding lever and is less common: Exc-Mint: \$1100-1650.

Contarex Electronic (Super Electronic) (10.2800 body) - 1970-72. "Electronic" on front. Chrome body, mint: \$2000; exc: \$1300. Black body, mint: \$2500; exc: \$1650.

Contarex Hologon (10.0659 outfit) - 1970-72. "Hologon" on front. Fixed focus lens 15mm/f8, linear type (not a fisheye). With camera, grip, cable release, special neutral density graduated filter, and case for all: Mint \$7500; Exc \$5000. Camera only, Mint: \$5000; Exc: \$3000.

Contarex Hologon handgrip - \$150-225

Contarex Microscope Camera - "Zeiss Ikon" in block letters on top. No lens, viewfinder, or exposure meter. Interchangeable backs. Once thought rare, now more easily found and in less demand. \$250-375.

Contarex Lenses - These lenses, made between 1959 and 1973 by Carl Zeiss, Oberkochen are seldom equalled and never surpassed even with today's technology. Up to 1965, 135mm and shorter lenses have chrome finish, and 180mm and longer have black finish. After 1965, all were black finished. *If price is given only for MINT, deduct 25-50% for EXCELLENT.*

16mm f2.8 fisheye Distagon (11.2442) 1973. Rare. Mint \$3000; Exc \$2000.

18mm f4 Distagon (11.2418) 1967-73. With rose-colored focussing screen and adapter ring for B96 filters. Mint \$2250; Exc \$1500.

21mm f4.5 Biogon (11.2402) 1960-63. (For Bullseye only.) With finder: Mint \$750; Exc \$500. Less 30-40% without finder.

25mm f2.8 Distagon (11.2408) 1963-73.

Black: Mint \$1200; Exc \$800. Chrome: Mint \$1050; Exc \$700.

35mm f4 Distagon Chrome (11.2403) 1960-73. Mint \$450; Exc \$300.

35mm f4 Blitz Distagon Black (11.2413) 1966-73. Built-in flash automation. Mint \$600; Exc \$400.

35mm f4 PA Curtagon (11.2430) 1973. Made by Schneider, but mounted and sold by Zeiss Ikon, Stuttgart. Automatic stop down. Perspective control by lateral movement of up to 7mm in any of 4 directions. Rare. With B56 filter ring: Mint \$1000; Exc \$700.

35mm f2 Distagon (11.2414) 1965-73. Mint \$1200; Exc \$800.

50mm f4 S-Planar (11.2415) 1963-68. For critical close ups to 3". Very rare. Mint \$1500; Exc \$1000.

50mm f2.8 Tessar (11.2501). Black: Mint \$400; Exc \$265. Chrome: Mint \$275; Exc \$180.

50mm f2 Planar Chrome (11.2401) 1960-73. Mint \$180; Exc \$120.

50mm f2 Blitz Planar Black (11.2412) 1966-73. Mint \$325; Exc \$225.

55mm f1.4 Planar (11.2407) 1965-73. Black: Mint \$450; Exc \$300. Chrome: Mint \$325; Exc \$215.

85mm f2 Sonnar (11.2404) 1960-73. Black: Mint \$900; Exc \$600. Chrome: Mint \$750; Exc \$500.

85mm f1.4 Planar (11.2444) 1974. Very rare. Reportedly 400 made. Mint \$3250; Exc \$2000.

115mm f3.5 Tessar (11.2417) 1960-73. For use with bellows. Mint \$1000; Exc \$670. Bellows: \$225. Lens rare; bellows very common.

135mm f4 Sonnar (11.2405) 1960-73. Black: Mint \$400; Exc \$265. Chrome: Mint \$300: Exc \$200.

135mm f2.8 Olympia-Sonnar (11.2409) 1965-73. Mint \$600; Exc \$400.

180mm f2.8 Olympia-Sonnar (11.2425) 1967-73. Very rare. Mint \$3000; Exc \$2000.

250mm f4 Sonnar (11.2406) 1960-63. Manual preset ring focus. Mint \$600; Exc \$400.

250mm f4 Olympia-Sonnar (11.2421) 1963-73. Knob focus auto stop-down. Mint \$1500; Exc \$1000.

400mm f5.6 Tele Tessar (11.2434) 1970-73. Very rare. Mint \$4000; Exc \$2700.

500mm f4.5 Mirotar (11.2420) Catadioptric. 1963-73. Very rare. Mint \$6000; Exc \$4000.

1000mm f5.6 Mirotar (11.2422) Catadioptric. 1964-70. Super rare. Mint \$15.000; Exc \$10,000.

40-120mm f2.8 Vario-Sonnar (11.2423) 1970-73. Rare. With grip: Mint \$3500; Exc \$2350.

85-250 f4 Vario-Sonnar (11.2424) 1970-73. Very rare. With grip: Mint \$4000; Exc \$2700

Monocular 8x30B with 27mm threaded eyepiece to fit Contaflex SLR or Contarex by use of an adapter. First model (1960) (20.1629) with eyepiece focus and line for 140 feet. \$225. Second model (1963) with front end focussing and a distance scale. (This second model is the most common type seen.) \$225. Third model (1969) (11.1206) has porro prism with front end focus. This model is straight and looks like a small refracting telescope. \$300.

Adapter to use monocular with 50mm f2 Planar: \$60.

Adapter to use monocular with 50mm f1.4 Planar: \$80.

contax series - Introduced in 1932 as a top quality rangefinder 35mm system camera, the Contax cameras were manufactured until 1961 with the exception of the 1944-52 period. Dr. Stanley Bishop assisted Mead Kibbey in the preparation of this section. For further details on Contax cameras and lenses, we would recommend any of various books by Hans-Jürgen Kuc, normally available from Lindemanns Buchbandlung (see advertising section). The Zeiss Historica Society is also highly recommended as a continuing source of information and inspiration (see club listings).

Contax

Contax I (540/24) - 1932-36. Identifying features: black enamel finish, square appearance, "Contax" in white on upper front and winding knob on front to operator's right of lens. See variations listed below.

Contax I(a) - Serial numbers starting with "AU" or "AV". No low (below 1/25) shutter speeds, no "foot" on tripod socket and often had one or more raised "dimples" over ends of shafts on front of camera. Viewfinder window closer to the center of the camera than rangefinder window is. With contemporary lens: \$600-900.

Contax I(b) - Same as the I(a) in appearance except front bezel extends across front to viewing and rangefinder window. No "dimples" as model I(a). \$400-600

Contax I(c) - "Foot" on tripod socket, slow speeds added, guard attached to lens bezel surrounds slow speed setting ring. Like the above models, it has no button to unlock infinity stop when external bayonet lenses are in use. \$300-450.

Contax I(d) - Same as the I(c), but button to release infinity lock present at 1 o'clock from lens, and distance scale around base of lens mount now finished in chrome with black numbers rather than in black with white numbers as on earlier models. \$300-450. Quite a few in circulation with defects, replaced parts, repainted, etc. These sell regularly at German auctions, below these prices.

Contax I(e) - Same as I(d), except view-finder window moved to outside of range-finder window, and a shallow vertical groove in front bezel between lens mount containing word "Contax" and focus wheel. \$400-600. Worn and defective examples sell regularly for \$175-250.

Contax I(f) - Same as I(e), but has 4 screws in accessory shoe, and the marker for setting shutter speeds changed from an apparent slotted screw head to a small pointer. \$400-600.

Contax II (543/24) - 1936-42. Identified by satin chrome finish on top and trim. Winding and speed setting on top right (viewed from behind), shutter speeds to $1/_{1250}$, and rangefinder and viewfinder windows combined. A superb rugged camera. Early models have speeds $1/_{120}$, $1/_{200}$, later ones have $1/_{125}$, $1/_{250}$. It can be differentiated from the postwar Contax II(a) by its larger size, a narrow frame around the small rangefinder window, and the absence of sync connection on upper back. With Sonnar 50mm f1.5 or f2 or Tessar f3.5 or f2.8. Superb condition: \$350-500. Excellent: \$175-250. Very common.

Contax Rifle (543/75) - c1937. Contax II camera with f2.8 180mm "Olympia" Sonnar, Flektoskop mirror box, and rifle stock. One of the rarest camera collectibles. About 4 known in collections per Cornwall 9/92 catalog where one was sold for DM 20,000 (about \$13,500).

Jena Contax (II) - c1947. Very similar to pre-war Contax II. Says "Carl Zeiss Jena" in shoe. Back is made of brass, not aluminum. Black bezel around self-timer. Lettering style is slightly different. Rare. \$600-900.

Contax III (544/24) - 1936-42. Same as the Contax II, except had built in, uncoupled exposure meter on top and rewind knob was much higher. \$175-250.

Contax, Contax S, Contax D, and Contax F - Variations of the Contax II and SLR pentaprism versions which were produced after WWII in East Germany. They tended to be of inferior quality and sell in the range of \$50-150. These cameras are covered in more detail under the manufacturer"Pentacon".

Contax II(a) (563/24) - 1950-61. An excellent quality camera produced at Stuttgart and identified by satin chrome top, "Contax" on front, wide frame around right rangefinder window, sync fitting on back near top, and film speed and type indicator on rewind knob.

First model (c1950-54): all numbers on speed setting dial are black. Sync attachment looks like flat plunger in socket. Requires special attachment to convert

mechanical motion to electric contact. (#1361 for bulbs, #1366 for electronic flash.) \$200-300.

Second model (c1954-61): Same, but numbers on speed dial in color $(1-1/_{25}$ black, $1/_{50}$ yellow, 100-1250 red) and regular p.c. flash connector at rear. Many of these are still in use. MINT condition brings \$350-500. EXC: \$250-375.

Contax IIIa - Same as the IIa, except uncoupled exposure meter on top. First model (black dial): \$250-375. Second model (colored dial): \$300-450. (Mint condition brings 25-35% more.)

Contax "No-Name" - see Mashpriborintorg "No-Name" Kiev.

Prewar Contax Lenses - Earliest were black enamel and heavy chrome trim. These are worth from a little to a lot more than the later satin chrome versions. All these lenses plus innumerable Contax accessories are described in "Contax Photography", a Zeiss booklet reprinted in 1981 by David Gorski, 244 Cutler St., Waukesha, WI 53186, and still available from him for \$10.95. Even the view finders in the Contax series are collected and vary from \$20 up to several hundred dollars in value. Serial numbers range from about 1,270,000 to just under 3,000,000.

28mm f8 non-coupledwide angle Tessar: \$120-180.

35mm f4.5 Orthometar. \$250-375. **35mm f2.8** Biogon (fits only pre-war

Contaxes): \$75-100.

40mm f2 Biotar. Black: \$600-900. Chrome: \$600-900.

42.5mm f2 Biotar (marked "41/4cm"). Rare; only about 10 of these are known to exist. \$1500-2000.

50mm f3.5 Tessar: \$60-90. Add \$12-20 if black front ring (for Contax I).
50mm f2.8 Tessar: \$60-90. Add \$12-20

if black front ring (for Contax I).

50mm f2 Sonnar: Rigid mount: \$60-90.

Collapsible mount: \$20-30. * **50mm f1.5** Sonnar: \$45-60. *Add \$8-15*

for black. **85mm f4** Triotar: Black: \$100-150.

Chrome: \$75-100.

85mm f2 Sonnar: Prewar black: \$250-375. Prewar chrome: \$100-150.

135mm f4 Sonnar: Black: \$175-250. Chrome: \$90-130.

180mm f6.3 Tele-Tessar (direct mount): Some marked "K", others not. Black: \$500-750. Chrome: \$400-600.

180mm f2.8 Sonnar ("Olympia Sonnar") (direct mount): \$1500-2000.

180mm f2.8 Sonnar ("Olympia Sonnar") in flektoskop (inverted image), with case: \$1500-2000.

300mm f8 Tele-Tessar (direct or Flektoskop mount): Some marked "K", others not. \$1700-2400.

500mm f8 Fern (distance) lens in direct or Flektoskop mount. Rare. Direct mount: \$3200-4600. With Flektoskop and case: \$2400-3200.

Postwar Contax lenses - Chrome finish throughout range. Fern 500mm, Sonnar f2.8/180mm, and Tessar f3.5/115mm offered in black also. Long lenses were not available in direct mount after the war. Some of these lenses went through various changes of style and engraving in the early 1950's. Originally made by Carl Zeiss Jena. From about 1951-1953 they were marked Zeiss-Opton and made in Oberkochen. After

about 1953, they were marked Carl Zeiss, but were made in Oberkochen, not Jena. Oberkochen lenses are listed with bestellnummer (order number). Postwar Carl Zeiss Jena lenses begin at 3,000,000.

21mm f4 Biogon (563/013): \$120-180. (Add \$90 for finder.)

25mm f4 Topogon (Carl Zeiss Jena). Rare. \$750-1000.

35mm f3.5 Planar (563/014): \$120-180. **35mm f2.8** Biometar (Carl Zeiss Jena): \$175-250.

35mm f2.8 Biogon (563/09): \$120-180. **50mm f3.5** Tessar (Carl Zeiss Jena) or (543/00): \$75-100.

50mm f2.8 Tessar (Carl Zeiss Jena): \$25-35.

50mm f2 Sonnar (Carl Zeiss Jena) or (543/59): \$45-60.

50mm f1.5 Sonnar (Carl Zeiss Jena) or (543/60): \$50-75.

75mm f1.5 Biotar (Carl Zeiss Jena). Super rare. \$800-1200.

85mm f4 Triotar (543/02): \$100-150. 85mm f2 Sonnar (563/05): \$100-150.

85mm f2 Sonnar (563/05): \$100-150. **115mm f3.5** Panflex Tessar (5522/01), for bellows. Rare. \$750-1000.

135mm f4 Sonnar (543/64): \$75-100. **180mm f2.8** Sonnar (Carl Zeiss Jena). Flektoskop, Flektometer or Panflex mount. Rare. \$1200-1800.

300mm f4 Sonnar (Carl Zeiss Jena). Flektoskop, Flektometer, or Panflex mount. Rare. \$2400-3200.

500mm f8 Fern (Carl Zeiss Jena). Flektoskop, Flektometer, or Panflex mount and case. (In October 1952, this lens cost \$835.) Infrequently offered for sale. Estimate: \$2400-3200.

Stereotar C outfit (810/01, 20.2000). Twin lens assembly, separating prism, special viewfinder, close up lenses, and leather case: \$2000-3000.

Contessa Series - Post-war 35mm full frame cameras.

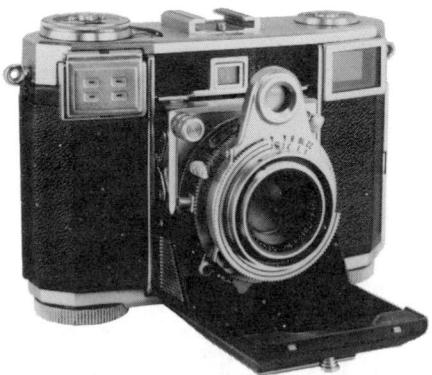

Contessa-35 (533/24), 1950-55 - A fine quality folding 35 with center door somewhat like a Retina. Built-in dualrange, uncoupled exposure meter. "Contessa" in gold on leather door covering, and round rangefinder window directly above lens. Shutter will not fire unless camera has film and it is advanced. Tessar 45mm/f2.8. First version (1950-53), Compur Rapid, X sync. Second version (1953-55), Synchro Compur, MX sync. \$150-225.

Contessa-35 (533/24), 1960-61 - Very different from the first 2 versions. Rigid lens mount. Built-in exposure meter. "Contessa" on top. Tessar 50mm/f2.8. Pronto $1/_{30}$ - $1/_{250}$. \$50-75.

Contessa LK (10.0637) - 1963-65. "Contessa LK" on top. No rangefinder. Coupled match needle exposure meter. Tessar 50mm/f2.8 lens, Prontor 500 LK shutter. Sells regularly at German auctions: \$35-50. Asking prices twice as high in UK and USA.

Contessa LKE (10.0638) - 1963-65. "Contessa LKE" on top. Like the LK, but with coupled rangefinder. \$60-90.

Contessa LBE (10.0639) - 1965-67. "Contessa LBE" on top. Like the LKE, but automatic flash control by linkage between distance and aperature setting. \$50-75.

Contessa S-310 (10.0351) - 1971. Small very well made rigid mount automatic 35, with manual overide. "S-310" on front. Tessar 40mm/f2.8. Pronto S500 Electronic shutter, exposures to 8 seconds. \$120-180.

Contessa S-312 (10.0354) - "S-312" on front. Like the S-310, but with coupled rangefinder. \$150-225.

Contessamatic E (10.0645) - 1960-63. "Contessa" on top-front of lens mount. No name on top. Tessar 50mm/f2.8. Prontor SLK "Special" shutter, 1-500, MX sync. Coupled rangefinder. Exposure meter. \$35-50.

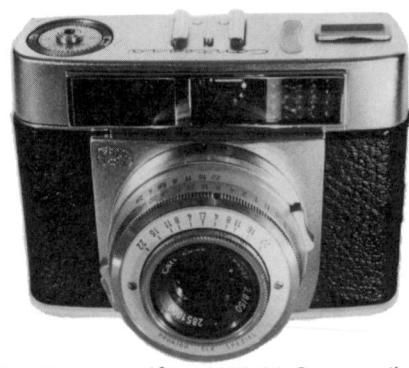

Contessamatic - 1960-61. Same as the "E", but no rangefinder, and Prontor SLK shutter. \$45-60.

Contessamat - 1964-65. "Contessamat" on top. Fully automatic. Color Pantar 45mm/f2.8. Prontormatic 30-125 shutter. Coupled exposure meter. No rangefinder. \$35-50.

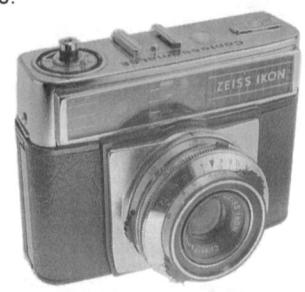

Contessamat SE (10.0654) - 1963-65. "Contessamat SE" on top. Like the Contessamat, but with coupled rangefinder, Prontormatic500 shutter, 30-500. \$35-50.

Contessamat STE - 1965. "Contessamat STE" on top. Like the SE, but Tessar 50mm/f2.8 in Prontormatic 500 SL shutter, 1-500. \$45-60.

Contessamat SBE (10.0652) - 1963-67. "Contessamat SBE" on top in black. "Flashmatic" in red letters. Like the STE,

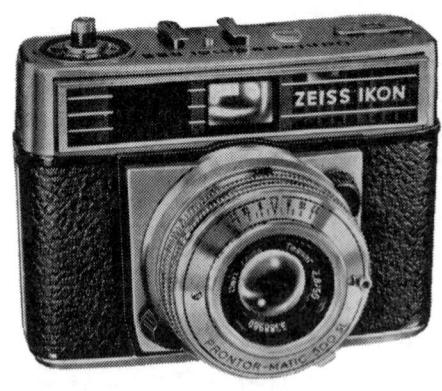

but covered flash contacts on top. Automatic flash control by linking distance and diaphragm settings. \$45-60.

Contina I (522/24) - 1952-55. 35mm folding camera with center door. "Contina" in gold letters on door. Model number on leather of back by back latch. Novar 45mm/f3.5 in Prontor SV or Tessar f2.8/45mm in Synchro Compur. \$45-60.

Contina la (526/24) - 1956-58. Rigid mount lens. "Contina" under the lens and on bezel at 1 o'clock from lens. Model number in leather of back next to catch. Novicar 45mm/f2.8 (1956-57) or Pantar 45mm/f2.8 (1958). \$30-45.

Contina Ic (10.0603) - 1958-60. Restyled Contina Ia. Larger top housing, larger viewfinder window. Pantar 45mm/f2.8; Prontor-SVS 1-300 shutter. \$35-50.

contina II (524/24) - 1952-53. 35mm folding camera with center door. "Contina" on door. Model number in leather of back near catch. Uncoupled built-in rangefinder. Opton-Tessar 45mm/f2.8 in Synchro Compur 1-500, MX or Novar f3.5 in Prontor SV. \$50-75.

contina lla (527/24) - 1956-58. Rigid mount lens. "Contina" on front under lens. Model number on back. Rapid wind lever. Built in uncoupled exposure meter, match

needle on top. 45mm Novar f3.5 or Novicar f2.8. Prontor SVS 1-300, MX sync. Common.\$45-60.

contina III (529/24) - 1955-58. A system camera, with the same specifications as Contina IIa, except Pantar 45mm/f2.8 convertible lens. "Contina" on front bezel. Model number on back. Uses all lenses of the Contaflex Alpha series. \$50-75.

Contina III Lenses

30mm f4 Pantar (1001): \$35-50. 75mm f4 Pantar (1002): \$75-100. Steritar D for 3-D pictures (814): \$120-180. 30mm wide angle finder (422): \$30-45. Telephoto finder (423): \$30-45. Telephoto rangefinder (correct field of view for 75mm Pantar) (425): \$35-50. Universal finder for all items above (426):

for 75mm Pantar) (425): \$35-50. Universal finder for all items above (426): \$75-100. Contina III Microscope Camera

Contina III Microscope Camera - Body of the Contina III, but modified for use with standard Zeiss Microscope Connecting funnel. No lens. Ibsor B self-cocking shutter, 1-125, X sync. No exposure meter, rangefinder, viewfinder or name, except "Zeiss-Ikon" in middle of back. Usual shutter release button does not release shutter, but must be depressed to advance shutter. Rare. \$120-180.

Contina (10.0626) - 1962-65. Rigid mount 35mm. "Contina" on top. Color Pantar 45mm/f2.8. Pronto shutter to 250, X sync, self-timer. \$25-35.

Contina L (10.0605) - 1964-65. "Contina L" on top. Like the Contina, but with built-in uncoupled exposure meter. Prontor 250 shutter, 30-250. \$25-35.

Contina LK (10.0637) - 1963-65. "Contina LK" on top. Like the "L", but coupled exposure meter. \$35-50 MINT.

Continette (10.0625) - 1960-61. "Continette" on front beside viewfinder. Rigid mount 35mm, without rangefinder or exposure meter. Pronto shutter 30-250, self-timer. Lucinar 45mm/f2.8. (This lens was not used on any other Zeiss Ikon camera.) \$35-50.

Deckrullo, Deckrullo Nettel - 1926-28. Strut-folding cameras. Focal plane shutters to 2800. Formerly made by Contessa-Nettel Camerawerk, now by Contessa-Nettel Division of Zeiss-Ikon, and continuing after 1929 as the "Nettel" camera (870 series). (See Zeiss Nettel.)

camera (870 series). (See Zeiss Nettel.)
- **6.5x9cm (36), 9x12cm (90)** - Zeiss
Tessar f4.5 or f2.7, or Triotar f3.5. \$120-180.

- 10x15cm (120), 13x18 (165) - Zeiss Tessar f4.5 or Triotar f3.5. \$120-180.

Baby Deckrulio (12, 870) - 1926-29. 4.5x6cm plate camera. Strut-folding, with bed. Focal plane shutter to 1200. 80mm Zeiss Tessar f4.5 or f2.7 lens. Camera focus knob on top. \$300-450.

Deckrullo Tropical, Deckrullo Nettel Tropical - Same shutter/ lens combinations as the Deckrullo. \$600-900.

Donata (68/1, 227/3, 227/7) - 1927-31. Inexpensive folding plate camera, 6.5x9 and 9x12cm sizes. Name usually on or under handle. Preminar, Dominar or Tessar f4.5 lens in Compur. \$50-75.

Duchessa (5, 302) - c1926-29. Single extension folding bed camera with trellis side struts. 4.5x6cm plates. Radial lever focusing. Tessar f4.5/75mm lens in Compurshutter. \$200-300.

Duroll, 9x12cm - c1926-27. Folding bed camera, continued from the Contessa model. Takes 8.2x10.7cm on rollfilm or 9x12cm plates. Dominar or Tessar lens. \$60-90.

Elegante (816) - 1927-34. Field camera with rigid front. Square bellows. Wood with brass. \$400-600.

Erabox - 1934-38. Inexpensive version of the Box Tengor. "Erabox" around lens. 120 film. 4.5x6cm: \$45-60. 6x9cm: \$30-45.

Ergo (301) - 1927-31. Detective camera made to look like a monocular. Shoots at right angles to direction of viewing. "Ergo" in eyepiece area. 4.5x6cm plates. Tessar 55mm/f4.5. Self-cocking shutter. Very rare. \$1200-1800.

Ermanox (858) - 1927-31. 4.5x6cm plate camera. 85mm Ernostar f1.8 or rare f2 lens. FP shutter 20-1200. Rigid helical focusing. \$1500-2000.

Ermanox (858/3, 858/7, 858/11) - 1927. Strut-folding, bellows cameras. Ernostar f1.8 lens, FP shutter to 1000. 6.5x9cm (858/3) is fairly rare: \$1000-1500. 9x12cm (858/7) is super rare: \$3500-5500. 10x15 and 13x18cm sizes are listed in original catalogs, but are so rare that they are impossible to price.

Ermanox Reflex - 1927-29. Reflex 4.5x6cm plate camera. Ernostar 105mm/f1.8 lens in rigid helical focus mount. FP shutter 20-1200. \$2000-3000.

Erni (27, 27/3) - 1927-30. Box plate camera. Celluloid focusing screen. Very rare. \$175-250. A 6.5x9cm recently sold at auction for \$125, while a 4.5x6cm model went unsold at \$285.

Favorit (265, 265/7, 265/9, 265/11) - 1927-35. Black bodied plate camera of excellent quality. Name or number usually on handle, number on outside of door near hinge. Interchangeable lenses Tessar or Dominar f4.5 lens. 13x18cm size: Very rare. Estimate: \$250-375. Other sizes: \$175-250.

Favorit Tropical (266/1, 266/7, 266/9) - 1927-31. Teakwood plate camera of excellent quality. Brown leather handle with name and model number. Tessar or Dominar f4.5 in Compur shutter. Price varies, depending on size and condition. \$600-900.

Halloh (505/1) - c1927. Single extension folding bed camera, similar to lcarette series. 8x10.5cm on rollfilm. Tessar f4.5/120; Dial set Compur. \$75-100.

Hochtourist - c1927-31. Double extension wood view camera. Brass trim. Square bellows. Vertical and horizontal front movements. Sizes 5x7", 8x10", and 10x12". Usually without model name on camera, but with "Zeiss-Ikon" round metal plate. Very rare. No active trading exists. Infrequent sales records indicate prices in \$250-375 range. See D.B. Tubbs "Zeiss Ikon Cameras 1926-39" for pictures.

Hologon - see Contarex Hologon under this manufacturer.

Icarette - 1927-36. In formats 4x6.5, 6x6, 6x9, 6.5x11, and 8x10.5cm, plus one model which used 6x9cm rollfilm or 6.5x9cm plates. Most say "Icarette" on handle or in leather on body. There were over 60 different lens/shutter combinations offered and 4 qualities of bodies, #509, #500, #512, and the fanciest #551/2. With the notable exception of #500/12, which has reached \$160 at auction, or an absolutely like new example, price range is \$50-75.

Icarex - 1967-73. An intermediate priced 35mm system camera. All had cloth focal plane shutter, 1/2-1000, B, X sync. Some models are marked "PRO". A cup of coffee to the person who knows why! One can find the "PRO" marking on any early black Zeiss-Ikon Icarex 35 to a late chrome Zeiss-Ikon Voigtländer Icarex 35S TM.

Icarex 35 (10.2200) - Bayonet mount. Interchangeable viewing screens, view-finders, and lenses. With Ultron f1.8: \$150-225. With Color Pantar 50mm/f2.8: \$100-150. With Tessar 50mm/f2.8: \$100-150. Add \$30-45 for black body.

Icarex 35 "TM" - Threaded 42mm lens mount, marked "TM" at 1 o'clock from the lens. With Tessar 50mm/f2.8: \$150-225. With Ultron 50mm/f1.8: \$150-225.

Icarex 35 CS - Either of the Icarex 35 models becomes an Icarex 35 CS by the addition of a pentaprism viewfinder containing a through-the-lens CdS meter. The finder says "Icarex 35 CS" on its front, and looks like a part of the camera. \$100-150.

ZEISS...

Icarex 35S - intro. 1970. TM (10.3600) and BM (10.3300) models. Differs from the Icarex 35 in that the viewfinders and view screens are not interchangeable. Built-in CdS meter coupled with stop-down metering. Five Zeiss lenses available for the TM model, 9 for the BM model. Chrome or black versions. With Pantar: \$90-130. Tessar f2.8: \$100-150. Ultron f1.8: \$150-225. For black models, add \$30-45.

Icarex Lenses - All take 50mm bayonet or 56mm screw-over filters and shades.

Bayonet mount:

35mm f3.4 Skoparex (11.2003): \$75-100. **50mm f2.8** Color Pantar (11.2001): \$30-45

50mm f2.8 Tessar (11.2002): \$35-50. **50mm f1.8** Ultron (11.2014): \$90-130.

90mm f3.4 Dynarex (11.2004): \$90-130. **135mm f4** Super Dynarex (11.2005): \$90-130.

200mm f4 Super Dynarex (11.2008): \$175-250.

400mm f5 Telomar (11.2010). Rare: \$350-500.

36-82mm f2.8 Zoomar (11.2012): \$250-375.

Thread mount:

25mm f4 Distagon (11.3503). Rare: \$150-225.

35mm f3.4 Skoparex (11.3510): \$75-

50mm f2.8 Tessar (11.35??): \$50-75. **50mm f1.8** Ultron (11.3502): \$90-130. **135mm f4** Super Dynarex (11.3511): \$90-130.

Ideal - 1927-38. Quality double extension folding plate camera usually having the name and model number stamped on the leather body covering under the handle. The 9x12cm size was the most common, followed by the 6.5x9cm. They were offered with Compur shutters, and Dominar, Tessar, or Double Protar lenses, the Tessars being by far the most common. Interchangeablelens and shutter on all but the 6.5x9cm size. All had special "pop-off" backs. 6.5x9 (250/3): \$75-100. 9x12 (250/7): \$75-100. 10x15 (250/9), rare: \$90-130. 13x18 (250/11), very rare: \$100-150.

Ikoflex cameras - 1934-60. Twin lens reflex for 6x6cm format. "Ikoflex" on front.

Ikoflex (850/16) - 1934-37. Original "coffee can" model. All black enamel finish on cast magnesium body. 80mm Novar f4.5 or 6.3 lens. Derval, Klio, or Compur-Rapid shutter. 2 film counters (for 120 and 620 films); lever focus under lens; "Ikoflex" on shutter above lens. Early version has art-deco finder hood, but later hoods are leather covered like other models. Occasionally \$200-300 but most sales \$150-225

Ikoflex I (850/16) - 1939-51. This is basically the same camera that was earlier called the Ikoflex II (1937-39). Slight changes were made to the body design when production was resumed under the Ikoflex I name. Nameplate is black, with a small chromed area surrounding the name "Ikoflex". Chrome trim. 75mm Tessar or Novar f3.5. Compur, Klio or Prontor-S shutter to 250. Knob focus. \$120-180.

Ikoflex Ia (854/16) - 1952-56. "Ikoflex" in chrome against a black background on front of viewfinder. 75mm Novar or Opton Tessar f3.5. Prontor SV to 300. Does not have a folding shutter release. Auction sales \$250-375 in top condition. Normal range: \$100-150.

Ikoflex Ib (856/16) - 1956-58. Improved version of the Ia. 75mm Tessar or Novar f3.5 in 1956/57; Novar only in 1957/58. Prontor SVS shutter. Folding shutter release. Focusing hood opens and closes with single action, magnifiers over diaphragm and shutter speed dials. No exposure meter. \$100-150.

ikoflex Ic (886/16) - 1956-60. Similar to the lb, but with built-in exposure meter. Needle visible on ground glass inside hood. MINT: \$300-450. Normal range: \$150-225.

Ikoflex II (851/16) - 1936-39. "Ikoflex" nameplate on front is all chrome. Zeiss Tessar 75mm f3.5 in Compur Rapid 1-500, or Zeiss Triotar 75mm f3.8 in Compur 1-300. Auto film counter. Viewing lens in chromed tube appears to stick out further than on other models. Focus lever in 1937, knob in 1938-39. (This basic model was continued as the Ikoflex I.) \$90-130.

Ikoflex II/III (852/16) - 1938-1940's. Entire area of taking and viewing lenses is surrounded by a front housing, with 2 peep windows above the viewing lens. Lens aperture and shutter speed show in the peep windows. Aperture and shutter speed are set by levers under shutter housing. Double exposure prevention. This model was introduced in 1938 as the Ikoflex III, but was renamed the "New Style Ikoflex III" in 1939 (when the original Ikoflex II (851/16) was discontinued). Zeiss Tessar 75mm/f3.5 lens in Compur Rapid 1-500, or Zeiss Triotar 75mm/f3.5 in Compur 1-300. \$150-225.

Ikoflex IIa (855/16, early) - 1950-52. Similar to the Ikoflex II, but the front housing surrounds only the taking lens, with the peep windows located on both sides of the viewing lens. Flash sync. Tessar 75mm/f3.5, Compur Rapid shutter. \$100-150.

Ikoflex IIa (855/16, re-styled) - 1953-56. Features similar to the earlier IIa, but the peep windows are combined into one window above the viewing lens. Shutter and aperture set by wheels. Body design like the Favorite, but no meter. Tessar 75mm/f3.5; Synchro-Compur shutter. \$100-150.

Ikoflex III (853/16) - 1939-40. Only Ikoflex with huge Albada finder on front of viewing hood (like Contaflex TLR). Crank advances film and winds shutter. Tessar

80mm/f2.8. Compur Rapid $1-1/_{400}$ or $1/_{500}$. in LIKE NEW condition has brought \$1000-1500. MINT: \$400-600. EXC condition most common: \$250-375.

Ikoflex Favorit (887/16) - 1957-60. Last of the Ikoflex line. Tessar 75mm/f3.5. Synchro Compur MXV to 1/500. Built in LVS exposure meter. Cross-coupled shutter and aperture set by wheels. MINT has brought \$600-900. EXC+: \$300-450. AVERAGE:\$175-250.

Ikomatic A (10.0552) - 1964-65. Inexpensive square-looking 126 cartridge cámera. "Ikomatic A" on lower front. Color Citar 45mm/f6.3 lens. Shutter 1 /₉₀ for daylight, 1 /₃₀ for flash. Built in electric eye exposure control. Hot shoe. \$20-30.

Ikomatic F (10.0551) - 1964-65. Same general appearance as the "A", but has Frontar zone focus lens. No exposure control. Built-in pop-up reflector for AG-1 bulbs on top of camera. "Ikomatic-F" on lower front. \$20-30.

Ikonette (504/12) - 1929-31. Small rollfilm camera for 127 film. Frontar 80mm/f9. Self-cocking shutter. The whole back comes off to load the film. There were at least 2 variations in the body catch mechanism. \$50-75.

Ikonette 35 (500/24) - c1958. A unique 35mm camera (for Zeiss) made entirely of grey high impact plastic. Body is curved into a kidney shape and a single lever on the front winds the film, advances the counter, and cocks the shutter on a long stroke. The same lever then releases shutter on a short stroke. Red flag appears in the viewfinder when the shutter is cocked. Two-tone grey and blue plastic case with name on front available (1256/24). Reportedly, the camera suffered problems with light leaks, so Zeiss gathered and destroyed many of them. \$45-60.

Ikonta cameras - 1929-56. Early models also known as Ikomats in the U.S.A. All had front cell focus lenses.

Ikonta (**520/14**) - 1931. 5x7.5cm. With Tessar 80mm/f4.5 in Compur shutter: \$50-75. With Novar 80mm/f6.3 in Derval shutter: \$45-60.

Ikonta (520/18) - 3x4cm rollfilm. Referred to as "Baby Ikonta". Tessar 50mm/f3.5 (1936): \$250-375. Novar 50mm/f3.5 (1936): \$120-180. Novar f6.3, f4.5 or Tessar f4.5 (1932): \$90-130.

Ikonta A (520) - 1933-40. 4.5x6cm on 120 film. Compur shutter. Can reach \$150-225 at auction. Normal range with Tessar 80mm/f3.5: \$75-100. With Novar 80mm/f4.5:\$45-60.

Ikonta A (521) - c1940's. 4.5x6cm size. With Tessar 75mm/f3.5 in Compur Rapid or Synchro Compur shutter: \$100-150. With 75mm Novar f3.5 or f4.5 in Prontor or Compur: \$45-60.

Ikonta B (520/16) - 1937-39. For 12 exposures 6x6cm on 120. With Tessar 75mm/f3.5 in Compur Rapid: \$100-150. With 75mm Novar f3.5 or f4.5 in Compur or Klio shutter: \$50-75.

Ikonta B (521/16) - 1948-53. Similar to the 520/16, but with chrome lens mount and more chrome trim. Rare with Opton Tessar 75mm/f3.5: \$120-180. With Novar f3.5: \$50-75. With Novar f4.5: \$45-60.

Ikonta B (523/16) - 1954-56. (Also called Ikonta II and IIb). Similar to the 520/16 and 521/16, but with chrome top housing with non-folding finder. Opton Tessar or Novar f3.5. Prontor SV or Synchro Compur shutter. Uncommon. \$175-250.

Ikonta B (524/16) Mess-Ikonta - 1954-56. Built in uncoupled rangefinder. With Tessar 75mm/f3.5 in Synchro Compur: \$120-180. With 75mm Novar f3.5 or f4.5 in Prontor SV shutter: \$75-100.

Ikonta C (520/2) - 1930-40. 6x9cm on 120. With 105mm lenses: Tessar f4.5: \$60-90. Tessar f3.8 (1936-37 only): \$60-90. Novar f6.3: \$35-50. Simplest version has Frontar lens in simple IBT shutter. \$30-45.

Ikonta C (521/2) - Postwar. With Tessar 105mm/f3.5: \$75-100. With Novar f3.5 or f4.5: \$45-60.

Ikonta C (523/2) - 1950-56. Heavy chrome trim at top. Uncommon. With 105mm Tessar f3.5, Novar f3.5: \$120-180. With Novar f4.5 lens: \$100-150.

Ikonta C (524/2) - 1954-56. Like the 523/2 but with built in uncoupled range-finder. With Tessar: \$150-225. With Novar f4.5 or f3.5: \$75-100.

Ikonta D (520/15) - 1931-39. Ikomats seem to be more common in this size than Ikontas. Early versions for 116 film, later for 616 film. With Tessar 120mm/f4.5 in Compur: \$75-100. With 120mm Novar f4.5 or f6.3 in Derval shutter: \$35-50.

Ikonta 35 (522/24) - 1949-53. Folding 35mm with central door and very rigid front standard. 45mm Novar f3.5, Tessar f2.8, or Xenar f2.8 (1949-51 only). "Ikonta" in leather on back. Later models had accessory shoe. \$45-60.

Juwel (275/7) - 1927-38. 9x12cm plate camera. Superb quality, all metal, leather covered with rotating back. Rising/falling, shifting/tilting front. Pop-off backs. Triple extension by means of two rack-and-pinion knobs on folding bed; one moves back and front, one moves lens standard. Interchangeable bayonet lenses. "Juwel" or "Universal Juwel" on or under the handle. Price depends on condition and lens. \$400-600.

Juwel (275/11) - 1927-39.13x18cm. As above, but lens interchanges with aluminum "board". Was used extensively by Ansel Adams. With a Triple convertable Protar, this was Zeiss's most expensive camera throughout the prewar years. Quite rare, still usable. With Tessar 210mm/f4.5: \$500-750. With Protar: \$600-900.

Kolibri (523/18) - 1930-35. Compact camera, 16 exposures 3x4cm on 127 film. "Kolibri" below lens in leather. Lens extends for picture taking on brightly polished chromed tube. Came with unique shaped case in brown or black. Looking at hinge on right side of open case is a screw in "foot" which is inserted in lens mount for vertical still pictures. Uses 50mm lenses. With Telma shutter- Novar f4.5: \$150-225; Novar f3.5, rare: \$175-250. With Rimset Compur shutter- Tessar f3.5, most com-

mon: \$200-300; Tessar f2.8, rare: \$300-450; Biotar f2, super rare (called "Night Kolibri"): \$800-1200. Microscope version with no lens/shutter, very rare: \$250-375.

Kosmopolit - 1927-34. Wood double extension field camera with brass trim. Reversing back, vertical and horizontal front movements (no swing). Tapered bellows. 5x7" (818, 818/11) or 7x91/2" (819, 818/20) size. Very seldom offered. \$250-375.

Liliput - 1927-28. Tiny strut folding plate camera. Celluloid focusing screen. Struts are inside the bellows. f12.5 lens. 4.5x6cm (361) or 6.5x9cm (370). \$120-180.

Lloyd (510/17) - 1926-31. Black leather covered folding rollfilm camera, can also take 9x12cm cut film. Ground glass focusing by sliding out a back cover plate. "Lloyd" in leather on front. Tessar 120mm/f4.5in Compur. \$45-60.

Maximar A (107/1, 207/3) - 1927-39. 6.5x9cm folding plate camera. Slide in holders. "Maximar" on or below handle in leather. 105mm Tessar or Preminar Anastigmat f4.5 in Compur. Uncommon with green leather: \$200-300. Black: \$75-100.

Maximar B (207/1, 207/7) - 1927-39. Similar to the "A", but for 9x12cm. Tessar 135mm/f4.5 in Compur, or 135mm Novar f6.3 or Dominar f4.5 in Klio. \$75-100.

Maximar (207/9) - 1927-37. Similar, but 10x15cm. Tessar f4.5/165mm in Compur. Rare. \$75-100.

Miroflex A (859/3) - c1930-36. Folding 6.5x9cm SLR plate camera. Focal plane shutter 3-2000. Can be used as a press camera by leaving the mirror up, focusing hood folded, and using the wire finder. "Miroflex" in leather on front. With Tessar 145mm/f2.7, 135mm/f3.5 or Bio Tessar 135mm/f2.8: \$300-450. With Tessar 120mm/f4.5:\$300-450.

Miroflex B (859/7) - c1927-36. Similar

to the "A", but 9x12cm. More common than the 6.5x9cm size which was introduced later. Exists with Contessa Nettel markings on some parts as it was introduced about the time of the merger. With 165mm Tessar f3.5, f2.7, or Bio Tessar f2.8: \$250-375. With Tessar f4.5: \$250-375.

Nettar 515/2

Nettar - Bob (510) was known as the Nettar (510) in England. Inexpensive folding rollfilm cameras. "Nettar" on leather. 1937-41: 4.5x6cm (515), 6x6cm (515/16), and 6x9cm (515/2). 1949-57 (Fancier style with body release and chrome top): 6x6cm "Signal Nettar" also called II(b) = (518/16) and 6x9cm (517/2) or IIc (518/2). With Tessar: \$35-50. With Novar or Nettar lens: \$30-45.

Nettax (538/24) - 1936-38. 35mm. Basic body is the same as the Super Nettel II, but there is no folding bed and bellows. Rotating rangefinder window attached to interchangeable lens. Focal plane shutter to 1000. With Tessar 50mm/f2.8, rare: \$750-1000 clean & working; \$400-600 with inoperable shutter. With Tessar 50mm/f3.5, rarest: add \$100-150. For additional Triotar 105mm/f5.6 lens, add \$400-600.

Nettax (513/16) - 1955-57. Folding 6x6cm rollfilm camera. Chrome top. Built in uncoupled exposure meter. Novar 75mm/f4.5, Pronto shutter. \$75-100.

Nettel - 1929-37 (some sizes discontinued before 1937). "Nettel" below the focal plane shutter winding/setting knob. Black leather covered press camera. 4.5x6cm (870), 6.5x9cm (870/3), 9x12cm (870/7), 10x15cm (870/9), 5x7" (870/11) sizes, with the 9x12cm being the most common. \$50-150.

Nettel, Tropen (Tropical) - Focal plane press camera made of polished teak with brown leather bellows. 6.5x9cm (871/3), 9x12cm (871/7), 10x15cm (871/9), 5x7" (871/11) sizes. A very nice clean 10x15cm outfit with three teak plateholders, teak FPA and case reached \$1200 at auction in July 1988. A more typical range for camera only: \$600-900. Illustrated at top of next column.

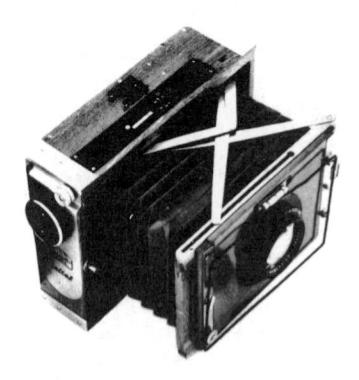

Nettel, Tropen

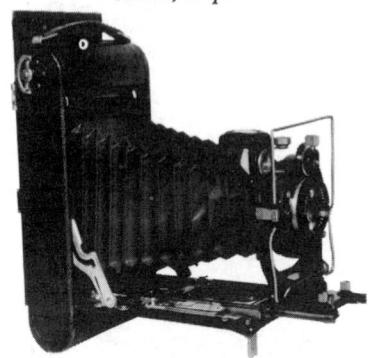

Nixe - 1927-34. High quality double extension folding cameras. "Nixe" on handle or in body leather. Dominar, Tessar, or Double Protar lens. 551/17 for 8x10.5cm rollfilm or 9x12cm cut film; 551/6 for 8x14cm rollfilm or 9x14cm cut film. \$75-100.

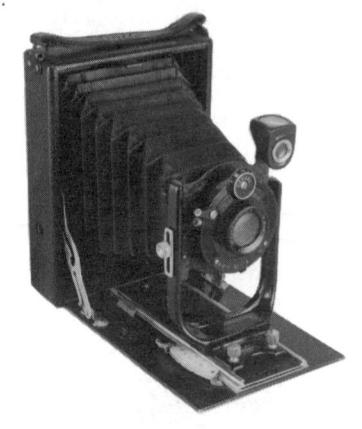

Onito - 1927-29. Inexpensive single extension folding plate cameras. Novar f6.3 lens, lever focus. 6.5x9cm (126/3) or 9x12cm (126/7). Uncommon. Several in top condition have sold at auction for \$90-130. Normal range \$45-60.

Orix (308) - 1928-34. Quality double extension folding camera, 10x15cm plates. (Special spring back model also made.) Rack-and-pinion focus. Usually seen with Tessar 150mm/f4.5lens. \$75-100.

Palmos-O - 1927-28. 4.5x6cm plate camera with struts and folding door. Sold in Europe in 1927 only as the "Minimum Palmos". High-speed Tessar f2.7/80mm lens. Focal plane shutter 1/50-1/1000. Rare. \$500-750.

Perfekt - c1927-31. Double extension, polished mahogany view camera. Tapered bellows. Vertical and horizontal front movements. Sizes 5x7" (834, 834/11, 835, 835/11) and 18x24cm (836, 837, 834/20, 835/20). Usually without model name on camera, but with "Zeiss-Ikon" round metal plate. Very rare. No active trading exists. Infrequent sales records indicate prices in \$300-450.

Piccolette (545/12) - 1927-30 in Germany, 1927-32 in the U.S.A. Inexpensive all metal strut camera for 4x6.5cm on 127 film. Metal front pulls out for use. "Piccolette" below lens, "Zeiss-Ikon" above. Rare with Tessar 75mm/f4.5 lens: MINT: \$300-450. EXC: \$200-300. More common with Achromat f11, Novar f6.3: \$75-100.

Piccolette-Luxus (546/12) - 1927-30. Deluxe model with folding bed and lazy tong struts. Brown leather covering and bellows. 75mm Dominar or Tessar f4.5 lens, dial-set Compurshutter. \$250-375.

Plaskop - 1927-30. Stereo box cameras. **602/1 -** 45x107mm. "Plaskop" under left lens (viewed from front). f12 lenses. No brilliant finder. \$120-180.

603/1 - 45x107mm. "Plaskop" in oval on left (viewed from front). Better model than the 602/1, with Novar f6.8/60mm lenses. No brilliant finder. \$175-250.

603/4 - 6x13cm. Like the 603/1, but a larger size. Brilliant finder in top center. \$250-375.

Polyskop - 1927-30. Precision stereo box cameras. Black leather covering. Septum magazine for 12 plates. Brilliant finder in top center. Tessar f4.5 lenses in Compur dial set stereo shutter. 45x107mm (609/1), or 6x13cm (609/4). \$250-375.

Simplex (112/7) - 1928-30. Inexpensive folding camera for 9x12cm plates. "Simplex" in leather under handle. "Zeiss Ikon" under lens on front of front standard. Frontar 140mm/f9 or Novar 135mm/f6.3. \$45-60.

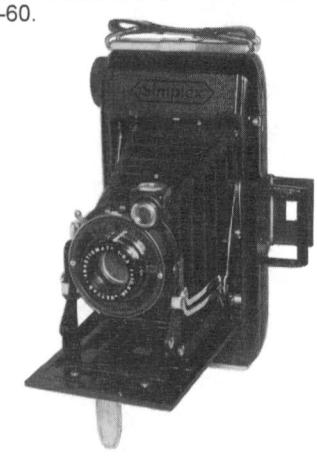

Simplex (511/2) - 6x9cm brown plastic rollfilm camera. "Simplex" on body. Several variations of struts and hardware exist. Nettar 150mm/f6.3 in Telma or Derval shutter. \$75-100.

Simplex-Ernoflex - SLR. "Ernemann" on side in 1927-29 version, "Simplex Ernoflex" over lens from 1930-on. Ernoplast f4.5 or f3.5, Ernon f3.5, or Tessar f4.5 lens. Helical focusing. Focal plane shutter 20-1000. 4.5x6cm (853), 6.5x9cm (853/3), or 9x12cm (853/7). Rare. 4.5x6cm size: \$750-1000. 6.5x9cm or 9x12cm size: \$250-375.

Sirene - Inexpensive folding plate camera. "Sirene" under handle. 1927: 6.5x9cm (135/3), 9x12cm (135/7- this number was later used on Volta). 1930-31: 8x10.5cm (135/5) made for the American market. Dominar 135mm/f4.5 lens. Compurshutter. Rare. \$50-75.

SL-706 (10.3700) - 1972-73. An improved version of the Icarex. "SL-706" identification on body at 11 o'clock direction from the Iens. Zeiss Ienses. Open aperture metering. These cameras were remaindered out by Cambridge Camera at \$257, with case, and most are seen in mint condition. (The identical camera was later produced in Singapore under the name Voigtländer VSL-1.) With Ultron f1.8 Iens: \$250-375.

Sonnet - 1927-30. Teakwood folding plate camera. Brown leather covering on door and brown bellows. "Sonnet" inside door at front. Radial lever focusing. Dominar or Tessar f4.5, or Novar f6.3 lens. Originally came with 3 German silver film holders. 4.5x6cm (303) or 6.5x9cm (303/3): \$450-700.

Stereax, 6x13cm - c1926-28. Strutfolding focal plane stereo camera, a continuation of the Stereax from Contessa-Nettel. Left lensboard may be reversed for use as panoramic camera. Tessar 90mm/f4.5 lenses. Focal plane shutter 1/10-1200. Rare with the Zeiss name. One sold at auction in Germany in 3/86 for \$750 in nearly mint condition with original box. We have no recent sales on record.

Stereo-Ernoflex (621/1) - 1927-29. Top quality folding stereo. Door on hood extends across entire top of camera. 75mm Ernotar f4.5, Ernon or Tessar f3.5 lenses. Focal plane shutter $1/20^{-1}/1000$. \$1200-1800. (Illustrated on p.189 under Ernemann.)

Stereo-Simplex-Ernoflex (615/1) - 1927-1930. Medium quality non-folding stereo box camera. "Ernemann" on front between lenses. Reflex viewing hood cover occupies half of the top of the camera, the other half has a pop-up frame finder. 75mm Ernon f3.5 or Tessar f4.5/75mm or 80mm lenses. Focal plane shutter. \$750-1000. (Illustrated on p.189 under Ernemann.)

Stereo Ideal (651) - 6x13cm folding plate stereo camera, black leather covering. Identified on the handle. 1927 version with dial-set Compur shutters, 1928 version with Compound shutters. Tessar 90mm/f4.5.\$250-375.

Stereo Ideal (650) - Similar to 651, but larger 9x18cm size for films. Compur; Tessar 120mm/f4.5lenses. \$300-450.

Stereo Nettel - 1927-30. Scissors strut stereo cameras. Black leather covering. Knob focus. Tessar f4.5 lenses. Focal plane shutter. Wire finder. Removable roller blind inside separates the two images, or allows for full frame use. 6x13cm (613/4): \$300-450. 10x15cm (613/9): \$250-375.

Stereo Nettel, Tropical - Same as the Stereo Nettel, but in teakwood with brown bellows. 6x13cm (614/4) or 10x15cm (614/9). \$750-1000.

Stereolette-Cupido (611) - 1927-28. 45x107mm folding plate stereo camera. Black leather covering. "Stereolette-Cupido" on handle, "Stereolette" on outside of door. \$250-375.

Steroco (612/1) - 1927-30. Stereo box camera for 45x107mm plates. Tapered shape. Leather covered. "Steroco" on upper front, "Zeiss-Ikon" below. Tessar 55mm/f6.3 lenses. Derval or Dial-set Compurshutter. Rare. \$300-450.

Suevia - c1926-27. Folding-bed camera for 6.5x9cm plates. Nostar f6.8 or Contessa-Nettel Periskop f11 lens in Derval 25-100 shutter. Uncommon. \$45-60.

Super Ikonta Series - Top quality black leather covered folding rollfilm cameras, with rangefinder of the rotating wedge type gear coupled to front cell focussing lens. The early cheaper lens models were sometimes called "Super Ikomat" before WWII in the U.S.A. Introduced in 1934, they were continued in gradually improving forms until 1959 or 1960. The most recent models with MX sync have increased in value because they have been rediscovered as usable cameras... a lower cost nostalgic alternative to such modern cameras as the new folding Plaubel Makinas.

Super Ikonta A (530) - 1934-37. 16 exposures 4.5x6cm on 120 rollfilm. Usually seen with Tessar 70mm/f3.5 uncoated lens. No sync. Body release from 1935-37. Direct finder (not Albada). \$150-225.

Super Ikonta A (531) - 1937-50. Same as the above, but with body release, Albada finder, and double exposure prevention. Usually found with 75mm Tessar f3.5 lens. Novar f3.5 lens is rare. Produced with Schneider Xenar in 1948. No sync. \$150-300.

Super Ikonta A (531) - 1950-56. Chrome top. Normal lens is Tessar 75mm/f3.5. Compur Rapid, X sync, until 1952; later MX sync; and finally Synchro Compur. The latest model with Synchro Compur is increasing in demand as a usable camera. Asking prices \$1500+ in Tokyo for a mint example. Mint with MX sync will sell for \$750-1000 in USA. EXC: \$350-500. Compur Rapid model: \$250-375

Super Ikonta B (530/16) - 1935-37. 11 exposures 6x6cm on 120. Separate rangefinder/viewfinder windows. 80mm f2.8 or (rarely) f3.5 Tessar. Compur Rapid to 400. No sync. Lens/shutter housing black enameled. Some of the earliest say "Super Ikomat" on the door. GERMANY: \$200-300. USA: \$150-225. In 1936 a model was produced in meters with European tripod socket and "Super Six 530/16" on the back of the camera and front of the ER case. These are rare, but only a modest premium seems obtainable.

Super Ikonta B (532/16) - 1937-56. Single window range/viewfinder. Lens/shutter housing in black enamel through 1948, chrome after 1948. "Super Ikonta 532/16" in back leather. Tessar

80mm/f2.8. Compur Rapid shutter, no sync to 1951. Synchro Compur shutter, MX sync 1951-on. (Some Compur Rapid models c1951 have X sync.) Synchro Compur: \$250-375. Compur Rapid: \$150-225

Super Ikonta BX (533/16) (early) - 1937-52. Uncoupled exposure meter. 12 exposures 6x6cm on 120. Double exposure and blank exposure prevention. "Super Ikonta- 533/16" in leather on back. Tessar 80mm/f2.8 in Compur Rapid to 400. Exposure meter in DIN or Scheiner before 1948, ASA after 1948. \$120-180.

Super Ikonta BX (533/16) (later) - 1952-57. Uncoupled exposure meter in chrome and lower profile than the 1937-52 type. "Super Ikonta 533/16" on back. Synchro Compur MX shutter to 500. Coated Tessar or Opton Tessar lens. \$250-375.

Super Ikonta III (531/16) - 1954-58. A redesigned "B" with no exposure meter. Smaller than the "B". No "front window" at lens for rangefinder. Synchro Compur MX shutter to 500. 75mm Novar or Opton Tessar (until 1956) f3.5. Tessar: \$200-300. Novar: \$150-225.

Super Ikonta IV (534/16) - 1956-60. Like the III, but with built in exposure meter using the LVS system (where you lock in a guide number on shutter, after which shutter and diaphragm settings move together). "534/16" in leather on back by latch. Tessar 75mm/f3.5 only. (During 1983, KEH Camera sold off NEW Super Ikonta IV's for \$395.) \$300-450.

Super Ikonta C (530/2) - 1934-36. "Super Ikonta" or "Super Ikomat" in leather on front. "530/2" in back leather by hinge. 6x9cm format. Black enamel finish, nickel plated fittings. No body release. Triotar 120mm/f4.5 in Klio shutter, or 105mm Tessar f4.5 or f3.8 in Compur to 250 or Compur-Rapidto 400. \$120-180.

Super Ikonta C (531/2) - 1936-50. Chrome front on RF. "531/2" in leather by back hinge. Albada finder. Body release, double exposure prevention. Tessar 105mm f3.8 until 1938, f4.5 or f3.5 after 1938. Compur to 250, or Compur-Rapid to 400. Some have single ruby window for 6x9cm only, others have two rear windows for 6x9cm or 4.5x6cm. \$200-300.

Super Ikonta C (531/2) - 1950-55. "531/2" in leather by back latch. Double exposure and blank exposure prevention. Tessar 105mm/f3.5. (Rare with 106mm Opton Tessar f3.5). Compur Rapid, X sync, or Synchro Compur, MX sync. This model is both a usable and collectable and many are sold in Japan. MINT with MX sync: \$750-1000.EXC+\$400-600.

Super Ikonta D (530/15) - 1934-36. "Super Ikomat" or "Super Ikonta" in front leather. "530/15" in leather by back hinge. Black enamel on rangefinder. 6.5x11cm on 616 film, mask for 1/2-frame (5.5x6.5cm). Flip-up mask in viewfinder for 1/2-frame. No body release. 120mm Tessar f4.5 in Compurto 250, or Triotar (rare) f4.5 in Klio shutter 5-100. \$175-250.

Super Ikonta D (530/15) - 1936-39. "530/15" by back latch. Bright chrome on front of viewfinder. Albada viewfinder with 1/₂-frame marks. Body release. No double exposure prevention. Compur to 250 or Compur Rapid to 400. No sync. \$175-250.

Super Nettel (536/24) - 1934-37. 35mm folding bellows camera. Black enamel and leather. "Super Nettel" in leather on door. Focal plane shutter 5-1000. 1934-36, 50mm Tessar f3.5 or f2.8 lens; 1935-37, Triotar f3.5. \$300-450.

Super Nettel II (537/24) - 1936-38 Similar to the first model, but with polished chrome door and matte chrome top. Tessar 50mm/f2.8. Reportedly less than 2000 made. \$750-1000.

Symbolica (10.6035) - 1959-62.35mm viewfinder camera. Coupled match needle exposure meter. "Symbolica" on top. Tessar 50mm/f2.8, front cell focus. \$45-60.

Taxo (126/7)

Taxo - Inexpensive folding plate camera, single extension. "Taxo" on body under 105mm/f11, handle. Periskop Novar 105mm or 135mm f6.3, Frontar, or Dominar lens. Derval shutter. Two variations:

1927-31 - Focus by sliding front standard on track, 6.5x9cm (122/3) or 9x12cm (122/7). \$50-75. 1927-30 - Focus by radial lever, 6.5x9cm

(126/3) or 9x12cm (126/7), \$50-75

Tenax - 1927. Popular strut-folding plate cameras. "Tenax" or "Taschen Tenax" on front or top. These appear to be clean-up items which were never actually manufactured by or marked "Zeiss Ikon". 4.5x6, 6.5x9, and 45x107mm (stereo) sizes. Various lenses. \$120-180.

Tenax I (570/27) - 1930-41. 35mm camera for 50 exposures 24x24mm on a 36 exposure roll. "Tenax" under lens. No rangefinder. Novar 35mm/f3.5 lens. Compur shutter, cocked and film advanced by left-hand lever. \$60-90.

Tenax I (East Germany) - c1948-53. This model was made by the East German "VEB Zeiss Ikon" which later became "VEB Pentacon" after settlement of the trademark disputes. Like the 570/27, but also available with coated Tessar 37.5mm/f3.5 lens. Flash sync contact on top of shutter. "Zeiss Ikon" above lens, "Tenax" below. Early versions, c1948, have Compur shutter. Later with unmarked Tempor shutter. Originally with folding optical finder and folding advance layer. New top house and folding advance lever. New top housing, c1953, with incorporated optical finder. Advance lever has solid metal knob. Common in Germany. \$60-90.

Tenax II with Contameter
Tenax II (580/27) - 1937-41. More expensive and earlier version with coupled rangefinder, interchangeable lenses, and shoe for viewfinders and contameter (1339). Most often found with Tessar 40mm/f2.8: \$300-450. With Sonnar 40mm/f2: \$300-450.

Tenax II Accessories:

2.7cm Orthometar f4.5 - Wide

angle lens. \$400-600.

- 7.5cm Sonnar f4 - Telephoto lens \$400-600.

Contameter (1339) - Close-up rangefinder for focusing at 8", 12", and 20". \$90-130

Tenax Automatic (10.0651) - 1960-63. Full frame 35mm. "Tenax" at 11 o'clock from lens on exposure meter window. Automatic exposure control by selenium cell. No rangefinder. Tessar 50mm/f2.8 in Prontormat-S shutter. Front cell focus. Metal parts plated in shiny or dull chrome. \$35-50.

Tengoflex (85/16) - 1941-42. Box camera for 6x6cm exposures on 120 film. "Tengoflex" on front. Large brilliant finder on top, giving the appearance of a twin lens reflex. Extremely rare. Several sales 1974-81 in the range of \$300-450. One sale at 9/86 auction for \$675. Recent sales and offers in the \$300-900 range. You be the judge.

Tessco (76/1) - 1927. Double extension 9x12cm folding plate camera. "Tessco" in leather of handle. Seen with 1 of 5 different lenses, from Periskop f11 to Tessar f4.5. Rare. \$75-100.

Toska (400) - c1927. Triple extension, horizontal, folding bed camera for 13x18cm plates. Litonar 180mm/f6.8 in Cronos B shutter. \$200-300.

Trona (210 series) - 1927-30. Quality folding plate camera, double extension, screw controlled rise and shift. "Trona" and model number under handle. Dominar or Tessar f4.5 lens. 9x12cm (210/7): \$50-75. 6.5x9cm (210/3) or 8.5x11cm (210/5): \$75-100. The 8.5x11cm (210/5) was apparently made for the English and American market for use with $31/4 \times 41/4$ " film. This size is rare; no recorded sales.

Trona (212/7) - c1928-36. 9x12cm folding plate camera similar to the 210 series. Tessar lens, Compur shutter. \$60-

Trona (214 series) - 1929-38. A fancier version, with aluminum ground glass back (frequently exchanged for a regular back). Tessar f3.5 lens in Compur shutter (rimset after 1930). "Trona" and model number on body under handle. 6.5x9cm (214/3): \$100-150. 9x12cm (214/7): \$75-100. (Slightly less for f4.5 models.)

Tropen Adoro - 1927-36. Polished

teak, folding plate camera. Brown leather covering on door and back. Brown double extension bellows. "Tropen Adoro" and model number on leather of door. Tessar f4.5 lens, Compur shutter. Sizes: 6.5x9cm (230/3), 105 or 120mm lens. 9x12cm (230/7), 135 or 150mm lens. 10x15cm (230/9), 165 or 180mm lens. Has reached \$1400 at auction. Normally \$600-900.

Tropica - 1927-31 (to 1935 in foreign catalogs). A heavy polished teak folding plate camera, the second most expensive camera in 1930 Zeiss line. Strongly reinforced with German silver corners and battens. No leather anywhere on the outside, even the door on the ground glass back is teak. Black bellows. Back rotates 1/4 turn. "Zeiss-Ikon" between pull knobs on front stand. 14 different lenses available, all in Compur shutter. Sizes 9x12cm (285/7) and 10x15cm (285/9) are both rare. The 5x7" (285/11) is VERY rare. Sales records are hard to find. Estimate: \$1000-1500.

Unette (550) - 1927-30. Wood box camera, with leatherette covering. For paper-backed rollfilm, 22x31mm. "Unette" on front in leatherette over lens, "Zeisslkon" over lens, "Ernemann" on side. Metal frame finder at top rear. 40mm/f12.5 lens. Very rare. Only one known sale in 1980 at \$225.

Victrix (101) - 1927-31. Small folding plate camera for 4.5x6cm. "Victrix 101" in leather on camera top. "Zeiss Ikon" on lens, between pulls, and on door. 75mm Novar f6.3, Dominar f4.5, or Tessar. Compurshutter. \$120-180.

Volta - 1927-31. Inexpensive folding plate cameras. Single extension. "Volta" on body under handle, "Zeiss Ikon" on door. Dominar or Tessar lens, Klio or Compur shutter. Radial arm focusing in 6.5x9cm (146/3) or 9x12cm (146/7).

Focusing by slide front standard in 6.5x9cm (135/3) or 9x12cm (135/7). (10x15cm and 13x18cm sizes were sold in 1926/27 as clean up of old stock on hand at the time of the union.) Voltas are not common.\$45-60.

ZENITH CAMERA CORP.

Comet - c1947. Plastic camera for 4x6cm on 127 film. Vertical style. Telescoping front. \$12-20.

Comet Flash - c1948. Plastic camera with aluminum top and bottom. 4x6cm on 127, \$12-20.

Sharpshooter - c1948. Black & silver metal box camera. Identical to the J.E. Mergott Co. JEM Jr. \$12-20.

Vu-Flash "120" - Hammertone finished 6x9cm box camera. \$12-20.

ZENITH EDELWEISS - Folding rollfilm camera for 6x6cm on 620 film. \$20-30.

ZENITH FILM CORP. Winpro 35, Synchro Flash - c1948. Gray plastic 35mm. f7/40mm. \$20-30.

ZENZA (Tokyo) Named for Zenzaburo Yoshino, the company founder. Original camera designs and prototypes of the mid-1950's resulted in the first Bronica camera in late 1958. Although even the older Bronica cameras fit into the "user" category, they are not considered reliable by today's standards. Users generally try to avoid the D, S, S2, C, and C2 models. Since some of them are already 30 years old, perhaps we collectors should begin to retire a few of them. These prices are competitive with the user market for clean, working examples. Non-working examples often sell for much less, as they are impractical to repair for further use.

Bronica D (Deluxe) - c1958. The first

Bronica D (Deluxe) - c1958. The first Bronica, an SLR for 6x6cm on 120 film. Outward styling is similar to the Hasselblad, but it is not a "copy" (as are some Russian cameras). Indeed, it was very highly rated and immediately recognized as a very innovative design. One of the novel and useful design features was a mirror which flipped down, rather than up. This allowed the use of deep-seated wide angle lens designs. A single large knob controls shutter tensioning, film advance, and focusing. Interchangeable film backs, automatic diaphragm with instant reopening. Nikkor-H f2.8/7.5cm normal lens. Clean and working: \$300-450.

Bronica S - c1961. Replaced the D. Revised body style looks fully Bronica, with less resemblance to Hasselblad. Can be distinguished from D by wider chrome corners, separate but coaxial focus and advance control (folding advance crank in middle of focus knob). Independent mirror release button on bottom below shutter release. Removable film magazine with hinged back allows loading on or off camera. Shutter B,1-1000. With Auto-Nikkor f2.8/75mm normal lens & back, clean and working: \$250-375.

Bronica C, C2 - 1965. Introduced helical focusing. This removable helicoid focusing mount became the standard for Bronica until the introduction of the leaf-shuttered ETR camera. The original C was quickly replaced by C2, which allows 120 or 220 film. C & C2 do not have interchangeable backs; take removable film inserts. Clean and working: \$250-375.

Bronica S2 - 1965. Introduced shortly after the C as an upscale model with interchangeable backs. Features are similar to the S, but with removable focusing helix instead of rack & pinion. New backs allow use of either 120 or 220 film. Interchangeable film inserts available in two formats: 6x6cm 12 or 24 exposures or 4.5x6cm 16 or 32 exposures. Black or chrome body. With normal lens, clean & working: \$250-375.

Bronica \$2A - c1971. A more robust version of the \$2. Externally the only difference is a smaller, flatter advance knob with a black crank, and the model number next to the serial number. Internally, the advance mechanism has been strengthened with steel gears, larger polished teeth, and a slip clutch to prevent gear damage which plagued the earlier models. Interchangeable backs with removable film inserts. Focusing screens, magnifiers and lenses are interchangeable with the C and \$2.\$300-450.

Bronica EC - c1972. A completely new body design, incorporating an electronically controlled shutter. Split mirror, most of which flips up while a small part flips down. Optional electronically coupled meter finder. Slightly larger and heavier than the S2A. Backs and finders not interchangeable with earlier models, but the removable bayonet lens mount was retained, allowing use of earlier lenses. \$300-450.

Bronica EC-TL - c1975. Outwardly similar to the EC, but with fully automatic aperture-priority metering system built into the body. Silicon blue cells mounted behind semi-transparent mirror give center-weighted metering. A third cell measures the light from the finder screen to eliminate its effect on exposure readings. Removable focusing helix compatible with

earlier models; uses any lenses to date except the 105mm leaf-shutter Nikkor. Backs compatible with EC. With standard lens: 75mm f2.8 Nikkor PC. \$400-600.

Bronica ETR - 1976. A radically new Bronica for 4.5x6cm format. Each lens has a leaf shutter, electronically controlled from the body. An accessory speed grip with lateral advance lever and a prism finder make the camera handle more like a 35mm than a typical medium format camera. Interchangeable 75mm f2.8 Zenzanon MC lens; interchangeable magazine backs; interchangeable finders. Accepts motor drive. Body: \$175-250.

Bronica ETRC - c1978. A lower-priced version of the ETR. Esentially the same except that it does not have interchangeable backs. Takes interchangeable film inserts, but not Polaroid or 70mm backs. Finders, motor drive and other accessories same as ETR. Body: \$150-225.

Bronica ETRS - c1979. Refined version of the ETR. Simplified lens removal control, strap lugs redesigned; AE finder contacts gold plated; other minor improvements. Same interchangeable lenses and accessories. Body: \$200-300.

Bronica ETRSi - c1988. Current model featuring TTL OTF flash metering. It will accept lenses, backs, and finders from your 1976 ETR, but this new body is definitely more usable than collectible. See your local dealer.

Bronica SQ - 1980. Practically speaking, this model is a bit new for our collector's guide. Historically, however, it marks the end of an era for Bronica. For 22 years, Bronica used only focal plane shutters in their 6x6cm cameras. When Hasselblad returned to using focal plane shutters with their 2000FC. Bronical plane shutters with their 2000FC, Bronica's advertising adopted an "I told you so" attitude. Ironically, within a few short years, Bronica introduced the very successful leaf-shuttered ETR series for 4.5x6cm. Then in 1980, they expanded the leaf shutter concept to their 6x6 cameras with the SQ series. Gone is the oft flaunted instant return mirror, sacrificed for the advantages of the electronically controlled Seiko leaf shutter. The SQ series continues with SQ-A, SQ-A/M, and SQ-Ai. All of these machines are too usable to sit on a shelf and gather dust, so collector values are not an issue. It is not the purpose of this guide to give values for recent usable equipment.

BRONICA LENSES - As the Bronica system evolved, the lens mounts and specifications changed. We have listed Bronica lenses by the models they were intended to fit. In most cases there is a physical change in the mount and/or appearance of the lens. From a collector's viewpoint, the lens should be not only of the proper mount, but also should be of the correct age. The following list groups "compatible" lenses, but there may be minor variations when a similar lens spans several models.

Lens Mount Compatibility - Generally, we can divide Bronica cameras into the following groups, each of which shares the same mount. Early Bronicas include Models D, S. When the D was introduced, only three lenses were available. This range had expanded to 7 Nikkor lenses from 50-500mm by the introduction of the S in 1961. C/S2/EC series cameras introduced the removable focusing helix; includes models

S2, S2A, C2, EC, EC-TL. This new focusing mount retained the same bayonet flange, so all lenses are still interchangeable back to the first model D. Zenzanon E & PE lenses have leaf shutters, and fit the ETR, ETRC, ETRS, ETRSi cameras, which are 4.5x6cm format. Shutter speeds are electronically controlled by the body. The lenses mount with a new 4-claw bayonet, and have six gold-plated electrical contacts. Zenzanon S & PS lenses fit the SQ, SQ-A, SQ-A/M, SQ-Ai cameras. Zenzanon PG lenses fit the GS-1 camera.

Note: Early lenses are listed as "auto", "semi-auto", or "preset" indicating diaphragm operation. By the mid-1960's, all lenses had automatic diaphragms and are usually called "Auto-Nikkor" or Zenzanon" in advertising, although the word "Auto" is usually not engraved on the lens itself. Early lenses are marked in cm, not mm; we have listed all in mm, but made notes of some cm markings. Zenzanon "MC" lenses are multi-coated; some MC are not marked with their model type, usually for S2A/EC-TL or ETR series. PE and PS lenses are refined versions of the E and S series.

Nikkor Lens Codes: Nikkor lenses were standard equipment for Bronica cameras. The letter codes indicate the number of lens elements: U=1 B=2 T=3 Q=4 P=5 H=6 S=7 O=8 N=9 D=10

Prices listed below with "D\$" are the approximate discounted "street prices" when new. Mint used examples generally sell for similar prices.

Note: Most Bronica lenses and accessories are more usable than "collectible", so we will

leave pricing to your local dealer.

40mm f4 Nikkor-D (EC) - \$400-600. 40mm f4 Zenzanon MC (S2A/EC-TL) \$300-450.

40mm f4 Zenzanon MC E (ETR. ETRS) - D\$600.\$400-600 40mm f4 Zenzanon-PE (ETRSi) -\$550-800.

40mm f4 Zenzanon-PS (SQ-A) 40mm f4 Zenzanon-S (SQ) - D\$735. 45mm f4.5 Komura auto (C,S2) -\$250-350.

50mm f4.5 Zenzanon-PG (GS-1) -D\$860.\$600-800

50mm f2.8 Nikkor auto (EC) - \$175-

50mm f2.8 Komura auto (\$2A/ EC-TL)

50mm f2.8 Zenzanon MC (S2A/ EC-TL) - \$250-350.

50mm f2.8 Zenzanon MC E (ETR. ETRS) - D\$530.\$400-550.

50mm f2.8 Zenzanon-PE (ETRSi) 50mm f3.5 Komura auto (C,S2) -\$150-250

50mm f3.5 Nikkor-H auto (D,early) - marked 5cm. \$150-225. 50mm f3.5 Zenzanon-PS (SQ-A) -

\$2000-3000.

50mm f3.5 Zenzanon-S (SQ) -

D\$660. \$450-700. 50mm f4.5 Zenzanon-PG (GS-1) 55mm f4.5 Zenzanon-PCS (ETR..)

65mm f4.0 Zenzanon-PS (SQ-A) -

65mm f4.0 Zenzanon-PG (GS-1) -D\$690. \$450-700.

75mm f2.8 Nikkor-P auto (D,early) - marked 7.5cm. \$75-100. 75mm f2.8 Nikkor-P-C (EC-TL) -(multicoated), \$75-100.

75mm f2.8 Zenzanon MC (EC-TL) 75mm f2.8 Zenzanon MC E (ETR, ETRS) - D\$350.\$200-300. 75mm f2.8 Zenzanon-PE (ETRSi) -\$250-350

80mm f2.4 Zenzanon (MC) (S2A/ EC-TL) - \$50-75. 80mm f2.8 Zenzanon-S (SQ) -D\$500. \$250-350.

80mm f2.8 Zenzanon-PS (SQ-A) -\$400-550

100mm f2.8 Zenzanon auto (\$2A) -

100mm f2.8 Komura auto (C,S2) -\$100-150

100mm f3.5 Zenzanon-PG (GS-1) -D\$485. \$300-450

100mm f4.0 Macro Zenzanon E -D\$630. \$450-650.

100mm f4.0 Zenzanon-PE (ETRSi) 100mm f4.0 Zenzanon-PS (SO-A)

105mm f3.5 Nikkor with leaf shutter (S2,S2A,EC) - Built-in, fully synchronized leaf shutter, 1-1/₅₀₀. Not usable on EC-TL. \$250-400.

105mm f3.5 Zenzanon-E (ETR..) -

D\$460.\$350-500.

105mm f3.5 Zenzanon-S (SQ) -\$350-500.

110mm f4.0 Zenzanon-PG macro (GS-1) - D\$870. \$650-850. 110mm f4.0 Zenzanon-PS macro (SQ-A) - D\$795. \$600-800. 110mm f4.0 Zenzanon-S macro (SO)

135mm f3.5 Nikkor-Q, auto (D, early) - marked 13.5cm. \$150-225. 135mm f2.3 Komura (\$2,early) -\$100-150.

150mm f3.5 Komura auto (C, S2,S2A,EC-TL) - \$120-180. 150mm f3.5 Zenzanon MC (EC, EC-TL) - \$120-180. 150mm f3.5 Zenzanon-E (ETR..) -D\$530. \$450-550.

150mm f3.5 Zenzanon-PE (ETRSi) 150mm f3.5 Zenzanon-S (SQ) -D\$680, \$450-700.

150mm f4 Zenzanon MC (ETR,ETRS) \$350-450

150mm f4.0 Zenzanon-PG (GS-1) -D\$690.\$500-650. 150mm f4.0 Zenzanon-PS (SO-A)

180mm f2.5 Nikkor-H preset (D, early) - marked 18cm

200mm f3.5 Zenzanon (MC) (S2A/ EC-TL) - \$175-250.

200mm f3.5 Komura auto (C.S2) -

200mm f4 Nikkor-P auto (C, S2, early) - \$200-300.

200mm f4 Auto Komura (\$2A/ EC-TL) - \$100-150

200mm f4.5 Zenzanon-E (ETR..) -D\$640. \$500-700.

200mm f4.5 Zenzanon-PE (ETRSi) 200mm f4.5 Zenzanon-S (SQ) -D\$710.

200mm f4.5 Zenzanon-PG (GS-1) -D\$800. \$600-750.

200mm f4.5 Zenzanon-PS (SQ-A)

250mm f4 Nikkor-Q preset (D, early) - marked 25cm. \$200-300. 250mm f4 Zenzanon MC (ETR,ETRS)

ZENZA...

250mm f5.6 Zenzanon-E (ETR..) - D\$680, \$500-700.

250mm f5.6 Zenzanon-PE (ETRSi) 250mm f5.6 Zenzanon-S (SQ) D\$710.

250mm f5.6 Zenzanon-PG (GS-1) - D\$860.\$650-850.

250mm f5.6 Zenzanon-PS (SQ-A)

300mm f4.5 Auto Zenzanon (**S2**, early) - \$300-450. **300mm f5 Komura preset (C,S2)** - \$120-180.

300mm f5.6 Nikkor-P (EC-TL) - \$350-500.

350mm f4.5 Nikkor-T semi-auto (D,early) - marked 35cm. \$1700-2400.

400mm f4.5 Nikkor-Q (C,S2,EC,EC-TL) - Attaches to camera through accessory focusing mount which also contains automatic diaphragmsystem. \$350-500. **400mm f6.3 Komura preset (C,S2,S2A, EC-TL)** - \$250-350.

500mm f5 Nikkor-T preset (D, early) - marked 50cm. \$1500-2500. 500mm f7 Komura preset (C,S2) - \$250-350

500mm f8 Zenzanon-E (ETR..) - D\$1600.\$1200-1700.

500mm f8 Zenzanon-Ell (ETRSi) - Standard telephoto; black barrel.

500mm f8 Zenzanon-PE (ETRSi) - Two elements of low diffractive index and low dispersion glass; floating elements;

white barrel.
500mm f8 Zenzanon-PG (GS-1) -

D\$4800.\$3500-5000.

500mm f8 Zenzanon-PS (SQ-A) - \$1000-1500.

500mm f8 Zenzanon-S (SQ) - \$1000-1500

600mm f5.6 Nikkor-P (S2,EC) - head attaches to auxiliary focus mount. \$500-750.

800mm f8 Nikkor-P (EC) - \$800-1200. **1200mm f11 Nikkor-P (EC) -** \$1000-1500.

BRONICA ZOOM LENSES: 70-140mm f4.5 Zenzanon-E (ETR..) - D\$2330

75-150mm f4.5 Zenzanon-S (SQ) - D\$2490.

125-250mm f5.6 Zenzanon-E (ETR..) - 17 elements in 14 groups; focus to 76cm in macro mode. D\$3600.

140-280mm f5.6 Zenzanon-S (SQ) - D\$2800.

BRONICA FOCUSING MOUNTS:

Focusing mount 81505 - for Nikkor 400mm, 600mm lenses (C,S2,etc.). \$200-300.

Focusing mount 30430 - for Komura 300, 400, 500mm lenses (C,S2,etc.). \$50-75.

BRONICA TELECONVERTERS: Designed to increase focal length and image magnification without decreasing minimum focusing distance.

distance.
1.4X Tele-Converter C (CS-1) - D\$450.

1.4X Tele-Converter PE (ETRSi) - 2X Tele-Converter E (ETR...) - D\$400.

2X Tele-Converter G (GS-1) - D\$450. 2X Tele-Converter PE (ETRSi)

2X Tele-Converter S (SQ) - D\$450.

BRONICA BACKS: Most Bronica cameras had interchangeable backs. Exceptions are models C, C2, and ETRC, which accepted interchangeable film inserts, but would not take specialty backs. As the body styles changed, so did the backs which fit them. They may be grouped: D,S,EC,ETR,SQ,GS. 120/220 rollbacks - Most sell in the \$100-225 range to users.

70mm backs - \$200-300. Polaroid backs - \$150-225.

ZICOFLEX MODEL IV - c1950's. Twinlens reflex for 120 film. Externally gear-coupled Zico Anastigmat f3.5/80cm lenses B,1-200 shutter. Uncommon. \$120-180.

ZION (Ed. Zion, Paris)

Pocket Z - c1920's. Folding strut-type camera for 6.5x9cm plates. Rex Luxia or Boyer Sapphir lens. Dial Compur shutter. Leather bellows. Metal body. \$100-150.

Pocket Z, stereo - c1928. Strut-folding camera for 6x13cm plates. Zion Anastigmat f6.3/75mm lenses. Gitzo stereo shutter. \$200-300.

Simili Jumelle, 6.5x9cm - c1893. Rigid-bodied camera for 6.5x9cm plates in magazine back. Zion Anastigmat lens. Guillotine shutter. Folding Newton finder. \$175-250.

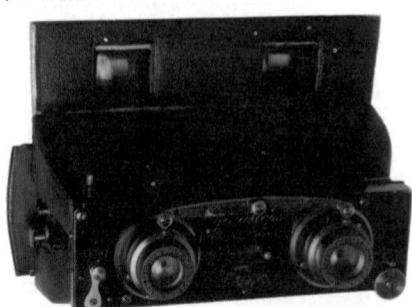

Zionscope - c1900. Stereo camera for 45x107mm plates. Unusual binocular viewfinder and hinged body. \$350-500.

ZODIAC - Novelty 4x4cm "Diana" style camera, \$1-10.

ZORKI - see KRASNOGORSK

ZUIHO OPTICAL CO. (Japan) Honor - c1956-59. Rangefinder 35, Leica copy. Konishiroku Hexar f3.5/50mm, FP shutter 1-500; or Honor f1.9/50mm, FP 1-

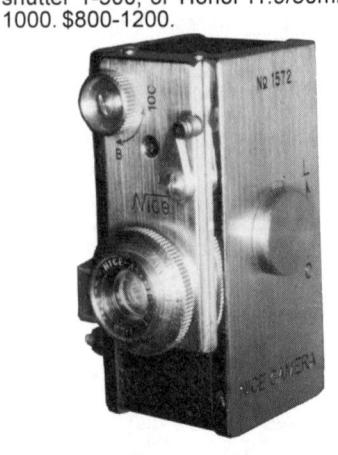

ZUIHO SOKURYO KIKI K.K. (Zuiho Optical & Measuring Instruments Co. Ltd., Tokyo)

Nice - c1946-1949. A very rare subminiature, styled much like the Riken Steky. Some discrepancy about its date of manufacture. One source in Japan dates it to 1949. One of the few extant examples came with original photographs taken in 1946 by a USA serviceman who purchased the camera in Japan in 1945 or 1946. It appears to be either a predecessor or an imitator of the Steky. Based on the evidence we have seen, we suspect that it was made before the Steky, probably in late 1945 or early 1946. Only a few known to exist. Most recent sale, Christie's 12/91, at \$1600.

ZULAUF (G. Zulauf, Zurich) Original manufacturer of the Bebe and Polyscop cameras which continued successfully as Ica cameras after Zulauf joined the recently formed Ica organization in 1911.

Bebe - Compact camera for 4.5x6cm plates. Before 1911 it was distributed by Carl Zeiss and Krauss. Logo on camera is G.Z.C. in oval. \$200-300.

Polyscop - c1910, then continued as an loa model. Stereo camera for 45x107mm plates in magazine back. \$250-375.

ZUNOW OPTICAL INDUSTRY

Zunow - c1958. First Japanese 35mm SLR with auto diaphragm. Instant return mirror. Interchangeable pentaprism or waist level finders. With Zunow 50mm/f1.8 or 58mm/f1.2 lens in threaded bayonet mount. Rare. At \$3000, people would wait in line to buy. \$3500-5500 or more.

in line to buy. \$3500-5500 or more. **Zunow 50mm/f1.1 lens** - c1953.

Most often found in Nikon bayonet mount, but also made in Leica screwmount. \$1200-1800 mint in Japan. \$500-750

elsewhere.

COLLECTING MOTION PICTURE CAMERAS

Many photographic and persistence of vision developments, over a long period of time, led to the advent of motion pictures. True motion picture cameras, as we know them, did not come into being until the 1890's, and few such cameras were made during that very early period. Some were one-of-a-kind. The very few surviving pre-1900 cameras are in museums and private collections with perhaps a very few in attics, basements or warehouses throughout the world.

From about 1900 on, a variety of motion picture cameras appeared. Some were manufactured for sale to the growing number of motion picture studios and others were made by the studios themselves. A small number were made for amateurs

The collecting of motion picture cameras from this period on can be a fascinating hobby. The limited number of early cameras available makes collecting challenging. In addition, some of the early cameras do not carry identification because some manufacturers borrowed freely from the designs of others and there were many patent infringment problems. This lack of identification calls for research by the collector to identify some of the cameras.

In the early motion picture days there were many film widths. The 35mm width pioneered by Edison (U.S.A.) and Lumiere (France) became the standard for professional motion pictures. Most of the cameras available to collectors are of the 35mm variety and they are found in a wide array of sizes, shapes, and configurations.

It is interesting to note, however, that even before 1900 there were $17^{1/2}$ mm cameras and projectors for use by amateurs. Several amateur cameras using different $17^{1/2}$ film perforation configurations were made over the years. Cameras using 10, 11, 15, 22, 32, 40, 60, and 70mm film widths were also made. Motion picture cameras were made that used glass plates and circular discs of film for sequential exposures.

In 1912, Pathe of France introduced a 28mm projector and a large library of 28mm feature films for home use. A limited number of 28mm cameras followed. Also in 1912, Edison introduced a 22mm projector (3 rows of pictures per width) and a library of their films, but no 22mm cameras were offered to the public

were offered to the public.

Movie cameras did not become available

in appreciable numbers until after the introduction of the amateur film formats of 16mm in the U.S.A. and 91/2mm in Europe in 1923. Amateur motion pictures then became very popular because the new 16 and 91/2mm cameras were easy to use and the new reversal films were economical and had a safety film base.

With the subsequent introduction of 8mm cameras and film in 1932 and Super 8 in 1965 the motion picture camera collector can specialize in many ways, for example: particular format, country of origin, chronological period, manufacturer, or first models, etc. To those just entering the

fascinating hobby of motion picture camera collecting: Happy Collecting.

Much of the information in the movie section is due to the efforts of several collectors who specialize in movie equipment. Wes Lambert is a long time collector who specializes in the very early motion picture cameras.

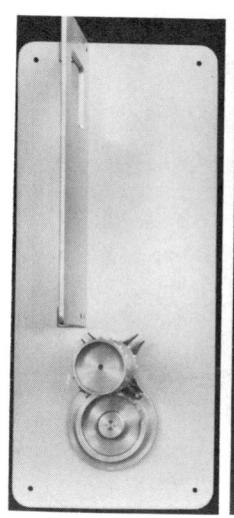

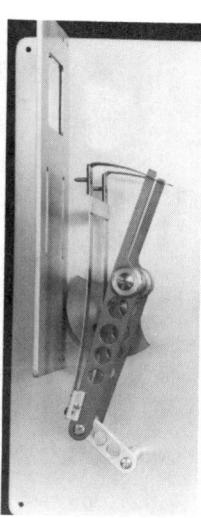

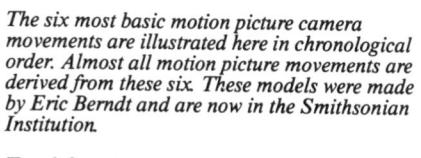

Top, left to right: Demeny Beater movement, patented 1893; Lumiere-Pathe movement, patented 1895; Geneva Star movement, patented 1896; Prestwich movement, patented 1899.

Bottom left to right: Williamson movement, patented 1908; Chronik movement, patented 1913.

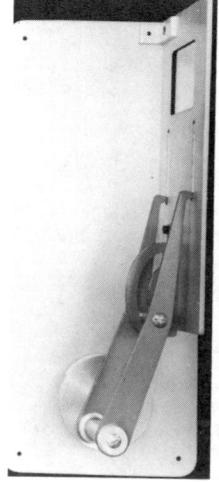

He lectures and displays his cameras in museums, cinema schools and camera clubs. He provided most of the information and photographs for the early 35mm cameras, and a few of the others, as well as updated price estimates for these rare early cameras. To correspond with him, write to: 1568 Dapple Ave., Camarillo, CA 93010. Tel 805-482-5331.

Cynthia Repinski provided the information on the cameras of the Universal Camera Corp. of New York City. Cindy specializes in both movie and still cameras from Universal. For further information on Universal cameras, please consult her book, The Univex Story published by Centennial Photo (see advertising section for details)

(see advertising section for details.)
Much of the 8 and 16mm camera information was prepared by Joan McKeown for the 5th edition of this guide. This was greatly expanded in the sixth edition through the courtesy of Mr. Alan Kattelle. He not only expanded the number of cameras and the historical information concerning them, but also initiated an entirely new section on movie projectors. Cine collectors may write to him at: 50 Old County Road; Hudson, MA 01749.

Editor's Note on Pricing Trends: While the editors are active collectors of still cameras, we do not collect cine cameras or equipment. However, our pricing research encompasses cine equipment. From the standpoint of statis-

tics, we see trends emerging in the collecting of movie camras which parallel what has already happened with still cameras. Early hand-cranked cameras are showing continued strength and increasing prices. Middle-priced cameras (most 16mm spring-wind types) are relatively stable. Lower priced, common cameras, particularly 8mm amateur cameras, have weak and unstable prices because supply greatly exceeds demand.

AGFA (Berlin)

Movematic - c1958. 8mm cine with focusing Movestar f1.9/13mm lens. Gray crinkle-finished metal body. Optical eyelevel finder. Manual or auto exposure. Spring motor 16 fps. \$30-45.

Movex 8 - c1937. 8mm movie camera taking a 10m length of single-8 film in Agfa-Kassettes. Black lacquered metal body; rectangular shape. Optical eye-level finder. Spring motor drive, 16 fps. Interchangeable Agfa Kine Anastigmat f2.8/12mmfocusing lens. \$30-45.

Movex 8L - c1939. 8mm movie camera taking a 10m single-8 Agfa-Kassette. Black lacquered metal body; rectangular shape. Optical eye-level finder. Spring motor drive, 16 fps. Agfa Kine Anastigmat f2.8/12mm fixed focus lens. Coupled meter. \$25-35.

MOVIE: AGFA -----

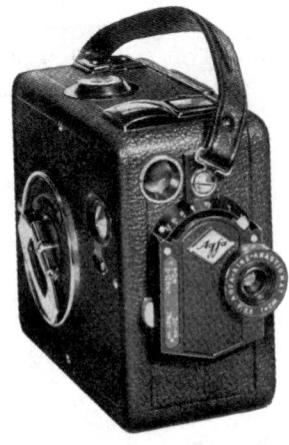

Movex 16-12B - c1928. 16mm movie camera taking a 12m Agfa-Kassette. Black leather covered metal body; rectangular shape. Waist-level brilliant finder and eyelevel Newton finder. Spring motor drive, 16 fps. Agfa Kine Anastigmat f3.5/20mm focusing lens. \$75-100.

Movex 16-12L - c1931. Identical to the 16-12B except with Agfa Symmetar f1.5/20mm lens. \$75-100.

Movex 30B, 30L - c1932. 16mm movie camera taking 100' spools. Blue leather covered metal body, oval in shape. Optical eye-level finder. Spring drive. Model 30L has 8-12-16 fps; Model 30B also has 32 fps. Interchangeable Kine Anastigmat f2.8/20mmfocusing lens. \$100-150.

Movex 88 - c1957. 8mm movie camera, using double 8 film on 25' spools. Gray crinkle-finished metal body. Optical eyelevel finder. Spring motor, 16 fps. Agfa Kine Anastigmat f2.5/11mm lens. Made in focusing and fixed focus versions. \$12-20.

Movex 88L - c1958. Similar to the Movex 88, but with built-in coupled meter. Agfa Movexar f1.9/13mm focusing lens. \$20-30.

Movex Automatic I - c1958. Double-8 movie camera using 25' spools. Gray crinkle enameled metal body. Optical eye-level finder. Spring motor, 16 fps. Agfa Movestar f1.9/12.5mm focusing lens. Automatic light meter. \$15-25.

Movex Automatic II - c1963. Double-8 movie camera taking 25' spools. Two-tone grey hammertone metal body. Optical eye-level finder. Spring motor, 18 fps. Agfa Movestar f1.9/12.5mm focusing lens. Automatic light meter. Features are almost identical to the Movex Automatic I, but the body is re-designed to give it a more modern appearance. Not much interest, but might sell for \$25-35 with wide and tele lenses.

Movex Reflex - 1963. 8mm movie camera using spools. Spring motor. Reflex viewing, electric eye visible in viewfinder. Schneider Varigon zoom f1.8/7.5-37.5mm. \$60-90.

Movexoom - 1963. Battery-driven 8mm movie camera using spool film. Gray and black enamel body. Reflex viewing. Coupled electric eye. Variogon f1.8/9-30mm manual zoom lens. \$45-60.

AKELEY CAMERA, INC. (New York)

Carl Akeley, a famous naturalist, scientist, and inventor, found fault with the best available motion picture cameras for use in photographing wild animals in Africa. He then designed this camera system.

Akeley 35mm Motion Picture Camera - 1914. The Akeley camera features interchangeable taking and viewing lens pairs, and can use very long telephoto lenses. The viewfinder eyepiece optics are articulated. A unique dual gyroscope mechanism built into the tripod head provides a very smooth one hand pan and tilt. The 200 foot film magazines are the displacement type and include the supply/takeup sprocket for fast reload. The Akeley was affectionately known as the "pancake" and was a favorite of newsreel and sports cameramen for decades. Range: \$1500-4500. Camera shown is Serial No. 2.

ANSCO

Cine Ansco - c1930. The first 16mm amateur movie camera from Ansco. Includes Models A & B. Black or brown leather covered metal body; rectangular in shape. Optical eye-level finder. Spring motor, 8-64 fps. Interchangeable fixed focus Agfa Anastigmat f3.5 lens. \$30-45.

Ansco Risdon Model A - c1931. 16mm movie camera manufactured by Risdon Mfg. Co., Naugatuck, Connecticut. Takes 50' spools. Black crinkle-finish lacquered metal body. Optical eye-level finder. Spring motor, 16 fps. B&L llex f3.5/1" fixed focus lens. \$20-30.

ARGUS

Automatic 8 - 8mm movie camera.
Two-tone green lacquered metal body.
Battery-operated motor. Cinepar
f1.8/13mm lens. Coupled meter. \$12-20.

ARNOLD & RICHTER (Munich, Germany)

Kinarri 35 - c1925. This is the first Arri camera. The name was derived from KINe & ARnold & RIchter. The Arri name which became synonymous with professional cinematography actually was used first on a camera designed for amateur use. Drum-shaped aluminum body. Handcranked movement for 35mm film on 15m spools. Arrinar f2.7/40mm lens. \$1500-2000.

Tropical Kinarri - c1927. 35mm exposures on a 25' film cassette. Body is square with rounded corners indstead of drum-shaped. Black-painted finish. Triotar f3.5/35mm. Hand-crank. Rare. \$1700-2400.

ARROW WORKS FOTO NEWS SHA (Japan)
Arrow Cine Camera, Model 50 c1934. Well-made 16mm spool camera.
Spring motor, 3 speeds. Focusing Dallmeyer f1.8. Closely resembles the Victor 16's. \$100-150.

ASSOCIATED PHOTO PRODUCTS (New York)

Magazine Pocket - c1951. There is no identification whatsoever on this camera, but it is otherwise a clone of the IPC Simplex Pockette 16mm magazine camera. B&L f3/35mm lens. Telescoping finder. Footage indicator. Gray crinkle finish. \$20-30.

AURORA STANDARD - 8mm. 2-tone grey body, built-in exposure meter. f2.8 coated lens. \$20-30.

AUTO TRIUMPH 8 - Battery-powered 8mm cine. Made in Japan. 2-tone grey metal body, built-in exposure meter. Cinitronic f1.8/13mmlens. \$1-10.

BARKER BROS. (LOS ANGELES, CA) King Barker 35mm Motion Picture Camera - 1917. This camera, known as "The Educator" was manufactured by the Angeles Camera Co. for Barker Bros., a pioneer California furniture Co. It is almost identical to an early English Williamson type camera but "The Educator" can also be used as a projector and a printer. The camera was often used to photograph local events in small towns for projection in the local theater. This camera was also sold under the Omnio Mfg. Co. name. Range: \$1200-1800.

BAUER

Bauer 88B - c1954. 8mm spool film camera. Hammertone lacquered light blue finish. f1.9 lens. Electric eye/match needle exposure control. Four speeds. \$30-45.

Bauer 88L - c1961. 8mm spool film camera. Grey hammertone finish. Bauer Iscovaron Zoom lens f1.8/9-30mm. Springwind motor to 64 fps. \$20-30.

BEAULIEU Reflex Control - c1962. Double-8 spring-wind camera. Spool film. 12-64 fps, 5 speed. Has motor for zoom lens, Schneider Variogon f1.8/8-48mm. Grey body. Reflex viewing. \$60-90.

BELL AND HOWELL (Chicago, IL, USA)

Bell & Howell Cine Camera #2709 - This excellent studio camera was considered a revolutionary design when introduced in 1912. It features all metal construction with an external dual magazine. A four lens turret is incorporated and preview viewing and focusing can be accomplished through the taking lens. The most sophisticated feature is the fixed registration pins that engage two film perforations during exposure. This feature and the overall precision of this camera led to its use in studios throughout the world. Although

------- MOVIE: BELL & HOWELL

initially a hand crank camera, electric motor drive was soon used. Bell and Howell 2709 cameras are plentiful but are quite expensive for the collector as they are still in use as animation and special effects cameras. Range: \$2000-6000.

Eyemo 35mm Motion Picture Camera - 1926. The Eyemo camera is the 35mm version of the very successful Filmo 16mm camera introduced 3 years earlier. The Eyemo is a rugged camera that found great use in newsreel photography. Many Eyemo cameras were used by the U.S. Military during World War II. Range: \$175-250.

Filmo 70 - A series of 16mm motion picture cameras introduced in 1923 and lasting until 1979 when Bell & Howell sold the business. The first Filmo camera was introduced shortly after the Cine Kodak and Victor 16mm cameras. The Filmo is an excellent design that had previously appeared briefly as a 17½mm camera. A compact die cast metal body encloses 100′ film spools and a heavy spring drive motor. It has a rugged version of the very successful Lumiere/Pathe film transport movement.

Filmo 70A - 1923. Black crackel finish.

Filmo 70A - 1923. Black crackel finish. Eye-level finder. Spring motor wound by large key on the side. 8-16 fps. Interchangeable Taylor Hobson f3.5/1" fixed

focus lens. \$60-90.

Filmo 70AC - 1932. Same as the 70A, except with "Morgana System", an early additive color system. Very rare. Price not established.

Filmo 70AD - c1926. Called "Golf Model". Equipped with 110° shutter, supposedly to permit better analysis of a golfer's swing. \$45-60.

Filmo 70C - 1927. First Filmo with 3-lens turret. \$50-75.

Filmo 70D - c1929. Similar to the 70C, but has a more compact turret. 7 speeds, 8-64 fps. \$60-90.

Filmo 70DL - c1951. Brown crackle-finish body. 3-lens turret viewfinder brings correct viewfinder lens into use to match the taking lens. Parallax-compensation from 3" to infinity. Super Comat f1.9/1" normal lens. \$100-150.

Filmo 70DR, 70HR - 1955. Last of the Filmo 70 series. Professional features such as critical focuser, frame counter. Adapted for external magazines and motor drive. Still in use professionally. \$150-225.

Filmo 70G - c1939. Takes slow motion pictures only, operating at 128 fps (eight times the normal speed). Has single interchangeable lens mount instead of 3-lens turret. Taylor-Hobson Kinic f1.5/1" focusing lens. \$300-450.

Filmo 70J - 1948. Called the "Specialist". A special professional turret model with shift-over slide base. Very rare. One reported sale (1/92) at \$750.

Filmo 70SR - c1963. Features similar to the 70HR, but adapted for slow motion only, operating at 128 fps. \$175-250.

Filmo 75 - c1928. 16mm, taking 100' spools. Spring motor, 16 fps. Oval shape. Black, brown, or grey intricately tooled leather covering. Eye-level finder. Interchangeable Taylor Hobson f3.5/20mm fixed focus lens. \$90-130.

Filmo 75 A-5 - 1931. Parallax view-finder. Black pebbled leather. \$100-150.

Filmo 121-A - 1934. Bell & Howell's first 16mm magazine movie camera. Uses "Pockette" or "old style" magazines. Brown leatherette and brown lacquered aluminum body. Optical eye-level and waist-level finders. Spring motor 16-24 fps. Interchangeable Cooke Anastigmat f2.7/1" fixed focus lens. \$20-30.

Filmo 127-A - 1935. First U.S. made single 8mm movie camera. Called "Filmo Straight Eight". Spring motor 8-32 fps. Interchangeable Mytal Anastigmat f2.5/12.5mm lens. Uncommon. \$75-100.

Filmo 141-A, 141-B - 1937. 16mm magazine movie cameras for new Eastman Kodak magazines. Art-deco black enamel metal body. Optical eye-level finder. Spring motor. 141-A has 8-32 fps; 141-B has 16-64 fps. Interchangeable Taylor Hobson f3.5/1" lens. \$30-45.

Filmo Aristocrat Turret 8 - c1940. Same as the Filmo Sportster, but with 3-lens turret. \$75-100.

Filmo Auto Load - c1940. 16mm magazine movie camera. Brown plastic covered aluminum body. Eye-level finder. Spring motor, 8-32 fps. Interchangeable Lumax f1.9/1" lens. \$12-20.

Filmo Auto Load Speedster - c1941. Identical to the Filmo Auto Load, but with speeds of 16-64 fps. \$12-20.

Filmo Auto Master - c1941-50. Same as the Filmo Auto Load, but with 3-lens turret. Lens turret also holds the viewfinder objectives, rotating the correct viewfinder into place to match the lens in use. A typical 3-lens set includes Taylor-Hobson f1.5/1", f4.5/4" and f2.7/17mm. \$45-60.

Filmo Companion - c1941. Double-8 spool load movie camera. Brown leatherette and painted metal body. Eye-level finder. Spring motor, 8-32 fps. Interchangeable Anastigmat f3.5/12.5mm fixed focus lens. \$1-10.

Filmo Sportster (Double Run Eight) - c1939-50. Double-8 movie camera. Early models only say "Filmo Double Run Eight". Later models also say "Sportster". Grey body. Similar to the Filmo Companion, but 16-64 fps. \$30-45.

Filmo Turret Double Run 8 - c1939. Same as the Filmo Sportster (Double Run Eight), but with 3-lens turret. Matching viewfinder objectives also mount on the turret head. Typical 3-lens set includes f2.5/12.5mm, f2.7/1", f3.5/1.5". \$20-30.

Magazine Camera-172 - c1947. 8mm magazine movie camera. Brown leatherette covered metal body. Eye-level finder. Spring motor, 16-64 fps. Interchangeable focusing Comat f1.9, f2.5, f3.5/1/2" lenses. Available in single lens or 2-lens turret models. \$1-10.

Magazine 200 - 16mm magazine movie camera, an updated version of the Filmo Auto Load/ Auto Master series. Chromed

MOVIE: BELL & HOWELL... ------

metal body with tan leather. Optical eyelevel finder. Spring motor, 16-64 fps. Interchangeable Taylor Hobson Cooke f1.9/1" lens. Three versions:

200 Auto-Load - c1952. Single lens

200 Auto-Load - c1952. Single lens version. \$30-45.

200-T Auto-Load - c1952. Two-lens turret. \$100-150 with 3 lenses. With 1 lens: \$30-45.

200 TA Auto Master - c1954. Threelens turret. One sold at auction with 3 lenses for \$250.

200EE - c1956. 16mm automatic iris control (battery operated) movie camera, advertised as the first and most famous 16mm EE camera. Also called the world's only 16mm EE movie camera in 1959. Magazine or spool-loading models. Brushed chrome aluminum body with black leatherette. Optical eye-level finder. Spring motor drive, 16-64 fps. Super Comat f1.9/20mm focusing lens. WA and Tele auxiliary lenses available. \$30-45.

220 - c1954. 8mm movie camera referred to in ads as the Wilshire. Gray die-cast aluminum body. Optical eye-level finder. Spring motor. Super Comat f2.5/10mm lens. "Sun Dial" as on the 252. (see below). \$20-30.

240A - c1954. 16mm movie camera, with automatic loading feature for 100' rollfilm. Fast crank-winding spring motor, 5 speeds, 8-48 fps. Remaining power indicator and automatic run-down stop. Footage counter. Die-cast aluminum body with black morocco covering and satin chrome finish. Sunomatic f1.9/20mm focusing lens or f2.5/20mm fixed focus lens. \$30-45.

240 Electric Eye - 1957. 16mm camera for 100' spools. Accepts single or double perforated films. Spring motor, 5 speeds. Automatic film threading. Remaining power dial and footage counter. Automatic exposure control. Super Comat f1.9/20mm lens. \$60-90.

252 - intro. 1954. 8mm movie camera, referred to in ads as the Monterey. Two-

tone brown die-cast aluminum body. Optical eye-level finder, marked for telephoto attachment. Spring motor, 16 fps. Super Comat f2.3/10mm fixed focus lens. "Sun Dial" diaphragm setting allows the user to set the dial for the lighting conditions and the diaphragm is set accordingly. Available in single lens or 3-lens turret models. \$20-30.

319 - Double-8mm movie camera. Twotone brown body. Spring motor, 10-40 fps. Super Comat f1.9/10mm lens. \$1-10.

Bell & Howell Projectors
Design 57-A - 1923. First 16mm projector by B&H. 400' capacity; 200w lamp; belt drive to take up and rewind. First model of Design 57 series is distinguished by round base, single condenser slot, fixed resistance. \$30-45.

Later models, 57-B, -C, etc. - Have oval base, auxiliary slot for Kodacolor filter, and variable resistor for motor. \$12-20.

Design 120-A - 1933. "Filmosound". First B&H 16mm sound-on-film projector. 1600' capacity; 500w lamp; power rewind; built-in amplifier. Estimate: \$35-50.

Design 122-A Filmo 8 Projector - 1934. First B&H 8mm projector. 200' capacity; 400w lamp; geared takeup and power rewind. Estimate: \$25-35.

BELL MANUFACTURING CO. (Des Plaines, IL)
Bell Motion Picture Camera,
Model 10 - c1936. 16mm movie camera
taking 50' spools. Black crinkle painted
metal body. Oval shape. Small sportsfinder. Spring motor. Fixed focus lens.
\$25-35.

BLAUPUNKT-WERKE Blaupunkt E-8 - c1950. Rare 8mm movie camera, taking 10m Agfa-Movex Kassettes. Spring wind by a large lever, 16 fps. Rodenstock Ronar f1.9/10mm in fixed-focus mount. Direct optical viewfinder. Black lacquered crinkle-finish metal body. \$200-300.

BOLSEY See the still camera section for a description of the Bolsey 8 (page 60).

BRISKIN MFG. CO. (Santa Monica, CA)
Briskin 8 - c1947. Regular 8mm magazine camera. 4-speed spring motor. Telescoping finder. Available in black pebble or brown alligator finish. \$25-35.

Butcher Empire 35mm

BRUMBERGER

8mm-E3L, T3L - 8mm movie camera, 3-lens turret. Grey and black body. f1.8/13mm Brumberger normal lens. With tele, normal, and wide angle lenses: \$12-20.

ENTCHER AND SONS LTD. (London, England)
Empire 35mm Motion Picture Camera - c1912. This wood body, hand crank amateur camera is simple and basic in design. Has 100' internal magazines, fixed focus f6.3/50mm lens. The price was modest and the operation elementary. The English Ensign and Jury cameras are almost identical. Range: \$750-1500. Il-

CAMERA CORP. OF AMERICA (Chicago) Originally named "Candid Camera Corp. of America" 1938-1945, but shortened to "Camera Corp of America" in

lustrated bottom of previous column.

Cine Perfex Double Eight - 1947. 8mm magazine camera using 25' Kodak magazines. Footage counter. Spring motor drive, 8-32 fps. 3-lens turret with focusing Velostigmat lenses; f2.5/1/2", f2.5/1", f3.5/11/2". Through-the-body viewfinder has built-in masks for different lenses. Uncommon. \$15-25.

CAMERA PROJECTOR LTD. (London, England)
Midas 91/2mm Motion Picture Camera/Projector - 1933. The Midas 91/2mm camera is unusual in that it is a camera and a projector. An internal battery pack provided power to drive the camera. As a projector it was hand cranked and illuminiation power was provided by the battery pack. Range: \$90-130.

CAMERAS LTD. (Slough, England)

Dekko - c1934. 9.5mm movie camera for 10m Pathe-size cartridge. Black bakelite

art deco. Optical eye-level body. Spring motor, 16-64 fps. Interchangeable Taylor Hobson f2.5/23mm fixed focus. \$35-50.

Dekko Model 104 - c1937. Similar to the Dekko, but black lacquered alumnium body. Speeds 8, 16, 64 fps. Viewfinder has parallax compensation. Ross f1.9/1" or Dallmeyerf1.5/1" focusing lens. \$30-45.

Campbell Cello closed (above) and with back open showing the large internal film magazine (below).

CAMPBELL (A.S. Campbell Co., Boston, MA)

Cello - c1918. 35mm hand-cranked movie camera. Leather covered wood body. Combination chain and belt drive. Internal wood magazine holds approx. 75' of film. B&L Tessar f3.5 lens. \$300-450.

CAMPRO LTD. (Home Cine Cameras, Ltd., London)

Campro - c1927. 35mm movie camera that could also be used as a projector by attaching two special lamp housings. Black metal and wood body is partly leather covered and partly painted. Folding Newton finder. Hand crank, 1 rotation per 8 frames. Uses 100' spool. Dallmeyer focusing f3.5 lens. \$250-375.

Campro Cine Camera-Projector - c1935. 9.5mm movie camera, taking 10m Pathe cartridges (later model also used Campro-cassettes). Black crinkle finish metal body. Sportsfinder on top. Spring motor, 16 fps. f3.5 fixed focus lens. Camera could also be used as a projector with an accessory attachment. \$35-50.

CANON (Japan)

Canon Eight-T - 1957. 8mm spool film camera with 2-lens turret. Viewfinder for 6.5mm, 13mm, 25mm, and 38mm lenses. Automatic parallax adjustment via cam surface on lens barrel. Ground glass focusing finder. Spring motor. \$35-50.

Canonet 8 - 8mm. Canon Zoom f1.8/10-

25mm lens. 12-24 fps. \$25-35.

CARENA S.A. (Geneva, Switzerland) Autocarena - c1962. 8mm spool film. Black leather-covered metal body. Optical eye-level viewfinder. Spring motor is wound by turning the "pistol grip" style handle. 8-32 fps. Steinheil Culminar f1.9/13mmlens. \$30-45.

Carena Zoomex - 1962. 8mm spool camera. Electric eye, manual or automatic exposure control. Angenieux f1.8/7.5-35mm zoom lens. Spring motor wound by turning grip. Reflex viewing. \$20-30.

Gevaert Geva 8 - 1954. 8mm cine. Unique deco slim metal body in brown crinkle finish, brown leatherette trim. Som Berthiot Cinor f1.9/12.5mm fixed focus. Spring motor wind, 8,16,24 fps (also a 4-speed model, 8-32 fps). Rotating filters in from of lens for B&W and type A color film. Ingenious pop-out viewfinders. \$30-45.

CHRONIK BROS. MFG. (New York, USA) Originally, tool and die makers.
Chronik Bros. 35mm Motion Picture Camera - 1908. This camera is a typical example of the Chronik Brothers' excellent workmanship and design. The unique film transport is a Chronik patent. The camera features through the lens viewing and convenient control on the lens diaphragm and focusing. Range: \$1500-3000.

CINCINNATI CLOCK AND INSTRU-MENT CO. (Ohio)

Cinklox, Model 3-S - c1937. 16mm spool camera. Spring motor with slow motion, normal and high speed settings. Wollensak f2.5/1" fixed focus lens. (See Paragon for similar camera.) \$20-30.

COMPENDICA - c1961. Interesting still/cine camera. Takes 336 photos on a 25' roll of 16mm or double 8mm film. Spring wind, 10 fps. BIM. Optical eye-level viewfinder. Camera converts to a projector. Compendica f2.9/25mm lens. \$20-30.

----- MOVIE: DEBRIE

CORONET (Birmingham, England)
Coronet, Models A, B, C - c1932.
9.5mm movie cameras taking 10m Pathe
cassettes. Black leather covered metal
body. Optical eye-level finder. Spring
motor, 16 fps. Coronar Anastigmat f3.9
lens with four stops. \$50-75.

DARLING (Alfred Darling, Brighton, England)

Bioscope - c1916. 35mm hand-crank. Rectangular wooden body, wooden 50m spools. Rotary shutter. \$1200-1800.

DEBRIE (Etablissements Andre Debrie, Paris)

Parvo Interview 35mm Motion Picture Camera - 1908. This wood body, hand crank studio camera has co-axial 400' internal film magazines. It features critical focusing on the film, variable shutter, frame rate indicator, lever control for focus and lens aperture setting, and a precise footage counter. The design and workmanship on this camera are of excellent quality. A metal body model was also made that could use an electric motor drive. Range: \$1500-2000.

Parvo Model JK - c1925. Precision 35mm hand-cranked cine camera. Heavy aluminum body, black side panels. Features include an automatic diaphragm that adjusts during each exposure to give the best image at any range. \$800-1200.

Sept 35mm Motion Picture Camera System - 1922. This precision, compact, short film length 35mm movie camera is extremely versatile. It is a spring motor driven, 250 exposure, pin registered camera system for a: motion picture camera, sequential camera, still camera, and with the addition of a lamphouse, motion picture projector, film strip projec-

MOVIE: DEJUR-AMSCO -----

tor, still enlarger and negative film to positive film cine printer. From these seven functions comes the name "Sept". The Sept design is based on an earlier Italian camera. The camera shown is a 1925 model Sept with a larger spring motor. Range: \$120-180.

DEJUR-AMSCO CORP. (New York) **Citation** - c1950. 8mm spool-film camera. Spring-wind, 12-48 fps. Optical eye-level viewfinder. Interchangeable single-lens mount. Raptar f2.5 or

f1.9/13mm lens. Brown lacquered metal body. \$20-30.

DeJur-8 - c1948. Small, magazine-load, 8mm cine camera. 16-64 fps. Three-lens turret. Adjustment in optical viewfinder for different lenses. \$15-25.

DeJur Electra Power Pan - 1962. 8mm spool camera with spring motor, zoom lens, and 120° panning in either direction. Viewfinder adjusts to zoom lens. Automatic or manual exposure control, backlight control. Uncommon. \$25-35.

Embassy Magazine 8 - c1949. 8mm cine camera taking 7.5m cassettes. Wollensak Dejur f1.9/13mm lens, 1,23-64 fps. Brown leather covered metal body. \$1-10.

DEVRY CORPORATION (Chicago, IL)

The DeVry Corporation was founded in 1913 by Herman A. DeVry, a former arcade worker and motion picture operator, to manufacture portable projectors "...practical for use by traveling salesmen and by schools." In 1929, the company merged with Q.R.S. Corp., the famed music roll company. The marriage lasted less than three years, but during that time, a number of motion picture and still picture products were produced, variously labeled "QRS" "DeVry" or "QRS." DeVry". In late 1931 or early 1932, the company was re-organized, the music roll business left under new ownership, and H.A. DeVry continued in the motion picture business under the name Herman A DeVry, Inc. Mr. DeVry died in 1941. His sons carried on the business until 1954, when the company was purchased by Bell & Howell.

DeVry, 16mm - c1930. Various models

were made with only slight variations. Black or grey cast metal body; large rectangular shape. 100' spools. Folding Newton finder. Spring motor; some models also have a hand crank. Interchangeable Graf f3.5/20mm fixed focus lens. \$30-45.

DeVry 16mm Deluxe - 1930. Same shape as the DeVry Home Movie Camera, but with molded bakelite body and 3-lens turret. \$120-180

DeVry Standard - 1926. Rugged, all-

metal newsreel-type cine camera, using 35mm 100' film spools. Nicknamed "The Lunch Box" because of its rectangular shape. Spring motor. Some DeVry cameras were actually launched in captured German V2 rockets at the White Sands Missile Range after World War II. The DeVry also found use as a rapid sequential still camera in sports work. \$120-180.

DeVry Home Movie Camera - 1930. 16mm camera using 100' spools. Die-cast aluminum body. Spring motor. Model 57 has fixed focus f3.5 lens. Models 67 to 97 have focusing f3.5, f2.5, and f1.8 lenses. \$35-50.

QRS-DeVry Home Movie Camera -1929. Bulky all-metal 16mm camera using 100' spools. Spring motor. First model was a camera only; later models doubled as a projector when mounted on an accessory stand and 3-blade projector shutter was substituted for the camera shutter. Camera only: \$15-25. With projector: \$30-45.

DeVry Projectors:

DeVry Portable Motion Picture Projector - 1928 Suitcase-type 35mm silent projector. Entire mechanism is built into one case. 1000' reels mounted coaxially below lamp and lens head. Motor drive. \$45-60.

Cinetone - c1928. 16mm silent projector; 300w; 400' capacity. Motor also drives 12", 78 rpm turntable seated on a common base. Record and film had starting marks to permit synchronization. Films were supplied by DeVry; records were made by Victor Talking Machine Co. This was one of the early attempts to provide sound with 16mm film. \$250-375

DeVry Type ESF Projector - 1931. 35mm Sound-on-film portable projector. 500w projector in one case; 4-tube amplifier/speaker in separate case. \$100-150.

Dilk-Fa - c1950. 16mm movie camera, taking 10m spools. Spring motor, 1, 16-64 fps. 3-lens turret with viewfinder objectives to match each lens. One nice outfit sold at auction with Plasmat f1.5/25mm, Trioplan f2.8/50mm and f2.8/75mm lenses for \$345.

DITMAR (Vienna, Austria) Ditmar, 9.5mm - c1938. 9.5mm movie

camera taking 10m Ditmar cassettes. Black leatherette covered metal body. Eyelevel finder. Spring wind motor, 16-32 fps. Steinheil Cassar f2.9/20mm fixed focus lens. Built-in light meter. \$35-50.

DRALOWID-WERK (Berlin) Dralowid Reporter 8 - c1953. 8mm spool load movie camera. Green leather covered metal body. Eye-level finder. Spring motor is wound by pulling a cord. Minox Wetzlar Dralonar f2.5/12.5mm fixed focus lens. \$50-75.

EASTMAN KODAK CO. (Rochester, NY)

Brownie Movie Cameras - c1951-63. Double-8 spool load movie cameras. Various models with single lens or 3-lens turret. Brown leatherette or brown lacquered bodies. Folding frame or Newton finders. Spring wind motor, 16 fps. Interchangeable fixed focus f1.9 or f2.7 lenses. Turret models also have wide angle and tele lenses. See below for a few individual listings. Generally, turret models: \$8-15. Single lens models: \$1-10.

Brownie Movie Camera, model - 1951. 8mm spool camera with spring motor, open finder, and f2.7/13mm lens. Originaly sold for \$47.50. \$1-10.

Brownie Fun Saver - 1963-68. This was the last Brownie movie camera. Plain black body, no frills. \$1-10.

Brownie Turret, Exposure Meter Model - 1958. With Scopesight and 3lens turret with f1.9 lenses. This was the most expensive Brownie, selling for \$99.50. \$20-30.

Cine-Kodak - 1923. (Called Model A beginning in 1925 when the Model B was introduced.) This is the first Kodak movie camera. It introduced the new Eastman 16mm safety film for the amatuer. A substantial cost savings was brought about by the small 16mm format and the fact that the original film was processed by Eastman to a positive rather than a negative, thereby eliminating the extra step to make a positive print. Hand crank, one rotation per 8 frames. All metal black painted body, large boxy square shape. Eye-level finder. Kodak Anastigmat f3.5/25mm focusing lens. Camera only: \$200-300.

Variations:

- -- Electric Motor Drive Introduced Jan. 1924, for \$25. Battery operated drive with built-in waist-level finder. Battery charging kit was available as an extra. \$120-180. Add \$100-150 for the charging kit.
- -- Waist Level Finder April 1924. A waist-level finder was added to the camera. Thereafter, the electric motor drive was available without a waist level finder. The camera shown is a 1925 version with the waist-level finder.

-- **f1.9/25mm lens** - Feb. 1926. Original price of \$200.

-- Slow Motion Attachment - July 1926. List price was \$20.

-- Single Frame Attachment - Feb. 1927. List price of \$20.

Cine-Kodak Model B - 1925-31. 16mm movie camera using 100' spools. Leather covered metal body. Rectangular and not as boxy looking as the Model A. Newton finder and waist level brilliant finder. Kodak Anastigmat 25mm fixed focus lens. Spring motor, 16 fps. First model with f6.5 lens, black leather: \$25-35. Later models, 1928-on, f3.5 lens in brown or grey: \$15-30.

Cine Kodak Model BB, Model BB Junior - 1929. 16mm movie cameras using 50' spools. Leather covered metal body. Newton finder. Interchangeable fixed focus f3.5 or focusing f1.9/25mm Kodak Anastigmat. Spring motor, 8,16 fps. Blue, brown, or grey: \$30-45. Black: \$15-25.

Cine Kodak Model E - c1937-46. 16mm movie camera taking 100' spools. Black crinkle finish metal body. Advertising for this peculiar shaped model said it "...safely clears hat brims." Optical eye-

level finder. Spring motor, 16-64 fps. Interchangeable Kodak Anastigmat lens: fixed focus f3.5/20mm or focusing f1.9/25mm. \$25-35.

Cine Kodak Model K - 1930-46, making this the longest-lived 16mm model. Takes 100' spools. Leather covered metal body. Folding Newton finder and waist level brilliant finder. Spring motor, 8,16 fps. Interchangeable Kodak Anastigmat f1.9/25mm focusing lens. Blue, brown, or grey: \$60-90. Black: \$35-50.

Cine-Kodak K-100 - c1955. 16mm cine camera, taking 100' spool film. Spring motor 16-64 fps. Auxiliary external electric motor can also be attached. Single interchangeable lens mount. Ektar f1.9 or f1.4/25mm lens. Optical eye-level view-finder. This camera filled the gap between the 16mm amateur Cine-Kodak Royal and the professional Cine-Kodak Special II, by providing some professional features such as larger film spool, special-effects features, 5 speeds, and interchangeable lens. \$150-225.

Cine Kodak Model M - 1930 (the shortest-lived model). Economy version of the Model K (above). Fixed focus f3.5/20mm lens. No waist level finder. 16 fps only. \$30-45.

Cine Kodak 8 - c1932-47. Leather covered metal body in gray, brown, or black. Newton finder in the handle. Spring motor, 16 fps. Kodak Anastigmat 13mm lens.

- **Model 20** The first 8mm spool load movie camera using 25' double-8 film. Fixed focus f3.5, \$8-15.
- Model 25 Fixed focus f2.7. \$20-30.
- Model 60 Interchangeablef1.9 focusing lens and machine-turned interior. \$20-30.

Cine-Kodak Reliant - c1949. Low-priced alternative to the Cine-Kodak Magazine 8. Uses 8mm spool film instead of film magazine. 16-48 fps. Cine Ektanon

MOVIE: EASTMAN

f1.9 or f2.7/13mm lens. Spring wind motor. \$8-15.

Cine-Kodak Royal - 1950. 16mm magazine camera with spring motor, interchangeablelens. \$15-25.

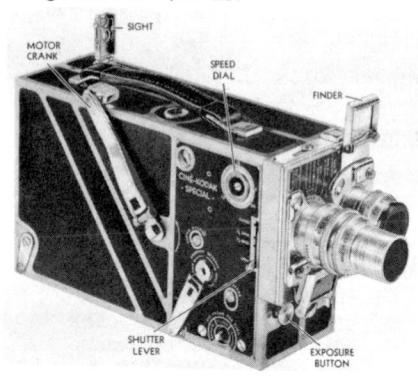

Cine-Kodak Special (1933-47); Cine-Kodak Special II (1948-61) -16mm magazine movie cameras. Left side of body is the magazine containing the film

16mm magazine movie cameras. Left side of body is the magazine containing the film spools. The magazine can be removed at any time and replaced by another. 100' and 200' magazines were available. 2-lens turret with interchangeable focusing Kodak Anastigmat f1.9/25mm and f2.7/15mm lenses. Spring motor 8-64 fps. \$300-450.

Magazine Cine Kodak (1936-45); Cine Kodak Magazine 16 (1945-50)

 Body style and features similar to their 8mm counterparts, but for 16mm movies using 50' magazines. \$20-30.

Magazine Cine-Kodak Eight Model 90 (1940-46); Cine-Kodak Magazine 8 (1946-55) -Eastman Kodak's first magazine 8. Similar

Eastman Kodak's first magazine 8. Similar to the Model 60 (above), but takes a 25' reversing magazine. Optical eye-level finder. 16-64 fps. \$20-30.

Kodak Cine Automatic Cameras - 1959-61. Six versions, all with coupled EE, 8mm spool load, spring motor. Single lens, 3-lens turret, or zoom lenses. Values vary according to lens: \$5-40.

Kodak Cine Scopemeter - c1959. Double-8 spool load movie camera. Built-in meter. Optical eye-level finder in housing with meter. Spring motor, 16 fps. 3-lens turret with Ektanar f1.9 normal, tele, and wide angle lenses. \$12-20.

Kodak Electric 8 Automatic - 1962. First 8mm Kodak camera with battery drive and casette loading. Kodak Duex 8 cassette was user-loaded with 25' spool which was flipped over for a second 25' run. One single lens model and two zoom lens models were produced, including the Kodak Electric 8 Zoom Reflex camera which was Kodak's most expensive movie

MOVIE: EASTMAN...

camera, listing at \$295. Reflex model, rare: \$60-90. Others: \$1-10.

Kodak Escort 8 - 1964. Eastman Kodak's last regular 8mm camera. Spool load, spring motor, coupled EE. Fixed focus and zoom f1.6 models. Type A (swing out) filter. \$12-20.

Kodak Zoom 8 Reflex - 1960. Two models, with reflex viewing. \$25-35.

Eastman Kodak Projectors:

Kodascope - 1923. 16mm motor drive projector; 14v, 56w lamp; 400' reel. First 16mm projector. Earliest model distinguished by small lamp house, enclosed reels, no carrying handle, no oil tubes. 200w lamp furnished after 1924. \$120-180.

Kodascope Model A, Series K - 1926. Similar to above, but with lens and condensers for use with Kodacolor film. \$30-45.

Kodascope Model B - 1927. Advanced 16mm projector of unusual design. Folding reel arms at rear of projector with self-threading guides. Forward, reverse and still projection. Power rewind. 400' reels; 200w, 56v lamp; 1" or 2" lens. Black or bronze finish with chrome plated fittings, threading light. Original price, with 2" lens, carrying case, extra lamp, oil can, and splicing kit: \$300-450. Common. \$20-30.

Library Kodascope, open (above) and closed Library Kodascope - 1929. This is a Model B projector, in bronze, with a walnut case, folding translucent screen for rear projection with 1" lens, or direct projection with 2" lens. The octagonal shaped case has an ebony inlay and solid bronze octagonal handles, and looks something like a casket. A matching walnut cabinet, 33" high, was available, which had a folding shelf for splicing, turntable top, storage space for the projector, a floor screen and stand, 26 reels of film, splicer, etc. EKC records show that approximately 1500 Library Kodascopes were produced, and less than 500 cabinets. A few of the Kodascopes with the cabinet were recently sold at \$750. Projector and case: \$150-

Kodascope Model C - 1926. Compact 16mm projector. 400' reels; folding reel arms; 100w lamp. In 1928, the same projector was offered in a carrying case with 51/₂x7" translucent screen, and 1" lens for rear projection or 2" lens for direct projection. This outfit was called the Business Kodascope. \$20-30.

Kodascope Eight Model 20 - 1932. First 8mm projector. 200' reels, belt drive to take-up and rewind. First model furnished with 6v auto headlight bulb, later in same year furnished with 100w, 110v lamp. \$12-20.

Sound Kodascope Special - 1937-42. Kodak's first 16mm sound-on-film projector. 2",f/16 lens; 750w lamp; 1600' reels; takeup reel runs at right angle to upper reel. Separate amplifier and speaker case. Very high quality design, priced at \$800. Rarest of EKC's projectors; less than 500 made. \$350-500.

ECLAIR (Paris)

Cameflex - Cine camera with 35mm film magazines. 3-lens turret with Kinoptik Fulgior f1.3/50mm, Special cine Kinoptik f3.5/400mm. One recorded sale: \$3600.

EDISON (Thomas A. Edison, Inc., Orange, NJ) Edison Projecting Kinetoscope

Edison Projecting Kinetoscope c1899. Hand-cranked or motor-driven 35mm projector. Mechanism mounted in 2-piece oak case. Bolt-on 1000' supply reel chamber. No takeup reel; film was caught in cloth bag. Four-slot Geneva intermittent; 2-blade no-fire shutter. Framing by rack & pinion raising entire mechanism. Separate light source. \$350-500.

Edison Home Kinetoscope - 1912. Special 22mm hand-cranked projector. This projector was designed by Edison to make home projection safe for the amateur. The film was cellulose acetate based "safety" film supplied by Eastman, and carried three rows of images across the width, each row projected in succession. Cast iron mechanism housing mounted on wood base with sheet metal lamp house, usually with small carbon-arc lamp, although acetylene lamphouse was available. Projector available with three lens

systems, and also could be used to project special Edison glass slides. \$500-750.

ELF EIGHT Model 1A - 1960's. 8mm made in Japan. Cheap black plastic electric body. Then aluminum front plate with red stenciling. Fixed focus ATARU f1.9/13mm lens, single speed. Simple exposure guide on film door. Powered by 2 "C" batteries. Optical viewfinder. Probably used for promotions. \$1-10.

ELMO CAMERA CO. LTD (Japan) Distributed by Honeywell Photographic Products in the U.S.A.

Honeywell Elmo Dual-Filmatic and Honeywell Elmo Tri-Filmatic 8mm Zoom - 1966. These battery-powered 8mm cameras were the first to accept all three 8mm formats by means of interchangeable backs. The Dual-Filmatic accepted Super 8 and Single 8; the Tri-Filmatic accepted Super 8, Single 8, and Regular 8. Both cameras featured automatic/manual exposure control and remote control jack. Elmo f1.8/9-36mm lens with power or manual zoom; auxiliary telephoto lens available. Single frame or 18,24 fps, plus reverse (for Single 8 and Regular 8 only). Tri-Filmatic, very few made: \$150-225. Dual-Filmatic: \$75-100.

EMEL (Etablissement Emel, Paris) Emel Model C93 - c1939. Advanced 8mm spool camera featuring 3-lens turret with Berthiot-Cinor lenses, multi-focal finder with parallax correction, frame counter and film-remaining meter. Spring motor, 5 speeds plus single frame and continuous run. Backwind shaft. \$90-130.

ERCSAM (Paris)

Auto Camex - c1960. 8mm spool load movie camera. Reflex viewing. Spring motor, 8-64 fps. Focusing Pan-Cinor zoom lens. \$35-50.

Camex Reflex 8 - c1956. First 8mm movie camera with continuous reflex viewing. Double-8 film on 25' spools. Spring motor, 8-32 fps. Interchangeable Som Berthiot f1.9/12.5mm focusing lens. \$90-130.

ERNEMANN AG (Dresden, Germany) Kino I - 1902. Ernemann entered the amateur motion picture field with this very early, center perforation, 171/2mm motion picture camera. It has a leather covered wood body. The Kino I is a well built movie camera using a Williamson type film transport with a quality Ernemann lens and a variable shutter. Range: \$2000-3000.

MOVIE: FUJI

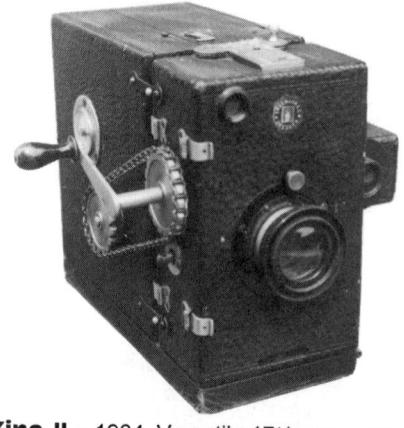

Kino II - 1904. Versatile 171/2mm, center perforation, amateur camera/printer/projector. Features unusual even for professional cameras of its time. The intermittent film transport has an eight arm Geneva cross movement. A reciprocating glass platen at the aperture applies pressure during exposure. A fast lens was used. The Kino II shown has a large co-axial film magazine and studio type viewfinder for straight and reflex viewing. Range: \$1200-2400.

Kino Model E - 1917. 35mm motion picture camera. Wood body, hand crank studio camera has co-axial 400' internal film magazines. Its appearance and operation are very similar to the 1908 Debrie Parvo camera. Range: \$1200-1800.

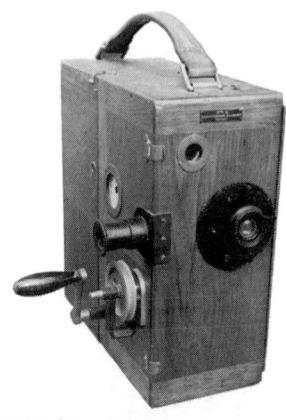

Normal Kino Models A, B, C - 1908-18. 35mm wood-bodied hand cranked motion picture field camera. The film magazines are internal, one above the other. Some Kino cameras have Lumiere/Pathe type film transports and some have Williamson type transports. The Model A has a 200' film capacity; the B, 400'; and the C, 100'. \$1200-1800.

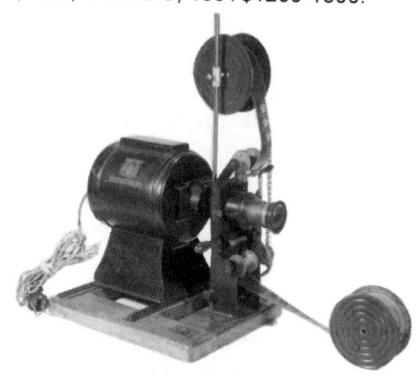

Ernemann Projectors: Kinopticon - c1919. Hand-cranked

35mm projector, using Demeny "beater" film advance. Two-blade shutter, chain drive. Incandescent lamp house on common wood base. Lamp house slides over for use as magic lantern for 48mm slides. Film supply reel standard; no takeup reel. \$250-375.

ERTEL WERKE (Munich, Germany)

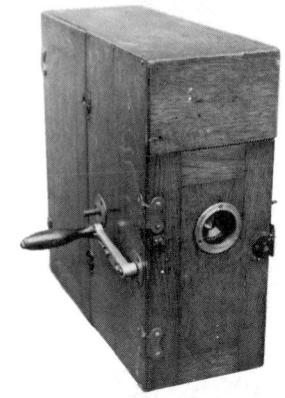

Filmette I - 1920. The Ertel 35mm motion picture camera is a well made, wood body, hand cranked field camera. Folding sportsfinder on side. Brass parts are lacquered black. Ertel Glaukar f3.1 50mm lens. Lens focus and aperture control is accomplished by conveniently placed levers. Range: \$1000-1500.

Filmette II - c1923. Similar to the Filmette I, but folding Newton finder, Ertoplan f3.1 50mm lens. Polished brass parts. \$750-1000.

EUMIC (Vienna, Austria)

Eumig C-3 - c1938-55. Double-8 movie camera taking 25' spools. Black or grey patterned metal body. Optical eye-level finder. Spring motor, 8-32 fps. Early models with Trioplan f2.7/12.5mm, later with Reichert Solar f1.9/12.5mm. \$20-30.

Eumig C-39 - c1938. Similar in style to the black C-3, but for 9.5mm film in daylight-loading cassette. Steinheil Cassar f2.7/18mm lens. \$45-60.

Eumig C5 Zoom-Reflex - 1961. 8mm battery-driven spool camera. Eumig f1.8/10-40mm manual zoom, recessed into body of camera. Automatic exposure control, footage counter, outlet for synchronous sound recording with tape recorder. Die cast aluminum body with grey crinkle finish. \$15-25.

Eumig C16 - c1956. 16mm movie camera for 100' spools. Lacquered metal body with green leather. Spring motor, 16-64 fps. Semi-automatic coupled meter. Eumigar f1.9/25mm focusing lens. \$175-250.

Eumig C16 R - c1957. Same features as the C16, but has WA Eumicronar .5x and Tele-Eumacronar 2x auxiliary lenses on mounts that can be rotated into place over the normal lens. Viewfinder has parallax compensation. \$250-375.

Eumig Electric - c1955. Double-8 movie camera taking 25' spools. Green crinkle finish metal body. Eye-level finder. Battery driven motor, 16 fps. Eugon f2.7/12.5mmlens. \$8-15.

Eumig Electric R - c1958. Same features as the Electric, but has auxiliary

WA .5x and Tele 2x lenses on turret mount. \$30-45.

Eumig Servomatic - c1958. Double-8 spool-load cine camera. Electric motor takes 4.5v batteries. 16 fps. BIM. Two-tone grey lacquered metal body. Schneider Xenoplan f1.8/13mm fixed focus lens accepts wide-angle Curtar 0.5x and TeleLongar 2x attachments. \$12-20.

EXCEL PROJECTOR CORP. (Chicago) Excel 16mm No. 40 - c1938. 16mm camera, 50' spools. Spring motor. Noteworthy for cylindirical shutter, single-claw pull down with register pin amd no feed sprocket. Excel f3.5/28mm lens in nonstandard mount. Diecast body, brown crinkle finish. Uncommon. \$30-45.

Excel 8mm, No. 38 - Nearly identical to the 16mm No. 40, above. Uncommon. \$30-45.

FAIRCHILD CAMERA AND INSTRUMENT CORP.

Fairchild Cinephonic Eight - 1960. First 8mm sound-on-film camera, using pre-striped double-8 film with magnetic recording track for direct recording of sound while filming. Built-in transistorized recording amplifier. Camera driven by special nicad rechargeable battery. 3-lens turret. Exposure meter screws onto lens turret for reading. Standard, WA, and Tele lenses available. \$100-150.

Fairchild Cinephonic Eight Sound Zoom - 1963. Like the listing above, but with Fairchild f1.8/10-30mmzoom lens and coupled Sekonic Photo-Meter. \$100-150.

Fairchild Projectors:

Cinephonic - 1960. 8mm sound-on-film projector, companion to the Fairchild Cinephonic cameras. Magnetic striped film; 400' reels. Projector will play back, overlay, or record. 3/4" f16 lens. Sound level indicator. Separate unit houses speaker, extension cable, microphone, and reel. \$35-50.

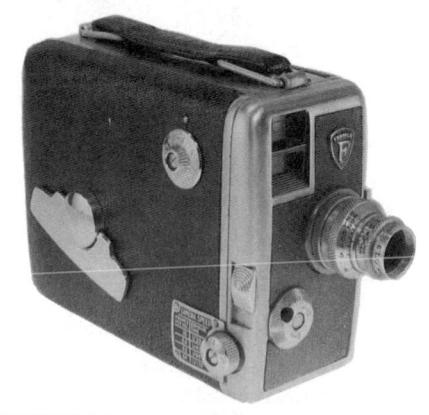

FRANKLIN PHOTOGRAPHIC INDUSTRIES INC. (Chicago)
Franklin Magazine 8 - 1948. Compact 8mm camera using 25' magazines. Manufactured under EKC's patents. Spring motor, 16-64 fps. Wollensak f2.5/1/2" lens. A 2-lens turret model was also made. \$15-25.

FUJI PHOTO FILM CO., LTD (Japan)
Fujica Single-8 P1 - c1965. Single-8
battery operated camera using special Fuji
Single-8 drop-in cartridge. Electric eye,
needle visible in finder. \$12-20. Later
models offered zoom lens, backwinding
capability, reflex viewing, \$20-30.

MOVIE: GERMAN-AMERICAN -----

GERMAN-AMERICAN CINEMATO-GRAPH AND FILM CO. (New York and Berlin) Everhard Schneider, the founder of the German-American Cinematograph and Film Co. designed and made a series of cine cameras as well as motion picture projectors, printers and film perforators. Edison filed suit against Schneider in 1898 for patent violation. This German-American Co. did not survive World War I.

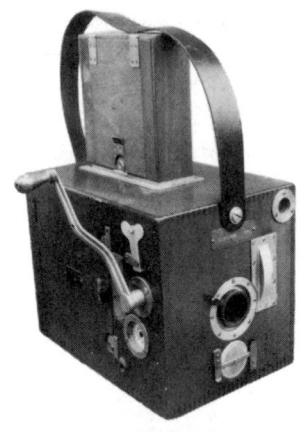

Everhard Schneider 35mm Motion Picture Camera - c1898. This very early motion picture camera was the first of a series of fine equipment. Has an external film supply magazine and an internal take-up magazine. Although some mechanical parts of the camera are castings, several are hand made. Range: \$3500-5500.

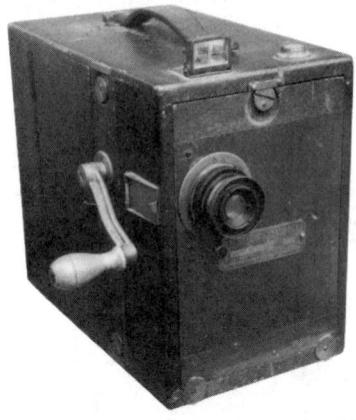

Everhard Schneider 35mm Motion Picture Camera - c1910. This camera is an example of Schneider's less elaborate, wood body, hand crank, field type motion picture camera. 200' co-axial internal magazines are used. Range: \$1000-1500.

GEYER (Karl Geyer Maschinen und Apparatebau GmbH, Berlin)
Cine-Geyer AK26 - c1925. 16mm amateur cine camera, taking 30m spool film. Black lacquered metal body. Spring motor, 16 fps. Optical eye-level viewfinder as well as waist-level viewfinder. Triotar f2.9/25mm focusing lens. \$350-500.

GUSTAV AMIGO (Berlin, Germany) Amigo 35mm Motion Picture Camera - 1920. Though basic in design, the Amigo is a well constructed field camera and is capable of fine work. A Williamson type film transport is used. Range: \$1000-1500. Illustrated at top of next column.

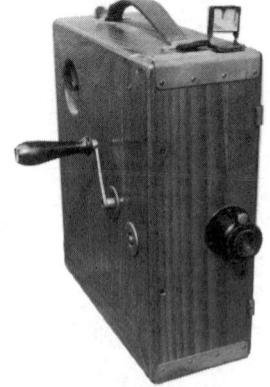

Gustav Amigo 35mm

HOUGHTON Ensign Autokinecam - c1930. 16mm movie camera with 100' spool. Spring motor or hand cranked. Single lens. 3 speeds. \$35-50.

Ensign Auto-Kinecam 16 Type B - c1935. 16mm movie camera, 100' spools. Crinkle-finish black metal body. Eye-level finder near the top, Newton finder mounted on the side. Spring motor, 8-32 fps and hand wind. Interchangeable Dallmeyer Anastigmat f2.9/1" focusing lens. \$75-100.

Ensign Super-Kinecam - 1931. 16mm, 100' spools. Hand crank or spring motor 8-64 fps. 3-lens turret. Quadri-focal finder, auxillary parallax correction. \$75-100.

ICA A.G. (Dresden, Germany)
Kinamo 15mm - c1921. Compact
15mm cine camera, made in 2 sizes for
15m lca cassettes or 25m cassettes.
Hand-crank. Black leather-covered body,
folding frame finder. Tessar or Dominar
f3.5/40mm focusing lens. \$60-90.

Kinamo 35mm Motion Picture

Camera - 1924. This compact, hand cranked, amateur camera uses 50' magazines. It has a leather covered metal body. An accessory spring motor drive was also available. It is of quality design and construction. In 1926, the Ica company joined with Contessa-Nettel-Werke, Zeiss, Goerz, and Ernemann to form the Zeiss Ikon Co. Production of the Kinamo continued and more versatile models were produced. Range: \$100-200.

IKONOGRAPH CO. OF AMERICA (New

York) Founded about 1905 by Enoch J. Rector, a somewhat notorious film impressario. This company was one of the first to offer a line of projectors designed for the amateur. The films were 17.5mm nitrate stock, center perforated at the frame line, reduction printed from standard 35mm commercial films, and were supplied by the Ikonograph Co. in 40' cans, with titles such as "The Tramp's Bath".

Ikonograph Model B - c1905. Handcranked 17.5mm projector. Due to its extremely simple mechanism, the projector could be run backward as well as forward, thus bringing a popular Hollywood trick to the home projectionist. Several models were produced, all hand cranked, with illumination by incandescent or acetylene lamp. \$125-250.

INDUSTRIAL SYNDICATE OF CINO-SCOPE (Italy and Paris, France) Cinoscope 35mm Motion Picture Camera - 1924. This leather covered metal hand crank camera was made in Italy and sold in France. The camera has a Kador f3.5/50mm lens. It uses 100' magazines and has Geneva Cross film transport. With the addition of a lamphouse and reel arms, the camera can be used as a projector. Range: \$800-1200.

INTERNATIONAL PROJECTOR CORP. (NY)

Simplex Pockette - 1931. First U.S.-made 16mm magazine camera, used "old style" EKC/IPC magazine. Waist-level finder, sportsfinder on side; optional top-

MOVIE: LEITZ

Keystone K-22

mounted telescope viewfinder with parallax. Spring motor, 12-16 fps. Footage counter. Black or grey aluminum body with embossed art-deco pattern. Non-interchangeable fixed focus f3.5 lens. Later models, c1933, had interchangeable focusing Kodak Anastigmat f3.5/1". \$25-35.

IRWIN CORP. (NY) Irwin Magazine Model 16 - c1930. Among the first U.S.-made 16mm magazine cameras. Takes Irwin 50' magazines. Rectangular metal body. Spring motor, 16 fps. f4.5/1" lens. Hexagonal tube or open top-mountedfinder, \$20-30.

Irwin Magazine Model 21 - Like the Model 16, but with f4.5 lens, 4 speeds, and through-bodyfinder. \$20-30.

Irwin Magazine Model 24 - Like the Model 21, but with f3.5 lens. \$20-30.

KBARU (Quartz) 2M - c1960's, Russian double-eight movie camera. Gray enamelled body. Spring wind, 8-32 fps. f1.9/12.5mm lens. Coupled meter. With hand grip: \$12-20.

KEYSTONE MFG. CO. (Boston) Founded in 1919 to manufacture toy movie projectors, formerly supplied by European manufacturers

Capri Models - c1950's. Models K-25. K-27, K-30. 8mm spool load movie cameras. Grey or brown leather covered body. Single lens and 3-lens turret models. Elgeet f1.9 lens. \$1-10.

Keystone A Models - c1930's-1940's. A series of 16mm spool load cameras (models A, A-3, A-7, A-9, A-12). Oval metal bodies are either leather covered or lacquered. In black, brown, or grey. Eyelevel finder. Spring motor, 12-64 fps on

most models. Some models have an interchangeable lens. \$20-30.

Keystone Movie Camera, Model C c1931. 16mm spool load movie camera. Black crinkle finish metal body. Eye level finder. Hand crank. Oval body like the later "A" models. Ilex f3.5/1" lens. \$35-50.

Keystone K-8, K-22 - 1930's-1940's. Like the "A" models, but for 8mm film. \$1-10. Illustrated at top of previous column.

Keystone Projectors: Early projector models were mostly 35mm, hand-cranked, and cheaply made. Only a few representative or unusual models of projectors will be listed.

Moviegraph - c1919. Hand-cranked 35mm projector. Toy-like quality. Early ones marked "Patent Applied For". \$35-50.

Moviegraph - c1920. Hand-cranked simple projector. One of very few U.S.-made projectors for Pathe's 28mm film which has three perforations on one side and one perforation on the other. No shutter; no film takeup. \$30-45.

Supreme - c1930. Hand-cranked 9.5mm projector for 400' reels or 30' and 60' cassettes. Double sprocket drive; 3-color filter. Only known U.S.-made 9.5mm projector. \$50-75.

KLIX MANUFACTURING CO. (Chicago) Klix 35mm Motion Picture Camera 1918. Compact amateur hand crank cine camera with unusual reciprocating shutter. A Geneva Cross film transport movement is used. A heavy flywheel helps for smooth cranking. This camera has 25' film magazines. A larger Model 2 camera has 100' magazines. Both cameras can be used as projectors with the addition of an adapter kit that includes a lamphouse, reel arms,

special shutter, etc. Range: \$500-750.

KODEL ELEC. & MFG. CO. (Cincinnati, Ohio)

Kemco Homovie - c1930. Unusual system for 16mm safety film. Unique design to take four frames in each 16mm frame. Film transport moved in boustrophedonic pattern (2 exposures left to right across film, down 1/2 frame, then right to left, etc.) 100' of film gave the equivalent of 400' in number of exposures. Individual exposures measure 3.65x4.8mm. The spring-motor driven camera was housed in a bakelite case and used an f3.5/15mm lens. The projector was motor-driven, and could project either the Kemco system or the conventional full-frame by selecting the proper condenser lens. 250w, 50v lamp. Very rare. No known sales. Estimate: \$1000-1500.

KURIBAYASHI CAMERA WORKS

A little known fact, Kuribayashi Camera produced three different cine models from 1962 through 1966. Apparently few were ever produced, making these models very

Petri Eight - 1962. Fixed focus Petri f1.8/13mm lens with aperture set by electric eye. Battery powered film transport and shutter (16 fps). Rare. \$30-45.

Petri Power Eight - 1964. Petri Eight with Petri f1.8/9-25mm lens with power zoom control. Rare. Price unknown.

Petri Super Eight - 1966. CdS photometer controlled Petri f1.8/8.5-34mm lens with power zoom feature. Battery powered film transport with 18 or 32 fps setting. Drop-in super eight film loads. Rare. Price unknown.

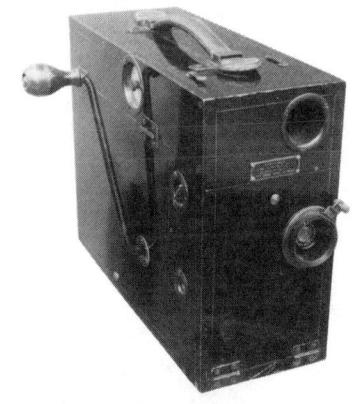

L.A. MOTION PICTURE CO. (Los Angeles, CA) Also known as Angeles Camera Co. Produced original Cine camera designs and also made close copies of the designs of others. During WWI they were able to meet requirements of domestic studios for European type cameras that were not available. They also made cameras that were sold under the brand names of others.

35mm Motion Picture Camera c1914-23. There is no model name on this well made, metal bodied, hand crank camera. It has several features, including 400' internal co-axial magazines. Range: \$800-1200.

LEITZ (E. Leitz, Wetzlar)

Leicina 85 - 1960. 8mm spool camera, battery operated. Reflex viewing. Built-in fixfocus Dygon f2/15mm lens with snap-on Wide-angle Dygon f2/9mm and Tele-Dygon f2/36mm supplementary lenses. Automatic exposure control with reading in

MOVIE: LEITZ... -----

viewfinder. Film exposed gauge also visible in finder. \$35-50.

Leicina 8SV - c1964. Similar to the Leicina 8S, but f1.8/7.5-35mm Zoom lens, 16 and 24 fps. \$60-90.

LINHOF (München, Germany)

Coco - c1921. 17.5mm film in 15m cassettes. Black leather covered metal body. Folding Newton finder. Interchangeable Linhof Helan f3/40mm or Colan f4.5/30mm fixed focus lens. Very rare! One sold at auction in 6/92 for about \$900.

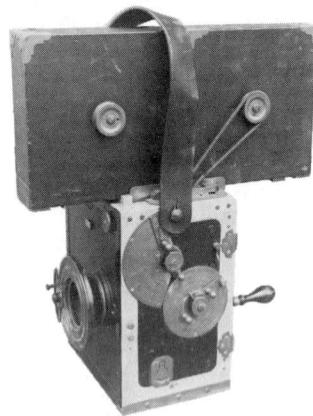

LUBIN (Sigmund Lubin, Philadelphia, PA) Sigmund "Pop" Lubin, a European immigrant, was quite knowledgeable in optics, chemistry, and mechanics. He was a very early motion picture entrepreneur. He manufactured motion picture equipment for his own studio use. At one time, however, he did offer a camera, a projector, and a phonograph for use by those starting in the motion picture business, for a modest \$150. The buyers later found that the camera and projector used only film supplied and printed by Lubin. Much of his equipment was very similar to that of other manufacturers but his versions were always an improvement. He did hold motion picture equipment patents and was involved with Edison in the Motion Picture Patent Company, a trust formed to control the motion picture industry.

Lubin 35mm Studio Motion Picture Camera - 1908. This was the workhorse of the Lubin studios. It is very similar to the Pathe studio camera but has heavier gearing, a metal body, and a speed governor. Range: \$3000-6000.

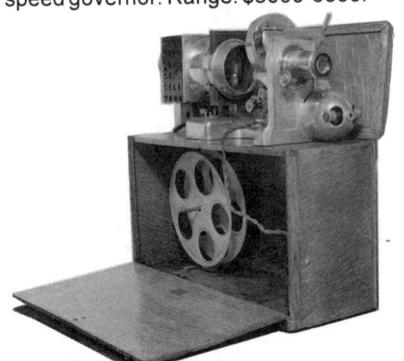

MAGGARD-BRADLEY INC.
(Morehead, KY)
Cosmograph Model 16-R - c1925.
35mm "suitcase" projector of unusual design. Cast aluminum projector mechanism is seated on top of wood carrying case; film is threaded from supply and take-up reels in staggered array below. Lamp house and condenser swing back for

lantern slide projection with auxiliary lens. Electric motor drive. \$50-75.

MANSFIELD INDUSTRIES, INC. (Chicago)

Mansfield Model 160 - c1954. 16mm spool-film cine camera taking 50' or 100' rolls. Grey crinkle-finish metal body. Spring-wind. f1.9 or f2.5/1" lens. Optical eye-level viewfinder. \$35-50.

MARLO - c1930. No maker's name on this 16mm 100' spool camera, but it is identical in almost every detail to the DeVry 16mm cameras, and has a DeVry patent number inside. Spring motor. Graf f5.6/29mm lens. Black crinkle finish. Brass nameplate says "Marlo". \$75-100.

MEOPTA

Admira A8F - Similar to the A8G, below, but with BIM. \$20-30.

Admira A8G - c1964. Slim, tapered 8mm camera with spring wind motor, 16 fps. Mirar f2.8/12.5mm fixed focus lens. Light and dark grey lacquered metal body. \$1-10.

MILLER CINE CO. (England)
Miller Cine Model CA - c1953. 8mm spool load movie camera. Brown leather covered metal body. Spring motor, 8-64 fps. Eye-level finder. Interchangeable fixed focus Anastigmat f2.5/12.5 lens. \$1-10.

MITCHELL CAMERA CORPORATION

(Glendale, CA)
Mitchell - 1920. The Mitchell studio camera was a major milestone in motion picture camera design when introduced in 1920. It is somewhat similar in appearance to the earlier Bell and Howell 2709 studio camera, but has a simpler through-thetaking-lens previewing system. Mitchell registration pins are reciprocal and hold the film perforations precisely during exposure. A wide range of accessories are available. The low operational noise level of the Mitchell compared to the Bell and Howell, soon had it replacing the Bell and Howell after the advent of sound movies. The Mitchell soon became the most popular studio camera. It is still in use to this day and its current high price is based on its status as a usable camera. Range: \$6000-12,000.

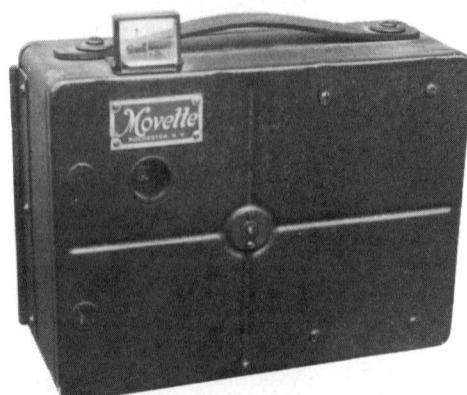

MOVETTE CAMERA CORP.
(Rochester, NY.) Reorganized as Movette, Inc. after 1918.
Movette 171/2mm Motion Picture Camera - 1917. This amateur hand

Camera - 1917. This amateur hand cranked camera uses $17^{1/2}$ mm film that has two round perforations on each side of the picture frame. The shutter has a fixed opening and the lens has a fixed aperture

and focus. The camera used a simple type film magazine. The processed positive print on safety film was returned from Eastman on a similar magazine for use in the companion projector. A library of feature films was offered. This home motion picture system featured simplicity. Camera only: \$350-500. Projector: \$120-180.

MOVIEMATIC CAMERA CORP. (New York)

Moviematic - 1935. Inexpensively made all-metal rectangular 16mm magazine cameras. Spring motor. Side mounted open finder. Moviematic furnished films in special magazines holding approximately 11' of film: M40 for snapshots; M50 for movie (flip) books; M60 for projection. "Mercury" model with rounded ends: \$25-35. Models with bright nickel, copperplated, or cross-hatched pattern faceplates: \$8-15.

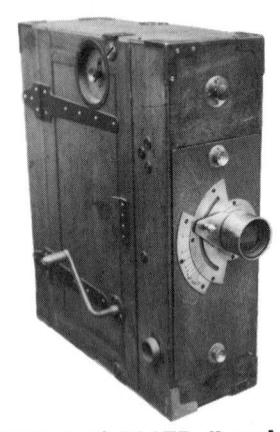

MOY (Ernest F.) LTD. (London, England)
Moy and Bastie's 35mm Motion
Picture Camera - 1909. This wood body camera used internal 400' magazines, one above the other. The Moy uses a variable shutter and a unique film transport movement called a drunken screw. Critical focusing is accomplished by viewing the image through the film. A variant of this model has the lens mounted on what would normally be the side and has dual shutters so it can be used as a projector head. Range: \$1500-3500.

NEWMAN & SINCLAIR (London) Auto Kine Camera, Model E - c1946.
35mm spring driven movie camera, 10-32 fps. Holds spools up to 200'. Polished, patterned Duralumin body. Eye-level finder. Ross Xpres f3.5 lens. \$200-300.

NIPPON KOGAKU (Japan)

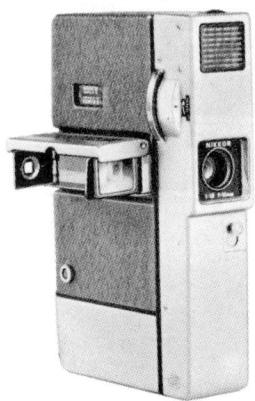

Nikkorex 8, 8F - c1962. Slim 8mm spool load movie cameras. Battery operat-

ed motor, 16 fps. Chrome with brown leatherette covering. Nikkor f1.8/10mm fixed focus lens. Electric eye CdS exposure meter. The model 8 has a folding optical eye-level finder. Model 8F has a thru-the-lens reflex finder. \$8-15.

Nikkorex Zoom-8 - 1963. Battery operated 8mm spool camera. Manual zoom Nikkor f1.8/8-32mm lens. Automatic/manual exposure control with visible needle. Split-image rangefinder focusing, reflex viewing. Film counter. Battery test. \$20-30.

NIZO (Niezoldi & Kramer GmbH, Nizo-Braun AG, Munich)
Cine Nizo 8E Models A, B, C c1930's. 8mm spool load movie cameras.
Rectangular metal bodies, black leather covered. Spring motor, 6-64 fps. Interchangeable Voigtländer Skopar f2.7/
12.5mm focusing lens. In addition to the optical eye-level finder found on the Model A, Models B and C have a waist level

Cine Nizo 91/2 Model A - c1925. Boxy 9.5mm movie camera using Pathe cassettes. Black leather covered metal body. Eye-level finder. Spring motor, 16 fps, and hand crank. Meyer Trioplan f3.5/77mm fixed focus lens. "N.K.M" manufacturers plate on front. \$75-100.

finder. \$35-50.

Cine Nizo 91/2 Model F - c1925. Boxy 9.5mm movie camera using Pathe cassettes. Black leather covered metal body. Folding Newton finder. Spring motor, 16-32 fps. Steinheil Cassar f2.8/20mm fixed focus lens. \$30-45.

Cine Nizo 91/2 Model M - c1933. 9.5mm cine camera taking 15' Nizo cassettes. Like the Cine Nize 16L, except for size. 8-24 fps. \$75-100.

Cine Nizo 16B - c1927. Similar to the Cine Nizo $9^{-1}/_2$ Model A, but for 16mm film. \$90-130.

Cine Nizo 16L - c1930's. 16mm movie cameras taking 50' spools. Black crackle finish metal body. Optical eye-level finder. Spring motor, early version 8-24 fps, later one for 8-64 fps. Interchangeable Meyer f1.5/20mmfocusing lens. \$90-130.

Exposomat 8R - c1955. 8mm movie camera for 25' Rapid cassette. Built-in meter. Grey crinkle finish metal body. Eyelevel finder. Spring motor, 16-24 fps. Fixed focus Ronar f1.9/12.5mmlens. \$12-20.

Exposomat 8T - c1958. Almost identical to the Exposomat 8R, but for spool film instead of Rapid cassettes. Steinheil Culminon f1.9/13mm fixed focus. \$12-20.

Heliomatic - A series of once very expensive 8mm cameras with many features. **Heliomatic Allmat 8** - Auto-exposure.

Heliomatic Allmat 8 - Auto-exposure. Large selenium meter on top. Rodenstock Ronar f1.9/12.5mm and 2-lens-turret with wide angle converter Ronagon R 6.5 and teleconverter Eutelon R 2x25. \$75-100. Heliomatic Allmat 8B - Similar to

Allmat 8B - Similar to Allmat 8B, but turret with wide angle converter Ronagon R6.5 and tele-converter Eutelon 7I 2 8x37 5 \$120-180

Eutelon 7I 2.8x37.5.\$120-180. **Heliomatic 8 Focovario -** c1961.

8mm spool-loading cine camera with Schneider Variogon 8-48mm/f1.8 or Angenieux 9-36mm/f1.4 Zoom lens.

Coupled exposure meter. Spring wind 8-48 fps. Eye-level reflex focusing. Grey lac-

quered metal body. \$100-150.

Heliomatic Reflex 8 - c1961. 3-lens-turret with non-changeable focusing Heligaron f1.6/6.5mm, Ronar f1.9/12.5mm or Heligon f1.5/12.5mm and Euron f2.8/37.5mm. \$150-225.

Heliomatic Reflex 8A - c1961. Similar to Reflex 8, but interchangeable D-mount tele lenses. \$175-250.

Heliomatic Reflex 8B - c1961. Similar to Reflex 8, but interchangeable D-mount normal and tele lenses. \$200-300.

Heliomatic 8 S2R - c1951. 8mm spool load movie camera. Grey crinkle finish metal body. Spring motor, 8-64 fps. Coupled meter. Focusing Rodenstock Heligon f1.5/12.5mm and Euron f2.8/37.5mm lenses. \$50-75.

PAILLARD A.G. (Geneva, Switzerland)

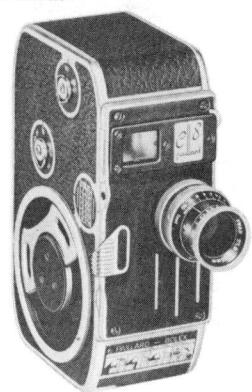

Bolex B8, C8, D8, H8, L8, L8V - A series of double 8mm cameras, with only minor differences in body design or features. Spring motor. Black leather covered metal body. f0.9 to f4 lenses available. D-mount.

L8 (1942) - single interchangeable lens cannot be used on C/B/D/H8 models; 16 fps.

L8V (1946) - single interchangeablelens; 12,16,32 fps.

B8 (1953) - 2-lens turret; 8-64 fps.

C8 (1954) - single interchangeable lens; 8-64 fps

All of the above models sell in the range of \$30-45.

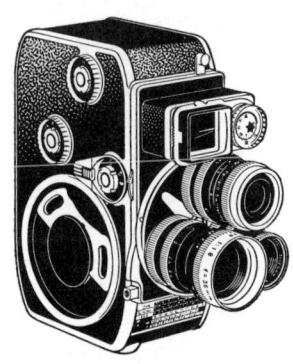

Bolex D8L

B8L, C8SL, D8L - c1958. Like the B8, and C8 models above, but with built-in light meter. B8L and D8L are 2-lens and 3-lens turret models, 12-64 fps. C8SL has a single lens and 18 fps. D8L: with 3 lenses, \$100-150; with 1 lens, \$60-90. B8L: \$45-60. C8SL: \$75-100.

H8 - intro. 1936. Same body style as the H16, but for 8mm movies. Heavier construction than the later L8, B8, and C8

MOVIE: PAILLARD

models. Black leather covered metal body. Optical eye-level finder. Spring motor, 8-64 fps. Standard with D-mount. Also found with interchangeable focusing lenses on a 3-lens turret. Meyer Kino Plasmat f1.5/12.5mm, Meyer Trioplan f2.8/36mm and f2.8/20mm. With 3 lenses: \$150-225. With standard D-mount lens: \$60-90.

H8 Reflex - c1956-65. Metal body with C-mount for special lenses: Reflex Pan Cinor 40, automatic Kern Vario-Switar 36EE, Switar f1.6/5.5mm to Macro-Yvar f3.3/150mm. \$400-600, depending on lenses.

H-8 Supreme - Same as the H-16 Supreme, but for 8mm film. \$100-150.

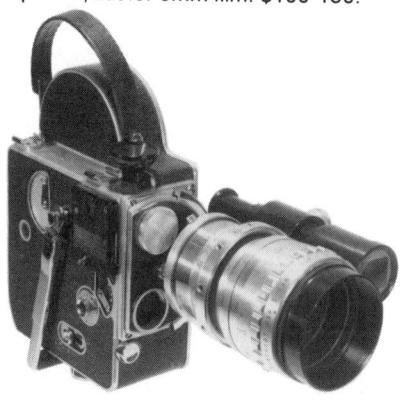

H-16 - intro. 1935. 16mm movie camera for 100' spools. Automatic film threading. Black leather covered metal body. Optical eye-level finder. Spring motor, 8-64 fps. Interchangeable lenses mounted on a 3-lens turret. Meyer Trioplan f2.8/75mm, Meyer Plasmat f1.5/6mm and f1.5/25mm. \$120-180.

H-16 Deluxe - c1950. An updated version with "Octameter" viewfinder showing field of view for eight different lenses 16mm to 6". Eye-level focus through all lenses. \$175-250.

H-16 Leader - c1950. Similar to the Standard H-16 (above), but with thru-thelens waist level reflex viewing. Achromatic eyepiece. \$120-180.

H-16 M - c1962. Similar to H16, but no turret or built-in viewer. C-mount 10mm to 150mm lenses. Uses multifocal-viewer or Berthiot zoom Pan Cinor 85 f2/17-85mm with split-image viewing system. Made for use in a special housing for submarine photography \$300-450.

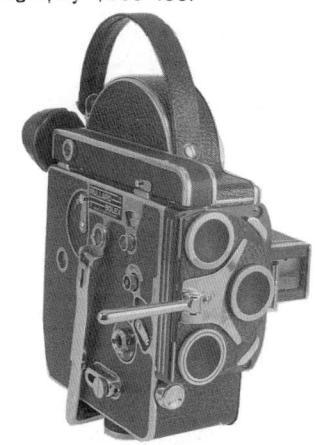

H-16 Reflex - c1950. Similar to the Standard H-16 (above), but with an eye-

MOVIE: PAILLARD...

level reflex thru-the-lens viewfinder, like the H-8 Reflex. "H16 REFLEX" engraved on top of lens panel. Switar Reflex f1.6/10mm to Switar Reflex f1.4/50mm tele lenses, Yvar f2.8/75 to Yvar f4/150mm. \$350-500.

H-16 Supreme - c1954. Has built-in turret lever to facilitate the rotation of the lens turret. \$200-300.

P1 - c1962. 8mm TTL-Reflex split-image cine camera. Based on C-8 metal camera body, but with non-changeable Berthiot Zoom Pan Cinor 40 f1.9/8-40mm. Built-in exposure meter. 1,12-64 fps. \$75-100.

P2 - c1962. Simplified version of the P1. Berthiot Pan Cinor 30 f1.9/30mm lens. No split-image focusing. \$50-75.

P3 - c1962. Similar to the P1, but mixed-image focus system. \$60-90.

P4 - c1963. Similar to the S1, but with Pan Cinor 36 f1.9/9-36mm lens. 1,12,18,40 fps. \$45-60.

Zoom Reflex Automatic K1 - c1962. 8mm. New metal body design with fixed psitol grip. Spring motor, 1,12,18,24,40 fps. Manual and automatic CdS exposure system. Variable sector-aperture. Power-zoom Kern-Paillard Vario-Switar f1.9/8-36mm. TTL-viewer, frame and film counter, \$45-60.

Zoom Reflex Automatic K2 - c1964. Similar to the K1, but modified exposure system. \$75-100.

Zoom Reflex Automatic \$1 - c1964. Similar to the K1, but Schneider Variogon f1.8/9-30mm lens. Special wideangle converter Schnedier Vario-Curtar 9.75x changes soom range from 6.75 to 22.5mm. \$75-100.

Bolex Projectors:

Bolex Cinema G816 - c1939. Electric-drive 16mm projector which can convert to either 8mm or 9.5mm with accessory kits of suitable spindles, sprockets, and guide rollers. 50mm/f1.6 lens; 750w lamp. Uncommon.\$120-180.

PARAGON CAMERA CO. (Fond du Lac. WISCONSIN)

Paragon Model 33 - 1933. 16mm spool load, with through-body finder. Wollensak f3.5 lens. Spring motor, single speed (3-speed model made in 1938). Footage counter. Almost identical to Cinklox, possibly a predessorto it. \$45-60.

PATHE FRERES, PATHE S.A., (Paris, France) A major European motion picture company, they introduced the 28mm movie format and reduced a large 35mm feature movie library to 28mm safety film to increase their home movie business. The 28mm format provided a modest savings in film size, cost, and more importantly, the use of fire resistant film in the home. 28mm projectors were made by Pathe of France and subsequently by Hall Projector and Victor Animatograph of the USA. A few amatuer 28mm cameras were also made.

Motocamera - c1928. 9.5mm movie camera using 10m Pathe cassettes. Spring motor, 16 fps. Leather covered metal body. Eye-level finder built into the camera body instead of the folding frame finder found on the earlier Pathe Baby. Krauss Trinar f3.5/20mm fixed focus lens. \$30-45.

Motocamera Luxe - c1932. Similar, but with 3 speeds and Zeiss or Krauss f2.9 or f2.7 lens. \$50-75.

Motocamera 16 - c1933. 16mm movie camera using cassettes. Black leather covered metal body. Spring motor, 16 fps. Krauss Trinar f3/25mm lens. This 16mm model is not nearly as common as the 9.5mm model listed above. \$100-150.

Pathe, 35mm - 1905. Motion picture studio camera. This leather covered wood body hand crank camera uses external 400' magazines mounted on top. The film transport mechanism is based on the movement used in the pioneer Lumiere Cinematograph camera and is still used in the modern Bell & Howell Filmo and Eyemo cameras. In the years just before WWI the Pathe was used on more movies throughout the world than any other camera. It is difficult to find a pristine Pathe as they were heavily used and generally modified to update them. Lubin, Angeles and Wilart made similar cameras in the USA. Range: \$2400-3200.

Pathe, 28mm - 1912. A scaled down version of Pathe's successful 35mm field camera. An economical 28mm version of the English Williamson/Butcher type camera was also offered later by Pathescope of America. Range: \$2000-3000.

Pathe Baby - 1923-25. 9.5mm hand cranked movie camera, taking 9m Pathe cassettes. One rotation per 8 frames. Extremely compact leather covered metal body. Folding sportsfinder. Roussel Kynor 3.5/20mm fixed focus lens. The 91/2mm width amatuer film format was introduced in Europe at about the same time 16mm film was introduced in the USA. The 91/2mm film perforations are in the center of the film, between frames. The picture format extends to almost the width of the film thereby providing efficient film use.

The film has a safety, reversal type base that could be processed by the user. $91/_{2}$ mm movie cameras were popular in Europe and the British empire. \$35-50.

Pathe Baby, with motor - c1926-27. Similar to the original model, but body is about twice the width to accomodate the spring motor. 16 fps. Hermagis f3.5/20mm fixed focus lens. \$35-50.

Pathe Baby, with Camo motor -Larger motor than the listing above. Marked "Camo" and "Swiss movement Suisse". Kynor f3.5/20mm lens. \$100-150.

Pathe Mondial B - c1932. Similar to the Motocamera (above), but slightly smaller body, and black painted instead of leather covered. Trioplan f2.8/20mm lens. \$30-45.

Pathe National I - c1930. 9.5mm movie camera taking 9m Type H Pathe cassette. Black painted metal body. Eyelevel finder. Spring motor, 16 fps. Krauss Trinar f3.5/20mm fixed focus lens. \$30-45.

Pathe National II - c1940's. Improved version of the National I. Grey crinkle finish body. 8-32 fps. Interchangeable Som Berthiot focusing f1.9/20mmlens. \$30-45.

Pathe Projectors:

Pathe Kok Home Cinematograph 1912. Hand-cranked projector for Pathe's new safety film on cellulose acetate base. Illumination by low voltage lamp, fed from small generator which was driven by the same mechanism that operated the film advance. Films, up to 400', were reduction prints from commercial negatives, supplied by Pathe. The large polychrome rendition of a rooster (Pathe's trademark) on the case cover is one of the attractions of this historic projector. With excellent decal: \$150-225.

MOVIE: REVERE

auxiliary lantern slide lens: \$350 and up. Projector head only: \$120-180.

New Premier Pathescope - c1920. Electric drive 28mm projector of rugged construction, manufactured and marketed in the U.S. by Pathescope Co. of America, Inc. Geneva intermittent, large 3-blade shutter in front of lens. \$50-75.

Pathe-Baby - 1922. 9.5mm projector. First model hand-cranked; later, motor drive was available. Cassette loaded with 8.5m of film, caught in glass-front chamber, from which it is rewound by hand. Fixed resistor for low-voltage lamp. Unique film-notch system gave automatic delay at title frames for substantial economy in film. Films supplied by Pathe were reduction prints of commercial films. A library of over 100 titles was available. Die-cast shutter/flywheel is usually deformed and inoperable; as such: \$25-35. Working: \$35-50.

Pathe Kid - 1930. Hand-cranked 9.5mm projector, scaled-down version of Pathe Baby. No glass on lower film receptacle. Separate "cage" resistor. Sold by Pathex, Inc. NY. \$25-35.

PENTACON (VEB Zeiss Ikon)

AK 8 - c1955. 8mm movie camera using 25' film spools. Metal body with imitation leather covering. Optical eye-level view-finder. Spring motor, 16 fps. C.Z. Triotar 12.8 lens. \$20-30.

POLAROID CORP. (Boston, MA)
Polavision Land Camera - 1977.
Battery-driven Super 8 instant movie camera. Special Super 8 film rated ASA 40, in Polaroid cartridge holding approximately 42' (2 minutes, 40 seconds of filming). Polaroid f1.8/12.5-24mm manual zoom lens. Two focus positions: 6'-15', 15'-infinity. Single speed, 18 fps. Reflex viewing. Flag in viewfinder for low light. Warning light for beginning and end or usable film. Battery check light. Film is developed to positive in special developer/player. Plug-in is 110v, 170 watt light available. Camera with player, lights, cords, etc.: \$120-180. Camera only: \$25-35.

POWER (Nicholas Power Co., NY)

This manufacturer of 35mm theatre projectors appears to have begun operation prior to 1899. The Company was merged with International Projector Corp., about 1920.

national Projector Corp. about 1920.

Cameragraph - First models, such as No. 3 were built on a wooden frame, much like the 1899 Edison Projecting Kinetoscope. No. 4, c1905, was the first all-metal model. No. 6, c1906, featured the first automatic fire shutter built in the U.S.A. and was the last of the "open mechanism" design. Complete with lamphouse, lamp,

PRESTWICH MANUFACTURING CO. (London, England)
Prestwich 35mm Motion Picture
Camera - 1908. This wood body camera
uses internal 400' magazines, one above
the other. The patented Prestwich film
transport movement is used. The lens is
focused by rack and pinion. The lensboard
swings out for access to the variable
shutter. Critical focusing is accomplished
by viewing the image through the film. 200'
models were also made. The Pitman and
DeFranne cameras, made in the U.S.A.
are almost identical to the Prestwich.

Q.R.S. CO. (Chicago)

Range: \$2000-3000.

Q.R.S. Projector - c1929. 16mm projector/camera combination consisting of base motor and lamphouse, into which the appropriate Q.R.S. or Q.R.S.-DeVry 16mm camera is fitted. The correct camera is identiifed by: "window" lens on left side where lamp house fits; 3-bladed projector shutter which replaces camera shutter; projection position for aperture blade. Camera and projector base: \$35-50.

Q.R.S. Model B - c1930. 16mm inexpensive projector, some models hand-cranked, some with motor drive. \$20-30.

RCA VICTOR CO. INC. (Camden, NJ) RCA Sound Camera - 1935. World's first 16mm sound-on-film camera. Sound recorded by built-in microphone placed close to operator's mouth when camera was in normal operating position. Sound track was variable area type, recorded by light beam from battery-powered 4-volt auto-headlight type bulb. Eastman 16mm Sound Recording Panchromatic Safety film. Spring motor driven. 3-lens turret with

Universal focus f3.5 normally supplied. Rare. \$500-750.

REVERE CAMERA CO. (Chicago)

Revere, 8mm - 1940's-1950's. Turret models, including 44, 60, 63, 67, 84, 99: \$12-20. Various single lens magazine models, including 40, 61, 70, 77, 88, and Rangerand spool load model 55: \$8-15.

Revere 101, 103 - 1956. 16mm spring motor cameras taking 100' spools. The 101 came with Wollensak f2.5 lens; the 103 with 3-lens turret and one lens. Each lens had objective finders like the Kodak K-100. Listed at roughly half the K-100 price, these cameras typified the aggressive competition Revere offered the "big guys" at this time. \$35-50.

Revere Eye-Matic CA-1 to CA-7-1958. 8mm automatic exposure control cameras. Spring motor. Spool and magazine load. Various combinations of singlelens and turret styles. CA-7 with Zoom lens: \$12-20. Others: \$1-10.

Revere Magazine 16 - c1948. 16mm magazine movie camera. Brushed chrome and grey or brown leather covered metal body. Optical eye-level finder. Spring wind, 12-48 fps. Interchangeable Wollensak

MOVIE: REVERE... ------

Raptar focusing lens. Single-lens models have f1.9/1" lens. Turret models also have f2.7/17mm and f4/3" lenses. \$20-30.

Revere Super 8mm - 1939. Despite its name, its not a Super-8 camera at all, but Revere's entry in the brief "craze" for single-8, started in 1936 by Univex, and almost over when this otherwise undistinguished camera came on the market. Single-8 Panchromatic film in 30' spools, made for Revere by Agfa-Ansco. Spring motor. Fixed focus f3.5/1/2" lens. Rare. \$50-75.

RISDON MFG. CO. (Naugatuck, Connecticut)

Risdon Model A - 1931. 16mm spring motor camera using 50' spools. Stamped steel body with black crinkle finish. Simple f3.5 lens, waterhouse stops. Top-mounted telescoping finder. Cameras were later distributed by Agfa-Ansco and the nameplate changed to "Ansco-Risdon". Risdon models: \$30-45. Ansco-Risdon models: \$20-30.

SANKYO Sankyo 8-CM - 1963. Compact 8mm spool camera. Pronon f1.8/8.5-26mm zoom lens. Battery drive, 12-24 fps. Fold-ing grip/battery holder. Reflex viewing. Coupled EE for film speeds ASA 10-200. Footage counter. \$12-20.

SCHALIE COLLEE (Switzerland) s.c. Kamera - c1932. Spring wind camera, 16 fps. 16mm on 15m spools. Vertical duraluminum body with rounded ends, polished hammertone finish. Trioplan f2.8/25mm lens. \$300-450.

SEKONIC TRADING CO. LTD. (Toyko) Sekonic Dual Run Simplomat 100 -1962. 8mm spool load spring motor camera with unique "flip over" film chamber permitting full 50' run without rethreading. Auto exposure control. Zoom f1.8/11.5-32mm lens. Reflex viewing. Footage counter. \$30-45.

Sekonic Dualmatic 50 Model 130 c1963. Economy version of the above. Fixed f1.8/13mm lens. Non-reflex viewing. \$20-30.

SIEMENS & HALSKE AG (Berlin) Siemens B - c1933. 16mm movie camera taking special 50' Siemens magazines. Black leather covered body. Optical eye-level and waist level finders. Spring motor, 8, 16, 64 fps. Busch Glaukar f2.8/20mm focusing lens. \$50-75.

Siemens C - c1934. Similar in style and features to the Siemens B, but with 8, 16, 24, 64 fps and a better lens. Meyer Siemar f1.5/20mm focusing lens. \$100-150.

Siemens C II - c1938. Similar to the Siemens C, but lens is coupled to the meter. Meyer Optimat f1.5/20 focusing lens. \$75-100.

Siemens F - c1936. Similar to Siemens C, but allows for single fram exposures. Interchangeable lens. With Schneider Xenon f1.5/25mm: \$75-100. With Meyer-Kino-Plasmatf1.5/25mm: \$60-90.

Siemens 8R - c1939. Double-8 spool film cine camera. Black crackle-finish metal body. Spring wind. Rodenstock Sironar f2.2/1cm fixed focus lens. \$60-90.

SINEMAT MOTION PICTURE CO. (USA) Sinemat Duplex 171/2mm Motion Picture Camera - c1915. Amateur, hand-cranked, metal body motion picture camera. Standard 35mm film was split lengthwise, providing perforations only on one side. Fixed focus, fixed opening lens. Can also be used as a projector. The single opening shutter is disengaged and a dual opening shutter is engaged when used as a projector. Range: \$750-1000.

SOCIETY OF CINEMA PLATES (Paris, France)

Olikos - 1912. Uses 18- 9.5x9cm glass plates to produce a 90 second movie. The camera, with the addition of a lamphouse is used as a projector. A conventional lens, shutter, and hand crank is used. A unique mechanism takes each plate through a sequence of positions at the focal plane of the camera. Each plate, in turn, is automatically positioned so a series of seven pictures is taken from right to left on the top of the plate. The plate is then immediately moved up and another sequence of seven photographs is taken from left to right and so on for a series of 12 rows of seven or 84 photographs on each plate. Each following plate is automatically positioned and sequenced for a total of a 1512 frame movie. The plate positioning mechanism is precise enough so that the time interval between photographs is acceptably consistent. Few Olikos camera were made. Range: \$2000-3000.

SPORT-2 - c1960. Double-8 movie camera. Battery operated motor. T-40 f2.8/10mm lens. \$15-25.

STEWART-WARNER (Chicago) **Buddy 8 Model 532-A -** 8mm spool camera. Through-body viewfinder, folding sportsfinder on side. \$12-20.

Companion 8 (Model 532B) - intro. 1933. 8mm spool load movie camera.

Smaller version of the Hollywood camera listed below. Black lacquered metal body, oval shaped. Spring motor, 12, 16, 48 fps. Interchangeable Wollensak Velostigmat f3.5/12.5mmlens. \$1-10.

Deluxe Hollywood Model - 1932. 16mm camera similar to the 531-B, but with new lens mount for standard C-mount 16mm lenses. Side-mounted telescopic finder. \$25-35.

Hollywood (Model 531-B) - c1931. 16mm spool load movie camera. Black lacquered metal body, oval shape. Eyelevel finder. Spring motor, 8-64 fps. Stewart Warner f3.5/25mm lens. \$20-30.

TECHNICOLOR CORP. (Hollywood, CA) Technicolor Automatic 8 - c1960. Battery driven 8mm spool camera. Coupled EE. Type A swing-out filter. Footage counter. Technor f1.8/13mm lens. \$1-10.

UNIVERSAL CAMERA CO. (Chicago)

Not to be confused with the later "Universal Camera Corporation" of New York City.

Universal 35mm Motion Picture
Camera - 1914. This camera, in the classic early English design, has internal 200' film magazines, one above the other. (400' cameras were made for the US Army during World War I.) The film transport mechanism is similar to the early French Lumiere/Pathe movement. The wood body is painted black or khaki and the front and side doors are aluminum with a distinctive engine turned finish. While primarily a field camera, the Universal with added features became a studio camera. Range: \$1000-1500.

UNIVERSAL CAMERA CORP. (New York City) Not to be confused with the earlier "Universal Camera Co." of Chicago.
CINE 8 CAMERAS:

A-8 - c1936. Die-cast metal, black finish.
MOVIE: VICTOR

Interchangeable f5.6 Ilex Univar. Collapsible viewfinder. Used Univex 30' patented spools of Single-8 film. Common. \$12-20.

B-8 - c1939. "True View" model. Die-cast metal, antique bronze finish. Interchangeable f5.6 llex Univar or f3.5 Wollensak lenses. Built-on telescopic viewfinder above the body. Used Univex Single-8 film. \$15-25.

C-8 - c1939. "Exposition" or "World's Fair" models. Die-cast metal, antique bronze finish. Interchangeable llex Univar f4.5 or f5.6 lenses. Built-in viewfinder. Used Univex Single-8 film. \$12-20.

C-8 Turret model - c1939. Same features as the standard C-8, but with 3-lens turret. Sold with f4.5 llex Univar or f3.5 Wollensak Univar lens. Optional Wollensak Univar lenses were: f2.7/1/2", f1.9/1/2", f3.5/1" Telephoto, f3.5/11/2" Telephoto. Scarce with f3.5, f1.9 and a Telephoto lens: \$150-225. Also uncommon with f4.5 or f3.5 only: \$50-75.

D-8 - c1941. Dual 8mm "Cinemaster" model, taking Univex Single-8 or standard Double-8 film. Die-cast metal with green finish. Interchangeable f4.5 or f6.3 llex Univar. Built-in viewfinder. Single speed. Scarce. \$75-100.

E-8 - c1941. Dual 8mm "Cinemaster" model, taking Univex Single-8 or standard Double-8 film. Die-cast metal, antique bronze finish. Interchangeable Univar f3.5, f2.7, or f2.5 lens. Built-in combination extinction meter and viewfinder. Three speeds. Scarce. \$75-100.

F-8 - c1941. Dual 8mm "Cinemaster" model. Similar to E-8, but grey satin finish and front and rear chrome plates. \$20-30.

G-8 - c1946. Dual 8mm "Cinemaster II" model. Similar to F-8, except for minor improvements in the film transport system. Sold with f3.5 or f2.5 Universal Univar lens. Common. \$15-25.

H-8 - early 1950's. "Cinemaster II" model. Identical to G-8, except only standard Double-8 film could be used. This was the last cine camera made by Universal. Scarce. \$75-100.

Universal Projectors:

Univex P-8 - c1936. Electric 8mm projector - 100 watts, AC only. Later P-8 models upgraded to 150 watts. Die cast and pressed steel construction, black enamel finish. 200' reel capacity. Companion projector to Universal's first cine camera, the Univex Model A-8. Common. With carrying case: \$35-50. Projector only: \$15-25.

Univex P-500 - c1939. Electric 8mm projector - 600 watts, AC/DC. Die cast and pressed steel construction, antique bronze

enamel finish. Speed control adjustment, still picture projection, 200' reel capacity. Companion projector to Universal's Exposition and World's Fair cine camera, the Univex Model C-8. Common. With carrying case: \$45-60. Projector only: \$20-30.

Universal "Cinematic" P-750 - c1947. Electric 8mm projector - 750 watts, AC/DC. Full die cast construction, antique bronze enamel finish. Fully gear-driven, single "clutch" control for forward, reverse and still picture projection, 400' reel capacity. Universal coated lens. Frequent mechanical problems with this model. Scarce. With carrying case: \$100-150. Projector only: \$75-100.

Universal "Cinematic" P-752 - c1948. Similar to Model P-750, except for modification made to eliminate the gear problems of the earlier Cinematic model. The single "Clutch" control of the earlier model was replaced by two separate controls: one for still picture projection and one for forward/reverse projection. Finished in gray enamel as a companion projector to Universal's Cinemaster II cine camera. Scarce. With carrying case: \$90-130. Projector only: \$60-90.

Universal PC-500 - c1946. Similar to Model P-500, except for Universal coated lens. Common. With carrying case: \$45-60. Projector only: \$20-30.

Univex PU-8 - c1937. Similar to Model P-8, except for 200 watt, AC/DC operation with added speed control adjustment. Uncommon. With carrying case, \$50-75. Projector only: \$30-45.

Universal Tonemaster - c1947. Electric 16mm film/sound projector - 1000 watts, AC/DC. Two-piece aluminium case, 2000' reel capacity. Universal coated lens. Unique "armless" design, reels mount directly on main unit. Scarce. \$120-180.

Universal Accessories:
Cine Optical Viewfinder M-27 c1936. All metal black enamel tubularshaped viewfinder, used with Univar f5.6,
f3.5, or f2.7 lenses. Not common. \$12-20.

Cine Optical Viewfinder M-29 - c1937. Similar to M-27 viewfinder, except used with Univar f1.9 or telephoto lenses. Rare. \$35-50.

Splicer Kit - c1936. Includes splicer, water and cement bottles, and knife. Common. Complete kit: \$8-15.

Standard Titler Outfit - c1936. Includes all metal black enamel collapsible titler, silver pencil and title cards. Common. Complete outfit: \$12-20.

Automatic Titler - c1938. All metal black enamel self-standing unit has 36 character openings in three horizontal rows for composing titles. Titler has 36 cog wheels on the back for positioning title characters. RARE. \$60-90.

URIU SEIKI (Tokyo)

Cinemax 85E - c1960's. Double-8 movie camera. Spring motor, 12-48 fps. Cinemax Auto Zoom 8.5-42.5mm f1.6 lens. Automatic meter. \$1-10.

U.S.CINEMATOGRAPH CO. (Chicago) 35mm Motion Picture Camera c1916. This wood body, leather covered field camera has 200' co-axial internal magazines. Its film transport movement is

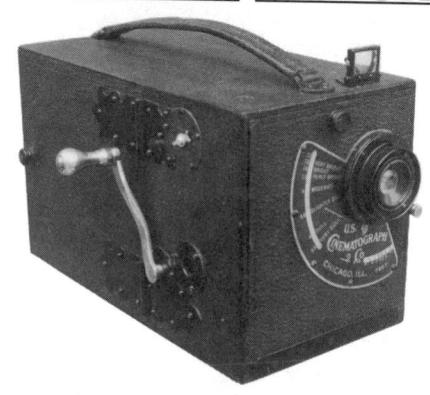

somewhat unique. It has a variable shutter and through the film critical focusing. This camera was also sold under the name "Davsco". Range: \$750-1000.

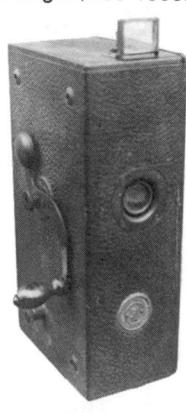

VICAM PHOTO APPLIANCE CORP. (Philadelphia, PA)

Baby Standard - 1923. 35mm motion picture camera. This wood body, hand cranked camera featured simple design and construction, rather than small film size, to provide economical use for the amateur. A fixed focus lens is used with a two opening waterhouse stop bar. Internal 25' film magazines are used. A removable port in the rear allows the use as a projector. A die cast aluminum body model was also offered. Range: \$350-500.

VICTOR ANIMATOGRAPH CO. (Davenport, IA) Alexander F. Victor's first "motion picture machine" was a spiral disk projector resembling the Urban Spirograph. Patented Nov. 29, 1910; how many of these projectors were actually produced is unknown.

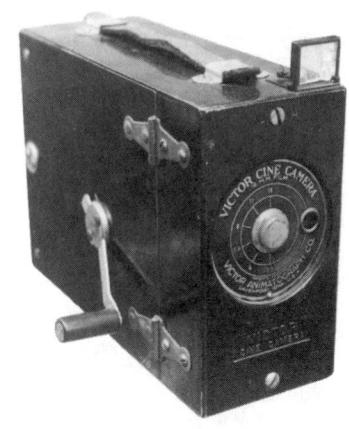

Victor - 1923. This basic hand crank 16mm camera was produced shortly after the introduction of the Cine Kodak 16mm system. It uses a double push claw for a

MOVIE: VICTOR... ------

film transport. The fixed focus lens is fitted with wheel stops. Range: \$175-250.

Victor, Models 3, 4, 5 - late 1920's-early 1940's. 16mm movie cameras taking 100' spools. Black or brown crinkle lacquered finish on metal body. Newton finder and reflex critical focus eyepiece. Spring motor, 8-64 fps. Interchangeable lenses. Model 3 for single lens: Wollensak Cine Velostigmat f3.5/1" fixed focus. Models 4 and 5 have a 3-lens turret with focusing lenses: Wollensak f2.7/17mm, Cooke f3.5/2", and f1.9/1". With 3 lenses: \$90-130. With single lens: \$35-50.

Victor Ultra Cine Camera - 1924. 16mm battery-driven version of the 1923 Victor Cine Camera. Thomas Willard, of the Willard Storage Battery Co., is credited with designing this rare modification of the hand-cranked Victor. Compartment for rechargeable battery at rear of camera, powering small electric motor placed in forward bottom part of camera. Less than 100 of these cameras were produced. \$500-750.

Victor Projectors: Victor Animatograph - 1914. 35mm semi-theatre projector, hand-cranked, upright construction. 1000' reel enclosures

top and bottom, chain drive to Geneva intermittent. \$100-150.

Safety Cinema - 1917. 28mm "safety film", 3 perforations per frame each side. Failed commercially for lack of suitable film. Rare. \$150-225.

Home Cinema - 1920. 28mm Pathe safety film, 3 perforations on one side, one on the other. Victor's last attempt to keep the 28mm format alive in this country. Rare. \$150-225.

Cine Projector - 1923. 16mm EKC direct reversal film. Victor's first projector for the new EKC 16mm film system. Marketed simultaneously with the Victor Cine Camera. Hand-cranked, co-axial 400' reels. 32cp, 12v lamp. \$150-225.

Cine Projector Model 3 - c1928. 16mm motor-driven, single sprocket. 400' reels on retractable arms. \$35-50.

VITAGRAPH COMPANY OF AMERICA (New York)

Vitagraph - 1915. This wood body, hand crank camera was a ruggedly built inhouse design of the Vitagraph Studios. The design is complex and it is a fine looking camera with lots of external brass. It is somewhat unique for this type of camera in that it is loaded from its right camera side rather than the left. Range: \$2000-3000.

VITALUX CAMERA CO. (Milwaukee,

WI) The Vitalux system was invented in 1918 by a German immigrant to New York City named Herman C. Schlicker. It was manufactured by a company formed by the prominent motion picture executive John R. Freuler.

The Vitalux Camera - 1922. The camera took a spiral of 1664 images (each slightly larger than present day Super 8) on an endless loop of film 5" wide by 171/2" long. The film was Eastman Safety negative, and was loaded in a steel magazine. The camera was die-cast aluminum. Handcranked. Goerz Hypar f3.5/20mm lens. Only 2 of these are known to exist. Estimate: \$1000-1500.

Vitalux Projector - 1922. Companion projector to the Vitalux camera (above). 5"x171/2" loop of EKC safety negative film. Hand-cranked, with optional motor drive; 250w lamp, cast-iron frame. Weight of motor, 25lbs. \$200-300.

VITASCOPE CORP. (Providence, RI)
Movie Maker - c1931. 16mm movie
camera, taking 50' spools. Hand crank,
one rotation per 8 frames. Black crinkle
finish metal body. Small waist level finder.
Simple lens. \$20-30.

WILLIAMSON LTD. (London, England)
Williamson 35mm Motion Picture
Camera - 1909. This wood body camera
uses internal 400' magazines, one above
the other. The patented Williamson film
transport movement and a variable shutter
are used. Critical focusing is accomplished
by viewing the image through the film. 200'
models were also made. A 100' basic
design camera, similar to Empire was
made. Some Williamson cameras are

called tropical models and have numerous brass inlays to reduce expansion and shrinkage in the wood body. Range: \$1000-4000.

WILLIAMSON KINEMATOGRAPH CO. (London)

Paragon - c1921. 35mm hand-cranked cine camera taking 400' film magazines. Polished teak body with inlaid brass. Interior lined with sheet aluminum. 3-lens turret holds Taylor-Hobson Cooke Anastigmat lenses: 2"/f3.1, 3"/f3.1, 4"/f4.5. \$2800-4000.

WITTNAUER CAMERA CO. (NYC) Automatic Zoom 800 - 1959. 8mm battery drive spool load camera/projector combination like the Cine-Twin. Wittnauer f1.6 zoom lens, front-mounted coupled electric eye. \$75-100.

Cine-Simplex - c1958. 8mm battery-drive spool load camera, without the projector conversion that the Cine-Twin has. Made in two models: 4-lens turret with optional screw-in EE exposure meter, or single Elgeet f1.8/13mm Synchronex lens with "wrap-around" electric eye for automatic exposure control. \$35-50.

wittnauer Cine-Twin - 1957. Battery powered 8mm spool load movie camera/projector. Die cast body. Electric eye exposure meter. 4-lens turret holding standard, WA, and Tele camera lenses plus projector lens. 5-position telescope finder. Camera contains the reel arms and bulb. It is mounted on a base containing the electric motor and blower for projector operation. \$50-75. This is the original model, invented and patented in 1959 by J.W. Oxberry, inventor of the fames Oxberry Animation Stand.

MOVIE: ZIX

WOLLENSAK OPTICAL CO. (Chicago) Model 8 - Grey and black 8mm movie camera. Eye-level finder. Elgeet f1.9/1/2" focusing lens. \$1-10.

Model 23 - c1956. 8mm magazine camera. 3-lens turret. Eye-level finder. Spring motor, 5 speeds. Matte aluminum and black. \$1-10.

Model 42 - 1957. 8mm spool load with spring motor. f1.9 lens, waterhouse stops, aperture adjustment. \$8-15.

Model 43, 43-D - Like the Model 42, but with 3-lens turret. Model 43-D has 5 speeds. \$8-15.

Model 46 - c1958. 8mm spool load movie. Electric eye. 3-lens turret with Raptar f1.8 normal, tele, and wide angle lenses. \$1-10.

Model 46 Eye-Matic - 1958. 8mm spool load, spring motor. Coupled EE. f-stop visible in viewfinder. Footage counter. Hammertonegray lacquered finish. \$8-15.

Model 57 Eye-Matic - 1958. 8mm magazine camera similar to Model 46 Eye-

Matic, but with Wollensak f1.8 zoom lens which is powered by camera motor. Also featured "heart-beat" device to assure operator that film was advancing properly, a feature shared by several similar Revere magazine cameras of that period. This camera is marked inside "Made for Wollensak Optical Co. by Revere Camera Co." and probably marks the take-over of Wollensak by Revere. Revere was acquired by the 3M Company at about this time. \$8-15.

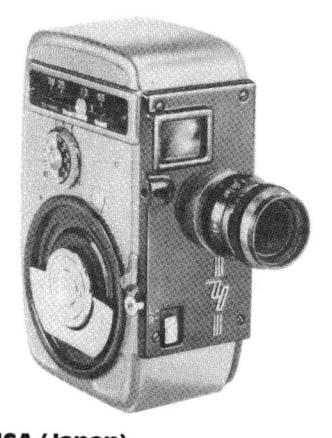

YASHICA (Japan)
Yashica 8, T-8 - c1959. 8mm spool load movie cameras. Grey and black die-cast aluminum bodies. Spring motor, 16 fps on model 8, 8-64 fps on model T-8. Zoomtype viewfinder for 6.5-38mm lenses. Model 8 has a single interchangeable Yashikor f1.9/13mm lens. T-8 has a 2-lens turret for Yashinon f1.4/13mm normal, 38mm tele, or 6.5mm wide angle lenses.

ZEISS Kinamo N25 -c1927. 35mm cine camera using Zeiss film cassettes. Spring wind motor attaches to the side of the body. Black leather covered metal body. Tessar f2.7/40mm lens. Folding wire frame finder on top. \$150-225.

\$1-10.

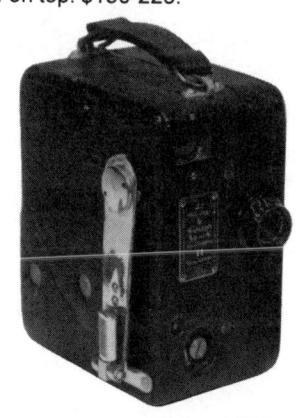

Kinamo \$10 - c1928. 16mm movie camera taking a 10m special Zeiss magazine. Very small body compared to other 16mm movie cameras. Black leather covered metal body. Optical eye-level finder. Spring motor, 16 fps. Zeiss Tessar f2.7/15mmfixed focus lens. \$60-90.

Moviflex Super - c1964. All-electric 8mm reflex. Green metalic lacquered metal body. Zeiss motor zoom Vario Sonnar f1.9/7.5-30mm lens. Manual or auto aperture setting, split image RF, film counter. Attachable pistol grip has addi-

tional battery. Takes 1,16, or 48 fps. \$90-130.

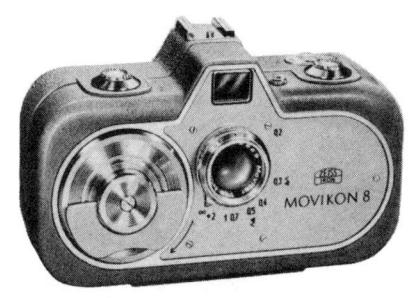

Movikon 8 - c1952. 8mm movie camera taking 25' spools. Interesting horizontal body design. Brown or grey crinkle finish metal body. Eye-level finder. Spring motor. Early version only 16 fps; later for 16-48 fps. Focusing Zeiss Movitar f1.9/10mm lens. \$60-90.

Movikon 8 B - c1959. Similar to the Movikon 8, but with built-in light meter. Grey crinkle finish body. \$60-90.

Movikon 16 - c1936. 16mm spool load movie camera. Black leather covered metal body. Eye-level and waist-level finders, and separate critical focus sight. Spring motor, 12-64 fps. Interchangeable Sonnarf1.4/25mmlens. \$250-375.

Movinette 8B - c1959. Similar to the Movikon 8 B, but Triotar f2.8/1cm lens, single speed spring motor 16 fps. \$45-60.

ZENIT (USSR) Zenit - c1960's. Spring wind 8mm, 12,64 fps. Built-in meter. Jupiter f1.9 lens. \$25-

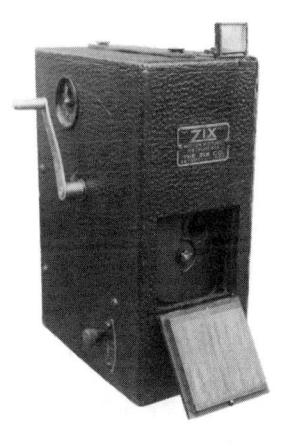

ZIX COMPANY (Detroit, MI)

Zix - 1920. Wood body, leather covered, hand crank 35mm motion picture camera for amateur use. It is unusual in that the shutter is mounted forward of the lens, the lens is mounted midpoint in the camera box and the film plane is at the rear of the camera. The lens is focused by a knob on the side. The film transport is Geneva Cross. The camera can be used as a projector. Range: \$500-1000.

NON-CAMERAS

This section of the book lists items which look like cameras but actually serve a different purpose. Functional cameras are in the main section of this guide. Many of these are recent items. Their "collectible" value is generally not based on rarity or demand, but more realistically is the retail price at which they currently are or recently were available. On these items, we have listed their approximate retail price. Items which have not been available new for some time may have prices which reflect the current market value rather than the original price. There is not a steady supply and demand for these items, as for most real cameras, so the values given should be taken only as a point of reference. This is one area of collecting where fun and enjoyment still reigns over prices. Use your own judgement for pricing, and this list to help identify items you have found or

would like to find.

A few camera dealers have complained that this chapter of the book is a waste of space. From a purely mercenary viewpoint, this is probably true, since there is probably no great profit in selling novelties. However, since nearly every major camera collector also collects these related items, this chapter remains in the book by popular demand from collectors.

The items in this section are grouped by function, and the functional types are in alphabetical order:

alphabetical order: **Advertising Specialties** Air Freshener **Albums** Bags (Handbags, Shoulder bags) Banks **Belt Buckles** Candle Candy & Gum **Cigarette Lighters** Clocks Coasters **Compacts & Vanities** Containers Convertors **Dart & Pellet Shooters Decanters & Flasks** Dishes & Tableware Dolls with Cameras Jewelry Keychains, Key Ring Fobs Lights Masks Mouse, Worm, & Surprise Cameras Music Box Ornamental Pencil Erasers, Sharpeners, Stationery **Phonographs Picture Frames Planters Printing Frames Puzzies & Games Radios Rubber Stamps** Salt & Pepper Shakers Screwdriver Soap **Squirt Cameras** Statuettes & Figurines **Toy Cameras** Toys & Cames, unspecified

This list is only a sampling of the many camera-like novelites which have been

Vehicles

Viewing Devices

produced. Readers contributions welcomed to expand this section.

ADVERTISING SPECIALTIES

are

RALPH WILSON PLASTICS CO. Wilsonart Maximum Exposure - 1989. Oversized "film cartridge" used as part of a contest soliciting new ideas from customers for Wilson's plastic laminates. A plastic filmstrip with advertising message & photos pulls out from the cartridge. The cartridge also contains product samples and contest rules. A very well designed

AIR FRESHENER

and executed advertising specialty. \$1-10.

SOLIDEX INC. (Los Angeles, CA) Minera Air Freshener - c1984. Room air freshener disguised as a zoom lens. Perfect for the high-tech bathroom, or to keep your camera bags smelling nice. \$1-10.

ALBUMS

ALBUM - Photo album shaped like 35mm SLR. Holds 24 prints 31/₄x5". \$1-10.

ANCHOR INTERNATIONAL B.V.

(Holland) Probably the same company as "Anker" below, but spelled differently.

"Tourist Camera" Foto Album - c1988. Single album designed to resemble the Graphic 35 rangefinder camera. Holds 60 10x15cm photos in plastic pages. \$1-10

ANKER INTERNATIONAL PLC (See also "Anchor" above.)

"Ariane" Photo Albums (SLR style) - c1988. Set of 2 albums in a slipcover which resembles a 35mm SLR camera. The album covers repeat the design of the slipcover, and when in position, the spines form a composite image of the camera top. Each album has 30 double-sided plastic sleeves, 10x15cm. Made in Korea. About \$8-15.

Benjamin Camera - c1988. Set of 4 albums styled like a view camera and labeled "The Benjamin Camera" on the front. The spines of the four albums, when aligned in the slipcase, form a composite image of the side of the view camera. Each album has 20 plastic sleeves for 10x15cm photos. Made in Korea. About \$15.

BAGS (HANDBAGS, SHOULDER BAGS)

Shoulder Bag - c1985. Rigid plastic carrying bag with a shoulder strap. Shaped like a large camera. The "lens" and back are transparent plastic tinted in magenta or pale green. Retail about \$11.

SILVER LENS CAMERA BAG - c1987. Soft plastic bag shaped like 35mm autofocus camera. White or black. \$1-10.

NON-CAMERAS: CANDY & GUM |

BANKS

EASTMAN KODAK CO.

Kodak Disc Bank - c1983. Black plastic bank shaped like Kodak Disc camera. Aluminum-colored covering. \$1-10.

Two styles of the Instamatic Camera Bank Instamatic Camera Bank - c1967-70. Given free to customers who purchased 2 rolls of Kodak color film. Styles include: front identical to Instamatic 100 Camera (1967-68) and styled like Instamatic 124 Camera (1968-69). Black plastic body. Printed front behind clear plastic. "Instant Savings for Instamatic Cameras" molded into back. Originally purchased by dealers for \$5.00 per carton of 25. \$1-10.

KATO KOGEI Conica - Glazed ceramic coin bank,

styled like Konica C35 EF3 camera. Black, red. or white. \$15-25.

KODAK BANK - Early cast metal type. Shaped like a Brownie box camera. The door reads "Kodak Bank". This bank was not made by Kodak. Manufacturer unknown. Marked "Patent Pending 1905". It was offered for sale as late as 1914 by Butler Brothers, a toy distributor. \$90-130.

PICCOLETTE CAMERA BANK - Ceramic coin bank shaped like Piccolette camera. \$12-20.

PIGGY BANK - c1991. Ceramic piggy bank, 31.5cm tall. Happy, human-like piggy, wearing a beret and sweater, and with a TLR camera on neckstrap. \$35-50.

POCKET COIN BANK - Black plastic coin bank shaped like 110 pocket camera. "Pocket Coin Bank" on aluminum-colored top. \$1-10.

ROLLEICORD - Ceramic bank styled like Rolleicord TLR. White iridescent glaze with gold trim. Clear plastic lenses. \$35-50.

TUPPERWARE - Black plastic bank with grey plastic knobs and lens. Lettered rings around lens set combination "tumblers" to open lens. "Tupper Toys" on front of top housing. \$1-10.

BELT BUCKLES

LEWIS BUCKLES (Chicago) Camera Buckles - c1980's. Cast metal belt buckles shaped like cameras or with bas-relief cameras as the major design. Available in various styles for different brands of cameras. About \$5.

CANDLE

CAMERA CANDLE - Black wax candle shaped like 35mm SLR, 2x3". Gold or aluminum-colored trim. \$15-25.

MICKEY MOUSE CANDLE - Hand painted wax candle, 85mm tall, in shape of Mickey Mouse holding a camera. \$1-2.

CANDY & GUM

AKUTAGAWA CONFECTIONERY CO. LTD. (Tokyo)

Chocolate Camera - c1981. A well-detailed scaled-down chocolate model of the Canon AE-1 camera. A perfect gift for the man who wants to have his camera and eat it too. Retail price: \$5.

NON-CAMERAS: CANDY & GUM

DONRUSS CO. (Memphis, TN) Hot Flash Chewing Gum - c1984.
Red or yellow plastic container shaped like SLR. "Hot Flash" on front of prism. Lens removes to open. Contains small pellets of chewing gum. \$1-10.

FERRERO
Pocket Coffee Espresso - 1990.
Candy package designed to resemble an oversize 35mm flash camera to celebrate "Father's Day" in Italy. "19.3.90 festa del Papa" on front. Sold at camera collector shows for \$15 when new. Maybe as the candy gets stale, the price will drop.

CIGARETTE LIGHTERS

AKW (Ankyu Workshop, Tokyo)
Perfect-Lighter - Lighter shaped like
35mm camera. Metal covering with
stamped cherry tree design. Tree trunk
and branches on back. Some traces of
Leica styling include slow speed knob and
focus lever. "Perfect" engraved on top,
along with model number DI or DII. Actuator button is marked "pushing". "AKW
Tokyo" on bottom. Another variation is
leatherette covered, and marked "ANKYU
WORKSHOP IN TOKYO" on bottom. With
tripod: \$45-60.

BROWN & BIGELOW (St. Paul, MN) Kodak Film - Lighter in shape of small red roll of film on a film spool. Pulls apart to reveal "RediXite" lighter. \$75-100.

CANON LIGHTER - Lucite butane lighter with Canon Logo. \$12-20.

CONT-LITE TABLE LIGHTER - Bakelite-bodied cigarette lighter styled like 35mm camera with cable release and tripod. "CONT-LITE" on back; "Cont-Lite Table Lighter" on original box. \$20-30.

CONTINENTAL CAMERA-LIGHTER - Bakelite-bodied lighter, styled like 35mm camera. "CONTINENTAL NEW YORK" around lens. No other identification. "Made

in Occupied Japan" molded in bottom. With tripod and cable release: \$20-30.

FILM CARTRIDGE LIGHTER - c1988. Gas lighters in the shape of a 35mm film cartridge. Various patterns including Kodak and Fuji films, or decorative designs. \$1-10.

FOTO-FLASH - Russian copy of the Leica-styled Japanese camera lighters. "FOTO-FLASH" molded in the back in Cyrillic characters. Inset picture on front of the Russian poet, Essenine. Uncommon. \$50-75.

GELY-BOX - c1930's. Small metal "box camera" is a mechanical cigarette lighter. The flint rides on top of a rotating abrasive wheel which is powered by a spring-motor. Cigarette tip is inserted into small hole above "shutter" to be lit by sparks. Rare. \$150-225.

K.K.W.
Camera-Lighter - Lighter styled like
35mm camera. Bakelite body with no
name on back. Compass built into front.
"Made in occupied Japan" on bottom.
"K.K.W. CAMERA LIGHTER" on lens rim.
With tripod: \$20-30.

Photo-Flash Camera-Lighter -Lighter styled like 35mm camera. "Photo-Flash" molded in back of bakelite body. Compass inset in front. "K.K.W. P.P 13449 Japan" on bottom. With tripod: \$20-30.

KYOEI TRADING CO. (Tokyo) Mino Flex Snap Lite - Cigarette lighter styled in the form of a small TLR, 5cm high. Made in Occupied Japan. With tripod and cable release. \$35-50.

LUCKY-LITE CAMERA-LIGHTER - Cigarette lighter/telescope shaped like 35mm camera. Bakelite body. "Lucky-Lite" molded in back. Telescope through center of camera in lens position. Front lens focus. Made in Occupied Japan. \$25-35.

LUMIX CAMERA-LIGHTER - Small cigarette lighter styled like a Leica IIIc. "Winding knob" with numbered skirt functions as shutter release lock. Top housing definitely Leica-styled (unlike other lighters). "Slow speed dial" on front. Viewfinder round rangefinder windows on front. Side by side eyepieces on back. Focus lever on "Excellent Cherry" lens. Metal covering in either cherry blossom or leopard spot pattern. Made in Occupied Japan. \$25-35.

MATCH KING - Lighter styled like small Piccolette camera. Top knob unscrews and withdraws attached "match" from the

Mugette Camera-Lighter

wicking where it has soaked up a smallamount of fluid. Match is then struck on the side of the case. Speed dial is marked "Falcon". \$20-30.

MUGETTE CAMERA-LIGHTER - Small black or brown bakelite lighter styled like Piccolette camera. Speed dial is marked "Triumpf". Made in Germany. \$25-35. *Illustrated bottom of previous page.*

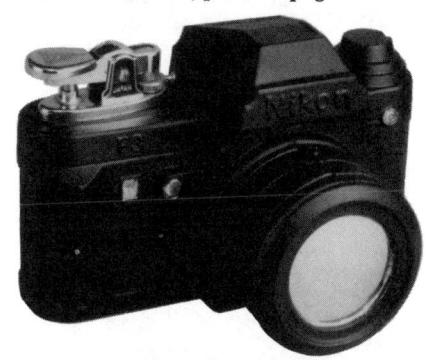

NIKON F3 TABLE LIGHTER - c1987. Cast metal, about 85% scale of Nikon F3. Butane lighter in position of shutter release and speed dial. Made in Japan. \$12-20.

NST

Phenix camera-lighter (bakelite) - Black bakelite lighter styled like 35mm camera. Made in Occupied Japan. "NST" on focus ring. "Phenix" molded in back. Compass on front. With tripod: \$15-25.

Phenix camera-lighter (metal covering) - Lighter styled like 35mm camera. Thin metal covering with stamped flower pattern on front. Back engraved with dragon design. Made in Occupied Japan. "NST" on focus scale. \$20-30.

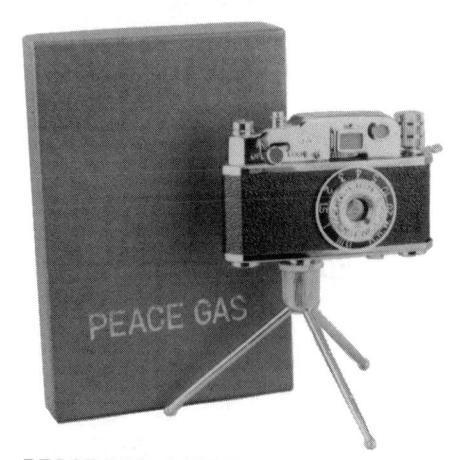

PEACE-GAS CAMERA-LIGHTER - Gas lighter styled like 35mm camera. "Peace-Gas" molded in back of bakelite body. No compass on front. With tripod and cable release: \$20-30.

PENGUIN TRY CAMERA-LIGHTER

NON-CAMERAS: CLOCKS

c1986. Small rectangular gas lighter with front and back plates printed to resemble a camera. \$1-10.

PERFEOT LIGHTER - Cigarette lighter styled as 35mm camera. "PERFEOT (sic) LIGHTER" on lens rim. No other identification. Thin metal covering stamped with cherry blossom pattern. "Made in Occupied Japan" on back. \$20-30.

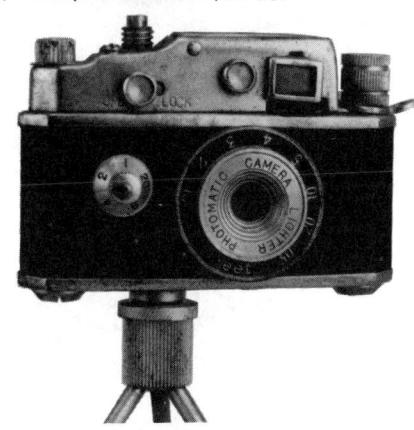

PHOTOMATIC - Camera-styled lighter on tripod. "Slow-speeddial" on front. \$15-25.

RIVIERA CAMERA-EYE SUPER LIGHT-ER (BR-C3 or KO-M2) - c1987. Gas lighters styled like miniature Konica C35 EF3. Black, blue, or red plastic body. Pressing "electronic flash" ignites lighter. \$8-15.

S.M.R. (Japan)

PENTAX ME Cigarette Lighter - Cast metal table model cigarette lighter, styled after the Pentax ME camera. The lighter insert is the refillable gas type. Retail price in 1983 about \$35.00.

View Camera Cigarette Lighter - Cast metal table model cigarette lighter, styled after a folding-bed view camera. Refillable gas lighter insert. Current value \$20-30.

SUN ARROW (Japan)
KadocK-II Personal Caslighter Lighter disguised as a 120 film roll. Styling
imitates Kodak packaging. One version
even imitates Kodak trade dress in yellow,
red and black colors. Another version is in
silver and black. \$20-30.

WOND-O-LITE - Lighter and cigarette case in shape of TLR. About 50mm square by 92mm high. Fill point is marked "Fluid lens". Back opens to hold cigarettes. \$45-60.

CLOCK

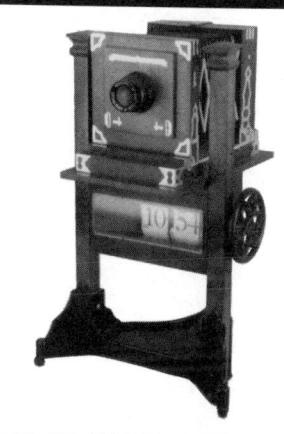

COPAL CO. LTD. (Japan)
Asanuma Clock - Brown plastic scale model of a studio camera on a stand. A mechanical digital clock is in the stand below the camera. The lens of the camera is marked "Asanuma & Co. Established in 1871". Auction high Christie's 2/89 \$125. Normally \$60-90.

NIKON CERAMIC CLOCK - Black & white ceramic Nikon with wind-up alarm clock in lens position. \$50-75.

NON-CAMERAS: COASTERS

COASTERS

FRIENDLY HOME PARTIES INC. (Albany, NY)
Camera Coaster Set - Set of six wooden coasters with cork inserts. Storage rack designed like view camera on tripod.

Chamfered edges of coasters resemble bellows. About \$5.

COMPACTS & VANITIES

In addition to the camera-shaped compacts below, there are some real cameras which are built into makeup boxes, compacts, etc. These are listed in the main part of the book, under such diverse names as Ansco Photo Vanity, Vanity Kodak cameras, and Kunik Petie Vanity.

COMPACT, CHANGE PURSE, CIGAR-ETTE CASE - Unidentified manufacturer. Suede covered compact with comb, lipstick, cigarette case and lighter, and change purse. \$30-45.

GIREY

Kamra-Pak Vanity - Small metal compact shaped like a folding camera. Front door conceals mirror and makeup. Winding knob is a lipstick. Various colored coverings, including colored leatherettes and imitation mother-of-pearl. Metal parts in brass or chrome. Often found with U.S. Navy emblem. Some collectors have expressed the opinion that the resemblance to a camera is coincidental. The name "Kamra-Pak" used by Girey confirms their intentional design as camera lookalikes. That name is found on the original box, however, and not on the compact itself which has only the Girey name. \$20-30

Kamra-Pak Commemoratives - Special designs of the common compact were made for major events. Examples include the San Francisco Bay 1939 and Century of Progress 1933. \$35-50.

Purse, Compact, & Lipstick - Unidentified manufacturer. Suede covered purse with round compact in lens position, lipstick in winding knob position. Top flap opens to small purse. \$35-50.

Unidentified compact - Slightly larger than the common Girey Kamra-Pak. This compact has a door on each side. A mirror and makeup powder are on one side; a manicure set or cigarette case on the other. The winding key conceals the lipstick tube. Available in several finishes, including suede leather and brightly colored leather patterns. Complete: \$35-50.

Unidentified compact - Rectangular brass and brass plated steel body with black enamel. Round brass front door in lens position has mirror and opens to powder compartment. Lipstick in film knob. \$45-60.

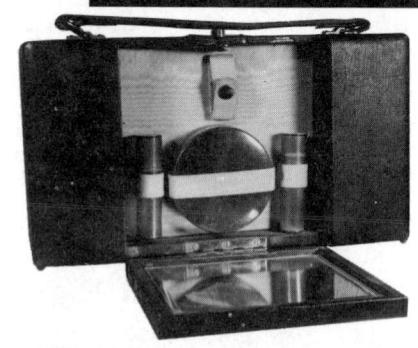

Vanity Case - Shaped somewhat like an early Blair Folding Hawkeye camera. Inside the rectangular front door are found the mirror and makeup items. \$50-75.

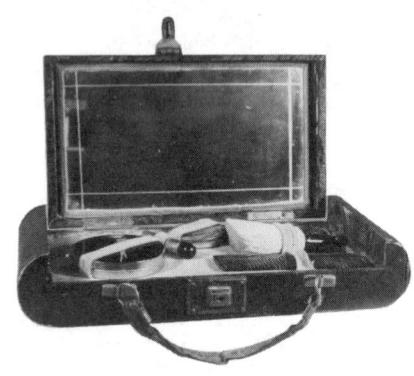

Vanity kits - Several variations of same basic style. Vanity case is shaped like a large folding rollfilm camera in the folded position. The interior houses a makeup set including compact, lipstick, rouge, and comb. Several different exterior coverings, and some have ornamental lens or small mirror in red window position. \$50-75.

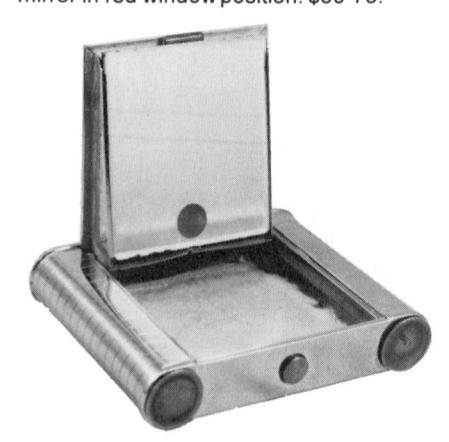

VENUS-RAY COMPACT - Brass-lacquered chrome compact with horizontal ribs. Shaped like a miniature Ikonta 6x6. Battery-powered lighted mirror in the door of the makeup compartment. The winding knobs conceal the batteries at the rounded ends of the body. \$35-50.

WADSWORTH

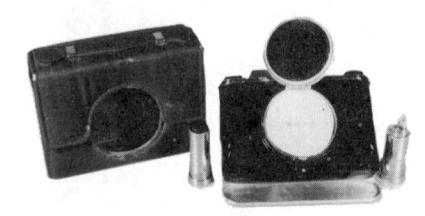

Compakit - Camera-shapedvanity case.

NON-CAMERAS: CONVERTORS

Round front door has shutter speeds and fstops. Knobs contain lipstick and cigarette lighter. Bottom opens to cigarette case. Fitted case has opening for "lens". \$50-75.

Wadsworth Vanity & Cigarette Case - Styled like folding rollfilm camera, closed position. Suede covering. \$30-45.

CONTAINERS

ASH TRAY WITH VIEW CAMERA - Ceramic glazed ash tray with view camera on one side, photographing two pigs. Made in England. 21/4" high. \$100-150.

CANDY BOX - c1920? Cardboard box, $2^{1}/_{2}$ " cube shape, designed like an early box camera. Reportedly used as a Christmas tree decoration, \$35-50.

GIBSON (C.R.) CO. (Norwalk, CT)
Camera Note Box - Cardboard box
with note cards and envelopes. Exterior is
extremely realistic lithograph of No. 2
Brownie. Design Copyright 1983 by Philip
Sykes. Retail price was \$8.50, but it would
easily bring double that amount today.

IAN LOGAN LTD. (England)
Foto-File - Cardboard box for storing photographs. Styled to look like an Agfa box camera. \$1-10.

INCENSE BURNER/SWISS PHOTOGRA- PHER - 5" high wooden incense burner made in the form of a photographer with a view camera. Made in Germany. \$25-35. *Illustrated at top of next column.*

JEWELRY CASE - c1930s. Shaped like a folding camera. Green body. Mirror inside. \$30-45.

Incense Burner/Swiss Photographer

KODAK DISC 4000 Photokina '82 - Shallow covered ceramic dish, shaped and decorated to resemble the Kodak Disc camera. The nameplate is actually the same as used on the real camera. Could be used as a cigarette box, etc. Given as a promotional item at the 1982 Photokina. \$20-30.

MYSTERY MUG - c1920's? Leatherette covered wooden box "camera" is actually a disguised storage box for an enameled metal mug. The mug is shaped like a miniature chamber pot. Perhaps it was designed for use as a cuspidor which could be hidden from view. Rare. Estimate: \$90-130.

TOURIST POTTERY - 91/4" custom-made pottery jug. Rounded shape has a man's head as a stopper and is painted with a tie and camera around his neck. Made in USA. \$250-375.

WELCH (Peter Welch, Yorkshire)
Film Cassette Cookie Jar - Oversized
film cassette with removable lid. Commissioned by Coverdale & Fletcher Photographers; designed & made by Peter Welch.
\$30-45.

ZEISS Advertising Ashtray - Has photos on it of Tropical Deckrullo Nettel, Ica Tudor, Krügener Delta. \$60-90.

CONVERTORS

For those who don't understand this modern science-fiction terminology, "convertors" are robot-like people who convert to mechanical objects. Ask your kids.

CAVALIER/Camera A-1 - Toy camera which converts to ray-gun and flashlight. Battery operated light and sound effects. \$12-20.

CHIEN HSIN PLASTIC FAC. CO. LTD. (Taiwan)

Camera Pistol 116 - Toy disguised as a camera. Opens to become a cap gun. "Camera Pistol 116" on back. \$1-10.

COMWISE INDUSTRY CO. LTD. Camera Laser Gun 3-in-1 - c1982.
This toy is shaped like a camera, but with a flashlight in the lens position. Converts to a toy laser gun. \$8-15.

DAH YANG TOYS (Taiwan) Cap gun camera - Toy disguised as a camera. Opens to become a cap gun. \$1-10

NON-CAMERAS: CONVERTORS

GALOOB (Lewis Galoob Toys, Inc., San Francisco)

Beddy-Bye Bear - c1984-85. Small pink and blue plastic charm converts from a camera to a teddy bear in bed. One of a series of nine "Sweet Secrets" charms. Retail about \$4.

LI PING CO. LTD. (Taiwan)
Cambot Wonderful Slide Robot c1985. Robot converts to camera shape,
functions as a 35mm slide viewer. In the
absence of exhaustive research, we can
only report that the package illustrates red,
blue, and yellow variations. Also interesting: the body has holes for a speaker, and
"volume" and "tuning" molded near the
edge. This indicates that a radio-equipped
version may also exist. \$12-20.

Mark MA-1 as camera and robot. Film can in upper photo gives size reference.

BAADK

MA-1 camera-robot - Small SLR-type camera converts to robot. Copyright 1984 by Select, New York and Mark, Japan. Retail about \$2.50. Illustrated bottom of previous column.

Snap-Shot Secret Gun CH-337 - Toy disguised as a camera. Opens to become a cap gun. 'Snap Shot' on front. 'Secret Gun' on back. \$1-10.

MICROX ROBOT-TO-CAMERA - c1984. Three robots combine to make Microx camera. It does not function as a camera, but can be used as a telescope. Retail about \$8-10.

SHELCORE INC. (So. Plainfield, NJ) Change-A-Toy - c1985. A children's toy which converts from a camera to a car with a few simple motions. White, blue, yellow, and red plastic. Retail about \$8.

TAIFONG Camera Shooter NIKO Nikosound 112XL - c1983. Toy styled like movie camera. Features include gun, flashlight, telescope 3.5x, laser gun. Provisions for built-in radio, but the only example we have seen did not have one. Retail about \$12.00

DART & PELLET SHOOTERS

JA-RU
Pellet Shooting Camera - c1980.
Small camera-shaped pellet shooter.
Comes with box of pellets which resembles film box. \$2-3.

KUZUWA TOY Trick Ompus XA Bickri Camera - Small black or red toy shaped like Olympus XA camera with sliding front door. Shutter release pops open lens, revealing a small funny face picture. Continued pressure ejects the funny face "dart" at the subject. Darts are stored in a film box which imitates Kodak trade dress. Original package also contains sugar coated chewing gum. \$12-20.

LINDSTROM TOOL & TOY CO. INC. (Bridgeport, Conn.)
Candid Camera Target Shot Masonite target, 9" square. Blue, green, aqua, yellow, and red sections, with photos of various planes. One plane (in 9:00 position) is inverted. Metal "Candid Camera Gun" camera, spring-loaded to shoot darts. Set with darts and boards: \$45-60. Camera only, without darts: \$12-20.

DECANTERS & FLASKS

CAMERA-FLASK, Art-Deco - Boxy, rectangular flask. Hollow cylinder through center of flask holds two nested shot glasses. "Tin Lined" stamped into bottom. Measures 14x7x4.5cm. Black & silver colored. \$60-90.

NON-CAMERAS: DECANTERS & FLASKS

CAMERA-FLASK, Folding Camera Style (American) - Several different styles, shaped like a folding rollfilm camera in the closed position. Glass flask bottle inside leatherette covered wood body or leather covered aluminum body. \$50-75.

CAMERA-FLASK, Folding Camera style (German) - Very well made, all metal with genuine leather covering. Winding knob conceals set of four nested metal shot glasses. Corner of camera body twists off to pour contents. Beautifully crafted. \$120-180.

CANDID SHOT - Ceramic decanter styled like 35mm. Winding knob is cork stopper. Two shot glasses in pouch. \$12-20.

Mr. Tourist and Mr. Photographer decanters

Mr. Photographer - 1979. Ceramic liquor decanter in the shape of an elf-like man with a view camera. Two sizes: 12¹/₄" high: \$50-75.6" high: \$30-45.

Mr. Tourist - 1979. Ceramic liquor decanter in the shape of an elf-like man with a suitcase and camera. Two sizes: 121/4" high: \$50-75. 6" high: \$30-45.

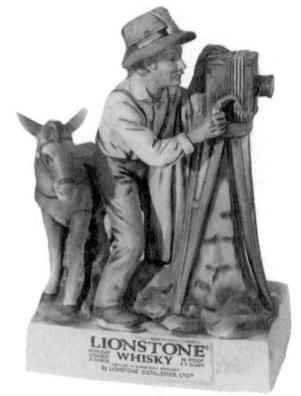

LIONSTONE DISTILLERIES, LTD. The Photographer - Ceramic decanter in the style of old-time photographer William H. Jackson. Pack-mule stands behind the photographer. Made in two sizes: 91/₄" high: \$120-180. 51/₄" high: \$60-90.

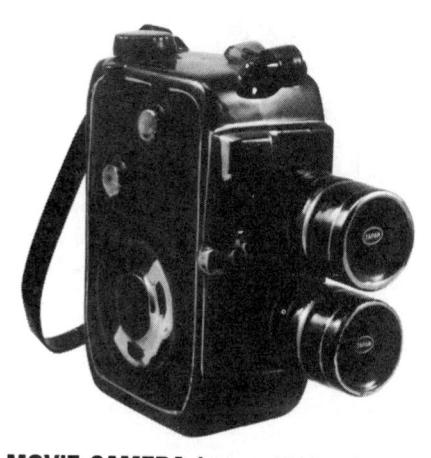

MOVIE CAMERA (no name) - Ceramic decanter shaped like movie camera. Black glaze with gold trim. Two shot glasses for lenses. \$12-20.

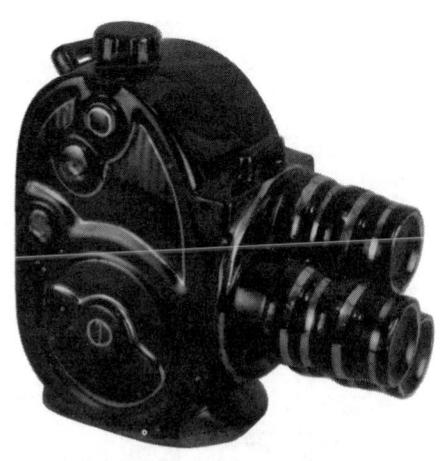

MOVIE CAMERA (three-lens) - Nameless ceramic decanter, very similar to the Relco Movie Shot, but with non-removable lenses. \$12-20.

REFLEX SHOT - Ceramic decanter shaped like TLR. Black glaze with gold trim. Cork stopper in top. Two shot glasses for lenses. \$12-20. *Illustrated at top of next column*.

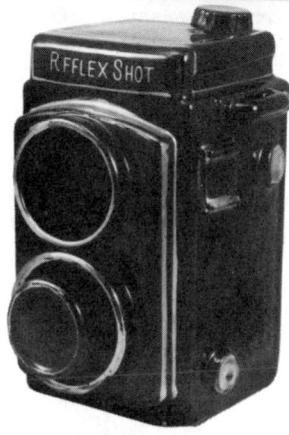

Reflex Shot

RELCO (Japan) Movie Shot - Ceramic decanter shaped like three-lens turret movie camera. The lenses are actually removable and usable as shot glasses. Black glazing with gold trim. \$12-20.

SIMS DISTILLERY
Apollo Man on Moon - 1968-69.
Commeorative decanter of an astronaut on the moon, holding a camera. 111/4" high.
White with gold frim \$175-250

White with gold trim. \$175-250..

SWANK
Camera Flack - Plactic flock should

Camera Flask - Plastic flask shaped like 35mm SLR. Winding knobs conceal spout and air vent. Clear slot on back and clear lens are useful to gauge level of contents. Comes with a small plastic funnel. \$8-15.

Schnapps-O-Flex - Ceramic decanter shaped like a TLR with a flash attachment on the left side. Black glazed with silver trim. The flash reflector removes to reveal the pouring spout for your favorite beverage. Complete outfit includes black ceram-

NON-CAMERAS: DECANTERS & FLASKS

ic shotglass in "Schnapps-O-Chrome"box resembling Kodak 35mm film box. Outfit: \$25-35. Flask w/flash only: \$12-20.

UNIVEX MERCURY DECANTER

Ceramic decanter shaped like Univex Mercury camera. Glazed in all black, or black body with white shutter housing, lens, speed knobs, and viewfinder window. \$12-20.

DISHES & TABLEWARE

CHAMPAGNE GLASS From 1911 Shriners convention. Shows man with view camera on a stand and a factory building in Rochester, NY. \$90-130.

CHEESE DISH - Ceramic tray with cover shaped like folding camera. "Say Cheese" printed in bottom of dish. \$45-60.

COOKIE FLEX - Ceramic cookie jar in the form of a TLR. Black glazed finish, white nameplate. Measures 19cm tall. \$45-60.

ENESCO IMPORTS CORP.

Ceramic Mug - c1985. Exterior has illustration of 35mm SLR. Black interior has printed slogan, "Photographers do it in the dark". \$1-10.

"You press the KODAK MUG button We do the rest" - Ivory colored coffee mug with brown printing. Drawing of woman photographing young girl with original Kodak Camera. Made in Korea for Kodak Australasia. \$12-20.

McDONALDS

Great Muppet Caper drinking glass - c1981. Two different glasses with pictures featuring Gonzo with his camera. One depicts Gonzo in a hot air balloon, the other in a bus. Cost 60 cents new in 1981. Current value \$1-10.

NIKON MUG - Plastic cup with the Nikon logo. \$8-15.

PHOTOMANIAC MUG - White ceramic

mug made in China. "Photomaniac" and drawing of camera on one side. \$1-10.

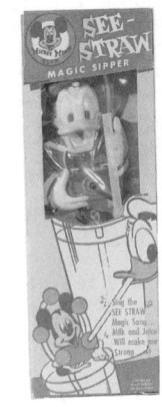

WALT DISNEY PRODUCTIONS (USA) **See Straw** - 10¹/₄" "magic sipper" straw. Packaging has a picture of Donald Duck holding a camera. \$15.

WILTON (Columbia, PA) Kodak 1880-1980 Centennial Plate

- Cast metal plate, 10" diameter. "A 100-year start on tomorrow" on rim. Center area has bas-relief scene of woman with the original Kodak Camera, photographing a young girl as a boy watches. \$50-75.

WORLD'S GREATEST PHOTOGRAPHER MUG - White ceramic coffee mug with design in colors. \$1-10.

DOLLS WITH CAMERAS

G.I. JOE ASTRONAUT WRIST CAMERA - Cheap soft plastic "camera" with elastic wrist band for the astronaut doll. Would also fit a child's finger as a ring. \$1-10.

KNICKERBOCKER TOY CO. (Middlesex, NJ)

Snoopy The Astronaut - Snoopy doll with space suit, helmet, and camera. Also includes moon shoes, life support system, vehicle, flag, and Woodstock. \$15-25.

MATTEL Fashion Photo Barbie - Imitation camera for fashion photography connected to doll by a tube. Turning camera lens causes doll to change positions. Copyright 1977. \$20-30.

JEWELRY

AMERICAN GREETINGS CO. Mr. Weekend Button whimsical decorative button illustrating a man with a camera. About \$1.00.

Charms: Happy (left) and JAS 300 (right)

CAMERA CHARM - c1986. Small blue, red, or white plastic charms shaped like 35mm rangefinder or SLR cameras. Usually with small bell and plastic clip attached. Occasionally with name such as "Happy" on front of lens. About 3 for \$1.

CAMERA-CHARM JAS 300 - Small plastic charm, styled like 35mm RF camera. "JAS 300" on back. \$0.25

CAMERA-CHARM, silver - Charm styled like a 35mm camera and flash. \$8-15.

CANON AE-1 PROGRAM LAPEL PIN - Small brass lapel pin inlaid with black & white enamel. About \$1.

Enlarged to show detail

KODAK AUSTRALASIA LAPEL PIN - Made by Swann & Hudson in Australia, this 15x20mm pin features a yellow kangaroo with red boxing gloves on a green background.\$1-10.

"KODAK 25" LAPEL PIN - c1957. Silver lapel pin given to employees with 25 years service with the company \$75-100.

Dagwood Keychain

NON-CAMERAS: LIGHTS

KRUGENER DELTA-CAR LAPEL PIN DVPCA 10th Anniv. - Tiny replica of the Krugener trademark (Delta camera on wheels with rear cab). Fashioned in sterling silver for the Delaware Valley Photographic Collectors Assn. in 1984. \$20-30.

LEICA II TIE TAC - Picture of a black Leica II on a white background. \$1-10.

MAGAZINE PENDANT - Tiny reproduction of 35mm cartridge of Kodacolor II, Agfa, or Fuji film. Only one inch tall. Comes with neck chain and matching box. \$1-10.

PHOTOGRAPHY STAMP TIETAC -Exact reproduction of the 1978 USA 15 cent photography postage stamp made into a cloisonné tie tac. \$1-10.

SMILE CAMERA CLIP - Small plastic facade of 35mm SLR which looks very much like porcelain. Pink or yellow enamel trim and matching cord. Metal spring clip glued to back. \$1-10.

YASHICA TIE CLIP - \$1-10.

KEYCHAINS, KEY RING FOBS

CAMERA KEYCHAIN - c1986. Small plastic and metal camera with attached keychain. Levers and knobs are movable. Retail \$1.50.

CAMERA KEYCHAIN, NIKON F3 - Soft black plastic fob attached to keyring. Line drawing of Nikon F3 printed on one side. Back side used for advertising. \$1.

DUPUIS COMICS (Spain) Barney Rubble Keychain - c1989.
Small rubbery figurine of Barney Rubble holding a view camera on a tripod, and

with a keychain attached to the top of his head, \$1-10.

Dagwood Keychain - c1991. Rubbery figurine of the Dagwood comic character, holding a 35mm SLR in his right hand. Keychain attached to his head. \$1-10. *Illustrated bottom of first column.*

GOLD HORSE (Taiwan) Enjicolor F-II

Keepcolor II - Key fobs shaped as 35mm cassettes, and with the same paper wrapper as the pencil erasers of the same name. To further confuse the issue, they are marked "pencil eraser" even though they are key chain fobs. Retail under \$1.

KODAK NASCAR AUTO - Double-sided antique brass colored miniature Nascar auto with number 4 and "Kodak Film" on side. Attached to split ring. \$1-10

MICKEY MOUSE VIDEO PHOTOGRA-PHER - Small rubbery plastic figure of Mickey with video camera, attached to key chain. Made in Hong Kong. \$1-10

NATURALCOLOR FILM CARTRIDGE - Pseudo film cartridge on a keychain. Film pulls out to reveal 15 views of the Grand Canyon (or other attraction). Back side of view strip is a telephone index with metric & inch rulers. About \$5.

LICHTS

CAMERA KEYCHAIN FLASHLIGHT - c1986. Small black plastic camera-shaped flashlight. Rear button pushes miniature watch battery against bulb contacts. Keychain attached to strap lug. \$1-2.

FLASH-IT CORP. (Miami, Florida) Switchplate cover (photographer)

 Ivory plastic cover for electric light switch.
 Features "flasher" photographer with two cameras around his neck and another on a tripod. His trousers are around his ankles and the light switch is in an embarrassing position. \$1-10.

Switchplate cover (tourist) - Ivory plastic cover for electric light switch: a tourist photographer with Hawaiian patterned shirt stands in front of the ocean with a sailboat in the background. He has a camera around his neck, a drink in one hand, and shopping bag in the other. His trousers are around his ankles; the light switch is in an obvious position. \$1-10.

FOTOX - Reddish-brown bakelite flashlight styled like Piccolette. Unusual bulb with solid glass front in lens position. Made in Saxony. \$25-35.

PHOTOGRAPHER LAMP - c1987. Ceramic statuette of a photographer with his view camera. Bare light bulb in lens position. \$35-50.

SASPARILLA DECO DESIGNS LTD. (New York, NY)

Camera-lamp - White ceramic nightlight designed like 35mm camera. Made in Japan. Copyright 1980. \$30-45.

WANG'S ALLIANCE CORP. Hollywood Studio Lamp - c1988.

NON-CAMERAS: LIGHTS

Small table lamp shaped like a movie camera. About \$15.

MASK

SPEARHEAD INDUSTRIES, INC. (Minneapolis)

Camera Mask - c1983. Rubber face mask shaped like SLR camera and hands holding it. \$12-20.

MOUSE CAMERAS, WORM CAMERAS, SURPRISE CAMERAS

BICOH 36 - Painted metal. Kiken Bicoh "lens". Shutter latch releases pink worm. Made in Japan. No. 6817612.\$1-10.

COMMONWEALTH PLASTICS CORP. Jack-in-the Camera Sr. - Small black plastic "camera". When release lever is pressed, a small smiling face springs through the front of the lens. \$1-10.

FRIEND BOY'S CAMERA - Eye-level style Mouse camera. \$1-10.

HIT-SIZE - Miniature worm camera about the size of a Hit-type camera. \$1-10.

KING FLEX - Minature TLR-style worm camera. \$1-10.

PANOMATIC 126 - Mouse camera shaped like 126 cartridge camera. Same old mouse in a new package. \$1-10.

PRINCE FLEX - Miniature TLR-style worm camera. \$1-10.

SNAKE CAMERA (folding bellows style) - Small cardboard bodied folding camera with bellows. Behind the shutter door lurks a green fabric-covered coiled spring with a snake-like head. Fabulous, fragile, and rare. \$50-75.

WONDER CAMERA FRIEND - Eye-level style mouse camera. \$1-10.

WONDER SPECIAL CAMERA - Eye-level style mouse camera. \$1-10.

NON-CAMERAS: ORNAMENTAL

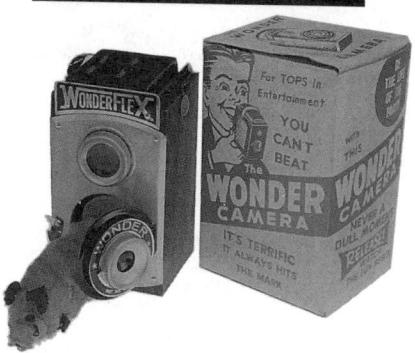

WONDERFLEX COMET **SPECIAL** CAMERA - TLR styled mouse camera. Also sold under the name "Wonderflex Wonder Special Camera". Made in Japan. \$1-10.

MUSIC BOX

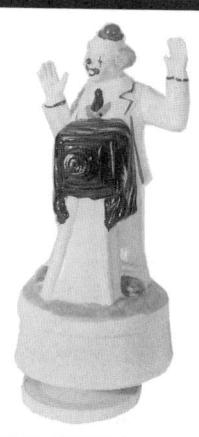

CLOWN WITH VIEW CAMERA - Ceramic figure of a clown with a view camera has a music box built into the base. 81/4" high. Made in Taiwan. \$25-35.

GIRL HOLDING CAMERA - Ceramic figurine with music box in base. Girl holding camera. Cat seated on nearby chair. Music box plays "Everything Is Beautiful". Retail in 1983: \$12.

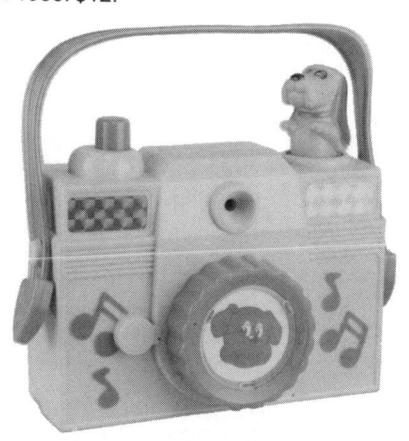

Pound Puppies Musical Toy

ILLCO TOY CO. (Illfelder Toy Co. Inc., New York City.) Cabbage Patch Kids Musical Toy Camera - Copr.1984. A music box shaped like a camera. Available in two styles: Lavender body with white trim (plays "Farmer in the Dell") and cream body with lavender trim (plays "Old MacDonald".) About \$6.

Mickey Mouse Musical Toy Camera Music box shaped like a camera. Turning lens winds the mechanism. Pressing the release plays "Rock-a-bye-Baby", and a small Mickey Mouse or Donald Duck head turns around on top. Red camera has Mickey head on top, Donald face on lens. Yellow camera has Donald head on top,

Puppies Musical Camera - c1986. Music box shaped like camera. Tan plastic with red trim. Plays "Turkey in the Straw". Retail \$6. Illustrated bottom of previous column.

Mickey face on lens. \$8-15.

Smurf Musical Toy Camera - Blue plastic camera-shaped music box toy. Plays "Rock-a-bye-Baby". Smurf head turns around on top. Copyright 1982. Retail about \$5.

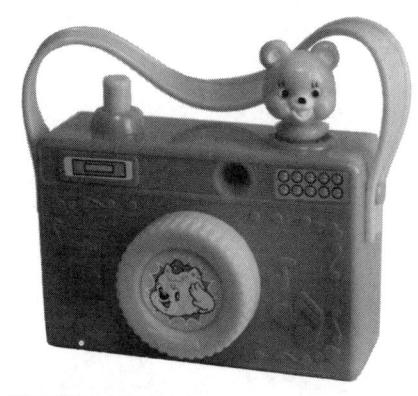

SANKYO SEIKI MFG. CO. LTD. (Tokyo) Snap-Me-Happy Musical Camera Toy - c1976. Music box shaped like camera. Red plastic body with yellow trim. Pressing release button plays "Frere Jacques" and yellow bear's head rotates in flashcube position. Made in Hong Kong for Sankyo. Retail about \$11.

TEDDY BEAR MUSIC BOX - 5" high ceramic teddy bear with a music box base.

ORNAMENTAL (NON-FUNCTIONAL)

These are decorative, non-functional items.

CAMERA WITH BIRDIE - Miniature cast metal camera on tripod. 4" high. Birdie on stick above lensboard, \$1-10.

CAST METAL TOY SLR - Small redenameled cast metal model of 35mm SLR.

De FOTOGRAF - 8" stained glass oval of Photographer with wooden camera on a tripod. \$90-130.

DURHAM INDUSTRIES INC. (New York, NY) Holly Hobbie Doll House Camera -Small cast metal view camera with tripod. About \$8-15.

HASSELBLAD CRYSTAL 500C - c1980. Crystal replica of Hasselblad 500C, hand crafted, numbered, and engraved. \$250-

HASSELBLAD PLUSH TOY - Oversized stuffed Hassie for those of us who can't afford the crystal one. Black velour and gray terry-cloth. \$1-10.

LIKA - c1987. Wooden toy camera styled like a Leica M-3 camera. Very nicely craft-

NON-CAMERAS: ORNAMENTAL

ed. "Lika" branded in top. Made in USA. About \$35.

LIMOGES MINIATURE CAMERA - Tiny ceramic view camera on a tripod. Has a cobalt-blue or white glazing finish. Trim and tripod are both in gold. Blue: \$17. White: \$15.

ROYAL HOLLAND PEWTER
Camera with birdie - Small pewter
view camera on tripod with birdie sitting on
bellows. \$50-75.

SHACKMAN (B.) & CO.
Glass Camera on Tripod - Small
novelty glass camera on metal tripod.
Copyright 1981. \$6.

STERLING SILVER VIEW CAMERA - 3" high. \$45-60.

PENCIL ERASERS, SHARPENERS, STATIONERY ITEMS

BEAU BROWNIE PENCIL SHARPENER - Small, nicely crafted metal replica of the Beau Brownie with built-in pencil sharpener. Camera body catches the shavings and front removes for emptying. Uncommon. No sales data. Estimate \$25+

BIG BIRD WITH BUTTERFLY PENCIL -Blue pencil covered with butterflies. Big Bird figure stands on top of pencil, holding a camera. A butterfly flies around his head, suspended on a pivoting frame. Taiwan. About \$1.

cast metal paperweight commemorating the 100th year of the Cipiere family's camera shop on the "Boulevard de la Photo" in Paris. Given to selected clients by the owner. \$12-20.

DOLPHIN WITH CAMERA - Pencil sharpener built into base of small ceramic figurine of dolphin holding camera. Made in China. \$1-2.

EASTMAN KODAK CO. Kodacolor VR 200 - Pencil sharpener shaped like oversized 35mm cartridge. Made in Hong Kong. \$1-2.

FILM ROLL CALCULATOR - c1992. Slightly oversized 35mm film cartridge. Film with number pad extends from cartridge; LCD display on side of cartridge. Label variations: "Calcuchrome"; Agfacolor Maxi XRG 100 label with address of Agfa-Gevaert Ltd., England; probably others. About \$12-20.

GOLD HORSE
Enjicolor F-11 Eraser - Rubber eraser shaped like a small 35mm film cartridge. Green and white color mimics Fujicolor film. \$1-2.

Keepcolor II Eraser - Rubber eraser shaped like small 35mm film cartridge. Black & yellow label for "Keepcolor II" film, "Process C-41", imitates Kodak trade dress. \$1-2.

HALL & KEANE DESIGN LTD. Camera Kit - Consists of a pencil sharpener and eraser. In the same series as the Memo set below. Retail about \$1.50.

HELIX LTD. (England)
Camera pencil box - Molded plastic in grey and black, shaped to resemble a 35mm SLR camera. The shutter release button is actually a yellow pencil eraser; the lens removes for use as a magnifying glass; a 35mm cassette inside the camera removes for use as a pencil sharpener; the camera back contains a school timetable. The inside of the camera is suitable for holding pencils, crayons, etc. Retail price about \$6.

NON-CAMERAS: PLANTERS

JUGUETES MARTI (Spain)
Pencil Sharpener (VPK style) - Cast
metal pencil sharpener shaped like Vest
Pocket Autographic Kodak. While the
autographic door is historically accurate,
the film advance lever added to the back
tends to confuse Kodak scholars. \$1-10.

MEMO SET - Contains eraser, notebook, pencil sharpener and pencil stylized to relate to photography Eraser is covered by paper to look like an Instamatic camera; sharpener is shaped and covered to look like two 35mm cassettes and the notebook is called "Photographers Notebook". Retail price about \$2.25.

PENCIL ERASER - c1985. Pencil eraser shaped like tiny 35mm. Made of green rubber-like substance. Neck strap at top; hole in bottom to mount on pencil. \$1-2.

PENCIL-SHARPENER CAMERA (Hong Kong) - Cast metal pencil sharpener shaped like a view camera. Bellows made of plastic. "Made in Hong Kong" on side of bellows. Retail about \$2.

PENCIL-SHARPENER CAMERA (Spain)
- Cast metal pencil sharpener shaped like view camera. Bellows are also cast metal, unlike the copies from Hong Kong.

Play/Me trademark and "Made in Spain" on bottom. Retail about \$3-4.

PENCIL SHARPENER EGFECOLOR 400
- Plastic pencil sharpener shaped like a film can. Red, blue, and yellow label mimics Agfacolor. Retail \$1.50.

PENCIL SHARPENER ENJICOLOR F-II - Plastic pencil sharpener shaped like a film can. Red, green, and white label mimics Fujicolor. Retail \$1.50.

PENCIL SHARPENER KEEPCOLOR II - Plastic pencil sharpener shaped like a film can. Yellow black label mimics Kodacolor. Retail \$1.50.

PENCIL SHARPENER LANTERN PROJECTOR - Heavy metal construction, shaped like an old-fashioned lantern slide projector. \$4.

SUNNY MC-8 - c1989. Blue vinyl zippered pencil case. Printed design on front and back resembles 35mm autofocus camera with flash. Contains pencil sharpener, eraser, tablet, ruler, stencils, pens & pencil. About \$5.

WONDER FILM RULER - c1984. Flexible 30cm ruler styled like 35mm transparency strip with moving lenticular images. Packed in plastic cannister in yellow film box which mimics Kodak trade dress. \$1-10.

PHONOGRAPHS

COLIBRI - Pre-war phonograph made to look like a Zeiss Kinamo movie camera when closed. Made in Belgium. \$95.

PETER PAN GRAMOPHONE - Portable hand-cranked 78 rpm phonograph which resembles a box camera when closed. Black leather covered. \$150-225.

THORENS EXCELDA - Portable hand-cranked 78 rpm phonograph. Packs neatly

into a metal case shaped like a folding roll-film camera. Available in black, blue, brown, or green enamel finish. \$120-180.

PICTURE FRAMES

CAMERA PICTURE FRAME - c1989. Large ceramic camera which displays photo behind lens opening. Measures 17x13x7cm. Black and silver. \$12-20.

EXCLUSIVE GIFTS

Photo Frame - c1989. Ceramic picture frame in shape of 35mm RF camera. Black and grey. Lens opening 6cm diameter frames photo. Length 11.5cm, height 8.5cm. Made in Taiwan. Retail about \$6.

PLANTERS

CAMERA PLANTER (35mm SLR) - c1988. Approximately life-sized ceramic planter shaped like 35mm SLR, available in black or red glazed finish. About \$7.

CAMERA PLANTER (View Camera) - Heavy cast plaster planter (or pen holder) styled like c1900 view camera. Apparently sold unfinished at craft shops. "Kinwood Camera" appears to be molded into the back, possibly the manufacturer. Nicely finished: \$20. Unfinished: \$8-15.

NON-CAMERAS: PLANTERS

NAPCO PLANTER - Ceramic planter shaped like Mamiya RB-67 camera. Black with silver trim. \$8-15.

PRINTING FRAME

ELVIN (Japan)
Magic Sun Picture Camera - Small cardboard box with a hinged glass back. Printed design resembles a 35mm or TLR-style camera. Box contains "printing-out" paper for making prints from negatives by two-minute exposure to sunlight. \$1-10.

GAKKEN CO. (Tokyo) The Gakken Co., publishers of science magazines for school children, has produced an interesting variety of cameras to teach photography. In addition to the real cameras, they have made a few of what we call the "non-cameras" including these printing frames and an ant farm.

Taiyou Kamera Model 84-K1-08 - 1984. Black plastic camera-shaped printing frame. Front door opens by pushing

Taiyou Kankou Kamera

shutter button. Negatives, paper sheets load inside hinged blue back door. \$1-10.

Taiyou Kankou Kamera Model 84-3K-10 - 1984. Black, red and clear plastic printing frame. Uses rolls of printing-out paper with supplied cartoon negatives. Knob advances paper for next exposure. The camera's name means "sun sightseeing camera". \$1-10. Illustrated at bottom of previous column.

HUCKLEBERRY HOUND FLICKERS - 1970's. Sun-exposure kit. \$12-20.

PUZZLES & GAMES

EASTMAN KODAK CO.

Dice Cup - Red plastic dice cup with Kodak logo. Five yellow dice with Kodak logo included. \$12-20.

Kolorcube - Everybody has heard of Rubik's cube. This is a special version with the Kodak logo on each square of each side. \$8-15.

ENSIGN PLAYING CARDS - c1920s. Ensign film logo on box. "Ensign the Good Tempered Film" on back of cards. \$12-20.

KONICA PLAYING CARDS - \$7.

MUPPET PUZZLE "The Photographer" - Plastic puzzle of a wooden view camera with Kermit, Gonzo, and Fozzle. \$1-10

PUZZLE CAMERA - Three-dimensional puzzle shaped like small 35mm RF camera. Made in Japan. \$1-10.

SNAPSHOT - Jigsaw puzzle of an old photograph. Box resembles a Brownie box camera. \$1-10.

WARREN COMPANY (Lafayette, Indiana)

Click! Jigsaw Puzzle - c1986. Square jigsaw puzzle, 52x52 cm, with over 550 pieces. Full-color photo of photographic accessories & memorabilia. Original retail about \$5. Currently selling for \$12-20 if you can find one.

RADIOS

AMICO - Transistor radio shaped like Olympus OM-1 camera. Speaker is in lens mount. \$12-20.

DESIGNER RADIO-LIGHT-MIRROR- Transistor radio shaped like 110 pocket camera. Built-in flashlight. Battery door has mirror inside. Also sold under the names "Diel", "Stewart" and "Romantica".\$1-10.

EAST ASIA CAMERA-RADIO-FLASH-LIGHT - Transistor radio shaped like SLR. Flashlight in lens position. Comes with mounting bracket for bicycle. \$12-20.

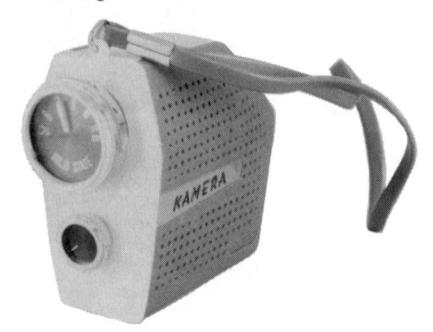

KAMERA - Small transistor radio shaped like a movie camera. Volume and tuning knobs in lens positions. Requires one AA battery. Made in Hong Kong. \$8-15.

NON-CAMERAS: SOAP

KODACOLOR 400 FILM RADIO - Transistor radio shaped and colored like a box of Kodak film. Radio box also mimics Kodak film packaging. Made in Hong Kong. \$20-30.

KODAK INSTANT COLOR FILM PR10 - Transistor radio shaped and colored like a box of Kodak's now defunct instant film. Operates on one 9v battery. Made in Hong Kong. \$12-20.

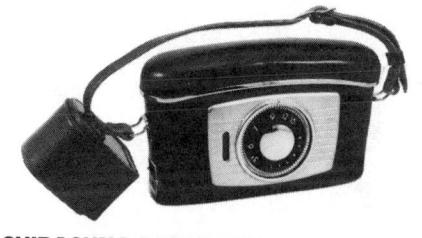

SHIRASUNA DENKI MFG. CO. LTD. Silver Pocket Radio - Vacuum tube radio in leather case designed to look like a camera case. Uses one "B" battery and one "A" battery. Small "filter case" on strap contains earphone and antenna wire. \$45-60.

STEWART RADIO-LIGHT-MIRROR - Transistor radio shaped like a 110 pocket camera. Built-in flashlight. Battery compartment door has mirror inside. Made in Hong Kong. Also sold under the names "Designer", "Diel", & "Romantica".\$1-10.

TOUR PARTNER - Styled like a large camera. Includes radio, lamp, horn and fittings for attaching it to a bicycle. About \$8-15

RUBBER STAMPS

BUTTERFLY ORIGINALS LTD. (Cherry Hill, NJ)
Cabbage Patch Kids Figurine Stamper - c1984. Small figurine of Cabbage Patch Doll holding a camera. The base has a rubber stamp (Smile!) and ink pad. Retail \$2.50.

KODACLONE SLIDE - A cute rubberstamp which mimics Kodak's logo on a 35mm slide mount. "Processed by clones" adds an interesting touch. \$8-10.

SALT & PEPPER SHAKERS

BOOK & CAMERA - Set includes one small open book and one bellows camera. \$12-20.

MOVIE CAMERA & PROJECTOR - Made of wood. \$20-30.

ROLLFILM CAMERA - The "camera" is in two parts. Body is pepper; bellows & front standard is salt. \$20-30.

SASPARILLA DECO DESIGNS LTD.
Camera Salt & Pepper - Set of two
miniature 35mm-styled ceramic shakers.
One is black, the other is white. Retail \$6.

SCREWDRIVER

WF CAMERA-SCREWDRIVER-KEYCHAIN - Small red plastic "camera" with screwdriver bit in lens position. Interchangeable bits store in body. Keychain attached to strap lug. "WF" molded in back, \$1-10.

SOAP

AVON PRODUCTS, INC.
(New York, NY)
"Watch the Birdie" Soap - c1962-64.
A cake of soap on a rope with a 'birdie' on the lens. "Avon" on back. With box: \$35-50.

WOLFF PRODUCTS
(Long Island City, NY)
Camera Soap-on-a-rope - A six-ounce
bar of soap shaped like a camera. Engraved "E Soapon". \$8-15.

NON-CAMERAS: SQUIRT CAMERAS

SOUIRT CAMERAS

AMSCAN INC. (Taiwan) Amscan is a distributor in the U.S. and Canada. Other countries will surely find this toy under another name.

Squirting Camera - Copy of the wellmade Japanese "Flash Shiba" and the poorer "Cohen" from Hong Kong, this brings quality to a new low, while retaining the basic features. See Shiba for further description. Retail: \$1.

ARLISS COMPANY INC.

(Brooklyn, N.Y.) Squirt Camera - Black plastic water camera with brass nozzle above lens. Similar to the "Squirt Pix" from Premier Plastics Co. \$1-10.

BATTLESTAR GALACTICA - Small plastic squirt camera with Battlestar Galactica emblem on front. \$1-10.

CHARTERKING LTD. Wipe-out - c1988. Combination of a Cohen squirt camera packaged with two bottles of disappearingink. Retail \$2.

COHEN - c1986. Black or colored plastic squirt camera from Hong Kong. Copy of the Shiba Aqua Camera. Retail \$2. Illustrated at top of next column.

Cohen

COMET SPECIAL CAMERA - This small metal TLR looks like a mouse camera but contains a small bulb of water waiting to be squirted by the long stroke lever on the camera's right side. \$1-10.

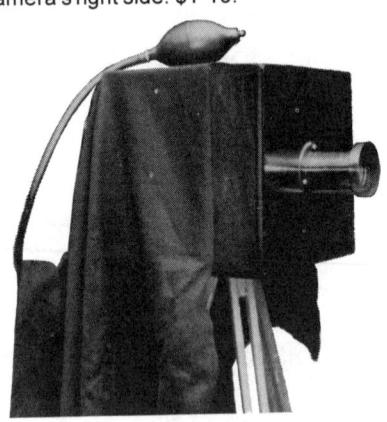

TRICK CAMERA

DIRECTIONS

Remove rubber tubing from nozzle of bulb; fill bulb with water and replace tubing.

When candidate is seated to be "photographed" the "photographed" places canner about eight or ten feet from him and takes focus by sighting through peep hole of lense. To make the "exposure" press the bulb.

DeMoulin Bros. & Co.,
Mirs. of Lodge Supplies, Burleaque and Side Degree Paraphernalia,
Uniforms, Banners, Badges, Eic.
Greenville, Illinois.

DE MOULIN BROS. & CO.

(Greenville, IL)

Trick Camera - c1925. An early wooden box squirt camera. Cubical wooden box, 20cm on a side, with a brass lens tube on the front. Some later models appear to have an aluminum disk with a lens mounted. The squirt tube runs along the bottom of the lens tube and is attached to a rubber hose and bulb outside the rear of the box. which is covered with a black focusing cloth. The rubber bulb is filled with water and then attached to the squirt tube. The subject is sighted through a tube which runs from the back to the front through the lens tube. The instructions say "To make the 'exposure', press the bulb." \$400-600.

DICK TRACY SOUIRT GUN CAMERA -Square plastic squirt camera in Dick Tracy motif. \$4.

FOTOMAT Squirt Camera - Well-made squirt camera, shape and size like 126 cartridge camera. Made in Hungary. No relation to Fotomat film stores in the U.S.A. \$1-10.

GREEN PINE WATER CAMERA - c1987. Square black plastic water camera from Hong Kong. Retail \$2.

GUCKI - c1986. Black plastic squirt camera made in W. Germany. Retail \$2.

Trick Squirt Camera No. 803 - Retail

JAK PAK INC. (Milwaukee, Wisconsin) Squirt Camera X-315 - c1986. Black

plastic squirt camera made in Hong Kong. Back of body has "WK Toys" molded in, which is probably the actual manufacturer. Retail about \$1.

NON-CAMERAS: SQUIRT CAMERAS

L.S. (Hong Kong)

Squirt Camera - Black plastic squeezetype water camera with molded features of the Leica M-3. "L.S. No. 625" molded on back. \$1-10.

LUEN TAT MFG. CO. (China) **Splash Flash Deluxe** - c1989. Black plastic "camera", "flash" attached to sliding front door. Styled like the popular point & shoot cameras. Squirts water from a pivoting "rewind knob", an idea borrowed from the original Japanese Flash Shiba. \$1-10.

MAGIC INTRODUCTION CO. (N.Y.) Magic Pocket Camera - c1890's Rectangular wooden block, carved to resemble a small bellows camera. Behind the deceitful metal rear "plateholder" lies a rubber squeeze bulb with a metal nozzle protruding toward the front. On the back 'plateholder" door is a photo with the legend, "Result produced by the Magic Pocket Camera". This was no doubt intended to further deceive the potential victim. In one recent case, it also deceived an experienced and respected collector. \$300-450.

PHOTO-BIJOU LANCE-EAU - c1930's. Charming little leatherette covered wooden body with imitation lens. Small plastic bulb in rear compartment with tube aimed through front. No identification on camera, only on the box. Rare. One verified sale in late 1987 in original box for \$100.

PREMIER PLASTICS CO. (Brooklyn, NY)

Squirt Pix - Black plastic body. Automatic water shooting camera. With original box: \$12-20. Camera only: \$1-10. Illustrated at top of next column.

Premier Squirt Pix

REDBOX 707 - Small plastic squeezetype squirt camera. Originally sold in a "Little Kingdom Special Agent" kit which included pistol, handcuffs, badge, and passport. Kit: \$8-15. Squirt camera only: \$1-10

SAFARI FOTO AQUA (FOTOVISION) -Rigid plastic water camera with rear plunger. "Safari Foto Aqua" is molded on front. Sticker on front with "Fotovision" name could be just one name variation. Assembled from parts of many colors, so many color variations. \$1-10.

SHIBA

Aqua Camera Flash Shiba - c1984. Small "camera" which squirts water from the "winding knob". Knob rotates to allow squirting in a different direction. The instructions suggest that after squirting somebody by taking their picture, you give them the chance to do the same to you (but only after you reverse the direction of the knob!) This double-trouble toy comes

in black, red, white, silver, or gold. Retail about \$3.

"Instamatic" style water camera -No. 314A. Made in Hong Kong. \$1-2.

Water Camera No. 402 - Black or red plastic water camera. Chrome trim on front. "T.H." trademark and "No. 402" on back. Mushroom top on shutter release. Cloth strap. Retail: under \$1.

T.K.

Squirt Camera "Diana Style" No. 686TK - This "camera" looks exactly like the cheap "Diana-type" cameras for 120 rollfilm, but squirts water. Made in Hong Kong. \$1-10

Water Camera No. 677 - Black plastic squirt camera. Chrome trim on front. "Made in Hong Kong" on back. Thin shutter button. Plastic strap. Retail: under \$1.

VOHO Squirt Camera - Small rubber squirt camera styled like a Hit camera. Cream colored body with aluminum paint on top, front, and "latch". "Made in Occupied Japan" molded into bottom. Also available in a black model. Uncommon. \$1-10.

WATER CAMERA, Leica-styled -Black rubber squeeze-type squirt camera made in Occupied Japan. Styling resembles Leica camera. Squirts from "slowspeed dial". Trimmed with aluminum and gold colored paints. \$1-10.

WATER CAMERA - Black plastic squirt camera. White top and bottom. Chrome lens rim. Made in Hong Kong. \$1-10.

WATER CAMERA NO. 014 - Simple plastic squeeze-type squirt camera. Made in Hong Kong. Retail \$.30.

STATUETTES & FIGURINES

ALDON PHOTOGRAPHER - Wooden figurine 30cm (12") tall. Man holds one camera to his face, two others hang at his sides. Made in China. Retail: \$19.00

BEACHCOMBER - 1985. Ceramic figure of "chunky" man in swimming trunks, carrying a camera. 7" high. Taiwan. \$30.

BEAR WITH FLASH CAMERA (tree ornament) - Small hand-painted wooden ornament for Christmas tree or wherever else little bears hang out. \$1-10.

BOY PHOTOGRAPHER & HIS GIRL - A pair of ceramic figures. The boy holds a camera; the girl is posing for him. 5" high. Made in Japan. \$25-35. *Illustrated at top of next column.*

BOY WITH VIEW CAMERA (Hummel style) - Ceramic figure of a boy with a view camera. Style resembles the Hummel figurine. 51/4" high. \$25-35. *Illustrated in next column*.

Boy Photographer & his Girl

Boy with View Camera (Hummel style)

BROWNIE BAKING CO. (Spokane, Washington)
Brownie - Metal figure resembling the Palmer Cox Brownie. 31/4" high. \$25-35.

BROWNIE HOLDING A BROWNIE (metal) - Palmer Cox Brownie crosslegged on a toad-stool holding a Brownie box camera. Metal, 61/4" high. \$75-100.

BROWNIE HOLDING BROWNIE (painted) - 1930s. Made in Czechoslovakia. Painted figure of Palmer Cox Brownie holding a brown Brownie box camera. 23" high. \$150-225.

BULLY Tintin Figurine - Created by

Belgian cartoonist Hergé (Georges Remy) in 1927, this cartoon character has been popular in the French language ever since. Just as Mickey Mouse has a following of collectors, so does Tintin. There are several sizes of figurines of Tintin with his camera and suitcase. Illustrated here is a small one which retails in France for \$3.

DEAR (Italy) Young posing couple - 8" high by 71/4". Girl holds her hat in her hand while boy kneels on grass. Wood base. \$120-180.

EMMET KELLY "Watch The Birdie" -The famous clown holds a camera at arm's length to take a self-portrait. 111/4" high. Made in USA. \$210.

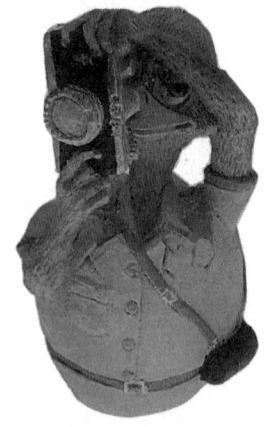

ENESCO CORP. Eggbert "Eggsposure" - c1990. Small clay figurine of photographer chicken emerging from egg. \$8-15.

Precious Moments "Baby's First Picture" - 1983. Photographer stands behind a large view camera, photographing a small child. 5" high. \$35.

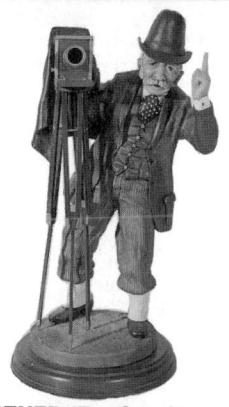

FAIRWEATHER (England) The Photographer - Highly detailed, bronze figure of a photographer with a view camera. 12" high. \$200-300.

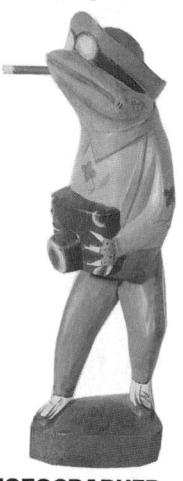

FROG PHOTOGRAPHER - 151/4" high wooden figure of a well-dressed frog, smoking a cigarette, and holding a camera. Made in Mexico. \$85.

GIRL WITH CAMERA - Painted ceramic figurine. Girl with view camera. Camera rests on the face of a cat on a chair. Made in Taiwan. \$20-30.

GIRL PHOTOGRAPHER, Japanese - 51/2" high ceramic figure of cute girl photographer. Made in Japan. \$25-35.

GNOME "CHEESE" - 51/₂" high sculpted figure of a gnome with a large view camera. \$250-375. *Illustrated at top of next column*.

GNOME "FLASH" - 7" high sculpted figure of a gnome with folded field camera. Made in USA, \$49.

Gnome "Cheese"

GOEBEL (West Germany)

Boy with 35mm camera - 6" high figure of a boy photographer with an equimentbag at his feet. \$125.

Gerd - 1979. A 51/₄" high, 71/₄" long, snorkling photographer with a fish as his subject. \$60.

Goofy - 6" high ceramic figure of Walt Disney Production's Goofy character. \$75-100.

Rad Head Photographer - 6" high porcelain figurine of boy holding a folding

rollfilm camera with his dog resting at his feet. \$65.

HANNA-BARBERA
Barney Rubble with camera c1989. 55mm tall rubbery figurine of
Barney Rubble holding a tripod with a
camera. Made in Spain. About \$5.

HIPPOPOTAMUS WITH CAMERA - Soft plastic hippo stands 18cm tall. Advertising figure for East German "Pentacon" company. It holds a small camera and a trumpet. \$20-30.

HUMMEL (West Germany) The Photographer - 1953. Young boy crouches behind a large view camera with his drooping eared dog sitting between the tripod legs. 5" high, porcelain. \$300-450.

LEFTON CHINA Man with camera - Hand painted ceramic figurine. Man with camera on tripod. Powder flash unit in left hand. Box of plates at his feet. Made in Taiwan. Retail: about \$30.

LLADRO - Stylish photographer stands beside a studio camera. 13" high, glazed procelain. \$260.

LUCY RIGG Teddy Bear Photographers - c1985.
A set of two small figurines, 8.5cm tall.
One is a girl and one a boy teddy bear, each holding a camera. Retail about \$10 each, usually sold as a pair.

LUSTRE FAME INC.
Mouse with camera (tree ornament) - c1992. Small white mouse with flash camera, sitting on a 35mm film cartridge. "Merry Christmas" greeting on cartridge label. Brass ring on top of mouse's head to hang from tree. Retail about \$5.

MATCH-MAKER - 21/4" high, 4" long, pewter figurine. Photographer holding a hand camera, photographing a well-dressed couple. Made in USA. \$42.

MATHEW BRADY - 2" miniature figurine of Mathew Brady photographing General Grant. Pot metal. \$45-60.

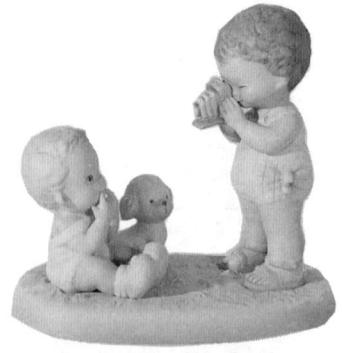

MEMORIES OF YESTERYEAR - 5" high porcelain figure of a young boy photographing a younger child with a folding rollfilm camera. Made in Taiwan. \$35-50.

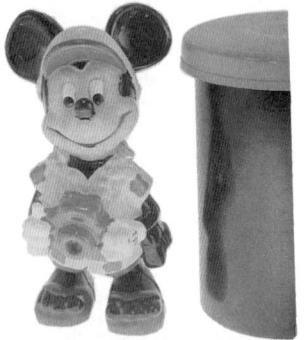

MINNIE MOUSE PHOTOGRAPHER - Small rubbery plastic figurine of Minnie Mouse in Hawaiian outfit, holding a camera. Made in China. Retail: \$2.50.

MONKEY WITH CAMERA - 21/4" ceramic. Made in Uruguay. \$12-20.

old couple sitting on a log - 6" high ceramic figure, made in Taiwan. Elderly man and woman are sitting on a log taking a self-portrait. \$50-75.

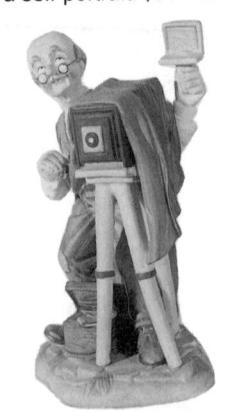

OLD TIME PHOTOGRAPHER - Old photographer stands by a studio camera with powder flash in his left hand. 7" high, ceramic. Made in Japan. \$45-60.

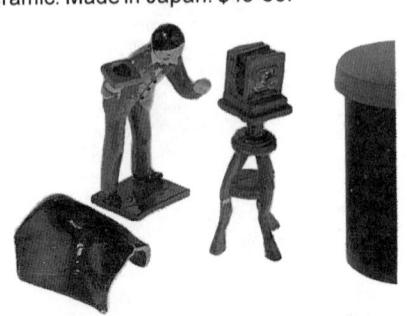

PHOTOGRAPHER, CAMERA, DARK

CLOTH - Hand-painted pewter figurine set includes three pieces. Photographer leans with his face to a camera on stand. Dark cloth fits over the two pieces. Made in UK. About \$20.

PHOTOGRAPHER, 1930'S STYLE - 8" porcelain photographer with view camera. Made in Taiwan. \$30.

PHOTOGRAPHER TROPHY - Cast metal figure of man holding TLR. About 5" (125mm) tall. Similar trophy features man with Speed Graphic. More recent types have 35mm SLR. \$8-15.

PIG WITH CAMERA - Small figurine (57mm tall) of a waving pig with a black 35mm camera on a neckstrap. Green trousers, blue shirt, yellow tie, pink vest. Made in China. About \$5.

PLAYMOBIL (Zirndorf, Germany)
Photographer with View Camera c1989. Plastic figurine of bearded photographer with a view camera on tripod. \$510. Illustrated at top of next page.

Playmobil Photographer

POLI (Italy)

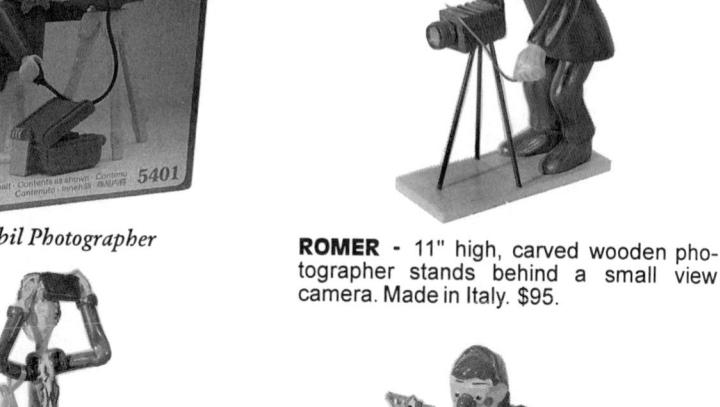

RON LEE (USA) Clown Photographer - 5" high figure of a clown photographer.\$99.

ROYAL CROWN (Taiwan) Boy Holding Camera - Figurine of boy seated on stump holding camera. Retail in 1983: \$12.

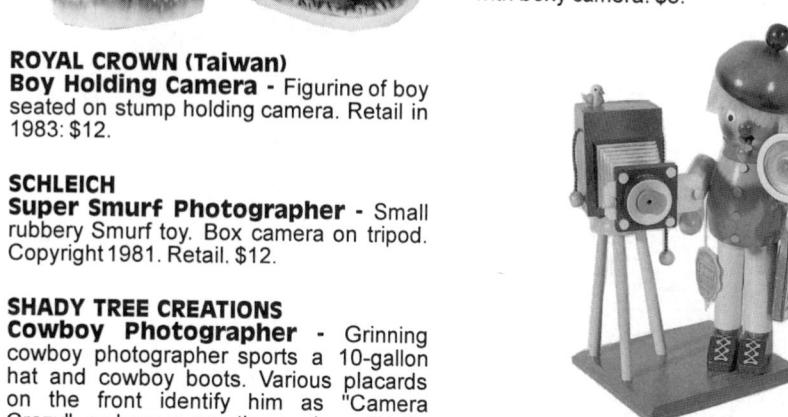

SWISS-LIKE PHOTOGRAPHER - 9" high wood figure of a Swiss-style photographer standing beside a view camera. \$125

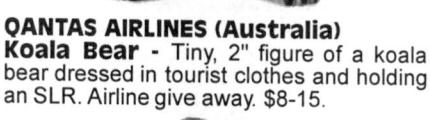

Tourist Photographer - Tall, thin

photographer holds a 35mm camera. 8" high, porcelain. \$30-45.

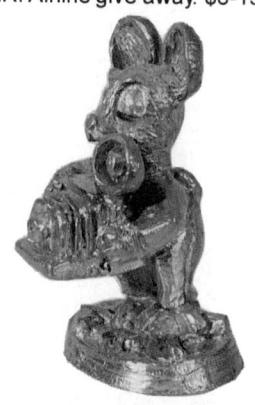

RABBIT PHOTOGRAPHER - Tiny, 13/4" pewter figurine of a rabbit standing upright holding a press camera. Made in USA. \$27.

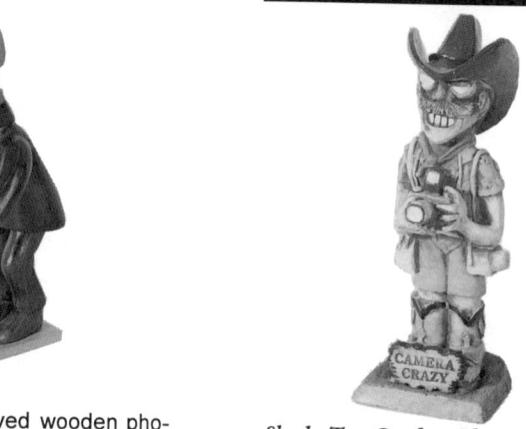

Shady Tree Cowboy Photographer

holding camera. Large eyes, nose, and sandaled feet protrude from furry body. "Nikon" SLR in left hand. "SHUTTER BUG" placard between feet. \$8-15.

SQUIRREL HOLDING CAMERA - Multicolored ceramic, 4" tall. Taiwan. \$15.

STARLUX PHOTOGRAPHER FIGURINE Tiny plastic figurine, 32mm tall, of man with boxy camera. \$3.

Crazy", or bear a greeting such as "Hello From Las Vegas". 111/4" high, molded.

\$26. Illustrated at top of next column.

TURTLE LOVE - One turtle stands on two legs, holding a press camera while another reclines on a rock engraved with the word "LOVE". 21/4" high, ceramic. \$15.

TOY CAMERAS

These are kid's toys made to look like and imitate the functions of real cameras.

20 CRAZE - Black, pink, & green toy shaped like a camera. Front pops out when shutter is pressed. Picture of comic character on front. \$1-10.

AMBI TOYS Focus Pocus - c1985. Yellow plastic. Front springs open and little man pops out. Retail about \$10.

ARCO INDUSTRIES LTD. (New York)
Take-A-Picture - Toy camera styled
after Kodak Colorburst 250 camera. Includes 12 pre-printed photos which eject
when shutter is depressed. Made in Hong
Kong. Copyright 1982. Retail: \$3.

BATTAT INC. (Plattsburgh, N.Y. &

Montreal, Quebec; Fareham, UK) My First Camera - 1992. Made in China by Combi. Brightly colored plastic camera. Pushing shutter button causes small man to pop up from top, picture to appear in rear window. Turning lens rim makes clicking sounds. For children 11/2+ years. Retail: \$13.

BARBIE DOLL CAMERA - Tiny grey plastic "camera" accessory for "Barbie" doll. Under \$1.

BLUE BOX TOY (New York, NY)

Click-N-Flick Mini Viewer - c1986. Toy shaped like movie camera. Hand crank flickers shutter for movie effect in viewfinder. Retail about \$2.

Turn-N-Click Mini Camera - Childrens toy shaped like 35mm camera. Lens clicks when turned. Pushing the shutter raises "flashcube" with smilling sun. \$1-10.

BRIGHT STAR - Black plastic toy camera made in Hong Kong. Shutter button clicks;

winding knob turns. No other functions. A 'no frills' toy. \$1-10.

BURGER KING (USA) Cirl Photographer in Car - 1990 promotional item, made in China for Burger King, USA. Girl, sitting in a car, holds a camera in one hand and a flash in the other. The car itself is shaped like a camera, with the girl sitting in the "lens". 21/2" high, plastic. \$8-15.

EASTMAN KODAK CO."Smile" Bear - 12" high stuffed teddy bear wears a Kodak vest and Kodak hat, and sports a tag with "Smile". Made in Korea. \$15.

FISHER PRICE TOYS Crazy Camera - c1988. Toy shaped like SLR with electronic flash. Lens rings position special effects and colored filters in viewfinder. Retail \$12.

NON-CAMERAS: TOY CAMERAS

GARFIELD TOURIST - 81/₄" high stuffed Garfield teddy bear wears tourist clothes and has a camera around its neck. Made in Korea. \$21.

GILMAN LITTLE SPORT - c1930's. Small cardboard box, similar in size and shape to the Japanese "yen" box cameras. Appears to take picture of friends, then small paper prints are developed in water. Drawings of animals appear on the prints when dipped in water. Uncommon.\$75-100.

ILLCO TOY CO.
Sesame Street Pop-Out Toy
Camera - c1990. Red plastic toy "camera". Big Bird face on the front door. Pressing button causes door to open and seated figure of Big Bird to pop out. Retail \$5.

IRWIN

Grand Camera - Black plastic toy camera which holds a quantity of printed pictures. Sliding a lever on the back ejects pictures one by one. \$1-10. *Illustrated at top of next column.*

KENNER

Picture-Quick - Toy camera styled like Kodak EK-4 Instant Camera. Knob ejects pre-printed pictures through bottom slot. Dated 1977 on back. \$7.

Irwin Grand Camera

LUCKY STAR ENTERPRISE & CO. LTD. (Taipei)

Inst-and Camera - c1989. A poor quality toy imitation of Polaroid camera. Pushing shutter ejects one of six pre-printed pictures. Side lever tensions spring. \$5.

MATTEL INC. (El Segundo, CA)

Chatter-Pal - c1980. Pastel-colored plastic camera. Pull string activates photo-related recorded messages. \$1-10.

Disney Fun Bubbles Play Camera - c1990. Blue plastic toy camera. Uses battery power to blow soap bubbles through lens when shutter button is pressed. Turning lens changes optical effects in finder. Mickey Mouse bas-relief

figure on front; Mickey silhouette as stopper on top. New price: \$20.

MINIATURE CAMERA (DOLL HOUSE CAMERA) - Miniature black wooden

camera, usually packaged with a miniature "Kodak 126-12 Film" package. There are several variations in style, as these are hand-madein Taiwan. \$1-2.

MERRY MATIC FLASH CAMERA - Small black plastic camera-shaped toy. Pressing shutter makes clicking sound and lights flashlight bulb. Operates on one AA battery. \$1-10.

MUFFY VANDERBEAR "Out of Africa" - 8" stuffed teddy bear has a camera tied to one arm and a tag reading "Muffy Vanderbear Out of Africa". Made in USA. \$35-50.

MY FIRST BUDDYS

Fun Camera - c1989. Bright yellow plastic "camera" with blue & red trim. Flash louvers open when shutter button is pushed to give flash effect. Lens effects include colors, kaleidoscope, and distortion lenses. \$12-20.

NON-CAMERAS: TOY CAMERAS

PLAYMATES TOYS INC. (La Mirada, California)

My Li'l Camera - c1988. Bright yellow plastic "camera" with blue & red trim. Advance lever changes images in "film reminder" frame on back. Front button pops up flash. Shutter button raises red flashbulb. \$8-15.

PLAYSKOOL

Busy Camera - c1989. Bright yellow "camera" with right hand grip. Designed for babies 6-24 months of age. Clicks, squeaks, rattles. \$12-20.

SCHAPER MFG. CO. (Minneapolis, MN)

Tendertoys Camera - c1986. Child's stuffed toy shaped like a camera. Red, blue, yellow, and white vinyl fabric covering. Squeaks when squeezed. Retail \$8.

SHELCORE INC. (So. Plainfield, NJ) Clicker Bear - c1985. One of a series of "Squeeze-A-Mals", soft vinyl infant toys. This is a small teddy bear holding a camera. Tan, green, magenta & white. Squeaks when squeezed. Original retail about \$3.

TOHO Hello Kitty Talking Camera - c1985. Toy shaped like large red & white camera with kitty on front. Shutter button activates recordings: "Be Happy Honey", "You look great", "Show me your teeth", "Say cheese", "Don't be shy", "You are the best". \$15-25.

TOMY Ring-a-dingy Camera- Child's toy shaped like a camera. Lens turns with clicking sound. Film advance lever clicks and returns. Shutter button rings bell. Copyright 1982. Other Ring-a-dingy toys are Telephone, Typewriter, and Cash Register. \$5.

TOYPOWER MFG. CO. LTD. Just Like Daddy's Camera - Toy camera with "simulated working Detachable Kaleidoscope and lenses. Copyright 1983. \$5.

TRAVELER - Snappily dressed traveler holds a flash camera. 7" high mechanical toy. Identified on the original box. Made in Japan. With box: \$110.

UNIMAX TOYS LTD. (Kowloon, Hong Kong) Magic Camera - 1987-. Yellow plastic pops up the flash and opens the front door, attached to whiich is a monkey head making a face. Retail \$6.

TOYS & GAMES NOT OTHERWISE SPECIFIED

BEAR WITH FLASH CAMERA - Mechanical bear with camera. Wind-up mechanism raises camera to bear's eye and battery operated flash fires. Made in China. \$15-25.

DUNCAN Kodak Yo-Yo - Wooden yo-yo with Kodak logo. Retail about \$5.92

EASTMAN KODAK CO. Walking film box - Spring-operated mechanism with walking feet is mounted in Kodacolor 400 film box. \$1-10.

EFS (Burlingame, CA) Camp Out - Set of small toy camping items. Includes wrist compass, camera, canteen, flashlight, walkie-talkie, lantern, and radio. \$1.50.

NON-CAMERAS: VEHICLES

GAKKEN CO. (Tokyo) Ant Farm Camera - 1986. Translucent plastic "camera" is designed to be used as an ant farm or to teach very basic principles of camera construction. \$1-10.

LANCO SCREEN COMPANY
BOO-BOO Bear with camera c1960's. Small rubber squeeze-toy of
seated bear with flash camera. Boo-Boo is
the popular sidekick of cartoon character
Yogi Bear. Made in Spain. \$1-10.

Fabuland Patrick Parrot - Toy parrot with flash camera. Also has motorcycle and pipe wrench. Made to interlock with Lego building blocks. Copyright 1982. Retail: \$3.

PLAYWELL
Camera Kaleidoscope - c1988.
Spring-wound musical kaleidoscope
shaped like bright yellow camera. Plays
the tune "London Bridge". Retail \$15.

PORTRAIT STUDIO - Small cardboard model of an early portrait studio with skylights. Folds flat. \$50-75.

TOMY Roving Eye Camera - A clockwork mechanism allows the camera to walk around; the eye moves around, and the magnifying glass moves up and down. Retail about \$3.

TOTSY MFG. CO. INC. Flair Doll Camera - Part of a package of 30 doll accessories is a miniscule model of a 35mm SLR with flash. Get out your bifocals to find this one. Retail \$1.50.

WALKING CAMERA - Copy of the Tomy Roving Eye Camera, cheaper overall appearance, quality. Retail about \$3.

WINNER TOY (New York, NY)
Jet Setter - Doll-size travel kit. Includes
camera, suitcase, purse, passport, money,
etc. About \$1.

VEHICLES

HOBBYCAR S.A. (Lausanne, Switzerland) Designer and distributor of a large line of model cars under the "Elicor" label, manufactured in France by L.B.S. of Martignat. Our interest is only in those with photographic theme.

Ford V8 Camionette 1934, Kodak - Cast metal model of Ford delivery van in Kodak motif. Yellow body, red fenders and running boards. Retail in France: \$18.

Ford V8 Delivery Sedan 1932 - Similar to above, but with black plastic representation of soft top, and with rear bumper. Retail \$18.

NON-CAMERAS: VEHICLES

LLEDO PROMOTIONAL MODELS (Enfield, England)

Fox Talbot Van - c1989. Small diecast Model A Ford delivery van with a commemorative logo "150 Years Fox Talbot" on the side. White enameled body, green top. \$12-20.

Kodak Van - c1983. Small toy Model T Ford truck with Kodak Film advertising. Cast metal with enameled exterior; plastic trim. Made in England. Part of Lledo's "Models of Days Gone" series. No longer available. Retail price was around \$4, but generally selling now among collectors for \$15-25.

PHOTOING ON CAR - c1950's. Battery operated toy automobile, made in China. Horn sounds and headlights flash when it starts. Upon stopping, girl passenger turns with camera and flashbulb lights. New in box, these have sold for as much as \$90-130, but they usually bring \$35-50, and are not hard to find.

TOYCRAFTER Wooden Kodak Truck/whistle -

c1985. Wooden whistle shaped like a truck. "Products by Kodak" logo on side of truck. \$1-10.

WINROSS (Rochester, NY) Kodak Truck 1880-1980 - Toy truck issued for the Kodak Centennial in 1980. Detachable semi-trailer with operable rear doors. Metal construction, white enameled with yellow trim. The original models, such as this, are no longer available, and sell for about \$100-150. Current models, when available, retail for about \$50.

Bird viewer, but the "Hello Kitty" sits on top. \$8-15.

CAMERA

VIEWING DEVICES

CAMERA-CHARM/VIEWER Small camera with stanhope-size photos of Washington D.C. inside. New. Gold: \$35. Silver: \$28.

CAMERA-VIEWER - Small viewer shaped like a camera with 18 views of the Canadian Rockies or some other scenic spot. \$1-10

Camera-Viewers: Key chain type (left) Vepla-Venezia Capri (center) Small scenic viewer (right)

CAMERA-VIEWER KEY CHAIN - Small SLR-shaped, with views of New York City, Toronto, other major cities, zoo animals, undressed ladies, etc. Made in Hong Kong. \$1-10

CHILD GUIDANCE PLAYTHINGS INC. (Subsid. of Gabriel Industries, Inc., Bronx, NY)

Hello Kitty 3-D Camera - 7" plastic three-dimensionalviewer, similar to the Big

Street Big Bird's 3-D Sesame Three-dimensional viewer Camera shaped like a camera. 24 different pictures with the alphabet letters. Copyright 1978. \$12-20.

DU ALL PRODUCTS CO. (New York) Camera Scope - Kaleidoscope shaped like rigid bodied rollfilm camera. Cardboard construction with red leatherette covering. Uncommon. \$120-180.

EAGLE VIEW 88 CAMERA - c1985. Plastic viewer shaped like 35mm SLR.

NON-CAMERAS: VIEWERS

Shutter button changes 24 transparency views of zoo animals. Several variations of colors, caption language, etc. \$1-10.

EPOCH LIGHTED SLIDE VIEWER - c1950s. Stamped metal slide viewer in shape of camera, complete with neck strap. Leatherette trim panels. Made in Japan. \$12-20.

FISHER-PRICE TOYS
(East Aurora, NY)
Movie Viewer - Hand-cranked toy
viewer for 8mm films in special interchangeablecartridges. \$1-10.

Picture Story Camera - c1967. Viewer shaped like boxy 35mm camera

Fujimoto Flexlide 35, closed & open

with flashcube. Shutter button advances 8 transparencies and rotates cube. \$1-10.

Pocket Camera - Viewer shaped like 110 pocket camera with flashcube. Shutter advances 27 photos of zoo animals. \$1-10.

FUJIMOTO PHOTO MFG. CO. LTD. Flexlide 35 - Projector for 35mm slides in standard 2x2" mounts. Designed to fold for compactness and resemble a 6x6cm TLR in the folded position. Uncommon. \$50-75. *Illustrated at bottom of previous column*.

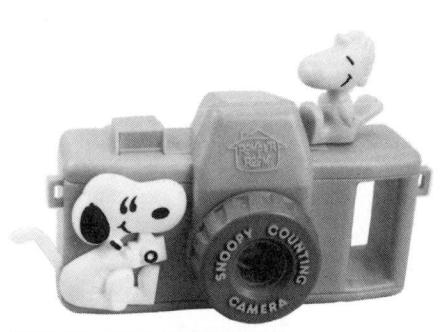

HASBRO INDUSTRIES, INC. (Pawtucket, RI)
Romper Room Snoopy Counting
Camera - Children's viewer shaped like a camera. Snoopy on front, Woodstock on top. Number of characters in each scene matches the film counter digit, teaching the children to count. Retail in 1981: \$6.

JA-RU (Jacksonville, Florida) Home Movie Super-8 Auto-matic c1984. Toy film viewer shaped like a movie camera. Includes interchangeable cylinders with translucent illustrations. New in package: \$1-10.

"LEICA" VIEWER - Black and grey plastic viewer shaped like a Leica camera. With 18 "Views of beautiful Rhein". "Made in Germany, US-Zone, BPa. DBGM. St. & Co." For the Leica collector who has everything. One sold at 10/86 auction for about \$100.

McDONALDS CORP. Search Team - c1991. Small kaleidoscope shaped like a 35mm SLR camera. Multi-faceted lens turns to change the view. Blue & yellow plastic. \$1-10.

STEVEN MFG CO. (Herman, MO)

Talking Vue Camera - Viewer shaped like a camera. Contains 16 animal cartoon pictures. Six different voice messages play when string is pulled. \$8-15.

VEPLA-VENEZIA Camera-Viewer35mm SLR-shaped viewer. Has 14 views of the island of Capri. Made in Italy. \$1-10. See the listing of Camera-Viewer on the previous page for an illustration of this viewer.

ACCESSORIES SECTION

The accessories section is a relatively new addition to the Price Guide. We are indebted to Mr. Fred Waterman for his efforts in compiling this listing. The initial compiling of such a list is a time-consuming and frustrating task, since collectors and dealers are not accustomed to using "standardized" names for many of these items. In addition to the organizational problems encountered, Mr. Waterman has continued to discover that the prices of the more "modern" equipment (1940's-present) are still in a state of flux, some rising, some falling, some remaining constant, with no apparent pattern. Where a single price is given, generally it may be assumed that it is based on a single sale or on a limited number of sales at the same price. Where a range is given, this is the normal range at which we have recorded sales, or offers to buy or sell. In time, this section of the book will take a more firm shape as the accessories market stabilizes and as our base of data expands to allow for better overall tracking of prices in this segment of the market. As with any part of this book, we welcome your comments, criticisms, and suggested additions to make this section better or more useful. For this edition, we have divided accessories into the following categories:

ADVERTISING ITEMS BACK ADAPTERS (Plates, Rollfilm, Filmpacks) BELLOWS for CLOSE-UP CLOSE-UP ATTACHMENTS DARKROOM DEVELOPING EQUIPMENT: **DRYING RACKS OUTFITS SCALES TANKS THERMOMETERS TIMERS** MISC. **DARKROOM PRINTING EQUIPMENT:** ENLARGERS MASKS, MOUNTS PRINTERS RETOUCHING MISC. DARKROOM SAFELIGHTS **EXPOSURE METERS FINDERS FLASHES LENSES** without Shutters **LENSES** in Shutters MICROSCOPE ADAPTERS PLATES/ SHEET FILM/ ROLLFILM, ETC. **POSING AIDS RANGEFINDERS** SELF-TIMERS SHUTTERS STEREO VIEWERS **TRIPODS WATERHOUSE STOPS**

Please note that the intent of this section is not to list the types of accessories in common use among photographers today, but rather to list those accessories whose main attractions are collectibility and historical interest.

ADVERTISING ITEMS

Daguerreian Era

41/4x71/4" Broadside - from a catalogue for Whipple's establishment. \$40.

12x10" Broadside - advertising miniatures by E.S. Hayden. \$100-150.

hand bill - \$75-100.

newspaper ads - Daguerreian or Ambrotype. \$4.

trade tokens - \$65-85.

Kodak Signs

1930's. Art-deco double-sided triangle in red, blue, yellow enamel. \$250-375.

1950's. Fiber optics illumination makes it twinkle and change colors. \$125.

1950's. Metal and plastic lighted sign. \$65.

3'x10". "Kodak" in 1920's style red neon lettering. New. \$300-450.

Red and yellow metal, "We Sell Kodak Film", \$65.

Magazine ads - 1920's and 1930's. \$4.

Store Displays

Easel. 1930's Verichrome Film display in red. \$90.

Film Box. Large Autographic Kodak Film display box: \$50-75. Smaller, for counter display: \$6-10.

Glass case with 3 shelves for Verichrome film. 1930's. \$190.

Poster, 1950's framed photo of 3 fighter jets in flight. \$35.

BACK ADAPTERS

BALDA rollfilm holder - Various sizes. \$20-30.

CALUMET C2 120 rollfilm holder for 4x5" cameras. \$90.

EASTMAN KODAK CO.

2x3" through 5x7" film pack adapter. \$5-8. Early wood and brass rollholder. \$30-50. 41/₄x61/₂" early wood rollholder with brass fittings. \$39.

Bantam Kodachrome - 1 4x6" sliding back accessory for 828 rollfilm. \$30. Kodak Reflex to Bantam

adapter - \$8-15 No. 3 Special Combination Back -

With ground glass, 2 holders. \$60.

No. 3A Folding Pocket Kodak Combination Back - With ground glass, 6 holders, dark cloth. \$40-50 Premo Film Pack Adapters - Wood.

3x4", 4x5": \$2-4. 5x7": \$3-5.

Recomar apadters - Various types. \$30-65.

GRAFLEX

film pack adapters, 2x3" to 4x5". \$4-8. rollfilm back with 828 adapter. \$20.

Graflex rollfilm holders:

No. 22 - 120 rilm. For 4x5": \$80. For 31/₄x41/₄": \$65-75. For 21/₄x31/₄": \$75. **No. 23 -** 8 exp. on 120 film. For 4x5": \$75-90. For 2x3": \$65-75. **No. 51 -** For 122 film: \$15. With 828

Bantam adapter: \$20.

No. 53 - For 5" film. \$25

Graphic RH-10 - For Graflock back. 10 exp. on 120 film. \$70-95.

Graphic RH-12 - Lever wind rollholder.

Graphic RH-20 - Rapid wind rollholder.

Adapt-A-Roll 620 - Miniature Speed Graphic rollfilm back, 6x9cm on 620. \$35.

IHAGEE

Bantam 828 adapter kit - \$15. Plate back, c1932-34, for 1931-34 Baby Rolleiflex. Rare. \$225-275. Plate back for 6x6cm Rolleiflex, with ground glass and holders. \$40-60. 16 or 24 exp. kit for Rolleiflex T or Rolleicord Va, Vb. \$20.

MACKENZIE & CO. (Glasgow) MacKenzie-Wishart Patent Day light Slide - Adapter back which fits in place of a normal wooden double darkslide on British cameras. Back door hinges open to accept single plates in special black celluloid holders with cloth slide. Exterior darkslide of the adapter couples with the cloth slide of the interior plateholder so that a single motion uncovers or recovers the plate. The single celluloid holders take considerably less space than normal darkslides (plateholders). With a set of sheaths. \$12-20.

PLAUBEL Makina 120 adapter - \$60.

RADA 120 rollbacks

for 6x9cm plate cameras. \$40-50. for 6x9cm with 15/8x21/4" mask for 9x12cm bellows camera, \$120. for 9x12cm plate cameras. \$30-40.

6.5x9cm back - Allows the use of 120 film, 6x9cm, on a 6.5x9cm folding plate camera. \$45-50.

9x12cm back - Allows the use of 120 film, 6x9cm, on a 9x12cm folding plate camera. \$35-45

116 back. \$20.

SUYDAM No. 117R - 120 rollfilm adapter for 4x5" Graphic backs. Also works on Kodak Medalist. \$25-35.

TOKYO KOGAKU Topcon 250-exposure back - For Topcon RE Super, Super D, and DM. \$75-100.

ZEISS IKON A.G. Contax II/III plate back adapter -#543/13.\$150 Super Ikonta B/BX Bantam adapter - \$20-30.

BELLOWS for CLOSE-UP

Most models, such as those from Accura, Asahi Kogaku single rail bellows, Ihagee, Kopil, Miranda, Novoflex dual track for Exakta, Piesker, Prinz, Topcon, have a price range of \$15-35.

ASAHI KOGAKU

Bellows II - Universal screw-mount. With slide copier attachment. \$50-75.

NOVOFLEX

bellows outfit for universal screw-mounts. Includes bellows, shade, slide copy attachment. \$50-75. Exa Bellows. \$50-75 Model II bellows. \$50-75.

TOPCON

Bellows II - Dual rail; includes shade, slide copier, and macro stage which fits on the bellows to hold small objects. \$50-80.

ZEISS Contarex bellows attachment - \$175-250.

CLOSE-UP ATTACHMENTS

Most items fall into the following price ranges, independent of manufacturer. Single lenses - \$5-15. Lens sets - \$15-35. Close-up stands with tables - \$50-75.

Multiple item kits - \$50-75. Kodak Retina Copy Kit - for Retina

Reflex S. IV. IIIS: \$90-115. **IHAGEE Vielzweck Copy Stand** Outfit - Dual track, with bellows,

ACCESSORIES: DARKROOM THERMOMETERS

slide/copier, etc. \$175-225.

NIPPON KOGAKU K.K. See Main camera section for a list of Nikon RF accessories.

Close-up System for Nikon Rangefinders - includes double rail focobell bellows, reflex housing with angle finder, microscope adapter, and adapters to use the outfit with Miranda and universal screwmount cameras. \$200-300.

Repro-Copy Outfit PFB-2 - Copystand with baseboard and chrome upright and with geared head for F, F2, Nikkor mount. \$110-135.

Contameter - Close-up rangefinders for models of Contax, Contina, Contessa, and late Tenax, \$75-100.

Copy stand outfit 5520/1 - 1930's. Wood base, masks, rings. Rare. \$400-475.

<u>DARKROOM DEVELOPING EQUIPMENT: CHEMICALS</u>

ANSCO M-A Developer - tube. \$1.00 ARGO - Developing powder in tube. \$1.00

BURKE & JAMES

Rexo Metol Quinol Developer - Box of 6 tubes, for paper plates and films. Original price was \$0.25, \$4,

DEFENDER Sepia Toner - in glass tube, \$1-10

EASTMAN KODAK CO.

Eastman bottle. \$15.

Eastman brown glass bottle, with complete graphic label. \$12.

Kodak 5 gallon ceramic chemical jug, with trademark on side. \$250-375.

Glass beakers: 3 oz, unusual shape: \$25. 4 oz: \$8. 8 oz: \$14. 32 oz: \$18.

Eastman Ammonium Bichromate in glass bottle marked "EKC". \$5

Eastman Developing Powders - 6

envelopes in a box. \$5

Eastman Hydrochinon Developing Powders - for plate and film. Box with 6 packets. \$5.

Eastman Kodelun - in 1 oz. brown Kodak-embossed bottle. Has lead-foil Kodak-embossedtop. \$8.

Eastman MQ Developer - in glass tube. Original price was \$0.05. \$1.00. Box of 3 envelopes: \$1-10

Eastman Nepera solution - in 4 oz. brown Kodak-embossed bottle. Has leadfoil Kodak-embossed top. In original box. c1910. \$15.

Eastman Potassium Ferricyanide in glass bottle. \$4.

Eastman Potassium Meta-Bisulphite - in 1 oz brown Kodak-embossed bottle. Has wax-covered cork. \$8-15

Eastman Spectal Developing Powders - 4 glass tubes in a box. \$7 Eastman Universal Developing Powders - in 5 glass tubes. \$9.

Eastman Intensifier - in glass tube. \$1-10

Kodak Chromium Intensifier - 6

Eastman Kodak Pyro - 5 pair in a box.

Kodak Reducer and Stain Remover - in glass tube marked "EKC", \$3.

Kodelon - 1 oz embossed bottle with lead foil top. \$12.

GENNERT Pure Hydroquinine - 2" circular container. \$12.

MINOX Fine Grain Developer package contains developer in sealed vials. \$6.

SENECA M.Q. Developer - in glass tube. \$1

TABLOID - developing tablets in glass bottle, \$4

<u>DARKROOM DEVELOPING EQUIPMENT: DRYING RACKS</u> 4x5" folding wooden drying rack for glass plates, \$1-10.

<u>DARKROOM DEVELOPING</u> <u>EQUIPMENT:</u> <u>OUTFITS</u>

AMBRECT Daguerreotype processing apparatus - includes mercury pot, buffing stick, 2 fuming boxes. \$500-750.

ANSCO Developing Outfit - includes 4x5 contact printer, graduate, clips, therm. developing tank, safelight, trays, chemi-

BURKE & JAMES Ingento Developing & Printing Outfit No. 1 - c1909 3 developing trays, 2 tubes of M.Q. developer, 1 printing frame, Rexo/Acid Hypo, 4 oz. graduate, Rexo paper, ruby candle lamp. Original price: \$1.00. \$20.

EASTMAN KODAK CO. A-B-C Photo Lab Outfit, Model A -Steel print box, 3 trays, thermometer, graduate, tong, developer, fixer, safelight,

A-B-C Darkroom Outfit - 1940's. 31/4x51/2" trays, glass graduate, film clips, print frame, stirring rod, instructions. \$20.

Kodacraft Printing Kit - 1962 #611. Metal frame with masks for 7 film sizes, trays, chemicals, thermometer, paper, etc. \$15-20

3A Developing and Printing Outfit - c1920's. Trays, beakers, paper. \$25-30.

 $\frac{DARKROOM}{EQUIPMENT:} \frac{DEVELOPING}{SCALES}$ BAUSCH & LOMB - darkroom scales.

\$50.

EASTMAN KODAK CO.

instructions. \$20-30.

nickel darkroom scale. \$38.

Studio Scale - Black and brass, double pan, wooden base: \$80. Chrome and wood: \$70.

TROEMMER Philadelphia Scale - Wood and glass on four sides. Front door lifts. \$75.

OHAUS Dial-o-Gram Touch-n-Weigh

PELOUZE Mfg Co. Rexo #8 Scale -Avordupois and metric system. \$30.

SEEDERER & KOHL BUSCH - Glass enclosed scales with brass interior post. Front & rear panels lift up. Size: 18h x 16w x 9"d. \$115.

<u>DARKROOM DEVELOPING</u> <u>EQUIPMENT: TANKS</u>

brass developing tank for glass plates. Has a dial. \$15.

metal tank for 45x107mm stereo glass plates, with lid and filling sport. Holds 6 plates vertically. Scarce. \$40.

metal footed washing tank for 45x107mm stereo glass plates. Holds 24 plates vertically. Scarce. \$65.

nickel-plated daylight developing tank for 120 film. Orange transparent apron and 2 winding handles. Uncommon. \$15-25.

AMATO - processing tank, nickel, 45x107mm. \$12.

ANSCO Anscomatic - Round plastic, adj. reel and combination thermometer/stir rod. \$4.

BURKE & JAMES

glass plate developing tank. Nickel, rectangular box for 4x5" plates, with wire rack, rectangular funnel and hook. \$15 Rexo metal developing tank - \$12.

DALLON Cut Film Tanks

for 4.5x6cm film. \$8-15. for 9x12cm film. Nickel-silver. \$20.

ENVOY 6 - 1/2 oz bakelite developing tank. \$6.

EASTMAN KODAK CO.

Kodak stainless steel tank, 4x5". \$40. nickel tank, 5x7". \$8-15. Dayload tank - 1940's-1950's. Black plastic. \$15-20.

Brownie Developing Box - 1910's. Brass. \$50.

Developing Tank Model E - c1904. Metal with turning handles and 2 rounded compartments for rollfilm up to 5" wide. \$15

Kodak Film Tank - c1905-37. Consists of a wooden "winding box" in which the film is wound in combination with a lightproof apron onto a reel. The reel is then placed into a nickel-plated cylindrical tank for development. The complete outfit includes the wooden box with two cranks, apron, reel, and tank. Made in sizes for $2^{1}/_{2}^{1}$, $3^{1}/_{2}^{1}$, 5^{1} , and 7^{1} films. \$30-45.

Premo Film Pack Tank - \$8-15.

ESSEX - 35mm daylight-loading tank, builtin thermometer. Frame counter. \$12-20.

FR CORP.

Adjustable Developing Tank - for 4x5 or smaller cut films. \$8-15.

Adjustable Roll **Developing Tank Model 2 -** c1950. Bakelite, for 35mm to 116 film. Original price: \$3.95. \$1-10.

GENNERT Auto Tank - c1905. \$8-15.

GOERZ (C.P.) Tenax Developing Tank - Brass with chrome finish. \$12.

KALIMAR - Stainless steel tank for 35mm film reels. For 1 reel: \$6. For 5 reels: \$20.

MINOX Developing Tank - \$10-15. With thermometer: \$25-35

NIKKOR - stainless steel for 122 film. \$15.

OFFICINE GALILEO (Italy) GaMi 16 Developing Tank - Black metal with spiral winding mechanism (similar to Minox). \$110-135.

PLANO - Round with adjustable reel. \$3.

 Wet-plate collodion dipping tank Heavy glass container in fitted wooden holder with lid and lifter. 121/4x153/4" \$200-300.

YANKEE - Round. Adjustable reel. \$3-5.

<u>DARKROOM</u> <u>DEVELOPI</u>NG EQUIPMENT: THERMOMETERS

ANSCO - stirring rod/thermometer.\$5.

BURKE & JAMES

Ingento #3 Thermometer - metal.

Ingento #4 Thermometer - 51/2" long. \$7.

ACCESSORIES: DARKROOM THERMOMETERS...

EASTMAN KODAK CO.

5" thermometer, curved metal with hook at top. In a cardboard box. \$5. stirring rod/thermometer in wooden tube. \$14.

Minox Thermometer - 4" length. In cardboard tube. \$6.

<u>DARKROOM DEVELOPING</u> <u>EQUIPMENT: TIMERS</u>

BURKE & JAMES Luxor Photo Timer - c1930s. \$8. Perle Audible Timer - \$6.

EASTMAN KODAK - timer, red key wind

- 60 minute clock timer - Round red clock on red metal base. Large minute hand and small second hand. Face swivels on pins on either side. \$25-30.

Model B. Interval. 1940's. \$18.

FR CORP. Interval Timer - art-deco. \$1-10. Time-O-Lite - M49: \$15. P49: \$15.

<u>DARKROOM DEVELOPING</u> <u>EQUIPMENT: MISC</u>

Developing trays - Brand preference only slightly affects the prices of these items. Glass trays: \$15-25. Hard rubber trays: common, \$2-5.

Hydrometer - 1930's. For testing specific gravity of solutions. \$12.

<u>DARKROOM PRINTING EQUIPMENT:</u> <u>ENLARGERS</u>

EASTMAN KODAK Brownie #2 Enlarging Camera -Black cloth-reinforced cardboard, for 21/4x31/4" to 5x7" negatives. \$35.

Brownie #3 Enlarging Camera

c1920's-1930's.\$45

Direct Positive B&W kit - 1956. \$6. Kodak Enlarging Outfit Camera - Bausch & Lomb RR f4 lens. \$80.

No. 1 Kodak Enlarging Camera - 61/2x81/2". Red bellows. \$100-150.

Home Enlarger - 1930s. Wood. \$45-65. Kodak Miniature Enlarger - Ektar f4.5/50mm lens. \$75-100.

16mm Enlarger - Body based on Jiffy Kodak Six-16 camera. Enlarges movie frames onto Six-16 rollfilm. \$12-20.

Kodak Easel, 11x14" - masking paper board, 2 blade. \$35.

Vest Pocket Enlarging Camera -Black cloth-reinforced cardboard. \$30.

FEDERAL Enlarging Camera - With stand, light, holder. \$30.

<u>DARKROOM PRINTING EQUIPMENT:</u> <u>MASKS, MOUNTS</u>

ANTHONY & SCOVILLE Vignetter -Wood. With set of Mannings masks. \$15.

BURKE & JAMES Morrison Vignet-

EASTMAN KODAK CO. - mounts for panoramicphotos, c1900. \$3 per dozen.

GENNERT Montauk Post Card **Masks** - For $31/_4$ x $51/_2$ " negatives. Original price: \$0.15 per dozen. \$1-2.

MANNING, A.B. (Chicago) Manning's Masks - Package of 10 masks with 2 center pieces for 4x5" printing frames. Original price: \$0.25. \$1-2.

<u>DARKROOM PRINTING EQUIPMENT:</u> **PRINTERS**

wooden contact printer with electric light. 7x17" (banquet size): \$70. 5x7": \$35. 4x5":

BURKE & JAMES - 8x10" wood contact printer. \$45.

EASTMAN KODAK CO.

wooden printing frame. 21/4x31/4, 31/4x41/4, or 31/2x51/2", 4x5". \$2-3. **Auto Mask Print Frame** - 4x5".

Wooden. \$12.

Kodak Amateur Printer - dovetailed oak box, 10x7x8". \$15

Eastman Printer No. 8, Model 2 - A contact printer. \$40.

Eastman Printing Frame - for Stereo Brownie, \$75-100.

<u>DARKROOM PRINTING EQUIPMENT:</u> <u>RETOUCHING</u>

retouching easel for 8x10" or smaller glass plates. With mirror and swivel reflector in base, sliding hand rest, adjustable hood. \$30-45.

SPECIALTY CO. ALBERT Troian Junior Retouching Set - includes bottles of varnish, pumice, opaque, colored inks, sand paper, brushes, pencils, and pens. \$5.

ANTHONY & SCOVILL - retouching easel. Wooden, adjustable ground glass easel with drawer for utensils. \$35-50.

BURKE & JAMES Ingento Retouching Desk No. 2 -Oak with black interior, 16x12". \$30-45. Ingento Retouching Outfit - \$6.

REYNOLDS CO. No. Photo Oil Color Box - 1940's. Wooden box with 10 tubes of colors, 3 bottles of solutions, \$5

EASTMAN KODAK

retouching colors kit, boxed. \$24 retouching desk, dark wood. \$25-35. Transparent Oil Color Set - 1935. 15 small tubes of colors in wooden box. \$25.

DARKROOM PRINTING EQUIPMENT: MISC

BURKE & JAMES Print Burnisher c1900. \$18.

CHANDLER Paper trimmer - 1930's. 6" blade cuts a scalloped edge. \$35.

EASTMAN KODAK CO. Straightener, Print Eastman Model A - c1924. \$30-45. Kodak Paper Trimmer - Wooden,

12x12": \$25-35. No. 2, 7x8": \$15-20. **Hand print rollers -** with wooden handles. Double roller: \$11. Rollers in

DARKROOM SAFELIGHTS

red kerosene safelight. \$13.

33/4", 73/4", 10": \$7-9.

AETNA No. 4 Kerosene lantern c1890. With 4x5" glass. \$17.

AGFA Safelight - Brown metal box with rounded back. Bulb base sticks out back. Amber glass on front. \$2-5.

BURKE & JAMES Ingento Darkroom Light - Large black metal kerosene lantern with large red glass front, small round red glass on one side, square white glass on the other (covered by a door). Movable reflector inside. \$20-30.

Ingento #6 Kerosene Safelight -

Red with hinged door, red and amber glass. \$20-25.

Ingento #9 Oil Safelight - \$15-20. Ingento Ruby Candle Lamp No. 17 Rectangular red metal box. Red glass pulls out the top when you lift the flap to light the candle. Orig price: \$0.40. \$12-15.

EASTMAN KODAK CO. Brownie Darkroom Lamp A - paper.

\$5-8

Brownie Darkroom Lamp B - Round plastic cover on a black bakelite base that screws into a socket. 7w bulb. Plastic covers were red, yellow, or green. \$8-15.

Brownie Darkroom Lamp Series 2

- A red Dixie cup-like device with cover on the wide end. 71/2w lamp inside. Lamp base protrudes out narrow end. \$7-10. Brownie Safelight - c1930's. Green.

Brownie Safelight Lamp Model D -

Kodak Candle Lamp - c1910's. Red canvas on folding wire frame. Metal bottom holds candle; metal top has vent. \$15-25. Kodak Kerosene Lamp - c1890. 4x5"

glass. \$20-25. Kodak Kerosene Safelight - Red with top hinged door and red and amber glass. \$20-25.

POCKET TIM Kerosene Darkroom Lamp - \$18.

REX Kerosene Safelight - \$13.

ROCHESTER OPTICAL CO. Universal No. 1 Darkroom Kerosene Lamp - \$20-25.

EXPOSURE METERS

AGFA DIN Exposure Calculator - 1936. Aluminum. \$5 Lucimat - \$8-15 Lucimeter - 1950's. Selenium. \$8-15 Lucimeter M - Photoelectric. Incident light attachment. Cream and gray color.

ALPEX - 1957. Clip-on selenium. \$5.

Lucimeter S - \$8.

AMBASSADOR - Japan. CdS. Built-in reflex viewfinder, \$12.

ANSCO Light Meter - c1925. Extinction. Circular with square at top. While aimed at the light source, a wheel is turned to line up two red dots. \$8-15. Also sold as Milner Light Gauge, c1920.

ARGUS CM-2 Meter - For C33, C44, C44R. \$15-

L-3 - Hand-held selenium. \$6.

L44 - Shoe mount. \$6.

LC3 - Clip-on for Match-Matic. \$8-15.

LS-3 - for C3 Standard, \$8-12.

ASAHI KOGAKU

Clip-on CdS meter for very early Pentax models. \$50+

Spotmeter V - \$150

AVO

Smethurst - 1937. Selenium. \$12-20. Smethurst Highlight - 1938. Patent based on use of opal glass in front of selenium cell. Uncommon in U.S.: \$25. Europe: \$8-15.

BELL & HOWELL Photometer - 1931. Battery operated cine meter. \$30.

ACCESSORIES: EXPOSURE METERS

BERTRAM

Amateur - 1953. Selenium. \$12-20. Chrolon - 1953. Selenium. Junior version

of the Chronos. \$8-15

Chronos - 1950. Selenium. Shaped like a pocket watch. Opening the lid automatically opens the two doors in front of the cell. Scales for still and cine. \$9-15.

Chrostar - 1952, \$20-30.

Critic - \$5.

Automat - 1955-60. Selenium. \$8-15.

Bewi Jr. - 1930s. \$8-15.

Boy - Selenium. \$7.

Electro Bewi - 1937. Selenium meter with DIN scale and extinction meter in lid. \$20-30

Electro Standard - 1938. Selenium.

Electro Super - 1937. Selenium meter with DIN scale and extinction meter in lid. \$20-30

Extinction Meters - 1930's. Tubular.

Piccolo - 1960. Clip-on. \$25-35.

Quick - 1960. Selenium. Gray or ivory

Super L - CdS. \$25

Tele Bewi - 1930's. Tubular extinction meter is attached to a second barrel incorporating a rangefinder; turning scales on both barrels. \$50.

BOWER - Small gray meter with foot for camera shoe. \$8.

BURGESS BATTERY CO. - 1964. Sliderule type card with Burgess Photo Flash Guide on one side and Photo Exposure Guide on other. Original cost \$.25. Now:

BURROUGHS-WELLCOME Began making exposure calculator tables in 1907, later incorporating them in the Diary and producing them until the 1970's.

Photo Exposure Calculator, Handbook, and Diary - Leather folder containing exposure hints and tables, a calculator wheel, info on the company's chemicals, diary pages for recording pictures taken and a pencil.

1909: \$25.

1915: \$20.

1927: \$15. 1935: \$15.

1939: \$13.

CALUMET Flashmeter - \$18.

CANON auxiliary CdS meter - 1965-67. For models for FP and FT. \$20-30.

CAPITAL Model D-1 - Selenium, \$20.

CHARDELLE Meteor MFC-50 - 1940. Pocket flash calculator in shape of a slide rule. \$1-10.

CHOU

Promatic 1 - Blue selenium meter. \$3. Promatic Auto-Dial - Hand-held selenium meter with ASA, DIN, and EVS scales.

COMBI Combimeter - 1952. Rangefinder with built-in extinction meter, DIN scale. With camera shoe. \$10-19.

CORFIELD - 1951. Extinction meter. \$20

CORONET Model B - \$7.

DECOUDIN (J. DeCoudin, Paris) Photometre - c1887. Brass extinction meter. Meter was placed on the ground glass to read the correct setting, \$120-180.

DEJUR AMSCO CORP. All the meters listed below are selenium meters.

Model 5A - \$6.

Model 5B - 1946. \$8 Model 6A - c1946-47, \$11.

Model 40 Critic - Large metal pre-WWII meter. Weston scale. \$5.

Model LM-46A - Made under contract for the U.S. Air Force. USA scale. \$17. Model 50 - c1945. ASA scale. \$8-10.

Model SD - \$7.

Dual Professional - 1947-53. Selenium. Two position hood, \$12-20.

DIRECTOR PRODUCTS CORP. Selenium type meters made by several different companies.

Brockway meters:

Model A - 1941. (Photo Research Corp.)

Director M-2 - 1949. (Brockway Director Corp.) \$20-25.

M-3 - 1955. (Photo Research Corp.) \$10-

S - 1957. (Photo Research Corp.) \$10-15.

Norwood Director meters:

Model B - 1947. (American Bolex Co.) Top professional meter before the popularity of the Luna Pro. \$25-45.

Model C - 1950. (Director Products Corp.) Precursor to Sekonic L28C2. \$18-

Model D - (Director Products Corp.) \$15-

Model E - (Director Products Corp.) \$15.

Flashrite - (Director Products Corp.) Rangefinder/calculator.\$18-22.

Speedrite - 1940's. (Director Products Corp.) Rangefinder/calculator.\$18-22. Super Director - 1958. (Walz.) \$25-30.

DORN, JOSEPH (Germany) Chum -1947. Selenium. Brown bakelite. (Also called Prix (1938), Priz (1953). \$20-25.

DREM (Germany) Made a variety of telescopic extinction meters, 1924-39. First exports to the U.S. in 1931.

Cinemeter - \$15-25. Cinephot - \$14-18.

Cinephot Automatic - \$12-20. Dremo - 1931. Extinction meter. \$50.

Dremophot - Visual extinction meter. Brass calculator scales. \$8-15.

Dremoscop - Black with nickel finish. \$13-17

Instoscope - \$12-20. Justodrem - \$15-25

Justophot - c1929. All nickel finish.

Leicascop - \$15-25.

EASTMAN KODAK

Kodalux L - Shoe mounted for Retina cameras. First model, 1956, has square chrome body. Second model, 1959, has sliding incident light cover. \$20-30.

EXCELSIOR WERK Picoskop - c1953. Selenium, \$8-15.

EXOPHOT - 1939. Extinction. \$15.

FEDERAL Ideal - 1947. Direct reading selenium meter. \$7.

F.R. (NY) Model EM-1 - 1953. Selenium. \$8.

FRANKE & HEIDECKE Rollei Iris Diaphragm attachment

 1932-34. Designed primarily for checking depth of field, it also functioned as an

extinction meter. Attaches to the viewing lens of pre-war 6x6cm models. All black or black and chrome versions. \$35-50.

Rolleilux - 1950's. Selenium meter built into Rollei bayonet lenshood. \$50.

Rolleiphot - 1938. Version of the Diaphot for f2.8/6cm or 7.5cm lenses. Chrome and black, \$35-40.

GEC - England. 1947. Round bakelite selenium. \$20.

GENERAL ELECTRIC Selenium meters

DW-40 - \$5

DW-47 - 1938. Hexagonal-shaped.\$22. DW-49 - Foot candle meter. Signal Corp Model \$25.

8DW40Y1 - \$12. 8DW47Y11 - \$19.

8DW48Y6 - 1939, \$8-15. **8DW58Y1 -** \$10-12.

8DW58Y4 - measures in foot candles.

8DW58Y4A - 1957. \$13.

8DW58Y5 - \$16.

DW-68 - 1951. All-metal version of the DW58, \$10-15.

PC-1 Color Control Meter Kit -1956. With filter kit and case. \$20.

PR-1 - 1949. ASA 1000: \$20. ASA 1600:

PR-2 - 1953-56. \$15.

PR-3 Golden Crown - \$18-22. PR-3 Mascot - \$8

PR-22 - Clip on Polaroid. \$3-6.

PR-23 - \$6.

PR-23A - 1951. Polaroid EVS. \$3-5.

PR-23B - Polaroid. \$3-5. PR-30 Mascot - \$8-15

PR-35 Mascot II - \$8-15. Model 213 - foot candle meter. \$7.

W 49 - foot candle meter. \$8.

Junior Model - \$12.

G.M. INSTRUMENTS Selenium meters

Skan - 1946. \$7. Skan B - 1946, \$8. Skan Quick - \$7.

GOLD CREST PR104 - \$1-10 XL7 - CdS. \$18.

GOSSEN

Bisix - \$2 Blendux - 1933. Cine version of Ombrux.

C-Mate - \$18.

Dual-Sixon c1953. Selenium meter

with roller-blind. \$13. LunaPro - 1969. \$60.

LunaSix - 1969. CdS. \$45-55 LunaSix 3 - c1970. CdS. \$75-100.

Majosix - c1959. Black bakelite. \$30-45.

Majus - 1930's. \$90-130.

Multi-Pro - c1970. Battery-powered. 2 LED's indicate over or under-exposure.

Ombrux - 1933. Selenium. \$8-15. Ombrux 2 - c1951, Selenium, \$8-15. Photolux - 1933. Selenium. \$8-15.

Photoscop - 1936. Selenium. \$9. Pilot, Pilot 2 - Selenium. \$12-20. Retina Meter - Selenium, \$13.

Scout - Selenium incident/reflected light meter. \$8-15.

Scout 2 - Selenium. \$15.

Sixon - 1952-58. Selenium with rollerblind incident light cover. \$5-10.

Sixtar 2 - CdS. \$12-20.

Sixti - c1956. Clip-in selenium. \$12-20. Sixticolor - Early circular meter. Ivory color. \$50-75.

ACCESSORIES: EXPOSURE METERS...

Sixtino - Selenium, ASA 6400. \$8-15. Sixtomat - 1952-58. CdS, with white rollerblind incident light cover. \$12-20. Sixtomat X3 - 1951. Selenium. \$8.

Sixtry - 1952-58. Selenium with roller-blind incident light cover. \$8-15.

Sixtus - 1937-55. Meter slides into selfcontained plastic case. \$9-14.

Super Pilot - CdS. \$25-35. Trisix - 1952-58. Selenium with rollerblind incident light cover. Color temperature scale. \$8-15.

GROSSMANN (Dr. Joachim) Gracophot - c1932. (Berlin.) Light/ distance meter. Rare. \$200-300.

HARVEY Exposure Meter - 1915. Pocket style. Film and plate calculator. \$20.

HEYDES

Aktino Photometer - 1904-30. Cylindrical extinction meter. Made in two sizes. \$25-35

Photo-Telemeter - c1930's. \$12-20.

HICKOK Photrix SS - 1941. Selenium. \$12.

HONEYWELL - Coupled CdS meter for Pentax models H1-H3r. \$12.

HURTER & DRIFFIELD

Actinograph, first model - patented 1888; produced in 1892. Calculator using different rollers for various latitudes. Mahogany box holds rollers and calculation scales. \$150-250.

second model Actinograph, c1901. Slide-rule type calculator. Sold in mahogany case with different slides for time of day, weather conditions, etc. Sold by Marions. \$150.

ICA Diaphot - 1921. Slim, round extinction meter. \$12-20.

IDEAL Exposure Scale - 1908-14. Plate calculator in the form of a circular slide rule. \$15.

IHAGEE

Exakta Lightmeter IIa - Selenium.

Examat - 1967. TTL CdS meter prism for the Exakta. Made by Harwix. \$80.

Macro/Micro Photometer Selenium meter fits behind the lens for TTL microscopy uses. \$80.

Prism meter - 1958. Combination of direct viewfinder and selenium meter built into prism. \$50-75.

Travamat - 1966. TTL prism. Made by Schaat, \$80.

ILFORD

Exposure calculator - 1893. Disc form in cardboard or aluminium. \$10-50. **Selenium meters -** Model A, 1936. Model B, 1938. Model C, 1950. \$15.

IMPERIAL Actinometer - 1901. Variety of diary-type meters. \$5.

KALART CO. Meter - with shoe. \$8.

KALIMAR Selenium meters Auto Dial - \$7.

Model A-1 - \$7. Model B-1 - \$7.

Model K-420 - Miniature meter that fits in an accessory shoe. \$5-10.

P-A-L - 1958. Made in accessory shoe or wrist strap styles. \$4.

Sure EX - ASA 25-125. \$1-10

KIESEWETTER Photoskop K - c1934. Photo-electric. \$45-60.

KINOX

Model 3 - Selenium. \$3. Super Automat - CdS. \$10.

KNIGHT meter - \$5.

KONICA - Shoe-mount selenium meter for Konica III, IIIa. \$8.

LANGE Addiphot - 1932. Pocket extinction meter in slide rule form with varying apertures, \$13.

LAWRENCE Flash Rule - 1946. Slide rule calculator for Wabash flash bulbs. \$6.

LEITZ (Ernst Leitz GmbH) Leica Meter M - \$50.

LENTAR meter - \$4.

LUMY - Germany. Extinction. Red or brown bakelite. \$15.

MAXUM INSTRUMENT CO. (N.J.) Pierce Exposure Meter - Rectangular plastic extinction meter with dials. \$9.

METRAWATT

Horvex 3 - 1956. White and brown body. \$9-12

Horvex Argus-L3 - early 1950's. \$7. Horvex Minilux - 1953. Shoe mount selenium. \$7

LC60 - 1939. Bakelite selenium meter for Leica III. Shoe mounted. \$40.

Model M - 1955. Selenium meter for

Leica M. \$20. Model MC - 1957. Selenium meter for Leica M. \$20.

Model MR - 1966. Cds. Early version has extended switch: \$35. Later version with recessed switch: \$60.

Metraphot - 1934. Clip-on cylindrical selenium meter. \$30-45.

Metraphot 2 - 1951-53. Shoe mounted selenium meter for Leica. \$15.

Metraphot 3 - Shoe-mount selenium meter. \$12-20.

Metrastar - \$8-15.

Polaroid 620 - 1957. Selenium meter.

Polaroid 625 - 1958. \$5.

Tempiphot - 1937. Bakelite. First selenium meter to have a booster cell attachment. \$15-25. (Booster adds \$8-15 to the value.)

Tempophot - 1936. Early version of the Tempiphot. \$20.

Tempoplex - 1937. Extinction meter.

Tribolux - 1950. Photometer similar in design to the Tempoplex. \$30.

MIMOSA AMERICAN CORP. Extinction meters

Leudi - c1934-40. American model with no cine scale: \$5-10. European model, c1940, with cine scale: \$5.

Leudi II - 1938. \$5-8. **Leudi 3 -** 1940. \$5-8.

Lite - 1950. \$5.

MINIREX II - 1952-60. (US Zone of Germany). Two-tone selenium meter. Colors: red and cream or green and black. \$12-15.

MINOLTA

Auto Meter 2 - \$15. Auto Meter 3 - \$5. Color Meter 2 - Old style. \$150. Selenium meter - \$18.

SR meter - \$40.

MINOX

Minox Meter - 1952. \$20-30.

Minosix - 1952. Same meter as above listing. \$50-75.

MIRANDA

Models F, FV, G - Clip-on CdS meters. \$13

Meter Prism - Cell in face. For Models C-F. \$15-25.

MONOCADRAN Realt-Deluxe - 1956. Selenium, DIN/SCH, \$15.

MÜLLER & ZIEGLER Electrophot c1933. Photo-electric. Round body. \$90-

M.V. Metrovick - 1939. Square selenium meter. \$5.

NEBRO Visual - c1950. Extinction. Ivorycolored. \$15.

NIPPON KOGAKU - Meter for S series.

PELMET Extinction meter - 1952. Can be mounted on watch strap. \$8-15.

PETRI Clip-on meter - \$30.

PHAOSTRON CO. (Alahambra, CA) Phaostron - Model A (1939), B (1940), C (1941). Model D (1940) is larger, made by Eisenber Instruments, also sold as Commander. Square, bakelite, batteryoperated comparison meter. Knob in center varies brightness of inside bulb to match that of outside light. Both are seen through a little window on top. \$12-15.

PHILLIPS - 1896. Slide-rule type calculator. Boxwood or aluminum. Actinometer in ib. \$60-90.

PHOTOSKOP - 1934-38. Clyindrical selenium meter. \$35-50.

PICTOL FOCAL - \$60.

PIERCE meter - \$5-8.

POSOGRAPH -1921-32. Mechanical calculator with interdependent sliders to give exposure. English and French versions. \$50.

REX 300 - Cream, gold, red colored body.

RHAMSTINE

Electrophot DH - 1931. Considered to be the world's first photo electric exposure meter, preceding the Weston 617 by a few months. Uses battery to supplement cell. \$60. Other models produced in the 1930's-1940's.

RIKEN Ricoh meter - Foot mount for Ricoh 35's. \$1-10.

SALFORD ELECTRICAL INSTS. SEI Photometer - 1947. Sophisticated spot photometer. \$90-130.

SCHLICHTER (Dr. W.) Aktinometer -1927-32. Telescopic extinction meter. \$12-20

SEARS

Tower selenium meter - Shoe mount, ASA 10-200. \$14.

Tower meter - Made in West Germany. \$12-20.

SEDIC P-120 - \$8.

P-130 - \$4.
ACCESSORIES: FINDERS

PR-60 - 1971. CdS. Jeweled movement, shock proof. \$5.

SEIKO Sekonic meters

246 - Foot candle meter. \$25.

Auto Leader - \$8-12.

Auto Leader II - \$8. Auto Leader III - \$8-15

Auto-Lumi - Selenium. \$8. Auto-Lumi 86 - Selenium. \$8-15. Auto-Lumi 158 - Selenium. \$8-13.

Delux, Model I - \$12. LC-2 - \$8.

L6 - 1956. \$8.

L8 - 1957. Selenium. Miniature version of the Weston Master V. ASA 1600. \$8.

L398 - \$30.

L428 - Silicon cell incident or reflected

meter. \$30.

Leader #32 - \$12-15. Leader #36 - \$12-16. Leader #38 - \$11-14.

Micro - Clip-on CdS meter. \$14.

Micro Leader - CdS. \$12.

Studio - Modernized version of Norwood Director. Deluxe: \$38. Normal: \$25.

SHOWA-KODEN Sunset Unitic M31 -1956. Selenium. \$8.

SOLIGOR

Auto-Read - 1956. Selenium. \$5.

Selector - CdS. \$5

Selectric - 1964. CdS. \$5.

SPECTRA

Combi 500 - \$25.

Tri-Color - \$175-250. Universal - \$23.

Flash-Slide-A-Guide 1951. Slide rule calculator. Original cost: \$.10. Currently: \$1-10.

Practos - intro. 1932. Telescopic extinction meter. Black and chrome. \$10-14. Practos Junior - intro. 1936, \$4.

TURL - 1950. Photometer. \$60

UNITTIC meter - Lens mount version: \$8-15. Shoe mount selenium version: \$5.

UNIVERSAL Univex extinction meters

Chromed aluminum. For Mercury I: \$8-15. For Mercury II: \$7.

Candid - 1938. Tubular. \$12.

Cine - 1938. Telescoping style. \$8.

Instoscop - 1939. \$15-20

Utilitron Range-O-Matic combination rangefinder and exposure meter. \$15-20.

VICEROY - CdS. High/low scales, incident light dome. \$8-15.

VIVITAR

Model 35 - Selenium, \$16. SL - CdS. Reflect/incident. \$12-15.

VOIGTLÄNDER Brillant meter - 1936. Extinction meter clips over the viewing lens of the Brillant TLRs. \$20.

VOTAR Hyper VII - \$4

Hyper VIII - \$6.

WALZ Selenium meters. Coronet B - 1956. Copy of Leica M. \$6. Electric Eye Model P - \$6. M1 - 1955. Cine meter. \$1-10.

Micro - Small shoe-mount selenium meter. \$1-10.

Polaroid - 1955, \$5.

WATKINS The line of Bee actinometers was patented in 1902 and continued until 1939. At least 26 models were made.

Bee - 1905-10. Shape of a pocket watch. Calibrated in HD and US stops. \$20.

Bee Autochrome - \$30.

Bee Colour Plate - Similar to the Bee, but with a different glass face. \$25.

Bee Fall - \$25

Bee Filmo Filmo - Similar, but has scales for cine work. \$25.

Bee Focal Plane - \$25.

Bee Indoor - \$25.

Bee Small Cine - c1920. For 35mm cine cameras, \$25

Bee Snapshot - \$25

Bee Snipe - 1920's. Simple version. \$8-

Bee Studio - \$25

Dial meter - 1900. Predecessor of the Bee. \$60.

Queen Bee - 1903. Silver plated luxury version of the Bee. \$200-300

Oueen Bee Chronograph - 1911. The Queen Bee with a stopwatch or full hunter pocket watch in the back. \$500-750.

Standard - 1890-1923. Brass barrel cylindrical actinometer with chain and timing pendulum by the end cap. Rare. \$75-125

Standard - 1905. Magnalium version. (Aluminum and chrome plate also available in various years.) Rare. \$150.

WELCH Model 3588 - Foot candle meter. \$8.

WESTON

Model 560 Master VI - 1972. \$8-15. Model 617 - 1932. Streamlined pocket meter with two selenium photocells, one on each side of the meter. One of the first photo-electric meters powered solely by its own photo cells. \$30.

Model 617, Type 2 - 1933. Rectangular body with rounded ends, single photocell. \$15

- Leicameter 617 (Type 2) - Version made for Leicas. \$40.

Model 627 - 1934. Round meter shaped like a compass. \$20.

Model 627, Type 2 Cine - Selenium.

Model 650 - 1935. Octagonal shaped selenium meter. \$25

- Leicameter 650 - Version made for Leica. \$40

Model 715 Master I - 1938. Selenium.

Model 717 Master I - c1940. Selenium. First successful meter of the Master series; about twice as thick as later models. \$15

Model 720 Master I - 1940. Selenium. \$12-20.

Model 735 Master II - 1946-53. Silver

and dark gray selenium meter. \$12-17.

Model 736 Master II - 1952. Cine. \$12-20

Model 737 Master III - 1958, \$9-14. Model 744 - \$8.

Model 745 Master IV - 1960. Stainless steel case; needle lock. Easy to read. \$12-

Model 748 Master V - 1963. Selenium. \$13-20.

Model 756 Illumination Meter -

Model 819 - 1938. Cine version of the Model 650. \$30.

Model 850 Junior - 1939. Inexpensive selenium meter. \$8-15.

Model 852 Cadet - Selenium. \$6-12. Model 853 Direct Reading - Selenium. Direct read F-stop, LV, or Pol. \$8-15.

Model 863 - \$4. Euromaster - 1977, \$30.

Master Invercome - Incident type. \$4. Pixie - \$12-15.

Ranger - \$15. Ranger 9 - \$50-75

Ranger 9 Model 348 - \$75-100. Universal - \$8.

WILLO Cinemeter - 1932. Telescopic extinction meter. \$15.

WIMMER Lichtfix - c1934. Rectangular version. \$50-75.

WYNNE'S

Infallible 1894-1905. Actinometer shaped like a silver pocket watch. US stops for plates. \$30-45.

Infallible (silver) - Luxury version in solid silver, hallmarked. \$150.

Infallible Hunter - 1914-37. Similar to the Infallible, but with hinged cover over face. \$30.

Infallible Print Meter - 1896. \$60.

YAMATAK Model NE-200 Deluxe -1971. CdS. \$5.

YASHICA Selenium meter - ASA to 800. 1" square. \$8-15.

ZEISS IKON A.G.

Diaphot #1321/7 - 1926-34. Extinction meter, same as the Ica Diaphot. \$8-18.

Helios #1325/3 - 1935. First Zeiss photoelectric exposure meter. Shoemounts on the Contax. Black or brown bakelite. Rare. \$150.

Helicon - 1936. Similar to the Helios, but with Super Ikonta style rangefinder. \$200-

Ikophot #1328/1 - 1940. \$12-20. **Ikophot** #13290 - 1953. Selenium. Early versions in black; later are creamcolored. \$20

Ikophot-Rapid - c1956. Selenium. \$8-

FINDERS

90mm finder - \$14.

Multi-Focal Zoom Finder 28-135 -Parallax corrected. \$35-50.

Multi-Focal Zoom Finder 200mm - Identical to the Tewe and Nikon finders, but with a scale range of 35, 50, 75, 85, 90, 100, 135, 150, 180, and 200mm focal lengths. Parallax base. \$45. 135mm Brightline finder - Nikon SP style, parallax base. Black. \$13.

ARGUS

ALPEX

Multi-focal or Turret Viewfinder -30/50/100mm.\$25-35

Viewfinder 35/100mm - fits in shoe. Black plastic. \$12-20.

Zoom finder - with flash connection. \$20-30

Pentax Folding Sportsfinder - Fits onto accessory shoe. \$18-22

Right Angle Finder - \$35. CONCAVA Tessina waist level finder - Chrome. \$22.

DEJUR-AMSCO Rangefinder - Mounting clip. \$1-10.

DeMORNAY BUDD Focusing Reflex Viewfinder Model 288 - 1946. Shoe

ACCESSORIES: FINDERS...

mount, for Leica and Contax II. 5cm/f3.5 lens and 6x magnifier for gg screen. Rare. \$100-150.

EASTMAN KODAK CO. 35/80mm Optical Multifinder - for Retina Models lb, IIc, IIIc - \$35-50. Right Angle Optical Finder - for

Kodak Ektra. \$40. Right Angle Optical Finder - for

Retina Reflex. \$45-60

35/80mm Sportsfinder - \$20-30. Retina Sportsfinder 50/80mm - for Retina II. IIa. \$25-35

Retina Folding Sports Finder - for 50mm Retina. \$15-25.

Retina Sports Finder, Model C - for all rangefinder and reflex Retinas. \$25-35. Signet Multi-frame finder - for Signet 80. \$30.

FRANKE & HEIDECKE Rollei Eye-Level Prism Finder - Fits all Rolleicords, and Rolleiflex E2 and 3F. \$170-215

Rollei Sports Finder - Hasselbladstyle sportsfinder. Fits on the hood of all Rolleicords and Rolleiflex Automats below #1,100,XXX.\$15-18.

FUTURA 35-100mm universal finder - c1950. \$45-60.

GRAFLEX

flip-up optical viewfinder for early 4x5" Graphic. \$18.

Graflex/Norita eye level finder -

Speed/Crown Graphic - Top mount parallax finder, slide on. \$8-15.

HEINEMAN, O.G.

Auxiliary Sportsfinder - Slips over hood of all Rolleiflexes below #1,099,XXX (1937-1946), and non-Rollei cameras. Has parallax correction. \$15

Eye-level prism finder - \$155.

waist-level finder, various models. \$10-15. eye-level finder, various models. \$20-35.

Magnear finder - \$25-30.

Real - Scarce. \$50.
Right Angle Magnifying Viewer with diopter adjustment. \$40.

Folding Sportsfinder ILOCA Chrome, for Pentax. Offset dual shoe; level in the folding joint. \$20-25

KONISHIROKU **Koni-Omegaflex** waist level finder - \$12.

KOWA 6 waist level finder - \$35.

K.W. (KAMERA WERKSTATTEN A.G.) Magnear - \$30.

Praktina or Praktisix waist-level finder - \$16-20.

MAMIYA TLR waist-level finder -\$18.

MINOLTA 35mm Vertical Multi-finder - For RF cameras. \$30-45.

135mm tubular finder - chrome. \$15-25.

Right angle mirror finder - for Model B - \$18 finder brilliant Waist level chrome. \$22.

MIRANDA Eye-level Prism Finder - various models. \$13.

Sensorex, Sensorex II Eye-level Finder - Black and chrome. With accessory shoe: \$10-15.

Waist-level Finders - various models.

VF-1 Finder - Waist level. \$20-30. VF-3 Finder - Early style critical magnifier finder. \$20-30.

NEOCA 50mm Brightline finder -\$40

SHOKAI Walz Universal NIHON Finder - \$20-30.

PENTACON frame finder - c1950s. \$16-20

SANDMAR Zoom-Vue Finder, 35-135mm - For Argus. \$22.

TANAKA OPTICAL CO. Tanack 35mm finder - \$8-15. Tanack 135mm finder - \$15 35-135mm Varifocal Tanack finder - \$30.

TEWE **Multi-focus** 35-135mm **700m** Finder - original, with 35, 38, 45, 50, 85, 90, 135 range. Copy of the Nikon Varifocal finder. \$35-50.

Multi-focus 35-150mm Zoom Finder - 1950's. \$50-75.

TOKYO KOGAKU Finders - Right angle, universal zoom, varifocal zoom, and waist level versions. \$30-35.

VOIGTLÄNDER Kontur 35mm Viewfinder - \$20-30. Right angle finder, #344/45 - \$45-

Turnit 3 Finder 35/50/100 - Black, for Prominent. \$35-50.

WALZ Waist level finder - Copy of Leitz AUFSU. \$30.

WIRCIN Edixamat Waist Level Finder - \$8.

WHITTAKER Micro 16 eye level finder - \$12-20.

YASHICA Atoron Electro waist level finder - \$8.

FLASHES

German Pocket Magnesium Flasholder, c1920's. Hinged case (similar in style to a cigarette case) holds a roll of magnesium ribbon threaded through a flat tube. The tube flips up vertically when the case is opened. Silver finish. \$30.

AGFA KAMERAWERKE Agfalux-C - for cubes. \$1-10 Agfalux-K - for AG-1. \$4. Magnesium Flash - spring-wind. \$55-

Tully-K - for AG-1. \$1-10

ALPEX Pocket Flash, Type BC - fan, slips on accessory shoe. \$3.

ARGUS **Argus Flashes**

Argus C. \$8. Argus C3. \$4. Argus C4. \$5. Argus C44. \$5

Argus F, for hot shoe. \$6. Argus 75. \$4.

Argoflash - \$8-15. Folding Flash Unit, #760 - for hot shoe. \$1-10.

Flash Bracket, #799 - for C4 or 44. \$1-

BELL & HOWELL TDC Stereo Vivid Flash Unit - \$20.

BOLSEY

Flashes - for Bolsey or Jubilee. \$1-10.

BURKE & JAMES

Ingento Flash Pan No. 1 - 12" metal trough on a metal rod with a wooden handle. Spring-activated pin, released by thumb, strikes paper cap in trough and ignites powder. \$22.

CANON

B-1 bulb flash unit for early RF models. \$20. Flash for Canon VT. \$13.

CIRO Ciro-flex flash kit - \$1-10.

EASTMAN KODAK Brownie Flasholder - for 620 flash. \$1-10

Brownie Flasholder, Type 2 - \$1-10 Crown Magazine Flash Lamp - \$30-

Duaflex Flasholder - \$1-10 Ektamite flasholder - \$5.

Ektra 35 flash unit - \$50. Flash cartridges, No. 1 - metal can of

Flashgun - for Ektra. \$15 Flasholder Model B - \$3

Flasholder, Kodak Reflex - \$8-15. Flash sheet holder - \$40-50.

Flash sheets, No. 3 - envelope of 12. \$8-15

Generator Flasholder Type 1, No. 771 - Fires M2 or No. 5 bulb without batteries for cameras with screw-in flasholder fittings. \$8-15.

Generator Flasholder Type 2, No. 772 - Has shoe bracket and cord for most flash synched cameras. \$8-15.

Hawkeye Flashgun - \$1-10

Kodablitz - Shoe mount, for Retina. Made in Germany A small plastic box with flip-up lid that becomes the reflector. Takes AG-1 bulbs. \$1-10.

Kodak Flash Cartridges - in tin box.

Kodak Handy Reflector, Model C -Cardboard reflectors that unfold and fit (with metal rings) around bulbs in floor lamps. Come 2 in a box. \$20.

Kodak Magnesium Ribbon Holder -Metal, teardrop-shaped holder. Roll of magnesium ribbon dispenses out the top.

\$35-45.

Kodak Standard Flasholder - Uses #5 bulbs. Bakelite handle takes "C" batteries or Kodak BC flashpack. Large plastic reflector with polished chrome finish for #5 bulbs. Mounting bracket for bottom tripod socket; ASA connectors on body and attached cord. \$1-10.

Kodalite Flasholder - for #5 bulbs. \$3. Kodalite IV Flasholder - for #5 and M2 bulbs. \$4

Kodalite Midget Flasholder - For Kodak Stereo. \$5.

Kodalite Super M40 - \$4. Pocket Flasholder B-1 - folds. \$3.

 Bracket with Retina Flasholder midget flash holder. \$15.

Rotary Flasholder - Holds 6 bulbs that are manually moved into position. Type 1: \$4. Type 2: \$5

Senior Synchronizer Speedgun Model E - \$4

Spreader Flash Cartridge Pistol c1902. Flash cartridge is placed on top of tray. Leather-covered wooden handle is beneath. Has trigger release. \$45-60.

ACCESSORIES: LENSES (without shutters)

EDISON Mazda foil flash lamp - \$1-

FEDERAL MFG. & ENGINEERING CORP. Fed-Flash flash unit No. 1-A

FRANKE & HEIDECKE

Rollei Flash I - Fold-up clamp, cord, and single arm bayonet. \$12-20.

Rollei Flash II - dual arm bayonet. \$20-

Rollei model 16 flash - \$12-20.

GEISS Contact Flash Synchronizer -\$1-10

GOLD CREST BC7 - tilt, fan flash. \$1-10

BC - bulb flash. \$2-6.

Graflite flash - with reflector. \$5-7.

GRAHAM Flash Synchronizer - for Graflex. \$42.

HONEYWELL Tilt-A-Mite - fan flash. \$3.

IHAGEE Bulbflash outfit - Scarce. \$40.

INTERNATIONAL FLARE-SIGNAL CO. (Ohio) - Metal flash pistol looking somewhat like a flare gun. In wooden box with flash cartridge: \$450-500.

KAISER Kalux - AG-1 unit. \$1-10

KALART CO.

BC Flash #411C - for TLR's, \$1-10 Kalart "Safety First" Deluxe Speed Flash - Combination battery case and reflector. Kalabrack extension bracket, test lamp, and passive synchronizer unit for cameras with self-setting auto shutters \$1-

KALIMAR Select-O-Flash - Bar holds 1-4 bulbs. \$6

MARSHALL (JOHN) Meteor Flashlamp, Model B - 1929. Magnesium powder flash using prime caps. \$30

MICROMATIC SPEED FLASH - 1937. Calibrated to adjust the sync to match different cameras. With cable release, \$15.

MERCK - 1 oz of magnesium. \$15.

MINOLTA

16MG flash - \$1-10.

Baby BC-III - for subminiatures. \$8.

AG-1 flasholder - for Minox B: \$1-10. For Minox C/III: \$15.

Cube Flash C4 - for Minox EC. \$12-20. Fan flash Model B - \$10-15.

FC Flash - \$15.

FL4 Flash - \$4.

TC Flash - \$30.

NICHOLS (CHARLES H.)

Portrait Flash Lamp - Flash powder ignites by blowing the flame from the kerosene lamp through a hole in the metal back plate. It could be raised to 10', \$160.

NIPPON KOGAKU

BC-IV Flash - for S2. \$12-20. BC6 Flash - for Nikon RF's. \$12-20. DC-IV Flash - \$25.

M-B C-5 Flash - \$12-20.

Model V - \$11.

PAPERCAPS - Cylindrical wood container with 150 caps. \$12.

RAINBOW Pocket Flash - with fan reflector \$5

REVERE Model 24 - flash for Revere Stereo 33, \$12-20

RIKEN OPTICAL Ricoh Fan Flash - \$1-10. Ricohlite V Flash - Holds 5 bulbs. \$1-

SANFORD Flashgun holder - with bracket for Stereo Realist, \$12.

SANEI SANGYO Samoca fan top - for hot shoe or cord. \$6.

SAWYER Viewmaster Calculator Flash Unit - \$20

SMITH (J.H.) & SONS

Actino Cartridge Holder - 5x8" metal reflector on cardboard handle. The round wooden cartridge sits on a small shelf, with a fuse running through a hole in the back. Original price: \$0.50. \$25-35.

Actino #12 Flash Cartridges - Box of 6, \$18.

Actino #30 Flash Cartridges - Box of 6. \$18.

UNIVERSAL CAMERA CORP. Mercury Photoflash Unit - With separate calculator wheel, IB, box: \$15.

Flash only: \$8. Minute 16 Flash Unit - \$15-25. Univex Photoflash Reflector Unit. No. F15. - \$8.

VICTOR Flash Powder, Normal Grade - Glass bottle inside cardboard can. \$18.

VOIGTLÄNDER

Flash-Case - Front cover of leather case flops down to reveal flash reflector. For Prominent and Vitessa. Takes #5 bulbs. Original price: \$30. \$8-15.

WALZ Flashmaster - \$16.

WESTPHALEN Little Sunny - Handheld carbon arc sun gun. \$17.

WHITE

Realist BC - \$10-19. Realist Flash ST52 - \$15-22

Realist Photoflash Model 1661 -

WHITEHOUSE PRODUCTS Beacon Flash Unit 2 - \$2-6.

WHITTAKER Micro flash - for Micro 16: \$15-25.

WITTNAUER BC Flash - \$8.

WOLLENSAK-10 - \$19.

YASHICA Autotron Flash - \$4.

ZEISS IKON A.G. Ikoblitz Flash - \$7.

<u>LENSES (without Shutters)</u> unmarked daguerreian lens -1/4-plate \$300-450.

1/2-plate daguerreian lens - "verres combinés". \$400-600.

310mm unmarked brass barrel lens with geared focusing. Hinged lenscap. \$40.

unmarked in brass barrel with focus knob, slot for waterhouse stops. With set of stops: \$75-100. 10" unmarked in brass barrel with focus

knob, slot for waterhouse stops. \$55. 10"/f9 5x8 Premier Rapid Rectilinear. Brass barrel, 3" long. Waterhouse stops. \$50.

31/2" unmarked stereo lenses with rotating stops. \$125.

5" Carte-de-Visite 4-lens set. Brass tubes mounted on 5x61/4" brass plate. c1860's. \$275.

Patent Globe lens - 1860. \$250-375.

ANTHONY (E & HT) & CO. Single Achromatic 254mm - Brass barrel, rotating diaphragm with 5 stops.

Anthony Achromatic 260mm - Brass barrel, Daguerrotype style, rotating diaphragmwith 4 stops. \$90.

BAUSCH & LOMB

f18 Zeiss Anastigmat, Series V -

120mm/f20 Zeiss Anastigmat -Brass. \$36

150mm/f12.5 Zeiss Anastigmat -Brass barrel, rotating diaphragm with 6 stops. \$79.

150mm Bausch & Lomb Optical Co. - Brass barrel, geared focusing. \$40. 165mm/f8 Planatograph - Brass.

254mm Bausch & Lomb Optical Co. - Brass barrel, geared focusing. \$35. 265mm/f20 Zeiss Protar, Series V

 11x14", brass barrel. \$40. 355mm Bausch & Lomb Optical Co. - Mfd. for Lubin Mfg. Co. Brass barrel,

geared focusing. \$20. 375mm/f4.5 Zeiss Protrait Unar No. 9 - Brass barrel, adjustable soft focus-

ing. \$100-150. **5x7"/f4.5 Tessar -** Brass barrel. \$50.

8x10" Tessar Ic - coated. \$95. 8x10 Plastigmat 12" - US 3-128, built-in diaphragm with mounting ring. \$100-150

8x10"/f18 Protar, Series V - brass barrel, internal diaphragm. \$60.

45/8"/f6.3 Tessar - Black barrel mount, round flange. \$20.

41/4x31/4" Rapid Rectilinear - Brass barrel, waterhouse stops. Leather cap. \$75-100.

254mm/f8 Beck Symmetrical -Brass barrel. \$50.

BURKE & JAMES 230mm No. 1 Ajax Brass barrel, geared focusing, \$20.

BURKHOLDER, J.H. (Mansfield, Ohio) 8x10 Wide Angle - Waterhouse stops. Mounted on 6x6" board, \$35.

CEPHALOSCOPE f8 Portrait lens -Brass with retaining ring. \$69.

DALLMEYER, J.H. 455mm 12x10" Rapid Rectilinear -Brass barrel, f8-64, \$45

12x10 London Rapid Rectilinear pat. 6/30/1868. With mounting ring. \$200-300

25x21 Rapid Rectilinear - Pat. June 30, 1868. Brass barrel, waterhouse stops. 8" long, 51/2" dia. \$110.

5" Triple Achromatic - Brass barrel,

flange and slot for waterhouse stops. \$50. 8" long Brass #6 - \$75-100.

Daguerreotype lens - 31/4" long, 21/4" dia. Brass barrel, brass sunshade. Sleeve focus, waterhouse stops. \$175.

DARLOT OPTICIEN whole plate daguerreian lens -\$400-600.

81/2" - brass, front-mounted lens. f-stops on 3 levers. \$80.

90mm No. 2 - Brass barrel, built-in 3

ACCESSORIES: LENSES (without shutters)...

200mm - Brass barrel, built-in 3 lever stops. \$175.

255mm - Brass barrel, built-in 3 lever stops. \$135.

430mm - Brass barrel, geared focus.

4 Gem Lenses - Brass tubes, mounted on brass board. No stops. Possibly for CDV wet plate. \$600-900.

Wide Angle - Brass barrel, waterhouse stops. With flange, \$50.

3" Wide Angle Landscape - c1870's. 3 lever-activated internal stops. Flared rear element. With flange. \$75-100.

DEKER & Co. (Chicago) Convertible 8x10 Wide Angle Rectilinear - Brass barrel, waterhouse stops. \$50.

DEMPSTER, ROBERT (Omaha, NE) 8x10 Improved Hawkeye extreme wide angle - f16-512.\$40.

DEROGY OPTN (Paris) Brass bound lens - rack and pinion focusing barrel. \$50.

EASTERN OPTICAL 14" brass double Anastigmat - \$59.

EASTMAN KODAK 7"/f2.5 Aero Ektar - \$80 71/2"/f4.5 Anastigmat - barrel. \$30. 81/2"/f4.5 Anastigmat - barrel. \$65. 10"/f4.5 Anastigmat - in barrel. Correct size for 5x7" Graflex. With front cap. \$105. 12" Portrait - in barrel. \$85.

21"/f10 Anastigmat - in barrel. \$150. 280mm/f8 Hawkeye Portrait Rapid Rectlinear 8x10 - Brass barrel. \$50

f4 Hawkeye Portrait Series A, No. 3 - Brass barrel, diffusing focus. \$150.

OPTICAL MFG. ENTERPRISE 125mm Enterprise - Brass barrel, geared focusing. \$20.

FRENCH (Benjamin French & Co., Boston) 6"/f5 - Brass barrel, 21/4" long. Rack and pinion focusing, waterhouse stops. \$126.

GOERZ, C.P. 160mm/f4 Rapid Rectilinear - Brass barrel. \$40

180mm/f6 Doppel-Anastigmat c1905. Brass barrel. \$30.

300mm/f4.6 Doppel-Anastigmat c1905. Brass barrel. \$55.

500mm/f4.5 Dogmar - coated. On large lensboard. \$200-300.

Dagor lenses in brass barrel:

60mm/f6.8 - \$45 135mm/f6.8 - \$60-90. 150mm/f6.8 - \$90 103/4"/f6.8 - \$220. 111/2"/f6.8 - \$260. 12"/f6.8 - \$260.

GRAF-BISHOP Doublet - soft focus, for view camera. With flange, \$60.

455mm/f8 Anastigmat - Brass barrel. \$75-100.

GRAY (R.D.) Periscope Lens #10 -1870's. Brass, 6" long, 4" diameter, 36" focal length. \$100-150.

GUNDLACH 5x7" Wide Angle - Brass barrel, rotating diaphragmwith 6 stops. \$60.

8x10" Wide Angle - Brass barrel, waterhousestops. \$80

61/2x81/2" Wide Angle - Early wetplate lens in brass barrel. Waterhouse stops. \$50.

HARRISON, C.C. These are American Daguerreian lenses, in brass barrels. 41/2" long, 25/8" dia., no flange, with cap. 1851. \$250-375.

51/2" long, 21/2" dia., rack and pinion focus, waterhousestops, no flange. \$150. 6" long, 23/4" dia., rack & pinion focus, waterhousestops. \$275.

7" focal length - Radial drive, slotted for stops. With shade, no flange. \$240.

12" focal length - Radial drive. With flange: \$300-450.

HOLMES, BOOTH & HAYDEN (N.Y.) 170mm - Brass barrel, geared focus.

American Daguerreian lenses brass barrels:

6" focal length, radial drive. With shade.

7" focal length, rack and pinion focus. With mounting ring and original board. \$275. 9" focal length, radial drive, slotted, no flange. 1856. \$195.

10" focal length, 7" long, 4" dia. \$295. 12" focal length, radial drive, slot for waterhousestops. \$300-450.

12" focal length, radial drive. c1850's. Slightly flared front rim and flange. 71/2" long, 4" dia. \$300-450.

long, 23/4" dia. Rack and pinion focus, waterhousestops. Leather cap. \$275. 61/2" long, 3" dia. 1855. Slotted for stops, radial drive. \$295.

KOEHLER 210mm/f16 Commercial 8x10 Wide Angle - Brass barrel, rotating diaphragmwith 5 stops. \$60.

LANCASTER Rectigraph - c1905. Brass bound, iris diaphragm. Size: 2.8x3cm. \$40.

LAVERNE (A.) & CO. 200mm/f8 Panorthoscopic Obis - Brass barrel.

LONDON STEREOSCOPIC 125mm/f11 coy's Wide Angle - Brass barrel, rotating diaphragmwith 5 stops. \$65.

MANHATTAN OPTICAL CO. 240mm/f4 Extra Rapid Rectilinear Lens No. 3 - Brass barrel. \$25.

MARION & CO. (London) The Soho 15x12 lens - \$60.

MEYER 141/2/f4 Double Plasmat - in barrel. \$120.

MORLEY & COOPER Whole plate Portrait Lens - Brass-bound, rack and pinion focusing. Waterhouse stops. \$51.

MULLETT third series wide angle 8" lens - with rotating waterhouse stops. \$55.

NEHRING (N.Y.) 8x10 Convertible Rectilinear - Brass barrel, single waterhouse stop. \$45.

OKOLI GESELLSCHAFT 240mm/f4.5 Okolinar Series T - Brass barrel. \$75-

PECK Co. 10x12 to 12x14/f8 Rapid Rectilinear Portrait, Series 770. -

135/f6.8 Eurynar - c1908. Nickel barrel. In decorative Koilos shutter. \$30. 240mm/f6.8 Doppel Anastigmat Eurynar - Brass barrel. \$75-100.

ROSS (London) 120mm Actinic Doublet - Brass barrel, rotating diaphragm with 5 stops.

255mm/f5 Unar - Brass barrel, internal diaphram. \$60.

5"/f4 Xpres 5x7 Wide Angle - Brass barrel - \$60. 7"/f7.7 Double Anastigmat - Brass

barrel, internal diaphragm. With flange. \$40.

81/₄"/f4 Express - \$230. 81/₂"/f4.5 Xpres - in barrel. \$75-100. 10"/f6.3 Homocentric - Brass barrel. With flange, \$60

14"/f8.5 Rapid Symmetrical 9x7 -Brass barrel, waterhouse stops. 31/4" long, 17/8" dia. With leather cap. \$55. 18"/f5.6 Homocentric in barrel.

\$100-150. SCHNEIDER-KREUZNACH

90mm/f6.8 Angulon - Brass barrel, on 25/8" metal board. \$35. 180mm/f5.5 Tele-Xenar - For Bertram Press camera. Very Rare. \$130.

210mm/f4.5 Xenar - \$50-55. 240mm/f4.5 Xenar - coated. \$100-

SCIENTIFIC LENS CO. 200mm/f8, 8x10 Wide Angle -Brass barrel, rotating diaphragm with 5 stops, \$45-60 7"/f16, 8x10 Wide Angle - \$40.

12"/f8 No. 2 Portrait - Brass barrel.

SCOVILL & ADAMS Morrison Wide Angle - Brass barrel. For 8x10" view camera. \$75-100. Waterbury Stereo lens set - on lensboard. \$185.

SEARS Auxiliary lens set - early 1900's. Set of 6 lenses which slip over 11/4" diameter camera lenses, for enlarging, portrait, wide angle, telephoto. Ray filter, duplicator, \$20.

SENECA CAMERA CO. 5x7 Rapid Convertible - \$50.

SIMPKINSON & MILLER 355mm/f8, 8x10 Premier Rapid Rectilinear -Brass barrel. \$20.

SOMERVILLE (J.C.) (St. Louis) 8x10"/f8 No. 3A - Brass barrel. \$55. Portrait - 1880's. 16" focal length, 7" long, 5" dia. Non-focusing, slotted, flange. \$135

Universal No. 1957 - waterhouse stops. \$140.

STERLING 200mm/f16, 8x10 Improved Wide Angle - Brass barrel.

ST. LOUIS PHOTO SUPPLY CO. 8x10 335mm Rapid Rectilinear Portrait - Brass barrel. \$75-100.

150mm/f12 Orthostigmat - \$45. 360mm/f4 Cassar Speed Portrait -\$100-150

TAYLOR HOBSON 81/4"/f4.5 - black barrel, internal adjust**ACCESSORIES: PLATES/etc.**

able diaphragm, uncoated. \$20.

TAYLOR HOBSON COOKE Brass barrel lenses:

325mm/f4.5 Anastigmat, Series II

325mm/f5.6 Anastigmat, Series IV

330/f8 Anastigmat. Series V - \$115. 61/2"/f6.5 Wide Angle - on lensboard. \$49

TURNER-REICH Lens Set, Series II -14", 18", 24", 28" lenses that are used in different combinations in one barrel to give 9 different focal lengths. \$250-375.

VEGA 3" Stereo Lenses - Adjustable internal diaphrams. With mounting flanges. \$300-450.

VOIGTLÄNDER & SOHN

No. 5 - 51/2" long, 41/4" dia. Waterhouse stops. \$140

18" Euryscope No. 5 - Brass barrel.

slot for waterhouse stops. \$85. Euryscope IV, No. 2 - Brass barrel,

with waterhouse slide, \$80. Portrait No. 6 - Brass barrel, 9" long, dia. 5 waterhouse stops. \$150.

14" lens - Brass barrel, 6 aperture discs in holder. \$95.

280mm Landschafts No. 4 - in barrel. Rotating diaphragm with 4 stops. \$49. 14" Wet-plate lens - Brass barrel, rack

and pinion focus, slot for waterhouse stops. With flange and shade. \$120.

18" Wet-plate lens - Slot for waterhouse stops. \$220

Half-plate daguerreian lens - \$350-

WILLARD & CO. 430mm lens - Brass barrel, geared focus. \$120.

WOLLENSAK OPTICAL

162mm/f4.5 Raptar - in barrel, \$45. 5x7" Rapid Convertible - \$35. 61/2"/f4.5 Velostigmat - in barrel.

\$35 61/2"/f12.5, 8x10 Wide Angle - in

7"/f4.5 Velostigmat Series II - black.

71/2" Velostigmat - in barrel, \$30. 81/4"/f4.5 Velostigmat, Series II -

f3.8 Vitax Portrait Lens No. 3 - 11"

long, 6" dia. \$175. 18"/f4 Diffused Focus Verito - in barrel, on 9x9 board. With Packard shutter.

WRAY (London) 91/2" focal length. 8x10 - 3" long. \$75.

ZEISS (Carl Zeiss Jena) 180mm/f6.3 Jena Tessar - \$20. 180mm/f4.5 Jena Tessar - \$40. 210mm/f4.5 Tessar - in barrel, no

diaphragm. \$30. 360mm/f4.5 Jena Tessar - c1920. \$130.

51/2" Protar, Series V - 140mm. Brass barrel. \$65.

LENSES in Shutters

BAUSCH & LOMB 135mm/f8 Symmetrical - Brass, in double piston shutter. \$12 US4 Rapid Rectilinear 165mm. Brass barrel, Unicum shutter. \$30. 5x7"/f4.5 Tessar Ic - in Ilex Acme shutter, \$125 5x7"/f8 Planatograph - brass and nickel Wollensak Auto 1/₁₀₀ shutter. \$30. **5x7"/f8 Rapid Rectilinear -** brass Wollensak Jr. shutter, 21/2x31/2" board.

CONLEY 250mm/f6.8 Anastigmat in Conley Auto Shutter. \$30.

EASTMAN

127mm/f4.7 Ektar - coated lens, Graflex Supermaticx-sync shutter, \$60. 305mm/f4.8 12" Portrait - in #5 llex MX Synchro shutter, coated: \$300-450. On 6x6 board, in Universal Synchro Shutter: \$255

GOERZ, C.P.
75mm Hypergon Doppel-Anastigmat Series X, No. 000a - Star-shaped wheel, rotated by air, prevents overexposure of center of the plate. Scarce. \$2000-3000

240/f6 Doppel-Anastigmat - c1900. Brass bound. Universal shutter. \$55-60.

Dagor lenses: 90mm/f8 Wide Angle Dagor - in Synchro Compur. \$350-550.

100mm/f6.8 - in Compound.\$250. 111mm/f8 W.A. - in Compur. \$650. 125mm/f6.8 - in Compound. \$250. 130mm/f6.8 - in Compound. \$250.

150mm/f9 W.A. - in Compur. \$350-

180mm/f6.8 - in Prontor. \$350. 240mm/f6.8 - in Compur. \$350-390. 420mm/f7.7 - in Ilex synched shutter. \$700-1100.

GUNDLACH

f11 Achromat - Wollensak Jr. brass shutter. \$20.

Korona Triple Convertible Anastigmat - 81/2"/f6.3, 15"/f11. 18"/f16. Rapax shutter. \$150-225.

130mm/f11 - Brass, single piston shut-

5x7" Symmetrical - single piston shutter. \$15.

ILEX

77mm/f4.5 Paragon - in 00 Acme 1/₃₀₀ shutter, on 25/₈" square metal board. \$35-50.

51/2"/f4.5 Paragon - coated, 140mm, in Acme #3 shutter, \$60

MEYER

120mm/f6.3, 5x7 Wide Angle Aristostigmat - Dial Compur shutter.

31/8"/f6.3, 4x5 Wide Angle Aristostigmat - 80mm, Compur shutter.

PROSCH MFG. CO.

Stereo Wide Angle lenses - c1880s. Stereo Triplex shutter. \$575-600.

125mm - Triplex brass shutter, 5 rotating stops in external shutter mechanism. \$105. 290mm - Triplex brass shutter, 5 rotating stops in external shutter mechanism, \$125

SEROCO 5x7 Rapid Rectilinear - in Unicum shutter. \$20-30.

SCIENTIFIC LENS CO. 100/f4 Wide Angle Symmetrical No. 2 - Double piston automatic shutter. \$10.

ROCHESTER OPTICAL CO. 150mm/f6.8 Victor - Brass, Bausch & Lomb shutter. \$20-30.
155mm/f8, 4x5 Rapid Rectilinear -

Brass, double piston Unicum shutter. \$20-30.

SCHNEIDER-KREUZNACH

80mm/f2.8 Xenotar - MX Compur shutter. \$100-150

90mm/f6.8 Angulon - uncoated, in unsynched shutter. \$75

120mm/f6.8 Angulon - Compur S, 1/₂₀₀ shutter. \$90. **135mm/f4.7**

Xenar - coated, in Compur MX shutter. \$115.

150mm/f2.8 Xenotar - coated, in Compurshutter. Leather cap. \$300-450. 150mm/f5.6 Symmar-S - Copal shutter, front cap. \$190.

VOIGTLÄNDER

61/2"/US 4 Dynar - Early 5-element version of the Heliar. Bionic shutter. \$60. 330mm/f7.7, 13" Collinear Compound-typeshutter. \$300-450.

WOLLENSAK

61/4"/f12.5 Wide Angle Series IIIa in Betax #3 shutter, for 8x10 camera. \$150-225

61/2"/f6.3 Velostigmat, Series IV -

in Betax, X sync. \$60. 7"/f6.8 Vinco-Anastigmat - Betax #2 Automatic shutter. \$39

12"/f4.5 Velostigmat - in Studio shutter: \$65. Coated, in Betax, X sync. \$300-450

12"/f4.5 Velostigmat Series II - in "Regular" 2-blade shutter with cocking lever and air retard. \$65

162mm/f4.5 Raptar - coated, in Alphax shutter, \$95.

210mm/f4.5 Raptar - in Betax, X sync. \$150.

ZEISS (Carl Zeiss Jena)

165mm/f6.3 Jena Tessar In Compurshutter. \$25

180mm/f4.5 Jena Tessar In Compurshutter. \$40.

180mm/f6.3 Jena Tessar - c1919. In Compurshutter. \$40.

300mm/f4.5 Tessar - in Alphax or Betax shutter, \$150-225.

MICROSCOPE ADAPTERS

EASTMAN KODAK CO. Instamatic Reflex Adapter - \$25-35. Retina Reflex Adapter - \$36. Adapter Kit Model B - (Kodak A.G.) for Retina IIc, IIIc. \$65 **Microscope Attachment and** Camera Holder Model D - for Retina cameras. \$25-35.

IHAGEE

Adapter Type I - \$15-25. Adapter Type II - \$20-30

Exakta microscope attachment -

Exakta microscope attachment, Type 2 - \$200. Long microscope adapter - \$30.

KOPIL Exakta-mount microscope adapter - \$15

ZEISS IKON A.G.

#1525/20.1615 - for Contaflex I, II. \$12-

#1528/20.1620 for Contaflex Alpha/Beta. \$12-20.

PLATES/SHEET FILM/ROLLFILM, ETC. AGFA/ANSCO Memo 35mm film cassette - metal, semi-circular, \$8.

BERNING Robot Film Cassette - \$1-10.

ACCESSORIES: PLATES/etc. ...

CONCAVA Tessina film cassette -\$1-10

CRAMER Lightening Photo Dry Plate - 5x7", expiration date of 1902. Box of 12. \$20-30.

CRYSTAR FILM CO. (Japan)
Panchro Crystar film - 1968. for Hittype cameras. Box of 6 rolls (10 exp.). \$5.

DEBRIE Sept 35mm film cassette -

EASTMAN KODAK CO. **Dry Plates -** Box of 31/₄x41/₄": \$5-10. 4x5": \$6-12.

Glass Plate Negatives - Box of 61/2x81/2". \$8-12.

Daylight Film Loader - Bakelite, 35mm. \$7.

Verichrome Film Pack - dated 1941, unopened 12 pack. \$7.

Verichrome Pan VP120 - 1951. Unopened.\$5.

Verichrome Pan VP130 - unopened.

GAMI reloadable film cartridge -\$10-15.

HIT Panchromatic - 10 exp. roll. 3 for \$1.00.

ILFORD Compass Film plates unopened package, 35x43mm. for Compass camera. \$7.

PHOTAVIT-WERK Photavit Film cassette - \$7.

Golden Ricoh 16mm film - Kodachrome ASA 10, or B&W ASA 100. \$8. Ricoh Film cassette - \$7. Steky 16mm film - Panchromatic, 24 exposure. Expired 2/1950. \$3.

SAKURA SEIKI CO. Petal Film Cartridge - Round or octagonal version. \$14-20.

TYNAR CORP. 16mm film cassette metal. \$18-20.

UNIVERSAL Minute 16 cassette - plastic. \$10-15. Uni-Pan film magazine - for Minute

Univex film spool - \$12-18. Univex #100 - Standard 8mm Safety Reversible cine film. Expired 5/1940. \$7.

YASHICA Y-16 film cassette - \$10.

ZEISS Contax reloadable film cassette - pre-1945.\$8.

POSING AIDS

CHILD'S SEAT - ornate, carved oak. Seat is adjstable. \$85.

IRUM Headrest Stand - Stamped 1875. With clamp. \$500-750.

POSING CHAIR - 1870's. Square, one arm style. \$300-450.

POSING STAND - replacement head clamp. \$200-300.

TWEETY BIRD - 1880. Brass bird child's toy. Uses air pressure to sing. \$105.

VICTORY Canary Songster - 1920's. Fill the well with water, blow on the tube, and the little brass bird warbles. \$50.

RANGEFINDERS

ACCURA rangefinder - \$8-15.

AICO Telex - Shoe-mounted.\$1-10.

Baldameter - c1930s. \$7. Distanzer - \$17.

BODAN rangefinder - \$9.

COMBI Combimeter - post-WWII. Combination rangefinder and extinction meter. \$10-19.

DEJUR Rangefinder - \$8-15.

DOLLAND Rangefinder - Long base. \$12.

EASTMAN KODAK Pocket Rangefinder - Clip-on. \$20-Service Rangefinder - Chrome. \$15-

Split-image Rangefinder - Mounts vertically. \$20-22.

EDSCARP Field Rangefinder - \$18.

FEDERAL Ideal Pocket Rangefinder - Black bakelite. \$1-10.

FRANKE & HEIDECKE

Rolleimeters - 1950's. Prismatic focusing rangefinder for the f2.8 and f3.5 nonremovable hood cameras. \$45.

HAWK rangefinder - Black/chrome body. \$8-15.

HEYDE Photo-Telemeter - Pocket split-image rangefinder. \$17 Pocket Rangefinder. \$7.

J.L. Major rangefinder - France. Small pocket RF, focuses 8" to infinity. \$12-20

KALART Style F Rangefinder - \$15-

KI SET Rangefinder - Chrome. \$8.

MASTRA Rangefinder - \$25.

MEDIS Rangefinder - Silver/black or gray body. \$8-15.

MEYER (Hugo) Pocket Rangefinder

PHAOSTRON Superimposed Rangefinder - \$5.

PHOTOPIA Watameter - 1950's. Colors: silver/ black, silver/grey, olive green. \$12-16.

Watameter II - Grey. \$14.

Watameter Super Rangefinder -

POLLUX Rangefinder - \$8-15.

PRAZIA rangefinder - \$17.

PULLIN Pocket Rangefinder - Depth of field scales for 2", 3", 4.5" lenses. \$20.

RONDO rangefinder - Black/chrome.

SAYMOUNT Rangefinder - \$11.

SCHNEIDER Proximeter I, II - for Braun. c1950s. Proximeter II - for Agfa. \$4.

Vitomatic II. \$25.

TOWER Flash O Meter - rangefinder used to determine which flash bulb to use.

UNITY Rangefinder - clip-on style. \$8.

UNIVERSAL Mercury Rangefinder -1939. Fits in accessory shoe. \$50.

VOTAR Rangefinder - clip-on with feet. \$7.

WALZ rangefinder - \$8.

ZEISS IKON A.G. Rangefinder - Hand-held version for early folding cameras. \$35. Rangefinder #425 - 75mm. \$60.

SELF-TIMERS

AGFA Self-Timer - \$3

ALPEX Self-timer - for Leica/Yashica. \$4.

CANON Self-timer II - \$30.

EASTMAN KODAK CO.

piston-type. \$1-10. 1933 self-timer in art-deco box. \$12-20.

ELITE Self-timer - \$5.

FOCAL Universal - 15 sec. With Polaroid and Leica adapters. \$4.

HAKA Autoknips I - \$7. Autoknips II - Greater range than the Autoknips I. \$6-9.

HANSA Self-timer - \$6.

KOPIL Self-timer - \$5-7.

MINORI Self-timer - \$15.

PHOTO CLIP - Swiss. \$18.

WALZ Self-Timer Assembly - \$6.

SHUTTERS

CONLEY 5x5" Packard-type - with bulb release and hose on a board: \$15-20. Shutter only on a recessed 9x9" board:

EASTMAN KODAK CO. Triple Action shutter - Side valve. \$12.

GOERZ Stereo Compur - 2 lens flanges. \$60.

CRAFLEX Focal Plane Shutter - For 5x7" camera: \$60. For 8x10" camera. \$120.

ILEX

00 Acme - 1/300 shutter, chrome. \$15. #3 Ilex - X-sync. Marked for 5"/f4.5 Ilex Paragon lens. \$50.

LANCASTER - Adjustable rubber-band activated shutter. \$25-35.

PACKARD

ideal - synchro shutter. \$20. Ideal No. 6 - on lensboard. \$30.

Rollerblind shutter - String set; speeds $1/_{15}$ - $1/_{90}$ and time. In rectangular wooden box that fastens on the front of the lens with a set screw. \$35.

THORNTON-PICKARD Stereo rollerblind shutter - c1900. Wooden. For mono and stereo. \$25.

STEREO VIEWERS

cloth-covered stereoscope. Very early. \$175.

c1930's hand-held viewer. Black metal. \$25.

lighted stereoscope with base. \$115. Portable Combination Graphoscope - For viewing stereo cards with a pair of lenses, or cabinet cards with a single lens. 51/2x9" wood base. \$80.

AMERICAN STEREOSCOPE CO.

The Stereo-Gothard - Hand-held viewer with enclosed area for storing cards. \$112.

BAIRD (ANDREW H.)

The Lothian Stereoscope - c1875. Brass and wood. Separates into 4 pieces when handle is removed, for easy storage in a box. Adjustable viewing lenses. \$250-375.

BATES (Joseph) (Boston) Holmes Bates Stereoscope - Pedestal-mounted, Holmes-style viewer. All wood: \$100-150. Hand-held: \$45-55.

BECK (R. & J., London) Achromatic Stereoscope - Table-top model with Achromtic lenses. Rack and pinion focus, hinged mirror, swinging card holder. Mahogany case is used as the stand for the viewer. Sold with large foorstanding mahogany table/cabinet: \$500-750.

BECKER, ALEXANDER (N.Y.) Pedestal Stereoscope - c1859. Wood body with internal septum. Dual eyepiece. \$250-375.

Tabletop Stereo Viewer - c1859. Rosewood or walnut. Holds 36 paper or glass views. \$500-750.

BREWSTER-Style Stereoscope -

c1890's. Tabletop viewer. Light wood. 17" high. Viewing hoods on both sides. \$300-330.

BREWSTER-Style Stereoscope -

c1890. Wooden viewer on a stand, 15" high. Black laquered base, brass center post. \$250-375.

BREWSTER-Style Stereoscope - Smaller, less decorative versions sell from

\$120-180.

BRUMBERGER Viewer - Focusing. Ebonite finish. Battery operated. \$35.

BUSH Viewer #Y-5081 - Rare. \$150.

CUTTS, SUTTON & SON (Sheffield) Achromatic Stereoscope - Rack focusing. \$263.

EASTMAN KODAK CO. Kodaslide I - \$75-100.

Kodasiide II - \$75-100. Kodasiide II - \$100-150.

FEARN, (FRANCIS H.) Stereo Graphscope - Huge viewer with inlaid wood designs. Screw focus. \$500-750.

GAUMONT (Paris) Automatic Table Stereoscope- Wide pedestal base. Brown metal body with imitation wood-grain finish. Slide focus. \$120.

ICA A.G. Viewer - wooden, 45x107mm. \$75.

ACCESSORIES: WATERHOUSE STOPS

IVES Stereokromskop Viewer - Wood body. Uses glass color-separation slides to show views in color. In original box, with ib and extra kromograms: \$1450.

KAWIN Stereo hand viewer - \$35.

KEYSTONE - c1900. Hand-held stereo viewer. Wood with aluminum hood. \$45-55.

MASCHER'S Union Case/Viewer - 1/4-plate size with stereo tintypes inside. \$400-600.

MEAGHER (London) Cabinet Stereoscope - Large wooden cabinet stereoscope. Ornate wood-craved trim around top and eyepieces. Focusing eyepieces. \$360.

NEGRETTI & ZAMBRA
Rowsell's Stereographoscope
Burr walnut. With magnifier. \$175-250.

NEW YORK STEREOSCOPIC CO. Brewster viewer - Early. Leather viewer with gold-stamped design. \$200-300.

PLANOX Stereoscope - French tabletop viewer. Large wooden body. Rack and pinion focus; eyepiece adjustment. Internal mechanism for changing slides. \$175-250.

PRIMUS Perfect Stereoscope - Wood viewer with internal septum. Brass fittings. Rack and pinion focus, lens adjustment with swinging mirror. \$170-240.

RADEX Gem Stereo viewer - \$18

ROWSELL Parlor Graphoscope - c1875. Folding table model, 23x12" walnut base. \$200-300.

SMITH, BECK and BECK
Achromatic Cabinet Stereoscope Walnut stereo card cabinet stereoscope -

Walnut stereo card cabinet stores cards and the viewer. Viewer fits into mounting plate on top of cabinet. Brass lens panel, rack focusing, tilt adjustment. \$250-375. **Hand-held** - c1865. Polished mahogany

and brass. \$500-750.

Mirror Stereoscope - Rack focusing. \$65.

UNDERWOOD & UNDERWOOD Sun Sculpture - Holmes-type hand-held viewer. \$120-180.

UNIS-FRANCE Hand Stereoscope - burled wood finish. \$165.

WATSON & SONS (London) Stereo-graphscope - Mahogany pedestal viewer. Swinging magnifier. \$150-170.

WHITE
Realist Viewer No. 2061 - Interocular
adjustment Battery operated. \$60.
Stereo Realist Viewer - Red button.
\$85-100.

WHITING Sculptoscope Stereo Viewer - Coin-operated viewer containing a series of colored lithographs. Large rectangular shape, 131/2"x101/2"x7". Viewing eyepiece at top front. Label says "Whiting's Travel System. \$775.

ZEISS-IKON Focusing Viewer, 6x13cm - 1920's. Wood, hand-held, ground glass for light diffusion and hinged panel on top with mirror for reflected light. \$150-175.

TRIPODS

AGFA wood tripod - Olive colored with geared center column. \$75.

ANSCO wood tripod - geared center post. \$75.

EASTMAN KODAK CO.

folding, light-weight wood tripod. 1910's. \$75.

metal tripod - #1: \$8-15. #2: \$20.

Bullet, Model H - \$8-15.

Bulls-Eye, Models B and C - Double extension wooden tripod. \$8-15.

Flexo, Model C - \$8-15.

Kodapod - \$8-15.

FOLMER GRAFLEX Wooden tripods. Crown #1 - 1920's. Extends to 6'. \$20. Crown #2 - \$30. Crown #4 - \$40. Tripod for Cirkut Camera/Outfit - including turntable head. For No. 10: \$250-375. For Nos. 5,6. or 8: \$120-140.

FRANKE & HEIDECKE Rolleifix - Quick Release Tripod Adapter. \$20-30.

PIGNONS Alpa tripod - \$85.

SUNART PHOTO CO. - double extension wooden tripod. \$12.

THALHAMMER CO. - 1940's. Wooden legs and metal mount. \$40.

ZEISS 12" tripod - Nickel and black enamel. \$24.

WATERHOUSE STOPS

ANTHONY (E. & H.T.) CO. Brass WH stops Set of 2 - 21/2"-3", \$13. Set of 3 - 2" wide. \$18. Set of 4 - 13/8"-215/16", \$20. Set of 5 - 11/2"-27/16", \$25. Set of 7 - \$35. Set of 8 - \$45.

LEICA SERIAL NUMBERS

	LEI	CA SERIAL	MOMRE	=K2		
Leica Nr. Modell	Baujahr	Leica Nr. Mod	ell Baujahr	Leica Nr. 171901-172250	Modell	Baujahr 1935
100- 130 I	1923	154151-154200 II 154201-154800 III	1935 1935	172251-172300	111	1935
131- 1000 l 1001- 2445 l	1925 1926	154801-154900 Stan	Chr 1935	172301-172350	IIIa	1935 1935
2446- 5433 I	1926-27	154901-156200 III 156201-156850 IIIa 1	1935 000 1935	172351-172600 172601-172800		1935
5434- 5700 I 5701- 6300 Compur	1928 1926-29	156851-157250 III	1935	172801-173000	Standard	1935
6301- 13100 I	1928	157251-157400 II	1935	173001-173125 173126-173176	IIIa III	1935 1935
13101- 13300 Compur	1929	157401-158300 IIIa 158301-158350 Stan	1935 dard 1935	173177-173425	IIIa	1935
13301- 21478 21479- 21810 Compur	1929 1930	158351-158400 II	1935	173426-173475	 o	1935 1935
21811- 34450 l	1930	158401-158650 IIIa 158651-159000 III	1935 1935	173476-173500 173501-173650	Standard	1935
34451- 34802 Compur 34803- 34817 I Luxus	1930 1930	159001-159200 Illa	1935	173651-173675	Illa	1935
34803- 34617 1Euxus 34818- 60000 I	1930	159201-159350 Stan	ndard 1935 1935	173676-173725 173726-173825	III IIIa	1935 1935
60001- 71199 l	1931 1932	159351-159550 III 159551-159625 IIIa	1935	173826-173900	111	1935
71200-101000 II 101001-106000 Standard	1932	159626-159675 III	1935	173901-174025 174026-174075	IIIa	1935 1935
106001-107600 II	1933	159676-160325 IIIa 160326-160375 III	1935 1935	174076-174100		1935
107601-107757 III 107758-108650 II	1934 1934	160376-160450 Illa	1935	174101-174125		1935 1935
108651-108700 III	1933	160451-160700 II 160701-161150 I Sta	1935 n 1935	174126-174150 174151-174400		1935
108701-109000 II 109001-111550 III	1933 1933	161151-161450 II	1935	174401-174650	II	1935
111551-111580 II Chr	1933	161451-161550 Illa	1935 1935	174651-174675 174676-174750	IIIa	1935 1935
111581-112000 III	1933 1933	161551-161600 III 161601-161800 IIIa	1935	174751-174950	Illa	1935
112001-112500 II Chr 112501-114400 III	1933	161801-161950 III C	hr 1935	174951-175125	III IIIo	1935 1935
114401-114050 Stan Chr	1933	161951-162100 IIIa 162101-162175 III	1935 1935	175126-175200 175201-175350	IIIa III	1935
114051-114052 Reporter 114053-114400 III	1933 1934	162176-162350 Illa	1935	175351-175450	Illa	1935
114401-115300 II Chr	1933	162351-162400 III	1935	175451-175500 175501-175700	Standard	1935 1935
115301-115650 III	1934 1934	162401-162500 IIIa 162501-162625 III	1935 1935	175701-175750	III	1935
115651-115900 II Chr 115901-116000 Stan Chr	1934	162626-162675 Illa	1935	175751-175850 175851-175900	Illa	1935 1935
116001-123000 III Chr	1933	162676-162750 III 162751-162800 IIIa	1935 1935	175901-176100	IIIa	1935
123001-123580 Standard 123581-124800 III Chr	1934 1933	162801-162825 III	1935	176101-176150	III	1935 1935
124801-126200 III Chr	1933	162826-162925 IIIa 162926-162975 III	1935 1935	176151-176250 176251-176300	IIIa	1935
126201-126800 III 126801-137400 III	1933 1934	162926-162975 III 162976-163050 IIIa	1005	176301-176600	Illa	1935
137401-137625 Standard	1934	163051-163100 III	1935	176601-177000 177001-177400		1935 1935
137626-138700 III Chr	1934 1934	163101-163225 IIIa 163226-163250 III	1935 1935	177401-177550	III	1935
138701-138950 Stan Chr 138951-139900 III Chr	1934	163251-163400 Illa	1935	177551-177600	Illa	1935 1935
139901-139950 Standard	1934	163401-163450 Sta 163451-163550 IIIa		177601-177700 177701-177800	Standard	1935
139951-140000 II 140001-141500 III Chr	1934 1934	163551-163775 III	1935	177801-177900	IIIa	1935
141501-141850 Standard	1934	163776-163950 IIIa	1935 ndard 1935	177901-178000 178001-178100		1935 1935
141851-141900 II 141901-142250 III Chr	1934 1934	163951-164150 Sta 164151-164275 Illa	1935 1935	178101-178250	III	1935
142251-142350 II	1934	164276-164675 III	1935	178251-178550 178551-178600	IIIa	1935 1935
142351-142500 III	1934	164676-164900 IIIa 164901-165000 II	1935 1935	178601-179200	IIIa	1935
142501-142700 I Stan 142701-143425 III	1934 1934	165001-165100 III	1935	179201-179250	III	1935 1935
143426-143750 II Chr	1934	165101-165300 II 165301-165500 Sta	1935 ndard 1935	179251-179500 179501-179575		1935
143751-143900 Standard 143901-144200 III	1934 1934	165501-165975 III	1935	179576-179800	Standard	1935
144201-144400 II	1934	165976-166075 Illa	1935 1935	179801-179900 179901-180100	IIIa	1935 1935
144401-144500 Standard 144501-145600 III	1934 1934	166076-166600 III 166601-166750 IIIa	1935	180101-180400	III	1935
145601-145800 Standard	1934	166751-166900 III	1935	180401-180475 180476-180700		1935 1935
145801-146200 III	1934 1934	166901-167050 IIIa 167051-167175 III	1935 1935	180701-180800	Standard	1935
146201-146375 II 146376-146675 III	1934	167176-167200 Illa	1935	180801-181000 181001-181450		1935 1935
146676-146775 II	1934	167201-167225 III 167226-167700 IIIa	1935 1935	181451-181550		1935
146776-147000 III 147001-147075 Standard	1934 1934	167701-167750 III	1935	181551-181600	IIIa	1935 1935
147076-147175 II	1934	167751-168000 Sta 168001-168200 II	ndard 1935 1935	181601-181700 181701-182000		1935
147176-147875 Stan Chr 147876-148025 II Chr	1934 1934	168201-168250 III	1935	182001-182050	III	1935
148026-148850 III Chr	1934	168251-168325 Illa	1935 1935	182051-182300 182301-182350	IIIa III	1935 1935
148851-148950 II Chr 148951-149350 III Chr	1934 1935	168326-168400 III 168401-168500 IIIa	1935	182351-182500	Illa	1935
149351-149350 III CIII 149351-149450 Stan Chr	1934-35	168501-168600 III	1935	182501-182700 182701-182850	Standard	1935 1935
149451-149550 II Chr	1934-35	168601-168725 IIIa 168726-168750 III	1935 1935	182851-183500	illa	1935
149551-150000 III Chr 150001-150200 Reporter	1935 1934-36	168751-168850 Illa	1935	183501-183600) [[1935 1935-36
150201-150850 III Chr	1934-35	168851-169000 Sta 169001-169200 III	andard 1935 1935	183601-183750 183751-184400) Illa	1936
150851-151100 Standard 151101-151225 III	1935 1935	169201-169350 Sta	andard 1935	184401-184450)	1936
151226-151300 II	1935	169351-169450 II	1935 1935	184451-184700 184701-184750) IIIa) III	1936 1936
151301-152500 III 152501-152600 Stan Chr	1935 1935	169451-169550 III 169551-169650 II	1935	184751-184800) IIIa	1936
152601-153175 III Chr	1935	169651-170150 Illa	a 1935	184801-184950 184951-185200)) a	1936 1936
153176-153225 II	1935 1935	170151-170500 III 170501-171300 IIIa	1935 a 1935	185201-185350)	1936
153226-153550 III 153551-153700 II	1935	171301-171550 II	1935	185351-185500) II	1936 1936
153701-154150 III	1935	171551-171900 Sta	andard 1935	185501-185650	Januaru	1900

L	LICA	SENIAL NUM	DEN;	o (cont.)	
Leica Nr. Modell	Baujahr	Leica Nr. Modell	Raujahr		Davish
185651-185700 III	1936	203301-203400 Standard	1936	227051-227600 IIIa	Baujahr 1936-37
185701-185800 Standard		203401-204100 IIIa	1936	227601-227650 III	1936-37
185801-186100 IIIa 186101-186200 III	1936	204101-204200 III	1936	227651-231500 IIIa	1936-37
186201-186500 IIIa	1936	204201-204300 IIIa	1936	231501-231600	1936-37
186501-186550 III	1936 1936	204301-204500 II 204501-204600 III	1936	231601-231800 IIIa	1936-37
186551-186800 IIIa	1936	204601-204800 IIIa	1936	231801-231900 III	1936-37
186801-186900 III	1936	204801-205000 III	1936	231901-232200 iiia	1936-37
186901-186950 IIIa	1936	205001-205100 IIIa	1936 1936	232201-232500 III	1936-37
186951-187000 III	1936	205101-205300 III	1936	232501-232800 IIIa	1936-37
187001-187100 IIIa	1936	205301-205400 IIIa	1936	232801-232900 III 232901-233400 IIIa	1936-37
187101-187200 III	1936	205401-205500 II	1936	233401-233500 III	1936-37
187201-187400 IIIa	1936	205501-205700 Standard	1936	233501-233700 Standard	1936-37 1936-37
187401-187500 III 187501-187650 II	1936	205701-207300 IIIa	1936	233701-233800 III	1936-37
187651-187775 III	1936	207301-207400 II	1936	233801-234000 IIIa	1936-37
187776-187785 IIIa	1936 1936	207401-207600 Standard	1936	234001-234100 II	1936-37
187786-187850 III	1936	207601-207800 III 207801-208000 IIIa	1936	234101-234200 III	1936-37
187851-188100 IIIa	1936	208001-208000 IIIa 208001-208300 III	1936	234201-234500 IIIa	1936-37
188101-188300 III	1936	208301-208600 IIIa	1936 1936	234501-234600 III	1936-37
188301-188600 Standard	1936	208601-208800 III	1936	234601-235100 IIIa	1937
188601-188750 II	1936	208801-209000 ilia	1936	235101-235200 III 235201-235800 IIIa	1937
188751-189300 IIIa	1936	209001-209600 III	1936	235801-235875 III	1937
189301-189475 III	1936	209601-209900 II	1936	235876-236200 IIIa	1937 1937
189476-189800 IIIa 189801-189900 III	1936	209901-210100 IIIa	1936	236201-236300 III	1937
189901-190200 IIIa	1936	210101-210200 III	1936	236301-236500 IIIa	1937
190201-190500	1936 1936	210201-210400 IIIa	1936	236501-236700 II	1937
190501-190700 IIIa	1936	210401-210900 Standard 210901-211000 III	1936	236701-236800 IIIa	1937
190701-190900 III	1936	211001-211600 IIIa	1936	236801-236900	1937
190901-191100 IIIa	1936	211601-211700 III	1936 1936	236901-237000 IIIa	1937
191101-191200 III	1936	211701-211800 IIIa	1936	237001-237200 III 237201-237500 IIIa	1937
191201-191300 II	1936	211801-211900 II	1936	237501-237600 III	1937 1937
191301-191350 IIIa	1936	211901-212400 IIIa	1936	237601-238000 IIIa	1937
191351-191500 III 191501-191650 II	1936	212401-212700 Standard	1936	238001-238100 III	1937
191651-191750 Standard	1936	212701-212800 IIIa	1936	238101-238500 IIIa	1937
191751-191850 III	1936 1936	212801-213200 III	1936	238501-238600 III	1937
191851-192100 IIIa	1936	213201-213300 IIIa 213301-213600 Standard	1936	238601-238800 IIIa	1937
192101-192400 III	1936	213601-213700 II	1936	238801-238825 III	1937
192401-192500 IIIa	1936	213701-214400 IIIa	1936 1936	238826-238900 IIIa	1937
192501-192800 III	1936	214401-214800 Standard	1936	238901-239000 III 239001-239100 IIIa	1937
192801-192950 II	1936	214801-215300 IIIa	1936	239101-239300 III	1937
192951-193200 IIIa	1936	215301-216000 III	1936	239301-239400 IIIa	1937 1937
193201-193450 Standard	1936	216001-216300 IIIa	1936	239401-239600 III	1937
193451-193500 IIIa 193501-193600 III	1936	216301-216500 II	1936	239601-239700 IIIa	1937
193601-194300 IIIa	1936 1936	216501-216800 IIIa	1936	239701-239800 III	1937
194301-194650 III	1936	216801-217000 III 217001-217200 IIIa	1936	239801-240000 Standard	1937
194651-194850 II	1936	217201-217200 IIIa 217201-217300 III	1936	240001-241000 IIIb	1937-38
194851-194950 Standard	1936		1936 1936	241001-241100 IIIa	1937-38
194951-196200 IIIa	1936	217501-217700 III	1937	241101-241300 III 241301-241500 IIIa	1937-38
196201-196300 III	1936	217701-217900 II	1936-37	241501-241500 IIIa 241501-241700 II	1937-38
196301-196400 IIIa	1936	217901-218300 IIIa	1936-37	241701-241900 Standard	1937-38
196401-196550 II 196551-196750 Standard	1936	218301-218700 II	1936	241901-242000 II	1937-38
196751-196750 Standard	1936	218701-218800 III	1936	242001-243000 IIIb	1937-38
197401-197500 Standard	1936 1936	218801-219600 IIIa	1936	243001-243400 IIIa	1937-38
197501-197550 IIIa	1936	219601-219800 II 219801-219900 IIIa	1936	243401-243500 III	1937-38
197551-197800 III	1936	219101-220000 III	1936 1936	243501-243800 II	1937-38
197801-198200 IIIa	1936	220001-220300 IIIa	1936	243801-244100 IIIa 244101-244200 III	1937-38
198201-198400 III	1936	220301-220500 II	1937	244201-244400 Standard	1937-38
198401-198800 IIIa	1936	220501-220600 IIIa	1936	244401-244600 III	1937-38 1937-38
198801-198900 III 198901-199200 IIIa	1936	220601-220700 III	1936	244601-244800 IIIa	1937-38
199201-199300 III	1936 1936	220701-220900 IIIa	1936	244801-245000 Standard	1937-38
199301-199500 IIIa	1936	220901-221000 III 221001-221300 IIIa	1936	245001-245100 IIIa	1937-38
199501-199600 III	1936	221301-221400 III	1936	245101-245300 III	1937-38
199601-199800 II	1936	221401-222150 IIIa	1936 1936	245301-246200 IIIa	1937-38
199801-200100 IIIa	1936	222151-222200	1936	246201-246300 III	1937-38
200101-200200 III	1936	222201-222300 IIIa	1936	246301-246400 IIIa 246401-246500 III	1937-38
200201-200500 IIIa	1936	222301-222700 Standard	1937	246501-246700 II	1937-38
200501-200650 II	1936	222701-223000 II	1937	246701-247500 IIIa	1937-38 1937-38
200651-200750 Standard 200751-201100 III	1936	223001-223300 III	1937	247501-247600 II	1937-38
201101-201200 III	1936 1936	223301-223600 IIIa	1936	247601-248300 IIIa	1937-38
201201-201300 IIIa	1936	223601-223700 III	1936	248301-248400 II	1937-38
201301-201400 III	1936	223701-224600 IIIa 224601-224800 Standard	1936-37	248401-248600 Standard	1937-38
201401-201600 IIIa	1936	224801-224800 Standard 224801-224900 IIIa	1936-37 1936-37	248601-248900 IIIa	1937
201601-201700 Standard	1936	224901-225000 III	1936-37	248901-249000 III	1937
201701-202300 IIIa	1936	225001-225200 IIIa	1936-37	249001-249200 IIIa 249201-249400 II	1937
202301-202450 II	1936	225201-225300 III	1936-37	249401-249500 III	1937
202451-202600 IIIa	1936	225301-225400 IIIa	1936-37	249501-249700 Standard	1937 1937
202601-202700 III 202701-202800 IIIa	1936	225401-225600 III	1936-37	249701-249800 IIIa	1937
	1936 1936	225601-226300 IIIa 226301-226400 III	1936-37	249801-249900 III	1937
202901-203100 IIIa	1936		1936-37	249901-250300 IIIa	1937
203101-203300 III	1936		1936-37 1936-37	250301-250400 III	1937
		III	1330-37	250401-251200 IIIa	1937

L	EICA	SEKIAL IN	OIVI	DENO			
Leica Nr. Modell	Baujahr	Leica Nr.	Modell	Baujahr	Leica Nr.	Modell	Baujahr
251201-251300 II	1937	275701-275800 275801-276400 276401-277000 277001-277100 277101-277500	lla	1938	302901-303200 303201-303300 303301-303700 303701-303800	IIIa	1938
251301-251500 Standard	1937	275801-276400 I	11	1938	303201-303300	111	1938
251501-251600 Illa	1937	276401-277000 I	lla	1938	303301-303700	Illa	1938
251601-251800 II	1937	277001-277100	!!	1938			
251301-251500 Standard 251501-251600 IIIa 251601-251800 III 251801-252000 III 252001-252200 III 252201-252900 IIIa 252901-253200 IIIa 253901-253200 IIIa 253201-253400 III 253401-253500 IIIa 253601-253600 III 253601-253800 Standard 253801-254000 IIIa 254001-254200 III	1937	277101-277500 J	lla	1938	303801-303900	Standard	1938
252001-252200 II	1937				303801-303900 303901-304400 304401-304500 304501-304700 304701-304800 304801-305000 305001-305600 305601-305700	IIIa III	1930
252201-252900 Illa	1937	277901-278100	!.	1938	304401-304500	III IIIa	1938
252901-253000 III	1937	278101-278200 1	II IIo	1936	304701-304800	III III	1938
253001-253200 IIIa	1937	278501-278525 1	IIa II	1938	304801-304900	iiia	1938
253201-253400 III	1937	278526-278550	lla	1938	304901-305000	III	1938
253401-253500 IIIa	1937	277901-278100 277901-278100 278101-278200 278201-278500 278501-278525 278526-278550 278551-278600	II	1938	305001-305600	Illa	1938
253501-253600 III	1937	278601-278800	Standard	1938	305601-305700	111	1938
253801-254000 Illa	1937	278601-278800 S 278801-279000 I 279001-279200 I 279201-279400 I 279401-280000 I 280001-286500 I 286501-286800 S	lla	1938			
254001-254200 III	1937	279001-279200 I	Ш	1938	305801-306200	Illa	1938
254201-254600 Illa	1937	279201-279400 I	II	1938	306201-306300	iii	1938
254601-254800 II	1937	279401-280000	IIIa	1938	306301-306500	!!.	1938
254801-254900 III	1937	280001-286500 1	IIID Ctandard	1938	306501-306600	IIIa	1938
253801-254000 IIIa 254001-254200 III 254201-254600 IIIa 254601-254800 II 254801-254900 III 254901-256400 IIIa	1937	286501-286800	Standard	1930	305801-306200 306201-306300 306301-306500 306501-306600 306601-306800 306801-307000 307001-307500	III	1938
256401-256600 Standard	1937	286801-287000 1	III IIIo	1936	307001-307500	illa	1938
256601-256800 IIIa	1937	287201-287300	IIIa III	1938	30/501-308000	SIADOARO	1900
256801-256900 III	1937	287301-287400	IIIa	1938	308001-308100	Illa	1938
250901-257400 IIId	1937	287401-287600	II	1938	308101-308200	111	1938
256601-256800 IIIa 256801-256900 III 256901-257400 IIIa 257401-257525 III 257526-257600 IIIa	1937	287601-288000	Illa	1938	308001-308100 308101-308200 308201-308300	II	1938
257601-257800 Standard	1937	288001-290200	IIIb	1938-39	308301-308500	Standard	1938
257801-258200 III	1937	290201-290500	IIIa	1938	308501-308600	111	1938
258201-259500 IIIa	1937	290501-290800	111	1938	308601-308700	IIIa	1938
257801-258200 III 258201-259500 IIIa 259501-259800 II	1937	286301-286300 0 286801-287000 1 287001-287200 1 287201-287300 1 287301-287400 287401-287600 1 287601-288000 288001-290200 290201-290500 290501-290800 290801-291000 290801-291200 290801-2912001-2912001 291201-291200	Illa	1938	308501-308600 308601-308700 308701-308800 308801-309000	III	1938
259801-259900 Standard	1937				308801-309000	Standard	1938
259901-260000 Illa	1937	291201-291500 291501-291600 291601-291800	IIIa	1938	309001-309200 309201-309300 309301-309400 309301-309500 309501-309700 309701-310000 310201-310400 310401-310500 310601-311000 311001-311200 311201-311400 311401-311700 311701-311800 311801-311900 311901-312000	Illa	1938
260001-260100 Reporter	1937	291501-291600	 o	1938	309201-309300	IIIa III	1938
260101-260200 IIIa 260201-260600 III 260601-260800 IIIa 260801-260900 III 260901-261200 IIIa 261201-261300 III 261301-261600 III 261601-261800 IIIa	1937	291801-291800	IIIa Standard	1930	309401-309500	IIIa	1938
260201-260600 III	1937	292001-292200		1938	309501-309700	II	1938
260601-260800 IIIa	1937	000001 000400	Ctandard	1029	309701-310000	illa	1938-39
260801-260900 III	1937	292401-292600	Illa	1938	310001-310200	III	1938-39
260901-261200 IIIa 261201-261300 III	1937	292601-292700	III	1938	310201-310400	IIIa	1938-39
261201-261500 III	1937	292701-293000	IIIa	1938	310401-310500	111	1938-39
261501-261600 III	1937	293001-293100	III	1938	310501-310600	Illa	1939
261601-261800 Illa	1937	293101-293200	Illa	1938	310601-311000	III	1938-39
		293201-293400	III	1938	311001-311200	!!	1938
262001-262800 Illa	1937	293401-293500	!!.	1938	311201-311400	IIIa	1939
262001-262800 IIIa 262801-263800 IIIa 263001-263600 IIIa 263601-263900 II 263901-264000 III 264001-264800 IIIa	1937	292401-292400 292401-292600 292601-292700 292701-293000 293001-293100 293101-293200 293201-293400 293401-293500 293501-293900	IIIa	1938	311401-311700	III	1939
263001-263600 Illa	1937				311701-311600	IIIa III	1939
263601-263900 II	1937	294001-294600 294601-294800 294801-294900 294901-295100 295101-295200 295201-295300	IIID	1939	311901-311900	IIIa	1939
263901-264000 III	1937	294601-294600	! !.	1938	312001-312200	Standard	1939
264001-264800 IIIa	1937	294601-294900	III IIIa	1938	312201-312400	Illa	1939
264801-265000 Standard	1937	295101-295200	III	1938	312201-312400 312401-312500	III	1939
265001-266000 IIIb 266001-266100 IIIa 266101-266200 III 266201-266400 IIIa 266401-266500 III	1937	295201-295300	IIIa	1938	312501-312800	Standard	1939
266101-266200 III	1937	295301-295400	Standard	1938	312801-313000 313001-313100 313101-313200	IIIa	1939
266201-266400 IIIa	1937	295401-295500	III	1938	313001-313100	III	1939
266401-266500 III	1937	295501-296000	IIIa	1938	010101010200	u	1000
266501-266800 II	1937	296001-296200		1938	313201-313300		1939
266801-266900 Illa	1937	296201-296500		1938	313301-313400	IIIa Ctandard	1939
266901-267000 III	1937	296501-296600		1938	313401-313500		1939 1939
267001-267700 Illa	1937	296601-296900		1938	313501-313600 313601-314000	!!!	1939
267701-267800 III	1937	296901-297100 297101-297200		1938 1938	314001-314100		1939
267801-267900 Illa	1937	297101-297200		1938	314101-314300		1939
267901-268000 Standard	1937 1937-38	297401-297900		1938	314301-314500		1939
268001-268100 IIIa 268101-268200 III	1938	297901-298000		1938	314501-314600		1939
268201-268400 Illa	1937	298001-299000		1938	314601-314700		1939
268401-268500 III	1938	299001-299200		1938	314701-314800		1939
268501-268700 IIIa	1938	299201-299500		1938	314801-314900		1939
268701-268800 III	1938	299501-299600		1938	314901-315000		1939
268801-269300 Illa	1938	299601-299800		1938	315001-315100		1939 1939
269301-269400 III	1938	299801-299900	[]]	1938	315101-315400		1939
269401-269600 IIIa	1938	299901-300000			315401-315500 315501-315700		1939
269601-269700 III	1938	300001-300100 300101-300200			315701-315800		1939
269701-270100 Illa	1938	300101-300200		1938	315801-316100		1939
270101-270200 III	1938 1938	300301-300400			316101-316400		1939
270201-270300 Illa	1938	00301-300700		1938	316401-316700		1939
270301-270400 III 270401-271000 IIIa	1938	300701-300800	III	1938	316701-316900		1939
271001-271100 IIIa 271001-271100 II	1938	300801-301000	Illa	1938	316901-317000	II	1939
271101-271600 Standard		301001-301100		1938	317001-318000		1939
271601-271700 II	1938	301101-301400	IIIa	1938	318001-318200		1939
271701-271700 III	1938	301401-301500	III	1938	318201-318300		1939
271801-272300 IIIa	1938	301501-301600		1938	318301-318500		1939
272301-272400 II	1938	301601-301700			318501-318800 318801-318900	II IIIa	1939 1939
272401-274800 Illa	1938	301701-301800		1938	318901-319000	IIIa	1939
274801-275200 III	1938	301801-301900 301901-302000		1938 1938	319001-320000		1939
275201-275350 Illa	1938 1938	301901-302000		1938	320001-320200		1939
275351-275650 II	1938	302501-302800		1938	320201-320400		1939
275651-275675 IIIa 275676-275700 III	1938	302801-302900		1938	320401-320600		1939
213010-213100 III	1000						

	LIVA	SENIAL NUM	DEK2	(cont.)	
Leica Nr. Modell	Baujahr	Leica Nr. Modell	Raujahr	NAME OF TAXABLE PARTY OF TAXABLE PARTY.	
320601-320700 II 320701-321000 Standard	1939	352301-352500 Reporter	1940-42	Leica Nr. Modell 805001-805100 M3 ELC	Baujahr
321001-322000 IIIb		352501-352900 II	1940-42	805101-807500 M3	1955 1955
322001-322200 II	1939 1939	352901-353600 Standard	1940-42	807501-808500 If	1956
322201-322700 Standard	1939	353601-353800 Reporter 353801-354000 Standard	1942-43	808501-810000 IIf	1956
322701-322800 IIIa	1939	354001-354050 IIIa	1942-47 1941-47	810001-815000 IIIf	1956
322801-323000 III	1939	354051-354075 IIIa	1941-46	815001-816000 If	1956
323001-324000 IIIb	1939		1947	816001-816900 M3 816901-817000 M3 ELC	1956
324001-324100 Reporter 324101-324700 IIIa		354076-354100 354101-354200 a 354201-354400	1947	817001-820500 M3	1956 1956
324701-324800 III	1939 1939	354201-354400 II	1942-44	820501-821500 IIf	1956
324801-325000 II	1939	354401-355000 IIIb 355001-355650 Standard	1946	821501-822000 IIf	1956
325001-325200 IIIa	1939	355651-356500	1947-48	822001-822900 If	1956
325201-325275 III	1939	356501-356550 IIIa	1947-48	822901-823000 IIIf Kit 823001-823500 IIIf	1956
325276-325300 IIIa 325301-325400 I	1939	356551-356700 II	1947-48	823501-823867 IIIf ELC	1956 1956
325401-325600 IIIa	1939 1939	356701-357200 Illa	1948-50	823868-825000 IIIf	1956
325601-325800 III	1939	357201-358500 358501-358650 II	1040	825001-826000 IIIa	1956
325801-325900 IIIa	1939	358651-360000	1948	826001-829750 IIIg	1956
325901-326000 II 326001-327000 IIIb	1939	360001-360100 IIIa	1940-42	829751-829850 IIIf ELC 829851-830000 M3 ELC	1956
327001-327200 III	1939 1939	361001-367000 IIIc	1940	830001-837500 M3	1956 1956
327201-327400 III	1939	367001-367325 IIIc	1941-44	837501-837620 M3 FLC	1956
327401-327500 IIIa	1939	367326-367500 IIIc 367501-368800 IIIc	1945	837621-837720 IIIf FLC	1956
327501-327600 III	1939	368801-368950 IIIc	1940-41 1941	837721-839620 M3	1956
327.601-327800 IIIa	1939	368951-369000 IIIc	1941	839621-839700 M3 ELC	1956
327801-328000 Standard 328001-329000 IIIb		369001-369050 IIIc	1941	839701-840500 M3 840501-840820 M3 ELC	1956
329001-329400 Standard	1939	369051-369450 IIIc	1941	840821-844780 M3	1956
329401-329600 II	1939 1939	369451-390000 IIIc	1941-42	844781-845000 M3 ELC	1956 1956
329601-329800 IIIa	1939	390001-397650 IIIc 397651-399999	1943-46	845001-845380 IIIa FLC	1956
329801-329900 III	1939	400000-440000 IIIc	1040 47	845381-850900 IIIa	1956
329901-330000 IIIa	1939	440001-449999 IIC	1946-47	850901-851000 If	1956
330001-330200	1939	450000 IIIc	1948-51 1949	851001-854000 M3	1956
330201-330300 II	1939	450001-451000 IIc	1951	854001-858000 M3 858001-861600 IIIg	1957
330301-330500 Standard 330501-330700 III	1939	451001-455000 IIf	1951	861601-862000 IIIg ELC	1957
330701-330800 IIIa	1939 1939	455001-460000 Ic	1949-50	MP-1 - MP-11 MP	1957 1956
330801-331000 Standard	1939	460001-465000 IIIc 465001-480000 IIIc	1948-49	862001-866620 M3	1957
331001-332000 IIIh	1939	480001-495000 IIIC	1949	866621-867000 M3 FLC	1957
332001-332500 IIIa	1939	495001-520000 IIIc	1949-50 1950	867001-871200 IIIg	1957
332501-332600 III	1939	520001-524000 Ic	1950-51	871201-872000 IIIg ELC 872001-877000 M3	1957
332601-333000 IIIa 333001-333100 III	1939	524001-525000 IIIc	1950-51	877001-882000 IIIg	1957
333101-333300 IIIa	1939 1939	525001-540000 IIIf	1950-51	882001-886700 M3	1957 1957
333301-333600 Standard	1939	540001-560000 IIIf	1951	MP-13-MP-150 MP RIK	1957
333601-334000 IIIb	1939	560001-562800 Ic 562801-565000 If	1951	MP-151-MP-450 MP Chr	1957
334001-334200 III	1939	565001-570000 IIIf	1951 1951	886701-887000 M3 FLC	1957
334201-334400 IIIa	1939	570001-575000 IIf	1951-52	887001-888000 lg 888001-893000 lllg	1957
334401-334600 III 334601-335000 IIIa	1939	575001-580000 If	1952-53	893001-894000 M4	1957
335001-337000 IIIb	1939	580001-610000 IIIf	1951-52	894001-894570 M3 ELC	1957 1957
337001-337200 II	1939-40 1939	610001-611000 IIIf ELC	1952	894571-898000 M3	1957
337201-337400 IIIa	1939	611001-615000 III 615001-650000 IIII	1952-53	898001-903000 M3	1057
337401-337500 III	1939	650001-655000 III	1952-53 1953	903001-903300 M3 FLC	1957
337501-337900 IIIa	1939	655001-673000 IIIf	1953	903301-907000 IIIa	1957
337901-338100 II 338101-338200 IIIa	1939	673001-674999 If	1953-54	907001-910000 lg 910001-910500 M3	1957
338201-338600 III	1939	675000 IIIf	1953	910501-910600 M3 Olv	1957 1957
338601-338900 IIIa	1939 1939	675001-680000 IIf	1953-54	910601-915000 M3	1957
338901-339000 III	1939	680001-682000 IIf 682001-684000 If	1954	915001-915200 M3	1957
339001-340000 IIIb	1939-40	684001-685000 IIIf ELC	1955 1953	915201-916000 M3	1957
340001-340200 IIIa	1939	685001-699999 IIIf Vorl	1953	916001-919250 M3 919251-920500 M3	1958
340201-340400 III 340401-340600 IIIa	1939	700000 M3	1954	920501-920520 M3	1958
	1939 1939	700001-710000 M3	1954	920501-924400 M3	1958 1958
340701-341000 IIIa	1939	710001-711000 IIIf Vorl	1954	924401-924500 M3 FLC	1958
341001-341300 II	1939-40	711001-713000 IIf 713001-729000 IIIf Vorl	1954	924501-924568 la	1958
341301-341500 Standard	1939	729001-730000 IIIf Vorl	1954 1954	924569-924588 Ia	1958
341501-341700 III	1939	730001-746450 M3	1955	924589-926000 lg	1958
	1939	746451-746500 M3 FLC	1955	926001-926200 M2 926201-926700 lg	1957
	1939 1939	746501-750000 M3	1955	926701-928922 M3	1958 1959
342201-342300 III	1939	750001-759700 M3	1955	928923-929000 Post	1958
342301-342900 IIIa	1939	759701-760000 M3 ELC 760001-762000 If	1955	929001-931000 M2	1958
342901-343100 III	1939	762001-765000 IIf	1955 1955	931001-933000 M2	1958
	1939	765001-773000 IIIf Vorl	1955	933001-934000 IIIg	1958
	1939-40	773001-774000 IIIf FLC	1955	934001-934200 IIIg ELC 934201-935000 IIIg	1958
348601-349000 IIIh	1939-40 1940	774001-775000 IIIf	1955	935001-935512 MP2	1958 1958
349001-349050 Reporter	1940	775001-780000 M3	1955	935513-937500 M2	1958
349051-349300 Standard	1940		1955	937501-937620 M2	1958
349301-351100 IIIb	1940		1957 1955	937621-937650 M2 FLC	1958
351101-351150 II	1940	787001-789000 IIf	1955	937651-940000 M2	1958
	1940	789001-790000 If	1955	940001-942900 M2 942901-943000 M2 ELC	1958
352101-352150 Standard	1940 1940	790001-799000 IIIf	1955	943001-944000 IIIa	1958 1958
	1940		1956	944001-946000 MŽ	1958
,		200000 000000 IVIS	1955		1958

L	EICA	SENIAL NUM	DENS	(COIIL)	
Leica Nr. Modell	Baujahr	Leica Nr. Modell	Baujahr	Leica Nr. Modell	Baujahr
946301-946400 M2 ELC	1958	1023001-1027800 M3	1961	1130301-1132900 M2	1965
946401-946900 M2	1958	1027801-1028000 M3 ELC 1028001-1028600 M1	1961 1961	1132901-1133000 M2 ELC 1133001-1134000 M3	1965 1965
946901-947000 M2 ELC 947001-948000 M2	1958 1958	1028601-1028600 MT	1961	1134001-1134150 M3 Lack	1965
948001-948500 IIIg	1958	1031801-1032000 M2 Blk	1961	1134151-1135000 M3	1965
948501-948600 MŽ ELC	1958	1032001-1035400 M3	1961	1135001-1135100 M3 ELC	1965
948601-949100 M2 Blk	1958	1035401-1035925 M1	1961	1135101-1136000 M3	1965
949101-949400 M2 Vorl	1958	1035926-1036000 M1 Olv 1036001-1036050 M2 ELC	1961 1961	1136001-1136500 MD 1136501-1137000 MD	1965 1966
949401-950000 M2 950001-950300 M1	1959 1959	1036051-1036050 M2 ELC	1961	1137001-1138900 M2	1966
950301-951900 M3	1959	1036351-1037950 M2	1961	1138901-1139000 M2 ELC	1966
951901-952000 M3 ELC	1959	1037951-1038000 M2 ELC	1962	1139001-1140900 M3	1966
952001-952015 MP2	1959	1038001-1038800 M3 1038801-1039000 M3 Blk	1961 1961	1140901-1141000 M3 ELC 1141001-1141896 MD	1966 1966
952016-952500 M1 952501-954800 M3	1959 1959	1038601-1039000 M3 BIK	1961	1141897-1141968 Post	1966
954801-954900 M3 ELC	1959	1040001-1040066 M1	1962	1141969-1142000 Post24x27	1966
954901-955000 M3 ELC	1959	1040067-1040068 M3	1962	1142001-1145000 M2	1966
955001-956500 IIIg	1959	1040069-1040070 M1	1961 1961	1145001-1155000 Flex 1155001-1157590 M3	1966 1966
956501-957000 M1 957001-959400 M3	1959 1959	1040071 M3 1040072-1040094 M1	1961	1157591-1157600 M3 Lack	1966
959401-959500 M3 Blk	1959	1040095-1040096 M3	1962	1157601-1158995 M3	1966
959501-960200 M2 Vorl	1959	1040097-1040600 M1	1961	1158996-1159000 M3 Olv	1966
960201-960500 M2	1959	1040601-1043000 M3	1961	1159001-1160200 MDa 1160201-1160820 MD	1966 1966
960501-961500 M2 961501-961700 M3 ELC	1959 1959	1043001-1043800 M2 1043801-1044000 M2 Blk	1962 1962	1160821-1161420 MDa	1966
961701-961700 M3 ELC	1959	1044001-1046000 M3 Blk	1962	1161421-1163770 M2	1966
966501-967500 M1	1959	1046001-1046500 M1	1962	1163771-1164046 M2 Mot	1966
967501-968350 M2	1959	1046501-1047800 M3	1962	1164047-1164845 M2	1966
968351-968500 M3 ELC	1959	1047801-1048000 M3 ELC 1048001-1050000 M2	1962 1962	1164846-1164865 M3 1164866-1164940 Post24x36	1966 1967
968501-970000 IIIg 970001-971500 M2	1959 1959	1048001-1050000 M2 1050001-1050500 M1	1962	1164941-1165000 M2	1967
971501-972000 IIIg	1959	1050501-1053100 M2	1962	1165001-1173000 Flex	1967
972001-974700 M3	1959	1053101-1053250 M2 Lack	1962	1173001-1173250 SL	1968
947401-975000 M3 ELC	1959	1053251-1054900 M2 1054901-1055000 M2 ELC	1962 1962	1173251-1174700 Flex 1174701-1175000 SL	1968 1968
975001-975800 M2 975801-976100 M2 Vorl	1959 1960	1054901-1053000 M2 ELC 1055001-1059849 M3	1962	1175001-1178000 M4	1967
976101-976500 M2 Voli	1959	1059850-1059999 M3 Lack	1962	1178001-1178100 M4 ELC	1967
976501-979500 M3	1959	1060000 M3	1962	1178101-1185000 M4	1967
979501-980450 M1	1959	1060001-1060500 M1	1962	1185001-1185150 M4 Mot	1968 1968
980451-980500 M1 Olv	1960 1959	1060501-1061700 M2 1061701-1061800 M2 ELC	1962 1962	1185151-1185290 M4 Lack 1185291-1185300 Post24x27	
980501-982000 IIIg 982001-982150 M2 Vorl	1960	1061801-1063000 M2	1962	1185301-1195000 M4	1968-69
982151-982900 M2	1959	1063001-1065000 M3	1962	1195001-1205000 SL	1968
982901-983500 M2 Vorl	1959	1065001-1065200 M3 ELC	1962	1205001-1206736 MDa	1968-69
983501-984000 M2	1959 1959	1065201-1067500 M3 1067501-1067870 M1	1962 1963	1206737-1206891 M4 Mot 1206892-1206941 Post24x36	1969 1969
984001-984200 M3 ELC 984201-987000 M3	1959	1067871-1068000 Post	1963	1206942-1206961 Post24x27	1969
987001-987200 M3 ELC	1960	1068001-1070000 M2	1963	1206962-1206999 M3 Olv	1968
987201-987300 M2 ELC	1960	1070001-1074000 M3	1963	1207000 M2 Lack	1968
987301-987600 lg	1960	1074001-1074500 M1 1074501-1077000 M2	1963 1963	1207001-1207480 M4 Lack 1207481-1215000 M4	1968-69 1968-69
987601-987900 IIIg 987901-988025 IIIg Blk	1960 1960	1077001-1080000 M3	1963	1215001-1225000 SL	1969
988026-988350 IIIg	1960	1080001-1085000 Flex	1964-65	1225001-1225800 M4 Lack	1969
988351-988650 MŽ	1960	1085001-1085450 M1	1963	1225801-1235000 M4	1969
988651-989250 M2 Vorl	1960	1085451-1085500 M1 1085501-1088000 M2	1963 1963	1235001-1245000 SL 1245001-1246200 MDa	1969 1969
989251-989650 M2 Vorl 989651-989800 M2	1960 1960	1088001-1091000 M3	1963	1246001-1248100 M4 Lack	1969-70
989801-990500 M2 Vorl	1960	1091001-1091300 M1	1964	1248101-1248200 M4 Mot	1969
990501-990750 M2 Blk	1960	1091301-1093500 M2	1964	1248201-1250200 M2R	1969-70
990751-993500 M3	1960 1960	1093501-1093750 M2 Lack 1093751-1093800 M2 ELC	1964 1964	1250201-1254650 M4 1254651-1255000 MDa	1970 1969
993501-993750 M3 Blk 993751-995000 M2	1960	1093731-10933000 M2 LLG	1964	1255001-1265000 SL	1970
995001-995100 M2 ELC	1960	1097701-1097850 M3 Lack	1964	1265001-1266000 MDa	1970
995101-995400 M2 Vorl	1960	1097851-1098000 M3 ELC	1964	1266001-1266100 M4 Lack 1266101-1266131 M4 Olv	1970-71
995401-996000 M2	1960 1960	1098001-1098100 M1 1098101-1098183 M1 Olv	1964 1964	1266101-1266131 M4 ON	1970 1970
996001-998000 M3 998001-998300 M3 ELC	1960	1098184-1098300 M1	1964	1267101-1267500 M4 Mot	1970
998301-1000000 M3	1960	1098301-1099800 M2	1964	1267501-1273921 M4	1970-71
1000001-1003700 M3	1960	1099801-1099900 M2 ELC	1964	1273922-1273925 Post24x27	
1003701-1004000 M3 ELC	1960	1099901-1100000 M2 1100001-1102000 M3	1964 1964	1273926-1274000 Post24x36 1274001-1274100 M4 Mot	1971
1004001-1005100 M2 Vorl 1005101-1005350 M2 Vorl	1960 1960	1102001-1102500 MS	1964	1274101-1275000 MDa	1971
1005351-1005450 M2 ELC	1960	1102501-1102800 MD	1964	1275001-1285000 SL	1970-71
1005451-1005750 M2	1960	1102801-1102900 M1	1964		
1005751-1005770 M2 LW	1960	1102901-1103000 M3	1965 1965		
1005771-1007000 M2 1007001-1011000 M3	1960 1960	1103001-1104900 M2 1104901-1105000 M2 ELC	1965	8	
1011001-1014000 M2	1960	1105001-1106900 M3	1965		
1014001-1014300 M3 ELC	1960	1106901-1107000 M3 ELC	1965		
1014301-1017000 M3	1960	1107001-1109000 M2 1109001-1110500 M3	1965 1965		
1017001-1017500 M1 1017501-1017900 M2	1961 1961	11105001-1110500 M3	1965		
1017901-1017900 M2 1017901-1018000 M2 ELC	1961	1112001-1114975 M2	1965		
1018001-1020100 M2	1961	1114976-1115000 Post	1965		
1020101-1020200 M2 ELC	1961 1961	1115001-1128000 Flex 1128001-1128400 MD	1965 1965		
1020201-1022000 M2 1022001-1022700 M3	1961	1128401-1128400 MD	1965	8	
1022701-1023000 M3 ELC	1961	1130001-1130300 M2 Lack	1965		

SCHNEIDER AND ZEISS LENS NUMBERS

SERIAL NUMBERS OF ZEISS LENSES BY YEAR OF MANUFACTURE

Many European cameras from the period from World War I to World War II were equipped with Zeiss lenses, all of which are serial numbered. This chart provides the basis for estimating the production date of a camera. Under normal circumstances, the camera is likely to have been assembled within about a year of the lens date.

This chart is used with the kind permission of George Gilbert from his book Collecting Photographica.

YEAR 1912 1913 1914 1915 1916	SERIAL NUMBERS 173418-200520 208473-249350 249886-252739 282820-
1917	289087-298157
1918	298115-322748
1919	322799-351611
1920	375194-419823
1921	433273-438361
1922	422899-498006
1923	561270-578297
1924	631869-
1925	652230-681743
1926	666790-703198
1927	722196-798251
1928	903096-
1929	919794-1016885
1930	922488-1239697
1931	1239699-1365582
1932	1364483-1389279
1933	1436671-1456003
1934	1500474-1590000
1935	1615764-1752303
1936	1674882-1942806
1937	1930150-2219775
1938	2267991-2527984
1939	2527999-2651211
1940 1941 1942	2678326-2790346 2799599-

MANUFACTURING DATES OF SCHNEIDER LENSES Serial No. Month/Yr. 30,000 Dec 1919 40,000 May 1920 50,000 Jan 1922 100,000 Jan 1925 200,000 Jun 1928 300,000 Feb 1929 400,000 Apr 1931 500,000 Jun 1932 600,000 Aug 1933 700,000 Oct 1934 800,000 Sep 1935 900,000 May 1936 1,000,000 Nov 1936 2,000,000 Sep 1948 May 1952 3,000,000 4,000,000 Oct 1954 5,000,000 Feb 1957 6,000,000 May 1959 7,000,000 Feb 1961 8,000,000 Mar 1963 9,000,000 Feb 1965 10,000,000 Jan 1967 11,000,000 Nov 1968 Sep 1972 12,000,000 13,000,000 Dec 1976 14,000,000 Oct 1983

------ UNITED STATES PATENT NUMBERS ------

DATING CAMERAS BY UNITED STATES PATENT NUMBERS

Patent dates can often be helpful in dating cameras, shutters or other accessories. One must be careful, however, not to conclude that the item was manufactured in the year the patent was issued. This is usually not the case. The patent date serves to indicate the year *after* which the item was made. Often the patents had been issued for five years or more before an item was produced bearing the patent number. Many products continued to carry the patent numbers for many years after the patent was issued. Thus a camera manufactured in 1930 could have a 1905 patent date.

The first numbered patents were issued in 1836, just before the advent of photography. Originally the law required that the patent date (but not the number) be put on the product. The present requirement to place the patent number on the item or its container began on April 1, 1927. Many earlier products, however, bore the patent number even though it was not required by law.

The following table lists the first patent number for the indicated year.

YEAR	NUMBER	YEAR	NUMBER	YEAR	NUMBER
1836 1837	1 110	1887 1888	355,291 375,720	1938 1939	2,104,004 2,142,080
1838	546	1889	395,305	1940	2,185,170
1839 1840	1,061 1,465	1890 1891	418,665 443,987	1941 1942	2,227,418 2,268,540
1841	1,923	1892	466,315	1943	2,307,007
1842	2,413	1893	488,976	1944	2,338,081
1843 1844	2,901 3,395	1894 1895	511,744 531,619	1945 1946	2,366,154 2,391,856
1845	3,873	1896	552,502	1947	2,413,675
1846 1847	4,348 4,914	1897 1898	574,369 596,467	1948 1949	2,433,824 2,457,797
1848	5,409	1899	616,871	1950	2,492,941
1849	5,993	1900	640,167	1951	2,536,016
1850 1851	6,891 7,865	1901 1902	664,827 690,385	1952 1953	2,580,379 2,624,046
1852	8,622	1903	717,521	1954	2,664,562
1853 1854	9,512 10,358	1904 1905	748,567 778,834	1955 1956	2,698,434 2,728,913
1855	12,117	1906	808,618	1957	2,775,762
1856	14,009	1907 1908	839,799	1958 1959	2,818,567
1857 1858	16,324 19,010	1908	875,679 908,436	1960	2,866,973 2,919,443
1859	22,477	1910	945,010	1961	2,966,681
1860 1861	26,642 31,005	1911 1912	980,178 1,013,095	1962 1963	3,015,103 3,070,801
1862	34,045	1913	1,049,326	1964	3,116,487
1863 1864	37,266 41,047	1914 1915	1,083,267 1,123,212	1965 1966	3,163,865 3,226,729
1865	45,085	1916	1,166,419	1967	3,295,143
1866	51,784	1917	1,210,389	1968	3,360,800
1867 1868	60,658 72,959	1918 1919	1,251,458 1,290,027	1969 1970	3,419,907 3,487,470
1869	85,503	1920	1,326,899	1971	3,551,909
1870 1871	98,460 110,617	1921 1922	1,364,063 1,401,948	1972 1973	3,631,539 3,707,729
1872	122,304	1923	1,440,362	1974	3,781,914
1873	134,504	1924	1,478,996	1975	3,858,241
1874 1875	146,120 158,350	1925 1926	1,521,590 1,568,040	1976 1977	3,930,271 4,000,520
1876	171,641	1927	1,612,790	1978	4,065,812
1877 1878	158,813 198,733	1928 1929	1,654,521 1,696,897	1979 1980	4,131,952 4,180,167
1879	211,078	1930	1,742,181	1981	4,242,757
1880 1881	223,211	1931 1932	1,787,424	1982 1983	4,308,622 4,366,579
1882	236,137 251,685	1933	1,839,190 1,892,663	1984	4,423,523
1883	269,820	1934	1,941,449	1985	4,490,855
1884 1885	291,016 310,163	1935 1936	1,985,878 2,026,516	1986 1987	4,562,596 4,645,548
1886	333,494	1937	2,066,309	1988	4,716,594

2451 CAP BANX 11770434 1211 Power Supply 11770450 3 heads 102A FIASh 126 FAN Cooled \$ 1400, CROWN Graphic W/135 f4.7 \$175, 919891 OPTAR BI 155) TOP R.F. PG 221 May 8,9, 530 1000 9921 Smetana Road Minnetonka, MN 55 343 T 379 2321

INDEX

"Watch the Birdie" Soap (Avon), 487 110 Camera (Gakken), 206 1919 Speed Reflex (Kuribayashi), 268 2-A Sterling (Sterling Camera), 394 20 Craze, 494 3-D Stereo Camera (Coronet), 128 A Daylight Kodak Camera (Eastman), 152 A Ordinary Kodak Camera (Eastman), 163 A.D.Y.C Koinor 4x4, 52 Academy (Marion), 300 Accuraflex, 50 ACE CAMÉRA EQUIPS. Sure-Flex, 50 Acme (Watson), 422 Acon 35 (Ars Optical), 74 Acro (Acro Scientific Prod.), 50 Acro Model R (Acro Scientific Prod.), 50 Acro Model V (Acro Scientific Prod.), 50 ACRO SCIENTIFIC PROD. Acro Model R, 50 Acro Model V, 50 Acro-Flash (Herold), 232 **ADAMS** Aidex, 50 Challenge, 50 Club, 50 De Luxe, 50 Focal Plane Vesta, 51 Hand Camera, 50 Hat Detective Camera, 50 Ideal, 50 Idento, 50 Minex, 50 Minex Tropical, 50 Minex Tropical Stereoscopic Reflex, 51 Rollfilm Vesta, 51 Royal, 51 Vaido, 51 Vaido Tropical, 51 Verto, 51 Vesta, 51 Vesta Model A, 51 Videx, 51 Yale No. 1, No. 2, 51 Yale Stereo Detective No. 5, 51 ADAMS & WESTLAKE Adlake Regular, 51 Adlake Repeater, 51 Adlake Special, 51 Adams Auto 35 (Rondo), 372 Adickes (Ruberg & Renner), 374 Adina, 51 Adina (Vredeborch), 420 Adlake Regular (Adams & Westlake), 51 Adlake Repeater (Adams & Westlake), 51 Adlake Special (Adams & Westlake), 51 Adler Semi (Riken), 364 Admira A8F, A8G (Meopta), 464 Admiral (Ansco), 62 Adoro (Contessa), 123 Adoro (Zeiss Ikon), 437 ADOX KAMERAWERK Adox, Adox II, Adox III, 51 Adox 300, 51 Adox 35, 51 Adox 66, 51 Adrette, 51 Adrette II, 51 Blitz, 51 Golf, 51 Golf IA Rapid, 51 Golf IIA, IIIA, 51 Juka, 51 Polomat, 52 Rollfilm camera, 52 Sport, 52 Start, 52 Adrette, Adrette II (Adox), 51

Adventurer (Imperial), 247 Adventurer (Wittnauer), 429 Advertising Ashtray (Zeiss), 477 ADVERTISINGSPECIALTIES, 472 ADVERTISINGSPECIALTIES,472
Advocate (Ilford), 246
Advocate X-ray (Ilford), 246
Aerial camera (Minolta), 308
Aerial Camera (Plaubel), 355
Aerial Camera (Thornton-Pickard), 400
Aerial Camera (Zeiss Ikon), 437
Aerial Camera HKT (Hasselblad), 229
Aerial Camera KE 28B 52 Aerial Camera KE-28B, 52 Aerogard Can Camera, 52 Afex (Norisan), 336 AFIOM Kristall, 52 Wega II, IIa, 52 Afpi (Wünsche), 430 Afpi Model III (Wünsche), 430 Agat 18 (Belomo), 89 Ageb (Busch), 104 AGFA Agfaflex, 52 Agfaflex I - IV, 52 Agfamatic 200 sensor, 52 Agfamatic 2000 pocket, 52 Agfamatic 2008 tele pocket, 52 Agfamatic 3008 pocket, 52 Agfamatic 901 motor, 52 Ambi-Silette, 52 Ambiflex, 52 Automatic 66, 52 Autostar X-126, 52 Billette, 53 Billette, 53
Billy, 53
Billy 0, 53
Billy Compur, 53
Billy I, 53
Billy I Luxus, 53
Billy III, 53
Billy III, 53 Billy Optima, 53 Billy Record 4.5, 6.3, 7.7, 8.8, 53 Billy Record I, II, 53 Billy Record 1, 1 Billy-Clack, 53 Box 24, 53 Box 44, 53 Box 54, 54 Box B-2, 54 Box cameras, 53 Box-Spezial (Nr 64), 54 Clack, 54 Click (rapid cassette), 54 Click I, II, 54 Colorflex I, II, 54 Flexilette, 54 Folding Plate cameras, 54 Folding Rollfilm cameras, 54 Iso Rapid I, IF, IC, 54 Isobox, 54 Isoflash Rapid, 54 Isoflash Rapid C, 54 Isola, 54 Isola I, II, 54 Isolar, 54 Isolar Luxus, 54 Isolette, 54 Isolette 4.5, 54 Isolette I, II, 54 Isolette III, 55 Isolette L, 55 Isolette V, 55 Isolette V, 55 Isoly, 55 Isoly (I), 55 Isoly II, IIa, 55 Isoly III, IIIa, 55 Isoly Junior, 55 Isoly-Mat, 55 Isomat-Rapid, 55 Isorette, 55 Karat, 55 Karat 2.8, 3.5, 4.5, 6.3, 55

Karat 12, 55 Karat 36, 55 Karat IV, 55 Karomat, 55 Moto-Rapid C, 55 Motor-Kamera, 55 Motor-Kamera, 55 Movematic, 453 Movex 16-12B, 16-12L, 454 Movex 30B, 30L, 454 Movex 8, 8L, 453 Movex 88, 88L, 454 Movex Automatic I, II, 454 Movex Reflex, 454 Movexoom, 454 Nitor, 55 Opal Luxus, 55 Optima II, IIIS, 55
Optima III, IIIS, 55
Optima III, IIIS, 55
Optima III, IIIS, 55 Optima Parat, 55 Optima Rapid 125C, 55 Optima Reflex, 55 Paramat, 55 Parat, Parat I, 55 Preis-Box, 56 Record I, II, III, 56 Registrier-Kamera,56 Schul-Prämie Box, 56 Selecta, 56 Selecta-Flex, 56 Selecta-M, 56 Selectronic S Sensor, 56 Silette, 56 Silette (I), 56 Silette Automatic, 56 Silette F, 56 Silette F, 56 Silette II, 56 Silette L, 56 Silette LK, 56 Silette Rapid, Rapid I, 56 Silette Rapid F, Rapid L, 56 Silette SL, SLE, 56 Solina, 56 Solinette, Solinette II, 56 Solinette (non-folding), 56 Speedex, 56 Speedex No. 1, 56 Speedex No. 2, 57 Standard, 57 Super Isolette, 55 Super Silette, L, LK, 56 Super Solina, 56 Super Solinette, 56 Superior, 57 Synchro-Box, 57 Synchro-Box (Made in India), 57 Trolita, 57 Trolix, 57 Ventura 66, 57 Ventura 66 Deluxe, 57 Ventura 69, 57 Ventura 69 Deluxe, 57 AGFA-ANSCO Agfa-Ansco Box, 57 Cadet A-8, 57 Cadet B-2, 57 Cadet B-2 Texas Centennial, 58 Cadet D-6, 58 Captain, 58 Chief, 58 Clipper PD-16, 58 Clipper Special, 58 Major, 58 Memo (full frame), 58 Memo (half-frame), 58 Pioneer, 58 Plenax, 58 Readyset Traveler, 58 Shur-Flash, 58 Shur-Shot Regular, 58

AGFA Shur-Shot

Shur-Shot Special, 58 Speedex B2 6x6cm, 58 Speedex Jr., 58 Tripar PB-20, 58 View cameras, 58 Viking, 59
Agfaflex (Agfa), 52
Agfamatic 200 sensor (Agfa), 52
Agfamatic 2000 pocket (Agfa), 52
Agfamatic 2008 tele pocket (Agfa), 52
Agfamatic 3008 pocket (Agfa), 52 Agfamatic 3008 pocket (Agfa), 52 Agfamatic 901 motor (Agfa), 52 Agiflash (Agilux), 59 Agiflash 35 (Agilux), 59 Agiflash 44 (Agilux), 59 Agiflex (Agilux), 59 Agifold (rangefindermodel) (Agilux), 59 **AĞILUX** Agiflash, 59 Agiflash 35, 59 Agiflash 44, 59 Agiflex, 59 Agifold (rangefindermodel), 59 Agima, 59 Agimatic, 59 Auto Flash Super 44, 59 Colt 44, 59 Agima (Agilux), 59 Agimatic (Agilux), 59 Ahi, 59 Ahi, 59
Aidex (Adams), 50
Aiglon, 59
Aiglon (ATOMS), 81
Aiglon Reflex (ATOMS), 81
AIR FRESHENER, 472
AIR KING PRODUCTSCO.
Air King Camera Radio, 59
AIRES CAMERA IND. CO.
Aires 35-IIIC, 59
Aires 35-V, 59
Aires Automat, 59 Aires Automat, 59 Airesflex, 59 Airesflex Z, 59 Penta 35, 59 Penta 35 LM, 60 Radar-Eye, 60 Viceroy, 60 Viscount, 60 Airesflex (Aires), 59 Airesflex Z (Aires), 59 **AIVAS** Beginner's Camera, 60 Ajax (Alsaphot), 60 Ajax (Coronet), 126 AK 8 (Pentacon), 467 Akarelle (Apparate & Kamerabau), 71 Akarette 0, (Apparate & Kamerabau), 71 Akarette I, II (Apparate & Kamerabau), 71 Akarex I, III (Apparate & Kamerabau),71 AKELEY CAMERA 35mm Motion Picture Camera, 454 Akira TC-002, 60 Akrom I (Bencini), 89 AKTIEBOLAGETSvenska Camera, 60 AKUTAGAWACONFECTIONERYCO. Chocolate Camera, 473 Perfect-Lighter, 474 Al-Vista Cameras (Multiscope), 321 Al-Vista Senior (Multiscope), 321 Alas (E.F.I.C.A.), 180 Alba (Gamma), 208 Alba 63 (Albini), 60 Albert (Shincho), 386 ALBINÌ Alba 63, 60 Album, 472 ALBUMS, 472 Aldon Photographer, 490 Alethoscope (Joux), 250 Alfa (Ferrania), 194

Alfa (WZFO), 431 Alfa 2 (WZFO), 431 ALFA OPTICALCO. Cosmoflex, 60 Alfax Model I (Kimura), 256 ALIBERT Kauffer Photo-Sacà Main, 60 Alino (Contessa), 123 Allno (Contessa), 123
Alka 16 (Wirgin), 427
Alka Box (Vredeborch), 420
All Distance Ensign (Houghton), 235
Allbright (Ruberg & Renner), 374
ALLIED CAMERA SUPPLYCO. Carlton Reflex, 60 Allox (Roche), 368
Almaz-103 (Lomo), 293
Alome (Tougodo), 404
Alpa (Standard) (Pignons), 353
Alpa 10d (Pignons), 354
Alpa 10f (Pignons), 354
Alpa 10s (Pignons), 354
Alpa 11a (Pignons), 354
Alpa 11e (Pignons), 354
Alpa 11e (Pignons), 354
Alpa 11es (Pignons), 354
Alpa 11es (Pignons), 354
Alpa 11f (Pignons), 354
Alpa 11s (Pignons), 354
Alpa 11s (Pignons), 354
Alpa 11s (Pignons), 354
Alpa 11s (Pignons), 354
Alpa 16 (Pignons), 353
Alpa 46 (Pignons), 353
Alpa 56 (Pignons), 353
Alpa 66 (Pignons), 353
Alpa 66 (Pignons), 353
Alpa 66 (Pignons), 353
Alpa 76/Pignons), 353
Alpa 76/Pignons), 353
Alpa 76/Pignons), 353
Alpa 78/Pignons), 353
Alpa 86 (Pignons), 353
Alpa 78/Pignons), 353
Alpa 86 (Pignons), 353
Alpa 86 (Pignons), 353
Alpa 86 (Pignons), 353
Alpa 96 (Pignons), 353
Alpa 96 (Pignons), 353
Alpa 96 (Pignons), 353
Alpa 96 (Pignons), 353 Allox (Roche), 368 Almaz-103 (Lomo), 293 Alpa 7s/8 (Pignons), 353 Alpa 8b (Pignons), 353 Alpa 9d (Pignons), 353 Alpa 9f (Pignons), 354 Alpa Master (Pignons), 354 Alpa Prisma Reflex (III) (Pignons), 353 Alpa Reflex (I) (Pignons), 353 Alpa Reflex (II) (Pignons), 353 Alpa Reflex (II) (Pignons), 353 Alpa S.81 (Pignons), 354 Alpenflex (Hachiyo), 225 Alpha (Ica), 241 Alpha (Watson), 422 Alpin (Voigtländer), 415 Alpin Stereo-Panoram(Voigtländer), 415 Alpina M35 (Yamato), 432 ALSAPHOT Ajax, 60 Cady, 60 Cyclope, 60 D'Assas, 60 D'Assas-Lux, 60 Dauphin, Dauphin II, 61 Maine, 61 Alta (Misuzu), 317 Alta Automatic (Reichenbach), 361 Alta D (Reichenbach), 361 Altessa (Royer), 374 ALTHEIMER& BAER Photo-Craft, 61 Altiflex (Eho-Altissa), 181 Altiscop (Eho-Altissa), 181 Altissa (Eho-Altissa), 181 Altissa II (Eho-Altissa), 181 ALTISSA KAMERAWERK,61 Altix (I) (pre-war) (Eho-Altissa), 181 Altix III (Eho-Altissa), 181 Altix IV (Eho-Altissa), 181 Altix NB (Eho-Altissa), 181

Altix-N (Eho-Altissa), 181 Altura (Contessa), 123 Aluminium Bound Instantograph (Lancaster), 276 Aluminum Xit (Shew), 386 Alvix, 61 Amateur Field Camera (Goldmann), 215 Ambassador(Coronet), 126 Amber (Thornton-Pickard), 400 **AMBITOYS** Focus Pocus, 494 Ambi-Silette (Agfa), 52 Ambiflex (Agfa), 52 AMC 67 Instant Load (Balda), 83 AMC M235 (Braun), 100 **AMCA** Sportshot Senior Twenty, 50 Amco, 61 Amerex, 61 AMERICANADV. & RESEARCH Cub. 61 AMERICAN CAMERA CO. Demon Detective Camera, 61 AMERICAN CAMERA MFG. CO. Buckeye, 61 Buckeye Special, 61 Folding Poco, 61 No. 1 Tourist Buckeye, 61 No. 2 and 3 Buckeye, 61 No. 8 Folding Buckeye, 61 Triple Bed Poco, No. 19, 61 AMERICAN FAR EAST Santa Claus Camera, 62 AMERICAN GREETINGS CO. Mr. Weekend Button, 480 AMERICANMINUTE PHOTO CO. American Sleeve Machine, 62 AMERICAN OPTICAL CO. Flammang's Patent Camera, 62 Henry Clay Camera, 62 John Stock Wet Plate Camera, 62 Plate camera, 5x8", 62 Revolving Back Camera, 62 View camera, 62 Wet Plate Camera, 4-tube, 62 AMERICAN RAND CORP. Photo Binocular 110, 62 AMERICAN RAYLO CORP. Raylo Color Camera, 62 AMERICANSAFETY RAZOR CORP. ASR Fotodisc, 62 American Sleeve Machine (American Minute Photo Co.), 62 AMICA INTERNATIONAL Amimatic, 62 Eyelux, 62 Amico, 486 Amiflex Amiflex II (Kanto), 252 Amiga (Siaf), 387 Amigo 35mm Motion Picture Camera (Gustav Amigo), 462 Amimatic (Amica International), 62 Amourette (O.T.A.G.), 346 Amplion-Reflex (Potthoff), 358 AMSCAN Squirting Camera, 488 Anastigmat Ensignette (Houghton), 238 Anca (10, 14, 25, 28) (Nagel), 323 Ancam (City Sale), 120 ANCHOR INTERNATIONAL Tourist Camera Foto Album, 472 Andante 100 (Precision Camera), 359 ANDERSON(J.A.) Studio camera, multiplying back, 62 Ango (Goerz), 213 Ango Stereo (Goerz), 213 Animatic 600 (Bencini), 90 ANKER INTERNATIONAL
Ariane Photo Albums (SLR style), 472 Benjamin Camera, 472 Anniversary Kodak (Eastman), 140 Anniversary Speed Graphic (Graflex), 222

Altix V (Eho-Altissa), 181

ARGUS A

Anny, 62 No. 3 Ansco Junior, 65 No. 3 Buster Brown, 63 Duplex Novelette Stereo, 69 Anny-35 (Houay), 235 Anny-44 (Hoei), 234 ANSCHÜTZ Fairy Camera, 69 No. 3 Folding Ansco, 64 Gem Box, 69 Klondike, 69 No. 3 Folding Buster Brown, 63 Rollda, 62 No. 3 Goodwin, 65 Lilliput Detective Camera, 69 Anschütz (Goerz), 213 Anschütz Deluxe (Goerz), 213 No. 3 Goodwin, 65
No. 3A Ansco Junior, 65
No. 3A Buster Brown, 63
No. 3A Folding Ansco, 64
No. 3A Folding Buster Brown, 63
No. 3A Folding Goodwin, 65
No. 4 Folding Ansco, 64
No. 5 Folding Ansco, 64
No. 6 Folding Ansco, 64 Normandie, 69 Novel, 69 Anschütz Stereo (Goerz), 213 Novelette, 69 ANSCO Novelette Stereo, 69 Admiral, 62 PDQ, 69 Ansco Junior, 65 Portrait Camera, 70 Ansco Risdon Model A, 454 Ansco Special, 62 Ansco View, 68 Satchel Detective Camera, 70 No. 6 Folding Ansco, 65 No. 7 Folding Ansco, 65 No. 9 Ansco, 65 Schmid's Patent Detective Camera, 70 Solograph, 70 Stereo Solograph, 70 Anscoflex, Anscoflex II, 63 Anscomark M, 63 Panda, 66 Photo Vanity, 66 Victor, 70 Anscomatic Cadet, 63 Victoria Four-Tube, 70 Anscoset III, 63 Arrow, 63 Pioneer, 66 View cameras, 70 Readyflash, 66 Vincent, 70 ANTHONY& SCOVILL Readyset (No.1, 1A, Eagle, etc.), 66 Readyset Royal, Nos. 1, 1A, 66 Automatic No. 1A, 63 Ansco No. 2, 70 Ansco No. 3, 70 Automatic Reflex, 63 Readyset Special, Nos. 1, 1A, 66 Rediflex, 66 Autoset CdS, 63 Antique Oak Detective (Scovill), 378 Regent, 66 Royal, No. 1A, 66 Semi-AutomaticAnsco, 66 Antique Tripod Cameras (Gakken), 206 Bingo No. 2, 63 Box cameras, 63 Box cameras, 71 Focal Plane Camera, 71 Rajar No. 6, 71 Shur-Flash, 67 Shur-Shot, 67 Shur-Shot Jr., 67 Buster Brown, 63 Buster Brown Junior, 64 Buster Brown Special, Nos. O, 2, 2A, 63 Cadet (I), 64 Cadet B2 and D-6 box cameras, 64 Reflex, 71 Speedex, 67 Vest Pocket, 71 Apollo 120 (Nishida), 336 Speedex 1A, 67 Cadet Flash, 64 Cadet II, Cadet III, 64 Speedex 45, 67 Apollo Man on Moon (Sims), 479 APPARATE& KAMERABAU Speedex 6.3, 67 Cadet Reflex, 64 Speedex Jr., 67 Akarelle, 71 Century of Progress, 64 Cine Ansco, 454 Speedex Special, 67 Akarette 0, I, II, 71 Speedex Special R, 67 Standard Speedex, 67 Akarex I, III, 71 Clipper, Clipper Special, 64 Color Clipper, 64 Commander, 64 Commercial View, 64 Arette, 71 Studio, 67 Arette A, 71 Sundial Camera, 67 Super Memar, 65 Super Memar LVS, 65 Arette Automatic S, SE, SLK, 71 Arette Bn, 71 Craftsman Kit, 64 Arette Bw, 71 Arette C, 71 DeLuxe No. 1, 64 Dollar Box Camera, 64 Super Regent, 66 Super Regent LVS, 66 Super Speedex, 67 Arette Dn, 71 Flash Champion, 64 Arette la - ld, 71 Flash Clipper, 64 Folding Ansco, 64 Titan, 67 Vest Pocket Ansco, 67 Vest Pocket Junior, 67 Arette P, 71 Arette W, 71 Optina IA, 71 APPLETON Folding Buster Brown Cameras, 63 Goodwin, 65 Vest Pocket Model A, 67 Vest Pocket No. 0, 67 Junior Press Photographer,65 Juniorette No. 1, 65 Criterion, 71 Vest Pocket No. 1, 67 Aptus Ferrotype Camera (Moore), 320 Karomat, 65 Vest Pocket No. 2, 67 Aqua Camera Flash Shiba (Shiba), 489 Kiddie Camera, 65 Lancer, Lancer LG, 65 Vest Pocket Readyset, 67 Aquascan Camera KG-20A (Data), 133 Arcadia (Molta Co.) (Minolta), 306 Vest Pocket Speedex No. 3, 68 Memar, 65 Memar, 65 Memo (1927 type), 66 Memo (1940 type), 66 Memo (Boy Scout model), 66 Memo (wood finished), 66 Memo Automatic 66 Viking, 68 ARCO INDUSTRIÉS Viking, 66
Viking Readyset, 68
Ansco Autoset (Minolta), 310
Ansco Junior (Ansco), 65
Ansco No. 2 (Anthony & Scovill), 70
Ansco No. 3 (Anthony & Scovill), 70
Ansco View (Ansco), 68 Take-A-Picture, 494 Arcoflex, 71 ARCON
Micro-110 (in can), 71
Arette (Apparate & Kamerabau), 71
Arette A (Apparate & Kamerabau), 71
Arette Automatic S, SE, SLK
(Apparate & Kamerabau), 71
Arette Bn (Apparate & Kamerabau), 71
Arette Bw (Apparate & Kamerabau), 71
Arette C (Apparate & Kamerabau), 71
Arette In (Apparate & Kamerabau), 71
Arette Ib (Apparate & Kamerabau), 71
Arette Ib (Apparate & Kamerabau), 71
Arette Ic (Apparate & Kamerabau), 71
Arette Id (Apparate & Kamerabau), 71
Arette P (Apparate & Kamerabau), 71
Arette W (Apparate & Kamerabau), 71 ARCON Memo Automatic, 66 Memo II Automatic (GAF), 66 Memory Kit, 66 Anscoflex, Anscoflex II (Ansco), 63 Anscomark M (Ansco), 63 Anscomatic 726 (Kuribayashi), 272 No. 0 Buster Brown, 63 No. 0 Buster Brown, 63 No. 0 Buster Brown Special, 63 No. 1 Ansco Junior, 65 No. 1 Folding Ansco, 64 No. 1 Folding Buster Brown, 63 No. 1 Goodwin Jr., 65 No. 1 Special Folding Ansco, 64 No. 10 Ansco, 65 Anscomatic Cadet (Ansco), 63 Anscoset (Ansco), 63 Anscoset III (Ansco), 63 Ant Farm Camera (Gakken), 497 ANTHONY Ascot, 68 Ascot Cycle No. 1, 68 Ascot Folding, 68 Bijou, 68 No. 1A Ansco Junior, 65 No. 1A Folding Ansco, 64 No. 1A Folding Goodwin, 65 Arette W (Apparate & Kamerabau), 71 Box cameras, 68 Buckeye, 68 Arex (Schwarzbauer), 378 Argo (C.M.F.), 121 No. 2 Buster Brown, 63 No. 2 Buster Brown Special, 63 No. 2 Folding Buster Brown, 63 Champion, 68 ARGÚS Clifton, 68 Climax Detective, 68 Argoflex, 72 Argoflex 40, 72 No. 2 Goodwin, 65 No. 2A Buster Brown, 63 No. 2A Buster Brown Special, 63 No. 2A Folding Buster Brown, 63 Climax Enlarging Cameras, 68 Climax Imperial, 69 Climax Portrait Camera, 69 Argoflex E, EF, EM, 72 Argoflex Seventy-five, 72 Argus 21 (Markfinder), 72 No. 2A Goodwin, 65 Compact Camera, 69 Argus 75, 72 Argus A, 71 No. 2C Ansco Junior, 65 Daylight Enlarging Camera, 69 Duplex Novelette, 69 No. 2C Buster Brown, 63

Argus A (126 cartridge), 72

ARGUS A2

Argus A2 (A2B), 72 Argus A2F, 72 Argus A3, 72 Argus A4, 72 Argus A4, 72
Argus AA (Argoflash), 72
Argus AF, 72
Argus B, 72
Argus C, 72
Argus C2, 73
Argus C20, 73
Argus C3, 73
Argus C3, 73
Argus C3, 73
Argus C3, 73 Argus C33, 73 Argus C4, C4R, 73 Argus C44, C44R, 73 Argus C44, C44K, 73 Argus CC (Colorcamera), 73 Argus FA, 72 Argus K, 73 Argus Model M, 74 Argus Seventy-five, 72 Argus Seventy-five (Australia), 72 Argus SLR, 74 Argus Solid State Electronic, 74 Argus Super Seventy-five, 72 Argus V-100, 74 Automatic 8, 454 Autronic 1, Autronic 35, Autronic C3, 72 Camro 28, 73 Delco 828, 73 Golden Shield (Matchmatic C-3), 73 Lady Carefree, 73 Minca 28, 74
Argus (Contessa), 124
Argus (Nettel), 325
Argus Reflex (Watson), 422 Argus Repeating Camera (Mason), 301 Argus STL 1000 (Argus/Cosina), 74 ARGUS/COSINA Argus STL 1000, 74 Ariane Photo Albums (Anker), 472 ARLISS CO. Squirt Camera, 488 ARNOLD Karma-Flex, 74 Karma-Flex 4x4, 74 Karma-Flex 6x6cm, 74 Karma-Lux, 74 Karma-Sport, 74 ARNOLD& RICHTER Kinarri 35, 454 Tropical Kinarri, 454 Arrow (Ansco), 63 ARROWWORKS Arrow WURNS
Arrow Cine Camera, Model 50, 454
ARS OPTICAL CO. LTD.
Acon 35, 74
Sky 35 Model II, 74
Arsen (Takahashi), 398
Arti-Six, 75 Artist Hand Camera (London Stereoscopic), 293 Artist Reflex (London Stereoscopic), 293 Artist Reflex, Tropical (London Stereoscopic), 293 AS DE TREFLE As Phot, 75 Asahi (Yen camera), 435 ASAHÌ Asahiflex Cameras, 75 Asahiflex I, Ia, 75 Asahiflex IIA, IIB, 75 Honeywell Pentax Spotmatic IIa, 77 Honeywell Spotmatic SP 1000, 77 Honeywell Spotmatic SP 1000, 77 Pentax (original), 75 Pentax 6x7, 80 Pentax Auto 110, 80 Pentax Auto 110 (transparent), 80 Pentax Auto 110 Super, 80 Pentax ES, ESII, 77 Pentax H1, H1a, 76 Pentax H2, 75

Pentax H3, H3v, 76 Pentax K, 75 Pentax K1000, K1000 SE, 77 Pentax K2, K2DMD, 77 Pentax KM, 77 Pentax KX, 77 Pentax LX, 78 Pentax ME, 77 Pentax ME Super, 78 Pentax ME-F, 78 Pentax ME-SE, 78 Pentax MG, 78 Pentax MV, 78 Pentax MV-1, 78 Pentax MX, 78 Pentax S, 75 Pentax S1, S1a, 76 Pentax S2, 75 Pentax S3, 76 Pentax SL, 76 Pentax SP500, 76 Pentax Spotmatic (SP), 76 Pentax Spotmatic 1000 (SP 1000), 77 Pentax Spotmatic F, 77 Pentax Spotmatic II, 76 Pentax Spotmatic IIa, 77 Pentax Super S2, 76 Pentax SV, 76 ASAHI OPTICAL Letix, 81 Super Olympic Model D, 81 Asahiflex Cameras (Asahi), 75 Asahigo, 81 Asanuma Clock (Copal), 475 ASANUMATRADING CO. Kansha-go Field Camera, 81 Kansha-go Field Camera, 81 Robo-Cam, 81 Torel 110 "National", 81 Torel 110 Talking Camera, 81 Ascot (Anthony), 68 Ascot Cycle No. 1 (Anthony), 68 Ascot Folding (Anthony), 68 Ash Tray With View Camera, 477 ASIA AMERICAN INDUSTRIES Orinox Binocular Camera, 81 Asiana, 81 ASR Fotodisc, 62 ASSOCIATEDPHOTO PRODUCTS Magazine Pocket, 454 Astoria Super-6 IIIB (Ehira), 180 Astra, 81
Astra (M.I.O.M.), 314
Astra (Rodenstock), 371
Astra 35F-X (K.W.), 272
Astraflex 1000 (Wirgin), 427
Astraflex 35 (K.W.), 272
Astraflex 35 (K.W.), 272
Astraflex Auto 35 (Pentacon), 348
Astraflex-II (Feinontisches), 193 Astraflex-II (Feinoptisches), 193 Astrocam 110 (Estes), 190 Astropic, 81 ATAK Inka, 81 ATKINSON, J.J. Stereo camera, 81 Tailboard camera, 81 Wet plate field camera, 81 Atlas 35 (Yamato), 432 Atlas Deluxe (Yamato), 432 Atlas II (Yamato), 432 ATLAS-RAND Mark IV, 81 Atlasix (Nishida), 336 Atoflex (ATOMS), 81 Atom (Hüttig), 239 ATOM OPTICAL WORKS Atom-Six-I, Atom-Six-II, 81 **ATOMS** Aiglon, 81 Aiglon Reflex, 81 Atoflex, 81 Atom (Ica), 241 Attache Case Camera 007, 81

Auction records, 49
AURORA PRODUCTS CORP.
Ready Ranger Tele-photo Camera, 81
Aurora Standard, 454 Austral No. 1A (Baker & Rouse), 82 Autra (Wirgin), 427 Autix (Kolbe & Schulze), 259 Auto 35/Reflex (Bell & Howell), 88 Auto Camera Mark 3 (Shackman), 385 Auto Camex (Ercsam), 460 Auto Colorsnap 35 (Eastman), 141
Auto Fifty (United States Camera), 408
Auto Fixt Focus (Defiance), 134 Auto Flash Super 44 (Agilux), 59 Auto Flash Super 44 (Agilux), 59
Auto Forty (United States Camera), 408
Auto Graflex (Graflex), 218
Auto Graflex Junior (Graflex), 218
Auto Kine Camera (Newman), 464
Auto Malik (Leidolf), 278
Auto Minolta (Minolta), 308 Auto Semi First (Kuribayashi), 269 Auto Semi Minolta (Minolta), 307 Auto Sensorex EE (Miranda), 316 Auto Triumph 8, 454
Auto-Lux 35 (Mamiya), 297
Autocarena (Carena), 457
Autoflex (Kiyabashi), 257
Autoflex (Optikotechna), 345 Autographic Kodak Cam. (Eastman), 141 Autographic Kodak Junior Cameras (Eastman), 141 (Eastman), 141 Autographic Kodak Special Camera (Eastman), 141 Autoload 340 (Bell & Howell), 88 Autoload 341 (Bell & Howell), 88 Autoload 342 (Bell & Howell), 88 Automan (Thornton-Pickard),400 Automat (Franke & Heidecke), 202 Automat (MX-EVS) (F & H), 203 Automat (MX-sync.) (F & H), 203 Automat (X-sync.) (F & H), 202 Automat 120, 82 Automatic (United States Camera), 409 Automatic 8 (Argus), 454 Automatic 35 Camera (Eastman), 141 Automatic 35B Camera (Eastman), 142 Automatic 35F Camera (Eastman), 142 Automatic 35R4 Camera (Eastman), 142 Automatic 66 (Agfa), 52 Automatic-1034(Revere), 362 Automatic Magazine (Houghton), 235 Automatic No. 1A (Ansco), 63 AUTOMATICRADIO MFG. CO. Tom Thumb Camera Radio, 82 Automatic Reflex (Ansco), 63 Automatic Zoom 800 (Wittnauer), 470 Automatica (Durst), 139 Automaton (Wittnauer), 429 Autopak 400-X (Minolta), 313 Autopak 400-X (Minolta), 313 Autopak 500 (Minolta), 313 Autopak 550 (Minolta), 313 Autopak 600-X (Minolta), 313 Autopak 700 (Minolta), 313 Autopak 800 (Minolta), 313 Autorange 16-20 Ensign (Houghton), 235 Autorange 220 Ensign (Houghton), 235 Autorange 820 Ensign (Houghton), 235 Autoset, Autoset CdS (Ansco), 63 Autostar X-126 (Agfa), 52 Autostar X-126 (Agfa), 52 Autronic (Argus), 72 **AVANT** Quad Model 32-100 As, 82 Aviso (Ica), 241 AVON PRODUCTS "Watch the Birdie" Soap, 487 Avus (Voigtländer), 415 AZ-1 (Fuji Photo), 205 Azore V (King), 256 Azur (Boumsell), 99

B&RMANUFACTURINGCO.

Photoette#115,82 B & W MANUFACTURINGCO. Erkania, 84 Fixfocus, 84 Press King, 82 B Daylight Kodak Camera (Eastman), 152 B Ordinary Kodak Camera (Eastman), 163 Front-Box, 84 Gloria, 84 Barry, 85 BARTHELEMY Glorina, 84 Babette, 82 Hansa 35, 84 Jubilette, 84 Baby (Yen camera), 435 Baby Al-Vista (Multiscope), 321 Baby Balnet (Fuji), 204 Juventa, 84 Juwella, 84 Lady Debutante, 84 Baby Brownie BAUCHET New York World's Fair (Eastman), 144 Baby Brownie Camera (Eastman), 144 Lisette, 84 Micky Rollbox, 84 Piccochic, 84 Baby Brownie Special (Eastman), 12
Baby Camera, 82
Baby Deckrullo (Zeiss Ikon), 442
Baby Finazzi, 82
Baby Flex, 82
Baby Hawk-Eye (Blair), 95
Baby Hawkeye (Eastman), 157
Baby Kinsi (Riken), 364
Baby Lyra (Fuji), 205
Baby Makina (Plaubel), 355
Baby Minolta (Minolta), 307
Baby Nebro (Nebro), 324
Baby Pearl (Konishiroku), 259
Baby Pixie (Gnome), 213
Baby Powell (Rex), 362
Baby Reflex (Yen camera), 435
Baby Ruby (Ruberg & Renner), 374
Baby Semi First (Kuribayashi), 268 Baby Brownie Special (Eastman), 144 Pierrette, 84 Pixie Slip-On, 86 Pinette, 84 Poka, Poka II, 84 Pontina, 84 Primula, 84 Bauer, 86 BAUER Bauer RX1, RX2, 86 BAZIN & LEROY Rigona, 84 Rollbox, 85 Rollfilm-Kamera, 85 Servo-Baldamat, 85 Le Stereocycle, 86 Springbox, 85 Super Baldamatic, 85 Super Baldamatic I, 85 Super Baldax, 85 Super Baldina, 85 Super Baldinette, 85 Super Pontura, 85 Baldafix (Balda), 83 Baby Semi First (Kuribayashi), 268 Baby Sibyl (Newman & Guardia), 326 Baby Special (Yen camera), 435 Baby Sports (Yen camera), 435 Baldak-Box (Balda), 83 Baldalette (Balda), 83 Baldalux (Balda), 83 Baby Sports (Yen camera), 435
Baby Standard (Vicam), 469
Baby-Box (Zeiss Ikon), 437
Baby-Box Tengor (Zeiss Ikon), 437
Baby-Lynx (Pontiac), 358
Baby-Max (Tougodo), 405
Babysem (S.E.M.), 383
BACO ACCESSORIESCO.
Baco Press Club, 82 Baldamatic I, II, III (Balda), 83 Baldamatic I, II, III (Balda), 83 Baldax (Balda), 83 Baldaxette (Balda), 83 Baldessa (Balda), 83 Baldessa F (Balda), 83 Baldessa LF (Balda), 83 Baldessamat (Balda), 83 Baldessamat F, RF (Balda), 83 Baldessamat F, RF (Balda), 83 BEAUGERS Lubo 41, 86 BEAULIEU Reflex Control, 454 Baco Press Club. 82 BAGS (HANDBAGS, SHOULDER BAGS), Imp, 86 Baldi (Balda), 83 Baldina (Balda), 83 Pro. 86 **BAIRD** Single lens stereo camera, 82 Baldinette (Balda), 83 Tropical Field Camera, 82 Bakelite (Gallus), 207 BAKER (W.G.) Baldini (Balda), 83 Baldix (Balda), 83 Baldixette (Balda), 83 BAKER (W.G.)
Improved Crescent Camera, 82
BAKER & ROUSE
Austral No. 1A, 82
Bakélite (Pontiac), 358
Bakina Rakina (Fototecnica), 200
Baky (Wirgin), 427
Balda Box (Balda), 83
Balda Kamera (Balda), 83 Baldur Box (Zeiss Ikon), 437 Baldwin-Flex (National Camera Co.), 323 Beaumat, 86 Beauty Super-L, 86 Lightomatic, 86 Balilla (Zeiss Ikon), 437 **BALLIN RABE** Varicon SL. 86 Folding plate camera, 9x12cm, 85 Ban, 85 Banco 4.5 (Kaftanski), 251 Balda-Kamera(Balda), 83 BALDA-WERK Banco Perfect (Kaftanski), 251 Bandi (Fototecnica), 200 AMC 67 Instant Load, 83 Banier, 85 BANKS, 473 Balda Box, 83 Balda-Kamera,83 Banner, 85 Banquet cameras (Folmer & Schwing), Baldafix, 83 Baldak-Box, 83 Bantam original f12.5 (Eastman), 142 Bantam original f6.3 (Eastman), 142 Bantam f4.5 (Eastman), 142 Bantam f5.6 (Eastman), 142 Bantam f6.3 (Eastman), 142 Bantam f8 (Eastman), 142 Baldalette, 83 Baldalux, 83 BEĆK Baldamatic I, II, III, 83 Baldax 6x6, 83 Baldax V.P., 83 Baldaxette, 83 British Ensign, 86 Cornex Model A, 86 Dai Cornex, 86 F.O.P. Frena, 87 Baldessa, 83 Bantam Colorsnap (Eastman), 142 Bantam Military model (Eastman), 142 Baldessa F, 83 Baldessa Ia, Ib, 83 Baldessa LF, 83 Folding Frena, 87 Frena, 87 Bantam RF Camera (Eastman), 142 Bantam Special Camera (Eastman), 142 Baldessamat, 83 BaldessamatF, RF, 83 Baldi, 83 Baoca BC-9, 85 Barbie Cameramatic (Vanity Fair), 413 Barbie Doll Camera, 494 Zambex, 87 Baldina, 83 Barclay (Yamato), 432 Barco, 85 BARKER BROS. Baldinette, 83 Baldini, 83 Baldix, 83 King Barker Motion Picture Camera, 454 Baldixette, 83 Barney Rubble Keychain (Dupuis Comics), Beginner's Camera (Aivas), 60 Beewee-Kamera,83 Doppel-Box,83 Beica, 87 Barney Rubble with camera (Hanna-BEIER Electronic 544, 84

BEIER Beier-Flex

BARON CAMERAWORKS Baron Six, 85 BARRY PRODUCTS CO. Stereo Magazine Camera, 85 My First Camera, 494 Battlestar Galactica, 488 Mosquito I, 85
Mosquito II, 85
BAUDINET INTERNATIONAL Bauer 88B, 88L, 454 BB Baby Semi First (Kuribayashi), 269 BB Semi First (Kuribayashi), 269 Beachcomber, 490 Beacon, Beacon II (Whitehouse), 426 Beacon 225 (Whitehouse), 426 Beacon Reflex (Whitehouse), 426 Bear Camera (Kiddie Camera), 254 BEAR PHOTO CO.
Bear Photo Special, 86
Bear Photo Special (Bear Photo Co.), 86 Bear with Flash Camera, 496
Bear with Flash Camera (tree ornament), Beau Brownie Camera (Eastman), 144 Beau Brownie Pencil Sharpener, 484 Beaumat (Beauty Camera Co.), 86 BEAURLINE INDUSTRIES Beauta Miniature Candid (Rolls), 372 Beauty (Taiyodo Koki), 398
Beauty 35 Super (Taiyodo Koki), 398
Beauty 35 Super II (Taiyodo Koki), 398
BEAUTY CAMERA CO. Varicon SL, 86
Beauty Canter (Taiyodo Koki), 398
Beauty Super-L (Beauty Camera Co.), 86
Beauty Super L (Taiyodo Koki), 398
Beautycord (Taiyodo Koki), 398
Beautycord S (Taiyodo Koki), 398
Beautyflex (Taiyodo Koki), 398
Beautyflex III (Taiyodo Koki), 398
Beautyflex S (Taiyodo Koki), 398
Beautyflex S (Taiyodo Koki), 398
Bebe (Zeiss Ikon), 438
Bebe (Zulauf), 452
Beby Pilot (Tachibana), 397
BECK Beck's New Pocket Camera, 86 Frena Presentation Model, 87 Hill's Cloud Camera, 87 Telephoto Cornex, 87 Beddy-Bye Bear (Galoob), 478 Bedfordflex, 87 Bee Bee (Burleigh Brooks), 103 Beewee-Kamera(Balda), 83

Beier-Flex, 87

Barbera), 491

BEIER Beiermatic

BERNER BELL CAMERA CO. Beiermatic, 87 Field camera, 13x18cm, 91 BERNING Bell's Straight-Working Panorama, 89 BELL INTERNATIONAL Beira, 87 Beirax, 87 Beirette, 87 Robot I, 91 Robot II, IIa, 92 Robot Junior, 92 Robot Luftwaffe Model, 92 Bell Kamra Model KTC-62, 89 BELL MANUFACTURINGCO. Beirette II, 87 Bell Motion Picture Camera, 456 Beirette Junior II, 87 Bell-14, 88 Bell's Straight-Working Panorama, 89 Bella (4x6.5 cm) (Bilora), 93 Beirette K, 87 Beirette VSN, 87 Robot Luttwaffe Model, 92 Robot Recorder 24, 24e, 24F, 92 Robot Royal 18, 92 Robot Royal 24, 92 Robot Royal 36, 92 Robot Royal III, 92 Robot Star, 92 Box, Box 0, I, II, 87 Edith II, 88 Bella (4x6.5 cm) (Bil Bella 35 (Bilora), 93 Bella 44 (Bilora), 93 Bella 46 (Bilora), 93 Bella 66 (Bilora), 93 Bella D (Bilora), 93 Folding sheet film cameras, 88 Lotte II, 88 Precisa, 88 Rifax, 88 Rifax (Rangefindermodel), 88 Bellaluxa 4/4 (Bilora), 93 BELLCRAFTCREATIONS Can-Tex, 89 Robot Star 25, 92 Robot Star 50, 92 Robot Star II (Vollautomat), 92 Voran, 88 Beier-Flex (Beier), 87 Beiermatic (Beier), 87 BEIJING CAMERA FACTORY Berry (Ernemann), 184 BERTRAM BELLIENI Jumelle, 89 Bertram-Kamera,92 BERTSCH Stereo Jumelle, 89 Great Wall DF-2, 88 Great Wall SZ-1, 88 Bellina 127 (Bilora), 93 Chambre Automatique, 93 BESELER (CHARLES) CO. Press camera, 93 Belmira (Belca), 88 Belmira (Welta), 423 Beira (Beier), 87 Beirax (Beier), 87 BELOMÒ Press camera, 93
Bessa (early models) (Voigtländer), 415
Bessa 46 "Baby Bessa" (Voigtländer), 416
Bessa 66 "Baby Bessa" (Voigtländer), 416
Bessa I, II (Voigtländer), 416
Bessa RF (Voigtländer), 416
Bessamatic (Voigtländer), 416
Bessamatic CS (Voigtländer), 416
Bessamatic Deluxe (Voigtländer), 416
Bessamatic M (Voigtländer), 416
Bessamatic M (Voigtländer), 416 Beirette (Beier), 87 Agat 18, 89 Chaika, 89 Beirette II (Beier), 87 Beirette Junior II (Beier), 87 Beirette K (Beier), 87 Beirette VSN (Beier), 87 BELCA-WERK Chaika 2M, 89 Chaika II, III, 89 Estafeta, 89 Vilia, 89 Vilia-Auto (BNANR-ABTO),89 Belfoca (I), 88 Belfoca II, 88 Belplasca (Belca), 88 BELT BUCKLES, 473 Beltica (Belca), 88 Belmira, 88 Belplasca, 88 Beltica, 88 Beltica II, 88 Besta, 93 Besta, 93 Bettax (Zeh), 435 Bébé (Ica), 241 BIAL & FREUND Field Camera, 93 Beltica II (Belca), 88 Ben Akiba (Lehmann), 278 Ben Akiba Replica (Lehmann), 278 BENCINI Belco, 88 Belco (IDAM), 244 Belfoca (I) (Belca), 88 Belfoca II (Belca), 88 Magazine Camera, 93 Akrom I, 89 Plate Camera, 93 BIANCHI Animatic 600, 90 BELL & HOWELL Auto 35/Reflex, 88 Comet 3, III, 90 Comet II, 90 Tropical Stereo Camera, 93 Bicoh 36, 482 Biflex 35, 93 Autoload 340, 88 Autoload 341, 88 Autoload 342, 88 Comet NK 135, 90 Comet S, 90 Big Bird with Butterfly Pencil, 484 Dial 35, 88 Big Shot (Polaroid), 357 Bijou (Anthony), 68 Bijou (Kern), 253 Cometa, 90 Electric Eye 127, 88 Foton, 89 Koroll, 90 Koroll 24, 24 S, 90 Koroll II, 90 Koroll S, 90 Minicomet, 90 Stereo Colorist I, II, 89 Bijou (Voigtländer), 416 Bildmeister Studio Camera (Bermpohl), 91 Stereo Vivid, 89 BELL AND HOWELL BILLCLIFF 200EE, 456 Field Camera, 93 Royalty, 93 Studio Camera, 93 Rolet, 90 220, 456 BENETFINK 240 Electric Eye, 456 Lightning Detective Camera, 90 Lightning Hand Camera, 90 Speedy Detective Camera, 90 Studio Camera, 93
Billette (Agfa), 53
Billy (Agfa), 53
Billy 0 (Agfa), 53
Billy 1 (Agfa), 53
Billy I (Agfa), 53
Billy II (Agfa), 53
Billy III (Agfa), 53
Billy Ompur (Agfa), 53
Billy Optima (Agfa), 53
Billy Record 4.5, 6.3, 7.7, 8.8 (Agfa), 53
Billy Record I, II (Agfa), 53
Billy-Clack (Agfa), 53 240A, 456 252, 456 319, 456 Benjamin Camera (Anker), 472 BENSON DRY PLATE & CAMERA CO. Bell & Howell Cine Camera, 454 Eyemo 35mm Motion Picture, 455 Filmo 121-A, 455 Filmo 127-A, 455 Filmo 141-A, 141-B, 455 Filmo 70, 455 Filmo 70AC, 455 Filmo 70AC, 455 Filmo 70C, 455 Street camera, 90 Victor, 90 Bentley BX-3, 90 BENTZIN Folding Focal Plane Camera, 90 Landschaftskamera,91 Planovista, 90 Billy-Clack (Agfa), 53 BILORA Primar (Plan Primar), 91 Filmo 70C, 455 Filmo 70D, 455 Primar Klapp Reflex, 91 Primar Reflex, 91 Bella (4x6.5 cm), 93 Bella 35, 93 Bella 44, 93 Bella 46, 93 Bella 66, 93 Filmo 70DL, 455 Filmo 70DR, 70HR, 455 Primarette, 91 Primarflex, 91 Filmo 70G, 455 Filmo 70J, 455 Filmo 70SR, 455 Primarflex II, 91 Rechteck Primar, 91 Stereo Reflex Primar, 91 Bella D, 93 Filmo 75, 455 Bellaluxa 4/4, 93 Bellina 127, 93 Stereo-FokalPrimar, 91 Filmo 75 A-5, 455 Bera (KIEV Kiev-Vega), 255 Bergheil (Voigtländer), 415 Bergheil Deluxe (Voigtländer), 415 Filmo Aristocrat Turret 8, 455 Blitz Box, 93 Blitz Boy, 93 Bonita 66, 93 Filmo Auto Load, 455 Filmo Auto Load Speedster, 455 BERMPOHL& CO.

Bermpohl's Naturfarbenkamera,91 Filmo Auto Master, 455
Filmo Companion, 455
Filmo Sportster (Double Run Eight), 455
Filmo Turret Double Run 8, 455 Box Cameras, 93 Boy, 94 Cariphot, 94 Bildmeister Studio Camera, 91 Miethe/BermpohlCamera, 91 BERNARDPRODUCTS Mikro-Box outfit, 94 Magazine 200, 455 Quelle Box, 94 Faultless Miniature, 91 Magazine Camera-172,455

Radix, 94 Stahl Box, 94 Standard Box, 94 Bilux (ISO), 249 BING Fita, 94 Bingo No. 2 (Ansco), 63 Bino/Cam 7800 (Tasco), 400 Bino/Cam 8000 (Tasco), 400 Binoca Picture Binocular, 94 Binocular camera (London Stereoscopic). 293 Bioflex, 94
Bioflex (Tokiwa), 403
Bioscope (Caillon), 106
Bioscope (Darling), 457
Birdland (Sanders & Crowhurst), 375
BIRDSEYE CAMERA CORP.
Birdsave Flash Camera 94 Birdseye Flash Camera, 94
Birdseye Flash Camera, 94
BIRMINGHAMPHOTOGRAPHICCO.
Criterion, 94
BIRNBAUM Box, 94 Filmoskop, 94 Perforeta, 94
Super Perforeta, 94
BIRNIE (A.) Field camera, 94 **BISCHOFF** Detective camera, 94 Bislent, 94 BITTNER Roka Luxus, 94
Black Beauty (Seneca), 384
BLAIR CAMERA CO.
Baby Hawk-Eye, 95
Boston Detective Camera, 95
Century Hawk-Eye, 95
Columbus 95 Columbus, 95 CombinationCamera, 95 Combination Camera, 95
English Compact Reversible Back, 95
Focusing Weno Hawk-Eye, 95
Folding '95 Hawk-Eye, 95
Folding Hawk-Eye 5x7, 95
Hawk-Eye Box '95, 96
Hawk-Eye Camera, 95
Hawk-Eye Junior, 96
Improved Reversible Back Camera, 96
Kamaret 96 Kamaret, 96
Lucidograph, 96
No. 2 Weno Hawk-Eye, 96
No. 3 Folding Hawk-Eye, 95
No. 3 Folding Hawk-Eye, 95
No. 3 Folding Hawk-Eye, 95
No. 3 Weno Hawk-Eye, 96
No. 3B Folding Hawk-Eye, 95
No. 4 Folding Hawk-Eye, 95
No. 4 Folding Hawk-Eye, 95
No. 4 Folding Weno Hawk-Eye, 95
No. 4 Weno Hawk-Eye, 96
No. 6 Weno Hawk-Eye, 96
No. 7 Weno Hawk-Eye, 96
Reversible Back Camera, 96
Special Folding Weno Hawk-Eye, 96
Stereo Hawk-Eye, 96
Stereo Weno, 96
Stereo Weno Hawk-Eye, 96
Tourist Hawk-Eye, 96 Kamaret, 96 Stereo Weno Hawk-Eye, 96
Tourist Hawk-Eye, 96
Tourist Hawk-Eye Special, 96
View cameras, 96
Weno Hawk-Eye, 96
BLAND & CO., 96
BLAUPUNKT-WERKE
BlaupunktE-8, 456
Blitz (Adox) 51 Blitz (Adox), 51 Blitz Box (Bilora), 93 Blitz Boy (Bilora), 93 Blitz-Hexi (Hamaphot), 227 Bloc-Metal 41 (Pontiac), 358 Bloc-Metal 45 (Pontiac), 358 **BLOCH**

Photo-BouquinStereoscopique,96

Photo-Cravate, 96 Physio-Pocket, 96 Physiographe(binocular), 97 Physiographe (binocular), 97
Physiographe (monocular), 96
Physiographe Stereo, 97
Block-Notes (Gaumont), 209
Block-Notes Stereo (Gaumont), 209
Blockmaster One-Shot (Eves), 190
BLUE BOX TOY
Click-N-Flick Mini Viewer, 494
Turn N. Click Mini Company (A) Turn-N-Click Mini Camera, 494 Bo-Peep (Manhattan), 299 Bob (510, 510/2) (Zeiss Ikon), 438 Bob (510, 510/2) (Zeiss Ikon), 438
Bob 0 (Ernemann), 184
Bob 00 (Ernemann), 184
Bob II (Ernemann), 184
Bob III (horizontal style) (Ernemann), 184
Bob III (vertical style) (Ernemann), 184
Bob IV (Ernemann), 184
Bob IV (Ernemann), 184 Bob IV (Ernemann), 184 Bob IV, 9x14cm (Ernemann), 185 Bob IV (Zeiss Ikon), 438 Bob V (Ernemann), 185 Bob V (Stereo) (Ernemann), 185 Bob V (Zeiss Ikon), 438 Bob X (Ernemann), 185 Bob XV (Ernemann), 185 Bob XV (Ernemann), 185 Bob XV Stereo (Ernemann), 185 Robby 97 Bob XV Stereo (Ernemann) Bobby, 97 Bobette I (Ernemann), 185 Bobette I (Zeiss Ikon), 438 Bobette II (Ernemann), 185 Bobette II (Zeiss Ikon), 438 BOCHOD, 97 Bolca (Standard) (Pignons), 353 Bolca I (Pignons), 353 Bolex B8, B8L (Paillard), 465 Bolex C8, C8SL (Paillard), 465 Bolex Cinema G8 (Paillard), 466 Bolex D8L (Paillard), 465 Bolex H-16 (Paillard), 465 Bolex H-16 Deluxe (Paillard), 465 Bolex H-16 Leader (Paillard), 465 Bolex H-16 M (Paillard), 465 Bolex H-16 Reflex (Paillard), 465 Bolex H-16 Reliex (Paillard), 465 Bolex H-16 Supreme (Paillard), 466 Bolex H8 (Paillard), 465 Bolex H8 Reflex (Paillard), 465 Bolex H8 Supreme (Paillard), 465 Bolex L8, L8V (Paillard), 465 BOLLES & SMITH Patent Camera Box, 97 BOLSEYCORP Air Force model, 97 Army model, PH324A, 97 Army model, PH324A, Bolsey 8, 98 Bolsey B, 97 Bolsey B2, 97 Bolsey B22, 97 Bolsey B3, 97 Bolsey BB Special, 97 Bolsey C, 97 Bolsey C22, 97 Bolsey G22, 97 Bolsey Reflex, 98 Bolsey Uniset 8, 98 Bolseyflex, 97 Explorer, 98 Jubilee, 98 La Belle Pal, 98 Bolseyflex (Bolsey), 97 BOLTA-WERK Boltavit, 98 Photavit, 98 Boltax I, II, III (Miyagawa), 317 Bonafix (Franka-Werk), 200 Bonita 66 (Bilora), 93 Bonny Six (Yamato), 432 Boo-Boo Bear with camera (Lanco), 497 Book & Camera Salt & Pepper Shakers, 487 Book Camera (Gakken), 206 Book Camera (Scovill), 378 **BOOTS**

BRAUN Norica III

Boots Comet 404-X, 98 Boots Field Camera, 98 Boots Special, 98 BOREUX Nanna 1, 99 BORSUM CAMERA CO. Borsum New Model Reflex, 99 Borsum Reflex, 99 BOSTON CAMERA CO. Hawk-Eye Detective, 99 BOSTON CAMERA MFG. CO. Bull's-Eye box cameras, 99 Boston Detective Camera (Blair), 95 BOUMSELL Azur, 99 Box Metal, 99 Longchamp, 99 Photo-Magic, 99 BOWER Bower 35, 99 Bower - X, 99 Bower (Misuzu), 317 Box (Beier), 87 Box (Birnbaum), 94 Box (Birnbaum), 94 Box (Voigtländer), 416 Box 0 (Beier), 87 Box 24 (Agfa), 53 Box 44 (Agfa), 53 Box 54 (Agfa), 54 Box B-2 (Agfa), 54 Box camera, 100
Box camera (Agfa), 53
Box camera (Ansco), 63
Box camera (Ansco), 68 Box camera (Anthony), 68
Box camera (APM), 71
Box Camera (Bilora), 93
Box camera (Coronet), 126
Box camera (Ferrania), 194
Box camera (Filma), 196 Box camera (Lloyd), 292 Box camera (Lumiere), 294 Box camera (Peerless), 348 Box camera (Peerless), 348
Box camera (Ray), 360
Box Ensign 2-1/4B (Houghton), 235
Box I (Beier), 87
Box II (Beier), 88
Box Kolex (Kolar), 258
Box Metal (Boumsell), 99 Box Metal (Boumsell), 99
Box Tengor (Goerz), 213
Box Tengor (Zeiss Ikkon), 438
Box-Nebro (Nebro), 324
Box-Spezial (Nr 64) (Agfa), 54
Boy (Bilora), 94
Boy Holding Camera (Royal Crown), 493
Boy Photographer& his Girl, 490
Boy Scout Brownie Cam. (Eastman), 143
Boy Scout Kodak Camera (Eastman), 143
Boy with 35mm camera (Goebel), 491 Boy with 35mm camera (Goebel), 491 Boy with view camera (Hummel style), 490 Boyer, 100 BRACK & CO. Field camera, 100 **BRADAC** Kamarad (I), 100 Kamarad MII, 100 Bramham (Gaumont), 209
BRAND CAMERA CO.
Brand Press View (Brand 17), 100 Brass Bound Instantograph (Lancaster), BRAUN AMC M235, 100 Gloria, 100 Gloriette, 100 Imperial 6x6, 100 Imperial Box 6x6, 6x9, 100 Luxa six, 100 Nimco, 100 Norca, 100 Norica I, 100 Norica II, 100 Norica II Super, 100 Norica III, 100

BRAUN Norica IV

Pax, 100 Paxette, 101 Paxette Automatic Super III, 101 Paxette Electromatic, 101 Paxette I, Ib, 101 Paxette IIM, 101 Paxette Reflex, 101 Paxette Reflex Automatic, 101 Paxette Reflex lb, 101 Paxette Reliex ID, 101
Paxiflash, 101
Paxina I, II, 101
Reporter, 101
Super Colorette, 101
Super Paxette, 101
Super Paxette II, IB, IL, 101
Super Paxette II, IIB, IIBL, IIL, 101
Super Vier, 101 Super Vier, 101 Briefmarken Camera (Ica), 241 Bright Star, 494 Brillant (Voigtländer), 416 Brin's Patent Camera, 101 BRINKERT Efbe, 101 Brinox (Knoedler), 257 BRIOIS Thompson's Revolver Camera, 101 BRISKIN MFG. CO. Briskin 8, 456 British (Chapman), 118 British Ensign (Beck), 86 British Ensign (Houghton), 235 BRITISH FERROTYPECO. Telephot Button Camera, 102 Bronica C, C2 (Zenza), 450 Bronica D (Deluxe) (Zenza), 450 Bronica EC (Zenza), 450 Bronica EC-TL (Zenza), 450 Bronica ETR (Zenza), 451 Bronica ETRS (Zenza), 451 Bronica ETRS (Zenza), 451 Bronica ETRSi (Zenza), 451 BRONICA LENSES (Zenza), 451 Bronica S (Zenza), 450 Bronica S2 (Zenza), 450 Bronica S2A (Zenza), 450 Bronica SQ (Zenza), 451 Brooch camera (Mazur), 302 **BROOKLYNCAMERACO** Brooklyn Camera, 102 Brooks Veriwide (Burleigh Brooks), 103 BROWN & BIGELOW Kodak Film, 474 BROWNELL Stereo Camera, 102 Brownie 127 (1965 type) (Eastman), 144 Brownie 127 Camera (Eastman), 144 Brownie 44A, 44B (Eastman), 144 Brownie 620 (Eastman), 144 Brownie Auto 27 Camera (Eastman), 144 BROWNIE BAKING CO. Brownie Figurine, 490 Brownie Bull's-Eye Cam. (Eastman), 145 Brownie Bullet Camera (Eastman), 145 Brownie Bullet II Camera (Eastman), 145
Brownie Bullet II Camera (Eastman), 145
Brownie Camera original (Eastman), 143
Brownie Camera (1900) (Eastman), 143
Brownie Camera (1980) (Eastman), 143
Brownie Chiquita Camera (Eastman), 145 Brownie Cresta (Eastman), 145 Brownie Cresta II (Eastman), 145 Brownie Cresta III (Eastman), 145 Brownie Fiesta Camera (Eastman), 145 Brownie Flash 20 Camera (Eastman), 145 Brownie Flash B (Eastman), 146 Brownie Flash Camera (Eastman), 145 Brownie Flash II (Eastman), 145 Brownie Flash III (Eastman), 145 Brownie Flash IV (Eastman), 145 Brownie Flash Six-20 Camera (Eastman), 146, 148

Brownie Flashmite 20 Camera (Eastman),

146

Brownie Fun Saver (Eastman), 458 Brownie Hawkeye Camera (Eastman), 147 Brownie Holding a Brownie, 490 Brownie Holiday Camera (Eastman), 147 Brownie Junior 620 Cam. (Eastman), 147 Brownie Model I (Eastman), 147 Brownie Movie Cameras (Éastman), 458 Brownie Pliant Six-20 (Eastman), 147 Brownie Reflex 20 Camera (Eastman), 147 Brownie Reflex Camera (Eastman), 147 Brownie Six-20 Models C,D,E (Eastman), 147 Brownie Six-20 Model F (Eastman), 148 Brownie Starflash Camera (Eastman), 148 Brownie Starflash Coca-Cola (Eastman), Brownie Starflex Camera (Eastman), 149 Brownie Starlet Camera (Eastman), 149 Brownie Starluxe (Eastman), 149 Brownie Starluxe 4 (Eastman), 149 Brownie Starluxe II (Eastman), 149 Brownie Starmatic Camera (Eastman), 149 Brownie Starmeter Cam. (Eastman), 149 Brownie Starmite Camera (Eastman), 149 Brownie Super 27 (Eastman), 149 Brownie Target Camera (Eastman), 149 Brownie Turret Exposure Meter Model (Eastman), 458 Brownie Twin 20 Camera (Eastman), 150 Brownie Vecta (Eastman), 150 BRUMBERGER 8mm-E3L, T3L, 456 Brumberger 35, 102 **BRUNS** Detective camera, 102 BRÜCKNER Field camera, 102 Schüler-Apparat(Student camera), 102 Union Model III, 102 Buccaneer (Universal), 409 Buckeye (American Camera), 61 Buckeye (Anthony), 68 Buckeye (Cardinal Corp.), 114 Buckeye Camera (Eastman), 150 Buckeye Special (American Camera), 61 Buddie 2A (Sterling Camera), 394 Buddy 8 (Stewart-Warner), 468 Buena 35-S (Tougodo), 405 BUESS Multiprint, 102 Bugs Bunny (Helm), 231 Buick Model 1, 102 BULL Detective, 102 Bull's-Eye box cameras (Boston), 99 Bull's-Eye Cameras (Eastman), 150
Bull's-Eye Special Camera (Eastman), 150
BULLARDCAMERA CO. Folding Magazine Camera, 102 Folding plate camera, 102 Bullet Camera (Eastman), 150 Bullet Camera (plastic) (Eastman), 150 Bullet Camera, New York World's Fair (Eastman), 150 Bullet Special Camera (Eastman), 150 BULLY Tintin Figurine, 490 Bunny (Vredeborch), 420 BURGERKING Girl Photographerin Car, 494 BURKE & JAMES Columbia 35, 102 Cub, 102 Grover, 103 Ingento, 103 Korelle, 103 No. 1A Folding Rexo, 103 No. 1A Ingento Jr., 103 No. 1A Rexo Jr., 103 No. 2C Rexo Jr., 103 No. 3 Folding Rexo, 103 No. 3 Rexo Jr., 103 No. 3A Folding Ingento, 103

No. 3A Folding Rexo, 103 No. 3A Ingento Jr., 103 Panoram 120, 103 PH-6-A, 103 Press/View cameras, 103 Rembrandt Portrait Camera, 103 Rexo Box, 103 Rexoette No. 2, 103 Vest Pocket Rexo, 103 Watson Press, 103
Watson-HolmesFingerprintCamera, 103
BURLEIGHBROOKSINC. Bee Bee, 103 Brooks Veriwide, 103 **BURR** Stereo camera, 103 Wet plate camera, 103 BURTON MFG. CO. Clinicamera, 103 BUSCH (Emil) Ageb, 104 Folding plate camera, 103, 104 Folding rollfilm cameras, 104 Freewheel, 103 Heda, 104 Stereo Beecam, 104 Stereo Reflex, 104 Vier-Sechs, 104 BUSCH CAMERA CORP. Pressman, 104 Verascope F-40, 104 Buster Brown (Ansco), 63 Buster Brown Junior (Ansco), 64 Buster Brown Special Nos. O, 2, 2A (Ansco), 63 Busy Bee (Seneca), 384 Busy Camera (Playskool), 496 BUTCHER Cameo, 104 Cameo Stereo, 104 Carbine cameras, 104 Clincher, 104 Coronet, 104 Dandycam Automatic Camera, 104 Klimax, 104 Little Nipper, 105 Maxim, 105 Midg, 105 National, 105 Pilot No. 2, 105 Pom-Pom No. 3, 105 Popular Carbine, 105 Popular Pressman, 105 Primus, 105 Primus So-Li-To, 105 Reflex Carbine, 105 Royal Mail Postage Stamp Camera, 105 Stereolette, 105 Tropical Watch Pocket Carbine, 106 Watch Pocket Carbine, 106 Watch Pocket Klimax, 106 BUTCHERAND SONS Empire 35mm Motion Picture, 456 BUTLER Universal, 106 BUTLER (E.T.) Patent Three-Colour Separation, 106 BUTLER BROS. Pennant Camera No. 20, 106 BUTTERFLYORIGINALS LTD Cabbage Patch Kids Figurine Stamper, 487 Button tintype camera (Mountford), 320 BÜLTER & STAMMER Folding camera, 102 C Daylight Kodak Camera (Eastman), 152 C Ordinary Kodak Camera (Eastman), 163 C.M.C., 121 C.M.F

Argo, 121

Delta, 121

Eno, 121

CARDINAL

Gabri, 121 Robi, 121 C.O.M.I. Luxia, Luxia II, 122 C35 (Hanimex), 228 C30 (Talliflex), 220 C60 (Closter), 121 Cabbage Patch Kids 110 (Playtime), 356 Cabbage Patch Kids Figurine Stamper (Butterfly), 487 Cabbage Patch Kids Musical Toy (Illco), Cadet, 106 Cadet, 106
Cadet (Coronet), 126
Cadet (I) (Ansco), 64
Cadet A-8 (Agfa-Ansco), 57
Cadet B-2 (Agfa-Ansco), 57
Cadet B-2 (Ansco), 64
Cadet B-2 Texas Centennial (Agfa-Ansco), Cadet D-6 (Agfa-Ansco), 58 Cadet D-6 (Ansco), 64 Cadet Flash (Ansco), 64 Cadet II, Cadet III (Ansco), 64 Cadet Reflex (Ansco), 64 CADOT ScenographePanoramique, 106 Cady (Alsaphot), 60 CAILLON Bioscope, 106 Kaloscope, 106 Megascope, 106 Scopea, 106 Caleb (Demaria), 135 CALUMETMFG. CO. Calumet 4x5 View, 106 Calypso (Spirotechnique), 392 Cam-O (United States Cam-O), 408 CAM-O CORP. Ident, 106 Camara Siena, 106 Cambinox (Möller), 317 Cambot Wonderful Slide Robot (Li Ping), 478 478
Cambridge (Marion), 300
Cameflex (Eclair), 460
Camel (Polaroid), 357
Camel Model II (Tohokoken), 403
Camelot (S.J.C. & Co.), 389
Cameo (Butcher), 104
Cameo (Coronet), 126
Cameo Stereo (Butcher), 104 Camera, 106 Camera (Super Excella), 106 Camera Buckles (Lewis), 473 Camera Candle, 473 Camera Cham, 481 Camera City View (Seneca), 384 Camera Coaster Set (Friendly Home Parties), 476
CAMERA CORP. OF AMERICA
Cee-Ay 35, 107
Cine Perfex Double Eight, 456
Perfex DeLuxe, 107
Perfex Eight, 457 Perfex Fifty-Five, 107 Perfex Forty-Four, 107 Perfex One-O-One, 107 Perfex One-O-Two, 107 Perfex One-O-Two, 107
Perfex Speed Candid, 107
Perfex Thirty-Three, 107
Perfex Twenty-Two, 107
Camera Flask (Swank), 479
Camera Kaleidoscope (Playwell), 497
Camera Keychain, 481
Camera Kit Wonderful Camera (Multiple), 321 Camera Kit (Hall & Keane), 484 Camera Laser Gun 3-in-1 (Conwise), 477 CAMERA MAN INC. Champion, 107 President, 107 Silver King, 107 Camera Mask (Spearhead), 482

Camera Note Box (Gibson), 477 Camera Obscura, 107 Camera pencil box (Helix), 484 Camera Picture Frame, 485 Camera Pistol 116 (Chien Hsin), 477 Camera Planter, 485 Camera Planter, 485
CAMERA PROJECTORLTD.
Midas Motion Picture Camera, 456
Camera Salt & Pepper (Sasparilla), 487
Camera Scope (Du All), 498
Camera Sopoter NIKO Nikosound (Taifong), 478
Camera Soap-on-a-rope(Wolff), 487
Camera with Birdie, 483 Camera with birdie (Royal Holland), 484 Camera-Charm/Viewer,498 Camera-Flack,478 Camera-Flack, 478
Camera-lamp (Sasparilla), 482
Camera-Lighter (K.K.W.), 474
Camera-Lite (Suzuki), 397
Camera-Lite Seastar (Suzuki), 397
Camera-Screwdriver-keychain, 487 Camera-Viewer, 498 Camera-ViewerCapri (Vepla-Venezia), Camera-ViewerKey Chain, 498 Cameradio (Universal Radio), 411 Cameragraph(Power), 467 CAMERASLTD. Dekko, 456 Dekko Model 104, 457 Camerette, 107 CAMERONSURGICAL SPECIAL TYCO. Cavicamera, 107
Camex Reflex 8 (Ercsam), 460
Camex Six (Mamiya), 297
Camflex (National Instrument), 323
CAMOJECTLTD. Camp Fire Girls Kodak (Eastman), 151 Camp Out (EFS), 496 CAMPBELL Cello, 457 Camping (Goldstein), 215 CAMPROLTD Campro, 457 Campro Cine Camera-Projector, 457 Camro 28 (Argus), 73 Can Camera 110 TX Coca-Cola (Tizer), 403 Can Cameras (Eiko), 182 Can-Tex (Bellcraft), 89 CANADIAN CAMERA & OPTICAL CO. Gem Glencoe No. 7, 108 Glencoe No. 4, 108
Candex Jr. (General Prod.), 209
Candex Miniature Camera (General Prod.), 209 CANDID CAMERA SUPPLY CO. Minifoto Junior, 108 Candid Camera Target Shot (Lindstrom). 478 Candid Flash Camera (Flash Camera Co.), 197 Candid Shot, 479 CANDLE, 473 CANDY & GUM, 473 Candy Box, 477 CANON Canomatic C-30, 114 Canomatic M70, 114 Canon / NK Hansa, 108 Canon 1950, 110 Canon 7, 7s, 7sZ, 111 Canon A-1, 113 Canon AE-1, AE-1 Program, 113 Canon AT-1, 113 Canon AV-1, 113 Canon EF, 112 Canon Eight-T, 457 Canon EX Auto QL, 112 Canon EX-EE, 112

Canon F-1(N) (or New F-1), 113 Canon F-1(N) 1984 Olympics, 113 Canon F-1n, 112 Canon F-1n 1980 Olympics, 112 Canon F-1n 1980 Oly Canon FP, 112 Canon FT QL, 112 Canon FTb QL, 112 Canon FTbn QL, 112 Canon Hansa, 108 Canon Hansa, 108
Canon IIA, 110
Canon IIAF, 110
Canon IIB, 109
Canon IID1, 110
Canon IID1, 110
Canon IIF, 110
Canon IIF, 110
Canon IIF, 110
Canon IIIA, 110
Canon IIS, 110
Canon IVS, 110
Canon IVF, 110
Canon IVSB2, 110 Canon IVSB2, 110
Canon J, 109
Canon J-II, 109
Canon J-S, 109
Canon L-1, L-2, L-3, 111
Canon NS, 109
Canon P, 111 Canon P, 111
Canon Pellix, Pellix QL, 112
Canon S, 109
Canon S-II, 109
Canon TL QL, TLb QL, 112
Canon TX, 112
Canon VI-L, VI-T, 111
Canon VI, VL-2, 111
Canon VT, 110
Canon VT-Deluxe 111 Canon VT, 110
Canon VT-Deluxe, 111
Canon VT-Deluxe-M, 111
Canon VT-Deluxe-Z, 111
Canonet, 114
Canonet, 457
Canonex, 112 Canonflex, 112 Canonflex, 112
Canonflex R2000, 112
Canonflex RM, RP, 112
Demi, 114
Dial 35, 114
J SERIES, 109
KWANON SERIES, 108 Original Canon, 109
ORIGINAL SERIES (1935-1940), 108
Seiki S-II, 109
SEIKI-KOGAKUCANONS, 108 SEIKI-KOGAKUCANONS, 108
SEIKI-KOGAKUCANONS, 108
Snappy'84, 114
Canon AE-1 Program Lapel Pin, 481
Canon Lighter, 474
Canonet (Canon), 114
Canonet8 (Canon), 457
Canonex (Canon), 112
Canonflex (Canon), 112
Canonflex R2000 (Canon), 112
Canonflex RM, RP (Canon), 112
Cap gun camera (Dah Yang), 477
Capital MX-II, 114
Capri Models (Keystone), 463
Capta, Capta II, (J.M.V.), 250
Capta-Baby (J.M.V.), 250
Captain (Agfa-Ansco), 58
Captain (Coronet), 126
Captain (Wittnauer), 429 Captain (Wittnauer), 429 Carbine cameras (Butcher), 104 Cardinal 120 (Metropolitan), 304 CARDINAL CORP. Buckeye, 114 Cardinal, 114 Cinex, 114 Photo Champ, 114

Canon F-1, 112

CARENA

CARENAS.A. Autocarena, 457 Carena Zoomex, 457 Gevaert Geva 8, 457 Cariphot (Bilora), 94 CARL ZEISS JENA Werra, Werra I, Ic, 114 Werra II, 114 Werra III, 114 Werra IV, 114 Werra Microscope Camera, 114 Werra V, 114 Werramatic, 114 Carl-6 Model II (Kigawa), 255 Carlton (London Stereoscopic), 294 Carlton (Condon Stereoscopic), 294
Carlton (Rochester Optical), 369
Carlton (Utility), 413
Carlton Reflex (Allied Camera Supply), 60
Carlton Reflex (Utility), 411 Carmen, 115 CARPENTIER(Jules) Photo Jumelle, (115)
Cartridge Hawk-Eye Cam. (Eastman), 157
Cartridge Kodak Cameras (Eastman), 151
Cartridge Premo Cameras (Eastman), 165
Casca I, II (Steinheil), 393
CASH BUYERS UNION
Maxim Camera, 145 Maxim Camera, 115 Cast Metal Toy SLR, 483 Cavalier EE Auto 35 (Taron), 399 Cavalier II (K.W.), 272 Cavalier/CameraA-1, 477 Cavicamera (Cameron), 107 CBC, 115 Ce-Nei-Fix (Neithold), 324 Ce-Nei-Fix (Neithold), 324
Cecil Camera, 115
Cee-Ay 35 (Camera Corp. of Amer.), 107
Cello (Campbell), 457
Century 35 (Graflex), 223
CENTURY CAMERA CO.
Copying/Enlarging/Reducing,115
Field camera, 115
Grand, Grand Sr., 115
Long Focus Grand, 115
Petite 115 Petite, 115
Stereo Model 46, 115
Studio camera, 115
Century Graphic (Graflex), 221 Century Hawk-Eye (Blair), 95 Century of Progress
World's Fair Souvenir (Eastman), 151 Century of Progress (Ansco), 64 Century of Progress Norton (Norton), 336 Century Universal (Graflex), 223 Century Universal Camera (Eastman), 151 Ceramic Mug (Enesco), 480 CERTEX S.A. Digna, 116 Indiana Jones Camara Safari, 116 Werlisa, 116 **CERTO** Certi, 116 Certix, 116 Certo Six, 116 Certo-phot, 116 Certolob XI, 116 Certonet, 116 Certonet XIV, 116 Certonet XV Luxus, 116 Certoplat, 116 Certoruf, 116 Certoruhm, 116 Certosport, 116 Certotix, 116 Certotrop, 116 Damen-Kamera,116 Dollina, 116 Dollina "0", 117 Dollina I, II, III, 117 Dolly 3x4 (miniature), 117 Dolly Vest Pocket, 117 Doppel Box, 117 Durata, 117

Kafota, 117 KN35, 117 Plate camera, 117 Super 35, 117 Super Dollina, II, 117 Supersport Dolly, 117 Certo-phot (Certo), 116 Certolob XI (Certo), 116 Certonet (Certo), 116 Certonet XIV (Certo), 116 Certonet XV Luxus (Certo), 116 Certonet XV Luxus (Certo), 116
Certoplat (Certo), 116
Certoruf (Certo), 116
Certoruhm (Certo), 116
Certosport (Certo), 116
Certotix (Certo), 116
Certotix (Certo), 116
Certotrop (Certo), 116
Cewes-Film-Klapp(Süddeutsches), 395
CHADWICK (W.I.) Hand Camera, 118 Stereo Camera, 118 Tailboard camera, 118 CHADWICK-MILLER Fun-Face Camera, 118 Chaika (Belomo), 89
Chaika 2M (Belomo), 89
Chaika II, III (Belomo), 89
Challenge (Adams), 50
Challenge (Lizars), 292
Challenge Dayspool (Lizars), 292
Challenge Dayspool Stereoscopic Tropical Challenge Dayspool Tropical (Lizars), 292 Challenge Junior Dayspool (Lizars), 292 Challenge Magazine Camera (Lizars), 292 Challenge Stereo Camera (Lizars), 292 Challenger (S.E.M.), 383 Challenger (Wittnauer), 429 Chambre Automatique (Bertsch), 93 Chambre Automatique (Bertsch Chambre de Voyage, 118 Champagne Glass, 480 Champion (Anthony), 68 Champion (Camera Man), 107 Champion II, 118 Change-A-Toy(Shelcore), 478 CHAPMAN(J.T.) Forward Siderigger Camera, 118
Millers Patent Detective "The British", 118 Stereoscopic Field Camera, 118 The British, 118 Charlie Tuna (Whitehouse), 426 Charmy, 118 CHARTERKINGLTD Wipe-out, 488 Chase, 118 CHASE MAGAZINE CAMERA CO. Chase Magazine Camera, 118 Chatter-Pal (Mattel), 495 Chautauqua (Seneca), 384 Cheese Dish, 480 CHEVALIER (Charles), 118 Chevron Camera (Eastman), 151 Chic (Taron), 400 CHICAGO CAMERA CO. Photake, 118 CHICAGO FERROTYPECO. Mandel No. 2 Post Card Machine, 118 Mandelette, 118 Wonder Automatic Cannon, 118 Chief (Agfa-Ansco), 58 Chief 1A (Seneca), 384 CHIEN HSIN PLASTIC Camera Pistol 116, 477 CHILD GUIDANCE PLAYTHINGS
Hello Kitty 3-D Camera, 498
Sesame Street Big Bird's 3-D Camera, CHILD GUIDANCE PRODUCTS Mick-A-Matic, 119
Chiyoca 35 (I) (Chiyoda), 119
Chiyoca 35-IF (Chiyoda), 119
Chiyoca Model IIF (Chiyoda), 119
CHIYODA CAMERA CO., 119

CHIYODA KOGAKU SEIKO CO. Konan-16Automat, 119 Minolta, 119 **CHIYODA SHOKAI** Chiyoca 35 (I), 119 Chiyoca 35-IF, 119 Chiyoca Model IIF, 119 Chiyoko, 119
Chiyotax Model IIIF, 119
CHIYOTAX CAMERA CO., 119
Chocolate Camera (Akutagawa), 473
CHRISLIN PHOTO INDUSTRY CHRISLIN PHOTO INDUSTRY
Chrislin Insta Camera, 119
Chrome Six I, II, III (Olympus), 338
Chrome Six IV (Olympus), 339
Chrome Six RII (Olympus), 339
Chrome Six V (Olympus), 339
CHRONIK BROS. MFG. Chronik Bros. 35mm Motion Picture, 457 CHUO PHOTO SUPPLY Harmony, 119 Churchie's Official Spy Camera, 119 Churchill (Monarch), 318 Cia Stereo, 119 CIGARETTELIGHTERS, 474 **CIMA KG** Cima 44, Cima 44 S, 119 Luxette, Luxette S, 119 CINCINNATICLOCK AND INSTRUMENT Cincklox, Model 3-S, 457
Cine Ansco (Ansco), 454
Cine Kodak 8 (Eastman), 459
Cine Kodak Magazine 16 (Eastman), 459
Cine Kodak Model BB, Model BB Junior (Eastman), 459 (Eastman), 459
Cine Kodak Model E (Eastman), 459
Cine Kodak Model K (Eastman), 459
Cine Kodak Model M (Eastman), 459
Cine Nizo 8E (Nizo), 465
Cine Nizo 9-1/2 (Nizo), 465
Cine Nizo 16B, 16L (Nizo), 465
Cine Perfex Double Eight (Camera Corp. of America), 456 Cine Vero (Kyoto), 275 Cine-Geyer AK26 (Geyer), 462 Cine-Geyer AK26 (Geyer), 462
Cine-Kodak (Eastman), 458
Cine-Kodak K-100 (Eastman), 459
Cine-Kodak Magazine 8 (Eastman), 459
Cine-Kodak Model B (Eastman), 459
Cine-Kodak Reliant (Eastman), 459
Cine-Kodak Royal (Eastman), 459
Cine-Kodak Special, II (Eastman), 459
Cine-Simplex (Wittnauer), 470
Cinemax 85E (Uriu Seiki), 469
CINESCOPIE
Cinescopic, 119 Cinescopic, 119 Cinescopic, 119
Photoscopic, 119
Cinex (Cardinal Corp.), 114
Cinex (Imperial), 247
Cinex (Spartus), 391
Cinex Candid Camera (Craftsman), 129
Cinex Candid Camera (King Sales), 256 Cinex Deluxe, 119 Cinklox (Cincinnati Clock), 457 Cinoscope (Industrial Syndicate), 462 Cinoscope (Industrial Syndicate), 462
Cipiere Paperweight, 484
Cirkut Cameras/ Outfits (Eastman), 151
Ciro 35 (Graflex), 223
CIRO CAMERAS
Ciro 35, 120
Ciroflex, 120
Ciroflex (Ciro), 120
Citation (Deiur-Amsco), 458 Citation (Dejur-Amsco), 458 Citex, 120 Citoklapp (Rodenstock), 371 Citohette (Rodenstock), 371 Citoskop (Zeiss Ikon), 438 Citoskop Stereo (Contessa), 124 CITY SALE & EXCHANGE Ancam, 120 Field camera, 120 Planex, 120 Salex Reflex, 120

Salex Tropical Reflex, 120 Triple Diamond, 120 CIVICA INDUSTRIES
Civica PG-1, 120
Clack (Agfa), 54
Clack I (Rietzschel), 363
Clack Luxus (Rietzschel), 363 Clarissa (Lorenz), 294 Clarissa Nacht-Kamera (Graefe & Bardorf), 217 Clarovid, Clarovid II (Rodenstock), 371 Clartex 6/6 (Olbia), 337 CLARUS CAMERA MFG. CO. MS-35, 120 Classic 35, 120 Classic 35 (Craftsmen's Guild), 129 Classic 35 IV (Fujita), 206 Classic II, 120 Classic III, 120 Classic IV, 121 Clic (IDAM), 244 Click (rapid cassette) (Agfa), 54 Click (Tapid cassette) (Agfa), 54
Click (Tougodo), 405
Click I (Agfa), 54
Click II (Agfa), 54
Click-N-Flick Mini Viewer (Blue Box), 494
Click-I Jigsaw Puzzle (Warren), 486
Clicker Bear (Shelcore), 496 Clicker Bear (Shelcore), 496
Clickit Sports (Destech), 136
Clifton (Anthony), 68
Climax Detective (Anthony), 68
Climax Enlarging Cameras (Anthony), 68
Climax Imperial (Anthony), 69
Climax Portrait Camera (Anthony), 69
Clinicamera (Burton), 104
Clinicamera (Burton), 103 Clincher (Butcher), 104
Clinicamera (Burton), 103
Clipper (Ansco), 64
Clipper (Coronet), 126
Clipper PD-16 (Agfa-Ansco), 58
Clipper Special (Agfa-Ansco), 58
Clipper Special (Ansco), 64
Clix 120 (Metropolitan), 304
Clix 120 Elite (Metropolitan), 304
Clix Deluxe (Metropolitan), 304
Clix Miniature (Metropolitan), 304
Clix Miniature (Metropolitan), 304
Clix Miniature Camera (General Page 1988) Clix Miniature Camera (General Prod.), Clix-Master (Metropolitan), 304 Clix-O-Flex (Metropolitan), 304 Clix-Supreme (Metropolitan), 304 CLOCK, 475 CLOSE & CONE Quad, 121 Close Focus Camera (Kugler), 266 CLOSTER C60, 121 Closter IIa, 121 Olympic, 121 Princess, 121 Sport, 121 Sprint, 121 Clown Camera (Kiddie Camera), 254 Clown Girl (Kiddie Camera), 254 Clown Photographer (Ron, 493 Clown with View Camera, 483 Club (Adams), 50 COASTERS, 476 Coat Pocket Tenax (Goerz), 214 Cocarette (Contessa), 124 Cocarette (Zeiss Ikon), 438 Cocarette Luxus (Contessa), 124 Cocarette Luxus (Zeiss Ikon), 438 Coco (Linhof), 464 Cohen, 488 Colibri, 121 Colibri, 485 Colibri (Tischler), 402 Colibri II, 121 Colis Postal (Enjalbert), 183

Collapsible camera (Horne & Thornthwaite), 234

College (Thornton-Pickard), 400 Collegiate Camera No. 3, 121 COLLINS (C.G.) The Society, 121 Colly (Tougodo), 405 Colonel (National Instrument), 323 Colorei (National Institution), 323 Color Clipper, Flash Clipper (Ansco), 64 Color-flex (Monroe Sales), 319 Colora (Zeiss Ikon), 438 Colora F (Zeiss Ikon), 439 Colorado (S.E.M.), 383 Colorburst (Eastman), 151 Coloreta (Optikotechna), 345 Colorflash Deluxe, 121 Colorflex I, II (Agfa), 54 Colorsnap 35 (Eastman), 152 Colt 44 (Agilux), 59
Colt 44 (Kalimar), 251
Columbia 35 (Burke & James), 102
COLUMBIA OPTICAL & CAMERA CO. Pecto, 121-122 Columbus (Blair), 95 Combat Graphic (Graflex), 221
CombinationCamera (Blair), 95
Combined 1/4-plate, Postcard, Stereo,
Plate & Rollfilm Camera (Ernemann), 185
Comet (Bencini), 90 Comet (Zenith), 450 Comet 3, III (Bencini), 90 Comet II (Bencini), 90 Comet Flash (Zenith), 450 Comet NK 135 (Bencini), 90 Comet S (Bencini), 90 Comet Special Camera, 488 Commercial Camera, 400
Cometa (Bencini), 90
Comex (Fuji), 205
Commander(Ansco), 64
Commander2 (Coronet), 127
Commercial Cameras (Deardorff), 134 Commercial View (Ansco), 64 COMMONWEALTHPLASTICS CORP. Jack-in-the Camera Sr., 482 Comodor 127 (Indo), 248 Compact (Pearsall), 347 Compact 126 XR (Indo), 248 Compact Camera (Anthony), 69 Compact D.E. Cycle Montauk (Gennert). Compact Graflex (Graflex), 219 COMPACTS & VANITIES, 476 Compact, Change Purse, Cigarette Case, COMPAGNIEFRANCAISEDE PHOTOGRAPHIE Photosphere, 122 Photosphere, 122
Compakit (Wadsworth), 476
Companion (Mason), 301
Companion (Mayfield), 302
Companion8 (Stewart-Warner), 468
CompanionReflex (Kuh), 266
Compañera (Eastman), 152
COMPASS CAMERAS LTD. Compass Camera, 122 Compco Miraflex & Reflex cameras, 122 Compendica, 457 Competitor View (Seneca), 384 Competitor View Stereo (Seneca), 384 COMWISE INDUSTRY CO. Camera Laser Gun 3-in-1, 477 CONCAVAS.A. Tessina, 122 Watch, 122 Concealed Vest Camera, (Stirn), 394 Condor (Newmann & Heilemann), 325 Condor I (Galileo), 207 Condor I, Ic (Ferrania), 194 Condor Junior (Ferrania), 194 Condor Luxus (Rietzschel), 363 Condoretta (Ferrania), 194 Cone Pocket Kodak (Eastman), 152 Conica (Kato Kogei), 473 CONLEY CAMERA CO.

CONTESSA Nettix

Conley Junior, 122 Folding Kewpie Camera, 122 Folding Plate Camera, 122 Folding Rollfilm Camera, 122 Kewpie, 123 Long Focus Revolving Back Conley, 123 Magazine Camera, 123 No. 2 Kewpie, 123 No. 2A Kewpie, 123 No. 2C Kewpie, 123 No. 3 Kewpie, 123 No. 3A Kewpie, 123 Panoramic Camera, 123 Shamrock Folding, 123 Snap No. 2, 123 Stereo box camera, 123 Stereo Magazine camera, 123 Stereoscopic Professional, 123 Truphoto No. 2, 123 View Camera, 122 Consul (Coronet), 127 Consul (Pentacon), 348 Cont-Lite Table Lighter, 474 Contaflex (Zeiss Ikon), 439 Contaflex (Zeiss Ikon), 439
Contaflex I (Zeiss Ikon), 439
Contaflex II (Zeiss Ikon), 439
Contaflex III (Zeiss Ikon), 439
Contaflex IV (Zeiss Ikon), 439
Contaflex 126 (Zeiss Ikon), 439
Contaflex Alpha (Zeiss Ikon), 439
Contaflex Perima (Zeiss Ikon), 439 Contaflex Prima (Zeiss Ikon), 439 Contaflex Rapid (Zeiss Ikon), 439 Contaflex S Automatic (Zeiss Ikon), 439 Contaflex Super (Zeiss Ikon), 439 Contaflex Super B (Zeiss Ikon), 439 Contaflex Super BC (Zeiss Ikon), 439 CONTAINERS,477 Contarex "Bullseye" (Zeiss Ikon), 439 Contarex Cameras (Zeiss Ikon), 439 Contarex Electronic (Zeiss Ikon), 440 Contarex Hologon (Zeiss Ikon), 440 Contarex Lenses (Zeiss Ikon), 440 Contarex Microscope (Zeiss Ikon), 440 Contarex Professional (Zeiss Ikon), 440 Contarex Special (Zeiss Ikon), 440 Contarex Super (Zeiss Ikon), 440 Contax (Zeiss Ikon), 441 Contax I (Zeiss Ikon), 440 Contax II, II(a) (Zeiss Ikon), 441 Contax III, III(a) (Zeiss Ikon), 441 Contax D (Pentacon), 348 Contax D (Zeiss Ikon), 441 Contax E (Pentacon), 348 Contax F (Pentacon), 348 Contax F (Pentacon), 348 Contax F (Zeiss Ikon), 441 Contax F (Zeiss Ikon), 441
Contax FB (Pentacon), 348
Contax FM (Pentacon), 348
Contax Lenses (Zeiss Ikon), 441
Contax "No-Name" (Zeiss Ikon), 441
Contax Rifle (Zeiss Ikon), 441
Contax S (Pentacon), 441 Contax S (Pentacon), 348 Contax S (Zeiss Ikon), 441 Contax Series (Zeiss Ikon), 440 CONTESSA Adoro, 123 Alino, 123 Altura, 123 Argus, 124 Citoskop Stereo, 124 Cocarette, 124 Cocarette Luxus, 124 Deckrullo (Tropical model), 124
Deckrullo Stereo (Tropical), 124
Deckrullo-Nettel, 124
Deckrullo-Nettel Stereo, 124 Donata, 124 Duchessa, 124 Duchessa Stereo, 124 Duroll, 124 Ergo, 124 Miroflex, 124 Nettix, 124

CONTESSA Onito

Onito, 124 Piccolette, 124 Piccolette Luxus, 124 Pixie, 124 Recto, 124 Sonnar, 125 Sonnet, 125 Sonnet Tropical, 125 Stereax, 125 Steroco, 125 Suevia, 125 Taxo, 125 Tessco, 125 Tropical Adoro, 123 Tropical model plate cameras, 125 Tropical model plate cameras, 12 Contessa (Drexler & Nagel), 137 Contessa LBE (Zeiss Ikon), 442 Contessa LKE (Zeiss Ikon), 442 Contessa S-310 (Zeiss Ikon), 442 Contessa S-312 (Zeiss Ikon), 442 Contessa S-3 IU (Zeiss Ikon), 442
Contessa Series (Zeiss Ikon), 441
Contessa-35 (Zeiss Ikon), 441
Contessamat (Zeiss Ikon), 441
Contessamat SBE (Zeiss Ikon), 442
Contessamat SE (Zeiss Ikon), 442
Contessamat STE (Zeiss Ikon), 442
Contessamat C(Zeiss Ikon), 442
Contessamatic (Zeiss Ikon), 442
Contessamatic (Zeiss Ikon), 442
Contina (Zeiss Ikon), 442
Contina (Zeiss Ikon), 442
Contina II, Ia (Zeiss Ikon), 442
Contina III (Zeiss Ikon), 442
Continental (Wittnauer), 429
CONTINENTAL CAMERA CO.
Insta-Load I, II, 125 Insta-Load I, II, 125 Insta-Load1, II, 125
Continental Camera-Lighter,474
Continente (10.0625) (Zeiss Ikon), 442
Contura (Stereo Corporation), 394
CONVERTORS,477
Conway Camera (Coronet), 127
Conway Camera (Standard), 393
Conway Super Flash (Coronet), 127
CONY INDUSTRIES CORP.
Triples BCR-111, 125 Triplon BCR-111, 125 Cookie Flex, 480 COPALCO Asanuma Clock, 475 Copy Stand (Franke & Heidecke), 201 Copying/EnlargingCamera (Century), 115 Coquette Camera (Eastman), 152 CORD CORD
Cord Box 6x9, 125
CORFIELD(K.G.)
Corfield 66, 125
Periflex, 125
Periflex (1), 125
Periflex 2, 125
Periflex 3, 3a, 3b, 125
Periflex Bold Star, 125
Periflex Interplan, 125 Periflex Interplan, 125 Corina (Druopta), 138 Cornex Model A (Beck), 86 CORNU CO. Fama, 125 Ontobloc, 125 Ontoflex, 126 Ontoscope, 126 Ontoscope 3D, 126 Reyna Cross III, 126 Reyna II, 126 Week-End Bob, 126 Corona (K.S.K.), 266 CORONET Coronet, Models A, B, C, 457 Coronet (Butcher), 104 Coronet (Houghton), 235 CORONET CAMERA CO 3-D Stereo Camera, 128 Ajax, 126 Ambassador, 126

Box cameras, 126 Cadet, 126 Cadet, 126 Cameo, 126 Captain, 126 Clipper, 126 Commander2, 127 Consul, 127 Conway Camera, 127 Conway Super Flash, 127 Coronet 66, 127 Coronet Camera, 127 Coronet Camera, 127 Cub, 127 Cub Flash, 127 Dynamic 12, 127 Eclair Box, 127 Eclair Lux, 127 F-20 Coro-Flash, 128 Fildia, 128 Flashmaster, 128 Folding Rollfilm Camera, 128 Midget, 128 Plate box camera, 128 Polo, 128 Rapide, 128 Rapide, 128 Rapier, 128 Rex, 128 Rex Flash, 128 Twelve-20, 128 Victor, 128 Viscount, 128 Vogue, 129 Correspondent(Dallmeyer), 132 Correspondent (Dailmeyer), Corrida (Ica), 241 Corsair I, II (Universal), 409 Cosmic, 129 Cosmic-35 (GOMZ), 216 COSMO CAMERA CO. Cosmo 35, 129 Micronta 35, 129 Micronta 35, 129
Cosmoflex (Alfa Optical Co.), 60
Cosmograph (Maggard-Bradley),464
Cosmopolite (Français), 200
Cosmos (Negretti), 324
COUFFIN (Pierre)
Malik Reflex, 129
Countdown90 (Polaroid), 357
Countdown90 (Polaroid), 357 Countess (London & Paris), 293 Courier Model V (Harbers), 228 Courier Model V (Harbers), 226 Cowboy Photographer (Shady Tree Creations), 493 Cowi (Widmer), 427 CRAFTEX PRODUCTS Hollywood Reflex, 129 Craftsman (Ilford), 247 Craftsman Kit (Ansco), 64 CRAFTSMANSALES CO. Cinex Candid Camera, 129 CRAFTSMEN'SGUILD Classic 35, 129 Crazy Camera (Fisher Price), 494 Crest-Flex, 129 CRESTLINE Empire-Baby, 129
Criterion (Appleton), 71
Criterion (Birmingham), 94
Criterion View (Gundlach), 224
Croma Color 16, 129 Crown Camera, 129 CROWN CAMERA CO. Dandy Photo Camera, 129 Crown Graphic Special (Graflex), 221 Crown View (Graflex), 223 CRUISER CAMERA CO. Cruiser, 129 CRUVER-PETERSCO. Palko camera, 129 Crystar, 129
CRYSTAR OPTICAL CO.
Crystar 15, 130
Crystar 25, 130
Crystar 35-S, 130
Crystarflex, 130
Cister 120 Sister, 130

Crystarflex (Crystar), 130 Cub (American Adv. & Research), 61 Cub (Burke & James), 102 Cub (Burke & James), 102
Cub (Coronet), 127
Cub Flash (Coronet), 127
Cubex IV (Imperial), 247
Cupido (Hüttig), 239
Cupido (Ica), 241
Curlew I, II,III (Kershaw), 253
CURTIS Curtis Color Master, 130 Curtis Color Scout, 130 CUSSONS & CO. Tailboard camera, 130 Cyclographeà foyer fixe (Damoizeau), 132 Cyclone, 130
Cyclone Cameras (Rochester Optical), 369 Cyclone Junior (Rochester Optical), 369 Cyclone Jr. (Western), 425 Cyclone Senior (Rochester Optical), 369 Cyclone Sr. (Western), 425 Cyclope (Alsaphot), 60 Cyclops (Toko), 403 Cyko Reko (Rochester Optical), 369 D'Assas (Alsaphot), 60 D'Assas-Lux (Alsaphot), 60 D35 (Hanimex), 228 Da-Brite (Herold), 232 Daci, Daci Royal (Dacora), 130 Daco, Daco II (Dacora), 130 DACO DANGELMAIER, 130 **DACORA KAMERAWERK** Daci, Daci Royal, 130 Daco, Daco II, 130 Dacora I, II, 130 Dacora-Matic 4D, 130 Digna, 130 Dignette, 130 Instacora E, 131 Royal, 131 Subita, 131 Super Dignette, 131 Daguerreotype"cannon"(Voigtländer), 416 Daguerreotype"cannon"replica Daguerreotype"cannon"replica (Voigtländer),417
DaguerreotypeCamera, 131
DaguerreotypeCamera (Giroux), 212
Daguerreotypecamera (Lewis), 290
DaguerreotypeCamera Replicas, 131
Dagwood Keychain, 481
DAH YANG TOYS
Cap gun camera, 477
Dai Cornex (Beck), 86
DAIDO SEIKI CO.
Daido Six Model I, 131 Daido Six Model I, 131 DAIICHI KOGAKU Ichicon 35, 131 Semi Primo, 131 Waltax Acme, 131 Waltax I, 131 Waltax Jr., 131 Waltax Senior, 131 Zenobia, 131 Zenobiaflex, 131 **DAISHIN SEIKI** Hobby Junior, 131 DAITOH OPTICALCO. Grace, 131 Grace Six, 131 Dale, 131 DALKA INDUSTRIES Dalka Candid, 132
DALLMEYER(J.H.)
Correspondent, 132
Naturalist's Reflex Camera, 132 Naturalists Hand Camera, 132 New Naturalists' Hand Camera, 132 Snapshot Camera, 132 Special Press Reflex, 132 Speed Camera, 132 Stereo Wet Plate camera, 132

DONRUSS

Studio camera, 132 Wet Plate camera, 132 Wet Plate Sliding Box Camera, 132 DeJur-8, 458 Detective magazine camera (Suter), 396 DETROLACORP. Dekon SR, 135 Embassy Magazine 8, 458 Detrola 400, 136 Detrola A, 136 DAME, STODDARD & KENDALL Dekko (Cameras Ltd), 456 Dekko Model 104 (Cameras Ltd), 457 Hub, 132 Detrola A, 136 Detrola B, 136 Detrola D, 136 Detrola E, 136 Detrola G, GW, 136 Detrola H, HW, 136 Detrola K, KW, 136 Dekko Model 104 (Camera Dekon SR (Dejur), 135 Delco 828 (Argus), 73 Delco 828 (Deluxe), 135 Delmar (Sears), 379 Delmonta (Montanus), 319 Delta (C.M.F.), 121 Delta (Fex/Indo), 195 Delta (Ica), 241 Damen-Kamera(Certo), 116 DAMOIZEAU Cyclographeà foyer fixe, 132 DAN CAMERAWORKS Dan 35, 132 Super Dan 35, 132 DANCER (J.B.) Dette Spezial-Camera, 137 DEVAUX (A.) Stereo Camera, 132 le Prismac, 137
DEVIN COLORGRAPHCO.
Tri-Color Camera, 137 Tailboard view camera, 132 Dandy Photo Camera (Crown), 129 Delta (Imperial), 247 Delta (plate & rollfilm) (Krügener), 265 Delta (plate camera) (Krügener), 265 Dandycam Automatic (Butcher), 104 DEVRY, 137 DEVRY Daphne (Orion), 345 DARIER (Albert) Delta (rollfilm) (Krügener), 266 Delta Detective (Krügener), 266
Delta Magazine Camera (Krügener), 266
Delta Patronen-Flach-Kamera (Krügener), DeVry 16mm, 458 Escopette, 132 DARLING DeVry Home Movie Camera, 458 DeVry Projectors, 458 DeVry Standard, 458 QRS-DeVry Home Movie Camera, 458 Bioscope, 457 Darling-16 (Shincho), 386 DARLOT Delta Periskop (Krügener), 266 Delta Stereo (Krügener), 266
Delta Stereo (Lennor), 289
Delta-Teddy (Krügener), 266
DELTAH CORPORATION Devus, 137 DEYROLLE Rapide, 132 DART & PELLET SHOOTERS, 478 Dasco (Monarch), 318 Scenographe, 137 Dial 35 (Bell & Howell), 88 Dial 35 (Canon), 114 DATA CORPORATION Deltah Unifocus, 135 Deltex (Imperial), 247 Aquascan Camera KG-20A, 133 Dauphin, Dauphin II (Alsaphot), 61 Diamant, 137
Diamond Gun Ferrotype (Int'l Metal & Deliex (Imperial), 247
Deluxe (Newman & Guardia), 326
Deluxe Century of Progress (Utility), 411
Deluxe Hollywood (Stewart-Warner), 468
DeLuxe No. 1 (Ansco), 64
DELUXE PRODUCTS CO. Dave, 133
Davy Crockett, 133
Davy Crockett (Herbert George), 231
Day-Xit (Shew), 386
DAYDARKSPECIALTYCO.
Photo Postcard Cameras, 133
Tintype Camera, 133
Daylight Enlarging Camera (Anthony), 69
Daylight Kodak Camera (Eastman), 152
De Fotograf, 483
De Luxe (Adams), 50
DE MOULIN BROS.
Trick Camera 488 Dave, 133 Ferrotype), 248 Diamond Jr., 137 Diana, 137 Diana (Mozar), 320 Diana (Welta), 423 Diana Deluxe Camera, 137 Delco 828, 135 Remington, 135
DELUXE READING CORP. Diax (I), Ia, Ib (Voss), 420 Diax II, IIa, IIb (Voss), 420 Diaxette (Voss), 420 Secret Sam Attache Case, 135 Secret Sam's Spy Dictionary, 135 Deluxe Six-Twenty Twin Lens Reflex Dice Cup (Eastman), 486 Dici (Pontos), 358 (Imperial), 247 DEMARIA Dick Tracy (Laurie), 278 Dick Tracy (Seymore), 385 Dick Tracy (Seymour), 385 Trick Camera, 488 Caleb, 135 Dehel, 135 **DEAR** Young posing couple, 490 DEARDORFF (L.F.) 4x5" cameras, 134 5x7" cameras, 133 Field camera, 135 Dick Tracy Squirt Gun Camera, 488 Jumelle Capsa, 135 Digna (Certex), 116 Digna (Dacora), 130 Plate Camera, 135 Telka II, III, 136 Dignette (Dacora), 130 8x10" cameras, 133 11x14" cameras, 134 Telka X, XX, 136 DILK Dilk-Fa, 458 Dionne F2, 137 Demi (Canon), 114 DEMILLY AN Series, 133 RN Series, 133
Baby Deardorff V4, 134
Commercial Cameras, 134
Folding Field Cameras, 134
Home Portrait, 134
Triamapro, 134 Midelly, 136 Diplomat, 137 Demon Detective (American Camera Co.), Direct Positive Camera (Mourfield), 320 Direct positive camera (Wabash), 421 Direct Positive Street Camera (Glossick), Derby (Gallus), 207
Derby (Ihagee), 244
Derby (original) (Foth), 198
Derby (I) (Foth), 199
Derby II (Foth), 199
Derby-Lux (Gallus), 207
Derlux (Gallus), 207
DEROGY
Field camera, 136 Debonair, 134 Direct positive street camera (Thompson), DEBRIE 400 Parvo Interview 35mm, 457 Disc Camera (US News), 411 Parvo Model JK, 457 Parvo Model JK, 457 Sept, 134 Sept 35mm Motion Picture System, 457 DECANTERS& FLASKS, 478 Deceptive Angle Graphic (Graflex), 221 Deckrullo (Nettel), 325 Deckrullo (Zeiss Ikon), 442 Deckrullo (Tropical model) (Contessa), 124 Deckrullo-Nettel (Zeiss Ikon), 442 Deckrullo-Nettel Stereo (Contessa), 124 Deckrullo Nettel Tropical (Zeiss Ikon), 442 Deckrullo Stereo (Tropical) (Contessa), Disc Cameras (Eastman), 152 DISHES & TABLEWARE, 480 Disney Fun Bubbles (Mattel), 495 Field camera, 136 Dispatch Detective (London Stereoscopic), Single lens stereo camera, 136 294 Wooden plate camera, 136 Designer Radio-Light-Mirror, 486 DITMAR DITMAR
Ditmar 9.5mm, 458
Ditto 99 (Finetta), 197
Diva (Phoba), 350
Dixi (Ruberg & Renner), 374
Dog Camera (Kiddie Camera), 254
Dolca 35 (Model I) (Tokyo Koken), 404
Dollar Box Camera (Ansco), 64
Dolling (Carto), 117 DESTECHINC.
Clickit Sports, 136 Detective Camera (Bischoff), 94
Detective camera (Bruns), 102
Detective camera (Bull), 102 Deckrullo Stereo (Tropical) (Contessa), Detective camera (Bull), 102
Detective Camera (Dossert), 137
Detective camera (Lamperti), 276
Detective camera (McGhie), 302
Detective camera (Mendel), 303
Detective camera (Molteni), 318
Detective camera (Nicholls), 328 124 Dollina (Certo), 117
DOLLS WITH CAMERAS, 480
Dolly 3x4 (miniature) (Certo), 117
Dolly Vest Pocket (Certo), 117 Deckrullo Tropical (Zeiss Ikon), 442 DEFIANCEMFG. CO. Auto Fixt Focus, 134 Dehel (Demaria), 135 Deitzflex, 135 DEJUR-AMSCOCORP. Dolly Vest Pocket (Certo), 117
Dolphin with Camera, 484
Dominant (King), 256
Donald Duck (Herbert George), 231
Donald Duck (Toy's Clan), 406
Donata (Contessa), 124 Detective camera (Pock), 356
Detective camera (Richard (F.M.)), 363 Citation, 458
DeJur D-1, 135
DeJur D-3, 135 Detective camera (Smith), 389 Detective camera (Steinheil), 393 Donata (Zeiss Ikon), 442 DONRUSS CO. DeJur Electra Power Pan, 458 Detective Camera (Watson), 422 Dejur Reflex Model DR-10, DR-20, 135

Hot Flash Chewing Gum, 474

Detective Magazine camera (Stirn), 394

DOPPEL-BOX

Doppel-Box (Balda), 83 Doppel Box (Certo), 117 Dories, 137 Doris Semi P (Tokyo Seiki), 404 DORYU CAMERACO. Doryu 2-16, 137 DOSSERT DETECTIVE CAMERA CO. Detective Camera, 137 Double Shutter Camera (Ernemann), 185 DOVER FILM CORP. Dover 620 A, 137 DRALOWID-WERK Dralowid Reporter 8, 458 Drepy (Pierrat), 352
DREXEL CAMERA CO.
Drexel Jr. Miniature, 137
DREXLER & NAGEL Contessa, 137 DRGM, DRP, 138 DRUCKER (Albert) Ranger, 138 Druex (Druopta), 138 Drug (Dpyr) (Krasnogorski), 262 Druh (WZFO), 431 Druoflex I (Druopta), 138 DRUOPTA Corina, 138 Druex, 138 Druoflex I, 138 Efekta, 138 Stereo camera, 138 Vega II, III, 138 DU ALL PRODUCTSCO. Camera Scope, 498 Duaflex Cameras (Eastman), 152 Dual Reflex (Irwin), 248 Dual-finderrollfilm camera (Lieberman), 290 Dubla (Welta), 423 DUBRONI Dubroni camera, 138 Wet plate tailboard camera, 138 Duca (Durst), 139 DUCATI Ducati, 138 Ducati Sogno "Per Collaboratore",139 Duchess (London & Paris), 293 Duchessa (Contessa), 124 Duchessa (Zeiss Ikon), 443 Duchessa Stereo (Contessa), 124 DUERDEN Field camera, 139 Duex Camera (Eastman), 152 **DUFA** Fit, Fit II, 139 Pionyr, 139 Duflex (Gamma Works), 208 DUNCAN Kodak Yo-Yo, 496 Duo (Seneca), 384 Duo Flash, 139 Duo Six-20 Camera (Eastman), 152 Duo Six-20 Series II Cam. (Eastman), 152 Duo Six-20 Series II Camera w/RF (Eastman), 153 Duovex (Universal), 409 Duplex 120 (ISO), 249 Duplex cameras (Ihagee), 244 Duplex Ruby Reflex (Thornton-Pickard), 400 Duplex Ruby Reflex "Overseas" (Tropical) (Thornton-Pickard),400
Duplex Super 120 (ISO), 249
DUPUIS COMICS
Barney Rubble Keychain, 481 Durata (Certo), 117
DURHAMINDUSTRIES
Holly Hobbie Doll House Camera, 483
Duroll (Contessa), 124
Duroll (Zeiss Ikon), 443
DURST S.A. Automatica, 139 Duca, 139

Durst 66, 139 Gil, 139 Dynamatic, Dynamatic II (Voigtländer), 417 Dynamic 12 (Coronet), 127 E.F.I.C.A. S.R.L. Alas, 180 Splendor 120, 180 Suprema, 180 E.L.C. E.L.C.
I'As, 182
E.R.A.C. SELLING CO. LTD.
Erac Mercury I Pistol Camera, 184
Eagle Eye (Pho-Tak), 350
Eagle View 88 Camera, 498
Eaglet (Fototecnica), 200
Eaglet (Hanimex), 228
EARL PRODUCTS CO.
Scenex, 139
EARTH K.K.
Guzzi 139 Guzzi, 139 East Asia Camera-Radio-Flashlight,486 EASTERNSPECIALTYMFG. CO. Springfield Union Camera, 139
EASTMANDRY PLATE & FILM CO., 140
EASTMANKODAKCO. A Daylight Kodak Camera, 152 A Daylight Kodak Camera, 152 A Ordinary Kodak Camera, 163 Anniversary Kodak Camera, 140 Auto Colorsnap 35, 141 Autographic Kodak Cameras, 141 Autographic Kodak Junior Cameras, 141 Autographic Kodak Special Camera, 141 Automatic 35 Camera, 141 Automatic 35B Camera, 142 Automatic 35F4 Camera, 142 Automatic 35R4 Camera, 142 Autosnap. 142 Autosnap, 142 B Daylight Kodak Camera, 152 B Ordinary Kodak Camera, 163 Baby Brownie New York World's Fair, 144 Baby Brownie Special, 144 Baby Hawkeye, 157 Bantam, original f12.5, 142 Bantam, original f12.5, 142
Bantam, original f6.3, 142
Bantam f4.5, 142
Bantam f5.6, 142
Bantam f6.3, 142
Bantam f8, 142
Bantam Colorsnap, 142
Bantam Military model, 142
Bantam RF Camera, 142
Bantam RF Camera, 142 Bantam Special Camera, 142 Beau Brownie Camera, 144
Boy Scout Brownie Camera, 143 Boy Scout Kodak Camera, 143 Brownie 127 Camera, 144 Brownie 44A, 44B, 144 Brownie 620, 144 Brownie Auto 27 Camera, 144 Brownie Bull's-Eye Camera, 145 Brownie Bullet Camera, 145 Brownie Bullet II Camera, 145 Brownie Camera, original, 143 Brownie Camera (1900 type), 143 Brownie Camera (1980 type), 143 Brownie Chiquita Camera, 145 Brownie Cresta, II, III, 145 Brownie Fiesta Camera, 145 Brownie Flash Camera, 145 Brownie Flash Camera, 145
Brownie Flash II, 145
Brownie Flash II (Australia), 145
Brownie Flash III, 145
Brownie Flash IV, 145
Brownie Flash IV, 145
Brownie Flash 20 Camera, 145
Brownie Flash Six-20 Camera, 146, 148
Brownie Flash Six-20 Camera, 146 Brownie Fun Saver, 458 Brownie Hawkeye Camera, 147

Brownie Junior 620 Camera, 147 Brownie Model I, 147 Brownie Movie Cameras, 458 Brownie Pliant Six-20, 147 Brownie Reflex 20 Camera, 147 Brownie Reflex Camera, 147 Brownie Six-20 Camera Models C, D, E, Brownie Six-20 Camera Model F, 148 Brownie Starflash Camera, 148 Brownie Starflash Coca-Cola, 148 Brownie Starflex Camera, 149 Brownie Starlet Camera, 149 Brownie Starluxe, II, 4, 149 Brownie Starmatic Camera, 149 Brownie Starmeter Camera, 149 Brownie Starmite Camera, 149 Brownie Super 27, 149 Brownie Target Six-16 Camera, 149 Brownie Target Six-20 Camera, 149 Brownie Turret, Exposure Meter Model, Brownie Twin 20 Camera, 150 Brownie Vecta, 150 Buckeye Camera, 150
Bull's-Eye Cameras, 150
Bull's-Eye Special Camera, 150
Bullet Camera, 150 Bullet Camera (plastic), 150 Bullet Camera New York World's Fair, Bullet Special Camera, 150
C Daylight Kodak Camera, 152
C Ordinary Kodak Camera, 163
Camp Fire Girls Kodak, 151
Cartridge Hawk-Eye Camera, 157
Cartridge Kodak Cameras, 151
Cartridge Premo Cameras, 165
Century of Progress, World's Fair Souvenir, 151 Century Universal Camera, 151 Chevron Camera, 151 Cine-Kodak, 458 Cine Kodak 8, 459 Cine Kodak Magazine 16, 459 Cine-Kodak Model B, 459 Cine Kodak Model BB, Model BB Junior, 459 Cine Kodak Model E, 459 Cine Kodak Model K, 459 Cine-Kodak K-100, 459 Cine Kodak Model M, 459 Cine-Kodak Magazine 8, 459 Cine-Kodak Reliant, 459 Cine-KodakRoyal, 459 Cine-KodakSpecial, II, 459 Cirkut Cameras, Cirkut Outfits, 151 Colorburst, 151 Colorsnap 35, 35 Model 2, 152 Compañera, 152 Companera, 152
Cone Pocket Kodak, 152
Coquette Camera, 152
Daylight Kodak Camera, 152
Dice Cup, 486
Disc Cameras, 152
Duaflex Cameras, 152 Duex Camera, 152 Duo Six-20 Camera, 152 Duo Six-20 Series II Camera, 152 Duo Six-20 Series II Camera w/RF, 153 Eastman Plate Camera, 153 Empire State Camera, 153 Eureka Cameras, 153 Falcon Camera, 153 Fiesta Instant Camera, 153 Fiftieth Anniversary Camera, 153
Film Pack Hawk-Eye "DRINK FIRST
AID", 157
Film Pack Hawk-Eye Camera, 157 Film Premo Cameras, 165
Filmplate Premo Camera, 165
Filmplate Premo Special Camera, 165 Fisher-Price Camera, 154

Brownie Holiday Camera, 147

Flash Bantam Camera, 142 Flat Folding Kodak Camera, 154 Flexo Kodak Camera, No. 2, 154 Fling 35, 154 Flush Back Kodak Camera, No. 3, 154 Folding Autographic Brownie Cam., 146 Folding Brownie Camera, 146 Folding Brownie Six-20, 146 Folding Cartridge Hawk-Eye Cam., 157 Folding Cartridge Premo Cameras, 165 Folding Film Pack Hawk-Eye Cam., 157 Folding Hawk-Eye Camera, 157
Folding Hawk-Eye Special Cameras, 157
Folding Kodak Cameras, 154
Folding Pocket Brownie Camera, 146 Folding Pocket Brownie Gamera, 140
Folding Pocket Kodak Camera, 155
Folding Rainbow Hawk-Eye Camera, 158
Fox Co. (Rainbow Hawk-Eye), 158 Genesee Outfit, 156 George Washington Bicentennial Camera, 156 Gift Kodak Camera, No. 1A, 156 Girl Guide Kodak Camera, 156 Girl Scout Kodak Camera, 156 Handle, Handle 2 Instant Cameras, 156 Happy Times Instant Camera, 156 Hawk-Eye Cameras, 157 Hawk-Eye No. 2, No. 2A, 157 Hawk-Eye Special Cameras, 158 Hawkette Camera, No. 2, 156 Hawkeye Ace, Hawkeye Ace Deluxe, 157 Hawkeye Flashfun, Flashfun II, 157 Hawkeye Instamatic Cameras, 158 Hawkeye Model BB, 157 Instamatic Cameras, 159 Instamatic Camera Bank, 473 Instamatic Reflex, 159
Instamatic S-10 & S-20, 159
Instamatic X-30 Olympic, 159 Instant Cameras, 159 Jiffy Kodak Six-16, 159 Jiffy Kodak Six-16, 159
Jiffy Kodak Six-16, Series II, 160
Jiffy Kodak Six-20, 160
Jiffy Kodak Six-20, Series II, 160
Jiffy Kodak Vest Pocket, 160
Kodacolor VR 200, 484
Kodac V 25 Campage 161 Kodak 35 Camera, 161 Kodak 35 Camera (Military Model), 161 Kodak 35 Camera, with Rangefinder, 161 Kodak 66 Model III, 161 Kodak A Modele 11, 160 Kodak Box 620, 620C Camera, 160 Kodak Camera (original), 140 Kodak Camera (replica), 140 Kodak Cine Automatic Cameras, 459 Kodak Cine Scopemeter, 459 Kodak Disc Bank, 473 Kodak Ektra, 153 Kodak Ektra 1,2,100,200,250Cam., 153 Kodak Ektra II, 153 Kodak Electric 8 Automatic, 459 Kodak Enlarger 16mm, 160 Kodak Ensemble, 153 Kodak Escort 8, 460 Kodak Jr. Six-16, 160 Kodak Jr. Six-16, Series II, 160 Kodak Jr. Six-16, Series III, 160 Kodak Jr. Six-20, 160 Kodak Jr. Six-20, Series II, 160 Kodak Jr. Six-20, Series III, 160 Kodak Junior Cameras, 160 Kodak Junior 0, 160 Kodak Junior 0, 160 Kodak Junior I, 160 Kodak Junior II, 160 Kodak Junior 620, 160 Kodak Pliant Modele B11, 163 Kodak Reflex (original), 160 Kodak Reflex IA, 161 Kodak Reflex II, 161 Kodak Senior Cameras, 175 Kodak Series II Series III Cam Kodak Series II, Series III Cameras, 161 Kodak Six-16 Camera, 176 Kodak Six-16, Improved, 176

Kodak Six-20 Camera, 176 Kodak Six-20, Improved, 176 Kodak Special Six-16 Camera, 177 Kodak Special Six-20 Camera, 177 Kodak Sport Special Camera Outfit, 177 Kodak Startech Camera, 177 Kodak Stereo Cameras, 177 Kodak Suprema Camera, 177 Kodak Tele-Ektra Cameras, 178 Kodak Tele-Instamatic Cameras, 178 Kodak Tourist, II Camera, 178 Kodak Trimlite Instamatic Cameras, 178 Kodak Winner Pocket Camera, 179 Kodak Zoom 8 Reflex, 460 KodamaticInstant Cameras, 161 Kodascope, 460 Kodascope Eight Model 20, 460 Kodascope Model A, B, C, 460 Kodet Cameras, 161 Kolorcube, 486 Library Kodascope, 460 Magazine Cine-Kodak Eight, 459 Matchbox Camera, 162 Medalist Cameras, 162 Medalist I, II, 162 Mickey-Matic, 162 Monitor Cameras, 162 Monitor Six-16, Six-20, 162 Motormatic 35, 35F, 35R4 Camera, 162 Nagel, 162
No. 0 Brownie Camera, 143
No. 0 Folding Pocket Kodak, 155
No. 0 Premo Junior Camera, 165 No. 00 Cartridge Premo Camera, 165 No. 1 Autographic Kodak Junior Camera, 141 No. 1 AutographicKodak Special Camera, 141 No. 1 Brownie Camera, 143 No. 1 Cone Pocket Kodak, 152 No. 1 Film Premo Camera, 165 No. 1 Folding Pocket Kodak, 155 No. 1 Kodak Camera, 140 No. 1 Kodak Junior Camera, 160 No. 1 Kodak Series III Camera, 161 No. 1 Panoram Kodak Camera, 163 No. 1 Pocket Kodak Camera, 164 No. 1 Pocket Kodak Junior Camera, 164 No. 1 Pocket Kodak Series II Camera, No. 1 Pocket Kodak Special Camera, 164 No. 1 Premo Junior Camera, 165 No. 1A Autographic Kodak Camera, 141 No. 1A Autographic Kodak Junior Camera, 141 No. 1A Autographic Kodak Special Camera, 141 No. 1A Folding Hawk-Eye Camera, 157
No. 1A Folding Pocket Kodak, 155
No. 1A Folding Pocket Kodak Camera
R.R. Type, 155
No. 1A Folding Pocket Kodak Special Camera, 155 No. 1A Kodak Junior Camera, 160 No. 1A Kodak Series III Camera, 161 No. 1A Pocket Kodak Camera, 164 No. 1A Pocket Kodak Junior Cam., 164 No. 1A Pocket Kodak Series II Cam., 164 No. 1A Pocket Kodak Special Cam., 164 No. 1A Premo Junior Camera, 165 No. 1A Six-Three Kodak Camera, 176 No. 1A Special Kodak Camera, 176 No. 1A Speed Kodak Camera, 177 No. 2 Beau Brownie Camera, 144 No. 2 Brownie Camera, 143 No. 2 Bull's-Eye Camera, 150 No. 2 Bull's-Eye Carriera, 150
No. 2 Bull's-Eye Special Camera, 150
No. 2 Bullet Camera, 150
No. 2 Bullet Special Camera, 150
No. 2 Cartridge Hawk-Eye Camera, 157

EASTMAN No. 3A

No. 2 Falcon Camera, 153 No. 2 Falcon Improved Model, 153 No. 2 Film Pack Hawk-Eye Camera, 157 No. 2 Folding Autographic Brownie Camera, 146 No. 2 Folding Brownie Camera, 146 No. 2 Folding Bull's-Eye Camera, 150 No. 2 Folding Cartridge Hawk-Eve Camera, 157 No. 2 Folding Cartridge Premo Cam., 165 No. 2 Folding Hawk-Eye Special Camera, No. 2 Folding Pocket Brownie Camera, 146 No. 2 Folding Pocket Kodak, 155 No. 2 Folding Rainbow Hawk-Eye Camera, 158 No. 2 Folding Rainbow Hawk-Eye Special Cameras, 158 No. 2 Kodak Camera, 140 No. 2 Rainbow Hawk-Eye Camera, 158 No. 2 Stereo Brownie Camera, 149 No. 2 Stereo Kodak Camera, 177 No. 2 Weno Hawk-Eye Camera, 159 No. 2A Beau Brownie Camera, 144 No. 2A Brownie Camera, 144
No. 2A Cartridge Hawk-Eye Camera, 157
No. 2A Cartridge Premo Camera, 165 No. 2A Film Pack Hawk-Eye Camera, No. 2A Folding Autographic Brownie Camera, 146 No. 2A Folding Cartridge Hawk-Eye Camera, 157 No. 2A Folding Cartridge Premo Camera, No. 2A Folding Hawk-Eye Special Camera, 157 No. 2A Folding Pocket Brownie Camera, No. 2A Folding Rainbow Hawk-Eye Camera, 158 No. 2A Rainbow Hawk-Eye Camera, 158 No. 2C Autographic Kodak Junior Camera, 141 No. 2C Autographic Kodak Special Camera, 141 No. 2C Brownie Camera, 144 No. 2C Cartridge Premo Camera, 165 No. 2C Folding Autographic Brownie Camera, 146 No. 2C Folding Cartridge Premo Camera, No. 2C Kodak Series III Camera, 161 No. 2C Pocket Kodak Camera, 164 No. 2C Pocket Kodak Special Cam., 164 No. 3 Autographic Kodak Camera, 141 No. 3 Autographic Kodak Special Camera, 141 No. 3 Brownie Camera, 144 No. 3 Bull's-Eye Camera, 150 No. 3 Cartridge Kodak Camera, 151 No. 3 Film Premo Camera, 165 No. 3 Folding Brownie Camera, 146 No. 3 Folding Hawk-Eye Camera, 157 No. 3 Folding Hawk-Eye Special Camera, No. 3 Folding Kodet Camera, 161 No. 3 Folding Pocket Kodak, 155 No. 3 Folding Pocket Kodak, Deluxe, 155 No. 3 Kodak Camera, 140 No. 3 Kodak Camera, 140
No. 3 Kodak Jr. Camera, 140
No. 3 Kodak Series III Camera, 161
No. 3 Pocket Kodak Special Camera, 164
No. 3 Premo Junior Camera, 165
No. 3 Six-Three Kodak Camera, 176
No. 3 Special Kodak Camera, 176 No. 3 Special Kodak Camera, 176 No. 3A Autographic Kodak Camera, 141 No. 3A Autographic Kodak Junior Camera, 141 No. 3A Autographic Kodak Special Camera, 141 No. 3A Folding Autographic Brownie

No. 2 Cartridge Premo Camera, 165

No. 2 Eureka Camera, 153

No. 2 Eureka Jr. Camera, 153

EASTMAN No. 3A Folding

Camera, 146 No. 3A Folding Brownie Camera, 146 No. 3A Folding Cartridge Hawk-Eye Camera, 157 No. 3A Folding Cartridge Premo Camera, No. 3A Folding Hawk-Eye Camera, 157 No. 3A Folding Hawk-Eye Special Camera, 157 No. 3A Folding Pocket Kodak, 156 No. 3A Kodak Series II Camera, 161 No. 3A Kodak Series III Camera, 161 No. 3A Panoram Kodak Camera, 163 No. 3A Pocket Kodak Camera, 164 No. 3A Signal Corps Model K-3, 141 No. 3A Six-Three Kodak Camera, 176 No. 3A Special Kodak Camera, 176 No. 4 Autographic Kodak Camera, 141 No. 4 Bull's-Eye Camera, 150 No. 4 Bull's-Eye Special Camera, 150 No. 4 Bullet Camera, 150 No. 4 Bullet Special Camera, 150 No. 4 Cartridge Kodak Camera, 151 No. 4 Eureka Camera, 153 No. 4 Folding Hawk-Eye Camera, 157
No. 4 Folding Kodak Camera, 154
No. 4 Folding Kodet Camera, 161
No. 4 Folding Kodet Junior Camera, 162
No. 4 Folding Kodet Special Camera, 162
No. 4 Folding Rodet Kodak, 156 No. 4 Folding Pocket Kodak, 156 No. 4 Kodak Camera, 140 No. 4 Kodak Jr. Camera, 140 No. 4 Kodet Camera, 161 No. 4 Panoram Kodak Camera, 163 No. 4 Premo Junior Camera, 165 No. 4 Premo Junior Camera, 163
No. 4 Weno Hawk-Eye Camera, 159
No. 4A Autographic Kodak Camera, 141
No. 4A Folding Kodak Camera, 154
No. 4A Speed Kodak Camera, 177
No. 5 Cartridge Kodak Camera, 151
No. 5 Cirkut Camera, 151 No. 5 Folding Kodak Camera, 154 No. 5 Folding Kodak Stereo Camera, 154 No. 5 Folding Kodak Stereo Camera, 154
No. 5 Folding Kodet Camera, 162
No. 5 Folding Kodet Special Camera, 162
No. 5 Weno Hawk-Eye Camera, 159
No. 6 Cirkut Camera, 151
No. 6 Cirkut Outfit, 151 No. 6 Folding Kodak Improved, 154
No. 7 Weno Hawk-Eye Camera, 159
No. 8 Cirkut Outfit, 151 No. 10 Cirkut Camera, 151 No. 16 Cirkut Camera, 151 Ordinary Kodak Camera, 163 Panoram Kodak Camera, 163 Peer 100, 163 Petite Camera, 163 Pin-hole Camera, 163 Pleaser, Pleaser II, 163 Plico, 163 Pocket A-1 Camera, 163 Pocket B-1 Camera, 163 Pocket Instamatic Cameras, 163 Pocket Kodak (box types), 163 Pocket Kodak (folding types), 164 Pocket Kodak Cameras, 163 Pocket Kodak Junior Cameras, 164 Pocket Kodak Series II Cameras, 164 Pocket Kodak Special Camera, 164 Pocket Premo C, 166 Pocket Premo C, 166 Pony, 164 Pony 135, 164 Pony 135 (Made in France), 164 Pony 828, 164 Pony IV, 164 Pony IV, 164 Pony Premo Cameras, 166 Popular Brownie Camera, 147 Portrait Brownie Camera, 147 Portrait Hawkeye, No. 2, 158 Portrait Hawkeye A-Star-A, 158 Premo Box Film Camera, 164

Premo Cameras, 164 Premo Folding Cameras, 165 Premo Junior Cameras, 165 Premo No. 8, 165 Premo No. 9, 165 Premo No. 12, 165 Premoette Cameras, 166 Premoette (no number), 166 Premoette Junior Cameras, 166 Premoette Junior (no number), 166 Premoette Junior No. 1, 166 Premoette Junior No. 1 Special, 166 Premoette Junior No. 1A, 166
Premoette Junior No. 1A Special, 166
Premoette No. 1, No. 1A, 166 Premoette Senior Cameras, 166 Premoette Special Cameras, 166 Premograph Cameras, 167 Pupille, 167 Quick Focus Kodak Camera, No. 3B, 167 Radiograph Copying Camera, 167 Rainbow Hawk-Eye Camera, 158 Ranca Camera, 167 Recomar Cameras, 167 Regent, II Camera, 167 Regular Kodak Cameras, 167 Retina (original model- Type 117), 167 Retina (Orginal Model 17), 168 Retina (Type 118), 168 Retina (I) (Type 119), 168 Retina I (Type 010), 168 Retina I (Type 013), 169 Retina I (Type 141), 168 Retina I (Type 143), 168 Retina I (Type 148), 168 Retina I (Type 149), 168 Retina I (Type 160/I), 168 Retina Ia (Type 015), 169 Retina Ib (Type 018), 169 Retina IB (Type 019), 169 Retina IB (Type 019/0), 169 Retina I BS (Type 040), 172 Retina IF (Type 046), 172 Retina II (Type 011), 170 Retina IF (Type 046), 172
Retina II (Type 011), 170
Retina II (Type 014), 170
Retina II (Type 014), 170
Retina II (Type 122), 169
Retina II (Type 142), 169
Retina IIa (Type 016), 170
Retina IIa (Type 020), 170
Retina IIc (Type 029), 170
Retina IIC (Type 029), 170
Retina IIIc (Type 021), 170
Retina IIIc (Type 021), 170
Retina IIIc (Type 021), 170
Retina IIIc (Type 028), 171
Retina IIIC (Type 028), 171
Retina IIIS (Type 028), 171
Retina IIIS (Type 024), 171
Retina IIIS (Type 024), 171
Retina Automatic I (Type 038), 171
Retina Automatic II (Type 039), 171
Retina Automatic III (Type 039), 171
Retina Reflex (Type 025/0), 172
Retina Reflex III (Type 041), 172
Retina Reflex IV (Type 051), 173
Retina Reflex S (Type 034), 172
Retina Reflex S (Type 034), 172
Retina S2 (Type 060), 172
Retina S2 (Type 061), 173
Retinette (Type 012), 173
Retinette (Type 017), 173
Retinette (Type 030), 174 Retinette (Type 022), 174
Retinette (Type 147), 173
Retinette I (Type 030), 174
Retinette IA (Type 035), 174
Retinette IA (Type 035/7), 174
Retinette IA (Type 042), 174
Retinette IA (Type 044), 174
Retinette IB (Type 045), 175
Retinette IB (Type 045), 175
Retinette II (Type 160), 173
Retinette II (Type 036), 175

Retinette IIB (Type 031), 175 Retinette f (Type 022/7), 174 Retinette f (Type 030/7), 174 Rio-400, 175 Screen Focus Kodak Camera, No. 4, 175 Signal Corps Model KE-7(1), 176 Signet 30, 175 Signet 35, 175 Signet 40, 175 Signet 50, 176 Signet 80, 176 Six-16 Brownie Camera, 147 Six-16 Brownie Junior Camera, 147 Six-16 Brownie Special Camera, 147 Six-16 Folding Hawk-Eye Camera, 157 Six-16 Kodak Senior, 175 Six-20 Boy Scout Brownie Camera, 143 Six-20 Brownie B, 147 Six-20 Brownie Camera (USA type), 147 Six-20 Brownie Junior Camera, 147 Six-20 Brownie Special Camera, 147 Six-20 Bull's-Eye Brownie Camera, 148 Six-20 Flash Brownie Camera, 148 Six-20 Folding Brownie (model 2), 148 Six-20 Folding Hawk-Eye Camera, 157 Six-20 Kodak A, 176 Six-20 Kodak B, 176 Six-20 Kodak Junior, 176 Six-20 Kodak Senior, 175 Six-20 Portrait Brownie, 148 Six-Three Kodak Cameras, 176 "Smile" Bear, 494 Sound Kodascope Special, 460 Special Kodak Cameras, 176 Speed Kodak Camera, 177 Star Premo, 166 Stereo Brownie Camera, 149 Stereo Hawk-Eye Camera, 158 Stereo Kodak Cameras, 177 Sterling II, 177 Super Kodak Six-20, 177 Target Brownie Six-16 Camera, 149 Target Brownie Six-20 Camera, 149 Target Hawk-Eye Cameras, 158 Tim's Official Camera, 158 Tourist Camera, 178 Vanity Kodak Camera, 178 Vanity Kodak Ensemble, 178 Vest Pocket Autographic Kodak Camera, 178 Vest Pocket Autographic Kodak Special Camera, 178 Vest Pocket Hawk-Eye Camera, 158 Vest Pocket Kodak Camera, 178 Vest Pocket Kodak Model B Camera, 178 Vest Pocket Kodak Series III Camera, 178 Vest Pocket Kodak Special Camera (early type), 178 Vest Pocket Kodak Special Camera (later type), 179 Vest Pocket Rainbow Hawk-Eye Camera, View Cameras, 179 Vigilant Junior Six-16, Six-20, 179 Vigilant Six-16, Six-20, 179 Vollenda 620, 179 Vollenda Junior 616, 620, 179 Vollenda, 179 Walking film box, 496 Weno Hawk-Eye Cameras, 158 Winner Camera, 1988 Olympics, 179 World's Fair Fflas Camera, 179 Zenith Kodak Cameras, 180 Eastman Plate Camera (Eastman), 153 Easy-Load (Expo), 191 EBNER 4.5x6cm, 180 6x9cm, 180 Ebony 35 (Hoei), 234 Ebony 35 De-Luxe (Hoei), 234 Ebony Deluxe IIS (Hoei), 234 Echo 8 (Suzuki), 397

ERNEMANN Ernette

Electric Eye 35, 35R (Honeywell), 234 Electro 35 (Yashica), 434 Electro AX (Yashica), 434 Electro Shot (Minolta), 310 Electro Shot (Minolta), 310 Electronic, 182 Electronic 544 (Balda), 84 Electus (Krügener), 266 Elega-35 (Nitto), 336 Elegant (Ica), 241 Elegante (816) (Zeiss Ikon), 443 Elettra I, II (Sirio), 389 Elf (Spiegel), 392 Elf Eight Model 1A, 460 Elflex Deluxe Camera, 182 Elge (Gaumont), 209
ELGIN LABORATORIES
Elgin, 182
Elgin Miniature, 182 Elioflex, 2 (Ferrania), 194 Elite, 182 Elite (Merkel), 304 Elite (Wünsche), 430 Elite-Fex (Fex/Indo), 195 Eliy (Lumiere), 294 Eliy Club (Lumiere), 294 ELLISON KAMRA COMPANY Ellison Kamra, 182 ELMO CAMERA CO Honeywell Elmo Tri-Filmatic Zoom, 460
ELMO CO. LTD.
Elmoflex, 182
Elmoflex (Elmo), 182
ELOP KAMERAWERK Elca, Elca II, 183 Magic Sun Picture Camera, 486 Elvo (Ro-To), 367 Embassy Magazine 8 (Dejur-Amsco), 458 Emel Model C93, 460 Emerald, 183 Emi 35A (Oshiro), 346 Emi K 35 (Oshiro), 346 EMMERLING& RICHTER Field Camera, 183 Emmet Kelly "Watch The Birdie", 490 Empire, 183 Empire 120, 183 Empire 120, 183
Empire 35mm Cine (Butcher), 456
Empire Scout, 183
Empire State Camera (Eastman), 153
Empire State View (Rochester Opt.), 369
Empire-Baby (Crestline), 129 Empress (Houghton), 235 Emson, 183 ENCORE CAMERA CO. Encore Camera, 183 Encore De Luxe Camera, 183 Hollywood Camera, 183 ENESCO Ceramic Mug, 480 ENESCO CORP. Eggbert "Eggsposure",490 Precious Moments "Baby's First Picture". English Compact Reversible Back Camera (Blair), 95 Enica-SX (Nikoh), 328 **ENJALBERT** Colis Postal, 183 Photo Revolver de Poche, 183 Touriste, 183
Enjicolor F-II (Gold Horse), 481, 484
Eno (C.M.F.), 121
Enolde (Kochmann), 257 Enolde I, II, III (Kochmann), 258
Ensign Auto-Kinecam16 (Houghton), 462
Ensign Autokinecam (Houghton), 462 Ensign Autospeed (Houghton), 235 Ensign box cameras (Houghton), 236 Ensign Cadet (Houghton), 236 Ensign Cameo (Houghton), 236

Echoflex, 180

Cameflex, 460

ECLAIR

Ecla Box (Vredeborch), 420 Eclair, 180

Eclair Box (Coronet), 127 Eclair Lux (Coronet), 127 Eclipse (Horsman), 235 Eclipse (Shew), 386 Eclipse 120, 180 EDBAR INTERNATIONALCORP.

Edison Home Kinetoscope, 460

Edixa Prismaflex (Wirgin), 428
Edixa Reflex (Wirgin), 428
Edixa Reflex B, C, D (Wirgin), 428
Edixa Stereo (Wirgin), 428
Edixa Stereo II, IIa (Wirgin), 428
Edixa Stereo III, IIIa (Wirgin), 428
Edixa-Mat B, BL (Wirgin), 428
Edixa-Mat C, CL (Wirgin), 428
Edixa-Mat D, DL (Wirgin), 428
Edixaflex (Wirgin), 428
Edixaflex (Wirgin), 428
Efbe (Brinkert), 101
Efekta (Druopta), 138
EFS

Camp Out, 496 Eggbert "Eggsposure" (Enesco), 490 EHIRA K.S.K.

Eho Stereo Box camera (Eho-Altissa), 181 EHO-ALTISSA

Astoria Super-6 IIIB, 180 Ehira Chrome Six, 180

Weha Chrome Six, 180

Eho box (Eho-Altissa), 181

Altiscop, 181 Altissa, Altissa II, 181

Eho Stereo Box camera, 181

Eight-20 King Penguin (Kershaw), 253 Eight-20 Penguin (Kershaw), 253 EIKO CO. LTD

Ehira-Six, 180

Altiflex, 181

Altissa, Altiss Altix (I), 181 Altix III, 181 Altix IV, 181 Altix NB, 181 Altix V, 181

Eho box, 181

Noviflex, 182

Popular, 182 EIKO-DO CO.

Eldon, 182

Eno Stereo bux ca Gehaflex, 181 Juwel, 182 Mantel-Box 2, 182 Super Altissa, 182 EICHAPFEL

Can Cameras, 182

Elbow flex, 182 Elca, Elca II (Elop), 183

Electra II (Hanimex), 228

Ugein Model III, III A, 182

Ejot (Jansen), 249 Eka (Krauss), 265 Elbaflex VX1000 (Ihagee), 244 ELBOW CAMERA FIRM

Electric Eye 127 (Bell & Howell), 88

Weha Light, 180

EFS

Edison Projecting Kinetoscope, 460

Edison Projecting Kinetoscope, 460
Edith II (Beier), 88
Edixa (Wirgin), 428
Edixa II (Wirgin), 428
Edixa 16, 16M, 16MB, 16S (Wirgin), 428
Edixa Electronica (Wirgin), 428
Edixa Flex B (Wirgin), 428
Edixa Prismaflex (Wirgin), 428
Edixa Reflex (Wirgin), 428

V.P. Twin, 180 Edelweiss Deluxe (Ise), 248

Eder Patent Camera, 180 Edina (Wirgin), 428 Edinex (Wirgin), 428 Edinex 120 (Wirgin), 428

Ensign Carbine (Tropical) (Houghton), 236 Ensign Commando (Houghton), 236 Ensign Cupid (Houghton), 236 Ensign Cupia (Houghton), 236 Ensign Deluxe Reflex (Houghton), 237 Ensign Double-8 (Houghton), 236 Ensign Ful-Vue (Houghton), 236 Ensign Ful-Vue Super (Houghton), 236 Ensign Greyhound (Houghton), 236 Ensign Greynound (Houghton), 236 ENSIGN LTD., 183 Ensign Mascot A3, D3 (Houghton), 236 Ensign Mickey Mouse (Houghton), 236 Ensign Midget Model 22 (Houghton), 237 Ensign Midget Model 33 (Houghton), 237 Ensign Midget Silver Jubilee models Ensign Midget Silver Jubilee models (Houghton), 237
Ensign Multex (Houghton), 237
Ensign Playing Cards, 486
Ensign Pocket E-20 (Houghton), 237
Ensign Popular Reflex (Houghton), 237
Ensign Ranger, Ranger II, Ranger Special Ensign Ranger, Ranger II, Ranger Speci (Houghton), 237 Ensign Reflex (Houghton), 237 Ensign Roll Film Reflex (Houghton), 237 Ensign Roll Film Reflex Tropical (Houghton), 237 Ensign Selfix models (Houghton), 237 Ensign Special Reflex (Houghton), 237 Ensign Special Reflex Tropical (Houghton), 237
Ensign Speed Film Reflex (Houghton), 238
Ensign Speed Film Reflex Tropical (Houghton), 238 Ensign Super Speed Cameo (Houghton), 238 Ensign Super-Kinecam (Houghton), 462 Ensignette (Houghton), 238
Ensignette Deluxe (Houghton), 238 Ensignette No. 2 (silver) (Houghton), 238 ENTERPRISECAMERA & OPTICAL CO. Little Wonder, 183 Little Wonder (the Boston), 183 Enterprise Repeating Camera, 183 Envoy (Ilford), 247 Envoy Wide Angle (Photo Dev.), 351 Epatant, 184
Epifoka (Vrsofot), 421
Epoch Lighted Slide Viewer, 499
Epochs (Taiyodo Koki), 398 Erabox (Zeiss Ikon), 443 Ercona (I), II (Pentacon), 348 ERCSAM Auto Camex, 460 Camex Reflex 8, 460 Ergo (301) (Zeiss Ikon), 443 Ergo (Contessa), 124 ERIKSEN Pistol Camera, 184 Erkania (Balda), 84 ERKO FOTOWERKE Erko, 184 Ermanox (Ernemann), 185 Ermanox (Zeiss Ikon), 443 Ermanox Reflex (Ernemann), 185 Ermanox Reflex (Zeiss Ikon), 443 ERNEMANN Berry, 184 Bob 0, 00, 184 Bob I, II, III, 184 Bob IV, 184 Bob IV, 9x14cm, 185 Bob V, 185 Bob V (stereo), 185 Bob X, 185 Bob XV, 185 Bob XV, 185 Bob XV Stereo, 185 Bobette I, II, 185 Combined 1/4-pl., Postcard, Stereo, 185 Double Shutter Camera, 185 Ermanox, 185 Ermanox Reflex, 185 Ernette, 185

Ensign Carbine (Houghton), 236

ERNEMANN Erni

Erni, 185 Ernoflex Folding Reflex, 185 Ernoflex Folding Reflex Model I, II, 186 Film K, 186 Film U, 186 Folding Reflex (Klapp Reflex), 186 Globus, 186 Globus Stereo, 186 Heag 0, 00, 186 Heag I, 186 Heag II, 186 Heag III, 186 Heag III, 186 Heag III (stereo), 187 Heag IV (stereo), 187 Heag IX Universal Camera, 187 Heag V, 187 Heag V, 187
Heag VI (Zwei-Verschluss-Camera),187
Heag VI Stereo, 187
Heag VII, 187
Heag XII, 187
Heag XII, 187
Heag XII (stereo), 187
Heag XIV, 188
Heag XV, 188
Heag XV, 188
Kino I, 460
Kino II, 461
Kino Model E, 461
Kinopticon, 461 Kinopticon, 461 Klapp cameras, 188 Klapp Reflex, 186 Klapp Stereo, 188 Liliput, 188 Liliput Stereo, 188 Magazine Box, 188 Mignon-Kamera,189 Miniature Klapp, 189 Miniature Klapp-Reflex,189 Normal Kino, 461 Reflex, 189 Rolf I, II, 189 Simplex, 189 Simplex, 109 Simplex Ernoflex, 189 Stereo Bob, 189 Stereo Ernoflex, 189 Stereo Ernoflex, 189
Stereo Reflex, 189
Stereo Simplex, 189
Stereo Simplex Ernoflex, 189
Stereoscop-Camera, 189
Tropical cameras, 189
Tropical Heag VI, 189
Tropical Heag XI, 190
Tropical Klapp, 190
Unette, 190
Universal Universal, 190 Velo Klapp, 190 Zwei-Verschluss-Camera,190 Ernemann Ring Camera (Mazur), 302 Ernette (Ernemann), 185 Ernette (Ernemann), 185
Erni (Zeiss Ikon), 443
Ernoflex Folding Reflex (Ernemann), 185
Ernoflex Folding Reflex Model I, II
(Ernemann), 186 Ernos (Photoprint), 352 Errtee button tintype camera (Talbot), 399 Errtee folding plate camera (Talbot), 399 Errtee folding rollfilm camera (Talbot), 399 ERTEL WERKE Filmette I, II, 461
Esco (Seischab), 383
Escopette (Darier), 132
ESPINO BARROS E HIJOS S.A. Noba, 190 Espionage Camera (FRENCH), 190 Espi, (Spitzer), 392 Essem, 190 Essex, 190 Estafeta (Belomo), 89 **ESTES INDUSTRIES** Astrocam 110, 190

Etareta, 190 Etah, 190 Etareta (Eta), 190 ETTELSONCORP. Mickey Mouse Camera, 190 EULITZ Grisette, 190 **EUMIG** Eumig C-3, 461
Eumig C-39, 461
Eumig C16, C16R, 461
Eumig C5 Zoom-Reflex, 461
Eumig Electric, Electric R, 461
Eumig Servomatic, 461 Eumig Servomatic, 461
Eumigetta (I), Eumigetta 2, 190
Eura (Ferrania), 194
Euralux 44 (Ferrania), 194
Eureka (Rouch), 373
Eureka Cameras (Eastman), 153 Evans Box (Vredeborch), 420
Everhard Schneider 35mm Motion Picture Camera (German-American),462 Blockmaster One-Shot, 190 Blockmaster One-Shot, 190
Exa models (Ihagee), 244
Exa System (Rheinmetall), 362
Exactor (Pacific Products), 346
Exakta (original) (Ihagee), 244
Exakta 66 (Ihagee), 245
Exakta A (Ihagee), 244
Exakta B (Ihagee), 244
Exakta EDX 3 (Ihagee), 245
Exakta FE 2000 (Ihagee), 245
Exakta II (Ihagee), 245
Exakta Jr. (Ihagee), 245
Exakta Jr. (Ihagee), 245 Exakta II (Ihagee), 245
Exakta Jr. (Ihagee), 245
Exakta Real (Ihagee), 245
Exakta RTL 1000 (Ihagee), 245
Exakta TL 500, TL 1000 (Ihagee), 245
Exakta Twin TL (Ihagee), 245
Exakta V (Varex) (Ihagee), 245
Exakta VX (Varex VX) (Ihagee), 245
Exakta VX 11A, VX IIB (Ihagee), 245
EXCEL PROJECTOR CORP.
Excel 8mm, No. 38, 461 Excel 8mm, No. 38, 461 Excel 16mm No. 40, 461 Excell (Le Docte), 278 Excella, 191
Excelsior (Rouch), 373
Excelsior (Semmendinger),384 Excelsior (Wünsche), 430 EXCLUSIVEGIFTS Photo Frame, 485 Exco, 191 Exhibit (Junka), 250 Explorer (Bolsey), 98 EXPO CAMERACO. Easy-Load, 191 Focal Plane Police Camera, 191
Police Camera, 191
Watch Camera, 191
Exposomat8R, 8T (Nizo), 465
Eye Camera (Gakken), 206
Eyelux (Amica International), 62 Eyematic EE 127 (Revere), 362 Eyemo 35mm Cine (Bell & Howell), 455 F-20 Coro-Flash (Coronet), 128 F-21 (Krasnogorsk), 262 F-21 Button Camera (Krasnogorsk), 262 F.O.P. Frena (Beck), 87 FABRIK FOTOGRAFISCHEAPPARATE Fotal, 191 Fabuland Patrick Parrot (Lego), 497 Facile (Fallowfield), 191
FAIRCHILD CAMERA
Fairchild Cinephonic Eight, 461
FAIRWEATHER

Falcon (Utility), 412 Falcon-Abbey Electricamera (Utility), 412 Falcon Camera (Eastman), 153
FALCON CAMERA CO.
Falcon Miniature, 191
Falcon Miniature Deluxe, 191 Falcon Miniature Deluxe, 191
Falcon Monicam Senior, 191
Falcon Rocket, 191
Falcon-Flex (Utility), 413
Falcon Junior 16 (Utility), 412
Falcon Midget (Utility), 413
Falcon Midget (Utility), 413
Falcon Midget 16 (Utility), 412
Falcon Minette (Utility), 412
Falcon Minicam Junior (Utility), 412
Falcon Minicam Senior (Utility), 412
Falcon Model F, FE (Utility), 412
Falcon Model F, GE (Utility), 412
Falcon Model G, GE (Utility), 412
Falcon Press Flash (Utility), 412
Falcon Press Flash (Utility), 412
Falcon Special (Utility), 412
FALLER (Eugene)
Field Camera, 191
Wet-plate camera, 191
FALLOWFIELD
Facile, 191
Misul Hand Comera, 192 Falcon Minicam Senior, 191 Facile, 191 Miall Hand Camera, 192 Peritus No. 1, 192 Popular Ferrotype Camera, 192 Prismotype, 192 Studio Camera, 192 Tailboard cameras, 192 Victoria, 192
Wet plate 9-lens camera, 192
FALZ & WERNER
Field camera, 192 Universal Salon, 192 Fama, 192 Fama (Cornu), 125 Family (Mamiya), 297 FAP Norca A, B, 192 Norca Pin-Up, 192 Rower, 192 FARROW(E.H.) Field Camera, 193 Fashion Photo Barbie (Mattel), 480 Faultless Miniature (Bernard), 91 Fautitiess Minature (Bernard), 91
Favor (Wöhler), 430
Favorit (Ica), 241
Favorit (Wünsche), 431
Favorit (Zeiss Ikon), 443
Favorit Tropical (Ica), 241
Favorit (Rochester Camera Mfg.), 368
Favorite (Rochester Camera Mfg.), 368 Feca (reflex) (Vormbruck), 420 FED Fed, 193 Fed-1, 193 Fed 2, 193 Fed 3, 193 Fed 4, 193 Fed 10, 193 Fed 11 (Atlas), 193 Fed-C, 193 Fed Micron, Micron-2, 193 Fed Micron, Micron-2, 193
Zarya (Zapa), 193
Fed-Flash (Federal), 193
Fed-Zorki (Krasnogorsk), 264
FEDERALMFG. & ENGINEERINGCO.
Fed-Flash, 193
FEINAK-WERKE Folding plate camera, 193 Feininger Farb Fotolehre, 193 FEINOPTISCHESWERK Astraflex-II, 193 FEINWERKTECHNIK GmbH Mec-16, 193 Mec-16 SB, 194 Mec 16 (new style), 194

Photographer, 491

Field camera, 191

Fairy Camera (Anthony), 69 FAISSAT (J.)

Faller Falls Of the second		FUCAFLE
Felica, Felita (Vredeborch), 420	Field camera (Hill), 233	198
Felicetta (Vredeborch), 420 FERRANIA	Field camera (Hobbies), 234	Finger Print Camera (Sirchie), 389
Alfa, 194	Field camera (Hoh & Hahne), 234	Finger-Print Camera (Graflex), 223
Box camera, 194	Field camera (Husbands), 239	Fips Microphot, 197
Condorl, Ic, 194	Field camera (Huth Bros.), 239	Fips Pocket Camera, 197
Condor Junior, 194	Field camera (Jonte), 250 Field camera (Kleffel), 257	FIRST CAMERA WORKS 197
Condoretta, 194	Field camera (Knoll), 257	First Center (Kuribayashi) 269
Elioflex, Elioflex 2, 194	Field camera (Kullenberg), 266	FIRST ETUI Camera (Kurihayashi) 268
Eura, 194	Field camera (LePage), 289	First Hand (Kuribayashi), 268
Euralux 44, 194	Field camera (Liesegang), 290	First Reflex (Kuribayashi), 269
lbis, 194	Field camera (Lloyd), 292	First Roll (Kuribayashi), 268 First Six (Kuribayashi), 269
Ibis 34, 194 Ibis 6/6, 194	Field Camera (Loeber), 292	First Six I, III, V (Tokiwa), 403
Lince 2, 194	Field camera (London Stereoscopic), 294	First Speed Pocket (Kuribayashi), 269
Lince Rapid, 194	Field camera (Lorillon), 294	rirstilex (Tokiwa), 403
Lince Supermatic, 194	Field camera (Lüttke), 295	Firstflex 35 (Tokiwa) 403
Rondine, 194	Field Camera (Mackenstein), 296 Field camera (Marion), 300	FISCHER
Tanit, 194	Field camera (Mason), 300	Nikette, II, 197
Zeta Duplex, Duplex 2, 194	Field camera (McGhie), 302	Fischer Baby (Marchand), 299
FERRERO	Field Camera (Meyer), 305	FISHER PRICE TOYS
Pocket Coffee Espresso, 474	Field camera (Meyer & Kaste), 305	Crazy Camera, 494
FERRO	Field camera (Naylor), 324	Fisher-Price Camera (Eastman), 154 FISHER-PRICETOYS
G.F. 81 or 82 Ring Camera, 195	Field Camera (Negretti), 324	Movie Viewer, 499
Ferrotype 4-tube camera (Peck), 348 Ferrotype camera (Laack), 275	Field camera (Neumann), 325	Picture Story Camera, 499
FERTSCH	Field camera (Photographie Vulg.), 352	Pocket Camera, 499
Feca, 195	Field camera (Plaul), 356	Fit, Fit II (Dufa), 139
Festival (Wittnauer), 429	Field camera (Prescott), 359	Fita (Bing), 94
FETTER	Field camera (Reynolds & Branson), 362 Field Camera (Ross), 372	Five Goats (Guangzhou) 224
Folding Camera, 195	Field camera (Ross), 372 Field camera (Sands Hunter), 376	FIVE STAR CAMERA CO.
Photo-Eclair, 195	Field camera (Scovill), 379	Five Star Candid Camera, 197
FETZINGER	Field Camera (Sönnecken), 390	Fixfocus (Balda), 84
Field camera, 195	Field camera (Stegemann), 393	Flair Doll Camera (Totsy), 497
Fex (Czechoslovakia), 195	Field camera (Thowe), 402	Flammang's Patent (American Opt.), 62 Flash 120 (Macy), 296
FEX/INDO	Field camera (Trotter), 407	Flash 6x9 (Marchand), 299
Delta, 195 Elite-Fex, 195	Field camera (Underwood), 408	Flash Bantam Camera (Eastman), 142
Fex, 195	Field camera (Vojta), 419	riash box (Genos), 21()
Graf, 195	Field camera (Watson), 422	FLASH CAMERA CO.
Juni-Boy 6x6, 195	Field camera (Winter), 427 Field camera (Wünsche), 431	Candid Flash Camera, 197
Pari-Fex, 196	Fiesta Instant Camera (Eastman), 153	Flash Champion (Ansco), 64
Rubi-Fex 4x4, 196	Fifieth Anniversary Camera (Eastman),	Flash Clipper (Ansco), 64
Sport-Fex, 196	153	Flash Master (Monarch), 318
Super-Boy, 196	Fildia (Coronet), 128	FLASH-ITCORP.
Superfex, 196	Filius-Kamera(Isoplast), 249	Switchplate cover (photographer), 481 Switchplate cover (tourist), 482
Superior, 196	Film Cartridge Lighter, 474	Flash-Master (Herold), 232
Ultra-Fex, 196 Ultra-Reflex, 196	Film Cassette Cookie Jar (Welch), 477	Flash-Master(Seymour), 385
Uni-Fex, 196	Film K (Ernemann), 186	Flash-O-Set, Flash-O-Set II (Yashica) 43
Weber Fex, 196	Film Pack Hawk-Eye Cam. (Eastman), 157	Flashline, 197
FIAMMA	Film Premo Cameras (Eastman), 165	Flashmaster(Coronet), 128
Fiamma Box, 196	Film Roll Calculator, 484 Film U (Ernemann), 186	Flat Back Ensign (Houghton) 235
Fibiru (Ruberg & Renner), 374	FILMA	Flat Folding Kodak (Eastman), 154
Fibituro (Ruberg & Renner), 375	Box cameras, 196	Fleetwood (Monarch), 318
Fightner's Excelsior Detective (Hüttig) 240	Filmett (Seneca), 384	Flektar, 197 Flex-Master (Monarch), 318
Field & Studio camera (Mazo), 302	Filmette I, II (Ertel), 461	Flex-Master (Spencer), 392
Field camera (Berner), 91 Field Camera (Bial & Freund), 93	Filmo 121-A (Bell & Howell), 455	Flex-O-Cord (Kojima), 258
Field Camera (Billcliff), 93	Filmo 127-A (Bell & Howell), 455	Flexaret (Meopta), 303
Field camera (Birnie), 94	Filmo 141-A, 141-B (Bell & Howell), 455	Flexette (Optikotechna), 345
Field camera (Brack), 100	Filmo 70 models (Bell & Howell), 455 Filmo 75 models (Bell & Howell), 455	Flexilette (Agfa), 54
Field camera (Brückner), 102	Filmo Aristocrat (Bell & Howell), 455	Flexlide 35 (Fujimoto), 499
Field camera (Century), 115	Filmo Auto Load (Bell & Howell), 455	Flexo (Lippische), 292
Field camera (City Sale), 120	Filmo Auto Master (Bell & Howell), 455	Flexo Kodak Cam., No. 2 (Eastman), 154
Field camera (Demaria), 135	Filmo Companion (Bell & Howell), 455	Flexo Richard (Lippische), 292 Flexora (Lippische), 292
Field camera (Derogy), 136	Filmo Sportster (Bell & Howell), 455	Flick-15 (Eppische), 292 Flick-15 (Eppische), 292
Field Camera (Duerden), 139	Filmo Turret Double Run 8 (Bell & Howell).	Fling 35 (Eastman), 154
Field Camera (Emmerling & Richter), 183 Field Camera (English style) (Meyer), 304	455	Flocon RF, 197
Field camera (Faissat), 191	Filmor (Fototecnica), 200	Flush Back Kodak Camera (Eastman) 15
Field Camera (Faller), 191	Filmos (Leonar), 289 Filmos (Lüttke), 295	$FOCA(^{\circ})(1946 \text{ type})(OPI_FOCA)(344)$
Field camera (Falz & Werner), 192	Filmoskop (Birnbaum), 94	Foca (**) (1945 type) (O.P.LFOCA), 344
Field Camera (Farrow), 193	Filmplate Premo Camera (Eastman), 165	Foca (**) (1945 type) (O.P.LFOCA), 344 Foca (**) PF2B (O.P.LFOCA), 344
Field camera (Fetzinger), 195	Filmplate Premo Special (Eastman), 165	100a() PF3. PF3L(O P L -FOCA) 344
Field camera (Frost & Shipham), 204	FINETTA-WERK	FUCA ("") PF3L "AIR" (U.P.LFOCA) 342
Field camera (Gandolfi), 208	Ditto 99, 197	Foca Marly (O.P.LFOCA), 345 Foca Standard (*) (O.P.LFOCA), 344
Field camera (Goecker), 213	Finetta, 197	Foca U.R. (O.P.LFOCA), 344
Field camera (Goldmann), 215 Field camera (Havenhand), 230	Finetta 88, 197	Foca Universel, Universel R
Field camera (Havenhand), 230 Field camera (Herbst), 232	Finetta 99, 99L, 197	(O.P.LFOCA), 344
Field Camera (Hermagis), 232	Finetta Super, 197 Finette, 197	Foca URC (O.P.LFOCA), 345
Field Camera (Hess & Sattler), 233	Finger Print Camera (Folmer & Schwing),	Focatlex, II (O.P.LFOCA) 345
	gor i mit Gamera (Folitier & Schwing),	Focaflex Automatic (O.P.LFOCA), 345

FOCAL PLANE

Focal Plane Camera (APM), 71 Focal plane camera (Tucht), 407 Focal Plane Eclipse (Shew), 386 Focal Plane Imperial Two-Shutter Camera (Thornton-Pickard),400 Focal Plane Police Camera (Expo), 191 Focal plane postcard camera (Reflex Camera), 361 (Reflex Carriera), 30 1
Focal Plane Vesta (Adams), 51
Focasport (O.P.L.-FOCA), 345
Focus Pocus (Ambi Toys), 494
Focusing Weno Hawk-Eye (Blair), 95
Fodor 35 (Taron), 400
Fodor Box Syncrona (Vredeborch), 420
Fodorflex, 197 Fodorflex, 197 Foinix (Foitzik), 197 Foinix 35mm (Foitzik), 197 **FOITZIK** Foinix, 197 Foinix 35mm, 197 Reporter, 197 Unca, 197 Visobella, 197 Fokaflex, 198 Foldex, Foldex 30 (Pho-Tak), 350 Folding '95 Hawk-Eye (Blair), 95 Folding Ansco (Ansco), 64
Folding Autographic Brownie Camera Folding Autographic Brownie Camera (Eastman), 146
Folding B.B. (Vive), 414
Folding bed plate (Loeber Br.), 293
Folding-bed plate camera (Plaubel), 355
Folding Brownie Camera (Eastman), 146
Folding Brownie Six-20 (Eastman), 146
Folding Buster Brown (Ansco), 63
Folding camera (Bülter & Stammer), 102
Folding Camera (Fetter), 195
Folding camera (Herlango), 232
Folding camera (Mackenstein), 296
Folding camera (S.P.O.), 392
Folding camera (Sönnecken), 390
Folding Cartridge Hawk-Eye Cameras (Eastman), 157 (Eastman), 157 Folding Cartridge Premo (Eastman), 165 Folding Ensign 2-1/4B (Houghton), 236 Folding Film Pack Hawk-Eye Camera (Eastman), 157 Folding Focal Plane Camera (Bentzin), 90 Folding Focal Plane Camera (Bentzin), 90
Folding Frena (Beck), 87
Folding Hawk-Eye 5x7 (Blair), 95
Folding Hawk-Eye Camera (Eastman), 157
Folding Hawk-Eye Special (Eastman), 157
Folding Kewpie Camera (Conley), 122
Folding Klito (Houghton), 238
Folding Kodak Cameras (Eastman), 154
Folding Magazine Camera (Bullard), 102
Folding Montauk (Gennert), 210
Folding Plate camera (Agfa), 54 Folding Plate camera (Agfa), 54
Folding plate camera (Ballin Rabe), 85 Folding plate camera (Bullard), 102
Folding plate camera (Busch), 103, 104
Folding Plate Camera (Conley), 122
Folding plate camera (Feinak-Werke), 193 Folding plate camera (Felliak-Weike), 193
Folding plate camera (Glunz), 212
Folding Plate Camera (Herlango), 232
Folding plate camera (Hoh & Hahne), 234
Folding plate camera (Hüttig), 240
Folding plate camera (Ica), 241
Folding plate camera (Ica), 241 Folding plate camera (Lüttke), 295 Folding plate camera (Monroe), 318 Folding plate camera (Nettel), 325 Folding plate camera (Netter), 325 Folding plate camera (Riddell), 363 Folding plate camera (Roland), 371 Folding Plate Camera (Seneca), 384 Folding plate camera (Steinheil), 394 Folding plate camera (Suter), 396 Folding plate camera (Thornton-Pickard), 401 Folding plate camera (Thowe), 402
Folding plate camera (Voigtländer), 417
Folding plate camera (Wilkin), 427
Folding Plate Camera with changing box (Lawley), 278

Folding plate camera, focal plane (Murer), Folding plate/rollfilm camera (Lüttke), 295 Folding plate/sheetfilm (Rodenstock), 371 Folding Pocket Brownie Camera (Eastman), 146 Folding Pocket Cyko No. 1 (Rochester Optical), 369 Folding Pocket Kodak Camera (Eastman), 155 Folding Poco, (American Camera), 61 Folding Premo Camera (Rochester Optical), 370 Folding Rainbow Hawk-Eye Camera (Eastman), 158 (Eastman), 158
Folding Rainbow Hawk-Eye Special
Cameras (Eastman), 158
Folding Reflex (Ernemann), 186
Folding Reflex (Goerz), 213
Folding Reflex (Ica), 243
Folding Reflex (Ica), 243
Folding Reflex (Ica), 243 Folding Reflex (Newman & Guardia), 326 Folding Rochester (Rochester Camera Mfg. Co.), 368 Folding Rollfilm camera (Agfa), 54 Folding Rollfilm camera (Agfa), 54
Folding rollfilm camera (Busch), 104
Folding Rollfilm Camera (Conley), 122
Folding Rollfilm Camera (Coronet), 128
Folding Rollfilm camera (Foth), 199
Folding Rollfilm Camera (Gallus), 207
Folding rollfilm camera (Goerz), 213
Folding rollfilm camera (Lüttke), 295
Folding Rollfilm camera (Rodenstock), 371
Folding Rollfilm Camera (Seehold), 382 Folding rollfilm camera (Rodenstock), 37 Folding Rollfilm Camera (Seebold), 382 Folding rollfilm camera (SNK), 389 Folding rollfilm camera (Voigtländer), 417 Folding rollfilm camera, Deluxe (Foth), 199 Folding rollfilm models (Glunz), 212 Folding Ruby (Thornton-Pickard), 401 Folding Scout (Seneca), 384
Folding sheet film cameras (Beier), 88 Folding Spido (Gaumont), 209 Folding Twin Lens Camera (Ross), 372 FOLMER & SCHWING Banquet cameras, 198 Finger Print Camera, 198 Multiple Camera, 198 Sky Scraper Camera, 198 Ford V8 Camionette 1934 Kodak (Hobbycar), 497 Ford V8 Delivery Sedan (Hobbycar), 497 Ford's Tom Thumb Camera (Jurnick), 251 Fornidar 30 (Nagel), 323 **FORTE** Optifort, 198
Forward Siderigger (Chapman), 118
FOSTER INSTRUMENTSPTY LTD.
Swiftshot "Made in Australia", 198 Swiftshot Model A, 198 Fotal (Fabrik Foto.), 191 Fotax Flexo, 198 Fotax Mini, Fotax Mini IIa, 198 FOTET CAMERA CO. Fotet, 198 Fotex, 198 FOTH Derby (original), 198 Derby (I), II, 199 Folding rollfilm camera, 199 Foth-Flex, II, 199 Fotima Reflex, 199 Foto Nic (Nic), 327 Foto-File (Ian Logan), 477 Foto-Fips (Waldes), 421 Foto-Flash, 474 FOTO-FLEXCORP. Foto-Flex, 199 Foto-Füller (Kunik), 266 Foto-Füller (Luxus) (Kunik), 267 FOTO-QUELLE Revue 3, 199 Revue-4, 199 Revue 16 KB, 199

Fotobox (MOM), 318 FOTOBRAS Magica-flex, 199 **FOTOCHROME** Fotochrome Camera, 200 Fotochrome Camera (Kuribayashi), 272 FOTOFEX-KAMERAS Minifex, 200 Visor-Fex, 200 Fotojack (Fuji Photo), 205 Fotokor (GOMZ), 216 FOTOMAT Squirt Camera, 488
Foton (Bell & Howell), 89
Fotonesa (G.P.M.), 217
FOTOTECNICA
FOTOTE CALIFORNIA Bakina Rakina, 200 Bandi, 200 Eaglet, 200 Filmor, 200 Herman, 200 Rayelle, 200 Rayflex, 200 Tennar, Tennar Junior, 200 Fotox, 482 Fotron & Fotron III (Traid), 406 Four-tube camera (Thorpe), 402 Fowell Cinefilm, 200 Fox Co. (Eastman Rainbow Hawk-Eye), 158 Fox Talbot Van (Lledo), 498 FR CORP. FR Auto-Eye II, 200 Franceville, 200 Franceville (L.F.G. & CO.), 290 Francia (Mackenstein), 296 Francia Stereo (Mackenstein), 296 **FRANCKH** Opticus Photographe, 200 Francya, 200 FRANÇAIS Cosmopolite, 200 Kinegraphe, 200 Photo-Magazin, 200 Français (L.F.G. & CO.), 290 Frank Six (Tosei), 404 Franka 16 (Wirgin), 428 FRANKA PHOTOGRAPHICCORP. Kentucky Fried Chicken, 201 NBA 76ers, 201 St. Louis Steamers, 201 FRANKA-WERK Bonafix, 200 Franka, 200 Frankarette, 201 Rolfix, II, 201 Rolfix Jr., 201 Solid Record, 201 Solida, 201 Solida I, II, 201 Solida III, IIIL, 201 Solida Jr., 201 Frankarette (Franka-Werk), 201 FRANKE & HEIDECKE Automat, 202 Automat, 202
Automat (MX-EVS), 203
Automat (MX-sync.), 203
Automat (X-sync.), 202
Copy Stand, 201
Heidoscop, 201
Ifbaflex M102, 201
Mutar, 201
New Standard, 203 New Standard, 203 Old Standard, 203 Rollei 35, 201 Rollei 35B, 201 Rollei 35C, 201 Rollei 35C, 201 Rollei 35S, 35SE, 201 Rollei 35T, 35TE, 201 Rollei A110, 201 Rollei A26, 201 Rollei E110, 201

Revue Mini-Star, 199
GEVABOX

Rollei-16, 16S, 201 ST 901, 205 Rolleicord I, 202 Gamma (subminiature), 208 GAMMA WORKS Winchester, 205 Fujica Drive (Fuji Photo), 205 Rolleicord I, 202
Rolleicord II, 202
Rolleicord III, 202
Rolleicord IV, 202
Rolleicord IV, 202
Rolleicord V, 202
Rolleicord Va, Vb, 202
Rolleidoscop, 202
Rolleiflex, 202
Rolleiflex, 202
Rolleiflex, 202 Fujica Drive (Fuji Photo), 205
Fujica Half (Fuji Photo), 205
Fujica Mini (Fuji Photo), 205
Fujica Rapid S, S2 (Fuji Photo), 205
Fujica Single-8 P1 (Fuji), 461
Fujica V2 (Fuji Photo), 205
Fujicaflex (Fuji Photo), 205
Fujicarex, II (Fuji Photo), 205
FUJIMOTO MFG. CO. Duflex, 208 Pajta's, 208 GANDOLFI Field camera, 208 Tropical camera, 208 Universal, 208 Universal Stereo, 208 GAP Box (Paris), 347 GAP Super (Paris), 347 Garant (Welta), 423 Rolleiflex I, original, 202 Rolleiflex 2.8 models, 203 Rolleiflex 3.5 models, 203 Prince Peerless, 206
Semi Prince, Semi Prince II, 206
FUJIMOTO PHOTO MFG. CO. Garfield Tourist, 495 Rolleiflex 3.5 models, 203
Rolleiflex 4x4, original, 204
Rolleiflex E, E2, E3, 203
Rolleiflex F, 203
Rolleiflex Grey Baby, 204
Rolleiflex Post-War Black Baby, 204
Rolleiflex SL26, 203
Rolleiflex SL35, SL35E, 203
Rolleiflex SL35M, SL35ME, 203
Rolleiflex T, 203
Rolleiflex T, 203
Rolleimagic (I). II. 204 FUJIMOTOFHOTOMICS. CO. Flexlide 35, 499 Fujipet, Fujipet EE (Fuji Photo), 205 Fujita 66SL, 66SQ, 66ST (Fujita), 206 FUJITA OPT. IND. Classic 35 IV, 206 GARLAND Wet Plate camera, 208 Gatling 72, 208
Gatling f1.7 (Standard Projector), 393
GATTO Sonne IV, 208
Gaudin Daguerreotype (Lerebours), 289
GAUMONT Fujita 66SL, 66SQ, 66ST, 206 Full-Vue (Spencer), 392 Fulvueflex Synchroflash (Ross Ensign), Block-Notes, 209 Block-Notes Stereo, 209 Rolleimagic(I), II, 204 Rolleiwide, 204 Fun Camera (My First Buddys), 495 Bramham, 209 Fun-Face Camera (Chadwick-Miller), 118 Elge, 209 Folding Spido, 209 Sports Rolleiflex, 204 Furet (Guérin), 224 FUTURA KAMERA WERK Studio, 203 Tele Rolleiflex, 204 Miniature, 209 Futura (Futura Standard), 206 Polain No. 1, 209 Reporter, 209 Tripod head, 201 Futura-P, 206 Futura-S, SIII, 206 Wide-Angle Rolleiflex (Rolleiwide), 204 FRANKLINPHOTOGRAPHIC Reporter, Tropical model, 209 Futurit, 206 Spido, 209 Franklin Magazine 8, 461 Spido, 209 Stereo cameras, 209 Stereo Spido, 209 Gear (Watson), 422 Gehaflex (Eho-Altissa), 181 Gelto D III (Toakoki), 403 FX-1 (Yashica), 434 FX-2 (Yashica), 434 FRANKS (A.) Presto, 204 Fraphot, 204 Frati 120, 204 Transistomatic Radio Camera, 209 Frati De Lujo, 204 G.F. 81 and 82 Ring Camera (Ferro), 195 G.G.S. Gely-Box, 474 Freccia, 204 Gem 16, Model II (Morita), 320 Fred Flintstone (Hanna-Barbera), 228 Gem 16, Model II (Morita), 320 Gem Apparatus (Lancaster), 276 Gem Box (Anthony), 69 Gem Glencoe (Canadian Camera), 108 Gem Poco (Rochester Camera Mfg.), 368 Gemflex (Showa), 387 Gemmy (Okada), 337 General (Rocket Camera Co.), 370 GENERAL PRODUCTSCO. Candex Jr., 209 Lucky, 211 Luckyflex, 211 G.I. Joe (Nasta), 323 Freewheel (Busch), 103 Freleca Magic F, 204 Frena (Beck), 87 G.I. Joe Astronaut Wrist Camera, 480 Frena Presentation Model (Beck), 87 FRENNET Fotonesa, 217 Gabri (C.M.F.), 121 GABRIEL TOY CO. U-2 Spy Plane, 206 GAERTIG & THIEMANN Ideal Model VI, 206 Gaica Semi, 206 Stereoscopic Reflex, 204 Frica, 204 Friend Boy's Camera, 482 FRIENDLY HOME PARTIES Candex Miniature Camera, 209 Camera Coaster Set, 476 Frog Photographer, 491 Front-Box (Balda), 84 FROST & SHIPHAM LTD. Field, 204 Clix Miniature Camera, 209 Genesse Outfit (Eastman), 156 GENIE CAMERA CO. GAKKENCO. 110 Camera, 206 Genie, 209 Ant Farm Camera, 497 GENNERT FT-2, 204 FT-2 (Krasnogorsk), 263 Antique Tripod Cameras, 206 Book Camera, 206 Compact D.E. Cycle Montauk, 209 Folding Montauk, 210 Fuji, 204 FUJI KOGAKU SEIKI Eye Camera, 206 Golf Montauk, 210 Long Focus Montauk, 210 Robot Camera, 206 Soccer Ball Camera, 207 Baby Balnet, 204 Baby Lyra, 205 Montauk, 209 Taiyou Kamera, 486 Montauk III, 210 Montauk rollfilm camera, 210 Comex, 205 Taiyou Kanleria, 466 Taiyou Kankou Kamera, 486 GALILEO OPTICAL Condor I, 207 Gami 16, 207 Lyra 4.5x6cm (Semi-Lyra), 205 Lyra Six, Lyra Six III, 205 Penny Picture camera, 210 Stereoscopic Montauk, 210 Lyraflex, Lyraflex F, Lyraflex J, 205 Wet Plate Camera, 4-lens, 210 Lyrax, 205 FUJI PHOTO FILM CO. AZ-1, 205 **GALLUS** GENOS K.G. Bakelite, 207 Flash Box, 210 AZ-1, 205
Fotojack, 205
Fujica Drive, 205
Fujica Half, 205
Fujica Mini, 205
Fujica Rapid S, Rapid S2, 205
Fujica Single-8 P1, 461
Fujica V2, 205
Fujicaflex, 205
Fujicarex, Fujicarex II, 205
Fujicarex, Fujicarex EE, 205
Pet 35, 205
Police Academy 6, 205 Derby, 207 Genos, 210 Derby-Lux, 207 Derlux, 207 Folding Rollfilm Camera, 207 Genos Fix, 210 Genos Rapid, 210 Genos Special, 210 Stereo camera, 207 Special Fix, 210 George Washington Bicentennial Camera **GALOOB** Beddy-Bye Bear, 478 GALTER PRODUCTS (Eastman), 156 Gerd (Goebel), 491 GERLACH Hopalong Cassidy Camera, 207
Majestic, 208
Pickwik, 208
Regal, Regal Miniature, 208
Sunbeam 120, 208 Ideal Color 35, 210 Trixette, 210 GERMAN-AMER.CINEMATOGRAPH Police Academy 6, 205 ST 605, 205 ST 701, 205 ST 705, 205 Everhard Schneider 35mm, 462 Gami 16 (Galileo), 207 GAMMA **GERSCHEL** Mosaic, 210 Alba, 208 Gevabox 6x6 (Gevaert), 210 Gevabox 6x9 (Gevaert), 210 ST 705W, 205 Gamma (35mm), 208 Perla A I, 208 ST 801, 205 Gevabox Special (Gevaert), 210

GEVAERT

OF A VPIVI		
GEVAERT	GOEBEL	Komsomoletz, 216
Gevabox 6x6, 210	Boy with 35mm camera, 491	Lubitel, 216
Gevabox 6x9, 210	Gerd, 491	Lubitel 2, 217
Gevabox Special, 210	Goofy, 491	Lubitel 166, 166B, 217
	Rad Head Photographer,491	Maliutka, 217
Gevalux 144, 211	GOECKER	Moment (MOMEHM), 217
Gevaphot, 211	Field camera, 213	Smena, 217
Ofo, 211	GOERZ	Smena SL, 217
Rex-Lujo, 211		Smena Symbol, 217
Gevaert Geva 8 (Carena), 457	Ango, 213	Sport (Cnopm), 217
Gevalux 144 (Gevaert), 211	Ango Stereo, 213	Sputnik (CNYTHNK), 217
Gevaphot (Gevaert), 211	Anschütz, 213	
Gewir (Wirgin), 428	Anschütz Deluxe, 213	Turist (Mypucm), 217
Gewirette (Wirgin), 428	Anschütz Stereo, 213	Voskhod, 217
GEYER	Box Tengor, 213	Goodwin (Ansco), 65
Cine-Geyer AK26, 462	Coat Pocket Tenax, 214	GOODWINFILM & CAMERACO., 217
GEYMET & ALKER	Folding Reflex, 213	Goofy (Goebel), 491
Jumelle de Nicour, 211	Folding rollfilm cameras, 213	GOYOCO.
Gezi, II, 211	ManufocTenax, 214	Rosko Brilliant 620, 217
GIBBS	Minicord, Minicord III, 214	Grace, Grace Six (Daitoh), 131
Gibbs View Camera, 211	Minicord Enlarger, 214	Gradosol, Gradosol Lujo (Siaf), 387
	Photo-Stereo-Binocle,214	GRAEFE & BARDORF
GIBSON	Roll Tenax, 214	Clarissa Nacht-Kamera, 217
Stereo camera, 211	Roll Tenax Luxus, 214	Graf (Fex/Indo), 195
GIBSON (C.R.) CO.	Roll Tengor, 214	GRAFLEX
Camera Note Box, 477	Stereo Tenax, 214	Anniversary Speed Graphic, 222
Gift Kodak Camera		Auto Graflex, 218
No. 1A (Eastman), 156	Taro Tenax, 214	Auto Graflex Junior, 218
Gil (Durst), 139	Tenax, 214	Century 35, 223
Gilbert (Hunter), 239	Tenax Tropical, 214	Century Graphic, 221
GILLES-FALLER	Vest Pocket Tenax (plate type), 214	
Studio camera, 211	GOLD HORSE	Century Universal, 223
Gilman Little Sport, 495	Enjicolor F-II, 481, 484	Ciro 35, 223
GINREIKOKI	KeepcolorII, 481, 484	Combat Graphic, 221
Vesta, 211	Golda (Goldammer), 214	Compact Graflex, 219
Vester-Six, 211	GOLDAMMER	Crown Graphic Special, 221
GIRARD	Golda, 214	Crown View, 223
Le Reve, 212	Goldeck 16, 214	Deceptive Angle Graphic, 221
	Goldeck 6X6, 214	Finger-Print Camera, 223
GIREY	Goldix, 215	Graflex (original), 218
Kamra-PakCommemoratives,476	GuGo, 215	Graflex 1A, 218
Kamra-PakVanity, 476	Goldeck 16 (Goldammer), 214	Graflex 3A, 218
Purse, Compact, & Lipstick, 476	Goldeck 6X6 (Goldammer), 214	Graflex 22, 223
Vanity Case, Vanity kits, 476	Golden Ricoh 16 (Riken), 364	Graflex Series B, 219
Girl Guide Kodak Camera (Eastman), 156		Graphic 35 models, 221
Girl holding camera, 483	Golden Shield (Argus), 73	Graphic camera, 221
Girl Photographer, 491	Golden Steky (Riken), 364	Graphic Sr., 221
Girl Photographerin Car (Burger King),	Goldi (Zeh), 436	Graphic View, View II, 223
494	Goldix (Goldammer), 215	
Girl Scout Falcon (Utility), 413	GOLDMANN	Home Portrait Graflex, 219
Girl Scout Kodak Camera (Eastman), 156	Amateur Field Camera, 215	Inspectograph Camera, 223
Girl Scout Official Camera (Trusite), 407	Field camera, 215	KE-4(1) 70mm Combat Camera, 223
Girl Scout Universal), 409	Press camera, 215	Military model KE-12(1) and (2), 222
Girl with Camera, 491	Universal Detective Camera, 215	Military Model PH-47-E, PH-47-H, 222
GIROUX	Universal Stereo Camera, 215	Miniature Speed Graphic, 222
DaguerreotypeCamera, 212	GOLDSTEIN	National Graflex, 219
Giroux DaguerreotypeReplica, 212	Camping, 215	Naturalists' Graflex, 219
	Goldy, Goldy Metabox, 215	No. 0 Graphic, 220
GIRVAN (T.F.)	Olympic, 215	Norita, 223
Kapai Camera, 212	Spring, 215	Pacemaker Crown Graphic, 221
Glass Camera on Tripod (Shackman), 484	Starmetal Goldy, 215	Pacemaker Speed Graphic, 222
Glencoe No. 4 (Canadian Camera), 108	Week End, 215	Photorecord, 223
Glink (Juhasz), 250	Goldy (Goldstein), 215	Pre-anniversary Speed Graphic, 222
Global, 212	Coldy Metabox (Coldstein) 215	Press Graflex, 219
Global 35 (GOMZ), 216	Goldy Metabox (Goldstein), 215	R.B. Graflex Junior, 219
Globus (Ernemann), 186	Golf (Adox), 51	R.B. Graflex Series B, C, D, 220
Globus Stereo (Ernemann), 186	Golf IA Rapid (Adox), 51	R.B. Super D Graflex, 220
Gloria (Balda), 84	Golf IIA (Adox), 51	R.B. Tele Graflex, 220
Gloria (Braun), 100	Golf IIIA (Adox), 51	Reversible Back Cycle Graphic, 221
Gloriette (Braun), 100	Golf Montauk (Gennert), 210	Reversible Back Cycle Graphic, 221 Reversible Back Cycle Graphic Special,
Glorina (Balda), 84	GOLTZ & BREUTMANN	
GLOSSICKMFG. CO.	Klein-Mentor, 215	221
Direct Positive Street Camera, 212	Mentor Compur Reflex, 215	Reversible Back Graflex, 219
GLUNZ	Mentor Dreivier, 216	Revolving Back Auto Graflex, 219
Folding plate camera, 212	Mentor Folding Reflex (Klappreflex), 216	Revolving Back Cycle Graphic, 222
Folding rollfilm models, 212	Mentor II, 216	Speed Graphics, 222
Ingo, 212	Mentor Reflex, 216	Stereo Auto Graflex, 220
Glyphoscope (Richard), 363	Mentor Sport Reflex, 216	Stereo Graflex, 220
	Mentor Stereo Reflex, 216	Stereo Graphic (35mm), 222
Gnco, 212	Mentor Studio Camera, 216	Stereoscopic Graphic, 222
Gno III, 213	Mentor Studio Reflex, 216	Super Graphic, 222
Gnoflex, 213	Mentorett, 216	Super Speed Graphic, 222
Gnom (Hüttig), 240	GOMZ	Tourist Graflex, 220
Gnome "Cheese" and "Flash", 491		XL, 223
GNOME PHOTOGRAPHICPRODUCTS	Cosmic-35, 216 Fotokor, 216	XLRF, 223
Baby Pixie, 213		XLS, 223
Pixie, 213	Global 35, 216 Junost (10HOCMb), 216	XLSW, 224
Go Bots 110 Camera (Playtime), 356	Juliosi (TOHOOMD), 2 To	

HELIOS

Grand (Century), 115	Halina 6-4 (Haking), 225	HADIIKAMA
Grand Camera (Irwin), 495	Halina A1 (Haking), 226	HARUKAWA
Grand Sr. (Century), 115	Halina-Baby(Haking), 226	Septon Pen Camera, 229 Septon Penletto, 229
Graphic camera (Graflex), 221	Halina-PrefectSenior (Haking) 226	Harvard camera (Mason), 301
Graphic 35 models (Graffex), 221	Halina Viceroy (Haking), 226	HASBROINDUSTRIES
Graphic Sr. (Graflex), 221	HALL & KEANE DESIGN	Romper Room Snoopy Counting
Graphic View, View II (Graflex), 223 GRAY	Camera Kit, 484	Camera, 499
Vest Camera, 224	HALL CAMERA CO.	HASSELBLAD
View camera, 224 View camera, 224	Mirror Reflex Camera, 226	Aerial Camera HK7, 229
Great Muppet Caper drinking glass	Pocket Camera, 226	500C, 230
(McDonalds), 480	Halloh (Ica), 241	500C/M, 230
Great Wall DF-2 (Beijing), 88	Halloh (Krügener), 266	500C/M Anniversary, 230
Great Wall SZ-1 (Beijing), 88	Halloh (Zeiss Ikon), 443	500EL, 230
GREEN CAMERA WORKS	HALMA Halma Flex, 227	500EL/M, 230
Green 6x6, 224	Halma-44, 226	500EL/M"10 Years on the Moon", 230
Green Pine Water Camera, 488	Halma-Auto, 226	500EL/M"20 Years in Space" 230
GREENPOINTOPTICALCO	Halmat, 227	500ELX, 230
View Camera, 224	HAMAPHOT	1000F, 229
GRIFFIN	Blitz-Hexi, 227	1600F, 229 2000FC, 230
Pocket Cyko Cameras, 224	Hexi-0, 227	2000FC/M,230
GRIFFITHS	Hexi-I, 227	2000FCW,230
Guinea Detective Camera, 224	Hexi-Lux, 227	Hasselblad's Pocket Kamera, 229
Grisette (Eulitz), 190	Modell P56L, P56M Exportmodell, 227	SWC, SWC/M, 230
GROSSÈR, 224	Modell P66, 227	Super Wide Angle, 230
Grover (Burke & James), 103 GRUNDMANN	Moni, 227	Svenska Express, 229
Leipzig Detective Camera, 224	Hamco, 227	Hasselblad Crystal 500C 483
Stereo camera, 224	Hamilton Super-Flex, 227	Hasselblad Plush Tov. 483
GSK-99 (Konishiroku), 259	HANAU	Hasselblad Svea (Svensson), 397
GUANGZHOUCAMERA FACTORY	le Marsouin, 227 Passe-Partout, 227	Hat Detective Camera (Adams), 50
Five Goats, 224	Pocket-Focal, 227	HAVENHAND
Gucki, 488	Stereo-Pocket-Focal,227	Field camera, 230
Gucki (Welta), 423	Hand Camera (Adams), 50	Hawk-Eye Box '95 (Blair), 96
GUERIN	Hand Camera (Chadwick), 118	Hawk-Eye Camera (Blair), 95
Furet, 224	Hand Camera (Lechner), 278	Hawk-Eye Cameras (Eastman), 157 Hawk-Eye Detective (Boston), 99
GuGo (Goldammer), 215	Hand-Camera(Stegemann), 393	Hawk-Eye Junior (Blair), 96
Guilford, 224 GUILLEMINOT	Handle, Handle 2 (Eastman), 156	Hawk-Eye Nos. 2, 2A (Eastman), 157
Guilleminot Detective Camera, 224	Handy (Rochester Optical), 369	Hawk-Eye Special Cam. (Eastman) 158
Guinea Detective Camera (Griffiths), 224	Handy Box (Mefag), 303 HANEEL	Hawkette Camera (Eastman), 156
Guinea Xit (Shew), 386	Tri-Vision Stereo, 227	Hawkeye Ace, Deluxe (Eastman) 157
GUNDLACH	Hanimar (Hanimex), 228	Hawkeye Flashfun, II (Eastman), 157
Criterion View, 224	HANIMEX (Hammex), 228	Hawkeye Instamatic Cam. (Eastman), 158
Korona, 224	C35, 228	Hawkeye Model BB (Eastman), 157
Korona Panoramic View, 225	D35, 228	Heag 0, 00 (Ernemann), 186 Heag I (Ernemann), 186
Korona Stereo, 225	Eaglet, 228	Heag I Stereo (Ernemann), 186
Long Focus Korona, 225 Milburn Korona, 225	Electra II, 228	Head II (Ernemann) 186
GUSTAVAMIGO	Hanimar, 228	Heag III (Ernemann), 186
Amigo 35mm Motion Picture, 462	Holiday, Holiday 35, Holiday II, 228	Heag III (stereo) (Ernemann), 187
Guzzi (Earth), 139	Mini, 228 RF-35, 228	Heag IV (stereo) (Ernemann), 187
Gymea Minor (prototype) (Pinnock), 354	Standard 120 Box, 228	Head IX Universal (Ernemann) 187
	Hanken (Riken), 364	Heag V (Ernemann), 187
Haaga Syncrona Box (Vredeborch), 420	HANNA-BARBERA	Heag VI (Zwei-Verschl.) (Ernemann), 187
HACHIYOKOGAKUKOGYO	Barney Rubble with camera, 491	Heag VI Stereo (Zwei-Verschluss-Camera (Ernemann), 187
Alpenflex, 225	Fred Flintstone, 228	Heag VII (Ernemann), 187
Supre-Macy, 225 Haco Junior, 225	Huckelberry Hound, 228	Heag XI (Ernemann), 187
Hacoflex, 225	Yogi Bear, 228	Heag XII (Ernemann), 187
Hacon (Norisan), 336	Hansa 35 (Balda), 84	Heag XII (stereo) (Ernemann), 187
HADDS MFG. CO., 225	HANSEN Norka, 228	Head XIV (Ernemann) 188
Hadson, 225	Hapo models (Photo-Porst), 351	Heag XVI (Ernemann), 188
HAGI MFG.	Haponette B (Photo-Porst), 351	Heag XV, (Ernemann), 188
Clover, 225	Happi-Time (Herbert George), 231	HEALTHWAYS
Clover Six, Clover Six B, 225	Happy, 228	Mako Shark, 230 Heda (Busch), 104
HAKING	Happy (K.W.), 272	HEGELEIN
Halina 35, 35X, 225	Happy (Molta Co.) (Minolta), 306	Watch Camera, 230
Halina 6-4, 225 Halina A1, 226	Happy Times Instant Camera (Eastman),	Heidoscop (Franke & Heidecke) 201
Halina Viceroy, 226	156	HEILAND PHOTO PRODUCTS
Halina-Baby, 226	HARBERS Courier Model V, 228	Premiere, 230
Halina-PrefectSenior, 226	Paris, 228	Hekla (Ica), 242
Kinoflex Deluxe, 226	HARBOE	Heli-Clack, (Rietzschel), 363
Kinoflex Super Reflex, 226	Wood box camera, 228	Heliar Reflex (Voigtländer), 417 HELIN-NOBLE
Micronta 35X, 226	HARE	Noble 126, 230
Revolution 89, 226	Stereo Wet plate camera, 229	Heliomatic (Nizo), 465
Roy Box, 226 Star-Lite Super Reflex, 226	Tailboard Camera, 229	Heliomatic 8 Focovario (Nizo), 465
Star-Lite Super Reflex, 226 Sunscope, 226	Tourist camera, 229	Heliomatic 8 S2R (Nizo), 465
Votar Flex, 226	Harmony (Chuo Photo), 119	Heliomatic Allmat 8, 8B (Nizo), 465
Wales Reflex, 226	HARRINGTONS Ton 2-1/4 A Box, 229	Heliomatic Reflex 8, 8A, 8B (Nizo) 465
Halina 35, 35X (Haking), 225	Hartex, 229	Helios (Hüttig), 240
		Helios (Neumann), 325

HELIX

Horizont (Krasnogorsk), 263 Hexi-0 (Hamaphot), 227 Horizontal Reflex (Thornton-Pickard),401 HORNE & THORNTHWAITE Hexi-I (Hamaphot), 227 Camera pencil box, 484 Hello Kitty 3-D (Child Guidance), 498
Hello Kitty Camera (Sanrio), 377
Hello Kitty Talking Camera (Toho), 496
HELM TOY CORP. Hexi-Lux (Hamaphot), 227 HG TOYS INC. Masters of the Universe, 233 Princess of Power She-Ra, 233 HELM TOY CORP.
Bugs Bunny, 231
Mickey Mouse, 231
Mickey Mouse Head (110 film), 231
Punky Brewster, 231
Snoopy-Matic, 231
Hemerascope, 231 Hi-Flash, 233 Hi-Matic (Minolta), 309 Hi-Matic 7 (Minolta), 310 Hi-Matic 9 (Minolta), 310 HORŚMAN Hicro Color Camera (Hess-Ives), 233 High Speed Pattern (Newman & Guardia), HOUAY Anny-35, 235 HOUGHTON HENDREN
Octopus "The Weekender",231 326 Highking (Yen camera), 435 HILCO EXPORTCO. HENNING Hilco Camera, 233 Hilcon, 233 Rhaco Folding Plate Camera, 231 Rhaco Monopol, 231 Henry Clay (American Optical Co.), 62 HENSOLDT HILGER Three-ColourCamera, 233 Hilka (Yamato), 432 Henso Reporter, 231 Henso Standard, 231 HERBERT GEORGE CO. Coronet, 235 Field camera, 233 Empress, 235 Hill's Cloud Camera (Beck), 87 Davy Crockett, 231 Donald Duck Camera, 231 Flick-N-Flash, 231 Hippopotamuswith Camera, 491 Hirondelle La Parisienne, 233 Hit (Tougodo), 405 Happi-Time, 231 Herco 12, 231 Hit Type Cameras, 234 Hit-Size Worm camera, 482 Hitgo (Yen camera), 435 HOBBIES LTD. Herco Imperial 620 Snap Shot, 231 Herco-flex 6-20, 231 Imperial Debonair, 231 Imperial Mark XII Flash, 231 Imperial Reflex, 231 Imperial Satellite 127, 231 Field camera, 234 Hobby Junior (Daishin), 131 HOBBYCAR Ford V8 Camionette 1934, Kodak, 497 Ford V8 Delivery Sedan 1932, 497 Hobiflex Model III (Tougodo), 405 Imperial Satellite Flash, 231 Insta-Flash, 231 Hobiflex Model III (Tougodo), Hobix (Tougodo), 405
Hobix D I (Tougodo), 405
Hobix Junior (Tougodo), 405
Hochtourist (Zeiss Ikon), 443
HOEI INDUSTRIALCO.
Anny-44, 234
Ebony 35, 35 De-Luxe, 234
Ebony Deluxe IIS, 234
HOFERT, 234
HOFFMAN DISTILLING CO.
Mr. Photographer. 479 Official "Scout" cameras, 232 Roy Rogers & Trigger, 232 Roy Rogers Jr., 232 Royal, 232 Savoy, Savoy Mark II, 232 Stylex, 232 HERBST & FIRL Field camera, 232 Studio camera, 232 Herco 12 (Herbert George), 231 Herco Imperial 620 (Herbert George), 231 Herco-flex 6-20 (Herbert George), 231 Mr. Photographer, 479 Mr. Tourist, 479 **HERLANGO** HOH & HAHNE Folding camera, 232 Folding Plate Camera, 232 HERMAGIS Field camera, 234 Folding plate camera, 234 Holborn Magazine (Houghton), 238 Holborn Postage Stamp (Houghton), 238 Field Camera, 232 Micromegas, 232 Velocigraphe, 232 Velocigraphe Stereo, 232 Holiday, II, 35 (Hanimex), 228 Holly Hobbie (Vanity Fair), 413 Holly Hobbie Doll House (Durham), 483 Herman (Fototecnica), 200 Hollycam Special, 234 HEROLDMFG. CO. Acro-Flash, 232 Da-Brite, 232 Hollycam Special, 234
Hollywood (Encore), 183
Hollywood (Ruberg & Renner), 375
Hollywood (Stewart-Warner), 468
Hollywood Duplo (Ruberg & Renner), 375
Hollywood Reflex (Craftex), 129
Hollywood Studio Lamp (Wang's), 482
Hologon (Zeiss Ikon Contarex), 443
Home Movie Super-8 (Ja-Ru), 499 Flash-Master, 232 Herold 40, 232 Photo-Master, 232 Sparta-Fold V, 232 Spartacord, 232 Home Movie Super-8 (Ja-Ru), 499 Home Portrait (Deardorff), 134 Home Portrait Graflex (Graflex), 219 Spartus 35, 233 Spartus 35F, 35F Model 400, 233 Spartus 120 Flash Camera, 233 Spartus Co-Flash, 233 Sunbeam 120, 127, Six-Twenty, 233 Homeos (Richard), 363 Homeoscope(Richard), 363 Homer, 234 Herzog Amateur Camera, 233 Herzog Amateur Camera (Herzog), 233 HESEKIEL **HERZOG** Homer 16, 234 Homer No. 1 (Kambayashi), 252 HONEYWELL Shuttle, 238 Electric Eye 35, 35R, 234 Honeywell Elmo Tri-Filmatic (Elmo), 460 Original Spiegel Reflex, 233 Pompadour, 233 HESS & SATTLER Ticka, 238 Honeywell Pentax Spotmatic IIa (Asahi), Field Camera, 233 Honeywell Spotmatic F (Asahi), 77 Honeywell Spotmatic SP 1000 (Asahi), 77 Honor (Zuiho), 452 Universal Camera Duplex I, 233 HESS-IVES CORP. Hicro Color Camera, 233 HETHERINGTON& HIBBEN Hopalong Cassidy Camera (Galter), 207 Hope (Sugaya), 395 Horizont, 234 Hetherington Magazine Camera, 233 Hexacon (Pentacon), 348

Collapsible camera, 234 Powell's Stereoscopic Camera, 234 Wet plate camera, 235 Wet plate triple-lens stereo, 235 Eclipse, 235 Hot Flash Chewing Gum (Donruss), 474 All Distance Ensign Cameras, 235 Anastigmat Ensignette, 238 Anastigmatensignette, 236 Automatic Magazine Camera, 235 Autorange 16-20 Ensign, 235 Autorange 220 Ensign, 235 Autorange 820 Ensign, 235 Box Ensign 2-1/4B, 235 British Ensign, 235 Ensign Auto-Kinecam16 Type B, 462 Ensign Autokinecam, 462 Ensign Autospeed, 235 Ensign Aductspeed, 236 Ensign box cameras, 236 Ensign Cadet, 236 Ensign Cameo, 236 Ensign Carbine, 236 Ensign Carbine (Tropical models), 236 Ensign Commando, 236 Ensign Cupid, 236 Ensign Cupid, 236
Ensign Deluxe Reflex, 237
Ensign Double-8, 236
Ensign Ful-Vue, 236
Ensign Ful-Vue Super, 236
Ensign Greyhound, 236
Ensign Mascot A3, D3, 236
Ensign Mickey Mouse, 236
Ensign Midget Model 22, 236
Ensign Midget Model 33, 237
Ensign Midget Model 55, 237
Ensign Midget Silver Jubilee models, 237
Ensign Midget Silver Jubilee models, 237 Ensign Multex, 237 Ensign Pocket E-20, 237 Ensign Popular Reflex, 237 Ensign Pressman Reflex, 237 Ensign Ranger, II, Special, 237 Ensign Reflex, 237 Ensign Reflex, 237
Ensign Roll Film Reflex, 237
Ensign Roll Film Reflex, Tropical, 237
Ensign Selfix models, 237
Ensign Special Reflex, 237
Ensign Special Reflex, Tropical, 237
Ensign Speed Film Reflex, 238
Ensign Speed Film Reflex, Tropical, 238
Ensign Speed Film Reflex, Tropical, 238 Ensign Super Speed Cameo, 238 Ensign Super-Kinecam, 462 Ensignette, 238 Ensignette Deluxe, 238
Ensignette No. 2 (silver), 238
Flat Back Ensign, 235 Folding Ensign 2-1/4B, 236
Folding Klito, 238
Holborn Magazine Camera, 238
Holborn Postage Stamp Camera, 238 Junior Box Ensign, 236 Klito, No. 0, 238 Mascot No. 1, 238 Pocket Ensign 2-1/4, 237 Royal Mail Stereolette, 238 Studio camera, 238 Ticka, Focal plane model, 238 Ticka, solid silver, 238 Ticka, Watch-Face model, 239 Ticka Enlarger, 239
Ticka Replica, 238
Triple Victo, 239
Triple Victo, Tropical Model, 239 Tudor, 239

IMPERIAL Lark

Vest Pocket Ensign, 238 Kinamo 35mm Cine, 462 Klapp-Stereo-Palmos,242 Exakta V (Varex), 245 Exakta VX (Varex VX), 245 Exakta VX 500, VX 1000, 245 Victo, 239 Victo-Superbe, 239 Lloyd, 242 Lloyd, 242 Lloyd Stereo, 242 Lloyd-Cupido560, 242 Lola 135, 136, 242 Maximar, 242 Minimal 235, 242 HOWARD Exakta VX IIA (Varex IIA), 245 Exakta VX IIB (Varex IIB), 245 Reo Miniature, 239 **HOWE** Ihagee folding plate cameras, 246 Pinhole camera, 239 Inagee folding rollfilm cameras, 246 Kine Exakta I, 245 Huashan DF-S (Xibei), 431 Hub (Box camera) (Dame Minimum Palmos, 242 Newgold, 246 Stoddard & Kendall), 132 Nelson 225, 242 Hub (Folding) (Dame Stoddard & Kendall), 132 Huckelberry Hound (Hanna-Barbera),228 Huckleberry Hound Flickers, 486 Night Exakta, 245 Nero, 242 Parvola, 246 Patent Klapp Reflex, 246 Niklas 109, 243 Nixe, 243 Orix 209, 243 Photoknips, 246 Plan-Paff, 246 Roll-Paff-Reflex, 246 Hulk Hogan (Remco), 362 Periscop, 243 Plaskop, 243 HUMMĔĹ Stereo camera, 246 The Photographer, 491 Polyscop, 243 Reflex 748, 750, 756, 756/1, 243 Reporter (Record), 243 Ultrix, 246 Ultrix Stereo, 246 HUNTER Gilbert, 239 Victor, 246 Hunter 35, 239 Purma Plus, 239 Sirene, 243 Zweiverschluss Duplex, 246 Stereo Ideal, 243 Ihagee folding plate cameras (Ihagee), 246 Purma Special, 239 HUNTER & SANDS Stereo Minimum Palmos (693), 243 Ihagee folding rollfilm (Ihagee), 246 IKKO SHA CO. Stereo Reicka, 243 Tourist Camera, 239 Stereo Toska (680), 243 Start 35, 246 Hunter 35 (Steiner), 393 HURLBUTMFG. CO. Stereofix, 243 Start 35, Z-45 Start 35 K, K-II, 246 Ikoflex (850/16) (Zeiss Ikon), 444 Ikoflex Favorit (887/16) (Zeiss Ikon), 444 Stereolette 610, 611, 243 Velox Magazine Camera, 239 Stereolette Cupido (620), 243 Ikoflex Favorit (887/16) (Zeiss Ikon), 44 Ikoflex I, Ia, Ib, Ic (Zeiss Ikon), 444 Ikoflex II (851/16) (Zeiss Ikon), 444 Ikoflex III (852/16) (Zeiss Ikon), 444 Ikoflex III (855/16) (Zeiss Ikon), 444 Ikoflex III (853/16) (Zeiss Ikon), 444 Ikoflex III (853/16) (Zeiss Ikon), 444 Ikomatic A (10.0552) (Zeiss Ikon), 444 Ikomatic F (10.0551) (Zeiss Ikon), 444 Ikonette (504/12) (Zeiss Ikon), 444 Ikonette 35 (500/24) (Zeiss Ikon), 444 Ikonette 35 (500/2 HUSBANDS Teddy, 243 Field camera, 239 Toska, 243 HUTH BROS. Trilby 18, 243 Field camera, 239 Triplex, 243 HÜTTIG Trix, 243 Atom, 239 Trona, 244 Cupido, 239 Tropica, 244 Fichtner's Excelsior Detective, 240 Tudor Reflex, 244 Folding plate camera, 240 Gnom, 240 Helios, 240 Ideal, 240 Ideal Stereo, 240 Victrix, 244 Volta, 244 **IKONOGRAPHCO** Icar 180 (Ica), 242 Icarette (Ica), 242 Ikonograph Model B, 462 Ikonta (520/14) (Zeiss Ikon), 444 Ikonta (520/18) (Zeiss Ikon), 444 Ikonta 35 (522/24) (Zeiss Ikon), 445 Ikonta A models (Zeiss Ikon), 445 Ikonta C models (Zeiss Ikon), 445 Icarette (Zeiss Ikon), 443 Juwel, 240 Icarex models (Zeiss Ikon), 443 Lloyd, 240 Ichicon 35 (Daiichi), 131 Magazine cameras, 240 ICO S.C. Merkur, 240 Liberty-620, 244 Monopol, 240 **IDAM** Ikonta D (520/15) (Zeiss Ikon), 445 Nelson, 240 Belco, 244 Clic, 244 **ILFORD** Record Stereo Camera, 240 Advocate, 246 Stereo Detective, 240 Roc, 244 Advocate X-ray, 246 Craftsman, 247 Stereolette, 240 Ideal (Adams), 50 Ideal (Hüttig), 240 Ideal (Ica), 242 Toska, 240 Trilby, 241 Envoy, 247 Sporti 4, 247 Tropical plate camera, 241 Ideal (Rochester Optical), 369 Ideal (Vredeborch), 420 Sportsman, 247 HYATT Sportsmaster, 247 Patent Stamp Camera, 241 Ideal (Zeiss Ikon), 443 Sprite, 247 Sprite 35, 247 Ideal Color 35 (Gerlach), 210
Ideal Model VI (Gaertig & Thiemann), 206
Ideal Stereo (Hüttig), 240
IDEAL TOY CORP. I.G.B. Camera, 244 IAN LOGAN LTD Witness, 247 ILLCO TOY CO. Foto-File, 477 Cabbage Patch Kids Musical, 483
Mickey Mouse Musical Toy Camera, 483
Pound Puppies Musical Toy Camera, 483
Sesame Street Pop-Out, 495
Smurf Musical Toy Camera, 483 Ibis (Ferrania), 194 Kookie Kamera, 244 Ibis 34 (Ferrania), 194 Ident (Cam-O), 106 Ibis 6/6 (Ferrania), 194 Idento (Adams), 50 Ifbaflex M102 (Franke & Heidecke), 201 **ICA** Alpha, 241 **IHAGEE** lloca I, Ia, II, IIa (Witt), 429 lloca Quick A, B (Witt), 429 lloca Rapid models (Witt), 429 lloca Reporter (Witt), 429 Atom, 241 Aviso, 241 Bébé, 241 Derby, 244 Duplex cameras, 244 Elbaflex VX1000, 244 Exa, 244 Briefmarken Camera, 241 Iloca Stereo (Witt), 429 Iloca Stereo Rapid (Witt), 429 Imp (Beaurline), 86 Corrida, 241 Exa 500, 244 Cupido, 241 Exa Ia, Ib, 244 Exa II, IIa, IIb, 244 Delta, 241 Impera (Indo), 248 Elegant, 241 Exakta (original), 244 Imperial 6x6 (Braun), 100 Imperial Box 6x6 (Braun), 100 Exakta (Original), 244 Exakta 66, 245 Exakta A, 244 Exakta B, 244 Exakta C, 244 Exakta EDX 3, 245 Exakta FE 2000, 245 Favorit, 241 Favorit Tropical, 241 Imperial Box 6x9 (Braun), 100 Folding plate cameras, 241 IMPERIAL CAMERA & MFG. CO. Folding Reflex, 243 Magazine camera, 247 IMPERIAL CAMERA CORP. Halloh 505, 506, 510, 511, 241 Hekla, 242 Adventurer, 247 Icar 180, 242 Icarette, 242 Exakta II, 245 Cinex, 247 Cubex IV, 247 Exakta Jr., 245 Ideal, 242 Exakta Real, 245 Exakta RTL 1000, 245 Delta, 247 Ingo 395, 242 Deltex, 247 Juwel (Universal Juwel), 242 Exakta TL 500, TL 1000, 245 Deluxe Six-Twenty Twin Lens Reflex, 247

Lark, 247

Exakta Twin TL, 245

Kinamo 15mm, 462

IMPERIAL Mark

Mark 27, 247 Mark XII Flash, 247 Matey 127 Flash, 247 Mercury Satellite 127, 247 Nor-Flash 127, 247 Rambler Flash Camera, 247 Reflex, 247 Roy, 247 Satellite II, 247 Savoy, 247 Scout cameras, 247 Six-twenty, 247 Six-twenty Reflex, 247 Imperial Debonair (Herbert George), 231 Imperial Mark XII Flash (Herbert George), Imperial Perfecta (Thornton-Pickard), 401 Imperial Pocket (Thornton-Pickard),401 Imperial Reflex (Herbert George), 231 Imperial Satellite 127 (Herbert George), Imperial Satellite Flash (Herbert George), Imperial Stereo (Thornton-Pickard),401 Imperial Triple Extension (Thornton-Pickard),401 Improved Crescent Camera (Baker), 82 Improved Reversible Back (Blair), 96 IMPULSELTD. Voltron Starshooter 110, 247 In-B-Teens (Solar Mates), 390 Incense Burner/Swiss Photographer, 477 Incredible Hulk (Vanity Fair), 413 Indiana Jones Camara Safari (Certex), 116 INDO Comodor 127, 248 Compact 126 XR, 248 Impera, 248 Safari, Safari X, 248 INDRA CAMERA Ges.mbH. Indra-Lux, 248 INDUMAG Leduc X-127, 248
INDUSTRIAL SYNDICATE OF
CINOSCOPE Cinoscope 35mm Cine, 462 Inette, 248 Inflex, 248 Infra (Oehler), 337 Ingento (Burke & James), 103 INGERSOLL Shure-Shot, 248 Ingo (Glunz), 212 Ingo 395 (Ica), 242 Inka (Atak), 81 Insa (Alak), 61 Inos (I), Inos II (Voigtländer), 417 Inspectograph Camera (Graflex), 223 Inst-and Camera (Lucky Star), 495 Insta-Flash (Herbert George), 231 Insta-Load I, II (Continental), 125 Instacora E (Dacora), 131 Instamatic Camera Bank (Eastman), 473 Instamatic Cameras (Eastman), 159 Instamatic Reflex (Eastman), 159
Instamatic S-10 & S-20 (Eastman), 159 Instamatic style water camera (Shiba), 489
Instamatic X-30 Olympic (Eastman), 159
Instant Cameras (Eastman), 159 Instanto (Underwood), 408 Instantographview (Lancaster), 276
INTERNATIONALMETAL & FERROTYPE Diamond Gun Ferrotype, 248
International Patent (Lancaster), 276
INTERNATIONAL PROJECTOR CORP. Simplex Pockette, 462 Invicta (Ro-To), 367 Invincibel (Mader), 296 Invisible Camera (Talbot (Walter)), 399 Iris, Iris Deluxe (Universal), 410 Irving (Scovill), 379 IRWIN Dual Reflex, 248 Grand Camera, 495

Irwin Kandor, 248 Irwin Reflex, 248 Kandor Komet, 248 Super-Tri-Reflex,248 IRWIN CORP. Irwin Magazine, 463 Edelweiss Deluxe, 248 ISGOTOWLENO,248 ISING Isis, 249 Isoflex I, 249 Puck, 249 Pucky, I, Ia, II, 249 Isis (Ising), 249 Iskra (Krasnogorsk), 263 Iskra-2 (Krasnogorsk), 263 Bilux, 249 Duplex 120, 249 Duplex Super 120, 249 Reporter, 249 Reporter, 249 Standard, 249 Iso Rapid I, IF, IC (Agfa), 54 Isobox (Agfa), 54 Isocaflex (Isokawa), 249 Isoflash Rapid, Rapid C (Agfa), 54 Isoflex I (Ising), 249 ISOKAWA KOKI Isocaflex, 249 Isola, Isola I, II (Agfa), 54 Isolar (Agfa), 54 Isolar Luxus (Agfa), 54 Isolar Luxus (Agfa), 54
Isolette (Agfa), 54
Isolette I (Agfa), 54
Isolette II (Agfa), 55
Isolette III (Agfa), 55
Isolette V (Agfa), 55
Isoly (Agfa), 55
Isoly (Agfa), 55
Isoly Mat (Agfa), 55
Isoly-Mat (Agfa), 55
Isonat-Rapid (Affa), 55 Isomat-Rapid (Agfa), 55 ISOPLAST Filius-Kamera, 249 Isorette (Agfa), 55 Itakit (S.T.M. & Co.), 394 **ITEK** Quad 32-40, 249 **IVES** Kromskop Triple Camera, 249 J.M.V. Capta, Capta II, 250 Capta-Baby, 250 Super-capta, 250

J.V. Le Gousset, 251 JA-RU Home Movie Super-8 Auto-matic, 499 Pellet Shooting Camera, 478 Trick Squirt Camera No. 803, 488 Jack-in-the-CameraSr. (Commonwealth), 482 Jacky (M.I.O.M.), 314 JAK PAK Kiddie Camera, 249 Squirt Camera X-315, 488 JANSEN Eiot, 249 Janua (San Giorgio), 375 JAPY & CIE. le Pascal, 249 Jay Dee, 249 JEANNERET Monobloc, 249 Jem Jr. 120, 250 Jem Jr. 120, Girl Scout, 250 Jena Contax (II) (Zeiss Ikon), 441

Jet Setter (Winner Toy), 497

Jewel Sixteen (Wirecraft), 427

Jenic, 250

Jewell 16, 250 JEWELRY, 480 Jewelry Case, 477 Jiffy Kodak Six-16 (Eastman), 159-160 Jiffy Kodak Six-20 (Eastman), 160 Jiffy Kodak Vest Pocket (Eastman), 160 Jippo, 250 John Player Special (Kiev), 254 John Stock Wet Plate (American Opt.), 62 Jolly (Kamera Werkstätten), 272 JONTE Field camera, 250 JOS-PE Tri-Color Camera, 250 Jota Box, 250 **JOUGLA** Sinnox, 250 **JOUX** Alethoscope, 250 Ortho Jumelle Duplex, 250 Steno-Jumelle, 250 Steno-Jumelle/Stereo, 250 Joya (Laboratorios Mecanicos), 275 Jubilar (Voigtländer), 417 Jubilee (Bolsey), 98 Jubilette (Balda), 84 JUGUETESMARTI Pencil Sharpener (VPK style), 485 JUHASZ Glink, 250 Juka (Adox), 51 Julia, 250 Julia (Wünsche), 431 JUMEAU & JANNIN Le Cristallos, 250 Jumelle (Bellieni), 89 Jumelle Capsa (Demaria), 135 Jumelle de Nicour (Geymet & Alker), 211 Jumelle Photographique (Mackenstein), Jumelle Stereo (Papigny), 346 Jumelle-style magazine (Krügener), 266 Juni-Boy 6x6 (Fex/Indo), 195
Junior (Mamiya), 297
Junior (Vredeborch), 420
Junior Box Ensign (Houghton), 236
Junior Camera, 250
Junior Reflex (Reflex Camera), 361
Junior Repecial Ruby Reflex Junior Special Ruby Reflex (Thornton-Pickard),401 Juniorette No. 1 (Ansco), 65 JUNKA-WERKE Exhibit, 250 Junka, 251 Junost (10H0CMb) (GOMZ), 216 JURNICK Ford's Tom Thumb Camera, 251 Just Like Daddy's Camera (Toypower), JUSTEN PRODUCTS Justen, 251 Juventa (Balda), 84 Juwel (Zeiss Ikon), 445 Juwel (Eho-Altissa), 182 Juwel (Hüttig), 240 Juwel (Universal Juwel) (Ica), 242 Juwel (Wünsche), 431 Juwella (Balda), 84 K.I. Monobar (Kennedy), 253 K.K., 257 K.K.W.

Camera-Lighter,474 Photo-Flash Camera-Lighter,474 K.S.K. Corona, 266 K.W.

Astra 35F-X, 272 Astraflex 35, 272 Cavalier II, 272 Happy, 272 Kawee, 272

Kapai Camera (Girvan), 212 Kapsa (Vasconcellos), 413 Karat models (Agfa), 55 Kardan (Linhof), 291 Kardon (Premier), 359 Kardon Signal Corps Model (Premier), 359 Patent Etui, 6.5x9cm, 272 Clown Camera, 254 Patent Etui, 9x12cm, 273 Pentaflex, Pentaflex SL, 273 Clown Girl, 254 Dog Camera, 254 Pilot 6, 273 Santa Claus, 254 Pilot Reflex, 273 Pilot Super, 273 Pocket Dalco, 273 Kiddie Camera (Ansco), 65 Kiddie Camera (Jak-Pak), 249 Pocket Dalco, 273
Praktica, 273
Praktica "L" Series, 274
Praktica FX, 273
Praktica FX2, 273
Praktica FX3, 273
Praktica IV, IVB, IVBM, 273
Praktica IVF, IVFB, 273
Praktica LVF, 274
Praktica LLC, 274
Praktica LTL, 274
Praktica Nova, Nova B, 274 Karma-Flex (Arnold), 74 KIEVARSENAL Karma-Flex (Arriold), 74 Karma-Flex 6x6cm (Arnold), 74 Karma-Lux (Arnold), 74 Karma-Sport (Arnold), 74 Bera (Kiev-Vega), 255 John Player Special, 254 Kiev, 254 Kiev 1989, 255 Karomat (Agfa), 55 Karomat (Ansco), 65 Karoron (Kuribayashi), 270 Kiev 30, 30M, 255 Kiev 35A (KNEB 35A), 255 Kiev-10 Automat (aBmomam), 255 Karoron RF (Kuribayashi), 270 Karoron S, S-II (Kuribayashi), 270 Kiev-15 TEE, 255 Kiev-15 TEE, 25 Kiev-2, 2A, 254 Kiev-3, 3A, 254 Kiev-4, 4A, 255 Kiev-5, 255 Kiev-6C, 255 KASHIWA Motoca, 252 Kassin, 252 Praktica Nova, Nova B, 274 Praktica PL Nova I, IB, 274 Katei (Yen camera), 435 KATO KOGEI Praktica Prisma, 274 Praktica Prisma, 274
Praktica Super TL, 274
Praktica VF, 274
Prakticamat, 274
Praktiflex, 274
Praktiflex FX, 275
Praktiflex II, 274 KATO KOGEI Conica, 473 Kauffer Photo-Sacà Main (Alibert), 60 Kawee (K.W.), 272 Kbaru (Quartz) 2M, 463 KE-4(1) 70mm Combat (Graflex), 223 Keepcolor II (Gold Horse), 481, 484 KEITH CAMERA CO. Kiev-80, 255 Kiev-88, 88 TTL, 255 Kneb, 255 No-Name Contax (Kiev), 255 No-Name Contax (Kiev), No-Name Kiev, 255 Salyut, Salyut-S, 255 Zenit 80 (Zenith 80), 255 KIGAWA OPTICAL Carl-6 Model II, 255 Kiko Semi, 255 Praktina FX, 275 Praktina IIa, 275 Keith Portrait Camera, 252 Kelvin Maior (S.E.D.E.), 382 Kelvin Minor (S.E.D.E.), 382 Praktisix, Praktisix II. 275 Reflex-Box, 275 Rival Reflex, 275 KadocK-II Personal Gaslighter Tsubasa 6x6, 255 Kemco Homovie (Kodel), 463 KEMPER Tsubasa Baby Chrome, 255 Tsubasa Chrome, 255 (Sun Arrow), 475 Kafota (Certo), 117 KAFTANSKI Kombi, 252 Tsubasa Semi, 256 Kenflex, 252 Kenflex (Tokiwa), 403 Tsubasa Super Semi, 256 Tsubasa Super Semi, 25 Tsubasaflex Junior, 256 Kiko 6, 256 Kiko Semi (Kigawa), 255 KIKO-DO CO. Superflex Babby, 256 Banco 4.5, 251 Banco Perfect, 251 Kaftax, 251 Kenilworth Camera, 252 KENNEDYINSTRUMENTSLTD. K.I. Monobar, 253 Kaftax (Kaftanski), 251 KALART CO. KENNER Picture-Quick, 495 KENNGOTT Kiku 16, Model II (Morita), 320 Kalart Press camera, 251 Kali-flex (Kalimar), 251 KALIMAR Colt 44, 251 KILFITT Mecaflex, 256 Kim (S.E.M.), 383 KIMURA OPTICAL WORKS Alfax Model I, 256 Matador, 253 Phoenix, 253 Plate camera, 253 Kali-flex, 251 Kalimar 44, 251 Kalimar A, 251 Plate camera, Tropical, 253 Supra No. 2, 253 Kin-Dar Stereo camera (Kinder), 256 Kin-Dar Stereo camera (Kinder), 2 Kinaflex (Kinn), 257 Kinamo 15mm (Ica), 462 Kinamo 35mm (Ica), 462 Kinamo N25 (Zeiss), 471 Kinamo S10 (Zeiss), 471 Kinarri 35 (Arnold & Richter), 454 Kinax (I) (Kinn), 257 Kinax II (Kinn), 257 Kinax Alsace (Kinn), 257 Kinax Baby (Kinn), 257 Kinax Junior (Kinn), 257 KINDER CO. Kent, 253 Kalimar Reflex, 251 Kentucky Fried Chicken (Franka Photo.), Kalimar Six Sixty, 251 TLR 100, 252 Kalimar/RegulaReflex K650 (King), 256 Kera Jr. (Vredeborch), 420 KERN Kallo (Kowa), 261 Bijou, 253 Kalloflex (Kowa), 261 KALOS CAMERABAUGMBH Rollfilm camera, 253 Stereo Kern SS, 253 KERSHAW Kalos, 252 Kalos, 252 Kalos Spezial, 252 Kaloscope (Caillon), 106 Kamarad (I) (Bradac), 100 Kamarad MII (Bradac), 100 Kamaret (Blair), 96 KAMBAYASHI& CO. LTD. Homer No. 1, 252 KAMERA & APPARATEBAU Sport-Box 2, Sport-Box 3, 252 Kamera radio, 486 KAMERA WERKSTÄTTEN Curlew I, II, III, 253 Curiew I, II, III, 253 Eight-20 King Penguin, 253 Eight-20 Penguin, 253 Kershaw 110, 253 Kershaw 450, 253 Kershaw Patent Reflex, 254 Peregrine I, II, III, 254 KINDER CO. Kin-Dar Stereo camera, 256 Kine Exakta I (Ihagee), 245 Kinegraphe (Français), 200 King (Yen camera), 435 Raven, 254
Kewpie (Conley), 123
KEYCHAINS, KEY RING FOBS, 481
KEYS STEREOPRODUCTS KING Azore V, 256 Dominant, 256 KAMERAWERKSTÄTTEN Kalimar/RegulaReflex K650, 256 Mastra V35, 256 Regula, 256 Regula Citalux 300, 256 Jolly, 272 KAMERAWERKETHARANDT Vitaflex, 252 Trivision Camera, 254 KEYSTONE Supreme, 463 Wizard XF1000, 254 Kamerette, 252 Kamerette Junior, 252 Regula Citalux 300, 256
Regula Reflex 2000 CTL, 256
Regula Reflex CTL, 256
Regula Reflex K650, 256
Regula Reflex SL, 256
King Barker 35mm Cine (Barker), 454
King Camera (American), 256
King Camera (Japanese), 256
King Camera (Metropolitan Supply), 304
King Flex 482 KEYSTONEFERROTYPECAMERA CO. Kamerette Special, 252 Kamerette Special, 252
Kamerama (Egg Camera), 252
Kamra-Pak Commemoratives (Girey), 476
Kamra-Pak Vanity (Girey), 476
Kamrex (Lancaster), 276
Kando Reflex (Monarch), 318
Kandor Komet (Irwin), 248
Kansha on Field Chambar Street camera, 254 KEYSTONEMFG. CO. Capri Models, 463 Keystone A Models, 463 Keystone K-8, K-22, 463 Keystone Movie Camera, Model C, 463 Moviegraph, 463 King Flex, 482
King Poco (Rochester Camera Mfg.), 368
KING SALES CO. Kansha-go Field Camera (Asanuma), 81 KANTO OPTICAL WORKS Amiflex, Amiflex II, 252 KGB Ring Camera (Mazur), 302 KIDDIE CAMERA, 254 KIDDIE CAMERA Cinex Candid Camera, 256 King Super (Yen camera), 435 Kao (Seneca), 384 Bear Camera, 254

KING'S

Konan 16 (Minolta), 312 Konan-16 Automat (Chiyoda), 119 Koni-OmegaRapid, M (Konishiroku), 259 Koni-Omegaflex M (Konishiroku), 259 King's Camera, 257 King's Own Tropical (London Stereo.), 294 Kodak A Modele 11 (Eastman), 160 Kodak Australasia Lapel Pin, 481 Kodak Bank, 473
Kodak Box 620 Camera (Eastman), 160
Kodak Camera (original) (Eastman), 140
Kodak Camera (replica) (Eastman), 140
Kodak Cine Automatic (Eastman), 459 Kingston, 257 KINN Konica (Konishiroku), 259 Konica Auto S (Konishiroku), 260 Kinaflex, 257 Kinax (I), 257 Kinax II, 257 Kinax Alsace, 257 Kinax Baby, 257 Konica Autoreflex models (Konishiroku), Kodak Cine Scopemeter (Eastman), 459 Kodak Disc 4000 Photokina 82, 477 Konica F, FM, FP, FS (Konishiroku), 260 Konica II (Konishiroku), 259 Konica III (Konishiroku), 259 Konica IIIA, IIIM (Konishiroku), 260 Konica Playing Cards, 486 Kodak Disc Bank (Eastman), 473 Kodak Ektra models (Eastman), 153 Kodak Electric 8 Automatic (Eastman), 459 Kinax Junior, 257 Super Kinax, 257 Kinnear's Patent Wet Plate Landscape Kodak Enlarger 16mm (Eastman), 160 Camera (Ross), 372 Kodak Ensemble (Eastman), 153 Kodak Escort 8 (Eastman), 460 Konilette models (Konishiroku), 260 KONISHIROKUKOGAKU Kino I (Ernemann), 460 Kino II (Ernemann), 461 Kino Model E (Ernemann), 461 Baby Pearl, 259 GSK-99, 259 Kodak Film (Brown & Bigelow), 474 Kodak Instant Color Film PR10, 487 Kino-44 (Tougodo), 405 Kodak Jr. Six-16 (Eastman), 160 Kodak Jr. Six-20 (Eastman), 160 Koni-OmegaRapid, 259 Kinobox, 257 Kinoflex Deluxe (Haking), 226 Koni-OmegaRapid M, 259 Koni-OmegaflexM, 259 Kodak Junior Cameras (Eastman), 160 Kinoflex Super Reflex (Haking), 226 Konica, 259 Kodak Junior 0 (Eastman), 160 KINON Kodak Junior I, II (Eastman), 160 Kodak Junior I, II (Eastman), 160 Kodak Junior 620 (Eastman), 160 Kodak Mug, 480 Kodak Nascar Auto, 481 Kodak Plant Modele B11 (Eastman), 163 Konica II, 259 Konica III, 259 Konica IIIA, 260 Konica IIIM, 260 Kinon SC-1, 257 Kinopticon (Ernemann), 461 Kinusa K-77, 257 KIRK Stereo camera, 257 Konica Auto S, 260 Kitkat, 257 Kodak Reflex (original) (Eastman), 160 Kodak Reflex IA (Eastman), 161 Kodak Reflex II (Eastman), 161 Konica Autoreflex, 260 Konica Autoreflex, 260
Konica Autoreflex A, A3, 260
Konica Autoreflex T, T2, 260
Konica Autoreflex T3, T3N, 260
Konica Autoreflex T4, 260
Konica Autoreflex TC, 260
Konica F, 260
Konica FM, 260
Konica FP, 260
Konica FS, 260
Konica FS, 260
Konilette, II, 260
Konilette 35, 260
Pearl (Showa 8), 260 Kitty, 257 KIYABASHI KOGAKU Autoflex, 257 Kodak Senior Cameras (Eastman), 175 Klapp, 257 Kodak Series II, III (Eastman), 161 Kodak Six-16 Camera (Eastman), 176 Kodak Six-20 Camera (Eastman), 176 Klapp camera (Loeber), 292 Klapp cameras (Ernemann), 188 Klapp Reflex (Ernemann), 186 Kodak Special Six-16 (Eastman), 177 Kodak Special Six-20 (Eastman), 177 Kodak Sport Special (Eastman), 177 Klapp Stereo (Ernemann), 188 Klapp-Stereo-Palmos(Ica), 242 Kleer-Vu Feather-Weight, 257 Kodak Startech Camera (Eastman), 177 Kodak Stereo Cameras (Eastman), 177 Field camera, 257 Klein-Edinex (127 film) (Wirgin), 428 Klein-Mentor (Goltz & Breutmann), 215 Kodak Suprema Camera (Eastman), 177 Kodak Tele-Ektra Cam. (Eastman), 178 Kodak Tele-Instamatic (Eastman), 178 Pearl (Showa 8), 260 Pearl I, 260 Pearl II, 260 Pearl IV, 260 Pearl No. 2, 260 Kleinfilm Kamera (Steinheil), 394 Klimax (Butcher), 104 Klimax (Vredeborch), 420 Kodak Tourist Camera (Eastman), 178 Kodak Tourist II Camera (Eastman), 178 Pearlette, 260 Kodak Trimlite Instamatic Cameras Klito, No. 0 (Houghton), 238 KLIX MANUFACTURINGCO Rapid Omega 100 and 200, 260 (Eastman), 178 Kodak Truck 1880-1980(Winross), 498 Rokuoh-ShaMachine-gunCamera, 261 Klix 35mm Motion Picture Camera, 463 Sakura (Vest Pocket Camera), 261 Semi-Pearl, 261 Kodak Van (Lledo), 498 Klondike (Anthony), 69 KLOPCIC Kodak Winner Pocket (Eastman), 179 Kodak Yo-Yo (Duncan), 496 Snappy, 261 Klopcic, 257 Klopcic Reporter, 257 Snappy Camera Set, 261 Kookie Kamera (Ideal Toy Corp.), 244 Korelle (Burke & James), 103 Kodak Zoom 8 Reflex (Eastman), 460 KodamaticInstant Cam. (Eastman), 161 KN35 (Certo), 117 Kodascope (Eastman), 460 Knack Detective (Scovill), 379 KNEB (Kiev), 254 KNICKERBOCKERTOY CO. Kodascope Eight Model 20 (Eastman), 460 Kodascope Model A, B, C, (Eastman), 460 KODEL ELEC. & MFG. CO. Korelle K (Kochmann), 258 Korelle P (Kochmann), 258 Koroll, II (Bencini), 90 Koroll 24, 24 S (Bencini), 90 Koroll S (Bencini), 90 Snoopy The Astronaut, 480 KNIGHT & SONS Kemco Homovie, 463 Knights No. 3 Sliding-box camera, 257 KNOEDLER KAMERABAU Kodet Cameras (Eastman), 161 Korona (Gundlach), 224 Korona Panoramic View (Gundlach), 225 Korona Stereo (Gundlach), 225 Kogaku, 258 Koinor 4x4 (A.D.Y.C.), 52 KOJIMA OPTICAL Flex-O-Cord, 258 Brinox, 257 KNOLL KORSTEN Field camera, 257 Mikono-Flex P, 258 Kokka Hand (Kuribayashi), 268 Litote, 261 Knox (Wünsche), 431 Korvette (Mamiya), 297 Koala Bear (Qantas), 493 Koseido (Yen camera), 435 Kosmo-Clack Stereo (Rietzschel), 363 Kola (Kolar), 259 Kola Diar (Kolar), 259 KOLAR Stereo wet plate camera, 257 KOCHMANN Kosmopolit (Zeiss Ikon), 445 Kosmos Optics Kit (Logix Enterprises), 293 Box Kolex, 258 Kola, 259 Kola Diar, 259 Enolde, 257 KOSSATZ Enolde I, II, III, 258 Spiegel-Reflex,261 KOWA OPTICAL Kallo, 261 Korelle cameras, 258 Korelle K, 258 Korelle P, 258 Kolar, 259 Kolarex, 259 Kolex, 259 KOLBE & SCHULZE Kalloflex, 261 Reflex-Korelle, 258 Komaflex-S, 261 Strut-folding, 258 Kowa E, 261 Kowa H, 261 Autix, 259 Kolibri (523/18) (Zeiss Ikon), 445 Kolorcube (Eastman), 486 Kodaclone Slide, 487 Kodacolor 400 Film Radio, 487 Kowa SE, 261 Kowa SER, 261 Kowa SET, 261 Kowa SETR, SETR2, 262 Kodacolor VR 200 (Eastman), 484 Kolt (Okada), 337 Komaflex-S (Kowa), 261 Kodak 1880-1980 Centennial Plate (Wilton), 480 Kombi (Kemper), 252 KoMcoMoleu (GOMZ), 216 Kodak 25 Lapel Pin, 481 Kowa Six, Six MM, 262 Kodak 35 Camera (Eastman), 161 Kowa Super 66, 262 Kowa SW, 262 Kodak 35 Camera with RF (Eastman), 161 Komlosy, 259 Komsomoletz (GOMZ), 216 Konair Ruby (Yamato), 432 Kodak 35 (Military) (Eastman), 161 Kodak 66 Model III (Eastman), 161

Kowa UW190, 262

LANCASTER Aluminum Bound

Kowaflex E, 262 Ramera, 262 Super Lark Zen-99, 262 Zen-99, 262 Kowaflex E (Kowa), 262 KOZY CAMERA CO. Pocket Kozy, 262 Pocket Kozy, Improved, 262 KÖHNLEIN Wiko Standard, 258 KRAFTWORKS Kraft, 262 KRANZ Sliding-box DaguerreotypeCamera, 262 KRASNOGORSKMECHANICAL FACTORY"KMZ" Drug (Dpyr), 262 F-21, 262 F-21 Button Camera, 262 Fed-Zorki, 264 FT-2, 263 Horizont, 263 Iskra, 263 Iskra-2, 263 Mir, 263 Moscow (MOSKWA), 263 Narciss, 263 Start (Cmapm), 263 Zenit, 263 Zenit 19, 264 Zenit 3, Zenit 3M, Zenum 3M, 263 Zenit 4, 263 Zenit 5, 263 Zenit 5, 263 Zenit 6, 263 Zenit-B, 264 Zenit-C, 263 Zenit E, EM, ET, 264 Zenit Photo Sniper, 264 Zenit TTL, 264 Zenum 3M, 263 Zorki, 264 Zorki, 264 Zorki 2, 2C, 264 Zorki 3, 3C, 3M, 264 Zorki 4, 4K, 264 Zorki 5, 264 Zorki 6, 264 Zorki 10, 264 Zorki 11, 265 Zorki 12, 265 Zorki C (S), 264 KRAUSS (E.) Eka, 265 Mondain, 265 Photo-Revolver, 265 Takyr, 265 KRAUSS (G.A.) Nanos, 265 Peggy I, II, 265 Rollette, 265 Rollette Luxus, 265 Stereoplast, 265 Kreca (Kremp), 265 KREMP Kreca, 265 Kristall (AFIOM), 52 KROHNKE Photo-Oda, 265 Kromskop Triple Camera (Ives), 249 Krugener Delta-Car Lapel Pin DVPCA, 481 Kruxo Favorit (Vredeborch), 420 KRÜGENER Delta, 265-266 Delta Detective, 266 Delta Magazine Camera, 266 Delta Patronen-Flach-Kamera,266 Delta Periskop, 266 Delta Stereo, 266 Delta-Teddy, 266 Electus, 266 Halloh, 266 Jumelle-style magazine camera, 266 Million, 266 Minimum Delta, 266

Normal Simplex, 266 Plaskop 45x107mm, 266 Plaskop 6x13cm, 266 Plastoscop, 266 Simplex Magazine, 266 Taschenbuch-Camera,266 Taschenbuch Replica, 266 Krügener's Patent Book (Marion), 300 KUEHN Lomara, 266 Lomaraskop, 266 **KUGLER** Close Focus Camera, 266 CompanionReflex, 266 KULLENBERG Field camera, 266 KUNIK Foto-Füller, 266 Foto-Füller (Luxus), 267 Mickey Mouse Camera, 267 Ompex 16, 267 Petie, 267 Petie Lighter, 267 Petie Vanity, 267 Petietux, 267 Petitax, 267 Petitux IV, 267 Tuxi, 267 Tuximat, 267 Kurbi & Niggeloh, 267 Kuri Camera (Kuribayashi), 269 KURIBAYASHI 1919 Speed Reflex, 268 Anscomatic 726, 272 Auto Semi First, 269 Baby Semi First, 268 BB Baby Semi First, 269 BB Semi First, 269 First Center, 269 First Etui Camera, 268 First Hand, 268 First Reflex, 269 First Roll, 268 First Six, 269 First Speed Pocket, 269 Fotochrome Camera, 272 Karoron RF, 270 Karoron S, S-II, 270 Kokka Hand, 268 Kuri Camera, 269 Lo Ruby Camera, 269 Mikuni, 268 Petri (35) 2.8, 270 Petri 1.8 Color Super, 270 Petri 1.9 Color Super, 270 Petri 2.8 Color Super, 270 Petri 35, 270 Petri 35 1.9, 270 Petri 35 2.0, 270 Petri 35 RE, 271 Petri 35X, MX, 270 Petri Auto Rapid, 272 Petri Auto Rapid, 272 Petri Automate, 270 Petri Color 35, 35E, 271 Petri Compact, 271 Petri Compact 17, 271 Petri Compact E, 271 Petri Computor 35, 271 Petri EBn, 270 Petri ES Auto 1.7 and 2.8, 271 Petri FA-1, 272 Petri Flex Seven, 271 Petri Fiex Seven, 2 Petri Flex V, 271 Petri FT, FT-II 272 Petri FT 500, 272 Petri FT 1000, 272 Petri FT EE, 272 Petri FTE, 272 Petri FTX, 272 Petri Grip-Pack 110, 272 Petri Half, 271

Petri Half, Junior, Compact, 271 Petri Hi-Lite, 271 Petri Instant Back, 272 Petri Junior, 271 Petri M 35, 271 Petri MFT 1000, 272 Petri Micro Compact, 271 Petri Micro MF-1, 272 Petri Penta, 271 Petri Penta (Flex) V3, 271
Petri Penta (Flex) V6, V6-II, 271
Petri Penta V2, 271
Petri Pocket 2, 272 Petri Prest, 271 Petri Pro Seven, 270 Petri Push-Pull 110, 272 Petri Racer, 270 Petri RF, RF 120, 269 Petri Semi, II, III, 269 Petri Seven, 270 Petri Seven S, S-II, 270 Petri Super, Super V, 269 Petriflex, 270 Romax Hand, 268 Semi First, 268 Tokiwa Hand, 268 KURIBAYASHICAMERAWORKS Petri Eight, 463 Petri Power Eight, 463 Petri Super Eight, 463 KUZUWATOY Trick Ompus XA Bickri Camera, 478 KWANON SERIES (Canon), 108 Kwikflex (Tokiwa), 403 KYOEI TRADING CO. Mino Flex Snap Lite, 474 KYOTO PRECISION MFG. Cine Vero, 275 KYOTO SEIKI CO. Lovely, 275 L.A. MOTION PICTURE CO. 35mm Motion Picture Camera, 463 L.F.G. & CO. Franceville, 290 Français, 290 L.S. Squirt Camera, 489 L'As (E.L.C.), 182 L'Epatant, 184 La Belle Pal (Bolsey), 98 LA CROSSE CAMERA CO. Snapshot, 275 LA ROSE Rapitake, 275 LAACK Ferrotype camera, 275 Merkur, 275 Padie, 275 Tropical camera, 275 Wanderer, 275 LABARRE Tailboard camera, 275 LABORATORIOSMECANICOSM.C. Joya, 275 LACHAIZE Mecilux, 276 LACON CAMERA CO. Lacon C, 276 Ladies Camera (Lancaster), 276 Ladies Gem Camera (Lancaster), 277 Ladies Hand camera (Rietzschel), 363 Lady Carefree (Argus), 73 Lady Debutante (Balda), 84 Lafayette 35 (Tokiwa), 403 LAMPERTI & GARBAGNATI Detective camera, 276 Spiegamentorapido, 276 Wet plate camera, 276 LANCART Xyz, 276 LANCASTER Aluminium Bound Instantograph, 276

LANCASTER Brass Bound

Brass Bound Instantograph, 276 Gem Apparatus, 276 Instantographview, 276 International Patent, 276 Kamrex, 276 Ladies Camera, 276 Ladies Gem Camera, 277 Meritoire, 277 Meritoire Stereo, 277 Merveilleux, 277 Omnigraph, 277 Portable Instantograph, 277 Postage Stamp Cameras, 277 Rover, 277 Special Brass Bound Instantograph, 277 Stereo Instantograph, 277 Watch Camera, 277 Lancer (Ansco), 65 Lancer LG (Ansco), 65 LANCO SCREEN COMPANY Boo-Boo Bear with camera, 497 Landschaftskamera(Bentzin), 91 LANE Woodbury Universal Tourist, 278 Lark (Imperial), 247 Laurelflex (Tokyo Kogaku), 403 LAURIE IMPORT LTD. Dick Tracy, 278
Miniature Novelty Camera, 278
LAVA-SIMPLEX Simplex Snapper, 278 LAVEC Lavec LT-002, 278 LAWLEY Folding Plate Camera, 278 Wet plate camera, 278 Le Cent Vues (Mollier), 317 Le Cristallos (Jumeau & Jannin), 250 LE DOCTE Excell, 278 Le Gousset (J.V.), 251 Le Marsouin (Hanau), 227 Le Multicolore (Rochechouard), 368 Le Pascal (Japy & Cie.), 249 Le Prismac (Devaux), 137 Le Reve (Girard), 212 Le Stereocycle (Bazin & Leroy), 86 Leader (Tougodo), 405 Leader Camera, 278 LEADWORKS Shoulder Bag, 472 Lec Junior (M.I.O.M.), 314 LECHNER Hand Camera, 278 Leduc X-127 (Indumag), 248 LEE INDUSTRIES Leecrest, 278 LEECH & SCHMIDT Tailboard camera, 278 Leecrest (Lee), 278 **LEFTON CHINA** Man with camera, 491 Legionaire (Wittnauer), 429 Fabuland Patrick Parrot, 497 LEHMAN Pelar-Camera,278 LEHMANN Ben Akiba, 278
Ben Akiba Replica, 278
Leica 0-Series (Leitz), 281
Leica 72 (Leitz), 283
Leica 110 Prototype (Leitz), 286
Leica 250 Reporter (Leitz), 282 Leica CL (Leitz), 285 Leica CL 50 Jahre model (Leitz), 285 Leica CL 50 Jahre model (Lei Leica I (A) (Leitz), 281 Leica I (B) (Leitz), 281 Leica I (C) (Leitz), 281 Leica I (C) Luxus (Leitz), 281 Leica I Luxus (Leitz), 281 Leica Ic (Leitz), 283 Leica If (Leitz), 283

Leica If Swedish 3 crown (Leitz), 283
Leica Ig (Leitz), 283
Leica II (D) (Leitz), 282
Leica II Tie Tac, 481
Leica IIc (Leitz), 283
Leica IIf (Leitz), 283
Leica III (F) (Leitz), 282
Leica IIIa "Monté en Sarre" (Leitz), 282
Leica IIIa (G) (Leitz), 282
Leica IIIb (G) (Leitz), 282
Leica IIIb Luftwaffen Eigentum (Leitz), 282
Leica IIIc "K-Model" (Leitz), 282
Leica IIIc Luftwaffe (Leitz), 282
Leica IIIc Luftwaffe (Leitz), 282
Leica IIIc Luftwaffe (Leitz), 282
Leica IIIc Syehrmacht (Leitz), 282
Leica IIIc Wehrmacht (Leitz), 282
Leica IIIc, grey (Leitz), 282 Leica If Swedish 3 crown (Leitz), 283 Leica IIIc, grey (Leitz), 282 Leica IIId (Leitz), 283 Leica IIIf (Leitz), 283 Leica IIIf (Swedish Army) (Leitz), 283 Leica IIIf (Swedish Army) (Leitz), 283
Leica IIIg (Leitz), 283
Leica IIIg Swedish Crown (Leitz), 283
Leica IIIg Swedish Crown (Leitz), 283
Leica IIIg, black (Leitz), 283
Leica KE-7A (Leitz), 284
Leica Luxus Replica (Leitz), 281
Leica M1 (Leitz), 284
Leica M2, black paint (Leitz), 284
Leica M2, chrome (Leitz), 284
Leica M2, Grey finish (Leitz), 284
Leica M2, motorized (Leitz), 284
Leica M2 MOT, M2M (Leitz), 284
Leica M2R (Leitz), 284
Leica M2S (Leitz), 284
Leica M2S (Leitz), 284
Leica M3 (Leitz), 284
Leica M3 (Leitz), 284 Leica M3 (Leitz), 283 Leica M3, black paint (Leitz), 284 Leica M3, olive (Leitz), 284 Leica M3, Oilve (Leitz), 264
Leica M4 (Leitz), 284
Leica M4 50 Jahre Model (Leitz), 284
Leica M4-2, black (Leitz), 285
Leica M4-2, gold (Leitz), 285
Leica M4-P (Leitz), 285
Leica M4-P, 70th Anniversary (Leitz), 285 Leica M4, black chrome (Leitz), 284 Leica M4, black enamel (Leitz), 284 Leica M4, olive (Leitz), 284 Leica M4, olive (Leitz), 284
Leica M4, silver chrome (Leitz), 284
Leica M4, M4 Mot (Leitz), 284
Leica M5 (Leitz), 285
Leica M5 Fiftieth Anniversary (Leitz), 285
Leica M6 (Leitz), 285
Leica M6, Columbo '92 (Leitz), 285
Leica M6, Commemorative (Leitz), 285
Leica M6, Commemorative (Leitz), 285
Leica M6, Rooster (Leitz), 285
Leica MD (Leitz), 284
Leica MD-2 (Leitz), 284
Leica MDa (Leitz), 284 Leica MD-2 (Leitz), 284 Leica MDa (Leitz), 284 Leica Mifilmca (Leitz), 281 Leica MP, MP2 (Leitz), 284 Leica R3 (Leitz), 286 Leica R3 Gold (Leitz), 286 Leica R3 Mot (Leitz), 286 Leica R3 Safari (Leitz), 286 Leica R4 (Leitz), 286 Leica R4 Mot (Leitz), 286 Leica R4S (Leitz), 286 Leica R4, Gold (Leitz), 286 Leica R6 Platinum (Leitz), 286 Leica Single-Shot(Leitz), 283 Leica Standard (E) (Leitz), 282 Leica Standard (E) (Leitz), 282 Leica Viewer, 499 Leicaflex (Leitz), 285 Leicaflex SL (Leitz), 285 Leicaflex SL Mot (Leitz), 285 Leicaflex SL Olympic (Leitz), 285 Leicaflex SL2 (Leitz), 286 Leicaflex SL2 50 Jahre Model (Leitz), 286 Leicaflex SL2 Mot (Leitz), 286 Leicina 8S (Leitz), 463 Leicina 8SV (Leitz), 464 LEIDOLF LEIDOLF Auto Malik, 278

Lordomat, Lordomat II, 278 Lordomat C-35, 278 Lordomat SE, Lordomat SLE, 278 Lordomatic, Lordomatic II, 278 Lordox, 279 Lordox Blitz, 279 Leidox Leidox II (Leidolf), 278 Leipzig Detective (Grundmann), 224 LEITZ (Ernst Leitz GmbH) Leica 0-Series, 281 Leica 110 Prototype, 286 Leica 250 Reporter, 282 Leica 72, 283 Leica CL, 285 Leica CL 50 Jahre model, 285 Leica I (A), 281 Leica I (B), 281 Leica I (C), 281 Leica I (C) Luxus, 281 Leica I Luxus, 281 Leica Ic, 283 Leica If, 283 Leica If Swedish 3 crown, 283 Leica Ig, 283 Leica II (D), 282 Leica IIc, 283 Leica III (F), 283 Leica III (F), 282 Leica IIIa "Monté en Sarre", 282 Leica IIIa (G), 282 Leica IIIb (G), 282 Leica IIIb Luftwaffen Eigentum, 282 Leica IIIc, 282 Leica IIIc, grey, 282 Leica IIIc "K-Model",282 Leica IIIc Luftwaffe, 282 Leica IIIc Wehrmacht, 282 Leica IIId, 283 Leica IIIf, 283 Leica IIIf (Swedish Army), 283 Leica IIIg, 283 Leica IIIg, black, 283 Leica IIIg Swedish Crown Model, 283 Leica KE-7A, 284 Leica Luxus Replica, 281 Leica Luxus Replica, 281 Leica M1, 284 Leica M1 Military Green, 284 Leica M2, black paint, 284 Leica M2, chrome, 284 Leica M2, Grey finish, 284 Leica M2, motorized, 284 Leica M2 MOT, M2M, 284 Leica M2R, 284 Leica M3, 283 Leica M3, black paint, 284 Leica M3, olive, 284 Leica M3, Dlack paint, 264 Leica M3, Olive, 284 Leica M4, 284 Leica M4, black chrome, 284 Leica M4, black enamel, 284 Leica M4, olive, 284 Leica M4, silver chrome, 284 Leica M4, 2 black, 285 Leica M4-2, black, 285 Leica M4-2, gold, 285 Leica M4-P, 285 Leica M4-P, 70th Anniversary, 285 Leica M4M, M4 Mot, 284 Leica M5, 285 Leica M5 Fiftieth Anniversary model, 285 Leica M6, 285 Leica M6 CommemorativeModels, 285 Leica M6, Columbo '92, 285 Leica M6, LHSA 25th Anniversary, 285 Leica M6, Rooster, 285 Leica MD, MD-2, 284 Leica MDa, 284 Leica Mifilmca, 281 Leica MP, MP2, 284 Leica R3, 286 Leica R3 Gold, 286 Leica R3 Mot, 286

Leidox, Leidox II, 278

Leica R3 Safari, 286 Lightning Hand Camera (Benetfink), 90 Lightomatic (Beauty Camera Co.), 86 LOEBER BROTHERS Leica R4, 286 Leica R4, Gold, 286 Leica R4 Mot, 286 Leica R4S, 286 Leica R6 Platinum, 286 Folding bed plate camera, 293 Logikit (Logix Enterprises), 293 LOGIX ENTERPRISES LIGHTS, 481 Lika, 483 Lika, 483
Likings Deluxe, 291
Liliput, 291
Liliput (Ernemann), 188
Liliput (Zeiss Ikon), 445
Liliput Stereo (Ernemann), 188
Liliput Detective Camera (Anthony), 69
Limit (Thornton-Pickard), 401 Kosmos Optics Kit, 293 Logikit, 293 Loisirs (M.I.O.M.), 314 Leica Single-Shot, 283 Leica Single-Shot, 283 Leica Standard (E), 282 Leicaflex, 285 Leicaflex SL, 285 Leicaflex SL Mot, 285 Leicaflex SL Olympic, 285 Leicaflex SL2, 286 Leicaflex SL2 50 Jahre Model, 286 Leicaflex SL2 Mot, 286 Leicaflex SL2 Mot, 286 Lola (Ica), 242 Lola (Wünsche), 431 Lola Stereo (Wünsche), 431 LOLLIER Limit (Thornton-Pickard), 401 Limoges Miniature Camera, 484 Lina, Lina-S, 291 Linca Modele L-50, 291 Lince 2 (Ferrania), 194 Lince Rapid (Ferrania), 194 Stereo-Marine-Lollier,293 LOMAN & CO. Loman Reflex, 293 Lomara (Kuehn), 266 Lomaraskop (Kuehn), 266 LOMO Leicina 8S, 463 Leicina 8SV, 464 Lince Supermatic (Ferrania), 194 Ur-Leica (Original), 279 Ur-Leica (Replica), 279 LENINGRAD Lindar (Linden), 291 LINDEN Almaz-103, 293 Lomo 135 BC, 135 M, 293 LONDON & PARIS OPTIC & CLOCK CO. Lindar, 291 Lindi, 291 Leningrad, 289 LENNOR Delta Stereo, 289 Lenz, 289 Countess, 293 Reporter 66, 291 Lindi (Linden), 291 LINDSTROMTOOL & TOY CO. Duchess, 293
Princess May, 293
LONDON STEREOSCOPIC& PHOTO LEONAR Candid Camera Target Shot, 478 Artist Hand Camera, 293 Artist Reflex, 293 Artist Reflex, Tropical, 293 Filmos, 289 Leonar, 289 Linex (Lionel), 291 LINHOF Coco, 464 LINHOF PRÄZISIONS KAMERAWERK early folding cameras, 291 Perkeo Model IV, 289 Leotax Cameras (Showa), 387 Binocular camera, 293 Carlton, 294 **LEPAGE** Dispatch Detective, 294 Field camera, 289 LEREBOURS Kardan, 291 Field cameras, 294 Standard Präzisionskamera, 291 Stereo Panorama, 291 King's Own Tropical, 294 Gaudin Daguerreotypecamera, 289 Parvex, 294 Tailboard stereo camera, 294 **LEROY** Technika I, III, 291 Technika Press 23, 291 Linos (Lüttke), 295 Minimus, 289 Tailboard stereo camera, 294
Twin Lens Artist Hand Camera, 294
Vesca, 294
Vesca Stereo, 294 Stereo Panoramique, 289 LESUEUR & DUCOS du HAURON Lion (Yen camera), 435 LIONEL MFG. CO. Melanochromoscope,289 Letix (Asahi Optical), 81 LEULLIER Linex, 291 LIONSTONEDISTILLERIES Wet plate camera, 294
Lone Ranger (Victory), 414
Long Focus Grand (Century), 115 Summum, 289 Photographer,479 LIPPISCHECAMERAFABRIK Long Focus Grand (Century), 115
Long Focus Korona (Gundlach), 225
Long Focus Montauk (Gennert), 210
Long Focus Premo (Rochester Opt.), 370
Long Focus Revolving Back (Conley), 123
Long Focus Thornward
(Montgomery Ward), 319
Long-Focus Wizard (Manhattan), 299
Long-Focus Wizard (Manhattan), 299
Long (Niell & Simons), 328
Lord IVB, 5D (Okaya), 337
Lordomat C-35 (Leidolf), 278
Lordomat SE, Lordomat SLE (Leidolf), 278
Lordomat, Lordomat II (Leidolf), 278
Lordomat, Lordomat II (Leidolf), 278 Summum Sterechrome, 289 Flexo, 292 Flexo Richard, 292 LEVI Leviathan Surprise Detective, 289 Minia Camera, 289 Pullman Detective, 289 Flexora, 292 Optimet (I), 292 Rollop, 292 Leviathan Surprise Detective (Levi), 289 LEVY-ROTH Rollop Automatic, 292 Lirba, 292 Lisette (Balda), 84 Minnigraph, 290 LEWIS Daguerreotypecamera, 290 Litote (Korsten), 261 Wet Plate camera, 290 LEWIS BUCKLES Little Nipper (Butcher), 105 Little Wonder (Enterprise), 183 Little Wonder (Ruberg & Renner), 375 LIZARS Camera Buckles, 473 Lewis-style Daguerreotype (Palmer & Longking), 346
LEXA MANUFACTURINGCO. Lordomat, Lordomat II (Leidolf), 278 Lordox (Leidolf), 279 Lordox Blitz (Leidolf), 279 Challenge, 292
Challenge Dayspool, 292
Challenge Dayspool Stereoscopic
Tropical, 292 Lexa 20, 290 LORENZ LI PING CO Clarissa, 294 LORILLON Challenge Dayspool Tropical, 292 Challenge Junior Dayspool, 292 Challenge Magazine Camera, 292 Challenge Stereo Camera, 292 Rambler, 292 Cambot Wonderful Slide Robot, 478 Liberty View (Northern Photo), 336 Field camera, 294 Liberty-620 (Ico S.C.), 244 Library Kodascope (Eastman), 460 Librette (Nagel), 323 Lotte II (Beier), 88 Love (Sonora), 391 Lovely (Kyoto), 275 LIEBE Lladro, 491 LLEDO PROMOTIONALMODELS Fox Talbot Van, 498 Monobloc, 290 LIEBERMAN& GORTZ LUBIN
Lubin 35mm Studio Cine, 464
Lubitel (GOMZ), 216
Lubitel 2 (GOMZ), 217
Lubitel 166, 166B (GOMZ), 217
Lubo 41 (Beaugers), 86
Lucidograph (Blair), 96
Lucine, 294
Lucky, 294
Lucky, (G.G.S.), 211
Lucky-Lite Camera-Lighter, 474
LUCKY STAR ENTERPRISE
Inst-and Camera, 495
Lucky Strike (Mast), 301
Luckyflex (G.G.S.), 211
LUCY RIGG
Teddy Bear Photographers, 492 LUBIN Dual-finder rollfilm camera, 290 Kodak Van, 498 LIESEGANG Lloyd (Zeiss Ikon), 445 LLOYD (Andrew J.) Box camera, 292 LLOYD (Fred V.A.) Field camera, 290 LIFE TIME Life Time 120 Synchro Flash, 290 LIFE-O-RAMACORP. Life-O-Rama, 290 Life-O-RamaIII, 290 Light, 290 Light (Yen camera), 435 LIGHT INDUSTRIAL PRODUCTS Seaguil 4, 290 Field camera, 292 Lloyd (Hüttig), 240 Lloyd (Ica), 242 Lloyd Stereo (Ica), 242 Lloyd-Cupido560 (Ica), 242 Lloyd's, 292 Seagull 4, 290 Seagull No. 203, 291 Light Super, 291 Lo Ruby Camera (Kuribayashi), 269 LOEBER Field Camera, 292 Lightning (Schuneman & Evans), 378 Klapp camera, 292 Teddy Bear Photographers, 492 Lightning Detective (Benetfink), 90 Magazine Camera, 293 Ludix, 294

LUEN

Mamiyaflex Junior, 298 Flash 120, 296 LUEN TAT MFG. CO. Macy M-16, 296 Supre-Macy, 296 Mammy, 298 Myrapid, 298 Splash Flash Deluxe, 489 Lumibox (Lumiere), 295 Pistol camera, 298 Prismat NP, PH, 298 Lumica (Oshiro), 346 Lumiclub (Lumiere), 295 LUMIERE Madel 35, 296 MADER Saturn, 298 Invincibel, 296 Super Deluxe, 298 Madison I, 296 Box camera, 294 Mammy (Mamiya), 298 Man with camera (Lefton), 491 Mandel Automatic PDQ (PDQ), 347 Magazine 35 (Mamiya), 297 Magazine 200 (Bell & Howell), 455 Magazine Box (Ernemann), 188 Eljy, 294 Eljy Club, 294 Lumibox, 295 Lumiclub, 295 Magazine Box (Ernemann), 188
Magazine box camera (Watson), 422
Magazine Camera (Bial & Freund), 93
Magazine Camera (Conley), 123
Magazine camera (Hüttig), 240
Magazine camera (Imperical), 247
Magazine Camera (Loeber), 293
Magazine camera (Lundelius), 295
Magazine camera (Neumann), 325
Magazine camera (Neumann), 325 Mandelette (Chicago Ferrotype), 118
Manex (Vredeborch), 420
MANHATTANOPTICAL CO.
Bo-Peep, 299 Lumirex, 295 Lumix F, 295 Lux-Box, 295 Long-FocusWizard, 299 Night Hawk Detective, 299 Optax, 295 Periphote, 295 Wizard, 299 Wizard Duplex, 299 Wizard Special, 299 Maniga, 299 Scout-Box, 295 Sinox, 295 Starter, 295 Magazine camera (New Ideas), 325 Magazine camera (Pipon), 354 Magazine camera (Swinden), 397 Sterelux, 295 Maniga 3x4cm, 299 Maniga Manetta, 299 MANSFIELD Stereiux, 295
Super Eljy, 294
Lumika 35, 295
Luminor (Manufacture Française), 299
Lumirex (Lumiere), 295
Lumix Camera-Lighter, 474
Lumix F (Lumiere), 295
LUNDELIUSMFG. CO. Magazine Camera (Tella), 400
Magazine Camera (Vojta), 419
Magazine Camera-172 (Bell & Howell), Mansfield Automatic 127, 299 MANSFIELDHOLIDAY 455 Skylark, 299 Skylark V, 299 MANSFIELDINDUSTRIES Magazine Cine-Kodak Eight (Eastman), Magazine Cyclone (Rochester Opt.), 369 Magazine Cyclone (Western), 425 Magazine Pendant, 481 Magazine camera, 295 LURE CAMERA LTD. Mansfield Model 160, 464 Mantel-Box2 (Eho-Altissa), 182 MANUFACTURE FRANÇAISE D'ARMES ET CYCLES Lure, 295 LUSTRE FAME Magazine Pocket (Associated Photo), 454 MAGGARD-BRADLEY Cosmograph Model 16-R, 464 Mouse with camera (tree ornament), 492 Lutin (O.T.A.G.), 346 Luminor, 299 Nécessaire de Photographie "Luminor", Magic Camera (Unimax), 496 MAGIC INTRODUCTIONCO. Magic Pocket Camera, 489 Lux-Box (Lumiere), 295 Luxa six (Braun), 100 Luxette, Luxette S (Cima KG.), 119 Luxia, Luxia II (C.O.M.I.), 122 ManufocTenax (Goerz), 214 MAR-CRESTMFG. CORP. Photoret Watch Camera, 296 Mar-Crest, 299 MARCHAND Luzo (Robinson), 367 LÜTTKE Presto, 296 Magic Sun Picture Camera (Elvin), 486 Magica-flex (Fotobras), 199 MAGNACAMCORP. Fischer Baby, 299 Flash 6x9, 299 MARION & CO. Field camera, 295 Filmos, 295 Folding camera, 295 Linos, 295 MAGNACAMCORP.
Wristamatic Model 30, 297
Magnar-Kamera(Carl Zeiss Jena), 436
Maine (Alsaphot), 61
Majestic (Galter), 208
Majestic (Monarch), 318
Majestic (Spencer), 392 Academy, 300 Cambridge, 300 Transvaal, 295 Vidol, 295 Field camera, 300 Krügener's Patent Book Camera, 300 Vidol, 295
Lycon M3 (Yamato), 432
Lynx, Lynx II (Pontiac), 358
Lynx 14 (Yashica), 434
Lynx 1000 (Yashica), 434
Lynx PPL-500XL(Pacific Products), 346
Lyra 4.5x6cm (Semi-Lyra) (Fuji), 205
Lyra Six, Lyra Six III (Fuji), 205
Lyraflex, Lyraflex F, Lyraflex J (Fuji), 205
Lyrax (Fuji), 205 Metal Miniature, 300 Modern, 300 Parcel Detective, 300 Perfection, 300 Major (Agfa-Ansco), 58
Major (National Instrument), 324
Makina (I) (Plaubel), 355
Makina I/II conversion (Plaubel), 355 Radial Hand camera, 300 Makina I/II conversion (Plaubel), 355
Makina II (Plaubel), 355
Makina III, IIS (Plaubel), 355
Makina III (Plaubel), 355
Makinette (Plaubel), 355
Mako Shark (Healthways), 230
MAL-IT CAMERA MFG. CO. Soho Reflex, 300 Soho Stereo Reflex, 300 Soho Stereo Tropical Reflex, 300 Soho Tropical Reflex, 300 MARK M.I.O.M. MA-1 camera-robot, 478 MA-1 camera-robot, 4/8 Snap-ShotSecret Gun CH-337, 478 Mark III Hythe (Thornton-Pickard), 401 Mark IV (Atlas-Rand), 81 Mark IV (Sawyers), 377 Mark 27 (Imperial), 247 Mark S-2, 300 Mark XII Flash (Imperial), 247 Astra, 314 Mal-It Camera, 297 Jacky, 314 Lec Junior, 314 Malcaflex, 297 Malcaflex (Musashi), 322 Loisirs, 314 Miom, 314 Malik Reflex (Couffin), 129 Maliutka (GOMZ), 217 MAMIYA CAMERA CO. Photax (original), 314 Photax "Blindé", 314 Auto-Lux 35, 297 Photax V, 314
Rex, 315
M.P.C. (Mechanical Plate Changing) MARKS Camex Six, 297 Family, 297 Marksman Six-20, 300 Marksman (Pho-Tak), 350 Marksman Six-20 (Marks), 300 Junior, 297 (Vive), 414 MA-1 camera-robot(Mark), 478 MACKENSTEIN Korvette, 297 Marlboro, 300 Magazine 35, 297 Magazine 35, 297
Mamiya 23 Cameras, 297
Mamiya 6, 297
Mamiya-16, 297
Mamiya-16 Police Model, 297
Mamiya/Sekor (CWP), 298
Mamiya/Sekor 500 DTL, TL, 298
Mamiya/Sekor 528 AL, TL, 298
Mamiya/Sekor 1000 DTL, TL, 298
Mamiya/Sekor 1000 DTL, TL, 298
Mamiya/Sekor 1000 DTL, TL, 298 Marlo, 464 MARLOWBROS Field Camera, 296 Folding camera, 296 Francia, 296 MB, No. 2 and No. 4, 300 Mars 99 (Wünsche), 431 Francia Stereo, 296 Jumelle Photographique,296 Mars Detectiv-Stereoskop(Wünsche), 431 Mars Detective (Wünsche), 431 MARSHALOPTICAL WORKS Photo Livre, 296 Pinhole camera, 296 Marshal Press, 301 Stereo Jumelle, 296 MACRIS-BOUCHER Nil Melior Stereo, 296 MACVANMFG. CO. MARTAIN Mamiya/SekorAuto X1000, XTL, 298 Mamiya/SekorDSX 500, 1000, 298 Mamiya/SekorMSX 500, 1000, 299 Mamiyaflex Automatic A, A-II, 297 View Camera, 301 Maruso (Yen camera), 435 MARUSO TRADING CO. Macvan Reflex 5-7 Studio camera, 296 Spy-14, 301 Mamiyaflex I, II, 298 Mamiyaflex C, C2, 298 Macy 120 (Pho-Tak), 350 MACY ASSOCIATES Top, Top II Camera, 301

MIETHE

Marvel, 301 Tailboard camera, 302 Merlin (United Optical), 408 Marvel (Putnam), 359 MARVEL PRODUCTSINC. Wet plate bellows camera, 303 Merry Matic Flash Camera, 495 Wet plate sliding-box camera, 303 Mec-16 (Feinwerk), 193 MERTEN MarVette, 301 Merit Box, 304 Marvel S-16 (Sears), 379 Marvel S-20 (Sears), 379 Marvel-flex (Sears), 379 MarVette (Marvel), 301 MARYNEN Mec 16 (new style) (Feinwerk), 194 Mec-16 SB (Feinwerk), 194 Mecabox, 303 Mecaflex (Kilfitt), 256 Merveilleux (Lancaster), 277 Mess-Ikonta (Zeiss Ikon Ikonta B), 445 Metal Miniature (Marion), 300 Metascoflex, 304 Metascotiex, 304
Meteor (Taiyodo Koki), 398
Meteor (Universal), 410
Metharette (Merkel), 304
Metraflex II (Tougodo), 405
METRO MFG. CO.
Metro Flash, 304
Metro Flash No. 1 Deluxe, 304
Metro Cam (Metropolitan), 204 Mecilux (Lachaize), 276 Mecum, 303 Studio camera, 301 Mascot (Scovill), 379 Mascot (Shimura), 386 Medalist Cameras (Eastman), 162 MEFAG Mascot No. 1 (Houghton), 238 MASHPRIBORINTORG, 301 Handy Box, 303 Megascope (Caillon), 106 Mego Matic, 303 Megor (Meyer), 305 MEGURO KOGAKU MASK, 482 MASON Metro-Cam (Metropolitan), 304 Metro-Flex (Metropolitan), 304 METROPOLITANINDUSTRIES Cardinal 120, 304 Field camera, 301 MASON (Perry) Melcon, 303 Argus Repeating Camera, 301 Companion, 301 Meikai (Tougodo), 405 Meikai EL (Tougodo), 405 Meiritto No. 3 (Tougodo), 405 Meister Korelle (Wefo), 423 Clix 120, 304 Harvard camera, 301 Phoenix Dollar Camera, 301 MAST DEVELOPMENTCO. Clix 120 Elite, 304 Clix Deluxe, 304 Meisupi cameras (Tougodo), 405 Meisupii Half (Tougodo), 405 Meisupii Ia (Tougodo), 405 Meisupii Ia (Tougodo), 405 Melanochromoscope(Lesueur), 289 Clix Miniature, 304 Lucky Strike, 301 Master Reflex (Wefo), 423 Masters of the Universe (HG Toys), 233 Clix Miniature, 304
Clix-Master, 304
Clix-O-Flex, 304
Clix-O-Flex, 304
Metro-Cam, 304
Metro-Flex, 304
Rival 120 Elite, 304
METROPOLITANSUPPLYCO. Mastra V35 (King), 256 Matador (Kenngott), 253 Melanochromoscope(Lesueur), 289
Melcon (Meguro), 303
Memar (Ansco), 65
Memo (Agfa-Ansco), 58
Memo (Ansco), 65-66
Memo (Boy Scout model) (Ansco), 66
Memo (wood finished) (Ansco), 66
Memo (Automotiv (Ansco), 66 Match King, 475 Match-Maker, 492 Matchbox Camera (Eastman), 162 Matey 127 Flash (Imperial), 247 King Camera, 304 MEYER (Ferd. Franz) Mathew Brady figurine, 492 Maton (Multipose), 321 Memo Automatic (Ansco), 66 Field Camera (English style), 304 Field Camera (revolving bellows), 305 Memo II Automatic (GAF) (Ansco), 66 MATTEL Memo Set, 485 Field Camera (square bellows), 305 MEYER (Hugo) Chatter-Pal, 495 Memories of Yesteryear, 492 Disney Fun Bubbles Play Camera, 495 Fashion Photo Barbie, 480 Memory Kit (Ansco), 66 MENDEL Megor, 305 Silar, 305 MEYER & KASTE MAW OF LONDON Detective camera, 303 Nustyle, 302 Nustyle DeLuxe Fashion Model, 302 MAWSON Triomphant, 303 MENDOZA Field camera, 305 MF Stereo Camera, 305 Miall Hand Camera (Fallowfield), 192 Mick-A-Matic (Child Guidance), 119 View camera, 303 Mentor II (Goltz & Breutmann), 216 Mentor Compur Reflex (Goltz & Wet plate camera, 302 Wet plate stereo camera, 302 Maxim Camera (Cash Buyers Union), 115 Mickey Mouse (Helm), 231
Mickey Mouse Camera (Ettelson), 190
Mickey Mouse Camera (Ettelson), 190
Mickey Mouse Camera (Kunik), 267
Mickey Mouse Candle, 473
Mickey Mouse Head (110 film) (Helm), 231
Mickey Mouse Wideo Photographer, 481
Mickey Mouse Video Photographer, 481
Mickey Matic (Fastman), 162 Breutmann), 215
Mentor Dreivier (Goltz & Breutmann), 216
Mentor Folding Reflex (Goltz & Maxim MF-IX, 302 Maxim Nos. 1-4 (Butcher), 105 Maximar (207/9) (Zeiss Ikon), 445 Breutmann), 216
Mentor Reflex (Goltz & Breutmann), 216
Mentor Sport Reflex (Goltz & Breutmann), Maximar (Ica), 242 Maximar A, B (Zeiss Ikon), 445 Maxxum (Minolta), 311 MAY, ROBERTS & CO. Mickey-Matic (Eastman), 162 Mentor Stereo Reflex (Goltz & Micky Rollbox (Balda), 84 Micro 110 Sandringham, 302 May Fair, 302 MAYFIELDCOBB & CO. Breutmann), 216 Mentor Studio Camera (Goltz & Breutmann), 216 (Cat & Fish), 305 (Cheeseburger),305 (Panda),305 Companion, 302 Mentor Studio Reflex (Goltz & Breutmann), MAZO plain camera, 305 Field & Studio camera, 302 MENTOR-KAMERA-FABRIK303 Micro 16 (Whittaker), 426 MICRO PRECISION PRODUCTS Stereo camera, 302 Mentorett (Goltz & Breutmann), 216 MEOPTA MAZUR Microcord, 305 Brooch camera, 302 Christies "KGB" Ring Camera, 302 Admira A8F, A8G, 464 Flexaret, 303 Mikroma, II, 303 Microflex, 305 Micro-110 (in can) (Arcon), 71 Microcord (Micro Precision), 305 Microflex (Micro Precision), 305 "Ernemann"Ring Camera, 302
"Russian" "KGB" Ring Camera, 302
"Warsavie" Ring Camera, 302 Milona, 303 Opema, II, 303 Stereo 35, 303 Micromegas (Hermagis), 232 Micronta 35 (Cosmo), 129 Micronta 35X (Haking), 226 MB, No. 2 and No. 4 (Marlow), 300 McBEAN Stereo 35, 303
Stereo Mikroma (I), II, 303
Mercury (Universal), 410
Mercury II (Model CX) (Universal), 410
Mercury Satellite 127 (Imperial), 247
Mergott (J.E.) Co, 250
MERIDIAN INSTRUMENTCORP.
Meridian, 304
Merit 304
Merit Boy (Merten), 304 Stereo Tourist, 302 McCROSSAN Microntaflex, 305 Microx Robot-To-Camera,478
Midas 9-1/2mm Cine (Camera Projector), Wet plate camera, 302 **McDONALDS** 456 Great Muppet Caper drinking glass, 480 McDONALDSCORP. MIDDL OPTICAL WORKS Middl 120-A, 305 MIDDLEMISS(W.) Search Team, 499 McGHIE and Co. Detective camera, 302 MIDDLEMISS (W.)
Middlemiss Patent Camera, 305
Midelly (Demilly), 136
Midg (Butcher), 105
Midget, 305
Midget (Coronet), 128
Midget Jilona cameras (Misuzu), 317
Midget Marvel (Wirgin), 428
Midget Model III (Misuzu), 317
Miethe/BermpohlCamera (Bermpohl), 91 Merit Box (Merten), 304 Meritoire (Lancaster), 277 Meritoire Stereo (Lancaster), 277 Field camera, 302 Studio View, 302 MERKEL McKELLEN Elite, 304 Metharette, 304 Treble Patent Camera, 302 Me 35 4-U (United States Projector), 409 MEAGHER Minerva, 304 Merkur (Hüttig), 240 Merkur (Laack), 275 Stereo camera, 302

MIGHTY

Mighty (Toyo Kogaku), 406 Mighty gift box (Toyo Kogaku), 406 Mighty Midget, 305 Autopak 700, 313 Autopak 800, 313 Semi-Minoltal, 307 Semi Minolta II, 307 Semi Minolta III, 307 Semi-Minolta III, 307 Semi-Minolta P, 307 Sonocon 16mm MB-ZA, 313 Baby Minolta, 307 Mighty Midget, 305
Mignon (Czechoslovakia), 305
Mignon (Raaco), 360
Mignon-Kamera(Ernemann), 189
Mihama Six IIIA (Suruga), 396
Mikado (Nishida), 336
Mikono-Flex P (Kojima), 258
Mikro-Box outfit (Bilora), 94
Mikro-Box comerce (Meopta), 303 Electro Shot, 310 Happy (Molta Co.), 306 Hi-Matic 7, 310 Uniomat, III, 309 Minolta (Chiyoda), 119 Minon 35 (Yamato), 432 Hi-Matic 9, 310 Konan 16, 312 Minon Six II (Yamato), 432 MINOX Maxxum, 311 Miniflex, 312 Minolta, 307 Mikroma cameras (Meopta), 303 Mikuni (Kuribayashi), 268 "Made in USSR", 313 Minox A, 314 Minox B, 314 Minolta 110 Zoom SLR, 313 Minolta 110 Zoom SLR Mark II, 313 Minolta 16 EE, 313 MIKUT Minox BL, 314 Mikut Color Camera, 305 Milbro, 305 Minox C, 314 Minox EC, 314 Minox II, 313 Minolta 16 EE II, 313 Milburn Korona (Gundlach), 225 Military model KE-12(1) (Graflex), 222 Military model KE-12(2) (Graflex), 222 Military Model PH-47-E (Graflex), 222 Military Model PH-47-H (Graflex), 222 MILLER CINE CO. Minolta 16 EE II, 313 Minolta 16 Model I, II, 312 Minolta 16 Model P, 312 Minolta 16 PS, 313 Minolta 16 QT, 313 Minolta 24 Rapid, 310 Minox II, 313
Minox III, 313
Minox III, Gold-plated, 313
Minox III-S, 314
Minox LX, 314
Minox LX Gold (Minox Selection), 314
Minox with Cigarette Lighter, 314
Original model, 313
Salesman's Kit 314 Minolta 35 (first model), 308 Minolta 35 Model II, 308 Minolta 35 Model IIB, 308 Miller Cine Model CA, 464 Millers Patent Detective "The British" Minolta 35 Model IIB, 308
Minolta A, 308
Minolta A2, 308
Minolta A3, 308
Minolta A5, 308
Minolta A5, 308
Minolta AL, 309
Minolta AL-2, 309
Minolta AL-7, 309
Minolta AL-8, 309
Minolta Autocord, Autocord RA, 312
Minolta Autocord CdS I, II, III, 312
Minolta Autocord L, LMX, 312
Minolta Automat, 312
Minolta Autopress, 308
Minolta Autowide, 309 (Chapman), 118 Salesman's Kit, 314 Million (Krügener), 266 Million (Yen camera), 435 MINSK MECHANICALZAVOD, 314 Minute 16 (Universal), 410 Miom (M.I.O.M.), 314 Miloflex, 305 Milona (Meopta), 303 MIMOSA Mir (Krasnogorsk), 263 Miracle, 315 Mimosa I, 305 Mimosa II, 306 Mimy (Yashica), 434 Minca 28 (Argus), 74 Mine Six IIF (Takane), 398 Mine Six Super 66 (Takane), 398 Minera Air Freshener (Solidex), 472 Mirage, 315 MIRANDA CAMERA CO. Auto Sensorex EE, 316 Miranda A, 315 Miranda All, 315 Miranda Automex, II, III, 316 Miranda B, 315 Miranda C, 316 Miranda D, 316 Minerva (Merkel), 304 Minetta, 306 Minolta Autowide, 309 Minolta Autowide, 309
Minolta Best, 307
Minolta ER, 311
Minolta Hi-Matic, 309
Minolta Marble, 307
Minolta Memo, 308
Minolta Repo, Repo-S, 309
Minolta Six 207 Minex (Adams), 50
Minex Tropical (Adams), 50
Minex Tropical Stereoscopic Reflex
(Adams), 51 Miranda DR, 316 Miranda DX-3, 316 Miranda F, Fv, 316 Miranda G, 316 Miranda S, ST, 316 Mini (Hanimex), 228 Mini Electro 35 Automatic (Yamato), 432 Minolta Six, 307 Minolta Sky, 309 Minolta SR-1, 310 Mini Electro 35 Automatic (Yamato), Minia-Camera, 306 Minia Camera (Levi), 289 Miniatur-Clack 109 (Rietzschel), 364 Miniature (Gaumont), 209 Miniature Camera (Doll House), 495 Miniature Klapp (Ernemann), 189 Miranda T, TII, 315 Sensomat, 316 Sensomat RE, RE-II, 316 Minolta SR-1S, 310 Minolta SR-2, 310 Minolta SR-3, 310 Sensoret, 316 Sensorex, II, 316 Miroflex (Contessa), 124 Minolta SR-3, 310 Minolta SR-505, 311 Minolta SR-7, 311 Minolta SR-M, 311 Minolta SRT Super, 311 Minolta SRT-100, 311 Miniature Klapp (Ernemann), 189
Miniature Klapp-Reflex (Ernemann), 189
Miniature Novelty Camera (Laurie), 278
Miniature Speed Graphic (Graflex), 222
Minicomet (Bencini), 90
Minicord, III (Goerz), 214
Minicord Enlarger (Goerz), 214
Minifex (Fotofex), 200
Miniflex (Minolta), 312
Minifoto Junior (Candid), 108
Minimal 235 (Ica), 242
Minimax-lite (Nikoh), 328 Miroflex A, B (Zeiss Ikon), 445 Mirroflex, 317 Mirror Reflex (Hall Camera Co.), 226 MISUZU Minolta SRT-100,311 Minolta SRT-101,311 Minolta SRT-101B,311 Minolta SRT-102,311 Alta, 317 Bower, 317 Midget Jilona cameras, 317 Midget Model III, 317 Minolta SRT-102, 311
Minolta SRT-200, 311
Minolta SRT-201, 311
Minolta SRT-202, 311
Minolta SRT-303, 311
Minolta SRT-303B, 311
Minolta SRT-MC, SRT-MCII, 311
Minolta SRT-SC, SRT-SCII, 311
Minolta SRT-SC, 309
Minolta V2, 309
Minolta V3, 309
Minolta V9, 309
Minolta V9, 307 Vest Alex, 317 MITCHELL CAMERA CORPORATION Mitchell, 464 Minimax-lite (Nikoh), 328 Mithra 47, 317 Minimum Delta (Krügener), 266 Minimum Palmos (Ica), 242 Minimum Palmos (Carl Zeiss Jena), 436 Mity, 317
Mity, 317
Mity, 317
MIYAGAWASEISAKUSHO
Boltax I, II, III, 317
Picny, 317
Silver, 317
MIZUHO KOKI
Mizuho Six 317 Minimum Palmos Stereo (Carl Zeiss Jena), 436 Minimus (Leroy), 289 Minion (Tokyo Kogaku), 403 Minion 35 (Tokyo Kogaku), 403 Minister, II, D (Yashica), 434 Minnie Mouse Photographer, 492 Minolta Vest, 307 Minolta XD-7, XD-11, XD, 311 Minolta XE-5 (XE-1), 311 Minolta XE-7 (XE), 311 Mizuho-Six, 317 Mizuho-Six Model V, 317 MOCKBA, 317 Modell P56L (Hamaphot), 227 Modell P56M (Hamaphot), 227 Minnigraph (Levy-Roth), 290 Mino Flex Snap Lite (Kyoei), 474 MINOLTA Minolta XK, 311 Minolta-16 MG, 313 Modell P66 (Hamaphot), 227 Minolta-16 MG-S, 313 Modern (Marion), 300 Minoltacord, Minoltacord Automat, 312 Minoltaflex (I), 312 Minoltaflex II, IIB, III, 312 Aerial camera, 308 Ansco Autoset, 310 Arcadia (Molta Co.), 306 Auto Minolta, 308 Modock, 317 MOLLIER Le Cent Vues, 317 Minoltina-P, 310 Minoltina-S, 310 Auto Minoita, 308 Auto Semi Minoita, 307 Autopak 400-X, 313 Autopak 500, 313 Autopak 550, 313 Autopak 600-X, 313 MOLTENI Detective camera, 318 Nifca-Dox, 306 MOM Nifca-Klapp, 306 Nifca-Sport, 306 Fotobox, 318 Nifcalette, 306 Mometta, 318

NATIONAL CAMERA

Mometta II, 318
Mometta III, 318 Mometta Junior, 318
Momikon, 318
Moment (MOMEHM) (GOMZ), 217
Mometta cameras (MOM), 318
Monikon (MOM), 318
MONARCHMFG. CO. Churchill, 318
Dasco, 318
Flash Master, 318
Fleetwood, 318
Flex-Master, 318
Kando Reflex, 318 Majestic, 318
Monarch 620, 318
Pickwik, 318
Pickwik Reflex, 318
Remington, 318
Royal Reflex, 318 MONARCKMFG. CO.
Monarck, 318
Mondain (Krauss), 265
Moni (Hamaphot), 227
Monitor (Rochester Optical), 369
Monitor Cameras (Eastman), 162 Monkey with Camera, 492
MONO-WERK
Mono 00, 318
Mono Spiegel-Reflex, 318
Mono-Trumpf,318
Monoscop, 318 Monobloc(Jeanneret), 249
Monobloc(Liebe), 290
Monopol (Hüttig), 240
Monoscop (Mono-Werk), 318
MONROE CAMERA CÓ.
Folding plate cameras, 318 Pocket Monroe A, 318
Pocket Monroe No. 2, 318
Vest Pocket Monroe, 318
MONROE SALES CO.
Color-flex, 319
Montana (Montanus), 319 MONTANUS
Delmonta, 319
Montana, 319
Montiflex, 319
Rocca Automatic, 319
Rocca Familia, 319 Rocca LK, 319
Rocca Super Reflex, 319
Montauk (Gennert), 209
Montauk III (Gennert), 210
Montauk rollfilm camera (Gennert), 210
Monte 35 (Shinsei), 386 Monte Carlo
Monte Carlo Special (Monti), 320
MONTGOMERYWARD
Long Focus Thornward, 319
Model B, 319 MW, 319
Thornward Dandy, 319
Wardette, 319
Wardflex, 319
Wardflex II, 319
Wards 25, 319 Wards 35, 319
Wards 35-EE, 319
Wards am 550, 320
Wards x100, 320
Wards xp400, 320
MONTI Monte Carlo, Monte Carlo Special, 320
Montiflex (Montanus), 319
Moonflex, 320
MOORE & CO.
Aptus Ferrotype Camera, 320 MOORSE
Single-lens Stereo, 320
MORITA TRADING CO.

Gem 16, Model II, 320

Kiku 16, Model II, 320

Saica, 320 MORLEY Wet plate camera, 320 Wet plate stereo camera, 320 Mosaic (Gerschel), 210 Moscow (MOSKWA) (Krasnogorsk), 263 Mosquito I, II (Bauchet), 85 Moto-Rapid C (Agfa), 55 Motoca (Kashiwa), 252 Motocamera (Pathe), 466 Motocamera 16 (Pathe), 466 Motocamera Luxe (Pathe), 466 Motor-Kamera (Agfa), 55 Motormatic Cameras (Eastman), 162 MOTOSHIMAOPTICAL WORKS Zeitax, 320 MOUNTFORD Button tintype camera, 320 MOURFIELD Direct Positive Camera, 320 MOUSE, WORM CAMERAS, 482 Mouse with camera (tree ornament) (Lustre Fame), 492 Movematic (Agfa), 453 MOVETTE CAMERA CORP. Movette 17-1/2mm Cine, 464 Movexte 17-1/2mm Cine, 404 Movex 16-12B, 16-12L (Agfa), 454 Movex 30B, 30L (Agfa), 454 Movex 8, 8L (Agfa), 453 Movex 8, 8RL (Agfa), 454 Movex Automatici, II (Agfa), 454 Movex Reflex (Agfa), 454 Movexoom (Agfa), 454 Movie Camera & Projector Salt & Pepper Shakers, 487 Movie Camera decanter, 479 MOVIE CAMERAS, 453 Movie Maker (Vitascope), 470 Movie Shot (Relco), 479 Movie Viewer (Fisher-Price), 499 Moviegraph (Keystone), 463 MOVIEMATIC CAMERA CORP. Moviematic, 464 Moviflex Super (Zeiss), 471 Movikon 16 (Zeiss), 471 Movikon 8, 8B (Zeiss), 471 Movinette 8B (Zeiss), 471 MOY Moy and Bastie's 35mm Cine, 464 MOZAR Diana, 320 MÖLLER Cambinox, 317 Mr. Photographer(Hoffman), 479 Mr. Tourist (Hoffman), 479 Mr. Weekend Button (American Greetings), 480 MS-35 (Clarus), 120 Muffy Vanderbear "Out of Africa", 495 Mugette Camera-Lighter, 475 MULTI-SPEEDSHUTTER CO Multi-Speed Precision Camera, 321 Simplex, 321 Multiple Camera (Folmer & Schwing), 198 MULTIPLETOYMAKERS Camera Kit, Wonderful Camera, 321 Multiple-lens camera (Wing), 427
Multiplying Camera (Schaub), 378
Multiplying Camera (Schaub), 389
Multiplying View Camera (Wing), 427
MULTIPOSEPORTABLECAMERAS Maton, 321 Multiprint (Buess), 102 MULTISCOPE& FILM CO. Al-Vista 4B, 321 Al-Vista 4G, 321 Al-Vista 4G, 321 Al-Vista 5B, 321 Al-Vista 5C, 321

Al-Vista 7F, 321 Al-Vista Panoramic Cameras, 321 Al-Vista Senior, 321 Baby Al-Vista, 321 Multo Nettel (Steinheil), 394 MUNDUS Mundus Color, 321 Mundus Color 60, 321 Mundus Color 65, 321 Muppet Puzzle "The Photographer",486 MURER & DURONI Folding plate cameras, focal plane, 322 Muro, 321 Newness Express, 321 Piccolo, 322 Reflex, 322 SL, SL Special, 322 Sprite, 322 Stereo, 322 Stereo Box, 322 Stereo Reflex, 322 UF, 322 UP-M, 322 Muro (Murer), 321 MUSASHIMANUFACTURINGCO. Malcaflex, 322 MUSASHINOKOKI Optika IIa, 322 Rittreck 6x6, 322 Rittreck IIa, 322 Warner 6x6, 322 MUSE OPTICAL CO Museflex, Model M. 322 MUSIC BOX, 483 Mutar (Franke & Heidecke), 201 MUTSCHLER, ROBERTSÓN, & CO., 322 MÜLLER Noris, 320 MÜNSTERKAMERABAU Phips, 321 MW (MontgomeryWard), 319 MY FIRST BUDDYS Fun Camera, 495 My First Camera (Battat), 494 My Li'l Camera (Playmates), 496 Mycro (Sanwa), 377 MYCROCAMÉRA CO., 322 Mycro IIIA (Sanwa), 377 Mykey-4, 322 Mykro-Fine (Southern), 391 Mykro Fine Color 16, 323 Myracle (Sugaya), 395 Myrapid (Mamiya), 298 Mystery Mug, 477 MYSTIC PLATE CAMERA CO. Mystic Button Camera, 323

N-Box (Vredeborch), 420 N&S Reflex (Sinclair), 388 Naco (National Camera Co.), 323 NAGEL Anca (10,14,25,28),323 Fornidar 30, 323 Librette (65,74,75,79),323 Pupille, 323 Ranca, 323 Recomar, 323 Vollenda, 323 Nagel (Eastman), 162 Namco Multi-Flex (North American), 336 Nanna 1 (Boreux), 99 Nanos (Krauss), 265 Napco Planter, 486 Narciss (Krasnogorsk), 263 NASTA INDUSTRIES INC. G.I. Joe, 323 Reese's Peanut Butter Cups, 323 NATIONAL Radicame CR-1, Radio/Flash CR-1, 323 Radio/FlashCR-2, 323 National (Butcher), 105 NATIONAL CAMÉRA CO.

Al-Vista 5D, 321

Al-Vista 5F, 321 Al-Vista 7D, 321

Al-Vista 7E, 321

NATIONAL GRAFLEX

New Ideal Sibyl (Newman & Guardia), 326 NIHON SEIKI Baldwin-Flex, 323 Nescon 35, 328 Ranger 35, 328 NEW IDEAS MFG. CO Naco, 323 Magazine camera, 325 National Graflex (Graflex), 219 Tourist Multiple, 325 New Model View (Rochester Optical), 369 Soligor 45, 328 NATIONALINSTRUMENTCORP. Sollgor 45, 328
Nikette, II (Fischer), 197
Nikko Flex (Nippon Koken), 335
Nikkorex 8, 8F (Nippon Kogaku), 464
Nikkorex 35, 35-2 (Nippon Kogaku), 329
Nikkorex Auto 35 (Nippon Kogaku), 329
Nikkorex F (Nippon Kogaku), 329
Nikkorex Zoom-8 (Nippon Kogaku), 465
Nikkorex Zoom-35 (Nippon Kogaku), 329
Nikkorex Zoom-36 (Nippon Kogaku), 329
Nikkorex Zoom-36 (Nippon Kogaku), 329 Camflex, 323 Colonel, 323 New Naturalists' Hand Camera (Dallmeyer), 132 Major, 324 New Olympic (Olympic Camera), 337 New Premier Pathescope (Pathe), 467 New Rocket (Rocket Camera Co.), 370 National Miniature (National Silver), 324 NATIONALPHOTOCOLORCORP One-Shot Color Camera, 324 NATIONAL SILVER CO. New Special Sibyl (Newman & Guardia), National Miniature, 324 Nikkormat models, (Nippon Kogaku), 329 Niklas 109 (Ica), 243 New Standard (Franke & Heidecke), 203 NEW TAIWAN PHOTOGRAPHICCORP. Naturalcolor Film Cartridge, 481 Naturalists' Graflex (Graflex), 219 Yumeka 35-R5, 325 Niko, 328 Naturalist's Reflex (Dallmeyer), 132 Naturalists Hand Camera (Dallmeyer), 132 NIKOH CO. Enica-SX, 328 NEW YORK FERROTYPECO. Tintype camera, 326
Newgold (Ihagee), 246
NEWMAN & GUARDIA
Baby Sibyl, 326
Deluxe, 326
Folding Reflex, 326 Navax (Westfälische), 425 Minimax-lite, 328 **NAYLOR** Nova Micron, 328 Field camera, 324 Supra Photolite, 328 NBA 76ers (Franka Photo.), 201 Nikon I (Nippon Kogaku), 329 Nea Fotos (Ro-To), 367 Nikon Ceramic Clock, 475 Nikon Ceramic Clock, 4/5
Nikon EL2 (Nippon Kogaku), 332
Nikon F "Nikkor F" (Nippon Kogaku), 331
Nikon F (cutaway) (Nippon Kogaku), 331
Nikon F (NASA) (Nippon Kogaku), 331
Nikon F (Nippon Kogaku), 331
Nikon F High Speed (Nippon Kogaku), 332
Nikon F Photomic models (Nippon K.), 332
Nikon F 2 (Nippon Kogaku), 332 **NEBRO** High Speed Pattern, 326 New Ideal Sibyl, 326 Baby Nebro, 324 Box-Nebro, 324 New Special Sibyl, 326 Nydia, 326 Nebro Flash, 324 Super Nebro, 324 Postcard Sibyl, 326 Necka Jr., 324 NEFOTAF Sibyl, 326 Sibyl Deluxe, 326 Neofox II, 324 Nikon F Priotoriic models (Nippon K.), 332 Nikon F2 (Nippon Kogaku), 332 Nikon F2A "25 Years" (Nippon Kog.), 332 Nikon F2A Photomic (Nippon Kog.), 332 Nikon F2AS (Nippon Kogaku), 332 Nikon F2S Photomic (Nippon Kog.), 332 Sibyl Excelsior, 326 **NEGRAINDUSTRIAL** Sibyl Stereo, 326 Sibyl Vitesse, 326 Nera 35, 324 **NEGRETTI& ZAMBRA** Special Stereoscope Rollfilm Sibyl, 326 Cosmos, 324 Stereoscopic Pattern, 326 Field Camera, 324 Trellis, 326 One-Lens Stereo Camera, 324 Nikon F2SB Photomic (Nippon Kog.), 332 Twin Lens Pattern, 326 Stereo Camera, 324 Nikon F2T (Nippon Kogaku), 332 Nikon F3 (Nippon Kogaku), 332 Nikon F3 Table Lighter, 475 Universal Pattern B, 327 NEWMAN & SINCLAIR **NEIDIG** Perlux (24x24mm), 324 Perlux (24x36mm), 324 Perlux II, IIa, 324 Auto Kine Camera, Model E, 464 Nikon F3 Table Lighter, 475
Nikon F3AF (Nippon Kogaku), 332
Nikon F3HP (Nippon Kogaku), 332
Nikon F3T (Nippon Kogaku), 332
Nikon F3T (Nippon Kogaku), 332
Nikon F4 (Nippon Kogaku), 332
Nikon FA (Nippon Kogaku), 332
Nikon FE (Nippon Kogaku), 332
Nikon FE (Nippon Kogaku), 332 Newness Express (Murer), 321 NEWTON NEITHOLD Tailboard camera, 327 NEWTON PHOTO PRODUCTS Ce-Nei-Fix, 324 Nelson (Hüttig), 240 Newton New Vue, 327 Nelson 225 (Ica), 242 Nécessaire de Photographie "Luminor" NEMRODMETZELER (Manufacture Française), 299 Siluro, 324 Nenita (Ruberg & Renner), 375 Neo Fot A, 325 Nikon FE2 (Nippon Kogaku), 332 Nikon FG (Nippon Kogaku), 332 Nikon FG20 (Nippon Kogaku), 332 NIAGARA CAMERA CO. Niagara#2, 327 NIC **NEOCA** Nikon FM (Nippon Kogaku), 332 Nikon FM2 (Nippon Kogaku), 332 Foto Nic, 327 Neoca 1S, 325 Neoca 2S, 325 Neoca IVS, 325 **NICCA CAMERAWORKS** NICCA CAMERA WORK Nicca (Original), 327 Nicca 3-F, 3-S, 327 Nicca 33, 327 Nicca 4, 327 Nicca 5, 5L, 327 Nicca III (Type-3), 327 Nicca IIIA, 327 Nikon FM2n (Nippon Kogaku), 332 Nikon M (Nippon Kogaku), 329 Nikon M (Nippon Kogaku), 329
Nikon Mug, 480
Nikon N2000 (Nippon Kogaku), 332
Nikon N2020 AF (Nippon Kogaku), 332
Nikon S (Nippon Kogaku), 329
Nikon S2 (Nippon Kogaku), 330
Nikon S3, S3M (Nippon Kogaku), 330
Nikon S4 (Nippon Kogaku), 330
Nikon SP (Nippon Kogaku), 330
Nil Melior Stereo (Macris-Boucher), 296
Nimco (Braun) 100 Robin, 325 Torca-35, 325 Neofox II (Nefotak), 324 Nera 35 (Negra Industrial), 324 Nero (Ica), 242 Nescon 35 (Nihon Seiki), 328 Nettar (Zeiss Ikon), 446 Nicca IIIB, 327 Nicca IIIL, 328 Nicca IIIS, 327 Nettax (513/16) (Zeiss Ikon), 446 Nettax (538/24) (Zeiss Ikon), 446 Nettel (Zeiss Ikon), 446 NETTEL KAMERAWERK Nippon, 327 Nimco (Braun), 100 Snider 35, 327 Nicca L-3, 328 Nimrod Automan (Thornton-Pickard),400 Ninoka NK-700, 328 Argus, 325 Deckrullo, 325 Nice (Zuiho), 452 Nippon (Nicca), 327 Folding plate cameras, 325 Sonnet, 325 Sonnet (Tropical model), 325 Nichibei (Yen camera), 435 Nippon AR-4392, 328 NIPPON KOGAKU NICHIRYOTRADING CO. Nicnon Binocular Camera, 328 Nikkorex 8, 8F, 464 Nikkorex 35, 35-2, 329 Stereax 6x13cm, 325 Stereo Deckrullo Nettel, Tropical, 325 **NICHOLLS** Detective camera, 328 Nikkorex Auto 35, 329 Nicnon Binocular Camera (Nichiryo), 328 Tropical Deckrullo Nettel, 325 Nikkorex F, 329 Nikkorex Zoom-8, 465 **NIELL & SIMONS** Nettel-Klapp-Camera(Süddeutsches), 395 Nettel, Tropen (Tropical) (Zeiss Ikon), 446 Lopa, 328 Nikkorex Zoom 35, 329 Nifca-Dox (Minolta), 306 Nettix (Contessa), 124 Nikkormat EL, ELW, 329 Nikkormat FS, 329 Nifca-Klapp (Minolta), 306 Nifca-Sport (Minolta), 306 NEUMANN (Felix) Field camera, 325 Nikkormat FT, FT2, FT3, FTN, 329 Nifcalette (Minolta), 306 Helios, 325 Night Exakta (Ihagee), 245 Night Hawk Detective (Manhattan), 299 NIHON KOKI CO. Nikon I, 329 Magazine camera, 325 Nikon EL2, 332 NEUMANN& HEILEMANN Nikon F, 331 Nikon F "Nikkor F", 331 Nikon F (cutaway), 331 Nikon F (NASA), 331 Condor, 325 New Folding Stereo (Target), 399 New Gem (Wing), 427 Well Standard Model I, 328 NIHON PRECISION INDUSTRY Zany, 328 New Hit, 325

		NO. 3 KEWPIE
Nikon F High Speed, 332 Nikon F Photomic, 332 Nikon F Photomic FTn, 332 Nikon F Photomic T, 332 Nikon F Photomic Tn, 332 Nikon F2, 332	No. 1 Folding Pocket Kodak (Eastman), 155 No. 1 Goodwin Jr. (Ansco), 65 No. 1 Kodak Camera (Eastman), 140 No. 1 Kodak Junior Cam. (Eastman), 160 No. 1 Kodak Series III (Eastman), 161	No. 2 Plait Pliant (Photo-Plait), 351 No. 2 Rainbow Hawk-Eye Camera (Eastman), 158 No. 2 Scout (Seneca), 384 No. 2 Stereo Brownie (Eastman), 149 No. 2 Stereo Kodak (Eastman), 177
Nikon F2 Photomic, 332 Nikon F2A 25 Years, 332 Nikon F2A Photomic, 332 Nikon F2AS, 332 Nikon F2S Photomic, 332 Nikon F2SB Photomic, 332 Nikon F2T, 332	No. 1 Panoram Kodak (Eastman), 163 No. 1 Pocket Kodak Cam. (Eastman), 164 No. 1 Pocket Kodak Junior (Eastman), 164 No. 1 Pocket Kodak Series II Camera (Eastman), 164 No. 1 Pocket Kodak Special Camera (Eastman), 164	No. 2 Weno Hawk-Eye (Blair), 96 No. 2 Weno Hawk-Eye (Eastman), 159 No. 2A Beau Brownie (Eastman), 144 No. 2A Brownie Camera (Eastman), 144 No. 2A Buster Brown (Ansco), 63 No. 2A Buster Brown Special (Ansco), 63
Nikon F3, 332 Nikon F3AF, 332 Nikon F3HP, 332 Nikon F3P, 332 Nikon F3T, 332 Nikon F4, 332	No. 1 Premo Junior Cam. (Eastman), 165 No. 1 Seneca Junior (Seneca), 384 No. 1 Special Folding Ansco (Ansco), 64 No. 1 Tourist Buckeye (Amer. Camera), 61 No. 1A Ansco Junior (Ansco), 65 No. 1A Autographic Kodak (Eastman), 141	No. 2A Cartridge Hawk-Eye Camera (Eastman), 157 No. 2A Cartridge Premo (Eastman), 165 No. 2A Film Pack Hawk-Eye Camera (Eastman), 157 No. 2A Folding Autographic Brownie Camera (Eastman), 146
Nikon FA, 332 Nikon FE, 332 Nikon FE2, 332 Nikon FG, 332 Nikon FG20, 332 Nikon FM, 332 Nikon FM2, FM2n, 332	No. 1A Autographic Kodak Junior Camera (Eastman), 141 No. 1A Autographic Kodak Special Camera (Eastman), 141 No. 1A Folding Ansco (Ansco), 64 No. 1A Folding Goodwin (Ansco), 65 No. 1A Folding Hawk-Eye (Eastman), 157	No. 2A Folding Buster Brown (Ansco), 63 No. 2A Folding Cartridge Hawk-Eye Camera (Eastman), 157 No. 2A Folding Cartridge Premo Camera (Eastman), 165 No. 2A Folding Hawk-Eye Special Camera
Nikon M, 329 Nikon N2000, 332 Nikon N2020 AF, 332 Nikon S, 329 Nikon S2, 330 Nikon S3, 330	No. 1A Folding Pocket Kodak Cameras (Eastman), 155 No. 1A Folding Rexo (Burke & James), 103 No. 1A Ingento Jr. (Burke & James), 103 No. 1A Kodak Junior Cam. (Eastman), 160	(Eastman), 157 No. 2A Folding Pocket Brownie Camera (Eastman), 146 No. 2A Folding Rainbow Hawk-Eye Camera (Eastman), 158 No. 2A Folding Scout (Seneca), 384 No. 2A Goodwin (Ansco), 65
Nikon S3M, 330 Nikon S4, 330 Nikon SP, 330 NIPPON KOKEN Nikko Flex, 335 NIPPON KOSOKKI	No. 1A Kodak Series III (Eastman), 161 No. 1A Pocket Kodak (Eastman), 164 No. 1A Pocket Kodak Junior Camera (Eastman), 164 No. 1A Pocket Kodak Series II Camera (Eastman), 164	No. 2A Kewpie (Conley), 123 No. 2A Rainbow Hawk-Eye Camera (Eastman), 158 No. 2A Scout (Seneca), 384 No. 2C Ansco Junior (Ansco), 65 No. 2C Autographic Kodak Junior Camera
Taroflex, 335 NISHIDA KOGAKU Apollo 120, 336 Atlasix, 336 Mikado, 336 Wester Autorol, 336 Nitor (Agfa), 55	No. 1A Pocket Kodak Special Camera (Eastman), 164 No. 1A Premo Junior Cam. (Eastman), 165 No. 1A Rexo Jr. (Burke & James), 103 No. 1A Six-Three Kodak (Eastman), 176 No. 1A Special Kodak (Eastman), 176 No. 1A Speed Kodak (Eastman), 177	(Eastman), 141 No. 2C Autographic Kodak Special Camera (Eastman), 141 No. 2C Brownie Camera (Eastman), 144 No. 2C Buster Brown (Ansco), 63 No. 2C Cartridge Premo (Eastman), 165
NItto Camera (Yen camera), 435 NITTO SEIKO Elega-35, 336 Nixe (Ica), 243 Nixe (Zeiss Ikon), 446 Nixette (Nixon), 336	No. 2 Beau Brownie Cam. (Eastman), 144 No. 2 Brownie Camera (Eastman), 143 No. 2 Brownie Camera (Eastman), 143 No. 2 Bulkeye (American Camera), 61 No. 2 Bull's-Eye Camera (Eastman), 150 No. 2 Bull's-Eye Special (Eastman), 150 No. 2 Bullet Camera (Eastman), 150	No. 2C Folding Autographic Brownie Camera (Eastman), 146 No. 2C Folding Cartridge Premo Camera (Eastman), 165 No. 2C Folding Scout (Seneca), 384 No. 2C Kewpie (Conley), 123 No. 2C Kodak Series III (Eastman), 161
NIXON CAMERA-WERK Nixette, 336 NIZO Cine Nizo 16B, 16L, 465 Cine Nizo 8E, 465 Cine Nizo 9-1/2, 465	No. 2 Bullet Special (Eastman), 150 No. 2 Buster Brown (Ansco), 63 No. 2 Buster Brown Special (Ansco), 63 No. 2 Cartridge Hawk-Eye Camera (Eastman), 157 No. 2 Cartridge Premo (Eastman), 165	No. 2C Pocket Kodak (Eastman), 164 No. 2C Pocket Kodak Special Camera (Eastman), 164 No. 2C Rexo Jr. (Burke & James), 103 No. 3 Ansco Junior (Ansco), 65 No. 3 Autographic Kodak Camera
Exposomat8R, 8T, 465 Heliomatic, 465 Heliomatic8 Focovario, 465 Heliomatic8 S2R, 465 HeliomaticAllmat 8, 8B, 465 Heliomatic Reflex 8, 8A, 8B, 465 No-Name Contax (Kiev), 255	No. 2 Eclipse (Horsman), 235 No. 2 Eureka Camera (Eastman), 153 No. 2 Eureka Jr. Camera (Eastman), 153 No. 2 Falcon Camera (Eastman), 153 No. 2 Falcon Improved (Eastman), 153 No. 2 Film Pack Hawk-Eye (Eastman), 157 No. 2 Folding Autographic Brownie	(Eastman), 141 No. 3 Autographic Kodak Special Camera (Eastman), 141 No. 3 Brownie Camera (Eastman), 144 No. 3 Buckeye (American Camera), 61 No. 3 Bull's-Eye Camera (Eastman), 150 No. 3 Buster Brown (Ansco), 63
No-Name Kiev (Kiev), 255 No. 0 Brownie Camera (Eastman), 143 No. 0 Buster Brown (Ansco), 63 No. 0 Buster Brown Special (Ansco), 63 No. 0 Folding Pocket Kodak (Eastman), 155 No. 0 Graphic (Graflex), 220	Camera (Eastman), 146 No. 2 Folding Brownie (Eastman), 146 No. 2 Folding Bull's-Eye (Eastman), 150 No. 2 Folding Buster Brown (Ansco), 63 No. 2 Folding Cartridge Hawk-Eye Camera (Eastman), 157 No. 2 Folding Cartridge Premo Camera	No. 3 Cartridge Kodak (Eastman), 151 No. 3 Combination Hawk-Eye (Blair), 95 No. 3 Eclipse (Horsman), 235 No. 3 Film Premo Camera (Eastman), 165 No. 3 Folding Ansco (Ansco), 64 No. 3 Folding Brownie (Eastman), 146 No. 3 Folding Buster Brown (Ansco), 63
No. 0 Premo Junior Cam. (Eastman), 165 No. 00 Cartridge Premo (Eastman), 165 No. 1 Ansco Junior (Ansco), 65 No. 1 Autographic Kodak Junior Camera (Eastman), 141 No. 1 Autographic Kodak Special Camera (Eastman), 141	(Eastman), 165 No. 2 Folding Hawk-Eye Special Camera (Eastman), 157 No. 2 Folding Pocket Brownie Camera (Eastman), 146 No. 2 Folding Pocket Kodak Camera (Eastman), 155	No. 3 Folding Hawk-Eye (Blair), 95 No. 3 Folding Hawk-Eye (Eastman), 157 No. 3 Folding Hawk-Eye Special Camera (Eastman), 157 No. 3 Folding Hawkeye (Blair), 95 No. 3 Folding Kodet (Eastman), 161 No. 3 Folding Pocket Kodak (Eastman),
No. 1 Brownie Camera (Eastman), 143 No. 1 Cone Pocket Kodak (Eastman), 152 No. 1 Film Premo Camera (Eastman), 165 No. 1 Folding Ansco (Ansco), 64 No. 1 Folding Buster Brown (Ansco), 63	No. 2 Folding Rainbow Hawk-Eye Camera (Eastman), 158 No. 2 Goodwin (Ansco), 65 No. 2 Kewpie (Conley), 123 No. 2 Kodak Camera (Eastman), 140	No. 3 Folding Rexo (Burke & James), 103 No. 3 Folding Scout (Seneca), 385 No. 3 Goodwin (Ansco), 65 No. 3 Kewpie (Conley), 123

<u>NO. 3 KODAK</u>		
No. 3 Kodak Camera (Eastman), 140	No. 5 Folding Kodak Stereo Camera	Foca Marly, 345
No. 3 Kodak Jr. Camera (Eastman), 140	(Eastman), 154	Foca PF2B Marine Nationale, 344 Foca Standard (*), 344
No. 3 Kodak Series III (Eastman), 161 No. 3 Magazine Camera (Tella), 400	No. 5 Folding Kodet Cam. (Eastman), 162 No. 5 Folding Kodet Special	Foca U.R., 345
No. 3 Pocket Kodak Special Camera	Camera (Eastman), 162	Foca U.R. "Marine Nationale", 345
(Eastman), 164	No. 5 Weno Hawk-Eye (Eastman), 159	Foca Universel, Universel R, 344
No. 3 Premo Junior Cam. (Eastman), 165	No. 6 Cirkut Camera (Eastman), 151 No. 6 Cirkut Outfit (Eastman), 151	Foca URC, 345 Foca URC "Marine Nationale", 345
No. 3 Rexo Jr. (Burke & James), 103 No. 3 Scout (Seneca), 384	No. 6 Folding Ansco (Ansco), 65	Focaflex, II 345
No. 3 Six-Three Kodak (Eastman), 176	No. 6 Folding Kodak Camera Improved	Focaflex Automatic, 345
No. 3 Special Kodak (Eastman), 176	(Eastman), 154 No. 6 Weno Hawk-Eye (Blair), 96	Focasport, 345 O.T.A.G.
No. 3 Weno Hawk-Eye (Blair), 96 No. 3A Ansco Junior (Ansco), 65	No. 7 Folding Ansco (Ansco), 65	Amourette, 346
No. 3A AutographicKodak (Eastman), 141	No. 7 Weno Hawk-Eye (Blair), 96	Lutin, 346
No. 3A Autographic Kodak Junior Camera	No. 7 Weno Hawk-Eye Camera	OBERGASSNER Oga, 337
(Eastman), 141 No. 3A AutographicKodak Special	(Eastman), 159 No. 8 Cirkut Outfit (Eastman), 151	Ogamatic, 337
Camera (Eastman), 141	No. 8 Folding Buckeye (American	Ocean OX-2, 337
No. 3A Buster Brown (Ansco), 63	Camera), 61	Octopus "The Weekender" (Hendren), 231 OEHLER
No. 3A Folding Ansco (Ansco), 64 No. 3A Folding Autographic Brownie	No. 9 Ansco (Ansco), 65 No. 10 Ansco (Ansco), 65	Infra, 337
Camera (Eastman), 146	No. 10 Cirkut Camera (Eastman), 151	Official "Scout" cameras (Herbert George),
No. 3A Folding Brownie Camera	No. 16 Cirkut Camera (Eastman), 151	232 Ofo (Gevaert), 211
(Eastman), 146	Noba (Espino Barros), 190 Noble 126 (Helin-Noble), 230	Oga (Obergassner), 337
No. 3A Folding Buster Brown (Ansco), 63 No. 3A Folding Cartridge Hawk-Eye	Noco-Flex (WZFO), 431	Ogamatic (Obergassner), 337
Camera (Eastman), 157	Nodark Tintype (Popular Photograph), 358	OKADA KOGAKU
No. 3A Folding Cartridge Premo Camera	Nomad 127, Nomad 620 (Sawyers), 377 Nomar No. 1, 336	Gemmy, 337 Kolt, 337
(Eastman), 165 No. 3A Folding Goodwin (Ansco), 65	Nor-Flash 127 (Imperial), 247	Waltax (I), 337
No. 3A Folding Hawk-Eye Camera	Norca (Braun), 100	Walz Baby, 337
(Eastman), 157	Norca A, B (FAP), 192 Norca Pin-Up (FAP), 192	OKAM Okam, 337
No. 3A Folding Hawk-Eye Special Camera (Eastman), 157	Nordetta 3-D (Vredeborch), 420	Okam (simple model), 337
No. 3A Folding Ingento (Burke & James),	Nordina (Vredeborch), 420	OKAYA OPTICAL WORKS
103	Nori (Norisan), 336	Lord 5D, 337 Lord IVB, 337
No. 3A Folding Pocket Kodak (Eastman), 156	Norica I (Braun), 100 Norica II, II Super (Braun), 100	Oko Semi, 337
No. 3A Folding Rexo (Burke & James),	Norica III (Braun), 100	OLBIA
103	Norica IV (Braun), 100	Clartex 6/6, 337 Olbia BX, 337
No. 3A Folding Scout (Seneca), 385 No. 3A Ingento Jr. (Burke & James), 103	Noris (Müller), 320 NORISANAPPARATEBAU	Old Couple Sitting on a Log, 492
No. 3A Kewpie (Conley), 123	Afex, 336	Old Standard (Franke & Heidecke), 203
No. 3A Kodak Series II, III (Eastman), 161	Hacon, 336	Old Time Photographer, 492 Olikos (Society of Cinema), 468
No. 3A Panoram Kodak (Eastman), 163 No. 3A Pocket Kodak (Eastman), 164	Nori, 336 Norita (Graflex), 223	Olympic (Closter), 121
No. 3A Scout (Seneca), 384	Norka (Hansen), 228	Olympic (Goldstein), 215
No. 3A Signal Corps K-3 (Eastman), 141	Normal Kino (Ernemann), 461	OĽYMPIČ CAMERÁ WORKS New Olympic, 337
No. 3A Six-Three Kodak (Eastman), 176 No. 3A Special Kodak (Eastman), 176	Normal Peco (Plaubel), 355 Normal Simplex (Krügener), 266	Olympic Junior, 337
No. 3B Folding Hawk-Eye (Blair), 95	Normandie (Anthony), 69	Semi-Olympic, 337
No. 4 Autographic Kodak (Eastman), 141	NORTHAMERICANMEG. CO.	Super-Olympic, 337 Vest Olympic, 337
No. 4 Bull's-Eye Camera (Eastman), 150	Namco Multi-Flex, 336 NORTHERNPHOTO SUPPLY CO.	OLYMPÚSKOGAKU
No. 4 Bull's-Eye Special (Eastman), 150 No. 4 Bullet Camera (Eastman), 150	Liberty View, 336	Chrome Six I, 338
No. 4 Bullet Special (Eastman), 150	NORTÓNLABORATORIES	Chrome Six II, 338 Chrome Six III, 338
No. 4 Cartridge Kodak (Eastman), 151	Norton, 336 Norton, Century of Progress, 336	Chrome Six IV, 339
No. 4 Eureka Camera (Eastman), 153 No. 4 Folding Ansco (Ansco), 64	Norton-Univex (Universal), 410	Chrome Six RII, 339
No. 4 Folding Hawk-Eye (Blair), 95	Nova, 336	Chrome Six V, 339
No. 4 Folding Hawk-Eye (Eastman), 157	Nova Micron (Nikoh), 328 Novel (Anthony), 69	FTL, 343 O-Product, 343
No. 4 Folding Kodak (Éastman), 154 No. 4 Folding Kodet (Eastman), 161	Novelette Stereo (Anthony), 69	Olympus 35 I, II, III, 341
No. 4 Folding Kodet Junior (Eastman), 162	Novelette, Duplex Novelette (Anthony), 69	Olympus 35 IV, 341
No. 4 Folding Kodet Special Camera	Novelties, 336 Noviflex (Eichapfel), 182	Olympus 35 IVa, IVb, 342 Olympus 35 Va, Vb, 342
(Eastman), 162 No. 4 Folding Pocket Kodak Camera	NOVO CAMERACO.	Olympus 35-K, 342
(Eastman), 156	Novo 35 Super 2.8, 337	Olympus 35-S, 35-S II, 342
No. 4 Folding Weno Hawk-Eye (Blair), 95	NST Phenix camera-lighter,475	Olympus Ace, 343 Olympus Ace E, 343
No. 4 Kodak Camera (Eastman), 140 No. 4 Kodak Jr. Camera (Eastman), 140	Nustyle (Maw), 302	Olympus Auto, 343
No. 4 Kodet Camera (Eastman), 161	Nustyle DeLuxe (Maw), 302	Olympus Auto B, 343
No. 4 Panoram Kodak (Eastman), 163	Nydia (Newman & Guardia), 326	Olympus Auto Eye, Auto Eye II, 343 Olympus Flex A2.8, 339
No. 4 Premo Junior Cam. (Eastman), 165 No. 4 Weno Hawk-Eye (Blair), 96	Nymco, 337 Nymco Folding Camera, 337	Olympus Flex A3.5, A3.5II, 339
No. 4 Weno Hawk-Eye (Eastman), 159	•	Olympus Flex B I, BII, 339
No. 4A AutographicKodak (Eastman), 141	O-Product(Olympus), 343 O.P.LFOCA	Olympus M-1, 343 Olympus OM-1, 343
No. 4A Folding Kodak (Eastman), 154 No. 4A Speed Kodak (Eastman), 177	Foca (*) (1946 type), 344	Olympus OM-1 MD, 344
No. 5 Cartridge Kodak (Eastman), 151	Foca (**) (1945 type), 344	Olympus OM-10, 344
No. 5 Cirkut Čamera (Eastman), 151	Foca (**) PF2B, 344 Foca (***) PF3, PF3L, 344	Olýmpus OM-1N MD, 344 Olympus OM-2 MD, 344
No. 5 Folding Ansco (Ansco), 64 No. 5 Folding Kodak (Eastman), 154	Foca (***) PF3L "AIR", 344	Olympus OM-2N MD, 344
or olding froduit (Education);	FFC	

PECTO

Orix (Pentacon), 348 Orix (Zeiss Ikon), 446 Olympus Six, 338 Olympus Six, 338
Olympus Standard, 338
Olympus Wide, 342
Olympus Wide II, 342
Olympus Wide E, 342
Olympus Wide S, 342
Olympus-S "Electro Set", 343
Olympus-S (CdS), 343
Pen 340 Vog, 347 Paris (Harbers), 228 Paris (Widmayer), 427 ORNAMENTAL,483 Ortho Jumelle Duplex (Joux), 250 OSHIRO OPTICAL WORKS Parisien, 347 PARK Emi 35A, 346 Emi K 35, 346 Tailboard cameras, 347 Twin Lens Reflex, 347 Victoria, 347 PARKER PEN CO. Lumica, 346 Pen, 340 Pen D, 340 Pen D3, 340 Pen D3, 340 Sierra 35, 346 Spinney, 346 Three Cs, 346 Parker Camera, 347 Parva (San Giorgio), 375 Parvex (London Stereoscopic), 294 OTTEWILL Pen EE, 340 Pen EE-2, 341 Pen EE-3, 341 Sliding-box camera, 346 OWLA KOKI Parvo Interview 35mm Motion Picture Camera (Debrie), 457 Parvo Model JK (Debrie), 457 Owla Stereo, 346 Pen EE-EL, 340 Pen EED, 341 Parvo Model JK (Debrie), 457
Parvola (Ihagee), 246
Passe-Partout (Hanau), 227
Patent Camera Box (Bolles & Smith), 97
Patent Etui (K.W.), 272-273
Patent Klapp Reflex (Ihagee), 246
Patent Portable Camera (Rouch), 373 Oxford Automan (Thornton-Pickard), 400 Oxford Minicam (Shaw), 386 Pen EES, 340 Pen EES-EL, 340 Pen EES2, 341 P.A.C (Tougodo), 405 Pacemaker Crown Graphic (Graflex), 221 Pen EM, 340 Pacemaker Speed Graphic (Graflex), 222 Pen FT, 341 Pen FT, 341 Pen FV, 341 Pacific, 346
PACIFIC PRODUCTSLTD. Patent Reflex (Reflex Camera), 361 Patent Stamp Camera (Hyatt), 241 Exactor, 346 Lynx PPL-500XL, 346 Patent Three-Colour Separation (Butler), Pen Rapid EED, EES, 340 Pen S 2.8, S 3.5, 340 Pen W (Wide), 340 Pack 126 (Viennaplex), 414 Padie (Laack), 275 Patent-Sport-Reflex(Schmitz & Thienemann),378 Semi-Olympus Model I, II, 338 Omega 120 (Simmon), 388 PAILLARDA.G PATHE FRERES Motocamera, 466 Bolex B8, B8L, 465 Bolex C8, C8SL, 465 OMI Sunshine, 344
Omnigraph (Lancaster), 277
Ompex 16 (Kunik), 267
One-Lens Stereo Camera (Negretti), 324
One-Shot Color Camera (National Photo-Motocamera 16, 466 Bolex Cinema G8, 466 Motocamera Luxe, 466 New Premier Pathescope, 467 Bolex D8L, 465 Bolex H8, Bolex H8 Reflex, 465 Pathe, 28mm, 466
Pathe Baby, 466
Pathe Baby, with Camo motor, 466
Pathe Baby, with motor, 466
Pathe Baby, with Motor, 466
Pathe Kid, 467 Bolex H8 Supreme, 465 Bolex H-16, 465 Bolex H-16 Deluxe, 465 Color), 324
Onito (Contessa), 124
Onito (Zeiss Ikon), 446
Ontobloc (Cornu), 125
Ontoflex (Cornu), 126 Bolex H-16 Leader, 465 Bolex H-16 M, 465 Bolex H-16 Reflex, 465 Pathe Kok Home Cinematograph, 466 Bolex H-16 Supreme, 466 Bolex L8, L8V, 465 P1, P2, P3, P4, 466 Pathe Mondial B, 466 Ontoscope (Cornu), 126 Ontoscope 3D (Cornu), 126 Pathe National I, II, 466 Pathe-Baby, 467 Pax (Braun), 100 Opal Luxus (Agfa), 55 Opema, Opema II (Meopta), 303 Zoom Reflex Automatic K1, K2, 466 Zoom Reflex Automatic S1, 466 Pax (Braun), 100
Pax (I) (Yamato), 432
Pax Golden View (Yamato), 432
Pax Jr. (Yamato), 432
Pax M2 (Yamato), 432
Pax M3 (Yamato), 433
Pax M4 (Yamato), 433 Opema, Opema II (Meopta), 303
Optax (Lumiere), 295
Opticus Photographe(Franckh), 200
Optiflex (Optikotechna), 345
Optifort (Forte), 198
Optika IIa (Musashino), 322
OPTIKOTECHNA Pajta's (Gamma Works), 208 Pajta's (Garinia vvoins), 200 Paj Jr. (Yamato), 432 Paj M4 (Yamato), 432 Pajko camera (Cruver-Peters), 129 Palmat Automatic (Yamato), 432 Palmer (Rocket Camera Co.), 370 PALMER & LONGKING Pax Ruby (Yamato), 433 Autoflex, 345 Coloreta, 345 Flexette, 345 Pax Sunscope (Yamato), 433 Paxette (Braun), 101 Lewis-style Daguerreotypecamera, 346 Palmos-O (Zeiss Ikon), 446 Paxette Automatic Super III (Braun), 101
Paxette Electromatic (Braun), 101
Paxette I, Ib (Braun), 101
Paxette IIM (Braun), 101 Optiflex, 345 Panax, 346 Spektareta, 345 Panda (Ansco), 66 Panomatic 126, 482 PANON CAMERA CO. Spektareta, 345
Optima cameras (Agfa), 55
Optima Parat (Agfa), 55
Optima Rapid 125C (Agfa), 55
Optima Reflex (Agfa), 55
Optimet (I) (Lippische), 292
Optimus Camera DeLuxe (Perken), 350
Optimus Detective (Perken), 350
Optimus Folding Camera (Perken), 350
Optimus Long Focus (Perken), 350
Optimus Long Focus (Perken), 350
Optima IA (Apparate & Kamerabau), 71
Optomax Syncrona (Vredeborch), 420
Orangina Camera (Tizer), 403 Paxette IIM (Braun), 101
Paxette Reflex (Braun), 101
Paxette Reflex Automatic (Braun), 101
Paxette Reflex Ib (Braun), 101
Paxiflash (Braun), 101
Paxina I, II (Braun), 101 Panon Wide Angle Camera, 346 Panophic, 346 Widelux, 346 Panophic (Panon), 346 Panoram 120 (Burke & James), 103 Panoram Kodak Camera (Eastman), 163 **PCA** Prismat V-90, 347 Panoramic Camera (Conley), 123 Panoramic camera (Turret), 407 PD-16 (Agfa-Ansco), 58 PDQ (Anthony), 69 PDQ CAMERACO. Panorascope(Simda), 388
PANORAXOPTICAL IND. CO.
Panorax 35-ZI, 346 Orangina Camera (Tizer), 403
Ordinary Kodak Camera (Eastman), 163
Orenac III (S.E.M.), 383
ORIENT CAMERA CO. Mandel Automatic PDQ, Model G, 347 PDQ, Model H, 347 PDQ Photo Button Camera, 347 Pansondontropic(Wood Bros.), 430 Panta (Rodehüser), 371 Peace, 347 Orient Camera Model-P, 345 Original Spiegel Reflex (Hesekiel), 233 PAPIGNY Peace Baby Flex, 347 Peace III, 347 Jumelle Stereo, 346
Paragon (Williamson Kinematograph),470
PARAGON CAMERA CO. Orinox Binocular (Asia American), 81 Peace-Gas Camera-Lighter, 475 Orion Camera, Model Simplicite, 345 Peacock III (Toyo Kogaku), 406 Pearl cameras (Konishiroku), 260 Orion Camera, No. 142, 345 Paragon Model 33, 466 Paramat (Agfa), 55 ORION WERK Pearlette (Konishiroku), 260 PEARSALL Parat, Parat I (Agfa), 55 Parcel Detective (Marion), 300 Daphne, 345 Orion box camera, 346 Rio 44C, 346 Compact, 347 Pari-Fex (Fex/Indo), 196 PECK Rio folding plate cameras, 346 **PARIS** Ferrotype, 4-tube camera, 348 Rio folding rollfilm cameras, 346 Tropen Rio 2C, 5C, 346 Orix (Ica), 243 GAP Box 3x4cm, 347 GAP Box 6x9cm, 347 Wet plate camera, 348 Peckham Wray (Wray), 430 GAP Super, 347

Pecto cameras (Columbia), 121-122

PEER

Petite Camera (Eastman), 163 Pentax LX (Asahi), 78 Peer 100, 348 Peer 100 (Eastman), 163 Pentax ME (Asahi), 77 Pentax ME Cigarette Lighter (S.M.R.), 475 Pentax ME-F (Asahi), 78 Petite Kamarette (Blair), 96 Petite Kamarette (Blair), 96
Petitux IV (Kunik), 267
Petri (35) 2.8 (Kuribayashi), 270
Petri 1.8 Color Super (Kuribayashi), 270
Petri 1.9 Color Super (Kuribayashi), 270
Petri 2.8 Color Super (Kuribayashi), 270
Petri 35 (Kuribayashi), 270
Petri 35 (Kuribayashi), 270 Peerflekta (I), II, V (Welta), 423 PEERLESSMFG. CO. Pentax ME-SÈ (Asahi), 78 Box camera, 348 Pentax ME Super (Asahi), 78 Pentax MG (Asahi), 78 Pentax MV, MV-1 (Asahi), 78 Pentax MX (Asahi), 78 Peerless view (Rochester Optical), 369 Peerless view (Rochester Optical), 36 Peggy I, II (Krauss), 265 Pelar-Camera (Lehman), 278 Pellet Shooting Camera (Ja-Ru), 478 Pen (Olympus), 340 Pen D, D2, D3 (Olympus), 340 Pen EE (Olympus), 341 Pen EE-3 (Olympus), 341 Pen EE-EL (Olympus), 340 Pen EED (Olympus), 341 Pen EES (Olympus), 341 Petri 35 (Kuribayashi), 270
Petri 35 RE (Kuribayashi), 271
Petri 35X, MX (Kuribayashi), 270
Petri Auto Rapid (Kuribayashi), 270
Petri Automate (Kuribayashi), 270
PETRI CAMERA CO., 268
Petri Color 35, 35E (Kuribayashi), 271
Petri Compact, 17, E (Kuribayashi), 271
Petri Egn (Kuribayashi), 270
Petri Eight (Kuribayashi), 463
Petri ES Auto (Kuribayashi), 271
Petri FA-1 (Kuribayashi), 271 Pentax MX (Asahi), 78
Pentax S (Asahi), 75
Pentax S1, S1a (Asahi), 76
Pentax S2 (Asahi), 75
Pentax S3 (Asahi), 76
Pentax SL (Asahi), 76
Pentax SP500 (Asahi), 76
Pentax Spotmatic (SP) (Asahi), 76
Pentax Spotmatic 1000 (SP 1000) (Asahi), 77 Pen EES (Olympus), 340 Pen EES-EL (Olympus), 340 Pen EES2 (Olympus), 341 Pentax Spotmatic F (SPF) (Asahi), 77 Pentax Spotmatic II (SPII) (Asahi), 76 Petri ES Auto (Kuribayashi), 271
Petri FA-1 (Kuribayashi), 272
Petri Flex Seven (Kuribayashi), 271
Petri Flex V (Kuribayashi), 271
Petri FT (Kuribayashi), 272
Petri FT-II (Kuribayashi), 272
Petri FT 500, FT 1000 (Kuribayashi), 272 Pen EES2 (Olympus), 341
Pen EM (Olympus), 340
Pen F, FT, FV (Olympus), 341
Pen Rapid EED, EES (Olympus), 340
Pen S 2.8, 3.5 (Olympus), 340
Pen W (Wide) (Olympus), 340
Pencil Eraser, 485
PENCIL / STATIONERYITEMS, 484
Pencil Sharpener (Juguetes), 485 Pentax Spotmatic IIa (Asahi), 77 Pentax Spotmatic Motor Drive (Asahi), 76 Pentax Super S2 (Asahi), 76 Pentax SV (Asahi), 76 Penti, Penti II (Pentacon), 349 Pentina, E, FM (Pentacon), 349 Pentona, Pentona II (Pentacon), 349 Petri FT EE (Kuribayashi), 272 Petri FTE (Kuribayashi), 272 Petri FTX (Kuribayashi), 272 Petri Grip-Pack 110 (Kuribayashi), 272 Pencil Sharpener (Juguetes), 485 Pencil-Sharpener Camera, 485 Pentor Super TL (Pentacon), 349 Pencil Sharpener Egfecolor 400, 485 Pencil Sharpener Enjicolor F-II, 485 Pencil Sharpener Keepcolor II, 485 Pepita, 349 Pepita, 349
Peregrine I, II, III (Kershaw), 254
Perfect Camera, 349
Perfect Detective (Photo Hall), 351
Perfect Jumelle (Photo Hall), 351
Perfect-Lighter (AKW), 474
Perfection (Marion), 300
Perfection (Sears), 379
Perfect, folding plate (Photo Hall), 351
Perfekt (Zeiss Ikon), 446
Perfekta (Rheipmetall), 362 Petri Half (Kuribayashi), 27 Petri Hi-Lite (Kuribayashi), 271 Petri Instant Back (Kuribayashi), 272 Pencil Sharpener Lantern Projector, 485 Penguin Try Camera-Lighter, 475 Pennant Camera No. 20 (Butler), 106 Petri Junior (Kuribayashi), 271 Petri M 35 (Kuribayashi), 271 Petri MFT 1000 (Kuribayashi), 272 Penny Picture camera (Gennert), 210 PENROSE Petri Micro Compact (Kuribayashi), 271 Petri Micro MF-1 (Kuribayashi), 272 Studio camera, 348 Penta 35 (Aires), 59 Penta 35 LM (Aires), 60 Petri Penta (Kuribayashi), 271 Petri Penta V2 (Kuribayashi), 271 Perfekta (Rheinmetall), 362 Perfekta (Welta), 423 Perfekta II (Rheinmetall), 363 Petri Penta (Flex) V3 (Kuribayashi), 271
Petri Penta (Flex) V6 (Kuribayashi), 271
Petri Penta (Flex) V6-II (Kuribayashi), 271
Petri Pocket 2 (Kuribayashi), 272
Petri Pocket 2 (Kuribayashi), 272 Penta J (Yashica), 435 PENTACON Perfeot Lighter, 475
Perfex DeLuxe (Camera Corp.), 107 AK 8, 467 Astraflex Auto 35, 348 Consul, 348 Contax D, 348 Petri Power Eight (Kuribayashi), 463 Petri Prest (Kuribayashi), 271 Petri Pro Seven (Kuribayashi), 270 Petri Push-Pull 110 (Kuribayashi), 272 Perfex Fifty-Five (Camera Corp.), 107 Perfex Forty-Four (Camera Corp.), 107
Perfex One-O-One (Camera Corp.), 107
Perfex One-O-Two (Camera Corp.), 107
Perfex Speed Candid (Camera Corp.), 107 Contax E, 348 Contax F, 348 Contax FB, 348 Petri Push-Pull 110 (Kuribayashi), 272
Petri Racer (Kuribayashi), 270
Petri RF (Kuribayashi), 269
Petri RF 120 (Kuribayashi), 269
Petri Semi, II, III (Kuribayashi), 269
Petri Seven (Kuribayashi), 270
Petri Seven S, S-II (Kuribayashi), 270
Petri Super (Kuribayashi), 269
Petri Super (Kuribayashi), 269 Perfex Thirty-Three (Camera Corp.), 107 Perfex Twenty-Two (Camera Corp.), 107 Contax FM, 348 Contax S, 348 Ercona (I), II, 348 Perforeta (Birnbaum), 94 Periflex models (Corfield), 125 Periphote (Lumiere), 295 Hexacon, 348 Orix, 348 Periscop (Ica), 243 Peritus No. 1 (Fallowfield), 192 PERKA PRÄZISIONS KAMERAWERK Pentacon, 348 Pentacon "No-Name", 349 Pentacon F, 349 Pentacon FB, FBM, 349 Petri Super Eight (Kuribayashi), 463 Petri Super V (Kuribayashi), 269 Petriflex (Kuribayashi), 270 Perka, 349 PFCA, 350 PH-6-A (Burke & James), 103 PERKEN Pentacon FM, 349 Optimus Camera DeLuxe, 350 Optimus Detective, 350 Pentacon Super, 349 Penti, Penti II, 349 Phenix camera-lighter(NST), 475 **PHILIPS** Optimus Folding Camera, 350 Pentina, Pentina E, Pentina FM, 349 Philips Box Flash, 350 Philps (Münster), 321 PHO-TAKCORP. Eagle Eye, 350 Foldex, Foldex 30, 350 Optimus Long Focus Camera, 350 Rayment's Patent, 350 Pentona, Pentona II, 349 Pentor Super TL, 349 Prakti, 349 Studio camera, 350 Praktica, 349 Ritacon F, 349 Taxona, 349 Tailboard camera, 350 Perkeo, 3x4cm (Voigtländer), 417 Perkeo E (Voigtländer), 417 Perkeo I, II (Voigtländer), 417 Perkeo Model IV (Leonar), 289 Perla A I (Gamma), 208 Macy 120, 350 Marksman, 350 Verikon, 349 Verikon, 349
Pentaflex, Pentaflex SL (K.W.), 273
Pentamatic (Yashica), 435
Pentax (original) (Asahi), 75
Pentax 6x7 (Asahi), 80
Pentax Auto 110 (Asahi), 80
Pentax Auto 110 Super (Asahi), 80
Pentax ES, ESII (Asahi), 77
Pentax H1, H1a (Asahi), 76
Pentax H2 (Asahi), 76 Reflex I, 350 Scout 120 Flash, 350 Spectator Flash, 350 Trailblazer 120, 350 Perle (Welta), 423 Perle (Welta), 424 Perlus (Neidig), 324 Perlux II, IIa (Neidig), 324 Pet 35 (Fuji Photo), 205 Traveler 120, 350 **PHOBA** Diva, 350 Petal (Sakura), 375 Peter Pan Gramophone, 485 Phocira, 350
Phoenix (Kenngott), 253
Phoenix Dollar Camera (Mason), 301
PHONOGRAPHS, 485 Pentax H1, H1a (Asahi), 76 Pentax H2 (Asahi), 75 Pentax H3, H3v (Asahi), 76 Pentax K (Asahi), 75 Pentax K2, K2DMD (Asahi), 77 Pentax K1000, K1000 SE (Asahi), 77 Petie (Kunik), 267 Petie Lighter (Kunik), 267 Petie Vanity (Kunik), 267 Petietux (Kunik), 267 Photake (Chicago Camera Co.), 118 Photavit (35mm) (Bolta), 98 Photavit (828) (Bolta), 98 Petitax (Kunik), 267 Petite (Century), 115 Pentax KM (Asahi), 77 Photavit (Bolta-size) (Bolta), 98 Pentax KX (Asahi), 77

PLEASER

PHOTAVIT-WERK **PHOTOREX** Pinette (Balda), 84 Photavit, 350
Photina, Photina III, 351
Photax "Blindé" (M.I.O.M.), 314
Photax (original) (M.I.O.M.), 314
Photax V (M.I.O.M.), 314
Photina, Photina III (Photavit-Werk), 351
Photo Binocular 110 (American Rand), 62
Photo Champ (Cardinal Corp.), 114
PHOTO DEVELOPMENTSLTD.
Envoy Wide Angle, 351
Photo Frame (Exclusive Gifts), 485
PHOTO HALL Photavit, 350 Rex Reflex B1, 352 Rex Reflex B2, 352 Pinhole camera (Howe), 239 Pinhole camera (Mackenstein), 296 Rex Reflex Standard, 352 PINHOLE CAMERA CO. Photoscopic (Cinescopie), 119 Pinhole Camera, 354 PINNOCK Photoscopic (Cinescopie), 119
Photosphere (Compagnie Francaise), 122
Photrix Quick B (Witt), 429
Photrix Stereo (Witt), 429
Physio-Pocket (Bloch), 96
Physiographe (binocular) (Bloch), 97 35 (prototype), 354 Gymea Minor (prototype), 354 Studio, 354 Pioneer, 354 Physiographe (monocular) (Bloch), 96 Pioneer (Agfa-Ansco), 58 Pioneer (Ansco), 66 Pionier Deko, 354 Pionyr (Dufa), 139 PIPON Physiographe Stereo (Bloch), 97 Pic, 352 PHOTO HALL
Perfect, folding plate, 351
Perfect Detective, 351 Piccochic (Balda), 84
Piccolette (545/12) (Zeiss Ikon), 446
Piccolette (Contessa), 124
Piccolette Camera Bank, 473 Perfect Jumelle, 351 Stereo camera, 351 Magazine camera, 354 Self-Worker, 354 Self-Worker, 354
Pistol Aircraft camera (Williamson), 427
Pistol Camera (Eriksen), 184
Pistol camera (Mamiya), 298
Pistol camera (Mamiya), 298
Pistol camera (Mamiya), 298
Pistol contessa), 124
Pixie (Contessa), 124
Pixie (Gnome), 213
Pixie (Whittaker), 426
Pixie Custom (Whittaker), 426
Pixie Slip-On (Baudinet), 86
Plait Pliant (Photo-Plait), 351
Plan-Paff (Ihagee), 246
Planex (City Sale), 120
Planovista (Bentzin), 90
PLANOVISTASEEING CAMERALTD., 354 Photo Jumelle (Carpentier), 115 Piccolette Luxus (Contessa), 124 Piccolette-Luxus (546/12) (Zeiss Ikon), 446 Photo Livre (Mackenstein), 296 Piccolette-Luxus (546/12) (Zeis Piccolo (Murer), 322 Piccolo (Photo-Opera), 351 Pickwik (Galter), 208 Pickwik (Monarch), 318 Pickwik Reflex (Monarch), 318 Photo Master, 351 Photo Master Super 16 Twin 620, 351 Photo Master Twin 620, 351 PHOTO MATERIALSCO. Trokonet, 351 Photo Miami, 351 Picny (Miyagawa), 317 Picta Twin 620 (Rolls), 372 PICTURE FRAMES, 485 Photo Postcard Cameras (Daydark), 133 Photo Quint, 352 Photo Revolver de Poche (Enjalbert), 183 PHOTO SEE CORP. Picture Master, 352 Picture Story Camera (Fisher-Price), 499 Picture-Quick (Kenner), 495 Photo-See, 352 Photo Vanity (Ansco), 66 Photo-Bijou Lance-Eau, 489 PIERRA' Drepy, 352
Pierrette (Balda), 84
Pig with Camera, 492
Pigeon, Pigeon III (Shinano), 386
Pigeonflex (Yashina), 435 Photo-BouquinStereoscopique(Bloch), 96 Photo-Box, 351 Photo-Craft (Altheimer & Baer), 61 PLANTERS, 485 Plascaflex PS 35 (Potthoff), 358 Plaskop (Ica), 243 Photo-Cravate (Bloch), 96
Photo-Eclair (Fetter), 195
Photo-Flash Camera-Lighter (K.K.W.), 474
PHOTO-IT MFG. CO.
The Photo-It, 351 Plaskop (Krügener), 266 Plaskop (Zeiss Ikon), 446 PLASMAT GmbH PIĞGOTT Sliding-boxwet plate camera, 352 Piggy Bank, 473 PIGNONS Piggy Bank, 473
PIGNONS
Alpa (Standard), 353
Alpa 4, 353
Alpa 4a, 353
Alpa 4b, 4b Omega, 353
Alpa 5a, 353
Alpa 5a, 353
Alpa 6b, 353
Alpa 6c, 353
Alpa 6c, 353
Alpa 7s/8, 353
Alpa 7s/8, 353
Alpa 7s/8, 353
Alpa 9d, 353
Alpa 9d, 353
Alpa 9d, 353
Alpa 10d, 354
Alpa 10d, 354
Alpa 11e, 354
Alpa 11e, 354
Alpa 11e, 354
Alpa 11e, 354
Alpa 11f, 354
Alpa 11f, 354
Alpa 11m, 354
Alpa 11m, 354
Alpa 11m, 354
Alpa 11m, 354 Roland, 354
PLASTICS DEVELOPMENT CORP.
Snapshooter, 355 Photo-Magazin(Français), 200 Photo-Magic(Boumsell), 99 SnapshooterBicentennial 1976, 355 Plastoscop (Krügener), 266 Plate box camera (Coronet), 128 Photo-Master(Herold), 232 Photo-Oda (Krohnke), 265 PHOTO-OPERA Plate box camera (Coronet), 128
Plate camera (American Optical Co.), 62
Plate Camera (Bial & Freund), 93
Plate camera (Certo), 117
Plate Camera (Demaria), 135
Plate Camera (Sears), 379
Plate cameras (Kenngott), 253
Plate camera, Tropical (Kenngott), 253
Platten Tip I (Rietzschel), 364
Pl AUBFI Piccolo, 351 PHOTO-PACCAMERAMFG. CO. PHOTO-PAC CAMERA MFG Photo-Pac, 351 PHOTO-PLAIT No. 2 Plait Pliant, 351 Plait Pliant, 351 PHOTO-PORST Hapo 5, 10, 45, 351 Hapo 35, 36, 351 Hapo 66, 66E, 351 Haponette B, 351 Porst EX55 Electronic, 352 Porst KX50, 352 PLAUBEL Aerial Camera, 355 Baby Makina, 355 Folding-bedplate camera, 355
Makina (I), 355
Makina I/II conversion, 355
Makina II, IIa, IIb, 355
Makina IIS, 355
Makina III, 255 Porst KX50, 352 Photo-Revolver(Krauss), 265 Photo-Stereo-Binocle(Goerz), 214 Photo-Ticket (Turillon), 407 Photoette#115 (B & R Mfr.), 82 Photographer (Fairweather), 491 Makina III, 355 Makinette, 355 Photographer(Fairweather), 491
Photographer(Hummel), 491
Photographerdecanter (Lionstone), 479
PhotographerLamp, 482
PhotographerTrophy, 492
Photographerwith View (Playmobil), 492
Photographer, Camera, Dark Cloth, 492
PHOTOGRAPHIEVULGARISATRICE
Field camera, 352 Normal Peco, 355 Prazision Peco, 355 Roll-Op (II), 355 Stereo Makina, 356 Alpa 11n, 354 Alpa 11p, 354 Alpa 11r, 354 Veriwide 100, 356 Alpa 11s, 354 Alpa 11si, 354 Alpa 11z, 354 PLAUL Field camera, 356 Plavic, 356 Playlab Sr., 356 PLAYMATESTOYS My Li'l Camera, 496 PLAYMOBIL Field camera, 352 Alpa Master, 354 Alpa Prisma Reflex (III), 353 Alpa Reflex (I), 353 Alpa Reflex (II), 353 Alpa S.81, 354 Photography Stamp Tietac, 481 Photoing on Car, 498 Photoknips (Ihagee), 246 Photolet, 352 Photomaniac Mug, 480 Photomatic 475 Photographerwith View Camera, 492 PLAYSKOOL Alpa 5.81, 354
Bolca (Standard), 353
Bolca I, 353
Pilot 6 (K.W.), 273
Pilot No. 2 (Butcher), 105
Pilot Reflex (K.W.), 273
Pilot Super (K.W.), 273 Photomatic, 475 Busy Camera, 496
PLAYTIME PRODUCTS
Cabbage Patch Kids 110 Camera, 356
Go Bots 110 Camera, 356 Photon 120 Camera, 352 Photopal (Scott-Atwater), 378 PHOTOPRINT Ernos, 352 **PLAYWELL** Photorecord (Graflex), 223 Pin-hole Camera (Eastman), 163 Pin-Zip 126 (Time-Field), 402 Camera Kaleidoscope, 497 Photoret Watch Camera (Magic), 296 Pleaser, Pleaser II (Eastman), 163

PLENAX

Police Camera (Expo), 191

Plenax (Agfa-Ansco), 58 Plico (Eastman), 163 Plik, 356 Polo (Coronet), 128 Polomat (Adox), 52 Prazision Peco (Plaubel), 355 Pre-anniversary Speed Graphic (Graflex), Polyfoto, 358 Polyscop (Ica), 243 Polyscop (Zulauf), 452 Polyskop (Zeiss Ikon), 446 Pom-Pom No. 3 (Butcher), 105 Precious Moments "Baby's First Picture" **PLUS** (Enesco), 490
Precisa (Beier), 88
PRECISION CAMERAINC.
Andante 100, 359 Plusflex 35, 356 Pluto Six (Shichiyo), 386 PMC Automatic Rapid (Riken), 364 POCK Pompadour(Hesekiel), 233 PONTIAC Preis-Box (Agfa), 56 Premier (Rochester Optical), 369 PREMIER INSTRUMENTCO. Detective camera, 356 Pocket (Yen camera), 435 PONTIAC
Baby-Lynx, 358
Bakélite, 358
Bloc-Metal 41, 358
Bloc-Metal 45, 358
Lynx, Lynx II, 358
Super Lynx, I, II, 358
Pontina (Balda), 84
PONTOS OPTIKAI
Dici, 358
Pony (Fastman), 164 Pocket A-1 Camera (Eastman), 163 Kardon, 359 Pocket B-1 Camera (Eastman), 163 Kardon Signal Corps Model, 359 PREMIER PLASTICS CO. Pocket Camera (Fisher-Price), 499 Pocket Camera (Hall Camera Co.), 226 Squirt Pix, 489 Pocket Coffee Espresso (Ferrero), 474 Premiere (Heiland), 230 Pocket Coin Bank, 473 Premo Box Film Camera (Eastman), 164 Premo Cameras (Eastman), 164 Pocket Cyko Cameras (Griffin), 224 Pocket Cyko Cameras (Griffin), 224
Pocket Dalco (K.W.), 273
Pocket Ensign 2-1/4 (Houghton), 237
Pocket Instamatic Cam. (Eastman), 163
Pocket Kodak (box types) (Eastman), 163
Pocket Kodak (folding) (Eastman), 164
Pocket Kodak Junior Cam. (Eastman), 164
Pocket Kodak Series II (Eastman), 164
Pocket Kodak Special (Eastman), 164
Pocket Kozy (Kozy), 262
Pocket Magda, 356
Pocket Monroe A (Monroe), 318 Premo cameras (Rochester Optical), 369 Premo Folding Cameras (Eastman), 165 Pony (Eastman), 164 Pony 135 (Eastman), 164 Pony 828 (Eastman), 164 Premo Folding Film Camera (Rochester Pony II (Eastman), 164 Pony IV (Eastman), 164 Optical), 370 Premo Junior Cameras (Eastman), 165 Premo Nos. 8, 9, 12 (Eastman), 165 Premo Reflecting (Rochester Optical), 370 Premo Sr. Stereo (Rochester Optical), 370 Pony Premo Cameras (Eastman), 166 Pony Premo No. 5 (Rochester Opt.), 370 Poppy (Shin Nippon), 386 Premoette (no number) (Eastman), 166 Premoette Cameras (Eastman), 166 Populair (Tahbes), 397 Popular (Eiko), 182
Popular Brownie Camera (Eastman), 147
Popular Carbine (Butcher), 105
Popular Ferrotype (Fallowfield), 192
POPULAR PHOTOGRAPHCO. Pocket Monroe A (Monroe), 318 Pocket Monroe No. 2 (Monroe), 318 Pocket Platos, 356 Premoette Junior Cameras (Eastman), 166
Premoette Junior Special (Eastman), 166
Premoette Senior Cam. (Eastman), 166
Premoette Special Cam. (Eastman), 166 Pocket Poco A (Rochester Cam. Mfg), 368 Pocket Premo (Eastman), 166 Pocket Premo (Rochester Optical), 370 Premograph Cameras (Eastman), 167 PRESCOTT& CO. Nodark Tintype Camera, 358 Popular Pressman (Butcher), 105 Pocket Premo C (Eastman), 166 Pocket Premo C (Eastman), 16
Pocket Ray (Ray), 360
Pocket Seneca (Seneca), 384
Pocket Titbit (Tylar), 407
Pocket Z (Zion), 452
Pocket Z stereo (Zion), 452
Pocket Zar (Western), 425
Pocket-Focal (Hanau), 227
Pocket-Focal (Hanau), 227
Pocket-Focal (Hanau), 227 Field camera, 359 President (Camera Man), 107 Porst EX55 Electronic (Photo-Porst), 352 Porst KX50 (Photo-Porst), 352 Portable Divided Camera (Ross), 372 Press camera (Beseler), 93
Press camera (Goldmann), 215
Press camera (Soho), 390
Press camera (Van Neck), 413
Press Graflex (Graflex), 219
Press King (B & W Mfr.), 82 Portable Instantograph (Lancaster), 277
Portrait Brownie Camera (Eastman), 147
Portrait Camera (Anthony), 70
Portrait Hawkeye, No. 2 (Eastman), 158 Portrait Hawkeye A-Star-A (Eastman), 158 Poco (Rochester Camera Mfg.), 368 Press Van (Suzuki), 397 Portrait Studio, 497 Poka, Poka II (Balda), 84 Polain No. 1 (Gaumont), 209 Press/View cameras (Burke & James), 103 Pressman (Busch), 104 Postage Stamp Camera (Lancaster), 277 Postage stamp camera (Wünsche), 431 Postcard Sibyl (Newman & Guardia), 326 POLAROID Presto (Franks), 204
Presto (Magic), 296
PRESTWICHMANUFACTURING Big Shot, 357 Camel, 357 Potenza Camera, 358 POTTHOFF Camel, 357
Countdown90, 357
Polaroid 100 ("Automatic 100"), 357
Polaroid 100 (rollfilm), 357
Polaroid 101, 102, 103, 104, 357
Polaroid 110 (Pathfinder), 357
Polaroid 110A (Pathfinder), 357
Polaroid 110B (Pathfinder), 357
Polaroid 110B (Pathfinder), 357 Prestwich 35mm Cine, 467 Amplion-Reflex, 358 Plascaflex PS 35, 358 Précides, 359
Primar (Plan Primar) (Bentzin), 91
Primar Klapp Reflex (Bentzin), 91
Primar Reflex (Bentzin), 91 Pound Puppies Musical Toy Camera (Illco), 483 POUVA Primarette (Bentzin), 91 Primarflex, II (Bentzin), 91 Start, 358 Polaroid 120, 125, 135, 357 Polaroid 150, 357 Powell's Stereoscopic Camera (Horne & Primo, 359 Thornthwaite), 234 Primo Jr. (Sawyers Mark IV), 377 Primo Jr., Primo Jr. II (Tokyo Kogaku), 404 Primoflex (Tokyo Kogaku), 404 Primoflex Automat (Tokyo Kogaku), 404 Polaroid 160, 357 Polaroid 180, 357 **POWER** Cameragraph, 467 Prakti (Pentacon), 349 Praktica (K.W.), 273 Praktica (Pentacon), 349 Polaroid 185, 357 Polaroid 190, 357 Polaroid 195, 357 Primula (Balda), 84 Primus Nos. 1, 2, 3 (Butcher), 105 Primus So-Li-To (Butcher), 105 Praktica FX (K.W.), 273 Praktica FX2 (K.W.), 273 Praktica FX3 (K.W.), 273 Praktica IV (K.W.), 273 Polaroid 415, 357 Polaroid 700, 357 Polaroid 80 (Highlander), 356 Polaroid 800, 357 Prince, 359
Prince Flex, 482
Prince Peerless (Fujimoto), 206 Praktica IVB, IVBM (K.W.), 273 Praktica IVF, IVFB (K.W.), 273 Praktica L (K.W.), 274 Polaroid 80A (Highlander), 356 Polaroid 80B, 356 Prince Ruby, 359 Princess (Closter), 121 Polaroid 850, 357 Polaroid 900, 357 Praktica LB (K.W.), 274 Praktica LLC (K.W.), 274 Praktica LTL (K.W.), 274 Princess (Spitzer), 392 Princess May (London & Paris), 293 Princess of Power She-Ra (HG Toys), 233 Polaroid 95, 356 Praktica LTL (K.W.), 274
Praktica Nova, Nova B (K.W.), 274
Praktica PL Nova I, IB (K.W.), 274
Praktica Prisma (K.W.), 274
Praktica Super TL (K.W.), 274
Praktica VF (K.W.), 274
Praktica WF (K.W.), 274
Praktiflex (K.W.), 274
Praktiflex II (K.W.), 274
Praktiflex II (K.W.), 275
Praktina IIa (K.W.), 275
Praktisix. Praktisix II (K.W.), 275
Praktisix. Praktisix II (K.W.), 275 Polaroid 95A, 357 PRINTEX PRODUCTS Polaroid 95B (Speedliner), 357 Printex, 359 PRINTING FRAME, 486 Polaroid J-33, 357 Polaroid J-66, 357 Prismat NP (Mamiya), 298 Prismat PH (Mamiya), 298 Prismat V-90 (PCA), 347 Polavision Land Camera, 467 Swinger Model 20, 357 Swinger Sentinel M15, 357 SX-70 (Deluxe Model), 357 Polavision Land Camera (Polaroid), 467 Prismotype (Fallowfield), 192 Pro (Beaurline), 86 Pro Camera, 359 Prominent (Voigtländer), 417 Tourist Photographer, 493 Prominent II (Voigtländer), 417 Police Academy 6 (Fuji Photo), 205

Prona Tropical, 359

Praktisix, Praktisix II (K.W.), 275

RETINETTE

PRONTA	Ray Jr., 360	Alta Automatic, 361
Pronta Lux PL, 359	Ray Nos. 1, 2, 4, 6, 7, 360	Alta D, 361
Prontoklapp (Rodenstock), 371 Proskar, 359	Telephoto Ray Model C. 360	Reicka (Wünsche), 431
Proud Chrome Six III (Sumida), 395	Rayelle (Fototecnica), 200	REID & SIGRIST
PROUD CO.	Rayflex (Fototecnica), 200	Reid I, 362
Rosen Semi, 359	Raylo Color Camera (American Raylo), 62	Reid Ia, 362
Proud Model 50 (Sumida), 395	Rayment's Patent (Perken), 350 R.B. Graflex Junior (Graflex), 219	Reid I and Ia Military, 362
Puck (Ising), 249	R.B. Graflex Series B (Graflex), 220	Reid II, 362
Puck Special (Thornton-Pickard), 401	R.B. Graflex Series C (Graflex), 220	Reid III, 362
Pucky (Ising), 249	R.B. Graflex Series D (Graflex), 220	REISE CAMERA CO., 119
Pucky I, Ia, II (Ising), 249	R.B. Super D Graflex (Graflex), 220	Reko (Rochester Optical), 370 RELCO
Pullman Detective (Levi), 289	R.B. Tele Graflex (Graflex), 220	Movie Shot, 479
Punky Brewster (Helm), 231	RCA VICTOR CO.	Reliance, 362
Pupille (Eastman), 167 Pupille (Nagel), 323	RCA Sound Camera, 467	Rembrandt Portrait (Burke & James) 103
Purma Plus (Hunter), 239	Ready Ranger Tele-photo Camera Gun	REMCOTOYS
Purma Special (Hunter), 239	(Aurora), 81	Hulk Hogan, 362
Purse, Compact, & Lipstick (Girey), 476	Readyflash (Ansco), 66 Readyset cameras (Ansco), 66	Teenage Mutant Ninja Turtles, 362
PUTNAM	Readyset Royal, Nos. 1, 1A (Ansco), 66	Teenage Mutant Ninja Turtles Talking
Marvel, 359	Readyset Special, Nos. 1, 1A (Ansco), 66	Camera, 362
Puzzle Camera, 486	Readyset Traveler (Agfa-Ansco), 58	Remington (Deluxe), 135 Remington (Monarch), 318
PUZZLES & GAMES, 486	Real Camera, 360	Remington Miniature Camera, 362
PYNE	Realist 35 (White), 426	Reo Miniature (Howard), 239
Stereoscopic Camera, 359	Realist 45 (White), 426	Reporter (Braun), 101
Q.P., 359	Rechteck Primar (Bentzin), 91	Reporter (Foitzik), 197
Q.R.S. CO.	Recomar Cameras (Eastman), 167	Reporter (Gaumont), 209
Q.R.S. Model B, 467	Recomar Cameras (Nagel), 323	Reporter (ISO), 249
Q.R.S. Projector, 467	Record Camera, 360 Record I, II, III (Agfa), 56	Reporter (Record) (Ica), 243
Q.R.SDeVRYCORP.	Record Stereo Camera (Hüttig), 240	Reporter (Wirgin), 428
Q.R.S. Kamra, 359	RECTAFLEX	Reporter 66 (Linden), 291
QANTASAIRLINES	Rectaflex Junior, 360	Reporter Junior II (Vredeborch), 421 Reporter Max, 362
Koala Bear, 493	Rectaflex Rotor, 360	Reporter, Tropical model (Gaumont), 209
QRS-DeVry Home Movie (Devry), 458	Rectaflex Standard, 360	Retina (original: Type 117) (Fastman) 167
Quad (Close & Cone), 121	Recto (Contessa), 124	Retina (Type 118) (Eastman) 168
Quad 32-40 (Itek), 249 Quad Model 32-100 As (Avant), 82	Red Flag 20, 361	Retina (I) (Type 119) (Eastman), 168
Quelle Box (Bilora), 94	Redbox 707, 489	Retina (I) (Type 126) (Eastman), 168
Quick Focus Kodak Camera	REDDING Redding's Patent Luze 361	Retina I (Type 010) (Eastman), 168
No. 3B (Eastman), 167	Redding's Patent Luzo, 361 Rediflex (Ansco), 66	Retina I (Type 013) (Eastman), 169
	Reese's Peanut Butter Cups (Nasta), 323	Retina I (Type 141) (Eastman), 168
RAACO	Reflecta (Welta), 424	Retina I (Type 143) (Eastman), 168 Retina I (Type 148) (Eastman), 168
Mignon, 360	Reflekta, II, III (Welta), 424	Retina I (Type 149) (Eastman), 168
Rabbit Photographer, 493	Reflex (APM), 71	Retina I (Type 160/I) (Eastman), 168
Rad Head Photographer (Goebel), 491	Reflex (Ernemann), 189	Retina la (Type 015) (Eastman), 169
Radar-Eye (Aires), 60 Radial (Welta), 424	Reflex (Ica), 243	Retina lb (Type 018) (Eastman), 169
Radial Hand camera (Marion), 300	Reflex (Imperial), 247	Retina IB (Type 019) (Fastman) 169
Radicame CR-1 (National), 323	Reflex (Murer), 322 Reflex (Ross), 372	Ketina IB (Type 019/0) (Fastman) 160
Radio/Flash CR-1, CR-2 (National), 323	Reflex, II (United States Camera), 409	Retina i B5 (Type 040) (Eastman), 172
Radiograph Copy Camera (Eastman) 167	Reflex I (Pho-Tak), 350	Retina IF (Type 046) (Eastman), 172
RADIOS, 486	Reflex 66, 361	Retina II (Type 011) (Eastman), 170 Retina II (Type 014) (Eastman), 170
Radix, 360	Reflex Beauty (Taiyodo Koki), 398	Retina II (Type 122) (Eastman), 169
Radix (Bilora), 94	Reflex-Box (K.W.), 275	Retina II (Type 142) (Eastman), 169
Rainbow Hawk-Eye Cam. (Eastman), 158 RAJAR LTD., 360	Reflex camera (Reflex Camera), 361	Retina IIa (Type 016) (Eastman), 170
Rajar No. 6 (APM), 71	REFLEX CAMÈRA CO.	Retina IIa (Type 150) (Eastman), 169
Rakso, 360	Focal plane postcard camera, 361	Retina IIc (Type 020) (Eastman), 170
Raleigh, 360	Junior Reflex, 361 Patent Reflex Hand camera, 361	Retina IIC (Type 029) (Eastman), 170
RALPH WILSON PLASTICS CO.	Reflex camera, 361	Retina IIF (Type 047) (Eastman), 172
Wilsonart Maximum Exposure, 472	Reflex Carbine (Butcher), 105	Retina IIS (Type 024) (Eastman), 171 Retina IIIc (Type 021) (Eastman), 170
Rambler (Lizars), 292	Reflex Control (Beaulieu), 454	Retina IIIc (Type 021) (Eastman), 170
Rambler Flash Camera (Imperial), 247	Reflex-Korelle (Kochmann), 258	Retina IIIC (Type 028) (Eastman), 171
Ramera (Kowa), 262	Reflex Shot, 479	Retina IIIC (Type 028/N) (Eastman), 171
Ranca (Nagel), 323 Ranca Camera (Eastman), 167	Reform-Clack (Rietzschel), 364	Retina IIIS (Type 027) (Eastman), 171
Randorflex, 360	Regal (Galter), 208	Retina Accessories, 173
Ranger (Drucker), 138	Regal Flash Master, 361 Regal Miniature, 361	Retina Automatic I (038) (Eastman), 171
Ranger 35 (Nihon Seiki), 328	Regal Miniature (Galter), 208	Retina Automatic II (032) (Eastman), 171
RANKOLORLABORATORIES	Regent, 361	Retina Automatic III (039) (Eastman), 171 Retina Lenses, 173
Rank, 360	Regent (Ansco), 66	Retina Reflex (Type 025) (Eastman), 172
Rapid Omega 100, 200 (Konishiroku), 260	Regent Camera (Eastman), 167	Retina Reflex (Type 025/0) (Eastman), 172
Rapide (Coronet), 128	Regent II Camera (Eastman), 167	Retina Reflex III (041) (Eastman), 172
Rapide (Darlot), 132	Registrier-Kamera(Agfa), 56	Retina Reflex IV (051) (Eastman) 173
Rapier (Coronét), 128 Rapitake (La Rose), 275	Regula (King), 256	Retina Reflex IV (051/N) (Eastman), 173
Raven (Kershaw), 254	Regula Citalux 300 (King), 256	Retina Reflex S (034) (Eastman), 172
RAY CAMERA CO.	Regula Reflex 2000 CTL (King), 256 Regula Reflex CTL (King), 256	Retina S1 (Type 060) (Eastman), 172
Box camera, 360	Regula Reflex C1E (King), 256	Retina S2 (Type 061) (Eastman), 172
Pocket Ray, 360	Regula Reflex SL (King), 256	Retinette (Type 012) (Eastman), 173
Ray A, 360	Regular Kodak Cameras (Eastman), 167	Retinette (Type 017) (Eastman), 173 Retinette (Type 022) (Eastman), 174
Ray C, 360	REICHENBACH, MOREY & WILL CO.	Retinette (Type 147) (Eastman), 173
		, , , , , , , , , , , , , , , , , , , ,

PRONTA

RETINETTE I

<u>RETINETTE I</u>		
Retinette I (Type 030) (Eastman), 174	Richlet 35 (Rich-Ray), 363	Ricohflex Dia, 366
Retinette IA (Type 035) (Eastman), 174	RICHTER Rica-Flex, 363	Ricohflex TLS-401, 366 Ricohl Mod. 1, 366
Retinette IA (Type 035/7) (Eastman), 174 Retinette IA (Type 042) (Eastman), 174	Rica-Flex, 363 Ricoh 16 (Riken), 364	Ricohmatic 225, 366
Retinette IA (Type 042) (Eastman), 174	Ricoh 35 (Riken), 365	Ricohmatic 35, 366
Retinette IB (Type 037) (Eastman), 174	Ricoh 35 Deluxe (Riken), 365	Ricohmatic 44, 366
Retinette IB (Type 045) (Eastman), 175	Ricoh 35 Flex (Riken), 365	Ricolet II 366
Retinette II (Type 026) (Eastman), 175	Ricoh 35S (Riken), 365 Ricoh 126C-Flex TLS (Riken), 365	Ricolet II, 366 Ricolet S, 366
Retinette II (Type 160) (Eastman), 173 Retinette IIA (Type 036) (Eastman), 175	Ricoh 300, 300S (Riken), 365	Roico, 366
Retinette IIB (Type 031) (Eastman), 175	Ricoh 500 (Riken), 365	Semi Heil, 366
Retinette f (Type 022/7) (Eastman), 174	Ricoh Auto 35, 35-L, 35-V (Riken), 365	Steky, 366
Retinette f (Type 030/7) (Eastman), 174	Ricoh Auto 66 (Riken), 365 Ricoh Auto Half, Half SE (Riken), 365	Steky "Made in Tokyo", 366 Steky II, III, IIIa, IIIb, 366
REVERE CAMERA CO. Automatic-1034,362	Ricoh Auto Shot (Riken), 365	Super Ricohflex, 367
Eye-Matic CA-1 to CA-7, 467	Ricoh Auto TLS EE (Riken), 365	RILEY RESEARCH
Eyematic EE 127, 362	Ricoh Diacord G, L (Riken), 365	Rilex Press, 367 Rilo, 367
Revere, 8mm, 467	Ricoh Singlex, II, TLS (Riken), 365 Ricoh Six (Riken), 365	Rimei Box, 367
Revere 101, 103, 467 Revere Magazine 16, 467	Ricoh SLX 500 (Riken), 366	Ring Cameras, 367
Revere Super 8mm, 468	Ricoh Super 44 (Riken), 366	Ring Cameras (Mazur), 302
Stereo 33, 362	Ricoh Teleca 240 (Riken), 366	Ring-a-dingy Camera (Tomy), 496 Rio cameras (Orion), 346
Reversible Back Camera (Blair), 96	Ricohflex (Riken), 366 Ricohflex Dia (Riken), 366	Rio-400 (Eastman), 175
Reversible Back Cycle Graphic (Graflex),	Riconflex TLS-401 (Riken), 366	Rippa (Yamato), 433
221 Reversible Back Cycle Graphic Special	Ricohl Mod. I (Riken), 366	Rippaflex, 367
(Graflex), 221	Ricohmatic 35 (Riken), 366	Rippaflex (Yamato), 433
Reversible Back Graflex (Graflex), 219	Ricohmatic 44 (Riken), 366 Ricohmatic 225 (Riken), 366	RISDON MFG. CO. Risdon Model A, 468
Reversible Back Premo (Rochester	Ricolet, II, S (Riken), 366	Risdon Model A (Ansco), 454
Optical), 370 Revolution 89 (Haking), 226	Ricsor (Yamato), 433	Ritacon F (Pentacon), 349
Revolving Back Auto Graflex (Graflex),	RIDDELL	Rittreck 6x6 (Musashino), 322 Rittreck IIa (Musashino), 322
219	Folding plate camera, 363 RIETZSCHEL	Rival, 367
Revolving Back Camera. (American Optical Co.), 62	Clack I, 363	Rival 35, 367
Revolving Back Cycle Graphic (Graflex),	Clack Luxus, 363	Rival 120, 367
222	Condor Luxus, 363 Heli-Clack, horizontal type, 363	Rival 120 Elite (Metropolitan), 304 Rival Reflex (K.W.), 275
Revue 3 (Foto-Quelle), 199 Revue-4 (Foto-Quelle), 199	Kosmo-Clack Stereo, 363	Riviera Camera-Eye Super Lighter, 475
Revue 16 KB (Foto-Quelle), 199	Ladies Hand camera, 363	RIXA KAMERABAU
Revue Mini-Star (Foto-Quelle), 199	Miniatur-Clack 109, 364	Rixa, 367 RO-TO
REWO	Platten Tip I, 364 Reform-Clack,364	Elvo, 367
Rewo Louise, 362 REX	Taschen Clack 128, 364	Invicta, 367
Baby Powell, 362	Universal Heli-Clack, 364	Nea Fotos, 367 Roamer I (Universal), 410
Rex (Coronet), 128	Rifax (Beier), 88 Rifax (Rangefindermodel) (Beier), 88	Roamer II (Universal), 410
Rex (M.I.O.M.), 315 Rex Flash (Coronet), 128	Rigi-box (Straco), 395	Roamer 63 (Universal), 410
Rex Kaysons (Yamato), 433	Rigona (Balda), 84	ROBBIN PRODUCTS
REX MAGAZINE CAMERA CO.	RIKEN OPTICAL	Robbin Reflex, 367 Robi (C.M.F.), 121
Rex Magazine Camera, 362 Rex Miniature (Utility), 413	Adler Semi, 364 Baby Kinsi, 364	Robin (Neoca), 325
Rex Reflex B1, B2 (Photorex), 352	Golden Ricoh 16, 364	Robin Hood Camera (Standard), 393
Rex Reflex Standard (Photorex), 352	Golden Steky, 364	ROBINSON Luzo, 367
Rex-Lujo (Gevaert), 211	Hanken, 364 PMC Automatic Rapid, 364	Robo-Cam(Asanuma), 81
Rexo Box (Burke & James), 103 Rexoette No. 2 (Burke & James), 103	Ricoh 16, 364	Robot Camera (Gakken), 206
REYGONAUD	Ricoh 35, 365	Robot I (Berning), 91
Stand camera, 362	Ricoh 35 Deluxe, 365 Ricoh 35 Flex, 365	Robot II, IIa (Berning), 92 Robot Junior (Berning), 92
Reyna II (Cornu), 126 Reyna Cross III (Cornu), 126	Ricoh 35S, 365	Robot Luftwaffe Model (Berning), 92
Reyna Cross III (Royet), 374	Ricoh 126C-FlexTLS, 365	Robot Recorder 24, 24e, 24F (Berning), 92
REYNOLDS& BRANSON	Ricoh 300, 365	Robot Recorder 36 (Berning), 92 Robot Royal III (Berning), 92
Field camera, 362 RF-35 (Hanimex), 228	Ricoh 300S, 365 Ricoh 500, 365	Robot Royal 18 (Berning), 92
Rhaco Folding Plate (Henning), 231	Ricoh Auto 35, 365	Robot Royal 24 (Berning), 92
Rhaco Monopol (Henning), 231	Ricoh Auto 35-L, 365	Robot Royal 36 (Berning), 92 Robot Star (Berning), 92
RHEINMETALL	Ricoh Auto 35-V, 365 Ricoh Auto 66, 365	Robot Star 25 (Berning), 92
Exa System, 362 Perfekta, 362	Ricoh Auto Half, 365	Robot Star 50 (Berning), 92
Perfekta II, 363	Ricoh Auto Half SE, 365	Robot Star II (Vollautomat) (Berning), 92
Rica-Flex (Richter), 363	Ricoh Auto Shot, 365 Ricoh Auto TLS EE, 365	Robra (Rodenstock), 371 Roc (IDAM), 244
RICH-RAÝTRADIÑGCO.	Ricoh Diacord G, 365	ROCAMCOPRODUCTS
Rich-Ray, 363 Richlet 35, 363	Ricoh Diacord L, 365	Rocamco, 367
RICHARD (F.M.)	Ricoh Singlex, 365	Rocamco No. 3 Daylight Loading Rollfilm Camera, 368
Detective, 363	Ricoh Singlex II, 365 Ricoh Singlex TLS, 365	Rocca Automatic (Montanus), 319
RICHARD (Jules) Glyphoscope, 363	Ricoh Six, 365	Rocca Familia (Montanus), 319
Homeos, 363	Ricoh SLX 500, 366	Rocca LK (Montanus), 319 Rocca Super Reflex (Montanus), 319
Homeoscope,363	Ricoh Super 44, 366 Ricoh Teleca 240, 366	ROCHE
Verascope, 363 Verascope F40, 363	Ricohflex, 366	Allox, 368
V 01 00 00 po 1 -10, 000		

Rox, 368 ROCHECHOUARD Le Multicolore, 368 ROCHESTERCAMERA & SUPPLY, 368 ROCHESTERCAMERAMFG. CO. Favorite, 368 Folding Rochester, 368 Gem Poco, 368 Gem Poco, folding, 368 King Poco, 368 Pocket Poco A, 368 Poco Cameras, 368 Stereo Poco, 368 Tuxedo, 369 View, 369 ROCHESTEROPTICAL & CAMERA, 368 ROCHESTEROPTICAL CO. Carlton, 369 Cyclone Cameras, 369 Cyclone Junior, 369 Cyclone Senior, 369 Cyko Reko, 369 Empire State View, 369 Folding Pocket Cyko No. 1, 369 Folding Premo Camera, 370 Handy, 369 Ideal, 369 Long Focus Premo, 370 Magazine Cyclone, 369 Monitor, 369 New Model Improved View, 369 New Model View, 369 Peerless view, 369 Pocket Premo, 370 Pony Premo No. 5, 370 Premier box camera, 369 Premier folding camera, 369 Premo cameras, 369 Premo Folding Film Camera No. 1, 370 Premo Folding Film Camera No. 3, 370 Premo Reflecting Camera, 370 Premo Sr. Stereo, 370 Reko, 370 Reversible Back Premo, 370 Rochester Stereo Camera, 370 Snappa, 370 Universal, 370 Rocket (Weimet), 423 ROCKET CAMERA CO. General, 370 New Rocket, 370 Palmer, 370 Rocket Camera, 370 RODEHÜSER Panta, 371 Rodella (Rodenstock), 371 RODENSTOCK Astra, 371 Citoklapp, 371 Citonette, 371 Clarovid, Clarovid II, 371 Folding plate/sheetfilm camera, 371 Folding rollfilm camera, 371 Prontoklapp, 371 Robra, 371 Rodella, 371 Rodinett, 371 Rofina II, 371 Wedar, Wedar II, 371
Ysella, 371
Rodinett (Rodenstock), 371
Rofina II (Rodenstock), 371
Rojers Junior, 371
Rojeco (Riken), 366
Roka Luxus (Bittner), 94
ROKION-SHA 371 ROKUOH-SHA,371 Rokuoh-ShaMachine-gunCamera (Konishiroku), 261 **ROKUWACO** Stereo Rocca, 371 ROLAND Folding plate camera, 371 Roland (Plasmat), 354

Rolet (Bencini), 90 Rolf I, II (Ernemann), 189 Rolfix, II, Jr. (Franka-Werk), 201 Roll Film Seneca (Seneca), 384 Roll Tenax (Goerz), 214 Roll Tenax Luxus (Goerz), 214 Roll Tenax Luxus (Goerz), 214 Roll-Op (II) (Plaubel), 355 Roll-Paff-Reflex (Ihagee), 246 Rollbox (Balda), 85 Rollda (Anschütz), 62 Rollei-16 (Franke & Heidecke), 201 Rollei-16S (Franke & Heidecke), 201 Rollei-35 (Franke & Heidecke), 201 Rollei 35 (Franke & Heidecke), 201 Rollei 35E (Franke & Heidecke), 201 Rollei 35E (Franke & Heidecke), 201 Rollei 35E (Franke & Heidecke), 201 Rollei 35S (Franke & Heidecke), 201 Rollei 355 (Franke & Heidecke), 201 Rollei 35T (Franke & Heidecke), 201 Rollei 35T (Franke & Heidecke), 201 Rollei 35TE (Franke & Heidecke), 201 Rollei A26 (Franke & Heidecke), 201 Rollei A110 (Franke & Heidecke), 201 Rollei E110 (Franke & Heidecke), 201 Rolleicord, 473
Rolleicord (Franke & Heidecke), 202
Rolleicord I (Franke & Heidecke), 202
Rolleicord Ia (Franke & Heidecke), 202
Rolleicord II (Franke & Heidecke), 202
Rolleicord III (Franke & Heidecke), 202
Rolleicord IV (Franke & Heidecke), 202
Rolleicord V (Franke & Heidecke), 202
Rolleicord Va (Franke & Heidecke), 202
Rolleicord Vb (Franke & Heidecke), 202
Rolleicord Vb (Franke & Heidecke), 202
Rolleidoscop (Franke & Heidecke), 202
Rolleiflex (Franke & Heidecke), 202 Rolleicord, 473 Rolleidoscop(Franke & Heidecke), 202 Rolleiflex (Franke & Heidecke), 203 Rolleiflex 2.8A (Franke & Heidecke), 203 Rolleiflex 2.8B (Franke & Heidecke), 203 Rolleiflex 2.8C (Franke & Heidecke), 203 Rolleiflex 2.8D (Franke & Heidecke), 203 Rolleiflex 2.8E (Franke & Heidecke), 203 Rolleiflex 2.8E (Franke & Heidecke), 203
Rolleiflex 2.8E2 (Franke & Heidecke), 203
Rolleiflex 2.8E3 (Franke & Heidecke), 203
Rolleiflex 2.8F (Franke & Heidecke), 203
Rolleiflex 2.8F (Arunn (F & H), 203
Rolleiflex 3.5E (Franke & Heidecke), 203
Rolleiflex 3.5E2 (Franke & Heidecke), 203
Rolleiflex 3.5E3 (Franke & Heidecke), 203
Rolleiflex 3.5F (Franke & Heidecke), 203
Rolleiflex 3.5F Police (F & H), 203
Rolleiflex 4x4 (Franke & Heidecke), 204
Rolleiflex E (Franke & Heidecke), 204 Rolleiflex 4x4 (Franke & Heidecke), 204
Rolleiflex E (Franke & Heidecke), 203
Rolleiflex E2 (Franke & Heidecke), 203
Rolleiflex E3 (Franke & Heidecke), 203
Rolleiflex F (Franke & Heidecke), 203
Rolleiflex Grey Baby (F & H), 204
Rolleiflex Post-War Black Baby (Franke & Heidecke), 204
Rolleiflex S1 26 (Franke & Heidecke), 202 Heidecke), 204
Rolleiflex SL26 (Franke & Heidecke), 203
Rolleiflex SL35 (Franke & Heidecke), 203
Rolleiflex SL35E (Franke & Heidecke), 203
Rolleiflex SL35M (F & H), 203
Rolleiflex SL35ME (F & H), 203
Rolleiflex T (Franke & Heidecke), 203
Rolleimagic (I) (Franke & Heidecke), 204
Rolleimagic II (Franke & Heidecke), 204
Rolleimagic II (Franke & Heidecke), 204 Rolleiwide (Franke & Heidecke), 204 Rollette (Krauss), 265 Rollette Luxus (Krauss), 265 Rollex (Scapec), 377 Rollex 20 (United States Camera), 409 Rollfilm camera (Adox), 52 Rollfilm camera (Kern), 253 Rollfilm Camera Salt & Pepper Shakers, Rollfilm-Kamera (Balda), 85 Rollfilm Vesta (Adams), 51 Rollo-Frex, 371 Rollop (Lippische), 292 Rollop Automatic (Lippische), 292 ROLLS CAMERA MFG. CO. Beauta Miniature Candid, 372 Picta Twin 620, 372

Rolls, 372 Rolls Twin 620, 372 Super Rolls 35mm, 372 Super Rolls Seven Seven, 372 Romax Hand (Kuribayashi), 268 Romer, 493 Romper Room Snoopy Counting Camera (Hasbro), 499 **RON LEÉ** Clown Photographer, 493 Rondine (Ferrania), 194 RONDO CAMERA CO. Adams Auto 35, 372 Rondo Colormatic, 372 Rondo Rondomatic, 372 Rorox, 372 Rosen Semi (Proud Co.), 359 Rosko, 372 Rosko Brilliant 620 (Goyo), 217 Roskoflex, 372 ROSS Field Camera, 372 Folding Twin Lens Camera, 372 Kinnear's Patent Wet Plate Landscape Camera, 372 Portable Divided Camera, 372 Reflex, 372 Stereo camera, 372 Sutton Panoramic Camera, 372 Tailboard camera (dry plate), 373
Tropical Reflex, 373
Twin lens reflex (double door style), 373 Wet plate camera (sliding box style), 373 Wet plate camera (tailboard style), 373 Wet plate Stereo (sliding-box style), 373 Wet plate Stereo (tailboard style), 373 ROSS ENSIGN LTD Fulvueflex Synchroflash, 373 Snapper, 373 ROTH Reflex, 373 ROTHLAR-OPTIK Rothlar/Gezi4x4, 373 ROUCH Eureka, 373 Excelsior, 373 Patent Portable Camera, 373 ROUSSEL Stella Jumelle, 373 Rover, 373 Rover (Lancaster), 277 Roving Eye Camera (Tomy), 497 Rower (FAP), 192 Rox (Roche), 368 Roy (Imperial), 247 Roy Box (Haking), 226 Roy Rogers & Trigger (Herbert George), Roy Rogers Jr. (Herbert George), 232 Royal (Adams), 51 Royal (Dacora), 131 Royal (Herbert George), 232 Royal #1 (Royal-Hamilton), 374 Royal, No. 1A (Ansco), 66 ROYAL CAMERA CO. Royal 35, 373 Royal 35M, 374 ROYAL CROWN Boy Holding Camera, 493 ROYAL HOLLAND PEWTER Camera with birdie, 484 Royal Mail Postage Stamp Camera (Butcher), 105 Royal Mail Stereolette (Houghton), 238 Royal Reflex (Monarch), 318 Royal Ruby (Thornton-Pickard),401 ROYAL-HAMILTON Royal#1, 374 Royalcord, 374 Royalty (Billcliff), 93 ROYCEMFG. CO. Royce Reflex, 374

ROYER

Salyut (Kiev), 255

Salyut-S (Kiev), 255 Samoca 35, 35II, 35III, 35IV (Sanei), 376 Samoca 35 M-28 (Sanei), 376 SCHAPERMFG. CO. **ROYER** Tendertoys Camera, 496 Altessa, 374 Royer A, 374 Savoy II, 374 Savoyflex, 374 Savoyflex II, 374 SCHATZ & SONS Samoca 35 Mr-Zo (Sariel), 376 Samoca 35 Super (Sanei), 376 Samoca EM (Sanei), 376 Samoca EE (Sanei), 376 Samoca LE (Sanei), 376 Samocaflex 35, 35 II (Sanei), 376 SAN GIORGIO Sola, 378 SCHAUB Multiplying Camera, 378 Scheecaflex, 378 Savoyflex Automatique, 374 Teleroy, 374 ROYET SCHIANSKY Universal Studio Camera, 378 SCHLEICH Janua, 375 Parva, 375 Reyna Cross III, 374 RUBBER STAMPS, 487 RUBERG & RENNER Super Smurf Photographer, 493 Schmid's Patent Detective (Anthony), 70 SANDERS & CROWHURST SCHMITZ& THIENEMANN Patent-Sport-Reflex,378 Birdland, 375
SANDERSONCAMERA WORKS
Sanderson "Deluxe", 376
Sanderson "Regular", 376
Sanderson "Regular", 376 Adickes, 374 Allbright, 374 Baby Ruby, 374 Dixi, 374 Uniflex Reflex Meteor, 378 Schnapps-O-Flex(Swank), 479 Schul-Prämie Box (Agfa), 56 SCHUNEMAN& EVANS Fibiru, 374 Fibituro, 375 Sanderson Field camera, 375 Sanderson Field, aluminium bound, 376 Lightning, 378 Schüler-Apparat(Student) (Brückner), 102 Schülerkamera, 378 Hollywood, 375 Hollywood Duplo, 375 Little Wonder, 375 Sanderson Tropical Field Camera, 376 Sanderson Tropical Hand and Stand, 376 Sandringham(May), 302 SANDS, HUNTER & CO. SCHWARZBAUER Nenita, 375 Arex, 378 Ruberg, 375 Ruberg Futuro, 375 Field cameras, 376
SANEI SANGYO
Samoca 35, 35II, 35III, 35IV, 376
Samoca 35 M-28, 376
Samoca 35 Super, 376
Samoca 35 V, 376
Samoca EM, 376
Samoca IF, 376 Scopea (Caillon), 106 SCOTT-ATWATERMFG. CO. Rubi-Fex 4x4 (Fex/Indo), 196 Rubina Sixteen Model II (Tokyo Koki), 404 Photopal, 378 Scout (Seneca), 384 Scout (Wittnauer), 429 Scout 120 Flash (Pho-Tak), 350 Rubix 16 (Sugaya), 395 Rubix 16 Model III (Sugaya), 395 Ruby (Thornton-Pickard), 401 Ruby Deluxe Reflex (Thornton-Pickard), Scout-Box (Lumière), 295 Scout cameras (Imperial), 247 Samoca LE, 376 Samocaflex 35, 376 401 SCOVILL Ruby Reflex (Thornton-Pickard),401 Antique Oak Detective, 378 Book Camera, 378 Field cameras, 379 Samocaflex 35 II, 376 Ruby Speed Camera (Thornton-Pickard), SANEIKOKI Starrich 35, 377 SANGER-SHEPHERD Rubyette (Thornton-Pickard), 402 Irving, 379 Knack Detective, 379 Ruthine, 375 Three-color camera, 377 Ruvinal II, III (Shoei), 387 Mascot, 379 Scovill Detective, 379 SANKYO S.C. Kamera (Schalie Collee), 468 S.C.A.T. Sankyo 8-CM, 468 SANKYO SEIKI MFG. CO. St. Louis, 379 Stereo Solograph, 379 Triad Detective, 379 Snap-Me-HappyMusical Camera, 483 SANRIO CO. LTD. Scat, 378 S.E.D.E. View cameras, 379 Hello Kitty Camera, 377 Kelvin Maior, 382 Waterbury Detective Camera, 379
Waterbury Detective, Improved, 379
Waterbury Stereo, 379
Waterbury View, 379
Waterbury View, 379 Santa Claus (American Far East), 62 Santa Claus (Kiddie Camera), 254 SANWA CO. LTD. Kelvin Minor, 382 Vinkel 50, 382 Vinkel Deluxe, 382 Mycro (original model), 377 S.E.M. Wet plate camera, 379 Screen Focus Kodak Cam. (Eastman), 175 SCREWDRIVER,487 Mycro, 377 Mycro IIIA, 377 Babysem (first type), 383 Babysem (new type), 383 Challenger, 383 Suzuki Baby I, 377 Seagull 4 (Light), 290 Seagull No. 203 (Light), 291 Search Team (McDonalds), 499 SAS GmbH Colorado, 383 Sassex, 377 SASPARILLADECO DESIGNS LTD Kim, 383 Orenac III, 383 **SEARS** Camera Salt & Pepper, 487 Semflex Joie de Vivre 45, 383 Delmar, 379 Marvel S-16, 379 Marvel S-20, 379 Marvel-flex, 379 Camera-lamp, 482 Sassex (SAS), 377 Semflex Otomatic, 383 Semflex Standard, 383 Satchel Detective Camera (Anthony), 70 Semflex Studio Standard, 383 Satchel Detective Camera (Al Satellite, 377 Satellite II (Imperial), 247 Saturn (Mamiya), 298 Savoy (Herbert George), 232 Savoy (Imperial), 247 Savoy II (Royer), 374 S.F.O.M. Perfection, 379 Sfomax, 385 S.J.C. & CO. Plate Camera, 379 Seroco folding plate camera, 380 Camelot, 389 Seroco Magazine, 380 S.M.R. Savoy (Imperial), 247
Savoy II (Royer), 374
Savoy Mark II (Herbert George), 232
Savoyflex (Royer), 374
Savoyflex II (Royer), 374
Savoyflex Automatique (Royer), 374
SAWYERS Seroco Stereo, 380 Pentax ME Cigarette Lighter, 475 View Camera Cigarette Lighter, 475 Tower 10A, 380 Tower 16, 380 Tower 18A, 380 S.P.O. Folding camera, 392 S.T.M. & CO. Itakit, 394 Sabre 620 (Shaw-Harrison), 386 Tower 18B, 380 Tower 19, 380 Tower 22, 380 Mark IV, 377 Nomad 127, Nomad 620, 377 Tower 22, 380 Tower 23, 380 Tower 24, 380 Tower 26, 380 Tower 32 A, 380 Tower 32 B, 380 Tower 33, 380 Tower 34, 380 Tower 37, 380 Sabre 620 (Shaw-Harrison), 366
Safari (Indo), 248
Safari Foto Aqua (Fotovision), 489
Safari X (Indo), 248
Saica (Morita), 320
SAINT-ETIENNE Primo Jr. (Mark IV), 377 View-Master Personal Stereo, 377 View-master Stereo Color, 377 SCAPEC Rollex, 377 Scat (S.C.A.T.), 378 Scenex (Earl), 139 Scenographe (Deyrolle), 137 Universelle, 375 Sakura Vest Pocket Camera (Konishiroku), SAKURA SEIKI CO. Tower 39 Automatic 35, 381 ScenographePanoramique(Cadot), 106 SCHAAP& CO. Petal, 375
Salex Reflex (City Sale), 120
Salex Tropical Reflex (City Sale), 120
SALT & PEPPER SHAKERS, 487 Tower 41, 381 Tower 44, 381 Tower 45, 381 Tower 46, 381 Van Albada Stereo, 378 **SCHALIE COLLEE**

S.C. Kamera, 468

SIGNET

Tower 50 (35mm), 381 Tower 50 (rollfilm), 381 Tower 51 (35mm), 381 Tower 51 (rollfilm), 381 Tower 55, 381 Tower 127EF, 381 Folding plate cameras, 384 Folding Scout, 384 Kao, 384 SHICHIYO OPTICAL CO. Pluto Six, 386 SHIMURA KOKI No. 1 Seneca Junior, 384 No. 2 Scout, 384 No. 2A Folding Scout, 384 No. 2A Scout, 384 No. 2C Folding Scout, 384 No. 3 Folding Scout, 385 No. 3 Scout, 384 Mascot, 386 SHIN NIPPON Poppy, 386 SHINANO CAMERA CO. Tower Automatic 127, 381 Tower Bonita Model 14, 381 Pigeon, 386 Tower Camflash 127, II 127, 381 Tower Companion, 381 Pigeon III, 386 SHINCHO SEIKI CO. No. 3 Folding Scout, 365 No. 3 Scout, 384 No. 3A Folding Scout, 385 No. 3A Scout, 384 Tower Flash, Flash 120, 381 Albert, 386 Tower Hide Away, 381 Tower Junior, 381 Darling-16, 386 SHINSEI OPTICAL WORKS Monte 35, 386 Pocket Seneca, 384 Tower No. 5, 380 Tower One-Twenty, Flash, 381 Tower Phanton, 381 Roll Film Seneca No. 1, No. 1A, 384 Scout, 384 SHIRASUNADENKI MFG. CO. Silver Pocket Radio, 487 SHOEI MFG. CO. Ruvinal II, III, 387 Senco No. 1, 385 Seneca Junior, 384 Tower Pixie 127, Pixie II 127, 382 Tower Pixle 127, Pixle II Tower Reflex, 382 Tower Reflex Type, 382 Tower Skipper, 382 Tower Stereo, 382 Tower Type 3, 380 Stereo View, 385 Trio, 385 Uno, 385 Shoulder Bag (Leadworks), 472 SHOWA KOGAKU Gemflex, 387 Vest Pocket, 385 View cameras, 385 Seneca Junior (Seneca), 384 Leotax DII MIOJ, 387 Tower Type 3, 380 Trumpfreflex, 382 Leotax DIII MIOJ, 387 Leotax DIV, 387 Seneca Junior (Serieca), 304 Sensomat (Miranda), 316 Sensomat RE, RE-II (Miranda), 316 Sensoret (Miranda), 316 Seastal, 382 Leotax F, 387 Leotax FV, 387 Leotax G, 387 SECAM Sensoret (Miranda), 316 Sensorex, II (Miranda), 316 Sept (Debrie), 134, 457 Septon Pen Camera (Harukawa), 229 Septon Penletto (Harukawa), 229 Seroco folding plate camera (Sears), 380 Stereophot, 382 Stylophot "Luxe" or "Deluxe" model, 382 Stylophot "Standard" or "Color", 382 Leotax K, 387 Leotax K3, 387 Leotax Model I, 387 Secret Sam Attache Case (Deluxe), 135 Secret Sam's Spy Dictionary (Deluxe), 135 SEDIC LTD, 382 Leotax NR III, 387 Leotax S, 387 Seroco Magazine (Sears), 380 See, 382 Seroco Stereo (Sears), 380 Servo-Baldamat(Balda), 85 Leotax Special, 387 See Straw (Walt Disney), 480 SEEBOLD INVISIBLE CAMERA CORP. Leotax Special, 387 Leotax Special B, 387 Leotax Special DII, 387 Leotax Special DIII, 387 Leotax T, 387 Leotax T2, 387 Sesame Street Big Bird's 3-D Camera Folding Rollfilm Camera, 382 (Child Guidance), 498 Sesame Street Pop-Out Toy Camera SEEMAN (Illco), 495 Seville Super SW 500, 385 SEYMORE PRODUCTS Stereo camera, 382 Seetorette, 383 SEIKI KOGAKU CO. Seiki, 383 Leotax T2L (Elite), 387 Leotax TV, 387 Brenda Starr Cub Reporter, 385 Seiki S-II (Canon), 109 SEIKI-KOGAKUCANONS (Canon), 108 Dick Tracy, 385 SEYMOURSALES Leotax TV2 (Merit), 387 Semi-Leotax, 387 Shur-Flash (Agfa-Ansco), 58 Shur-Flash (Ansco), 67 SEISCHAB Dick Tracy, 385 Flash-Master, 385 Esco, 383 SEKONIC TRADING CO. Sekonic Dual Run Simplomat 100, 468 Shur-Flash (Ansco), 67 Shur-Shot (Ansco), 67 Shur-Shot Jr. (Ansco), 67 Shur-Shot Regular (Agfa-Ansco), 58 Shur-Shot (Ingersoll), 248 Sfomax (S.F.O.M.), 385 SGDG, 385 SHACKMAN Sekonic Dualmatic 50 Model 130, 468 Sekonic Dualmatic 50 Model 130, 468 Selecta (Agfa), 56 Selecta-Flex (Agfa), 56 Selecta-M (Agfa), 56 Selectronic S Sensor (Agfa), 56 Self-Worker (Pipon), 354 Semflex Joie de Vivre 45 (S.E.M.), 383 Semflex Standard (S.E.M.), 383 Semflex Standard (S.E.M.), 383 Auto Camera, Mark 3, 385 SHACKMAN(B.) & CO. Glass Camera on Tripod, 484 SHADYTREE CREATIONS Shutter Bug, 493 Shuttle (Houghton), 238 Cowboy Photographer, 493 SIAF Shaja, 385 Shakey's, 385 Shalco, 385 Amiga, 387 Gradosol, 387 Semilex Standard (S.E.M.), 383
Semilex Studio Standard (S.E.M.), 383
Semi-AutomaticAnsco (Ansco), 66
Semi First (Kuribayashi), 268
Semi Heil (Riken), 366
Semi Kinka (Yamamoto), 432
Semi Kreis, 383 Gradosol Lujo, 387 Shamrock Folding (Conley), 123 SHANGHAI CAMERA FACTORY Shanghai 58-I, 58-II, 386 Sibyl Cameras (Newman & Guardia), 326 Sibyl Deluxe (Newman & Guardia), 326 Sibyl Excelsior (Newman & Guardia), 326 Shanshui B. 386 Sibyl Stereo (Newman & Guardia), 326 Sibyl Vitesse (Newman & Guardia), 326 Sica (Welta), 424 Sico (Simons), 388 SIDA GmbH Sharpshooter(Zenith), 450 SHAW Semi Kreis, 383
Semi-Leotax (Showa), 387
Semi-Minoltal, II, III (Minolta), 307
Semi-Minolta P (Minolta), 307
Semi-Olympic (Olympic Camera), 337
Semi-Olympus Model I, II (Olympus), 338
Semi-Pearl (Konishiroku), 261
Semi Primo (Daiichi), 131
Semi Prince, II (Fujimoto), 206
SEMMENDINGER Oxford Minicam, 386 SHAW-HARRISON Sabre 620, 386 Sida, 387 Sida Extra, 387 Valiant 620, 386 Shayo, 386 SHELCORE Sida Standard, 388 Sidax, 388 Turf, 388 Change-A-Toy,478 Sidax (Sida), 388 SIEMENS & HALSKE Siemens 8R, 468 Clicker Bear, 496 SEMMENDINGER Excelsior, 384 SHEW Aluminum Xit, 386 Day-Xit, 386 Senco No. 1 (Seneca), 385 SENECA Siemens B, 468 Siemens C, C II, 468 Siemens F, 468 Eclipse, 386 Black Beauty, 384 Focal Plane Eclipse, 386 Guinea Xit, 386 Busy Bee, 384 Camera Chief View, 384 Chautauqua, 384 Siemens F, 468
Sierra 35 (Oshiro), 346
Signal Corps Combat (Simmon), 388
Signal Corps KE-7(1) (Eastman), 176
Signet 30 (Eastman), 175
Signet 35 (Eastman), 175
Signet 40 (Eastman), 175
Signet 50 (Eastman), 176
Signet 80 (Eastman), 176 Stereo Field Camera, 386 Tailboard camera, 386 Chief 1A, 384 Xit, 386 Competitor View, 384 Xit Stereoscopic, 386 Competitor View, Stereo, 384 SHIBA Duo, 384 Aqua Camera Flash Shiba, 489 Filmett, 384 Instamatic style water camera, 489

SIGRISTE

Soho Reflex (Marion), 300 Soho Stereo Reflex (Marion), 300 SIGRISTE Six-20 Brownie (Eastman), 147 Sigriste, 388 Sigriste Stereo, 388 Six-20 Brownie B (Eastman), 147 Six-20 Brownie Junior (Eastman), 147 Six-20 Brownie Special (Eastman), 147 Soho Stereo Tropical Reflex (Marion), 300 Soho Tropical Reflex (Marion), 300 Sil-Bear, 388 Sil-Bear, 388
Silar (Meyer), 305
Silette (Agfa), 56
Silette (I), II (Agfa), 56
Silette Automatic (Agfa), 56
Silette F (Agfa), 56
Silette L, LK (Agfa), 56
Silette Rapid models (Agfa), 56
Silette SL, SLE (Agfa), 56 Sokol Automat, 390 Sola (Schatz), 378 SOLAR MATES In-B-Teens, 390 Six-20 Bull's-Eye Brownie (Eastman), 148 Six-20 Flash Brownie (Eastman), 148 Six-20 Folding Brownie (Eastman), 148 Six-20 Folding Hawk-Eye (Eastman), 157 Six-20 Kodak A (Eastman), 176 Six-20 Kodak B (Eastman), 176 Six-20 Kodak Junior (Eastman), 176 Six-20 Kodak Senior (Eastman), 175 Siluro (Nemrod), 324 Silva, 388 Six-20 Portrait Brownie (Eastman), 148 Six-twenty (Imperial), 247 Silver (Miyagawa), 317 Silver King (Camera Man), 107 Silver Lens Camera Bag, 472 Silver Pocket Radio (Shirasuna), 487 Six-twenty Reflex (Imperial), 247 SOLIDEX SKAIFE Pistolgraph, 389 Skolnick (WKOAbHNK), 389 Sky 35 Model II (Ars Optical), 74 Sky Scraper (Folmer & Schwing), 198 SOLIGOR Soligor 35, 390 Soligor 45, 390 Soligor 66, 390 Simco Box, 388 SIMDA Sky Scraper (Folmer & Schwing), 198 Skyflex, 389 Skylark (Mansfield Holiday), 299 Skylark V (Mansfield Holiday), 299 Skymaster (Yamato), 433 SKYVIEW CAMERACO. Skyview Aerial Camera Model D, 389 Skyview Aerial Camera Model K, 389 SL-706 (10.3700) (Zeiss Ikon), 447 Sliding-box camera (Ottewill), 346 Sliding-box Daguerreotype (Kranz), 262 Sliding-box wet plate (Piggott), 352 Panorascope, 388 Simflex 35 (Yamato), 433 Simili Jumelle (Zion), 452 SIMMON BROTHERS Omega 120, 388 Signal Corps Combat Camera, 388 SIMONS Sico, 388 Simplex (Ernemann), 189 Simplex (Multi-Speed), 321
Simplex (Zeiss Ikon), 446
Simplex Ernoflex (Ernemann), 189
Simplex Magazine (Krügener), 266
Simplex Pockette (International Projector), Sliding-boxwet plate (Piggott), 352 Slip-on (Simpro), 388 Slomexa (Vredeborch), 421 SMEDLEY& CO. Up-to-Date, 389 462 Smena models (GOMZ), 217 Smena Symbol (GOMZ), 217 Simplex Snapper (Lava-Simplex), 278 Simplex-Ernoflex(Zeiss Ikon), 447 SIMPROCORP. of AMERICA Smile Bear (Eastman), 494 Smile Camera Clip, 481 SOUTHERN Simpro-X, 388 SIMPRO INTERNATIONAL **SMITH** Slip-on, 388 SIMS DISTILLERY Detective camera, 389 Multiplying Camera, 389 Smurf Musical Toy Camera (Illco), 483 Snake Camera, 482 Apollo Man on Moon, 479 Sincere, 388 Snap 16, 389 SINCLAIR Snap No. 2 (Conley), 123 Snap-Me-HappyMusical Camera Toy N&S Reflex, 388 Traveller Roll-Film Camera, 388 Traveller Una, 389 (Sankyo), 483 Tropical Una, 389 Tropical Una Deluxe, 389 Snap-Shot Secret Gun CH-337 (Mark), 478 Snappa (Rochester Optical), 370 Snappa (Thornton-Pickard), 402 Una, 389 Una Deluxe, 389
SINEMAT MOTION PICTURE CO. Snapper (Ross Ensign), 373 Snapper (Koss Ensign), 3/3 Snappy, 389 Snappy (Konishiroku), 261 Snappy '84 (Canon), 114 Snappy Camera Set (Konishiroku), 261 Snapshooter (Plastics Development), 355 Snapshooter Bicentennial 1976 (Plastics Cinex, 391 Spartacord, 391 Sinemat Duplex 17-1/2mm Motion Picture Camera, 468 Sing 88, 388, 838, 389 Single lens stereo camera (Baird), 82 Single lens stereo camera (Derogy), 136 Single-lens Stereo (Moorse), 320 Sinnox (Jougla), 250 Sinox (Lumiere), 295 Development), 355 Snapshot (La Crosse), 275 Snapshot Camera (Dallmeyer), 132 Snapshot Puzzle, 486 Snider 35 (Nicca), 327 SNK CAMERA WORKS Folding rollfilm camera, 389 Siraton, 389 SIRCHIE Finger Print Camera, 389 Sirene (Ica), 243 Sirene (Zeiss Ikon), 447 Sun B, 390 SIRIO Elettra I, 389 Elettra II, 389 Snoopy Astronaut (Knickerbocker), 480 Snoopy-Matic(Helm), 231 SOAP, 487 Sisley Model 1 (Takane), 398 Sisley 2A (Takane), 398 Sisley 3A (Takane), 399 Sister (Crystar), 130 SITACONCO. (Lancaster), 277 Soccer Ball Camera (Gakken), 207 Society (Collins), 121 SOCIETY OF CINEMA PLATES Olikos, 468 SOHO Sitacon ST-3, 389 Press camera, 390 Soho Altrex, 390 Siva, 389 Six-Three Kodak Cameras (Eastman), 176 Six-16 Brownie Camera (Eastman), 147 Six-16 Brownie Junior (Eastman), 147 Six-16 Brownie Special (Eastman), 147 Soho Cadet, 390 Soho Model B, 390 Soho Myna Model SK12, 390 Soho Pilot, 390 Six-16 Folding Hawk-Eye (Eastman), 157 Six-16 Kodak Senior (Eastman), 175 Six-20 Boy Scout Brownie (Eastman), 143 Soho Precision, 390 Soho Vest Pocket, 390

Sunpet 826, 390 Sulpet 826, 390 Solid Record (Franka-Werk), 201 Solida (Franka-Werk), 201 Solida (Welta), 424 Solida I, II, III, IIIL (Franka-Werk), 201 Solida Jr. (Franka-Werk), 201 Minera Air Freshener, 472 Soligor Reflex, Reflex II, Semi-Auto, 390 Soligor 45 (Nihon Seiki), 328 Solina (Agfa), 56 Solinette, Solinette II (Agfa), 56 Solograph (Anthony), 70 SOMMER Sommer Modell R.I, 391 Sonmer Modell R.I., 391 Sonnar (Contessa), 125 Sonne IV (Gatto), 208 Sonnet (Contessa), 125 Sonnet (Nettel), 325 Sonnet (Tropical model) (Nettel), 325 Sonnet (Zeiss Ikon), 447 Sonnet Tropical (Contessa), 125 Sonocon 16mm MB-ZA (Minolta), 313 **SONORA INDUSTRIAL** Love, 391 Sound Kodascope Special (Eastman), 460 Mykro-Fine, 391 Souvenir Camera (Vive), 414 SÖNNECKEN& CO. Field Camera, 390 Field Camera, 390
Folding camera, 390
Sparta-FoldV (Herold), 232
Spartacord (Herold), 232
Spartacord (Spartus), 391
Spartaflex (Spartus), 391
Spartus 35 (Herold), 233
Spartus 35F, 35F Model 400 (Herold), 233
Spartus 120 Flash Camera (Herold), 233 Spartus 120 Flash Camera (Herold), 233 Spartus Co-Flash (Herold), 233 SPARTUS CORP. Spartaflex, 391 Spartus 35, 35F, 391 Spartus box cameras, 391 Spartus folding cameras, 391 Spartus Full-Vue, 391 Spartus Junior Model, 391 Spartus Press Flash, 391 Spartus Super R-I, 391 Spartus Vanguard, 391 Spartus Miniature (Utility), 413 Spartus Miniature (Wholesale Photo), 426 SPEARHEADINDUSTRIES Camera Mask, 482 Special Brass Bound Instantograph Special Camera, 392 Special Fix (Genos), 210 Special Folding Weno Hawk-Eye (Blair), 96 Special King (Yen camera), 435 Special Kodak Cameras (Eastman), 176 Special Press Reflex (Dallmeyer), 132 Special Ruby (Thornton-Pickard), 402 Special Ruby Reflex (Thornton-Pickard), Special Stereoscope Rollfilm Sibyl (Newman & Guardia), 326 Spectator Flash, (Pho-Tak), 350

Spectra Super II, 392 Speed Camera (Dallmeyer), 132 Speed Graphics (Graflex), 222 Speed Kodak Camera (Eastman), 177 SPEED-O-MATICCORP. Speed-O-Matic, 392
Speedex, 392
Speedex (Ansco), 67
Speedex (O (Agfa), 56
Speedex No. 1 (Agfa), 56
Speedex No. 2 (Agfa), 57
Speedex No. 2 (Agfa), 56
Speedex No. 2 (Ansco), 67
Speedex No. (Agfa-Ansco), 58
Speedex Jr. (Agfa-Ansco), 58
Speedex No. (Ansco), 67
Speedex Special (Ansco), 67 Speed-O-Matic, 392 Speedex Special (Ansco), 67 Speedex Special R (Ansco), 67 Speedy Detective Camera (Benetfink), 90 SPEICH Stereo Speich, 392 Spektareta (Optikotechna), 345 SPENCERCO. Flex-Master, 392 Full-Vue, 392 Majestic, 392 SPICER BROS Studio camera, 392 Spider-Man(Vanity Fair), 413 Spido (Gaumont), 209 Spiegamentorapido (Lamperti), 276 SPIEGEL Elf, 392 Spiegel-Reflex(Kossatz), 261 Spinney (Oshiro), 346 SPIROTECHNIQUE Calypso, 392 SPITZER Espi, 392 Princess, 392 Splash Flash Deluxe (Luen Tat), 489 Splash Flash Deluxe (Luen Tat Splendidflex, 392 Splendor 120 (E.F.I.C.A.), 180 Sport (Adox), 52 Sport (Closter), 121 Sport (Cnopm) (GOMZ), 217 Sport (Wünsche), 431 Sport (Zeh), 436 Sport-2, 486 Sport-2, 868 Sport-2, 468
Sport-Box (Kamera & Apparatebau), 252
Sport-Fex (Fex/Indo), 196
Sporti 4 (Ilford), 247
Sports Illustrated, 392
Sports Rolleiflex (Franke & Heidecke), 204
Sportshot Senior Twenty (ACMA), 50
Sportsman (Ilford), 247
Sportsmaster (Ilford), 247
Sportsmaster (Ilford), 247
Spring (Goldstein), 215
Springhox (Balda), 85 Spring (Goldstein), 215
Springbox (Balda), 85
Springbox (Balda), 85
Springfield Union Camera (Eastern), 139
Sprint (Closter), 121
Sprite (Ilford), 247
Sprite (Murer), 322
Sprite 35 (Ilford), 247
Sputnik, 392
Sputnik (CNYTHNK) (GOMZ), 217
Spy Camera, 392
Spy-14 (Maruso), 301
Squirrel Holding Camera, 493
Squirt Camera (Arliss), 488
Squirt Camera (Fotomat), 488
Squirt Camera (L.S.), 489
Squirt Camera (Voho), 489 Squirt Camera (L.S.), 489
Squirt Camera (Voho), 489
Squirt Camera "Diana Style" (T.K.), 489
Squirt Camera X-315 (Jak Pak), 488
SQUIRT CAMERAS, 488
Squirt Pix (Premier), 489
Squirting Camera (Amscan), 488
ST 605 (Fuji Photo), 205
ST 701 (Fuji Photo), 205
ST 705, ST 705W (Fuji Photo), 205

ST 801, ST 901 (Fuji Photo), 205 St. Louis (Scovill), 379 St. Louis Steamers (Franka Photo.), 201 Stafetta-duo (Vredeborch), 421 Stahl Box (Bilora), 94 Stand camera (Reygonaud), 362 Standard (Agfa), 57 Standard (ISO), 249 Standard, deluxe (Agfa), 57 Standard 120 Box (Hanimex), 228 Standard Box (Bilora), 94 Standard Camera (Hong Kong), 392 STANDARD CAMERAS Conway Camera, 393 Robin Hood Camera, 393 Robin Hood Camera, 393
Standard Camera No. 2, 393
Standard Präzisionskamera (Linhof), 291
STANDARDPROJECTOR&
EQUIPMENTCO.
Gatling f1.7, 393
Standard Speedex (Ansco), 67
Star Camera (Watson Supply), 422
Star-Lite, 393
StarJ its Super Poffey (Haking), 206 Star-Lite Super Reflex (Haking), 226 Star Premo (Eastman), 166 Starflex, 393 Starlite (Yamato), 433 Starlux PhotographerFigurine, 493 Starmetal Goldy (Goldstein), 215 Starrich 35 (Saneikoki), 377 Starrich 35 (Saneikoki), 377 Start (Adox), 52 Start (Cmapm) (Krasnogorsk), 263 Start (Pouva), 358 Start (WZFO), 431 Start 35 models (Ikko Sha), 246 Start-B (WZFO), 431 Starter (Lumiere), 295 STATUETTES& FIGURINES, 490 STEGEMANN STEGEMANN Field camera, 393 Hand-Camera, 393 Stereo Hand-Camera,393 STEINECKKAMERAWERK Steineck ABC Wristwatch camera, 393 STEINER OPTIK Hunter 35, 393 Steinette, 393 Steinette (Steiner), 393 STEINHEIL Casca I, II, 393 Detective camera, 393 Folding plate camera, 394 Kleinfilm Kamera, 394 Multo Nettel, 394 Stereo Detective, 394
Stereo Detective, 394
Tropical camera, 394
Steky (Riken), 366
Steky "Made in Tokyo" (Riken), 366
Steky II, III, IIIa, IIIb (Riken), 366
Stella (Svensson), 397 Stella Jumelle (Roussel), 373 Stellar, 394 Stellar Flash Camera, 394 Stellarflex, 394 Stellarflex, 394
Steno-Jumelle(Joux), 250
Steno-JumelleStereo (Joux), 250
Stere-All (Universal), 410
Stereax (Contessa), 125
Stereax (Nettel), 325
Stereax (Zeiss Ikon), 447
Stereflektoskop (Voigtländer), 417
Sterelux (Lumiere), 295
Stereo (Murer), 322
Stereo 33 (Revere), 362
Stereo 35 (Meopta), 303
Stereo Auto Graflex (Graflex), 220 Stereo Auto Graflex (Graflex), 220 Stereo Beecam (Busch), 104 Stereo Bob (Ernemann), 189 Stereo box camera (Conley), 123 Stereo Box (Murer), 322 Stereo Brownie Camera (Eastman), 149 Stereo camera (Atkinson), 81 Stereo Camera (Brownell), 102

STEREO WENO

Stereo camera (Burr), 103 Stereo Camera (Chadwick), 118 Stereo Camera (Dancer), 132 Stereo Camera (Dancer), 132 Stereo camera (Druopta), 138 Stereo camera (Gallus), 207 Stereo camera (Gallus), 209 Stereo camera (Gibson), 211 Stereo camera (Grundmann), 224 Stereo camera (Hagee), 246 Stereo camera (Mazo), 302 Stereo camera (Meagher), 302 Stereo Camera (Negretti), 324 Stereo Camera (Negretti), 324 Stereo camera (Photo Hall), 351 Stereo camera (Ross), 372 Stereo camera (Seeman), 382 Stereo Colorist I, II (Bell & Howell), 89 STEREO CORPORATION Contura, 394 Stereo Deckrullo Nettel Tropical (Nettel), Stereo Detective (Hüttig), 240 Stereo Detective (Steinheil), 394 Stereo Detective (Suter), 396 Stereo Detective (Suter), 396
Stereo Detective Magazine (Suter), 397
Stereo Ernoflex (Ernemann), 189
Stereo-Ernoflex (621/1) (Zeiss Ikon), 447
Stereo Field Camera (Shew), 386
Stereo-Fokal Primar (Bentzin), 91
Stereo Graflex (Graflex), 220
Stereo Graphic (35mm) (Graflex), 222
Stereo Graphic (Wray), 430
Stereo Hand-Camera (Stegemann), 393
Stereo Hawk-Eye (Blair), 96
Stereo Hawk-Eye Camera (Eastman), 158
Stereo Hit (Tougodo), 405
Stereo Ideal (Ica), 243
Stereo Ideal (Zeiss Ikon), 447
Stereo Instantograph (Lancaster), 277
Stereo Jumelle (Bellieni), 89
Stereo Jumelle (Mackenstein), 296 Stereo Jumelle (Mackenstein), 296 Stereo Kern SS (Kern), 253 Stereo Kodak Cameras (Eastman), 177 Stereo Kodak Cameras (Eastman), 177
Stereo Magazine Camera (Barthelemy), 85
Stereo Magazine camera (Conley), 123
Stereo Makina (Plaubel), 356
Stereo-Marine-Lollier(Lollier), 293
Stereo Mikroma (I), II (Meopta), 303
Stereo Minimum Palmos (693) (Ica), 243
Stereo Model 46 (Century), 115
Stereo Model 46 (Century), 115
Stereo Nettel (Zeiss Ikon), 447
Stereo Nettel, Tropical (Zeiss Ikon), 447
Stereo Palmos (Carl Zeiss Jena), 436
Stereo Panorama (Linhof), 291
Stereo Panoramique (Leroy), 289
Stereo Pocket (Tiranty), 402
Stereo-Pocket-Focal (Hanau), 227
Stereo Poco (Rochester Camera Mfg), 368 Stereo-Pocket-Focal(Hanau), 227
Stereo Poco (Rochester Camera Mfg), 368
Stereo Puck (Thornton-Pickard), 402
Stereo Realist (White), 426
Stereo Realist Custom (White), 426
Stereo Realist Macro (White), 426
Stereo Reflex (Busch), 104
Stereo Reflex (Ernemann), 189
Stereo Reflex (Murer), 322
Stereo Reflex Primar (Bentzin), 91
Stereo Reicka (Ica), 243
Stereo Rocca (Rokuwa), 371 Stereo Rocca (Rokuwa), 371 Stereo rollfilm box camera (Sumner), 396 Stereo Simplex (Ernemann), 189 Stereo Simplex Ernoflex (Ernemann), 189 Stereo Simplex Ernoflex (Ernemann), 189
Stereo-Simplex-Ernoflex(Zeiss Ikon), 447
Stereo Solograph (Anthony), 70
Stereo Solograph (Scovill), 379
Stereo Speich (Speich), 392
Stereo Spido (Gaumont), 209
Stereo Tenax (Goerz), 214
Stereo Toska (680) (Ica), 243
Stereo Tourist (McBean), 302
Stereo View (Songean), 305 Stereo View (Seneca), 385 Stereo Vivid (Bell & Howell), 89 Stereo Weno (Blair), 96 Stereo Weno Hawk-Eye (Blair), 96

STEREO WET PLATE

Stereo Wet Plate camera (Dallmeyer), 132 Stereo Wet plate camera (Hare), 229 Stereo wet plate camera (Koch), 257 Stereo Wet plate cameras (Stock), 395 STEREOCRAFTERS Videon, 394 Videon II, 394 Videon II, 394
Stereofix (Ica), 243
Stereograph (Underwood), 408
Stereolette (Butcher), 105
Stereolette (Hüttig), 240
Stereolette 610, 611 (Ica), 243
Stereolette Cupido (620) (Ica), 243
Stereolette-Cupido (611) (Zeiss Ikon), 447
Stereophot (Secan), 382 Stereophot (Secam), 382 Stereophotoskop(Voigtländer), 418 Stereoplast (Krauss), 265 Stereoscop-Camera (Ernemann), 189 Stereoscopic Binocular (Watson), 422 Stereoscopic Camera (Pyne), 359 STEREOSCOPICCO., 293 Stereoscopic Field (Chapman), 118 Stereoscopic Graphic (Graflex), 222 Stereoscopic Montauk (Gennert), 210 Stereoscopic Pattern (Newman & Guardia), 326 Stereoscopic Professional (Conley), 123 Stereoscopic Reflex (Frennet), 204 Stereoscopic Reliex (Fremiet Sterling, 394 STERLINGCAMERA CORP. 2-A Sterling, 394 Buddie 2A, 394 Sterling II (Eastman), 177 Sterling Miniature, 394
Sterling Silver View Camera, 484
Steroco (Contessa), 125 Steroco (Zeiss Ikon), 447 STEVENMFG CO. Talking Vue Camera, 499 Stewart Radio-Light-Mirror, 487 STEWART-WARNER Buddy 8 Model 532-A, 468 Companion8 (Model 532B), 468 Deluxe Hollywood Model, 468 Hollywood (Model 531-B), 468 Concealed Vest Camera, No. 1, 394 Concealed Vest Camera, No. 2, 394 Detective Magazine camera, 394 STOCK Stereo Wet plate cameras, 395 Stolen cameras, 49 Stop (Box Camera Stop), 395 STOCKIG Union camera, 395 Union Zwei-Verschluss, 395 **STRACO** Rigi-box, 395 STRAHM& CO., 395 Street camera (Benson), 90 Street camera (Keystone), 254 STUDENT CAMERA CO. Student No. 1, 395 Student No. 2, 395 Studio camera (Ansco), 67 Studio Camera (Billcliff), 93 Studio camera (Century), 115 Studio camera (Dallmeyer), 132 Studio Camera (Fallowfield), 192 Studio camera (Franke & Heidecke), 203 Studio camera (Gilles-Faller), 211 Studio camera (Herbst), 232 Studio camera (Herbst), 232 Studio camera (Houghton), 238 Studio camera (Marynen), 301 Studio camera (Penrose), 348 Studio camera (Perken), 350 Studio camera (Pinnock), 354 Studio camera (Spicer), 392 Studio camera, multiplying back (Anderson (J.A.)), 62 Studio View (McGhie), 302 Stylex (Herbert George), 232 Stylophot "Luxe" or "Deluxe" (Secam), 382

Stylophot "Standard" or "Color" (Secam), Subita (Dacora), 131 Suevia (Contessa), 125 Suevia (Zeiss Ikon), 447 SUGAYA KOKI Hope (Sugaya Model II), 395 Myracle, Model II, 395 Rubix 16, 395 Rubix 16 Model III, 395 SUMIDA OPTICAL WORKS Proud Model 50, 395 Proud Chrome Six III, 395 Summa Report (Tiranti), 402 Summum (Leullier), 289 Summum Sterechrome (Leullier), 289 SUMNER Stereo rollfilm box camera, 396 Sun, 396 SUN ARROW KadocK-II Personal Gaslighter, 475 Sun B (SNK Camera), 390 SUNART PHOTO CO. Sunart folding view, 396 Sunart Junior, 396 Sunbeam 120 (Galter), 208 Sunbeam 120 (Herold), 233 Sunbeam 127 (Herold), 233 SUNBEAM CAMERACO. Sunbeam Minicam, 396 Sunbeam Six Twenty, 396 Sunbeam Six-Twenty (Herold), 233 Sundial Camera (Ansco), 67 Sunny, 396 Sunny-Bunch(Vanity Fair), 413 Sunny MC-8, 485 Sunpet, 396 Sunpet 826 (Solar Mates), 390 Sunpet 826 Bazooka, 396 Sunscope (Haking), 226 Sunshine (OMI), 344 Supedex VP 35 S, 396 Super 35 (Certo), 117 Super Altissa (Eho-Altissa), 182 Super Baldamatic, I (Balda), 85 Super Baldax (Balda), 85 Super Baldina (Balda), 85 Super Baldinette (Balda), 85 Super Bessa (Voigtländer), 416 Super-Boy (Fex/Indo), 196 Super Camera, 396 Super-capta(J.M.V.), 250 Super Colorette (Braun), 101 Super Dan 35 (Dan), 132 Super Deluxe (Mamiya), 298 Super Dignette (Dacora), 131 Super Dollina, II (Certo), 117 Super Eljy (Lumière), 294 Super Graphic (Graflex), 222 Super Ikonta A (Zeiss Ikon), 447 Super Ikonta B (Zeiss Ikon), 447 Super Ikonta BX (Zeiss Ikon), 448 Super Ikonta C (Zeiss Ikon), 448 Super Ikonta D (Zeiss Ikon), 448 Super Ikonta III (Zeiss Ikon), 448 Super Ikonta IV (Zeiss Ikon), 448 Super Isolette (Agfa), 55 Super Kinax (Kinn), 257 Super Kodak Six-20 (Eastman), 177 Super Lark Zen-99 (Kowa), 262 Super Lark Zen-99 (Kowa), 262 Super Lynx, I, II (Pontiac), 358 Super Memar, LVS (Ansco), 65 Super Nebro (Nebro), 324 Super Nettel (536/24) (Zeiss Ikon), 448 Super Nettel II (537/24) (Zeiss Ikon), 449 Super-Olympic (Olympic Camera), 337 Super Olympic Model D (Asahi Optical), 81 Super Paxette models (Braun), 101 Super Perforeta (Birnbaum), 94 Super Pontura (Balda), 85 Super Regent (Ansco), 66 Super Regent LVS (Ansco), 66 Super Ricohflex (Riken), 367

Super Rolls 35mm (Rolls), 372 Super Rolls Seven Seven (Rolls), 372 Super Rolls Seven Seven (Rolls), 372 Super Silette (Agfa), 56 Super Smurf Photographer(Schleich), 493 Super Solina (Agfa), 56 Super Solinette (Agfa), 56 Super Speed Graphic (Graflex), 222 Super Speedex (Ansco), 67 Super Star (Vanity Fair), 413 Super-Tri-Reflex(Irwin), 248 Super Vier (Braun), 101 Super Welmy (Taisei Koki), 397 Super Westomat 35 (Taisei Koki), 397 Super Wide Angle (Hasselblad), 230 Superb (Voigtländer), 418 Superfekta (Welta), 424 Superfex (Fex/Indo), 196 Superflex Baby (Kiko-Do), 256 Superior (Agfa), 57 Superior (Fex/Indo), 196 Superior Flash Camera 120, 396 Supersport Dolly (Certo), 117 Supersport Dolly (Certo), 11/ Supra No. 2 (Kenngott), 253 Supra Photolite (Nikoh), 328 Supre-Macy (Hachiyo), 225 Supre-Macy (Macy), 296 Suprema (E.F.I.C.A.), 180 Supreme (Keystone), 463 Sure-Flex (Ace Camera Equips.), 50 SURUGA SEIKI CO. Mihama Six IIIA, 396 Detective magazine camera, 396 Folding plate camera, 396 Stereo Detective, 396 Stereo Detective, Magazine, 397 Stereo Detective, Magazine, 337 Stereo Muro, 397 Sutton Panoramic Camera (Ross), 372 Suzuki Baby I (Sanwa), 377 SUZUKI OPTICAL CO. Camera-Lite, 397 Camera-Lite Seastar, 397 Echo 8, 397 Press Van, 397 SÜDDEUTSCHESCAMERAWERK Cewes-Film-Klapp-Camera,395 Nettel-Klapp-Camera,395 Svenska Express (Hasselblad), 229 Svenska Magazine (Aktiebolaget), 60 SVENSSON Hasselblad Svea, 397 Stella, 397 Swallow, 397 **SWANK** Camera Flask, 479 Schnapps-O-Flex,479 Sweet-16 Model-A (Tougodo), 405 Swiftshot "Made in Australia" (Foster), 198 Swiftshot Model A (Foster), 198 SWINDEN and EARP Magazine camera, 397 Swinger Model 20 (Polaroid), 357 Swinger Sentinel M15 (Polaroid), 357 Swiss-Box, 397 Swiss-like Photographer, 493 Switchplate cover (photographer) (Flash-It), 481 Switchplate cover (tourist) (Flash-It), 482 SX-70 (Deluxe Model) (Polaroid), 357 Symbol (Welta), 424 Symbolica (10.6035) (Zeiss Ikon), 449 Synchro-Box(Agfa), 57 Synchro-Box(Made in India) (Agfa), 57 Synchrona (Tahbes), 397 T & W Detective Camera (Tisdell), 403 T.H.Water Camera No. 402, 489 T.K. Squirt Camera "Diana Style", 489

Water Camera No. 677, 489

T.S.C

Tacker, 407

Tac Deluxe (Yamato), 433 TACHIBANATRADING CO. Tanack IIIS, 399 Tanack IIISa, 399 Thorens Excelda, 485 THORNTON-PICKARDMFG. CO. Beby Pilot, 397 Tanack IV-S, 399 Tanack SD, 399 Tanack V3, 399 Tanack VP, 399 Tacker (T.S.C.), 407 TAHBES Aerial Camera, Type C, 400 Amber, 400 Automan, 400 Populair, 397 Automan, 400
College, 400
Duplex Ruby Reflex, 400
Duplex Ruby Reflex "Overseas"
(Tropical), 400
Focal Plane Imperial Two-Shutter Synchrona, 397 Tanit (Ferrania), 194 TARGET Camera Shooter Nikosound 112XL, 478 New Folding Stereo, 399 Tailboard camera (Atkinson), 81
Tailboard camera (Chadwick), 118
Tailboard camera (Cussons), 130
Tailboard camera (Fallowfield), 192
Tailboard camera (Hare), 229
Tailboard camera (Labarre), 278 Target Brownie Six-16 (Eastman), 149 Target Brownie Six-20 (Eastman), 149 Camera, 400 Target Hawk-Eye Cam. (Eastman), 158 Folding plate camera, 401 Folding Ruby, 401 Horizontal Reflex, 401 Taro Tenax (Goerz), 214 Taroflex (Nippon Kosokki), 335 TARON CO. Cavalier EE Auto 35, 399 Imperial Perfecta, 401 Imperial Pocket, 401 Imperial Stereo, 401 Tailboard camera (Leech), 278 Tailboard camera (Meagher), 302 Chic, 400 Tailboard camera (Newton), 327 Tailboard camera (Park), 347 Tailboard camera (Perken), 350 Fodor 35, 400 Taron 35, 400 Imperial Triple Extension, 401 Junior Special Ruby Reflex, 401 Tailboard camera (Ross), 373
Tailboard camera (Shew), 386
Tailboard camera (Taylor), 400
Tailboard camera (Wittman), 429 Taron Super LM, 400 Taschen Clack 128 (Rietzschel), 364
Taschenbuch-Camera(Krügener), 266
Taschenbuch Replica (Krügener), 266 Limit, 401 Mark III Hythe Camera, 401 Nimrod Automan, 400 Oxford Automan, 400 Puck Special, 401 Tailboard camera (Wratten), 430 Bino/Cam 7800, 400 Bino/Cam 8000, 400 Royal Ruby, 401 Tailboard stereo (London Stereoscopic), Ruby, 401 Ruby Deluxe Reflex, 401 294 Tauber, 400 Taxo (Contessa), 125 Tailboard view camera (Dancer), 132 Tailboard view camera (Trambouze), 407 Ruby Reflex, 401 Taxo (Zeiss Ikon), 449 Taxona (Pentacon), 349 TAISEI KOKI
Super Welmy, 397
Super Westomat 35, 397
Welmy 35, 397
Welmy M-3, 398
Welmy Six, Welmy Six E, 397 Ruby Speed Camera, 402 Rubyette No. 1, No. 2, No. 3, 402 TAYLOR Snappa, 402 Special Ruby, 402 Special Ruby Reflex, 402 Tailboard camera, 400 View camera, 400 TECHNICOLORCORP. Stereo Puck, 402 Tribune, 402 Techni-Pak 1, 400 Welmy Wide, 398 Westomat, 398 TAIYODO KOKI Technicolor Automatic 8, 468 Victory Reflex, 402 Technika I, III (Linhof), 291 Weenie, 402 Technika Press 23 (Linhof), 291 Beauty, 398 Beauty 35 Super, 398 Beauty 35 Super II, 398 Thornward Dandy (Montgomery Ward), Teddy (Ica), 243 319 Teddy Bear Music Box, 483 THORPE Teddy Bear Photographers(Lucy Rigg), Four-tube camera, 402 THOWE CAMERAWERK Beauty Canter, 398 Beauty Super L, 398 Beautycord, 398 492 TEDDY CAMERA CO. Field camera, 402 Folding plate camera, 402 Beautycord S, 398 Beautyflex, 398 Beautyflex III, 398 Beautyflex S, 398 Teddy Model A, 400 Teemee, 400 Thowette, 402 Teenage Mutant Ninja Turtles (Remco), Tropical Plate Camera, 402 Thowette (Thowe), 402 Three Cs (Oshiro), 346 Teenage Mutant Ninja Turtles Talking Epochs, 398 Meteor, 398 Reflex Beauty, 398 Three Cs (Oshiro), 346
Three-color (Sanger-Shepherd),377
Three-ColourCamera (Hilger), 233
Ticka (Houghton), 238
Ticka Enlarger (Houghton), 239
Ticka, Focal plane model (Houghton), 238
Ticka Replica (Houghton), 238
Ticka, solid silver (Houghton), 238
Ticka, Watch-Face model (Houghton), 239
Tiezonette 402 Camera (Remco), 362 Tele Rolleiflex (Franke & Heidecke), 204 Telephot Vega (Vega), 413
Telephoto Cornex (Beck), 87
Telephoto Ray Model C (Ray), 360 Vestkam, 398 TAIYOKOKICO. _Viscawide-16,398 Taiyou Kamera 84-K1-08 (Gakken), 486 Telephoto Ray Model C (Ray), 360 Teleroy (Royer), 374 Taiyou Kankou Kamera 84-3K-10 (Gakken), 486 TAKAHASHIOPTICALWORKS Telka II (Demaria), 136 Telka III (Demaria), 136 Telka X (Demaria), 136 Telka XX (Demaria), 136 Ticka, Watch-Face model (Houghton), 239 Tiezonette, 402 Tim's Official Camera (Eastman Rainbow Hawk-Eye), 158 Time, 402 Time FC-100, 402 TIME-FIELDCO. Arsen, 398 TAKAMINEOPTICAL WORKS, 398 TAKANEOPTICAL CO. Mine Six IIF, 398 Mine Six Super 66, 398 TELLA CAMERA CO.
Magazine Camera, 400
No. 3 Magazine Camera, 400 Pin-Zip 126, 402 Sisley 2A, 398 Sisley 3A, 399 Tenax (Goerz), 214 Tenax (Zeiss Ikon), 449 Tenax Automatic (Zeiss Ikon), 449 Tintin Figurine (Bully), 490 Tintype Camera (Daydark), 133 Sisley Model 1, 398 Take-A-Picture (Arco), 494 TakIV (Walker), 421 Tintype camera (New York Ferrotype), 326 Tenax I (Zeiss Ikon), 449 Tenax I (East Germany) (Zeiss Ikon), 449 Tenax II (Zeiss Ikon), 449 Tiny, 402 TIRANTI Summa Report, 402 Takka, 399 Takyr (Krauss), 265 TALBOT Tenax Tropical (Goerz), 214 TIRANTY Tendertoys Camera (Schaper), 496 ST 280, 402 Stereo Pocket, 402 Errtee button tintype camera, 399
Errtee folding plate camera, 399
Errtee folding rollfilm camera, 399
TALBOT (Walter)
Invisible Camera, 399 Tendertoys Camera (Schaper), 496
Tengoflex (85/16) (Zeiss Ikon), 449
Tennar, Tennar Junior (Fototecnica), 200
Tessco (Contessa), 125
Tessco (Zeiss Ikon), 449
Tessina (Concava), 122 **TISCHLER** Colibri, 402 TISDELÌ T & W Detective Camera, 403 TALBOT & EAMER CO. Tex, 400 Tisdell Hand Camera, 403 Tit-bit (Tylar), 407 Titan (Ansco), 67 Tivoli, 403 Talmer, 399 Talking Vue Camera (Steven Mfg), 499 Texar Box (Vredeborch), 421 **THOMAS** Talmer (Talbot & Eamer), 399 Wet plate camera, 400 THOMPSON TANAKA KOGAKU Tanack IIC, 399 Tanack IIIF, 399 TIZER CO. Direct positive street camera, 400

Thompson's Revolver (Briois), 101

Can Camera 110 TX Coca-Cola, 403

Orangina Camera, 403

TLR 100

TLR 100 (Kalimar), 252 TOAKOKI SEISAKUSHO Gelto D III, 403 TOGODO OPTICAL CO., 403 TOGODOSANGYOLTD., 404 TOHO Hello Kitty Talking Camera, 496 TOHOKOKENCAMERA CO. Camel Model II, 403 Tokiwa Hand (Kuribayashi), 268 TOKIWA SEIKI CO. Bioflex, 403 First Six I, III, V, 403 Firstflex, 403 Firstflex 35, 403 Kenflex, 403 Kwikflex, 403 Lafayette 35, 403 Windsorflex, 35mm, 403 TOKO PHOTO CO. Cyclops, 403 Teleca, 403
Tokyo (Yen camera), 435
TOKYO KOGAKU
Laurelflex, 403 Minion, 403 Minion 35, 403 Primo Jr., Primo Jr. II, 404 Primoflex, 404 Primoflex Automat, 404 Topcoflex, 404 Topcoflex Automat, 404 Topcon 35-L, 404 Topcon Auto 100, 404 Topcon Auto 100, 404
Topcon B, 404
Topcon C, 404
Topcon D-1, 404
Topcon R, 404
Topcon RE Super, 404 Topcon Super D, 404 Topcon Uni, 404 TOKYO KOKEN CO. Dolca 35 (Model I), 404 TOKYO KOKI CO. Rubina Sixteen Model II, 404 TOKYO SEIKI CO.
Doris Semi P, 404
Tom Thumb Camera Radio (Automatic Radio Mfg. Co.), 82 TOMY Ring-a-dingy Camera, 496 Roving Eye Camera, 497 Ton 2-1/4 A Box (Harringtons), 229 Tone (Toyo Kogaku), 406 Top, 404 Top Camera (Maruso), 301 TOP CAMERA WORKS Top, 404
Top II Camera (Maruso), 301
Topcoflex (Tokyo Kogaku), 404
Topcoflex Automat (Tokyo Kogaku), 404
Topcon 35-L (Tokyo Kogaku), 404
Topcon Auto 100 (Tokyo Kogaku), 404
Topcon B (Tokyo Kogaku), 404
Topcon C (Tokyo Kogaku), 404
Topcon C (Tokyo Kogaku), 404
Topcon R (Tokyo Kogaku), 404
Topcon R (Tokyo Kogaku), 404
Topcon Super (Tokyo Kogaku), 404
Topcon Uni (Tokyo Kogaku), 404 Top, 404 Topcon Uni (Tokyo Kogaku), 404 Topper, 404 Torca-35 (Neoca), 325 Torel 110 "National" (Asanuma), 81 Torel 110 Talking Camera (Asanuma), 81 TOSEI OPTICAL Frank Six, 404 Frank Six Model IV, 404 Toska (Hüttig), 240 Toska (Ica), 243 Toska (Zeiss Ikon), 449 TOTSY MFG. CO. Flair Doll Camera, 497 Tougo Camera (Tougodo), 406

Tougo Camera (Yen camera), 435 TOUGODOOPTICAL Alome, 404 Baby-Max, 405 Buena 35-S, 405 Click, 405 Colly, 405 Hit, 405 Hobiflex, Model III, 405 Hobix, 405 Hobix DI, 405 Hobix Junior, 405 Kino-44, 405 Leader, 405 Meikai, 405 Meikai EL, 405 Meiritto No. 3, 405 Meisupi I, 405 Meisupi II, 405 Meisupi IV, 405 Meisupi IV, 405 Meisupii Half, 405 Meisupii Ia, 405 Metraflex II, 405 P.A.C., 405 Stereo Hit, 405 Sweet-16 Model-A, 405 Tougo Camera, 406 Toyoca 16, 406
Toyoca 35, 406
Toyoca 35-S, 406
Toyoca Ace, 406
Toyocaflex, 406
Toyocaflex, 406 Toyocaflex 35, 406 Tour Partner, 487 Tour Partner, 487
Tourist Camera (Eastman), 178
Tourist Camera (Hare), 229
Tourist Camera (Hunter & Sands), 239
Tourist Camera Foto Album (Anchor), 472
Tourist Graflex (Graflex), 220
Tourist Hawk-Eye (Blair), 96
Tourist Hawk-Eye Special (Blair), 96
Tourist Magazine No. 3 (Vive), 414
Tourist Multiple (New Ideas), 325
Tourist Photographer (Poli), 493 Tourist Photographer(Poli), 493 Tourist Pottery, 477 Touriste (Enjalbert), 183 Tower 10A (Sears), 380 Tower 16 (Sears), 380 Tower 18A, 18B (Sears), 380 Tower 19 (Sears), 380 Tower 22 (Sears), 380 Tower 23 (Sears), 380 Tower 24 (Sears), 380 Tower 26 (Sears), 380 Tower 29 (Sears), 380 Tower 32A, 32B (Sears), 380 Tower 33 (Sears), 380 Tower 34 (Sears), 380 Tower 37 (Sears), 380 Tower 39 Automatic 35 (Sears), 381 Tower 41 (Sears), 381 Tower 44 (Sears), 381 Tower 45 (Sears), 381 Tower 46 (Sears), 381 Tower 50 (35mm) (Sears), 381 Tower 50 (rollfilm) (Sears), 381 Tower 51 (35mm) (Sears), 381 Tower 51 (rollfilm) (Sears), 381 Tower 51 (rollfilm) (Sears), 381
Tower 127EF (Sears), 381
Tower Automatic 127 (Sears), 381
Tower Bonita Model 14 (Sears), 381
Tower Camflash 127, II 127 (Sears), 381 Tower Carrinasti 127, 11 127 (Sears), 36 Tower Companion (Sears), 381 Tower Flash, Flash 120 (Sears), 381 Tower Hide Away (Sears), 381 Tower No. 5 (Sears), 380 Tower One-Twenty, Flash (Sears), 381 Tower Phantom (Sears), 381 Tower Pixie 127, Pixie II 127 (Sears), 382 Tower Reflex (Sears), 382

Tower Reflex Type (Sears), 382 Tower Skipper (Sears), 382 Tower Snappy (Sears), 382 Tower Stereo (Sears), 382 Tower Type 3 (Sears), 380 Town, 406 TOY CAMERAS, 494 TOY'S CLAN Donald Duck Camera, 406 TOYCRAFTER Wooden Kodak Truck/whistle, 498 **TOYO KOGAKU** Mighty, 406 Mighty, gift box, 406 Peacock III, 406 Tone, 406 Tovoca, 406 Toyoca 16 (Tougodo), 406 Toyoca 35, 35-S (Tougodo), 406 Toyoca Ace (Tougodo), 406 Toyocaflex (Tougodo), 406 Toyocaflex 35 (Tougodo), 406 TOYPOWERMFG. CO. Just Like Daddy's Camera, 496 TOYS & GAMES, 496 TRAID CORPORATION Fotron & Fotron III, 406 Trailblazer 120 (Pho-Tak), 350 TRAMBOUZE Tailboard view camera, 407 Transistomatic Radio Camera (G.E.C.), Transvaal (Lüttke), 295 Traveler, 407, 496 Traveler 120 (Pho-Tak), 350 Traveller, 407 Traveller Roll-Film Camera (Sinclair), 388 Traveller Una (Sinclair), 389 Treble Patent Camera (McKellen), 302 Trellis (Newman & Guardia), 326
Tri-Color Camera (Devin), 137
Tri-Color Camera (Jos-Pe), 250
Tri-Vision Stereo (Haneel), 227
Triad Detective (Scovill), 379
Triamapro (Deardorff), 134 Tribune (Thornton-Pickard),402 Trick Camera (De Moulin), 488 Trick Ompus XA Bickri (Kuzuma),478 Trick Squirt Camera No. 803 (Ja-Ru), 488 Trilby (Hüttig), 241 Trilby 18 (Ica), 243
Trio (Seneca), 385
Trio (Welta), 424
Triofley, 407 Trioflex, 407 Triomphant (Mendel), 303 Tripar PB-20 (Agfa-Ansco), 58 Triple Bed Poco, (American Camera), 61 Triple Diamond (City Sale), 120 Triple Victo (Houghton), 239 Triple Victo Tropical (Houghton), 239 Triplex (Ica), 243
Triplon BCR-111 (Cony), 125
Tripod head (Franke & Heidecke), 201
Trivision Camera (Keys), 254 Trix (Ica), 243 Trixette (Gerlach), 210 Trokonet (Photo Materials), 351 Trolita (Agfa), 57 Trolix (Agfa), 57 Trona (Ica), 244 Trona (Zeiss Ikon), 449 Tropen Adoro (Zeiss Ikon), 449 Tropen Rio 2C, 5C (Orion), 346 Tropica (Ica), 244 Tropica (Zeiss Ikon), 450
Tropical Adoro (Contessa), 123
Tropical Alpha (Watson), 422
Tropical camera (Ernemann), 189 Tropical camera (Gandolfi), 208 Tropical camera (Laack), 275 Tropical camera (Steinheil), 394 Tropical Deckrullo Nettel (Nettel), 325 Tropical Field Camera (Baird), 82

V.P. Twin

(Ernemann), 189
Tropical Heag XI (Ernemann), 190
Tropical Kinarri (Arnold & Richter), 454
Tropical Klapp (Ernemann), 190 Tropical Plate cameras (Contessa), 125
Tropical plate camera (Hüttig), 241
Tropical Plate Camera (Thowe), 402
Tropical Reflex (Ross), 373
Tropical Stereo Camera (Bianchi), 93 Tropical Una (Sinclair), 389
Tropical Una Deluxe (Sinclair), 389
Tropical Watch Pocket Carbine (Butcher), TROTTER Field camera, 407 Tru-View, 407 Trumpfreflex (Sears), 382 Truphoto No. 2 (Conley), 123 TRUSITE CAMERA CO. Girl Scout Official Camera, 407 Trusite Minicam, 407
Tsubasa 6x6 (Kigawa), 255
Tsubasa Baby Chrome (Kigawa), 255 Tsubasa Chrome (Kigawa), 255 Tsubasa Semi (Kigawa), 256 Tsubasa Super Semi (Kigawa), 256 Tsubasaflex Junior (Kigawa), 256 TUCHT Focal plane camera, 407 Tudor (Houghton), 239 Tudor Reflex (Ica), 244 Tuka (Vasconcellos), 413 Tupperwarebank, 473 Turf (Sida), 388 TURILLON
Photo-Ticket, 407
Turist (Mypucm) (GOMZ), 217
Turn-N-Click Mini Camera (Blue Box), 494
TURRET CAMERA CO. Panoramic camera, 407 Turtle Love, 494 Tuxedo (Rochester Camera Mfg. Co.), 369 Tuxi (Kunik), 267 Tuximat (Kunik), 267 Twelve-20 (Coronet), 128
Twin Lens Artist Hand Camera (London Stereoscopic), 294 Twin Lens Camera (Watson), 422 Twin Lens Pattern (Newman & Guardia), 326 Twin Lens Reflex (Park), 347 Twin lens reflex (Ross), 373 Twin Lens Reflex (Wirgin), 428 Twin Lens Vive (Vive), 414 Twinflex (Universal), 410 **TYLAR** Pocket Titbit, 407 Tit-bit, 407 TYNAR CORP Tynar, 407 U-2 Spy Plane (Gabriel), 206 U.S.CINEMATOGRAPHCO. 35mm Motion Picture Camera, 469 **UCA** Ucaflex, 407 Ucanett, 407 Ucet (United Camera), 408 Ugein Model III (Eiko-Do), 182 ULCA CAMERA CORP. Ultra, 407
Ultra-Fex (Fex/Indo), 196
Ultra-Reflex (Fex/Indo), 196
Ultramatic, CS (Voigtländer), 418
Ultrix (Auto, Simplex) (Ihagee), 246 Ultrix (Cameo, Weeny) (Ihagee), 246 Ultrix (Cameo, Weeny) (Ina Ultrix Stereo (Ihagee), 246 Umbra (Underwood), 408 Una (Sinclair), 389 Una Deluxe (Sinclair), 389 Unca (Foitzik), 197 UNDERWOOD

Tropical Heag VI (Zwei-Verschluss)

Field cameras, 408 Instanto, 408 Stereograph, 408 Umbra, 408 Unette (550) (Zeiss Ikon), 450 Unette (Ernemann), 190 UNGER & HOFFMAN Verax, 408 Verax Gloria, 408 Verax Superb, 408 Uni-Fex (Fex/Indo), 196 Unibox, 408 Uniflash (Universal), 411 Uniflex Models I & II (Universal), 411 Uniflex Reflex Meteor (Schmitz & Thienemann),378 UNIMARK PHOTO INC. Unimatic 606, 408 Unimatic 707, 408 UNIMAX TOYS Magic Camera, 496 Uniomat, III (Minolta), 309 Union-Box (Vredeborch), 421 Union camera (Stöckig), 395 Union Model III (Brückner), 102 UNION OPTICAL CO.
Union C-II, 408
Union Zwei-Verschluss (Stöckig), 395
UNITED CAMERA CO. Ucet. 408 **UNITED OPTICAL INSTRUMENTS** Merlin, 408 UNITED STATES CAM-O CORP. Cam-O, 408 UNITED STATES CAMERA CORP. Auto Fifty, 408 Auto Forty, 408 Automatic, 409 Reflex, Reflex II, 409 Rollex 20, 409 USC 35, 409 Vagabond 120 Eveready Flash, 409 UNITED STATES PROJECTOR & ELECTRONICSCORP. Me 35 4-U, 409 Universal (Butler), 106 Universal (Ernemann), 190 Universal (Gandolfi), 208 Universal (Rochester Optical), 370 UNIVERSALCAMERA CO. Universal 35mm Cine, 468 UNIVERSAL CAMERA CORP. Buccaneer, 409 Corsair I, 409 Corsair II, 409 Duovex, 409 Girl Scout Model AF Univex, 409 Iris, 410 Iris Deluxe, 410 Mercury (Model CC), 410 Mercury (Model CC-1500), 410 Mercury II (Model CX), 410 Meteor, 410 Minute 16, 410 Norton-Univex, 410 Roamer I, 410 Roamer I, 410 Roamer II, 410 Stere-All, 410 Twinflex, 410 Uniflash, 411 Uniflex, Models I & II, 411 Universal Projectors, 469 Univex, Model A, 411 Univex, Model A, Century of Progress, Univex A-8, 468 Univex AF, AF-2, AF-3, AF-4, AF-5, 411 Univex AF, Special models, 411 Univex B-8, 469 Univex C-8, 469 Univex C-8 Turret model, 469 Univex D-8, 469

Univex E-8, 469 Univex G-8, 469 Univex G-8, 469 Univex H-8, 469 Vitar, 411 Zenith, 411 Universal Detective (Goldmann), 215 Universal Duplex I (Hess & Sattler), 233 Universal Heli-Clack (Rietzschel), 364 Universal Palmos (Carl Zeiss Jena), 436 Universal Pattern B, (Newman & Guardia), Un versal Projectors (Universal), 469 UNIVERSAL RADIO MFG. CO. Cameradio, 411 Universal Salon (Falz & Werner), 192 Universal Special Pattern B (Newman & Guardia), 327 Universal Stereo (Gandolfi), 208 Universal Stereo Camera (Goldmann), 215 Universal Studio Camera (Schiansky), 378 Universelle (Saint-Etienne), 375 UNIVEX Univex Supra, 411 Univex A-8 (Universal), 468 Univex AF, AF-2, AF-3, AF-4, AF-5 (Universal), 411 Univex AF, Special models (Universal), Univex B-8 (Universal), 469 Univex C-8 (Universal), 469 Univex C-8 Turret model (Universal), 469 Univex C-8 (Universal), 469 Univex E-8 (Universal), 469 Univex F-8 (Universal), 469 Univex G-8 (Universal), 469 Univex H-8 (Universal), 469 Univex Mercury Decanter, 480 Univex Model A (Universal), 411 Univex Model A Century of Progress (Universal), 411 Uno (Seneca), 385 Up-to-Date (Smedley), 389 Ur-Leica (Original) (Leitz), 279 Ur-Leica (Replica) (Leitz), 279 Urania, 41 URIU SEIKI Cinemax 85E, 469 US NEWS & WORLD REPORT Disc Camera, 411 USC 35 (United States Camera), 409 UTILITY MFG. CO. Carlton, 413 Carlton Reflex, 411 Deluxe Century of Progress, 411 Falcon, 412 Falcon Junior 16, 412 Falcon Junior Model, 412 Falcon Midget, 413 Falcon Midget 16, 412 Falcon Minette, 412 Falcon Miniature, 412 Falcon Minicam Junior, 412 Falcon Minicam Senior, 412 Falcon Model F, 412 Falcon Model FE, 412 Falcon Model Four, 412 Falcon Model G. 412 Falcon Model GE, 412 Falcon Model V-16, 412 Falcon Press Flash, 412 Falcon Press Flash, 412
Falcon-Special, 412
Falcon-Abbey Electricamera, 412
Falcon-Flex, 3x4cm, 413
Falcon-Flex, 6x6cm, 413
Girl Scout Falcon, 413
Rex Miniature, 413 Spartus Miniature, 413 Utitars, 413 UYEDA CAMERA Vero Four, 413 V.P. Twin (Edbar), 180

VAG

Virtus (Voigtländer), 418 Viscawide-16 (Taiyokoki), 398 Viscount (Aires), 60 Viscount (Coronet), 128 Vag (Voigtländer), 418 Vest Pocket No. 2 (Ansco), 67 Vagabond 120 (United States Cam.), 409 Vest Pocket Rainbow Hawk-Eye Camera Vaido (Adams), 51 (Eastman), 158 Vest Pocket Readyset (Ansco), 67
Vest Pocket Rexo (Burke & James), 103
Vest Pocket Speedex No. 3 (Ansco), 68
Vest Pocket Tenax (Goerz), 214
Vesta (Adams), 51 Vaido Tropical (Adams), 51 Valiant 620 (Shaw-Harrison), 386 Van Albada Stereo (Schaap), 378 Van Dyke Bitters Camera, 413 Visobella (Foitzik), 197 Visor-Fex (Fotofex), 200 Vista Colour, 414 Vitaflex (KamerawerkeTharandt), 252 VITAGRAPHCO. VAN NECK Vesta (Adams), 51 Vesta (Ginrei), 211 Vesta Model A (Adams), 51 Vester-Six (Ginrei), 211 Press camera, 413 Vanguard,413 Vanguard (Spartus), 391 Vitagraph, 470 VITALUX CAMERA CO. Vestkam (Taiyodo Koki), 398 VICAM PHOTO APPLIANCECORP. Vanity Case (Girey), 476 VANITY FAIR Vitalux, 470 Vitar (Universal), 411 VITASCOPECORP. Barbie Cameramatic, 413 Baby Standard, 469 Holly Hobbie, 413 Vicamphoto, 413 Movie Maker, 470 Movie Maker, 470
Vitessa models (Voigtländer), 418
Vito (Voigtländer), 418
Vito Automatic (Voigtländer), 419
Vito B, BL (Voigtländer), 419
Vito C, CD, CL, CLR (Voigtländer), 419
Vito II, IIa, III (Voigtländer), 418
Vitomatic I, Ia, Ib (Voigtländer), 419
Vitomatic IIII (Voigtländer), 419
Vitomatic IIII (Voigtländer), 419 Viceroy (Aires), 60 Victo (Houghton), 239 Victo-Superbe (Houghton), 239 Victor (Anthony), 70 Incredible Hulk, 413 Spider-Man, 413 Sunny-Bunch, 413 Super Star, 413 Vanity kits (Girey), 476 Victor (Benson), 90 Victor (Coronet), 128 Victor (Ihagee), 246 VICTOR ANIMATOGRAPHCO. Vanity Kodak Camera (Eastman), 178 Vanity Kodak Ensemble (Eastman), 178 Vanneck (Watson), 422 Vitomatic II, IIa, IIb (Voigtländer), 419
Vitorat (Voigtländer), 419
Vitoret (Voigtländer), 419
Vitoret D (Voigtländer), 419
Vitoret DR apid (Voigtländer), 419
Vitoret DR (Voigtländer), 419
Vitoret F (Voigtländer), 419
Vitoret R (Voigtländer), 419
Vitorat R (Voigtländer), 419
Vitorat (Voigt Varioto SL (Beauty Camera Co.), 86 VARSITY CAMERA CORP. Varsity Model V, 413 Victor, 469 Victor, Models 3, 4, 5, 470 Victor Ultra Cine Camera, 470 Victoria (Fallowfield), 192
Victoria (Park), 347
Victoria Four-Tube (Anthony), 70
Victory Camera (Yen camera), 435 VASCÓNCELLOS Kapsa, 413 Tuka, 413 Vauxhall, 413 Vega II (Druopta), 138 Vega III (Druopta), 138 VICTORYMFG. CO. Lone Ranger, 414 Victory Reflex (Thornton-Pickard), 402 Victrix (Ica), 244 VEGA S.A Telephot Vega, 413 M.P.C. (Mechanical Plate Changing), 414 Victrix (Zeiss Ikon), 450 Vida (Voigtländer), 418 Vidax (Vidmar), 414 Souvenir Camera, 414 Tourist Magazine No. 3, 414 Vega, 413 VEHICLES, 497 Twin Lens Vive, 414 Vive Nos. 1, 2, 4, 414 Vog (Paris), 347 Velo Klapp (Ernemann), 190 Videon, II (Stereocrafters), 394 Videx (Adams), 51 VIDMAR CAMERA CO. Velocigraphe (Hermagis), 232 Velocigraphe Stereo (Hermagis), 232 Vogue (Coronet), 129 VOHO Velox Magazine Camera (Hurlbut), 239 Vidax, 414 Vidol (Lüttke), 295 Squirt Camera, 489 Venaret, 413 Venaret, 413
Ventura 66, 69 (Agfa), 57
Ventura 66, 69 Deluxe (Agfa), 57
Venus-Ray Compact, 476
VEPLA-VENEZIA
Camera-Viewer Capri, 499 Voigt, 414 Voigt Junior Model 1, 414 VOIGTLÄNDER& SOHN VIENNAPLEX Pack 126, 414 Vier-Sechs (Busch), 104 View camera (Agfa-Ansco), 58
View camera (American Optical Co.), 62
View camera (Anthony), 70
View camera (Blair), 96
View Camera (Conley), 122
View Camera (Eastman), 179 Alpin, 415 Alpin Stereo-Panoram,415 Avus, folding plate, 415 Verascope (Richard), 363 Verascope (Richard), 363
Verascope F-40 (Busch), 104
Verascope F40 (Richard), 363
Verax (Unger & Hoffman), 408
Verax Gloria (Unger & Hoffman), 408
Verax Superb (Unger & Hoffman), 408
Verikon (Pentacon), 349
Verivide 100 (Plaubel), 356
Vero Four (Uyeda), 413
Verto (Adams), 51 Avus, rollfilm models, 415 Avus, rollfilm models, 415 Bergheil, 415 Bersheil Deluxe, 415 Bessa (early models), 415 Bessa 46 "Baby Bessa", 416 Bessa 66 "Baby Bessa", 416 Bessa RF, 416 Bessa matter 416 View camera (Gray), 224 View Camera (Greenpoint), 224 View Camera (Martain), 301 View camera (Mendoza), 303 View camera (Rochester Cam. Mfg), 369 Verto (Adams), 51
Vesca (London Stereoscopic), 294
Vesca Stereo (London Stereoscopic), 294 View camera (Scovill), 379 View camera (Seneca), 385 Bessamatic, 416 Bessamatic CS. 416 Bessamatic Deluxe, 416 View camera (Taylor), 400 Vesca Stereo (London Stereoscopic), Vest Alex (Misuzu), 317 Vest Camera (Gray), 224 Vest Olympic (Olympic Camera), 337 Vest Pocket (APM), 71 Vest Pocket (Seneca), 385 Vest Pocket (Apsca), 67 View Camera (Wanaus), 422 Bessamatic M, 416 Bijou, 416 Box, 416 View Camera (Wing), 427 View Camera Cigarette Lighter (S.M.R.), Brillant, 416 Daguerreotype"cannon", 416 View-Master Personal Stereo (Sawyers), Daguerreotype cannon replica, 417
Dynamatic, Dynamatic II, 417
Folding plate cameras, 417 Vest Pocket Ansco (Ansco), 67 Vest Pocket Autographic Kodak Camera View-masterStereo Color (Sawyers), 377 (Eastman), 178 VIEWING DEVICES, 498 Vest Pocket Autographic Kodak Special Camera (Eastman), 178 Vest Pocket Ensign (Houghton), 238 Vest Pocket Hawk-Eye (Eastman), 158 Vest Pocket Junior (Ansco), 67 Vest Pocket Kodak Cam. (Eastman), 178 Folding rollfilm cameras, 417 Heliar Reflex, 417 Inos (I), 417 Inos II, 417 Viflex, 414 Viflex, 414
Vigilant Junior Six-16 (Eastman), 179
Vigilant Junior Six-20 (Eastman), 179
Vigilant Six-16 (Eastman), 179
Vigilant Six-20 (Eastman), 179
Viking (Agfa-Ansco), 59
Viking (Ansco), 68
Viking Camera (Wedemeyer), 423
Viking Panadyset (Ansco), 68 Jubilar, 417 Perkeo E, 417 Perkeo E, 417 Vest Pocket Kodak Model B Camera Perkeo I, 417 (Eastman), 178 Viking Readyset (Ansco), 68 Vilia (Belomo), 89 Vilia-Auto (BNANR-ABTO)(Belomo), 89 Perkeo II, 417 Vest Pocket Kodak Series III Camera Prominent, 417 Prominent II, 417 (Eastman), 178 Vest Pocket Kodak Special Cameras (Eastman), 178-179 Vest Pocket Model A (Ansco), 67 Vest Pocket Monroe (Monroe), 318 Vincent (Anthony), 70 Vinkel 50 (S.E.D.E.), 382 Vinkel Deluxe (S.E.D.E.), 382 Stereflektoskop, 417 Stereophotoskop,418 Super Bessa, 416 Vest Pocket No. 0 (Ansco), 67 Vest Pocket No. 1 (Ansco), 67 Superb, 418 Ultramatic, 418 Aerial reconnaissance camera, 414

WERLISA

Ultramatic CS, 418 Union-Box, 421 Field camera, 422 Vag, 418 Vida, 418 Vrede Box, 421 Gear. 422 Vril (Watson), 422 Magazine box camera, 422 Virtus, 418 Vitessa, 418 Vitessa L, 418 VRSOFOT Stereoscopic Binocular Camera, 422 Epifoka, 421 Tropical Alpha, 422 Vu-Flash "120" (Zenith), 450 Twin Lens Camera, 422 Vitessa N, 418 Vanneck, 422 Vril, 422 Vitessa T, 418 WABASH PHOTO SUPPLY Vito, 418 Vito Automatic, 419 Direct positive camera, 421 WADSWORTH Watson 35 (Welta), 424 Watson Press (Burke & James), 103 WATSONSUPPLYHOUSE Vito B, 419 Vito BL, 419 Vito C, 419 Vito CD, 419 Compakit, 476 Wadsworth Vanity & Cigarette Case, 477 Star Camera, 422 Watson-HolmesFingerprint(Burke & James), 103 WAUCKOSIN WAITE Wet plate Stereo, 421 WALDES & CO. Vito CL, 419 Vito CLR, 419 Vito II, 418 Foto-Fips, 421 WALDORF CAMERA CO. Waldorf Minicam, 421 Waranette, 422 Weber Fex (Fex/Indo), 196 WEBSTERINDUSTRIES Vito IIa, 419 Vito III, 419 Wales Reflex (Haking), 226 Winpro 35, 423 Wedar, Wedar II, 371 WEDEMEYER Vitomatic I, 419 Wales-Baby, 421 WALKER CO. Vitomatic Ia, 419 Vitomatic Ib, 419 Vitomatic IIa, 419 Walker's American Challenge, 421 Viking Camera, 423 Week End (Goldstein), 215 Week-End Bob (Cornu), 126 Weenie (Thornton-Pickard), 402 Walker's Pocket Camera, 421 WALKER MANUFACTURINGCO. Vitomatic IIb, 419 Vitomatic IIIb, 419 TakIV, 421 Vitoret, 419 Vitoret D, 419 Vitoret D Rapid, 419 Walking Camera, 497 Walking film box (Eastman), 496 **WEFO** Master Reflex, 423
Meister Korelle, 423
Wega II, IIa (AFIOM), 52
Weha Chrome Six (Ehira), 180 Walklenz, 421 WALLACEHEATONLTD. Vitoret DR, 419 Vitoret F, 419 Vitoret R, 419 Zodel, 421 WALT DISNEY PRODUCTIONS Weha Light (Ehira), 180
WEIMET PHOTO PRODUCTSCO. See Straw, 480 Walta (Welta), 424 Waltax (I) (Okada), 337 Waltax I (Daiichi), 131 Vitrona, 419 VOJTA Rocket, 423 Field camera, 419 WELCH Magazine Camera, 419 Film Cassette Cookie Jar, 477 Well Standard Model I (Nihon), 328 VOKAR CORPORATION Vokar, Models A, B, 419 Vokar I, II, 419 Waltax Acme (Daiichi), 131 Waltax Jr. (Daiichi), 131 Waltax Senior (Daiichi), 131 Welmy 35 (Taisei Koki), 397 Welmy M-3 (Taisei Koki), 398 Welmy Six, Welmy Six E (Taisei Koki), 397 Vollenda (Eastman), 179 Vollenda (Nagel), 323 Vollenda 620 (Eastman), 179 Walz Baby (Okada), 337 WALZ CO. Walz Automat, 421 Welmy Wide (Taisei Koki), 398 Welta (Welta), 424 Welta 35 (Welta), 424 WELTA KAMERA-WERKE Vollenda 520 (Eastman), 179
Vollenda Junior 616 (Eastman), 179
Vollenda Junior 620 (Eastman), 179
Volta (Zeiss Ikon), 450
Volta 105, 106 (Ica), 244
Volta 125, 146 (Ica), 244
Voltron Starshooter 110 (Impulse), 247
VOOMP Walz Envoy 35, 421 Walz-wide, 421 Walzflex, Walzflex IIIA, 422 Belmira, 423 WANAUS Diana, 423 Dubla, 423 Garant, 423 View Camera, 422 Wanderer (Laack), 275 WANG'S ALLIANCE CORP Gucki, 423 Voomp, 420 Voran (Beier), 88 VORMBRUCKCAMERABAU Hollywood Studio Lamp, 482 Peerflekta (I), II, V, 423 Perfekta, 423 Hollywood Studio Lamp, 482
Waranette (Wauckosin), 422
Wardette (Montgomery Ward), 319
Wardflex (Montgomery Ward), 319
Wardflex II (Montgomery Ward), 319
Wards 25 (Montgomery Ward), 319
Wards 35, 35-EE (Montgomery Ward), 319
Wards am 550 (Montgomery Ward), 320
Wards x100 (Montgomery Ward), 320
Wards xp400 (Montgomery Ward), 320
Warner 6x6 (Musashino), 322
WARREN COMPANY
Click! Jigsaw Puzzle 486 Perle, 423 Feca (reflex), 420 Voskhod (GOMZ), 217 Radial, 424 Reflecta, 424 VOSS Reflekta, 424 Diax (I), Ia, Ib, 420 Diax II, IIa, IIb, 420 Diaxette, 420 Reflekta II, 424 Reflekta III, 424 Sica, 424 Votar Flex (Haking), 226 Vrede Box (Vredeborch), 421 VREDEBORCH Solida, 424 Superfekta, 424 Symbol, 424 Click! Jigsaw Puzzle, 486 Warsavie Ring Camera (Mazur), 302 Adina, 420 Trio, 424 Walta, 424 Watson 35, 424 Alka Box, 420 Bunny, 420 Ecla Box, 420 WARWICK WARWICK
Warwick No. 2 Camera, 422
Watch (Concava), 122
Watch Camera (Expo), 191
Watch Camera (Hegelein), 230
Watch Camera (Lancaster), 277
Watch Pocket Carbine (Butcher), 106
Water Camera, 489 Welta, 424 Welta 35, 424 Evans Box, 420 Felica, Felita, 420 Weltaflex, 424 Felicetta, 420 Fodor Box Syncrona, 420 Weltax, 424
Welti (I), Ic, II, 424
Weltini, Weltini II, 425
Weltin, 425 Haaga Syncrona Box, 420 Ideal, 420 Junior, 420 Water Camera, 489 Water Camera No. 402 (T.H.), 489 Water Camera No. 677 (T.K.), 489 Weltur, 425 Kera Jr., 420 Klimax, 420 Kruxo Favorit, 420 Weltur, 425
Weltaflex (Welta), 424
Weltax (Welta), 424
Welti (I), Ic, II (Welta), 424
Weltini, Weltini II (Welta), 425
Weltix (Welta), 425
Weltur (Welta), 425
Wembley Spect 425 Waterbury Detective Camera (Scovill), 379 Waterbury Detective, Improved (Scovill), Manex, 420 N-Box, 420 Nordetta 3-D, 420 Waterbury Stereo (Scovill), 379 Nordina, 420 Waterbury View (Scovill), 379 WATSON Acme, 422 Wembley Sports, 425 Optomax Syncrona, 420 WENK Reporter Junior II, 421 Wenka, 425 Slomexa, 421 Alpha, 422 Weno Hawk-Eye (Blair), 96 Stafetta-duo, 421 Argus Reflex, 422 Weno Hawk-Eye Cameras (Eastman), 158 Texar Box, 421 Detective Camera, 422 Werlisa (Certex), 116

WERRA

Werra (Carl Zeiss Jena), 114	Wilca Automatic, 427	Wit-eez (Wittie), 429
Werra II (Carl Zeiss Jena), 114	WILKIN WELSH CO. Folding plate camera, 427	Witness (Ilford), 247 WITT
Werra III (Carl Zeiss Jena), 114 Werra IV (Carl Zeiss Jena), 114	WILLIAMSONKINEMATOGRAPHCO.	Iloca I, Ia, II, IIa, 429
Werra Microscope (Carl Zeiss Jena), 114	Paragon, 470	Iloca Quick A, 429
Werra V (Carl Zeiss Jena), 114	WILLIAMSONLTD	Iloca Quick B, 429
Werramatic (Carl Zeiss Jena), 114	Williamson 35mm Cine, 470 WILLIAMSONMANUFACTURINGCO.	Iloca Rapid models, 429 Iloca Reporter, 429
Werra, Werra I, Ic (Carl Zeiss Jena), 114 Wester Autorol (Nishida), 336	Pistol Aircraft camera, 427	Iloca Stereo, Original, 429
WESTERNCAMERAMFG. CO.	Wilsonart Maximum Exposure (Ralph	Iloca Stereo, Models I, II, IIa, 429
Cyclone Jr., 425	Wilson), 472 WILTON	Iloca Stereo Rapid, 429 Photrix Quick B, 429
Cýclone Sr., 425 Magazine Cyclone No. 2, 425	Kodak 1880-1980 Centennial Plate, 480	Photrix Stereo, 429
Magazine Cyclone No. 3, 425	Winchester (Fuji Photo), 205	WITTIE MFG.
Magazine Cyclone No. 4, 425	Windsor, 427	Wit-eez, 429 WITTMAN
Magazine Cyclone No. 5, 425	WINDSOR CAMERA CO. Windsor 35, 427	Tailboard camera, 429
Pocket Zar, 425 WESTFÄLISCHEKAMERA	Windsor Stereo, 427	WITTNAUER
Navax, 425	WindsorWX-3, 427	Adventurer, 429
Westomat (Taisei Koki), 398	Windsorflex, 427 Windsorflex, 35mm (Tokiwa), 403	Automaton, 429 Captain, 429
Weston WX-7, 425 Wet plate 9-lens camera (Fallowfield), 192	WING	Challenger, 429
Wet plate bellows camera (Meagher), 303	Multiple-lens camera, 427	Continental, 429
Wet plate camera (Burr), 103	Multiplying View Camera, 427	Festival, 429 Legionaire, 429
Wet Plate camera (Dallmeyer), 132 Wet Plate camera (Garland), 208	New Gem, 427 View Camera, 427	Scout, 429
Wet plate camera (Gandid), 200 Wet plate camera (Horne & Thornthwaite),	Winner Camera	Wittnette Automatic Electric Eye, 429
235	1988 Olympics (Eastman), 179	Wittnette Deluxe, 429 Wittnette Reflex, 430
Wet plate camera (Lamperti), 276	WINNERTOY Jet Setter, 497	WITTNAUERCAMERACO.
Wet plate camera (Lawley), 278 Wet Plate camera (Lewis), 290	Winpro 35	Automatic Zoom 800, 470
Wet plate camera (London Stereoscopic),	Synchro Flash (Zenith), 450	Cine-Simplex, 470
294	Winpro 35 (Webster), 423	Wittnauer Cine-Twin, 470 Wittnette Deluxe (Wittnauer), 429
Wet plate camera (Mawson), 302 Wet plate camera (McCrossan), 302	WINROSS Kodak Truck 1880-1980,498	Wittnette Reflex (Wittnauer), 430
Wet plate camera (Morley), 320	WINTER	Wizard (Manhattan), 299
Wet plate camera (Peck), 348	Field camera, 427	Wizard Duplex (Manhattan), 299 Wizard Special (Manhattan), 299
Wet plate camera (Scovill), 379	Wipe-out (Charterking), 488 WIRECRAFTCO.	Wizard XF1000 (Keystone), 254
Wet plate camera (Thomas), 400 Wet Plate Cameras, 425	Jewel Sixteen, 427	WOLFFPRODUCTS
Wet Plate Camera, 4-lens (Gennert), 210	WIRGIN	Camera Soap-on-a-rope,487
Wet Plate Camera, 4-tube (American	Alka 16, 427 Astraflex 1000, 427	WOLLENSAKOPTICALCO. Model 23, 471
Optical Co.), 62 Wet plate field camera (Atkinson), 81	Astraflex 1000, 427 Astraflex 1000 LM, 427	Model 42, 471
Wet Plate Sliding Box (Dallmeyer), 132	Auta, 427	Model 43, 43-D, 471
Wet plate sliding-box (Meagher), 303	Baky, 427	Model 46, 471 Model 46 Eye-Matic, 471
Wet plate sliding box (Ross), 373 Wet plate sliding box (Wood), 430	Edina, 428 Edinex, 428	Model 57 Eye-Matic, 471
Wet plate tailboard camera (Dubroni), 138	Edinex 120, 428	Model 8, 471
Wet plate, tailboard style (Ross), 373	Edixa, 428	Wollensak Stereo, Model 10, 430 Wond-O-Lite, 475
Wet plate stereo camera (Mayson), 302	Edixa II, 428 Edixa 16, 16M, 16MB, 16S, 428	Wonder Automatic Cannon Photo Button
Wet plate stereo camera (Morley), 320 Wet plate Stereo (Ross), 373	Edixa Electronica, 428	Machine (Chicago Ferrotype), 118
Wet plate Stereo (Waite), 421	Edixa Flex B, 428	Wonder Camera, 430
Wet plate triple-lens stereo (Horne &	Edixa Prismaflex, 428 Edixa Reflex, 428	Wonder Camera Friend, 482 Wonder Film Ruler, 485
Thornthwaite),235 Wet-plate camera (Faller), 191	Edixa Reflex B, 428	Wonder Special Camera, 482
WHITE	Edixa Reflex C, 428	Wonderflex, 430
Realist 35, 426	Edixa Reflex D, 428 Edixa Stereo, 428	Wonderflex Comet Special Camera, 483 Wonderflex Wonder (mouse camera), 483
Realist 45 (Model 1045), 426 Stereo Realist, 426	Edixa Stereo II, IIa, 428	WOOD
Stereo Realist Custom (Model 1050), 426	Edixa Stereo III, IIIa, 428	Wet plate camera, sliding box, 430
Stereo Realist Macro (Model 1060), 426	Edixa-Mat B, BL, 428	Wood box camera (Harboe), 228 WOOD BROS.
WHITEHOUSEPRODUCTS Beacon, Beacon II, 426	Edixa-Mat C, CL, 428 Edixa-Mat D, DL, 428	Pansondontropiccamera, 430
Beacon 225, 426	Edixaflex, 428	Woodbury Universal Tourist (Lane), 278
Beacon Reflex, 426	Franka 16, 428	Wooden Kodak Truck/whistle (Toycrafter), 498
Charlie Tuna, 426	Gewir, 428 Gewirette, 428	Wooden plate camera (Derogy), 136
WHITTAKER Micro 16, 426	Klein-Edinex(127 film), 428	World's Fair Flash Camera (Eastman), 179
Pixie, 426	Midget Marvel, 428	World's Greatest PhotographerMug, 480
Pixie Custom, 426	Reporter, 428 Twin Lens Reflex, 428	WOHLER Favor, 430
WHOLESALEPHOTO SUPPLY CO. Spartus Miniature, 426	Wirgin Deluxe, 429	WRATTEN& WAINWRIGHT
Wide-Angle Rolleiflex (Rolleiwide) (Franke	Wirgin folding rollfilm camera, 429	Tailboard camera, 430
& Heidecke), 204	Wirgin Stereo, 429 Wirgin TLR, 429	WRAY OPTICAL WORKS Peckham Wray, 430
Widelux (Panon), 346 WIDMAYER	Wirginex (Baky), 429	Stereo Graphic, 430
Paris, 427	Wirgin Deluxe (Wirgin), 429	Wrayflex, 430
WIDMER	Wirgin folding rollfilm camera (Wirgin), 429	Wrayflex I, 430 Wrayflex Ia, 430
Cowi, 427 Wiko Standard (Köhnlein), 258	Wirgin Stereo (Wirgin), 429 Wirgin TLR (Wirgin), 429	Wrayflex II, 430
WILCA KAMERABAU	Wirginex (Baky) (Wirgin), 429	Wrist Watch Camera, 430
Wristamatic Model 30 (Magnacam), 297 FX-2, 434 Lynx 1000, 434 WÜNSCHE Afpi, 430 Afpi Model III, 430 Lynx 14, 434 Mimy, 434 Minister, 434 Elite, 430 Excelsior, 430 Minister D, 434 Minister II, 434 Favorit, 431 Field cameras, 431 Penta J, 435 Julia, 431 Pentamatic, 435 Yashica 44, 433 Yashica 44A, 433 Yashica 44LM, 433 Yashica 635, 433 Juwel, 431 Knox, 431 Lola, 431 Lola Stereo, 431 Mars 99, 431 Yashica 72E, 434 Mars Detectiv-Stereoskop, 431 Yashica 8, T-8, 471 Yashica A, 434 Yashica Atoron, 434 Mars Detective, 431 Postage stamp camera, 431 Reicka, 431 Yashica Atoron Electro, 434 Sport, 431 WZFO Yashica C, 434 Yashica D, 434 Yashica E, 434 Yashica EE, 434 Alfa, 431 Alfa 2, 431 Druh, 431 Yashica J. 434 Yashica J-3, 434 Noco-Flex, 431 Start, 431 Start-B, 431 Yashica J-5, 434 Yashica J-P, 434 Yashica LM, 434 XIBEI OPTICAL Yashica Rapide, 435 Yashica Rapide, 435 Yashica Rookie, 435 Yashica Sequelle, 435 Yashica YE, 435 Yashica YF, 435 Yashica YF, 435 Huashan DF-S, 431 Xit (Shew), 386 Xit Stereoscopic (Shew), 386 XL (Graflex), 223 XLRF (Graflex), 223 XLRF KS-9 (Graflex), 223 XLS (Graflex), 223 XLSW (Graflex), 224 Xyz (Lancart), 276 Yashica-Mat, 435 Yashica-MatLM, 435 Yashimaflex, 435 Yashica Tie Clip, 481 YASHINA SEIKI YALE CAMERACO. Yale Camera, 432 Pigeonflex, 435 Yale Nos. 1 and 2 (Adams), 51 Yen-Kame, 435 Yale Stereo Detective No. 5 (Adams), 51 YAMAMOTOCAMERA CO. Yogi Bear (Hanna-Barbera), 228 Young posing couple (Dear), 490 Ysella (Rodenstock), 371 Yumeka 35-R5 (New Taiwan), 325 Semi Kinka, 432 YAMATO KOKI Alpina M35, 432 Yunon YN 500, 435 Atlas 35, 432 Atlas Deluxe, 432 Yuuhigo (Yen camera), 435 Atlas II, 432 Barclay, 432 Bonny Six, 432 Zambex (Beck), 87 Zany (Nihon), 328 Zarya (Zapa) (Fed), 193 Zeca (Zeh), 436 Zeca-Flex (Zeh), 436 Hilka, 432 Konair Ruby, 432 Lycon M3, 432 Mini Electro 35 Automatic, 432 Minon 35, 432 Bettax, 435 Coloprint, 435 Minon Six II, 432 Goldi 3x4, 436 Goldi 4x6, 436 Pal Jr., 432 Pal M4, 432 Sport, 436 Palmat Automatic, 432 Zeca, 436 Zeca-Flex, 436 Pax (I), 432 Pax Golden View, 432 ZEISS Pax Jr., 432 Pax M2, 432 Pax M3, 433 Pax M4, 433 Advertising Ashtray, 477 Kinamo N25, 471 Kinamo S10, 471 Moviflex Super, 471 Pax Ruby, 433 Movikon 8, 471 Pax Sunscope, 433 Pax Sunscope, 4.3. Rex Kaysons, 433 Ricsor, 433 Rippa, 433 Rippaflex, 433 Simflex 35, 433 Skymaster, 433 Movikon 8 B. 471 Movikon 16, 471 Movinette 8B, 471 ZEISS (CARL ZEISS JENA) Magnar-Kamera,436 Minimum Palmos, 436 Minimum Palmos Stereo, 436 Starlite, 433 Stereo Palmos, 436 Tac Deluxe, 433 Universal Palmos, 436 ZEISS IKON YANKA (Belomo Chaika), 89 YASHICA Adoro, 437 Electro 35, 434 Aerial Camera, 13x18cm, 437 Electro AX, 434 Baby Deckrullo, 442 Flash-O-Set, 434 Baby-Box 54/18, 437 Flash-O-Set II, 434 Baby-Box Tengor, 437 FX-1, 434 Baldur Box (51), 437

ZEISS Contina III Baldur Box 51/2, 437

Balilla, 437 Bebe (342/3), 438 Bebe (342), 438 Bob (510, 510/2), 438 Bob IV, V, 438 Bobette I (549), 438 Bobette II (548), 438 Box Tengor 54, 438 Box Tengor 54/2, 438 Box Tengor 54/12, 438 Box Tengor 54/14, 438 Box Tengor 54/15, 438 Box Tengor 55/2, 438 Box Tengor 56/2, 438 Box Tengor 760, 438 Citoskop (671/1), 438 Cocarette, 438 Cocarette Luxus, 438 Colora, 438 Colora F, 439 Contaflex (860/24), 439

Contaflex (860/24), 439 Contaflex I (861/24), 439 Contaflex II (862/24), 439 Contaflex III (863/24), 439 Contaflex IV (864/24), 439 Contaflex Alpha (10.1241), 439 Contaflex Beta (10.1251), 439 Contaflex Prima (10.1251), 439 Contaflex Rapid (10.1261), 439 Contaflex S Automatic (10.1263)

Contaflex Rapid (10.1261), 439
Contaflex S Automatic (10.1273-BL), 439
Contaflex Super (10.1262), 439
Contaflex Super (10.1271), 439
Contaflex Super B (10.1272), 439
Contaflex Super BC "BW", 439
Contaflex Super BC (10.1273), 439
Contarex "Bullseye" (10.2401), 439
Contarex Electronic (Super Electronic), 440

Contarex Hologon, 440 Contarex Lenses, 440

Contarex Microscope Camera, 440 Contarex Professional (10.2700), 440 Contarex Special (10.2500), 440 Contarex Super (10.2600), 440

Contax (441 Contax I (540/24), 440 Contax I(a), 440 Contax I(b), 440 Contax I(c), 440 Contax I(d), 440 Contax I(e), 440 Contax I(f), 440 Contax II (543/24), 441 Contax II(a) (563/24), 441 Contax III (544/24), 441 Contax Illa, 441 Contax D, 441 Contax F, 441 Contax Lenses, 441

Contax "No-Name", 441 Contax Rifle, 441 Contax S, 441 Contax S, 441 Contessa LBE (10.0639), 442 Contessa LK (10.0637), 442 Contessa LKE (10.0638), 442 Contessa S-310 (10.0351), 442 Contessa S-312 (10.0354), 442 Contessa 35 (533/24), 441 Contessa 35 (533/24), 441 Contessa 35 (533/24), 441

Contessamat SBE (10.0652), 442 ContessamatSE (10.0654), 442 ContessamatSTE, 442

Contessamatic, 442 ContessamaticE, 442 Contina (10.0626), 442 Contina I (522/24), 442 Contina la (526/24), 442 Contina la (526/24), 442 Contina ll (524/24), 442 Contina ll (527/24), 442 Contina ll (527/24), 442

Contina III Microscope Camera, 442

ZEISS Contina L

Contina L (10.0605), 442 Contina LK (10.0637), 442 Continette (10.0625), 442 Deckrullo, Deckrullo Nettel, 442 Deckrullo Tropical, Deckrullo Nettel Tropical, 442 Donata, 442 Duchessa, 443 Duroll, 443 Elegante (816), 443 Erabox, 443 Ergo (301), 443 Ermanox, 443 Ermanox (858), 443 Ermanox Reflex, 443 Erni, 443 Favorit, 443 Favorit Tropical, 443 Halloh (505/1), 443 Hochtourist, 443 Hochtourist, 443
Hologon (Contarex Hologon), 443
Icarette, 443
Icarex, 443
Icarex 35 (10.2200), 443
Icarex 35 CS, 443
Icarex 35 S, 443
Icarex 35 TM", 443 Icarex Lenses, 443 Ideal, 443 Ikoflex (850/16), 444 Ikoflex I (850/16), 444 Ikoflex I (854/16), 444 Ikoflex Ib (856/16), 444 Ikoflex Ic (886/16), 444 Ikoflex II (851/16), 444 Ikoflex II/III (852/16), 444 Ikoflex IIa (855/16, re-styled), 444 Ikoflex II/III (852/16), 444
Ikoflex IIa (855/16, re-styled)
Ikoflex IIa (855/16), 444
Ikoflex III (853/16), 444
Ikoflex Favorit (887/16), 444
Ikoflex Favorit (887/16), 444
Ikomatic A (10.0552), 444
Ikomatic F (10.0551), 444
Ikonette (504/12), 444
Ikonette 35 (500/24), 444
Ikonta (520/14), 444
Ikonta (520/18), 445
Ikonta A (521), 445
Ikonta A (521), 445
Ikonta B (520/16), 445
Ikonta B (521/16), 445
Ikonta B (524/16), 445
Ikonta C (520/2), 445
Ikonta C (521/2), 445
Ikonta C (521/2), 445
Ikonta C (521/2), 445
Ikonta C (521/2), 445
Ikonta C (524/2), 445
Ikonta C (520/15), 445 Jena Contax (II), 441 Juwel (275/11), 445 Juwel (275/7), 445 Kolibri (523/18), 445 Kosmopolit, 445 Liliput, 445 Liloyd (510/17), 445 Maximar (207/9), 445 Maximar A, 445 Maximar B, 445 Mess-Ikonta (Ikonta B), 445 Miroflex A (859/3), 445 Miroflex B (859/7), 445 Nettar, 446 Nettax (513/16), 446 Nettax (538/24), 446 Nettel, 446 Nettel, Tropen (Tropical), 446 Nixe, 446 Onito, 446 Orix (308), 446 Palmos-O, 446 Perfekt, 446 Piccolette (545/12), 446 Piccolette-Luxus (546/12), 446

Plaskop, 446 Polyskop, 446 Simplex (112/7), 446 Simplex (511/2), 446 Simplex-Ernoflex,447 Sirene, 447 SL-706 (10.3700), 447 Sonnet, 447 Stereax, 447 Stereo Ideal (650), 447 Stereo Ideal (651), 447 Stereo Nettel, 447 Stereo Nettel, Tropical, 447 Stereo-Ernoflex(621/1), 447 Stereo-Simplex-Ernoflex(615/1), 447 Stereolette-Cupido(611), 447 Steroco (612/1), 447 Suevia, 447
Super Ikonta A (530), 447
Super Ikonta A (531), 447
Super Ikonta B (530/16), 447
Super Ikonta B (532/16), 447
Super Ikonta B (532/16), 447
Super Ikonta BX (533/16) (early), 448
Super Ikonta BX (533/16) (later), 448
Super Ikonta C (530/2), 448
Super Ikonta C (531/2), 448
Super Ikonta D (530/15), 448
Super Ikonta III (531/16), 448
Super Ikonta IV (534/16), 448
Super Nettel (536/24), 448
Super Nettel II (537/24), 449
Symbolica (10.6035), 449 Suevia, 447 Symbolica (10.6035), 449 Taxo, 449 Tenax, 449 Tenax Automatic (10.0651), 449 Tenax Automatic (10.0651), 449 Tenax I (570/27), 449 Tenax I (580/27), 449 Tengoflex (85/16), 449 Tessco (76/1), 449 Tessco (76/1), 449 Toska (400), 449 Trona (210 series), 449 Trona (212/7), 449 Trona (214 series), 449 Tropen Adoro, 449 Tropica, 450 Unette (550), 450 Victrix (101), 450 Volta, 450 Zeitax (Motoshima), 320 Zen-99 (Kowa), 262 ZENIT Zenit, 471 Zenit (Krasnogorsk), 263
Zenit 3, (Krasnogorsk), 263
Zenit 3M, Zenum 3M (Krasnogorsk), 263
Zenit 4 (Krasnogorsk), 263
Zenit 5 (Krasnogorsk), 263
Zenit 6 (Krasnogorsk), 264
Zenit 80 (Zenith 80) (Kiev), 255
Zenit-B (Krasnogorsk), 264
Zenit-C (Krasnogorsk), 264
Zenit E (Krasnogorsk), 264
Zenit EM (Krasnogorsk), 264
Zenit ET (Krasnogorsk), 264
Zenit ET (Krasnogorsk), 264
Zenit TL (Krasnogorsk), 264
Zenit TL (Krasnogorsk), 264
Zenit TL (Krasnogorsk), 264 Zenit (Krasnogorsk), 263 Zenit TTL (Krasnogorsk), 264 Zenith (Universal), 411 ZENITH CAMERA CORP Comet, 450 Comet Flash, 450 Sharpshooter, 450 Vu-Flash "120", 450 Zenith Edelweiss, 450 ZENITH FILM CORP. Winpro 35, Synchro Flash, 450 Zenith Kodak Cameras (Eastman), 180 Zenobia (Daiichi), 131

Bronica EC, 450 Bronica EC-TL, 450 Bronica ETR, 451 Bronica ETRC, 451 Bronica ETRS, 451 Bronica ETRSi, 451 **BRONICALENSES, 451** Bronica S, 450 Bronica S2, 450 Bronica S2A, 450 Bronica SQ, 451 Zeta Duplex, Duplex 2 (Ferrania), 194 Zicaflex Model IV, 452 ZION Pocket Z, 452 Pocket Z, stereo, 452 Simili Jumelle, 452 Zionscope (Zion), 452 Zionscope (Zion), 452 ZIX CO Zix, 471 Zodel (Wallace), 421 Zodiac, 452 Zoom Reflex Automatic K1 (Paillard), 466 Zoom Reflex Automatic K1 (Paillard), 466
Zoom Reflex Automatic K2 (Paillard), 466
Zoom Reflex Automatic S1 (Paillard), 466
Zorki (Krasnogorsk), 264
Zorki 2 (Krasnogorsk), 264
Zorki 2C (Krasnogorsk), 264
Zorki 3 (Krasnogorsk), 264
Zorki 3C (Krasnogorsk), 264
Zorki 3M (Krasnogorsk), 264
Zorki 4 (Krasnogorsk), 264
Zorki 4 (Krasnogorsk), 264
Zorki 5 (Krasnogorsk), 264
Zorki 6 (Krasnogorsk), 264
Zorki 10 (Krasnogorsk), 264 Zorki 6 (Krasnogorsk), 264
Zorki 10 (Krasnogorsk), 264
Zorki 11 (Krasnogorsk), 265
Zorki 12 (Krasnogorsk), 265
Zorki C (S) (Krasnogorsk), 264
Zorki Cameras (Krasnogorsk), 264 ZUIHO OPTICALCO. Honor, 452 ZUIHO SOKURYOKIKI Nice, 452 ZULAUF Bebe, 452 Polyscop, 452 ZUNOW OPTICAL INDUSTRY Zunow, 452 Zwei-Verschluss-Camera(Ernemann), 190 Zweiverschluss Duplex (Ihagee), 246

Bronica D (Deluxe), 450

Zenobiaflex(Daiichi), 131 Zenum 3M (Krasnogorsk), 263

Bronica C, C2, 450

ZENZA

CENTENNIAL PHOTO SERVICE

Publisher of books about cameras & camera history

PRICE GUIDE TO ANTIQUE AND CLASSIC CAMERAS
COLLECTORS GUIDE TO KODAK CAMERAS
COLLECTORS GUIDE TO ROLLEI CAMERAS
THE UNIVEX STORY
KURIBAYASHI-PETRI CAMERAS
UNION CASES, A COLLECTORS GUIDE

AVAILABLE WORLDWIDE AT BETTER BOOKSTORES AND CAMERA SHOPS. If you do not find locally, please contact your distributor listed on page two of this guide.

IF YOU WOULD LIKE ADVANCE NOTICE FOR THE NEXT EDITION OF McKeown's price guide to antique & classic cameras, Including the chance to get pre-publication discount and early shipping, please send your name & address to:

> Centennial Photo Service 11595 State Road 70 Grantsburg, WI 54840-7135 USA

CLASSIC CAMERA

A Really New Magazine for the Collectors

Classic Camera is an high quality and prestigious European magazine founded 3 years ago by Editrice Progresso, the most important photographic publishing company in Italy.

Other magazines published by EP:

Zoom, Progresso Fotografico, Tutti Fotografi.

Classic Camera is a fundamental reference magazine for the Italian and the European collectors.

Classic Camera, quarterly, Italian language. Viale Piceno 14, 20129 Milano, Italy. Fax: +39/2/71.30.30 Subscription rate \$ 39.00

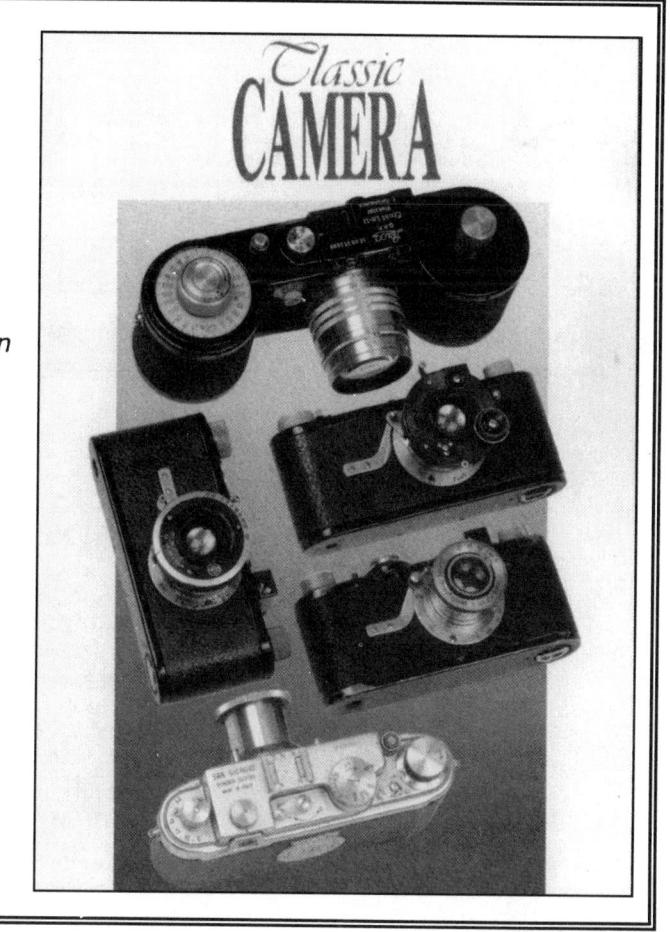

WE PAY TOP PRICES FOR COLLECTIBLE CAMERAS

FUJII CAMERASBuyers of Collectibles

SHINJI FUJII

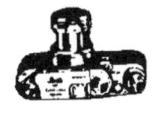

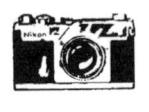

DON'T KNOW WHAT MODEL CAMERA YOU HAVE?

We are known for our helpful information on identifying collectibles. This McKeown's Price Guide is the best source of information to a wide range of collectible cameras that we've found, but even so, figuring which model is which can often be puzzling. That's why we print information and identification pointers on LEICA, ROLLEI, VOIGTLANDER, CANON and ZEISS cameras. *See our Leica identification chart in the Leica section of this book. As always, feel free to call us toll free 1-800-782-7314 for help in identifying your equipment.

PROFESSIONAL BUYERS OF COLLECTIBLE CAMERAS

→ → SEE OUR BUYING LIST → → Now Buying These and Many More → → →

ត្*ត* ត្រ

HOW WE WORK

● CALL us for a quote.
② SHIP your camera to us.
③ IMMEDIATE payment on inspection.

 We will call you to come to a mutual agreement if there are any problems, and/or prompt return shipment at our expense. We specialize in Collections.

It's Free – It's Easy Call Toll Free

Our professional buyers come to you.

We attend many shows all over the U.S. Call us to check our show schedule!

Boston • Tucson • Miami Meadowlands, NJ • San Jose Chicago • Pasadena/LA Area San Francisco/Bay Area Detroit • Denver • Seattle

IT'S EASY AND IT'S FREE! CALL US FOR A QUOTE!

\$\$\$\$\$\$\$\$\$\$\$\$\$\$\$ We buy these and many more! Call toll-free today! \$1-800-782-7314 • 1705 14TH ST., SUITE 325, BOULDER, CO 80302 • 303-443-3097

WE PAY TOP PRICES FOR COLLECTIBLE CAMERAS

FUJII CAMERAS

Buyers of Collectibles 1-800-782-7314 TOLL FREE!

SHINJI FUJII

We only buy. Sorry, we do not sell. LESLEY BELL

50/3.5 Elmar BM,SM 65/3.5 Elmar

90/2 Summicron BM,SM

90/2.8 Elmarit BM,SM

90/2.8 Tele Elmarit BM

90/4 Elmar BM COLL

90/4 Elmar SM Black Fat

105/6.3 Mountain Elmar 125/2.5 Hektor

135/2.8 Elmarit 135/4 Elmar BM,SM

180/2.8 Tele Elmarit

Leica Accessories - CALL!!

135/4 Tele Elmar

200/4 Telyt

200/4 5 Telvt

280/4.8 Telyt

400/5 Telyt

73/1.9 Hektor

85/1.5 Summarex

90/2.2 Thambar

90/4 Elmar BM 3

Flements

90/4 Elmar-C

100/2 Kinoptik 150/2.8 Kinoptik 150/4.5 Kinoptik 200/2.8 Cine Kinoptik 300/4 Kinoptik 11Fi

11SI CHROME 11SI BLACK

Other Alpa Cameras Wanted Reflex I

Reflex II BOLCA Bolca I BOLCA Standard BOLSEY Reflex

Canon

Rangefinder Cameras NK/Hansa

Hansa J-11

NS SEIKI S-II CANON S-II 1950 Common Rangefinder

Models IVSB2 VT-Deluxe VI-T P - BLACK ONLY Black RF Canons

Rangefinder Lenses 50/0.95 Canon Lens

KODAK

Bantam Special Retina IIC, Large C Retina IIIC, Large C Super 6-20

Leica

Rangefinder Cameras I (A) w/Anastigmat I (A) w/Elmax I (A) w/Elmar I (A) w/Hektor Compur (B) Dial Set Compur (B) Rim Set (C) Non-Standard Mount

(C) Standard Mount Standard (E) II (D) IIIA (G)

IIIF Black Dial IIIF Red Dial HIF Red Dial Self Timer IIF Red Dial IF Black Dial

IF Red Dial IIIG IG M1 M2 МЗ M4

M5

MDa CL w/40mm Single Shot both types SLR Leicaflex Original SLR Leicaflex SL and SL2 Leica Rangefinder Lenses Stereo Stemar Complete

15/8 Zeiss Hologon

28/5.6 Summaron

Complete

21/3.4 Super Angulon BM

21/4 Super Angulon BM,SM 28/2.8 Elmarit

35/2 Summicron BM SM

35/2 Summicron BM WE

35/2.8 Summaron BM WE

35/2.8 Summaron BM

35/2.8 Summaron SM

40/2 Summicron-C

40/2.8 Elmarit-C

50/1.2 Noctilux 50/1.5 Summarit

50/2 Rigid Summar

50/2 Summicron Rigid

50/2 Summicron Rigid

50/1 Noctilux

50/1.5 Xenon

BM.SM

BM. WF

50/2 Summicron

50/2.5 Hektor SM

50/2.8 Elmar BM,SM

BM.SM.COL

We specialize in buying collections. Our professional buyers will come to you. 1-800-782-7314

COPIES

ALTA ASAHIFLEX I ASAHIFLEX IIA ASAHIFLEX IIB CASCA CHIYOCA 35MM RF **GAMMA** GOKOKU HONOR ICHICON KARDON LEOTAX LOOK MELCON ORIGINAL

MELCON II NICCA NIPPON NR III RFID TANACK V3 TANACK VP

TANACK SD TOWER MINOLTA 35 early

MINOLTA

Auto Semi Minolta 35 RF (1st Model) 4 digit sr - very early

KONIM

Riga Gold Models

Nikon

Rangefinder Cameras

OF TOZ S2 SP **S4**

S3M Very Early F. F2T Display Dummy Nikons Nikon Rangefinder Lenses 21 mm through 1000 mm

YvigHänder

Bessa I Baby Bessa Bessa W/ Rangefinder Bessa II

Vitessa Vito **Prominents** Superb W/Heliar

Rollei

Tele Rolle Rolleiwide Baby Black 4X4 35 German

CONTAX Rangefinder

IIA and IIIA Rangefinder lenses re-war & Post-War **Contax Accessories** Contarex Cameras and

Lenses Contarex Professional Contarex Special Contarex Super Contarex Electronic Contarex Lenses 16 -1000mm plus zoom lenses Contarex Accessories

ZEISS - OTHER

Contessa - 35mm Foldir Contina w/Tessar Folding Hologon Camera Ikonta Baby w/Tessar Lens Ikonta w/Tessar Lens Ikoflex IC **Ikoflex Favorit** Stereotar C Outfit Super Ikonta all types

OTHER

GALILEO Gami Minicord KONICA F IHAGEE Kine Exakta I -Round Window LECOULTRE Compass MIRANDA Miranda T w/ Zunow lens ROBOT ROBOT Royal 36S Royal 24S TROPICAL Contessa Nettel Mint Only
TROPICAL Ica - Mint Only
TROPICAL Zeiss Tropicals 4X5 - Mint Only ZUNOW Lenses Wanted

***KEY:** SM -screwmount, BM -bayonet mount, WE -with eyes, COL -collapsible, RIG -rigid, RF -rangefinder

Call us to check our show schedule!

We regularly visit these cities for trade shows:

Boston • Tucson • Miami Meadowlands, NJ . San Jose Chicago • Pasadena/LA Area San Francisco/Bay Area

Detroit • Denver • Seattle

For collections, we visit you! 6 6 6 6 6 6 6 6 6 6

HOW WE WORK

1 CALL us for a quote. 2 SHIP your camera to us.

3 IMMEDIATE payment on inspection.

 We will call you to come to a mutual agreement if there are any problems, and/or prompt return shipment at our expense.

Top Prices Paid. Call for a quote today! It's Easy! It's Free!

.......

We buy these and many more! Call toll-free today! \$\$\$\$\$\$\$\$\$\$\$ \$\$\$\$\$\$\$\$\$\$\$ 1-800-782-7314 • 1705 14TH ST., SUITE 325, BOULDER, CO 80302 • 303-443-3097

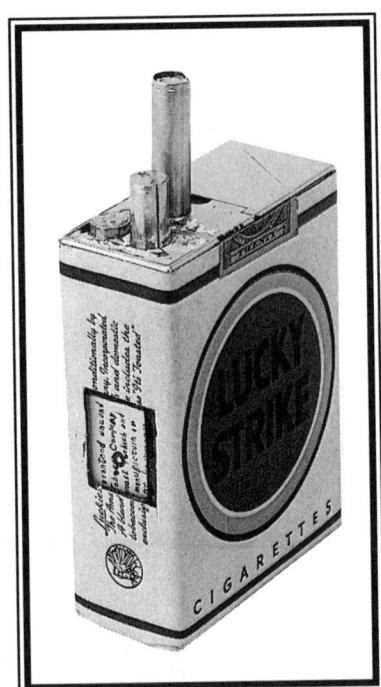

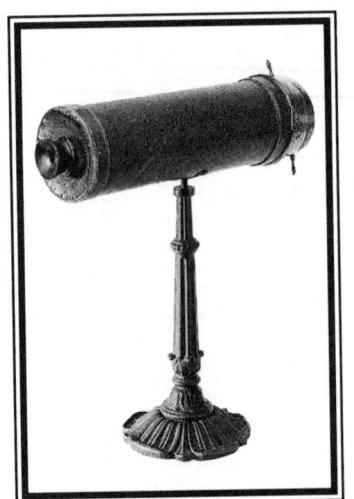

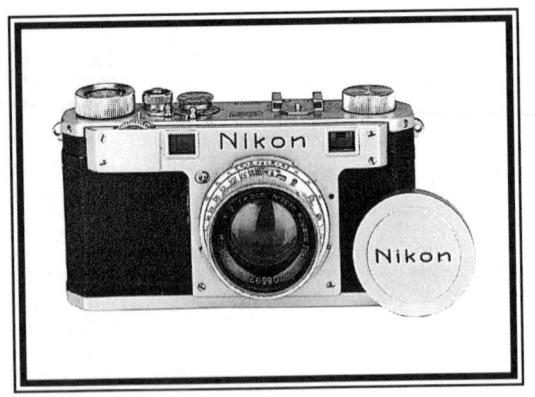

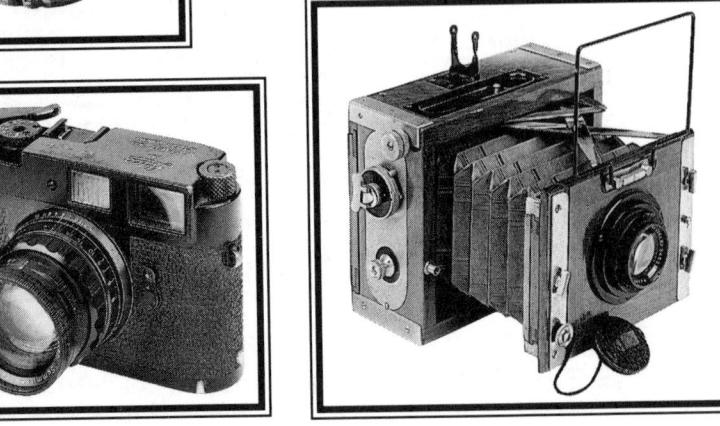

CAMERAS AND

SECULIAR ASSESSMENT AS

A selection of cameras, optical toys and photographic equipment sold in recent sales.

OPTICAL TOYS

Christie's South Kensington are the world's leading auctioneers of cameras, optical toys and photographic equipment. We began sales in 1972 and currently hold all the major record prices including the world auction record set in November 1993 at £,39,600 for a gold Adams Minex de luxe camera.

We hold eight sales a year including a special sale of Leica each Summer. Illustrated catalogues are published four weeks beforehand and lots sold range from £50 upwards.

Whether you have a single piece or a whole collection to sell or if you are building a collection Christie's can offer an efficient worldwide service. Our specialists travel to all parts of the world and can arrange to visit to view a collection.

For a free brochure describing our sales (in English, Japanese, German and French) please contact Michael Pritchard on (+44) 071 321 3279.

85 Old Brompton Road, London SW7 3LD Tel: (+44) 071 581 7611 Fax: (+44) 071 321 3321

Hoffman's Bookshop

211 East Arcadia Avenue Columbus, Ohio 43202

(614) 267-0203 Fax: (614) 267-7737

CALL, WRITE OR FAX US TO
BE PLACED ON OUR PHOTOGRAPHY
BOOK MAILING LIST.

WE BUY AND SELL PHOTO AND CAMERA BOOKS OF ALL TYPES AND ISSUE REGULAR LISTS OF BOOKS FOR SALE.

SHOP OPEN TUES. - SAT. 11-5.

Eland Tina Hoffman with help from Jack + Kate

For the best deals in London – deal with London's best!

Central & N.W. City locations.

COLLECTORS CAMERAS

Antique, Classic & Unusual Cameras & Optical Toys bought & sold.

P.O. Box 16, Pinner, Middx HA5 4HN Tel. 081 428 4773 London

ACR BOOKS

WILLIAM P. CARROLL

8500 LA ENTRADA WHITTIER, CA 90605

(310) 693-8421 • FAX (310) 945-6011

FEATURING:

- NEW AND USED BOOKS ON CAMERAS AND THE HISTORY OF PHOTOGRAPHY
 — SEND FOR CATALOG —
- BOOKS ON LANTERNS, LANTERN SLIDES, PRE-CINEMA and CINEMA HISTORY and OPTICAL TOYS
 - SEND FOR LIST -
- ANTIQUE AND CLASSIC CAMERAS
- UNSOLICITED CRITIQUES

LOOKING FOR:

- EARLY SHUTTERS
- EARLY KALEIDOSCOPES
- EARLY EXPOSURE DETERMINING DEVICES
- SMALL FORMAT ROLLFILM TLR CAMERAS

Photo-Historical Publications

Rare and Unusual Cameras FOR SALE Important Collections Purchased Immediate Payment

P.H. van Hasbroeck Photo-Historical Publications 34 Bury Walk London SW3 6QB Tel. 071 352 8494 Fax. 071 823 9058

GUILD CAMERA "A CAMERA COLLECTOR'S SHOP"

HUGE INVENTORY OF QUALITY USED COLLECTIBLE CAMERAS. WE SPECIALIZE IN LEICA, NIKON, CANON, RARE AND UNUSUAL CLASSIC CAMERAS.

- WE BUY COLLECTIBLES.
 Call Sandy Ritz or Jim Aboud.
 Over 45 years of fair dealing.
- Send \$1.00 for our 4-times-a-year catalog, with monthly updates to serious collectors.

ORDERS: 1-800-238-2647 INFORMATION: 1-602-264-5808

737 WEST CAMELBACK ROAD PHOENIX, ARIZONA 85013 FAX: 1-602-234-0221

CAMERA

J.L. Korten

Collector of Olympus wants to buy:

- Early Olympus Cameras
- Olympus Twin Lens Reflex
- Pen F, FT, FV Cameras + System
- Pen F Lenses: 20mm, 25mm, 60mm,
 38mm macro, 250mm, 400mm, 800mm + Zooms
- OM System
- Highest Price Paid.
- Available for Advice after 19:00 ET
- Phone/Fax: 31-10-4204295

J.L. Korten P.O.Box 8035 3009 AA Rotterdam Holland

Jay O. Tepper Classic Camera Exporters

We have been exporting cameras for more than 20 years. We buy in the U.S. and ship throughout the world. If you have cameras for sale, please let us know.

Send for free monthly export catalog.

Jay O. Tepper 313 North Quaker Lane West Hartford, CT 06119 U.S.A. Telephone 203-233-2851 Fax 203-233-6164

CAMERA LUCIDA

Fine Cameras Photographic Images **Optical Toys**

BUY SELL TRADE WORLDWIDE

SUNIL SIKKA

489 BOSTON ROAD BILLERICA, MA 01821 USA (508) 670-5270 OFFICE (508) 670-1408 FAX

FINE ANTIQUE CAMERAS AND OPTICAL ITEMS

I buy complete collections. I sell and trade from my collection. Write to me, I know what you want.

Frederic HOCH

41, rue de la Dordogne 67150 ERSTEIN - FRANCE

Phone: 33-88 98 04 37 - 7:00 pm Fax: 33-88-98-94-50

I Collect Nikon

P.F. Lownds P.O.Box 10132 3004 AC Rotterdam

tel-fax: 31-10-4159136

I wish to purchase for my collection

- Nikon Rangefinder cameras
- early Nikon F
- Nikon F2 High Speed and Data cameras
- microscopes
- binoculars
- cameras with Nikon lens
- anything marked Nikon Kogaku

Also available for advice after 19:00 hrs Euro-time

Only the Western Photographic Collectors Association gives you: membership in a world-class collectors organization, affiliation with the California Museum of Photography, dynamite trade shows, participation in historical publications projects (currently under way, "The Complete History of Graflex"), AND the PHOTOGRAPHIST; our quarterly 24 page magazine filled with great articles, illustrations, wisdom, humor, and lots of old cameras. Want more? Be a contributor - join the WPCA now! Send \$25 for regular membership (Photographist plus monthly meeting notices) or \$20 for corresponding membership (Photographist only). Foreign air mail \$30.

> WPCA, P.O. Box 4294, Whittier, CA 90607, or phone (310) 693-8421 for more information.

ED ROMNEY HAS CAMERA REPAIR MANUALS FOR MOST CAMERAS, OLD AND NEW

Including: Alpa, Argus, Bellows Making, Contax, Canon, Exakta VP to RTL, Graflex, Kodak Medalist, Ektra, Hasselblad 1000, 500c/cm, Konica Autoreflex, Leica, I to M4, Mamiya RB, TLR's, Mercury, Minolta, Miranda, Nikkormat, Nikon RF, SLR's, Olympus OM-1, OM-2, XA, Pentax, Praktica, Pentacon 6, Rapid Omega, Retina, Rolleiflex TLR, Topcon, Yashicamat.

Beginners should buy our well known REVISED BASIC TRAINING IN CAMERA REPAIR which covers Compur, Copal and most other leaf shutters, cloth and metal focal plane shutters, rangefinders, autofocus systems, meters, mirrors, lenses, wind systems, testing, cleaning, lubrication and adjustment, a generic text so you can fix most cameras. It costs \$25 plus \$4 shipp. US, \$6 Can. \$10 overseas. Our antique camera text covers old brass pneumatic shutter repair and wood camera preservation. We also sell special tools, lubricants and supplies used in the trade. We ship worldwide. Visa, Mastercard OK. Write or phone to order—or for free catalog.

ROMNEY, Box 96 Emlenton, PA 16373 USA Phone (412) 867-0314

bergmann fototechnik

FINE REPAIR AND RESTORATION OF CLASSIC CAMERAS

We specialize in functional as well as cosmetic restoration of valuable collectible cameras, lenses and accessories, including:

- remodeling, chrome-plating and lacquering of damaged or deformed external body-parts
- renovating or replacing of leather and leatherette coverings with materials of identical appearance
- parts reconstruction and fabrication
- polishing and coating of glass elements

DIPL.-ING. DIRK BERGMANN
SEEBLICK 11, 42399 WUPPERTAL, GERMANY
Phone: 49-202-611516 Fax: 49-202-611813

LINDEMANNS

- Publisher
- Wholesaler
- · Book Store

The specialist in literature for camera collectors.

Mailorder to all countries.

LINDEMANNS BUCHHANDLUNG NADLERSTRASSE 10 D-70173 STUTTGART

Tel.: (0049) 711-233499 Fax: (0049) 711-2369672

KOH'S

Camera Sales & Service, Inc.

We Buy, Sell & Trade

Specializing in Rollei, Leica, Bronica & Other Fine Photo Equipment

2 Heitz Place Hicksville, NY 11801 U.S.A.

Tel: (516) 933-9790/91 Fax: (516) 933-7799

PRIVATE COLLECTOR pays top prices for EARLY AND UNUSUAL

CAMERAS

Panorama, Detective, Color, Daguerreotype, Wetplate, etc.

Single items and collections welcome

WRITE, CALL OR FAX

FRED SPIRA 158-17 Riverside Drive Whitestone, NY 11357

Telephone: (718) 767-6761 Fax: (718) 767-5297

JOIN THE NIKON HISTORICAL SOCIETY

Dedicated to the History & Lore of the Nikon Rangefinder System FOR OVER A DECADE!

For Information

Write:

ROBERT ROTOLONI, ED./PUB. P.O. BOX 3213 MUNSTER, IN. 46321 USA FAX: 708-868-2352

SERVING THE NIKON COLLECTOR SINCE 1983

OVER 250 MEMBERS WORLDWIDE

PRIVATE COLLECTOR PAYS TOP PRICES FOR

KODAK

Cameras & Accessories in Original Boxes

ESPECIALLY

String-set & Early Kodaks in Original Boxes Colored Kodaks in Original Boxes Pre-1900 Kodak Catalogues

I ALSO COLLECT KODAK

Advertising • Catalogues • Posters • Window Displays
Film • Summer Girls • Point of Purchase Materials
Glass, Metal & Wooden Store Signs

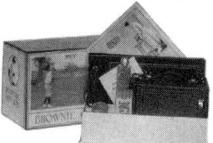

The Brownie Gift Box

I have collected Kodaks in their original boxes since 1979. If you are a collecter and dont't need your original boxes, I would like to here from you.

Charles Kamerman • (503) 323-4290

FINE CAMERAS FOR COLLECTORS

JERRY BROD JOAN BROD

Zeiss, Leica, Nikon, Alpa, Rollei and many others

BUY ~ SELL

P.O. Box 41096 Telephone Phila. PA 19127-0096 610-527-2862

BURTON RUBIN D.D.S.

Nikon and other fine Japanese rangefinder cameras

4580 Broadway New York, NY 10040, USA (212) 567-2908 FAX (212) 942-2700 FIELDGRASS GALE

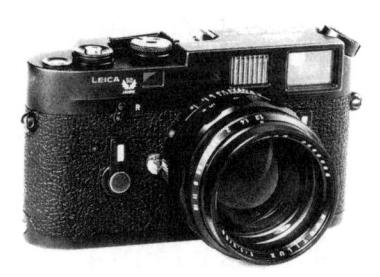

Britain's largest stock of secondhand Leica and Nikon. Send your wants-list to Peter Walnes or Jon Harris. We ship worldwide.

Fieldgrass & Gale Ltd.,
The Business Village, Broomhill Road, London SW18 4JQ.
Tel: (0)81-870 7611 Fax: (0)81-870 6551

After April 16th 1995, numbers will change to: Tel: (0)181-870 7611 Fax: (0)181-870 6551 Trading Worldwide

RARE-ANTIQUE-CLASSIC COLLECTIBLE PHOTOGRAPHICA

Specializing in LEICA, NIKON, CANON and many other makes.

One of the finest camera & lens collections. List on request.

We pay top prices for the unusual.

Louis E. Sneh

Beverly Hills Camera Shop Inc.

P.O. Box 7727 Beverly Hills, CA 90212-7727

> Tel: (310) 396-2192 Fax: (310) 396-9931

In Europe call Tel: (41) 29-45365

CAMERAS & IMAGES WANTED

For consignment in U.S. auction. We'll find the top paying buyer for your quality cameras and images

call

Vintage Cameras and Imagery

(802)472-5831 V.C.I., P.O. Box 1248 Hardwick,VT 05843

PITTSBURGH

CAMERA EXCHANGE

529 EAST OHIO STREET

PITTSBURGH

PA 15212

"CALL US FIRST"

1 800 722 6372

"COLLECTORS OF FINE PHOTOGRAPHICA"

19th CENTURY PHOTOGRAPHIC IMAGES

BUYERS OF COLLECTIBLES

CAMERAS LENS AND ACCESSORIES
DEALERS IN THE EARLY AND UNUSUAL
WE BUY WE SELL WE TRADE
Voice 412 422 6372 Fax 412 231 1217

J. Albert & Co.

CAMERA SERVICE CENTER

We pride ourselves on our expert service. Our team of highly qualified technicians can service most any photographic equipment, including but not limited to:

Leica, Canon, & Nikon RF Shutter Curtains, Zeiss Ikon, Exakta, Voigtlander, Robot, Older 35mm SLRs, Widelux, Retina Reflex, Kodak Cameras & Projectors, Pentacon, Hasselblad, Rollei TLR, Plaubel, Large Format Shutters & Cameras.

> We can fabricate some parts. We also carry Varta batteries.

Most repairs carry our 6 mo. warranty. Give us a call 9 a.m. to 5 p.m. Monday thru Friday, we would love to hear from you.

(805) 684-4533 • Fax (805) 684-8444 1015 Casitas Pass Road #210 • Carpinteria, CA 93013

Replica Daguerreian

Ideal for the Photo-reenactor or just as a display in your home. Each Camera is constructed with 1/2 inch Mahogany and Pine; complete with new bellows and removable ground glass holder. Ideal for use with DAG Plates, or ASA 25 sheet film via lens cap removal exposure method. USABLE with standard 4x5 film holders.

YOUR period lens completes the outfit.. (Lens should be in the 5 to 7 inch focal range and not much more that 2 1/2 to 3 inch diameter.) Delivery in 30 to 45 days

current price \$400.00. includes postage in U.S overseas shipping extra deposit required; TRADES Considered call or write for details

DOUG JORDAN - Box 20194 ST.PETERSBURG,FL.,33702 evenings (813) 577-9627

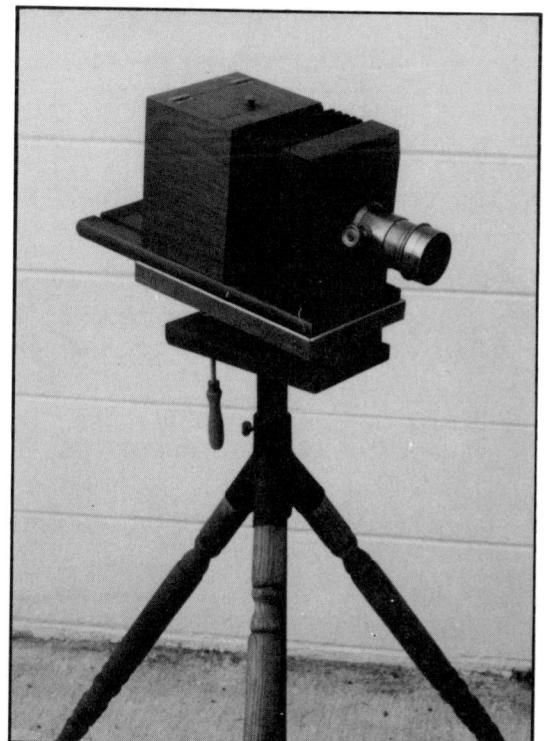

POWELL'S CAMERA EXCHANGE

PHONE: (919) 362 - 4476

FAX: (919) 362 - 4489

P. O. BOX 2

APEX, N.C. - USA

27502 - 0002

Louis Powell

WE BUY, SELL and TRADE

FINE GERMAN CAMERAS

Midwest Photo Shopper

Subscribe to the newest source of used photo related equipment in the U.S.

The Midwest Photo Shopper is published 12 times per year, and is loaded with deals on the

widest variety of used photographic equipment. From subminiature to large format... from antiques and collectibles to the most current digital imaging equipment, almost everything shows up in our pages, and at prices that will have you believing you're reading an issue 5 years old!! Subscribe now and you will soon feel like *The Midwest Photo Shopper* is an old friend (with great connections). Subscription rates in the U.S. are only \$7.50 per year, Canada and Mexico-\$14.00 per year, Overseas-\$29.50 (AirMail). Send check or money-order to:

Midwest Photo Shopper- Dept. JM 518 Guttenberg Heights Fergus Falls, MN 56537

GUN CAMERAS

ARE MY SPECIALTY

Richard Ogden Box 26 Chapman, NE 68827 USA

Tel: 308-986-2247 Fax: 308-986-2298

ALSO WANTED
Submarine Periscope
Early Aerial Cameras
Beverage Can Cameras

CHUCK RUBIN

PHOTOGRAPHICS

Let your senses be

DAZZLED

at the vast selection of our Quality used equipment!

35-MEDIUM-LARGE LIGHTING-DARKROOM ****ALWAYS BUYING AND SELLING***

QUALITY ANTIQUES, SUBMINIATURES STEREOVIEWS AND DAGUERREOTYPES

If you are ever near Louisville...

Chuck Rubin

Bob Hunter

1031 Bardstown Road VOICE> 502 452 6171 Louisville, KY 40204

FAX> 502 452 6627

THE ANTIQUE CAMERA CO.

at Andrews Cameras (Est. 1969)

We buy and sell all types of collectable cameras and pay high prices for mint or rare examples

SINGLE ITEMS OR COMPLETE COLLECTIONS PURCHASED

Please contact :- Peter Loy or Roger Andrews

Worldwide mail order.
A complete list of our current stock is available on request.

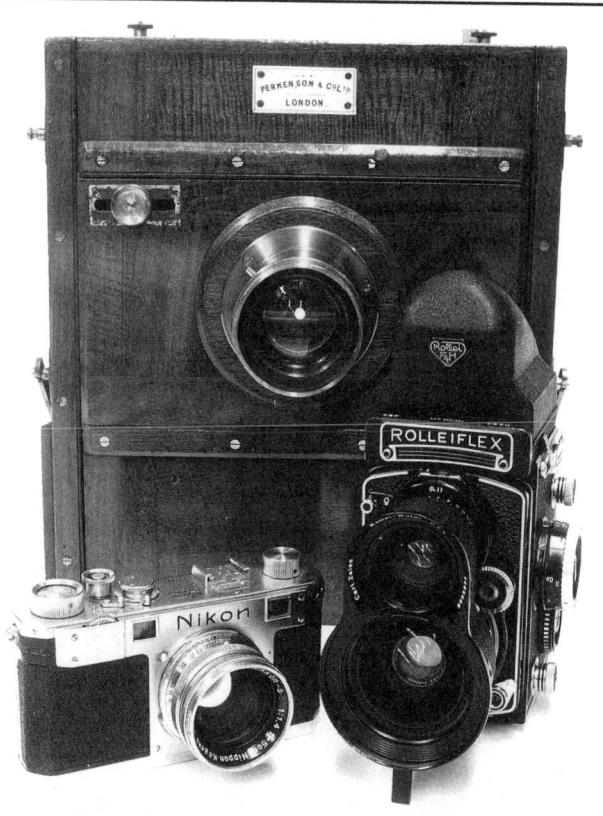

ANDREWS CAMERAS, 16 BROAD STREET, TEDDINGTON, MIDDLESEX, TW11 8RF, ENGLAND (WE ARE JUST 10 MILES FROM CENTRAL LONDON) TEL: 081 977 1064 FAX: 081 977 4716

You are invited to join the

Movie Machine Society

For all those interested in the technological history of the machines that make a moving image—from Arriflexes to Zoopraxiscopes. Membership includes a subscription to our quarterly, SIXTEEN FRAMES. Call or Write:

Alan Kattelle 50 Old County Rd. Hudson, MA 01749 Ph.: (508) 562-9184

The Historical Society for

Retina Cameras

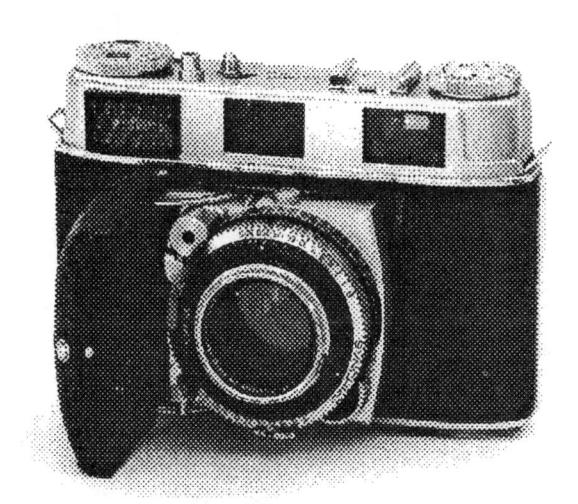

For membership information contact:

David L Jentz 51312 Mayflower Road South Bend, Indiana 46628 Ph. (219) 272-0599

FACTORY AUTHORIZED DISTRIBUTOR

FOR SALES

88, LENSES AND **60, ACCESSORIES** 19, W/SPLIT SCREEN

35 A LIKE MINOX EL 303 SUB-MINIATURE LIKE MINOLTA 16

IF YOU DON'T SEE OUR LOGO WYYOU'RE PLAYING RUSSIAN ROULETTE!

ALSO: FED STEREO CAMERA FED 5C (LEICA TYPE) SPUTNICK 120 STEREO COLLECTABLE LIST AVAILABLE

CALL, WRITE OR FAX FOR BEST PRICES!! DON'T BE SHY—IF YOU DIDN'T BUY FROM US—WE MAY STILL MAKE YOU SMILE!

PHONE 203-869-3883 **DIVISION OF** ENS EXCHANGE 535 E. PUTNAM AVE. COS COB, CT 06807

FAX 203-629-3399

Rollei

Hotel de France, St. Saviour's Road, St. Helier, Jersey, Channel Islands JE2 7LA Tel; (0534)73102 Fax: (0534) 35354 Telex; (0534) 4192308

Club Rollei
A Camera Club with a difference!

Club Rollei is situated in the
Hotel de France, Jersey, Channel Islands.
The club magazine is published four times a year.
The joining fee is £20.00 Europe, £23.00 the rest of the world which includes a year subscription which is £16.00 per annum to be paid annually after the first year.

We accept members from all over the world and already have a wide membership in the U.S.A., Australia and the Far East

> Please pay by credit card. Visa, Mastercard or Eurocard

Have you got your copy of the
Complete Rollei T.L.R. Collector's Guide?

The T.L.R. Users Manual

1929 to 1994

An Original HOVE FOTO BOOKS

Ian Parker

Have you read The History of Rollei by Ian Parker

Now available from the: Jersey Photographic Museum

Hotel de France, St. Saviour's Road St. Helier, Jersey, Channel Islands, JE2 7LA Tel: (0534) 73102 Fax: (0534) 35354

Europe
English soft back £12.00 Hardback £16.00 post paid
German Hardback £17.50 Post paid
Rest of the world
Softback £13.00 Hardback £17.50 post paid
Please pay by credit card

Vintage Cameras Ltd.

256 KIRKDALE LONDON SE26 4NL TEL: (+44) 081-778 5416 FAX: (+44) 081-778 5841

THE WORLD'S OLDEST ESTABLISHED COMPANY DEALING SOLELY IN PHOTOGRAPHICA

REGULAR LISTS SENT TO OUR SUBSCRIBERS

SHOWROOM OPEN 9 am - 5 pm Mon. - Sat.

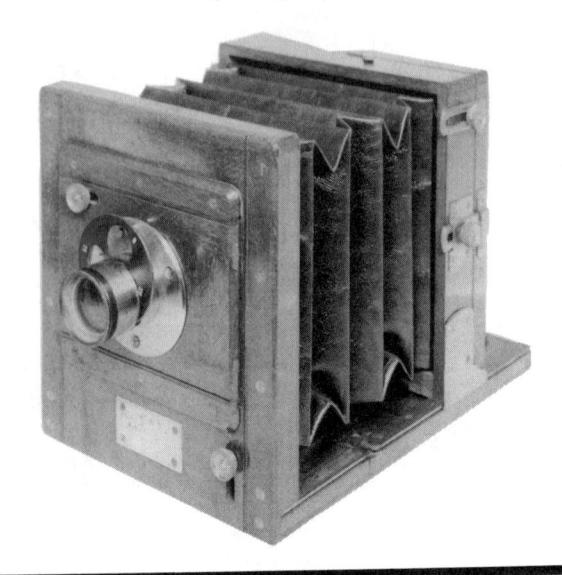

DAN BLACK

Leica and Other Fine Cameras

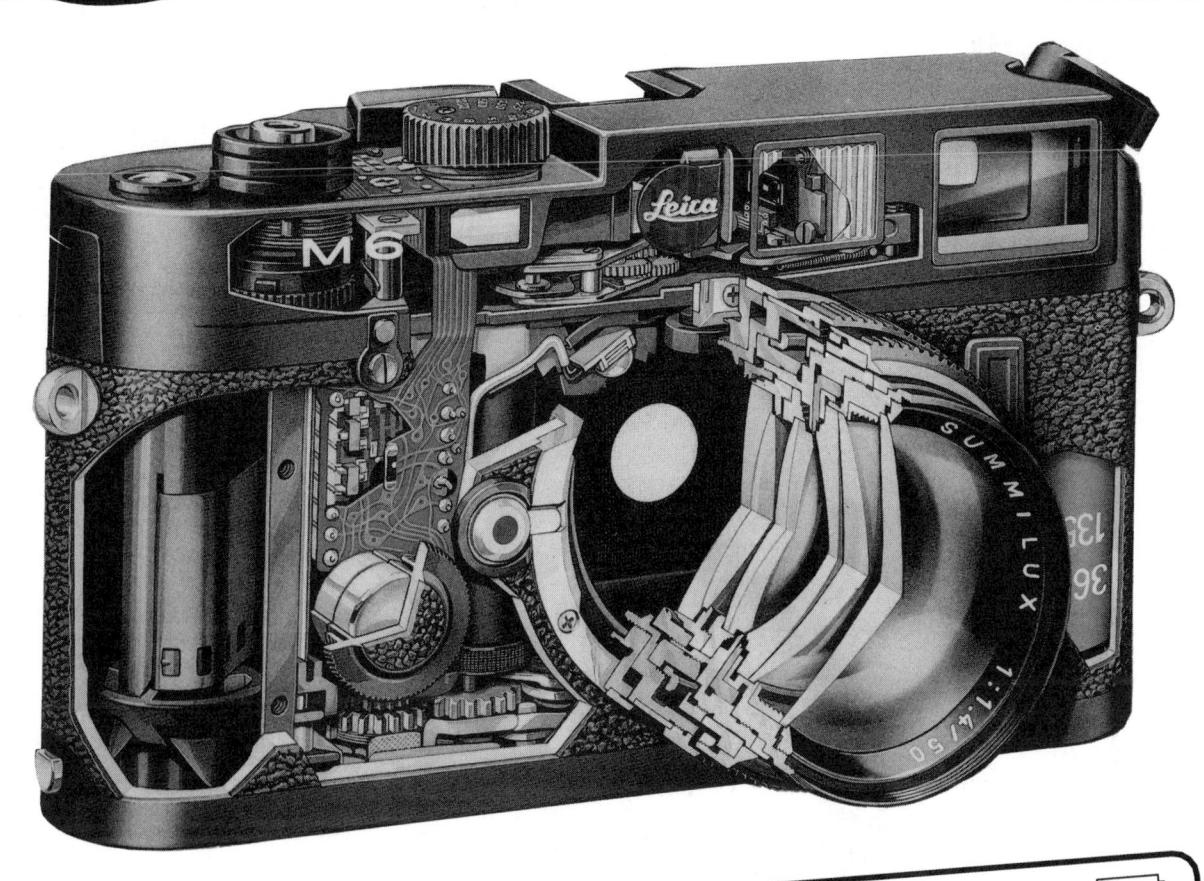

BUY SELL TRADE

AUTHORIZED LEICA DEALER

P.O. Box 2072 Bala Cynwyd, PA 19004-6072 USA

(610) 664-7345 FAX (610) 667-5950 9 AM to 5:30 PM EST

First and only French Collectors' Club

Six magazines each year Since 1979

NIEPCE-LUMISH Président :

M. FRANCESCH Jean-Paul Résidence Bonnevay 1 B, rue Professeur Marcel Dargent F-69008 LYON FRANCE \$\infty\$ 78 74 84 22

Information: SAUDAX Arnaud - 19, impasse l'Arrayo - F-64290 GAN - FRANCE

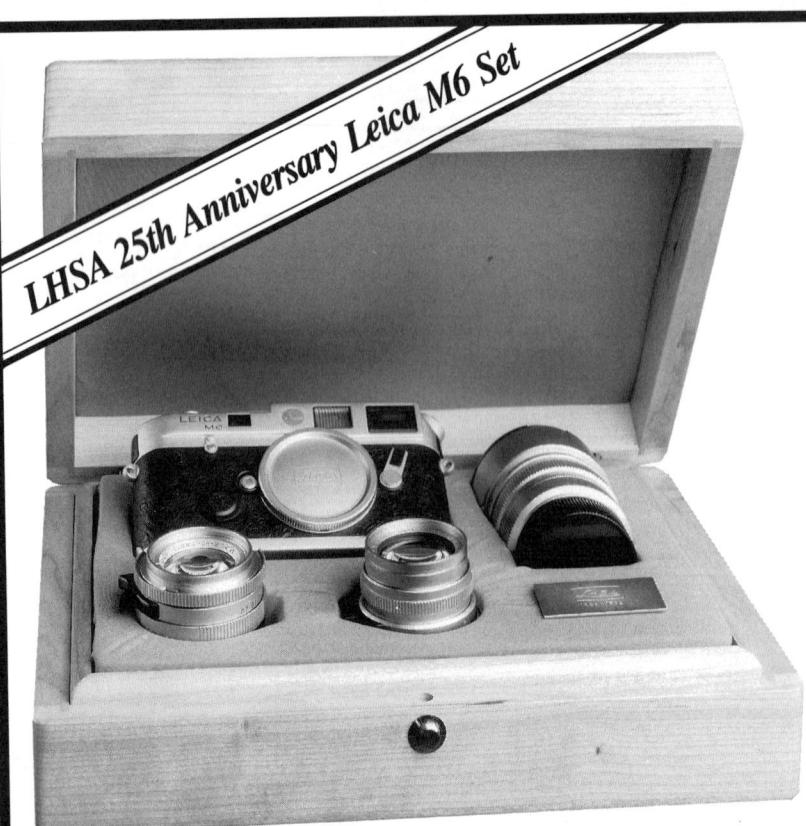

This limited-edition commemorative Leica M6 set is available for purchase by LHSA members only.

Leica Historical Society of America Marks 25 Years! In 1968 a small group of camera enthusiasts founded the Leica Historical Society of America. Today LHSA boasts over 1600 members worldwide who share information about collecting and using the incomparable Leica 35mm system.

 $\mathcal{E}_{ ext{xclusive Benefits of Membership}}$ —

Published quarterly, our VIEWFINDER magazine showcases Leica history, collectibles and outstanding images. Four times a year LHSA publishes the Leica Catalog exclusively for members to buy, sell or swap Leica equipment and accessories. We also hold an annual meeting and trade fair that provides a chance for members to learn and socialize.

Want to Learn More? If you enjoy Leica photography and collecting, this is the organization for you. Dues are modest and the benefits are great! Write for a membership application today:

Stanley E. Hodges, Jr. • LHSA Secretary-Treasurer 7611 Dornoch Lane • Dallas, TX 75248-2327 U.S.A.

A MAGAZINE DEDICATED TO PHOTOGRAPHIC INFORMATION, EQUIPMENT AND IMAGES

Subscribe now and receive the best and most informative publication featuring buying and selling of photographic equipment, classic cameras and images.

With your subscription, you will receive by first class mail, ten issues of **CameraShopper**, each with many pages of classified and display ads, articles on modern and collectible photographica, photographic exhibits and an extensive camera show calendar.

United States- First Class \$20
Canada and Mexico- First Class Air Mail \$25
Europe, Asia and all other continents- First Class Air Mail \$75.
All subscriptions must be paid in U.S. funds,
checks drawn on U.S. banks, Visa or Master Card. No Eurochecks.

Send to:
CameraShopper
Post Office Box 370279
West Hartford, CT 06137-0279
USA

For a sample issue In the U.S. send \$3 Everywhere else send \$5 Phone orders 203-232-1195 anytime answering machine after office hours Fax orders 203-233-6164 anytime

THE AFFORDABLE PLACE TO ADVERTISE

The PHOTO EMPORIUM Inc.

Specializing in Stereo & Large Format

WE BUY & SELL

4304 1/2 W. Lawrence Ave. Chicago, IL 60630 USA

We ship all over the world.

(including whole collections)

We are a Full Service Dealer:

for most major brands of <u>new</u> equipment & supplies.

Jeffery D. Trilling store (312) 777-3915 office / fax (312) 777-3515

One of the Largest Dealers in the U.S. of: **STEREO**

Cameras, Viewers, Projectors, Accessories, Supplies, etc.

FULLY OVERHAULED & WARRANTEED EQUIPMENT

"We service what we sell."

USABLE / CLASSIC LARGE FORMAT

CAMERAS

Deardorff, Folmer & Schwing, Linhof, Graflex, etc.

LENSES

Dagor, Artar, Commercial Ektar, Protar, etc.

Send us a Fax with what you're looking for & we will get back to you if we can help.

We also deal with almost every other type of photographic collectible!!

Europe's Leading Store For Camera Collectors

67 Great Russell Street, London WC1, ENGLAND. Tel: London 071-831 3640.
Fax London 071-831 3956 open Monday-Saturday 9am-5.30pm

JESSOP CLASSIC was opened in 1988, and was the first major retail outlet to dedicate an entire store to the discerning collector. Jessop Classic is a division of Jessop of Leicester Limited which currently has 69 photographic/video retail stores in the United Kingdom (the largest independently owned retail chain in the U.K.). A Company which has a reputation for honesty and integrity, recently recommended by the coveted Amature Photographer Dealer of the Year Award.

Jessop of Leicester's policy on modern second-hand photographic equipment is simple, to ensure we give the customer top prices when purchasing equipment and offer fair prices when selling. Jessops have extended this policy to the collectors market. Whether it's a single item or an entire collection you can be assured of a fair price when buying, selling or exchanging. With thousands of customers worldwide Jessop Classic is truly a market leader, and although many others have attempted to copy our style we are widely recognised as being at the forefront of the vintage camera market.

TOP PRICES PAID

For all makes of

- Vintage cameras
- Vintage lenses Magic lanterns • Optical toys
 - Accessories
 - Collectors books

Why not drop us a line with your name and address and requirements and we will regularly send you a "free" copy of our latest price list, and advise you when that much sought after piece of equipment you require comes into our stock.

We are situated in the heart of London opposite the British Museum, a few minutes walk from Holborn and Tottenham Court underground stations.

We accept
Access/Mastercard
Visa/Barclaycard
Switch, American Express
Diners, and JCB.

The Museum exhibits a collection of vintage cameras and images. It maintains a photo-techniques and photo-history library, and provides programs for both young people and adults. Admission is free. Nicholas Ciampa is the Director and George Helmke the Curator.

VISIT ON SATURDAYS 10 to 4 or SUNDAYS 1 to 4 OR BY APPOINTMENT. CALL (908) 757-5507 614 GREENBROOK ROAD, NORTH PLAINFIELD NJ 07063

PHOTOGRAPHIC COLLECTORS CLUB OF GREAT BRITAIN

The PCCGB was formed in 1977 and currently has a worldwide membership of 1000 enthusiasts. The Club exists "for promoting the study and collection of historical photographic equipment and images".

To achieve these aims the Club holds regular meetings, publishes a quarterly journal, *Photographica World*, and newsletter, *Tailboard*, which includes a postal auction. *Photographica*, our established international collectors fair is held in central London on a Sunday early in May. The fair forms the climax of a number of events held during the week for collectors of cameras and images.

We extend an invitation for you to join. For further information and current membership rates contact:

PCCGB, 5 Station Industrial Estate, Prudhoe, Northumberland NE42 6NP. England.

B B

Tine Antique Cameras Photographic Images

We buy collections and fine individual items.

Allen & Hilary Weiner • 80 Central Park West • N.Y.C. 10023

TEL.: (212) 787 • 8357

FAX: (212) 496 • 6502

Dealers by appointment.

WEBUY&SELL WORLDWIDE

NOT JUST TO JAPAN.

Be cautious of buyers who buy for only one store in Japan . . . it could cost you thousands (or tens of thousands) of dollars when you sell your collection!!! WHY??

As we go press, the Japanese economy is in serious trouble. It's in its worst economic crisis since WWII. Its stock market has collapsed. Its real estate market has collapsed. The interest in collectible cameras has collapsed. Selling your collectible cameras to dealers who deal ONLY in Japan CANNOT offer you the cameras' top prices. You are almost assured a better price if sold to any company who deals WORLDWIDE . . . who resells all over the globe . . . including the *HOTTEST* current markets in EUROPE, S.E. ASIA . . . and in some cases, the USA.

REINKE / INTERNATIONAL / FOTODEALER

PAYS

TOP \$ £ \$ DM \$ Y \$ FOR CAMERAS

WE HAVE PURCHASED MANY COLLECTIONS
AROUND THE WORLD

WE WILL TRAVEL THE USA . . . OR WORLDWIDE . .
TO BUY COLLECTIONS (OR ACCUMULATIONS)
OF PHOTO EQUIPMENT

We buy everything the Japanese buyers buy . . . plus MANY other items sought by our customers worldwide . . . antique, medium format, stereo, professional, subminiature, view cameras, 35mm movie equipment, panoramic, camera lenses, camera accessories, newer used equipment, Nikon autofocus items, etc.

IMMEDIATE PAYMENT FOR YOUR PHOTO ITEMS

- · Phone or fax us for a quote
- · Ship item(s) for inspection
 - **☞** WE WILL PAY YOUR SHIPPING COSTS
- Instant payment sent out to you upon inspection approval

WE BUY
AND
WE SELL
to ANYONE
No silly games

in the
Collectible
Camera
Business

FREE CATALOG

Write or fax to receive our latest (or next) catalog or the most current "Preview List."

Please tell us your collecting wishes. We'll enter you into our computer and search items for you, and contact you personally.

カタロク"を欲しい方は Fax 又はころらの方に手紙を下さい。

We are looking for a few more GOOD CUSTOMERS

We sell Leicas, Contarex, Zeiss, Leica copies, Nikon R/F and many others.

ELIZABETH

REINKE / INTERNATIONAL / FOTODEALER

DEALERS OF USED & COLLECTIBLE PHOTOGRAPHIC EQUIPMENT
We Buy, Sell and Trade Worldwide

Banjo Branch Road, Mars Hill, North Carolina 28754 USA Phone (704) 689-5338 • Fax (704) 689-5463

SUZUKI CAMERA PAYS TOP DOLLAR!

WE ARE LOOKING FOR THE FOLLOWING MINT EQUIPMENT: BROOKS VERIWIDE, BUSCH NICOLAPERSHEID, DEARDORFF, GOERZ HYPERGON, GRAFLEX, HASSELBLAD, KODAK CAMERAS & VIEW LENSES, LEICA, LINHOF CAMERAS & LENSES, ROLLEI, SINAR NORMA STD., UNIVERSAL HELIAR, VOIGTLÄNDER CAMERAS & VIEW LENSES, WOLLENSAK VERITO, ZEISS CAMERAS & LENSES AND MANY MORE!

CALL/FAX FOR A QUOTE TODAY!

714-840-8372

5942 EDINGER AVE. SUITE 113 HUNTINGTON BEACH, CA 92649 SUZUKI CAMERA ESTABLISHED 1953

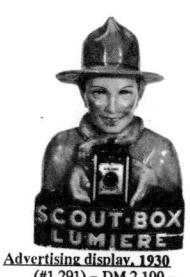

(#1.291) - DM 2.100, \$ 1.239.-/£ 840.-

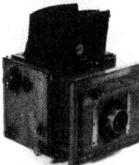

Hesekiel-Tropical-Reflex, 1893 (#1.376) – DM 4.200,-\$ 2,478.-/£ 1,680.-

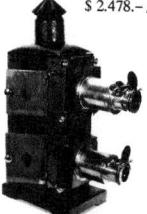

Bi-unial magic lantern, 1880 (#1.401) - DM 6.600,-\$ 3.894.- / £ 2.640.

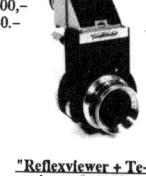

\$ 566.- / £ 384.-

Stereo-Coinoperated <u>viewer, 1980</u> (#1.150) – DM 3.480,–

\$ 2.053.-/£ 1.392.-

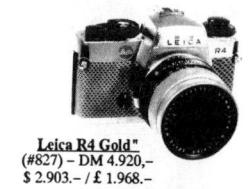

Stereo-Musical-Automata, 1900 (#1.136) – DM 8.160,-\$ 4.815.- / £ 3.265.-

"Scopitone", 1959 (#1.541) – DM 8.400,-\$ 4.956.– / £ 3.360.–

"Vega", 1900 (#1.367) - DM 3.000,-\$ 1.770.- / £ 1.200.-

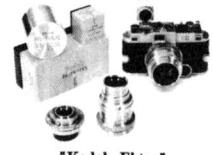

outfit, 1942 (#723) – DM 2.040.–

Stereoscope "Zeiss Ikon", 1930 (#774) - DM 1.200,-\$ 708.-/£ 480.-

"Leica-Safari", 1977 (#825) - DM 3.600,-\$ 2.124.-/£ 1.440.-

Movie poster, 1930 (#1.556) – DM 600.–

<u>World's famous</u> **Speciality Auctions "Photographica & Fil**

We're currently looking for interesting single items and entire collections for our regular speciality auctions.

High sales quotas of 95% and more (!!), top prices never reached anywhere else, and our worldwide activities guarantee you optimum sales success.

Please check the margins for some of the latest realized results.

We're currently looking for rare classical "photohistorica" like:

- **★ Classical cameras**
- * Lenses & accessories
- * Professional cameras
- * Stereo cameras + viewers
- **Optical apparatus & toys:** (Magic lanterns, Praxinoscopes, Žoetropes, etc.)
- - **★ Early projecting apparatus**
 - * Pre-cinema material: (Mutoscopes, Filoscopes, etc.)
 - **★ Classic photographs**
 - * Rare movie posters (pre 1955)

Sell your "goodies" at top prices on world's leading market: . . . at Auction Team Breker, where world's leading market for Technical Antiques has been established . . . " ("Antiques & Auction News", PA/USA).

Use our fully illustrated catalogues to achieve sales success. They're internationally requested reference books and price guides!

If you're looking for something special or have an item to sell, please contact us or send us your list with photographs. We'll be glad to advise you.

Consignments are always welcome!

AUCTION TEAM KÖLN

Breker – The Specialists

P.O.Box 50 11 19 · D-50971 Koeln, Germany 雷 -/49/221-387049 · Fax: -/49/221-374878

In the USA please contact our representative Jane Herz at: (813) $925-0385 \star Fax$ (813) 925-0487

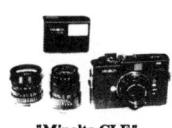

<u>"Minolta CLE"</u> (#828) – DM 3.000,-\$ 1.770.- / £ 1.200.

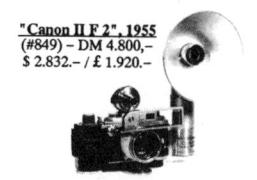

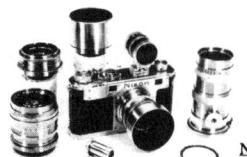

\$ 1.770.-/£ 1.200.-

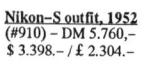

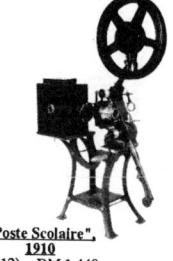

"Poste Scolaire", 1910 (#1.512) – DM 1.440,– \$ 850.–/£ 576.–

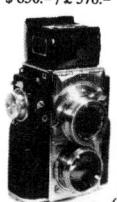

"Minox Riga", 1938 (#1.270) – DM 2.640,-\$ 1.558.- / £ 1.056.-

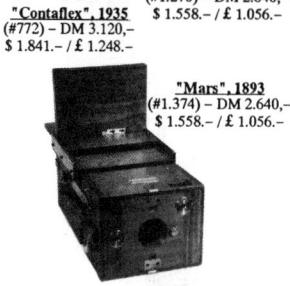

"Ives' Kromskop", 1899 (#1.026) – DM 3.600,–

\$ 2.124.- / £ 1.440.

Leica M1", 1959 815) – DM 4,560,

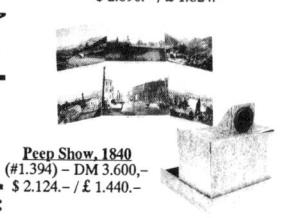

Classic Collector, the catalogue of Classic Collection, is published four times a year. Illustrated throughout in colour and black and white, it features news on collecting, informative articles about collectable cameras, plus the latest lists of cameras, lenses, accessories, images, new and secondhand books for sale at Classic Collection.

Even if you are not ready to buy from Classic Collection Classic Collector will keep you up to date with the collecting scene. It will also give you the opportunity of using the special Computer Camera Search, available to regular customers.

Send for a free copy or subscribe to make sure you don't miss an issue. Subscriptions are £5 for the next four issues in the UK, £7 for Europe and £10 for the rest of the world. Fill out the

coupon below and send

Poledse send the close the copy of Classic Collector. enclose send the a free copy of Classic for s

classic

THE PREMIER INDEPENDENT STORE FOR THE CAMERA COLLECTOR

We want your cameras

Whether you're selling or part exchanging, check **Classic Collection first.** Because we sell cameras worldwide, we offer the best prices for your collectable cameras. Wherever you are, call us for a valuation

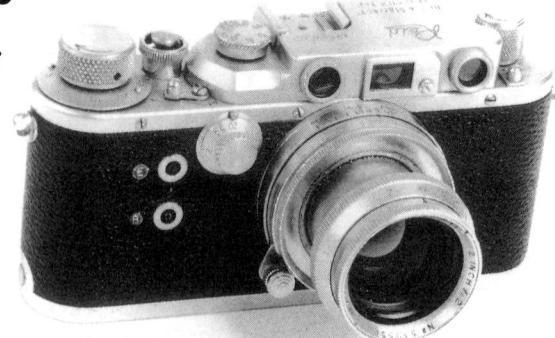

- we collect from almost anywhere in the world.

Classic Collection

NOW OPEN: Classic Collection Photo Books, with departments for all photographic books,

- Amateur and professional photography
- Art books
- Photographic reference books
- Technical and photo technique titles
- And of course shelves of books and instruction manuals, both new and secondhand, for the collector. Just two doors away from Classic Collection this is London's foremost photographic book shop.

Classic Collection Photo Books,

Collectors' books Classic Collection PUBLICATIONS

Spy Camera £39.95 Leica Copies £39.95

4 Galen Place, London WC1A 2JR, UK Telephone: (UK) + 71-831 6000 Fax: (UK) + 71-831 5424 send me the next four

Buying and selling Worldwide

LONDON W. Tare

experience Classic Collection Leica Specialist

Buying cameras at Classic Collection is a classic experience. It's the premier independent store for the camera collector, the ideal place to browse, buy and sell. Classic Collection are specialists in Leica, Rollei, Zeiss, Nikon, Canon, Leica copies, Russian equipment, stereo, subminiature, spy and detective cameras... in fact most collectable cameras, lenses and accessories. Visit Classic Collection the next time you are in London. Subscribe to Classic Collector, the catalogue of Classic Collection and order by mail order. Or take advantage of the computerised camera search service, designed to find exactly the equipment you are looking for to complete your collection.

2 Pied Bull Yard, Bury Place, London WC1A 2JR, ENGLAND Tel: (UK) +71-831 6000 Fax: (UK) +71-831 5424 Open Monday - Saturday 9.00 am - 5.30 pm

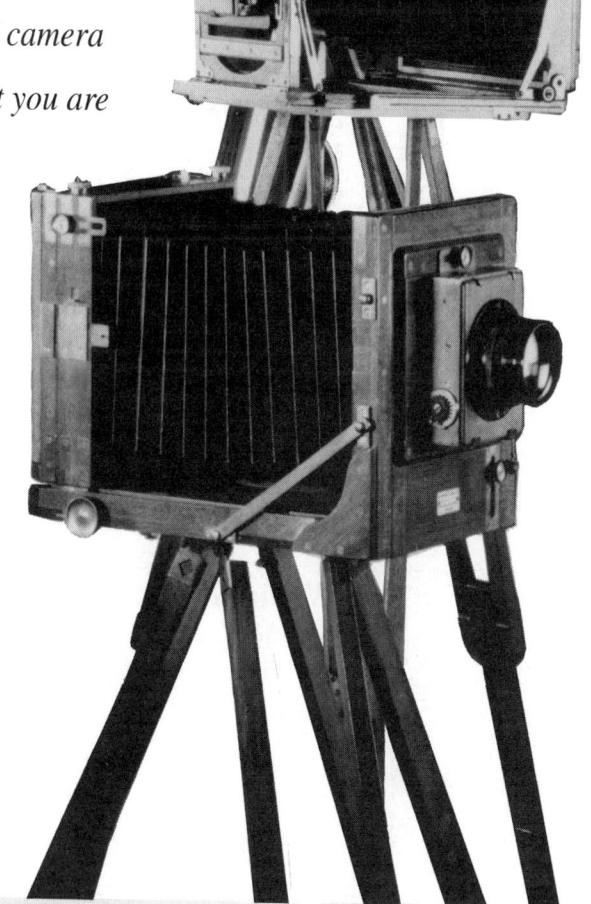

The Photography People

42 West 18th Street • New York, NY 10011 212-741-0052 • 800-223-2500 FAX: 212-463-7223

TOP DOLLAR FOR YOUR EQUIPMENT!

We are specializing in professional used camera equipment—buying, selling, trading. The full product line of: Leica, Rolleiflex, Zeiss Contax, Voigtlander, Tessina, Minox, Alpa. Hasselblad, Linhoff, Canon & Nikon range finders, Kodak Retinas, Robot, Stereo Realist, etc. Lenses, cases and general accessories.

Dear Reader,

For your convenience we have a Trade-in Service. Your old or unwanted equipment, that might have a greater value than you think, will be gladly traded or bought by us. Please mail your items with your name, address and phone number to our attention.

We will evaluate it and make an offer as soon as possible, assuring you the fairest and highest prices.

If you would not be satisfied, we will return your items to you prepaid and insured.

We hope you will take advantage of this excellent service.

Cordially yours, Trade & Used Department